2001

2001

WOMEN IN WORLD HISTORY

A Biographical Encyclopedia

WOMEN IN WORLD HISTORY

A Biographical Encyclopedia

VOLUME
11
Mek-N

Anne Commire, Editor
Deborah Klezmer, Associate Editor

YORKIN PUBLICATIONS

GALE GROUP

Detroit
New York
San Francisco
London
Boston
Woodbridge, CT

Yorkin Publications

Anne Commire, *Editor*
Deborah Klezmer, *Associate Editor*
Barbara Morgan, *Assistant Editor*

Eileen O'Pasek, Gail Schermer, Patricia Coombs, James Fox,
Catherine Cappelli, Karen Rikkers, *Editorial Assistants*
Karen Walker, *Assistant for Genealogical Charts*

Special acknowledgment is due to Peg Yorkin who made this project possible.

Thanks also to Karin and John Haag, Bob Schermer, and to
the Gale Group staff, in particular Dedria Bryfonski, Linda Hubbard, John Schmittroth, Cynthia Baldwin,
Tracey Rowens, Randy Bassett, Christine O'Bryan, Rebecca Parks, and especially Sharon Malinowski.

The Gale Group

Sharon Malinowski, *Senior Editor*
Rebecca Parks, *Editor*
Laura Brandau, *Assistant Editor*
Linda S. Hubbard, *Managing Editor*

Margaret A. Chamberlain, *Permissions Specialist*
Mary K. Grimes, *Image Cataloger*

Mary Beth Trimper, *Production Director*
Evi Seoud, *Assistant Production Manager*

Cynthia Baldwin, *Product Design Manager*
Tracey Rowens, *Cover and Page Designer*
Michael Logusz, *Graphic Artist*

Barbara Yarrow, *Graphic Services Manager*
Randy Bassett, *Image Database Supervisor*
Dan Newell, *Imaging Specialist*
Christine O'Bryan, *Graphics Desktop Publisher*
Dan Bono, *Technical Support*

Library of Congress Catalog Card Number 99-24692
A CIP record is available from the British Library

ISBN 0-7876-4069-7
Printed in the United States of America.

Library of Congress Cataloging-in-Publication Data

Women in world history : a biographical encyclopedia / Anne Commire, editor, Deborah Klezmer, associate editor.
 p. cm.
Includes bibliographical references and index.
ISBN 0-7876-3736-X (set). — ISBN 0-7876-4069-7 (v. 10). —
ISBN 0-7876-4070-0 (v. 11) — ISBN 0-7876-4071-9 (v. 12) — ISBN 0-7876-4072-7 (v. 13) — ISBN 0-7876-4073-5 (v. 14)
 1. Women—History Encyclopedias. 2. Women—Biography Encyclopedias.
I. Commire, Anne. II. Klezmer, Deborah.
 HQ1115.W6 1999 99-24692
 920.72'03—DC21

10 9 8 7 6 5 4 3 2 1

dowment for the Arts (NEA) composer assistance grant.

Mekeel's approach to music is eclectic and reflects her diverse interests. Often drama is used as a catalyst. For example, *Corridors of Dreams* (1972), *Serena* (1975), and *Alarums and Excursions* (1978) use multilingual texts. Some of her compositions employ as many as eight languages, and the execution of the text is an integral part of the composition. In Mekeel's instrumental works, her combination of instruments and voice is unique, and the sound of words is an important part of her timbral resources. She avoids reliance on institutional musical organizations like the orchestra, preferring to choose instruments and groupings of musicians which allow her to innovate.

John Haag,
Athens, Georgia

Mek

Mekarska, Adèle (1839–1901).

See Mink, Paule.

Mekeel, Joyce (1931—)

American composer, harpsichordist, pianist, anthropologist and professor. Born in New Haven, Connecticut, on July 6, 1931; attended the Yale School of Music, 1957–60.

Born in New Haven, Connecticut, in 1931, Joyce Mekeel studied at the Longy School of Music (1952–55) and with *Nadia Boulanger at the National Conservatory in France (1955–57). She attended the Yale School of Music (1957–60), where she studied harpsichord with Gustav Leonhardt and theory with David Kraehenbuehl. She then pursued further study at Princeton. Mekeel was awarded a fellowship to the MacDowell Colony, an Ingram-Merrill grant in composition (1964), and a Radcliffe Institute grant (1969–70). She taught at the New England Conservatory (1964–70), while also composing for the **Ina Hahn** Dance Company.

When Mekeel was appointed assistant professor of theory and composition at Boston University in 1970, she became involved with the university's electronic studio, which she directed. She continued to concertize as a harpsichordist as well as to compose for McCarter Theatre productions in Princeton. In 1971, Mekeel spent the summer in West Africa studying ethnomusicology. In 1975, she was awarded the National En-

Melania the Elder (c. 350–c. 410)

Roman who founded two of the earliest Christian religious communities. Born around 350 CE; died around 410 CE; granddaughter of Antonius Marcellinus; grandmother of Melania the Younger; married possibly Valerius Maximus (a praetorian praefect), probably in 365; children: three sons, including Valerius Publicola (father of Melania the Younger).

Melania the Elder (so called to distinguish her from her namesake granddaughter) was from a Roman Senatorial family (her paternal grandfather, Antonius Marcellinus, served as consul in 341) with Spanish roots. Her family was also extremely wealthy and Christian—a religion which Melania the Elder avidly pursued as a young woman in Rome. Her husband was of an equally prestigious family, the Valerian, and was perhaps the Valerius Maximus who held the office of praetorian praefect in the 360s. If this was so, then a young Melania married a much older man, probably about the year 365. Despite the probable difference in their ages, this union produced three sons before Melania was widowed at the age of 22. The death of her husband was followed within months by the deaths of two of her children, leaving only Valerius Publicola (the eventual father of *Melania the Younger) to reach adulthood.

In one sense the tragedy of these triple deaths liberated Melania the Elder, for instead of remarrying, she left Rome for Egypt and Palestine, there to associate with the holy men and women who dominated the Church of the period as priests, bishops, monks and nuns. Rome

was then, in Christian terms, far less developed than were Jerusalem, Alexandria and their surrounding areas. Melania the Elder was able to pursue her dream of visiting the East because she had given birth to three children who had lived past the age of two. By Roman law, she thus had earned the right to certain freedoms denied women who could not boast of that accomplishment. What Melania the Elder originally intended to do with her surviving son is unclear. One source reports that she took him at least as far as Sicily when she left Rome, seemingly intent upon bringing him with her to the East. If so, she changed her mind, for Valerius Publicola was reared in Rome under the care of a guardian, where, although without a mother's care, he never suffered for the lack of money. Mother and son would not see each other again until she returned to Rome, probably some 37 years later.

Like many Christians of her time, Melania the Elder wished to disassociate herself from material possessions (although she retained control of a huge estate throughout her life which she used to fund her religious career) and to deny as many bodily pleasures as possible in order to cultivate the spirit, thus to prepare for the hereafter. It was common especially for Roman women bent upon such purification to withdraw from the world into their own homes, where they fasted and prayed in a self-imposed isolation—albeit one which could be reversed simply by walking out into any public thoroughfare. Melania the Elder, however, both knew of the monastic movement which had only recently swept the Christian East and had the financial wherewithal to travel there and experience it firsthand.

The early monastic movement involved holy men and women who sought the isolation of inhospitable locales where they lived lives of bodily denial, so as to subordinate all physical desires to the will of the spirit, to study and interpret sacred scripture without any distractions, and to engage in what was thought a very real struggle against demons, who thus engaged would be unable to tempt less resolute Christians back in everyday society. These hermits were among the "stars" of the late 4th-century Christian world, and their passion to root out evil in themselves and in the world was deemed charismatic by just about everyone. Although their wish to live in the wilderness was in large part generated by the fact that they would thus be removed from other human beings, the self-imposed isolation of these holy figures was self-defeating, for as their fame grew, more and more of their Christian brethren followed them into the desert in order

to be in their physical proximity. This soon necessitated a second stage of monastic development: that in which communities of voluntary disciples had to be organized, both to prevent them from being a distraction to the original attraction and to give them something constructive, and hopefully, "orthodox," to do. The idea of organized Christian communities somehow set aside from everyday society—and therefore also set aside from religious authority—thus arose. These communities were at once both inspirational and troublesome: the former because "God's soldiers" were known to be "out there" leading the struggle against the forces of Satan, and the latter because, without the proper oversight by religious authority, there was the potential for these communities to be side-tracked into doctrinal deviancy.

Whatever the potential pitfalls, Melania the Elder wished to devote herself to physical denial, spiritual struggle, and religious study, and found what she needed to do so in the East. Upon her arrival there, she familiarized herself with the vibrant religious life of Egypt by visiting both the influential See of Alexandria and the hermits of the desert. Perhaps one of the more important reasons Melania the Elder did so was that she had become very fond of the theological writings of Origen (born c. 185 in Alexandria), which she had come to know through the Latin translations of her contemporary Rufinus. Later, when she moved on to Jerusalem in the late 370s, Melania founded and endowed a convent for herself and a monastery in honor of Rufinus (who remained in the West) on the Mount of Olives. These were not only among the earliest such establishments founded, they also fostered the asceticism Melania the Elder thought essential for salvation and a study of scripture in the tradition of Origen. This tradition, popular especially in the East, interpreted the Bible in the light of significant philosophical principles which had first been set forth by pagan thinkers. Although for a long time no one questioned the orthodoxy of such an approach to the Gospels, this began to change in the 390s, especially in the West. Thereafter, the orthodoxy of those working in the tradition of Origen came increasingly under fire.

Melania the Elder never thought of herself as a heretic. Indeed, she thought of herself as a bastion of orthodoxy. For example, when the Arian emperor Valens persecuted those in Egypt who espoused the orthodoxy of the Trinity, Melania gave them shelter. Because she was a disciple of Origen, however, others began to question her orthodoxy. Even as the weight of

Church opinion began to swing toward the anti-Origenists, Melania the Elder maintained her allegiance to Origen's interpretive assumptions, and kept close ties with others (such as Rufinus, Evagrius Ponticus, and Palladius) who did likewise. This choice eventually set her at odds with the likes of the famous Jerome and his female associate *Paula, both of whom had monastic communities of their own near Bethlehem. As the argument over the orthodoxy of Origen's tradition heated up, so did the rivalry between the houses of Melania the Elder and Rufinus on the one hand and those of Jerome and Paula on the other—violence even occasionally flared. Indeed, by about 399 the controversy was so intense that Melania decided to return to Rome for a period. This decision, however, probably had less to do with a desire to let things in the East cool off than it did to Melania's desire to put forth the case for Origen to her granddaughter. Melania the Younger's Senatorial status, kinship to Melania the Elder, and growing fame as a religious zealot in her own right made her an attractive target for proselytizing by the anti-Origen faction—if the younger Melania could be won over by them, then the elder's position could be seriously weakened.

Thus Melania the Elder returned to Rome (by way of Sicily, where she gave to Paulinus of Nola a piece of wood thought to be from the true cross) and to her kin. If doctrinal matters were Melania the Elder's primary reason for her homecoming, it probably failed, for although Melania the Younger did not go out of her way to embarrass her grandmother, neither did she fall into Origen's camp. In fact during her own religious career, Melania the Younger took some pains to disassociate herself from her grandmother's memory and foundation, while simultaneously cultivating good relations with Jerome. It is not surprising, therefore, that tradition has it that the personal relationship between the two Melanias was a stormy one.

It is not known how long Melania the Elder remained in the West, but she probably did not stay long. Returning to her beloved community in Jerusalem, Melania continued her work in the manner of Origen and the defense of her orthodoxy until she died about the year 410.

William Greenwalt,
Associate Professor of Classical History,
Santa Clara University, Santa Clara, California

Melania the Younger (c. 385–439)

Roman ascetic who was an important patron of the early Christian Church. Born around 385; died in 439 CE; daughter of Valerius Publicola (son of Melania the Elder) and Albina; married Valerius Pinianus (son of Valerius Severus, the Roman prefect), around 399.

The daughter of Valerius Publicola (the son of *Melania the Elder) and Albina, Melania the Younger was born around 385. Her parents were from extremely wealthy and well-connected Roman families of Senatorial rank; for example, her maternal grandfather, Ceionius Rufius Albinus, served as the prefect of Rome, a post reserved for the most elite, between 389 and 391 CE. On her father's side, Melania's family had been Christian for at least a couple of generations before her birth—a testimony to the growing impact of Christianity on Rome's ruling class in the mid-4th century. Her maternal ancestors, however, had been both important members of the pagan establishment and slower to embrace Christianity; her great-grandmother **Caecina Lolliana** was a priestess of Isis, and her great-uncle Publilius Ceionius Caecina Albinus was a pontifex. In fact, Melania's maternal grandfather was probably pagan, as is suggested by the fact that his son (Melania's uncle), Rufius Antonius Agrypnius Volusianus, converted to Christianity, largely because of Melania's advocacy, only shortly before his death. If Melania the Younger's maternal grandfather remained a pagan throughout his life, he nevertheless was tolerant of Christianity, as is intimated by the following: he (perhaps) took a Christian wife; he seems to have corresponded with St. Ambrose of Milan; he clearly married his daughter Albina to a Christian; he allowed her to convert to Christianity if she had not already been raised in the faith by a Christian mother; and he did nothing to interfere with the Christian upbringing of Melania the Younger. Rome in the mid-4th century was a fairly tolerant place where a Christian and a pagan could rub elbows and even marry without necessarily adopting the other's religion. (This tolerance was lost in subsequent generations as the Church, encouraged by Christian emperors, eradicated the last vestiges of pagan Rome.) Melania the Younger may have had a brother, but if so, he died without issue and probably young.

When she was 14, Melania the Younger wed a distant relative, the 17-year-old Christian Valerius Pinianus (a son of Valerius Severus, the Roman prefect of 382). This union reunited two threads of an ancient house, in order to foster political influence and consolidate the immense economic resources which each side of the family individually possessed. The marriage does not seem to have pleased Melania the Younger,

whose ascetic religious inclination had already been incited by the example of her grandmother Melania the Elder. Desiring a life of ascetic chastity but pressured by her family to generate heirs who could maintain the family's station and wealth, Melania the Younger reluctantly acceded to her father's wishes. Her marriage resulted in two pregnancies: the first producing a daughter and the second a stillborn son—a birth which almost killed Melania. Not long after this heartbreak, Melania the Younger's daughter, not yet two, also died. The shock of the double deaths convinced both Melania and her husband Pinian that her original wish to eschew intimate relations was also God's will. As a result, although they continued to live together, the couple renounced conjugal relations and began to experiment with an austere way of life which was the antithesis of their upbringing.

Accomplishing the latter was not an easy task, for the couple possessed vast estates, great movable wealth, and huge numbers of slaves across three continents. These they began to sell off, beginning with their Italian and Spanish properties, in order to fund a number of Christian works. Melania the Younger's father, although himself a generous patron of Christian causes, stoutly opposed their decision to divest entirely their worldly goods, as well as their choice to remain childless—for he saw no shame in secular Christianity and did not relish the thought that he would never know grandchildren. Unable to make headway with his willful daughter, however, the dying Valerius Publicola at last made a virtue out of necessity and reconciled with Melania the Younger on her terms.

Also opposed to Melania's and Pinian's decision to disburse their wealth was Pinian's brother, Severus, who attempted legal action in order to maintain their family's control of the estate being so purposefully liquidated by the couple. Presumably, Severus' case revolved around the fact that neither Melania the Younger nor Pinian was 25 years old—the age of legal authority for such actions—when they began their wholesale sell-off around 405. Nonetheless, this attempt failed when Melania the Younger, exploiting the connections which came with her wealth and station, approached Honorius, the emperor of the Roman West, through ◄❧ **Serena** (Honorius' mother-in-law and the wife of Stilicho, who at the time was Honorius' most important general), probably in the year 408. Through Serena's successful advocacy, Honorius not only allowed Melania and Pinian to act as they saw fit, he even ordered bureaucrats dispersed throughout the empire to act as agents on behalf of their divestment.

Much, but not all, of Melania's and Pinian's estate in Italy and Spain was thereby converted to cash by 410, in which year a double disaster hurt both interests. First, Honorius executed Serena and Stilicho for political reasons (the game at the imperial court was played for high stakes), and second, the Visigoths invaded Italy and sacked Rome. Before both disasters occurred, however, Melania and Pinian, with her mother in tow (Melania was all the family Albina had after the death of her husband), had made their way to North Africa to hasten the sell-off of properties there. Thus, they escaped both the fallout of the emperor's anger aimed at their political friends, and the ravages of the Visigoths, although they did lose their unsold Italian properties as a result of the appearance of the barbarians.

In North Africa, the trio established themselves on land they owned near Thagaste, the small hometown of St. Augustine, where they grew close to that great bishop's brother, Alypius. From this location, they oversaw the conversion of most of their African estates into cash which they used both to adorn the church of Thagaste and to distribute to the needy through local monasteries and convents. Concerning the latter, so much money was spent so quickly to so little lasting effect that Augustine, Alypius, and Aurelius, bishop of Carthage, advised the well-intentioned threesome to give up on trying to feed all of the poor and to concentrate on investing in the spiritual future. Melania, Pinian and Albina heeded this advice and endowed both a monastery and a convent, their first such foundations. About this time, an episode which had the potential of rupturing the friendship between Augustine, Melania and Pinian occurred, in which the people of Hippo (where Augustine was bishop) attempted to force ordination upon Pinian so that he could become their priest. This was deftly avoided by Pinian, who rather sought the life of a recluse, but local feelings were bruised and he had to swear that he would not take orders elsewhere.

Melania the Younger, Pinian and Albina remained in North Africa for about seven years, during which time they embraced more and more isolated asceticism: their clothes became little more than rags, their fasts became longer and more frequent, and all comforts were purposefully shunned (they lived in barren monastic cells and even had their beds constructed so as to make sleeping a torture). Throughout all of this, they spent most of their time in prayer, studying scripture, and working; in Melania the Younger's case, this frequently meant copying

❧▶

Serena (d. 410).

See Placidia, Galla for sidebar.

books. When they did strike out into the larger world, it was to advise the less driven to avoid heresy at all costs and to embrace a life of chastity (even going so far as to bribe men and women to remain chaste). The issue of heresy was a personal one to Melania the Younger, for her famous grandmother Melania the Elder had had her reputation tainted through her association with the increasingly discredited theology of Origen. Although Melania the Younger stayed clear of that particular pitfall, the world of the early 5th century was fraught with theological dangers, and reputations could be permanently lost if one fell in with the wrong theological sort.

However real their desire to withdraw from the world might have been, Melania and Pinian found their fame begin to spread, increasingly bringing the outside world to their doors. Perhaps motivated by a desire to cut back on the attention that ascetic piety drew at that time, and perhaps also influenced by the erosion of North African social stability in the wake of Rome's continuing collapse before the barbarian invasions, Melania the Younger, Pinian and Albina left Thagaste (417) to journey to the Holy Land. The traveled by way of Alexandria and Egypt (in the footsteps of Melania the Elder), where they met many of the most famous priests and bishops (like Cyril) of the day, as well as many of the charismatic Christian hermits (like Nestoros) who were exerting so much influence over the contemporary practice of the Christian faith. Their stay in Egypt obviously left an indelible impression on the pilgrims, because even though they continued on to Jerusalem to establish their permanent residence there, they nevertheless took a subsequent opportunity to return to Egypt so as to press their largesse upon the reluctant holy women and men of that land.

In Jerusalem, the threesome took up their abodes in tiny cells constructed on the Mount of Olives, close to, but definitely distinct from, the religious community which a generation before had been founded by Melania the Elder. It seems that Melania the Younger wanted it known that her theology was not that of her grandmother, a notion that was further driven home by her friendly visits to Jerome, her grandmother's theological rival. On the Mount of Olives, both Albina (c. 430) and Pinian (c. 431) died, losses which left their mark on Melania the Younger. Her mother's death caused her to abandon all social contact for a year, after which she founded a second convent (her first since North Africa), situated on the Mount of Olives. Although Melania the Younger declined to become this community's leader, she did write its rule and in-

tervened to make life more palatable for its members when the austerity of their abbess tried even the most devout. After Pinian's death, Melania the Younger engaged in a second period of mourning, this time for four years, after which she established a second monastery, also on the Mount of Olives, in his memory. Interestingly, by the time of this, her final, foundation, Melania the Younger's money had run out, for the construction of this community was dependent upon a gift of cash which she received from an admirer.

Soon after Melania the Younger set up these communities, she learned that her (as yet) pagan uncle, Volusian, was traveling to Constantinople upon imperial business. Desiring that he should embrace Christianity, and wishing to see the greatest city of the Roman world, she decided to visit the capital of the Eastern Empire herself. Among the entourage accompanying her was Gerontius, the priest whom she probably met in Jerusalem and who wrote the chronicle of her life from which most of the information about her comes. The journey from Jerusalem to Constantinople was a triumph of sorts, for her fame had preceded her virtually everywhere she went. Her reception also was one as befitted a celebrity: among those Melania the Younger met was the Empress *Eudocia (c. 400–460), who was so impressed by Melania's piety that she would one day return Melania the favor by visiting her in Jerusalem. Moreover, her journey had its intended effect, for although Volusian died in Constantinople, he did so only after having received baptism.

Melania the Younger thereafter returned to Jerusalem and her cell on the Mount of Olives. There she resumed her ascetic life while continuing her sponsorship of Christian building: in addition to the religious communities which were constructed under her patronage, she built a chapel of the Apostolion and a martyrium to hold relics attributed to Zachariah, Stephen, and the 40 martyrs of Sebaste. Melania the Younger was so busy with these various activities that she left Jerusalem only one time after her return from Constantinople. When Eudocia made her way to Jerusalem, in part to preside over the installment of relics in Melania's martyrium (Eudocia had a vested interest: she had wanted these relics for projects of her own), Melania the Younger met her at the port city of Sidon. The last three or so years of Melania's life thus were largely given over to spiritual struggle, prayer and study. Throughout, her reputation continued to grow—so much so that when she died in 439, Melania the Younger was mourned not only by those living in her communities, but by

all Christians, great as well as humble. No taint of unorthodoxy affixed itself to her memory. In fact, present at her death was **Paula the Younger,** whose grandmother ***Paula** (347–404) had (with Jerome) been among Melania the Elder's most ardent theological critics. It seems that Melania the Younger rehabilitated the reputation of her family in the minds of those who constituted the Church's orthodox faction.

<div align="right">

William Greenwalt,
Associate Professor of Classical History,
Santa Clara University, Santa Clara, California

</div>

Melba, Nellie (1861–1931)

First Australian prima donna, with a voice like a nightingale, who ruled Covent Garden for nearly 40 years. Name variations: Dame Nellie Melba; Helen Porter Armstrong. Born Helen Porter Mitchell on May 19, 1861, in Melbourne, Victoria, Australia; died of paratyphoid fever on February 23, 1931, in Sydney, New South Wales, Australia; daughter of David Mitchell (a building contractor) and Isabella (Dow) Mitchell; studied singing with Pietro Cecchi, 1879–86, and Mathilde Marchesi, 1886–87; married Charles Armstrong, on December 22, 1882 (divorced 1900); children: one son, George Armstrong (b. October 16, 1883).

Decided to make career of singing (1883); moved to London (1886); studied with Marchesi in Paris (1886–87); changed name to Melba (December 31, 1886); made grand opera debut in Brussels (1887); made Covent Garden debut (1888); made first Australian tour (1902); made first Australian country town tour (1909); co-founded Melba-Williamson Opera Company (1911); made Dame Commander of the British Empire (1918); published autobiography Melodies and Memories *(1925); gave Covent Garden farewell concert (June 8, 1926); returned to Australia for farewell tour (January 1927); made Dame Grand Cross of the British Empire (1927); gave final opera performance (August 7, 1928).*

Main opera roles (details of first performances are noted where known; Melba performed all these roles frequently throughout her long career): Gilda in Verdi's Rigoletto *(debut, October 13, 1887, at Théâtre Royale de la Monnaie, Brussels); Violetta in Verdi's* La Traviata *(1887 season at the Monnaie, Brussels); Lucia in Donizetti's* Lucia di Lammermoor *(first sung during 1887 season at the Monnaie, Brussels, then debut May 24, 1888, at Covent Garden, London); Juliette in Gounod's* Roméo et Juliette *(debut June 15, 1889, at Covent Garden); Mimi in Puccini's* La Bohème *(July 1, 1899, Covent Garden); Marguerite in Gounod's* Faust, *Ophelie in Thomas'* Hamlet, *Nedda in Leoncavallo's* Pagliacci *(all 1893, at Covent Garden); Rosina in Rossini's* The Barber of Seville; *Desdemona in Verdi's* Otello.

Perhaps the greatest prima donna the opera world has ever known, Nellie Melba was born into a prosperous Australian family on May 19, 1861. Both her mother **Isabella Dow Mitchell** and her father David Mitchell had immigrated from Scotland to settle in Melbourne (now the capital city of Victoria), where David, predicting that many people would need houses once the Australian gold rush ended, set up as a brickmaker and building contractor. His prediction proved true, and he established a good life for himself and his family, which eventually grew to include eight surviving children. In the 1860s, Australia had been colonized for just over 70 years, and society was not sophisticated. Only 25 years old, Melbourne had grown rapidly during the gold rush days into a city of about 140,000 residents, and although it was the financial center of the country it was a dry, uninteresting place. There was no operatic tradition, and people were more concerned with making a living in this new, difficult country than in developing a rich culture. Nonetheless, Melba's family life in the Melbourne suburb of Richmond was musical; her mother was a talented pianist, organist, and harpist, her father played the violin and sang bass, and her sister Belle and brother Ernest both sang well. Melba, Belle, and Ernest were also excellent whistlers, which was considered a vulgar habit, particularly for girls. Despite this, Melba, who rarely stopped what she was doing to please others, hummed constantly as a child, often driving her mother nearly to distraction. (She later realized that humming was excellent exercise for the voice, and employed this method when teaching her own students.)

Her first public appearance was at age eight, when she sang some songs and accompanied herself on the piano at a concert at the Richmond Town Hall. Though she was not an infant prodigy, she was convinced that she had musical genius, and as a child she was disappointed in her family's apparent lack of interest in her singing. Her father in particular, while proud of her abilities, never praised her. Years later, she noted in her autobiography: "Throughout my life there has always been one man who meant more than all others, one man for whose praise I thirsted, whose character I have tried to copy—my father."

After receiving her early schooling from her mother and two aunts, all of whom were well

educated, Melba became a boarder at Leigh House, a private school in Melbourne. She continued studying music, and at the age of 12 became the organist at Scots Church, a Presbyterian church built by her father. In 1875, at age 14, she attended the new Presbyterian Ladies' College, where she had her first formal singing studies and continued her organ and piano lessons. Elocution (the art of public speaking), English and music were her favorite subjects. A lively, rebellious tomboy with a direct personality, able even at that age to dominate any gather-

ing, Melba avoided the daily 6 AM cold showers at Leigh House by bathing under an umbrella and occasionally muddied her Sunday clothes to avoid having to go to church. She often went skinny-dipping with the local boys in the Yarra River after school, and she would continue to prefer the company of men throughout her life.

In 1879, Melba began singing lessons with Pietro Cecchi, an Italian tenor who had settled in Melbourne. Another student, hearing her sing an aria, commented to Cecchi: "What a glorious voice that girl has!" "Yes," he replied. "It's going to enthrall the world." Although Melba by then had begun to have serious thoughts about a career in singing, she kept them to herself, for daughters of wealthy parents in the Australian colonies were not expected to have a career. A good marriage and plenty of children was what was expected, with painting, embroidery and flower-arranging to pass the time.

After completing her education in 1880, Melba stayed home to look after her ailing mother, sharing household duties with her sister Annie and continuing her piano and singing studies. Isabella Mitchell died in October 1881, and only three months later Vere, at four years old the youngest daughter, became ill and died suddenly. The family was devastated. After some months of grieving, David Mitchell decided to combine rest with work, agreeing to build a sugar mill near Mackay, a seaport in North Queensland. His two eldest daughters accompanied him on the 2,200-kilometer trip by steamboat from cold Melbourne to tropical Queensland. Queensland was wild country, and around Mackay there were only a few thousand settlers working in the sugar-cane industry. The elegant sisters were therefore a welcome addition to the town, and Melba soon met Charles Nesbitt Armstrong, an Irish baronet's son who was the manager of a nearby sugar plantation. Armstrong was handsome, young, and well educated, with good breeding and a title, but he also had no money, a strong temper, and a reputation as a wild and adventurous equestrian. Despite her father's opposition to her choice of a penniless man, Melba married Armstrong on December 22, 1882.

From the start, their marriage was doomed. Armstrong had no interest in music, and Melba had no intention of being a dutiful and submissive wife. She briefly resumed her singing lessons with Cecchi when they went to Melbourne for their honeymoon, and after returning to their home in a small town near Mackay in April 1883, she became increasingly unsettled. The constant rain, lack of high society, and primitive living conditions did not suit her, and she found no outlet for her endless energy, curiosity and ambition. Melba kept singing, and occasionally gave public concerts in Mackay. During this first year of her marriage, she started to yearn for a career in singing. She also became pregnant and gave birth to her only child, George, on October 16, 1883.

After she had a number of quarrels with Armstrong about her career, he finally agreed to let her return to Melbourne to continue her studies and to help their finances, which were in very bad shape. She wrote to Cecchi in late 1883, telling him of her decision. On January 19, 1884, Melba and her son boarded a ship for Melbourne, leaving Armstrong behind at the plantation. She never returned to Mackay. Her father was happy to have his daughter and grandson living with him, and although he did not approve of Melba's singing ambitions, he did not try to deter her. She continued her lessons with Cecchi, fine-tuning her voice, and gave her first serious concert on May 17, 1884, at the Melbourne Town Hall. Here she met John Lemmone, an Australian flautist who became one of her dearest friends and acted as her manager and accompanist in later years.

Melba wanted desperately to travel to Europe, but had no opportunity to do so until her father was chosen to go to London as the state's commissioner to the Indian and Colonial Exhibition. She accompanied him, along with her husband and son and her sisters Annie and Belle, when he sailed for London on March 11, 1886. Soon after their arrival on May 1, Melba obtained an appointment in Paris with the world-famous singing teacher *Mathilde Marchesi, and moved to Paris with her son in July 1886. It is written that after Marchesi heard Melba sing she ran out of the room to tell her husband Salvatore, "I have found a star!" Melba was taken on by Marchesi, who promised to make something extraordinary of her in one year. Life was sometimes difficult, with long hours, a young son to care for, little money, and occasional visits from her argumentative husband (who was living in England), but Melba thrived on the work.

Cecchi had been an excellent teacher, and Melba owed much of her technique and success to him. However, in her autobiography she wrote that, just before she left for London, Cecchi insisted that she owed fees for past lessons, and threatened to seize her luggage if she did not pay up. Although she claimed that she refused to

speak of him after this, and had to unlearn everything he had taught her, it is known that she wrote friendly letters to him after her arrival in London. In any case, she could not have achieved such a quick success in Europe without his training. John Hetherington, in his biography *Melba*, wrote that once she became a prima donna, "she preferred to be known as a pupil, not of the great Mathilde Marchesi and the obscure colonial teacher Pietro Cecchi, but of the great Mathilde Marchesi alone." Melba was a self-acknowledged snob who often dramatized the events of her life, and much of her autobiography, though entertaining, is not accurate. "She liked to re-shape, to re-order, and then to embroider," writes Hetherington.

Melba began to sing at soirées (evening parties) around Paris, and became known for her *coloratura* singing (with florid, ornamental vocal trills and runs)—she had a silvery, birdlike, delicate voice, well suited to light lyric opera roles. Critics tended to be divided—some said that she was shrill, unimaginative, icy, cold and heartless; others described her voice as pure, heavenly, faultless, silvery, golden, pure crystal, effortless. From all accounts, however, she had an incredible facility and technical mastery, and could sing her full range (from B flat below middle C to F two octaves up, a full three notes above the range of most sopranos) very softly while still making herself heard over a full orchestra.

She rang in the new year of 1887 with a new last name, Melba, derived from her hometown of Melbourne and designed to catch the public's imagination. At last, on October 13, 1887, she made her European debut, singing the role of Gilda in Verdi's tragic opera *Rigoletto*, at the Théâtre Royale de la Monnaie in Brussels, Belgium. (That she was able to appear at all was due only to the sudden death of the Czech impresario Strakosch, who had held her contract and refused her permission to sing there.) Madame Marchesi later wrote: "The very next day and afterwards it was nothing but a chorus of praise everywhere; the entire press of Brussels declaring the young artiste to be a star of the first magnitude."

In the midst of all this, Armstrong arrived unexpectedly in Brussels, where he and Melba continued to argue. This appears to have marked the end of their marriage, for they kept apart after that, although they would not divorce until 1900. George remained with Melba for a time before attending boarding school in England, after which he went with his father to Texas.

In the meantime, a new life had opened up for Melba. It was an exciting and complicated yet comfortable existence, filled primarily with the many roles as well as stagecraft, makeup and acting skills she needed to learn. Among the friends who helped her were Australian playwright Haddon Chambers, the famous French actress *Sarah Bernhardt, and numerous composers. As Melba wrote: "I have been most fortunate, for in the operatic roles with which I am most closely identified, I had the invaluable assistance of the composers themselves—Gounod, Verdi, Delibes, Ambroise Thomas, Leoncavallo, Saint-Saëns, Massenet, Pucchini."

She made her debut at London's famed Covent Garden on May 24, 1888. **Lady de Grey**, a powerful patron of the theater, had forced the reluctant manager, Augustus Harris, to hire her. There was little publicity, and the concerts were less than successful. Melba fled to the Continent, vowing never to return. However, Lady de Grey wrote to her persistently, promising that things would be done differently the next time if only she would come back. Eventually Melba agreed, and gave her second Covent Garden concert on June 15, 1889, appearing opposite tenor Jean de Reszke in Gounod's *Roméo et Juliette*. The house was packed, and this time she conquered the city. Soon "Melba Nights" at Covent Garden brought out royalty, diamond tiaras, furs, and starched white shirts. Lady de Grey became Melba's first sponsor, important ally and great friend, supporting her at Covent Garden and introducing her into fashionable London society. Jean de Reszke also became a lifelong friend and colleague, with neither showing any envy of the other's success—a rare trait in opera singers generally, and in Melba as well.

Another great friend was the young duke of Orléans, a member of the French royal family, with whom Melba had a love affair between 1890 and 1892. Eventually, however, legal action from her husband and the gossip columns of European newspapers brought the relationship to an unhappy end. She never discussed details of their liaison, but it seems that she never had such a great love again, and sorely missed it. When it came to friends, Melba preferred them wealthy and titled. She loved knowing royalty, and sang before all the crowned heads of Europe.

Domineering and outspoken, Melba was a law unto herself. She would write to her sisters in Australia and tell them how to raise their children. She also became very wealthy, earning on average £1,000 per week, and often as much as $10,000 for one (American) concert—a phe-

nomenal amount in those times. For many years, she held the record for highest-paid performer in Australia. Like her father an astute entrepreneur, Melba never squandered her wealth. She invested in property, and often financially helped young Australian artists and musicians. Still, when she traveled—which was most of the time—it was done in royal style. Possessed of a complicated, unpredictable personality, Melba could be kind and generous, as well as arrogant, aggressive, and ruthless. She was realistic about her abilities, impatient with fools, shrewd with money, and worked extremely hard. She would send free tickets year after year to anyone who had helped her, or cook bacon and eggs herself for hard-working musicians. Yet she would also make sure that any talented young soprano who threatened her position as prima donna had no chance of singing at Covent Garden, and she made many operatic enemies. The famous chef Escoffier created the dessert Pêche Melba in her honor. Melba toast, thinly sliced dried bread, was also named after her, as were many products such as perfumes, often without her consent.

In 1899, Puccini selected her as the ideal Mimi for his opera *La Bohème*, coaching her thoroughly in the role. Mimi suited her well, and from the time she first performed it at Covent Garden that year it became both a favorite of hers and her most famous role. The tenor Enrico Caruso often played Rodolfo to her Mimi, and they were a wonderful team. Practical jokes were popular with her and her friends both on stage and off; during a performance of the tragic *La Bohème*, Caruso once put a hot sausage in her hand instead of the expected cold key; Melba barely managed to keep a straight face.

In the early years of the new century, she was constantly in demand. Finally, after living in Europe for 14 years, she returned home to tour and visit her family. Melba was welcomed home like royalty, and her Australian tour in 1902 was a huge success. In 1904, she began making gramophone recordings which helped popularize that machine in England; she would make over 150 recordings in all. Melba appeared in America as well, at New York's Metropolitan Opera House and at Hammerstein's Manhattan Opera House, and toured most of Europe, including Russia. In 1909, she fulfilled a dream by giving her first Australian country town tour, keeping ticket prices low to allow all social classes to hear her. In later years, she ran "Concerts for the People" in Melbourne and Sydney on the same principle.

During 1911 and 1912, Melba spent a great deal of time in Australia, setting up the Melba-Williamson Opera Company with J.C. Williamson, an Australian theater magnate. She also oversaw, imperiously, the construction of a home she named Coombe Cottage, in Lilydale, Victoria, where she had loved to visit as a child.

Returning to Australia when World War I broke out in Europe in 1914, Melba worked tirelessly for the war effort, energetically knitting socks and singing in benefit concerts in Australia, the U.S., and Canada that raised over £100,000 for war charities. Her father died in March 1916, while she was sailing back to Australia after a concert tour in America. That year Melba also taught singing at the Albert Street Conservatorium in Melbourne. After the war, in 1918, she was made Dame Commander of the British Empire in recognition of her services to the war effort. Her son George had returned to Australia with his second wife Evie, an accomplished mezzo-soprano who would occasionally sing in concerts with Melba, and the three spent much time traveling together.

Melba looked forward to her return to London in 1919, but once there she was dismayed by the changes the war had wrought. The Edwardian days of "Melba Nights" at Covent Garden were gone. The city was war-torn and dirty, and many of her friends had died in the intervening years. She wrote about that opening concert at Covent Garden:

> I find myself looking into the great space of the auditorium, and feeling once again that I am singing to an audience of ghosts. Lady de Grey had gone, Alfred de Rothschild had gone, and so many others, all gone; and yet I felt them there, I seemed in my imagination to see their faces again, looking out from the shadows in their boxes, and it was for them rather than for this great audience that I sang.

Melba's autobiography *Melodies and Memories* was published in 1925, ghostwritten by a young British writer, Beverley Nichols, who would later remark that "ghosted is a very apposite word, because she was so anxious to appear as an angel of sweetness and light that all the guts and humour had to be taken out if it." Despite this, the book reveals much about her personal and professional lives.

Melba finally gave her Covent Garden farewell concert on June 8, 1926—a sad and painful moment, as she said goodbye to her artistic home of nearly 40 years. Unbeknownst to her, the concert, including her emotional farewell speech, was recorded for posterity. Although this was the first of many farewell performances over

the next two years, the Covent Garden event was the most important, as it signaled the beginning of the end. At her final opera performance on August 7, 1927, given when she was 66, her voice still sounded fresh and young—an incredible accomplishment. The careful treatment of her instrument (apart from one disastrous attempt at Wagner in 1896, which nearly ruined her vocal cords), as well as her natural ability, had extended her career to an astonishing 40 years.

Just as the Australian summer was starting in November 1928, Melba traveled to Europe for one last visit to her old haunts. She also visited Egypt, where she became ill with an unidentified virus similar to typhoid. She returned to Australia in November 1930, and was hospitalized in Sydney soon afterwards. Dame Nellie Melba died on February 23, 1931, at age 69. Tributes poured in from far and wide. She was buried at Lilydale, next to her father. Her gravestone bears the words *Addio, senza rancore* (Farewell, without bitterness)—the dying words of Mimi in *La Bohème*.

SOURCES:

Hetherington, John. *Melba.* Melbourne: F.W. Cheshire, 1967.

Melba, Dame Nellie. *Melodies and Memories.* NY: Books for Libraries Press, 1926, reprinted 1970.

Melba, Nellie. "Music as a Profession," in *The Lone Hand.* February 1, 1909, pp. 357–362.

Sadie, Stanley, ed. *The New Grove Dictionary of Music and Musicians.* Volume 12. London: Macmillan, 1980.

Wechsberg, Joseph. *Red Plush and Black Velvet.* London: Weidenfeld and Nicolson, 1961.

SUGGESTED READING:

Marchesi, Mathilde. *Marchesi and Music: Passages from the Life of a Famous Singing Teacher.* New York: Harper & Brothers, 1898.

McDonald, Roger. *Melba, the novel.* Sydney: Collins, 1988.

Melba, Nellie. "The Gift of Song," in *Century Magazine.* June 1907.

Moran, William, ed. *Nellie Melba, A Contemporary Review, with discography.* London: Greenwood Press, 1985.

Rosenthal, Harold. *Two Centuries of Opera at Covent Garden.* London: Putnam, 1958.

RELATED MEDIA:

Melba (113 min., Technicolor film), starring American soprano *Patrice Munsel as Dame Nellie Melba, directed by Lewis Milestone, produced by Sam Spiegel, Horizon, 1953.

Peach Melba: Melba's Last Farewell, a play by **Theresa Radic**. Sydney: Currency Press, 1990.

COLLECTIONS:

Lemmone, John. Collection of papers relating to Dame Nellie Melba, 1911–1928. Letters, cards, photographs, financial statements and news cuttings, located in the National Library of Australia, Canberra, ACT, Australia.

Denise Sutherland, freelance writer, Canberra, Australia

Melbourne, Elizabeth (d. 1818).
See Lamb, Caroline for sidebar.

Melbourne, Lady (1785–1828).
See Lamb, Caroline.

Melesend.
Variant of Melisande.

Melisande (fl. 1100)

French noblewoman. *Flourished around 1100; married Hugh of Rethel; children: Baldwin II, king of Jerusalem (r. 1118–1131).*

Melisande (1105–1161)

Queen-regnant of Jerusalem. *Name variations: Melesend; Mélisande; Melissande; Melisend; Mélisende or Melisende; Melisinda, Mélisinde, or Melisinde. Born in 1105 in the Frankish principality of Jerusalem; died on November 30, 1161, in Jerusalem; daughter of Baldwin II, count of Edessa, later king of Jerusalem (r. 1118–1131), and Morphia of Melitene; sister of Hodierna of Jerusalem (c. 1115–after 1162), Alice of Jerusalem (c. 1106–?), and Joveta of Jerusalem (1120–?); became second wife of Count Foulques also known as Fulk V, count of Anjou, king of Jerusalem (r. 1131–1143), on June 2, 1129 (died 1143); children: Baldwin III (1130–1162), king of Jerusalem (r. 1143–1162); Amalric I (1136–1174), king of Jerusalem (r. 1162–1174).*

Named heiress of Jerusalem (1128); married (1129); succeeded Baldwin II (1131); rebellion of Hugh of Le Puiset (1134); established convent of Bethany (1138); widowed and was crowned as co-ruler with son (1143); failure of Second Crusade (1148); endured rebellion of son Baldwin III and division of kingdom (1152); reconciled and co-ruled (1153–1160); suffered stroke (1160).

Melisande ruled as queen-regnant and co-ruler of the principality of Jerusalem. Her father Count Baldwin, a French noble, had fought in the successful First Crusade of 1097, when Frankish knights and others had conquered Jerusalem and the surrounding territories and established Christian kingdoms for themselves. Baldwin had become count of Edessa; his cousin, another Baldwin, eventually became king of Jerusalem. Count Baldwin married a wealthy Armenian princess, *Morphia of Melitene, with whom he had four children, all daughters: Melisande, the eldest, ❧➤ Alice of Jerusalem, *Hodierna of Jerusalem, and *Joveta of Jerusalem. In 1118, while on a pilgrimage to

See sidebar on the following page

☙▶ Alice of Jerusalem (c. 1106–?)

*Princess and regent of Antioch who reigned from 1135 to 1136. Name variations: Alais or Alix. Born around 1106 in the Frankish principality of Jerusalem; died after 1162 in Antioch; second daughter of Baldwin II, count of Edessa, later king of Jerusalem (r. 1118–1131), and *Morphia of Melitene (fl. 1085–1120); sister of *Hodierna of Jerusalem (c. 1115–after 1162), Melisande (1105–1161), and *Joveta of Jerusalem; married Bohemond or Bohemund II, prince of Antioch (r. 1126–1130), in 1126; children: Constance of Antioch (1128–1164), co-ruler of Antioch (r. 1130–1163).*

An intelligent and well-educated princess, Alice of Jerusalem was married in 1126 to Bohemund II, the newly crowned prince of Antioch, in northern Syria. This alliance between the two most powerful Christian territories set up by the Franks after the First Crusade was considered necessary to protect both from the Muslim armies who sought to regain their conquered lands. In 1128, their first and only child, *Constance of Antioch, was born.

Two years later, Bohemund was killed in battle against an army of Danishmend Turks. According to feudal law, Antioch should pass to the prince's oldest son, or, in lieu of a male heir, to a daughter. But Constance was only two years old, and a female ruler, especially a child, was undesirable in this war-torn region. Princess Alice had her own plans, however. Instead of waiting for her father Baldwin II, as overlord of Antioch, to appoint a regent, she assumed the regency herself. It was soon rumored that she wanted to act not as regent, but as a reigning sovereign. Her actions lost her the support of the Antiochenes, who wanted a strong, adult male warrior-prince to protect Antioch from its enemies.

In a desperate move to retain her authority, Alice sent a messenger to the great Muslim *atabeg* (prince) Zengi, offering to pay him homage if he would help her retain Antioch; her father's troops, en route to Antioch to assert Baldwin's authority as overlord, captured the messenger and had him hanged for treason. Baldwin II forgave Alice for her rebellion, but he did remove her from the regency and banish her to Lattakieh, her dower lands. Baldwin himself assumed the regency, but he died only a short while later, leaving the regency to Count Joscelin of Edessa. When Joscelin himself died a few weeks later, the barons of Antioch refused to accept his son and successor as their new regent, leaving Antioch temporarily without a leader.

On Baldwin II's death, Alice's sister *Melisande and her husband, Fulk V of Anjou, had succeeded to the throne of Jerusalem. Alice unsuccessfully challenged Fulk's right to rule as overlord of Antioch; the final result was that he held the regency in name only, while the city's Patriarch Bernard held actual power. When Bernard died in 1135, the populace of Antioch elected Radulph of Domfront to succeed him; Radulph, who did not support Fulk's authority, assumed the office without waiting for canonical election to confirm his position and immediately began negotiating with Alice, still in Lattakieh. Alice appealed to her sister Melisande, Fulk's wife and co-ruler, to help her regain her power. With Melisande lending support to her sister, Fulk had no choice but to allow Alice to return to Antioch, where she shared the rule with Radulph, until he fell from power after alienating the clergy a short time later. Ruling alone but without a solid base of support, Alice sought a means of securing her position and that of her daughter.

She offered the hand of her daughter to the son of the Byzantine emperor Manuel Comnenus. At that time, however, the Christian states of the East regarded the Byzantine Empire as an enemy almost as dangerous as the Muslims, and Fulk of Jerusalem was informed of her action. He quickly sent a secret message to Raymond I of Poitiers, the younger son of the wealthy duke of Aquitaine. When Raymond arrived in Antioch in 1136, he asked Alice for her hand in marriage. Having little reason to doubt his story, she agreed. Raymond then had Constance kidnapped and taken to the cathedral, where the Patriarch Radulph, now working against Alice, quickly married them. Confronted with the accomplished fact and well aware that she did not have the support necessary to fight Raymond, Alice had little choice but to retire to her estates once again, where she spent the remainder of her life.

Although Constance's marriage marked the end of Alice's political career, Alice had the satisfaction of seeing Raymond's anti-Byzantine policies fail completely. He antagonized the emperor, instead of courting an alliance with him as Alice had done. In 1137, the Byzantine army, led by the new emperor John Comnenus, besieged Antioch until Raymond was forced to surrender the city. By that time even King Fulk refused to come to the aid of Antioch, knowing that his army was no match for the well-armed Byzantine troops. Many Antiochenes recognized, too late, the wisdom of Alice's pro-Byzantine policies.

SOURCES:

Hamilton, Bernard. "Women in the Crusader States: Queens of Jerusalem," in *Medieval Women*. Edited by Derek Baker. Oxford: Basil Blackwell, 1978.

Prawer, J. *The Latin Kingdom of Jerusalem*. London: Thames and Hudson, 1972.

Laura York,
Riverside, California

Jerusalem, Count Baldwin of Edessa chanced to be present for the funeral of his cousin, King Baldwin I, and soon found himself elected his cousin's successor as Baldwin II. Melisande, instead of being the heiress of Edessa, thus became the heiress to the throne of Jerusalem.

Like her sisters, Melisande received an education befitting her rank and her parents' wealth. She was well taught in languages, art, and history, and from her parents' example she developed the intense piety which would characterize her throughout her life. In 1128, Baldwin II began to search for a suitable husband for Melisande, who would co-rule with her. Because Frankish property laws and the legal system were disadvantagous to women, and because women were excluded from warfare and military leadership, it was considered necessary for a reigning queen to have a powerful husband to remain effective. It was unusual that Baldwin II waited until Melisande was in her 20s before seeking a marriage partner for her; most noblewomen at the time were betrothed as children and married in their teens. His council asked the king of France to pick a husband from among the French nobility; the king's choice fell on Fulk V, count of Anjou, a 40-year-old widower whose military and political skills had made him one of the wealthiest lords of the kingdom. An ambitious but pious man, Fulk could hardly refuse the hand of the heiress of Jerusalem. On June 2, 1129, he and Melisande were married in Jerusalem amid great celebration. In his chronicles of Melisande's life, William of Tyre noted that Melisande was less than enthusiastic about the match, but this is hardly surprising, for at 24 she was married to a stranger almost twice her age for purely political reasons. From later actions, it can be concluded that Melisande and Fulk never became a close couple. Nonetheless, in the year after her marriage Melisande gave birth to a son, called Baldwin (III) after his grandfather.

King Baldwin II's plans for how much power his daughter would wield on her succession are the subject of some debate. However, it appears that he intended for Melisande and Fulk to be co-rulers; that is, that neither one would be the only reigning monarch, but that they would share power equally. Baldwin II would have reason to fear making Fulk his heir, for Fulk could repudiate Melisande and make his grown sons with his first wife *Ermentrude, countess of Maine, his heirs—thus ending Baldwin II's dynasty. Yet to make Fulk only a king-consort would severely limit his effectiveness as a military leader, in an era of constant warfare.

Thus, joint rule was the best possible solution. After the marriage, Baldwin II began to include his daughter and son-in-law in various acts and charters.

Baldwin II died in August 1131, and on September 14 Melisande and Fulk were crowned in the Church of the Holy Sepulcher. Although Fulk had seemed amenable to co-ruling with his wife before their accession, afterwards he strove to disempower Melisande and retain all authority for himself. For nearly five years, all royal charters and public acts were made in Fulk's name only. Although he was a powerful king, his power grab turned many barons against him and made the queen a sympathetic figure. But Fulk's right to rule was initially questioned by many lords of the Christian states, since he was not related by blood to the ruling family. The opposition to Fulk's right to act as overlord of the states, as Baldwin had, was led by Princess Alice; in early 1132, she publicly denied Fulk's authority over Antioch and claimed the regency for herself once again. Alice found support for her position among several powerful lords, but she still lacked the backing of the people of Antioch, who secretly summoned King Fulk to inform him of Alice's plans. Her allies were not strong enough to defeat the army Fulk brought to Antioch, but the two sides were evenly matched enough that Fulk did not have the power to punish the rebels. Alice remained at Lattakieh while Fulk, although becoming nominal regent himself, let the city's Patriarch Bernard have the real authority.

Around 1134, the court and barons of Jerusalem took sides between the queen and king in a conflict over the rebellion of the knight Hugh of Le Puiset. Hugh had been a childhood companion of the queen who remained at court after her marriage; following her succession, there were rumors of a romantic relationship between them. Hugh's enemies helped spread these rumors to the king, who became jealous, and soon the men were openly antagonistic. Hugh was eventually accused of plotting against Fulk's life and fled to Jaffa, refusing the king's command to give himself up. The rebellion was short-lived, and Hugh was forced to submit to Fulk, who sentenced him to three years' exile.

The story of Hugh's rebellion reveals the hostility between the king's supporters and those whose loyalties lay with Melisande. There was more to Hugh's importance than the gossip about an affair with the queen—Hugh was Melisande's second cousin and her closest male kin, and thus

a natural choice for leader of Melisande's supporters. Melisande also had the favor of the patriarchs of the church, who were angered at the way Fulk had pushed his wife, King Baldwin II's daughter, out of power. Thus, although he was successful in ending the rebellion, Fulk was forced to realize that his power could not be secure as long as he antagonized Melisande's supporters. As for herself, Melisande was infuriated by Fulk's treatment of her and of her cousin Hugh; it was said that for a time Fulk was so afraid of his wife and her barons that he even feared for his safety. After this time, Fulk was careful to include Melisande in every royal act and to consult with her on all matters of state. From 1134 on, Melisande acted as a true co-ruler, as her father had planned, rather than as a consort only.

Melisande was] a woman of wisdom and circumspection, courageous and as wise as any prince in the world.

—**William of Tyre**

Fulk's change of heart, dictated though it was by political need, led to a reconciliation between the king and queen. In 1136, their second child, a son named Amalric (I), was born. Between 1136 and 1143, Melisande revealed a talent for leadership and a clear understanding of the importance of patronage—making gifts of land and title to her supporters in reward for their loyalty. She also acted on behalf of her three sisters. Her youngest sister Joveta had become a nun; Melisande felt that the daughter of a king should be more than a mere sister, and so she established a convent at Bethany in 1138, making it clear that Joveta, who was only 18, would become its abbess as soon as she was old enough to handle the responsibility. Bethany was no minor convent; an extensive settlement, it was lavishly furnished and endowed with acres of arable land. The queen also supported her sister Alice of Jerusalem's wish to become regent of Antioch. Although many of Alice's subjects did not want a female ruler and King Fulk had in 1135 tried to make himself regent of Antioch, Melisande negotiated an agreement whereby Fulk remained regent in name, but power was actually shared by Alice and her ally, the new patriarch of Antioch.

In 1143, Fulk was killed in a hunting accident. Melisande, though grieving publicly as was expected of her, immediately took the government into her own hands. Her son and Fulk's heir, now Baldwin III, was only 13 years old. Although in most similar cases a mother would act as regent on behalf of a young son, Melisande's position as queen-regnant made her situation exceptional. She did not view herself as holding power only in her son's name, but as a reigning monarch. To demonstrate this point, Melisande and her son were crowned together on Christmas Day, 1143; it was the queen's second coronation as a ruler. Although she did associate Baldwin III's name with hers in royal acts after 1143, she gave no indication of relinquishing power when he came of age in 1145; indeed, she did not even mark the occasion with any public celebrations.

Late in 1144, the Christian-held city of Edessa fell to a besieging Muslim army. Deeply concerned with this growing threat to Jerusalem's safety, Melisande sought help from the Christian kingdoms of Europe. She wrote to Bernard of Clairvaux, the powerful Cistercian abbot, and asked him to preach a new crusade to fend off the Muslims. Led by King Louis VII of France and his queen, ***Eleanor of Aquitaine**, a tremendous army arrived in the Holy Land in the spring of 1148, after months of preparation and more months en route. At an assembly called by Melisande in June 1148, the leaders of the Second Crusade decided to attack Damascus, a Christian-friendly city. It was a politically absurd decision which ultimately cost the crusaders thousands of lives. Such bad decision-making and infighting between the leaders made the crusade a complete fiasco, and when the surviving crusaders returned to Europe, Jerusalem was no safer from Muslim invasion than it had been before, and the Muslims still held Edessa. Jerusalem would have to look to itself and its neighboring Christian territories for its defense.

After the failed crusade, a serious conflict arose between the boy-king Baldwin III and Melisande. Although as a child Baldwin had had no choice but to let his mother reign, after coming of age he began to resent Melisande's authority. By 1150, this resentment had broken down their relationship so much that Melisande ceased including Baldwin III's name on official documents. Thus she began to disempower her son in a way similar to Fulk's treatment of her before 1134; and, as before, barons and courtiers were forced to choose sides. In early 1152, Baldwin III demanded that the patriarch of Jerusalem crown him again, without his mother present. The patriarch refused, and Baldwin sought another means of gaining the authority he felt was wrongly denied him.

He summoned the high court and demanded that the kingdom be divided between himself and Melisande. Against their better judgment, the court agreed; Melisande favored this solu-

tion and her influence carried the majority of the court. Had this solution been permanent, it surely would have endangered the kingdom, since Jerusalem had to be united to defend itself from its many enemies. Although Melisande has been criticized for agreeing to the partitioning of Jerusalem, she must have thought it preferable to the alternative, which was civil war.

Despite her hopes, however, it was only a few weeks after the division of the kingdom—Melisande ruling Samaria and Judea, and Baldwin III holding the north—when Baldwin invaded his mother's half. Showing himself a competent general, Baldwin III won the support of many southern barons and was admitted to Jerusalem. He laid siege to the Tower of David, where Melisande and her remaining supporters, including her younger son Amalric had secured themselves. Temporarily deserted by most of her supporters in the face of Baldwin's military success, Melisande agreed to terms. She relinquished her authority in exchange for a grant of the city of Nablus. However, Baldwin III underestimated his mother's determination and her prestige if he believed she would retire gracefully.

In the summer of 1152, only weeks after Melisande's retirement, she attended a general assembly of the lords of the kingdom at Tripoli. The purpose of the assembly was to choose a new husband for ❧▶ **Constance of Antioch**, princess of Antioch and niece to Melisande, who had been ruling alone since the death of her husband Raymond I of Poitiers in 1149. With the threat of invasion by the Muslim forces in north Syria increasing every day, Baldwin III needed a strong male ruler for Antioch, the northernmost of the Christian territories. However, Constance refused to remarry, despite the arguments made by both Melisande and Melisande's sister Hodierna, countess of Tripoli. During the assembly, Melisande also attempted to reconcile Hodierna with her estranged husband, Raymond II of Tripoli. The active presence of the queen at the conference underscored the fact that she still held great influence over events and would involve herself in state affairs with or without Baldwin III's permission.

In fact, her participation in the assembly led Baldwin III to adopt a new attitude towards his mother. Like his father Fulk before him, Baldwin came to realize that he needed his mother's good will and that of her supporters to retain his authority. Melisande's right to rule was undisputed among the clergy; furthermore, her sister Hodierna had become regent of Tripoli on Raymond II's death soon after the assembly had

❧▶ **Constance of Antioch** (1128–1164)

Co-ruler of Antioch. Born in 1128; deposed in 1163; died in 1164; daughter of Bohemond or Bohemund II, prince of Antioch (r. 1126–1130), and ***Alice of Jerusalem;*** *married Raymond I of Poitiers (d. 1149, son of William IX of Aquitaine), prince of Antioch, around 1140; married Reginald also known as Reynald of Chatillon (d. 1187), prince of Antioch (r. 1153–1160), in 1153; children: (first marriage) Bohemond or Bohemund III the Stammerer, prince of Antioch (r. 1163–1201);* ***Marie of Antioch*** *(d. 1183, who married Manuel I Comnenus);* ***Philippa of Antioch;*** *(second marriage)* ***Anne of Chatillon-Antioche*** *(c. 1155–c. 1185, who married Bela III, king of Hungary). Reynald's second wife was* **Stephania.**

been held, and her niece Constance was still sole ruler of Antioch. Thus, in 1153, mother and son were reconciled. From then on, Melisande and Baldwin III were named together in public documents as rulers of Jerusalem. She was involved in both internal affairs and foreign policy decisions and enjoyed again the power she had held before Baldwin's rebellion. Melisande was acclaimed as a pious and benevolent benefactor; she gave liberally to religious orders and hospitals, and gave generous endowments to the Church of the Holy Sepulcher. She was also an important patron of the arts, commissioning among other works a lavish Psalter, known as Queen Melisande's Psalter, now located in the British Museum.

In the winter of 1160, Melisande, age 55, suffered a stroke, after which she could no longer act as queen. She was nursed during her illness by her devoted sisters Hodierna and Joveta. Queen Melisande died on September 11, 1161, and was buried alongside her mother at the shrine of Our Lady of Josaphat in Jerusalem. Her son Baldwin III followed her in death only a few months later, in February 1162, and her younger son Amalric I succeeded his brother, ruling until his own death in 1174.

SOURCES:
Hamilton, Bernard. "Women in the Crusader States: Queens of Jerusalem" in *Medieval Women*. Edited by Derek Baker. Oxford: Basil Blackwell, 1978.
Prawer, J. *The Latin Kingdom of Jerusalem*. London: Thames and Hudson, 1972.

SUGGESTED READING:
Hallam, Elizabeth, ed. *Chronicles of the Crusades*. NY: Weidenfeld and Nicholson, 1989.
Payne, Robert. *The Dream and the Tomb: A History of the Crusades*. NY: Macmillan, 1984.

Laura York,
freelance writer in women's history and medieval history,
Riverside, California

Melisande (fl. 1200s)

*Princess of Antioch. Name variations: Melisinda. Flourished in the 1200s; daughter of *Isabella I of Jerusalem (d. 1205) and Aimery de Lusignan (brother of Guy de Lusignan) also known as Amalric II, king of Jerusalem (r. 1197–1205), king of Cyprus; married Bohemond or Bohemund IV the One Eyed, prince of Antioch (r. 1201–1216, 1219–1233); children: *Mary of Antioch (d. 1277). Bohemund IV was also the father of Bohemund V and Henry of Antioch.*

Mélisende or Melisende.

Variant of Melisande.

Mélisinda or Melisinde.

Variant of Melisande.

Melissanthi (c. 1907–c. 1991)

Greek poet whose writings evolved from an assumption of divine presence to an existentialist point of view. Name variations: Eve Chougia; Hebe Chougia; Ivi Chougia; Eve Koúyia or Kouyia; Hebe Koúyia; Ivi Koúyia; Ivi Skandalakes; Ivi Skandhalaki; Ivi Koughia-Skandalaki; Skandalákis. Born Ivi Koughia (also seen as Kouyia) in Athens, Greece, on April 7, 1907 (some sources cite 1910); died in Athens, Greece, on November 9, 1991 (some sources cite 1990); married Ioánnis (Giannes) Skandalákis, in 1932.

Won numerous prizes, including the Kostis Palamas Award, the National Poetry Award, and the Gold Cross of the Order of Deeds of Merit.

In her long, productive life, Greek poet Melissanthi explored a range of intellectual interests that were reflected in her work. She was born in Athens in 1907 into a family whose roots are in the Peloponnesus. Melissanthi studied foreign languages (English, French, and German), music and journalism, and also developed an interest in painting. After graduation, she began a career as a secondary schoolteacher of French and took on some journalistic assignments. In 1932, she married Ioánnis Skandalákis, a lawyer and politician from Lakonia who also authored a number of philosophical works.

Her talent for poetry had been discerned at an early age. She began to practice the translation of poetry with the encouragement of Octave Merlier of the French Institute of Athens. Melissanthi published her first collection of poems, *Insect Voices*, in 1930. The next year, her *Prophecies* caused a sensation with a small but select group of readers, establishing her as the first Greek woman poet to explore in modern terms some of the metaphysical dimensions of human existence. Attracted to the psychology of Carl Jung, she was one of the first authors in Greece to accept the idea that many of the recurring images in her work were anchored in the realm of archetypes.

From 1930 through 1986, Melissanthi was remarkably productive, publishing fifteen books of verse, a book of criticism, two books of translations of foreign poets (Pierre Garnier and *Emily Dickinson), and two children's books. She also published translations of many other foreign authors including Claudel, Péguy, and Verlaine from the French, Rainer Maria Rilke and *Nelly Sachs from the German, and Durrell, Wilde, Yeats, and Eliot (*Mary Anne Evans) from the English. She translated the entire Longfellow *Song of Hiawatha* into Greek in manuscript form, although only fragments have been published to date. Robert Frost was among the modern American poets whose works appeared in her translations.

An essentially lyrical poet, Melissanthi underwent a religious crisis that led to a rethinking of her life and work. In the 1930s, when she was a member of a generation of writers who gave to Greece a profusion of poetic inspiration, her poems took on a deeper hue. Ending in a world war that would bring tragedy to the Greek people, that decade led to significant changes in Greek literature and brought to a close a long but exhausted tradition of expression. In her explorations of traditional classical concepts, Melissanthi attempted to substitute emotion and intuition for reason in her verse.

She won many awards and prizes starting in 1936, when her despairing *Return of the Prodigal* received the Athens Academy of Arts and Sciences Award for Poetry. Her poems have appeared in over two dozen anthologies in numerous foreign languages, and individual poems of Melissanthi's have been translated into English, French, German, Italian, Spanish, Swedish, Polish, Rumanian, Bulgarian, and Serbo-Croatian.

The publication of her collected poems in 1974 reaffirmed her important role in modern Greek poetic expression. A master of the art of translation, Melissanthi, writes Andréas Angelákis, "proves that translation can be re-creation," and her "existential agony and metaphysical interiority" are said to remain relevant; in one of Melissanthi's last works, *Itinerary* (1986), she lamented the loss of a sense of the sacred in the modern world, which she saw as destroyed by the march of utilitarian pragma-

tism. She did not, however, abandon all hope. "Learning again to see things and each other with the eyes of the poet," she noted, "man can perhaps restore the world to its original beauty and sanctity."

SOURCES:

Antzaka, Sophia. *He Pnevmatiki kai Poiitiki Poreia tis Melissanthis: Meleti.* Athens, Greece: Antinea, 1974.

Dalven, Rae, ed. and trans. *Modern Greek Poetry.* 2nd ed. NY: Russell & Russell, 1971.

Fríar, Kimon, ed. *Modern Greek Poetry.* NY: Simon and Schuster, 1973.

Gianos, Mary P., ed. *Introduction to Modern Greek Literature: An Anthology of Fiction, Drama, and Poetry.* Translations by Mary P. Gianos and Kimon Fríar. NY: Twayne, 1969.

Melissanthi. *Hailing the Ascending Morn: Selected Poems.* Translated and introduced by Maria Voelker-Kamainea. Athens, Greece: Prosperos, 1987.

———. *Nyexis: kai ekdoches.* Athens, Greece: "Prosperos," 1990.

"Melissanthi," in *Modern Poetry in Translation.* No. 34. Summer 1978, pp. 8–9.

Robinson, Christopher. "'Helen or Penelope?' Women Writers, Myth and the Problem of Gender Roles," in Peter Mackridge, ed. *Ancient Greek Myth in Modern Greek Poetry: Essays in Memory of C.A. Trypanis.* Portland, OR: Frank Cass, 1996, pp. 109–120.

Ta poiimata tis Melissanthis (1930–1974). Athens, Greece: Philon, 1975.

John Haag,
Associate Professor of History,
University of Georgia, Athens, Georgia

Melita or Melitta.

Variant of Melissa or Melusine.

Mellon, Harriot (c. 1777–1837).

See Burdett-Coutts, Angela for sidebar.

Mellon, Sarah Jane (1824–1909)

English actress. Born Sarah Jane Woolgar in 1824; died in 1909; married Alfred Mellon (leading violinist with the Royal Italian Opera in London and musical director at the Adelphi and Haymarket theaters), in 1858.

A versatile actress who could play comedy and tragedy, Sarah Jane Mellon first appeared on stage at Plymouth in 1836. In 1843, she began performing at the Adelphi and remained there for several years, most notably originating the part of Lemuel in Buckstone's *Flowers of the Forest* in 1847. She played Florizel in *Perdita* (1856), Ophelia in *Hamlet* (1857), Catherine Duval in *The Dead Heart* (1850), Mrs. Cratchit in *A Christmas Carol* (1860), Anne Chute in *The Colleen Brown* (1860), and Mrs. O'Kelly in *The Shaughraun*; she also created the part of Miss Sniffe in *A Bridal Tour* (1880). Mellon retired in 1883.

Melnik, Faina (b. 1945)

Ukrainian discus champion. Name variations: Myelnik. Born in June 1945.

Faina Melnik won the Olympic gold medal in the discus in Munich in 1972 with a throw of 66.62 meters. From 1971 to 1975, she was almost unbeatable, setting the record 11 times, from 64.22 meters to 70.50 meters. She first passed the 70-meter mark on August 20, 1975, in Zurich. Melnik won the European championships twice, in 1971 and 1974. In 1976 in the Montreal Olympics, she finished a disappointing fourth and never seemed to recapture her power.

Meloney, Marie (1878–1943)

American journalist and editor. Name variations: Mrs. William Brown Meloney; Marie Mattingly; Missie. Born Marie Mattingly in Bardstown, Kentucky, on December 8, 1878; died in Pawling, New York, on June 23, 1943; daughter of Cyprian Peter Mattingly (a physician) and Sarah Irwin Mattingly (1852–1934); educated privately by her mother who was editor of the Kentucky Magazine *and taught at Washington College for Girls; married William Brown Meloney (an editor on the New York* Sun*), in June 1904.*

A leading American journalist, Marie Meloney was editor of the Sunday magazine of the New York *Herald Tribune* and later of *This Week* magazine. When her early ambition, a career as a pianist, ended abruptly because of a disabling accident, Meloney joined the staff of the *Washington Post* as a reporter (1895), and then the Washington Bureau of the Denver *Post* (1897–99). Moving to New York, she worked briefly for the *World* (1900) before signing on with the *Sun* (1901–04). Following her marriage, she retired for ten years. She was named editor of the *Woman's Magazine* (1914–20), associate editor of *Everybody's* (1917–20), and editor of the *Delineator* (1921–26). In 1926, she became editor of the New York *Herald Tribune*'s Sunday magazine, and in 1935 was named editor of *This Week.*

Melpomene (fl. 1896)

One of the first female marathon runners. Flourished around 1896.

The original Olympic Games were first recorded in 776 BCE, although they may have begun as early as 1350 BCE, and were held in

honor of the god Zeus in Olympia, western Greece, every four years until the emperor Theodosius the Great ended the custom in 393 CE. Women were forbidden from participating or watching. In 1896, the modern Olympic Games were revived in Athens as an international competition for amateur athletes. Times had changed sufficiently in the intervening 15 centuries for the organizers to allow women to watch the games, but they were still forbidden from participating. One young woman, a Greek athlete known as Melpomene, decided to compete anyway.

The name by which she is known to history was not her real one (Melpomene was the muse of tragedy in Greek mythology, and the athlete most likely assumed the alias because her family disapproved of her plans), and nothing of her origins or later life has been traced. What is known is that prior to the start of the games she petitioned Olympic authorities for permission to compete in the marathon, which was to start in Marathon, Greece, and end with a final lap in the stadium in Athens. Denied entry because of her gender, she went to the competition dressed as a man and managed to blend in among the 24-odd male runners as the race began. Although it became evident early on that a woman had entered the race (in part because she ran slower than the men), she was not prevented from continuing. Some of the runners dropped out along the way. Melpomene was occasionally jeered by spectators, but kept going. Officials barred her from entering the stadium for the final lap, so she completed the marathon by circling the outside of the stadium, finishing in four and a half hours. The first women's athletic events were introduced at the 1928 summer Olympics in Amsterdam. Now, over a hundred years after she ran, women marathon runners regularly post times several hours faster than Melpomene's.

SOURCES:

Grace and Glory: A Century of Women in the Olympics. Chicago: Triumph Books, 1996.

Randall, David. *Great Sporting Eccentrics.* NY: Richardson Steirman & Black, 1988.

Grant Eldridge,
freelance writer, Pontiac, Michigan

Melusina or Melusine.

Variant of Melisande or Melisenda.

Memphis Minnie (1897–1973).

See Douglas, Lizzie.

Menchik, Vera (1906–1944)

Russian-born Czech-British chess player, who reigned as the women's world champion from 1927 until her death in a German bombing attack during World War II. Name variations: Mencik; Vera Mencikova or Věra Menčíková; Vera Menchik-Stevenson; Vera Stevenson; Mrs. R.H.S. Stevenson. Born Vera Francevna Menchiková in Moscow on February 16, 1906; died in Kent, England, on June 27, 1944; had a Czech father and British mother; sister of Olga; married R.H.S. Stevenson (secretary of the British Chess Federation), in 1937 (died 1943).

Born in Russia in 1906 to a Czech father and a British mother, Vera Menchik moved in 1921 with her parents to Great Britain; the country that was to be her home. By this time, her remarkable abilities as a chess player had already been noted. Soon after their arrival, she won the British girls' championship. Her remarkable aptitude for chess was greatly enhanced by her coach, the Hungarian grandmaster Geza Maroczy, who had also immigrated to England as a result of the postwar chaos in Central Europe. Menchik lived near Maroczy's home in Hastings and had the benefit of learning and receiving encouragement from a virtuoso chess player rather than having to rely on the much more modest talents found at most local chess clubs. Under Maroczy's tutelage, Menchik soon entered a completely different class of chess playing than other gifted young players.

In 1927, the International Federation of Chess (FIDE) established the first world championship for women. This was held in London at the same time as the first international team championship, the first of many Chess Olympiads to come. By scoring 10 wins and 1 draw in 11 games, the 21-year-old Menchik won the championship effortlessly, thus becoming the first women's world chess champion. From then on, she went on to win every women's world championship until her death: Hamburg (1930), 7 points out of 8 games; Prague (1931), 8 of 8; Folkestone (1933), 14 of 14; Warsaw (1935), 9 of 9; Stockholm (1937), 14 of 14; and Buenos Aires (1939), 18 of 19. In these seven championship matches, Menchik maintained an amazing level of superior chess skill, losing only 1 game out of the total of 83 games played.

Soon after she became the women's world champion, Menchik began to play against some of the game's most eminent male players. In 1928, she participated in a Masters Tournament in Scarborough, achieving a 50% score among men and prompting a newspaper to comment: "Of all the sensational aspects of this event, the greatest was Vera Menchik's presence." Over the next decade, while winning the international women's championships, she also played and de-

Postage stamp from the Czech Republic honoring Vera Menchik.

feated many of the game's greatest players, all of whom were men. Among them were Edgar Colle, Dr. Max Euwe, Sultan Khan, Karel Opocensky, Samuel Reshevsky, Sir George Thomas, and Frederick Yates. From Menchik's earliest years as the women's champion, it proved to be unwise for great male chess players to underestimate her abilities.

At the 1929 Karlsbad International Tournament, a prestigious event that drew such giants of the game as José Capablanca, Aron Nimzowitsch, and Savielly Tartakower, Menchik was at first dismissed as a lightweight, a "young girl" who could not possibly compete with seasoned chess masters. Viennese master Albert Becker jokingly suggested that if anyone lost to her they would be inducted into an unlikely organization he called the Vera Menchik Club. Becker was soon defeated by Menchik at Karlsbad, effectively becoming the charter member of the Vera Menchik Club, which would grow into a sizeable entity. Even Dr. Max Euwe, a superb player who was to become a world champion, eventually became a "double member" of Vera's club.

In the early 1930s, Menchik proved to be a formidable adversary to male chess masters. At the Ramsgate competition in 1929, she finished just behind the powerful player Akiba Rubinstein, and one-half point behind the renowned Cuban player José Capablanca. At the same tournament, she finished ahead of both her

coach Geza Maroczy and the celebrated George Koltanowski. In other tournaments with the best male players in the game, she finished second in London (1932 and 1934), third in Maribor (1934), third in Great Yarmouth (1935), and third in Montevideo (1939). Although Capablanca defeated her a total of nine times, contemporary chess enthusiasts were impressed by the quality of Menchik's playing against the world champion. Some chess writers described her style as that of "a very scientific player," but also praised her ability to recognize the necessity of using new ideas when the situation called for a touch of innovation.

Chess remained largely a male preserve in the 1930s, even though Menchik's achievements called into question some sexist assumptions. Grandmaster Alexander Alekhine continued to display traces of the widespread prejudice against women in chess held by the game's leading players when he commented: "Vera Menchik is an extremely capable chess player; if she continues her work and training, she will graduate from her current status as an average master and become a first-class International Master." Even he, who was quite aware of Menchik's abilities, could not quite conceive of the idea that one day chess would have a woman grandmaster. Indeed, the title of woman's grandmaster would not be introduced to the game until 1977. It is possible that Alekhine's prejudices were a reflection of

his overall political and social views, which drew him into throwing his lot with the Nazis during World War II. Disgraced after the war, he escaped to Spain and then Portugal, where he died in 1946.

In the Soviet Union, a more liberal attitude toward women in the game of chess appeared to have taken root in the 1930s. By the mid-1920s, only a few years after Menchik's departure from Russia, women's chess had become an activity that was both highly organized and encouraged by the new Soviet regime. In 1931, the National Congress of the Communist Party went so far as to decree a new level of support for women's chess as a state-approved activity, a directive that took concrete form in 1932 when a Soviet women's championship was officially created. Menchik's visit to Moscow in 1935 gave a powerful boost to the already thriving arena of Soviet women's chess. She was enthusiastically received throughout her stay, and after her departure it became clear that women's chess had become a permanent feature of the world of Soviet sport.

In 1934 and 1937, Menchik put her women's championship title at stake in unofficially arranged individual matches with her most serious challenger, the outstanding German player **Sonja Graf**. On both occasions, Menchik defeated Graf decisively. (Oddly enough, both women, although they continued to play under their maiden names, would marry men named Stevenson, creating a situation whereby two Mrs. Stevensons vied for top place in women's chess.) These matches decisively settled the question of who was the leading woman in world chess, even though some controversy remained as to whether or not the games had been official FIDE events or merely off-the-record private matches.

Until recently, chess historians have largely neglected women's role in the game, which is still an almost exclusively male domain. Opinions as to the place Vera Menchik holds in the history of chess vary considerably, and a consensus has yet to be established. Her death in wartime ended her life in mid-career, and it will never be known how much better a player she might have become had she lived another three or four decades. Nathan Divinsky has raised questions about the quality of her performance in men's tournaments in the 1930s, in which she participated as the first woman in history invited to compete against male players. Although she achieved a number of "fine wins" over such world-class players as Euwe, Reshevsky, and Sultan Khan, Divinsky has written that these can only be seen as "modest overall results," and he goes on to suggest that Menchik's best result was the third place she achieved at Maribor in 1934, where she finished ahead of Grandmaster Rudolf Spielmann. Some chess historians have minimized Menchik's 1942 victory over Jacques Mieses, arguing that Mieses, who was a brilliant but also at times uneven player, was 77 years old at the time. Despite these caveats, it was obvious to contemporary professionals and lay people alike that Menchik was a chess player of formidable talent, tenacity, and judgment.

Although she had been born in Russia, Menchik became solidly British in her values and loyalties over the years. In 1937, she married R.H.S. Stevenson, a major figure in the national chess scene as secretary of the British Chess Federation, who died in 1943. Both Vera's mother and her sister **Olga** continued to live in Britain, and as the tide of World War II swung in favor of the Allies, they and Vera began to look ahead to times of peace when she could once more concentrate fully on chess, which included participating in international tournaments. This hope would not be realized. On June 27, 1944, Vera Menchik, her sister Olga and her mother were all killed in a German air raid on Kent. The postal administration of the Czech Republic issued a commemorative postage stamp for Věra Menčíková on February 14, 1996, to coincide with celebrations honoring her on the 90th anniversary of her birth.

SOURCES:

Alekhine, Alexander. *Nazi Articles*. Edited by Ken Whyld. Caistor: Ken Whyld, 1986.

Brace, Edward R. *An Illustrated Dictionary of Chess*. NY: David McKay, 1977.

Bykova, E.I. *Vera Menchik*. Moscow, 1957.

Chernev, Irving, and Fred Reinfeld. *The Fireside Book of Chess*. NY: Simon and Schuster, 1976.

Crystal, David. *The Cambridge Biographical Encyclopedia*. 2nd ed. NY: Cambridge University Press, 1998.

Divinsky, Nathan. *The Chess Encyclopedia*. New York and Oxford: Facts on File, 1991.

Eales, Richard. *Chess: The History of a Game*. New York and Oxford: Facts on File, 1985.

Gizycki, Jerzy. *A History of Chess*. London: The Abbey Library, 1972.

Graham, John. *Women in Chess: Players in the Modern Age*. Jefferson, NC: McFarland, 1987.

Hartston, William. *The Kings of Chess: A History of Chess Traced Through the Lives of Its Greatest Players*. NY: Harper & Row, 1985.

Hooper, David, and Kenneth Whyld. *The Oxford Companion to Chess*. 2nd ed. NY: Oxford University Press, 1996.

"Mrs. Vera Stevenson," in *The Times* [London]. June 30, 1944, p. 7.

Schonberg, Harold C. *Grandmasters of Chess*. Rev. ed. NY: W.W. Norton, 1981.

Skinner, Leonard M. and Robert G.P. Verhoeven. *Alexander Alekhine's Chess Games, 1902–1946: 2543*

Games of the Former World Champion, Many Annotated by Alekhine, with 1868 Diagrams, Fully Indexed. Jefferson, NC: McFarland, 1998.

Winter, E.G., ed. *World Chess Champions.* Oxford and NY: Pergamon Press, 1981.

John Haag,
Associate Professor of History,
University of Georgia, Athens, Georgia

Menchú, Rigoberta (1959—)

Mayan indigenous-rights activist who won the 1992 Nobel Peace Prize. Name variations: Rigoberta Menchu; Rigoberta Menchú Tum or Menchú-Tum. Pronunciation: Ree-go-BER-ta Men-CHU. Born on January 9, 1959, in Chimel, Guatemala; daughter of Vicente Menchú (a peasant and political organizer) and Juana Tum (a peasant midwife and healer); married Ángel Canil also seen as Angel Camile, in January 1998; children: Mash Nahual J'a.

Overthrow of Arbenz government (1954); birth of Rigoberta Menchú (1959); great earthquake (February 1976); organization of CUC (1976–78); Panzós massacre (May 1978); torture and murder of Petrocinio Menchú Tum (September 1979); massacre at the Spanish embassy and death of Vicente Menchú (January 1980); torture and murder of Juana Tum (April 1980); Menchú's escape to Mexico (1980); first publication of Me llamo Rigoberta Menchú *(I, Rigoberta Menchú, 1983); brief arrest of Menchú on her return to Guatemala (1988); Menchú awarded the Nobel Peace Prize (October 16, 1992); Peace Prize conferred (December 10, 1992); Menchú heads United Nations' Decade of Indigenous Peoples (1993—).*

Born on January 9, 1959, in Chimel near San Miguel Uspantán, El Quiché province, Guatemala, Rigoberta Menchú survived poverty and violent oppression to win the Nobel Peace Prize in 1992. Her parents, Vicente Menchú and **Juana Tum**, were Mayan peasants. Most of the information about her childhood comes from Rigoberta's reminiscences, compiled and organized by Venezuelan anthropologist **Elisabeth Burgos-Debray** and published in 1983 as *I, Rigoberta Menchú: An Indian Woman in Guatemala.* Although widely read and admired, the memoir also provoked controversy after the 1999 publication of a book by anthropologist David Stoll which asserted that Menchú exaggerated and even fabricated certain events.

Her obscure birth occurred five years after one of the most traumatic events in Guatemalan history, the 1954 coup that overthrew the left-leaning government of Jacobo Arbenz Guzmán. Arbenz's populist policies included agrarian re-form and higher agricultural wages for the peasantry. Such changes threatened the Guatemalan elite and foreign corporations such as the U.S.-owned United Fruit Company, which had vast land holdings in the country. Pressure from United Fruit and fear that communist influence was spreading among Arbenz supporters led the Eisenhower administration to intervene. In May 1954, a C.I.A.-backed force invaded from Honduras and by late June had forced Arbenz from power. Colonel Carlos Castillo Armas, a long-time Arbenz adversary and leader of the invasion, became president of Guatemala and quickly set about to undo the Arbenz reforms. This clearly harmed peasants like Menchú's parents because Castillo Armas eliminated the agrarian reform program, outlawed peasant organizations, and took the vote away from illiterates, including most of the country's indigenous population. The army arrested and briefly held her father Vicente after the 1954 coup, as it waged a campaign of intimidation against everyone suspected of being a peasant activist.

Thus Rigoberta, who had five older brothers and sisters, was born at a time when peasant conditions had worsened and social tensions within Guatemala intensified. Along with other members of the community, her parents tried to clear and farm land in the mountains of western Guatemala. They grew corn and beans, raised pigs and chickens, and supplemented their diet with foods they gathered from the tropical forest. They took their beans down the mountain trail to San Miguel Uspantán to market so they could buy soap, salt, and chiles. According to Menchú, her parents had no legal title to the lands and lived under constant fear that through the corrupt courts or by outright violence, mining corporations and cattle ranchers would dispossess them. Yet the Mayas considered the land sacred, an essential link to nature, making them even more determined to resist such attacks. Rigoberta's father also waged a long legal battle with a relative over land, a fact missing from her account.

Menchú's life in the mountains was geographically, culturally, and ethnically isolated. No roads or public transportation linked her home to the outside world. Only a difficult trail, traveled by people on foot and by pack animals, gave access to her community. All members of the community were Quiché Mayas, who found it difficult to communicate with those who spoke any of the other 20 or so Mayan dialects. Almost no one knew Spanish or how to read and write, which separated them from the Guatemalan elite and middle class. So did their Mayan culture. When Rigoberta was born, her

community promised to teach her, as it did with all children, "to keep the secrets of our people, so that our culture and customs will be preserved." She learned to keep the community's traditional religious rituals secret, especially from the Catholic missionaries. Menchú related that her father opposed her desire to learn to read. He reportedly believed that education destroyed Mayan communities because those who became literate moved off to the cities. In their desire to better themselves, they abandoned their culture and became *ladinos,* aping the Western, capitalist urban culture. Nonetheless, she studied with distinction for several years at schools operated by Belgian nuns from the Order of the Sacred Family.

Menchú also claims she went with her family to work on the coastal cotton and coffee *fincas* (plantations). Ladino labor recruiters hauled them, crammed into the back of a big, tarpaulin-covered truck. Compared to the relatively free life in the mountains, *finca* work was awful, something peasants endured only out of desperation for the meager wages. One of the tragedies of Mayan peasant life was the fact that even when they managed to carve a small farm out of marginal mountainous land, such agriculture rarely provided enough food and income to support the family. Nor was the farm big enough to employ the whole family on a year-round basis. To survive, they had to go to the *fincas.* The plantation owners profited from migrant workers such as Menchú. Because the peasants supported themselves part of the year in the mountains, the owners only had to provide food and a small wage for the time Rigoberta and her family were at the *finca.* And the finca owner and his overseers tried to hold the wages to a minimum.

As an adult, Menchú recalled that when she was eight years old, she began working full days picking coffee and cotton. One of her older brothers, Felipe, died from pesticide poisoning when the foreman put the workers back into the coffee field shortly after it had been sprayed. Another season working on the *fincas* brought the death of her little brother Nicolas, weak from disease and malnutrition (an allegation apparently not borne out by the facts); at the time Rigoberta's father was working on another *finca.* Menchú claims that her mother Juana had no money to pay for a funeral for the small child, and the overseer refused to let them take time off work to bury him. When the family defied him and had a traditional funeral anyway, he sent them packing without any wages. They had to borrow money to get back to the mountains. Of the experience, Menchú commented, "I remember it with enormous hatred. That hatred has stayed with me until today."

Despite Mayan attempts to preserve their culture, work on the fincas was socially disruptive. At the plantations, Rigoberta and her family usually found themselves housed in large sheds with workers who spoke other dialects and with whom they felt little cultural affinity. Sometimes her father went to another plantation to work, leaving her mother to do *finca* labor and take care of the children at the same time. This left them with little protection against unattached young males, many of whom had been drafted for a stint in the Guatemalan army and, at the end of their service, returned to life among the Mayas, bringing with them vices and violence learned in the military. Although Menchú apparently did not personally suffer such abuse, ex-soldiers sexually abused girls on the *fincas,* and prostitution was also a problem. Some workers succumbed to alcohol. Rigoberta's father sometimes drank up the family's scanty earnings at the cantina on the plantation.

When she turned ten years old, Rigoberta passed through the Mayan rituals that symbolized her passage into adulthood. Two years later, her parents gave her some animals to care for: a lamb, a pig, and two chickens. A Catholic priest who occasionally visited the village selected her as a catechist. She helped teach the villagers and organize them as part of Catholic Action, a social assistance program designed by left-leaning clergy to organize the peasantry. (Her success at school belies her assertion that at the time she spoke only Quiché, could not read or write, and had little knowledge of the world outside her community and the *fincas.*) As she assumed additional responsibilities, she also became increasingly conscious of the social and political tensions that weighed down on her community in the early 1970s. The main conflict was over land, although according to critics, Menchú's published recollections are misleading. She reported that large landholders in the region tried to claim the community's lands and that her father Vicente led village efforts to secure legal title to them and fend off the landholders. He allegedly gathered scarce funds from the community to pay fees required by the National Institute for Agrarian Transformation and secured official documents. Unfortunately neither he nor the other villagers knew Spanish or could read the papers they had signed. In reality, however, most of the family's legal troubles sprang from a long-festering land dispute with some of her mother's relatives.

Rigoberta Menchú

On one of his trips to Guatemala City, Vicente Menchú took Rigoberta with him, giving her her first glimpse of the alien world of the capital. She returned to Guatemala City as a 13-year-old, this time to work as a maid. Menchú recounted the experience a decade later when she was more politically and socially aware, and thus it is impossible to know how she felt and understood at the time. Nonetheless, her description of those months is a poignant story of what countless Mayan girls have endured in the homes of the upper and middle class. Her employer despised the new servant girl, whom she considered dirty, stupid, and lazy. Menchú hated her in turn. Rigoberta, of course, had little experience in cooking, washing, and cleaning in urban conditions, and was fortunate that the family had another maid who trained her. The family fed its dog better than the two Mayan girls, however, and most of Menchú's wages went to buy clothing and shoes since her employer refused to let her dress as she would have in the mountains. When the woman fired the other servant following an argument, Rigoberta lost her confidant and felt increasingly isolated and unhappy. Eventually Menchú quit, despite the family's pleas to stay on.

Around the same time, she received word that her father had been arrested. Vicente had become ever more active in efforts to organize the Mayan peasantry to resist encroachments on community lands and indigenous culture. Some of the large landholders managed to have him incarcerated, and it took 14 months for his family and community to secure his release. Forced to deal with the Spanish-speaking bureaucracy, Menchú and the others found themselves at an awful disadvantage, and the cost of preparing depositions and other affidavits sorely taxed the community's resources. The experience, she noted afterward, led her to the decision that she must learn Spanish (a curious assertion in light of her earlier education); otherwise she could not defend herself and her people against their enemies. She also came to see Spanish as crucial to helping the various Mayan groups communicate with each other, as their dialects were not mutually intelligible. Thus, learning Spanish ironically became for Menchú a way of preserving Mayan culture: she understood that the indigenous groups needed to unite in order to protect their interests, and such cooperation would only be possible through the common language of Spanish.

Rigoberta and her family found themselves drawn ever more deeply into the turmoil and brutality that engulfed Guatemala and Central American during the 1970s. Leftist guerrillas fought to seize power in El Salvador, Nicaragua, and Guatemala, drawing support from popular discontent with the abuse of power by conservative elites and the military. The U.S. government supported the regimes in power, despite their sometimes brutal and oppressive records, as part of its Cold War strategy to check the spread of communist influence in the hemisphere. In Guatemala, however, the troubles also reflected a growing political awareness on the part of the urban lower class and the peasantry, who began to organize themselves. To make matters worse, the great earthquake of 1976 left hundreds of thousands of the poor homeless, swelling social distress and class and ethnic antagonism. In the mid-1970s, Vicente Menchú became an organizer for the Committee of Peasant Unity (Comité de Unidad Campesina or CUC), and in 1979 Rigoberta also joined it, partly because of her father's influence and partly because of the Committee's links to Catholic Action. With primarily Indian leadership, the CUC carried out a well-organized demonstration in the capital on May 1, 1978. For the first time, the Mayas had a political voice through CUC. The Guatemalan regime quickly branded the CUC as a subversive organization, especially when it began cooperating with the labor unions. The military and death squads targeted CUC activists for assassination. In May 1978, at Panzós, the army turned even more homicidal: it massacred over a hundred Kekchí Indians and wounded several hundred more who were protesting against forced removal from lands they had been farming. According to political observer **Susanne Jonas**, the Panzós killings marked "a clear manifestation of the army's view of the Indian population as 'subversive.'"

As the long-festering civil war grew bloodier, it brought tragedy for Rigoberta and her family. On September 9, 1979, the military snatched her 16-year-old brother Petrocinio from the village. This was likely in retaliation for the family's participation in the occupation of the Guatemalan congress building. At any rate, for two weeks they tortured him. Then they took his living but devastated body to Chajul, along with several other similarly tortured prisoners. In *I, Rigoberta*, Menchú tells of witnessing her brother's death on September 23, when the military poured gasoline on the captives and set them on fire. Some have questioned whether Rigoberta was really present at Chajul and whether her details about Petrocinio's murder are accurate, but whatever the case, Petrocinio's death did not intimidate the Menchús into passivity. Her father continued his work with CUC and, according to Menchú, he also joined the guerrillas. He was one of the demonstrators who, on January 31, 1980, peacefully occupied the Spanish embassy in Guatemala City. They petitioned the Spanish ambassador to press for an investigation into the atrocities the government was committing against the Mayas in the provinces of El Quiché, Huehuetenango, and San Marcos. Although the ambassador demanded that the Guatemalan government allow him to deal peacefully with the demonstration, police and military forces besieged the embassy, set the building on fire with incendiary devices, and killed all the protesters but one. The next day, Vicente Menchú was kidnapped from his hospital bed and murdered, a martyr to the indigenous cause like those who had died in the embassy flames.

While CUC organized a vast Indian and ladino strike that idled the coffee and cotton plantations in the spring of 1980, government security forces targeted Rigoberta and her mother Juana, a midwife and healer. They seized Juana on April 19 and raped and tortured her for days. Then they tied her to a tree and allowed her to die in great agony from the infected, putrefying wounds. Rigoberta and her brothers could do nothing. Certain death awaited them if they tried to rescue her. More politicized because of the

murders of her family, Menchú became one of the leading figures in the January 31 Popular Front, which commemorated the massacre at the Spanish embassy. She was determined to continue the fight for indigenous rights, and the Front also commemorated her father's death. Of him, she said, "I'd say he was a complete man in human terms," a moving testament to his years of struggle against poverty and oppression.

With the murders of her brother, father, and mother and Rigoberta's own activism, her life was also at great risk. Security forces nearly seized her in Huehuetenango. Her health drained by anxiety and an ulcer, she found temporary refuge working at a convent in Guatemala City. Worried that the nuns might discover her identity, she soon decided to leave the country, although two of her sisters took up arms with the guerrillas. Supporters managed to fly Menchú out of Guatemala into exile in Mexico in 1980. "The pain never ceased," she said: "my mother, another of my brothers, a nephew, my sister-in-law, each time was a dramatic discovery. I could have gone to the fight with the guerrillas; however, I opted for exile, and in Mexico I decided to give everything for peace."

In Mexico, Bishop Samuel Ruiz helped her travel to San Cristobal de las Casas in the state of Chiapas, where two of Rigoberta's sisters were living in the refugee camps of Guatemalans who had fled for their lives across the border. Working hard to improve her Spanish, she became a spokesperson in exile for the January 31 Popular Front and a representative of CUC. Soon she attracted the attention of human-rights organizations, European leftists, and others trying to support the opponents of the Guatemalan regime. In January 1982, she flew to Paris to meet with European groups opposed to the military dictatorship. A Canadian supporter introduced her to anthropologist Elisabeth Burgos-Debray, and Arturo Taracena, a CUC activist, encouraged the two to compile an account of Menchú's life. She was only 23 at the time, yet Burgos-Debray recalled, "Her youthful air soon faded when she had to talk about the dramatic events that had overtaken her family. When she talked about that, you could see the suffering in her eyes, they lost their youthful sparkle and became the eyes of a mature woman who has known what it means to suffer." Even so, Menchú could not bring herself to discuss some episodes, such as the emotionally devastating months following her mother's murder.

The publication of *I, Rigoberta Menchú* made her an international figure. It increased her visibility as a spokesperson for the oppressed of Guatemala and indigenous peoples. Writes **Alice Brittin**, "henceforth, Rigoberta would be recognized as the 'voice' of the poor and disenfranchised peoples of Latin America." In 1983, the United Nations invited her to participate in its activities related to human rights, especially its conferences that dealt with the protection of ethnic minorities. A Spanish director made a documentary about her. Meanwhile, some U.S. conservatives criticized her narrative as propaganda manipulated by international leftists. And the violence in Guatemala continued. By 1985, 30 years of civil war had claimed, by some estimates, 100,000 lives, plus another 40,000 who had simply disappeared and were presumed dead.

Menchú's international stature made her an ever more inconvenient and embarrassing foe for the Guatemalan regime. Rigoberta returned to Guatemala for a short visit in 1986 and again in 1988. On the latter occasion, security forces arrested her and refused to release her until she requested amnesty under a peace program offered to the guerrillas. The government tried to undercut her nomination for the Nobel Peace Prize by advancing its own candidate, **Elisa Molina de Stahl**, a wealthy *ladina*. By that time, however, Menchú enjoyed broad popular support within Guatemala, and Adolfo Pérez Esquivel and Bishop Desmond Tutu, both Peace Prize winners, pushed her nomination. She survived three attempts on her life while in Guatemala awaiting the Nobel decision. On October 16, 1992, the Nobel committee awarded her the Peace Prize "in recognition of her work for social justice and ethnocultural reconciliation based on respect for the rights of indigenous peoples." It also commended her decision to seek peaceful solutions despite the violence inflicted upon her family and her people. News of the award brought jubilation to the Mayan majority in Guatemala and grudging congratulations from President Jorge Serrano.

With funds from the prize and financial support from international organizations, Menchú established the Rigoberta Menchú Foundation, purposely headquartering it in Guatemala as a symbol of her peaceful campaign for ethnic reconciliation. One of her chief goals has been the return of Mayan refugees from southern Mexico to their homelands in Guatemala. She successfully campaigned for the United Nations to designate 1993 the Year of the Indigenous Peoples, and the U.N. named her its Good Will Ambassador. Intelligent but largely self-taught, she has received a number of honorary doctorates, and indigenous peoples throughout the hemisphere

seek her advice and support for their causes. She is married to Ángel Canil and has a son, Mash Nahual J'a. In Guatemala, guerrilla and government representatives signed an agreement on December 29, 1996, to end the civil war. Meanwhile, Menchú's struggle for peace and ethnic understanding has continued, a fight that, she says, "purifies and shapes the future."

SOURCES:

Black, George. *Garrison Guatemala*. London: Zed Books, 1984.

Brittin, Alice A. "Close Encounters of the Third World Kind: Rigoberta Menchú and Elisabeth Burgos' *Me llamo Rigoberta Menchú*," in *Latin American Perspectives*. Vol. 22, no. 4. Fall 1995, pp. 100–114.

Jonas, Susanne. *The Battle for Guatemala: Rebels, Death Squads, and U.S. Power*. Boulder, CO: Westview Press, 1991.

Menchú, Rigoberta. *I, Rigoberta Menchú: An Indian Woman in Guatemala*. NY: Verso, 1984.

Minà, Gianni. *Un continente desaparecido*. Mexico City: Editorial Diana, 1996.

Rohter, Larry. "Noble Winner Accused of Stretching Truth in Her Autobiography," in *The New York Times*. December 15, 1998.

Stoll, David. *Rigoberta Menchú and the Story of All Poor Guatemalans*. Boulder, CO: Westview Press, 1999.

SUGGESTED READING:

Menchú, Rigoberta. *Crossing Borders: An Autobiography*. NY: Verso, 1998.

Kendall W. Brown,
Professor of History, Brigham Young University, Provo, Utah

Mencia de Haro (d. 1270)

Queen of Portugal. Died in 1270; daughter of Diego Lopez, count of Vizcaya; married Sancho II (1207–1248), king of Portugal (r. 1223–1248), around 1246.

Mendelssohn, Dorothea

(1764–1839)

German-Jewish-born salonnière and writer who played an important role in the intellectual life of Berlin during a crucial stage in both European history and Jewish emancipation. Name variations: Brendel Mendelssohn; Beniken Mendelssohn; Caroline Veit or Madame Veit; Dorothea Schlegel; Dorothea von Schlegel; Dorothea von Schlegel von Gottleben; Dorothea Mendelssohn Veit Schlegel. Born Brendel Mendelssohn in Berlin on October 24, 1764 (some sources cite 1763 or 1765); died in Frankfurt am Main on August 3, 1839; daughter of Moses Mendelssohn (1729–1786, a Jewish philosopher) and Fromet Gugenheim Mendelssohn; sister of Henriette Mendelssohn (1768–1831), Rebekah Mendelssohn (born Reikel, later called Recha), Sara Mendelssohn, Sisa Mendelssohn, Abraham Mendelssohn, Hayyim Mendelssohn, Joseph Mendelssohn, Mendel Abraham Mendelssohn, and Nathan Mendelssohn; married Simon Veit (separated 1797, divorced); married Friedrich von Schlegel (1772–1829, a Romantic theorist), in 1804; children: (first marriage) two daughters, both of whom died in infancy; sons, Johannes Veit; Philipp Veit.

Born in the final decades of the *Aufklärung*, Germany's version of the Enlightenment, Dorothea Mendelssohn would both witness and play an active role in the great transformations that forever changed the course of European history. She saw the eclipse of the Age of Reason; participated in the rapid emancipation and acculturation of Germany's Jewish elite; and, as the host of one of Berlin's most brilliant salons, situated herself at the very center of the emerging Romantic movement. Along with many of her contemporaries, Mendelssohn was both inspired and shocked by the energies unleashed by the French Revolution and Napoleon Bonaparte.

She was born Brendel Mendelssohn in 1764, the eldest daughter of the Jewish philosopher Moses Mendelssohn (1729–1786). An intellectually gifted girl, she received an excellent education. Her father—whose odyssey had taken him from the ghetto of Dessau where he was born the son of a poor Torah scribe to a position of acclaim as one of the world's greatest philosophers of religion—eloquently argued that both as a people and as individuals Jews deserved the full rights and burdens of modern citizenship. Dorothea's mother **Fromet Gugenheim Mendelssohn** had illustrious forebears including Jewish financiers of both the Prussian and Viennese courts; one of Fromet's ancestors was *Glückel of Hameln. The Mendelssohn family reflected this desire to participate in all aspects of a confidently advancing civilization. As citizens of Berlin whose people had barely emerged from the restrictions imposed on Jews in medieval ghettoes, the Mendelssohn children became active players in the transformation of Prussian, and indeed all of German, intellectual and cultural life.

In 1784, Brendel Mendelssohn entered into an approved union by marrying the banker Simon Veit. Refusing to fall into a role of passive domesticity, Dorothea, as she now called herself, soon tired of her daily routine and began to search for ways to expand her intellectual horizons. Upper-class Berlin in the early 1790s was in the grip of an *Aufbruchstimmung*—an expectant, even electrical mood of change. New ideas were the order of the day in politics, the arts,

and literature. It was not in the homes of the old aristocracy or higher bureaucracy that these currents were discussed and debated. Rather, it was the salons of Berlin, the elegant drawing rooms of the city's newly emancipated Jewish bourgeoisie, that provided the locations for encounters between Jews and gentiles, mostly young men and women who sought to better understand the complex times in which they lived.

In the intellectually and socially free atmosphere of these salons, presided over by Jewish women such as *Henriette Herz and *Rahel Varnhagen, Dorothea quickly discovered that she was more than able to hold her own with some of the best minds of the day. In the absence of physical beauty, her intelligence, passionate nature, and educational background made an attractive figure. She initially founded a reading society, and this soon evolved into a full-scale literary salon where restless young Prussian nobles met equally restless daughters of wealthy Berlin Jewish families. In this common meeting ground, intellectual, cultural and erotic energies fused to create a powerful new spirit of inquiry and innovation. The suffocating class and caste system of the Prussian monarchy seemed to melt away in what historian **Deborah Hertz** has characterized as an atmosphere of "relaxed sensuality." Young Jewish women saw in these salons "a new social universe," separate from an often restricted bourgeois world, where they could discuss the important issues of the day with interesting young males, mostly Christian, who worked as civil servants, writers, tutors, professors, and preachers, among other professions. Romantic attachments often resulted, and a significant number of Jewish women, including Dorothea, divorced their Jewish husbands. What followed in most of these cases was marriage to a gentile spouse and, eventually, conversion to Christianity.

In 1798, Dorothea, then mistress of one of the most popular of Berlin's 14 salons, met and quickly fell in love with Friedrich von Schlegel (1772–1829), a man almost a decade her junior who was rapidly emerging as one of the leading theorists of the revolutionary new *Weltanschauung* of Romanticism. Ignoring the scandal her action provoked, in 1797 Dorothea left her husband and began living with her lover. In 1799, now divorced, she accompanied Friedrich to the city of Jena, where he and other writers (Johann Gottfried Fichte, F.W.J. Schelling, and the mystical poet Novalis) were feverishly creating a Romantic philosophy of art and life. From 1801 to 1804, the couple lived in Paris, a metropolis that remained the political and intellectual heart of

Western civilization. They were notorious throughout Europe for their affair which had begun as Dorothea's adultery. Friedrich wrote about it at length in his autobiographical erotic novel *Lucinde* (1799), which presents a case for the necessity of fusing sacred and profane varieties of love. Dorothea shared his beliefs, disdaining marriage as an absurd bourgeois impediment to human freedom. In addition to collaborating with Schlegel on a number of his literary projects during these years, in 1801 Dorothea published a novel of her own, *Florentin*, which although modeled after Johann Wolfgang von Goethe's *Wilhelm Meister* was nevertheless regarded by contemporary critics and readers as a work of considerable artistic substance. She was also strongly influenced by the literary developments of the day in France and in 1807 published her translation of *Germaine de Staël's *Corinne*.

In 1804, Dorothea and Friedrich married. At this time, she converted to Lutheranism, remarking to her friend the religious philosopher Friedrich Schleiermacher that unlike Judaism (which she had come to abhor and regard as backward and permeated with superstitions), Protestantism not only represented the religion of Jesus Christ but also embodied the spirit of the highest possible *Kultur,* that of contemporary Prussia and Germany. Soon, however, Dorothea and her husband found themselves among the many Romantic writers who were increasingly attracted to Roman Catholicism, and they became convinced that the only true faith was that centered in Rome. By now, Romanticism had evolved from a radical early phase, which enthusiastically supported the liberating spirit of the French Revolution, to the point where many former radicals, now aging and disillusioned by the events in France and elsewhere, felt that the only antidote to the illnesses of their day was to be found in venerable traditions, both secular and religious. In 1808 both Dorothea and Friedrich converted to Roman Catholicism, which they regarded as the only faith able to provide a safe harbor against the raging storms of modernity. Her conversion was deeply upsetting to her family. Dorothea was strongly rebuked by her sister Henriette and, for a time, was treated as a virtual pariah within the extended Mendelssohn family. Ironically, four years later, in 1812, Henriette too would convert to Catholicism, and in time brothers Abraham and Nathan would also leave Judaism for Christianity.

In 1809, Dorothea and Friedrich moved to Vienna, the nerve center of conservative Romanticism. While Schlegel worked at the court of Austria's emperor and edited the journals

Deutsches Museum and *Concordia,* Dorothea resumed her role as a salonnière, presiding over a brilliant assemblage of writers, artists, and politicians which included such luminaries of the day as ***Karoline Pichler** and Joseph von Eichendorff. In 1815, after earning the approbation of the conservative Habsburg court for his work at the Congress of Vienna, Friedrich von Schlegel was raised to the Austrian nobility as Friedrich von Schlegel von Gottleben, a title which also became part of his Jewish-born wife's name. He died in January 1829. Dorothea was rescued from a future of poverty by the intervention of her friend, Austrian chancellor Clemens von Metternich, who persuaded the emperor to authorize a lifelong pension for her. In 1830, she left Vienna for Frankfurt am Main to live with her son, the painter Philipp Veit. After a long life that both witnessed and influenced several epochs of European history, she died in Frankfurt am Main on August 3, 1839.

Berlin's salons flourished from around 1780 until 1806, when a new spirit emerged in Prussia as a result of its catastrophic military defeat by Napoleonic France. The disaster of 1806, which revealed not only the military weakness of the Prussian army and state but also the social backwardness of Prussia's semi-feudal society, ended the "frivolities" associated with the salons. Jewish salons now lost favor with the Berlin elite as a new spirit of German nationalism grew among the intellectual classes. In some cases, this nationalist concept of *Deutschtum* went so far as to call for exclusion of any further Jewish participation in the public life of the emerging German nation. Prussian-German patriotism was often defined in "Christian" terms, and for some this meant that private slurs and jokes directed against the Jewish bourgeoisie could be aired in public. Despite these disturbing trends, Prussia's Jews made great progress during this period. Among the most important innovations which made possible the integration of Jews into the dominant culture were the salons that had been presided over by women like Dorothea Mendelssohn.

SOURCES:

Altman, Alexander. *Moses Mendelssohn: A Biographical Study.* London and Portland, OR: Littman Library of Jewish Civilization, 1998.

Baron, Salo Wittmayer. *Die Judenfrage auf dem Wiener Kongress, auf Grund von zum Teil ungedruckten Quellen dargestellt.* Vienna: Löwit Verlag, 1920.

Behrens, Katja, ed. *Frauen der Romantik: Porträts in Briefen.* Frankfurt am Main: Insel Verlag, 1995.

———, ed. *Frauenbriefe der Romantik.* Frankfurt am Main: Insel Verlag, 1981.

Hargrave, Mary. *Some German Women and Their Salons.* London: T.W. Laurie, 1912.

Hensel, Sebastian. *The Mendelssohn Family (1729–1847) from Letters and Journals.* Translated by Carl Klingemann. 2nd revised ed. 2 vols. NY: Harper & Brothers, 1881.

Hertz, Deborah. *Jewish High Society in Old Regime Berlin.* New Haven, CT: Yale University Press, 1988.

———. "Salonieres and Literary Women in Late Eighteenth-Century Berlin," in *New German Critique.* No. 14. Spring 1978, pp. 97–108.

———. "Why Did the Christian Gentleman Assault the Jüdischer Elegant? Four Conversion Stories from Berlin, 1816–1825," in *Year Book of the Leo Baeck Institute.* Vol. 40, 1995, pp. 85–106.

Heyden-Rynsch, Verena von der. *Europäische Salons: Höhepunkte einer versunkenen weiblichen Kultur.* Munich: Artemis & Winkler Verlag, 1992.

Katz, Jacob. *Out of the Ghetto: The Social Background of Jewish Emancipation, 1770–1870.* NY: Schocken Books, 1978.

Meyer, Bertha. *Salon Sketches: Biographical Studies of Berlin Salons of the Enlightenment.* NY: Bloch, 1938.

Meyer, Michael A. *The Origins of the Modern Jew: Jewish Identity and European Culture in Germany, 1749–1824.* Detroit: Wayne State University Press, 1984.

———, et al., eds. *German-Jewish History in Modern Times, Volume 2: Emancipation and Acculturation 1780–1871.* NY: Columbia University Press, 1997.

Quennell, Peter, ed. *Affairs of the Mind: The Salon in Europe and America From the 18th to the 20th Century.* Washington, DC: New Republic Books, 1980.

Reissner, Hanns G. "Begegnung zwischen Deutschen und Juden im Zeichen der Romantik," in Hans Liebeschütz and Arnold Paucker, eds., *Das Judentum in der Deutschen Umwelt, 1800–1850.* Tübingen: J.C.B. Mohr (Paul Siebeck), 1977, pp. 325–357.

Stern, Carola. *"Ich möchte mir Flügel wünschen": Das Leben der Dorothea Schlegel.* Reinbek bei Hamburg: Rowohlt Verlag, 1990.

Varnhagen von Ense, Karl August. *Galerie von Bildnissen aus Rahel's Umgang und Briefwechsel.* 2 vols. Leipzig: Gebrüder Reichenbach, 1836.

John Haag,
Associate Professor of History,
University of Georgia, Athens, Georgia

Mendelssohn, Fanny (1805–1847).

See Mendelssohn-Hensel, Fanny.

Mendelssohn, Henriette

(1768–1831)

German-Jewish-born governess, teacher and Berlin society leader. Name variations: Henrietta Mendelssohn; Marie Mendelssohn. Born Yente Mendelssohn in Berlin in 1768; died in 1831; daughter of Moses Mendelssohn (1729–1786, a Jewish philosopher) and Fromet Gugenheim Mendelssohn; sister of Dorothea Mendelssohn (1764–1839); Rebekah Mendelssohn (born Reikel, later called Recha),

Sara Mendelssohn, Sisa Mendelssohn, Abraham Mendelssohn, Hayyim Mendelssohn, Joseph Mendelssohn, Mendel Abraham Mendelssohn, and Nathan Mendelssohn; never married.

Henriette Mendelssohn was born Yente Mendelssohn in Berlin in 1768, the youngest daughter of Moses and **Fromet Gugenheim Mendelssohn**. She changed her name to Henriette in adulthood. Henriette inherited her father's intellectual brilliance and moral sensitivity, as well as his physical deformity (spinal curvature). Determined to play an active role in society, and aware of the unlikelihood of marriage, Henriette Mendelssohn chose to become a teacher, moving first to Paris, where she served as a governess and teacher, and then to Vienna, where she was the director of a boarding school.

While in Paris, Mendelssohn established a salon that attracted most of that city's intellectual luminaries, including *****Madame de Staël**, Benjamin Constant, Spontini, and her sister *****Dorothea Mendelssohn** and Dorothea's lover—and later, husband—Friedrich von Schlegel. Henriette moved in the highest social circles, becoming tutor to the daughter of General Sebastiani. Although she had previously rebuked her sister Dorothea for abandoning Judaism for Roman Catholcism, in 1812, after the death of their mother Fromet, Henriette was baptized into the Roman Catholic Church, taking the name Marie. She died in 1831.

SOURCES:

Altmann, Alexander. *Moses Mendelssohn: A Biographical Study.* London and Portland, OR: Littman Library of Jewish Civilization, 1998.

Baron, Salo Wittmayer. *Die Judenfrage auf dem Wiener Kongress, auf Grund von zum Teil ungedruckten Quellen dargestellt.* Vienna: Löwit Verlag, 1920.

Hensel, Sebastian. *The Mendelssohn Family (1729–1847) from Letters and Journals.* Translated by Carl Klingemann. 2nd revised ed. 2 vols. NY: Harper & Brothers, 1881.

Varnhagen von Ense, Karl August. *Galerie von Bildnissen aus Rahel's Umgang und Briefwechsel.* 2 vols. Leipzig: Gebrüder Reichenbach, 1836.

John Haag,
Associate Professor of History,
University of Georgia, Athens, Georgia

Mendelssohn-Hensel, Fanny

(1805–1847)

German composer and performer whose works were increasingly performed and recorded in the late 20th century and whose playing and compositions have been compared favorably to those of her more famous brother Felix Mendelssohn. Name variations: Fanny Cäcilie; Fanny Hensel; Fanny Mendelssohn; Fanny Cäcilia Mendelssohn; Fanny Mendelssohn-Bartholdy. Born Cäcilie Mendelssohn in Hamburg, Germany, on November 14, 1805; died in Berlin on May 14, 1847; daughter of Abraham Mendelssohn (an international banker) and Lea (Salomon) Mendelssohn (a gifted amateur musician); married Wilhelm Hensel (a court painter), on October 3, 1829; children: one son, Sebastian (b. 1830).

Became Fanny Mendelssohn-Bartholdy, converting with her family from Judaism to Protestantism at age 11, the same year she wrote her first musical composition (1816); sponsored the first of her musical salons while still in her teens (1822); after her marriage, conducted large weekly musical salons which became highly influential in Berlin's musical and social circles; at age 40, despite her brother's opposition, announced her intention to publish her compositions (1846); had published some sixty of her several hundred compositions by the time of her death (1847).

The lives of Fanny Mendelssohn-Hensel and her brother Felix Mendelssohn provide a striking illustration of the way in which societal and familial expectations of appropriate behavior for women in the 19th century could impact even the wealthy and highly talented. Born only three years apart into a rich and cultured German-Jewish family, both sister and brother showed early an extraordinary aptitude for music which their parents encouraged. Yet while Felix gave his first public performance at age nine and quickly went on to a lauded and very public career as a composer and pianist, throughout her life Fanny was strongly discouraged by her family (including her brother) from performing in public or even publishing her numerous compositions.

The first of four children of Abraham and **Lea Salomon Mendelssohn**, Fanny Mendelssohn-Hensel was born in Hamburg, Germany, in 1805. Both her mother's and her father's sides of the family had grown wealthy as international bankers, and around 1811 the Mendelssohns moved to Berlin, where they spared no expense on their children's education; Fanny and her siblings were probably among the best educated children of their era. The product of the Enlightenment approach to learning, they began their lessons each day at dawn, reading Goethe and Shakespeare before moving on to science and drawing. As the two oldest children, Fanny and Felix were educated together, and developed a particularly close relationship which would remain central to both of their lives. Lea

Mendelssohn, who was a gifted musician, was the first to instruct them in music, and soon they were inventing games that centered on composing. Mendelssohn-Hensel wrote her first composition at age 11, in honor of her father's birthday. She proved to be a much more gifted pianist than Felix, but took great joy in his accomplishments and sought his opinion on virtually every topic. Later, when he left home to expand his musical horizons, she missed him desperately and wrote to him frequently; on her wedding day, she wrote:

> I am very composed, Dear Felix, and your picture is next to me, but as I write your name again and almost see you in person before my very eyes, I cry. . . . Actually I've always known that I could never experience anything that would remove you from my memory for even one-tenth of a moment. . . . Your love has provided me with an inner worth, and I will never stop holding myself in high esteem as long as you love me.

The early years of the 19th century saw the beginning of what would be called the Jewish Enlightenment, in which Jews slowly began to receive equal rights in Europe. (This eventual development would be due in no small part to the writings of Mendelssohn-Hensel's grandfather, the philosopher Moses Mendelssohn.) Jews were, however, under great pressure both to conform to the society around them and to convert to Christianity, particularly as they began moving in the higher (Christian) echelons of society. When Mendelssohn-Hensel was 11, her father had the members of his family baptized as Protestants, and they took the "Christian" name of Mendelssohn-Bartholdy. A devout and upright man, Abraham never fully rejected his Jewish heritage, and frequently emphasized the correlation between Judaism and Christianity; he made it clear to his children that the reason for their conversion was to offer them better opportunities. (Many members of the family, expressing their ambivalence about the necessity of converting, nonetheless refused to use the name "Bartholdy.") The wealth of the Mendelssohn family, as well as their status as newly converted Jews, caused them to adhere rigidly to the accepted notion of a woman's place in the world. Mendelssohn-Hensel's parents wanted her life to be shaped by the social conventions prescribed for women of her class. Had she been born in less prosperous circumstances, she might well have lived as *Clara Schumann did, performing on the concert stage and earning an income that supported first her father and then her husband; but the lack of any need for Mendelssohn-Hensel to earn income compounded the constraints placed on her by the fact that she was Jewish.

On October 3, 1829, Mendelssohn-Hensel married the court painter Wilhelm Hensel, in what would prove to be a successful and happy marriage. The couple moved into a house on the grounds of the large Mendelssohn complex, where they would remain their entire married life. Wilhelm always encouraged Mendelssohn-Hensel in her musical abilities, and wanted her to receive recognition for her composing; had she relied solely on his advice, she would almost certainly have published more of her music. However, the rest of her family, particularly her father and Felix, were adamantly opposed to the publication of her compositions because they felt it would demean the family name, and for a long time she acceded to their wishes. A year after the wedding, a son Sebastian was born, and Mendelssohn-Hensel had difficulties adjusting to her new roles as wife and mother. When she wrote to Felix that she no longer had enough time to devote to composition, he wrote back that if he had a child, its interests would come

Fanny
Mendels-
sohn-Hensel

first. To his credit, Felix did understand that composing was important to her, and voiced his concerns about his sister's feelings in letters to his friends.

As early as 1822, when she was only 17, Mendelssohn-Hensel had hosted a salon. (Her maternal great-aunt, **Sarah Itzig Levy**, had hosted a musical salon in Berlin for many decades; many of the musical manuscripts she gathered form a significant part of the collection now in the Singakademie Library.) In the late 18th and early 19th centuries, the salons offered women opportunities to exert considerable social and cultural power. In cultural centers like Berlin, London, Paris, and Vienna, women could determine the popular fashions in literature, music, and the arts by offering the settings in which such works were presented and discussed. Private but open to those who were invited, the salon was an acceptable place for women to display their abilities. In the years after her marriage, the salons of Mendelssohn-Hensel became an important outlet both for her and for her guests. According to one author: "The Sunday musicales provided a forum for Fanny's talents in which the Mendelssohns maintained their privacy, and Europe came to their living room." Of Mendelssohn-Hensel's playing, a visitor wrote to Felix, "Fanny . . . played fugues and passacaglias by memory with admirable accuracy."

In the beginning, her salons functioned as a weekly gathering of intimate friends. Gradually, however, they grew to include more than one hundred, then two hundred, people. Mendelssohn-Hensel decided who would perform, chose the music, selected the musicians, and rehearsed them. Guests at various times included violinist Joseph Joachim, Clara Schumann, composer Robert Schumann, and the soprano *Jenny Lind. Members of high society also vied for invitations, and there were sometimes as many as eight princesses in attendance. These concerts also gave Mendelssohn-Hensel free reign to produce and create special events, sometimes featuring whole choirs and orchestras, and she often performed her compositions. In 1833, she wrote cheerfully to Felix, "In general I'm making a great deal of music this winter and am extremely happy with it. My Sunday musicales are still brilliant."

The composing also continued, with a number of her compositions being played in public by her now-famous brother and even published under his name. In England, when Queen *Victoria complimented several of his piano pieces, he acknowledged some as the work of his sister.

Mendelssohn-Hensel wrote for voice and piano as well as string quartets, chorales and other religious works. She sent many of these pieces to Felix, once writing, "I want to ask your advice, although I'm perfectly capable of making such decisions when I'm alone." He occasionally criticized her for deviating from standard musical form, and although she admitted she might be wrong, she did not alter her work in response. Her harmonies were often unexpected, but in her mature works the style was distinct, particularly in its lyricism, and she was recognized by many as a talented composer.

> *P*erhaps for [your brother Felix] music will become a profession, while for you it will always remain but an ornament; never can and should it become the foundation of your existence and daily life.
>
> —**Abraham Mendelssohn in a letter to his daughter, Fanny**

Mendelssohn-Hensel had wanted all of her life to go to Italy, and had often thought that she would have gone there alone on a glorious, romantic adventure if she had been born a man. In 1839–40, in fulfillment of her wish, the Hensel family took a trip to Italy. The high point of the year was a six-month stay in Rome where they became part of the artistic circle clustered around the French painter Ingres. Meeting fellow artists, performing for them, and talking with them was a delight for both Fanny, the composer, and Wilhelm, the painter. Day after day, they enjoyed picnics in the countryside, explored the sights, and spent late evenings devoted to music and discussion. In Rome, Mendelssohn-Hensel enjoyed recognition as a talented composer and musician foremost, and as a woman second. Toward the end of what was perhaps the happiest period of her life, she wrote:

> It will cost us a hard struggle to leave Rome. I could not have believed that it would have made such a deep impression upon me. I must not conceal from myself that the atmosphere of admiration and homage in which I have lived may have something to do with it, for . . . I never was made so much of as I have been here, and that this is very pleasant nobody can deny.

It was probably in Rome that Mendelssohn-Hensel began to consider publishing her work, and Wilhelm Hensel no doubt played a crucial role in her decision. Although tolerant of the extremely close-knit family life of his in-laws, he also recognized the creative toll it took on his wife, who before this trip had never been physically separated from her family. Even

Mendelssohn-Hensel eventually accepted his observation that when Felix was around, her creativity seemed to diminish. Psychological independence could not take place, Wilhelm believed, until physical separation was achieved. That his observation apparently proved correct was, perhaps, the most important outcome of their trip to Rome. At age 40, Mendelssohn-Hensel decided to seek publication for her music, breaking out of the narrow confines that had been imposed on her for two decades. Writing to Felix, she nonetheless remained typically self-deprecating:

> Actually I wouldn't expect you to read this rubbish now, busy as you are, if I didn't have to tell you something. But since I know from the start that you won't like it, it's a bit awkward to get under way. So laugh at me or not, as you wish: I'm afraid of my brothers at age 40, as I was of Father at age 14—or, more aptly expressed, desirous of pleasing you and everyone I've loved throughout my life. And when I now know in advance that it won't be the case, I thus feel RATHER uncomfortable. In a word, I'm beginning to publish.

Collections of her work began to appear in 1846. Of her hundreds of compositions, only sixty were published before her life was suddenly cut short when she suffered a stroke and died on May 14, 1847. Mendelssohn-Hensel was only 42 years old, and her younger brother Felix, then at the apogee of his career as Europe's foremost composer, collapsed when he learned of her death and never recovered. He died a few months later.

The music of Fanny Mendelssohn-Hensel, appreciated by limited but enthusiastic audiences during the mid-19th century, was gradually forgotten for several reasons. The fact that she was a woman caused her works to be dismissed as "feminine." As well, her reputation at the time was closely linked with her brother's, and less than two decades after his death his compositions were also being labeled "feminine" by such composers as Richard Wagner, who wished to eradicate from German life such products of "Jewish" culture. As anti-Semitism grew, Felix Mendelssohn's compositions were played less and less frequently. For much of the 20th century, Mendelssohn-Hensel was known to history primarily as Felix's beloved and also talented sister. After World War II, however, the works of Felix Mendelssohn were rehabilitated. The works of his sister, safeguarded for generations by friends and family, were eventually preserved in good number as a collection of the Preussische Staatsbibliothek. From the later years of the 20th century on, they gradually have found new audiences, and Mendelssohn-Hensel's reputation has grown. Through modern performances and recordings, she has now achieved what her family so anxiously sought to avoid—a name as a truly fine and publicly recognized composer.

SOURCES:

Citron, Marcia J., ed. and trans. *The Letters of Fanny Hensel to Felix Mendelssohn.* Stuyvesant, NY: Pendragon, 1987.

Rothenberg, Sarah. "'This Far, But No Farther': Fanny Mendelssohn-Hensel's Unfinished Journey," in *The Musical Quarterly.* Vol. 77, no. 4. Winter 1993, pp. 689–708.

Sabean, David Warren. "Fanny and Felix Mendelssohn-Bartholdy and the Question of Incest," in *The Musical Quarterly.* Vol. 77, no. 4. Winter 1993, pp. 709–717.

Steinberg, Michael P. "Culture, Gender, and Music: A Forum on the Mendelssohn Family," in *The Musical Quarterly.* Vol. 77, no. 4. Winter 1993, pp. 648–683.

Todd, R. Larry, ed. *Mendelssohn and His World.* Princeton, NJ: Princeton University Press, 1991.

Toews, John E. "Memory and Gender in the Remaking of Fanny Mendelssohn's Musical Identity: The Chorale in Das Jahr," in *The Musical Quarterly.* Vol. 77, no. 4. Winter 1993, pp. 727–748.

Whalen, Meg Freeman. "Fanny Mendelssohn Hensel's Sunday Musicales," in *Women of Note Quarterly.* Vol. 2, no. 1. February 1994, pp. 9–20.

John Haag,
Associate Professor, University of Georgia, Athens, Georgia

Mendenhall, Dorothy Reed

(1874–1964)

American physician and pioneer in women's and children's health care. Born Dorothy Reed on September 22, 1874 (some sources cite 1875), in Columbus, Ohio; died on July 31, 1964, in Chester, Connecticut; daughter of William Pratt Reed (a shoe manufacturer) and Grace (Kimball) Reed; Smith College, B.L., 1895; Johns Hopkins Medical School, M.D., 1900; married Charles Elwood Mendenhall (a physics professor), on February 14, 1906; children: Margaret (b. 1907, died shortly after birth); Richard (1908–1910); Thomas Corwin (b. 1910); John Talcott (b. 1912).

Made first trip to Europe (1887); entered Smith College (1891); made important discovery in Hodgkin's disease research (c. 1901); joined staff of New York Babies Hospital (1903); moved to Wisconsin (c. 1906); joined faculty of University of Wisconsin–Madison (1914); became medical officer for U.S. Children's Bureau (1917); represented United States at International Child Welfare Conference (1919); conducted study of childbirth practices in United States and Denmark (1926–29).

Selected writings: Milk: The Indispensable Food for Children *(1918); (contributed six chapters)* Child Care and Child Welfare: Outlines for Study *(1921);* Midwifery in Denmark *(1929).*

Dorothy Reed Mendenhall made exceptional advances in the field of women's and children's medicine in an era when few of her gender were able to surmount the obstacles and prejudices toward women entering the scientific professions. Mendenhall was born in 1874 in Columbus, Ohio; her father, a shoe manufacturer, died when she was near the age of six. She was taught at home by her grandmother, spent summers with her mother's relatives in New York State, and often traveled to Europe. In her teen years, she was taught by a governess both at home and in Germany. Planning to become a journalist, Mendenhall enrolled in Smith College, but by the time she graduated in 1895 she had developed a fascination with the natural sciences. She applied to Johns Hopkins Medical School, and entered in 1896 after taking extra science courses at Massachusetts Institute of Technology. She and another female Johns Hopkins student, **Margaret Long**, became the first women to work at a U.S. naval hospital when they were posted to the Brooklyn Navy Yard Hospital in 1898.

Mendenhall graduated with her M.D. in 1900, and received a fellowship in pathology at Johns Hopkins the following year. In this line of work she assisted in autopsies, taught bacteriology classes, and researched Hodgkin's disease. At the time, the affliction was considered a version of the infectious bacterial disease tuberculosis, but Mendenhall's findings proved conclusively that it was not (it is a form of cancer affecting the lymphatic system). She was the object of international scientific attention as a result, and the cell she discovered that is present in the blood of Hodgkin's sufferers was named the Reed-Sternberg or Sternberg-Reed cell in her honor. She declined the reappointment Johns Hopkins offered her to protest the lack of opportunities for women at the school. In 1902, she took a residency at New York Infirmary for Women and Children and the following year became the New York Babies Hospital's first resident doctor. She continued in this post until her 1906 marriage to Charles Elwood Mendenhall, a professor of physics. With him, she moved to Madison, Wisconsin, and began a family.

Even Mendenhall's knowledge of medicine could not prevent her from becoming a victim of the gross abuses endemic to women's health care during this era: in 1907, her first child died just a few hours after birth as a result of medical malpractice that also left Mendenhall suffering from puerperal fever and injuries. Her second child, born in 1908, died two years later after a fall. After the birth of two more sons, she returned to work in 1914, when she became a home eco-

nomics lecturer at the University of Wisconsin at Madison. She also began conducting research into infant mortality, lectured new and expectant mothers on health care, and wrote informational bulletins. In 1915, she coordinated several government and volunteer resources to set up the state of Wisconsin's first infant welfare clinic, in Madison. For the next two decades, Mendenhall supervised this clinic and four more like it in the city; by 1937, the city could boast the lowest infant mortality rate in the country.

Around the time of World War I, Mendenhall served as a medical officer for the U.S. Children's Bureau, and traveled overseas after the end of the conflict to study war orphanages in Belgium and France. She was also a key player in a comprehensive statistical survey of the height and weight of all U.S. children under the age of six. The collected data was used to formulate growth-measurement norms, and the findings also helped to call attention to malnutrition. Mendenhall wrote several educational publications on these matters for the American Red Cross and for various government agencies, including 1918's *Milk: The Indispensable Food for Children,* and six chapters included in *Child Care and Child Welfare: Outlines for Study*, published by the U.S. Children's Bureau in 1921. She also undertook a three-year study of childbirth practices in the U.S. and Denmark, and concluded in her 1929 work *Midwifery in Denmark* that Denmark's mortality rate for infants and mothers was lower due to the holdover practice of midwives, in contrast to the American system, in which male medical professionals had helped to bring about laws that banned midwifery as illegal medical practice in the 19th century.

After Mendenhall's husband died in 1935, she traveled extensively in Central America and Mexico, and spent her remaining years in Tryon, North Carolina. She died in July 1964 in Connecticut. Her surviving family—two sons, one of whom became president of Smith College and another who followed in his mother's footsteps and became a doctor—established the Dorothy Reed Mendenhall Scholarship for a deserving female medical student at Johns Hopkins University. Sabin-Reed Hall at Smith College was dedicated in honor of ***Florence Sabin** and Dorothy Reed Mendenhall in 1965.

SOURCES:

Read, Phyllis J. and Bernard L. Witlieb. *The Book of Women's Firsts.* NY: Random House, 1992.

Sicherman, Barbara, and Carol Hurd Green, eds. *Notable American Women: The Modern Period.* Cambridge, MA: The Belknap Press of Harvard University, 1980.

Carol Brennan,
Grosse Pointe, Michigan

Mendes, Gracia (1510–1569).

See Nasi, Gracia Mendes.

Mendès, Judith (1845–1917).

See Gautier, Judith.

Mendl, Lady (1865–1950).

See de Wolfe, Elsie.

Mendoza, Ana de (fl. late 1400s)

Portuguese mistress of John II. Flourished in the late 1400s; had liaison with Juan or John II (1455–1495), king of Portugal (r. 1481–1495); children: (with John II) Jorge de Lancastre, duke of Coimbra.

Mendoza, Ana de (1540–1592)

Spanish aristocrat and princess of Eboli. Name variations: Princesa de Eboli; princess of Eboli. Born in Cifuentes, near Guadalajara, Spain, in 1540; baptized on June 29, 1540; died on February 2, 1592; daughter of Diego Hurtado de Mendoza, count of Mélito, and Catalina de Silva; married Ruy Gómez de Silva, prince of Eboli, on April 18, 1553 (died 1572); children: ten, including a daughter who married the Duke of Medina Sidonia, commander of the Spanish Armada against England in 1588.

Ana de Mendoza was born in Cifuentes, near Guadalajara, Spain, in 1540, the only child of Diego Hurtado de Mendoza, count of Mélito, and **Catalina de Silva**. As a Mendoza, she was from one of Spain's great aristocratic families. In 1552, Prince Philip (later Philip II, king of Spain) requested her parents' permission for Ana's marriage to Ruy Gómez de Silva, one of his closest companions and advisers. Although Ana apparently married Ruy Gómez in April 1553, her parents stipulated that she wait two years before living with him as his wife because of her youth.

Their married life was delayed even longer, however, when Ruy Gómez went with Prince Philip to England and the Low Countries. Ruy and Ana began living as husband and wife in 1559, upon Philip II's return to Spain. They were together for 13 years, during which time Ana gave birth to 10 children. She also lost her right eye from a blow or accident, and her most famous portrait shows Ana wearing a patch over the injured socket. She enjoyed a life of privilege and wealth, married to one of the most influential members of Philip II's court. As a reward for Ruy Gómez's service, Philip II made his minister prince of Eboli. Thus, Ana became a princess.

After many years as Philip II's chief adviser, Ruy Gómez died in 1572, and from then on Ana's life devolved into scandal, controversy, and imprisonment. The princess first retired to a Carmelite convent she had founded in Pastrana, but her insistence on being accorded comforts and deference alienated the nuns there, who demanded that she leave. Ana returned to court and in 1576 or 1577 became the intimate of Antonio Pérez, her husband's protegé and one of Philip II's secretaries and chief advisers. The nature of her relationship with Pérez is unclear: earlier historians saw it as sexual, but recent scholars believe the pair connived to reveal state secrets to the Portuguese. The princess apparently hoped to marry a daughter to Theodósio, duke of Barcelos, who was one of Philip II's chief rivals for the Portuguese throne should King Sebastian die childless. When Philip ordered Pérez's arrest in 1579 for the assassination of Juan de Escobedo, he also imprisoned the princess of Eboli. Confined first to the Pinto Tower south of Madrid and then in the fortress of Santorcaz, she was finally restricted to her own castle in Pastrana, a form of house arrest. Though Philip allowed her children to visit whenever and for as long as they desired and the princess oversaw her properties and other affairs, she could not leave her quarters in the castle. The princess might have secured her freedom by attempting to mollify Philip II, but instead she remained arrogant and quarrelsome. In the test of wills, Philip was equally resolute, and the princess never secured her liberty. She died on February 2, 1592.

Allegations that at some point she was Philip's mistress are probably false. Before her marriage to Eboli, she was very young and Philip was abroad. Surviving evidence gives little support to the existence of such a liaison during her marriage. Afterward, when her beauty was marred by the loss of her eye and she was the mother of ten children, it is hard to believe that Philip would have been attracted to her. Furthermore, in his later years, the king showed little interest in extramarital dalliances. Philip's enemies likely concocted such rumors. *Kate O'Brien's highly successful novel *That Lady*, based on the life of Ana de Mendoza, was made into a 1955 Hollywood film with *Olivia de Havilland in the title role.

SOURCES:

Marañón, Gregorio. *Antonio Pérez: el hombre, el drama, la época*. 2 ed. Madrid: Espasa-Calpe, 1948.

Muro, Gaspar. *Vida de la princesa de Eboli*. Madrid: Mariano Murillo, 1877.

Pierson, Peter. *Philip II of Spain*. London: Thames and Hudson, 1975.

Kendall W. Brown,
Professor of History, Brigham Young University, Provo, Utah

Mendoza, Juana B. Guitérrez de
(1875–1942).

See Gutiérrez de Mendoza, Juana Belén.

Menen (1899–1962)

*Empress of Ethiopia. Born Menen Asfaw in Dessié, Ethiopia, in March 1899; died after many years of ill health on February 15, 1962, in Addis Ababa, Ethiopia; daughter of Asfaw Mikael Ambassel (jantirar [ruler] of Anbassel or Ambassel) and Sehin Mikael (daughter of King Michael of Wollo and sister of Lij Iyasu); niece of Lij Eyasu also known as Lij Iyasu, king of Ethiopia; cousin of Amde Mikael; married Lul Sagad (a Shewan noble) also known as Ras Leulseged Atnaf Seged (died 1916); married Ras Tafari, later known as Haile Selassie I (1892–1975), emperor of Ethiopia (r. 1930–1974), on July 31, 1911, in Harar, Ethiopia; children: (first marriage) Gabre Iqziabher Asfa (b. 1909); (second marriage) Princess Tenagne Worq also seen as Tenagnework (b. 1913); Asfa Wossen (1916–1997), known under title Meredazmatch (1931–1997), also 65th emperor of Ethiopia as Amha Selassie I (r. 1975–1997); Princess Zenabe Worq also seen as Zenebework (1918–1933); Princess *Tsahai Worq also seen as Tsehai (1919–1942); Prince Makonnen (1923–1957); Prince Sahle Selassie (1931–1962).*

In 1911, Ras Tafari, who would later be known as Haile Selassie I, married Menen Asfaw, niece of Lij Iyasu, king of Ethiopia. It was a union fraught with political significance. In 1916, Haile Selassie deposed Lij Iyasu in a coup. In 1930, Menen was crowned empress of Ethiopia upon the coronation of her husband as emperor.

The couple had six children together (Haile Selassie also had a daughter from an earlier first marriage), and Menen remained a trusted advisor to her husband until her death in 1962. Haile Selassie died in Addis Ababa on August 27, 1975.

Menetewab (c. 1720–1770)

Ethiopian empress and regent. Name variations: Mentuab; Berhan Magass (Glory of Grace). Regent of Ethopia (Gondar) from 1730 to 1760. Christened Welleta Georgis around 1720; died in 1770; married Emperor Baqaffa or Bakaffa, in the 1720s (died 1729); children: Iyasu II (died 1755), emperor of Ethiopia.

On the death of her husband Emperor Bakaffa in 1729, Menetewab was made regent of Ethiopia for her son Iyasu II. But as he had lit-

tle interest in ruling, she controlled the government until Iyasu's death in 1755. Known for her nepotism, she managed to weaken the empire and endured many revolts by Ethiopian nobles. In 1755, she had her grandson Ioas made emperor but gradually lost influence to her daughter-in-law's family. Her power ended at the time of Ioas' death in 1769.

Menken, Adah Isaacs (1835–1868)

American actress and poet whose beauty and daring made her one of the great celebrities of the era. Name variations: Mazeppa. Born Adah Bertha Theodore on June 15, 1835, in Chartrain (now Milneburg), Louisiana; died of tuberculosis and peritonitis in Paris, France, on August 10, 1868; daughter of Auguste Theodore (a shopkeeper) and Marie Theodore; possibly attended some public schools in New Orleans; tutored by schoolteacher stepfather, Campbell Josephs; married Alexander Isaac Menken (a musician and dry goods salesman), on October 3, 1856; married John Carmel Heenan (a prizefighter), on September 3, 1859; married Robert Henry Newell (a writer and editor known by pen name Orpheus C. Kerr), on September 24, 1862; married James Paul Barkley (occupation unknown), on August 19, 1866; children: one died in infancy (b. 1860); Louis Dudevant Victor Emmanuel Barkley (later given new identity by adoptive parents).

Made first stage appearance as Pauline in The Lady of Lyons, *Shreveport, Louisiana (1857); made New Orleans debut as Bianca in* Fazio *(1857); moved to New York (1859); made New York debut as Widow Cheerly in* The Soldier's Daughter *(1859); opened in most famous role as Tartar Boy in* Mazeppa, *Albany (1861); made San Francisco debut in* Mazeppa *(1863); made London debut in* Mazeppa *(1864); lived in London and Paris (late 1860s); made Paris debut in* The Pirates of the Savannah *(1866). A collection of poems,* Infelicia, *published posthumously, London (1868).*

Though a terrible Civil War raged in the United States in 1864, most Londoners paid scant attention to the plight of their English-speaking brethren. Accounts of battles appeared in newspapers, but longstanding apathy about the former colonies could hardly be shaken by a cursory and impersonal exposure to the carnage. The United States and its citizens, Victorians believed, had little to offer. The young republic lacked great art, literature, and drama. A "wilderness" when colonized by Europeans, a cultural wilderness it remained, especially in the

throes of war. But that autumn, one American created a stir like that of few other previous visitors to London of any nationality. Fashionable people seemed concerned with nothing else but her visit, and four weeks of public performances were sold out in advance. Adah Isaacs Menken had come to England prepared to conquer the London stage.

Lo! This is she that was the world's delight.

—Algernon Swinburne

The people of Great Britain hardly constituted the first to succumb to Menken's charms, and would not be the last. During the decade of the 1860s, she was America's most celebrated entertainer, a remarkable achievement for a woman of common origins. The fact that Menken came from modest beginnings is, however, one of the very few aspects of her background all biographers agree upon. Menken obfuscated much of her past in a shroud of secrecy and fantasy. She fabricated stories about her youth to gain publicity and to fit the interests of the listener. As she began her acting career, she claimed her father was a prominent New Orleans merchant. She later said she was the daughter of Ricardo los Fuertes, a Portuguese noble. She also told people she was the daughter of an Irish boxer, a Confederate officer who died during the Civil War, and a French immigrant to New Orleans, to name just some of her "fathers." All of these tales were untrue. Some biographers believe she may have actually told the truth to the elder Alexander Dumas when she remarked that her father was a free man of color. Auguste Theodore, a poor shopkeeper from Chartrain (now Milneburg), Louisiana, was listed as her father in the registry of the parish where Adah was born. There is no evidence of his ethnicity, which constituted a less significant issue in the New Orleans area than any other place in the United States at the time. **Marie Theodore**, Adah's mother, was probably born in Bordeaux, France.

It is certain that Adah Bertha Theodore was born on April 11, 1835, and that Auguste Theodore died six months afterward. Marie sold the shop and moved to a boarding house in New Orleans, where she met Campbell Josephs. They would marry in 1836. Josephs taught Latin and Greek at a private boys' school, the St. Charles Academy. Though there is evidence Marie paid inadequate attention to her daughter from the earlier marriage, Campbell Josephs raised Adah as his own child. Under his tutelage, she learned Latin, Greek, French, Hebrew, and Spanish while quite young. She studied the classics, attended the theater, and read poetry. Josephs believed in regular exercise for children, which included dancing and horseback riding (the academy had a stable). Adah's riding proficiency would serve her well later in life.

Adah's education represented a remarkable opportunity for a young woman of the time. Her equally extraordinary intellect prepared her for a unique life—and she would certainly live life to the fullest. Campbell Josephs died in 1852, leaving the family destitute as was often the case with the death of the male head of a household. Menken advertised her services as a language tutor, and traveled from house to house teaching girls from affluent homes. She may have been the sole wage earner in the family for some time.

Menken kept a diary when she began working, and this surviving document provides a great deal of evidence about her independent thinking and willingness to challenge convention. She read Nathaniel Hawthorne's "scandalous" *The Scarlet Letter* and expressed her admiration for Hester Prynne, "a wonderful woman . . . lovely and strong." Of Chillingworth, Adah noted: "I would have killed him." About this time, she entered the male realm of politics, speaking on behalf of presidential candidate Franklin Pierce at public rallies. Her outraged mother told her to stop, but Menken refused. As she observed in her diary, "The woman of today is not a slave, but free!" This sentiment reflected her view, but hardly prevailing attitudes in antebellum America. How many 17-year-old women were mounting speaking platforms in the United States in 1852? Menken's experience was rare.

In October 1853, Baron Friedrich von Eberstadt asked Adah to accompany him to Havana, Cuba, where it seems she became his mistress. Eberstadt was an Austrian noble whose daughter Adah had tutored. In later memoirs, she claimed to have danced as the "Queen of the Plaza" in Havana, though it seems likely she turned to prostitution to survive after the baron abandoned her. While looking for gainful employment on the stage upon her return to the United States in 1856, she met Alexander Isaac Menken, the son of a dry goods manufacturer from Cincinnati, Ohio. Though he wished to be a professional violinist or orchestra conductor, Isaac was probably working for his father as a traveling salesman. Within a day, he proposed marriage to the young woman of striking beauty and exceptional intelligence. They were immediately married on October 3, 1856.

Adah
Isaacs
Menken

Isaac was Jewish, and whether Adah had grown up in a Jewish family or converted to Judaism in 1856 is unknown. She remained true to the Jewish faith the rest of her life. Isaac's fortunes soured during the economic recession of 1857, and Adah turned to the stage to make ends meet. She made her debut in March at James Charles' theater in Shreveport, Louisiana, as Pauline in *The Lady of Lyons*. Her New Orleans debut at Crisp's Gaiety, as Bianca in *Fazio*, occurred on August 29. Hardly a great actress, the pretty, somewhat exotic-looking young woman provided a striking physical presence on stage. Audiences received her well. Adah Isaacs (she added the "s" to her stage name) Menken continued to perform in New Orleans and toured the southeast and midwest. In 1859, she sought wider recognition, however, and the Menkens moved to New York City.

Adah Menken made her New York debut in March 1859 at Purdy's National Theater in the role of the Widow Cheerly in *The Soldier's Daughter*. It was a small part, but the petite dark-haired, dark-eyed actress won over audiences. The play closed after a short run, though Menken secured a larger role in a second play, *The French Spy*, where her fluency in French helped earn her good reviews. This part would

be followed by a third at the Purdy theater, in *The Three-Foot Man*, a play which also closed quickly. Adah had great difficulty finding work for a time afterward.

During 1859, Adah Menken's personal life also grew complicated and, ultimately, somewhat scandalous. Isaac's relationship with Adah grew increasingly strained after the move to New York. He wanted to go home to Cincinnati; she insisted she would become a famous actress on the New York stage. Isaac was probably jealous of her early successes, though they were modest, and grew increasingly disturbed about her flirtatious demeanor. He also became incensed about her new habit of smoking cigarettes in public. Although it was a fad among men, few women dared to smoke openly, but Adah loved to defy convention. As her husband's protests mounted, Adah noted in her diary, "I have told Isaac I will leave him if he does not stop badgering me with his sermons on cigarettes. I do not criticize him for smoking segaros. . . . I will not submit to the dictation of any man." In July, Isaac gave up hope "dictating" anything to his wife, announced his separation from her, and left New York.

Now alone, Menken had to rely on her acting and writing to make ends meet. Before the move to New York, she had published some poems in the *Cincinnati Israelite*, and showed them to Edwin James, the editor of a New York newspaper, *The Clipper*. He began publishing her poetry at five dollars a piece, an arrangement that continued for many years. At the *Clipper* offices, James introduced Menken to John Carmel Heenan, a leading prizefighter from Benicia, California. Johnnie Heenan stood 6'2", weighed well over 200 pounds, sported a heavy black mustache, and claimed to be the boxing champion of America. No other American boxer seemed prepared to dispute this assertion. The "Benicia Boy" took an immediate liking to Adah, and she began to accompany the massive boxer to public events. On September 3, they were married in secret, though word about the union leaked out within a few months.

The period following Adah's second marriage was among the darkest in her life. Isaac Menken announced that he had not secured a divorce from his wife, thus she was a bigamist. He would subsequently initiate the divorce proceedings, if a bit belatedly. New husband Johnnie was a heavy drinking carouser who spent little time with his wife. Despite rumors prevalent at the time, there is no evidence that he physically abused Adah, though there were also reports that she landed punches on his face. These stories may have been circulated by Adah and her associates to create some publicity for the young actress. The boxer would abandon Adah in 1860 to travel to London to fight the international boxing champion Tom Sayers. The barefisted brawl lasted over 2 hours and 37 rounds, during which Heenan knocked down Sayers 20 times. Fearful that the "Benicia Boy" was going to kill Sayers, promoters called the fight and declared it a draw. Well compensated for the event, Heenan returned to New York in July and repudiated his marriage to Adah. In his absence, she had given birth to his son, though the child died in infancy.

Menken sunk into depression in the wake of these tragic events. She learned of her mother's death, as well, and it would not be until early 1861 that she summoned the strength to return to the stage. Her trials and tribulations had added to her notoriety, and Adah remained committed to the ultimate goal of becoming a beloved actress. She believed the right role to win the affection of audiences would eventually present itself, and such a part did materialize in 1861. Ironically, the role for which Menken achieved her desired popularity was not as a woman, but a boy. She played the Tartar youth in *Mazeppa*, an adaptation of Lord Byron's poem. The traditional climax of the play involved the boy, stripped of his clothes by his captors and lashed to the back of a wild horse, riding up to papier-maché cliffs to disappear into the clouds. The dramatic end was dulled a bit by the tradition of tying a stuffed manikin to an old nag which slowly ascended some stairs. Adah and her new manager, James Murdoch, had a better idea.

Experienced with horses, Menken would ride the animal herself at the end of the play, clad in skin-colored tights to appear naked. The advantage of playing a boy proved beneficial because an unclothed female character could not appear on stage. The melodrama opened on June 3, 1861, at the Green Street Theater in Albany in front of a massive crowd. Unsure whether or not she was actually naked, the audience was shocked but excited by the spectacle of Adah riding up the platform through the crowd. Thunderous ovations greeted her nightly, and Adah Isaacs Menken (the name she would always use on stage) found the fame she long desired. *Mazeppa* opened at New York's Broadway Theater shortly after the Albany success. With hair cut short like that of a boy and atop Black Bess, she gave a performance that was the cultural sensation of one of the darkest years in

Adah
Isaacs
Menken

American history. To an editorial writer in the *New York Post*, it was "a pleasure and a duty to see her in *Mazeppa*." He went on to suggest that "Miss Menken places the male in her audience at a disadvantage. She is so lovely that she numbs the mind, and the senses reel."

New York audiences flocked to see the "Naked Lady," as she came to be known. Menken's salary rose to an incredible $500 per week. She bought an impressive house, and the literary and other cultural elite made this residence at 458 Seventh Avenue a center of New

York intellectual life. Menken proved a brilliant host at her salon. "She could discourse fluently on matters pertaining to literature," noted frequent visitor Robert Henry Newell, a writer and editor of the *Mercury,* as well as "the sciences and the latest news of the world." Walt Whitman and Fitz-James O'Brien became devoted friends. As the nation sunk deeper into civil war, a Southerner became the North's newest celebrity.

The Civil War did have an impact on Adah Menken's career. *Mazeppa* went on tour where Adah was well received in Trenton and Baltimore, among other cities. She faced occasional catcalls about her Southern heritage, however, and after making some pro-secessionist statements (likely designed to generate publicity) faced arrest in Maryland. She wriggled out of this problem with ease, and ticket sales in Baltimore soared. Adah Menken had become a master of staying in the public eye. She also married a third time, to Robert Henry Newell, who was also known by the pen name, "Orpheus C. Kerr." Though the relationship was rocky at best, the two sailed for San Francisco on July 13, 1863, where she dazzled some of the most appreciative audiences she ever encountered.

Tom Maguire, owner of the impressive Opera House in San Francisco, had approached Menken's agent, James Murdoch, with a stunning offer. He would pay her $1,500 per week for a 12-week appearance in the nation's fastest growing city. San Francisco proved the perfect place to further Menken's fame. A tiny settlement before the Gold Rush of the late 1840s, it contained nearly 100,000 residents by 1863. A dynamic city of dramatic contrasts—it was both a rough frontier town and a place where prominent citizens wore the latest French fashions—it included a number of large, elaborate theaters.

There was no easy route to California at the time and rather than the dangerous overland passage or the long voyage around Cape Horn, Menken chose the more popular "Atlantic-Panama-Pacific" trip. Just days after the carnage at Gettysburg ended, Adah and husband Robert boarded the *Sao Jorge.* It was certainly a good idea to leave the war-weary East and head to the West Coast. At Porto Bello, they began the 50-mile overland journey through the jungle toward Panama City. Harassed by "swarms of mosquitos, flies, gnats and an infinite host of other flying and crawling creatures," as Newell reported in an article for the *Mercury,* the Menken party faced a challenging journey. They would happily board the *Palace Queen,* though the tedious trip

strained Adah's relationship with Robert, an estrangement that would never be repaired.

Tom Maguire had promoted Menken's visit effectively. A large number of citizens turned out for her arrival, then packed the Opera House for a gala reception where Adah charmed San Francisco's elite. *Mazeppa* sold out for its entire run. From the first night to the last, the audiences literally went wild during the climatic "Naked Lady" scene. She also performed in *Dick Turpin, The French Spy,* and *Three Fast Women,* among other plays. When not on the stage, Menken spent much of her time with "Golden Era" authors Bret Harte, Artemus Ward, Warren Stoddard, and Joaquin Miller. She probably met Mark Twain, though he was never counted among her devoted admirers. It seems every other prominent man in San Francisco wished to meet with Adah, and rumors spread about affairs with local millionaires. Newell did return to New York within a few weeks of their arrival as Adah's third marriage fell apart. Excerpts from Menken's unreliable diary support the conclusion that she did have affairs, but as in many aspects of Adah's life, separating fact from fiction is impossible.

After an exciting and lucrative run in the Golden Gate City, Menken's party began the return trip to the East, this time overland, beginning in December. Adah stopped in the silver boom town of Virginia City where a raucous crowd of miners made the stop a financial success, to say the least. Estimates placed the value of gifts and payments of silver and shares of stock at $100,000 or more, and even if this figure is somewhat exaggerated, she certainly did return to New York a wealthy woman. After finding war-weary Easterners less inclined to go to the theater during the fourth year of fighting, Menken agreed to travel to London to take advantage of her growing notoriety abroad. She sailed for Europe in April 1864.

Mazeppa opened on October 3 at Astley's Theater. London newspapers carried on a lively discussion before this date about whether English audiences would embrace the play and its controversial star. But on opening night Menken took about two dozen curtain calls. As *Bell's* observed, "The most popular of American actresses has conquered us." Mirroring her United States experiences, literary figures were drawn to "the goddess," including novelists Charles Dickens and Charles Reade, and artists Edward Burne-Jones and Dante Gabriel Rossetti. She formed her closest association with poet Algernon Charles Swinburne, who wrote "Laus Veneris" for her. After a brief trip back to New

York, Menken returned to London in 1865 with *Child of the Sun*, by John Brougham. When audience numbers dropped off somewhat, its six-week run was followed by another of *Mazeppa*. Her celebrity status well established in England, and with numerous prominent admirers at her side continuously, Menken felt very much "at home" there.

In 1866, believing the time was right for another American tour, Menken played New York and other major cities to packed houses. Having divorced Robert Newell in 1865, she also married once more on August 19, 1866. Her fourth husband was James Paul Barkley, a wealthy American about whom little is known. The fact that a pregnant Adah sailed for Europe three days after the ceremony, never to see Barkley again, certainly limited his relevance. Obviously, the marriage was designed to minimize the scandal of Menken's impending motherhood.

Adah Menken went to France this time, to give birth to her child and to conquer the Paris stage. Louis Dudevant Victor Emmanuel Barkley was born in November. Menken soon went into rehearsal for the opening of *The Pirates of the Savannah* (*Les Pirates de la Savane*), which was received by both audiences and critics with unbounded praise. The Theatre de la Gaite sold out every night as patrons gawked at Menken wearing revealing costumes. Artists and writers flocked to her side once again, including Théophile Gautier and the elder Alexander Dumas, with whom some scandalous photographs were taken. While in France, Menken would develop a close relationship to another woman, Amadine Aurore Lucie Dupin, the novelist known by the pseudonym of *George Sand. The aging author became a trusted advisor and supporter of the American actress who claimed her place as the Paris sensation of 1867; Sand also served as godmother to Adah's son.

When *Pirates* closed, Adah Menken stood as one of the great celebrities of the Western world. A powerful ambitious drive and diverse talents had taken her to the grand position she coveted since childhood. She defied Victorian convention while earning a huge salary. Prominent writers and artists sought her company. Newspapers and magazines reported her every move, and stories about her, true and false, maintained her fame. But Menken was hardly satisfied. She believed true immortality would come with the publication of her best poems, and she set to work on such a collection, *Infelicia*.

Much of Adah Menken's success as an actress stemmed from her personal beauty, willing-ness to push the limits of convention in revealing her body in public performances, and gift for generating publicity. It is unlikely her talents as a stage performer would have, on their own, made her famous. But there was more to Adah Menken than the "Naked Lady" persona. As she once remarked, she was "possessed of two souls, one that lives on the surface of life, pleasing and pleased: the other as deep and unfathomable as the ocean: a mystery to me and all who know me." Menken's poetry reflected this depth. "Judith," one of the best received of her poems, addressed a martial theme:

> And the Philistines spread themselves in the valley of Rephaim
> They shall yet be delivered into my hands.
> For the God of Battles has gone before me!
> The sword of the mouth shall smite them to dust.
> I have slept in the darkness—
> But the seventh angel awoke me, and giving me a sword of flame, points to the blue-ribbed cloud, that lifts his reeking head above the mountain.
> Thus I am the prophet.
> I see the dawn that heralds to my waiting soul the advent of power.

Of this poem and dozens of others, literary critics have found much to praise of Menken's natural talent, though her technique could hardly match the great poets she admired so much.

As she awaited the appearance of *Infelicia*, Menken took *Pirates* to London in 1868, where it was received with little enthusiasm by English audiences. By many accounts, her performance lacked the energy of previous efforts. The tired actress, probably suffering from ill health, gave her last performance on May 10 at Sadler's Wells Theater. She then returned to Paris to prepare for that city's opening of the play, still anticipating the publication of *Infelicia*. Tragically, Adah Menken would experience neither goal. While rehearsing on June 9, she collapsed on stage, and was bedridden for the next month. Physicians could not provide a clear diagnosis, though they assured her she would recover. The doctors were wrong. On August 10, Menken died, probably of peritonitis and tuberculosis. Initially buried in the Pere Lachaise Cemetery, her coffin was moved by Ed James to the Jewish section of Montparnasse Cemetery in 1869. George Sand arranged for a secret adoption of Menken's son to a good home. His identity remained secret, and nothing is known about his life after his mother's passing.

Eight days after Adah Menken's death, *Infelicia* was published in London, dedicated to Charles Dickens. The great novelist, like Whit-

man, Swinburne, and other admirers counted among the leading literary figures of the age, knew that Menken was neither a brilliant actress nor writer. But Dickens believed that Menken possessed the heart and intellect of a great poet. Swinburne wrote on his copy of *Infelicia*, "Lo! This is she that was the world's delight." Adah Isaacs Menken was a woman of various talents and extraordinary ambition, and few Americans of any era have lived a more fascinating life.

SOURCES:

Lesser, Allen. *Enchanting Rebel: The Secret of Adah Isaacs Menken*. Port Washington, NY: Kennikat Press, 1947.

Lewis, Paul. *Queen of the Plaza*. NY: Funk and Wagnalls, 1964.

Wilkins, Thurman. "Adah Isaacs Menken," in *Notable American Women*. Vol. 2. Cambridge, MA: Harvard University Press, 1971, pp. 526–529.

SUGGESTED READING:

Menken, Adah Isaacs. *Infelicia*. North Stratfield, NH: Ayer Co., 1970.

Thomas, Donald. *Swinburne: The Poet in His World*. London: Weidenfeld and Nicolson, 1979.

John M. Craig,
Professor of History, Slippery Rock University, Slippery Rock, Pennsylvania, author of *Lucia Ames Mead and the American Peace Movement* and numerous articles on activist American women

Menken, Marie (1909–1970)

American filmmaker, artist, and actress. Born in 1909; died in 1970; married Willard Maas (a filmmaker).

Selected filmography: Visual Variations on Noguchi *(1945);* Hurry! Hurry! *(1957);* Faucets *(1960);* Arabesque for Kenneth Anger *(1961);* Eye Music in Red Major *(1961);* Mood Mondrian *(1961–63);* Go Go Go *(1963);* Andy Warhol *(1965);* Drips in Strips *(1965);* Excursion *(1968);* Watts with Eggs *(1969).*

Marie Menken did not begin making movies until she was in her mid-30s, after she purchased a movie camera in a pawn shop. Shortly thereafter, she created her first film, *Visual Variations on Noguchi* (1945), in which the statues of Isamu Noguchi appeared as if they were in motion through the innovative use of light. Through her almost exclusive use of handheld shots, Menken is credited with freeing the movie camera from the tripod, and her films have been praised for their "love for jolting visual rhythms." Her next film, 1957's *Hurry! Hurry!*, observes sperm cells through a microscope. In addition to creating "experimental" or "underground" films, Menken was also an abstract artist and painter who exhibited at the Brooklyn Museum and the Baltimore Museum of Art. Married to the filmmaker Willard Maas,

she acted in and served as cinematographer on all his films, as well as acting in films by other underground filmmakers. (In 1965, she made a biographical film about Andy Warhol and appeared in his film *The Life of Juanita Castro*.) Menken preferred to keep her art and her livelihood separate, and throughout her artistic career worked as an editor at the Time-Life corporation. Her last film, *Watts with Eggs*, was finished a year before her death in 1970.

SOURCES:

Acker, Ally. *Reel Women: Pioneers of the Cinema 1896 to the Present*. NY: Continuum, 1991.

Grant Eldridge,
freelance writer, Pontiac, Michigan

Menou, Mlle (c. 1642–1700).

See Bejart, Armande.

Menteith, countess of.

See Graham, Margaret (d. 1380).

Menter, Sophie (1846–1918)

German pianist, one of Liszt's best students, who composed several pieces which were orchestrated by Tchaikovsky and which she played with him as conductor. Name variations: Sofie Menter. Born in Munich, Germany, on July 29, 1846; died in Munich on February 23, 1918; taught at the St. Petersburg Conservatory from 1883 to 1887.

Born in Munich in 1846, Sophie Menter studied with Carl Tausig and then with Franz Liszt. She was perhaps Liszt's greatest female student and had a highly successful career. Liszt believed her to be "of exceptional virtuosity . . . an incomparable pianist . . . a pianist of the highest rank." In 1881, the aging composer went to Rome to attend a concert by Menter, reporting that her playing was "absolutely faultless" and compared favorably with the three or four most famous male pianists. Ernst Pauer praised her for "nobility of feeling, tenderness and warmth of expression," noting that her "technical execution baffles description." From 1883 to 1887, Menter taught at the St. Petersburg Conservatory. As a composer, she created a number of attractive pieces including *Ungarische Zigeunerweisen* for Piano and Orchestra, which was orchestrated by Tchaikovsky and played by Menter under Tchaikovsky's baton in Odessa on February 4, 1893.

John Haag,
Athens, Georgia

Mentuab (c. 1720–1770).

See Menetewab.

Menuhin, Hephzibah (1920–1981)

American pianist and social activist who concertized widely in the United States and Europe, often with her brother. Born on May 20, 1920, in San Francisco, California; died in London, England, on January 1, 1981; daughter of Moshe Mnuchin (who would later change his name to Moshe Menuhin) and Marutha Menuhin (1896–1996); sister of Yaltah Menuhin and the famous violinist Yehudi Menuhin (1916–1999); married Lindsay Nicholas; married Richard Hauser.

Hephzibah Menuhin was born in 1920 in San Francisco, California, the daughter of Moshe Menuhin and *Marutha Menuhin. In Hebrew, the name Hephzibah means "the desired one" or "the longed-for one." A prodigy like her brother, the famous violinist Yehudi Menuhin, Hephzibah gave her first public performance as a pianist in 1928. After studies in San Francisco, she journeyed to Paris to continue her education with Marcel Ciampi. A distinguished musician in her own right, she also toured widely as a duo partner with her brother in the United States and Europe. She also developed a solid reputation for her sparkling chamber music performances, including such popular favorites as Schubert's "Trout" quintet, and performed concertos, particularly those of Mozart. Hephzibah's social activism focused on achieving justice and peace in the world.

SOURCES:

Dubal, David. *Conversations with Menuhin.* NY: Harcourt Brace Jovanovich, 1992.

"Hephzibah Menuhin," in Janet Podell, *et al.*, eds. *The Annual Obituary 1981.* NY: St. Martin's Press, 1982, pp. 2–3.

"———," in *The Times* [London]. January 3, 1981, p. 14.

"———," in *The Times* [London]. January 22, 1981, p. 16.

Menuhin, Moshe. *The Menuhin Saga: The Autobiography of Moshe Menuhin.* London: Sidgwick & Jackson, 1984.

Menuhin, Yehudi. *Unfinished Journey.* London: Methuen, 1996.

"Menuhin Sister Dies at 60," in *The Times* [London]. January 2, 1981, p. 4.

Palmer, Tony. *Menuhin: A Family Portrait.* London: Faber and Faber Limited, 1991.

Rolfe, Lionel Menuhin. *The Menuhins: A Family Odyssey.* San Francisco: Panjandrum/Aris Books, 1978.

Sophie Menter

Slonimsky, Nicolas, ed. *Baker's Biographical Dictionary of Musicians.* 8th ed. NY: Schirmer Books, 1992.

"Yehudi Menuhin," in *The Economist.* Vol. 350, no. 8111. March 20, 1999, p. 91.

RELATED MEDIA:

"The Menuhin Family" (LP recording, Seraphim S-60072).

Monsaingeon, Bruno (videocassette, EMI MVD-4914753), "The Violin of the Century," 1996.

"A Tribute to Hephzibah Menuhin" (two audiocassettes), Sydney: Australian Broadcasting Corporation, 1981.

John Haag,
Associate Professor of History,
University of Georgia, Athens, Georgia

Menuhin, Marutha (1896–1996)

Russian-born mother of the renowned musicians Yehudi, Hephzibah, and Yaltah Menuhin. Born Marutha Sher in the Crimea, near Yalta, Russia, on January 7, 1896; died on November 15, 1996; daughter of Nahum Sher and Sarah Liba Sher; had six brothers and sisters; married Moshe Mnuchin (who would later change his name to Moshe Menuhin), in 1914; children: daughters, Hephzibah Menuhin (1920–1981); Yaltah Menuhin (b. 1921); son, Yehudi Menuhin (1916–1999).

Born in the Crimea on January 7, 1896, Marutha Sher was the only one of seven siblings to survive beyond infancy. Her family belonged to the Karaite (Scripturalist) sect, a tiny group of Jewish fundamentalists who were reputed by some scholars to have once been Christians who converted en masse to Judaism. Marutha grew up to be a woman of stunning beauty with blonde hair and striking blue eyes, which lent credence to the suggestion that she might have been of Tartar or Circassian ancestry. Some attributed the streak of fierceness in her personality to this possible ancestry.

To escape the anti-Jewish pogroms of tsarist Russia, Marutha was taken by her mother **Sarah Sher** to Palestine in 1904. Marutha's father Nahum remained in Russia, in effect abandoning his family. Life was difficult in Turkish-ruled Palestine, where the impoverished province's Jews were only a minority of the total population. Eventually Marutha's mother decided that they would leave Palestine and resettle in a safer place, the United States, a country which was to transform Marutha's life. Before they emigrated, Marutha met the charming, intelligent Moshe Mnuchin (who would subsequently change his name to Moshe Menuhin). Some years later, after they both had arrived in New York City, they met again and fell in love. They married in 1914, and in April 1916 Marutha gave birth to their first child, a son,

Yehudi Menuhin. Soon after, the family moved to San Francisco. Two daughters were added to the family: *Hephzibah Menuhin in January 1920 and *Yaltah Menuhin in October 1921. All three children would become respected musicians. Yehudi was discovered to be a prodigy on the violin and gave a successful New York debut in 1925. By 1927, he was performing to astonished audiences in Paris. In 1929, he performed with the Berlin Philharmonic Orchestra, with Bruno Walter conducting. (He would go on to a career that lasted almost three-quarters of a century and made him one of the best-known violinists of modern times.)

Marutha and her husband were living modestly in San Francisco as teachers, both working for the city's Jewish Education Board, when the talents of their daughters, Hephzibah and Yaltah, were also revealed. Both parents quit their jobs to devote themselves full time to their children's careers. Marutha's nature would later earn her the perhaps somewhat misplaced accusation of being a tyrant, a criticism made by her daughter Yaltah. Yehudi would describe his mother as "unerring in purpose, unhesitating and even ruthless in means." She was demanding not only of her family but also of herself. As a young woman, Marutha slept in her corset to preserve her 22-inch waist. Whenever she had a cut, she treated the wound with painful caustic soda, and her unconventional manner of bathing was based on a regimen of ice-cold water mixed with grapefruit skins and an unpleasant-smelling Russian drink called kvass. Unwilling to abandon traditions from her childhood, she relied for most of her life on a potent home-brewed version of koumiss, a Crimean concoction of mare's milk and other ingredients which always remained secret.

Until the end of her life, Marutha Menuhin watched over her children's lives and careers. She died in her 100th year on November 15, 1996, having outlived her daughter Hephzibah by almost 16 years. Little more than two years after his mother's death, Yehudi Menuhin died on March 12, 1999, aged 82.

SOURCES:

Dubal, David. *Conversations with Menuhin.* NY: Harcourt Brace Jovanovich, 1992.

"Marutha Menuhin," in *The Times* [London]. November 21, 1996, p. 25.

Menuhi, Yehudi. *Unfinished Journey.* London: Methuen, 1996.

Palmer, Tony. *Menuhin: A Family Portrait.* London: Faber and Faber, 1991.

Rolfe, Lionel Menuhin. *The Menuhins: A Family Odyssey.* San Francisco: Aris Books, 1978.

John Haag,
Associate Professor of History,
University of Georgia, Athens, Georgia

Menuhin, Yaltah (1921—)

*American-born pianist and member of the musically brilliant Menuhin family. Name variations: Yalta Menuhin. Born in San Francisco, California, on October 7, 1921; daughter of Moshe Menuhin and *Marutha Sher Menuhin; sister of Yehudi Menuhin (1916–1999) and *Hephzibah Menuhin (1920–1981); married William Stix; married Joel Ryce; children: two sons.*

Yaltah Menuhin shared the talent of a remarkable musical family. Although her sister *Hephzibah Menuhin was far better known as a pianist than she, and her brother Yehudi Menuhin became one of the best-known violinists of modern times, Yaltah too would enjoy a life in music. She began to play the piano at age three. Within a year, wishing to play music as well as her siblings (even though she was more than five years younger than Yehudi and almost two years younger than Hephzibah), she was taken to Paris because her brother and sister had begun to study there. In Paris, the piano professor Marcel Ciampi had accepted Hephzibah as a pupil but would not hear of giving lessons to her younger sister. Yaltah took matters into her own hands, rushing to the piano where she began to play the opening bars of Schumann's *Kinderscenen*. Then and there, Ciampi agreed to teach Yaltah along with her siblings. Yaltah's piano training continued in New York at the Juilliard School, where her teacher was Carl Friedberg. Her brother Yehudi once described her style of musical performance as "more poetic, more emotional" than that of his sister Hephzibah.

On rare occasions, music lovers could witness the three Menuhins performing together, as when Hephzibah and Yaltah played Mozart's Concerto for Two Pianos in E-flat Major, K. 365, with Yehudi conducting the orchestra (this performance is preserved in a recording on the Seraphim label). Yaltah has appeared worldwide as a soloist as well as an accompanist to leading instrumentalists. Perhaps her most charming performances were those in which she played duo piano works with her second husband, Joel Ryce, with whom she won the Harriet Cohen International Music Award in 1962. Among her best recordings are those that she made with Ryce for the EMI, Deutsche Grammophon, Everest, and World Record Club labels.

SOURCES:

Grindea, Carola. "Three Menuhins," in *Clavier: A Magazine for Pianists & Organists*. Vol. 23, no. 9. November 1984, pp. 28–32.

Menuhin, Yehudi. *Unfinished Journey*. London: Methuen, 1996.

Palmer, Tony. *Menuhin: A Family Portrait*. London: Faber and Faber, 1991.

John Haag,
Associate Professor of History,
University of Georgia, Athens, Georgia

Menzies, Katerine.

See Stammers, Kay.

Merab (fl. 1000 BCE)

*Biblical woman. Eldest of the two daughters of King Saul and *Ahinoam: sister of Michal (fl. 1000 BCE); married Adriel of Abel-Meholab; children: five sons.*

In an arrangement brokered by her father King Saul, Merab was betrothed to David following his victory over the giant Goliath. She apparently took issue with the agreement, however, so David was given the hand of her younger sister *Michal instead. Merab later married Adriel of Abel-Meholab and gave birth to five sons, all of whom were put to death by the Gibeonites.

Mercadier, Jeanne (1740–?).

See Baret, Jeanne.

Mercé, Antonia (c. 1886–1936)

Argentine-born dancer of Spanish ballet flamenco. Name variations: La Argentina; Antonia Mercé. Born Antonia Mercé around 1886 in Argentina; died in Bayonne, France, in 1936.

Antonia Mercé, born in Argentina around 1886, was taught flamenco by her parents. Moving to Europe, she became La Argentina and the "first lady of the Spanish Ballet." Mercé represented a change in flamenco, breaking from its Gypsy (Roma) dance accompanied by guitar. Ballet flamenco combined various forms of dance, including classical, with large troupes for theatrical audiences. Although she retained some elements of flamenco's folk origins, her performances appealed less to purists than to the broader public. She toured widely outside Spain, helping popularize her stylized flamenco among international spectators. Interestingly, her chief rival as "Queen of the Castenets" was another woman called "Argentinita," *Encarnación Lopez. Antonia Mercé died in Bayonne, France, in 1936.

SOURCES:

Pohren, D. E. *Lives and Legends of Flamenco*. Sevilla: Society of Spanish Studies, 1964.

Kendall W. Brown,
Professor of History, Brigham Young University, Provo, Utah

Mercedes of the Two Sicilies

(1910–2000).

See Maria de las Mercedes.

Mercer, Mabel (1900–1983)

British-American nightclub singer. Born in 1900 (some sources cite 1890) in Staffordshire, England; died in 1983.

Moved to Paris (c. 1931); moved to New York City (1941); appeared at Le Ruban Bleu nightclub, New York City (1938, 1941); appeared at other Manhattan nightclubs, including Tony's (1942–49) and the Byline Room (1949–57); continued performing until late in life.

Selected albums: (Atl 1213) Mabel Mercer Sings Cole Porter; (Atl 1244) Midnight at Mabel Mercer's; (Atl 1301) Once in a Blue Moon; (Atl 1322) Merely Marvelous; (Atl 2–602) The Art of Mabel Mercer; (Atl S–604) Mabel Mercer at Town Hall; (Atl 402) Songs by Mabel Mercer; (De DL–4472) Mabel Mercer Sings.

New York nightclub singer and recording artist Mabel Mercer influenced a generation of performers and became indelibly associated with the vocal style known as parlando, a method of half-singing, half-speaking that emphasizes the emotional content in a song's lyrics. Born in Staffordshire, England, in 1900 to an African-American musician father and a white English actress mother, Mercer was schooled for a time in a convent but left at the age of 14 to live with her aunt. She then became part of a music-hall act with her cousins called The Five Romanys, so named because they were supposed to be of Gypsy (Roma) origin. Because her skin was darker than that of her cousins, Mercer was often teased by audiences and family alike; on one occasion, her cousins tried to wash off some of her pigment with soap and water.

Mercer moved from the English vaudeville circuit to performing in musical comedy on the London stage, and for a time conducted an orchestra. She was allegedly discovered by *Josephine Baker and by the early 1930s was appearing at Bricktop's, the legendary Parisian nightclub owned by American *Ada "Bricktop" Smith. Arriving in New York City in 1941, Mercer immediately found long-term employment that made her one of Manhattan's most popular supper-club performers. Her nightclub engagements were years-long affairs and included stints at Le Ruban Bleu, Tony's (from 1942 to 1949), and both versions of the Byline Room (from 1949 to 1957); she also sang at the RSVP Club and for a time had her own venue.

Her repertoire consisted mostly of Broadway tunes, including the works of Cole Porter (who had frequently visited Bricktop's to hear her), Rodgers and Hart, and, later in her career, Stephen Sondheim. She was said to be able to perform over 1,000 songs, however, and was by no means limited to Broadway. She sat on a chair to sing, and was accompanied only by a pianist. Frank Sinatra, who went often to see her at Tony's during her seven-year engagement there, cited Mercer as a great influence upon his own vocal phrasings, as did others, including *Billie Holiday, *Peggy Lee, and Tony Bennett. Mercer recorded a number of albums for Atlantic, including a tribute to Cole Porter and the two-record set *The Art of Mabel Mercer*. In 1975, at her gala 75th birthday party at New York City's St. Regis Hotel, the St. Regis Room where she had frequently performed was renamed the Mabel Mercer Room. Mercer continued to sing professionally until late in life, dividing her time between New York City and a farmhouse in Chatham in upstate New York. She died in 1983.

SOURCES:

Biography News. March–April 1975, p. 387.

Hemming, Roy, and David Hajdu. *Discovering Great Singers of Classic Pop.* NY: Newmarket Press, 1991.

Kinkel, Roger D. *The Complete Encyclopedia of Popular Music and Jazz 1900–1950.* Vol. 3. New Rochelle, NY: Arlington House Publishers, 1974.

Carol Brennan,
Grosse Pointe, Michigan

Mercia, countess of.

See Godiva (c. 1040–1080).

Mercia, queen of.

See Emma (fl. 600s).
See Ermenburga (fl. late 600s).
See Ostrith (d. 697).
See Orthryth (fl. late 7th c.).
See Ermenilda (d. about 700).
See Cynethryth (fl. 736–796).
See Ethelswyth (c. 843–889).
See Ethelflaed (869–918).
See Ethelflaed for sidebar on Elfwyn (c. 882–?).

Mabel Mercer

Mercians, Lady of the.

See Ethelflaed (869–918).

Mercier, Euphrasie (1823–?)

French murderer. Born in 1823 in the French province of Nord; died in a French prison after 1886.

Euphrasie Mercier and her four siblings grew up in Nord, a province in the northeast region of France, with a devoutly religious father. In addition to Euphrasie, there were Zacharie, Camille, Honorine, and Sidonie—all Biblical given names—and only she and Zacharie were considered unaffected by the insanity suffered by the rest of the children, who attracted unwanted attention to themselves with acts such as writing to the pope and claiming to be guilty of the most monstrous of sins. Her brother Camille claimed that a steam engine had devoured his brain.

After her father died, Euphrasie Mercier inherited a large sum of money, but it was squandered on her siblings (who were likely unable to support themselves), and after it was gone she worked in low-wage jobs in various parts of Europe, probably with them in tow. Yet Mercier was doubtless an intelligent woman, and by the time she neared 60 had managed to open her own boot shop on Paris' Boulevard Haussmann. There she met **Elodie Ménétret**, a well-to-do woman of 42, who felt sorry for Mercier after befriending her and learning about the Mercier family and its dementia. Ménétret invited Mercier to move into her home in Villemomble, outside Paris, and to live with her as a paid companion. Mercier accepted the offer, and moved to Villemomble in March 1883. Soon she gave Ménétret cause to worry, however: Ménétret had led a less-than-chaste life and had profited somewhat by her connections. When Mercier began making reference to this past and to Ménétret's vulnerability to jewel thieves, Ménétret dismissed her within a few weeks. Mercier refused to leave the house.

By the end of April 1883, Mercier was informing callers to the house that Ménétret had entered a convent. The police arrived to look into the matter, and Mercier produced a note in Ménétret's handwriting that left everything to "Mlle Mercier." Authorities seemed satisfied by the note, perhaps because of Ménétret's past, and left Mercier alone. Soon, her unbalanced siblings moved in with her and were seen wearing Ménétret's clothes. Mercier pawned her benefactor's jewels, fraudulently obtained her power of attorney, and regularly, and successfully, blackmailed her former lovers. In 1885, Mercier and her siblings were joined by her niece and nephew. The latter, Alphonse Chateauneuf, noticed that his aunt performed strange quasi-religious rituals and seemed preoccupied with a dahlia bed in the garden; once she almost killed a dog that began digging there. After she rebuffed his attempt to blackmail her, he went to the police and told them of his suspicions about Ménétret's fate. This time they investigated further, and Mercier was arrested after charred bones were found buried under the dahlias. Dental records confirmed that the remains were indeed Ménétret's. A search of the house uncovered an 1881 newspaper clipping from *Le Figaro* secreted behind a mirror; the story detailed a murder in Italy and the manner in which the corpse had been buried in the garden. At her trial in April 1886, Mercier's niece and nephew testified against her, and she was sentenced to 20 years in prison. The exact date on which she died there is not known.

SOURCES:
Nash, Jay Robert. *Look for the Woman.* NY: M. Evans, 1981.

Carol Brennan,
Grosse Pointe, Michigan

Mercoeur, duchess of.

See Mancini, Laure (1635–1657).

Mercouri, Melina (1923–1994)

Greek actress and politician who achieved international stardom in the movies Stella *and* Never on Sunday, *spent seven years in exile while Greece was ruled by a right-wing military junta, then returned home to serve in Parliament and as minister of culture and science. Name variations: Merkouri. Born Maria Amalia Mercouris in Athens, Greece, on October 18, 1923; died on March 6, 1994, in New York City; daughter of Irene and Stamatis Mercouris (a member of the Greek Chamber of Deputies and minister of the interior); married Panayiotis Harokopos, in 1940; married Jules Dassin (a director), in 1966; no children.*

Enrolled in the Academy of the National Theater as a teenager where she studied classical Greek tragedy for three years; after bit parts, starred in Mourning Becomes Electra, A Streetcar Named Desire, *and* The Seven Year Itch *before moving on to such movies as* Stella, He Who Must Die, Never on Sunday, *and* Topkapi; *quickly became a star; fought vehemently against the anti-democratic colonels who staged a coup in Greece, forcing her into exile after they took power (1967); returned to Greece after the*

overthrow of the military regime and won a seat in Parliament, a rare accomplishment for a woman in Greece (1974); appointed minister of culture and science, a position she held for eight years (1980).

Filmography: (title role) Stella *(directed by Cacoyannis, 1955); (as *Mary Magdalene)* Celui qui doit mourir *(He Who Must Die, Dassin, 1975);* The Gypsy and the Gentleman *(Losey, 1958);* La Loi *(Le Legge, also known as* Where the Hot Wind Blows, *Dassin, 1959); (as Ilya)* Pote tin kyriaki *(Never on Sunday, Dassin, 1960);* Vive Henri IV—Vive l'amour *(Autant-Lara, 1962);* Il guidizio universale *(The Last Judgment, Di Sica, 1962); (as Magda)* The Victors *(Foreman, 1963); (as Elizabeth Lipp)* Topkapi *(Dassin, 1964); (as Jenny)* Les Pianos méchaniques *(The Uninhibited, Bardem, 1965); (as Aurora-Celeste)* A Man Could Get Killed *(Neame and Owen, 1966); (as Maria)* 10:30 P.M. Summer *(Dassin, 1966); (as Queen Lil)* Gaily, Gaily *(Jewison, 1969); (as Nina Kacew)* La Promesse de l'aube *(Promise at Dawn, Dassin, 1970);* Once Is Not Enough *(Green, 1975);* Nasty Habits *(Lindsay-Hogg, 1976); (as Maya/Medea)* A Dream of Passion *(Dassin, 1978); (commentator)* Diving for Roman Plunder: The Cousteau Odyssey *(documentary, 1980);* Keine zufällige Geschichte *(Not by Coincidence, Kerr, 1984).*

Maria Amalia Mercouris was born on October 18, 1923, into a political family, a fact which marked her entire life. The Mercouris home was a gathering place for politicians, philosophers, and artists, and the little girl's first memories were of ardent discussions held there. Her maternal grandfather Spiros Mercouris was mayor of Athens for more than 30 years and her father Stamatis Mercouris served in the Greek Chamber of Deputies and as minister of the interior. Although politics was strictly a male sphere in Greece at the time, she visualized herself as an elected official even in early childhood.

Much of her life centered around her maternal grandfather, who called her "Melina" from *meli*, the Greek word for honey. He doted on the little girl, and frequently took her to the theatrical productions they both loved. Melina was a poor student, but became fluent in French, German and English as well as Greek. A fiercely independent child, she would slip out of her house at the young age of eight to go to the cinema or to cafes to listen to music. She and a friend would often dress up to perform in cafés, until her mother discovered she was sneaking out, and she was punished. When she finally graduated from high school, her grandfather had the city band play while he proudly affixed her diploma to the wall.

Upper-class girls did not become actresses in Greece, a fact which did not deter Melina's ambitions. At age 17, she eloped with a wealthy aristocrat, Panayiotis Harokopos, a man many years her senior. This marriage gave the young woman exactly what she wanted. Describing her first husband, she wrote:

> Politically he was conservative, not to say reactionary, but he had extremely liberal ideas on the role of women. He didn't try to turn me into a submissive wife. He didn't even make me take his name, as was normal at the time. I stayed Melina Mercouri for him and for everyone he introduced me to. That's how I broke free from my family and how I was able to study and prepare for the audition that would get me into the Drama School of the National Theater of Greece.

Mercouri's entry into the National Theater coincided with the Nazi occupation of Greece in World War II, and her involvement with her studies was so intense that she paid little attention to the political situation. Mercouri was determined, she said, to "live each day to the fullest and to hell with anything else, including ideals and hopes for liberation. . . . I was a parasitical, useless human being, and when I risked my life, I risked it for something as futile as a game of cards or an amusing evening." This description may have been unduly harsh because her younger brother served in the resistance while she did not. An anecdote she told of the time does not paint a picture of a selfish narcissist during wartime occupation:

> One day I was in a tavern with three friends when three SS men entered. They were dead drunk. They asked us to sit at their table. When we didn't move, one of them drew a revolver. My three friends got up then and went over to join them. I don't know what got into me because my head was empty, but I didn't move. The SS man was furious, he kept on at me. He pointed the pistol and started counting, "Eins, zwei, drei. . . ." I still didn't move. I wasn't scared. He fired, and the glass in front of me shattered. Now I was furious, and I got up and started shouting insults at him. I never considered that he might keep on firing. I wasn't thinking of anything. Then the military police arrived and dragged him out of the tavern.

By the time Greece was liberated from the Nazis on October 12, 1944, Mercouri was ready to make her debut on the Athens stage. Changing her last name from Mercouris to Mercouri, she played a member of the resistance in Alexis Solomon's *The Path of Freedom*, a performance which was poorly received, partly because the public resented seeing a member of the Greek ruling class portray a resistance fighter. Her first suc-

cess was in the role of Lavinia Mannon in Eugene O'Neill's *Mourning Becomes Electra*, and she became a star after she played Blanche DuBois in Tennessee Williams' *A Streetcar Named Desire*. Mercouri attributed her success to the play's director, Karolos Koun. Triumphs continued not only in Greece but also in Paris where she appeared in *Les Compagnons de la Marjolaine*, *Il était une gare*, and *Le Moulin de la Galette*.

In the mid-1950s, as Greek films became more sophisticated and began to receive interna-

tional acclaim, Mercouri's career also began to soar. In 1956, she starred in Michael Cacoyannis' film *Stella*, which won her the Best Actress award at the Cannes film festival. Written by Iacovos Campanellis, the part was originally created for Mercouri as a stage role, but Cacoyannis saw it as a movie. Describing the character of Stella, a modern and emancipated Greek woman, Cacoyannis said, "She's vibrant. She's proud of her body. She's proud of her liberty. She has lovers and she has friends. She refuses to think of marriage as a form of security, and she doesn't want society's blessing. She's suspicious of everything society approves of."

I was born Greek.
—Melina Mercouri

Mercouri loved the role of Stella, which remained a lifelong favorite. Her next movie, *Celui qui doit mourir* (*He Who Must Die*), was based on Nikos Kazantzakis' novel *The Greek Passion*, and was directed by Jules Dassin, the American-born expatriate from McCarthyism and the Hollywood blacklist. The movie marked the beginning of a partnership which would become lifelong when Mercouri married the director, after living with him for several years, in 1966.

On screen, Mercouri was in her element. *Stella* and *He Who Must Die* attracted European attention. Although Greek cinema was considered to be on the fringes of the medium at the time, Mercouri's third film with Dassin, *Never on Sunday*, took the world by storm. The story of a prostitute in the port of Piraeus who refuses to work on Sunday so that she can devote herself to cultural activities fit Mercouri perfectly. She seemed to understand what was important in life even when her circumstances were less than ideal. Filmed for less than $200,000, the movie made millions and launched Mercouri as an international star. Tawny haired, green eyed, with a husky voice, she epitomized the liberated woman of the '60s.

Mercouri continued to play a variety of roles, including the tragic heroine in *Phaedra* and a thief with a sense of humor in *Topkapi*. In 1967, Dassin wrote and directed a musical version of *Never on Sunday*, called *Ilya Darling*, for Broadway, in which Mercouri starred. The show was a hit, and Mercouri's career was in full swing in April 1967 when her world was suddenly changed with the toppling of the elected Greek government by a group of army colonels.

Although Mercouri's father organized the first committee against the dictatorship, she re-

mained silent at first, uncertain about what she should do. Describing her fears at the time, Mercouri recounted, "if I spoke out, I might never be able to go back. . . . For forty days, I didn't sleep. I was very afraid to take a position. But the dictators in Greece promoted my name in tourism and advertisements, and I came to feel that if I didn't come out strongly against them, I would be a collaborator."

Faced with news of thousands of arrests in her country, Mercouri began to speak out from New York against the unlawful new government. The colonels wasted little time in punishing the actress, stripping her of her citizenship and confiscating her property. When a British journalist informed Mercouri that Stylianos Patakos, the Greek vice premier, had declared her a non-Greek, she replied, "I was born Greek, I shall die Greek. Mr. Patakos was born a Fascist. He will die a Fascist."

International support for the star was quickly forthcoming. In New York City, "Melina is a Greek" buttons popped up everywhere. People stopped her on the street to give small donations for the Greek resistance. When the U.S. government recognized the colonels, Mercouri was infuriated; she also denounced the Soviet Union for condemning the junta while doing business with it. Her outspokenness quickly affected her everyday life. Jules Dassin recalled that a bomb would sometimes be found under a podium where she was to speak, or the "FBI would inform [them] that there was an assassination plot," and Melina would go onstage in *Ilya Darling* "not knowing whether her murderers were in the audience or when a gunshot might ring out." Mercouri continued, nevertheless, to be outspoken in her opposition. Describing her actions, she said:

> The coup d'état affected me like a rape. You can't react calmly to being raped. You shout, you protest, you scratch. I was abroad when the colonels seized power. Well, I shouted as loud as I could. I shouted, I sang, I danced for liberty. I wasn't a spoiled child anymore. I was someone to be reckoned with.

Recalling those seven years of exile, Mercouri noted: "To live in exile is something that is very, very strange. You become somebody else. Because at the same time you become somebody more international. . . . I became less nationalistic, and at the same time I [cried] more for Greece."

In August 1974, the junta of the colonels was finally ended, and Mercouri was elated to be able to go home. Not long after her return, she began a new phase of her life; she entered politics:

When we went back to Greece, after the fall of the colonels, I hesitated for a bit. Should I stay in politics full time? Then Andreas Papandreou rang up to ask me to be a candidate in the legislative elections, for the Piraeus, the second district. It was a difficult constituency for a woman. The voters were sailors, miners, macho types. I pointed out that I would feel more comfortable in Athens where . . . my grandfather had been mayor and my father had been a deputy. Papandreou won me over by his reply. He said, "Melina, you celebrated Piraeus in *Never on Sunday* and made it known around the world. In Piraeus you'll be able to smash the right and the left as well." I put forward my candidacy.

Tackling her new role, she was an atypical figure in Greece—a female politician.

I campaigned in the same way that I rehearse parts in the theater. Furiously, but with pleasure. I used to go into cafés and play backgammon with the old men. That improved my standing, because I used to win. I campaigned door to door, and people would gather groups together in their homes, anything from ten to thirty people. I immersed myself in their everyday problems, which were huge. There had been terrible rains that year, and there were serious drainage problems, all the more urgent because the buildings didn't have very solid foundations and the state of the roads were deplorable. Gradually these people's problems became my own. One day I even took to the streets with them against the police.

There were five candidates for the seat in Piraeus, but Mercouri won in the first round of voting. Happy to be back in the Greek political mainstream, she continued to act, mainly in the theater, and loved her busy, active life.

In 1980, Andreas Papandreou presented Mercouri with a new challenge, when he asked her to join his cabinet as minister of culture. For eight years she fulfilled this role, describing herself as a barefoot minister who "never sat at a desk." As the actress explained, "Desks create a distance between people. So I had a table brought in and when people came to see me, I would get up and we'd go over and sit down there side by side. It was strange how much easier conversations became." Her goal was to highlight Greek culture to make her people aware of their rich heritage. She explained her reasons to an American readership:

Your films are shown in every theater in Greece. How many Greek films have had wide distribution in the United States? Two. Your average film has a $10 million budget. If one of our films costs $200,000 it is considered a superproduction. Your best authors are translated into Greek. How many

of ours can you find in English? We cannot compete with you, but neither can we lose our Greek identity. It is my job to preserve our identity, to ask for a better balance between our culture and yours. I don't want to fight against anyone else's culture, but I will fight for my own.

One of her greatest battles as minister of culture was to restore the "Elgin" marbles to Greece. The 247 feet of marble frieze and 15 metopes were part of the Parthenon, the most famous structure of classical Athens, and had been removed to England in 1801–03 by Lord Elgin, then British Ambassador of the Sublime Porte, to "save them from destruction" at a time when Greece was under the rule of the Ottoman Turks, who cared little about what happened to the carvings off the building. According to Mercouri, "Lord Elgin was guilty of vandalism. He took possession of archaeological treasures purely to decorate his country home in Scotland." In fact, they have been housed and protected for a long time in the British Museum, which did not deter Mercouri from making her point about original ownership. "When you know you're fighting for something just, something which is right," she said, "it gives you wings." Her stance found considerable sympathy among people of the Third World who had come to feel that Europeans could no longer justify a long history of abrogating foreign properties of value.

In a 1978 interview, Mercouri summed up the difficulties of a modern independent woman, and a star:

It's not independence that makes for solitude—real independence. It's because society says that a woman who is alone—without being a couple—is lonely. It could be very normal for a woman to be alone the way a man can be alone. But it's not, with the way society is set up, the financial breaks, the conditions. It's especially hard for a woman who is not very young. In the film [*Medea*], the woman I play is forty-five or fifty years old. She's a woman who's been raised to be very dependent on men. She's an actress, and actresses are especially dependent on men because men control the cinema. An actress must be beautiful, photogenic. She has to make many sacrifices to becomes an actress—or rather to become a *star*, because the woman in the film is a star. And being a star means being exploited by men. A star is a divine object—beautiful, with no wrinkles, ageless. A star is also a woman who ages the fastest and who, ultimately, is the most alone.

Mercouri herself, however, had found an important role beyond stardom. In 1990, at age 65,

she ran for the office of mayor of Athens and lost. She was a chain smoker, rarely without a cigarette in her hand, and she was overtaken eventually by cancer. On March 6, 1994, she died in New York, and her body was flown back to Athens, where it lay in state before a huge funeral, held on March 10. Greeks mourned her passing, and in the country where democracy began, they declared her their "uncrowned queen."

SOURCES:

Alleman, Richard. "Melina Mercouri: The Actress Finds a New Role," in *Vogue*. Vol. 168, no. 11. November 1978, pp. 252–257.

Allen, Peter S. "Films. Lord Elgin and Some Stones of No Value," in *Archaeology*. Vol. 42, no. 2. March–April 1989, p. 72–73.

Elandi, Bahgat, and Adel Rifatt. "Interview with Melina Mercouri," in *UNESCO Courier*. Vol. 44, no. 12. December 1991, pp. 8–13.

Flint, Peter B. "Melina Mercouri, Actress and Politician, Is Dead," in *The New York Times Biographical Service*. March 1994, pp. 376–377.

Georgakas, Dan. "Never on Sunday (Pote Tin Kyriaki)," in *Magill's Survey of Cinema: Foreign Language Films*. Vol. 5. Englewood, Cliffs, NJ: Salem Press, 1985, pp. 2177–2180.

Ginger, Stephanie. "Mercurial Melina's Marbles," in *Contemporary Review*. Vol. 243, no. 1415. December 1983, pp. 311–313.

Hess, John L. "Melina Mercouri," in *The New York Times Biographical Edition*. October 20, 1972, p. 1826.

Kemp, Philip. "Mercouri, Melina," in *Actors and Actresses*. Edited by Nicholas Thomas. Detroit, MI: St. James Press, 1990, pp. 668–669.

Klemesrud, Judy. "She Can't Get Greece Out of Her Mind," in *The New York Times Biographical Edition*. March 4, 1971, p. 573.

"The Long Goodbye," in *Guardian*. March 11, 1994, section 2, p. 19.

"Melina's Last Battle," in *UNESCO Courier*. Vol. 47, no. 9. September 1994, p. 34.

"Mercouri, Melina," in *Current Biography 1965*. NY: H.W. Wilson, pp. 289–291.

"———," in *1988 Current Biography Yearbook*. NY: H.W. Wilson, pp. 379–383.

Mercouri, Melina. *I Was Born Greek*. Garden City, NY: Doubleday, 1971.

"Mercouri Makes Last Journey as All Greece Mourns," in *Guardian*. March 8, 1994, section 1, p. 13.

"Milestones: Melina Mercouri," in *Time*. Vol. 136, no. 2. July 9, 1990, p. 54.

"Obituaries: Melina Mercouri," in *The Times* [London]. March 7, 1994, p. 19.

Smith, Helena. "Greece Buries Its Uncrowned Queen," in *Guardian*. March 11, 1994, section 1, p. 12.

———. "'A Symbol of What Our Little Country Could Do,'" in *Guardian*. March 9, 1994, section 1, p. 12.

——— and Ronald Bergan. "The Woman Who Was Greece," in *Guardian*. March 7,1994, section 2, p. 12.

Steel, Ronald. "Even on Sunday. Diplomacy as a Full-Time Job," in *Vanity Fair*. Vol. 46, no. 6. August 1983, pp. 86–89.

Karin Loewen Haag,
freelance writer, Athens, Georgia

Mercuriade of Salerno (fl. 1200)

Italian physician and professor. Flourished around 1200 (some sources cite the 14th century) in Salerno, Italy.

A professional doctor and instructor in Salerno, Italy, Mercuriade had studied at the medical school at Salerno, at the time the most famous of its kind. She specialized in the art of surgery and gained renown for her healing abilities. Mercuriade is believed to have written at least four treatises on medicine, concerning surgery and herbal treatments.

Laura York,
Riverside, California

Mereau-Brentano, Sophie (1770–1806)

*German poet and novelist. Born in 1770; died in childbirth in 1806; married Friedrich Mereau, professor of jurisprudence (divorced 1801); married Clemens Brentano (a poet), in 1803; sister-in-law of *Bettine von Arnim (1785–1859).*

One of the leaders of the Romantic movement, Sophie Mereau-Brentano was a resident of Jena, one of the most active cultural centers in 18th-century Germany. She established her career at a young age, achieving financial independence by translating major literary texts, notably those of Giovanni Boccaccio (1313–1375) and *Germaine de Staël. Mereau-Brentano also published her own poetry in the important literary journals of the day, some of which she edited. One of her most acclaimed works was her appraisal of the 17th-century French intellectual *Ninon de Lenclos, whose letters she published. In this work, Mereau-Brentano advocates women's erotic emancipation, a subject she also explored in her novels *Das Blüthenalter der Empfindung* (*The Blossoming of Sensitivity*, 1794) and *Amanda and Eduard* (1803). Mereau-Brentano was married to Friedrich Mereau, a professor of jurisprudence whom she divorced in 1801. She then married the poet Clemens Brentano in 1803. She died in childbirth three years later.

Meredith, Louisa Anne (1812–1895)

Australian botanist and poet. Name variations: Louisa Anne Twamley; Louisa Meredith; Mrs. Charles Meredith. Born Louisa Anne Twamley on July 20, 1812, in Birmingham, England; died on October 21,

1895, in Victoria, Tasmania, Australia; daughter of Thomas Twamley (a farmer and miller) and Louisa Anne (Meredith) Twamley; educated at home; married Charles Meredith (later a member of the Tasmanian Parliament), on April 18, 1839; children: George (b. 1840); Charles (b. 1844); Owen (b. 1847); one son who died young.

Published first book (1835); moved to New South Wales (1840); wrote first children's book (1860); co-founded Tasmanian branch of Society for the Prevention of Cruelty to Animals (1878); granted government pension (1884).

Selected writings: Notes and Sketches of New South Wales (1844); My Home in Tasmania (1852); Over the Straits: A Visit to Victoria (1861); Some of My Bush Friends in Tasmania (1860); Phoebe's Mother (1869); Our Island Home (1879); Tasmanian Friends and Foes, Feathered, Furred, and Finned: A Family Chronicle of Country Life (1880); Waratah Rhymes for Young Australia (1891).

Louisa Anne Meredith was the first Australian woman to achieve literary renown in international circles. Her accounts of the often arduous and sometimes alien conditions of life for English immigrants to the new land of Australia were popular with readers both at home and in Europe. Meredith also possessed a progressive mind, championing conservation causes and animal rights in her day and helping raise awareness for those issues through her writing as well as her husband's political prominence. Meredith's father was already 55 years old when she was born in Birmingham, England, in 1812, and as an adult she would become financially responsible for her elderly mother for many years. She began writing and drawing at a young age, and when her father died in 1834 she displayed such self-possession that she was approved in her bid to take over his job as Birmingham's corn inspector. Her first book, *Poems*, was published in 1835. Over the next few years, she continued to write and draw under her given name of Louisa Anne Twamley, exhibiting her work in Birmingham and gaining a reputation as a forthright voice on literary matters with her articles and reviews.

New South Wales in Australia had been founded by the British as a penal colony in 1788, and opened to immigration by free settlers in 1820. Van Diemen's Land (now Tasmania), an island off the coast of Australia, had been settled in 1803 and established as a separate colony in 1825. Meredith had cousins in Van Diemen's Land, and when one of them came to England to settle business matters, they fell in love. She mar-

ried Charles Meredith in April 1839, and immediately sailed with him to the Antipodes for a planned five-year stay that became permanent. The sea journey alone took four months, and Meredith wrote of it in *Notes and Sketches of New South Wales*, published in 1844. She would write numerous other accounts of life in Australia, which was often hazardous and a far cry from the England she had known. Dangerous wild animals, tropical illnesses, and odd plants and insects were just some of the risks she wrote of, but Meredith saw the humor and beauty in her new world and took obvious delight in it. In 1840, she gave birth to the first of four sons, one of whom would die young, and continued her literary career unabated.

Meredith was the compiler and illustrator of several books about the plant and animal life in Australia. Although not formally educated, she was skilled enough in scientific observation that her plates became respected in the academic world for their accuracy of detail; she also corresponded with leading botanists in Europe and Australia regarding her findings. Publications such as *Some of My Bush Friends in Tasmania* (1860) and *Our Island Home* (1879) are two examples highlighting her artistic talents. She also wrote and illustrated books of poetry for children and adults as well as two novels, but these latter were not as well received as her travelogues and entertaining first-person accounts of life in Australia.

Meredith and her husband struggled financially for much of their married life. In 1860 he won election to the Parliament in Tasmania, and held his seat for the next 19 years. By then Meredith had become an important figure in the animal welfare movement in Australia, and was a co-founder of the Tasmanian branch of the Society for the Prevention of Cruelty to Animals in 1878. Her husband's position furthered these interests—for instance, he introduced a bill to protect the black swan, the feathers of which were cruelly harvested, as his wife had written of in *My Home in Tasmania* (1852). He died in 1880, and four years later the government granted Meredith a modest pension for her contributions to art and science. Still impoverished, she died in 1895. A biography of Meredith by **Vivienne Rae Ellis**, *Louisa Anne Meredith: A Tigress in Exile*, was published in 1979.

SOURCES:

Buck, Claire, ed. *The Bloomsbury Guide to Women's Literature*. NY: Prentice Hall, 1992.

Radi, Heather, ed. *200 Australian Women: A Redress Anthology*. NSW, Australia: Women's Redress Press, 1988.

Shillinglaw, Ann. "Louisa Anne Meredith," in *Dictionary of Literary Biography*, Vol. 166: *British Travel Writers, 1837–1875*. Detroit, MI: Gale Research, 1996, pp. 259–264.

Wilde, William H., Joy Hooton, and Barry Andrews. *The Oxford Companion to Australian Literature*. Melbourne: Oxford University Press, 1985.

Carol Brennan,
Grosse Pointe, Michigan

Meredyth, Bess (1890–1969)

American screenwriter. Born Helen MacGlashan in Buffalo, New York, in 1890; died in 1969.

Selected filmography: The Twin Triangle *(1916);* Spellbound *(1916);* Bring Home Father *(1917);* The Little Orphan *(1917);* Pay Me *(1917);* Scandal *(1917);* The Grain of Dust *(1918); (also co-directed with Lucas)* Morgan's Raiders *(1918);* The Romance of Tarzan *(1918);* The Girl From Nowhere *(1919);* The Grim Comedian *(1921);* The Dangerous Age *(1922);* One Clear Call *(1922);* Rose o' the Sea *(1922);* The Woman He Married *(1922);* The Song of Life *(1922);* Stranger of the Night *(1923);* The Red Lilly *(1924);* Thy Name Is Woman *(1924);* A Slave of Fashion *(1925);* The Love Hour *(1925);* Ben-Hur *(1926);* The Sea Beast *(1926);* Don Juan *(1926);* When a Man Loves *(1927);* The Magic Flame *(1927);* Rose of the Golden West *(1927);* The Little Shepherd of Kingdom Come *(1928);* The Yellow Lily *(1928);* The Mysterious Lady *(1928);* A Woman of Affairs *(1928);* Wonder of Women *(1929);* Chasing Rainbows *(1930);* In Gay Madrid *(1930);* The Sea Bat *(1930);* Our Blushing Brides *(1930);* Romance *(1930);* The Prodigal *(*The Southerner, *1931);* West of Broadway *(1931);* Cuban Love Song *(1931);* Laughing Sinners *(1931);* The Phantom of Paris *(1931);* Strange Interlude *(1932);* Looking Forward *(1933);* The Affairs of Cellini *(1934);* The Mighty Barnum *(1934);* Folies Bergere *(1935);* Metropolitan *(1935);* Half Angel *(1936);* Under Two Flags *(1936); (story only)* Charlie Chan at the Opera *(1936);* The Great Hospital Mystery *(1937); (co-adaptation only)* The Mark of Zorro *(1940);* That Night in Rio *(1941);* The Unsuspected *(1947).*

Although she began her career as an extra for D.W. Griffith at Biograph, Bess Meredyth made her greatest contribution as a screenwriter. Her credits are numerous, and include scripts for some of the most notable silent and sound pictures of her era, including *Ben-Hur* and *The Sea Beast*. Unfortunately, Meredyth's name slipped into obscurity and little was recorded about her life.

Merete Ulfsdatter (fl. 1320–1370).

See Margaret I of Denmark for sidebar.

Merezhkovski, Zinaida Nikolaevna (1869–1945).

See Gippius, Zinaida.

Meri, La (b. 1898).

See La Meri.

Merian, Maria Sybilla (1647–1717)

German-Dutch entomologist and artist who helped establish the field of entomology, made drawings and writings preeminent in the field, and traveled extensively in South America gathering specimens for her work. Born Maria Sybilla Merian in Frankfurt am Main, Germany, on April 2, 1647; died in Amsterdam, the Netherlands, on January 13, 1717; daughter of Matthäus Merian (an engraver and topographer) and his second wife, Johanna (Heim) Merian; married Johannes Graf, in 1665 (divorced around 1686); children: Johanna Helena Graf; Dorothea Graf Gsell.

Worked as an artist, engraver, and manufacturer of paints; established reputation as an entomologist and scientific illustrator (c. 1675–78); published illustrated treatise on caterpillars and their food supply (1679); published Neues Blumenbuch *(1680); lived as member of Labadist Commune (1678–88); divorced her husband and resumed using her maiden name (1685 or 1686); voyaged to Surinam in South America for scientific study and to illustrate her discoveries (1699–1701); published major scientific work,* Metamorphosis insectorum Surinamensium *(1705).*

Publications: Florum Fasciculi tres *(Flower Collection in Three Parts, c. 1675–1678);* The Miraculous Transformations of Caterpillars and Their Strange Flower Nourishment *(1679);* Neues Blumenbuch *(1680); illustrations for Joannes Goedaert's* Metamorphosis et historia naturalis insectorum; Metamorphosis insectorum Surinamensium *(1705).*

Born in Frankfurt am Main, Germany, on April 2, 1647, Maria Sybilla Merian was the daughter of a well-known engraver and topographer, Matthäus Merian, and his second wife, **Johanna Heim**. Johanna ran the prosperous publishing house inherited through Matthäus's first wife, **Maria de Bry**, while Matthäus supplied the engraved plates for the firm's published works. The Merian family was large; Maria Sybilla, the eldest child of Johanna and Matthäus, had seven older half-siblings. Before her fourth birthday, her father died, and within the year her mother

married Jacob Marrell, a flower painter who had learned his trade in Holland.

Maria Sybilla showed an early interest and ability in drawing, which Marrell recognized and encouraged, despite the fact that her mother wanted her to specialize in needlework. The training she received from her stepfather and his apprentices gave her an entrée into art. Her education was not especially remarkable for the time, since women by then had a significant history of achievement in art, and many were active in painters' guilds. Merian's career differed from that of young men of the time primarily in that she worked solely in the shop of her stepfather rather than traveling and serving as a journeyman to several masters over a period of years. Marrell himself was a prominent artist who traveled frequently and was once away for five years, enabling Maria Sybilla to study under the masters who temporarily took his place. In this way her exposure was broadened, and she became a meticulous observer, well able to accurately reproduce what she saw.

From her early youth, Merian was interested insects, especially in silkworms and their cocoons. The first work on entomology, by Thomas Moufet, had been published only 12 years before her birth, and comparatively little was known at the time about insects. (During Merian's lifetime, the classics were a more respected field of study than were scientific pursuits, with the result that many women who were excluded from studying the classics chose to study science, and that nearly all women and men who studied the sciences were largely self-educated and forced to finance their studies.) The notion, held since the time of Aristotle, that insects grew spontaneously out of decaying matter, was not dispelled until 1668 (by Francesco Redi), so Merian had the opportunity to make her own discoveries in this very new field. She first kept silkworms, and then other caterpillars, in brood boxes, closely observing their metamorphosis. She then began to document the changes in her paintings and on paper. She learned about the plants on which they fed, and the ideal temperatures for their survival, and eventually studied Latin in order to read contemporary scientific literature.

At 18, Merian married one of her stepfather's pupils, Johannes Andreas Graf of Nuremberg. Three years later their first daughter, **Johanna Helena**, was born, and the couple moved to Nuremberg. Because Graf was a spendthrift, Merian took up textile painting and embroidery to earn extra income. For her works done on silk

and linen (mostly reversible tablecloths, but once also a tent for a general), she developed colorfast paints, extracted from plants and fruit, which were considered outstanding. She shared the secret of their manufacture with another flower painter, **Magdalena Furst**, giving them both an advantage in the market. Merian also published a number of her designs in a book, *Florum Fasciculi tres* (Flower Collection in Three Parts), completed between 1675 and 1678.

In 1678, the year her second daughter Dorothea (**Dorothea Gsell**) was born, Merian began to engrave the first of 50 plates of the work which would establish her reputation as an entomologist and scientific illustrator. In *The Miraculous Transformations of Caterpillars and Their Strange Flower Nourishment*, a lengthy introduction explained her long interest in insects. Each insect was depicted on its host plant, and each entry gave detailed observations of the caterpillar's development from pupae to butterfly. Most of the plates for this work were etched by the artist herself, because Merian was afraid to entrust them to artisans less familiar with the material. The quality of the work was helped by the recently developed technology of engraving on copper instead of wood, a technique which

Maria
Sybilla
Merian

allowed illustrations in much finer detail than had previously been available. Merian invented her own technique for printing, because she wanted the plates to have the more natural effect of watercolor. She first inked a plate and pressed it onto the paper, then pressed a second wetted sheet of paper onto the still freshly inked first paper. The print would thus appear on the second, wetted sheet with the lines softened and unobtrusive and far more natural.

Merian's marriage was probably less than satisfactory. Johannes Graf was beset by legal difficulties, although whether these were caused by debts or embezzlement is not certain. In any case, he left his wife and two daughters, and Merian returned with her children to her family in Frankfurt, where her stepfather had died in 1681. There she published the second part of *The Miraculous Transformations* under her maiden name.

Merian's half-brother Caspar had become involved with a religious group, the Labadists, or Children of Light, one of many pietist sects which flourished after the Reformation. Caspar Merian was already living in a religious commune established by the Labadists in a castle in West Friesland, in Holland, when Merian, her mother, and daughters joined him there in 1685. There is some question as to whether or not Merian's reasons for joining the commune were purely religious. The Labadists did not believe in formal marriage, and all evidence indicates she was not a strict Labadist but used the sect as a means of escape from her marriage to Johannes Graf. When he visited the commune in 1686 to entreat her to return to him, she refused. From this point on, she stopped using her married name, and she obtained a divorce from Graf. Throughout this time, she had continued her studies of flora and fauna as well as of Latin.

Merian left the Labadist community after it began to break up in 1688. Following the death of her mother in 1691, she gave up her civic rights in Frankfurt and moved to Amsterdam, a rich city engaged in trade in the East and West Indies. There she supported her family by selling her fabric paintings and manufacturing paints, and worked on the preparation of 127 illustrations for Joannes Goedaert's *Metamorphosis et historia naturalis insectorum*. She also met Caspar Commelin, director of the botanical garden, and began to study the many natural history collections in Amsterdam. Disappointed that only dead specimens were available, Merian decided, at age 52, to go to South America, to study insects in their natural habitat.

In 1699, after an arduous three-month journey, Merian and her daughter Dorothea arrived in the remote Dutch colony of Surinam, on the northernmost rim of South America. The colony boasted a Labadist mission and a capital city, Paramaribo, with "500 houses made of wood and two of brick," so well protected by tangled mangrove swamps that pirates made no attempt to raid it. Merian began to gather specimens from the hot and humid jungle, observe plant and insect life, and to annotate her findings in drawings and notes. She also studied snakes, lizards, wasps, and spiders, at times cutting down trees to obtain her specimens. Meticulously recording her every discovery, she made some startling observations, including the habits of a large hunting spider which attacked and devoured hummingbirds in their nests.

In Surinam, Merian contracted yellow fever and malaria, and was forced to entrust her collection of specimens to others. She gathered much information from the native inhabitants, although sometimes she questioned the scientific truth of what she was told. She also became critical of the planters because of their treatment of the Indians, who told her that "they commit suicide because they are treated so badly, and because they believe they will be born again, free and living in their own land." Merian reported that the planters "mock me, because I am interested in something other than [the growing and selling of] sugar," but she worked in Surinam for two years, until bad health forced her to return to the Netherlands.

In Amsterdam, Merian's specimens—a crocodile, snakes, iguanas, turtles, butterflies and other insects, many never before seen in Europe, and all preserved in brandy—were put on display in the town hall. After selling some specimens and illustrations to recoup the cost of the trip, she completed her major work, *Metamorphosis insectorum Surinamensium*, published in three volumes in 1705. In 60 illustrations, she detailed the life cycles of various caterpillars, worms, maggots, moths, butterflies, beetles, bees, and flies; she also illustrated the plants on which they fed. Production of the work was extremely expensive, as Merian employed the most famous engravers and used the best paper "so that the connoisseur of art as well as the lover of insects could study it with pleasure and joy."

The monumental work created a sensation. Critics praised its "plants never before described or drawn," saying it was the "first and strangest work painted in America." By incorporating her discoveries into an already existing body of

Metamorphosis
Insectorum
Surinamensium
*by Maria Sybilla
Merian.*

knowledge gathered by Thomas Moufet, Joannes Goedaert, Jan Swammerdam, and others, Merian's work broadened the field of entomology, but she was cautious in the presentation of her findings, because so much of her information differed from standard texts. Careful not to claim too much, she simply presented her observations, allowing readers to draw their own conclusions. She also departed from standard scientific practice by using native American rather than Latin plant names. The text sometimes included practical information, a common practice in natural

histories of the period; in describing the pineapple, for instance, she wrote, "one eats it raw and cooked, one can make wine and brandy from it." When writing about the cassava root eaten in America by both Indians and Europeans, she wrote, "If the root is eaten raw, one dies of its poisons; if prepared correctly it makes a tasty bread similar to Dutch Zwieback."

By 1771, 19 editions of the tremendously successful *Metamorphosis* had been published. It became a fixture in natural history libraries as well as in drawing rooms, and remained the main source of information about South America's tropical insects until the end of the century. Peter the Great, tsar of Russia, became one of her greatest admirers, and Christoph Arnold wrote that "what Gesner, Wotton, Penn and Muset have neglected to do has come to life in Germany through the hands of a clever woman."

In 1714, Merian's daughter Johanna and her husband left for Surinam to continue collecting. The following year Merian suffered a stroke, and lived thereafter with Dorothea and her husband George Gsell, a painter and engraver. She died in Amsterdam on January 13, 1717, before Johanna's return. Dorothea and her husband were persuaded by Peter the Great to move to his court at St. Petersburg, where they continued Merian's work and trained the painters who accompanied the Danish explorer Vitus Bering on his discovery of the northern route to the Americas.

The Swedish botanist Carolus Linnaeus, whose system of classification for plants is still used, cited Merian's work over 100 times in his own work; the German explorer Alexander von Humboldt had his portrait painted holding the flower of a plant species he had named for her. Merian's reputation as a scientist was unblemished until the 19th century, when with the rise of the middle class, which felt women should "remain in their place," it became fashionable to downplay the accomplishments of women. Recently Merian's work has again attracted much attention, and numerous articles have been written about her and her work. In Germany, her scientific achievements were recognized when she was honored with a postage stamp. Illustrations by Merian can be found today in collections in St. Petersburg and the British Museum. To date, six plants, nine butterflies, and two beetles have been named for Merian.

SOURCES:

Erlanger, Liselotte. "Maria Sybilla Merian. 17th Century Entomologist, Artist, and Traveler," in *Insect World Digest*. Vol. 3, no. 2. March–April 1976, pp. 12–21.

Phillips, Patricia. *The Scientific Lady: A Social History of Women's Scientific Interests 1520–1918.* NY: St. Martin's Press, 1990.

Schiebinger, Londa. *The Mind Has No Sex? Women in the Origins of Modern Science.* Cambridge, MA: Harvard University Press, 1989.

"A Surinam Portfolio," in *Natural History*. Vol. 71, no. 10. December 1962, pp. 28–41.

Tufts, Eleanor. *Our Hidden Heritage: Five Centuries of Women Artists.* NY: Paddington Press, 1974.

Valiant, Sharon D. "Questioning the Caterpillar," in *Natural History*. Vol. 101, no. 12. December 1992, pp. 46–59.

Karin Haag,
freelance writer, Athens, Georgia

Merici, Angela (1474–1540).

See Angela of Brescia.

Méricourt, Théroigne de (1762–1817).

See Théroigne de Méricourt, Anne-Josèphe.

Merit-neith (fl. c. 3100 BCE).

See Mer-neith.

Merkel, Una (1903–1986)

American actress who was nominated for an Academy Award for her performance in Summer and Smoke. *Born on December 10, 1903, in Covington, Kentucky; died in 1986; daughter of a traveling merchant; married Ronald L. Burka, in 1932 (divorced 1946).*

Selected plays: Two by Two *(1925);* Pigs *(1944);* Coquette *(1944);* Three's a Family *(1944);* The Remarkable Mr. Pennypacker *(1953);* The Ponder Heart *(1956);* Take Me Along *(1959).*

Selected filmography: Abraham Lincoln *(1930);* Private Lives *(1931);* The Maltese Falcon *(1931);* Red-Headed Woman *(1932);* 42nd Street *(1933);* Blonde Bombshell *(1933);* The Merry Widow *(1934);* Cat's Paw *(1934);* Biography of a Bachelor Girl *(1935);* Riff-Raff *(1936);* Saratoga *(1937);* On Borrowed Time *(1939);* Destry Rides Again *(1939);* Road to Zanzibar *(1941);* My Blue Heaven *(1950);* The Kentuckian *(1955);* The Parent Trap *(1961);* Summer and Smoke *(1961).*

Una Merkel, a character actress of the 1930s, was usually cast in jaunty female supporting roles. Born in 1903, she was the daughter of a traveling merchant who took his entire family on the road with him; as a result, Merkel did not begin attending school until the age of nine. She grew up in Philadelphia and later in New York City, where she took dance and acting classes. As a teen, she modeled for movie magazines, which led her to roles as an extra in motion pictures being filmed at various New York studios. She bore a resemblance to *Lillian Gish,

a great screen star of the day, and was cast to play her sister in a film that was never made. Merkel's first speaking part came in the Broadway play *Two by Two* in 1925, and she spent the next few years as a cast member in two long-running stage productions, *Pigs* and then *Coquette*, alongside *Helen Hayes.

Merkel made her film debut in the role of *Ann Rutledge in *Abraham Lincoln*, a D.W. Griffith epic that starred Walter Huston, and after a role in 1931's *Private Lives* was signed to a Metro-Goldwyn-Mayer contract. She was an attractive actress, but not glamorous, and this somewhat limited her roles in the Hollywood fantasy factory of her day. She appeared in such films as *Blonde Bombshell, Cat's Paw, Riff-Raff, Saratoga*, and *On Borrowed Time*, all made between 1933 and 1939. In them, Merkel appeared alongside some of the greatest stars of the era, among them Clark Gable, *Jean Harlow, Jack Benny, and Lionel Barrymore. For the 1939 movie *Destry Rides Again*, she engaged in a memorable on-screen fight with *Marlene Dietrich.

After a 15-year hiatus from Broadway, Merkel returned there in 1944 with *Three's a Family*. She won a Tony Award in 1956 for her role on Broadway in *The Ponder Heart*, and received her only Academy Award nomination for her performance as *Geraldine Page's dissipated mother in the 1961 film version of Tennessee Williams' *Summer and Smoke*. Tragedy blighted her life in later years: her mother killed herself in 1945, nearly poisoning Merkel with gas in the process, and the actress herself survived a suicide attempt in 1952. In the early 1970s, she was living in Los Angeles with her father, who was then in his 90s. Una Merkel died in 1986.

SOURCES:

Katz, Ephraim. *The Film Encyclopedia*. NY: HarperCollins, 1994.

Lamparski, Richard. *Whatever Became of . . . ?* 3rd Series. NY: Crown, 1970.

Carol Brennan,
Grosse Pointe, Michigan

Merman, Ethel (1912–1984)

American entertainer, a fixture in Broadway musicals of the 1940s and 1950s, who starred in the original productions of Annie Get Your Gun, Call Me Madam, *and* Gypsy. *Born Ethel Agnes Zimmerman on January 16, 1912, in New York City; died in New York on February 15, 1984; daughter of Edward Zimmerman (an accountant) and Agnes Zimmerman; married William Smith, in 1940 (divorced 1941); married Robert Levitt, in 1941 (divorced 1952); married Robert Six, in 1953 (divorced 1960); married Ernest Borgnine (an actor), in 1964 (divorced the same year); children: (second marriage) Ethel Levitt (died 1967); Robert Levitt, Jr.*

Although she never trained professionally as a singer, her powerful, exuberant singing style and flawless diction became locally famous when she began performing in small nightclubs while working during the day as a stenographer; discovered by a Broadway producer, made her stage debut in the Gershwins' Girl Crazy (1930); became a fixture of the Broadway musical stage (1940s and 1950s), starring in the original productions of such musicals as Annie Get Your Gun, Call Me Madam, *and* Gypsy; *also appeared in many film musicals (1940s–1950s); continued to work in non-musical films until just a few years before her death (1984).*

Filmography: Follow the Leader *(1930);* We're Not Dressing *(1934);* Kid Millions *(1934);* The Big Broadcast of 1936 *(1936);* Anything Goes *(1936);* Strike Me Pink *(1936);* Happy Landing *(1938);* Alexander's Ragtime Band *(1938);* Straight Place and Show *(1938);* Stage Door Canteen *(1943);* Call Me Madam *(1953);* There's No Business Like Show Business *(1954);* It's a Mad, Mad, Mad, Mad World *(1963);* The Art of Love *(1965); (voice only)* Journey Back to Oz *(1974); (cameo)* Won Ton Ton—The Dog Who Saved Hollywood *(1976); (cameo)* Airplane *(1980).*

The young woman who arrived at George Gershwin's elegant Riverside Drive apartment in New York City one afternoon in 1930 seemed perfectly ordinary, one of the many young hopefuls the great composer had auditioned in past weeks for his new Broadway musical. As usual, he had prepared audition sheets for three songs from the show and, after the usual polite conversation, sat down at the piano and began playing. Gershwin later admitted he was unprepared for the voice which filled his living room and which would, over the next 30 years, be variously compared to a trumpet, a bulldozer, a freshly tapped gusher, and a cyclone. Gershwin was so impressed that afternoon that he offered to change anything in any of the songs that the young woman didn't like, even though she had never before appeared in a Broadway musical. "Oh, no, Mr. Gershwin, they'll do very nicely," Ethel Merman confidently replied, launching her career as the queen of the American musical stage. "Miss Merman is the Everest of American musical comedy simply because she's there," one reviewer wrote of her some years later. "Her presence has all the subtlety of a block of marble."

It would be tempting to tell a story of hardship and struggle on Ethel Merman's way to stardom, but the fact is that she became one of

America's best-known celebrities with her first appearance on a Broadway stage, after being encouraged and nurtured by parents who had raised her in a comfortable middle-class setting in Astoria, just across the Queensboro Bridge from Manhattan. She was born on January 16, 1912—although for years her official birth year was listed as 1909, the year Merman adopted to convince the producers of her first show in 1930 that she was a legal 21. Neither of her parents—**Agnes Zimmerman** and Edward Zimmerman, an accountant—were from a show-business background, but both enjoyed going to the theater and often took their daughter on Friday nights to see the show at the venerable Palace Theater on Seventh Avenue, where Merman never forgot how effortlessly such vaudeville stars as *Fanny Brice, *Sophie Tucker and *Blossom Seeley held their audiences. "When they'd get on stage," Merman remembered, "I'd think—oh, boy, *I* could do that." Then there was Paramount's Astoria Studios just blocks from Merman's house in Queens, where glimpses of the day's movie stars could be had by poking a hole in the wall surrounding the lot. It was obvious to both parents that their daughter was as fascinated as they were by the entertainment world and, further, had a knack for belting out a song at amateur theatrical nights at the Astoria Republican Club, of which they were proud members. Throughout her childhood, "Little Ethel Zimmerman" was a popular attraction at gatherings of the Knights of Columbus, the Masons and, during World War I, at the Army's training camp in Queens, often accompanied by her father on the piano on such snappy little numbers as "Since Maggie Dooley Did the Hooley-Hooley."

While proud of Ethel's natural gift, the Zimmermans regarded show business as a perilous way to make a living and insisted that Merman enroll in a stenographic course after graduating from high school in 1928. They further insisted that she take a job offered to her at the Bragg-Kliesrath Vacuum Booster Brake Company in Long Island City. Ethel was delighted to discover, however, that her boss was another theater enthusiast and, even better, had numerous friends in the business. Through his influence, Merman spent several evenings a week appearing in small nightclubs, registering with theatrical agents and browsing the shelves at music publishers for the latest songs of the day. In 1929, little more than a year after beginning her nocturnal career, Merman signed a contract with agent Lou Irwin, who had been impressed that he could clearly hear every word she sang

through the din and bustle of a well-known club called Little Russia, just off Sixth Avenue in what was then Manhattan's thriving club district. Irwin, who represented such notables as *Helen Morgan and the Ritz Brothers, soon found her a contract with Warner Bros. to appear in short musical films for $125 a week, more than three times what she earned as a stenographer. Merman was equally impressed by the fact that Warner Bros. had to pay her even if she didn't work in any given week. Further, Irwin teamed her with Jimmy Durante in a well-received cabaret act. By late 1929, even though the stock market lay in ruins and the Great Depression had begun to grip the nation, Merman had made it to the Palace in the company of a pianist Irwin had found for her with whom she had worked up a vaudeville act. Discovering that Zimmerman was too long to fit on a theater marquee, Ethel removed the first syllable of her surname and became Ethel Merman.

In the audience one evening was Vinton Freedley, a producer then in the midst of mounting a new Broadway musical called *Girl Crazy*, with a score by George Gershwin and his brother Ira. It was Freedley who arranged for Merman's audition with Gershwin that afternoon and who ultimately cast her in the role of the sassy nightclub singer Kate Fothergill. The authors of the musical's book, Howard Lindsay and Russell Crouse, became such Merman fans that they enlarged her role and personally coached Ethel in playing to a big Broadway house. The audience on opening night, lulled by the familiar romantic intimacy of a Gershwin show, was electrified halfway into the first act when Merman strode on stage in a red blouse and black, slit satin skirt to belt out "Sam and Delilah," Gershwin's decidedly modern retelling of the famous lovers' story:

> Delilah was a floozy,
> She didn't give a damn.

"The audience yelped with surprise and pleasure," Merman later reported. "To be truthful, I thought my garter had snapped or I'd lost something." But that was only for starters, as the audience discovered just before the curtain rang down for intermission, when Ethel gave them "I Got Rhythm," the first time that Broadway anthem was heard in public and the first time any Broadway audience had heard a singer precisely hit a high C and hold it effortlessly, at full volume, for 16 bars. "Miss Merman can hold a note longer than the Chase Manhattan Bank," one critic wrote in the next morning's reviews. Gershwin had rushed to Merman's dress-

ing room as soon as the curtain went down and pleaded with her never to go near a professional singing teacher.

Merman's overnight reputation as an electrifying showstopper became the talk of Broadway and produced her second job offer, for a show which had been having trouble in out-of-town tryouts and desperately needed some adrenaline. It was the 11th edition of George White's *Scandals*, a rival revue to Flo Ziegfeld's even longer-running *Follies*. Merman, who went into rehearsal with the show in Atlantic City, first appeared in the Newark production in September 1931 and opened in a much-improved Broadway version the next month in a cast that included Rudy Vallee, *Alice Faye*, and Ray Bolger. Merman's rendition of "Life Is Just a Bowl of Cherries" for *Scandals* promptly became another overnight hit. Even more treasures were in store for the 1934 production of Cole Porter's *Anything Goes,* most of which were sung by Merman in her role as Reno Sweeney; along with the title tune, she belted out "You're the Top," "Blow, Gabriel, Blow," and "I Get a Kick Out of You." The show gave Ethel her longest run on Broadway to date, at 420 performances, and reviews that firmly installed her in the pantheon of musical-comedy goddesses. "Miss Merman reigns supreme as the exponent of a style she seems to have invented," wrote one critic. *Anything Goes* was followed by two more Cole Porter vehicles, *Red, Hot and Blue* in 1936, and 1939's *DuBarry Was a Lady*, playing opposite Bert Lahr. Neither show is much remembered, and even Merman referred to *DuBarry Was a Lady* as a "tired businessman's entertainment." Even so, Ethel's boisterous handling of "Eadie Was a Lady" in the first show, and her work with Bert Lahr singing "Friendship" in the second, added two more songs to her growing list of musical milestones.

America beyond Broadway got to know Merman by way of a string of big-budget Hollywood musicals during the 1930s and early 1940s, starting with 1930's *Follow the Leader* and 1934's *We're Not Dressing*, in which Ethel was required to sing a number called "It's the Animal in Me" while a chorus line of elephants plodded through a dance behind her. The song was mercifully cut from the final version of that picture but was inserted in *The Big Broadcast of 1936* even though Merman never set foot on the lot during shooting of the later film. The fact that she was paid for two films while actually working in only one did little to improve Merman's low opinion of film work. "Everything seemed fake," she later wrote. "Worse still, there

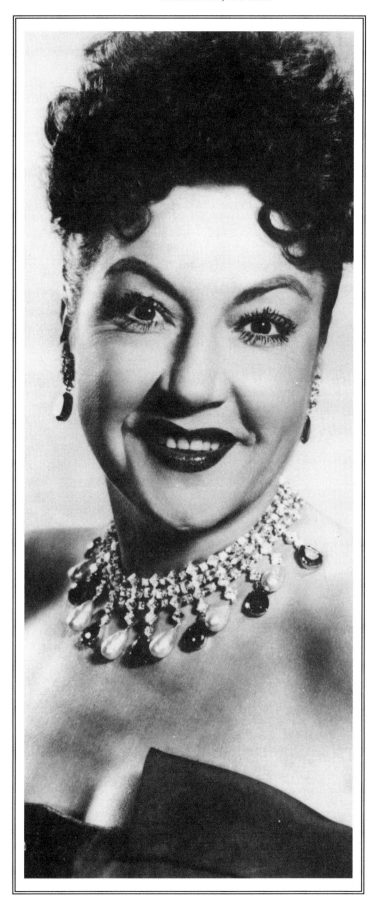

seemed to be no reason for the way things were done. I liked to be in control. You couldn't be in films." However lukewarm, Merman's relationship with Hollywood nonetheless continued through much of her career, while radio and recordings brought her into even more homes. Her early recordings were from the scores of her Broadway hits, but soon she was producing albums of popular standards and new works written especially for the studio. Radio audiences listened to her on "Rhythm at Eight," a short-lived network radio show which aired for four months in 1935, as well as guest appearances on more well-known broadcasts like "The Fleischman's Hour," hosted by Rudy Vallee.

I sing honest. Loud, but honest.

—Ethel Merman

But the stage remained her first love. If a musical wasn't on offer, Merman was more than willing to appear in the lavish musical revues that were all that remained of a dying vaudeville, sharing the bill with such stars as George Jessel and Jack Haley. Such was her standing by 1937 that 25,000 turned out to hear her sing at an outdoor memorial concert for George Gershwin, who had died of a brain tumor at the height of his career. The 1940s were her most successful decade, opening with her first solo billing as Hattie Malone—"a brassy broad who hung out with sailors and didn't speak correct," as Merman described her—in *Panama Hattie*. She created the role of the equally brassy Blossom Hart in her fourth Cole Porter show, 1943's *Something for the Boys*. Her blend of brilliant technical expertise with Porter's earthy lyrics led one reviewer to call her "the bridge between *Lily Pons and *Mae West."

It was Irving Berlin, however, who provided Merman with the triumph of her career to that point as the sharp-shooting *Annie Oakley in Berlin's *Annie Get Your Gun*. Among the numbers Berlin entrusted to Ethel's handling were "There's No Business Like Show Business," "You Can't Get a Man With a Gun," and "They Say It's Wonderful." The show opened to great acclaim in 1946 and became the first Broadway musical to run more than 1,000 performances, racking up 1,147 of them before closing in 1947. "With all due respect to the Gershwins and Cole," Merman later said, "Irving gave me range, allowing me a kind of vulnerability that was missing in girls like Blossom Hart and Hattie Malone." Her respect for Berlin was gratefully returned. "You make even a lousy song sound good," Berlin told her, and promptly set about creating the score for a second collaboration:

1950's *Call Me Madam*. Based on the life of Washington socialite *Perle Mesta, it featured a book by her *Girl Crazy* collaborators Howard Lindsay and Russell Crouse, whose habit of tinkering with a show long after it should have been "frozen" began to annoy Merman. Such was her clout by now that she was able to stop the habit cold. "Boys, as of right now I am Miss Birdseye of 1950," she famously told them after the show had been finalized in tryouts and was on its way to Broadway. "I am frozen," she warned them. "Not a comma." Although the show was less of a success than *Annie Get Your Gun*, Merman's growing expertise as an actress, and not just the singer with the leather lungs, made critics sit up and take notice. "She has such a fine grasp of the art of comic acting that she practically has it by the throat," one of them said; while another declared that "when Ethel sang, you could see it and feel it."

While Merman established herself with relative ease as the reigning diva of mid-century Broadway, her private life was less smooth. "The truth is, I'm very unhappy when I'm in love," Merman said, and her four marriages seemed to bear this out. Her first marriage in 1940 to a Hollywood agent named Robert Smith lasted less than a year. With her career just beginning its upward climb, Merman was unwilling to join Smith in California and the couple never even lived together after their wedding in New York. (After their divorce in 1941, Smith reportedly quipped to a friend, "How much 'I Got Rhythm' can a man take before breakfast?") Her second marriage in 1941 to journalist and publisher Robert D. Levitt was the most successful of her four marriages, perhaps because Levitt had no interest in the theater and kept his distance from her professional life. "For all the interest he showed in my career, I could have been a secretary," Merman recalled. The marriage produced a daughter, also named Ethel, and a son, Robert Jr., before it started to unravel and ended in divorce in 1952. The following year, Merman married Robert Six, an airline executive and the only person who managed to convince her to retire from show business and settle down as a housewife in Denver, Colorado. Merman survived this domestic episode until 1956, when she returned to the stage in *Happy Hunting*, a musical based on the romance and marriage of *Grace Kelly and Prince Rainier III of Monaco. Although it brought her first Tony nomination, even Merman admitted that the show was "a jeep among limousines. If you didn't mind the bumpy ride," she said, "it got you there." In 1960, amid charges that Six had misused her

money and had indulged in numerous affairs, Merman filed for divorce. She refused to speak in public about her fourth marriage to actor Ernest Borgnine in 1964, which lasted all of 38 days. In her autobiography, the chapter bearing the title "My Marriage to Ernest Borgnine" is a blank page.

Happy Hunting may have been a mediocre vehicle for her return to the stage, but Merman's next role was the one for which she is chiefly remembered and which she herself considered the peak of her career. Approached by producer Arthur Laurents with a show he said was completely unlike her usual material, Merman seized on the opportunity. "I want to act," she told Laurents, who thereupon invited her to composer Jule Styne's apartment to listen to the score for a new musical Styne had just written with a young Stephen Sondheim. It was a show Styne described to her not as a musical, but as a drama with music. Merman burst into tears after first hearing the score of *Gypsy*, based on the memoirs of *Gypsy Rose Lee. "These were dramatic songs with dimension," she later said of Styne's work. "He was reaching out, stretching himself, just as I wanted to do."

As Laurents had promised, Merman's creation of the formidable, terrifying Mama Rose was a new experience for her, and for her audience. Mama Rose has eight numbers in the show, culminating in the ferociously bitter "Rose's Turn" rather than the traditional starry-eyed show closer which Broadway expected. None of the numbers were intended to be the usual Merman showstopper, none of them had what Ethel always called a "sock ending," and most were bookended by tightly integrated dialogue, reducing applause that could disrupt the story's momentum. Rose's first entrance at the top of the show was even more startling. Instead of striding on stage as usual and belting out her first number, Merman entered the theater from the rear as Mama Rose, interrupting a vaudeville rehearsal of a number starring Rose's daughter, Louise (based on Lee). "I came stalking down the aisle like a jungle mother," Merman later said, "wearing my old coat with the big collar and the belt way down below my waist, and the funny hat with the big bow. I was carrying my dog Chowsie, swinging the big old pocketbook, and looking most unattractive . . . shouting 'Sing out, Louise!' It was new and it was terrific and it immediately told you what kind of person Mama Rose was." *Gypsy* took Broadway by storm when it opened in 1959 and brought Merman a New York Drama Critics Circle award as Best Ac-

tress, although she lost her second Tony nomination to *Mary Martin for *The Sound of Music*. ("How're you going to buck a nun?" Ethel joked to friends.)

Gypsy proved to be the last of Merman's original Broadway creations. Apart from a revival of *Annie Get Your Gun* in 1966, and a brief tour of duty as one of several actresses who replaced *Carol Channing in *Hello, Dolly!* during 1970, Merman never again headlined a Broadway musical. But by now she was a national institution. She sang at the White House and drew enormous crowds during her tour of the United States and Europe with her own Ethel Merman Show during the mid-1970s. She had always been comfortable in front of a television camera, having first appeared in that medium back in 1953 in a program marking Ford Motor Company's 50th anniversary. Now, in late career, she wasn't above appearing as a singing missionary in an episode of "Tarzan" during the 1960s, as a next door neighbor in "That Girl" during the 1970s, and as a love-struck widow on an installment of "The Love Boat" in the 1980s. Although the blockbuster film musicals of 30 years before were long gone, Ethel found work as the loud-mouthed Mrs. Marcus in Stanley Kramer's 1963 *It's a Mad, Mad, Mad, Mad World* and as a bordello madam in 1965's *The Art of Love*. Broadway paid tribute to her accomplishments with a Special Achievement Award in 1972. Five years later, Merman made her final Broadway appearance in a review called *Together on Broadway*, appearing with her old friend Mary Martin.

When she wasn't working, Ethel frequented the flea markets which were her favorite form of relaxation and which added to the collection of Raggedy Ann dolls she had been building since her early days in the theater. She published a volume of memoirs in 1978, in which she spoke of the deep religious faith that had seen her through the death of her daughter in 1967 from an overdose of a prescribed medication for depression—an accident, Merman claimed, and not the suicide at which the media had hinted. (Her son became a respected theatrical lighting designer.) But by the time of her *Ethel Merman in Concert* performance at Carnegie Hall in May 1982, friends had noticed a decline in Merman's usually robust health. There were troubling fainting spells, a bout with the painful nerve disease sciatica and, most troubling, periods of unpredictable behavior and memory loss. Finally, after collapsing in her New York apartment in April 1983, the cause of Merman's ailments was traced to an inoperable brain tumor. Nine months later, on February 15, 1984, Ethel Merman died in a New York hospital.

Broadway's sparkling lights were dimmed in her memory on the evening of February 20 in silent tribute to the woman whose vitality and boundless enthusiasm for show business had sent her clarion voice into the farthest reaches of the biggest houses on the Great White Way, in productions from which the fabric of Broadway legend was woven. She had, she admitted, been lucky enough to be part of an extraordinary chapter in American musical theater. "In a way, I'm the last of a kind," Merman wrote six years before her death, declaring that the creative talent which produced shows like *Anything Goes*, *Annie Get Your Gun*, and *Gypsy* no longer existed. "I wouldn't change one thing about my professional life," she wrote with satisfaction. "I'm the gal who makes Cinderella a sob story."

SOURCES:

Bryan, George. *Ethel Merman: A Bio-Bibliography*. NY: Greenwood Press, 1992.

Merman, Ethel, with George Eells. *Merman*. NY: Simon & Schuster, 1978.

Norman Powers,
writer-producer, Chelsea Lane Productions, New York

Mer-neith (fl. c. 3100 BCE)

Early queen of Egypt and possibly regent on behalf of an underaged son. Name variations: Merit-neith or Merit-Neit; Meryet-Nit. Flourished around 3100 BCE; probable daughter of King Djer, mother of King Den.

Pougy, Liane de.
See Barney, Natalie Clifford for sidebar.

Alençon, Emilienne d'.
See Uzès, Anne, Duchesse d' for sidebar.

If this person was a woman (which is not completely certain), she attained a position seldom equaled by a woman at the dawn of Egypt's history. Certainly she owned funerary monuments which rivaled a king's in size and subsidiary graves, and a treasury is attested for her as well. On the other hand, she appears not to have held a king's titles. Thus this person is assumed by most scholars today to have been a queen, of ancient Egypt's 1st Dynasty, probable daughter of King Djer and mother of King Den. Like the queen *Neithotep before her, Mer-neith also wrote her name within the kingly serekh design, and thus is believed to have served as regent for her son King Den and initiated the title of King's Mother. She was recorded as a ruler centuries later on the king list now in Palermo.

Barbara S. Lesko,
Department of Egyptology, Brown University,
Providence, Rhode Island

Mero, Yolanda (1887–1963)

Hungarian pianist who was widely known on American concert stages. Born in Budapest on August 30, 1887; died in New York City on October 17, 1963.

Yoland Mero studied with her father and then with **Augusta Rennebaum**, who had been a pupil of Franz Liszt. In 1910, she made her first tour of the United States with great success. From that time on, she played mostly in America, and her many recordings reveal a fiery artist with an extremely efficient technique.

John Haag,
Athens, Georgia

Mérode, Cléo de (c. 1875–1966)

Celebrated French dancer and mistress of King Leopold II of the Belgians. Name variations: Cleo de Merode. Born around 1875 (some sources cite 1873); died of arteriosclerosis on October 17, 1966, in Paris, France.

Joined Paris Opera corps de ballet (c. 1887); met King Leopold II of the Belgians (c. 1893); made tour of United States (1897).

Cléo de Mérode was a celebrated dancer of the Belle Epoque era whose name became inextricably linked with that of Belgium's aging king when she became his mistress. De Mérode was ranked along with other noted and iconoclastic beauties of the day, such as ◀ **Liane de Pougy** and ◀ **Emilienne d'Alençon**, and lived and thrived in an era of opulence and amoral scandals that was brought to an end with the onset of World War I.

De Mérode was probably born around 1875, and joined the corps de ballet of the famed Paris Opera around the age of 12. She met King Leopold II of the Belgians probably about six years later. The king was vilified both in the press and privately, described as the most despised monarch in Europe even before the 1904 revelations of his brutal treatment of the population of his Congo colonies, and gleefully lambasted in political cartoons for his randy ways, parsimonious habits, and mercenary callousness towards his sister *Carlota, empress of Mexico, his wife *Maria Henriette of Austria, and his daughters *Louise of Belgium, *Stephanie of Belgium, and *Clementine of Belgium. He preferred to spend his time in Paris—his wife, in fact, would die alone—and had long exhibited a fondness for Parisian dancers. Legend has it that Leopold summoned de Mérode to his private box for an introduction during the intermission of *Aïda*; her delay in returning postponed the rise of the curtain for the second act by half an hour. Subsequently, de Mérode spent ten years as his mistress—Leopold was well over 60 by then—and she also became a target for the European pa-

pers. One cartoon depicted Leopold showering her with jewels and saying, "These are only part of what I stole from my daughters, *cherie!*" Both denied that they were having an affair, but his ministers in Brussels nevertheless derisively referred to him as "Cléopold" behind his back.

De Mérode continued in her career as a well-regarded dancer during the liaison, and performed all over Europe, including before King Edward VII of England and at the courts of Denmark and Russia. She starred at the Opera Comique in Paris, but found little success on her one American tour in 1897. She was so well known that an adaptation of her stage coif (her hair was parted in the center and the rest gathered in a chignon) became popular and was called the "Cléo de Mérode." Although Leopold subsequently went on to other mistresses and other scandals before his death in 1909, for the remainder of her long life de Mérode was unable to sever her name from her royal affair. She lived in the French countryside during World War II, and in 1950 launched a libel suit against a book that she felt portrayed her in an unflattering light. She was awarded a symbolic single franc by a French court. Cléo de Mérode died in Paris at the age of 91 in October 1966.

SOURCES:
Kelen, Betty. *The Mistresses: Domestic Scandals of Nineteenth-Century Monarchs.* NY: Barnes & Noble Books, 1966.
The New York Times (obituary). October 17, 1966.

Carol Brennan,
Grosse Pointe, Michigan

Merovingians, queen of the.

See Basine (fl. 465).
See Galswintha (d. c. 568).
See Fredegund (c. 547–597).
See Fredegund for sidebar on Brunhilda (c. 533–613).
See Fredegund for sidebar on Audovera (d. 580).

Merriam, Florence (1863–1948).

See Bailey, Florence.

Merril, Judith (1923–1997)

American science-fiction writer and lauded anthologist. Name variations: Josephine Juliet Grossman; (pseudonyms) Ernest Hamilton, Cyril Judd, Rose Sharon, Eric Thorstein. Born Josephine Juliet Grossman on January 21, 1923, in New York City; died of heart failure on September 12, 1997, in Toronto, Ontario, Canada; daughter of Schlomo Grossman and Ethel (Hurwitch) Grossman; attended City College (now City College of New York), 1939–40; Rochdale

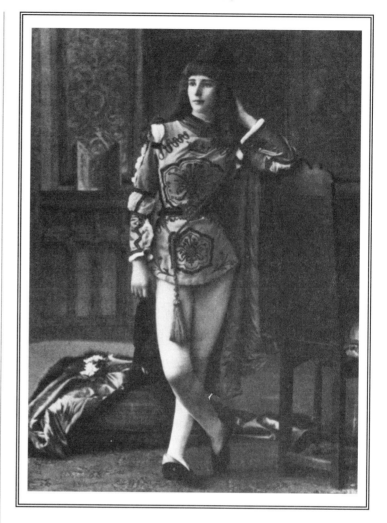

Cléo de Mérode

College, B.A., 1970; married three times, once to Frederick Pohl (a science-fiction writer) from 1949 to 1953; children: Merril Zissman McDonald; Ann Pohl.

Hired at Bantam Books (1947); first short story published (1948); first science-fiction novel published (1950); edited first "Year's Best" anthology (1956); moved to Canada (1968); donated literary resources to Toronto Public Library (1970); received Canadian Science Fiction and Fantasy Award (1983).

Selected writings: Shadow on the Hearth *(1950);* The Petrified Planet *(1953);* The Tomorrow People *(1960);* Out of Bounds *(1960);* Daughters of the Earth and Other Stories *(1968);* Survival Ship and Other Stories *(1973);* The Best of Judith Merril *(1976).*

One of the premier writers of science fiction in America during the genre's flourishing years after World War II, Judith Merril was also, along with **C.L. Moore** and ***Leigh Brackett,** one of the few women in that male-dominated field. Her stories and novels were notable for their realistic characterizations of women—characteri-

zations that were, like herself, a relative rarity in the genre at the time. Merril later became known as a leading anthologist of science fiction, and the literary collection she donated to the Toronto Public Library now bears her name.

Merril was born Josephine Juliet Grossman in New York City in 1923. She attended City College for a time, but by 1943 was working as a research assistant and ghostwriter. Hired as an editor at Bantam Books in 1947, Merril also became involved with a group of young science-fiction devotees in the New York City area. She was a founding member of the Hydra Club, and was the only female member of the Futurians, which counted Isaac Asimov, C.M. Kornbluth, and Frederick Pohl among its roster of fledgling sci-fi writers. Merril was married to Pohl from 1949 to 1953, but had already taken a pen name borrowed in part from her daughter by a previous marriage, Merril. Her first short story, "That Only a Mother," about a woman's devotion to her baby who was born horribly mutilated by radiation, was published in 1948. She was soon a regular contributor of stories to *Startling Stories* and *Astounding Science Fiction*, and these, along with her novellas and novels, won praise for her unique point of view, though she never achieved the commercial success of her male colleagues. Her first novel, *Shadow on the Hearth*, appeared in 1950. A timely tale of nuclear holocaust, it was soon made into a teleplay, "Atomic Attack," for Motorola Playhouse. She also wrote *The Petrified Planet* (1953), *The Tomorrow People* (1960), *Out of Bounds* (1960), and numerous short stories collected in several volumes. Her work was published under divers pseudonyms, almost all of them male.

Merril served as book editor and reviewer for the *Magazine of Fantasy and Science Fiction* for a decade beginning in 1959. She also became known as a leading anthologist of science-fiction stories, radio plays, and television scripts, and for this work she gained especial renown. A founding member of the Science Fiction Research Association, she served as the editor of several volumes of *The Year's Best Science Fiction* between 1956 and 1968, just before she moved to Canada. She taught writing in Toronto at several institutions, and edited numerous other anthologies, including *SF: The Best of the Best* (1967), *England Swings SF: Stories of Speculative Fiction* (1968), and *Tesseracts* (1985). Merril also translated science-fiction stories from Japanese. The extensive collection she donated to the Toronto Public Library in 1970 became the basis for the Merril Collection. Merril divided her time between Toronto and Jamaica

in her later years, and died of heart failure in September 1997.

SOURCES:
Buck, Claire, ed. *The Bloomsbury Guide to Women's Literature.* NY: Prentice Hall, 1992.
The Day [New London, CT]. September 18, 1997.
Time. September 29, 1997, p. 23.

Carol Brennan,
Grosse Pointe, Michigan

Merrill, Dina (1925—)

American actress. Born Nedenia Hutton on December 9, 1925, in New York City; youngest daughter of Marjorie Merriweather Post and E.F. Hutton (a stockbroker and founder of the Wall Street firm); cousin of **Barbara Hutton* (1912–1979); *attended George Washington University for one year; studied at the American Academy of Dramatic Arts; married Stanley F. Rumbough, Jr., in 1946 (divorced 1966); married Cliff Robertson (an actor), on December 21, 1966 (divorced 1989); married Ted Hartley (an actor and partner in their production company, RKO Pavilion), in November 1989; children: (first marriage) Stanley Rumbough; Nina Rumbough; (second marriage) Heather Robertson.*

Selected filmography: Desk Set *(1957);* A Nice Little Bank That Should Be Robbed *(1958);* Operation Petticoat *(1959);* Don't Give Up the Ship *(1959);* Butterfield 8 *(1960);* The Sundowners *(1960);* The Young Savages *(1961);* The Courtship of Eddie's Father *(1963);* I'll Take Sweden *(1965);* The Meal *(1975);* Deliver Us From Evil *(1975);* The Greatest *(1977);* A Wedding *(1978);* Just Tell Me What You Want *(1980);* Twisted *(1986);* Caddyshack II *(1988);* True Colors *(1991); (cameo)* The Player *(1992); (cameo)* Mighty Joe Young *(1998).*

The daughter of ***Marjorie Merriweather Post**, heiress to the Post cereal fortune, and E.F. Hutton, who founded the Wall Street firm that bears his name, Dina Merrill dismayed her proper parents when she dropped out of college to study acting at the American Academy of Dramatic Arts. She appeared on television and on Broadway before making her screen debut in 1957's *Desk Set*, with ***Katharine Hepburn** and Spencer Tracy. Often cast as an American aristocrat, in keeping with her blonde, well-bred looks, Merrill appeared in a number of other films, including *Operation Petticoat* (1959), with Cary Grant and Tony Curtis, *Butterfield 8* (1960), for which ***Elizabeth Taylor** won an Academy Award, and Vincente Minnelli's *The Courtship of Eddie's Father* (1963). She also frequently appeared on television, in guest spots on

weekly series and in movies of the week. Married for over 20 years to actor Cliff Robertson, Merrill divorced him in 1989 and married Ted Hartley, a former television actor and investment banker. Together they bought the venerable but shaky RKO Pictures, and, with Hartley as chair and Merrill as creative director, in 1998 released *Mighty Joe Young*, a successful remake of the 1949 RKO film about a huge gorilla brought from the jungle to Los Angeles; Merrill appeared in a cameo role in the film.

SOURCES:

People Weekly. April 19, 1999, pp. 79–80.

Merrill, Flora (1867–1921).

See Denison, Flora MacDonald.

Merriman, Nan (1920—)

*American mezzo-soprano. Born Katherine-Ann Merriman on April 28, 1920, in Pittsburgh, Pennsylvania; studied with Alexia Bassian and *Lotte Lehmann.*

Made debut with Cincinnati Summer Opera (1942), Piccolo Scala (1955–56), Glyndebourne (1956); frequently sang with Toscanini's NBC Symphony broadcasts; retired (1965).

Known more for her radio performances with the NBC Symphony than her presence on the operatic stage, Nan Merriman was praised for her performances in all roles, large or small. Celebrated also as a recording artist, her performance of the contralto solos in Mahler's *Das Lied von der Erde* are considered exceptional. Merriman, who did not ignore popular music, also recorded American show tunes as well as excerpts from musicals. Despite these forays into popular culture, she was especially well known as Dorabella in *Cosi fan tutte*, which she recorded twice. At age 45, she opted to retire.

<div align="right">

John Haag,
Athens, Georgia

</div>

Merritt, Anna Lea (1844–1930)

American expatriate artist and one of the first women whose work was purchased by the British government. Name variations: Anna Massey Merritt; Anna Massey Lea Merritt; Anna W. Lea Merritt. Born in 1844 in Philadelphia, Pennsylvania; died in 1930; married Henry Merritt (an artist and critic), in 1877 (died 1877).

Made grand tour of Europe (1867); won medal at Philadelphia Centennial Exposition (1876); married and widowed (1877); first exhibited at the Royal Academy (1878); settled in Hurstborne Tarrant, England (1890); won medal at the Chicago World's Columbian Exposition (1893); wrote first book (1902).

Nan Merriman

Selected writings: A Hamlet in Old Hampshire (1902); Love Locked Out: The Memoirs of Anna Lea Merritt.

Selected paintings: The Pied Piper of Hamelin; Camilla; Eve Overcome by Remorse; James Russell Lowell *(1882)*; War *(1883)*; Love Locked Out *(1884)*.

Anna Lea Merritt was an accomplished portraitist and genre painter in the decades of the late 19th and early 20th centuries who lived and worked abroad for much of her adult life. Though she was thoroughly modern herself, her style was anything but, reflecting the more conservative movement in England that hearkened back to the allegorical styles of Italian Renaissance painting.

Merritt was born in Philadelphia in 1844 into an established Quaker family. Educated privately, she took drawing lessons from the age of

seven, and as a young woman made an extensive "grand tour" of Europe with her family beginning in 1867. She used the opportunity to study art for extended periods in both Rome and Dresden, Germany. In London in 1871, she met artist and art critic Henry Merritt, and began an apprenticeship of sorts that eventually resulted in their 1877 marriage (he reportedly proposed by saying, "Little pupil, let us be married"). He was many years her senior, and died not long after the wedding.

Anna Lea Merritt

By this time Merritt had already established herself as an artist: she took a medal at the important Centennial Exposition in Philadelphia in 1876, and began exhibiting at the annual salons of the Royal Academy in 1878. Over the next two decades, she executed her most eminent works and achieved her greatest successes. Typical of Merritt's style, the 1883 painting *War* depicts a gathering of women in ornate Renaissance dress on a balcony, watching a Roman military parade. Their faces show angst and sorrow, while a small boy at one woman's side gazes off into the distance, a hunting horn in his hand. Merritt meant the work to serve as a commentary upon the folly of war, pointing out how it ravages the lives of the wives and children left behind. Her 1884 painting *Love Locked Out* is a confectionery allegorical work depicting Cupid pushing at an ornate golden door. Now hanging in the Tate Gallery in London, it was the first work of art by a woman ever purchased by the British government (through the Chantrey Bequest), although it was openly derided at the time.

In 1890, Merritt moved to Hurstborne Tarrant, a small village in Hampshire, England, which she wrote of in her 1902 book *A Hamlet in Old Hampshire*. She exhibited at the Chicago World's Columbian Exposition in 1893, winning a medal for *Eve Overcome by Remorse*, and began a mural for a Surrey church, St. Martin's, that same year. She was also a highly regarded portraitist; one notable example of this is her *James Russell Lowell*, which now hangs at Harvard University. A member of the Royal Society of Painters-Etchers, Merritt nevertheless maintained strong ties with Philadelphia and the American artistic community throughout her life; she was the organizer of the "American Artists at Home and Abroad" for the Pennsylvania Academy in 1881.

Anna Lea Merritt, who died in 1930, lived and worked in an era when female artists rarely achieved prominence or financial stability in comparison to their male counterparts. She always asserted that discrimination had never blighted her career, but did write a magazine article in 1900 titled "Letter to Artists, Especially Women Artists," in which she teasingly declared that women could achieve far more in life if they, like men, were allowed to take a wife as a helpmate to perform all the mundane chores of life. Her writings survive in *Love Locked Out: The Memoirs of Anna Lea Merritt*.

SOURCES:
Rubinstein, Charlotte Streifer. *American Women Artists from Early Indian Times to the Present*. Avon, 1982.

Carol Brennan,
Grosse Pointe, Michigan

Meryet-Nit (fl. c. 3100 BCE).
See Mer-neith.

Merz, Sue (b. 1972).
See Team USA: Women's Ice Hockey at Nagano.

Meshullemeth
Biblical woman. Married Manasseh, the 14th king of Judah; children: Amon, who succeeded his father to the throne.

Messalina, Statilia (fl. 66–68 CE)
Roman empress. Born of high birth and flourished around 66–68 CE; third and last wife of Nero (37–68 CE).

Wealthy and intelligent, Statilia Messalina was the third wife of Nero. Surviving his death in 68 CE, she intended to marry Marcus Salvius Otho (32–69 CE), second husband of ❧ **Poppaea Sabina** (d. 65), the following year, but was prevented by his defeat at Bedriacum and subsequent suicide.

Messalina, Valeria (c. 23–48 CE)
Roman empress, notorious for deviously influencing political affairs and for sexual indiscretions, who was executed for an alleged involvement in a plot to overthrow her husband Emperor Claudius. Name

❧▶
Poppaea Sabina (d. 65). *See Agrippina the Younger for sidebar.*

variations: Messallina. Born in Rome around 23 CE (date is speculative); executed for alleged treason in 48 CE; daughter of M. Valerius Messalla Barbatus and Domitia Lepida, both members of the dynastic Julio-Claudian family; married Claudius, c. 38 CE, who became Roman emperor in 41 CE; children: daughter, Octavia (c. 39–62); son, Tiberius Claudius Caesar Germanicus, later named Britannicus.

Young, attractive, clever, and self-interested, Valeria Messalina found herself near the center of political power in Rome during the 1st century CE. She exploited every possibility to maintain her position, earning in the process a reputation for being cruel, manipulative, and sexually voracious. Ultimately, she overplayed her hand and paid for it with her life.

Nothing is known of her childhood (the approximate date of her birth, 23 CE, is speculative) but it is known that she was a politically desirable wife because of her prestigious pedigree: her great-grandmother on both her maternal and paternal side was *Octavia (69 BCE–11 CE), sister of the first great Roman emperor Augustus. Messalina's immediate family enjoyed the favor of Emperor Caligula for having remained loyal to his mother *Agrippina the Elder during her persecution and then execution by the emperor Tiberius. When Messalina, who was considered a beautiful young woman, was at a proper or even late age for marriage, her family used their advantages to seek out the best possible husband for her. This man was Claudius, uncle of the emperor.

Claudius' main assets were his membership in the royal family and his good standing with Caligula, who allowed him to participate in the administration of the empire. Furthermore, Claudius was Messalina's cousin (once removed)—a perfectly respectable relationship, and one which would keep power and resources within the Julio-Claudian family. Nonetheless, Messalina may not have been overjoyed with the prospect of a life with Claudius. At 48, he was old for her by Roman standards, even if she were already in her 20s (some sources claim she was much younger), and he was plagued with physical problems which had caused his family to mistakenly assume that he was mentally deficient. (His mother *Antonia Minor had supposedly called him "a little monster.") This erroneous assumption, as Claudius himself would later note, had protected his life during periods of political instability, but it could hardly have added to his charms as a prospective bridegroom. No one dreamed he would become the next emperor.

To marry Messalina, Claudius divorced his second wife *Paetina "for no good reason" (as Suetonius, one ancient biographer, unsympathetically recounts). The marriage took place in 38 CE. Within one year, Messalina proved her fertility by bearing a daughter, whom they named *Octavia (c. 39–62). In 41, Caligula, who was mentally unstable, vicious, and widely feared, was assassinated by the Praetorian Guard (a military elite, whose job, ironically, was to protect the emperor). After the assassination, the guard found Claudius hiding behind a curtain, fearing for his life. Instead of killing him, they proclaimed him emperor. Under the threat of force, the Senate unhappily confirmed his emperorship. Then Claudius attempted to placate the Senate, but he managed to obtain only an uneasy relationship with those elite men. Needing any support he could get, he turned instead to those with whom he had a long-standing relationship of trust—his loyal and talented freedmen (former slaves who still served their former masters)—to help him in his administration of the vast Roman Empire.

Messalina, too, was a key to stabilizing Claudius' claim to the throne. She not only brought the political support of her extended family, but she also gave birth to their second child and first son, Tiberius Claudius Caesar Germanicus ("Britannicus"), just three weeks after Claudius was confirmed as emperor. Having a clear heir to the throne both solidified Claudius' position and strengthened Messalina's personal influence. As the wife of the emperor, Messalina was one of the most powerful women

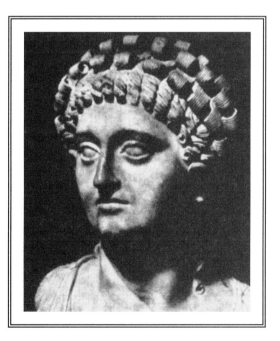

Valeria Messalina

in Rome, but she nonetheless needed to protect her advantages. To fortify her position, she used sex, blackmail, key appointments, trials, and alliances. The ancient historians, who are unanimously antipathetic towards her, clearly believed that such tactics also gave her means to indulge in personal vice.

Some stories recounting Messalina's many marital infidelities are exaggerated to the point of undermining their veracity; nonetheless, the consensus from antiquity gives credence at least to the general rumors of promiscuity. (She was certainly not alone in this, as the many stories of decadence during the decline of the Roman Empire can attest.) Among the particular rumors which have followed Messalina down through the ages are that she solicited men in common taverns, danced naked in the Forum, and once bet a famous Roman prostitute that she could beat her at her own game; Pliny the Elder notes that she won the bet, "for within the space of twenty-four hours she cohabited twenty-five times." The Roman historian Tacitus mentions by name many prominent men with whom Messalina had relationships, suggesting that she was merely giving in to wayward proclivities. The fact that she monopolized the attentions of the famous dancer, Mnester, who could do her no political favors, argues for this interpretation. Cassius Dio, however, interprets her escapades as purposefully directed toward political ends. For instance, he describes her contrivance to involve many prominent women in a group sex session at which their husbands were in attendance. Those men who attended were awarded with various offices and honors through her influence with Claudius, but their actions also made them vulnerable, should she wish it, to charges of "pandering." Meanwhile, those who did not attend were undermined politically or destroyed.

> [Messalina] toyed with national affairs to satisfy her appetites.
>
> —Tacitus

Claudius appears to have been truly infatuated with his wife (Suetonius uses the words "extravagant love" to describe his feelings), and to have trusted her completely. When he conquered parts of Britain, he included his family in the triumph (a formal and prestigious procession and ritual). Messalina followed the emperor's chariot in a covered carriage—which actually came before the generals who had won honors in the campaign—and "Britannicus" was added to her son's name in commemoration at this time. The implications of these honors were not lost on the status-conscious Romans, and, as

long as her children were young, no one was foolish enough to accuse her publicly of adultery. Such an accusation would have called her children's paternity into question, an unwise reflection on Claudius which would have brought down his wrath on the accuser.

The ancient historians do not consider Claudius' behavior towards his wife as points in his favor. They paint a generally negative picture of him, portraying Claudius as the dupe of each of his successive wives in concert with his favored freedmen. Clearly the imperial household was managed in a new manner during his reign. "Claudius fell so deeply under the influence of these freedmen and wives," writes Suetonius, "that he seemed to be their servant rather than their emperor; and distributed honors, army commands, indulgences or punishments according to their wishes, however capricious, seldom even aware of what he was about." Was an ignorant Claudius manipulated by Messalina, as the ancient sources would have us believe? Some modern scholars speculate that he worked in unspoken or even overt agreement with her, using his wife as an informal but powerful tool to deal with any perceived threat to his throne. Whether or not this was the case, it is clear that Messalina brought her own creativity and motivations to the task of solidifying imperial power.

She did not limit her tactics to sexual entanglements alone, however, and recognized the value of a well-placed man who was beholden and therefore loyal to her. For instance, when one of the commanders of the Praetorian Guard threatened to disclose her risqué activities to her husband, she had him demoted and managed to have Lusius Geta, a man of her choice, appointed to this position instead.

She also recognized the value of a well-paid prosecutor, whom she found in P. Suillius. He initiated scores of trials for Messalina against people she wanted removed from circulation. (When his service to her would be clearly revealed after her death, he was charged with "fraudulent prosecutions" and brought to trial himself. In his defense, he claimed that he had merely been obeying Messalina's orders. Because he had received huge sums of money for the tasks he had undertaken, however, he was declared guilty on his own account and executed.)

On one notorious occasion, Messalina eliminated a prominent and seemingly loyal senator, Decimus Valerius Asiaticus, who had formerly accompanied Claudius on his campaign in Britain. Asiaticus was involved in an affair with **Poppaea Sabina**, a wealthy and beautiful

woman of whom Messalina was jealous, and he was also in the process of constructing a beautiful park which, according to Tacitus (who is never at a loss for providing sordid motives), Messalina coveted. To see to his undoing, she enlisted the help of Suillius to prosecute Asiaticus. She also arranged for Sosibius—the man who owed to Messalina his appointment as Britannicus' tutor—to convince Claudius of imminent danger. Dutifully, Sosibius pointed out to Claudius that Asiaticus' power was growing in Rome, and also that Asiaticus had connections in Gaul, where he could motivate his supporters into an uprising. Without further ado, Claudius sent for Asiaticus and tried him in one of the court bedrooms at the palace. Had the emperor followed accepted procedure, Asiaticus would have been tried by his peers in the Senate; the unorthodox palace trial signaled to all observers both the personal nature of the perceived threat and Messalina's influence. When Asiaticus presented his defense, Messalina cried. She did not, however, intercede. After he was condemned to die, she also engineered the suicide of his paramour Poppaea Sabina, by threatening her with punishments worse than self-destruction. (Apparently unaware of Messalina's attack on Poppaea, Claudius invited the unfortunate woman's husband to dinner a few days later and then inquired why Poppaea was not in attendance as well.) As a result of this affair, Messalina received Asiaticus' gardens.

Messalina also allied with various of Claudius' freedman whom the emperor trusted implicitly with his administration and who thus held comparable influence to her own. Her work with Narcissus, one of Claudius' most trusted freedmen, accomplished what neither could have individually. In one famous incident, which is recounted in several ancient sources, the two orchestrated a plan to dispose of Appius Silanus, a prominent Roman senator who had been governor of Eastern Spain. Claudius had attempted to co-opt Silanus' support by arranging a marriage for him with Messalina's mother, ❧▶ **Domitia Lepida**, but for reasons that are not entirely clear, Messalina perceived Silanus as a threat. Although the ancient sources attribute the motive for what followed to Silanus refusing to make love with her, there is some evidence that he actually may have been involved in a conspiracy against the emperor. Executing the elaborate plan he and Messalina had contrived, Narcissus ran into Claudius' bedroom just before daybreak and recounted a dream in which Silanus had violently attacked Claudius. Messalina woke up and, feigning astonishment, claimed

❧▶ *Domitia Lepida*. See Agrippina the Younger for sidebar.

❧▶ **Poppaea Sabina** (d. 47 CE)
*Roman matron. Birth date unknown; committed suicide in 47 CE; daughter of Poppaeus Sabinus, governor of Moesia for 24 years; married; mistress of Valerius Asiaticus; children: *Poppaea Sabina (d. 65), Roman empress and wife of Nero.*

she had dreamed the same dream several nights in a row. In the meantime, the two conspirators had summoned the unsuspecting Silanus to visit Claudius, hoping the emperor would interpret the visit as proof positive of an intent to murder; Claudius sentenced the unlucky man to death.

Although Messalina possessed great influence over her husband, she was aware that her position was not invulnerable. Thus she unflaggingly sought to undermine perceived rivals, including *Agrippina the Younger and *Julia Livilla, the two surviving sisters of the former emperor Caligula. Sent into exile by Caligula for suspected treason, they had been recalled to Rome upon Claudius' accession. Messalina "persecuted" Agrippina the Younger, which provoked a general sympathy for her, but Agrippina was clever enough to maintain a low profile. Julia Livilla, however, was a beautiful woman who often spent time alone with Claudius, and who refused to give Messalina the respect due her. This inspired Messalina's hatred, and she accused Julia Livilla of having an affair with the philosopher-politician Seneca—an accusation important mainly for the implications of a conspiracy. As a result, Seneca was given a formal trial which resulted in his banishment to the island of Corsica. Julia Livilla was banished without a trial and then killed.

In the end, Messalina was destroyed by the conjunction of power and sex which apparently dominated her life. According to Tacitus, she became infatuated with Gaius Silius, "the best-looking young man in Rome," whom she forced to divorce his wife so she could have him to herself. Gaius Silius knew better than to refuse the woman who could engineer his downfall and death, so he abandoned himself to the affair. Messalina showered him with wealth and distinction, engineering his nomination for the important office of consul and actually moving furniture and slaves from the royal palace into his house.

Claudius was seemingly unaware of his wife's dalliances, and might have remained so had not Messalina and G. Silius decided to make the relationship public. Tacitus portrays G. Silius as the one who urged that they should risk all,

while Messalina was unenthusiastic. Her motive for giving in, says Tacitus, was the outrageousness of being called Silius' wife when she was still married to Claudius. So while Claudius was out of town performing religious duties, they celebrated a public marriage. Even Tacitus seems to think the story sounds incredible and takes extra pains to show he is not inventing it:

> It will seem fantastic, I know, that in a city where nothing escapes notice or comment, any human beings could have felt themselves so secure. Much more so that, on an appointed day and before invited signatories, a consul designate and the emperor's wife should have been joined together in formal marriage "for the purpose of rearing children"; that she should have listened to the diviners' words, assumed the wedding-veil, sacrificed to the gods; that the pair should have taken their places at a banquet, embraced, and finally spent the night as man and wife. But I am not inventing marvels. What I have told, and shall tell, is the truth. Older men heard and recorded it. (Trans. by Michael Grant.)

Juvenal, the biting satirist from the following century, recounts the story poetically:

> What advice, do you suppose,
> Should one give the young man whom Caesar's
> wife is determined
> To marry? . . .
> She sits there, waiting for him,
> Veiled as a bride, while their marriage-bed is prepared
> In the public gardens. . . .
> Did you think these were secret doings
> Known only to intimate friends? But the lady's
> determined
> On a proper, official wedding. . . . If
> You refuse her commands, you'll die before lighting-up time;
> If you do the deed, you'll get a brief respite
> Better do what you're told, if a few more days'
> existence
> Matter that much. But whichever you reckon the
> quicker
> And easier way, your lily neck still gets the chop.
> (Trans. by Peter Green.)

The marriage could not have been considered legal, because Messalina could not be re-married legally without a divorce from Claudius. Nonetheless, all members of the imperial court recognized this "marriage" as a threat to Claudius' life, and thus also to their own positions. Tacitus describes a meeting among Claudius' powerful freedmen in which they discussed the various courses of action open to them. Narcissus, Messalina's erstwhile accomplice, now became the key figure in her downfall. He decided that the best plan would be to denounce her to Claudius suddenly, for all the freedmen feared that she would engineer their assassinations if she had any inkling of their intentions. (Not long before, Messalina had in fact betrayed another freedman, Polybius, who had been executed despite agreements with her.) Claudius' freedmen sent two of the emperor's favorite mistresses to break the news to him, so that each could corroborate the other's story.

Having duly revealed their information, the women urged Claudius to summon Narcissus to verify it. When he arrived at Ostia, where Claudius had prolonged his stay, Narcissus claimed that Messalina's adulteries and the imperial gifts to Silius could be overlooked, but not the public wedding. "Nation, senate, and army have witnessed her wedding to Silius," he said. "Act promptly, or her new husband controls Rome!" Panic-stricken, Claudius kept asking whether or not he was still emperor. His concern was not idle, for had he been displaced, it would have meant certain death. Taking his freedman's advice, he appointed Narcissus commander of the Praetorian Guard for one day, temporarily replacing Geta, who was still loyal to Messalina.

Meanwhile, Messalina had been enjoying a mock grape-harvest and a Bacchic revelry with Silius and friends. When rumors arrived that Claudius was on the way, the party dispersed. Messalina decided that her most effective defense would be to meet Claudius in person. To pave her way, she sent ahead their children, Octavia and Britannicus, to meet him. She also enlisted the support of the highest Vestal priestess, and then rode in a humble garden cart to meet Claudius, who was on his way back to Rome with Narcissus.

When her cart met the emperor's entourage, the two people Claudius had trusted the most engaged in a life-and-death struggle. While Messalina cried that Claudius must listen to the mother of his children, Narcissus shouted about the wedding to Silius, drowning her out and distracting Claudius with a list he had prepared beforehand enumerating her infidelities. The high priestess joined in the fray, demanding that Messalina not be executed without having her side of the story heard. Claudius "remained strangely silent," and Narcissus finally agreed that the emperor would later hear Messalina's defense.

Narcissus then escorted Claudius to Silius' home, where, in addition to imperial belongings, Claudius discovered a statue of Silius' previously executed father, placed there in defiance of a senatorial decree. Seeing the material evidence, Claudius allowed himself to be led toward the Praetorian camp for protection. Ashamed and barely able to speak, the emperor managed to ad-

dress the guard briefly. By this time, most of Messalina's friends had been rounded up by officers of the Praetorian Guard, which noisily demanded that all offenders be executed. Silius asked for a quick death. Many others were executed as well.

Claudius' anger began to wane after he dined, however, and he ordered that "the poor woman" should appear the next day to defend herself. Realizing that he would lose the struggle if Messalina appeared in person before Claudius, Narcissus took advantage of his temporary authority and ordered the Praetorian Guard to kill Messalina, implying that he was carrying out the emperor's orders. Tacitus comments: "Indeed, if Narcissus had not speedily caused her death, the fatal blow would have rebounded on her accuser." Messalina, who had composed a defense for herself in anticipation of her meeting with Claudius the following day, was in the gardens she had stolen from Asiaticus. Although mother and daughter had previously been at odds, Domitia Lepida had come to Messalina's side. She told Messalina that her life was over, and advised her to make a decent end. When the guards arrived, Messalina took up a dagger to kill herself, but faltered. The guard accomplished what she could not, and her body was left with her mother.

Claudius was still at the dinner table when news of Messalina's death arrived. Details were not given, and the emperor did not ask. He called for more wine and continued his party. In the following days, he appeared to be in shock, "emotionless," giving "no sign of hatred, satisfaction, anger, distress, or any other human feeling." The Senate decreed that Messalina's statues and her name should be removed from all public and private sites.

The power structure of the imperial household was shaken, and each freedman who had some influence put forward a candidate for a new wife, hoping to strengthen his own position. The candidate Narcissus proposed lost out. Agrippina the Younger, whom Messalina had once feared as a potential rival, became Claudius' powerful fourth wife. (As it turned out, Messalina had been correct in pegging Seneca as a supporter of her rivals, for one of Agrippina's first actions after her marriage was to convince Claudius to recall the philosopher from exile and place him in a key position at court.) When Claudius was poisoned to death by Agrippina several years later, Narcissus lost his life as well. The deaths of Messalina's children, Britannicus and Octavia, followed within the next few years.

Scholars have discussed at length the question of whether or not Messalina's "marriage" to Silius was indicative of an actual threat to Claudius' rule. Many hold that they were merely indulging in a hedonistic whim and inadvertently provided an opportunity for Narcissus to undermine Messalina's influence in the imperial court. On the other hand, as a young noble and consul-designate for the year 48 CE, traditionally a prominent political position, Silius was clearly among the ranks of those who resented the emperorship of Claudius and had only accepted it reluctantly. It is also true that Narcissus had little to gain by seeing Messalina replaced with another powerful woman who might be less inclined to ally with him. Either he misjudged the future, or he saw her affair with Silius as not just another scandal but as a threat to the whole imperial household, of which he was a part. Tacitus suggests as one possible theory that there was indeed a plot to overthrow Claudius and that Messalina hoped to maintain her position in the empire by becoming the actual wife of Silius before the coup took place.

This points to the ultimate problem inherent in Messalina's very real power. Although she was influential not only with the emperor himself but with the many men for whom she had obtained important political appointments, and although she was able to destroy a number of her rivals, she was limited by the fact that her power depended on the favor of her husband. She finally lost that favor, and with it her life.

SOURCES:
Ancient:
Cassius Dio Cocceianus. *Roman History.* Translated by Earnest Cary. Vol. VII. Loeb Classical Library. Cambridge, MA: Harvard University Press, 1924.
Juvenal. *Sixteen Satires.* Satires VI and X. Translated by Peter Green, 1967. NY: Viking Penguin, 1987.
Suetonius. "Life of Claudius," in *Lives of the Twelve Caesars.* Translated by Robert Graves, 1957. Revised by Michael Grant, 1979. NY: Viking Penguin, 1986.
Tacitus. *Annals of Imperial Rome.* Translated by Michael Grant, 1956. NY: Viking Penguin, 1987.
Modern:
Balsdon, J.P.V.D. *Roman Women: Their History and Habits.* NY: Barnes & Noble, 1963.
Bauman, Richard. *Women in Politics in Ancient Rome.* NY: Routledge, 1992.
Levick, Barbara. *Claudius.* New Haven, CT: Yale University Press, 1990.
Oxford Classical Dictionary.

Sylvia Gray Kaplan,
Adjunct Faculty, Humanities,
Marylhurst College, Marylhurst, Oregon

Messene (fl. early 12th c. BCE)

Greek heroine, possibly mythological, whose urging led to the conquering of a land which was then named in her honor. Flourished in the early 12th century BCE in Greece.

Allegedly a figure of the Greek Bronze ("Mycenaean") Age prior to the Trojan war (early 12th century BCE), Messene is more a mythological than a historical figure. Nevertheless, her story is as follows: Messene was the daughter of King Triopas of Argos (the most powerful Greek king of his day) and she married Polycaon, the younger son of Lelex, another powerful lord whose land would later be known as Laconia. Since Polycaon's brother (Myles) was heir to their father's realm, when Polycaon married Messene he did so without a kingdom to call his own. Thinking this an intolerable status for any husband of hers, Messene allegedly convinced her father and father-in-law to mount a joint military operation against the land which lay to the west of Laconia so that it could be Polycaon's to rule. This venture was a success, and Polycaon's new realm was re-named "Messene" to honor her role in its conquest.

Once settled in the land which bore her name, Messene is said to have established a local version of the mystery cult which flourished most famously at Eleusis. This undoubtedly refers to the historical existence in Messene of religious customs akin to those which were celebrated at Eleusis, the population of which traced its roots back to Mycenaean Greece, whereas the Greeks who controlled Messene after about 1000 BCE (that is, long after Messene is said to have lived) were Dorians of one sort or another. Originally from Sparta, Dorians had seized the land in the late 8th century BCE and generally took pride in the differences which distinguished them from the descendants of those who had controlled Messene during the Mycenaean period, whom the Dorians had enslaved. After Messene's death, a temple was established in her honor at Ithome, where she was represented by a marble statue inlaid with gold and where she received the chthonic worship appropriate to a heroine (a once powerful, but now dead human being, whose remains were thought to retain some of the power which the now-living imagined that the once-living had possessed).

Messene's worship as a heroine is historically attested. Whatever truth may lie at the heart of these tales is unknown, but the Greeks of the historical period frequently invented such characters as Messene to explain regional names, tribal relationships and/or customs, the origins of which were no longer understood when the myths in their present form began to circulate.

William Greenwalt,
Associate Professor of Classical History,
Santa Clara University, Santa Clara, California

Messenger, Margaret (1948—)

Viscountess Lascelles. Name variations: Margaret Lascelles. Born on April 15, 1948, in Cheltenham, Gloucestershire, England; daughter of Edgar Messenger and Margaret (Black) Messenger; married David Lascelles, viscount Lascelles, on February 12, 1979; children: **Emily Lascelles** *(b. 1975);* **Benjamin Lascelles** *(b. 1978);* **Alexander Lascelles** *(b. 1980);* **Edward Lascelles** *(b. 1982).*

Messick, Dale (1906—)

American cartoonist who created the comic strip "Brenda Starr, Reporter." Name variations: changed name from Dalia to Dale in 1927 because of bias against women cartoonists among art editors. Born Dalia Messick in South Bend, Indiana, in 1906; daughter of Cephas Messick (an art teacher) and Bertha Messick (a milliner); studied at the Art Institute of Chicago; married and divorced; married Oscar Strom (divorced); children: (first marriage) one daughter named Starr (Mrs. Jack Rohrman, b. 1942).

Back in the late 1920s and 1930s when Dale Messick was peddling her comic-strip boards to publishers, cartooning, like so many other fields, was a male-dominated business not open to women. Messick changed her name from Dalia to Dale in hopes of getting a foot in the door, only to find that after landing an appointment to see an art editor, she usually received an invitation to lunch instead of an offer to work. Due in large part to her determination, women cartoonists have finally made their mark, including **Lynn Johnston** ("For Better or For Worse"), **Nicole Hollander** ("Sylvia"), and **Cathy Guisewite** ("Cathy"). Messick's own ground-breaking strip, "Brenda Starr, Reporter," is still in syndication, well over half a century after it first appeared.

Dale Messick was born in 1906 in South Bend, Indiana. Her father Cephas was an art teacher in Gary and held down a second job as a sign painter to provide for his daughter and four sons. Her mother **Bertha Messick**, a milliner, became a painter herself at age 78. (At age 90, Bertha had a one-woman show at the Palmer House in Chicago.) Messick was a poor student, possibly because she was so myopic that she did not even learn to tell time until she was a teenager; she repeated the third and eighth grades, and quit high school for a year before her parents convinced her to finish. Messick began drawing at an early age, with great encouragement from her father, who would sketch sunbonneted babies for her to copy. In school, she drew continu-

ous story strips for her schoolmates, inspired by favorite heroines from the silent movie serials that she loved so much.

Messick's formal art training was meager; she spent a summer at the Art Institute of Chicago and a year or so at a commercial art school. For her first job she painted pinup girls on oilcloth tire covers for Orange Crush, a popular soft drink. She then moved on to designing greeting cards for companies in Indiana, Chicago, and, finally, New York. While drawing cards by day, Messick worked evenings experimenting with the comic-strip character that would eventually become Brenda Starr. Though no one took her seriously, she somehow rebounded from each rejection with more intensity than ever.

One particularly discouraging interview with Joseph Medill Patterson of the New York *Daily News* turned out to be Messick's break. Although Patterson told her outright that he would never hire a woman, his assistant **Mollie Slott**—who would later head up the Chicago Tribune-New York News Syndicate—saw something promising in Messick's discarded strips. Together, they reworked Messick's adventuresome red-headed heroine from a bandit into a reporter and named her Brenda, after **Brenda Frazier**, a glamorous debutante of the time. Starr, as in star reporter, was added as her last name. Though Patterson was still not interested in printing the strip, he allowed it to be sold to other newspapers. "Brenda Starr, Reporter" first appeared in June 1940 as a Sunday strip in several papers of the Chicago Tribune-New York News Syndicate, and became a daily strip in 1945. It was only after Patterson's death that it appeared in the *Daily News*. Brenda Starr remained the number one comic-strip heroine for 40 years, at one time appearing in over 100 papers in the United States, five foreign papers, and boasting a readership exceeding 40 million.

Brenda was as feisty and unpredictable as Messick herself. Modeled on *Rita Hayworth, Brenda Starr arrived as a full-blown reporter who was tired of covering ice cream socials and longed for action. The first episode showed an irate Brenda demanding a truly challenging assignment, and finally landing one so tough that no man on the paper would take it. So began the adventures that would take Brenda Starr from jungles to the Arctic, with encounters with demented scientists, ravenous animals, and other assorted scoundrels along the way. Messick never worked from a plot outline; instead, she relied on inspiration fueled by her imagination— or sometimes her dreams—to provide story

Dale Messick

lines. Bits and pieces from her own colorful life also turned up from time to time.

One constant in Brenda Starr's otherwise unpredictable life was the mystery man Basil St. John, who was inspired by an assistant who briefly worked for Messick. "He was no good as an artist, but he wore this black patch over one eye, and I was fascinated," she said. Basil, suffering from a rare hereditary disease with "mental symptoms" that helped explain his frequent disappearances, came and went in Brenda Starr's life for 29 years, until Messick grew tired of finding ways to get rid of him and finally had the couple marry. Messick herself, wed and divorced twice, thought marriage the worst thing she ever did. "I'd like a new man every four years. I get bored sometimes, you know. Old-fashioned marriage is old hat."

In a career that spanned some 40 years, Messick never missed one of her 365 yearly deadlines. Extremely disciplined, she seldom vacationed and worked from a hospital bed when her only child Starr was born and while recovering from a car accident in which her jaw and collarbone were broken. Her working day routinely began at about 7 AM with a song and a "costume," anything from a fluffy negligee and bedroom slippers to a Mexican Gypsy outfit with

❦▶ Sutter, Linda (1941–1995)

American cartoonist. Born in Greenwich, Connecticut, in 1941; died in Cambridge, Massachusetts, on December 18, 1995; daughter of Clifford S. Sutter and Suzanne T. Sutter; graduated from Vassar College, 1971; married; children: son Joshua C. Empson.

A former TV reporter for Channel 5 in New York City during the 1970s, Linda Sutter took over the "Brenda Starr" comic strip from 1982 to 1985. She went on from there to Harvard Divinity School, hoping to be ordained in the Episcopal Church, but she was felled by cancer and died in 1995, age 54.

❦▶ Fradon, Ramona (1926—)

American cartoonist. Born in New York in 1926; attended the Art Students League of New York.

Raised in Westchester County, New York, Ramona Fradon was one of the few women in the 1950s to land a job with a comic-book publisher. During her career, she drew many of the best-known superheroes, including Superman, Batman, and Plastic Man. In 1985, Fradon took over as artist for *Dale Messick's popular "Brenda Starr" comic strip, working with writer *Mary T. Schmich.

❦▶ Schmich, Mary Teresa (1954—)

American journalist and writer of the comic strip "Brenda Starr.". Born in 1954; eldest of eight children of a housepainter and homemaker in Savannah, Georgia; graduated with a liberal arts degree from Pomona College, Claremont, California; studied at Stanford; never married.

Unlike *Dale Messick, the original creator of "Brenda Starr, Reporter," Mary Schmich had 15 years of newspaper experience when she began writing the comic strip after Messick's retirement. Tribune Media Service, owners of the Orlando *Sentinel*, where Schmich was writing feature stories, asked her to take over Brenda's story line only, while an artist rendered the drawings. Schmich agreed, taking Brenda with her when she left Florida in 1992 to join the Chicago *Tribune*.

Schmich's approach was to keep the best of Brenda's checkered past, while easing her into the present. "I could not take a character with 45 years of life behind her and turn her into a character I would have invented 45 year ago," Schmich told *Boston Globe* reporters. "I mean, Brenda had a past—a lot of marks on her heart." Brenda's modern persona is a bit less vampy, works harder, and has aged to her mid-30s. Schmich admits to using Brenda as a sounding board. "The strip's a great way to vent all your thoughts about life," she said.

Brenda goes everywhere with Schmich, who even brought the feisty red-head with her when she went east in the fall of 1995, for a yearlong Nieman Foundation fellowship at Harvard University. While in Boston, Schmich put Brenda to work investigating Big Bucks Espresso, a coffee-bar chain, whose shady owner, Buzz Bucks, was up to no good.

SOURCES:
"Names and Faces," in *The Boston Globe*. February 17, 1996.

SUGGESTED READING:
"Author! Author!," in *People Weekly*. August 25, 1997.

<div align="right">

Barbara Morgan,
Melrose, Massachusetts

</div>

boots, depending on her mood. The creative process itself was aided by several assistants: one drew backgrounds, the male characters, and did the lettering; another was responsible for buildings and automobiles. Messick, wielding a pen and brush in her left hand, blocked the stories, did comic-panel roughs, and drew the figure of Brenda Starr, slimming her down or curving her out depending on her outfit. The strips were often passed back and forth among the drawing boards of the artists. The work environment was relaxed at best, with music blaring and Messick singing—or sometimes dancing—along. Meditative periods were punctuated with gasps or sighs, depending on Brenda's situation, and bursts of dialogue, tried out in what Messick imagined to be the voices of the characters.

Over the years Messick was criticized for her uncertain artwork, improbable story lines, and occasional improprieties. The now defunct Boston *Post* once had a staff artist draw a high-necked dress over Brenda's over-exposed attributes, and in 1949 *Oveta Culp Hobby, publisher of the Houston *Post*, ordered the strip out of her paper when Brenda Starr took up smoking polka-dot cigars. Those in the newspaper business often voiced objection to Messick's ignorance of journalism and disregard for authenticity. One journalist called her "the dame who put press cards back in reporters' hats after reporters stopped wearing hats." Another executive editor flatly refused to run Brenda Starr, saying, "She does a disservice to the industry." Messick remained unconcerned. "I don't know too much about what's going on around me. . . . Authenticity is something I always try to avoid."

Messick wrote one book based on the comic strip, *Brenda Starr, Girl Reporter*, and *Brenda*

Starr, a movie featuring **Brooke Shields**, came and went in 1989. Messick retired in 1980, leaving Chicago for Santa Rosa, California, where she busied herself drawing caricatures of visitors to the Cygnet Art Gallery and taking painting lessons. (The strip was taken over by ◄⅜ **Linda Sutter**.) Like Brenda, Messick clung to her youthful image. At age 69, she dressed like a 40-year-old and continued to dye her hair red in imitation of her famous character. "Never let another old bag outprop you," she often said. Dale Messick may have finally deserted her timeless heroine, but Brenda, eternally 23, lives on in the hands of artist ◄⅜ **Ramona Fradon** and writer ◄⅜ **Mary T. Schmich**.

SOURCES:

Browning, Norma Lee. "First Lady of the Funnies," in *The Saturday Evening Post*. November 19, 1960.

Hurd, Jud. "Brenda Starr," in *Cartoonist Profiles*. December 1972.

Johnson, Flora. "Brenda Starr's Toughest Assignment," in *Ms.* Vol. 4, no. 6. December 1975, pp. 33–37.

Sujka, Sharon C. "34 Years in Chicago Tribune: Dale Messick Hasn't Missed Daily 'Brenda Starr' Deadline," in *Editor and Publisher*. November 23, 1974.

Barbara Morgan,
Melrose, Massachusetts

Messine, de la (1836–1936).

See Adam, Juliette la Messine.

Mesta, Perle (1889–1975)

Washington hostess and U.S. ambassador to Luxemburg. Name variations: Pearl Reid Skirvin. Born Pearl Reid Skirvin on October 12, 1889, in Sturgis, Michigan; died of hemolytic anemia in Oklahoma City, Oklahoma, on March 16, 1975; daughter of William Balser Skirvin (an oil prospector) and Harriet Elizabeth (Reid) Skirvin; married George Mesta (a businessman), on February 12, 1917 (died 1925); no children.

Perle Mesta was born Pearl Skirvin in Sturgis, Michigan, in 1889, one of three children of **Harriet Reid Skirvin**, a college graduate (somewhat unusual for the place and time) and William Skirvin, an oil prospector who traveled between the Midwest and Texas. When Mesta was a teen, her father moved the family to Oklahoma, where he built a grand hotel in Oklahoma City. Mesta attended a private school in Galveston, Texas, and studied music in Chicago in hopes of pursuing a career as a singer. In her mid-20s, she met engineer George Mesta, whom she married in New York City in February 1917. Her husband was the founder of Pittsburgh's Mesta Machine Company, and not long after their marriage he was called to government service as a defense-industry consultant when the United States entered World War I. The couple moved to the nation's capital, and in this way Mesta's career as a Washington socialite began, for she immediately became active with the Washington Stage Door Canteen for service personnel.

After the war, the Mestas traveled extensively in Europe. In 1925, George Mesta died, and Perle abandoned Pittsburgh forever, though she did inherit and wield much control of the machine company. With her father, she also began making lucrative investments in oil and land in the American Southwest (she would inherit a great deal of money from him when he died in 1944). In 1929, she purchased a mansion in the posh seafront town of Newport, Rhode Island. Her contacts with prominent political figures continued after her husband's death—he had been a campaign contributor and friend of Calvin Coolidge—and for a time Mesta was romantically linked with Charles Curtis, Herbert Hoover's vice-president. Mesta was an active Republican, and in the mid-1930s she also became a champion of women's rights. She campaigned for passage of the Equal Rights Amendment, joined the National Woman's Party in 1938, rising to its executive council, and was also active in the World Women's Party and held the post of its international publicity chair for a time.

Mesta switched political allegiances around 1940 after becoming disillusioned with Republican Party politics, especially with the defeat of the candidate that year, Wendell Willkie, whom she had supported. Instead, she became the great ally of a rising Missouri Democrat, Harry Truman, and held a celebrated fundraiser for him prior to the 1944 elections at her Skirvin Hotel in Oklahoma City. Truman became Franklin D. Roosevelt's vice-president, and succeeded him after Roosevelt's death in April 1945. Mesta's success as a Washington scene-maker and party-giver, it has been said, was tied to the political success of this most prominent ally; moreover, the new president's wife, *Bess Truman, disliked large-scale entertaining, and the hostessing tasks thus fell to Mesta. (In 1946, she threw *Margaret Truman's coming-out party.)

Though Mesta was a Christian Scientist and never drank alcohol, she did not hesitate to serve it. Her soirees at both her D.C. home, Les Ormes, and her Newport mansion were a choice mix of the rich and powerful of both political persuasions. She continued to distinguish herself with a savvy business mind as well. She raised a great deal of money for Democratic Party coffers, and

Perle
Mesta

administration curtailed her social influence in the nation's capital, but in the late 1950s she was a great supporter of Democrat Lyndon B. Johnson. She abandoned the Democratic Party when Johnson failed to win the presidential nomination in 1960, and that act made her somewhat *persona non grata* with the subsequent Kennedy administration. Though Mesta had no children of her own, she was deeply attached to her nieces and nephews. She returned to Oklahoma City to be near her brother when her health began failing in her 80s, and died there of hemolytic anemia a year later in March 1975.

SOURCES:

Current Biography 1949. NY: H.W. Wilson, 1949.

Lamparski, Richard. *Whatever Became Of . . . ?* 5th Series. NY: Crown, 1974.

McHenry, Robert, ed. *Famous American Women.* NY: Dover, 1980.

Sicherman, Barbara, and Carol Hurd Green, eds. *Notable American Women: The Modern Period.* Cambridge, MA: The Belknap Press of Harvard University Press, 1980.

SUGGESTED READING:

Mesta, Perle, with Robert Cahn. *Perle: My Story,* 1960.

RELATED MEDIA:

Call Me Madam (117 min. film), directed by Walter Lang, starring Ethel Merman, Donald O'Connor, George Sanders, and *Vera-Ellen, released in 1953.

Carol Brennan,
freelance writer, Grosse Pointe Park, Michigan

allegedly helped save the party from financial disaster during the 1948 elections. Truman was reelected that year, and, as thanks, named Mesta Envoy Extraordinary and Minister Plenipotentiary to Luxemburg. She became only the third female ambassador in American history (following *Ruth Bryan Owen Rohde, ambassador to Denmark, and *Florence Jaffray Harriman, ambassador to Norway). Mesta approached her new job as anything but a ski vacation: although Luxemburg was a tiny European duchy, the fifth-smallest country in the world, it was at the time the world's seventh-largest steel producer, and her long experience with Mesta Machine made her a perfect candidate for the job. She was also pleased that the duchy was governed by a woman, Grand Duchess *Charlotte.

Mesta was, however, pilloried in the press. Reportedly, on her first day as ambassador a member of her staff inquired as to how she would like to be addressed, and she replied "You can call me Madam Minister," which the papers misquoted it as the more arch "You can call me Madam." *Call Me Madam* became the title of a hit musical by Irving Berlin that debuted on Broadway in 1950; it enjoyed a successful two-year run with *Ethel Merman as an exuberant, Mesta-like female ambassador, and was later made into a movie. The tribute was said to have delighted Mesta, especially the musical's centerpiece number, "The Hostess with the Mostes'."

Perle Mesta retired as ambassador in 1953, and divided her time between Washington and Rhode Island. A new Republican presidential

Mészáros, Márta (1931—)

Prolific Hungarian screenwriter and film director.
Name variations: Marta Meszaros. Born on September 19, 1931, in Budapest, Hungary; daughter of Laszlos Mészáros and a mother who died while Mészáros was young; attended VGIK (Moscow Academy of Cinematographic Art); married a Rumanian citizen, in 1957 (marriage ended 1959); married Miklos Jancso (a director), around 1966.

Fled Hungary with family (1936); returned to Hungary (1946); made first short film (1954); moved to Rumania (c. 1955); returned to Hungary (1959); joined Mafilm Group 4 (mid-1960s); made first feature film (1968); won Berlin Film Festival Golden Bear award (1975); won Fipresci Prize at Cannes Film Festival (1976); won Cannes Film Festival Special Jury Prize (1984).

Selected filmography: The Girl *(1968);* Binding Sentiments *(1969);* Don't Cry, Pretty Girls *(1970);* Riddance *(1973);* Adoption *(1975);* 9 Months *(1976);* Two Women *(1977);* Just Like at Home *(1978);* On the Move *(1979);* The Heiresses *(1980);* Mother and Daughter *(1981);* Silent Cry *(1982);* Land of Mirages *(1983);* Diary for My Children *(1984);* Diary for My

Loves (1987); Bye Bye Red Riding Hood (1989); Travel Diary (1989); Diary for My Father and Mother (1990); My Preferred Opera: Portrait of Barbara Hendrix (1990); Looking for Romeo (documentary, 1991); Gypsy Romeo (1991); The Last Soviet Star (1991); Sisi (television, 1992).

Filmmaker Márta Mészáros has achieved international renown for her thoughtful, incisive portrayals of life behind the former Iron Curtain, but she is also a critical and commercial success, a rarity for a filmmaker of any origin. According to film critic Derek Elly, she "has created a body of feature work which, for sheer thematic and stylistic homogeneity, ranks among the best in current world cinema." Since the late 1960s, her movies have dealt with such tough issues as the subjugation of women, urban vs. rural frictions, alcoholism, and children reared in state orphanages—which was, for the generation born in Eastern Europe during and immediately after World War II, not an uncommon childhood.

Mészáros herself had a comfortable early life, albeit one disrupted by political strife and war.

Márta
Mészáros

Born in Budapest in 1931, the daughter of renowned sculptor Laszlos Mészáros, she and her family were forced to flee to the Soviet Union as a result of her father's socialist convictions. Though she returned to Hungary for a short time after World War II in 1946, she received her education in Russia, including schooling at the Moscow Academy of Cinematographic Art. Back in Hungary, she worked for Newsreel Studios in Budapest and, beginning in 1954 with *Smiling Again*, made four short films. Moving to Rumania in the mid-1950s, she married a Rumanian, but the marriage was brief and she returned to Hungary once more in 1959. She began making short documentary films, some concerning science, such as *Mass Production of Eggs*, and others on Hungarian history and culture. In the mid-1960s, Mészáros became involved with the state film cooperative Mafilm Group 4, through which she met her future husband, director Miklos Jancso.

Mészáros made a successful debut as a feature-film director with *The Girl* in 1968. It starred Hungarian pop singer **Kati Kovacs** in a tale of a young factory worker who embarks upon a search for her biological parents and is justifiably disappointed when she finds them. *Binding Sentiments*, released the following year, was a bit more humorous, though the subject matter was anything but: a young man's mother drinks too much and grieves over her late, famous husband, so the son installs his spirited fiancée, who has a psychologically sadistic streak, at the mother's lakeside villa to keep an eye on her. That film also starred Kovacs in the role of the younger woman.

In 1970, Mészáros released *Don't Cry, Pretty Girls*, which included some musical numbers; three years later came *Riddance*, a Romeo-and-Juliet tale about Hungarian parents unwilling to accept their son's girlfriend, who has no family and grew up in an orphanage. For 1975's *Adoption*, about a 40-ish woman who wants a child, Mészáros took the Golden Bear prize at that year's Berlin Film Festival. Her next film, *Nine Months*, was also her first in color. Released in 1976, it chronicles the love affair between a factory worker and her engineer boss. *Nine Months* is also notable for Mészáros' filming of an actual birth by the film's star, **Lili Monori**, at the end of the movie. In 1977's *Two Women*, Mészáros again addressed feminist issues and the plight of working women with unhappy marriages in the contemporary world.

Just Like at Home, released in 1978, was a bit off-beat for the director: a male university student befriends a ten-year-old girl, and her parents allow her to live with him in Budapest in order to receive better schooling; his girlfriend is resentful, and in the end he learns far more about life than his young charge. *On the Move*, Mészáros' 1979 work, chronicles the tale of a French scientist who visits her mother's grave in Poland and has an affair with an actor. *The Heiresses*, released in 1980, was Mészáros' first period film. Set during World War II, it centers around a rich, highborn woman married to a military officer. She is infertile, but needs an heir to inherit her family money, and therefore convinces a young Jewish woman to carry her husband's child in secret. A romance develops between her husband and the young woman, and in the end the heiress reports them both to the authorities, who put the husband in prison and send the young woman to a concentration camp. (This latter reflects the fact that Hungarian Jews were sent to concentration camps in 1944.)

Mother and Daughter (also released in France as *Anna*) was a 1981 co-production with a French studio. In it, a Budapest clothing designer spots a French couple with their young daughter, who looks suspiciously like the same child the designer had to give up when she fled Hungary and then Vienna during the 1956 political upheavals. Obsessed with her long-lost daughter, she follows the family to Paris. Mészáros produced two other films during the early 1980s, *Silent Cry* (1982) and *Land of Mirages*, a 1983 adaptation of Gogol's *The Inspector General*, before devoting herself to *Diary for My Children*, released in 1984. That film is clearly autobiographical: a young girl flees Hungary with her family and lands in Stalinist Russia, where she leads a privileged communist life before rebelling against its elitism as a young adult. Mészáros was awarded the Special Jury Prize at the Cannes Film Festival that year for the film.

Her other works include *Diary for My Loves*, released in 1987, and *Bye Bye Red Riding Hood*, a 1989 update of the classic fairy tale. Shot partially in Montreal, it was the first ever Canadian-Hungarian joint film production. With the collapse of the Eastern Bloc's Soviet-dominated political structure beginning in 1989, Mészáros was free to turn her pen and lens to even more incisive topics. One of these works is 1991's *Looking for Romeo*, a documentary set in Hungary about the Gypsy (Roma) population, who are the target of discrimination throughout much of Eastern Europe. A feature film from the same year, *Gypsy Romeo*, is another Romeo-and-Juliet tale, about an "illicit" romance between a Hungarian teen and her Roma boyfriend. Also in 1991, Mészáros co-wrote and

directed *The Last Soviet Star*, the story of Stalin's favorite screen actress, **Liubov Orlova*. *Sisi*, her 26-segment work about the life and times of Empress **Elizabeth of Bavaria* (1837–1898), was shown on Hungarian television in 1992.

SOURCES:

Acker, Ally. *Reel Women: Pioneers of the Cinema from 1896 to the Present.* NY: Continuum, 1991.

Katz, Ephraim. *The Film Encyclopedia.* NY: Harper-Collins, 1994.

Lyon, Christopher, ed. *The International Dictionary of Films and Filmmakers.* Vol. II. *Directors/Filmmakers.* Detroit: St. James Press, 1984.

Portuges, Catherine. *Screen Memories: The Hungarian Cinema of Márta Mészáros.* Bloomington, IN: Indiana University Press, 1993.

Wakeman, John. *World Film Directors, Vol. II: 1945–1985.* NY: H.W. Wilson, 1988.

Carol Brennan,
Grosse Pointe, Michigan

Meta.

Variant of Margaret.

Metalious, Grace (1924–1964)

American author who had a meteoric rise to fame with the publication of **Peyton Place**. *Name variations: Grace DeRepentigny Metalious. Born Grace de Repentigny in Manchester, New Hampshire, on September 8, 1924; died on February 25, 1964, of chronic liver disease; daughter of Alfred Abert de Repentigny (a printer) and Laurette (Royer) de Repentigny; attended public schools in Manchester, New Hampshire; married George Metalious, on February 27, 1943 (divorced February 25, 1958); married T.J. Martin, on February 28, 1958 (divorced October 6, 1960); supposedly remarried George Metalious, on October 8, 1960, but no record exists; children: (first marriage)* **Marsha Metalious Dupuis**; *Christopher Metalious;* **Cynthia Metalious**.

Selected works: Peyton Place *(1956);* Return to Peyton Place *(1959);* The Tight White Collar *(1960);* No Adam in Eden *(1963).*

Grace Metalious, a housewife from the dreary mill town of Manchester, New Hampshire, burst onto the American literary scene in 1956, setting off shockwaves with the publication of her novel *Peyton Place*. Considered quite sexually explicit at the time, the novel explored, questioned, and challenged both the 1950s conservative, restrictive, and idealistic view of women's place in society and conformity in general.

Grace de Repentigny was born in 1924 and spent her childhood years in the industrial mill town of Manchester, New Hampshire, with a mother who fantasized constantly about a better life and a father who was often forced to work several jobs to support the family. Lonely and isolated as a young child, and even more so after her parents divorced, Grace began writing at an early age. In high school, she met and fell in love with George Metalious, but because of his Greek ancestry her family initially refused to let them marry. The couple decided that their only option was to "live in sin," which quickly convinced both sets of parents to agree to their marriage, which took place on February 27, 1943.

During World War II, American women achieved new freedom and independence, filling many jobs and roles previously assumed by men. After the war ended, men expected women to put aside their newly gained independence and return to domesticity and conformity. When her husband returned from the war and enrolled at the University of New Hampshire, Metalious, by this time a mother, felt trapped. She continued writing, but was criticized for her unkempt appearance and for being a poor housewife and mother. Always insecure about her accomplishments and worried that she was not "woman enough" because she had been advised by a doctor not to have any more children, and that her husband would not love her because of this, she said she turned to the typewriter in order to be able to create something.

After her husband graduated from college, she became the "schoolteacher's wife," a role she hated. One of the few times she felt free and happy was when she and her family took an impromptu trip throughout the south and west. Upon their return to New Hampshire, Metalious once again felt socially ostracized for violating the traditional feminine values of a perfect mother and wife. She began writing a novel about local people (The Quiet Place) and also completed *The Tree and the Blossom* (which later became *Peyton Place*). Gilmanton, New Hampshire, where the Metaliouses lived, served as the setting for the fictional town of Peyton Place, and many of the story's characters supposedly were based on Gilmanton residents. Her submissions to publishers were rejected consistently until she selected Jacques Chambrun as her literary agent. Chambrun had a shady reputation for pocketing his clients' money, but did submit *The Tree and the Blossom* to several publishers, all of whom rejected it. However, freelance manuscript reader **Leona Nevler**, who read it while it was making the rounds of publishing houses, remembered the novel and recommended it to **Kathryn G. Messner**, president and edi-

tor-in-chief of Julian Messner, Inc. Messner obtained the manuscript from Chambrun, stayed home that night to read it, and the next day changed Metalious' life forever.

Messner, who took a maternal attitude with Metalious, cut the novel's long descriptions down to size and deleted some graphic passages, but left intact the tight, interlocking plot. *Peyton Place* was published on September 24, 1956, and, despite almost uniform unkindness from critics, stayed on the bestseller list for 26 weeks. It sold 104,000 copies in one month, breaking all records, and became the second bestselling novel in the United States up to that time. The following year it was made into a popular movie that starred *Lana Turner and was nominated for several Academy Awards; it was also later the basis for the first prime-time television soap opera. Gilmanton, New Hampshire, and Metalious were the subject of a huge media blitz, and George Metalious was fired from his job as a grammar school principal. No reason was given, although it was generally acknowledged to have been the result of his wife's racy book. The barrage of publicity brought added stress to the couple's marriage, and Metalious began drinking to escape her fears. During this time, she met and fell in love with disc jockey T.J. Martin in Laconia, New Hampshire. Although still married to George, she made Martin her "manager" and traveled and partied with him extensively. She finally divorced George on February 25, 1958, and days later married Martin.

With the great success of *Peyton Place*, Metalious was expected to produce more work in the same vein, but she claimed that her quarrels and emotional ups and downs kept her from writing what she planned to be her next book, *The Tight White Collar* (finally published in 1960). Despite their violent arguments, Metalious and her new husband genuinely seemed to love each other, and for a time both gave up drinking. However, she eventually became convinced that Martin wanted to change her image, and reverted to drinking. Under increasing pressure to produce, she churned out *Return to Peyton Place* (published in 1959) in just 30 days.

Adding to her distress was the fact that her mother Laurette sued her after they were involved in an automobile accident together. In September 1959, her mother was awarded money and left for Florida; Metalious and her family never heard from her again. She also discovered that her agent, Jacques Chambrun, was stealing from her. The escalating pressure resulted in Metalious' dis-

appearing for two weeks, during which time she consoled herself with alcohol.

Despondent and unable to write after her reappearance, Metalious accepted George back into her life after he convinced her to go to Martha's Vineyard with him and their children. On October 6, 1960, she divorced Martin, and supposedly remarried George two days later in Elkton, Maryland, although no record of the remarriage exists. In March 1961, she terminated her business with her agent. September 1963 saw the publication of *No Adam in Eden*, supposedly the story of George Metalious' family, but by this time their marriage was faltering again. In 1963, journalist John Rees befriended Metalious and became her manager and lover. She fell ill during a trip to Boston with him, and after a brief hospitalization died on February 25, 1964, of chronic liver disease. Her will left everything to Rees.

SOURCES:
Toth, Emily. *Inside Peyton Place: The Life of Grace Metalious.* NY: Doubleday, 1981.
Vasudevan, Aruna, ed. *Twentieth-Century Romance and Historical Writers.* 3rd ed. London and Detroit: St. James Press, 1994.

SUGGESTED READING:
Baker, Carlos. "Small Town Peep Show," (review of *Peyton Place*), in *The New York Times Book Review.* September 23, 1956, Sec. VII, p. 4.
Carbine, Patricia. "Peyton Place," in *Look.* March 18, 1958, p. 108.
Metalious, George, and June O'Shea. *The Girl from "Peyton Place."* NY: Dell, 1965.

RELATED MEDIA:
Peyton Place (157 min. film), starring Lana Turner, **Hope Lange**, Arthur Kennedy, Lloyd Nolan, *Betty Field, and *Mildred Dunnock, released by Twentieth Century-Fox in 1957.
Return to Peyton Place (122 min. film), starring **Carol Lynley**, Jeff Chandler, *Eleanor Parker, *Mary Astor, and *Tuesday Weld, released by Twentieth Century-Fox in 1961.

Jo Anne Meginnes,
freelance writer, Brookfield, Vermont

Metcalf, Augusta Isabella Corson (1881–1971)

American artist of the West. Born in Kansas in 1881; died in Oklahoma in 1971.

Dubbed the "Sage Brush Artist," Augusta Metcalf moved with her family to Oklahoma's Indian Country in 1886 and for a half century painted scenes of the area near Durham, where she spent most of her life. Her first home in Oklahoma was a 10x12-foot shack, where she lived until 1892, when the family moved to a picket

house on the Washita River. She started drawing horses when she was nine, using the sides of a white stone house near her own. Completely self-taught, she sent some of her first efforts to an uncle in San Francisco, who advised her to learn how to draw the horses' feet (instead of hiding them in the grass), and to use color only after she had mastered drawing. After practicing for a number of years, she felt expert enough to send an ad to the *Sportsman's Review*. Illustrated with a bucking horse, it announced: "I paint everything but portraits." Metcalf had a solo exhibition at the Oklahoma Art Center in 1949 and a showing at Grand Central Galleries in New York in 1958. She was elected to Oklahoma's Hall of Fame in 1968.

Barbara Morgan,
Melrose, Massachusetts

Metcalfe, Alexandra (b. 1903).
See Curzon, Mary for sidebar.

Metnedjenet (c. 1360–1326 BCE).
See Mutnedjmet.

Metz, queen of.
See Suavegotta (fl. 504).
See Deoteria (fl. 535).
See Vuldetrade (fl. 550).

Mew, Charlotte (1869–1928)
British poet and short-story writer whose work has fallen into unwarranted obscurity. Name variations: Charlotte Mary Mew. Born Charlotte Mary Mew on November 15, 1869, in London, England; died after ingesting poison on March 24, 1928, in London; daughter of Frederick Mew (an architect) and Anne (Kendall) Mew; attended University College, London.

First short story published (1894); death of her father (1898); visited Paris (1902); first book of poetry published (1916); received civil-list pension for contributions to English letters (1922).

Selected writings: The Farmer's Bride *(1916, enlarged edition published in United States as* Saturday Market, *1921);* The Rambling Sailor *(1929);* Collected Poems of Charlotte Mew *(1953);* Mew: Collected Poems and Prose *(1982).*

Charlotte Mew, whose contributions to Georgian-era English letters have been largely forgotten by modern literary scholarship, was born in 1869 in the London district of Bloomsbury. Both her father and grandfather were architects, but her father's spendthrift ways soon brought the family from prosperity down into the genteel poverty in which Mew would live much of the rest of her life. Of the seven Mew children, two died in infancy, another at the age of five, and two were institutionalized as young adults for what was probably schizophrenia, the cost of their care further straining the family finances. To avoid the possibility of passing on the mental illness, Mew and her sister **Anne** made a vow not to marry. Mew attended private schools, and as a young woman took classes at University College in London. Her first short story, "Passed," was published in July 1894 in the *Yellow Book*, a new journal illustrated by Aubrey Beardsley that was considered racy in look and content. The story concerns a young, middle-class woman, venturing out alone in London to visit a famous church, who is accosted by a destitute girl. The young woman is brought through the London slums to the bedside of the dead sister of the girl, who then collapses on the distraught narrator. Upon seeing the girl on the street at a later date, now dressed like a prostitute, the narrator suffers a nervous breakdown.

Such themes and otherworldly crises prevailed in Mew's fiction and poetry, which gradually began to achieve modest renown. Her articles, essays, and reviews were published in periodicals, including *Temple Bar, New Statesman,* and the *Nation,* but she never earned much money from them. She and her sister Anne supported themselves and their mother after the death of their father in 1898, with Anne working as a painter of antique furniture, a laborious, lowly occupation. Only around 1912, when Mew was already in her early 40s, did she begin to receive solid literary recognition for her work. This was partly the result of her acquaintance with **Amy Dawson Scott**, a London literary patron who helped found the writer's organization International PEN. With Scott's encouragement and contacts, Mew began giving readings and was invited by Harold and **Alida Monro** to compile a volume of poetry for publication by their Poetry Bookshop Press. *The Farmer's Bride* was published in 1916, and Louis Untermeyer called one of the poems, "Madeleine in Church," "one of the few 'great' poems of our day—I am tempted to write after due deliberation and a fifth rereading, that it is among the finest poems published in the last forty years." When an enlarged edition of the book was published as *Saturday Market* in the United States five years later, it won praise from *Rebecca West and H.D. (*Hilda Doolittle). Much of Mew's work was in free verse, marked by rich detail and the use of color and scents as motifs. "Madeleine in Church" and "In Nunhead Cemetery" read

more like dramatic monologues than traditional poetry, and have been consistently praised by latter-day critics.

Mew's stories and verse usually centered around women who were forced to submerge their identities for one reason or another. Women who chose the solitary life of a religious vocation also figured in her plots, specifically with the tales "In the Curé's Garden" and "An Open Door." Her work attracted the attention of such stellar English literary figures as Thomas Hardy, who became Mew's friend and mentor of sorts in what turned out to be the last years of both their lives. Hardy and colleagues John Masefield and Walter de la Mare wrote a recommendation that secured for Mew a civil-list pension in 1922, somewhat easing her financial situation. Yet the death of her mother in 1923 and increasing personal difficulties slowed down the pace of her writing, although in 1924 *Virginia Woolf called her "the greatest living poetess."

Some of these personal difficulties may have been romantic. Mew was described as aloof and reserved (Harold Monro noted that it was the kind of reserve "that amounted to secretiveness"), perhaps in part because she was ashamed of her poverty, but biographers have speculated that on two occasions she was in love with women who rebuffed her. The first was **Ella D'Arcy**, a writer whom she knew during her *Yellow Book* days, and the second, later, was writer *May Sinclair. These rejections were apparently tremendous blows to Mew.

When her beloved sister Anne died in 1927 from cancer, she was entirely devastated. She even worried that Anne had been buried alive, an event that occurs in her 1903 short story "A White Night," in which three tourists are accidentally locked inside the church of a convent in rural Spain one night and witness an odd procession of monks who entomb a young, screaming woman beneath the stones of the floor. Mew was attempting to recuperate from her sister's death in a dismal London nursing home one year later when she went out and purchased the cheapest disinfectant she could find. Upon her return, she drank it and died the same day. A collection of her stories, *The Rambling Sailor*, was published in 1929. Only these two volumes of her writing have survived, for it is thought that she destroyed a good deal of her papers before her suicide. Later editions of her work also have been published, most recently 1982's *Mew: Collected Poems and Prose.*

SOURCES:

Buck, Claire, ed. *The Bloomsbury Guide to Women's Literature.* NY: Prentice Hall, 1992.

Kunitz, Stanley J., and Howard Haycraft, eds. *Twentieth Century Authors.* NY: H.W. Wilson, 1942.

Owens, Jill Tedford. "Charlotte Mew," in *Dictionary of Literary Biography,* Vol. 135: *British Short-Fiction Writers, 1880–1914: The Realist Tradition.* Detroit, MI: Gale Research, 1994, pp. 217–225.

Severance, Sibyl. "Charlotte Mew," in *Dictionary of Literary Biography,* Vol. 19: *British Poets, 1880–1914.* Detroit, MI: Gale Research, 1983, pp. 308–313.

Shattock, Joanne. *The Oxford Guide to British Women Writers.* Oxford & NY: Oxford University Press, 1993.

SUGGESTED READING:

Fitzgerald, Penelope. *Charlotte Mew and Her Friends,* 1984.

Showalter, Elaine, ed. and intro. *Daughters of Decadence: Women Writers in the Fin-de-Siècle.* New Brunswick, NJ: Rutgers University Press, 1993 (includes "A White Night").

Carol Brennan,
Grosse Pointe, Michigan

Mexia, Ynes (1870–1938)

Mexican-American botanical explorer whose research expeditions contributed greatly to the modern scientific classification of plants of the Americas. Name variations: Ynez Mexia. Born Ynes Enriquetta Julietta Mexia on May 24, 1870, in the Georgetown section of Washington, D.C.; died of lung cancer on July 12, 1938, in Berkeley, California; daughter of Enrique Antonio Mexia (a diplomat) and Sarah R. (Wilmer) Mexia; attended the University of California, 1921–37; married Herman E. de Laue, around 1898 (died 1904); married Augustin A. de Raygados, in 1907 (marriage ended c. 1908); no children.

Moved to San Francisco (1908); made first botanical expedition to collect plants (c. 1925); traveled to South America (1929–32).

Though Ynes Mexia spent little more than a decade as a working botanist, her expeditions and research remain integral to the scientific classification of thousands of plants indigenous to the Western hemisphere. Mexia was born in 1870 in Washington, D.C. Her mother's family was of Maryland Catholic heritage, and her father was said to have been a diplomat for the Mexican government in Washington; his father, in turn, had been the founder of Mexico's Federalist Party. A town in Texas' Limestone County was once their family land, and bears the family name. Mexia moved to Philadelphia as a teenager, and went to private schools there and in Ontario and Maryland. She considered entering a convent, but her father's will stipulated that she would be disinherited if she did. Around 1898, she wed Herman E. de Laue, a merchant in Mexico City. She then, after the death of her fa-

ther, suffered through a contentious legal battle over his will, facing her father's mistress and illegitimate heir in court. De Laue died around 1904, and a few years later Mexia married Augustin A. de Raygados, an apparently disastrous choice for a partner. Marital stress led her to a nervous breakdown, and she moved to San Francisco to recuperate. He died soon after.

In San Francisco, Mexia became involved in social work, and also found physical and spiritual restoration through Sierra Club hikes in the area. While taking classes at the University of California in 1921 (which she would continue intermittently for the next 16 years), she began to develop a great interest in botany. A 1925 summer course at Hopkins Marine Station in Pacific Grove led her to pursue it decisively, and shortly thereafter, in the company of a botanist from Stanford University, **Roxana Stinchfeld Ferris**, she made her first trip to Mexico to categorize plants. Though Mexia was injured in a fall, she soldiered on and brought back 500 plants, one of which, *Mimosa mexiae*, was named after her. She then began working with a curator at the University of California Herbarium who helped her arrange travel and sales of plants to other institutions to finance her expeditions. Although she never earned a science degree, Mexia quickly emerged as a born plant researcher. In particular, she learned how to dry her specimens—which were usually accustomed to the damp of the Mesoamerican rain forest—for transport, so that she lost very few along the way in her journeys. (Her first instructor in specimen preservation had been botanist ***Alice Eastwood**.) After a 1928 trip to Alaska's Mt. McKinley, in late 1929 Mexia embarked upon her most ambitious expedition, to South America. The trip involved 25,000 miles up the Amazon River on a steamship, then travel by canoe for another 5,000 miles; for one leg of it, she also got around on a balsa raft made for her by her guides. She returned to San Francisco in 1932 with over 65,000 specimens, mainly from Brazil and Peru. The Sierra Club *Bulletin* published her accounts of this trip.

Mexia appears to have loved her dangerous and isolated calling, during the course of which she often came into contact with poisonous plants and underwent the most arduous and comfortless of journeys. Her work was greatly valued by her contemporaries, since it clarified problems and errors of prior, and sometimes slipshod, research. For a time Mexia worked for the Ecuadoran government, and in 1935 joined a University of California botanical expedition on another months-long trip to South America,

this time to the Andes mountain region. At age 65, she proved an invaluable companion to her younger, more inexperienced colleagues. In the spring of 1938, Mexia came down with intestinal problems during a collecting trip to Mexico and returned to San Francisco, where she died of lung cancer that July.

SOURCES:
Bailey, Brooke. *The Remarkable Lives of 100 Women Healers and Scientists.* Holbrook, MA: Bob Adams, 1994.
Edgerly, Lois, ed. *Give Her This Day.* Gardiner, ME: Tilbury House, 1990.
James, Edward T., ed. *Notable American Women, 1607–1950.* Cambridge, MA: The Belknap Press of Harvard University Press, 1971.

COLLECTIONS:
Ynes Mexia's papers are held at the University and Jepson Herbaria at the University of California, Berkeley, and at the Botany Gray Herbarium at Harvard University.

Carol Brennan,
Grosse Pointe, Michigan

Mexican Nun, the (1651–1695).

See Juana Inés de la Cruz.

Mexico, empress of.

See Carlota (1840–1927).

Meyer, Agnes (1887–1970)

American writer, social reformer, and newspaper publisher. Name variations: Agnes Elizabeth Ernst Meyer; Agnes Ernst Meyer. Born Agnes Elizabeth Ernst on January 2, 1887, in New York, New York; died of cancer on September 1, 1970, in Mt. Kisco, New York; daughter of Frederic H. Ernst and Lucy (Schmidt) Ernst; Barnard College, B.A., 1907; attended the Sorbonne (Universite de Paris), c. 1908–09; attended Columbia University, 1911–12; married Eugene Meyer (a financier, presidential adviser, and later newspaper publisher), on February 12, 1910; children: **Florence Meyer Homolka; Elizabeth Meyer Lorentz; Katharine Graham; Ruth Meyer;** *Eugene Meyer III.*

Hired as a reporter (1907); lived in Paris (1909); became involved in charity work (1912); was a delegate to Republican National Convention (1924); husband purchased Washington Post *(1933); became part-owner of the paper (1935); traveled to wartime England as a reporter for the* Post *(1942); began agitating for creation of cabinet department for social services (1944); federal Department of Health, Education, and Welfare created (1953); widowed (1959).*

Selected writings: Chinese Painting as Reflected in the Thought and Art of Li-Lung-Mien, 1070–1106 *(1923);* Journey Through Chaos *(1944);* Education

for a New Morality; Out of These Roots *(autobiography, 1953)*.

Although Agnes Meyer achieved prominence and power through the traditional ways for women of her era—inheritance and marriage—the manner in which she wielded that influence marked her as an iconoclast. Her involvement in the family business, the *Washington Post*, helped make it one of the most influential newspapers in the nation; moreover, the determination and will she passed on to her daughter, *Katharine Graham, made both the *Post* and Graham herself, as its publisher, a significant force in Washington and the nation's politics.

Meyer was born Agnes Elizabeth Ernst in 1887 into a wealthy New York German family, and grew up in both Manhattan and Pelham, New York. Her father was an attorney who for much of her young life encouraged her to pursue her intellectual interests, but opposed her when she expressed a desire to earn a college degree. Meyer was thus forced to pay her own way

Agnes Meyer

though Barnard College in New York City, and though she found the school stultifying in structure and intellectual atmosphere, she graduated with a B.A. in 1907. She was later named a trustee of Barnard and actively worked to rectify some of the more mediocre aspects of the women's college. After graduation, Meyer obtained a job as the first woman reporter for the *New York Sun*, but quit the following year to study at the Sorbonne in Paris. There she came to know many prominent expatriate and European figures of the era, including photographer Edward Steichen, writer *Gertrude Stein and her brother Leo Stein, and sculptor Auguste Rodin. She and German emigré writer Thomas Mann enjoyed a lifelong friendship as well. Meyer's research while in France as a fledgling art scholar would eventually result in her first book, *Chinese Painting as Reflected in the Thought and Art of Li-Lung-Mien, 1070–1106*, published in 1923.

Meyer returned home and married financier Eugene Meyer in February 1910. For a time, she took classes at Columbia University, but quit with the birth of her first child in 1911. She became involved in charity work, helping to establish maternity centers for New York City's disadvantaged along with a group of similarly well-heeled and reform-minded women. In time, her growing family—she and Eugene would become parents to five children in all—relocated to Seven Springs Farm, located in the Westchester County village of Mount Kisco. Meyer was active in the county's recreation commission from 1923 to 1941, but she and her husband were also ardent Republicans and soon entered a larger social arena. In 1924, Meyer served as a delegate to the Republican National Convention. After the 1932 election of Democrat Franklin D. Roosevelt to the White House, Meyer wrote articles critical of his planned "New Deal" projects, especially the massive Works Progress (later Works Projects) Administration that was designed to provide jobs for the millions unemployed due to the Depression.

Meyer's financier husband had been active in several presidential administrations in varying capacities. In 1933, at the "suggestion" of Roosevelt, he retired from his post as chair of the Board of the Reconstruction Finance Corporation, and then bought a minor D.C. newspaper, the *Washington Post*. He named his wife vice-president, and she became part-owner in 1935. Over the next 15 years, the Meyers vastly improved the newspaper's focus and fortunes, quadrupling its circulation by 1949. Meyer played an active role in the paper's editorial content and wrote numerous features and series herself: in

1942, for instance, she traveled to wartime England and sent back stories about how the civilian population was coping with food shortages, evacuations, and the Blitzkrieg. Beginning in 1943, Meyer traversed the wartime United States and wrote a series of articles for the *Post* about the shocking conditions in war plants, where workers and families were housed in sometimes abominable conditions. The reportage caused such an outcry that the Pentagon took steps to rectify the situation. The accounts were all reprinted in pamphlet form in 1943 as *America's Home Front*, and the following year in a book titled *Journey Through Chaos*.

After the war, Meyer was active in promoting veterans' issues, and was also a champion of desegregation. In 1945, she organized the Woman's Foundation, an all-purpose social service organization, and though she had been anything but a stay-at-home mother herself—she had often traveled to Europe alone, and had left her children in the care of hired help for much of their early lives—Meyer decried the social ills which she believed stemmed from the "average" American woman's neglect of her duties of motherhood. She also actively solicited the federal government to create a cabinet post for "health, education, and security"; Meyer's dream was to have small neighborhood community centers as the locus point from which citizens could learn about health issues, improve their minds, and receive forms of government-funded assistance. After several years of Congressional debate, Meyer finally saw her idea take form with the 1953 creation of the Department of Health, Education, and Welfare.

Meyer continued to play a role in the *Washington Post* throughout much of her life, but also wrote for numerous other publications, including *Collier's*, *The New York Times Book Review*, and the *Atlantic Monthly*. Eugene Meyer died in 1959, having in 1946 made daughter Katharine Graham's husband, Philip Graham, his successor as publisher. When Philip Graham committed suicide in 1963, Katharine Graham stepped into the job she would hold until her retirement in 1991. Agnes Meyer died in 1970.

SOURCES:

Current Biography 1949. NY: H.W. Wilson, 1949.

Sicherman, Barbara, and Carol Hurd Green, eds. *Notable American Women: The Modern Period*. Cambridge, MA: The Belknap Press of Harvard University Press, 1980.

Weatherford, Doris. *American Women's History*. NY: Prentice Hall, 1994.

Carol Brennan,
Grosse Pointe, Michigan

Meyer, Annie Nathan (1867–1951)

American author and a founder of Barnard College.
Name variations: Annie Nathan; Annie Florance Nathan. Born Anne Nathan in New York City on February 19, 1867; died in New York City on September 23, 1951; youngest of two daughters and two sons of Robert Weeks Nathan (a stockbroker and later a passenger agent for a railroad) and Annie Augusta (Florance) Nathan (d. 1878); younger sister of Maud Nathan (1862–1946); home-schooled; attended Columbia College, 1885–1887; married Alfred Meyer (a physician), on February 15, 1887; children: Margaret Meyer (1894–1923).

The younger sister of *Maud Nathan, a prominent suffragist and social welfare leader, Annie Nathan Meyer is best remembered as a founder of Barnard College, the women's affiliate of Columbia University. She was also a prolific writer, turning out novels, plays, short stories, and essays in which she often extolled women's strengths and abilities. In a lecture on "Woman's Place in Letters" given in Chicago in 1893, she took on assumptions of male superiority in the art of literature:

> I heard the other day that Mr. Brander Matthews [professor of literature at Columbia] so keenly misses the sense of humor in woman that he has resolved the next time he marries to marry a man. No, I am not going to get angry about it, it hits Mrs. Matthews so much harder than it hits me; nor am I going to assist Mr. Matthews to prove his cause by taking his skit too seriously. But I cannot resist just a reference to the delightful quality of the humor of *Agnes Repplier, *Mary E. Wilkins Freeman, *Sarah Orne Jewett, Mrs. W.K. Clifford, and Mrs. [*Pearl] Craigie, who is generally known by her pen name of John Oliver Hobbs. The humor of the last is so subtle, so whimsical, and so utterly pervasive that I have a suspicion in my mind that Mr. Matthews, in his ignorance of the *nom de plume*, was thinking of taking a certain Mr. John Oliver Hobbs as that second wife.

However, Meyer's feminist views, unlike those of her sister, did not extend to the vote, however, and her anti-suffrage stance somewhat clouded her message. "Her career remains intriguing as an unresolved amalgam of encouragement for the full development of women's talents and distrust of those who would restructure women's roles," writes **Linda K. Kerber** in *Notable American Women: The Modern Period*.

Meyer, who descended from a prominent family of Sephardic Jews, had a difficult childhood. Her father Robert Nathan, a member of

Annie
Nathan
Meyer

the New York Stock Exchange, failed in business in 1875, and the family moved from New York City to Green Bay, Wisconsin, where a friend found him a job as a passenger agent for a railroad. The Nathan marriage did not survive the reversal of fortune, and Meyer's mother Annie turned to drugs and became suicidal. She died in a Chicago hospital in 1878, after which Meyer was sent to live with her grandparents back in New York. As a child, Meyer had been home-schooled by her mother, and she attended public school only briefly while the family was in Chicago. From 1885 to 1887, she was enrolled in the Collegiate Course for Women at Columbia College (an extension reading course), but withdrew in February 1887 to marry Alfred Meyer, a prominent physician.

Following her marriage, Meyer began working to establish a fully accredited women's college to be affiliated with Columbia. She circulated her ideas for the venture in an article in the *Nation* and prepared a support petition which was signed by 50 prominent New Yorkers. She also secured independent funding for the project, receiving her first substantial contribution from her husband. In an attempt to broaden support for the venture, she proposed naming the college after Columbia's late president Frederick A.P. Barnard, who had been a strong advocate of education for women. Modeled after Harvard's Annex (later Radcliffe College), Barnard College opened its doors in September 1889, occupying quarters that Meyer had leased in anticipation of success.

Meyer remained a trustee of the institution from 1893 to 1942, although there was lingering resentment over her assumption that she had been the sole creator of the college. During her trusteeship, she continued to raise money for the school, and took particular pains to assure a Jewish presence among the student body. She also played a role in recruiting black students and was instrumental in securing independent funds for *Zora Neale Hurston, who was accepted at Barnard without an adequate scholarship.

Meyer's extensive writings included three novels, an autobiography (first published in 1935 as *Barnard Beginnings,* but revised into a chattier version, *It's Been Fun*, published in 1951), several books of nonfiction, and 26 plays, one of which, *The Advertising of Kate*, had a brief life on Broadway in 1922. (Another of her plays, *Black Soul*, written in 1925, was mounted at the Provincetown Playhouse in 1932, in a production subsidized by Meyer.) She also contributed numerous articles and short stories to the popular journals of the day, including *The Bookman*, *World's Work, Century, Harper's, Smart Set*, and *North American Review*. Meyer's writings reveal her deep ambivalence about the value of women's work outside the home. While she was often sympathetic to working women and praised their capabilities in such books as *Women's Work in America, Helen Brent, M.D*, and her play *The Dominant Sex*, she also believed that only the most extraordinary married women should attempt a career outside the home. "Bitter complaints that women who were active in reform politics neglected their families appeared repeatedly in Meyer's work," writes Kerber, citing Meyer's essay "Woman's Assumption of Sex Superiority." Meyer saw particular danger in giving women the vote, and gave numerous anti-suffrage speeches. When the vote was won, Kerber says, Meyer, in frequent letters to the editor, "reminded her readers that votes for women had not ushered in a new era of social responsibility."

The Meyers' marriage was described as happy. The couple had one daughter, **Margaret Meyer** (b. 1894), who graduated from Barnard in 1915. Shortly after her marriage in 1923, Margaret died in what her mother called "an accident with a pistol." Meyer, who was always considered eccentric, grew more so following her daughter's death. She died of a heart attack in 1951.

SOURCES:

McHenry, Robert, ed. *Famous American Women.* NY: Dover, 1983.

Sicherman, Barbara, and Carol Hurd Green, eds. *Notable American Women: The Modern Period.* Cambridge, MA: The Belknap Press of Harvard University Press, 1980.

COLLECTIONS:

Annie Nathan Meyer's papers are held at the American Jewish Archives in Cincinnati, Ohio.

Barbara Morgan,
Melrose, Massachusetts

Meyer, Debbie (1952—)

American swimmer. Name variations: Deborah Elizabeth Reyes. Born Deborah Elizabeth Meyer on August

ᴅebbie ᴍeyer

14, 1952, in Haddonfield, New Jersey; daughter of Leonard Meyer.

Was the first woman to win Olympic gold medals in three individual swimming events at the same Olympic Games and to set Olympic records in each race (won gold medals in 800-meter freestyle, 400- meter freestyle, and 200-meter freestyle in Mexico City Olympics in 1968).

Poor health led Debbie Meyer into competitive swimming. Though she was born in 1952 in Haddonfield, New Jersey, in childhood she

moved with her family to sunny Sacramento, California, because of her asthma. The family also thought that swimming might develop Debbie's lungs, so she began swimming under the supervision of Sherman Chavoor, coach of the U.S. Women's Olympic Team. Chavoor emphasized conditioning and required his pupils to swim long distances before entering shorter events. Swimming and the warm climate soon improved Meyer's asthma, and she proved to be a talented swimmer. In 1967, she set world records in the 400- and 800-meter freestyle events in the Pan American Games in Winnipeg, Canada. Meyer then dominated the 1968 Olympic trials, setting freestyle world records of 2:6.7 in the 200 meters; 4:24.5 in the 400 meters; and 9:10.4 in the 800 meters. Her performance reminded many of Jesse Owens, who set four world records in the 1935 BTC track and field meet.

The 1968 Olympics were not easy for Meyer. She had only recently gotten over painful bursitis in her left shoulder, and came down with a stomach ailment in Mexico City. She won the 400-meter freestyle in 4:31.8 for her first gold. The next day her stomach cramps were worse, but Meyer took no medication for fear she would be disqualified. Nonetheless, she posted her fastest qualifying time in the 800-meter freestyle. In the 200 meter held the same day, weakened by both the qualifying race and her queasy stomach, Meyer fought off **Jan Henne**'s challenge to win the 200-meter freestyle in 2:10.5. Meyer then won her third gold in the 800-meter freestyle in 9:24.0. She became the first woman to win gold medals in three individual swimming events at the same Olympic Games and to set an Olympic record in each race.

Debbie Meyer retired from competition before the 1972 Olympics with six American, three Olympic, and two Pan American game records. She was inducted into the Women's Sports Foundation Hall of Fame in 1987.

Karin L. Haag,
freelance writer, Athens, Georgia

Meyer, Lucy (1849–1922)

Prominent Methodist writer, social reformer, physician, and founder of a training school for Methodist women social workers in Chicago. Name variations: Lucy Jane Rider Meyer; Lucy Rider Meyer. Born on September 9, 1849, in New Haven, Vermont; died of Bright's disease and heart problems on March 16, 1922, in Chicago, Illinois; daughter of Richard Dunning Rider (a farmer) and Jane (Child) Rider; attended New Hampton Literary Institute, 1867; degree from Oberlin College, 1872; attended Woman's Medical College of Pennsylvania, 1873–75; attended Massachusetts Institute of Technology, 1877–78; Women's Medical College of Chicago, M.D., 1887; married Josiah Shelly Meyer, on May 23, 1885; children: son Shelly Rider.

Moved to Canada (c. 1868); taught freed slaves in North Carolina (c. 1869); became teacher at Oberlin College (early 1870s); returned to Vermont (c. 1875); became principal of Troy Conference Academy (1876); moved to Illinois (1879); became secretary of the Illinois State Sunday School Association (1881); co-founded first deaconess home in United States (1885); founded journal for deaconesses (1886); formed the Methodist Deaconess Association (1908).

Selected writings: Children's Meetings and How to Conduct Them *(1885);* Real Fairy Folks: Explorations in the World of Atoms *(1887);* Deaconesses: Biblical, Early Church, European, American . . . *(1889);* Mary North *(novel, 1903).*

Lucy Rider Meyer was a leading force in Methodist urban social work, and with her husband co-founded a pioneering training ground and residence for deaconesses in the United States in the 1880s. Deaconesses were Protestant lay women who devoted their lives to ministering to the poor, and Meyer, who lived a long life filled with a wide array of careers and scholarship, was one such woman.

Born in Vermont in 1849, Meyer had six siblings from her father's first marriage, as well as two younger brothers; both sides of her family were descended from some of New England's first European settlers. At age 13, she had a born-again experience at a Methodist revival meeting. After graduating in 1867 from the New Hampton Literary Institute in Fairfax, Vermont, she moved to Canada for a time to work as a tutor to a French family. She next taught at a Quaker school for freed slaves in Greensboro, North Carolina, and returned to New England with two young African-American women whom she helped establish themselves there. At Oberlin College, she was both a student and a teacher, and earned a degree in 1872. She also became engaged there to a young man who planned to become a medical missionary, and as a result she began studying medicine as well, enrolling in the Woman's Medical College of Pennsylvania in 1873. In 1875, however, her fiancé died, after which she spent some isolated years in Vermont caring for her aging parents. During this time, she wrote poetry and Bible tales, and began work on a science textbook, *Real Fairy*

Folks: Explorations in the World of Atoms, which would be published in 1887.

In 1876, Meyer was hired as principal of Troy Conference Academy in Poultney, Vermont, but left the post the following year to study chemistry at the Massachusetts Institute of Technology. She then moved to Illinois when she became a professor of chemistry at a small college in the city of Lebanon, but she grew dissatisfied with teaching and resigned in 1881 to take a job as secretary of the Illinois State Sunday School Association. In 1885, she married a Chicago businessman, Josiah Shelly Meyer, who shared her devoutness and commitment to social service. That year, with four students in rented rooms, they established the Chicago Training School for City, Home, and Foreign Missions. Their aim was to introduce young women to the knowledge, both religious and practical, that they would need to minister to the growing number of urban poor. With this in mind, Meyer returned to medical school, this time at the Women's Medical College of Chicago, and earned her M.D. in 1887.

That same year, the Meyers formally founded their permanent home for deaconesses in Chicago. Its residents served as social workers in the area, and even wore an ecclesiastical-type garment. The women took no vows, and received no salary except for a small living allowance. All elements were modeled on a school for Lutheran women in Kaiserswerth, Germany, that had been founded in 1836. In 1888, the Meyers' efforts were formally sanctioned by the governing body of the Methodist Church, which set down formal guidelines for deaconesses. For years Meyer edited a publication called the *Deaconess Advocate*, and wrote a history of the movement published in 1889 titled *Deaconesses: Biblical, Early Church, European, American....*

Accordingly, Meyer was the leading figure in the American deaconess movement, but she eventually came into conflict with others in the church who saw the role of the deaconess differently. Contentious battles with other deaconesses, particularly those of the Methodist Woman's Home Missionary Society, marked her later years, and she came to disagree with the way in which the church's view of their mission work had changed. Meyer worked tirelessly to maintain her Chicago school's independence from church authority, forming the separate Methodist Deaconess Association in 1908, but she also encountered problems with her husband over the aim of their school. Josiah Meyer was of a more conservative mind than Lucy; she rec-

ognized changes in society and knew that deaconesses must address those changes in their work if they were to remain effective. Meyer came to know social reformer **Jane Addams*, the founder of Hull House, and invited her to serve as a lecturer at the Chicago Training School; its board, however, vetoed the idea since Addams and Hull House were unaffiliated with any religious denomination.

Meyer wrote numerous Sunday school stories, and a novel of social protest, *Mary North*, that was published in 1903. For a time she also studied divinity at the University of Chicago. The enrollment in her school declined, however, and she and her husband handed it over to another group in 1917. The Chicago Training School had by then spawned 40 philanthropic institutions in the city and its suburbs, including an orphanage, a senior citizens' home, and the Wesley Memorial Hospital, in which Meyer died in 1922.

SOURCES:

James, Edward T., ed. *Notable American Women, 1607–1950*. Cambridge, MA: The Belknap Press of Harvard University Press, 1971.

Read, Phyllis J., and Bernard L. Witlieb. *The Book of Women's Firsts*. NY: Random House, 1992.

Carol Brennan,
Grosse Pointe, Michigan

Meyers, Ann (1955—)

American basketball player. Name variations: Ann Meyers Drysdale. Born in San Diego, California, on March 25, 1955; graduated from the University of California, Los Angeles; married Don Drysdale (Los Angeles Dodgers' pitcher and broadcaster), in 1986 (died 1993); children: Don Jr.; Darren; and Drew Ann.

A pioneer in women's basketball, Ann Meyers accomplished a number of important athletic "firsts." She was the first high school player to make the U.S. national women's basketball team, and the first woman to receive a full athletic scholarship from a major university; she was also the first four-time All-American at UCLA, and the first woman to sign a contract with a men's NBA team. "You don't win every game," she told the *Orange County Register*. "There are a lot of defeats in sports. It teaches you to maybe be a little stronger in life after sports." Indeed, the more recent events of Meyers' life have tested her in ways she never encountered on the basketball court.

One of 11 children, Meyers was born and raised in California. Her father Bob Meyers played guard for Marquette University and the

Milwaukee Shooting Stars, and her brother Dave played basketball for UCLA and the Milwaukee Bucks. Ann learned the game early, but her interest in athletics came at a price. "I was a tomboy. I didn't fit in with the girls," she recalls. "I always had short hair. Long hair didn't go in sports for me. The boys didn't really accept me. Yet the guys liked me because I was a ballplayer. I was caught in the middle."

Because her parents argued her case, Meyers was allowed to play on boys' teams during elementary school, but from junior high on she was relegated to the women's teams. In high school, she excelled in every sport she pursued, winning letters in field hockey, badminton, tennis, softball, volleyball, track and field, and basketball— her best sport. While still in high school, she was named to the U.S. national team; she also participated in the 1976 Olympic games in Montreal, Canada, where the American women's basketball team won a silver medal. Meyers was the first woman to receive a full athletic scholarship from UCLA and won All-American honors all four years she was there, taking the team to a national championship in 1978. That year, she was the recipient of the prestigious Broderick Cup and was named Collegiate Woman Athlete of the year by the National Association for Girls and Women in Sports.

After college, Meyers hoped for a basketball career in the NBA, but it seemed unlikely that she could break that barrier. In an unprecedented move, however, the Indiana Pacers signed her to a contract in 1979, although after a three-day tryout, she was cut from the team. In 1980, after a stint with the Pacers' broadcasting crew, she spent a season with the now defunct New Jersey Gems of the Women's Professional Basketball League, where she was named Most Valuable Player. She left in a contract dispute after one season and pursued further broadcasting opportunities, often doing color commentary for women's basketball and also performing game analysis at the 1984 Los Angeles Olympics.

In 1986, Meyers married Hall of Fame Dodger pitcher Don Drysdale, whom she had met while participating in a televised women's "Superstars" competition in 1979. She continued to work in broadcasting while also beginning a family, which eventually grew to include three children, two boys and a girl. In May 1993, with her husband and children looking on, Meyers was inducted into the Basketball Hall of Fame, a high point in her life. Just two months later, Drysdale died suddenly of a heart attack while broadcasting a game.

It was a challenge for Meyers to continue her career (she now works for ESPN and NBC). "Don would have been the first one to kick me in the backside to keep going," she told the *New York Daily News*, also crediting Drysdale with teaching her independence. "I'm forced to make decisions now that maybe Don would've made or we would've made together. Now, I've got to make those decisions. They're difficult sometimes, but it makes you stronger because you have no one to rely on." Meyers' abiding passion for sports also provides inspiration, even though she is no longer on the basketball court. She believes her continued interest will serve her well as she ages. "You have to have something in your life," she has said. "You have to have that edge. You have to have a challenge to get up each morning and want to keep going."

SOURCES:

Fagan, Greg. "She Had Next," in *TV Guide.* August 1, 1998.

Johnson, Anne Janette. *Great Women in Sports.* Detroit, MI: Visible Ink, 1998.

Woolum, Janet. *Outstanding Women Athletes.* Phoenix, AZ: Oryx Press, 1992.

Meyers, Jan (1928—)

Six-term U.S. congressional representative from Kansas. Born on July 20, 1928, in Lincoln, Nebraska; William Woods College, A.F.A., 1948; University of Nebraska, B.A., 1951.

Elected to city council (1967); elected to Kansas legislature (1972); elected to U.S. House of Representatives (1984); retired from Congress (1996).

Jan Meyers served six terms in the lower chamber of the U.S. Congress as a Republican representing Kansas' Third District during the heyday of the Reagan-Bush era of Republican vitality. Meyers' political career was notable for her support of women's reproductive freedoms, since one of the mainstays of the Republican political platform during these years was a curtailing by law of those rights. Born in Lincoln, Nebraska, in 1928, Meyers earned an associate degree in fine arts from William Woods College in 1948, and then pursued a bachelor's degree from the University of Nebraska, which she received in 1951. For a time after college, she worked in advertising and public relations. In 1967, she won election to the Overland Park City Council, the governing board of that large suburb of Kansas City, and held its president's chair for two years before departing when she won election to the Kansas state legislature in 1972. She

served in the state house until 1984, and continued to demonstrate a clear support for women's rights issues. During her time in Topeka, she authored a bill that limited the use in court of rape victims' sexual histories.

In 1978, Meyers ran for a seat in the Senate primary, losing to *Nancy Kassebaum. Meyers won the Third District seat representing Kansas in the U.S. House of Representatives in 1984. During her first term, she served on the Committee on Science and Technology as well as on the Select Committee on Aging. Re-elected in 1986, she moved up to a spot on the prestigious Senate Committee on Foreign Affairs, where she focused some of her efforts on curtailing international drug trafficking while serving on the International Narcotics Control Task Force, and also served on the Small Business Committee. A strong proponent of the Equal Rights Amendment (ERA) and a member of the Women's Congressional Caucus, she also served as vice-chair of the Energy and Environment Study Conference. Meyers was consistently re-elected by her constituency through 1994, and announced her retirement at the end of that term.

SOURCES:

*Carabillo, Toni, and Judith Meuli. *The Feminization of Power.* Los Angeles, CA: The Fund for the Feminist Majority, 1988.

Office of the Historian. *Women in Congress, 1917–1990.* Commission on the Bicentenary of the U.S. House of Representatives, 1991.

Carol Brennan,
Grosse Pointe, Michigan

Meyerson, Golda (1898–1978).
See Meir, Golda.

Meyfarth, Ulrike (1956—)
West German high jumper. Born on May 4, 1956, in West Germany; grew up in Munich.

Won Olympic gold medals in the high jump in Munich (1972) and Los Angeles (1984).

In the Munich Olympic Games in 1972, a 16-year-old schoolgirl from Köln-Rodenkirchen, West Germany, jumped 2.75 inches higher than she had ever done before, winning a gold medal and equaling the world record at 6'3½". She was the youngest competitor, male or female, to win an individual Olympic track-and-field event. It took Ulrike Meyfarth 12 more years to have the chance for a second gold. She was eliminated in early qualifying rounds during the 1976 Olympics in Montreal, and the 1980 Games were boycotted. The 6' Meyfarth turned

down modeling offers, stayed in competition, and faced her chief rival *Sara Simeoni of Italy in the 1984 Olympics at Los Angeles. Meyfarth cleared 6'7½" on her first jump, breaking Simeoni's 1980 Olympic record of 6'5½". Meyfarth was now the oldest woman high-jump winner in Olympic history.

Meynell, Alice (1847–1922).
See Butler, Elizabeth Thompson for sidebar.

Meynell, Alicia (fl. 1804–1805)
English equestrian. Born around 1782; flourished around 1804–05.

On August 25, 1804, Alicia Meynell competed in a horce race over a four-mile course at York, becoming the first woman known to have done so. The mistress of a Colonel Thornton, 22-year-old Meynell was riding his horse Vingarillo sidesaddle under the name Mrs.

Jan Meyers

Thornton against Captain William Flint and his horse Thornville. Though Meynell was a pre-race favorite and held the lead for the first three miles, her 20-year-old horse faded and Flint was victorious. The following year, Meynell competed once again in August, winning two races: the first, by default; the second, by half a neck.

Meynell, Viola (1886–1956).

See Butler, Elizabeth Thompson for sidebar.

Meyner, Helen Stevenson

(1929–1997)

U.S. congressional representative from January 3, 1975, to January 3, 1979. Born Helen Day Stevenson on March 5, 1929, in New York City; died in 1997; attended Colorado Springs College, 1946–50; married Robert B. Meyner (governor of New Jersey, 1953–62), in 1957; children: one son (born and died on February 11, 1970).

Helen
Stevenson
Meyner

A distant cousin of two-time Democratic presidential nominee and U.S. ambassador to the United Nations Adlai Stevenson, Helen Stevenson Meyner was born on March 5, 1929, in New York City. After attending Colorado Springs College from 1946 to 1950, she served as a Red Cross field worker in the Korean conflict until 1952. She then worked briefly as a guide at the United Nations before taking a job as a consumer advisor for an airline in 1953.

Meyner married New Jersey governor Robert B. Meyner, the first Democratic governor of that state for more than a decade, in 1957. She began writing a weekly column for the *Newark Star-Ledger* after her husband left office in 1962, and hosted a television interview program broadcast in New York and New Jersey from 1965 to 1968. In 1971, she began serving on the New Jersey State Rehabilitation Commission, in which capacity she continued into the 1990s.

Meyner was in the middle of writing a biography of *Katherine Mansfield in 1972 when a Democratic candidate for Congress from the 13th District of New Jersey failed to meet the seven-year citizenship requirement for election. Meyner stepped in as a replacement candidate. Although she lost to the incumbent, Joseph J. Maraziti, she defeated him in the subsequent election two years later. While serving two terms in Congress, Meyner served on the Committee on Foreign Affairs and played a significant role in international affairs. While opposing the expulsion of Israel from the United Nations, she condemned the UN's 1975 resolution equating Zionism with racism, and backed efforts to tie U.S. economic aid to the Philippines to the reduction of human rights abuses in that country. She also served on the Select Committee on Aging and the Committee on the District of Columbia. Meyner worked to protect the traditional industries of her constituents, supporting tariff protection for U.S. textile manufacturers and ensuring that military establishments in her district were kept in operation. A proponent of the Equal Rights Amendment, in 1976 she lobbied her fellow Democratic state senators for their continued support of the ERA. Helen Meyner was defeated in her bid to secure a third term in Congress in 1978. She moved to Florida after the death of her husband in 1990, and died in 1997.

SOURCES:

Office of the Historian. *Women in Congress, 1917–1990.* Commission on the Bicentenary of the U.S. House of Representatives, 1991.

Grant Eldridge,
freelance writer, Pontiac, Michigan

Meysenburg, Malwida von

(1816–1903)

German salonnière and writer. Name variations: Malvida von Meysenburg. Born in 1816; died in 1903.

A socialist and a supporter of the 1848 Revolution, writer Malwida von Meysenburg was forced to leave Berlin in 1852. Thereafter, she lived variously in England, Paris, and Rome, conducting salons that attracted such luminaries as the Italian patriot Giuseppe Garibaldi (1807–1882), and German philosopher Friedrich Nietzsche (1844–1900). During her later years in Rome, she greatly influenced French novelist Romain Rolland (1866–1944), with whom she shared stories about her famous circle of friends. Meysenburg's writings are mostly autobiographical and include *Eine Reise nach Ostende (A Journey to Ostend*, 1849), and *Memoiren einer Idealistin* (1876), which was published in English as *Rebel in Bombazine: Memoirs of Malvida von Meysenburg* (1936).

Meysey-Wigley, Caroline (1801–1873).

See Clive, Caroline.

Miahuaxochitl (d. 1551).

See Malinche for sidebar on Tecuichpo.

Michael of Kent (b. 1945)

Princess. Name variations: Marie-Christine von Reibnitz. Born Marie Christine Agnes Hedwig Ida von Reibnitz on January 15, 1945, in Karlovy Vary (Karlsbad), Czech Republic; daughter of Gunther von Reibnitz and Marie-Anne, countess Szapary; married Tom Troubridge, in 1971 (annulled, 1978); married Prince Michael of Kent (Michael Windsor), on June 30, 1978; children: (second marriage) Frederick Windsor (b. 1979); Gabriella Windsor (b. 1981).

Michaëlis, Karin (1872–1950)

Danish novelist and short-story writer. Name variations: Michaelis; Karin Michaëlis Stangeland; Karin Michaëlis-Stangeland. Born Katharina Marie Bech-Brøndum at Randers, Denmark, on March 20, 1872; died in 1950; daughter of Jac Brøndum; her mother's maiden name was Bech; sister of the Baroness Dahlerup; educated in private schools and with tutors; married Sophus Michaëlis (1865–1932, a Danish author), around 1893 (divorced 1911); married Charles Emil Stangeland (an American), in 1912.

Selected writings: author of more than 50 books, including The Child *(Barnet, 1902);* The Mummy *(Lillemor, 1902);* The Dangerous Age *(Den Farlige Alder, 1911), and its sequel* Elsie Lindtner *(1912);* The Governor *(1913);* The Girl with the Flowerpot *(1925);* Bibi: A Little Danish Girl *(1927);* Venture's End *(1927);* Bibi Goes Travelling *(1935);* Green Island *(1936); (memoirs)* The Tree of Good and Evil *(Trået på Godt og Ondt, 1924–1930); (memoirs)* Wonderful World *(Vidunderlige Verden, 1948–1950).*

Karin Michaëlis' best-known novel was *The Dangerous Age: Letters and Fragments from a Woman's Diary (Den Farlige Alder)*, which was serialized in the *Revue de Paris* in 1911 before being published in hardcover. In Germany, where 80,000 copies were sold, its feminist theme which concluded that "between the sexes reigns an ineradicable hostility" was enough of a threat to prompt cartoons and caricatures, especially in *Jugend*. The book, wrote Marcel Prévost, was the "most sincere, the most complete, the most humble and the most disquieting feminine confession perhaps ever written."

Growing up poor in Randers, Denmark, Michaëlis moved to Copenhagen at age 20, married the well-known Danish poet Sophus Michaëlis, and lived a nomadic life in Germany, Austria, England, and the United States, while writing in Danish and German. During World War I, she was actively pro-German, working with the underprivileged and the suffering, championing women and the poor. During World War II, she was anti-Nazi, aiding German Jews, Communists, and artists fleeing to Denmark. Because of this, her books were burned in the Third Reich, and she lived alone and impoverished in New York until her death in 1950. Michaëlis also wrote the popular "Bibi" series for children, about an untamed girl who lives with her father and travels through Denmark.

Michaiah.

Variant of Maacah.

Michal (fl. 1000 BCE)

*Biblical woman. Flourished about 1000 BCE; youngest of two daughters of Saul (first king of the Jewish nation) and Ahinoam; sister of *Merab; first wife of David (r. 1010–970 BCE); no children.*

Due to Yahweh's aid (which Saul knew he himself had lost), David became Saul's principal commander and won one campaign after the

next. When Michal, younger daughter of Saul and *Ahinoam, fell in love with David, Saul offered her in marriage. The Biblical passage (1 Samuel 18:20) which introduces Michal is the only place in the Hebrew Bible which specifies the love of a woman for a man. Instead of asking a bride-price for Michal, Saul asked David to give him the foreskins of 100 Philistines, anticipating that David would die in the attempt to kill his enemies and gather this grisly form of payment. But David killed 200 and, after counting out the foreskins at Saul's feet, took his bride.

Determined to be rid of David, Saul decided on assassination, but with the help of Michal and her brother Jonathan, David was able to escape to a succession of hiding places. Members of his family and other Israelites dissatisfied with Saul joined him where he lived as an outlaw at the Cave of Adullam. They formed the basis of the private army which was to serve David loyally throughout his future life and help to consolidate his power.

We never learn whether David loved Michal, or whether it was, for him, simply a marriage for political advancement. Later events suggest that she became madly jealous of actual and possible rivals. For example, David brought to Jerusalem the Ark of the Covenant, the central icon of the Israelites' religion, in an elaborate ritual procession. "David and the whole House of Israel danced before Yahweh with all their might, singing to the accompaniment of harps, lyres, tambourines, sistrums and cymbals" (2 Samuel 6:6). Michal criticized him for "making an exhibition of himself under the eyes of his servant-maids, making an exhibition of himself like a buffoon." Not at all, David reproached her; he had been dancing for Yahweh, "who chose me in preference to your father and his whole family, to make me leader of Israel" (2 Samuel 6:20). Michal endured lifelong infertility, though the narrative is ambiguous about whether she was childless simply because David would no longer sleep with her or because she was barren. David certainly had many other wives, in effect a harem, and much of his later reign was given over to squabbling and feuding among his many sons for preferment and succession.

Michel, Louise (1830–1905)

French anarchist and writer whose heroism during the Paris Commune insurrection and subsequent imprisonments, and example of selfless devotion to her ideals, made her one of the most celebrated female revolutionaries of her time. Name variations: "La Vierge Rouge" (The Red Virgin). *Pronunciation: Loo-EESE Mee-SHELL. Born Clémence-Louise Michel on May 29, 1830, in Vroncourt (Haute-Marne), France; died in Marseille of pneumonia and exhaustion, on January 9, 1905, and was buried in Levallois-Perret Cemetery, Paris; daughter of Marie-Anne (called Marianne) Michel (1808–1885), a servant, and an unknown father, probably Marie-Anne's master, Etienne-Charles Demahis, or (more likely) his son Laurent; educated at home and then took teacher's training for three months at Lagny in Madame Duval's school (1851) and at Chaumont (1851–52); never married and had no descendants.*

Founded and ran private schools off and on in Haute-Marne (1852–56[?]); taught in private schools in Paris, gradually becoming interested in left-wing politics (c. 1856–70); was active during the siege of Paris (Franco-Prussian War), running a school for poor children, taking part in demonstrations, and working on vigilance committees (1870–71); continued social work and teaching but also became a nurse and soldier during the Paris Commune, was arrested and sentenced to deportation to a prison colony for life (1871); after imprisonment in France (1871–73), sent to New Caledonia, where she taught the native Kanakas until amnestied (1873–80); triumphantly returned to France, began a career of anarchist speech-making, and was imprisoned (1883–86); mother died (1885); shot in the head at Le Havre by a would-be assassin (1888); arrested for incitement but released, then moved to London (1890); after a triumphal return to Paris, resided alternately in Paris and London, making frequent speaking tours in France until her death (1895–1905); return of her body to Paris for burial occasioned a huge but peaceful leftist demonstration (1905).

Principal writings (published in Paris unless otherwise noted): Mémoires (F. Roy, 1886, English version, The Red Virgin: Memoirs of Louise Michel, ed. and trans. by Bullitt Lowry and Elizabeth Ellington Gunter. University, AL: University of Alabama Press, 1981); La Commune (P.-V. Stock, 1898). Selected other works: Le Livre du jour de l'an, historiettes, contes et légendes pour les enfants (J. Brare, 1872); La Misère, en collaboration avec Jean Guétré (A. Fayard, 1882); Les Méprisées, en collaboration avec Jean Guétré (A. Fayard, 1882); Le Bâtard impérial, en collaboration avec Jean Winter (Librairie nationale, 1883); La Fille du peuple en collaboration avec Adolphe Grippa (Librairie nationale, 1883); Légendes et Chants de gestes canaques (Kéva, 1885); Les Microbes humains (E. Dentu, 1886); Le Coq rouge, drame en 6 actes et 8 tableaux (Edinger, 1888); Le

Monde nouveau (E. Dentu, 1888); Les Crimes de l'époque (N. Blanpain, 1888); A travers la vie, poésies (A. Fayard, 1894); Oeuvres posthumes, t. I: Avant la Commune (Alfortville: Librairie internationaliste, 1905); Le Claque-dents (E. Dentu, n.d.).

If she perhaps was not the most famous woman in France when she faced the 4th Council of War for sentencing on December 16, 1871, Louise Michel—garbed in black as she would be for the rest of her life—was undoubtedly the most notorious. Eighteen months before, at the outbreak of the Franco-Prussian War, it would have been quite impossible to predict that this Paris schoolmistress would emerge from near total obscurity to command such attention. Those fevered months changed her life forever; in a very real sense, she spent her remaining years trying to recapture that moment.

Louise Michel, a romantic who wrote poetry all her life, was born in the hamlet of Vroncourt in 1830 during the heyday of the Romantic movement in France and passed her first 20 years in the romantic setting par excellence of a gloomy, tumbled-down château, nicknamed "The Tomb," in one of the most rural of *départements*, Haute-Marne (some 140 air miles ESE of Paris), the same region that had once sent forth *Joan of Arc. Her mother **Marianne Michel**, one of six children of a widow of literate and pious peasant stock, was taken in by an aristocratic family and raised with their children. Louise was the daughter of Marianne and either Laurent, the son, or Laurent's father, Etienne-Charles Demahis. After some family storms, Laurent moved to a nearby property, while Marianne and Louise stayed where they were. Louise always considered Laurent her father and called Etienne-Charles and his wife, **Louise-Charlotte-Maxence Demahis** (née Porcquet), her grandparents. They treated her with utmost kindness, and the local peasantry respectfully called her "Mademoiselle Demahis" despite the scandal of her birth.

Louise's grandmother's death (1850), preceded by those of her grandfather (1844) and father (1847), abruptly closed what to most appearances was an idyllic childhood, for Laurent's widow sold the château, thus forcing her and her mother out—though with a modest inheritance of 8.5 hectares (21 acres) and 8–10,000 francs from the grandfather's will. Louise had been very well educated, to a limited extent in the local school but mostly at home. Both the Demahis and Porcquets were of the *noblesse de la robe* (the judicial and administrative nobility). Etienne-Charles had been inspired by the Enlightenment's gospel of liberty and human rights. During the French Revolution (1789–99), he altered his name to "Demahis" from the aristocratic "de Mahis" and, unlike most nobles, remained true to the Revolution's principles after the Bourbons returned in 1814. Louise, obviously bright and imaginative, drank in colorful stories of the Revolution and staged scaffold speeches and mock executions with her playmates.

While she was feeding on legends of the Revolution and even more romanticized legends of her presumed Celtic (Breton) and Corsican ancestors, her grandfather also recognized in her a parallel streak of realism and hence encouraged her to read widely in the sciences, to collect specimens, and to perform simple experiments. (She later recorded her disgust at the omission of science in the education traditionally given to girls.) At the same time, however, she was influenced by the piety of her Michel relations, notably an Aunt Victoire, and her grandfather's death; she even thought of becoming a nun to pray for his irreligious soul. The religious life was not out of the question; marriage, given her education and individualistic, liberated personality, seemed problematic and, besides, held little attraction for her. She was "ugly," as she described herself: a high, sloping forehead, a large nose, a very wide mouth with a thin upper lip and pouting lower lip, skinny arms and legs, a deep voice, and robust gestures and movements. Her eyes—very dark and luminous—were about her only attractive physical feature. In her early teens, two local suitors showed up. She found their male pretensions to lordship ridiculous and told them so. She later would write, "I have always looked upon marriage without love as a kind of prostitution."

Two other traits from her childhood stand out. She loved animals of every kind and always kept numerous pets. The unthinking cruelty of the peasants toward animals sickened her. She later declared that "the origin of my revolt against the powerful was my horror at the tortures inflicted on animals." The other trait was her habit of giving away to the needy whatever might be at hand, whether hers or not. She seemed devoid of any proprietary sense and as a child would steal food or money from her grandparents (who were in narrow straits) to give away, even after warnings. Her sympathy for any sufferers, human or animal, simply overrode ordinary prudence or even regard for the generally accepted rights of others.

Forced now to support herself and her mother, Michel became a schoolmistress, about

the only choice (save for a nun's habit) for an educated, respectable, single young woman. She earned certification (1852) through courses at Madame Duval's school in Lagny and the state institute in nearby Chaumont and began a career, in private schools, the details of which are vague because for unknown reasons her professional file vanished from the archives near the turn of the century and because her *Mémoires* (1886) is thin and unreliable on this period. She opened her own school in Audeloncourt in 1852, went off to Paris in 1853 to teach, but returned to Haute-Marne because her mother was ill; Michel tried to start another school in Audeloncourt, failed, opened one in Clefmont (1854–55), left and started one in Millières (1855), and finally, in 1855 or 1856, left Haute-Marne for good to teach in Paris, first at Madame Vollier's school and then, having sold the last of her land to finance it (1865), at her own school at 5, rue des Cloys, later (1868) at 24, rue Oudot.

> *I* have finished. If you are not cowards, kill me.
>
> —Louise Michel to her court-martial judges, 1871

Louise Michel was a talented teacher, intelligent, informed, imaginative—and unconventional. In her *Mémoires,* written after she had become a famous revolutionary, she portrayed herself as, even in Haute-Marne, an outspoken Republican and hence often in trouble with Emperor Napoleon III's officials. For example, she had her pupils sing the forbidden "Marseillais," told them not to pray for the emperor's health as they had been taught, and was reproved by the prefect of Haute-Marne himself for writing a piece in the local paper implying that Napoleon III was a new Domitian, a persecuting Roman emperor. Yet the authorities repeatedly granted her permission to open schools and furnished her with letters of recommendation, which they surely would not have done had her opinions and behavior been as politically "advanced" as she later asserted. In fact, her opinions evolved over a long time, for it is not clear that she became a Republican before the 1860s. Until then, she seemed most influenced by a misty medieval royalism, the Catholic fervor and social conscience of Félicité de Lamennais, and the romantic (but now increasingly Republican) humanitarianism of Victor Hugo—with whom, remarkably, while still in her teens she began a correspondence which lasted until his death in 1885.

Michel doubtless had felt stifled in Haute-Marne. Paris freed her to fulfill her intense desires for knowledge and self-expression. She be-

came a regular at public courses of all kinds, notably the sciences, and at Republican lectures by Eugène Pelletan, Jules Favre, and others, steadily gravitating leftward. She encountered feminism in the Société de Droit des Femmes (run by **Mme Jules Simon**, *André Léo, and *Marie Deraismes**), which advocated equal education and better pay, and in 1869 she became secretary of the Société Démocratique de Moralisation, dedicated to finding workers food and jobs. She also encountered the Blanquists, followers of the Republican revolutionary conspirator Auguste Blanqui, and may have joined Karl Marx's International Workingmen's Association.

Michel's debut in political agitation came on January 12, 1870, when, dressed as a man ("so as not to bother or be bothered by anyone") and carrying a concealed knife, she joined the immense demonstration at the funeral of Victor Noir, a Republican journalist assassinated by Prince Pierre Bonaparte. "Almost everyone who turned up at the funeral," she later wrote, "expected to go home again in a republic, or not to go home at all." But no insurrection occurred. The pattern would become fixed for her: forever hoping—even expecting—the next meeting or demonstration or uprising would set in motion The Revolution which would open the gates to Humanity's glorious future. As fate would have it, the dramas played out in the Franco-Prussian War (July 19, 1870–January 28, 1871), including the great siege of Paris, and the ensuing bloody tragedy of the Paris Commune (March 18–May 28, 1871) would supply immediate reinforcement for this pattern. Their melodramatic trappings and intensity swept Michel into an unrestrained involvement from start to finish.

She took part in peace demonstrations on the eve of the war, but once France was invaded she became a fiery patriot, infuriated at the government's incompetence. She first drew serious notice when, with two other women (André Léo and **Adèle Esquiros**), she circulated a letter from the historian Jules Michelet calling for the release of several Blanquists arrested for seizing weapons from a barracks in order to overthrow Napoleon III's regime. They took the letter with several thousand signatures straight to the military governor of Paris, an almost scandalous thing for women to do. The appeal failed, but the fall of the French Empire on September 4, after the battle of Sédan, saved the rebels. During the ensuing great siege of Paris by two German armies, Michel ran a school for 200 girls aged 6–12 and a shelter for younger refugees, but she also organized the Women's Vigilance Committee of

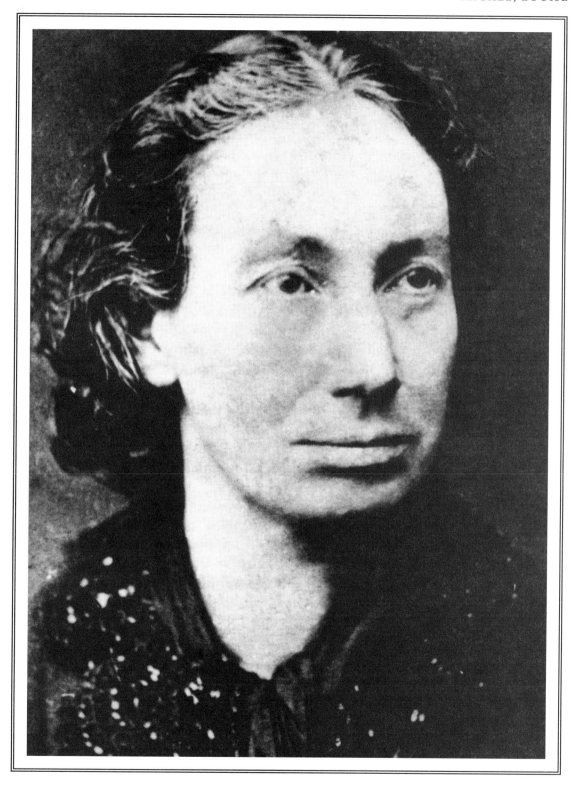

Louise
Michel

Montmartre and was active in both and in the men's committee: "No one was very much bothered by the sex of those who were doing their duty." These committees roused spirits, denounced slackers, cared for soldiers, and saw to enforcement of siege regulations. Michel also joined demonstrations—to send aid to besieged Strasbourg, to protest the Republican government's lack of military and democratic zeal (October 31), to advocate enrollment of women (for which she was jailed on December 1–2 on a mistaken charge that she had organized it), and fi-

nally a violent demonstration (January 22) opposing surrender, when she dressed as a National Guard and carried a carbine.

By late January, resistance to German troops throughout France had been crushed, the country was exhausted, and a majority of the French wanted peace. Only the Radical Republicans and Socialists wanted to continue the war "to the last ditch." After two months of growing mistrust between the government (who were negotiating peace terms with the Germans from Versailles) and the suffering populace of Paris, the Paris Commune revolt began when the government suddenly tried on the night of March 17–18 to seize the artillery being held by the Paris National Guard. It was Louise Michel who first spread the alarm through Montmartre (the most important site) and who marched up the heights at dawn, at the head of a throng, to foil the seizure. It was her magic moment: "The Butte was enveloped in a white light, a splendid dawn of deliverance." The government, its attempt bloodily foiled, settled in to besiege the rebel city, now dominated by an amalgam of left-wing elements.

Michel was the outstanding female soldier of the Commune: "I love the smell of powder," she confessed. In the uniform of the 61st Battalion of the National Guard, she fought with utter disregard for her life, earning the affection of the soldiers though not of most officers, who disliked having women on battlefields. Tireless, she also organized ambulance nurses to remove the wounded from the field, nursed soldiers herself, continued with the Montmartre Vigilance Committee, presided over a "Club de la Révolution" which passed all manner of radical proposals (including a total revamping of all laws and the judiciary), sent in ideas for educational reform, continued her school and refuge, and once even slipped through the lines to Versailles and back to prove that her (rather harebrained) proposal to assassinate French president Louis Thiers was feasible. She was not, however, a high-level leader, e.g., on the Central Committee of the "Union of Women for the Defense of Paris and the Care of the Wounded" led by the Marxist *Elizabeth Dmitrieff, or a "captain of guerrillas" as the government later charged.

Michel fought to the last when Montmartre fell early in "Bloody Week" (May 21–28), barely escaped death or capture, but gave herself up (May 23) to release her mother, who was being held hostage for her capture. She endured the horrors of the march to Versailles and the encampment on the Sartory plain, was singled out with some other "ringleaders" and twice examined by a court-martial, and finally was tried (December 16), convicted of armed rebellion (after more serious charges were dropped), and condemned to life under guard in a prison colony. She had admitted only the minimum at first, but especially after her pleas failed to save one of the Commune's leaders, Théophile Ferré, she defiantly confessed everything and even claimed responsibility for acts she had not committed. She probably had fallen in love with Ferré (though he did not reciprocate), and his execution (November 28) left a permanent wound in her heart. At her trial, she made a sensational appearance garbed and veiled in black, a spectral symbol of 25,000 dead Communards, accepted no attorney, challenged the judges to put her to death, and refused to appeal her conviction. Victor Hugo afterward exalted her bravery in a long poem, "Viro Major." (Verlaine would do likewise upon her 1883 conviction.)

After a long delay, Michel sailed on a prison ship to New Caledonia (August 24–December 10, 1873). During the voyage, her friend and fellow convict ✒➤ **Nathalie Lemel** completed Michel's conversion to anarchism which her experiences in the Commune had begun. Michel had told her judges that the Commune had meant "government by the governed while awaiting a great simplification." The failure of all the leaders of every political stripe during the war, including the Commune, had convinced her that "power itself is worthless, no one can do anything with it, and it's dead." Her long political evolution had ended: she was a devoted anarchist to the end of her days.

Life in the New Caledonia prison colony was difficult at best. Michel became revered by her fellow prisoners as a saint, selflessly caring for them, nursing and teaching and giving away whatever she had to the needy. Typically, she took a keen interest in her natural surroundings, conducted botanical experiments which helped to develop a strand of wheat suitable to hot climes, and through observing the native Kanakas helped to pioneer a new science—ethnography. She taught some to read and sided with them during their ill-fated revolt (1878) against the harsh French rule. Back in France, meanwhile, a long struggle resulted in a general amnesty for all the convicted Communards. Louise Michel, whose notoriety in 1871 had blossomed into fame during her exile, returned in triumph to Paris on November 9, 1880.

For the last 25 years of her life, Michel—when not in prison—lived a treadmill existence

of travel and speech-making for anarchist and other left-wing causes. Dressed always in black and preaching even the most radical ideas calmly but with compelling conviction, she held great sway over audiences large or (as they often were toward the end) small. The police tracked her every move, while she, with her streak of mischievousness, enjoyed confounding them. Yet she was often amazingly naive about situations and over-trustful of people around her. She was jailed several times: 15 days in 1882 for disrespect toward authorities; solitary confinement, March 30, 1883–January 14, 1886 (though with some visits allowed to attend her dying mother) on a largely framed-up charge of inciting unemployed demonstrators to pillage; September–November 1886 for attempted incitement; April 30–June 4, 1890, for incitement of violence; and on September 16, 1897, arrest and deportation from Belgium. Fearing (with good reason) that the authorities might have her declared insane and put away for life, she took refuge in London (July 29, 1890) and did not return to France until November 13, 1895; thereafter, she alternated between London and Paris. She wanted to visit the United States and Russia, but nervous governments blocked her. Virtually all her public activity was confined to France, with Scotland, Belgium, the Netherlands, and Algeria the only other places she visited even briefly. Michel raised considerable funds for her causes over the years but often gave away what little she retained for her keep. She always hoped her voluminous writings would support her, but in vain. Until she died, she received a monthly allowance from the radical journalist, scandalmonger, and fellow deportee to New Caledonia, Count Victor ("Henri") Rochefort; also *Anne, duchesse d'Uzès, a wealthy feminist (and royalist), gave her money when she would ask.

On January 22, 1888, while speaking in Le Havre, Michel was shot by a drunken man who took offense at her views. The bullet lodged permanently in her left temporal region. She took pity on the man and his poor family and refused to press charges. Her views on violence in fact betrayed a certain ambivalence. During the wave of anarchist bombings and assassinations in the 1890s, she stood by the perpetrators; but she herself believed humanity would be freed of its oppressors by a "spontaneous" general strike or uprising by the oppressed which did not have to be ignited by "the Deed" or the use of terror. When she joined the peace movement around 1900, she even began to suggest that The Revolution might be made peacefully. As for the Marxists, she sometimes shared causes (especial-

Lemel, Nathalie (1827–1921)

French socialist, anarchist, and Communard. Born in 1827; died in 1921.

Member of the Socialist International, Nathalie Lemel became involved in radical politics during the epidemic of strikes and growing spread of trade-unionism in the France of the 1860s. Once a bookbinder, she founded a workers' restaurant with another bookbinder during the Paris Commune of 1871, but was deported with *Louise Michel after the fall of the Commune. She later returned to France (1880) and continued her work with socialist and feminist groups until the start of World War I.

ly labor issues) and platforms with them but finally split with them for good in 1896, charging that they were founding a "new state religion," "a new papacy" with an "infallible hierarchy."

Michel was an outspoken feminist, but unconventional. She preached absolute equality and respect between the sexes. At her 1883 trial, she stated, typically, "What is surprising to you, what is appalling to you, is that a woman is daring to defend herself. People aren't accustomed to seeing a woman who dares to think." Husbands and wives should be "companions." But as an anarchist, she put no stock in voting and thus none in women's suffrage *per se*. Women should in no way separate their cause from humanity's, the fight for progress and universal peace. By 1890, she also was not favoring promoting work for women outside the home; in any event, women should not *have* to work outside. And by 1899, she was advising poor parents against giving too much education to their daughters lest they encourage a taste for luxury and thus incline them toward prostitution, which she abominated.

While on yet another tour, Michel died on January 9, 1905, in a drab Marseille hotel from pneumonia compounded by exhaustion. Anarchism was a decade past its peak, yet such was her fame and the respect for her courage and integrity that her Paris funeral drew upwards of 50,000 people. To the government's relief, the demonstration was largely peaceful. Coincidentally, that very day (January 22) "Bloody Sunday" in St. Petersburg began the Revolution of 1905, harbinger of the Russian Revolution she had lately been predicting.

During her life, Michel was aided and cared for by a succession of female companions—**Julie Longchamps** (in the 1850s–60s), **Marie Ferré** (d.

1882, sister of Théophile), Nathalie Lemel, and (from 1890) **Charlotte Vauvelle**. Absent firm evidence, speculations abounded then and later that she was a lesbian, a virgin, no virgin, bisexual, had relations with Ferré or Hugo, and so on. But her strongest attachment was to her mother, whose care was her constant concern and for whose tragedy she, the bastard daughter, probably felt responsible. Her *Mémoires*, published a year after her mother's death, constantly evokes the terrible pain of that separation.

Michel was no theorist of anarchism. She knew Prince Kropotkin well, for example, but paid little attention to his—or anyone else's—philosophy. When not speaking, she wrote—not anarchist tracts, but vast reams of poetry (some of it fairly good) and endless, wildly disordered, absurd, blood-and-thunder novels nobody could read. Her *Mémoires* and account of the Commune, though, are of permanent value, however unreliable in their details. Asked what she would put in place of society's existing organization, she replied, "That doesn't disturb me much. After the Revolution some grand and productive idea of social renovation will emerge from the inspiration of the moment." Nor was she a party organizer or operative. During the Boulanger crisis (1885–89) and the great Dreyfus Affair (1894–99), she deplored the divisions among the anarchists, though she herself condemned militarism and anti-Semitism, but she refused to be lured to support any faction or the threatened Third Republic.

Rather, Louise Michel was a secular saint, prophet, and martyr, whose trials, exile, imprisonments, and endless pilgrimage through meeting halls and demonstrations caused millions to admire her courage if not necessarily her opinions. She glimpsed a vision on that charge up to the Butte de Montmartre, and it led her on: "When the Revolution comes, you and I and all humanity will be transformed. . . . That hope is worth all the sufferings we undergo as we move through the horrors of life."

SOURCES:

Durand, Pierre. *Louise Michel, la passion*. Paris: Messidor, 1987.

Edwards, Stewart. *The Paris Commune 1871*. London: Eyre & Spottiswoode, 1971.

Girault, Ernest. *La Bonne Louise: Psychologie de Louise Michel*. Paris: Bibliothèque des Auteurs Modernes, 1906.

Goldsmith, Margaret. *Seven Women against the World*. London: Methuen, 1935, pp. 91–117.

Kieffer, Martin. "Louise Michel, the 'Red Virgin,'" in *American Society Legion of Honor Magazine*. Vol. 44, no. 1, 1973, pp. 35–53.

Lejeune, Paule. *Louise Michel, l'indomptable*. Paris: Editions des Femmes, 1978.

Michel, Louise. *The Red Virgin: Memoirs of Louise Michel*. Edited and translated by Bullitt Lowry and Elizabeth Ellington Gunter. University, AL: The University of Alabama Press, 1981.

Mullaney, Marie Marmo. "Sexual Politics in the Career and Legend of Louise Michel," in *Signs*. Vol. 15. Winter 1990, pp. 302–322.

Thomas, Edith. *Louise Michel ou la Velléda de l'anarchie*. Paris: Gallimard, 1971.

———. *The Women Incendiaries*. Translated by James and Starr Atkinson. NY: George Braziller, 1966. Trans. of *Les Pétroleuses* (Paris: Editions Gallimard, 1963).

SUGGESTED READING:

Boyer, Irma. *Louise Michel: "la Vierge Rouge."* Paris: A. Delpeuch, 1927.

Horne, Alistair. *The Fall of Paris: The Siege and the Commune, 1870–71*. NY: St. Martin's Press, 1965.

Hugo, Victor. *Oeuvres complètes de Victor Hugo*. Paris: Albin Michel/Imprimerie Nationale, 1935. "Viro Major," 12:82–3; notes, 12:360–61, 404; and plate, 12:489.

Lissagaray, Prosper Oliver. *History of the Commune of 1871*. Translated by *Eleanor Marx-Aveling*. NY: Monthly Review Press, 1967 (1886).

Rougerie, Jacques. *Procès des Communards, présentés par Jacques Rougerie*. Paris: Julliard, 1964.

Thomas, Edith. *Louise Michel*. Translated by Penelope Williams. Montreal: Black Rose Books, 1980. Trans. of *Louise Michel ou la Velléda de l'anarchie* (Paris: Gallimard, 1971).

Tuchman, Barbara. *The Proud Tower: A Portrait of the World before the War, 1890–1941*. NY: Macmillan, 1966. "The Idea and the Deed," pp. 63–113 (on anarchism).

Verlaine, Paul. *Oeuvres complètes de Paul Verlaine*. Paris: Albert Messein, 1911. "Ballade en l'honneur de Louise Michel," vol. 2, pp. 39–40.

COLLECTIONS:

Louise Michel's letters and manuscripts are located principally in Paris in the Bibliothèque historique de la Ville de Paris, the Bibliothèque *Marguerite Durand*, the Bibliothèque nationale, the Hôtel de Ville de Paris, the Musée de Montreuil, and the Musée Victor Hugo; her personal papers are in Amsterdam (Netherlands) at the International Institute of Social History. In Paris, the Archives historiques de la préfecture de police contains important dossiers and clippings on her activities.

RELATED MEDIA:

"The Paris Commune: 1871." Films for the Humanities and Sciences (FFH). Princeton, NJ.

David S. Newhall,
Professor of History, Centre College, Danville, Kentucky, and author of *Clemenceau: A Life at War* (Edwin Mellen Press, 1991)

Michelina of Pesaro (1300–1356)

Saint. Name variations: Michelina Malatesta; Blessed Michelina. Born Michelina Matelli in Pesaro, in the Marches of Ancona, in 1300; died on June 19, 1356; married Lord Malatesta, duke of Rimini, in 1312 (died 1320); children: one who did not survive to adulthood.

Married at 12 and widowed at 20, Michelina of Pesaro also lost her only child shortly thereafter. Meanwhile, she had befriended a Franciscan tertiary by the name of Siriana and, following the loss of her loved ones, she joined the Franciscans in their work. Striving to achieve the perfect life, she humbled herself and worked for the poor, despite her family's growing objections. They eventually declared her mad and had her imprisoned in a tower so she would no longer be an embarrassment. However, her mild-mannered ways soon won over her jailers, and she was freed to continue her good works. Along with the poor, she also devoted herself to the care of lepers, whom she treated like beloved children. Purportedly, she miraculously restored some of them to health by kissing their leprous sores. Around 1356, Michelina sensed that her life was nearing its end, and she used her remaining time to visit the Holy Land. She died returning from her pilgrimage on June 19, 1356, the feast of the Holy Trinity. Her feast day is June 19.

Michelle Valois (1394–1422)

*Duchess of Burgundy. Name variations: Michelle de France. Born in 1394; died on July 8, 1422, in Ghent, Flanders, Belgium; daughter of Charles VI, king of France (r. 1380–1422), and *Isabeau of Bavaria (1371–1435); sister of Charles VII (1403–1461), king of France (r. 1422–1461); became, around 1415, first wife of Philip the Good, duke of Burgundy (r. 1419–1467). Philip the Good later married *Bonne of Artois (d. 1425), then *Isabella of Portugal (1397–1471).*

Michiko (1934—)

Empress of Japan. Born Michiko Shoda in October 1934; married Akihito (b. 1933), emperor of Japan, in 1959; children: son Crown Prince Naruhito (b. 1960).

A confident, intelligent college student, Michiko Shoda married Akihito, the crown prince of Japan, in 1959. Traditionalists were horrified. Michiko had attended a Roman Catholic college (though she was not a Christian), and she was also a commoner. A crown prince of Japan had never before married a commoner. Akihito's mother *Nagako sided with the traditionalists, and Michiko was criticized for breast-feeding her babies, carrying them in public, and attempting to raise them herself. Tensions between Michiko and her mother-in-law continued for years. When Michiko suspected her lady-in-waiting of spying for Nagako, she

and Akihito tried to dismiss her. The Imperial Household Agency, however, would not allow it. In 1963, Michiko possibly suffered the first of two nervous breakdowns.

Akihito became emperor on the death of his father Hirohito in 1989. In October 1993, the Japanese press attacked Michiko, accusing her of being domineering toward her husband, a flagrant transgression in the male-dominated nation. Michiko, who tends toward nervousness in public, fell unconscious the following day, on her 59th birthday, and reputedly could not speak for the next six months. When she regained her voice, no official explanation was offered for her affliction. The royal family has been at odds with the Japanese media ever since.

Mida.

Variant of Ida.

Middleton, Alice (c. 1472–1545).

See More, Alice.

Middleton, Jane (1645–1692).

See Myddelton, Jane.

Miegel, Agnes (1879–1964)

German poet and short-story writer whose books, set in East Prussia and written in the spirit of Blut und Boden *(Blood and Soil) Romanticism, were popular with a nationalistic and conservative readership before, during, and after the Third Reich. Born in Königsberg, East Prussia (modern-day Kaliningrad, Russia), on March 9, 1879; died in Bad Salzuflen on October 26, 1964; daughter of Gustav Adolf Miegel and Helene Wilhelmine Miegel.*

Agnes Miegel was born an only child in Königsberg, East Prussia, the city whose most illustrious inhabitant was the great philosopher Immanuel Kant (1724–1804). The daughter of a merchant, she grew up in a socially stable and culturally conservative environment and spent her childhood primarily among solidly middle-class adults. When she was 15, her parents sent her off to a boarding school in Weimar, the city of Goethe and Schiller, where she was impressed by the profusion of theater and concert performances that were offered virtually every day and evening. After a year in Weimar, she returned to Königsberg where her ambitious parents enrolled her in painting classes, believing that their daughter had an artist's soul. Although Miegel had little talent as a painter, the classes did sharpen her already considerable powers of observation. During this period, she wrote poems constantly, experiencing an emotional life largely through her pen. When she found enough courage, Miegel sent a batch of her best verses to a noted author and critic of the day, Carl Busse, who responded positively.

In 1901, she saw her first publication, in an issue of the venerable *Göttinger Musenalmanach* which contained 17 of her ballads and 13 of her lyric poems. The same year, having completed a course that qualified her to work as a pediatric nurse, she became seriously ill after contracting scarlet fever while working in a children's ward. Also in 1901, she celebrated the release of her first book of poems, *Gedichte* (Poems), which boasted the imprint of Cotta, one of Germany's most respected publishing houses. Several highly original works were among the 27 ballads and 63 poems included in *Gedichte*. In "The Prayer of a Young Maiden," a young woman prays for God to take the life of her lover if he should ever marry someone else. Many of the poems reveal an intense love of Königsberg, the stark landscape of Ostpreussen (East Prussia) with its hauntingly beautiful *Bernsteinküste* (amber coast), the region from Pillau to Cranz where fossilized resin often washes up on the beaches. The book's ballads tell of historical personalities, fascinating individuals such as *Cleopatra (VII)* and *Mary Stuart*.

In the fall of 1902, Miegel went to England to accept the invitation of a friend who taught at a boarding school in Bristol. She worked as a housemother and spent her spare hours writing a number of ballads that would stand the test of time as some of her best work, including "Jane," "Lady Gwen" and "Die Nibelungen."

In 1904, after having returned to Germany, she went to Berlin to study for a teaching degree. Once again, Miegel became seriously ill and was forced to break off her studies. Her mother suffered a mental breakdown in 1906 and had to be institutionalized. Miegel remained home to be with her father, who was going blind. Although sometimes depressed by her situation and the narrow provincialism of Königsberg, she accepted her situation and found some comfort in writing on a regular and disciplined basis. In 1907, her *Balladen und Lieder* (Ballads and Songs) was published to high critical acclaim, with some going so far as to state that several of the ballads had attained something close to perfection. Readers seeking Neo-Romantic moods were more than pleased by those ballads that conjured up the world of pre-Christian nature spirits, and other ballads in the work recalled a world of medieval chivalry that enabled readers to forget, at least for awhile, the troubled, industrialized 20th century, a world that had been *entzaubert* (stripped of magic). As if battling forces hostile to the spirit, Miegel's ballads are suffused with recurring references to supernatural and mysterious essences.

For a few days at the start of World War I, she and other East Prussians feared that their frontier province would be conquered by Russian armies. But a decisive victory by Field Marshal Paul von Hindenburg at the battle of Tannenberg crushed the Russians, raising nationalistic spirits throughout Germany. Years later in 1936, when Germany was already under Nazi rule, Miegel would recall the "glories" of these days in her book *Deutsche Balladen* (German Ballads), depicting in verse Paul von Hindenburg and his solders as veritable Teutonic heroes. In 1916, at a mid-point in the exhausting war, she received the Kleist Prize, which effectively proclaimed her Germany's most eminent poet of the day. Miegel's father died during the war, and another traumatic loss took place in 1919 when

East Prussia was cut off from the remainder of the German Reich by a Polish Corridor and the newly created Free City of Danzig, both of which were imposed on a defeated Germany in the harsh Treaty of Versailles signed on June 28. In 1920, Miegel began covering cultural events for the long-established conservative Königsberg newspaper, the *Ostpreussische Zeitung*. Her journalism was popular in nationalist circles and with the older generation of East Prussians. In 1924, she was awarded an honorary doctorate by the University of Königsberg. By 1926, her recurring bad health made it necessary for her to resign her newspaper post.

That year, Miegel published what was to be her longest prose work, *Geschichten aus Alt-Preussen* (Stories from Old Prussia), a collection of four stories which was a skillful mixture of history and myth. One of the tales, the novella "Die Fahrt der sieben Ordensbrüder" (The Journey of the Seven Knights of the Teutonic Order), was quickly embraced by cultural traditionalists as a classic work embodying undying German virtues of honor and courage. Set in the 1280s, the story tells of the self-annihilation of a noble Prussian family upon the death of the last pagan Prussian prince. Miegel emphasizes the deep differences between the *Weltanschauungen* of the leader of the Christian knights, Friedrich von Wolfenbüttel, and the leader of the pagan Prussians, Skurdas. Representing the ideal Christian knight, Friedrich is of mixed race, the son of a noble German father and a Saracen mother. Called "Salomo" because of profound wisdom, he is presented as a man free of religious or racial intolerance, who is a great leader with a chivalrous, compassionate, and disciplined nature. His Christian compassion is contrasted with the pagan stubbornness of Skurdas, whose heroism cannot disguise the doom that hangs over his way of life which is fated to be replaced by a "higher" culture and ethos, that of the German Christians. The new order Miegel depicted emerging in the 13th century was part of what she—and her readers—held to be the inevitable mission of Germans in the eastern frontier of Europe where Teutons and Slavs had clashed for almost a millennium. For Miegel, the Germans had brought, and would continue to bring, a higher civilization to the lands of the east, turning a formless, shapeless "wilderness" into a cultivated and well-disciplined landscape.

With the publication of *Geschichten aus Alt-Preussen*, Miegel was turned into an unofficial spokesperson for East Prussia's history and traditions. A great commercial success, particularly in East Prussia and the largely Lutheran

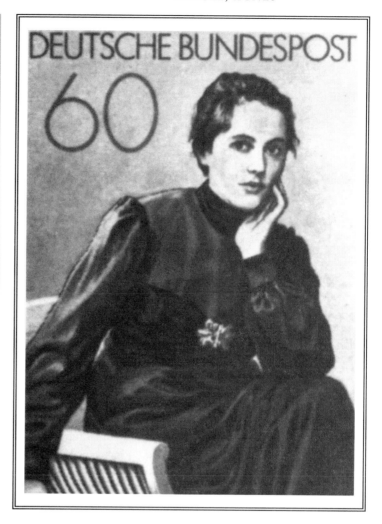

northern regions of eastern and northern Germany, the book was chiefly ignored by literary critics, many of whom regarded Miegel's prose as being too conservative and sentimental for modern taste. Those attuned to new literary currents dismissed the author as a hopeless reactionary, not only in artistic but also in social and political terms. To a large extent, although they revealed their liberal and radical biases, these assessments were generally correct. Both she and her readers were uncomfortable with, and indeed often hostile to, such modern trends as democracy, mass culture, women's rights, and cultural innovation. Miegel was greatly conservative in most areas, and her love of East Prussia's traditions, history, and pre-industrial life was in fact linked to a literary tradition called *Blut und Boden* (Blood and Soil), which regarded individuals as having a genuine identity only to the extent that they were part of a larger historical, ethnic and racial chain of continuity.

Miegel's Romantic views of a German way of life threatened by alien forces paralleled the

West German stamp of Agnes Miegel issued on February 14, 1979.

ideology of the political extreme right, which was led by the German National People's Party, and the newly created radical right, best exemplified by Adolf Hitler's NSDAP (National Socialist German Worker's Party; Nazis). Like most conservative Germans, Miegel threw her support to the Nazis when they seized power in 1933. Her own career benefited considerably from Hitler's new dictatorship. That same year, she was elected to a Prussian Academy of the Arts which had been ruthlessly purged of its democratic, liberal, and Jewish members. Also in 1933, she was appointed to serve as a senator in a thoroughly Nazified German Academy of Poetry, a body which also included such notorious Nazi "literary artists" as Hanns Johst and Erwin Guido Kolbenheyer. Her books were universally praised in Nazi newspapers and magazines, and Miegel often gave poetry readings on the now-regimented radio system. In 1936, she received one of Nazi Germany's most prestigious cultural awards, the Herder Prize.

Miegel joined the Nazi Party in 1937. Her personal devotion to Adolf Hitler was expressed in a hymn that appeared in her 1940 verse collection *Ostland: Gedichte* (Land in the East: Poems). On the eve of war in March 1939, she celebrated her 60th birthday by authorizing the publication of a revised and enlarged edition of her first poetry collection, which by that time had gone through an astonishing 19 editions and printings. The German press now customarily referred to her as *Mutter Ostpreussen* (Mother East Prussia). With the start of World War II in September 1939, she felt it her duty to support the war effort of the Reich by giving poetry readings throughout Germany. These poetry readings, some of which were recorded and broadcast on the Reich radio network, continued for the next several years even as the war turned against Nazi Germany. Her literary prestige continued to soar. Some of her poems were included in the 1940 anthology of war verse entitled *Vom wehrhaften Geiste* (On the Valiant Spirit), and in the same year she was awarded the Goethe Prize of the City of Frankfurt am Main.

In August 1944, large areas of Miegel's beloved city of Königsberg were reduced to smoking rubble when the Soviet Air Force mounted a successful aerial attack. In December, she held her last public reading in her hometown, and a number of weeks after this she was evacuated from the city just before its surrender. Along with more than two million Germans from East Prussia, she was now a penniless displaced person. Miegel lived in a refugee camp in Denmark until October 1946, when she was evacuated to the Western sector of Germany. Eventually, she resided in two furnished rooms in Bad Nenndorf, near Hannover. Published in 1949, her first postwar book, a small verse collection entitled *Du aber bleibst in mir* (But You Remain in Me) brought together poems written since she had left Königsberg. Not surprisingly, the book began with a poem entitled "Farewell to Königsberg." The same year, she also published a collection of five stories entitled *Die Blume der Götter* (The Flower of the Gods). Only one of the five is set in Germany, and the tone of the stories lacks the mythical and irrational overtones found in her *Geschichten aus Alt-Preussen*. After publishing one more story collection in 1951, Miegel concentrated her energies on editing her collected works, of which six volumes appeared in print from 1952 through 1955 (a seventh volume appeared posthumously in 1965).

As West Germany's economic miracle gave that new state's citizens prosperity and leisure, many of them, particularly expatriates from East Prussia, found solace from their wartime suffering by reading Miegel's ballads and poems. A political force to be reckoned with, the *Flüchtlinge* (refugees) played a significant role in the public life of the Federal Republic of Germany for more than three decades. As the years passed, contact with the writings of Agnes Miegel helped them to recapture the spirit if not the reality of a way of life that had been lost. She died in Bad Salzuflen on October 26, 1964. Miegel was depicted on a postage stamp issued on February 14, 1979, by the post office of the German Federal Republic to commemorate the centennial of her birth.

SOURCES:
"Aufruf der Kulturschaffenden," in *Völkischer Beobachter*. August 18, 1934.
Baird, Jay W. *To Die for Germany: Heroes in the Nazi Pantheon*. Bloomington: Indiana University Press, 1992.
Denkler, Horst, and Karl Prümm, eds. *Die deutsche Literatur im Dritten Reich: Themen—Traditionen—Wirkungen*. Stuttgart: Philipp Reclam jun., 1976.
Fechter, Paul. *Agnes Miegel: Eine preussische Frau*. Berlin: Frundsberg-Verlag G.m.b.H., 1933.
Hoffmann, Klaus-Dieter. "Agnes Miegels Menschenbild," Ph.D. dissertation, University of Iowa, 1967.
In jenen Tagen . . . Schriftsteller zwischen Reichstagsbrand und Bücherverbrennung: Eine Dokumentation. Leipzig and Weimar: Gustav Kiepenheuer Verlag, 1983.
Ketelsen, Uwe-Karsten. *Literatur und Drittes Reich*. Schernfeld: SH-Verlag, 1992.
Knaurs Konversations-Lexikon A–Z. Berlin: Verlag von Th. Knaur Nachf., 1934.
Langenbucher, Hellmuth. *Volkhafte Dichtung der Zeit*. 6th ed. Berlin: Junker und Dünnhaupt Verlag, 1941.

Loewy, Ernst. *Literatur unterm Hakenkreuz—Das Dritte Reich und seine Dichtung: Eine Dokumentation.* Frankfurt am Main: Europäische Verlagsanstalt, 1966.

Matulis, Anatole C. "Lithuanian Culture in the Prose Works of Hermann Sudermann, Ernst Wiechert, and Agnes Miegel," Ph.D. dissertation, Michigan State University, 1963.

Matull, Wilhelm, ed. *Grosse Deutsche aus Ostpreussen.* Munich: Gräfe und Unzer Verlag, 1970.

Miegel, Agnes. *Das Bernsteinherz: Erzählungen.* Leipzig: P. Reclam jun., 1944.

———. *Es war ein Land: Gedichte und Geschichten aus Ostpreussen.* Cologne: Eugen Diederichs Verlag, 1983.

———. *Die Fahrt der sieben Ordensbrüder.* Jena: Eugen Diederichs Verlag, 1939.

———. *Kirchen im Ordensland.* Königsberg: Gräfe und Unzer Verlag, 1933.

———. *Mein Bernsteinland und meine Stadt.* Königsberg: Gräfe und Unzer Verlag, 1944.

———. *Die Meinen: Erinnerungen.* Düsseldorf: Eugen Diederichs Verlag, 1951.

———. *Ostland: Gedichte.* Jena: Eugen Diederichs Verlag, 1940.

———. *Die Schlacht von Rudau.* 3rd ed. Königsberg: Gräfe und Unzer Verlag, 1944.

———. *Spaziergänge einer Ostpreussin: Feuilletons aud den zwanziger Jahren.* Edited by Anni Piorreck. 3rd ed. Munich: Eugen Diederichs Verlag, 1989.

Mittenzwei, Werner. *Der Untergang einer Akademie oder die Mentalität des ewigen Deutschen: Der Einfluss der nationalkonservativen Dichter an der Preussischen Akademie der Künste 1918 bis 1947.* Berlin and Weimar: Aufbau-Verlag, 1992.

Schnell, Ralf. *Dichtung in finsteren Zeiten: Deutsche Literatur und Faschismus.* Reinbek bei Hamburg: Rowohlt Taschenbuch Verlag, 1998.

Stockhorst, Erich. *Fünftausend Köpfe: Wer war was im Dritten Reich.* Velbert and Kettwig: blick und bild Verlag S. Kappe KG, 1967.

Willeke, Audrone B. "The Image of the Heathen Prussians in German Literature," in *Colloquia Germanica.* Vol. 23, no. 3–4, 1990, pp. 223–239.

Wulf, Joseph. *Literatur und Dichtung im Dritten Reich: Eine Dokumentation.* Gütersloh: Sigbert Mohn Verlag, 1963.

RELATED MEDIA:

"Heimatland Ostpreussen: Agnes Miegel liest aus eigenen Dichtungen" (Philips LP recording 843 959 PY).

<div align="right">

John Haag,
Associate Professor of History,
University of Georgia, Athens, Georgia

</div>

Mieth, Hansel (1909–1998)

American photographer. Name variations: Hansel Mieth Hagel. Born in 1909; died at a friend's home in Santa Rosa, California, on February 14, 1998.

Hansel Mieth used her camera to document the Great Depression and World War II for *Time, Fortune,* and *Life* magazines. At the time of her death, at age 88, she lived on a ranch in Santa Rosa, California.

Migliaccio, Lucia (fl. 1810–1825)

Queen of the Two Sicilies. Mistress, then wife, of Ferdinand IV (1751–1825), king of Naples and Sicily (r. 1759–1806, 1815–1825), later known as Ferdinand I, king of the Two Sicilies (r. 1816–1825). Ferdinand's first wife was *Maria Carolina (1752–1814).

Mignot, Claudine Françoise (c. 1617–1711)

French adventurer. Name variations: commonly called Marie. Born near Grenoble, at Meylan, around 1617; died on November 30, 1711; married Pierre des Portes d'Amblérieux (treasurer of the province of Dauphiny); married François de l'Hôpital (a marshal of France); morganatic marriage with John Casimir, ex-king of Poland, in 1672.

Claudine Françoise Mignot, known as Marie Mignot, was born near Grenoble, at Meylan, around 1617. At age 16, she caught the eye of the secretary of Pierre des Portes d'Amblérieux, who was treasurer of the province of Dauphiny. Though Amblérieux promised his secretary that he would champion a marriage, he married the young woman himself and left her his fortune. His will, however, was disputed by his family, and Mignot went to Paris in 1653 to secure its fulfilment. She sought the protection of François de l'Hôpital, marshal of France, who was then a man of 75. They were married within a week of their first meeting, and after seven years of marriage he died, leaving her part of his estate. By a third and morganatic marriage in 1672 with John Casimir, the ex-king of Poland, a few weeks before his death, Mignot received a third fortune. Immediately on her marriage with Amblérieux, she had begun to educate herself, and her wealth and talents assured her a welcome in Paris. She retired in her old age to a Carmelite convent in the city, where she died on November 30, 1711. The history of her life, freely revised, was the subject of a play by Bayard and Paul Duport, *Marie Mignot* (1829).

Mihrimah (1522–1575).

See Reign of Women.

Mila, Adriana (fl. 1469–1502).

See Lucrezia Borgia for sidebar.

Milan, duchess of.

See Este, Beatrice d' (d. 1334).
See Visconti, Catherine (c. 1360–1404).
See Maria of Savoy (fl. 1400).

See Visconti, Bianca Maria (1423–1470).
See Bona of Savoy (c. 1450–c. 1505).
See joint entry on Este, Beatrice d' and Isabella d'Este for sidebar on Isabella of Naples (1470–1524).
See Sforza, Bianca Maria (1472–1510).
See Este, Beatrice d' (1475–1497).
See Christina of Denmark (1521–1590).

Milanov, Zinka (1906–1989)

Croatian soprano. Born Mira Zinka Teresa Kunç in Zagreb, Croatia, on May 17, 1906; died on May 30, 1989, in New York; married Predrag Milanov (a theater director and actor), in 1937 (divorced); married General Ljubomir Ilic, in 1947; studied at Zagreb Academy with Milka Ternina, Maria Kostrencic, and Fernando Carpi.

Made debut at the Ljubliana Opera in Il Trovatore *(1927); Zagreb Opera (1928–35); Metropolitan Opera in* Il Trovatore *(December 17, 1937); Teatro all Scala (1950); retired (1966).*

Zinka Milanov will be remembered for her larger-than-life stage persona as well as for her voice. Her performances were a throwback to an earlier era in opera when all stars played in the "grand manner." "To an age of somewhat dislocated musical values," wrote Irvin Kolodin, "Zinka Milanov stands as a kind of magnetic pole of old-fashioned musical virtue." Milanov's voice was huge and could dominate any ensemble easily. She chose, however, to make certain that her voice suited the total production. In the early years of her career, she performed widely throughout Yugoslavia for very little money. Often she made long train rides for a single performance. In this way, Milanov introduced a great deal of opera to her country, performing Turandot in 1929 only three years after its premiere. When Bruno Walter heard her in Vienna in 1936, he sent her to Toscanini, who engaged her for his 1937 production of Verdi's Requiem at Salzburg. That same year, she debuted at the Metropolitan Opera in New York City. Although many appreciated her marvelous voice, her public recognition was not as great as that of other stars. "It is a tragedy for operatic singing that [*Maria Callas] rather than Milanov became the postwar icon," wrote Hugh Canning. Despite that, she had a wide following and was the principal soprano in New York until the closing of the old Metropolitan on April 16, 1966. Recordings document her stupendous voice.

John Haag,
Athens, Georgia

Milashkina, Tamara Andreyevna (1934—)

Russian soprano. Born in Astrakhan on September 13, 1934.

Was the first Soviet singer to perform at La Scala; made a National Artist of the USSR (1973).

Tamara Milashkina was still a student when she was engaged as a soloist at the Bolshoi Opera in 1958. She had studied at the Moscow Conservatory with **Yelena Katulskaya**. Four years later, she appeared as Lida in Verdi's *La battaglia di Legnano* at La Scala, becoming the first Soviet singer to appear in this revered opera house. Milashkina was particularly well known for her portrayal of Tchaikovsky heroines Tatyana, Lisa, and Mariya and was filmed as Feroniya in Rimsky-Korsakov's *Legend of the Invisible City of Kitezh* in 1966. She also appeared in Prokofiev's *War and Peace* as Natasha and as Lyubka in *Semyon Kotko*. Her voice was known for its unusual warmth and beauty. In addition to appearances throughout Europe, Milashkina also sang at the Metropolitan Opera.

John Haag,
Athens, Georgia

Milbank, Helen (1909–1997).
See Kirkpatrick, Helen.

Milbanke, Anne (1792–1860).
See Lovelace, Ada Byron for sidebar.

Milbanke, Elizabeth (d. 1818).
See Lamb, Caroline for sidebar on Lady Elizabeth Melbourne.

Milburg (d. 722?)

*English saint and abbess. Name variations: Mildburga or Mildburh. Died around 722; daughter of Merowald or Merwald, king of Mercia, and Ermenburga, the abbess of Minster; sister of *Mildgyth and Saint *Mildred.*

Saint Milburg, daughter of Merowald, king of Mercia, and *Ermenburga, the abbess of Minster, built a nunnery at Winwick or Wenlock in 680 which was restored by the earl of Shrewsbury in 1080. Milburg is reputed to have been a miracle worker. Her feast day is February 23.

Milcah

Biblical woman. One of the five daughters of Zelophehad, of the Manasseh tribe.

When Zelophehad died without male heirs, Milcah and her sisters *Mahlah, *Noah, *Hoglah, and *Tirzah were given permission by Moses to share in their father's estate. The sisters were required, however, to marry within their own tribe so that the inheritance would be kept within the Manasseh.

Milcah

Biblical woman. Daughter of Haran; married Nahor; children: eight.

Mildburga or Mildburh (d. 722?).

> See Milburg.

Mildenburg, Anne Bahr (1872–1947).

> See Bahr-Mildenburg, Anna.

Milder-Hauptmann, Anna

(1785–1838)

Austrian soprano who was a well-known performer in early 19th-century Europe. Name variations: Pauline Anna Milder-Hauptmann; Mme Milder. Born in Constantinople on December 13, 1785 (some sources cite 1781); died in Vienna, Austria, on May 29, 1838.

Anna Milder-Hauptmann was a pupil of Salieri, Mozart's famous nemesis. She debuted at the Theater an der Wien as Juno in 1803 in Süssmayer's *Der Spiegel von Arkadien*. She sang all three versions of Beethoven's *Fidelio*, in 1805, 1806, and 1815. When Cherubini wrote *Faniska* in 1806, she created the title role and in 1814 did the same again in the first Viennese performance of *Médée*. By 1816, Milder-Hauptmann had moved to Berlin, where she played Emmeline in *Die Schweizerfamilie* by Weigl. At the Berlin Hofoper, she created Namouna in *Nurmahal* in 1822 while Spontini was music director. In 1829, she created Irmengard in *Agnes von Hohenstaufen*. A quarrel with Spontini caused her to leave Berlin and return to Vienna, where she sang until her retirement in 1836. A dramatic singer, Milder-Hauptmann possessed a voice that was penetrating and powerful.

John Haag,
Athens, Georgia

Mildgyth (fl. early 700s)

*Mercian princess. Name variations: Mildgithe. Flourished in the early 700s; daughter of Merowald or Merwald, king of Mercia, and *Ermenburga, the abbess of*

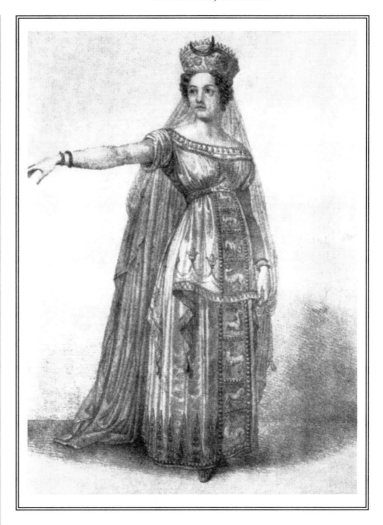

Minster; sister of saints *Mildred and *Milburg; great-niece of Egbert, king of the English. Mildgyth became a nun.*

Anna Milder-Hauptmann

Mildmay, Audrey (1900–1953)

English lyric soprano who was a founder of the Glyndebourne Festival. Born Audrey Louise St. John in Herstmonceux, Sussex, England, on December 19, 1900; died in London on May 31, 1953; married John Christie, in 1931.

Audrey Mildmay, born Audrey Louise St. John in Herstmonceux, Sussex, in 1900, trained in London and in Vienna, where she studied with Jani Strasser. In 1927–28, she toured North America; she then joined the Carl Rosa company, staying with that group until her marriage to wealthy aristocrat John Christie in 1931. To showcase Mildmay's vocal talents, Christie designed an opera house on their estate at Glyndebourne which seated 311. Thus, the Glyndebourne Festival was born. Christie wanted to

open the festival with *Don Giovanni* or *Die Walküre*, but Mildmay convinced him that *Le nozze di Figaro* (*The Marriage of Figaro*) and *Cosi fan tutte* were more suited to Glyndebourne's small theater. The beauty of the surroundings continue to attract the world's finest performers, and because of the smallness of the place a sense of ensemble emerges which can be heard in numerous recordings of numerous performers. Mildmay performed Susanna, Zerlina and Norina between 1934 and 1939 and the Mozart tradition would remain strong at Glyndebourne. She also appeared as Gretel, Micaëla, Olympia, Musetta, and Nedda. Mildmay retired in 1943 and died ten years later. Glyndebourne is still one of the world's premier festivals, and as such it remains a lasting tribute to Mildmay and her husband.

SOURCES:

Duffy, Martha. "Smiles of a Summer Night," in *Time*. Vol. 143, no. 24. June 13, 1994, pp. 68–70.

Sadie, Stanley, ed. *New Grove Dictionary of Music and Musicians*. 20 vols. NY: Macmillan, 1980.

John Haag,
Athens, Georgia

Mildred.

Variant of Mildrid, Mildryth, or Mildthryth.

Milena

Mildred (d. 700?)

English saint and abbess. Name variations: Mildryth or Mildthryth (thryth *means commanding or threatening; thus, Mildthryth means "one who is gently or mildly strict"). Died around 700; daughter of Merowald or Merwald, king of Mercia, and Ermenburga, the abbess of Minster; sister of* ***Mildgyth** *and Saint* ***Milburg**; *great-niece of Egbert, king of the English.*

***Ermenburga**, queen of the Mercia, sent her daughter Mildred over to France, to the Abbey of Chelles, near Paris, where Mildred took the veil and was tutored in ecclesiastical learning. But she was persecuted by the abbess and returned to England, where she was appointed abbess of her mother's newly founded Monastery of Minstre. St. Theodorus, archbishop of Canterbury, conducted the installation service, and 70 girls joined the community on the same occasion.

St. Mildred proved to be a gentle and humble leader, and by her own holy life and example pointed the way for her charges. After a lingering and painful illness, Mildred died at the close of the 7th century. The monastery over which she had presided was on several occasions plundered by the Danes and the nuns and clerks murdered, most notably in 980 and 1011. After 1011, the monastery ceased to be occupied by any but a few secular priests, and in 1033 St. Mildred's remains were transferred to the monastery of St. Austin's at Canterbury, where, according to William of Malmesbury, they were venerated above all other relics, and many miracles were wrought by them. Two churches in London were dedicated to St. Mildred, one in Bread Street (1170) and the other in the Poultry (1247).

Mildreda.

Variant of Mildred, Mildryth, or Mildthryth.

Mildrid.

Variant of Mildred, Mildryth, or Mildthryth.

Milena (1847–1923)

Queen of Montenegro. Name variations: Milena Vukotich or Vukotic. Born on April 22, 1847; died on March 16, 1923; daughter of Peter or Petar Vukotic from Cevom (an influential member of the Senate); married Nicholas Petrovic (1840–1921), prince of Montenegro (r. 1860–1910), king of Montenegro (r. 1910–1918), on September 8, 1860; children: nine daughters and three sons, including ***Zorka of Montenegro** *(1864–1890);* ***Militza of Montenegro** *(1866–1951);* ***Anastasia Petrovitch-Njegos** *(1868–1935);*

Daniel (1871–1939); *Elena of Montenegro (1873–1952); Anna (who married Francis of Battenberg); Mirko (who married Natalia Constantinovich); Xenia (Ksenija); Vjera; Peter.

Miles, Lizzie (1895–1963)

American blues singer in the cabaret style who performed throughout the U.S. Born Elizabeth Landreaux on March 31, 1895, in New Orleans, Louisiana; died on March 17, 1963, in New Orleans.

Lizzie Miles was a product of New Orleans through and through. Born on Bourbon Street, she was a light-skinned Creole with a big voice. In her youth, she joined up with a circus before going on to vaudeville and tent shows. She began to sing pop ballads, vaudeville standards, and jazz numbers in both French and English. Working her way up, she performed with King Oliver and Kid Ory in New Orleans. Eventually, she went north to Chicago and New York, and even to Paris, always working clubs and cabarets; her style was urbane and sophisticated. Miles recorded for the Okeh label in 1921 and also for Emerson, Columbia, and Victor, though she did not make an enormous amount of recordings. After the heyday of the blues in the 1920s, Miles retired in the 1930s. She made a comeback in the 1950s with the Bob Scobey Band and appeared at the Monterey Jazz Festival in 1958. She died of a heart attack in 1963.

John Haag,
Athens, Georgia

Milford Haven, marchioness of.

See Victoria of Hesse Darmstadt (1863–1950).

Milh al-Attara (fl. 840s)

Arabian singer. Flourished in the 840s at the court of Caliph al-Mutawakki (r. 847–861) in Samarra; associated with Shariyya, the great Arabian singer.

Little is known of the life of Milh al-Attara, whose name, possibly bestowed because of her love for scent, means "the perfumer." She was certainly a slave trained in the art of singing; she also had the good fortune to become part of the court of Caliph al-Mutawakki, who was greatly interested in the work of songstresses. Many of the most talented resided at his court. Milh al-Attara was described as an outstanding singer which must have been the case, given her presence at court. The only written instance from her life occurred when the great *Shariyya had per-

formed a song for the caliph. When he asked who had composed it, she did not know, but then Milh al-Attara told him who had composed it, thus demonstrating that she was knowledgeable as well as talented.

John Haag,
Athens, Georgia

Milholland, Inez (1886–1916).

See Boissevain, Inez M.

Milicent or Millicent.

Variant of Melissa, Melita, or Melusine.

Militza of Montenegro (1866–1951)

*Princess of Montenegro. Name variations: Militza Petrovitch-Njegos; Milica. Born on July 26, 1866; died on September 5, 1951; daughter of Queen *Milena (1847–1923) and Nicholas, prince of Montenegro (r. 1860–1910), king of Montenegro (r. 1910–1918); married Peter Nicholaevitch (grandson of Tsar Nicholas I of Russia and *Charlotte of Prussia), in August 1889; children: three.*

Mill, Chris Evert (b. 1954).

See Evert, Chris.

Mill, Harriet Taylor (1807–1858).

See Taylor, Harriet.

Millar, Gertie (1879–1952)

British actress. Born in 1879 in England, probably in or near Manchester; died in 1952; married Lionel Monckton (a theatrical composer), in 1902 (died); married William Humble Ward (1867–1932), 2nd earl of Dudley, in 1924.

Gertie Millar was born in 1879, and made her first stage appearance in a Manchester, England, pantomime in 1893. She subsequently moved to London to play in musical comedies, including *The Toreador* (1901), *Our Miss Gibbs* (1909), *The Quaker Girl* (1910), and *A Country Girl* (1914). Millar had married Lionel Monckton, who composed accompaniment for musical theater, in 1902, and became known as London's premier "Gaiety Girl" by the mid-1920s. Following Monckton's death, Millar married William Humble Ward, the 2nd earl of Dudley, in 1924. She died in 1952.

Grant Eldridge,
freelance writer, Pontiac, Michigan

Millay, Edna St. Vincent

(1892–1950)

Pulitzer Prize-winning American poet, seen as exemplary of the "modern woman," whose work captured the spirit of the post-World War I generation. Name variations: (pseudonym) Nancy Boyd. Born in Rockland, Maine, on February 22, 1892; died of a heart attack at Steepletop on October 19, 1950; first of the three daughters of Cora (Buzzelle) Millay (a nurse) and Henry Tolman Millay (a schoolteacher); sister of Norma Millay; graduated from Vassar, 1917; married Eugen Boissevain (a businessman), on July 18, 1923 (died August 1949).

Selected writings: Renascence and Other Poems *(NY: Kennerley, 1917);* A Few Figs from Thistles *(NY: Shay, 1920);* Aria da Capo, Chapbook *(NY: Kennerley, 1920);* Second April *(NY: Kennerley, 1921);* The Lamp and the Bell *(NY: Shay, 1921);* Two Slatterns and a King *(Cincinnati: Kidd, 1921);* The Ballad of the Harp-Weaver *(NY: Shay, 1922);* The Harp-Weaver and Other Poems *(NY: Harper, 1923);* Poems *(London: Secker, 1923);* Renascence *(NY: Anderson Galleries, 1924); (as Nancy Boyd)* Distressing Dialogues *(NY: Harper, 1924);* Three Plays *(NY: Harper, 1926); (score)* The King's Henchman *(libretto by Millay and music by Deems Taylor, Birmingham, U.K.: Fischer, 1926);* The King's Henchman: A Play in Three Acts *(NY: Harper, 1927);* Fear *(NY: Sacco-Vanzetti National League, 1927);* The Buck in the Snow and Other Poems *(NY: Harper, 1928);* Edna St. Vincent Millay's Poems Selected for Young People *(NY: Harper, 1929);* Fatal Interview, Sonnets *(NY: Harper, 1931);* The Princess Marries the Page: A Play in One Act *(NY: Harper, 1932);* Wine from These Grapes *(NY: Harper, 1934);* Vacation Song *(Hanover, NH: Baker Library Press, 1936);* Conversation at Midnight *(NY: Harper, 1937);* Huntsman, What Quarry? *(NY: Harper; 1939);* "There Are No Islands Any More" *(NY: Harper, 1940);* Make Bright the Arrows: 1940 Notebook *(NY: Harper, 1940);* Collected Sonnets *(NY: Harper, 1941);* The Murder of Lidice *(NY: Harper, 1942);* Collected Lyrics *(NY: Harper, 1943);* Second April and The Buck in the Snow *(NY: Harper, 1950); (edited by Norma Millay)* Mine the Harvest *(NY: Harper, 1954); (edited by N. Millay)* Collected Poems *(NY: Harper, 1956).*

Despite a writing career that spanned nearly four decades, and a canon that ranges from lyrics to verse plays and political commentary, Edna St. Vincent Millay is probably best known for her early works, particularly "Renascence" (1912), *A Few Figs from Thistles* (1920), and *Second April* (1921). "Renascence"—a 214-line poem revealing a mystical view of the universe, God, and death—caused a sensation as the work of a 20-year-old woman. *A Few Figs from Thistles*, a celebration of feminism and free love, caught the mood of Greenwich Village life in the racy postwar period of the 1920s. *Second April* further explored the already favorite Millay themes of death, love, and nature. Millay's admirers also commend *Aria da Capo* (1920), a verse play on the foolishness of war, and she is seen as among the most skilled of sonnet writers, especially with "Euclid alone has looked on Beauty bare" (1923) and the sequences "Epitaph for the Race of Man" (1934) and "Sonnets from an Ungrafted Tree" (1923).

Although critical opinion of Millay's work waned after her successes in the 1920s and 1930s, her later, more politicized, writings remained largely popular with the reading public. "For most of this century," writes John Timberman Newcomb, "Edna St. Vincent Millay was among the most widely-known and read of all American literary figures. Yet at the peak of her popular reputation there began an intensive effort in certain critical circles to marginalize Millay's poetry, which by the time of her death in 1950 had succeeded in destroying much of her critical reputation." After several decades, scholars and literary critics began to reexamine Millay's later work, prompting new discussions on the intersections between artistic, social, and political forms of expression.

Millay was born in Rockland, Maine, on February 22, 1892, the first of three daughters of **Cora Buzzelle Millay** and Henry Tolman Millay. In 1900, Cora Millay divorced her husband, an educator with a fondness for poker playing, and settled with her girls in Camden, Maine, providing for the family by nursing. Millay would retain a lifelong devotion to her mother, who encouraged in all her daughters self-reliance and a love for music and books. The musical talent of Vincent (as Millay was known in the family) was so obvious that a local teacher gave her piano lessons, hoping to prepare her for a musical career. After a few years, the plan was abandoned, but music remained a source of pleasure, a subject for poetry, and undoubtedly the basis for her unfailing sense of poetic rhythm.

Millay's early interest in literature became dominant and, augmented by her responsiveness to nature, soon found expression in original compositions. When she was 14, her poem "Forest Trees" was published in *St. Nicholas* magazine, a popular children's periodical that printed

Edna St. Vincent Millay

a number of her juvenile works. At Camden High School, she wrote for and eventually became editor of the school magazine. She recited an original poem at her graduation (1909), showing a third side of her early interest in the arts: dramatic performance.

In 1912, at her mother's urging, Millay submitted a long poem entitled "Renaissance" to a contest designed to select pieces for an anthology called *The Lyric Year*. Ferdinand Earle, one of the judges, was delighted with the entry from E. Vincent Millay (as she then called herself), and

he persuaded her to change the title to "Renascence." Earle fully expected the poem to win first prize, but other judges were not in agreement, and the poem ranked only fourth in the final tally. Nevertheless, when *The Lyric Year* was published in November 1912, "Renascence" received immediate critical acclaim. Two of the earliest to write their congratulations, poets Witter Bynner and Arthur Davison Ficke, became Millay's close friends.

Written in traditional tetrameter couplets, "Renascence" chronicles the poet's spiritual and emotional development. The enclosed, childlike perspective of the opening, "All I could see from where I stood/ Was three long mountains and a wood," soon gives way to the persistence of the inquiring mind: "And reaching up my hand to try,/ I screamed to feel it touch the sky." Feeling the pressures of a sympathetic response to all humanity, the young narrator is driven to death underground, but her will to live and the reviving power of nature in the image of rain recall the transformed individual, who can now cry, "God, I can push the grass apart/ And lay my finger on thy heart!" The heightened spiritual awareness gained by the imaginative experience is shown in the final stanza, which starkly contrasts in perspective to the first: "The soul can split the sky in two,/ And let the face of God shine through." Many critics were impressed by the poem's youthful freshness, its strong emotional impact, and, in the words of *Harriet Monroe, its "sense of infinity."

Caroline B. Dow of the National Training School of the YWCA heard Millay read "Renascence" in Camden and helped her secure a scholarship to Vassar. Millay was already in her 20s when she attended Barnard College for a semester to prepare for entrance exams to the all-female Vassar where she was to be very much involved in campus life as well as her studies. She published poems and plays in the Vassar *Miscellany*; acted regularly in school dramas, playing the lead in her own *The Princess Marries the Page* (published in 1932); and composed lyrics for a 1915 Founder's Day marching song. Her studies were concentrated on literature, drama, and both classic and modern languages. Critical biographer Norman Brittin notes, "Her education reinforced the influence of the classics upon her and insured that she would be a learned poet, one more like a Milton, Shelley, or Tennyson than a Whitman or Vachel Lindsay." Indeed, though Millay's poetry would always be termed "American" in flavor, her images and allusions were often based on the classics, while her rhythms and sentiments were forever invit-

ing comparison to established poets from John Donne to A.E. Housman.

The Vassar years also had an effect on Millay's outlook, either stimulating or solidifying the active feminist principles that were evident in her later poetry. She displayed a strong independence, particularly apparent in her bridling at rigid dormitory rules, and shared her affections with women. She wrote to British actress **Wynne Matthison**: "You wrote me a beautiful letter,—I wonder if you meant it to be as beautiful as it was.—I think you did; for somehow I know that your feeling for me, however slight it is, is of the nature of love."

Not long after her graduation, Millay's first volume of poetry *Renascence and Other Poems* was published by Mitchell Kennerley (1917). In addition to the title poem, it included 22 others, many of which had been published earlier in periodicals. Critics again responded warmly to "Renascence." The last six poems in the volume are sonnets, and though these are not considered remarkable they gave indications of the uniquely "feminine perspective" that was to elicit praise. The appearance of this volume made Millay a presence in the literary world but brought her no financial rewards. Hoping to make a living through acting, Millay returned to New York City. Both she and her sister **Norma Millay** settled in Greenwich Village, home of the Provincetown Players, which Edna joined. Women's rights and free love were accepted parts of the living code in the Village, and the reality of World War I, with its daily records of young lives lost, heightened the determination to experience life to the fullest. Millay's independent nature was suited to this atmosphere, and she was to become notorious for her bohemian lifestyle. The attractive redhead with green eyes and diminutive build (at five feet tall), who had been involved in intense female relationships at Vassar, soon had a line of male suitors vying for her attention. Max Eastman recounted a story about Millay in *Great Companions* which, if accurate, offers a glimpse into the poet's view of her own sexuality. Eastman describes Millay at a cocktail party talking to a psychologist about her recurring headaches. When the psychologist asked, "I wonder if it has ever occurred to you that you might perhaps, although you are hardly conscious of it, have an occasional impulse toward a person of your own sex?" Millay reportedly responded, "Oh, you mean I'm homosexual! Of course I am, and heterosexual, too, but what's that got to do with my headache?" Floyd Dell was the first of the male lovers Millay was to have in the Village.

In 1918, she finally met Arthur Davison Ficke, with whom she had corresponded since his first congratulations on the publication of "Renascence." Ficke, an accomplished sonneteer, had obviously influenced her experimentation with the form, and through their correspondence she had come to think of the married man as her spiritual mentor. While he was in New York on his way to a military posting in France, they had an intense three-day affair. The experience found direct expression in love letters and sonnets written to Ficke (such as "Into the golden vessel of great song") and featured indirectly in much of her other work. Although the ardor cooled, they remained lifelong friends.

Meanwhile, Millay lived in poverty, noting that the writers in the Village were "very, very poor and very, very merry." She made no money from her acting and had to work hard to sell a few poems. One of her chief sources of revenue at this time was *Ainslee's*, a magazine with no literary pretensions. Since she was paid by the line, poetry did not bring a great return, so she began turning out prose, along with some light poetry, under the pseudonym of Nancy Boyd. These pieces were later collected in *Distressing Dialogues* by "Nancy Boyd" (1924), with a coy preface by Edna St. Vincent Millay.

In 1920, Millay met *Vanity Fair* editor Edmund Wilson, whose later marriage proposal she would turn down. (He described her as "a spokesman for the human spirit . . . with an intoxicating effect on people.") With his influence, she began to have most of her work published in *Vanity Fair*, earning much-needed capital and receiving the exposure which gave rise to the popularity the poet was to maintain for many years. She also continued her acting, writing, and directing work in the theater.

Millay's second volume of poetry, *A Few Figs from Thistles*, was published by Frank Shay in 1920. The arch tone of this collection did not please reviewers. It did, however, clearly reflect the impression that the fast life and fleeting loves had made on her. The feelings may have been shallow, as seen in lines from "To the Not Impossible Him"—

> The fabric of my faithful love
> No power shall dim or ravel
> Whilst I stay here,—but oh, my dear,
> If I should ever travel!

—but the saucy kick at convention seen in this poem and others, such as the "First Fig" with its memorable "My candle burns at both ends," appealed to the postwar generation. Here too was the voice of feminism: women as well as men

could be casual in their treatment of sexual love, go on with life when the affair was over, and look forward to the next involvement. With these ideas, Millay became a speaker for a younger generation who identified with her defiance of convention. In the public eye, her significance was embodied not only in her poetry, but also in her persona which readers endowed with a symbolic status: that of the independent woman who had sovereignty over all aspects of her own existence. Writing much later in his *Lives of the Poets* (1961), Louis Untermeyer put forth a reason for the popularity of her poetry during this period: "Plain and rhetorical, traditional in form and unorthodox in spirit, it satisfied the reader's dual desire for familiarity and surprise."

Millay finished *Aria da Capo*, a one-act verse play, for the 1919–20 Provincetown Players season, and it proved to be the outstanding success of the year for them. Starkly dramatic in its concept and construction, the play delivers a powerful statement about the folly of war and the callous disregard for human life. The year

Edna
St. Vincent
Millay

brought the additional reward of a $100 prize from *Poetry* magazine for "The Bean-Stalk," which was to appear in Millay's next published collection, *Second April* (1921). Overwork and an active life, however, also brought illness and nervous exhaustion. But at the beginning of 1921, she was able to sail for Europe, thanks to *Vanity Fair* editor Frank Crowninshield, who paid her a regular wage for pieces she would send from abroad. In her two years away, Nancy Boyd articles comprised Millay's chief bread-and-butter writing.

The appearance of *Second April* in 1921 brought poetry similar to that in earlier Millay collections. The juvenile piece "Journey" celebrates nature ("The world is mine: blue hill, still silver lake"), and the clear, childlike spirit is also joyfully exercised in the prizewinning "The Bean-Stalk":

> Ho, Giant! This is I!
> I have built me a bean-stalk into your sky!
> La,—but it's lovely, up so high!

In the same collection, the image of "The Blue-Flag in the Bog" elevates nature as the only thing that makes heaven bearable to a child destroyed by a holocaust.

Even in the familiar themes, a sense of disenchantment is pervasive in the volume. "Spring" asks, "To what purpose, April, do you return again?/ Beauty is not enough." Through skillful use of concrete objects, "Lament" gives a poignant sense of a family's loss at the death of a father:

> There'll be in his pockets
> Things he used to put there,
> Keys and pennies
> Covered with tobacco.

A more personal record of loss, the sequence "Memorial to D.C.," for Vassar friend **Dorothy Coleman**, culminates in a precise image: "Once the ivory box is broken,/ Beats the golden bird no more." Norman Brittin saw Millay's disenchantment with New York City especially in "Ode to Silence," a technically accomplished poem on the search for peace which contained the classical allusions and poetic diction admired by some readers and deplored by others. Perhaps the most highly praised qualities of the collection were the maturing outlook of the poet who cries out for continued life through his work in "The Poet and His Book" and the deft musicality of such lines as "Suns that shine by night,/ Mountains made from valleys" from this poem and "There will be rose and rhododendron/ When you are dead and under ground" from "Elegy Before Death."

Early in 1921, at the beginning of her stay in Europe, Millay finished the five-act verse play *The Lamp and the Bell* commissioned for the 50th anniversary of Vassar's Alumnae Association, and the play was published by Shay in the same year. The germ of its story is the Grimm brothers' tale "Snow White and Rose Red," but the play is fleshed out as an Elizabethan drama. In addition to the two main characters, Bianca (Snow White) and the robust Beatrice (Rose Red), who become sisters when their parents marry, the play features a multitude of characters that provided a suitable number of parts for the alumnae extravaganza. The story of Bianca and Beatrice's friendship explores the themes of female love and feminism, and it has been speculated that only for such an occasion could the poet feel unconstrained enough to play with these ideas so freely.

Though more-recent commentators, such as Brittin, have disliked the stereotypes and contrivances—and Millay herself thought the play would surely suffer in obvious comparison to Elizabethan works—Mark Van Doren, writing in 1921, found the drama delightful, predicting it would be "best remembered as a delicate riot of gay asides and impeccable metaphors, Elizabethan to the bottom yet not in the least derivative; it bubbles pure poetry."

Another verse play, *Two Slatterns and a King*, was published in the same year. This work, in regular four-foot couplets, was both written and produced at Vassar, and it is considered an easily dismissed farce. Borrowing again from fairy tales, Millay used the theme of the king seeking a suitable bride. He desires the tidiest woman in the kingdom, but, because of an odd series of accidents, he mistakenly chooses Slut instead of Tidy.

Millay's European travels took her to France, England, Albania, Italy, Austria, and Hungary. These were undoubtedly years of adventure and discovery, but they were also lonely ones for the poet. Both of her younger sisters married, and Arthur Davison Ficke, whose marriage was breaking up, had already formed a close relationship with **Gladys Brown**. Millay accepted a long-distance marriage proposal from poet Witter Bynner, Ficke's closest friend, though there is some question about the seriousness of the offer. After a short period of time, both agreed that the match would not work. By the spring of 1922, Millay was able to bring her mother to Europe, boosting the spirits of both women. Despite her ill health and concentration on the Nancy Boyd pieces, Millay did publish some poetry that year, including a pamphlet of her poem *The Ballad of the Harp-Weaver*.

The spring of 1923 found Millay back in New York. She was paired at a party with Eugen Boissevain (whom she had met at previous Village gatherings) as lovers in a game of charades. Boissevain was a 43-year-old businessman and widower. Though the two had shown no interest in each other before, a strong attraction developed on that single night, and they were married on July 18, 1923. Immediately after the wedding, Boissevain took Millay to the hospital for intestinal surgery. This caring was to be a trademark of their marriage, as he relieved her of the burden of everyday details. Boissevain was also an ardent feminist and had a high regard for the significance of Millay's writing. Their marriage has been described as open and unconventional, but not much is known about Millay's personal life following their union.

The Harp-Weaver and Other Poems was prepared during her convalescence and was published in 1923 by Harper and Brothers, with whom Millay was to form a lasting business association. While Millay suffered at the hands of some critics (John Gould Fletcher summarily dismissed the title poem as "the unforgettable rhythm of Mother Goose, the verbal utterance of a primer—all used to deal out an idea which is wishy-washy to the point of intellectual feebleness"), others saw far more in the work and it earned Millay the Pulitzer Prize for Poetry, making her the first woman to be so honored. *The Harp-Weaver* includes some of Millay's most well-known sonnets. The 17-part series, "Sonnets from an Ungrafted Tree," gives a revealing picture of a woman returning to her estranged husband only to ease his death. The woman's memories and actions are sharply focused, and the poems are filled with detailed pictures of homely New England farm life.

By far Millay's best-known sonnet is that which begins "Euclid alone has looked on Beauty bare." The poet had already received praise for her search for beauty in nature and in people, but here she transcends the simply personal, elevating beauty through the mathematical conceit. Mere mortals must forego the sight of beauty and hope at most for the sound of the feminized ideal: "Fortunate they/ Who, though once only and then but far away,/ Have heard her massive sandal set on stone." Oscar Cargill testified to the sonnet's continuing power when he wrote in 1941 that this was a work one could return to and find something fresh.

The years that followed were busy ones. Millay did a Midwestern reading tour in 1924 and found to her disappointment that audiences knew only the poems from *A Few Figs from Thistles*. In the same year, showing an increasing public involvement in social issues, she read her poem "The Pioneer" at a National Women's Party celebration in Washington, D.C., to mark the anniversary of the Seneca Falls Equal Rights meeting (this sonnet was later dedicated to feminist Inez Milholland [*Inez M. Boissevain], her husband's first wife). Shortly after, Millay and her husband set out on a lengthy tour which took them to the Orient, India, and France. Upon returning, they purchased a rambling old farm, which they named Steepletop, in Austerlitz, New York. This retreat from the city would be their home for the rest of their lives. The first academic recognition of Millay's poetry came in 1925 when Tufts University granted her an honorary Litt.D., the first of many she would receive.

In 1926, Millay combined her three major talents—poetry, drama, and music—in the libretto for *The King's Henchman*, an opera by Deems Taylor. The story recounts the tragic undoing of a 10th-century liegeman who betrays his lord's trust by marrying the woman he was sent to bring to the king, were she found acceptable. Performed by the Metropolitan Opera, the work was well received.

Increasingly drawn to social protest, Millay wrote to withdraw her name from the League of American Penwomen in 1927 because they had expelled poet *Elinor Wylie, who had broken the rules of convention by living with a married man. John Newcomb has attributed the politicization of Millay's work which began during this period to the Sacco-Vanzetti case. Nicola Sacco and Bartolomeo Vanzetti, Italian immigrants and anarchists, were found guilty of a robbery and murder which occurred near Boston at a shoe factory. Widely believed to be innocent, the two were sentenced to death, and many felt that their status as foreigners and anarchists had led to their convictions. Millay was among the numerous American writers who rallied on their behalf, and on August 10, 1927, two days before the scheduled executions, she was arrested with *Dorothy Parker, *Katherine Anne Porter, *Lola Ridge, Mike Gold, John Dos Passos, and others for picketing the Boston State House. Thanks to worldwide protests, the execution date was pushed back to August 24. Elizabeth Majerus notes that Millay was "unique" among writers on the left who lent their voices to protests against the executions because she was able to "use her prominence as a poet to gain publicity and some measure of influence regarding the case." Two days prior to the executions, she met in person with Massachusetts gov-

ernor Alvan Fuller to appeal for clemency on Sacco and Vanzetti's behalf. A letter to Fuller from Millay followed in which she urged him to look again at his conscience.

On August 22, Millay's unrhymed poem "Justice Denied in Massachusetts" ran in *The New York Times*. "In this context," writes Newcomb, "surrounded by worldwide protests and the preparations for the executions, 'Justice Denied' functioned quite literally as news, as its title, modelled on a screaming newspaper headline, acknowledged." The efforts of Millay and others were to no avail, and Sacco and Vanzetti were executed on August 24, 1927. Newcomb regards Millay's disillusionment as having "triggered a fundamental and permanent shift in the tone of her poetry, in which an aesthetic of 'mature' bitterness superseded one of 'immature' beauty." Majerus sees the turning point as one which inspired her "to break down the boundary between political critique and serious poetry in her work. . . . [R]ather than protecting her reputation as a poet from her political commitments, from this point in her career she used that reputation to speak out about the political matters that concerned her." In the years to come, many in the critical establishment would express great displeasure with Millay's choice to mix political ideas with lyrical artistry.

"Justice Denied in Massachusetts" was included in her collection *The Buck in the Snow and Other Poems,* which was published in 1928 to mixed reviews. Though deploring the somber tone, Untermeyer was pleased by the experimentation with line, such as in the final stanza of "The Anguish":

> The anguish of the world is on my tongue;
> My bowl is filled to the brim with it; there is
> more than I can eat.
> Happy are the toothless old and the toothless
> young,
> That cannot rend this meat.

Insisting that death, especially senseless death, must be fought against, and that comfort and sense have to be found in life, the poet found them characteristically in nature and in the sublime order of music, expressed with her customary deft handling of form. Writing in the January–March 1930 issue of *Sewanee Review*, Edd Winfield Parks noted an emerging philosophy and considered the work a benchmark, predicting that the poet could not keep up the lyric intensity with the passing years.

Millay's next collection, published in 1931, was a bold undertaking. *Fatal Interview*, which takes its title from a Donne line, is a sequence of 52 sonnets telling the story of a love affair. Recent evidence has indicated that an affair Millay had at this time with George Dillon, the much younger man with whom she was to translate Baudelaire's *Flowers of Evil*, was the inspiration for this tale of love won and lost. The sustained theme and the blending of classicism and sensibility gave a more reflective and universal quality to the work than in other Millay love poems, a quality which did not please all contemporary readers. Many missed the strong, purely personal note; others believed, with Allen Tate, that Millay had failed to probe the symbols she used as a frame. But whether they saw the collection as a rejuvenation of the sonnet form or as a clever exercise in its manipulation, reviewers praised her technical performance.

By the time *Wine from These Grapes* appeared in 1934, Millay had suffered the death of her mother and was experiencing increasing anxiety over the fate of humankind as global tensions escalated. These two events—one personal and one universal—dominated the contents of the volume, and a more objective viewpoint in Millay's treatment of death is apparent. Not only was the poet mature in years, but she also had traveled extensively. In the controlled, predominantly Petrarchan sonnet sequence "Epitaph for the Race of Man," she achieved a sharp picture of the history of living things, the best in man's nature, and the unexplainable certainty of his self-destruction. The style is rhetorical and contains some highly elaborated conceits, such as her comparison of man to a split diamond "set in brass on the swart thumb of Doom."

Reviewers such as Percy Hutchison and Harold Lewis Cook praised the sequence, many considering it one of her best. In "Childhood Is the Kingdom Where Nobody Dies," Millay, always attuned to the child's perspective, successfully captures the child's voice in free verse. The use of cataloguing and extended line conveys the impatience of children dealing with adults who pay no attention to the important things: "To be grown up is to sit at the table with people who have died,/ who neither listen nor speak."

Millay spent 1935 working, both in New York with George Dillon and in Paris, on the translation of Baudelaire's *Flowers of Evil*, which was published in 1936. The chief feature of the translation was the retaining of Baudelaire's hexameter line. In 1936, her controversial *Conversation at Midnight* (1937), the most experimental of Millay's efforts, was underway. When the first copy was destroyed in a hotel fire while the poet was vacationing in Florida, the

work had to be completely redone. More than 100 pages long and written in play form, *Conversation at Midnight* concerns the after-dinner conversation of several acquaintances at the New York home of the independently wealthy Ricardo. The host is a liberal agnostic, and his guests include a stockbroker, a painter, a writer of short stories, a poet who is also a communist, a Roman Catholic priest, and a young advertiser. The opinions of these guests vary as much as their ages and professions. Although talk begins innocuously enough with the subject of hunting, it wanders inevitably to women and eventually to contemporary social issues, eliciting verbal attacks which very nearly lead to blows after the priest has left. At the end, Ricardo pours them all a final drink, and they leave. Millay used a variety of poetic forms in the delivery. At times the characters speak in sonnets, and in the humorous discussion of women their accents are those of Ogden Nash. While John Gilland Brunini, William Plomer, and John Peale Bishop were dismayed by the odd mix of line and rhythms and disappointed by the inconclusiveness of the argument, Peter Monro Jack and Basil Davenport applauded this distinctive break from her usual style, hailing the work as a faithful portrayal of the troubled period.

In 1936, Millay suffered a back injury in an automobile accident. Added to her already frail health, it was to hamper her work for years. Her next collection of poetry, *Huntsman, What Quarry?*, did not appear until 1939, and it contained six elegiac poems to her friend Elinor Wylie. Robert Francis, recommending the collection as representative of the essential Millay, pointed to the dramatic quality of the poems—"the poet appearing in one part after another, effective in each"—as the key to success with readers. He missed, however, a consistent poetic vision.

In the 1940s, the atrocities of Hitler's Germany forced Millay to take a different position from her former pacifism, and she put her talent to work for the war effort. Opinions abound on both the justification and quality of works like her *Make Bright the Arrows: 1940 Notebook*, which prompted some to see Millay as "prostituting" her talent for the sake of politics. Others, however, have expressed dramatically different views, including appreciation for, in Majerus' words, Millay "putting her reputation as a serious poet to work for the cause of justice." *The Murder of Lidice*, a propaganda piece written by Millay for the Writers' War Board in 1942, recounts the German destruction of the Czech village through the story of two village lovers planning to marry on that very day.

The strain of these years resulted in a nervous breakdown in 1944, and recovery was slow for Millay. Several friends died in the 1940s, most notably Arthur Davison Ficke in 1945. Eugen Boissevain, her mainstay, died in August 1949. Though Millay never recovered emotionally or physically, she continued to write, planning another collection. Still at work, she died of a heart attack at Steepletop on October 19, 1950.

Mine the Harvest was published posthumously in 1954 and includes Millay's last poems as well as unpublished ones from earlier in her career. The volume shows a close observation of nature and a reflective cast, of the individual looking for an affirmation of life and the strength to endure one's declining years. Millay's old spirit also breaks into the collection. "How innocent we lie among/ The righteous!" shows her approval of taking love where it can be found, and her poetic philosophy is put forth in the sonnet "I will put Chaos into fourteen lines."

Millay's poetry continues to attract young readers who find their feelings matched in her words. Brittin, in his revised *Edna St. Vincent Millay*, blames modernist editors of anthologies for much of the neglect of the poet in the 1950s and 1960s. Newcomb comments that surveys of the criticism of Millay's work through the 1930s yield only one consensus: "that of her enormous renown." While it is possible that some critics had trouble taking her later, more politicized, work seriously because of her status as a woman writer, it is equally possible that the critical establishment, which was accustomed to the lyric poetry of her younger years, had certain expectations of Millay's work which did not include her expression of a social and political consciousness. Nierman's 1977 bibliography of criticism and Brittin's 1982 revision, along with other recent publications, give testimony to an increased interest in Millay's work, which may lead to the much-needed consideration of the mature work of one of the 20th century's most prominent lyrical voices.

SOURCES:

Brittin, Norman A. *Edna St. Vincent Millay*. NY: Twayne, 1967, revised 1982.

Cheney, Anne. *Millay in Greenwich Village*. University of Alabama Press, 1975.

Majerus, Elizabeth. "Multiply Marginal: The Forgotten Careers of Edna St. Vincent Millay." Copyright 1999.

Newcomb, John Timberman. "The Woman as Political Poet: Edna St. Vincent Millay and the Mid-century Canon," in *Criticism*. Vol. 37, no. 2. Spring 1995, p. 261–264.

Nierman, Judith. *Edna St. Vincent Millay: A Reference Guide*. Boston: G.K. Hall, 1977.

Yost, Karl. *A Bibliography of the Works of Edna St. Vincent Millay.* NY: Harper, 1937.

COLLECTIONS:

Papers: The Library of Congress, the Berg Collection at the New York Public Library, and the Beinecke Library at Yale University have the largest collections of Millay's papers.

Freely adapted from **Paula L. Hart**,
University of British Columbia, for *Dictionary of Literary Biography*,
Volume 45: *American Poets, 1880–1945*, First Series. A Bruccoli
Clark Layman Book. Edited by Peter Quartermain, University of
British Columbia. Gale Research, 1986, pp. 264–276.

Mille, Agnes de (1905–1993).

See de Mille, Agnes.

Miller, Alice Duer (1874–1942)

American novelist and poet who is best known for her long narrative poem that became a runaway bestseller, **The White Cliffs.** *Name variations: Mrs. Alice Miller. Pronunciation: DUE-er. Born Alice Duer in New York City on July 28, 1874; died in New York on August 22, 1942; daughter of James G.K. Duer and Elizabeth (Meads) Duer; graduated from Barnard College, June 1899; married Henry Wise Miller (a Wall Street broker), in October 1899; children: son Denning.*

Selected writings: The Modern Obstacle *(1903);* Calderon's Prisoner *(1903);* Less Than Kin *(1909);* The Blue Arch *(1910);* Come Out of the Kitchen *(1916);* The Charm School *(1919);* The Beauty and the Bolshevist *(1920);* Manslaughter *(1921);* The Priceless Pearl *(1924);* The Reluctant Duchess *(1925);* Gowns by Roberta *(became the successful Kern-Harbach musical comedy* Roberta, *1933);* Death Sentence *(1935);* The Rising Star *(1937);* Not for Love *(1937);* And One Was Beautiful *(1938);* The White Cliffs *(1940);* I Have Loved England *(1941).*

Written in 1940, the year before the United States entered World War II, *The White Cliffs* was an American tribute to the courage of the people of Great Britain, who had been under furious bombardment and the threat of invasion by the Germans since 1939. The long narrative poem, essentially a novel in verse, tells the story of an Englishwoman who loses both a husband and a son in the war, and strongly conveys the sentiments of one who considers her country worth dying for:

> I have loved England, dearly and deeply
> Since that first morning, shining and pure,
> The white cliffs of Dover I saw rising steeply
> Out of the sea that once made her secure.

Alice Duer Miller was a well-known writer in her mid-60s when this work was rejected by several publishers. It finally appeared in a small printing and became a runaway bestseller after it was read over the radio by actress *Lynn Fontanne. The book sold over 125,000 copies in the U.S alone in the first 10 months after its publication and appeared in abridged form in *Life* magazine. According to Stanley Kunitz, "Critics seemed to agree that the emotions aroused by *The White Cliffs* has little to do with the quality of the verse," but Noel Coward, one of the most gifted writers of his day, was both kinder and more astute in observing:

> I should imagine that even a Hottentot, providing he had a reasonable knowledge of the English language, could not fail to be impressed and touched by the sincerity, quality and charm of this book, but I am an Englishman and as such obviously prejudiced, very prejudiced, indeed, and very grateful.

Alice Miller had a prominent background; she was the granddaughter of Rufus King, the American ambassador to England in 1844. In October 1899, following her graduation from Barnard College, she married Henry Wise Miller, who would later become a successful stockbroker. In the early years of their marriage, Alice Miller augmented the household income by teaching mathematics, selling coffee at night, and writing fiction. After her story "Come Out of the Kitchen" had been accepted by the *Saturday Evening Post* and her husband landed a job on Wall Street, family finances were never a worry. The Millers spent most of their time in New York City, in an apartment overlooking the East River, but they also lived in Costa Rica, Scotland, London, and on the French Riviera. Writing also brought Miller to Hollywood many times for brief periods.

A social-minded feminist and longtime Giants fan, Miller was a founder and the first president of the Women's City Club in New York, a club considered radical for fostering what were then thought to be iconoclastic views about city planning, health education, and crime prevention. In 1939, she wrote the history of her alma mater, *Barnard College: The First Fifty Years,* with **Susan Myers**.

In 1935, *Come Out of the Pantry,* based on Miller's story "Come Out of the Kitchen," was filmed in England, starring *Fay Wray and Jack Buchanan. *The White Cliffs of Dover* was released by MGM in 1944, when World War II was at its height, and starred *Irene Dunne, Peter Lawford, *Gladys Cooper, and Dame *May Whitty. Describing the movie's reception, Jay Robert Nash reports, Britons "living in the U.S.

sobbed." Miller, however, had died two years earlier, in 1942, after an eight-month illness.

SOURCES:

Block, Maxine, ed. *Current Biography 1941.* NY: H.W. Wilson, 1941.

Kunitz, Stanley J., and Howard Haycraft. *Twentieth Century Authors.* NY: H.W. Wilson, 1942.

Nash, Jay Robert, and Stanley Ralph Ross. *Motion Picture Guide.* Chicago: Cinebooks, 1987.

Miller, Ann (1919—)

American dancer and actress. Name variations: Lucy Ann Collier; Lucille Ann Collier. Born Johnnie Lucille Collier on April 12, 1919 (she claims 1923), in Chireno (some sources say Houston), Texas; daughter of John Alfred Collier (a criminal lawyer) and Clara Collier; married Reese Llewellyn Milner (a millionaire industrialist), on February 16, 1946 (divorced); married William Moss (a Texas oilman), in 1958 (divorced May 1961); married Arthur Cameron (a Texas oil millionaire), in 1961 (marriage annulled 1962); no children.

Published autobiography, Miller's High Life *(1972).*

Filmography: The Devil on Horseback *(1936);* New Faces of 1937 *(1937);* Life of the Party *(1937);* Stage Door *(1937);* Radio City Revels *(1938);* Having a Wonderful Time *(1938);* Tarnished Angel *(1938);* You Can't Take It With You *(1938);* Room Service *(1938);* Melody Ranch *(1940);* Too Many Girls *(1940);* Hit Parade of 1941 *(1940);* Go West, Young Lady *(1941);* Time Out for Rhythm *(1941);* Priorities on Parade *(1942);* True to the Army *(1942);* Reveille with Beverly *(1943);* What's Buzzin' Cousin? *(1943);* Carolina Blues *(1944);* Jam Session *(1944);* Hey, Rookie *(1944);* Eadie Was a Lady *(1945);* Eve Knew Her Apples *(1945);* Thrill of Brazil *(1946);* Easter Parade *(1948);* The Kissing Bandit *(1948);* On the Town *(1949);* Watch the Birdie *(1950);* Texas Carnival *(1951);* Two Tickets to Broadway *(1951);* Lovely to Look At *(1952);* Small Town Girl *(1953);* Kiss Me Kate *(1953);* Deep in My Heart *(1954);* Hit the Deck *(1955);* The Opposite Sex *(1956);* The Great American Pastime *(1956);* Won Ton Ton, the Dog Who Saved Hollywood *(1975);* Lucy and Desi: A Home Movie *(1993);* That's Entertainment! III *(1994).*

Selected theater: George White's Scandals of 1939 *(1939);* Can-Can *(1969); title role in revival of* Mame *(New York City, May 1969–January 1970); summer tour of* Hello Dolly! *(1971); summer tour of* Anything Goes *(1972);* Panama Hattie *and* Cactus Flower *(1978–79); starring role in* Sugar Babies *(opened October 8, 1979, at New York City's Mark Hellinger Theater; London run, September 1988–January 1989 at Savoy Theater).*

Selected television: "The Bob Hope Show" *(October 6, 1957);* "The Perry Como Show" *(1959);* "The Ed Sullivan Show" *(1960);* "The Hollywood Palace" *(1964); appeared on many interview shows, including the* "Conan O'Brien" *and* "Tom Snyder" *shows (1994); guest starred on* **Ann-Margret** *special* "Dames at Sea"; "Love Boat"; "Out of This World" *(1991);* "Home Improvement" *(1993).*

Selected discography: Dames at Sea *(Bell System K-4900);* Deep in My Heart *(MGM E-3153, MGM SES 54ST);* Easter Parade *(MGM E-502, MGM E-3227, MGM SES-40ST);* Hit the Deck *(MGM E-3163, MGM SES-43ST);* Kiss Me Kate *(MGM E-3077, Metro M/MS-525, MGM SES-44ST);* Lovely to Look At *(MGM E-150, MGM E-3230, MGM SES-50ST);* On the Town *(Show Biz 5603, Caliban 6023);* Small Town Girl *(Scarce Rarities 5503);* Sugar Babies *(Col Special Products BE-8302);* Two Tickets to Broadway *(RCA LPM-39).*

Known for her vivaciousness, rapid-fire tap dancing, and fantastic legs, actress and dancer

Ann Miller

Ann Miller was in show business for most of her life, starring in 40 motion pictures, numerous Broadway shows and national tours, and making many television appearances. Sent by her mother to dancing school at the age of three to cure a case of rickets, Ann (then known as Johnnie Lucille) soon became adept at "quick-style" dancing and performed at many local functions. Her parents divorced when she was 11, and her mother, who had dreams of making Ann a star, toted her off to Hollywood where Ann continued dancing at local functions and won a talent contest. At 17, she was hired for a brief chorus job in *The Devil on Horseback* (1936).

Actress *Lucille Ball discovered her in 1936 working at the Bal Tabarin Club in San Francisco, and arranged for a screen test. She was then hired by RKO and, with her name changed to Ann Miller, appeared in *New Faces of 1937*, dancing in her famous fast style. Miller appeared in a host of other films for RKO, including *Stage Door* (1937), *Radio City Revels* (1938), and *Room Service* (1938), before leaving for New York City to join the Three Stooges on stage in *George White's Scandals of 1939*. Although the show was short-lived, it did serve to gain her attention. "Ann is terrific. She's an eye tonic, has loads of style and a personality that whirls with hurricane force across the footlights," wrote Robert Coleman in the *New York Daily Mirror*. She returned to RKO for third billing in *Too Many Girls* (1940), starring Lucille Ball and *Frances Langford. Gene Autry's horse was her main competition in Autry's Western *Melody Ranch* (1940).

After she performed in *Time Out for Rhythm* (1941) for Columbia, the studio signed Miller to a long-term contract. Her job was to highlight the minor musicals the studio churned out by the dozen, including *Go West, Young Lady* (1941), *Reveille with Beverly* (1943), *Hey, Rookie* (1944), and *Jam Session* (1944), all of which made money. Her gorgeous figure and competent singing were also highlighted in *Eadie Was a Lady* (1945) and *Eve Knew Her Apples* (1945). Just as she was about to star in a major screen musical for Columbia, *The Petty Girl*, Miller's new husband, millionaire industrialist Reese Llewellyn Milner, demanded that she abandon her career. Columbia sued, winning a $150,000 settlement against her, which she settled by starring in *The Thrill of Brazil* (1946). According to Miller, her drunken husband then beat her and threw her down a flight of stairs while she was pregnant, causing her to have a miscarriage and breaking her back. The couple divorced, and her studio contract lapsed.

After an injury forced **Cyd Charisse** to withdraw from *Easter Parade* (1948), MGM's Louis B. Mayer, who had been impressed by Miller's performance in *Eadie Was a Lady*, gave her Charisse's part. During the course of the film, in which she lost Fred Astaire to ***Judy Garland**, she performed a flashy tap-dance number, "Shaking the Blues Away," while still wearing a back brace from her fall down the stairs. MGM signed Miller to star in musicals, and she appeared in *The Kissing Bandit* (1948), *On the Town* (1949) with Gene Kelly, *Watch the Birdie* (1950), and *Texas Carnival* (1951) with ***Esther Williams**. In 1953, she performed in both of her best MGM films, *Small Town Girl* and Cole Porter's *Kiss Me Kate*. Her roles dwindled as MGM's fortunes began to fade, however, and although in 1956 she appeared in *The Opposite Sex*, a remake of ***Clare Booth Luce**'s *The Women*, she ended her relationship with MGM after not receiving a role that she had been promised in *Silk Stockings*.

In 1958, Miller married Texas oilman William Moss. The disastrous marriage lasted three years; 13 days after her divorce in May 1961, she wed another Texas oilman, Arthur Cameron. That marriage was annulled in 1962.

Miller began doing television shows in the late 1950s, and also occasionally performed in night clubs. As a personal friend of hotelier Conrad Hilton, she served as "unofficial ambassador" at Hilton Hotel openings worldwide. From 1969 to 1970, Miller starred in *Mame* on Broadway, enjoying success in the role for which **Angela Lansbury** had won a Tony Award, and later was herself nominated for a Tony for her performance with Mickey Rooney in *Sugar Babies*, which opened in 1979 and ran for three years on Broadway and four years on tour. Miller and Rooney also appeared in the six-month London run of *Sugar Babies* in 1989, for which she received a nomination for the Laurence Olivier Award.

Miller, whose autobiography *Miller's High Life* was published in 1972, has been the recipient of many awards, including the George M. Cohan Award for best female entertainer in 1980 and the *Sarah Siddons Award for best performer of the year for *Sugar Babies* in 1984. Other awards include a Lifetime Achievement Award from the University of Southern California, the Gene Autry Golden Boot Award for her performances in Westerns, the Gypsy Award for lifetime achievement from the Dance Society of America in 1993, and a lifetime achievement award from the Inner Critics Circle of Arizona.

A pair of her tap shoes are on display at the Smithsonian Institution in Washington, D.C.

SOURCES:

Parish, James Robert, and Michael R. Pitts. *Hollywood Songsters*. NY: Garland, 1991.

Quinlan, David, ed. *The Film Lover's Companion*. Carol, 1997.

SUGGESTED READING:

Current Biography. NY: H.W. Wilson, 1980.

Jo Anne Meginnes,
freelance writer, Brookfield, Vermont

Miller, Annie Jenness (b. 1859)

American dress reformer, author and lecturer. Name variations: Mrs. Jenness Miller. Born in the White Mountains of New Hampshire on January 28, 1859; daughter of Solomon Jenness and Susan (Wendell) Jenness (both of old New England stock); educated in Boston by private tutors; married Conrad Miller, in 1887.

Annie Jenness Miller was widely known as an advocate of dress reform for women. About 1885, she became editor and proprietor of the *Jenness Miller Monthly*, in which she advocated her views. Miller gave over 1,000 lectures in the U.S. and Canada on athletics and dress, and designed a costume for women which she claimed "fulfilled the requirements of both hygiene and art." She wrote: "One who carefully examines the pages of fashion magazines, and looks into the history of dress, will find the conclusion forced upon him that there has never been any attempt upon the part of fashion makers to clothe the body consistently. Novelty, exaggeration and display have been the ends sought. The body has been cramped and distorted, its requirements for health and comfort disregarded accoding to the caprice of fashion's arbiters." Her books included *Mother and Babe* (1892) and *Creating a Home* (1896).

Miller, Bertha Mahony

(1882–1969)

American bookseller, editor, children's literature specialist, and originator of the Horn Book Magazine. *Name variations: Bertha Everett Mahony Miller; Bertha E. Miller. Born Bertha Everett Mahony in Rockport, Massachusetts, on March 13, 1882; died of a stroke at her home in Ashburnham, Massachusetts, on May 14, 1969; daughter of Daniel Mahony (a railroad station passenger agent) and Mary Lane (Everett) Mahony (a music teacher); graduated from Gloucester (Massachusetts) High School; attended training class at high school and served as a student-teacher there for one year (1901–02); completed special one-year secretarial course intended for college graduates, Simmons College for Women, 1903; married William Davis Miller (president of a furniture concern), in 1932; no children.*

Was assistant secretary, Women's Education and Industrial Union (WEIU), Boston (1906); opened the Bookshop for Boys and Girls (1916); co-founded Horn Book Magazine (1924). Awards: Constance Lindsay Skinner Award, Women's National Book Association (1955); American Library Association tribute (1959); Regina Medal, Catholic Library Association (1967).

*Selected writings: (with Elinor Whitney Field) Realms of Gold in Children's Books (1929), Contemporary Illustrators of Children's Books (1930), Five Years of Children's Books (1936), Newbery Medal Books: 1922–1955 (1955), Caldecott Medal Books: 1938–1957 (1957); compiler or editor with others: Illustrators of Children's Books, 1744–1945 (1947), Writing and Criticism: A Book for *Margery Bianco (1951), Illustrators of Children's Books, 1946–1956 (1958).*

Bertha Mahony Miller instituted innovative ideas to promote children's interest in reading. As an editor, she was responsible for the discovery and promotion of children's writers and artists, and co-founded the first American magazine to deal exclusively with children's literature.

The eldest of four children and the first of two daughters of Daniel and **Mary Lane Mahony**, Miller spent an idyllic childhood wandering the woods and meadows near her home on Cape Ann in Massachusetts. Her father, a passenger agent for the local Boston and Maine Railroad station, and her mother, a music teacher, shared a common love of music and books, which they passed on to their children. At age 11, Miller's life changed radically with the death of her mother. Although she now had added responsibilities within the household, she graduated from high school with honors, and then went on to attend a training class at the high school and serve as a student-teacher there for a year (1901–02). She enrolled in a one-year secretarial course designed for college graduates at Simmons College for Women, and completed it with distinction in 1903.

Miller began her career in books as a shop assistant at the New Library, a combination bookstore and lending library in Boston. In 1906, she moved to the Women's Education and

Industrial Union (WEIU), a nonprofit social service agency begun by prominent Boston women, where she worked as assistant secretary to president *Mary Morton Kehew and treasurer Helen Peirce. She also organized an amateur theater group, The Children's Players. While looking for material for this group, she was exposed to children's literature, which led her eventually to two of this field's biggest names, Alice M. Jordan of the Boston Public Library and *Anne Carroll Moore of the New York Public Library, both of whom had set up children's rooms in their institutions. Miller was inspired by their work and began to plan her own reading room. In October 1916, with the financial support of the WEIU, she opened the Bookshop for Boys and Girls in the Union's headquarters. Among her innovations at her book shop were Books for Boys and Girls—A Suggestive Purchase List (1916, 1917, 1919, 1922) and the Caravan, a mobile extension of the bookshop which toured New England during the summer. Elinor Whitney (Field), who taught English at the private Milton Academy in Milton, Massachusetts, joined Miller in the book shop in 1919; their collaboration would continue for 50 years. Together they added an adult room stocked with books about children, and started storytelling sessions and art exhibits. In 1924, they founded the Horn Book Magazine, the first American magazine to focus solely on children's literature.

After her marriage in 1932 to William Davis Miller, president of the furniture concern W.F. Whitney Company, Bertha Mahony Miller divided her time between Boston and the Millers' farmhouse in Ashburnham, Massachusetts. After the marriage of Elinor Whitney to William Field, headmaster of Milton Academy, in 1936, the foursome, along with the magazine's printer, Thomas Todd, formed the Horn Book, Inc., publishing company. (This endeavor finally ended Miller's long relationship with the WEIU.)

Horn Book, Inc., was a major force in the discovery and promotion of children's writers and artists, publishing such authors as *Wanda Gág, *Beatrix Potter, and Nora Unwin. Miller's achievements brought her many honors, including the Constance Lindsay Skinner Award (1955), a tribute from the American Library Association (1959), and the Catholic Library Association's Regina Medal (1967). In 1959, her career was capped with A Horn Book Sampler. After the death of her husband that year, Miller remained as chair of the board of Horn Book, Inc., although her activities were limited by arteriosclerosis. After her death from a stroke at her Ashburnham home in May 1969, the Jordan-

Miller Memorial Course in Children's Literature was instituted at the Boston Public Library. In 1974, the University of Southern California opened the Bertha Mahony Miller Seminar Room. At the start of the 21st century, the Horn Book Magazine, in accordance with Bertha Mahony Miller's stated purpose, continues "to blow the horn for fine books for boys and girls."

SOURCES:

Sicherman, Barbara, and Carol Hurd Green, eds. Notable American Women, The Modern Period. Cambridge, MA: The Belknap Press of Harvard University Press, 1980.

<div align="right">**Jo Anne Meginnes**,
freelance writer, Brookfield, Vermont</div>

Miller, Cheryl (1964—)

African-American basketball player. Born in Riverside, California, on January 3, 1964; third of five children of Saul Miller and Carrie Miller; sister of Reggie Miller (a basketball player for the NBA); graduated from Riverside Polytechnic High School, 1982; graduated from the University of Southern California.

Awards: named four-time All-American; won final four Most Valuable Player honors after tournaments (1983 and 1984); named Sports Illustrated National Player of the Year (1985); inducted into the Basketball Hall of Fame (1995).

Led the University of Southern California team to successive NCAA championships (1983 and 1984); was a member of championship U.S. team of the World University Games (1983); anchored the gold medal U.S. Olympic team (1984).

"I feel grateful that I grew up when I did," says basketball champion Cheryl Miller, who was born in Riverside, California, in 1964, the third of five children. "So many great Black athletes paved the way for me. . . . They pushed, they persevered, and whether they knew it or not, they were opening doors that will never be closed again." Miller also credits much of her success to her father, who had seen his share of racial discrimination and encouraged his children to be just a little better than the rest, in the classroom and on the athletic field. "[Dad] told us that if a White coach had to choose between a Black athlete and a White athlete of similar skills, he would choose the White athlete. Every time," she wrote in Ebony. "The moral therefore was that it was not enough for us to be good—we had to be flat out better." As a result, Miller and her brother, NBA star Reggie Miller, grew up very sure of themselves and their talent. Their confidence was sometimes interpreted as arrogance or cockiness.

Miller learned basketball while playing with her brothers in the back yard. At age 11, she tried out for a local boys' team, but after out-performing the coach's son, she was denied a place on the squad. By the time she reached Riverside Polytechnic High School, Miller's talent had fully blossomed, and the 6'2" teenager led her high school's varsity team to a 132–4 record during her four years of play. She became the first woman to dunk a basketball in regulation play and was named to *Parade Magazine*'s All-American Team for four consecutive years.

It surprised no one that 250 colleges and universities offered Miller scholarships, making her the most heavily recruited female athlete of her day. She chose the University of Southern California where she majored in communication and came to dominate USC's women's basketball team. Miller led the team to back-to-back NCAA titles, and by the end of her college career had broken the NCAA women's career records for scoring, free throws, field goals, rebounds, blocking, and steals. In 1983, Miller also played

for teams representing the United States in the Pan American Games and in the World University Games, where she scored 37 points in the finals, helping the team win the championship. Her career peaked in 1984, when she was the leading scorer for the gold-medal U.S. Olympic team. For a short time afterwards, she enjoyed superstar status, appearing on magazine covers and making television appearances, including an interview with *Barbara Walters and a guest spot on "Cagney and Lacey."

By the time her college career ended, Miller had won most of the major basketball awards, including the Broderick Award (1984, 1985), the Wade Trophy (1985), and the Naismith Trophy (1984, 1985, 1986); she was also named the Women's Basketball Coaches' Association Player of the Year (1985, 1986) and Female College Athlete of the Year (1984). Following graduation, she was offered jobs with the Harlem Globetrotters and with a European women's league, but she chose instead to play with the U.S. national team. After winning gold medals at the Goodwill Games in Moscow and at the World

Cheryl Miller

Basketball championship, Miller suffered a severe knee injury which ended her playing career.

After retiring, Miller served for two seasons as head basketball coach at her alma mater, then became a full-time college basketball commentator with ABC-TV. In 1995, she joined Turner Sports as a reporter for NBA coverage on the TNT and TBS networks. In November 1996, she became the first woman analyst to work on a nationally televised NBA game. When the Women's National Basketball Association (WNBA) was formed, Miller became head coach and general manager of the Phoenix Mercury.

In May 1995, escorted by her childhood idol, Julius Erving, who called her "the greatest women's player ever," Miller was inducted into the Basketball Hall of Fame. One of only eleven women so honored (including *Anne Donovan who was inducted in the same ceremony), Miller reflected on her stunning career. "I wasn't the greatest athlete and I couldn't jump out of the gym and I wasn't an extraordinary ball handler," she told the *Los Angeles Times*. "I was just someone who loved the game so very much and had a passion for sport and life."

SOURCES:

Johnson, Anne Janette. *Great Women in Sports*. Detroit, MI: Visible Ink, 1998.

Tynan, Trudy. "As always, Kareem rises to the top," in The [New London] *Day*. May 16, 1995.

Woolum, Janet. *Outstanding Women Athletes*. Phoenix, AZ: Oryx Press, 1992.

Miller, Dorothy Canning (b. 1904)

American museum curator, one of the first of her gender in the U.S., who designed several of the earliest major exhibits of American abstract expressionist art. Born Dorothy Canning Miller in 1904 in Hopedale, Massachusetts; daughter of Arthur Barrett Miller and Edith Almena (Canning) Miller; Smith College, B.A., 1925, honorary Doctor of Humane Letters, 1959; completed ten-month museum-training course at Newark Museum; attended New York University Institute of Fine Arts, 1926–27; married Holger Cahill (a curator and administrator), on August 17, 1938.

Born in Hopedale, Massachusetts, in 1904, Dorothy Canning Miller was pushed by her family to become an artist from an early age. She attended Smith College and majored in art, but soon realized that although she had developed some technical ability, she lacked the desire and determination to become a true artist. She took all the art history courses the college offered, but was unable to gain much information on mod-

ern art, as the attitude of many colleges, and of many critics, during the 1920s was dismissive toward modern artists.

In 1925, the Newark Museum offered the first museum-training course in the United States. Upon graduation from Smith, Miller entered this program with eight others, and was introduced by one of her teachers, Holger Cahill (whom she later married), to the work of modern artists. Cahill was friendly with many of the artists who were working in New York City at the time, and he took his eager students into their studios to listen and talk to them. After completing the training course, Miller was hired, along with the rest of her classmates, to reorganize the Newark Museum, with her first job being the setting up of two empty galleries in the new building. The young apprentices were also required to serve as models for the museum's collection of costumes and to guide school classes, women's clubs, and other groups through the galleries. Miller remained at the museum for four years, until she learned about the opening of the Museum of Modern Art (MoMA) in New York City in 1929. Determined that that was where she wanted to be, she abandoned a good job during the Depression and went to New York City with no promise of employment. For several years, she could not obtain steady work, but managed to get by with odd jobs including cataloging artwork at the Montclair Art Museum.

In 1932, Alfred Barr, the innovative director of MoMA, took a leave of absence because of illness, and Holger Cahill was asked to take over for the duration. Cahill requested Miller's assistance, and she became a "part-time, dollar-an-hour worker at the Museum of Modern Art." Among the exhibitions she worked on were "American Folk Art: The Art of the Common Man in America, 1750–1900," and "American Sources of Modern Art." She also collaborated on the Municipal Exhibitions held in the RCA building, which included the work of approximately 5,000 artists from New York. When Barr returned in 1934 she was asked to remain as his assistant. The first show she organized alone at MoMA was the WPA (Works Progress [later Projects] Administration) Federal Art Project Show in 1936. Cahill was in charge of the WPA Federal Art Project, and together they traveled the country, discovering and meeting many of the new, young artists of the era.

In 1942, MoMA began planning to mount an all-American show the following year with no New York artists (who had a decided edge over their brethren in other parts of the country

in terms of getting exhibited and attracting collectors). Miller was appointed the curator of painting and sculpture at the museum in 1943, thus becoming one of the few female curators in America at the time, and was put in charge of the upcoming exhibit. Again she traveled the country seeking out new artists, and was instrumental in persuading Seattle artist Morris Graves to exhibit his work in the show. This 1943 display began a series of groundbreaking exhibits (including ones in 1946, 1952, and 1956) that Miller curated at MoMA; among the artists she selected for these shows, many of whom had never had major exhibitions before, were Jackson Pollock, Mark Rothko, Clyfford Still, Morris Graves, Mark Tobey, *Louise Nevelson, Jasper Johns, Robert Rauschenberg, and Robert Indiana.

Dorothy Miller became curator of museum collections in 1947, a position she would hold for the next 20 years; from 1968 until her retirement in 1969, she was a senior curator at the museum. A member of the art committee of Chase Manhattan Bank since 1959, she became a trustee of numerous institutions after her retirement. She was named an honorary trustee of the Museum of Modern Art in 1984.

SOURCES:

Gilbert, Lynn, and Gaylen Moore. *Particular Passions: Talks with Women Who Have Shaped Our Times.* NY: Clarkson N. Potter, 1981.

COLLECTIONS:

Dorothy Canning Miller's papers are held in the archives at the Museum of Modern Art in New York City.

Jo Anne Meginnes,
freelance writer, Brookfield, Vermont

Miller, Elizabeth Smith (1822–1911).

See Bloomer, Amelia for sidebar.

Miller, Flora Whitney (b. 1897).

See Whitney, Flora Payne.

Miller, Frieda S. (1889–1973)

American labor reformer and government official.
Born Frieda Segelke Miller in LaCrosse, Wisconsin, on April 16, 1889; died in New York City of pneumonia on July 21, 1973; one of two daughters born to James Gordon Miller and Erna (Segelke) Miller; B.A., 1911, Milwaukee-Downer College; graduate work, 1911–15, University of Chicago; honorary Ph.D., 1940, Russell Sage College; lifelong companion, Pauline Newman; children: Elizabeth (adopted, 1923).

Was executive secretary, Philadelphia Women's Trade Union League (WTUL, 1917–23); was a factory inspector for the International Ladies' Garment Work-

ers Union (ILGWU, 1924–26); did private charity work (1926–29); served as director, Division of Women in Industry, New York Department of Labor (1929–38); was active in the International Labor Organization (1930s–50s); served as labor commissioner for the state of New York (1938–42); was special assistant on labor to ambassador to Great Britain, John G. Winant (1943); was director of the Women's Bureau of the U.S. Department of Labor (1944–52); served as representative on the United Nations' commission on the International Union for Child Welfare (1960s).

Frieda S. Miller

Frieda S. Miller was born in LaCrosse, Wisconsin, on April 16, 1889. When she was only five years old, her mother died, and her father sent her and her younger sister to live with their maternal grandparents. Miller's grandfather owned a large manufacturing company and, even as a child, Frieda was impressed by the loyalty his employees held towards their fair-minded employer. This early impression stayed with her. As an adult, she stressed the need for labor laws, especially regarding mediation, to insure a positive and stable relationship between employer and employee.

After receiving her undergraduate degree at Milwaukee-Downer College in 1911, Miller did four years of graduate work in labor economics and political science at the University of Chicago. Before completing her dissertation, however, she left the university and joined the social economy department of Bryn Mawr College as a research assistant. A year later, in 1917, she became executive secretary for the Philadelphia Women's Trade Union League, a cross-class alliance dedicated to the organization and education of and legislation for working-class women. There, Miller met the woman who became her partner, ❧▶ Pauline Newman. A Russian immigrant, garment worker and organizer for the International Ladies' Garment Workers Union (ILGWU), Newman was, by 1918, president of the Philadelphia WTUL. In 1923, both Miller and Newman resigned from their WTUL posi-

❧▶
See sidebar
on the
following page

❧▸ Newman, Pauline (1887–1986)

*American labor activist. Born in Russia on October 18, 1887; died in April 1986 in New York; lifelong friend of *Rose Schneiderman and *Clara Lemlich; lived with *Frieda S. Miller (1889–1973).*

One of nearly 500 women who worked at the Triangle Shirtwaist Factory in New York City, Pauline Newman wrote about the miserable working conditions of the factory that became a deadly inferno on March 25, 1911. Shortly before the fire, Newman had quit her job to become a labor organizer, but she joined the huge march to commemorate the deaths of her fellow workers in early April. "It looked like the entire city of New York was at the parade," she wrote, "If you could call it a parade. And it was pouring. It was as if nature were weeping." Newman was the first full-time woman organizer for the International Ladies' Garment Workers Union (ILGWU). She founded the ILGWU's Health Center and was director of health education from 1918 to 1980. Newman was also an advisor to the U.S. Department of Labor in the 1930s and 1940s, and was on the board of directors for Bryn Mawr Summer School for Women Workers.

tions and went to Europe to attend the Third International Congress of Working Women. While in Germany, Miller adopted a baby whom she and Newman raised.

During the 1920s, Miller worked for two years as a factory inspector for the ILGWU Joint Board of Sanitary Control. She also was employed as an investigator for the New York State Charities Aid Association, looking into housing conditions for the elderly on Welfare Island and Staten Island. In 1929, her friend *Frances Perkins, then state labor commissioner, appointed Miller head of the New York Labor Department's Division of Women in Industry. In 1938, Miller became labor commissioner for the state of New York, the second woman, after Perkins, to hold that office. Six years later, in 1944, Miller moved to Washington, D.C., succeeding *Mary Anderson (1872–1964) as head of the Women's Bureau of the U.S. Department of Labor. A year later, Miller formed the Labor Advisory Committee of the Women's Bureau, bringing trade union women into that government agency for the first time. She was instrumental in addressing the problems of women in industry in the postwar economy. An advocate of equal pay for equal work, Miller did not support the Equal Rights Amendment, fearing that it would "take away from women hard-earned industrial gains which have led to a better standard of living."

When a Republican president, Dwight Eisenhower, took office in 1953, Miller was asked to resign from the Women's Bureau. Throughout the 1950s, she continued her work with the International Labor Organization (ILO). She had been associated with the ILO since 1936 when then-president Franklin D. Roosevelt appointed her a delegate to the ILO's Inter-American Regional Conference. During the 1960s, although by then in her 70s, Miller was a representative for the United Nations' International Union for Child Welfare. She officially retired in 1967, moving into a New York City nursing home in 1969. She died there of pneumonia in 1973.

SOURCES:

Sicherman, Barbara, and Carol Hurd Green, eds. *Notable American Women: The Modern Period.* Cambridge, MA: The Belknap Press of Harvard University Press, 1980, pp. 478–479.

Rothe, Anna, ed. *Current Biography 1945.* NY: H.W. Wilson, 1945, pp. 405–407.

COLLECTIONS:

Frieda S. Miller Papers, Schlesinger Library, Radcliffe College.

<div align="right">

Kathleen Banks Nutter,
Manuscripts Processor at the Sophia Smith Collection, Smith
College, Northampton, Massachusetts

</div>

Miller, Harriet Mann (1831–1918).

See Miller, Olive Thorne.

Miller, Kathy Switzer (b. 1947).

See Samuelson, Joan Benoit for sidebar on Kathy Switzer.

Miller, Lee (1907–1977)

American photographer. Born Elizabeth Miller in Poughkeepsie, New York, in 1907; died in Chiddingly, England, in 1977; only daughter and one of three children of Theodore Miller (an engineer and an executive at De Laval Cream Separator Company); educated in private schools; studied painting, theatrical design and lighting at the Art Students League, 1927–29; married Aziz Eloui Bey (an Egyptian businessman), in 1934 (separated 1939, divorced 1947); married Roland Penrose (an English painter and art collector), in 1947; children: (second marriage) Antony Penrose.

One of America's foremost women photographers from the 1920s to the 1940s, and a leading proponent of Surrealism, Lee Miller reinvented herself several times during her lifetime. A stunning blonde, she gave up a successful career as a photographic fashion model to take up the camera herself and then in 1945 became a

war correspondent for *Vogue* magazine, contributing eloquent text to accompany her photographs. Following the war, she endured years of off-and-on depression, then emerged in 1954 to take up a new career as a gourmand and chef. During the last 20 years of her life, Miller refused to exhibit, discuss, or publish her photographs, and seemed to care little about her place in history. Eight years after her death, however, her son Antony Penrose rekindled interest in Miller with the publication of her biography, *The Lives of Lee Miller* (1985), followed by a volume of her war photographs, *Lee Miller's War* (1992). **Jane Livingston**'s collection, *Lee Miller, Photographer*, published in 1989, also helped reestablish Miller as a uniquely talented photographer.

Elizabeth Miller (shortened to Liz, then Li-Li, then Lee) was born in Poughkeepsie, New York, in 1907, the first child and only daughter of an engineer/inventor who was also an amateur photographer. She admitted to being kicked out of every private school around Poughkeepsie and as a teenager was sent off to study in Paris.

She wound up working at a theatre in Montmartre and hanging out with the arty set. After a year, her father fetched her back to New York, where she made the acquaintance of Condé Nast, who had recently acquired *Vogue* magazine. Before long, she was a top model at *Vogue* and was posing for the cameras of Edward Steichen, Arnold Genthe, and George Hoyningen-Huene. While in Manhattan, she studied painting, scenic design, and lighting at the Art Students League and in 1929 returned to France to apprentice with American Surrealist and photographer Man Ray. The two fell in love and lived together for three years, during which time Miller had contact with many of the young artists in the Surrealist movement, including Jean Cocteau, who starred her in his classic 1930 film *The Blood of a Poet*.

In 1932, ready to assume her place behind the camera, Miller returned to New York and opened a portrait studio with her brother Erik. Two years later, however, she was swept away by the Egyptian tycoon and noble Aziz Eloui Bey, whom she wed at City Hall while a matri-

Lee Miller, Self-Portrait, *1933*.

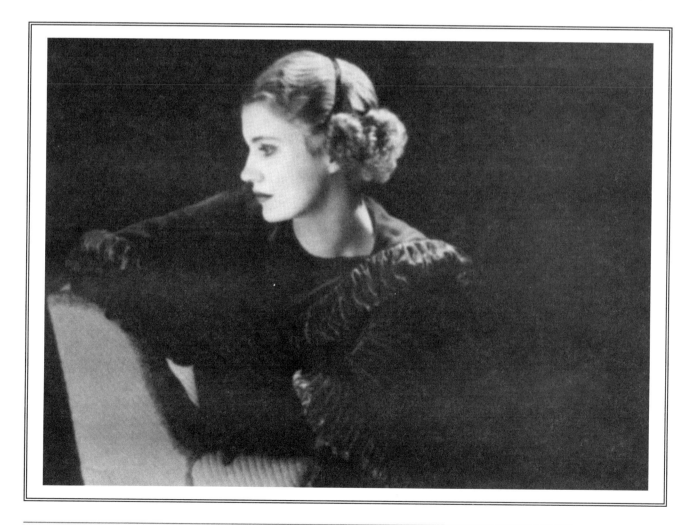

monial clerk lectured her on the pitfalls of inter-racial marriage. She then sailed off to a life of leisure in Cairo and Alexandria. In 1937, bored, she returned to Paris, where, through painter Max Ernst, she met Roland Penrose, an expatriate English surrealist and collector who would later become the founder of London's Institute of Contemporary Art and the official biographer of Pablo Picasso. The two fell passionately in love, although it took Miller several years to break with Bey. She was separated in 1939 and finally divorced in 1947 and joined Penrose in England. (The couple did not marry until 1947, the year their son Antony was born.) From 1940 to 1945, Miller served as the head of *Vogue*'s London studios, doing fashion layouts and general stories. Meanwhile, the house she shared with Penrose became a gathering place for notable artists, journalists, and politicians in England and, by all accounts, it was the scene of some extremely lively parties.

At the start of World War II, Miller began a series of photographs documenting the London Blitz, which was edited as *Grim Glory: Pictures of Britain Under Fire*, with a text by Edward R. Murrow. When most of her friends signed on as war correspondents, Miller applied for accreditation to the U.S. Armed Forces, giving up a life of comfort to record the gritty business of war. "I chuckled to myself at a monstrous irony," wrote David E. Scherman, the renowned war photojournalist and friend of Miller's, who remembers her as an obsessive clothes-horse and hypochondriac who downed an arsenal of digestive potions with every meal. "Now, in the excitement—and joy—of battle, all this nonsense went out the window," he recalled. "For about a year, with occasional exceptions, she looked like an unmade, unwashed bed, dressed in o. d. [olive drab] fatigues and dirty GI boots, and she wolfed down, without pill or powder, whatever chow the current mess-sergeant saw fit to shovel up."

Miller accompanied the Allied troops through Europe, not only recording the war in startling surrealistic photographs, but filing equally graphic dispatches which she typed on a beat-up Hermes Baby typewriter she carted along wherever she went. "I'll never see acid-yellow and gray again, where shells burst near snow without seeing the pale, quivering faces of replacements, gray and yellow with apprehension—their fumbling hands and furtive, short-sighted glances at the field they must cross," she wrote during the bitter Alsace campaign. At the close of the war, Miller visited and photographed Buchenwald and Dachau, and was inhabiting Hitler's apartment in Munich when his death was announced. (In Antony's book of her war photographs, there is a shot of her taking a bath in Hitler's tub.) Later, she photographed the burning of his fortress at Berchtesgaden. Miller's photos and dispatches were regularly published within the pages of *Vogue*, which, according to Antony, created its own Surrealistic effect. "The grim skeletal corpses of Buchenwald are separated by a few thicknesses of paper from delightful recipes to be prepared by beautiful women dressed in sumptuous gowns."

While Miller tends to be defined by her war photographs, particularly her pictures of Dachau, her portraits and landscapes are also compelling. **Elsa Dorfman**, in a review of Jane Livingston's book, notes that all of Miller's images are infused with a surrealist sensibility. "It isn't hard with a camera—the ultimate surreal instrument—to select from the environment to convey a surrealist vision, but whereas often surrealist images depend on manipulation and collage, Miller's depend on astute juxtaposition, a sense of framing and camera angle." Miller also produced exceptional portraits, including some of the best ever taken of Picasso, who remained her friend for 50 years. Dorfman describes her approach to portraiture as honest and direct, exemplified by her pictures of the prison guards at Buchenwald. "She was not afraid to bring her camera close to her subject. She trusted her subjects to be themselves. She did not clutter up her image with extraneous details."

The war may have given purpose to Miller's life, but it also exacted a toll. According to her son Antony, who was born after the war, she almost never talked about her experiences although she retained an irrational hatred of the Germans until her dying day. It was not until he began writing her biography in 1977 that Antony found his mother's photographs, and also discovered the revealing texts she wrote during the war. "She had been so self-deprecating about her life and so dissolute in her later years when I knew her that I could hardly believe she was the author of this startlingly vivid text," he wrote. Antony recalls that only after years of depression and alcohol abuse did his mother finally emerge from her despair to take up a new career in the kitchen. (Her last professional photographs were for her husband's book on Picasso, which in its latest edition includes snapshots of the artist that Miller took as late as 1970.) She became a graduate of the Cordon Bleu, creating remarkable dishes which she served to her friends at elaborate dinner parties. In her later years, she also took up music, and when her husband bought a farm in Sussex, she

became an accomplished botanist and gardener. At age 70, she learned to play chess.

Antony's biography coincided with a solo exhibition of Miller's work, *The Lives of Lee Miller*, at the Staley-Wise Gallery in New York (1985) and spawned two retrospectives: one at the Photographers' Gallery in London (1986), and another at the San Francisco Museum of Modern Art (1987), which then toured the country.

SOURCES:

Dorfman, Elsa. "A Review by Elsa Dorfman," in *The Women's Review of Books*. Vol. II, no. 1. October 1989.

Penrose, Antony, ed. *Lee Miller's War: Photographer and Correspondent with the Allies in Europe 1944–45.* Boston, MA: Little, Brown, 1992.

Barbara Morgan,
Melrose, Massachusetts

Miller, Marilyn (1898–1936)

Popular American musical-comedy actress. Born on September 1, 1898 (some sources cite 1896), in Evansville, Indiana; died suddenly of an acute infection in New York City on April 7, 1936; third and youngest daughter of Edwin D. Reynolds (an electrician) and Ada (Thompson) Reynolds; married Frank Carter (an actor), on May 24, 1919 (died 1920); married Jack Pickford (an actor), on July 30, 1922 (divorced 1927); married Chester L. O'Brien (a chorus man), on October 1, 1934; no children.

Selected theater: appeared in Schubert revues, The Passing Show of 1914, The Passing Show of 1915, The Show of Wonders *(1916), and* The Passing Show of 1917; Fancy Free; Ziegfeld Follies *(1918);* Sally *(Amsterdam Theater in New York City, 1920–1923);* Peter Pan *(1924);* Sunny *(Jerome Kern, Oscar Hammerstein, Otto Harbach, 1925);* Rosalie *(Sigmund Romberg, George Gershwin and others, 1928);* Smiles *(Vincent Youmans and others, 1930);* As Thousands Cheer *(Irving Berlin and Moss Hart, 1933).*

Born on September 1, 1898, in Evansville, Indiana, Marilyn Miller grew up to become a musical-comedy star who sang and danced her way into the hearts of millions of Americans and was particularly associated with Jerome Kern's song "Look for the Silver Lining." Shortly after she was born, her mother **Ada Thompson** divorced her father Edwin D. Reynolds and married actor Oscar "Caro" Miller, whose last name was taken by the three Reynolds children. When she was four, Miller joined her oldest sister and parents as "Mlle. Sugarplum" in their vaudeville act "The Columbian Trio" (which

eventually became known as "The Five Columbians"), making her stage debut in August 1903 in Dayton, Ohio. For ten years, the popular act toured the Midwest (although avoiding large cities with their strict interpretation of child labor laws) and several foreign countries. Miller may not have had particularly fond memories of those childhood years of touring; after her death, it was discovered that her will stipulated that her stepfather should receive nothing from her estate.

In 1913, Lee Shubert discovered Miller at a London nightclub. She returned to America and for four years appeared in Schubert revues: *The Passing Show of 1914*, *The Passing Show of 1915*, *The Show of Wonders* in 1916, and *The Passing Show of 1917*. In 1918, the storied Florenz Ziegfeld began managing her career, and she appeared in *Fancy Free* and the *Ziegfeld Follies* (1918). In 1920, Ziegfeld put her in the starring role in the musical comedy *Sally*, in which she stopped the show with "Look for the Silver Lining."

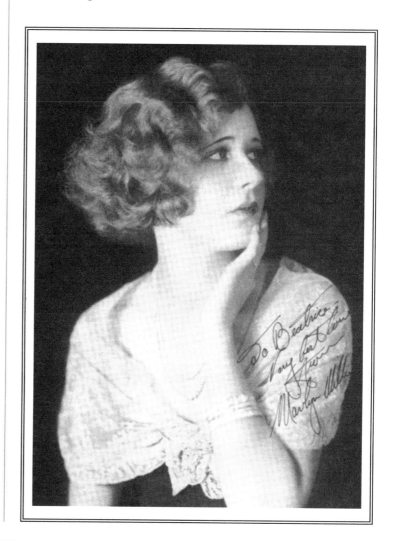

Marilyn Miller

Her only straight dramatic appearance followed in 1924 in *Peter Pan*, directed by Charles Dillingham. The next year she starred in an elaborate production of *Sunny*, in which she played a circus performer who attracts the love of a wealthy society man. Miller excelled as the golden-haired wonder girl in such upbeat, flashy productions, and she appeared in three more, *Rosalie* (1928), *Smiles* (1930) and *As Thousands Cheer* (1933), an Irving Berlin-Moss Hart confection that also starred *Ethel Waters** and Clifton Webb. In 1929, she went to Hollywood to make the film version of *Sally*, which was followed by the movie *Sunny* in 1930 and *Her Majesty, Love* in 1931.

On April 7, 1936, with her third husband Chester L. O'Brien (a chorus man in *As Thousands Cheer*) at her side, the 37-year-old Miller died at Doctors Hospital in New York City of an acute infection. She was buried in Woodlawn Cemetery in New York City. In the 1946 film biography of Jerome Kern, *Till the Clouds Roll By*, she was portrayed by *Judy Garland*, who sang "Look for the Silver Lining." That song also provided the title for the film biography of Miller herself that was released in 1949, starring *June Haver** and Ray Bolger.

SOURCES:

James, Edward T., ed. *Notable American Women, 1607–1950*. Cambridge, MA: The Belknap Press of Harvard University Press, 1971.

McHenry, Robert, ed. *Famous American Women*. NY: Dover, 1980.

COLLECTIONS:

Scrapbooks, clippings and unclassified material in the Theater Collection of the New York Public Library at Lincoln Center, New York City.

Jo Anne Meginnes,
freelance writer, Brookfield, Vermont

Miller, Olive Thorne

(1831–1918)

American nature writer and author of children's books. Name variations: Harriet Mann; Harriet M. Miller. Born Harriet Mann on June 25, 1831, in Auburn, New York; died on December 25, 1918, in Los Angeles, California; only daughter of Seth Hunt Mann (a banker) and Mary (Holbrook) Mann; education included a "select school" in Ohio; married Watts Miller (a businessman), on August 15, 1854; children: Harriet Mabel Miller (b. 1856); Charles Watts Miller (b. 1858); Mary Mann Miller (b. 1859); Robert Erle Miller (b. 1868).

Selected writings: Little Folks in Feathers and Fur, and Others in Neither *(1875);* Nimpo's Troubles *(1879);* Queer Pets at Marcy's *(1880);* Little People of Asia *(1882);* Bird-Ways *(1885);* In Nesting Time *(1888);* Four Handed Folk *(1890);* The Woman's Club *(1891);* Little Brothers of the Air *(1892);* A Bird-Lover in the West *(1894);* The First Book of Birds *(1899);* The Second Book of Birds: Bird Families *(1901);* True Bird Stories from My Notebook *(1903);* With the Birds in Maine *(1904);* Kristy's Queer Christmas *(1904);* Kristy's Surprise Party *(1905);* Kristy's Rainyday Picnic *(1906);* What Happened to Barbara *(1907);* The Bird Our Brother: A Contribution to the Study of the Bird as He Is in Life *(1908);* The Children's Book of Birds *(1915).*

Born Harriet Mann on June 25, 1831, the eldest of four children, Olive Thorne Miller grew up to become one of the most popular writers about birds in her time. She was also a political activist who urged people to stop the commercial use of bird feathers, and exhorted women to enter the field of ornithology. A shy child, Miller enjoyed reading and began writing at an early age, while spending her childhood in Ohio, Wisconsin, Illinois and elsewhere due to her father's belief that success was always just around the corner.

In 1854, she married Watts Miller, a businessman, in Rock Island, Illinois, and soon settled with him in Chicago. Because her husband's family, as she noted, believed that "the dishcloth was mightier than the pen," she gave up writing for a time and devoted her days to raising her four children, born between 1856 and 1868. She eventually returned to writing, and in 1870 one of her "sugar-coated pills of knowledge" for children appeared as an article in a religious weekly. In the next decade, she wrote hundreds of essays for children. Her stories for children were usually signed Olive Thorne, and her nature sketches were signed Harriet M. Miller. Many of these sketches went into the book *Little Folks in Feathers and Fur* (1875), while a set of stories appeared as *Nimpo's Troubles* in 1879. It is generally acknowledged that Miller's children's stories have no special merit, but her books of nature sketches, for children and adults alike, are still read.

Miller and her family moved to Brooklyn, New York, around the time her first book was

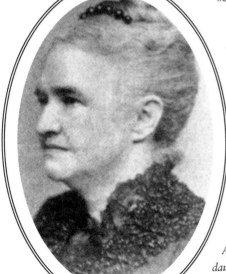

Olive
Thorne
Miller

published. In 1880, her friend **Sara A. Hubbard,** who was visiting from Chicago, took her bird-watching in Brooklyn's Prospect Park. Miller was fascinated, and her devotion to the study of birds would increase to such an extent that she turned one room of her house into a wintertime aviary, allowing birds to fly free within it and peck at the walls while she watched (she would then release the birds in the spring.) *Bird-Ways,* published in 1885 under the pen name of Olive Thorne Miller, was the result of her first efforts at bird-watching and was aimed at adults. *In Nesting Time* (1888) and *Little Brothers of the Air* (1892) followed. Her best books on birds are considered to be *A Bird-Lover in the West* (1894) and *With the Birds in Maine* (1904). Miller also lectured on ornithology, in her later years shedding her shyness and becoming a self-assured, well-spoken woman. Her books were popular with the public, but were also respected by professional ornithologists for the close observation and accuracy she brought to the subject. An active member of Sorosis and the Brooklyn Woman's Club (an interest reflected in her 1891 book *The Woman's Club*), and a close friend of *Florence Merriam Bailey, who also wrote about birds, Miller strongly encouraged other women to pursue ornithology. She considered them "particularly suited" to do so, believing that women were endowed with the "infinite patience, perseverance, untiring devotion, . . . quick eye and ear, and . . . sympathetic heart" necessary for the task.

After her husband's death in 1904, Olive Thorne Miller moved to Los Angeles, where she wrote the last six of her books. *The Children's Book of Birds*, her final publication, was released in 1915, three years before she died at age 88.

SOURCES:

Edgerly, Lois Stiles, ed. *Give Her This Day*. Gardiner, ME: Tilbury House, 1990.

James, Edward T., ed. *Notable American Women, 1607–1950*. Cambridge, MA: The Belknap Press of Harvard University Press, 1971.

McHenry, Robert, ed. *Famous American Women*. NY: Dover, 1980.

Norwood, Vera. *Made From This Earth: American Women and Nature*. Chapel Hill & London: University of North Carolina Press, 1993.

Ogilvie, Marilyn Bailey. *Women in Science: Antiquity through the Nineteenth Century*. Cambridge, MA: MIT Press, 1986.

Jo Anne Meginnes,
freelance writer, Brookfield, Vermont

Miller, Perry.

See O'Keeffe, Georgia for sidebar on Perry Miller Adato.

Miller, Susanne (1915—)

Bulgarian-born German historian, known as the leading historian of the German Social Democratic movement, whose research and persuasive arguments have earned her a worldwide reputation as a scholar. Born Susanne Strasser in Sofia, Bulgaria, on May 14, 1915; daughter of an Austrian banker; studied at the University of Vienna; received Ph.D. from University of Bonn, 1963; married Horace Miller; married Willi Eichler.

Moved from Austria to London (1934); moved to Germany (1946); wrote a large number of books examining the complexities of the relationship between the Social Democratic movement and political power, including the difficulties of creating a democratic spirit in Germany; retired (1978) but remained active in German public life.

Susanne Miller was born in Sofia, Bulgaria, in 1915. As the daughter of a wealthy Austrian Jewish banker, she grew up both in Bulgaria and postwar Vienna, where her father had business interests. Both nations were on the losing side in World War I and suffered immensely in political, economical and moral terms. The brief upsurge of left-wing populism in Bulgaria in the early 1920s, which included an attempted Communist revolution, was drowned in a bloody right-wing reaction that cost many lives and blighted the nation. Austria, too, paid a high price for its defeat. After 1920, Vienna was a "Red" city ruled by reform-minded Social Democrats, but the forces of reaction and fascism grew steadily during these years, particularly in the Austrian provinces where hatred of "immoral and Jewish-controlled" Vienna was deeply rooted among the urban bourgeoisie and many of the peasants.

Alert to conditions in Vienna, young Susanne soon became aware of her own privileged status in a city where the poverty and insecurity of the working classes was all around her. As a student at the University of Vienna in the early 1930s, she was confronted by the brutality of fascism when Nazi students, who were passively supported by many faculty members, physically assaulted Jewish, Socialist, Communist and other students whom they deemed to be "un-German." In February 1934, she witnessed the bloody suppression by a reactionary government of the Social Democratic Party, the last champions of democracy in Austria. After spending the summer of 1934 in London as an au pair in order to study English, she effectively severed her ties to Austria and began to live mostly in England. Free but poor, she supported herself for the next decade by working at a vegetarian

restaurant located between Leicester Square and Picadilly Circus. In her leisure time, she gave talks to women's groups affiliated with the Labour Party on the growing threat of fascism. Frustrated by circumstances in her desire to achieve a higher education, she read voraciously and closely followed the rapidly deteriorating political situation in Europe and the world.

During World War II, she entered into a pro forma marriage with Labour Party activist Horace Miller. Acquisition of a British passport would prove essential in later years, when Susanne Miller carried out her plans to return to the Continent to help in the reconstruction of democracy in Central Europe after the defeat of Nazi Germany.

In 1944, Miller became the personal secretary as well as the companion of Willi Eichler, a leader of the International Socialist League of Struggle (ISK). The ideology of this splinter organization of German-speaking socialists was based not on Marxism but on an elitist goal of freedom and ethical advancement as the basis for social reform, as opposed to a regime based purely on economics and compulsion. Miller was strongly influenced by the charismatic Eichler, for whom socialism was an idealistic and universal aspiration applicable to all humanity.

With the defeat of Nazi Germany in 1945, both Miller and Eichler made plans to return to Germany. She supported Eichler's efforts to bring about a unification of the often hostile factions among the German Social Democratic exile community in the United Kingdom. With this task largely accomplished, they moved in 1946 to occupied Germany, where they married. Settling in the war-devastated city of Cologne, Miller worked with great determination among Social Democratic (SPD) women's groups, while Eichler served as chief editor of the *Rheinische Zeitung*.

By 1952, Miller's successes in Cologne brought her to the attention of the national SPD leadership, who selected her to work in the party's national executive committee in Bonn. Here she participated in the internal debates which in 1959 resulted in the adoption of the landmark Bad Godesberg declaration. This declaration finally severed the last ties of the SPD to Marxist ideology, including the idea of class struggle and the dictatorship of the proletariat. Although most of her work had been done behind the scenes, Miller had played a key role in facilitating the party's transition from a 19th-century organization, drawing its strength from a militant industrial working class, to a modern mass-consensus party, which was based on ideals of ethically grounded democratic socialism.

With decades of political upheaval, war, and personal insecurity now behind her, in 1959 Miller activated her long-delayed plans to study for an academic career. She enrolled at the University of Bonn and was fortunate in earning her doctorate in history under the direction of the eminent scholar Karl Dietrich Bracher. Published in 1964, her dissertation *Das Problem der Freiheit im Sozialismus* was a broadly conceived study of the problem of freedom in Social Democratic theory and practice in German history. Her thesis, namely that since 1848 German Social Democracy had been carrying a double burden of not only fighting for the economic and social advancement of the proletariat but also for the achievement of bourgeois liberty and republican virtue in a profoundly authoritarian society, would be a major theme in all of her subsequent research.

Over the next decades, Miller would publish almost a dozen books on Social Democracy's crucial participation in modern German history. Her 1974 study of the SPD role in World War I utilized not only printed and archival sources but also oral testimony, and it received the highest praise from established experts in the field. Among those who lauded the work was veteran socialist historian Carl Landauer; in the *American Historical Review*, he praised the volume as "a great contribution to the history of socialism." Additional books by Miller which investigated similar historical problems also earned enthusiastic reviews in virtually all of the important scholarly journals. In collaboration with Heinrich Potthoff, she published a concise history of the German Social Democratic movement aimed at non-specialists (1981), which sold well. By 1991, the work appeared in its seventh edition, necessitated in part by the dramatic events of 1989–90 when the German Democratic Republic collapsed, bringing about German unification in early October 1990.

Although she officially retired in 1978, Miller remained active into the 1990s, serving on various scholarly committees including the SPD executive committee's Historical Commission. She continued to publish works for general readers and remained a conscientious citizen of Germany's democratic society, participating in mass rallies against racism and neo-Nazism, as well as speaking out in favor of tolerance and conciliation. In a 1985 speech on the occasion of Susanne Miller's 70th birthday, former chancellor Willy Brandt pointed out that the underlying

inspiration of her work had always been the will to assist in the creation of a better society in which working people would be able to live "good, meaningful and fulfilled lives."

SOURCES:

Breitman, Richard. "Negative Integration and Parliamentary Politics: Literature on German Social Democracy, 1890–1933," in *Central European History.* Vol. 13, no. 2. June 1980, pp. 175–197.

Haag, John. "Miller, Susanne 1915—," in Kelly Boyd, ed., *Encyclopedia of Historians and Historical Writing.* 2 vols. London and Chicago: Fitzroy Dearborn, 1999, Vol. 2, pp. 819–822.

Miller, Susanne. *Sozialistischer Widerstand im Exil: Prag-Paris-London.* Berlin: Gedenkstätte deutscher Widerstand, 1984.

"Tens of Thousands join Anti-Racism Rally in Bonn," in *The Reuter Library Report.* November 14, 1992.

John Haag,
Associate Professor of History,
University of Georgia, Athens, Georgia

Millet, Cleusa (c. 1931–1998)

Afro-Brazilian religious leader. Name variations: Mãe Cleusa do Gantois. Born around 1931; died on October 15, 1998; daughter of Alvaro MacDowell and Mãe (means mother) Menininha do Gantois or Mother Menininha, also known as Maria Escolástica da Conceição Nazareth or Maria Escolastica da Conceicao Nazare; children: four sons and a daughter, including Mônica and Zeno.

Cleusa Millet was the daughter of Alvaro MacDowell and **Mãe Menininha,** or Mother Menininha, the most important high priestess of the Afro-Brazilian religion called Candomblé. Millet spent much of her childhood at the Gantois (Ilê Iya Omin Axé Iya Massé) *terreiro* or ritual center in Salvador, the capital of the Brazilian state of Bahia. From a young age, she learned from her mother the songs, dances, and rituals associated with the worship of the *orixás* (animist divinities of African, especially Yoruban, origin). She watched her mother go into trances as the orixá Oxum communicated through her, and eventually Millet was initiated and began to show such abilities herself. The orixá Nànà (the most ancient of the female divinities) communicated through her. Meanwhile, however, she also trained and worked as a nurse.

Millet's mother had inherited the Gantois terreiro from her own aunt, **Mãe Pulcheria,** who had received it from her mother, **Maria Julia da Conceição Nazareth,** the terreiro's founder. Mãe Menininha was consequently anxious to pass the terreiro on to one of her own daughters, and Millet showed the most capacity. Yet Millet was reluctant to assume the responsibility, despite determined efforts by Mãe Menininha to persuade her, and only took over at Gantois in September 1987, the year after her mother's death.

Mãe Cleusa officiated as *ialorixá* (high priestess) of Gantois until her death from a heart attack in October 1998. As a mãe-de-santo (mother-of-saint) or ialorixá, she initiated others, interpreted divinations, performed rituals to secure the good will of the orixás, and while in trances became the vehicle for divine communication. Worshipers' offerings supported her and the terreiro. On the surface, Candomblé was syncretic: most worshipers were at least nominally Catholic, they often equated individual orixás with Catholic saints, and the Catholic hierarchy and police sometimes raided the terreiros and persecuted those practicing Candomblé. By the time Mãe Cleusa took over the Gantois terreiro, however, Candomblé showed more and more openly its African roots. Brazil had begun to recognize it as an authentic cultural manifestation of African heritage.

SOURCES:

Butler, Kim. "Menininha do Gantois, Mãe," in *Encyclopedia of Latin American History and Culture.* Vol. III. Ed. by Barbara A. Tenenbaum. 5 vols. NY: Scribner, 1996, p. 584.

Landes, Ruth. *The City of Women.* Albuquerque: University of New Mexico Press, 1994.

Silva, Vagner Gonçalves da. *Candomblé e Umbanda: caminhos da devoção brasileira.* São Paulo: Editora Ática, 1994.

Kendall W. Brown,
Professor of History, Brigham Young University, Provo, Utah

Millett, Kate (1934—)

American writer, feminist, political activist and sculptor whose 1970 book Sexual Politics *has become a feminist classic. Born Katherine Murray Millett on September 14, 1934, in St. Paul, Minnesota; daughter of James Albert Millett (an engineer) and Helen (Feely) Millett (a teacher and seller of insurance); University of Minnesota, B.A. (magna cum laude), 1956; St. Hilda's College, Oxford, M.A. (first class honors), 1958; Columbia University, Ph.D. (with distinction), 1970; married Fumio Yoshimura (a sculptor), in 1965 (divorced); no children.*

Became actively involved in the civil-rights movement (1960s) and was one of the early committee members of the National Organization for Women (NOW, 1966); published Sexual Politics *(1970), which was hailed as a manifesto on the inequity of gender distinctions in Western culture; made a documentary film about women,* Three Lives *(1971); published first autobiographical work,* Flying *(1974); was*

involved in feminist politics, particularly in demonstrations for Equal Rights Amendment (1970s); remains active in feminist and civil-rights issues and continues to work as a sculptor.

Selected writings: (nonfiction) Token Learning *(1967),* Sexual Politics *(1970),* The Prostitution Papers *(1971),* The Basement: Meditations on Human Sacrifice *(1979, rev. ed. 1991),* Going to Iran *(1981),* The Politics of Cruelty: An Essay on the Literature of Political Imprisonment *(1994),* Writing Selves: Contemporary Feminist Autobiography *(1995); (autobiographical works)* Flying *(1974),* Sita *(1977, rev. ed. 1992),* The Loony-Bin Trip *(1990),* A.D.: A Memoir *(1995).*

Kate Millett's name has been synonymous with the women's liberation movement since the publication of her doctoral dissertation, *Sexual Politics*, in 1970. Exploring through a dissection of literature and political philosophy the premise that male/female relationships are power-structured, and that this must change before women can obtain equality, the book has since been ranked with *Simone de Beauvoir's The Second Sex and *Betty Friedan's The Feminine Mystique in its importance in the canon of feminist writing, and Millett's candid views on overall social—not just sexual—change have proved enduringly controversial.

Born Katherine Murray Millett in St. Paul, Minnesota, in 1934, Millett was 14 when her father abandoned the family. Her mother, who had a college degree, had great difficulty finding a job in the postwar era that favored employing men, who were presumed to be the breadwinners of their households, over women, forcing her to work selling insurance. (**Helen Feely Millett** received only her commissions; her male co-workers received both commissions and a salary.) Despite the family's difficult financial circumstances, Millett graduated from the University of Minnesota in 1956, and then went to Oxford University for two years of graduate study, earning her master's degree in 1958. In 1959, she moved to a loft in the Bowery in New York City to pursue painting and sculpting, supporting herself by teaching kindergarten in Harlem. From 1961 to 1963, she lived in Japan, teaching English at Waseda University and continuing her study of sculpting. In Japan, Millett met sculptor Fumio Yoshimura, whom she married in the United States in 1965 (they were later divorced). She would remain active as a sculptor throughout her writing career, occasionally exhibiting in one-woman shows in New York up through the 1990s.

Upon her return to the United States, Millett became involved with the burgeoning civil-rights movement and joined the Congress of Racial Equality (CORE) while teaching at Barnard College. In 1965, as chair of the education committee of the newly formed National Organization for Women (NOW), she gave impassioned speeches on women's liberation, abortion reform, and other progressive causes. Barnard was not impressed with her political activities, and in 1968 relieved her of her duties. When she returned to teaching the following year, she was working on her doctoral thesis, which in 1970 won her a doctoral degree with distinction from Columbia University and was published later that year as *Sexual Politics*.

Selling 80,000 copies in its first year of publication, *Sexual Politics* became a bestseller as well as a landmark in the women's liberation movement, and catapulted Millett into celebrity. The national media cast her as a spokeswoman for women's liberation (she was on the cover of *Time*'s August 1970 issue), causing some in the movement to brand her elitist and arrogant for presuming to speak for them. Later that autumn, she was challenged to publicly confirm her lesbianism, which she did to a crowded auditorium at Columbia University. As the movement was already showing signs of the coming power struggle between various factions, one of which was the so-called "radical lesbians" that critics loved to use as a punching bag and a bogeyman for the entire movement, Millett's affirmation of her sexuality caused a public uproar replete with newspapers' and magazines' predictions of what damage it would do to her cause. She found it extremely difficult to deal with her abrupt transition from "obscure teacher" to public figure, and her struggles during this time were chronicled in her 1974 autobiographical book, *Flying*. Later autobiographical works include *Sita* (1977), an intimate analysis of the breakup of a three-year relationship with a lover, and *A.D.: A Memoir* (1995).

During the 1970s, Millett was actively involved in feminist politics, particularly in demonstrations for the Equal Rights Amendment, and also focused her energies on numerous social ills. In 1979, she visited Iran to examine women's rights in the newly instituted Islamic republic, but was expelled by Ayatollah Khomeini's government, experiences recounted in *Going to Iran* (1981). The year 1979 also saw the publication of *The Basement: Meditations on a Case of Human Sacrifice* (republished in a revised edition in 1991), considered by some critics to be her strongest work since *Sexual Politics*. A chilling examination of the brutal 1965 torture-death of

an Indianapolis teenager, **Sylvia Likens**, which had haunted Millett for years, *The Basement* detailed the psychological effects of torture on the perpetrators, victim, and witnesses. (A wider consideration of this theme would follow in her 1994 work, *The Politics of Cruelty: An Essay on the Literature of Political Imprisonment*.)

Millett's attempts to retain control over her life during the 1970s gradually took a toll. Her productivity as a writer and artist suffered, and her struggle to deal with manic depression became critical. In 1980, after removing herself from lithium, a drug with multiple debilitating side-effects which she had used to control her illness, her behavior became erratic and her family had her institutionalized. Between 1982 and 1985, Millett chronicled her experiences with the mental health industry in a series of journals, which five years later were published as *The Loony-Bin Trip*. With the help of friends, she obtained her release and returned to her farm in New York, where she slowly and successfully withdrew from lithium in 1989.

Still active in civil-rights issues and as an artist and writer, Kate Millett divides her time between her loft in New York City and her Christmas tree farm in Poughkeepsie, New York, which in summertime serves as a retreat for women artists.

SOURCES:

Buck, Claire, ed. *The Bloomsbury Guide to Women's Literature.* NY: Prentice Hall, 1992.

Contemporary Authors New Revision Series. Vol. 53. Detroit, MI: Gale Research.

Current Biography. NY: H.W. Wilson, 1995.

Uglow, Jennifer S., ed. and comp. *The International Dictionary of Women's Biography.* NY: Continuum, 1989.

SUGGESTED READING:

Art in America. December 1995, p. 92.

Life. September 4, 1970.

Los Angeles Times Book Review. September 16, 1979; July 7, 1991, p. 10.

Mademoiselle. February 1971.

Ms. February 1981; May 1988; September–October 1995, p. 78.

Nation. April 17, 1982.

New Republic, August 1, 1970; July 6–13, 1974; July 7–14, 1979; May 16, 1994, pp. 33–38.

New Statesman & Society. August 5, 1994, p. 38.

Newsweek. July 27, 1970; July 15, 1974.

The New Yorker. August 9, 1974.

The New York Times. July 20, 1970; August 5, 1970; August 6, 1970; August 27, 1970; September 6, 1970; December 18, 1970; November 5, 1971; May 13, 1977.

The New York Times Book Review. September 6, 1970; June 23, 1974; May 29, 1977; September 9, 1979; May 16, 1982; June 3, 1990, p. 12; June 16, 1991, p. 28; August 13, 1995, p. 17.

Observer. November 20, 1994, p. 719; August 13, 1995, p. 17.

People. April 2, 1979.

Saturday Review. August 29, 1970; June 15, 1974; May 28, 1977.

Seattle Post-Intelligencer. March 4, 1973.

Time. August 31, 1970; December 14, 1970; July 26, 1971; July 1, 1974; May 9, 1977.

Times Literary Supplement. April 9, 1971; October 7, 1977; November 8, 1991, p. 10; September 2, 1994, p. 32.

Tribune Books (Chicago). June 3, 1990, p. 5.

Washington Post Book World. January 8, 1978; May 13, 1990, p. 7.

Women's Review of Books. October 1990, pp. 7–8; June 1994, pp. 1, 3–4.

Jo Anne Meginnes,
freelance writer, Brookfield, Vermont

Millie.

Variant of Emily.

Milligan, Alice (1866–1953)

Irish writer, one of the first dramatists of the Celtic Twilight, who became an influential propagandist for the Irish nationalist movement in the early 20th century. Name variations: I.O.; Iris Olkyrn. Born Alice Letitia Milligan on September 14, 1866, in Omagh, County Tyrone, Ireland; died in Tyrcur, Omagh, on April 13, 1953; daughter of Seaton Forest Milligan (a businessman) and Charlotte (Burns) Milligan; sister of Charlotte Milligan Fox (1864–1916); educated at Methodist College, Belfast, and King's College, London.

Awards: Honorary D.Litt, National University of Ireland (1941).

Co-founded, with Anna Johnston (Ethna Carbery), journals Northern Patriot *and* Shan Van Vocht; *was a prolific contributor to various Irish journals; was an organizer for the Gaelic League; was a founder member of Ulster Anti-Partition Council.*

Selected publications: (with Seaton F. Milligan) Glimpses of Erin *(London: Ward, 1888); (play)* The Last Feast of the Fianna *(Dublin: Nutt, 1900);* Hero Lays *(Dublin: Maunsel, 1908); (with W.H. Milligan)* Sons of the Sea Kings *(Dublin: Gill, 1914); (play)* The Daughter of Donagh *(Dublin: Martin Lester, 1920); (with W.H. Milligan)* The Dynamite Drummer *(Dublin: Martin Lester, n.d.); (with Ethna Carbery and Seumas MacManus)* We Sang for Ireland *(Dublin: Gill, 1950); (selected, edited and with an introduction by Henry Mangan)* Poems *(Dublin: Gill, 1954); (ed. by Sheila Turner Johnston)* The Harper of the Only God: A Selection of Poetry by Alice Milligan *(Omagh: Colourpoint Press, 1993).*

Alice Milligan was born in 1866, the third of thirteen children of **Charlotte Burns Milligan** and Seaton Milligan, a prosperous Ulster busi-

nessman. Alice had a comfortable, happy childhood in Omagh from where her father commuted to work in Belfast. Her poem "When I was a Little Girl" describes her Omagh childhood and her consciousness of seeing things differently from others. Seaton Milligan had a considerable influence on his daughter. His business took him around the countryside, and he acquired an impressive knowledge of local history, archaeology, and antiquities which he passed on to Alice and to some of his other children. His eldest daughter ◄ Charlotte Milligan Fox became a well-known collector of folk songs and founded the Irish Folk Song Society. In 1911, Charlotte published *Annals of the Irish Harpers,* which was a standard reference book for many years. Seaton was elected a member of the Royal Irish Academy in 1887 and a fellow in 1888. He contributed articles to the journal of the Royal Society of Antiquaries of Ireland and organized archaeological expeditions. He was also interested in working-class education, and organized talks and lectures for the local workingmen's institute. His children were free to use his extensive library, and Alice later wrote that her father made sure that they knew history and also discussed international affairs and literature with them. Another influence was the formidable family servant Jane who joined the household the year Alice was born. Jane had been a servant in the house of *Mary Ann McCracken, sister of Henry Joy McCracken, one of the leaders of the 1798 rebellion in Ulster. Mary Ann had offered to stay with her brother until his execution. Alice absorbed all this knowledge, and she and her father collaborated on a short tourist guide, *Glimpses of Erin,* published in 1888. In the book Seaton wrote that "patriotism . . . far from being an irrational sentiment is entirely rational and desirable from a utilitarian point of view. It is as much so from a Christian standpoint. By

✤► Fox, Charlotte Milligan (1864–1916)

*Irish singer and collector of folksongs. Born Charlotte Milligan on March 17, 1864, in Omagh, County Tyrone, Ireland; died in London, England, on March 25, 1916; daughter of Seaton Forest Milligan (a businessman) and Charlotte (Burns) Milligan; sister of *Alice Milligan (1866–1953); married.*

In 1904, Charlotte Milligan Fox founded the Irish Folk Song Society. A musician in her own right, she toured Ireland, collecting folk songs and airs and recording them on gramophone. In 1911, Fox published *Annals of the Irish Harpers* from the papers of musician and antiquarian Edward Bunting, a work which remained a standard reference book for many years.

living in our own land and doing our best to benefit it, we can best carry out the command 'Do unto others as you would that they should do to you.'" It was a view that Alice shared wholeheartedly.

When Alice was 12, the family moved to Belfast when her father was made a director of his firm. Seaton was determined that his daughters would have a good education, and in 1879 she went to Methodist College where she excelled academically, winning prizes in music, mathematics, English, Scripture, and science. Milligan later expressed regret that so little Irish history and culture was taught at the school, but made up for this lack on her own. She started to learn Irish although this was not completely unfamiliar to her: her great-uncle, Armour Alcorn, spoke it to the young men who worked on his farm. Her first poems were published in the school magazine *Eos*. After leaving Methodist College in 1886, Alice, unlike her sisters, did not go to Germany to finish her education but went instead to the Ladies' Department of King's College, London, where she studied English history and literature. But she did not graduate and returned to Ireland in 1887. Later that year, she obtained a temporary teaching post at the Ladies Collegiate School in Derry where she met **Marjorie Arthur**, the music teacher there, who became one of her few close friends.

In 1888, after again rejecting her parents' offer to send her to Germany, Milligan went to Dublin for three years to learn Irish language and literature. She studied at the Royal Irish Academy and at the National Library. Culturally and politically, it was a stimulating time to be in the Irish capital. There were the first stirrings of the Irish cultural renaissance, and Charles Stewart Parnell, leader of the Irish party at Westminster, was at the height of his political powers. But in 1890, Parnell's career was irreparably damaged after the scandal when he was cited in the William and *Kitty O'Shea divorce case. In June 1891, Milligan attended a political meeting in Dublin at which Parnell was present and was struck by his sad expression: "he looked beaten and ashamed." She was bitter against the Catholic Church for rejecting Parnell and expressed these feelings in two later poems, "Bonnie Charlie" and "At Maynooth."

Milligan returned to Belfast shortly after this and for the next three years remained at home with her family. Politically, she was increasingly at odds with the society around her, as the polarization of opinion over self-government for Ireland became entrenched. The vast majority of the

prosperous, Protestant, Ulster middle class that Milligan came from was vehemently opposed to any form of self-government for Ireland, believing that their prosperity was bound up with the rest of Britain. Within her own family, Alice's nationalist sympathies provoked disagreements, though her parents were always tolerant of her views. Her biographer **Sheila Turner Johnston** speculates that potential suitors from her own background were also put off by her nationalism yet Milligan herself regarded mixed marriages of Protestants to Catholics with disapproval, as evident in her poem "The Heretic." Later, she was to take issue with those who regarded Protestantism and nationalism as incompatible.

In February 1892, Marjorie Arthur died suddenly, an event Milligan commemorated in some of her finest poems, "Nocturne," "March Violets," "Lyrics in Memory of a Sea Lover," "The White Wave Following" and "If This Could Be." Later that year, her favorite brother Seaton left for Ceylon and for some time after this Alice suffered from depression. The next year was to be a watershed for Milligan. She decided to write professionally and completed a novel, *The Royal Democrat.* She also started another novel, *The Daughter of Donagh,* which eventually became a play. In May 1893, *United Irishman* published her poem "Lugh Lamh-Fada," which received warm praise from other nationalist writers. In the same year, her family moved to the Cave Hill area of Belfast where many writers and politicians lived, among them Robert Johnston and his daughter *Anna Johnston MacManus (whose pen name was Ethna Carbery), and F.J. Biggar, a former member of Parliament whose house, Ardrigh, was a prominent political and cultural center. It was in 1893 that Alice met W.B. Yeats and AE (G.W. Russell) for the first time, and Yeats visited her when lecturing in Belfast in November 1893. Although their views on literature and politics diverged considerably and Yeats was lukewarm about her poetry, advising her to stick to drama, they would remain friends until his death in January 1939.

In 1895, Milligan became actively involved in a number of organizations in Belfast: she was president of the Belfast branch of the Irish Women's Association, and also became an organizer for the Gaelic League which had been founded in Dublin in 1893. But the most important new group was the Henry Joy McCracken Literary Society, set up in February 1895, which was such a success that its committee decided to publish a paper, the *Northern Patriot,* and appointed Milligan and Anna Johnston as editors. The first issue appeared in October 1895, in

Alice Milligan

which the editors declared in the editorial that they wished to enlist nationalists from around the country "to deliver sound and instructive addresses to our members. By this means the North [Ulster] will be put in touch with the other provinces, and a bond of love and union will cement all in pushing forward the good old cause that has braved unceasing persecution for seven centuries." But this overtly political tone was unwelcome to the committee of the McCracken Society, and after three issues it dispensed with the services of Milligan and Johnston. They promptly set up a new journal of their own, *Shan Van Vocht.* The rival journals appeared side by side for almost two years until the *Northern Patriot* ceased publication in November 1897.

Shan Van Vocht (in Irish "poor old woman," a metaphor for Ireland) was one of the most influential of the various literary and political journals which emerged in Ireland at the turn of the century. It gave a platform to the women's movement and to James Connolly, the socialist republican leader, who complained to Alice that too many of the new societies and committees which had sprung up were obsessed with the past. Milligan and Johnston also helped to organize home reading circles which were coordinated through

Shan Van Vocht. The Donegal writer Seumas MacManus wrote that they both had "revived Irish nationalism when it was perishing." In 1898, Alice was the Ulster organizing secretary of the 1798 rebellion centenary, and under the auspices of *Shan Van Vocht* published a biography of one of the rebellion's leaders Wolfe Tone. She and Johnston also wrote many little plays, some in Irish, which they toured around the north of Ireland. However, in 1899, with the launching of a new journal, *United Irishman*, by their friends Arthur Griffith and William Rooney, Alice and Anna decided to give up *Shan Van Vocht*.

Irish literature cannot be developed in any hedged-in peaceful place, whilst a conflict is raging around. It must be in the thick of the fight.

—Alice Milligan

In February 1900, the Irish Literary Theatre, one of the forerunners of the Abbey Theatre, staged Milligan's play *The Last Feast of the Fianna*, the first of a trilogy which subsequently included *Oisín Tír na nÓg* and *Oisín and Pádraig* (both 1909). Yeats praised *The Last Feast of the Fianna* but the following year he and Lady *Augusta Gregory rejected Milligan's *The Daughter of Donagh*. Despite this rejection, her plays and tableaux were performed all over Ireland at festivals. In 1901, Anna Johnston married Seumas MacManus but died tragically the following year, and in 1903 Alice's sister **Evelyn** died. These deaths distressed her greatly, but she continued to write and to teach and lecture for the Gaelic League, an experience she commemorated in her poem "The Man on the Wheel." In 1908, she published her most successful book of poetry, *Hero Lays*, which was edited by AE. He thought she wrote the best patriotic poetry but also insisted, despite her opposition, that the volume include the autobiographical "When I Was a Little Girl." It proved one of the most popular poems in the book. In 1910, she helped her sister Charlotte with her research for the Folk Song Society, and together they paid a nostalgic visit to Omagh to take down some local songs. In 1914, her brother William returned to Ireland from Chicago, and they collaborated on a novel, *Songs of the Sea Kings*. In an article for the 1914 July–August issue of the *Irish Review*, the academic and writer Thomas McDonagh wrote that Alice Milligan was "the most Irish of living poets, and therefore the best." He compared her to Thomas Davis, the leader of the Young Ireland movement of the 1840s, who was, like Milligan, primarily a propagandist, though McDonagh considered that she had a better command of word and phrase than Davis.

Sheila Turner Johnston has noted the ambivalence between Alice Milligan's stirring patriotic prose and her abhorrence of violence. She celebrated Irish heroes and patriots; "she idealized organization, strategy, discipline and self-denying obedience to orders. Her romantic visions were of marching soldiers and green flags flying." But as far back as the October 1896 issue of *Shan Van Vocht*, she had condemned the use of dynamite methods:

> Those who would stoop to suggest, or organize, or carry out anything of the sort, degrade the name of their country, and in the eyes of the whole world render her less worthy of Nationhood. Ireland's cause is high and holy: When Irishmen cease to regard it as so, the faith which has sustained the strife of ages will perish and she will sink into hopeless bondage. . . . Stern and terrible deeds are often done and may justly be done in such a strife as ours; but this method of bomb throwing and blowing up buildings, without aim or reason other than the mere desire for vengeance is imbecile and wrong.

Milligan had to cope alone with her parents' increasing ill-health and the strains of the First World War. The year 1916 was to prove a shattering one. Her mother died in January 1916, her sister Charlotte died two months later in March, and within weeks of this came her father's death on April 6. These personal tragedies were followed by a political one three weeks later, when the Easter Rebellion took place in Dublin. The aftermath of the rebellion with its executions and arrests affected Milligan deeply. Thomas McDonagh, her admiring reviewer of 1914, was one of those executed, as was James Connolly who had written for *Shan Van Vocht*. ✦▶ **Sinéad Flanagan**, who had acted in some of her plays and with whom she remained on friendly terms, was married to Eamon de Valera, who was sentenced to penal servitude for life. But most harrowing of all for Milligan was the fate of her friend Roger Casement, whom she had first met in 1904 at F.J. Biggar's house Ardrigh. Casement was arrested shortly before the rebellion after arriving secretly back in Ireland from an abortive attempt to secure German support for the rebels. He was put on trial for treason in London, and Alice attended the trial with another close friend of Casement, the historian *Alice Stopford Green. The result was a foregone conclusion, and Milligan was outside Pentonville Prison on August 3, 1916, when Casement was executed. She wrote about these experiences in two poems, "The Ash Tree of Uis-

neach" (dedicated to Alice Stopford Green) and "In The Wirral" (dedicated to another friend, **Ita McNeill**, who had also been in London for the trial). Milligan published other poems in the period of 1917–19, most of which appeared in P.J. Little's journal *Young Ireland*.

After this, Milligan's life became increasingly dominated by family and financial problems. In her early 50s, she had no steady income. She went to live in England in 1919 but briefly returned to Ireland with her brother William in 1920, at the height of the Irish war of independence. In a cruelly ironic twist for Alice, William, who had served in the British army, was given 24 hours to leave Dublin or be shot by the Irish Republican Army. William and Alice then went to Belfast. Alice was distressed by the political divisions which followed the signing of the Anglo-Irish Treaty in December 1921, and was horrified by the civil war which broke out in June 1922. Worst of all for her, Ireland was now partitioned into two states, the 26 counties of the Irish Free State and the 6 counties of Northern Ireland which included her beloved Tyrone. She and William spent ten years in England before finally returning in the 1930s to Northern Ireland where William secured a minor job with the Northern Ireland civil service. William, his wife and son, and Alice lived in a village near Omagh. Her nephew, of whom she was very fond, died in 1934 aged only 26. William died three years later. Milligan published a few poems in de Valera's *Irish Press* whose editor, M.J. MacManus, was an old friend. In 1938, she was the only woman signatory of a pamphlet issued by the Northern Council for Unity protesting the partition of Ireland. During the Second World War, after the death of her sister-in-law, Alice went to live in Antrim. She visited Dublin in 1941 to receive an honorary doctorate from the National University of Ireland, the chancellor of which was Eamon de Valera. In 1943, the Tyrone Feis (festival) held in Omagh presented her with a testimonial from friends all over Ireland. Her reminiscences were recorded by both the BBC and by Radio Eireann.

Alice Milligan's poems and plays were scattered throughout the nationalist press, and she never made any effort to collect them herself, a task she left to others such as F.J. Biggar; they had served their purpose, and that was enough as far as she was concerned. But in 1950, to her great pleasure, the Dublin publishers M.H. Gill released *We Sang for Ireland*, a selection of poetry by Alice Milligan, Ethna Carbery, and Seumas MacManus. It was a happy reminder of *Shan Van Vocht*. In 1951, Milligan moved back to

❧➤ **Flanagan, Sinéad** (b. around 1878)

*Irish actress and wife of the first president of Ireland. Name variations: Sinead Flanagan; Sinéad de Valera. Born Sinéad Flanagan around 1878; attended Irish College, 1909; married Eamon de Valera (1882–1975, first president of Ireland), in January 1910; children: two daughters, **Emer de Valera** and **Máirín de Valera** (b. April 1912, a professor of Botany at Galway University); and five sons, Éamonn, Ruairí, Terry, Vivion, and Brian.*

Sinéad Flanagan, a popular and politically active member of the Gaelic League, was one of Eamon de Valera's teachers. He soon fell in love with the vibrant, dedicated woman, who was four years his senior, and they were married on January 8, 1910. Insisting that the ceremony be performed in Gaelic, they had to teach the priest the proper words. In 1932, soon after Eamon became head of the Irish government, Sinéad began to write for children in Irish and English. Although the wife of a very public figure, she was unassuming and avoided the limelight.

Tyrcur near Omagh, where she died on April 13, 1953. The inscription on her gravestone reads: "She loved no other place but Ireland." After the start of the troubles in Northern Ireland, attempts were made to chisel away the inscription and on one occasion explosives were used to try to destroy the memorial.

SOURCES:

Johnston, Sheila Turner. *Alice: A Life of Alice Milligan.* Omagh, Northern Ireland: Colourpoint Press, 1994.

O'Hehir, Kathryn. *Alice Milligan: The Celtic Twilight's Forgotten Star.* University of North Dakota, Ph.D. thesis, 1991.

SUGGESTED READING:

Boyd, Ernest. *Ireland's Literary Renaissance.* Dublin: 1916 (rev. ed. 1922, rep. Dublin: Allen Figgis, 1968).

Davis, Richard. *Arthur Griffith and Non-Violent Sinn Fein.* Dublin: Anvil Press, 1974.

Yeats, W.B. *Memoirs.* Edited by Denis Donoghue. London: Macmillan, 1972.

Deirdre McMahon,
lecturer in history at Mary Immaculate College,
University of Limerick, Limerick, Ireland

Milligan, Charlotte (1864–1916).

See Milligan, Alice for sidebar on Charlotte Milligan Fox.

Millin, Sarah (1888–1968)

Jewish South African writer. Born Sarah Gertrude Liebson on March 3, 1888, in Zagar, Lithuania; died on July 6, 1968; daughter of Isaiah Liebson (a busi-

nessman) and Olga (Friedmann) Liebson; completed high school, 1904; earned music teacher's certificate, 1906; married Philip Millin, on December 1, 1912 (died 1952).

Awards: honorary doctorate, University of Witwatersrand, Johannesburg (March 1952).

Family emigrated to South Africa (August 1888); began publishing in magazines (after 1906); began her first novel (1916); began correspondence with Katherine Mansfield (1920); published bestseller God's Stepchildren *(1924); founded the South Africa PEN writer's club on the recommendation of John Galsworthy (1928); began biography of Jan Smuts (1932); played host to Chaim and *Vera Weizmann (1933); became Jan Smuts' confidante during WWII; campaigned for Ian Smith's government in Zimbabwe (1965).*

Selected writings: Adams Rest *(London: Collins, 1922);* An Artist in the Family *(London: Constable, 1928);* The Burning Man *(London: Heinemann, 1952);* Cecil Rhodes *(NY: Harper, 1933);* The Coming of the Lord *(NY: Liveright, 1928);* The Dark Gods *(NY: Harper, 1941);* The Dark River *(London: Collins, 1919);* The Fiddler *(London: Constable, 1929);* General Smuts *(London: Faber and Faber, 1936);* God's Stepchildren *(London: Constable, 1924);* Goodbye, Dear England *(London: Heinemann, 1965);* The Jordans *(London: Collins, 1923);* King of the Bastards *(NY: Harper, 1949);* Mary Glenn *(London: Constable, 1925);* The Measure of My Days *(NY: Abelard-Schuman, 1955);* Men on a Voyage *(London: Constable, 1930);* Middle-Class *(London: Collins, 1921);* The Night is Long *(London: Faber and Faber, 1941);* The People of South Africa *(London: Constable, 1951);* The Sons of Mrs. Aab *(London: Chatto & Windus, 1931);* South Africa *(London: Collins, 1941);* The South Africans *(London: Constable, 1926);* Three Men Die *(NY: Harper, 1934);* Two Bucks Without Hair *(Central News Agency: Johannesburg, 1957);* War Diary *(Vol. 1:* World Blackout, *1944, Vol. 2:* The Reeling Earth, *1945, Vol. 3:* The Pit of the Abyss, *1946, Vol. 4:* The Sound of the Trumpet, *1947, Vol. 5:* Fire out of Heaven, *1947, Vol. 6:* The Seven Thunders, *1948, London: Faber and Faber 1944–1948);* What Hath a Man? *(Chatto & Windus: London, 1938); (contributing editor)* White Africans Are Also People *(Cape Town: Timmins, 1966);* The Wizard Bird *(Central News Agency: Johannesburg, 1962).*

From the beginning, Sarah Gertrude Millin was eager for influence and to her credit, at the height of her career, she had achieved that and considerable fame as well. Beginning with novels, her writing developed into social history even as she became increasingly interested in politics. The success of her books gained Millin entrée to high society in England and America. In addition, her friendships with the prominent South African settlers Jan Smuts and J.H. Hofmeyr gave her an inside view into the critical historical moments of her day.

Sarah Millin was born Sarah Gertrude Liebson, the daughter of Isaiah Liebson, a businessman, and **Olga Friedmann Liebson**, in Zagar, Lithuania, on March 3, 1888; the Millins moved to South Africa that same August. Sarah decided that she would be a writer when she was six years old. When she was eight, her parents sent her away to school, determined that their children would receive a better education than that available at the mining settlement of Waldeck's Plant where they lived. After finishing high school, Millin refused to go to college, despite having graduated with first-class honors. Instead, she returned home to her parents and began writing short stories and essays. Soon her work was appearing in local magazines and newspapers. Over the next 50 years, she went on to publish more than 30 books and countless essays and columns.

Her attitudes reflected the views of the settler population of South Africa. She disliked Africans and was obsessed with race and blood purity; these themes appeared again and again in her novels. Although she was never able to admit to the connection between anti-Semitism and her own racism, others were, and her bestseller *God's Stepchildren* was used by the Nazis as part of their pro-Aryan propaganda. Horrified, Millin, who was herself Jewish and a supporter of Zionism, used her influence to lobby against both appeasement of Hitler by England and growing anti-Semitism in South Africa.

Just before the beginning of World War II, Smuts was appointed prime minister. By then, Millin had developed a close relationship with him while writing his biography, and Smuts now invited her to record the war as his confidante. Despite her success as a novelist, Millin felt that fiction was ill-suited to the gravity of the times. She welcomed this chance to continue her political writing.

Millin had married a lawyer, Philip Millin, when she was 24; her glamorous career as a writer was matched by his accomplishments on the South African bench. They were devoted to each other, and his restrained nature helped temper her extreme tendencies. In 1952, overcome by poor health and overwork, Philip Millin died of a heart attack. A devastated Sarah went into prolonged mourning. When she returned to soci-

ety three years later, she found her standing greatly diminished. Smuts and Hofmeyr had died in the years after the war, taking with them her access to political intrigues. On the streets, opposition to apartheid was growing and the independence movements throughout the continent made it clear that the days of white supremacy were coming to an end. In settler mythology, however, the circling of the wagons to protect the community from perceived danger has a strong hold on the imagination. Millin's anti-African sentiments only became more extreme.

As before, she was unable to keep her prejudice out of her writing. The literary community was appalled and distanced itself from her. Without the moderating influence of her husband, she became increasingly eccentric and antisocial. She spent the last few years of her life campaigning for the settler government of pre-independence Zimbabwe. At the beginning of July 1968, she fell sick and was hospitalized. On July 6, she suffered a thrombosis and died, alone. Wrote *Nadine Gordimer: "Her egotism cast a kind of spell of isolation around her, in that house, in the end I suppose. And yet she had such a big mind—one of the few real intellects in this country."

SOURCES:

Rubin, Martin. *Sarah Gertrude Millin: A South African Life*. London: AD Donker, 1977.

Whyte, Morag. *Bibliography of the Works of Sarah Gertrude Millin*. Cape Town: School of Librarianship, University of Cape Town, 1952.

SUGGESTED READING:

Davis, Jane. *South Africa: A Botched Civilization?: Racial Conflict and Identity in Selected South African Novels*. Lanham: University Press of America, 1997.

COLLECTIONS:

Sarah Gertrude Millin Collection, University of Witwatersrand, Johannesburg, South Africa.

Muhonjia Khaminwa,
freelance writer, Cambridge, Massachusetts

Millington, Jean and June

American musicians who formed the group Fanny, the first all-female rock 'n' roll band to sign a contract with a major record label.

Millington, Jean (1949—).

Born Jean Yolanda Millington in the Philippines in 1949.

Millington, June (1950—).

Born June Elizabeth Millington in the Philippines in 1950.

Jean and June Millington were born in the Philippines but moved to California with their family in 1961, where they soon became involved in surf music and rock 'n' roll. After mastering the ukelele, the sisters graduated to guitar, and were quickly copying solos by the great guitarists of the time, including Jerry Garcia, Jimi Hendrix, and Eric Clapton. When their boyfriends formed a surf music band in the mid-1960s, the sisters formed an all-girl band so they could perform between their boyfriends' sets. Before long the Millingtons' group had surpassed that of their now exboyfriends, and, under the name the Svelts, they played at YMCAs, school dances, and other minor gigs.

By June's senior year of high school, the Svelts' manager had absconded to Hawaii with their earnings, and many in the group were planning leave the band to attend college. In 1968, during what was thought to be the band's last summer, the Svelts made several trips to Los Angeles to perform, and were "discovered" by Richard Perry, a producer at Warner Bros. who had also signed the pop singer Tiny Tim. Perry signed the Svelts to a recording contract, marking the first time that an all-female rock 'n' roll band was signed by a major label. The band changed their name to Fanny, and with **Alice DeBuhr** on drums, **Nicole (Nickey) Barclay** on keyboards, Jean Millington on bass, and June Millington on lead guitar (she had switched from rhythm guitar after their lead guitarist **Addie Clement** quit), the band released their first, self-titled album in 1970. *Fanny* was followed by *Charity Ball* (with an eponymous single that made it to #40 on the charts) in 1970, *Fanny Hill* in 1972, and *Mothers Pride* in 1973.

That same year, June Millington quit the band to make demo records and play background music for various bands. Fanny recorded one more album, *Rock and Roll Survivors*, before breaking up in 1975. Jean and June Millington have continued to perform together and recorded an album, *Ladies on the Stage*, which June co-produced. June Millington has been involved in the women's music movement since the late 1970s, and has produced albums by performers including **Cris Williamson, Holly Near**, and **Mary Watkins**.

SOURCES:

Garr, Gillian G. *She's A Rebel: The History of Women in Rock & Roll*. Seal Press, 1992.

Grant Eldridge,
freelance writer, Pontiac, Michigan

Million Dollar Mermaid (1886–1975).

See Kellerman, Annette.

Mills, Eleanor (1888–1922)

American murder victim whose sensational case remains unsolved. *Murdered on September 16, 1922; married to the church sexton.*

In September 1922, the bodies of Eleanor Mills, an Episcopal choir singer, and her pastor, Reverend Edward Wheeler Hall, were discovered in De Russey's Lane, reputedly a "lover's lane," located in New Brunswick, New Jersey. The slayings had two key ingredients needed to attract the attention of the world press; scandal (both victims were connected with a church and married, but not to each other) and sensation (the slayings were particularly brutal). Hall had been shot in the head; Mills had been shot three times in the forehead, and her throat was slashed, her tongue cut out. Their love letters had been tossed around their bodies for a final touch. At the time, there were no suspects, but four years later the New York *Daily Mirror* began to run a series of articles claiming evidence that **Frances Hall**, wife of the reverend, had killed the couple with the help of two brothers and a male cousin.

The trial in Somerville, New Jersey, was the big event of 1926, attended by 300 reporters. **Jane Gibson**, whom the press quickly dubbed the "Pig Woman" because she raised pigs on a farm near the lane, testified from a hospital bed rolled into the courtroom that she had seen the killings and could identify Frances Hall and her relatives. But Gibson's testimony was inconsistent with her deposition before a grand jury four years previous, and Frances Hall's lawyers pounced. Nor did it help Gibson's credibility when her mother sat in the front row muttering, "She's a liar, a liar, a liar. That's what she is and what she's always been." Then Frances Hall testified, cool and composed, and the press named her the "Iron Widow." When all four defendants were found not guilty, Frances Hall promptly sued the *Daily Mirror*. The case remains unsolved.

Mills, Florence (1895–1927).

See Women of the Harlem Renaissance.

Milner, Brenda Atkinson (1918—)

English-born Canadian psychologist who pioneered in the discipline of neuropsychology. *Born Brenda Atkinson Langford in Manchester, England, in 1918; Cambridge University, M.A., 1949; attended the Montreal Neurological Institute; McGill University, Ph.D., 1952.*

Educated at Cambridge University in England, psychologist Brenda Milner emigrated to Canada in 1944, to join the Institute de Psychologie at the Université de Montreal. She received her Ph.D. from McGill University in 1952, completing a study of the intellectual effects of temporal lobe damage in humans. She then went on to serve concurrently at the Montreal Neurological Institute and as a professor at McGill University, where she became one of the pioneers in neuropsychology. Milner is best known for her investigations into brain function, particularly how the brain structure creates new memory. Much of her research has involved patients with profound amnesia following brain excisions for the treatment of epilepsy. Her work has not only added substantively to the scientific understanding of how the various areas of the brain function in relationship to learning, memory, and speech, but has aided in the diagnosis and treatment of temporal-lobe epilepsy.

Over the years, Milner's work has attracted graduate students from around the world who have gone on to establish clinical departments of neuropsychology in medical institutions throughout Canada. She still lectures in brain research and is an active member of many neurological and psychological organizations. Milner has received numerous honors for her pioneering work, including the Wilder Penfield Prize for Biomedical Research from the Province of Quebec in 1993, and fellowships in the Royal Society of Canada and the Royal Society of London. She was named an Officer of the Order of Canada in 1984, and an Officier de L'Ordre national du Québec in 1995.

Barbara Morgan,
Melrose, Massachusetts

Milo, Adriana (fl. 1469–1502).

See Lucrezia Borgia for sidebar.

Milonia Caesonia (d. 41 CE)

Roman noblewoman. *Murdered in 41 CE; fourth wife of Caligula (12–41), Roman emperor (r. 37–41); children: (Julia) Drusilla (c. 37–c. 41 CE).*

Milonia Caesonia was the fourth wife of the Roman emperor Caligula. In 41 CE, a successful conspiracy was carried out by a tribune of the Praetorian Guard who held both personal and public grievances against Caligula. Hatred for Caligula was so great, in fact, that after he had been assassinated, Milonia Caesonia was killed as well, and their daughter ***Drusilla***'s "brains were dashed out against a wall."

Milosevic, Mirjana (b. 1942).

See Markovic, Mirjana.

Miloslavskaia, Maria (1626–1669).

See Sophia Alekseyevna for sidebar.

Milto (fl. 415–370 BCE).

See Aspasia the Younger.

Milton, Frances (c. 1779–1863).

See Trollope, Frances.

Min (1851–1895)

Queen of the Yi Dynasty in Korea. Name variations: Bin; Empress Min; Empress Myongsong; Empress Myungsong. Born Ja-young Min in 1851 (some sources cite c. 1840); ruled from 1882 to 1895; assassinated by the Japanese on August 20, 1895; married Yi T'ae Wang also known as Kojong (1852–1919), king of Korea (r. 1863–1907), in March 1866; children: son Sunjong (b. 1874), the last king of Korea (r. 1907–1910).

During the mid-19th century, the Choson (Yi) Dynasty of Korea, which had ruled the country since 1392, was in jeopardy. Traditional customs were losing their significance, while Japan, Russia, and the West were pressuring for an "open-door policy." China wanted to recapture its traditional position of dominance over the Choson dynasty; Russia was casting its eyes southward; and Japan had serious designs on annexing Korea. The possibilities of invasion from all corners added to Korea's tension.

Chuljong, the 25th king of the dynasty, passed away in 1864 without an heir. As was customary in these circumstances, the queen mother took possession of the king's seal, the symbol of enthronement; after consulting statesmen, she adopted 13-year-old Kojong and gave him the king's seal. Kojong's father thus became the *taewongun* (grand prince) and ruled in place of his underage son. In 1866 the *taewongun* arranged for his son to marry a young orphaned woman from a poor family, the second cousin of his own wife; the grand prince hoped that by marrying Kojong to a woman with no parents or wealth he would prevent her family from influencing Kojong, and thus solidify his own power over both his son and the kingdom.

Min, also called Ja-young Min or Myungsong, was 15 years old at the time of her marriage. Initially the *taewongun* was pleased with his daughter-in-law, who was beautiful, intelligent, and apparently devoted to him and to Kojong. However, she was also strong and ambitious, and soon was exerting enormous power behind the scenes, vying with her father-in-law to dominate her weak-minded and dissolute young husband. When Min, who as yet was childless, found her position as queen made precarious by the birth of a son to Kojong's mistress, with whom he was apparently in love, the struggle intensified. By negotiating with the *taewongun*'s enemies at court, she succeeded in driving him from court in 1873, the year Kojong came of age, and reconciled with her husband. The following year she gave birth to a son, which assured her place as queen-consort. Kojong's weak character and lack of interest in the day-to-day administration of his kingdom allowed Min to become in many ways the *de facto* ruler of Korea. She showed considerable political skill, placing her relatives in top government offices and maneuvering among the competing noble factions to consolidate her power.

Like her father-in-law, Min opposed the "opening" of Korea and those who wanted to Westernize the country, but she soon had to succumb to mounting pressures from abroad. When the Japanese chose Kanghwa Island, located near Korea's capital of Seoul, for their military base, Min spurned urgings to mobilize an army and tried to avoid war by signing a diplomatic treaty on February 27, 1876. In the treaty, which opened Korea to Japanese trading, Japan recognized Korea as an "autonomous" state, but shortly thereafter a pro-Japanese faction began to emerge in the Korean government. Min and Kojong pursued their policy of slow modernization until 1882. In that year, Min was forced to escape from the capital and take refuge with her sister after a revolt by some soldiers targeted the queen and the Japanese soldiers stationed in Seoul. Kojong then recalled his father, who had secretly supported the rebellion. The restored *taewongun* announced that Queen Min was dead and even ordered a funeral to be held for her. Within a few weeks, however, the *taewongun* had been taken prisoner by the Chinese army, and Min returned to Seoul in triumph.

Fearing the growing imperialism of the Japanese, she shifted her policies to favor the Chinese instead. Russia and various Western countries, wanting to avoid Japanese hegemony in the region, also began to pressure for treaties of their own. Thus, in the 1880s, Min had little choice but to sign trade treaties with the United States, England, Germany, Italy, and Russia, gradually bringing Korea into the industrial and modern trade era. She was nonetheless determined that the court would fight the pernicious influence of the West as ardently as possible, which brought

her into conflict with the many progressives at court who believed Westernization of Korea would be beneficial. The resulting factionalism made it almost impossible for Min to strengthen her country. The economy degenerated and the military was kept underpaid, while the government appeared to be at the mercy of foreigners.

When in 1889 the farmers rebelled against a corrupted feudal society and tried to overthrow the monarchy (the Tonghak rebellion), Min turned to her giant neighbor for help and China agreed to send troops. But China had an agreement with Japan not to send troops into Korea without notifying them, and the Japanese soon turned the situation to their advantage. Unbidden and unwanted, Japan also sent troops to the aid of Korea. Though the farmers' insurrection was soon quelled with promises to abolish slavery and provide relief for farmers, and the Koreans began a series of reforms with the intent of importing Western culture and technology, both China and Japan refused to withdraw. The queen's next political crisis came in 1894, when she faced a coup d'etat by radicals who, supported by Japan, wanted Korea to undergo rapid industrial and social modernization such as Japan had implemented. Royalist Korean soldiers and their Chinese allies soon retook the government and restored Min, but the rebellion served as a pretext for both Japan and China to send new troops to Korea, launching the Sino-Japanese War (1894–95). Fought primarily in Korea, the war ended with a decisive victory by Japan and the Treaty of Shimonoseki, signed in 1895, in which China was forced to grant Korean independence. In reality, this amounted to Japan gaining control over Korea.

Min vehemently opposed Japan's informal annexation of Korea. To the leaders of Japan who looked forward to ruling as they had planned, the decisive and wise Min, considered the one bright spark in a corrupt Korean court, was nothing but trouble. Following the war, she made overtures to Russia, a powerful enemy of Japan and thus an important potential ally for Korea against Japanese aggression. In reaction to this threatened alliance, the Japanese administration decided that Queen Min had to be removed from power. At dawn on August 20, 1895, in a plot code-named "Fox Hunt" and engineered by Viscount Miura Goro, the Japanese minister to Korea, Japanese troops entered Kyongbokkung palace (today's Toksugung Palace) by force. Crushing resistance by royal bodyguards and demanding to know the whereabouts of the queen, they made a thorough search of the palace, killing some who refused to cooperate while threatening others. No one gave the queen away. Convinced that Min was disguised as one of the court women, the Japanese then murdered two of them; it is said that the queen, seeing this, then came forward. Her enemies threw her to the ground and trampled on her. She was stabbed over and over by Takahashi Genji, and her corpse was burned with kerosene in a nearby wood. Kojong was not harmed.

Koreans and foreign missions were outraged. The Japanese government quickly recalled those involved, detaining them briefly at Hiroshima Prison as a subterfuge. Their trial, writes Japanese historian Yamabe Kentaro, was "a deliberate miscarriage of justice, designed to protect the culprits." None were convicted. After he recovered from shock, Kojong tried and executed traitorous Koreans involved with the assassination. Then, on October 11, he granted a new title, Myongsong, to his deceased wife; a state funeral followed one month later. This incident is known in Korean history as the *Ulmi sabyon.*

King Kojong continued to rule as a puppet king under the competing Japanese and Russian military forces. Korea became a Japanese protectorate under Hirobumi Ito in 1904, and in 1907 Kojong was forced to abdicate. Min's son then succeeded as King Sunjong, although he, too, was only a figurehead. In 1910, Korea was formally annexed by Japan, forcing Sunjong from power and ending five centuries of rule by the Yi (Choson) dynasty.

Queen Min is one of the most controversial figures in Korean history. Some view her as a charismatic politician and diplomat who tried to lead the country into a new era; others deem her a manipulative, power-seeking woman. The 1997 Korean opera, *The Last Empress,* sets out to reexamine Queen Min's life in the context of her time, especially within the male-dominated Confucian culture which refused to accept a strong female leader. The opera opened to rave reviews at New York's Lincoln Center in August 1997.

SOURCES:

Kim, C. Eugene, and Han-kyo Kim. *Korea and the Politics of Imperialism, 1876–1910.* Berkeley, CA: University of California Press, 1967.

Kim, Yung-Chung. *Women of Korea: A History from Ancient Times to 1945.* Seoul, Korea: Ewha Woman's University Press, 1976.

RELATED MEDIA:

The Last Empress, a Korean opera, directed by Yun Ho-Jin, based on a book by Yi Mun-Yol, music by Kim Hee-Gab, title role alternately played by Lee Tae-Won and Kim Won-Jung, was first staged in Korea in 1995 in commemoration of the centennial of Queen Min's death.

Laura York,
Riverside, California

Minck, Paule (1839–1901).

See Mink, Paule.

Miner, Myrtilla (1815–1864)

American educator and pioneer in education for African-American girls. Born on March 4, 1815, near Brookfield, New York; died on December 17, 1864, in Washington, D.C.; daughter of Seth Miner (a farmer) and Eleanor (Smith) Miner.

Growing up in central New York in a large farm family, Myrtilla Miner displayed an early enthusiasm for learning, and picked hops to earn money for books despite suffering from a debilitating spinal disorder. Her unmarried aunt **Ann Miner** taught a private school in their family home, which may have inspired Myrtilla to become a schoolteacher herself. Her formal education began at the Female Domestic Seminary in Clinton, New York, but with her painful spinal treatments she could not endure the manual labor required by the school's program. In 1840, she transferred to the Clover Street Seminary in Rochester, New York. After completing her education she taught there for a year in 1844, and then taught at the Richmond Street School in Providence, Rhode Island, from 1845 to 1846.

In 1847, she transferred to the Newton Female Institute in Whitesville, Mississippi. There, she was shocked by the condition of the slaves and sought to conduct classes for young African-American girls. When her idea was refused (teaching slaves to read and write was frowned upon in the South, and in some Southern states it was illegal) she returned to New York, where she briefly taught in the town of Friendship in 1849. That same year, at a friend's home, she met two abolitionists who encouraged her to open a school for African-Americans in Washington, D.C. Receptive to the idea after her experiences in Mississippi, she was also encouraged by the Reverend Henry Ward Beecher, and by a $100 contribution from **Ednah Thomas**, a Quaker philanthropist. Such undertakings had brought persecution upon those who had attempted them in the past (*See Prudence Crandall*), and even African-American abolitionist leader Frederick Douglass advised against it. But the "slender, wiry, pale (not over healthy), but singularly animated" Miner, as Douglass described her, went to Washington, D.C., rented a room, and opened the Colored Girls School on December 3, 1851.

"Many ladies refused to take me to board because I would teach colored girls, and much

else of obloquy and contempt have I endured because I would be about my Master's business. I heed it not, though I am to-night informed that the new mayor will abolish all colored schools. I care not," Miner wrote to a friend some six months after establishing her school. Despite local opposition which eventually forced three moves over two years and had Miner waving a pistol to fend off angry crowds, the school's initial enrollment of six had grown to forty in two months, and it had many ardent supporters, particularly among Quakers. Hundreds of visitors came to tour this extraordinary educational institution, including the family of President Franklin Pierce. *Harriet Beecher Stowe donated $1,000 of her royalties from *Uncle Tom's Cabin* to it. In 1856, the school came under the care of trustees, including Henry Ward Beecher and Johns Hopkins. Its prosperity drew even more opposition, as in 1857 when a former Washington mayor attacked it. Nevertheless, driven by her fundamental belief in the need for the abolition of slavery, which she considered "a vast increasing evil," Miner continued to run the school with creativity and fastidiousness. She assembled a library of 1,500 books, and brought scholars in to give lectures. She encouraged activities such as nature study, gardening, and astronomy. Physical fitness and hygiene were stressed. Students were taught a full scope of academic subjects and domestic skills, but the school's focus was on training teachers—by 1858 six former students were teaching at their own schools.

Throughout her career Miner's health problems had hindered her and forced her to take periodic leaves. By the late 1850s, others such as *Emily Howland and **Lydia Mann** (Horace Mann's sister) were running the school, yet Miner constantly promoted it wherever she went, collecting funds, books, and equipment. Despite these efforts, her illness and the Civil War forced the school to close in 1860, and she went to California seeking to improve her health. There she earned a living as a clairvoyant and magnetic healer, both of which were gaining in public fascination at the time. In 1863, her supporters in Congress were successful in gaining the school a charter as the Institution for the Education of Colored Youth, but Miner did not live to see it reopened. In 1864, she was thrown from a carriage in Petaluma, California, and, shortly after a long journey back to Washington that year, she died of tuberculosis probably exacerbated by her injuries.

After the Civil War, the school she had founded was renamed the Miner Normal School,

*P*atsy
*M*ink

and as such ran intermittently until 1879, when it was incorporated into the Washington, D.C., public school system. It was renamed the Miner Teachers College in 1929, and in 1955, following the outlawing of school segregation in the United States, it was merged with another school to form the District of Columbia Teachers College. Though her name is gone from the school, Myrtilla Miner is remembered for her steadfast vision, reason, warmth, and courage.

SOURCES:
Edgerly, Lois Stiles, ed. *Give Her This Day*. Gardiner, ME: Tilbury House, 1990.

James, Edward T., ed. *Notable American Women, 1607–1950*. Cambridge, MA: The Belknap Press of Harvard University Press, 1971.

McHenry, Robert, ed. *Famous American Women*. NY: Dover, 1980.

SUGGESTED READING:
O'Connor, Ellen. *Myrtilla Miner: A Memoir*, 1885.

COLLECTIONS:
The Myrtilla Miner Papers, Library of Congress, Washington, D.C.

Jacquie Maurice,
Calgary, Alberta, Canada

Minervina (fl. 290–307).

See Helena (c. 255–239) for sidebar.

Minifie, Susannah (c. 1740–1800).

See Gunning, Susannah.

Minijima, Kiyo (1833–1919)

Japanese businesswoman and philanthropist. Name variations: Mrs. Kiyo Minijima. Born in 1833; died in 1919.

In 1897, Kiyo Minijima's husband died; he had bequeathed her his savings, which she invested in real estate until she owned 570 acres in Tokyo, where values increased rapidly. With her business sagacity, she became the wealthiest woman in Japan. She founded in succession a bank, a trust company, and a real estate company, and conducted them all with a firm hand. Minijima was rigidly honest in all her dealings; her word was her bond. In November 1918, she donated $250,000 to the city of Tokyo to assist the cause of education.

Mink, Patsy (1927—)

U.S. congressional representative from Hawaii. Name variations: Patsy Takemoto Mink; Patsy T. Mink. Born Patsy Matsu Takemoto on December 6, 1927, in Paia, Maui, Hawaii; daughter of Suematsu Takemoto and Mitama Tateyama Takemoto; graduated from University of Hawaii at Honolulu, B.A. in zoology and chemistry, 1948; earned law degree at University of Chicago, 1951; married John Francis Mink (a geologist); children: Gwendolyn Rachel (known as Wendy) Mink (who is a professor of political science at University of California, Santa Cruz).

Elected to Hawaii House of Representatives (1956); elected to Hawaii state senate (1958); elected to U.S. House of Representatives (1964); served on Honolulu City Council (1983–87); returned to U.S. House of Representatives (1990).

Democrat Patsy Mink's long political career has centered on defending the rights of minorities and women and on advocating governmental support of varied educational opportunities. Born in 1927 in a small village on the Hawaiian island of Maui, she attended a local high school, then went on to Wilson College in Pennsylvania and the University of Nebraska before returning to Hawaii to graduate from the University of Hawaii in 1948. After earning her law degree from the University of Chicago in 1951 she returned home to Hawaii

that year to open a law practice, and embarked on what eventually proved to be a successful and fast-paced career. Mink lectured at the University of Hawaii's law school, and served as the attorney of the Hawaii House of Representatives in 1955. Her involvement in politics had begun with participation in the Young Democrats; by 1956, she was elected to the Hawaii House of Representatives, and by 1958 to Hawaii's Senate. Hawaii, then a U.S. territory, had been seeking statehood for many years, and in the state legislature Mink worked for the statehood movement while also concentrating on education and "equal pay for equal work" issues.

After Hawaii became a state in 1959, Mink did not win the Democratic nomination for the at-large seat in the U.S. House of Representatives, but in 1964 she won one of Hawaii's two House seats. Over the next several years, she served on the Committee on Education and Labor, the Committee on Interior and Insular Affairs, and the Budget Committee. Her committee assignments blended well with the work she had focused on in the Hawaii state legislature. She introduced or sponsored many acts such as the first child-care bill and legislation establishing programs like student loans, bilingual education, and Head Start. Mink advocated education for the disabled, school lunch programs, and emergency school aid for schools trying to wipe out segregation, and also worked for the successful passage of Title IX, which enforced parity in public schools' spending of federal funds for boys' and girls' sports. In 1972 she was invited by a group from the state of Oregon to enter the presidential primary there, and attained 2% of the vote. She supported the political and economic development of the Trust Territory in the Pacific, and as chair of the Subcommittee on Mines and Mining she was the lead author of the Strip-Mining Act and the Mineral Leasing Act of 1976.

Mink supported President Lyndon Johnson's domestic program, but was an early critic of his administration's expansion of the American military presence in Vietnam. She later opposed the Vietnam War, a position that contradicted the feelings of many of her constituents. She also rejected Johnson's request for a tax increase, fearing that the additional revenue would be used for military rather than social purposes. In defense of equal rights for women, Mink authored and sponsored the Women's Educational Equity Act in 1974. She was the only congressional member to testify against Richard M. Nixon's unsuccessful nomination of G. Harrold Carswell to the U.S. Supreme Court. It would be "an affront to the women of America," she said,

since Carswell had denied women's employment rights while an appellate judge.

Patsy Mink remained active in politics after losing a bid for the Democratic nomination to the U.S. Senate in 1976. She was an assistant secretary of state for oceans and international environmental affairs in 1977 and 1978, and over the next three years served as president of the Americans for Democratic Action. Returning to Hawaii, she was elected to the Honolulu City Council and served from 1983 until 1987, while chairing the council until 1985. After the appointment of Hawaii Representative Daniel Akaka to the Senate and his resignation from the House of Representatives, Mink won a special election in 1990 to fill the vacancy. She was consistently re-elected throughout the 1990s, serving on the Committee on Education and the Workforce and the Committee on Government Reform, and was the democratic regional whip in 1997–98.

SOURCES:

*Carabillo, Toni, and Judith Meuli. *The Feminization of Power.* Los Angeles, CA: The Fund for the Feminist Majority, 1988.

Compton's Interactive Encyclopedia. Compton's New-Media, Inc., 1996.

Office of the Historian. *Women in Congress, 1917–1990.* Commission on the Bicentenary of the U.S. House of Representatives, 1991.

<div style="text-align: right">

Jacquie Maurice,
Calgary, Alberta, Canada

</div>

Mink, Paule (1839–1901)

French revolutionary socialist, feminist, orator, and journalist who was a tireless agitator and organizer.

Name variations: Mink or Minck is a pseudonym of Adèle Paulina Mekarska. Pronunciation: pohl meenk. Born Adèle Paulina Mekarska in Clermont-Ferrand (Puy-de-Dôme), France, on November 9, 1839, to Polish exiles; died in Auteuil (Seine) on April 28, 1901; buried at Père La Chaise cemetery in Paris; daughter of Count Jean Nepomucène Mekarski and Jeanne-Blanche Cornelly de la Perrière; well educated at home or at unknown schools; married to and separated from (at unknown dates) Prince Bohdanowicz (an engineer); married Maxime Négro (a mechanic), in 1881; children: (first marriage) two daughters, Anna and Wanda (d. 1870); (with painter Jean-Baptiste Noro) two daughters, Mignon and Jeanne-Héna; (second marriage) two sons, Lucifer-Blanqui-Vercingetorix-Révolution (b. 1882, died in infancy) and Spartacus-Blanqui-Révolution (b. 1884, renamed Maxime by a civil tribunal).

Began public speaking on women's issues (1868); played a heroic role in the Franco-Prussian War and the Paris Commune uprising (1870–71); lived in Switzerland as a political refugee (1871–80); returned to

France and aroused a storm at the socialist congress (1880); jailed following a demonstration (1881); joined Guesde's French Workers' Party (1882); opposed Auclert on women's suffrage (1884); left the French Workers' Party, joined the Revolutionary Socialist Party (Blanquist) and Women's Solidarity, and ran for Parliament (1892–93); was an outspoken Dreyfusard during the Affair (1897–99); left Solidarity (1900).

Paule Mink came by her vocation of revolutionary socialist quite honestly. Her father, Count Jean Nepomucène Mekarski, a nephew of Prince Joseph Antoine Poniatowski and cousin of Stanislaus II Poniatowski, the last king of Poland, was an aide-de-camp in the Russian army who fled to France in 1831 after taking part in the Polish uprising of 1830. He eventually got a humble job as an agent in the tax office in Clermont-Ferrand (Puy-de-Dôme) and became an adherent of the Saint-Simonian school of utopian socialism. Her mother, **Jeanne-Blanche Cornelly de la Perrière**, who may have married Mekarski in Warsaw, was from a minor noble French family settled in Poland, where they belonged to the untitled nobility. Adèle Paulina Mekarska, born in Clermont-Ferrand on November 9, 1839, had two younger brothers, both of whom took part in the doomed Polish revolt of 1863: Louis, who became a prominent engineer, and Jules, a surveyor, who became commissioner of police in the Paris Commune uprising of 1871. Although she never visited her ancestral land, Mink was a Polish patriot all her life and aided Polish émigrés in France.

We must suppress capitalist exploitation, there is no other way.

—**Paule Mink, 1897**

Virtually nothing is known of her life before she burst upon the political scene in 1868 as a feminist orator and militant socialist republican. She was well educated, but where and how is unknown. At age 16, apparently, she became a republican, opposed to Napoléon III's imperial regime, and perhaps rejected Catholicism around this time. Probably while still in her teens she moved to Paris, where she taught languages, became a skilled seamstress (an occupation which supported her through many hard times), joined Republican and feminist societies, and got into journalism. When and why she adopted the name Paule Mink (or Minck, as she also spelled it) is, again, unknown. Nor is it known when she married and separated from a Polish émigré engineer, Prince Bohdanowicz, with whom she had daughters Anna and Wanda.

Mink became known in feminist circles in the latter 1860s. She joined *André Léo's Society for the Demand of Women's Rights (1866) and also Couture (1867) and founded (c. 1868) a feminist mutual benefit association, the Fraternal Society of Women Workers. Her public notoriety began when Napoléon III's regime passed a law enlarging freedoms of speech, assembly, and the press which allowed women to speak in public meetings. Mink joined *Maria Deraismes, *Louise Michel, and André Léo in a lecture series on women's work given at the Tivoli-Vauxhall from July 16 to November 1, 1869. She discovered a talent and went on to become one of a mere handful of women in her time who could dominate mostly male-attended (and often rowdy) public meetings, in contrast to the more sedate lecture format used by most women. Gustave Lefrançais described her about this time:

> Among the women who habitually speak in the meetings, one notices especially citizenness Paule Mink, a small woman, very dark, a bit sarcastic, and with a very energetic speaking style. The voice is a little harsh, but she expresses herself easily. She makes witty fun of her contradictors rather than debate them and does not appear to have very fixed ideas on the divers conceptions which divide the socialists. But she is tireless in spreading the word.

At the Tivoli-Vauxhall, she defended women's right to work outside the home, which most men, many influenced by the socialist Pierre-Joseph Proudhon, feared as a threat to their jobs and wages. "All women are not wives and mothers," said Mink; "some could not be or did not want to be, some are not yet, others are no longer. . . . Equal pay for equal work, this is the only true justice."

Paule Mink wanted women to have the rights in politics, work, and marriage enjoyed by men in France since 1789 and urged women to use force if necessary. From 1868 on, she distinguished herself from most feminists by saying that "the people and women should liberate each other." She thought women to be more down-to-earth revolutionaries than men, "who make beautiful theories that are good for nothing." As a paper described her, she was "practical" and "concrete" in her approach. From the outset, the watchword of her life, writes Alain Dalotel, was "independence." Her socialism was always much influenced by the Russian anarchist Michael Bakunin (1814–1876)—independent, anti-authoritarian, anti-statist. Government of, by, and for the people would bring true liberty and with it the end of most police functions.

From 1868 through the Franco-Prussian War and the Commune (1870–71), Mink was intensely active. She began to tour the provinces to spread her gospel. In 1869, she launched a fiery paper, *Les Mouches et l'Araignée* (the people being the "flies" and Napoléon III the "spider"), which, predictably, was suppressed after two issues. She also joined the International Workingmen's Association (the "First International" or IWA). In 1870, she collaborated on or at least lent her name to La Réforme sociale, the organ of Rouen's IWA group, and joined Léon Richer and Maria Deraismes' Association for the Rights of Women, a split-off from Léo's society.

Like her idol, the republican revolutionary Auguste Blanqui (1805–1881), Mink was a fierce patriot. During the war, she and her brother Louis went to Auxerre (Yonne), where she fought the invaders and tried to arouse the citizens to throw out the "capitulard" government and form a commune allied with besieged Paris. While crossing Prussian lines with documents, she and her daughter Wanda were fired upon, and Wanda was killed. (Thereafter, Anna assumed Wanda's name.) The government offered Mink the Legion of Honor, but she refused it. After the armistice in January 1871, she went to Paris and took part in the March 18 insurrection establishing the Commune; it opposed the government, now at Versailles and negotiating a final peace with the new German Empire. During the Commune (March 18–May 28), she wrote for Vesnier's *La Paris libre*, preaching "allout" war and railing against the quarrels in the Commune's leadership; was, with André Léo and Louise Michel, a member of the Montmartre Vigilance Committee; was active in predominately female political clubs meeting at the churches of Saint-Sulpice, Notre-Dame de la Croix, and Saint-Nicolas-des-Champs; opened a school for children of soldiers and working women at Saint-Pierre de Montmartre; and with her brother Jules slipped out of Paris several times to try to rally provincial support. She was in the provinces when the Commune was crushed during "Bloody Week." To escape arrest, she fled to Switzerland, allegedly in the tender of a locomotive. There she was joined by her lover and late commander of the Commune's 22nd battalion, Jean-Baptiste Noro (b. 1842), described by Lucien Descaves as "a fine swordsman and crosseyed painter." A court sentenced her in absentia (and fellow émigrés ✥➧ **Anna Jaclard,** *****Elizabeth Dmitrieff,** André Léo, and *****Marguerite Tinayre**) to deportation for life to the prison colony in New Caledonia.

In September 1871 at Lausanne, Mink and André Léo defended the Commune before the Fifth Congress of Peace and Liberty. During the 1870s, she lived in poverty mostly in Geneva with her daughter Anna ("Wanda") and Noro, with whom she had daughters Mignon and Jeanne Héna. Mink sewed straw hats, gave language lessons, lectured, wrote for small papers, and by 1879 was spoken of as the "director" of the French émigrés. It was in Switzerland that she came under the influence of Bakunin and met the French Marxist leader Jules Guesde (1845–1922). With the amnesty of 1880, she returned to France and plunged into revolutionary socialist speaking, writing, and organizing.

At the socialist congress in Le Havre in 1880, she caused an uproar by refusing to yield the floor when the "cooperatists" (moderates) passed a resolution against the "collectivists" (revolutionaries). She spoke in favor of women's rights and for "complete" and "identical" education for children of both sexes. When the collectivists organized their own congress the next day, she joined them. At the congress in 1882 in Saint-Étienne, she sided with Guesde against Paul Brousse, who favored reformist municipal socialism. When the Guesdists walked out, Mink stayed behind to try to convert the Broussists. Guesde then founded the Workers' Party of France (POF), which conformed to his Marxist views, and Mink joined it despite her sympathy for the insurrectionary views of Blanqui's disciples. Probably she appreciated the POF's willingness to allow her to raise feminist concerns; also, she wanted much more attention paid to the provinces, which the Paris-oriented Blanquists tended to ignore. In 1884, she was a delegate to the POF's congress in Roubaix.

Meanwhile, in 1880 she, Louise Michel, and Blanqui organized a noisy agitation in favor of a "social" republic. With Michel, Mink contributed to the first anarchist paper, *La Révolution sociale,* and she began writing for *La Socialiste.* As the result of a demonstration in Marseille protesting the condemnation of *****Gesia Gelfman,** the Russian "mother of revolution," Mink was sentenced on May 10, 1881, to a month in jail. The authorities threatened to expel her as a Pole, but a fellow revolutionary, a mechanic named Maxime Négro, offered to marry her to prevent this. She agreed, he recognized and legitimized Mignon and Jeanne Héna, and she had two children with him, provocatively named Lucifer-Blanqui-Vercingetorix-Révolution (b. 1882 but died within two months) and Spartacus-Blanqui-Révolution (b. 1884), whose name the authorities refused to register, choosing Maxime instead. The family lived mostly in Montpellier and "in the most frightful misery," it was reported. Mink's health declined, not helped by her failed attempt with Négro to

◀✥
Jaclard, Anna.
See
Kovalevskaya,
Sophia for
sidebar.

found a paper, *Qui Vive*, and by her continual trips around France—especially in the center and southeast and sometimes with Guesde—preaching the gospel, organizing groups and labor unions, and spreading brochures and pamphlets.

Although Mink supported women's rights, she caused consternation in 1884 by standing up after a lecture by the suffragist ***Hubertine Auclert** and opposing votes for women, saying (as did much of the French left up until 1944) that women were still too much influenced by the Catholic clergy. Not surprisingly, in 1885 she declined an invitation from the Women's Socialist Federation to run for Parliament as a protest candidate. She replied from Algeria that illness had forced her to leave public life but that she would decline in any event because "I do not believe that women will have their situation ameliorated by the conquest of their political rights, but only the social transformation of our old world."

Mink began to drift away from the POF by the late 1880s. She objected to its failure to take a strong stand against General Georges Boulanger's populist movement and to its shift away from revolution and toward parliamentary politics. She began to advocate a general strike by all workers as the way to bring on the Revolution: "The general strike is here, it is just around the corner." But the party congress at Marseille in 1892 would not endorse it. With that, she left Négro in Montpellier and moved with two daughters to Paris, where she now came into close contact with the feminist movement. She began to believe that economic equality for women might be substantially furthered through the granting of civil and political rights. The president of Women's Solidarity, ***Eugénie Potonié-Pierre** (1844–1898), persuaded her to run (symbolically) for Parliament in 1893. Though no socialist party endorsed Mink, she resigned from the POF and ran anyway, to no effect. Despite the party's lack of interest in women's issues, she then joined (1893) the Blanquist party, the Central Revolutionary Committee (after 1898 the Revolutionary Socialist Party, or PSR), led by Édouard Vaillant (1840–1915), because its interest in action and the general strike and its relative lack of dogmatism gave her more leeway. Also in that crowded year she was active in the Workers' House, a cooperative, where she gave lessons and led the women's group; participated in the agitation sparked by the government's crackdown on political activity at the Paris labor exchange (*bourse de travail*); and on October 29 was sentenced to six days in jail for insulting authorities during a bitter coal strike in which she led a demonstration by 2,000 women at Liéven (Pas-de-Calais).

Mink meanwhile contributed to the weekly *Revue socialiste,* the 1892 edition of *L'Almanach de la question sociale et du centenaire de la République, La Petite République* (1894), and Maurice Barrès' *La Cocarde* (before resigning in 1895), and she participated with Michel in a revival of the anarchists' *La Libre Pensée.* From 1891, she regularly wrote for G. Argyriadès' *La Question sociale*—often penning touching vignettes of the tribulations of the poor in the mode of **Séverine*—and from September 1894 to April 1897 (when it closed) she was its editorial secretary. In 1894, she also wrote two plays—*Qui l'emportera?* (Who Will Prevail?) and *Le Pain de la honte* (The Bread of Shame)—for the *théâtre social* she promoted with the *bourse* leader Fernand Pelloutier.

Sadly, all these labors earned her precious little money. A report in 1894 said Mink had "two bad beds, three chairs," and had moved five times because she could not pay her rent. She placed notices in newspapers seeking work teaching, proofreading, or lecturing, and sometimes she had to wear wooden shoes.

Mink's last years saw little easing of her activity. She sympathized with the anarchists during their heyday in the 1890s, corresponding with Enrico Malatesta, associating with Sébastien Faure, and defending Louise Michel. (A grandson of Mink's said she sheltered Italian anarchist Santo Cesario before he assassinated French President Sadi Carnot in 1894.) In 1895, she toured with Michel, proclaiming that women should demand "not emancipation but complete justice" and end their "slavery" at work and at home, with revolution the means. The Dreyfus Affair (1897–99), however, sowed division on the left. Mink broke with Michel when the latter refused to repudiate her friend (and patron) Henri Rochefort despite the journalist's anti-Semitism and extreme nationalism. Mink contributed to **Marguerite Durand*'s all-female newspaper *La Fronde* and to *L'Aurore,* which published Émile Zola's "J'accuse." She grew stridently antimilitarist and antipatriotic, mocking the "honor" of the army and the "cult" of patriotism, therewith becoming an inspirer of the antimilitarism which took hold in the labor movement after 1901. Likewise, she denounced the socialist Alexandre Millerand for accepting a post in the Waldeck-Rousseau ministry (1899–1901), which included General Galliffet, "the Butcher of the Commune."

Mink's organizational work continued unabated. From 1896 until her death in 1901, she

was in effect the leader of the socialist women's movement. She was repeatedly a delegate from Women's Solidarity to congresses, including one in 1896 sponsored by Solidarity and the French League for the Rights of Women, the POF congress of 1896, and the international feminist congress in Brussels in 1897, where she insisted that it is capitalism, not feminist radicalism, that tears women from hearth and home: "we must suppress capitalist exploitation, there is no other way." In 1899, she attended (from Solidarity) the congress of socialist organizations, the beginning of the movement for unity which was to come to fruition in 1905. In 1900, however, she left Solidarity because of its slide to the right following Petonié-Pierre's death and founded the short-lived Revolutionary Socialist Group of the Citizenesses of Paris (likely an affiliate of the PSR), which she represented at the second socialist congress that year—her last such appearance.

Paule Mink died on April 28, 1901, worn out and bitter. Her funeral coincided with the annual leftist demonstration on May Day. An immense crowd, watched by throngs of police and 1,300 soldiers, followed her remains to Père La Chaise, where the Communards had made their last stand. Representatives of every leftist organization orated, the crowds sang the "International" and the "Carmagnol," the red flags flew, and a respectable number of brawls with the police broke out—all to honor one of the last surviving female icons of the Commune. She would have enjoyed it immensely.

Despite the often chaotic and always poverty-ridden life Mink led, she was a good and gentle mother to her children. She always regarded the family as society's basic unit, although she did want roles within it redistributed. She gave her children an excellent education, instilling in them, of course, her political views. She had little truck with theories as such and was never much of a Marxist. Her socialism was independent, writes Dalotel, "a mélange of anarchism and humanitarianism directly linked to the social question." Her dream was of a unified socialism composed of both sexes and willing to use force to bring about the Revolution. She was both a feminist and a revolutionary. On the whole she subordinated her feminism to her revolutionary faith, but in the early 1890s she came to believe that worthwhile civil and political rights for women could be pried from the capitalist system—pending the arrival of the Revolution, which would end the oppression of men and women alike.

All her life she flirted with the anarchists. She was never willing to go quite as far as they in theory or practice. But she would never condemn them or their methods, and in her heart she was, with her faith in the imminent Revolution, a member of that band of dreamers who, in *Barbara Tuchman's words, embodied "the last movement among the masses on behalf of individual liberty, the last hope of living unregulated, the last fist shaken against the encroaching State, before the State, the party, the union, the organization, closed in."

SOURCES:

Bidelman, Patrick K. *Pariahs Stand Up! The Founding of the Liberal Feminist Movement in France, 1858–1889.* Westport, CT: Greenwood Press, 1982.

The Continuum Dictionary of Women's Biography. Jennifer S. Uglow, ed. NY: Continuum, 1989.

Dalotel, Alain, ed. *Paule Minck, communarde et feministe (1839–1901): Les mouches et l'araignée, la travail des femmes, et autres textes.* Paris: Syros, 1981.

Decaux, Alain. *Histoire des françaises*, Vol. 2: *La Révolte.* Paris: Librairie Académique Perrin, 1972.

Dictionnaire biographique du mouvement ouvrier français. Sous la direction de Jean Maitron. Paris: Éditions Ouvrières, 1964—.

Hause, Steven C. *Women's Suffrage and Social Politics in the French Third Republic.* Princeton, NJ: Princeton University Press, 1984.

Hellerstein, Erma Olafsen, Leslie Parker Hume, and Karen M. Offen, eds. *Victorian Women: A Documentary Account of Women's Lives in Nineteenth-Century England, France, and the United States.* Stanford, CA: Stanford University Press, 1981.

Moses, Claire. *French Feminism in the Nineteenth Century.* Albany, NY: SUNY Press, 1984.

Pujol, Geneviève, and Madeleine Romer, eds. *Dictionnaire biographique des militants, XIXᵉ–XXᵉ siècles: De l'éducation populaire à l'action culturelle.* Paris: L'Harmattan, 1996.

Rabaut, Jean. *Histoire des féminismes français.* Paris: Éditions Stock, 1978.

Sowerwine, Charles. *Sisters or Citizens? Women and Socialism in France since 1876.* Cambridge: Cambridge University Press, 1982.

Thomas, Edith. *Louise Michel ou la Velléda de l'anarchie.* Paris: Gallimard, 1971.

———. *The Women Incendiaries.* Trans. James and Starr Atkinson. NY: George Braziller, 1966.

Tuchman, Barbara W. *The Proud Tower: A Portrait of the World before the War.* NY: Macmillan, 1961.

Willard, Claude. *Les Guesdistes.* Paris: Éditions Sociales, 1965.

SUGGESTED READING:

Carr, Edward Hallett. *Michael Bakunin.* London: Macmillan, 1937.

Edwards, Stewart. *The Paris Commune 1871.* London: Eyre & Spottiswoode, 1971.

Historical Dictionary of the Third French Republic, 1870–1940. Patrick H. Hutton, ed. Westport, CT: Greenwood Press, 1986.

Horne, Alistair. *The Fall of Paris: The Siege and the Commune, 1870–71.* NY: St. Martin's Press, 1965.

Hutton, Patrick H. *The Cult of the Revolutionary Tradition: The Blanquists in French Politics, 1864–1893.* Berkeley, CA: University of California Press, 1981.

Lefrançais, Gustave. *Souvenirs d'un révolutionnaire.* Brussels: "Temps Nouveau," 1902.

Lissagaray, Prosper Olivier. *History of the Commune of 1871.* Trans. by *Eleanor Marx-Aveling. NY: Monthly Review Press, 1967 (1886).

McMillan, James F. *Housewife or Harlot: The Place of Women in French Society, 1870–1940.* NY: St. Martin's Press, 1981.

Michael Bakunin: Selected Writings. Arthur Lehning, ed. NY: Grove Press, 1973.

Noland, Aaron. *The Founding of the French Socialist Party (1893–1905).* NY: H. Fertig, 1970 (1956).

Osmin, Léon. *Figures de jadis: Les Pionniers obscurs du socialisme.* Paris: Éditions "Nouveau Prométhée," 1934 (contains a chapter on Mink).

Sonn, Richard D. *Anarchism and Cultural Politics in Fin de Siècle France.* Lincoln, NE: University of Nebraska Press, 1989.

Woodcock, George, ed. *The Anarchist Reader.* Atlantic Highlands, NJ: Humanities Press, 1977.

DOCUMENTS:

Paris: Bibliothèque Marguerite-Durand.

David S. Newhall,
Professor Emeritus of History, Centre College, and author of
Clemenceau: A Life at War (Edwin Mellen Press, 1991)

Minnie.

Variant of Wilhemina.

Minoka-Hill, Rosa (1876–1952)

Native American physician. Name variations: Lillie Rosa Minoka-Hill; Lillie Rosa Minoka Hill; L. Rosa Minoka. Born Lillie Minoka on August 30, 1876, on the St. Regis Reservation in New York State; died of a heart attack on March 18, 1952, in Fond du Lac, Wisconsin; daughter of Joshua G. Allen (a Quaker physician) and a Mohawk mother who died shortly after her birth; Woman's Medical College of Pennsylvania, M.D., 1899; married Charles Abram Hill (a farmer), in 1905 (died 1916); children: Rosa Melissa Hill (b. 1906); Charles Allan Hill (b. 1906); Norbert Seabrook Hill (b. 1912); Alfred Grahame Hill (b. 1913); Jane Frances and Josephine Marie Hill (twins, b. 1915).

Graduated from medical school (1899); abandoned medical practice for marriage (1905); widowed (1916); licensed to practice medicine (1934); named Outstanding American Indian of the Year by the Indian Council Fire, Chicago (1947); given honorary lifetime membership by the State Medical Society of Wisconsin (1949).

Rosa Minoka-Hill was born Lillie Rosa Minoka on the St. Regis Reservation in northern New York State in 1876, to a Mohawk mother and a Quaker physician father from Philadelphia. Mohawk family tradition relates that Minoka's mother died shortly after childbirth. Her

father decided to keep Minoka with her mother's family until she was five, when he felt she would be old enough to come to Philadelphia to attend the Grahame Institute, a Quaker boarding school. She later recalled memories of arriving in Philadelphia, "looking and feeling strange . . . [a] little wooden Indian who hardly dared look right or left." Her father renamed her Rosa, thinking her "too dark to be a lily," but he taught her about her Native American heritage.

Graduating from high school in 1895 and wanting to live the Quaker way of "doing good," Minoka-Hill planned to become a nurse, but her family persuaded her that medical school was a better choice for a woman of her education. She first spent a year in Quebec, Canada, studying French at a convent. There, impressed by the sisters' work, she eventually made the decision to convert to Catholicism. Her father accepted her conversion, and when she returned to Philadelphia he financed her studies at the Woman's Medical College of Pennsylvania. After graduating in 1899, Minoka-Hill interned at the Woman's Hospital in Philadelphia, then treated impoverished immigrant women at the Women's Clinic. She later established a private practice with **Frances Tyson**, a fellow Woman's Medical College graduate.

While working at a government boarding school for Native Americans, she met Oneida student **Anna Hill**, who introduced Minoka-Hill to her future husband, Anna's brother Charles Abram Hill. A farmer, Hill wanted a farmer's wife, and when they married in 1905 and settled on his farm in Oneida, Wisconsin, Minoka-Hill agreed to abandon her medical practice. Rural life was rough and simple compared to the city life she was used to, and, after she adjusted to the change, her medical background eventually drew her back into practice. She added to her academic knowledge the herbal remedies of Oneida medicine men and women from the reservation. Soon her services were sought by neighbors who did not trust their community physician. Although she did not hold a Wisconsin medical license, local Brown County doctors who knew her encouraged her to treat those who came to her, and her husband ultimately accepted his wife's talents with pride.

Over the next nine years, Minoka-Hill had six children, and when her husband died in 1916 they were not left with much. Friends in Philadelphia encouraged her to return East, but she refused, later noting, "In Wisconsin I found my work." When Oneida's sole doctor left in 1917, Minoka-Hill became the community's only

trained physician. From her "kitchen-clinic" she diligently attended to her neighbors, even when her own children became ill during the 1918–19 influenza pandemic. Busy and dedicated, she would often enlist a neighbor to baby-sit or take her youngest children with her on house calls, but primarily she schooled her children in independence and taught them to take care of each other. She accepted patients from seven in the morning until ten at night, treating them with medicines and herbals supplied by doctors in nearby Green Bay and by her old college friend and former partner Frances Tyson. She accepted food or farm labor in exchange for her services, and trekked long distances to make house calls.

The Great Depression took a large financial toll on the widowed and unlicensed Minoka-Hill and her family. Green Bay physicians encouraged her to take the two-day Wisconsin medical exam, so that she could admit patients to the hospital and be reimbursed by the Federal Relief Office; they also loaned her the $100 application fee. In 1934, 35 years after she had graduated from medical school, Minoka-Hill again received a license to practice medicine. She continued her practice in Oneida for the rest of life. Throughout, she varied her fees according to a patient's ability to pay, remarking, "If I charged too much, I wouldn't have a very good chance of going to heaven." She also taught nutrition, hygiene, and preventative medicine to her patients. In 1946, a heart attack forced her to quit making house calls, but she continued to see neighbors in her kitchen-clinic.

Among other honors, Minoka-Hill was adopted by the Oneida tribe and given the name "You-da-gent" ("she who serves"), was named Outstanding American Indian of the Year by the Indian Council Fire in Chicago in 1947, and was given an honorary lifetime membership by the State Medical Society of Wisconsin in 1949. The Society also funded her trip to the American Medical Association national convention, and to her 50th college reunion. After her death in 1952, a memorial to Minoka-Hill was erected outside of Oneida, Wisconsin, inscribed: "Physician, good Samaritan, and friend to all religions in this community. . . . 'I was sick and you visited me.'"

SOURCES:

Sicherman, Barbara, and Carol Hurd Green, eds. *Notable American Women: The Modern Period*. Cambridge, MA: The Belknap Press of Harvard University, 1980.

COLLECTIONS:

A clippings file is held by the Archives Division, State Historical Society of Wisconsin.

Jacquie Maurice,
Calgary, Alberta, Canada

Minor, Virginia L. (1824–1894)

American suffrage leader and Civil War relief worker. Born Virginia Louisa Minor on March 27, 1824, in Caroline County, Virginia; died of liver disease on August 14, 1894, in St. Louis, Missouri; daughter of Warner Minor (a landowner and university "hotel-keeper") and Maria (Timberlake) Minor; married Francis Minor (an attorney), on August 31, 1843; children: Francis Gilmer Minor (1852–1866).

Was co-founder and president of the Woman Suffrage Association of Missouri (1867–71); filed lawsuit against St. Louis registrar and lost (1872); Supreme Court upheld lower courts' ruling on lawsuit (1874); was president of the St. Louis branch of the National Woman Suffrage Association (1879–90) and the St. Louis branch of the National American Woman Suffrage Association (1890–92).

Descended from a Dutch sea captain who settled in Virginia in the late 1600s, and possessing a distinguished family lineage, Virginia Louisa Minor was born in Caroline County, Virginia, in 1824. In 1826, her family moved to Charlottesville when her well-respected father was chosen by the University of Virginia to manage both the material and moral details of its dormitories. Other than this, little is known about her early life and education. On August 31, 1843, she married Francis Minor, a distant cousin who had graduated from Princeton and the University of Virginia Law School. They lived for one year in Mississippi, then settled permanently in St. Louis, Missouri, in 1844. In 1852, they had one son, Francis Gilmer, who would be killed in a shooting accident 14 years later.

Although both Virginians, the Minors supported the Union cause upon the outbreak of the Civil War in 1861, and Minor joined the recently founded St. Louis Ladies Union Aid Society. Established to assist injured soldiers and their families, it soon became the largest affiliate of the Western Sanitary Commission, which supported army hospitals with food and supplies and helped the destitute refugees who flocked to the cities from rural areas that had become battlegrounds. As she witnessed women successfully handling the complexities of running a relief organization, Minor's belief that women merited political equality was cemented. When the Commission disbanded at the end of the war in 1865, she and a few other women, in an expansion of the new idea of African-American enfranchisement, turned their civic attentions to the voting rights of women. Minor was the first woman in Missouri to publicly support suffrage.

In early 1867, she secured 355 signatures on a petition urging that a proposed constitutional amendment which would allow (male) African-Americans to vote also include women. It was submitted to the state legislature, where it was overwhelmingly rejected. Regrouping to increase their effectiveness, she and her fellow suffrage workers formed the Woman Suffrage Association of Missouri in 1867, with Minor as president. She was reelected every year and served until 1871, when she resigned because the association voted to align itself with the American Woman Suffrage Association (AWSA) under *Lucy Stone. Minor herself belonged to the rival National Woman Suffrage Association (NWSA), led by *Susan B. Anthony and *Elizabeth Cady Stanton, which later, in 1879, formed a St. Louis branch with Minor as president.

In these roles, Minor was an intelligent, effective, and charming advocate for suffrage who spoke frequently before legislative and congressional committees. She is probably best known, however, for the legal strategies she pursued along with her husband, who was himself an ardent suffragist. They contended that existing laws supported suffrage in that a woman's right to vote as a citizen was already ensured by the Constitution and the 14th Amendment (which begins by stating that all "persons" born or naturalized in the United States are considered citizens of the country and of the state in which they reside). The Minors presented that argument in 1869 to the NWSA, which endorsed and adopted it. In 1872, Minor and her husband filed a test case against a St. Louis registrar who had denied her voter registration, and after losing the case in lower courts, appealed it to the U.S. Supreme Court. In *Minor* v. *Happensett* in 1874, the Supreme Court held unanimously that women's political rights were controlled by the states, and that U.S. citizenship did not necessarily confer suffrage on anyone. Although it was unsuccessful, the case helped to highlight the suffrage movement in the minds of the American public.

After the NWSA merged with Lucy Stone's AWSA to form the National American Woman Suffrage Association (NAWSA) in 1890, Minor retained her position as president of the St. Louis branch, and retired in 1892 due only to her advancing years and poor health. She died from an abscess of the liver two years later, at age 70, and was buried without benefit of clergy, whom she felt had opposed her life-long cause of suffrage.

SOURCES:

James, Edward T., ed. *Notable American Women, 1607–1950*. Cambridge, MA: The Belknap Press of Harvard University Press, 1971.

McHenry, Robert, ed. *Famous American Women*. NY: Dover, 1980.

Jacquie Maurice,
Calgary, Alberta, Canada

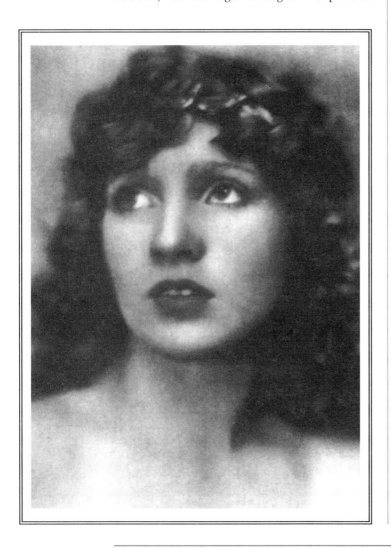

*Mary
Miles
Minter*

Minter, Mary Miles (1902–1984)

American actress whose brief career was abruptly ended by scandal. Name variations: Juliet Shelby. Born Juliet Reilly on April 1, 1902 (some sources cite 1898) in Shreveport, Louisiana; died of heart failure on August 4, 1984, in Santa Monica, California; daughter of Charlotte Shelby; married Brandon O'Hildebrandt (died 1965).

Selected filmography: The Fairy and the Waif *(1915);* Always in the Way *(1915);* Barbara Frietchie *(1915);* Dimples *(1916);* Faith *(1916);* Her Country's Call *(1917);* The Gentle Intruder *(1917);* The Eyes of Julia Deep *(1918);* The Ghost of Rosie Taylor *(1918);* Anne of Green Gables *(1919);* The Amazing Imposter *(1919);* Nurse Marjorie *(1920);* Judy of Rogue's Harbor *(1920);* A Cumberland Romance *(1920);* All Souls' Eve *(1921);* Tillie *(1922);* The Cowboy and the

Lady *(1922)*; South of Suva *(1922)*; The Trail of the Lonesome Pine *(1923)*; Drums of Fate *(1923)*.

Mary Miles Minter was born Juliet Reilly in Shreveport, Louisiana, in 1902. Minter appeared on stage for the first time at the age of five, as "Little Juliet Shelby," in the Arnold Daly production of *Cameo Kirby*. Although her acting talent was less than impressive, Minter's good looks won her a contract with the Metro film studio in Hollywood, California, in 1915. She went on to star in minor films, including *Barbara Frietchie* (1915), *Dimples* (1916), and *The Ghost of Rosie Taylor* (1918). After moving to the Realart-Paramount studio in 1918, the following year she starred in *Anne of Green Gables*, the first film version of the *L.M. Montgomery novel.

Minter was "associated" with William Desmond Taylor, a director and ladies' man whose murder in February 1922 rocked Hollywood. Taylor had also been involved with actress *Mabel Normand, and although neither was seriously suspected of the crime, in the course of the investigation it came out that each actress had visited him privately on the night he was shot. Despite the fact that she had several pictures waiting for release, including 1923's *The Trail of the Lonesome Pine*, which would prove to be her most notable, Minter's career was over. (Normand was a more valuable star, but the blow dealt to her career by the scandal was fatally compounded later the same year by a separate murder committed by her chauffeur, supposedly with her pistol.)

After a short stay in New York City, Minter spent the rest of her life in Santa Monica, California, living comfortably off real-estate investments. She survived a vicious beating during a robbery of her home in 1981, and died in 1984 of heart failure. Taylor's murder was never officially solved. Director King Vidor began an investigation of the crime in 1967, detailed in the posthumous publication of *A Cast of Killers* (1986); his conclusion that the murder was committed by Minter's mother **Charlotte Shelby** has now been accepted by many.

SOURCES:

Finch, John Richard, *et al. Close-Ups From the Golden Age of Silent Cinema*. NY: A.S. Barnes, 1978.

Katz, Ephraim. *The Film Encyclopedia*. NY: Harper-Collins, 1994.

Grant Eldridge,
freelance writer, Pontiac, Michigan

Minton, Yvonne (1938—)

Australian mezzo-soprano. Born Yvonne Fay Minton on December 4, 1938, in Sydney, Australia; studied with Marjorie Walker at the Sydney Conservatory, Henry Cummings and Joan Cross in London; married William Barclay, in 1965; children: one son, one daughter.

*Won *Kathleen Ferrier prize and Hertogenbosch Competition (1961); debuted as Britten's Lucretia, London (1964); performed at Covent Garden (since 1965); debuted at the Metropolitan Opera (1973) and the Paris Opéra (1976); named Commander of the Order of the British Empire (1980).*

Yvonne Minton has concentrated on opera of the 19th and 20th centuries, rarely venturing into baroque, classical (excepting Mozart), or early romantic opera. Wagnerian and 20th-century opera have been her focus. She was born in Sydney, Australia, in 1938 and began her career as Lucretia in Benjamin Britten's opera; this experience with a modern master seems to have left a permanent mark. Minton has performed in operas by Berg, Wagner, Bartók, Berlioz, Strauss, and Mozart. Her voice has most often been compared with one of her contemporaries, *Frederica von Stade.

John Haag,
Athens, Georgia

Minythyia (fl. 334 BCE).

See Thalestris.

Miolan-Carvalho, Marie (1827–1895)

French soprano. Name variations: Marie Carvalho; Marie Carvalho-Miolan. Born Marie Caroline Felix-Miolan in Marseilles, France, on December 31, 1827; died at Chateau-Puys, near Dieppe, France, on July 10, 1895; studied with her father F. Félix-Miolan, then in Paris with Duprez; married Leon Carvalho (an impresario), in 1853.

Noted French singer Marie Miolan-Carvalho made her debut as Isabella in *Robert le Diable* in Brest in 1849. She appeared with the Paris Opera from 1849 to 1855 and from 1868 to 1885 and created the roles of Marguerite, Baucis, Juliette, and Mireille for Gounod. In 1860, she went to London where she also sang with great success. One of the most celebrated singers of her time, Miolan-Carvalho retired in 1885.

Mira Bai (1498–1547)

Indian queen, poet, and songwriter. Name variations: Meera; Mirabai. Born in Merta in 1498; died in Dwarka in 1547 (some sources cite 1573); brought up in the court of her grandfather in the worship of the Hindu god Vishnu; married Prince Bhoj Raj of Mewar, in 1516.

A rebel in thought and religion, Mira Bai was educated at home, as was often the case with members of the Indian nobility, receiving a thorough religious and musical training. At age 18, she married Prince Bhoj Raj of Mewar; it was a short alliance as he died of wounds sustained in battle in 1521. After his death, the local king tried to poison her. "Mira is dancing with bells tied on her ankles," she wrote. "People say Mira has gone mad." Fleeing, she devoted the rest of her life to the worship of Krishna, a reincarnation of Vishnu, leaving her palace to travel on foot to Krishna's sacred places. She began to care for the poor and was severely criticized for her involvement with the untouchables. Humorous, daring, and elated, she sang songs and wrote poems that demonstrate her religious fervor.

Mira Bai is India's best-known woman poet. Though her poems were written in Hindi, they were translated early into other Indian languages. A biography has been written by Usha Nilsson.

SOURCES:

Barnstone, Aliki, and Willis Barnstone. *A Book of Women Poets From Antiquity to Now.* NY: Schocken, 1980.

Cohen, Aaron I. *International Encyclopedia of Women Composers.* 2 vols. NY: Books & Music (USA), 1987.

John Haag,
Athens, Georgia

Mirabal de González, Patria
(1924–1960).

See Mirabal Sisters.

Mirabal de Guzmán, María Teresa
(1936–1960).

See Mirabal Sisters.

Mirabal de Tavárez, Minerva
(1927–1960).

See Mirabal Sisters.

Mirabal Sisters

Dominican Republic political activists who in the generation after their deaths were transformed into national martyrs, feminist icons and revolutionary heroes. Name variations: Las Mariposas (The Butterflies).

Mirabal de González, Patria (1924–1960). Born Patria Mercedes Mirabal on February 27, 1924; assassinated by command of the dictator of the Dominican Republic, Generalissimo Rafael Leonidas Trujillo Molina, on November 25, 1960; daughter of Enrique Mirabal and Mercedes Mirabal; had sisters Minerva, María Teresa, and Dedé; married; children: son, Nelson González Mirabal (became chief aide to the nation's vice president, Jaime David Fernandez Mirabal).

Mirabal de Tavárez, Minerva (1927–1960). Born Minerva Mirabal on March 12, 1927; assassinated by command of the dictator of the Dominican Republic, Generalissimo Rafael Leonidas Trujillo Molina, on November 25, 1960; daughter of Enrique Mirabal and Mercedes Mirabal; had sisters Patria, María Teresa, and Dedé; married; children: Minou Tavárez Mirabal (became the deputy foreign minister of the Dominican Republic).

Mirabal de Guzmán, María Teresa (1936–1960). Name variations: Maria Teresa Mirabal; (nickname) Maté. Born María Teresa Mirabal on October 15, 1936; assassinated by command of the dictator of the Dominican Republic, Generalissimo Rafael Leonidas Trujillo Molina, on November 25, 1960; daughter of Enrique Mirabal and Mercedes Mirabal; had sisters Minerva, Patria, and Dedé; married.

Born into a family of landowners, the four Mirabal sisters—Patria, Minerva, María Teresa, and **Dedé**—grew up in a highly conservative and sheltered environment in the rural town of Ojo de Agua in Salcedo Province, Dominican Republic. Their father Enrique kept them on a tight rein. Although their mother **Mercedes** was barely literate, she recognized the importance of education. Mercedes convinced her husband that if their daughter Patria, who hoped to become a nun, sought to be educated, then the path to learning should not be denied her sisters. As they matured, all four sisters developed social consciences, realizing that daily life in their country had been distorted for an entire generation as a result of Rafael Trujillo's dictatorship.

For more than three decades, the Caribbean nation of the Dominican Republic was ruled by Generalissimo Rafael Leonidas Trujillo Molina (1891–1961), a megalomaniac who held on to power through terror, intimidation and corruption. He established his regime in 1930 with the approval of the United States, which had recently ended its occupation of the Dominican Republic and above all else desired stability in the region for economic and strategic reasons. A military officer trained by the U.S. Marine Corps, Trujillo "won" the Dominican presidency in May 1930, in a contested election. By the time he officially took office as president on August 16, 1930, he had used terrorism to end the lives of enough real and potential opponents to look forward to a regime with little, if any, organized opposition to his rule.

The nature of his lust for power and wealth was crystal clear by the end of the first decade of

the Era of Trujillo. He was feared, powerful, and rich by the time he became commander-in-chief of his nation's armed forces. His investments in urban properties only whetted his appetite for more wealth and, once established in the presidential office, he took personal control of the nation's salt production. Now the owner of the Barahona salt mines, Trujillo promulgated a law prohibiting the traditional production of sea salt, which was virtually free, so that the people would have to purchase salt produced at his mine. With the monopoly in place, he raised the price of salt from 60 cents to $3 for a hundred pounds. He soon established a meat monopoly by taking over the slaughterhouses in the capital, Santo Domingo de Guzmán, and eventually his network of monopolies included rice and milk. Trujillo also created a bank for cashing government checks that was managed by his wife **María Martínez Trujillo**. By the time his first presidential term ended in August 1934, he was by far the richest man in the Dominican Republic.

Trujillo also received an honorary doctorate from the national university and an appointment as a professor of political economy. Among the countless honorific titles bestowed on him over the years were Benefactor of the Fatherland, Restorer of Financial Independence, and Father of the New Fatherland. In 1936, the name of the national capital was changed from Santo Domingo de Guzmán to Ciudad Trujillo. October 24, the day of his birth, became a national holiday, and in 1955 he celebrated 25 years of his rule, proclaiming that entire year to be the "Year of the Benefactor." In the final years of his dictatorship, Trujillo was demanding that the Roman Catholic Church bestow on him the title of "Benefactor of the Church," but—possibly sensing that his days were numbered—it refused to do so.

One of the Mirabal sisters, Minerva, had firsthand knowledge of the dictator's nature. At age 22, having turned down sexual overtures from Trujillo, she was jailed and banned from continuing her law studies. During three years under house arrest at her parents' home in Ojo de Agua, she passed the time painting watercolors and writing poetry about the suffering en-

Dominican Republic stamp honoring the Mirabal sisters, issued in 1985.

República Dominicana 10¢

correos 1985

PATRIA
MINERVA 25 AÑOS Ma. TERESA
MUERTE HERMANAS MIRABAL

dured by the exploited poor in her country. Eventually, Minerva returned to her law studies and graduated with the highest honors from the National Autonomous University of the Dominican Republic.

The successful Cuban revolution, which led to the coming to power of Fidel Castro in January 1959, played a major role in radicalizing many Dominicans, including the Mirabal sisters. In the first phase of the Cuban revolution, before it became enmeshed in the bipolar struggles of the Cold War, many Latin Americans could detect a major step forward in the struggle for social justice in a part of the world where millions had long been denied the basic elements of a decent life. As the desire for social justice began to stir in the Dominican Republic in 1959, the response of the Trujillo dictatorship was swift and brutal. Hundreds were imprisoned, many were tortured, and some simply disappeared, never to be seen again.

For almost his entire dictatorship, Trujillo appeared to be impervious to attack by his enemies. Invasions by Dominican exiles—the first in June 1949 and the second exactly one decade later in June 1959—proved miserable failures. The latter invasion was a catastrophe, even though it had received considerable backing from Castro and included a number of veterans of the anti-Batista guerillas who had fought in Cuba's Sierra Maestra mountains. Despite these demoralizing defeats, the anti-Trujillo underground forces within the Dominican Republic continued to plan and plot for the overthrow of the hated dictatorship. By 1959, these revolutionaries included the Mirabal sisters, each of whom had different reasons for their participation in such a dangerous undertaking. The eldest sister Patria joined the underground because of an essentially religious thirst for justice and peace. Minerva was intent on becoming a tough-minded, fearless revolutionary free of any illusions about the dangers she was facing. The other two sisters were a study in contrasts: María Teresa, the youngest and most naïve, believed that something must be done to rid her nation of the evil Trujillo, whereas Dedé, the only sister who would survive, never completely accepted the rationale of resistance.

By 1960, Patria, Minerva, María Teresa, and their husbands had become thoroughly enmeshed in the growing anti-Trujillo resistance movement that began to sweep the Dominican Republic. Their husbands, having been involved with the failed revolt of June 1959, were arrested and imprisoned. The United States—which had long supported Trujillo's dictatorship as a pillar of pro-business, anti-Communist stability in the region—now began to distance itself from a regime whose very existence provided Fidel Castro and other Latin American revolutionaries with more than sufficient justification for a revolutionary upheaval. Known within the underground Movimiento Revolucionario 14 de Junio (MR14J) by the code name of Mariposa (butterfly), the sisters soon became known for their activities to agents of Trujillo's secret police, the dreaded SIM. They were arrested but released after a short time (for Minerva, this was the third imprisonment in her revolutionary career).

By the closing months of 1960, Trujillo had lost patience with the revolutionary movement and particularly with the Mirabal sisters. He had toyed with the idea of assassination for some time but had been talked out of it by advisors, who impressed on him the negative image this would create for his regime and possibly for him personally. Now, however, incensed by their fearless refusal to cease their oppositional activities, Trujillo gave orders to kill the sisters. Enticed by a ruse, the Mirabal sisters thought that their request to see their imprisoned husbands had finally been approved. On the way to the prison on November 25, 1960, they were arrested, subjected to horrific torture, and killed.

To hide the nature of the crime, their bodies (and that of their driver, Rufino de la Cruz) were placed in their own jeep which was pushed over a high cliff a short distance beyond Santiago, off the winding mountain road that crosses the Cordillera Septentrional to Puerto Plata. When the deaths were reported in the press, including Trujillo's puppet newspaper *El Caribe*, few readers at home or abroad were fooled by the story of an "automobile accident" that took the lives of Patria, Minerva, and María Teresa Mirabal. Soon, reports of torture inflicted on the sisters before their vehicle plunged off the cliff appeared in a story in *The New York Times*.

A number of months before his own assassination, Trujillo chose the same stretch of mountain road where the Mirabal sisters' jeep had fallen as the site for an evening stroll. With him was an intimate associate who knew the details of the assassinations. Pausing, Trujillo gazed silently over the precipice and down the steep slope. Then to the surprise of his companion, he said, "This is where the Mirabal women died—a horrible crime that foolish people blame the government for. Such good women, and so defenseless!" On the evening of May 30, 1961, Trujillo was shot dead in a machine-gun attack on his

limousine led by a former general who had fallen from grace because his sister had become a member of the resistance.

With the end of the Trujillo dictatorship, Dominicans expected their country to move easily toward democracy, having been denied its blessings for so long. However, unrest, instability, poverty, and social inequality continued to plague the nation into the next decades, and the ghosts of the past were not easily put to rest. Trujillo's last puppet president, Joaquin Balaguer, remained a major player in the Dominican political game, not retiring (under pressure) until 1996. The Mirabal family had to accept the catastrophe that had befallen them. The surviving sister Dedé helped the widowers to raise the children who had been deprived of their mothers.

By the 1980s, Dominicans had begun to appreciate the supreme sacrifice made on their behalf by the Mirabal sisters. Books, articles, museum exhibitions and a commemorative postage stamp issued on December 18, 1985, all testified to a national urge to honor these women. Throughout Latin America, the Mirabal sisters became feminist icons, with the anniversary of their deaths being commemorated every November 25 as the International Day of Violence Against Women. A powerful novel by Dominican-born poet and writer **Julia Alvarez**, whose parents had gone into exile with her in 1960 to escape Trujillo's wrath, appeared in 1994 as *In the Time of the Butterflies*.

In the Dominican Republic, the next generation of Mirabals has stepped on the public stage of that hopeful nation. Patria's son, Nelson González Mirabal, became chief aide to the nation's vice president, Jaime David Fernandez Mirabal. **Minou Tavárez Mirabal**, who was only four years old when her mother Minerva was killed, became the deputy foreign minister of the Dominican Republic. The Foreign Ministry is located in a mansion that once belonged to the Trujillo clan. Working in an office that was the bedroom of the dictator's daughter **Angelita** led Minou Mirabal to conclude that her own presence there was proof that "we are stronger" than the forces represented by the Trujillo Era.

In February 1997, Santo Domingo unveiled a refurbished 137-foot obelisk which had been placed there many decades before by Trujillo to grace the Malecon, the capital's busy seaside promenade. Now covered with a mural depicting images of the Mirabal sisters—the three martyred ones and the survivor Dedé—it no longer honors the long-dead and disgraced dictator. The work was sponsored by the national tele-

phone company Codetel, whose president said that honoring the sisters this way offered a eulogy to "the struggle of many men and women for Dominican liberty," while also atoning for "the ignominious motive that gave birth to this monument." Dominicans, particularly the nation's women, had long regarded the phallic obelisk as an embodiment of both the Trujillo dictatorship and the machismo values that permeated his life and regime, and which continue to flourish in Latin America. Its replacement by a mural honoring women was interpreted by Minou Tavárez Mirabal as "a victory that is not only political but one of gender."

SOURCES:

Alvarez, Julia. *In the Time of the Butterflies*. Chapel Hill, NC: Algonquin Books of Chapel Hill, 1994.

Aquino Garcia, Miguel. *Tres Heroinas y un Tirano: La Historia Veridica de las Hermanas Mirabal y su asesinato por Rafael Leonidas Trujillo*. Santo Domingo: [s.n.], 1996.

Behar, Ruth. "Revolutions of the Heart," in *Women's Review of Books*. Vol. 12, no. 8. May 1995, pp. 6–7.

Crassweller, Robert D. *Trujillo: The Life and Times of a Caribbean Dictator*. NY: Macmillan, 1966.

Diederich, Bernard. *Trujillo: The Death of the Dictator*. Princeton, NJ: Markus Wiener, 1998.

Ferreras, Ramon Alberto. *Las Mirabal*. Santo Domingo: Editorial del Nordeste, 1982.

————. *Trujillo y sus mujeres*. 3rd ed. Santo Domingo: Editorial del Nordeste, 1989.

Galíndez, Jesús de. *The Era of Trujillo, Dominican Dictator*. Edited by Russell H. Fitzgibbon. Tucson, AZ: University of Arizona Press, 1973.

Galvan, William. *Minerva Mirabal: Historia de una Heroina*. 2nd ed. Santo Domingo: Editora Universitaria UASD, 1985.

Julia, Julio Jaime. *Haz de Luces*. Santo Domingo: CIPAF, 1990.

Mena, Jennifer. "Women on the Verge . . . Four Brash Latina Writers Transform the Literary Landscape," in *Hispanic Magazine*. Vol. 8, no. 2. March 1995, pp. 22–24, 26.

"The Mirabel [sic] Sisters," in *The Topical Woman*. Vol. 16, no. 2. Spring 1994, pp. 460–461.

Mujica, Barbara. "The Sisters Mirabal," in *The World & I*. Vol. 10, no. 4. April 1995, pp. 328–333.

Pons, Frank Moya. *The Dominican Republic: A National History*. Princeton, NJ: Markus Wiener, 1998.

Puleo, Gus. "Remembering and Reconstructing the Mirabal Sisters in Julia Alvarez's *In the Time of the Butterflies*," in *Bilingual Review*. Vol. 23, no. 1. January–April 1998, pp. 11–20.

Rohter, Larry. "Santo Domingo Journal: The Three Sisters, Avenged—A Dominican Drama," in *The New York Times*. February 15, 1997, section I, p. 4.

John Haag,
Associate Professor of History,
University of Georgia, Athens, Georgia

Mirabeau Martel, Comtesse de

(1850–1932).

See Martel de Janville, Comtesse de.

Miramion, Madame de
(1629–1696)

Frenchwoman noted for her good works. Name variations: Marie Bonneau. Born in Paris, France, in 1629; died in Paris in 1696.

After an unhappy childhood, Madame de Miramion founded the House of Refuge, the establishment of Ste.-Pélagie, and the original community of 12 young women which later became the Congrégation des Miramiones. Madame de Miramion became its superior and upon her death left her great fortune to this and other benevolent institutions.

Miranda, countess of.

See Nilsson, Christine (1843–1921).

Miranda, Carmen (1909–1955)

*Brazilian singer who conquered Broadway and Hollywood during the 1940s. Name variations: Maria do Carmo Miranda da Cunha; "The Lady with the Tutti-Frutti Hat"; "The Brazilian Bombshell"; "A Pequena Notável." Born Maria do Carmo Miranda da Cunha on February 9, 1909, in the town of Marco de Canavezes near the northern city of Oporto, Portugal; died in Los Angeles, California, on August 5, 1955, and was buried in Rio de Janeiro on August 13, 1955; second of six children of José Maria Pinto da Cunha and Maria Emília Miranda da Cunha; sister of **Aurora Miranda da Cunha**; married David Sebastian, on March 17, 1947.*

Immigrated to Brazil (1910); made her first hit recording, "Taí" (1930); offered first starring role in a movie (1932); death of her father (June 6, 1938); signed contract with Lee Shubert to appear on Broadway (1939); became an international star in Down Argentine Way *(1940); had disappointing return to Brazil (1940); was chief Latin star in Hollywood's "Good Neighbor" films (1940–1945).*

Filmography: O Carnaval Cantando no Rio *(1932);* A Voz do Carnaval *(Brazil, 1933);* Alô, Alô Brasil *(Brazil, 1935);* Estudantes *(Brazil, 1935);* Alô, Alô Carnaval *(Brazil, 1936);* Banana da Terra *(Brazil, 1939);* Down Argentine Way *(U.S., 1940);* That Night in Rio *(U.S., 1941);* Week-End in Havana *(U.S., 1941);* Springtime in the Rockies *(U.S., 1942);* The Gang's All Here *(U.S., 1943);* Four Jills in a Jeep *(U.S., 1944);* Greenwich Village *(U.S., 1944);* Something for the Boys *(U.S., 1944);* Doll Face *(U.S., 1946);* If I'm Lucky *(U.S., 1946);* Copacabana *(U.S., 1947);* A Date

With Judy *(U.S., 1948);* Nancy Goes to Rio *(U.S., 1950);* Scared Stiff *(U.S., 1953).*

Born on February 9, 1909, in the Portuguese town of Marco de Canavezes near the northern city of Oporto, Carmen Miranda was the daughter of José Maria Pinto da Cunha and **Maria Emília Miranda da Cunha**. Christened Maria do Carmo Miranda da Cunha, she was the second of six children. The following year, her father immigrated to Brazil, where he found work as a barber. Along with her mother and sister, Carmen followed a few months later. They moved to a poor working-class neighborhood near the docks of Rio de Janeiro, with her mother helping to prepare and serve meals in the boarding house where they lived. Enrollment in St. Teresa School, operated as an act of charity by nuns from the St. Vincent order, gave Carmen some refuge from her family's poverty. She also had the chance to sing in school-sponsored musical and theatrical events and performed on the radio for fund-raising efforts. Her years at St. Teresa (1919–1925) provided her only formal education. In 1925, she had to quit school and find work to help support the struggling family.

For a while, she worked in a millinery shop, specializing in the design and manufacture of women's hats, but shortly Miranda also began making her way in the Brazilian entertainment business. In 1926, she appeared as an extra in a Brazilian movie and began to sing publicly. Her first break came in 1928, when friends introduced her to Josué de Barros, a famous musician who composed samba, the traditional music of Northeastern Brazil. Miranda began performing some of Josué's compositions, and by early 1929 was singing on the radio. She did so, however, under the name Carmen Miranda, apparently so that her strait-laced father would not know that his daughter had entered the scandalous world of singers, actors, and artists.

With Josué's backing, Miranda secured a contract with RCA Victor and made two records with moderate success. In so doing, she attracted the attention of another composer, Jouvert de Carvalho. Impressed by Rio de Janeiro's response to her energetic voice, Jouvert met Carmen and wrote "Taí" ("*P'ra Você Gostar de Mim*") for her. It became Brazil's top-selling record of 1930 and made Miranda a national sensation. When he discovered her ruse, Carmen's father was furious, but by then there was nothing that could hold back her rising fame or financial success. Her country adored the 5'1" singer's sensuality, energy, and humor.

Opposite page
Carmen
Miranda

After a trip to the northeastern states of Bahia and Pernambuco in late 1932, Carmen increasingly associated herself with the music and costumes of that region. Salvador da Bahia had been the colonial capital of Brazil, and the sugar-growing regions of the Northeast had received many of the African slaves imported by the planters. She loved the sights and sounds of the Northeast, especially the African-inspired samba and the women's traditional dress. Soon she began appearing on stage in *bahiana* clothing: turban, wide-starched skirt, and heavy jewelry, with a bare midriff and the typical sandals substituted by five-inch platform heels. It became her trademark, especially after she appeared in the Brazilian film *Banana da Terra* which featured a remarkable song-and-dance number entitled "*O que é que a bahiana tem?*" ("What Does the Bahian Girl Have?"). Before long, writes **Martha Gil-Montero**, Carmen Miranda was inseparable from the Bahian "costume, seductive gestures and tropical gaiety."

Meanwhile, she made annual trips to Argentina to perform in Buenos Aires and developed her own stage show, which drew large crowds to Rio de Janeiro's Cassino da Urca. Besides sambas, she sang and danced other Latin music, including tangos and congas. Her first starring role in a movie had been in *O Carnaval Cantando no Rio* (1932), followed by *A Voz do Carnaval* (1933), *Alô, Alô Brasil* and *Estudantes* (both 1935), *Alô, Alô Carnaval* (1936), and the aforementioned *A Banana da Terra* (1939). At this point, however, Miranda's main success came from her recordings and stage shows rather than from movies.

The next upward step in her career came in 1939. Broadway producer Lee Shubert caught her act at the Cassino da Urca and hired her to perform in *The Streets of Paris*. She sailed for New York on May 4, 1939, to the acclaim of her compatriots who believed she would popularize Brazilian music and culture in the United States. Although her act was brief and sung in Portuguese, she was the hit of the show, and New Yorkers received her enthusiastically. Miranda spoke a limited and exotic English but was enthusiastic about her life in the U.S.: "Money, money, money . . . hot dog. I say yes, no, and I say money, money, money, and I say turkey sandwich and I say grape juice." Walter Winchell dubbed her the "Brazilian Bombshell."

Later that year, Germany invaded Poland and World War II began. With Europe engulfed in the conflagration, U.S. politicians and show-business producers tried to cement American ties to

the rest of the hemisphere. When he became president in 1933, Franklin Delano Roosevelt had proposed that the United States be a "Good Neighbor" to Latin America. Pan-American solidarity became even more important to the U.S. during World War II. American leaders hoped to forestall Axis penetration into Latin America, including Brazil which had many citizens of German descent. In fact, the Brazilian *Estado Novo* government of Getúlio Vargas had quasi-fascist characteristics, although the dictator did not ally his nation with Hitler and Mussolini. Meanwhile, the U.S. entertainment industry saw its European market disappear and hoped to recoup some profits by making its movies and productions more appealing to Latin American audiences. With Nelson Rockefeller as its director, the Office of the Coordinator of Inter-American Affairs established a motion-picture section, which deliberately promoted "films with Latin American themes," according to historian Allen L. Woll.

\mathcal{S}he differed from every movie musical star that Hollywood had yet discovered. Her costume was a combination of native Bahian dress and a designer's nightmare. With bare legs and midriff, she wore sweeping half-open skirts and tons of colorful costume jewelry. She introduced the turban to the American scene, and topped it with the fruits of her native Brazil.

—Allen L. Woll

Given Carmen's immense success on Broadway, it is not surprising that she caught Hollywood's attention. Aside from her potential box-office appeal south of the border, American movie makers were anxious to help the war effort by producing films that would strengthen the ties between the nations of the Western Hemisphere. Furthermore, swing music had passed its peak of popularity, and U.S. audiences were enthralled with Latin rhythms. Miranda fit perfectly with Hollywood's political and business needs, and Darryl Zanuck's 20th Century-Fox hired her to perform in the forthcoming *Down Argentine Way* (1940) with *Betty Grable** and Don Ameche. Zanuck sent a camera crew to New York to film Carmen's part, three song-and-dance numbers intended to give local color and authenticity to the movie. U.S. audiences loved the film, and it received several Academy Award nominations. Writes Clive Hirschhorn: "Carmen Miranda was the real hit of the show—despite the fact (or maybe because of it) that she had nothing whatsoever to do with the plot." On the other hand, no one seemed to worry about the suitability of a Brazilian singing in Portuguese and dressed as a Bahian yet posing as an Argentine. In fact, Hollywood seemed to have little understanding of Latin America at all.

On July 10, 1940, Miranda returned triumphantly to Rio de Janeiro. Clad in a dress and turban in the green and gold of the Brazilian flag, she basked in the adulation of crowds that greeted her at the docks. A few days later, she appeared in a benefit performance at the Cassino da Urca. She greeted the audience in English and performed several non-Brazilian numbers from her Broadway repertory. To her dismay, the crowd responded with catcalls and little applause. Miranda left the stage in tears and immediately canceled the remainder of her schedule at the Cassino. She had badly misread her audience, the elite of Rio, who had been led to believe that Carmen had carried Brazilian culture to the U.S. only to discover that she had returned "Americanized." In part it was her fault, but she had not anticipated the cultural nationalism of her disdainful audience. She returned to the stage a week later with a very successful new show, defying her critics with new songs such as "*Disseram que Voltei Americanisada*" ("They Say I Returned Americanized"). Even so, the snub by Rio's elite pained and depressed her, and Miranda delayed her next return to Brazil for several years.

She was back in New York by October 1940 and shortly traveled on to California, ready to continue her seven-year contract with 20th Century-Fox. Filming soon began on *That Night in Rio* (1941), in which she starred alongside Don Ameche and *Alice Faye**. It was a colorful extravaganza, wonderful escapist fare for a public anxious about the Depression and the world war. Miranda stole every scene she appeared in, personifying "a culture full of zest and charm, unclouded by intense emotion or political ambivalence," according to **Cynthia Enloe**. *Weekend in Havana* soon followed, with John Payne, Alice Faye, and Cesar Romero. Carmen's Bahian image became so widely known from those two movies that Mickey Rooney impersonated her in *Babes on Broadway* (1942). Some Cuban critics complained, however, that neither Carmen nor 20th Century-Fox showed any understanding of or sensitivity to the reality of Havana. *Springtime in the Rockies* (1942) was another propaganda piece for hemispheric unity, mixing together Carmen, Cesar Romero, U.S. stars such as Betty Grable and John Payne, and the Canadian Rockies. Wrote a critic for *Time* magazine: "Only the addition of an Eskimo and

a penguin could have made the show still more hemispheric in scope."

Nonetheless, Miranda had become a major star. On March 23, 1941, Grauman's Chinese Theater immortalized her name as well as her hand and shoe prints on its sidewalk. Her income rose, but Miranda resented having to pay 50% to Lee Shubert, who had signed her to the original, exploitative contract. In 1942, she bought her way out of it. She also purchased a mansion in Hollywood, at 616 North Bedford Drive. It provided ample room for her family (her mother Doña Maria and sister Aurora, an aspiring actress, often lived with her) and became a gathering place for Brazilians who visited Los Angeles. For a star, she rarely frequented the Hollywood social scene, preferring the security of family and Brazilian friends. Work and worrying about work came first.

By the time Miranda starred in *The Gang's All Here* (1943), her Bahian image had become a caricature of itself. Director Busby Berkeley outfitted her in an outlandish banana-and-strawberry headdress and surrounded her with scantily clad dancers wearing tall bananas on their heads. Yet American audiences loved her campy performance, and she became the "Lady in the Tutti-Frutti Hat." Brazilians were torn between admiration for her success and bewilderment, if not resentment, at her characterization. When *The Gang's All Here* reached Brazil, its phallic bananas drew the wrath of Getúlio Vargas' censors.

The extravagance of her production numbers and her occasional forays onto the live stage netted Carmen Miranda a substantial income during the war. Indeed, she earned over $201,000 in 1945. This made her the highest-paid woman in the United States and placed her ninth in all of Hollywood. Talent and good fortune had raised Miranda from the poverty of her childhood in Rio. Yet the memory of those years meant that she rarely felt secure in her American prosperity. Never a classical beauty, she resorted to plastic surgery to enhance the appearance of her nose in 1943. Dissatisfied with the results, she underwent a second operation in St. Louis the following year. A resulting infection nearly killed her.

As soon as World War II ended, the U.S. saw no need to continue its Pan-American campaign. Hollywood again had access to markets in Europe and Asia, where war-weary moviegoers flooded into theaters. Because she embodied the excessive pandering to Latin American audiences during WWII, peace cut into her film opportunities. When her contract with 20th Century-Fox ended, she decided to remain independent rather than tie herself to one studio. Writes Woll, "she shuffled from studio to studio in second-rate comedies and musicals": United Artists' *Copacabana* (1947), MGM's *A Date with Judy* (1948), and Paramount's *Scared Stiff* (1953).

While the entertainment gossip reporters occasionally noted rumors about her romantic liaisons (including a romance with Getúlio Vargas), Miranda was surprisingly discreet about her private life. In fact, given her carefully cultivated sensuous image, her personal behavior was remarkably conservative by Hollywood standards. She refused to succumb to Darryl Zanuck's attempted seductions. Other suitors were dismayed to find that she sometimes took her mother or sister along as a chaperon. When asked about romantic interests, she claimed to be in love with an anonymous Brazilian, perhaps thinking wistfully of an early romance with Mário Miranda da Cunha. But Carmen was not willing to sacrifice her career, and perhaps feared that a Brazilian husband would have restricted her professional life in favor of traditional gender roles.

In arranging her own contracts, Miranda met David Sebastian, a Hollywood hanger-on and sometime producer. They fell in love, and Carmen probably also saw him as someone who could help manage her freelance career. She and David married on March 17, 1947. They were delighted when Carmen became pregnant, but the happiness ended in miscarriage in 1948. She had often talked about getting married and raising a large family, but by the late 1940s such ambitions probably meant giving up her performing career. Marital tensions led David and Carmen to separate in 1949, although they later reconciled. Some Brazilians thought the Queen of Samba should not have married a "gringo."

By 1950, the peak of Carmen Miranda's popularity had passed, but she continued to make occasional movies and perform on stage. Her European tour of 1953 was a great success, and enthusiastic crowds greeted her from Havana to Las Vegas to New York. But it was harder for her to muster the physical energy that had captivated earlier audiences, and she increasingly turned to amphetamines, sleeping pills, and alcohol to regulate her moods. Short periods of intense work gave way to long weeks of lethargy. Manic energy turned into prolonged depression. Her stamina could not sustain the hectic days and nights that she easily had tolerated 20 years earlier. In late 1953, Miranda's depression became so acute that her doctor, W.L. Marxer, prescribed a series of electric shock treatments in a Palm Springs sanitorium.

If anything, her condition worsened. Carmen's sister Aurora had returned to Brazil, and David lacked the patience to deal with someone so ill and dependent. Friends were shocked by her state. In late 1954, Aurora returned and persuaded Carmen to accompany her to Brazil for a vacation. They arrived in São Paulo on December 3, where Carmen mustered the energy to greet and briefly entertain reporters and fans. But she collapsed from the physical and emotional strain during her flight to Rio. After an absence of 14 years, Miranda spent her first weeks at home under close medical supervision. She recovered some of her strength and mental stability, cheered by the warm reception accorded her by Brazilians. Tempted to remain in Rio, she eventually rejoined David in the U.S., after a five-month absence.

Perhaps the essence of her being required that the Brazilian bombshell resurrect her career. At any rate, Carmen performed on television and in Las Vegas, where she fell on stage. A bout with pneumonia during an appearance in Havana sapped her strength. Having returned to the Hollywood life, she reverted to her compulsive schedule, disregarding her precarious health. Early in her career, Miranda had effortlessly memorized her parts; now she had memory lapses on stage. Something was wrong, but doctors could not detect its cause.

Her end came on August 5, 1955. She had taken ill while filming an appearance on the Jimmy Durante television show. Even so, at home she entertained guests until the early morning. Preparing for bed, Carmen suffered a fatal heart attack. David found her body the next day. Following a funeral mass on August 8, her body was flown to Brazil for burial in Rio de Janeiro. A nation in mourning received its daughter home. On August 13, massive crowds accompanied the procession bearing her remains to the São João Bautista Cemetery. That December, the mayor proclaimed the creation of a museum to her memory, for which David Sebastian had contributed some of her belongings. The Carmen Miranda Museum opened in 1957.

SOURCES:

Brito, Dulce Damasceno de. *O ABC de Carmen Miranda.* São Paulo: Companhia Editora Nacional, 1986.

Enloe, Cynthia. *Bananas, Beaches & Bases: Making Feminist Sense of International Politics.* London: Pandora, 1989.

Gil-Montero, Martha. *Brazilian Bombshell: The Biography of Carmen Miranda.* NY: Donald I. Fine, 1989.

Hirschhorn, Clive. *The Hollywood Musical.* London: Octopus Books, 1981.

Woll, Allen L. *The Latin Image in American Film.* 2nd ed. UCLA Latin American Studies, vol. 50. Los Angeles: UCLA Latin American Center Publications, 1980.

SUGGESTED READING:

Barsante, Cássio Emmanuel. *Carmen Miranda.* Rio de Janeiro: Europa Empresa Gráfica e Editora, 1985.

Nasser, David. *A Vida Trepidante de Carmen Miranda.* Rio de Janeiro: Edições O Cruzeiro, 1966.

Oliveira, Aloysio de. *De banda pra lua.* Rio de Janeiro: Editora Record, 1983.

Queiroz, José J. *Carmen Miranda: Vida, Glória, Amor e Morte.* Rio de Janeiro, Companhia Brasileira de Artes Gráficas, 1956.

RELATED MEDIA:

"Carmen Miranda: Bananas Is My Business," documentary produced (with David Meyer) and narrated for PBS by **Helena Solberg**, first aired in October 1995.

Kendall W. Brown,
Professor of History, Brigham Young University, Provo, Utah

Miranda, Isa (1909–1982)

One of Italy's leading actresses. Born Inèes Isabella Sampietro in Milan, Italy, on July 5, 1909; died of an infected bone fracture in Rome, Italy, on July 8, 1982; married Alfredo Guarini (a film producer).

Selected filmography: Tenebre *(1933);* La Signora di Tutti *(1934);* Come le Foglie *(Like the Leaves, 1934);* Du bist mein Glück *(Ger., 1936);* Passaporto Rosso *(1936);* Il Fu Mattia Pascal *(L'Homme de nulle part also released as* The Late Mathias Pascal *and* The Man From Nowhere, *1936);* Scipione l'Africano *(Scipio Africanus, 1937);* Una Donna fra due Mondi *(Between Two Worlds, 1937);* Le Menzogne di Nina Petrovna *(The Lie of Nina Petrovna, Fr., 1937);* Hotel Imperial *(US, 1939);* Adventure in Diamonds *(US, 1940);* Malombra *(1942);* Zazà *(1943);* Lo Sbaglio di essere Vivo *(My Widow and I, 1945);* Au-delà des Grilles *(Fr.-It., also known as* Le Mura di Malapaga, *1948, released as* The Walls of Malapaga, *1949);* La Ronde *(Fr., 1950);* Les sept Péchès capitaux *(The Seven Deadly Sins, Fr.-It., 1952);* Siamo Donne *(We the Women, 1953);* Avant le Deluge *(1953);* Rasputin *(1954);* Summer Madness *(Summertime, UK-US, 1955);* Il Tesoro di Rommel *(1956);* Une Manche it la Belle *(What Price Murder, Fr., 1957);* La Noia *(The Empty Canvas, 1963);* The Yellow Rolls-Royce *(UK, 1964);* The Shoes of the Fisherman *(UK-It., 1968);* Das Bildnis des Dorian Gray *(Dorian Gray, Ger.-It.-Liecht., 1970);* Il Portiere di Notte *(The Night Porter, It.-UK, 1974);* Le Faro da Padre *(Bambina, 1974).*

A leading actress of international films, Italian-born Isa Miranda trained for the stage at Milan Academy and was a bit player in Italian films when she was selected by the great German director Max Ophuls to play the lead in *La Signora di Tutti* (1934), one of the first films he made after leaving Germany following the Reichstag fire. Miranda went on to star in many Ital-

ian, German, French, and British films, winning the Best Actress award at the Cannes Film Festival for her performance in *Au-delà des Grilles*, released for English-speaking audiences as *The Walls of Malapaga* in 1949. Her American films included *Hotel Imperial* (1939) and *Adventure in Diamonds* (1940). Miranda also appeared on the Italian stage and television and was respected as a poet, novelist, and painter. She was married to the film producer Alfredo Guarini.

Mireille (1906–1996)

French composer, singer and actress who played a major role in promoting the cause of the French popular chanson. Born Mireille Hartuch in Paris, France, on September 30, 1906; died in Paris on December 29, 1996; daughter of Hendel Hartuch and Mathilde Rubinstein Hartuch; married Emmanuel Berl (a noted editor), in 1936 (died 1976).

Author of more than 600 songs, a memorable stage performer, and a mentor and teacher to several generations of French singers, the diminutive and charismatic Mireille taught 80,000 students, many of whom would go on to stardom.

She was born Mireille Hartuch in Paris in 1906, to a mother who had been born in Great Britain and a father who had immigrated to France from Poland and who supported his family by working as a furrier. Although her background was truly cosmopolitan, Mireille was a quintessential Parisian, living her entire life, aside from the period of the Nazi occupation, in her beloved birthplace.

Her musical talents were spotted early. At age ten, she was heard playing the piano by Francis Planté, a virtuoso who had known Rossini and Liszt. Planté took charge of Mireille's musical education; he also had to regretfully inform her parents that despite her talents she would never have a career as a concert pianist because her small hands prevented her from covering an octave. Her energies were not to be blocked, however, and she was soon appearing on stage at the Odéon Theater as Cherubino in *The Marriage of Figaro* and Puck in *A Midsummer Night's Dream*.

By the time she was in her late teens, Mireille had discovered that she had a gift for musical composition and started an artistic collaboration with Jean Nohain, a lawyer with a talent for writing song lyrics. The team's long and successful work together began in 1928 when their "American-style" operetta *Fouchtra*

Isa Miranda

was published (it would never be performed in its entirety on stage). Mireille, who used only her first name, had by now become a successful actress. She played alongside the young Jean Gabin in the operetta *Flossie* and broke into motion pictures, appearing in a short film with superstar Buster Keaton. Well established in Paris, Mireille appeared in London at the Café de Paris, then crossed the Atlantic to take the lead role in Noel Coward's production of *Manon la Crevette* on Broadway. While in the United States, she met virtually everyone of note in the entertainment world, including George Gershwin and Cole Porter, and was invited to Hollywood to compose several film scores.

Although she had already achieved considerable fame in Paris, Mireille's major breakthrough took place in the grim Depression year of 1932. Her music publisher persuaded the popular cabaret duo Pills et Tabet to perform a number, "Couchés dans le Foin" (Lying in the Hay), from her operetta *Fouchtra*. The combination of Mireille's tune and Jean Nohain's witty lyrics made the song a smash hit, and almost overnight a new style in French popular music was born. Light and carefree, the sound was a major departure from the previous style and proved a perfect

fit for people in need of escape from the grim realities of the day. Years later, Charles Trenet would attempt to explain the transformation: "I was lucky to arrive at a time when, thanks to Mireille and Jean Nohain, French song had undergone a veritable revolution and people no longer believed that a music-hall artiste had to stand there and utter idiotic rhymes."

Over the next decades, nearly all of France's great popular singers would sing chansons crafted by the team of Mireille-Nohain, including Jacques Brel ("Le Petit Chemin"), Maurice Chevalier ("Quand un Vicomte"), Yves Montand ("Une Demoiselle sur une Balançoire"), and Maurice Sablon. Mireille herself began performing her own compositions in public starting in 1934, and she also made numerous recordings. With a light, slightly sharp voice and perfect diction, she won over her audiences by sheer force of personality, since, according to her friend Sacha Guitry, she was "lucky not to be handicapped by a big voice."

In 1936, Mireille married the noted editor Emmanuel Berl. Calling him "my Voltaire" and claiming never to have read any of her husband's books, she had a happy marriage which would end only with Berl's death in 1976. Both of Jewish ancestry, Mireille and Berl found themselves at great risk during the German occupation of France that began in the summer of 1940. They fled to the provinces, saving themselves and the noted author André Malraux from being arrested by either the Germans or their French collaborators who hunted down Jews and anti-fascists. Mireille played an active role in the French resistance. On one occasion, she was able to prevent a German attack on the Maquis, the French armed resistance which had become active in their region.

Back in Paris after the Nazi occupation ended, she continued her career with confidence and panache. In 1954, believing that the basic skills needed to compose and perform French popular songs could be taught as an academic discipline, Mireille founded her Petit Conservatoire de la Chanson. Located in Paris' Rue de l'Université, this school was the first attempt in history to teach the art of the French chanson, both in terms of artistic creation (composition) and re-creation (performance). Although initially looked upon somewhat skeptically by cabaret performers and hardened veterans of the entertainment industry, the school not only survived but flourished. By the late 1990s, it had provided instruction to an astonishing 80,000 students. Doubtless some individuals enrolled simply to sit in a class taught by Mireille, an increasingly legendary artist, but of the students who completed the courses many went on to successful careers in France, Belgium and other Francophone nations, including such superstars as Hugues Aufray, **Françoise Hardy**, and **Colette Magny**. Despite these impressive results, Mireille remained modest, commenting simply, "It is always the students who teach me. I have never taught anyone anything. Charm and *gouaille* cannot be inculcated. What I can do is help, detect, talk."

Mireille's final years were rich in honors. She was invited to sing with such superstars as Georges Brassens, and at age 86, in 1991, she made her first video. In 1995, in one of her last public appearances, she gave an extraordinary solo performance at the Salle Gémier. Loyal fans were overjoyed to see her—"a still sparkling presence" in a Lacroix gown—singing song after favorite song while standing behind her trademark, a white grand piano. With Mireille's death in Paris on December 29, 1996, the French chanson lost one of its greatest creative spirits.

SOURCES:
"Mireille," in *The Times* [London]. January 6, 1997, p. 21.

John Haag,
Associate Professor of History,
University of Georgia, Athens, Georgia

Miremont, countess of.
See Madeleine de Saint-Nectaire (fl. 1575).

Mirhrimah (1525–1575).
See Mihrimah in Reign of Women.

Miriam.
Variant of Mary.

Miriam
Biblical woman. A daughter of Ezrah, of the tribe of Judah.

Miriam the Prophet
(fl. c. 13th or 14th c. BCE)
Hebrew prophet who was the sister of Moses and Aaron. Name variations: Miriam the Jewess; Miriam the Prophetess; Mary the Jewess; Mariam. Flourished in the 13th or 14th century BCE; born in Alexandria, Egypt; died at Kadesh; daughter of Jochebed; sister of Moses and Aaron.

Miriam the Prophet is a well-known Biblical figure, most often associated with her criticism of Moses and subsequent punishment by God, and with leading the Israelite women in song and dance after the escape from Egypt. The elder

sister of Moses, the legendary prophet and leader of Israel, she first appears in the Bible as a young Hebrew girl living in the capital of Egypt, watching from among the reeds as her baby brother floats on the Nile River in a basket. Having been placed there by their mother *Jochebed to save him from the slaughter of Hebrew boys ordered by the Pharaoh, he is soon discovered by an Egyptian princess. Miriam, seeing this, rushes to the scene and suggests to the princess that the infant needs a nurse. When the princess agrees, Miriam fetches Jochebed, who is appointed as the boy's nurse.

As Miriam watched, her brother Moses was raised as Egyptian royalty until he was exiled. Forty years later, he received a calling from God to lead Israel out of slavery. After the departing Israelites had crossed the divinely parted Red Sea (or the Sea of Reeds according to some sources), leaving their Egyptian pursuers in the closing waters behind them, Miriam led the women in a jubilee song and dance. She later displayed prophetic powers; some say she prophesied her brother's extraordinary destiny when he was just an infant. The last public events in her life took place after Moses married *Zipporah, a Cushite (or Ethiopian, or, simply, foreign) woman. Miriam, backed by her brother Aaron, criticized him for his choice and as punishment from God she was stricken with a white leprosy. Moses intervened on her behalf and she was healed, but, in accordance with God's strictures, was banished in shame for seven days.

Miriam as a historical figure is often commingled, or by some accounts erroneously confused, with an influential Alexandrian alchemist and inventor of the 1st, 2nd or 3rd century CE, *Mary the Jewess, who is known by some of the same alternative appellations as Moses' sister. The apparent discrepancy between the time periods when each one lived suggests they are different women, but many sources treat them as the same person, simply clouded by the mists of history and myth. Some attribute the connection to the ancient alchemists' penchant for things mystical and exalted; they are said to have often appropriated historical names for themselves. Others say the link may originate from the concept of alchemy as a gift from God to his prophets or to the Hebrews alone.

SOURCES:
Doberer, Kurt K. *The Goldmakers*. London, 1948, pp. 21–22.
King, William C. *Woman: Her Position, Influence, and Achievement Throughout the Civilized World: From the Garden of Eden to the Twentieth Century*. Springfield, MA: King-Richardson, 1900.

SUGGESTED READING:
The Bible. Exodus 15; Numbers 12:1–17.

Jacquie Maurice,
Calgary, Alberta, Canada

Miriam the Prophet (fl. 1st, 2nd, or 3rd c.).

See Mary the Jewess.

Miró, Pilar (1940–1997)

Innovative Spanish film director. Name variations: Pilar Miro; Pilar Miro Romero. Born in 1940 in Madrid, Spain; died of a heart attack on October 19, 1997, in Madrid.

Selected filmography: La Petición *(The Demand, 1976);* El Crimen de Cuenca *(The Cuenca Crime, 1979);* Gary Cooper que estas en los Cielos *(Gary Cooper Who Art in Heaven, 1980);* Hablamos esta Noche *(Let's Talk Tonight, 1982);* Werther *(1986).*

After studying screenwriting at Spain's Official School of Cinematography, in 1963 Pilar Miró became that country's first woman television director. She was then 23. Her first feature film, *La Petición* (The Demand), released in 1976, caused controversy due to its feminist themes. Three years later, her international reputation was assured with *El Crimen de Cuenca* (The Cuenca Crime), which depicted in detail the repressive measures of Spain's Guardia Civil. The film was banned there, and Miró was brought to military trial. *Gary Cooper que estas en los Cielos* (Gary Cooper Who Art in Heaven), an autobiographical film with a feminist slant, was released in 1980, followed by *Hablamos esta Noche* (Let's Talk Tonight) in 1982. Miró was the Director General of Cinematography in the Spanish Ministry of Culture from 1982 until 1986, which was also the year she released her final feature film, *Werther*. She then headed the state television until her resignation in 1989, which has been variously attributed either to charges of misappropriation of funds or as a protest against the industry's discrimination of women. Shortly before her death from a heart attack in Madrid on October 19, 1997, she directed the televised wedding of Princess *Cristina (b. 1965), daughter of King **Juan Carlos** and *Sophia of Greece.

SOURCES:
Katz, Ephraim. *The Film Encyclopedia*. NY: HarperCollins, 1994.
"Pilar Miró" (obituary), in *Classic Images*. No. 270. December 1997, p. 55.

Jacquie Maurice,
Calgary, Alberta, Canada

Misme, Jane (1865–1935)

French feminist journalist. Pronunciation: MEEM. Born Jeanne Maurice in France in 1865; died in 1935; married Louis Misme, in 1888; children: daughter, Clotilde (b. 1889).

Born in France in 1865, Jeanne Maurice married a Lyons architect, Louis Misme, in 1888. They moved in 1893 to Paris, where she began to write for *Le Figaro* and *Le Matin*. She became involved in feminist activities when she joined *Jeanne Schmahl's L'Avant-courrière (The Advance Messenger) as its secretary. The organization was devoted to persuading Parliament to enact two specific reforms: the right of women to bear legal witness to public and private acts, and the right of women, including wives, to have full control of their own income. Schmahl's moderate feminism, focused on achieving practical reforms through conventional methods and rejecting partisan political appeals, permanently influenced Misme's approach to feminist activity.

*Juliette Adam opened the columns of *La Nouvelle Revue* to Schmahl and Misme. In due course Misme joined *Marguerite Durand's *La Fronde* (1897–1905) after hesitating for a year because of Schmahl's objections and her own misgivings about the propriety of this pioneering all-female daily. She was a regular contributor, especially writing drama criticism—a novelty for a woman columnist—under the pen name "Jane." After *La Fronde* became a monthly supplement of *L'Action* in 1903 due to financial exigencies, Misme stayed on until its demise in March 1905. She then emerged as a leader in her own right when she set out in October 1905 with *La Fronde*'s former financial columnist, **Mathilde Méliot**, to garner support to found a weekly. *La Française* appeared on October 21, 1906, and in time became the most important single publication in France devoted to women's life and issues, lasting to 1939. The paper was organized as a cooperative, with its collaborators required to purchase shares. From the start, Misme succeeded in attracting a wide variety of supporters, including notably the *Duchesse d'Uzès, because she insisted upon an apolitical stance and, as she promised, "a moderate and seemly tone without pedantry or dogmatism." The paper would seek to prove the validity of feminism by "the demonstration of facts and acts" while advocating "modern and sensible ideas." As she put it in 1910, women's claims would have no chance of being generally understood and accepted "until their propagation, disengaged from any political, philosophical, or re-ligious attachments, will clearly show what they are: a cause in the general interest." The paper also sponsored a circle offering courses, conferences, lectures, concerts, and theatricals, which attracted support from the upper bourgeoisie and aristocracy. Along these same lines, she co-founded (1908) and was vice-president of the Permanent Congress of International Feminism, which sponsored monthly meetings with foreign women residing or visiting in Paris in order to exchange ideas and information.

At first, *La Française* stayed clear of political causes, concentrating on familiar topics with broad support among women such as alcoholism, prostitution, pornography, and depopulation. Women's suffrage, she later admitted, seemed "terribly subversive" in those days, and the paper hence confined itself to sympathetic reportage but not active participation. This changed, however, when Schmahl—who had disbanded L'Avant-courrière, following passage of the "Schmahl Law" in 1907 giving women control of their income—floated a project for a non-partisan organization that would push for suffrage. Misme opened *La Française*'s columns to Schmahl for a series of articles in January 1909, and on February 13, 1909, the French Union for Women's Suffrage (UFSF) was founded, destined to become the leading suffragist organization in France until the vote was granted in 1944. Misme was named secretary-general and was expected to work under Schmahl's close supervision.

In December 1910, the UFSF's central committee underwent a painful crisis as a result of the huge success *Cécile Brunschvicg, an outspoken defender of the Third Republic, was having recruiting new members. Schmahl, imperious and increasingly difficult to deal with, challenged Brunschvicg's methods, which she charged were violating the non-partisan character of the UFSF and potentially alienating possible conservative and Catholic recruits. Schmahl lost, resigned as president, and went into a lonely retirement. Misme had sided with Brunschvicg against her old companion and gave up her secretary-generalship to Brunschvicg, who now became the principal leader of the organization. Misme had concluded that Schmahl's personality was no longer suited to leadership of the kind necessary to conciliate many points of view and that Brunschvicg's talents and recruiting successes promised a brighter future—which proved to be the case.

La Française continued despite steady financial losses; in 1911, *Sarah Monod and **Julie Puaux** (Mme Jules) **Siegfried** saved it from an

imminent demise. The paper's moderate tone no doubt helped it to survive by attracting and holding a wide range of readers. Misme continued advocacy of suffrage and undertook speaking engagements in the provinces for the UFSF. But she adamantly opposed the methods of the English "suffragettes" in the pre-1914 years. An "innate caution in the French temperament," she maintained, meant that "French suffragists are not ready for these gigantic parades that England and America constantly see. They will not be ready for a long time." French women should be "suffragists, not suffragettes." To do otherwise, she stated, would draw ridicule, which (as the adage has it) is fatal in France.

At the outbreak of the First World War (1914–18), Misme stopped publishing *La Française*. She soon resumed but dropped the feminist columns to concentrate on boosting morale. The suffragist campaign should be discontinued, she wrote, because "while the ordeal our country is suffering continues, it will not be proper for anyone to speak of her rights." Misme turned to problems women were experiencing in the war; she also waged a strong fight against alcoholism. The suffrage question revived at the war's end, with the women's movement divided and quarreling. Misme again advocated moderation, denouncing as "suffragist maximalists" those whose demands for full suffrage immediately rather than for a partial suffrage—e.g., for municipal elections—would, she believed, doom the whole movement at this juncture. As it turned out, the Chamber of Deputies passed a suffrage bill in 1919, but the Senate defeated it in 1922 and blocked it thereafter.

In 1920, Misme, who had been writing also in Gustave Téry's *L'Oeuvre*, was forced by illness to turn *La Française* into a monthly. In 1924, the National Council of French Women (CNFF), the national umbrella organization and hence moderate and relatively apolitical, appropriately took it over, with Brunschvicg, now president of the UFSF, assuming its direction in 1926. In her last years, Misme helped Brunschvicg organize the Estates-General of Feminism (1929), which laid women's issues before the country in well-publicized campaigns. She also presided over the press section of the CNFF and was convener (1930–34) of the letters committee of the International Council of Women.

Jane Misme was responsible for founding and editing the most important women's periodical of its time in France. Next to Jeanne Schmahl, she was arguably the greatest exemplar of a firm but moderate feminism, which she believed, for many sound reasons, best suited France's case. While outspokenly opposed to altering traditional sexual morality for women—like Brunschvicg, she would rather have men adopt women's traditionally strict standards—she warmly favored women becoming involved in the workplace and the professions as a means of fulfilling their potentialities. She thought that women's work experiences in the First World War would result in a permanent change of attitude and an end to one of the chief causes of women's inferior status—a status she devoted her life to eradicating.

SOURCES:

Hause, Steven C., with Anne R. Kenney. *Women's Suffrage and Social Politics in the French Third Republic*. Princeton, NJ: Princeton University Press, 1984.

Historical Dictionary of the Third French Republic 1870–1940. 2 vols. Edited by Patrick H. Hutton. NY: Greenwood Press, 1986.

Klejman, Laurence, and Florence Rochefort. *L'Égalité en marche: Le féminisme sous la Troisième République*. Paris: Presses de la Fondation nationale des sciences politiques, 1989.

McMillan, James F. *Housewife or Harlot: The Place of Women in French Society 1870–1940*. NY: St. Martin's Press, 1981.

Rabaut, Jean. *Histoire des féminismes français*. Paris: Stock, 1978.

David S. Newhall,
Professor of History Emeritus, Centre College, and author of
Clemenceau: A Life at War (Edwin Mellen Press, 1991)

Mistinguett (1875–1956)

French singer-dancer who was one of her nation's best-known entertainers. Born Jeanne-Marie Bourgeois on April 5, 1875 (some sources cite 1873), in Enghien, France; died on January 5, 1956, at her home near Paris; daughter of a mattress manufacturer and a seamstress; had a brother, Marcel; children: (with a Brazilian named de Lima) one son, Léopold (born out of wedlock in 1900).

After studying singing and dance in Paris as a teenager, made her first appearance on a music-hall stage (1893); by the outbreak of World War I (1917), had become one of the most popular and highly paid Parisian music-hall performers, known for her elaborately produced shows with their earthy humor, gaudy costumes, and semi-nudity; between the two World Wars (1919–39), became France's best-known entertainer and attracted audiences in Britain and the U.S. as well; continued performing well into her 70s until ill health forced her retirement from the stage (1950s).

Mistinguett was the most recognizable woman in France during the first half of the 20th century, admired by millions of French men

for her beautifully sculptured legs and by an equal number of French women for her luxurious wardrobe and ebullient lifestyle. More intimate acquaintances loved her with passionate admiration, trembled at her formidable temper, and swarmed around her to receive the bounty of her sexual and material favors. Mistinguett was the "Queen of the Paris night," ruling over a realm of smoky music halls and casinos where rough-edged audiences shouted and whistled and threw money on the stage, and in which the entertainment featured plenty of exposed flesh and bawdy humor. She emerged from this tumultuous milieu as both superstar and national icon, a "spiritual diva," wrote *Colette, "who possesses the most beautiful legs in Paris and the most gracious smile in the whole world."

The public was the most exacting of all my lovers.

—Mistinguett

To the villagers of Enghien, a country town not far from Paris, she had been simply Jeanne-Marie Bourgeois, the mischievous daughter of a local mattress manufacturer and a seamstress, born on April 5, 1875. The future for little "Jeannot," as she was nicknamed, seemed as bleak as that of any child raised in a poor country town by indifferent parents occupied with earning a living. Monsieur Bourgeois put his daughter to work stuffing mattresses when she was barely of school age. Then there was Madame Bourgeois' sewing and "feather dressing" business, where an extra pair of hands was always needed, especially after the birth of a brother, Marcel. "My mother . . . was very fashionable and liked to wear enormous hats," Mistinguett later wrote, two traditions the younger woman would dedicate her life to propagating. "She gossiped a lot and was forever talking to herself, pretending that she was on the stage. The thing is, she would have made a very good actress." Jeannot's childhood was thrown into further turmoil when her father died of tetanus after gashing his arm on a length of rusty chicken wire.

Fortunately, there were occasional distractions. One was Jeannot's Parisian aunt, Tante Florentine, with whom she was sent to stay during school holidays. Tante Florentine was fond of horses, more particularly of the money that could be made betting on them, and often took her niece with her to the auctions and race tracks that surrounded Paris and into the cafés and bistros peopled by hustlers, ne'er-do-wells, and hangers-on. An uncle who played violin in several music-hall orchestras completed Jeannot's early education in the French demimonde. Then, too, there were boys, in whom Jeannot

took an early and enthusiastic interest. She claimed to have lost her virginity at 15 but remembered little about it except that she had been chewing licorice root at the time and had difficulty deciding where to spit out the juice.

The catalyst for Jeannot's future fame came on the day Madame Bourgeois sent her daughter to deliver a bill to a music-hall singer of some repute, **Anna Thibaud**, who had recently taken a house in Enghien and had availed herself of Madame Bourgeois' interior decorating talents. Like other famous chanteuses of the day, Thibaud was accompanied in her travels by a retinue of mostly male admirers who saw to her needs while trading on their attachment to her. A later age would have called them "groupies." Jeannot, entranced by the gaiety and high spirits filling the Thibaud ménage, revealed her dreams of being an actress only to be greeted with hoots of derision and Thibaud's unsympathetic opinion that she was too ugly for the stage. Jeannot never forgot the cruel taunts and, as if to prove Thibaud wrong, was soon staging her own musical entertainments in her father's old mattress shop, enlisting her friends as talent and her mother as the scenery and costume designer. Her version of Moliére's *Le Medecin Malgré Lui*, in which she cast her girlfriends in all the male parts, was the talk of Enghien.

Madame Bourgeois, convinced that her daughter's musical talents might prove profitable, promptly arranged for violin lessons with a teacher in Paris; but Jeannot found the lessons boring and her fellow students, who were from more affluent and sophisticated homes, patronizing. Her teacher's opinion that she would not be ready to perform publicly for at least ten years hastened Jeannot's decision to quit the violin, take singing lessons instead, and adopt her first *nom de théatre* by using the name of the railroad stop in Enghien. The newly christened "Princesse de la Pointe-Raquet," when not studying her scales and vibrato in a classroom off the Champs Elysée, sang with her classmates on street corners, or in the Jardin des Tuileries and the nearby Place de la Concorde. She dutifully returned home to Enghien each night, but sometimes not before visiting Paris' many bistros and "café-concerts," choosing **Alice Ozy** as her favorite musical-hall performer. It was a wise choice, for Ozy would return the compliment many times over.

Ozy sang, danced, and played the flute in her act at the Eldorado with grace, wit, and a remarkably even temper, considering the rowdy nature of her audiences, the male members of

Mistinguett

which would often crowd the stage with sexual taunts and hopeful offers of money for an assignation between shows. Jeannot's admiration inspired her to adopt many of Ozy's mannerisms and eventually to ask for an introduction. Unlike Thibaud, Alice Ozy felt that the tall, round-faced village girl might have a talent for the stage, and began spending a few minutes each day teaching Jeannot deportment and stage technique. Before long, Ozy had introduced Jeannot to her agent-producer, Monsieur Saint-Marcel. It was Saint-Marcel who gave Jeannot her sec-

ond stage name, "Miss Helyett," the name of a character in one of Ozy's musical revues; and it was Saint-Marcel who found Jeannot her first public appearances in small bistros, where "Miss Helyett" would be given one song and any tips that an audience might care to bestow. Mistinguett would never forget the lessons she learned before these working-class audiences who demanded diverting entertainment and a glimpse of the good life for their hard-earned francs. "She played to the galleries, not the stalls," one acquaintance noted at the height of Mistinguett's career.

Even during these early years, the future Mistinguett attracted attention for the playful sexual banter that had made the dignified matrons of Enghien blush, and for the physical agility with which she moved about the stage. Then, too, there were her handmade costumes, sprouting feathers and twinkling with sequins, and the enormous, complex hats that put anything her mother had designed to shame. The most famous of them was a creation in astrakhan and silver ribbon, sporting two stuffed birds which Jeannot had trapped and prepared herself. Although the hat attracted swarms of flies during Paris' humid summers, it became so famous that a noted fashion designer of the time sketched her wearing it and included it in a published volume of his drawings.

In 1893, Saint-Marcel offered Jeannot her first major booking and the name by which she would be known to the world. Saint-Marcel was that year writing a new revue for the Casino de Paris, one of the city's most popular and elegant music halls, and a far cry from the smaller, rowdier halls which Jeannot had been playing. These smaller clubs were known in Parisian slang as *guinguettes*. Jeannot, thrilled at Saint-Marcel's offer of a song in his new show at such a famous venue, immediately announced she would change her name for the occasion to "Miss Guinguette." Saint-Marcel shortened it and sent her on stage as "Mistinguett" with the number he had written for her. "I'm the Casino Kid!," Mistinguett musically announced at her entrance,

> Fresh as a poppy,
> But shapely and laughing
> And always having fun!

Saint-Marcel, complaining that her voice was weak and difficult to hear over the orchestra and the din of admiring shouts and whistles from her audience, suggested she study more famous artists and copy their style. Mistinguett refused. "If I was a second rate star, at least I was myself," she later said.

Of more concern to Saint-Marcel was the company his young client was keeping, particularly Louis Leplée, known as much for his drug dealing and male prostitution as for his music-hall act. It was Leplée who convinced Mistinguett to forsake Enghien and move permanently to Paris, where he set about introducing her to the seedy nocturnal world centered around the Place Pigalle and Montmartre. By the turn of the century, Mistinguett had acquired her own bevy of fawning male admirers, many of whom fought among themselves for the right to sleep on the floor of her bedroom or, as the ultimate reward, in her bed. Now the toast of the Parisian demimonde, Mistinguett attracted even more attention during an engagement at Le Trianon, where an impatient male patron unable to hear her voice shouted out "Higher!" Mistinguett obligingly hiked her skirts to the very limits of decency and shouted back, "How much higher do you want it to go?" Although some shocked patrons left the hall in protest, the resulting publicity pleased the house manager to such an extent that he doubled Mistinguett's salary.

Thoroughly alarmed at this turn of events, Saint-Marcel sent her on a tour of the provinces only to discover that *tout Paris* was clamoring for her return. Mistinguett's notoriety meant even better bookings at prominent clubs like L'Alcazar d'Eté and La Cigale, patronized by the best society. The prince of Wales, the future Edward VII, was a passionate admirer, as was the "fat, slovenly Englishman," she recalled, who paid an adoring visit to her dressing room. She remained unimpressed when he introduced himself as Oscar Wilde, in exile after his English disgrace and soon to meet his end in a lonely Paris hotel room. Another suitor was a wealthy Brazilian named de Lima who, Mistinguett announced in 1900, was the father of the child she was carrying. She saw pregnancy as no reason to leave the stage and continued performing until three months before the birth of a son, Léopold, whom de Lima agreed to raise in Brazil while Mistinguett set about solidifying her career.

Now sufficiently in demand to negotiate with producers and casino owners herself, she fired Saint-Marcel and set about her steady climb to the top of Parisian theatrical life by cleaning up what had become a decidedly soiled reputation. She left the Place Pigalle behind for more genteel quarters near the Gare de l'Est, jettisoned questionable friends like Leplée (whose later murder would be the talk of Paris), and refined her personal habits as much as she could stand, although sacrificing an active sex life was not among her penances. "Sex is the only habit I

never wanted to give up," she declared. "It is good for the figure and the soul."

She began frequenting more sophisticated clubs where wealthier promoters could be found. One of them sent her on a tour of Russia, while another offered her a part in a show opening in Brussels and, after assuring himself that Mistinguett could now restrain herself on stage, a part in what became her first commercial success, *Coup de Jarnac.* Soon producers and songwriters were writing shows especially for her and mounting them at the most opulent music halls Paris could offer, while Mistinguett's public and private life became inextricably bound. "It's been hard putting on an act twenty-four hours a day," she confessed. Even her many lovers were chosen with her public in mind. "The ideal partner," she said, "is the one who makes the public say 'They go well together,' and not the one you personally like the most."

In 1909, Mistinguett and one of her "ideal partners," dancer Max Dearly, took Paris by storm with their *valse chaloupée,* which became known to English audiences as the "Apache Dance." Dearly, notorious for his physically abusive affairs with women, had created a violently erotic *pas de deux* depicting a fight between a menacing thug and a prostitute from whom he steals money. During the course of the dance, the female partner is thrown to the floor, tossed in the air, and eventually dragged from the stage for an implied sexual assault. Rehearsals with Dearly often ended in bruises and cuts and, in one instance, a split lip, not to mention a number of ripped short skirts and broken high heels that Dearly made a part of the act. The dance was first presented in July 1909 at Le Moulin Rouge, the audience's titillation being heightened by what appeared to be a very real hatred between Mistinguett and Dearly, who dragged her offstage by the hair as the curtain came down to thunderous applause. To heighten the public's awareness of the act, Mistinguett would often excoriate Dearly in public; but privately, she confessed to a great deal of respect for her partner. "[The Apache Dance] came at a period in my life when I was pitched between the theater and the music hall, at a time when I did not know which way to turn," she later said, describing Dearly as "a great artiste. Compared to him," she said, "I was nothing."

Mistinguett and Dearly performed their *valse chaloupée* periodically over the next ten years. Their relationship ended when Mistinguett refused to appear with him in London because of a more lucrative offer in Paris. She

had, in fact, become increasingly more difficult as her popularity and power soared. She was known to break contracts, leave a show with no notice if something better came along, and torment set designers and choreographers with her shrill demands and relentless perfectionism. She was addressed with fearful respect as "La Miss." Acquaintances fervently hoped that the pattern might be broken when it became obvious that Mistinguett had fallen in love with a young singer and dancer whom she set about promoting. His name was Maurice Chevalier.

Chevalier, the son of a suburban Paris housepainter, was 23 at the time and had been singing and dancing since his teens. His tenuous voice and mediocre dancing were overcome by the spontaneous charm of his stage manner, the very essence of the dapper, carefree *boulevardier.* "He put a song over as if he were humming it to himself for pleasure," Mistinguett said, "with a rhythm and sureness that took my breath away." Because of Mistinguett's attentions to his career and his person, Chevalier would become France's most famous international entertainer with a stage, radio, and film career that would eclipse her own and continue for some 20 years after her death.

He had been just one of her many dressing-room admirers, however, sometimes even occupying a lower spot on the same bill with her, until Mistinguett was offered a lucrative contract to produce and star in a new musical extravaganza at the Folies Bergère in 1911. Mistinguett invented a new dance for the production, not as violent or erotic as Dearly's but every bit as athletic. She called it *la valse renversante* (the "topsy-turvy" waltz), and decided her partner would be the handsome young Chevalier, more than ten years her junior. The complicated choreography required the two of them to leap on top of tables, sending bottles and glasses flying; to somersault and cartwheel across the stage as chairs and people scattered; and, at the end, to run at each other from opposite sides of the stage, dive to the floor, and wrap themselves in a carpet. During extensive rehearsals, Mistinguett later claimed, she taught Chevalier everything she knew about stage deportment and mannerisms. "In those days, he was a great, shy, unsophisticated lad," Mistinguett wrote in her memoirs, "completely wrapped up in his own dreams. He would never have gotten anywhere without me." Their love affair was passionate and very public, Chevalier even confiding to male friends that Mistinguett's hand would be firmly attached to a particularly sensitive part of his anatomy as they lay together wrapped in the carpet at the end of their act.

Mistinguett's Folies Bergère revue opened in December 1911 to great acclaim and temporarily took Parisians' minds off the dangerously explosive state of affairs on the Continent. Equally diverting was a number of popular operettas in which she appeared in increasingly complex and startling costumes, one production requiring no less than 12 changes. She explored the new medium of film during these years, too, playing in 14 silent movies between 1913 and 1916, often in the kind of rags-to-riches role that reflected her own life. But she confessed to a certain discomfort before "that machine with a glass eye," with its unforgiving gaze and none of the feedback she expected from a live audience. "I don't much like making films," she complained. "The director is in control too much of the time, and not Mistinguett."

At the outbreak of war in August 1914, Chevalier was among the hundreds of thousands of French citizens called to duty, much to Mistinguett's distress. Even the arrival from Brazil of her son Lèopold, now 14 years old, failed to console her. A successful tour of Italy just before that country entered the war as a French ally, during which she was hailed as a symbol of French resistance to German imperialism, also did little to dispel her depression. Although she had once declared that her lovers "had very little meaning" offstage, Chevalier was the exception to her rule. For the first time in her career, she burst into tears on stage during a 1915 benefit concert for wounded soldiers in Paris as she sang:

> I feel small, so small
> No one sees me,
> Or knows I'm there.
> I know now that
> There's no sunshine or light
> For poor folk like us!

In January 1916, Mistinguett learned that Chevalier had been wounded and was being held in a German prisoner-of-war camp. Frantic, and unable to obtain the necessary documents to visit him, Mistinguett managed to wrest a promise of his release by means of an extraordinary appeal to Alphonso XIII, the king of neutral Spain and an ardent fan. But as she traveled to Geneva to meet Chevalier, French authorities had been alerted that a popular entertainer was spying for the Germans and accused her of such treacherous behavior. She was allowed to continue on her journey only when chanteuse *Margaretha Gertrud Zelle was revealed as the notorious Mata Hari and was executed. In Geneva, the Germans refused to release Chevalier unless Mistinguett became the next Mata Hari, to which she agreed only after secretly making a

deal with the French to act as a double-spy—a daring maneuver which backfired and left her in the hands of the Germans and scheduled to be shot. Her life was saved at the last moment when her release was exchanged for that of several German wives and daughters being held in France. Arriving back in Paris, Mistinguett was reunited at last with Chevalier. But she soon discovered that the war had taken its toll on their relationship. Chevalier had suffered a nervous collapse during his captivity and now found that Paris audiences had forgotten all about him. "He knew he would have to go back to square one with his career," Mistinguett later wrote. "I never minded helping him, and I tried to ignore the fact that when he finally found the one thing he had been searching for, he would not be sharing it with me." Nonetheless, Chevalier's career was resuscitated largely through the efforts of Mistinguett, who refused lucrative deals from producers unless Chevalier's name was also on the marquee next to hers. But by 1918 and the end of the war, Chevalier had left her for actress Léonie Bathiat, who had taken the stage name *Arletty. "His absence dominated the rest of my life," Mistinguett wrote bitterly years later. "I never found a single reason to justify loving him. He used me, and as soon as he got what he wanted, he dumped me."

The former lovers did not appear on stage together for a year, after Mistinguett's first appearance in New York, which began badly when it was discovered that several of her costumes had been left behind in France. She failed to ignite Broadway audiences and returned home after only a month. She and Chevalier shared the same bill in the 1919 revue *Paris Qui Danse,* the start of a long series of *Paris Qui . . .* revues distinguished as being the first to include complete female nudity. A second Broadway appearance in 1936 met with greater success, but while Chevalier's fame spread internationally, Mistinguett's remained mostly confined to France and its colonial outposts. Even on her home ground, she was being eclipsed by younger talent, most famously the American *Josephine Baker. Baker's dark skin generously displayed in costumes Mistinguett could never have imagined 20 years earlier mesmerized and entranced Parisian audiences, but Mistinguett declared Baker's act vulgar. "One day, sex will take over," she said primly. Nearing 60 and unable to compete with the bared breasts and naked bottoms of the new crop of revues, Mistinguett now found herself a nostalgic symbol of what life had been like before the war, in the heady days of *la belle époque.* In what was generally considered

the best of her revues, 1938's *Féerie de Paris* at the Casino de Paris, Mistinguett—wearing 40 pounds of feathers, trailing a 20-foot train, and balancing a 7-foot-tall headdress—still managed to descend a silver stairway at her entrance with her usual elegant grace. Her opening number, *Je Cherche un Millionaire,* became the bestselling recording in France that year and had sold more than five million copies by the time World War II erupted in 1939.

She was on her way back from a tour of Argentina when France declared war on Germany for the second time in less than 30 years. "I was too old to be used as a spy," Mistinguett recalled almost 20 years later. "The only way I could [help boost morale] was by entertaining." But as the Germans pressed closer to Paris, Mistinguett decided to forsake her beloved city and move to Antibes, on the French Côte d'Azur, taking care to exchange all her francs for gold ingots and bury them in the garden of Bougival, her home just outside the capital city. She spent a year in the south, much talked about by the locals for her boisterous, colorful entourage and her loud parties, but a year away from the stage and her audiences was too much for her. She returned to German-occupied Paris in 1941, weeping at the sight of the huge swastika flying from the Arc de Triomphe.

Much has been written about the Parisian artistic community's relations with the city's occupiers, and Mistinguett, along with Chevalier and many of her colleagues, was suspected by some of collaborating with the Nazis during the war. But, as was the case with Chevalier, Mistinguett appears guilty of nothing more than a passive resistance to the Germans. While Josephine Baker smuggled Resistance messages in her sheet music and *Edith Piaf used her mobility to deliver fake identity papers to prisoners of war, Mistinguett merely continued performing. She did speak out against the collaborationist administration of Pierre Laval, and often hid anti-Hitler and pro-Resistance messages in the dense Parisian *argot* in which her songs were written. She was never accused publicly after the war of collaborating. (Indeed, the only performer actually to be found guilty was Arletty, Chevalier's former lover, who had carried on an affair during the war years with a German officer.) When victorious Resistance troops marched down the Champs Elysée in the summer of 1944, Mistinguett donned full stage regalia to bicycle alongside the soldiers shouting "Vive de Gaulle!" The men roared back, "Vive La Miss!"

Although she was 65 at war's end and was suffering from a painful knee ailment, Mist-

inguett carried on with as much enthusiasm as before the conflict. She brought her new show to Britain, toured Morocco, and, in 1949, opened in the last of her *Paris Qui . . .* revues at the Casino de Paris, *Paris Qui S'Amuse.* At her entrance, the entire hall rose to its feet to applaud her, one spectator said, "as if greeting the President himself." Despite two minor heart attacks, an appendectomy, and a hysterectomy, Mistinguett departed for a North American tour early in 1951, opening in Montreal and traveling to Broadway in April. "A star's life," she wrote in her memoirs published in 1954, "should be one long performance." In 1955, however, even Mistinguett realized that 60 years on the stage was long enough for anyone. There was no official announcement of her retirement, merely the news that the great entertainer had decided on a much-needed rest at Bougival. Friends realized the end was near when, late that year, Mistinguett took to her bed and refused visits from all but the closest of her acquaintances. On January 5, 1956, she died of a cerebral hemorrhage. Mistinguett was buried in Enghien after lying in state at Paris' Eglise de la Madeleine, not far from the Place de la Concorde, where she had sung in the streets as a young girl.

"How I will miss her!" lamented Chevalier; while those present at her deathbed reported that Mistinguett's own affection for Chevalier remained to the end. "He was the best of them all!," she had sighed. But there was one amour which superseded even Chevalier. "My real lovers are the ones I've never seen—the men and women sitting there, up in the gallery," she once said. "I belonged to the public, because I owed them everything."

SOURCES:

Bret, David. *The Mistinguett Legend.* London: Robson Books, 1990.

Mistinguett. *Mistinguett: Queen of the Paris Night.* Translated by Lucienne Hill. London: Elek Books, 1954.

Norman Powers,
writer-producer, Chelsea Lane Productions, New York

Mistral, Gabriela (1889–1957)

Nobel Prize-winning Chilean poet who was also a noted educator, humanist and social reformer. Name variations: Lucila Godoy Alcayaga. Pronunciation: Gahb-ree-A-la Mee-STRAHL. Born Lucila Godoy Alcavaga on April 7, 1889, in Vicuña, in the northern province of Coquimbo, Chile; died on January 10, 1957, in Hempstead, New York, of pancreatic cancer; daughter of Jerónimo Godoy Villanueva (a poet, teacher and minstrel) and Petronila Alcayaga Rojas; awarded

teaching certificate from Escuela Normal Nº 1 in Santiago, 1910; never married; no children.

Suicide of her boyfriend (1909) had determining effect on her life; won major poetry prize (1914); invited to Mexico to participate in educational reform (1922); attached to the Committee of Arts and Letters of the League of Nations (1926–29); made life consul by the Chilean government (1935); won Nobel Prize for Literature (1945); made triumphal return to Chile (1954).

Selected works—poetry: Desolación *(Desolation, 1922);* Ternura *(Tenderness, 1924);* Tala *(Felling, 1938);* Lagar *(Wine Press, 1954).*

A tumultuous and prolonged ovation in the Swedish concert hall announced the winner of the Nobel Prize for Literature in December 1945. For the fifth time, the award went to a woman, and for the first time to a Latin American writer. Gabriela Mistral's warm humanism and heightened sense of spirituality represented a profound departure from a war-torn world. When she accepted the diploma and medallion from the hands of King Gustav V of Sweden, the event marked not only her own deserved triumph but also that of Latin American letters, long neglected by the Academy. The improbable, that a timid and lonely child from the Valley of Elqui in Chile would ultimately win such a prize, had proven plausible. It had been a difficult journey.

*S*he carried the human substance of America, at once magical and Biblical, in her spirit and her very bones.

—Germán Arciniegas

That journey began early in the morning of April 7, 1889, in a house on Calle Maipú in Vicuña, a small town in northern Coquimbo Province, when **Petronila Alcayaga Rojas** gave birth to a baby daughter. Baptized Lucila, she spent her early years a modest home that included Mistral's father Jerónimo Godoy, who was a teacher, poet and minstrel, her mother Petronila, and a half-sister Emelina. Jerónimo had a reputation as a bit of a bohemian, and his marriage was under constant stress. When Lucila Godoy Alcayaga was three, her father abandoned the family to make his fortune and never returned.

Although some biographers speak in general terms of a happy childhood for Mistral, this was not apparently the case. Efrain Szmulewicz notes that because the young Lucila resembled her departed father, her half-sister and especially her mother treated her coldly. Her isolation became more pronounced when the family moved to the small village of Monte Grande. Apparently she

had few if any playmates, no friends, and a mother who gave her no comfort. Accordingly Mistral, who was often left alone, grew to love the wild nature that surrounded Monte Grande which opened the door to her vivid imagination. Nature and its objects became her friends and may well have accounted for the primitive naturalism that would characterize much of her later work.

In primary school, Mistral had a reputation for being "distracted" and a "sentimental dreamer." Other students treated her coolly and on at least one occasion made her the scapegoat for a theft which she did not commit. Frequently, she would lapse into a pensive and melancholic silence which some biographers have attributed to the absence of her father. She tended to contrast her thoughts and dreams with the reality around her, a trait which informed her later writing.

El Coquimbo, a modest publication in Villa la Serena, published Mistral's first verses in 1903–04 when she was just 14 years old. Because of her timidity and isolation at school she was filled with self-doubt and used a series of revealing pseudonyms—Alguien (Someone), Alma (Soul), or Soledad (Alone). The publisher of the journal, Bernardo Ossandón, was of great comfort to Mistral and soon both her verse and prose began to be noticed. Her path-breaking prose in another periodical, *La Voz de Elqui,* brought her to the attention of educators who in 1905 enrolled her in a specialized institute where she could begin teacher training.

While she was an aide in the school of La Cantera, Mistral met the first love of her life, a young railroad worker named Romelio Ureta. Many versions of Mistral's affair with Ureta exist but all agree that the relationship and his suicide in 1909 were the wellspring of some of the most powerful and sad poems of love in the Spanish language. News of his death prompted Mistral to seek solace in her poetry, and she dedicated her life to the education of children.

In 1910, Mistral finally completed all of the requirements needed to be certified as a teacher and held a variety of positions in several secondary schools in different parts of Chile. Her poetry and prose became increasingly freed from the strictures of her early models, notably the modernistic style of the Nicaraguan poet Rubén Darío and the Colombian José María Vargas Vila, and she developed a fresh style of her own. By 1911, her writing was regularly featured in the Chilean press and was also published in other Latin American countries.

A watershed in the emergence of her reputation occurred in 1914 when Mistral submitted

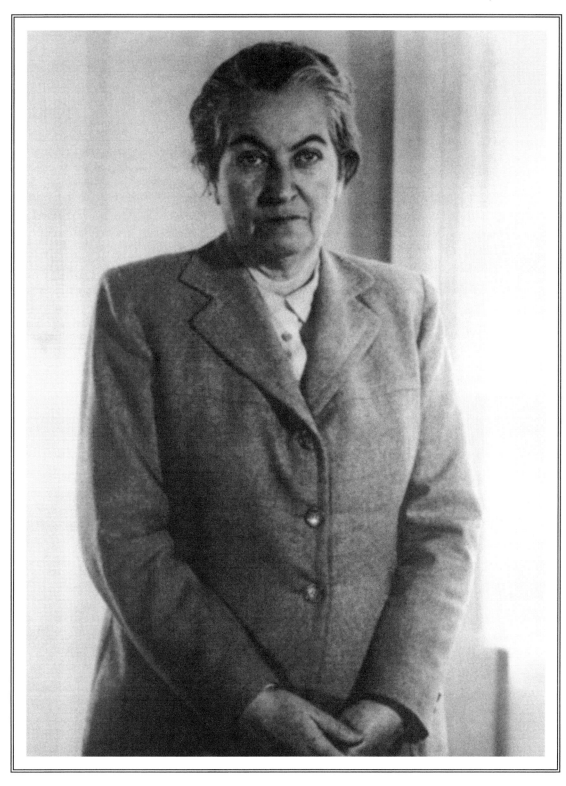

Gabriela Mistral

three "Sonnets of Death" for consideration in a Santiago poetry contest called the Juegos de Florales. The sonnets created a sensation and produced her first triumph. Based on her feelings and emotional turmoil following the suicide of Romelio Ureta, the sonnets won her first prize, a laurel crown, and gold medal. A now widely known and respected poet, Lucila Godoy Alcayaga began to use the pseudonym Gabriela Mistral. Biographers disagree about the roots of the pseudonym. Some claim that Gabriela was chosen because of her admiration of the Italian

poet Gabriele D'Anunzio; others say that it was due to her fondness for the work of Dante Gabriel Rossetti and several claim the name derived from the Archangel Gabriel, the bringer of good news. There is similar disagreement about her choice of Mistral. While some claim the name honors Fédérico Mistral, the poet from Provençe, others assert that the name is taken from the French wind called the mistral. A clue may lie in one of Gabriela Mistral's own poems, "La Granjera" (The Woman Granger), where she writes of the "Wind and Archangel whose name she bears." Most convincing, however, is the explanation of biographer **Marta Elena Samatan** who agrees that Mistral derives from the wind but also suggests that Gabriela was the name of one of Lucila's childhood dolls and a favorite name.

In Chile's southernmost city, Punta Arenas, the wind is a constant feature and it was here, in 1918, that Mistral became director and professor of language at the Liceo de Niñas (Girls' School). The bleak, windswept Patagonian landscape would find a place in her poetry. Mistral spent two years in Punta Arenas and, in commemoration of her sojourn, the sculptor **Laura Rodig** cast a statue in bronze. When Mistral's students heard this, according to Szmulewicz, they pressed Rodig for a copy for their school. "Bring me two tons of bronze and I'll do it," she jokingly told them. Two days later, Rodig was questioned by the police, who accused her of inciting the students to theft. Apparently, all the professionals in Punta Arenas had lost their nameplates. Such was the fervor and loyalty Mistral stirred among her students.

Even though Mistral had not published a single book of verse, she was well known in Latin America as a poet of profound depth and expression. She was director of Liceo Nº 6 in Santiago when, in 1922, she was sought out by José Vasconcelos, Mexico's celebrated secretary of education. Mistral had corresponded with Vasconcelos over issues of educational reform in Mexico, and, after a visit to Brazil, he returned home via Chile. Following an interview in Santiago, Vasconcelos invited a willing Mistral to come to Mexico to help in the reform, development, and restructuring of the country's public schools and libraries.

Close to her home in Villa Obregón, near Mexico City, Mistral inaugurated the school "Gabriela Mistral" for young women. In addition to duties associated with educational reform, she also internalized the plight of Mexico's rural masses, most of whom were indigenous. It was in Mexico that Mistral refined her sense of identity; she was not only Chilean, but also American; she was not only of Basque heritage, but also indigenous American. As she wrote in the poem "Niño Mexicano" (Mexican Boy), he nourished her with the "balsam of the Mayas from whom I was exiled."

Meanwhile, in New York, Federico Onís, through the auspices of the Spanish Institute, scoured the periodicals and newspapers of Latin America in an attempt to assemble from scattered bits and pieces a cohesive collection of Mistral's poetry. The result was the publication of *Desolación* in 1922. Critical acclaim followed. The collection was heralded as a departure from modernism and foreign influences. An individualism free from adornment and flourish flowed forth that set Gabriela Mistral apart from her contemporaries. Her poetry was simple, yet profound. Strongly present are maternal overtones as evidenced in Mistral's love of children and the teaching profession; apparent, too, is her love of nature. There are also despair and pessimism, violent language and confrontation with death, but these are somewhat tempered with an abiding Christian faith. That faith, in 1922, was still uncertain. Death remained an enemy.

Mistral reached the apex of her teaching career in 1923 when she was named "Teacher of the Nation" by the Chilean government. In the following year, a new collection of poems entitled *Ternura* (Tenderness) were directed toward children. Many were set to music. Death continued as an undercurrent and critic **Catherine Vera** noted that many verses described the "precariousness of a young child's life in which death is as near as sleep." Retirement from teaching in 1925 was accompanied, according to Szmulewicz, by a period of religious crisis and the emergence of a mysticism that portrayed death as a form of liberation and union with the larger universe.

From the mid-1920s and for most of the rest her life, Gabriela Mistral traveled widely. Working closely with the League of Nations, she collaborated with the organization's Committee of Arts and Letters and with the Institute for Intellectual Cooperation. While in Europe, she was riveted by the war being waged by U.S. marines against the guerrillas of Augusto Sandino in Nicaragua. Sandino himself had written to her in 1927 and explained the origins of his armed resistance to the United States. Mistral contributed an article sympathetic to Sandino's cause to *Repertorio Americano*, a Costa Rican newspaper. Historian Neill Macaulay wrote that Mistral was obsessed with the "spectacular con-

cept of a clash of races," and she urged the formation of a Hispanic League to fight in Nicaragua. After the bloody Battle of Ocotal and alleged marine atrocities, Mistral proclaimed Rubén Darío and Sandino "the glory of Nicaragua." Other prose pieces praised Sandino's "crazy little army" and eulogized him after his assassination.

As a Latin American, Gabriela Mistral was frustrated by U.S. policy toward the region which seemed to reflect, in the words of **Margot Arce de Vazquez**, an "almost complete ignorance of Hispanic spirit, culture, customs, and idiosyncracies." Many of her prose pieces that appeared scattered in Latin American newspapers focused on the issue of Pan Americanism and, although she was sharply critical of the United States, Mistral nevertheless hoped for an eventual understanding between the two Americas. In 1931, she traveled to the United States and was given the opportunity to lecture at Barnard, Vassar, and Middlebury colleges; a year later, she taught at the University of Puerto Rico. *Pan American Magazine* in April 1932 published her "Message to American Youth" in which she declared: "We of North and South America have accepted with our heritage of geographic unity a certain common destiny which should find a three-fold fulfillment on our continent in an adequate standard of living, perfect democracy, and ample liberty."

Many Latin American nations subsidize their writers and artists by giving them diplomatic posts. Chile made Gabriela Mistral consul to Naples in 1932, to Madrid in 1933, and a life consul in 1935. In the latter capacity, her consulship was portable, i.e., she was consul wherever she happened to be at the time. As war clouds began to gather over Europe, and Fascism and Nazism became entrenched, Gabriela Mistral reached the height of her creative powers.

The publication of *Tala* (The Felling) in 1938 revealed the mature poet. Critic **Sidonia Carmen Rosenbaum** noted in 1945 that Mistral's motifs became more varied and were spiritually rich. Her maternity now embraced everything with great depth; her Americanism erased boundaries and embodied a Western Hemisphere idea of unity in diversity. Landscapes, people, history and destiny—and an abiding faith in social justice—spill across its pages. *Tala* also attacked political authoritarianism and the proceeds of the book were dedicated to Basque orphans of the Spanish Civil War, a gesture which reportedly raised the ire of Francisco Franco, the Fascist victor in the war. Mistral's

Christian underpinnings are clear and reflect her philosophy. "I am a Christian, a thorough democrat," she once said. "I believe that Christianity, in its most profound social sense, can save the world's peoples."

When World War II broke out, Mistral moved from Nice to Brazil, where she became the Chilean consul in Petrópolis. Writing in the publication *Free World* early in 1943, she again addressed the issue of inter-American unity. Racial prejudice, "that great paganistic and collective evil . . . , the idolatry of the skin, exists both within and between the Americas," she wrote. North American cultural arrogance was also a factor, for the average citizen of the United States did "not believe that the average man in Latin America has a cultural rank equal to his own." Looking toward a better future, Mistral concluded: "I write as a prophet when I say that the century of the common man will be built in the Americas only on common ground in education, regardless of race, creed, or language."

Sorrow again visited Mistral in Petrópolis with the death by suicide in 1943 of her nephew Juan Miguel Godoy, affectionately called Yin Yin, whom she had virtually adopted as a son. This was devastating, especially as it came so close in time to the suicide of another good friend, the writer Stefan Zweig. But good news arrived in Brazil in 1945 when Mistral was informed that she had won the Nobel Prize for Literature. After receiving her honor in Stockholm, she traveled to New York where she served on the United Nations Subcommittee on the Status of Women. According to *The New York Times,* she resigned because she found the organization too militant. Other accounts claim that she disagreed with the goals of the subcommittee, which sought special protective legislation for women to achieve equality with men. In her words, special legislation "does not equalize. It lowers women. Common legislation raises womanhood's standards, it gives equality."

In the closing years of her life, Mistral continued to travel widely and returned for one last triumphal trip to her homeland of Chile in 1954. *Lagar* (The Winepress), which continued the themes and motifs of her earlier work, appeared in the same year. It was also in 1954 that she was asked to contribute a paper to Columbia University's Bicentennial Conference on "Responsible Freedom in the Americas." Mistral focused on education and targeted xenophobia:

> A hatred, stark or veiled, muted or blatant, silently undermines and blights the life of certain nations. It is among the most serious

defects that affect the world, a deep-seated, persistent malady. In village or city, in institutions which hold themselves great or illustrious, one often sees, and all too plain, what they proudly call racial or national pride, which is a survival from a bygone epoch that has not been wholly effaced. It is xenophobia. . . .

Hatred of the foreigner becomes a patriotic virtue in some countries. . . .

For Mistral, education was the key to eradicating the evils of xenophobic nationalism.

Gabriela Mistral died on January 10, 1957, at Hempstead General Hospital on Long Island of pancreatic cancer. Her remains were carried by air to Chile where ultimately, in accordance with her wishes, she was interred in Monte Grande.

SOURCES:

Arce de Vazquez, Margot. *Gabriela Mistral: The Poet and Her Work*. Trans. by Helene Masslo Anderson. NY: New York University Press, 1964.

Figueira, Gastón. *De la vida y la obra de Gabriela Mistral*. Montevideo: Talleres Gráficos Gaceta Comercial, 1959.

Mistral, Gabriela. *"Image and Word in Education,"* in Angel del Río, ed., *Responsible Freedom in the Americas*. Garden City, NY: Doubleday, 1955, pp. 84–91.

Rubilar, Guillermo. *Gabriela, Maestra y Poetisa Rediviva; Pablo, Poeta de los Cuatro Puntos Cardinales*. Santiago de Chile: Ediciones Juan Firula, 1972.

Samatan, Marta Elena. *Gabriela Mistral: Campesina del Valle de Elqui*. Buenos Aires: Instituto Amigos del Libro Argentino, 1969.

———. *Los Dias y los Años de Gabriela Mistral*. Puebla, Mexico: Editorial José M. Cajica, Jr., 1973.

Szmulewicz, Efrain. *Gabriela Mistral: Biografía Emótiva*. 6th ed. Santiago de Chile: Ediciones Rumbos, 1988.

SUGGESTED READING:

Dana, Doris, trans. and ed. *Selected Poems of Gabriela Mistral*. Baltimore: The Johns Hopkins Press, 1971.

Paul B. Goodwin, **Jr.**,
Professor of History, University of Connecticut,
Storrs, Connecticut

Mitchel, Jane (1820–1899).

See Mitchel, Jenny.

Mitchel, Jenny (1820–1899)

Irish nationalist who joined her husband John Mitchel in exile. Name variations: Jane Mitchel. Born Jane Verner in County Armagh, Ireland, in 1820 (month and day unknown); died in Brooklyn, New York, on December 31, 1899; only daughter of James Verner and Mary Ward; educated at Miss Bryden's School, Newry, County Down, Ireland; married John Mitchel (a lawyer and Irish nationalist), on December 12, 1836; children: three daughters, Isabel, Henrietta (d. 1863), and Minnie; three sons, James, John (d. 1864), and Willie (d. 1863).

Although much of her adventurous life after her marriage to John Mitchel attracted considerable publicity, Jenny Mitchel's early life is shrouded in mystery. Born in 1820 in County Armagh, Ireland, she lived with her brother Richard and mother **Mary Ward** under the protection of Captain James Verner, whose last name was taken by both Jenny and Richard. There is no evidence that Mary and James married, and after James Verner's death in 1847 his family, who were prosperous landowners, would deny that Jenny and Richard were his children. The siblings had a comfortable upbringing, and Jenny received a good education at Miss Bryden's School for Young Ladies in Newry, County Down.

She was 15 when she met 21-year-old John Mitchel, who was studying law. They married secretly in 1836 and eloped to England. An irate James Verner followed, and John was brought back to Ireland and arrested on charges of abduction. These were dropped, however, and the couple went to live at Dromalane in County Down with John's family, to whom Jenny became very close. John Mitchel practiced as a lawyer and also farmed, but he became increasingly involved in radical nationalist politics. He began to write for *The Nation*, the journal of the Young Ireland movement, and in 1845 was invited to move to Dublin to become the chief editorial writer for the paper. By this time, he and Jenny had four children. In old age, Jenny would say that the momentous years 1845–49 were a blur. She and John were part of the brilliant circle of writers and poets who worked for *The Nation*, and her hospitality became famous, being praised by Thomas Carlyle who spent an evening at their house. Their fifth child Mary (Minnie) was born in Dublin.

By the beginning of 1848, plans for a rebellion were being hatched but before they came to fruition John Mitchel was arrested that May on charges of treason-felony. If he were found guilty, the sentence would be transportation to a penal colony. Jenny told the press: "I have not hitherto allowed any fears I might feel for my children's safety, or my own, to interfere with that line of policy which my husband thought it his duty to pursue, and I do not intend to do so now." After John was found guilty and sentenced to 14 years' transportation, Jenny believed that an attempt to rescue her husband should have been made, and never forgave some of his associates who did not agree. In the wake of the trial, the contents of her home were confiscated and sold. She and her children moved back to Newry, and a fund of several thousand

pounds was raised to help them which Jenny intended to use to rejoin her husband.

John Mitchel was originally sent to Bermuda but his health declined there, and a year later the British authorities decided to move him on to Van Diemen's Land (Tasmania). With her children, Jenny finally set out to join him in January 1851; the Mitchels settled in the village of Bothwell and took up farming. In September 1852, their last child Isabel was born. Although the family had a pleasant life in Bothwell, John became increasingly restless, and in 1853 he decided to escape to America. Jenny supported the decision, believing that the educational opportunities in the U.S. would be better for the children. She and John met up in Tahiti, and they reached San Francisco in August 1853. But Irish-American activities were based in New York and, though she wished to stay in California, the family embarked on another epic journey to the East coast by way of Nicaragua and Cuba. "Poor Jenny," John wrote. "She might as well have married a homeless Bedouin or wandering Tartar."

The Mitchels settled in Brooklyn, in what became Jenny's favorite residence, and John started a newspaper called *The Citizen*. However, his pro-slavery views soon brought him into conflict with other Irish exiles who, apart from their dislike of slavery, disapproved of John involving himself in issues that had nothing to do with Irish independence. Within a short time, his persistent restlessness again manifested itself, and in 1855, despite Jenny's deep reluctance, he moved the family to a farm in the Tennessee backwoods. Jenny's biographer **Rebecca O'Conner** has called the time in Tennessee a "wasteland." They had few acquaintances and the local library was for men only. Firsthand encounters with slavery also spurred Jenny's determination never to own a slave. The farm was unsuccessful, and the Mitchels moved to Knoxville and then to Washington.

In 1859 the family, minus the two elder sons James and Johnnie, went to Paris; they were still there when the American Civil War broke out. James and Johnnie joined the Confederate forces and shortly afterwards their younger brother Willie, Jenny's favorite child, also joined up when he and John returned secretly to the United States. Jenny was left in Paris, where in May 1863 her eldest daughter Henrietta died. In July, Willie was killed at Gettysburg, although confirmation of his death was slow in coming. Jenny and her two surviving daughters returned to America in December 1863; during the journey, their ship was attacked by Union forces off the Delaware coast and they lost all their belongings. They made their way from Wilmington to the Confederate capital of Richmond, but by spring 1864 Union forces were moving towards Richmond. In July 1864, Johnnie was killed at Fort Sumter. Over the following winter, the family suffered from poor health as food shortages increased. When the war ended John Mitchel was interned at Fort Monroe in Virginia during which time the family was helped with money from Irish friends in Washington and New York. On his release in October 1865, he returned to Paris where he acted as an agent for the Irish revolutionary group the Fenian Brotherhood. He was given permission to return to the States at the end of 1866, and to her delight Jenny moved back to Brooklyn where she renewed old Irish friendships.

In 1874, her lack of enthusiasm was obvious when John was invited to return to Ireland and stand for Parliament. She did not go with him, and he was accompanied by two of their children. John was elected in March 1875 but died suddenly a few days later and was buried near the family home at Dromalane, at Jenny's express wish. She remained in Brooklyn because it would have taken her weeks to travel to Ireland. A Mitchel Memorial Fund was set up which raised $30,000 and ensured her a comfortable old age. Family tragedy still awaited her with the death of her youngest daughter Isabel in childbirth, but Jenny built a house for herself and her surviving daughter Minnie; her surviving son James also lived in New York. After her death on December 31, 1899, an obituary noted the "high qualities of mind and heart which made her to the last day of her life loyal to the ideal she had chosen in her girlhood."

SOURCES:

O'Conner, Rebecca. *Jenny Mitchel: Young Irelander.* Dublin and Tucson: O'Conner Trust Publishers, 1988.

Deirdre McMahon, lecturer in history at Mary Immaculate College, University of Limerick, Limerick, Ireland

Mitchell, Abbie (1884–1960)

African-American singer and actress. Born on September 25, 1884, in New York City; died on March 16, 1960, in New York City; daughter of Luella (Holliday) Mitchell and a father whose last name was Mitchell; studied with Harry T. Burleigh and Emilia Serrano; married Will Marion Cook (a composer), in 1899 (divorced 1908); children: Marion Abigail Cook (b. 1900); Will Mercer Cook (b. 1903).

Made stage debut at age 13 (1898); gave command performance before the tsar of Russia (1908); taught voice at Tuskegee Institute (1931–34); served as executive secretary of the Negro Actors Guild of America.

Selected musical and dramatic theater roles: Clorindy: The Origin of the Cakewalk *(1898);* Jes Lak White Folks *(1899);* In Dahomey *(1903);* The Southerners *(1904);* Bandana Land *(1908);* The Red Moon *(1908);* In Abraham's Bosom *(1926);* Coquette *(1927);* Cavalleria Rusticana *(1934);* Porgy and Bess *(1935);* Mulatto *(1937);* The Little Foxes *(1939).*

An accomplished singer and stage actress of international fame, Abbie Mitchell was born on September 25, 1884, the only child of an African-American mother and a Jewish father. Raised by a maternal aunt in Baltimore, Maryland, where she was enrolled in a convent, Mitchell showed a talent for singing while she was still very young. She studied voice under Harry T. Burleigh and Emilia Serrano, and at only 13 years old she debuted in *Clorindy: The Origin of the Cakewalk*. The popular play was described by one critic as "the first demonstration of the possibilities of syncopated Negro music," and, in selecting her for the chorus of this musical comedy, its composer Will Marion Cook launched Mitchell's career at a time when a new age was dawning for African-Americans in theater.

Mitchell, described as woman of rare beauty, married Cook in 1899 and became part of an elite group of black theater personalities. They had two children, daughter **Marion Abigail Cook**, born in 1900, and Will Mercer Cook, born in 1903. Marion was raised by relatives (as Mitchell had been), but Will traveled abroad with his mother from his infancy; he would later become a professor at Howard University, and a U.S. ambassador to Niger and to Senegal. From 1899 to 1908, Mitchell appeared both in America and abroad, often in shows that were produced or composed by her husband, and they maintained their professional association after divorcing in 1908.

In 1903, Mitchell first won international acclaim when she appeared in the vaudeville show *In Dahomey* before King Edward VII at Buckingham Palace in London. The play sparked the cakewalk dance craze in London, and then made vaudeville history by opening at the New York Theater in Times Square. She sang for a time with *Sissieretta Jones' Black Patti Troubadours, and in 1908 appeared at a command performance before Russian tsar Nicholas II. Mitchell later toured Europe with a jazz group known as the Memphis (formerly Nashville) Students. Then recognized mainly for the "mellifluousness and purity" of her singing voice, she joined the all-black stock company of Harlem's Lafayette Theater in 1915 as a leading dramatic actress, and began honing her acting skills. She appeared there until 1920, when she returned to Europe with Cook's Southern (American) Syncopated Orchestra, again as a singer.

Through the 1920s and 1930s, Mitchell cultivated a large concert repertoire, singing contemporary songs by her ex-husband, by *Florence Price, and by *Margaret Bonds, with whom she was close friends, as well as operatic arias in recitals at concert halls across America and Europe. She mingled with noted opera singers of her day, but her dream of becoming one was never to materialize. A perfectionist, she studied voice in Paris to further develop her already extraordinary vocal expertise. A Chicago *Daily News* writer said of her in 1930, "I have never before heard singing of such consistently sage and beautiful workmanship. . . . Miss Mitchell stands quite alone among all the singers of the present day." She also taught voice at Alabama's Tuskegee Institute for a few years, and sang on NBC radio shows.

During the same period, Mitchell starred in the Pulitzer Prize-winning play *In Abraham's Bosom*, appeared with *Helen Hayes in *Coquette*, and appeared in Langston Hughes' *Mulatto*, a play which was banned in Philadelphia for fear that its theme might trigger racial friction. As a dramatic actress, she was noted for her elegant bearing and stage presence. She is probably best remembered for her roles as the original Clara in George Gershwin's *Porgy and Bess*, and as Addie in the 1939 production of *Lillian Hellman's *The Little Foxes*.

Although she no longer played leading roles after *The Little Foxes*, Mitchell remained involved in the theater, serving as executive secretary of the Negro Actors Guild. She also ceased singing in concert halls, instead teaching voice and lecturing. As her ex-husband's music fell out of fashion, Mitchell's fame also dimmed. She endured a lengthy illness before dying in New York City in 1960, by which point she was known primarily as the former wife of Will Marion Cook.

SOURCES:

Sicherman, Barbara, and Carol Hurd Green, eds. *Notable American Women: The Modern Period.* Cambridge, MA: The Belknap Press of Harvard University, 1980.

Smith, Jessie Carney, ed. *Notable Black American Women.* Detroit, MI: Gale Research, 1992.

A file of newspaper clippings about Abbie Mitchell is held by the Schomburg Center for Research in Black Culture, N.Y. Public Library.

Jacquie Maurice,
Calgary, Alberta, Canada

Mitchell, Hannah (1871–1956)

British suffragist and politician. Born in 1871 in Derbyshire, England; died in 1956; daughter of John Webster (a farmer); married Gibbon Mitchell, in 1895.

Hannah Mitchell was born in Derbyshire, England, in 1871. She attended school for only two weeks and spent most her time helping her mother with domestic chores. Mitchell rebelled against the drudgery of rural life, however, and ran away from home in 1885 after a particularly violent disagreement with her mother. She found employment as a dressmaker in the town of Bolton, where she slowly taught herself to read and write. She also became active in socialist politics and the local trade-union movement, and met Gibbon Mitchell, whom she married in 1895.

The Mitchells had a progressive marriage that included equal distribution of household chores, but Mitchell yearned for a life outside the home and soon became active in the women's suffrage movement. She joined the Women's Social and Political Union in 1904, but became disenchanted with *Emmeline and *Christabel Pankhurst's leadership and in 1907, along with *Charlotte Despard and others, moved to the new Women's Freedom League. A pacifist, Mitchell opposed British involvement in World War I and spent the war years working for the Women's Peace Council. After the war, she returned to politics and in 1924 was elected to the Manchester city council. Her autobiography, *The Hard Way Up*, was published after her death in 1956.

Grant Eldridge,
freelance writer, Pontiac, Michigan

Mitchell, Jackie (1914–1987)

American baseball player who was a minor-league pitcher for the Chattanooga Lookouts when she struck out Babe Ruth and Lou Gehrig. Born Virne Beatrice Mitchell in 1914; died in 1987; daughter of Joe Mitchell (a physician); married Eugene Gilbert; no children.

The second woman ever to sign a men's minor-league baseball contract (*Lizzie Arlington being the first), pitcher Jackie Mitchell may have had one of the briefest careers as a minor-league player ever recorded. She signed with the Chattanooga (Tennessee) Lookouts in March 1931, and her contract was rescinded just one month later, after she struck out Babe Ruth and Lou Gehrig back-to-back in a controversial exhibition game between the Lookouts and the New York Yankees on April 2, 1931. While debate raged as to whether Mitchell's appearance in the game was legitimate or merely a publicity stunt, baseball commissioner Kenesaw Landis stepped in and stripped Mitchell of her contract and banned her from further major and minor-league play, claiming that life in baseball was simply "too strenuous" for a woman. It was a serious blow to Mitchell, who was a talented athlete and might well have had a pioneering career in professional baseball.

Jackie Mitchell was born in 1914 and raised in Chattanooga, Tennessee, where her father was a physician. A premature baby weighing only four pounds at birth, she was raised on a regimen of fresh air and exercise to build up her strength. "I was out at the sandlots with father from as long as I can remember," she once recalled. At the age of seven or eight, Mitchell was taught to pitch by Dazzy Vance of the Brooklyn Dodgers, and as a teenager she once struck out nine men in an amateur game. In March 1931, fresh from Norman Elberfeld's baseball camp in Atlanta, and with her father acting as her agent, Mitchell signed with Joe Engel, a former pitcher for the Washington Senators and owner of the Class AA Chattanooga Lookouts. A master of promotion, Engel once raffled off a house to increase attendance at his team's games, and on another occasion staged an elephant hunt, so signing Mitchell may indeed have been just another gimmick. For the 17-year-old Mitchell, however, the contract promised instant riches. "To tell the truth, all I want is to stay in professional baseball long enough to get money to buy a roadster," she told a local paper. In a later statement, however, she expressed more serious goals: "I hope to pitch for years to come and shall try to get into a World Series."

When Engel announced that his rookie southpaw would play in an exhibition game against the New York Yankees, who were returning home from spring training, sports columnists were outraged. "I suppose that in the next town the Yankees enter they will find a squad that has a female impersonator in left field, a sword swallower at short and a trained seal behind the plate," sniped the *New York Daily News*. "Times in the South are not only tough but silly." The conservative *Sporting News* refused even to carry the story. "Quit your

Jackie
Mitchell

kidding," they wrote back to a local reporter. "What is Chattanooga trying to do? Burlesque the game?"

As it turned out, the much-anticipated Yankees-Lookouts match-up on April 1 was post-poned to April 2 because of rain, which only added to the drama. Four thousand fans filed into Engel Stadium to witness the event, along with scores of reporters, men from wire services, and even a film crew. Manager Bert Neihoff did not start Mitchell, but sent her to the mound

early in the first inning, after pitcher Clyde Barfoot gave up a double and a single, giving the Yankees a 1–0 lead after the first two batters. Third in the lineup was the formidable "Sultan of Swat," Babe Ruth.

Sporting a white uniform made especially for her by the Spalding Company, Mitchell took a few warm-up throws before Ruth stepped to the plate. Ruth took ball one, Mitchell's deadly drop ball, then swung and missed the next two pitches. The fourth pitch was a called strike. In what may have been a staged performance, Ruth "kicked the dirt, called the umpire a few dirty names, gave his bat a wild heave and stomped off to the Yanks' dugout." Famed Lou Gehrig followed Ruth to the plate, striking out on the first three pitches. He seemed to take his hitless turn at bat in stride, however, shaking his head and grinning on his way back to the dugout, while Tony Lazzeri made his way to the plate. Lazzeri fouled off Mitchell's first pitch and took the next four, drawing a base on balls. At that point, Neihoff pulled Mitchell off the mound and reinstated Barfoot. The Yankees ultimately won the game 14–4.

For a brief time, Mitchell was a celebrity. Hailed as "the girl who struck out Ruth and Gehrig," she received so many letters of congratulations that her father had to hire a secretary to answer them. As might be expected, the teenager took Commissioner Landis' pronouncement hard, especially when no one—not even her parents—protested his ban or came to her defense. Within a month, however, she was back on the field as the star attraction of the new Junior Lookouts, a team hastily put together to capitalize on her fame. Mitchell toured eastern Tennessee with the team, pitching the first two or three innings of each game and proving quite a draw. When she returned to Chattanooga in May 1931 to face **Margaret Nabel** and the New York Bloomer Girls, the game was another sellout. Mitchell held the Bloomers hitless during her three innings at the mound, and the Juniors won the game, 7–4.

By the summer of 1931, Mitchell had so many offers to pitch in exhibition games that she decided to quit the Junior Lookouts and tour. After two years on the road (with her mother and father chaperoning), she signed with the House of David, a series of barnstorming teams that originated out of Benton Harbor, Michigan, and were popular with baseball fans across the country. Mitchell traveled with the House for seven years, pitching an inning or two a day against local teams. She eventually returned to Chattanooga and went to work in her father's office. When she was in her 50s, she married Eugene Gilbert, a man she had known since childhood, and slipped into obscurity.

In 1975, Mitchell's story reemerged when a California man wrote to Alan Morris, sports editor of the *Chattanooga News-Free Press*, asking what had happened to Jackie Mitchell, the girl who struck out Babe Ruth. Morris then recounted the story in an article, after which Mitchell received another round of congratulatory letters from people who found her story remarkable. At the time, she was still hopeful about women in baseball. "I'm interested in keeping up with what's happening in female athletics and efforts of the girls to play against the boys," she told reporters. "There is one woman umpire in professional baseball now and maybe some day there will be a player in the big leagues."

David Jenkins, another sports reporter for the *Chattanooga News-Free Press*, who befriended Mitchell during the last years of her life, viewed the film of her striking out Ruth and Gehrig and felt that it was inconclusive. "She threw well enough to have the ball do things," he said. "It was a drop ball, a sinker. . . . The players may have gone along with the thing in good fun, but that doesn't mean they weren't struck out. She might have been doing more than they expected her to do." Jenkins also expressed the belief that Mitchell was victimized by Landis and might have battled for her career with a little support. "If Engel had backed Jackie in trying to assert her right to play baseball—in asserting the validity of the contract—she would probably have gone ahead and fought against the rescinding of the contract. But nobody backed her." Jackie Mitchell died in 1987, at the age of 73.

SOURCES:
Gregorich, Barbara. *Women at Play: The Story of Women in Baseball.* NY: Harcourt Brace, 1993.

Barbara Morgan,
Melrose, Massachusetts

Mitchell, Joan (1926–1992)

American abstract painter. Born on February 12, 1926, in Chicago, Illinois; died of lung cancer on October 30, 1992, in France; daughter of James Herbert Mitchell (a physician) and Marion Strobel (a poet and editor); attended Smith College, 1942–44; Art Institute of Chicago, B.F.A., 1947, M.F.A., 1950; married Barney Rossett (an editor and publisher), in 1949 (separated 1951).

Joan Mitchell, who is now considered one of the greatest abstract artists of her generation,

was born in Chicago in 1926. Her mother **Marion Strobel** was a poet and an editor of *Poetry* magazine, and, as a child growing up in the family's house on Lake Michigan, Joan met such poets as *Edna St. Vincent Millay, Ezra Pound, T.S. Eliot and Dylan Thomas. Mitchell studied English for two years at Smith College before returning to her hometown to attend the Art Institute of Chicago, from which she received a B.F.A. in 1947 and an M.F.A. in 1950. While working on her graduate degree, she spent some time in France on a scholarship and also briefly studied in New York City with Hans Hofmann, whose teaching methods drove her from his class even as his technique proved to have a lasting influence on her style. Another artist who had an important impact on her work was Arshile Gorky, particularly in his use of bare canvas.

Mitchell was married in 1949 to Barney Rossett, the founder of Grove Press (they separated two years later). Grove published some of the most innovative fiction of the era, including that of Samuel Beckett, with whom she became good friends. While she periodically visited France during the 1950s, Mitchell lived for most of the decade on St. Mark's Place in New York City's East Village. She was a member of The Club, founded by the New York school of abstract expressionists, and took part in the influential Ninth Street Show in 1951. Her first one-woman show in New York the following year was called a "savage debut" by *ART News* magazine, and her importance as a New York artist was acknowledged by the mid-1950s. While always abstract, her paintings, with vigorous, coursing strokes, vivid colors, and often some use of bare canvas or sharply delineated dark bars, are generally agreed to call up images of light and water and sky, what one critic has called "inscapes" rather than landscapes. "I paint from remembered landscapes that I carry with me—and remembered feelings of them, which of course become transformed," said Mitchell. She continued to exhibit both at group and individual shows and spent time with a hard-drinking crowd of artists and writers, including Franz Kline, Willem de Kooning and Frank O'Hara. (She titled one of her 1957 paintings after O'Hara's poem "To the Harbormaster.")

In 1959, Mitchell moved to France, where she would remain until her death. She lived initially in Paris, and soon began a relationship with Canadian-born Jean-Paul Riopelle that would last for 25 years. Riopelle was also an abstract painter, and in the male-dominated art world of the time he gained more fame than Mitchell, although he is now generally considered a lesser

artist. She painted mostly large (or as one critic has sized them, "large to very large to huge") canvases, some in multiple panels. In 1968, she moved to Vétheuil, France, near the famous Giverny garden of Claude Monet. Although her "fierce cathedrals of color" were inspired by the same landscape that had inspired Monet, Mitchell noted that she much preferred the work of Vincent Van Gogh. Over the years she painted a number of works inspired by sunflowers. "They look so wonderful when young," she said, "and they are so very moving when they are dying." Although Mitchell was a prolific painter and her work is held in major museums and private collections both in America and Europe, she is by no means as well known as other American abstract expressionists of her stature. Mitchell died in 1992, after a long bout with lung cancer. A request in her will to her friend Klaus Kertess resulted in his *Joan Mitchell* (1997), the first major examination of her work and life.

SOURCES AND SUGGESTED READING:

Bernstock, Judith E. *Joan Mitchell*. NY: Hudson Hills Press, 1997.
Kertess, Klaus. *Joan Mitchell*. NY: Abrams, 1997.
Publishers Weekly. March 17, 1997, p. 69.

Jacquie Maurice,
Calgary, Alberta, Canada

Mitchell, Joni (1943—)

Influential and iconoclastic Canadian singer and songwriter. Name variations: Roberta Joan Anderson. Born Roberta Joan Anderson on November 1, 1943, in Fort Macleod, Alberta, Canada; daughter of Bill Anderson (a Royal Canadian officer turned store manager) and Myrtle (McKee) Anderson (a teacher); attended high school in Saskatoon (graduated 1963); spent one year at College of Art and Design, Alberta; married Chuck Mitchell (a musician), in 1965 (divorced 1967); married Larry Klein (a musician), in 1982 (divorced 1992); children: (with Brad MacMath) daughter, Kilauren Gibb (b. 1965).

Suffered from polio at age nine; studied piano as a child and later taught herself to play guitar; began performing at the Depression club in Calgary (1963); moved to Toronto and then to Detroit to perform as a folk singer; moved to New York (1967); early songs recorded by Judy Collins and Tom Rush; met David Crosby in Florida club (1967); recorded first album under his guidance (1968); wrote generational anthem "Woodstock," brought to fame by Crosby, Stills and Nash (1970). Over the course of more than 30 years, recorded more than 20 albums; pushed boundaries of folk-rock genre; credited with creating confessional singer-songwriter genre; experimented with jazz,

working with artists including Charles Mingus, Wayne Shorter and the L.A. Express; collaborated with Mingus on his last project, and performed and recorded with numerous influential rock artists, including James Taylor, Carole King, Jackson Browne and Neil Young. Painted and exhibited throughout 1980s and 1990s, creating art for all her albums. Awards include Grammys (1974 and 1994) and Billboard magazine's Century Award (1995); inducted into Canada's Juno Hall of Fame (1981), Rock and Roll Hall of Fame and Songwriters' Hall of Fame (both 1997).

Albums include: Joni Mitchell (1968); Clouds (1969); Ladies of the Canyon (1970); Blue (1971); For the Roses (1972); Court and Spark (1974); Miles of Aisles (1974); The Hissing of Summer Lawns (1975); Hejira (1976); Don Juan's Reckless Daughter (1977); Mingus (1979); Shadows and Light (1980); Wild Things Run Fast (1982); Dog Eat Dog (1985); Chalk Mark in a Rain Storm (1988); Night Ride Home (1991); Turbulent Indigo (1994); Hits & Misses (1996); Taming the Tiger (1998); Both Sides Now (2000).

Singer, songwriter, muse and cultural touchstone, Joni Mitchell is one of the most distinctive and influential figures in 20th-century popular music. Having ranged from folk to rock to jazz in a long and often groundbreaking career, Mitchell is cited as an inspiration by numerous musicians and performers and lauded for her musical experimentation and poetic lyrics. As a fiercely independent female performer in a hits-driven, male-dominated industry, however, Mitchell has achieved her legendary status without the consistent commercial success of many of her peers and imitators.

Joni Mitchell was born Roberta Joan Anderson in the town of Fort Macleod in Alberta, Canada, on November 1, 1943. Her parents Bill Anderson, a Royal Canadian officer turned store manager, and **Myrtle McKee Anderson**, a former schoolteacher, took their only child to live in North Battleford, Saskatchewan, not long after the end of World War II. She began studying piano at age seven, but chafed under the traditional discipline of her lessons and abandoned them after a year and a half. Instead, having shown a natural talent for drawing, she had aspirations of becoming a painter. The family moved again when Mitchell was nine, to Methodist-founded Saskatoon, where she contracted polio. Though she defied doctors' predictions that she would never walk again, she lived with the effects of post-polio syndrome for the

rest of her life. Encouraged by her seventh-grade English teacher, her artistic interests broadened to include writing poetry (she would later dedicate her first record to him, noting that he "taught me to love words"). And all the while, she was listening to jazz LPs and tuning in to a rock 'n' roll radio show from Texas. Using a Pete Seeger instruction book, she taught herself to play a baritone ukelele, bought because she could not afford a guitar.

After graduating from high school in 1963, Mitchell left Saskatoon for Calgary, where she enrolled in the Alberta College of Art. Her love of music was gradually surpassing her love of painting (though she would go on to paint the cover art for most of her albums), despite an initial lack of ambition towards becoming a musician: "I just wanted to accompany people singing bawdy songs at weeny roasts," she later claimed. In Calgary, she became a regular performer at a club called the Depression. After her first year at art school, during which she found her courses "not particularly creative," she traveled to Toronto to see *Buffy Sainte-Marie at the Mariposa Folk Festival. Mitchell decided stay in Toronto and find work on the coffee-house circuit as a folk singer.

Her first year was difficult. Unable to afford membership in the musicians' union, she worked at department stores to make ends meet while playing when she could in Toronto's Yorkville district. In February 1965, shortly after she had broken up with her boyfriend Brad MacMath, she gave birth to a daughter. Penniless and desperate in an era when single motherhood still carried a grave social stigma, Mitchell put her baby in foster care. After folk singer Chuck Mitchell suggested that he could help her keep the child if they got married, she agreed, against her better judgment ("I went down the aisle saying, 'I can get out of this,'" she told *Vogue* magazine in 1994). When the marriage looked as shaky as she had feared it would be, she decided to give her infant up for adoption. The decision would cause her much guilt and sadness in the future, and she would later note that a number of cryptic songs on her various albums were private messages to her unknown daughter.

That summer she and her husband moved to Detroit, where they performed together to some acclaim in local clubs. Mitchell made some important musical contacts in Detroit, among them folk singer Eric Anderson, who helped her refine her guitar techniques (she wanted to "play the guitar like an orchestra"). She divorced her husband in 1967, and early that year moved to New

York City, to break into the thriving folk-rock scene there. Mitchell acquired a manager, Elliot Roberts—who discovered her playing in New York's Café Au Go-Go—and started performing her own songs in small clubs up and down the East Coast. Soon her work came to the attention of more established performers. "The Urge for Going" was recorded by both folk singer Tom Rush and country star George Hamilton IV (Rush also recorded her song "The Circle Game"), and other songs were picked up by Buffy Sainte-Marie and by Dave Von Ronk, among others. In 1968, **Judy Collins** would have a hit with "Both Sides Now," which has since gone on to become one of Mitchell's best-known songs.

I'm a painter first, and a painter—unlike a musician—is driven to innovate.

—Joni Mitchell

In 1967, at the invitation of producer Joe Boyd, Mitchell toured England as the opening act for the Incredible String Band. After returning from England, she performed at the Gaslight South folk club in Coconut Grove, Florida, where she met musician David Crosby. They became lovers, and he became an important supporter of her music. With his help, she signed a record deal with Reprise to make an all-acoustic album (a radical idea at the time) with Crosby as producer. Her first album, *Joni Mitchell* (also known as *Song for a Seagull*), was released in 1968. She chose not to include any of her songs which had been recorded by other artists, and instead offered a new set of sparely arranged, atmospheric folk songs. This album, which featured Mitchell on piano and guitar, along with Stephen Stills on bass, established her hallmark early style—pure, powerful vocals, complex songs and guitar-playing, and metaphor-heavy lyrics.

The focus of her career now shifted to Los Angeles, where she lived first with Crosby and then with her new lover, Graham Nash. She toured almost continually, playing at festivals and opening for Crosby, Stills and Nash. In 1967, she released her second album, *Clouds*, featuring her own version of "Both Sides Now" and "Chelsea Morning" (the song for which Bill Clinton and **Hillary Rodham Clinton** named their only daughter). This album was more successful than her debut, reaching #31 on the charts and winning the Grammy Award for Best Folk Performance the following spring. The year 1970 was to become a banner year for Mitchell in terms of critical and popular success. Following *Clouds* with *Ladies of the Canyon*, recorded while she was living with Nash in Laurel Canyon, she enjoyed her first gold album and international success. Meanwhile, Crosby, Stills and Nash reached #11 on the U.S. pop charts with her song "Woodstock" ("And I dreamed I saw the bombers/ Riding shotgun in the sky/ And they were turning into butterflies"), which immediately became the lasting anthem of a generation and of that landmark event in pop culture. Ironically enough, Mitchell herself had not performed at Woodstock, opting out—allegedly on the advice of David Geffen—in order to make a TV talk show appearance.

Newfound celebrity and a grueling touring schedule gradually began to feel oppressive to Mitchell, and she took time off to travel in Europe. After singing backup on *Carole King's album *Tapestry* and performing on then-lover James Taylor's #1 hit "You've Got a Friend" (written by King), she released her most acclaimed album, *Blue*, in the summer of 1971. Hailed as a classic and credited with launching the confessional singer-songwriter genre, *Blue* reflected what she has described as her "emotionally transparent" state of mind. Mitchell has always resisted suggestions that her songs are all autobiographical, however, and prefers to portray her style as conversational rather than confessional, as singing "with an ear for the music and meter of the spoken word."

Although Mitchell left Los Angeles to live in privacy on the coast of British Columbia, she retained musical ties to what had become the center of the country-rock scene. Her next album, 1972's *For the Roses*, was recorded for David Geffen's new Asylum label during what she later described as "a time of withdrawal from society, and intense self-examination." A strong seller, the album explored her feelings about her turbulent romantic life and the complications of stardom. A review in *The New York Times* called her "a songwriter and singer of genius," praising each song as "a gem glistening with her elegant way with language." *For the Roses* featured her first real hit single ("You Turn Me On, I'm a Radio"), and also marked a shift in musical direction, introducing orchestral arrangements into her distinctive brand of folk-pop.

Her follow-up album, *Court and Spark* (1974), was an even bigger commercial success. It included her first and, to date, only top ten single ("Help Me," which she later dismissed as "a throwaway song"). The album reached #2 on the *Billboard* charts, and she toured North America and Britain to support sales, moving back to an L.A. base with her boyfriend John Guerin, who was the drummer for the L.A. Ex-

press. The album was nominated for four Grammy Awards, including Album of the Year (which she lost to Stevie Wonder) and Best Pop Vocal Performance (which she lost, more controversially, to **Olivia Newton-John**'s "I Honestly Love You"). The confident, jazz-inflected *Court and Spark* was to be Mitchell's commercial high point. To further exploit her soaring popular appeal, a live album called *Miles of Aisles* was released later that year.

A critical backlash followed with the release of *The Hissing of Summer Lawns* in 1975; *Rolling Stone* magazine named it the year's worst album. Stubborn and resolute, Mitchell shrugged off the criticism and joined up with Bob Dylan's Rolling Thunder Review. In 1976, she appeared at the Band's farewell concert in San Francisco and in the documentary about the concert, *The Last Waltz*. However, she maintained a preference for more intimate club settings throughout her career. "I never liked the roar of a big crowd," she said. "I could never adjust to the sound of people gasping at the mere mention of my name." Also in 1976 she re-

leased *Hejira*, an album inspired by a cross-country road trip (during which she "gave up everything but smoking") she had recently taken after breaking up with Guerin. Mellow and jazzy, *Hejira* featured both Guerin and jazz bassist Jaco Pastorius and became her seventh consecutive gold album. Although the record was heralded by critics, Mitchell still felt hounded by the fickleness and commercial demands of the music business. She recorded the ambitious Latin-Afro-inspired double album, *Don Juan's Reckless Daughter* (1978), "on the tail of persecution. . . . I just had to fulfill my contract."

After hearing *Don Juan's Reckless Daughter*, jazz legend Charles Mingus asked Mitchell to collaborate on a project based on T.S. Eliot's *Four Quartets*. This work was abandoned, but their collaboration continued when Mingus offered Mitchell six melodies he had written especially for her. She flew to New York and stayed at her apartment at the Regency Hotel to write lyrics for these songs. Already wheelchair-bound, Mingus was dying of Lou Gehrig's disease at this time, and Mitchell never heard him play. She accompa-

nied him down to Mexico, where he consulted a faith-healer, and where he would die early in 1979. (On her return trip, she spent five days at the home of artist *Georgia O'Keeffe.) Mitchell claimed that Mingus had reached out to her because he "wanted his stock to go up before he died. There was an element of choosing me to write his epitaph, make sure he got a bigger funeral." Their work together was the foundation of her next album, *Mingus* (1979). Although its sound seemed to indicate that she had become a full-blown jazz artist, the album owed little to the era's fashionable jazz-rock fusion movement, and it was ignored by both jazz and pop radio. Many of her fans felt estranged from her new sound and from lyrics less confessional than they expected; *Mingus* was her only album in that decade that did not reach gold status.

In 1980, she released another live album, *Shadows and Light*, and early the following year was inducted into Canada's Juno Hall of Fame by Canadian Prime Minister Pierre Trudeau. Inspired by reggae and rhythmic rock heard on a vacation in the Caribbean, Mitchell returned to the studio in 1982 to record *Wild Things Run Fast* for David Geffen's new eponymous label. It was a time of change for her once again, both musically and personally; the album marked a step away from her jazz explorations, and was also the first in over a decade for which she hired a producer. After 17 years, she parted company with her manager Elliot Roberts and signed with Peter Asher. Later that year, at Roberts' home, she married Larry Klein, the bass player on *Wild Things Run Fast*.

Despite an exhaustive world tour, the album was not a major success; Mitchell later claimed that she grossed only $35,000 after months of touring. Having continued to create the paintings for her album covers, she turned her fuller attention to art once again, and exhibited twice in 1984. The following year, Geffen brought in New Wave synth-hitmaker Thomas Dolby to produce Mitchell's next record, *Dog Eat Dog*, an awkward attempt to give her a more contemporary sound that she resented. The release party for the album was held at the James Corcoran Gallery in Los Angeles and billed as "Joni Mitchell: New Paintings, New Songs."

Again disappointed with her album sales, Mitchell canceled plans to tour and turned her attention to painting, although she continued to participate in numerous all-star benefit concerts for favorite causes. Traveling with Larry Klein to the U.K., where he was working with Peter Gabriel on the album *So*, she began work on the songs released in 1988 as *Chalk Mark in a Rain*

Storm. Guest vocalists on the album included Gabriel, Billy Idol, Tom Petty, Don Henley, and Willie Nelson. Touring the world to promote this more pop-oriented effort, Mitchell held her first ever "for sale" art exhibition, in the Parco Gallery in Tokyo. In 1991, she released *Night Ride Home*, an album embraced by critics as a return to her '70s form. Equally positive reviews greeted 1994's *Turbulent Indigo*, released on the Reprise label after she had a financial dispute with Geffen. A melancholy album that followed her separation from Klein, *Turbulent Indigo* won Grammy Awards for Best Pop Album and Best Album Packaging.

In 1995, Mitchell received *Billboard* magazine's Century Award, its highest honor for creative achievement. Her career anthology *Hits & Misses* was released in 1996, although she refused to do the typical greatest-hits tours, declaring, "I will not be a living jukebox." After *Hits & Misses*, and some public nudging by Stephen Holden, music critic for *The New York Times*, the Rock and Roll Hall of Fame inducted Mitchell in 1997 (she did not attend the ceremony); she was also inducted into the Songwriters' Hall of Fame shortly thereafter. That same year, she met the daughter she had given up for adoption, **Kilauren Gibb**, who was by then a mother herself. They went on to build a close relationship, and Mitchell revels in her grandchildren. *Taming the Tiger* (1998) prominently featured her new computerized electric guitar. *Both Sides Now*, an album of old standards and love songs by such artists as *Billie Holiday*, *Ella Fitzgerald* and Frank Sinatra, as well as several of her own songs, all backed by a full orchestra, was released in 2000.

It has often been suggested—not least by Mitchell herself—that the depth of her musicianship was frequently overlooked while she was pigeonholed as a sensitive, poetic female artist. She recalled the disappointment of playing the just-recorded *Court and Spark* to Geffen and a group of male friends, including Bob Dylan, all of whom listened with polite indifference only to then thrill to the sounds of Dylan's new *Planet Waves* ("an ordinary record" by comparison, she felt). Increasingly cited as their primary inspiration by artists as diverse as **Sarah McLachlan**, *Chrissie Hynde*, **Tori Amos**, **Courtney Love** and Morrissey, Mitchell has proved an often ungrateful muse, openly deriding most current music and believing her musical successors enjoy a far greater level of commercial success and artistic respect than she ever received, and with far less merit. Writer **Lisa Kennedy** suggests that there have been times "when Joni Mitchell has appeared like a ghost listening in at

her own wake to the glowing assessments of her early years, even as yet another Joni continued to do the work of song making."

"In the same way that Van Gogh searched for his own color schemes, I searched for my own harmonic voice," she once declared. "[I] found it, and spent a career being dismissed as too jazzy."

SOURCES:

O'Dair, Barbara, ed. *Trouble Girls: The Rolling Stone Book of Women in Rock*. NY: Random House, 1997.

People Weekly. October 12, 1998, p. 108.

Rees, Dafydd, and Wile Crampton. *DK Encyclopedia of Rock Stars*. DK Publishing, 1996.

White, Timothy. *Rock Lives: Profiles and Interviews*. NY: Henry Holt, 1990.

Paula Morris, D.Phil.,
Brooklyn, New York

Mitchell, Juliet (1940—)

British feminist. Born in New Zealand in 1940; attended King Alfred School in London; received degree in English from St. Anne's College, Oxford; postgraduate study at Oxford.

Juliet Mitchell was born in New Zealand in 1940, but moved with her family to England at the age of four. She received her secondary education at the King Alfred School in Hampstead, London, and went on to obtain a degree in English from St. Anne's College at Oxford. Mitchell completed postgraduate studies at Oxford, and became a lecturer at the University of Leeds in 1962. After one year in that position, she sought a new appointment and eventually transferred to the University of Reading in 1965. While at Reading she published her first book, *Women: The Longest Revolution*, in 1966.

Mitchell retired from academia to concentrate on writing and lecturing in 1971. She released a second book, *Women's Estate*, in 1972, and a third, *Psychoanalysis and Feminism*, in 1974. Gaining renown in the United Kingdom as an advocate of socialism and feminism, Mitchell served on the editorial boards of periodicals including *New Left Review*, *Social Praxis*, and *Signs*. She collaborated with feminist **Ann Oakley** to edit *The Rights and Wrongs of Women*, a collection of essays, in 1976.

Grant Eldridge,
freelance writer, Pontiac, Michigan

Mitchell, Lucy (1845–1888)

American archaeologist. Born Lucy Myers Wright on March 20, 1845, in Urmia, Persia (now Orūmīyeh, Iran); died in Lausanne, Switzerland, on March 10, 1888; *attended Mt. Holyoke Seminary; married Samuel S. Mitchell (a missionary), in 1867.*

Born Lucy Myers Wright in Urmia, Persia (now Orūmīyeh, Iran), on March 20, 1845, Lucy Mitchell was the daughter of a missionary to Nestorian Christians. She spent her formative years in Persia and gained a conversational ability in both the Syriac and Arabic languages, as well as in French, German, and Italian. Mitchell moved to the United States in 1860 and enrolled at Mt. Holyoke Seminary, but left school in 1864 to rejoin her father in Syria. Following his death in 1865, she returned to the United States.

Lucy married missionary Samuel S. Mitchell in 1867, and the couple returned to Syria on a mission shortly thereafter. There she began work on a dictionary of modern Syriac, which remained unpublished after her husband's failing health forced them to leave Syria for Rome. (The manuscript is now held by Cambridge University.) While in Rome, Mitchell began studying ancient art and by 1876 was giving lectures on Greek and Roman sculpture. Despite her lack of formal archaeological training, her scholarship earned her studying privileges at many leading museums and libraries, and Mitchell collaborated with the most noted archaeologists of her day. She published *A History of Ancient Sculpture* and a companion volume of plates, *Selections from Ancient Sculpture*, in 1883. Mitchell's work received praise from both professional archaeologists and the public, and in 1884 she became just the second woman elected to the German Archaeological Institute. She traveled to Berlin that year to begin preparation of a book on Greek pottery and vase painting, but poor health forced her to abandon the project in 1886. Lucy Mitchell died in Lausanne, Switzerland, on March 10, 1888.

SOURCES:

McHenry, Robert, ed. *Famous American Women*. NY: Dover, 1980.

Grant Eldridge,
freelance writer, Pontiac, Michigan

Mitchell, Lucy Sprague (1878–1967)

American educator and children's author. Born Lucy Sprague in Chicago, Illinois, on July 2, 1878; died of a heart attack on October 15, 1967; fourth of six children of Otho Sprague (a wholesale grocer) and Lucia (Atwood) Sprague; married Wesley Clair Mitchell (1874–1948, an economist), on April 6, 1912 (died 1948); children: four.

Loneliness, privacy, and secrecy dominated Lucy Sprague Mitchell's growing-up years which she shared with five siblings. "I kept to myself as much as I could in that crowded house," she recalled, "and tried my best not to let anyone in on anything I cared about." Attending Radcliffe against the wishes of her father, Mitchell went on to become the first dean of women at the University of California at Berkeley, starting out as advisor to the dean in 1903. She devoted her life to the education of children.

In 1916, she and her husband, economist Wesley Clair Mitchell, along with **Harriet Johnson**, founded the Bureau of Educational Experiments, later known as the Bank Street College of Education. Mitchell was also responsible for its Writer's Laboratory, inviting publishing professionals to attend. This was no "common garden variety course" wrote *Edith Thatcher Hurd. "If you survived Lucy's classes on language, the laboratory was the 'whipped cream,' an intense but richly rewarding experience." Mitchell's own *Here and Now Story Book*, published in 1921, was widely recognized as a radical departure in the writing for children. She argued that children's stories should start with the familiar, something from the child's world, before opening out to broaden that world. In the introduction, she also maintained that form was just as important as content and proposed a new child-centered literature, using rhythm, rhyme, and repetition. Her credo: "While we are learning, there is hope."

SUGGESTED READING:

Antler, Joyce. *Lucy Sprague Mitchell: The Making of a Modern Woman*. New Haven, CT: Yale University Press, 1987.

Mitchell, Lucy Sprague. *Two Lives: The Story of Wesley Clair Mitchell and Myself*. NY: Simon and Schuster, 1953.

Mitchell, Maggie (1832–1918).

See Mitchell, Margaret J.

Mitchell, Margaret (1900–1949)

American author who won the Pulitzer Prize for Gone With the Wind. *Name variations: Peggy Mitchell; Peg Marsh. Born Margaret Munnerlyn Mitchell on November 8, 1900, in Atlanta, Georgia; died on August 16, 1949, from injuries suffered when she was struck near her home by an automobile; daughter of Eugene Muse Mitchell (an Atlanta lawyer) and Mary Isabel (Stephens) Mitchell, known as May Belle; married Berrien "Red" Upshaw, on September 2, 1922 (divorced 1924); married John Marsh, on July 4, 1925; no children.*

Except for a year spent at Smith College in Massachusetts, spent nearly all her life in Atlanta, working for a time for the Atlanta Journal *before an ankle injury forced her to leave the paper; during convalescence, began work on the first of what would be many drafts of her epic novel,* Gone With the Wind, *written over a period of nine years; published* Gone With the Wind *(1936); won the Pulitzer Prize (1937); attended premiere of David O. Selznick's award-winning film of her book (1939); became an international celebrity, with her book translated into more than two dozen languages, before the outbreak of World War II; was an outspoken advocate of authors' rights and pursued several legal actions through the courts to protect her rights to her novel. An earlier novella,* Lost Laysen, *was discovered in 1994.*

The joking began whenever Margaret Mitchell's friends came to visit her cramped apartment on Atlanta's Crescent Avenue. "The Dump," as Mitchell wryly called it, had become a hangout during the Depression for the group of journalist friends of which she and her husband John Marsh were members in good standing, a result of their work at the *Atlanta Journal*. Now, with Mitchell retired from the paper because of troublesome health, the apartment had become a sort of giant filing cabinet for the novel everyone knew she had been working on since the late 1920s. The manuscript pages that no one was allowed to read peeked out of drawers, or acted as levelers for tipsy furniture or, stacked waist-high, as a place to balance one's drink during a visit. "We all joked about it: 'Well, you know she's writing the World's Greatest Novel'," journalist Harvey Smith recalled many years later. "And, by God, she *was*!" Smith's description of *Gone With the Wind* is entirely accurate, for the only book to have sold more copies is the Bible. In a sense, Mitchell had been writing her epic of Southern survival since childhood. Her older brother Stephens Mitchell once claimed that his little sister had been scribbling away when she was just ten years old, even these early efforts often featuring a plucky Civil War heroine beset by hard times and besieged by the advances of aggressive men, often Yankees. Only four of these tales survive, among them the story of a Union officer caught behind Confederate lines who falls in love with a daughter of the South.

Mitchell's fictional settings and characters were hardly surprising, given her family history and surroundings. Her father Eugene Muse Mitchell was a well-known Atlanta lawyer whose family name had been common all over

the South from Revolutionary War days, belonging to famous planters, preachers and patriots. He was often described as the perfect Southern gentleman, although the less charitably inclined considered him emotionally inhibited and dull. No one could accuse his wife, **May Belle Mitchell**, of the same. Born Mary Isabel Stephens, she was descended from Irish immigrants who had come to Atlanta in the 1850s to establish a successful retail business. She was gregarious, outspoken, and much respected for her fiery temper. Particularly infuriating to May Belle was the complacent nature of genteel Southern women who refused to support her efforts for the suffrage movement and for increased educational opportunities for their gender.

History hung around Margaret's childhood as heavily as the humid air of an Atlanta summer. The rambling Victorian house perched high on Jackson Street where Mitchell was born on November 8, 1900, had a commanding view of the city Sherman had burned to the ground less than 40 years before, and had served as a Confederate hospital before the disaster. Crumbling old mansions whose owners had not survived the War of Northern Aggression could still be seen just a short buggy ride away; veterans of the great conflict were still in plentiful supply, full of stories for the little Mitchell girl with the strawberry-blonde hair and blue eyes; and the city's troubled racial heritage burst into full flame in 1906, when Margaret was just five, as angry mobs of whites and African-Americans clashed in the streets and an all-white militia camped on the lawn of the house.

Even more memorable were the stories Mitchell heard as a girl during summer visits with relatives at the Stephenses' country retreat, Rural Home, out among the dirt roads of Clayton County. There, her aunts and uncles and grandparents told stories of a war that seemed to have happened only yesterday. "I sat on the bony knees of veterans and the fat, slippery laps of great-aunts," Mitchell later wrote, "and heard them talk about . . . how nice thick wrapping paper felt when put between the skin and the corset, in the cold days during the blockade when woolen goods were scarce, and how Grandpa Mitchell walked nearly fifty miles after the battle of Sharpsburg with his skull cracked in two places from a bullet. They didn't talk of these happenings as history . . . but just as part of their lives, and not especially epic parts." The stories seemed so fresh that Mitchell often joked to friends she had not realized the South had lost the war until she was ten years old.

But May Belle was determined that her daughter's future would not be directed by past glories or tragedies, and instilled in Margaret early on the need for independent thinking. When Mitchell once complained that her school work, especially mathematics, was boring, May Belle hoisted her into a buggy and drove out to suburban Atlanta, past the dilapidated plantations collapsing into the red clay. She pointed out to Margaret that fine young ladies just like herself had once lived there, "charming, embroidering, china-painting one-time belles who, after the war had deprived them of their means, degenerated pitifully." "She told me," Mitchell remembered many years later, "that my own world was going to explode under me someday, and God help me if I didn't have some weapon to meet the world." To May Belle, that weapon was education and a voice at the ballot box.

In 1912, the Mitchells moved to a new house at 1149 Peachtree Street, on the north side of Atlanta. Modern-day Atlanta's most commercially developed area, it was in those days a newly opened suburb of the city, divided into spacious lots where whites could escape the tensions of the older part of the city which had produced the race riots six years earlier. During these years, Mitchell witnessed the devastating fire of 1917 that destroyed antebellum Atlanta, including the old Mitchell home on Jackson Street, and left 10,000 homeless. Many old-timers found it eerily similar to Sherman's fiery conquest of that same section of the city, especially when martial law was declared in the fire's aftermath and armed troops roamed the streets.

Along with other girls of her race and station, Margaret attended whites-only public schools through the sixth grade and was then enrolled in private schools to finish her adolescent education. Soldiers flooded Atlanta again as she became a young woman, the city being an important training site for World War I troops. Mitchell's first love affair, however, was not with a dashing Southern military man but with an aristocratic young New Yorker who had been sent to Atlanta for boot camp. Eugene's objections to his daughter's infatuation with a Yankee were to little effect, since May Belle thought the young man from another world would broaden Margaret's horizons; and, as she predicted, Margaret's crush evaporated quickly enough once the young man was shipped off to Europe.

Eugene's protestations over May Belle's choice of a college for Margaret were equally fruitless. May Belle had chosen Smith College in Northampton, Massachusetts, about as far away

from Southern sensibilities as one could get. A childhood friend of Margaret's was enrolled at the school, from whose parents May Belle had first learned of *Sophia Smith's donation nearly a century earlier to found a college that would provide an education for young ladies equal to that available to young men. Then, too, there was the proximity of Northampton to New York, which mother and daughter visited in the spring of 1918 and which would be a source of further intellectual stimulation. Mitchell was less enthusiastic than her mother about the idea, especially after a summer visit to an errant Stephens relative who had married a Northerner and moved to Greenwich, Connecticut. There was too much ostentation, Margaret complained to her father in a letter back home, too much Yankee emphasis on money and possessions. But in September of 1918, Mitchell began her freshman term at Smith.

Her first weeks away from the strictures of Southern maidenhood were heady ones. "I seemed to feel something within my innermost 'me' uncoiling and stretching and awakening," she wrote in her diary of that autumn. But her soaring spirits soon came back to earth, a Northern earth that had no place for magnolias or peach trees and where one lived in small stuffy rooms to avoid the freezing temperatures, rather than enjoying cool evenings on broad verandas. Her growing distress in such unfamiliar surroundings burst out in the now-famous incident in which Margaret demanded to be switched to another history class rather than share a classroom with one of Smith's few African-American students. It was an odd incident in light of Mitchell's future actions and quickly shrugged off as Southern eccentricity by many of her Yankee acquaintances, for whom a black person in a college classroom was an equally new experience. Mitchell complained to her mother that her poor history grades were a result of her protest and accused the teacher of hypocrisy, wanting to know if the professor had ever "undressed and nursed a Negro woman, or sat on a drunk Negro man's head to keep him from being shot by police," as Margaret had done during the tense atmosphere in the aftermath of the Atlanta fire. Mitchell later said that she had been close to a nervous breakdown during her time at Smith, although she must have hidden it exceedingly well from classmates who remembered her sense of humor and ability to get along with just about everyone.

As the winter term was beginning in January of 1919, Mitchell learned that her mother had fallen ill with the deadly strain of influenza that claimed hundreds of thousands of lives in the pandemic of 1918–19. May Belle died a day before Margaret arrived back in Atlanta. "I should have liked to have known her after I was grown up," Mitchell lamented, but May Belle had done the next best thing by dictating a lengthy letter to her daughter before she died. "Care for your father when he is old, but never let this or anyone else's life interfere with your real life," she advised. "Give of yourself with both hands and overflowing heart, but give only the excess, after you have lived your own life." Mitchell attempted to heed the letter's admonitions, returning to Smith to complete the winter term; but she left permanently in June of that year to assume the management of her father's household.

"Frankly, I wouldn't call housekeeping a bed of roses," she groused after a few months back in Atlanta marked by frequent disputes with gardeners, chauffeurs, cooks and maids. But there was some solace to be found from the active social life presented to a young white woman of good family in Atlanta, and a good deal of amusement in raising the carefully applied eyebrows of Atlanta matrons in a manner that would have made May Belle proud. Margaret's coming out in the fall of 1920 was sedate enough, but her charity work at African-American hospitals was considered sufficiently ill-advised to deny her entry into the Junior League, white society's charitable organization for its young ladies. Then there was Margaret's scandalous public performance with a male partner of the Apache Dance, an erotic *pas de deux* imported from Paris which was then taking the country by storm. This was enough to attract the attention of the *Atlanta Journal*'s society gossip columnist, "Polly Peachtree," who suggested that Miss Mitchell was being seen in the company of far too many men than was good for her. "She has in her brief life . . . had more men really, truly 'dead in love' with her, more honest to goodness suitors than almost any other girl in Atlanta," the columnist sniffed. Among the young suitors was Henry Love Angel, a childhood sweetheart on whom Mitchell would bestow a gift that would cause quite a stir 70 years later, John Marsh, a quiet, studious newspaper reporter, and Berrien "Red" Upshaw, the rowdy son of an old north Georgia family whose escapades were the talk of Atlanta. Margaret, it was said, had as many as five suitors at a time. "I think a man who makes improper proposals is a positive necessity in a girl's life," she wrote in her diary, although she quickly followed the statement by insisting she had never actually accepted any of them.

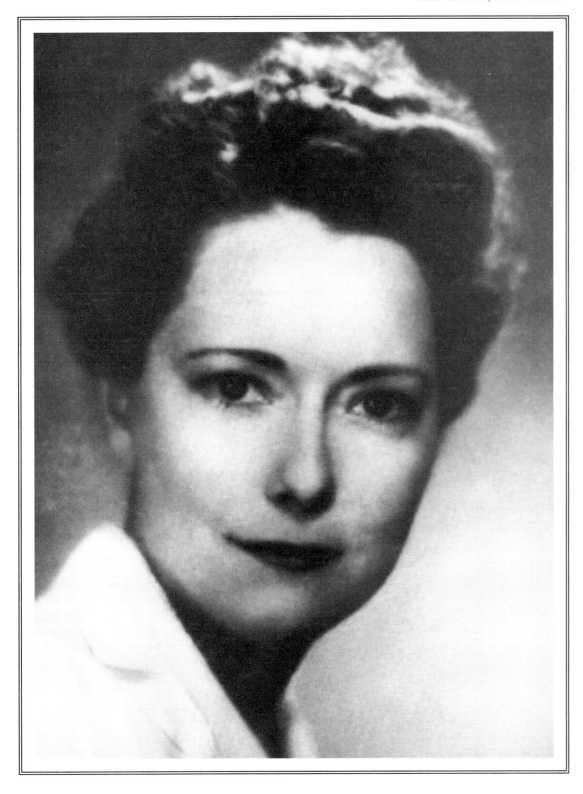

It was Red Upshaw who finally won her hand, and they were married on September 2, 1922. Mitchell, one friend said, went through with it only because she felt sorry for Upshaw, and no one was surprised when the marriage foundered after only ten months. Upshaw, de-scribed by his own father as "nervous and eccentric," had no skills to speak of and occupied himself with bootlegging liquor during those Prohibition years, while objecting to Margaret's success in landing a job with the *Atlanta Journal.* Particularly upsetting to him was Mitchell's

insistence on using her maiden name for her by-line. Upshaw argued constantly with Eugene, with whom the couple lived, until Mitchell finally told her husband to leave and filed for a divorce. Margaret described this period as one of "black depression" for which she blamed a fall from a horse and a subsequent series of illnesses and injuries.

The newspaper job provided some relief. Her first attempt to get herself hired as a staff reporter had been rebuffed, there being no female reporters on the staff and no desire on the editor's part to set a precedent. But when she heard that the lone woman who wrote for the paper's Sunday magazine section had left to have a baby, Mitchell got herself an interview with the magazine's editor. Angus Perkerson either believed the tales Margaret spun about her previous experience or admired the imagination that invented them. "I had no newspaper experience and had never had my hands on a typewriter," Mitchell later wrote, "but by telling poor Angus . . . outrageous lies about how I had worked on the Springfield [Massachusetts] Republican . . . and swearing I was a speed demon on a Remington, I got the job." She wrote over a hundred pieces for the magazine during three-and-a-half years, including book reviews, gossip columns, advice to the lovelorn, or whatever else Perkerson threw her way. Perkerson paid her what, to him, must have been the highest compliment by once telling her that she wrote "like a man." He was particularly impressed by her ability to capture the personalities of her subjects so vividly that illustrations were hardly needed for her articles. Also of interest to Perkerson, no doubt, was Mitchell's apparent attachment to the *Journal*'s copy editor, the same John Marsh she had once rejected in favor of Red Upshaw.

Marsh had been Upshaw's roommate when both men had been pursuing Margaret Mitchell, then known as Peg or Peggy, and he confessed to being in love with her ever since returning from his World War I service. "John hardly talked at all, but he was very polite, a gentleman, a real gentle man," Perkerson later said of him. "And he was devoted to her, too, waited on her hand and foot." Others were less kind, considering Marsh dull and pedantic and hardly a match for the vivacious Margaret. But she accepted Marsh's proposal to her on the condition that she see a bit of the world without him before settling down. She wanted, she said, "to visit the ends of the earth, and judge them," but her planned journey of discovery to South America and Europe ended at her first stop, Cuba, where the perils of a woman traveling alone became ev-ident. "Latin gentlemen," she told her diary, "have as much chivalry in their souls as hungry sharks." She was back in Atlanta by early 1925 and married John Marsh on July 4.

This time, Mitchell insisted she and her husband live in their own home and not her father's. Their apartment on Crescent Court in mid-town Atlanta was convenient to the *Journal*'s offices but had little else to recommend it. "The Dump," in fact, became somewhat of a prison during the winter of 1926, when a mysterious arthritic condition in one ankle proved so serious that Margaret could hardly walk and was forced to rely on special shoes or crutches to navigate the apartment. By the summer of that year, her black moods had returned. "Just at present I'm about as pleasant to live with as a porcupine or a snapping turtle," she wrote to a friend in July. She had left the *Journal* some months earlier, encouraged by Marsh's suggestion that she turn her talents to writing fiction; but a Jazz Age novel she began was quickly abandoned along with another about a fading Southern belle and her mulatto lover. But in between earning money with freelance projects from the *Journal,* she kept pecking away at a third project. It was a Civil War romance she probably began in late 1926 or early 1927, written in bits and pieces over the next several years. "She made such little noise, I thought she was only writing a letter to a friend," the housekeeper later told expectant reporters when *Gone With the Wind* was finally published.

Mitchell said little about the book while she was writing it, except to tell a visitor in 1930: "It stinks and I don't know why I bother with it." Even after its publication, she was reluctant to discuss the book's genesis. She had the entire story in her head from the start, she said, but wrote it so haphazardly that the last chapter, in which Melanie dies, was actually the one she wrote first. She claimed she could have written her sweeping tale in a year, instead of ten, but found it hard to write full-time because it was such an ordeal for her. "Night after night I have labored and labored and have wound up with not more than two pages," she groused to one interviewer. "After reading these efforts on the morning after, I have whittled and whittled until I had no more than six lines salvaged. Then I had to start all over again." She denied rumors that her husband had helped her write it, claiming he had never even read it until after it had been sold. She objected to all attempts to trace the origin of her characters, although it is hard not see at least a little of May Belle Mitchell's fiery Irish temper in Scarlett O'Hara (originally

named Pansy), or Red Upshaw's belligerence in Rhett Butler, or Eugene Mitchell's southern gentility in Ashley Wilkes; but she viewed all such comparisons with scorn. "If you publish that Bela Lugosi is like *Shirley Temple [Black] or that *Deanna Durbin is like Jimmy Cagney," she wrote the editor of *Photoplay,* "your error would be no greater."

Even more irksome to her were complaints from Southerners that *Gone With the Wind* betrayed the South, with a heroine who turns her back on her heritage. Mitchell admitted that the novel was not what she called a "moon on the magnolias" view of the South, but was an accurate picture of a ruptured society visited with a terrible war for its sins. "There never was anything to those folks but money and darkies," Mitchell has Grandma Fontaine say in the book, "and now that the money and the darkies are gone, those folks will be Cracker in another generation." Margaret admitted to being embarrassed when she was included on lists of "Southern" writers, with their nostalgic geography of white-columned mansions, loyal slaves, and gentle masters. "North Georgia was certainly no such country, if it ever existed anywhere," she pointed out, "and I took great pains to describe north Georgia as it was."

But in 1931, when Mitchell finished writing a first draft of what she considered a second-rate novel, those debates and discussions were still in the future. She and John moved that year into a new apartment on 17th Street, closer to downtown Atlanta, where Margaret attempted for the next two years to come up with something the novel still lacked, a first chapter. Her health problems returned, particularly after a car accident in 1934 which left her unable to move her head and neck for three months afterward. But she was sufficiently recovered by the autumn of 1934 to attend the Georgia Writers Conference, where she sat next to George Latham, a book scout for the Macmillan Company who was on an annual tour to find new material for publication. A friend of Margaret's, who had left Atlanta some years earlier and moved to New York, worked for Macmillan, and had told Latham to look up Peggy Mitchell and ask about the novel everyone knew she had been working on for years. Latham asked to see the manuscript several times during the evening, Mitchell claiming each time she had nothing to show him. But as Latham packed the next day to catch a train for Charleston, Margaret called to say she was downstairs in the hotel lobby with something to give him. She presented him with a stack of 70 manila envelopes. "Take the damn

thing before I change my mind," she said before hurrying away. The manuscript had no title, no first chapter, and was in a state of haphazard organization; but Latham knew what he had after reading just a dozen pages. "I see in it the making of a really important and significant book," he wrote to her from Charleston. Mitchell's answering telegram begged him to send it all back, for she had had second thoughts. "I have felt that there was something lacking in me that other authors . . . possessed," she later said, which was "that passionate belief in the good quality of their work." But by the time Latham had returned to New York, leaving a trail of encouraging telegrams behind him, Margaret had agreed to look at a contract.

> *I* didn't know being an author was like this, or I don't think I'd have been an author.
>
> —**Margaret Mitchell**

Macmillan might have hoped for speedy negotiations with a first-time author, forgetting that Margaret's father was a lawyer. She was particularly worried about the contract's suggestion in nearly inscrutable legalese that she, and not Macmillan, was responsible for protecting the novel against any infringement of its copyright. The tone of the negotiations took a turn for the worse when Mitchell found out that Macmillan, which had agreed to act as her agent in selling film rights to the book, had then struck its own deal with a literary agent Mitchell disliked, splitting the commission. When Macmillan asked for a revision of her royalty schedule after such matters had already been agreed upon, Mitchell and her brother traveled personally to New York, where Macmillan complained that the book's final length of 400,000 words was greater than anticipated and would raise printing costs. Margaret finally agreed to royalties of 10%, rather than the original 15%. After more wrangling and Macmillan's assurances that the contract was "standard and acceptable," Margaret signed in May of 1936 for an advance against royalties of $5,000. "I can't even endure to look at the book because I nearly throw up at the sight of it," Mitchell complained after nine months of legal haggling, during which she had also finally written the book's first chapter, added new material, and revised the entire manuscript following Macmillan's suggestions.

Latham had predicted that *Gone With the Wind* would be a "very significant publication" and saw to it that galley proofs were circulating six months before the June publication date. His

judgment was correct, for the book was already being hailed as "one of the greatest man and woman stories every written" as it was being shipped to stores. Even historian Henry Steele Commager was impressed by Mitchell's work which, he said, somehow managed to make something significant out of the most timeworn elements. "It rises triumphantly over this material," he wrote, "and becomes, if not a work of art, a dramatic recreation of life itself." Latham had done his work so well that bidding for film rights had begun months before the book reached the shelves, even though Mitchell had publicly stated in 1936 that she did not consider the book promising movie material. Warner Bros. thought the book was a perfect vehicle for *Bette Davis; MGM wanted it for *Katharine Hepburn; and every actress from *Barbara Stanwyck to *Tallulah Bankhead was badgering their studio heads to outbid everyone else. But it was independent producer David O. Selznick who moved the quickest when he received a telegram from *Kay Brown at his New York office, urging, "DROP EVERYTHING AND BUY IT!" He paid an unprecedented $500,000 for the rights and launched the famous search for his Scarlett, settling on the English actress *Vivien Leigh to play opposite Clark Gable's Rhett Butler in the Academy Award-winning production that would premiere in Atlanta three years later. When the first anniversary of the book's publication arrived, by which time well over one million copies had been sold, a reporter for the *Atlanta Constitution* presented himself at Mitchell's apartment one evening asking for her reaction to that afternoon's announcement. Seeing her blank expression, the reporter explained that *Gone With the Wind* had just won the Pulitzer Prize. The next morning, Mitchell said, "reporters were slithering out of cracks in the floor."

Mitchell became just as much of a celebrity as her book, but its success overwhelmed the rest of her life. She never published another novel, caught up in an endless round of public appearances and lectures and preoccupied with costly and frustrating legal battles to protect her copyright, as her contract with Macmillan required her to do. Her guardianship of her rights was so diligent that she soon gained a reputation among publishers as somewhat of a crank, and among writers as a champion of authors' rights. One lawsuit alone, which arose when a Dutch publisher attempted to print an unauthorized edition, dragged on for ten years before Mitchell finally prevailed. "I go to pieces under heavy nervous strain," she had once confided to a friend, and the considerable strains of the decade fol-

lowing *Gone With the Wind*'s appearance took their toll. There was a gradual worsening of the spinal condition that had plagued her since the car accident of 1934, arthritic ailments, and an operation for "intestinal adhesions." By the mid-1940s, she was unable to walk properly without the aid of a back brace.

She and John often found at least a few hours of respite by frequently going to see films, which was their evening's activity on the night of August 11, 1949. After parking the car across from the movie theater they often went to on Peachtree Street, John Marsh had guided his wife halfway across the busy thoroughfare when the couple noticed an approaching car that seemed to be out of control. While John stood his ground to watch the dangerous car swerve off down a side street, he failed to stop Margaret from bolting back toward the sidewalk and into the path of a taxicab. She never regained consciousness and died five days later from brain damage.

But her epic story and its characters live on, more than a half century after her death, as does the history of legal entanglements and melodrama that surrounded their birth and first ten years of life. A planned 1978 sequel to *Gone With the Wind* and a companion movie were both blocked by a court ruling in favor of the Mitchell estate, which claimed it had never authorized the sequel and had the sole right to do so. The novel the estate subsequently commissioned, **Alexandra Ripley**'s *Scarlett*, was published in 1991, followed by a 1994 TV miniseries based on the book. A second authorized sequel, *Tara*, by English writer **Emma Tennant**, was ultimately rejected for publication by the estate, while Southern novelist Pat Conroy began work on an authorized account of the events covered in the original story but told from Rhett's point of view. In Atlanta, attempts to preserve the house on Crescent Court from demolition have been stymied twice by arson-related fires, while others point out the drab building's lack of architectural significance and Mitchell's own derogatory description of the place while she lived there.

In accordance with Mitchell's will, John Marsh destroyed most of his wife's personal papers and manuscripts of her early work. Only four of the short stories she wrote as a girl survive, for example. But Mitchell had forgotten about the gift she had given to one of her suitors, Henry Angel, in those long-ago days as an Atlanta debutante. In 1994, Angel's son, then 71 years old, revealed the existence of a packet addressed in Mitchell's hand which had been given

From the movie
Gone With the
Wind, *starring*
Vivien Leigh.

to him by his father in 1952, but which had lain unopened at the bottom of a drawer ever since. Among the letters Margaret had written to Henry Angel and the faded snapshots of 70 years before was something of wider interest—a novella Mitchell must have written sometime during or just after World War I. *Lost Laysen*, published in 1996, was a South Seas romance notable more for its surprise appearance than for its quality. "I don't know why my father never mentioned her," the younger Henry said of his father's courting. "Heck, if I'd known, don't

you think I'd have asked him to get passes for the *Gone With the Wind* premiere? Everybody in Atlanta wanted to go."

In light of Mitchell's youthful outburst over a black classmate at Smith College, another development is more intriguing still. Dr. Otis Smith, the first African-American pediatrician to be certified by the state of Georgia and a past president of the Atlanta chapter of the NAACP, revealed in 1996 that a large portion of his college tuition during World War II had been paid for by none other than Margaret Mitchell, who had set up an anonymous scholarship fund for African-American medical students in 1941. Smith, one of 50 beneficiaries of Mitchell's fund, had not been told the name of his benefactor until the late 1970s and remained silent until hearing of Atlanta's effort to establish a Margaret Mitchell Museum. It was also disclosed that Mitchell lent her anonymous financial support to early efforts during the 1940s to desegregate Atlanta's police department.

"Margaret puzzles me," May Belle Mitchell once wrote a friend. "I don't know whether she is headed for success or failure, but in any event, she will be her own honest self." As usual, May Belle was exactly right.

SOURCES:

Edwards, Anne. *Road to Tara*. NY: Ticknor and Fields, 1985.

Hubbard, Kim. "Buried Treasure," in *People Weekly*. Vol. 45, no. 19. May 13, 1996.

Pyron, Darden. *Southern Daughter: The Life of Margaret Mitchell*. NY: Oxford University Press, 1991.

SUGGESTED READING:

Harwell, Richard, ed. *Margaret Mitchell's "Gone With the Wind" Letters, 1936–1949*. NY: Macmillan, 1976.

Mitchell, Margaret. *Before Scarlett: Girlhood Writings of Margaret Mitchell*. Edited by Jane Eskridge. Hill Street Press, 2000.

———. *Margaret Mitchell, Reporter*. Hill Street Press, 2000.

Walker, Marianne. *Margaret Mitchell & John Marsh: The Love Story Behind* Gone With the Wind. GA: Peachtree, 1993.

<div align="right">

Norman Powers,
writer-producer, Chelsea Lane Productions, New York

</div>

Mitchell, Margaret J. (1832–1918)

American actress. Name variations: Maggie Mitchell. Born Margaret Julia Mitchell in New York City on June 14, 1832; died at her home in New York City of a cerebral hemorrhage on March 22, 1918; buried in Greenwood Cemetery, Brooklyn; daughter of Charles S. Mitchell (of Scottish birth) and Ann (Dodson) Mitchell (of English birth); half-sister of Mary Mitchell and Emma Mitchell, a child actress; married for one week, in 1850s (divorced); married Henry T. Paddock (her manager), on October 15, 1868 (divorced 1888); married Charles Mace, known as Charles Abbott (an actor); children: (first marriage) Julian Mitchell; (second marriage) Fanchon Paddock; Harry M. Paddock.

Margaret J. Mitchell, known as Maggie, played child parts on the stage before she was five years old, and made her debut as an adult on June 2, 1851, as Julia in *The Soldier's Daughter* at the Chambers Street Theatre in New York City. In 1860, she originated the part of Fanchon, in *Fanchon the Cricket*, which she played for many years, and with which her name is permanently associated. The play was adapted for her from *Charlotte Birch-Pfeiffer*'s dramatization of *George Sand*'s *Le Petite Fadette*. Other roles in which Mitchell was popular were Jane Eyre, Mignon, Little Barefoot, the Pearl of Savoy, and Nan, the Good-for-Nothing. She retired in 1892.

Mitchell, Maria (1818–1889)

American astronomer and educator who discovered a new comet and became one of the best-known faculty members at Vassar College. Born Maria Mitchell on August 1, 1818, on the island of Nantucket, Massachusetts; died of "brain disease" on June 28, 1889, in Lynn, Massachusetts; third of ten children, nine of whom lived to maturity, of William Mitchell (a cooper, teacher, and astronomer) and Lydia (Coleman) Mitchell; attended her father's school; attended academy of Cyrus Peirce; never married.

Born into a family of Quakers; attended local schools; at age 12, recorded a solar eclipse with her father (1831); opened own schools for girls briefly; was librarian at the Nantucket Athenaeum for 20 years; assisted father with the Coast Survey and made thousands of accurate observations; left Quaker religion (1843); discovered a new comet (1848) and was awarded a gold medal by the king of Denmark; elected to the American Academy of Arts and Sciences in Boston; appointed one of the original computists for the new American Ephemeria and Nautical Almanac (1849); elected to the American Association for the Advancement of Science (1850); moved to Lynn, Massachusetts, with widowed father (1861); enticed by Matthew Vassar to join the faculty at Vassar College where he built the third largest observatory in the country for her; taught at Vassar (1865–88); elected to the American Philosophical Society (1869); elected vice-president of the American Social Science Association (1873); was one of the founders of the Associa-

tion for the Advancement of Women (1873); served as president of AAW (1875 and 1876) and chaired the science committee until her death.

Selected publications: various articles in Silliman's Journal, The Nantucket Inquirer, Scientific American, The Century, Hours at Home; *also wrote "Editor's Preface" to Guillemin's* Wonders of the Moon.

In 1831, when Maria Mitchell was 12 years old, she charted, with her father's assistance, a total eclipse of the sun. According to her biographer **Helen Wright,** Mitchell never forgot the power of that experience: "the darkness, the stillness, the dawning sense that she was part of a great and orderly universe."

Born in 1818 into a Quaker family, Maria Mitchell grew up in Nantucket, Massachusetts, where life was dominated by the sea and the stars. Nantucket was then the greatest whaling port in the world, and knowledge of the skies in order to navigate the oceans was imperative. The third of ten children, nine of whom lived to maturity, Maria was a particular favorite of her absent-minded father whose love of astronomy she inherited. At the time of Maria's birth, William Mitchell was a cooper. In 1827, he became the master of the first free school on Nantucket and in 1836 a cashier of the Pacific Bank. But his real interest was astronomy, and soon he was commissioned to rate the chronometers for the Nantucket whaling fleet by checking them with stellar observations. Gradually, Maria began to help her father, and, as she said later, her love of mathematics, her father's example, and her Nantucket environment led to her love of astronomy.

Maria's mother **Lydia Mitchell** was a more stern and unloving parent, likely because of multiple births, lack of income, and a devout Quakerism. Mitchell's biographer tells of a day when William told Lydia that it was time to call in their children from the garden and send the neighbor children home. "But" Lydia replied, "they are all thine, husband." Years later, Maria Mitchell would characterize her childhood in a way her mother would have approved. "Our want of opportunity was our opportunity—our privations were our privileges, our needs were our stimulants—we are what we are partly because we had little and wanted much, and it is hard to tell which was the more powerful factor."

Mitchell grew in her powers of observation even while she defied strictures about studiousness. In her first dame school (schools run by widows to support themselves and their children similar to many modern-day childcare arrangements) and, later, in the school her father operated,

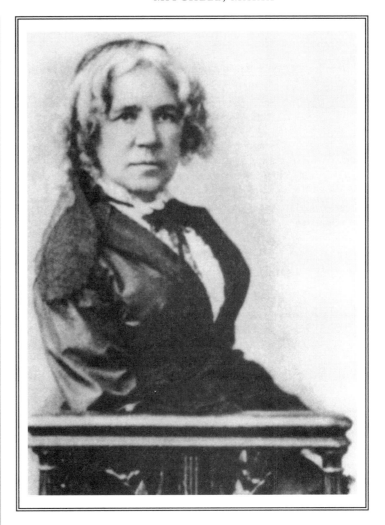

Maria Mitchell

Maria's interest in the stars deepened. It was when she attended Cyrus Peirce's School for Young Ladies, however, that her mathematical ability was nurtured. Peirce, who would later be appointed by Horace Mann to head the first normal school (teacher-training institutions) in America, recognized her self-discipline and the imaginative spirit which allowed her to see every angle of a problem. "I was born of only ordinary capacity," she said, "but of extraordinary persistency."

In 1835, after a brief stint as Peirce's assistant, Maria Mitchell, at age 17, opened a school for girls. Despite her concern that none would attend, the school was a success, and girls from a wide variety of backgrounds sought and gained admission. However, financial reverses for her father coupled with a new opportunity to earn money led her to close her school and accept the position of librarian for the new Nantucket Athenaeum Library, a post she would hold for 20 years. Since the library was open afternoons and some evenings, Mitchell used her time to become self-educated, including teaching herself German.

In 1843, Maria Mitchell underwent a spiritual crisis and asked to be "disowned" by the Quakers. They complied, and she then attended, but never joined, the Unitarian Church. Shortly thereafter, her father was made head of the Pacific Bank, the family's fortunes improved, and Maria's life was changed forever. William had built a small observatory on top of the bank, where he and Maria spent most evenings observing the stars. On the night of October 1, 1847, William wrote in his notebook, "This evening at half past ten Maria discovered a telescopic comet five degrees above Polaris." The discovery made Maria Mitchell world famous. On November 20, William C. Bond of Harvard College noted: "It seems that Maria Mitchell's comet has not been previously seen in Europe." In 1831, the king of Denmark, Frederick VI, had commissioned a gold medal to be awarded to the first discoverer of a telescopic comet and, as Edward Everett, president of Harvard College, wrote to the famous historian George Bancroft, "It would be pleasant to have the Nantucket girl carry off the prize from all the greybeards and observatories in Europe." Despite the fact that the Nantucket "girl" was 29 years old, an American woman winning the medal would be considered a great coup on both sides of the Atlantic and, after considerable discussion, the king awarded the medal to Mitchell.

Nature made woman an observer. . . .

The schools and schoolbooks have spoiled her.

—Maria Mitchell

In 1848, Maria Mitchell was elected to the American Academy of Arts and Sciences, the first (and, until 1943, the only) woman so honored. The great botanist Asa Gray, who was secretary of the organization, protested this action on the part of the Academy and on the original certificate the word "Fellow" is crossed out and the words "Honorary Member" written in. However, all other members seem to have considered her a full-fledged participant, as her name was consistently published under "Fellow." In 1850, when the naturalist Louis Agassiz proposed her name to the Association for the Advancement of Science, Mitchell was unanimously elected and again was the first woman so chosen. Her accounts of these meetings indicate that she was not overly awed by all these honors. "It is really amusing to find one's self lionized in a city [New York] where one has visited quietly for years. . . . I suspect that the whole corps of science laughs in its sleeve at the farce." In 1849, Mitchell was asked to serve as a computist for the American Nautical Almanac and,

for 19 years, held that position in addition to her other duties.

In 1861, after the death of her mother, Maria and her father moved to a married sister's home in Lynn, Massachusetts. Shortly thereafter, she was approached by Matthew Vassar, who was preparing to open the first truly equal college for women in Poughkeepsie, New York. Vassar was anxious to have a prominent woman scientist on the faculty, and Mitchell was highly qualified and available. After some hesitation because of her lack of formal education, Mitchell was persuaded to take the position when Vassar offered to build her the third largest observatory in the country.

Thus, at age 46, Maria Mitchell moved to Poughkeepsie with her widowed father and began her career as a college professor. But Mitchell distrusted authority. "Women, more than men are bound by tradition and authority," she wrote. "What the father, the brother, the doctor, and the minister have said has been received undoubtedly. Until women throw off this reverence for authority they will not develop." She at first refused to appear at chapel; finally, at the pleading of Matthew Vassar, she agreed to attend but sat in the very back so she could "think her own thoughts." Likewise, she refused to give students conventional grades since, "You cannot mark a human mind because there is no intellectual unit," and she refused to report student absences because, "To some the precision of military drill is the poetry of motion. I mourn over any loss of individuality." While one former student said she was "brusque but brilliant," Mitchell, nevertheless, inspired several students to become scientists and always included students on her field trips and in her observational schedules. Three former pupils, *Mary Whitney, *Christine Ladd-Franklin, and *Ellen Swallow Richards, became leaders in the movement to increase opportunities for women in science. In addition, until 1932, the professors of astronomy at Vassar had all been students or grandstudents of Maria Mitchell.

Mitchell also became a fighter for equal salaries for women faculty at Vassar. In 1873, when Dr. Edward Clarke of Boston published *Sex in Education* which asserted that, at Vassar, women's health was being ruined by intensive study, she took the offensive and helped to found the Association for the Advancement of Women (AAW) in New York City. Mitchell served as president of the new organization from 1874 to 1876 and as chair of its committee on science from 1876 to 1888. Throughout the

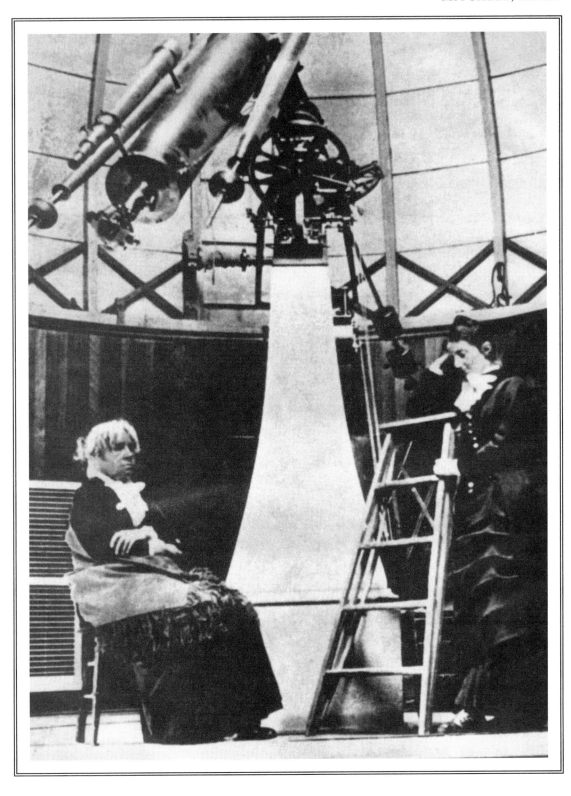

Maria Mitchell (seated), with her assistant Mary Watson Whitney.

1870s and 1880s, the AAW held an annual "Congress of Women," where issues such as temperance, women's suffrage, domestic science, higher education for women, and openings for women in the professions were all discussed. The organization provided a vehicle for Mitchell

to promote the interests of women in science; in her presidential address in 1875, she noted: "In my younger days. . . . I used to say, 'How much women need exact science,' but since I have known some workers in science who were not always true to the teachings of nature, who have

loved self more than science, I have now said, 'How much science needs women.'"

Recognition of the influence Maria Mitchell possessed in the broader realm was accorded her when, in 1869, she was the first woman elected to the American Philosophical Society (which had been founded by Benjamin Franklin in Philadelphia). In 1873, she was made a vice-president of the American Social Science Association.

In 1888, her health failing, Mitchell retired from Vassar and returned to Lynn to live with her sister. She died the following year, at age 70, of what was reported to be a "brain disease." In a book of extracts from Mitchell's diaries and letters, her sister **Phebe Mitchell Kendall** (who unfortunately then destroyed the original documents out of what, she said, was deference to her sister's private nature) quotes the president of Vassar as saying, "If I were to select for comment the one most striking trait of her character, I would name her *genuiness.* . . . She has been an impressive figure in our time, and one whose influence lives."

SOURCES:

Kendall, Phebe Mitchell, ed. *Maria Mitchell: Life, Letters, and Journals.* Boston, MA: Lee and Shepard, 1896.

Rossiter, Margaret W. *Women Scientists In America: Struggles and Strategies to 1940.* Baltimore, MD: Johns Hopkins University Press, 1982.

Wright, Helen. "Maria Mitchell" in *Notable American Women: A Biographical Dictionary.* Cambridge, MA: Belknap Press, 1971.

———. *Sweeper in the Sky: The Life of Maria Mitchell First Woman Astronomer in America.* NY: Macmillan, 1949.

SUGGESTED READING:

Conable, Charlotte. *Women at Cornell: The Myth of Equal Education.* Ithaca, NY: Cornell University Press, 1977.

Kohlstedt, Sally Gregory. "Maria Mitchell: The Advancement of Women in Science," in *New England Quarterly.* Vol. 51, 1978, pp. 39–63.

Newcomer, Mabel. *A Century of Higher Education for American Women.* NY: Harper and Brothers, 1959.

Rossiter, Margaret W. *Women Scientists in America: Struggles and Strategies from 1940 to the Present.* Baltimore, MD: Johns Hopkins University Press, 1995.

COLLECTIONS:

William C. Bond Collection, Widmer Library, Harvard University, Cambridge, Massachusetts; Massachusetts Historical Society; Maria Mitchell Collection, Vassar College Archives, Poughkeepsie, New York; Maria Mitchell Library, Nantucket, Massachusetts.

Anne J. Russ,
Professor of Sociology, Wells College, Aurora, New York

Mitchell, Martha (1918–1976)

*Controversial and outspoken public figure and wife of John Mitchell, the former U.S. attorney general convicted in the Watergate scandal that brought down the Nixon administration. Name variations: Martha Elizabeth Beall Mitchell. Born Martha Elizabeth Beall on September 2, 1918, in Pine Bluff, Arkansas; died of multiple myeloma on May 31, 1976, in New York City; daughter of George Virgil Beall (a cotton broker) and Arie (Ferguson) Beall (a teacher); graduated from the University of Miami, 1942; married Clyde Jennings, Jr., in 1946 (divorced 1957); married John Newton Mitchell, in 1957; children: (first marriage) Clyde Jay Jennings (b. November 2, 1947); (second marriage) Martha Elizabeth, Jr., called **Marty Mitchell** (b. January 10, 1961).*

Awards and honors: Distinguished Citizen's Award from Washington Host Lions Club (1972); hometown of Pine Bluff, Arkansas, placed on National Register of Historic Places (1978); U.S. Highway Expressway renamed the Martha Mitchell Expressway (1978).

Perhaps one of the most controversial women in late 20th-century American politics, Martha Mitchell was the colorful, brassy wife of John Mitchell, the U.S. attorney general who was imprisoned for his part in the 1970s Watergate scandal. She was an upper-class Republican who wore flamboyant clothes and hairdos to get attention, smoked and drank with abandon, was keenly observant and loudly spoke her mind on everything; she also had a lifelong tendency to embellish facts. During Watergate, she considered herself the most persecuted woman in history; when a friend suggested that perhaps *Joan of Arc had been more persecuted, Mitchell replied, "She only burned!"

Martha Mitchell was born in 1918 in Pine Bluff, Arkansas, into a family that could trace its roots to genteel pre-revolutionary families. Her maternal grandparents were plantation owners and her mother Arie Ferguson Beall, called "Miss Arie," was a busy teacher of elocution. A pretty and bright child, Mitchell developed a stubborn streak as she resisted family efforts to break her of her left-handedness, which was then considered a flaw. She was probably dyslexic, and to compensate she collected quotes. Ironically, one of her favorites urged something she never could do: "Always behave as if nothing has happened, no matter what has happened." Her mother was, uncharacteristically for her day, "seldom home . . . always busy with her many civic clubs and her pupils," and Mitchell resented it. However, she idolized her father George Virgil Beall, who took her to the cotton and stock exchanges to teach her about trading.

From him, she inherited a love of gambling with cards and in her adult years emulated him in liking to dress well, speak her mind, and smoke heavily. When she was about 11, a fire burned down the family home and they moved into apartments. This nearly coincided with the onset of the Great Depression, as a result of which her mother had to work more and her father lost his job. Shortly thereafter, he abruptly abandoned the family. Mitchell would not speak of him after that, having decided to consider him dead. When she was an adult and a celebrity, she often claimed that he had died before she could remember him, although in fact he shot himself in October 1943. She was 25 at the time, and was with him when he died two days later.

The caption under Mitchell's high-school yearbook picture read: "I love its gentle warble, I love its gentle flow, I love to wind my tongue up, and I love to let it go," and after graduating from high school she wanted to be an actress. She therefore attended Stephens College in Missouri, where she studied under actress *Maude Adams. After a year there, she hoped to tour with an acting company, but her mother's belief that nice Southern girls should either get married or teach squelched that idea. Instead she transferred to the University of Arkansas, where she joined the Chi Omega sorority and concentrated on her active social life. An average student, she transferred the following year to the University of Miami (due to "allergies"), and met Al Capone while dating his son "Sonny" Capone before graduating in February 1942.

Mitchell worked that year as a teacher in Florida and in Mobile, Alabama, before returning home to Pine Bluff. There she worked as a receptionist at the Pine Bluff Arsenal. In July 1945, when the commanding officer of the arsenal was transferred to Washington, D.C., Mitchell arranged to transfer with him, a turning point she later claimed to regret, saying, "I would have been all right if I'd never left the South." In Washington, she met Army captain Clyde Jennings, whom she married on October 5, 1946. Jennings had by then left the military, and they moved to New York City, living first in Queens, where their son Jay was born in 1947, and then in Manhattan. The marriage was rocky; they separated in 1956 and were divorced the following year.

Sometime before May 1956, Martha had begun dating Wall Street lawyer John Mitchell. Eleven days after divorcing his first wife on December 19, 1957, he and Martha married. They were a wealthy couple who spent their evenings discussing his work and the state of the country over drinks, but early on, others observed John treating her "like a child," and this was to continue throughout their marriage. Mitchell also disliked the fact that he often left her to sit at home alone when he felt his job demanded it. Three years after their only child Martha, called Marty, was born in January 1961, they moved to affluent Rye, New York. There Mitchell frequently hosted big, expensive parties, one of which was for a man named Richard M. Nixon, who had joined a Wall Street law firm after a failed bid for governor of California in 1962. Although for most of her life she had been relatively apolitical, Mitchell became an avid believer in Nixon's abilities, and by the time his law firm merged with John's in 1967 she had turned her husband, an erstwhile backer of John F. Kennedy, into a Nixon admirer. He shortly became the campaign manager of Nixon's bid for the 1968 Republican presidential nomination. Mitchell, elated, expected to be heavily involved in the campaign, but to her frustration and anger she was virtually excluded. Adding to her aggravation were her husband's frequent absences in service to the campaign and her dislike of Nixon's wife *Patricia Nixon; again Martha sat at home alone, often drinking. She regularly called John's campaign offices to complain and even threatened him with divorce, eventually being sent on the first of numerous trips to a psychiatric hospital to "dry out."

After he won the presidential election, Nixon appointed John Mitchell to the post of U.S. attorney general. In early 1969, Nixon told Mitchell that she would be taking "an active part in his plans to turn the country around." A staunch conservative, she believed the United States was being betrayed by liberals, and she greatly feared Communism. She therefore took her "active part" seriously, and continually tried to find purposeful ways for herself and other wives of Cabinet members to take part in government. While deploring the straitlaced protocol of Washington social life, she also frequently appeared at, and relished, charity events and embassy functions. Nixon, according to Mitchell, thought of government property and services as his own, and the people in his favor thus enjoyed many perks. The Mitchells flew on Air Force One, lounged at Camp David, and entertained for free both on board the presidential yacht *Sequoia* and in a staffed house in Key Biscayne. Mitchell basked in the lifestyle of a Cabinet wife, as she loved to entertain and to spend money. Nixon authorized round-the-clock FBI protection for the Mitchell family (because, as he told

her, he intended to attack organized crime so forcefully that all their lives would be endangered). A first in history, this protection was unpopular with taxpayers who thought Mitchell abused the service by having FBI agents help her shop and carry her luggage; taxpayers also objected to her having a government car and chauffeur at her disposal 24 hours a day.

Mitchell's life was relatively private during her first ten months as a Cabinet wife. Nixon, she later said, saw the press as an enemy, and in keeping with his advice she kept her distance from them. With her need to be an insider, however, it was by this time common practice for her to eavesdrop on phone calls between John Mitchell and the president. Although she was later the most strident critic of Nixon and his administration's "dirty tricks," Mitchell remained silent during this period because she was becoming convinced that it was necessary for the government to deceive the people in order to "save the country." Her silence lasted only until November 1969, when she appeared on the "CBS Morning News" and talked about the "liberal Communists" whom she said were among the anti-Vietnam War demonstrators. She later denounced the war, but her fear of Communism and her need to speak her mind were powerful motivators.

Although her comments got her into "a heck of a mess" with the administration, she soon decided that the members of the press were not the enemies Nixon and her husband made them out to be, and continued making candid statements to reporters. In 1970, she was barred from flying on Air Force One after she told an on-board press pool that the Vietnam War "stinks!" Mitchell declared that she did not believe in "that no-comment business"—she felt public figures had a responsibility to the nation, and should not use that phrase unless they really had no opinions. She spoke vehemently, ingenuously, and frequently about almost everything: desegregation, education, politicians, the Supreme Court. She advocated wage, price, and rent controls when the Nixon administration was set against them. These forthright commentaries, often dispensed in late-night phone calls to reporters, made her the most talked-about, despised, and admired Cabinet wife in U.S. history. A free-speaking Cabinet wife who was also conservative was simply unprecedented, and soon 76% of the American people knew her name. She was called an *enfant terrible*, a heroine, a scatterbrain, and a loudmouth. American hairdressers voted her "worst-tressed." Middle America and the silent majority loved her for

saying publicly the things they spoke of privately, young people valued her candidness and honesty even when they disagreed with her ideas, and many Republicans thought she might be "an anti-establishment plot by the press" designed to make the Nixon administration look bad. At one point she received up to 400 pieces of mail a day and insisted on answering them all. Having discovered publicity, she loved it, and she and the press used each other—as one commentator noted, "the press wrote about Martha because she couldn't be ignored. She was good copy."

For the most part her husband offered no objection, and Nixon at one time said to her, "Give 'em hell." However, John Mitchell did forbid her to work with one organization he felt was "too political," and would not let her visit college campuses because he thought they were too dangerous. By 1970, Mitchell had begun feeling disenchanted with the administration; she knew about and lamented what she called the White House's "dirty tricks" against Democrats and its other liberal "enemies," and she resented her husband's devotion to the job that took him away from her because she believed he had achieved his social status partly thanks to her. Mitchell had mixed feelings about the role women were then expected to fill in society; she wanted John to "take care of her," but she also wanted recognition for her dedication and effort as a public figure. Inside the administration, her outbursts were increasingly met with the question "what will we do about Martha?"

In March 1972, John resigned his post as attorney general to direct the Committee for Re-Election of the President (famously known by its acronym CREEP), in which Mitchell, despite her growing disenchantment, had been working since 1971. By the spring of 1972, she was keeping up a grueling campaign schedule, but she was not even listed on the committee's roster; considering herself a high-ranking member, she was infuriated by the lack of recognition. She soon became suspicious that Nixon officials were banishing her and spying on her. While still publicly supportive of his campaign, she started to "annoy the hell out of them the way they were annoying" her, making private demands and threats. Nixon and others would later maintain that she was suffering from severe mental and emotional problems during this time, and that John was too preoccupied with her problems to properly do his job.

The weekend of June 17, 1972, Mitchell went (reluctantly, because Pat Nixon was also

going) with John, their daughter Marty, and a group of committee members and officials on a campaign fund-raising trip to California. Early Saturday morning, John Mitchell received a call in their hotel room reporting that five men, including the committee's security chief, had been caught breaking into and burglarizing the Democratic National Committee headquarters at the Watergate Hotel. He said nothing to his wife. Throughout the rest of the weekend she thought people around her were acting strangely, and at its end John Mitchell suggested that she stay in California for a rest. He then flew back to Washington with most of the entourage; when Mitchell ultimately found a newspaper and discovered what was going on, she was furious at being excluded. Later, further enraged at her husband's evasiveness over the telephone, and medicated both by Scotch and painkillers she had been given for accidentally burning her hand while lighting a cigarette, she called her favorite reporter, UPI's *Helen Thomas. As she spoke about being "sick and tired" of what was going on, committee security people who had remained with her in California entered her hotel room, threw her aside, and disconnected the phone. In a subsequent call, she told Thomas that the phone had gone dead during their last conversation because it had been ripped out, and that she had been drugged and beaten. "I'm black and blue," she said. "I'm a political prisoner." She revealed no administration secrets during that first call, but committee members feared that inevitably she would and, indeed, having eavesdropped and rummaged through her husband's papers, she possessed much inside information. Mitchell later alleged that while in California she was under constant surveillance and was attacked and beaten for telling the truth.

In later months, she talked frequently to reporters about wanting her husband away from the "outrageous and dirty campaign tricks . . . and dishonest deeds" of politics. She claimed that statements some officials had made were "goddamn lies" and hinted that she had more truth to tell, but would have to wait until "after the election." She often revealed to reporters that she was phoning from a bathroom, balcony, or other peculiar place. Administration officials told the press that her claims were the ravings of a sick woman who did not have any inside information anyway. At the time, most politicians and journalists deemed her stories to be exaggerations born of alcoholism. Women tended to believe her more than men, but the women's movement was then very new, and Mitchell had never

allied herself with it, so no defense of her came from that quarter. Eventually she coerced John into resigning as Nixon's campaign manager, although it has since been speculated that in fact he resigned only to aid the Watergate cover-up (he later took a similar job, albeit an advisory one). At the time, Mitchell was living in a Washington apartment with a uniformed nurse to attend to her, but it was unclear whether she was a recluse or a virtual prisoner. Despite the Republicans' success in keeping her away from their national convention, she continued to make news. In the fall of 1972 the Mitchells moved to New York City, with Mitchell still saying she was afraid of the power of the president and his administration, and that they were trying to have her institutionalized to discredit and silence her.

After Nixon's re-election, the Mitchells were not asked to the regular events of the January 1973 inauguration. As the full Watergate story began playing out during 1973, Mitchell earned some sheepish respect from those who had dismissed her stories. Much of what she had said was proven true, but the press still treated her with skepticism and condescension. When the White House later "cut off" John Mitchell, Mitchell grew even more wrathful and wanted to clear his name. She tried to get him to enter a plea-bargain, but he refused, and they argued so much and so bitterly that he stopped speaking to her. In July she watched his testimony before the Senate Committee on television at a friend's house in Mississippi, angry and drinking and even talking about suicide. She returned to New York City later that month. In September, John Mitchell walked out on her without letting her know he was never coming back, much like her father had done. She filed a separation suit against him which was destined to be a long, drawn-out exercise. Still craving publicity, she made television appearances and gave interviews to newspapers and magazines throughout 1974. Having found in her husband's files a damaging 1972 private memo from Nixon to John Mitchell, she phoned many Republican senators and others to warn them that Nixon had deserted them, but none believed her. On August 9, 1974, knowing that otherwise he would be impeached, Richard Nixon resigned the presidency. On January 1, 1975, John Mitchell and three others were found guilty in the Watergate conspiracy. After his sentencing he remarked, "It could have been . . . worse. They could have sentenced me to spend the rest of my life with Martha Mitchell." (He began serving his time in prison in 1977, after the U.S. Supreme Court refused his appeal.)

Martha Mitchell was diagnosed with an advanced stage of multiple myeloma, an incurable blood disease, in October 1975. She lived long enough to see her son Jay married, but died at age 57 on May 31, 1976, at Memorial Sloan-Kettering Cancer Center in New York City. At her funeral, there appeared an unsigned floral display which spelled out the phrase "Martha was right." The year after she died, in a famous television interview with David Frost, Nixon commented: "If it hadn't been for Martha, there would have been no Watergate." Some were outraged at his accusation, believing that if it were not for her the corruption would have continued. Others said his comment had "honored her beyond all expectations."

SOURCES:

Compton's Interactive Encyclopedia. Compton's New-Media, 1996.

McLendon, Winzola. *Martha: The Life of Martha Mitchell.* NY: Random House, 1979.

Weatherford, Doris. *American Women's History.* NY: Prentice Hall, 1994.

Jacquie Maurice,
Calgary, Alberta, Canada

Roma
Mitchell

Mitchell, Roma (1913–2000)

Australian feminist, lawyer, and judge who was the first woman governor of an Australian state, South Australia. Name variations: Dame Roma Mitchell. *Born Roma Flinders Mitchell in Adelaide, Australia, on October 2, 1913; died on March 5, 2000; daughter of Harold Mitchell (a lawyer) and Maude Mitchell; attended St. Aloysius' Convent College; graduated from Adelaide University; admitted to the bar, 1934; never married; no children.*

Appointed first female Queen's Counsel (1962); became the first female Supreme Court judge (1965); was appointed the founding chair of the Australian Human Rights Commission (1981); made a Dame Commander of the Order of the British Empire (1982); made a Companion in the Order of Australia (1991); became the first female chancellor of a university (1983); became the first female state governor (1991); awarded the Commander of the Royal Victoria Order (2000).

The granddaughter of a judge and the daughter of a lawyer, Roma Mitchell studied law at Adelaide University, where she helped to found the Women Law Students' Society after being denied admittance to the all-male Law Students' Society. She was recognized as the best student in her class upon her graduation, and was admitted to the bar in 1934, embarking on a career that would focus on criminal law, women's rights and human rights. In 1962, Mitchell became the first woman in Australia to be appointed Queen's Counsel, and that year was instrumental in the successful campaign to allow women to serve as jurors; as Queen's Counsel, she was also a strong proponent of equal pay for equal work. In 1965, she became the first woman supreme court judge in Australia (at her retirement from the bench in 1983, no other women had been so appointed). During her tenure, she served as chair of the South Australian Criminal Law and Penal Methods Reform Committee (1970–81) and for several years also chaired the Parole Board. She became the founding chair of the Australian Human Rights Committee in 1981, a position she considered of particular importance and one which she would hold until 1986. A longtime member of the Adelaide University Council, in 1983 she became the school's chancellor and the first woman chancellor of a university in Australia. She resigned from the university when she was appointed governor of South Australia in 1991, again becoming the first woman in the country to serve in such a position. A popular governor

who continued to advocate for women's equality and human rights, in 1994 she became Patron of the Centenary of Women's Suffrage.

Mitchell was often described as a "conservative feminist" (in the early 1980s she stated measuredly that "women should be able to take whatever place they are fitted to take in the professions") and pointed to as an example of what a woman with ability can achieve without help of special legislation or legal quotas. However, the very rejoicing caused by each of the many firsts she achieved—and the following years of being not simply first but only—eventually caused a change in her perspective. By the last years of her career she favored affirmative action for women, and in the late 1990s expressed the desire to live long enough to see a woman's appointment to a position of high authority merit "no more publicity than the appointment of a man." Alert to the end, she died on March 5, 2000, and was given a state funeral.

SOURCES:
"Roma Mitchell," in *The Economist*. March 11, 2000.

Mitchell, Ruth (c. 1888–1969)

*American author whose adventures as the only American woman member of the Yugoslav Chetnik resistance forces during World War II kept her embroiled for years in bitter political controversies. Born around 1888; died in Belas, Portugal, on October 24, 1969; daughter of John Lendrum Mitchell (U.S. congressional representative, 1891–93, and senator, 1893–99) and Harriet Danforth (Becker) Mitchell; sister of William "Billy" Mitchell (1879–1936, brigadier general and advocate of the uses of air power in modern warfare); married Stanley Knowles; children: **Ruth Knowles**; John Knowles.*

Ruth Mitchell—daughter of a reforming U.S. senator, granddaughter of a robber baron, and sister of the famous and controversial advocate of naval aerial bombing, General William "Billy" Mitchell—gravitated toward a life of travel and intrigue. Although her inherited wealth would have enabled her to live a life of leisure, she chose instead to embark on a series of adventures that provided material for her writings. She came from a clan of Scots and her ancestry included strong-willed and unpredictable women and men. Her paternal grandfather, Alexander Mitchell, had left a modest bank clerkship in Aberdeenshire in 1839, arriving as a young man on the Wisconsin frontier. By the time of the Civil War little more than two decades later, he had turned a tiny insurance firm and a bank into the nucleus of a financial empire. As president of what was then the world's largest rail system, the 5000-mile Chicago, St. Paul & Milwaukee Railroad, he (like other robber barons of his day) accumulated a vast personal fortune that remained virtually untouched by taxation. In his final years, his financial empire centered around the giant Marine National Exchange Bank, and at his death, Alexander Mitchell was known to people in the Midwest as "the Rothschild of Milwaukee."

Ruth's father John Lendrum Mitchell inherited the business empire, but his interests were literature and the arts, experimental farming, philanthropy, and politics. Spending much of his youth traveling, he spoke five languages and was educated in Dresden, Geneva, and Munich. The Mitchell manor house, situated on an estate near Milwaukee named Meadowmere, was a showplace for displaying exquisite works of art, antique furniture, and other rare items John had discovered on his travels. Elected to the House of Representatives in 1891 and to the Senate two years later at a time when the United States was in the throes of economic depression, John Mitchell was a pioneer of advanced social thinking. He shocked his fellow millionaires in Congress by advocating such radical measures as the eight-hour work day, the progressive income tax, an anti-injunction law, and the "free silver" monetary reforms proposed by William Jennings Bryan.

His freckled, red-haired daughter grew up in Washington, D.C., in a large house on Capitol Hill, in the block now occupied by the Old Senate Office Building. While her father spent countless hours working for progressive legislation, Ruth's mother Harriet ran a tight ship at home. Six feet tall, **Harriet Mitchell** sat so rigidly upright that she never touched the back of her chair. She had ten children in all, of whom by far the most famous would be Billy, her first child, born in Nice, France. In time, Ruth's big brother Bill would be known as Brigadier General Billy Mitchell, a tireless advocate of the uses of air power who revolutionized modern warfare. Convinced that his thinking was correct, he antagonized many traditionalists in the U.S. military establishment and before his death in 1936 saw his career destroyed when his ideas threatened not only the status quo but powerful individuals whose rank rested on old patterns.

Although she grew up with nine competitive siblings, Ruth's unique personality developed early in life. Because of her family's wealth and social prominence, she displayed formidable self-confidence and as a child thought nothing of

carrying on adult conversations with such luminaries as President William McKinley. She enjoyed the family's extensive travels and lived in Germany for a number of years, learning to speak perfect German. An expert equestrian, she could also perform creditably on the lute and violin. Although she felt at home throughout the world, Mitchell was particularly drawn to England, where she and her husband Stanley Knowles lived during World War I. During this period, she had two children, a son John and a daughter Ruth.

She and her family lived in the English countryside of Surrey at Chiddingfold Manor, and Mitchell transformed the coach house there into a miniature theater. Every year, 200 local children were kept busy making costumes and painting scenery for plays, written by Mitchell, in which they performed. The Chiddingfold Players became famous in the area, earning praise from the local press and drawing considerable audiences. With energy to spare, Mitchell launched a publication, the *Friendship Travel Magazine*, to share her love of travel with children. Within three years, the magazine had 50,000 subscribers. When letters came in asking if the places described in the magazine could actually be visited, Mitchell created a travel bureau, "The Young Adventurers," an early form of young people's travel based on low-budget reliance on hiking and youth hostels. Soon, thousands were seen rambling through less-trod regions of Belgium, France, and Germany, where they often spent their nights in renovated castles.

The rise of Nazi power in Germany ended Mitchell's experiment in international friendship. The Third Reich banned the German branch of the Young Adventurers program, seeing it as a threat to the spirit of nationalistic exclusivity they wished to cultivate among German youth. Seeking a new outlet, Mitchell took up photography, a skill she mastered quickly. A number of newspapers and magazines began buying her photographs, and she was soon in the Balkans on assignment. Sent to Albania in 1938 by the *Illustrated London News* to cover the wedding of King Zog and Queen *Geraldine, Mitchell fell in love with the impoverished, history-rich region.

She was living in Yugoslavia in a house on the Adriatic when the Balkans were drawn into the expanding carnage of World War II. In late 1940, Fascist Italy invaded Greece but was badly defeated. By early 1941, Adolf Hitler had decided to bail out his bumbling ally and expand Nazi Germany's power into the Balkans. A nationalist coup d'état directed against multinational Yugoslavia's pro-Axis government sealed that nation's fate in late March 1941.

Sharing the impetuous personality of her late brother, the following month Mitchell appeared in newspaper stories across the United States. In an Associated Press news story dated April 2, 1941, she was described as having been sworn in as the first American woman member of the Komitaji, a near-legendary group of Serbian guerilla fighters who had a history of 400 years of mountain warfare against the region's Ottoman Turkish occupiers. Becoming a member of the general staff as a dispatch rider, she swore to defend Serbia's liberty to the death in the presence of Kosta Pechanatz, the white-bearded leader of the Komitaji. On the table in front of her were the implements of initiation, a dagger and a revolver. High in a corner of the room was a skull and crossbones, all that remained of a young man who had recently been killed. Pechanatz crossed her name off the list of those who had just applied for membership, explaining to her: "We just cross the name off, my girl, because we consider you dead when you become one of us. We value our lives as nothing. We may all be dead in a few weeks. I expect to die myself this time. How about you?" Mitchell replied instantly, "I am willing, too." Pechanatz then handed her a vial of poison, telling her it was a Komitaji boast that no member would be taken alive by the foe.

On April 6, 1941, the German *Luftwaffe* bombed Belgrade, reducing the city to rubble. Mitchell joined the exodus of refugees fleeing from the stricken city, walking on foot for ten days to reach Dubrovnik on the Adriatic. Here she was able to secure a travel document from an Italian officer and was ready to board a small ship to escape the German forces who had just arrived in the area. To celebrate her impending departure, she decided to go for a final swim. On the way back to her room, with a wet bathing suit slung over her shoulders, Mitchell was arrested by a German soldier. He allowed her to change her clothes, which enabled her to hide her Chetnik papers (with the onset of war, the Serb patriots of the Komitaji now called themselves Chetniks). Had these incriminating documents been found on her, Mitchell's fate would have been grim indeed.

Imprisoned by the German occupation government in Belgrade, she was accused of spying and court-martialed twice. After the second trial, which lasted four days, she was sentenced to death. Speaking to the judges in perfect Ger-

man, she told them of the serious impact such a measure would have on U.S. public opinion. The judges then informed her that the evidence in the case would be transmitted to Berlin for reconsideration on a higher level. For the next several months, Mitchell was moved from prison to prison—from Belgrade to Graz, to Salzburg, and then finally to an internment camp at Liebenau in Württemberg, the area of southwestern Germany close to the Swiss frontier. Throughout the time of her detention, Mitchell's family and friends, many of them influential, worked behind the scenes in Switzerland to secure her release. In 1942, even though the United States and Nazi Germany were now at war, she was released (along with 184 other Americans in exchange for German nationals living in the United States) and repatriated home on the Swedish ocean liner *Drottningholm*.

The *Drottningholm* arrived safely in New York harbor in late June 1942. Mitchell was clothed stylishly in a dress that she said was the result of the combined efforts of several hundred British women with whom she had shared internment. Her hat, which came from Hendaye on the French-Spanish border, looked, according to *The New York Times* report, "as though it was fresh off Fifth Avenue." By no means averse to publicity, Mitchell was at the White House in late August to present President Roosevelt with a basket woven from the wrappings of Red Cross food packages, a token of thanks from the more than 300 British women who had also been kept at Liebenau along with Mitchell.

Scarcely settled in, Mitchell became an indefatigable defender of the Yugoslav Chetnik cause in the United States. By early 1943, the Chetniks were losing a fierce propaganda war fought by the anti-Nazi forces in Yugoslavia for Allied support. The Chetniks, led by Draza Mihajlovic (Mihailovich), were a Serb-dominated guerilla movement that was often accused of collaborating with the occupying German and Italian forces in order to gain an advantage over their rivals, the Communist-led partisan forces of Josip Broz Tito. Fiercely loyal to the Chetniks and strongly anti-Communist, Mitchell used every opportunity to make a convincing case for continued American support for the Mihajlovic forces. As honorary chair of the Serbian National Defense Committee in the United States, she spoke before many organizations, gave interviews, and published a book, *The Serbs Choose War*, as well as a pamphlet entitled *Ruth Mitchell, Chetnik, Tells the Facts about the Fighting Serbs, Mihailovich, and "Yugoslavia."* Her efforts were in vain, because by mid-1943

both the British and American governments had decided, largely for military and strategic reasons, to switch their support from the Chetniks to Tito's partisans.

Incensed, Mitchell felt that she and her fellow Chetniks had been betrayed. She continued to appeal to public opinion to reconsider policy changes favoring Tito and attacked Elmer Davis, director of the Office of War Information, whom she accused of having delayed publication of her book. Davis responded by suggesting that Mitchell had been "making all sorts of wild statements." Soon she was no longer part of a mainstream dialogue. Instead, she found a receptive intellectual home in the pages of *The American Mercury*, a journal of the extreme Right that in July 1943 published an article in which she alleged that Mihajlovic and his forces had been the targets of a "worldwide communist smear that failed." Whereas the reality of the situation was much more complex and often muddled, to Mitchell "her" Chetniks—whom she saw as victims of a frame-up—represented the forces of Good, while Tito—whom she incorrectly described as a Hungarian, and who had been "parachuted in from Russia during November 1941"—was an incarnation of Evil.

Tito's partisan forces, assisted by the Soviet Army, liberated Yugoslavia in 1944–45. The Chetniks, branded as Nazi collaborators, were either executed on the spot or placed on trial as traitors to the new Yugoslavia. At the Mihajlovic trial in Belgrade in 1946, the chief of security for the quisling government, Dragomir Yovanovitch, claimed that the woman he had seen in Gestapo headquarters in Belgrade in August 1941, in the company of a group of collaborationist Chetniks, was none other than Ruth Mitchell. In the United States, Mitchell responded to Yovanovitch's serious charges by admitting that she had indeed been seen with the Gestapo on the occasion of her arrest and court-martial for Chetnik activities.

The matter was never clarified, and much remains unexplained regarding Ruth Mitchell's activities in the Balkans before and after April 1941. Was she arrested while on an intelligence mission for the British? Was she simply a wealthy American tourist and adventurer caught up in the maelstrom of events? Was she a double agent? While it is possible that documents in some archive yet to be opened will clear up the matter, it is more likely that we will never know what precisely motivated her activities. Perhaps she was an amateur spy, and not a very good one at that. As early as mid-May 1941, only a few

weeks after she had so dramatically sworn allegiance to the Chetnik cause, Mitchell was described by a Montenegrin Chetnik leader as having become a "nuisance" to his organization.

Ruth Mitchell faded from the public view after the mid-1940s and returned to Europe. In 1953, she published a biography of her famous brother, *My Brother Bill*. She lived her final years in Albufeira, Portugal, and died in a nursing home in Belas, Portugal, on October 24, 1969.

SOURCES:
"Bombing Can't Win, Elmer Davis Says," in *The New York Times*. August 10, 1943, p. 5.
"Chetnik Trial Told of Ruth Mitchell," in *The New York Times*. June 21, 1946, p. 9.
"Croat Chief is Put On Komitaji 'List,'" in *The New York Times*. May 14, 1941, p. 6.
Davis, Burke. *The Billy Mitchell Affair*. NY: Random House, 1967.
"Fight on Fascism Urged by Adamic," in *The New York Times*. December 13, 1943, p. 7.
"Gen. Mitchell's Sister Safe in Nazi Prison," in *The New York Times*. June 7, 1942, p. 17.
"Late Gen. Mitchell's Sister Joins Yugoslav Komitaji to Fight Nazis," in *The New York Times*. April 3, 1941, p. 3.
Lawrence, Christie Norman. "Danielle—Chetnik," in Irwin R. Blacker, ed., *Irregulars, Partisans, Guerrillas: Great Stories from Rogers' Rangers to the Haganah*. NY: Simon and Schuster, 1954, pp. 268–285.
Milazzo, Matteo Joseph. *The Chetnik Movement and the Yugoslav Resistance*. Baltimore, MD: Johns Hopkins University Press, 1975.
Mitchell, Ruth. "General Mihailovich: The Story of a Frame-Up," in *The American Mercury*. Vol. 57, no. 235. July 1943, pp. 25–34.
———. *My Brother Bill: The Life of General "Billy" Mitchell*. NY: Harcourt, Brace, 1953.
———. *Ruth Mitchell, Chetnik, Tells the Facts about the Fighting Serbs, Mihailovich, and "Yugoslavia."* Arlington, VA: The Serbian National Defense Council, 1943.
———. *The Serbs Choose War*. Garden City, NY: Doubleday, Doran, 1943.
"New York Man Dies on Evacuation Ship Sailing From Lisbon With 949 of Americans," in *The New York Times*. June 21, 1942, p. 22.
"President Gets Basket From British Women," in *The New York Times*. August 26, 1942, p. 8.
"Renews Attack on OWI," in *The New York Times*. July 16, 1943, p. 5.
Robertson, W. Graham. *Old Chiddingfold: A Village Pageant-Play*. Chiddingfold, Surrey: The Pageant Committee, 1921.
"Ruth Mitchell at Lisbon," in *The New York Times*. June 19, 1942, p. 3.
"Ruth Mitchell, Who Fought With Chetniks, 81, Dies," in *The New York Times*. October 26, 1969, p. 82.
"Serb Patriot Held in Yugoslav Row," in *The New York Times*. July 13, 1943, p. 9.
"Serb Warned on Threat," in *The New York Times*. July 17, 1943, p. 6.
Thayer, Mary Van Rensselaer. "Ruth Mitchell: American Chetnik," in *The American Mercury*. Vol. 56, no. 229. January 1943, pp. 16–23.
"Tito is Condemned by Miss Mitchell," in *The New York Times*. June 24, 1946, p. 7.

John Haag,
Associate Professor of History,
University of Georgia, Athens, Georgia

Mitchell, Yvonne (1925–1979)

British actress. Born in London, England, in 1925; died of cancer in 1979.

Selected filmography: Queen of Spades *(1949);* Children of Chance *(1951);* Turn the Key Softly *(1953);* The Divided Heart *(1954);* Escapade *(1955);* Yield to the Night *(Blonde Sinner, 1956);* Woman in a Dressing Gown *(1957);* Passionate Summer *(1958);* Tiger Bay *(1959);* Sapphire *(1959);* Conspiracy of Hearts *(1960);* The Trials of Oscar Wilde *(1960);* Johnny Nobody *(1961);* The Main Attraction *(1963);* Genghis Khan *(1965);* The Corpse *(Crucible of Horror, 1970);* The Great Waltz *(1972);* Demons of the Mind *(1974);* Widow's Nest *(US-Sp., 1977).*

Making her stage debut at the age of 14, British actress Yvonne Mitchell rose to prominence with the Old Vic, portraying roles as varied as Ophelia in *Hamlet* and Eliza Doolittle in *Pygmalion*. One of Britain's leading stage performers during the 1940s and 1950s, she also worked in film and television, becoming well known for her "anguished" roles. Mitchell won the British Film Academy Award for her performance in *The Divided Heart* (1954) and a Berlin Festival Award for *Woman in a Dressing Gown* (1957). She also wrote plays, novels, and an autobiography, *Actress* (1957).

Mitchison, Naomi (1897–1999)

Scots-English novelist, poet, and playwright who sought to delineate women's adventure-quest in fiction as well as in private and political life, voicing women's issues in the socialist wing of the Labor Party in London during the 1930s, in Scotland as a major writer in the Scottish Renaissance, and as a Scottish nationalist during the 1940s and 1950s. Pronunciation: MIT-chi-son. Name variations: Lady Mitchison from 1964 but preferred to be called Naomi Mitchison. Born Naomi Margaret Haldane on November 1, 1897, in Edinburgh, Scotland; died at age 101 on January 11, 1999, at her home on the Mull of Kintyre in Scotland; daughter of Louisa Kathleen (Trotter) Haldane and John Scott Haldane, known as J.S. Haldane (an eminent physiologist and philosopher); sister of

J.B.S. Haldane (a geneticist and philosopher); niece of Elizabeth Haldane (1862–1937); attended Oxford Preparatory School for Boys (renamed Dragon School) until age 12, followed by private education at home, and one year of study at St. Anne's College in Oxford; married Gilbert Richard Mitchison (CBE, QC, created a Baron [Life Peer], 1964), in February 1916 (died 1970); children: Geoff Mitchison; Dennis Mitchison; Murdoch Mitchison; Lois Mitchison; Avrion Mitchison; Valentine Mitchison.

Awards: Palmes de l'Academie Française (1923); D. Univ., Sterling (1976); D. Litt. Strathclyde (1983); D. Univ., Dundee (1985); made honorary fellow at St. Anne's College, Oxford (1980) and Wolfson College, Oxford (1983); awarded Order of the British Empire (1985); Regents' Lecturer, University of California, San Diego (1984).

Elected to Argyll County Council (1945–48 and 1953–65); appointed to Highland and Island Advisory Panel (1947–65), and to the Highlands and Islands Development Council (1966–76); tribal mother to the Bakgatla, Botswana (1963–1999).

Selected publications—historical and political fiction: The Conquered (1923); When the Bough Breaks and Other Stories (1924); Cloud Cuckoo Land (1925); Black Sparta: Greek Stories (1929); Barbarian Stories (1929); The Corn King and the Spring Queen (1931); The Delicate Fire: Short Stories and Poems (1933); We Have Been Warned (1936); The Blood of the Martyrs (1939); The Bull Calves (1947); Lobsters on the Agenda (1952); Early in Orcadia (1987).

Selected science and fantasy fiction: Beyond This Limit (illustrated by Wyndham Lewis, 1935); The Fourth Pig (1936); Memoirs of a Spacewoman (1962); Solution Three (1975); The Vegetable War (1980); Not By Bread Alone (1983).

Selected poetry: The Laburnum Branch (1926); The Alban Goes Out (1939); The Cleansing of the Knife and Other Poems (1978).

Selected plays: Nix-Nought-Nothing: Four Plays for Children (1928); (with L.E. Gielgud) The Price of Freedom (1931); An End and a Beginning and Other Plays (1937); (with L.E. Gielgud) As It Was in the Beginning (1939); (with Dennis Macintosh) Spindrift (1951).

Selected children's literature: Boys and Girls and Gods (1931); The Big House (1950); Travel Light (1952); Graeme and the Dragon (1954); The Swan's Road (1954); The Land the Ravens Found (1954); The Far Harbour (1957); Judy and Lakshimi (1959); The Rib of the Green Umbrella (1960); The Young Alexander the Great (1960); Karensgaard: The Story of a Danish Farm (1961); The Young Alfred the Great

(1962); The Fairy Who Couldn't Tell a Lie (1963); Alexander the Great (1963); Ketse and the Chief (1965); Friends and Enemies (1966); The Big Surprise (1967); African Heroes (1968); The Family at Ditlabeng (1970); Sunrise Tomorrow: A Story of Botswana (1973); Snake! (1976); (with Dick Mitchison) The Two Magicians (1979).

Selected history, biography, edited work: Anna Comnena (1928); Comments on Birth Control (1930); An Outline for Boys and Girls and Their Parents (ed., 1932); Socrates (with Richard Crossman, 1937); Re-educating Scotland (ed., 1944); What the Human Race Is Up To (ed., 1962); The Africans: A History (1970); A Life for Africa: The Story of Bram Fischer (1973); Margaret Cole 1883–1980 (1982).

Selected social commentary: The Home and a Changing Civilization (1934); The Moral Basis of Politics (1938); Men and Herring (with Dennis Macintosh, 1949); Oil for the Highlands? (1974).

Memoirs: Vienna Diary (1934); Return to the Fairy Hill (1966); Small Talk: Memoirs of an Edwardian Childhood (1973); All Change Here: Girlhood and Marriage (1979); You May Well Ask: A Memoir 1920–1940 (1979); Mucking Around: Five Continents over Fifty Years (1981); Among You Taking Notes: Wartime Diary 1939–45 (ed. Dorothy Sheridan, 1985).

In 1910, Naomi Haldane, aged 13, squeaked and chittered to her 300 guinea pigs; she was convinced she had learned their language and imagined she could think like one of their own. Together with her older brother, J.B.S. Haldane, she had carpeted the front lawn of their Oxford home on the Banbury Road with cages for guinea pigs, plus fast-breeding rats and mice. Brother and sister were gathering data about genetic change, even dissecting dead creatures in order to measure their young; as teenagers, separately, they published their scientific findings. Objectively observant, yet empathizing, Naomi was practicing skills that would contribute to her artistry as a novelist who could dispassionately imagine herself in the skins of creatures vastly different from her upper-middle-class, Scots-English origins. In 1962, in her science-fiction novel *Memoirs of a Spacewoman*, Mitchison invents a female hero, a scientist gifted with empathy, who surmounts the biological determinants of her bipartite structure (two arms, two legs, and so on) which frame her thinking in mere human, bipolar categories; she is on the frontier of universal, sentient life, a peace maker.

Between 1923 and 1995, Naomi Mitchison produced over 80 books, many of which place

her squarely in the wave of 20th-century women writers striving to invent paths for women's psychological development and creative participation in culture. In the historical novels and short stories which established her earliest reputation, she explored conflicts between loyalties and between such concepts as myth and history, idealism and materialism, socialism and individualism; she also explored the possibilities, sometimes honestly gloomy, for women's self-determination in history. In *The Conquered* (1923), she kills the sister and sends the brother into the world to witness Caesar's conquest of Gaul; in *Cloud Cuckoo Land* (1925), she creates a main woman character who dies gruesomely during a self-inflicted abortion; finally in *The Corn King and the Spring Queen* (1931), she develops a woman hero, Erif Der (Red Fire when read backwards), who traverses three Hellenic societies in the 3rd century BCE, successfully questing for self in history and community. In her agricultural community of origin, Erif Der rebels against dutifully playing the Spring Queen to her husband, the Corn King, to regenerate the seasons in patriarchal ritual:

> It was [her father] who would sweep aside [her husband]'s rags and show himself, [her father] who would plunge down on her, [her father] who was the image of God and Man and her possessor and master! . . . [S]he flung up her arms against the rhythm, and jumped clear out of it, off the booth, into the furrow ankle-deep.

Disillusioned and alienated, Erif Der journeys first to Sparta where she participates in a secular and socialist revolution and then to decadent Egypt, where she is an agent of a new mystery religion, the likes of which, according to James Frazer in *The Golden Bough,* would eventually provide a model for Christian sacrifice. *The Corn King and the Spring Queen* is a significant as well as artistically successful achievement. Alexander Scott in *Contemporary Novelists* praises Mitchison's work without even mentioning its importance for women's issues: "This novel is unsurpassed in 20th-century British historical fiction for range and variety of scene and characterization, for political awareness, and for religious depth."

In the early 1930s in her political novel *We Have Been Warned,* Mitchison delineates a contemporary woman hero who is a spiritual descendent of *The Corn King and the Spring Queen*'s Erif Der. This woman hero lives in the ideological turmoil generated by the conflict between socialism and communism in the British Labor Party. She frankly uses birth control devices and rationally, rather than passionately, chooses lovers. Without historical distance to obfuscate, the lineaments of the woman hero were more visible and distressing to readers in the mid-'30s. *We Have Been Warned* was something of a scandal when it was published in 1935. A reviewer for the *Times Literary Supplement,* for instance, refused to comment extensively because the novel caused such continuous embarrassment, ostensibly provoked by descriptions of sexual intimacy between middle-class women and working-class men. Undaunted, Mitchison continued to write women's quest romance in historical novels, children's books, and science fiction for another 65 years.

Born in her maternal grandparents' home in Edinburgh on November 1, 1897, Naomi Margaret Haldane was the second child of **Louisa Trotter Haldane** and John Scott Haldane whose main place of residence was Oxford where he was a fellow and then a reader at New College. Known as J.S. Haldane, he maintained a laboratory in his home where he performed experiments that informed his work in the physiology of respiration. Although J.S. was politically liberal and humanitarian, Louisa was an ardent imperialist, often speaking for the Victoria League. As a child, Naomi lived during the academic year in Oxford, inhaling the fumes of scientific rationalism exuding from her father's laboratory. Each summer, she lived near the ancestral Haldane Gleneagles, at Cloan, her paternal grandmother's estate in Scotland, where she imbibed Celtic mythology and magic along with the Haldane family's high standards for achievement. Mitchison was greatly influenced by her Haldane grandmother who encouraged her writing, especially her detailed descriptions of plants, and by her Aunt *Elizabeth Haldane*'s example as a writer and public figure; Elizabeth Haldane was the first woman in Scotland to be appointed Justice of the Peace.

Naomi attended Oxford Preparatory School for Boys, renamed Dragon School, where she was often the only girl. She was privileged to receive the best education available for boys of her class, including tutelage in the classics. She was, however, removed from school the day she began to menstruate, thereafter to receive her education at home and to be restricted by Edwardian standards for girls. In *Small Talk,* she remembers: "It was all very discouraging and I acquiesced in it, as indeed in other discouragements, but no doubt resentments and determinations built up inside." After age 12, she was essentially self-educated, although her brother, J.B.S. Haldane, and Aldous Huxley, then a

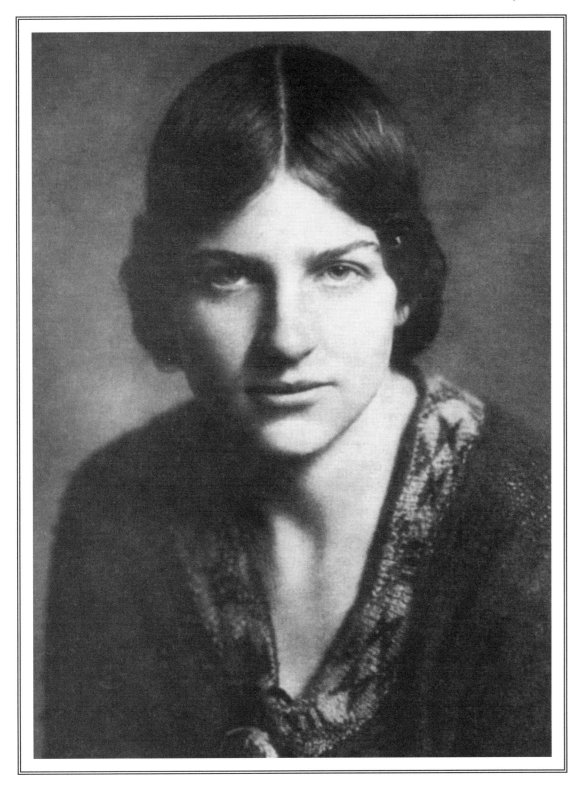

teenager living with the Haldanes, were influential intellectual companions. She yearned to be a scientist, the valued masculine activity of the Haldane household. Although she would later take science classes at St. Anne's in Oxford as a day student, she did not matriculate.

In 1913, when she was 16, Mitchison wrote her first play for performance, which was followed by another in July of 1914 before the First World War began in August. In the summer of 1915, she was allowed to work as a volunteer auxiliary nurse at St. Thomas Hospital in Lon-

don before scarlet fever returned her home. She married Dick Mitchison, a calvary officer at the time, in February 1916, when she was 19 years old; he returned to the war front and she to her parents' home for three more years, there to give birth to her first son Geoff in 1918 and her second son Dennis in 1919.

In London during the 1920s, while Dick established his law practice, Naomi began to write in earnest, receiving the Palmes de L'Académie Française for her first novel, *The Conquered*, which she later remembered writing on a desk attached to the handle of the baby carriage in which she pushed her third son Murdoch, who was born in 1922. (He was followed by Lois in 1925, Avrion in 1928, and Valentine in 1930.) Throughout the 1920s, Naomi Mitchison was becoming famous as a writer, publishing at least a book a year, most of which was fiction set in Classical Greece and Rome. After her first son Geoff died of spinal meningitis in 1928, she wrote her 700-page opus, *The Corn King and the Spring Queen* (1931), in which she incorporated and critiqued the dominant androcentric systems of knowledge of the political economist Karl Marx, of the anthropologist James Frazer, and of the psychoanalyst Sigmund Freud.

The nearer we get to the human side of truth and especially to art, which is intensely human— a Sabbath made for men—the more we find that the sex of the seeker or researcher or writer makes a difference in the result.

—Naomi Mitchison

In the '20s, Mitchison participated on a committee that oversaw a birth-control clinic in North Kensington modeled on one begun by *Marie Stopes, author of *Married Love*. Mitchison advocated empowering women to control spacing of babies, if they chose to have them at all. She perceived that a woman was biologically prevented from adventure-questing in the wide world so long as she was subject to undesired pregnancies, the dangers of childbirth, and the responsibilities of lactation and nurturing. Her involvement in the birth-control movement is clearly reflected in her writing about women in *Cloud Cuckoo Land* (1925), *The Corn King and the Spring Queen*, *We Have Been Warned* (1935), and in sociological tracts such as "Comments on Birth-Control" written for *Criterion Miscellany* (No. 12, 1930) and *The Home and a Changing Civilization* (1934). She lectured for Norman Haire's World Sexual Reform League in

1929 and wrote magazine articles about sexology and the family during 1932 and 1933. She and her husband practiced a philosophy of open sexual option within a committed marriage. She was influential in the lives of the writer and politician *Elizabeth Longford and the artist *Gertrude Hermes.

Between 1929 and 1932, Mitchison wrote critical essays about D.H. Lawrence, Wyndham Lewis, Gerald Heard, and Sigmund Freud for *Time and Tide*, a magazine whose editorial intention was to sponsor women intellectuals who wrote about international politics and literature; it advocated a form of equal-rights feminism which coincided with her own. In an unpublished book about feminism that she started to write in the late 1920s, Mitchison begins:

> If one is in this curious position of being a woman, one cannot unquestioningly accept the ordinary historical point of view about the values of civilisation. Why not? Because up to the last few years all historians have been men. . . . And so far we have only the man's view of civilisation and the trend of human thought and culture.

The Mitchisons shifted their political allegiance from the Liberal to the Labor Party in 1930; Dick stood unsuccessfully for Parliament in King's Norton in Birmingham, as he would again in 1935. He became an insider in the socialist wing of the Labor Party, participating with Douglas and *Margaret Cole (1893–1980) in organizing the Society for Socialist Inquiry and Propaganda, then bringing the New Fabian Research Bureau and its *Quarterly* into being. Having electioneered in Birmingham in 1930 for her husband, in 1935 Naomi stood unsuccessfully as Labor Candidate for Parliament for the Scottish Universities.

In 1932, Mitchison participated in a Fabian Society expedition, led by *Beatrice Webb, which journeyed to the Soviet Union. There she observed women's lives in a Communist regime. One of her characters in *We Have Been Warned* concludes that women would have less than men to gain from a socialist revolution: "I'm not so far from *praxis* as you are, Tom, after having had four children; modern medicine hasn't got far enough to prevent childbirth being devilishly alike for all women."

Meanwhile, Mitchison's opinions about women's issues and the family were generating criticism and hostility from those in established positions of authority. In 1932, she edited *An Outline for Boys and Girls and Their Parents*, a collection of essays written by various left intellectuals about all areas of knowledge; it was de-

nounced by the archbishop of Canterbury and the headmasters of Eton and several leading boys' schools and castigated for its presumed attack on the institution of the family because one of its essayists had praised child-care centers in the Soviet Union. Lady *Margaret Rhondda, editor of *Time and Tide,* defended *An Outline*: she maintained that these gentlemen, attempting to "bracket atheism, anti-theism and the destruction of the family," were speaking for the threatened patriarchy. In 1935, Mitchison's novel, which incorporated her experiences in Birmingham's working-class neighborhoods and her travels to the Soviet Union, was published; *We Have Been Warned,* a woman's quest novel situated in the historical present, was condemned by Conservative, Socialist, and Communist reviewers alike. "Feminism" was becoming a term of disparagement. In *We Have Been Warned,* she creates a woman hero who is accused of belonging to the "squawking sisterhood," then boxed on the side of her head by a "gentleman" wearing a public school tie: "You haven't time to teach her now, said the words; you haven't time to rape her now said the tone."

In March 1934, Mitchison was an emissary of the British Labor Party to Vienna, where she witnessed the suffering aftermath of the violent suppression of Austrian socialism by fascist forces. Her observation of the counter-revolution, recorded in *Vienna Diary* (1934), made her one of the first voices in Britain to sound a warning about European fascism building toward another world war. In February 1935, she traveled to the United States where she joined the Sharecroppers Union, an organization of black and white tenant farmers who were protesting landowner exploitation; she helped lead public demonstrations in Arkansas when such activities were quite dangerous. In Vienna and Arkansas, Mitchison had witnessed poverty, injustice, and intense suffering. These experiences, together with her recognition that Britain was on the brink of another catastrophic war, inspired her to write *The Moral Basis of Politics* (1938), a sociological search for the Just Society in which people are free to seek "security, status, and fun," themes which she explored in her subsequent historical novels, *The Blood of the Martyrs* (1939) and *The Bull Calves* (1947). In her private life, Mitchison also sought this Just Society.

During the Second World War, Mitchison, now in her 40s, settled in Carradale in the Scottish Highlands; she was pregnant with her seventh child, who died after birth. Dick Mitchison remained in London and Hendon, working with Douglas Cole on Labor policies which laid the foundation for the welfare state implemented after the war. Amicably, he and Naomi would seldom share domiciles during the 30 years that remained of their married life. Scotland was now Naomi's home. During the war, she harbored refugees; arduously, she learned to farm, grow turnips, raise sheep, and run a dairy; for fun, she poached with the local fishermen for whom she wrote a play that they performed. Her frequent contributions to the *New Statesman* and *Nation* record these rural experiences. Practicing socialism, she opened her feudal lands to all her neighbors, providing a place to construct a Village Hall, the first secular meeting place in the community. She kept a war journal for Tom Harrisson's Mass Observation survey, over a million words that were reduced to 150,000 for publication in *Among You Taking Notes: Wartime Diary 1939–45* (1985). She also wrote *The Bull Calves* (1947) about her Scottish Haldane ancestors; it is a love story in which middle-aged forgiveness shapes a private Just Society. Politically, while initiating a local chapter of the Labor Party, Mitchison gravitated toward the Scottish National Party, which was vitally committed to addressing Highland problems of fishing, crofting, and depopulation. As vice-chair, she helped organize the Scottish Convention Movement whose non-political agenda was congenial to her Labor affiliation; through the Convention, she became a close friend of the Scottish writer Neil Gunn.

At the end of the Second World War, Dick Mitchison was elected to Parliament, representing Manchester during the ensuing 19 years until 1964 when he was made a Life Peer. Naomi Mitchison was elected to the Argyll County Council, serving between 1945 and 1948 and then again between 1953 and 1965. She was also asked to represent Argyll on the Highland Panel, an advisory group appointed by the Labor government; she participated between 1947 and 1973. A valued expert on fishing and crofting, she nevertheless took greatest pleasure in sponsoring the establishment of village halls. Her novel *Lobsters on the Agenda* (1952) incorporates her Highland political experiences. In 1959, because of her influence gathering matching funds from the national government, Carradale was able to construct a new harbor.

As the Cold War with the Soviet Union began, Mitchison helped organize and then was elected vice-president of the Authors' World Peace Appeal (AWPA), an organization of over 70 writers who wished to encourage international peace. Together with *Doris Lessing, she visited the Soviet Union in 1952 to establish communication with Russian writers. The Labor Party

disassociated itself from the AWPA in 1953, proscribing it along with 40 other organizations because of fears that they were fronts for the Communist Party. This charge infuriated Mitchison who had debated her brother J.B.S.'s Communism for two decades. Mitchison was now writing children's literature, including *The Land the Ravens Found* (1954), a literary effort to avoid the war she feared was brewing between the United States and the Soviet Union. She was particularly concerned about hydrogen bombs, as NATO installations were established in Scotland. In 1959, she was a main speaker at a mass nuclear disarmament rally, and in 1961 in Glasgow she helped lead a march of 10,000 opponents of the Polaris missile base planned for the Holy Loch.

Mitchison began to write science fiction in 1962, galvanized by her anxiety about human survival. Her future utopias are inhabited by women whose communicative gifts will insure peace in the sentient universe. In *Memoirs of a Spacewoman*, women choose to conceive children from different fathers, including some who are non-human. In *Solution Three* (1975), Mitchison posits a utopian state which privileges gay and lesbian sexualities.

In 1963, Mitchison, aged 65, was adopted as the tribal mother of the chief of the Bakgatla in Botswana. As she made quite clear in *The Return to Fairy Hill* (1966), in the Botswanan city of Mochudi, in her mind, was like the agricultural community she had imagined in her historical novels. Visiting Botswana over 18 times between 1963 and 1988, Mitchison tried to help the Bakgatla avoid what she considered the pitfalls of individualism and capitalism. She is described by **Lois Picard**, in *The Politics of Development in Botswana* (1987), as a key influence on Linchwe II, "a young and able chief convinced that a bridge could be built between socialism and traditionalism."

In her 80s and 90s, Naomi Mitchison retained her vital interest in global issues, speaking and writing against apartheid in South Africa and sponsoring FREEZE, an international organization lobbying governments to stand against nuclear war. Although she preferred not to be labeled feminist in her later years, she lent her support in 1983 to the women at Greenham Common who lived in tents protesting against the placement of yet another cruise missile on British soil. Naomi Mitchison died, at age 101, on January 11, 1999, at her home on the Mull of Kintyre in Scotland. In Britain and the United States, interest in the writing of Naomi Mitchi-son surged during the feminist movement of the later part of the 20th century. Moreover, she continues to be honored in Scotland as one of the country's major writers.

SOURCES:

Mitchison, Naomi. *All Change Here: Girlhood and Marriage.* London: Bodley Head, 1979.

———. *Mucking Around: Five Continents over Fifty Years.* London: Gollancz, 1981.

———. *Naomi Mitchison's Vienna Diary.* London: Victor Gollancz, 1934.

———. *Return to the Fairy Hill.* London: Heinemann, 1966.

———. *Small Talk: Memoirs of an Edwardian Childhood.* London: Bodley Head, 1973.

———. *You May Well Ask: A Memoir 1920–1940.* London: Gollancz, 1979.

SUGGESTED READING:

Benton, Jill. *Naomi Mitchison: A Biography.* London and San Francisco: Pandora, 1992.

Lefanu, Sarah. "Politics in Naomi Mitchison's *Solution Three*," in *Utopian and Science Fiction by Women: Worlds of Difference.* Eds. Jane L. Donawerth and Carol A. Kolmerten. NY: Syracuse University Press, 1995.

Longford, Elizabeth. *The Pebbled Shore.* London: Weidenfeld and Nicolson, 1986.

Sheridan, Dorothy, ed. *Among You Taking Notes: Wartime Diary 1939–45.* London: Gollancz, 1985.

Squier, Susan. "Afterword," in *Solution Three.* Reprint. NY: The Feminist Press, 1995.

Vickery, John. *The Literary Impact of "The Golden Bough."* Princeton, NJ: Princeton University Press, 1973.

RELATED MEDIA:

"Naomi Mitchison" (60 min. film), aired on BBC, 1988.

COLLECTIONS:

Correspondence and manuscripts located in the Haldane Archive, National Library of Scotland, Edinburgh.

Correspondence located in the Julian Huxley papers, the Fondren Library, Rice University, Texas.

Manuscripts and correspondence located in the Mitchison Archive, the Harry Ransom Research Center, the University of Texas, Austin.

Second World War diary and essays located in the Tom Harrisson Mass Observation Archive, the University of Sussex.

Jill Benton,
Professor of English and World Literature,
Pitzer College, The Claremont Colleges, California

Mitford, Deborah (1920—)

*English socialite, businesswoman, and duchess of Devonshire. Name variations: Debo. Born Deborah Vivian Mitford in 1920; daughter of David Freeman-Mitford, 2nd Baron Redesdale, and Sydney Bowles; sister of Nancy Mitford (1904–1973), Jessica Mitford (1917–1996), Diana Mitford (b. 1910), and Unity Mitford (1914–1948); married Andrew Cavendish, duke of Devonshire, on April 19, 1941 (his brother William married *Kathleen Kennedy, elder sister of John F.*

Kennedy); children: Emma Cavendish (b. 1943); Peregrine Cavendish (b. 1944); Sophia Cavendish (b. 1957); three other children died at birth.

Deborah Mitford was born in England in 1920, the daughter of Baron and Baroness Redesdale and the sister of *Nancy Mitford, *Jessica Mitford, *Diana Mitford, and *Unity Mitford. Unlike her rebellious sisters, Deborah Mitford avoided politics and became an entrepreneur, running food, book, and garden furniture shops at Chatsworth; she wrote one book about Chatsworth entitled *The House*. Annoyed once with her brother Tom, she remarked caustically, "This family consists of three giants [Nancy, Diana and Unity], three dwarfs [Pam, Jessica, and herself] and one brute."

SOURCES AND SUGGESTED READING:
Guinness, Jonathan and Catherine. *The House of Mitford.* London: Hutchinson, 1984.

Mitford, Diana (1910—)

English socialite and wife of Fascist leader Oswald Mosley. Name variations: Lady Diana Mosley. Born on June 17, 1910; daughter of David Freeman-Mitford, 2nd Baron Redesdale, and Sydney Bowles; sister of Nancy Mitford (1904–1973), Jessica Mitford (1917–1996), Deborah Mitford (b. 1920), and Unity Mitford (1914–1948); married Bryan Guinness (later Lord Moyne), in January 1929 (divorced 1934); married Sir Oswald Mosley (a politician and founder of the British Union of Fascists), in 1936 (died 1980); children: (first marriage) Jonathan Guinness; Desmond Guinness; (second marriage) Alexander Mosley; Max Mosley.

Diana Mitford was born in England in 1910, the daughter of Baron and Baroness Redesdale and the sister of *Nancy Mitford, *Jessica Mitford, *Deborah Mitford, and *Unity Mitford. Diana grew up enthralled by the books of Lytton Strachey, Bertrand Russell, Aldous Huxley and J.B.S. Haldane, about which she noted, "I loved them for their wit and irreverence and their rejection of accepted standards." She married an heir to the Guinness brewing fortune before she was 20, and with her husband was active in the London social scene of the young and wealthy upper crust. (Evelyn Waugh, who was a close friend, dedicated his satire *Vile Bodies* to Mitford and her husband.) At 23, she met Oswald Mosley, a Labour politician who had grown increasingly disaffected with his party and settled on Fascism as the only hope of saving England from its economic woes. Fascism

was still a fairly new ideology then, having first come to prominence with Benito Mussolini's rise to power in Italy in 1922, and there were many who found in it a welcome antidote to the abrupt social and economic changes that had roiled the world in the years after World War I. Mitford, too, became a staunch believer, and in the process fell in love with Mosley. Though she had a husband and two young children, and he was both married and a notorious womanizer, she left her family to become his mistress. A few months later, in October 1932, Mosley founded the National Union of Fascists (also known as the British Union of Fascists), soon to become notorious for the violent thuggery of its "blackshirt" members.

Over the next few years Mitford became friendly with Adolf Hitler, whom she greatly admired (though she did not worship him as did her sister Unity), and had no difficulty in accepting the Nazi attitude towards Jews. Mosley's organization also became increasingly anti-Semitic throughout the 1930s, which was in part what led finally to a backlash from the public and from the government. In 1936, following the death of his first wife ❧➤ **Cynthia Mosley**, Mitford and Mosley married secretly in Berlin at the house of Josef and *Magda Goebbels. Hitler attended the ceremony, and gave the newlyweds a framed photograph of himself which they would display proudly for years.

At the start of World War II, Mitford and her husband, who had been spending much of their time in Germany, returned to England. Now a national pariah, Mosley was promptly imprisoned (his union had already been proscribed by the government), and there was some grumbling that his wife remained free. A short time later, having given birth to her son Max some two months before, Mitford was arrested as a "dangerous woman." Along with enemy aliens and various others who were suspect in time of war, she spent over three years (1940–43) in Holloway prison without trial. In 1943, Winston Churchill, who was one of Mitford's cousins, transferred her and her husband to joint house arrest for the remainder of the war. This caused a public outcry, and Jessica Mitford was among those who wanted them sent back to prison. After the war Mitford and Mosley faced many years of vilification, which apparently bothered her not in the least. Though Lady ❧➤ **Maud Cunard** remained a loyal friend, Diana and her sister Jessica weren't always "on speakers." Mitford's 1977 autobiography *A Life of Contrasts*, considered a little too "unrepentant" by the British press, only served to renew the public's animosity. In 1980, the year of

◄❧
Mosley, Cynthia.
See Curzon, Mary Leiter for sidebar.

◄❧
Cunard, Maud.
See Cunard, Nancy for sidebar.

her husband's death, she also published *The Duchess of Windsor*, a biography of her friend *Wallis Warfield Simpson. *The House of Mitford: Portrait of a Family* (1984) was written by her eldest son Jonathan Guinness and her granddaughter **Catherine Guinness**.

SOURCES AND SUGGESTED READING:

Dalley, Jan. *Diana Mosley.* NY: Knopf, 2000.

Guinness, Jonathan and Catherine. *The House of Mitford.* London: Hutchinson, 1984.

Mosley, Diana. *A Life of Contrasts* (autobiographical). London: 1977.

Mitford, Jessica (1917–1996)

British-born American radical and "muckraking" writer, whose bestseller, The American Way of Death, *led to reforms of the American funeral industry.* Name variations: Decca. Born Jessica Lucy Mitford in Batsford Mansion, Gloucestershire, England, on September 11, 1917; died on July 23, 1996, at her home in Oakland, California; sixth of the seven children of David Freeman-Mitford, 2nd Lord Redesdale, and Sydney Bowles, six of whom were girls; sister of Nancy Mitford (1904–1973), Deborah Mitford (b. 1920), Diana Mitford (b. 1910), Unity Mitford (1914–1948), Pamela Mitford (b. November 25, 1907), and Thomas Mitford (born January 1909; killed in action 1945); eloped with her cousin Esmond Romilly, February 1937 (killed in action 1941); married Robert Treuhaft, on June 21, 1943; children: (first marriage) Julia Romilly (1937–1938); Constancia ("Dinky") Romilly (b. 1940); (second marriage) Benjamin Treuhaft (b. 1946).*

Emigrated to America (1939); naturalized (1944); left Communist Party (1958); had success with The American Way of Death *(1962).*

Selected writings: Daughters and Rebels *(Boston: Houghton Mifflin, 1960, titled* Hons and Rebels *in England);* The American Way of Death *(NY: Simon and Schuster, 1963);* The Trial of Dr. Spock *(NY: Knopf, 1969);* Kind and Usual Punishment *(NY: Knopf, 1973);* A Fine Old Conflict *(London: Michael Joseph, 1977);* Poison Penmanship: The Gentle Art of Muckracking *(NY: Knopf, 1979);* Grace Had an English Heart: The Story of Grace Darling, Heroine and Victorian Superstar *(NY: Dutton, 1988);* The American Way of Birth *(NY: Knopf, 1992); (posthumously)* The American Way of Death Revisited *(Knopf, 1998).*

Lord and Lady Redesdale of Swinbrook raised one of the most extraordinary families in recent British history. Of their daughters, *Nancy, the oldest, became a comic novelist of the first rank, *Diana married the British fascist leader Os-

wald Mosley, ✒▶ **Unity** befriended Hitler and killed herself when her beloved England and Germany went to war, and *Deborah became the duchess of Devonshire. None had a more interesting or unusual life, nor greater gifts, than Jessica Mitford, who alone of the family spent most of her adult life in America and lived good-humoredly at the center of a succession of controversies.

Born in 1917, she was brought up according to her parents' many eccentric notions. For example, her mother believed in "the good body" and denied that medical aid was ever necessary. Twice Jessica broke her arm before the age of ten, but in each case the good body was left to heal itself (without apparent catastrophic effects). The children enjoyed large farm animals as pets (Jessica had a sheep while Unity had a goat and a snake named Enid) and thought nothing of taking them to church on Sundays. Lord Redesdale himself held a hereditary seat in the House of Lords but rarely bestirred himself to attend or vote, except on issues which particularly vexed him, such as the outrageous idea that women should be permitted to take their parliamentary seats alongside the men. The general political tenor of the household was extremely conservative, and the family was one of many in Britain to feel at least a latent sympathy for fascism in the early days of the Great Depression, when Italy and Germany appeared to be addressing the crisis with vigor. Jessica ("Decca") was educated mainly at home, though she longed to go to school, and was a bored adolescent, saving money for her "Running Away Fund."

As her sisters Diana and Unity became more and closely aligned with men of the right, Jessica found herself drawn in the opposite direction. She was 19 when the Spanish Civil War began and felt a strong attachment to the Loyalist forces fighting against Francisco Franco's insurrection. An encounter with her second cousin Esmond Romilly was the decisive event of her youth. He was just back from Spain where he had fought in a British detachment of the International Brigade at the Battle of Boadilla, and was one of very few survivors of what had turned into a catastrophic defeat. Romilly (also a cousin of Winston Churchill) was already notorious. At age 16, he had run away from his boarding school, Wellington, and taken refuge in a Communist Party bookshop in the East End of London. From there, he and his brother Giles ran a subversive magazine, *Out of Bounds*, aimed at other "public school" boys still swatting away at their lessons and practicing military drill in the approved fashion of the British Army. Esmond Romilly wrote an autobiography based

Mitford, Unity (1914–1948)

English socialite and Nazi sympathizer. Name variations: Bobo. Born Unity Valkyrie Mitford on August 8, 1914; christened "Unity" after Unity More, an actress admired by her mother, and "Valkyrie" after the war maidens; died on May 28, 1948; daughter of David Freeman-Mitford, 2nd Baron Redesdale, and Sydney Bowles; sister of Nancy Mitford (1904–1973), Jessica Mitford (1917–1996), Diana Mitford (b. 1910), and Deborah Mitford (b. 1920).

Unity Mitford was born in England in 1914, the daughter of Baron and Baroness Redesdale and the sister of *Nancy Mitford, *Jessica Mitford, *Diana Mitford, and *Deborah Mitford. At age 19, when Unity journeyed with her sister Diana on a sightseeing jaunt through Germany, the two ended up at a German Party Congress, and an impressionable Unity became infatuated with the Nazi movement. "The Nazi salute—'Heil Hitler!' with hand upraised—became her standard greeting to everyone, family, friends, the astonished postmistress of Swinbrook Village," wrote her younger sister Jessica in *Daughters and Rebels*.

After successfully badgering her parents into acquiescence, Unity returned to Berlin in 1934 to study German. She also began to hang around a favorite restaurant of Adolf Hitler's in order to meet him, convinced he was "the greatest man of all time." On February 1935, a delirious Unity wrote her mother:

> I went alone to lunch at the Osteria and sat at the little table by the stove. . . . At about three, when I had finished my lunch, the Führer came and sat down at his usual table with two other men. . . . About ten minutes after he arrived, he spoke to the manager, and the manager came over to me and said 'The Führer would like to speak to you.' I got up and went over to him and he stood up and saluted and shook hands and introduced me to the others and asked me to sit down next to him. I sat and talked to him for about half an hour. . . .

Rosa (the fat waitress) came and whispered to me: 'Shall I bring you a post-card?' So I said yes, really to please her. . . . I was rather embarrassed to ask him to sign it.

As translated by her brother Tom, Hitler had written "To Miss Unity Mitford, as a friendly memento of Germany and Adolf Hitler." The 20-year-old Unity was delighted. "I am so happy I wouldn't mind a bit dying," she rhapsodized, "I certainly never did anything to deserve such an honour."

For the next five years, she became an adoring disciple and friend of Hitler; they met and conversed 140 times. But Unity would soon be confused by divided loyalties. On September 3, 1939, when told by the British consulate that England was about to declare war, Unity went to the gauleiter (district leader) of Munich and requested that, if anything happened to her, she be buried there with her signed photograph of Hitler and her party badge. She then walked to the Englischer Garten and fired a pistol at her right temple. But the hapless Unity, who was being tailed by men of the gauleiter, was rushed to a German hospital where she miraculously survived. Her mother escorted her back to Britain in January of 1940. "She is very happy to be back," wrote her sister Nancy, "[she] keeps on saying 'I thought you all hated me but I don't remember why.'"

Though Unity would regain some of her memory, she was brain-damaged and had regressed to the mental age of an 11-year-old. She would die eight years later, having contracted a severe bout of meningitis from the old bullet wound. Unity Mitford was the subject of a book by David Pryce-Jones, which was dramatized for television by John Mortimer and starred **Lesley-Anne Down**, though her nephew Jonathan Guinness contends that "David Pryce-Jones writes of Unity, and therefore of her family, from a point of view too hostile to permit much insight."

SOURCES AND SUGGESTED READING:
Guinness, Jonathan and Catherine. *The House of Mitford*. London: Hutchinson, 1984.

on this experience, also entitled *Out of Bounds,* followed by a second, *Boadilla,* publishing both books before he was 21.

Jessica Mitford was delighted by Esmond Romilly's daring and his political radicalism and asked him to let her accompany him when he returned to Spain. Within a few days, they were in France, had declared their love for one another, and began to live as a married couple. Together they returned to Spain, this time on the less lethal northern front. They spent several weeks reporting to the British radical press on the worsening state of the Loyalist position until their well-placed relatives in the British government directed a Royal Navy destroyer to go ashore in Bilbao and pick them up. After a few months in France, during which they were formally married and lived by writing news stories, they returned to Britain and set up house in the East End of London. For a while, Esmond ran a gambling den (after losing his own savings in France at the game of *boule*), then worked for an advertising agency, while Jessica prepared to

give birth. Her daughter Julia was born at the end of 1937, and five months later caught measles. Unconcerned, the local nurses told Jessica that she would pass on her own immunity through breast feeding. But Jessica's own upbringing had been so secluded that she had never had measles, and in May 1938 Julia died.

Medical jargon is particularly confusing. I remember a horrifying moment in my doctor's office when the doctor was called out of the room and I took a surreptitious peek at my file. "Head: negative," he had written. When he returned I confronted him with this unkind diagnosis. He said stiffly that it was not as bad as I supposed and that in the future I should refrain from reading my file, which was confidential and for his use only.

—Jessica Mitford, *Poison Penmanship*

As the 1930s came to an end, a general European war began to seem increasingly likely. Jessica and Esmond were afraid that Britain, under its conservative government, might make an alliance with Nazi Germany against Soviet Russia. As ardent Soviet sympathizers (this was the era of the "Popular Front"), they dreaded the prospect of becoming involved in a war on what to them would have been the wrong side, and to avoid this they emigrated to the United States. For a year, they moved frequently up and down the East Coast, Jessica working at one point in a clothing store and Esmond even resorting to selling silk stockings from door to door and taking a crash course in cocktail-mixing and barman's tricks.

Soon after the war began, however, in September 1939, with Britain taking the anti-Nazi side, Esmond volunteered for action by joining the Royal Canadian Air Force and training for air combat. He was shipped back to Europe just before the birth of their daughter **Constancia ("Dinky") Romilly**, who was born in Chicago at the time of the 1940 Democratic Convention which nominated President Franklin Roosevelt for an unprecedented third term in office. Esmond's squadron began to fly bombing missions over Germany. On one mission, on a foggy night in November 1941, his plane radioed base that it had developed mechanical trouble and must return. But it crashed into the North Sea, and all the crew were killed.

These events of her early life Jessica Mitford later described in a brilliant autobiography,

Daughters and Rebels (1960), her first published book. Now a young widow and mother, she decided to stay in America and began to work for the Office of Price Administration in Washington, then moved to a similar job on the West Coast. There she married Robert Treuhaft, a radical lawyer with whom she had been working in Washington and who had followed her to the West Coast, and together they became activists in the Communist Party USA. Their son Benjamin was born in 1946. During the war, America's alliance with the Soviet Union made Communist Party membership relatively unremarkable, but the rapid deterioration of diplomatic relations at war's end, and the onset of the Cold War, suddenly made American Communists seem, in official eyes, no better than enemy agents or ideological traitors. The era of McCarthyism which ensued witnessed the purging of Communists and their sympathizers from many government departments, trade unions, and universities.

Living in Oakland, California, the Treuhafts were not trying to foment Communist revolution but they were trying to transform one aspect of everyday life, America's deep-seated racial prejudice, in the name of color-blind solidarity throughout the American working class. They were active members of the Civil Rights Congress (CRC), a Communist "Front" organization dedicated to dismantling the legal structure of racism. One of CRC's many aims was to break down geographical segregation. Black couples seeking to buy houses in Oakland were often frozen out by white sellers and their neighbors, so white CRC members would make the arrangements with the seller, as if they were the intending buyers, then would hand the property to its black buyer when the deal was made. The Treuhafts entered into this trick with gusto.

The House Committee on Un-American Activities (HUAC) toured the United States in the late 1940s and early 1950s, investigating "Communist Front" activities of this kind, and it subpoenaed Jessica Mitford when she was secretary of her local branch of CRC. Determined not to give the Committee the CRC membership list (since for many members exposure would lead to dismissal from their jobs), she doggedly took the Fifth Amendment in answer to every question put to her by the Committee. One of the congressional representatives asked sarcastically whether she was a member of the Berkeley Tennis Association but even to that question, Jessica, believing that he had said "Tenants," answered: "I refuse to answer, on the ground that my answer might tend to incriminate me," provoking a roar of laughter from the assembled

crowd. She was dismissed before the issue of the membership list arose, and, rather than return home where another summons might arrive, went to hide with other Communist friends until the Committee left town.

In *A Fine Old Conflict* (1977), sequel to *Daughters and Rebels,* Mitford described the many odd and unlikely characters she met in the Communist Party (CP) and described how she and another lawyer's wife, **Daisy Rossman,** would try to recruit new members in tough working-class districts of Oakland.

Daisy . . . had a vast and enviable collection of hats—chic porkpies, floppy straws, velvet berets, silk toques, flowered chiffons, turbans—and always appeared in one of these superb creations when we set forth on our neighborhood visits. She was also horribly shy, and would begin to shake visibly as we approached some worker's front door. "Good evening" she would say, in low trembling tones. . . . I would then spring to her rescue and start rattling on about the forthcoming meeting: "It's going to be absolutely marvellous and frightfully interesting. . . . *Do* come, I'm sure you'll simply *love* it."

Mitford also recalled the odd experience of seeing old "comrades" who had been FBI stooges all along, giving their own testimony at the HUAC hearings.

Persecution from outside and disillusionment from within thinned the ranks of the American Communist Party in the early and mid-1950s. Soon the full revelation of Stalin's atrocities began to emerge, following Nikita Khrushchev's 1956 speech to the 20th Congress of the Soviet Union, prompting Jessica and Robert Treuhaft also to leave the party in 1958. From first to last it had been, in their eyes, fully compatible with American ideals—they certainly never saw themselves as enemy agents. Their work on behalf of African-Americans continued, however, and following the Montgomery bus boycott of 1955–56, the activist phase of the civil rights movement began. Frequently in the following years, Mitford drove down to the deep south to help organize rallies, strikes, sit-ins, and to lobby city and state governments in Alabama, Mississippi, and Georgia. She was a close friend of the Durr family of Montgomery, Alabama, one member of whom was Clifford Durr, the lawyer who represented *Rosa Parks in the court case which sparked the boycott.

Now in her 40s, Mitford had written occasional newspaper articles, usually on civil rights issues, and a spoof on Communist jargon (*Lifeitselfmanship*), but as the 1950s ended she began a new career as a writer in earnest. In 1963, she scored an immense hit with her second book, *The American Way of Death,* a "muckraking" expose of the American funeral industry. Her husband was active in a movement to promote economical funerals and had heard dozens of stories about bereaved people being deceived and plundered by unscrupulous undertakers. Now they decided to make a systematic study of the trade as it was then carried on. Jessica early realized that her best entree into the esoteric jargon of this gruesome business was through trade journals, and so she became an avid reader of *Casket and Sunnyside, Mortuary Management,* and *Concept: The Journal of Creative Ideas for Cemeteries,* all of which advertised and carried articles about caskets, embalming machinery, funeral home decor, and even "grief therapy." As she showed, undertakers in the mid-20th century faced a rather severe demographic problem—the declining death rate. They tried to compensate for the decreasing number of corpses by raising the per-unit cost of funerals, lobbying state governments to legislate mandatory embalming and other costly processes. What made the book a success was Mitford's dazzling literary skill. With a rhetoric always indignant but never bitter, Mitford managed to make a somber topic hilariously funny, and 30 years later the book remains a classic piece of humorous writing as well as a compendium of amazing facts about nefarious undertakers.

As the book topped bestseller charts, she toured the country, appearing on TV and radio shows to discuss the issue. She was called before government committees, now as a "friendly" witness, arguing on behalf of reforms to protect bereaved customers from wily undertakers, and was rewarded by witnessing a succession of modifications to state laws. She was also a consultant when Hollywood made a film based on Evelyn Waugh's novel *The Loved One* (Waugh was a close friend of her sister Nancy). From then on, her writing never lacked an appreciative audience, and she became a literary celebrity of the 1960s.

Living within a mile of the University of California, Berkeley, the Treuhafts became involved in the free speech movement which began there the next year—Treuhaft represented many of the students arrested in the Sproul Hall sit-ins. When Dr. Benjamin Spock, the famous pediatrician, was put on trial for encouraging students to resist the Vietnam War draft in 1968, Mitford covered the trial from beginning to end, and wrote *The Trial of Dr. Spock* (1969). This book is part memoir, part history of the growing antiwar movement, and part protest against the idea of prosecuting people for criminal conspiracy.

> The law of conspiracy is so irrational, its implications so far removed from ordinary human experience or modes of thought, that like the Theory of Relativity it escapes just beyond the boundaries of the mind. One can dimly understand it while an expert is explaining it, but minutes later it is not easy to tell it back. The elusive quality of conspiracy as a legal concept contributes to its deadliness as a prosecutor's tool and compounds the difficulties of defending against it.

Again the blessing of her humorous style enlivened what might otherwise have been a drily technical account, and made a superb contrast with much of the grimly serious literature provoked by the war protesters. Her sketch of the 85-year-old judge, Francis Ford, who swiveled restlessly in his chair as though driving a dodgem car and hectored lawyers, witnesses and defendants alike was particularly entertaining.

A generation of middle-class students was introduced to the sharp end of law enforcement by the civil rights and antiwar movements, and their experiences prompted Jessica Mitford to

turn her investigative eye from the courtroom to the prison system for her next expose, aided now with a Guggenheim fellowship for 1972. *Kind and Usual Punishment* (1973) was the upshot of this work, a scorching indictment of the American prison system. Mitford showed how strongly skewed against poor and black people the prison system had become, and how routinely prisoners' elementary rights were violated once they went behind bars. She persuaded the authorities of a women's prison in Washington, D.C., to incarcerate her for a few days so that she could get a taste of life "inside," but she spent almost her entire stay protesting her treatment and demanding redress in a way ordinary prisoners hoping for parole would hardly have dared. A central theme of the book was the protest against indeterminate sentencing. A sentence of "two to fifteen years" could have a liberal appearance at first glance, giving the impression that a prisoner might enjoy leniency in return for good behavior. In practice, it made prisoners the slaves of a constant agonizing uncertainty, repeatedly dashing their hopes of release, and making them powerless in the face of capricious guards and warders. She also published a long insightful interview on this question with George Jackson, author of *Soledad Brother,* a denunciation of the prison system by one of its victims, shortly before his death in a San Quentin prison gun battle.

As an established and respected writer, Mitford undertook a range of investigative assignments which piqued her curiosity in the 1960s and 1970s, gathering them later in *Poison Penmanship* (1979) and commenting on the way they constituted her practical education in muckraking. She even taught college courses on muckraking at San Jose State University and at Yale. Remaining as deeply committed to the cause of the left as she had been in her Communist years, she visited Nicaragua and El Salvador in the mid-1980s with a committee of activist women, trying to promote the cause of popular democracy and to gather accurate information in an area of the world increasingly beset by violent revolution. Undaunted by a heart attack which forced her to return home prematurely, she maintained a busy writing schedule through the 1980s and into the early 1990s, writing a memoir of her old London friend Philip Toynbee (son of the historian Arnold Toynbee), a history of the semi-legendary English heroine *Grace Darling*, and another exposé, *The American Way of Birth* (1992).

As with her view of the other end of the life cycle, Mitford found a way of making the highly technical world of obstetrics and gynecology accessible to the lay reader in a vigorous prose peppered with indignant asides. Just as the undertakers had unscrupulously taken death into their hands and grown rich, she showed, so had the doctors laid their own heavy hands upon life's opening moments. She demonstrated how doctors' greed, frequent incompetence, and control of scarce resources, has forced up the price of giving birth, and driven safe natal care right out of reach for many middle- and low-income families. Insurers and lawyers also came under the lash. The heroes of this book were the nurse-midwives, who recognized that childbirth is not a sickness which requires extensive drug treatment and elaborate electrical monitoring, but rather, in nine out of ten cases, a natural process which a woman with sympathetic helpers can manage without all the paraphernalia. Mitford treated the prevalence of caesarian sections as an epidemic and proposed a dozen simple measures to bring costs under control without jeopardizing mothers' and babies' well-being. As in all her books, she depicted a world in which it was easy to sort out the good people from the bad. A deeply moral tale, it is cathartic to read and impossible not to enjoy, if sometimes tendentious.

Jessica Mitford represented the British upper classes at their best: fearless in defense of her convictions, intelligent, articulate, witty, and versatile. Without a grain of snobbery, and widely admired in Britain and America, she wrote consistently on behalf of the non-specialist, and reassured readers that they did have rights, that their rights should be honored, and that they need not dread being swallowed up by an anonymous society. In many respects a radical individualist, she never found it easy to become a part of the Communist collective, but her special gifts made her an invaluable ally in every cause she espoused. And as she recognized wryly, she did far more to advance her causes once she had left the party than she ever did within it, surrendering an audience of dozens but winning an audience of millions.

SOURCES:

Guinness, Jonathan and Catherine. *The House of Mitford.* London: Hutchinson, 1984.

Ingram, Kevin. *Rebel: The Short Life of Esmond Romilly.* London: Widenfeld & Nicolson, 1985.

Mitford, Jessica. *The American Way of Birth.* NY: Knopf, 1992.

———. *The American Way of Death.* NY: Simon and Schuster, 1963.

———. *Daughters and Rebels* (autobiography). Boston: Houghton Mifflin, 1960.

———. *A Fine Old Conflict* (autobiographical). London: Michael Joseph, 1977.

———. *Kind and Usual Punishment.* NY: Knopf, 1973.

———. *Poison Penmanship: The Gentle Art of Muck-raking*. NY: Knopf, 1979.

———. *The Trial of Dr. Spock*. NY: Knopf, 1969.

RELATED MEDIA:

The Mitford Girls (a play).

Patrick Allitt,
Professor of History, Emory University, Atlanta, Georgia

Mitford, Mary Russell (1787–1855)

English author whose evocation of the English countryside has proved the most lasting aspect of her many writings. Born Mary Russell Mitford on December 16, 1787, in Alresford, Hampshire, England; died in Swallowfield, Berkshire, on January 10, 1855; daughter of George Mitford (a medical practitioner) and Mary (Russell) Mitford; educated at a private school in London, 1798–1804; never married; no children.

Moved with her family between Alresford, Lyme Regis and Reading before settling in the vicinity of the latter town for the remainder of her life; began to write poetry in her late teens, then drama and country sketches in her early 30s; wrote prolifically, often through pressure to earn an income; in later life, had the reputation of a "bluestocking" who knew many of the leading authors of her day; awarded the civil list pension (1842).

Selected publications: Our Village *(Whittaker, 5 vols, 1824–32);* Belford Regis: Sketches of a Country Town *(Bentley, 1835).*

On Saturday, December 16, 1797, Dr. George Mitford took a stroll with his daughter through the streets of London. It was her birthday. During the outing, they entered what she later described as "a not very tempting-looking place," a lottery office. There he invited her to choose a ticket as a birthday present, and she selected number 2,224 because the digits totalled ten, her age that day. The lottery was drawn in Dublin, some weeks later, and number 2,224 won the huge prize of £20,000; the win repaired the fortunes of the Mitford family. Yet, with hindsight, the success can be seen as strengthening the reckless belief of George Mitford that material wealth was a matter of good luck. His daughter perhaps shared some of his irrational optimism; she certainly had to engage in a lifelong struggle to avert the worst consequences of his financial irresponsibility. To commemorate the lottery win, he commissioned a Wedgwood dinner service embellished with his coat of arms, the Irish harp and the number 2,224. As his daughter remarked in her *Recollections:* "That fragile and perishable ware outlasted the more perishable money."

George Mitford claimed to hold a medical degree from the University of Edinburgh, but investigators have uncovered no evidence of such an award. More probably, he acquired his medical knowledge, as was possible at the time, as a surgeon's pupil and by working in a hospital. His proficiency as a doctor and the consequences for his patients, whether good or evil, are of little importance, for he lacked those systematic powers of application that would have enabled him to build up a successful practice. Though having the qualities of intelligence and amiability, all his life he preferred amusement and diversion. His good looks and great personal charm were the assets he exploited within the upper-class society he frequented, but eventually these were insufficient to save him from bankruptcy.

George's first great stroke of good fortune was to marry an heiress. **Mary Russell** was the only surviving child of a prosperous and socially well-connected cleric. On inheriting an estate of £28,000 in cash, as well as houses and land, she had moved to the small town of Alresford in southern England. There she was introduced, by the dean of Winchester, to George Mitford, who also maintained he had a connection with an old, titled family (though the validity of this claim has been doubted). Undeterred by her plain looks and relatively advanced age—at 35, she was 10 years his elder—George Mitford courted Mary Russell and the two were soon married, in October 1785.

Towards the end of 1786, the couple had a son Francis, but he died in infancy; on December 16, 1787, a daughter was born and named Mary after her mother. She grew slowly, but her small stature contrasted with her mental precocity: by age three, she was able to read. To astonish and amuse his visitors, Dr. Mitford would stand the tiny child on the table for her to read aloud from the newspapers. In 1791, the family moved to Reading, then a flourishing market town in the Thames valley, about 35 miles from London. There George had some patients, though he preferred to spend his time at the card table. He was a compulsive gambler and despite some success he often lost. When not gambling indoors, he pursued wagers outdoors—particularly in the hare-coursing field—and he bred his own greyhounds for the sport. Within a few years, there were rumors that the doctor had nearly ruined his family by his gambling and other reckless speculations (George put money into a number of schemes involving high profits and high risks, which usually showed evidence of only the latter). Perhaps believing a change of residence would produce a change of fortune, he moved to Lyme

Regis, in Dorset, in 1795. Characteristically, he rented one of the town's best houses, in which the then prime minister William Pitt had once lived. Within 12 months, the family moved on to London, where they were able to afford only dingy lodgings while Mary's father struggled to regain his former prosperity. A small income from a trust fund set up for Mrs. Mitford, the capital of which her husband could not get his hands on, probably saved them from destitution.

Suddenly, early in 1798, the struggle ended with the Irish lottery prize. Learning nothing from his previous experiences, George immediately resumed his free-spending ways. On deciding that a gentleman such as he should inhabit a country house, he had one constructed near Reading. It was not completed until 1804; the family meanwhile lived in a rented house in Reading, where George threw himself into the town's social and political affairs (in politics he was a Whig, and during his life met most of the leading figures in the party). Mary's education was added to between 1798 and 1802 by her attendance at a girls' school in Hans Place, London. The level of instruction was high, particularly in the French language which the girls were expected to use when speaking to each other.

Mary's early habit of reading never left her; during her later teens, she read scores of books. In 1806, she traveled north with her father on a visit to friends and relations that included an invitation to a large dinner party at Alnwick Castle, the seat of the duke of Northumberland. Another notable visit, in 1808, was to the home of William Cobbett, the radical journalist. There were also holidays in London, the theaters of which were of great interest to Mary who also enjoyed the capital city's social round. Her publication in 1810 of *Miscellaneous Poems* gave her a modest literary success and widened her circle of contacts. In 1811, she brought out a second, enlarged, edition of her verses, as well as a long narrative poem, *Christina, the Maid of the South Seas*. The proofs of this work were read by Samuel Taylor Coleridge, a poet with an established reputation and a friend of George Mitford. Coleridge appears to have substituted some of her work with what she described as "his own beautiful lines." He also provided help with her next narrative poem, *Blanche of Castille* (*Blanche of Castile), but despite his encouragement and the popularity it enjoyed after publication in Britain and America, her poetry has not retained any critical reputation. Mitford perhaps, after a few more months of versifying, realized that her output was mediocre and gave up. Many years later, she wrote to *Elizabeth

Barrett Browning: "I had (of this proof of tolerable taste I am rather proud) the sense to see [the poems] were good for nothing; so I left off writing for ten or fifteen years."

The break from writing was not long, and might be partly explained by the continued decline in her father's financial standing. Their home was auctioned in 1811 for £5,985, but characteristically George Mitford became involved in a legal case with the purchaser: this dragged on until 1819 and cost both parties more than the value of the house. While the case was in the courts, the Mitfords continued in residence, in a state of genteel poverty, although Mary frequently visited London. In 1818, for example, she attended a dinner party and sat next to the duke of Sussex, the sixth son of King George III; the Mitfords were never quite destitute enough to be excluded from polite society. Her lack of a fortune might have discouraged suitors. All who knew her admired her powers of conversation and the beautifully musical voice with which she spoke, but equally all agreed that she had her mother's plain looks, was somewhat plump and of short stature. Biographers have discovered no affairs of the heart, and hints from her own writings suggest that she

*Mary
Russell
Mitford*

chose to devote herself to the support of her parents, whose own marriage also perhaps was a poor advertisement for the state of matrimony.

Mary Mitford's combination of garrulous enthusiasm with gentle wit and sincere interest in the inhabitants of her village provide the perfect tone for communicating the humble chronicles of Three Mile Cross.

—W.J. Keith

The Mitfords' unsettled circumstances during the 1810s might have discouraged Mary from writing for publication, but she was—as she remained all her life—an enormously prolific letter writer. One regular correspondent was Sir William Elford. Both were early admirers of *Jane Austen's novels and it was to him she made the oft-quoted remark, "Mamma says" Jane Austen was the "prettiest, silliest, most affected husband-hunting butterfly she ever remembers." A letter to Elford of January 1814 gives a glimpse of a style of writing Mitford was to make her own. This was the lyrical and fluent prose with which she captured the atmosphere of the English countryside. She wrote:

> Here the scene has been lovely beyond any winter piece I ever beheld; a world formed of something much whiter than ivory—as white, indeed, as snow—but carved with a delicacy, a lightness, a precision to which the massy, ungraceful tottering snow could never pretend. Rime was the architect; every tree, every shrub, every blade of grass was clothed with its pure incrustations; but so thinly, so delicately clothed, that every twig, every fibre, every ramification remained perfect; alike indeed in colour, but displaying in form to the fullest extent the endless, infinite variety of Nature. This diversity of form never appeared so striking as when all the difference of colour was at an end—never so lovely as when breaking with its soft yet well-defined outline on a sky rather gray than blue. It was a scene which really defies description. The shrubberies were slightly different; there some little modification of colour obtruded itself. The saffron-tinted leaves of the cut-leaved oak, fringed round with their snowy border—the rich seed-vessels or the sweet briar, blushing through their light veil—and the flexible branches of the broom, weighed down, yet half unloaded of their fine burden, and peeping out in their bright verdure like spring in the lap of winter; all this was yesterday enchanting. To-day it is levelled and annihilated by the heavy uniformity of snow.

She was later to say that when she handled such scenes for publication, a great deal of effort was necessary in order to write in a seemingly spontaneous and lucid style.

However, before Mitford began to specialize in village themes, she tried her hand at playwriting. In 1820, the Mitfords had finally given up their country house and moved to a cottage in Three Mile Cross, a village about three miles from Reading. Aware that a successful play could bring its author several hundred pounds, she began to write dramatic works on historical themes. At first, she may not have been motivated purely by money, but the seemingly endless revisions called for by theater managers reduced composition to a dreary chore. She was also drawn, very reluctantly, into the rivalry between the two leading actors of the day, Charles Kemble and William Charles Macready. Eventually, her play *Julian* was performed at Covent Garden in 1823 and brought her £200. *Foscari*, which she had begun earlier, was not put on the stage until 1826. Her tragedy *Rienzi* enjoyed a successful season at Drury Lane in 1828 and became popular in America where *Charlotte Cushman* took the role of Claudia.

While a play might yield a large fee, shorter articles for the magazines paid only a few guineas. This income, however, could be regular for an author able to cater to the public taste. Mitford therefore began to submit to publishers some brief, light sketches, the most successful of which appeared in the *Lady's Magazine* in the early 1820s as "Our Village." Later, she was to claim that all were based on real persons and events, though no doubt these were enlivened and rearranged. It was a classic example of an author achieving success by writing about what she knew best, though she perhaps drew some inspiration from the scenes and characters of country life published by Washington Irving in *The Sketch Book* (1819). So popular were these pieces that soon her publisher was calling for more. She took advantage of public demand: a collection of her writings appeared in 1824 under the title *Our Village: Sketches of Rural Character and Scenery*. Her book was generally well reviewed, with the *Quarterly Review* for example commenting: "We scarcely know a more agreeable portfolio of trifles for the amusement of an idle hour." In the next few years, she wrote four more volumes of *Our Village*. All had a good sale and were widely read in the United States, but at a time when authors sold their copyright, rather than receive royalties, and when foreign publishers often pirated books, her income was not in proportion to the popularity of the volumes.

In 1830, she edited a book, *Stories of American Life by American Authors*, which did sufficiently well to warrant a similar compilation in

1832, *Lights and Shadows of American Life*. Her omnivorous taste for literature extended to that of the United States, which she helped to make better known in England. An early American acquaintance was *Catharine Sedgwick, who sent her a copy of her novel *Clarence* in 1830 and was to stay at her cottage in 1839, the same summer that Daniel Webster paid Mitford a visit. (On his return home, he sent her some seeds of American flowers for her cherished garden.) *Belford Regis*, tales based on Mitford's knowledge of Reading, appeared in three volumes in 1835 and her *Country Stories* (1837) amounted to a sixth volume of the *Our Village* sketches.

These successes, however, did not solve her financial problems. In her extensive correspondence she often complained of the sense of sickness that a pen and bottle of ink caused her—so long and often did she have to sit at her desk producing manuscripts for publishers in order to bring in an income. In 1837, the Whig prime minister Lord Melbourne granted her a civil list pension of £100 a year, which he had been pressed to do by among others Lord Devonshire and Lord Holland. She had a wide circle of admirers and, despite living in an obscure village in a humble cottage, distinguished literary visitors regularly traveled to see her. Several left accounts of their visits. For example, George Ticknor, the American author, recorded in his journal a visit of 1835:

> We found Miss Mitford living literally in a cottage neither ornée nor poetical—except inasmuch as it had a small garden crowded with the richest and most beautiful profusion of flowers—where she lives with her father, a fresh, stout old man who is in his seventy-fifth year. She herself seemed about fifty, short and fat, with very gray hair, perfectly visible under her cap, and nicely arranged in front. She has the simplest and kindest manners, and entertained us for two hours with the most animated conversation and a great variety of anecdote, without any of the pretensions of an author by profession.

A painting by John Lucas, now in the National Portrait Gallery, was agreed by those who viewed it to have caught both the homely appearance and alert character described by Ticknor.

Her mother had died in 1830, but George Mitford, who was then 82, remained active and as extravagant as his daughter's income would allow until his demise in 1842. Usually, accounts of the family portray him unfavorably. The *Dictionary of National Biography*, for example, states he was "selfish, unprincipled and extravagant, with an unhappy love of speculation and whist." However deep his flaws, there is no doubt that his daughter was devoted to him. In 1811, at the time when George Mitford was selling the family home, she assured him:

> Whatever those embarrassments may be, of one thing I am certain, that the world does not contain so proud, so happy, or so fond a daughter. I would not exchange my father, even though we toiled together for our daily bread, for any man on earth, though he could pour all the gold of Peru into my lap. Whilst we are together, we can never be wretched; and when all our debts are paid, we shall be happy. God bless you, my dearest and most beloved father!

Though vastly more practical than he ever was, Mary perhaps had some sympathy for his almost childish optimism and his Micawber-like belief that something would turn up. While only once (despite further attempts) did a lottery win save them, there were friends who tried to help. After George Mitford's death—in debt to an extent of several hundred pounds—a public subscription was launched. Within a short time over £1,600 had been donated, often by well-known figures, including Queen *Victoria, Lady Byron (✤➤ **Anne Milbanke**), *Maria Edgeworth and the archbishop of Dublin. The surplus after the debts had been paid was passed to Mary to supplement her other income.

By the 1840s, Mitford's health was declining. Years of anxiety, long hours of literary work (to produce, ironically, prose that sparkled with gaiety and wit) and the discomforts of a damp and draughty cottage had helped give her bronchitis, rheumatism, and digestive troubles. Weakened by these, she was susceptible to attacks of fever and nervous prostration. Her literary output perhaps faltered, but it by no means dried up. She began her autobiography, which appeared in three volumes in 1852 as *Recollections of a Literary Life* and demonstrated her immense knowledge of literature (her cottage was packed with some 6,000 books, and she had borrowed many others from the circulating libraries). In 1854, she brought out her *Dramatic Works* and in the same year completed a novel, *Atherton,* the only lengthy work of fiction she produced. Ruskin wrote to her with praise; he found "an indescribable character about it, in common with all your works—an indescribable perfume and sweetness, as of lily of the valley and honey, utterly unattained by any other writer." Literary critics, however, have usually concluded that she lacked the creative imagination that is to be found in the work of the true novelist.

Her present-day reputation largely rests on *Our Village*. At a time when towns and industry

➤✤
Milbanke, Anne.
See Lovelace,
Ada Byron,
Countess of,
for sidebar.

were growing, her portrayal of rural England was reassuring. Her comment while recommending Charles Dickens' *Pickwick Papers* might also apply to her own work: "a lady might read it all aloud." Modern readers are apt to find the discursive style and homely virtues too cloying, yet these cheerful and animated sketches of people and scenes (particularly the glorious cottage garden she created) were fixed on the page with such vivacity that the colors have remained fresh. To quote a brief example, from an essay that was particularly admired by Catharine Sedgwick and *Felicia Hemans:

> A London fog is a sad thing, as every inhabitant of London knows full well: dingy, dusky, dirty, damp; an atmosphere black as smoke and wet as steam, that wraps round you like a blanket; a cloud reaching from earth to heaven. . . . Of all detestable things a London fog is the most detestable.
>
> Now a country fog is quite another matter. . . . This last lovely autumn has given us more foggy mornings, or rather more foggy days, than I ever remember to have seen in Berkshire: days beginning in a soft and vapoury mistiness, enveloping the whole country in a veil, snowy, fleecy, and light, as the smoke which one often sees circling in the distance from some cottage chimney, or as the still whiter clouds which float around the moon, and finishing in sunsets of a surprising richness and beauty when the mist is lifted up from the earth and turned into a canopy of unrivalled gorgeousness, purple, rosy and golden.

Among others who admired her work was Elizabeth Barrett Browning. Their correspondence extended over a lengthy period and gives much information about the personalities and interests of both women. Mitford presented her with a cocker spaniel named Flush; it was immortalized by Browning's pen.

Although the house in Three Mile Cross was not so cramped as the word *cottage* (a word employed by all who visited) suggests, it was poorly maintained. In 1851, therefore, she decided to move to a house in Swallowfield, about three miles away. In this cottage, as she and her visitors habitually referred to it, she settled in with her small domestic staff (even in their most impoverished phases, the Mitfords managed to employ—if not always regularly pay—a couple of servants). A frequent visitor there was the author and cleric Charles Kingsley who lived a few miles away at Eversley. Though all who recall going to Swallowfield in that part of her life found in their host all the old powers of intellect and much of the old vivacity, Mitford was approaching the condition of an invalid. An acci-

dent in 1853, when the carriage in which she was a passenger overturned, led to several months during which she could only be moved in a wheelchair. Though very weak, she wrote letters to her many friends and, as she had all her life, avidly devoured books. In one of her last letters on January 1, 1855, she wrote:

> It has pleased Providence to preserve to me my calmness of mind and clearness of intellect, and also my powers of reading by day and by night, and which is still more my love of poetry and literature, my cheerfulness and my enjoyment of little things. This very day, not only my common pensioners, the dear robins, but a saucy troop of sparrows, and a little shining bird of passage, whose name I forget, have all been pecking at once at their tray of bread-crumbs outside the window.

A few days later, on January 10, she died. On January 18, Mary Russell Mitford was buried, as she had anticipated, "where the sun glances through the great elms in the beautiful churchyard of Swallowfield."

SOURCES:

Astin, Marjorie. *Mary Mitford: Her Circle and Her Books.* London: Douglas, 1930.

Chorley, Henry. *The Letters of Mary Russell Mitford.* London: Bentley, 1870.

Hill, Constance. *Mary Russell Mitford and Her Surroundings.* London and NY: John Lane, 1920.

Lee, Elizabeth. *Mary Russell Mitford: Correspondence with Charles Boner & John Ruskin.* London: Fisher Unwin, 1910.

L'Estrange, A.G. *The Life of Mary Russell Mitford.* London: Bentley, 1870.

Miller, Betty. *Elizabeth Barrett to Miss Mitford: Unpublished Letters.* London: Murray, 1954.

Mitford, Mary Russell. *Recollections of a Literary Life; or Books, Places and People.* London: Bentley, 1852.

Watson, Vera. *Mary Russell Mitford.* London: Evans Brothers [1949].

SUGGESTED READING:

Keith, W.J. *The Rural Tradition: William Cobbett, Gilbert White and other Non-fiction Prose Writers of the English Countryside.* Toronto: University of Toronto Press, 1975.

COLLECTIONS:

The main collection of Mary Russell Mitford's papers is in the town library at Reading, Berkshire.

D.E. Martin,
Lecturer in History, University of Sheffield, Sheffield, England

Mitford, Nancy (1904–1973)

English writer. Born Nancy Freeman Mitford in London, England, on November 28, 1904; died of fibromyositis on June 30, 1973; eldest daughter of David Freeman-Mitford, Lord Redesdale, and Sydney Bowles; sister of Jessica Mitford (1917–1996), Diana

Mitford (b. 1910), Deborah Mitford (1920—), and Unity Mitford (1914–1948); married the Hon. Peter Rodd, in November 1933 (separated 1945, marriage dissolved 1958); had long relationship with Fabrice, duc de Sauveterre (a hero of the French resistance).

Nancy Mitford was the eldest of the Mitford brood, which continued to increase even though she found it "extremely unnecessary" at the time. She was born in England in 1904, the daughter of Baron and Baroness Redesdale and later the sister of *Diana Mitford, *Jessica Mitford, *Unity Mitford, and *Deborah Mitford. Along with the rest of the Mitford girls, Nancy was assigned to nurses and governesses, isolated from her peers, and educated at home. (Brother Tom was the only one sent out for training.) Though she had a less severe reaction to her parents than did her younger sister Jessica, Nancy did recall being fascinated by the sinking of the *Titanic*; from then on, she had a habit of scanning the *Daily News* for accounts of shipwrecks, looking for her parents' names among the "regretted victims."

In retrospect, Nancy considered herself a tyrannical older sister. In her book *Daughters and Rebels*, Jessica heartily agreed. "She was sharp-tongued," wrote Jessica. "If one took particular trouble to do one's hair, Nancy might remark over a carefully positioned ringlet, 'You look like the oldest and ugliest of the *Brontë sisters.'" But in actuality, Nancy was devoted to her younger sisters and far more forgiving of their world-stage shenanigans. Jessica also had to admit that Nancy's little acts of rebellion opened the way for them. Jessica "dimly remembered the hushed pall that hung over the house, meals eaten day after day in silence, when Nancy at the age of twenty had her hair shingled. Nancy using lipstick, Nancy playing the newly fashionable ukulele, Nancy wearing trousers, Nancy smoking a cigarette—she had broken ground for all of us, but only at terrific cost." Finally, when the family migrated to the country during the war years of 1910–14, Nancy was given partial freedom to attend the Frances Holland day school; at age 16, she attended a finishing school at Hatherop Castle.

Following World War II and a failed marriage, Nancy Mitford settled in Paris, France, and then in Versailles, where she remained for the rest of her life. An ardent Francophile, she formed an enduring relationship with Fabrice, duc de Sauveterre, a hero of the French resistance. She was the author of several satirical novels known for their biting wit, including *Love in Cold Climate* (1949), *The Blessing*

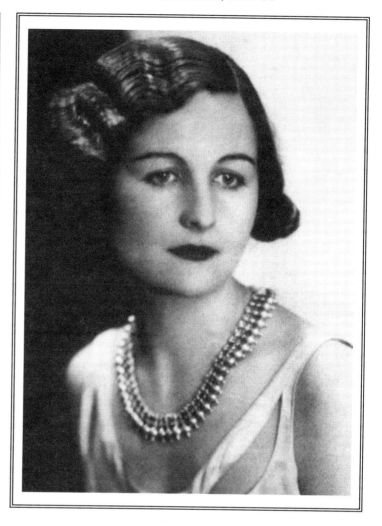

Nancy Mitford

(1951), *Noblesse Oblige* (1956), *Don't Tell Alfred* (1960) and *Pursuit of Love* (1945), which verged on the autobiographical and sold over one million copies. *Wigs on the Green* was a sardonic book about her sister Unity and the British Union of Fascists. She also wrote four historical biographies: *Madame de Pompadour* (1953), *Voltaire in Love* (1957), *The Sun King* (1966), and *Frederick the Great* (1970). After enduring a painful illness for several years, Nancy Mitford died in 1973. "She would have been such a marvellous sharp old lady," said her sister Diana, "dealing out snubs and jokes to new generations. Her life seems almost too sad to contemplate, despite great successes with the books." A biography of Nancy Mitford was filmed for British television by Julian Jebb.

SOURCES AND SUGGESTED READING:

Acton, Harold. *Nancy Mitford.* NY: Harper & Row, 1975.

Guinness, Jonathan and Catherine. *The House of Mitford.* London: Hutchinson, 1984.

Mosley, Charlotte, ed. *Love from Nancy: The Letters of Nancy Mitford.* NY: Houghton, 1993.

Mitford, Unity (1914–1948).

See Mitford, Jessica for sidebar.

Mitsuye Yamada (b. 1923).

See Yamada, Mitsuye.

Mittermaier, Rosi (1950—)

West German skier. Born in Reit im Winkel, West Germany, near the Austrian border, on August 5, 1950; sister of skier Evi Mittermaier, who came in 8th in the giant slalom in the 1976 Olympics.

Won the World Cup overall and slalom (1976); won three Olympic medals in the Innsbruck Winter Games: gold medal in the downhill with a time of 1:46.16, gold medal in the slalom with a time of 1:30.54, and silver medal in the giant slalom (1976).

Born in 1950 in Reit im Winkel, West Germany, near the Austrian border, Rosi Mittermaier skied for a decade before she won her first medal in a major downhill race. During these years, she was well known on the international slopes as a fierce competitor, but fellow skiers affectionately called her "Omi" (Granny), alluding to her senior status. (Her sister **Evi Mittermaier** was also a competitive skier.) In the 1968 Olympic Winter Games in Grenoble, Rosi had placed 25th in the downhill, was disqualified in the slalom, and had come in 20th in the giant slalom. She had improved at the Sapporo Winter Games in 1972, placing 6th in the downhill, 12th in the giant slalom, and 17th in the slalom. Despite her disappointing finishes, Mittermaier had always worn a smile.

When the 26-year-old Mittermaier entered her third Olympics, the 1976 Winter Games in Innsbruck, Austria, no one expected a stellar performance, but she proved that age was no disadvantage. The popular Rosi, a hotel and restaurant waitress during the off-season, was helped by the retirement of ***Annemarie Proell-Moser** and the absence of flu-plagued ***Marie-Thérèse Nadig**. Mittermaier's first event was the downhill on February 8; the pre-race favorite was **Brigitte Totschnigg** of Austria. When the skiers met at the bottom, Mittermaier's time was 1:46.16 to Totschnigg's 1:46.68. She had beaten Totschnigg by $^{52}/_{100}$ths of a second. It was not only a gold medal for Mittermaier, but her first major downhill victory. (***Cindy Nelson** of the U.S. captured the bronze.)

Three days later, on February 11, with the population of Reit im Winkel anxiously lining the slopes to watch the hometown sisters Mittermaier, Rosi proved her win was no fluke. She took the gold in the slalom by surpassing **Claudia Giordani** of Italy's time by $^{33}/_{100}$ths of a second; ***Hanni Wenzel** of Liechtenstein took the bronze. At this point, Mittermaier was praying for a gold in the giant slalom. It would then be a clean sweep of all three alpine events, making her the first woman skier to achieve an Olympic grand slam. Television networks had a huge story, sportscasters were ecstatic, and television viewers around the world who had become entranced with the West German were praying along with her.

On February 13, in Mittermaier's third and final race, **Kathy Kreiner** of Canada surprised even herself as she tore down the course for the giant slalom and crossed the finish line in 1:29.13 seconds. Rosi, who followed, was $^{54}/_{100}$ths of a second ahead of Kreiner at the intermediate mark as the townspeople of Reit im Winkel cheered with gusto. However, when she completed her descent, the time of 1:29.25 flashed on the scoreboard. Kreiner had squeaked out a gold medal by $^{12}/_{100}$ths of a second, and

Rosi Mittermaier

Rosi Mittermaier had to settle for a silver. (Evi Mittermaier came in 8th in the same event.) When the press and photographers crowded around Rosi to commiserate and record the anguish of her loss, she was still smiling.

<div align="right">

Karin Loewen Haag,
Athens, Georgia

</div>

Mitterrand, Danielle (1924—)

Former first lady of France and human-rights activist. Born Danielle Gouze in 1924; married François Mitterrand (president of France, 1981–95, died January 8, 1996); children: two sons.

Danielle Mitterrand, who for more than half a century was married to François Mitterrand, France's longest-serving president, is an important and committed human-rights activist, well known for her work on behalf of the Kurdish citizens of Iraq. Never afraid of controversy, in 1986 she founded France Libertés, a humanitarian organization that agitated foreign governments with its outspoken support for dissidents and ethnic minorities. France Libertés is recognized by the French government and consults with the United Nations Economic and Social Council.

François left office in May 1995, after a 14-year Socialist presidency. That year Danielle donated about 150 pieces of never-worn jewelry, which she had received from various heads of state during her term as France's first lady, to be auctioned for benefit of France Libertés. She had always promised that the pieces (then estimated at a value of about $300,000 to $400,000) would be "well-used." After her husband's death the following year, there was much comment in the American press over the fact that his long-time mistress **Anne Pingeot** and their 22-year-old daughter **Mazarine Pingeot** attended his funeral along with Danielle Mitterrand. Although Mitterrand wrote in her autobiography, "My husband excelled in the art of seducing the girls who came through here," she was tolerant of his indiscretions, saying, "I think the French, and indeed many people around the world, have had enough of this hypocrisy of conformity."

SOURCES:

Bachrach, Judy. "Of Hypocrisy and Lust: When Will Washington Surrender Its Idealism About Sex?" in *The Washington Post Magazine.* February 22, 1998, p. W18.

The Day [New London, CT]. October 9, 1995, December 6, 1995.

"True life adventures" (book review), in *Women's Review of Books.* December 1996.

<div align="right">

Jacquie Maurice,
Calgary, Alberta, Canada

</div>

Miura, Tamaki (1884–1946)

Japanese soprano. Born on February 22, 1884, in Tokyo, Japan; died on May 26, 1946, in Tokyo.

Tamaki Miura, recognized as Japan's first international opera star, was born in Tokyo on February 22, 1884. She studied with the famous opera teacher Junker while still in Japan, and then moved to Germany to complete her training with Petzold and Sarcoli. Miura returned to Tokyo to make her debut in Gluck's *Euridice* in 1909. Her fame quickly became international, and she appeared at the London Opera House in 1915, with the Chicago Civic Opera in 1918, and in Rome in 1921. She also toured the United States with the Naples opera company in 1924. Composer Aldo Franchetti was so impressed with Miura's voice that he wrote an opera, *Namiko-San*, specifically for her, which she premiered at the Chicago Civic Opera in 1925. She died in Tokyo on May 26, 1946.

<div align="right">

Grant Eldridge,
freelance writer, Pontiac, Michigan

</div>

M'Kolly, Mary (1754–1832).

See "Two Mollies."

Mleczko, A.J. (1975—).

See Team USA: Women's Ice Hockey at Nagano.

Mmanthatisi (c. 1780–c. 1836)

Tlokwa leader. Born around 1780 in the present Orange Free State, South Africa; died around 1836; married; children: at least several sons.

Mmanthatisi was born around 1780 into the Tlokwa tribe in what is now the Orange Free State in the Republic of South Africa. She married the chief of her tribe and had several sons. At the time of her husband's death in 1817, their eldest son was only 13 years old, so Mmanthatisi became tribal regent with complete responsibility for leading the Tlokwa. Her rule came during a time of turmoil, the *Mfecane* (the crushing), which historian John Omer-Cooper has described as "one of the great formative events of African history." Both the Zulu and the Boers (Dutch colonial farmers) were campaigning to assert their dominance in southern Africa; the Zulus, under Shaka, were conquering great swathes of land, causing local tribes to flee, while the Boers were taking over other great swathes of land and causing yet more refugees. Mmanthatisi planned military operations for the Tlokwa, although she did not personally partici-

pate in any of their battles with the Boers and Zulus, and her warriors were legendary for their ferocity. A missionary wrote of Mmanthatisi: "It was said that a mighty woman . . . was at the head of an invincible army, numerous as locusts, marching onward among the interior nations, carrying destruction and ruin wherever she went." Eventually, after much fighting, the Tlokwa migrated to what is now Lesotho, out of the reach of both Boers and Zulus. Once she had led her tribe to safety, Mmanthatisi turned the chieftainship over to her son. She died in approximately 1836.

Grant Eldridge,
freelance writer, Pontiac, Michigan

Mnishek, Marina (c. 1588–1614).

See Mniszek, Marina.

Mniszchówna, Marina (c. 1588–1614).

See Mniszek, Marina.

Mniszek, Marina (c. 1588–1614)

Daughter of a Polish noble who became empress of Russia as the wife of Tsar Dmitri the Pretender during the Time of Troubles in the 17th century. Name variations: Marina Mnizek; Marina Mniszech, Mniszeck, Mnishek, Mniszchówna, or Muizeck. Pronunciation: Ma-rina Men-is-chek. Born Marina Mniszek in Sambor, Poland, around 1588; died in Kaluga, Russia, in 1614; daughter of Jerzy (George) Mniszek (palatine of Sandomierz) and Jadwiga Tarlówna; married Demetrius the False also known as Dmitry or Dmitri the First Pretender, tsar of Russia (r. 1605–1606), in 1606; married Dmitri the Second Pretender, in 1608; married Ivan M. Zarutski; children: (second marriage) Ivan (b. 1611).

On May 8, 1606, Marina Mniszek was married to Tsar Dmitri (the First Pretender) in the Church of the Virgin in Moscow. As she entered the church, her hair was covered with gold, pearls, and precious stones that cost fabulous sums, while the small gem-covered diadem worn upon her brow was valued at 70,000 rubles. She was escorted by the wives of Prince Fyodor Mstislavsky and Prince Fyodor Nagoi, and the marriage ceremony was conducted by the patriarch of Moscow in the Muscovite rites of the Orthodox church. Eleven days later, the tsar was murdered, and Marina entered an exciting but turbulent life of intrigue and adventure.

Marina Mniszek was born around 1588 in Sambor, Poland. Her father George Mniszek, a descendant of a Moravian family that came to Poland in 1533, was a prominent noble who held titles as palatine of Sandomierz, castellan of Radom and starosta of Lvov, Sambor, Sokal, and Rohatyn. Her mother **Jadwiga Tarlówna** was also from a prominent family. In 1588, shortly before Marina's birth, George was appointed to govern the royal estate and manage the royal saltworks at Sambor. Marina, one of ten children, grew up in Sambor as a peer of nobles and princes, but in 1603, having lived beyond his means, her father had to sell personal property to avoid bankruptcy and ruin. It was at this time that he and Marina became entangled in the intrigue of international politics involving the throne of Russia.

In the summer of 1603, while bathing, Prince Adam Wisniowiecki, son-in-law of George Mniszek, had slapped and cursed a youthful servant for his inefficiency. Dropping to his knees, the frightened boy made a startling revelation: he declared himself to be Dmitri, the son of Tsar Ivan IV the Terrible of Russia (r. 1533–1584). He made this claim despite the fact that Dmitri had died as a child in 1591, most likely as the result of an accident which enemies of Boris Godunov (r. 1598–1605), then the tsar's advisor, claimed was murder carried out at Godunov's instigation. Prince Adam, probably motivated by Russian thefts of two of his estates, immediately accepted the servant as Dmitri, prince of Muscovy. After furnishing him with magnificent clothing and jewelry, Prince Adam solicited support from his Polish superiors. While Dmitri received no instant official recognition from the Polish government, his support by several powerful Polish and Lithuanian nobles secured him an invitation to visit the royal court at Krakow.

Prince Adam, who escorted Dmitri to Krakow, made a detour to the castle of Sambor and the court of George Mniszek, father of Adam's wife **Ursula**. It was there that Dmitri met Ursula's younger sister, Marina, and fell instantly in love. Petite and beautiful, though a little thin by Russian standards, Marina had a small mouth, long nose, sparkling eyes, and prominent forehead which reflected a young lady of immense pride and vivacious charm. An excellent portrait of her, painted at that time, can be seen in Wawel Castle in Krakow. Whether Marina's wily approach to her young suitor was flirtatiously innocent or deliberately employed to promote her ambitious but insolvent father is uncertain. There was an obvious effort to detain Dmitri so that the romantic relationship could continue to grow. With priests and prelates in tow, George and Marina worked to convince the Orthodox Dmitri that he must convert to Roman Catholicism if he

were to wed the devout Marina. In late February, Dmitri impetuously announced to George his willingness to convert and marry.

George Mniszek supported the marriage of his daughter to Dmitri as a means of regaining his lost fortunes. Marina's feelings are not known, but she certainly had her own ambition to become empress of Russia and probably felt pressure from the Catholic clergy who saw her as a vehicle to convert Russia to the Roman Catholic religion. Although the love may have been one-sided, she agreed to marry Dmitri if the marriage terms were acceptable; as the future would show, Marina was ambitious and unscrupulous in making bold and dramatic decisions. The contract, favorable to both the bride and her father, was signed on May 24, 1604. The agreement provided George with both lands and money and Marina with total sovereignty over the realms of Novgorod and Pskov, with the privilege of maintaining her own religious institutions and practices in those principalities. It also provided Sigismund III, king of Poland, with lands and Dmitri's partnership in a Catholic alliance against Turkey and Sweden. The marriage would take place only when Dmitri became tsar.

Politics in both Poland and Russia played a major role in Marina's immediate future. Dmitri's patronage from King Sigismund and several Polish princes suggested their intention to utilize him as an instrument of their national policy against Russia. His promise to reunify the Western and Eastern churches and his willingness to convert to Latin Christianity won him the ardent support of the Roman Catholic Church. It is also likely that his support was secretly engineered by the Russian enemies of Tsar Boris Godunov, particularly the *boyar* (noble) aristocracy led by the Romanov family who considered Godunov a usurper. The "Time of Troubles" in Russia, with unrest, dissatisfaction, and widespread famine, proved to be more valuable to Dmitri's cause than aid from Poland and Lithuania. It would be wrong to assume that Dmitri's ties to Poland, the Latin Church and dissident Russians made him their political creation. Each group used him to their purpose or advantage, but he was a Russian phenomenon. Dmitri and multitudes of suffering Russians believed in his mission, although his Polish supporters and Russian conspirators did not believe he was the true son of Tsar Ivan IV.

In eastern Poland, Dmitri gathered an army of Polish adventurers, Russian defectors, and the usual Cossack rebels. While Polish authorities looked the other way, Dmitri the First Pretender led a small army of some 4,000 men into Russia in October 1604. He proclaimed that Godunov was a usurper and easily won his first battle. Towns rang bells and opened their gates to him, and new Russian volunteers soon outnumbered the Poles in his army. He suffered occasional reversals but continued to push toward Moscow, the prestige of his name and the abhorrent social conditions in Russia, not the size of his army, proving to be his greatest strengths. In January 1605, however, Dmitri's army was soundly defeated by Godunov's forces, and he and some of his malcontents barely escaped capture. As they reorganized and prepared to advance once more, Boris Godunov died suddenly in April 1605. The weakness of the Russian, now leaderless and divided, enabled Dmitri to triumph. He entered Moscow on June 20, 1605, brutally executed most of the surviving members of the Godunov family, and raped *Xenia Godunova, Boris' daughter, and forced her to become his mistress. The mother of the Dmitri who had died in 1591, *Maria Nagaia, met with and accepted him as her son, as did an important noble and Godunov enemy, Basil Shuiski.

At seventeen, she was empress of a vast land and millions of subjects.

—Philip L. Barbour

After gaining the Russian throne, Dmitri endeavored to pursue an independent domestic and foreign policy. As his own power increased, the importance he placed on the lavish promises he made in the marriage contract diminished. Marina's departure for Moscow was delayed by Sigismund and George Mniszek as a means of keeping some influence over Dmitri. Between the time of his invasion of Russia and his entry into Moscow, he had not corresponded with Marina and very little with her father. Following his coronation, Dmitri requested permission for Marina to leave Poland for Moscow and proposed that they be married by proxy to allow her to enter Russia with the ceremony appropriate for an empress. On November 22, 1605, in the Firlej mansion on the Great Market Place in Krakow, Marina was wed by proxy to Afanasy Ivanovitch Vlasyev, who represented Tsar Dmitri. Following the ceremony, Vlasyev's attendants brought her lavish gifts from her husband. There were bracelets of rubies and emeralds, crosses of sapphires, colorful satins brocaded with silver and gold, a topaz pelican, a ship made of pearls, a golden ox with a belly full of diamonds, and a gilded silver elephant containing an elaborate musical clock. King Sigismund,

who attended the ceremonies, danced with Marina and counseled her before she withdrew from the reception.

Escorted by her father, relatives and servants numbering at least 2,000, Marina left Sambor on March 2. Her large, boisterous and arrogant Polish cortege entered Moscow on May 2, 1606. Already insulted by the tsar's marriage to an unconverted Roman Catholic foreigner, the Muscovites resented the behavior and manners of her Polish retinue. The 18-year-old Marina, spoiled by all the attention and by her self-important belief that she would restore her father's fortune, help her native Poland, and further the cause of Catholicism, began to exhibit the unimperial behavior of an overindulged teenager, which she was. Though showered with finery, she was deprived of her Polish ladies-in-waiting and virtually imprisoned under the strict rules of an Orthodox convent. Dmitri wanted her to stay at the convent as a show of piety on their part because the wedding had to be carried out according to Orthodox ritual. But Marina was dissatisfied with his attempts to alleviate her feelings, and Dmitri finally relented, bringing her to the palace two days before the ceremony. This upset the Orthodox clergy and fanned the flames of rebellion growing within the clergy, nobles, and army.

The wedding and coronation took place in the Orthodox Cathedral of the Virgin on May 8, 1606. A great number of Poles were invited to the palace ceremonies, while few Russians were even admitted to the Kremlin courtyard. The Russians accepted this humiliation but were angered by the marriage and coronation. Marina wore a red velvet robe, garishly covered in diamonds, pearls, rubies and sapphires, and a diamond crown. Dmitri's coronation robes were so laden with jewels that a weaker man could not have worn them. Their failure to take communion in the Orthodox cathedral and the dancing of Polish mazurkas later at the banquet finally broke the clumsy truce between Russian and Pole and resulted in small, sporadic confrontations.

There had been indications of serious political plots against Dmitri prior to the wedding and coronation, but he had dismissed their importance. His brief reign had been troubled from the outset. He had alienated Orthodox Russians by his thinly veiled hostility toward Orthodoxy, his heavy financial exactions on the church, and his disregard for all Russian customs and etiquette. His proclivity for surrounding himself with Poles, and for favoring certain Russian families, like the Romanovs, as well as his arrogance and corrup-

tion, had eroded his relationship with the common people. The major factor, however, was his failure to win support among the anti-Godunov princes who rallied around Basil Shuiski, the man who both had originally confirmed the death of the real Dmitri and endorsed Dmitri the First Pretender's own legitimacy. Shuiski revoked his support of Tsar Dmitri, announcing that he was in fact not the son of Ivan the Terrible; Maria Ngaia, Dmitri's erstwhile mother, did the same.

On May 17, 1606, a mob that included Shuiski's own men stormed the tsar's apartments, murdered Dmitri, and desecrated his body. Though some 3,000 Poles and Russians were murdered by the frenzied mob, Marina hid during the attack on the apartments under the ample skirts of **Pani Kazanowska,** an imposing and fearless Polish lady-in-waiting. Marina later surrendered and was briefly imprisoned with her father and others. They were later moved to Yaroslavl, and by a treaty between new Tsar Basil (IV) Shuiski and the Polish government were to be repatriated to their native land on June 28, 1608.

Returning to Moscow, Marina was forced to renounce all claims to the title of empress in exchange for this repatriation; she had no alternative but to agree. On their way home to Poland, Marina and George were seized by forces loyal to a second false Dmitri (Dmitri the Second Pretender) who had raised an army and established a rebel government in Tushino, just a few miles from Moscow. This incident seems to have been planned in advance, and no element of surprise was evident. What occurred at the meeting between Marina, George, and the Tushino Brigand, as he was known by the Russians, is shrouded in mystery. George Mniszek apparently knew the new Dmitri was not the tsar of Russia but joined the conspiracy on the promise of financial rewards and the province of Severia. Marina, probably disappointed that the Brigand was not truly her husband, and persuaded by her father, recognized the new pretender as her husband Tsar Dmitri. Around September 12, 1608, she married the Tushino Brigand with whom she would eventually have a son. Taking advantage of Tsar Basil's unpopularity, the Brigand briefly conquered large areas to the east, north, and northwest of Moscow in the latter part of 1608, but his ineptitude and failure to bring about reform cost him popular support from the masses. Marina's letters during this time indicate her dissatisfaction with the loathsome and coarse pretender and her pretension that her claim to the Russian throne was based on the legitimacy of her coronation. The Brigand was forced to abandon

Tushino in December 1609. Marina, disguised in a hussar uniform, escaped to Dimitrov and later rejoined her husband in his new capital, Kaluga, remaining with him until he was murdered by Peter Urusov, a Tatar guard, on December 10, 1610. Though she was then in the last stages of her pregnancy, she was still independent enough to refuse an invitation from King Sigismund to return to Poland.

Following the Brigand's death, Marina was protected by the Don Cossack leader Ivan Mikhailovitch Zarutski, with whom she had already fallen in love. Her son Ivan was born in January 1611 and was baptized according to Orthodox rites. Zarutski and other Cossacks tried to advance the candidacy of Ivan to the Russian throne, but both Marina's and Ivan's claims were rejected throughout Russia. Forced to flee, Marina and Zarutski, whom she had married, established a headquarters in Astrakhan in the spring of 1613. Isolated by the emergence of a strong government in Moscow under Tsar Michael Romanov (r. 1613–1645), Marina and Zarutski unsuccessfully sought support from the shah of Persia for a military campaign along the Volga River to Moscow. Their support, even among the rebellious Cossacks, had deteriorated to the point that they were expelled from Astrakhan by the angry citizens. In desperation, they turned to the Iaik (Ural) Cossacks, but the Iaik betrayed them by turning them over to the Russian army on June 25, 1614. Marina was brought to Moscow in chains with 500 guards to prevent her and her son from either escaping or being rescued by another adventurer. By order of the tsar, Zarutski was impaled and four-year-old Ivan was publicly hanged at the Serpukhov Gate. Marina died shortly thereafter, probably from grief, in a prison in Kolomna.

Marina Mniszek's tenacious spirit and her tragic death produced a lasting impression on the Russian people. She was admired by the Cossacks who had supported her from the beginning and feared by the Russian princes who had suffered from her presence during the "Time of Troubles." Most Muscovites saw her as a heretical witch; in one of the many ballads composed about her and the First Pretender, Marina escaped the palace assault by turning herself into a magpie and flying through the window. Regardless of their admiration or hatred, most Russians believed she possessed supernatural powers.

SOURCES:

Barbour, Philip L. *Dimitry Called the Pretender*. Boston, MA: Houghton Mifflin, 1966.

Graham, Stephan. *Boris Godunov*. New Haven, CT: Yale University Press, 1933.

Merimee, Prosper. *Demetrius the Imposter*. Translated by A.R. Scoble. London: n.p., 1853.

Purchas, Samuel. *Hakluytus Posthumus or Purchas His Pilgrims*. Vol. 14. Glasgow: James MacLehose and Sons, 1906.

Rowland, Daniel B. "Marina Mniszek 1588?–1614," in *Modern Encyclopedia of Russian and Soviet History*. Vol. 22, 1981, pp. 241–243.

Vernadsky, George. *The Tsardom of Moscow 1547–1682*. 2 vols. New Haven, CT: Yale University Press, 1969.

SUGGESTED READING:

Hirschberg, Aleksander. *Maryna Mniszchówna*. Lvov: n.p., 1906.

Howe, Sonia E., ed. *The False Dimitri*. London: Williams and Norgate, 1916.

Lindeman, I.K. *Marinkina bashnia v Kolomne i vopros o smerti m. Mnishek*. Moscow: n.p., 1910.

Margeret, Jacques. *The Russian Empire and Grand Duchy of Moscow: A 17th Century French Account*. Edited and translated by Chester S.L. Dunning. Pittsburgh, PA: University of Pittsburgh Press, 1983.

Platonov, S.F. *Moscow and the West*. Edited and translated by Joseph L. Wieczynski. Hattiesburg, MS: Academic International Press, 1972.

Titov, A. *Dnevnik M. Mnishek*. Moscow: A.A. Tntoba, 1908.

RELATED MEDIA:

Moussorgsky, Modest. *Boris Godunov* (opera in four acts). Translated by John Gutman. NY: Fred Rullman, 1953 (there are many other translations of this opera based on Pushkin's dramatic play).

Pushkin, Aleksandr Sergeevich. *Boris Godunov*. Translated by Philip L. Barbour. NY: Columbia University Press, 1953 (there are many other translations of this historical drama).

Phillip E. Koerper,
Professor of History, Jacksonville State University,
Jacksonville, Alabama

Mnizek, Marina (c. 1588–1614).

See Mniszek, Marina.

Mntwana, Ida (fl. 1949–1955)

Member of the African National Congress Youth League, president of the ANC Women's League and first national president of the Federation of South African Women. Name variations: Mtwana, Mtwa. Pronunciation: M-N-twa-na. Died during the Treason trials (1956–1961).

Elected president of the African National Congress Women's League (1949); signed invitation for inaugural conference of the Federation of South African Women (FSAW, 1953); speaker at conference, elected first National President of FSAW (1954); resigned from FSAW (1955).

On April 2, 1944, the African National Congress Youth League (ANCYL) was launched

in response to the demands of the younger members of the African National Congress. Unlike their conservative elders, the Youth Leaguers were eager to turn the ANC into a mass movement that would use civil disobedience to fight for the liberation of the African peoples of South Africa. Since its formation in 1912, the ANC had been dominated by members of the small African elite who were campaigning for equal participation in the government of the "whites-only" Union of South Africa. By 1944, a vocal faction had developed who saw that the future of the struggle depended on including the majority of the population. This "freshman class" included Walter Sisulu, Ida Mntwana, Nelson Mandela, *Lilian Ngoyi and Oliver Tambo. They would launch the ANC in a direction that after much struggle would lead to the formation of the free Republic of South Africa in 1994.

In 1949, **Madie-Hall Xuma** resigned from the presidency of the ANC Women's League (ANCWL) and was replaced by Ida Mntwana. The ANC Women's League had been established in 1944, at the same time as the Congress Youth League. Its mandate was to increase the participation of women in the struggle for liberation, attend to women's issues, and oppose apartheid policies that specifically targeted women. Madie-Hall Xuma was the African-American wife of Dr. A.B. Xuma, the president of the ANC. Under her leadership, the Women's League focused on teaching domestic skills, organizing charity functions, and establishing self-help programs, the kind of work expected of middle-class women. Much like women's clubs in other parts of the world, the Women's League did not have an overtly political agenda. Taking over the presidency, Mntwana brought with her the radical ideals of the Congress Youth League.

By that time, the ANCWL was establishing branches at the township level throughout the country. Threatened by the changes to the pass law and the passage of the Bantu Education Act (1953), the women of South Africa joined the struggle for the rights of full citizenship. Through the branches, women from all backgrounds joined the ANCWL. The Women's League was key to organizing South African women's participation in demonstrations, marches, boycotts, strikes and civil disobedience especially over the issue of passes.

In 1913 and again in 1936, 87% of the land in South Africa had been reserved exclusively for white ownership and occupation. The majority African population had the status of migrants whenever they left the reserves (the 13% of the country where they were supposed to live). The Pass Laws required that all African men register with the local authorities and obtain a pass. The authorities could thereby monitor their movements in and out of the "white" areas where they sought work. In the early '50s, the Abolition of Pass Laws and Co-ordination of Documents Act (1952) was passed to extend the system to cover women. It was against this new legislation that South African women protested most forcefully through the 1950s.

By 1953, the need for an autonomous organization to advocate for women's issues was becoming apparent. The following year, women from around the country met in Johannesburg to form a multiracial organization, the Federation of South African Women (FSAW). As president of the ANCWL, Mntwana spoke during the opening ceremonies, urging women to "fight for their children's rights and future." A Women's Charter was presented and adopted, calling for South African women to demand their rights both as women within their communities and as the disenfranchised under the apartheid government. Despite the strong presence of members of the African National Congress and the Congress Alliance at the conference, the delegates were determined to articulate women's particular goals with respect to apartheid and not to serve simply as a "women's" branch of the established organizations. At the same time, they would ensure that women's issues were represented in the agendas of the nationalists.

Ida Mntwana was elected the first national president of the Federation of South African Women. Other members of the National Executive Committee, all well known in the liberation struggle, included **Gladys Smith**, Lilian Ngoyi, **Bertha Mikze, Florence Matomela, Ray Alexander** and *Annie Silinga.

Mntwana's position as head of the ANCWL brought her into conflict with other members of the FSAW over how to structure the membership. Mntwana and other members of her home branch, the Transvaal ANCWL, advocated for a federation of affiliated organizations. Women would join by virtue of their membership in existing organizations. Ray Alexander and many of the other delegates preferred women joining as individuals. The ANC feared that this would put the FSAW in competition with the ANCWL, for unlike the FSAW, the ANCWL was part of the ANC and ultimately had to adhere to ANC policies. In the end, the influence of the ANC prevailed and the women's organization was constituted as a federation. In March 1955, Mntwana

resigned from her position as president of the FSAW and died sometime during the Treason trials (1956–1961). When South Africa's Women's Monument, built to honor the vital part women played in the fight against apartheid, was unveiled on August 9, 2000, Ida Mntwana was among those women cited as "torchbearers" during President Thabo Mbeki's address.

SOURCES:

Van Vuuren, Nancy. *Women Against Apartheid: The Fight for Freedom in South Africa, 1920–1975.* Palo Alto, CA: R&E Research Associates, 1979.

Walker, Cheryl. *Women and Resistance in South Africa.* NY: Monthly Review Press, 1982, 1991.

SUGGESTED READING:

Lapchick, Richard E., and Stephanie Urdang. *Oppression and Resistance: The Struggle of Women in Southern Africa.* CT: Greenwood Press, 1982.

Mandela, Nelson Rolihlahla. *Long Walk to Freedom: The Autobiography of Nelson Mandela.* MA: Little, Brown, 1995.

Muhonjia Khaminwa,
writer, Cambridge, Massachusetts

Mock, Jerrie (1925—)

American aviator who in 1964 became the first woman to fly solo around the world. Name variations: Mrs. Russell C. Mock. Born Geraldine Lois Fredritz on November 22, 1925, in Newark, Ohio; daughter of Timothy J. Fredritz and Blanche (Wright) Fredritz; attended Ohio State University, 1943–45; married Russell C. Mock, on March 21, 1945; children: Roger, Gary, and Valerie.

After majoring in aeronautical engineering at Ohio State University, Jerrie Mock began flying lessons in 1957 and received her pilot's license the following year. She was then hired to manage the Logan County Airport in Lincoln County, Illinois, and worked there until 1960, when she became the manager of Price Field, a general aviation airport in Columbus, Ohio.

On April 17, 1964, Mock became the first woman to fly solo around the world. Her record-setting flight, which had begun on March 19, took 29 days, 11 hours, and 59 minutes (including 21 stopovers), during which she flew 22,858.8 miles in a Cessna 180. In the course of this flight, Mock also became the first person to fly alone across the Pacific Ocean from west to east, the first person to fly a single-engine plane across the Pacific in either direction, and the first woman to fly solo from coast to coast by going around the world. In honor of her achievement, she was presented with the Federal Aviation Agency (FAA)'s Gold Medal Award by President Lyndon B. Johnson, on May 4, 1964. She was also appointed to the post of vice-chair of the FAA's Women's Aviation Advisory Committee. Having set a total of 21 world records in aviation, Mock retired from flying in November 1969 to become a missionary in New Guinea.

Ellen Dennis French,
freelance writer, Murrieta, California

Model, Lisette (1901–1983)

Austrian-born photographer. Name variations: Elise Seybert; Lisette Stern. Pronunciation: Moh-DELL. Born Elise Amelie Felicie Stern on November 10, 1901, in Vienna, Austria; died on March 30, 1983, in New York City; daughter of Victor Hypolite Josef Calas Stern, later Seybert (a Viennese doctor), and Françoise Antoinette Felicite (Picus) Stern (a French clerk); married Evsei (Evsa) Konstantinovich Model (a Russian painter), on September 7, 1937, in Paris; no children.

Moved to Paris (1926); immigrated to United States (1938); had first works purchased by Museum of Modern Art (1940); signed contract with Harper's Bazaar (1941); became American citizen (1944); began teaching at New School for Social Research (1951); awarded Guggenheim fellowship (1965); had portfolio published (1977); Camera magazine devoted December issue to her work (1977); had second portfolio published (1979); held exhibitions in Tokyo, Ottawa, Venice, Australia, Paris, and Germany (1980–81); had retrospective at Parsons Exhibition Center, New York City (1983).

Selected works: "Promenade des Anglais" (series, 1934–35); "Famous Gambler" (1938); "Reflections" (series, 1940); "Running Legs" (series, 1941); "Coney Island Bather" (1941); "Wall Street Banker" (1941); "Lower East Side" (series, 1941–47).

The photographic images created by Lisette Model, much like the artist herself, were often controversial, contradictory, and political in nature. Her pictures explored the social landscapes of both pre-World War II Europe and postwar America, and probed the inner landscapes of the subjects of her portraiture. Despite her lasting fame as a photographer in the United States, and to a lesser extent in her native Europe, no full-length biography has chronicled her unique life, and much of the reason for this lack lies with Model herself. She discouraged most potential biographers, and those projects which she did support were doomed to failure because of constant "revisions" she made in her life story. She refused to give the same account twice.

Model was born Elise Amelie Felicie Stern on November 10, 1901, into a wealthy bour-

geois family in Vienna. She was the second of three children of Victor Stern, a Jewish doctor of the imperial army, and **Felicie Picus Stern**, who as a young woman had left her homeland of France to work at the Austrian court. A native of Vienna who also held extensive lands in Italy, Victor was a well-educated man who passed on to his children his enjoyment in collecting books and playing classical piano. Felicie was a devout Catholic, and baptized her children into the Catholic Church despite her husband's Jewish faith. When Lisette was about a year old, Victor had the family name legally changed to the non-Semitic Seybert; an attempt to mitigate personal repercussions from the growing anti-Semitism in Austria and across Europe, such changes of name were a common occurrence among European Jews during the years preceding 1914.

The economic disasters following World War I brought financial ruin to many Austrian middle-class families, and in comparison to many of their fellow Austrians the Seyberts' sufferings were not great. They were forced to give up many luxuries they had previously taken for granted, but they retained enough capital to ensure a good education for the children and to afford travel and various other pastimes. Lisette and her siblings Olga and Salvator were instructed at home by private tutors, learning to speak Italian and French along with their native German. Acquaintances of the family remembered Lisette as a girl who usually kept to herself, but one who also loved to create imaginative tales and entertain others by acting them out. There is speculation that she may have been sexually molested by her father; friends characterize her descriptions of her childhood as painful, even unbearable at times, in relation to her father, and her tendency toward behavior that was alternately introverted and melodramatic may point to some sort of abuse. As a photographer, Model often justified her invasions of privacy of the poor, who were the subjects of her work, on the grounds that she, too, had known want and suffering.

At age 17, Lisette began serious study of the piano with composer Edward Steuermann, and in 1920 she entered the Schwarzwald School, a private institution for girls which encouraged creativity and exploration of the arts while preparing students for the intellectual rigors of university studies. She remained there as a part-time student for two years, developing a strong passion for music, particularly piano and voice, and dreaming of becoming a concert pianist or a professional singer. At no point during this period did she show interest in the field of photography or any of the visual arts; music was to be her means of artistic expression until she entered her 30s.

At Schwarzwald, Lisette's principal instructor was Arnold Schonberg, a gifted composer and former Expressionist painter under whom she studied harmony, instrumentation, counterpoint, and musical analysis. He also introduced her to the vibrant world of Austria's then-flourishing avant-garde art scene, and she embraced the broader notions of art in its new and revolutionary forms, as biting social criticism and radical political statement. The influence of Schonberg and his contemporaries can be seen in much of Model's later photographic work; as the Expressionists did, her pictures were to satirize her culture, questioning its values and ethics, and to explore the emotional and psychological workings of the human mind. Nonetheless, she would show an ambivalence towards her privileged education, as she would with many aspects of her life. In later years, she often proudly denied having received any formal art education, justifying her statement by the fact that she had not been a full-time pupil at Schwarzwald (although she had studied there for two years under one of Austria's most gifted composers). At other times, she claimed to have studied at the state-run Austrian Gymnasium, which favored strict discipline over fostering creativity.

In 1924, Model began voice studies with *Marie Gutheil-Schoder, a gifted singer who was also a friend of Arnold Schonberg. In June of that year, Victor Seybert, whose health had been deteriorating since a diagnosis of cancer and severe depression in 1917, died at age 58. Even during the last phases of his illness, he had struggled to protect the family's wealth, and had been successful in investing what remained of their fortune in an Italian pharmaceutical company. Two years later, Felicie Seybert decided to return to her native France. Model and Olga accompanied her, while Salvator, who was married and ill with tuberculosis, remained in Vienna. When Felicie and Olga decided to leave Paris to settle on the Cote d'Azur in Nice, Model chose to remain behind and continue her voice lessons.

In Paris, where she lived alone for the next ten years, Model was the eager student of **Marya Freund**, a Polish soprano and celebrated voice teacher who preferred the "new" musical genres and who was also an associate of Schonberg. During this time, in which she supported herself through the family money, Model demonstrated a growing political identity as well as independence of spirit, but she also underwent several years of psychoanalytic treatment (which has

been taken as further evidence of some deep childhood trauma). While she freely chose to make Paris her home, she later recalled the years there from 1926 to 1933 as a time of great loneliness. Apart from her singing lessons, she spent considerable time in various Parisian bistros or wandered the streets, and often visited her mother and sister in Nice.

In 1933, despite an obvious and acknowledged talent, Model abandoned her voice lessons and stopped dreaming of becoming a professional singer. She never fully explained her reasons for this unexpected change, sometimes placing the blame on "inadequate" teachers and at other times on not feeling comfortable in the music environment of Paris; her sister and friends have suggested that she lacked the discipline, and even sufficient natural ability, for such a career. Whatever the reasons, her rejection of the medium that had long been her passion was sudden and complete, and left her, at age 32, in search of other forms of expression.

For a time she studied painting with landscape painter Andre Lhote. Although he had also instructed the photographers Henri Cartier-Bresson and George Hoyningen-Huene, it was her sister Olga who truly introduced Model to photography. Olga's interest in photography dated back to childhood, and after moving to Nice she had worked as an apprentice photographer at several studios before becoming a medical photographer in the emerging field of micrography. In 1934, Olga taught her sister basic photographic and darkroom skills. Model soon began using her camera to photograph Parisian streets, and the diverse people who inhabited them, as well as family and friends. That same year, she began to see her fledgling hobby in terms of a career, as a result of a conversation about the deteriorating political situation in Europe with fellow ex-Schonberg student Hanns Eisler. A Marxist, composer, and collaborator with Bertolt Brecht, Eisler was in self-imposed exile from Berlin after the Nazi Party's rise to power. He warned that Adolf Hitler's ideology, and the rising tide of fascism, made it dangerous for anyone to be a left-wing artist in Europe with no job training or survival skills. With, indeed, no job training, and dependent for survival on her family's wealth, Model decided to become not an artist but a photojournalist.

That same summer, while staying with her mother, she took a series of photographs of pedestrians along the Promenade des Anglais in Nice. Her subjects were the idle rich—American, Russian, and French—and a perfect match to her awareness and interests: people similar to her in background, richly costumed and secure in their wealth, but alien to her in terms of their values. Intensely aware of their positions of privilege even as she denied her own, Model brought an intimate awareness to the portraits, several of which were published the following winter in the radical Marxist journal *Regards*. Under her images of the "Promenade des Anglais" appeared captions criticizing the "ugly middle class" who "loll in white armchairs . . . boredom, disdain, the most insolent stupidity and sometimes brutality mark these faces." Although Model often denied a deeply leftist political outlook, she undoubtedly knew the context in which these images would be used when she agreed to their publication in *Regards*.

Model increased the pace of her work after this first public exposure of her photographs. While still fascinated by the theme of the idle and arrogant rich, she also turned to capturing images of street people, beggars, and the blind as they struggled to survive in Paris and Nice. Seen together, these disparate images provide a glimpse into the wide class distinctions of 1930s France.

> The art of the split second is my means of exploring.
>
> —Lisette Model

Around this time, in either Nice or Paris, she met Evsei Model. Born in 1899, Evsei, called Evsa, was a Russian Jew from a wealthy family who emigrated before the Russian Revolution to avoid being drafted into the army. He had traveled to China, Japan, Singapore, Bombay, and the Middle East before landing in Italy and then in France, where he studied painting and graphic design. From 1927 to 1930, he had operated a combined art gallery and bookstore in Paris, exhibiting his own works there as well as in other Parisian galleries. After the bookstore closed, he had continued his artistic work in both Paris and Nice. Evsa moved in with Lisette in February 1936, and occasionally traveled with her on the extended trips to the Italian cities of Milan, Trento and Pamparato she often was required to make in the late 1930s to oversee her family's investments. Her work was already attracting the interest of numerous agents, and by late 1936 she sold several more photographs.

Lisette and Evsa were married in a civil ceremony in Paris on September 7, 1937, and the following spring decided to emigrate to the United States. With the rise of fascism leading Europe toward the brink of international war, they

were both highly vulnerable, since neither Lisette, who was half-Jewish, nor Evsa, a Jewish refugee, held French citizenship. In August 1938, Model withdrew what money she could from Italy. They received their visas for departure in September and on October 8 arrived in New York City.

Model fell in love at once with the vibrant, crowded and active city; both she and Evsa began producing works reflected their new sources of inspiration. Still captivated by the energy of city streets, Model often photographed in Wall Street and on the Bowery, as well as in the city's cabarets and cafes. She created many images in 1939, although, true to her contradictory nature, she usually claimed in interviews that she did not use her camera for her first 18 months in America. She and her husband made many friends in the artistic community, and these friends acted as contacts for the couple as they sought new audiences for their work. In 1940, when Model was introduced to photographer Ansel Adams and photohistorian Beaumont Newhall, she already counted among her acquaintances the photographers *Berenice Abbott and Ralph Steiner, photography critic Elizabeth McCausland, and Alexey Brodovitch, the legendary art director of *Harper's Bazaar*. She was fascinated by the study of deliberately created images, and began photographing the window displays on Fifth Avenue and other retail areas, exploring the theme of American glamour. In an interview, she noted: "I found that America was the country of making images of everybody, everything. Everything had to have an image. . . . One day I sitting in a kind of bar, and I saw a politician projecting his image, and I said to myself, 'Glamour, the image of our image—that is my project.'"

Model found a much greater market for her photographs in New York than she had in France, but by 1940 the capital she and Evsa had been living on was running out. When she approached the Museum of Modern Art (MoMA) for a job as a darkroom technician, Beaumont Newhall, now the curator of the museum's nascent department of photography, was so impressed by examples of her work that he told her the museum would rather buy her prints than hire her. "First Reflection," part of her series on windows and one of her best-known images, became the first of many of her works which MoMA would acquire over the course of 26 years.

In December 1940, a selection of Model's "Reflections" photographs appeared in *Cue* magazine, and "French Scene" (which had also been acquired by MoMA) was included in the exhibition "Sixty Photographs: A Survey of Camera Aesthetics," marking the creation of MoMA's Department of Photography. The first of her photographs to be exhibited in the United States, it secured her reputation, and in the following year her images would appear in a variety of shows and magazines. In January 1941, seven pictures from the "Promenade des Anglais" series appeared in *PM's Weekly* illustrating "Why France Fell." Her "Running Legs" series—all images of legs and feet on the sidewalks of New York—was published and reviewed in *US Camera* in February, and in May a solo exhibition opened at the New York Photo League. In July, her "Coney Island Bather," shot on assignment, illustrated the article "How Coney Island Got That Way" in *Harper's Bazaar*. The photo's subject, an overweight woman in a bathing suit on the beach at Coney Island, received considerable criticism from *Harper's* readers who found the subject matter distasteful. In October 1941, "Wall Street Banker" appeared in *Complete Photographer* magazine.

In 1942, when World War II was well under way, Model spent considerable time photographing on New York's Lower East Side, often within the neighborhood's restaurants and bars. Images from this period appeared in *US Camera* and *Harper's Bazaar*. When their status as aliens and their Jewish backgrounds brought both Lisette and Evsa under suspicion from the federal government that year, Model was forced to request letters from her professional acquaintances attesting to her political neutrality and moral character. Perhaps as a means of proving her non-partisanship, she began to photograph war rallies, and several of these images were published in the November issue of *Look* magazine. Her photographs, on a variety of themes, appeared in photographic and general interest magazines, primarily *Harper's Bazaar*, throughout the 1940s.

In July 1944, when she and Evsa received their naturalization papers, she legally changed her first name from Elise to Lisette. In October of that year, they received word that her brother Salvator and his wife had been deported from France to Germany, and that her mother was extremely ill with cancer. Amid the thriving New York art community, during the war years the Models lived mostly on what they could generate from sales and exhibitions, because the Seybert properties in war-torn Italy were providing no revenue. Felicie and Olga struggled in Nice, and at times were close to starving. Lisette and Evsa

did what they could to support Felicie on their meager earnings, and tried to sell their existing works. In November 1944 came news from Europe that Felicie had died on October 21. Some three years later, Model would receive confirmation from Germany that her brother had died during the war in a Nazi concentration camp.

In 1946, with the war over, the Models traveled to San Francisco, where they spent a year becoming acquainted with artists and photographers working on the West Coast. That August, at the California Palace of the Legion of Honor, an exhibition of Model's prints was held which featured portraits of some of the leading artists of the day, including surrealist painter Salvador Dali and photographers Edward Weston, *Dorothea Lange, *Imogen Cunningham, and Ansel Adams. (Many of these pictures would also appear in the February 1947 issue of *Harper's Bazaar*.) The trip strengthened Model's friendship with Adams, and the two would provide artistic support for each other for many years.

In New York again, in the spring of 1949 Model applied for a Guggenheim fellowship to create a book on New York City. Despite a recommendation from Adams and the exhibition of her work as part of the "Four Photographers" show at MoMA, her application was turned down. She and Evsa returned to the West that year to complete an assignment on Reno, Nevada, for *Harper's*, while 15 of her photos went on the road in MoMA's "Leading Photographers" traveling exhibition, which toured the country until 1954. From Reno, Model and her husband went on to California to visit some of his relatives, and in August she accepted a teaching position in documentary photography at the California School of Fine Arts. Students there recall her as an inspiring, demanding instructor who did not believe lectures could teach photography; it had to be learned, she said, by doing.

She returned with Evsa to New York City in 1950, and the following year began teaching at the New School for Social Research, a job she would hold until her death; she also gave private lessons to help support herself and her husband. Model was recognized as an outstanding teacher, one whose influence on her students would have assured her lasting recognition even if her own work had not earned her a place among the great modern photographers. She staunchly refused to show her own work in her classes, and, as she had at the California School of Fine Arts, frequently took her classes around the city on photography outings. Influencing everything from their attitude towards the medi-

um itself to their choice of subject matter, she pushed many of her students into producing lasting images. The celebrated American photographer *Diane Arbus, a student and close friend of Model's for many years, is one of many who viewed her as their most inspiring instructor and major artistic influence. Confrontational and harshly critical, she had a passion for her art that could arouse others to equal passion. Yet the demands that teaching placed on her time and energy decreased the time she could devote to her own photography. From 1952 to 1956, she worked sporadically on a book of photographs of jazz musicians, for whom she had conceived a great admiration during her first months in New York in the 1930s, but the book was never completed due to lack of funds. While most of her time throughout the 1950s and 1960s was spent teaching, her work continued to appear in exhibitions and galleries around New York and Boston.

In 1965, on her second application, Model was awarded a Guggenheim fellowship to photograph the people of New York City. During the 1960s and 1970s, her life was characterized by a lasting dedication to her students and to her work at the New School, although she found the time to create many new works of her own. These newer works appeared in exhibitions across the country, from New York to Washington, D.C., to San Francisco, and joined permanent collections from the Smithsonian to the National Gallery of Canada to the Philadelphia College of Art. In 1970, she was awarded a large grant from the Ingram Merrill Foundation to prepare a study on modern photography, and in 1973 she received the Creative Artists Public Service Program award.

Although she continued to photograph and teach, after 1973 Model was semi-retired. In January 1976, Evsa, who had been forced to give up his successful painting career when his health began to decline in the late 1960s, suffered a massive heart attack. After months of painful illness, he died quietly at home that October. He had been Model's primary emotional support throughout their 39-year marriage, as she had been both his primary emotional and financial support. She said of him in a late interview, "He was life itself." Although she continued to lecture after 1976, her photographic output dwindled away; she had outlived most of her friends and many of her students, including Arbus, who had committed suicide in 1971.

In 1977, a portfolio of Model's images was published in book format by Graphics Interna-

tional; another portfolio-book, proposed by the publishers of *Aperture* magazine, was published in 1979. The years 1980 and 1981 saw the worldwide exhibition of her prints in Japan, Australia, Venice, Canada, Paris, and Germany. In 1982, Model made a trip to France, where she was awarded the Medal of the City of Paris in a ceremony celebrating her long commitment to her artistic vision and her contribution to modern photography. On March 4, 1983, she gave her last lecture, at Haverford College. Twelve days later, a retrospective of her life's work called *Lisette Model: A Celebration of Genius*, opened at the Parsons Exhibition Center in New York City. Late that same month, she entered New York Hospital, where she died on March 30, at the age of 82.

SOURCES:

Rosenblum, Naomi. *A History of Women Photographers.* NY: Abbeville Press, 1994.

Thomas, Ann, ed. *Lisette Model.* Ottawa: National Gallery of Canada, 1990.

SUGGESTED READING:

Lisette Model. *Lisette Model.* Millerton, NY: Aperture, 1979.

———. *Lisette Model: Portfolio.* Washington, DC: Graphics International, 1976.

———. *Lisette Model: A Retrospective.* New Orleans, LA: New Orleans Museum of Art, 1981.

Vestal, David. "Lisette Model: The Much Admired Photographer-Teacher," in *Popular Photography.* Vol. 86. May 1980, pp. 114–119.

COLLECTIONS:

Archives of the estate of Lisette Model are located at the National Gallery of Canada in Ottawa.

Heather Moore,
freelance writer, Northampton, Massachusetts

Modena, duchess of.

See Este, Virginia d' (b. 1573?).
See Martinozzi, Laura (fl. 1658).
See Charlotte-Aglae (1700–1761).
See Maria Beatrice of Sardinia (1792–1840).
See Adelgunde of Bavaria (1823–1914).

Moders, Mary (1643–1673)

Adventurous Elizabethan-era Englishwoman who was first celebrated and later hanged for her fraudulent exploits. Name variations: Meders; also known as the German Princess. Born on January 11, 1643, in England; died by hanging on January 2, 1673, in Tyburn, England; daughter of a chorister at Canterbury cathedral; married a man named Stedman; married a man named Day, in Dover; married John Carleton, around 1663; children: (first marriage) two who died young.

Charged with bigamy; acquitted; fled to Germany; returned to England; married a third time; *charged with bigamy and acquitted; became a success on stage (1663); convicted of robbery and transported to Jamaica as punishment; escaped back to England and discovered; hanged (1673).*

Unwittingly, Mary Moders may have helped to perpetuate the archaic belief that teaching a woman to read was a dangerous act. She was born in 1643, probably near Canterbury, England, the daughter of a chorister at the cathedral there. After being taught how to read by her father, which was at the time a rare occurrence for girls of her modest social status, she became a voracious bookworm, and borrowed often from the church library. Moders was particularly entranced with books that featured cunning and beautiful heroines who triumphed over adverse and unfair circumstances. As a teenager, she even began to think of herself as a princess or noblewoman. Blessed with intelligence as well as beauty in an era when learned women—even aristocratic ones—were often considered "unfeminine," she had an excellent memory and picked up several languages. Had she been born into the noble milieu she so desired, Moders might have found an outlet for her energies in holding literary salons, advising kings, or even writing novels herself under a pseudonym, but the circumstances of her background prevented her from entering such worlds.

Instead, Moders was probably forced into wedlock to an apprentice shoemaker, a situation she likely found loathsome. Her two children died as infants, and she seemed determined to live beyond her husband's means. She then left him and went to Dover, where she married a surgeon named Day. He was well-to-do and could keep her in the lifestyle she desired, but in time she was found out as a bigamist and a trial was held at Maidstone. Since her first husband could not afford to travel to the trial and testify against her, the case was dismissed. Moders next went to Holland, and then to Germany, where she did quite well working in a Cologne brothel. One elderly client in particular she charmed into giving her a valuable medal bestowed on him for services to the king of Sweden; when she agreed to marry him, she managed to extract a large sum of money from him as well. In a matter of hours, she had fled with everything, sold the medal in Amsterdam, and returned to England.

When she arrived in Billingsgate in March 1663, Moders was an attractive 20-year-old in need of a meal and lodging. In those days, it was extremely difficult for a woman to travel alone, and a solitary one in a strange town was usually

suspected of being a prostitute. That first day back, Moders went for breakfast to a tavern patronized by wealthy young men, several of whom made suggestive remarks upon seeing her alone. In response, she cried and won their friendship by telling them she was actually a German princess whose father had disapproved of her suitor and cast her out of the house. The well-connected young men gave her money, and the innkeeper put her up for free. In turn, his brother-in-law John Carleton fell in love with her and, though he was wealthy, Moders pretended to be uninterested because he was a "commoner." Carleton wooed her successfully nevertheless, and they were wed. Shortly after the ceremony, however, an anonymous letter was sent to Carleton's father that unmasked her identity. Moders was tried for bigamy a second time, this time at the Old Bailey, but her first two husbands did not appear at the trial and she was again set free.

Moders was by now quite famous in England, and she was offered excellent money to perform on the London stage. Later in 1663 she starred in *The German Princess*, which was based on her exploits and written for her by the playwright Holden. It was a box-office success, and even the diarist Samuel Pepys was particularly entranced by Moders and saw the play several times. Backstage, affluent men both married and single clamored for her company, and after entering into liaisons Moders blackmailed some of them. After the play's run ended, she began enlisting the service of an accomplice who pretended to be her husband; she would then bring a suitor home and be "discovered" with him by her jealous and angry "spouse." The suitor, fearing a publicized scandal, would pay them a sum of money and flee. (It is doubtful she invented this scheme, but it has remained popular with con artists since.) Moders also cheated merchants by ordering costly goods and having them sent to addresses where she knew the residents to be away on vacation; she then intercepted them upon delivery.

A life of crime proved detrimental to her famed beauty, however, and Moders was considered to have lost her charms by her late 20s. Enamored men whom she might bilk grew scarcer, and for money she began stealing silver tankards from taverns and reselling them. When she took one from Covent Garden and was caught, she was sent to the prison at Newgate, found guilty of robbery, and sentenced to death. Such harsh sentences for property theft were common at the time, but someone (perhaps an old paramour) interceded on her behalf and the sentence was com-

muted to banishment. Moders therefore was boarded onto a ship with other criminals and sent off to Jamaica. However, she apparently had a bit of gold with her that she managed to conceal—likely the gift of another admirer—and some two years later used it to get back to England.

Mary Moders was living in a boarding house in London when, through sheer bad luck, a guard from one of the prisons in which she had been incarcerated made a casual inspection of the house for stolen goods and recognized her. After she was sentenced to death for returning to England, she claimed she was pregnant. There was a well-established precedent of women "pleading their bellies" because they would not be executed until after they had delivered, but midwives who inspected her found she was lying. Moders was publicly hanged in Tyburn in January 1673, and buried in St. Martin's Churchyard. Her career may be summed up from lines she spoke during the epilogue to *The German Princess*:

> The world's a cheat, and we that move in it,
> In our degrees, do exercise our wit;
> And better 'tis to get a glorious name,
> However got, than live by common fame.

SOURCES:

Nash, Robert Jay. *Look for the Woman.* NY: M. Evans, 1981.

Carol Brennan,
Grosse Pointe, Michigan

Modersohn-Becker, Paula

(1876–1907)

German painter whose striking and imaginative pictures moved beyond the naturalism and realism of late 19th-century German art to make her a pioneer of German Expressionism at the start of the 20th century. Name variations: Paula Becker; Paula Modersohn-Becker. Pronunciation: MOE-der-son. Born Paula Becker in Dresden, Germany, on February 8, 1876; died in Worpswede of a heart attack following childbirth on November 21, 1907; daughter of Carl Woldemar Becker (a civil engineer employed by the railroad) and Mathilde von Bültzingslöwen Becker (a descendant of a minor aristocratic family with ties to the military); studied to be a governess at the Bremen Teachers' Training Seminary (1893–95) and studied art in London (1892), Berlin (1897–98), and Paris (1900–07); married Otto Modersohn, on May 25, 1901; children: Mathilde Modersohn (b. 1907); (stepdaughter) Elspeth Modersohn.

Settled in artists' colony at Worpswede (1898); had first public exhibit of her painting (1899); on first trip to Paris, met Rainer Maria Rilke (1900); on sec-

ond trip to Paris, met Auguste Rodin (1903); made third trip to Paris (1905); estranged from her husband, started fourth (and most extended stay in Paris), gave second exhibit of her painting, reconciled with her husband (1906); returned to Worpswede, became pregnant, rendered final paintings.

Selected paintings: Elspeth *(Ludwig-Roselius Collection, Bremen, 1902);* Clara Rilke-Westhoff *(Kunsthalle Bremen, 1905);* Self-Portrait on her Sixth Wedding Day *(Ludwig-Roselius Collection, Bremen, 1906);* Self-Portrait with Camellia Branch *(Museum Folkwang, Essen, 1907).*

Paula Modersohn-Becker lived only 31 years and sold only one painting. Although she was haunted by fears of early death and deeply immersed in her family responsibilities, she nonetheless produced forceful, important works of art. In all, her career produced 400 paintings and 1,000 drawings. Note critics **Anne Sutherland Harris** and **Linda Nochlin**: "She was the first German painter to assimilate the Post-Impressionist currents she discovered for herself in Paris." Freeing herself from the conservative art world in her native country, she developed a personal style, "creating some unquestioned masterpieces during her brief career."

Paula Modersohn-Becker spent most of her short life in the Germany of Kaiser Wilhelm II (r. 1888–1918), although a crucial influence on her art and personality was a series of four stays in Paris. Beyond her role as an artist, Modersohn-Becker's life exemplifies the tension between a talented woman's desire to have a satisfying career and the competing claims of family life.

Germany in the early 20th century contained groups of artists who wished to break away from the rigid standards exemplified by the teaching in the Munich and Düsseldorf art academies. They wanted to paint rural landscapes and the experiences of German country dwellers. Many of them took refuge in rural artists' colonies, like Worpswede near Bremen where Modersohn-Becker worked for much of her life. There they could set their own agenda. Such groups sometimes reflected romantic ideas current in German culture such as those of Julius Langbehn in *Rembrandt as Educator*. In that widely influential work, Langbehn wrote about the need to escape the harsh, divided society of modern, industrialized Germany. He called for a return to a unified cultural community stressing the virtues of rural life. While these interesting developments took place on the German scene, Paris remained the international center of the art world, the magnet that attracted a host of aspiring artists from other lands.

In Germany as in other European countries, feminist agitation for greater rights and opportunities for women challenged a status quo in which men dominated society. European women were restricted in a variety of ways. Even their possibility of becoming artists was hampered by restrictions on their admission to leading art schools, and, if admitted, on their right to study alongside men and to compete for prizes.

Paula Becker was born in Dresden on February 8, 1876. The door to a future career as an artist was opened in part by the cultivated, upper-middle-class environment in which she grew up. Her father was a civil engineer who worked for the railroad; her mother was a member of an aristocratic family with a tradition of service in the military. The third of seven children, she moved with her family to Bremen when she was 12.

As a proper daughter of the German bourgeoisie, Paula was expected to marry or, at the least, to train for appropriate employment, such as a career as a governess. While never wholeheartedly in favor of her ambitions as an artist, her parents nevertheless recognized her early talent in drawing and gave her significant support, permitting her to study art in Bremen and London. Returning to Germany in 1893, she bowed to convention and her parents' wishes by attending a teachers' college where she completed the course with flying colors.

In 1896, now in Berlin, Modersohn-Becker returned to her passion for art. Living with her uncle's family in the suburbs, she studied at a school for women artists and spent her spare time in Berlin viewing paintings. She now started her lifelong practice of intense and lengthy visits to the art museums in every city she visited. Her stay in Berlin led to her encounter with an important proponent for German feminism, **Natalie von Milde**. Von Milde was leading a campaign to end legal restrictions on German women's involvement with political meetings and organizations. After hearing von Milde, Paula gave in to her brother's objections and refused to sign the petition the feminist leader was promoting. She was attracted by the reasoning behind the petition, but von Milde's rhetoric, she noted, "immediately puts me on the male side." She was also inclined "to let the important men handle the issue and to believe in their judgment."

The aspiring young painter began her extended association with the artists' colony at Worpswede in the summer of 1897. Through a

family friend, she was able to study with Fritz Mackensen, a rising German artist who was a founding member of the colony. Located a few miles outside Bremen, Worpswede offered a dramatic rural landscape, inexpensive housing, and willing models among the picturesque peasant population. For young German artists enamored with Langbehn's call for a return to a purer, rural Germany, colonies like Worpswede, of which there were several, were a way to put their dreams into action. Other young Germans pursued Langbehn's dream by their passion for hiking and folk songs.

Modersohn-Becker's family, who had mixed feelings about her ambitions, now emphasized their desire for her to pursue a conventional existence. With one son in medical school and family finances in some difficulty, Paula's father urged her to take a post as a governess. Despite her passion for art—she had haunted the museums in Vienna the previous year—Modersohn-Becker agreed in 1898 to put her fulltime art studies aside for a year. "In my free time," she wrote, "I'll draw so that my hand won't grow stiff." Luckily for her career as an artist, however, she then received a small inheritance that allowed her to support herself without becoming a governess.

At Worpswede, Modersohn-Becker found herself restless as the pupil of Fritz Mackensen. Mackensen and the other Worpswede painters may have chosen new subjects for their painting, but they continued to emphasize many of the techniques of traditional 19th-century German art. The lessons that Mackensen taught her emphasized the need to capture nature with meticulous drawing and precise detail. Even before the trips to Paris that encouraged her to give full scope to her individual creativity, Modersohn-Becker sought to discover a deeper reality. She turned away from the landscape painting favored by many at Worpswede, looking instead to human subjects from the village community. It was her hope to paint them in an incisive and empathetic way, digging beneath superficial appearances. She expressed her ambition by citing the thoughts of *Marie Bashkirtseff, the young Russian painter who had died in 1884, leaving a revealing personal diary. "I say as she does," Modersohn-Becker wrote. "If only I can become something."

In March 1899, she first met Otto Modersohn, a fellow painter at Worpswede. Her letters at this time present a young woman filled with a mixture of exhilaration and doubt. "I see my goals will part from yours," she wrote her sister Milly who seemed headed for conventional life as a married woman. "Nevertheless, I must fol-

low them." To her mother, she confessed: "I want to make of myself the finest that can be. I know it's selfish but it's a selfishness that is great and noble and that gives itself to a tremendous cause." By this point in her career, she had explored the possibilities in painting female nudes, children, the peasants of Worpswede, and still-lifes. Nonetheless, the first paintings she exhibited in a group show in Bremen in 1899 received a harsh response from the critics.

At the start of 1900, the ambitious but uncertain young painter started the first of her four visits to Paris. Even here women artists were not on a par with their male counterparts—they were barred, for example, from competing for major prizes. Still, they had greater freedom in attending art classes and painting from nude models than was available in Germany. Modersohn-Becker plunged into her formal studies in the morning, then devoted her formidable energies to the museums of Paris in the afternoons. The rich variety of work present in Paris came to her as a revelation. In her several visits to the French capital, she immersed herself both in the work of innovators like Paul Cézanne, Paul Gauguin, and Auguste Rodin, and in the artistic legacy of the Ancient World and the Middle Ages.

Old Peasant Woman Praying, *painting by Paula Modersohn-Becker.*

Her return to Worpswede in mid-1900 heightened the tensions in both her personal and professional life. Otto Modersohn had recently become a widower, and he now sought the company of his young fellow artist. Her parents, who continued to oppose her plans for a career as a painter, objected as well to her personal involvement with this older man. In her painting, she followed the inspiration of the contemporary artists she had encountered in Paris, moving increasingly far from the conventional painting her colleagues at Worpswede were producing. In a way that perhaps reflected the various pressures she felt, Modersohn-Becker began to express concerns about her mortality. "I know I will not live very long," she wrote in July 1900. But, "if love blooms for me before I go and if I paint three good pictures, then I can leave willingly with flowers in my hands and hair."

The desire burns in me to be great in simplicity.

—Paula Modersohn-Becker

The year 1900 brought her the start of a deep friendship with Rainer Maria Rilke, a frequent visitor to Worpswede. More important was her growing involvement with Otto Modersohn. She noted their common interest in art. "Getting married shouldn't be a reason for me not to become something," she wrote her mother. But she was even more emphatic in stressing her desire for motherhood and her hopes that her future husband would be a good influence on her. "I'm such a complicated person, so perpetually trembling," and she hoped his calmness would help her. Her affection for her husband-to-be, whom she referred to as her "red beard" and "red king," was obvious in her letters to him.

Within a year after her marriage in May 1901, Modersohn-Becker was immersed in a web of personal difficulties. She was shaken by the death of her father and by the rupture of her longstanding friendship with fellow artist **Clara Westhoff**, who had withdrawn from their intimacy after marrying Rilke. Most disturbing of all, her own marriage proved disappointing. By early 1902, she was telling her journal that she was as lonely as she had been as a child. The lifelong yearning for "a companion for one's soul," which had sustained her through the years, she now saw as a disappointing illusion. At this time, she again expressed her premonition of an early death: visiting the grave of Otto's first wife, Paula set down detailed specifications for her own final resting place.

She found herself sustained during the rest of the year, however, by a growing confidence in her painting. In letters to her relatives, she noted her growing creative power and her desire to move away from the techniques Mackensen practiced. She spoke of painting in "runic characters," with her own voice "growing greater within me and broader." Her style indeed reflected the massive runic letters of the alphabet of ancient tribes of pre-Christian Germany. The painting she made of her stepdaughter Elspeth, which Paula saw as a stylistic breakthrough in her work, showed the child as a flat, massive figure dominating a small landscape.

A second trip to Paris, this time for six weeks in 1903, brought new artistic stimulation and new pangs of guilt over her obligations to her family. She visited the Louvre daily and immersed herself in Japanese art and the work of Rodin. Paris struck her as a city with "champagne in the air" and art everywhere, and she urged her husband to join her. At the same time, she knew her ties to Otto and Elspeth would make her pay a heavy price for the things she was learning in Paris. Her equivocal status in the art world was reflected when she visited her hero Rodin. Rilke introduced her with a written note that described her as "the wife of a distinguished painter."

Modersohn-Becker spent the next two years in Worpswede in an active life that combined her roles as wife, stepmother, and painter. Occasionally, she expressed a deep-seated frustration with the shape of her life. Otto's brief absence on a trip led her to remark, "I feel so divinely free."

In 1905, she returned to Paris for her third visit, once again for only six weeks. By now, she accepted the fact that modern artists such as Matisse, whose works fascinated her, had no appeal for Otto. She wanted to stay for a year if she were free to do so: "Within the walls of this city reign an enormous life and an enormous spirit. It has an almost mystical effect on me." Back in Worpswede her work showed a new surge of originality, but she found the prospect of motherhood increasingly appealing. Visiting the houses of the peasants she painted, she found a new crop of children, and, she noted, "I looked at all this wriggling new life with undisguised envy."

The crisis in her marriage came in February 1906. She left her husband, urging him to realize that the two of them could go on without each other. Moving to Paris for her fourth and most extended stay, she wrote Otto to exclaim (in the past tense), "How I loved you," and regretting the pain she knew she was causing. Nonetheless,

she insisted on the need to test herself in the world. By May, she told her sister that she was living in the happiest period of her life. To her friend the sculptor Bernhard Hoetger, she declared: "I've begun to believe that I will become something." She worked night and day, happily sleeping surrounded by her paintings. Nonetheless, her letters and journal were filled with concerns about the suffering she was inflicting on her family. By the close of 1906, Paula and Otto had renewed their marriage. They moved in together in Paris and made plans to return to Worpswede the following spring. At the same time, Modersohn-Becker received her first taste of public praise. The art critic of the *Bremen Nachrichten* greeted her work on exhibit in the north German city by noting her "serious and powerful talent," nurtured by her stay in Paris, and marked by "an exceptional power." This was only her second exhibit, and the response was dramatically different from the criticism she had received in 1899.

Now recognized as a rising young painter, Modersohn-Becker was still caught in a swirl of emotions. The praise she had received, she wrote her sister in mid-November 1906, "gave me more satisfaction than pleasure," since she found her true satisfaction in creation, not in the fact that others noticed. She and Otto now planned to return to Worpswede, and she expected to be content there so long as she had a place where she could continue her work. In another of her references to an early death, she declared she would be "grateful for whatever part of love has come my way. As long as one stays healthy and doesn't die too soon."

Modersohn-Becker's last year of life saw her return to Worpswede in the spring of 1907. She unexpectedly found herself pregnant and spent the summer and fall months in severe discomfort. Nonetheless, she continued to paint, to review and criticize the work she had just completed, and even to plan a new trip to Paris. On November 2, she gave birth to a girl whom she named Mathilde. Surviving photographs show mother and child during their brief time together. On November 21, her physician gave Modersohn-Becker permission to get out of bed. She had barely arisen, combed her hair, and pinned on some roses when she died from a sudden heart attack. Almost a year to the day later, a heartbroken Rainer Maria Rilke presented his publisher with his "Requiem (For a Friend)," lamenting her tragic death.

Critics have lauded the work Modersohn-Becker produced in her last years and hailed her,

along with Emile Nolde, as a pioneer of German Expressionism. In Expressionism, as art historian Werner Haftmann and his collaborators have written, "The center of gravity no longer lay in things themselves, but in the sensation they produced, for which a new language now had to be found." Thus, after her stays in Paris, the young German painter sought to reach "the simple core of things and convey the gripping emotion ignited by this new reality." Her monumental images, simplified forms, and striking colors sought and obtained a profound reality. Feminist critic **Whitney Chadwick** has noted how Modersohn-Becker applied these techniques to the female nude, producing "monumental images of idealized motherhood." Perhaps the most telling comment on her works came from Otto Modersohn before his marriage to Paula. "Everything about them breathed a strong, individual experience, a rare, creative individuality in form and color."

SOURCES:

Chadwick, Whitney. *Women, Art, and Society*. London: Thames and Hudson, 1990.

Haftmann, Werner, *et al. German Art of the Twentieth Century*. NY: Museum of Modern Art, 1957.

Harris, Anne Sutherland, and Linda Nochlin. *Women Artists: 1550–1990*. NY: Alfred A. Knopf, 1976.

The Letters and Journals of Paula Modersohn-Becker. Translated and annotated by J. Diane Radycki. Metuchen, NJ: Scarecrow Press, 1980.

Perry, Gillian. *Paula Modersohn-Becker: Her Life and Work*. NY: Harper & Row, 1979.

Petersen, Karen, and J.J. Wilson. *Women Artists: Recognition and Reappraisal from the Early Middle Ages to the Twentieth Century*. NY: New York University Press, 1976.

Wydenbruck, Nora. *Rilke: Man and Poet*. 1950. Reprint. Westport, CT: Greenwood Press, 1972.

SUGGESTED READING:

Busch, Gunter, ed. *Paula Modersohn-Becker: The Letters and Journals*. Northwestern, 1990.

Greer, Germaine. *The Obstacle Race: The Fortunes of Women Painters and Their Work*. NY: Farrar Straus Giroux, 1979.

Parker, Rozsika, and Griselda Pollock. *Old Mistresses: Women, Art, and Ideology*. NY: Pantheon Books, 1981.

Neil M. Heyman,
Professor of History, San Diego State University,
San Diego, California

Modesta of Trier (d. about 680)

*Saint. Died around 680; niece of *Ida of Nivelles; cousin of St. *Gertrude of Nivelles (626–659).*

Modesta of Trier founded the monastery of Horren, at Trier, in the buildings of the ancient public granary (*borreum*). Her feast day is October 6.

Modjeska, Helena (1840–1909)

Polish-born actress and fervent Polish patriot who gained fame as a major interpreter of Shakespearean plays for 19th-century American audiences. Name variations: Modrejewska or Modrzejewski; Countess Bozenta or Countess Chlapowski. Pronunciation: Hell-LAY-nuh Mow-JESS-kuh. Born Jadwiga Opid on October 12, 1840, in Cracow, Poland; died on April 9, 1909, on Bay Island (Modjeska Island), California; daughter of Michael Opid (a music teacher) and Jozefa Benda Opid; educated at St. Joseph Convent school; married Gustav Sinnmayer who later called himself Gustav Modrzejewski; married Count Bozenta Chlapowski, on September 12, 1868; children: (first marriage) one son, Rudolph (b. 1861); daughter, Marylka (1862–1865).

Made her professional debut in Poland (1861); established acting company with husband (1862); began performing at Cracow theater (1865); performed at Warsaw Imperial Theater (1868); arrived in U.S. and settled with Chlapowski in area of Anaheim, California (1876); made her U.S. debut in San Francisco (1877); made her debuts in New York, Boston, and Washington, D.C. (1877); performed in London and Paris (1878); attended 50th jubilee in Poland for writings of novelist Jozef Kraszewski (1879); became U.S. citizen (1883); made professional tour of Poland and England (1884–85); was guest speaker at Chicago World's Fair (1893); banned from further appearances in Russian-occupied Poland (1894); played benefit in New York's Metropolitan Opera House (1905).

Most famous performances were in Adrienne Lecouvreur, As You Like It, Romeo and Juliet, *and* Camille.

"I value most highly . . . the privilege I shared with several illustrious countrymen of mine in proving to the outside world that our unfortunate and much-maligned nation, Poland, is always alive, and cannot be relegated to oblivion," Polish-born actress Helena Modjeska wrote in her autobiography. Fiercely patriotic, she sought to use her career to advance the cause of Polish independence from foreign rule. When she appeared on the stage in her native country, crowds cheered not only her performances but also her status as a symbol of Polish nationalism. Eventually, Russian authorities refused to let her appear on stage in the section of Poland they controlled. One consequence was that most of her career unfolded in the United States, although she also performed in many European capitals. Of the three major international stage actresses of the late 19th century—Modjeska,

the Italian actress *Eleonora Duse, and the French actress *Sarah Bernhardt—only Modjeska devoted most of her career to performing in America. Historically, she is less well known, however, than either Bernhardt or Duse. When she is remembered, it is as a major popularizer of Shakespearean plays for 19th-century American audiences. Yet she considered the United States to be only her base of operation; to the end, she thought of Poland as her true home.

The ninth of ten children, Helena Modjeska was initially given the first name of the 14th-century Polish-Hungarian queen, *Jadwiga. Helena's mother **Jozefa Benda Opid** was the widow of Simon Benda, a well-to-do merchant. Modjeska was born in 1840 after her mother married Michael Opid, a music teacher at a school in her native city of Cracow. Although at least one biographer insisted that Modjeska's father was a Polish prince, Wladyslaw Sanguszko, Modjeska regarded Opid as her father. He gave her the name "Helena" because her head was small and well-formed, but he usually called her by the Polish diminutive form, "Helicia." Although he died at age 43 (when Modjeska was five), she retained strong memories of him, recalling that he loved to play music for the family—"music was his passion," she wrote—and tell stories to the children in the family. He frequently read to Modjeska from the *Odyssey* and *Iliad* of Homer. In her words, he had a "warm, unsophisticated heart, a most vivid imagination, and a great love of music." Modjeska remembered her mother as a person of "great energy, and great activity," very quick and outspoken. In contrast to the quiet Opid, she made "rash judgments" and "often regretted hasty words."

The Poland in which Modjeska grew to adulthood technically did not exist. During the late 1700s, Poland had been swallowed up and partitioned by three of its neighbors—Russia, Prussia, and Austria. It would continue under the domination of foreign powers until 1919. While she lived in Poland, Modjeska spent most of her time in sections under Russian or Austrian (German-speaking) control. She recalled that her family "never liked to speak Russian or German, such was the resentment that we cherished in our heart toward these nations."

One of Modjeska's vivid childhood memories was seeing the excitement in her neighborhood during the Polish revolt against foreign rule between the years 1848 and 1850. She remembered seeing many of their neighbors building barricades by hauling chairs, beds, and tables into the streets. She also recalled hearing

shouts for swords or pistols. Her most vivid memory was of huddling with her mother in the basement of their home while the sound of Russian cannon thundered nearby.

Modjeska's only formal education was at the St. Joseph Convent school in Cracow, which she entered in 1850. When Opid died, his holdings included a large amount of real estate, but many of the buildings he owned were destroyed in the great Cracow fire of 1850 and in the Polish revolts of 1848–50. Nevertheless, the family remained prosperous enough that Modjeska's mother decided to send both Modjeska and her sister Josephine to the convent school, which they were escorted to and from by the family maid.

At St. Joseph, Modjeska studied Polish history, grammar, math, Greek and Roman history, and music. By age 14, she had developed a special admiration for Polish poets such as Adam Mickiewicz and Juliusz Slowacki, but she showed disdain for anything connected with Germany or the German language. When the Austrian school inspector visited the school, the sisters took care to make sure that Helena was not asked to answer any "German questions."

Modjeska, a self-described "rebellious" child who liked to develop her own interests, later wrote: "I cannot be grateful enough to my dear mother for never encouraging my inclination to the stage." Two of her half-brothers, Joseph and Felix Benda, were interested in the stage, however, and eventually took up theatrical careers. When her brothers staged amateur theatricals at home, they also played the female roles; Modjeska was not allowed to join in. After the brothers grew to adulthood, the younger Modjeska organized her own family theatricals.

When Modjeska was 12, a Pole with a German name, Gustav Sinnmayer, began to live with her family. Sinnmayer opened her eyes to the classics and to the world outside Cracow, introducing her to the German writers Johann Wolfgang von Goethe and Johann C.G. von Schiller. He took her to see a Schiller play, explaining the plot as the action unfolded onstage. As a result, she reported that she "thought better of the Germans" and began, the next morning, to read Schiller's plays, with the help of a German dictionary. "By the time I came to [the play] *Mary Stuart*, I understood German quite well," she reported. She also discovered the plays of William Shakespeare, particularly *Hamlet, The Merchant of Venice*, and *Two Gentlemen from Verona*.

After she graduated from the St. Joseph school at the age of 14, Modjeska continued to

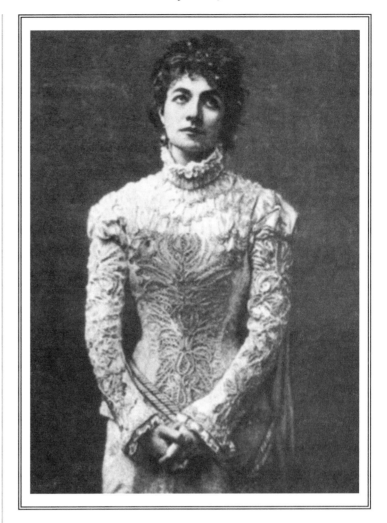

educate herself by reading, both alone and in family groups, from the writings of Polish poets, as well as from the English writers Charles Dickens and Walter Scott, and the French playwright Alexander Dumas *père*. She also tried her hand at playwriting, creating, at age 14, a play about the Greek struggle for independence from Turkey.

Some writers think that Modjeska's mother had sent her daughter to the convent school with the specific goal of preparing her to be the bride of Sinnmayer, who was 20 years older. Accounts of her life are vague regarding her marriage to Sinnmayer. One writer insists that Sinnmayer preferred a quick and quiet wedding when Modjeska became pregnant, but that Modjeska's mother would have none of it, instead inviting more than 60 relatives to the wedding. (In her autobiography, Modjeska told of Sinnmayer's proposal of marriage to her, but she did not mention details of a wedding, nor did she provide a wedding date.) As a gesture to his bride, Sinnmayer gave himself a Polish last name (Modrzejewski), telling her that she would not

have to carry a German name. When she began appearing on stage—her first public performances, at age 16, were in plays such as *Camille*—she gave herself a simplified version of his adopted name—"Modjeska."

Their son Rudolph Modrzejewski—later a prominent bridge designer and builder in the United States—was born "prematurely." In the resulting scandal, the couple decided to leave Cracow and take up residence in Bochnia, a provincial town famous for its salt mines, which they chose because Sinnmayer owned land there.

Sinnmayer arranged for her to appear in plays at the local theater, as well as at a theater in Rumania. By 1862, their company had grown to 32 members. Because the group often played in the German-controlled section of Poland, the company allied itself with a German theater company, and the two theatrical troupes alternated theater dates.

To get out of myself, to forget all about Helena Modjeska, to throw my whole soul into the assumed character, . . . to be moved by its emotions, thrilled by its passions, . . . —in one word, to identify myself with it and reincarnate another soul and body, this became my idea.

—Helena Modjeska

Modjeska's performances included serious plays by the French writer Victor Hugo and plays by Polish writers, including the comedy *Sluby Panienskie* (*A Maiden's Vow*) by Aleksander Fredro, whom she described as "our Polish Molière." Deciding that beauty alone was no guarantee of success on the stage, Modjeska began to spend several hours a day working on improving the quality of her voice, partly to add deeper tones—"trying to get my voice one shade lower every time."

A daughter, Marylka, was born in 1862, only two hours after Modjeska had appeared in an exhausting five-act play. After Marylka died in 1865, Sinnmayer disappeared from Modjeska's life, but exactly what happened is blurred. In her memoirs, Modjeska insisted that Sinnmayer abandoned her after the death of their daughter and that she never saw him again. One writer insisted that Sinnmayer died under "mysterious circumstances" in a salt mine, although it was unclear whether from suicide or from a fatal injury incurred in a fight.

Proclaiming the "disappearance" of Sinnmayer to be "God's will," Modjeska announced that she would continue to appear on the stage in order to support herself and her son. In 1865, she accepted an offer of a contract with a theater in Cracow. While there, she noticed in the audience a man with a "memorable face and a slightly sarcastic smile," and she asked a fellow actor who the "intelligent-looking young man" was. She was told that he was Count Bozenta Chlapowski, a member of a prominent Polish noble family who had gained fame for serving the armies of the French emperor Napoleon Bonaparte (seen by Poles as a possible "liberator" from foreign rule). They spent increasing amounts of time together. "He admired my Polish," said Modjeska, "while I admired his French." He read to her from the French writer Alphonse de Lamartine; she read to him from the works of Polish poets.

Their marriage, on September 12, 1868, was viewed as unconventional by Polish high society. She admitted that marriages of actresses into aristocratic families were rare events in Poland "where there still exists a great many old prejudices and notions." Their home became a gathering place for Polish writers and artists, but she was criticized for continuing her career; wives of nobles were expected to devote their time to family social matters. Although Modjeska attributed the criticism to jealousy by other actors, she was hurt when another theatrical company parodied the newly married couple. Yet the marriage did have career advantages: during the same year as her marriage, she was invited to appear in the Warsaw Imperial Theater.

Although she had been preparing to appear in German plays, in 1874 she abandoned that idea and began to learn English. One reason for the change was her fascination with Shakespeare. Another was her husband's increasing interest in establishing a Polish agricultural "colony" in the United States. Their friend Henryk Sienkiewicz, the author of *Quo Vadis,* was writing to them from the U.S., telling of the large number of Polish emigres that he had encountered. Another friend, the Shakespearean actor Maurice Neville, was praising the freedom he had found in the United States, adding that it was a country "hungering for culture."

The couple set out for America in 1876, spending a brief time in New York City before traveling on. They eventually reached the Pacific coast via a land crossing of the Isthmus of Panama. Modjeska's first impressions of New York City and the U.S. were not positive. She did not like New York, with its "millions of buses, iron railways, and such a mass of signboards . . . that

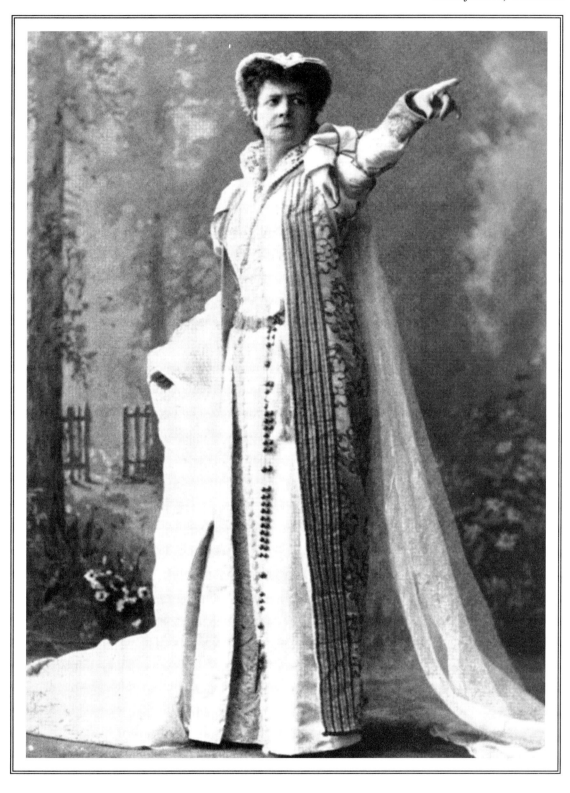

*Modjeska as
Mary Stuart.*

sometimes you couldn't tell the true color of the building. . . . And besides, the city is pretty dirty." She also thought that in America, "Men are appraised according to how much money they make. If the answer is, 'He's worth half a million,' no one asks where the half-million came from. On the other hand, if the answer is, 'He is a . . . scholar . . . but has no money,' nobody pays any attention to the poor devil."

After landing at Los Angeles in 1876, the couple traveled to the Anaheim area, where their

new colony, named "Arden," was established. The small number of men in the colony—who, for a time, included Sienkiewicz—worked in the fields, while Modjeska was the colony's cook. Both Modjeska and her husband were enchanted with the view of the Santa Ana mountains nearby, but they were not so happy with the "hot and sultry" Santa Ana winds. Inconsistent rain doomed the project; when crops began failing, and her husband lost some $20,000 in land speculation, Modjeska decided to learn English well enough that she could perform in the United States. Even though she would eventually perfect her command of the language, she was still speaking less-than-perfect English when she made her American debut at San Francisco in August 1877, playing the title role, in English, in *Adrienne Lecouvreur.*

Although Modjeska and her husband took out U.S. citizenships during the 1880s, only toward the end of her life did she come to regard the United States as a permanent residence. Much of her career, she lived in hotels, both in the U.S. and Europe. She returned to perform in Poland a number of times, with notable trips in 1882 and 1884–85. While she gave a number of performances in Poland during these visits, the trips were also opportunities to participate in memorable events, such as the 50th-anniversary jubilee of the publishing career of the Polish novelist Jozef Kraszewski in 1879. She became known for her generosity in participating in benefits in Polish theaters, and she was willing to do the same in America when Polish-American groups asked for her help.

On one occasion, performing in Poland cost her 10,000 rubles, a fine she had to pay because she had not taken a formal leave of absence when she went to the United States. Modjeska was convinced that the fine was a vindictive measure, instigated by the Russian authorities in Poland who were alarmed by the kind of reception Polish audiences gave her. In fact, her appearances on the stage in Russian-controlled Poland often became the occasion for patriotic demonstrations by her audiences. After one performance, men in the cheering crowd lifted her onto their shoulders and carried her down the center aisle of the theater. Russian governing officials, who were determined that such a scene would never be repeated, occupied all of the best seats at one of her subsequent performances, shutting out Poles who had already bought tickets.

When Modjeska spoke publicly about foreign occupation of Poland, she was especially critical of Russian authorities. She told American reporters: "The political condition of the Poles under Russia grows worse every day. . . . [T]he current tsar of Russia is a stupid blockhead. . . . [H]e thinks he can russify everything. . . . He has crushed the Poles, [and] now he is trying to drive the Jews out of Poland." When a group of Polish-American women asked her to speak on the topic of "The Organized Development of the Polish Women" at the Chicago World's Fair of 1893, she arrived dressed in the national colors of red and white. She gave a matter-of-fact talk, using many statistics. Before she finished, however, she referred to a broken drinking glass lying on the podium and added, "Like this glass now shattered, let the empire of the Russian tyrants be broken."

When a new tsar assumed the Russian throne in 1894, many Poles hoped that his government would adopt liberalizing policies. In this hopeful atmosphere, the Warsaw Imperial Theater invited Modjeska to appear on its stage. When Modjeska and her husband arrived in Warsaw, however, they were forced to meet with the Warsaw police chief, told that they were never to set foot on Russian soil again, and escorted back to their train by police. Still nurturing unhappy memories from her childhood of what life was like in the Austrian-occupied section of Poland, Modjeska decided not to perform there either. By 1902, she changed her mind; so, it appears, did Russian authorities. Invited to help raise money for a Cracow theater, she traveled to Europe in that year and performed in parts of both Russia and Austrian-occupied Poland.

The years between 1877 and 1905 were years of constant touring, as Modjeska traveled with her husband across the United States, playing in the larger cities such as Boston, Cleveland, New York, or St. Louis, as well as in smaller ones such as Quincy, Illinois. Following her San Francisco debut, she performed in New York City. She had to borrow train fare to go, but she found that she enjoyed the city, and especially Central Park, more than she had expected.

New York reviews were strongly favorable. Her *Adrienne Lecouvreur*, a play by the French dramatist Augustin Scribe, was a continued success; *Camille*, which she performed next in New York City, was a triumph. In subsequent tours of both American cities and European capitals such as London, Paris, and Vienna, Modjeska played an astonishing range of roles, more than 200 in all. Performing in either English or Polish, she showed great skill in both comedy and tragedy, exhibiting an acting style that was widely

praised for its naturalness. She gained a reputation for creating "warm, breathing characters" on the stage. Critics particularly mentioned her "large, dark, liquid eyes" and the "expressive low tones" of her voice.

Modjeska was disappointed that she could not make American audiences respond to Henrik Ibsen's *A Doll's House*, which had become a hit in Poland. Instead, she came to be known in the States mostly for her Shakespearean roles, particularly her performances as Rosalind in *As You Like It* and Juliet in *Romeo and Juliet*. It was often said that she did more to popularize Shakespeare in 19th-century America than any other theatrical figure. "Of all the English writers," she noted, "it was Shakespeare with whose works I felt most at home." Her Juliet was praised by one reviewer for its unique combination of "controlled passion and frenzied desperation."

Unlike other European actresses who appeared in America, Modjeska was at ease in talking with reporters. She understood the need to accommodate the constant demand for "publicity" in the U.S., and she allowed press releases to list her age as six years less than it actually was. With a reputation for being both generous and unpretentious, Modjeska usually did not ask to be addressed by the title of "Countess." American newspaper reports, however, often referred to her as "Countess Bozenta" or "Countess Chlapowski."

As her fame grew, her audiences increasingly included the famous and the socially prominent. When she played in Boston, the attendees included Oliver Wendell Holmes as well as Henry Wadsworth Longfellow, who, at more than 70 years of age, told her: "I have seen many actresses play Camille, but you, my dear, are far superior to all of them." In Washington, she met General William Sherman and Carl Schurz and was invited to call on first lady *Frances Folsom Cleveland* at the White House; in St. Louis, she was introduced to Eugene Field. In London, the prince of Wales came to see her perform "several times," she reported.

Modjeska showed no jealousy when, as early as the 1880s, two other European actresses began appearing in the United States—Bernhardt and Duse. After seeing Duse perform, Modjeska found her acting "extraordinary," although she believed that Duse's style was more "naturalistic and philosophical" than her own. Her opinion of Bernhardt was more qualified. When Bernhardt came to see Modjeska on stage, she arrived, carrying a large bouquet of flowers, during the middle of the second act. Seemingly

oblivious to the distraction she had caused in the audience, she visited backstage after the performance to congratulate Modjeska. Modjeska thought that the congratulations sounded less than sincere. But Modjeska's increasing age, and the emergence of Duse and Bernhardt, seemed to have a negative effect on her career. Although bookings became less frequent, Modjeska refused to appear in vaudeville, as many of her friends suggested. In fact, she turned down an offer of $60,000 a year to appear on one vaudeville circuit.

In 1903, she settled in Arden as her permanent home, but, missing the excitement of the stage, she did not remain there long. In 1905, she considered retiring because of lack of bookings before accepting an invitation to appear that year in a charity benefit at the New York Metropolitan Opera house. She withdrew from acting temporarily in 1906, after she suffered a bad fall in the home of friends in Los Angeles. In 1908, she was coaxed out of retirement to participate in a benefit for victims of the Messina earthquake. It was her last public appearance. The next month, she and her husband sold their holdings in Arden and moved to a large house on Bay Island (also named Modjeska Island), California.

When Modjeska died at her home on Bay Island on April 8, 1909, her death became an international event, reported as widely in Europe as in the United States. Funeral services, held in both in Los Angeles and in Poland, were attended by the pianist Ignace Paderewski and the writer Sienkiewicz, among others. Although over 80 years later, she is little known, she left a distinctive kind of legacy: a number of American geographical sites were named after her, including a waterfall in Nevada, and a town near Los Angeles. In Louisville, Kentucky, a local candy maker was so impressed with one of her performances that he named a candy after her.

As these honors demonstrated, Modjeska's legacy lay in the extent to which she stimulated the growth of the theater in the United States in the late 19th century. Her appearances were highly anticipated events, in both major American cities and small towns. For some members of her audience, it was their first glimpse of a Shakespeare comedy or tragedy. It was even said that she could keep an American audience enraptured by reciting the alphabet—which she sometimes did in Polish. During her 40-year career, her large American audiences believed that they could appreciate the Modjeska "magic," even if they could not always understand the language she was speaking.

SOURCES:

Coleman, Arthur. *Wanderers Twain: Modjeska and Sienkiewicz*. Cheshire, CT: Cherry Hill Books, 1964.

Coleman, Marion Moore. *Fair Rosalind: The American Career of Helena Modjeska*. Cheshire, CT: Cherry Hill Books, 1969.

Gronowicz, Antoni. *Modjeska: Her Life and Loves*. NY: Thomas Yoseloff, 1956.

Modjeska, Helena. *Memories and Impressions of Helena Modjeska: An Autobiography*. New York and London: Benjamin Blom, 1910.

SUGGESTED READING:

Kosberg, Martin. *The Polish Colony of California, 1876–1914*. San Francisco: R and R Research Associates, 1971.

Payne, Theodore. *Life on the Modjeska Ranch in the Gay 90s*. Los Angeles: n.p., 1962.

Sontag, Susan. *In America*. NY: Farrar, Straus & Giroux, 2000 (novel loosely based on Modjeska's life).

COLLECTIONS:

Significant collections of the papers and correspondence of Modjeska are in the Huntington Library, San Marino, California; the theater collection of Houghton Library, Harvard University; and (for her scrapbook) the theater collection of the New York City Public Library.

Niles Holt,
Professor of History, Illinois State University, Normal, Illinois

Mödl, Martha (1912—)

German mezzo-soprano and soprano. Born on March 22, 1912, in Nuremberg, Germany; studied with Klinck-Schneider at Nuremberg Conservatory.

Debuted as Hänsel in Nuremberg (1942); sang mezzo roles in Düsseldorf (1945–49) and Hamburg Staatsoper (1947–55); made Covent Garden debut as Carmen (1949); debuted at Bayreuth (1951–67); debuted at Metropolitan Opera (1957).

\mathcal{M}artha
\mathcal{M}ödl

Martha Mödl, whose singing career began late in life, did not perform on the operatic stage until she was 30; she attributed the longevity of her working life to this late start. Beginning as a performer of light mezzo-soprano repertory, Mödl then moved into more dramatic Wagnerian roles. At the first postwar festival held at Bayreuth in 1951, she appeared as Kundry in Wagner's *Parsifal*, later performing Isolde and Brünnhilde. She recorded the *Walküre* with the great conductor Wilhelm Furtwängler for EMI before recording the entire Ring cycle with the same conductor. These performances were a touchstone for all modern interpretations. In the 1960s, Mödl returned to roles in her natural mezzo range because the strain in her upper register had become more and more apparent. Mödl was a dominating stage presence as well as a powerful singer. Her performances at Bayreuth in the early 1950s remain the most memorable of her long career.

John Haag,
Athens, Georgia

Modotti, Tina (1896–1942)

Italian photographer—specializing in portraits, still lifes, architecture, and documentary work—and activist. Born Assunta Adelaide Luigia Modotti on August 16, 1896, in Udine, Italy; died on January 5, 1942, in Mexico City, Mexico; daughter of Giuseppe Modotti (a mason) and Assunta Modotti; married Roubaix de L'Abrie Richey (an American poet and painter), in 1917 (died 1922); no children.

Emigrated to United States (1913); lived in Los Angeles following marriage (1917); appeared in several films (1920–21); met photographer Edward Weston (1920); began liaison with Weston (1921); following death of husband, moved to Mexico with Weston as assistant, apprentice, model, and mistress (1922); took first serious photograph in Mexico (1923); began publishing work (1926); joined Communist Party (1927); met Vittorio Vidali (June 1927); began affair with Cuban revolutionary Julio Antonio Mella (June 1928); Mella assassinated (January 1929); although not involved, arrested, then deported following assassination attempt on Mexican president (February 1930); moved to Soviet Union (fall 1930); abandoned photography in favor of revolutionary party work (1931); left Soviet Union, was barred from entering Spain and moved to Paris (1934); joined Vidali in Spain (1935); active in Spanish Civil War (1936–39); returned to Mexico as a refugee (April 1939).

Although largely unrecognized as an artist and known primarily as the apprentice and mistress of American photographer Edward Weston before the 1970s, Tina Modotti has since assumed her place in the pantheon of important 20th-century photographers; she was also an ardent revolutionary and Communist Party member. Born Assunta Adelaide Luigia Modotti in 1896 in Udine, Italy, as a small child she was called "Assuntina," which gradually became "Tina." She was the second of six children of As-

sunta and Giuseppe Modotti, a mason who emigrated to the United States when she was a child. She worked at an Udine textile factory to help support the family during her father's absence, and in 1913 joined him in San Francisco, where she soon found work in a similar factory. After the rest of the family arrived in the United States, Modotti was the only one of the six children who worked. Eventually she left the factory, turning to dressmaking and delivery work to earn more money, and also took part in some amateur theater productions in the Italian quarter of the city. At the Pan Pacific International Exposition in San Francisco in 1915, she met Roubaix de L'Abrie Richey, or "Robo," an American poet and painter of French-Canadian ancestry. The couple married two years later and moved to Los Angeles, where in 1920 Modotti began to appear in films, usually cast as a Gypsy or a harem girl.

That same year she met photographer Edward Weston, whose aesthetic would influence much of 20th-century American photography. They began an affair in 1921, although it appears to have been no threat to her marriage. Seeking a more favorable artistic environment, Richey went to Mexico in December 1921. There he caught smallpox and died the following February. Modotti traveled to Mexico to handle the funeral arrangements for her husband, and returned there in 1923 with Weston, acting as his assistant, apprentice, and model. They lived in Mexico City, associating with artists and political revolutionaries. Modotti, who took her first serious photograph in Mexico in 1923, helped Weston provide photographs for **Anita Brenner**'s book *Idols behind Altars*. Modotti began to specialize in portraits, still lifes, architecture, and documentary photographs, and gradually produced a respectable body of work. She and Weston held a joint exhibit in 1925 at the State Museum in Guadalajara; they exhibited together again in 1926. That year, she also began publishing her work in the Mexican magazines *Formas* and *Mexican Folkways*. Her biographer **Mildred Constantine** notes that Modotti's work "attracted accolades not only from her fellow artists, but also from the thousands of workers who passed in awe before her irrefutable denunciations of the living conditions of the poor."

In 1926, Modotti and Weston separated, and he returned to his family in Glendale, California, although they remained devoted friends and corresponded regularly until 1931. By the time of his departure, she already may have become involved with Xavier Guererro, a revolutionary whom she had first met in Los Angeles in 1923. In 1927, she formally joined the Com-

Tina Modotti

munist Party and met Italian political activist Vittorio Vidali, who would become her mentor and, later, her companion. Modotti's reputation as a photographer continued to grow, and her work was much in demand, with requests from the Pacific International Salon of Photographic Art, the *British Journal of Photography*, and New York City's *Creative Art* magazine. During this time, she also often worked with the editor of *El Machete*, the official organ of the Mexican Communist Party. In June 1928, she met Cuban revolutionary Julio Antonio Mella, and by September they were living together. Their affair was to be short-lived, however, for in January 1929 Mella was assassinated while they walked to their apartment. An investigation cleared Modotti of any involvement, and implicated the Mexican government and police.

On February 5, 1930, President Pascual Ortiz Rubio was the victim of an assassination attempt soon after his inauguration. Although she had not been involved, Modotti was arrested and accused of being a party to a conspiracy to kill the president. She was detained for 13 days and then deported from Mexico. Modotti had refused the visa the United States had offered her on condition that she cease her political activity,

and so she sailed for Europe. In Rotterdam, met with the news that Italy was demanding her extradition, she was granted temporary asylum under the condition that she leave Dutch territory immediately. Communist Party associates arranged for her entry to Germany, and she spent the next six months in Berlin before moving to the Soviet Union in the fall of 1930. There she renewed her friendship with Vittorio Vidali.

Although photography was a respected occupation, having enjoyed a significant role in the development of the Soviet arts scene in the 1920s, Modotti appears to have abandoned her camera after 1931 in favor of full immersion in political activity. For the next several years, she worked for the Soviet International Red Aid, both inside the Soviet Union and in Europe. In 1934, she left Moscow to join Vidali in Spain, where he had been living since the Spanish Republic had superseded the monarchy in 1931. She was turned back at the border, however, and lived temporarily in Paris, supporting herself by translating and continuing to work for the Communist underground. At the end of 1935, Modotti was finally allowed entry into Spain. The Spanish Civil War began in July 1936, and, as "Maria," she worked with Vidali as a Republican revolutionary. Vidali, known as "Carlos Contreras," formed the famed Fifth Regiment, in which Modotti enlisted. She worked at the front and also as a reporter for the Spanish Red Aid weekly, *Ayuda*. When Franco's Nationalists won the war in 1939, Modotti returned as a refugee to Mexico, where the political climate had changed in her absence.

There, Modotti worked as a translator and continued to function as a political activist. In the early 1940s, she returned to photography, but on January 5, 1942, after leaving a friend's home late at night, she died in the back seat of a taxi. Although it was persistently rumored that she had been poisoned, it is more likely that she suffered a massive heart attack. Thousands of mourners attended her funeral, after which she was buried at the Pantheon of Dolores.

SOURCES:
Constantine, Mildred. *Tina Modotti: A Fragile Life*. San Francisco, CA: Chronicle Books, 1993.
Publishers Weekly. September 4, 1995.
Rosenblum, Naomi. *A History of Women Photographers*. NY: Abbeville Press, 1994.

SUGGESTED READING:
Albers, Patricia. *Shadows, Fire, and Snow: The Life of Tina Modotti*. NY: Clarkson Potter, 1999.
Hooks, Margaret. *Tina Modotti: Photographer and Revolutionary*. San Francisco, CA: Harper, 1993.
Lowe, Sarah M. *Tina Modotti: Photographs*. NY: Abrams, 1995.

Ellen Dennis French,
freelance writer, Murrieta, California

Modthryth (fl. 520)
German princess and warrior. Name variations: *Modthrith. Flourished in 520 in Germany.*

A fierce warrior, Modthryth was the daughter of the king of a Germanic tribe. The early Middle Ages, with its conglomeration of tribal kingdoms and petty warfare, saw a flourishing of opportunity for sword-bearing women to rise to fame. It is difficult to separate fact from fiction in the lives told of women like Modthryth, who became the basis of several characters in epic literature; still, it is clear that she was well schooled in the art of warfare, and that she proved a formidable foe to the men who challenged her or perhaps even, it is reported, dared seek her hand in marriage.

Laura York,
Riverside, California

Modwenna (d. 518)
Saint. Name variations: *Moninne. Died in Dundee in 518; buried at Burton-on-Trent; daughter of the king of Iveagh.*

Said to have been blessed by St. Patrick, Modwenna was an Irish princess who founded churches at Louth, Wexford, Kileevy, Armagh, Swords, and the Aran Islands. She also journeyed "with other maidens" to England where she established churches from Warwickshire to Dundee, Scotland. She died in Dundee in 518.

Moe, Karen (1952—)
American swimmer. Name variations: *Karen Patricia Moe. Born in Santa Clara, California, on January 22, 1952.*

Karen Moe was born in Santa Clara, California, in the early 1950s. Always an avid swimmer, she began training in earnest when the women's Olympic swimming program expanded for the 1968 Games. At the 1972 Olympics in Munich, Moe became the first American woman to win a gold medal in the 200-meter butterfly, with a time of 2:15:57. (Americans **Lynn Ann Colella** and **Ellie Daniel** won the silver and bronze medals in the same event.) Moe returned to the Olympics in Montreal in 1976, and although she improved her time in the 200-meter butterfly to 2:12:90, other competitors had also improved, and she finished fourth. Moe retired from competitive swimming following the 1976 Games.

Grant Eldridge,
freelance writer, Pontiac, Michigan

Moffat, Gwen (1924—)

British mountaineer who became the first woman to qualify as a climbing and mountaineering guide. Born Gwen Goddard in Brighton, England, in July 1924; married Gordon Moffat, in 1949; married Johnnies Lees, in 1952 (divorced 1969); children: Sheena (b. 1949).

Selected writings: Space Beneath my Feet *(Hodder & Stoughton, 1961);* Two Star Red *(Hodder & Stoughton, 1964);* On My Home Ground *(Hodder & Stoughton, 1968).*

At age 22, Gwen Moffat began climbing in Wales, after a stint with the Land Army and an unauthorized leave from the Auxiliary Territorial Service. (She would serve time for this youthful indiscretion.) After obtaining her hard-won Guide's Certificate, she became the first qualified female rock climbing and mountaineering guide in Britain. Moffat began writing around her climbing career; she also wrote crime novels and books on the environment.

Moffatt, Mary (1820–1862).

See Livingstone, Mary Moffatt.

Moffatt, Mary Smith (1795–1870)

British missionary to Africa. Born Mary Smith in 1795 in New Windsor, England; died in 1870 in England; daughter of James Smith and Mary (Gray) Smith; married Robert Moffatt (a missionary), on December 27, 1819; children: ten, including Mary Moffatt Livingstone (1820–1862, who married David Livingstone), and several who died.

Born in 1795 in New Windsor, England, Mary Smith Moffatt grew up in Dukinfield, England, the daughter of James Smith, a Scotsman, and **Mary Gray Smith**. Her education at a Moravian school in England fostered in her a desire to pursue a life of "Christian service," and as a young woman she became engaged to missionary Robert Moffatt. When she was 24, she sailed to South Africa, where they were married in Cape Town in December 1819. The couple then journeyed 600 miles inland to Kuruman, in the interior of Cape Province, living initially in a mud hut. Their first child, *Mary Moffatt Livingstone, who would later marry the missionary and explorer David Livingstone, was born there in 1820, and Moffatt would have nine more children, several of whom died young.

The first years of the Moffatts' efforts to convert the local tribes to Christianity were made difficult by language barriers as well as by the resistance of the tribespeople themselves, who balked at attempts to make them into "Dutchmen." In 1828, however, the locals began embracing Christianity in record numbers, and the mission enjoyed a time of new peace and prosperity. Moffatt and her husband journeyed to England for a time in 1839, then returned to the mission at Kuruman Station. In 1870, when she was 75, they finally retired from missionary work and returned to England, where Moffatt died soon after their arrival.

SOURCES:
Deen, Edith. *Great Women of the Christian Faith.* NY: Harper & Row, 1959.

Ellen Dennis French,
freelance writer, Murrieta, California

Moffitt, Billie Jean (b. 1943).

See King, Billie Jean.

Moffo, Anna (1932—)

American soprano. Born on June 27, 1932, in Wayne, Pennsylvania; daughter of Nicolas Moffo (a shoemaker) and Regina (Cinti) Moffo; graduated (as valedictorian) from Radnor High School, in Wayne, Pennsylvania; studied at the Curtis Institute of Music, Philadelphia, Pennsylvania, with Giannini-Gregory and at the Accademia di Santa Cecilia, in Rome, Italy, with Luigi Ricci and Mercedes Llopart; married Mario Lanfranchi (a film director and later her manager), on December 8, 1957 (divorced 1972); married Robert Sarnoff (former RCA chair), in 1974 (died 1997); no children.

An American-born soprano of international renown, Anna Moffo was also one of the first opera stars to be acclaimed for her looks as well as her singing. Following her Metropolitan Opera debut in November 1959, Harold C. Schonberg of *The New York Times* called her "one of the most beautiful women ever to grace the stage of an opera house."

Although her talent blossomed at an early age, Moffo did not settle on a singing career until she was in her late teens. Born to Italian-Americans in Wayne, Pennsylvania, in 1932, she made her stage debut at age seven, singing a rendition of "Mighty Lak a Rose" for a school assembly. She continued to perform at family and community events throughout her childhood, but remained untrained. In high school, she excelled in academics and also played on the tennis and basketball teams. After graduating at the head of her class, she was offered a Hollywood film contract which she declined, saying she intended to become a nun. Moffo soon changed her mind,

however, and began preparing for a singing career. She spent four years at the Curtis Institute of Music in Philadelphia, then enrolled at Rome's Accademia di Santa Cecilia under a Fulbright grant. Her early engagements included radio performances and an appearance in an Italian television production of *Madame Butterfly*, staged by Mario Lanfranchi, who later became her husband and manager. They would marry in 1957.

In 1955, Moffo made her stage debut in Spoleto, Italy, as Norina in *Don Pasquale*, and in 1957 she appeared at La Scala in *Falstaff*. In the fall of that year, she also made her American debut, singing the role of Mimi in *La Bohème* with the Lyric Opera of Chicago. Her Metropolitan debut in 1959 was as the fragile consumptive Violetta in *La Traviata*, a role that some critics found too ambitious for the young singer. Moffo returned to the Met for the 1960–61 season to sing three new roles: Gilda in *Rigoletto*; Adina in the farcical *L'Elisir d'Amore*; and the slave girl Liù in a lavish production of *Turandot*, which also included **Bir-

git Nilsson** and Franco Corelli in leading roles. "Miss Moffo has a fine voice and excellent ear," wrote Paul Henry Lang in the *Herald Tribune* of her performance in *Rigoletto*, "and she knows what to do with both. She can sing a delectable pianissimo and although obviously a dramatic soprano, she is entirely at home in the coloratura passages—the staccatos were clear and on the dot."

Moffo enjoyed a 17-year run with the Met, during which time she gave 220 performances in 18 operas. Throughout her career, the singer also found many additional avenues by which she reached new audiences. Always active in television, she had her own series in Italy, "The Anna Moffo Show," which ran from 1960 to 1973. She also appeared in over 20 films (including several in which she played straight dramatic roles), and made numerous recordings, including *La Traviata*, *Madame Butterfly*, *La Rondine*, and *La Bohème* with **Maria Callas**.

Moffo was divorced from Lanfranchi in 1972, and in 1974 married former RCA chair Robert Sarnoff, who would die in 1997. In 1974, Moffo also suffered a vocal breakdown, but fortunately was able to resume her career in 1976. Through the years, the singer continued to expand her repertoire; during the late 1970s, she began singing the heavier Verdi roles, such as Leonora in *Il Trovatore* and Lina in *Stiffelio*. In 1991, she added the title role in Bellini's *Norma*. Recently, Moffo received an honorary degree from her alma mater, the Curtis Institute, and on November 14, 1999, she celebrated the 40th anniversary of her Metropolitan debut.

SOURCES:
Moritz, Charles, ed. *Current Biography 1961*. NY: H.W. Wilson, 1961.
New York *Herald Tribune*. January 20, 1961.

Anna
Moffo

Mogador, Céleste (1824–1909).
See Chabrillan, Céleste de.

Mohawk Princess, The (1861–1913).
See Johnson, E. Pauline.

Mohl, Mary (1793–1883)

English salonnière. Name variations: Madame Mohl. Born Mary Clarke in 1793; died in 1883; educated in a convent school; married Julius Mohl (an orientalist), in 1847.

For 40 years, Madame Mohl's receptions in Paris were attended by the city's literati. Among

her friends were Madame *Juliette Récamier and Chateaubriand.

Moholy, Lucia (1894–1989)

Czech photographer and filmmaker. Name variations: Lucia Moholy-Nagy. Born Lucia Schultz or Schulz in Karlin, Austria-Hungary, in 1894; died in Zurich, Switzerland, in 1989; graduated from Prague University, 1912; married László Moholy-Nagy (a photographer and artist), in 1921 (divorced).

Lucia Moholy was born Lucia Schultz in 1894 in Karlin, a small town near Prague in what is now the Czech Republic. She studied history and philosophy at Prague University, from which she graduated in 1912. Moholy worked as an editor for various publishers from 1915 to 1918, when she became an art and theater critic. She met the Hungarian-born photographer László Moholy-Nagy in 1920, married him the following year, and subsequently obtained Hungarian citizenship. When her husband became a member of the prestigious Bauhaus school of architecture, the couple moved to Weimar, Germany, where Moholy took a position as an apprentice in the Ecknar photographic studio from 1923 to 1924. The Moholys followed the Bauhaus school when it moved to Dessau, Germany, in 1925, and during that year and the next compiled a historic series of photographic portraits of the school's teachers and their associates. In 1929, Moholy left the Bauhaus to move to Berlin, where she made photographs of her husband's stage designs. The following year, she served as curator of the historical section of the Stuttgart *Film und Foto* exhibition.

Moholy separated from her husband in 1929 after he fell in love with the assistant who would later become his second wife, *Sibyl Moholy-Nagy. After her divorce, she moved to Paris in 1933 and the following year to London, where she opened a photographic portrait studio. Moholy wrote a history of photography in 1939, and supplemented her income by freelancing for a variety of British publications. She became a British citizen in 1940. The United Nations Educational, Scientific, and Cultural Organization (UNESCO) commissioned her to film the cultural heritage of the Near and Middle East in 1946, and she was named a member of the Royal Photographic Society of Great Britain in 1948. Moholy moved to Switzerland in 1959 and died in Zurich in 1989.

SOURCES:

Rosenblum, Naomi. *A History of Women Photographers.* NY: Abbeville Press, 1994.

Grant Eldridge,
freelance writer, Pontiac, Michigan

Moholy-Nagy, Sibyl (1903–1971)

German-born American architectural historian and critic. Born Dorothea Maria Pauline Alice Sibylle Pietzsch in Dresden, Germany, on October 29, 1903 (some sources cite 1893); died in New York City on January 8, 1971; daughter of Martin Pietzsch and Fanny Clauss Pietzsch; studied at the universities of Frankfurt am Main and Leipzig; married Lazzlo also seen as Laslo or László Moholy-Nagy (1895–1946, a Hungarian-born artist), in 1932; children: daughters, Claudia Moholy-Nagy and Hattula Moholy-Nagy.

Sibyl Moholy-Nagy had several careers that were interrupted but never halted by marriage, motherhood, and the political upheavals that convulsed Central Europe in the 1930s. In Europe, she worked as an actress, writer, and artistic collaborator of her husband László Moholy-Nagy, one of the most innovative teachers at pre-Hitler Germany's Bauhaus school of design. After his death, she launched a successful career of her own in America as a teacher and writer, quickly becoming a major voice in the field of architectural history and criticism who was respected for her scholarship as well as for her astute, sometimes controversial, opinions.

Born Sibyl Pietzsch in Dresden in 1903, she grew up in an artistic and intellectual environment. Her architect father Martin Pietzsch was director of the Dresden Academy of Art, and the latest ideas in art, literature, and philosophy were discussed over the dinner table. She graduated from the prestigious Dresden-Neustadt Municipal Lyceum and went on to study at the universities of Frankfurt am Main and Leipzig. Soon drawn to a career on the stage, Sibyl appeared in various plays in Berlin, Breslau, and Frankfurt am Main. A versatile actress, she played in both parlor comedies and Shakespearean roles. She accepted a position as head of the dramatic department of the Tobis motion-picture syndicate, where most of her work centered on writing and upgrading movie scripts. During this time, she met Hungarian-born artist László Moholy-Nagy.

Born in a small village in southern Hungary, László was on the threshold of a promising career as an artist when he went into exile in 1919 after the collapse of the Hungarian Soviet Re-

public, which he and many intellectuals had supported. After a brief stay in Vienna, he went to Berlin, where innovation in the arts flourished under the liberal regime of Germany's Weimar Republic. Within a brief time, László had joined a circle of avant-garde artists in Berlin which included such noted innovators as Raoul Hausmann and Hans Richter, leading exponents of the Dada philosophy, as well as the leader of the Dutch De Stijl group, Theo van Doesburg, and the Russian constructivist El Lissitzky. In January 1921, László married Lucia Schultz (*Lucia Moholy), who collaborated with him on many of his pioneering photographic projects, including the photogram technique, in which, by placing objects on photographic film or paper and exposing them to light, a cameraless image is created. By 1922, he had come to the attention of Walter Gropius, director of the famous Bauhaus school of design in Weimar. In April 1923, not yet 28, László joined the Bauhaus faculty as head of the school's metal workshop and was responsible for its preliminary course (Vorkurs), becoming the institution's youngest master teacher.

Starting in 1926, he began working with Sibyl Pietzsch of the Tobis film syndicate to produce a series of highly innovative motion pictures that remain cinema classics to this day. The first of these was *Berliner Stilleben* (Berlin Still Life), which would be followed by *Marseille Vieux Port* (The Old Port of Marseille, 1929) and *Ein Lichtspiel: Schwarz, Weiss, Grau* (Lightplay: Black, White, Gray, 1930), which features László's much-discussed Light-Space Modulator, a kinetic sculpture designed to display light. By 1929, László's marriage was in crisis, and he separated from Lucia. Sibyl's relationship with him, which had begun as an artistic collaboration, was now much more than that, and in 1932 the couple married. That same year, László, collaborating with Sibyl, released another innovative film entitled *Grossstadt-Zigeuner* (Gypsies of the Metropolis). The most interesting feature of the film was its reliance on jumpcut editing, which emphasized motion. By early 1933, the Nazis had come to power in Germany and progressive artists like the Moholy-Nagys found themselves on the losing side of what had been for years not only a political but also a cultural war. They were further endangered because László was considered Jewish by the new regime even though he had no religious affiliations and had been raised as a Calvinist Christian during his youth in Hungary.

By 1934, László had been able to reestablish his artistic career in Amsterdam, continuing his work in photography, particularly in the area of color processing. The Dutch rayon industry commissioned him to create an exhibition of its products and production methods. Nonetheless, economic prospects for refugees from Nazi Germany in the Netherlands were less than ideal, and, since Sibyl had by now given birth to two daughters, the family moved to London in May 1935. For the next two years, she concentrated on raising their children while her husband collaborated on three books, including one with John Betjeman, *An Oxford University Chest*. Informally, Sibyl provided advice to her husband on his various projects, which included production of films as well as display and art designs for the menswear store Simpson's of Picadilly. With war clouds gathering on the European horizon, the Moholy-Nagys were enthusiastic when László received an invitation from the Chicago Association of Arts and Industries in June 1937 to emigrate to the United States to take up an important post. Having been recommended by Gropius, who was now head of the Department of Architecture at Harvard University, László was appointed director of the New Bauhaus, American School of Design. With an innovator like László at its head, and backed by wealthy individuals such as Marshall Field as well as by a number of major Midwestern corporations, the school appeared to have bright prospects when its doors opened on October 18, 1937.

Unfortunately, both László and his prominent business supporters had been too optimistic about the chances of transplanting the ideas of Weimar Germany's design visionaries to an America still not completely free of a depression mentality. The United States was not yet ready for such new concepts, and—with the nation's economy fragile at best despite more than five years of New Deal legislation—the New Bauhaus, American School of Design was forced to close its doors in December 1938. In turn, László opened the School of Design (later known as the Institute of Design, or "I.D.") in Chicago in 1939. Funding for the "I.D." came from his own limited resources and support from the Container Corporation of America's Walter Paepcke.

Sibyl collaborated with László during the war years and also began a teaching career of her own. Starting in 1941, she headed the humanities division at the School of Design, teaching courses that investigated the history of architecture and current issues in architectural theory and practice. László's achievements during this period included designing the Parker "51" pen and developing an art program for the rehabili-

tation of wounded war veterans. He was continuing his work, which included experiments with the new material of Plexiglas, when he became ill and was diagnosed with leukemia in July 1945. László did not stop working and was honored with a retrospective exhibition—the only one in his lifetime—at the Cincinnati Museum of Art which opened in February 1946. He was sworn in as a naturalized U.S. citizen in April and would live less than another year, dying in Chicago on November 24, 1946. In the final months of his life, László and Sibyl worked together on his last book, *Vision in Motion*, which she saw through the editorial process. Published posthumously in 1947, *Vision in Motion* was quickly recognized as a standard treatise for art and design education throughout the world.

After the initial shock of his death had passed, Sibyl, whose experience in the art world was rich and varied, determined to continue with her own career. She needed to support her daughters and was confident that she would be able to make significant contributions of her own. Sibyl resigned from her assignment at the Institute of Design and from 1947 through 1949 was an associate professor of art at Bradley University. In 1950, she published her first major work, an account of the life of her late husband. Entitled *Moholy-Nagy: Experiment in Totality*, the book was well received. It became a classic study of László's life, work, and aesthetic philosophy, and appeared in a second edition in 1969.

By the early 1950s, Sibyl was well established in a career as a teacher and writer. She lectured at the University of California, Berkeley, from 1949 through 1951. Many readers looked forward to her articles in the architectural press which invariably revealed strong opinions, persuasively expressed. At New York City's Pratt Institute, where she became a professor of the history of architecture in 1951, she was seen by her students, in the words of William H. Jordy, as "an eloquent historian and sharp critic of architecture and design." Scarcely a month went by without an article of hers appearing in *Progressive Architecture* or other leading professional journals. Never one to mince words—and fearless when it came to taking on the high priests of architecture—she was one of the first to raise basic questions about both the aesthetic quality and social utility of modern architecture. Her comments on the sterile glass and steel towers of Mies van der Rohe's 1951 Lake Shore Drive apartment buildings were remarkably prescient, noting that the units stifled human impulses for interaction through their unrelenting uniformity, how little privacy they provided, and how much they lacked the quality of simple humanity in their lightless and airless bathrooms and kitchens, impassable dining bays, and living rooms facing each other.

Speaking at a session of the Symposium of Modern Architecture held at Columbia University in 1964, she was one of the first to publicly accuse van der Rohe, who was at that time still alive and enjoying immense international prestige as one of the founding fathers of modern architecture, of having collaborated with the Nazi regime before he left Germany for the United States in 1937. As an anti-Nazi German of impeccable credentials, Moholy-Nagy characterized van der Rohe as having been "a traitor to all of us and a traitor to everything we had fought for." Van der Rohe had been the only leading Bauhaus artist to sign an appeal to German artists and intellectuals, urging them to support Hitler and his regime, that was published in the Nazi newspaper *Völkischer Beobachter* in 1934—an act that Moholy-Nagy continued to regard as nothing less than "a terrible stab in the back for us."

In the last years of her life, Moholy-Nagy felt some sense of accomplishment that derived from her life and ideas. She attempted to pass on her own and her husband's ideals to the next generation, not only in her books and articles but also through lectures and interaction with students at the Pratt Institute, Harvard University, the Massachusetts Institute of Technology, and other centers of architectural excellence. She wrote several books that received an enthusiastic reception from both architectural circles and a more sophisticated reading public. A few days before her death in New York City on January 8, 1971, Sibyl Moholy-Nagy received word that she had been named "critic of the year" by the American Institute of Architects.

SOURCES:

"Architectural Criticism: Four Women," in *Progressive Architecture*. Vol. 58, no. 3. March 1977, pp. 56–57.

Bauhaus-Archiv. *Bauhaus Berlin: Auflösung Dessau 1932, Schliessung Berlin 1933, Bauhäusler und Drittes Reich*. Berlin: Kunstverlag Weingarten, 1985.

Hochman, Elaine S. *Architects of Fortune: Mies van der Rohe and the Third Reich*. NY: Weidenfeld & Nicolson, 1989.

Hofner-Kulenkamp, Gabriele. "Versprengte Europäerinnen: Deutschsprachige Kunsthistorikerinnen im Exil," in *Exilforschung: Ein internationales Jahrbuch*. Vol. 11, 1993, pp. 190–202.

Jordy, William H. "The Aftermath of the Bauhaus in America: Gropius, Mies, and Breuer," in Donald Fleming and Bernard Bailyn, eds., *The Intellectual Migration: Europe and America, 1930–1960*. Cambridge, MA: The Belknap Press of Harvard University Press, 1969, pp. 485–526.

Kostelanetz, Richard. *Moholy-Nagy*. NY: Frederick A. Praeger, 1970.

Moholy-Nagy, Sibyl. *Carlos Raul Villanueva and the Architecture of Venezuela*. NY: Frederick A. Praeger, 1964.

———. "The Diaspora," in *Journal of the Society of Architectural Historians*. Vol. 24. March 1965.

———. *Matrix of Man: An Illustrated History of Urban Environment*. NY: Frederick A. Praeger, 1968.

———. *Moholy-Nagy: Experiment in Totality*. 2nd ed. Cambridge, MA: MIT Press, 1969.

———. *Native Genius in Anonymous Architecture in North America*. NY: Schocken Books, 1976.

Passuth, Krisztina. *Moholy-Nagy*. NY: Thames and Hudson, 1987.

"Sibyl Moholy-Nagy, Architectural Critic, Is Dead," in *The New York Times Biographical Edition*. January 9, 1971, p. 75.

COLLECTIONS:

Sibyl Moholy-Nagy Papers, Smithsonian Institution Archives of American Art, Washington, D.C.

John Haag,
Associate Professor of History,
University of Georgia, Athens, Georgia

Mohun, Elizabeth

*Countess of Salisbury. Name variations: Elizabeth Montacute. Daughter of John Mohun, 2nd baron Mohun of Dunster, and *Joan Mohun; sister of *Philippa Mohun (d. 1431); married William Montacute (1328–1397), 2nd earl of Salisbury; children: William Montacute (d. 1382).*

Mohun, Joan

*Baroness Mohun of Dunster. Name variations: Joan Burghersh. Born Joan Burghersh; daughter of Bartholomew Burghersh, 3rd baron Burghersh, and Elizabeth Verdon; married John Mohun, 2nd baron Mohun of Dunster; children: *Philippa Mohun (d. 1431); *Elizabeth Mohun, countess of Salisbury.*

Mohun, Philippa (d. 1431)

*Duchess of York. Died on July 17, 1431; buried in Westminster Abbey; daughter of John Mohun, 2nd baron Mohun of Dunster, and *Joan Mohun; sister of *Elizabeth Mohun, countess of Salisbury; married Edward Plantagenet, 2nd duke of York, in 1396 (d. 1415).*

Mohzolini, Anna (1716–1774).

See Manzolini, Anna Morandi.

Moillon, Louise (1610–1696)

French still-life painter. Born in 1610 (some sources cite 1615, others 1609) in Paris; died in 1696 in Paris; daughter of Nicolas Moillon (a painter and picture

dealer) and Marie Gilbert; married Etienne Girardot (a wood merchant), in 1640; children: at least three.

Selected paintings: The Fruit Seller *(1629);* At the Greengrocer *(1630);* Basket of Fruit with a Bunch of Asparagus *(1630);* A Dish of Grapes with Figs *(1631);* Basket of Apricots *(1635);* Still Life with Grapes and Vine Leaves *(1637);* Still Life with Grapes, Melons, Squashes and Apples *(1637);* The Lunch *(n.d.);* Still Life of Curaçao Oranges *(n.d.);* Still Life with Peaches, Asparagus, Artichokes and Strawberries *(n.d.). Most paintings produced before 1642; career resumed in 1670s.*

Although still-life painting originated in the Low Countries of Flanders and the Netherlands at the beginning of the 16th century, Louise Moillon, whose contemporaries included Jean Picart, Lubin Baugin, and Pierre Dubois, is considered a pioneer of the genre in France, having produced most of her dated works before 1642. Art historians **Ann Sutherland Harris** and **Linda Nochlin** unequivocally call Moillon "one of the finest still-life painters of the first half of the 17th century in France." Her works are primarily studies of fruit, although she also occasionally painted vegetables; several of her paintings, notably *The Fruit Seller* (1629) and *At the Greengrocer* (1630), also successfully integrate human figures within the still-life composition.

Moillon was born in Paris in 1610, one of seven children of Nicolas Moillon, a Protestant painter and picture dealer, and **Marie Gilbert**, the daughter of a goldsmith. Although she may have received her earliest artistic instruction from her father, he died when she was about nine, and it is generally agreed that the man her mother soon married, François Garnier, was the more important influence on the young artist. Garnier was also a painter and picture dealer, and even before he married Moillon's mother he drew up documents providing for the sale of Moillon's future works, an indication that he saw great promise in the child.

Her earliest known work, dated 1629, is a still-life depicting peaches. More restrained than the riotous extravagance of the typical Dutch still-life, Moillon's paintings have been hailed for their elegance and beautiful composition, and more than 30 extant works have been attributed to her thus far. Most of these date from before 1642. Moillon married wood merchant Etienne Girardot in November 1640, and had at least three children, and it is speculated that the domestic responsibilities of marriage and motherhood interrupted her artistic career. She seems to have begun painting again in the 1670s. Her

last dated work, a still-life of peaches and grapes, is dated 1682, and hangs in the Museum of Strasbourg. Most of her known paintings are in private French collections, although *At the Greengrocer* hangs in the Louvre, and *Basket of Fruit with a Bunch of Asparagus* (1630) is held by the Art Institute of Chicago. Little is known about Moillon's later life except that, as a Protestant, she suffered persecution both before and after the 1685 revocation of the Edict of Nantes. She died in Paris in 1696.

SOURCES:

Harris, Ann Sutherland, and Linda Nochlin. *Women Artists: 1550–1950*. NY: Alfred A. Knopf, 1976.

Uglow, Jennifer S., ed. and comp. *The International Dictionary of Women's Biography*. NY: Continuum, 1989.

Ellen Dennis French,
freelance writer, Murrieta, California

Moisant, Matilde (c. 1877–1964)

Aviation pioneer who was the second American woman to receive a pilot's license and a partner of her brothers Alfred and John in the Moisants' airfield, flight school, plane factory and air circus. Name variations: Tudy, Tillie. Pronunciations: MOY-sant or MWAH-zawnt. Born Matilde Josephine Moisant on a farm near Manteno, Illinois, around 1877 or 1878; died in La Crescenta, California, in 1964; daughter of Medore Moisant and Josephine (Fortier) Moisant; attended public high school in Alameda, California; never married; no children.

Awards: Rodman Wanamaker Trophy (altitude record for women, September 24, 1911).

Spent childhood with French-Canadian immigrant parents on several farms in southern Illinois; on the death of her father, moved to Alameda, California, with her mother and six siblings (1887); departed Alameda for a sugar plantation owned by her oldest brother Alfred in Sonsonate, El Salvador (1909); left El Salvador for New York City (1910); earned pilot's license after 32 minutes of instruction (1911); led an air circus in Mexico in the midst of a revolution (1911); was a member of the Early Birds association; after a crash—the fifth of her career—at Wichita Falls, Texas (April 14, 1912), retired from flying and spent the remainder of her life in Los Angeles and La Crescenta.

Matilde Moisant was destined to be an active partner in the pioneering aviation business of her brothers, John and Alfred, and eventually to become a pilot of a Blériot XI, a frail aircraft built mostly of wood, cloth, and piano wire. But the beautiful and petite woman gained her goals by following the code of delicate femininity called for by the tenets of her time. She also chose to remain unmarried in an era when a single woman was regarded as pitiful. The sixth of seven children of French-Canadian immigrants Medore and **Josephine Moisant**, Matilde spent her childhood on various farms owned by her father in southern Illinois.

At his death, when Matilde was nine, her oldest brother Alfred moved the entire family to Alameda, California, where she attended elementary and high school. From Alameda, Alfred moved the family again, this time to a sugar plantation he had acquired in El Salvador. When her mother died there in 1901, Matilde, at 14, with the aid of her younger sister, **Louise Moisant**, managed the Santa Emelia hacienda, known throughout the country for its hospitality during years of political unrest that at one time led to soldiers of the Salvadorian Army occupying the property.

Much of the turmoil involving the Moisants in Salvadorian politics was caused by Matilde's youngest brother John who had become a gun-slinging aide of Juan Zelaya, the president of Nicaragua. Zelaya was determined to overthrow the government of El Salvador, and to this end John led two armed invasions of the country. Following his second failed attack in 1910, John became a fugitive hunted by the U.S. Navy. He escaped to New York City where Alfred, Matilde and Louise later joined him and where he convinced Alfred and Matilde that aviation held the key to their futures.

Leaving his brother and sisters to settle in New York, John went to France to become an aviator. Never having flown before, he built an aluminum-bodied plane and crashed on his first flight. While building a second plane, he took three lessons at the aviation school of Louis Blériot, one of France's leading airplane designers. And on only his sixth flight, he set three world records, becoming the first man to cross the English Channel with a passenger (Blériot had done it solo in 1910) and to fly from Paris to London with a passenger and in the same plane.

While John was in France, Alfred, aided by Matilde, established an airfield, an aircraft factory and a flying school and, after John returned, an air circus, the Moisant International Aviators, Inc. The group included three Frenchmen, Roland Garros, René Barrier and René Simon; a Swiss, Edmond Audemars, and three Americans, Charles Hamilton, John J. Frisbie, and Joseph Seymour. When they took to the road, Matilde accompanied them and assisted Alfred in making arrangements for rooms and

meals. John's brief career of five months ended in New Orleans on December 31, 1910, when he crashed and died in an attempt to win the Michelin Cup for speed and endurance.

After seven months of mourning her brother's death, Matilde was ready to replace John as leader of the Moisant air circus. At age 33, she moved into the Atlantic City Hotel in Garden City, New York, to be near the Moisant field. There she took her first flying lessons from André Houpert, a Frenchman whom John had hired as a flying instructor. Matilde proved to be an apt pupil, setting an all-time record for the shortest composite training time to gain a pilot's license—32 minutes. (Years later, at her request, the Aero Club of America verified this as the shortest training time in licensing history.)

Matilde chose to become the second, rather than the first woman to be licensed so that her friend and fellow student *Harriet Quimby could be first. Quimby, a New York journalist and sole support of her aging parents, intended to fly for a living and needed the publicity.

Less than six weeks after Matilde received her license, she and Quimby were among the four women listed in the program as contestants in an air meet at Nassau field in Long Island. The other two were *Blanche Stuart Scott, the first U.S. woman to fly, and Hélène Dutrieu, a famous French pilot and the first woman aviator to fly with a passenger. All had planned to compete for the Rodman Wanamaker trophy on the third day of the meet, but finally only Moisant did. Quimby refused to fly on a Sunday; Dutrieu had arrived from France only the day before, and her plane had not yet been assembled; and Scott was ruled ineligible because she did not yet have a flying license that she had intended to try for during the meet. So on Sunday, September 24, 1911, in her Blériot XI, Matilde ascended to 1,200 feet, breaking Dutrieu's previous altitude record.

On October 9, 1911, also a Sunday, Matilde chose to ignore a county sheriff's order to refrain from flying on the Sabbath and took off from Nassau field for Alfred's field in Mineola, touching off a wild chase with Matilde in the air and three deputies in a police car on the ground, all followed by a procession of cars filled with friends and spectators. On landing at the Moisant field, she was rescued from the deputies by a friend with a car, setting off yet another Keystone Cop pursuit. A number of New York newspapers reported the chase the next day, one with a cartoon that Matilde herself described as "a picture of the cutest little witch you ever saw sitting on a broom, waving to the officers."

In November of 1911, Alfred arranged a show in Mexico City, taking Matilde, Harriet Quimby, and two other fliers with him. After attending a number of parties given in her honor by President-elect Francisco Madero, Matilde delivered a thank-you message by air, flying over Chapultepec Palace with a bouquet of flowers anchored to a rock. Madero responded immediately: "I got your flowers. Now if that had been a bomb I wouldn't be here today because it dropped right on the patio."

After the Mexico City show, which made Matilde the first woman ever to fly in that country, the other fliers abruptly broke with the Moisant International Aviators—Quimby to plan for her ultimately successful flight across the English Channel, and the two men because of disagreements with Alfred over financial and travel arrangements. Despite these unexpected defections, and despite the fact that various revolutionary forces throughout the country were engaged in armed conflict both among themselves and with the federal government forces, Matilde took the show to the cities Alfred had booked outside the capital. Accompanied only by Houpert and her mechanics, for the next two months she barnstormed in city after city, demonstrating both the Moisant aircraft and her own flying skills. Few of the amazed spectators had ever seen an airplane before and few if any were even cognizant of the fact that Matilde was risking her life almost every time she took off into the dangerously thin air and treacherous wind currents of the high-altitude countryside. As Houpert commented later: "Miss Moisant again showed her wonderful nerve, for in all my experience I have never found such air currents. . . . Few men would have attempted to fly but Miss Moisant, with true nerve, took her machine up where it was risking one's life. In nerve she is equally as strong as was poor old Johnny."

It wasn't until Torreon, 340 miles north of Guadalajara, that the revolution finally caught up with her. There, rebel troops shunted the Moisant Pullman and its aircraft-carrying freight car onto a side-track, while Matilde, the only Spanish-speaker among them, negotiated daily for their food, supplies and safety. By the time government troops broke the rebel siege, it was clear that the military turmoil had made further flying in Mexico impossible. As their train made its slow retreat across Chihuahua State to Laredo, Texas, troops from one side or the other constantly pounded on the windows of their car and threatened to enter but, Houpert said, Matilde faced them down at every stop. When their train finally arrived in New Orleans,

Houpert again credited Matilde's courage and determination for the Moisant troupe's survival. "Few men could have managed our affairs as well," he said, "and had it not been for the cool-headedness of our little woman manager, we would have gotten into serious complications."

If Matilde had been entertaining any thoughts of resting up after her Mexican ordeal, that was not to be. For while she was battling air currents and armies in Mexico, brother Alfred was booking her and Houpert for two months of exhibition flights in Louisiana and Texas. The

tour began in New Orleans, where one newspaper reported that "several thousand people at the City Park race track were thrilled by her skill and daring maneuvers." Moving on to Shreveport, Louisiana, where the customary air-show site of a race track was replaced by a golf course, Matilde narrowly escaped death when she bounced onto wet grass and landed upside down in a sand trap. This, her fourth accident, brought demands from her sister Louise that she give up flying.

Matilde promised she would fly just one more time, at a show scheduled for Wichita Falls, Texas. There, on April 14, before a crowd that had waited all day to watch what had been announced as her last flight, she barely cleared the park fence on take-off only to be forced down outside the park ten minutes later by a sputtering motor. Told the plane needed only minor repairs and overruling Houpert's warning that it was too windy, she decided to go up again, saying: "This is my last flight and I want it to be my best." Landing for a second time in a wind storm, she was horrified to see that a crowd of spectators, unfamiliar with aircraft and not knowing that a landing plane needed taxi space before coming to a full stop, had swarmed onto the landing area. To avoid hitting the crowd, Matilde nosed the plane down until the wheels touched, then brought it back up over the crowd before it slammed nose first into the ground beyond them. Propeller fragments cut into the gas tanks, fuel spewed over red-hot exhaust pipes and the entire aircraft was engulfed in flames. Houpert dragged her from the plane, her coat singed and burning. Before leaving the field and ever the lady, Matilde apologized to the spectators for appearing in a soiled and torn flying suit. She never flew again. Nor did she ever learn how to drive an automobile.

Matilde Moisant died in 1964 at the age of 86 in La Crescenta, California, and was buried next to the grave of her bother, John, at the Portal of the Folded Wings in North Hollywood, California. At a memorial service attended by many members of the Early Birds, fellow pioneer pilots, the speaker said: "Rarely have we had one of our members more deserving of public praise and acclaim, yet so retiring and self-effacing."

SOURCES:

Alameda City Directory, 1888.

Alameda Daily Argus, 1883–1891.

National Archives, Washington, DC: Record Group 84. Records of Foreign Service Posts. El Salvador and Nicaragua.

SUGGESTED READING:

Rich, Doris L. *The Magnificent Moisants*. Washington and London: Smithsonian Institution Press, 1998.

COLLECTIONS:

The Reminiscences of Matilde Moisant, Oral History Research Office, Columbia University, New York, 1960.

<div align="right">

Doris L. Rich,
author of *Amelia Earhart: A Biography* (1989), *Queen Bess: Daredevil Aviator* (1993), and *The Magnificent Moisants* (1998), all Smithsonian Institution Press

</div>

Moïse, Penina (1797–1880)

Jewish-American hymn writer. Name variations: Penina Moise. Born on April 23, 1797, in Charleston, South Carolina; died on September 13, 1880, in Charleston; daughter of Abraham Moïse (a storekeeper) and Sarah Moïse; never married; no children.

Penina Moise was born in 1797, the sixth child and younger daughter of Abraham and **Sarah Moïse**. Her parents, who fled the slave insurrection on Santo Domingo in 1791, had settled in Charleston, South Carolina, where Abraham established a small store in which he sold muslin, linen, and tea. He died when Moïse was 12, forcing her to drop out of school in order to help support her eight siblings. Although much of her time was spent making lace and embroidery to sell, she managed to study and write at night, and her close association with the Charleston Jewish community further contributed to her intellectual stimulation. In 1830, Moïse began publishing her poetry in the *Charleston Courier* and in other newspapers and journals, including *Godey's Lady's Book* and *Herriot's Magazine*. In 1833, a small volume of her poems appeared, entitled *Fancy's Sketch Book*. It included light satires, epigrams, and lyrics covering such conventional themes as love, death, and nature. *Fancy's Sketch Book* earned praise for its wit and use of clever word play, but many of the poems also revealed a profound awareness of social and moral problems. The book likewise showcased Moïse's familiarity with Greek mythology, the Bible, Shakespeare, music, art, and history.

A devout Jew, Moïse was a member of Charleston's Congregation Beth Elohim and from 1842 served as the superintendent of its Sunday School, which was set up along the lines of the school founded by *Rebecca Gratz in Philadelphia. She wrote verses on Jewish themes and composed hymns for the synagogue's services, which were published in 1856 as *Hymns Written for the Use of Hebrew Congregations*. Her hymns, which are imbued with faith in God's mercy, were still being published in Jewish hymnals over 150 years after they first were sung at Beth Elohim.

A staunch supporter of the Confederacy during the Civil War, Moïse fled to the town of Sumter after Charleston was attacked by Union forces. She returned to Charleston after the war and opened a school for girls with her widowed sister, **Rachel Levy**. Although she was poor and nearly blind, Moïse maintained a cheerful spirit and was known for composing rhymes to help the children in their studies. She continued her active participation in the local Jewish community and also continued to write poetry, dictating her creations to her niece **Jacqueline Levy** or scrawling them on a slate she kept under her pillow at night. Moïse died in 1880, at the age of 83. *Secular and Religious Works of Penina Moïse*, a collection of her hymns and poems, was published in 1911.

SOURCES:

Appleton's Cyclopaedia of American Biography. Reprint ed., Detroit, MI: Gale Research, 1968.

Blain, Virginia, *et. al. The Feminist Companion to Literature in English*. New Haven, CT: Yale University Press, 1990.

Burke, W.J., and Will D. Howe. *American Authors and Books*. 3rd rev. ed. NY: Crown, 1972.

James, Edward T., ed. *Notable American Women, 1607–1950*. Cambridge, MA: The Belknap Press of Harvard University Press, 1971.

Kunitz, Stanley J., and Howard Haycraft, eds. *American Authors 1600–1900*. NY: H.W. Wilson, 1938.

Mainiero, Lina, ed. *American Women Writers*. NY: Frederick Ungar, 1982.

Rebecca Parks,
Detroit, Michigan

Moiseiwitsch, Tanya (1914—)

British stage and costume designer. Pronunciation: Moy-ZAY-e-vich. Born on December 3, 1914, in London, England; daughter of Benno Moiseiwitsch (a concert pianist) and Daisy Kennedy (a violinist); attended various private schools in England and the Central School of Arts and Crafts, London; married Felix Krish (an RAF pilot), during World War II (died); no children.

Designed first production, for The Faithful *at the Westminster Theatre, London (1934); designed over 50 productions for the Abbey Theatre in Dublin (1935–39); designed for productions in London, Liverpool, and Bristol (1940–53); designed sets and costumes for productions in Britain and America and for annual festivals in Stratford, Ontario, Canada, Edinburgh, and Piccolo Teatro, Milan, among others (from 1955).*

Awards: Diplome D'Honneur, Canadian Conference of the Arts; Honorary Doctor of Literature, Birmingham University (1964); named CBE (1976); Honorary Fellow, Ontario College of Art (1979).

One of Britain's foremost set and costume designers, Tanya Moiseiwitsch was born in London on December 3, 1914. The daughter of accomplished musicians—her parents were Benno Moiseiwitsch, a concert pianist, and **Daisy Kennedy**, an Australian violinist—she took Irish harp and piano lessons while a child. After studying the piano until she was 16, she was finally persuaded that she was not up to a career as a concert pianist, and enrolled in London's Central School of Arts and Crafts intending to pursue a career in art. During her first year there, she met *Lilian Baylis, the manager of the Old Vic Theatre, and volunteered to help with costume design for the theater's production of the opera *Snow Maiden*. Now interested in theater design, she applied at the Old Vic as an apprentice and was accepted as a scene painting student.

Following her successful apprenticeship at the Old Vic, Moiseiwitsch became an assistant to **Ruth Keating**, the designer at the Westminster Theatre. Moiseiwitsch designed sets for two student productions at the Westminster, so impressing director Hugh Hunt that he invited her to go with him as designer to the Abbey Theatre in Dublin. *The Deuce of Jacks*, the first production in what was intended to be a three-month trial

Tanya Moiseiwitsch

period for Moiseiwitsch, proved so successful that between 1936 and 1939 she designed for over 50 productions at the Abbey. In 1939, she moved to the Q Theatre in London, and the following year took part in her first production in the West End, with *The Golden Cuckoo*. Moiseiwitsch designed sets at the Oxford Playhouse from 1941 to 1944, moving that year to the Old Vic's Liverpool Playhouse company, where she designed the production of John Burrell's acclaimed version of *Uncle Vanya*, starring Laurence Olivier, *Sybil Thorndike, and Ralph Richardson. This marked the beginning of Moiseiwitsch's long alliance with the Old Vic and director Tyrone Guthrie, the theater's administrator in London. Together, they would be responsible for some of the foremost British stage productions of the postwar period, including *Cyrano de Bergerac* (1946) and *Peter Grimes* (1947).

In the winter season of 1952–53, Moiseiwitsch designed for the Stratford Theatre Festival in Ontario, Canada, working with Guthrie and Cecil Clarke. Their efforts produced a wedge-shaped "apron" stage which projected into the middle of an amphitheater, allowing a more intimate connection between actors and audience. Theater critic Brooks Atkinson, in *The New York Times*, called this innovation (which is an adaptation of Elizabethan staging techniques) "the most vital instrument in the production of Shakespeare that most of us have ever seen." Moiseiwitsch designed costumes and sets for *Richard III* and *All's Well That Ends Well* that first season in Stratford, for *The Taming of the Shrew*, *Measure for Measure*, and *Oedipus Rex* in 1954, and for *Oedipus*, *Julius Caesar*, and *The Merchant of Venice* in 1955. Her minimalist designs for *Oedipus*, including costumes based on ancient Greek theater, stirred up some controversy, and critics were divided on the effect of the unusual production.

During the 1960s and 1970s, Moiseiwitsch continued to design for productions at the Old Vic and at numerous festivals, including the Piccolo Teatro in Milan and the Edinburgh Festival. She also designed productions in the United States, particularly at the new theater in Minneapolis that had been co-founded by and named after Tyrone Guthrie. These productions include *Hamlet*, *The Three Sisters*, and *The Miser* (all 1963), *Saint Joan* (1964), and *The Cherry Orchard* (1965). In addition, Moiseiwitsch designed for several American operas in the 1970s, including the 1976 world premiere of *The Voyage of Edgar Allan Poe* at the Minnesota Opera and the 1977 production of *Rigoletto* at New York City's Metropolitan Opera. She

was named a Commander of the British Empire (CBE) in 1976.

SOURCES:
Current Biography 1955. NY: H.W. Wilson, 1956.
Who's Who in the Theatre, Vol. I. 17th ed. Edited by Ian Herbert. Detroit, MI: Gale Research, 1981.

<div align="right">

Ellen Dennis French,
freelance writer, Murrieta, California

</div>

Mold or Molde.
Variant of Matilda or Maud.

Molesworth, Mary Louisa
(1839–1921)

English novelist and children's author. Name variations: Mrs. Molesworth; Louisa Molesworth or Louise Molesworth; (pseudonym) Ennis Graham. Born Mary Louisa Stewart on May 29, 1839 (some sources cite 1838), in Rotterdam, Holland; died on July 20, 1921, in London, England; daughter of Charles Augustus Stewart and Agnes Janet (Wilson) Stewart; educated privately, and also attended school in Switzerland; married Major Richard Molesworth (a career military man), in 1861 (separated 1879); children: Violet (1863–1869); Cicely (b. 1863); Juliet (b. 1865); Olive (b. 1867); Richard Walter Stewart (died young in 1869); Richard Bevil (b. 1870); Lionel Charles (b. 1873).

Married (1861); gave birth to the first of seven children (1863); first two children died (1869); published first romance novel (1870); wrote first book for children (1875); separated from husband (1879); published last title (1911).

Selected writings: Lover and Husband *(1870)*; She Was Young and He Was Old *(1872)*; Cicely: A Story of Three Years *(1874)*; Tell Me a Story *(1875)*; Carrots: Just a Little Boy *(1876)*; The Cuckoo Clock *(1877)*; Hathercourt Rectory *(1878)*; The Tapestry Room *(1879)*; Miss Bouverie *(1880)*; Hermy: The Story of a Little Girl *(1881)*; Rosy *(1882)*; Two Little Waifs *(1883)*; Lettice *(1884)*; Us: An Old-Fashioned Story *(1885)*; A Charge Fulfilled *(1886)*; Marrying and Giving in Marriage *(1887)*; Little Miss Peggy: Only a Nursery Story *(1887)*; The Third Miss St. Quentin *(1888)*; Four Ghost Stories *(1888)*; That Girl in Black, and Bronzie *(1889)*; The Rectory Children *(1889)*; The Green Casket, and Other Stories *(1890)*; Family Troubles *(1890)*; The Children of the Castle *(1890)*; The Red Grange *(1891)*; The Man with the Pan Pipes, and Other Stories *(1892)*; Leona *(1892)*; An Enchanted Garden: Fairy Stories *(1892)*; Imogen, or Only Eighteen *(1892)*; The Next-Door House *(1893)*; Blanche *(1894)*; Opposite Neighbours *(1895)*;

Uncanny Tales *(1896);* The Oriel Window *(1896);* Meg Langholme *(1897);* The Laurel Walk *(1898);* The Grim House *(1899);* The Three Witches *(1900);* The Blue Bay *(1901);* Peterkin *(1902);* The Ruby Ring *(1904);* Jasper *(1906);* Fairies—Of Sorts *(1908);* The Story of a Year *(1910);* Fairies Afield *(1911).*

Mary Louisa Molesworth was a popular and acclaimed author of children's literature, novels and short stories in Victorian England. Born Mary Louisa Stewart in Holland in 1838, she returned to England as a child with her family—who were actually Scottish in heritage—and she and her six siblings grew up primarily in the Manchester area, where her father was in the shipping business. When Molesworth was young, her maternal grandmother regaled the children with epic tales told from memory, or improvised as she went along. This induced a love of literature in Molesworth, and she grew into a voracious reader as a youth. Yet the strict religious tenets she lived under as a child made her wary of morality tales, then common fodder for children's books, and later she was inspired to create stories for children that did not attempt to strike the fear of God into them.

Like many women of her day, Molesworth was educated at home, and later spent some time at a school in Switzerland. (It has also been speculated that she may have received tutoring from William Gaskell, the husband of *Elizabeth Gaskell, who also lived in Manchester.) Mary began to write when she was still a teen, and some of these stories were published in magazines. In 1861, she married Richard Molesworth, an army captain, with whom she would have four daughters and three sons. Her first daughter and first son both died in 1869, and her husband had a lingering head wound from the Crimean War that was later thought to be the root of his difficult temperament. It was not a solid marriage, and Molesworth may have attempted her first novel as a palliative for depression after the deaths of her two children. The plots of the first three novels she wrote—as well as those of many of her works for adult readers—concerned miserable marital unions. These were *Lover and Husband* (1870), *She Was Young and He Was Old* (1872), and *Cicely: A Story of Three Years* (1874). These and most of Molesworth's other works of fiction for adults were essentially romances, and are now considered worthy of little critical attention.

Molesworth took the name of a friend who had died, Ennis Graham, as her pen name, and used it until about 1874. In 1875, she began writing books for children, and had great success with the first, *Tell Me a Story* (1875). Like many of her other children's books, it was illustrated by Walter Crane. She continued to write at least one to three books each year for several decades, most of them for children; Princess *Alexandra of Denmark, later the queen of England, reportedly read Molesworth's books to her children when they were young. Another juvenile tale that was extremely well received was *Carrots: Just a Little Boy* (1876), which sold thousands of copies with its unassuming plot about a little red-haired boy and his familiar childhood travails. Even the future king of Italy, Victor Emmanuel III, wrote to Molesworth and told her how much he liked the book and the impact it had upon him when he was mourning the loss of his grandfather, Victor Emmanuel II. *Carrots* and the best of Molesworth's other children's tales, including *The Cuckoo Clock* (1877), are considered much more durable in their charm than her adult books, and critics have noted that her success was perhaps attributable for the easy and entertaining way in which she presented and solved the dilemmas faced by middle-class children. Many of these titles were published by the Society for Promoting Christian Knowledge, though Molesworth enjoyed a long relationship with the Macmillan publishing house as well. The numerous ghost stories she wrote—some set in the gloom of a German forest, such as those in *Four Ghost Stories* (1888)—also earned her praise, and many continue to be reprinted in modern collections of Victorian ghost stories.

Mary Louisa Molesworth was separated from her husband in 1879 (he would die in 1900), and lived in France and Germany for a time before returning to England permanently. She continued to write fiction until well in her 70s, publishing her last book, *Fairies Afield,* in 1911. She died in July 1921.

SOURCES:

Julian, Linda Anne. "Louise Molesworth," in *Dictionary of Literary Biography,* Vol. 135: *British Short-Fiction Writers, 1880–1914: The Realist Tradition.* Detroit, MI: Gale Research, 1994, pp. 226–233.

Kunitz, Stanley J., ed. *British Authors of the Nineteenth Century.* NY: H.W. Wilson, 1936.

Mitchell, Sally, ed. *Victorian Britain: An Encyclopedia.* NY: Garland, 1988.

SUGGESTED READING:

Green, Roger Lancelyn. *Mrs. Molesworth.* London: Bodley Head, 1961, NY: Walck, 1964.

<div align="right">

Carol Brennan,
Grosse Pointe, Michigan

</div>

Molinari, Susan *(1958—)*

American congresswoman. Born on March 27, 1958, *in Staten Island, New York; daughter of representative*

Guy Victor Molinari (1928—); graduated from St. Joseph Hill Academy, 1976; State University of New York, Albany, B.A., 1980, M.A., 1982; married representative Bill Paxon (1954—); children: one daughter, Susan Ruby (b. 1996).

Served on Republican National Committee (1983–84); was a member of the New York City Council (1986–90); elected as a Republican to the 101st Congress by special election (March 20, 1990), and to four succeeding Congresses; resigned (1997) to become CBS television anchorwoman; given a visiting fellowship to Harvard University's Kennedy School of Government (1999); formed lobbying group with Michael McCurry, former White House Chief of Staff (1999); wrote book, Representative Mom: Balancing Budgets, Bill and Baby in the U.S. Congress, *with Elinor Burkett (1999).*

Susan Molinari was born in Staten Island, New York, in March 1958, daughter of representative Guy Molinari and granddaughter of Robert S. Molinari, a member of the New York

\mathcal{S}usan
\mathcal{M}olinari

state assembly in the mid-1940s. She received her B.A. in 1980 and her M.A. in political communications in 1982 from the State University of New York at Albany.

Molinari first worked in Washington for the Republican Governors Association and the Republican National Committee, before returning to New York City. She won election to the city council in 1985 and served there as minority leader until her resignation in 1990.

When Guy Molinari resigned from the House of Representatives to become Staten Island borough president, Susan Molinari stood for his seat in New York's 14th District. In her campaign for Congress, Molinari emphasized environmental issues of concern to her district, including water pollution, ocean dumping, and protection of wetlands. After a special election on March 20, 1990, Molinari was elected as a Republican to the 101th Congress, and subsequently to the four succeeding Congresses.

Molinari's assignments included the Committee on Public Works and Transportation, the Committee on Small Business, the Committee on Resources and the Environment, and the Committee on the Budget. A co-founder of Republicans for Choice, Molinari achieved national recognition as a symbol of the youthful, moderate face of the much-vaunted "Republican Revolution," along with her husband, fellow Republican representative Bill Paxon. Molinari later described her role in the Republican Party as reminding GOP hard-liners of the complexity of Americans' lives; it was her job, she felt, to "educate the boys." At the age of just 38, Molinari was selected to give the keynote address at the 1996 Republican National Convention.

Molinari's youth, gender, marriage and prominence within the Republican Party brought her sometimes unflattering attention. She received flak after college friends publicly contradicted a 1992 interview in which Molinari claimed that she had never smoked marijuana. Critics castigated her marriage (and the birth of her daughter by Caesarian section just before Mother's Day, 1996) as a political public-relations stunt.

Claiming that she had hit the House's "woman wall," Molinari abruptly resigned from Congress on August 2, 1997, and stunned the Republican Party when, just a month later, she became anchor of the "CBS News Saturday Morning" television program. The show, with co-host Russ Mitchell, struggled to find an audience, and Molinari was fired in the summer of 1999.

Molinari took up a visiting fellowship at Harvard University's Kennedy School of Government that autumn and wrote a book, co-authored by **Elinor Burkett**, titled *Representative Mom: Balancing Budgets, Bill and Baby in the U.S. Congress*. By the end of 1999, she was heading a political lobbying group with former White House Chief of Staff Michael McCurry, promoting deregulation for broadband Internet technologies.

Paula Morris, D.Phil.,
Brooklyn, New York

Molines, Catherine (d. 1452).

See Howard, Catherine.

Moll Cutpurse (c. 1584–1659).

See Frith, Mary.

Molley, Captain (1751–c. 1800).

See entry titled "Two Mollies" for Margaret Corbin.

Mollison, Amy (1903–1941).

See Johnson, Amy.

Mollison, Ethel (1875–1949).

See Kelly, Ethel.

Molloy, Georgiana (1805–1842)

Amateur botanist and pioneer of the remote southwest region of Western Australia, whose collections of native Australian flora were the finest to arrive in Britain during her day. Born Georgiana Kennedy on May 23, 1805, near Carlisle in Cumberland, England; died on April 8, 1842, at Busselton, Western Australia, of complications following the difficult birth of her seventh child; daughter of David Kennedy (a country gentleman) and Mrs. Kennedy (first name unknown), nee Graham (a country gentlewoman); married Captain John Molloy (thought to be the illegitimate son of the duke of York), in 1829; children: seven, all born in the Swan River Colony, including two who died in infancy.

Spent childhood in the Border country in genteel circumstances; upon marriage, emigrated to the Swan River Colony (present-day Western Australia) to settle first in the remote Southwest corner at Augusta, and nine years later in the slightly larger settlement of Busselton, 80 miles to the north; lived in isolated and relatively primitive conditions; lost her first-born child, a daughter, several days after the birth; lost her third-born child, a son, when he was 19 months; struggled out of grief by collecting native Australian flora, sending thousands of seeds and plant specimens to Captain Mangles, gentleman horticulturist, in London, over a five-year period.

Georgiana Molloy's story reflects the triumph of the imagination in overcoming the hardships of pioneer life. Transported beyond the farthest outskirts of her known civilized world into territory she had to learn to love, Molloy, an early European settler in the Swan River Colony, turned to botany. She became known for the quality of her collections, which were sent back to England and thus provided a record of indigenous plant and flower life in Western Australia.

She was born Georgiana Kennedy in the remote Border country near Carlisle in Cumberland, England, on May 23, 1805. One of five children, she lived in a comfortable country house with ivy-clad walls which stood on spacious grounds. Georgiana was taught the genteel arts of singing, dancing, playing the pianoforte and harp, sewing, drawing and painting. History, geography and literature were taught, and a great deal of Scripture was learned by heart. It was also considered fitting for young ladies of a certain class to undertake nature study, and biographer **Alexandra Hasluck** tells us that the young Georgiana showed a great flair for botany.

In 1830, she arrived in the Swan River Colony (now Western Australia) as the bride of Captain John Molloy, who had seen active service in the wars against Napoleon and was a veteran of Waterloo. At 48, he was twice her age. They took up land 200 miles south of Perth (even now the most isolated city in the world) at the mouth of the Blackwood River. John Molloy was made Government Resident in charge of the tiny remote settlement called Augusta. Although several other women of Georgiana's age were there, rigid adherence to divisions of class and status prevented her from befriending them. The day on which Georgiana Molloy gave birth to their first daughter was so wet that an umbrella had to be held over her as she lay on the rough bed in their tent. The baby died some days later. In a letter to a friend, Georgiana wrote: "Language refuses to utter what I experienced when my child died in my arms in this dreary land, with no one but Molloy near me."

The isolation of early colonists like Georgiana Molloy was profound. Letters from England sometimes took over a year to arrive. Georgiana's sister died in England in March 1833, but news of her death did not reach Augusta until September 1834. Vessels called only occasionally at the little port, not more than three or four times a year, to supply the settlers' wants. If

crops failed occasionally, the results were rationing and hunger. Some of the settlers' stock strayed, and they had frequent losses in pigs, goats and sheep. One lighter incident for the Molloys occurred when their pony Jack, who had been missing for ten months in the bush, reappeared with a neighbor's mare and a fine colt between them.

Molloy hated what she called domestic drudgery: interminable butter and cheese making, cooking with desperately heavy pots, as well as washing, cleaning, sewing and all of the tasks she had to learn the hard way, by trial and error. Her efforts were widely admired. Charles Bussell, a local gentleman farmer, said of her: "I cannot speak of Mrs. Molloy in too high terms. She is perfectly lady-like, yet does not disdain the minutiae of domestic economy—an indispensable accomplishment in a settler's wife."

With her passionate love of flowers, Molloy found her garden to be one of her few delights. The seeds which she had brought with her from England and plants she had obtained on the voyage out at the Cape of Good Hope flourished in their new surroundings. To her sister, she wrote: "You could not send old Georgy a greater treat than some seeds, both floral and culinary, but they must be that year's growth. In return I will send you some Australian seeds. I should have sent them last time, but Molloy forgot where he put them."

The governor, Captain Stirling, and his wife were made welcome. **Ellen Stirling** was considered a charming person, and she and Georgiana would have found much of mutual interest. Within days of their visit, Molloy's second daughter was born. This time the child thrived and was to be a great joy to them.

Molloy's life in Swan River Colony included sitting on her veranda writing of the heavenly climate and observing the small, brilliantly colored birds; supervising planting and harvesting of wheat in her husband's absence; and standing with baby on hip and child at side, watching a windswept sea for a ship to arrive. She lost another child, a son of 19 months named Johnny who climbed from the cradle in which he had been placed just ten minutes before and was drowned in the garden well. This time the grief remained, and Molloy's spirit was broken.

She was roused from her grief some months later by a surprise request from a Captain Mangles, a London gentleman of leisure and cousin of Lady Stirling, who had an overwhelming interest in horticulture. Having apparently devoted himself to the growing and cataloguing of rare plants

of the British Isles, Mangles widened his interests after making a voyage to the young Swan River Colony. He thereupon made contact with as many interested collectors in the colony as possible, whom he asked to send him seeds and plants of West Australian flora to be grown experimentally in the gardens of the British Horticultural Society at Kensington and Chiswick in England.

Lady Stirling put him in touch with Georgiana Molloy. It was Mangles' intention to send seeds and plants to Swan River in boxes properly made for the purpose, which could then be filled again with indigenous seeds and plants and sent back. Slowly at first, to take her mind off the family's tragic loss, Molloy wandered through the bush with her two little girls, gathering seeds to be sent to England. At night, she packaged and labeled them with meticulous care. She dried and pressed flower and leaf of each variety of seed collected, and she mounted and numbered them in a *hortus siccus,* a special book she had been sent for the purpose, with the number of the plant corresponding to the number on its seed packet. Molloy had so many specimens that in addition she had to use a *hortus siccus* of her own which she had brought from England. She added a long explanatory letter.

Her collections were received in England with great delight. Mangles fully appreciated her interest in the project, love of plants and flowers, and the extreme care she took in seeing that only the finest specimens be sent in the best manner. In contrast to Molloy, other collectors, though more highly qualified as botanists, were sometimes careless about labeling plants with their locality and date of collection.

Mangles' request caused Molloy to take a deeper interest in the plants about her. She came to know their situation, time of flowering, soil, and amount of moisture required. With patience, she waited for seeds to ripen at different times. Insect pests were a problem, and Molloy took no chances, stating: "I have minutely examined every seed and know they are sound and fresh as they have all been gathered in the past five weeks during December and January." One of her parcels of seeds in 1841 contained 100 different species. She added: "Of the beautiful specimens, I have sent duplicates as far as I was able."

The various correspondents to whom Mangles distributed the seeds in England ranged from the earl of Orkney in the north to the Keeper of the Exotic Nursery at Chelsea in the south. All acknowledged the outstanding nature of Molloy's collections, which included many unknown and unnamed species. An excited let-

ter from Mr. Hailes of Newcastle stated that seeds from Swan River sent two years previously had flowered: it was a type of blue agapanthus, flowering for the first time in Britain. He wished to have it named after Molloy, but it was later found that this plant had already been identified elsewhere in the world.

After nine years, Molloy and her family reluctantly abandoned Augusta to move 80 miles north to a larger settlement at Busselton. Molloy's one compensation was the bush that she still had to explore, and many of the Vasse specimens were new to her and peculiar to the area. Collecting plants continued to be a source of pleasure for the whole family, her children delighting in the long walks in the bush and her "excellent husband" accompanying them whenever possible.

Molloy's health, however, began to decline after two more pregnancies and difficult births (she gave birth to a total of seven children including the two who died in infancy). Without adequate medical care, her strength ebbed away, and she died in 1842 at 37 years of age. Her body was buried within the nave of the church in Busselton, beside the two infants whose graves had been moved from Augusta. A small rose window at the western end of the church is a memorial to her which was given by her husband and family. A British horticulturist paid Molloy a glowing tribute: "Not one in ten thousand who go out to distant lands," he said, "has done what she did for the gardens of her native country."

Of the bond she formed with Captain Mangles, Molloy wrote on February 1, 1840:

> Our Acquaintance is both singular and tantalizing, and somewhat melancholy to me, my dear Sir, to reflect on. We shall never meet in this life. We may mutually smooth and cheer the rugged path of the World's Existence, even in its brightest condition, by strewing flowers in our Way, but we never can converse with each other, and I am sincere when I say, I never met with any one who so perfectly called forth and could sympathize with me in my prevailing passion for Flowers.

SOURCES:

Hasluck, Alexandra. *Portrait with Background: A Life of Georgiana Molloy.* Melbourne: Oxford University Press, 1979.

Lines, William. *An All Consuming Passion: Origins, Modernity, and the Australian Life of Georgiana Molloy.* Sydney: Allen and Unwin, 1994.

COLLECTIONS:

Western Australian Archives: Georgiana Molloy Papers, Battye Library.

<div align="right">

Lekkie Hopkins,
coordinator of Women's Studies,
Edith Cowan University, Perth, Western Australia, Australia;
Elizabeth Evans, mother of Lekkie Hopkins and a retired school
teacher, Bowen, North Queensland, Australia

</div>

Molony, Helena (1884–1967)

Irish nationalist and labor leader who strove to improve and protect the rights of women workers. Born in Dublin, Ireland, in January 1884; died in Dublin on January 28, 1967; never married; no children.

Little is known about Helena Molony's early years except that she was born in 1884 and brought up in Dublin. She was 19, "a young girl dreaming about Ireland" as she later recalled, when she heard *Maud Gonne speak at a meeting in Dublin in 1903. Gonne had founded the women's organization Inghinidhe na hEireann (Daughters of Ireland) in 1900, and Molony joined in 1903, becoming involved in teaching, acting, and radical political activism. She also taught children's classes arranged by Inghinidhe in the Irish language, Irish history, dancing and singing, and subsequently started a campaign for school meals. "Our aim," she said, "was to have a school refectory where a child could eat in a civilized fashion." In 1908, Molony became editor of *Bean na hEireann* (The Irishwoman), the monthly paper of Inghinidhe. Through the newspaper, she met Countess *Constance Markievicz* and was credited with influencing her in the cause of Irish independence.

Inghinidhe had been involved in a number of drama productions with various Dublin companies in the first years of the century. In 1909, Molony was invited to join the Abbey Theatre company and worked with them, off and on, for several years. In 1911, following protests against the visit of King George V and Queen *Mary of Teck* to Dublin, in which Molony took a leading part, she was arrested and charged with high treason, a highly dramatic charge which was later reduced to the more prosaic one of "using language derogatory to His Majesty." Molony was furious at the reduction: "In my heart of hearts I felt degraded by such a miserable accusation." On her release from prison, she immediately made a speech which resulted in another brief spell of imprisonment. To her disgust, her fine was paid by *Anna Parnell*, founder of the Ladies' Land League in the early 1880s and sister of Charles Stewart Parnell, the disgraced Irish leader who had died in 1891.

Molony then left Ireland briefly but returned in 1912. In autumn 1913, while performing at the Abbey, she also became involved in the "Lock-Out," the great strike which saw thousands of Dublin workers, demanding better pay and conditions, locked out of their jobs by their employers. After the Lock-Out ended in defeat for the workers, the labor leader James Connolly

asked Molony to help with the reorganization of the demoralized labor movement, and especially the women workers who had suffered particularly in the aftermath of the strike. She and Connolly revived the Workers' Cooperative, which helped women workers develop skills and markets for their goods. They also reorganized the Irish Women Workers' Union (IWWU), in which Molony had worked sporadically since 1911. She wrote later that she had "no experience or idea of any kind of organizing and it was really [Connolly] who did the work, coming with me to the various factory gates to try and enlist girls into the Union." She became secretary of the IWWU, which was based at Liberty Hall, the headquarters of Connolly's Irish Transport and General Workers' Union (ITGWU). She also worked on Connolly's various journals, including the *Irish Worker* which was suppressed by the authorities in 1914 following the outbreak of the First World War. At Connolly's request, Molony became the registered proprietor of its successor, *Workers' Republic*, which meant that she was legally responsible for any seditious material published in it, a risk she did not shirk.

In 1914, Molony joined the Irish Citizen Army and Cumann mBan (the League of Women), the women's auxiliary of the paramilitary Irish Volunteers which, following the outbreak of war, was soon planning a rebellion against British rule in Ireland. When the rebellion took place at Easter 1916, Molony was with the City Hall garrison, but the rebels surrendered after a week. Connolly was one of the leaders executed shortly afterwards. Molony, who was taken to Kilmainham Jail in Dublin, tried to tunnel out using a spoon before she and the other women prisoners were moved to England. Molony was one the last women prisoners to be released in December 1916. When Constance Markievicz was released the following year, Molony went to England to meet her.

After 1916, Helena Molony took an active role in the struggle for independence, continuing to work for Cumann na mBan and Sinn Fein. When civil war broke out in 1922, she took the side of those who opposed the terms of independence set out in the 1921 Anglo-Irish Treaty. After this, Molony's time was mainly devoted to labor activities. The IWWU had been reluctant to take sides in the civil war and stayed neutral. In 1929, Molony was elected to the executive of the Dublin Trades Council and the following year visited Russia as part of a DTC delegation. The visit aroused unfavorable comment within sections of the IWWU who objected to her "public connection with Communists." Molony was greatly re-

spected throughout the trade union movement in Ireland and by more conservative political leaders such as Eamon de Valera, but her radical socialism was always viewed with considerable wariness by certain members of the IWWU.

In the 1930s, Molony was active on behalf of women laundry workers who had no guaranteed working week and who were paid hourly. She also played a prominent role in opposing the government's 1935 Conditions of Employment Bill, which she regarded as a blatant attempt to protect male employment by restricting the rights of women workers. The bill caused a serious split in the Irish labor movement. In 1937, she was elected president of the Irish Trade Union Congress, but ill-health led to her absence from union affairs in this and the following year. After her return to work, she had particular responsibility for laundry workers, nurses, the rosary bead industry and cleaners, but poor health again intervened, and she resigned in October 1941. On her death in 1967 de Valera, now president of Ireland, paid tribute to Molony. "She stood firmly for the rights of women and their political equality with men in our society. She was admired and beloved by those who knew her as a noble Irish woman who had deeply at heart the welfare of our nation and its people."

SOURCES:

Fox, R.M. *Rebel Irishwomen.* Dublin: Talbot Press, 1935.
Irish Times. Dublin, January 30, 1967.
Jones, Mary. *These Obstreperous Lassies: A History of the Irish Women Workers' Union.* Dublin: Gill & Macmillan, 1988.
Taillon, Ruth. *When History was Made: The Women of 1916.* Belfast: Beyond the Pale Publications, 1996.

Deirdre McMahon,
lecturer in history at Mary Immaculate College,
University of Limerick, Limerick, Ireland

Molton, Flora (1908–1990)

American blues singer who influenced the Washington, D.C., jazz scene for more than half a century. Born in Louisa County, Virginia, in 1908; died in Washington, D.C., on May 31, 1990.

A guitarist as well as a singer, Flora Molton was a street performer who graduated to clubs and cabarets. Like many blues vocalists, she learned her art through gospel singing. At church, she played the organ and the accordion before moving on to the guitar which she strummed in the traditional bottleneck style. Molton moved to Washington, D.C., from rural Virginia in 1937. With jobs scarce, she supported herself by singing and playing on the city's streets. Gradually, she became a fixture in Washington's gospel and blues scene, a position she

maintained for over 50 years. Although blues became big business, Molton's career harks back to its roots, when the music was performed by poor blacks in poverty-stricken conditions.

John Haag,
Athens, Georgia

Mona Lisa (1474–?).

See del Giocondo, Lisa.

Monceaux, Marquise de (1573–1599).

See Estrées, Gabrielle d'.

Moncha.

Irish form of Monica.

Monckton, Mary (1746–1840)

Irish socialite and countess of Cork and Orrery. Born in 1746 in Galway, Ireland; died in County Cork, Ireland, in 1840; daughter of John Monckton, 1st Viscount Galway; married Edmund Boyle, 7th earl of Cork, in 1786.

Mary Monckton was born in 1746, the daughter of John Monckton, 1st Viscount Galway. Her parents were popular in artistic and literary circles, and parties at the family home were gatherings of some of the most talented people of the time. Monckton married Edmund Boyle, the 7th earl of Cork and Orrery, in 1786, and began entertaining on her own. Many of the finest writers of the late 18th and early 19th centuries attended her parties, including George Gordon, Lord Byron, Sir Walter Scott, and the playwright Richard Brinsley Sheridan, and it has been speculated that the characters of Lady Bellair in Benjamin Disraeli's *Henrietta Temple* and Mrs. Leo Hunter in Charles Dickens' *Pickwick Papers* were based on her. Monckton died in County Cork, Ireland, in 1840.

Grant Eldridge,
freelance writer, Pontiac, Michigan

Monegunde (fl. 6th c.)

Saint. Flourished in the 6th century.

Monegunde, a native of Chartres, led the life of a recluse in Chartres and then in Tours, near the tomb of St. Martin of Tours. Bishop Gregory of Tours wrote her biography. Monegunde's feast day is July 2.

Mongella, Gertrude (1945—)

Tanzanian educator, politician, diplomat, and activist who headed the 1995 United Nations Fourth World Conference on Women in Beijing. Name variations: Gertrude Ibengwe Mongella. Born on September 13, 1945, on Ukerewe, an island in Lake Victoria, Tanganyika (now the United Republic of Tanzania); attended Marianhill Secondary School; degree in education from Dar es Salaam University, 1970; married; children: one daughter and three sons.

Taught at Changombe Teachers College, Tanzania (1970–75); curriculum developer at Institute of Adult Education, Tanzania (1975–78); became one of few female members of Chama Cha Mapinduzi (Revolutionary Party); legislative council member (1975–82), central committee member (1982–87); served as school inspector of Eastern Zone School District (1981–82); appointed minister of state (1982); served as head of department of social welfare (1982–91); minister of lands, natural resources, and tourism (1985–87); minister without portfolio (1987–91); represented Tanzania at numerous international conferences (1980s); appointed High Commissioner to India (1991); member, board of trustees of the United Nations' International Research and Training Institute for the Advancement of Women (INSTRAW). Served as secretary-general, Fourth United Nations World Conference on Women (1992–95).

Internationally known for her efforts to improve the status of African women, Gertrude Mongella is also a vigorous defender of equal rights for women worldwide. She is still an anomaly, however: an educated female leader on a continent that traditionally reserves education and leadership for men. A Tanzanian diplomat, Mongella has held several government posts and has represented her country at numerous international conferences, in particular at those dealing with women's issues. In 1992, she was chosen to head the 1995 Fourth United Nations Conference on Women in Beijing, China.

Mongella was born on September 13, 1945, on the island of Ukerewe in Lake Victoria, Tanganyika. (A British colony until 1961, Tanganyika united with the island of Zanzibar to become the United Republic of Tanzania in 1964.) Breaking with local tradition, Mongella's father, a carpenter, sent all of his four children to school, encouraging them to achieve. Mongella left the island for the first time at age 12, to go to school hundreds of miles away in Morogoro. There she continued her education at Marianhill Secondary School, run by nuns of the Maryknoll order; as one of the country's few secondary schools, it was highly competitive. Upon graduation, she enrolled in the new Dar es Salaam University, earning a degree in education in 1970.

Mongella worked first as a teacher at Changombe Teachers College from 1970 to 1975, and then as a curriculum developer at Tanzania's Institute of Adult Education for the next three years. Having joined the ruling Chama Cha Mapinduzi, or Revolutionary Party, Mongella was one of its few female members. She entered public service in 1975, when the party appointed her to the East African Legislative Assembly. By 1982, she was appointed minister of state, in which capacity she had charge of women's affairs. This was the first of several ministerial posts she would hold, including minister of lands, natural resources, and tourism (1985–87), and minister without portfolio (1987–91). She represented Tanzania at many international conferences during the 1980s, several of which were devoted to women's issues. In 1985, she was vice-chair of the World Conference to Review and Appraise the Achievement of the United Nations Decade for Women. She was also chair of the African delegation to that conference.

Gertrude Mongella was appointed in 1991 to the ambassadorial post of High Commissioner to India. At that time she was also a member of the Board of Trustees for the United Nations' International Research and Training Institute for the Advancement of Women (INSTRAW). In 1992, United Nations secretary-general Boutros Boutros-Ghali chose Mongella to head the Fourth World Conference on Women, to be held in Beijing, China, in 1995. The event was touted as the most important conference about women in the history of the United Nations. Held in September 1995, the conference was attended by delegates from 185 nations, members of numerous non-governmental organizations (NGOs), and unprecedented numbers of African women. Topics discussed included HIV and AIDS infection, literacy and education, violence and abuse, and poverty.

Noting that change will occur when deep-seated attitudes and practices are approached with discussion and persuasion, Mongella has seen her efforts to improve women's conditions gather steam. *Newsweek* reported in 1995: "African women are asserting themselves as never before. Local feminist movements have gained momentum; many now oppose female genital mutilation and other kinds of violence against women—once chiefly the concern of Western human-rights organizations." Telling a *Maryknoll* reporter in 1995 that "women will change the world when they lead it," Mongella continues to seek advancement for women on all levels—educational, economic, social, and political.

SOURCES:
Contemporary Black Biography. Vol. 11. L. Mpho Mabunda and Shirelle Phelps, eds. Detroit, MI: Gale Research, 1996.
Newsweek. September 25, 1995.
Parade. March 5, 1995.

Ellen Dennis French,
freelance writer, Murrieta, California

Monica (331–387)

Devout Christian and mother of St. Augustine who agonized over Augustine's spiritual health until he fully embraced her faith, only shortly before she died.

Name variations: St. Monica. Pronunciation: MON-i-ka. Born in or near Thagaste (in modern Algeria) in 331 and named Monica (since she was eventually sainted, it is ironic that "Monica" derives from a north African pagan goddess, "Mon"); died at Ostia (in modern Italy) in 387; buried at Ostia, though her sanctified remains were later removed to Rome; married Patrick also known as Patricius; children: probably four, two sons, Navigius and Saint Augustine of Hippo (354–430), and two daughters (names unknown).

Thagaste at the time of Monica's birth lay in the formally Numidian wheat-belt of Roman North Africa, scores of miles from the Mediterranean Sea, inhabited by the ancient ancestors of the Berbers. Lush and productive in the 4th century, its land had been spared the destructive civil and foreign wars which had devastated other regions of the Roman Empire over the preceding century. Thagaste's population had long since been thoroughly assimilated into the Roman world, and in the 4th century was Christianizing along with the rest of the Mediterranean, although the Christianity of the period was far from the monolithic force it would become over the following millennium.

In 331, Monica was born into an Orthodox Christian household, living her first six years under the benign reign of Constantine, the empire's first Christian emperor. Had, however, Monica's parents not been Orthodox—for example, had they been tainted by the heretical notions of the Donatist Christians, or worse yet, by those of the Manichees—then the rule of Constantine would not have appeared so congenial. Monica's family was wealthy enough to own a few slaves but was otherwise unexceptional, and her rearing was undistinguishable from others of her class, religion and time. Although she certainly received little, if any, formal education, her devout parents saw to it that she could read and thus have access to the sacred texts which lay at the heart of their religiosity. Her limited exposure

to the world of learning almost certainly was not enough to slake her intellectual curiosity, but it introduced her to a larger world. As a result, when she had children, she (along with her husband) did everything possible to offer them the best schooling available in North Africa.

We know little about Monica's relationship with her parents, but they may have been distant figures, in contrast to what she would become as a mother. Her rearing was left primarily to an elderly maidservant, who had performed a similar service for Monica's father a generation earlier. This slave women, moreover, appears to have been a rigorous nanny. Something of Monica's early years can be gleaned from her son's later mention of her frequent fasts and enforced moderation—she ate and drank sparingly as a youth (at least when she was under supervision), was trained to serve her parents, was thoroughly steeped in the zealous traditions of the African Christian Church, and was almost always under the watchful eye of her nanny, who demanded decorous behavior.

An anecdote from Monica's teenage years, however, suggests that while she generally internalized the values of her parents, she nevertheless flirted with rebellion. For (as Augustine of Hippo wrote after her death) when her parents dined, Monica was obliged to help serve them by fetching the meal's wine from the cellar. At some time, she stole her first taste of alcohol, and found it to her liking. For a while thereafter, she fell into the habit of greedily toping when the backs of her supervisors were turned. This habit continued until a young slave of the household—who had stumbled across Monica's secret—used her knowledge to taunt Monica at an appropriately effective moment. Intending to wound, this young adversary had an unexpectedly salubrious impact on Monica, for as a result of this double shame—that is, her vice had been discovered, and by a slave to boot—Monica thereafter gave up drinking wine altogether, so Augustine tells us.

At the earliest appropriate age (although we are not told when that was), Monica's father arranged her marriage to an older, poorer, pagan, and somewhat surly neighbor named Patricius. Why this man was thought a suitable match for Monica is not known, but perhaps his association with a local grandee named Romanianus figured into the equation. Nevertheless, for all its ups and downs, this union proved a lasting and relatively successful one. Monica and Patricius had probably four children: two sons, Augustine of Hippo and Navigius, and two daugh-

ters whose names are unknown. Augustine, who would later become one of the most important figures in the history of Christian theology, appears to have been the oldest of these children and was born when Monica was 23.

Augustine portrayed his parents' marriage as fraught with difficulties, brought on primarily by Patricius' quick temper and poverty. Nevertheless, Augustine characterized his mother as diligent and appropriately submissive to her husband, and as an amiable conversant and non-gossiping peacemaker. She is said to have been a model of feminine resignation—often chastising those of her friends who dared publicly to criticize their husbands (more mild than her own) for the beatings these women received from their spouses. Whether or not Monica's criticism of her friends' legitimate complaints was sarcastic cannot be known, but it is certain that her son took Monica at face value. Regardless, she seems to have taken the measure of her husband, and to have been able to manipulate him without calling into question his nominal authority as the head of his household. Undoubtedly, this saved her many a beating, but it also allowed her effectively to dominate the management of her home, and eventually to lead Patricius to Christianity. Her method is described by Augustine, who asserts that as frequently as Patricius overheated in the midst of some argument, Monica refused to continue the discussion. Rather, she would wait out his anger, and then explain to a composed husband why she had been right all along. Thus, Monica tended to have her way without challenging her husband's authority. As such, she appears to have won hands down the battle of domestic diplomacy.

Equally deft was the conquest of her mother-in-law. As was customary, Patricius' widowed mother lived in his house. When Monica moved in, a rivalry erupted between her and her mother-in-law, each maneuvering to be the mistress of but one household. Egged on by some slaves, Patricius' mother was especially hard on Monica, who nevertheless took stock of the situation and overcame her mother-in-law's intransigence through quiet endurance and meekness. Eventually, Monica's deference won her "rival" over, to the point where, when certain slaves continued their attempts to sow discord, Monica's mother-in-law demanded of Patricius that he chastise those who would not be reconciled to her growing affection for Monica. Patricius reacted by having the troublemakers whipped. Harmony, we are told, thereafter existed among the women of the household. It thus appears that, although Monica was willing to manipulate through tact,

she possessed a steely determination to win others to her way of thinking while abiding by the social conventions of her time. No one, least of all her husband or her mother-in-law, would deter Monica from implementing the principles in which she believed.

Although Monica's pliant, but resilient, temperament seems to have been a major factor in the success of her marriage, there was probably another ingredient which should not be overlooked. For whatever reason Monica was given to Patricius, it seems clear that her natal family was more socially and economically prominent than his. Thus, coming into the marriage, she almost certainly possessed a significant enough dowry to insure that Patricius would treat her as well as he could and carefully value her input into the management of the household. (The husband had usufruct of a dowry, but it remained the wife's property; upon divorce it had to be returned to the wife, along with appropriate interest.) Although Patricius may often have unleashed his notorious temper, it would in almost every case have been in his long-term interests to swallow his pride and carefully honor Monica's opinion—that is, as long as she refrained from embarrassing him by openly challenging his authority.

Inspire . . . that as many as shall read these Confessions may at your altar remember your servant, Monica, with Patricius her sometime husband, by whose bodies I came into this life—how, I do not know.

—Augustine, *Confessions*

While nominally deferring to her husband, Monica nevertheless became a figure of note in her local Christian community, to which she introduced her children. Both Monica and Patricius were inordinately proud of their most famous offspring, although Augustine later acknowledged that his mother had the greater impact upon his development—primarily because she inevitably had his spiritual, as well as his temporal, well-being in mind from the very beginning. Regardless, both pushed Augustine toward worldly success through education. As a result, Augustine found his way to Carthage where he pursued a course of rhetorical study to prepare him for an imperial career. Shortly after he began his Carthaginian studies, however, Augustine's now-Christian father died (372). Thereafter, Monica followed Augustine so as to monitor his spiritual growth.

At Carthage, Augustine, reveling in the delights of the regional center, deplored his mother's obsessive hovering. As an independent young spirit, he sought to exploit Carthage's charms—he once quipped, "Oh God, please make me chaste . . . but not now"—especially its diverse intellectual offerings. There, he was introduced to the classical traditions of epic poetry through Virgil and philosophy through Cicero. The stylistic sophistication of such influences made the canonical Christian texts seem pale and simpleminded by comparison, and, as a result, Augustine rejected his Christian upbringing to dabble in philosophy and religious experimentation. Monica was aghast and made her feelings known, but for a time his mother's censure only sparked Augustine's rebellion. Apparently, when Augustine acted in such a way as to be characterized by Monica as "sinful," she claimed to experience anew the pangs of childbirth. When Augustine also settled down into a long-term liaison with a woman whose name is unknown (with whom he fathered his son, Adeodatus), Monica was fit to be tied, although she neither despaired of the power of prayer nor attempted to demand that her son choose between her love and that of his mistress.

After years of his mother's devotions, Augustine came to suspect an element of unspiritual desire in Monica's concerns, although he ultimately berated himself for such speculation. Nonetheless, Monica hung on through Augustine's fleshy and spiritual vicissitudes in Carthage, hoping to influence her promising son by the strength of her faith. Playing upon a complex love-hate relationship, when Augustine went too far in Monica's eyes—such as when he embraced the heretical theology of the Manichees—she chastised him by refusing him entry into her home. Thus, Monica and Augustine co-existed in Carthage, alternatively loving and sparring.

Long before Monica's spiritual hopes began to bear fruit, Augustine's temporal fortunes began to rise. Initially, success came in the form of teaching, for Augustine's natural ability as an orator led him to tutor other North Africans who would become imperial lawyers. Before long, however, Augustine became bored with the students he himself considered second-rate. In part because he had not found the intellectual or spiritual solace he sought after rejecting Monica's religion, and also seeking achievement in a less parochial environment, Augustine decided to leave Africa for Italy (383), initially scheming to pursue his ambitions without Monica. His departure from Africa had the ring of comedy about it, for Augustine, with his common-law wife, his son, and assorted friends, slipped aboard ship under the cover of darkness so that

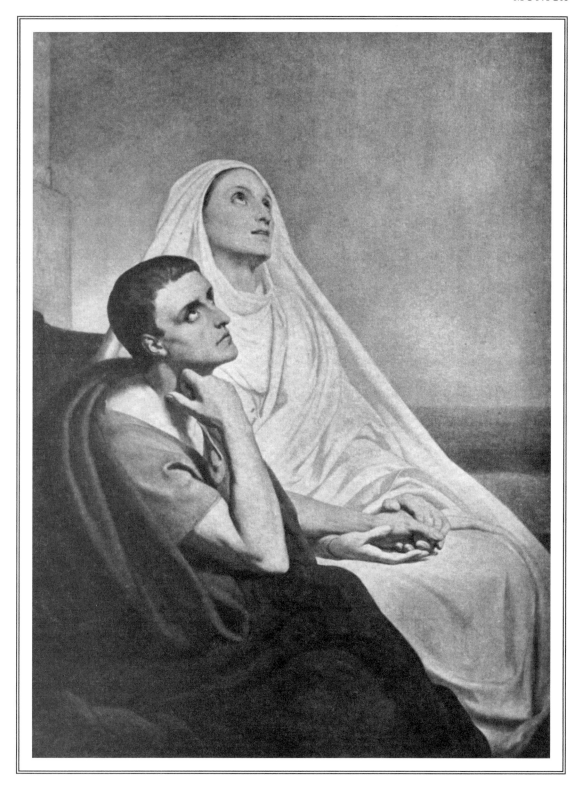

Monica with her son Augustine.

Monica would not learn of his flight until he had already sailed.

In Italy, Augustine went initially to Rome, the thousand-year-old symbolic capital of the empire which in his day continued to rule a Eu- ropean-Asian-African empire centered on the Mediterranean Sea. Although the appeal of Rome for the young provincial was manifest, Augustine soon discovered that the political focus of the Empire—and along with it, the promise of a stellar career—had shifted north-

ward to Milan, then the residence of the emperor in Italy. As a result, relying upon the patronage of Symmachus (the prefect of Rome), Augustine secured for himself an appointment to teach rhetoric in Milan (384). Few rhetorical appointments carried the status of Augustine's new position, for the empire's best orators flocked to the imperial court where their training would help run the empire and they would be heard by the emperor himself. It is clear that Monica's son had come a long way from the provincial backwater of Thagaste, and it is equally manifest that he was driven to do so largely by his mother's insistence that he pursue education as a vehicle of social advancement.

Learning of her son's achievement, obviously missing him, and probably hoping to enjoy some of the worldly fruits of his success, in 385 Monica also came to Milan. She had departed Africa as soon as the spring sailing season made the voyage possible. In Milan, she again hovered over Augustine, attempting both to direct his career and to reconvert him to Christianity. Since this was an era which saw legal marriage less as a relationship emerging from love and more as a partnership entered upon for social and material well-being, Monica negotiated an appropriate marriage for her up-and-coming son. Of course, Augustine already had a common-law wife (a partner of 15 years), and a son. Nevertheless, this relationship with a woman of no social position became a professional stumbling block for the ambitious careerist (and his mother) in one of the most status-conscious professions his world knew. Although never consummated, an appropriate engagement was entered, and the prospects of marriage into a prominent Milanese family forced Augustine to break with his long-standing companion. She returned to Africa and a celibate future, while Augustine seems genuinely to have suffered a deep emotional loss. Their son Adeodatus (as was then customary) remained with his father, in a close relationship. Although both parties were pained by this separation, the would-be marriage which precipitated it never occurred, largely because the woman to whom Augustine became engaged was underage. Before she was old enough to wed, Augustine experienced his most profound intellectual and spiritual conversion, leading him to abandon his temporal ambitions for the life of a religious contemplative.

This metamorphosis coincided with Augustine's reconversion to Christianity, a milestone brought about under the influence of Ambrose, the orthodox bishop of Milan and perhaps the most intellectually commanding Christian thinker of his generation. Naturally enough, Augustine became the associate of Ambrose through the agency of Monica. Upon her arrival in Milan, Monica joined Ambrose's religious community, and there fell under the spell of his charisma. Among other things, she joined in his battle against the Arian Christians of Milan and their patrons at the imperial court. (Arian Christians differed from those deemed "Orthodox" in their belief that Jesus had been born man and became god only through his passion. Thus, they believed that the "Son" was akin but inferior to the "Father.") Monica found Ambrose's intellectualism awe-inspiring. Augustine later noted that Ambrose, unlike anyone else he had ever met, actually read without moving his lips or softly verbalizing the written text. Under Ambrose's influence, Monica abandoned many of the "primitive" Christian traditions she had learned in Africa to which she had previously clung. Among these were Sabbath fasts, meals ritually taken at graves on certain feast days, ecstatic chanting and dancing, and a particular faith in dreams. These, Ambrose argued, were not authentically Christian, but rather smacked of the pagan cults which Christianity had nominally replaced.

As with Monica, so with Augustine. Having long belittled Monica's Christianity for its rustic ways, the artistically uninspiring prose of its texts, and its lack of intellectual depth, Augustine was introduced through Ambrose to a Christianity he had never dreamt of before—one which eschewed the false artistry of rhetorical flourish as it sought the truly profound through the exploitation of faith and reason simply proffered. As Monica, ecstatic, looked on, Augustine was transformed by Ambrose. Thereafter, Augustine rejected his prior aspirations and took baptism from Ambrose, along with his son and a few friends (Easter 387). Consequently, he decided to return to Africa with his friends and family, including Monica, to establish a secluded community dedicated to the serious study of scripture.

En route to Africa, Augustine's entourage made for Ostia from which it expected to sail. There, the troop rested for a while, more from the dizzying effects of their spiritual pilgrimage than from the rigors of actual travel. While at Ostia, Augustine and Monica engaged in a tender conversation, long remembered and later depicted by the son as a notable cap to their occasionally tempestuous relationship. The setting was at a window, overlooking a quiet garden oasis into which the bustle of the city could not penetrate. Both talked of looking forward to the future, and especially to the afterlife. Both ex-

pressed their desire to be one with God and anticipated the sweetness of that union. Time seemed to stand still, and both experienced a sensation of rising above the material world which bound their mortal bodies. A sense of soaring higher and higher followed as they inwardly mused, scarcely needing words to express what each knew the other was thinking. Finally, they reached an ecstatic state beyond words or reason, and love seemed to embrace both in its caress. As the moment broke, Monica spoke:

> Son, for mine own part I have no further delight in anything in this life. What I do here any longer, and to what end I am here, I know not, now that my hopes in this world are accomplished. One thing there was for which I desired for a while in this life, that I might see thee a Catholic Christian before I died. My God hath done this for me more abundantly, that I should now see thee withal, despising earthly happiness, become His servant: what do I here?

Augustine later understood this to be Monica's prophecy of her own death, for five days after she so spoke, she fell into a fever-induced coma. Although Monica had long expressed a desire to be buried in Thagaste with her husband, when she briefly regained her senses, she requested burial at Ostia. Immediately thereafter, she died. To the amazement of many, Augustine complied with his mother's final wish, understanding that Monica no longer believed it necessary for her physical remains to be interred with Patricius' for both to be reunited in the hereafter.

It is ironic that the extent of Monica's influence over her famous son can only be appreciated by his description of the grief he experienced at her passing. Although he believed her to be with God, he could nevertheless not immediately rejoice in her redemption, for her loss struck him the greatest blow of his life. While others around him wept, Augustine could not, until somewhat later at a public bath, after having moved through life in the meantime as if in a dream, he remembered a consolation once expressed by Ambrose. Then, and only then, did his pent-up emotion flow freely. He broke down and cried.

In Africa, Augustine would not be left alone long enough to enjoy the solitude he desired. Against his will, he was called to serve the city of Hippo (where he had sought to found his monastery), first as a priest (391) and finally as a bishop (395). In the latter capacity, he served both his local community as its Christian leader (dying in 430), and the Church at large as one of its most influential theologians ever. Monica, too, continued to have an impact in this world.

Her fame grew with that of her son to the extent that her grave became a site of pilgrimage. Indeed, so holy were her remains considered by the 15th century, that Pope Martin V removed them to Rome, where he reburied them in a church dedicated to St. Augustine.

SOURCES:

St. Augustine. *The Confessions.* Trans. by Edward B. Pusey. NY: Macmillan, 1961.

SUGGESTED READING:

Attwater, Donald. *The Penguin Dictionary of Saints.* 2nd ed. Harmondsworth: Penguin, 1983.

Brown, Peter. *Augustine of Hippo.* Berkeley, CA: University of California, 1967.

Frend, W.H.C. "A Note on the Berber Background in the Life of Augustine," in *Journal of Theological Studies.* Vol. 43, 1942, pp. 188–191.

William S. Greenwalt,
Associate Professor of Classical History,
Santa Clara University, Santa Clara, California

Moninne (d. 518).

See Modwenna.

Monique.

French form of Monica.

Monk, Maria (1816–1849)

Canadian woman who was the nominal author of a lurid and controversial anti-Catholic book. Born on June 1, 1816 (some sources cite 1817), probably in St. John's, Quebec, Canada; died on September 4, 1849 (some sources cite 1850), in New York City; daughter of William Monk (an army barracks yard orderly) and Isabella (Mills) Monk; may have married twice; children: two daughters.

Published Awful Disclosures of Maria Monk, As Exhibited in a Narrative of Her Sufferings during a Residence of Five Years as a Novice and Two Years as a Black Nun, in the Hotel Dieu Nunnery at Montreal.

Maria Monk was born on June 1, 1816, probably in St. John's, Quebec, Canada, the only daughter among five children of William Monk, an army barracks yard orderly, and **Isabella Mills Monk**. Subject to strange fantasies as a result of a childhood head injury, Monk had a troubled adolescence and was soon notorious for her promiscuity. She was confined for a time at a Catholic institution for prostitutes, located near Montreal's Hôtel Dieu Hospital and Convent and run by Hôtel Dieu nuns; it was presumably this familiarity with the organization which formed the basis for her later tales. In 1834, at age 18, she was discovered to be pregnant and forced to leave. Upon her exit from the institu-

tion, Monk met and presumably became the mistress of the Reverend William K. Hoyt, an anti-Catholic zealot. She went with him to New York City, where her first daughter was born in July 1835.

Prejudice against Catholics was running high in American cities at the time, fed by the waves of European Catholic immigrants arriving in the country; an Ursuline convent in Charlestown, Massachusetts, had been burned to the ground by a mob in 1834. In New York, Hoyt enlisted the aid of several fomenters associated with the *American Protestant Vindicator*, an anti-Catholic newspaper, and together these men wrote Monk's "autobiography." They may have been inspired as much by *Six Months in a Convent*, a recently published book by an ex-servant and so-called "escaped nun" named **Rebecca Theresa Reed**, as by Monk. *Awful Disclosures of Maria Monk, As Exhibited in a Narrative of Her Sufferings during a Residence of Five Years as a Novice and Two Years as a Black Nun, in the Hotel Dieu Nunnery at Montreal*, possibly based on fantasies or exaggerations Monk related to the men, and definitely further exaggerated by them, was first serialized in the *American Protestant Vindicator* in late 1835. Al-

leging that Hôtel Dieu nuns were routinely forced to submit to lustful priests, and that any who balked at this unsavory duty were summarily murdered, as were all resultant babies (Monk, or her ghostwriters, claimed that she had fled for her life with her baby, who had allegedly been sired by a priest), it appeared in book form in January 1836, and was a resounding success. A number of recent commentators have noted that the book's pornographic elements may have been as popular with the reading public as its anti-Catholic sentiments.

Awful Disclosures caused an immediate controversy, inflaming already hot anti-Catholic sentiment in some quarters, and sparking debate in others. Many prominent Catholics and Protestants stepped forward to denounce the book and the fraudulent smear on the nuns and priests of the Hôtel Dieu. Monk's own mother testified that her daughter had never been a practicing Catholic, nor had she spent seven years in a nunnery. Following a complete investigation, New York editor William L. Stone pronounced the story a hoax, which merely boosted sales even further. In 1837, Monk left Hoyt for the Reverend John J.L. Slocum, one of the collaborators on *Awful Disclosures*, and that year Slocum produced *Further Disclosures by Maria Monk*. Although this second book did not contain any new material, it served to keep the controversy alive, and *Awful Disclosures* continued to sell well. Monk received no money from the sales of either book.

Maria Monk dropped Slocum late in 1837 and gave birth to a second daughter in 1838. In 1849, while a resident in a house of prostitution in New York's seamy Five Points section, she was arrested for theft and was sent to the poorhouse on New York's Blackwell's Island (now Roosevelt Island). She died soon after her arrival, at age 33. Some 300,000 copies of *Awful Disclosures* were sold before the Civil War. A facsimile edition was reprinted in 1962.

SOURCES:

James, Edward T., ed. *Notable American Women, 1607–1950*. Cambridge, MA: The Belknap Press of Harvard University Press, 1971.

McHenry, Robert, ed. *Famous American Women*. NY: Dover, 1980.

Weatherford, Doris. *American Women's History*. NY: Prentice Hall, 1994.

Ellen Dennis French,
freelance writer, Murrieta, California

Maria Monk

Monnier, Adrienne (c. 1892–1955).

See Beach, Sylvia for sidebar.

Monod, Sarah (1836–1912)

French philanthropist and feminist. Pronunciation: mo-NO. Born in 1836; died in 1912; daughter of a pastor.

Sarah Monod, daughter of a celebrated pastor, was a member of one of the most prominent Protestant families in France. She became a field-hospital nurse during the Franco-Prussian War (1870–71), was long the editor of *La Femme* (1878—), and was a leading participant in many philanthropic enterprises and social causes, from promoting world peace and public health to combating juvenile delinquency, alcoholism, pornography, and prostitution. In June 1891, she founded the Versailles Conferences, which annually brought together leaders of Protestant women's charitable organizations. Encouraged by a visit by *May Wright Sewall, founder of the International Council of Women, these women gradually began to take an interest in the movement for women's rights.

Always garbed like a Quaker matron, with black bonnet and full round skirt, Monod was the soul of dignity and moderation, saying that "the best feminism should be the most feminine." She participated in the French feminist congress of 1889 and was an early member of *Jeanne Schmahl's L'Avant-courrière (The Advance Messenger, 1893), which advocated achieving specific, practicable reforms, beginning with the right of women to control their own income and to bear legal witness to public and private acts. At the Paris Exposition of 1900, Monod presided over the Second Congress of Feminine Works and Institutions (June 18–27), for which the Versailles Conference had taken the initiative. Some 230 reports were heard and discussed in a calm and orderly atmosphere. From a fusion of this meeting and the elements of the International Congress on the Conditions and Rights of Women held three months later, the National Council of French Women (CNFF), an umbrella federation of many kinds of women's organizations, was born on April 18, 1901. The founding of the CNFF was the earliest sign that French feminism might become a mass movement. Rather apolitical at first, it soon became active in the cause of women's suffrage. Monod was the CNFF's first president. **Julie Puaux** (Mme Jules) **Siegfried**, with whom she had helped to save *Jane Misme's La Française in 1911, succeeded her in 1912. From an initial membership of 21,000, the CNFF had grown to around 100,000.

Sarah Monod combined great moral authority with superior organizational abilities. Perhaps no other woman of her time in France could have brought together such a wide variety of women's organizations under one tent. As important as women's rights were to her, however, she regarded them as only a part, albeit a vital one, of the larger struggle for the social and moral regeneration of France and the world at large.

SOURCES:

Duby, Georges, and Michelle Perrot, directeurs. *Histoire des femmes en Occident.* Vol. 4: *Le XIXᵉ siècle.* Paris: Plon, 1991.

Hause, Steven C., with Anne R. Kenney. *Women's Suffrage and Social Politics in the French Third Republic.* Princeton, NJ: Princeton University Press, 1984.

Klejman, Laurence, and Florence Rochefort. *L'Égalité en marche: Le féminisme sous la Troisième République.* Paris: Presses de la Fondation nationale des sciences politiques, 1989.

Rabaut, Jean. *Histoire des féminismes français.* Paris: Stock, 1978.

David S. Newhall, Professor of History Emeritus, Centre College, author of *Clemenceau: A Life at War* (Edwin Mellen Press, 1991)

Monroe, Elizabeth (1768–1830)

American first lady (1817–1825) who had enjoyed success as a diplomat's wife but whose years in the White House were marred by ill health and misunderstanding. Born Elizabeth Kortright on June 30, 1768, in New York, New York; died on September 23, 1830, in Oak Hill, Virginia; one of four daughters and one son of Hannah (Aspinwall) Kortright and Captain Laurence Kortright (a merchant and a founder of the New York Chamber of Commerce); married James Monroe (later president of the U.S.), on February 16, 1786, in New York, New York; children: Eliza Hay Monroe (b. 1787); Maria Hester Monroe (1803–1850); and a son who died in infancy.

Elizabeth Monroe was 27 years old and traveling with her husband James Monroe, then ambassador to France, when they arrived in Paris in the midst of the French Revolution. Monroe soon learned that Madame *Marie Adrienne de Lafayette, wife of one of the great heroes of the American Revolution, was imprisoned under sentence of death by guillotine. Thinking that a direct appeal would be politically unwise, James dispatched Elizabeth to visit the prison, and she set off with only her servants in the official U.S. carriage. The display of American interest occasioned by the tearful meeting of the two women at the prison gate had the desired effect, and Madame de Lafayette was freed. In a show of admiration and affection, the French dubbed Elizabeth "la belle Americaine." Years later, as first lady in her own country, she would not enjoy such popularity.

Elizabeth, one of five children of Laurence and **Hannah Kortright**, grew up in New York's privileged mercantile society. Educated at home with her three sisters, and traveling extensively in Europe, she became a fine painter and spoke fluent French. Elizabeth met James Monroe at a social gathering and although, by some accounts, her family did not approve of his social status, they were married in February 1786. James was then serving as a delegate to the Continental Congress, and the couple settled in Philadelphia—then the seat of government—and began a family. They had two daughters, **Eliza Hay Monroe** (b. 1787) and **Maria Hester Monroe** (b. 1803). A son died in infancy.

For 17 years, James served as legislator and governor of Virginia and in foreign missions as ambassador to France, England, and Spain. Elizabeth accompanied him on all his foreign posts and gained a reputation as an elegant and charming hostess. However, when the couple returned from Europe so that James might serve as secretary of state under President James Madison, they were virtually unknown in Washington circles.

When James Monroe was elected president in 1817, Elizabeth was showing signs of rheumatism, forcing her to curtail her social duties and alter some of the established rules of Washington entertaining. In a complete departure from the warm and expansive style of her predecessor *****Dolley Madison**, Elizabeth set her own schedule of receptions and greeted guests with European formality, sitting on a raised platform. Somewhat shy and protective of her privacy as well as of her health, she was thought to be haughty and aloof. She further rankled wives of the diplomatic corps and other dignitaries by refusing to travel long distances on Washington's unpaved streets to make calls. The duty of receiving visitors was often delegated to her eldest daughter Eliza, a stickler for protocol who was once characterized as "an obstinate little firebrand." When Eliza announced that the wedding of her younger sister Maria, the first daughter of a president to be married in the White House, would include only family and close friends, Washington society was further alienated.

Although she cultivated few friendships, Elizabeth was credited with restoring the executive mansion with the addition of exquisite French imports, providing an elegant backdrop for state occasions. It was also under the Monroe administration that the building, left marred and sooty from the British torches that had set Washington in flames during the War of 1812, was painted a gleaming white. Elizabeth, a beauty into old age, was as regal and elegant as the settings she created. In many pictures, she appears in black velvet with an ermine wrap.

After two terms, the Monroes retired to their home in Oak Hill, Virginia, where Elizabeth's rheumatism grew steadily worse. She died of the disease on September 23, 1830, at age 62, and was buried at Oak Hill. The president died a year later. In 1903, Elizabeth Monroe was reinterred in Hollywood Cemetery in Richmond, Virginia, next to her husband.

SOURCES:

Healy, Diana Dixon. *America's First Ladies: Private Lives of the Presidential Wives.* NY: Atheneum, 1988.

James, Edward T., ed. *Notable American Women, 1607–1950.* Cambridge, MA: Belknap Press of Harvard University Press, 1971, pp. 561–562.

Melick, Arden David. *Wives of the Presidents.* Maplewood, NJ: Hammond, 1977.

Paletta, LuAnn. *The World Almanac of First Ladies.* NY: World Almanac, 1990.

Willard, Frances F., and Mary A. Livermore, eds. *A Woman of the Century: Biographical Sketches of Leading American Women.* NY: Charles Wells Moulton, 1893, pp. 561–562.

SUGGESTED READING:

Holloway, Lara C. *The Ladies of the White House,* 1880.

Elizabeth Monroe

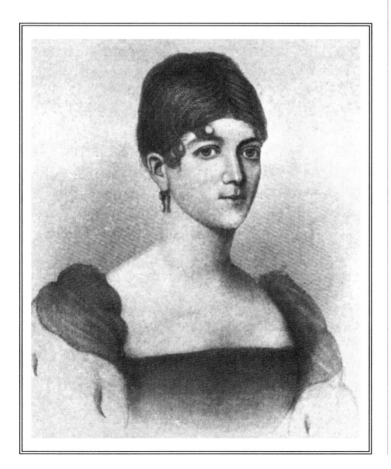

Barbara Morgan,
Melrose, Massachusetts

Monroe, Harriet (1860–1936)

American poet and essayist who revived enthusiasm for verse through the pages of Poetry, *the magazine she founded in 1912 and edited until her death in 1936. Born Harriet Monroe on December 23, 1860, in Chicago, Illinois; died on September 26, 1936, in Arequipa, Peru; graduated high school from the Visitation Convent of Georgetown in Washington, D.C., 1879; daughter of Henry S. Monroe (a lawyer) and Martha Mitchell Monroe; sister of* **Lucy Monroe Calhoun** *and* **Dora Monroe Root***; never married; no children.*

Art critic and travel writer for the Chicago Tribune *and other papers, commissioned to write the official poem (the "Columbian Ode") for the dedication of Chicago's World Columbian Exposition (1892); founded* Poetry: A Magazine of Verse *(1912); served as chief editor of* Poetry *(1912–36).*

Selected works: Valeria and Other Poems *(1891); "Columbian Ode" (1893); (biography)* John Wellborn Root *(1896);* The Passing Show *(1903);* You and I *(1914); (co-edited with Alice Corbin Henderson)* The New Poetry: An Anthology *(1917, expanded editions reissued 1923, 1932, and 1945);* The Difference and Other Poems *(1924);* Chosen Poems *(1935); (autobiography)* A Poet's Life: Seventy Years in a Changing World *(published posthumously, 1938). Neither her freelance work nor her editorial columns for* Poetry *have been republished.*

Harriet Monroe belonged to that dynamic generation of forward-thinking women who transformed Victorian America in the 1880s and 1890s, yet she made her greatest contribution to American cultural life among the modernists of the following century. Her divided existence handicaps those who try to evaluate her legacy. From the perspective of the 19th-century society which shaped her, she appears almost precocious. Monroe was career-minded, entrepreneurial, and cosmopolitan in her reading and travel. From the perspective of her 20th-century colleagues, however, Monroe seemed both provincial and prudish. Ironically, it was her Victorian formation which gave her the faith in human progress and the reverence for art needed to found and edit *Poetry: A Magazine of Verse*, and through *Poetry*, to rekindle American enthusiasm for verse.

Monroe's history is inseparable from that of her beloved native city, Chicago. Her father, Henry Stanton Monroe, migrated from upstate New York to Chicago in the 1850s in search of an "energetic growing town" in which to practice law. The family of Monroe's mother, **Martha Mitchell**, had also moved recently from Ohio to Chicago in pursuit of greater social and economic opportunities. During the 1850s and 1860s, Chicago fulfilled every expectation of the young couple: the city hummed with exciting politics, interesting legal cases, musical and theatrical arts, and a booming economy. Henry and Martha lost three infant sons, but three daughters and one son survived.

Harriet Monroe, the second daughter, born in 1860, had fond memories of her early childhood. Together with her sisters and brother, she explored the lakeside marshes and woods outside the home and their father's library within it. Maids, gardeners, and coachmen bustled about at the fringes of family life and provided reassuring proof of the household's prosperous situation.

Everything changed in 1871 when the great Chicago fire devastated the central city and destroyed both her father's law office and the illusion of a charmed life. Monroe always revered her father as a gifted lawyer and loving companion to his children, but he was not a dependable provider. Within a few years, the family left the handsome home of Harriet's childhood and embarked upon an erratic series of residential moves that mirrored their declining economic position. In her autobiography, Monroe noted only that Henry Monroe "made unfortunate connections" in later years and suffered from "unsystematic" accounting methods.

She was less generous toward her mother, whom she blamed for the tension in her parents' marriage. Martha Mitchell had had no opportunities for formal education and was happy to devote her attention to the home, while Henry Monroe adored books, society, and politics. Harriet concluded that her mother made a poor companion to her father. Monroe's fierce loyalty to her father may have blinded her to her mother's strengths, however, for while Henry Monroe encouraged Harriet's early interest in books, it was her mother who supervised the children's early education and exposed them to the theater and to music.

Growing awareness of her parents' marital and financial problems weighed heavily on 16-year-old Harriet. In 1876, the Monroe family traveled to Philadelphia to see the Centennial Exposition, the first of the great "World's Fairs"

to be held in America. Monroe was fascinated with the art galleries and the machinery exhibits, but on the return trip she was overcome with "lassitude." "Nervous prostration" was not uncommon among women of Harriet's class in Victorian America, and for many, including Harriet, it seemed to provide an acceptable excuse for retreating from social and family obligations. That fall and winter, Monroe withdrew from school and kept to her bed until "all my youthful troubles seemed to straighten out."

When Harriet recovered, she and her father traveled to the Visitation Convent of Georgetown in Washington where she completed high school in 1879. It took time for Harriet, who was neither Catholic nor religious, to appreciate the nuns' educational style. She had read widely among the books in her father's collection but within the convent she read more critically. The nuns were strict, Monroe recalled, but encouraged "a certain questing freedom of mind and spirit." Although Harriet never practiced any religion, convent life gave her an appreciation for the "charm, majesty and power of the religious instinct." Perhaps most important, as both educators and spiritual counselors, the nuns encouraged her to take herself seriously and regard her own life in terms of a vocation. Monroe emerged from Visitation Convent intent on winning fame as a poet or playwright.

It was one of the most impressive aspects of her intelligence that she, who was born and conditioned to so different an age of poetry, could have re-created herself and become one of the most enthusiastic sponsors of a new era in the art.

—Morton Dauwen Zabel

After graduation, she returned to live with her family in Chicago. The city had not only recovered from the fire of 1871, but it had been reborn as a dynamic center of social innovation. Progressive reformers like *Jane Addams in social work, *Florence Kelley in labor, and *Alice Hamilton in industrial medicine challenged traditional political and social practices, while revolutionary architects like Louis Sullivan rebuilt the Chicago skyline with the skyscraper. The expanding industries of meatpacking and railroads lured millions of immigrants from Europe and financed the construction of new mansions along the lakeshore. The excitement culminated in 1893 when Chicago hosted the World Columbian Exposition (the world's fair commemorating Columbus' voyage), and paraded a reborn Chicago before America.

During the 1880s, Monroe took full advantage of the city's attractions. She joined her siblings and friends at theaters, art galleries, and musical performances as well as at national political conventions held in town. She joined a female literary club, the Fortnightly, which gave her practice in composing essays and speaking before an audience. **Margaret Sullivan**, an editorial writer for the *Chicago Tribune*, encouraged Monroe's creative work but also urged her to write freelance articles on the local art scene. Sullivan also helped Monroe and her younger sister Lucy spend the winter of 1888–89 in New York City where Harriet reviewed New York music, art, and architecture for the *Tribune*. The job provided the two sisters with entry into the exciting literary circles of New York, especially that of E.C. Steadman, the editor of *Century Magazine*.

The trip to New York also gave Monroe a chance to meet the Scottish writer Robert Louis Stevenson as he traveled through the city. Monroe had written Stevenson in 1885 to praise his novel *The New Arabian Nights*, and during the next four years they exchanged occasional letters. At the meeting, she was surprised to find that Stevenson was just as unattractively ill as he had always claimed. In later years, she recounted the disenchanting encounter as an example of her over-romantic imagination, but it makes a better illustration of her early ability to reach out to authors through letters. Throughout her life, Monroe would remain a prolific and compassionate correspondent, sending forth comments, criticism and encouragement to writers at all stages of their careers.

In 1889, Monroe published her first poem, "With a Copy of Shelley," in *Century Magazine,* completed her first play, *Valeriana,* and was selected to write the words to the *Cantata* celebrating the inauguration of the new Louis Sullivan-designed Chicago Auditorium. She celebrated her successes, age 29, with a six-week visit to London and Paris.

Monroe did not have the same sense of progress in her personal life. As a young woman, she had assumed that love and marriage would inevitably accompany literary fame, but she found no one to share her dream of a "mutual grand passion" and by the 1890s she was ready to "retire from the great game" of courtship. In her memoirs, Monroe insisted that she was "content with the spinster's narrow lot," but several of her poems and essays suggest that she regretted never having had a child of her own. As she entered her 30s, she adjusted to a new role, however, and became an attentive aunt to her nieces and nephews.

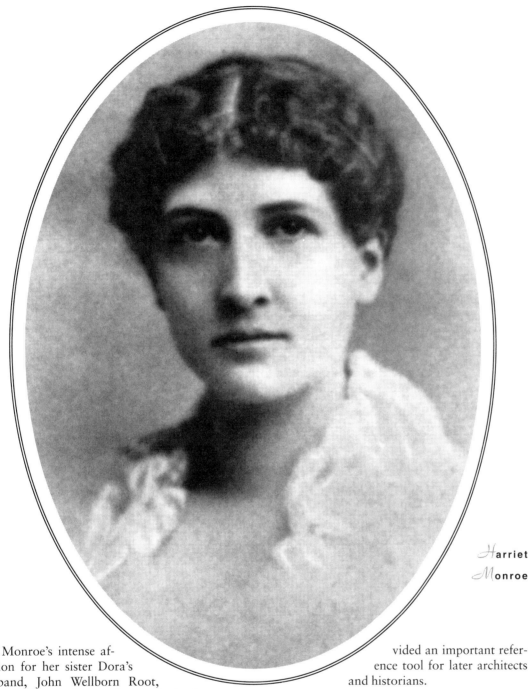

Harriet
Monroe

Monroe's intense affection for her sister Dora's husband, John Wellborn Root, contrasted with her cool appraisal of other men during her 20s. Root's tragic death from pneumonia in 1891 caused Monroe to relapse into the "lassitude" she had experienced as a girl. It also drove her to take on a project in architectural theory as she drafted *John Wellborn Root: His Life and Work*. Root had been one of the original consulting architects of the 1893 Columbian Fair and had hoped to use the fair to celebrate modern architecture and the new profession of city planning. Although Root's proposals were not adopted by fair organizers, Monroe's work preserved Root's vision and provided an important reference tool for later architects and historians.

Root's death also motivated Monroe to seek out the organizers of the Columbian Fair and demand that poetry be incorporated into the opening events. Monroe not only secured a promise that poetry would be honored alongside the other arts, she won a paid commission to write the "Commemoration Ode," a poem she saw partly as a tribute to Root. In 1892, she sat with the other artists honored at the dedication ceremony and listened to 5,000 voices sing her verses celebrating the "splendors and triumphs of modern civilization."

Monroe had secured the rights to market her commemoration poem, and although she sold very few of the pamphlets she had printed up for the fair (she used them to light the fire in her home the rest of the winter), she did successfully sue a major newspaper, the *New York World*, for having printed the poem without her permission. The suit, which dragged on until 1897, helped other writers protect their creative work. It also provided a much-needed financial windfall for Monroe who used the money to join her sisters living in Europe in 1898.

Throughout her middle years, Harriet Monroe earned her living by reviewing the arts for Chicago newspapers and national magazines and by teaching at local high schools. Her work did not bring her the "literary fame" she once coveted, but it did keep her in touch with aesthetic trends and with the powerful patrons of the Chicago art scene. In 1898, she joined the "Little Room," an art circle which welcomed creative women from any field to weekly discussions and occasional performances. The artists, sculptors, playwrights, and journalists of the Little Room encouraged Monroe to continue writing poems and plays, and in 1903 she published *The Passing Show*, a collection of five short plays written in blank verse.

The years 1905 to 1910 were filled with difficult transitions. Monroe had continued to share a home with her father (her mother died in 1892), her widowed sister Dora Root and the Root children, her younger sister and fellow art critic Lucy, and her brother William, but between 1903 and 1910 the family was scattered by deaths and marriages. Monroe lost another circle of support when the Little Room was gradually overtaken by male writers who renamed the group the Cliff Dwellers. Ironically, the Cliff Dwellers, who sought to raise the profile of the professional writer in Chicago, reflected the growth of public interest in literature that Monroe had long awaited. However, the Cliff Dwellers had little interest in linking themselves with women writers (whom they did not consider professionals) or poets.

In 1910, 50-year-old Monroe traveled across Europe and Russia to visit her sister Lucy in Peking, where Lucy's husband, John Calhoun, directed the U.S. Mission to China. The exciting trip provoked some serious reflection. The literary climate of Chicago was definitely quickening (in later years, the era would be known as the Chicago Renaissance), but poetry was sadly neglected. Monroe felt discouraged by her own "snail-paced" literary advance. She felt that she had matured as a poet since "Columbian Ode," yet she had found few opportunities to publish her poems. She realized that her situation was not unusual; every poet she knew complained that magazine editors regarded poetry not as art but as "filler material" for blank spaces.

Monroe became more dismayed when she contrasted the degraded place of poetry with the enthusiasm for the visual arts sweeping the city's elite. Not only were individuals amassing private collections, but donations poured into the Chicago Arts Institute which used the money to purchase European masterworks and fund scholarships and prizes for the city's young artists. There were obvious differences, Monroe reflected sadly, a poem could not be owned or conspicuously flaunted like a painting or sculpture, nor did the public think of poetry as evidence of high culture. Thus, while the Arts Institute committed millions to establish a "world class" art collection, poetry, "the oldest and most noble art," was left to fend for itself.

By the time Monroe returned from China to Chicago in 1911, she had begun to think of herself as more than a poet; she thought of herself as a defender of poetry. Friends encouraged her to found her own magazine and one Little Room colleague, Hobart Chatfield-Taylor, suggested that Monroe finance the magazine by persuading 100 prominent Chicago men and women to pledge $50 a year for five years. She canvassed the business district for months to raise the money. When not calling on Chicago's wealthiest, she spent her time at the library paging through back issues of magazines in a search for intriguing poets. Finally, when the money seemed assured, Monroe wrote 50 poets and invited them to submit their work to the proposed journal, *Poetry: A Magazine of Verse*.

In her initial invitation, Monroe extended three promises which would guide *Poetry* during its 24 years under her direction. First, she offered poets "a chance to be heard in their own place" before an audience prepared to regard poetry as art, not filler. Second, Monroe initiated her famous "open door policy" by promising to publish the best poetry regardless of style or source. Throughout her years as editor, she refused to be bound to any interpretive or regional school. Finally, she promised to regard poets as professionals and pay authors for their work. Monroe recruited another Little Room friend, **Alice Corbin Henderson**, to serve as assistant editor, and the first issue of *Poetry* was released in October 1912.

Poetry was spectacularly successful. American readers, who opened the first issue expecting to read pleasant couplets on flowers or romance, were angered to find themselves described as a "mass of dolts" in Ezra Pound's poem, "To Whistler-American." During subsequent issues, the magazine stunned the American audience with the work of Hamlin Garland, Conrad Aiken, Rupert Brooke, *Marianne Moore, Robert Frost, *Amy Lowell, and Vachel Lindsay. As early as 1913, critics began to acknowledge a "renaissance" of public interest in poetry. Monroe adopted Walt Whitman's maxim "to have great poets there must be great audiences, too" as the motto for *Poetry* and dedicated herself to educating the American public. She introduced Americans to new artistic movements such as Imagism, with its startling use of free verse formats and "unpoetic" language, and to the poetic traditions of China, Japan, and India. During its first five years, *Poetry* proved to be the critical outlet for the poetry revolution in America. In 1917, Monroe and Henderson co-edited *The New Poetry: An Anthology* and traced the contours of the literary transformation they had provoked.

From 1912 to 1917, *Poetry* benefited from the astute contributions of Ezra Pound. Pound was a young and virtually unknown American poet living in England when Monroe's invitation to submit poetry to the new magazine reached him, and he responded enthusiastically to her plan: "there is not another magazine in America which is not an insult to the serious artist and to the dignity of his art." Pound not only offered his poems, however, he offered his assistance in keeping *Poetry* in touch with literary trends in Britain and France. Monroe asked Pound to serve as foreign correspondent for the magazine, and from 1912 to 1917 he forwarded his own poems and essays as well as the work of *Hilda Doolittle (H.D.), T.S. Eliot, William Butler Yeats, and others.

Monroe recognized Pound's genius but the two did not always agree. Her "open door policy" rankled Pound, who championed the Imagist poets, and her frequent selection of Midwestern poets and topics led him to accuse her of bias. The two also disagreed on the merits of individual poems. Monroe's initial reluctance to publish all of T.S. Eliot's "The Love Song of J. Alfred Prufrock," was much publicized by Pound. Her discomfort with Eliot's work appears prudish now, but at the time she was the only American editor willing even to consider the poem.

In later years, Pound propagated the idea that he had singlehandedly dictated *Poetry*'s successful choices and that the magazine had col-

Henderson, Alice Corbin (1881–1949)

American poet and editor. Name variations: Alice Corbin. Born Alice Corbin in St. Louis, Missouri, in 1881; died in 1949; daughter of Fillmore Mallory Corbin and Lula Hebe (Carradine) Corbin; married William Penhallow Henderson (an artist), in 1905; children: one daughter Alice Henderson Evans.

Alice Corbin Henderson, associate editor of *Poetry* from 1912 to 1916, also wrote *Adam's Dream and Two Others Miracle Plays for Children* (1907), *The Spinning Woman of the Sky* (verse, 1912), *Red Earth* (verse, 1920), *The Sun Turns West* (verse, 1933), and *Brothers of Light, the Penitentes of the Southwest* (prose, 1937). She co-edited, with *Harriet Monroe, The New Poetry: An Anthology* (1917), with expanded editions reissued 1923, 1932, and 1945. Henderson, who lived in Santa Fe, also compiled *The Turquoise Trail*, an anthology of New Mexico poetry, in 1928.

lapsed into irrelevance when he resigned in 1917. Pound's role in *Poetry* had certainly been substantial, but Monroe was never a mere tool for his genius. Their frequent fights proved that each approached the editorial responsibilities seriously. It is true, however, that *Poetry* was not at the forefront of the poetic revolution after 1922. In part, Monroe's success had inspired the establishment of other little magazines, especially *Margaret Carolyn Anderson's *Little Review* (1914–29) which competed with *Poetry*. In addition, Monroe's personal preference for majestic, lyrical poetry was out of keeping with the disillusioned temper of the 1920s. Despite her lack of sympathy for some of the material, Monroe continued to show an uncanny knack for spotting and encouraging early talent. *Poetry* regularly introduced riveting new voices, like those of William Carlos Williams, Hart Crane, *Edna St. Vincent Millay, Wallace Stevens, and e.e. cummings. In the end, Monroe's greatest talent as editor proved to be her ability to remain detached from any single artistic current, and thus expose her readers to the greatest variety of poetry.

As editor of *Poetry,* Monroe had finally found the perfect match for her talents. As a poet and an art critic, she understood both the process and context of poetry. She also had the powerful connections, the gritty persistence, and the faith in the medium necessary to create the platform that poets desperately needed in 1912. She took her job as editor seriously; she complained that reviewing manuscripts was like "handling naked souls." Monroe was not merely an editor, however, she was a teacher of and

an advocate for poetry. Both those who received her encouraging and attentive correspondence, and those who visited her tiny office were impressed with her energy and kindness. "I had never been the actual mistress of any home which had sheltered me," she wrote, "but this little kingdom was mine, and I rather enjoyed dispensing its fleeting hospitalities." Of course, it was not merely kindness, but gritty determination which enabled Monroe to keep *Poetry* going through the literary infighting of the 1920s and the depression of the 1930s.

In the early 1930s, Monroe began to think of retiring. She encouraged her assistants to take over more of the magazine's management while she worked on her autobiography, *A Poet's Life*. In 1936, she carried drafts of the final chapters with her on a journey to the international PEN Conference in Buenos Aires. Once in South America, 75-year-old Monroe could not resist joining other writers on a journey to visit the Incan ruins of Machu Picchu. In Chicago, her colleagues had barely finished reading an excited letter from Monroe describing the proposed trip across the Andes when they received the news of her unexpected stroke and sudden death. Monroe was buried in Arequipa, Peru. The Harriet Monroe Modern Poetry Library at the University of Chicago, the Harriet Monroe Poetry Prize, and *Poetry* magazine, which celebrated its 75th anniversary in 1997, commemorate her achievement.

SOURCES:

Bremer, Sidney H. "*Willa Cather's Lost Chicago Sisters," in Squier, Susan Merrill, ed. *Women Writers and the City: Essays in Feminist Literary Criticism*. Knoxville, TN: University of Tennessee Press, 1984, pp. 210–229.

Cahill, Daniel J. *Harriet Monroe*. Twayne's United States Authors Series No. 222. NY: Twayne, 1973.

Massa, Ann. "Form Follows Function: The Construction of Harriet Monroe and Poetry, A Magazine of Verse," in Susan Albertine, ed., *A Living of Words: American Women in Print Culture*. Knoxville, TN: University of Tennessee Press, 1995, pp. 115–131.

Williams, Ellen. *Harriet Monroe and the Poetry Renaissance: The First Ten Years of Poetry, 1912–22*. Urbana, IL: University of Illinois Press, 1977.

Zabel, Morton Dauwen. "H.M.: In Memory, 1860–1936," in *Poetry*. Vol. 47. January 1961, pp. 241–254.

SUGGESTED READING:

Massa, Anna. "The 'Columbian Ode' and Poetry, A Magazine of Verse: Harriet Monroe's Entrepreneurial Triumphs," in *Journal of American Studies*. Vol. 20. April 1986, pp. 51–69.

COLLECTIONS:

Correspondence, unpublished work and *Poetry* archives located in the Personal Papers of Harriet Monroe, in the Harriet Monroe Modern Poetry Library of the Joseph Regenstein Library, University of Chicago.

Janice Lee Jayes,
historian, Washington, D.C.

Monroe, Marilyn (1926–1962)

One of the last stars of the Hollywood studio system and the most enduring of American cultural icons, whose appeal and allure have extended far beyond her brief life. Name variations: Norma Jeane Mortonson or Mortensen; Norma Jeane Baker; Norma Jean Mortonson. Born on June 1, 1926, in Los Angeles, California; died of a drug overdose on August 4, 1962, at home in Los Angeles; daughter of Gladys Baker Mortonson (also seen as Mortensen) and possibly C. Stanley Gifford (a salesman); married Jim Dougherty, on June 19, 1942 (divorced 1946); married Joe DiMaggio (the baseball player), on January 14, 1954 (divorced autumn 1954); married Arthur Miller (the playwright), on June 29, 1956 (divorced January 1961); no children.

Filmography: (bit) Scudda-Hoo! Scudda-Hay! (1948); (bit) Dangerous Years (1948); Ladies of the Chorus (1948); Love Happy (1950); A Ticket to Tomahawk (1950); The Asphalt Jungle (1950); All About Eve (1950); Right Cross (1950); The Fireball (1950); Hometown Story (1951); As Young As You Feel (1951); Love Nest (1951); Let's Make It Legal (1951); Clash by Night (1952); We're Not Married (1952); Don't Bother to Knock (1952); Monkey Business (1952); O. Henry's Full House (1952); Niagara (1953); Gentlemen Prefer Blondes (1953); How to Marry a Millionaire (1953); River of No Return (1954); There's No Business Like Show Business (1954); The Seven Year Itch (1955); Bus Stop (1956); The Prince and the Showgirl (1957); Some Like It Hot (1959); Let's Make Love (1960); The Misfits (1961).

In the years since her premature death, Marilyn Monroe has become an American icon: scores of books, including biographies, essays, poems, and thinly veiled fiction, have been published about her life; calendars, postcards, and glossy coffee-table collections of photographs abound; and the inspiration that her persona seems to offer writers and artists shows no sign of fading. Though she was not the most beautiful of women, her absolute ease in front of the camera, combined with a childlike eagerness for affection and apparent innocence, made her into one of the world's biggest movie stars, and with her platinum-blonde hair and abundance of curves she remains, to many, the embodiment of female sexuality.

Her life was lived, however, not as a goddess, but as a human being who endured more than her share of suffering. She was born Norma Jeane Mortonson in 1926, and her life-long emotional instability had its roots in her earliest

infancy, when her mother boarded her with another family at birth. **Gladys Baker Mortonson**, who at 24 was separated from her second husband, paid the Bolender family five dollars per week to care for the baby so she could keep her job at a film lab. The Bolenders were said to have treated her as one of their own, but they were harsh and strict and prone to punishing even their own children with a razor strop. Gladys compounded the problem by not allowing the Bolenders to adopt her baby and by insisting that Norma Jeane not address them as mother and father. The weekly visits by the woman she called mother only served to confuse the child.

Gladys Mortonson had her own problems. Her two children from her first marriage had been taken away from her, apparently by their father; she never saw them again. Neither of her husbands was Norma Jeane's father. His identity has never been established definitively, although he may have been C. Stanley Gifford, a suave salesman at the film lab with whom Gladys was deeply in love. He disappeared from her life after the birth of her daughter.

When Norma Jeane was six, Gladys, by working double shifts and borrowing money, managed to realize her dream of buying a white bungalow in Hollywood. For a short time, she made a happy home for her daughter. They had a second-hand piano, and the English couple to whom Gladys rented out most of the house taught the little girl to dance and sing, treats she had been deprived of in the intensely religious atmosphere of the Bolender home. Grauman's Egyptian Theater, where children were admitted for a dime, was nearby, and Norma Jeane spent hours watching Clark Gable, *Joan Crawford, Fred Astaire and *Ginger Rogers. In 1934, however, Gladys' recurrent depression worsened, and one day seven-year-old Norma Jeane returned home from school to find that her mother had been taken to the hospital. Gladys would remain in mental institutions for most of her daughter's life.

The English tenants kept Norma Jeane in the house as long as they could, and brought her along when finally they were forced to move to furnished rooms. When they returned to England, a close friend of her mother's, **Grace McKee**, found a family who wanted to adopt the eight-year-old. That family was about to move to New Orleans, however, so one of Gladys' co-workers volunteered to adopt her instead, so she could stay in Los Angeles. Gladys refused both offers. McKee became Norma Jeane's legal

guardian, but she was reluctant to take the girl into her own home because she had recently married a man with three children. Thus, in 1935, Norma Jeane entered the Los Angeles Orphans' Home. Although objective reports indicate that she was not treated poorly, the experience was terrifying, and the two years she spent in the orphanage would loom large in her adult psyche and haunt her for the rest of her life.

In 1937, McKee removed her from the orphanage, and Norma Jeane spent several months with foster families. One expected an inordinate amount of work from her, and the other included an alcoholic father. McKee was forced to take her into her own home, but after several years (according to the adult Monroe) McKee's husband, Doc Goddard, came into Norma Jeane's bedroom one night while drunk and kissed her. She told her story to McKee's aunt, **Ana Lower**, and "Aunt Ana" promptly took the precocious 14-year-old into her own home. Thus began what Monroe always remembered as the best year of her life, her first and best taste of unconditional love.

This, too, did not last. When Goddard decided to move his family to West Virginia, McKee, apparently believing that she needed to find a more permanent home for her charge, suggested to her neighbors that their 20-year-son Jim Dougherty marry Norma Jeane. They agreed, as did their son, who worked as both an embalmer at a funeral home and a night-shift fitter at Lockheed. McKee first thought it necessary for Norma Jeane to explain her illegitimacy to her fiancé; Monroe later said that was the first time she realized that her parents were never married and that the name Mortonson belonged to her mother's second husband. (Her mother's first husband had been a man named Baker, which for some unknown reason was the last name Norma Jeane used at school.)

The wedding was held on June 19, 1942, soon after she turned 16 and reached the legal age to marry. Dougherty, who later wrote a book about his life with Monroe, claimed that while she started out as a hopeless housekeeper and cook, he was otherwise quite happy with his young wife. Monroe told a different story: "I was a peculiar wife. . . . I liked boys and girls younger than me. I played games with them until my husband came out and started calling me to go to bed." Nonetheless, she did find in Dougherty a certain security; she called him "pop" and might have made him her sanctuary forever had he not joined the Merchant Marine in the war year of 1943. During his first year of

service, he was posted at Catalina Island off the Los Angeles coast, and Monroe, who had dropped out of high school, accompanied him there. The following year, however, he was sent overseas, and she returned to work at an aircraft factory, where an army photographer came by one day on assignment for *Yank* magazine. He took notice of the shapely 19-year-old and hired her as a freelance model. Within a year, she had appeared on the covers of over 30 magazines, and as her modeling career took off she became increasingly ambitious and increasingly cool to Dougherty during his leaves. On one such leave, Norma Jeane informed him of her new resolve: she wanted to be an actress.

It is the lost possibilities of Marilyn Monroe that capture our imaginations. It is the lost Norma Jeane, looking out of Marilyn's eyes, who captured our hearts.

—Gloria Steinem

In the summer of 1946, Dougherty paid a last visit to his wife to deliver their final divorce papers. He found her radiant, and she told him that just a few days earlier she had been offered a contract at $125 per week with Twentieth Century-Fox. (The studio's interest had been piqued after its executives spotted some suggestive, but not nude, photos of her in "girlie" magazines.) The studio, she added, had changed her name to Marilyn Monroe, but she apparently had some say in the matter: Monroe was her mother's maiden name. Though she had bleached her brown hair blonde—white was always her favorite color, to the point of obsession—she would never relinquish the high-pitched, child-like voice that would become her trademark.

For nearly the next eight years, Monroe focused almost exclusively on her career. Despite her impoverished, Depression-era childhood, her motivation was not to accumulate wealth or goods but to improve herself. She was insecure about almost every aspect of her person, especially her lack of education. She wanted more than anything to be both a movie star and an actress, to be famous and to deserve that fame. What little money she had was spent on books and acting lessons, while she wore the same two spotlessly clean dresses over and over. When she had a bit of money she would eat at drugstore counters, and when she had less, she ate peanut butter in her rented room. She had many escorts, for varied reasons, as well as several long-term liaisons with rich, older men; at least one of these, the agent Johnny Hyde, was eager to marry her—and, at 30 years her senior, make her a very rich widow—but she declined. Although

she later told several people that sometimes she had accepted small sums of money in exchange for sex when she was desperate for pocket change, many who later took a close look at her life were surprised that she made a point of never using her sexual charms for financial gain. Indeed, she often bragged that she had never been a "kept" woman.

As a fledging starlet in the last years of the Hollywood studio system, Monroe had no say over her early roles in such films as *Dangerous Years* and *Scudda-Hoo! Scudda-Hay!* (both 1948). Fox fired her after one year, in a move that was never explained, and she subsisted on modeling jobs until she was signed to a contract with Columbia. It, too, brought her only a few bit parts, but she had no intention of giving up: "My God, how I wanted to learn! To change, to improve! I didn't want anything else. Not men, not money, not love, but the ability to act. With the arc lights on me and the camera pointed at me, I suddenly knew myself. . . . I spent my salary on lessons. I bought books to read. I sneaked scripts off the set and sat up alone in my room reading them out loud."

Monroe's contract with Columbia lapsed. Unemployed, she posed nude for $50. Those famous photographs, released as a calendar, have since gone on to net the calendar company a cool $750,000; when asked by the press several years later to explain why she had posed, she replied simply, "I was hungry." Her life was looking particularly grim when she won a small part in the Marx Brothers' *Love Happy* (1950), the first film to capture her characteristic, and very sexy, walk. The publicity tour that followed attracted a good amount of attention from the press and the public.

A bigger break came that same year, when she was 24, with John Huston's *The Asphalt Jungle* (1950), a film about thieves and a jewel heist that still stands as one of the best of its kind. Her role as the young mistress of an aging criminal brought her good notices, but it did not lead to the kind of work she wanted. Monroe had switched back to Twentieth Century-Fox, and although she did receive a small part in *All About Eve* (1950), the enormously popular film starring *Bette Davis and *Anne Baxter, the studio gave her no other memorable roles. Still, for an actress who had logged less than 50 minutes of screen time, Monroe had become something of a star. Her easy appeal had not been lost on magazine editors, either; she had become the "pin-up girl" of choice and, in 1951, appeared on the cover of *Look* magazine.

Marilyn Monroe

One of her escorts that year was Elia Kazan, already an acclaimed director (and husband of **Molly Day Thatcher** and father of four children). As many of the men in her life did, he actively tutored Monroe, in his case about art and literature and, especially, politics; Kazan had been a member of the Communist party, and Senator Joseph McCarthy's witch hunt for Communists was gathering steam. In December 1950, he had introduced her to Arthur Miller, America's most celebrated playwright. Despite Monroe's ongoing affair with Kazan, and the fact that only a

few days before she had swallowed a handful of barbiturates in despair over the death of agent Johnny Hyde—her third of numerous suicide attempts, by her own count—she felt an immediate attraction to the married Miller.

Monroe next made a dozen "B" movies in rapid succession, most of them forgettable, although her work as a deranged baby-sitter in *Don't Bother to Knock* (1952) impressed **Anne Bancroft**, the actress who starred. The year 1953, however, served as a breakout, with her classic performance as Lorelei Lee, the quintessential not-so-dumb blonde golddigger, in *Gentlemen Prefer Blondes*. This frothy Howard Hawks-directed adaptation of *Anita Loos' comic novel showcased Monroe in clinging gowns and lavish furs (and, briefly, a tiara around her neck), and featured her breathily singing, "Diamonds Are a Girl's Best Friend." Marilyn Monroe was a movie star. Later the same year came *How to Marry a Millionaire*, with *Betty Grable and **Lauren Bacall**, a romp—although a sex romp, to be sure—that allowed her to show her considerable talent. During the filming of the movie, Grable, the World War II pin-up girl extraordinaire and once the highest-paid woman in Hollywood, reportedly told Monroe, "Honey, I've had it. Go get yours. It's your turn now." Unlike previous reviews, which had concentrated mostly on her face and figure, reviews for *How to Marry a Millionaire* consistently praised Monroe's gift for comedy.

During that hectic year, Monroe had been seeing Joe DiMaggio, the New York Yankees baseball player and national hero; for much of that time, he had been one lover among many, and not one of the most exciting. Conservative and aloof, he wanted a wife but no part of Hollywood life, and that may have become his strong suit for Monroe, who once described Hollywood as "a place where they'll pay you a thousand dollars for a kiss and fifty cents for your soul." Despite numerous signs of trouble (many sources agree that he was possessive and jealous), DiMaggio had increasingly become her safe haven from press and studio obligations. Her next film was Otto Preminger's *River of No Return* (1954), with Robert Mitchum. On January 14, 1954, shortly after shooting was completed, Monroe and DiMaggio were married in a civil ceremony at San Francisco City Hall. Some 500 people, having heard of the spur-of-the-moment proceedings, gathered outside. She was 27; he was 39.

Their two-week trip to an isolated cabin in the California mountains was perhaps the highlight of the union; immediately afterward, while on a very public "honeymoon" in Japan, the couple were already fighting over her revealing clothing and the attention she attracted.

During the first seven months of her marriage to DiMaggio, Monroe stayed away from Hollywood. This proved to be a smart career move; no longer indifferent to her charms, or to her box-office potential, Twentieth Century-Fox was eager to have her back. She went straight from the set of *There's No Business Like Show Business* (1954), a musical tribute to the songs of Irving Berlin that also starred *Ethel Merman, *Mitzi Gaynor and Johnnie Ray, to that of the hugely successful *The Seven Year Itch* (1955). Directed by Billy Wilder, this comedy was the story of a family man tempted by the sexy upstairs neighbor who moves in while his wife and children are away, and produced the famous photograph of Monroe standing over a subway grate while her dress billows upward. But just nine months after her wedding to DiMaggio his jealousy proved too great, and the unhappy couple divorced amid reports of private investigators, clandestine lovers and terrible fights.

In December 1954, just as pre-release word of mouth about *The Seven Year Itch* was catapulting her into Hollywood royalty, Monroe put on a black wig and, under the name Zelda Zonk, flew to New York City. She had been persuaded to make the move by Milton Greene, who would become her new agent. He and his wife took her into their Connecticut home and, as others had before them, tried to help her sort out her life. **Amy Greene** took her to see dress designers and gynecologists (Monroe suffered from severe menstrual pain, due to what was later diagnosed as endometriosis; she also had had numerous abortions, 13 by the time she was 29, which had done considerable damage to her uterus). This was one of several times she "adopted" an existing couple or family, moving in with them and accepting help, much as an orphan would do. In some cases, though not with the Greenes, she would make romantic advances to the man, thus spoiling the familial relationship.

As Monroe began to feel more confident on the East Coast, she moved into New York City and began to study with Lee Strasberg at the famed Actors Studio, home of "Method" acting and the training ground for some of the best American actors of the era. Lee and **Paula Strasberg** soon became another surrogate family (their daughter *Susan Strasberg, who had recently won rave reviews for her performance on Broadway in the title role of *The Diary of *Anne Frank*, would later write the book *Marilyn and*

Me: Sisters, Rivals, Friends). In February 1956, Monroe ended her year of self-imposed exile and returned to Los Angeles to make *Bus Stop*, based on the William Inge play. In anticipation of a hit, *Time* magazine put her on its cover in May, and predicted a glorious future for an already shining star. The report was not quite accurate; although she had made 24 films in the first seven years of her career, during the following, and final, seven years she would complete only five.

However, *Bus Stop* (1956), the first of those five, lived up to expectations. This story of a weary singer with a past and the naive young man who falls in love with her, in which Monroe sings a memorable version of "(That Old) Black Magic," proved a hit. Director Joshua Logan, who at first had been reluctant to hire her, became a convert: "I had no idea she had this incandescent talent. She made directing worthwhile. She had such fascinating things happen to her face and skin and hair and body as she read lines . . . she was inspiring." Critic Bosley Crowther wrote in *The New York Times* that she had "finally proved herself an actress."

For months, Monroe had been telling people she had fallen in love with Arthur Miller, who had written both *The Crucible* and the one-act version of *A View From the Bridge* since the pair had met in 1950, and whose own marriage to **Mary Slattery Miller** had recently failed. She also had an affair with actor Marlon Brando that year, but in June 1956, in White Plains, New York, she and Miller interrupted a judge at dinner to marry them in an impromptu ceremony. Monroe had just turned 30; Miller was 40. It would prove to be her lengthiest marriage, lasting three and a half years.

Soon after, the couple spent several months in London while Monroe filmed *The Prince and the Showgirl* (1957), a period piece with Sir Laurence Olivier that also co-starred ***Sybil Thorndike** and would prove to be moderately successful. Monroe's new marriage was off to a shaky start: her long battle with insomnia could no longer be fought successfully with sleeping pills, and, according to her business partner Milton Greene, she was up all night and drinking gin by morning. By November 1956, Monroe and Miller were back in New York City, at a new apartment on East 57th Street. They were very much in love, but there were troubles. In 1957, Miller was convicted of contempt of Congress by the House Committee on Un-American Activities for refusing to name names (the conviction would be overturned the following year by the U.S. Court of Appeals). That same year,

Monroe suffered a tubal pregnancy. The couple's response was to retreat to a Connecticut farmhouse. Although she delighted in playing the role of a country gentlewoman there, the failed pregnancy was the beginning of a downward spiral. As much as she loved Miller, Monroe was probably incapable of sustaining the kind of mature love that a successful marriage requires. She kept up her suicide attempts and her relationships with other men, and she was dramatically inconsistent in her fervent attempts to establish domesticity—doting on Miller's every want one day and leaving a roomful of dinner guests waiting the next.

In the summer of 1958, Monroe returned to Los Angeles to film *Some Like it Hot*, with Tony Curtis and Jack Lemmon as wanted men hiding amongst an all-woman orchestra. Director Billy Wilder, comparing the shoot to an airplane ride, said, "We were in mid-flight—and there was a nut on the plane." Monroe was drinking, cursing, unable to remember her lines, and arriving at dusk for late morning calls. But the film, which is now universally regarded as a comedy classic, received rave reviews, as did Monroe for her work as Sugar Kane; even Wilder conceded, "She has a certain magic that comes across, which no [other] actress in the business has."

Her next film was 1960's musical comedy *Let's Make Love*, which co-starred the French matinee idol and singer Yves Montand and boasted a cast including Tony Randall, Bing Crosby, Gene Kelly and Milton Berle. During filming Monroe and Miller lived in a bungalow at the Beverly Hills Hotel next door to a bungalow shared by Montand and his wife, actress ***Simone Signoret**, and Monroe's marriage disintegrated as she carried on an affair with her co-star. Around this time Miller decided to turn one of his short stories into his first screenplay, with a sizeable role for his wife. *The Misfits*, released in 1961, is a brooding tale set in the American West, concerning a woman in the middle of a divorce who falls in love with another man. That other man was played by longtime star Clark Gable, whose movies she had watched as a child. "What the hell is that girl's problem?" asked Gable (who died one week after filming was completed). "Goddamn it, I like her, but I damn near went nuts waiting for her to show." Director John Huston calculated that Monroe was taking up to 20 sleeping pills a day, topped off with vodka or champagne. In the mornings, her makeup artist often would do his work while she was still flat in bed. Monroe treated Miller harshly on the set, humiliating him, fighting with him, and kicking him out of her room.

After filming was finished in November 1960 and the couple returned to New York on separate flights, Monroe announced that the marriage was over.

The Misfits was not well received by critics, and neither was Monroe's work in it. She spent 1961 in and out of hospitals, first for mental problems and then for gynecological and gall bladder surgeries. She saw her latest psychiatrist, Dr. Ralph Greenson, almost every day.

It was during this difficult period that Monroe apparently became acquainted with recently elected President John F. Kennedy (to whom she so famously sang "Happy Birthday" in a flesh-colored dress) and his brother Robert Kennedy, the U.S. attorney general. The complete truth of these relationships, which have been the subject of much speculation and a number of books, is out of reach, but it is almost certain that the relationships did exist. John F. Kennedy is known to have had an active sex life outside of his marriage to *Jacqueline Kennedy, and there is little reason to think that his relationship with Marilyn Monroe—whatever the number of times they actually may have met—meant much to him in emotional terms. His brother was different. By 1960, Bobby Kennedy had been married to *Ethel Kennedy for ten years and had seven children. Monroe is one of the few women, and possibly the only one, to whom he was linked outside of his marriage. Reports of friends and acquaintances indicate that theirs may well have been an important, emotional bond.

At any rate, in the last year or two of her life, a special, secret man—she referred to him as "the General"—loomed large in Monroe's conversations with friends. It was an otherwise terrible time: she was drinking champagne all day and taking too many sleeping pills, was often disoriented, and had no meaningful work to occupy her time. She received a role in George Cukor's *Something's Got to Give*, a film she hoped would save her sinking career, but it ended in disaster when she was fired from the picture in June 1962, one week after her 36th birthday.

Two months later, on August 5, 1962, Marilyn Monroe was found dead of a drug overdose in her Brentwood bungalow. (It is generally accepted that she had died on the evening of August 4.) While the world mourned, only 24 people were invited to her private funeral arranged by Joe DiMaggio, who had been hoping for a reconciliation; at least one biographer claims that Monroe had already purchased a wedding gown for their remarriage. Although the press and public were stunned by the sad ending to Monroe's life, they were perhaps not entirely shocked, and her death was accepted as a suicide brought on by personal and professional despair.

In the months and years that followed, however, a number of people began to suspect that the circumstances of her death were more complicated than the accounts of suicide had suggested. Among the theories that have circulated are that Monroe was murdered by the Kennedys (or people in their employ) to save them from embarrassment, and, alternately, that she was murdered by political enemies of the Kennedys (specifically, Teamsters boss Jimmy Hoffa) to cause them embarrassment. Because of inept and insufficient police work at the time of her death, these theories are impossible to disprove. Marilyn Monroe died of an overdose of barbiturates, but it is possible, although not probable, that she did not give herself the last dose. (The coroner's report, which has caused much controversy, noted that there were no pill capsules in her stomach, and also that there was no syringe in the house.) Writer Anthony Summers, after a thorough investigation for *Goddess*, his book about Monroe, concludes that although the Kennedys and their brother-in-law Peter Lawford were almost certainly involved in a cover-up of the murky details of her death (manipulation of phone records, etc.), that cover-up appears to have been an attempt to keep secret the Kennedy involvement in her life, not in her death. Summers also notes that her overdose might well have been an accident, in the sense that Monroe probably had little notion of the number of pills she had taken that day.

No matter what the events of the final day of her life, an international luminary had died young. In the decades since, Marilyn Monroe's presence in popular culture has only grown, aided by artists and writers as diverse as Andy Warhol, *Jacqueline Susann, Norman Mailer, *Gloria Steinem, Joyce Carol Oates, Elton John and Madonna. Her life and death have taken on the dimensions of an American myth, and her indelible image remains nearly ubiquitous; in that sense, she is very much alive. Happiness may have eluded her, but celebrity certainly did not.

SOURCES:

Mailer, Norman. *Marilyn*. NY: Grosset & Dunlap, 1973.

McCann, Graham. *Marilyn Monroe*. New Brunswick, NJ: Rutgers University Press, 1988.

Steinem, Gloria. *Marilyn*. NY: Henry Holt, 1986.

Summers, Anthony. *Goddess: The Secret Lives of Marilyn Monroe*. NY: Macmillan, 1985.

Zolotow, Maurice. *Marilyn Monroe*. NY: Harcourt Brace, 1960.

SUGGESTED READING:

Gregory, Adela, and Milo Speriglio. *Crypt 33: The Saga of Marilyn Monroe—The Final Word*. Birch Lane, 1993.

Guiles, Fred Lawrence. *Norma Jean: The Life of Marilyn Monroe*. Paragon.

Leaming, Barbara. *Marilyn Monroe*. NY: Crown.

Monroe, Marilyn, *et al. My Story*. NY: Cooper Square Press, 2000 (rep. ed).

Rosten, Norman. *Marilyn: An Untold Story*. NY: Signet, 1973.

Slatzer, Robert. *The Life and Curious Death of Marilyn Monroe*. NY: Pinnacle, 1974.

Elizabeth L. Bland,
reporter, *Time* magazine

Mons, Anna (d. 1714)

Longtime mistress of Tsar Peter I of Russia. Born Anna Mons, probably in Moscow, during the 1670s; died in Moscow in August 1714; daughter of Johann Mons (sometimes seen as Monst or Munst), a German innkeeper in Moscow; no formal education; married M. de Kaiserling (Keyserling), in 1711; mistress of Peter I the Great (1672–1725), tsar of Russia (r. 1682–1725), from 1691 to 1703; no known children.

Sometime in 1691, Anna Mons, the teenage daughter of a German innkeeper in Moscow, met Tsar Peter I the Great of Russia. Peter, only 19 at the time, was well over six feet tall and already showing the dynamism and curiosity that was later to make him one of Russia's greatest rulers. He was immediately captivated by Anna's fair-haired beauty but even more by her vivaciousness and ribald sense of humor. Unlike Peter's own wife *Eudoxia Lopukhina** and most of the Russian women of his acquaintance—who tended to be reserved, secluded, conservative and tradition-bound—Anna Mons mixed easily with Peter's male friends and seemed like a breath of Western fresh air in stuffy Moscow. She soon became his mistress and for the next 12 years the tsar spent far more time with her than with Eudoxia or any other woman. Had Anna been more astute, she might have become Peter's second wife and tsarina of Russia. Instead, through greed and jealousy, she lost the tsar's affection in 1703 as well as many of the perquisites he had bestowed upon her. "She was an exceedingly beautiful young woman," wrote Alexander Gordon, "embued with all the talents to please, except prudence and good sense."

Peter met Anna in the Foreign Settlement (or German Quarter) of Moscow, an area set aside in 1652 by his father Tsar Alexis I for foreigners living in the Russian capital. This sequestering was done not for the convenience of foreign visitors but to isolate Orthodox and superstitious Russians from the way of life and heretical ideas of the increasing number of Westerners attracted to Russia as that country slowly began to modernize and end centuries of isolation and backwardness. One of those who came to Moscow in the second half of the 17th century was Johann Mons, who is variously described as a wine merchant or jeweler from the German town of Minden in Westphalia. He continued in the wine trade, set up an inn, and apparently was relatively prosperous. It is uncertain whether Anna, who had an older sister and at least one brother, was born in Westphalia or Moscow but she certainly grew up in the Foreign Settlement. Like many men and almost all women in Russia at the time, she received virtually no education, could write only in very poor German, and had a limited range of interests. She was pretty, however, and while still in her teens became the mistress of Francis Lefort, a Swiss soldier of fortune who had also settled in Moscow.

For Peter, who grew up in Preobrazhenskoe outside of Moscow and detested traditional Russian court life, the Foreign Settlement acted like a magnet. He would go there to observe Western dress and manners, discuss Western ideas and institutions, and partake in a Western lifestyle. He soon made the acquaintance of Lefort. At first, the two men spent their time drinking beer and discussing military tactics; in time, Lefort became the tsar's most influential advisor and his guide to all things Western. In 1691, on one of his visits to Lefort's house, Peter met Anna Mons. He was intrigued by her Western dress and manners, her easy camaraderie and quick wit. Lefort, sensing the tsar's interest and perhaps his own longterm gain, had no objection to Anna's switching her affections to his imposing Russian visitor.

For the next 12 years, she was the tsar's "loyal friend." Unlike Eudoxia, she was frequently seen in public with Peter and attended social occasions with him. As one of his biographers has remarked, "she could match him drink for drink and joke for joke." The tsar's pleasure in her company was reflected in the gifts he gave her: a new house in the Foreign Settlement, a large estate at Dudino with 295 peasant families to support it, and a portrait of himself set in a diamond-studded frame. In 1698, after an 18-month trip through Western Europe, Peter forced Eudoxia to enter a nunnery and apparently gave serious consideration to marrying Anna Mons. To conservative Russians it seemed that she had "bewitched" the tsar, influencing him to require that those in court wear wigs and foreign dress,

and supposedly collecting for herself the beard tax which he had imposed on his subjects. There is no doubt that she profited financially from her relationship with the tsar and promoted the material interests of her friends as well.

Mons' fall from grace came suddenly and unexpectedly in 1703. The precise cause of her denouemont is in dispute. It has been suggested that she was jealous of Peter's new interest in Catherine Skovronsky, an attractive Latvian peasant he had recently met, and sought to win back his affection by openly flirting with Kaiserling, the Prussian ambassador to Russia. It has also been argued that she was attracted by the long-term prospects of marriage to Kaiserling and went along with a suggestion that they request in writing the tsar's blessing of the union. When shown this and other evidence of his mistress' infidelity, the tsar purportedly told Kaiserling: "I brought up Mons for myself; I meant to marry her; you have seduced her, and you can keep her." The vengeful and equally unfaithful ruler deprived Anna of her estate and diamond-studded portrait and placed her under house arrest in the Foreign Settlement. Catherine Skovronsky took her place in his bed, had 12 children, became his second wife in 1712, and 13 years later succeeded him as ruler of Russia as *Catherine I. Anna, in the meantime, married Kaiserling in 1711 shortly before his death. She herself died in obscurity in Moscow during August 1714.

SOURCES:

Grey, Ian. *Peter the Great: Emperor of All Russia.* London: Hodder and Stoughton, 1960.

Massie, Robert K. *Peter the Great: His Life and World.* NY: Alfred A. Knopf, 1980.

<div align="right">

R.C. Elwood,
Professor of History, Carleton University, Ottawa, Canada

</div>

Monstiers-Mérinville, Marquise des (1863–1909).

See Caldwell, Mary Gwendolin.

Montacute.

Variant of Montagu.

Montacute, Alice (c. 1406–1463)

Duchess of Salisbury. Name variations: Alice Neville. Born around 1406; died in 1463; daughter of Thomas Montacute, 4th earl of Salisbury, and *Eleanor Holland (c. 1385–?); married Richard Neville, 1st earl of Salisbury, before 1428; children: Richard Neville (1428–1471), earl of Warwick (known as Warwick the Kingmaker); Thomas Neville (d. 1460); John Neville (1431–1471), marquess of Montagu; George Neville (c. 1433–1476), archbishop of York; Ralph Neville;

Robert Neville; *Joan Neville (who married William Fitzalan, 13th earl of Arundel); *Cecily Neville (who married Henry Beauchamp, duke and 6th earl of Warwick, and John Tiptoft, 1st earl of Worcester); *Alice Neville (who married Henry Fitzhugh, 5th Lord Fitzhugh of Ravensworth); *Eleanor Neville (who married Thomas Stanley, earl of Derby); *Catherine Neville (who married William Bonville, Lord Harrington, and William Hastings); *Margaret Neville (who married John de Vere, 13th earl of Oxford, and William Hastings, Lord Hastings).

Montacute, Anne (d. 1457)

Duchess of Exeter. Name variations: Anne Hankford; Anne Holland; Anne of Salisbury. Died on November 28, 1457; interred at St. Katherine by the Tower, London; daughter of John Montacute, 3rd earl of Salisbury, and *Maud Montacute; married Richard Hankford (1397–1430); became third wife of John Holland (1395–1447), duke of Huntington (r. 1416–1447), duke of Exeter (r. 1443–1447); children: (first marriage) *Anne Hankford (1431–1485); Thomasine Hankford, Baroness Fitz-Waryn (1422–1453). The Complete Peerage *makes it clear that John Holland's first wife* *Anne Stafford (d. 1432) was the mother of *Anne Holland *and not Anne Montacute as shown in other sources. John Holland's second wife was* *Beatrice of Portugal (d. 1439).

Montacute, Eleanor (c. 1385–?).

See Holland, Eleanor.

Montacute, Elizabeth.

See Mohun, Elizabeth.

Montacute, Joan (fl. 1300s)

Countess of Suffolk. Name variations: Joan de Ufford. Flourished in the 1300s; daughter of Edward Montacute, Baron Montacute, and **Alice Plantagenet** (d. 1351, granddaughter of Edward I, king of England); married William de Ufford (c. 1330–1382), 2nd earl of Suffolk.

Montacute, Margaret (fl. 1400s)

Baroness Ferrers of Groby. Name variations: Margaret de Montagu. Flourished in the 1400s; daughter of John Montacute, 3rd earl of Salisbury, and *Maud Montacute (fl. 1380s); married William Ferrers (d. 1445), 5th baron Ferrers of Groby. William Ferrers' second wife was **Philippa Clifford**, the mother of Henry Ferrers (d. 1394).

Montacute, Maud (fl. 1380s)

Countess of Salisbury. Name variations: Maud de Montagu; Maud Frounceys. Born Maud Francis or Maud Frounceys and flourished in the 1380s; married John Montacute, 3rd earl of Salisbury; children: *Anne Montacute (d. 1457), duchess of Exeter; Thomas Montacute, 4th earl of Salisbury (1388–1428);* *Margaret Montacute, Baroness Ferrers of Groby.*

Montacute, Philippa (fl. 1352)

Countess of March. Name variations: Philippa Mortimer. Flourished around 1352; daughter of William Montacute, 1st earl of Salisbury, and ✥➤ *Katharine Grandison; married Roger Mortimer (1328–1359), Baron Mortimer of Wigmore and 2nd earl of March; children: Edmund Mortimer (1352–1381), 3rd earl of March and earl of Ulster.*

Montagu.

Variant of Montacute.

Montagu, Elizabeth (1720–1800)

British socialite and author who reigned as London's foremost intellectual hostess for half a century. Born Elizabeth Robinson in York on October 2, 1720; died in London on August 25, 1800; eldest daughter of Matthew Robinson (a Yorkshire landowner) and Elizabeth Drake Robinson (a Cambridge heiress); sister of *Sarah Scott (1723–1795, then a well-known novelist); cousin by marriage of Lady* *Mary Wortley Montagu (1689–1762); education supervised by her grandfather Dr. Conyers Middleton, a Cambridge scholar; married Edward Montagu (a scholar), in 1742 (died 1775); children: one son, John (1743–1744).*

Publications: anonymous author of Essay on the Writings and Genius of Shakespeare *(1769); anonymous author of three dialogues in Lyttelton's* Dialogues of the Dead *(1760).*

Elizabeth Montagu, dubbed "Queen of the Blues" by Samuel Johnson, lived up to this title in her day, as a reigning hostess of London's intellectual society. Destined to span roughly two generations, the Bluestocking Circle, of which Montagu was an early member, became one of London's most celebrated societies for the leisured gentry. The circle began during the 1750s and 1760s as a conversation among friends, both women and men, who were interested in literature and other intellectual pursuits. Rather than wear the white silk stockings then worn by London's fashion-conscious gentry, one member of the circle, Benjamin Stillingfleet, started to attend their evening meetings dressed in blue worsted stockings, usually worn only by peasants. From Stillingfleet's provocative choice, the society's name was born.

One of 12 children, the precocious Montagu grew up largely in Cambridgeshire where she was supervised by her grandparents. Her grandfather, Conyers Middleton, was librarian of Cambridge University, and according to *The Cambridge History of English and American Literature* he "not only allowed her to come to his academic parties, but he would afterwards, with educational intent, require from her an account of the learned conversations at which she had been present." Her father Matthew Robinson encouraged her to be a worthy opponent to his own swift repartee, a practice he is said to have discontinued when she bested him in these verbal matches. *Cambridge History* also notes that she engaged in good-natured arguing with her brothers "till their emulation produced in their sister 'a diligence of application unusual at the time.'" This diligence earned Montagu a knowledge of French and Italian as well as some Latin, although she was reportedly not always eager to admit to the latter in deference to fashion. She was of fond of dancing and in her youth was known as "Fidget," once remarking, "Why shall a table that stands still require so many legs when I can fidget on two?" Montagu's literary interests may have been passed on to her by her mother **Elizabeth Drake Robinson**, who was related to the novelist Laurence Sterne.

While staying with her grandmother, Montagu met **Margaret Bentinck**, the duchess of Portland (daughter of the 2nd earl of Oxford who married the 2nd duke of Portland). Thanks to the friendship that developed between Montagu and Bentinck, Elizabeth was introduced to a cultivated circle of individuals, many of whom would be lifelong friends as well as worthy bluestockings.

Montagu was only 13 when her father brought her out into society at Bath and Tunbridge. In 1742, age 22, she married the wealthy Edward Montagu, a scholar and coal-owner 29 years her elder who was the grandson of the first earl of Sandwich. Their only child was born in 1743 and died within a year. Bereaved, Montagu engaged in social and intellectual pursuits with even greater determination. Not long into the marriage, when Edward's house in Dover Street proved too small for her entertaining, he built her a home on Hill Street which she hoped to make a central location for intellect and fashion. They moved in during 1748, and Montagu

◆❧
Grandison, Katharine (fl. 1305–1340). See Siege Warfare and Women.

began giving receptions in her famous Chinese Room. She wrote to *Fanny Boscawen in 1753 that the "Chinese Room was filled by a succession of people from eleven in the morning till eleven at night." Intellect took precedence for Montagu, who remarked that, regardless of their place in society, "I never invite idiots to my house." Guests would come to include **Margaret Cavendish Harley**, countess of Oxford, *Elizabeth Carter**, *Catherine Talbot**, *Elizabeth Vesey**, *Mary Delany**, Fanny Boscawen, *Anna Seward**, *Hester Chapone**, Edmund Burke, Joshua Reynolds, Lord Lyttelton, David Garrick, *Fanny Burney**, and *Hannah More**, as well as Johnson, Horace Walpole and, once, King George III. For 50 years, despite all competitors, Montagu would remain the preeminent hostess of intellectual gatherings in London.

According to *Cambridge History,* no precise information exists as to when Montagu began her bluestocking parties, but likely it was after she made Elizabeth Vesey's acquaintance. A "bluestocking philosophy," concerned with literature rather than politics, emerged as a means of what members called "rational entertainment" for women, and the Circle evolved into London's most famous women's-only society. Montagu, Catherine Talbot, Hester Chapone, and Elizabeth Carter were among the first generation of bluestockings. In addition to their meetings, members communicated through letters, discussing their personal and professional activities and ideas at length. Louis Kronenberger writes of the bluestockings: "Now, under the leadership of Mrs Montagu, these defiant bluestockings managed to acquire distinction and draw round them many eminent men of the day. They were a mixed group, some of them great ladies like the duchess of Portland, others hardworking middle-class women who lived virtually in Grub Street; but all were 'modern' and all had pronounced ideas." (Eventually, as political turmoil of the late 1760s destabilized European society, more conservative men and women would openly scorn the accomplishments of intellectual women, and "bluestocking" would become a term of ridicule.)

As "Queen of the Blues," Montagu held a distinguished place in London society and earned an intimate court of Platonic admirers. *Cambridge History* reports:

> Lord Lyttelton . . . was amazed, he once told her, that those "dangerous things . . . beauty, wit, wisdom, learning and virtue (to say nothing of wealth)" had not, long before, driven her from society. . . . Living as she did, in the limelight of a critical society, it

was inevitable that her character should be freely discussed. But, though her complacent vanity might, occasionally, be censured, her affectations deplored, her flattery derided, yet we are told that even those who were most diverted with her foibles would express a high opinion of her abilities.

Montagu's gatherings were more formal than those held by Vesey and the semi-circle in which her guests were arranged became nearly legendary. Kronenberger quotes the description of the arrangement from Fanny Burney's *Diary:*

> [T]he semi-circle that faced the fire retained during the whole evening its unbroken form, with a precision that made it seem described by a Brobdingnagian compass. The lady of the castle commonly placed herself at the upper end of the room, near the commencement of the curve, so as to be courteously visible to all her guests; having the person of highest rank or consequence properly on one side, and the person the most eminent for talents, sagaciously on the other. . . . No one ventured to break the ring.

In 1760, Elizabeth Montagu penned the last three dialogues in George Lyttelton's *Dialogues of the Dead.* Her contribution to the work was made anonymously, with her colloquys advertised as "composed by a different hand." Of the three dialogues (between Cadmus and Hercules; between Mercury and a fashionable modern lady; and between Plutarch, Charon and a modern bookseller), only the second is considered as reflective of her wit and learning. *Cambridge History* notes: "It is by far the wittiest of the whole collection, and met with unqualified success." The work earned her high praise from the bluestocking circle, and Montagu wrote to Elizabeth Carter: "I do not know but at last I may become an author in form. . . . The Dialogues, I mean the three worst, have had a more favourable reception than I expected."

Nine years later, she anonymously published *An Essay on the Writings and Genius of Shakespeare compared with the Greek and French Dramatic Poets, with some Remarks upon the Misrepresentation of Mons. de Voltaire.* Offense at Voltaire's contempt for Shakespeare (from whom Voltaire "had borrowed freely," notes *Cambridge History*) fueled this work which was to be the great literary effort of Montagu's life: "I was incited to this undertaking," she remarks in the introduction, "by great admiration of [Shakespeare's] genius, and still greater indignation at the treatment he has received from a French wit." Reviews were generally favorable, and it was felt that when the work was translated into French five years later it marred Voltaire's stand-

ing as an authority on Shakespeare. At the time, Samuel Johnson may have been alone in his perception of weaknesses in the essay. Although it was published anonymously, Montagu became known as the author of the work, and it brought her fame in England as well as adulation from the bluestockings (*Hester Lynch Piozzi, then known as Mrs. Thrale, called her "the first woman for literary knowledge in England").

Following her husband's death in 1775, Montagu proved herself to be a formidable business talent in managing the fortune and large estates which were left in her control. Although Walpole immediately assumed that she would marry again, she instead kept the company of a nephew.

In 1776, Montagu traveled to Paris, where she attended an attack on Shakespeare by Voltaire at the French Academy, and found that her *Essay* was well known. A celebrity there as well, she was welcomed at many Parisian salons. Meanwhile, her bluestocking colleagues worried that she might return from her travels with an inflated sense of herself. Their fears, however, were in misplaced. *Cambridge History* notes that Montagu returned to England "and was soon her former English self, something of a *poseuse* perhaps, a good deal of an egotist, but always possessing such brilliant qualities of mind and intellect, such a gift for steady friendship, that she remained firmly fixed as hitherto on her bluestocking throne, on which she had still more than twenty years to reign."

Montagu was noted for the financial assistance she provided to authors in need, a practice which earned her the title "female Maecenas of Hill Street" from Hannah More. Among those who received her patronage were the blind poet **Anna Williams** and Elizabeth Carter. Montagu also used her influence to assist authors in other ways. Her efforts helped spread the fame of James Beattie's *Essay on Truth,* and she promoted the career of Hannah More. Known for her generosity, Elizabeth was extremely popular with the colliers in the north and entertained the London chimney-sweeps every May Day.

She commissioned two great buildings in 1781, Sandleford Mansion in Kent and Montagu House in Portman Square, London. Montagu House was built from the designs of James Stuart and became the center for bluestocking meetings, parties, and other entertainments.

Elizabeth Montagu died in London on August 25, 1800. Her nephew Matthew Montagu oversaw publication of her letters, which ran to four volumes, in 1809 and 1813. In one (c.

1739), she had written: "I endeavor to be wise when I cannot be merry, easy when I cannot be glad, content when I cannot be mended and patient when there be no redress."

SOURCES:

Kronenberger, Louis. *Kings and Desperate Men: Life in Eighteenth-Century England.* NY: Alfred Knopf, 1942.

Montagu, Elizabeth. *Letters of Mrs. Elizabeth Montagu: With Some of the Letters of Her Correspondents.* London, 1809–1813 (reprinted AMS Press, 1934).

Ward and Trent, *et al. The Cambridge History of English and American Literature.* Vol. X, sec. XI. Vol. XI, sec. XV. NY: Putnam, 1907–21.

SUGGESTED READING:

Myers, Sylvia Harcstark. *The Bluestocking Circle: Women, Friendship, and the Life of the Mind in Eighteenth-Century England.* Oxford, 1990.

Montagu, Lady Mary Wortley

(1689–1762)

*Self-taught aristocrat of keen intelligence and sparkling wit, whose most enduring legacy can be found in her hundreds of surviving letters which incisively describe the mores of English high society, the mysteries of the East, and the life of an aristocratic exile in 18th-century Italy and France. Name variations: Mary Wortley-Montagu. Born Mary Pierrepont in London, England, in May 1689; died of breast cancer on August 21, 1762; eldest daughter of Evelyn Pierrepont, earl of Kingston, and Lady Mary Pierrepont (daughter of William Fielding, earl of Denbigh); privately tutored and self taught; cousin by marriage to *Elizabeth Montagu (1720–1800); married Edward Wortley Montagu, in August 1712; children: Edward Wortley Montagu (1713–1776, an author and traveler); Mary, Countess of Bute (b. 1718).*

Born into the English aristocracy (May 1689); showed a passion for learning in childhood and acquired considerable skill in languages, including Latin, though she had little formal instruction; pressured by her father to marry a man of suitable social status; instead, eloped to marry the man she loved, age 23 (1712); accompanied husband to a diplomatic posting in Turkey (1716), taking her young son and giving birth to her daughter before they returned to England (1718); fell deeply in love with a young Italian scholar (1736) and left England to be with him; spent the next 22 years on the Continent, returning to England eight months before she died (1762); letters and poetry published only after her death.

"I tremble for what we are doing. Are you sure you will love me forever? Shall we never repent? I fear, and I hope." These timorous yet res-

olute words were written by Lady Mary Pierrepont three days before her elopement with Edward Wortley Montagu. Their courtship had been a long and stormy one. Lady Mary was a lively and intelligent woman of striking beauty. Her father, the wealthy and socially prominent earl of Kingston, eager for a rich and titled match for his eldest daughter, refused to consider plain Mr. Edward Wortley Montagu. Mary and Edward secretly corresponded for three years, bickering for much of that time. Edward was easily made jealous and thought her flirtatious; Mary did her best to convince him that she was a serious and dependable woman, worthy of his love and trust. In August 1712, her father's plans to marry her off to another suitor forced Mary's hand. At her suggestion, the lovers eloped and were secretly married by special license.

The woman who was to win literary fame as Lady Mary Wortley Montagu had little formal education. Her mother died when Mary was only four years old, her father was distant and preoccupied and Mary's upbringing was left to her grandmother, **Elizabeth Pierrepont**. Montagu later described her education as "one of the worst in the world." Her governess, who had been her mother's nurse, "took so much pains from my infancy to fill my head with superstitious tales and false notions, it was none of her fault that I am not at this day afraid of witches and hobgoblins, or turned Methodist." However, driven by a natural curiosity and love of learning, Montagu discovered her father's libraries and by the age of 13 she had taught herself enough Latin to enjoy the great classical authors. Reading seemed to lead naturally to writing. A year later, she copied some of her prose and poetry compositions into an album and composed the following preface:

> I question not but here is very manny faults but if any reasonable Person considers 3 things they wou'd forgive them
>
> 1. I am a woman
>
> 2. without any advantage of Education
>
> 3. all these was writ at the age of 14.

Montagu's biographer, Robert Halsband, has observed that even her earliest writings show "a curious mixture of romantic emotionalism and cynical rationalism—the two contrasting sides of her own nature." Those contrasting facets of her temperament are clearly evident in her letters to Edward Wortley Montagu. Risking her father's anger and her reputation by writing to a man, assuring Edward that she would always love and never deceive him, she nevertheless insisted that he must also make a contribu-

tion to their happiness and grew weary of constantly reassuring him:

> I begin to be tired of my humility. I have carried my complaisances to you farther than I ought. You make new scruples, you have a great deal of fancy, and your distrusts being all of your own making are more immovable than if there was some real ground for them.

The frequent coolness evident in their courtship letters foreshadowed what was to become the tone of their marriage. Edward was 34 when he married the 23-year-old Mary Pierrepont, and he has been called "dour and humorless, without any genuine tenderness to match hers." She hoped that the birth of their son, Edward Wortley Montagu, Jr., in May 1713, would improve matters, but the reverse was the case. Edward spent much time in London, leaving her alone and lonely in the country. In 1714, after sending many affectionate and solicitous letters, she wrote frankly:

> I am very sensible that I parted with you in July, and 'tis now the middle of November. As if this was not hardship enough you do not tell me you are sorry for it. You write seldom and with so much indifference as shows you hardly think of me at all. . . . If your inclination is gone I had rather never receive a letter from you than one which in lieu of comfort for your absence gives me pain even beyond it.

In January 1715, Montagu's life brightened when she joined her husband in London. The death of Queen *Anne the previous year and the succession of George I to the throne meant that the Whig party, to which Edward had long been loyal, would finally secure power. Mary set out to win favor at court and to advance her husband's career. She also began her correspondence with Alexander Pope, soon to become England's preeminent poet. Montagu had written her first published piece the year before, a satirical essay which had appeared anonymously in the *Spectator*. Turning to poetry in 1715, she composed, with Pope and John Gay, the *Town Eclogues*, a satirical reworking of Virgil's pastoral eclogues, verses in which shepherd and shepherdesses were replaced by lords and ladies, thinly disguised representations of the London court figures she was coming to know well. The verses were not published but rather circulated in manuscript form among friends without mention of their authorship. However, in 1716, the three eclogues were illegally printed by an unscrupulous publisher, Edmund Curll, who attributed them to "a lady of quality." While she was proud of her learning and clearly enjoyed the whispers about her wit and poetic ability, Mon-

Lady
Mary
Wortley
Montagu

tagu was, in many ways, a product of her class. Throughout her life, she maintained very rigid ideas about the role and responsibilities of the aristocracy, while recognizing that others might regard her views as examples of "an old-fashioned way of thinking." Thus, while she reflect-ed in old age that "nobody ever had such various provocations to print as myself" she had "never aimed at the vanity of popular applause" and was convinced that persons of quality should content themselves with the applause of their friends.

In December 1715, Montagu was struck by smallpox, a dreaded scourge of the time. It could prove fatal; indeed her brother had died of the disease two years earlier at the age of 20. When it did not kill, it usually disfigured its victims, and Mary, whose beauty had been widely celebrated, was left with a deeply pitted skin and no eyelashes. The news, which came in April 1716, that her husband had been appointed Ambassador Extraordinary to the court of Turkey must have been welcome indeed. Mary loved traveling and enjoyed reading romances and books of travel; now was her chance to see the mysterious East for herself. Her only pangs of regret were engendered by the prospect of a lengthy separation from relatives and friends, since the usual term of appointment to such posts was 20 years. Pope, in particular, was desolate at the prospect of her departure. Highly strung and sensitive, plagued by recurrent illness and a curved spine, he had come to worship Montagu and told her: "I find I begin to behave my self worse to you than to any other woman, as I value you more. And yet if I thought I shou'd not see you again, I would say some things here, which I could not to your person."

Pope, whose letters were to become increasingly flirtatious, was not to be without the object of his passion for as long as he had feared. The family arrived at Adrianople, the capital of the Turkish Empire, in March 1717, and by September Edward had been recalled to England. Making no haste to answer the summons, however, the family did not leave Turkey until the summer of the following year, finally arriving in London in October 1718. It is from this period of less than two years abroad that much of Mary Wortley Montagu's literary fame springs. As well as keeping a journal (burned by her daughter after her death) and writing regularly to her many friends and to her sister, *Frances, countess of Mar, Mary assembled a collection of 52 letters, transcribed and revised into an album. This collection, which came to be known as the Embassy Letters, forms a cohesive narrative account of her travels, starting with her departure from England and ending with her return. It was the first of her works to be published under her own name, albeit not until after her death, and achieved remarkable popularity.

The editor of Montagu's letters calls her "unabashedly open-minded"; she cast her gaze everywhere and composed vividly detailed accounts of everything she saw, drawing comparisons which are far from the usual smug European self-congratulation. Indeed, she praised and often preferred the examples of daily living and customs which she observed in Europe and the East to the habits which she had left behind. Writing of the custom whereby married Viennese women attracted and encouraged young admirers, to the extent that they might have been said to have two husbands, "one that bears the name, and another that performs the duties," Montagu observed in a letter to her friend ❧ Elizabeth Rich:

> Thus you see, my dear, gallantry and good breeding are as different in different climates as morality and religion. Who have the rightest notions of both we shall never know till the Day of Judgement.

Montagu's moral and cultural relativism while abroad, in such sharp contrast to the rather conventional aristocratic views she expressed while in England, is a primary element in making the Embassy Letters such enthralling reading. She begins a letter addressed to her sister by describing every detail of a Turkish woman's dress and then moves on to comment on the morality and conduct of the ladies. Criticizing others who have written on the subject as either extremely discreet or extremely stupid, Montagu asserts: "'Tis very easy to see that they have more liberty than we have." The women's heavy veiled state of "perpetual masquerade," according to Lady Mary, allows them to "follow their inclinations without danger of discovery" and she concludes that, "upon the whole, I look upon the Turkish women as the only free people in the Empire." Throughout this series of letters, Montagu carefully deconstructs the exotic tales of other travelers, emphasizing the similarities as well as the contrasts between the two cultures. In the same letter to her sister, she points a moral that is quite the opposite of that in the earlier letter to Elizabeth Rich:

> Thus you see, dear sister, the manners of mankind do not differ so widely as our voyage writers would make us believe. Perhaps it would be more entertaining to add a few surprising customs of my own invention, but nothing seems to me so agreeable as truth.

Writing to Pope in June 1717, Montagu outlines her week's activities at her summer retreat outside Constantinople: "Monday setting of partridges, Tuesday reading English, Wednesday studying the Turkish language (in which, by the way, I am already very learned), Thursday classical authors, Friday spent in writing, Saturday at my needle, and Sunday admitting of visits and hearing music." Despite Edward's recall in the autumn of 1717, the family lingered in the East. Mary gave birth to a daughter (❧ Mary, Countess of Bute), who was named after her mother, in February 1718, and in March she fol-

lowed through on a resolution she had made the previous year and had her four-year-old son inoculated against the dreaded smallpox. Although it was not unknown in the West, indeed there had been published reports of the procedure in England in 1714 and 1716, Montagu first discovered inoculation against smallpox in the East, and she determined to promote it upon her return to England.

By October 1718, the family was back in London; Edward returned to Parliament and kept his seat for the rest of his life. Mary seems to have abandoned her attempts to further her husband's career and, commencing in 1722, she spent much of her time at their newly purchased country house in Twickenham, close to Pope's own retreat. Mary's reputation as a witty intellectual had been greatly enhanced by her travels. She continued to write brilliant letters to her sister, Lady Mar, and to other women friends; she also published an essay on the virtues of inoculation, under the pseudonym of "a Turkey Merchant," and found herself, along with Pope, at the center of a vibrant social circle.

The summer of 1722 saw the breakdown of Montagu's friendship with Pope. The reasons for the rift are unclear; speculation includes the allegation that Mary returned some sheets she had borrowed without laundering them, that she had found a new young admirer and Pope had become jealous, that he had found a younger woman to worship, that he had refused to write a satire when requested to do so by Mary and Lord Hervey and, perhaps the most likely possibility, that Pope had finally and unequivocally declared his love for her and she had laughed at him.

The years that followed the break with Pope were difficult ones for Montagu. Pope was now as passionate in his hatred as he had once been in his admiration and, in references to Mary which he barely bothered to disguise, his poems accused her of adultery, of having venereal disease, of meanness and predatory sexuality. A literary war began as other writers sprang to Montagu's defense; her reputation became the subject of widespread speculation and gossip. To make the situation worse, rumors were circulating about Montagu's possible romantic involvement with a French poet, Toussaint Rémond. The two had corresponded, and, when Mary lost some of his money in the famous collapse of the South Sea Bubble, he had threatened to publish her letters. Mary's father died in 1726, as did one of her sisters the following year. Also in 1727 her one remaining sibling, Frances, Lady Mar, had a mental breakdown and was to be the subject of

❧▸ **Rich, Elizabeth** (fl. 1710)

English baroness. *Name variations: Lady Rich. Born Elizabeth Griffith, probably in the 1680s; death date unknown; married Sir Robert Rich (1685–1768), 4th baronet and field marshal, around 1710; children: three sons and a daughter.*

Lady Elizabeth Rich, known to history as one of the correspondents of Lady *Mary Wortley Montagu, was probably born in the 1680s and was perhaps slightly older than Lady Mary, for she is described as a "decayed beauty" by the 1720s. She married Sir Robert Rich about 1710. Lady Rich has been variously referred to as "giddy" and "vain and frivolous" and was said to have affected a girlish simplicity all her life, which made her the victim of jokes and pranks.

❧▸ **Mary** (b. 1718)

Countess of Bute. *Name variations: Lady Bute; Mary Wortley Montagu or Wortley-Montagu; Mary Stuart. Born in February 1718; daughter of *Mary Wortley Montagu (1689–1762) and Edward Wortley Montagu; married John Stuart (1713–1792), 3rd earl of Bute (a powerful politician and secretary of state).*

a protracted custody dispute between Mary and the relatives of Lady Mar's husband. Montagu's own husband, soon to be described by a friend as "old and odd," buried himself in politics and his various business enterprises, leaving his wife completely without emotional support.

In the spring of 1736, when she was 47, Montagu met a handsome young Italian who was to transform her life. Francesco Algarotti was 24, a brilliant scientist and essayist from the University of Bologna who had come to England to seek patrons. Patronage was not slow to find him; Algarotti was bisexual and within two weeks of his arrival in England both Mary and her friend and literary champion, Lord Hervey, had fallen under his spell. Montagu's letters, always so elegantly constructed and polished, became as fervent and intemperate as those of a lovesick teenager. In August 1736, she wrote:

> I no longer know how to write to you. My feelings are too ardent; I could not possibly explain them or hide them. One would have to be affected by an enthusiasm similar to mine to endure my letters. I see all its folly without being able to correct myself.

Distressed at not having heard from Algarotti in September, she assured him that:

> an exchange of letters with me ought to give you a kind of pleasure. You will see (what has never been seen till now) the faithful picture of a woman's heart without evasion or

disguises, drawn to the life, who presents herself for what she is, and who neither hides nor glosses over anything from you.

Despite his frequent coolness, Montagu continued to pour out her heart, usually writing in French, a language in which she felt more comfortable when expressing deep emotion. Tormented by her feelings, she told Algarotti: "All that is certain is that I shall love you all my life in spite of your whims and my reason."

Perhaps in an effort to retain her reason and occupy herself during Algarotti's frequent travels, Montagu made a brief return to the world of politics, commencing in December 1737, when she published the first issue of a pro-government paper called *The Nonsense of Common Sense*. She had always been a supporter of Robert Walpole, now the leading minister, even though her husband disliked him, and, while keeping her identity hidden, she attempted to counter the Opposition paper, *Common Sense*. The paper did not achieve a wide circulation and was discontinued after nine issues. In March 1739, Algarotti returned to England and the two appear to have reached an agreement to live together in Venice. Telling her husband that she was traveling to improve her health, she left England in July 1739, not to return for almost 23 years.

You will see (what has never been seen till now) the faithful picture of a woman's heart without evasion or disguises, drawn to the life, who presents herself for what she is, and who neither hides nor glosses over anything from you.

—Lady Mary Wortley Montagu, *Letters*

It was commonly believed in the 18th century that long journeys did have healing qualities. As long ago as 1727, Montagu had written to her sister: "I have a mind to cross the water, to try what effect a new heaven and a new earth will have upon my spirit." Edward seems to have been in agreement with what he knew of her plans; he sent her large amount of baggage (among which there were 500 books, including Latin classics and translated versions of the Greek authors) after her and made sure that she received a regular allowance, but he made no mention of joining her.

Arriving in Venice to wait for Algarotti, Montagu found herself being treated as a celebrity. The Venetians were delighted to have this distinguished aristocratic exile in their midst, she observed in a letter to Edward: "I ver-

ily believe, if one of the pyramids of Egypt had traveled, it could not have been more followed." The warmth of her reception moderated Montagu's impatience at Algarotti's tardiness. She wrote calmly from Florence in October 1740: "I have left Venice and am ready to go where you wish. I await your orders to regulate my life." The young man did finally leave England in 1740 but not for Italy; he had been summoned to Prussia by his friend Frederick II the Great, who had just succeeded to the throne.

Horace Walpole, the writer and son of Robert Walpole, was a young man of 21 when he met Montagu in Florence in 1740. Already developing his satirical, mocking style, he recorded a disparaging picture of her slovenly appearance and painted face and noted that she "is laughed at by the whole town." Joseph Spence, another English traveler in Italy at the same time, recorded a different picture, one which captures the contradictions in her personality:

> Lady Mary is one of the most extraordinary shining characters in the world; but she shines like a comet; she is all irregular and always wandering. She is the most wise, most imprudent; loveliest, disagreeablest; best natured, cruelest woman in the world.

Almost two years after her departure from England, Montagu was finally reunited with Algarotti in Turin, but they were together only two months before Algarotti returned to Prussia. The cause of the rift is unknown; it was perhaps nothing more than Mary's realization that her dream of retirement with such an ambitious, worldly young man was quite impractical. Whatever the reason, as Montagu's biographer observes, "their friendship, which had run its unsteady course for five years, seemed to be ended, and neither her letters nor her vain hopes pursued him."

However, Montagu did continue to send letters to her family and friends. She seems not to have thought of returning to England but remained intimately connected with her homeland through her correspondence. She wrote regularly to Edward, still occasionally showing some of her youthful tenderness, as when she told him that she worried about his health when he did not write. They shared their concerns about their son, who had made an unsuitable marriage and had left England to avoid debtor's prison, and Mary rejoiced in the good qualities of their daughter, poignantly observing to her husband: "I hope her obedience and affection for you will make your life agreeable to you. She cannot have more than I have had; I wish the success may be greater."

For the next two decades, Montagu settled in various places in France and Italy: she lived in an old mill, which she converted into a house, in the beautiful medieval town of Avignon from 1742 to 1746. From 1746 to 1756, she took up residence in Brescia, Northern Italy, in an old palace which she refurbished, and between 1756 and 1761 she lived in Venice and Padua. As her eyesight grew poorer, she gave up her needlework and developed a passion for gardening, not merely growing flowers but, in addition to renovating all of her living quarters, undertaking major landscaping projects, growing vegetables, keeping cattle and poultry, even raising silk worms and growing tea. And despite her weakening eyesight, she continued to read voraciously, sometimes staying up all night to read the latest novels which her daughter sent from England. She retained her weakness for what she called "the gay part of reading"; it served to brighten a life, frequently lived "in solitude not unlike that of Robinson Crusoe," which must sometimes have been lonely. However, in her letters to her daughter, Montagu clearly struggled with her own weakness for the novel form and the sentimental and misleading plots and characterization she encountered: "All that reflection and experience can do is mitigate, we can never extinguish, our passions. I call by that name every sentiment that is not founded upon reason."

The tension between passion, by which Montagu means emotion, and reason was an especially difficult problem for 18th-century women because they were denied the opportunity to educate themselves and develop their rational faculties. Among the most fascinating of Montagu's letters are those in which she advises her daughter, Lady Bute, about the education of her own children, especially the daughters. No doubt thinking of the trouble that her dissolute son had brought her, Montagu advises her daughter to prepare for disappointments with her children and to try to avoid becoming overly fond of them. Writing in February 1750, she warns against allowing the daughters to assume they will all become great ladies: "You should teach yours to confine their desires to probabilities, to be as useful as possible to themselves, and to think privacy (as it is) the happiest state of life." She returns to the subject in January 1753, delighted at the news of Lady Bute's eldest daughter: "I am particularly pleased to hear she is a good arithmetician; it is the best proof of understanding." Montagu counsels that the girl's desire for learning should be encouraged: "Learning (if she has a real taste for it) will not only make her contented but happy in it. No en-

tertainment is so cheap as reading, nor any pleasure so lasting." However, she is to guard against considering herself learned when she has mastered Latin and Greek since: "True knowledge consists in knowing things, not words." Most important, she "is to conceal whatever learning she attains, with as much solicitude as she would hide crookedness or lameness" so as not to make people envious. Anticipating her daughter's reaction, Mary continues:

> You will tell me I have not observed this rule myself, but you are mistaken; it is only inevitable accident that has given me any reputation that way. I have always carefully avoided it, and ever thought it a misfortune.

Montagu clearly expected that her daughter would not welcome the learned education she was advocating, and in March she wrote further on the subject, justifying education "not only to make solitude tolerable but agreeable" in the event that the granddaughters, whom she regards as "a sort of lay nuns," find themselves living in the country or in a form of strict retirement like her own. She protests, in terms which were to become the familiar cry of the early feminist movement, "the unjust custom" of "debarring our sex from the advantages of learning, the men fancying the improvement of our understandings would only furnish us with more art to deceive them, which is directly contrary to the truth." That her unease at her daughter's reaction was well founded is demonstrated by the opening of a letter in June 1753:

> You see I was not mistaken in supposing we should have disputes concerning your daughters if we were together, since we can differ even at this distance. . . . However, everyone has a right to educate their children in their own way, and I shall speak no more on that subject.

As her husband's political prospects improved, Lady Bute seems to have worried more about her rather eccentric mother, and Mary clearly made an effort not to offend or worry her increasingly punctilious daughter. Since her childhood Montagu had been aware that her aristocratic birth would not allow her to publish anything under her own name and, as we have seen, she carefully concealed her identity when her works did appear. Nonetheless, she had a great reputation as a writer in Italy and, as she wrote to her daughter in 1753, was frequently complimented and even asked to donate copies of her works. That she came increasingly to resent this restriction on her creativity as she grew older is evident in the outburst which followed: "To say truth, there is no part of the world where our sex is treated with so much contempt as in England."

It was to England and to her overly fastidious daughter that Montagu returned in January 1762. Edward had died a year earlier, at age 83. He had never achieved a title or well-paying court office but had been so extremely parsimonious that he left an estate said to have been worth over a million pounds. Meanwhile, her daughter's husband had risen to become secretary of state and Lady Bute had begged her mother to return home. Probably already suffering from the effects of the breast cancer that was to kill her within eight months, Montagu finally agreed. Understandably concerned about her literary legacy, she gave a copy of her Embassy Letters to the minister of the English church in Rotterdam and apparently agreed that they might be published after her death.

Unhappy after only a few weeks in England, Montagu considered returning to Italy but was prevented by her rapidly deteriorating health. Given doses of hemlock to dull the pain, she faced death with calm fortitude, drawing up her will in which she left the bulk of her estate to her daughter and only one guinea to her profligate son. She died on August 21, 1762, at age 73. On her death bed, she expressed her wish that the two volumes of her Embassy Letters be published; her daughter was equally determined that they should not be. Lady Bute purchased the letters back from the minister to whom they had been entrusted, but nonetheless the first of many published editions appeared in May 1763. The minister had apparently allowed a couple of Englishmen to borrow them, and they had surreptitiously copied them. The letters were an instant success, and they were reprinted and pirated, along with selections of her poetry, countless times. Gradually the family's resistance diminished and, at last, a collected edition of her works appeared in 1835, edited by her great-grandson, Lord Wharncliffe.

Although approximately 900 of Lady Mary Wortley Montagu's letters survive, along with many examples of her poetry and political satire, much of her writing has been lost. Her daughter burned her lengthy series of journals, and Mary had exercised self-censorship. As she remarked in a letter to her daughter, written in 1758: "I am turning author in my old age." She had been working on a history of her own time and "as I write only for myself, I shall always think I am at liberty to make what digressions I think fit, proper or improper." But, remembering her position and aware of her daughter's concerns, she continued: "I can assure you I regularly burn every quire as soon as it is finished and mean nothing more than to divert my solitary hours."

It seems astonishing to the modern reader that the woman who defied the conventions of her day in so many ways should have been so obedient to the stricture which compelled her to hide her greatest gift. Had she been free to publish her work and polish her art there is little doubt that she would have been recognized in her own land as one of the major talents of her time. Yet she has left a substantial legacy despite her avoidance of the "vulgarity" of publication. While her poems and satires seem less effective than they were in her own day, divorced from the social and political context which gave rise to them, her extraordinary letters retain their power. Elegant and polished, intelligent and informative, spontaneous and passionate, affectionate and didactic, courageous and determined, they reveal a multifaceted woman in all of her many personas. They illuminate, as few other sources can, a significant time and place in history, and they allow us to know Lady Mary Wortley Montagu in a way that we can know few figures of the past. They are her enduring legacy.

SOURCES AND SUGGESTED READING:

Dictionary of National Biography, *s.v.*, Montagu, Lady Mary Wortley. London: Smith Elder, 1894.

Halsband, Robert. *The Life of Lady Mary Wortley Montagu*. London: Oxford University Press, 1961.

Lowenthal, Cynthia. *Lady Mary Wortley Montagu and the Eighteenth Century Familiar Letter*. Athens, GA: University of Georgia Press, 1994.

Montagu, Lady Mary Wortley. *Letters of the Right Honourable Lady M—y W—y M—e: Written during her Travels in Europe, Asia and Africa* 2 vols. London: T. Cadell, 1789.

———. *The Selected Letters of Lady Mary Wortley Montagu*. London: Longman, 1970.

(Dr.) Kathleen Garay,
Acting Director, Women's Studies Programme,
McMaster University, Hamilton, Canada

Montagu-Douglas-Scott, Alice
(b. 1901)

Duchess of Gloucester. Name variations: Princess Alice, duchess of Gloucester. Born Alice Christabel Montagu-Douglas-Scott on December 25, 1901; daughter of John Montagu-Douglas-Scott, duke of Buccleuch and Queensbury, and **Margaret Bridgeman***; married Henry Windsor (1900–1974), 1st duke of Gloucester, on November 6, 1935; children: William Windsor also known as Prince William of Gloucester (1941–1973); Richard Windsor (b. 1944), 2nd duke of Gloucester.*

SUGGESTED READING:

The Memoirs of Princess Alice, Duchess of Gloucester, 1983.

Montalba, Clara (1842–1929)

English artist. Born in Cheltenham, England, in 1842; died in 1929; eldest of four daughters of Antony Montalba and Emiline Montalba; studied with Eugene Isabey in Paris for four years; sister of artists Henrietta Skerrett Montalba (1856–1893), Ellen Montalba (fl. 1868–1902), and Hilda Montalba (d. 1919).

English landscape and marine painter Clara Montalba was made associate of the London Society of Painters in Water Colors in 1874 and of the Belgian Society in 1876. However, Montalba felt most at home in Venice, where she lived for many years. Among her works are several Venetian scenes and one of the port of Amsterdam. One art reviewer compared her to Corot. "Like the great Frenchman," he wrote, "Miss Montalba strives to interpret the sadder moods of Nature—when the wind moves the water a little mournfully, and the outlines of the objects become uncertain in the filmy air." Her sisters Ellen and Hilda were portrait and figure painters. Her other sister, *Henrietta Skerrett Montalba, was a sculptor.

Montalba, Henrietta Skerrett (1856–1893)

*English sculptor. Born in London, England, in 1856; died in Venice on September 14, 1893; daughter of Antony Montalba and Emiline Montalba; sister of *Clara Montalba (1842–1929), Ellen Montalba (fl. 1868–1902), and Hilda Montalba (d. 1919); studied at South Kensington, at the Belle Arti in Venice, and with Jules Dalou in London.*

Henrietta Montalba, who first exhibited at the Royal Academy in 1876, excelled in portrait and "fancy" busts, working mostly in terra cotta. Among her portrait busts is one of Robert Browning in terra-cotta (1883). Her other works include *A Dalecarlian Peasant Woman, The Raven,* and *A Venetian Boy Catching a Crab* (1893) which was exhibited in London and at the International Exhibition in Chicago. Like her sisters, Henrietta lived mostly in Venice.

Montalcini, Rita Levi (b. 1909).

See Levi-Montalcini, Rita.

Montana, Patsy (1909–1996)

First successful woman in country-and-western music. Born Rubye Blevins outside Jesseville, Arkansas, in 1909; died of heart failure on May 3, 1996, in San Jacinto, California.

Known for her yodeling songs, Patsy Montana was the first female country singer to dress in full cowgirl regalia—boots, hat, and fringe. She was also the first to become a million-seller. In 1936, Montana sold over a million copies of her own composition, "I Want to Be a Cowboy's Sweetheart"; through the years, the song was re-recorded by different artists on major labels, with **Suzy Bogguss** having the most popular cover on Capitol Records.

Born Rubye Blevins outside of Jesseville, Arkansas, in 1909, Montana was the only girl in a family of ten boys—a rough-and-tumble environment that probably served her well when she set out to become an entertainer in a male-dominated industry. Her popularity began with radio when she joined the WLS "National Barn Dance" in Chicago; she and the Prairie Ramblers became a program mainstay for the next 15 years.

Montana had a great influence on the style of many women singers who followed, including that of *Patsy Cline, writes Cline's biographer,

Patsy Montana

Margaret Jones: "As a cowgirl, [Montana] presented an alternative to the long-suffering wife, dutiful daughter and rube comedienne, the stock female characters of country. She was sassy and independent, on an equal footing with the cowboy." Montana retired briefly in the 1950s only to return to performing throughout the 1960s. She died of heart failure on May 3, 1996, in San Jacinto, California, at age 81.

SOURCES:

Jones, Margaret. *Patsy: The Life and Times of Patsy Cline.* NY: HarperCollins, 1994.

Montanaria (fl. 1272)

Bolognese illuminator. Flourished 1272 in Bologna, Italy.

The name of Montanaria, a professional lay book illustrator, is found in a business contract dated 1272 from Bologna, the flourishing intellectual center of Italy in the 13th century. A manuscript calligrapher, she is referred to as "Montanaria, wife of Onesto" in the contract, in which she agrees to prepare a book for an important book manufacturer named Bencivenne of Florence.

Laura York,
Riverside, California

Monte, Hilda (1914–1945)

German-Jewish journalist and anti-Nazi activist. Name variations: Eva Schneider; Hilde Meisel-Olday. Born Hilde Meisel in Vienna, Austria, on July 31, 1914; shot in Feldkirch while trying to escape on April 18, 1945; marriage of convenience with John Olday (a British anarchist writer and artist).

Born Hilde Meisel in Vienna in 1914 into an assimilated Jewish family, Hilde Monte grew up in a turbulent Berlin. The most formative event of her youth was meeting Hans Litten, a lawyer who defended Leftist radicals in the biased courts of the Weimar Republic. Attracted to revolutionary Marxism but critical of the near-paralysis of the Social Democrats and of the uncritically pro-Soviet line taken by the Communists, she was drawn to a small purist group, the Internationaler Sozialistischer Kampfbund (ISK), but was fortunately in London at the time of the Nazi takeover. She returned briefly to Germany before settling abroad permanently. Using the cover name "Hilda Monte," she traveled to Germany numerous times in the 1930s on secret ISK missions. British authorities discovered her clandestine work and were in the process of expelling her from the country when she entered into a marriage of convenience with the British anarchist writer and artist John Olday, which provided her with citizenship. Fiercely independent, in 1939 she broke with her former ISK comrades. During these years, she supported herself as a journalist, contributing articles to *The Vanguard, Tribune, Left News* and other radical journals.

During World War II, Monte published several well-received books. One of these, *Help Germany to Revolt!* (1942), written with fellow refugee Hellmut von Rauschenplat, was published under the auspices of the Fabian Society in the form of a "Letter to a Comrade in the Labour Party." She called on the Allies to foster the cause of a purging of German society of reactionary social elements and ideas that had made Hitlerism possible in the first place. In her 1943 book, *The Unity of Europe*, she proposed a Pan-European plan for the postwar world that would improve the standard of living of Europe's poorest nations, and in so doing strengthen democratic forces and prevent future instability and causes of war. Monte argued that reconstruction would have to go beyond capitalistic economic and social structures, culminating in a planned economy run by a European Central Authority. She argued that "victory cannot be won by the armed forces on land and sea, and in the air, alone. It has to be won in the political field as well." Her ideas in many ways mirror the concepts of European unity that began to form in Western Europe in the late 1940s.

By 1944, Monte was growing restless. Despite her successful teaching of British combat forces as well as her classes at London's Morley College for Working Men and Women, she desired a more active role in the liberation of Nazi Germany. Forgetting her earlier clashes over ideology, she once again took part in discussions of the ISK circle in London. She then joined a group that included Josef Kappius and others who trained for OSS secret missions on the Continent. In 1944, Monte went to Switzerland in order to enter Nazi Germany, establishing contacts in the Swiss Tessin region with members of the Austrian Resistance. It was on such an intelligence mission, using the alias of "Eva Schneider," that she was captured in Feldkirch (Austrian Vorarlberg) on the Austro-German border by frontier guards on April 18, 1945, during the final weeks of the war. Attempting to escape, she was fatally shot.

SOURCES:

Ginzel, Günther B. *Jüdischer Alltag in Deutschland 1933–1945.* Düsseldorf: Droste Verlag, 1984.

Leber, Annedore. *Das Gewissen steht auf: 64 Lebensbilder aus dem deutschen Widerstand.* Berlin: Mosaik Verlag, 1957.

Monte, Hilda. *The Unity of Europe.* London: Victor Gollancz, 1943.

———. *Where Freedom Perished.* London: Victor Gollancz, 1947.

Röder, Werner, and Herbert A. Strauss, eds. *Biographisches Handbuch der deutschsprachigen Emigration nach 1933.* 4 vols. Munich: K.G. Saur, 1980.

<div align="right">

John Haag,
Associate Professor of History,
University of Georgia, Athens, Georgia

</div>

Montefeltro, Elisabetta

*Noblewoman of Urbino. Name variations: Elisabetta Malatesta. Daughter of Federigo Montefeltro, duke of Urbino, and *Battista Sforza (1446–1472); married Roberto Malatesta.*

Montefeltro, Elisabetta

(1471–1526)

*Duchess of Urbino. Name variations: Elisabetta Gonzaga; Elisabeth or Elizabeth Gonzaga. Born in 1471; died in 1526; daughter of Frederigo also known as Federico Gonzaga (1441–1484), 3rd marquis of Mantua (r. 1478–1484), and *Margaret of Bavaria (1445–1479); sister of Francesco Gonzaga, Maddalena Sforza (1472–1490), and Chiara Gonzaga (1465–1505); sister-in-law of Isabella d'Este (1474–1539); married Guidobaldo Montefeltro (1472–1508), duke of Urbino.*

Born into a noble Italian family in 1471, Elisabetta Montefeltro is best known from the descriptions of her in the famous Renaissance treatise on the aristocracy, *The Book of the Courtier.* She was the younger sister of Marchese Francesco Gonzaga, ruler of Mantua. Elisabetta received the classical education highly valued in aristocratic women by Renaissance Italian families; this included study of languages, music, and classical literature. She showed considerable interest in the arts as well as in humanist scholarship, traits which would be further revealed in her years as duchess of Urbino.

At age 17, Elisabetta married Guidobaldo Montefeltro, the 16-year-old duke of Urbino. The marriage was arranged between Elisabetta's brother and Guidobaldo as a means of cementing a political alliance between the duchies of Urbino and Mantua. After the wedding, Elisabetta and her entourage moved to take up their new places at the artistic and intellectual court of Urbino. Urbino was, in the 16th century, a flourishing central Italian city, though not of the prominence of Florence or Venice. It nonetheless produced two important figures of Renaissance history, the painter Raphael and the court writer Baldassare Castiglione, and its duke, though still a young man, was respected as an intelligent and generous ruler.

But Elisabetta and Guidobaldo were not destined for a peaceful life, or for a particularly happy marriage. During the time they were married, Urbino was subject to repeated attacks by neighboring states set on conquering the duchy, creating a situation of almost constant warfare. Duke Guidobaldo was also the leader of the pope's armies, and so spent much of his time away on military campaigns fighting alternately for himself and for the papacy. Although the couple got along with each other and shared similar intellectual interests, Guidobaldo's physical infirmities—he suffered from gout, arthritis, and other illnesses—and his impotence prevented a normal marital relationship. As a result, Elisabetta had no children, leaving the question of who would succeed Guidobaldo another matter of deep concern for the already unstable duchy.

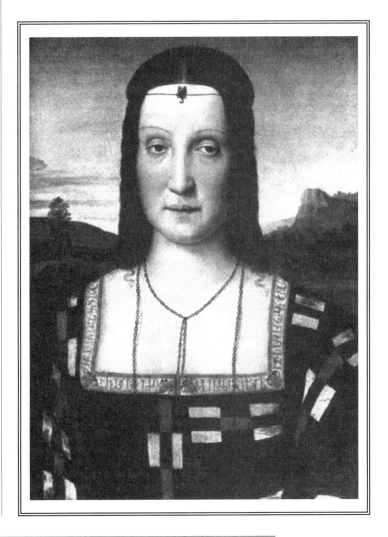

Elisabetta Montefeltro (1471–1526)

Yet the court Elisabetta led at Urbino was widely known for its magnificence, and for the talent of the artists and scholars it attracted and patronized. These included Unico Aretino and Pietro Bembo, both of whom became famous for their poetry, much of which was dedicated to Elisabetta. Castiglione would immortalize Duchess Elisabetta in his most famous work, *The Book of the Courtier*, first published in 1528. Castiglione lived at Elisabetta's court for many years and grew to know the duchess and her courtiers well. He drew on his experiences there in composing *The Book of the Courtier*, which is written as a guidebook of behavior for those seeking a place in an aristocratic household. Using Urbino as its model, it describes a court life where behavior is strictly regulated and ritualized, and where concepts of honor and social hierarchy are the most important considerations of daily life. Castiglione describes leisurely days filled with philosophical, abstract conversations or hunting and falconry by the duchess, her ladies, and the gentlemen scholars and artists living at court.

But *The Courtier* is also a memoir, written after the ducal couple had died, and Castiglione dedicated his work to the memory of Elisabetta, whom he describes in superlatives as wise, generous, gracious, and beautiful. Elisabetta also contributed to the visual arts as a patron of numerous Renaissance painters, including Raphael Sanzio, who was a native of Urbino. Among his preserved works is a portrait of the duchess, now at the Uffizi gallery in Florence, which shows a rather plain, dark-haired, middle-aged woman against a broad, desolate landscape. The duchess maintained a close relationship with another famous patron of the arts, her sister-in-law ◄❧ Isabella d'Este, marchioness of Mantua. Elisabetta often traveled to Mantua on long visits. She seems to have found at Mantua the close personal relationships which she lacked at Urbino; her brother Francesco, her sisters, *Maddalena Sforza* and *Chiara Gonzaga*, and her sister-in-law Isabella all showed her great affection, which brought her back to the Mantuan court as often as she could manage. When she was at home in Urbino, Elisabetta maintained a constant correspondence with all her family in Mantua, especially Isabella.

Elisabetta was widowed in 1508 at the sudden death of her 36-year-old husband. Although she thus lost her title as duchess and in theory lost her place at court, Elisabetta remained at the center of Urbino's intellectual and social life for the rest of her days. Her husband's successor, his nephew Francesco Maria della Rovere, was him-

❧►
Isabella d'Este.
See joint entry on Este, Beatrice d' and Isabella d'.

self married, but his wife (Elisabetta's niece *Eleonora Gonzaga* [1493–1543]) never achieved the same acclaim that the former duchess enjoyed. The dowager Duchess Elisabetta was greatly mourned by the people of Urbino on her death at age 55 in 1526.

SOURCES:

Castiglione, Baldassare. *The Book of the Courtier.* Trans. by George Bull. Baltimore, MD: Penguin, 1976.
Dennistoun, James. *Memoirs of the Dukes of Urbino, 1440–1630.* Vol. I. NY: John Lane, 1909.
Simon, Kate. *A Renaissance Tapestry: The Gonzaga of Mantua.* NY: Harper & Row, 1988.

Laura York,
Riverside, California

Montefeltro, Giovanna

*Noblewoman of Urbino. Name variations: Giovanna della Rovere. Daughter of Federigo Montefeltro, duke of Urbino, and *Battista Sforza* (1446–1472); married Giovanni della Rovere (1458–1501); children: Francesco Maria della Rovere (1490–1538, who married *Eleonora Gonzaga* [1493–1543]).*

Montefeltro, Isotta (1425–1456).

See Este, Isotta d'.

Montenegro, queen of.

See Milena (1847–1923).

Monterey, Carlotta (1888–1970).

See O'Neill, Carlotta.

Montes, Lola (1818–1861).

See Montez, Lola.

Montesi, Wilma (1932–1953)

Italian model whose unsolved murder created a political scandal. Born in Rome, Italy, in 1932; died in Rome in April 1953.

The murder of 21-year-old Italian model Wilma Montesi, whose body washed up on a beach near Ostia in April 1953, set off a chain of events that nearly destroyed the government of Italian prime minister Mario Scelba. It was initially presumed that she had drowned through some sad accident, despite the fact that some of her clothing was missing when she was found. Over six months later, however, a local newspaper editor published allegations that unnamed members of a certain elite men's club in Rome had been complicit in her accidental death through a drug overdose. A number of the club's members, as well as its manager, Ugo Montagna, sued for libel. What they had per-

haps not expected were the witnesses testifying for the defense, who included Montagna's former mistress, **Adriana Caglio.** She painted a picture of illicit drug use and casual sex indulged in by highly placed members of society, named Montagna as a drug dealer, and claimed that Gian Piero Piccioni, whose father was the minister of foreign affairs, had killed Wilma Montesi. She further stated that she had accompanied Piccioni and Montagna to police headquarters several nights after Montesi's death and waited outside while they spent an hour within the building. "Now everything's fixed up," she claimed Montagna had said when they rejoined her. Rome's chief of police resigned after her testimony; the minister of foreign affairs' proffered resignation was not accepted by the government. When Piccioni testified that Wilma Montesi had tried to engage him in drug smuggling, the libel trial was put aside for further investigation of the criminal allegations.

Exhumation and closer examination of Montesi's body proved that she had indeed drowned, while struggling against some person who had held her head underwater. Piccioni was charged with manslaughter, Montagna with complicity, and the now ex-police chief, along with Caglio and a number of other people, with obstruction of justice. The investigation lasted for three more years and resulted in 92 volumes of evidence. The prosecution could not, however, prove exactly who had killed Wilma Montesi. Despite the vast corruption uncovered by the investigation, when the trial was held in Venice in 1957 it resulted in acquittal for all but Adriana Caglio, who received a suspended sentence. Montesi's murder, and the circumstances surrounding it, remain a mystery.

Montespan, Françoise, Marquise de (1640–1707)

Brilliant mistress of Louis XIV, during his most successful years, who lived a life of splendor, scandal, and sincere repentance. Name variations: Athénaïs or Athenais; Madame de Montespan. Pronunciation: Fran-SWAHZ mar-KAY-sa der MOHN-TES-PAH. Born Françoise de Rochechouart de Mortemart on October 5, 1640, in the Château de Lussac near Lussac-les-Châteaux (Vienne); died at Bourbon-l'Archambault (Allier), May 27, 1707, probably of heart disease and an overdose of emetic, and was buried in the Church of the Franciscans (Cordeliers) in Poitiers (Vienne); daughter of Gabriel de Rochechouart, marquis (later duke) de Mortemart, and Diane de Grandseigne (d.

1666); educated at the Convent of Sainte-Marie at Saintes (Charente-Maritime); married Louis-Henry de Pardaillan de Gondrin, marquis de Montespan, in 1663; children: (with husband) Marie-Christine (1663–1675), Louis-Antoine, marquis (later duke) d'Antin (1665–1736); (with Louis XIV, king of France [r. 1643–1715]) Louise (1669–1672), Louis-Auguste de Bourbon (1670–1736), duke of Maine, Louis-César de Bourbon (1672–1683), count of Vexin, Louise-Françoise de Bourbon (1673–1743), countess of Nantes, Louise-Marie-Anne de Bourbon (1674–1681), countess of Tours, Françoise-Marie de Bourbon (1677–1749), countess of Blois, Louis-Alexandre de Bourbon (1678–1737), count of Toulouse.

Came to court (1660); married the Marquis de Montespan (1663); became Louis XIV's mistress (1667); the "Reign of the Three Queens," (1668–74); separated from her husband (1674); under Church pressure, ceased sexual relations with Louis (1675–76); probably ceased relations with Louis permanently (1678); secretly implicated in the Poisons affair (1680–81); took over supervision of the Daughters of Saint Joseph (1681); left the court (1691); founded the Hospice of the Holy Family (1693); transferred the Hospice to her Château d'Oiron (1703).

Rochechouart. Mortemart. So distinguished were these names that their holders, tracing their noble ancestry to misty times long before the Crusades, granted precedence only to the La Rochefoucaulds and viewed the reigning Bourbons as parvenus. Françoise de Rochechouart de Mortemart, later known as Madame de Montespan, was the third of five children born to **Diane de Grandseigne.** Diane, daughter of Jean, seigneur de Marsillac, and **Catherine de la Beraudière** (of the prominent Frottier de la Messelière family), was the wife of Gabriel de Rochechouart, marquis of Mortemart and of Lussac and Vivonne, prince of Tonnay-Charente. He had grown up with Louis XIII (r. 1610–1643), campaigned with him, supported cardinals Richelieu and Mazarin, and been lavishly rewarded: appointment as First Gentleman of the King's Bedchamber, Knight of the Order of the Holy Spirit, governor and lieutenant general of the lands and bishoprics of Metz, Toul, and Verdun, and, by letters-patent of 1650 (confirmed in 1663), the raising of the marquisate of Mortemart to a peer-duchy of France. Diane, a lady-of-honor to *Anne of Austria, the mother of Louis XIV (b. 1638, r. 1643–1715), was delicately beautiful, pious, cheerful, wise, charitable, and musically gifted. Gabriel was handsome, intelligent, a lover of music, hunting, dancing, dining, conversation, and sex, and possessed the famous

Mortemart wit, described by Voltaire as "a singular trick of conversation mingling pleasantries, naïveté, and finesse." He engaged in numerous extramarital affairs. Her patience exhausted, Diane obtained a separation in 1663.

Save for the fourth child, Marie-Christine, a nun of whom little is known, Françoise's siblings became highly prominent. **Gabrielle de Thianges** (1634–1696) married the marquis of Thianges and became a fixture at court. Louis-Victor (1636–1688), Louis XIV's closest childhood playmate, was made duke of Vivonne and a marshal of the army. **Marie-Madeleine-Gabrielle** (1645–1704), who became abbess of the famous abbey of Fontevrault in 1670, won universal esteem for her wisdom, piety, and administrative skill. Contemporaries disagreed as to which of the daughters was the most beautiful. All the children, moreover, were blessed with brains and the Mortemart wit.

> *In a word, a triumphant beauty intended to be admired by all the ambassadors.*
>
> —Madame de Sévigné

Françoise was born deep in the country fastness of the West in Poitou at the mighty Château de Lussac, of which only the ruins of a gigantic drawbridge now remain. Like her sisters, she was raised mostly by peasant domestics while her parents were off at court. At about 13, she followed Gabrielle at the convent school of Sainte-Marie in Saintes (Charente-Maritime). Education there was casual. Manners and religion took precedence, with elements of reading, writing, arithmetic, some liturgical Latin, household management, and sewing following at a distance. Even for the 17th century, Françoise's spelling and grammar remained extraordinarily unstable.

Leaving school around 1658, she came to court in 1660 and through her mother's influence became a maid-of-honor to *Henrietta Anne, duchess of Orléans (1644–1670), wife of Louis XIV's only brother, Philippe Bourbon-Orléans, known as Monsieur. Françoise conducted herself in a seemly manner, pious and chaste. Although she danced with Louis in a ballet, *Hercule Amoureux* (1662), he—surprisingly for him—took no special note of her, probably because he was in thrall to *Louise de La Vallière, his first serious love after an adolescent idyll with *Marie Mancini. Pretty, gentle Louise loved Louis with a passion which overbore her shame at her weakness. Françoise was said to have remarked about being the king's mistress, "If I were unlucky enough to have that misfortune happen to me, I'd hide myself for the rest of my life."

In 1661, she became engaged to young Louis-Alexandre de La Trémouille, marquis of Noirmoutiers. Unfortunately, he seconded the Prince de Charlais in an eight-man affray (January 1662) in which Henry de Pardaillon, marquis d'Antin, was killed, and he had to flee into exile to escape execution for violating the edict against duelling. He died five years later fighting for the Portuguese against Spain. Mourning her loss after his flight, Françoise met the grieving younger brother of d'Antin, Louis-Henry de Pardaillon de Gondrin, marquis de Montespan (1640–1701). They fell in love, a contract was signed (January 28, 1663), and they were married in Paris at Saint-Sulpice on February 6. The king and other royals refused to sign the contract because one uncle of Louis-Henry had taken the wrong side during the Fronde uprising (1648–53) and another, the archbishop of Sens, was a leader of the Jansenists, a dissident puritanical movement. Due to the families' financial situations, the complicated contract left the couple with a comfortable income of 22,500 livres annually but little ready capital.

Louis-Henry was a dashing Gascon spendthrift, impetuous, ambitious, and addicted to gambling. Financial troubles descended immediately, abetted by the births of Marie-Christine, baptized on November 17, 1663, and Louis-Antoine, the future duc d'Antin, born on September 5, 1665. Françoise stayed involved in the expensive court scene, where she drew some unfavorable attention by participating in an intrigue in Henrietta Anne's entourage. She also frequented the literary salon at the Hôtel d'Albret, home of a cousin of Louis-Henry. Following the fashion of using classical pseudonyms found among attendees at such salons devoted to the reading of flowery, overwrought poetry and novels written in the *style précieux*, she began to call herself Athénaïs, the name by which she was known thereafter. Marriage had cost her her position as maid-of-honor; helped by Monsieur and her brother, she was chosen one of the Queen *Maria Teresa's (1638–1683) six ladies-of-honor in the spring of 1664. Louis-Henry, meanwhile, bored and chafing to win fame and fortune as a soldier, borrowed heavily to join a disastrous campaign in Algeria in 1664 and returned broke. Badly advised, Françoise invested in a business venture which collapsed in a welter of lawsuits that would not be settled until 1684. At the beginning of 1667, the year she became the king's mistress, the future looked bleak.

Occupying a place in the queen's intimate circle and having become a close friend of La Vallière, Madame de Montespan was in a strong

position to draw the king's attention when his ardor for La Vallière began to cool. Historians have sharply disagreed over which one—Louis or Françoise—set out to conquer the other. *Madame de Caylus and the duke de Saint-Simon reported that she warned her husband that the king was falling in love with her; she asked to go back to Gascony, where he was raising a company to fight on the Spanish frontier, but he paid no attention. Again, historians divide over the truth of this report. About Montespan's attractiveness, however, there is universal agreement. "Blond hair," wrote a contemporary, Primi Visconti, "large, azure-blue eyes, an aquiline but well-formed nose, a small, vermilion mouth, very beautiful teeth—in a word, a perfect face. As for her body, she was of medium height and well-proportioned. Her color, of a marvelous whiteness, made her shine among all." Everyone remarked on her gracefulness and extraordinary wit. At her death Saint-Simon would write, "She was the best company in the world. . . .There was never anything like her conversation; it was an incomparable blend of wit, eloquence, and the most delicate politeness. She had such an odd way of putting things, and such a natural genius for hitting off the right expression, that she seemed to have a language peculiar to herself."

The earliest mention of a brewing affair came in November 1666. At length, on May 4, 1667, the king was seen riding in a carriage alone with Montespan. On the 13th, he made La Vallière a duchess and had their daughter legitimized—a sign he was preparing to drop her. Telling her to remain behind because of her pregnancy, on the 16th he and the queen with Montespan and many of the court left for Amiens, where he then went to the front with his army to begin the War of Devolution (1667–68). In June, he rejoined the entourage at Avesnes, probably to see Montespan. Meanwhile, La Vallière, sensing the danger to her position, had sped to join the party. Louis received her coolly. In a famous remark, Montespan in the presence of the outraged queen observed, "God help me from being the mistress of the King, but if I am ever so unfortunate, I would never have the effrontery to present myself before the Queen." God did not help, it seems, for it was probably at Avesnes between June 9 and 14 that she and Louis began sexual relations.

The king's new liaison posed formidable problems. Would Montespan's husband prove compliant? Would the church? It took an especially dim view of this "double adultery"; at least La Vallière was single. Louis, who in honesty refused to call a sin by some other name, knew he was setting a bad example to his people and all Europe.

Montespan's husband turned into a major headache. During the languid Roussillon (Pyrenees) campaign in 1667, he got embroiled with the authorities over an escapade with a local girl. He returned to Paris early in 1668 to raise more money and left for Roussillon, it seems, amazingly, still ignorant of his wife's infidelity. In June, however, he got leave, went to Versailles, and began to behave in violent and bizarre ways to protest his being cuckolded. His discovery that summer that his wife was pregnant by the king only fed the flames. After a violent scene when he burst into the home of Montespan's closest friend, he crossed the line when he decked his carriage in black and told the king, who asked him about it, that he was in mourning for his wife, who had "disappeared." Louis had him jailed (September 20–October 7) and then exiled to his family lands in Guienne. There he reportedly held a mock funeral for his wife and mounted huge horns on his carriage to advertise his cuckoldry. In 1669, he was allowed to rejoin the army but caused a new uproar when he abducted a local girl and his men attacked the

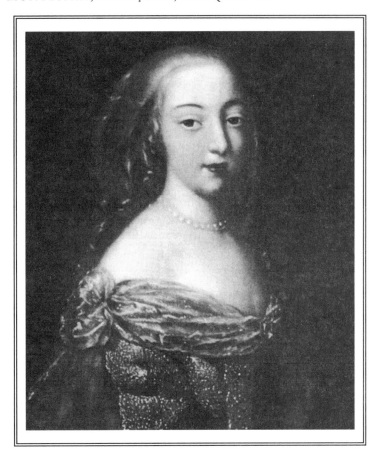

Madame de Montespan

citizenry. A royal order disbanded his company in December; to avoid arrest, he fled to Spain with his son—and a high official's wife. Facing probable disinheritance, in 1670 he begged the king's pardon, which Louis prudently granted rather than risk embarrassment at his hands at the court of Spain among the queen's relatives. Meanwhile, in July 1670, Montespan applied for a separation, but it sank in a procedural swamp. On her reapplication in 1674, the Parlement of Paris hastened to please the king and granted a settlement which would have ruined Louis-Henry. She did not want that, however, and on July 21 the two reached an agreement which saved his financial skin.

The threat posed to the "absolute" monarch's image by a rather daft, wronged husband helped create the truly baroque interlude (1668–74) dubbed "The Reign of the Three Queens": the official queen, the dim and dowdy Maria Teresa, with whom the king dutifully copulated twice a month; the official mistress, La Vallière, who hoped Louis would return but who finally stayed on to endure public humiliation to punish herself for her sins; and the unofficial but real mistress, Montespan, who, to avoid offending public sensibilities too much and to help keep her husband from bringing a hugely embarrassing lawsuit over the paternity of her children by the king, had to bear and raise them in secrecy while posing as a friend of La Vallière's, whose apartment Louis would publicly enter in order to reach Montespan's nest next door "secretly." This living arrangement was preserved wherever the royal household stayed, even on military campaigns. It ended only when La Vallière, after an abortive attempt at departing in 1671, finally left on April 21, 1674, to become a Carmelite nun, in which calling she remained until her death in 1710.

That same month, Louis decided to build a palace for Montespan and their children. Clagny, near the palace of Versailles, designed by Jules Hardouin-Mansart with gardens by Le Nôtre, took ten years to build and cost 2,448,000 livres. Only pictures of this magnificent creation survive, for it was demolished by Louis XVI before the Revolution to expand the town of Versailles. In the 1670s, Montespan was at the peak of her influence while Louis was overawing Europe with his constructions and military triumphs. Her dazzling beauty and wit outshone all rivals, and, much abetted by her sister Gabrielle de Thianges, her patronage of artists, writers, and musicians, gave the court of the Sun King an intellectual sheen to match its material eclat. Among her favorites were Molière; La Fontaine; especial-

ly Boileau and Racine, who regularly read before her; the painter Pierre Mignard; musicians Michel Lambert and Jean-Baptiste Lulli; and the librettist Philippe Quinault. The decoration one sees today on the grounds of Versailles—the falls, ponds, canal, fountains, and statues—owed much to her. She played no political role—which Louis forbade to his mistresses—but forged close relations with Jean-Baptiste Colbert, his chief minister, and found good places and marriages for her friends and family. Her father, for example, was mollified by being named (1669) governor of Paris and the Ile de France, and her brother became (1669) general of the galleys (most of the Mediterranean navy) and a marshal (1675).

Knowing Louis' proclivities, Montespan kept none but virtuous ladies and rather homely maids in her entourage. Time proved she made a mistake, however, when she had Louis name as governess of their children the widow of the poet Paul Scarron, the virtuous Françoise d'Aubigné (the future *Marquise de Maintenon), whom she had met at the Hôtel d'Albret. Five years older than Montespan, Mme Maintenon, who would be Louis' second wife, was attractive, intelligent, subtle, and patient. She worked terribly hard raising Montespan's children in secrecy. The first two, Louise (1669–1672) and the duke of Maine (1670–1736), were raised in separate residences in Paris, but after the count of Vexin was born (1672) they were brought under one roof, and by the summer of 1674 they and their later siblings were being housed at court and at Clagny. Temperamental opposites, Montespan and Maintenon inevitably clashed over the children's upbringing, made worse by the king's growing fondness for the governess' soothing company, a contrast to his proud mistress' rages and barbed witticisms. Montespan would shower the children with attention and gifts when she could find time for them and complained of Maintenon's strictness. It is often said that she was a bad mother. While not groundless, the charge seems overdrawn. When the count of Vexin died at 11, for example, it was observed that for six days and nights she had never left his bedside.

Montespan's reign was abruptly interrupted at Easter in 1675 when a courageous priest refused to grant her absolution, saying she must end her adultery. She appealed to Louis, who was told to do likewise by Bishop Bossuet. Pressured by their consciences, they ended their relations, thus reconciling with the Church, and for a year saw each other only in public. Louis, however, thinking it would be unjust, refused to banish her from court. Deciding to end an awkward semi-exile, he rode to Clagny in July 1676 with several

of the most grave and respectable ladies to announce it to her personally. However, the two soon moved to an alcove, where they were seen in an obviously intimate conversation. Rejoining the company, they paused, bowed, and then passed into an adjacent bedroom, from whence unmistakable sounds presently emerged. The next spring the future Duchess of Orléans was born, to be followed in 1678 by the last of their seven children, the future count of Toulouse. As the Savoyard ambassador once remarked about Montespan's fertility, "Her fuse is easily lit."

Montespan now seemed stronger than ever. She occupied 20 rooms on the first floor at Versailles while the queen had only 11 on the second. Her *train de vie* was more magnificent than ever. Her traveling entourage numbered up to 50, including a dozen mounted guards. Behind the scenes, however, her imperious airs, willfulness, and angry outbursts grated on Louis. Public wit could easily turn to private shrewishness. He carried on a succession of affairs, notably with the **Princesse de Soubise** and Madame **Marie de Ludres** and culminating in a passionate round with Marie-Angélique, ❦➤ **Duchesse de Fontanges**, in 1678–80. Sexual relations between Montespan and Louis probably lapsed after the 1678 birth of Toulouse. She grew very fat and gambled excessively. It was probably the Affair of the Poisons which finally doomed her future relations with Louis—that and the ascendancy of Madame de Maintenon, who by 1681 had conquered his heart for good.

Nothing in Montespan's life is more controversial than her role in the Poisons affair. Pathology and toxicology at the time being infant sciences at best, poison usually could not be detected; hence accusations of poisoning were common when unexpected deaths occurred. Moreover, 17th-century religion was a compound of ardent faith, mysticism, gross superstition, and pagan survivals from the Middle Ages. Masses pleased God, and charms could placate Satan. Paris housed a swarm of sorcerers, alchemists, fortune-tellers, abortionists ("angelmakers"), poisoners, mediums, and quacks of every hue. A crackdown on this hive began in September 1677, and in April 1679 a special secret court, the Chambre Ardente, was set up to avoid growing scandal and publicity. It was the arrest (March 1679) and burning (February 1680) of sorceress and poisoner ❦➤ **Catherine Deshayes** Monvoisin ("la Voisin") that revealed the involvement of court personages in this underworld. Montespan's name finally surfaced, in secret, during the summer of 1680 when Voisin's imprisoned daughter began to talk. Briefly, she

❦➤ **Fontanges, Duchesse de** (1661–1681)

French royal. Name variations: Marie Angélique de Fontanges. Born Marie-Angélique de Scorraille de Roussilles in 1661; died in 1681; mistress of Louis XIV, king of France. Marie-Angélique de Roussilles was created the duchesse of Fontanges by Louis XIV.

and several other prisoners variously asserted, sometimes under torture, that Montespan (1) had had two renegade priests make spells and bless love potions in 1667–68 to win the king's love and bring death or banishment to La Vallière; (2) had used love potions on the king thereafter; (3) had tried to poison the king; (4) had murdered Mlle. de Fontanges by poison (1681); and (5) had ordered black masses in 1673, 1675, and 1677–80 and participated by being the masked, prone, naked woman whose belly was used as the altar, masses during which a newborn or aborted infant would be killed and its blood used as the wine in the chalice, the object of the masses being to ward off her rivals, keep the king's love, or cause him to die if he were unfaithful.

Stunned by these grisly revelations, Louis could not possibly allow such allegations against a mother of his children to come to light. His chief minister Colbert, whose daughter had recently married one of Montespan's nephews, examined the evidence early in 1681 and, aided by a famed lawyer, wrote a strong refutation of its worth. On May 14, 1681, Louis ordered the testimony against Montespan (and her sister, Mme de Thianges, and sister-in-law, Mme de Vivonne) removed from the file. The Chambre Ardente finished its work on other cases in July 1682, but Montespan's accusers were secretly imprisoned for life in sundry dungeons on the king's personal orders (*lettres de cachet*). She was never interrogated nor were she and her accusers made to confront each other.

Historians' judgment on this immensely complicated affair have tended to become less unfavorable toward Montespan than they usually were before the early 20th century. A consensus appears to support the following: (1) the events of 1667–68 were probably true, and through a personal maid, **Claude de Vin des OEillets** (1638–1687), Montespan was in contact with Voisin and others, obtaining aphrodisiacs and charms to keep the king's favor; (2) Fontanges died of natural causes, not poison; (3) Montespan had nothing to do with any plot to

➤❦ *Catherine Deshayes. See entry titled French "Witches."*

poison the king, but des OEillets, who had three children with Louis (one of whom survived), may have used her as a cover for her own attempts, in concert with a mysterious Englishman, to poison the king after he refused to legitimize their daughter; and (4) the accounts of the black masses contain significant discrepancies and an air of implausibility in light of Montespan's known character, standing, and activities, but cannot be ruled out definitively—hence, the Scottish verdict "not proved" best applies here.

Amazingly, the charges against Montespan remained secret until long after her death, known only to three or four of Louis' most trusted officials. It is impossible to decipher his real opinion. Colbert's refutation doubtless weighed heavily, but Louis probably felt at least some suspicion that she had used aphrodisiacs. Typically, he showered favors on her while her real status was sinking. In 1679, he had named her Superintendent of the Queen's Household (an astonishing appointment for a royal mistress) and granted her the status of a duchess (Louis-Henry having refused the title of duke out of pride); and during the height of the Affair in 1681 he gave her powers to sign for the duke of Maine and legitimized her last two children, the second, third, and fourth having already been legitimized in 1673 and the fifth in 1676. Louis visited her (with others) twice daily, from 2 to 2:30 PM between mass and dinner, and from 11 PM to midnight after supper, still lured by her conversation and spontaneity. But after the queen's death (July 30, 1683) and his secret marriage to Mme de Maintenon (probably in late 1683 or early 1684), she steadily lost status. In December 1684, Montespan was relegated to a small apartment on the ground floor at Versailles and so began to spend much time at Clagny. In 1686, she was left off a travel list despite large parties she had given in 1685 and 1686, and the court snubbed the wedding of her legitimate son, d'Antin; in 1687, the king ceased his daily visits. Montespan was becoming a ghost at Versailles, as had happened to La Vallière before her. At last, when Louis assigned supervision of her youngest daughter to the wife of the duke of Maine's governor, thus depriving her of any pretext to stay at court, she asked him on March 15, 1691, for permission to retire to the convent of the Daughters of Saint Joseph. He granted it with more alacrity than she expected.

Montespan had always retained a tie to the Church. From the mid-1670s, her piety deepened slowly but steadily. The childhood deaths of her legitimate daughter (1675), the countess of Tours (1681), and the always sickly count of Vexin (1683) tore her heart. She became intensely active in charitable works: she founded (1678) a hospital for the elderly at Saint-Germain-en-Laye; expanded it (1682) at Fillancourt nearby; enlarged the general hospital and founded (1681) a boarding school for girls at Saint-Germain; started (1686) an orphans' hospital at Fontainebleau which became (1695) the Hospital of the Holy Family, educating 60 orphans; and furnished a house for the Oratorians at Saumur. Montespan gave her greatest attention in the 1680s and 1690s, however, to the Daughters of Saint Joseph, who educated poor and orphaned girls at an edifice in Paris on the rue Saint-Dominique (nowadays housing the Ministry of Defense). She contributed heavily from 1676 and in 1681 was given full powers, because of its financial woes, to reform its rule and choose personnel and pupils. She turned the order for a time toward making upholstery for Versailles and high-quality embroidery, a forerunner of Maintenon's Saint-Cyr project.

Her final major foundation (1693) became her most lasting monument—the Hospice of the Holy Family, originally a refuge for a hundred indigents she began at Fontevrault, where her sister was abbess. In 1700, Montespan bought the beautiful Château d'Oiron, in Deux-Sèvres between Thouars and Loudun, and transferred the hospice there in 1703. Her portrait as *Mary Magdalene by Pierre Mignard still graces the expanded hospice's principal salon.

Bringing true Christian humility to her proud spirit proved an arduous enterprise. She chose a stern director, Pierre François d'Arères de La Tour, a famous Oratorian, who persuaded her to flee the court for good and give up a dream that Louis would return after Maintenon's death. Instead, as an ultimate penance, he made her ask pardon of her husband and offer to rejoin him. He, of course, refused her—only (in an astonishing finale) to appoint her his executor and affirm his love for her in his will just before he died in 1701. In her later years, Montespan feared solitude and the night and the specter of death and damnation. She mortified her flesh with fasts, rough cloth underclothes and bedding, and iron-pointed bracelets, garters, and a belt. She even curbed her famous tongue, a heroic achievement. Her repentance was spectacular, in short, although she never was given the credit for it that La Vallière got for hers. Montespan explained her new insight into herself and humanity in a letter: "We are ourselves most of the time a large crowd, and we often converse in our souls with a numerous populace of passions, designs, inclinations, and tumults

which . . . prevents us from hearing God, who speaks to our hearts and who alone should be our world, our all."

In May 1707, in her 67th year, Montespan went for a cure to the famous spa at Bourbon-l'Archambault (Allier) as she had often done since 1676. She was feeling more strongly the premonitions of death she had experienced since the death in 1704 of her abbess sister. Probably subject to heart disease, Montespan became suddenly ill with shortness of breath and fainting. A young woman companion gave her a huge overdose of an emetic which gravely weakened her. She faded slowly for days, passing in and out of consciousness, but was fully able to ask forgiveness of everyone, confess, and serenely receive the sacraments—dying the kind of death the 17th century admired. Near 3 AM on May 27, she expired. Her last word was "Pardon."

Her passing was greatly mourned by her son Toulouse and her daughters—**Louise-Françoise de Bourbon**, countess of Nantes, and ❧▶ **Françoise-Marie de Bourbon**, countess of Blois—but not by d'Antin or Maine. Nor by the court nor Louis, who received the news with regal indifference, although some accounts connect the news with a long walk he took in a garden alone. Montespan was placed beside her mother and brother in the Mortemart tomb in the Franciscan (Cordeliers) church at Poitiers (Vienne). The church later was destroyed and the tomb desecrated during the Revolution. A famous, macabre story, somewhat suspect, says that she had wished to have her entrails placed in the abbey of Saint-Menoux near Bourbon. The peasant charged with taking the container there was disturbed by an odor and opened it. Horrified at what he saw, he dumped the contents into a ditch. It so happened that a herd of pigs was coming down the road. The sequel can be imagined.

Montespan's children and their descendants played notable historical roles. Louis loved his children, and it was doubtless their presence which preserved her place at court for a decade after she had ceased to be his mistress. When he lost his son (his sole surviving legitimate child), grandson, and eldest great-grandson in 11 months, he inserted Maine and Toulouse in the line of succession (July 29, 1714), an act nullified (July 1, 1717) after his death in 1715. D'Antin, "the courtier's courtier," succeeded Hardouin-Mansart in the important post of Superintendent of the King's Buildings, Maine was loaded with lands and sinecures, and the able Toulouse became head of the navy. Louis could not find foreign princes for Mlls de Nantes and

❧▶ **Françoise-Marie de Bourbon** (1677–1749)

*Countess of Blois and duchess of Orléans. Name variations: Mlle de Blois; Françoise-Marie de Blois; Francoise de Blois. Born on May 25, 1677; died on February 1, 1749; illegitimate daughter of Louis XIV, king of France (r. 1643–1715), and *Françoise, Marquise de Montespan (1640–1707); married Philip Bourbon-Orléans (1674–1723), 2nd duke of Orléans (r. 1701–1723), on February 18, 1692; children: *Marie Louise (1695–1719, who married Charles, duke of Berri); Louise Adelaide (1698–1743); *Charlotte-Aglae (1700–1761, who married Francis III of Modena); Philippe Louis (1703–1752), 3rd duke of Orléans; *Louise Elizabeth (1709–1750, who married Louis I, king of Spain); *Philippa-Elizabeth (1714–1734); *Louise-Diana (1716–1736).*

de Blois, so they were married to French princes of the blood, Nantes to Louis III de Bourbon-Condé (their son becoming Louis XV's prime minister, 1723–26), and Blois, after much difficulty, to Louis' nephew, the future duke of Orléans and (after Louis' death) regent of France (1715–23). Through Blois, Montespan became the great-great-great-grandmother of Louis-Philippe, France's last reigning king (r. 1830–1848), and through his ten children "the Grandmother of Europe," a direct ancestor of the present occupants of or claimants to the thrones of France, Portugal, Spain, Italy, Belgium, Bulgaria, Brazil, Württemberg, and Luxemburg. Also, the tragic Empress *Carlota of Mexico and Archduke Rudolf of Habsburg, of the Meyerling tragedy, descended from her.

For over 30 years (1660–91), Madame de Montespan was a striking presence at the court of France's Sun King, and for at least 11 (1667–78) she was its true queen. Indeed, in most respects she was the only fully queenly presence at Louis' side during his entire reign. It was with her that he emerged from his timid and awkward youth. *Anne de Longueville, sister of the Great Condé, wrote that Louis' conquest of the brilliant Montespan "finally gave him confidence in himself, in his pride as a male. She revealed to him the power of his charm and his seduction." A ravishing beauty with a mind to match, she was a mistress to be shown off to the ambassadors, as *Madame de Sévigné put it. Montespan had a sense of and taste for royal *grandeur*, and she inspired in Louis a similar passion. His immense building projects and his most successful military ventures drew quite direct inspiration from her. As Louis Bertrand, one

of the king's most insightful biographers, wrote, "Manifestly, Louis XIV wanted to shine [paraître] in Montespan's eyes." It has even been seriously asserted, for example, that a major reason for his starting the Dutch War (1672–78) was to win glory before his mistress, whom he often commanded to accompany him in the field even when she was well along in a pregnancy.

As a result of this passionate affair, Montespan changed. From a fresh, pure, pious, restrained wife trapped in a marriage to a bizarre spendthrift who deserved no respect, she became a blazing goddess, revelling in the lusts of the flesh with a notoriously fleshly man. Proud of having been chosen, of having won, she became capricious, haughty, and imperious, and wielded a wickedly witty tongue without restraint. Louis spent a vast fortune on her; she acted as if she deserved every *sou* of it. How striking, then, that after her fall and the private agony of the Poisons affair, she embarked on a quarter century of penitence and good works. Not for her a merely showy piety. Rather, she made herself become what she finally thought in her heart a Christian must be: humble before God and ready to forgive and ask forgiveness. "Pardon" was her last word. It would seem only fair to grant that she had finally earned it.

SOURCES:

Bailly, Auguste. "La Marquise de Montespan," in *Historia*. No. 126, 1957, pp. 405–411.

Barker, Nancy Nichols. *Brother to the Sun King: Philippe, Duke of Orleans*. Baltimore, MD: Johns Hopkins Press, 1989.

Bernier, Olivier. *Louis XIV: A Royal Life*. NY: Doubleday, 1987.

Buranelli, Vincent. *Louis XIV*. NY: Twayne, 1966.

Carré, Lt.-Col. Henri. "Madame de Montespan a-t-elle trempé dans l'affaire des poisons?" in *Historia*. No. 162, 1961, pp. 565ff.

Decker, Michel de. *Madame de Montespan: La Grande Sultane*. Paris: Perrin, 1985.

Ekberg, Carl J. *The Failure of Louis XIV's Dutch War*. Chapel Hill: University of North Carolina Press, 1979.

Gaxotte, Pierre. *La France de Louis XIV*. Paris: Hachette, 1946.

Lewis, W.H. *The Splendid Century*. NY: William Sloane Associates, 1953.

———. *The Sunset of the Splendid Century: The Life and Times of Louis Auguste de Bourbon, Duc de Maine, 1670–1736*. NY: William Sloane Associates, 1955.

Mongrédien, Georges. *La Vie privée de Louis XIV*. Paris: Hachette, 1938.

Murat, Inès. *Colbert*. Trans. by Robert Francis Cook and Jeannie Van Asselt. Charlottesville, VA: University of Virginia Press, 1984.

Petitfils, Jean-Christian. *Madame de Montespan*. Paris: Fayard, 1988.

Rat, Maurice. *La Royale Montespan*. Paris: Librairie Plon, 1959.

Wolf, John B. *Louis XIV*. NY: W.W. Norton, 1968.

SUGGESTED READING:

Audiat, Pierre. *Madame de Montespan*. Paris: Fasquelle, 1938.

Bertrand, Louis. *La Vie amoureuse de Louis XIV: Essai psychologique historique*. Paris: E. Flammarion, 1924.

Bussy-Rabutin [Roger de Rabutin, Comte de Bussy]. *Mémoires et histoires amoureuses des Gaules*. Paris: Athéna, 1949 (numerous editions).

Caylus, Marthe-Marguerite Le Valois de Villette, Comtesse de. *Souvenirs*. Paris: Mercure de France, 1965 (numerous editions).

Clément, Pierre. *Madame de Montespan et Louis XIV*. Paris: L. A. Didier, 1868.

Estarvielle, Jacques. *Monsieur de Montespan*. Paris: Firmin Didot, 1929.

Gibson, Wendy. *Women in Seventeenth-Century France*. NY: St. Martin's Press, 1989.

Langlois, Marcel. *Madame de Maintenon*. Paris: Plon, 1932.

Lemoine, Jean. *Madame de Montespan et la legende des poisons*. Paris: Henri Leclerc, 1908.

Mitford, Nancy. *The Sun King*. NY: Harper & Row, 1966.

Mongrédien, Georges. *Madame de Montespan et l'affaire des poisons*. Paris: Hachette, 1953.

Mossiker, Frances. *The Affair of the Poisons*. NY: Knopf, 1969.

Petitfils, Jean-Christian. *L'Affaire des poisons*. Paris: Albin Michel, 1977.

Saint-Simon, Louis de Rouvroy, Duc de. *Mémoires*. Paris: Hachette, 1856–58 (numerous editions).

Sévigné, Madame de Rabutin-Chantal, Marquise de. *Correspondance*. Paris: Gallimard, 1972–78 (numerous editions).

Truc, Gonzague. *Madame de Montespan*. Paris: A. Colin, 1936.

Williams, H. Noël. *Madame de Montespan and Louis XIV*. NY: Scribner, 1910.

Zévaès, Alexandre. "Que sont devenues les entrailles de Mme. de Montespan?" in *Miroir de l'histoire*. No. 79, 1952, pp. 343–348.

Ziegler, Gilette, ed. *At the Court of Versailles: Eye-witness Reports from the Reign of Louis XIV*. Trans. by Simon Watson Taylor. NY: E. Dutton, 1966.

David S. Newhall,
Professor Emeritus of History, Centre College, Danville, Kentucky

Montesson, Charlotte Jeanne Béraud de la Haye de Riou, marquise de (1737–1805)

Duchess of Orléans. Name variations: Charlotte de la Haye. Born in Paris of an old Breton family in 1737 (some sources cite 1736); died on February 8, 1805 (some sources cite 1806); daughter of Johann Béraud de la Haye; married Jean Baptiste, marquis de Montesson, around 1754 (d. 1769); secretly married Louis Philippe (1725–1785), 4th duke of Orléans (r. 1752–1785), on July 29, 1773. Louis Philippe's first wife was **Louisa Henrietta de Conti** *(1726–1759).*

Charlotte Jeanne Béraud de la Haye de Riou, marquise de Montesson, was born in 1737 in

Paris of an old Breton family. About 1754, at age 17, she married Jean Baptiste, marquis de Montesson, who died in 1769. Montesson's intelligence and beauty attracted the attention of Louis Philippe, duke of Orléans, whom she secretly married in 1773 with the authorization of the king, Louis XV. For her husband's amusement, she set up a little theater and wrote and acted in several plays, including *Mme de Chazelle*. Montesson, who was imprisoned for some time during the Terror but was released after the fall of Robespierre, became a close friend of the empress *Josephine and was a prominent figure at the beginning of the empire. Her poetry was published as *Mélanges de poésie* in 1782, and the French government gave her a pension. The best edition of her plays appeared in seven volumes under the title of *Oeuvres anonymes* in 1782–1785, although only 12 copies were printed.

SUGGESTED READING:

Capon, G., and R. Ive-Plessis. *Les Théâtres clandestins du XVIIIᵉ siècle* (1904).

Strenger, G. "La Société de la marquise de Montesson," in *Nouvelle revue*. 1902.

Montessori, Maria (1870–1952)

Italian doctor, scientist and pioneer children's educator. Pronunciation: Mont-ES-OR-ee. Born Maria Montessori on August 31, 1870, in Chiaravalle, near Ancona, Italy; died on May 6, 1952, at Noordwijk-on-Sea, Holland; only child of Alessandro Montessori (a soldier and civil servant) and Renilde Stoppani; educated at state schools and the University of Rome, graduated Doctor of Medicine, 1890; never married; children: one son, Mario (b. 1898 or 1901).

Awards: Honorary fellowship from the Educational Institute of Scotland (1946); Legion d'Honneur from the French government (1949).

Selected writings: The Montessori Method: Scientific Pedagogy as Applied to Child Education in the "Children's Houses" *(1912);* The Advanced Montessori Method *(1913);* Pedagogical Anthropology *(1913);* Dr. Montessori's Own Handbook *(1914);* The Child in the Church *(1930);* The Mass Explained to Children *(1932);* The Secret of Childhood *(1936);* The Reform of Education During and After Adolescence *(1939);* What You Should Know About Your Child *(1940);* Education for a New World *(1946);* The Discovery of the Child *(1948);* The Absorbent Mind *(1949);* To Educate the Human Potential *(1950).*

On a warm evening in early summer, 1914, over 5,000 enthusiasts crammed into Carnegie Hall in New York City. Drawn from all walks of life, they held a common interest: to solve the many difficulties associated with children's education. The principal speaker was Maria Montessori, whose thoughts on that subject were then widely regarded as the most perceptive and influential of their kind anywhere in the world.

Maria was born on August 31, 1870, in the small town of Chiaravalle, near Ancona on the Adriatic coast of Italy. Her father Alessandro, who was descended from one of the numerous petty noble families of the area, had earlier established a distinguished record as a soldier. Following his retirement from the army, he had become a civil servant in Ancona, earning himself a reputation as an implacable bureaucrat and stolid defender of traditional conservative values. Maria's mother Renilde was primarily known for her piety and her lifelong commitment to and encouragement of charitable works among the poor. She seems to have developed a particularly close rapport with her only child. In fact, until Renilde's death in 1912, she and Maria maintained a faithful correspondence.

At the local state schools in Ancona, which she attended from an early age, Montessori displayed no special aptitudes or talents in any particular field of study. Neither did she appear to be an ambitious child, preferring, rather, to spend most of her time helping her mother in charitable endeavors. This situation changed in 1882, following her parents' decision to move to Rome. The standard of education there was far better, and Maria quickly blossomed into an accomplished scholar. At age 14, for example, she displayed an understanding of mathematical principles that was well in advance of her peers.

It was in these circumstances that her parents attempted to encourage her to become a teacher, then a well-regarded career path for women. Ironically, given her later interests, Montessori flatly refused to consider such an option. Rather, she expressed a keen desire to study engineering and to this end enrolled in a small technical school. This desire did not last; shortly thereafter, Montessori's interests turned, first to biology and then to medicine.

Alessandro strongly disapproved of this latter development and tried to discourage his daughter. He pointed out that medicine was an all-male profession and that Montessori would find it impossible to gain admittance to university. Despite this, and with Renilde's covert support, Maria persevered and won a scholarship to enter the Faculty of Medicine at the University of Rome. Though she was faced throughout her student years with many instances of discrimina-

tion, petty jealousy and persecution, Montessori never wavered in her determination. In 1896, she qualified as the first female M.D. to be licensed in Italy.

Later the same year, she spoke at a feminist congress in Berlin, Germany. Her experiences as a medical student had given her a unique insight into the plight of women attempting to enter the work force. Montessori's impressive speech, which was widely reported and commented on in the left-wing European press, led to further invitations to similar gatherings. For instance, in London in 1900, she spoke out in a similarly rousing manner against the exploitation of child labor in industry.

From 1896 on, however, Montessori was principally immersed in her medical career. Shortly after her graduation, she was appointed an assistant doctor in Rome University's psychiatric clinic. One of her duties was to visit the various asylums in the city to select patients to be brought to the clinic for treatment. Montessori was shocked to discover the many children who at the time were confined alongside adults in these asylums. Noting that the children's rooms were bare of any form of stimulation, such as toys, she quickly came to the conclusion that their problem was primarily educational and not medical. In 1899, Montessori laid out this view, in an address entitled "Moral Education," before a distinguished educational conference in Turin. As a result, Dr. Guido Bacelli, then minister of education in the Italian government, invited her to give a series of lectures further exploring this issue. This in turn led to the establishment of the first Orthophrenic school in the country, which provided facilities to train teachers in the special needs of retarded children.

Montessori served as the first director of this school and, during her term of office, traveled widely, studying new educational developments in the field. Soon, she was thinking of expanding what she had learned into other areas of children's education. She had a conviction, "so deep as to be of the nature of an intuition," she said, and it "became my controlling idea. I became convinced that similar methods applied to normal children would develop and set free their personality in a marvelous and surprising way."

In 1901, she resigned as director in order to re-register as a student at Rome University. Montessori believed that before she could set about developing new educational principles, she had to understand a great deal more about the methods and arguments of other disciplines, particularly psychology and philosophy. There

may also have been a more personal reason. Around this time (some sources cite 1898, the majority favor 1901), Montessori gave birth to a son, Mario. The child's father was a colleague of Montessori's named Dr. Montesano. For reasons unclear, both families opposed the idea of marriage, and Montessori had little choice but to give up her son to a wet nurse. Indeed, until her mother's death in 1912, Montessori had very little contact with the child.

It was not long after these events that the directors of the Institutio Romano Dei Beni Stabili, one of the most prominent building societies in Rome, began formulating plans to build two large blocks of apartments in the city. These apartments were to be erected in the San Lorenzo quarter then infamous for its squalor, poverty, crime, and overcrowding. The new buildings, however, were of high quality and were open to any current resident of the quarter on the condition that he or she would keep the property in good condition, refrain from all manner of social vices, and engage in a positive attempt to reform his or her life.

This project was largely successful but ran into one difficulty. With parents at work and the older children at the local state school, many younger children (aged 3 to 6) were left to fend for themselves. The local authorities moved to rectify this situation and decided to open a small school where these children could receive proper attention. Thanks to her already established reputation, they asked Montessori to assume responsibility for this center. Although she had many other duties and obligations at this time (since 1904 she had held the chair of anthropology at Rome University, and was continuing her medical practice in various clinics and hospitals throughout the city), she had no doubts about the importance of this school and enthusiastically agreed. Montessori later recalled that, during the opening ceremony of the school early in 1906, she "had a strange feeling which made me announce emphatically that here was the opening of an undertaking of which the whole world would one day speak."

Over the next three years, her frequent visits to the school led her to a number of what can only be described as revolutionary insights into the methods of children's education. She became convinced that there were certain important and identifiable characteristics of childhood which were hidden or denied by traditional educational methods. All children, she thought, possessed a range of personal qualities quite different from those normally attributed to them. The purpose

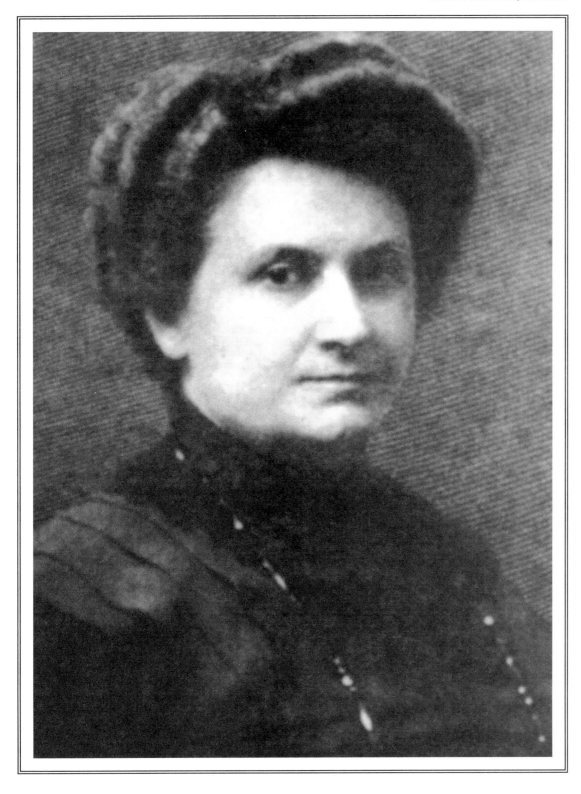

Maria Montessori

of education, therefore, must be to release these qualities in order to create a new and higher form of personality. It is the principles engaged in this effort to uncover the "New Child" which form the basis of what is still known today as the "Montessori Method."

The Montessori Method is not easily summarized. Montessori always insisted that its foundational principles could only properly be applied by teachers who had undergone a long process of training. In other words, they cannot be read as a simple list applicable anywhere but,

rather, as a methodology which must be creatively engaged in specially selected environments with the special needs of each particular child in mind. With that proviso, the following represents the main elements of Montessori's vision.

(1) The mainspring of all children's efforts is their spontaneous interest in their surroundings and so there is no need for adults to use force or persuasion; (2) children have a psychological need to engage in repetitive behavior (no matter how meaningless this might appear); (3) small children have an innate sense of order; (4) all children should be permitted a free choice of activity in order to promote their personal independence; (5) children prefer work to play; (6) no child sets any store by a system of rewards and punishments; (7) each child has a love and need for occasional periods of silence; (8) all children enjoy a profound sense of personal dignity; (9) all children engage in spontaneous self-discipline.

She knew that she had discovered a key which could unlock immeasurable constructive energies for human development.

—E.M. Standing

In a series of books first published in Italian in 1909, Montessori sought to explain the apparent success of her methods. These books were translated into over 20 foreign languages and Montessori found herself acclaimed as an international celebrity. Many teachers traveled to Rome in search of instruction in her methods, and she received numerous requests to tour abroad and lecture. In these circumstances, Montessori realized that she had to resign all her academic and medical positions in order to concentrate completely on spreading her educational principles to all corners of the globe.

In 1911, the first school run on the Montessori Method opened in Tarrytown, New York. The following year, Montessori's book, *The Montessori Method: Scientific Pedagogy as Applied to Child Education in the "Children's Houses,"* was published in the United States attracting widespread interest and becoming a bestseller. This eventually prompted Edward McClure, the wealthy publisher of *McClure's Magazine*, to invite Montessori to the United States with the promise that he would fund an institute dedicated to investigating and promoting her work. Though greatly tempted by this offer, she eventually declined, but she did agree to come in 1914 to conduct a cross-country series of lectures. So successful was this tour that Montessori returned the following year to Cali-

fornia to organize the first special training courses for teachers. On this occasion, she was accompanied by her son Mario who remained in Hollywood to open his own Montessori school.

Montessori's ideas found increasingly enthusiastic support throughout the world. In Germany, Austria, Holland, Russia, India, China, Japan, and Chile special "Children's Houses" were built, often with Montessori's direct collaboration. In 1916, she traveled to Barcelona, Spain, where she founded a "Children's Chapel," thereby extending her principles to the specific field of religious education. Throughout this period, however, Montessori was consistently worried that her principles were being misunderstood and misapplied by well-meaning but unqualified individuals. She firmly believed that only she was qualified to interpret her theories in a proper fashion. As a result, she began to spend more of her time organizing and developing a new type of rigorous training course for specially selected groups of teachers. The first of these courses were held in England and Holland between 1918 and 1920.

Throughout the 1920s, however, enthusiasm for Montessori's methods, particularly in Europe, began to wane. As interest in child education developed, new theories evolved which made the Montessori Method appear rigid and inflexible. This situation was not helped by Montessori's own increasingly autocratic manner and her continued insistence that her theories could only be understood by the few who had received her direct instruction.

The only apparent exception to this trend was in Italy. In 1924, Montessori met the fascist dictator Benito Mussolini whom she persuaded into supporting her methods. As a result, she received a great deal of financial backing from the government, which was poured into the funding of schools and training centers. This success, however, was only short lived. In 1934, the state issued a decree requiring all children to wear a special uniform to school and to give the fascist salute each morning. When Montessori refused to countenance these measures, all the Montessori schools and centers were immediately closed.

As Europe drifted closer to war in the 1930s, Montessori's projects in other countries were similarly affected. The Nazi regime in Germany and Austria proscribed her work and the left-wing government that came to power in Barcelona at the beginning of the Spanish civil war in 1936 banned her religious schools. Since Montessori was in Barcelona at the time, she was apparently in some danger before British authorities arranged her escape to London.

In 1939, Montessori organized a training course at Benares University in Madras, India. She had long believed that the Indian sub-continent, with its mass illiteracy and appalling rates of poverty, was a fertile area for the reception of her ideas. When she was there, however, World War II began which meant that she, an Italian citizen, found herself trapped in a part of the British empire. The usual result in these cases would have been for the enemy alien to be interned for the duration of the conflict. Wisely, the British authorities decided that a 70-year-old woman of distinguished international reputation lent no threat to their war effort, and they allowed her to continue to travel and teach throughout India until 1945.

Following the end of the war, Montessori returned to Italy, where the newly formed government asked her to re-establish a system of Montessori schools. Shortly thereafter, she was offered a chair at the University of Berlin but declined the honor in order to return to India to complete her work training a new generation of teachers. For three years running (1949–51), she was nominated for the Nobel Peace Prize. In 1950, after her return from India, she served for a short period as the director of the International Center for Educational Studies at the University of Perugia in Italy.

Increasing ill health, however, eventually caused Montessori to resign from all her public positions and retire to Holland (where the international headquarters of the Montessori movement had been established). She continued to receive a variety of honors, such as an honorary Doctor of Philosophy from the University of Amsterdam, but was more pleased to realize that her method was once again beginning to receive widespread and serious attention from educational theorists. Maria Montessori, aged 81, died suddenly of a cerebral hemorrhage at her home in Holland on May 6, 1952.

SOURCES:

Kramer, Rita. *Maria Montessori: A Biography*. Chicago, IL: University of Chicago Press, 1976.

Montessori, Maria. *The Montessori Method: Scientific Pedagogy as Applied to Child Education in the "Children's Houses."* NY: Schocken Books, 1964.

Standing, E.M. *Maria Montessori: Her Life and Work*. NY: Mentor Books, 1954.

SUGGESTED READING:

Standing, E.M. *The Montessori Method: A Revolution in Education*. Fresno, CA: Academy Guild Press, 1962.

Dave Baxter,
Department of Philosophy, Wilfrid Laurier University,
Waterloo, Ontario, Canada

Montez, Lola (1818–1861)

Irish-born dancer, actress, courtesan and adventurer whose exploits and independent conduct made her a legendary figure of the mid-19th century. Name variations: Maria-Dolores Porris y Montes; Marie do Landsfeld Heald; Lolla Montes; Mrs. Eliza Gilbert; Countess of Landsfeld. Pronunciation: LO-la MON-tez. Born Maria Dolores Eliza Rosanna Gilbert in Limerick, Ireland, in 1818; died on January 17, 1861, in New York City; daughter of Edward Gilbert (an Irish officer in the British army), and a mother, name unknown, who was the illegitimate daughter of Irish nobleman Charles Oliver; received education typical of a military officer's daughter, including a year in a finishing school in Bath; married Thomas James, on July 23, 1837 (divorced 1842); married George Trafford Heald, in 1849 (died 1851); married Patrick Purdy Hull, on July 2, 1853 (separated soon thereafter); no children.

Taken to India as an infant (1819); sent to Scotland for her education after her father's death and her mother's remarriage (1826); moved to Bath (1830); moved to India with first husband (1837); returned to England and obtained a divorce (1842); made stage debut in London (1843); traveled to Dresden (1843); had affair with Franz Liszt (1843–45); was mistress of King Ludwig I of Bavaria (1846–48); immigrated to America and made New York stage debut (1851); toured eastern U.S. (1852–53); following San Francisco debut, performed in California mining camps (summer 1853); following third marriage, took up residence in Grass Valley, California (1853–55); made Australian stage tour (summer-autumn, 1855); traveled from New York to Europe and back (1856–57); began career as a lecturer (1858); made lecture tour of Ireland and England (1858–59); returned to New York (late 1859); felled by a stroke (1860).

In an era when it was almost impossible for a woman to survive economically without the protection of a husband, and when society usually ostracized a woman who chose to live on her own terms, Lola Montez led an extraordinary life. A beautiful woman with a deliberately larger-than-life personality, a dancer, actress, inveterate traveler, mistress of a king and paramour of many, she has been called "an astounding adventuress," "the Queen of Hearts," "The Wandering Bacchante," "the Darling of the Nation," and "the Woman without a Country." **Eleanor Perenyi**, a biographer of Montez's lover Franz Liszt, called her a "flaming whore"; Alexandre Dumas *père*, with whom she had a brief affair, said, "She has the evil eye. She will bring bad luck to every man who links his destiny with hers," yet remained her friend.

Throughout her life, she did everything in her power to sow confusion about the truth of her background and early days, claiming on occasion that she had been born in Spain, and at others that she was half Spanish through her mother. In fact, she was born Marie Dolores Eliza Rosanna Gilbert in Limerick, Ireland, in 1818 (a date she early changed to 1824). She was the daughter of Ensign Edward Gilbert, a young British army officer of good Irish family, and a woman (name unknown) who claimed to be of the Oliverres de Montalvo family of Madrid but was actually the illegitimate daughter of Charles Oliver, of Castle Oliver, and a peasant who lived on his estate near Cloghnafoy, County Limerick. The Oliver family had been settled in Limerick since 1645 and was indeed Irish, despite Lola's claims to the contrary and distinctly Latin (or black Irish) appearance. She readily admitted that she was born only two months after the marriage of her parents, both of whom were forthwith disowned by theirs.

I have known all that the world has to give—all!

—Lola Montez

As an infant, Lola was taken by her parents to India, where her father died of cholera at Dinapor. Her mother married his best friend, Lt. Patrick Craigie of the 38th Native Infantry quartered at Dacca, who was promoted to the rank of major when Lola was six. She was then sent to Montrose, Scotland, so that her step-grandfather could oversee her education. Unhappy there, she was sent to Bath, to the home of a family friend, Sir Jasper Michaels, commander in chief of the Bengal Forces. When Michaels sent his family to Paris to allow his daughter to study there, Lola accompanied them, and then spent a year attending a finishing school in Bath. Upon her mother's return to England, she and Lola quarrelled, and Lola eloped to Ireland with the first of her three husbands, a Captain Thomas James, who was 16 years her senior. After their marriage on July 23, 1837, the couple traveled to India, where Lola soon lost interest in her spouse. She returned to England in 1842 and divorced James. She also took a few dancing lessons, with the intent of embarking on a career as a Spanish dancer.

When she made her London debut on June 3, 1843, at Her Majesty's Theater in the Haymarket, the former Mrs. James was billed as "Donna Lola Montez of the Teatro Real in Seville." Among those in attendance was the dowager queen of England, *Adelaide of Saxe-Meiningen. Montez performed a dance called "El Oleano," which would remain in her reper-

toire throughout her career on stage, and though her talent was limited and her studies superficial, there was her extraordinary beauty as compensation. The evening was a popular if not a critical success, and launched Lola Montez on a brief but blazing stint as a dancer in Belgium, France, the German states, Poland, and Russia.

Everywhere she appeared she captivated men, and among her many torrid (if brief) liaisons were affairs with Emperor Nicholas I of Russia, Dumas *père*, and Liszt. Although she stayed with the senior Dumas at Monte-Cristo, his famous villa at Saint-Germain-en-Laye outside Paris, she did not, as is often claimed, become his mistress; a brief, extant letter she wrote to him, dated April 14, 1847, is couched not in romantic terms but in those of one old friend to another. A rare example of Montez as the lover and not the beloved was her romance with Liszt, a notorious philanderer with a devastating impact on women who may well have been the first celebrity in the modern sense of the term. They met first in 1842, when influential friends secured her an engagement at the Royal Theater in Dresden. She promptly fell in love, and in 1844 accompanied him on a journey to Constantinople (now Istanbul). However, by 1845, when she followed him to Bonn for the unveiling of a monument to Beethoven and claimed that he had invited her, Liszt avoided her. The fact that she was refused admittance to the town's leading hotel, the Gasthaus zum Stern, shows the level to which her reputation had sunk. That evening, Montez beguiled an elderly citizen into escorting her to the all-male banquet, where she jumped onto a table to perform a "Spanish" dance. Far from winning Liszt back to her, the incident caused such a furor that he and several other guests were forced to leave.

In 1846, after an unsuccessful appearance at the Paris Opera, Lola Montez arrived in Munich, the capital of Bavaria. Then 27 and at the height of her beauty and charm, she succeeded in captivating the heart of the art-loving King Ludwig I (not to be confused with his grandson, the notorious "Mad King Ludwig"), and soon became his mistress. Already 60 when the affair began, Ludwig was a scholar and a patron of the arts as well as the leader of the anti-French element in the German states. Although in the early years of his reign he had favored constitutional government and administrative reforms, and had supported the Greek struggle for independence against the Turks, as the years passed and the liberal movement in Europe grew he had become increasingly more conservative. Montez rejuvenated the king, who called her "the lovely

Andalusian" and "the Woman of Spain." The German historian Heinrich von Treitschke, who saw her at this time, described her as "shameless and impudent," but able "to converse with charm among friends, manage nettlesome horses, sing in a thrilling fashion and recite amorous poems in Spanish." Ludwig wrote her poetry, gave her the title of Graferin von Landsfeld (Countess of Landsfeld), and built her the lovely Italian-style Bijou Palace on Karolinen Platz in Munich. He also gave her a handsome income of 20,000 florins a year and commissioned Joseph Stieler to paint her portrait, which was then hung in a position of honor among his famed collection of old masters at the Residenz Palace. Montez had extraordinarily good—and expensive—taste, which it was Ludwig's joy to indulge, and she filled her palace with tapestries, crystal, Dresden china and other porcelains, finely bound books and sundry objets d'art. Her gardens were beautiful and her stables were filled with the finest horses and carriages.

For a while, Montez enjoyed remarkable power behind the throne. King Ludwig had in 1837 placed Karl Abel, a dedicated ultramontane (supporter of the absolute supremacy of the pope), in charge of his government, with the result that the country came under the domination of Catholic clergy. Montez, on the other hand, had become acquainted with the strongly anti-ultramontanist ideas of French priest Felicité Robert de Lamennais during her association with Liszt, and apparently decided to put them into practice. Hostile to the Jesuits and now considering Bavaria her adopted homeland, she tried to influence Ludwig in favor of liberalism and even secured Abel's dismissal. But her power proved short-lived, for the extravagance Ludwig lavished on her made them both unpopular, and this, combined with discontent over taxes and policies, led to the revolution of 1848. Ludwig was forced to abdicate in favor of his son Maximilian, and Montez hurriedly left the country.

After returning to London she married a guardsman, George Trafford Heald, in 1849, but the relationship was soon ended by his untimely death. In late 1851, at age 33, she immigrated to America, where she made her New York debut at the Broadway Theater on December 27. She then made a tour of eastern cities in a play based on her German adventures, *Lola Montez in Bavaria* (which was written not by her, as she claimed, but by Charles Ware). In Boston, Philadelphia, Washington, Cleveland, Cincinnati, and finally New Orleans, the performances were enlivened by her rendition of the "Spider Dance," a version of the Italian *tarantel-*

Lola Montez

la which was supposedly inspired by the movements of a girl attempting to ward off an attacking tarantula. Montez's interpretation of this dance was described as a combination of polka, waltz, mazurka, and jig, but it was most notable for the twitching and swirling of her skirts, which provided audiences with a glimpse of feminine charms usually hidden from public view in the mid-19th century.

From New Orleans, Montez embarked in the spring of 1853 for California, with an entourage that included her manager, musician, maid and secretary. The journey involved sailing to Panama and then traveling by coach to the Pacific, where they caught a ship called *The Northerner* and sailed up the coast. In May, Montez made her California debut at the American Theater in San Francisco, a city then only recently acquired from Mexico and booming with wealth from the mining camps of the California gold rush. Although newspapers opined that both her play and her acting were boring, and the engagement lasted less than three weeks, the raw, crowded town of new arrivals warmed to her. Soon afterward, she made a benefit appearance as *Charlotte Corday in a production of *The Reign of Terror*. This too garned poor no-

tices, and thereafter Montez confined her appearances to dancing in mining camps, where the audiences are said to have rewarded her renditions of the Spider Dance, El Oleano and the Sailors' Hornpipe (a big favorite) by tossing nuggets of gold at her.

On July 2, 1853, Montez married again, to Patrick Purdy Hall, at the Catholic Chapel on Mission Road. (The officiating priest was apparently unaware of her prior marriage to George Heald, although she had been signing the name "Marie de Landsfeld Heald" in San Francisco.) The newlyweds honeymooned in Sacramento before settling down in the small town of Grass Valley—a long way in every respect from London, Paris and Munich. Lola Montez's sojourn in Grass Valley has become the stuff of early California state history, legend and lore. After her third marriage proved to be of short duration, she bought the Meredith Cottage, the only home she ever owned, and occupied herself with hunting, fishing, riding, and gardening. As pets, she kept dogs, a goat, and a grizzly bear. She also entertained the local men, whose wives, for the obvious reasons of her occupation and reputation, would not go near her. It seems clear, however, that at that time Montez, who rejoiced in the company of men, did not particularly care for other women—or for what they thought of her.

Restless again, on June 6, 1855, Montez embarked aboard the *Jane A. Falkenburg* for a theatrical tour of Australia, accompanied on the ten-week sail by a mediocre company hired at her own cost. She made her debut at the Royal Victoria Theater in Sydney on August 23rd in *Lola Montez in Bavaria*. The troupe then wandered on to Melbourne and Geelong, performing in *Maidens Beware* and *The Eton Boy*, and to the mining town of Ballarat, where Montez offered a mixed bill that included a comedy, a farce, a domestic drama, and Shakespeare's *Antony and Cleopatra*. Her manager died on board ship while they were returning to America, an event which apparently shook her. Back in San Francisco, she found herself both short of funds and in poor health. It was about this time that she began to take an interest in spiritualism.

Montez announced her retirement from the stage during a two-week engagement at the American Theater, despite reviews that were markedly better than she had received at her debut there. On September 8, 1856, she auctioned off her jewelry, which consisted of 89 items made mostly of diamonds and gold. Deciding that she had had enough of California, she gave a one-week performance in Sacramento,

sold her cottage in Grass Valley, and, after a final week of appearances at San Francisco's Metropolitan Theater, sailed for New York aboard the Pacific Mail steamer *Orizabo* on November 20, 1856. When a cholera epidemic broke out on board, Montez did her share of caring for the sick. After her arrival in New York, she became seriously involved in spiritualism, which was then enjoying a great vogue in the United States. Claiming that "her voices" had told her to do so, she briefly abandoned the stage, and traveled to France the following spring.

In 1857 Montez left Europe, crossing the Atlantic for the third time, and appeared in New York once again in *Lola Montez in Bavaria*. The play was by then somewhat of a relic, and when it met with little success she switched to a double bill of *The Eton Boy* and *Follies of a Night*. She then took her act to Boston, where the public response was even worse. Probably realizing that she was slipping, she began holding public receptions where one could meet her for $1.00 and shake hands with her for $1.50. Lola Montez was reduced to a caricature of herself.

By the following year she had settled in New York City, where, at age 40, she transformed herself again. On February 3, 1858, in Hope Chapel, New York, she made her first public appearance as a lecturer, speaking on such topics as Beautiful Women, Gallantry, Heroines of History, Comic Aspects of Love, Wits and Women of Paris, Romanism (an attack on the Catholic Church which was much esteemed by Protestant audiences in that era of open religious prejudice), and her own life and adventures. Her awe-struck audiences were titillated by the opportunity to see a loose woman in the flesh and hear what she might say. In fact, what she said were the words of C. Chauncy Burr, who ghostwrote all her lectures, but as these could last as long as three hours the customers certainly got their money's worth. Though often ridiculed in the press, the lectures drew larger audiences than had her plays.

In these years, having lost the beauty—and the power—of her youth, Montez also turned to social reform, and in time even undertook rescue work with "fallen" women. She published her (ghostwritten) memoirs, a series of innocuous, untrustworthy, and quite unscandalous recollections most likely intended to garner income and publicity. (That this was successful is attested to by the fact that they were later serialized in the Paris newspaper *Le Figaro*.) She also published her lectures, and these too, especially *The Arts of Beauty or the Secrets of a Lady's Toilet*, which sold 50,000 copies in the Paris edition, were lu-

crative despite the blandness of their content ("a beautiful mind is the first thing required for a beautiful face").

In late November 1858, Montez was back in Ireland and England, lecturing on "America and its People" in Dublin, Manchester, Liverpool, Chester, Bath and Bristol. She arrived in London on April 7, 1859, and spent several months there before making her fifth Atlantic crossing to return to New York that autumn. There she grew disillusioned with spiritualism after catching one of her mediums in a typical spiritualist hoax, and became increasingly involved with the Methodist faith. While people who had known her in her youth were inclined to laugh at her religious feelings, new friends were struck by the sincerity of her conversion, and there seems to be no doubt that a strong spiritual side of her nature came to the fore at this stage of her life. Montez continued to lecture (offering *John Bull at Home* for a dollar, and then for 25 cents, without success) until the fall of 1860, when she was felled by a stroke at the early age of 42. With her health gone and her left side paralyzed, she was taken in by a Mrs. Buchanan, the wife of a prominent florist living in Astoria (then on Long Island, now in Queens), whom she had known as a schoolgirl in Scotland. Under the care of the Buchanans, she turned to the Episcopal faith, but it seems likely that she had lost most of her will to live. Lola Montez died only a few months later, on January 17, 1861. While her poor health and early death have been widely attributed to the excesses of her youth, they just as easily may have been the result of constant travel under the primitive conditions of the day. Contrary to the popular belief that she died penniless, she left enough to pay her debts and contribute to charities, including a $300 bequest to the Magdalen Society, which did rescue work among prostitutes in New York. She was buried in Greenwood Cemetery in Brooklyn, under a tombstone that identifies her as "Mrs. Eliza Gilbert."

The earliest known portrait of Lola Montez, painted in England by Auguste Husster in 1848, when she was 30, shows a young woman well worthy of her reputation as one of the great beauties of the day. Her hair is dark, her eyebrows rich, her nose and chin are small, and her large dark eyes gaze forthrightly from an oval face of the type much admired in her time. Her neck was extraordinarily beautiful, and contemporaries described her as tall, with a robust constitution and a curvaceous figure; to display these attributes, she wore low-necked dresses with snug bodices, and favored dark-colored

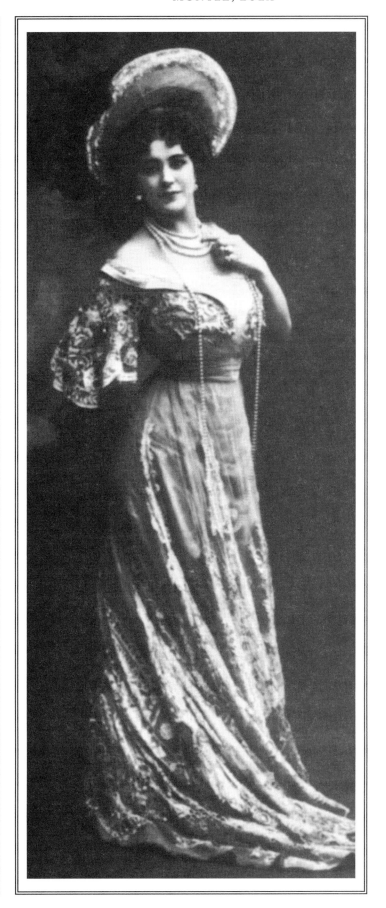

fabrics that set off her coloring. Later daguerreo-types confirm that her looks faded rapidly after her arrival in California, but above all she was said to possess an animated face that readily displayed her sparkling personality, something no portrait or photograph can convey.

She was neither a good actress nor a particularly good dancer, and she seems to have gotten by on the stage largely through exhibitionism and sheer nerve; yet throughout her career she attracted immediate and sensational attention in every new place she appeared. Long before the advent of modern media as we know them today, Montez was aware of the value of publicity, and was skilled at keeping her name in the papers. She was always ready with a letter to the editor, constantly rebutted what she called calumnies and slanders, and knew the box-office value of hauling her detractors into court. On stage, she would interrupt her show to respond to catcalls, and at the end of a performance often regaled the audience with a long-winded speech addressing the abuses and indignities she considered heaped upon her by the press. At age 35, she was famous throughout the Western world, and almost entirely due to her own legwork.

Montez's travels were extraordinary for a woman alone in a period when steamships, railroads, and modern hotels were still in their infancy. It is doubtful that any woman had ever traveled so much before *Sarah Bernhardt, and Bernhardt was much older before she broke Montez's record. Before she was 40, Lola Montez had traveled from Ireland to India and from London and Paris to Constantinople, Russia and Australia; she crossed the Indian Ocean four times, the Atlantic five times, and the Pacific twice (though wisely always avoiding any visit to her "ancestral" Spain).

A woman to be reckoned with, she was obviously in open rebellion against a society that placed barriers in front of any woman who chose not to follow the traditional path accorded her by men. But however immoral her life may have seemed to society, she could not be considered amoral; she does not appear to have been either selfish or greedy, and by all accounts her later religious conversion was perfectly sincere. She has been described as mercurial, irritable, foolish and reckless, but never cruel. On the contrary, she was resourceful, courageous, good-natured and generous, and could be gracious, soft-spoken, considerate and kind. She also enjoyed shocking people, not only allowing herself to be photographed holding a cigarette but actually smoking in public, a practice for which women were arrested in the U.S. as late as 1920. A charmer with a talent for conversation, and obviously intelligent, she was also shrewd, educating herself as she moved through her career and then using what she had learned to reinvent herself. That she created an enduring legend is evident from the rash of books, articles, and pamphlets about her that appeared in the first years after her death. Around that same time a woman claiming to be her daughter toured the lecture circuit; as late as 1888, a medium also claimed to be her daughter, and in 1929 an Austrian medium claimed to be her reincarnation. In Germany, her name has become synonymous with a siren who leads men to their destruction. In the novel *Die Blaue Engel* ("The Blue Angel," 1906), the loose heroine is named "Lola," and when the story was made into a motion picture starring *Marlene Dietrich in 1929, the character was rechristened "Lola-Lola," apparently to double the suggestive implications. In English, the best biographies of Lola Montez are those by D'Auvergne and, particularly, Wyndham; others exist in French, German and Spanish, many of them potboilers happy to pass on the gossip and rumors of her day (a number of which were launched by Montez herself). A novel based on her life by Thomas E. Harré, *The Heavenly Sinner: The Life and Times of Lola Montez*, was published by McCaulay (New York, 1935); another by Edison Marshall, *The Infinite Woman*, was published by Farrar, Straus (New York, 1950).

SOURCES:

Foley, Doris. *The Divine Eccentric: Lola Montez and the Newspapers*. Los Angeles, CA: Westernlore Press, 1969.

Perenyi, Eleanor. *Liszt the Artist as Romantic Hero*. Boston, MA: Little, Brown, 1974.

Ross, Ishbel. *The Uncrowned Queen: The Life of Lola Montez*. NY: Harper & Row, 1972.

Trowbridge, William R. *Seven Splendid Sinners*. London: T.F. Unwin, 1909.

Wyndham, Horace. *The Magnificent Montez: From Courtesan to Convert*. NY: B. Blom, 1935 (reprint 1969).

SUGGESTED READING:

D'Auvergne, Edmund. *Lola Montez: An Adventuress of the Forties*. London: T.N. Laurie, 1909.

Goldberg, Isaac. *Queen of Hearts: The Passionate Pilgrimage of Lola Montez*. NY: John Day, 1936.

Montez, Lola. *The Arts of Beauty*. NY: Dick & Fitzgerald, 1858.

———. *The Lectures of* NY: Rudd & Carleton, 1859.

Seymour, Bruce. *Lola Montez: A Life*. New Haven, CT: Yale University Press, 1996.

Robert H. Hewsen,
Professor of History, Rowan University, Glassboro, New Jersey

Montez, Maria (1918–1951)

Spanish actress. Born Maria Africa Vidal de Santo Silas on June 6, 1918, in the Dominican Republic;

died in 1951; married first husband (marriage ended); married Jean-Pierre Aumont (an actor), in 1943; children (second marriage): Tina Aumont also known as Tina Marquand (b. 1946).

Selected filmography: The Invisible Woman *(1940);* Lucky Devils *(1941);* That Night in Rio *(1941);* South of Tahiti *(1941);* Moonlight in Hawaii *(1941);* The Mystery of Marie Roget *(1942);* Arabian Nights *(1942);* White Savage *(1943);* Cobra Woman *(1944);* Ali Baba and the Forty Thieves *(1944);* Follow the Boys *(1944);* Gypsy Wildcat *(1944);* Sudan *(1945);* Tangier *(1946);* Pirates of Monterey *(1947);* Siren of Atlantis *(1949);* Hans le Marin *(The Wicked City, Fr., 1950);* Amore e Sangue *(City of Violence, It.-Ger., 1951).*

Maria Montez was born in 1918 in the Dominican Republic, the daughter of a Spanish consular official stationed there. An "exotic"-looking brunette, she was recruited by the Universal film studio in Hollywood, despite her inexperience as an actress, and first appeared on film in *The Invisible Woman* in 1940. Known by the mid-1940s as the "Queen of Technicolor," Montez appeared in numerous adventure movies that often included camels or pirates, such as *Arabian Nights* (1942, in which she played Scheherazade), *Ali Baba and the Forty Thieves* (1944), and *Tangier* (1946). She married French actor Jean-Pierre Aumont in 1943, and their daughter, **Tina Aumont**, also became an actress, primarily in European films. After her roles at Universal became more infrequent in the late 1940s, Montez and her husband moved to Europe, where she acted in a number of action films. She died unexpectedly in 1951, drowning in the bathtub after apparently having a heart attack; her films, now considered high camp, have since attracted a cult following.

Grant Eldridge,
freelance writer, Pontiac, Michigan

Montez, Minnie (1836–1914).

See Leslie, Miriam Folline Squier.

Montfort, Amicia (fl. 1208)

Countess of Leicester. *Name variations: Amicia Beaumont; Amice of Montfort. Flourished around 1208; daughter of Robert Beaumont (1130–1190), 3rd earl of Leicester, and* **Patronil de Gremtemesnil;** *married Simon (IV) Montfort (c. 1150–1218), earl of Leicester; children: Simon (V) Montfort (c. 1208–1265), earl of Leicester.*

Montfort, countess of (c. 1310–c. 1376).

See Jeanne de Montfort.

Maria
Montez

Montfort, Eleanor de (1215–1275).

See Eleanor of Montfort.

Montfort, Eleanor de (1252–1282).

See Eleanor of Montfort.

Montfort, Jeanne de (c. 1310–c. 1376).

See Jeanne de Montfort.

Montgomery, countess.

See Bauer, Karoline (1807–1877).

Montgomery, countess of.

See Clifford, Anne (1590–1676).

Montgomery, Elizabeth
(1933–1995)

American television actress. Born on April 15, 1933, in Los Angeles, California; died of colon cancer on May 18, 1995, in Beverly Hills, California; daughter of Robert Montgomery (an actor) and Elizabeth (Allen) Bryan Montgomery (an actress known as Elizabeth Allen); attended Westlake School for Girls, Los Angeles; attended the Spence School, New York City; studied acting at American Academy of Dramatic Arts, New York City; married Frederick Gallatin Cammann, in 1954 (divorced 1955); married Gig

Young (an actor), in 1957 (divorced 1963); married William Asher (a producer), in 1963 (divorced 1974); married Robert Foxworth (an actor), in 1993; children: (third marriage) William, Jr.; Robert; Rebecca.

Selected television roles: series: "Robert Montgomery Presents" (NBC, 1953–54, 1956), "Bewitched" (ABC, 1964–1972); movies: "The Victim" (ABC, 1972), "Mrs. Sundance" (ABC, 1974), "A Case of Rape" (NBC, 1974), "The Legend of Lizzie Borden" (ABC, 1975), "Dark Victory" (NBC, 1976), "A Killing Affair" (CBS, 1977), "Jennifer: A Woman's Story" (NBC, 1979), "An Act of Violence" (CBS, 1979), "Belle Starr" (CBS, 1980), "When the Circus Came to Town" (CBS, 1981), "The Rules of Marriage" (CBS, 1982), "Second Sight: A Love Story" (CBS, 1984), "Between the Darkness and the Dawn" (NBC, 1985), "Amos" (CBS, 1985), "Sins of the Mother" (CBS, 1991), "With Murder in Mind" (also known as "With Savage Intent," CBS, 1992), "Black Widow Murders: The Blanche Taylor Moore Story" (NBC, 1993), "The Corpse Had a Familiar Face" (CBS, 1994), "Deadline for Murder" (CBS, 1995); miniseries: "The Awakening Land" (NBC, 1978); television pilots: "The Boston Terrier" (ABC, 1963), "Missing Pieces" (CBS, 1983); episodic: "Robert Montgomery Presents" (NBC, 1951), "Armstrong

Circle Theatre" (NBC, 1953, 1954), "Kraft Theatre" (NBC, 1954, 1955, 1957), "Studio One" (CBS, 1955, 1958), "Appointment with Adventure" (CBS, 1955), "Warner Bros. Presents" (ABC, 1956), "Climax" (CBS, 1956), "Suspicion" (NBC, 1958), "DuPont Show of the Month" (CBS, 1958), "Cimarron City" (NBC, 1958), "Alfred Hitchcock Presents" (CBS, 1958), "*Loretta Young Show" (NBC, 1959), "Riverboat" (NBC, 1959), "Johnny Staccato" (NBC, 1959), "Wagon Train" (NBC, 1959), "National Velvet" (NBC, 1960), "Tab Hunter Show" (NBC, 1960), "Alcoa Presents One Step Beyond" (ABC, 1960), "The Untouchables" (ABC, 1960), "Twilight Zone" (CBS, 1961), "Theatre '62" (NBC, 1961), "Thriller" (NBC, 1961), "Frontier Circus" (CBS, 1961), "Checkmate" (CBS, 1962), "Alcoa Premiere" (ABC, 1962), "Saints and Sinners" (NBC, 1963), "Burke's Law" (ABC, 1963, 1964), "Rawhide" (CBS, 1963), "77 Sunset Strip" (ABC, 1963), "Eleventh Hour" (NBC, 1963), "The Flintstones" (voice only, ABC, 1965), "Hallmark Hall of Fame" (CBS, 1990).

Selected filmography: The Court Martial of Billy Mitchell (1955); Johnny Cool (1963); Who's Been Sleeping in My Bed? (1964); (narrator) Coverup: Behind the Iran-Contra Affair (1988); (narrator) The Panama Deception (1992).

Awards: Daniel Blum Theatre World Award (1954); Emmy award nomination, Best Actress in a Single Performance, for "The Rusty Heller Story" on "The Untouchables" (1961); Emmy award nominations, Best Actress in a Comedy Series, all for "Bewitched" (1966, 1967, 1968, 1969, 1970); Emmy award nomination, Best Actress in a Drama Special, for "A Case of Rape" (1974); Emmy award nomination, Best Actress in a Drama or Comedy Special, for "The Legend of Lizzie Borden" (1975); Emmy award nomination, Best Actress in a Limited Series, for "The Awakening Land" (1978).

Elizabeth Montgomery was born on April 15, 1933, in Los Angeles, California, one of two children of actor Robert Montgomery and stage actress **Elizabeth Allen**. Montgomery grew up in a mansion in Beverly Hills and attended the Westlake School for Girls, where at age five she made her first stage appearance, as the wolf in a French-language production of Little Red Riding Hood. After her parents divorced in 1950, Montgomery moved to New York City with her father, and attended the elite Spence School before enrolling at the American Academy of Dramatic Arts. She made her television debut in a 1951 episode of her father's NBC series "Robert Montgomery Presents," and had several stage

Elizabeth Montgomery

roles as ingenues, notably in the 1953 production *Late Love*, for which she received *Theatre World*'s Daniel Blum Award for most promising newcomer. By 1953, Montgomery had embarked on a solid television career that would continue for the rest of her life.

In 1954, Montgomery married New Yorker Frederick Gallatin Cammann, who was promptly expelled from the Social Register for marrying an actress. The marriage lasted only a year, ending without acrimony when Montgomery decided she needed to work in Hollywood to further her career. She was married to actor Gig Young from 1957 to 1963, the same year she met producer William Asher on the set of *Johnny Cool*. After their marriage later that year, Montgomery wanted to quit acting in favor of raising a family, but Asher felt this would be a waste of her talent. As a compromise, he secured her the television series "Bewitched," the production schedule of which was adjusted to accommodate her three pregnancies.

A huge success, "Bewitched" aired on ABC from 1964 to 1972, starring Montgomery as Samantha Stephens, a suburban housewife who happens to be a witch. Her husband, a hapless mortal named Darrin (played by Dick York, then by Dick Sargent), is tormented by his mother-in-law Endora (played by *Agnes Moorehead) and sputters ineffectually as Samantha casts spells with a twitch of her nose. The series was the number one show for four of its eight years, and was ABC's highest rated half-hour prime-time series before the arrival of "Happy Days"; it also garnered Montgomery five of her nine Emmy nominations, and made her a great favorite with television audiences. It has gone on to become a staple of late-night and cable television, earning Montgomery, who owned 20% of the show, millions in the process.

She continued to work regularly in television after "Bewitched" ended, appearing in 19 made-for-television movies over the next two decades. Notable among these are "A Case of Rape" (1974) and "The Legend of *Lizzie Borden" (1975), both of which earned her Emmy nominations (although she was nominated nine times, she never received an Emmy). "She always chose roles that challenged her and surprised the audience," her last husband Robert Foxworth told *People Weekly* in 1995. A very private person, Montgomery rarely divulged personal information, and declined to be interviewed during the last 20 years of her life; indeed, her 1993 marriage to Foxworth, with whom she had lived since the year after her ami-

cable 1974 divorce from Asher, was not disclosed to the public until after her death. Montgomery rarely made show business-related appearances, but regularly used her celebrity to benefit favorite causes, such as the AIDS Project Los Angeles and AmFAR, the American Foundation for AIDS Research. She also provided the narrations for **Barbara Trent**'s documentaries examining certain incidents from the Reagan-Bush administration, *Coverup: Behind the Iran-Contra Affair* (1988) and *The Panama Deception* (1992), which won an Oscar. Shortly after she completed filming the television version of reporter **Edna Buchanan**'s "Deadline for Murder" (1995), Montgomery was diagnosed with colon cancer. She died eight weeks later at her Beverly Hills home, on May 18, 1995.

SOURCES:

Contemporary Theatre, Film, and Television. Vol. 3. Ed. by Monica M. O'Donnell. Detroit, MI: Gale Research, 1986.

Contemporary Theatre, Film, and Television. Vol. 14. Ed. by Terrie M. Rooney. Detroit, MI: Gale Research, 1996.

People Weekly. June 5, 1995.

Ellen Dennis French,
freelance writer, Murrieta, California

Montgomery, Helen Barrett

(1861–1934)

American civic reformer, foreign mission worker, and philanthropist who was the first woman to translate the Greek New Testament into contemporary English. Born Nellie Barrett on July 31, 1861, in Kingsville, Ohio; died on October 19, 1934, in Summit, New Jersey; daughter of Adoniram Judson Barrett (a teacher, school principal, and Baptist minister) and Emily (Barrows) Barrett (a teacher); attended Livingston Park Seminary; Wellesley College, B.A., 1884; Brown University, M.A.; married William A. Montgomery (a businessman), on September 6, 1887; children: Edith.

Taught at the Rochester (New York) Free Academy (1884–85); taught at the Wellesley Preparatory School, Philadelphia (1885–87); organized a large Bible study class for women (1888), which she taught for 44 years; was licensed to preach by Lake Avenue Baptist Church in Rochester (1892); became first president of Women's Educational and Industrial Union of Rochester; was president of New York State Federation of Women's Clubs (1896–97); elected to Rochester school board (1899); worked to open University of Rochester to female students; elected president of Northern Baptist Convention (1921); delegate to Baptist World Alliance, Stockholm Congress (1923). Member: Women's Political Equality League

of Rochester; Rochester School Board; Women's Educational and Industrial Union of Rochester; New York State Federation of Women's Clubs; American Baptist Foreign Mission Society; National Federation of Women's Boards of Foreign Missions; Northern Baptist Convention. Awards: honorary doctorate degrees from Denison University, Franklin College, and Wellesley College.

Selected writings: Christus Redemptor *(1906);* Western Women in Eastern Lands *(1910);* The King's Highway *(1915);* The Bible and Missions; Prayer and Missions; From Jerusalem to Jerusalem; The Centenary Translation of the New Testament *(1924).*

Helen Barrett Montgomery, the first woman president of the Northern Baptist Convention, the first president of the Women's American Baptist Foreign Mission Society, and the first woman to translate the Greek New Testament into contemporary English, was born in Kingsville, Ohio, on July 31, 1861. She was the oldest of three children of **Emily Barrows Barrett**, a teacher, and Adoniram Judson Barrett, a teacher and school principal and later pastor of the Lake Avenue Baptist Church in Rochester, New York. It was her father who instilled in her a love for education as well as a deep devotion to church service. She enjoyed a happy, uneventful childhood, much of it on the grounds of an academy on Lowville, New York, where her father was principal. Montgomery studied Latin in high school and in 1880 entered Wellesley College, where she studied Greek and majored in education. After receiving a B.A. from Wellesley in 1884 (she would later earn a master's degree from Brown University), she taught at the Rochester Free Academy for a year, and from 1885 to 1887 taught at the Wellesley Preparatory School in Philadelphia. In September 1887 she married William Montgomery, a businessman who formed a successful company that produced automobile starters. He, too, was dedicated to church service, and was by all accounts supportive of his wife's activities; in 1913, he noted that, upon their marriage, "I realized that she had ability and training to do what I could never do. I resolved . . . never to interfere with any call that might come to her in the line of her work."

Following her marriage, Montgomery organized a large Bible study class for women at her father's church, which she subsequently taught for 44 years. In 1892, she was licensed to preach by the Lake Avenue Baptist Church, and although she was never ordained she frequently served as substitute pastor there. She became the first president of the Women's Educational and Industrial Union of Rochester in 1893. The union was a strong supporter of a municipal reform movement, and also of a restructuring of the Rochester school board; Montgomery was elected the first female member of the board in 1899. She served for ten years, during which time many new programs were instituted, including a dental clinic and the nation's first factory school.

Helen Montgomery also served as president of the New York State Federation of Women's Clubs in 1896 and 1897. She worked with her friend *Susan B. Anthony to raise funds to open the University of Rochester to female students, and joined the Women's Political Equality League of Rochester. In 1904, she began to take on speaking engagements across the country, largely on the educational work of missions. She was developing an increasing interest in Christian mission work, and eventually undertook a world tour to speak on the subject. Montgomery was president of the Woman's American Baptist Foreign Mission Society from 1914 to 1924. With **Martha Hillard MacLeish** and *Lucy Peabody**, in 1915 she was a co-founder of the World Wide Guild, an organization that grew to include chapters in Baptist churches throughout the United States, and also served as president of the National Federation of Women's Boards of Foreign Missions for the 1917–18 term. In 1921, she was elected president of the Northern Baptist Convention. She was the organization's first woman president, and, as such, the first woman to be elected to a position of such prominence in any major Christian denomination.

Montgomery also wrote extensively, publishing *Christus Redemptor*, a study of missions in the Pacific Islands, in 1906, and *Western Women in Eastern Lands*, an examination of the impact of women missionaries, in 1910. At the request of the Federation of Women's Boards of Foreign Missions, in 1913 she took a trip around the world to collect personal impressions of foreign missions. The result was published in 1915 as *The King's Highway*, which sold over 160,000 copies. In addition to her books on mission work, which also included *The Bible and Missions*, *Prayer and Missions*, and *From Jerusalem to Jerusalem*, Montgomery published *The Centenary Translation of the New Testament* (1924), a translation of the Greek New Testament into contemporary English. This, the first such translation by a woman, is considered perhaps her most important contribution to church work, and had undergone 15 printings by 1959.

Helen Barrett Montgomery's health began to decline following her husband's death in

1930. She died at her daughter's home in New Jersey on October 19, 1934, at age 73. She and her husband had given regularly and generously to various causes, including their church, and Montgomery's will contained $455,000 in bequests to over 80 causes, including churches, hospitals, missions, and colleges. Her obituary in *The Christian Century* noted, "With her passing there closed one of the most interesting as well as one of the most influential careers in recent American church annals."

SOURCES:

Deen, Edith. *Great Women of the Christian Faith*. NY: Harper & Row, 1959.

James, Edward T., ed. *Notable American Women, 1607–1950*. Cambridge, MA: The Belknap Press of Harvard University Press, 1971.

Read, Phyllis J., and Bernard L. Witlieb. *The Book of Women's Firsts*. NY: Random House, 1992.

<div align="right">

Ellen Dennis French,
freelance writer, Murrieta, California

</div>

Montgomery, Jemima (1807–1893).

See Tautphoeus, Baroness von.

Montgomery, Lucy Maud

(1874–1942)

World-renowned Canadian author of Anne of Green Gables and over 20 juvenile books and stories, who immortalized Canada's Prince Edward Island and the childhood experience. Name variations: Maud Montgomery. Born Lucy Maud Montgomery on November 30, 1874, in the tiny village of Clifton, Prince Edward Island, Canada; died in Toronto, Ontario, Canada, on April 24, 1942; daughter of Hugh John Montgomery (an entrepreneur) and Clara (Woolner Macneill) Montgomery; attended public school, Prince of Wales College, obtaining a teacher's license, and one year at Dalhousie University, 1895–96; married Reverend Ewan Macdonald, in July 1911; children: Chester (b. 1912); Hugh Alexander (stillborn August 1914); Stuart (b. 1915).

Lived with maternal grandparents (1876–91); composed first poem (1883); published first poem (1890); was a teacher for three years; was a newspaper columnist for one year; wrote and took care of aging grandmother (1902–11); published Anne of Green Gables *(June 1908); wrote eight "Anne" books (1908–39); became fellow of the Royal Society of the Arts (1923); was invested with the Order of the British Empire (1935); by the time of her death, over 21 books of fiction and countless stories and poems were published, and* Anne of Green Gables *had sold more than a million copies and was circulating the world in over 11 languages in book, movie, play or stage form (1942).*

Selected publications: Anne of Green Gables *(1908);* Anne of Avonlea *(1908);* Kilmeny of the Orchard *(1910);* The Story Girl *(1911);* Chronicles of Avonlea *(1912);* The Golden Road *(1913);* Anne of the Island *(1915);* The Watchman and Other Poems *(1916);* Anne's House of Dreams *(1917);* Rainbow Valley *(1919);* Rilla of Ingleside *(1921);* Emily of New Moon *(1923);* Emily Climbs *(1925);* The Blue Castle *(1926);* Emily's Quest *(1927);* Magic for Marigold *(1929); A* Tangled Web *(1931);* Pat of Silver Bush *(1933);* Mistress Pat *(1935);* Anne of Windy Poplars *(1936);* Jane of Lantern Hill *(1937);* Anne of Ingleside *(1939).*

In 1904, Lucy Maud Montgomery (called Maud by family and friends) was rummaging through some of her past writings and found an idea for a story in an old notebook. It read: "Elderly couple apply to orphan asylum for boy; by mistake a girl is sent to them." Believing the idea just might work, she sat down at her typewriter.

Lucy Maud Montgomery

Eighteen months later, Anne Shirley became not only the "girl sent by mistake," but also the tempestuous red-haired heroine of *Anne of Green Gables*. Montgomery suffered through four rejections of the manuscript and finally relegated it to the closet. Nonetheless, those "icy little rejection slips" did not deter her: "whatever gifts the gods had denied me they had at least dowered me with stick-to-it-iveness." Four years later, the 34-year-old author of countless poems and short stories received the first copy of *Anne of Green Gables* published by L.C. Page Publishing Company of Boston. As she held the attractively bound book with her name inscribed on it, she had little idea of the fame this story would bring her. Anne Shirley would become one of the most beloved children in fiction since the immortal Alice in Wonderland. *Anne of Green Gables* went to four editions in three months. By 1956, this novel and the more than 20 other novels written by Lucy Maud Montgomery comprised three million copies in British countries alone. Since 1954, *Anne of Green Gables* has circulated in more than seven million copies in Japan and in more than 15 languages. Montgomery became the quintessential writer of mythical childhood experiences on that fair, green isle of Prince Edward Island (P.E.I.).

I cannot remember the time when I was not writing or when I did not mean to be an author.

—Lucy Maud Montgomery

She was born in 1874 in a North Shore village on P.E.I. Her mother died when Lucy was 21 months old, and her father left Prince Edward Island for Western Canada. Her care and upbringing was in the hands of her maternal grandparents Alexander and **Lucy Macneill** until she was in her teens. In 1879, a violent headache resulting from a burn on her hand was incorrectly attributed to typhoid fever. "For the time being," said Montgomery, "I was splendidly, satisfyingly important." The Macneill homestead, "an old-fashioned Cavendish farmhouse, surrounded by apple orchards," was less than a mile away from the Atlantic and about 24 miles from the railway station. Thus Montgomery, a shy and lonely child, grew up in relative isolation until age six, when she began to attend public school. This seclusion did not appear to be a hindrance to the young girl's development. She would later describe the scene:

> Everything was invested with a kind of fairy grace and charm, emanating from my own fancy, the trees that whispered nightly around the old house where I slept, the woodsy nooks I explored, the homestead fields . . . the sea whose murmur was never out of my ears—all were radiant with "the glory and the dream." . . . [A]mid all the commonplaces of life, I was very near to a kingdom of ideal beauty.

Her natural inclination to regard all of nature as beautiful, coupled with her active imagination, gave way to imaginary friends and her love for cats and trees. "Trees have personalities of their own," she wrote, "being bound up with everything of joy and sorrow that visited my life, a life that was very simple and quiet." These trees would later find places in her fiction.

In addition to rock climbing and berry and apple picking, she began to write, a skill that came easily to her since the Macneill house was always full of books. The young Montgomery read Hans Andersen's *Tales,* poetry by Byron, Milton, Scott, and Longfellow, and novels such as *The Pickwick Papers.* Her writing habits developed early in life, and her imagination became "a passport to fairyland": "I had no companionship except that of books and solitary rambles in wood and fields. This drove me in on myself and early forced me to construct for myself a world of fancy and imagination very different indeed from the world in which I lived."

Her first poem was written when she was nine, the year she began keeping the journals which became an outlet for the feeling of "difference" she felt among her peers; she recorded her loneliness, and her curiosity about faith, evolution, and the divinity of Christ. Her surviving handwritten journals date from 1889 to her death in 1942. At age 11, she sent her first story to a publisher. Though it was rejected, the determined Montgomery wrote continuously through her teen years.

In a quest for adventure and freedom, so evident in her journal writing, she left Prince Edward Island in her teens. She settled for a year out "West" in Prince Albert, Saskatchewan, with her father, who had become a government official and real-estate agent, and his new wife. The area provided plenty of scope for her imagination. The prairie town was in the midst of forests, lakes, and rivers, and its population was varied. Success came for Montgomery there: the first publication of a 39-verse poem arrived in winter. "It was the first sweet bubble on the cup of success and of course it intoxicated me," Montgomery later wrote. Other verses and stories were printed in Montreal and Prince Albert newspapers. She continued to write while minding her baby half-sister Kate and sent stories to various magazines and newspapers. Rejections

followed, yet she "had learned the first, last, and middle lesson—Never give up!"

In 1891, her half-brother Bruce was born. Montgomery's stepmother could not cope with her, and she missed her beloved Island home: "I am ready to cut my throat in despair. Oh I *couldn't* live another year in this place if I were paid a thousand dollars an hour." Returning to Prince Edward Island in the summer of 1891, she prepared for examinations to enter Prince of Wales College in Charlottetown. Successful, she studied for one year and obtained her teacher's license. Her three years as a schoolteacher began at Bideford, P.E.I. Montgomery's ambition to become a writer never waned, and she diligently arose at 6 AM, wrapped herself in a heavy coat, and wrote by lamplight in a cold house until it was time to begin her teaching duties for the day. Later she would comment: "When people say to me, as they occasionally do, 'Oh, how I envy you your gift, how I wish I could write as you do,' I am inclined to wonder, with some inward amusement, how much they would have envied

me on those dark, cold winter mornings of my apprenticeship."

In the fall of 1895, Montgomery attended Dalhousie College in Halifax, taking a course in English literature. The winter of that year proved to be a happy one. Her "Big Week" brought a five-dollar check for a short story. It was her first payment for her writing, and she "did not squander it in riotous living" but rather bought five volumes of poetry with her earnings, feeling that she had finally "arrived." The 21-year-old Montgomery could now count herself as a paid, published author. The same week, she received $5 and $12 for further stories submitted much earlier. "I really felt quite bloated with so much wealth!"

After her successful winter in Halifax, she taught school for two more years, while also writing stories for Sunday-school publications and juvenile periodicals. When the death of her grandfather Macneill in 1898 left Montgomery's aging grandmother alone, she decided to do her "duty" to family by returning to Cavendish. For

From the movie Anne of Green Gables, *starring Megan Fellows as Anne and Colleen Dewhurst as Marilla.*

the next 13 years, Montgomery would write and care for her grandmother until Lucy Macneill's death in March 1911. Montgomery's father died of pneumonia in 1900. The following year, her work began getting accepted by U.S. journals. Now selling enough of her writing to keep her in food and clothing, she confided in her journal, "I never expect to be famous. I merely want to have a recognized place among good workers in my chosen profession."

From the autumn of 1901 to the summer of 1902, she wrote a weekly gossip column and edited a society paper. In these years of caring for her grandmother, Montgomery wrote and sold countless poems and stories. At times, editors asked her to write serials with fanciful plots, and these she produced. Though she only occasionally wrote what was dear to her heart, she was becoming successful. Her work ethic was formidable. In *Canadian Children's Literature* she was quoted as saying: "*To work at once, stick to it,* write something *every day,* even if you burn it up after writing it."

By 1904, she earned $591, then a large sum for a writer. That spring, she began that story from the idea found in a notebook. She had dreamt of writing a book but remained daunted by the prospect of it for some time. However, her imagination was spurred on by the thought of a girl sent by an orphanage to an elderly couple by mistake. She began to write of the famous Ann without an "e," and *Anne of Green Gables* began to take form in her little gable bedroom. Montgomery's favorite childhood haunts on the Island became the "Shore Road," "The Lake of Shining Waters" and "Lover's Lane" in the tale of Anne Shirley. She wrote of the myths of her girlhood and the legends of her imagination.

In April 1907, *Anne of Green Gables* was accepted by the publishing firm of L.C. Page. Montgomery wrote to her friend Ephraim Weber: "It is merely a juvenilish story, ostensibly for girls. . . . Grown ups may like it a little." By mid-September 1908, *Anne* was through its fourth edition. The book immediately brought wealth, fame, adulation from Mark Twain and Canadian poet Bliss Carman, and a publisher's contract with 10% of the royalties. Montgomery received over $7,000 in royalties in the first two years of publication—an amount unheard of in a province where the average yearly income for women was less than $300.

Anne of Avonlea, the sequel, was written in haste in the hot summer of 1908. The remaining six "Anne" volumes would be produced between 1908 and 1936. Montgomery also pub-

lished numerous other books in the early years of the 20th century, including a collection of poetry entitled *The Watchman and Other Poems* (1916). During these busy years, the author's fame spread, and she began to receive hundreds of letters from around the world about Anne. She also met the Canadian governor-general at his request and was received by literary clubs across Canada and the United States.

In November 1910, Montgomery was a guest at the home of her publisher, Lewis Coues Page, in Boston. "I lived more, learned more, and enjoyed more in those fourteen days," she remarked, "than I had done in the previous fourteen years." The relationship with Page, however, would not remain so amiable.

In 1911, several months after her grandmother died, Montgomery married a Presbyterian minister, Reverend Ewan Macdonald, to whom she had been secretly engaged since 1906. After an extended honeymoon abroad, they settled in Leaskdale and Montgomery lived the life of a country minister's wife. Her husband's position brought certain constraints ("What agonies I have endured betimes when I was dying to laugh, but dared not because I was the minister's wife"), and Montgomery's ideas were not always entirely in keeping with her role as a minister's wife: "Perhaps a *little* evil is necessary to give spice to existence—like the dash of cayenne that brings out the flavours of a salad and saves it from vapidity? Wouldn't it be a frightfully tasteless world if there were absolutely *no* evil?"

Their first son, Chester Cameron, was born in July 1912, and a second son, Hugh Alexander, was stillborn in August 1914. Montgomery worked tirelessly, devoting herself to church work, sick calls, quilting bees, and the Red Cross. World War I weighed heavily on her, to the point that she had trouble eating: "It is no joke but a simple fact that I have not had one decent dinner since the war began. . . . When I tell this to our comfortable, stolid country people who, from a combination of ignorance and lack of imagination, do not seem to realize the war at all, they laugh as if they thought I was trying to be funny. Those who perceive that I am in earnest think I am crazy."

In October 1915, her last son, Ewan Stuart, was born. The following year, she switched publishers due to problems with Page Co. and found a home at Frederick Stokes & Co. Under pressure, Montgomery allowed Page to publish *Further Chronicles of Avonlea,* the revised stories for which she dutifully sent them. The book appeared in 1920 and to the author's horror con-

tained not the revised stories but rather original drafts from 1912 which Page had in its vaults. Much of the material from these originals had already been used by Montgomery since 1912 in her published titles. The publication of *Further Chronicles* by Page could have exposed her to a breach of contract suit by Stokes; it also could have marred her literary credibility by including "no end of paragraphs and descriptions which were to be found in my other books." Montgomery sued Page:

> The case came up in May, 1920. I went down to Boston for it. Page's lawyer thought the case would be over in *two days*. My lawyer was not so optimistic and thought it would take three. *It took nearly nine years. . . . One whole day* those three grave lawyers and myself wrangled over the exact color of *Anne's* hair and the definition of "Titan" red. Ye gods, it *was* funny. . . . They had two "art experts" on the stand who flatly contradicted each other.

In October 1928, the final Page appeal was refused. Montgomery received profits Page had withheld as well as an injunction against the book.

In 1919, her husband was diagnosed with nervous prostration. While maintaining a strong sense of duty to family and church, she was prolific and continued to publish juvenile books such as the "Emily" series and the "Pat" books. *The Blue Castle* (1926) was an attempt to write for adults, as was *A Tangled Web* (1931). All the while, the "Anne" books became universally popular and were adapted for films (twice starring ❧▸ **Anne Shirley**), musicals, and plays the world over. Today *Anne of Green Gables* has become an annual festival in Charlottetown, P.E.I., to which thousands of tourists come each year to see Anne's house and the beauty of Prince Edward Island so vividly described by Montgomery. In 1939, a national park, embracing Cavendish and "Green Gables," was opened.

Lucy Maud Montgomery's life was a full one, although she suffered from poor health in her later years and an on going internal conflict with respect to her beliefs in Christianity and her role as a Presbyterian minister's wife. In 1934, her husband had a complete breakdown, which took its toll on her. In mid-1937, his health again deteriorated:

> It was more than nerves this time—for about two months in the summer he was a mental case, and among other symptoms, lost his memory completely. I could not bear to have him go to any institution for I knew no one could understand him as I did, for I have nursed him through so many of these attacks.

❧▸ Shirley, Anne (1917–1993)

American actress. Born Dawn Evelyeen Paris on April 17, 1917, in New York, New York; died of lung cancer on July 4, 1993, at her home in Los Angeles; married John Payne (an actor), in 1937 (divorced 1942); married Adrian Scott (a producer), in 1945 (divorced 1948); married Charles Lederer (a screenwriter), in 1949 (died 1976); children: (first marriage) Julie Payne; (third marriage) one son.

Anne Shirley was born Dawn Paris in New York City in 1917. When her father died 18 months later, her mother found work for her modeling baby clothes and in New York-based silent films, such as *The Miracle Child* (1923). Accompanying her mother to Hollywood, she worked as Dawn O'Day in *Pola Negri's The Spanish Dancer. She was also cast in *The Fast Set* (1924), *Riders of the Purple Sage* (1925), *Mother Knows Best* (1928), and *Liliom* (1930), and she played the tsar's daughter *Anastasia in *Rasputin and the Empress* (1932).

Mother and daughter were struggling throughout to put bread on the table. Then Shirley got her big break when rising RKO star **Mitzi Green** had to be replaced in the title role of the film adaptation of *Lucy Maud Montgomery's *Anne of Green Gables*. It was said that Green was being difficult—often a euphemism for contractual differences. At shooting's end, Dawn Paris changed her name to that of the movie's heroine, Anne Shirley. Within months, she was the juvenile lead on the RKO lot.

In addition to the sequel *Anne of Windy Poplars*, Shirley was featured in *Chasing Yesterday* (1935), *Chatterbox* (1936), *Mother Carey's Chickens* (1938), *Career* (1939), *Saturday's Children* (1940), *All That Money Can Buy* (1941), *The Powers Girl* (1942), and *Murder, My Sweet* (1944). Her most memorable role, besides the "Green Gables" series, was that of *Barbara Stanwyck's daughter Laurel in *Stella Dallas*; this role earned Shirley an Oscar nomination for Best Supporting Actress in 1937.

In 1945, at age 27, Anne Shirley abruptly quit acting. She told Richard Lamparski: "My mother wanted me to be a star so she could say she was Anne Shirley's mother. Well, I became one and now we're both happy. They were wonderful years but I did it all for her."

SOURCES:

Lamparski, Richard. *Whatever Became of . . . ?* 5th series. NY: Crown.

Despite many physical and emotional setbacks, Montgomery continued to write. *Pat of Silver Bush* and *Jane of Lantern Hill* appeared in 1933 and 1937, respectively. However, Montgomery had a nervous breakdown in the winter of 1937–38, which was followed by another in 1940. Few knew her true feelings about life except for Ephraim Weber, with whom she had carried on a 40-year correspondence. She conversed

with Weber on such issues as life after death, reincarnation, morals, and psychic experiences. These letters became her outlet for her true self as she felt her public self could never reveal her innermost beliefs and feelings. At the end of December 1940, she wrote him: "Dear Friend. I do not think I will ever recover. . . . Let us thank God for a long and true friendship." By 1941, now in her late 60s, she expressed a loss of hope for her recovery: "My husband is very miserable. I have tried to keep the secret of his melancholic attacks for twenty years, as people do not want a minister who is known to be such, but the burden broke me at last, as well as other things. And now the war. I do not think I will ever be well again." Lucy Maud Montgomery died on April 24, 1942. Her husband died two years later.

The hearts of young children and adults throughout the world have been captured by Montgomery's female characters—Anne, Emily, Pat and Jane. Prince Edward Island and Canada owe much to her. Through Montgomery's telling of girlhood myths and dreams in a beautiful regional setting, Canadian literature and P.E.I. have enjoyed fame for decades.

SOURCES:

Canadian Children's Literature. Vol. 1, no. 3. Canadian Children's Press, Autumn 1975.
Eggleston, Wilfrid, ed. *The Green Gables Letters.* Toronto: Ryerson Press, 1960.
Gillen, Mollie. *Lucy Maud Montgomery.* Don Mills: Fitzhenry & Whiteside, 1978.
———. *The Wheel of Things.* Toronto: Fitzhenry & Whiteside, 1975.
Montgomery, L.M. *The Alpine Path.* Don Mills: Fitzhenry & Whiteside, 1917.
Rubio, Mary, and Elizabeth Waterston. *The Selected Journals of L.M. Montgomery.* Vols. I–III. Toronto: Oxford University Press, 1987.
Waterston, Elizabeth. "Lucy Maud Montgomery" in *The Clear Spirit.* Edited by Mary Quayle Innis. Toronto: University of Toronto Press, 1966.

SUGGESTED READING:

Angus, Terry, and Shirley White. *Canadians All Portraits of Our People.* Toronto: Methuen, 1976.
Ridley, Hilda M. *L.M. Montgomery.* Toronto: McGraw-Hill, 1956.

COLLECTIONS:

Journals, photographs, account books, publishing records, personal library and memorabilia are located at the University of Guelph, Guelph, Ontario.

RELATED MEDIA:

Anne of Green Gables, Realart Pictures, 1919.
Anne of Green Gables (80 min.), starring Anne Shirley, RKO Radio Pictures, 1934.
Anne of Windy Poplars (85 min.), starring Anne Shirley, RKO Radio Pictures, 1940.
"Anne of Green Gables," adaptation by Julia Jones for BBC-1 television, 1972.
Anne of Green Gables (195 min.), Kevin Sullivan Productions, 1986.
Anne of Green Gables, The Sequel (232 min.), Kevin Sullivan Productions, 1986.
"Avonlea," television series based on stories by Montgomery, Disney Channel.

Natania East,
historian and freelance writer, British Columbia, Canada

Montgomery, Margaret (fl. 1438)

Countess of Lennox. Flourished around 1438; married John Stewart of Darnley, 1st earl of Lennox, in 1438 (d. around 1495); children: Matthew, 2nd earl of Lennox (d. 1513).

Montgomery, Mary (fl. 1891–1914)

Irish artist and metalworker. Flourished between 1891 and 1914 in Fivemiletown, County Tyrone, Ireland; studied metalworking in London; married.

Mary Montgomery was the wife of a landowner in Fivemiletown, County Tyrone, in what is now Northern Ireland, in the late 19th and early 20th centuries. She taught sewing and embroidery to local women to improve their income-generating potential before traveling to London, England, in 1891 to study repoussé metalwork. Montgomery proved to have natural metalworking talent, and by 1893 her work was shown at the Home Arts and Industries Exhibition (HAIE) at the Albert Hall in London. She also received numerous awards for her metalwork from the HAIE, the Royal Dublin Society, and the Cheltenham and Bristol exhibitions.

Montgomery returned to Fivemiletown, where she established her own metalworking school and organized annual exhibitions. The school made home furnishings such as frames and candlesticks, initially in copper and brass and later also in pewter and silver. Her work was greatly appreciated by both artists and the public, and Queen *Victoria is said to have purchased products made by the Fivemiletown school. Montgomery closed down the school and discontinued her exhibitions at the onset of World War I in August 1914.

SOURCES:

Newmann, Kate, comp. *Dictionary of Ulster Biography.* The Institute of Irish Studies, The Queen's University of Belfast, 1993.

Grant Eldridge,
freelance writer, Pontiac, Michigan

Montgomery, Peggy (1917—)

American actress. Name variations: Baby Peggy; Diana Serra Cary. Born Peggy Montgomery in Rock Island, Illinois, in 1917; daughter of a screen extra

and stuntman; married Gordon "Freckles" Ayres (a member of the cast of the Our Gang comedies); married Robert Cary (a painter); children: Mark.

Selected filmography: Peggy Behave (1922); The Darling of New York (1923); Captain January (1924); The Family Secret (1924); The Speed Demon (1925); April Fool (1926); The Hollywood Reporter (1926); Prisoners of the Storm (1926); Sensation Seekers (1927); The Sonora Kid (1927); Arizona Days (1928); Silent Trail (1928); West of Santa Fe (1928); Eight Girls in a Boat (1934); Having a Wonderful Time (1938).

Peggy Montgomery, known as Baby Peggy, was a popular child star throughout the 1920s, a female Jackie Coogan. From ages three to ten, she was featured in many two-reelers and over a dozen films. After childhood, she continued making low-budget Westerns under her real name, retiring from the screen in the mid-1930s. Montgomery went on to become a journalist, contributing to American Heritage, Esquire, and The Saturday Evening Post, as well as a store manager, a greeting-card executive, and a book buyer for the University of California at San Diego. In 1975, under the name Diana Serra Cary, she published a book about cowboy extras and stuntmen entitled The Hollywood Posse: The Story of a Gallant Band of Horsemen Who Made Movie History. She followed that with Hollywood Children (1979), an exposé on the life of child stars.

Monthermer, Margaret (fl. 1350)

Baroness Monthermer. Flourished around 1350; daughter of Thomas Monthermer, 2nd baron Monthermer, and Margaret Monthermer, baroness Monthermer; married John Montacute; children: John Montacute (c. 1350–1400), 3rd earl of Salisbury.

Montiel, Sarita (1928—)

Spanish singer and actress. Name variations: Sara Montiel. Born María Antonia Abad Fernández in Campo de Criptana, Ciudad Real, Spain, on March 10, 1928; married Anthony Mann (a film director), in 1957 (annulled 1963).

Selected filmography: Te Quiero para mi (1944); Bambu (1945); Por el Gran Premio (1946); Don Quijote de la Mancha (Don Quixote, 1947); Confidencia (1947); Vidas confusas (1947); Locura de Amor (The Mad Queen, 1948); El Capitan Veneno (1950); El Fuerte (1952); Emigrantes (1952); That Man from Tangier (US, 1953); Vera Cruz (US, 1954); Serenade (US, 1956); Run of the Arrow (US, 1957); El Último

Cuplé (1957); La Violetera (1958); Carmen de la Ronda (The Devil Made a Woman also known as A Girl Against Napoleon, 1959); Mi Ultimo Tango (1960); Pecado de Amor (1961); La Bella Lola (1962); Samba (1963); Varieties (1971).

Popular in the Spanish-speaking world as a singer and actress, Sarita Montiel appeared in numerous movies in her native Spain and in Mexico beginning in the 1940s. She made four Hollywood films during the 1950s, including That Man from Tangier (1953), Vera Cruz (1954), Serenade (1956), and Run of the Arrow (1957), in which her voice was dubbed by Angie Dickinson. After returning to Spain in 1957 she had her greatest success on screen with the hugely popular El Último Cuplé. She was married that same year to director Anthony Mann (the marriage would end in 1963) and appeared on stage and on television throughout the 1980s.

Montijo, Eugenie de (1826–1920).

See Eugenie.

Montpensier, Anne Marie Louise d'Orléans, Duchesse de (1627–1693)

French heiress and participant in the Fronde who provided in her memoirs a personal account of the splendor of the courts of Louis XIII and Louis XIV. Name variations: The Grand or Grande Mademoiselle, The Great Mademoiselle; La Grande Mademoiselle; Mlle d'Orleans Montpensier. Born on May 29, 1627, at the Louvre in Paris, France; died in Paris on April 5, 1693; daughter of Gaston d'Orléans (1608–1660), duke of Orléans (brother of Louis XIII, king of France, and known as "Monsieur"), and Marie de Bourbon (1606–1627), duchesse de Montpensier ("Madame"); never married; no children.

Born and raised in the court of Louis XIII; participated in the Fronde against Cardinal Mazarin (March–October 1652); exiled to St. Fargeau (1762–67); returned to the court of Louis XIV (1767); courted and almost married the duke de Lauzun (1666–70).

Anne Marie Louise d'Orléans was born into the incredible wealth and privilege that accompanied the royal family of France in the 17th century. Her father Gaston, duke of Orléans, was the brother of King Louis XIII, and as such he had the sole right to be addressed as "Mon-

sieur." Her mother, commonly referred to as "Madame," was ◀❧ **Marie de Bourbon,** duchesse de Montpensier, the richest heiress in France. The wedding of Gaston and Marie was a union of great national import. Not only were the scions of the two most powerful families coming together, but as Louis XIII and his queen *Anne of Austria were childless, the possibility existed that this union would provide an heir to the throne of France. The couple were married by Cardinal Richelieu, Louis XIII's closest counselor and the most powerful man in France, on August 5, 1626.

The marriage was ill-fated from the beginning. Marie de Bourbon, noted for her "sheep-like face and a character to match," was not the kind of woman to interest the dashing and impetuous Gaston, who had, in fact, already distinguished himself as an untrustworthy conspirator within the court. In the previous spring, he had been implicated in a plot to overthrow Richelieu. When caught, Gaston was forced to sign a document swearing his loyalty to Louis XIII and Richelieu, but soon after he was again drawn into a conspiracy. Caught the second time, he gave the first indication of the cowardly lack of loyalty he would show throughout his life. When he was threatened with losing his titles and property, he turned in his fellow conspirators, one of whom was executed. As further penance for his behavior, Gaston agreed to marry Marie de Bourbon.

It was into these curious circumstances that Anne Marie Louise d'Orléans was born on May 29, 1627. Marie de Bourbon died while giving

birth, thus making her newborn heir the richest infant in all of France, with the titles duchesse de Montpensier, duchesse de Châtellerault, duchesse de St. Fargeau, sovereign of Dombes, princess of Joinville and Laroche-sur-Yon, and dauphine d'Auvergne. Having been born female she was not, however, in line for the throne, which was prohibited by French law. Through her father, she was a *fille de France* (a princess of the blood, referred to as "Mademoiselle" and later "La Grande Mademoiselle"), niece of *Henrietta Maria, queen of England, and granddaughter of the first Bourbon monarch, Henry IV, and his queen *Marie de Medici.

Louis XIII and Anne of Austria were extremely fond of their little niece, and they visited her often at her apartments in the Louvre. Montpensier was grateful for their attention, but lavished all her youthful affection on her father. Although Gaston was an attentive father, he hardly merited the devotion his daughter heaped upon him. When she was only four years old, Gaston was caught in another plot against Richelieu and was exiled. He immediately took refuge with France's enemy, Charles IV, duke of Lorraine, and in January 1632 even married Charles' sister *Marguerite of Lorraine. Despite her tender age, Montpensier defended her father staunchly. She blamed Richelieu for his troubles and took to singing anti-Richelieu jingles, heard on Paris streets, up and down the corridors of the Louvre. Gaston was allowed to return from exile in 1634, when Mademoiselle was seven years old. He came to Paris alone and went to great lengths to entertain her and her friends with ballets and puppet shows.

On September 5, 1638, when Montpensier was 11 years old, Anne of Austria, after 21 years of marriage to Louis XIII, gave birth to a son, the future Louis XIV. All of Paris rejoiced, and 36-year-old Anne of Austria called Montpensier to her side to keep her company while she recuperated. Anne teasingly promised her niece that one day she would be her daughter-in-law, when Louis was old enough to marry. Mademoiselle was charmed with the idea and took to calling the baby her *petit mari*, or little husband. Several months later, when Richelieu heard her pet name for the future king, he was alarmed. He had no desire to give anyone the impression that he would countenance having the daughter of the disloyal Gaston on the throne of France. Richelieu called Montpensier before him, scolded her for her impertinence, and sent her away from Paris.

Richelieu died on December 4, 1642, and was followed the next spring by Louis XIII, who

❧▶ **Marie de Bourbon** (1606–1627)

Duchess of Auvergne and Montpensier. Name variations: Duchess of Auverne. Born in 1606; died in childbirth around May 29, 1627; daughter of Henri, duke of Montpensier (ruler of Auvergne, 1602–08), and Henriette de Joyeuse; married Gaston d'Orléans (1608–1660), duke of Orléans (brother of Louis XIII, king of France), in August 1626; children: Anne Marie Louise d'Orléans, duchesse de Montpensier (1627–1693).

Sole heiress of the Montpensier family, Marie de Bourbon was born in 1606, the daughter of Henri, duke of Montpensier, ruler of Auvergne, and **Henriette de Joyeuse**. When her father died in 1608, Marie de Bourbon inherited his rule. In August 1626, she married Gaston, duke of Orléans, brother of the king of France, Louis XIII. The following May, she died while giving birth to *Anne Marie Louise d'Orleans, duchess de Montpensier, who inherited her rule and her fabulous wealth.

Duchesse
de
Montpensier

died on May 14, 1643. Louis XIV became the king of France when he was not yet five years old. Anne of Austria was made sole regent, and she immediately announced the appointment of Cardinal Jules Mazarin as her prime minister. Many of the nobles of France were furious. Those who had disliked Richelieu and hoped to get their old privileges back after his death saw Mazarin as a powerful road block. The dissident nobles, of whom Gaston was a natural ringleader, were poised for the first opportunity to strike against this unwelcome interloper.

During the following year, Henrietta Maria, one of Louis XIII's sisters who had married the English king Charles I, arrived in Paris after a perilous flight from England.

Charles I was engaged in a civil war against his own Parliament, and in the face of several setbacks, he had sent his wife to the relative safety of her home court. When Henrietta Maria finally arrived, Montpensier noted that "she was in such a lamentable state that everyone pitied her." The prince of Wales (the future Charles II of England) followed his mother into exile and arrived in Paris in 1646. He was 16 or 17 when Montpensier was introduced to him. Montpensier, already 19, was not very impressed with her English cousin. She was also greatly annoyed that he could not speak or un-

derstand French. Henrietta Maria, with half an eye on Mademoiselle's immense fortune, did her best to arrange a marriage between her son and Montpensier. She prodded Charles into carrying on a half-hearted courtship, but in the end Montpensier refused to hazard her fortune on the chance that Charles could regain his kingdom. "Having always been happy and brought up in luxury, these considerations alarmed me greatly," she admitted.

As Montpensier entered her 20s, she vacillated often on the issue of marriage. Taller than average, with a large Bourbon nose and bad teeth, she was not by any standard a beauty, but her wealth and position made her a desirable commodity. She was intrigued with the possibility of marrying into a crown, and she flirted with the idea of marrying Holy Roman Emperor Ferdinand III. When she received word that Ferdinand was extremely pious, she began attending church more regularly and went so far as to spend an entire week determined to take vows as a Carmelite nun. In reality, however, Montpensier was much too fond of the frivolous court life to seriously consider taking religious orders. As to the possibility of marriage, the continuing disloyalties of her father worked against the odds that Mazarin would ever agree to her marriage to anyone, who could then become a potential enemy.

Her Memoirs are those of a woman absorbed in herself, rather than of a princess, witness of great events.

—Voltaire

The opening that Gaston and the other recalcitrant princes had been looking for since Mazarin's appointment finally arose in 1648, when the Parlement began resisting increased taxation. The aristocrats were quick to support Parlement's cause, and used the feud as a lever to rid themselves of the hated counselor. In a series of on-again, off-again military confrontations, the princes ignited a half-hearted civil disturbance which came to be known as the Fronde. They urged the Parisian mob to rise up against Mazarin, and the whole court, including Montpensier, was forced to flee Paris for St. Germain, where they lived in spartan conditions. Montpensier got her first taste of the power she could wield with the Parisian *Frondeurs* when she returned to the gates of the city and charmed them into letting her bring out mattresses, linens, and clothing. The disturbance ended when a peace was worked out with the Prince of Condé, who had been laying siege to Paris, and the court returned in April 1649.

In January 1652, the Fronde reignited. Although deeply involved in the conflict, Gaston was not very successful. In March, the town of Orléans was approached by Mazarin's troops who demanded entry in the name of the king. Faced with this crisis, the town fathers appealed to Gaston to come to Orléans and protect them. With his typical cowardice, Gaston procrastinated and refused to leave Paris. Montpensier, who had declared herself a dedicated *Frondeuse*, was unable to convince her father to go, and at his suggestion she went to Orléans herself. When she arrived, the city fathers refused her entry, out of fear of inciting the king's troops, and suggested that she stay at an inn until the troops passed, at which time they promised her a fit reception. Inflamed by the excitement, Montpensier refused to wait; instead, she marched up and down the bank of the moat until boatmen agreed to help her break in through the Port Brulée. With their help, she traversed the moat by scrambling over two boats and crawling over a long ladder; then some of the citizens broke a hole into the gate and shoved her inside the city walls. Once inside, she was led triumphantly through the city streets on a wooden chair, and the city fathers had no choice but to welcome her. Montpensier stayed in Orléans for five weeks, holding court and entertaining the local notables, while the king's troops did not enter the city. She was thrilled to receive a note from her father: "My daughter, you may imagine my delight at your deed; you have saved Orléans for me and assured Paris; everyone says that your action was worthy of the granddaughter of Henry the Great."

Thrilled with her new role as a revolutionary, Montpensier returned to Paris on May 4. In July, the Prince of Condé again laid siege to Paris, but Mazarin's troops threatened to cut them off from the city. Condé sent an appeal for help to Gaston, who feigned illness. Informed of the situation, Montpensier rushed to her father to try to convince him to help Condé. When he refused, claiming that he was not so sick as to be in bed but too sick to be out and about, she went by herself to meet with the prince. Bloody and dirty from a morning of fighting, Condé told her: "You behold a man in despair. I have lost all my friends." Energized by his plight, she met with the city leaders at the Hôtel de Ville to work out a compromise to let Condé's troops into Paris, then went to the top of the Bastille to view the battlefield. When she saw that the king's troops were about to cut off Condé's troops from the city gate, she ordered the soldiers on top of the Bastille to turn the cannons, which normally faced into the city, outward and

fire on the king's troops. They did so. When Mazarin received word that the cannons of the Bastille had been fired at the king's troops by order of Montpensier, he supposedly said, "that cannon-shot has killed her father."

Montpensier's actions, brave as they were, served only to prolong a conflict that was quickly becoming stale. Although Gaston and Condé both swore they would not make peace until Mazarin was removed from office, a Party of Peace was arising in Paris that had grown tired of the meaningless war. In the last months of this chapter of the Fronde, Condé, who despite the assistance he had received from her was given to making fun of Montpensier behind her back, offered to make her a captain of cavalry (this offer was made with the caveat that she raise her own regiment and pay for it with her own money). Intoxicated with her new self-image as an Amazonian warrior, she readily agreed. When her regiment had been raised and outfitted, she delighted in watching them pass in review. "I must confess," she later wrote, "I did think they looked very fine; never were troops better attired than mine. . . . I went a bit childish and

that I felt much pleasure and rejoicing in the sound of the trumpets."

But the Fronde was inevitably drawing to a close. The court returned to Paris victorious on October 13, 1652. Immediately, the leading Frondeurs were banished. Gaston panicked, uncertain whether to fight or to flee. Within a week of the court's return, Montpensier received a curt letter ordering her to leave her rooms in the Tuileries, where she had resided since she was a week old, by noon the next day. Frantic, she raced to the family's Luxembourg palace to see her father, who was too concerned for his own fate to have much sympathy for hers. Montpensier soon got a taste of what his earlier colleagues had suffered when a conspiracy fell apart: he angrily dismissed her by saying that he refused to intervene on her behalf—she had conducted herself so injudiciously that he would have nothing to do with her. Stunned, Montpensier protested that her actions at Orléans were done at his behest. Gaston replied with venom, "Don't you think, Mademoiselle, that it did you a lot of harm at Court? You enjoyed yourself so

Duchesse de Montpensier at the Bastille.

much playing the heroine and being told that you were on our side and had saved it twice, that, whatever happens to you in future, you will find consolation in the remembrance of all that praise that was lavished on you."

In the end, both Gaston and Montpensier were banished from Paris. Gaston, packed off to his castle at Limours, refused to let Montpensier come with him. Abandoned by her father and fearful of the growing rumors that she might be arrested, Montpensier slipped out of Paris early the next morning in a borrowed coach and set out for her property of St. Fargeau, which she had never seen. When her coach arrived there at two o'clock in the morning, she was horrified to find "an old house with neither doors nor windows; it filled me with dismay. They took me into a dreadful room, with an upright beam in the center. Fear, horror and grief took possession of me to such an extent that I began to cry; I thought myself most unhappy, being exiled from the Court, not having a better residence, and thinking that *this* was the finest of all my châteaux." Montpensier lived in exile from the court from 1652 until 1657.

Despite her longing for the splendor of court life, Mademoiselle nonetheless spent the next four years quite happily. She dedicated herself to fixing up her house to her satisfaction, writing her memoirs (which then had to be re-copied by her secretary Préfontaine to make them legible), riding, gardening, and traveling to other parts of France. The last half of her stay at St. Fargeau was sullied by a long, drawn-out controversy with her father over her inheritance. At the time she turned 25 and reached her majority in 1652, she knew almost nothing about how Gaston had handled her affairs. Once she began to read through her own accounts, it became evident that her father had been steadily siphoning money from her estates in order to pay for his huge gambling debts and support his second wife (Marguerite of Lorraine) and daughters (*Marguerite Louise of Orleans and *Françoise d'Orléans). Gaston first tried to evade her inquiries, then erupted into anger and indignation. In the end, he dismissed Montpensier's private secretary, Préfontaine, who had worked tirelessly to help her put her affairs in order. Bereft at the loss of her loyal confidant, Montpensier refused to hire another private secretary, insisting instead on writing all her own letters and keeping her own accounts.

Regardless of the peaceful life which Montpensier congratulated herself upon creating at St. Fargeau, it was obvious in her memoirs that she never gave up hope that she might one day return to court. Soon after his dispute with his daughter, Gaston made peace with Louis XIV by cavalierly renouncing all his former friends. Montpensier was deeply upset by the news, in light of the bad blood between them, but determined to take advantage of the opportunity. Swallowing her pride, she wrote Gaston promising to pay off his debts if he would intervene to secure the king's forgiveness of her. After receiving assurances that her apology would be heard, she set off in July 1657 to rendezvous with the court at Sedan. Louis XIV was now 18, and his younger brother, Philip, duke of Orléans (called "Monsieur" in his own right because he was brother of the reigning king), was 17. When the king and his brother arrived to greet Mademoiselle, Anne of Austria introduced her: "Here is a young lady who is very sorry to have behaved so badly but who will be very good in future." Louis XIV laughed; all was forgiven.

By the time of Montpensier's reconciliation with the court in 1657, she was 30, and still lacked serious marital prospects. She flirted briefly with the idea that she might be allowed to marry the young Monsieur. Effeminate, foppish and 13 years her junior, Philip of Orléans would not have been an ideal match, but as Montpensier noted in her memoirs, "Age does not matter to persons of our rank." Nothing ever came of her musings: Philip married *Henrietta Anne (1644–1670), sister of Charles II, in 1662, two years after Louis XIV had married the Infanta of Spain, *Maria Teresa of Spain (1638–1683). While Montpensier was accompanying the court on its pilgrimage to rendezvous with the Infanta and conclude a peace with Spain, she received word that Gaston d'Orléans had died suddenly, probably of a stroke, in February 1660. Despite the checkered nature of their recent relationship, Montpensier seems to have been genuinely grieved by his loss, plunging her household into deep mourning and covering everything in black. Gaston's death only increased her wealth, however. Even though she could not inherit his primary titles and properties (these reverted back to the king), she inherited practically all that remained of his personal fortune and possessions, since Gaston had no sons.

By 1666, Montpensier was nearing 40, and whisperings about her marriage schemes had all but died out. But Mademoiselle's romantic adventure had not yet begun. It was in that year that she first became acquainted with an up-and-coming star in Louis XIV's army, Antonin Nompar de Caumont, Marquis de Puyguilhem and Comte de Lauzun. Lauzun was the third son in a

minor French family, with no court connections and little money. After attending the military academy, he quickly distinguished himself in the royal army—he was made a colonel at age 24. He quickly advanced in the king's favor, despite a reputation for angry outbursts which twice landed him briefly in the Bastille. He was made captain of the first company of the king's guards, and soon thereafter struck up a friendship with Montpensier, who found him very agreeable and his conversation most extraordinary. Lauzun was described as "one of the smallest men that God ever made," with fair hair, a red nose and an untidy appearance. As Montpensier's friendship with Lauzun grew, she found herself, at 43, falling in love, and began making plans to marry him. Ignoring the reality that the court would look questionably upon her union with a man so much her social inferior, she assured herself that, at her age, she had the right to marry for happiness. As an added bonus, Montpensier mused, marriage to a Frenchman like Lauzun would allow her to remain in her beloved France.

Once her mind was made up to take on this project, she began her pursuit of Lauzun in earnest. The fact that Lauzun had never pursued her she attributed to his knowledge of his own inferior status. She began seeking him out actively, convinced that she would have to make the first move; when he seemed to be avoiding her, she comforted herself that he was simply showing wise restraint. Over the next several months, Lauzun seems to have become convinced of her meaning, and even to have become enamored with the idea, for marriage to Montpensier would elevate him to unthinkable heights and put France's largest fortune at his disposal. Whatever lack of passion he felt for her was more than made up for by the intoxicating possibility of becoming united to the royal family. But in 1670 Philip's wife, Henrietta Anne, died suddenly. Rumors immediately circulated that Montpensier would become the new Madame, and Louis XIV called her to speak with him: "Cousin," he addressed her, "the place is vacant: will you fill it?" Shaken, Montpensier could only reply that he was her master and in all things she would be subject to his will. Over the next several months, Montpensier summoned all her craft and poise to try to convince the king not to force her to marry Monsieur. She was careful to admit only to a desire to follow Louis' will. When she felt she had hedged sufficiently against the king's notorious obstinacy, she dared to tell him that while she respected Monsieur according to her duty, and was grateful for the honor done to her by the consideration of such a marriage, she preferred not to be married to Monsieur. Louis took the news calmly and merely replied that he would inform his brother that the marriage negotiations should be broken off.

Once rid of the fear of marriage to Monsieur, Montpensier was prepared to take her scheme of marrying Lauzun before the king as soon as possible. The first hurdle she faced, however, was to announce her intention clearly to Lauzun himself. This delicate task she handled by first telling him she had decided to marry. When he asked her the name of her intended, she refused to tell him but went home and wrote on a sheet of paper, "It is you." At their next meeting, she gave him the paper and asked that he think on it and write his answer in return. Lauzun's reply, received the following day, was dutifully recorded in her memoirs. He "complained that his zeal in my service should not have been rewarded by so cutting a mockery, and that he could not flatter himself by thinking that I meant it seriously; therefore he could not answer otherwise, but that I should always find him submissive, so great was his devotion to my wishes." Montpensier was heartened: "It was a very cautious letter," she wrote, "but through it all I could see what I wanted to see." When they finally spoke in private, Lauzun still would not take her request seriously: "I half-killed myself trying to persuade him," she recalled. When she finally secured his agreement, she immediately wrote to the king, asking for permission to marry Lauzun. Louis' reply was cool; he expressed surprise at her request and beseeched her to think it over. Mademoiselle accosted Louis in his private rooms and begged him, proclaiming her undying love for Lauzun. Louis again implored her to think it through carefully, since there were many who did not like Lauzun. In the end, he assured her that he would neither advise nor forbid the marriage.

Ecstatically, Montpensier threw herself into plans for the wedding. Queen Maria Teresa, dead set against the match, told her, "You would do far better never to marry and to keep your fortune for my son [Louis, Le Grand Dauphin]." The king's counselors, though they acquiesced only reluctantly to the marriage, advised the couple to marry immediately, before the political winds could shift the king's opinion. She put her lawyers to work drafting the documents that would make Lauzun the duke de Montpensier and scheduled the marriage for Thursday, December 17, 1670, at noon. The smallest and quietest of ceremonies was arranged, but at 10 AM news arrived that the contracts were not completed and the wedding would have to be postponed. Upon hearing the

news, Montpensier replied: "Then it must be to-morrow night [at midnight], for I will not marry on a Friday." But she had hesitated too long. At eight o'clock the following evening, an order arrived from the king demanding her to wait upon him. Montpensier turned to Lauzun's sister and said, "I am full of despair; my marriage is broken." She was correct.

Louis XIV broke the news to her as gently as he could: "I am sick at heart over what I have to say to you. I have been told that people are saying that I am sacrificing you in order to make the fortune of Monsieur de Lauzun, that this will do me harm abroad, and that I should not allow the affair to proceed further." Montpensier threw herself at his feet, saying, "Sire, better to kill me than to throw me into such a state." Louis gently reproved her, "Ah, why did you give [me] time to think it over? Why did you not hurry?" Montpensier protested that never before had she known Louis to break his word. She begged him to reconsider and accused him of selling her out to her enemies. But in the end Louis was firm: "Kings must please the public," he insisted, and Montpensier went home to cry herself insensible. For weeks she could not pass Lauzun without bursting into tears, and over time the disappointed aging woman came to be the butt of many Parisian jokes.

As the reality of the king's refusal settled in, Montpensier tried to resume something of a normal life. As for Lauzun, the king had not forbidden them from corresponding, and she relied heavily on his counsel, much as if they had indeed been married.

Suddenly, without warning, on November 25, 1671, word came that Lauzun had been arrested and sent to prison at Pignerol. No explanation was given (though in the court of Louis XIV, no explanation could have been expected), but contemporaries believed that Lauzun's imprisonment was a result of his longstanding feud with *Madame de Montespan, one of Louis XIV's mistresses. The king may have also feared that Montpensier would eventually tire of trying to persuade him to change his mind and marry Lauzun in secret.

Not daring to confront Louis XIV with Lauzun's arrest, Montpensier was confined to looking at Louis from across a room with tears in her eyes. Messages of Lauzun's condition were infrequent and alarming. His anger and indignation about his imprisonment later dissolved into personal neglect, complaints about his health and bouts of prayer, fasting and extreme piety. Montpensier's life, devoid of its zest and enjoy-

ment, became a heavy burden to her, and she determined to remain as much at the center of court life as possible, in the hope that she might one day convince Louis to relent. Lauzun languished in prison for almost ten years, but Montpensier never gave up on her love for him. Finally, in 1680, her allies hit upon a scheme to secure Lauzun's release. She began negotiations with Madame de Montespan to bequeath some of her property to Montespan's and Louis' son, the ten-year-old duke of Maine. In return, Montespan agreed to intervene with Louis on Lauzun's behalf. In the end, Montpensier was badly duped by Montespan. After she gave an incredible amount of her property away outright to the duke of Maine on the promise that Montespan would secure both Lauzun's release and permission for them to marry, Louis agreed only to allow Lauzun's release from prison; Montpensier was informed that on no account would Louis ever allow her and Lauzun to marry.

Disappointed again, but hopeful that she would at least be able to see Lauzun soon, Montpensier threw herself into the project of building a summer house on the Seine, near Choisy. She proudly described the house at Choisy in her memoirs, "It will be apparent, from all the details I have gone into, that I love Choisy; it is my own work; I made it entirely myself." The king presented her with a boat, "very pretty, painted, gilded, furnished in crimson damask with gold fringes," in which she could travel upriver to Paris.

Lauzun was allowed to leave Pignerol on April 22, 1681. After having been shut up in prison for almost ten years, he was not inclined to deprive himself of any enjoyment, and the resulting rumors aroused Montpensier's jealousy. To make matters worse, Lauzun began complaining in his letters that Mademoiselle had not given him enough money and property. By the time they were reunited in Paris, their relationship had soured. Although Lauzun greeted Montpensier by falling at her feet and thanking her for her help, and although some historians have speculated that they did indeed secretly marry at this time, he later reproved her for wearing colored ribbons in her hair like a young girl and accused her of wasting too much money on Choisy. He threw himself into Parisian society, spending large sums of money on clothing and jewelry and losing even larger sums at the gambling table. Despite the fact that Montpensier had arranged an income of 32,000 livres per year for him soon after his release from Pignerol, Lauzun complained incessantly that she left him in penury. Locked in what became a bizarre love-hate rela-

tionship, Montpensier and Lauzun quarrelled endlessly. Finally it became too much. After a final scene of recriminations in the summer of 1683 they parted, never to see each other again.

Montpensier lived on for ten more years, and during that time Lauzun made repeated attempts to reconcile with her. Having given up over half of her possessions on Lauzun's behalf, she seemed to have fallen out of love as completely as she had ever fallen into it. Up to the time of her death at 66, Montpensier continued to attend parties at Versailles and remained active in court life, but she refused to see Lauzun under any circumstances. In the spring of 1693, she fell ill of a disease of the bladder. While she was on her deathbed, Lauzun begged to see her; she refused. She died on Sunday, April 5, 1693, at the palace of Luxembourg she had inherited from her father. Lauzun survived her by 30 years. For almost a decade, he stunned the court by acting as a husband in mourning, wearing black and surrounding himself with pictures of Montpensier. After ten years of this, he married a girl of 14, and lived on until he died on November 19, 1723, at the age of 90.

Montpensier was both a product of her age and at odds with the values of womanhood held most dear during the ancient regime. Contemporaries considered her somewhat unfeminine, one commenting, "She is better adapted to handling a weapon than a spindle. She is proud, enterprising, and free in her speech, unwilling to tolerate contradiction, impatient, active, and ardent, incapable of dissimulation, and says what she thinks without heed." In an age when aristocratic women were expected to be beautiful, submissive and pious, Montpensier was considered overbearing, temperamental and unattractive. Although she lived in an age of great historical import, she seems not to have realized what she was witnessing. Indeed, when she resumed her memoirs in 1677 after a long hiatus, she recited her purpose: "Though I was born to great rank and wealth, though I have never harmed anyone, God has allowed my life to be afflicted by a thousand scourges. Such an example seems to me a worthy subject of reflection." Her memoirs are frustratingly myopic; however, through Montpensier's eyes we get a glimpse of the life of French society, particularly of the French court. Her personal reflections about eminent figures in Louis XIV's court bring them alive to us in a way that official documents never could. Her memoirs are also valuable as a reminder of the universality of the human condition—the aches and pains, the agony of disappointed love and the grind of daily affairs she chronicles make Montpensier as much a member of the human race as she was a member of the aristocracy of France's ancient regime.

SOURCES:

Barine, Arvède. *Louis XIV and La Grande Mademoiselle.* NY: Putnam, 1905.

Buchanan, Meriel. *The Great Mademoiselle.* London: Hutchinson, 1938.

Price, Eleanor C. *A Princess of the Old World.* NY: Putnam, 1907.

Sackville-West, Victoria. *Daughter of France: The life of Anne Marie Louise d'Orléans, Duchesse de Montpensier, 1627–1693, La Grande Mademoiselle.* NY: Doubleday, 1959.

Steegmuller, Francis. *La Grande Mademoiselle.* London: Hamish Hamilton, 1955.

Kimberly Estep Spangler,
Assistant Professor of History and Chair, Division of Religion and Humanities, Friends University, Wichita, Kansas

Montpensier, duchess of.

See Catherine of Guise (1552–c. 1594).

See Montpensier, Anne Marie Louise d'Orléans, Duchesse de for sidebar on Marie de Bourbon (1606–1627).

See Montpensier, Anne Marie Louise d'Orléans, duchess de (1627–1693).

See Louise Marie of Bourbon (1753–1821).

Montreal Massacre (1989)

Fourteen Canadian women who were murdered for being "feminists." Died on December 6, 1989: Geneviève Bergeron (21) was a second-year scholarship student in civil engineering; Hélène Colgan (23) was in her final year of mechanical engineering and looking forward to taking her master's degree; Nathalie Croteau (23) was in her last year of mechanical engineering; Barbara Daigneault (22) was in her final year of mechanical engineering and held a teaching assistantship; Anne-Marie Edward (21) was a first-year student in mechanical engineering; Maud Haviernick (29) was a second-year student in engineering materials, a branch of metallurgy, and a graduate in environmental design; Barbara Maria Klucznik (31) was a second-year engineering student specializing in engineering materials; Maryse Laganière (25) worked in the budget department of the Polytechnique; Maryse Leclair (23) was a fourth-year student in engineering materials; Anne-Marie Lemay (27) was a fourth-year student in mechanical engineering; Sonia Pelletier (28) was to graduate the next day in mechanical engineering; Michèle Richard (21) was a second-year student in engineering materials; Annie St-Arneault (23) was a mechanical engineering student; Annie Turcotte (21) was a first-year student in engineering materials.

On December 6, 1989, on the second-to-last day of classes at the Ecole Polytechnique, the engineering school of the University of Montreal, in Quebec, Canada, 14 women were massacred. The killer Marc Lépine strolled into the school with a .223 caliber Sturm, Ruger semi-automatic rifle, walked to the second floor corridor, and shot the first woman he encountered, **Maryse Laganière**, a recently married finance department employee. He then entered Room 303, which contained around 60 engineering students. In French, he told the women to move to one side of the room and the men to leave. The students thought it was a joke until Lépine fired two quick shots into the ceiling and said to the women, "You are all feminists. I hate feminists." He again instructed the men to leave the room. They did so without protest.

Out of the ten women students who remained, one tried to reason with him: "We're not feminists," she said. "We're only women who want an education." He replied by opening fire, and shot six women dead. He then walked out of the room and, moving from floor to floor, went to the cafeteria, where he killed three more women. He opened fire as soon as he entered Room 311; students scrambled beneath their desks. As he strolled across the desktops, he took aim at the women, and killed four more of them. In the melee, he also wounded 13 people, most of them women. Twenty minutes after the start of his rampage, Lépine shot himself in the head. It was the worst single massacre in Canadian history.

Lépine left a suicide note, but its exact contents were censored by the press. That same press, particularly the French-Canadian sector, was shocked and bewildered. How was it that the gunman killed only women? And why the Polytechnique? Most could not come up with answers to these questions. The media played down the overt sexism of the slayings. This was the isolated act of a madman, the experts maintained, and thus in no way a reflection of any larger strains in society. When some women tried to point out that isolated attacks of madmen were responsible for husbands murdering their wives all around the world, they were accused of exploiting the tragedy to further the cause of women. Women should not take this personally, warned politicians and experts. This was not the time to hold a forum on male violence. When some women used the word misogyny, they were accused of being shrill. "Yet if the killer had picked out a visible minority, everyone would have cried racism and remembered the Holocaust. Crimes against women have no his-

tory," wrote **Élaine Audet** in a letter submitted to but not published by *Le Devoir*. "Life goes on," said the talking heads.

Radio talk shows abounded with callers trying to understand the thinking of the young "madman." He had an unhappy childhood, an abusive father who beat his mother and his younger sister, bad relationships with women. Then again, said some callers, it had to be admitted that feminists have caused anger, that some men feel threatened. Why be surprised if some men explode, they explained, it's not like it used to be, when wives stayed at home. After all, women were taking jobs long held by men. "As more and more women . . . take their rightful place in society," wrote Audet at the time, "some men—so we hear—feel their identity is threatened. What kind of identity is this, if its existence is contingent on the non-existence of the Other?"

Less than a year later, some anonymous correspondent sent columnist **Francine Pelletier** of the Montreal daily *La Presse* a copy of the killer's suicide note. In essence: he killed for political reasons, he said, not economic. "I have decided to send the feminists, who have always ruined my life, to their Maker." He was enraged by feminists, he said, who wanted to keep the advantages of women (cheaper insurance and extended maternity leaves) while also taking advantages held by men. As a postscript, he appended a list of 19 women, "radical feminists," as he called them, whom he had intended to kill but sadly, he said, now lacked the time to do so. (Without their consent, the names and photographs of the women on this list were published; they included the vice-president of the Quebec union the CSN, and other women professionals, including a number of police officers.) "We don't understand," wrote **Mireille Brais** in a letter to *Le Devoir* at the time of the massacre, "because if we were to understand, we would know that the man who pulled that trigger was not alone."

SOURCES:

Malette, Louise, and Marie Chalouh. *The Montreal Massacre.* Translated by Marlene Wildeman. Charlottetown, Prince Edward Island: Gynergy Books, 1991.

"Montreal Massacre: Railing against feminists, a gunman kills 14 women on a Montreal campus, then shoots himself," in *Maclean's* magazine. December 18, 1989.

Montseny, Federica (1905–1994)

Anarchist leader, feminist, novelist, and writer on social issues, who became minister of health in the Republic during the Spanish Civil War, the first woman

to hold a ministerial post in Spanish history. Name variations: Frederica Montseny y Mañé. Pronunciation: Fay-day-REE-kah Mont-SAY-nee (in Spanish); Mun-SEIN or Moon-SAYN (in Catalonian). *Born Federica Montseny on February 12, 1905, in Madrid, Spain; died in Toulouse, France, on January 14, 1994; daughter of Juan Batista Montseny y Carret (used pseudonym Federico Urales), and Teresa Mañé (used pseudonym Soledad Gustavo); educated at home; married Germinal Esgleas, in 1930; children: Vida (b. ca. 1934); Germinal (b. June 1938); Blanca (b. March 1942).*

Edited, published and wrote for La Revista Blanca *(1923–36); joined FAI (the Iberian Anarchist Federation) (1928, or 1927 or 1933); served on the Anti-Fascist Militia Committee, Barcelona (July 1936); appointed minister of health and public assistance (November 4, 1936); arrived in Barcelona to mediate fighting between anarchists and others, and the Communists (May 5, 1937); resigned from the government (May 16, 1937); testified in favor of the political prisoners arrested in Barcelona (October 1937); fled Barcelona with her family and journeyed to France (January–February 1939); arrested by police of Vichy France (November 1941); court of Limoges rejected Spanish government's extradition request (November 1941); published the weekly* CNT *in Toulouse (after 1939); returned to Barcelona from exile (April 27, 1977).*

Publications: La Victoria: Novela en la que se narran los problemas de orden moral que se la presentan a una mujer de ideas modernas *(Barcelona, 1925);* El hijo de Clara *(Barcelona, 1927);* La indomable *(1928);* Tres vidas de mujer *(1937);* Militant anarchism and the reality in Spain *(Glasgow: Anti-Parliamentary Communist Federation, 1937);* Pasión y muerte de los españoles en Francia *(Toulouse, 1950);* María Silva, la Libertaria *(Toulouse, 1951);* Seis años de mi vida, 1939–1945 *(Barcelona, 1978).*

Federica Montseny was a remarkable example of an intellectual who was also a woman of action. Well known as a publisher and a writer on social, particularly women's, issues for *The Blank Sheet*, a distinguished anarchist journal, by the late 1920s she became actively involved in political work. In 1928 (other sources cite 1927 or 1933), she joined a secret anarchist organization, FAI, and was later an eloquent speaker for the huge syndicalist labor union, the CNT (the National Confederation of Labor). After the outbreak of the Spanish Civil War and of revolution in Catalonia, she emerged as an important figure in the ad hoc government of Barcelona. One of the most important anarchists and one of the most important women during the Spanish

Civil War (1936–39), she became minister of health of the Spanish Republic in November 1936. Her energy and imagination transformed a second-rate ministerial portfolio into a first-rate position. Among her many achievements, she was instrumental in making Spain the first country in Europe, outside the Soviet Union, to possess a system of safe and legal abortions.

Federica Montseny was born in 1905, the only child of two well-known anarchist writers, "the descendant," as she pointed out, "of a whole dynasty of anti-authoritarians." She "sucked anarchist milk at her mother's breast." **Teresa Mañé**, Federica's mother, was famous as the anarchist author "Soledad Gustavo." Juan Montseny, Federica's father, was an extreme individualist anarchist who in his writings adopted the pseudonym "Federico Urales." The family lived on a farm north of Barcelona. There young Federica lived, read, and educated herself. As a child, she astonished her father with her flawless knowledge of the kings and queens of Spain, and of the gods of Olympus with all their attributes. As he relates in his memoirs, Juan Montseny boasted to his friends: "I have a daughter who will be worthier than her parents." By 17, Federica had already written and published her first novel.

From the time she was 18, she worked closely with her father on producing *La Revista Blanca* (*The Blank Journal*), so called because of the habit of the government censors of rejecting anarchist articles, whose absence was made apparent by the lines or columns of empty space left in the publication. The historian Robert Kern considers *The Blank Journal* crucial in educating an entire generation of Spaniards in anarchist philosophy. Besides the distinguished array of foreign anarchists who wrote for this journal, Federica and her father also made major contributions. Federica wrote about 50 short novels, many on feminist themes, published by *The Blank Journal* in the series *La Novela Ideal* (1925–37) and *La Novela Libre* (1929–37). She wrote hundreds of articles as well, and assisted in the publishing, editing, and the typesetting, by hand, of the journal, which appeared every 15 days. She also wrote for the Montseny weekly, *El Luchador*.

To the greatest extent possible, Montseny believed in promoting individual liberty and self-development. She believed that the emancipation of women would lead to a quicker realization of the social revolution in Spain and called for "future-women" and "future-men" to lead the battle against sexism and a repressive society. "We ought not content ourselves *with all the rights which men have. We ought to aspire, with an in-*

domitable will, to all the rights he should have."
At the same time, she was against a narrowly de-
fined feminism: "Feminism? Never! Humanism?
Always!"

In 1924, Federica met her future husband,
Germinal Esgleas, who spent some time in
prison with Juan Montseny. In 1930, Federica
and Germinal were married in a civil ceremony.

In the late 1920s, she and her father quar-
reled with the anarcho-syndicalists at the AIT
(International Association of Workers) confer-
ence in Berlin, since the Montsenys worried
about the authoritarian tendencies of labor
unions and labor leaders. Federica, like her fami-
ly, saw in the village commune a better basis for
a free society. She championed the long Spanish
tradition of the "free commune," in which land
was socialized and production was directly in
the hands of the producers. She later said that
her beliefs owed more to the Spanish federalist
thinker Pi y Margall, than to Michael Bakunin,
the fire-breathing founder of modern anarchism.
Nonetheless, around 1928, protesting against
the government's arrest of her father, she joined
the secret Iberian Anarchist Federation (FAI).
The FAI aimed to unite Spanish and Portuguese
anarchists and also provided a base from which
to infiltrate and control such groups as the CNT,
the huge syndicalist labor union.

In April 1931, the king fled Spain, not long
after the collapse of the Primo De Rivera mili-
tary dictatorship, and Spain became a republic.
Journalists and writers could now publish more
freely than ever before. In her writing, Montseny
demanded immediate freedom for jailed anar-
chists, full rights for labor, and full political lib-
erty. She began to use her considerable oratorical
talents—fellow anarchists referred to her as "the
Lioness"—on behalf of FAI, praising it before
crowds of people as the only weapon available
to fight labor oppression. She also became active
in the CNT, and eventually, following the cre-
ation of a union for intellectuals and the liberal
professions, joined the organization.

In the tumultuous years which preceded the
outbreak of the Spanish Civil War, Montseny
sided with the left-wing anarchists and fought to
wrest the CNT from the control of the moder-
ates. The latter group nicknamed Federica "Miss
FAI" because of her militant support for radical
anarchism. In 1934, in this increasingly chaotic
and violent atmosphere, the Montsenys' pub-
lishing center was ransacked. Federica worked
to expand the anarchists' ties with the Socialist
labor union, the UGT, and also to develop a
joint militia force.

In July 1936, right-wing elements of the
Spanish army began a revolt, which soon devel-
oped into a full scale civil war to overthrow the
government of the Republic. Almost immediate-
ly, Fascist Italy and Nazi Germany backed the
revolt, pouring in troops and supplies to aid
General Francisco Franco and his army (who
were soon referred to as the Nationalists). A
general strike stopped the army from seizing
Barcelona, and the anarchists began cooperating
with Catalan nationalists, Trotskyites, Socialists,
and Communists in running the city. An "Anti-
Fascist Militia Committee" was set up to coordi-
nate these activities and resistance to the Nation-
alists. Montseny often participated in its meet-
ings as a representative, along with others, of the
CNT. She argued that the anarchists must take
part in this de facto government, because other-
wise a Fascist military dictatorship "worse than
Stalin's" would result. She also assumed the task
of forming an anarchist militia column, known
as Land and Liberty, to defend the city and drive
back the forces of General Franco.

With the success of the far Left in saving the
Republic from a military takeover, the CNT and
the FAI grew enormously, with the CNT claiming
a membership of three million and the FAI of
150,000. Federica became a member of the nation-
al committee of the FAI and during the autumn of
1936 acted temporarily as national secretary.

The danger that Madrid might fall any day
to the armies of General Franco and the inability
of the anarchists to advance on the Aragon front
in northeastern Spain caused the anarchists to
take the unprecedented step of joining the govern-
ment of the Republic. Four anarchists became
ministers, including Montseny, whom the CNT
chose to represent it. She took over the post of
minister of health and public assistance, the first
woman in Spanish history to achieve ministerial
rank, and the last for many decades. Montseny
became minister of health with the greatest reluc-
tance. At first, she had vehemently opposed the
idea of becoming a minister, but finally yielded to
pressure from CNT and FAI leaders. She, along
with the justice minister, Juan García Oliver, were
to represent the left wing of the CNT; the CNT's
national leadership, said Montseny, "hoped that I
would check the opposition of the puritans" (the
ideologically pure anarchists). As James Joll
points out, Montseny's "sincerity, integrity and
intellectual clarity commanded great respect."

Later, after she had resigned from the Cabi-
net, Federica would explain what it had cost her
to accept her post. As an anarchist, she had been
among those:

Federica
Montseny

who had always affirmed that through the State nothing at all could be achieved, that the words "government" and "authority" signified the negation of every possibility of freedom for men and for nations. . . . What inhibitions, what doubts, what anguish I had personally to overcome in order to accept that

post! . . . For me it implied a break with my life's work, with a whole past linked to the ideals of my parents. It meant . . . many tears.

But Montseny felt that this painful step was necessary, not only to stop Franco and his Fascist allies, but also because of the memory of what had

happened during the Russian Civil War of 1918–21, when the anarchist leader Makhno had avoided political entanglements and commitments. Although very successful at first, ultimately he had become isolated and had lost all of his revolutionary conquests in the Ukraine to the Bolsheviks.

Montseny endured many bitter experiences during her seven months in the government. Almost immediately after she and the other anarchist ministers arrived in Madrid, they were informed that the prime minister wished to transfer the seat of government to the seaport of Valencia, far from the front lines, since Madrid was in imminent danger of capture. The anarchists felt betrayed, as if they had been brought into the government simply to share the responsibility for moving the capital, a move which appeared cowardly, as if they were abandoning the people of Madrid to their fate. But, as was to occur time and again, lengthy discussions concluded with the anarchists reluctantly accepting the majority's decision. After journeying to Valencia, however, Montseny and the other anarchist ministers returned to Madrid to bolster the morale of the population. For several days, Montseny slept in the basement of the War Ministry. At the request of General Miaja, the military commander of Madrid, she rallied the fighting spirit of the anarchist forces, and journeyed to Albacete, the site of an arms depository, to obtain weapons for the capital.

Concerned with growing Communist influence over the Spanish government, Montseny sought to persuade the leadership of the CNT that the foremost anarchist military leader, Buenaventura Durruti, should leave the Aragon front in northeastern Spain and come to the aid of besieged Madrid. Despite his objections, Montseny and other anarchists finally convinced Durruti to come with 1,800 hand-picked men. The Republican command in Madrid placed Durruti's brigade in the most dangerous sector of the front, just in time, on November 15, to receive the brunt of a major Nationalist offensive to seize the capital. After ferocious fighting in which he lost 60% of his men, Durruti retreated but prevented the Nationalists from advancing into the heart of the capital. On November 19, he was fatally wounded, and died the next day. According to the historian Abel Paz, when the news of Durruti's death reached Montseny in Valencia, she broke down, weeping.

Despite all the obstacles she faced, Montseny transformed her modest Cabinet post into a major political position. As historian Kern points out, previously her post had been a mere directorship below Cabinet level. She fired the old bureaucrats and brought in social activists. Whenever possible, she sought public opinion on the development of social services before setting policy. She tried to involve delegates from the anarchist and socialist labor unions. Encountering opposition from other government ministries, Montseny resolved the problem by creating new organizations to implement her plans. She formed a Council of Social Supplies to purchase medical equipment, clothing, and food for the needy. She set up a council to attract doctors to help in developing public health projects, such as a massive inoculation campaign against infectious disease.

Montseny also pushed for the legalization of abortion, which, despite the resistance of some ministers, was finally decreed on Christmas Day 1936. Spain became the first country in the world (after the Soviet Union) to legalize abortion, and for a time it was the only country, since Stalin banned the procedure in 1936. Concerned about the repercussions of legalizing abortion, the government kept it virtually secret, not publishing the new law until March 5, 1937. In the end, however, doctors carried out thousands of abortions as a result of Montseny's law. Working with the anarchist minister of justice, Montseny amended the previous laws to provide for legally binding common-law marriages protecting both partners equally and removing the stigmatism from any children who were born to such unions. She also set up women's centers open to all, including prostitutes and unmarried mothers, and homes for the blind.

In January and February 1937, her efforts to find safe havens in France for Spanish orphans led to a trip to Geneva, Switzerland, to address the International Health Committee of the League of Nations. There she spoke on behalf of the women and children caught behind the lines of General Franco's army. Inside Spain, she gave scores of speeches to publicize the role of anarchism and of the revolution in making a better life for the people of the country.

Throughout the period of Montseny's ministry, tensions grew between the anarchists and the Communists. Inside the Cabinet, the anarchist and CNT ministers were forced inch by inch to yield up the "conquests of the Revolution," and allow the reimposition of national authority. As Montseny wrote, "The arguments of the Communists, Socialists, and Republicans were always the same: It was essential to give an appearance of legality to the Spanish Republic, to calm the fears of the British, French, and Americans."

The Soviet government, which was the major arms supplier for the Republic, supported this policy, tactfully but continuously pressuring the CNT and FAI leaders to accept, as Montseny described it, a "controlled democracy (a euphemistic term for a dictatorship)" in Spain. When Montseny planned to attend a meeting in Geneva of the International Health Committee of the League of Nations, the Soviet ambassador urged her to visit Russia, where she would be treated royally. On several occasions the ambassador also suggested that, while away, she send her daughter to Valencia to live in the ambassador's villa with his wife and children. When Montseny heard these suggestions "the blood froze in my veins." The ambassador's offer implied not hospitality but hostage-taking.

On May 3, 1937, growing tensions in Barcelona between the anarchists, Catalan nationalists, and the Communists erupted into full-scale fighting. Montseny explained later that the news of the battle had caught her and the other anarchist ministers completely by surprise. She had been so immersed in the work of her ministry that she had failed to notice the signs of a growing rift in the Catalan capital. The Spanish Communists had become bolder in their efforts to challenge and dominate the anarchists and other leftist groups. To stop the fighting in Barcelona, the Republican government wanted to assume control of public order and military affairs throughout Catalonia. During a four-hour Cabinet meeting, Montseny led the opposition to this measure, since it threatened to undermine the influence and authority of the anarchists in Spain. Although the vote went against the anarchist ministers, they were able to obtain a promise that the measure would not be put into effect until the anarchist and Socialist representatives had had a chance to negotiate a peaceful settlement.

Concerned that a protracted civil war in Barcelona and Catalonia would destroy the Republican war effort and ensure a swift victory for the armies of Franco, Montseny and the anarchist minister of labor rushed to Barcelona to mediate the crisis. Courageously, they drove through the streets of Barcelona, using all their influence to persuade the anarchists to stop fighting. Later, they sought to ensure safe passage for the special Republican guards whom the government sent to Barcelona to help restore order.

Despite their peacemaking, in the early morning of May 6 Communist hit squads tried to assassinate Montseny, as well as other leading anarchists. Escaping unharmed but infuriated by the continued treachery of the Spanish Communists, Montseny sped off to protest their actions to the local government authorities. Her car came under attack, and two of her companions were wounded, although she remained unhurt.

Determined to follow up their triumph in Barcelona, the Communists forced the resignation of the Socialist Largo Caballero's government. In a Cabinet meeting on May 15, 1937, Montseny sought to prove the complicity of the Communists in the May crisis in Barcelona, but the two Communist ministers simply walked out. Since the Spanish Republic was utterly dependent on military supplies from the Soviet Union, and Stalin demanded cooperation between the Communists and the Republic, the prime minister, together with the four anarchist ministers who had supported him, resigned on May 16.

In October 1937, the new government headed by Juan Negrín tried the leaders of POUM, a splinter Spanish Socialist party hated by Stalin, for the crime of rebellion during the Barcelona fighting. Montseny and Largo Caballero, the former prime minister, defended them, but to no avail. Forged evidence was used to convict the POUM members. After the end of this trial, the three leading anarchists, Montseny, Abad de Santillán, and García Birlán, visited President Manuel Azaña to denounce Negrín as a dictator and to demand a change of government. Azaña sympathized with the anarchists, but could do nothing.

In late December 1938, Franco began his final offensive into Catalonia and a month later captured half-starved Barcelona. Hundreds of thousands of refugees fled toward the French border, including Federica Montseny and her family. Montseny witnessed terrible scenes at the frontier. "I remember a horrible sight of a large group of wounded, who were driven back. The Senegalese [French colonial troops] with sticks in their hands beat them. The mass of humanity, howling and sobbing, fled beneath the blows. Those who fell to the ground were trampled on." The authorities gave permission to enter France to Federica's mother, an elderly woman who had broken her leg during the march and was being carried on a stretcher, but denied it to the others. "You can't go through," said the guard to Federica, as she held the hand of her five-year-old daughter Vida and clutched her seven-month-old son Germinal. "That's my mother!" pleaded Montseny, but the soldier simply shrugged his shoulders. In pouring rain, Federica stood waiting in the crowd for almost two days. Finally an official of the Catalonian government recognized the former minister and in-

terceded with the French authorities, who permitted Montseny and her family to cross.

Her difficulties, however, were far from over. In early November 1941, the Vichy government, which was collaborating with Hitler, arrested Montseny together with Largo Caballero. General Franco had applied to the French government for their extradition to Spain. Since other Republican politicians extradited to Spain had been executed, Montseny and Caballero faced firing squads should they be sent back. At the end of November, in consideration of Federica's pregnancy (her daughter was born in March 1942) and also, perhaps, of international pressure, the French court of Limoges rejected the extradition requests. Montseny's husband, however, remained in prison until after the Allied invasion of Normandy in June 1944.

Montseny's years of exile in Toulouse, southern France, were filled with activity. She took a leading role in reviving the CNT. Despite schisms, she helped develop a flourishing organization among the Spanish refugees in southern France and directed the publication of the periodicals *CNT* and *Espoir* (Hope). Montseny also participated in the largely unsuccessful attempts to create a secret anarchist organization inside Franco's Spain. On April 27, 1977, two years after Franco's death, she at last returned home to Spain, and presided over a great anarcho-syndicalist meeting in Barcelona.

SOURCES:

Ackelsberg, Martha. *Free Women of Spain: Anarchism and the Struggle for the Emancipation of Women.* Bloomington, IN: Indiana University Press, 1991.

Bolloten, Burnett. *The Spanish Civil War.* Chapel Hill, NC: University of North Carolina Press, 1991.

Carr, Raymond. *The Spanish Tragedy.* London: Weidenfeld and Nicolson, 1977.

Enciclopedia Universal Ilustrada Europeo-Americana. Suplemento Anual, 1977–1978. S.v. "Montseny (Federica)."

Fraser, Ronald. *Blood of Spain: The Experience of Civil War, 1936–1939.* London: Allen Lane, 1979.

Fredricks, Shirley. "Feminism: The Essential Ingredient in Federica Montseny's Anarchist Theory," in *European Women on the Left.* Edited by Jane Slaughter and Robert Kern. Westport, CT: Greenwood Press, 1981.

Joll, James. *The Anarchists.* NY: Grosset and Dunlap, 1966.

Kern, Robert. *Red Years–Black Years: A Political History of Spanish Anarchism, 1911–1937.* Philadelphia, PA: Institute for the Study of Human Issues, 1978.

MacDonald, Nancy. *Homage to the Spanish Exiles: Voices from the Spanish Civil War.* NY: Human Sciences Press, 1987.

Mitchell, David. *The Spanish Civil War.* Based on the Television Series. London: Granada, 1982.

Montseny, Federica. *Seis Años de mi vida, 1939–1945.* Barcelona: Galba, 1978.

Montseny Y Carret, Juan. *Mi Vida.* 3 vols. Barcelona: La Revista Blanca, 1930.

The New York Times. November 5, 1936, November 8 and 22, 1941, April 28, 1977.

Paz, Abel. *Durruti: The People Armed.* Translated by Nancy MacDonald. NY: Free Life Editions, 1977.

Peirats, José. *Anarchists in the Spanish Revolution.* London: Freedom Press, 1990.

Thomas, Hugh. *The Spanish Civil War.* Rev. and enlarged ed. NY: Harper and Row, 1977.

Woodcock, George. *Anarchism.* 2nd ed. Harmondsworth: Penguin, 1986.

Wyden, Peter. *The Passionate War: The Narrative History of the Spanish Civil War, 1936–1939.* NY: Simon and Schuster, 1983.

SUGGESTED READING:

Alcalde, Carmen. *Federica Montseny: Palabra en rojo y negro.* Barcelona, 1983.

Fredricks, Shirley. "Social and Political Thought of Federica Montseny, Spanish Anarchist, 1923–1937." Ph.D. dissertation, University of New Mexico, 1972.

Montseny, Federica, and Agusti Pons. *Converses amb Frederica Montseny: Frederica Montseny, sindicalisme i acracia.* Barcelona: 1977.

RELATED MEDIA:

"The Spanish Civil War" (VHS: 6 parts in 2 volumes), television documentary, including extensive interviews with Federica Montseny, Granada Television International-MPI Home Video, 1983–1987.

Richard Bach Jensen,
Assistant Professor of History at Louisiana Scholars' College, Northwestern State University, Natchitoches, Louisiana

Monvoisin, Catherine (d. 1680).

See French "Witches" for Catherine Deshayes.

Moodie, Geraldine (1853–1945)

Canadian photographer. Born Geraldine Fitzgibbons in Ottawa, Ontario, Canada, in 1853; died in Calgary, Alberta, Canada, in 1945; married John Douglas Moodie (an officer in the RCMP), in 1877; children: five.

Born in 1853 in Ottawa, Ontario, Geraldine Moodie married Royal Canadian Mounted Police officer John Douglas Moodie in 1877. They moved to Calgary, Alberta, in 1886, and between 1887 and 1899 relocated frequently throughout the Canadian west. In the 1890s, Moodie began photographing the Native Americans and frontierspeople she encountered near Battleford, Saskatchewan. While her husband served in the tail end of the Boer War in South Africa, Moodie lived in Moosomin, Saskatchewan, and continued photographing, primarily portraits and ethnographic studies. Upon his return from South Africa, John Moodie was named a governor of the Hudson's Bay Company, with powers to claim islands north of Canada for the Dominion. In 1904, Moodie accompanied her husband

on an expedition to the Arctic, where they remained until 1906. She traveled to England to photograph the coronation of King George V in 1911, and returned to the Arctic in 1915 for a year. Moodie moved with her husband to Duncan, British Columbia, in 1933, and ten years later settled in Calgary, where she died in 1945.

SOURCES:

Rosenblum, Naomi. *A History of Women Photographers.* Paris & NY: Abbeville Publishers, 1994.

<div align="right">

Grant Eldridge,
freelance writer, Pontiac, Michigan
</div>

Moodie, Susanna (1803–1885)

British-born Canadian writer, the youngest of England's literary Strickland sisters. Name variations: Susanna Strickland; Susanna Strickland Moodie. Born Susanna Strickland on December 6, 1803, in Suffolk, England; died on April 8, 1885, in Toronto, Canada; sixth daughter of Thomas Strickland (a retired manager of Greenland Dock) and Elizabeth (Homer) Strickland; sister of writers Agnes Strickland (1796–1874), Elizabeth Strickland (1794–1875), **Jane Margaret Strickland** *(1800–1888), Catherine Parr Traill (1802–1899), and Samuel Strickland; had no formal education; married John Wedderburn Dunbar Moodie (a writer and officer), in April 1831; children: seven, two of whom died young.*

Began literary career with sisters following father's death (1818); wrote sketches, stories, poems, and moral and historical stories for children, published in periodicals of the day; met Thomas Pringle, who introduced her to a group of London writers (1820s); submitted short sketches to La Belle Assemble (1827–29); emigrated with husband to Canada (1832); during eight years of pioneer life in Ontario submitted material to American, Canadian, and English journals; a principal contributor to Montreal's Literary Garland (1838–50); with husband, edited The Victoria Magazine (1847–48); published successful Roughing It in the Bush (1852) and Life in the Clearings (1853); followed with Mark Hurdlestone (1853) and Flora Lyndsay (1854); published last novel (1875).

Selected writings: Happy Because Good *(Dean, n.d.);* The Little Prisoner; or, Passion and Patience *(Dean & Munday, n.d.);* The Little Quaker; or, The Triumph of Virtue *(Cole, n.d.);* Profession and Principle *(Dean & Munday, n.d.);* Rowland Massingham *(Dean & Munday, n.d.);* Spartacus, A Roman Story *(Newman, 1822);* Hugh Latimer; or, The Schoolboy's Friendship *(Newman, 1828); (with Agnes Strickland)* Patriotic Songs *(Green & Soho, 1830);* Enthusiasm; and Other Poems *(Smith & Elder, 1831); (editor)* The History of Mary Prince *(Westley, 1831); (editor)* Negro Slavery Described by a Negro: Being the Narrative of Ashton Warner, a Native of St. Vincent's *(Smith & Elder, 1831); (editor, with J.W.D. Moodie)* The Victoria Magazine *(September 1847–August 1848, collected edition, University of British Columbia Press, 1968);* The Little Black Pony; and Other Stories *(Collins, 1850);* Roughing It in the Bush; or, Life in Canada *(2 vols., Bentley, 1852, revised, Hunter, Rose, 1871, modern edition, McClelland & Stewart, 1962);* Life in the Clearings Versus the Bush *(Bentley, 1853, modern edition, Macmillan, 1959);* Mark Hurdlestone *(2 vols., Bentley, 1853);* Flora Lyndsay; or, Passages in an Eventful Life *(2 vols., Bentley, 1854);* Matrimonial Speculations *(Bentley, 1854);* Geoffrey Moncton; or, The Faithless Guardian *(DeWitt & Davenport, 1855, republished as* The Monctons, A Novel, *2 vols., Bentley, 1856);* The World Before Them, A Novel *(3 vols., Bentley, 1868);* George Leatrim; or, The Mother's Test *(Hamilton, 1875).*

Writer Susanna Moodie was born Susanna Strickland on December 6, 1803, in Suffolk, England, the sixth daughter of Thomas Strickland, a retired manager of the Thames River's Greenland Dock, and **Elizabeth Homer Strickland.** Several of her siblings would also grow up to become writers; ***Agnes Strickland** and **Elizabeth Strickland** wrote popular biographies of several royal figures, while ***Catherine Parr Traill** and Samuel Strickland wrote about natural history. Although Moodie had no formal education, she acquired knowledge from her father's extensive library and was tutored by her older sisters.

Moodie began her writing career with her sisters in 1818, following their father's death. The sisters wrote short sketches, stories, and poems in addition to pieces on natural history and fables for children. She also became friends with several people of unorthodox religious views—Quakers and Dissenters—and converted from the Anglican religion, becoming a Congregationalist. Her interest in religion is apparent in much of her poetry and work for children, and can be seen in the devices of religious conversion and deathbed repentances in her fiction. Her career development was influenced by several people, among them James Bird, a Suffolk poet, writer ***Mary Russell Mitford,** and writer and editor Thomas Harral, who gave her the opportunity to publish in *La Belle Assemble.* The most influential, however, was Thomas Pringle, secretary of the Anti-Slavery Society. Through him, she became acquainted with a number of London writers and more deeply concerned with humanitarian issues of the day. Two projects she

undertook while living in Pringle's home were transcriptions of slave narratives: *The History of *Mary Prince* and *Negro Slavery Described by a Negro: Being the Narrative of Ashton Warner, a Native of St. Vincent's*. Both edited narratives were published in 1831.

Moodie collaborated with her sister Agnes on *Patriotic Songs* in 1830 and published her own volume of poetry, *Enthusiasm; and Other Poems*, in 1831. She married Lt. John Wedderburn Dunbar Moodie, a writer and officer, in April 1831, and in July 1832 they emigrated to Canada, where they purchased a farm in Ontario. Within 18 months, they moved to a backwoods area near Peterborough to be closer to her siblings Catherine and Samuel. The Moodies would spend eight years trying to make a success of pioneer life, to which neither was suited. Her husband served in the militia, and in 1839 was appointed sheriff of the Victoria District. In 1840, the family moved to Belleville, Ontario.

During their sojourn in the backwoods, Moodie wrote and submitted several items, most of which was poetry, to various American, Canadian, and English journals. In late 1838, she began to write for the Montreal periodical *Literary Garland* and soon became one of its principal contributors, publishing items for the next 12 years. In 1847 and 1848, the Moodies together edited *The Victoria Magazine*. They wrote most of the contents themselves, but Strickland siblings Agnes, Samuel, and Catherine also contributed.

The *Literary Garland* folded in 1851, and Moodie began to pull into book form several sketches from a series on the difficulty of primitive backwoods living. The result was published in 1852 as *Roughing It in the Bush*, now considered both her most significant book and an important depiction of early immigrant life in Canada. It sold well and was reprinted several times, although Moodie was also castigated in some quarters for the unvarnished, and at times unflattering, picture she painted of life in the new land. (Because the book, which in its original version included three chapters by her husband, bore little stylistic resemblance to her previous work, some have suggested that it was perhaps written entirely by her husband. Most critics, however, believe that it was written by Moodie herself.)

Life in the Clearings Versus the Bush, a sequel to *Roughing It*, was published in 1853, followed by *Mark Hurdlestone* (1853) and *Flora Lyndsay; or, Passages in an Eventful Life* (1854). All three have met with favorable criticism.

Moodie's last four novels, *Matrimonial Speculations* (1854), *Geoffrey Moncton; or, The Faithless Guardian* (1855), *The World Before Them* (1867), and *George Leatrim; or, The Mother's Test* (1875), did not fare so well, and are now little read. Her husband lost his position as sheriff in 1863 and was unable to find other employment thereafter, forcing Moodie to support the family through her writing and by painting and selling pictures of flowers. Following her husband's death in 1868, Moodie lived off and on with two of her children. She died in Toronto in 1885. In 1972 Canadian writer **Margaret Atwood** published *The Journals of Susanna Moodie*, a collection of poems that present a microcosm of the Canadian experience through events from Moodie's life.

SOURCES:

Buck, Claire, ed. *The Bloomsbury Guide to Women's Literature*. NY: Prentice Hall General Reference, 1992.
Dictionary of Literary Biography, Vol. 99: *Canadian Writers Before 1890*. W.H. New, ed. Detroit, MI: Gale, 1990.
Kunitz, Stanley J., ed. *British Authors of the Nineteenth Century*. NY: H.W. Wilson, 1936.

Ellen Dennis French,
freelance writer, Murrieta, California

Moody, Deborah (c. 1583–c. 1659)

Early American colonist and founder of several settlements in Brooklyn. Name variations: Lady Deborah Moody. Born Deborah Dunch in Avebury, Wiltshire, England, around 1583 (some sources cite 1580, some cite 1600); died in Gravesend, New Netherland, around 1659; daughter of Walter Dunch and Deborah (Pilkington) Dunch; granddaughter of James Pilkington, bishop of Durham; married Henry Moody of the manor of Garesdon, Wiltshire, on January 20, 1605 or 1606; children: Henry.

Following death of husband and a conflict with English authorities, emigrated to American colonies (1639); lived in Massachusetts until a disagreement with authorities over religious convictions prompted her to move to Dutch province of New Netherland (1643); received land grant and established first English settlement, Gravesend, and designed city layout; credited with designing areas known today as Midwood, Coney Island, Sheepshead Bay, and Bensonhurst.

A British-born early American colonist who is considered one of the founders of New York City's borough of Brooklyn, Deborah Moody was born around 1583 in Avebury, Wiltshire, England. She was one of five children of Walter Dunch, a member of Parliament in 1584 and 1588, and **Deborah Pilkington Dunch**, the

daughter of James Pilkington, bishop of Durham and a radical Protestant. Moody's father provided dowries for each of his four daughters before his death in 1594, and Deborah, the oldest, was married in 1605 or 1606 to Henry Moody of Garesdon manor, also in Wiltshire. They had one child, Henry, and during her marriage Moody apparently laid out several local villages, gaining knowledge of city planning. Her husband was knighted in 1606, granted a baronetcy in 1621 or 1622, and served as a member of Parliament in 1625, 1626, and from 1628 until his death a year later. Moody then moved to London, but permits were required to stay away from one's home, and in 1635, having overstayed the limit of her permit, she was ordered to return to Garesdon. This order outraged her sense of civil liberties and, in combination with the unpopularity of her unorthodox religious views, resulted in her decision to leave England to seek greater freedoms.

Moody sailed for the colonies in 1639, while already in her mid-50s. Settling in Massachusetts, she lived first in Lynn, where she was granted 400 acres of land by the Massachusetts General Court. In 1640, she was a member of a nonconformist church in Salem, but she was drawn to the Anabaptists, one of the most radical of the religious sects that formed after Martin Luther broke with the Catholic Church. It advocated, among other things, a separation of church and state, which was anathema to the Puritans. Chastised by the Massachusetts authorities for her views, Moody moved in 1643 to the Dutch province of New Netherland. A group of friends and like-minded followers went with her.

In New Netherland, authorities allowed Moody to start a settlement in the far southern reaches of what later became the city of Brooklyn (now the borough of Brooklyn in New York City). Here she purchased land from the Canarsie tribe and established the village of Gravesend, which was the first colonial settlement established and run by a woman. She apparently had second thoughts about staying in her new home after violent conflicts with local tribes forced the settlers to seek protection from the Dutch, but authorities in Massachusetts did not particularly want her to return there. (In 1644, an advisor to Governor John Winthrop told him not to allow her to return unless she would "leave her dangerous opinions behind her, for shee is an evil woman.") In 1645, Moody became the first woman to receive a land grant when the Dutch issued her a patent that December allowing freedom of worship and self-government. She then put her previous experi-

ence in city planning to use, designing and laying out street grids in Gravesend. Moody also later purchased much of the land surrounding Gravesend, designing the original villages of what are now the Brooklyn neighborhoods of Bensonhurst, Coney Island, Sheepshead Bay, and Midwood. She became an important citizen of New Netherland, and was well respected by its governor Peter Stuyvesant and by Willem Kieft, governor of New Amsterdam.

Deborah Moody reportedly became a Quaker in 1657, after missionaries of the new sect (which was much persecuted in the English colonies, as it was in England) arrived in the area. Some historical sources dispute her conversion, although it is known that Gravesend became a center for Quakerism soon after 1658. Acclaimed by a contemporary as a "wise and anciently religious woman," she died in the village she had founded sometime between November 1658 and May 1659.

SOURCES:

Griffin, Lynne, and Kelly McCann. *The Book of Women*. Holbrook, MA: Bob Adams, 1992.

James, Edward T., ed. *Notable American Women, 1607–1950*. Cambridge, MA: The Belknap Press of Harvard University Press, 1971.

100 American Women Who Made a Difference. Vol. 1, no. 1. Cowles, 1995.

Read, Phyllis J., and Bernard L. Witlieb. *The Book of Women's Firsts*. NY: Random House, 1992.

Ellen Dennis French,
freelance writer, Murrieta, California

Moody, Mrs. D.L. (1842–1903).

See Moody, Emma Revell.

Moody, Emma Revell (1842–1903)

British-born wife of American evangelist Dwight L. Moody. Name variations: Mrs. D.L. Moody. Born Emma Revell in 1842 in London, England; died in 1903 (some sources cite 1902) in Northfield, Massachusetts; daughter of Fleming Revell and Emma (Manning) Revell; married Dwight L. Moody (a Congregationalist evangelist), in 1862; children: Emma; W.R.; Paul.

Born in London, England, in 1842, Emma Revell Moody was raised a Baptist and emigrated with her family to Chicago in 1849. She was teaching Sunday School by age 15 and public school by age 17. She met her future husband Dwight L. Moody while taking a class at a mission school where he worked, and soon became a volunteer in his Congregational evangelical organization. They were married in 1862. Dwight

was a popular evangelist by the early 1870s, and Moody accompanied him as he traveled and preached (frequently backed by an organist) throughout the country; they had no permanent home until their last years. Moody took great pleasure in teaching children, including her own, and was with her husband when he founded the Northfield (Massachusetts) Seminary for girls in 1879, the Mount Hermon School for boys in 1881, and the Chicago Bible Institute (now the Moody Bible Institute) in 1889. She died at age 61 in Northfield, Massachusetts. Her granddaughter **Emma Moody Powell** wrote a biography of her, *Heavenly Destiny*.

Ellen Dennis French,
freelance writer, Murrieta, California

Moody, Mrs. F.S. (1905–1998).

See Wills, Helen Newington.

Moody, Helen Wills (1905–1998).

See Wills, Helen Newington.

Moon, Lottie (1840–1912)

American Southern Baptist missionary to China and founder and namesake of the Lottie Moon Christmas Offering. Born Charlotte Diggs Moon on December 12, 1840, in Crowe, Virginia; died on December 24, 1912, in Kobe, Japan; daughter of Edward Harris Moon (a plantation owner) and Anna Maria (Barclay) Moon; privately schooled by governesses; Hollins College, B.A., 1856; Albermarle Female Institute, M.A., 1861; never married; no children.

Had religious conversion (1859) during revival led by Dr. John A. Broadus in Charlottesville; returned home (1861) and assisted her elder sister, Orianna, one of the South's first female physicians, in Civil War hospitals; tutored children in Alabama and taught in a school for girls in Danville, Kentucky (beginning in 1865); with friends, established a school for girls in Cartersville, Georgia (1870).

When Lottie Moon's youngest sister, **Edmonia**, sailed in 1872 to serve as a Southern Baptist missionary in the Far East, Lottie began to reflect on her role and duty as a Christian. Making her decision "for Christ," Moon sailed in September 1873 to join her sister in China. She quickly learned to speak Chinese and acclimated to the surrounding customs and culture, settling with Edmonia in Tengchow in a house that soon became known as "The Home of the Crossroads." Due to her sister's worsening health, in 1876 Moon accompanied Edmonia back to the United States, returning to China by Christmas

1877. In 1885, she moved to more remote villages, centering her mission at Pingtu, an area no missionary had spent time in before, intent on broadening her ministry and her educational efforts on behalf of Chinese women. Always challenged by the lack of adequate funding for the most basic necessities, in 1888 Moon made a plea to the women of the Southern Baptist Church calling on them, in the spirit of Christmas, to share in the mission of China. In response, the Southern Baptist Woman's Missionary Union raised over $3,000. With these proceeds, the mission sponsored three additional woman missionaries in the Pingtu area, and by 1889 a Baptist church was founded there.

Moon returned to America on furlough in October 1891, appearing at the Southern Baptist Convention in Atlanta and, in 1893, in Nashville, speaking on the condition of the Baptist mission in China. During her remaining months of leave, she spoke to various women's organization throughout the Southern states, spreading the word of her work. She returned to China and her base at Tengchow in October 1893. The growing anti-Western and anti-Christian sentiments of the Boxer Rebellion soon demanded a relocation of most Western missionaries based in China, and in July 1900 Moon moved to Fukuola, Japan. She returned to Tengchow in April 1901.

The remaining years of Moon's mission in China were difficult, beginning with the Russo-Japanese War (1904–05) and culminating in the 1911 Chinese rebellion against the Manchu Dynasty which plunged the country into chaos. Although the American counsel advised all Americans to leave China at the outbreak of the hostilities, Moon remained. Finally, undernourished and near exhaustion, she gave her remaining funds to the Christians in Pingtu and to the Famine Relief Fund and followed the advice of the mission doctor, setting sail for Shanghai in December 1912 with a missionary nurse, **Cynthia Miller**. Leaving Shanghai for San Francisco on December 20, Lottie Moon died on board ship in the harbor of Kobe, Japan, on Christmas Eve. She was cremated and her ashes sent home to her family in Crowe, Virginia. Moon's missionary work in China was formidable, but she is best remembered for the Christmas offering which bears her name, begun by her pleas for assistance and nurtured by the Southern Baptist Woman's Missionary Union. The Lottie Moon Christmas Offering supports the building of churches, hospitals, and schools, the publication of missionary tracts, and provides homes and salaries for missionaries around the world.

SOURCES:

Lawrence, Una Roberts. *Lottie Moon*. Nashville, TN: Sunday School Board of the Southern Baptist Convention, 1927.

SUGGESTED READING:

Hyatt, Irwin T. *Our Ordered Lives Confess: Three Nineteenth-Century American Missionaries in East Shantung*. Harvard Studies in American-East Asian Relations, Vol. 8. Cambridge, MA: Harvard University Press, 1976.

COLLECTIONS:

Papers regarding Moon's mission to China, her letters, and articles are held by the Foreign Missions Board of the Southern Baptist Convention; other personal papers are held privately by the family.

<div align="right">

Amanda Carson Banks,
Vanderbilt Divinity School, Nashville, Tennessee

</div>

Mooney, Ria (1904–1973)

Irish actress, teacher, director, and first woman producer at the Abbey Theatre. Born Catherine Marea (one source cites Maria) in Dublin, Ireland, in 1904; died at St. Luke's Hospital, Dublin, on January 3, 1973; following a requiem mass at the Church of the Holy Cross, Dundrum, was interred at Glasnevin Cemetery; never married; no children.

Studied dance at Madame Rock's Dancing Academy in Dublin; began acting at age six; sang with Rathmines and Rathgar Musical Society in her teens; studied art at Metropolitan School of Art, Dublin; invited to join Abbey Theatre, Dublin (1924); selected by Sean O'Casey to play Rosie Redmond in initial presentation of The Plough and the Stars (1926); toured England and America with Molly Allgood; made U.S. acting debut (1927); joined Eva Le Gallienne at New York's Civic Repertory Theatre, serving as assistant director of plays (1928–34); joined Edwards-MacLiammóir company at Gate Theatre Company, Dublin (1934); produced verse plays at Abbey and Peacock Theatres for Austin Clarke's Dublin Verse-Speaking Society/Lyric Theatre Company; appointed teacher at Abbey School of Acting (August 1935); directed Abbey's experimental Peacock Theatre (1937); directed Gaiety Theatre School of Acting, Dublin (1944); became first woman producer of Abbey Theatre (1948); retired (1963). Member of the Royal Society of Antiquaries.

Selected theatrical performances: appeared as Alice in Brinsley MacNamara's Look at the Heffernans! (1926), Rosie Redmond in Sean O'Casey's The Plough and the Stars (1926), Mary Boyle in O'Casey's Juno and the Paycock (1928), Hon. Gwendolen Fairfax in Oscar Wilde's The Importance of Being Earnest (1933), First Fairy in Shakespeare's A Midsummer Night's Dream (1933), Miss Rowland in Eugene O'Neill's monologue Before Breakfast (1933), Lady Brute in John Vanbrugh's The Provok'd Wife (1933), Bride in E. W. Tocher's Storm Song (1934), Catherine Earnshaw in the stage adaptation of Thomas Hardy's The Return of the Native (1934), Ludmilla in Squaring the Circle (1935), Annie Kinsella in Teresa Deery's The King of Spain's Daughter (1935), Village Wooing (three short scenes by George B. Shaw, 1935), Miss Logan in Boyd's Shop (1936), First Musician in Deirdre (1936), Eileen Connolly in The Wild Goose (1936), Miss Jemima Cooney in Brigid (1937), Sister in Big House (1937), Cressida Pommery in Pommerys (1937), Nance in Frank O'Connor's Time's Pocket (1938), Hessy in A Spanish Soldier (1940), Mrs. Kennafick in Elizabeth Connor's Mount Prospect (1940), Nun in Francis Stuart's Strange Guest (1940), Sara Tansley in George Shiel's The Rugged Path (1941), Hannie Martin in Louis D'Alton's Lovers' Meeting (1941).

Selected theatrical productions: Robert Ferren's Assembly at Druim Ceat (1943); George Shiel's The New Regime (1944); Sean O'Casey's Red Roses for Me (1946).

Selected radio broadcasts: A Tree in Coole (feature on Lady Gregory, Radio Eireann, broadcast April 3, 1960); James Stephens' The Crock of Gold (reading with Harry Brogan, Radio Eireann, n.d.).

Selected recording: (with John Stevenson) "Glass of Beer," "Come to the Hills of Moran," and "The Rivals" from Abbey Theatre Songs and Poems (1937).

Adaptations: (with Donald Stauffer) Emily Brontë's Wuthering Heights (1934).

Filmography: Wicklow Gold (1922).

Ria Mooney was born in Dublin in 1904—the same year that the newly formed Abbey Theatre, which would play a singular role in her life, produced its first play. She began her acting career at age six in an annual production of Madame Rock's Dancing Academy at Dublin's Gaiety Theatre. In *The Abbey Theatre: The Rise of the Realists, 1910–1915*, Robert Hogan includes an excerpt from an unpublished manuscript in which Mooney recalled her childhood perceptions of the Abbey and the "odd" people she believed were connected with it. While gazing at passersby through her father's shop window, she would notice "the occasional odd-looking person" and be told that they were from the Abbey Theatre (e.g., W.B. Yeats and Æ [George Russell]—whom she remembered as tall and lanky men who walked with their hands behind their backs, the former with his head held high and the latter gazing downward—as well as James Stephens, a small "gnome"-like man with a big hat and long coat who wrote tales about the little people). Convinced that "only odd-

looking people belonged to this theatre," she decided that despite her "sneaking desire to be like them," it would not be at the expense of being attached to that "strange place."

When she was eight, Mooney recalled, her father took her to the Abbey Theatre to audition for the part of the Faery Child in Yeats' early play *The Land of Heart's Desire*. Possessed of a beautiful speaking voice, she read well and impressed the director, who offered her the part and suggested that she go into the mountains and return when she could read the lines "like the wind sighing through the trees." Thinking him "a little mad," Mooney had her early suspicions about oddity at the Abbey confirmed. As it turned out, she didn't get the part, much to the delight of her mother who, although desirous of a career at the Abbey for her daughter, thought the play a "pagan work."

Mooney's own childhood interests inclined to singing and dancing. She took lessons at Madame Rock's Dancing Academy for several years and sang with the Rathmines and Rathgar Musical Society in the Rathmines section of Dublin until age 16. A year or so later, she briefly considered becoming an artist and enrolled at Dublin's Metropolitan School of Art. Although she had gained recognition as a talented actress in her native city while still in her teens, it was not until 1924 that Mooney turned her interests and energy fully to the stage, to which she devoted the rest of her life.

An intense nationalism prevailed throughout the country at this time, and the Abbey Theatre (founded primarily by W.B. Yeats, Lady *Augusta Gregory, John Synge, and *Annie Horniman) was born out of this national pride. It evolved out of the National Irish Theatre Society for the purpose of producing native plays on native subjects. The Dublin population, which viewed the arts and its artists suspiciously, was powerfully concerned with the depiction of Irish tradition abroad. And in the fractious provincialism of the era, the Abbey Theatre and its playwrights endured much criticism and journalistic ridicule. "The Abbey," noted Thomas MacAnna, "has been attacked for being anti-national, anti-Irish, anti-Dublin Castle, anti-clerical, pro-government, and finally pro-Irish."

In 1924, at age 20, Mooney was invited to join the Abbey Theatre "after giving a striking performance at the Dublin Arts Club in Chekhov's *Proposal*," wrote Henry Boylan. She debuted in a performance of George Shiels' *The Retriever* and her improvement over the next two years was such that in 1926 Sean O'Casey

personally chose Mooney to play the part of the prostitute Rosie Redmond in the first production of his new play, *The Plough and the Stars* (the third of O'Casey's plays to be produced at the Abbey). O'Casey was a nationalist himself, but rather than seek the spirit of Ireland in folklore and legend he was a socialist who turned to the realism of contemporary urban life for his characters and themes, finding heroism in the survivors of society's ills.

Although Mooney turned in a critically acclaimed performance, a riot ensued when the audience took offense at the portrayal of a prostitute on the stage, and the author was attacked for disparaging Irish culture. According to Kit and Cyril O'Cérín, O'Casey's choice of Mooney to play the part was "vindicated, not only by her memorable performance, but also her defiance of the play's critics in the controversy that followed when even the threat of kidnap hung over her head." Mooney's collaboration with O'Casey continued throughout her career, and the O'Céríns note that controversy again beset the two 20 years later when Mooney directed O'Casey's *Red Roses for Me*.

Mooney appeared in a variety of roles at the Abbey before joining the Irish Players in London and touring England and America with Arthur Sinclair and Molly Allgood (whose stage name was *Maire O'Neill), sister of the Irish character actress *Sara Allgood. She made her U.S. debut in 1927, and was offered a contract as a junior actress under the direction of *Eva Le Gallienne at New York's Civic Repertory Theater (formed in 1926). A year later, she became assistant director of plays there, a position she held until 1934—just before the company's demise the following year.

After returning to Dublin, Mooney appeared with the Hilton Edward and Micheál MacLiammóir company at the Gate Theatre, performing in numerous plays. According to an *Irish Times* obituary, MacLiammóir characterized Mooney and her acting during this time: "Small, with night-black hair and long, slow-glancing green eyes, she had . . . a curious intensity like a steadily-burning inner fire, and her acting was poised, shapely and full of intelligence."

Rejoining the Abbey in 1934, with which she twice more toured the United States, Mooney began teaching at the Abbey School of Acting in August 1935 and directed her first play in 1937. She was also affiliated with F.J. McCormack and Fred Higgins in their work at the Abbey, and specialized in the production of verse plays at both the Abbey and Peacock Theatres

for Austin Clarke's Dublin Verse-Speaking Society/ Lyric Theatre Company. She left the Abbey in 1944, to become director of the Gaiety Theatre School of Acting, numbering among her students the Tony Award-winning actress **Anna Manahan** who, like her mentor, would also survive a riot during a Dublin performance (of *The Rose Tattoo*, in 1957).

Mooney directed the 1946 London production of O'Casey's *Red Roses for Me* before once again returning to the Abbey Theatre in 1948 to accept a position as its first woman producer—a post she held until her retirement in 1963. As a producer at the Abbey, she revived several plays of J.M. Synge, W.B. Yeats, Lady Gregory, Sean O'Casey, and others. These were arduous years for Mooney, during which she had to transform an essentially inexperienced group of actors culled from amateur dramatic societies into successful performers. Under her leadership, the Abbey delivered between 12 and 17 productions each season, but the challenges she endured evidently extended to her directors, as well. As Joseph Halloway pointed out, a year into her tenure as producer, she "seemed thoroughly disheartened by the way some of her directors cross her endeavors." Her dedication and commitment to the theatre were well known and were certainly proved on the evening of July 17, 1951, when a fire destroyed the Abbey. Due largely to her efforts and determination, *The Plough and the Stars* resumed production the next evening at the Peacock. When the Abbey moved to the Queen's Theatre during the construction of its new home, she moved with it.

Mooney continued to perform throughout her long career. Noted for an extraordinary variety of facial expressions, she was considered a gifted character actress. Lennox Robinson and Micheál ÓhAodha wrote that her performance in Eugene O'Neill's *Long Day's Journey Into Night* in 1962 "came at the end of a long career of fine characterisations" and, as noted by the O'Cérins, represented one of her greatest stage achievements. Upon her death in Dublin in January 1973, an *Irish Press* obituary published tributes from several of her colleagues. Playwright John McCann, who wrote a perennial Abbey favorite from the 1950s, *20 Years A-Wooing*, thought that "she was never given full credit for all she did as a producer." Citing Mooney's legendary devotion to her work, another colleague recalled, "She was unsparing in her efforts to get the best out of every production she undertook." At the time of her death, Mooney had been working on her autobiography, "The Days Before Yesterday."

SOURCES:

A Dictionary of Irish Biography. 3rd ed. Edited by Henry Boylan. Niwot, CO: Roberts Rinehart, 1998.

Irish Press [obituary]. January 4–5, 1973.

Irish Times [obituary]. January 4–6, 1973.

Joseph Halloway's Irish Theatre. Robert Hogan and Michael J. O'Neill, eds. Dixon, CA: Proscenium Press, Vol. 1: 1926–31, 1968; Vol. 2: 1932–37, 1969; Vol. 3: 1938–44.

MacAnna, Thomas. "Nationalism from the Abbey Stage," in *Theatre and Nationalism in Twentieth-Century Ireland*. Edited by Robert O'Driscoll. Toronto: University of Toronto Press, 1971, pp. 89–101.

Mikhail, E.H., ed. *The Abbey Theatre: Interviews and Recollections*. Totowa, NJ: Barnes & Noble Books, 1988.

Modern Irish Lives: Dictionary of 20th-century Irish Biography. Edited by Louis McRedmond. NY: St. Martin's Press, 1996.

Mooney, Ria, "Players and the Painted Stage" [an unpublished manuscript]. Edited by Val Mulkerns, in Robert Hogan, *The Abbey Theatre: The Rise of the Realists, 1910–1915*. Dublin: Dolmen Press, 1979, pp. 115–118.

O'Cérín, Kit and Cyril. *Women of Ireland: A Biographical Dictionary*. Minneapolis, MN: TírEolas Irish Books and Media, 1966, pp. 154–156.

ÓhAodha, Micheál and Lennox Robinson. *Pictures at the Abbey*. Mountrath, Portlaoise, Ireland: Dolmen Press in association with The Irish National Theatre Society Limited, 1983.

Sharon Malinowski,
Detroit, Michigan

Moore, Alice Ruth (1875–1935).

See Dunbar-Nelson, Alice.

Moore, Ann (1950—)

English equestrian. Born on August 20, 1950.

In the Munich Olympic Summer Games of 1972, Ann Moore rode her horse Psalm to a silver individual medal in Grand Prix jumping. Graziano Mancinelli of Italy won the gold.

Moore, Anne Carroll (1871–1961)

American librarian, lecturer, writer, and children's book critic who was a pioneer in the field of children's librarianship. Born Anne Carroll Moore on July 12, 1871, in Limerick, Maine; died on January 20, 1961, in New York City; daughter of Luther Sanborn Moore (a lawyer) and Sarah Hidden (Barker) Moore; attended Limerick Academy, 1881–89; attended Bradford Academy for Women, Bradford, Massachusetts, 1889–91; attended Pratt Institute Library School, Brooklyn, New York, 1895–96.

Became head of new children's department at Pratt Institute (1897); helped establish and was first

chair of the Club of Children's Librarians, American Library Association (1900); became supervisor of children's division of New York Public Library (1906), where she revolutionized children's library practices, expanded storytelling, and initiated book review programs; helped establish Children's Book Week, also began reviewing children's literature for The Bookman *(1918); issued annual list of "Children's Books Suggested as Holiday Gifts" (1918–41); edited "The Three Owls" column of criticism in* New York Herald Tribune *(1924–30); retired from New York Public Library (1940); accepted position with University of California at Berkeley graduate school of librarianship (1941).*

Member: American Library Association; English Speaking Union; New York State Library Association; New York Library Club. Received Pratt Institute Diploma of Honor (1932); honorary doctorates from University of Maine (1940) and Pratt Institute (1955); first ★Constance Lindsay Skinner Gold Medal from the Women's National Book Association (1940); Regina Medal from the Catholic Library Association (1960).

Selected writings: A List of Books Recommended for a Children's Library *(Iowa Printing, 1903);* Joseph A. Altsheler and American History *(1919);* Roads to Childhood: Views and Reviews of Children's Books *(Doran, 1920);* New Roads to Childhood *(Doran, 1923);* Nicholas: A Manhattan Christmas Story *(Putnam, 1924);* The Three Owls: A Book about Children's Books, Their Authors, Artists and Critics *(Macmillan, 1925);* Cross-Roads to Childhood *(Doran, 1926); (editor)* Washington Irving, Knickerbocker's History of New York *(Doubleday, Doran, 1928);* The Three Owls Second Book: Contemporary Criticism of Children's Books *(Coward-McCann, 1928); (editor)* Washington Irving, Bold Dragoon and Other Ghostly Tales *(Knopf, 1930);* The Three Owls Third Book: Contemporary Criticism of Children's Books *(Coward, 1931);* Nicholas and the Golden Goose *(Putnam, 1932);* Seven Stories High *(Compton, 1932);* The Choice of a Hobby: A Unique Descriptive List of Books Offering Inspiration and Guidance to Hobby Riders and Hobby Hunters *(Compton, 1934);* Reading for Pleasure *(Compton, 1935);* My Roads to Childhood: Views and Reviews of Children's Books *(Doubleday, Doran, 1939);* A Century of Kate Greenaway *(Warne, 1946); (editor with Bertha Mahony Miller, illustrated by Valenti Angelo)* Writing and Criticism: A Book for ★Margery Bianco *(The Horn Book, 1951); (author of appreciation)* ★Beatrix Potter, The Art of Beatrix Potter *(Warne, 1955).*

Anne Carroll Moore was born on July 12, 1871, in Limerick, Maine, the last of ten children of **Sarah Barker Moore** and Luther Sanborn Moore, a lawyer. She was also their only surviving daughter, and enjoyed a happy childhood with six doting older brothers. These early years would become the source of her deep love for children and her appreciation of the place reading should have in childhood. Moore graduated from Limerick Academy in 1889 and from Bradford Academy for Women in Bradford, Massachusetts, in 1891. It had been her childhood dream to grow up and read law with her father, and she did, for about six months, until her parents fell ill with influenza in January 1892. Both died within two days of each other. Later in 1892 one of her sisters-in-law died in childbirth (a common occurrence at the time), and Moore cared for two nieces for the following two years.

In 1895, having apparently given up her aspirations of becoming a lawyer, she entered the library school at Pratt Institute in Brooklyn, New York. The next year, she was asked to head the institute's new children's department, the first library area designed specifically for children in the country. (The young Leo Frank frequently visited the children's department; in 1913, after he was unjustly arrested and imprisoned in Atlanta for the murder of **Mary Phagan**, Moore traveled there to plead for his release before he was lynched.) During the ten years she spent at Pratt, Moore instituted storytelling hours and implemented her conceptual ideas of a children's library as an educational tool. At a meeting of the American Library Association (ALA) in 1900, she was the impetus in organizing the Club of Children's Librarians, and served as its first chair. (The club later became the ALA's Children's Services Division.)

In 1906, Moore moved to the New York Public Library, where she helped to establish and became supervisor of its first children's division. Within two years, she had achieved professional status for the children's librarians of the various branches of the New York Public Library system. She instituted storytelling hours here too, and did away with the age limits that barred children from some branch libraries. Moore studied the behavior and psychology of children, and established a calendar of special events, speakers, and exhibits designed to pique interest and stimulate intellectual growth among her small library patrons.

Moore was asked in 1918 to deliver a series of lectures on children's literature, which led the following year to the creation of an annual Children's Book Week. She also began regularly reviewing for *The Bookman* in 1918, and initiated

her annual "Children's Books Suggested as Holiday Gifts" list, which continued until 1941. Moore edited a page of children's literary criticism, "The Three Owls," for the *New York Herald Tribune* from 1924 to 1930. Considered by contemporaries "the yea or nay of all children's literature," the column appeared after 1936 in *The Horn Book Magazine*, which had been founded by her colleague and occasional collaborator *Bertha Mahony Miller. Moore wrote extensively, producing criticism and compilations of critical essays and lists, including *The Three Owls: A Book About Children's Books, Their Authors, Artists, and Critics* (1925), *Reading for Pleasure* (1935), and *A Century of *Kate Greenaway* (1946). She also authored two children's stories herself: *Nicholas: A Manhattan Christmas Story* (1924) and *Nicholas and the Golden Goose* (1932).

Anne Carroll Moore was forced to retire from the New York Public Library, very much against her will, in 1940, at the age of 70. The following year, she accepted an invitation to teach at the graduate school of librarianship at the University of California at Berkeley. She died in New York City in 1961 at the age of 89. A pioneer in her field, during her long career she revolutionized libraries' attitudes towards children's divisions and was integral in developing respect for children's literature. As her biographer **Frances Clarke Sayers** noted, she "was obsessed by the knowledge of what excellence in books could mean to children."

SOURCES:

Contemporary Authors. Detroit, MI: Gale Research, 1961.

Moore, Anne Carroll. *My Roads to Childhood.* Updated edition. Boston, MA: The Horn Book, 1961.

Sayers, Frances Clarke. *Anne Carroll Moore.* NY: Atheneum, 1972.

Sicherman, Barbara, and Carol Hurd Green, eds. *Notable American Women: The Modern Period.* Cambridge, MA: The Belknap Press of Harvard University Press, 1980.

Ellen Dennis French,
freelance writer, Murrieta, California

Moore, Audley (1898–1997)

African-American activist and organizer for civil rights, women's rights, and Pan-African nationalism.

Anne Carroll Moore

Name variations: Queen Mother Audley Moore. Born Audley Eloise Moore in 1898 in New Iberia, Louisiana; died on May 2, 1997, in Brooklyn, New York; daughter of Henry Moore (a former sheriff's deputy) and St. Cyr Moore; completed third grade; married; children: one son.

For over 80 years, Audley Moore was a driving force behind many economic and political efforts to better the lives of African-Americans. Her fierce devotion to these causes earned her the title of "Queen Mother" from the Ashanti people in Africa, a mark of respect so appropriate it became part of her name. Moore was born in New Iberia, Louisiana, in 1898, and began learning about the oppression of African-Americans at an early age from her own family's experiences; her great-grandmother, a slave, had been raped by her white owner, resulting in the birth of Moore's grandmother, and her grandfather had been lynched before his wife's eyes.

After her mother died when Moore was five, she and her younger sisters **Eloise** and **Lorita Moore** went to live with their maternal grandmother in New Iberia. Their father moved to New Orleans, where they joined him a few years later. The reunion was brief, however, as he died when Moore was in the fourth grade. Forced to drop out of school to care for and support her sisters, Moore lied about her age and became a hairdresser. Living in New Orleans in the early years of the 20th century meant she experienced racial violence and segregation firsthand, but she also witnessed the beginnings of racial pride.

During World War I, she and her sisters went to Anniston, Alabama, where she saw how badly black soldiers were treated. The sisters canvassed the black community for food and supplies for the soldiers, and Moore credited her sister Eloise with organizing the first USO in an abandoned church and becoming the first unofficial member of the Women's Army Corps (WAC). In Alabama, Moore continued to support her sisters primarily through her hairdressing and sewing skills. They later returned to New Orleans, where Moore married and opened a store with her husband.

In 1919, Marcus Garvey, the Jamaican activist who called for the establishment of an independent black nation and who had founded the Universal Negro Improvement Association in 1914, attempted to lecture in New Orleans. The first night police broke up the event and detained him. The following night, 3,500 blacks armed themselves (Moore herself carried two pistols) and marched to the hall, where Garvey had returned. As he began to speak, the police threatened to break up the lecture again. "At that point," Moore told an interviewer for *Black Scholar*, "everybody stood on the benches, every gun came out. Every gun said 'Speak, Garvey, speak.'. . . Just in case you think the white folks had us cowered down in those days in the South. And then Garvey said: 'And as I was saying.' . . . The police filed out of there like little puppy dogs. . . . [N]obody was afraid to die. You've got to be prepared to lose your life in order to gain your life." It was with this event that Moore began her lifelong struggle for civil rights, black consciousness, and nationhood. In the early 1920s, she joined Garvey's Universal Negro Improvement Association and supported his "Back to Africa" movement.

Like many other African-Americans, Moore, her husband, and sisters fled the South looking for better conditions and opportunities. After traveling to California and Chicago, in 1922 they settled in New York City's Harlem. Harlem, known then as "Black Manhattan," was a mecca of black culture, but under all the glitz most of its inhabitants lived with crowded housing, widespread unemployment and job discrimination, and poor health conditions. Moore was especially upset over the plight of black working women, most of whom were poorly paid domestic workers in white homes. Likening their situation to slavery, she founded the *Harriet Tubman Association and helped to organize these women.

In 1933, Moore joined the Communist Party because of its involvement in the defense of the notorious Scottsboro case (in which nine black youths had been falsely convicted of raping two white women, *Ruby Bates and Victoria Price), and because of the party's advocacy of voters' rights and civil rights. While active in the party, she fought racial segregation, helping to integrate major league baseball and the Coast Guard, fighting evictions, and organizing the first rent strikes in Harlem. Moore also joined *Mary McLeod Bethune's National Council of Negro Women, and was present at its organizational meeting in 1935. In the 1940s, she worked as the campaign manager for Benjamin E. Davis, Jr., an African-American Communist who served two terms on the New York City Council. But by 1950 she had become disillusioned with the party and resigned, declaring it to be "racist to the core."

Returning to Louisiana, Moore became an advocate for poor people in the South and formed the Universal Association of Ethiopian Women, Inc. This group was responsible for

restoring to the welfare rolls 23,000 black and white families who had been wrongly removed, and it also saved several African-American men from execution by the state of Louisiana. In the 1950s, Moore's Pan-American nationalism encompassed issues such as economic reparations for slavery, cultural identity, and education. She was responsible for establishing the Eloise Moore College of African Studies in Mount Addis Ababa, New York. Named for her sister, the school promoted African identity and vocational training for students who would then go on to teach others their skills. (The school burned down in 1961.) Moore was instrumental in making reparation a central issue before the rise of the civil-rights and Black Power movements, and in 1962 she met with President John F. Kennedy to discuss the subject. Moore was also responsible for forming the African-American Cultural Foundation, which spearheaded the movement to use the term "African-American" instead of "Negro" or "black." In addition, she was the founder of the World Federation of African People and a founding member, with her sister Lorita, of the Ethiopian Orthodox Church of North and South America, of which she became an abbess in 1969. (She later became an archabbess, and remained active in the church throughout her life.) Moore was also a founding member of the Congress of African Peoples (1970) and of the Republic of New Africa. These last two organizations were in part a result of her visits to Africa, to which she had traveled for the first time in 1966. She returned there often, visiting Ghana, Uganda, Guinea, Nigeria, Zimbabwe, and Tanzania, among other countries, meeting with heads of state and participating in conferences. It was while she was in Ghana that she was initiated as "Queen Mother" of the Ashanti, in recognition of her service to the African people.

In her later years, Moore concentrated on the issue of reparation for slavery, while also campaigning to establish a national monument in memory of Africans who died during the centuries in which slavery was legal in the United States. She attended the anti-war Women's Encampment at Seneca Falls, New York, in 1983, and in 1990, in South Africa, she was present at Nelson Mandela's triumphant release from over two decades of imprisonment. Moore was with *Betty Shabazz, the widow of Malcolm X, when Shabazz met with Louis Farrakhan, head of the Nation of Islam and X's vocal detractor, in 1995. That same year, Moore attended the Million Man March in Washington, D.C., with Jesse Jackson, still righteously angry and pursu-

ing her goals well into her ninth decade. Queen Mother Audley Moore died in Brooklyn in May 1997, at age 98. "Those who seek temporary security rather than basic liberty deserve neither," she once said. "We didn't want to be second class citizens. You would have sworn that second class was in the Constitution. Also that citizens have to fight for rights. Imagine a citizen having to fight for civil rights! The very thought of it is repulsive."

SOURCES:

Black Scholar (interview). Vol. 4. March–April, 1973, pp. 47–55.

Igus, Toyomi, ed. *Book of Black Heroes.* Vol. 2, *Great Women in the Struggle.* Just Us Books, 1991.

Smith, Jessie Carney, ed. *Notable Black American Women.* Detroit, MI: Gale Research, 1992.

SUGGESTED READING:

Black Women Oral History Interview with Queen Mother Audley Moore. Cambridge: Schleslinger Library, Radcliffe College, 1980.

Lanker, Brian. *I Dream a World.* NY: Stewart, Tabori & Chang, 1989, pp. 102–103.

Women of Courage. An Exhibition of Photographs by Judith Sedwick. Based on the Black Women Oral History Project, Schlesinger Library. Cambridge: Radcliffe College, 1984, p. 59.

COLLECTIONS:

An undated vita on Queen Mother Audley Moore, published by the World Federation of African People, Inc., is located in files at the Fisk University Library; see also the Black Women Oral History Collection at Radcliffe College.

Jo Anne Meginnes,
freelance writer, Brookfield, Vermont

Moore, Colleen (1902–1988)

American actress who was a popular star of the silent-movie era. Born Kathleen Morrison on August 19, 1902 (also seen as 1900), in Port Huron, Michigan; died in 1988; married John McCormick (production head of First National films), in 1923 (divorced 1930); married Albert P. Scott (a stockbroker), in 1932 (divorced 1934); married Homer P. Hargrave (a stockbroker), in 1937 (died 1966); married Paul Maginot (a building contractor), in 1982; children: one son.

Selected filmography: The Bad Boy (1917); An Old Fashioned Young Man (1917); Hands Up! (1917); The Savage (1917); A Hoosier Romance (1918); Little Orphan Annie (1918); The Busher (1919); The Wilderness Trail (1919); The Man in the Moonlight (1919); The Egg Crate Wallop (1919); Common Property (1919); The Cyclone (1920); When Dawn Came (1920); The Devil's Claim (1920); So Long Letty (1920); Dinty (1920); The Sky Pilot (1921); The Lotus Eater (1921); His Nibs (1921); Come on Over (1922); The Wall Flower (1922); Affinities (1922); Forsaking All Others (1922); Bro-

ken Chains *(1922); The Ninety and Nine (1922); Look Your Best (1923); The Nth Commandment (1923); Slippy McGee (1923); Broken Hearts of Broadway (1923); The Huntress (1923); April Showers (1923); Flaming Youth (1923); Through the Dark (1924); Painted People (1924); The Perfect Flapper (1924); Flirting With Love (1924); So Big (1925); Sally (1925); The Desert Flower (1925); We Moderns (1925); Irene (1926); Ella Cinders (1926); It Must Be Love (1926); Twinkletoes (1926); Orchids and Ermine (1927); Naughty but Nice (1927); Her Wild Oat (1928); Happiness Ahead (1928); Lilac Time (1928); Oh Kay! (1928); Synthetic Sin (1929); Why Be Good? (1929); Smiling Irish Eyes (1929); Footlights and Fools (1929); The Power and the Glory (1933); Social Register (1934); Success at Any Price (1934); The Scarlet Letter (1934).*

A slim brunette with a trademark Dutch boy bob and one blue and one brown eye, Colleen Moore was the personification of the exuberant flapper and one of the most successful

Colleen Moore

actresses of the silent era. "I was the spark that lit up Flaming Youth. Colleen Moore was the torch," said F. Scott Fitzgerald, explaining her influence. Despite her considerable talent, particularly in comic roles, Moore did not make a smooth transition into talkies, and retired from films in 1934 to pursue other interests.

Colleen Moore was born in Port Huron, Michigan, in 1902, but her father's respiratory ailments took the family south when she was still a child. She decided to become an actress after seeing *Maude Adams in a production of *Peter Pan*, and from the age of 12 compiled scrapbooks of her favorite film personalities. In her autobiography, *Silent Star* (1968), Moore writes that she got her first break in the movies through her uncle, newspaper editor Walter Howey, who helped studio head D.W. Griffith get his films *The Birth of a Nation* (1915) and *Intolerance* (1916) past the censors. As a return favor, Griffith gave Moore a contract. "I was a payoff," said Moore. (Some sources erroneously report that Moore had a role in *Intolerance*, but she did not sign with Griffith's company, Triangle-Fine Arts, until 1917.)

Sporting long dark curls *à la* *Mary Pickford, Moore played little girls in her early films. After she left Triangle in 1918, she was cast in her first leads in *A Hoosier Romance* and *Little Orphan Annie*, then made the rounds of studios until 1923, when she signed with First National. There, she made her breakthrough film *Flaming Youth* (1923), with Ben Lyon, who was her co-star again in *Painted People* (1924). By her third film with National, *The Perfect Flapper* (1924), Moore's short bob was the rage and her salary was an unprecedented $12,500 a week. "No longer did a girl have to be beautiful to be sought after. Any plain Jane could become a flapper," said Moore, explaining her sudden popularity. "No wonder they grabbed me to their hearts and made me their movie idol."

Having proven her ability in comic roles, Moore turned to drama in the first film version of *Edna Ferber's *So Big* (1925), in which she played a Midwestern farm woman, "a capital characterization helped by a simple and true-to-life make-up," reported *The New York Times*. Although Moore's reviews were good, the studio could make more money with comedies, and she was cast in lighter fare. Her next two films, *Sally* (1925) and *Irene* (1926), both adapted from Broadway musical hits, would be her best remembered, although the musical sequences were confined to a piano accompaniment. Moore's

movies of the late 1920s include *Orchids and Ermine* (1927), in which Mickey Rooney played an adult midget, and *Lilac Time* (1928), with Gary Cooper. An expensive film for its day ($1 million), the movie boasted sound effects and a synchronized musical score.

With the advent of sound, National merged with Warner Bros., and the studio sent Moore to *Constance Collier, in hopes of turning her little girl voice into something more acceptable. *Smiling Irish Eyes* (1929), her first talking picture, contained all the sound on discs, so there were no retakes and the film was cut as it went. Moore recalled it as "the longest, dullest film on record." Her subsequent talkies included *Footlights and Fools* (1929), with Fredric March, and *The Power and the Glory* (1933), with Spencer Tracy, which remained Moore's personal favorite. "It wasn't the longest part or anything like that, but it was every actress' delight to go from sixteen to sixty." Moore's last effort, *The Scarlet Letter* (1934), was a box-office failure, and she left films soon afterwards, claiming that she could no longer play the little girls the public demanded.

Colleen Moore was married four times; her last husband, building contractor Paul Maginot, whom she wed at age 83, survived her. She claimed that her first husband, John McCormick, who was head of production for National and oversaw her early career, was an alcoholic, and she divorced him in 1930 after seven years of marriage. Her second and third husbands were stockbrokers, which was probably a factor in her own financial savvy. In addition to an autobiography, *Silent Star*, she authored a book on investing, *How Women Can Make Money in the Stock Market*. She also published a book about her extraordinary collection of miniatures, *Colleen Moore's Doll House*. The priceless collection, housed in a doll house especially designed by studio set designer Horace Jackson, was displayed around the country for the benefit of children's charities and later became a prized exhibit at Chicago's Museum of Science and Industry. Moore spent her final years at her sprawling house "El Ranchito," in Templeton, California, and died in 1988.

SOURCES:

Drew, William M. *Speaking of Silents: First Ladies of the Screen*. Vestal, NY: Vestal Press, 1983.

Katz, Ephraim. *The Film Encyclopedia*. NY: HarperCollins, 1994.

Lamparski, Richard. *Whatever Happened to . . . ?* 2nd Series. NY: Crown, 1967.

Barbara Morgan,
Melrose, Massachusetts

Moore, Grace (1898–1947)

Noted American singer whose career included work in opera, musical comedy, concerts, movies, radio, and recordings. Born Mary Willie Grace Moore on December 5, 1898, in Slabtown, Tennessee; died in a plane crash at Copenhagen, Denmark, on January 26, 1947; daughter of Richard Lawson Moore (a manager in a lumber company) and Tessie Jane (Stokely) Moore; attended Ward-Belmont School for Girls, Nashville, 1916–17, Wilson-Greene School of Music, 1917–19; married Valentin Parera (a Spanish film actor), on July 15, 1931.

Moved with family to Knoxville, then to Jellico, Tennessee (1903); heard performance by Mary Garden (1917); made first concert appearance (1919); made first appearance in New York musical (1920); debuted with the Metropolitan Opera (1928); appeared in first Hollywood film (1931); starred in the smash film success One Night of Love *(1934); made debut in London (1935); awarded France's Legion of Honor (1939); made goodwill tours of Latin America (1940–41); went on wartime USO tours (1942–45); published her autobiography (1944); Hollywood film about her life,* So This is Love, *released (1953).*

Grace Moore was one of the first American-born singers to rise to the level of a star in grand opera. Her initial efforts to make a name for herself in the musical world brought her only to the Broadway stage and vaudeville, but by the age of 30 she had attained her ambition. Her career lasted for two decades until she died in a tragic plane crash following a concert in Denmark. Moore was a controversial figure for a number of reasons; despite her obvious talent as a singer, her performances were often uneven, and some critics had open reservations about the quality of her voice. Moreover, her mercurial personality—with a temperament that was strong even by the standard of opera stars—alienated many who knew her. Nonetheless, her work in film and radio helped make operatic music part of those entertainment media for the first time.

The future singing star was born on December 5, 1898. Her mother **Tessie Stokely Moore** was a member of a long-established family of landowners in the Great Smoky Mountain region of Tennessee. Her father Richard Lawson Moore was a recent arrival to the community who had come from North Carolina to help run the commissary of the local lumber company.

Uprooted when she was only five by her father's business ventures in various parts of Tennessee, Grace found herself living first in the

large city of Knoxville, then in the small coal-mining town of Jellico. In the summers, however, Tessie, Grace, and the other children returned to the area of Grace's birth. Thus, her country roots remained strong as she spent much of her childhood in rural Tennessee. Her first exposure to music was the fiddle-playing and other music that locals produced on homemade instruments for the annual harvest festival. An early source of tension in her life was her father's opposition—based on a rigid Baptist religious faith—to such frivolity.

Early on, the young girl gave signs of the mercurial personality that was to mark her life. The death of one of her younger brothers in 1906 brought on a family crisis to which she responded with truancy, foul language, and an episode of stealing. On another occasion several years later, she violated the Baptist Church's strict norms against dancing and was compelled to make a humiliating public apology for her conduct in front of her congregation. The event left a lasting impression, further undermining her willingness to submit to such restrictions.

An influence of another kind was her family's relative lack of religious and racial prejudice. Anxious to prosper in business, Richard Moore had cordial ties with Catholics, Jews, and even members of the local black community. His thrift and energy led to a prominent position as a dry-goods merchant, and his political work and connections brought him the reward of being named an honorary Tennessee colonel. As Moore's biographer **Rowena Farrar** notes, "Grace inherited her shrewdness, sales ability, and fierce drive to succeed from her father." Farrar attributes Moore's creativity, as well as her psychological propensity "to sulk and exaggerate," to her mother.

By the time Grace Moore left for the prestigious Ward-Belmont boarding school for girls in Nashville in the fall of 1916, she had already begun to set her sights on a career as a singer. She made a strong impression on the dean of the voice department at Ward-Belmont, but otherwise her several months there were a disaster. Her neglect of her studies, her lack of discipline, and her foul language led to her expulsion in January 1917. Twenty-four years later, at the height of her success, she was warmly welcomed on a return visit to the school, and she, in turn, established a scholarship fund to support students there.

Moore took the initiative in planning the next step in her education. She virtually compelled her father to let her attend the Wilson-Greene School of Music in Washington, D.C., by making all of the arrangements herself, then asking for his blessing. The school provided the aspiring singer with vocal training and an example of high standards. Singing in a local Baptist church, she earned her first professional income.

A crucial experience during her first year in Washington came when Moore attended a concert given by *Mary Garden and met the woman who was one of the leading musical figures of the day. Garden's performance to benefit wounded Allied soldiers made the teenage girl determined that she would use her own musical talent to rise to that level of eminence. For the first time, Moore wanted to become a star of opera. In time, she would become closely acquainted with Garden, and the older woman would repeatedly encourage Moore's ambitions.

Grace Moore made her operatic debut at the age of 20 on February 20, 1919, singing an aria from *Aïda* at Washington's National Theater, during the annual concert of the Wilson-Greene School. Only a few months later, she gave up her place at the school, and, despite her father's objections to her pursuing a stage career, set off for New York. He followed, tried to persuade her to change her mind, then gave up after she promised to appear only in lady-like plays.

After an impromptu appearance at a singing contest in a Greenwich Village night club, Moore was rewarded with a short stint as a modestly paid performer there. Her success brought her a permanent place and a substantial raise at the establishment, the Black Cat Cafe. She also found a range of new acquaintances with connections to the larger world of the theater. Less favorably, her vocal cords suffered severe damage from her frequent appearances in the poorly ventilated cafe. The damage was probably heightened by the advice she received from a mediocre singing teacher—the best she could afford at the time—who forced the pace of her voice's natural development. Only a consultation with a doctor, P. Mario Marafioti, who specialized in caring for the throats of the Metropolitan Opera's stars, set her on the right track. Marafioti ordered a regime of complete silence for three months, and he cautioned that even then she might remain unable to sing again. She obeyed his instructions to the letter, hibernating in a friend's Canadian vacation home on an island in the St. Lawrence River.

By the close of 1919, Moore had returned to performing. A vaudeville appearance in November led in turn to a part in a touring operetta, *The Chocolate Soldier*. After some unsuccessful

auditions and a brief part in a musical that failed to survive its pre-Broadway out-of-town tryouts, she made her Broadway debut in *Hitchy Koo* in 1920. She soon had the opportunity to fill in for the stricken star of the play, and, in short order, she was a popular showgirl, squired around town by some of New York's most privileged young men. She became acquainted with such luminaries of the financial world as Bernard Baruch while joining in the social activities of the group of writers and composers who congregated at the famous Round Table of the Algonquin Hotel. Her romance with George Biddle, the son of a prominent Philadelphia family and a rising artist and sculptor, nearly led to their marriage, but a combination of ambition and wanderlust convinced Moore that such a marriage would be premature for her.

Still hoping for a career in opera, Moore sailed for Europe and settled in Paris in 1922. As usual, she found it easy to enter elevated levels of the social and artistic scene, developing friendships with Cole Porter and Noel Coward. She was also able to contact her idol Mary Gar-

den who encouraged Moore's singing ambitions. Nonetheless, her declining bank account made it impossible for her to remain in Europe, and she accepted an offer from Irving Berlin to appear in the 1923 version of his *Music Box Review* in New York City.

Her appearance was a glowing success. One critic noted that Moore had "one of the rare soprano voices in which warmth and vitality vie with clearness and sweetness of tone." A darker part of her successful moment was the hostility that she aroused among her fellow performers. The length of her curtain calls, for example, led some to complain loudly that she should give others a chance to enjoy the plaudits. Moreover, the praise she received for her achievements on the Broadway stage failed to satisfy her ambition for an operatic career. In 1925, determined to move upward, she gave up her work on Broadway and returned to Europe for further study.

Three years of hard work with a number of European vocal teachers won her a contract with the Metropolitan Opera, and her debut

Grace Moore

performance was scheduled for the first part of 1928. Typically, Moore ignored a note of caution offered by a leading Italian conductor who heard her final audition. He advised her she was not yet ready for a New York audience and suggested gaining a year of experience in the smaller opera houses of Europe.

On February 7, 1928, in front of an audience that included many members of her family as well as a hundred fellow citizens of Tennessee who had come by special train to cheer her on, Grace Moore appeared as Mimi in *La Bohème*. Her performance was marred by her obvious nervousness in the early portions of the evening, but she received a wealth of good reviews. Even critics who did not like her performance, like W.J. Henderson of the *New York Sun*, praised the quality and warmth of her voice.

Her career now flourished. When Moore sang in Europe, her performance as Mimi at the Opéra-Comique in Paris drew an enthusiastic response from both critics and the audience. Soon afterward, she established herself as a vocal star on American radio when she appeared on NBC's "General Motors Hour." She then went on to try her luck in the movies.

I am the girl who took the high hat off grand opera.

—Grace Moore

Although Moore's first screen test made her look overweight, she was offered a movie contract by MGM with the stipulation that she lose 15 pounds and then continue to keep her weight at an acceptable level. With daily self-discipline, she lived on clear soup, crackers, and tea to become the slim beauty movie audiences would soon see in 1931's *A Lady's Morals*. The film, a biography of the 19th-century singing star *Jenny Lind, did not do well at the box office, and Moore's singing in the film suffered from poor recording techniques. She had no more notable success with her second film, *New Moon*. When MGM dropped her option, her film career seemed at a end, though she could console herself with the failure of other opera stars, like Lawrence Tibbett, to cross over into films in the early years of sound movies.

Moore suffered some kind of physical ailment in the early 1930s; Farrar alludes to the possibility that she underwent a botched abortion. In any case, she required a hysterectomy which ended her hope of someday having a large family. A brighter element in her life at this time was her romance with the Spanish film actor Valentin Parera, whom she married in Cannes on July 15, 1931.

The marriage weathered a number of strains. Moore's Southern family was reluctant to accept a dark-skinned Spanish Catholic. Moreover, her greater degree of professional success meant that Moore's husband had to adjust his life to her needs as a widely traveling singing star. He effectively took on the role of her business manager, and this led to remarks among their acquaintances that he was living off her talent in an unmanly fashion.

The impact of the Depression on the Metropolitan Opera made it difficult for the couple to rely upon Moore's career there. She soon turned to light opera and even to vaudeville performances, as well as frequent appearances on the radio. But her most important breakthrough came in 1934 when she starred in the Hollywood film *One Night of Love*. In it, she presented a variety of musical works, including substantial selections from grand opera. The film was nominated for an Academy Award, it drew large audiences, and it made Moore a box-office star. As a popular success, it proved that American film audiences would accept and even welcome movies that contained extended performances of serious music. As Moore herself later wrote in her autobiography, "It took grand opera to the ends of the world and brought a new public into the opera houses." As for her fellow performers, it "made all opera stars movie-minded."

In 1935, Moore began a regular half-hour broadcast on the NBC network. Singing weekly, she combined musical selections with a chatty conversation with her audience over topics concerning her life and her work. Her most popular song, "Ciribiribin," was an Italian folk tune which she had first heard in Italy on her honeymoon. The combination of her earnings from radio and the large sums she could now ask for her concert appearances made her wealthy enough to enjoy the privileges of a popular idol: a house in Beverly Hills, a staff of servants, and a flood of letters from her admirers. That same year, Moore had a wild success in her London debut at Covent Garden. At the subsequent party in her honor, she made the acquaintance of the prince of Wales, as well as other leaders of London society.

During the remaining years before the outbreak of World War II, the increasingly popular singer continued to make films, to appear on the radio, and to tour widely in both Europe and the United States. She was making a film version of Gustave Charpentier's opera *Louise* in the fall of 1938 when Adolf Hitler's threatened invasion of Czechoslovakia raised the possibility that the

project would be suspended. She remained in France in the face of a warning from the American ambassador for all Americans to return home at once. In August 1939, with war imminent, Grace Moore and her husband left Le Havre on a ship so crowded that cots were spread everywhere to hold 1,500 passengers desperate to escape from Europe. When the ship had been at sea for two days, word came through that the war had begun with Hitler's invasion of Poland.

The year following Moore's return to the United States was filled with a number of difficult developments. Her husband became seriously ill with tuberculosis and was forced into a long stay at the sanatorium at Saranac Lake, New York. Starting in the spring of 1940, Moore made an extensive tour of the United States and Canada; this was followed by a goodwill visit to Mexico sponsored by the American Department of State. The trip to Canada included being stranded on her railroad train by a blizzard, and the stay in Mexico was marked by the country's worst earthquake in 25 years. In the aftermath of the earthquake, American newspapers carried a story that she had been killed.

Under the strain of her husband's illness, Moore repeatedly exhibited the fiery temperament for which she was already famous. In one instance, during a second goodwill tour encompassing all of South America, she refused to appear at a party given in her honor by the foreign minister of Brazil because the minister's wife was not serving as the hostess of the event.

During the years of America's participation in World War II, Moore devoted much of her energy to entertaining the country's armed forces. "Wearing an exquisite concert gown," writes Farrar, "she would stride on stage and electrify the audience with her vitality, radiance, and good will." At the same time, her personal life drew increasingly critical comments. With her husband now an invalid, she became involved with a number of other men during her travels.

The war years also brought Moore into a new role as an author. The singer initially intended to write a book containing a collection of recipes she had obtained during her years as an enthusiastic amateur cook and patron of distinguished restaurants. The final product instead turned out to be the story of her life, and *You're Only Human Once* was published in March 1944. It soon reached the bestseller list.

In the final years of her life, Grace Moore toured widely in the U.S. and Europe. She was no longer the glamorous star of only a few years before: overweight and often distracted, she would sometimes lose her bearing on stage, and audiences found her forgetting the lyrics to a song or beginning to sing in the wrong key. Her singing technique, which had often been a target for critics throughout her career, now deteriorated dramatically. One notably bad performance as Mimi in *La Bohème* in New York City's Lewisohn Stadium in the summer of 1946 brought a cool response from her audience and scathing critical reviews.

Grace Moore performed for the last time in Copenhagen, Denmark, on Saturday, January 25, 1947. The following day, the plane taking her from Copenhagen's Kastrup Airport to her next engagement in Stockholm stalled after take-off and crashed. All 16 passengers—including Moore and Sweden's Prince Gustav Adolph—were killed along with the crew of six.

SOURCES:
Farrar, Rowena Rutherford. *Grace Moore and Her Many Worlds*. NY: Cornwall Books, 1982.
Moore, Grace. *You're Only Human Once*. Garden City, NY: Garden City, 1946.
Notable American Women, 1607–1950: A Biographical Dictionary. Vol. II. Edited by Edward T. James, *et al.* Cambridge, MA: Belknap Press of Harvard University Press, 1971.
Shipman, David. *The Great Movie Stars: The Golden Years*. NY: Bonanza Books, 1970.

SUGGESTED READING:
Rasponi, Lanfranco. *The Last Prima Donnas*. NY: Alfred A. Knopf, 1982.
Tuggle, Robert. *The Golden Age of Opera*. NY: Holt, Rinehart and Winston, 1983.

Neil M. Heyman,
Professor of History, San Diego State University, San Diego, California

Moore, Juanita (1922—)

African-American actress. Born in 1922.

Selected filmography: Lydia Bailey *(1952);* Affair in Trinidad *(1952);* Witness to Murder *(1954);* Women's Prison *(1955);* Ransom *(1956);* A Girl Can't Help It *(1956);* A Band of Angels *(1957);* Green Eyed Blonde *(1957);* Imitation of Life *(1959);* Tammy Tell Me True *(1961);* A Raisin in the Sun *(1961);* Walk on the Wild Side *(1962);* Papa's Delicate Condition *(1963);* The Singing Nun *(1966);* Rosie *(1968);* Up Tight *(1968);* The Skin Game *(1971);* Fox Style *(1973);* Thomasine and Bushrod *(1974);* Abby *(1974);* Two Moon Junction *(1988).*

A notable African-American character actress, Juanita Moore won an Academy Award nomination for Best Supporting Actress for her

role as a mother, entrepreneur, and housekeeper in Douglas Sirk's *Imitation of Life* (1959), starring *Lana Turner, Sandra Dee, and *Mahalia Jackson. Moore appeared frequently in supporting roles in films and on television from 1950 to 1980.

Moore, Marianne (1887–1972)

American poet, editor, and scholar who was a shaping force in the American Modernist tradition. Born Marianne Craig Moore on November 15, 1887, in Kirkwood, Missouri; died in New York on February 5, 1972; daughter of John Milton Moore and Mare (Warner) Moore (an English teacher); attended the Metzger Institute, Pennsylvania; Bryn Mawr College, B.A., 1909; graduated from Carlisle Commercial College, 1910; never married; no children.

Lived with her mother, brother, and maternal grandfather until she was seven; moved after grandfather's death to Carlisle, Pennsylvania (1894), where Mary Moore began work as a teacher; submitted poems to college literary magazine, Tipyn o'Bob (1907–10); cultivated an interest in 17th-century prose writers who remained influences on her work; traveled abroad (summer 1911); taught and coached at the U.S. Indian School in Carlisle (1911–15); first poem, a satire on war, appeared in the Egoist; other poems published in Poetry the same year (1915); work reviewed in Egoist by H.D., a Bryn Mawr classmate (1916); began keeping a notebook that became a storehouse of ideas for poems (1916); moved with her mother to New York City (1918); worked as private tutor, secretary, and assistant in the Hudson Park branch of the New York Public Library; became part of a circle that included Wallace Stevens, William Carlos Williams, and others; became acting editor of the Dial, influential literary magazine (1925–29); moved with her mother from Greenwich Village to Brooklyn (1929), where she lived for nearly 40 years; became critic and reviewer of works by many of her contemporaries (1920s); met Elizabeth Bishop (1934) and began a correspondence that lasted until her death; began translation of La Fontaine's Fables (1945); nursed her mother through numerous illnesses; Mary Moore died (1947); threw out the first baseball at Yankee Stadium (1968); continued to write and translate until shortly before her death.

Awards: Dial Award (1925); Helen Haire Levinson Prize from Poetry (1932); Ernest Hartsock Memorial Prize (1935); Shelley Memorial Award (1940); Guggenheim fellowship (1945); Pulitzer Prize (1951); National Book Award (1951); Bollingen Award (1953); National Medal for Literature (1968); membership in National Institute of Arts and Letters, American Academy of Arts and Letters, Chevalier de l'Ordre des Arts et des Lettres; 16 honorary degrees.

Selected writings: Poems (1921); Observations (1924); Selected Poems (1935); The Pangolin and Other Verse (1936); What Are Years (1941); Nevertheless (1944); Collected Poems (1951); The Fables of La Fontaine (1954); Predilections (1955); Like a Bulwark (1956); O to Be a Dragon (1959); A Marianne Moore Reader (1961); Tell, Me, Tell Me: Granite, Steel, and Other Topics (1966); The Complete Poems of Marianne Moore (1967); The Complete Poems of Marianne Moore (revised ed., 1981); The Complete Prose of Marianne Moore (1986).

In a 1966 interview for *Shenandoah*, the poet *Elizabeth Bishop expressed her discomfort with poetry that seemed complacent in its convictions and praised her friend Marianne Moore for writing poetry without reliance on a single myth or system. In Moore's poems, Bishop said, "a remarkable set of beliefs appears over and over again, a sort of backbone of faith." Bishop's metaphor contrasts myth with an organic structure that supports its body's weight without rigidity, a center constructed of small well-articulated components allowing a range of movements and postures. The metaphor also implies fragility; damage to the backbone has impact on the entire body. Bishop's image attributes all of its qualities—strength, flexibility, and vulnerability—to Moore's poetry. We see the body of work as if it were one of the many posed, agreeable animals found in Moore's work—Peter the cat, "springing about with froglike accuracy," or the jerboa, launching itself "as if on wings, from its match-thin hind legs."

Bishop's description of Moore's work is accurate as well as affectionate and can be of real service to the new reader of Moore's poetry, a sometimes daunting mixture of surprising perceptions, stylistic innovations, and quiet erudition. A committed reader will find the "backbone" and learn to delight in poetry that is both strong and lissome. The poems are rich in precise details, often gathered from careful observation of animals and human artifacts, but even those that seem most detached from human experience may gradually reveal themselves as gently ironic explorations of our shortcomings and follies.

Marianne Moore was born in 1887 in Kirkwood, Missouri (a suburb of St. Louis), home of the Reverend John Riddle Warner, her maternal grandfather. Her father John Milton Moore was

Marianne
Moore

institutionalized with mental illness before she was born, and they never met. Moore, her brother John, and their mother **Mary Moore** lived in Missouri until Marianne was seven years old, when her grandfather died, and then moved to Carlisle, Pennsylvania. Mary Moore found a

position teaching English at the Metzger Institute, and Moore was enrolled as a student there. Her first ambition was to be a painter, for which she showed some talent, but when she entered Bryn Mawr College she was leaning toward a concentration in English. Ironically, she was ac-

tively discouraged from this field of study, on the basis that her writing was not good enough; she majored in social science and biology instead, but submitted both poetry and short fiction to the college literary magazine. Poetry came to hold particular interest for Moore quite early and remained a focal point. (Although she contributed many important critical essays and reviews to American letters throughout her professional career, writing fiction claimed little of Moore's attention. A piece of fiction begun in 1929 was still unfinished four years later, when she mentioned it to a publisher, and was in fact never completed.)

After graduating from Bryn Mawr (1909) and Carlisle Commercial College (1910), Moore spent four years at the U.S. Indian School in Carlisle, where she taught stenography and bookkeeping and coached outdoor sports. Athletics remained an abiding passion: interviews with Moore in later years were often enlivened by her informed judgments on baseball, especially as played by her beloved Brooklyn Dodgers. Like the animals who most charmed her, athletes were "miracles of dexterity."

To explain grace requires a curious hand.

—Marianne Moore, from "The Pangolin"

Moore and her mother spent the summer of 1911 traveling in England and France and then settled back down to live together, as they did until Mary Moore's death. They remained in Carlisle until 1915, a momentous year for Moore. Her first poems were published that year, in the *Egoist*, *Poetry*, and *Others*, and she submitted a manuscript of more than 60 poems to Malory House for a series of works by modern poets. She was unsuccessful in the latter venture, but in 1916, Moore asked H.D. (*Hilda Doolittle) for help in finding a publisher. This manuscript eventually became *Poems* (1921), submitted by friends, without Moore's knowledge, and published by Egoist Press. The same year saw Moore in New York for a week's visit, a trip that had far-reaching consequences, both personal and professional. While there, she met several influential writers and artists, including the photographer Alfred Stieglitz; she also met Guido Bruno, who published four of her poems the following year.

Moore and her mother moved to New York in 1918, after a two-year residence in New Jersey, near her brother. Moore had been eager to make New York her center since her first brief visit, and the change satisfied long-time desires for a real community and a larger scope for her imagination. Her poem "New York" (1921) ends with a comment (quoting Henry James) on the "accessibility of experience" offered by the city. The 1910s and 1920s gave Moore a wide range of new experiences: she worked at a variety of jobs while writing and submitting poems shaped by themes that would engage her attention to the end of her life. Poems like "Poetry" (1919), in which Moore hopes for a future when poets will rise above "insolence and triviality" and make "a place for the genuine," explore claims for what writing can or should accomplish. The same period saw Moore struggling to deal with the effects of war and other challenges of modern life. "The Fish" (1921) describes an underwater scene, swirling around a cliff that is beautiful but devastated by "external marks of abuse." The juxtaposition of life and death closes with a characteristically cool but pointed conclusion. The chasm-side is both dead and eternal; "the sea grows old in it." Although the poem remains firmly placed underwater, the ominous images imply metaphorical connections to the world of human experience. Such oblique connections between the natural and the human realm are quite common to Moore's work.

Observations, published in 1925, confirmed impressions left by *Poems* (1921) that American poetry had something new in Moore's work. The poems were typically Modernist in many ways—clearly influenced by Imagist and French Symbolist forerunners—but certain stylistic elements were uniquely Moore's. The poems were composed of long sentences, owing much to prose styles, but chopped and arranged in lines of varying length. The form of a typical poem looks random at first: careful analysis reveals a tight construction utilizing both rhyme and meter. Unlike most metrical poetry in English, Moore's is composed on the basis of the *number* of syllables in a line, rather than on a pattern of stressed and unstressed syllables. She was influenced by French verse in this regard. Like the earlier volume, *Observations* included a number of poems written to or about favorite animals. She was particularly fond of animals with quirky habits of characteristics. Metaphorical comparisons and contrasts between animals and humans animate many of Moore's poems, but such connections are rarely direct and never cruel.

During the 1920s, Moore began a second career as critic and reviewer. Many of the prose pieces appeared in the *Dial*. Her comments on work by T.S. Eliot, Ezra Pound, Wallace Stevens, Elizabeth Bishop, William Carlos Williams, and other influential writers make interesting reading and remain helpful even now. She turned her

critical talents to good use as the acting and then permanent editor of the *Dial* (1925–29), where she remained until its demise. Moore and her mother moved from Greenwich Village to Brooklyn when the *Dial* ceased publication. Her editorship of the magazine coincided with a brief hiatus (1925–32) when Moore published no poems of her own.

Selected Poems came out in 1935, closely followed by *The Pangolin and Other Verse* (1936). These books further explore territory mapped out in earlier work. They contain some of Moore's finest poems and continue her experiments with free verse, the shape of the line, and her idiosyncratic use of quotations (always scrupulously punctuated and attributed to their sources), mostly prose passages drawn from her reading in various disciplines. Moore met Elizabeth Bishop in 1934, an occasion that fostered an important friendship and one of the most fruitful professional partnerships of the century. Wide-ranging correspondence between the two encouraged each to keep working; Moore's interest in rhyme was bolstered by Bishop's ingenuity in her own work.

During the 1940s and subsequent years, Moore produced fewer poems, and many critics see a decrease in the quality of her work, as well. She published *What Are Years* (1941) and *Nevertheless* (1944) and then no more poetry until *Like a Bulwark* (1956). Personal hardship accounted in part for the slow-down; her mother, long in frail health, began a serious decline in the 1940s and died in 1947. Moore's own health was precarious, and nursing her mother certainly took a great deal of heart and energy that might otherwise have gone into her writing. The project that tided Moore over during these years was a piece of translation that W.H. Auden asked her to take on. She began working on La Fontaine's *Fables* in 1945 and published the completed translation in 1954. During the 1950s, she translated shorter works and wrote a play. *Predilections*, a collection of her prose pieces, was published in 1955. Moore's last two books of poetry, *O to Be a Dragon* (1959) and *Tell Me, Tell Me: Granite, Steel, and Other Topics* (1966), were of uneven quality.

From the 1960s on, Moore was probably more famous as a lovable eccentric than as a poet. At some point in middle age, she had begun wearing a black cape and tricorn hat that became her trademarks. Her love of baseball and her loyalty to the Brooklyn Dodgers endeared her to many who would not otherwise have known her. In one well-publicized episode in her public life, in 1955 Moore had been asked to suggest names for the car eventually called the

Edsel. Her list, not surprisingly, contained a number of names of animals, chosen for their most agreeable or impressive qualities. Nevertheless, Moore's poetry and her critical acumen have established her as one of the central figures of the Modernist era. Her work is precise and difficult, although hardly impenetrable. Very few poems are about the speaker's experience in any direct way. They tend instead to look at human and natural worlds from a slight distance, employing precision and restraint in description, offering clear-eyed criticism and compassion in roughly equal measures. Moore's affection for creatures of all kinds is central to her work. Intellectual but not stuffy, the poetry and prose consider problems of experience, the predations of time, the chaos at the core of modern life, in ways that are both realistic and hopeful.

SOURCES:
Brown, Ashley. "An Interview with Elizabeth Bishop," in *Shenandoah*. Vol. 17. Winter 1966, pp. 3–19.
Costello, Bonnie. *Marianne Moore: Imaginary Possessions.* Cambridge, MA: Harvard University Press, 1981.
Kalstone, David. *Becoming a Poet.* NY: Farrar, Straus and Giroux, 1989.
Moore, Marianne. *The Complete Poems.* NY: Viking Press, 1981.

SUGGESTED READING:
Engel, Bernard F. *Marianne Moore.* NY: Twayne, 1989.
Hall, Donald. *Marianne Moore: The Cage and the Animal.* NY: Western, 1970.
Jarrell, Randall. "Her Shield," in *Poetry and the Age.* NY: Alfred A. Knopf, 1953.
Molesworth, Charles. *Marianne Moore: A Literary Life.* NY: Atheneum, 1990.
*Monroe, Harriet. "A Symposium on Marianne Moore," in *Poetry.* Vol. 19, 1922, pp. 208–216.
Ostriker, Alicia. *Stealing the Language: The Emergence of Women's Poetry in America.* Boston, MA: Beacon Press, 1986.

COLLECTIONS:
Correspondence and other papers located at Rosenbach Museum and Library, Philadelphia; Beinecke Rare Book and Manuscript Library, Yale University; Berg Collection, New York Public Library.

Mary M. Lacey,
Assistant Professor of English, Earlham College, Richmond, Indiana

Moore, Mary (1861–1931).

See Wyndham, Mary.

Moore, Queen Mother Audley (1898–1997).

See Moore, Audley.

Moorehead, Agnes (1900–1974)

American actress who was nominated for four Academy Awards. Born on December 6, 1900 (also seen as 1906), in Clinton, Massachusetts; died on April 30,

1974, in Rochester, Minnesota; eldest of two daughters of John Moorehead (a Presbyterian minister) and Mary Mildred (McCauley) Moorehead (a professional singer); attended school in Reedsburg, Wisconsin; Muskingum College in Ohio, B.A., 1928; University of Wisconsin, M.A.; Bradley University, honorary Ph.D.; graduated from the American Academy of Dramatic Arts, New York City, 1929; married John Griffith Lee (an actor), on June 6, 1930 (divorced 1952); married actor Robert Cist (divorced 1958); children: (adopted) son, Sean (b. 1949).

Selected filmography: Citizen Kane *(1941);* The Magnificent Ambersons *(1942);* The Big Street *(1942);* Journey into Fear *(1943);* The Youngest Profession *(1943);* Government Girl *(1943);* Jane Eyre *(1944);* Since You Went Away *(1944);* Dragon Seed *(1944);* The Seventh Cross *(1944);* Mrs. Parkington *(1944);* Tomorrow the World *(1944);* Keep Your Powder Dry *(1945);* Our Vines Have Tender Grapes *(1945);* Her Highness and the Bellboy *(1945);* Dark Passage *(1947);* The Lost Moment *(1947);* The Woman in White *(1948);* Summer Holiday *(1947);* Johnny Belinda *(1948);* Station West *(1948);* The Stratton Story *(1949);* The Great Sinner *(1949);* Without Honor *(1949);* Caged *(1950);* Fourteen Hours

(1951); Show Boat *(1951);* The Blue Veil *(1951);* The Adventures of Captain Fabian *(1951);* Captain Black Jack *(1952);* The Blazing Forest *(1952);* The Story of Three Loves *(1953);* Scandal at Scourie *(1953);* Those Redheads From Seattle *(1953);* Main Street to Broadway *(1953);* Magnificent Obsession *(1954);* Untamed *(1955);* The Left Hand of God *(1955);* All That Heaven Allows *(1956);* Meet Me in Las Vegas *(1956);* The Conqueror *(1956);* The Swan *(1956);* The Revolt of Mamie Stover *(1956);* Pardners *(1956);* The Opposite Sex *(1956);* The True Story of Jesse James *(1957);* ***Jeanne Eagels** *(1957);* The Story of Mankind *(1957);* Raintree County *(1957);* Night of the Quarter Moon *(1959);* Tempest *(1959);* The Bat *(1959);* Pollyanna *(1960);* Twenty Plus Two *(1961);* Bachelor in Paradise *(1961);* Jessica *(1962);* How the West Was Won *(1962);* Who's Minding the Store? *(1963);* Hush Hush . . . Sweet Charlotte *(1965);* The Singing Nun *(1966);* What's the Matter with Helen? *(1971);* Dear Dead Delilah *(1972); (voice only)* Charlotte's Web *(1973).*

Called a "character actress in the best sense of the term," Agnes Moorehead was a one-woman virtuoso. Orson Welles, who gave the actress her start in films, was the first to recognize her incredible range. "He thought I could play anything," Moorehead once remarked. "If it was a strange part, he said, 'Give it to Agnes. She can play it.'" In a career that spanned 44 years and encompassed radio, stage, film, and television, Moorehead portrayed characters of every age and sensibility, bringing to each role, regardless of its size, a supreme professionalism.

Of Scottish and Irish ancestry, Moorehead was born in 1900 in Clinton, Massachusetts, the eldest of two daughters of John Moorehead, a Presbyterian minister, and **Mary McCauley Moorehead**, an erstwhile professional singer. Agnes was strongly influenced by her mother's love of the arts, and made her performance debut at the age of three, singing "The Lord Is My Shepherd" in a church event. Although she wanted to be an actress from an early age, she took her father's advice and finished her education first, receiving a B.A. from Muskingum College, a religious institution in Ohio founded by her uncle. Moorehead then taught public speaking and English at a high school in Soldiers Grove, Wisconsin, during which time she was also heard as the "Female Tenor," on fledgling radio stations KSO and KMOX in St. Louis. When she had saved enough money, Moorehead went to New York City, where she enrolled in the American Academy of Dramatic Arts in 1927, teaching school to support herself. After

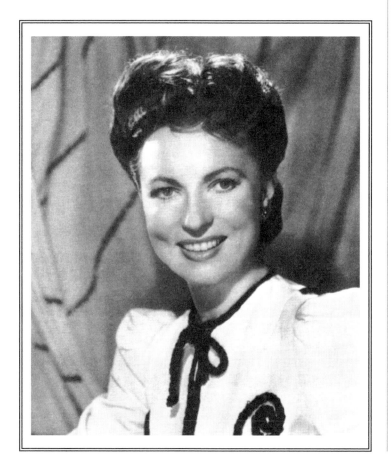

Agnes Moorehead

graduating in 1929, she started her acting career, playing small roles in Theater Guild productions of *Marco's Millions*, *Scarlet Pages*, *All the King's Horses*, *Soldiers and Women*, and *Candlelight*.

Moorehead was well on the road to establishing herself on stage when the Depression halted her progress. She turned once again to radio, taking part in literally thousands of shows (sometimes up to six a day), including "The March of Time," "The Shadow," and several daytime soap operas. In a 1939 performance on "Cavalcade of America," she played *Marie Dressler in a dramatized biography of the star, winning a rave review from *Variety*, especially for her vocal changes from youth to old age. A subsequent performance as one of several audibly terrified women in the background of the 1938 Mercury Theater of the Air's presentation of "War of the Worlds," caught the attention of Orson Welles and John Houseman who recruited her for the Mercury Players. When the group moved its base of operation to Hollywood in 1940, Moorehead went along.

Welles gave Moorehead small but pivotal roles in two of his early films: *Citizen Kane* (1941), in which she played Kane's mother, and *The Magnificent Ambersons* (1942), in which she portrayed the neurotic spinster Aunt Fanny, a performance that won her the New York Film Critics Award and an Academy Award nomination. In 1943, Moorehead was back on the radio on "Suspense," playing a bedridden invalid who overhears a plot on the telephone for her own murder in **Lucille Fletcher**'s "Sorry, Wrong Number." "From the woman's first faltering lines, through the series of growing dread to the final moments of gibbering semidelirium, it was a blood-chilling performance," reported *Variety*. The program was repeated a number of times over the next four years, and the recording eventually won a gold record. Moorehead, however, was passed over for the role in the film version, which went to *Barbara Stanwyck.

Moorehead, who played supporting roles in numerous movies, proved herself time and again. She received three additional Academy Award nominations for her portrayals in *Mrs. Parkington* (1944), *Johnny Belinda* (1948), and *Hush Hush . . . Sweet Charlotte* (1964). Along with films, Moorehead continued her radio work, playing Cora Dithers on the popular comedy "Blondie," and frequently joining Orson Welles in "Ceiling Unlimited" and "Hello Americans."

For three seasons beginning in 1951, Moorehead was part of the First Drama Quartet's dramatic reading of *Don Juan in Hell*, the rarely per-formed third act of G.B. Shaw's lengthy play *Man and Superman*. Actors Charles Boyer, Cedric Hardwicke, and Charles Laughton completed the quartet; their unusual performance was extremely well received. Describing Moorehead's Donna Ana, the New York *World Telegram*'s William Hawkins wrote: "The actress has the crisp, clean elegance of a lily. She falls into exquisite poses and moves like a self-appointed queen, to give the play its chief visual attraction." After performances in Stockton, California, and Washington, D.C., the Quartet undertook an international tour of high schools, churches, synagogues, and town halls, attracting capacity audiences.

At Charles Laughton's suggestion, Moorehead put together a one-woman show, *The Redhead*, comprised of a series of readings from sources as varied as James Thurber and the Bible. She toured the show in 1954, and intermittently over the next ten years. Later she mounted an international tour with a revised version, *Come Closer, I'll Give You an Earful*.

Agnes Moorehead also appeared on television, gaining wide recognition for her portrayal of Endora on the comedy series "Bewitched" (1963–1971). Although she was nominated for an Emmy Award three times for her role in the popular sit-com, she won the coveted award not for "Bewitched" but for a single appearance in an episode of "Wild, Wild West."

Distinguished by her red hair and her gothic beauty, Moorehead guarded her privacy, believing it was in her best interest to remain a mystery. In 1930, she married John Griffith Lee, an actor she had met when she was at the Academy of Dramatic Arts. The couple divorced in 1952, shortly after adopting a son, Sean. In 1953, Moorehead married another actor, Robert Gist, from whom she was soon separated, although they did not divorce until 1958. During her later years, she opened her own acting school and also lectured on acting at various colleges across the country. She made her final stage appearance in a 1973 revival of *Gigi*, just a year before she died of lung cancer.

SOURCES:
Current Biography 1952. NY: H.W. Wilson, 1952.
Katz, Ephraim. *The Film Encyclopedia*. NY: HarperCollins, 1994.
Sicherman, Barbara, and Carol Hurd Green, eds. *Notable American Women: The Modern Period*. Cambridge, MA: The Belknap Press, 1980.

SUGGESTED READING:
Sherk, Warren. *Agnes Moorehead: A Very Private Person*, 1976.

Barbara Morgan,
Melrose, Massachusetts

Mora, Constancia de la

(1906–1950)

Spanish activist during the Spanish Civil War (1936–39) who held the position of Censor for the Foreign Press Bureau, becoming its director in 1938, and was instrumental in the organization of the Joint Anti-Fascist Refugee Committee during WWII. Name variations: Connie; Constancia de la Mora y Maura. Pronunciation: Con-STAN-thee-ah day lah Mor-ah ee Mau-rah. Born Constancia de la Mora y Maura in Madrid, Spain, on January 28, 1906; died as a result of injuries received in an automobile accident in Guatemala on January 26, 1950; daughter of Germán de la Mora (a managing director of one of the most important electric companies in Madrid) and Constancia Maura (daughter of Prime Minister Antonio Maura); attended the Handmaids of the Sacred Heart convent school in Madrid, 1915–20; attended St. Mary's Convent School of Cambridge, 1920–23; married Manuel Bolín, in May 1927 (divorced 1932); married Ignacio Hidalgo de Cisneros, in 1933; chil-

Constancia de la Mora

dren: (first marriage) Constancia María de Lourdes Bolín Maura (known as "Luli").

Educated at home by an Irish nanny who taught her English (1910); was enrolled at a convent school (1915–20); continued education in Cambridge; returned to Madrid for social debut (1923–26); while vacationing in France, met Manuel Bolín of Málaga and became engaged (1926); married (1927); legally separated from husband and returned to Madrid (1931); took on first job—as a clerk—in a popular arts store; obtained one of the first divorces of the Spanish Republic (1932); married (1933); accompanied husband to Italy and Germany where he held the post of Air Attaché to the Spanish Embassy in Rome (1933–36); rebel forces staged a military coup against the legally elected government (July 1936), starting an international conflict known as the Spanish Civil War; joined the Spanish Communist Party (PCE, autumn 1936); became an active member of the National Committee of Antifascist Women, the central governing organ of AMA, the National Organization of Anti-Fascist Women; worked with the Ministry of Justice for the Protection of Minors; directed a hospice for abandoned or orphaned children; ordered by the Committee for the Protection of Minors to leave the capital, due to the intense bombings of Madrid (autumn 1936); evacuated, along with her 650 charges, to the Mediterranean city of Alicante and oversaw colonies for evacuated children; established a convalescent home for wounded aviators in Alicante; evacuated her daughter to the USSR; was the only woman to join the staff of censors of the Foreign Press Bureau in Valencia, the new capital of the Republic (1937); visited various fronts; attended the International Anti-Fascist Writers Conference in Valencia; evacuated with the rest of the Republican government to the coastal city of Barcelona (1937); promoted to chief of the Foreign Press Bureau—the only woman to hold this position in Spanish history (1938); accompanied the foreign minister to Geneva where they pleaded the Spanish cause before the League of Nations Assembly (May 1938); left Barcelona for the northern town of Figueras (January 1939); evacuated to France (February 1939); set up a makeshift press agency in Toulouse and became an impromptu speaker for the government of the Spanish Republic; left for U.S. to ask for military and humanitarian aid for the Spanish cause (February 1939); Franco declared his victory over the Spanish Republic (April 1); published autobiography In Place of Splendor (1939); relocated with family to Cuernavaca, Mexico (1940); was instrumental in the operation of the Joint Anti-Fascist Refugee Committee (1940–45).

Selected works: In Place of Splendor: Autobiography of a Spanish Woman *(Harcourt, Brace, 1939);* *Anna Seghers-Constancia de la Mora Tell the Story of the Joint Anti-Fascist Refugee Committee (NY: National Office, 1944).*

As a young girl growing up in one of Spain's most prominent political families, Connie de la Mora enjoyed a life of idle luxury devoted to debutante balls, elite social functions, royal shooting parties, Paris shopping trips, and exclusive vacations. Just as with other women of her class, she was expected to marry young and well: "For finding a husband was the real aim of my existence and I was never allowed to forget it," she wrote. De la Mora's life did not go according to her parents' plans. She married for love, not money; but it was a disastrous marriage that ended in divorce. Her experience as an independent single parent was to be the catalyst in her coming to realize the unequal status afforded to women in Spanish society and the inspiration for her political activism.

Connie de la Mora y Maura was born in 1906 in Madrid, Spain, to German de la Mora, chief executive officer of an electric company, and **Constancia Maura**, the eldest daughter of the conservative politician and prime minister Antonio Maura. In her autobiography, de la Mora observes, rather wryly, that she was aware early in life of "belong[ing] to Spain's privileged class: the rich. And yet I knew this before I could pronounce the Spanish word for it." She confesses, however, feeling uncomfortable in this role:

> In Zarauz I became a rebel against my heritage. Although it took twenty years and more to develop. I remember distinctly that my first feeling of hostility to my surroundings, my people, my life, was born in Zarauz. . . . I would probably not remember that uncomfortable feeling of my childhood except that it followed me all through my girlhood, into my life as a woman and citizen of Spain.

These feelings of alienation would accompany de la Mora throughout her life. The eldest of five children, she was brought up by an Irish nanny until her formal education began, at the age of nine, in strict Catholic schools. The five years spent under the repressive care of the religious order of the Handmaids of the Sacred Heart left an indelible mark on de la Mora and contributed to the formation of her progressive ideas regarding education and child rearing. She thought the instruction provided by the nuns was severely limited, offering her a narrowly focused and parochial education. Too young to at-

tend finishing school or make her societal debut, at age 14 she convinced her parents to send her to St. Mary's Convent School in Cambridge, England, to further her schooling. There, in contrast to her prior educational experience, de la Mora was allowed to explore a new world where women had the freedom to wander about without a chaperon, where women could speak freely, and where books were made readily available for inquisitive minds. In Cambridge, de la Mora blossomed and later recalled this period as one of the most joyful: "It was the one happy period of my life my parents gave me."

> *I* valued my independence. . . . I knew that I was violating every canon of the society I had been brought up in—Spanish women of my class accepted sorrow submissively, as the will of God. . . . But I was ready at long last to burn my bridges.
>
> —Constancia de la Mora

Upon her return to Spain, de la Mora prepared for her societal debut, a period filled with the never-ending social and religious obligations suitable to her stature. She was thought by many, she writes, to be "quite a catch, the granddaughter of Spain's most famous political leader—and on top of that—considered quite a beauty in Madrid." However, the life her parents had planned for their daughter assured her a mundane future, typical of upper-class Spanish women of the period. "At nineteen," she wrote, "I would be officially engaged to a solid, sensible gentleman with money and position. At twenty, I would have a great church wedding, a Paris trousseau, and a three months' wedding trip. And after that—well, but after that there was nothing to talk about. My life would be secure, settled, begun and ended at the same time."

True to her spirit, de la Mora refused to follow social convention and decided that she would marry only for love. In 1926, while vacationing in the exclusive French seaside resort of St.-Jean-de-Luz, she met Manuel Bolín of Málaga and became engaged within two weeks. The whirlwind romance led to marriage a year later. But troubles in the relationship appeared on her wedding night, said de la Mora. "I knew before morning that I did not, and never would, love my husband." During her brief marriage to Bolín, they lived in the Southern provincial city of Málaga, a far cry from the sophistication of Spain's capital, Madrid. De la Mora found it difficult to adjust to life in a small, provincial city as

was Málaga in the 1920s. Living with her in-laws only added to the tension in the marriage, so she convinced her husband that they should move out of his parents' home to their own place.

In 1928, de la Mora gave birth to her first and only child, a girl, Constancia Maria de Lourdes Bolín Maura, known as Luli. For a few months, things seemed to go well, until her husband insisted that he could no longer work for his father and that it would be best if they moved to Madrid. Bolín found it difficult to keep any job, and ultimately money troubles began to affect the young couple. De la Mora took matters into her own hands and set out to find a job in order to help support herself, her child, and her husband. This was a brave move, for married women of high social standing in Spain did not work. Through **Zenobia Camprubí**, a businesswoman married to poet and Nobel prizewinner Juan Ramón Jiménez, de la Mora found her first post, tutoring American journalists and their wives in Spanish and administrating the many apartments Camprubí owned throughout Madrid. That autumn, de la Mora worked in Arte Popular, a folk art shop owned by Camprubí and **Inés Muñoz**. Her marriage continued to disintegrate, and she finally decided to separate from her husband. Her decision to live independently as a single parent generated a fair amount of gossip and scandal among her social peers. Even so, de la Mora had her lawyer draw up the necessary legal papers in 1931, a year that would also prove to be an important milestone in Spanish history.

Following the abdication of King Alphonso XIII, a republic was established in 1931 by a weak coalition of centrist and left-centrist party leaders. This democratic regime, the second in Spain's history, initiated a series of economic, social, and political reforms that would ultimately drive the nation into civil strife. The liberalization process initiated by the new government particularly impacted women's lives. Many women of the urban middle class gained access to professions previously limited to men. Women were elected members of Parliament, led national trade unions, and undertook careers in law, medicine, and other scientific disciplines. Within two short years, women were granted constitutional equality, the right to vote, and the right to divorce their husbands.

De la Mora began this new period with a sense of adventure. As a single parent, she became keenly aware of the importance of politics and how it could effect change on an individual level: "Overnight I became a citizen of Spain," she

wrote. "And I was free and happy, and suddenly I wanted passionately to know about the world I lived in." Her new-found awareness was closely bound to the difficulties she encountered as a single working mother. De la Mora's alternative lifestyle was met with great disapproval by her family and friends. "A woman who wants to be 'independent'," she wrote, "will sooner or later end up as that of lowest of all things, a Republican, a traitor to the Monarchy. And in a fortnight I had lost all the friends I had known since my childhood." The country was divided between those conservative forces—such as the Church, the aristocracy, and the military—that supported the monarchy, and the Spanish people who supported the Republic and democratic reform. De la Mora aligned herself with the latter and actively engaged in the rebuilding of "our new country" by taking a job with the PNT, a government agency that supervised the writing and distribution of tourist information. De la Mora felt that she could contribute to dispelling the myths and animosities among Spaniards and foreigners by producing well written, accurate and helpful information about Spain. Soon discouraged by the lack of interest demonstrated by her superiors, however, she resigned her post and returned to the folk-art business to help her friends.

In 1931, de la Mora met a dashing young Air Force major, Ignacio Hidalgo de Cisneros. As their relationship intensified, she decided to divorce her husband and marry Hidalgo de Cisneros. For almost a year, she and Ignacio attended the parliamentary debates on the divorce bill. Finally on March 2, 1932, divorce became legal in Spain, and shortly thereafter she obtained one of the country's first divorces. In the small town of Alcalá de Henares (just outside Madrid), on January 16, 1933, Constancia de la Mora y Maura wed Ignacio Hidalgo de Cisneros in a civil ceremony. Their next few years were spent in Rome and Berlin where Ignacio had been assigned the post of military attaché. These experiences allowed de la Mora to witness firsthand National Syndicalism in the Third Reich and Fascism in Mussolini's Italy. While they were on foreign duty, Spain was undergoing many political changes: in the national elections of 1933, the ultra-conservative coalition CEDA (Spanish Confederation of the Independent Right) won with a landslide vote. When many of the reforms initiated by the prior government were suspended or eliminated by the new conservative coalition, minors, workers, and farmhands launched national strikes. The government forces struck with force and many thousands of workers (especially in the mining area of Asturias) were

killed. De la Mora returned to Spain in 1935 and resumed her previous employment in Madrid, even investing in the art shop.

New elections were held in February 1936. The Popular Front, a coalition of Leftist parties, won, and once again the country set its course for democratic reform. But this electoral victory would be short-lived. Riots and street violence kept the nation on edge. The right-wing Falange (modeled after the Italian Blackshirts) waged a campaign of violence against those sympathetic to democracy. The military, supported by the Church and the land owners, threatened to take over the legally elected government if law and order were not restored. Finally on July 17, 1936, General Francisco Franco and his troops staged a military revolt in the Spanish Protectorates of Morocco. The rebellion, carefully planned months ahead, was carried out swiftly by other military commanders throughout Spain. The Spanish Civil War had begun.

De la Mora clearly sympathized with the democratic forces under siege and quickly volunteered her services in defense of the Republic. Despite the fact that she was not affiliated with any political party or trade union, she managed to contact someone at the Ministry of Justice. Accompanied by a group of her closest friends, de la Mora was instructed by the Committee for the Protection of Minors to supervise an orphanage abandoned by the religious order that had previously been in charge. She directed the orphanage for a short time, introducing many changes that reflect her progressive approach to child-rearing. As the war raged, de la Mora saw her wards increase in number, but it was no longer a safe place for children, due to the intense bombings of Madrid in the autumn of 1936. The Republican government established a series of refugee camps for the children of Madrid on the Mediterranean coast. De la Mora was ordered by the Committee for the Protection of Minors to leave the capital with her 650 charges for the city of Alicante.

During this period, de la Mora joined the Spanish Communist Party and became an active member of the National Committee of Antifascist Women, the central governing organ of Agrupación de Mujeres Antifascistas (AMA), the National Organization of Anti-Fascist Women.

Upon hearing from Ignacio about the lack of adequate health care for wounded military personnel, de la Mora established a convalescent home for wounded aviators in Alicante while relinquishing her leadership of the children whom she had evacuated from Madrid. In December, she accepted the offer made by the Soviet government to care for Spanish Republican children until the end of the war and sent her daughter Luli to the USSR.

Due to the Madrid bombings, the Republican government relocated to the Mediterranean city of Valencia, just up the coast from Alicante. De la Mora also moved there, feeling that she had accomplished all she could in Alicante. Since she had a remarkable command of foreign languages, friends suggested that she could better help the anti-Fascist war effort abroad by joining the Foreign Press Bureau (FPB). In 1937, she became the only woman to join the staff of censors of the FPB. Her duties expanded from merely censoring press releases, written by the many journalists covering the war, to securing gasoline, procuring passes, arranging interviews with government officials, and accompanying various foreign journalists, such as *Josephine Herbst, Jean Ross, and *Martha Gellhorn, to various war fronts. That year, she also attended the International Anti-Fascist Writers Conference held in Valencia.

As the war raged on, the Republican forces were losing ground. Once again, the government relocated further north, to Barcelona, nearer the French border. In 1938, de la Mora, now a government official, also left Valencia to take up residence in Barcelona as chief of the Foreign Press Bureau—the only woman to hold this position in Spanish history. That May, the League of Nations would once more include the "Spanish issue" in its agenda. De la Mora was asked by the foreign minister, Julio Alvarez del Vayo, to accompany him to the meeting as a translator and representative for the Republican government. Their mission was not as successful as had been hoped, and France, Great Britain, and the United States did not override the Non-Intervention Pact.

Following the disaster at the Ebro front, the Republican forces had to abandon Barcelona. In January 1939, de la Mora, with the help of her staff, dismantled her office, destroyed all incriminating documents, and left for the northern town of Figueras. In February, it became clear that the war was coming to a close, and de la Mora was one of the 400,000 Spanish refugees evacuated to France. She temporarily relocated to the town of Perpignan and was reunited with her husband. Once again, realizing the importance of her government post, she set up a makeshift press agency in Toulouse and became an impromptu representative of the government of the Spanish Republic, now in exile. On February 10, she left for the United States where she

intended to ask for military as well as humanitarian aid for the Spanish cause. By the time she arrived in New York on March 3, however, Franco was very near victory. On April 1, he declared his conquest over the Spanish Republic. De la Mora's humanitarian mission was over before it began.

At the urging of her friend, the journalist Jay Allen, de la Mora wrote her autobiography, *In Place of Splendor*. Published in English in July 1939, with a second printing that November, it was translated into French, German, Italian, Spanish, and Russian among other languages. In 1940, taking advantage of the generous offer of the Mexican government to accept all Spanish Republican refugees, de la Mora relocated with her husband and daughter to Cuernavaca, and, like many other Spanish refugees, adopted Mexican citizenship. Little is known about her activities following the end of the Spanish Civil War. She continued her Communist Party affiliation as well as her work in support of Spanish refugees and was instrumental in the operation of the Joint Anti-Fascist Refugee Committee during the years 1940–45. While en route to the Guayaquil airport in Guatemala in 1950, she was killed in an automobile accident at the age of 44.

A remarkable woman, Constancia de la Mora did not hesitate to go against convention. She was deeply committed to effecting social change and strove hard to succeed in her goals. Allen Guttmann, in his analysis of the social progress initiated during the Spanish Republic, named Constancia de la Mora, among others, heir to the legacy of the American suffragist movement:

> It seemed that women like Constancia de la Mora, *Isabel de Palencia, *Margarita Nelken de Paul were about to inherit the legacy left by *Margaret Fuller, *Elizabeth Cady Stanton, *Lucretia Mott, and *Susan B. Anthony—to name only those women prominent in the crusade for women's rights.

SOURCES:

Bolloten, Burnett. *The Spanish Civil War*. Chapel Hill, NC: University of North Carolina Press, 1991.

Broué, Pierre, and Emile Teminé. *The Revolution and the Civil War in Spain*. Translated by Tony White. Cambridge: MIT Press, 1970.

Mora, Constancia de la. *In Place of Splendor: Autobiography of a Spanish Woman*. NY: Harcourt, Brace, 1939.

"Señorita de la Mora killed in Guatemala" (obituary) in *The New York Times*. January 29, 1950, p. 22.

SUGGESTED READING:

Brothers, Barbara. "Writing Against the Grain," in *Women Writing in Exile*. Edited by Mary Lynn Broe and Angela Ingram. Chapel Hill, NC: University of North Carolina Press, 1989.

Collaci, Mario. "No Compromises" (review of *In Place of Splendor*), in *Boston Transcript*. November 18, 1939, p. 2.

Field, Rose. "A Patrician in Republican Spain" (review of *In Place of Splendor*) in *The New York Times Book Review*. November 18, 1939, p. 6.

Greene, Patricia V. "Constancia de la Mora's *In Place of Splendor* and the Persistence of Memory," in *Journal of Interdisciplinary Literary Studies*. Vol. 5, no. 1, 1993, pp. 75–84.

Guttmann, Allen. *The Wound in the Heart: America and the Spanish Civil War*. NY: The Free Press of Glencoe, 1962.

H.M. "Sacrifice for Spain" (review of *In Place of Splendor*) in *Christian Science Monitor*. December 1, 1939, p. 20.

Mangini, Shirley. "Memories of Resistance: Female Activists of the Spanish Civil War," in *Signs*. Vol. 17, no. 1, 1991, pp. 171–186.

The New Yorker (review). November 18, 1939, p. 90.

Sheean, Vincent. "Constancia" (a review of *In Place of Splendor*), in *The New Republic*. December 6, 1939, p. 209.

Time (review). November 20, 1939, p. 83.

White, Leigh. "Spanish Testament" (review of *In Place of Splendor*) in *The Nation*. December 23, 1939, p. 713.

Patricia V. Greene,
Assistant Professor in the Department of Romance and Classical Languages, and in Women's Studies, at Michigan State University, East Lansing, Michigan

Moran, Gussie (1923—)

American tennis player whose claim to fame lies not in her game, but in wearing lace-trimmed panties as part of her outfit during the 1949 Wimbledon tournament.

Name variations: Gertrude Augusta Moran; "Gorgeous Gussie" Moran. Born in 1923 (some sources cite 1922, others 1924) in Santa Monica, California; daughter of Irish and German parents; married twice.

Won the Seabright mixed doubles crown with Pancho Segura (1946); won the National Clay Court Doubles with Mary Arnold Prentiss (1947); made the Top Ten of Tennis list (1947); won three titles (mixed doubles, women's doubles, and women's singles) at National Indoor Tennis championships (1949).

Born in Santa Monica, California, in 1923, Gussie Moran began playing tennis when she was 12; by age 16, she was counted among the more promising tennis prospects in southern California. She was coached by Bill Tilden and Eleanor Tennant, and her interest flagged only when Charlie Chaplin, who played with her regularly, warned that playing so often and hard would make her develop big muscles. Her enthusiasm for the game returned in 1945. When she began winning tennis titles around the country in the late 1940s, *Life* magazine added "Gorgeous" to her childhood nickname, and as "Gorgeous Gussie" she became a media sensation.

Eleanor Tennant.

See Connolly, Maureen for sidebar.

Moran was an extremely good tennis player, but not a great one. She fought her way to the quarterfinals at the Nationals in 1946, and reached the semifinals of the U.S. Nationals in 1948. Other accomplishments include a Seabright mixed doubles crown with Pancho Segura in 1946, and winning the National Clay Court doubles with **Mary Arnold Prentiss** in 1947. She also triumphed in her one and only Wightman Cup appearance, a doubles match in 1949, and in the spring of the same year won three titles—mixed doubles, women's doubles, and the coveted women's singles—at the National Indoor championships. Moran seemed to enjoy playing the glamour role more than the sport of tennis, and she entertained the press and public with a variety of publicity stunts, ranging from being measured for a new outfit at a press conference, and having her voluptuous measurements announced publicly, to performing a striptease behind a semi-transparent screen. But her biggest claim to fame came when Ted Tinling, who had been active in various roles in tennis for three decades, decided to design women's tennis clothes. He created a stylish outfit for her to wear at Wimbledon in 1949, and either he or Moran—accounts differ as to who should be credited—made the outfit more feminine by trimming the panties with lace. Only decades earlier women had still been playing tennis in full-length dresses with long sleeves and tightly-laced corsets, and the mere possibility of seeing a bit of lace-trimmed panties (Moran's dress reached almost to her knees) drew huge crowds to the match. Her outfit received front-page coverage on newspapers throughout the world, much to the well-bred dismay of Wimbledon officials, who charged Tinling with "drawing attention to the sexual area." Moran did not win Wimbledon that year, but the public loved the uproar, and her notoriety brought women's tennis to the attention of far more people than were usually interested in it.

"Gorgeous Gussie" retired from amateur tennis in the summer of 1950 and signed a professional contract with promoter Bobby Riggs, earning what was then the excellent sum of $25,000. She often played exhibition matches and gave tennis lessons, and portrayed herself on screen in the 1952 *Katharine Hepburn*-Spencer Tracy film *Pat and Mike*. She also designed and manufactured a line of tennis apparel for a time. Married twice, Moran moved to Manhattan in the 1960s, working as an advertising consultant for World Tennis and arranging fashion shows. She also appeared in commercials, and in 1968 covered the Wimbledon games for Westinghouse Radio.

SOURCES:

Haylett, John. *The Illustrated Encyclopedia of World Tennis*. Waymark, 1989.

*King, Billie Jean** with Cynthia Starr. *We Have Come A Long Way*. NY: Regina Ryan, 1988.

Lamparski, Richard. *Whatever Became of . . . ?* 2nd Series. NY: Crown, 1968.

<div align="right">

Jo Anne Meginnes,
freelance writer, Brookfield, Vermont

</div>

Moran, Lois (1907–1990)

American actress. Name variations: Lois Moran Young. Born Lois Darlington Dowling on March 1, 1907 (some sources cite 1908), in Pittsburgh, Pennsylvania; died on July 13, 1990, in Sedona, Arizona, of cancer; daughter of Roger Dowling and Gladys (Evans) Dowling; educated in Greensburgh, Pennsylvania, and the Lycée de Tours, France; married Clarence M. Young (assistant secretary of commerce and later Pan Am executive), in 1935; children: one son.

Selected filmography: La Galerie des Monstres (Fr., 1924); Feu Mathias Pascal (The Late Mathias Pascal or The Living Dead Man, Fr., 1925); Stella Dallas (1925); Just Suppose (1926); The Reckless Lady (1926); The Road to Mandalay (1926); Padlocked (1926); The Prince of Tempters (1926); God Gave Me Twenty Cents (1926); The Music Master (1927); The Whirlwind of Youth (1927); The Irresistible Lover (1927); Publicity Madness (1937); Sharp Shooters (1928); Love Hungry (1928); Don't Marry (1928); The River Pirate (1928); Blindfold (1928); True Heaven (1929); Making the Grade (1929); Joy Street (1929); Behind That Curtain (1929); Words and Music (1929); A Song of Kentucky (1929); Mammy (1930); Not Damaged (1930); The Dancers (1930); Under Suspicion (1931); Transatlantic (1931); The Spider (1931); Men in Her Life (1931); West of Broadway (1931).

Born in Pittsburgh in 1907, but raised in France by her widowed mother, actress Lois Moran was trained as a dancer and performed with the Paris National Opera for two years (1922–24); she also appeared in two French films. Her American debut in Samuel Goldwyn's *Stella Dallas* (1925), starring *Mrs. Leslie Carter*, was auspicious. Moran's subsequent efforts, however, were mediocre by comparison, and she retired from the screen in 1931 to return to the stage. She scored some success in stage musicals, notably on Broadway in *Of Thee I Sing* (1931), then abandoned her career to marry Clarence M. Young, an assistant secretary of commerce and later an executive at Pan Am. During the 1950s, Moran taught drama and

dance at Stanford University and appeared on the television series "Waterfront" (1953–56), co-starring Preston Foster.

Writer F. Scott Fitzgerald took a shine to Moran during her early days in Hollywood and reportedly based the character of Rosemary in his novel *Tender Is the Night* on her. Silent star *Eleanor Boardman, who was friendly with the Fitzgeralds, recalled that *Zelda Fitzgerald was so concerned about her husband's fixation on Moran that she herself became obsessed with the idea of becoming a ballet dancer.

SOURCES:

Drew, William M. *Speaking of Silents: First Ladies of the Screen.* Vestal, NY: Vestal Press, 1989.

Katz, Ephraim. *The Film Encyclopedia.* NY: Harper-Collins, 1994.

Moran, Mary Nimmo (1842–1899)

American landscape etching artist. Name variations: Mary Nimmo. Born on May 16, 1842, in Strathaven, Lanarkshire, Scotland; died of typhoid fever on September 25, 1899, in East Hampton, New York; only daughter of Archibald Nimmo (a weaver) and Mary Nimmo; received grammar school education; married Thomas Moran (an artist), in 1862; children: Paul Nimmo Moran (b. 1867); Mary Scott Moran; Ruth Bedford Moran.

Selected works: Evening, East Hampton; Bridge Over the Delaware; Newark From the Meadows; The Goose Pond; An Old Homestead; Florida Forest; Between the Gloaming and the Murk; and Conway Castle, Wales.

Born in Scotland on May 16, 1842, Mary Moran emigrated to the United States at the age of five, with her brother and widowed father. The family settled in Crescentville, Pennsylvania, where she received a grammar school education. When she was 16, she met Thomas Moran, an artist who would later gain fame for his Western scenes (his 1872 panorama *The Grand Canyon of the Yellowstone* would be purchased for $10,000 by Congress and installed in the Capitol). They were married four years later, in the summer of 1862, and lived in Philadelphia.

After their marriage, Moran's husband taught her to paint with oils and watercolors, and her talent was such that she soon exhibited some of her work at the Pennsylvania Academy of the Fine Arts and at the National Academy of Design in New York City. In 1867, after the birth of their first child, the Moran family traveled throughout France, Italy, and Switzerland, finding time to study art, visit galleries and mu-

seums, and meet the great French artist Camille Corot. They returned to the United States and established a home in Newark, New Jersey. Moran and her husband often sketched the surrounding countryside, and some of her best pictures are of this area (such as *Newark From the Meadows*, c. 1880). In the early 1870s, she toured the West with her husband, after which failing health usually prevented her from traveling with him. As Thomas Moran was about to leave on another trip to the Grand Tetons in 1879, he suggested that she try etching, which was much in vogue at the time.

Moran traveled to Easton, Pennsylvania, where she etched plates directly from nature, in a bold, free style. Upon his return, Thomas was so impressed with his wife's work that he submitted four of her plates to the New York Etching Club for an exhibition. They were accepted and in 1880 "M. Nimmo" was elected into the club. (She would later sign her etchings "M. Nimmo Moran" or "M.N.M.") Moran also exhibited etchings in Boston, and in 1881 she was invited to exhibit with the Royal Society of Painter-Etchers in London. Both she and her husband received certificates from Queen *Victoria, and she was named a member of the Royal Society as well. A trip to Great Britain in 1882 provided her with more artistic material, and she portrayed many English and Scottish scenes. Working at a furious pace during the 1880s, Moran became the foremost American woman in the etching field. Among her subjects were views of East Hampton, Long Island, where the Morans built a summer home in 1884, as well as New York City, the Pennsylvania hills, and the subtropical forests of Florida, which she visited twice. By 1889, she had etched nearly 70 plates. At the zenith of her career in 1893, she received a diploma and a medal for her etchings at the World's Columbian Exposition in Chicago. The public's love of etchings eventually declined, however, and with it the demand for her work. She did few plates in her later years. In 1899, exhausted from nursing her daughter Ruth through typhoid fever, Mary Moran died of the same disease at the family's home in East Hampton, at age 57.

SOURCES:

James, Edward T., ed. *Notable American Women, 1607–1950.* Cambridge, MA: The Belknap Press of Harvard University Press, 1971.

McHenry, Robert, ed. *Famous American Women.* NY: Dover, 1980.

Rubinstein, Charlotte Streifer. *American Women Artists.* Avon, 1982.

SUGGESTED READING:

Everett, Morris T. "The Etchings of Mrs. Mary Nimmo Moran," in *Brush and Pencil.* April 1901.

Gerdts, William H. *Museum* (Newark, New Jersey). Spring–summer 1963, p. 24.

Trumble, Alfred. *Thomas Moran, N.A. (and) Mary Nimmo Moran.* Pamphlet, 1889.

Van Rensselaer, Mariana G. "American Etchers," in *Century.* February 1883.

COLLECTIONS:

Paintings by Mary Nimmo Moran are held by the Newark (New Jersey) Museum, the East Hampton Free Library, and the Jefferson National Expansion Memorial in St. Louis. Collections of her etchings are at the New York Public Library, the Metropolitan Museum in New York City, the East Hampton Free Library, Guild Hall in East Hampton, the Graphic Arts Division of the Smithsonian Institution, and the Gilcrease Institute of American History and Art in Tulsa, Oklahoma.

Jo Anne Meginnes,
freelance writer, Brookfield, Vermont

Moran, Polly (1884–1952)

American comic actress. Born Pauline Theresa Moran on June 28, 1884, in Chicago, Illinois; died in 1952.

Filmography—shorts: The Janitor *(1913);* Ambrose's Little Hatchet *(1915);* Their Social Splash *(1915);* Those College Girls *(1915);* Her Painted Hero *(1915);* The Hunt *(1915);* Love Will Conquer *(1916);* The Village Blacksmith *(1916);* By Stork Delivery *(1916);* His Wild Oats *(1916);* Vampire Ambrose *(1916);* Safety First Ambrose *(1916);* Her Fame and Shame *(1917);* His Naughty Thought *(1917);* Cactus Nell *(1917);* She Needed a Doctor *(1917);* His Uncle Dudley *(1917);* Roping Her Romeo *(1917);* The Pullman Bride *(1917);* Sheriff Nell's Tussle *(1918);* Saucy Madeline *(1918);* The Battle Royal *(1918);* Two Tough Tenderfeet *(1918);* She Loved Him Plenty *(1918).*

Filmography—features: Skirts *(1921);* The Affairs of Anatol *(1921);* Luck *(1923);* The Callahans and the Murphys *(1927);* The Thirteenth Hour *(1927);* Buttons *(1927);* The Enemy *(1927);* London After Midnight *(1927);* The Divine Woman *(1928);* Bringing Up Father *(1928);* Rose-Marie *(1928);* Telling the World *(1928);* While the City Sleeps *(1928);* Show People *(1928);* China Bound *(1929);* The Hollywood Revue *(1929);* Honeymoon Speedway *(1929);* The Unholy Night *(1929);* So This is College *(1929);* Hot for Paris *(1929);* Chasing Rainbows *(1930);* The Girl Said No *(1930);* Caught Short *(1930);* Way Out West *(1930);* Remote Control *(1930);* Way for a Sailor *(1930);* Paid *(1930);* Reducing *(1931);* It's a Wise Child *(1931);* Politics *(1931);* Guilty Hands *(1931);* The Passionate Plumber *(1932);* Prosperity *(1932);* Alice in Wonderland *(1933);* Hollywood Party *(1934);* Down to Their Last Yacht *(1934);* Two Wise Maids *(1937);* Ladies in Distress *(1938);*

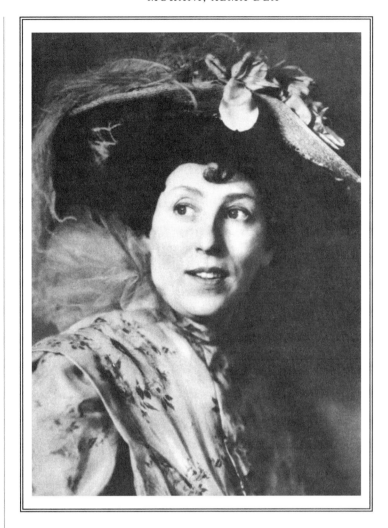

Ambush *(1939);* Tom Brown's School Days *(1940);* Adam's Rib *(1949);* The Yellow Cab Man *(1950).*

*Polly
Moran*

Making the most of her zany, buck-toothed appearance, comedian Polly Moran began her career in vaudeville, then crossed over into films around 1913. She appeared in numerous silent shorts with Mack Sennett before returning to the stage in 1918. Moran reemerged in feature films again during the 1920s, playing comic character roles. Particularly notable are a series of films with intriguing single-word titles that she made with *Marie Dressler during the early sound era, including *Reducing, Politics* (both in 1931), and *Prosperity* (1932).

Morani, Alma Dea (1907—)

American plastic surgeon. Born in New York City on March 21, 1907; daughter of Salvatore Morani (a sculptor) and Amalia (Gracci) Morani; New York University, B.S., 1928; Woman's Medical College, Pennsylvania, M.D., 1931.

Interned at St. James Hospital, Newark (1931–32); was surgeon resident, Woman's Medical Hospital, Philadelphia (1932–35); private practice, St. Louis University (1946–47); fellow in plastic surgery, University of Washington Medical School (1946–47); private practice in plastic surgery, Philadelphia (1948 on); associate surgeon, Roxborough Memorial Hospital (1940 on), Woman's Hospital (1938 on); chief of plastic surgery, St. Mary's Hospital (1948 on); professor of clinical surgery, Woman's Medical College (1950 on).

An American plastic surgeon and the first female member of the American Society of Plastic and Reconstructive Surgeons, Alma Dea Morani was drawn to the field of plastic surgery by her love of art, which had been inspired by her sculptor father Salvatore Morani. She has served as a role model for a generation of women who moved into a professional arena that previously had been occupied exclusively by men.

SUGGESTED READING:

Morantz, Regina Markell, *et al.*, eds. *In Her Own Words: Oral Histories of Women Physicians*. New Haven, CT: Yale University Press, 1985.

Solomon, M.P., and M.S. Granick, "Alma Dea Morani, MD—A Pioneer in Plastic Surgery," in *Annals of Plastic Surgery*. Vol. 38, no. 4. April 1997, pp. 431–436.

<div align="right">

John Haag,
Athens, Georgia

</div>

Morante, Elsa (1912–1985)

Noted Italian writer who used the techniques of "magic realism" to explore the way in which individuals have been shaped by the pains and traumas of childhood. Pronunciation: Moe-RANT-Tay. Born on August 18, 1912 (some accounts give alternative dates ranging from 1916 to 1918) in Rome, Italy; died in Rome on November 25, 1985, of a heart attack; daughter of Irma Poggibonsi Morante (a descendant of a Jewish family in Modena) and legally the daughter of Augusto Morante (a Sicilian schoolteacher); probably the daughter of Francesco Lo Monaco; largely self-educated, but some sources indicate that she studied briefly at the University of Rome; married Alberto Moravia (a writer), in 1941 (separated 1962).

Published first short stories (1935–36); met Alberto Moravia (1936); went into hiding to evade fascist police (1943); published first novel, Menzogna e sortilegio, and won the Viareggio prize (1948); won Strega prize (1957); wrote bestseller, La storia (1974); won Prix Medicis (1982); attempted suicide (1983, some authorities place this in 1984); publication of Maledetta benedetta (Cursed and Blessed), a family history by Marcello Morante (1986); posthumous publication of her diary (1989).

Major works: (novels) Menzogna e sortilegio (House of Liars, 1948), L'isola di Arturo (Arturo's Island, 1959), La storia: romanzo (History: A Novel, 1974), Aracoeli (1982); (poetry) Il mondo salvato dai ragazzini (The World Saved by Little Children, 1968), Alibi (Alibi); (short stories) Il gioco segreto (The Secret Garden, 1941), Lo scialle andaluso (The Andalusian Shawl, 1963).

Elsa Morante was one of Italy's most distinguished writers during the middle decades of the 20th century. The author of novels, poems, children's books, and essays, she won the greatest acclaim from some critics for her short stories. Morante achieved her highest level of fame, however, both inside Italy and before an international literary audience, with her bestselling novel *La storia* (*History: A Novel*), which appeared in 1974. It received a mixed critical reception but became the most popular Italian novel since Giuseppe di Lampedusa's *The Leopard* (1958). Resolutely original as a writer, notes **Sharon Wood**, Morante was "a permanent political and cultural dissident," someone always uncomfortable with the idea of categorizing her characters according to fashionable Marxist or feminist positions.

Most of Morante's writing focuses on the problems of troubled childhoods and difficult family lives. "Dissolute, damaged, or incomplete families stand in the background for many of her characters," writes **Alba Amoia**, and "Morante's dominant theme is how a lack of parental love can lead to children's despair and destruction." Many critics, however, find a quasi-political thread running through her work, one that denounces power and violence and lauds what Amoia called "an essentially anarchic concept of society."

Much of Morante's work is patently autobiographical, although she was notably reticent in talking about her personal background during her own lifetime. For years she refused to give interviews or to speak in public, maintaining the position that her readers could find out all they needed about her from her books. Critic Rocco Capozzi described her as "a solitary and even peevish personality." Her brother Marcello Morante's publication of a short family history in the year following her death has made it possible for students of Morante's work to make an informed inquiry into how her own experiences fed her writing. The posthumous publication of her own diary has also shed some light on the background of her work.

According to Amoia, Morante wrote in the style of "magic realism," which takes "the

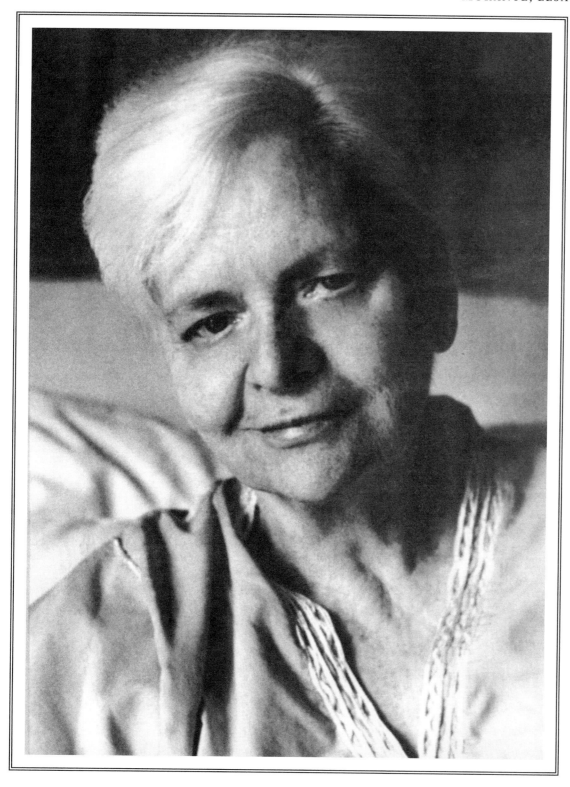

true-to-life" and transforms it into "an atmosphere of enchantment and bewitchment." Her effort to penetrate to the psychological core of her characters often involves what Amoia describes as a "dialogue between the ego and a fantasy figure." The large role that dreams play in Morante's work reflects her desire to penetrate to the subconscious level of her characters' minds. Other critics remark on the presence of a central narrator in many of her works, a participant in the story who is also the storyteller.

Morante was born in Rome under murky family circumstances on August 18, 1912. Legally her father was Augusto Morante, a Sicilian schoolteacher whose name the young girl took. Her mother was **Irma Poggibonsi Morante** from Modena in northern Italy. Since Augusto was unable to have children, Irma had five offspring, including Elsa, using a family friend, Francesco Lo Monaco, to aid her in conceiving. In defense of her mother's unconventional choice, Morante shortly before her own death described her mother as "the chastest of women."

The young girl's childhood years remain largely undocumented, but she apparently lived in poverty in the slums of Rome, then found an alternative home in her wealthy godmother's mansion. Although some authorities indicate that she studied for a time at the University of Rome, a more important formative development was a taste for literature Morante displayed at an early age and the vigorous program of self-education she pursued during her teenage years. Her particular literary mentors were the great novelists of the 19th century.

\mathcal{S}he is acutely modern in her awareness of the fragility of the human ego.

—Sharon Wood

Morante also began to write while she was still a teenager. Her first stories appeared, to no particular critical response, starting in 1935. One notable short story, "Le bellissime avventure di Caterì dalla trecciolina" ("The Most Beautiful Adventures of Caterì with a Pigtail"), was completed when she was merely 14. This work and many others received a degree of literary acclaim only in the decade prior to her death. Critics find in her early stories, many of which were published in the collection *Il gioco segreto* (*The Secret Garden*), themes that would continue to appear in her later, more polished work. Among these were the difficult relations between parents and their children, and the various dangers that sprang from love between the sexes. She continued throughout her writing career to use children and adolescents as main characters in her works.

Elsa Morante left home at the age of 16, by which time she had learned the secret of her parentage. She established a romantic liaison with the rising young writer Alberto Moravia around 1936. They married in Rome in 1941, then spent the next two years living and writing on the island of Capri. The two would separate, without ever formally divorcing, in 1962.

Morante first received a measure of critical acclaim for her novel *Menzogna and sortilegio* (*House of Liars*). Despite its failure to sell many copies, it won the prestigious Viareggio Prize for the year 1948. The story is set in Sicily at the turn of the century. Typically for most of Morante's works, the book shows no concern with the political background of events. A central character and the narrator of much of the book is the girl Elisa. With her unhappy childhood and her insight into the psychological pain it has caused her, Elisa is, at least in part, a figure who draws many of her characteristics from Morante herself. Like many of Morante's narrators, Elisa admits that what she remembers may well be false or distorted. "Half-remembered, half-imagined . . . like ghosts," writes Michael Caesar, "the actors in the family drama move in a space occupied pre-eminently by insomnia, fantasy, and day-dream." Centering on the lives of members of two Italian families at the turn of the 20th century, the novel explores the consequences of falsehoods people tell their intimate relations in an effort to win their affection. The book is marked by unhappy human relations as several of the main characters find their love for one another rejected.

The first time Morante enjoyed both wide critical success and a large popular audience came almost a decade later with the publication of *L'isola di Arturo* (*Arturo's Island*) in 1957. The royalties provided her, for the first time, with an adequate income and the means to travel. The novel's main character is a boy, Arturo. Like Elisa, he is enamored with the world of books. Arturo's adolescence is marked by the arrival of a stepmother, a girl from Naples not much older than himself, with whom he quickly becomes infatuated. In addition to this tangled situation, his early teenage years are disturbed as well by painful revelations about his father, a homosexual who abandons the family for a disreputable male lover.

During these years, Morante devoted much of her energy to poetry. Her verse was sometimes the product of her effort to take a respite from writing novels. *Alibi,* a set of 16 poems that appeared in 1958 and which contained works she had produced over the past two decades, also delves deeply into the nature of childhood experiences. The title of the revealing poem "Sheherazade" in *Alibi* not only indicates how Morante saw her role as a writer, but it also provides an insight into her techniques. The line "It is not my merit, but the heaven's/ that made me so fanciful" provides Capozzi with evidence that she saw her "magic realism" not as a choice

of styles but as one she was destined to follow. Indeed, by this time, the themes and techniques of Morante's writing had become evident. She tended to present her ideas through various narrator-protagonists who, notes Capozzi, "both hide and reveal the author's intimate desires, fears, delusions, and personal experiences related to love and rejection." He went on to note that her autobiographical narrator "like a modern Sheherazade" used the narration to "seek cathartic relief, self-therapy, and hope."

A notable event in Morante's married life was a nine-month period when she and Alberto Moravia were forced into hiding from fascist authorities in the coastal mountains between Rome and Naples during the closing months of 1943 and the first part of 1944. Italy had just left the Axis side in World War II, and German troops were occupying much of the countryside. Both of them used the experience as material for a later book: Moravia's 1957 novel *Two Women* and Morante's 1974 *La storia* (*History: A Novel*).

In the years following her split with Moravia, Morante lived a deliberately isolated existence. A writer famous for the slow, deliberate way that she produced her books, she used this period of solitude to great advantage. The result was *La storia,* along with a collection of short stories and her challenging book of poems, *The World Saved by the Little Children.*

Published in 1974 by the firm of Einaudi, Morante's novel *La Storia* became a bestseller both in Italy and abroad. The book is distinguished from her other novels by the presence of a third-person narrator who stands above the often horrible events being recounted. The narrator is identifiably female, and her often cutting comments are directed at both major events and the European leaders who played the crucial role in them. In an interview she granted shortly after the book had appeared, Morante described her reason for turning her work in such a new direction. "Now, almost an old woman, I felt I couldn't depart from this life without leaving the others a testimonial memory of the crucial epoch in which I was born." She saw her book, moreover, as a call for "communal awakening" and as "an accusation of all the fascisms of the world." Within a year, one million copies had been sold.

The book marked a major stylistic departure for Morante. Each of its nine chapters begin with a date, accompanied by the major historical events of both Italian and world history that marked it. The main content of the book, however, is the story of obscure, helpless individuals whose lives are being shaped, even destroyed by

these grand happenings. The book starts, for example, with the rape of an Italian schoolteacher by the German soldier. But the soldier too is painted as someone deprived of an independent will: "He knew precisely four words of Italian and of the world he knew little or nothing." Thus, he too is presumably a victim of larger events he cannot shape. He will, in fact, shortly die during the fighting in North Africa.

With the city of Rome during World War II as the background for events, the book examines the experiences of a variety of characters, principally members of a single, partly Jewish family. As usual, Morante focuses much of her attention on the character of a child. Useppe Raimundo is the son of the Italian-Jewish schoolteacher who had been forcibly impregnated by a German soldier. The product of this rape, Useppe is both handicapped and destined for an early death. Thus, Useppe is unique among Morante's other major characters; throughout her writing, her central figures are invariably disillusioned and embittered adults who have, nonetheless, survived their tragic childhoods. Some critics have found that the book's success came from its ability to evoke, in nostalgic fashion, the wartime years and the effort of the anti-Fascist resistance movement. Others insisted that the book was too far removed from any identification with Italian heroism to be praised. A second source of criticism came from members of the literary avant-garde who attacked the book for its relatively conventional style and structure.

The novel presents the message that history is a mere cavalcade of suffering, much of it inflicted on innocent youngsters like Useppe. Morante personalizes that suffering by telling the story of individual victims. Despite its popular and critical success, the book also put the author at the center of a bitter literary controversy led by Marxist critics who displayed their distaste for the work. In the view of Gregory Lucente, the book had a particular impact on intellectuals of a Marxist persuasion because it appeared at a time when the Italian Left seemed to be moving toward power. Thus, they were "less than comfortable with a book as pessimistic, depressing, and insistently prodding as Morante's novel." The factory workers in the book, for example, have no political consciousness let alone an attraction for Marxism, and the book as a whole was marked by a profound lack of faith in the prospects for the human condition. Morante thus rejected Marxist concepts, which she had claimed to accept earlier in her career, of the dominant and hopeful role of the class struggle in human affairs. Moreover, her sympathy for

the tiny victims of the workings of the world now stood above any political consideration. As Wood put it, "Morante controversially mourns the loss of the small cogs in the power machine—German and Italian, Nazi and partisan alike." Lucente declared: "Morante sees that all History is nothing but a story of sickness, oppression, and death . . . no one escapes alive."

Morante's last work was a notably gloomy novel, *Aracoeli*, which appeared in Italy in 1982. *Aracoeli* centers on the recollections of childhood present in the mind of the narrator, Manuele, a gloomy man in his early 40s. Like *L'isola di Arturo,* written 25 years before, the book explores the mind of a central male figure whose life has been dominated by rejection when he was a child. Notes Caesar, the book is distinguished by its "wonderful evocation of the unhappiness of childhood, of the anxiety of a child who senses . . . that he is in some way being left out, uncherished." Critics who believed that Morante saw her writing as a kind of therapy found firm evidence for their position in the author's final novel. At one point, the hero Manuele speaks of taking a final journey through memory to recapture his deceased mother and thus "attempting a last, absurd therapy to be cured of her."

In the closing years of her life, Morante suffered from the debilitating disease of hydrocephalus. The accumulation of fluid around her brain that characterizes the disease led to a decline in her mental powers to which she responded with an unsuccessful suicide attempt. Some authorities place the event in 1983; others indicate that it occurred the following year. In any case, now an invalid, she spent her remaining life in a nursing home in Rome.

In late 1984, approximately a year before her death, she gave a uniquely revealing interview to Jean-Noël Schifano, the writer who had translated her work into French. She spoke of her identification with the character of Arthur in *L'isola di Arturo* and her desire to have been born a boy; she also addressed such other painful issues as her suicide attempt and her failure to have children. Perhaps whimsically, she suggested that the mourners at her funeral have the pleasure of listening to music by Bach, Mozart, and Bob Dylan.

Elsa Morante died of a heart attack in Rome on November 25, 1985. Following Morante's death, Wood wrote of her as an author "whose deepest sympathies lie with the small, the oppressed, that which is unvalued by our social structures." In terms of Morante's stature in the literary world, according to Rocco Capozzi, "Her death . . . deprives Italy of one of its most prestigious authors."

SOURCES:

Amoia, Alba. *20th-Century Italian Women Writers: The Feminine Experience*. Carbondale, IL: Southern Illinois Press, 1996.

The Annual Obituary, 1985. Patricia Burgess, ed. Chicago, IL: St. James Press, 1988.

Capozzi, Rocco. "Elsa Morante: The Trauma of Possessive Love and Disillusionment," in *Contemporary Women Writers in Italy: A Modern Renaissance*. Edited by Santo L. Aricò. Amherst, MA: University of Massachusetts Press, 1990.

Caesar, Michael, and Peter Hainsworth, eds. *Writers and Society in Contemporary Italy*. Leamington Spa, Warwickshire, Eng.: Berg, 1984.

Lucente, Gregory. *Beautiful Fables: Self-consciousness in Italian Narrative from Manzoni to Calvino*. Baltimore, MD: Johns Hopkins Press, 1986.

Marotti, Maria Ornella. *Italian Women Writers from the Renaissance to the Present*. University Park, PA: The Pennsylvania State University Press, 1996.

Palotta, Augustus, ed. *Italian Novelists since World War II*. Detroit, MI: Gale Research, 1997.

Russell, Rinaldina, ed. *Italian Women Writers: A Bio-Bibliographical Sourcebook*. Westport, CT: Greenwood Press, 1994.

Wood, Sharon. *Italian Women's Writing, 1860–1994*. London: Athlone, 1995.

SUGGESTED READING:

Bondarella, Peter, and Julia Conaway Bondarella, eds. *Dictionary of Italian Literature*. Rev. ed. Westport, CT: Greenwood Press, 1996.

Cornish, Alison. "A King and a Star: the Cosmos of Morante's *L'isola di Arturo*," in *MLN*. January 1994, pp. 73–93.

Giorgio, Adalgisa. "Nature vs Culture: Repression, Rebellion and Madness in Elsa Morante's *Aracoeli*," in *MLN*. January 1994, pp. 93–117.

Lazzaro-Weis, Carol. *From Margins to Mainstream: Feminism and Fictional Modes in Italian Women's Writing, 1968–1990*. Philadelphia, PA: University of Pennsylvania Press, 1993.

Peterson, Thomas Erling. *Alberto Moravia*. NY: Twayne, 1996.

Wood, Sharon. "The Bewitched Mirror: Imagination and Narration in E. Morante," in *Modern Language Review*. April 1991, pp. 310–321.

Neil M. Heyman,
Professor of History, San Diego State University,
San Diego, California

Morata, Fulvia Olympia
(1526–1555)

Italian scholar. Name variations: also seen as Olympia Fulvia Morata. Born in Ferrara in 1526; died in Heidelberg, Germany, on October 25, 1555; buried at St. Peter's Church, Heidelberg; daughter of Fulvio Pellegrino Morata; had at least two brothers and two sisters; educated at home by her brothers, in Latin at

the court of Ferrara by Chilian Senf, and through self-study; married Andrea (or Andrew) Grunthler.

Selected works: orations, letters, and poems, published as Opera Omnia (1580).

Fulvia Olympia Morata received much of her early education from her brothers, one an expert in Greek, the other an expert in medicine and philosophy. She probably also learned from her father Fulvio Pellegrino Morata, a humanist scholar, who was duke of Ferrara for a time. Soon she began to pursue study on her own, with great success in philosophy, theology and literature. While still in her teens, she was writing in Latin and Greek, emulating the classical literary styles and composing critical philosophical essays. Her early poetry describes her enthusiasm for learning. While still young, she was welcomed at the court of *Renée of France (1510–1575), duchess of Ferrara, as a companion for Renée's daughter, Princess ❧▶ Anne of Ferrara. In the court at Ferrara, the young girls were both tutored in Latin by the scholar Chilian Senf.

Morata left the court for a few years to care for her dying father, and when she returned the situation was much altered. Princess Anne was gone, having married Francis, later the 2nd duke of Guise. Moreover, the Roman Inquisition of 1542 made religion a matter of such controversy that denizens of the court were not allowed to read scripture. Morata's father was a Calvinist, and though her own views were not strictly Calvinist, within the court she had befriended a group of people, including her Latin tutor, who had unorthodox religious views. Also among these was a German medical practitioner, Andrea Grunthler, whom she married.

Because of the religious hostility, Germans who had come to the court in the hope of finding Italian wives and settling in Italy were compelled to return home. Grunthler, with whom Morata was much in love, went ahead to secure a position in Schweinfurt, Franconia, as physician to a garrison of Spanish troops, after which she and her younger brother joined him. For a time while in Schweinfurt, she was able to continue her studies, which had become wholly focused on religion. She missed her mother and sisters very much, and they maintained steady correspondence despite the unreliability of the post. She also wrote to other Italians in exile and hoped that the other members of her family would join her to avoid religious persecution.

After a few years, however, Morata and her husband found themselves in the middle of a war. In 1553, the margrave Albert of Brandenburg, on

❧▶ **Anne of Ferrara** (1531–1607)

Duchess of Guise. Name variations: Anne of Este or Anna d'Este; Anne d'Este-Ferrare; Anne of Guise. Born in 1531; died in 1607; daughter of *Renée of France (1510–1575) and Ercole II (1508–1559), 4th duke of Ferrara and Modena; sister of *Lucrezia d'Este (1535–1598) and *Eleonora d'Este (1537–1581); married Francis (1519–1563), 2nd duke of Guise; married Jacques, duke of Geneva; children: (first marriage) Henry (1550–1588), 3rd duke of Guise; Carlo also known as Charles (1554–1611), duke of Mayenne; Louis (1555–1588), 2nd cardinal of Guise; *Catherine of Guise (1552–c. 1594, who married Louis de Bourbon, duke of Montpensier); and three others; (second marriage) Charles Emmanuel (b. 1567), duke of Nemours; Henry, duke of Nemours and Aumale.

one of his plundering expeditions, took possession of Schweinfurt and was in turn besieged by the Protestants. Half of the populace of Schweinfurt died. Morata's health suffered from the hardship of the war and the horrifying escape from Schweinfurt; as well, all her books and papers were lost. By the time Morata and Grunthler were rescued by Duke Erbach, she was wearing only an undershirt given her by another refugee. The duke secured Grunthler a medical position at Heidelberg, but Morata was very weak by that time. She died, age 29, just a few months after her arrival in Heidelburg. A monument to Morata, by Guillaume Roscalon, was financed by her childhood friend Anne of Ferrara, who had become duchess of Guise, and her friend Curione published what remained of her works and letters. They were also collected and published in monograph form by *Caroline Bowles Southey, wife of poet Robert Southey, in 1834.

SOURCES:

Bainton, Roland Herbert. *Women of the Reformation in Germany and Italy*. Boston: Beacon Press, 1974.

Kersey, Ethel M. *Women Philosophers: a Bio-critical Source Book*. NY: Greenwood Press, 1989.

SUGGESTED READING:

Gearey, Caroline. *Daughters of Italy*, 1886.

Catherine Hundleby, M.A. Philosophy, University of Guelph, Guelph, Ontario, Canada

Morath, Inge (1923—)

Austrian-born photographer. Born in 1923 in Graz, Austria; received degree from University of Berlin, 1944; married Arthur Miller (a playwright), in 1962; children: Rebecca Miller (b. 1962, a filmmaker and painter).

Inge Morath received her first camera as a gift in 1952, and has since gone on to become an internationally known photographer and photojournalist. The daughter of scientists, she was born in Graz, Austria, in 1923, and graduated from the University of Berlin in 1944. Caught in the chaos surrounding the end of World War II in Europe, Morath spent the following two years as an agricultural worker and airport employee in Berlin before finding employment as an editor and translator with the U.S. Information Service in Salzburg and Vienna in 1946. She became a freelance writer for radio and print media in 1949, and was hired as a writer for *Heute* magazine in 1951. After receiving her camera the following year, she bought a Leica and began working as an assistant to photojournalist Simon Guttman of the Report Agency of London.

Morath served as an assistant and researcher for photographer Henri Cartier-Bresson from 1953 to 1954, and became a member of the Magnum Photos agency in 1955. That year, she began traveling widely and photographing life in the countries she visited, a practice that has resulted in books including *De la Perse à l'Iran* (*From Persia to Iran*, 1958), *Tunisie* (1961), *In Russia* (1969), *Chinese Encounters* (1979), and *Russian Journal* (1991). Morath married American playwright Arthur Miller in 1962, the same year their daughter **Rebecca Miller** was born, and became an American citizen in 1966. She continued to travel extensively after her marriage, and photographed the first Chinese production of her husband's play *Death of a Salesman*, published as *Salesman in Beijing* (1984). She is also known for her photographs of such places as Mao Zedong's bedroom and Anton Chekhov's home, and for her photographic portraits of artists and political personalities. *Inge Morath: Portraits* (1999) includes portraits from the 1950s through the 1990s of Arthur Miller, Jean Cocteau, Saul Steinberg, *Janet Flanner, *Louise Bourgeois (b. 1911), *Audrey Hepburn, Pablo Picasso, *Nadezhda Mandelstam, *Marisol, *Mary McCarthy, Jerzy Kosinski, *Alice Roosevelt Longworth, Salman Rushdie, and *Doris Lessing, among many others.

Morath's photographs and photographic essays have been published in magazines, including *The Saturday Evening Post*, *Life*, *Paris-Match*, *Vogue*, and *Picture Post*. Her work has been exhibited in numerous galleries and major museums, including the Museum of Modern Art in Vienna, the Metropolitan Museum of Art in New York City, the Chicago Art Institute, the Kunsthaus in Zurich, the Royal Photographic Society in Bath, England, the Union of Photo-

journalists in Moscow, the Sala de Exposiciones del Canal de Isabel II in Madrid, and the Inge Morath Museum for Photography in Saxony, Germany. Among the awards she has received are the gold medal of the National Art Club, an honorary doctorate from the University of Connecticut, the Medal of Honor in gold from the City of Vienna, and the Great Austrian State Prize for Photography (1992). *Inge Morath: Life as a Photographer* was published in 1999.

SOURCES:

Morath, Inge, *et al. Inge Morath: Life as a Photographer*. Keyahoff Verlag, 1999.

Rosenblum, Naomi. *A History of Women Photographers*. Paris and NY: Abbeville Press, 1994.

<div align="right">**Grant Eldridge**,
freelance writer, Pontiac, Michigan</div>

Moray, countess of.

> *See Gruaidh.*
> *See Ross, Euphemia (d. 1387).*
> *See Stewart, Marjorie (d. after 1417).*

Mordaunt, Miss (1812–1858).

> *See Nisbett, Louisa Cranstoun.*

Mordvinova, Vera Aleksandrovna (1895–1966).

> *See Aleksandrovna, Vera.*

More, Alice (c. 1472–1545)

English gentlewoman who was the second wife of Thomas More. Name variations: Alice Middleton; Lady Alice More. Born around 1472; died in 1545; married a man named Middleton (died 1509); became second wife of Thomas More (1478–1535, English scholar and statesman who was slain for his opposition to detaching England from the spiritual authority of the Roman Catholic Church), in 1511; children: (first marriage) one daughter, Alice; four stepchildren.

Thomas More's first wife *Jane Colt More died in 1511, age 23, leaving him with four young children. Within a month, Thomas had married Alice Middleton, six years his senior and the widow of a London merchant, who had a ten-year-old daughter and considerable property. Erasmus and early biographers maintain that Thomas remarried to provide a mother for his children, but **Ruth Norrington** disagrees, claiming that Dame Alice was "the much-loved wife who always made him laugh, even in the last terrible days in the Tower." The marriage lasted 24 years, until Thomas More was executed for treason for denying Henry VIII supreme authority over the church. Norrington feels that Alice has

been maligned and misunderstood because of the popular prejudice against stepmothers. She is often depicted as petty, quarrelsome, ignorant, and stupid, and Thomas made her the brunt of many unkind jokes throughout his writings, though he praised her in his epitaph. (In a Latin epigram referring to both his wives, he also wrote: "O, how happily we could have lived all three together if fate and religion permitted.")

A practical, no-nonsense woman, with a sharp eye for accounts, Dame Alice presided with famous (or infamous, depending on the chronicler) efficiency over one of the most illustrious households in 16th-century England. During a grain shortage in 1528, Thomas More told the royal council that he was feeding 100 people daily at his house. "Dame Alice," writes Richard Marius, "must have been in charge of this operation." "She was obviously a strong woman," continues Marius, "with a sense of herself, but not well educated, lacking the words to refute her husband's sallies. So she made herself stubborn, the immemorial defense of those who feel themselves pushed to understand things beyond their grasp, and because of the stories told about her bad temper and her apparent foolishness, she comes down to us as an intellectual burden to her spouse and her main role in most accounts of [Thomas] More's life has been to demonstrate his meekness and goodness." Hans Holbein painted Dame Alice around 1527 or 1528.

SOURCES:

Marius, Richard. *Thomas More.* NY: Alfred A. Knopf, 1984.

Norrington, Ruth. *In the Shadow of a Saint: Lady Alice More.* London: Kylin Press, 1985.

More, Hannah (1745–1833)

English playwright, novelist, and tract writer whose talents were turned to evangelism within the Anglican Church, agitation against human slavery, and education for the working classes despite fame and the promise of an honored place among the most accomplished citizens of the Republic of Letters. Born Hannah More at Stapleton, Gloucestershire, England, on February 2, 1745; died without descendants in Clifton on September 7, 1833; daughter of Jacob More (a schoolmaster) and Mary Grace More; never married, no children.

Selected works: Percy *(1777);* The Bas-Bleu; or Conversation *(1786); (under name "Will Chip")* Village Politics *(1792);* Cheap Repository Tracts *(1795–98);* Thoughts on the Importance of the Manners of the Great to General Society *(1788);* Strictures on the Modern System of Female Education *(1799);* Coelebs in Search of a Wife *(1809).*

Made a decision in early womanhood that may now seem self-destructive, but, having once turned to God in preference to the world, never looked back and displayed a faith and a constancy that posterity is perhaps not equipped to understand; displaying intelligence at an early age, could read by age four and became proficient in the study of the classics; taught school with her sisters at Bristol and began to write (after 1757); ended long engagement with a Mr. Turner, a merchant (1773); published The Search after Happiness *(1773); had first play,* The Inflexible Captive, *presented at Bath (1774); associated with David Garrick and other literary figures (after 1773); acclaimed for her play* Percy *which was performed in London (1777–78); departed London and began religious writing at Cowslip Green, near Bristol (after 1779); published* Thoughts on the Importance of the Manners of the Great to General Society *(1788); opened first Sunday school in Cheddar (1789); published* The Slave Trade *(1790),* Village Politics *(1792), and* Coelebs in Search of a Wife *(1809).*

It is easy to summon up the picture of Hannah More as a quaint old woman, a relic of the 18th century who was outdated, even antiquated, long before her demise more than 30 years into the 19th century. Travelers to Barley Woods, the home of her old age, remarked on her frailty and the manners and language that seemed to belong to a time too far gone to remember. She must have seemed rigid, puritanical, and decidedly lacking in a modern point of view. All that, of course, is true. Yet such a picture does not do Hannah More justice. Born before the revolutions in America and France began the deconstruction of the unique era that was the English 18th century, Hannah did spring from a refined, elegant society that could not survive the egalitarian impulses of the modern world. She flourished in the theaters, drawing rooms, and assembly rooms of London, Bristol, and Bath, and she knew very well the pleasant pastimes, the brilliant conversation, the wit and charm of Georgian England. Yet, though at home in that cultivated company, she also saw its imperfections, its indifference to the lot of the poor, its complicity in human bondage, and its rejection of what More regarded as its essential heritage, the Christian religion. Prevented, as a woman, from taking direct political action to try to hold back the tide of vulgarity and secularism that would engulf and destroy her world, she took up the pen rather than the sword to wage a long and gallant retreat.

Hannah More, the fourth of five daughters, was born at Stapleton, a small settlement near Bristol in the western area of England, on February 2, 1745. Her father was Jacob More, a man who had lost a landed estate at law and became the schoolmaster at Fishponds at Stapleton. Hannah's mother was **Mary Grace More**, a farm girl with an assertive streak. Perhaps because of her father's position, Hannah grew up as a studious, intelligent girl who impressed the family and neighbors with her quick wit and superior memory. She could read by age four, probably because of the ready assistance of her older sisters, **Mary, Elizabeth**, and **Sarah**, all of whom were to become accomplished women themselves. Hannah's younger sister was **Martha** and, as the baby of the family, was known as Patty. Hannah's sisters shared her ambition, cleverness, and determination; they worked together all their lives and none of the girls would marry.

> That the knowledge of the Bible should lay men more open to the delusions of fanaticism on the one hand, or of Jacobinism on the other, appears so unlikely, that I should have thought the probability lay all on the other side.
>
> —Hannah More

It was with her sister Mary that Hannah began her long career as an educator. Mary opened a girls' school in Bristol in 1758, and Hannah joined her to help teach several subjects. Her own inclination was toward the classics, but, though no mathematician, she taught the other subjects as well. The school flourished, attained an enviable reputation, and continued long after the sisters' retirement. Hannah gained valuable experience in this period that assisted her in later, more ambitious schemes to educate the poor. The school also gave the young women a measure of financial security and a place in Bristol society.

For a few years, Hannah, although a lovely woman with a pleasant demeanor, seemed to be content to remain single like her sisters. Then, in 1767 she was engaged to Edward Turner of Belmont, a man of property who admired Hannah's poetry but who was 20 years older than she. At his estate, More would have had a comfortable life, but Turner repeatedly postponed the wedding, possibly because, while fond of her, he did not find her sufficiently tranquil for his taste. The engagement was eventually terminated in 1773, but the shamefaced gentleman smoothed the separation by granting Hannah an annuity of £200 per year. At his death, he bequeathed her another £1,000. She never seriously considered marriage again, though she was close to a number of men, including the actor David Garrick, the brilliant writer Horace Walpole, and William Wilburforce, the single greatest influence in the abolition of the slave trade in the British Empire.

It is just as well that More did not marry Turner, for she likely would have become a country lady without the driving motivation to write that led to the prodigious publications that flowed from her pen. In the event, Hannah turned to drama in a city, Bristol, that was an important center for the 18th-century theater. Several players came from London to perform in the town's theaters, and Hannah met many of them. She had written *The Search after Happiness,* according to her account, as a young girl, but it was not published until 1773. It was a simple story, in verse, about the need for women to be modest and accepting of the role assigned to their sex in this world. **Mary Alden Hopkins,** More's biographer, wrote: "Hannah believed destiny imposed one set of duties upon men and a completely different set upon women, although an exceptional woman might push her way a very short distance into what was essentially a male province." Although the work of an amateur, performed only at the girls' school, *The Search* represented More's entry into that expanding circle of "scribbling women" of the high 18th century.

The year 1773 also saw More's first visit to London. In the metropolis, she encountered a number of notables through the good offices of Sir Joshua Reynolds, the celebrated painter. Along with her sisters, Hannah was considered a delight, and more than them, she was considered a vivacious intellect. Not the least of the luminaries she encountered was the formidable Dr. Samuel Johnson, the most honored literary figure of the time. Johnson enjoyed her company, perhaps because he liked her poetry, perhaps because he liked pretty young women who adored him. Still another famous gentlemen who found Hannah irresistible was David Garrick, just then coming to the end of one of the great careers in theatrical history. Their friendship was widely noticed, but More was not simply the favorite of older men. Women liked her as well, and Mrs. Garrick (*Eva-Maria Veigel) treated her as she would a beloved daughter, even taking her into her house for weeks on end. It was a distracting experience for a young provincial woman of 24 to be so quickly taken to the bosom of London's finest circles, but Hannah handled herself very

well and prepared to make the best of her new and exciting connections.

More's visit to London probably inspired her to arrange for the performance of her tragedy, *The Inflexible Captive*, in Bath at the Theatre Royal. She had published the play earlier, and her friends, including Garrick, came for the opening night. The story involved noble characters of ancient Rome and Carthage, and the self-sacrifice of the hero, Regulus, appealed to the tastes of the time. In fact, the sentiments of the piece reflected the high-minded sense of dedication to a code of behavior that marked its author's long life. It was a huge success, making Hannah More a name known throughout the kingdom.

More's growing public expected more from the talented author, and they were not disappointed. In 1777 came *Ode to Dragon*, an elegy to the career of Garrick, and *Percy*, a historical tragedy, partly produced by Garrick, concerning conflict along the medieval Scottish border and the disasters attendant upon blood feuds. It, too, was a triumph, and Hannah reached the apogee of her critical success. Britain might be losing an empire in America, but in fashionable circles the talk was of the immensely talented Miss More. These were pleasant years for the West Country schoolmaster's daughter.

When David Garrick died in 1779, his passing wounded More deeply, and she discovered he had left a gap in her life that was never quite filled. She still moved in brilliant sets, and her play, *Fatal Falsehoods*, was performed the year of Garrick's death; but gradually she withdrew from the theater, a loss to her time and to posterity. Her friend's demise seemed to turn her thoughts back to the faith of her childhood. By degrees, her piety grew, and though she visited London annually to reaffirm old acquaintances, she spent more and more time in the Bristol region. In 1782, she built a cottage she called Cowslip Green in Somerset, close to Bristol and the Mendip Hills. Soon her sisters came to join her. There she took to the country life and a searching investigation of her spiritual life. Inevitably, Hannah felt the need to write about this developing interest.

Possibly because More was herself an honored figure among the English elite, knowing well Dr. Johnson, Edmund Burke, *Elizabeth Montagu**, David Hume, and Edward Gibbon, she thought that such people could and should directly affect the greater society by the force of example. It was this idea that led her to publish anonymously *Thoughts on the Importance of the Manners of the Great to General Society* in

Hannah More

1788. The book was popular despite its criticism of the very people Hannah had embraced in London society. It was, in fact, an admonishment to the cream of society to reform their worldly lives for the betterment of themselves and others. This certainly was not the same Hannah of *Percy* or of the clever, witty correspondence with Horace Walpole or David Garrick. But it was earnest. For whatever the younger Hannah More had conceived about her duty as a Christian, by 1788 she was convinced that her mission was to uphold the established church, defend the British state, and conserve social position and wealth. As Hopkins noted, Hannah "enjoyed that conviction of being right which is the reward for wholehearted acceptance of authority." More had become a conservative, but she soon came to see that she did not want to conserve everything.

One of the customs of her time that Hannah detested was the trade in African slaves. In this she was greatly influenced, as were so many others, by that tireless, crusading parliamentarian, William Wilburforce. Her poem, *The Slave Trade*, published in 1790, came as a direct result of her close friendship with Wilburforce whom she had known for years and to whom she had introduced

one of the founders of Methodism, Charles Wesley. But More and Wilburforce had broader reform interests. They also hoped to rekindle a spirit of true faith in the Anglican Church.

The Church of England became the center of More's life from the 1780s until her death. Both she and Wilburforce were recruited into a band known as the Clapham Sect, a circle of individuals who gathered in the London suburb of Clapham. Worried by the popular disorders attendant upon the developing Methodist movement, but repelled by the worldliness and indifference of the Anglican establishment, the Clapham Sect undertook an evangelical movement to encourage piety and at least some spiritual spark in their beloved English Church. For her part, More was encouraged by Wilburforce to follow the example of Robert Raikes, the founder of English Sunday schools. Wilburforce had accompanied Hannah on a short outing to the town of Cheddar in 1789. Depressed by the poverty and ignorance of the ordinary folk, he challenged More to act on their behalf. It was just the kind of project she could promote with her energy and her pen, and she threw herself into the effort to provide the children of the area with the rudimentary teachings of the Church. Naturally, she persuaded her sisters to help.

Hannah shortly encountered opposition to the new Sunday schools. Some believed any education, even in the faith, would encourage social envy and cause people to forget their duty to their betters. The sisters pressed on, however; they rented a house in Cheddar, hired a teacher, and soon had 500 children studying the Bible and the catechism, singing hymns, and saying prayers. They even managed to found a form of insurance society for the poor women of the area called Women's Benefit Societies. In time, Hannah undertook to have the children taught some simple skills during the week as well, and schools were opened at Axbridge, Barnwell, Barley Wood, and other locations, but she never intended that the children receive academic training. On the contrary, More believed that the poor of the earth must learn to accept their lot in life. She certainly did not sympathize with any attempt to overturn the established ways of the kingdom. Years later, in 1801, she wrote to the bishop of Bath and Wells defending her instruction and denying that she in any way, religious or political, encouraged "enthusiasm." "I do not vindicate enthusiasm," she wrote, "I dread it. But can the possibility that a few should become enthusiasts be justly pleaded as an argument for giving the *all* up to actual vice and barbarism?" Still, she was dismayed when decades afterward, the Sunday school movement was expanded to provide education to the poor beyond her simple curriculum.

It was suspicion of the evangelical movement and of More's Sunday schools that touched off the Blagdon Controversy. Between 1800 and 1804, conservative elements in the Anglican Church, seeing in the evangelicals a species of Methodism, charged that illegal religious meetings were being held at the Blagdon school by a master named Younge. There were demands that Younge be dismissed, but Hannah stubbornly refused, seeing the entire business as an attack on her activities. Inevitably, she was accused of Methodism. Many persons of distinction rallied to More, but her health suffered in the controversy that seemed to go on and on. Harsh pamphlets were published against her, and church officials eventually intervened and the Blagdon school was closed. Hannah was deeply hurt by the slanders to her good name and withdrew from the world for some time.

Well before the Blagdon Controversy, More had, like many English leaders, been alarmed by the French Revolution and its call for a radical restructuring of politics and society. Predictably, Hannah reacted fiercely to the anti-religious aspects of the Revolution and even overcame her distaste for anything "popish" by actively aiding the French refugee clergy and aristocrats who had fled to England. In 1792, she published *Village Politics, by Will Chip, a Country Carpenter*. It was a tract, rather than a book, condemning the dangerous notions of those who thought working people could either understand or responsibly exercise the "rights of man." Hannah rejected such propositions, believing activist writers like Tom Paine to be sowing the wind in stirring up ordinary people who must in the nature of things be poor and subservient. Her religion and her training persuaded her that society was fundamentally unchanging, that men and women have an appointed place in the state and that to challenge the political order was to challenge the natural order. It would only, as it had in France, unloose the devil in humanity and produce rivers of blood. More than likely, More accepted Plato's strictures in *The Republic* to the effect that society must be divided into rulers, guardians of the state, and workers. Each group's part should be determined by the education, wisdom, and capacities of the individuals within it. So, while sympathetic to the impoverished, Hannah could not condone providing them a secular education; it would do them no good and could cause both them and the state great harm.

She especially detested the atheistic elements of the Revolution in France and feared their propagation in England. With eloquence, More slashed at the presumption of the French leaders who supposed their nation had freed itself from the need of a transcendent God. In *On Religion and Public Education* in 1793, Hannah urged English people to demonstrate the purity of Anglicanism by befriending the French refugees, despite their erroneous Catholic religion. She argued that the French republicans were rebelling against God, not a king, and that French liberty was nothing more than license that would eventually destroy both liberty and happiness. Only religion, she declared, can "tame that savage, the natural human heart."

As she grew older, More's faith increased and her impatience with the failures of the human fancy grew apace. In the *Cheap Repository Tracts*, published between 1795 and 1798, the familiar condemnation of any alteration of the status quo was drummed into all who would read the repetitive, if earnest, pamphlets. As **Claudia Johnson** has written, in an introduction to *Considerations on Religion*, More simply did not regard politics and religion as separate spheres. Each was essential to the other.

Hannah More's last important literary achievement was a novel, *Coelebs in Search of a Wife*, published in 1809. It went through many editions and was popular in America as well as in England. *Coelebs* is, however, a sad story, though Hannah did not intend it so, because in it she essentially rejects much of what had been her greatness. So frightened had she become of the vices surrounding the young, that the heroine of *Coelebs* encounters all her difficulties because of an absorption in literature. So far had she traveled from her carefree days with David Garrick that Hannah, in her old age, denounced the stage and all its productions as ruinous of faith and morals.

More left Cowslip Green in 1802 and built a spacious house at Barley Wood. Her last years were passed in that comfortable home, and many of the great of the day came to converse with her. All of her sisters preceded her in death, and Hannah, no longer able to care for herself, was removed to a house in Clifton, near Bristol, in order for friends to watch over her. She died on September 7, 1833, at age 89, and was buried near her sisters at Barley Wood.

The reader of *Percy* may find it difficult to recognize the same author in *Coelebs in Search of a Wife*. Hannah More had become "Saint Hannah" in her old age. Yet the piety of the elderly spinster was but the continuation of the faith of the young playwright. It will not do simply to dismiss More as a reactionary without the wit to deal with change. Hannah understood better than most the far-reaching changes occurring in her society, and she did not fear them only because they challenged a familiar and comfortable way of life. She fought them because, for her, they constituted a challenge to faith and morality and, therefore, to God. Unlike many of her contemporaries, More did not see man as sufficient to himself. It was that very pride, that arrogance which bred atheism, revolution, and destruction. Within the context of her beliefs, she was perfectly logical and perfectly consistent. That is more than one can say for many of her critics, and most of them could not match her eloquence, nor probably her conviction.

SOURCES:

Cropper, Margaret. *Sparks Among the Stubble*. London: Longmans, Green, 1955, pp. 145–180.

Dictionary of National Biography. Vol. XIII. Edited by Sir Leslie Stephen and Sir Sidney Lee. 1963–64 ed. Oxford University Press, pp. 861–867.

Hopkins, Mary Alden. *Hannah More and Her Circle*. London: Longmans, Green, 1947.

More, Hannah. *Considerations on Religion and Public Education*. Introduction by Claudia Johnson. The Augustan Reprint Society, 1990.

SUGGESTED READING:

Thompson, Henry. *Life of Hannah More with Notices of her Sisters*. Cadell, 1838.

C. David Rice, Ph.D.,
Professor of History, Central Missouri State University,
Warrensburg, Missouri

More, Jane Colt (c. 1488–1511)

*English gentlewoman who was the first wife of Thomas More. Name variations: Jane Colte. Born Jane Colt around 1488; died in 1511; eldest of three daughters of John Colt of Essex, a family friend of Thomas More; became first wife of Thomas More (1478–1535, English scholar and statesman who was slain for his opposition to detaching England from the spiritual authority of the Roman Catholic Church), in 1505; children: *Margaret More Roper (1505–1544); Elizabeth More Daunce or Dancy (b. around 1506, who married William Daunce on September 29, 1525, the same day her sister Margaret married); Cecily More Heron (b. around 1507, who married Giles Heron in 1522); John More (who married Anne Cresacre in 1529).*

Erasmus claims that Thomas More selected the young, uneducated country girl Jane Colt to be his bride in order to make of her what he wished. He instructed her in art and music and

trained her to match his own tastes. When they attended church, he had her repeat the words of the sermon to be sure she understood them. At first, Jane Colt was often reduced to tears, then she rebelled. When her father advised More that a good beating would put her in line, More found the suggestion abhorrent. But Thomas More had a tendency to mock women, regarding them as stupid, foolish creatures. Though he felt girls should be educated as well as boys, he once told his daughters that even though they might not have anything to write about, they should write about nothing at length. Girls, being "loquacious by nature," should always have "a world to say about nothing at all." Erasmus, in his *The Praise of Folly*, was clearly referring to Thomas and Jane when he wrote: "I know a certain man named after me who gave his bride some imitation gems, assuring her (and he is a clever jokester) that they were not only real and genuine but also that they were of unparalleled and inestimable value. I ask you, what difference did it make to the girl since she feasted her eyes and mind no less pleasantly on glass and kept them hidden among her things as if they were an extraordinary treasure? Meanwhile, the husband avoided expense and profited by his wife's delusion, nor was she any less grateful to him than if he had given her some very costly gifts." Eventually, the couple made peace and had four children. Jane Colt, known by Thomas' friends as an "affable wife," died at age 23. Thomas More married Alice Middleton (***Alice More**), six years his senior and the widow of a London merchant, one month later.

Moreau, Jeanne (1928—)

Internationally renowned French actress. Born January 23, 1928, in Paris, France; daughter of French father Anatole Moreau (a restaurateur) and English mother Kathleen (Buckley) Moreau (an erstwhile entertainer); had one younger sister, Michelle; trained at the Paris Conservatory of Dramatic Art; married Jean-Louis Richard (an actor), in 1949 (divorced 1951); married William Friedkin (a director) in 1977 (divorced 1978); children: (first marriage) one son, Jérôme.

Made professional stage debut (1947); appeared in first film (1948); known mainly for work in legitimate theater until directed by Louis Malle in L'Ascenseur pour l'Echafaud *(1957) and* Les Amants *(1958), the latter establishing her international reputation as a sensuous symbol of French womanhood; has since appeared in more than 80 films, in addition to television and stage work, in Europe and the United States.*

Selected filmography: Dernier Amour *(1948);* Meurtres *(1950);* Pigalle-St. Germain-des-Prés *(1950);* L'Homme de ma Vie *(1952);* Il est Minuit Docteur Schweitzer *(1952);* Secrets d'Alcove *(1953);* Dortoir des Grandes *(1953);* Julietta *(1953);* Touches pas au Grisbi *(1954);* La Reine Margot *(1954);* Les Intrigantes *(1954);* Les Hommes en Blanc *(1955);* M'sieur la Caille *(1955);* Gas-Oil *(1955);* Le Salaire du Péché *(1956);* Jusqu'au Dernier *(1956);* Echec au Porteur *(1957);* L'Etrange M. Stève *(1957);* Trois Jours à Vivre *(1957);* Les Louves *(1957);* Ascenseur pour L'Echafaud *(Frantic, 1957);* Le Dos au Mur *(1958);* Les Amants *(1958);* Les Liaisons dangereuses *(1959);* Moderato Cantabile *(1960);* Jovanka e le Altre *(1960);* Le Dialogue des Carmélites *(1961);* La Notte *(1961);* Une Femme est une Femme *(1961);* Jules et Jim *(1961);* Le Baie des Anges *(1962);* Eva *(1962);* Le Procès *(1962);* Le Feu Follet *(1963);* The Victors *(1963);* Le Journal d'une Femme de Chambre *(1964);* Le Train *(1964);* Peau de Banane *(1964);* The Yellow Rolls-Royce *(1964);* Mata Hari *(1965);* Viva Maria *(1965);* Falstaff *(1966);* Mademoiselle *(1966);* The Sailor from Gibraltar *(1967);* Le plus vieux Métier du Monde *(1967);* La Mariée était à Noir *(1968);* Histoire Immortelle *(1968);* Great Catherine *(1968);* Le Corps de Diane *(1969);* Le Petit Théâtre de Jean Renoir *(1969);* Monte Walsh *(1970);* Alex in Wonderland *(1970);* Comtes à Rebours *(1970);* L'Humeur vagabonde *(1972);* Chére Louise *(1972);* Nathalie Granger *(1972);* Joanna Francesca *(1973);* Je t'aime *(1974);* Les Valseuses *(1974);* La Race des Seigneurs *(1974);* Le Jardin qui bascule *(1974);* Hu-Man *(1975);* Souvenirs d'en France *(1975); (also writer and director)* Lumière *(1976);* Mr. Klein *(1976);* The Last Tycoon *(1976); (director and co-writer only)* L'Adolescente *(1979);* Au-dela de cette Limite votre Ticket n'est plus valable *(1980);* Plein Sud *(1981);* Mille Milliards de Dollars *(1982);* Querelle *(1982);* La Truite *(1982);* Der Bauer von Babylon *(1983);* La Paltoquet *(1986);* Sauve-toi Lola *(1986);* Le Miraculé *(1987);* La Nuit d'Ocean *(1988);* La Femme Nikita *(1990);* Alberto Express *(1990);* La Femme fardée *(1991);* Anna Karamazoya *(1991);* The Suspended Step of the Stork *(1991);* Until the End of the World *(1992);* Map of the Human Heart *(1992);* La Vielle qui Marchait dans la Mer *(The Old Woman Who Walked in the Sea, 1992);* The Summer House *(1994);* The Proprietor *(1996).*

Anyone strolling along Rue Mansart in the Montmartre section of Paris during the early 1930s might have seen a gangly young girl carrying a steaming bowl of *potage à legumes* and a crusty baguette disappear into a tiny movie the-

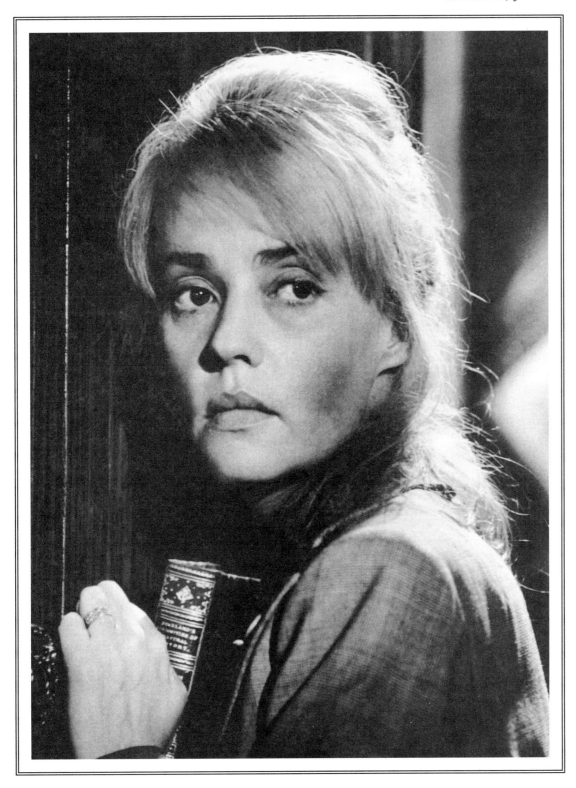

Jeanne
Moreau

ater. The more curious passerby, following this odd apparition, would have seen her scurry upstairs into the projection booth to watch whatever film was playing while the projectionist consumed the meal provided by the girl's father, who ran a café down the street. Crouching in the dark room with its flickering square of light, Jeanne Moreau felt strangely drawn to the characters she saw on screen, some of them more real to her than her own friends and family. "Acting is not a profession," she would say many years later, "it's a way of life. One completes the other."

Despite this almost daily exposure to the cinema, Moreau could not have imagined herself growing up to become an icon of the French cinema's postwar renaissance, even though her English mother had been in show business. **Kathleen Buckley** had first come to Paris in 1927 as a "Tiller Girl"—one of a troupe of British chorines hired to appear for several months at the Folies Bergères. Jeanne's father Anatole Moreau was a restaurateur from a small town near Vichy in central France, a pragmatic provincial who frowned on the frivolous lifestyle of people in show business. But even Anatole was unable to resist the attractions of Kathleen, who would take her meals between shows at La Cloche d'Or, which Anatole ran with his brother Arsène. Two months after their meeting, Kathleen discovered she was pregnant. Unable to hide the fact from her employers, she was dismissed from the chorus line and married Anatole shortly thereafter. "It was a big scandal because, of course, it was known she was pregnant," Moreau once recalled, "and worse than that, my father had been engaged to the daughter of the *boulangère* across the road." Her uncle Arsène paid for the wedding, and the couple settled down to await the boy child they planned to name Pierre. Anatole was so distraught at the birth of a daughter that he had to be fetched, drunk, from a local bar to register the birth; and it was only through the efforts of the registrar that Jeanne avoided being named Pierrette. Kathleen, meanwhile, mourned the loss of a career she was sure would have made her a star, often mentioning that she had been considering an offer to appear in America when she became pregnant.

Moreau's most formative years were spent, not in Paris, but near Vichy, where Anatole took his earnings from his partnership with his brother and opened the Hôtel l'Entente, installing his small family in his ancestral village nearby. It was in Mazirat that Jeanne attended a convent school and grew up a roughhouser, she said, "always with big scabs on both knees." She delighted in telling stories to relatives and friends with great dramatic flourish, acting all the parts, using appropriate gestures and accents. But with the death of her best friend from a childhood illness when Jeanne was seven years old, the sunny world of a country girl began to dim. "I started to feel there was an incredible sadness to things around me," Moreau recalled. She began to notice the darker elements caused by the isolation of village life—the resigned fatalism of the peasant women and her own parents' whispered arguments that reached her through thin bedroom walls. Kathleen confided to Jeanne that she had

a plan for the two of them to escape to England, leaving Anatole behind. The scheme only added to Moreau's sense of betrayal when a sister, **Michelle Moreau**, was born in 1937. Nine-year-old Jeanne hated the attention given to the new arrival and retreated into the secrecy and fantasies of adolescence.

Matters did not improve when France's prewar economic depression forced Anatole to close his hotel and move back to Paris, where the Moreaus lived in a tiny, airless tenement not far from Montmartre's Sacre Coeur while Anatole took odd jobs in hotels and restaurants. Most of the other rooms in the building were rented to prostitutes who would openly do business on the street outside and in the corridors. Moreau's most persistent memories of the time are of the fleas and bedbugs that infested the decrepit building, and her mother's deepening depression. Though Kathleen, by this time, had been living in France for nearly 20 years and spoke fluent French, she remained a foreigner and longed for her native Lancashire. Just before war broke out in 1939, Kathleen left Anatole and took her two daughters back to England, where Jeanne learned to take her tea with milk and sugar and dote on crumpets. She also became as familiar with English as she was with French—a talent that would stand her in good stead in coming years. "I'm very proud of being half English," she says, "and I think that as time passes my best English qualities are more and more visible."

After nearly a year in England, Kathleen began to regret her decision and determined to rejoin Anatole, who by now had fled the German invasion of Paris by moving to the south of France, where the invaders had not yet penetrated. Kathleen got as far south as Orléans before being stopped by a Nazi roadblock and forced back to Paris, where she and her daughters spent the rest of the war. Moreau would always remember the greed, corruption and cruelty that ruled France during the Nazi occupation, turning her memories into a film which she wrote and directed in 1978, *L'Adolescente*. She escaped the harsh realities of wartime by reading voraciously, taking ballet lessons, and, one day in 1943, skipping school with two friends to see a performance of Jean Anouilh's *Antigone*, her first exposure to legitimate theater. Shortly thereafter, at a performance of Racine's *Phèdre* at France's venerable national theater, the Comédie Française, Moreau knew she had found a way to deal with her grim view of the world. "In the theater," she says, "I found purity and reality existing together." Although Ana-

tole, who rejoined the family in Paris after the city was liberated by the Allies, fiercely resisted his daughter's intention to enter the theater world, Kathleen was more sympathetic. She saw to it that Jeanne was enrolled in the Paris Conservatory of Dramatic Art in 1946 before permanently separating from her husband and relocating with Michelle to England.

From the first time she stepped on a stage before an acting class, it was obvious to many that here was someone special. "She was not very centered, but was already extraordinary," remembered one classmate, Jean-Louis Richard. "I had no doubt about her future as an actress. She just got up on stage and was transformed." Near the end of her first year at the conservatory, Moreau was approached by a young actor named Jean Vilar, who was organizing what would become France's first outdoor arts festival, the Avignon Theater Festival, and would in later years guide Jeanne's career. Vilar cast Moreau in her first stage role, a small part in Maurice Clavel's *La Terrasse du Midi*, in the summer of 1947. In the fall of that year, just as she was starting her second year at the conservatory, Moreau was offered the part of Veroushka in an upcoming Comédie Française production of Chekhov's *A Month in the Country*. The play had rarely been performed in France, where relations with Russia had not often been cordial, but Moreau's earthy, naturalistic performance electrified the critics, filling the house every night with theatergoers eager to see this new young sensation. "I was a great success on opening night," Moreau has said, "but all I could think of was that my parents could not be there. I felt so alone." Indeed, Anatole scolded her for coming home so late that opening night, having no idea until reading the papers the next morning that his daughter was the toast of the city. Moreau gave Paris her Veroushka during the next year, after which she was offered a four-year contract with the company, becoming the youngest paid actress in the 300-year history of the Comédie Française.

While rehearsing for the company's 1949 production of *Othello,* Moreau discovered she was pregnant. The father was Jean-Louis Richard, the same actor who had so admired her during her first year at the conservatory. A day before the birth of their son Jérôme, the couple were married. "It was so stupid to be pushed into it," Moreau later said, in an odd echo of her mother's complaint 20 years earlier. "I had no disposition at all to be a mother." Unlike her mother, however, Moreau went right back to work, leaving her baby in the care of her moth-

er-in-law. Two years later, the couple separated and divorced, blaming conflicting work schedules for the end of their marriage. Jean-Louis went on to become a successful actor and screenwriter, appeared with Moreau in two films, and remained a close friend. "All my bad ideas about marriage came from my parents and their disharmony," Moreau admits. "But all the men I have ever loved, I will love forever."

> *I*f I hadn't been an actress, I might have been an hysteric.
> —**Jeanne Moreau**

Part of the reason Jeanne and Jean-Louis were so often apart was that Moreau had begun acting in films during the day to supplement her income from the theater, although she was not considered photogenic enough to become a major movie star. She received third billing in her first film, 1948's *Dernier Amour* (Last Love), a romantic thriller in which she played the woman who comes between husband and wife. The intimacy of the camera made her feel, she said, "like a butterfly pinned to a piece of paper," but the $300 she received for less than two weeks' work overrode any misgivings. After the upheavals of World War II, French cinema was at a low point, producing only derivative crime dramas and romantic comedies which imitated American films now flooding the European market. From 1948 to 1957, Moreau would play gun molls, prostitutes, and scandalous mistresses while cinematographers complained that her nose was too small and her mouth too big, and directors tried to control the theatrical gestures Moreau carried with her from the stage. Even so, she learned a good deal about filmmaking and acting, especially from leading man Jean Gabin, who taught her how to convey character through subtler gestures and gently indicated personality traits. Audiences soon began to accept her as a favorite character actress, even in her first color film, 1954's *La Reine Margot* (Queen Margot), a horribly lit and badly directed historical drama. "She looked like *Anne Boleyn on a bad day," one biographer has observed, "corseted to the gunwales in an orgy of ruffles and flounces, garish paste jewelry and boned waists." Moreau merely did what she was told, pocketed her paycheck, and redeemed herself on stage each night.

But when the Comédie Française offered her a 20-year contract in 1952, assuring her a virtual life membership in France's most exclusive theater, Moreau balked. In her five years with the company, she had become disillusioned with its

internal politics and instead decided to refuse both the theater company's offer and a lucrative seven-year contract offered to her by Paramount in America. In a few short years, she had become a recognized actress on the French stage and screen and had even been the subject of a *Paris-Match* cover story, but Moreau was looking for new challenges and accepted an offer from her old friend Jean Vilar, who was now directing the Théâtre Nationale Populaire, the best known of the country's many touring repertory companies. Under Vilar's guidance, the TNP transformed French theater by presenting contemporary, controversial works by new young playwrights. Released from the strictures of classical French theater, Moreau blossomed to the extent that after just two years she was appearing in her first play as an independent star, free of any company ties. The play was 1953's *L'heure Eblouissante* (*The Dazzling Hour*), a boulevard comedy in which Moreau played two roles—the ingenue and the older wife of her lover, neither of whom appeared on stage at the same time. The actress playing the wife had fallen ill shortly after the play's opening, and Moreau stayed up all night with her father learning the role's dialogue before her first performance as two very different characters. Audiences were amazed at the ease with which she switched from a bubbly, lissome young mistress to a bitter middle-aged woman during the show's entire run of 500 performances.

Although Moreau has always been reluctant to speak of her technique, she once noted that it had been some years after her triumph in *The Dazzling Hour* that she attended a Method acting class at New York's Actors Studio, with its emphasis on psychological motivation and identity with one's character; and she once complained to director John Frankenheimer during the shooting of 1964's *The Train* about Burt Lancaster's endless analysis of how he should pick up a prop during a scene together. "What an actor needs is a sense of involvement, of unconscious familiarity with his role—nothing more than that," she said. Whatever her secrets, Moreau used them to propel herself to the forefront of French dramatic theater during the mid-1950s with her performances in such plays as Jean Cocteau's *La Machine Infernale* (which Cocteau directed); as Eliza in Shaw's *Pygmalion*, directed by Jean Marais; and as Maggie in Peter Brooks' production of Tennessee Williams' *Cat on a Hot Tin Roof*, performed in English at the Théâtre des Bouffes du Nord. Her work even attracted the transatlantic attention of *The New York Times*, which reported: "Jeanne Moreau now belongs in the forefront of the young gener-

ation of French actors. Her incredible fervor and her attractive appearance have brought her a resounding personal triumph."

Among those mesmerized by Moreau's performance as Maggie was a young film director with a passionate attachment to a script he had just completed but with little money to do anything with it. Louis Malle had graduated two years earlier from the French government's film school and had just won the Palme d'Or at the Cannes Film Festival for co-directing Jacques Cousteau's first documentary film, *Le Monde du Silence* (Silent World), but Malle's heart was set on turning Noël Calef's thriller *Ascenseur pour L'Echafaud* (Elevator to the Scaffold) into his first dramatic film. Having followed Moreau's film career, noticing especially how she was able to convey subtle emotional changes on camera, Malle arranged a meeting and presented his idea with hopes that her attachment to the picture would help him complete the financing. Moreau was immediately attracted to the gritty story of a man and his mistress who conspire to murder the mistress' husband, and agreed to appear in what would become the opening salvo of the French cinema's so-called New Wave. The experience of shooting 1957's *Ascenseur pour L'Echafaud* (released in the United States as *Frantic*) was unlike anything Moreau had been used to in her ten-year, studio-financed film career. Malle's minuscule budget demanded a small crew shooting grainy black-and-white film on sidewalks and in hotel rooms using natural light. For Moreau, it meant supplying her own wardrobe, wearing no makeup, and being intimately involved in developing dialogue and action for her character according to the needs of each location. For Malle, it meant nearly complete control over every aspect of the picture, from writing the script to overseeing release prints—the *auteur* method of filmmaking so dear to modern graduates of film schools. For moviegoers, the film, with its score by Miles Davis, gave an immediate, visceral, exciting experience vastly different from one provided by the carefully controlled productions of major studios.

Ascenseur pour L'Echafaud opened a new phase in Moreau's career, placing her at the forefront of rebellious, innovative filmmaking, but it was the scandal surrounding her next picture with Malle that made her an international star. *Les Amants* (The Lovers), released in 1958, was a sexually frank exploration of upper-class ennui, in which Moreau played the bored wife of a wealthy business executive who flaunts her affair with a handsome, virile, middle-class paramour and, at the film's end, abandons her hus-

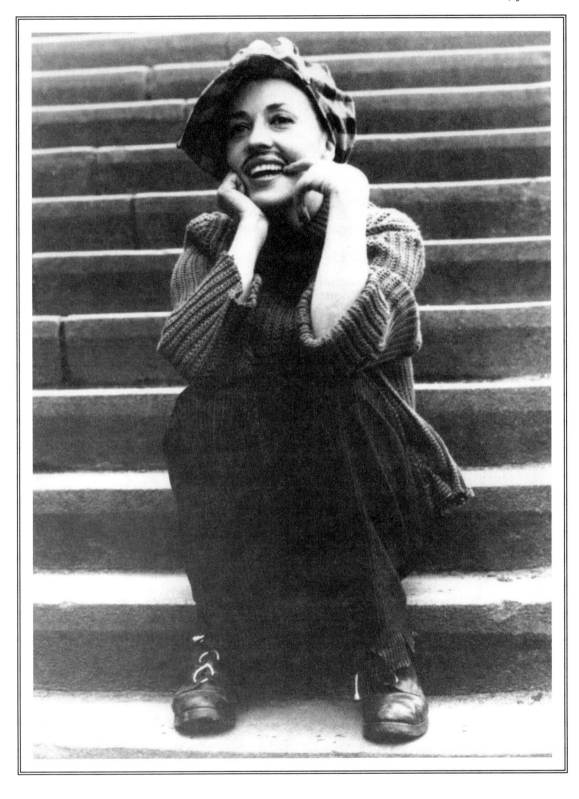

From the movie
Jules and Jim,
starring Jeanne
Moreau.

band and his vacuous lifestyle for her new lover. Although François Truffaut observed that the film's love scenes, which appear tame by modern-day standards, were handled "with absolute taste and perfect tact," Malle had great difficulty releasing the film without cuts in most countries.

In France, he refused to make any cuts at all and fought a long but successful battle with the government film office for a release permit. *Les Amants* was the first film made for commercial release which portrayed lovemaking in all its sensuous detail, focusing on the physical act it-

self and especially on Moreau's ecstatic reactions to her lover's ministrations. Moralists were further outraged when it was discovered that Moreau and Malle were carrying on their own passionate affair during production, having taken a house together near the location and arriving at the set together each day. But in later years, Moreau admitted to the confusion of personal and professional motives that fueled the affair. "I knew that if I played the love scenes just as Louis wanted, he could love me as an actress but hate me as a woman," she said. "I couldn't refuse to act as he wanted me to because I loved him." The affair ended almost as soon as the picture was finished, though the two later reconciled and remained friends for many years. Moreau, troubled by the film's notoriety and afraid that she would be stereotyped as a mere sex symbol, retired alone to the countryside to ponder her future.

She stayed away from films for the next year, going back to the theater for work and solace. It was Truffaut who coaxed her back to the screen by offering her a cameo in his own first film, 1959's *Les Quatre Cent Coups* (The 400 Blows), and thus prodded Moreau into her most productive period on film in a string of *nouvelle vogue* classics. The 1960s brought her first award from the Cannes Film Festival for her performance in Peter Brooks' *Moderato Cantabile*, along with a growing international reputation for her work in Michelangelo Antonioni's *La Notte* and, most famously, as the quixotic Catherine in Truffaut's *Jules et Jim* in 1963. In quintessential New Wave style, Truffaut's tale of a love triangle spanning some 30 years was shot on a tiny budget, with Moreau acting as co-producer and cooking lunches and dinners for cast and crew, although she remained close-mouthed about rumors of an affair with Truffaut. "We didn't live a love story," was all she would say. *Jules et Jim* brought Moreau her first Crystal Award from the French Film Academy for Best Actress. During these prolific years, she turned down several eager offers from Hollywood (including the role of Mrs. Robinson in Mike Nichols' *The Graduate*) but finally relented and appeared in one of her few action pictures, Martin Ritt's *Five Branded Women,* which Moreau later admitted she accepted in order to pay back taxes to the French government. Ritt's World War II saga of five women who join the Yugoslav resistance was an exception in Moreau's portfolio of otherwise carefully crafted films which emphasized character rather than action, including Orson Welles' *The Trial* and *Chimes at Midnight*, Joseph Losey's *Eva,* and Luís Buñuel's

Le Journal d'une Femme de Chambre (The Diary of a Chambermaid). Moreau's dramatic instincts, in fact, often worked against her financial security, for she would take a role which excited her without inquiring into the film's business credentials or its chances for commercial success. It is said, for example, that one of her finest performances, in Orson Welles' *The Deep*, has never been seen because Welles typically ran out of money and abandoned the picture.

The 1960s also marked what Moreau later called her "Rolls-Royce and champagne" period, for it was after completing work on *Jules et Jim* that she met *haute couture* designer Pierre Cardin. The two carried on a very public affair as darlings of the jet set for the next four years. Cardin designed an entire collection around her, used her as his chief photographic and runway model, and ushered her around glamorous parties at many of the several houses the couple maintained on the Riviera and in the Canary Islands, Greece, and on the Continent. It was on Cardin's advice that Moreau bought a Provençal farmhouse, Le Préverger, which became her sanctuary after she and Cardin separated. "I have a great admiration for him," Moreau said some years after, "but frankly I don't even remember why we parted." By the late 1960s, Moreau found herself emotionally and physically exhausted. At 40 years of age and with 50 films to her credit, she was no longer willing to be France's symbol of feminine sensuality and power. In 1968, she retired to the seclusion of Provence.

After a year of psychotherapy, Moreau was back in public view when she joined a protest against the country's abortion laws, which at the time could send a woman to jail for two years and force her to pay up to $1,000 in fines. Moreau joined other well-known and respected French women, including **Catherine Deneuve, Françoise Sagan,** and ***Marguerite Duras,** who publicly announced that they had had abortions (Moreau claimed three before the birth of her son) and challenged the government to take action against them. After five years of sometimes acrimonious dispute, it became legal in 1976 to not only have an abortion, but to have one at government expense during the first ten weeks of pregnancy.

While she was active politically, Moreau gracefully returned to the screen as a mature woman in 1971's *Chère Louise* (Dear Louise), about an affair between a woman of 40 and a young man of 20. "People aren't surprised when they see a man of sixty with a young girl of twenty," she said. "Why not the other way around?"

Four years later, Moreau wrote and directed her first film, *Lumière* (Light), raising most of the money herself at a time when there were few female directors in Europe. The film told the story of four actresses and their relations during one week of their lives. "There are so few good parts for women in films," she said. "That is because the men who write the scripts no longer know their women. The ones they know and sleep with and work with are no longer representative of all women, as they once were."

In February of 1977, Moreau married American director William Friedkin, whom she met in Paris while he was scouting locations for *The French Connection*. The press made much of the fact that Friedkin was more than a dozen years her junior, but it was professional rivalry that ended their short, stormy relationship, little more than a year later. Moreau claimed that Friedkin wanted her to stop using her own name professionally and, indeed, stop acting altogether, although she described it as the most passionate relationship of her life. Moreau had already begun directing her second film *L'Adolescente* which, like *Lumière*, was critically if not commercially successful. Now in her 50s, Moreau began accepting more daring roles—including Lysiane, the proprietor of a violent brothel in Rainer Werner Fassbinder's controversial *Querelle*—and created her own production company, Capella Films, which produced several television movies for English and French markets. But challenging film roles were difficult to find, and it was the stage that once again came to her rescue. Her performance in *Le Récit de la Servante Zerline* (Zerline's Story) was hailed throughout Europe as a stunning portrayal of an old servant woman who tells her life story to her employer, a virtual monologue that begins simply enough but builds to a harrowing conclusion. Moreau appeared as Zerline no fewer than 330 times in productions all over Europe and in Canada, and was awarded the Moliére, the French equivalent of America's Tony Award, as Best Actress in 1988.

In her fifth decade in films, Moreau began to enjoy renewed popularity from a fresh generation of theater and film enthusiasts. She was honored with retrospectives of her work, including one in 1992 at New York's Museum of Modern Art, and continued to present elegant, finely honed performances, such as the arthritic, domineering society doyenne in 1992's *La Vielle qui Marchait dans la Mer* (The Old Woman Who Walked in the Sea), for which she was presented with the French Film Academy's César Award as Best Actress of that year, and as the delightfully vulgar Lili in 1994's *The Summer House*. Holding firm to her conviction that acting and daily living are inextricably bound, Jeanne Moreau continued to speak out for equality and respect for the sexual and spiritual lives of women of all ages and particularly of those well past middle age. "I'll die . . . like everyone else," she once said, "but whether I die at seventy-five or eighty-five, I'll die young."

SOURCES:

"Failed Ballerina: Jeanne Moreau," in *The Economist*. Vol. 324, no 7770. August 1, 1992.

Gray, Marianne. *La Moreau: A Biography of Jeanne Moreau*. London: Little, Brown, 1994.

"Hot Number: Jeanne Moreau," in *The Economist*. Vol. 334, no. 7901. February 11, 1995.

Katz, Ephraim. *The Film Encyclopedia*. 2nd ed. NY: HarperCollins, 1994.

Norman Powers,
writer-director, Chelsea Lane Productions, New York

Moreau de Justo, Alicia

(1885–1986)

Noted Argentine feminist, fighter for the right of women to vote, medical doctor, writer, editor, and political activist who was a leader in the Socialist Party. Pronunciation: ah-LEE-seeah mo-ROW day HOOS-toe. Name variations: Alicia Moreau. Born Alicia Moreau on October 11, 1885, in London, England; died in Buenos Aires, Argentina, in 1986; daughter of Armando Moreau (later a journalist and influential member of the Argentine Socialist Party) and María Denampont de Moreau; attended primary school, Buenos Aires, Escuela Normal N° 1 (Normal School N° 1), Buenos Aires (1898–1904), Colegio Nacional Central (Central National College) (1906), Facultad de Medicina, Universidad de Buenos Aires (Medical School, University of Buenos Aires) (1907–14); married Juan Bautista Justo, in 1922 (died 1928); children: three, Juan, Luís, and Alicia.

Founded La Unión Nacional Feminista (National Feminist Union, 1918) and the Socialist Women's Suffrage Committee (1930); served as editor of the Socialist newspaper, La Vanguardia *(1956–62).*

Significant publications: La emancipación civil de la mujer *(The Civil Emancipation of Woman, 1919);* El feminismo en la evolución social *(Feminism in Social Evolution, 1911);* La mujer en la democracia *(The Woman in a Democracy, 1945);* El socialismo de Juan B. Justo *(The Socialism of Juan B. Justo, 1946);* Socialismo y la mujer *(Socialism and the Woman, 1946).*

Alicia Moreau de Justo, a leading feminist and a figure whose long life traced the history of socialism in Argentina, was born into a family

tradition of rebellion. Both her father Armando Moreau and mother **Maria Denampont** were French exiles in London, where they met and married. They had fled France in the tumultuous wake of the Franco-Prussian War and the unsuccessful revolutionary struggle known as the Paris Commune that raged through the spring of 1871.

Born on October 11, 1885, Alicia had an older sister **Luisa** and a brother Santiago. Not long after her birth, the family decided to move to a country "without barriers" and chose, somewhat naively, Argentina. There her father worked at a number of odd jobs, including a stint as a cook, before he emerged as an influential journalist and a leader in the fledgling Socialist Party, founded in 1894 by Juan B. Justo.

Female suffrage is true democracy: about one-half of the population is female—how can governments and legislatures call themselves representatives of the people when half of these people cannot vote or express their opinion?

—Alicia Moreau de Justo

Alicia was always close to her father and in her later years she remembered the stories he related about the Commune with its people in arms. A photograph in his possession, which showed the execution of prisoners, made a deep impression on her and sowed the seeds of a heroic ideal, that of popular emancipation. That troubling photograph led Moreau to the deeper study of French history in general, and the French Revolution in particular. As a teenager, she accompanied her father to meetings of the Socialist Party and a variety of popular demonstrations in turn-of-the-century Buenos Aires. In 1900, at age 15, she helped her friends **Fenia Chertkoff** and **Gabriela de Coni** found the Socialist Feminist center, an organization that pushed for protective legislation for working women.

Moreau's close contact with Argentine socialism in part accounts for her interest in women's rights. But a terrifying experience as a primary school student also had an impact on the precocious child. For a period of time, as she walked to and from school, she was stalked by a man. Once, when he got too close, she struck him with her book bag and he fled, never to return. The event was traumatic, and Moreau later interpreted it within the context of the low status of women in Argentine society and the anxious atmosphere associated with the develop-

ment of a young girl under what she called the "imperio masculino," or "male rule."

In 1898, Moreau enrolled in Escuela Normal Nº 1 (Normal School Number 1) in downtown Buenos Aires. Courses she took and teachers she encountered had a strong influence on her intellectual development. One class was taught by a future president of Argentina, Hipólito Yrigoyen. In another class, she was impressed with the commanding role assumed by women in Aristophanes' play, *Lysistrata*. In her second year, she was attracted to natural history because of the expertise and professionalism of one of her teachers, who was also the director of the Zoological Garden in Buenos Aires. She discussed everything, with her professors and with her peers, later noting, "I was never in agreement with things if I did not understand them." Among her favorite authors were Charles Darwin and his German adherent, Ernst Haeckel. Indeed, when Moreau was a young girl, her father had read her passages from Darwin's *Origin of Species*. Darwinism inspired Alicia to pursue a career in medicine, once she had graduated from the Escuela Normal. In her words: "that which had the most influence over my development, and that in the end led me to study medicine, was darwinism." As she told interviewer Blas Alberti:

> I came to respect men who observed, who used their hands to dissect, to use the microscope. . . . This love took me toward the study of all the sciences, and when I was sufficiently advanced in chemistry, physics, and the like, I looked for a place to study them further—and this took me to medicine.

Awarded her teacher's certificate in 1904, Moreau applied to the Medical Faculty of the University of Buenos Aires. Her entry was delayed a year because of a student strike in 1906, but she used the time to earn her bachelor's degree at the Colegio Nacional Central. To raise money for medical school, for she was virtually self-supporting, Moreau worked as a laboratory assistant for a psychologist at the University of Buenos Aires. From her professor, she learned about a scheduled international convention on free thought to be held in Buenos Aires and wanted to attend. Informed that she would have to prepare and read a paper, she wrote a piece on education. Although Moreau's paper by her own admission was not especially good, she did make contact with a number of leading intellectuals, including the Socialist doctor Angel Giménez. Giménez in 1898 had established the Sociedad Luz (Society of Light) which was dedicated to the education of the working class. Moreau

joined, and during 1907, her first year in medical school, lectured workers on alcoholism, tuberculosis, and syphilis. The emphasis was on prevention. It was also at this time that Giménez introduced her to the leaders of Argentine socialism: Augusto Bunge, Nicolás Repetto, Enrique Dickmann, Adolfo Dickmann, and Juan B. Justo. All were, or had been, students at, or graduates of, the Medical School of the University of Buenos Aires.

One of six women in her class, Moreau suffered from various degrees of prejudice and hostility. She told one interviewer that she "encountered great hostility from male students," although the faculty were generally supportive. Part of the hostility, she mischievously explained to **Marifran Carlson**, was attributed to "her own personal beauty." They were offended "because she did not want to marry any of them." Moreover, she explained that male students were angry because "they knew that women were naturally better doctors than men." While some students were contemptuous, others were indifferent and a few were sympathetic and tried to be of assistance.

Moreau was able to combine medical school with a growing interest in political action, especially as it touched issues important to women. As a Socialist, she subordinated personal ambition to the good of all people. While she befriended other feminists, such as **Julieta Lantieri** and **Elvira Rawson de Dellepiane**, she disapproved of their individualism. Carlson notes that Moreau felt that they "did not . . . put sufficient emphasis on the larger struggle for social justice." As late as 1977, in an interview, Moreau still cast Lantieri as an "egoist and a self-seeking individualist." But Moreau was in turn criticized for subordinating a feminist agenda to a Socialist one.

Argentine Socialists worked within a framework of evolution rather than revolution. Moreau, with her affinity for Darwinism, believed in the progressive evolution of society. While she was impressed with those women who chose the path of anarchism, she was opposed to clandestinity and the potential for violence. In 1907, Moreau and others worked hard to prepare legislation that would regulate the labor of women and children. Their bill was presented to Argentine lawmakers by Socialist senator Alfredo Palacios, and Law 5291 took effect in 1908. Although it was largely unenforced, that the law was passed at all attests to the thorough preparation of Moreau and to her associates and to a subtle shift in the political climate.

Even before she attended medical school, Moreau had contributed articles to *La Vanguardia* (The Vanguard), the newspaper of the Socialist Party, and her father's journal, *La Nueva Humanidad* (New Humanity). While still a student, in 1911, she wrote a short book, *El feminismo en la evolución social* (Feminism in Social Evolution) which approached socialism and feminism within a Darwinian context. The book, according to Carlson's analysis, noted that industrialism had made feminism a necessity if women were to enjoy the rightful fruits of their own labor. The maternal role, which traditionally had been used to isolate women from society, Moreau argued should *not* be used to exclude women from the public arena. Rather, the importance of women in the home, together with their new economic roles in the larger society, justified the granting of civil and political rights.

Moreau interned at the Hospital de Clínicas where she worked in the women's section and specialized in gynecology. Service in the hospital, by her own admission, allowed Moreau to ponder the role of women in Argentine society. The clinic was located on the site of a former house of prostitution and many of her patients were working prostitutes. Most of the young women were from the provinces and had been forced by necessity into their profession, which she likened to a form of slavery. While Moreau practiced medicine, the clinic also served as a laboratory for her social and political education. She was determined to raise the status of people in general, but with special attention to the emancipation of women.

In 1918, Moreau founded the Unión Feminista Nacional (National Feminist Union) to attract working-class women to the Socialist Party, the only party that supported female suffrage as well as reform of Argentina's patriarchal Civil Code. Members of the Union prepared the text of a suffrage bill and, even though Socialist members of the legislature failed to gain its passage, Moreau was pleased by the 8,000 signatures in its support. Just a year later, she published *La emancipación civil de la mujer* (The Civil Emancipation of Woman) in which she attacked the "child-doll personality" promoted by Argentine culture. Interestingly, she noted, while 87% of Argentine primary school teachers were women, these same women were denied civil and political rights. Throughout 1919, Moreau traveled to the interior provinces of Argentina, other Latin American countries, and the United States. To educate women and to convince them to fight for the right to vote were her guiding principles. While in New York, she met with American feminist *****Carrie Chapman Catt** and spoke to the International Congress of Women

Workers about the need for government-sponsored day-care centers, comprehensive maternity protection, equal pay for equal work, and a 40-hour work week. But if change were to occur, women had to gain the vote.

Many feminists in the United States and elsewhere who were seeking to secure female suffrage in societies concerned about social unrest—and 1919 was a nerve-wracking year for many governments—agreed that property and educational qualifications were necessary for all voters. Moreau vehemently disagreed and pushed the Socialist line that "qualified suffrage" was undemocratic and unfair. Never would Moreau compromise on this issue, and it helped to create a deep schism in Argentine feminism.

Congressional elections, scheduled for March 1920, was the occasion for Argentina's three main feminist organizations, Moreau's National Feminist Union, Lantieri's National Feminist Party, and Rawson de Dellepiane's Women's Rights Party, to hold their own mock election. Only the election united the groups. Moreau complained about Lantieri's self-seeking opportunism and felt that she should work more closely with the other groups. Lantieri's noisy, public campaign won most of the attention from the press. But it was Moreau's Socialist-affiliated Union that won most of the votes cast by women. Unfortunately, the number of women who voted was disappointingly low and the three feminist leaders agreed, in Carlson's words, "that the greatest enemy of female suffrage was female indifference."

Alicia Moreau married Juan B. Justo, the leader of the Socialist Party, in 1922. Although she gave birth to three children before her husband died in 1928, maternal concerns had little influence on the high level of Moreau's activism. In 1924, a curious coalition of feminists, anti-feminists, liberals, and conservatives fought a dignified and restrained battle for the passage of legislation that would protect women and children in the workplace. Moreau was allowed to present the feminist position to the Argentine Chamber of Deputies. Law 11.317, which was passed by Congress, limited non-agricultural work for women to 8 hours a day and 48 hours a week. Night work for women under age 18 was prohibited, women and children could not be hired for dangerous or unhealthy work, and provision was made for limited maternity protection. Although the law carried no regulatory provisions, feminists saw its passage as a victory. Feminists won another concession in 1926 when a reform of the Civil Code granted women more rights. But none of the legislation addressed what Moreau saw as the key issue—women's suffrage.

In 1930, she established the Socialist Women's Suffrage Committee and in 1931 published *El socialismo y la mujer* (Socialism and Woman). She argued that the only true democracy was one which allowed women to vote. Half of Argentina's population was unrepresented and unheard. Moreau again railed against the idea of the qualified vote and said: "We would prefer not to have the vote than to have it qualified." In this regard, she continued to be out of step with other feminists who felt that illiterates, for example, should not be able to vote.

In the 1930s in the pages of two magazines, *Claridad* (Illumination) and *Vida Feminina* (Woman's Life), Moreau created a character named doña Juana Pueblo (Joan People), who, in **Francine Masiello**'s phrase, "represented the emerging consciousness of modern, socialist woman." Juana Pueblo's Socratic dialogue with those supposedly wiser than herself opened insights into a wide range of themes, from cooperative farming, to congressional legislation, to the symbolism of the ritual of the Catholic Church. "But of greater importance," according to Masiello, Juana "learns through debate and reason to become engaged with social process and speak her mind in public."

Despite the hard work of feminists such as Moreau, a survey taken in 1936 revealed that 60% of Argentine women lacked an understanding as to what enfranchisement meant. In that same year, a conservative-dominated Senate rejected a petition that urged female suffrage circulated by Moreau, **Carmela Horne de Burmeister**, who founded the Argentine Association for Women's Suffrage, and *****Victoria Ocampo**, president of the Union of Argentine Women. At the same time, Ocampo, Moreau and Horne de Burmeister successfully resisted attempts by Congress to roll back the reforms of the Civil Code that had been passed a decade before. In the mid- and late-1930s, Moreau and Ocampo emerged as the two most influential leaders of the women's movement in Argentina.

As was so often the case with Moreau, her inflexible principles put a good deal of strain on her relationship with Ocampo. While both shared the same general perspective on the role of women, Ocampo, a member of the elite, did not believe that a levelling of society was a possible or desirable end. Moreau, of course, was an uncompromising democratic Socialist.

During World War II, both women, with a few others, served on the board of Acción Argentina (Argentine Action), an organization that supported the Allied cause. In the last year of the war, Moreau wrote *La mujer en la democracia* (The Woman in a Democracy) in which she urged the empowerment of women and the decentralization of the power of the state. Ironically, this was at the same time that Juan Domingo Perón was planning his ascent to power and, ultimately, dictatorial rule.

Moreau and most Socialists opposed Perón. Even when he enfranchised women in 1947, Moreau judged the effort a cynical move on Perón's part to enhance his own power base. She told interviewer Carlson in 1977 that despite half a century of "pleading and exhortation" by feminists, working-class women of Argentina "had chosen to follow a demagogue." The Perónist years, in Moreau's view, were a "tragedy that 'politically unclear women' had helped to bring upon the country." The hallmarks of the regime were anti-democratic and featured intimidation, persecution and imprisonment. Essentially, Moreau had underestimated both the personal appeal of Perón and the attractive power of Argentine nationalism and overestimated the appeal of feminism and socialism.

Argentina's Socialist Party never recovered from its eclipse during Perón's decade of rule. Moreau, despite advancing years, remained active in a movement that grew increasingly fissiparous (splintered). Between 1956 and 1962, she edited the party's newspaper, *La Vanguardia*, and was elected to the party's executive board in 1958. In an attempt to reunify a divided Socialist Party, Moreau in 1975 created and presided over a new organization, the Confederación Socialista Argentina (Argentine Socialist Confederation). Her efforts were successful, and in 1983 a new and unified Partido Socialista Popular (Popular Socialist Party) was created. Active until the end, Alicia Moreau de Justo died in 1986 in her 101st year, after a lifetime that encompassed the entire history of socialism and feminism in Argentina.

SOURCES:

Alberti, Blas. *Conversaciones con Alicia Moreau de Justo y Jorge Luis Borges.* Buenos Aires: Ediciones del Mar Dulce, 1985.

Carlson, Marifran. *Feminismo!: The Woman's Movement in Argentina from Its Beginnings to Eva Perón.* Chicago, IL: Academy Chicago, 1988.

Hollander, Nancy Caro. "Women: The Forgotten Half of Argentine History," in *Female and Male in Latin America: Essays.* Ann Pescatello, ed. Pittsburgh, PA: University of Pittsburgh Press, 1973, pp. 141–158.

Masiello, Francine. *Between Civilization and Barbarism: Women, Nation, and Literary Culture in Modern Argentina.* Lincoln, NB: University of Nebraska Press, 1992.

Perrone, Alberto M. "Entrevista con Alicia Moreau de Justo," in Alicia Moreau de Justo, *Qué es el socialismo en la Argentina.* Buenos Aires: Editorial Sudamericana, 1983, pp. 182–195.

SUGGESTED READING:

Miller, Francesca. *Latin American Women and the Search for Social Justice.* Hanover, NH: University Press of New England, 1991.

Newman, Kathleen. "The Modernization of Femininity: Argentina, 1916–1926," in Seminar on Feminism and Culture in Latin America. *Women, Culture, and Politics in Latin America.* Berkeley, CA: University of California Press, 1990, pp. 74–89.

Walter, Richard J. *The Socialist Party of Argentina, 1890–1930.* Austin, TX: University of Texas Press, 1977.

Paul B. Goodwin, Jr.,
Professor of History, University of Connecticut,
Storrs, Connecticut

Moreno, Luisa (1906–1992)

Latina labor organizer and civil rights activist who, facing deportation, left her adopted homeland in protest. Name variations: The California Whirlwind. Born in Guatemala on August 30, 1906; died in Guatemala in 1992; graduated from the Convent of the Holy Names, Oakland, California, mid-1920s; married to a Mexican artist by 1928 (divorced by mid-1930s); children: one daughter.

Worked as a journalist in Mexico for a Guatemalan newspaper (late 1920s); emigrated to U.S. (1928); after briefly working in the garment trade in New York City (early 1930s), became an organizer for the Needle Trades Workers International; became organizer for the American Federation of Labor (AFL) and (after 1936) for the Congress of Industrial Organizations (CIO); was co-founder of El Congreso de Pueblos que Hablan Espanol (the National Congress of Spanish Speaking Peoples, 1938); became organizer and international vice president, United Cannery, Agricultural, Packing, and Allied Workers of America (UCAPAWA, 1941–47); appointed to the California Fair Employment Practices Commission during World War II; made vice president, California CIO (1945); returned to Guatemala (1949) and became an active supporter of the democratic government of Jacobo Arbenz; moved to Mexico after the overthrow of the Arbenz government (1954); participated in the revamping of the Cuban education system after the 1959 revolution.

In 1949, facing certain deportation from the United States, Luisa Moreno opted to return voluntarily to Guatemala, the nation of her birth. Before she left, however, she spoke to the 12th Annual Convention of the California Congress

of Industrial Organizations (CIO), an organization she had helped found. Her message was one of warning. The Tenney Commission, a state-level forerunner to the national anti-Communist hysteria of the 1950s, was determined to expose and deport labor and political radicals such as Moreno. "Strange things are happening in this land," she told the convention:

> Things that are truly alien to traditions and threaten the very existence of those traditions. . . . Yes, tragically, the unmistakable signs are before us—before us, who really love America. . . . For it seems today, as the right to organize and strike was fought for and won, as the fight against discrimination is being fought but far from won, so the fight for the very fundamentals of American democracy must again be fought for and re-established.

By the time Luisa Moreno stood before those members of the California CIO, cautioning them that the current political conservatism threatened the rights of native-born and immigrant alike, she had been fighting for those rights for more than 20 years. Though she would be active in democratic politics in Guatemala and involved in the Cuban revolution of 1959, Moreno left the United States in 1949, fearful that all she had worked for would be erased. She was also bitterly disappointed that she could no longer be a part of the effort to sustain the rights now in jeopardy.

Strange things are happening in this land. . . .
And it is we who must sound the alarm, for the workers
and the people to take notice.

—Luisa Moreno

Luisa Moreno was born in Guatemala in 1906, the privileged daughter of a wealthy and prominent family. Like many daughters of the Guatemalan elite in the early 1920s, Moreno was educated in the United States, attending the prestigious Convent of the Holy Names in Oakland, California. She would later remember herself as a "rebellious teenager" who upset her conservative family by publicly demanding the expansion of education for Guatemalan women. Her first job was as a journalist for a Guatemalan newspaper. Assigned to Mexico City, she met the man she would soon marry, a Mexican artist. The young couple emigrated to the United States in 1928, settling in New York City.

The following year, the Great Depression began. With her husband unemployed, as was a fourth of the U.S. workforce, the now-pregnant Moreno found a job in a garment factory near Spanish Harlem in New York City. Conditions in the garment trades had always been difficult. Faced with long hours, seasonal employment, and low wages, the primarily immigrant workers had fought for union representation for years. The Depression only made conditions worse: those fortunate enough to still be employed saw their already low wages slashed. Working alongside Puerto Rican immigrants, many of whom were socialists, Luisa Moreno became radicalized.

While her upbringing and education set her apart from her co-workers in the garment factory, she did share their language. Even more important, many were women who like Moreno were forced to support children, and unemployed husbands, on meager wages. When her husband deserted her and their infant daughter, Moreno experienced firsthand the all-too-common hardship of unskilled women workers. Her work experiences, combined with her increasingly radical politics, caused Moreno to see union representation as the only way to increase wages and improve often dangerous or simply degrading work conditions. By the early 1930s, this daughter of an elite Guatemalan family became a full-time organizer for the Needle Trades Workers Industrial Union.

At the same time that she was fighting for the rights of workers, Moreno was also actively fighting against the discrimination of Spanish-speaking people, then so common in the America. In 1930, a demonstration was organized to protest the opening of the movie *Under a Texas Moon* (with *Myrna Loy as Lolita Romero in one of her early ethnic roles and Frank Fay playing a stereotypical "bandido" as Don Carlos), which Spanish-speaking immigrants saw as anti-Mexican. When the police forcibly broke up the demonstration, many protesters were injured, including one of the leaders who soon died of a fractured skull. Moreno joined several other New York Latino community leaders in organizing an even larger demonstration.

By the mid-1930s, she was working in Florida and Pennsylvania, organizing Italian and Cuban cigar makers for the American Federation of Labor (AFL). Union organizing was a demanding job, involving much travel and sometimes personal danger. Now officially divorced from her husband, Moreno had sole responsibility for her young daughter, who accompanied her when possible. However, it was frequently necessary for Moreno to board her child with sympathetic friends as she crossed the country organizing for the newly formed United Can-

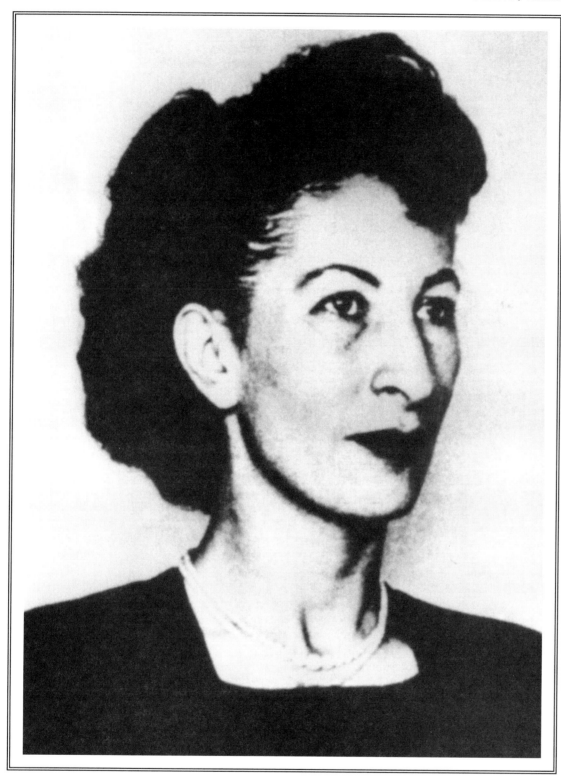

Luisa
Moreno

nery, Agricultural, Packing, and Allied Workers of America (UCAPAWA).

The UCAPAWA was born out of the increasingly widespread discontent within the AFL. At the 1936 AFL annual convention, an informal caucus met to discuss the AFL's apparent disinterest in organizing agricultural workers. The caucus, which included Moreno, asked the convention to sanction the formation of an agricultural and food processors union and to guarantee that the dues be set at a rate which the mem-

bers, among the lowest paid of American workers, could afford. When the AFL ignored the caucus and its demands, caucus members decided to create their own independent international union. Thus the UCAPAWA was born at much the same time that the Committee of Industrial Organizations was gaining strength within the AFL. The Committee, headed by veteran miners' union president John L. Lewis, would finally break off from the AFL in 1938, becoming the Congress of Industrial Organizations (CIO).

Unlike the AFL, the CIO actively sought to organize industrial workers as well as unskilled women, blacks and Latinos—categories of workers which the AFL had always deemed unorganizable. After 1935, New Deal legislation enacted to address the economic hardships caused by the Depression aided the formation of CIO-affiliated unions, including the UCAPAWA. Organizers such as Moreno were invaluable to the CIO as it established itself during the late 1930s. As a woman who spoke both Spanish and English, she could effectively organize large numbers of workers, specifically Spanish-speaking women, previously judged as incapable of union membership. In writing about the UCAPAWA, the historian **Vicki Ruiz** claims that "women organizing women proved a key to the union's success."

As an organizer for the UCAPAWA, Moreno spent the 1930s working with tobacco workers in Florida, sugar cane workers in Louisiana, pecan shellers and cotton pickers in Texas, and sugar beet workers in Colorado. The situation was the same everywhere—low pay, difficult if not dangerous work conditions, and unsanitary company housing. To all, Moreno delivered the same simple message: as American workers—whatever their ethnicity, race, or gender—they had the right to a decent wage, a safe work environment, and clean, affordable housing. Despite the frequently violent employer resistance to unionization, Moreno succeeded more than she failed. As her fellow CIO activist, friend, and colleague Bert Corona later remembered, "She was a small woman, under five feet tall, but she had a powerful gift for persuasion."

As a Latina, Moreno was acutely aware of the particular problems shared by all Spanish-speaking women workers who faced constant ethnic and gender discrimination. For most Latino workers, especially Mexican-Americans, it was as much an issue of civil rights as it was of worker rights. "You could not organize workers," Moreno said "in the face of violence and terror." To help combat that terror, she took a leave of absence from the UCAPAWA in 1938. Using her own limited funds, she traveled throughout the American Southwest organizing local chapters of El Congreso de Pueblos que Hablan Espanol (National Congress of Spanish Speaking Peoples).

From its inception, El Congreso was seen as a vehicle of the U.S. Communist Party, as was the UCAPAWA. Years later, when discussing the politics of the UCAPAWA, Moreno saw it as a "left" union rather than a Communist union. Whatever their political affiliation, both the UCAPAWA and El Congreso were radical for their time in the demands they made for worker and Latino rights. This radicalism soon came to the attention of the House Un-American Activities Committee (HUAC), then headed by Congressman Martin Dies. When HUAC learned that Moreno had arranged for the first national convention of El Congreso to be held at the University of New Mexico in March 1939, the committee reacted swiftly. HUAC put pressure on the university, threatening to investigate the faculty, and in consequence the Albuquerque gathering was postponed for a month and moved to Los Angeles.

Despite political repression, the first El Congreso national convention was testimony to the effective organizing of Moreno. Hundreds of Latinos, men and women, representing 136 unions and Latino community groups from across the U.S., met in Los Angeles in April 1939. For four days, convention-goers attended dozens of panels, most conducted in Spanish, addressing among other things labor issues, police brutality, and community relations. As Corona remembered, "Above all, the congregation of so many Spanish-speaking people stamped in my mind, and in the minds of many others, that we were a national minority and not just a regional one." At that time, the largest concentration of Latinos, primarily Mexican-Americans, lived and worked in California. Many, especially Latinas, toiled in the growing cannery industry. It was here that Moreno would spend her last ten years in America, organizing workers who were underpaid and at risk from unsafe machinery.

Late in 1940, Moreno took over the daily management of UCAPAWA Local 75. Just a year earlier, the mostly women workers employed by the California Sanitary Canning Company (Cal San), one of the largest canneries in Los Angeles, had walked out at the height of peach processing season, demanding union recognition. After three months of picketing, Local 75 won recognition and a closed shop. However, the difficult work of consolidating the union remained. Luisa Moreno was an excellent choice for this task.

While both Mexican-American and Russian Jews were employed at Cal San, the Latina workforce tended to speak only Spanish. Many disputes on the shop floor arose simply because Mexican-American workers could not communicate with their Anglo supervisors. Moreno was particularly adept at mediating these conflicts.

She also demanded consistent company compliance with government regulations and contract stipulations. Her leadership played a large part in the evolution of Local 75 into one of the UCAPAWA's strongest, most democratic affiliates. The local's strength allowed its members to play a significant part in organizing food processing workers elsewhere. In 1942, as the newly elected UCAPAWA vice-president, Moreno asked the Cal San workers to help her organize workers at the California Walnut Growers' Association plant. According to Ruiz, "the technique of using rank-and-file union members to lay the groundwork was both innovative and effective." Moreno's skills as an organizer and her involvement of union members soon won victories at the Walnut Growers' plant and two other plants as well. Out of this union drive was born Local 3, the second-largest UCAPAWA affiliate.

While Moreno was organizing the workers of southern California, the United States entered World War II. As the nation geared up for war, many employment opportunities opened up for Mexican- and African-American workers and for women in general. Southern California in particular was a center of defense work and, as white men went off to war, those long denied entry into skilled, well-paying jobs entered defense plants by the thousands. Long interested in the civil rights of minority workers, Moreno was an appropriate appointee to the California Fair Employment Practices Commission. For the duration of the war, she sought to ensure that workers were treated decently and paid fairly, no matter their gender, race, or ethnicity.

She also continued organizing for the UCAPAWA. In the fall of 1942, she directed an especially violent effort to organize workers at Val Vita in Fullerton, the largest cannery in California and one with the worst work conditions. Three-quarters of the workforce were Latinas, who were paid low wages and driven to the point of fainting during production speed-ups. Despite employer resistance which became violent, Moreno arranged for a National Labor Relations Board (NLRB) election which resulted in the formation of Local 2.

A year later, in 1943, she joined with fellow UCAPAWA organizer **Dixie Tiller** and rank-and-file union leader Pat Verble in the formation of the Citrus Workers Organizing Committee (CWOC). Patterned after the radical Steel Workers Organizing Committee (SWOC) of the 1930s, Moreno and CWOC organized scores of small food processing plants across the state of California. Dehydration plant workers, citrus pickers, and shed packers were all organized in one of the most successful campaigns in the history of the UCAPAWA. Eighteen months later, 31 NLRB elections brought union representation, improved work conditions, and increased wages to thousands of workers.

By 1945, Luisa Moreno had been elected a vice-president of the California CIO, and the UCAPAWA had a new name. At the 1944 convention, union members had voted to call their organization the Food, Tobacco, Agricultural, and Allied Workers of America (FTA), in recognition of the growing number of tobacco workers in the union. Newly christened, the California FTA would enter the immediate postwar era involved in its most bitter struggle, one which would prove ultimately unsuccessful. It would also be Moreno's last campaign on behalf of the workers for whom she had fought for almost 20 years.

In May 1945, the AFL granted the International Brotherhood of Teamsters the right to organize food processing workers in California. Seeking to block a Teamster takeover, the FTA launched a massive organizing drive in the canneries of northern California. When the FTA turned to Moreno to head up this effort, she called in a number of fellow FTA organizers as well as CIO leaders to assist her in the yearlong campaign to keep the Teamsters and the AFL out of what the FTA considered its territory. However, Moreno's skills and even the widespread support of the rank-and-file were not enough to counteract the frequently violent tactics employed by the Teamsters, as well as a charge by the California Processors and Growers Association that the FTA was a Communist union. The FTA lost the NLRB election in August 1946 and, by 1950, had shrunk from the seventh-largest CIO union to virtual non-existence.

For Moreno, this was a particularly bitter defeat. As a woman who had dedicated her life to union organizing, to lose such a critical battle which was really one of union against union was especially painful. In Moreno's mind, and to others like her, the AFL's attempts in the post-WWII era to undercut the gains made by CIO unions in the previous ten years only hurt those most in need of protection—the workers. Moreno had spent her career organizing those considered un-

organizable. Now she was branded as a subversive. Though she retired from public life in 1947, it was not soon enough. By 1948, she was under investigation by the state of California, suspected of being a Communist. Sure that she was about to be deported, as many soon would be, Moreno left the United States in 1949.

She returned to Guatemala in time for the 1950 election of Jacobo Arbenz, thought by some to be Communist-backed and repressive and by others to be one of the most democratic presidents in that nation's history. Seeking to restore national control of the economy, Arbenz challenged the authority of the United Fruit Company which had close ties to the U.S. government. Moreno was an enthusiastic supporter of Arbenz and his policies. The United States, on the other hand, was not, and supplied a Guatemalan exile force with the arms necessary for the overthrow of the elected president. Once again, Moreno became a political outsider. She then spent several years in Mexico before going to Cuba after the revolution there in 1959. One of the major goals of Cuban revolutionary leader Fidel Castro was to improve the country's educational system. Moreno assisted in this effort, playing a part in the near-eradication of illiteracy in Cuba within just a few years. Later returning to Guatemala, the land of her birth, she died there in 1992.

During the 20 years she spent in America, and for more than 40 years after that in Central America, Luisa Moreno's goals remained essentially the same. She devoted her life to the principles of economic justice, political freedom, and social equality. These were the goals she sought to bring to Latino workers in the United States and to the citizens of Guatemala and Cuba. Whether it was through union membership, national control of resources, or improved education, for Moreno the end result was to be the same—the promise of human dignity.

SOURCES:

Garcia, Mario T. *Memories of Chicano History: The Life and Narrative of Bert Corona.* Berkeley, CA: University of California Press, 1994.

Ruiz, Vicki L. *Cannery Women, Cannery Lives: Mexican Women, Unionization, and the California Food Processing Industry, 1930–1950.* Albuquerque, NM: University of New Mexico Press, 1987.

SUGGESTED READING:

Garcia, Mario T. *Mexican Americans: Leadership, Ideology, and Identity, 1930–1960.* New Haven, CT: Yale University Press, 1989.

Sanchez, George J. *Becoming Mexican American: Ethnicity, Culture, and Identity in Chicano Los Angeles, 1900–1945.* NY: Oxford University Press, 1993.

Kathleen Banks Nutter,
Manuscripts Processor at the Sophia Smith Collection,
Smith College, Northampton, Massachusetts

Moreno, Rita (1931—)

Puerto Rican actress, singer, and dancer who was the only performer ever to win all four of the entertainment world's major awards. Name variations: Rosita Moreno; Rosita Cosio. Born Rosa Dolores Alverio on December 11, 1931, in Humacao, Puerto Rico; daughter of Paco Alverio and Rosa Maria (Marcano) Alverio (a seamstress); attended P.S. 132 in New York City; took extension courses at the University of California and a year of acting lessons; married Leonard Gordon (a physician), in 1965; children: Fernanda Luisa (b. 1967).

Awards: Academy Award for Best Supporting Actress (1961) and Golden Globe Award, Best Supporting Actress in a Film (1962), both for West Side Story; *Grammy Award for Best Recording for Children (1972) for* The Electric Company; *Emmy Award for Best Supporting Actress in a Variety or Music Role (1975) for* Out to Lunch; **Antoinette Perry ("Tony") Award for Best Supporting Actress in a Drama (1975) for* The Ritz; *Emmy Award for Outstanding Continuing or Single Performance by a Supporting Actress in Variety or Music Role (1977) for* The Muppet Show; *Emmy Award, Outstanding Lead Actress for a Single Appearance in a Drama or Comedy Series (1978), and Emmy Award nomination, Best Actress in a Drama Series (1979), both for* The Rockford Files; *Emmy Award nomination, Best Performer (1982) for* Orphans, Waifs and Wards; *Emmy Award nomination, Best Supporting Actress in a Limited Series or Special (1982) for* Portrait of a Showgirl; *Emmy Award nomination, Best Actress in a Comedy Series (1983), for* 9 to 5; *Sarah Siddons Award (1985); Hispanic Heritage Award (1990).*

Selected filmography: Pagan Love Song *(1950);* The Toast of New Orleans *(1950);* Cattle Town *(1952);* The Ring *(1952);* Singin' in the Rain *(1952);* Fort Vengeance *(1953);* Latin Lovers *(1953);* El Alamein *(1954);* Garden of Evil *(1954);* Apache Uprising *(1955);* Untamed *(1955);* Seven Cities of Gold *(1955);* The Lieutenant Wore Skirts *(1956);* The Vagabond King *(1956);* The King and I *(1956);* The Deerslayer *(1957);* This Rebel Breed *(1960);* Summer and Smoke *(1961);* West Side Story *(1961);* Cry of Battle *(1963);* The Night of the Following Day *(1968);* Popi *(1969);* Marlowe *(1969);* Carnal Knowledge *(1971);* The Ritz *(1976);* The Boss's Son *(1979);* Happy Birthday, Gemini *(1980);* The Four Seasons *(1981);* Age Isn't Everything *(1991);* I Like It Like That *(1994);* Angus *(1995);* The Wharf Rat *(1995);* Women: First and Foremost—V.1 *(1995);* Women: First and Foremost—V.2 *(1995);* Women: First and Foremost—V.3 *(1995);* Women: First and Foremost—Collector's Boxed Set *(1995).*

Selected theater: Skydrift *(New York debut, Belasco Theater, 1945);* She Loves You *(London debut, Lyric Theater, 1964);* The Sign in Sidney Brustein's Window *(Longacre Theater, New York City, 1964);* Gantry *(George Abbott Theater, New York City, 1970);* The Last of the Red Hot Lovers *(Eugene O'Neill Theater, New York City, 1970);* Detective Story *(Shubert Theater, Philadelphia, PA, 1973);* The National Health *(Long Wharf Theater, New Haven, CT, 1973–74, then Circle in the Square, New York City, 1974);* The Ritz *(Longacre Theater, 1975);* The Rose Tattoo *(Long Wharf Theater, 1977);* Wally's Café *(Brooks Atkinson Theater, New York City, 1981);* The New Odd Couple *(Broadhurst Theater, New York City, 1985).*

Selected television appearances: (specials) "Dominic's Dream" *(CBS, 1974),* "The Rita Moreno Show" *(CBS, 1978),* "Blondes vs. Brunettes" *(ABC, 1984),* "Rita" *(also known as* "Rita Moreno Show," *CBS, 1986),* "The Ice Capades with Kirk Cameron" *(ABC, 1988),* "Championship Ballroom Dancing" *(PBS, 1991),* "All-Star Fiesta at Ford's" *(ABC, 1992),* "A Capitol Fourth 1993" *(PBS, 1993),* "The 65th Annual Academy Awards Presentation" *(ABC, 1993),* "A Woman's Health" *(PBS, 1994); also appeared in the specials* "Working" *(1982) and* "The Chemical People" *(1983); (series)* "The Rockford Files" *(NBC, beginning in 1974),* "9 to 5" *(ABC, 1982–83),* "Top of the Heap" *(Fox, 1991),* "The Class of the 20th Century" *(Arts & Entertainment, 1992),* "Bonkers" *(animated, syndicated, 1993),* "The Cosby Mysteries" *(NBC, 1994); also appeared in* "The Electric Company" *(1972); (episodic)* "The Muppet Show" *(syndicated, 1977),* "The Larry Sanders Show" *(HBO, 1992),* "Climax!," "Playhouse 90," "Schlitz Playhouse of Stars," *and* "Zane Grey Theater" *(all CBS),* "Fireside Theater" *(NBC); (other television appearances)* "Out to Lunch" *(ABC, c. 1974),* "Anatomy of a Seduction" *(CBS movie, 1979),* "Portrait of a Showgirl" *(CBS movie, c. 1981),* "*Evita Peron" *(NBC miniseries, 1981),* "Orphans, Waifs, and Wards" *(CBS, c. 1981).*

Selected discography: The Electric Company *(Sesame Street, 1972);* Media Portrayals of Latinos *(National Public Radio, 1982).*

Although undeniably talented, Rita Moreno had to endure many years of hard work to divorce herself from the stereotypical images of "Latin spitfire" or "Indian princess" that were frequently the only roles available for Hispanic actresses during the early years of her career. She went on to become the only person to earn all four of the entertainment business' top awards, a feat which landed her in the *Guinness Book of World Records.*

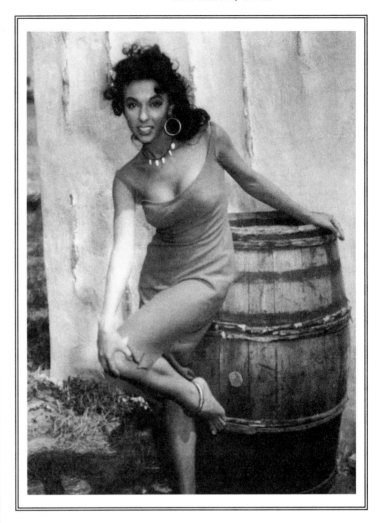

Rita Moreno

Moreno, born Rosa Dolores Alverio on December 11, 1931, in Humacao, Puerto Rico, never really got to know her father, as her parents divorced shortly after her birth. She was left with relatives in Puerto Rico while her mother went to New York City, hoping to improve the family's economic condition. Working as a seamstress in a lingerie factory, her mother was eventually able to earn enough to return to Puerto Rico and bring Moreno back with her to New York, where they lived in a Manhattan tenement. It was not long before Moreno, who enjoyed dancing even as a young child, was taking dancing lessons from Paco Cansino (*Rita Hayworth's uncle), and she soon began performing in the children's theater at Macy's and at weddings and bar mitzvahs. She attended P.S. 132 until age 13, when she quit school to become an actress.

Moreno's first professional employment, in which she was billed as "Rosita Cosio" and played the part of Angelina in the war drama *Skydrift* (1945), was short-lived, running only seven performances. During her teens, she sang

and danced in nightclubs in New York, Las Vegas, and Boston, and did dubbing for child stars including *Elizabeth Taylor, *Margaret O'Brien, and *Peggy Ann Garner in Hollywood films destined for Spanish audiences. In 1950, she made her film debut as a delinquent in United Artists' *So Young, So Bad*, and that year signed a contract with Metro-Goldwyn-Mayer. She had been calling herself "Rosita Moreno," and at the request of studio officials she shortened her first name to Rita. Moreno had minor roles in 25 movies, the most notable of which were *The Toast of New Orleans* (1950), with Mario Lanza, and *Pagan Love Song* (1950), with *Esther Williams. MGM then dropped her, but Moreno refused to quit acting and kept busy freelancing in Hollywood. She did obtain a small role in MGM's *Singin' in the Rain* (1952), but for the most part she was cast in stereotypical, ethnic roles, usually as the Latin vamp: *The Fabulous Señorita* (1952), *The Ring* (1952), *Cattle Town* (1952), *Latin Lovers* (1953), and *Jivaro* (1954). She also played an Arab in *El Alamein* (1953) and a Native American in both *Fort Vengeance* (1953) and *The Yellow Tomahawk* (1954). Disheartened by this typecasting, Moreno tried to escape her "Rita the Cheetah" image by going on stage in Tennessee Williams' *Camino Real*, but Williams objected to her voice and she quickly lost the part.

Moreno's stormy, longtime relationship with Marlon Brando, then at the peak of his career, and another relationship with Geordie Hormel, of the meat-packing empire, added to her notoriety. Things seemed to take a turn for the better when she was featured on the cover of *Life* magazine in 1954. Twentieth Century-Fox offered her a contract, and soon she was singing in *Garden of Evil* (1954) and doing a *Marilyn Monroe takeoff in *The Lieutenant Wore Skirts* (1955). Struggling to be taken seriously, Moreno underwent years of psychoanalysis, but was still unable to find a truly satisfying role until she was cast as a Burmese slave girl in the musical *The King and I* (1956). Despite some success, Moreno made only a few movies from 1956 to 1960: *The Vagabond King* (1956), *The Deerslayer* (1957), and *This Rebel Breed* (1960). She sought relief by again returning to the stage, this time in Arthur Miller's *A View from the Bridge* in theaters in Seattle, Washington, and California. Despondent over personal problems and the direction her career was taking, she unsuccessfully tried to commit suicide.

In 1961, Jerome Robbins cast Moreno in the supporting role of Anita in the movie version of *West Side Story*. She received raves for her performance, particularly her singing of the biting "America." The movie was a huge success, winning ten Academy Awards, one of which went to Moreno for Best Supporting Actress. From 1961 to 1971, she had roles in Tennessee Williams' *Summer and Smoke* (1961) and in *Cry of Battle* (1963). Seeking better roles, she went to London, where in 1964 she starred in Hal Prince's *She Loves Me*. British performance laws then forced her to return to the United States, where she acted in *Lorraine Hansberry's *The Sign in Sidney Brustein's Window* (1964). She received excellent reviews for her performance in Williams' *The Rose Tattoo* (1968) in Chicago, and the following year Brando helped her as she returned to her movie career in *The Night of the Following Day* (1969). Moreno also appeared in the movies *Marlowe* (1969), *Popi* (1969), and *Carnal Knowledge* (1971). She returned to the theater again in 1970, performing in *Gantry* (based on the Sinclair Lewis novel *Elmer Gantry*) and replacing **Linda Lavin** in *Last of the Red Hot Lovers*, both in New York.

In 1971, Moreno began appearing on the Children's Television Workshop's new show, "The Electric Company." She was intrigued with the educational opportunities the show offered as well as the chance to do what she called "low comedy—some zany, bizarre, eccentric stuff." A soundtrack of the show brought Moreno, Bill Cosby and others a 1972 Grammy award for the Best Recording for Children. In 1974, Moreno was invited to a performance at the Yale Repertory Theater of Terrence McNally's new play, *The Tubs*, a farce set in a homosexual bathhouse. She was stunned to see one of the characters, Googie Gomez, doing a number she had performed during breaks in the filming of *West Side Story*. Moreno had also sung this song, a rendition of "Everything's Coming Up Roses" with an exaggerated Spanish accent, at a party where McNally had been present. Retitled *The Ritz*, the play opened on January 20, 1975, at Broadway's Longacre Theater, with Moreno playing Googie. Although some felt her performance was offensive to Hispanics, Moreno said her character was only making fun of the stereotypical roles in which she had always been cast. *The Ritz* ran for 400 performances, and Moreno received a Tony Award for Best Supporting Actress. She also appeared in the motion-picture version of *The Ritz* (1976). She continued her work on television, and in 1977 won an Emmy for her appearances on "The Muppet Show" that year. She won another Emmy in 1978 for her performance in "The Paper Palace" episode of "The Rockford Files." Moreno also devel-

oped a nightclub act and appeared in several movies, including *The Boss's Son* (1979), *Happy Birthday, Gemini* (1980), and *The Four Seasons* (1981). She was nominated for another Emmy in 1982 for her role as a secretary in ABC's comedy series "9 to 5" (based on the movie with **Jane Fonda, Lily Tomlin** and **Dolly Parton**). Moreno appeared on stage in *Wally's Café* in 1981, and in 1985 she starred in a revised version of Neil Simon's *The Odd Couple*, playing Olive Madison to **Sally Struthers**' Florence Unger. That year she also received the *Sarah Siddons Award.

Married since June 1965 to Leonard Gordon, a retired internist and cardiologist who now serves as her personal manager, Moreno remains involved in a variety of activities. She has served on the boards of directors of Third World Cinema and the Alvin Ailey Dance Company and on the panel of the National Foundation of the Arts. She is committed to the Hispanic community and has a strong interest in education. Her daughter with Gordon, Fernanda Luisa, has appeared in her nightclub act and in several of her stage shows. Moreno and her husband maintain homes in Pacific Palisades, California, and in Manhattan.

SOURCES:

Current Biography Yearbook. NY: H.W. Wilson, 1985.

Rooney, Terrie M., ed. *Contemporary Theatre, Film and Television*. Detroit, MI: Gale Research, 1996.

Tardiff, Joseph C., and L. Mpho Mabunda, eds. *Dictionary of Hispanic Biography*. Detroit, MI: Gale Research, 1996.

Votaw, Carmen Delgado. *Puerto Rican Women*. Washington DC: National Conference of Puerto Rican Women, 1995.

SUGGESTED READING:

Hadley-Garcia, George. *Hispanic Hollywood: Hispanics in Motion Pictures*. 1990.

Hispanic. October 1989, pp. 30–33; December 1989, p. 40; September 1990, p. 56.

Ms. January–February 1991, pp. 93–95.

People Weekly. May 3, 1982, pp. 105–107; September 21, 1998, pp. 167–168.

Suntree, Susan. *Rita Moreno*. NY: Chelsea House, 1993.

Jo Anne Meginnes,
freelance writer, Brookfield, Vermont

Moren Vesaas, Halldis (1907–1995).

See Vesaas, Halldis Moren.

Morgan, Agnes Fay (1884–1968)

American biochemist who pioneered the development of home economics as a scientific discipline and spearheaded research in nutrition. Born Jane Agnes Fay on May 4, 1884, in Peoria, Illinois; died of a heart attack on July 20, 1968, in Berkeley, California; daughter of Patrick John Fay (a laborer who later became a builder) and Mary (Dooley) Fay; attended Vassar College; University of Chicago, B.S., 1904, M.S., 1905, Ph.D., 1914; married Arthur Ivason Morgan, in 1908; children: Arthur Ivason Jr. (b. 1923).

Taught chemistry at Hardin College, Mexico, Missouri (1905–06), the University of Montana (1907–08), and the University of Washington, where she organized an honor society for women in chemistry (1910–12); began teaching at University of California at Berkeley (1915), became full professor (1923), professor of home economics and biochemistry (1938–54), department chair (1923–54); received Garvan Medal from the American Chemical Society for her work on vitamins (1949); received Borden Award from the American Institute of Nutrition (1954).

Agnes Fay Morgan played a major role in transforming the field of home economics by making chemistry an integral part of the curriculum. She also did pioneering research on the biochemistry of vitamins, although she was proudest of her administrative accomplishments, which included building up one of the best home economics departments in the country during that era and organizing and chairing numerous meetings on nutrition.

Morgan was born on May 4, 1884, in Peoria, Illinois, the third of four children of Patrick John Fay and **Mary Fay**, both of whom had immigrated from Ireland. Neither of Agnes' two brothers attended college, but her excellence at Peoria High School brought her a full scholarship from a local benefactor. She attended Vassar College for a short time before transferring to the University of Chicago, where she earned a B.S. in chemistry in 1904 and an M.S. in 1905. Following graduation, she taught chemistry at Hardin College in Missouri (1905–06), the University of Montana (1907–08), and the University of Washington (1910–12), where she organized an honor society for women in chemistry. While in Montana, she met and married Arthur Ivason Morgan, a high school teacher and football coach, in 1908. The couple lived in Seattle for three years before she returned to Chicago, at her husband's urging, to earn her doctorate in physical and organic chemistry in 1914. The next year Morgan accepted an offer from the University of California, and the couple moved to Berkeley. She traveled up the ladder quickly at Berkeley, beginning as an assistant professor of nutrition in the new department of household sciences and arts, advancing to associate professor in 1919, and to full professor in 1923, when she was also appointed chair of the department.

This same year she gave birth to her only child, Arthur Ivason, Jr. She also held an appointment as a biochemist at the experiment station at Berkeley from 1938 to 1954.

The home economics department at Berkeley flourished under Morgan's leadership, becoming one of the best in the country. Nutrition was then only a fledgling field, and when Morgan taught a scientific human nutrition course in 1915 it was the first ever offered at the university. She emphasized research and was the first to make chemistry an integral part of the home economics curriculum. Most of her research centered on the biochemistry of vitamins, and she received the Garvan Medal of the American Chemical Society in 1949 for this work, as well as the Borden Award from the American Institute of Nutrition in 1954. She also was concerned with establishing standards for adequate human nutrition. Morgan was most proud of her accomplishments in administration, particularly those which built up the strength of the home economics department, and also of her organization and chairing of numerous national and international meetings on nutrition. In addition, in 1939 she conducted a study of the food at San Quentin Prison, served on a committee in 1960 which investigated the toxic effects of agricultural pesticides, published *Experimental Food Study* (1927, 1940), and worked with the Office of Scientific Research and Development during World War II as well as the U.S. Department of Agriculture. Morgan founded Alpha Nu, a local honor society for women in home economics, as well as a national society for women in chemistry, Iota Sigma Pi.

Agnes Fay Morgan received an honorary degree from the University of California in 1959, and in 1961 the home economics building was named in her honor. She was elected a fellow of the American Institute of Nutrition and was a member of the American Association for the Advancement of Science and the American Society of Biological Chemistry. Morgan remained active in academic and public affairs until she died of a heart attack in Berkeley in 1968.

SOURCES:

Bailey, Martha J. *American Women in Science*. Denver, CO: ABC-CLIO, 1994.

Sicherman, Barbara, and Carol Hurd Green, eds. *Notable American Women: The Modern Period*. Cambridge, MA: The Belknap Press of Harvard University Press, 1980.

COLLECTIONS:

Morgan's professional papers are held in the Bancroft Library, University of California, Berkeley.

Jo Anne Meginnes,
freelance writer, Brookfield, Vermont

Morgan, Ann Haven (1882–1966)

American zoologist and conservationist. Name variations: (nickname) Mayfly Morgan. Born Anna Haven Morgan on May 6, 1882, in Waterford, Connecticut; died of stomach cancer on June 5, 1966, at her home in South Hadley, Massachusetts; elder daughter of Stanley Griswold Morgan and Julia (Douglass) Morgan; received secondary education at Williams Memorial Institute, New London, Connecticut; attended Wellesley College, 1902–04; Cornell University, A.B., 1906, Ph.D., 1912; never married; no children.

Assistant and instructor of zoology, Mt. Holyoke College (1906–09); became associate professor (1914); served as chair of the zoology department (1916–47); became full professor (1918).

Selected writings: Field Book of Ponds and Streams: An Introduction to the Life of Fresh Water (1930); Field Book of Animals in Winter (1939); Kinships of Animals and Man: A Textbook of Animal Biology (1955).

Ann Haven Morgan was born in Waterford, Connecticut, on May 6, 1882, the eldest daughter and first of three children of Stanley and **Julia Douglass Morgan**. She had an early love of the outdoors and eagerly explored the fields and streams near her home. After her secondary education at Williams Memorial Institute in New London, Connecticut, she enrolled at Wellesley College in 1902. Two years later, she transferred to Cornell University, where she received an A.B. degree in 1906. Upon graduation, she was hired as an assistant and instructor of zoology at Mt. Holyoke College in South Hadley, Massachusetts. After three years there, she returned to Cornell and received her doctorate in 1912 with a dissertation on the biology of mayflies. It was her enthusiasm for this dissertation topic that earned her the nickname of "Mayfly Morgan." She quickly moved up the ladder after rejoining the faculty at Mt. Holyoke, becoming an associate professor in 1914, the chair of the zoology department in 1916 (a position she retained until her retirement in 1947), and a full professor in 1918. In the classroom or out in the field, Morgan always wore an old-fashioned shirtwaist, tie, and long skirt. She spent her summers conducting research and instructing at several institutions, including the Marine Biological Laboratory at Woods Hole, Massachusetts (1918, 1919, 1921, 1923) and the Tropical Laboratory in Kartabo, British Guiana (1926).

Ann Morgan considered herself a general zoologist. Over the years she expanded her studies to include not only aquatic insects but also

the habits and conditions of hibernating animals as well as issues of conservation and ecology. She was always able to communicate her observations and insights well, and her books have enjoyed continued popularity with the public. Her *Field Book of Ponds and Streams: An Introduction to the Life of Fresh Water* (1930) emphasizes each animal group and the concept of the ecological niche, or the specific place and function of the group in the wider ecosystem. Her *Field Book of Animals in Winter* (1939) deals mainly with the ecological issue of how animals survive the rigors of winter. *Animals in Winter*, a film based on this book, was made by Encyclopedia Britannica Films and released in 1949 for classroom use.

Morgan stressed the need for humans to understand wildlife and to value the environment. In the 1940s and 1950s, she was instrumental in reforming the science curriculum in schools and colleges to include ecology and conservation courses. Through a series of summer workshops for teachers, she sought to have ecology and conservation taught in conjunction with subjects such as geography, zoology, and sociology. She also served on the National Committee on Policies in Conservation Education. In her final book, *Kinships of Animals and Man: A Textbook of Animal Biology* (1955), she asserted: "Now that the wilderness is almost gone, we are beginning to be lonesome for it. We shall keep a refuge in our minds if we conserve the remnants."

During her teaching career, Ann Haven Morgan collected many honors and awards, including fellowships at Harvard, Yale, and Cornell, and election as a fellow of the American Association for the Advancement of Science. In 1933, she was one of only three women featured in that year's edition of *American Men in Science*. Upon her retirement from Mt. Holyoke in 1947, at age 65, she and her longtime companion, zoology professor **A. Elizabeth Adams**, visited the western United States and Canada to gather ideas for conservation awareness. Ann Morgan died of stomach cancer at her home in South Hadley, Massachusetts, on June 5, 1966, just as ecological awareness was gaining a foothold in America.

SOURCES:

Bailey, Brooke. *The Remarkable Lives of 100 Women Healers and Scientists*. Holbrook, MA: Bob Adams, 1994.

Sicherman, Barbara, and Carol Hurd Green, eds. *Notable American Women: The Modern Period*. Cambridge, MA: The Belknap Press of Harvard University, 1980.

SUGGESTED READING:

Alexander, Charles P. "Ann Haven Morgan, 1882–1966," in *Eatonia*. Vol. 8. 1967, pp. 1–3.

Bonta, Margaret Meyers. *Women in the Field: America's Pioneering Naturalists*. College Station, TX: Texas A&M University Press, 1991.

COLLECTIONS:

Morgan's papers are held at the Williston Memorial Library-Archives, Mt. Holyoke College, and in the Woman's Rights Collection, Schlesinger Library at Radcliffe College.

Jo Anne Meginnes,
freelance writer, Brookfield, Vermont

Morgan, Anna (1851–1936)

Chicago teacher who raised the standards of study for theater and speech during the late 19th and early 20th centuries. Born in 1851 in Fleming, New York; died of coronary sclerosis on August 27, 1936, in Chicago, Illinois; daughter of Allen Denison Morgan (a gentleman farmer who served briefly in the New York legislature) and Mary Jane (Thornton) Morgan; educated in schools in Auburn, New York; studied elocution at the Hershey School of Music, 1877.

Gained renown as dramatic reader with naturalistic style (early 1880s); brought many advanced plays and staging ideas to Chicago; opened school of dramatic arts, the Anna Morgan Studios, in Chicago's Fine Arts Building (1899); fostered cultural growth in Chicago (early 1900s); was instrumental in preparing the way for the "little theater" movement in America.

The oldest of three daughters and two sons of Allen and **Mary Jane Morgan**, Anna Morgan grew up and received her early schooling in the Auburn, New York, area. After her father's death, in 1876 the family moved to Chicago, where she studied elocution at the Hershey School of Music the following year. During a time when dramatic readings were usually affected and artificial, Morgan strove for a naturalistic style. She also tended toward more sophisticated material than was common but continued to perform standard popular pieces as well. From 1880 to 1883 she traveled extensively, part of the time for the Redpath Lyceum Bureau, and visited New York, Boston, and major cities in the Midwest. She joined the new Chicago Opera House Conservatory (later the Chicago Conservatory) as a dramatics teacher, and it was there that she nurtured and developed her skills in this field.

Morgan was responsible for bringing many advanced plays and innovative staging ideas to Chicago. She did not attempt to stage professional productions, instead holding most of her programs in intimate settings such as the conservatory's stage or her own studio. She presented everything from Greek tragedies and Shake-

speare to the works of Henrik Ibsen, George Bernard Shaw, and Maurice Maeterlinck, experimental dramatizations of novels and poems, and new plays by then-unknown dramatists, including **Alice Gerstenberg** and **Marjorie Benton Cooke**. Under Morgan's direction, Ibsen's *The Master Builder* (1895), Carlo Goldoni's *The Fan* (translated by Henry B. Fuller, 1898) and Shaw's *Candida* (1898) had their American premieres. She also produced Shaw's *Caesar and Cleopatra* in 1902 with an all-female cast. Other notable productions included William Butler Yeats' *The Hour Glass* (1905), Maeterlinck's *The Intruder* and *The Blue Bird*, and J.M. Synge's *The Shadow of the Glen*. In 1894, she discarded the usual elaborate sets and staged *Hamlet* and later *The Hour Glass* against a simple backdrop.

In 1898, Morgan resigned from the conservatory staff to open her own school, the Anna Morgan Studios (1899–1925), in Chicago's Fine Arts Building. The school's mission was not only to train actors (James Carew and **Sarah Truax** attended), but also to give students a solid background in the dramatic arts. Stage, literary and political history, playwriting, and practical courses in acting and stagecraft were offered. Students were expected to study deportment and etiquette and learned about house decorations and wearing jewels as well. She also embraced the Delsarte Method, a system of conveying emotion through gesture and body position.

Anna Morgan wrote three books: *An Hour with Delsarte* (1889), *Selected Readings* (1909), and *The Art of Speech and Deportment* (1909), and during the early 1900s enjoyed and thrived in the company of many Chicago artists. She was one of the founders of the Little Room, a loose organization whose members included *Harriet Monroe (later editor of *Poetry* magazine), Hamlin Garland, and Henry B. Fuller. Her studio became a salon which Richard Mansfield, Joseph Jefferson, *Ellen Terry, Henry Irving, and *Maxine Elliott visited. During trips abroad, Morgan met both Maeterlinck and Shaw. She declined numerous offers to teach in major cities around the world, choosing instead to remain in Chicago. Anna Morgan published her autobiography, *My Chicago*, in 1918, and died in that city of coronary sclerosis on August 27, 1936.

SOURCES:
James, Edward T., ed. *Notable American Women, 1607–1950*. Cambridge, MA: The Belknap Press of Harvard University Press, 1971.

SUGGESTED READING:
Clark, Herman. "The Little Room, A Famous Artist Group in the Chicago of Yesterday," in *Townsfolk*. May 1944.

Duffey, Bernard. *The Chicago Renaissance in American Letters*, 1954.
Fuller, Henry B. "The Upward Movement in Chicago," in *Atlantic Monthly*. October 1897.

COLLECTIONS:
Some of Anna Morgan's scrapbooks and letters are held by the Chicago Historical Society.

Jo Anne Meginnes,
freelance writer, Brookfield, Vermont

Morgan, Anne (1873–1952)

American philanthropist and social worker. Born Anne Tracy Morgan in New York City on July 25, 1873; died on January 29, 1952; youngest child of John Pierpont Morgan (1837–1913, the financier) and Frances Louisa (Tracy) Morgan; sister of J.P. Morgan (1867–1943); educated in private schools; never married; no children.

Daughter of "robber baron" and philanthropist John Pierpont Morgan and *Frances Louisa Morgan, Anne Morgan grew up at her family's country house in Highland Falls, upstate New York. Once described as a "shy girl who did not like society," Morgan made the debutante rounds but remained intensely private. "There was something pathetic about this splendid girl, full of vitality and eagerness," wrote her close friend Elisabeth Marbury, "yet who, as the youngest of a large family had never been allowed to grow up." It was Marbury who introduced Morgan to the world of doers—artists, designers, musicians, actors, singers, and social activists. With Marbury and *Florence Jaffray Harriman, Anne Morgan founded and was an early officer of the Colony Club (1903). She also devoted herself to the woman's department of the National Civic Federation. A believer in trade unions, she supported the shirtmakers' strikes in 1909 and 1910.

Some of Morgan's most important work took place in France. In 1912, for her friends Marbury and *Elsie de Wolfe, she added a wing to their Versailles villa, Trianon. When World War I broke out, the three friends established a home for the wounded near the villa, staffed by nuns from a nursing order, while Morgan became active in the American Fund for French Wounded. After the war, along with **Anne Murray Dike**, Morgan founded the American Committee for Devastated France; the group restored homes, shops, churches, and monuments; built barracks for the homeless; provided seed and livestock; established dispensaries, clinics, resthouses, and traveling canteens for soldiers; and provided training for the disabled, along with

Marbury, Elisabeth. See de Wolfe, Elsie for sidebar.

schools, libraries, camps. Though reserved, Morgan was an inveterate fund raiser, even going so far as to sponsor a lightweight boxing championship match between Benny Leonard and Ritchie Martin, which reaped $20,000 and the indignation of the clergy. Her activities brought her a medal from the National Institute of Social Science in 1915. In 1917, Morgan and Dike were awarded medals by the U.S. Department of Agriculture; they also received the Croix de Guerre with palm. In 1932, France made Morgan a Commander of the Legion of Honor; at that time, she was the only American woman to have received the decoration.

On the eve of World War II, at age 68, Morgan was still going strong and ahead of the game. With the support of General Maurice Gamelin, commander in chief of the French forces, she organized the American Friends of France (Comité Americain de Secours Civil), in 1938. By the time the first wave of Belgian refugees crossed the French border, she and her corps were there. American Friends of France would later merge with **Marion Dougherty**'s Fighting French Relief to form American Relief for France.

SOURCES:

Marbury, Elisabeth. *My Crystal Ball*, 1923.
Obituary. *The New York Times*. January 30, 1952, p. 25.
Rothe, Anna, ed. *Current Biography, 1946*. NY: H.W. Wilson, 1946.

Morgan, Barbara (1900–1992)

American artist and photographer who was especially known for her dance images. Born Barbara Brooks Johnson in Buffalo, Kansas, in 1900; died in Tarrytown, New York, in 1992; graduated from the University of California, Los Angeles, in 1923; married Willard Morgan (a writer and photographer), in 1925 (died 1967); children: Douglas (b. 1932); Lloyd (b. 1935).

Famous for her innovative dance photographs, Barbara Morgan established herself as a gifted fine artist before taking up the camera in 1930. Her husband, photographer and writer Willard Morgan, had urged Barbara to try photography, but it took the birth of her second child to pry her loose from her paint brushes. "I found that I couldn't take care of two children and paint," she told Franklin Cameron in a 1985 interview for *Petersen's Photographic*. "I was going crazy being away from my painting, but to my mind and heart, my children came first. My husband, still trying to coax me into photogra-

phy, finally succeeded. He offered to watch the kids at night so I could work in the darkroom; and on the weekends, when he could again be with the children, I'd go out and shoot whatever I wanted." In 1935, after seeing the *Martha Graham Dance Company perform, Morgan became interested in recording the dancer's movements in photographs. In her images of Graham, and in her later photographs of dancers *Doris Humphrey, Charles Weidman, Erick Hawkins, José Limón, and Merce Cunningham, Morgan not only captured the vitality of the American modern dance movement of the 1930s and 1940s, she also changed the course of American dance photography.

Anne Morgan

Barbara Morgan was born Barbara Brooks Johnson in 1900 in Buffalo, Kansas, and was raised on a peach farm in Pomona, California. **Vicki Goldberg** writes that when Morgan was about five, she looked at the picture above her bed and asked her parents how a tree got into her bedroom. When told that it wasn't a real tree but an image created by an artist, Morgan decided then and there that she too would become an artist. Morgan credits her father with alerting her to the organic energy in living forms, energy which later came to dominate all of her work. "[He was] the most stimulating force in my life. He taught how there were millions of atoms in every little thing—and that all the atoms were dancing."

Morgan studied art at the University of California, Los Angeles (UCLA), supplementing her courses with informal work in puppetry and stage lighting. After graduating in 1923, she taught art at the San Fernando High School for a year to support her painting. In 1925, she married Willard, and also began a five-year teaching stint at UCLA, conducting classes in design, woodcut, and landscape. Having the summers off, the Morgans traveled in Arizona and New Mexico, where they indulged their interest in Native American culture. "I always had a strong interest in American Indians; a lingering sense of guilt actually for what we had done to them," Barbara told Cameron. "Participating in their

culture was always a poignant experience for me. I was particularly enamored of their dancing. . . . To me, the Indian dances were primarily spiritual. Their chants were to God, thanking him for the rain and the sun that made the corn grow." She captured the spiritual energy of the ritual Native American dances in a colored woodcut print, *Rain Dancers* (1931). Two additional works, *Primitive Mysteries* and *Two Primitive Canticles,* were also inspired by her visits to the Southwest.

In 1930, Willard's career took the couple to New York, where Barbara's evolution as a photographer began. Her early exhibits reveal a wide variety of subject and techniques, including portraiture, light drawing (tracing images of a light source in motion), and photomontages (in which images are superimposed upon each other). She spent a lot of time experimenting. "Harkening back to my days as a painter," she said. "I was always trying to think of how I could go beyond that obvious click of the shutter. I didn't want my photography to be just an exercise in copycatting." In working with the camera, Morgan also employed her knowledge and respect for Chinese and Japanese art, which she had first experienced as an art student at UCLA. Believing that "art is an abstraction born of understanding the pattern of things," she felt that it was the artist's ultimate responsibility to add to nature rather than "steal" from it.

Morgan's collaboration with Martha Graham began in 1935, after she had seen the then-unknown dancer and her company perform, when mutual friends arranged for the two women to meet. Morgan asked Graham if she had drawn any of her inspiration from Native American dancing. "She said she certainly had: Indian dances were one of her greatest inspiration," Morgan recalled. "Without knowing what I was saying, I said, 'I'd like to do a book on your work.' She answered emphatically, 'I'll work with you,' and we shook hands."

Over the next five years, Morgan worked with Graham and her dance company, observing the dancers in the studio and in performance before attempting to take any pictures. "After I had seen a few experimental performances followed by the final performance, I wouldn't do anything," she told Cameron. "I'd just let the images drift around in my mind. After a week or two I would suddenly remember a gesture—ten, twelve different gestures that epitomized the dance. I'd tell Martha what I thought they were and, you know, we agreed every time." In an article in *Dance Magazine,* **Ernestine Stodelle** discusses

Morgan's ability to depict "the ecstasy of a gesture," in a dance photograph, using as an example Morgan's image of the vertical jump of three Graham dancers in a work called *Celebration* as they simultaneously leap into the air. "Kinesthetically at one with them, Morgan explains that she 'clicked at the instant when muscular effort to reach the elevation had been spent and momentary relaxation conveys triumph rather than strain.'" In 1941, Morgan published her stunning volume *Martha Graham: Sixteen Dances in Photographs*, for which she won the American Institute of Graphic Arts Trade Book Clinic Award.

By the time her book on Graham was completed, Morgan was an integral part of the modern dance scene in both New York and in Vermont, where, in 1938, she was the official photographer of the Bennington College Summer School of the Dance. There she produced some remarkable images of Doris Humphrey and Charles Weidman, who were engaged in some of their most productive work. An exceptional photo of Humphrey in her *Passacaglia in C Minor* is described by Stodelle as revealing the dancer-choreographer "in a typically eloquent vein of lyricism." Stodelle describes yet another image, the duet from *Square Dances,* in which "Morgan creates a charming counterpoint of light and shadow by focusing attention on Humphrey's smiling face as she playfully swings away from the tall, lean, shadowy figure of Weidman."

Another of Morgan's successful collaborations was with Mexican-American dancer José Limón, a disciple of Humphrey and Weidman, with whom she had an almost instant rapport. "Because I understood so much about the Southwest, I understood José," she said. Morgan produced three portraits of the dancer in his most powerful solos: "Peon" and "Indian" from *Mexican Suite*, and his stunning *Chaconne*. Some of Morgan's most unforgettable dance photographs, however, are of Merce Cunningham, whom she immortalized in one of his own works, the 1944 *Root of an Unfocus*, and in Graham's *El Penitente*. Most extraordinary, however, is a shot of a leaping Cunningham in a double-exposure photomontage called *Emergence*. "Head thrown back, legs tucked under, seemingly aloft in the clouds of a whirling universe, he looks like Shakespeare's Ariel in frenzied flight toward some distant moon," writes Stodelle.

Concurrent with her dance photographs, Morgan continued to produce photomontages and her unique light drawings. ("Light has somehow played a magic role in my life," Morgan once said, recalling that as a child she was so

fascinated by light that she would "try to meet the sun.") She also produced a second volume of photographs, *Summer Children* (1951), consisting of pictures of her own and other children at summer camp. These pictures, taken during the years of World War II, were Morgan's attempt to offer an expression of hope and courage during a difficult time in the nation's history.

During her career, Barbara Morgan had one-woman exhibitions at the Institute of American Indian Art, Santa Fe, the Pasadena Art Museum, the Museum of Modern Art, New York City, the George Eastman House, and the National Museum of Dance in Saratoga Springs, New York. The 1991 show in Saratoga Springs was unique in that it brought Morgan's drawings, prints, watercolors, and photographs together in one exhibit. Morgan received a grant from the National Endowment for the Arts in 1975, and participated in the *Women in Photography* exhibition at the San Francisco Museum of Art. The artist and photographer continued to work up until her death in 1992. "If I can't continue working, I don't want to live," she said at age 84. "So I work."

SOURCES:
Goldberg, Vicki. "A Woman's Place—Behind the Lens," in *Harper's Bazaar.* March 1981.
Mason, Jerry, ed. *Encyclopedia of Photography.* NY: Crown, 1984.
Rosenblum, Naomi. *A History of Women Photographers.* NY: Abbeville Press, 1994.
Stodelle, Ernestine. "Barbara Morgan: Emanations of Energy," in *Dance Magazine.* August 1991, pp. 44–47.

<div align="right">

Barbara Morgan,
Melrose, Massachusetts
</div>

Morgan, Claire (1921–1995).

See Highsmith, Patricia.

Morgan, Frances Louisa
(1845–1924)

American philanthropist and society matron. *Name variations: Mrs. J. Pierpont Morgan. Born Frances Louisa Tracy on May 15, 1845; died on November 16, 1924; daughter of Charles Tracy (a lawyer) and Louisa Kirkland Tracy; married J. Pierpont Morgan (1837–1913, the financier), on May 31, 1865; children: Louisa Pierpont Morgan Satterlee (b. March 10, 1866); J.P. Morgan (1867–1943, who married *Jane Norton Grew Morgan); Juliet Morgan Hamilton (b. July 1870); *Anne Morgan (1873–1952).*

Frances Louisa Morgan, called Fanny, married financier and so-called robber baron J. Pierpont Morgan in 1865, three years after his beloved first wife **Amelia Sturges Morgan** died of "galloping consumption" while still on their extended honeymoon. Frances Morgan gave birth to her first child less than nine and a half months after the wedding ceremony, and to her second a year later. She and her husband possessed quite different temperaments, however, and the workaholic J. Pierpont never spoke to her about his business matters; their marriage was troubled by the late 1870s. Both were prone to depression, and Morgan increasingly was subject to "sick" headaches and various ailments. When she was able, she partook of the usual activities available to women of her social station, attending lectures and operas and devoting time to philanthropical pursuits, including financial assistance to *Helen Keller. By the 1880s, her husband, whose numerous mistresses and general womanizing was so notorious that gossip said he had founded New York City's Lying-In Hospital solely for benefit of his illegitimate offspring, was taking advantage of her illnesses to send her off on extended journeys, on which she was often accompanied by one or more of her daughters. She kept a diary throughout much of her married life, and outlived her husband, who died in 1913.

SOURCES:
Strouse, Jean. *Morgan: American Financier.* NY: Random House, 1999.

Morgan, Helen (1900–1941)

American singer and actress best known for her role as Julie in the landmark musical Show Boat. *Born Helen Morgan (birth name sometimes given as Helen Riggins) on August 21, 1900; birthplace variously given as Danville, Illinois, and Toronto, Ontario; died on October 5, 1941, of cirrhosis of the liver; daughter of Lulu Morgan and probably Thomas Morgan; left high school before her sophomore year; married Maurice Mashke, Jr., in 1933 (divorced 1935); married Lloyd Johnson, in 1941.*

Began singing in small Chicago cabarets, where she established a reputation as a torch singer; became a star with her creation of the role of Julie in Broadway production of Show Boat *(1927), which she recreated on screen and in a Broadway revival (1932); had active nightclub career in New York and Chicago speakeasies during prohibition and was acquitted of federal charges filed under the Volstead Act after several raids by government agents; career declined afterward due to health problems brought on by alcoholism; was the subject of film* The Helen Morgan Story *(1947).*

Filmography: Show Boat *(1929);* Glorifying The American Girl *(1929);* Applause *(1930);* Roadhouse Nights *(1930);* You Belong To Me *(1934);* Marie Galante *(1934);* Sweet Music *(1935);* Go Into Your Dance *(1935);* Show Boat *(remake, 1936);* Frankie and Johnny *(1936).*

Cabbies and pedestrians threading their way through New York's Herald Square one summer day in 1918 had little use for the war bonds rally adding to the already clogged three-street intersection of 34th Street, Seventh Avenue, and Broadway. No matter that *__Mary Pickford__ was manning the table where bonds to help finance America's First World War efforts could be purchased for as little as 50 cents, or that vaudeville idol *__Gracie Fields__ was the featured performer that day. Amid the horns and shouts and clatter, even less attention was paid to the slim, dark-haired 18-year-old girl who, after buying a ten-dollar bond from Pickford, was allowed to climb up on the back of an Army truck to sing "Over There" in a breathy voice that was no match for the cacophony around her. It was Helen Morgan's first appearance on Broadway. A decade later, she would be headlining in the show that would define American musical comedy for the next 40 years.

⁂Mama, break out the Napoleon [brandy].

It's been one hell of a crazy day.

—Helen Morgan, following her 1928 federal indictment

Despite national fame, Morgan would remain very much an enigma to her adoring public; the beautiful dark-haired singer always seemed to keep her distance. One critic noted that the essence of her art was that "she never presses it all out." This reticence even surrounds the circumstances of her birth, with a number of versions current. Some accounts claim she was born Helen Riggins in a small Illinois railroad town, later adopting the name Morgan from a relative; others point to Toronto as her birthplace where, it was said, she had been born to Thomas and __Lulu Morgan__ in 1900. By this telling, Thomas—a fireman for the Canadian National Railroad—disappeared shortly after her birth, forcing Lulu to find work in a railroad workers' soup kitchen, her baby daughter safely stowed behind the potbellied stove. Morgan herself once said that she was of Scotch-German-Irish ancestry ("a real goulash," as she put it) and never went to Canada until she was older. It is certain, however, that Lulu and Helen were living in Danville, Illinois, by 1904, and that Lulu was, indeed, working in a railyard restaurant with her little girl in tow. Morgan, much loved by the trackmen who frequented the place, would often climb up on the cowcatcher of a handy locomotive to entertain them during their lunch hour with a song—a talent discovered and eagerly promoted by Lulu. Years later, Lulu would be sure to embroider the legend by telling how three-year-old Helen had climbed up on the ironing board one day to sing "Three Blind Mice" and noted that she would give all the money she made as a singer to friends.

In 1912, the railyard was visited by a reporter for the *Chicago Daily News,* on assignment to write a series of articles about the wives of railroad men. The reporter was __Amy Leslie__, a former actress who had appeared on stage under the name of Lillie West and who was still very much a fixture of the Chicago theater world. Leslie was sufficiently impressed with the 12-year-old Helen's singing that she offered to arrange a tryout engagement for her at one of several nightclubs owned by some Canadian friends. Lulu quickly agreed. Not long after, Helen and Lulu found themselves in Montreal, where Helen appeared at Club Le Troc in the city's French Quarter, singing some of the French-Canadian folk songs taught to her by admiring railroad men to such effect that her engagement was extended and patrons were being turned away at the door. But Morgan's first taste of fame was cut short when a child-welfare worker closed down the show, and mother and daughter were forced to move back to Chicago.

For the next six years, the two struggled to keep a roof over their heads, so much so that Morgan left high school after her freshman year to find work. There followed a dreary round of jobs in, among other places, a biscuit factory; a gelatin plant, from which she was fired for eating too much of the product; and a Cracker Jacks factory, from which she was also fired for slipping an extra prize into the boxes. She quit a job as a bill collector for the Chicago Telephone Company because she said it made her too sad, then went on to become a manicurist and a counter girl at Chicago's Marshall Field's department store. She never earned more than nine dollars a week. In later years, when asked what had made her so successful, Morgan would reply simply, "Hunger."

Lulu remained convinced that better things lay ahead, and urged Helen to accept the offer of a singing job at Chicago's Green Mill, a respectable night spot with a genteel clientele. The

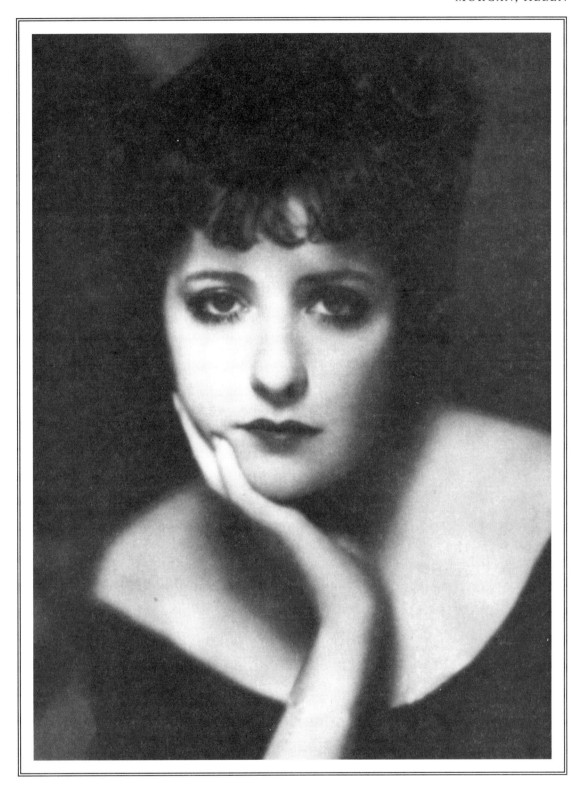

exposure gained her an invitation to enter the statewide Miss Illinois beauty pageant, which she won in 1918, followed by a similar victory in Canada, where she was crowned Miss Mount Royal in Montreal. The two titles were enough to win her and Lulu a trip to New York City, and her Broadway "debut" at the war bonds rally. The war ended later that year, and America entered a period of postwar prosperity and release, the "roaring '20s," which refused to be dampened by Congress' passage, in 1919, of the Volstead Act. Otherwise known as Prohibition,

it was an event that would have a very direct, and drastic, effect on Morgan in later life.

Despite the boom, life was still difficult for Morgan *mére et fille*. Lulu went to work as a housekeeper and as a store clerk while Helen looked for a job in show business with little success, forced to accept modeling jobs at art schools for an hourly fee. Her first break came when Florenz Ziegfeld hired her as a chorus girl in one of his opulent revues, *Sally,* starring his currently reigning star, *Marilyn Miller, who was billed "the dancing golden sprite." Helen thought she was auditioning for a singing job, but Ziegfeld merely told her she had good teeth, asked her to walk back and forth a few times, and put her in the chorus line, over Morgan's protests that she had no training as a dancer. It was an inauspicious beginning to a friendship that would last until Ziegfeld's death a decade later.

Morgan hoofed away in the back row for the show's entire run of 570 performances, but quickly found singing work when the show closed—first at Chicago's Café Montmartre and, later, at Billy Rose's Backstage Club, a tiny, charmless nightery over a garage on West 56th Street in New York. With Prohibition now in full force, the club was often raided by the minions of New York's administrator for Prohibition, Maurice Campbell, until Rose accepted an offer from two mobsters to take them on as partners, thus assuring that the right palms were greased and the club was left alone. Rose closed the club after six months, but during Morgan's time there, she came under the protective eye of the mob and forged the links with New York's raucous night life that would connect her with three of the city's most popular clubs—Helen Morgan's 54th Street Club, Chez Morgan, and Helen Morgan's Summer Home.

After the demise of Rose's enterprise, Morgan returned to the stage, appearing for two seasons in George White's *Scandals,* the rival production to Ziegfeld's annual *Follies.* Though she was just one of a cast of unbilled young hopefuls, at least she was allowed to sing and did not have to dance. White was sufficiently impressed to give her a week's solo run at the Palace Theater in the summer of 1927. The reviews were, if not raves, at least supportive, with *The New York Times* labeling her "a highly individualized chanteuse" possessing a "somnolent, smoldering personality with overtones of pathos which give her numbers, even the most banal of them, a certain charm and distinction." But it was her appearance in White's 1926 revue *Americana* the previous summer that led to more than positive

reviews. White had given her a solo spot in which she sang a song written for her, "Nobody Wants Me," from the top of the piano in the orchestra pit. The audience loved her, and one of their number decided he very much wanted her, indeed. He was Jerome Kern who, with Oscar Hammerstein II, had just finished a rewrite on a musical that would open the next year. Kern was having difficulty casting one of the characters in the show, the tragic part of a mulatto named Julie Dozier. The musical was *Show Boat,* and Broadway had never seen anything like it before.

Adapted from the 1926 *Edna Ferber novel, *Show Boat* was the first American musical to integrate song, story, and character at a time when most presentations on the musical stage were little more than variety shows with a flimsy plot connecting the numbers. From the moment the curtain went up on the show's opening number, "Ol' Man River," audiences knew they were seeing something markedly different. Not only was the number sung by a chorus of African-Americans, who never appeared on stage except as Stepin Fetchit-types in slapstick comedies, but the song itself was a moving depiction of a slave's hard life in the Mississippi of 1860—hardly what audiences of the time expected from a musical comedy.

Kern and Hammerstein endeavored to explore their racial subtext through the character of Julie, to whom they assigned "My Bill," a song Kern had written some years earlier, as well as a second number, "Can't Help Loving That Man of Mine." Both numbers called for a combination of sweet and sultry, and Kern found it that July night in 1927 when Morgan sang "Nobody Wants Me" bathed in the light of a single spot. Although she had had no dramatic experience, a secondary role, and the critics barely mentioned her, audiences lined up to buy tickets to see the show where "the dark haired woman sits on the piano and sings about her Bill." By the time the show closed in New York after 192 performances and went on the road, Morgan's name was in lights above even Flo Ziegfeld's, who by now had realized that she had more going for her than good teeth. "She is the *Sarah Bernhardt of musical comedy," he said. Oscar Hammerstein was more precise: "Everything she did was exactly right. Her instincts were sure. Nobody had to tell her how to move, gesture, or put over a song. She behaved like a veteran." Besides the road tour, Morgan would go on to appear in a silent-film version of the show in 1929, a Broadway revival in 1932, and a second, talking film released in 1936. Both "My Bill" and "Can't Help Loving That Man of Mine" became her signature songs,

with no nightclub performance complete until she had given the audience both.

The ten years from 1926 to 1936 marked the height of Morgan's career, during which she sometimes earned as much as $2,500 a week. During the first two of those years, besides playing Julie on Broadway, her nightclub schedule often required her to appear eight nights a week from one to three in the morning, after having done at least one performance in *Show Boat* earlier in the evening. She began accepting film roles in 1929, attracting a good deal of respectful attention for her performance as a fading burlesque queen in Rouben Mamoulian's *Applause* for MGM. During this period, she met and fell in love with Arthur Loew, the son of theater and film baron Marcus Loew, but she insisted on keeping the affair at arm's length unless Arthur agreed to divorce his wife, who was confined to a sanitarium. Loew was never able, or willing, to do so, and the experience left Morgan saddened and bitter. A more successful relationship developed with George Blackwood, a handsome film and stage actor who joined *Show Boat* just as it left New York for its national tour. He would remain one of Morgan's closest friends for the rest of her life, and, although Helen refused Blackwood's marriage proposals, their affection for each other was obvious to everyone.

It was Blackwood who unsuccessfully tried to wean Morgan away from something else that had become obvious to everyone with whom she worked—her drinking. By the time Blackwood joined the show, Morgan's alcoholism had become serious enough to be talked about, although always in private, safely hidden from the public eye by the Helen Morgan mystique. At first Blackwood went along with Morgan's ritual of consuming four ponies of brandy before going on stage each night; but one evening, when he was late getting to her dressing room, he found she had already downed the required four and was ready to imbibe four more on his arrival. "Helen just had to be fortified for that first [stage] entrance," he said years later, "and the strange thing was, the few times she went on without brandy, her performance wasn't quite up to par." Blackwood felt she needed alcohol to generate the persona of the long-suffering torch singer the public expected, but there were other theories. *Ruth Etting*, Morgan's rival, laid the blame squarely on Lulu, whom Etting privately claimed had pushed and prodded Morgan too hard and too quickly. Others said it was because of Morgan's unfulfilled love for Arthur Loew, while still oth-

ers pointed to psychological scarring left by her father's disappearance when Helen was barely three. Whatever the reasons, Morgan's addiction grew steadily worse, especially after she found herself facing federal charges of violating the Volstead Act.

There had been rumblings of trouble ahead ever since New Year's Eve of 1927, when federal agents under Maurice Campbell raided Chez Morgan with a particular vengeance, breaking furniture and injuring not a few patrons. Morgan herself was hauled off to the 30th Precinct, but the charges were later dropped after her lawyer prevailed on the U.S. attorney for New York, who admitted that Campbell had acted without due process of law.

Morgan's dislike for Campbell was shared by almost everyone in the business. He was despised as a wealthy ne'er-do-well, the son of a family which owned (and still owns) a chain of funeral parlors in greater New York. "Honey," Morgan told a friend after the New Year's raid, "all I ask is, when I die, don't let anybody pack me off to a Campbell's funeral parlor." Campbell was also widely known to be in the pocket of the U.S. assistant attorney general charged with enforcing the Prohibition laws, *Mabel Walker Willebrandt*. Willebrandt seemed to have a particularly strong determination to bring down Helen Morgan, even though New York's "Queen of the Nightclubs" was *Texas Guinan*, a ribald, earthy Texas woman who would greet her patrons each night with a loud "Hello, suckers!" But unlike Guinan, Morgan was known across the country, and her successful prosecution in New York state would both set a national example and provide a plum for Willebrandt's office.

In the spring of 1928, a wealthy Texas couple frequently swept into Morgan's new speakeasy, Helen Morgan's Summer Home, liberally throwing around wads of cash and free drinks, and inviting Morgan to sit at their table each night after her stage set. Plying her with brandy, they repeatedly expressed admiration for the success of her club, going so far as to ask her advice in opening their own place back home in Texas. "Then why don't you do as I do," Morgan reportedly told them. "There isn't any risk. Get a couple or three good fellows to go in with you. Then, if there's any trouble, you're just an employee. They'll take the blame." The couple promised to take her advice and soon went back to Texas.

Not long after, New York's "war of the nightclubs" broke out in earnest, with raids by

some 160 of Campbell's agents on 11 speakeasies during the night of June 28, 1928. Morgan's club, along with such popular spots as The Jungle, The Mime, The Furnace, and The Beaux Arts, were all cleared and shut down, with more than a hundred arrests made. Morgan escaped arrest, as did Guinan, but after Campbell let it be known that both women would be picked up unless they turned themselves in, the two of them appeared with an eager army of reporters and photographers at police headquarters. Charged and then released without bail, Morgan and Guinan were among the 108 named in indictments handed down by a federal grand jury on conspiracy to violate the prohibition laws. With Morgan's trial set for the following April, Mabel Willebrandt finally had her coup.

Morgan turned to the only person she felt could save her career, Flo Ziegfeld, who had been nicknamed "The Great White Father" by the countless showpeople he had helped out of scrapes. It was Ziegfeld who convinced Morgan to turn her back on night life, and who issued a press release announcing that "Miss Morgan has ended the cabaret chapter of her career. She will now conserve all her energies for her work as a featured artist of the legitimate stage." Guinan, never one to mince words, said bluntly, "As usual, they got the wrong party. She's just a dumb . . . kid."

The basis of Morgan's defense at her trial was the argument she'd used since the early club days—that she was merely an employee and had no knowledge of the club's activities, illegal or otherwise. But Willebrandt, anticipating the argument, had her proof from the undercover agents she had sent to the club disguised as the wealthy Texas couple. Morgan's lawyer, on the other hand, argued entrapment and challenged the prosecution to produce a shred of paper proving Morgan had been anything but an employee. Morgan was found not guilty of all charges against her (as was Guinan), but the strain of the trial was obvious to anyone, especially the reporters to whom Morgan tearfully said after the verdict, "I don't want to think about it anymore."

True to her word, she left the cabaret world until Prohibition was repealed in 1933 and concentrated on her stage and film work. Between 1930 and 1936, Morgan opened in another Kern-Hammerstein musical written especially for her, *Sweet Adeline*, which gave the world such songs as "Bicycle Built For Two" and "Hello My Baby"; starred in the revival of *Show Boat* in 1932; and appeared in six films, includ-

ing the all-talking remake of *Show Boat*. But her drinking grew worse, especially when Ziegfeld died in 1932. George Blackwood said that for weeks afterward, she would barely speak above a whisper offstage and would sit for long periods, silent and staring, with a drink in her hand. A 1933 marriage to a Cleveland attorney, Maurice Mashke, ended in divorce two years later.

By 1938, her health was too far gone to allow her to work, and Morgan spent most of that year at home with Lulu. She toured the Loew vaudeville circuit in 1939, but needed the help of a chalk line drawn from the wings to the microphone to get her on stage and did not have the coordination, let alone the strength, to assume her characteristic pose on top of the piano. When she opened at the Famous Door Club in New York, audiences noticed how distant she seemed, and one night she declined the usual requests to sing "My Bill." Touching her heart, her forehead, and then her lips, she whispered, "I'm so sorry. I have it *here*, but it has to come out *here* and *here*, and I just can't make it." She was ushered offstage.

But she struggled on. In the summer of 1941, she married a Los Angeles auto dealer, Lloyd Johnson, who accompanied her on a national tour of a revival of George White's *Scandals*. When the tour reached Chicago, Morgan was too ill to go on and was hospitalized. Three weeks later, on October 5, 1941, she died of cirrhosis of the liver. Johnson confessed they did not have the money to pay the hospital bills, and appealed to an actors' charity for help. Lulu had to ask relatives to pay for the funeral.

At an army camp in Missouri, where he was in training to fight in World War II, George Blackwood read about Morgan's death in the newspapers. He spent that night in a bar, drinking alone.

SOURCES:

Atkinson, Brooks. *Broadway*. NY: Macmillan, 1970.
Hart, Annie. Papers and Scrapbooks, 1922–1947. The New York Public Library, Billy Rose Collection.
Maxwell, Gilbert. *Helen Morgan: Her Life And Times*. NY: Hawthorn Books, 1974.

RELATED MEDIA:

The Helen Morgan Story, starring *Ann Blyth and directed by Michael Curtiz, Warner Bros., 1957.

Norman Powers,
writer-producer, Chelsea Lane Productions, New York

Morgan, Mrs. J.P. (1868–1925).

See Morgan, Jane Norton Grew.

Morgan, Mrs. J. Pierpont (1845–1924).

See Morgan, Frances Louisa.

Morgan, Jane Norton Grew

(1868–1925)

*American socialite. Name variations: Mrs. J.P. Morgan. Born Jane Norton Grew on September 20, 1868; died on August 14, 1925; daughter of Henry Sturgis Grew and Jane (Wigglesworth) Grew; married J.P. Morgan (1867–1943, a banker and son of *Frances Louisa Morgan and J. Pierpont Morgan), in December 1890; children: Junius Spencer Morgan (b. 1892); Jane Norton Morgan (b. 1893); Frances Tracy Morgan (b. 1897); Henry Grew Morgan (b. 1900).*

Jane Norton Grew Morgan was the wife of J.P. Morgan, son of the banker and railroad owner J. Pierpont Morgan, who once referred to her as "cold roast Boston." With her husband, she lived for some years in London, where she was presented to Queen *Victoria only a few years after that privilege was opened to non-aristocrats. Upon their return to New York City around 1905, the Morgans built and lived in a 45-room mansion complete with wine cellar, silver vault and ballroom. A portrait of Jane Morgan painted by John Singer Sargent now hangs in the Pierpont Morgan Library in New York City.

SOURCES:

Strouse, Jean. *Morgan: American Financier.* NY: Random House, 1999.

Morgan, Julia (1872–1957)

American architect who designed over 700 buildings but is best known for creating a modern-day castle for millionaire William Randolph Hearst. Born on January 20, 1872, in San Francisco, California; died on February 2, 1957, in San Francisco from a series of strokes; daughter of Charles Bill Morgan and Eliza Woodland (Parmelee) Morgan; attended grammar and high school in Oakland; first woman to enroll in the College of Engineering at the University of California, Berkeley; received diploma in Civil Engineering, 1894; first woman accepted in the department of architecture at the École des Beaux-Arts, Paris, France, and received certificate, 1902; passed the California state exam and became the state's first certified woman architect, 1904.

Moved West with parents where her father hoped to make a fortune in gold and silver mines (1878); after investment soured, traveled East with mother to spend a year with her grandparents; while in New York, formed a lasting friendship with cousin Lucy Thornton and Thornton's architect husband Pierre Lebrun, the first to influence her; while at Berkeley, met Phoebe Hearst, who became a lifelong friend and patron; in se-nior year, studied under Bernard Maybeck, a charismatic teacher and architect who suggested she try to enter the École des Beaux-Arts in Paris (1890–94); left Oakland for the East Coast and Europe where she traveled with a friend (1896); accepted at the École des Beaux-Arts after the incredible stress of preparing for the entrance exam (October 1898); was joined in Paris by her younger brother Avery; met Phoebe Hearst's son William Randolph Hearst (1903) which led to the most flamboyant architectural creation of her career, the Hearst Castle; devastated by the deaths of her two younger brothers (1913 and 1940).

Julia Morgan's professional milestones span 47 years: El Campanil (Bell Tower) at Mills College, Oakland (1903–04); library at Mills College (1905–06); Fairmont Hotel, San Francisco: reconstruction after the earthquake and fire (1906–07); Methodist Chinese Mission, San Francisco (1907–10); St. John's Presbyterian Church and Sunday School, Berkeley (1908–10); Kings Daughters Home for Incurables, Oakland (1908–12); Asilomar YWCA Conference Center, Pacific Grove, CA (1913–28); Honolulu YWCA buildings, Honolulu (1925–26); Berkeley Women's City Club (1929–30); Hearst Castle, San Simeon, California (1919–39); Wyntoon, Shasta, California (1933–41).

After the San Francisco earthquake in 1906, Julia Morgan had the formidable task of rebuilding the 600-room Fairmont Hotel. When the foreman was asked by a reporter if the building were truly in the charge of a woman, he answered that it was in the charge of an architect whose name happened to be Julia Morgan. The foreman's response exemplified the respect inspired by the young, slim, 5' tall architect.

Julia Morgan was born in 1872 in San Francisco, California, the daughter of Charles Bill Morgan and **Eliza Parmelee Morgan**. Her interest in architecture probably began during her trips to New York, where her Parmelee grandparents lived. Albert Parmelee, a self-made millionaire from an old Virginia family, had made his fortune on the cotton market before the Civil War. It was Albert who had financed the Morgan house and furnishings in Oakland, California, and who often sent his daughter Eliza money to travel on the new transcontinental train for visits to the East Coast. In 1878, Charles lost money in a gold mine, and Eliza took her children to spend a year in New York. Julia was six and eager for school; instead, she remained housebound the entire winter with scarlet fever, followed by recurrent ear infections. During that period, she developed a strong

friendship with her cousin **Lucy Thornton** and Lucy's husband Pierre Lebrun, a successful New York architect. It also may have been during this confinement that Morgan formed some of the ideas that would dominate her architectural philosophy. Her buildings usually included tall windows which allowed plenty of sunshine to fall on warm, wood floors, and her rooms conveyed a sense of space and airiness which may have been the perspective she missed most as she looked at the winter cityscape from her window. Back in California, she applied herself in school, studying math and science. She loved to solve problems. By the time she graduated from high school in 1890, Morgan had convinced her parents that she should attend the University of California at Berkeley. They agreed, on condition that her brother Avery escort her to and from school. Since Berkeley did not offer an architectural program, Morgan enrolled in the College of Engineering.

In her second year, Morgan joined Kappa Alpha Theta; the 27 members of the sorority rented a house near the university. These young women formed a supportive network, and several would later become Morgan's clients. At Berkeley, she met *Phoebe Hearst, a philanthropist who used her millions to promote education and the arts and to improve the status of women. Hearst became an enthusiastic promoter of the aspiring architect. In Morgan's senior year, as a star student in Bernard Maybeck's geometry class, she joined an advanced seminar at Maybeck's home where he employed the students in a building project. This was her first hands-on experience with architecture. Maybeck had studied at the acclaimed École des Beaux-Arts in Paris, as had Pierre Lebrun, and both men encouraged Morgan to do the same. She set out for Paris in 1896.

Upon her arrival, she began to prepare for the notoriously difficult entrance competition, studying French and the metric system while also apprenticing at one of the all-male *ateliers* (workshops) run by architects. She most feared the formidable oral examination but passed on her third try. Out of nearly 400 applicants, only 30 were accepted, and Morgan, who ranked 13th, was able to enroll in the department of architecture due to a slight administrative oversight. Women were not specifically barred from that discipline, but only because no one had anticipated that a woman would apply. Once in, she had to cope with the pressures of meeting deadlines. **Sara Holmes Boutelle** notes that students delivered their precious drawings in hand-carts they pushed through the streets of Paris as late as midnight.

After receiving her certificate from the École des Beaux-Arts in 1902, Morgan returned to California. The following year, she had an opportunity to test some of her newly acquired knowledge. Phoebe Hearst had donated money toward a building program at Berkeley and had asked John Galen Howard, the architect, to hire Morgan. She was put in charge of building the Greek amphitheater, which had to be completed before the graduation ceremony that was scheduled to take place only a few months later. The small-boned, 31-year-old woman in wire-rimmed glasses introduced her suspicious workers to reinforced concrete, a new technique she had studied at the Beaux-Arts. The outdoor theater was ready in time—except for the outer wall, which was still damp. President Theodore Roosevelt delivered the graduation address, unaware of the purpose of the colorful banners that had been sewn together at the last minute and draped over the back wall. Morgan used reinforced concrete again on her next assignment, which was the construction of a bell tower for Mills College in Oakland. Those who questioned her new methods were amazed when, after the devastating earthquake of 1906, the 72-foot-high tower remained standing and intact. As a result of this early success, the owners of the Fairmont Hotel hired her to rebuild their gutted luxury hotel, which had burned down after the 1906 quake; they hoped that her Beaux-Arts and engineering background would produce a handsome and strong structure. Morgan did not disappoint them, and the renovated hotel opened on time to commemorate the first anniversary of the disaster. The achievement was the more admirable considering that she was working from a shack, her own recently opened office having also burned down. (Morgan's decision to open her own office had been hastened when she overheard her boss, John Galen Howard, boast that he had hired a talented designer whom he paid next to nothing because she was a woman. He never forgave her for leaving him and, for 25 years, used his influence to keep her from working on Berkeley buildings. Although this might have destroyed other young architects, Morgan had no time to hold a grudge.)

A pale, blonde-haired woman, weighing about 100 pounds, Morgan possessed a frail appearance that belied a will of steel and enormous energy which enabled her to work on several projects at the same time. Her only hobby was Chinese calligraphy. Hating to draw attention to herself, she sought refuge in anonymity, and her

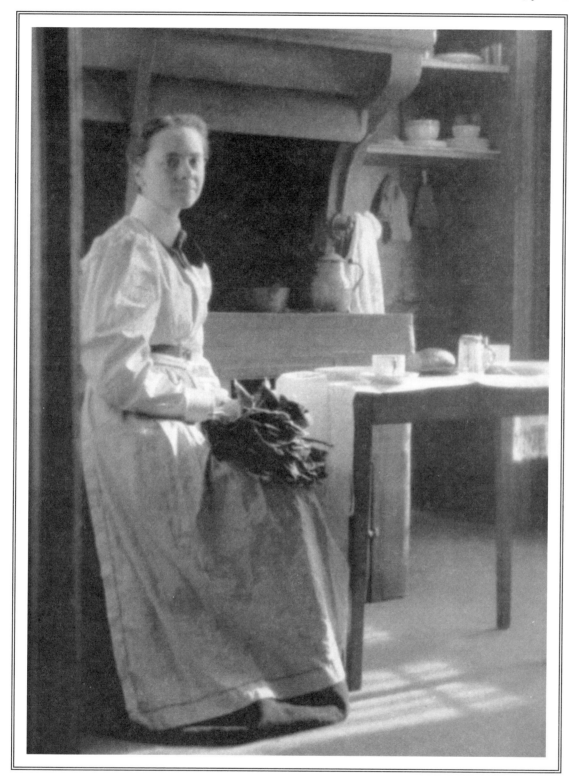

Julia Morgan

desire to avoid public attention became almost an obsession after a botched inner-ear surgery. During the operation, the doctor accidentally cut a facial nerve which left one side of her face partially paralyzed. While she had always shunned press interviews, after the operation she excused herself by claiming that it was inappropriate for an architect to be asymmetrical.

Morgan was completely at ease in her professional environment, however. She wore comfortable shoes, silk blouses and suits with big

pockets that bulged with pads and pencils, and did not carry a purse that might have hampered her in climbing scaffolds and 100-foot ladders. After the surgery, which also affected her sense of balance, she still climbed to the tops of buildings to inspect the on-going work, but she held onto a worker. Known as tough but fair and compassionate, Morgan could rip out a poorly installed fixture on the spot, but she could also praise a well-made tile or a beautifully carved door. When one of her favorite wood carvers refused to come to San Simeon to work on a later project because he did not want to leave his family, she built him a workshop in San Francisco and allowed him to ship his work.

My buildings will be my legacy.

—Julia Morgan

Although Morgan refused any political involvements and never called herself a suffragist, she hired many women and supported others with scholarships. She herself benefited greatly from the rising women's movement: a number of her commissions came from women professionals who were feminists, and, with many unskilled young women joining the work force, she received numerous contracts to build recreational, educational and residential buildings for women. Having shared a house with other women gave Morgan a special sensitivity. When she designed a YWCA (Young Women's Christian Association) building in San Francisco, she suggested including one or two private dining rooms with attached kitchens so the women could entertain their guests. A board member reminded Morgan that she was designing rooms for working girls who did not need to be spoiled. Morgan answered that, on the contrary, these were the women who needed to be spoiled. She also added a sewing room, a beauty parlor and a laundry room. When furnishing rooms, Morgan chose furniture that was simple yet elegant, but never stark. Her advice on buying chairs was to appoint a committee of three, one short, one tall, and one overweight, to try them out first. Of the national chain of YWCAs that Morgan built, the Oakland and Honolulu ones are still used today. Her Asilomar, a YWCA center, is now a California State monument, and, along with the Hearst Castle, is one of the two best revenue sources in the park system.

Located in Pacific Grove, Asilomar is a remarkable embodiment of the English Arts and Crafts movement. In 1913, Phoebe Hearst asked Morgan to design a conference center for the YWCA, to be built on 30 acres of coastal land she had donated to the association. The result is an exceptional group of buildings made of stone and redwood shingles that blends with the surrounding trees. Asilomar exemplifies Morgan's underlying belief that a structure should seem to grow from the site. Designed as a reaction to industrialism, this concept had originated in England with William Morris.

Making money or becoming famous did not play a part in Morgan's decision to take on a commission, but solving a problem did. In 1908, she accepted a contract to build St. John's Presbyterian Church, on a budget that allowed her no more than two dollars per square foot. She pondered the problem and finally came up with a spectacular design that included inexpensive but attractive redwood walls, a slanted floor and such high quality acoustics that the church is used for concerts and theatrical events.

Over the years, Morgan acquired a reputation as a "client's architect," and developed an uncanny ability to interpret her clients' dreams. She never refused a job because it was too small or too large; her commissions ranged from designing a playhouse for her taxi driver's daughters to creating a castle for one of the most eccentric millionaires in America. When she agreed to work for William Randolph Hearst, she knew it would involve commuting 300 miles on weekends. She did not know it would involve a 20-year commitment, lasting from 1919 to 1939.

When Phoebe Hearst died from the influenza epidemic that ravaged the world after World War I, Morgan lost both a friend and her most influential patron. In 1919, after his mother's death, William Randolph Hearst approached Morgan with his plan to build a "Jappo-Swisso bungalow" on top of a hill on some 270,000 acres of land he owned in San Luis Obispo County. The newspaper publisher and millionaire art collector was disillusioned with New York politics and planning to move back to California. The "bungalow" turned out to be a cross between a cathedral and a royal palace, and the ranch grew to look like a medieval village that had swallowed a Roman pool. Eventually, when Hearst brought a herd of Montana buffaloes to his "Enchanted Hill," Morgan added a zoo to her blueprints. The zoo required space for the daily truckloads of ice for the polar bears. When she came from San Francisco to work at San Simeon three weekends a month, she rode the night train, took a taxi from the station to San Simeon and, until a road was built, climbed to the top of the as-yet treeless hill by a horse-drawn carriage. When cars were able to drive to the "Casa Grande" (Main House), she referred to Hearst's cars as "guest machines."

San Simeon.

Morgan's job was to encompass her exuberant and volatile patron's dream and to incorporate in a single project a collection of treasures he had begun collecting as a boy. Phoebe once remarked that when her son "felt badly," he would go out and buy something. Had she judged from the stocked warehouses, Morgan must have concluded that William felt bad rather often. Some of the items included an ancient sarcophagus, choir stalls from European monasteries, Venetian windows, Arab lanterns, religious art, and such modern objects as a pool

table and working toilets. Few architects could have put up with the whims of a capricious man who had workers install a stone fireplace only to rip it out (along with a wall and part of a ceiling) and have it moved elsewhere, and then put back in its original place. The construction of the breathtaking Neptune pool involved pouring several tons of concrete vertically up a hill to create a retaining wall capable of holding more than a million gallons of water. Twice, Hearst decided to enlarge the structure and the wall had to be destroyed.

Morgan used humor, patience and professionalism in dealing with her client, and the Hearst Castle evolved as an extraordinary embodiment of a dream. The project easily could have been a disaster; instead, in Morgan's hands it turned out to be an engineering feat and an aesthetic triumph. When Hearst died in 1951, Morgan lost a client and a friend of three decades.

Her siblings were very important to Morgan, who never married and had no children. She always felt somewhat responsible for her younger brothers. Her sister Emma had become a lawyer, but brothers Parmelee, Avery and Sam inherited their father's easy charm rather than their mother's and sisters' ambition. Avery was satisfied working for Julia and happiest when she bought a car and he drove her around, as she never learned to drive. Sam, the youngest and favorite of the family, became a firefighter and died at the age of 26, when his fire truck toppled a building and he was crushed to death. Sam's death and, later on, Avery's death devastated Morgan. The three Morgan women led independent lives but maintained a good relationship, and Julia watched anxiously as her widowed mother's health deteriorated. Oakland was no longer a safe place to live, but their mother refused to move. When it became clear that Eliza could not be alone, Julia built a house for her, next to her sister's. On Thanksgiving Day, the family met at Emma's, and after dinner the daughters took their mother to her new house. She was confused at first, but once she saw the bedroom she felt at home, for Morgan had made an exact replica of her mother's former bedroom. With the new arrangement, Eliza was able to keep her independence while Emma watched over her.

With the death of William Randolph Hearst, Morgan lost her desire to work. She closed her office and asked a colleague to burn her blueprints. Two years later, at the age of 81, she was mugged and hospitalized. The shock brought on a series of small strokes, which forced her to re-main confined to her apartment for the last four years of her life. She died in 1957.

Although the Hearst Castle is Julia Morgan's best-known achievement, its eccentric flamboyance is not typical of her work. She felt at ease with a great diversity of styles: classical, gothic, Renaissance, Mediterranean, Spanish, Moorish, half-timbered English, Arts and Crafts and even Chinese. After World War II, a new architectural trend developed, the International Style; she disliked the cold, alienating, slick look of these new buildings that scorned historical references. She did not have a unique, rigid, style but instead submerged herself in her clients' visions and gave those visions substance. Her buildings evolved from a site, and were rooted in the traditions and needs of the people who would use them. The harmony of her designs came from a careful consideration of nature and the human element.

SOURCES:

Aidala, Thomas R. *Hearst Castle: San Simeon*. NY: Harrison House, 1981.

Boutelle, Sara Holmes. *Julia Morgan, Architect*. NY: Abbeville Press, 1988.

Longstreth, Richard W. *Julia Morgan: Architect*. Berkeley, CA: Architectural Heritage Association, 1977.

Swanberg, W.A. *Citizen Hearst: A Biography of William Randolph Hearst*. NY: Scribner, 1961.

Wadsworth, Ginger. *Julia Morgan: Architect of Dreams*. Minneapolis, MN: Lerner, 1990.

White, Anthony G. *Julia Morgan, Architect: A Selected Bibliography*. Architecture Series: Vance Bibliographies, June 1990.

Claire Hsu Accomando,
author of *Love and Rutabaga:
A Remembrance of the War Years* (St. Martin's Press, 1993)

Morgan, Maud (1903–1999)

American artist. Name variations: Maud Cabot. Born Maud Cabot in New York, New York, on March 1, 1903; died in Boston, Massachusetts, on March 14, 1999; daughter of Francis Higginson Cabot and Maud (Bonner) Cabot; married Patrick Morgan (an artist), around 1930 (separated around 1957, divorced 1980); children: one daughter; one son.

An icon of the Boston art world for over 50 years, Maud Morgan began painting around 1927 and launched her career in New York during the 1930s, exhibiting alongside abstract expressionists Jackson Pollock, Barnett Newman, and Mark Rothko. In 1939, having married, she moved to Andover, Massachusetts, leaving behind the renowned art circles that might have enhanced her fame. She taught for many years in Andover while raising a family and continuing

to paint. Following a separation from her husband in 1957, Morgan briefly took up residence in Boston, then settled in Cambridge, although she continued to travel extensively. At age 92, she published her autobiography, *Maud's Journey: A Life from Art*, which gave rise to two small exhibitions of her work: "Maud in the '90s," at the Art Complex Museum in Duxbury, Massachusetts, and "Maud Morgan: Celebrating a Life in Art," at the Boston Public Library. Morgan's extraordinary life, which included travel in remote Africa, friendships with Ernest Hemingway and John Cage, and a divorce at age 77, was as colorful as her paintings.

Maud Morgan was born in 1903 into the New York branch of the aristocratic Cabot family, and had a privileged but unhappy childhood at the hands of domineering parents. Her mother **Maud Bonner Cabot**, a big-game hunter, stalked moose and caribou in French Canada, where the family had a summer estate. In her autobiography, Morgan writes that her mother insisted that she too kill a moose before she made her debut. "It will give you something to talk about," said her mother. ("I did kill a moose," Morgan confided to interviewer John Koch, "and vowed never to do it again.") Morgan's early adult life also included trips to Russia, India (where she met Gandhi), and Paris, where she attended the Sorbonne and befriended Hemingway, who apparently surprised her with his cordiality. In Paris, she also met the love of her life, Whitney Cromwell, who was homosexual. After he died of pneumonia in 1930, Morgan married his roommate, artist Patrick Morgan, though she later admitted that she did not love him. It was Patrick who had first encouraged Morgan "to pick up a brush," although he may not have suspected at the time that she would soon be included in a number of prestigious exhibitions. Following her first important show, Morgan was extolled by the critics and sold works to the Whitney, the Metropolitan, and the Museum of Modern Art.

The Morgans lived in New York for much of the 1930s, during which time Maud was a student of Hans Hoffmann. After moving to Massachusetts, the couple raised two children, a daughter and a son, and taught at Abbot Academy and Phillips Academy. (Among their more prominent students were Frank Stella and Carl Andre.) Morgan also continued to pursue her own art career, exhibiting for years at the Addison Gallery of American Art in Andover. In addition to her work, she raised Shih Tzu dogs and helped run a folk-art group based near her family's home in Canada. Morgan's busy life, howev-

er, did not compensate for a miserable marriage, although it took her 27 years to summon up the courage to leave Patrick, and another 20 or so years to finalize a divorce. She later claimed that the day she obtained her final divorce decree was the day she recognized who she was.

Morgan's work, which ranges from abstract to representational, includes paintings in oil, watercolor, and gouache, as well as drawings, prints, and collages. "You don't find much beige in Morgan's paintings," writes **Christine Temin** of *The Boston Globe*. "She's a fan of fierce color; even in the charming 1990 oilstick drawing 'The Sweater Is Finished,' she can't resist dressing her feet in vivid lime-green." Temin also points out that Morgan's paintings frequently reflected her unhappy relationship with her husband. "Like *Frida Kahlo, whose art was often a record of her tormented marriage to Diego Rivera, Morgan's painting sometimes reflected a despairing soul," she writes. "While ostensibly abstract, her canvases often presented feelings and images as specific as the broken heart of her painting 'Denkmal,' a 1948 memorial to Cromwell."

Also reflective of Morgan's inner life is her series of self-portraits, which she said were her way of reaching "the real core of things." She portrayed herself in poses ranging from silly to heroic. In her 1993 self-portrait *My Rain Hat*, Morgan gazes out from under a voluminous white hat, while in *Facing the Storm*, she looks into a pale streaked background suggesting wind. "Like the figurehead of a ship, she stares into the storm as if it were the future," writes Temin. The artist's 1992 self-portrait, *The Rope*, is more ambiguous. An actual rope is attached to the top of the narrow canvas on which Morgan appears dressed in red, her face ashen, "as if decomposing," describes Temin. "Her eyes are cast down, so you can't read her expression, and her hand reaches up toward the rope, which is an enigma: It could equally suggest survival or suicide."

Maud Morgan continually renewed her artistic outlook by collaborating with other artists. She teamed with Bernard Toale on handmade paper pieces, with **Clara Wainwright** on a tapestry, and with Michael Silver on works combining photography and printmaking. "We operated like a friendly game of chess," said Silver, "with each other reacting to the other with moves and countermoves. The only difference was that we both won!" In their 1995 work, *Reflections*, they combined layers of transparencies and cyanotype printing, creating a rich blue background on which they superimposed a series of images. "Faces, staircases, a pear imprisoned

by the vertical bars of a slicer—these are some of the recognizable objects that float through the serene atmospheres Morgan and Silver have created," writes Temin. "In these collaborative works, Morgan continues a career-long dialogue between representational and abstract."

At age 93, when she was interviewed by Koch for the *Boston Globe Magazine*, Morgan had given up painting due to a lack of energy and the inability to lift her right arm enough to make a free brush stroke. At the time, however, she had newly discovered collage and was energized by it. "You suddenly put a piece of paper on another piece of paper—and then I just say out loud: 'That's plain beautiful!' I get very excited." At the end of the interview, Koch asked if she thought about death. "A bit," she replied. "My children are getting a little worried—they think we haven't done enough planning. So we all went and got little pieces of ground at Mount Auburn Cemetery. . . . We had a hysterical day." Morgan lived for three more years, succumbing to complications of pneumonia on March 14, 1999, at age 96.

SOURCES:

Koch, John. "The Interview," in *Boston Globe Magazine*. August 18, 1996.
McCabe, Bruce. "An Artist in her 90s for the '90s," in *Boston Globe*. May 6, 1995.
"Obituary," in *The Day* [New London, CT]. March 16, 1999.
Temin, Christine. "The Masterstrokes of Maud Morgan," in *Boston Globe*. June 28, 1995.
———. "Maud Morgan's Muddled Portrait," in *Boston Globe*. July 11, 1995.

Barbara Morgan,
Melrose, Massachusetts

Morgan, Michèle (1920—)

French film actress. Name variations: Michele Morgan. Born Simone Roussel on February 29, 1920, in Neuilly-sur-Seine, France; married William Marshall (an American actor), in 1942 (divorced 1949); married Henri Vidal (a French actor), in 1950 (died 1959); children: (first marriage) one son, Michael.

Studied drama and dance as a child; began appearing in small film roles (1935); by outbreak of World War II, was among the most popular screen personalities in France (1939); spent much of the war in Hollywood, making several films with American directors which were generally mediocre (1939–45); returned triumphantly to the French screen (1946), winning the Best Actress award at the Cannes Film Festival that year for her work in La Symphonie Pastorale; *maintained an active international screen career (1940s–1970s); was named a Chevalier of the French*

Legion Of Honor (1969); accepted mostly small roles and cameo appearances, as well as occasional television and stage work (1980s–1990s).

Selected filmography: Mademoiselle Mozart *(1935);* Le Mioche *(1936);* Gribouille *(1937);* Orage *(1938);* Quai des Brumes *(1938);* L'Entraîneuse *(1939);* Les Musiciens du Ciel *(1940);* Remorques *(1941);* La Loi du Nord *(1942);* Joan of Arc *(U.S., 1942);* Untel Père et Fils *(1943);* Two Tickets to London *(U.S., 1943);* Higher and Higher *(U.S., 1943);* Passage to Marseilles *(U.S., 1944);* The Chase *(U.S., 1946);* La Symphonie Pastorale *(1946);* The Fallen Idol *(U.K., 1948);* Fabiola *(It., 1948);* Aux Yeux du Souvenir *(1949);* La Belle que voilà *(1950);* The Naked Heart *(U.K.-Fr., 1950);* Le Château de Verre *(1950);* L'Etrange Madame X *(1951);* La Minute de Vérité *(1952);* Destinées *(1953);* Les Orgueilleux *(1953);* Obsession *(1954);* Napoléon *(1955);* Oasis *(1955);* Les Grandes Manoeuvres *(1955);* Marguerite de la Nuit *(1956);* Marie-Antoinette *(1956);* Retour de Manivelle *(1957);* The Vintage *(U.S., 1957);* Le Miroir a Deux Faces *(1958);* Maxime *(1958);* Racconti d'Estate *(It.-Fr., 1958);* Menschen im Hotel *(Ger.-Fr., 1959);* Le Scélérats *(1960);* Le Puits aux Trois Vérités *(1961);* Le Crime ne paie pas *(1962);* Landru *(1963);* Constance aux Enfers *(1964);* Lost Command *(U.S., 1964);* Benjamin *(U.S., 1966);* Le Chat et le Souris *(1975);* Robert et Robert *(1978);* Un Homme et une Femme: Vingt Ans déja *(1986);* Tutti stanno benne *(It.-Fr., 1990).*

Late in 1940, Michèle Morgan stepped before the camera on a Hollywood sound stage to screen test for Alfred Hitchcock's upcoming production, *Suspicion*. She had been suggested as the film's leading lady to play opposite Cary Grant, even though she had arrived in California only a few months before from France where, at age 20, she had already created a sensation on the screen. Hitchcock sat politely through the audition but announced a few days later that he had decided to cast ***Joan Fontaine** in the role, commenting that while the young French woman was certainly beautiful, her accent was much too thick. The great director's reaction typified Hollywood's indifferent response to Morgan. Although she would become France's most acclaimed actress after the war, she remains mostly unknown outside of Europe and still refers to her time in Hollywood as one of "shadows and light, rich in disillusionment."

Illusions had been Morgan's daily bread as a young girl, for she was sure she would grow up to be a film actress. In later years, she loved to tell the story of her father's excited return from

work one evening to report that an astrological- ly talented fellow worker had cast his daughter's horoscope and predicted she would be famous. She had been only three years old at the time, having been born Simone Roussel on February 29, 1920, in the comfortably middle-class Paris suburb of Neuilly-sur-Seine, the first of four chil- dren of Louis and **Georgette Roussel**. Louis, a manager at a Paris *parfumerie,* indulgently laughed at his daughter's fascination with movie magazines and their gossip while Georgette saw to it that she received dancing and gymnastic lessons. Everyone agreed the child was uncom- monly beautiful. When Morgan was ten, the *parfumerie* closed, and Louis moved his family to coastal Dieppe, in northern France, where he had relatives and found work in a family-owned *épicerie* (grocery shop). By this time, Morgan had announced that she wanted to be an actress. Four years later, she stepped onto a stage for the first time with a local ballet troupe at the Casino Dieppe and won second prize in a contest to find Dieppe's most photogenic young lady. As if to confirm her future plans, the photographer who

took her picture offered Morgan a trip back to Paris with him and an introduction to a produc- er friend. Louis balked at the idea of his 14-year- old daughter traveling alone with an older man, even when he was assured the photographer was happily married with two children. Georgette was more optimistic. Mother and daughter fi- nally convinced Louis when Morgan suggested that her younger brother Paul come along as a chaperon. In the fall of 1934, Michèle's child- hood illusions began to take shape.

Not long after she started formally studying dramatic technique with a private tutor, her bene- factor began to offer her introductions to director friends, all of whom were struck by Morgan's al- most otherworldly beauty and serene, open ex- pression. By November 1935, the 15-year-old was writing excitedly home to a friend in Dieppe, "I've worked four days so far, that's not so bad! Just this morning I got a letter inviting me to the premier of a film with *Loretta Young. It must be because [Young] is to be my model, and I must watch her well." Her work at this point was merely as an

Michèle
Morgan

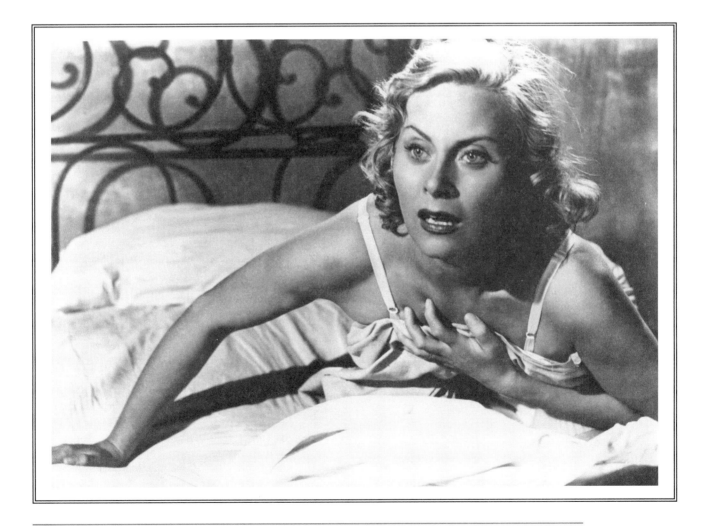

extra, and her scenes as such in her first film, *Mayerling*, were cut from the final version. She fared only slightly better in *La Vie Parisienne*; only a discerning viewer will be able to spot her in the crowd scenes. Morgan's first screen role of more than a few seconds, and still a silent one, came in Yvan Noé's *Madamoiselle Mozart*, in which she appears in a brief scene with *****Danielle Darrieux**. (The careers of the two young actresses would parallel each other. In later years, one film historian would write, "If Darrieux is the fantasy, Michèle Morgan is the mystery.") By this time, she reported to her Dieppe girlfriend that she had changed her name to Michèle Morgan, a director picking the last name while she came up with the first. "All my friends have taken a first name more sophisticated than Simone," she explained. "'Michèle' sounds fine and looks okay, so I have adopted it for all my new friends and fellow workers." The newly born Michèle finally spoke her first words on screen, in one line of dialogue, in *Le Mioche* (The Brat) in 1936. During the shoot, Morgan befriended the film's "script girl," who was a good friend of director Marc Allégret. Allégret was soon hearing about the "delightful, graceful ingenue" working on *Le Mioche*.

Everyone was used to seeing trembling little women with babies. To see a woman . . . wearing a trench coat and a beret, that was new!

—**Michèle Morgan**

"I just have to tell you some news that will give you . . . a great deal of pleasure!," Morgan wrote home to Dieppe. "I'm hired to be . . . in Marc Allégret's *Gribouille*! I don't know if you can imagine it, but I'm a little giddy myself!" Allégret, one of the most respected film directors in prewar France, had signed her to her first contract and given her the starring role in *Gribouille* opposite Raimu, a much-admired leading man of the day. Allégret had hired her after a screen test using a courtroom scene in which the film's Natalie, accused of murdering her lover, learns she has been acquitted by the jury. Released in 1939, *Gribouille* made Morgan a star; audiences were fascinated not only with her acting but with her trademark trench coat, beret and dangling cigarette. "Without [Natalie]," Morgan noted, "I would not have learned about myself as an actress. This story seemed to have been written by me, for me. A curious double personality began to work in me." This "double personality" produced a carefully studied, sensitive performance that was wholly new to French cinema before the war.

Allégret was so pleased with her work that he cast her in his next film, 1938's *Orage* (The Storm), in which Morgan played the lover of a married man who finally decides to return to his wife—the first of several intelligently played "other women" roles, in which momentary happiness only leads to disaster. At the end of *Orage,* Morgan's character kills herself; in her next film *L'Entraîneuse* (The Trainer, 1939), she is sent to prison; and in *Les Musiciens du ciel* (Heaven's Musicians, 1940), she dies a martyr's death for her devotion and loyalty to her lover.

Orage was the first of her films to be released in the United States, leading *The New York Times*' reviewer Frank Nugent to note: "Miss Morgan, a piquant newcomer, presents the other woman with charming naturalness." Praise was equally strong on both sides of the Atlantic for Morgan's work in *Quai des Brumes* (Port of Shadows, 1938), in which she played opposite the great French actor Jean Gabin for the first time. Director Marcel Carné's story of underworld skullduggery on the docks of Marseilles featured Morgan as a gangster's mistress, in yet another lovers' triangle which ends in destruction. French film critic Jacques Siclier felt that the screen chemistry between Morgan and Gabin "seems to embody the very history of our cinema." The film portrayed the dark mood of a country poised for war so effectively that the Nazis, who took control of Paris just after the film's release, banned it as morally corrupt. Morgan found herself in the south of France when the Germans invaded the north in 1940, having traveled to Cannes with Allégret for a planned film which never materialized. Meanwhile RKO, on the strength of her performances to date, had offered Morgan a Hollywood contract and a ticket out of the chaos of wartime Europe. She decided to accept, interrupting a brilliant career in France for what would be a mediocre one in America.

Hollywood was never quite sure what to do with Morgan's exotic beauty and subtle acting, and film historians have commented that she seemed to become invisible in a series of roles far beneath her talents. Among her first experiences on arriving in Hollywood was the audition for Hitchcock. Stung by the rejection after such success in France, she turned down the role of Ilsa in Michael Curtiz' classic *Casablanca*, leaving the part to be famously played by *****Ingrid Bergman**. In her first American picture, 1942's *Joan of Paris*, Morgan was inevitably cast as a French Resistance fighter who helps Allied pilots escape German prison camps. The film was largely ignored, and even Michèle would later say she disliked her work in the picture. As usual, Morgan's character dies at the end of the film, the same fate

awaiting her in *Two Tickets to London* (1943), another wartime melodrama. *Higher and Higher* (1943) had no such lofty theme; a vapid musical, it starred a young Frank Sinatra as a man about town who turns a maid (Morgan) into a debutante. The film is remarkable only in that Michèle uncharacteristically danced and sang for her leading man instead of dying for him. Critic Bosley Crowther's aside in *The New York Times* that Morgan was "a lovely and talented chick" was entirely in keeping with the overall tone of the film. Crowther was more severe in his review of 1944's *Passage to Marseilles*, another war picture in which she played Humphrey Bogart's long-suffering wife. Crowther dismissed her work as "pitifully silly."

While shooting *Higher and Higher* in late 1942, Morgan took advantage of a break and hurried to a nearby phone booth to make a call. It was occupied, she later reported, by a "great blond devil" of a man who carelessly left a revolver behind as he hurried away. The gun was a prop, and the "great blond devil" was actor William Marshall, who returned to the telephone booth to claim his property and ask Morgan for a date. The two were married in November of 1942. A son Michael was born two years later.

In 1945, with the war at an end, Morgan returned to France to shoot her first European picture in five years. It would prove to be the film for which she is chiefly remembered, and the one in which she recaptured her former screen stature. Jean Delannoy's *La Symphonie Pastorale* (1946), adapted by Andrè Gide from one of his own stories, told of a blind woman who is taken in by a minister's family, only to have both father and son fall in love with her with tragic results. Although the love triangle was certainly not new to her repertoire, Morgan's sensitive portrayal of the woman captured the attention of audiences throughout Europe. The reaction was equally positive in America, where Crowther's previous dismissals of Morgan's work now turned to praise. "Miss Morgan's performance," he wrote, "is an exquisite piece of art—tender, proud, and piteous in its comprehensions of the feelings of the blind." For her work in *La Symphonie Pastorale*, Morgan won the Best Actress award at the 1946 Cannes Film Festival.

Now at the peak of her career after her Hollywood limbo, Morgan began turning from roles as the desirable young heroine to the more mature love interest. In a British production, *The Fallen Idol* (1948), she played the mistress for whom Ralph Richardson commits murder, and in *The Naked Heart* (1949), she was reunited with director Marc Allégret in a story of a woman sheltered for most of her life in a convent school who is pursued by three potential lovers. As she rarely returned to the United States because of her work schedule in Europe, Morgan's marriage to Marshall began to deteriorate. Both took other actors as lovers—Morgan beginning a relationship with Henri Vidal, with whom she would appear in 1951's Italian costume drama, *Fabiola*. The marriage finally ended in divorce in May 1949, with Marshall retaining custody of young Michael. In January 1950, Morgan and Vidal were married in Paris.

From the time of her marriage to Vidal to his early death from kidney disease in 1959, Morgan would rarely be absent from the screen. She averaged one film a year, the most successful of this period being 1956's *Les Grande Manoevres*, directed by the venerable René Clair and featuring among its cast a young **Brigitte Bardot**. The pace slowed after Vidal's death, with a series of indifferent crime and action melodramas during the 1960s. The one exception was 1964's accomplished war drama *Lost Command*, in which Morgan was among an all-star international cast which included Anthony Quinn and George Segal.

By now the French New Wave was capturing the cinema world's attention. To many of the brash young directors of the New Wave, like Louis Malle and François Truffaut, Morgan belonged to an earlier film tradition, and one they were intent on subverting. Starting in the late 1960s, Morgan found good parts more elusive and turned her attention to other activities. She served as president of the Cannes Film Festival in 1971, was a member of the board of directors of France's government-owned television channel, FR3, and began accepting television work (her series *Le Tiroir Secret*, about a psychologist investigating her dead husband's past, was a huge success). In 1975, Morgan was made an officer of France's National Order of Merit, one of the country's highest civilian awards. She began accepting stage roles, too, notably in 1982's *Cherie*, which ran for 246 performances in Paris. In 1990, at age 70, Morgan turned in an exquisitely funny performance in the Italian-French comedy *Tutti stanno benne* (Everybody's Fine).

During her early career of the 1930s, Morgan's vulnerable heroines were sometimes seen as symbols of prewar Europe, destined for tragedy; while in the 1950s, as one of her country's most admired actresses, she was seen as representative of sophisticated French culture, a survivor of the war's destruction. But for

Michèle Morgan, the little girl whose dreams came true, work left little time for such theorizing. "One can't tell a story," she once wrote, "while one is still living it."

SOURCES:

Bouniq-Mercier, Claude. *Michèle Morgan*. Paris: Edition Colona, 1983.

Morgan, Michèle, with Marcelle Routier. *Avec ces yeux-la*. Paris: Editions Laffont, 1977 (published in English as *With Those Eyes*).

Nicholas, Thomas, ed. *International Dictionary of Films and Film Makers*. Vol. 3. Detroit, MI: St. James Press, 1992.

Norman Powers,
writer-producer, Chelsea Lane Productions, New York

Morgan, Sydney (1780–1859)

Irish novelist. Name variations: Miss Sydney Owenson; Lady Morgan. Born Sydney Owenson near Dublin, Ireland, on Christmas Day in 1780 (some sources cite 1783); died on April 14, 1859; daughter of Robert Owenson (an actor) and a mother, name unknown (the daughter of an English tradesman); worked as a governess (1798–1800); married Sir Charles Morgan (an eminent physician), in 1812; no children.

Lady Sydney Morgan was born Sydney Owenson in 1780 in Dublin, Ireland. In her early years, for the most part, she was brought up backstage by her actor father Robert Owenson. Morgan began her professional writing career at 21 with a volume of poems (1801) and a collection of Irish tunes, for which she composed the words, setting a trend that would later be adopted by Thomas Moore. Her first novel *St. Clair* (1804), heavily influenced by the work of Goethe and Rousseau, attracted immediate attention, but the book which made her reputation and brought her controversy was *The Wild Irish Girl* (1806). In it, she appeared as an ardent champion of her native country, a politician rather than a novelist, extolling the beauty of Irish scenery, the richness of the natural wealth of Ireland, and the noble traditions of its early history.

Having secured a high position in fashionable and literary society, she moved from Dublin to London and in 1812 married Sir Charles Morgan, an eminent physician. Books continued to flow from her pen, and in 1817 she published her detailed study of France under the Bourbon restoration. After it was angrily attacked in the Tory *Quarterly Review*, Morgan took her revenge indirectly in the novel *Florence MaCarthy* (1819), in which a *Quarterly* reviewer is imaginatively insulted. Sydney Morgan wrote many other books and was one of the most vivid and hotly discussed literary figures of her generation.

SUGGESTED READING:

Dixon, W.H., ed. *Lady Morgan's Memoirs: Autobiography, Diaries, and Correspondence*.

Fitzpatrick, W.J. *Lady Morgan: Her Career, Literary and Personal*.

Morgenstern, Lina B. (1830–1909)

German social reformer. Born Lina Bauer in 1830; died in 1909; married a Dr. Morgenstern.

At age 18, Lina B. Morgenstern organized a league to aid poor school children. After her marriage, she founded the Berlin Kindergarten Association and served as its president from 1860 to 1866. The Public Kitchens she established in Berlin to relieve economic distress were imitated in other large cities and constitute her most notable accomplishment. Morgenstern also founded a society for the protection of illegitimate children, and an academy for the instruction of young women in practical arts, and was the author of a number of books on domestic and educational subjects.

Morgue, Efua Theodora (1924–1996).

See Sutherland, Efua Theodora.

Morin, Nea (1906–1986)

British mountaineer. Born Nea Barnard in 1906; died in 1986; father was a member of the Alpine Club; married Jean Morin (a mountaineer), in 1928 (killed on a mission with the Free French forces in 1943); sister-in-law of climber Micheline Morin; children: Denise (b. 1931); Ian (b. 1935).

Made first all-female traverse of the Meije (1933); made first all-female ascent of the Aiguilles de Blaitière (1934); made first ascent of "Nea" on Clogwyn Y Grochan; was president of Ladies' Alpine Club (1947); was president of the Pinnacle Club (1954).

Arguably one of the greatest British female mountaineers between World Wars I and II, Nea Morin grew up climbing the nearby rocks of Tunbridge Wells. In 1926, she made her first trip to Chamonix with **Winifred "Jo" Marples** to traverse the Grands Charmoz and Aiguilles du Mummery-Ravanel, ascents of the Grépon and the Dent de Requin. After her 1928 marriage to mountaineer Jean Morin and a short stay in London, she joined the "Bleau" group, climbers who frequented the rocks at Fontainebleau, just

outside Paris. Her sister-in-law **Micheline Morin** trained there, along with **Alice Damesme**, who would be a lasting friend.

In 1933, Nea, Micheline, and Alice set out *en cordée féminine* (women-rope only) to successfully traverse the Meije in the Dauphine Alps (the last major peak in the Alps to be climbed). But two recent deaths in the attempt had their husbands only reluctantly giving their consent, which was still a necessity for wives in 1933. Attempting to climb manless was "by far the most difficult and trying part of our programme," wrote Nea. In 1934, the three friends ascended the Aiguille de Blaitière together, conquering all three peaks.

After the death of her husband during World War II, Morin stayed closer to home, climbing the rocks of Wales. In 1941, with J. Menlove Edwards as second, she had made the first ascent of Clogwyn Y Grochan; the route, which is 230 feet high and graded Severe, is now named Nea. She also led on an ascent of Curving Crack on Clogwyn du'r Arddu (the Black Cliff).

Morin's children, Denise and Ian, began climbing with her in 1947, and Denise and Nea Morin became one of the most successful mother-daughter teams in climbing history. In 1953, they climbed the North Face of the Cima Piccola di Lavaredo, the Traverse of the Vajolet Towers in the Dolomites, and the Traverse of the Weissmies, by the North Ridge and the Ordinary Route. In North Wales, they continued their assault of the classics.

Morin's last big Alpine climb, with **Janet Adam Smith** (Janet Carlton), was the 1958 Traverse of the Meije, guideless. In 1959, she joined Emlyn Jones' expedition up the North East Ridge of Ama Dablam in the Himalayas. The group retreated when two men disappeared in heavy flurries. Though Morin had now developed osteoarthritis in her hip and underwent an operation in 1963, she could still make climbs of Hard Severe grade. She returned and ascended "Nea" at age 70. In 1982, when she was 76, a stroke put an end to her distinguished career.

SOURCES:

Birkett, Bill, and Bill Peascod. *Women Climbing: 200 Years of Achievement.* London: A. & C. Black, 1989.

SUGGESTED READING:

Morin, Nea. *A Woman's Reach* (autobiography). Eyre & Spottiswoode, 1968.

Morini, Erica (1904–1995)

Austrian-born American violinist who played with major orchestras throughout the world. Born in Vienna, Austria, on January 5, 1904; died of heart failure in New York City on November 1, 1995; daughter of a music teacher; married Felice Siracusano (a Sicilian diamond broker who died in 1985).

When Erica Morini was three, she had perfect pitch. Hiding behind the large stove in her father's music studio, she would call out "wrong" when one of his students played or sang off key; he would then sit her at the piano, to pick out the correct note. By age five, she was performing in public. At a surprise party for the Austrian emperor Franz Josef, Erica was placed behind a screen until she finished playing; she then emerged before a dumbfounded emperor who thought he had been listening to a performance by a mature artist. Lifting her onto his lap, he asked what she would like for a reward. "A doll with eyes that move," she replied, a request he graciously granted.

Morini studied with her father before entering the Vienna Conservatory at age seven. In 1916, she debuted in Vienna, and over the years performed with the Leipzig Gewandhaus Orchestra and the Berlin Philharmonic Orchestra. In 1924, when Morini was 20, her father gave

Erica Morini

her a cherished gift, a 198-year-old Stradivarius violin he had managed to obtain for $10,000 in Paris. Named the Davidoff Stradivarius after the Russian cellist who had previously owned it, the instrument was known for its rich tones.

Morini spent three years in the United States after her New York debut at Carnegie Hall with the Metropolitan Opera Orchestra, and her playing was considered brilliant. She then returned to Europe to concertize until 1938, when she became one of the many Jewish musicians to flee Central Europe with the advent of the Nazis. Taking refuge in America, Morini settled in New York, married Felice Siracusano, a Sicilian diamond broker, and became an American citizen in 1943. During her career she toured America, South America, Australia, and the Far East, before retiring in 1976, a victim of arthritis in her fingers.

As Morini lay dying at Mount Sinai hospital in New York City in 1995, at age 90, someone stole her beloved Stradivarius, now 268 years old and worth over $3.5 million, which had been locked away in her bedroom closet. She returned home, still gravely ill, and died on November 1, 1995, unaware of the theft. She had willed profits from the sale of her violin to charities for the blind, elderly, and handicapped. Often called the world's greatest female violinist, Morini once griped in response, "Either I am a great violinist, or I am not."

John Haag,
Athens, Georgia

Morisot, Berthe (1841–1895)

French painter who was one of the most talented and prominent members of the Impressionist movement. Born Berthe Marie Pauline Morisot on January 14, 1841, in Bourges, France; died in Paris on March 2, 1895, of pneumonia; daughter of (Edme) Tiburce Morisot (a civil servant) and Marie-Joséphine-Cornélie Thomas; studied privately under a number of artists, including Camille Corot; married Eugène Manet (a landowner), on December 22, 1874 (died April 13, 1892); children: daughter Julie Manet (b. November 14, 1878).

Moved to Paris with family (1855); began drawing lessons with her sister Edma (1857); registered as a copyist at the Louvre (1858); exhibited with her sister at the Paris Salons (1864–68); exhibited alone (1870, 1872, 1873); participated in the first Impressionist exhibition (1874); participated in second exhibition (1876), third (1877), fifth (1880), sixth (1881), seventh (1882), and eighth (1886); exhibited with Les XX in Brussels, and was included in Durand-Ruel's New York Impressionist exhibition (1887); held first solo exhibition (1892); exhibited with Le Libre Esthetique in Brussels (1894).

Representative works: The Harbour at Lorient (1869), Mother and Sister of the Artist (1870), The Cradle (1872), Catching Butterflies (1873), At the Ball (1875), Psyche (1876), Summer's Day (1879), In the Dining Room (1886). Works contained in over a dozen collections in major museums, including Chicago Art Institute, Tate Gallery (London), Metropolitan Museum of Art (New York), Musée du Louvre (Paris), Doria Pampli (Rome), National Gallery of Art (Washington, D.C.). Signature: Berthe Morisot, sometimes BM.

On April 15, 1874, an exhibition of artworks opened at 35 boulevard des Capucines, the premises of Nadar, a prominent Parisian photographer. It was a rare occasion. The artists were exhibiting their works themselves, rather than through the Salon, the state-sponsored exhibition. Some critics applauded them for their initiative, others panned them. But it was the innovative style of some of the paintings which drew the largest and most hostile response. Although 30 artists exhibited a variety of styles, a small core of artists, who were challenging traditional conventions of representation, became the target of much abuse. This group, which became known as the Impressionists, altered forever the way Western culture regarded painting, and prominent among them was Berthe Morisot.

Morisot was born in Bourges on January 14, 1841, but before she was 12 her family had settled in Passy on the outskirts of Paris; it was to remain her home for the rest of her life. Passy was still a country district, and did not become officially part of Paris until 1859. Over the course of Morisot's lifelong residence, the town evolved into a lively suburb, while still retaining something of its village-like atmosphere. Victor Hugo called it "the capital of Paris."

Her father Tiburce Morisot was a civil servant during a period of almost constant bureaucratic confusion in France, and the family moved several times during her childhood. She was one of four children; her sisters **Yves** (born 1838) and **Edma** (born 1839) were older, while her brother Tiburce was younger, probably by seven years, but possibly by four. Her mother **Cornélie Thomas** came from a family of civil servants, and it was through the influence of Cornélie's father that Tiburce Morisot was able to secure a position as subprefect at Yssingeaux in the Haute-Loire a year after their marriage in 1835. Several promotions and moves followed, until

Berthe Morisot with a Bouquet of Violets, 1872. *Painting by Manet.*

Tiburce's bureaucratic career was essentially ruined by his opposition to the nationalization of royal property by the Second Empire. He was relegated to a minor post in Passy, where the Morisot family, nevertheless, enjoyed a comfortable bourgeois lifestyle.

Like all middle-class young women, the Morisot sisters were encouraged to take an amateur interest in music and art, and they took lessons in both. Such art lessons were always distinct from those in which men were trained to be professional artists; women were encouraged

only to dabble. The Morisot daughters first studied painting around 1855, under the tutelage of Geoffroy-Alphonse Chocarne, whose strict adherence to Neoclassical principles of style bored all of the Morisots, and apparently drove Yves away from painting permanently. Edma and Berthe, however, continued to study art under Joseph Guichard, who, while trained as a Neoclassicist, had to some extent abandoned the style of David and Ingres for the new Romantic style exemplified by Delacroix and Géricault. The warning which Guichard gave Mme Morisot about her daughters, reported in Armand Forreau's 1925 biography, is often quoted: "With natures like those of your daughters, my teaching won't end with giving them pretty little drawing-room accomplishments: they will become painters." Guichard expected this possibility to be alarming to the bourgeois Morisots, but instead Berthe and Edma continued to study, and registered as copyists at the Louvre by 1858. Guichard would later be one of those who considered Morisot the finest watercolorist of her time. During the early 1860s, the sisters made the acquaintance of many other artists, mostly at the Louvre, among them Felix Bracquemond, Henri Fantin-Latour, and Alfred Stevens.

[Morisot was] the magician whose work . . . stands comparison with that of anyone, and links itself, exquisitely, to the history of painting during an epoch of the century.

—Stéphane Mallarmé

The Morisots, perhaps influenced by other artists they met at the Louvre, eventually requested, in 1860, training in plein-air painting (painting outdoors in natural light), which Guichard himself was not particularly inclined towards. As a result, the sisters would be introduced to both Achille Oudinot and Camille Corot, although it is not entirely clear in what order. While it is certain that they studied under both artists, to what extent Corot actually taught the Morisots is unclear; he was opposed to formal training in general, and in particular did not often allow observers while he was working himself. Armand Fourreau reports that the sisters produced copies of Corot's work, in which task Edma was deemed by Corot more skilled. In any case, the sisters followed Corot's example of learning through plein-air painting, sometimes under the guidance of Oudinot, making summer trips to Ville d'Avray in 1861 and the Pyrenees in 1862 to do so. Of particular importance was the summer of 1863, spent at Le Chou, where the sisters painted under Oudinot's guidance. In 1864, the results of this summer's work were submitted to the Salon, which annually exhibited paintings under the sponsorship of the Fine Arts Ministry. Berthe's two exhibited works were entitled *Souvenir of the Banks of the Oise* and *Old Roadway at Auvers*. The same year, the Morisots built a studio for the sisters in the garden of their home.

In the summer of 1865, the family stayed on the Normandy coast, and also visited Brittany, where Edma painted a view of the Rance estuary. Berthe's first major work was executed during this summer, her *Thatched Cottage in Normandy*, one of the earliest examples of the developing Impressionist style as practiced by Morisot. It was exhibited at the Salon of 1866; at the 1865 Salon, she had showed *Study* and *Still Life*. Her first notice from a critic (Paul Mantz) noted her fine use of light and color, while emphasizing that still lifes were simple to paint, not requiring Academy training, and thus ideal for women. Despite frequent encounters with such attitudes, Berthe and Edma both began to place works on consignment with Alfred Cadart, a dealer who had also dealt with Édouard Manet. Berthe's efforts to be regarded as a professional were always hampered by the degree to which women were excluded from the overt marks of professionalism—the commissions, medals, prizes, and particularly academic qualifications. While there were no rules excluding them, tradition kept women from attending the École des Beaux-Arts, for example.

In 1868, while copying a Rubens in the Louvre, the Morisots were introduced by Fantin-Latour to Manet, who would become Berthe's closest colleague for many years. That same year, Edma became engaged to Adolphe Pontillon, an acquaintance of Manet's (Yves was already married, leaving Berthe as the only single daughter, much to her family's concern). After Edma's marriage in 1869, Berthe began to seek the company of other artists more frequently, among them Manet, Edgar Degas, Alfred Stevens, and Pierre Puvis de Chavannes. While visiting Edma in Lorient during the summer of 1869, Berthe produced two more of her finest early works, *The Harbour at Lorient*, which shows Edma seated on a parapet in the foreground, and *Young Woman at a Window*, which is also of Edma.

The relationship which developed between Morisot and Manet was one of professional loyalty. Morisot was often irked by Manet's treatment of her; to him, as to many of the era, she was a woman first. In 1870, an incident occurred which might have ruptured their friendship, though in the end it did not. Morisot was prepar-

The Harbor at Lorient, 1869. *Painting by Berthe Morisot.*

ing a portrait of her mother and sister for submission to the Salon, and her frustration with it led Manet to offer to view it for her. To Morisot's surprise and horror, Manet proceeded to alter the painting a little at a time, until he had gone over virtually all of the figure of Mme Morisot. The painting was submitted to the Salon, recalled, and resubmitted, the whole process being agonizing for Morisot. In all likelihood, Manet would not have felt free to alter the work of any painters as well established in style as Morisot had they been male. A number of letters written by Manet, although of an earlier date, tended to marginalize the Morisot sisters because of their sex. This inclination was evident in all the male artists of the day to some extent; women artists were not included in the fashionable cafe debates, and were more likely to be asked to act as models than to be consulted as peers. It appears, in fact, that a busy schedule of posing for both Stevens and Manet left little time for Morisot to submit any of her own work to the 1869 Salon.

Also in 1870, the Morisot family witnessed the outbreak in July of the Franco-Prussian War,

initiated by France over a diplomatic matter largely to provide glory for the Second Empire; instead, the war would lead to its fall. The conflict continued until January 1871, during much of which time bombardments took place not far from Passy, where Berthe continued to live with her parents. She was unable to work in oil, due to the militia being quartered in her studio, and it was during this period that she turned increasingly to watercolors, which suited her style well. Both watercolor and pastel (which she began to use frequently in 1871) strongly influenced her palette of oils. During the siege, hunger and cold took their toll; Morisot suffered from health problems for the rest of her life, and this period is often cited as partially responsible for them.

When, after the French defeat, the Prussian occupation began, the Morisots moved to the western side of Paris in order to be away from the expected vicinity of further conflict; the area just below Passy was the scene of Parisian resistance to the new national government elected under German supervision. The Commune, the independent Parisian government, was support-

ed by Manet and Degas, while Tiburce Morisot was in the service of the national government centered at Versailles. Morisot, finally fed up with not being able to work, left in May to stay with Edma, intent on producing paintings that would sell. Working in both oils and watercolors, she began to produce the work of a fully mature and independent artist. Her drive to become a professional was fueled by the end of the civil war, which apparently left her mother free to take up again the twin practices of belittling Berthe's art and seeking her a suitable husband.

Morisot finally sold her first four works in July 1872, to Paul Durand-Ruel, Manet's dealer. One of the first to realize the money to be made from dealing in the avant-garde, Durand-Ruel was also one of many to identify Manet and his circle as the next wave. Morisot's work gradually began to sell, for respectable sums, both to Durand-Ruel and to the public. In the summer of 1872, she made an important trip to Spain, studying the work of Goya and Velázquez, much as Manet had done. One of her best-known works, *The Cradle*, dates from 1872; it shows that Morisot had emerged as an independent artist, but also that she was producing work which was commercially viable. When the family moved in 1873 (still within Passy), Morisot found herself once more without a studio. She never bothered to have one again.

The Salons of 1872 and 1873 both reflected the conservative taste of their juries, and Morisot was among the entrants turned down. A number of artists, who like herself had been exhibited by Durand-Ruel and identified by him as "The Society of French Artists," determined to exhibit their work under their own control. Consequently, the Societé Anonyme Coopérative d'artistes-peintres, sculpteurs, graveurs was formed late in 1873, with Claude Monet, Edgar Degas, Camille Pissarro, Alfred Sisley, Pierre-Auguste Renoir, and Henri Rouart as the key figures. Morisot became formally associated with the group early in 1874, at the request of Degas, who had supplanted Manet over the years to become her closest colleague. Manet himself was not willing to exhibit with the Societé and advised Morisot against doing so. Morisot, the only woman of the 30 artists included in that exhibit at 35 boulevard des Capucines, showed ten works, possibly more, including *The Cradle* (1872). As noted, she was identified by critics as one of the core group of painters working in the new and unorthodox style which was labeled "impressionism" after a work of Monet's shown at the exhibit. Louis Leroy wrote in *Charivari:* "That young lady

does not waste time on reproducing a host of boring details. When she has a hand to paint, she simply applies as many brushstrokes as there are fingers and the job is done!"

Morisot vacationed with Edma and her family in Normandy during the summer of 1874. While there, she and Eugène Manet, the artist's brother, became engaged; they were married on December 22. Eugène, like both his brothers, was not compelled to work, being comfortably taken care of, and apparently was not driven to. He was a member of his brothers' circle of artistic and political friends, and himself painted (Degas invited him to participate in the exhibit of 1877, but he declined), but as far as is known his only profession was "landowner." In 1889, he published his novel, *Victims!*, which expressed some of the convictions of his family which had been revealed during the war, although it is set during the 1851 insurrections. The couple settled in the Morisot apartment, where Berthe took care of her mother, widowed the same year, until Cornélie's death in 1876.

Despite marriage, Morisot continued to pursue her career, placing herself in the forefront of the Impressionist movement. She was deeply committed to the efforts of artists to exhibit and sell their works without government control; this meant that she no longer exhibited at the Salons. In 1875, Monet, Renoir, Sisley, and Morisot organized a public auction of their works, a controversial event that was marked by violent disruption. While Morisot's work, in fact, fetched the highest price at the auction, the figures in general were quite low. At the second Impressionist exhibit, at the gallery of Durand-Ruel, the work of Morisot was singled out by hostile critics as being most representative of the horrible new style. However, by 1877 and the third exhibition (the first to be called Impressionist by the artists), the critics were also taking note of Morisot's genuine talent, what Georges Rivière called "an eye of extraordinary sensibility." Morisot's eye for the way light shapes color is considered the hallmark of her style, as well as that of Impressionism.

With the birth of her daughter **Julie Manet** in 1878, Morisot found her principle model for the rest of her life. That same year, *Les Peintres Impressionnistes* by Théodore Duret, the first history of the Impressionist movement, was published. In it, he identified the core members of the movement as Pissarro, Monet, Renoir, Sisley, and Morisot. In general, this view has never been challenged, but over the years the role of Morisot has been substantially downplayed in many accounts. She did not participate in the fourth exhi-

bition of the group. It is often suggested that the recent birth of her daughter was the main reason for her absence, and perhaps it was; but, at the same time, the fourth exhibition was the first one at which the increasing divergence among the artists was made apparent. Renoir, Sisley, and Cézanne did not participate as a result of Degas' insistence that they renounce the Salon.

In 1879, Morisot and *Mary Cassatt were largely responsible for the organization of the fifth Impressionist exhibition, at which Morisot was the main target of critical comment, in part because Monet, Renoir, and Sisley were not involved. The split between those Impressionists who still preferred the Salon and those who were committed to independent exhibition was essentially permanent, leaving Monet, Renoir, and Sisley outside the Impressionist core which would be represented by Degas, Pissarro, Morisot, and Cassatt, and a second generation which would include Paul Gauguin and the pointillists Georges Seurat and Paul Signac. Morisot was also the focus of critical notice because she was the artist who had most fully developed a truly Impressionistic style. This trend continued in the sixth exhibition, at which Morisot and Cassatt were the obvious champions of Impressionism, along with Pissarro. The success of Morisot and Cassatt contrasts sharply with the case of the other well-known woman to exhibit with the Impressionists, *Marie Bracquemond, whose career was cut short at the insistence of her husband. The only other woman to exhibit with the Impressionists, Jacque-François, remains virtually unknown.

The seventh Impressionist exhibit, in 1882, saw an effort to reconcile the original members of the group; Pissarro actively sought to have Monet and Renoir participate. The result was mixed; while works by Monet and Renoir were submitted by Durand-Ruel, Degas and Cassatt withdrew. Renoir had refused to exhibit with Degas. Pissarro also asked Édouard Manet to participate, but, as always, he preferred the Salon. Morisot's participation in this exhibit was somewhat haphazard. She was staying in Nice, while Eugène handled her submissions in Paris. Only one of her works was in place at the beginning of the exhibit (the other major artists had from 17 to 35), and only around nine by the end. As a result, she was not a strong presence and received little notice. The following year, she was devastated by the death of Édouard Manet; she and Eugène organized a retrospective exhibition and sale of his work.

That same year, Morisot and Manet moved into their newly constructed home at 40 rue de Villejust, where Morisot still did not maintain a studio; both worked in the living room. Increasingly after 1885, Morisot made preparatory drawings for her works, contrary to the supposed spontaneity of Impressionist method. Late in 1885, she began preparations for what would be the final Impressionist exhibit, selecting artists to replace Renoir and Monet, who again would not take part. In exasperation, Morisot wrote to her sister: "It seems to me that I am about the only one without any pettiness of character." Among the new exhibitors were Seurat and Signac, who developed pointillism. By this time, Impressionism was no longer the avant-garde; it was being replaced by a variety of styles which would come to be called Post-Impressionist, for lack of any term which better connected them. Morisot was widely seen as the last artist still working in a recognizably Impressionistic style.

More successful than this exhibit, perhaps, was Durand-Ruel's 1886 exhibition in New York, which included all of the embattled Impressionists. Also in 1886, Morisot produced one of her best-known and most often reproduced works, *In the Dining Room*. She continued to exhibit, often with the other Impressionists and often under the sponsorship of Durand-Ruel. However, like a number of the others, Morisot was eager to exhibit without the controlling interest of Durand-Ruel. In 1887, she was included in the Salon of the Twenty in Brussels, billed as the artistic event of the year, which brought together the work of the Impressionists (Morisot, Pissarro, and Seurat) with that of their Belgian contemporaries the Vingtistes. She also made her only appearance in the International Exhibition, sponsored by Georges Petit, another dealer. His exhibitions were extremely prestigious, and marked an artist as established, rather than avant-garde.

During the late 1880s, Morisot entertained more frequently, and her intimate friends consisted of her most frequent guests: Renoir, Monet, Degas, and the poet Stéphane Mallarmé. Her closest colleague during these years was Renoir, who, as his son wrote, "avoided artistic and literary sets like the plague," but was always happy to visit the Manet household. Another dear friend was Mallarmé, who shared her retiring personality.

Eugène Manet died on April 13, 1892, after a long illness, and Morisot, although she owned their house, moved to a small apartment with Julie at 10 rue Wéber. Only a month after his death, Morisot held the solo exhibition he had

encouraged. Sales and critical notice were good, and she continued to be regarded as one of France's foremost artists. In 1895, Berthe Morisot became ill with pulmonary congestion and died on March 2, age 54. She was buried beside her husband, and her brother-in-law and colleague Édouard Manet. Renoir would later tell his son that on hearing of the death of Morisot he "had a feeling of being all alone in a desert." In a letter to his son, Pissarro wrote that Morisot had "brought honour to our impressionist group which is vanishing—like all things." Indeed, the death of Berthe Morisot marked the end, in some ways, of the Impressionist era.

Over the years, Morisot's reputation with the public faded, although she was the subject of over a dozen exhibits around the world in the first half of the 20th century. One of the most important was the "Berthe Morisot and her Circle" exhibition which toured Canada and America in 1952–54. To some extent, the 1987 exhibit "Berthe Morisot—Impressionist," featuring 104 of her works, indicates that she is now receiving wider recognition as one of the most talented and influential artists of the late 19th century.

SOURCES:

Adler, Kathleen, and Tamar Garb. *Berthe Morisot*. Oxford: Phaidon, 1987.

Fourreau, Armand. *Berthe Morisot*. Translated by H. Wellington. London: The Bodley Head, 1925.

Garb, Tamar. *Women Impressionists*. Oxford: Phaidon, 1986.

Higonnet, Anne. *Berthe Morisot*. NY: Harper & Row, 1990.

Manet, Julie. *Growing Up With the Impressionists*. Translation of the diary of Julie Manet by Rosalind de Boland Roberts and Jane Roberts. London: Sotheby's, 1987.

Renoir, Jean. *Renoir, My Father*. Translated by Randolph and Dorothy Weaver. London: Collins, 1962.

Rey, Jean Dominique. *Berthe Morisot*. Translated by Shirley Jennings. Naefels, Switzerland: Bonfini Press, 1982.

Rouart, Denis. *The Correspondence of Berthe Morisot*. Translated by Betty W. Hubbard. London: Camden Press, 1986 (originally published in 1957).

Stuckey, Charles F., and William P. Scott. *Berthe Morisot, Impressionist*. NY: Hudson Hills Press, 1987.

Yeldham, Charlotte. *Women Artists in Nineteenth-Century France and England*. 2 vols. NY: Garland, 1984.

SUGGESTED READING:

Angoulvent, Monique. *Berthe Morisot*. Paris: Morance, 1933.

Bataille, M.L. and G. Wildenstein. *Berthe Morisot—catalogue des peintres, pastels et aquarelles*. Paris, 1961.

Duret, Theodore. *Manet and the French Impressionists*. Philadelphia, 1910.

Huissman, Philippe. *Morisot: Charmes*. Lausanne: International Art Books, 1962.

Morgan, Elizabeth. *Berthe Morisot, Drawings, Pastels and Watercolors*. NY: Shorewood, 1960.

Valery, Paul. *Degas, Manet, Morisot*. Vol. 12 of the *Collected Works of Paul Valery*. Translated by David Paul. NY: Pantheon, 1960.

COLLECTIONS:

Documents and some correspondence in the Durand-Ruel Archives, Paris. Most material in private collections.

RELATED MEDIA:

"Berthe Morisot, the Forgotten Impressionist" (VHS), Electronic Field Production Service, 1990.

William MacKenzie,
graduate student, University of Guelph, Ontario, Canada

Morley, Mrs. (1665–1714).

See Anne, queen of England.

Morpeth, Lady (1757–1806).

See Lamb, Caroline for sidebar on Georgiana Cavendish.

Morpeth, Lady (1783–1858).

See Cavendish, Georgiana.

Morphia of Melitene (fl. 1085–1120)

*Queen of Jerusalem. Name variations: Morphia of Melitin. Flourished between 1085 and 1120; born an Armenian noble; married Baldwin II, king of Jerusalem (r. 1118–1131); children: *Melisande (1105–1160), queen-regnant of Jerusalem; *Hodierna of Jerusalem (c. 1115–after 1162), countess and regent of Tripoli; *Alice of Jerusalem (b. around 1106); *Joveta of Jerusalem (b. 1120).*

Morphise (1737–1814).

See Pompadour, Jeanne-Antoinette for sidebar on Marie-Louise O'Murphy.

Morpurgo, Rachel (1790–1871)

Jewish poet. Born Rachel Luzzatto in Trieste in 1790; died in 1871; educated privately; married Jacob Morpurgo, around 1819; children: four.

Rachel Morpurgo was born in 1790 into a wealthy, prominent Jewish family in Trieste. Although it was then a part of Austria, Trieste had its cultural and linguistic roots in Italy, and its small Jewish community enjoyed a relative freedom not permitted in more anti-Semitic European cities. Morpurgo grew up in a family renowned for their scholars, including the famous philosopher and cabbalist Haim Moses Luzzatto and writer-scholar Samuel David Luzzatto. She carried on her family's scholarly tradition through close studies of the Torah and the Talmud, in addition to other medieval rabbinic texts, under the tutelage of her uncles Hezekiah

and David. In addition to her familiarity with Hebrew and Aramaic, she studied Italian literature and mathematics, and was reportedly able to read the Talmud at age 14.

At 18, Morpurgo began her lifelong occupation with poetry, which she wrote in Hebrew. Her poems, which expressed the sorrows of the people of Israel, her hopes for the redemption of the Jews, and faith that Zion would be rebuilt, won the admiration of other contemporary Jewish scholars. She often signed her work using the three initials from Rachel Morpurgo Hak'tanah, which, when spelled out in Hebrew, means "the worm." Though her self-imposed pseudonym reflects the modesty expected of and cultivated by Jewish women of the time, Morpurgo proved herself to be a woman of independence and determination. When her family disapproved of Jacob Morpurgo as her choice for a husband (most likely owing to the fact that he was a simple merchant), she refused to marry anyone else. Her family finally relented, and she married at age 29.

There are conflicting accounts of the Morpurgo marriage. One biographer maintained that it was quite happy, as Morpurgo found time to care for her four children in addition to pursuing her literary and intellectual interests. Other scholars indicate that she existed in a state of near-poverty and could only find time to write at night or during rare holidays. Near the end of her life, Morpurgo became acquainted with Lady **Judith Montefiore**, a wealthy Jewish society woman, and traveled with her to Palestine, thereby becoming one of the few European women to visit that land in the 17th century. Rachel Morpurgo died in 1871 at the age of 81. In 1890, on the centennial anniversary of her birth, her collected letters and poems were published in the volume *Rachel's Harp*.

SOURCES:

Henry, Sandra, and Emily Taitz. *Written Out of History: Our Jewish Foremothers*. 3rd ed. NY: Biblio Press, 1988.

Rebecca Parks,
Detroit, Michigan

Morrell, Ottoline (1873–1938)

English patron of the arts, salonnière, antiwar activist, and memoirist. Name variations: Lady Ottoline Morrell. Born Ottoline Violet Anne Cavendish-Bentinck on June 16, 1873, in London, England; died on April 21, 1938, in London; only daughter and youngest child of Lt.-General Arthur Bentinck and Augusta Mary Elizabeth (Browne) Bentinck (later Baroness Bolsover); attended St. Andrews University, Scotland, 1897; attended Somerville College, Oxford,
1899; married Philip Morrell, on February 8, 1902, in London (died 1943); children: (twins) daughter Julian Morrell and son Hugh (b. May 18, 1906, Hugh died three days later).

Successfully campaigned on behalf of husband Philip Morrell for Parliament (1907); held salon on Bedford Square, London (1908–15); began affair with Augustus John (1908); began affair with Henry Lamb (1909); met Lytton Strachey (1909); began affair with Bertrand Russell (1911); bought Garsington Manor (1913); met D.H. and Frieda Lawrence (1914); held salon on Gower Street, London (1928–38); traveled to India (1935).

"There used to be a great lady in Bedford Square who managed to make life seem a little amusing & interesting & adventurous, [or] so I used to think when I was young & wore a blue dress & Ottoline was like a Spanish galleon, hung with golden coins & lovely silken sails." *Virginia Woolf's description of her friend is accurate but incomplete. Lady Ottoline Morrell was indeed a lady, a titled English aristocrat who spurned her illustrious lineage to become a patron of budding literary and artistic talents of the early 20th century. She was eccentric, flamboyant, possessive, generous, and unconventional, a tall, imposing figure dressed in gaudy, rather disheveled, ornate costumes that drew curious stares even on the streets of London. "She had a heart of gold and a yen for men," another friend remarked.

A descendant of two old, eminent noble families, the Cavendishs and the Bentincks, Ottoline's father was in line to become duke of Portland, to inherit vast estates in England and Scotland, as well as the family manor of Welbeck. However, he died unexpectedly in 1877, when Ottoline was four years old, and her half-brother Arthur assumed the title. Ottoline lived at Welbeck with her mother and three older brothers, Henry, William, and Charles, until the duke married in 1889. Largely ignored by her considerably older siblings, Morrell recalled that she never felt "gay." Welbeck, as she remembered it, was "a place denuded of romance . . . human love and companionship," where "the air, I am sure, was always cold and dark and melancholy." On the other hand, Welbeck hosted a dazzling array of high society, including the prince of Wales (later King Edward VII). Despite the advantages of wealth and social status, Ottoline was a lonely child. Her maids dressed and groomed her, and governesses educated her. But her early life was not restricted to Welbeck; in London, Ottoline and her mother frequented the theater, opera,

and art galleries. Exposure to culture and weekly dance lessons were designed to prepare Ottoline for marriage into an aristocratic family of equal rank. But "the utter vapidity of the life of an upper-class lady" that Morrell witnessed at Welbeck influenced her future decisions.

After the duke's marriage, Ottoline and her mother (**Baroness Bolsover**) moved to St. Anne's Hill, Chertsey, and kept a house on Grosvenor Place in London. The baroness was in poor health, and for several years Morrell nursed her while managing their households and traveling to various health spas and clinics on the Continent. At age 19, Ottoline had her "coming out" as a debutante, attending parties, dances and teas, where, she said, she "felt totally out of place." Almost six feet tall, shy and withdrawn, she found refuge in religion; she rejected the artificiality of society which Welbeck represented, a life that was "not just hollow, but evil." In the winter of 1892, when she and her mother were in Florence, Ottoline contracted typhoid fever and convalesced at the villa of her aunt, Mrs. Scott, who had three daughters (one of them, ❧ **Nina Cavendish-Bentinck**, would be the mother of Her Majesty *Elizabeth Bowes-Lyon, wife of King George VI). On the journey home, they stopped in Paris, and the baroness bought fashionable clothes for Ottoline, and a pearl necklace that had belonged to *Marie Antoinette.

Not long after returning to London, her mother died, and Ottoline went to live with her brother Lord Henry and sister-in-law **Lady Henry Bentinck**. Once again she became a part of high society, a society which, Morrell regretted, "did not admit of thought or individuality, or indeed of liberty or cherishing any delicate ideas." She did not fit into this world of lavish, elegant house parties, of shooting parties on Portland's estate in Scotland. And the family disapproved of Morrell's serious mien, her "long face." She tried to please, but in her own way; she admired her family's philanthropy and good works, and attempted to emulate them by giving Bible lessons to the farmhands and footmen and doing charity among the cottagers at Welbeck. Friendless, withdrawn, and unhappy, Morrell was shocked one day to realize, as she recounted in her memoirs, "They [her family] do not like me. My presence among them is unwelcome to them."

Morrell still found a certain solace in religion, but it could not compensate for the alienation she felt among her own social class. She enjoyed visits to London where her aunt and cousins entertained interesting society figures. And her narrow view of the possibilities of living changed when a Bentinck cousin took her to meet **Mother Julian** at an Anglican convent in Cornwall. Mother Julian became her mentor and confidante, assuring Ottoline "that to love beautiful things and enjoy life was not evil." Slowly Morrell began to understand her mother's buying dresses and the pearl necklace for her in Paris. "This discovery was the first step towards her liberation," claimed her biographer, **Sandra Darroch**.

At age 23, Morrell took another step towards freedom; she decided to go abroad. Her brothers were skeptical at first, but a family conclave finally approved her request. A proper chaperon and a female friend accompanied Ottoline to Brussels, then to Germany, Austria, and Italy from late summer 1896 to March 1897. On returning to London, Morrell announced that she wanted to attend St. Andrews University in Scotland. Another family conference was convened; they feared Ottoline might become a frightful "bluestocking" who would embarrass the family, but they finally gave their consent. For the first time, Morrell was forced to function outside of her upper-class world. Ill-prepared for college-level work, she registered for a class in logic—a poor choice since Ottoline's mind was never logical. She left school and did not return the next year; poor health, the cold climate, and her aversion to logic were all factors in her decision.

Her brothers were anxious for her to marry, but Morrell had already determined not to tie herself to the type of man she met in her social milieu. In fact, she was attracted to men who were ineligible partners; in 1897, she met Herbert Henry Asquith, a leading figure in the Liberal Party, later prime minister (in 1908) and married to *Margot Asquith. Their friendship was deep, mutual, and lasting, and it may be assumed they were intimate at some time during their early relations. Less acceptable was Morrell's attraction to a Dr. Axel Munthe who treated nervous disorders in Rome. They fell in love when Ottoline visited him on the island of Capri in August 1898. Often alone together, they scandalized Ottoline's friend **Hilda Douglas-Pennant**. Only months later, when Morrell saw Munthe in Rome, he was "cold and cutting," saying he could not marry a religious fanatic who was also neurotic. Ottoline fled to her aunt's villa in Florence to recover. Obviously, Morrell's "yen for men" had as yet failed to lead to anything permanent.

Shortly thereafter, Morrell resolved to enroll in Somerville College, Oxford, where she studied history and political economy and was intro-

❧▶

Cavendish-Bentinck, Nina.

See Elizabeth Bowes-Lyon for sidebar.

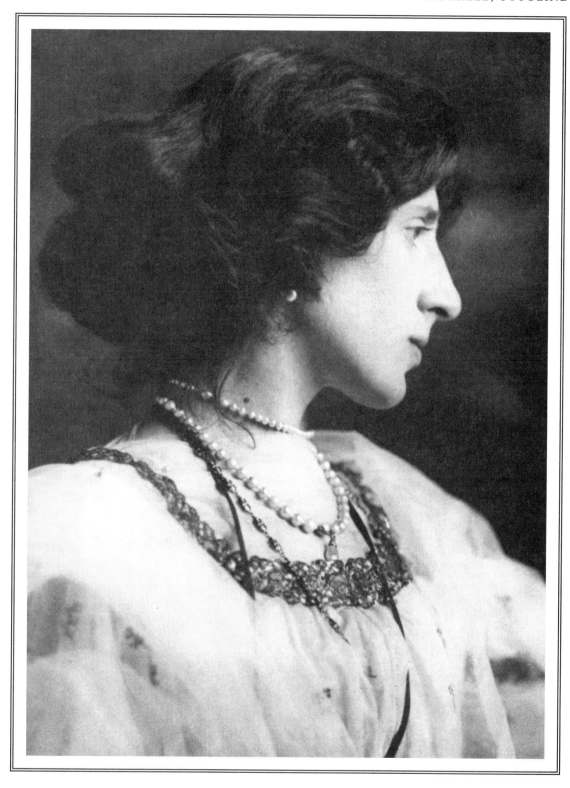

Ottoline
Morrell

duced to socialism by her tutor. At the end of the school term, Ottoline remained in Oxford where she met the man she would marry, Philip Morrell, son of the university's solicitor. The upper-middle class Morrells were well placed in local society. Ottoline left Oxford in December 1899 or Janu-

ary 1900 and returned to London, where she and Asquith renewed their relationship. Whether it evolved into an affair is not clear, but Ottoline was flattered that "a man of the world would pay court to her." Determined to escape from the stifling and artificial lifestyle of her brothers, she left

for a tour of Sicily and Italy with her friend Hilda. At age 27, Morrell realized that travel could not satisfy her "inner life"; Hilda saw marriage as the ultimate fulfillment, but Ottoline firmly rejected it as "a new kind of bondage."

It is indeed a damnably difficult thing to live fully, richly, gorgeously and yet courageously. To live on the grand scale.

—Ottoline Morrell

During the winter of 1901, Ottoline again met Philip Morrell at dinner parties. He was impressed with this statuesque woman from "a higher, more rarefied world" than his own, and they shared interests in art, books, and music. Philip had attended Eton and earned a law degree at Balliol. He had set up a branch of his father's law firm in London, but he clearly disliked the practice of law. While spending a weekend at the Morrell family home in Oxford, Philip asked Ottoline to marry him. Her extreme reluctance to commit herself is evident in their correspondence; Ottoline enumerated her several faults— she was deeply religious, strongwilled, and had a mind of her own. She also revealed that she received an allowance of £1,500 sterling from Portland each year, a considerable sum since one could live well in London on less than £300 a year. After Christmas 1901, Ottoline accepted his proposal, and they married the following February, to her family's great relief. Ottoline's brother Charles voiced the family's attitude towards their errant sister when he said to Philip, "Well, I am glad I am not in your shoes. I wouldn't undertake her for anything." Morrell later admitted that she married because she needed "someone or something" to enable her "to escape from the narrow world" in which she lived. In her memoirs, however, she also revealed: "I . . . clung to my solitary liberty. I believe in many women there is a strong intuitive feeling of pride in their solitary life so that when marriage comes it is, to a certain extent, a humiliation."

After a honeymoon in Italy, the couple settled in a house on Grosvenor Road, in a fashionable section of London. Almost immediately they became involved in national politics. Philip joined the Liberal League and decided to stand for Parliament from South Oxfordshire. Both Ottoline's and Philip's conservative families were outraged, and Philip's father forced him to resign from the family law firm, claiming that his Liberal leanings would alienate clients. Morrell campaigned on behalf of her husband and hoped-for liberal reforms, which she said, "helped me to a greater understanding of life."

But political life was too often prosaic, and Ottoline grew bored and restless. Only a year after her wedding, she met John Adam Cramb, a writer with whom she could visit art galleries, bookshops, and attend concerts. Ottoline made every effort to keep their rendezvous from Philip, even though he seldom made a fuss about much of anything; he "was infuriatingly broad-minded," as Ottoline later noted. But Ottoline learned a valuable lesson from her friendship with Cramb—an affair could be as constraining as a marriage. She could not, and would not, allow a man, any man, to dominate her life for any reason. And more important, nothing would be allowed to jeopardize her marriage. Cramb was but a minor figure in her life, a prelude to the great loves that came later. As a married woman, Morrell was free to begin her "real life," in a world revolving around the arts and peopled by many of the most famous artists and writers of the 20th century.

Morrell craved "communication and social contact," and she began inviting interesting people to dine at her house. Henry James and Lytton Strachey were among the first to become her close friends. Unfettered conversation with a free range of ideas appealed to Ottoline and her guests, and, as Strachey's biographer remarked, Morrell's "sensibilities were undisciplined and over-elaborate," but she also had "the power to make artists and writers feel that their ideas were immensely exciting and important to her." It is generally agreed that she herself lacked "enough natural talent to develop into a creative artist in her own right," but her ability to recognize and draw out a nascent artist or writer was widely acknowledged; the range and number of acclaimed persons whom she helped and encouraged is truly astonishing. All Morrell now needed was the proper setting for her social gatherings.

In 1905, there was another reason the Morrells needed a larger house—Ottoline was pregnant, and she was not pleased. She frankly regarded this development as "an assault upon her person, a burden, the breaking into her existence by an unknown foreigner." Philip had a career, and she felt she would have "to bear the burden of a child alone." However, once the Morrells had acquired their spacious, imposing Georgian house at 44 Bedford Square, a few blocks from the British Museum in the Bloomsbury area, Morrell was able to create an exciting, informal, but quietly elegant environment for her famous "at homes," her Thursday evenings. Her entrée into the ethereal Bloomsbury world of art and intellect had come through gatherings at the house of Virginia Woolf (then Virginia Stephen)

which Woolf shared with her sister *Vanessa Bell, an artist, and two brothers. When Morrell established her Thursday evening salon, she became more than a mere host to the social and cultural elite of London, she became the patron and champion of promising talents. From 1908 to 1915, her house became known "as probably the most civilized few hundred square feet in the world"; however, the "Smart Set" of Morrell's aristocratic circle were unable to fit into this bohemian world. Years later when Morrell was praised as a patron of the arts, an elderly noblewoman responded, "but she has betrayed our Order" (the English patrician class).

Morrell not only entertained artists and writers, she was involved in their private lives, helping them financially, supporting them emotionally, and encouraging their efforts. The eccentricities of artists particularly appealed to Ottoline's passionate, compassionate nature, and she would have a series of affairs with her protégés. Augustus John and Henry Lamb were among her lovers who eventually had to break away from her often smothering attentions; she showered letters and gifts on her favorites who in time came to resent her overly solicitous presence in their lives. When passion was exhausted, Morrell and her former paramours remained close friends. Philip soon recognized that his wife was "addicted to romantic figures" and that he could do nothing to change her ways. In any case, Philip's time was consumed by his political life in which Ottoline participated when necessary; she actively campaigned for him, attended and often spoke at meetings, and got her friend Asquith to support him.

Lady Ottoline Morrell had three great friendships in her life: Lytton Strachey whom she met in 1910, Bertrand Russell, the well-known mathematician and philosopher, and the novelist D.H. Lawrence. Lytton, "the archpriest of the Bloomsbury Group," was an intellectual, a homosexual, and had a devastating wit; Aldous Huxley said of him, "Mr. Strachey is the eighteenth century grown up, he is Voltaire at two hundred and thirty [years old]." Ottoline recognized his literary talent long before he became famous, and for his part, Morrell's "unquenchable, aristocratic air appealed immensely to his eighteenth-century respect for noble birth," writes Darroch; "left to themselves they carried on like a couple of high-spirited, teenage girls." Lytton and Ottoline could be silly and uninhibited in one another's company—even as Lytton tottered around the room in Morrell's high-heeled shoes. And they shared a romantic involvement with men, such as the artist Henry Lamb. Morrell was also close to several other Bloomsbury figures, many of whom in this tight-knit coterie were homosexual. It is to Lady Ottoline's credit that she openly associated with homosexuals at a time when the practice was almost universally condemned as a "perversion." At the same time, she thought Lytton "might be saved for the female sex," and even suggested that he marry her friend Ethel Sands, a lesbian. However, Morrell failed to "convert" him. Lytton was a welcome, permanent fixture in the outré social world Ottoline created in London and would create at her country house, Garsington Manor.

The man who had the most profound effect on Morrell's personal life was the brilliant, passionate Bertrand Russell, known as Bertie. On Sunday, March 19, 1911, she gave a small dinner party on Bedford Square for Russell who was staying the night on his way from Cambridge to lecture in Paris. Ottoline was anxious about her ability to converse with a man of his intellect whom she did not know well. After the guests departed, Morrell and Russell talked for hours; Ottoline realized that he was troubled and encouraged him to talk. He confided that he did not love his wife ✥➤ Alys, that he needed love and was tired of his "puritan way of life and longed for beauty and passion." In a few hours Russell had fallen in love, and no less amazing, they had "agreed to become lovers as soon as possible." On his return from Paris, Russell insisted they each inform their spouses of their love, but Ottoline hesitated and finally refused to confront Philip. She had a great deal to lose, for she loved her husband and her daughter Julian Morrell. Moreover, Ottoline wondered if she could hold Russell's interest in her or if she were out of her depth intellectually. And there was the question of their disparate views on religion. Russell was a staunch atheist. Morrell was admittedly flattered that this learned man would be interested in her, but she found him "strikingly unhandsome," he "lacked charm and gentleness and sympathy," and his insatiable sexual appetite was exhausting. Furthermore, "Bertie suffered from acute halitosis" which made kissing "something of an ordeal." Their relationship was different from the flirtations and sexual flings Morrell had had with Augustus John, Henry Lamb, Roger Fry, and several other attractive male admirers. In this instance, "Russell was competing with Philip not for her love but for her life." It is little wonder that Ottoline suffered from chronic ill health and had to escape to spas and clinics on the Continent, seeking a cure for her debilitating headaches. Other problems beset the lovers; Rus-

✥
Russell, Alys.
See Berenson,
Mary for sidebar.

sell's wife Alys threatened to create a public scandal and his brother-in-law informed Philip of Ottoline's infidelity in the most graphic sexual terms. And Russell disliked, perhaps was jealous of, Lytton with whom Ottoline was able to be "natural and gay"; Russell declared him "diseased and unnatural & only a very high degree of civilization enables a healthy person to stand him." The ever-tolerant Philip was not one of their problems, and soon he came to a mutual understanding with Ottoline which permitted her to indulge her emotional needs.

Despite poor health for which she underwent the most noxious treatments, Morrell kept her Thursday at homes and continued her involvement with Russell and former lovers. In 1912, her doctor recommended that she move to the country for two years; in March 1913, the Morrells bought Garsington Manor, near Oxford, a beautiful Tudor house of Cotswold stone set in 200 acres of gardens and farmland. Here for 14 years, writes Darroch, Morrell would preside over her "celebrated Renaissance court . . . [an] ornate, other-worldly environment [that] was soon the Mecca of all aspiring young writers and artists" and which became "a cultural legend." In this rarefied air "diplomats and aristocrats, fine ladies and their distinguished escorts" mingled with the Bloomsbury group and with as yet unknown writers and artists—Aldous Huxley, T.S. Eliot, John Maynard Keynes, George Santayana, *Katherine Mansfield, Mark Gertler, *Dora Carrington, Siegfried Sassoon, Graham Greene, and Stephen Spender. And Lady Ottoline served as patron, promoter, and host for this dazzling galaxy of cultural giants who peopled her house and restful garden at Garsington. The manor, Lytton claimed, was "very like Ottoline herself. . . very remarkable, very impressive, patched, gilded and preposterous."

Before moving to Garsington, Morrell had enjoyed a brilliant social season in London; her Thursday gatherings attracted London social and cultural lions, but she could still confide in her diary, "For many months I have felt a dire loneliness that nothing will ever relieve. I seem to have tried everyone and found them all wanting." And in August 1914, Ottoline also found the world wanting as Europe plunged into war. While "military fever" engulfed London, the Morrells were in despair. Ottoline was present in the House of Commons when Philip made his protest against British involvement in the conflict, eliciting "hostile murmurs" from his colleagues. Philip knew this might end his career, and it did. Their house became a center for the pacifist cause, and later Garsington would serve

as a haven for conscientious objectors who worked on the farm in lieu of military service. To Morrell "war was an ugly, evil force," and she found "the glorification of brutality" repugnant. The war caused rifts in relations with family and friends, but it brought Ottoline closer to the Bloomsbury crowd who shared her views. Morrell aided German nationals living in London who were being harassed and took in some Belgian and French refugees, including **Maria Nys** who eventually married Aldous Huxley; Morrell also made a large gift of money to equip a field hospital in France. She hated war, but could not ignore those who fought.

In 1914, Ottoline was uncertain about the future; civilization itself was threatened with destruction, and although Philip, and she and "Bertie," were happier together now, she confessed that she was "beginning to feel, if not old, certainly weary." But Morrell continued to attract many of the eminent figures in Britain to her levées despite the war. She was criticized by some who regarded gaiety and the pursuit of pleasure as unfitting behavior during the conflict. But Ottoline needed to cling to habit, to friends, in order to relieve her anxiety about the perils Britain faced. A kind of forced "normality" was imposed upon those who frequented Bedford Square and Garsington Manor. In her usual way, Morrell took charge of promoting the careers of the Jewish artist, Mark Gertler, and of D.H. Lawrence whose novels impressed her and whose "intuitive feel of life" she found compatible. Lawrence's wife *Frieda was not as captivated by Morrell as was her husband who was fascinated by Ottoline, a titled woman, the sister of a duke, and generous patron of the arts. Frieda Lawrence considered Morrell "a nice simple person who could be useful," and Ottoline, in turn, thought Frieda unworthy of Lawrence, "a rather blousy hausfrau."

On May 17, 1915, Morrell moved permanently to Garsington, which became the new center for her gatherings. She and Philip had invited the Lawrences to live in a cottage on the estate, but all four thought better of it, and the offer was withdrawn. But Ottoline still lavished them with gifts, even food. D.H. Lawrence's book, *The Rainbow,* had been banned, then seized and burned by the police, despite Philip's attempts to get the ban lifted. Ottoline gave Lawrence money so he could go to Florida, but he was denied permission to leave Britain and returned to Garsington. There guests from Japan to Chile mixed with the Garsington "regulars," Russell, Lytton, Aldous Huxley, and the Anglican bishop of Oxford, which made for a lively,

incongruous amalgamation of minds. At Christmas, Ottoline gave a large party for the villagers, with dancing and games in the large barn and each of the 100 children receiving a gift. As Lytton wrote to his mother, "It takes the daughter of a thousand earls to carry things off in that manner." No doubt Morrell felt an obligation as mistress of the manor to have good relations with the villagers, but she also had to divert her thoughts from the bloody trenches in France.

The 1916 Conscription Bill directly affected several of Morrell's friends, and Garsington became a haven for men who were granted conscientious-objector status. Philip employed them as farm laborers. Housing and feeding them, and their many friends who came to partake of the Morrells' hospitality, put a strain on the Morrells' resources. Lytton, fortunately, was declared medically unfit for military service, and after a tribunal hearing, returned to Garsington to recuperate from his ordeal. (This despite his repeated complaints that Ottoline's economizing did not provide him with adequate meals.) Ottoline had been present at Lytton's hearing, and she was also involved in other legal actions that affected her friends. When Russell refused to pay a fine imposed for writing and distributing an antiwar pamphlet, Ottoline helped raise money to pay the fine and save his library from being seized and sold. However, she was annoyed with Russell for spending his money on dancing lessons for T.S. Eliot's wife **Vivienne Eliot**, while he could not find the means to save his own books. Morrell also lobbied to save the life of an Irish nationalist, Sir Roger Casement, sentenced to hang for treason for his part in the Easter uprising. She appealed to Asquith to intervene, but when Casement's diary revealed that he was a homosexual, Asquith rejected her plea.

Ottoline Morrell had always been attracted to romantic and sensitive artists, but she felt that she had not yet found her perfect spiritual companion. But in 1916, she met the young poet and soldier Siegfried Sassoon, whose work she admired and promoted. He often stayed at Garsington during his leaves from active duty. Sassoon, however, never responded to Morrell's gestures towards greater intimacy. To him, she was too much of an idealist, and he considered her appearance "ludicrous"—when they first met Morrell was wearing "voluminous pale pink Turkish trousers" which shocked his staid British sensibilities. Sassoon was an astute observer and saw how many of Ottoline's intimates at Garsington used her caring nature to benefit their careers. "She had yet to learn that the writers and artists whom she befriended were capa-

ble of proving ungrateful," he wrote. Ironically, Sassoon turned out to be one of those who never thanked Ottoline, a bitter disappointment to her. And shortly, ingratitude on the part of other friends would be revealed publicly.

In late 1916, Lawrence sent Ottoline a copy of his new novel, *Women in Love,* and Morrell was appalled to find herself caricatured as Hermione Roddice, a woman with a "bizarre taste in clothes," certainly an observation made by anyone who knew Ottoline. Worse, he portrayed the character as demonic, envious, and filled with hate. Hermione lusts after Birkin, the narrator of the book who is patterned after Lawrence himself. Birkin shuns Hermione and falls in love with the heroine Ursula, based on Frieda Lawrence. Morrell was devastated by this cruel portrait, because it had been "written by someone whom I had trusted and liked." Further, "I was called every name from an 'old hag' obsessed with sex mania, to a corrupt Sapphist. . . . My dresses were dirty; I was rude and insolent to my guests." In her memoirs, Morrell noted: "The hurt that he had done me made a very great mark in my life." In addition, Lawrence had satirized Philip, Julian, Russell, and others, as well as the house and garden at Garsington. The fact that Lawrence's portrait contains some kernels of truth only hurt more. The wound took years to heal, and Morrell "vowed that never again would she leave herself so vulnerable." It is hard to imagine that Ottoline would not expect her writer friends to draw on the many eccentric and anomalous characters that inhabited her world for their works. And surely Morrell herself was among the most extraordinary of these characters. A few months later, she discovered that she was again made an object of derision. In early 1917, a play in London had a character called Lady Omega Muddle. Morrell was slowly and sadly coming to the realization that some of her friends "regarded her as a figure of fun." But this was not the last of the disappointments that Ottoline would suffer at this time. Bertie decided to break free from his entanglement with Ottoline; he decided to "kill her love" as he had done with his wife Alys. His frequent sexual forays had been accepted by Morrell who was always available to commiserate with Bertie and to reaffirm her love for him when his affairs proved unsatisfactory. Nevertheless, Russell's abrupt dismissal stunned her, for she was not prepared for it, and she was deeply hurt. "Don't let me go. . . . You have lost me," she wrote on the envelope of one of his letters. In January 1915, Ottoline had written to Russell, with some prescience, "It is worth all the sufferings of hell to love like this." Now she had experienced

the hell that love often brings. But the usual mutually necessary reconciliation ensued; Ottoline and Bertie needed one another—forever.

A more devastating blow was Ottoline's discovery that Philip had been unfaithful. Often ignored and slighted by Ottoline's "clever, sharp-tongued guests," Philip had managed finally to create a separate life of his own. Her life was collapsing. She never fully recovered from what she regarded as a bitter betrayal, and she erected a kind of *cordon sanitaire* around herself. Darroch described Morrell's condition as "a state of partial sanity." But Philip suffered too; for years he had been regarded as merely a part of the scenery, quiet, unassuming, undemanding. Moreover, ingratitude on the part of the conscientious objectors who were harbored at Garsington and rejection by the Liberal Party which ended his political career affected him. Philip, like Ottoline, collapsed under the stain.

Even Sassoon remained distant and aloof; he was to have been "the sympathetic soul" Morrell had always searched for. During a walk after having lunch in London, he told Ottoline she was "complicated and artificial" and failed to see her off at the train station when she left. Morrell realized sadly that she had deluded herself "with the belief that by giving one will receive something, but it isn't true."

By 1917, Morrell had begun inviting younger people to Garsington, including T.S. Eliot, Robert Graves, and several undergraduate students from Oxford, among them her brother Portland's son. One of her favorites was Aldous Huxley who found it easy to talk to Ottoline; "you and I are some of the few people who feel life is real, life is earnest," he wrote to her. But Morrell grew increasingly unhappy, disillusioned, and cynical. She still needed people despite her disappointments, and she continued to patronize promising talents such as Mark Gertler who was given a studio at Garsington and introduced to the smart society of the time. After the war, Sergei Diaghilev's Ballets Russes returned to London, and Morrell, who had known him previously, renewed their friendship and met Pablo Picasso who was designing the stage sets. Ottoline had always had a discriminating taste in poetry, and she was greatly impressed with the work of W.B. Yeats and T.S. Eliot who became fixtures in her postwar salon.

Lawrence's cruel portrait of Morrell in *Women in Love* was not to be the last of such characters modeled on his benefactor. In 1921, Ottoline was horrified to discover herself (as Priscilla Wimbush) and Garsington depicted in Aldous Huxley's *Crome Yellow*. This "gross betrayal" was followed by another demeaning portrayal by Huxley. In *Those Barren Leaves,* he produced a savage portrait of Ottoline as Mrs. Aldwinkle who, he wrote, "has sagging cheeks and a prominent chin. . . . she believes in passion, passionately; . . . and she has a weakness for great men. It is her greatest regret that she herself has no aptitude for any of the arts." Anyone who knew Morrell would recognize a grain of truth in his characterization, however exaggerated and malevolent. To her credit and her humaneness, Ottoline still tried to help her friends. She provided medical care for Vivienne Eliot (who died insane), offered solace to Russell's cast-off mistresses, and remained close to Virginia Woolf whose mental instability ended in her suicide. Morrell even forgave Lawrence who acknowledged her influence in his life and in others'. By way of a belated apology for Hermione Roddice, he wrote, "there's only one Ottoline. . . . The so-called portraits of Ottoline can't possibly be Ottoline—no one knows that better than an artist."

In 1928, the Morrells sold Garsington and bought a house in Bloomsbury on Gower Street. Garsington was too large, since their daughter Julian was now married, and too expensive to keep up. When the new owners of the manor asked Morrell where to shop for fish and meat, she replied, "Don't talk to me of fish. You may talk to me about poetry and literature, but not fish." Actually, Morrell knew absolutely nothing about fish or meat or anything associated with shopping for food or cooking; she "could hardly boil a kettle [of water] unaided" which explains why she always had a large house staff. Ottoline hoped to recreate her Thursday evening at homes on Gower Street, and she succeeded. To the familiar figures from her prewar salon, fresh, new talent appeared, including several young women. The gatherings, like Morrell herself, were more quiet, less raucous, than in previous years. If Ottoline had "learned to be content" in this life, she had also come to discern that she was "a magnet for egoists," the vampires that sucked one's life, as she expressed it.

Deafness and ill health plagued her, and her friends were dying: Lawrence died of tuberculosis in 1930, and Lytton died in 1932. Ottoline most likely agreed with Lytton's reflections on their exciting past when he wrote to her: "I don't think I want to go back. It was thrilling, enchanting, devastating, all at once—one was in a special (a very special) train, tearing along at breakneck speed—where?—one could only dimly guess. . . . Once is enough!" Morrell

began to consider publishing her memoirs; it pleased her to be writing something. Russell had already written his autobiography which Ottoline read in manuscript form, but she persuaded him not to publish it until after they were both dead. Morrell thought some revelations would be hurtful to Philip and her daughter. Following a divorce, Russell had married *Dora Russell some years earlier, had two children, and left Dora after she had had two children with another man. But "through all the sufferings of hell" their love affairs had brought them, Bertie and Ottoline remained steadfast friends.

During the 1930s, Morrell continued to travel on the Continent, and in 1935, she and Philip went to India where they received a royal reception. Philip planned to write a book on one of Ottoline's ancestors, William Bentinck, governor-general of India, who had suppressed the practice of suttee, the burning of widows on their husbands' funeral pyres. But from 1935 on, Ottoline's health rapidly deteriorated, and she spent long periods in nursing homes and clinics. Her doctor, who was widely regarded as a quack, used questionable methods of treating his patients. He put Morrell on a starvation diet and injected her with the controversial antibiotic Protonsil. When his methods came under investigation, he committed suicide. Ottoline Morrell died on April 21, 1938, after a nurse gave her an injection of the drug. She was buried on the family estate of Welbeck. Philip died five years later and was buried beside her.

Frieda Lawrence had once written to Morrell, whom she had come to admire, "I think the tragedy of your life has been that it was a small age you lived in and the men were small beer & the women too." But Lady Ottoline had made the age in which she lived bigger through devising her own unorthodox lifestyle and through her tremendous efforts on behalf of many of the giant talents of her time. "Conventionality is deadness," Morrell had written in her diary, "Be yet not conformed unto this world." She never was conventional, nor did she rein in her passions in order to conform to this world.

SOURCES:

Darroch, Sandra Jobson. *Ottoline: The Life of Lady Ottoline Morrell.* NY: Coward, McCann and Geohegan, 1975.

Morrell, Lady Ottoline. *Ottoline, The Early Memoirs 1873–1915.* Vol. 1. Edited by Robert Gathorne-Hardy. London: Farber, 1963.

Seymour, Miranda. *Ottoline Morrell: Life on a Grand Scale.* London: Sceptre, 1993, NY: Farrar, Straus, 1993.

SUGGESTED READING:

Holroyd, Michael. *Lytton Strachey: A Biography.* London: Penguin, 1971.

Lady Ottoline's Album: Snapshots and portraits of her famous contemporaries. Edited by Carolyn G. Heilbrun. London: Michael Joseph, 1976.

Morrell, Lady Ottoline. *Ottoline at Garsington, 1915–1918.* Vol. 2. Edited by Robert Gathorne-Hardy. London: Farber, 1974.

Russell, Bertrand. *The Autobiography.* Vols. 1 and 2. London: George Allen and Unwin, 1971.

COLLECTIONS:

Letters written to Lady Ottoline are located at the Humanities Research Center, University of Texas, Austin; her letters to Bertrand Russell are at McMaster University, Ontario, Canada.

Jeanne A. Ojala,
Professor of History, University of Utah, Salt Lake City, Utah

Morris, Clara (1847–1925)

American actress. Born on March 17, 1847 (some sources cite 1846 or 1848), in Toronto, Ontario, Canada; died of chronic endocarditis on November 20, 1925, in New Canaan, Connecticut; daughter of Charles La Montagne (a French-Canadian cab driver) and Sarah Jane Proctor (a servant); received about one year of formal schooling; married Frederick C. Harriott, on November 30, 1874; no children.

Selected theater: Man and Wife (*Fifth Avenue Theater, September 1870*); L'Article 47 (*1872*); appeared in Alixe, Jezebel, Madeleine Morel, No Name, Delmonico's, *and* The Wicked World (*Union Square Theater, November 1873*); Camille (*1874*); The New Leah (*1875*); Miss Multon (*1876*); Jane Eyre (*1877*); The New Magdalen (*1882*); The Two Orphans (*1904*).

Selected writings: A Silent Singer (*1899*); Life on the Stage: My Personal Experiences and Recollections (*1901*); A Pasteboard Crown (*1902*); Stage Confidences (*1902*); The Trouble Woman (*1904*); The Life of a Star (*1906*); Left in Charge (*1907*); New East Lynne (*1908*); Little Jim Crow, and Other Stories for Children (*1900*); A Strange Surprise (*1910*); Dressing-Room Receptions (*1911*).

Clara Morris was born in 1847 in Toronto, Canada, the oldest of three children born in the bigamous marriage of Charles La Montagne and **Sarah Jane Proctor**. Upon the discovery of her husband's other marriage, Proctor left her two younger children for adoption and fled with Clara to Cleveland, Ohio, where she took her grandmother's maiden name of Morrison. Clara received very little formal schooling during her childhood in Ohio and Illinois. At 13, she became a ballet girl in the stock company of the Cleveland Academy of Music, and shortened her name to Morris for stage purposes. Although she never rose in rank during her nine years there, she played many roles and appeared with touring

actors. In 1869, she played a season as leading lady at Wood's Theater in Cincinnati, spent the summer acting in Halifax, Nova Scotia, and then appeared in Louisville with Joseph Jefferson.

Morris made her New York City debut in September 1870 in *Man and Wife*, an adaptation of the Wilkie Collins novel directed by Augustin Daly, at the Fifth Avenue Theater. She so impressed Daly that during the next three years she starred in a number of his other plays, including *No Name* (also adapted from a Collins novel), *Delmonico's*, *L'Article 47*, *Alixe*, *Jezebel*, and *Madeleine Morel*. She was proclaimed the greatest "emotional" actress of her time for her portrayal of Cora, a disfigured and betrayed octoroon in *L'Article 47* (1872). Leaving Daly after they argued in 1873, she appeared in November of that year in *The Wicked World* at the Union Square Theater in New York, under the management of A.M. Palmer. Her portrayal in 1874 of the title role in *Camille* (*Alphonsine Plessis*) as a "winning gentle girl, more pure than worldly," also won much praise. That year Morris married

Clara Morris

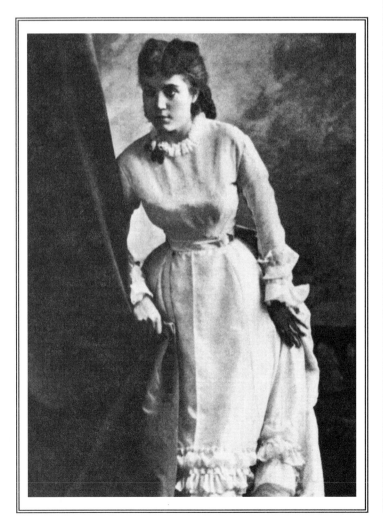

Frederick C. Harriott, a wealthy young descendant of two old New York families, who became her agent. In 1875 an attempt to establish herself as a tragic actress at Booth's Theater in *Evadne*, *Macbeth*, and *Jane Shore* failed. The following year, she returned to her "domestic emotionalism" and met with great success in *Miss Multon*, an adaptation of the bestselling novel *East Lynne* by *Ellen Wood (Mrs. Henry Wood). Morris also appeared in *The New Leah* (1875), *Jane Eyre* (1877), based on the *Charlotte Brontë novel, and *The New Magdalen* (1882).

Clara Morris continued to tour extensively, enchanting her audiences with her performances; reportedly she had a power of repressed feeling and passionate outburst that was startling. She was especially adept at portraying the long-suffering heroines of French and British melodrama. The taste for this particular type of theater waned, however, and changing fashions coupled with health problems brought her career to a close in the early 1890s.

After her retirement, Morris gave occasional lectures and began to write, contributing many articles on acting and theater to *McClure's*, the *Century*, and other magazines between 1900 and 1906, and writing daily articles for a newspaper for the following ten years. Some of this material appears in her books, which include *A Silent Singer* (1899), *A Pasteboard Crown* (1902), *The Trouble Woman* (1904), *Left in Charge* (1907), *New East Lynne* (1908), *A Strange Surprise* (1910), and *Dressing-Room Receptions* (1911). She also wrote a children's book, *Little Jim Crow, and Other Stories for Children* (1900), and three volumes of personal reminiscences and thoughts: *Life on the Stage: My Personal Experiences and Recollections* (1901), *Stage Confidences* (1902), and *The Life of a Star* (1906). The money she received from writing was instrumental in preventing the loss of her home, The Pines, in Riverdale, New York.

Morris performed in a revival of *The Two Orphans* in 1904, and did some work in vaudeville after that. In 1914, her husband died, and her mother, who had always lived with her, died in October 1917. Clara Morris died of chronic endocarditis eight years later, on November 20, 1925, in New Canaan, Connecticut. Her funeral was held at New York City's Little Church Around the Corner, a particular favorite among actors.

SOURCES:
James, Edward T., ed. *Notable American Women, 1607–1950*. Cambridge, MA: The Belknap Press of Harvard University Press, 1971.

McHenry, Robert, ed. *Famous American Women*. NY: Dover, 1980.

Morris, Clara. *Stage Confidences: Talks about Players & Play Acting.* Lothrop, 1902.

Wilson, Garff B. "Queen of Spasms: The Acting of Clara Morris," in *Speech Monographs.* November 1955.

Jo Anne Meginnes,
freelance writer, Brookfield, Vermont

Morris, Esther Hobart (1814–1902)

Suffragist and first American woman to hold an official government position. Name variations: Esther Hobart McQuigg Slack Morris. Born Esther Hobart McQuigg on August 8, 1814, near Spencer, Tioga County, New York; died on April 2, 1902, in Cheyenne, Wyoming; daughter of Daniel McQuigg and Charlotte (Hobart) McQuigg; married Artemus Slack (a civil engineer), on August 10, 1841 (died 1845); married John Morris (a merchant and store-keeper); children: (first marriage) Edward Archibald (b. 1842); (second marriage) John (died in infancy), Robert and Edward (twins, b. 1851).

Following the death of her first husband (1845), moved with her son to Peru, Illinois, and a short time later remarried; moved to Wyoming Territory, where she promoted the cause of women's suffrage (1869); appointed justice of the peace for South Pass City, Wyoming (1870), the first woman ever to hold such a position; left her husband and moved to Laramie, Wyoming (1871); was briefly on the ballot for state representative (1873); left Wyoming for New York but later returned and settled in Cheyenne, Wyoming (by 1890).

Esther Hobart Morris, the first American woman to hold an official government position, was born in New York State on August 8, 1814, the second daughter and eighth of eleven children born to Daniel and **Charlotte Hobart McQuigg**. By age 11, she was orphaned and sent to apprentice with a seamstress in Oswego, New York. She married Artemus Slack, a civil engineer with the Erie Railroad, on August 10, 1841, and they had one son, Edward Archibald, who was born the following year. Slack died three years later, leaving his young widow property in Illinois, so Esther and her son moved to that state, settling in Peru. Shortly after she arrived there she met and married John Morris, a prosperous merchant and shopkeeper, with whom she had three sons: John, who died as an infant, and twins Robert and Edward, born in 1851.

Esther Morris moved with her family to the booming gold rush camp of South Pass City in Wyoming Territory in 1869, where her husband opened a saloon and then turned to mining. Morris, who was nearly six feet tall, weighing a hefty 180 pounds, blunt and fiery in speech, was a born reformer. She used her persuasive powers to promote the idea of granting women the vote in Wyoming, and on December 10, 1869, that right was bestowed by the 21-member legislature. (Present-day thinking suggests that this law was passed to publicize the new territory and encourage women to migrate there.) This same group of lawmakers also gave married women control of their own property and provided for equal pay for women teachers, many years before most other states would even begin contemplating such legislation. In 1870, Morris was appointed justice of the peace of South Pass City, becoming the first woman in America to hold an official government position. The appointment drew attention in newspapers nationwide. South Pass City was a rowdy town, with no shortage of alcohol available to the miners, and during her short tenure of eight and a half months Morris tried over 70 minor cases without a reversal by higher courts. She regarded her appointment as "a test of woman's ability to hold public office." In June 1871 she issued a warrant against her husband on assault

Esther Hobart Morris

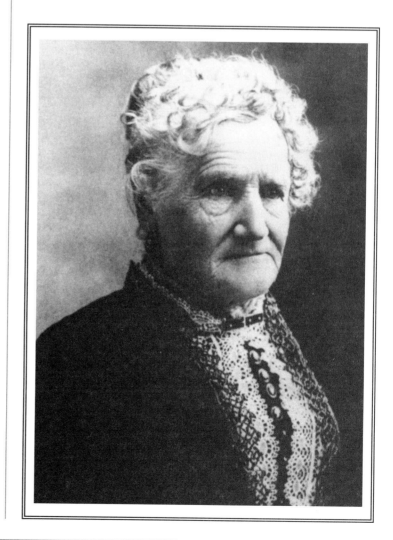

charges. They separated soon thereafter, and Morris moved to Laramie, Wyoming, where her oldest son Edward Slack was a newspaper editor.

In 1873, Morris was nominated for state representative from her county on a woman's ticket. She soon withdrew her candidacy, while taking pains to point out that her withdrawal was not a resignation from the "woman's cause." She moved back to New York in 1874, and in 1876 participated in the ceremonies surrounding the Declaration of Rights for Women at the Philadelphia Centennial Exhibition. She returned to Wyoming in 1890, settling in Cheyenne, where her son was now editor of the Cheyenne *Daily Leader*. Around that time his paper began describing her as the "Mother of Woman Suffrage." That year during the Wyoming statehood celebration, she was honored as a pioneer of suffrage. Morris was part of a tour by *Susan B. Anthony in 1893 when Colorado women received the vote, and attended a dinner given for Anthony in 1895. That year she was elected a delegate from Wyoming to the national suffrage convention in Cleveland. Esther Hobart Morris died in Cheyenne on April 2, 1902, at age 87. A 1920 pamphlet on Wyoming suffrage by local historian *Grace Raymond Hebard did much to solidify her reputation, and in 1960 statues honoring her were placed in Statuary Hall in the U.S. Capitol and in the state house in Cheyenne.

SOURCES:

James, Edward T., ed. *Notable American Women, 1607–1950*. Cambridge, MA: The Belknap Press of Harvard University Press, 1971.

McHenry, Robert, ed. *Famous American Women*. NY: Dover, 1980.

Weatherford, Doris. *American Women's History*. NY: Prentice Hall General Reference, 1994.

SUGGESTED READING:

Larson, T. A. *History of Wyoming*. 1965, pp. 84–94.

Willard, Frances E., and Mary A. Livermore, eds. *A Woman of the Century*, 1893.

COLLECTIONS:

Grace R. Hebard collection, Western Historical Research Center, University of Wyoming Library, contains a few letters from persons having recollections of Esther Morris, as well as newspaper clippings, articles and interviews.

Jo Anne Meginnes,
freelance writer, Brookfield, Vermont

Morrison, Adrienne (1889–1940).

See Bennett, Joan for sidebar.

Morrison, Toni (1931—)

Major contemporary African-American novelist whose writing is a means of reclaiming her people's

past. Born Chloe Anthony Wofford on February 18, 1931, in Lorain, Ohio; daughter of George Wofford (who migrated from Georgia) and Rahmah Willis Wofford (who grew up alternately in Birmingham, Alabama, and Kentucky, before following her husband to Lorain, Ohio, in search of work and a better life for their family); graduated B.A. in English with a minor in the classics from Howard University; M.A. in English from Cornell University; married Harold Morrison (a Jamaican architect), in 1958 (divorced 1964); children: two sons, Harold Ford Morrison and Slade Kevin Morrison.

Awards: National Book Critics Circle Award (1977); Distinguished Writer of 1978 by the American Academy of Arts and Letters; appointed by President Carter to the National Council on the Arts (1980); elected to the American Academy and Institute of Arts and Letters, Writer's Guild and Author's League (1981); Pulitzer Prize for Beloved (1988); Robert F. Kennedy Award and Melcher Book Award from the Unitarian Universalist Association (1988) for Beloved; Modern Language Association of America's Commonwealth Award in Literature (1989); Chianti Ruffino Antico Fattore International Award in Literature (1990); Nobel Prize for Literature (1993).

Grew up poor in the midwestern steel town of Lorain, Ohio; after graduating from Lorain High School (1949), went to Washington, D.C., to earn bachelor's degree in English from Howard University; received an M.A. from Cornell University (1955) and began a career as a professor, first at Texas Southern University and then at Howard, her undergraduate alma mater; left teaching post at Howard (1965), and began working as a textbook editor for Random House in Syracuse, N.Y.; moved to New York City (1967) to become a senior editor, publishing the work of other African-American writers; continued adjunct university teaching alternately at Yale, Bard College and S.U.N.Y. at Purchase; published her first novel, The Bluest Eye (1970), followed by Sula (1973); Song of Solomon became a main selection of the Book-of-the-Month Club before winning the National Book Critics Circle Award (1977); critical acclaim of her work grew steadily, and the American Academy of Arts and Letters named her Distinguished Writer (1978); left N.Y.C. to live on a house boat on the Hudson River (1979); after publication of Tar Baby (1981) was elected to the American Academy and Institute of Arts and Letters; that same year, made the cover of Newsweek, the first African-American woman to do so since writer and folklorist Zora Neale Hurston in 1943; ended her career in publishing (1984) when she accepted the Albert Schweitzer Professorship of the

Humanities at SUNY at Albany; published most highly acclaimed novel to date, Beloved (1987), *which won the Pulitzer Prize for Fiction; accepted a professorship in the Humanities at Princeton University (1989) in African-American studies and creative writing;* Jazz *and first book of essays,* Playing in the Dark: Whiteness and the Literary Imagination, *made* The New York Times' *bestseller list (1992); won the Nobel Prize for Literature (1993); published* Paradise *(1998); published children's book,* The Big Box *(1999).*

Selected publications: The Bluest Eye *(NY: Holt, Rinehart, and Winston, 1970);* Sula *(NY: Knopf, 1973);* Song of Solomon *(NY: Knopf, 1977);* Tar Baby *(NY: Knopf, 1981);* Beloved *(NY: Knopf, 1987);* Jazz *(NY: Knopf, 1992);* Playing in the Dark: Whiteness and the Literary Imagination *(Cambridge, MA: Harvard University Press, 1992);* Race-ing Justice, Engendering Power: Essays on Anita Hill, Clarence Thomas, and the Construction of Social Reality *(editor, NY: Pantheon Books, 1992);* Toni Morrison: The Nobel Lecture in Literature *(NY: Knopf, 1994);* Paradise *(NY: Knopf, 1998); (children's book)* The Big Box *(Jump at the Sun, 1999). Her lyrics to the 1983 musical,* New Orleans, *performed at New York's Public Theater; her script for* Dreaming Emmett, *produced by the Capital Repertory Company of Albany; her lyrics to* Honey and Rue, *song cycle performed by Kathleen Battle in 1993.*

The first African-American to bring home the coveted Nobel Prize for Literature in 1993, distinguished writer, editor and teacher as well as working mother, Toni Morrison has a literary career as stellar as it is short. She did not even begin writing fiction until middle age, having already established herself as a well-credentialed academic with a promising career in teaching and the editorial field. The prizes came steadily and from the first, including the National Book Critics Circle Award in 1977, and the American Academy of Arts and Letters Distinguished Writer Award for that same year, following the success of her third novel *Song of Solomon.* In 1988, for her fifth novel, *Beloved,* she garnered the Pulitzer Prize for Fiction, the Robert F. Kennedy Book Award, and the Melcher Book Award from the Unitarian Universalist Association. Her achievement was even more remarkable in light of her background as a child of the Depression and of the working poor, only one generation removed from her sharecropper grandparents on her mother's side.

She was born Chloe Anthony Wofford, the second of four children, on February 18, 1931,

on the "wrong side of the tracks" in the industrial midwestern town of Lorain, Ohio. Both her parents claimed southern lineage, choosing to escape the deep-rooted racism of the region that threatened their family. Her father George Wofford, who died before her third novel *Song of Solomon* appeared in 1977, grew up in Georgia. He left behind the race-torn state but not without a hardened hostility toward whites. His hatred developed into the view that whites were inferior to blacks. A hard-working family man who found gainful employ as a shipyard welder, Wofford reportedly worked three jobs to help his second born, Chloe, attend college. The second daughter and a sister to two younger brothers, Morrison distinguished herself by being the first to acquire a college education in her family. Her mother **Rahmah Wofford**, a positive and vital force in the tightly knit African-American community, involved herself in the church and community clubs. Morrison told **Betty Fussell** that her mother sang opera and jazz around the house and played piano at the silent movie houses.

Rahmah was the daughter of Solomon and **Adelia Willis**, poor Alabama sharecroppers who, under the influence of Christian mythology, drew their daughter's name from the Old Testament of the Bible. Toni Morrison looked to her grandmother Adelia as a model, as she told interviewer **Nellie McKay**, because she had the strength to leave "her home in the south with seven children and thirty dollars because she feared white sexual violence against her maturing daughters." In addition to the Christian influence, yet another kind of mysticism was at work in grandmother Adelia's use of a dream book to gamble when "playing the numbers." Adelia was also a midwife, Morrison reported to McKay, and people came from miles away seeking her care and advice. Grandfather Solomon, his sharecropper days behind him, became a carpenter and played the violin. Unlike her mother's family, Morrison's paternal grandparents were not as influential in her development, having died before she had the opportunity to know them.

In interviews, Morrison has spoken lovingly and admiringly of her richly eccentric and supportive family and black community. According to critic Wilfred Samuels, "This familial background, with an ambiance of historical and social consciousness, mysticism, master craftsmanship, and a love of excellence and work, helped to fashion Toni Morrison the artist." Her parents not only survived the Depression, racism, poverty and, briefly, a stint on welfare, but passed on to her the African-American oral tradition of storytelling. Threads of Morrison's

own narrative style may be traced back to those ghost stories charged with the mystical and the magical, particularly those narrated by her father. Her mother completed high school but her father lacked the benefits of a formal education. Nevertheless, both George and Rahmah Wofford encouraged their bright daughter to read from an early age, thus preparing her for a successful career in language, in both the distinctive oral tradition of her culture and the language of education. Morrison admitted to feeling "anonymous" in the middle-child position, with "no pride of place," according to interviewer **Dana Micucci**, stressing her early and avid interest in reading. Through her literary achievement, Morrison has obviously since forged her own outstanding place of pride.

Forthcoming and opinionated in her views on racial politics and literary aesthetics, Toni Morrison has remained guarded in matters concerning her private life. Her taciturnity, compounded by the absence of any biography, authorized or unauthorized, renders any biography meager and limited to information made public through interviews with the author herself. But shades of Morrison's growing up years may also be detected in her fiction. In her earliest novel *The Bluest Eye,* for example, we meet a community of poor blacks suffering the debilitating effects of poverty and racism with their survival instincts intact; all, that is, save for the tragic little black girl who mistook her imagined blue eyes for reality and salvation. In an interview with Charles Ruas, Morrison reported having based Pecola on a childhood friend who abandoned her belief in God because he did not grant her cherished blue eyes. In an exchange with Robert Stepto for the *Massachusetts Review,* Morrison admitted to relying heavily on her memory of the past as fodder for her fictional world and characters.

The bits and pieces of Morrison's cherished African-American community of characters from her past ring as true as the sense of place in her work—the small midwestern town flavor spiced by the omnipresent hatred of absent whites. Instead of longing for acceptance into the dominant white group, Morrison, like her fictional child-character Claudia, turned to the communal language, rituals and sustenance of her own people. In a *New York Times* interview with **Colette Dowling**, in fact, Morrison confessed to her kinship with Claudia who mistrusts the Shirley Temple idol, having herself "eschewed the plastic celebrities of white culture." Quite likely, her father's separatist views helped form Morrison's own. In the same article, she described herself in childhood as an avid reader who, encouraged by her teachers, excelled in school and was inducted into the National Honor Society.

Her post-high school years, beginning in 1949, saw Morrison leaving the midwest to attend Howard University in the Northeast, where she continued her early scholastic success. At this time, she also changed the difficult-to-pronounce Chloe to Toni and nurtured an interest in the theater, through which she became further acquainted with her African-American heritage. Despite her academic and personal advancement, Morrison has expressed longing for her people and roots necessarily left behind in Ohio. She told Dowling that she returns to that place and her past continually in her writing, because in order for black people to succeed "in this culture, they must always leave. There's a terrible price to pay Once you leave home, the things that feed you are not available to you anymore. . . . And the American life, the white life, that's certainly not available to you. So you really have to cut yourself off. Still, I can remember that world. I can savor it. I can write about it."

With her family's ongoing support, however, she pursued the academic and literary career that took her far from her modest beginnings. Her father worked several jobs at a time and her mother, whom Morrison held as a model alongside her grandmother, undertook "humiliating jobs" to help support her through graduate school. Apart from her involvement at Howard with the University Players Theater group, Morrison apparently attended assiduously to her school work, earning a B.A. in English with a minor in classics in 1953.

From Howard, she went directly to Cornell University, earning an M.A. in English literature, only to return to a teaching post at her undergraduate alma mater two years later. By 1958, she had embarked on a career, and a marriage to Harold Morrison, an architect of Jamaican descent. Morrison has divulged little about the six-year marriage that she ended following a family trip to Europe in 1964, but by that time she had given birth to Harold Ford (1961) and then returned home to Lorain where her second son, Slade Kevin, was born (1964).

The mid-1960s seem to have been a time of soul-searching for Morrison who remained in her hometown for a year or so. Certainly, at least, she was re-evaluating her career, and by 1965 she had relocated to Syracuse, New York, her two young sons in tow, to accept a position as a textbook editor with L.W. Singer, a division

Toni
Morrison

of Random House. Morrison did not see herself as a writer at this time, although she had joined a writer's group while teaching at Howard. It was in this group and at the start of her third decade that she wrote the short story that would later evolve into her groundbreaking novel, *The*

Bluest Eye. In several interviews, Morrison claimed to have written the story out of a desire to read an authentic rendering of her people, and was surprised later to find then little-known works of *Zora Neale Hurston, whom Morrison came to admire. Indeed, a budding writer

herself, Morrison used her editorial position to help other African-Americans get on to the literary map, publishing the work of such writers as **Toni Cade Bambara** and **Gayl Jones**. But by this time, 1968, Random House had promoted Morrison to senior editor, which required another move, this time to New York City, the hub of the publishing industry. There, she balanced the work and family responsibilities of a single parent, simultaneously concentrating on her manuscript of the little black girl who craved blue eyes and white acceptance. In interviews, Morrison has characterized this period as a lonely one, and her writing seemed to provide her with an avenue for self-exploration and interior dialogue. She never planned on being a writer, she told **Jane Bakerman**, but she was isolated and without anyone to talk to: "And then, after I had published, it was sort of a compulsive thing because it was a way of knowing, a way of thinking that I found really necessary." Holt published *The Bluest Eye* in 1970, marking the birth of a promising literary star.

I know I can't change the future but I can change the past. It is the past, not the future, which is infinite.

—Toni Morrison

A fledgling writer and a well-established editor by 1971, Morrison had also managed to reignite her teaching career. After a brief stint at the State University of New York (SUNY) at Purchase, she also taught at Yale (1976–78). By this time, however, she was a novelist whose star was on the rise, particularly after her second novel, *Sula* (1973), proved even more successful than her first. The accolades began arriving following her third critically acclaimed novel, *Song of Solomon*, which was published by Knopf in 1977. After making it on the Book-of-the-Month selection list, *Song of Solomon* won the National Book Critics Circle Award. Richard Wright's *Native Son* was the only other book by an African-American writer to be named to the list, a fact which testifies to Morrison's growing impact and appeal. The striking verisimilitude of her fictional world combined with her lyrical language had struck a chord. Toni Morrison would never again wonder if she were a writer.

By this time, she was living outside the city in Rockland County, New York, commuting to her office and juggling her editorial responsibilities with her fiction writing and occasional teaching. She has said that she worked on her writing in the evenings and when her children were sleeping, an amazing accomplishment for any mother let alone a working one. Her chil-

dren, who had attended United Nations International School in the city, were later transferred to public school in Spring Valley. Morrison, a conscientious mother, arranged her schedule around theirs, and taxied them to and from school. Her responsibilities mounted with the growing success of her work, and she managed the increased publicity and demands by shielding her time from social events and expectations and devoting herself to her work.

Her fourth novel *Tar Baby* came out in 1981, the year she was featured on the cover of *Newsweek*. By 1983, she was trying her hand in the theater with *New Orleans,* a musical for which she wrote the lyrics that went into limited production in New York, starring *Odetta. Dreaming Emmett* was produced in 1986 and marked her next and more serious attempt at playwriting. Commissioned by the New York State Writers Institute, it won the New York Governor's State Award. Morrison based the play on a historical account of a 14-year-old black boy who was beaten and killed in 1955 by a group of whites, allegedly for whistling at a white girl. The killers escaped unpunished, and Morrison's complex rendering of the story has the young boy returning to life to seek revenge. She saw his character as a representation of contemporary black youth and the violence that has become a way of life for them. The play extended Morrison's deep and abiding concern for her people, not as white people see them but as they see and understand themselves: "Black people have a story, and that story has to be heard."

After nearly 20 years in publishing, Morrison resigned in 1984 and accepted a professorship in the humanities at SUNY Albany, where she worked on *Dreaming Emmett*. This move obviously freed her to devote herself more to her own writing, while providing a steady income. During this period, she completed her most critically acclaimed novel to date, *Beloved* (1987), which won the Pulitzer Prize for that year and cinched her reputation as a heavyweight in the world of American letters. A story about a slave who kills her daughter rather than have her suffer at the hands of the white oppressor, *Beloved* sent shock waves through the reading world. Morrison reportedly spent two years thinking about the book and three years actually writing it. The intense and powerful novel touched on her vision of blacks reclaiming their past, accepting personal responsibility and finding acceptance in their community or "village." Though it was her most difficult book to write emotionally because of its painfully tragic content, Morrison remarked that if slaves could live it, no matter

how difficult or heart-wrenching, she could write it. Perhaps, too, *Beloved* was Morrison's way of paying tribute to her mother and grandmother and all the black mothers before them who served as both "safe harbor and ship" and toward whom she felt a strong responsibility.

In 1989, Morrison left Albany to accept a joint appointment in African-American studies and creative writing at Princeton University. Three years later, she saw her sixth novel, *Jazz*, published, along with a book of essays she both edited and introduced, *Playing in the Dark: Whiteness and the Literary Imagination*. Both made it to *The New York Times* bestseller list and helped solidify Morrison's reputation as a novelist with definite views on the aesthetics governing the work of black writers. Keenly attentive to racial politics, Morrison also edited *Race-ing Justice, En-gendering Power*, an anthology of essays on the Clarence Thomas-**Anita Hill** controversy. In 1993, she wrote the lyrics to a song cycle called *Honey and Rue* to the music of Andre Previn which was performed by opera diva **Kathleen Battle**. That same year, Toni Morrison made history as the first African-American to receive the Nobel Prize for Literature, the crowning achievement to nearly 25 years of creative work.

A powerful voice, an astonishing creative genius, and an astute mind characterize the public figure and writer known as Toni Morrison. The person who grew more elusive with fame, however, prefers to see herself as "a morally responsible human being," and that involves a "private struggle." Two abiding concerns seem to drive her moral responsibility: that which she owes to her children, and that which she owes as "role model for African-American women and for women in general." Both obligations hinge on how Morrison uses her writing for exploration and discovery.

In her remarks to the Swedish Academy members prior to her Nobel acceptance speech, Morrison narrated the story of the old blind woman being baited by a group of cynical young people. Holding a bird in their hands, they want to know if she could determine whether it is alive or dead. Likening the bird to language and the old woman to the writer, Morrison has the blind woman respond to the young people that she does not know if the bird is dead or alive, but she does know that the bird is in their hands. Like the old blind woman gifted with inner sight, Toni Morrison has used the gift of "language" to reconstruct and reclaim her people's past—surely a glorious gift to pass on to one's children and community, and to the world at large.

SOURCES:

Conversations with Toni Morrison. Edited by Danille Taylor-Guthrie. Jackson, MS: University Press of Mississippi, 1994.

Morrison, Toni. *The Bluest Eye.* NY: Holt, Rinehart, and Winston, 1970.

Samuels, Wilfred D. *Toni Morrison.* Boston, MA: Twayne, 1990.

Toni Morrison: The Nobel Lecture in Literature, 1993. NY: Knopf, 1994.

RELATED MEDIA:

Beloved (171 min. film), starring *****Oprah Winfrey**, Danny Glover, **Thandie Newton**, **Kimberly Elise**, and *****Beah Richards**, screenplay by Akosa Busia, Richard LaGravenese, and Adam Brooks, directed by Jonathan Demme, 1998.

Paradise (audio with four cassettes, 6.5 hrs), read by Toni Morrison, Random House, 1998.

Kathleen A. Waites Lamm,
Professor of English and Women's Studies at Nova Southeastern University in Fort Lauderdale, Florida

Morrow, Elizabeth Cutter (1873–1955).

See Lindbergh, Anne Morrow for sidebar.

Morrow, Virginia Tighe (1923–1995).

See Tighe, Virginia.

Morse, Ella Mae (1925–1999)

American pop-jazz vocalist during the big band era who was noted for her exuberant style. Born on September 12, 1925, in Mansfield, Texas; died in October 1999 of respiratory failure at the Western Arizona Regional Medical Center in Bullhead City, Arizona; daughter of George Morse (a drummer) and Ann Morse (played ragtime in her husband's dance band); quit school by age 14; married Dick Showalter (a bandleader), in 1939 (divorced 1944); married a doctor, in 1946 (divorced 1953); married Jack Bradford, in 1958; children: (early marriages) Richard, Marcia, Ann and Kenny; (third marriage) Dan and Laura.

Began singing with father's band (1934); claiming to be 19, got job with the Jimmy Dorsey Band (1939); joined band led by Freddie Slack; first recording, Cow-Cow Boogie, was a hit (1942); reunited with Slack to record House of Blue Lights (1946); recorded million-seller comeback hit The Blacksmith Blues (1952); recorded last album, The Morse Code (1959); had complete body of work released by Bear Family Records (1997).

Selected discography: "Cow-Cow Boogie" (Capitol, 1942); "Mister Five by Five" and "House of Blue Lights" (Capitol, 1946); "Shoo, Shoo, Baby," "No Love, No Nothin'," "Milkman, Keep Those Bottles Quiet," "The Patty-Cake Man," and "The Blacksmith Blues" (1952); album, The Morse Code (1959).

Films: Reveille with Beverly *(1943);* Ghost Catchers *(1944);* South of Dixie *(1944);* How Do You Do *(1945).*

Known as "The Cow-Cow Boogie Girl" in her later years, Ella Mae Morse was born in Mansfield, Texas, on September 12, 1925. Her father George Morse was a drummer from England who became the leader of a small dance band in Texas, and her mother **Ann Morse**, a native Texan, played ragtime and Dixieland piano in her husband's band. Thus it is not too surprising to find that Ella Mae Morse also possessed musical talent. In fact, by the time she was nine years old, Morse began singing with her father's band at local gatherings, accompanied by her mother at the piano. When the family moved to Paris, Texas, she befriended an elderly black guitar player who taught her the blues, which later proved to be a major influence on her style.

By 1939, Morse had quit school and married Dick Showalter, a musician who played under the name of Dick Walters. Turned down for work by Phil Harris, Rudolf Friml and Tommy Dorsey because she was only 13, Morse finally managed to obtain work with the Jimmy Dorsey Band by saying she was 19. Her employment was short-lived, however, and was terminated when her true age was discovered. She then moved to San Diego and worked at a Los Angeles ballroom before signing on as a singer with Freddie Slack, a former pianist with Dorsey, who was then working at the Pacific Square Ballroom in San Diego. Slack's band was signed by Johnny Mercer and Glenn Wallichs as the first artist on their new record label, Capitol Records. It was not long before the band and Morse recorded "Cow-Cow Boogie" (1942), and the novelty song soon became a huge hit on the pop charts. This same song, previously recorded by *Ella Fitzgerald for a film, had landed on the cutting-room floor. As a result of the record's success, Mercer later authorized that Morse be paid royalties on the recording rather than the flat $35 rate originally agreed upon, and Capitol signed Morse as a soloist. She remained with the company for the next 15 years, following up with many more hits, including "Mister Five by Five," "House of Blue Lights" (reuniting with Slack in 1946), "Shoo Shoo, Baby," "No Love, No Nothin'," and "Milkman, Keep Those Bottles Quiet." One of the country's top vocalists during the big band era, she became known for her engaging mixture of boogie-woogie, blues, jazz, swing and country. Her recording of "House of Blue Lights" is considered an important influence on rock 'n' roll.

Morse also appeared in several movies during the 1940s, including *Reveille with Beverly* (1942), *Ghost Catchers* (1944), *South of Dixie* (1944) and *How Do You Do* (1945).

Ella Mae Morse's personal life does not seem to have moved along as smoothly as her career during these years, although she did take several years off to start a family, returning briefly to the studio to record "The Blacksmith Blues" in 1952. In 1944, she divorced Showalter, and two years later married a doctor, with that union lasting until 1953. In 1958, Morse married Jack Bradford, a carpenter; the couple had two children. In 1959, she recorded her last album, *The Morse Code,* but she continued to appear professionally on occasion, including a tour during the 1970s and annual engagements at Disneyland with Ray McKinley's band. Capitol Records also reissued "Cow-Cow Boogie," and in 1997 a five-CD box set of her complete works was released by Bear Family Records. Morse spent her later years living in California and Arizona with her family. She died of respiratory failure in October 1999 at the Western Arizona Regional Medical Center, Bullhead City, at the age of 75.

Jo Anne Meginnes,
freelance writer, Brookfield, Vermont

Mortimer, Agnes (fl. 1347)

*Countess of Pembroke. Name variations: Agnes Hastings. Flourished in 1347; daughter of Roger Mortimer (c. 1287–1330), 1st earl of March, and *Joan Mortimer; married Laurence Hastings (c. 1320–1348), 1st earl of Pembroke; children: John Hastings (1347–1375), 2nd earl of Pembroke.*

Mortimer, Alianor (c. 1373–1405).

See Holland, Alianor.

Mortimer, Anne (1390–1411)

*Countess of Cambridge. Name variations: Lady Anne Mortimer. Born on December 27, 1390 (some sources cite 1388); died in childbirth in September 1411; buried at Kings Langley Church, Hertfordshire, England; daughter of Roger Mortimer (1374–1398), 4th earl of March, and *Alianor Holland (c. 1373–1405); married Richard of York also known as Richard of Conisbrough, 2nd earl of Cambridge, around May 1406 (died 1415); children: *Isabel (1409–1484, who married Thomas Grey and Henry Bourchier, 1st earl of Essex); Richard Plantagenet (1411–1460), 3rd duke of York.*

Anne Mortimer, chief heir to the rights of her great-grandfather Lionel, duke of Clarence, married Richard of York, 2nd earl of Cambridge. She died, age 21, in September 1411, shortly after giving birth to her son Richard Plantagenet, 3rd duke of York, who would be the father of English kings Edward IV and Richard III.

Mortimer, Babe or Barbara (1915–1978).

See Cushing Sisters for Babe Paley.

Mortimer, Beatrice (d. 1383)

*English noblewoman. Name variations: Beatrice de Braose. Died on October 16, 1383; daughter of Roger Mortimer (c. 1287–1330), 1st earl of March, and *Joan Mortimer; married Edward Plantagenet (grandson of Edward I, king of England), around 1327; married Thomas de Braose, Lord Brewes, around 1334; children: Beatrice de Braose (who married William, Baron Say); John de Braose (a knight); Thomas de Braose (a knight); Peter de Braose; Elizabeth de Braose; Joan de Braose.*

Mortimer, Catherine (c. 1313–?)

*Countess of Warwick. Name variations: Catherine Beauchamp; Katherine Beauchamp. Born around 1313; daughter of Robert Mortimer (c. 1287–1330), 1st earl of March, and *Joan Mortimer; married Thomas Beauchamp (c. 1313–1369), 3rd earl of Warwick, in 1328; children: Guy (d. 1369); Thomas, 4th earl of Warwick (1339–1401); Reynburne; William, lord of Abergavenny (d. 1419); John; Roger; Hierom; Maud Beauchamp; *Philippa Stafford (fl. 1368–1378); Alice Beauchamp; Joan Beauchamp; Isabel Beauchamp; Margaret Beauchamp (who became a nun at Shouldham on the death of her husband); Agnes Beauchamp; Juliana Beauchamp; Catherine Beauchamp (a nun at Wroxhall, Warwickshire).*

Mortimer, Catherine (d. before 1413)

*Countess of March. Name variations: Lady Mortimer; Katherine; Catherine Glendower. Born Catherine Glendower; died before December 1413; daughter of Owen Glendower and *Margaret Glendower; married Edmund Mortimer (1376–1438), 5th earl of March, in 1402.*

Catherine Mortimer lived during a period known as the Wars of the Roses, a time of upheaval in England. She was the daughter of Owen Glendower and the wife of Edmund Mortimer,

both rebels against the crown. From 1400 to 1402, Welsh leader Glendower waged a guerilla war against Henry IV. Edmund Mortimer, by strict rules of primogeniture the true heir of Richard II, also rebelled against King Henry and was captured. In William Shakespeare's *Henry IV, Part I,* Catherine is portrayed as Lady Mortimer.

Mortimer, Eleanor (c. 1395–1418)

*English noblewoman. Name variations: Eleanor Courtenay. Born around 1395; died, age 23, in 1418; daughter of Roger Mortimer (1374–1398), 4th earl of March, and *Alianor Holland; married Edward Courtenay (admiral of the fleet and son of Edward, 3rd earl of Devon), around 1409.*

Mortimer, Elizabeth (1371–1417).

See Percy, Elizabeth.

Mortimer, Isabel (fl. 1267)

*Countess of Arundel. Name variations: Isabel Fitzalan; Isabella Mortimer. Flourished around 1267; daughter of Roger Mortimer (d. 1282), baron Wigmore, and *Maud Mortimer (c. 1229–1301); married John Fitzalan (d. 1272), earl of Arundel; married Ralph d'Arderne; married Robert Hastings; children: (first marriage) Richard Fitzalan (1267–1302), 6th earl of Arundel; possibly Eleanor Fitzalan Percy (who married Henry Percy, 1st baron Percy).*

Mortimer, Joan (fl. 1300)

*Baroness Wigmore. Name variations: Joan de Genville, Genevill or Geneville. Flourished around 1300; born Joan de Genville; married Roger Mortimer (c. 1287–1330), 8th baron Wigmore, 1st earl of March; children: eight, including Edmund (d. 1331), 3rd baron Mortimer of Wigmore; *Catherine Mortimer (c. 1313–?), countess of Warwick; *Agnes Mortimer (fl. 1347), countess of Pembroke; *Beatrice Mortimer (d. 1383).*

Mortimer, Margaret (d. around 1296)

*Countess of Oxford. Died around 1296; interred at Grey Friars, Ipswich; daughter of *Maud Mortimer (c. 1229–1301) and Roger Mortimer (d. 1282), lord of Wigmore; married Robert de Vere, 6th earl of Oxford; children: Thomas de Vere (b. around 1282).*

Mortimer, Matilda (1925–1997).

See Mathilda, duchess of Argyll.

Mortimer, Maud (c. 1229–1301)

*Baroness Wigmore. Name variations: Maud de Braose. Born around 1229; died in 1301; daughter of William de Braose, lord of Abergavenny, and *Eve de Braose; granddaughter of Reginald, baron de Braose; married Roger Mortimer (d. 1282), lord of Wigmore; children: Ralph Mortimer; Edmund Mortimer (d. 1303), 1st lord Mortimer; Roger Mortimer (d. 1336); William Mortimer; Geoffrey Mortimer; *Isabel Mortimer (who married John Fitzalan); *Margaret Mortimer.*

Mortimer, Penelope (1918–1999)

Welsh novelist. Name variations: Ann Temple; Penelope Dimont; Penelope Ruth Mortimer. Born on September 19, 1918, in Rhyl, North Wales; died in October 1999 at a hospice in London, England; daughter of Arthur F.G. Fletcher (a cleric) and Amy Caroline Fletcher; attended Central Educational Bureau for Women in London and University of London; married Charles Dimont, in 1937 (divorced 1949); married John Clifford Mortimer (a playwright and lawyer), in 1949 (divorced 1972); children: (first marriage) Madelon, Caroline, Julia, Deborah; (second marriage) Sally and Jeremy.

Published first novel, Johanna *(under name Penelope Dimont), shortly before marriage to writer John Mortimer (1947); published popular novel,* The Pumpkin Eater *(1962); received Whitbread Award for nonfiction for* About Time *(1979); became well known for controversial biography of Elizabeth Bowes-Lyon, the queen mother (1986).*

Selected writings—novels: Johanna *(1947);* A Villa in Summer *(1954);* The Bright Prison *(1956);* Daddy's Gone A-Hunting *(1958);* The Pumpkin Eater *(1962);* My Friend Says It's Bullet-Proof *(1967);* The Home *(1971);* Long Distance *(1974);* The Handyman *(1983).*

Nonfiction (with husband John Mortimer): With Love and Lizards *(1957);* About Time: An Aspect of Autobiography *(1979);* Queen Elizabeth: A Life of the Queen Mother *(1986);* Queen Mother: An Alternative Portrait of Her Life and Times *(1995).*

Other: Saturday Lunch with the Brownings *(1960); (with John Mortimer)* Bunny Lake Is Missing *(screenplay, 1965);* Summer Story *(screenplay based on John Galsworthy's story* The Apple Tree, *1988);* Portrait of a Marriage *(screenplay, 1990).*

Penelope Mortimer was born on September 19, 1918, in North Wales, the daughter of Arthur F.G. Fletcher, a vicar who sometimes wavered in his faith, and **Amy Caroline Fletcher**. At age 16, Mortimer went to London and learned secretarial skills at the Central Educational Bureau for Women. She later attended the University of London, and in 1937 wed Charles Dimont, a correspondent for Reuters. They lived in Vienna. The couple divorced in 1949; that same year she married author John Mortimer. During the 1950s and 1960s, the couple often frequented the London social scene. Though seemingly in an ideal marriage, Mortimer reportedly suffered from bouts of depression, and the union ended in divorce in 1972.

Penelope's first novel, *Johanna* (1947), was published shortly before she married John. Her subsequent novels usually portrayed the institution of marriage in a semi-humorous way, and focused on the upper-middle class in Britain. *The Pumpkin Eater* (1962), dealing with a troubled marriage, offers a glimpse into Mortimer's own turbulent relationships with men. This story was filmed in 1964, starring James Mason and **Anne Bancroft**. Mortimer's Kafka-esque story, *Long Distance* (1974), enjoyed the distinction of being one of the very few novels to be published in its entirety in *The New Yorker*. She also received high praise for her two memoirs and several television screenplays. Her adaptation of *Portrait of a Marriage*, Nigel Nicholson's biography of his mother *Vita Sackville-West and father Harold Nicolson, proved upsetting to some viewers when it was aired in 1992 on PBS's *Masterpiece Theater* because of its frank portrayal of same-sex liaisons. Not one to shy from controversy, Mortimer wrote a biography of *Queen Elizabeth: A Life of the Queen Mother* (1986) which garnered mixed reviews, with some critics bristling at the author's portrayal of *Elizabeth Bowes-Lyon's romantic life before her marriage to future king George VI. Penelope Mortimer died in October 1999 at a London hospice, age 81.

Jo Anne Meginnes,
freelance writer, Brookfield, Vermont

Mortimer, Philippa (fl. 1352).

See Montacute, Philippa.

Mortimer, Philippa (1355–1382)

*Countess of Ulster and March. Name variations: Philippa Plantagenet; Philippa of Clarence. Born on August 16, 1355, in Eltham, Kent, England; died on January 5, 1382 (some sources cite January 7, 1378); buried at Wigmore, Hereford and Worcester, England; daughter of Lionel of Antwerp and *Elizabeth de Burgh (1332–1363); married Edmund Mortimer, 3rd earl of March, in 1368; children: *Elizabeth Percy*

*(1371–1417); Roger Mortimer (1374–1398), 4th earl of March; *Philippa Mortimer (1375–1401); Edmund Mortimer (1376–1438), 5th earl of March; John Mortimer (d. 1422).*

Mortimer, Philippa (1375–1401)

*Countess of Arundel. Name variations: Philippa Fitzalan; Philippa Poynings. Born on November 21, 1375, in Ludlow, Shropshire, England; died on September 24, 1401, in Halnaker, West Sussex, England; buried in Boxgrove, West Sussex; daughter of Edmund Mortimer, 3rd earl of March, and *Philippa Mortimer (1355–1382); married John Hastings (1372–1389), 3rd earl of Pembroke, around 1385 (died 1389); married Richard Fitzalan (1346–1397), 9th earl of Arundel, around 1390 (died 1397); married Thomas Poynings (d. 1429), 5th baron St. John; children: (second marriage) one.*

Morton, Lucy (1898–1980)

English swimmer. Born on February 23, 1898; died on August 26, 1980.

In 1924, England's Lucy Morton won a gold medal in the 200-meter breaststroke at the Paris Olympics with a time of 3:33.2. **Agnes Geraghty** of the United States came in second, while **Gladys Carson** of Great Britain placed third. American women won all of the swimming gold medals in 1924, except for the event won by Morton.

Moser, Mary (1744–1819)

German-born flower painter. Born in Germany in 1744; died in 1819; daughter of a Swiss gold-chaser and enameller; educated in England.

As a child, Mary Moser was exhibiting her flower paintings at the Society of Artists. By age 20, she was elected a founder member of the Royal Academy, along with one other woman, *Angelica Kauffmann, and exhibited there from 1768 to 1790. Moser was paid £900 to decorate one of the rooms at Frogmore for Queen *Charlotte of Mecklenburg-Strelitz (1744–1818), wife of George III. The queen was so pleased that she dubbed it "Miss Moser's room." Mary Moser painted professionally until age 53, when she married a friend's widower. Wrote Germaine Greer: "One of the pieces in the British Royal Collection shows that if she was the first significant British flower painter, she was also one of the best."

SOURCES:
Greer, Germaine. *The Obstacle Race.* NY: Farrar, Straus, 1979.

Moser-Proell, Annemarie (b. 1953).

See Proell-Moser, Annemarie.

Moses, Anna "Grandma"
(1860–1961)

American farmwife who became a nationally renowned painter of traditional scenes while in her 70s. Name variations: Grandma Moses. Born Anna Mary Robertson on September 7, 1860, near Greenwich, New York; died on December 13, 1961, in Hoosick Falls, New York; daughter of Russell King Robertson ("a farmer and an inventer and believer in refinement") and Margaret (Shanahan) Robertson (daughter of Irish immigrants); educated sporadically in local country schools; married Thomas Salmon Moses (a farmer), on November 9, 1887 (died 1927); children: ten (five died in infancy), including Anna (d. 1932), Winona, Hugh, Forrest and one other son.

Selected primary works: Apple Pickers; Sugaring Off; Out for the Christmas Trees; Catching the Thanksgiving Turkey; The Old Oaken Bucket; The Old Checkered House; Black Horses; From My Window. In 1935, at age 75, began to paint seriously and had her first one-woman show in October 1940.

Eighty years before the art world would recognize "Grandma Moses," Russell and **Margaret Shanahan Robertson** welcomed Anna Mary Robertson into their family of ten on September 7, 1860. Though Moses' childhood began during the Civil War, she remembered her first ten years as idyllic ones spent amid the "green meadows and wild woods" on the family farm near Greenwich, New York, in upstate Washington County. Some days she watched her immigrant grandfather Gregory Shanahan ply his trade as a shoemaker, and on others, she helped her mother with household chores, which included rocking her baby sister's cradle and learning to sew. In her free time, she "sported" with her brothers, floating rafts on the mill pond, roaming the woods to gather wild flowers, and building "air castles." Surrounded by relatives on all sides, Moses identified with her Scotch-Irish heritage. Later in life, she remembered all the stories she heard as a child about her orphaned grandmother **Bridget Devereaux,** who had immigrated from Ireland around 1836, and about her paternal relatives, who had arrived in time to see their son Hezekiah King fight

the Redcoats at Ticonderoga in 1777. "From the Kings I got art," said Moses, "from the Robertsons inventive faculty, from the Shanahans thrift, [from] the Devereaux generosity."

Anna turned ten in 1870, after which began what she called the "hard years." Following the Civil War, the nation entered an economic slump during which farmers were particularly hard hit. Moses usually kept busy helping at home or aiding her neighbors. At sporadic intervals, she attended school, which was held for three months in winter and three months in summer. Little girls attended only during the warm summer session so her schooling was, as she termed it, "limited." One school memory pertained to map-drawing exercises; she had a particular way of drawing mountains on the map which her teacher praised. In fact, he asked to keep the set of maps.

I would draw the picture, then color it with grape juice or berries any thing that was red and pretty in my way of thinking.

—Anna "Grandma" Moses

Moses found she had a flair for drawing, encouraged by her father who bought newsprint at a penny a sheet on which the children drew. Once she received some carpenter's blue and red chalk to take the place of her berry hues, a gift that made her feel "rich." Eventually, she dabbled in oil paint and rendered "lamb scapes," as her brothers called them, beneath brilliant sunsets. Her mother thought the young girl could find more profitable ways to spend her time, however, and at age 12 Moses went to work as a hired girl to earn her own living. She stayed with a local couple, "well along in years," nursing the invalid wife until her death; she also kept house, cooked, served dinner parties, and drove the rig to Sunday service for the husband. When this job ended, she drifted from job to job, caring for the sick and doing the work of a "hired girl." Eventually, she met Thomas Salmon Moses, a farmer by trade, and married him on November 9, 1887. She viewed marriage as an equal partnership, "a team," although, as she later admitted, at times she was the boss.

The young couple headed south to take charge of a horse ranch in South Carolina; in the course of their trip, Moses later said, they were "kidnapped" and "perswaded" to settle in the Shenandoah Valley of Virginia near Staunton. They remained there one year before moving down the valley to work on a dairy farm. At Staunton, she bought a cow, "the foundation of my million dollars." With the opportunity of the new dairy farm and her cow, Moses was soon producing 160 pounds of butter a week. Always thrifty, she had saved her earnings as a hired girl and now saved again. Her money-generating enterprises included making potato chips, a novelty in the late 19th century, and charging her husband interest when he borrowed $360 from her. In 1905, having saved enough to buy their own land, and homesick for New York, they moved back there and bought a farm near her roots in Eagle Bridge, Rensselaer County. There they again ran a dairy farm.

During the years of hard work and uncertainty in South Carolina, Anna Moses had given birth to ten children. When they returned north, she had to leave "five little graves" behind. Soon her surviving children married and moved away. Though her parents both died in 1909, her grandchildren, 11 in all, brightened her life. When her husband died on January 15, 1927, her youngest son Hugh and his wife Dorothy moved in to help her run the farm. As well, Moses took in boarders and raised chickens to augment the family income. When in 1932, her daughter Anna died, Moses went to Vermont to help raise Anna's children. She returned to Eagle Bridge in 1935, and at age 75, now known as Grandma Moses, found a little more time to pursue her own interests and develop her talents.

Moses always felt a need to capture and preserve her surroundings and memories. Sometimes this preservation resulted in actual preserves, such as her canned fruits and raspberry jam. At other times, her preservation depicted her surroundings. For Moses, the conservation in both mediums seemed interchangeable. "I exhibited a few at the Cambridge Fair. . . . I won a prize for my fruit and jam, but no pictures."

The pictures she painted were often as utilitarian as they were decorative. In 1918, she had once painted the fireboard when she ran out of wallpaper, having seen her father paint murals on the wall in lieu of wallpaper many years before. Sometimes her canvas was the old window of a caboose or the cover of a threshing machine. She also decorated her own furniture on occasion, for example, the pictures she painted on her "tip-top" table, which she later used as an easel. This periodic painting, begun before her husband's death, was just one manner of self-expression. When her daughter asked for a worsted picture, Moses stitched her a panorama, using worsted yarn in much the same way as she would later paint. Some later paintings, includ-

ing *Autumn in the Berkshires* and *By the Sea*, actually depicted the same scenes as previous worsted pictures. Only when her arthritis became too painful after the death of her husband did she heed her sister's advice and make oil painting her primary medium.

Grandma Moses found her inspiration in the scenes around her, though in literal terms she often used Currier & Ives for ideas, or half-tones from newspapers and magazines. After outlining with pencil the section she wished to recreate, she then superimposed one or more images into

her painting. She used whatever was at hand to create her pictures, including match sticks for fine work. Her technique was to apply separate brush strokes, as one would use embroidery floss, to create a three-dimensional effect.

By 1935, Moses found she had enough paintings to display them locally. Scenes like *The Old Oaken Bucket* were well received by her friends and neighbors, and she often recreated a painting at the request of an acquaintance. In 1938, amateur art collector Louis J. Caldor saw four of her paintings displayed in the local pharmacy and asked if there were more. The druggist handed him another ten, and with these tucked under his arm Caldor set off to find the artist. After meeting Grandma Moses, he departed for New York.

Caldor displayed her work for a year. In October 1939, he managed to get three paintings included in an exhibition of "Contemporary Unknown American Painters" at the Museum of Modern Art in New York City. Little came of that show, but another modern art dealer, Otto Kallir, liked what he saw and set up a solo-artist exhibition entitled "What a Farm Wife Painted" at New York City's Galerie St. Etienne. Only 4 of the 34 paintings displayed sold, but Gimbels' Department Store used the rest as part of a "Thanksgiving Festival" display.

The diminutive 80-year-old Moses, who was greeted by a hall full of women when she attended the show, seemed overwhelmed by the attention. Regaling her audience with stories of how she made her other "preserves," Moses then produced jars from her pockets as samples. "Grandma Moses Just Paints and Makes No Fuss About It" proclaimed one newspaper, and the public opened their hearts to her. As for the artist, she returned home to Eagle Bridge.

An exhibition in Washington, D.C., in early 1941 received good reviews but little else. Later that year, *The Old Oaken Bucket* won a prize from the Syracuse Museum of Fine Arts. Soon the paintings by the American "primitive" were in high demand. Sightseers dropped by her house to buy paintings and visit with the artist. Collectors vied for her work, and she was invited to many group exhibitions. Songwriter Cole Porter collected her work, and comedian Bob Hope lauded her spirit and "willingness to tackle something new."

By 1944, Kallir was displaying her work through traveling exhibitions which reached a broader public. Two years later, Moses signed an agreement with Brundage Cards for a line of greeting cards, and *Grandma Moses: American Primitive* was published. By 1947, the book was in reprints, Hallmark Cards had obtained her contract, and magazine articles about her were flooding the marketplace. Grandma Moses became an American icon. Her first radio broadcast for CBS took place in 1946; her television debut came in 1948. In 1950, a television documentary featuring Moses and narrated by Archibald MacLeish was nominated for an Academy Award. *Lillian Gish portrayed her in a biographical dramatization in 1952, the same year Moses' autobiography *My Life's History* was released. In 1955, Edward R. Murrow interviewed her. Her work reached Europe with an exhibition in 1954–55. All in all, Moses was the subject of nearly 150 solo shows and another 100 group exhibitions. Presidents began to favor her work, including Dwight D. Eisenhower, who received a commissioned painting in 1956. Harry S. Truman had been in yearly contact with her since their meeting in 1949. Even the new young president John F. Kennedy greeted her in 1961.

Typically, Moses could not understand the fuss when periodicals and people saluted her on her 100th birthday in 1960 and New York's governor Nelson A. Rockefeller declared it Grandma Moses Day. Though she danced a jig at her centennial, her health was failing. She became seriously ill in May 1961, and on July 18 was taken to the Health Center in Hoosick, New York. She nonetheless still wanted to paint, and her unauthorized forays caused her to be restrained to her bed. Pent up and frustrated, she celebrated her 101st birthday, though increasingly her mind wandered and she slept. On December 13, 1961, she died at the Health Center of arteriosclerotic heart disease.

During her career, Grandmas Moses completed approximately 2,000 paintings. She died an American legend, and in the years thereafter her art was viewed by more and more people. Grandma Moses found remarkable acceptance in an era that favored abstract expressionism and modern art like that created by Jackson Pollack. In a society threatened by nuclear destruction and just beginning to understand the ramifications of the Second World War, the art of Grandma Moses harked back to a simpler time. For people who had never experienced such a life, it was easy to idealize the common experiences of those who had worked the land of Jeffersonian America.

Grandma Moses is perhaps easier to understand as a symbol than as an artist. Clearly her art was atypical in the mid-20th century, yet it

was embraced by millions. Her palette consisted of those colors she liked, so good she could "almost eat them." Her canvas, she wrote, was "masonite tempered presd wood, the harder the better," which she covered with linseed oil and three coats of flat white paint. Her subjects were the people and places she knew and grew up with, the backbone of American folk art. Her technique was part George Seurat pointillism and part Claude Monet impressionism, though she developed it on her own. As she aged, her attention to color and style changed. Her color, detail, and energy invigorated her paintings and invited the viewer into their scenes.

Anna "Grandma" Moses stands out in many ways. The development of her artistic talent while she was a septuagenarian is in itself unusual. But perhaps the most outstanding feature of her life is its very "normalcy." Grandma Moses always lived up to her responsibilities; she generally did what was expected of her and was the epitome of a "good" farmwife of the late 19th and early 20th centuries. Yet her style, flair, and originality were such that an enforced wait of 75 years served only to enrich the talent and the memories she brought to her easel on the "tip-top" table.

Catching the Thanksgiving Turkey, *1943. Painting by Grandma Moses.*

SOURCES:

Eaton, Allen H. "Meadows and Wildwood of Grandma Moses, Her Life and Work Into Her 102nd Year." Unpublished manuscript.

Kallir, Jane. *Grandma Moses: The Artist Behind the Myth.* Secaucus, NJ: Wellfleet Press, 1982.

Kallir, Otto, ed. *Grandma Moses: American Primitive.* NY: Dryden Press, 1946.

McHenry, Robert, ed. *Famous American Women.* NY: Dover, 1980.

Sicherman, Barbara, and Carol Hurd Green, eds. *Notable American Women: The Modern Period.* Cambridge, MA: The Belknap Press of Harvard University Press, 1980.

Yglesias, Helen. "Grandma Moses—Farmwife into Legend," in *Starting Over: Early, Anew, Over and Late.* NY: Rawson, Wade, 1978.

SUGGESTED READING:

Armstrong, William H. *Barefoot in the Grass: The Story of Grandma Moses.* Garden City, NY: Doubleday, 1971.

Graves, Charles. *Grandma Moses, Favorite Painter.* Champagne, IL: Garrard, 1969.

Michaela Crawford Reaves,
Professor of History, California
Lutheran University, Thousand Oaks, California

Moses, Grandma (1860–1961).

See Moses, Anna "Grandma."

Moses or Mosey, Phoebe Anne (1860–1926).

See Oakley, Annie.

Mosher, Eliza Maria (1846–1928)

American physician and educator. Born on October 2, 1846, in Cayuga County, New York; died of pneumonia and a cerebral thrombosis on October 16, 1928, in New York City; daughter of Augustus Mosher and Maria (Sutton) Mosher; educated in local schools; completed preparatory course plus an extra year of study at the Friends' Academy in Union Springs, New York; entered the New England Hospital for Women and Children as an intern apprentice, 1869; University of Michigan, M.D., 1875; never married; no children.

Engaged in private practice in Poughkeepsie, New York (1875–77); appointed resident physician at Massachusetts Reformatory Prison for Women (1877); appointed superintendent of the prison (1880); forced to resign after accidental injury (1883); returned to private practice with Dr. Lucy M. Hall, with whom she also alternated semesters as resident physician and associate professor of physiology and hygiene at Vassar College (1883–87); organized medical training course at the Union Missionary Training Institute (1888); became lecturer on anatomy and hygiene at the Chautauqua, New York, summer school (1889); became dean of women and professor of hygiene at the University of Michigan (1896); resigned as dean due to ill health (1902); maintained private practice and gave lectures for rest of her life.

Born on October 2, 1846, Eliza Mosher was the youngest of six children of Augustus Mosher and **Maria Sutton Mosher**. She received her education at the local district school and at the Friends' Academy in Union Springs, New York, to which she returned for an extra year of study following her father's death in 1865. In 1867, after nursing her brother through his death from tuberculosis, she decided on a medical career. Despite opposition from family and friends, she entered the New England Hospital for Women and Children as an intern apprentice in 1869. Her medical schooling was delayed due to her mother's illness and eventual death, and she instead spent the winter of 1870–71 in Boston assisting Dr. *Lucy E. Sewall* in private practice. In 1871, she entered the University of Michigan, and after completing the medical course received her M.D. in 1875. Mosh-

er worked in private practice in Poughkeepsie, New York, until 1877, when she was asked to become resident physician at the new Massachusetts Reformatory Prison for Women (created through the efforts of *Ellen Cheney Johnson*). While there, she established hospital facilities and almost single-handedly dealt with the medical, surgical, and even dental care of the prisoners. For a brief period, she studied in France and England, and in 1880 she reluctantly accepted the superintendency of the prison. A knee injury in 1883 forced her resignation from that post.

For seven years, Mosher was in constant pain and dependent on crutches until a surgical operation she had devised was successfully performed on her knee. During this time, she managed to remain active and formed a practice in Brooklyn, New York, with Dr. **Lucy Mabel Hall (Brown)**, a former colleague at the reformatory. From 1883 to 1887, they also alternated semesters as resident physician and associate professor of physiology and hygiene at Vassar College. In 1888, Mosher founded the medical training course at the Union Missionary Institute in Brooklyn. The following year, she became a lecturer on anatomy and hygiene and examining physician to women students at the Chautauqua, New York, summer school of physical education.

Abandoning her private practice again, in 1896 she became dean of women and professor of hygiene—the first woman member of the faculty—at the University of Michigan. She also served as resident physician to women and director of physical education. These were not easy years for Mosher, for her initiation of a required program of calisthenics for women and her almost compulsive emphasis on posture did not make her the most popular person on campus. She had gained acceptance, however, by 1902, when she resigned because of her fear of a reoccurrence of the difficulties with her knee. (One source cites the cause as cancer.) These problems finally were cured by radical surgery in 1905 and 1906. For the remainder of her life, she practiced medicine privately in Brooklyn and occasionally lectured at Mt. Holyoke College, Adelphi College, Pratt Institute, and the Brooklyn YWCA. She was also active in many civic groups, and in 1924 she mobilized schoolchildren, women's clubs, and others in an attack on littering and dirty streets in Brooklyn. Active as well in many medical organizations, she was president of the Women's Medical Society of New York, honorary president of the Medical Women's National Association, and a founder of the American Women's Hospitals Committee. Mosher also served as senior editor (1905–28)

of the *Medical Women's Journal*, and was a founder of the American Posture League. She was interested in the medical benefits of good posture, and she designed and patented several types of posture chairs, including streetcar seats. Her 1912 book, *Health and Happiness: A Message to Girls*, was widely used. Mosher continued her medical practice until only a few months before her death from pneumonia and a cerebral thrombosis in New York City in 1928.

SOURCES:
James, Edward T., ed. *Notable American Women, 1607–1950.* Cambridge, MA: The Belknap Press of Harvard University Press, 1971.
McHenry, Robert, ed. *Famous American Women.* NY: Dover, 1980.

SUGGESTED READING:
Bugbee, Emma. *Woman Citizen.* April 4, 1925.
Hinsdale, Burke A. *History of the University of Michigan,* 1906.
Medical Woman's Journal (commemorative issue in Mosher's honor; includes reprints of professional papers as well as biographical material). May 1925.

COLLECTIONS:
Eliza Mosher's papers are held in the Michigan Historical Collections at the University of Michigan.

Jo Anne Meginnes,
freelance writer, Brookfield, Vermont

Moskowitz, Belle (1877–1933)

Reform advocate and public relations director for New York Governor Alfred E. Smith and one of the most influential women in politics during the 1920s.

Name variations: Belle Israels. Born Belle Lindner on October 5, 1877, in New York City; died in New York on January 2, 1933, of complications following a fall; daughter of Isidor Lindner (a watchmaker and cantor) and Esther (Freyer) Lindner; attended public elementary school, Horace Mann High School for Girls (1894), and enrolled for one year as a "special student" at New York's Teachers College, Columbia University; married Charles Israels, on November 11, 1903 (died 1911); married Henry Moskowitz, on November 22, 1914; children: (first marriage) Carlos, Miriam, Josef.

Worked as a program director at the Educational Alliance (1900–03); did social work, lobbying, and public relations for the United Hebrew Charities, the Council of Jewish Women, and the New York State Conference of Charities and Corrections (1903–09); was active in the dance-hall reform movement (1908–13); served as a labor negotiator for the Dress and Waist Manufacturers Association (1913–16); was executive secretary of Governor Alfred E. Smith's Reconstruction Committee (1919–21); was director, Industrial and Education Department, Universal Film Company (1920–22); was publicity director, Democratic State Committee (1923–28), and political consultant to Governor Smith, especially on presidential campaigns of 1924 and 1928; was owner-director of Publicity Associates (1928–33).

The nomination in 1928 of New York's Governor Al Smith as the Democratic presidential candidate shattered a number of precedents. Four years earlier, the convention had deadlocked for 103 ballots before compromising on West Virginia lawyer John W. Davis; in 1928, Al Smith was nominated on the first ballot. The party platform supported Prohibition, but Smith, whose power base was in the ethnic melting pot of New York City, did not. Despite opposition from a few fundamentalist Southern states, Al Smith was the first Roman Catholic presidential nominee. And less than a decade after women had won the right to vote, his principal campaign advisor was a woman.

Belle Moskowitz, who began work with Smith during his first campaign for the governorship ten years before, had listened to the proceedings on the radio along with Smith and their families in the upstairs hall of the executive mansion in Albany. Franklin Delano Roosevelt, Smith's choice to succeed him as governor of New York, made a rousing nominating speech. As the balloting continued, they went downstairs to greet well-wishers. When Ohio changed its vote to Smith, Moskowitz looked at the governor, sharing a long silent moment of triumph.

Moskowitz was born Belle Lindner on October 5, 1877, the sixth child of Isidor and **Esther Freyer Lindner**, but only the third (and sole daughter) to survive to adulthood. Belle's parents had immigrated to America from East Prussia in 1869, before the later wave of "new immigrants" intensified competition for jobs and housing. After running a successful watchmaking shop on Canal Street in Manhattan's Lower East Side, Isidor had been able to move his family to a three-story clapboard house in semi-rural Harlem before Belle was born. Behind the large display window of their ground-floor shop was a parlor where neighbors gathered to talk politics.

Esther was a conventional wife in some ways, a partner in an arranged marriage in which she deferred to her husband. But she had renounced the Old World *sheitel* (wig) and hoop skirts for American dress, and had once pursued and apprehended a would-be thief. Her grandchildren recollected that it was she who "ran the family." Her mother's indirect style of management influenced Belle, as did her father's scholarship. Isidor knew seven lan-

guages and served as cantor, temporary rabbi, and president of Temple Israel.

Belle's father took her with him on a trip to Europe when she was four or five years old. He sent her to a private high school, Horace Mann, the lab school for New York's Teachers College where the progressive curriculum included rhetoric and modern history, government, English literature, mathematics, and freehand drawing.

Moskowitz graduated from high school in 1894 and attended Teachers College as a special student. She planned to study for a career as a dramatic reader with **Ida Benfey**, whose public readings were popular New York theatrical events. After one year, Belle left to study with Heinrich Conried, later director of the Metropolitan Opera, and developed a character called "James, the Tailor-Made Girl." She presented monologues to private gatherings, and gave elocution lessons to children, but her parents preferred her to help in their shop rather than perform on a public stage.

> *Belle Moskowitz... had been Al Smith's tutor and mentor to an extraordinary degree.... Mrs. M. was Al Smith's tent-pole.*
>
> —Molly Dewson

Like many college women in the late 1890s, Moskowitz was drawn to the neighborhood settlement houses, which ran programs to help immigrants adjust to their new surroundings. In January 1900, she began social work downtown at the Educational Alliance, one of the settlements serving the growing Jewish population that had fled persecution in Eastern Europe and Russia. For three and a half years, Belle, drawing on her earlier interest in theater, organized exhibits where Eastside artists could display their work, and entertainments, including plays staged by children for national and Jewish holidays. Her work at the Alliance introduced her to many of the important people in her later life, including both of her husbands and lawyers Abram Elkus and Joseph Proskauer, who claimed they introduced her to Al Smith.

Belle resigned to marry Charles Henry Israels, an architect 12 years her senior, on November 11, 1903. In addition to designing apartment hotels and model tenements, Charles led a boys' club at the Educational Alliance where he had met Belle. The couple lived with Charles' widowed mother, **Florence Lazarus Israels**. Her mother-in-law's help with the children and housekeeping freed Belle to work outside the home, but there was often a tense family atmos-

phere. A slump in her husband's business prompted Belle to begin writing professionally at home around the time of the birth of their first child, Carlos, in 1904. In 1907, their daughter **Miriam** was born, followed in 1909 by Josef. (In 1911, a daughter died at birth.) The family moved to Yonkers in 1909 so the children could grow up in the country. Moskowitz nursed her infants, but then delegated some of the child care to nannies or grandparents when her activities took her away from home.

Continuing her career in social welfare, Moskowitz did editorial work for *Charities*, a magazine published by United Hebrew Charities. She also joined the New York section of the Council of Jewish Women, which was coping with the increased rate of Jewish immigration following the rise of pogroms. Her special interest was in children, particularly pregnant teenagers. In 1905, her first major project was the establishment of the Lakeview Home for Girls on Staten Island, where pregnant teens could receive vocational training. Through this work, she learned to analyze social problems and develop solutions. She also learned administrative skills, and gained experience with the state legislature.

Moskowitz also worked with broader-based reform groups, such as the New York State Conference of Charities and Corrections, which introduced her to the larger reform community. She served as that organization's assistant secretary in 1906, and organized its first exhibition, establishing a tradition of graphic presentation to support reform campaigns. An exhibit of 100 photographs, depicting the sad effects of child labor, was an urgent argument for parks and games. In 1908, she was named a vice-president, the first woman to so serve in the male-dominated organization (there would be no woman president until 1924). Belle continued her editorial work for *Charities*, acting as editorial assistant from 1908 to 1909, and through both activities developed expertise she would later use in public relations work for Al Smith.

In 1908, Moskowitz led a crusade for dance-hall reform. Her concern for sexually active teens led her on a quest for wholesome recreation for working girls, and she joined forces with temperance advocates to ban liquor from dance halls. She publicized conditions and aroused public opinion to pressure lawmakers through press conferences, articles and speeches, demonstrating a rare ability to attract support from a cross-section of the community, and in the process becoming one of New York's more

Belle Moskowitz

influential social reform-
ers. In 1910, a compromise
bill was passed to regulate alcohol
in dancing establishments, and over the
next three years, dance-hall reform movements
spread across the country.

In November 1911, when Moskowitz was
34 and her eldest child was seven, Charles devel-
oped bronchial pneumonia; he died two days
after their eighth wedding anniversary. His
mother moved to a boarding house, Belle's par-
ents moved in to help with the household, and
Moskowitz looked at once for paid work. She
first fell back on writing, producing "how to"
articles for women's magazines and a child-care

pamphlet for Metropoli-
tan Life Insurance. Within a
few months, she landed a job as
commercial recreation secretary for the
Playground and Recreation Association of
America, lobbying for state support of play-
grounds and supervised recreation, and serving
on the executive subcommittee for summer pro-
grams in Europe. By the summer of 1912, in ad-
dition to chairing 14 executive meetings, free-
lance writing, and continuing to work for dance-
hall reform, Moskowitz took the plunge into
party politics. The Progressive Party welcomed
women's participation, and she served as district
leader in her local ward in Yonkers, helping to
elect a Progressive alderman.

A suspected case of police corruption following the murder of a gambler who was to have testified before a grand jury created a public outcry for reform. Belle was the only woman on a citizens' committee organized to investigate the situation; serving with her was a former colleague from the Educational Alliance, Henry Moskowitz. Although the committee's recommendations never became law, its members formed the nucleus of a "fusion" movement to support anti-machine Democrats in the 1913 city elections. When John Purroy Mitchel, the reform candidate, was elected, he named Henry Moskowitz president of the Municipal Civil Service Commission. The salary enabled Henry to propose marriage to Belle.

Two years younger than she, Henry had been born in Rumania and immigrated to the United States as a young child. While a student at City College, he had helped Felix Adler found the downtown Ethical Society. He then earned a Ph.D. in philosophy in Europe and returned to the U.S. to work for social reform and industrial justice. Henry and Belle had worked together after the 1911 Triangle Shirtwaist Factory Fire, lobbying in Albany to pass regulations on factory inspection and working hours for women and children. In part due to their work, Assemblyman Al Smith, chair of the Ways and Means Committee, co-sponsored a bill to create the New York State Factory Investigating Commission. Belle and Henry were married on November 22, 1914.

Their joint income enabled the Moskowitzes to afford live-in help, and they employed a nanny, cook, and maid. Belle tried to be home by 5:00 PM for time alone with her children, making them feel loved even though they would have preferred to see her more. "A career is a splendid thing for a mother," Moskowitz believed. "It gives her a wider contact with life . . . through which she can better develop the budding personalities of her children."

In January 1913, Belle had accepted a position as a grievance clerk in the Dress and Waist Manufacturing Association, seeing it as an opportunity to have a real effect on industrial conditions. It was a taxing job, and she was fired that summer for having settled a majority of complaints in the unions' favor. She was rehired in January 1914 as chief clerk, moving up to manager of the labor department two months later. Although she helped arbitrate thousands of disputes, eventually conciliation proved unsatisfactory to both sides; unions and manufacturers gave up settling complaints through the grievance sys-

tem, and Belle Moskowitz left for good in the fall of 1916. She would later use her hard-won experience in resolving conflicts by creating mixed boards of representatives in her political career.

Moskowitz made her only attempt to run for public office shortly before her marriage in 1914. Endorsed by the progressives as state representative to the New York State Constitutional Convention, she finished ninth out of fifteen candidates. Family and personal illnesses sidelined her for a time. Three attempts to have children with Henry ended in miscarriage or the death of the child soon after birth. In 1916, she joined the Women's City Club of New York as a charter member, and organized Mayor Mitchel's Committee of Women on National Defense to coordinate war-related activities of women's groups. The network of powerful women she contacted through these activities became part of the power base she formed to support Smith and the state Democratic Party.

Al Smith, who came from a Catholic, mostly Irish, family, had left school after the eighth grade to help his widowed mother support the household. The Tammany Hall Democratic Club served as a surrogate parent, offering Smith a job as a process-server for the Commission of Jurors. In 1903, Smith was elected to the State Assembly, where he served for 12 years. Hard work earned him increasingly important committee assignments. Through his interest in labor issues, he became vice-chair of the Factory Investigating Commission. He then was elected sheriff of New York County, and, in 1917, president of the Board of Aldermen. In 1918, he was nominated by the Democratic Party for governor.

It was the first election in New York open to women voters, who had won suffrage the year before. An Independent Citizens Committee for Alfred E. Smith, comprised of professionals, lawyers, and reformers, one-third of them women, included Belle Moskowitz. She suggested a Women's Division to address the "social interests" of women and was put in charge. The end of the war seemed to Moskowitz an opportunity for new beginnings, and after Smith won the election she and *Frances Perkins presented Smith with a plan for a Reconstruction Commission. A blue-ribbon commission of experts, which included Democrats, Independents, and even Republican federal office-holders, it was set up to deal with the state's social, political, and economic problems. Smith named her the commission's executive secretary, and she chose Robert Moses as chief of staff. Although the Republicans in the legislature voted down the com-

mission's funding, fearing it would get Smith re-elected, private funds were raised. Moskowitz organized and coordinated all 11 committees and their reports, released in 1919 and 1920, which defined Smith's future programs in labor, public health, and government reorganization. Not coincidentally, they reflected many of Moskowitz's ideas about the relationship between society and government.

Belle Moskowitz enjoyed the use of power, but she was not personally ambitious. Like *Eleanor Roosevelt, Frances Perkins and other women, she was interested in politics not to advance her own career but to promote an agenda. She turned down offers of official posts, which made her more effective as Smith's strategist-at-large during his rise to power but left her adrift when his fortunes declined. Her self-effacing behavior protected Smith from criticism of "petticoat government," and was also in keeping with her traditional beliefs about male and female roles. Perkins, who worked closely with them both, noted: "Belle arranged things so that when they went before Al, it was so logical to make the decision that she'd already told you would be made . . . as though it were something that he had thought of." With women, however, she was more forthright about claiming power. Politicians and editors learned to come to her first, although New York political reporters respected her long-standing rule of never being quoted directly.

Moskowitz suggested programs to Smith, recruited people to implement the programs, and then publicized their success. The reconstruction plan she favored featured the reorganization of state government; industrial justice, including a 48-hour work week for women; and quality-of-life improvements such as better hospitals, low-cost housing, the state park parkways system promoted by Robert Moses, and an education policy to raise teachers' salaries and equalize schools across the state. Although Smith was defeated after his first term in 1920, he would be re-elected in 1922, 1924, and 1926, partly because of the popularity of reconstruction.

Moskowitz contributed to public acceptance of Smith's campaign for reform through innovative public-relations techniques. She was one of the first to recognize and develop the potential of public relations, beginning with her exhibits at the Education Alliance and continuing with staged events to promote her legislative agenda. To publicize Smith's reconstruction plan, she pioneered the use of film. In 1921 and 1922, while Smith was out of office, he worked on a plan for a Port Authority to serve New York and New Jersey. Moskowitz directed the publicity campaign for this plan as well, producing a film to show how the Port Authority would bring food more quickly to market. She also worked closely with women's groups to get Smith re-elected governor in 1922, and later to pass his legislative program though the Assembly. As the only person devoted full-time to his political success, she accepted the position of publicity director of the Democratic State Committee, and helped build a strong Women's Division, of which Eleanor Roosevelt was an important member, to campaign extensively throughout the state every year. In 1924, and especially in 1928, Moskowitz would work for Smith's nomination and election as president.

Alfred E. Smith was already a strong contender for the presidential nomination in 1924. Franklin D. Roosevelt, recovering from losing the use of his legs after a bout with polio, directed the preconvention campaign, while Belle Moskowitz dealt with publicity. She worked closely with women delegates to the Democratic convention, who now made up almost 14% of the total. FDR's rousing nomination speech was generally considered to have helped him more than Smith, who deadlocked with former President Woodrow Wilson's son-in-law, William Gibbs McAdoo. In desperation, the convention finally nominated the former ambassador to Great Britain, John Davis, who proved a lackluster candidate.

By 1927, Moskowitz considered the political situation auspicious. Smith had few rivals, and Southern Democrats knew they needed a candidate from the populous Northeast to win. She participated in strategy sessions as well as in publicity work, urging Smith to discuss openly the issue of his religion. She did not regularly meet with the "War Board" of men promoting Smith's candidacy, although she frequently consulted with a small inner circle drawn from the same group. Her source of power was her index of every person who had ever sent Smith a supportive letter; with this list, she cultivated contacts in the West and handled publicity about Western support in a way which made Smith appear unbeatable. Her strategy for California, where McAdoo was still strong, overrode a recommendation made by the War Board and helped Smith win the primary there.

After Smith's nomination, he chose John J. Raskob as chair of the Democratic National Committee (DNC), although Moskowitz and long-time advisor Joseph Proskauer opposed him. She also did not work well with Franklin Roo-

sevelt, the gubernatorial candidate for New York. Moskowitz was in charge of publicity, sending out daily press releases to 2,700 newspapers, arranging interviews, and working on Smith's speeches as well as on the DNC campaign handbook. She did not travel much outside of New York, and was not sensitive to attitudes in other parts of the country, which may have limited her effectiveness. More than that, however, Smith's liberal, provincial New York, anti-Prohibition demeanor was not appealing to voters in the conservative 1920s, and Smith was defeated, receiving 15 million votes to more than 21 million for Herbert Hoover. However, in an interview which appeared in the *New York Telegram* at the end of 1928, Moskowitz predicted that "unemployment may spread. . . . And hunger would bring a new interest in progressive ideas."

Moskowitz had hoped that FDR, now governor of New York, would hire her as his private secretary, as Smith suggested. But Roosevelt had Eleanor to advise him, and said he needed a strong man to lean on in public. Moskowitz opened her own public-relations firm, Publicity Associates, through which she earned far more than she had ever before. She also made writing and speaking engagements for Al Smith to keep him in the public eye. He allowed his name to be put forward at the 1932 Democratic convention, ostensibly in the interest of an open convention, but most Democrats wanted the party to unite behind the man most likely to win back the White House, Franklin Delano Roosevelt. Many of Roosevelt's New Deal policies would be based on the progressive programs he had inherited as governor of New York from Smith and Moskowitz.

On January 2, 1933, 55-year-old Belle Moskowitz died from complications following a fall on the steps of her house. Her death doomed Al Smith's efforts to remain a player on the political scene and ended an extraordinary alliance. In addition to the ethnic, religious, and cultural differences between them, there had been the difference in gender. Belle's granddaughter and biographer, **Elisabeth Israels Perry**, observed, "No male politician had ever relied so heavily on the advice of a woman outside his family." Smith posthumously paid tribute to the keenness of Belle Moskowitz's mind and its "ability to get at the essentials of a complicated question and to explain it briefly and simply," as well as to her tremendous capacity for work. Her obituary in *The New York Times* noted that during Al Smith's ascendancy in the Democratic Party, Belle Moskowitz "wielded more political power than any other woman in the United States."

SOURCES:
The New York Times (obituary and editorial). January 3, 1933.
Perry, Elisabeth Israels. *Belle Moskowitz: Feminine Politics and the Exercise of Power in the Age of Alfred E. Smith*. Oxford University Press, 1987.

COLLECTIONS:
Personal papers at Connecticut College, New London.

Kristie Miller,
author of *Ruth Hanna McCormick: A Life in Politics 1880–1944*,
University of New Mexico Press, 1992

Mosley, Diana (b. 1910).

See Mitford, Diana.

Mosson, Louise Berta (1884–1962).

See Hanson-Dyer, Louise.

Moszumanska-Nazar, Krystyna (1924—)

Polish composer and pianist who wrote numerous pieces for orchestra and chamber orchestra. Born in Lwow on September 5, 1924; president of the Cracow section of the Union of Polish Composers from 1962 to 1971.

Krystyna Moszumanska-Nazar studied composition under S. Wiecowicz and piano under J. Hoffman at the State Music College in Cracow. In 1964, she was appointed to the faculty of that same institution, eventually becoming a professor of composition and vice-rector. She also presided over the Union of Polish Composers in Cracow. Moszumanska-Nazar wrote extensively for orchestra, chamber orchestra, and piano. Her compositions were featured at international festivals of contemporary music throughout the world, and she also received numerous awards for her work, which has been characterized as densely dissonant in harmony.

John Haag,
Athens, Georgia

Mota, Rosa (1958—)

Distance runner who was the first Portuguese athlete to become a world champion in an Olympic sport and won the gold medal for the marathon at the 1988 Seoul games. Born on June 29, 1958, in the northern town of Foz do Douro near the city of Oporto, Portugal.

Won the Olympic bronze medal for the marathon at Los Angeles (1984); won the Olympic gold medal in the marathon at Seoul (1988).

Rosa Mota was born on June 29, 1958, in the northern Portuguese town of Foz do Douro

near the city of Oporto. At 14, she began running, mainly "for my health and to have fun," she said. Even when Mota became an athlete of international stature, she tried to run for pleasure. She gained national prominence as a teenager by winning the Portuguese championship for both the 1,500 and 3,000 meters in 1975 and 1976. In the process, she established a new national record for the 3,000 meters and then bettered it six times.

Physically stronger by the early 1980s, she began devoting herself to longer races, including the marathon, and quickly became a star on the international marathon circuit. She won the European championship in 1982, finished third in the Los Angeles Olympics behind front-runner *Joan Benoit Samuelson, triumphed in the 1987 World championship, and won the gold medal at the 1988 Seoul games. In so doing, she became the first Portuguese athlete to win a medal at the Olympic games and the first Portuguese woman to win the gold. Mota won the Boston marathon three times and was twice named Female Runner of the Year by *Runner's World*. From 1987 to 1991, she was the dominant female marathoner in the world. Her stature and winnings allowed her to move to Boulder, Colorado, a training center for many world-class athletes. One of the favorites to win the women's marathon in the Barcelona Olympic games, she failed to win a medal.

Mota's races often entailed detailed strategy in addition to her superb physical conditioning. For the 1988 Olympic Games, for example, she and her longtime coach and companion, José Pedrosa, studied the course and picked a precise point at a down-slope less than three miles from the finish where she was to burst from the pack of lead runners. During the race, Mota followed the strategy perfectly, breaking away from Australian **Lisa Martin** and East German **Katrin Dörre** to win the gold medal.

Her achievements did not come without impediments. When Mota began running as a youth in Portugal, people did not know how to react to a young woman running alone in the streets. Men jeered her and told her she ought to be "at home doing the housework." Even after she became an international star, the Portuguese track-and-field federation tried to control her racing. The marathon is so draining that to stay in top form a runner can participate in only a few races each year. Strong-willed, Mota set her own racing schedule and sometimes did not include the Portuguese or European championships, preferring to concentrate on events of

more prestige or bigger prizes. On occasion, the Portuguese federation threatened not to sanction her participation unless she cooperated by running in events they stipulated. In 1987, for example, the federation suspended her for four months and reprimanded her. Stated one Portuguese functionary in the federation's defense: "In any country an athlete has to represent the nation when called to do so." Nonetheless, Mota eventually prevailed in such disputes.

Barely over five feet tall and weighing around 100 pounds in her athletic prime, Mota refused to judge her races by the clock: "I don't measure my races by fastest times but by my effort." Rather than running against the clock, she instead competed with other athletes and with her own physical condition. "For me," she said, "medals are more important than times. Because medals stay forever. Times change." She attempted to achieve the maximum performance possible on a given day and course rather than worry about setting world records in the marathon. Thus, she was satisfied with a slow time in adverse weather or course conditions if she had raced wisely and competed at a peak level. Further elaborating on her approach to running, Mota noted: "I always try to run an easy pace. I like to finish strong. I don't like to finish tired. I never finish and think I can't do more. I like to think I always have more in me."

SOURCES:

Bloom, Marc. "Gold on Bronze," in *Runner's World*. March 27, 1992, p. 20.

Jolliffe, Jill. "Rosa Mota: Distance Runner Tackles A Marathon of Disputes," in *The New York Times Biographical Service*. August 1988, pp. 934–935.

Williams, Katy. "Running at the Mouth," in *Runner's World*. November 25, 1990, pp. 86–91.

Wischnia, Bob. "Rosa Mota," in *Runner's World*. February 26, 1991, p. 83.

Kendall W. Brown,
Professor of History, Brigham Young University, Provo, Utah

Motley, Constance Baker (1921—)

African-American lawyer, politician, and judge whose actions and decisions furthered the cause of civil rights in America. Name variations: Constance Baker; Connie Motley. Born in New Haven, Connecticut, on September 14, 1921; daughter of Willoughby Alba Baker and Rachel (Huggins) Baker; attended Fisk University, 1941–42; transferred to New York University, graduating 1943; entered Columbia Law School, 1943, graduated, 1946; married Joel Motley, in 1946; children: one son, Joel Jr.

Member of the NAACP Legal Defense and Education Fund (1946–63); member of the New York State House of Representatives (1964–65); Manhattan

Borough president (1965–66); Federal District Court Judge (1966—).

At age 17, while attending a lecture on the Supreme Court's ruling in the case of *Gaines* v. *the State of Missouri*, Constance Baker Motley was struck by the implications of this first civil-rights case to be heard by the Court in the 20th century. The case had concerned an African-American man by the name of Gaines who had applied for admission to the University of Missouri's all-white law school. The university, having refused him admission, had offered to pay his tuition at any out-of-state law school which would accept him. Such a proposal was a strategy used by many Southern universities at the time in an effort to meet the mandates of a federal "separate-but-equal" doctrine requiring all states to provide equivalent educational opportunities to both blacks and whites. Gaines had challenged the constitutionality of the university's actions, and the Supreme Court had ruled that all states must provide comparable educational opportunities *within their own borders*. Motley learned that while the case itself was not monumental, it nevertheless represented the possibility that the 14th Amendment's "equal protection" clause might be further applied to the issues of racial inequality in America. On that day in the late 1930s, Motley determined that she wanted to become a lawyer to personally facilitate such an application.

Born Constance Baker in 1921, one of 12 children in a family of limited means, Motley knew that it would not be easy for her to get to college. Her father was a cook at Yale University in New Haven, Connecticut, where Constance had been born, and his salary could hardly cover the daily expenses of maintaining such a large family, let alone the expense of a college education for even just one of his children. Undaunted, Motley graduated from high school and decided to work for a year, in the hopes of earning enough money to pay at least part of her college tuition. She would still have to receive a scholarship to make her dreams a reality, but as a bright and inquisitive student with an outstanding record of high school achievement, she felt certain that such a scholarship could be procured.

But 18-year-old Motley immediately encountered the insidious racial prejudice of the North. Noticing an advertisement for a dental assistant's position requiring no previous experience, she phoned the dentist and, after speaking with him, was enthusiastically asked to come to his office for a formal interview. Motley set out post-haste for the office, which was just three blocks away, and upon her arrival was met by a startled dentist who informed her that the position had been filled. Hurt, but not surprised, she eventually found a job with the National Youth Administration in New Haven.

Motley had been working for 18 months when she decided one evening to attend a meeting at the community center in Dixwell, a section of New Haven which was populated largely by African-Americans. The center's benefactor was Clarence Blakeslee, a wealthy white industrialist. He and the other members of the center's board were concerned by the lack of interest which the residents of Dixwell had been exhibiting in the community center, and they raised the question of why the apathy was so prevalent. Motley rose to her feet and suggested that it was because the black members of the community had not been given any responsibility for running the center; every member of the board of directors was either a white administrator from Yale or a white entrepreneur from downtown. The African-American residents of Dixwell, she asserted, could hardly be expected to take an interest in something which did not really belong to them.

Blakeslee was intrigued by Motley's assertiveness and by her astute observations. The next day, he sought out her identity, and, upon learning that she had been an honor student in high school, he telephoned her and made an astounding offer. It was his wish, he told her, that she be properly educated, and he was prepared to pay all of the costs of her education, both in college and in graduate school.

Motley decided to pursue at least part of her education in the South. Her understanding of what it meant to be black in America had been severely restricted by the fact that she had lived only in New Haven and had traveled very little outside of the state of Connecticut. She researched her options, and, after having read that Fisk University was one of the best black colleges in the country, decided to move to Nashville, Tennessee.

Her own parents had been immigrants from the Caribbean island of Nevis, and Motley had known only working-class African-Americans. At Fisk, however, she met middle-class African-American students whose parents, and sometimes even grandparents, had enjoyed the benefits of a college education. Her peers were the offspring of doctors, lawyers, teachers, and business people, and Motley developed a deep belief in the power of education to uplift the African-American community.

Constance
Baker
Motley

She also encountered in the South a white hostility toward African-Americans which she had never experienced in the North. Motley was familiar with the type of people who would refuse to hire blacks or even to live in the same neighborhood with them, but before she moved to Tennessee, she had never encountered the type of people who essentially saw blacks as being anthropologically and biologically inferior to whites. On her first visit home, she brought a "colored only" sign with her to show her parents; to her, Southern attitudes were so amazingly ridiculous that she did not think anyone from New Haven would believe her without proof. It was the Southern white attitude toward blacks which in part influenced her decision to transfer to New York University after having spent just 15 months at Fisk.

It should be noted that these 15 months spent in Nashville comprised half of her entire undergraduate career. Acutely aware of the time lost between high school and college, Motley attended summer classes to make up for it and was able to complete her degree in just two and a half years. After graduation in 1943, she attended Columbia Law School for the next three years, graduating in 1946. She married Joel Motley, who entered the real estate business, shortly thereafter, and took up a full-time posi-

tion with the NAACP Legal Defense and Education Fund. She was the first woman to join the Defense Fund, which at that time included just three other lawyers: Robert Carter, Edward Dudley, and Thurgood Marshall, who in 1967 would become an associate justice to the Supreme Court. The Defense Fund was, and still is, widely regarded as being the legal arm of the civil-rights movement. Anthony Lewis of *The New York Times* has called it "the creator of race relations law," since the Fund's lawyers have, over the years, "framed most of the civil rights cases that gave concrete meaning to the Constitution's generalities."

I don't believe anyone else could have survived two and a half years of Mississippi courts.

—**James H. Meredith**

Throughout the 17 years that she served on the Defense Fund, Motley participated in some of the most groundbreaking cases in civil-rights history. Beginning in 1947, she helped to formulate an argument for Herman Sweatt in his case against the University of Texas. An African-American, Sweatt had applied to the University of Texas Law School. In compliance with the 1938 Supreme Court ruling that a school could not force a black student to get his education in another state, the University of Texas had created a separate law school for Sweatt in the basement of a building in Austin. Motley and other members of the Defense Fund argued that the university could not possibly provide Sweatt with an "equal" education under such circumstances, since the ability to discuss with one's peers the dynamics of the law was an essential part of any legal education. In 1950, the Supreme Court agreed with the Defense Fund, stating that the white law school "obviously possessed to a far greater degree those qualities which are incapable of measurement but which make for greatness in a law school."

Motley also participated in the preparation of the historic *Brown* v. *Board of Education* case, which in 1954 effectively declared unconstitutional many of the segregationist policies of the Jim Crow South. This case exemplifies the fact that the Supreme Court is not bound by precedent, even precedent set by the court itself. Segregation had been declared viable by the Court in 1896, as a consequence of the *Plessy* v. *Ferguson* case. Homer Plessy, a man who was one-eighth African-American, had challenged the constitutionality of a law under which he had been arrested for entering a "white-only" railway car in Louisiana. The Supreme Court ruled that Plessy's argument was based on the "underlying fallacy"

that the "enforced separation of the two races stamps the colored race with a badge of inferiority." The doctrine of "separate but equal" was thus permitted to rule the South unrestrained well into the 20th century.

In an argument articulated by Thurgood Marshall and researched in part by Constance Baker Motley, the NAACP Legal Defense Fund called upon the Court to reevaluate its decision in the *Plessy* case. *Brown* v. *Board of Education* involved a fourth-grader named *Linda Brown, who had been denied admission to an all-white elementary school near her home in Topeka, Kansas, on the grounds of "separate but equal." Marshall, Motley, and other members of the NAACP's legal defense staff argued that in the area of education, "separate" necessarily connoted "unequal." The problem was not simply one of inadequate facilities for black children; that situation could, and had been, remedied in many school districts. The problem was that segregation had been shown to have a detrimental effect upon black children, in that it instilled in them a sense of inferiority. This sense of inferiority, in turn, inhibited the children from realizing their full potential as adult citizens. Noting that the 14th Amendment denied any state the ability to "abridge the privileges or immunities of citizens in the United States," the Defense Fund argued that segregation in public schools effectively amounted to a violation of the 14th Amendment. In 1954, the Supreme Court agreed.

For the next ten years, Motley would work tirelessly to ensure that the Court's decision was implemented. She represented elementary-level children in twelve Southern and three Northern states; she defended civil-rights leaders such as Ralph Abernathy and Martin Luther King, Jr., when they were arrested for demonstrating in Birmingham and Selma; and perhaps most notably, she defended James Meredith in his historic case against the University of Mississippi.

Meredith's case was brought in response to a staggering array of hurdles which the University of Mississippi had constructed to prevent his admission, despite the Supreme Court's recent ruling against segregated schools. His initial application for transfer had been denied on the grounds that it had been submitted on January 31, 1961, and that the school, in its own words, had found it necessary "to discontinue consideration of all applications . . . received after January 25, 1961." Meredith appealed to the NAACP, and Motley was assigned to the case.

Motley's first tactic was to have him reapply, after she had checked his application to en-

sure that it properly met every requirement. There was one requirement which Meredith was not going to be able to meet: six letters of recommendation from Ole Miss alumni. He did not know any graduates from the all-white institution, so he submitted six letters of reference from members of his black community instead. Motley assured him that this "recommendation hurdle" had already been mounted in a decision handed down in Georgia, and that he had the power of precedent on his side if Mississippi tried to use it to block his admission.

The university did use it to block his admission, despite the federal court's ruling in Georgia. Additionally, the registrar explained that Meredith's application for transfer was being denied because the institution which he was already attending, the all-black Jackson State College, was not a recognized member of the Southern Association of Colleges and Secondary Schools. The fact that Jackson, as a state school, was governed by the same Board of Trustees that governed Ole Miss seemed to make no difference.

Motley spent a grueling 15 months arguing Meredith's case, and it seemed that the University of Mississippi was not her only foe. The back wall of the courtroom in which she worked was decorated with a mural depicting the glories of the Old South, and each day she was forced to face positive images of slavery which she found to be demeaning and utterly false. Additionally, Judge Sidney C. Mize, who initially heard the case, denied Motley a restraining order which would have allowed Meredith temporary admission to the university's summer session, and he delayed his decision on the case for four months, during which time Meredith's attendance at Jackson State was bringing him closer and closer to graduation. If Motley did not succeed soon in securing Meredith's acceptance at Old Miss, the case would be moot. And, she finally had the reality of the Jim Crow South to deal with. Because the 1954 *Brown* ruling had declared unconstitutional only segregation in public schools, a policy of racial separation was still the norm in all other facets of Southern life. She had a difficult time finding restaurants which would serve her, and, because there were no suitable "colored hotels" in the area, for accommodations Motley was forced to rely upon the good will of African-American residents of Jackson and Biloxi, many of whom had their stores and houses consequently vandalized by whites in the area.

On February 3, 1962, Judge Mize ruled that Meredith's race had not been a factor in the university's decision to deny him admission. Motley appealed the case, and on June 25, 1962, the Fifth Circuit Court of Appeals ruled that "James H. Meredith's application was turned down solely because he was a Negro." The court ordered the university to enroll Meredith—an order which was openly defied by the governor of Mississippi, Ross R. Barnett. When Meredith attempted to enter the school's main hall, a riot erupted which lasted for 15 hours and was quelled only after 23,000 federal troops had been sent to the area.

Motley's career with the NAACP ended in February 1964, when she accepted a position in the New York state legislature vacated by State Senator James L. Watson, following his appointment to the New York civil court. Motley served for the remaining few months of Watson's term and was elected to the position in her own right in November 1964. She was the first black woman to serve in the state legislature, and indeed, at that time, she was the only female member of the entire political body.

It was not long, however, before she was nominated to fill another political vacancy; this time the position was that of Manhattan Borough president. In February 1965, the New York City council voted five to three to offer her the position which had been left vacant by Edward Dudley's appointment to the state supreme court. It has been reported that Motley may have had some misgivings about accepting the position, because she thought that it might interfere with a possible appointment to a federal judgeship. She did accept the position, however, and in fact ran for reelection in September 1965. As borough president, she directed her attention to issues of racism within the parameters of the city, attacking construction unions that practiced blatant discrimination against minorities and personally filing charges against taxi drivers who refused her as a customer because she was black. She also advocated that certain key municipal projects be located in Harlem, in an effort to revitalize the economy of that area.

While Motley was serving as borough president, Senator Robert F. Kennedy nominated her for the position of judge in the federal district court circuit. In January 1966, her nomination was confirmed. Many civil-rights activists were concerned that her ascension to the position would actually constitute a loss for the movement, because she had, as an attorney, shown herself to be vital to the movement's success. Motley allayed these fears by pointing out: "It will help overcome discrimination if the majority of the community has an opportunity to see

Negroes in positions of power and of equality." She added that she could also help the women's rights movement. She lamented that for the bulk of her career, she had been "too busy eliminating discrimination against race to fight discrimination against women."

In fact, some of her decisions have been viewed by many as victories for the women's rights movement. In 1978, she ruled that women reporters should be allowed to enter locker rooms at professional sporting events, thus ensuring that the field of sports broadcasting would be open to women. In 1994, she ruled that Vassar had been guilty of sex and age discrimination when, in 1986, it had denied tenure to Professor **Cynthia J. Fisher** because she was married and a mother.

In October 1995, Constance Baker Motley was inducted into the Women's Hall of Fame in Seneca Falls, New York. In her acceptance speech, she chose to focus not on the plight of women, nor even on the plight of African-Americans. She chose instead to honor Clarence Blakeslee, the man whose initial generosity had made possible her education and thus her career.

SOURCES:

Brenner, Marie. "Annals of Law: Judge Motley's Verdict," in *The New Yorker*. May 16, 1994, pp. 65–71.

Costikyan, Edward. *Politics in the Public Interest*. NY: Harcourt, Brace, and World, 1966.

Duckett, Alfred. *Changing of the Guard: The New Breed of Black Politicians*. NY: Coward, McCann, & Geoghegan, 1972.

Lamson, Peggy. *Few Are Chosen: American Women in Political Life Today*. Boston, MA: Houghton Mifflin, 1968.

Magner, Denise. "Judge Says Vassar Discriminated Against Married Women," in *Chronicle of Higher Education*. May 25, 1994, p. A17.

SUGGESTED READING:

Hunter-Gault, Charlayne. *In My Place*. NY: Farrar, Straus, Giroux, 1992.

Meredith, James H. *Three Years in Mississippi*. Bloomington, IN: University of Indiana Press, 1966.

Maura Jane Farrelly,
graduate student in history at Emory University, Atlanta, Georgia

Motoko, Hani (1873–1957).

See Hani Motoko.

Mott, Lucretia (1793–1880)

*American Quaker minister, abolitionist, and pioneer activist who was one of the first to advocate equal rights for women. Name variations: Lucretia Coffin Mott. Born Lucretia Coffin on January 3, 1793, on Nantucket Island, Massachusetts; died on November 11, 1880, at Roadside, Pennsylvania; daughter of Thomas Coffin Jr. (a sea captain and merchant), and Anna (Folger) Coffin; sister of *Martha Coffin Wright (1806–1875); attended private Quaker schools, and one year of public school; secondary education at Nine Partners, a Quaker boarding school in Dutchess County, New York; married James Mott, Jr., on April 10, 1811; children: Anna Mott; Thomas Mott (d. 1817); **Maria Mott**; Thomas Coffin Mott; Elizabeth Mott (d. 1865); Martha Mott.*

Appointed assistant teacher (1808); officially recognized as Quaker minister (1821); became a "Hicksite" (1827); organized female anti-slavery society in Philadelphia (1833); helped organize First Anti-Slavery Convention of American Women (1837); appointed delegate to World Anti-Slavery Convention in London (1840); helped organize first Woman's Rights Convention, Seneca Falls, New York (1848); served as president of American Equal Rights Association (1866–68); was president of Pennsylvania Peace Society (1870–80).

On Saturday, January 2, 1943, while America was in the midst of the Second World War, a celebration was held at the U.S. Capitol, organized not to rejoice over an important military victory but to honor the memory of Lucretia Mott on the weekend marking the 150th anniversary of her birth. Bands played and vocalists performed, and members of Congress joined with representatives of women's groups from around the world in offering praise for the life work of the abolitionist and Quaker minister who had been a champion of women's rights. **Anna Kelton Wiley** of the National Woman's Party, crediting Mott as the inspiration behind the 19th century woman's movement, described her as "A woman of saintly character and wide generosity to all suffering mankind, [yet she was] spoken of by the bigoted, ignorant and prejudiced of her time as an infidel, a heretic, and a disturber of the peace."

Lucretia Coffin Mott was born on Nantucket, an island about 30 miles south of Cape Cod, Massachusetts, in 1793, when whaling was the island's prime industry. Her father Thomas Coffin, Jr., was the captain of a Nantucket whaling ship and a descendant of Quakers who had settled on the island to avoid religious persecution in the 17th century. Her mother **Anna Folger Coffin** was also descended from the island's early Quakers, including Peter Folger, the grandfather of Benjamin Franklin.

Mott was the second child and second daughter, but since her older sister suffered from an undisclosed handicap—possibly mental—she

was given the responsibilities of eldest daughter as the family increased to a total of seven children. As captain of a whaling vessel, Thomas Coffin was away from home for long periods of time, and left his wife with power of attorney, in charge of the household and its economy. Although Anna Coffin's responsibilities were greater than those held by many women of the era, the shipping and whaling culture of Nantucket resulted in more than the usual trust being placed in the hands of its women. The role models she saw in her mother and other local women helped to build Mott's confidence in her own abilities.

In the early years of Mott's life, her family was financially comfortable. But around 1802, while sailing off the west coast of South America, Thomas Coffin was involved in a dispute with some Spaniards and was forced to leave his ship, *The Trial*, at Valparaiso. Although he eventually found passage home, arriving after an absence of almost a year, the incident put an end to his whaling career. In 1804, the family moved to Boston, where Thomas prospered as a merchant, and within two years he bought a comfortable brick home for his family. Nantucket remained dear to Mott's heart, and she returned there many times, introducing her children and grandchildren to the home of her youth.

On Nantucket, Lucretia had attended a Quaker-run school. In Boston, the Coffin children went first to a private school, which Thomas found snobbish and undemocratic, and later to public schools. When Lucretia was 13, she enrolled in Nine Partners Boarding School, a Quaker academy near present-day Poughkeepsie, New York, where boys and girls lived in separate quarters and attended separate classes. She excelled at her studies, and after two years was made an assistant teacher and offered a permanent staff position. When she joined several other teachers sharing lessons in French, she became better acquainted with a fellow staff member, James Mott, Jr., the grandson of the school superintendent. At about this time, Lucretia was shocked to learn the extent of the inequities in the salaries of male and female staff members when she found that James' income was significantly higher than that of the more experienced assistant principal, **Deborah Rogers**.

In 1809, Thomas Coffin embarked on a new business venture in the cut-nail industry, and moved his family to Philadelphia, then the nation's largest city. Having completed her schooling, Lucretia moved with the family, and James Mott, Jr., who had become her suitor,

soon gave up teaching to accept a position in Thomas Coffin's firm. The couple were married in a Meeting of Friends on April 10, 1811, and spent the next few months in the home of Lucretia's parents before settling into a modest home of their own.

In the economic depression that followed the War of 1812, both the Coffin and Mott households were vulnerable to financial instability. The cut-nail business was a failure; James Mott was left without a job, and Thomas was left with a loan on which a friend had defaulted. The family was in dire financial stress and faced greater difficulties after Thomas contracted typhus fever and died in 1815, leaving his wife and children to deal with the creditors.

> *If our principles are right, why should we be cowards?*
> —Lucretia Mott

The Motts briefly tried shopkeeping, but were forced to sell that business at a loss. James traveled to New York to work as a bank clerk, but soon returned to Philadelphia where he eventually set up a wholesale business in foreign and domestic staples. Lucretia was by then the mother of a daughter and a son, and in 1817 she began teaching at a Friends' school for girls to help maintain the family's income. That year both Lucretia and her son Thomas became ill with high fevers, and Thomas died. The following year, a third child, **Anna Mott**, was born, bringing an end to Lucretia's brief return to teaching.

The loss of her son caused Lucretia tremendous emotional pain, and she sought relief through religious readings and reflection. One day in a Friends' Meeting, she was moved to express herself with a simple offering of prayer, and the sympathetic encouragement she received led her to speak often. By 1821, she was officially recognized as a Quaker minister. This was an unusual honor for a woman as young as Lucretia, but she was gifted with a pleasant, clear speaking voice and the ability to present her thoughts with sincerity, using logical, simple language. Before long, however, she became a controversial figure, taking advantage of her position to challenge Quaker rules of discipline she believed to be unfair. One of the first rules against which she spoke was that against marriage to those outside of the religion. The rule required members of the Society of Friends who married non-Friends to be disowned, and even subjected parents of the errant newlywed to disownment for allowing the marriage.

Mott's family continued to grow. Like most women of her time, she altered and mended clothes to keep expenses low, but she also found time to read. Never one to doubt the abilities of her gender, she was particularly impressed by *Mary Wollstonecraft's *Vindication of the Rights of Woman*, first published in 1792, and fully agreed with the ideas of this early advocate for women's rights.

One burning issue then growing increasingly controversial was slavery. Throughout her life, Mott had opposed the institution of slavery, and during the 1820s it bothered her conscience that her husband, by then moderately successful as a wholesale merchant, was profiting over the handling of cotton. James was a member of the Pennsylvania Abolition Society, but the pressure of supporting his family seemed to leave him with no choice but to continue doing business with the slave-holding cotton growers of the South. By 1830, Mott had discontinued use of any products associated with slavery, and her husband yielded to his own conscience as well as to pressure from his wife, ceasing all dealings in cotton in favor of wool.

In the 1820s, issues were also tearing at the Society of Friends. Many members, including Mott, were disturbed by the growing power of the wealthy Philadelphia Quaker elders. The problem came to a climax when the elders decided to discipline an aged Quaker minister, Elias Hicks, for preaching heresy. Hicks had a large following as a preacher of fiery sermons that criticized both slavery and the new evangelicalism growing fashionable among some Friends, whom he believed were losing the true spirit of the religion. In 1827, the Society of Friends split over the controversy between the elders and Hicks. The Motts took Hicks' side, joining the group referred to as "Hicksites," and were forced to leave Lucretia's beloved Twelfth Street Meeting. Their choice also led to feuds within her own family.

The new Hicksite branch of Friends was eager for Mott's ministering talents, but her role as a mother kept her in the Philadelphia area. The birth of **Martha Mott**, the last of her six children, at the height of the controversy in 1828, allowed Lucretia to avoid active participation in the debate over the Hicksite-orthodox schism. A few years later, however, she began to journey to outlying areas of Pennsylvania and New Jersey, where the Quaker conflict was especially fierce, to speak strongly for the Hicksite camp. In the 1830s, she served for five years as a clerk to the Women's Yearly Meeting, was treasurer for two years, and participated in a variety of the society's activities.

In 1830, the Motts met William Lloyd Garrison, an abolitionist who believed in the immediate emancipation of the slaves. This stand was in conflict with the ideas of the gradualists, who believed that the abolition of slavery should be dealt with slowly. Garrison also disagreed with the Colonization Society, which proposed transporting blacks back to Africa and compensating slaveholders for the loss of their "property." Garrison appealed to the Motts for assistance in spreading his militant message in favor of speedy emancipation. The couple offered their home for meetings and arranged for Garrison to speak. Mott also took the then-radical step of inviting both men and women to participate in the gatherings.

In December 1833, Mott organized a female anti-slavery society in Philadelphia, one of the first women's political groups in the country. At its first meeting neither Mott nor any other woman felt capable of leading the group, and a man was asked to serve as chair. By the second meeting, however, the women had gained enough confidence to proceed on their own, with Mott taking a leading role. Most in the group were Quakers, but there were some Presbyterians and Unitarians, and several middle-class black women, a fact that the majority of Philadelphians found shocking. The membership grew rapidly to about 60 women.

By the mid-1830s, opposition to the anti-slavery movement, in particular those favoring immediate emancipation, was growing violent, as those sympathetic toward slavery feared the gains being made by the abolitionists. In several Northern states, including Pennsylvania, mobs destroyed businesses and homes of both blacks and abolitionists, and during a visit to Delaware Mott had stones thrown at her carriage. The Society of Friends tried to bar discussions of slavery from their meetings for fear of the discord it aroused, but Mott insisted on speaking on the subject as she traveled to Meetings as far away as Connecticut.

In 1837, with the help of Garrison supporter ◆ **Maria Chapman**, Lucretia organized the First Anti-Slavery Convention of American Women, in New York City, followed by a second convention in Philadelphia the following year. Because officials were reluctant to rent meeting halls to abolitionists for fear of the property being destroyed, Lucretia and her husband led a fund-raising campaign for the building of Philadelphia Hall, which was completed in time for the 1838 convention. The Motts routinely entertained abolitionists, and their own family had expanded to include sons-in-law and grand-

Chapman, Maria (1806–1885). See Grimké, Angelina E. for sidebar.

children by 1837, when they purchased a spa-
cious home with a dining room that could seat
50. Lucretia still did not forget the less fortunate
members of society, however, and beggars knew
they could always find food at her door. In the
1840s, she would join other Philadelphia

women in founding the Association for the Re-
lief and Employment of Poor Women.

During the Philadelphia convention rumors
abounded regarding the abolitionists' intentions.
The new idea of "woman's rights," promoted by

many, added to the ferment surrounding the issue of emancipation, and the public came to see the abolitionists as radicals intent upon destroying society's institutions. Workers had visions of losing their jobs to blacks, and many people worried about the destruction of the family unit if women were granted equality, as well as the upheaval that might result from interracial marriages. Mobs gathered outside the convention hall, threatening the proceedings, and following the fourth day of the convention the mob burst open the locked doors and set the hall on fire, burning it to the ground. When the rioters appeared set on finding new targets, a quick-thinking friend saved the Motts' home by yelling out, "On to the Motts!" and pointing in the wrong direction.

Despite the mob's terrifying actions, the abolitionist women did not falter in the fight for their cause. The final session of the convention was held in a schoolhouse. But the determination of women to speak out against slavery was increasing tensions among the abolitionists over the "woman question." In 1840, the American Anti-Slavery Society split into two factions, largely over the issue of the role of women within the organization.

In the summer of 1840, Lucretia and James Mott were on their way to London as delegates from Pennsylvania to a World Anti-Slavery Convention when the American Anti-Slavery Society they represented suffered a permanent split. Those remaining with William Lloyd Garrison, a supporter of women's rights, became known as the Old Organization, and the splinter group became the New Organization. Mott became the Old Organization's delegate to the national committee and a member of the executive committee, which was recognition of her role as America's leading female abolitionist.

In London, a debate soon ensued over whether women should be allowed to sit among the convention delegates. Despite some support among American leaders and two Englishmen who disagreed with their fellow countrymen, an overwhelming majority voted to exclude the female delegates from the convention proceedings. For Mott, a second serious disappointment occurred when she was treated rudely on behalf of British Quakers as a result of her alliance with the Hicksites. British Quakers had sided with the orthodox Friends during the time of the schism, and continued to view Hicks' supporters as heretics. Nevertheless, Mott's time in Britain was worthwhile. Seated quietly in the galleries during the convention, she made a number of friends, including *Elizabeth Cady Stanton, the young

bride of Henry Stanton, a delegate from the New Organization. In the days that followed, the two women spent hours discussing the injustice of workers devoted to the cause of abolition being denied participation in the deliberations simply because they were women. The action they felt moved to take to promote women's rights began a process that would lead to the 1848 Woman's Rights Convention in Seneca Falls, New York.

During the next several years, Mott's struggle with the Society of Friends over her anti-slavery activities deepened. The elders, angered by her occasional sermons in Unitarian churches, questioned whether her theology was not more Unitarian than Quaker. Although her adversaries did not have sufficient grounds to disown her, they made her ministry difficult by turning her away from meetings or ordering her not to speak. Many were disturbed by her reliance on a God-given "inner sense" for guidance rather than on dogma. When she upheld the belief (shared with early Quakers), that every day should be equally a day of worship, and a special day of Sabbath should be eliminated, she was charged with heresy both inside and outside the Society of Friends.

In the summer of 1848, Mott joined Elizabeth Cady Stanton and three other women at a tea party at Waterloo, New York, where they drafted a call for a woman's rights convention to be held at nearby Seneca Falls on July 19 and 20, 1848. Using the Declaration of Independence as a model, they drew up a "Declaration of Sentiments," adapting and paraphrasing the original document to express their grievances. James Mott was chosen to preside over the convention, Lucretia gave the opening address, and Stanton and several other women spoke. Despite her conviction that women and men should have equal status, Mott was shocked when Stanton submitted a resolution calling for women to be granted the right to vote, although she was soon persuaded of the rightness of the step.

Now in her mid-50s, Mott began devoting much of her energy to women's rights. Since the time she had attended Nine Partners, she had wanted to get equal pay for female teachers. She also advocated improved education for women, and their admission into the professions of science and medicine. She called for the repeal of laws giving men control over their wives' personal property, and she championed women's right to vote. She was often heckled by men in the audience when she spoke on these issues, and her speeches were often ridiculed in newspapers, but she persevered. Mott believed that once the women's rights movement got underway she

would be able to devote more time to the anti-slavery movement. But over the next 30 years she was continuously called upon for leadership, by Stanton, *Susan B. Anthony, *Lucy Stone and others in the women's rights movement. Meanwhile, the Motts' home was occasionally a refuge for escaped slaves, and she remained active in the American Anti-Slavery Society.

In 1857, the Motts moved to Roadside, a large country house north of Philadelphia, to lessen some of the demands on Lucretia as a speaker. Despite advancing age and physical weakness, she continued to entertain family and friends. In 1859, when John Brown led a raid on the federal arsenal at Harper's Ferry that was meant to incite a slave uprising, Mott did not see Brown as the hero he became for many abolitionists, but she felt sympathy for his wife, **Mary Anne Brown**, who was given shelter at Roadside throughout the period of John Brown's trial and execution.

Although Mott deplored war, after the Civil War began she believed it should be fought until slavery was ended. She was also a supporter of conscientious objectors, both Quaker and non-Quaker, and in her compassion for blacks she overcame her disdain for the military. When Camp William Penn became a military training center for enlisted blacks, she baked pastries, sponsored entertainments, and acted as a minister to the black soldiers and their wives.

Following the war, in May 1866 Mott was named president of the newly formed American Equal Rights Association. When she presided over the organization again in 1867, the group was divided over the issue of the 14th Amendment. In granting blacks the right to vote, the amendment specified *males* as the legal voters, and feminists believed the amendment should be opposed unless the word *male* was eliminated. Others felt that it was "the blacks' hour," and that they needed the vote to assure they would not be returned to slavery; Lucretia sided with the feminists.

Mott was greatly grieved by the loss of her daughter, **Elizabeth Mott**, who died of cancer in 1865, and by the loss of her husband, who succumbed to pneumonia in 1868. Despite her own frail condition, in May 1868 she again presided over the American Equal Rights Association's annual meeting. Though she continued working for social reforms, much of her attention was now focused on the issue of peace, and she served as president of the Pennsylvania Peace Society from 1870 until her death.

When Lucretia Mott died at age 87 on November 11, 1880, letters flowed into Roadside from across the country, filled with expressions of love. Memorial services were held by churches of varying denominations, peace societies, and the National Woman Suffrage Association, signifying her influence over a large cross-section of American society. Over 80 years after her death, the civil rights movement and the women's movement continued the struggle for equality to which she devoted her life.

SOURCES:

Bacon, Margaret Hope, *Valiant Friend: The Life of Lucretia Mott*. NY: Walker, 1980.

Cromwell, Otelia. *Lucretia Mott*. NY: Russell & Russell, 1958.

Hare, Lloyd C.M. *The Greatest American Woman: Lucretia Mott*. The American Historical Society, 1937, republished St. Clair Shores, MI: Scholarly Press, 1972.

National Woman's Party Papers, Group II. December 1942–January 1943. Washington, DC: Library of Congress.

SUGGESTED READING:

Flexner, Eleanor. *Century of Struggle: The Woman's Rights Movement in the United States*. NY: Atheneum, 1970.

COLLECTIONS:

Correspondence and diaries in Mott Manuscripts, Friends Historical Library, Swarthmore College; another large group is among the Garrison Papers, in Sophia Smith Collection, Smith College, Northampton, Massachusetts.

Correspondence between Elizabeth Cady Stanton and Mott among Elizabeth Cady Stanton Papers, Library of Congress, Washington, D.C.

June Melby Benowitz,
Instructor of American History at Keiser College, Sarasota, Florida

Motteville, Françoise Bertaut de
(c. 1621–1689)

French memoir writer. Name variations: Madame de Motteville; Madame Langlois de Motteville. Born Françoise Bertaut around 1621; died in 1689; daughter of Pierre Bertaut (a gentleman of the king's chamber) and a Spanish mother (who was the friend and private secretary of Anne of Austria); niece of the bishop-poet Jean Bertaut (1552–1611); married Nicolas Langlois, seigneur de Motteville, president of the Chambre des Comptes of Rouen, in 1639 (died 1641).

French memoir writer Françoise Bertaut de Motteville was the daughter of Pierre Bertaut, a gentleman of the king's chamber; she was also the niece of the bishop-poet Jean Bertaut. Her mother, a Spaniard, was the friend and private secretary of *Anne of Austria, wife of Louis XIII. At age seven, Françoise, who by then spoke Italian and Spanish, was also made a member of the queen's household and given a pension of

2,000 livres. The influence of Cardinal Richelieu, however, who wished to separate the queen from her Spanish connections, exiled mother and daughter to Normandy, where in 1639 the young woman was married to the octogenarian Nicolas Langlois, seigneur de Motteville, president of the Chambre des Comptes of Rouen. He died two years later at age 82.

In 1642, Anne of Austria, now the governor of France after the death of Richelieu and Louis XIII, summoned Mme de Motteville to court to become her lady-in-waiting. For 24 years, through all the intrigues and troubles of the Fronde, Mme de Motteville remained devoted to her mistress, eschewing party ties or interests. She was also a friend of *Henrietta Maria of England. Some letters of de Motteville's are preserved—especially a curious correspondence with "La Grande Mademoiselle" (*Anne Marie Louise d'Orleans, duchess de Montpensier), on marriage, but her chief work is her *Mémoires pour servir à l'histoire d'Anne d'Autriche*, which are in effect a history of Anne of Austria, covering events briefly until the date of Mme de Motteville's return to court, and then in complete detail. They give a faithful picture of the life of the court at that time. After nursing Anne of Austria for two years through the terminal stages of breast cancer, Mme de Motteville withdrew to the Convent of the Visitation in 1666 and spent her last years writing on the themes of religion and death.

The best edition of her *Mémoires* is that of M.F. Riaux (2nd ed., Paris, 1891, 4 vols.), containing the essay by Sainte-Beuve from Vol. V of his *Causeries du lundi*. Her memoirs were translated into English in 1726 and again by K.P. Wormeley in 3 vols., 1902.

SUGGESTED READING:

Beaurepaire, Charles de. *Recherches sur Madame de Motteville et sur sa famille*. Rouen, 1900.

Moulton, Louise Chandler

(1835–1908)

American writer and literary hostess. Born Ellen Louise Chandler on April 10, 1835, in Pomfret, Connecticut; died of Bright's disease on August 10, 1908, in Boston, Massachusetts; daughter of Lucius Lemuel Chandler and Louisa Rebecca (Clark) Chandler; attended Christ Church Hall in Pomfret, Connecticut; graduated from Emma Willard's Troy (N.Y.) Female Seminary, 1855; married William Upham Moulton, on August 27, 1855; children: daughter Florence Moulton; one son who died in infancy.

Selected writings: This, That, and the Other *(1854);* Bed-Time Stories *(1874–1880);* Some Women's

Hearts *(1874);* Poems *(1877);* Swallow-Flights and Other Poems *(1878);* Random Rambles *(1881);* Firelight Stories *(1883);* Ourselves and Our Neighbors: Short Chats on Social Topics *(1887);* Stories Told at Twilight *(1890);* The Collected Poems of Philip Bourke Marston *(editor, 1893);* Arthur O'Shaughnessy, His Life and His Work, with Selections from His Poems *(editor, 1894);* Lazy Tours in Spain and Elsewhere *(1896);* Poems and Sonnets of Louise Chandler Moulton *(1909).*

Louise Chandler Moulton was born on April 10, 1835, on the family farm near Pomfret, Connecticut. Her parents were stern New Englanders with strong Calvinistic leanings, and although she wanted for nothing materially, Louise had a lonely and somber childhood. Her classmates at Reverend Roswell Park's school in Pomfret, Christ Church Hall, included James McNeill Whistler and E.C. Stedman. Moulton had her first poem published in the daily paper in Norwich, Connecticut, at age 14, and in 1854 a collection of her poems and sketches was published as *This, That and the Other* and sold some 20,000 copies. She completed her education with a year at *Emma Willard's Troy (N.Y.) Female Seminary, and was class poet of her graduating class in June 1855. Six weeks after her graduation, she married William Upham Moulton, the editor and publisher of *The True Flag*, a Boston literary journal to which she had contributed. The couple settled in Boston and had two children, a daughter, **Florence Moulton**, and a son who died in infancy.

During her first year of marriage, Moulton published her second book, *Juno Clifford*, which received praise, and rapidly established herself as an important figure in Boston literary circles. In the years that followed, she published many verses, stories, and sketches in *Godey's Lady's Book*, *Atlantic Monthly*, *Scribner's*, *Youth's Companion*, *Harper's Bazaar*, and other magazines. In 1874, a volume of her narrative sketches appeared as *Some Women's Hearts*, and her children's stories were collected in several volumes of *Bed-Time Stories* (1874–80). Her first book of poetry was published to excellent reviews in 1877. There was a great deal of literary activity in Boston during the 1860s and 1870s, and Moulton became known for her Friday salons, which were frequented by Henry Wadsworth Longfellow, John Greenleaf Whittier, James Russell Lowell, Oliver Wendell Holmes, and Ralph Waldo Emerson. (Moulton was also friendly with such women writers as *Julia Ward Howe, ◄❧ Annie Adams Fields,

Fields, Annie Adams. See Jewett, Sarah Orne for sidebar.

*Sarah Orne Jewett, and *Harriet Prescott Spofford.) In later years, members of Boston's best families also attended these fashionable events, as did foreign celebrities.

In 1870, Moulton became the Boston literary correspondent for the *New York Tribune*, serving until 1876, and worked in the same position for the *Boston Sunday Herald* from 1887 to 1891. She had a sharp eye for talent and was generous with her praise. She did much to introduce American readers to new poets and writers, especially the Pre-Raphaelites and the French Symbolists. After her first visit to Europe in January 1876, Moulton usually spent her summers abroad, and London became her second home. The publication of her poems in England served to reinforce her social standing, and in 1877 in London, a breakfast given in her honor by Lord Houghton was attended by Robert Browning, Algernon Swinburne, George Eliot (*Mary Anne Evans), *Jean Ingelow, Gustave Doré, and William Makepeace Thackeray. She later met other literary giants, including Oscar Wilde and William Butler Yeats. For the next three decades, Moulton presided regally over her weekly salons in Boston for six months of the year and in London for the other six months. Much of her travel during these years was documented in sketches appearing in *Ourselves and Our Neighbors* (1887), *Random Rambles* (1881), and *Lazy Tours in Spain and Elsewhere* (1896). In 1889, another volume of verse, *In the Garden of Dreams*, confirmed her reputation as a poet. Moulton's work was highly personal and sensitive, in keeping with the spirit of the age. Her poems were particularly praised, and many were set to music by contemporary composers.

In her later years, Moulton's dread of aging became obvious, evidenced by a circle of younger and younger friends and her style of dress. Dissatisfied with the Calvinist faith of her childhood, for years she was identified with the Episcopal Trinity Church in Boston, but in her final months she reportedly found comfort in Christian Science. She died of Bright's disease in her Boston home in 1908, and was buried beside her husband in Mount Auburn Cemetery, in Cambridge, Massachusetts.

SOURCES:

James, Edward T., ed. *Notable American Women, 1607–1950*. Cambridge, MA: The Belknap Press of Harvard University Press, 1971.

McHenry, Robert, ed. *Famous American Women*. NY: Dover, 1980.

SUGGESTED READING:

Hart, John S. *Female Prose Writers of America*. 3rd ed., 1857, pp. 532–534.

Louise Chandler Moulton

Higginson, Thomas Wentworth. "Louise Chandler Moulton: An Appreciation," in *Boston Transcript*. August 12, 1908.

Howe, Julia Ward, ed. *Representative Women of New England*, 1904.

Spofford, Harriet Prescott. *Our Famous Women*, 1884.

Whiting, Lilian. *Louise Chandler Moulton, Poet and Friend*, 1910.

COLLECTIONS:

Fifty volumes of Louise Chandler Moulton's correspondence are in the Manuscript Division of the Library of Congress.

Jo Anne Meginnes,
freelance writer, Brookfield, Vermont

Mounsey, Tara (1978—).

See Team USA: Women's Ice Hockey at Nagano.

Mountbatten, Edwina Ashley
(1901–1960)

Countess Mountbatten of Burma who was vicereine of India. Name variations: Lady Mountbatten of Burma. Born Edwina Cynthia Annette Ashley in Lon-

don, England, on November 28, 1901; died on February 21, 1960, in Jesselton, North Borneo; eldest of two daughters of Colonel Wilfred William Ashley, baron Mount Temple of Lee (a member of Parliament), and Maud (Cassel) Ashley; attended The Links School, Eastbourne, Sussex; attended Alde House, Aldeburgh, Suffolk; married Lord Louis Mountbatten, on July 18, 1922; children: Patricia Mountbatten (b. 1924); Pamela Mountbatten (b. 1929).

Born into aristocracy and wealth (much of it provided by her maternal grandfather Ernest Cassel, a German multimillionaire and financial advisor to King Edward VII), Edwina Ashley and her younger sister **Mary** spent their childhood moving among the family residences, usually in the care of a nurse or governess. "Edwina led an unusually peripatetic life," writes biographer Richard Hough. "During her years of infancy a panorama of faces constantly paraded before her—friends and relatives, friends of friends and relatives of relatives—as she was taken, overwrapped like all children of her generation, from Dorset to Wilshire, to Hampshire, to Sussex, to Norfolk, to Yorkshire, and back to 13 Cadogan Square or 32 Bruton Street, London, or to Broadlands." Edwina's father Wilfred, who had desperately wanted a male heir, had little to do with his daughters, and her mother Maud, a delicate consumptive, died in 1911. Edwina accepted her mother's death like a little adult, taking solace in her pets and in caring for her younger sister. In 1914, Wilfred married **Muriel "Molly" Forbes-Sempill**, a woman described by one of Edwina's friends as "most unkind." Lord Mountbatten later called her "a wicked woman." Edwina studiously avoided her stepmother, a task that became easier when she was sent away to school in 1916.

At the exclusive Links School, in Sussex, Edwina suffered taunts from the other girls about her wealth and her German-Jewish heritage. She also struggled with the strict routine and sparse wartime meals. "Please take me away, dear Grandpa, if you love me at all," she plaintively wrote to Cassel, who was the adult she most often turned to during her formative years. With his intervention, she left after a year and was enrolled at Alde House, a finishing school of sorts. She left Alde just short of completing the year's course, and then talked her grandfather into a grand tour of Italy. Upon her return, she went to live with him at Brook House in London, serving on his social staff.

Not yet 20, Edwina already possessed enough charm and intelligence to perform ad-

mirably in her role as hostess of the lavish Brook House dinner parties. "Her conversation was clever and she spoke quickly, often in the form of questions," said one of her contemporaries. "She had this enormous curiosity about life and the world. And you could see she had this determination to succeed." In her off hours, Edwina enjoyed a rich and exciting social life, which culminated in an extravagant coming-out ball. She then joined the "fast set" of debutantes. one of whom, **Grace Vanderbilt**, introduced her to Lord Louis Mountbatten, known as Dickie, a cousin of the British royal family and an officer in the royal navy. A whirlwind courtship ensued, marred only by the death of Louis' father, followed closely by the death of Edwina's beloved grandfather.

The Ashley-Mountbatten nuptials were the highlight of the 1922 social season. Edwina spared no expense in planning the wedding, dipping into the cash reserves left to her by Cassel. A six-month honeymoon rounded out the elaborate festivities and included a tour of the United States, where the couple was received by President Warren Harding and also made an eagerly anticipated trip to Hollywood, where they hobnobbed with such stars as ***Mary Pickford**, Douglas Fairbanks, and Charlie Chaplin. Returning to England, they settled down in a luxurious mansion in Park Lane. While they were in fact a simple military couple, Edwina's large inheritance allowed them to indulge in a few extras, such as a stable of expensive cars, a yacht, an American speedboat, and a string of polo ponies. In 1926, after Louis was appointed to the flagship of the Mediterranean Fleet, they purchased a second house in Malta.

For the first ten years of her marriage, Edwina continued to revel in her inheritance, indulging her desires, be it for material possessions or romantic conquests. Even the births of her two daughters, ***Patricia** and ***Pamela Mountbatten**, did little to slow her, though acquaintances noticed that she frequently seemed dissatisfied. One friend of hers remarked at the time: "For Edwina, there was always something missing. She didn't know what it was or where it was but she was determined to find it."

In 1928, Edwina began an intense period of global travel, which was part of her desire to learn more about people and places. Various trips, usually in the company of a woman friend, took her to Mexico, Guatemala, Honduras, Jerusalem, Damascus, Baghdad, and Tehran. She visited the archaeological digs of Dr. Ernest Herzfeld at Persepolis, and trekked over the Andes and down to the Chilean side. She exam-

ined Inca ruins in Machu Picchu and studied Mayan civilization in the Yucatan. "Edwina's travels were a great mystery to me, and to a good many other men who knew her intimately," said one of her male admirers. "It was as if she wanted to get away from men for a while. She always traveled with women and she always seemed to go out of her way to live 'posh' or very primitively, risking her neck sometimes."

With the outbreak of World War II, Edwina found a true mission in life and underwent nothing short of a transformation. Joining the St. John Ambulance Association in 1939, she quickly rose to the position of Ambulance President for London, Hampshire, and the Isle of Wight. One of her early assignments was to inspect the bomb shelters around London, which held hordes of frightened men, women, and children during the Blitz. She threw herself wholeheartedly into her work, becoming a tireless crusader for improved conditions within the shelters, and often trading on her charm and connections with bureaucrats and officials to expedite matters. In 1941, she traveled to America with her husband, undertaking a tour of the country to personally thank those people and organizations which had aided the British war effort. She traveled in 28 states, making speeches in numerous cities along the way. "She spoke from the heart, and her audiences were moved," said one observer. "Her speeches were unadorned but the men and women who listened to this unvarnished prose learned how the British hospitals and ARP and voluntary societies functioned."

By September 1943, Louis had risen to Supreme Allied Commander in Southeast Asia, and both his and Edwina's war-time activities afforded them little time together, although by this point any intimacy between them was already over. When the liberation of France and Europe began in 1944, Edwina traveled to France, where the Red Cross and the Brigade were charged with inspecting the French and Allied hospitals and recommending future policy. The inspections subsequently took her to northern Europe, Italy, and finally, in 1945, to Southeast Asia. Following the American bombing of Hiroshima, Edwina became part of her husband's

Edwina Ashley Mountbatten

"Operation Zipper," which involved the rescue and recovery of the hundreds of thousands of Allied soldiers from Japanese prisoner-of-war camps. She inspected camps in Rangoon, Bangkok, Sumatra, and Singapore, flying some 33,000 miles in the process and often putting herself in harm's way.

In 1947, her husband was appointed viceroy of India with instructions to negotiate the transfer of power from Britain to the Indian people. Edwina entered the most profound period of her life, which included the beginning of her 14-year relationship with India's prime minister Jawaharlal Nehru, who was her only great love. Edwina, who had fallen under India's spell upon her introductory visit in 1922, first encountered Nehru in Singapore, in 1946, on the occasion of his initial meeting with her husband. At her insistence, Louis, who had fetched Nehru from the airport, made a detour to the YMCA, where Edwina was touring with some of her workers, just so she could meet him. "Lady Mountbatten was flat on the floor when my father and she met in Singapore," wrote Nehru's daughter *Indira Gandhi. "When my father went in everyone rushed and they just knocked her down. So the first thing they had to do, Lord Mountbatten and my father, was to rescue her and put her back on her feet." Edwina met Nehru for the second time on March 22, 1947, when she and Louis arrived at the Palam airport, Delhi, to take over duties as viceroy and vicereine of the country. They now found India besieged by turmoil, "on the brink of inter-racial, inter-religious, and inter-political anarchy," explains Hough. "Now that the old common enemy, the imperial power of Britain, was known to be pulling out, Sikhs, Moslems and Hindus had turned upon one another, communal riots were already raging in many parts—especially in Bihar and Bengal—and Gandhi the man of peace was carrying out his 'repentance tours' through the worst areas." As vicereine of this volatile country, Edwina, with her skills and experience as a politician and humanitarian, was a great asset. Knowing it was necessary to win over the influential and powerful men of the country, Edwina appealed to their wives, daughters, and sisters who were initially highly anti-British and suspicious of the Mountbattens. Slowly she won their trust and friendship. "She was quite marvellous," recalled a member of her staff. "They simply fell under her charm and pledged eternal love. She was almost better with women than men, and that's saying a lot."

Edwina's second task was to ease the suffering of the people in the riot-torn country, to provide relief, supervise evacuation, and inspect hospitals, which was much the same kind of work she had done during the war. She attacked her relief work with something akin to religious fervor. "What can one say of this amazing Englishwoman who goes among the poor and the sick and the suffering like some latter-day *Mary Magdalene?" queried one reporter on the scene. Norman Cliff, another journalist, wrote of Edwina's compassion. "To the disabled and heartbroken there came not a grand lady standing at a distance, but a mother and nurse who squatted in the midst of the dirty and diseased, took their soiled and trembling hands in hers and spoke quiet words of womanly comfort."

On August 15, 1947, the Mountbattens, having now been promoted to Earl and Countess Mountbatten of Burma (now Myanmar), presided over Independence Day ceremonies, which set off a new round of rioting, more murderous than before. Edwina renewed her efforts, uniting 15 organization under the banner of the United Council of Relief and Welfare as Delhi was turned into a refugee camp. "Her husband's ADCs became chary of going out with her, because she would stop in the midst of sniping to pick up bodies and take them to the local infirmaries," recalled **Marie Seton**, one of Nehru's biographers. "Her gigantic effort explains Nehru's reference to 'her healing touch.'"

Hough explains that the love between Edwina and Jawaharlal Nehru "was born out of their joint concern for the sufferings of India before and after the transfer of power," but there were also other factors at play. Nehru, lonely since the death of his wife ◀ **Kamala Nehru**, was drawn to Edwina on many levels, says his sister, *Vijaya Lakshmi Pandit**. "He responded to her intelligent companionship and her warm personality. They were always able to talk intelligently to one another. Nehru liked beautiful women, and she was a big influence on his life because she brought warmth and friendship based on a sharing of values and intellectual pursuit." There is still debate as to whether Edwina's relationship with Nehru extended to the physical, although most people in India at the time believed it did. Hough writes that certainly Louis thought they were lovers and was proud of the fact. After Edwina's death, Louis kept the correspondence between the two, referring to them as "the love letters," and confiding that they would ultimately be published. "Letters from him to me were always typed," he added, "But letters to Edwina were always hand-written."

Louis' post in India ended in the summer of 1948, and the couple returned to London. Later

Nehru, Kamala.
See Gandhi,
Indira for sidebar.

that year, they returned to Malta, where Louis took up his post as a simple rear-admiral, and Edwina became an officer's wife once again. She continued to see Nehru several times a year, usually in conjunction with her continuing work with St. John's Ambulance, the Red Cross, and the Save the Children charity. Throughout the 1950s, Edwina increased the tempo of her professional life despite the fragility of her health. In 1956, she began to suffer from angina, and in 1958 she had a small stroke which left a stiffness in her right cheek. Later that year, she contracted a virulent form of chickenpox from one of her grandchildren, from which she never really recovered. Nothing, however, could force her to reduce her frantic schedule, which included attendance at Nehru's 70th birthday celebration in London in November 1959, at which she delivered a tribute.

Edwina Mountbatten died in February 1960, at the last stop of an arduous tour which included interludes in Cyprus, Karachi, Delhi, Malaya, Singapore, and finally North Borneo, where she had been the guest of Robert Noel Turner, senior officer of the Colonial Service and acting governor. In Delhi, she had spent a few precious days with Nehru, who noticed how ill and strained she looked but, understanding her need to persevere, made no mention of it. Louis, who was awakened by a 3 AM phone call with the news of Edwina's death, called it "a poleaxe blow," although at her departure he had secretly wondered whether he would ever see her alive again.

As specified in her will, Edwina was buried at sea, her coffin carried out to the site on the frigate *Wakeful*. Nehru, in a final tribute, had arranged for an Indian warship to accompany the *Wakeful* on the journey. Much diminished by Edwina's death, Nehru died four years later, at the age of 75. Louis Mountbatten lost his life in August 1979, when an IRA terrorist bomb tore into a family pleasure boat in the Sligo Bay. Also killed was one of his twin grandsons, Nicholas.

SOURCES:
Dickins, Douglas. "Mountbatten," in *British Heritage*. February–March 1984.
Hough, Richard. *Edwina: Countess Mountbatten of Burma*. NY: William Morrow, 1984.

SELECTED READING:
Morgan, Janet. *Edwina Mountbatten: A Life of Her Own*. Scribner, 1991.

Barbara Morgan,
Melrose, Massachusetts

Mountbatten, Irene (1890–1956)

Marquise of Carisbrooke. Name variations: Irene Denison. Born Irene Frances Adza Denison on July 4, 1890, in London, England; died on July 16, 1956, in London; only daughter of William Denison, 2nd earl of Londesborough, and Lady Grace Fane; married Alexander Mountbatten, marquess of Carisbrooke, on July 19, 1917; children: Iris Mountbatten (1920–1982).

Mountbatten, Pamela (1929—)

*Daughter of the earl and countess of Burma. Name variations: Pamela Hicks. Born Pamela Carmen Mountbatten on April 19, 1929, in Barcelona, Spain; daughter of Louis Mountbatten, earl of Burma, and *Edwina Ashley Mountbatten (1901–1960); married David Hicks (an interior designer), in January 1960 (died 1998); children: Edwina Hicks (b. 1961); Ashley Hicks (b. 1963); India Hicks (b. 1967).*

Mountbatten, Patricia (1924—)

*Daughter of the earl and countess of Burma. Name variations: Patricia Knatchbull; Baroness Romsey. Born Patricia Edwina Mountbatten on February 14, 1924, in London, England; daughter of Louis Mountbatten, earl of Burma, and *Edwina Ashley Mountbatten (1901–1960); married John Knatchbull, 7th baron Brabourne, on October 26, 1946; children: Norton Knatchbull (b. 1947), Lord Romsey; Michael-John (b. 1950); Joanna Knatchbull (b. 1955); Amanda Knatchbull (b. 1957); Philip (b. 1961); Timothy (b. 1964); Nicholas (1964–1979); and one other.*

Mountfort, Susanna (c. 1667–1703).

See Verbruggen, Susanna.

Mourning Dove (c. 1888–1936)

First Native American woman to write and publish a novel. Name variations: Christal Quintasket; Christine Quintasket; Humishuma. Born in 1888 (some sources cite 1882, 1884, or 1885), near Bonner's Ferry, Idaho; died of influenza on August 8, 1936, in Medical Lake, Washington; daughter of Joseph Quintasket and Lucy (Stuikin) Quintasket; attended Sacred Heart convent school; attended business school, 1913–15; married Hector McLeod, in 1909 (marriage ended); married Fred Galler, on September 8, 1919; no children.

Made first communion (1899); death of mother (1902); began using pen name "Mourning Dove" (1912); met Lucullus V. McWhorter (1914); taught school in British Columbia (c. 1917); published first novel (1927); founded Colville Indian Association (1930).

Selected writings: Cogewea, The Half-Blood: A Depiction of the Great Montana Cattle Range *(1927);* Coyote Stories *(1933);* Tales of the Okanogans *(1976);* Mourning Dove: A Salishan Autobiography *(ed. by Jay Miller, 1990).*

Mourning Dove, who also used the Salishan version of her name, Humishuma, was a pioneering folklorist and novelist of the Inland Northwest. She is widely hailed as the first Native American woman to write a novel, but her literary collaboration with a white archaeologist, as well as her pro-tribal political activism, earned her enemies who disparaged her work. Still, Mourning Dove lived and wrote in an era when the aggressive imposition of white culture was rapidly eradicating much of Native American life, and her works preserve some of that era for posterity.

Mourning Dove spent much of her life in an area that now straddles the U.S.-Canadian border: present-day British Columbia, Washington state, Idaho, and Montana. She was listed on an 1895 census as being eight years old, but she was taller and larger than her classmates, so she actually may have been close to ten. Mourning Dove later said her birth had occurred on a canoe crossing the Kootenay River; her father was of Okanogan and Irish ancestry, while her mother was a full-blooded member of the Confederated Tribes of Colville; both were of the Salishan language group. Because of this mixed heritage, Mourning Dove never felt entirely at home in either Native or white culture. She was keenly interested in Colville history, as told to her by her beloved grandmother.

Sent off to a convent school, Mourning Dove suffered greatly when she was punished by the (native French) nuns for being unable to speak English. She returned home but later completed about three years of formal education at the Sacred Heart School, where she also became a practicing Roman Catholic for a time. She moved to Montana to teach on a reservation school, in part because the place offered proximity to her grandmother. It also presented her with a unique opportunity to witness the roundup by the U.S. government of the last remaining herd of wild bison, in 1908, an experience which had a marked impact on her and would appear in her later novel. In 1909, she married Hector McLeod, of Montana Flathead heritage, and they journeyed to Milwaukee by train for their honeymoon. McLeod gambled and was probably abusive, and their marriage was short-lived; he was shot to death many years later at a card table in Nevada.

Around 1913, Mourning Dove enrolled in business school in Calgary, Alberta, Canada, primarily after deciding to become a writer and realizing that she needed typing skills. In 1914, she met Lucullus V. McWhorter, an archaeologist and scholar of Native American culture, at the Walla Walla (Washington) Frontier Days celebration. The meeting launched a lifelong friendship and literary collaboration, and McWhorter enthusiastically encouraged her to write both Okanogan folktales for posterity as well as fiction. She began with fiction, but incorporated folktales into her story of a woman of mixed ancestry, like herself, who struggles to cope with a changing world while retaining a sense of tribal identity.

Mourning Dove finished *Cogewea, The Half-Blood: A Depiction of the Great Montana Cattle Range* in 1916, but its publication was delayed well over a decade, first because of World War I and later due to McWhorter's difficulty in finding a publisher. Finally it was issued by a Boston house, Four Seas, in 1927. The book's jacket credited Humishuma as the author, but noted it was "given through Shopowtan," otherwise known as McWhorter. For this, the work has been criticized, because McWhorter revised her first manuscript with a heavy hand, using the stilted, high-blown language common to 19th-century literary English. He also inserted extensive footnotes, epigraphs from white writers, and passages from Henry Wadsworth Longfellow's *Hiawatha.* Mourning Dove's own style was simple and direct, like the Salishan language itself, and her actual story of *Cogewea* remains exemplary as a romance of Native America told through the perspective of a Native American; as such, it was a groundbreaking literary event. (It is considered the first novel written by a Native American woman, although *E. Pauline Johnson had previously published poetry and *Gertrude Simmons Bonnin had published short stories.) Cogewea, of mixed heritage, has two sisters; one remains on the reservation and leads a traditional life, while the other marries a white rancher. When Cogewea herself marries, it ends disastrously. The theme of the betrayal of Indian women by white men is pervasive (the author's own paternal grandfather was Irish, and had married her grandmother under false pretenses), but concludes with Cogewea's spiritual reconciliation through a romance with a man of mixed heritage like herself. The roundup of the last free-range bison herd is also an integral and symbolic part of the story. Woven throughout the narrative are Okanogan tales Cogewea has learned from her grandmother.

Mourning Dove's next book, also written and published with the strong support of

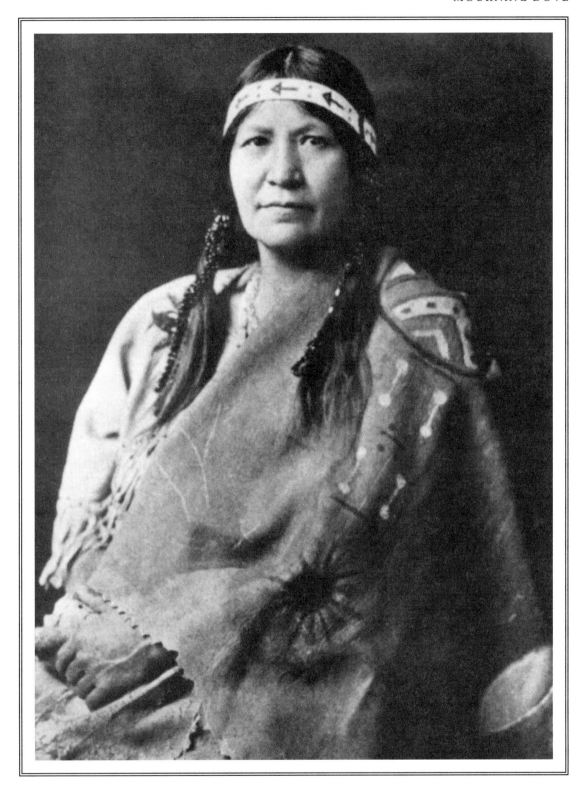

McWhorter, was a collection of Okanogan folk tales, *Coyote Stories* (1933). The coyote is the "trickster" figure in Native American tradition, and the stories she collected and transcribed over the course of several years feature the characteristic clever twists of plot. Yet even be-

fore the 1927 publication of *Cogewea*, Mourning Dove had already faced hostility from some in the Native American community, in part because of what was considered a transgression of the boundaries that kept Native culture and folktales sacred and inaccessible to whites.

Later, however, she become somewhat of a literary celebrity and well-known figure among the Native communities of the Inland Northwest. She also became an activist, at which point a few of her detractors claimed she had not really been the author of her books. In 1930, Mourning Dove founded the Colville Indian Association, which worked to resolve land claims and extract promised compensation from lumber companies and other white businesses. It also took an active role in fighting the abuses of the Bureau of Indian Affairs, the federal agency that controlled Native American life. She was elected to the Colville Tribal Council in 1936.

Mourning Dove had remarried in 1919 to a Wenatchee named Fred Galler. They lived for most of their married life as migrant laborers, without a home, and she collected her folklore in the evenings after working long days in the fields. She carried her typewriter everywhere. It was a difficult life; in a 1930 letter to McWhorter she noted: "I have had too much to do outside of my writing. . . . [A]fter working for ten hours in the blazing sun, and cooking my meals, I know I shall not have the time to look over very much mss. . . . [B]etween sand, grease, campfire, and real apple dirt I hope I can do the work." She also suffered a number of serious illnesses throughout her life, including rheumatism, pneumonia, and black measles. Mourning Dove died in August 1936 of severe influenza in a state hospital, probably at the age of 50. A trunkful of papers she left after her death was edited by Jay Miller and published in 1990 as *Mourning Dove: A Salishan Autobiography.*

SOURCES:

Bataille, Gretchen M., ed. *Native American Women.* NY: Garland, 1993.

Fisher, Dexter. "The Transformation of Tradition: A Study of Zitkala Sa and Mourning Dove, Two Transitional American Indian Writers," in *Critical Essays on Native American Literature.* Boston, MA: G.K. Hall, 1985.

Miller, Jay, ed. *Mourning Dove: A Salishan Autobiography.* Lincoln, NB: University of Nebraska Press, 1990.

Mourning Dove (Humishuma). *Cogewea, The Half-Blood: A Depiction of the Great Montana Cattle Range.* Boston, MA: Four Seas, 1927, rep. ed. Lincoln, NB: University of Nebraska Press, 1981.

——. *Coyote Stories.* Caldwell, ID: Caxton Printers, 1933, rep. ed. Lincoln, NB: University of Nebraska Press, 1990.

COLLECTIONS:

A number of Mourning Dove's letters to Lucullus McWhorter are held in the McWhorter Collection, Holland Library, Washington State University.

Carol Brennan,
Grosse Pointe, Michigan

Moutawakel, Nawal el (b. 1962).

See El Moutawakel, Nawal.

Movessian, Vicki (1972—).

See Team USA: Women's Ice Hockey at Nagano.

Mowatt, Anna Cora (1819–1870)

Author of Fashion, *the first American comedy of manners, who also defied convention as the first woman of her privileged class to become a professional actress. Name variations: Mrs. William Fouchee Ritchie; "Lily." Born Anna Cora Ogden on September 12, 1819, in Bordeaux, France; died on July 27, 1870, in St. Margaret's Wood, Twickenham, England; daughter of Samuel Gouverneur Ogden (a merchant and member of distinguished New York family) and Eliza (Lewis) Ogden; educated by extensive home reading and attendance at select academies for young ladies in New York; married James Mowatt, in October 1834 (died 1851); married William Fouchee Ritchie (a newspaper editor of Richmond, Virginia), in 1854.*

With family, returned from France to New York City (1826); appeared in and directed numerous family theatricals; attended her first professional theatrical performance, Fanny Kemble in The Hunchback *(1831); secretly married James Mowatt (1834); made her debut as elocutionist, Boston (1841); had her play* Fashion *produced at Park Theater, New York (March 1845); made her debut as actress at Park Theater, New York, in Bulwer-Lytton's* The Lady of Lyons *(June 1845); pursued highly successful career as starring actress in the U.S. and England (1845–54); was a charter and active member of the Mount Vernon Association to preserve George Washington's home.*

Selected writings: Pelayo or the Cavern of Cavadonga; Gulzara or the Persian Slave; The Gypsey Wanderer or the Stolen Child; Evelyn or a Heart Unmasked; Fashion; Armand; Fairy Fingers; *(autobiography)* Mimic Life: The Autobiography of an Actress.

"Long after [the War of 1812], the American theater remained in many ways subject to the English theater, and the story of its growth and development is the story of its struggle for artistic independence, a struggle less bloody but far more prolonged than the struggle for political independence," writes theater historian Barnard Hewitt. One unlikely warrior in that struggle was a delicate but spirited woman whose beauty and talent were attested to even by that demanding New York drama critic Edgar Allan Poe. Anna Cora Mowatt, daughter of a

wealthy and cultivated New York family, burst upon the theater world in the mid-19th century as both playwright and starring actress.

The first play published in what would become the United States had been *Androboros, a Biographical Farce in Three Acts,* written by Robert Hunter, governor of New York. Printed in 1714, *Androboros* was a savage and salty satire on the goings-on of the Provincial Council and the lieutenant governor. It seems never to have been produced. In 1716, the first American theater building of which we have any record was constructed in Williamsburg, Virginia, but for many years throughout the colonies, traveling players were often obliged to perform wherever space allowed—in courtrooms, warehouses, and "convenient" rooms.

It was not until 1752 that the Comedians of London, the first professional company to appear in the colonies, opened in a new and well-equipped theater in—again—Williamsburg with a performance of *The Merchant of Venice.* The cavalier spirit was clearly alive and well in the Old Dominion. Finely dressed folk in carriages and on horseback descended upon the new theater, thrilled as the energetic Shylock cried, "The pound of flesh is mine; 'tis dearly bought, and I will have it!" and applauded vigorously. The Comedians settled in for an 11-month run before moving on to other American cities.

Those cities were frequently less welcoming than the Virginians. The Quakers of Philadelphia considered theatrical performances an evil influence, and the Puritans of New England were strongly disapproving. Many respectable New Yorkers also frowned. Yet the number of theaters increased throughout the 18th century. Actors themselves remained suspect. No lady of good breeding would have considered exhibiting herself upon a public stage. Only a few Americans of any background, and no woman among them, were as yet writing plays. It was nearly a century after the Comedians' Williamsburg appearance when a daughter of the New World aristocracy—Knickerbocracy, as the editor of the *New York Mirror* called it—broke the mold.

Mowatt was born Anna Cora Ogden in 1819. Her father Samuel Gouverneur Ogden was a member of a distinguished New York family with a long and notable history in Colonial and Revolutionary America, and her mother **Eliza Lewis Ogden** was a granddaughter of a signer of the Declaration of Independence. She herself, the ninth of her parents' fourteen children, was born in Bordeaux, France, where her

father had business. She spent the early years of her childhood at La Castagne, which one historian has described as "a small but elegant late Renaissance château of twenty-two rooms." The "small" château seems to have been as crowded with books as with children. Anna, or Lily, as her family called her, later claimed to have read through Shakespeare "many times over" by her tenth birthday. At age four, she made her debut in a family theatrical performance as a judge in *Othello,* clad in a red robe and white wig while admonished not to laugh.

Such family presentations continued when the Ogdens returned in 1826 to their native New York. By her early teens, Mowatt had become the impresario, stage manager, and director of these presentations. Always a voracious reader and prolific scribbler, she was also a play doctor, revising well-known plays to suit the ages and abilities of her acting company. Playwriting itself came next, as she dramatized incidents from American history for her ardently patriotic family.

At 14, she directed and starred in a production of Voltaire's *Alzire* performed for a large audience of family and friends. Characteristically bold despite her slight stature, Mowatt headed a sibling delegation to request the necessary Spanish and Moorish attire from Edmund Simpson, manager of the Park Theater, who, though not a member of the Ogdens' social circle, lived opposite them and was "gentlemanly."

Soon Mowatt saw her first professional play. The English actress **Fanny Kemble,* appearing in *The Hunchback,* a popular melodrama, hypnotized her. Any thought that the theater must necessarily be a place of "sin and wickedness" was banished from her mind forever. She would later be an outspoken champion of both plays and actors.

> *H*er success is not the result of elaborate thought but creative genius.
>
> —"Old Drury," *The Charleston Courier*

For now, however, Anna was playing in her own real-life drama. James Mowatt, a cultivated New York lawyer twice her age, had begun to court her. Despite Samuel Ogden's opposition, James' suit was successful. Fifteen-year-old Anna, wearing a white muslin dress which she had created in six nights of secret, frantic sewing, met her groom at St. John's Park and was married by the pastor of New York's French church, l'Eglise de Saint Esprit. The pastor, who had himself eloped, was the only cleric willing to perform

the ceremony. While he was startled at first, Samuel Ogden soon accepted his new son-in-law.

James Mowatt's immediate concern was for the intellectual development of his young bride, and he read with her extensively in French and English. Both husband and wife were greatly attracted to the views of the Swedish mystic Swedenborg and would remain disciples. Mowatt had often written verses for family occasions. Now she composed an epic poem of 130 stanzas entitled "Pelayo or the Cavern of Cavadonga." "Pelayo" was published by Harpers' under the pen name "Isabel" and gained considerable attention—not all favorable—from reviewers. Anna promptly retorted with the lampoon "Reviewers Reviewed."

The young Mowatts' life at their estate Melrose was apparently idyllic but brief. Their prosperity was interrupted by illness for Anna, who had always been frail—she was probably tubercular—and threatened blindness for James. A stay in Europe was prescribed. Undergoing a somewhat arduous recuperation there, Mowatt went often to the theater, learned German, improved her music and read and studied extensively. Returning to America, she wrote and produced *Gulzara or the Slave Girl* for her usual enthusiastic private audience at Melrose. But in late 1841, James Mowatt, a victim of unfortunate real-estate investments, discovered that he was bankrupt. Beautiful Melrose must be sold.

For the first time, Mowatt considered becoming a professional actress; widely read in poetry and drama, she had a beautiful speaking voice and fine enunciation. Although she professed to admire feminine beauty quite different from her own, she could scarcely deny that others found her lovely and that she could hold an audience. Her husband, though concerned for her health, had no doubt of her ability. But dared she risk her own and her family's reputation? Even for Mowatt the leap was great, but there was a half step. She would give poetry readings. And Boston, the cultural center of the Republic with its Transcendentalists, would be the first site.

The Boston *Atlas,* in announcing the upcoming "entertainment," frankly admitted Mrs. Mowatt's motivation: "We learn that she resorts to this employment of her talents and acquirements with a view to rendering them productive of pecuniary emolument, in consequence of reverses to which her family has been subjected." The "pecuniary emolument" was forthcoming. Boston audiences were captivated by the slight woman in her white muslin dress reciting "The Lay of the Last Minstrel," "Woodman, Spare that Tree" and other popular poetry. "I read as often as possible from American poets," declared Mowatt, ever the patriot.

With her successful Boston appearance and others in Providence and New York, a new art was born. For the rest of the 19th century, elocutionists reciting popular and classical verse would draw large and enthusiastic audiences. But Mowatt's health and financial problems were not ended. Too frail to continue a strenuous series of recitations, she turned to writing—poems, essays for such popular magazines as *The Ladies Companion* and *Godey's,* novels, including *Evelyn or a Heart Unmasked,* and practical handbooks such as *Housekeeping Made Easy, Ball-Room Etiquette* and *Etiquette of Matrimony.* She also wrote a *Life of Goethe,* under a masculine pseudonym, since a lady could not openly write about a man. James Mowatt established an independent publishing company to profit more fully from his wife's literary prodigality.

The climax of three busy writing years came when a friend suggested that Anna compose a play about contemporary New York society which, with the city's growth, was changing rapidly. It was a subject Mowatt knew well. In less than a month, she wrote *Fashion,* a good-natured satire on the pretensions of her city's newly rich. The fake noble Count Jolimaitre, the poet T. Tennyson Twinkle, the native ingenue Serafina, the ambitious, not-quite-so-rich-as-they-seem parents, the Tiffanies—these and others were contrasted with the honest old farmer Adam Trueman who represented the sterling values which the Tiffanies had abandoned.

Mowatt had scored again. *Fashion,* accepted by the Park Theater for production in March 1845, was probably the earliest example of an American comedy of manners. Anna Cora Mowatt became the first American woman to write for the professional stage. Now she was introduced to a world which neither her impresario's role in home theatricals nor public poetry readings had prepared her—the other side of that great green curtain which traditionally separated theatrical productions from the unromantic details of production.

"The play was at once announced and put in rehearsal," Mowatt would recall in *The Autobiography of an Actress.* "The day before its representation I became anxious to witness one of these rehearsals, that I might form some idea of the chances of success. . . . The whole front of the building was so dark that we had to feel our

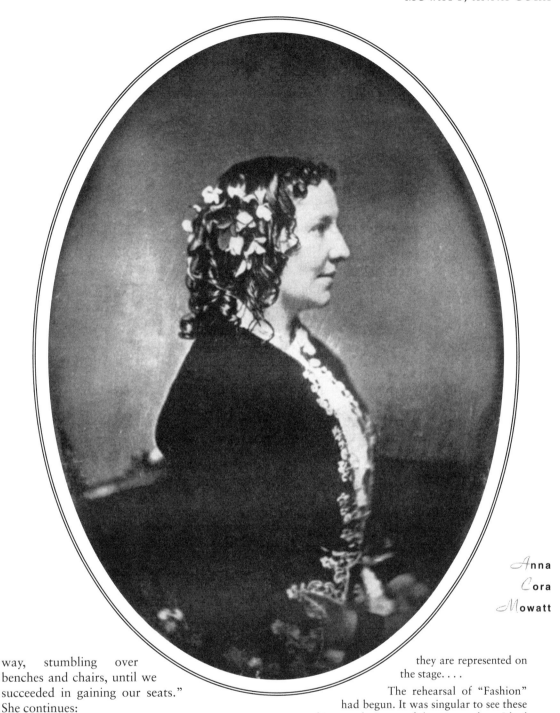

*A*nna *C*ora *M*owatt

way, stumbling over benches and chairs, until we succeeded in gaining our seats." She continues:

The stage was lighted by a single branch of gas, shooting up to the height of several feet in the centre of the footlights. It sent forth a dim, blue, spectral light, that gave a phantom-like appearance to surrounding objects. On the right of the stage was the prompter's table—on the left, the manager's table. Beneath the ghostly light sat a pale-faced prompter, with the manuscript of "Fashion" in his hand. At his side stood the "call boy," a child of about ten years of age. He held a long strip of paper, somewhat resembling the tailors' bills of young spendthrifts, as they are represented on the stage. . . .

The rehearsal of "Fashion" had begun. It was singular to see these kings and queens of the stage, whom I had been accustomed to behold decked in gold-embroidered robes and jewelled crowns, glittering in the full blaze of the foot-lights—now moving about in this "visible darkness," some of the men in "shocking bad hats" and rough overcoats, and the ladies in modern bonnets in place of tiaras or wreaths of flowers, and mantles and warm cloaks instead of peasant petticoats or brocade trains. I found it difficult to recognize the romantic heroes and injured heroines in whose sufferings I had so often sympathized.

Edgar Allan Poe, drama critic of the *Broadway Journal*, used *Fashion* as the subject of an essay crying out for a new American theater:

> It will no longer do to copy, even with absolute accuracy, the whole tone of even so ingenious and really spirited a thing as the *School for Scandal*. It was comparatively good in its day, but it would be positively bad at the present day, and imitations of it are inadmissible at any day.
>
> Bearing in mind the spirit of these observations, we may say that *Fashion* is theatrical but not dramatic. It is a pretty well arranged selection from the usual *routine* of stage characters, and stage manoeuvres, but there is not one particle of any nature beyond green-room nature, about it. No such events ever happened in fact, or ever could happen, as happen in *Fashion*. . . . Our fault-finding is on the score of deficiency in verisimilitude—in natural art—that is to say, on art based on the natural laws of man's heart and understanding. . . .
>
> We must discard all models. The Elizabethan theater should be abandoned. We need thought of our own—principles of dramatic action drawn not from the "old dramatists" but from the fountain of a Nature that can never grow old.
>
> It must be understood that we are not considering Mrs. Mowatt's comedy in particular, but the modern drama in general. . . . *Fashion*, upon the whole was well received by a large, fashionable and critical audience. . . . Compared with the generality of modern dramas, it is a good play—compared with most American dramas it is a *very* good one—estimated by the natural principles of dramatic art, it is altogether unworthy of notice.

Mowatt's audiences were more easily satisfied. She herself had not set out to reform the American theater. Besides, she was now occupied with making another decision. Managers were begging her to go upon the stage.

"I pondered long and seriously upon the consequences of entering the profession," she admitted. "Was it right? Was it wrong? were questions of highest moment. My respect for the opinions of 'Mrs. Grundy' had slowly melted away since I discovered that with that respectable representative of the world in general *success* sanctified all things; nothing was reprehensible but *failure*. . . . I reviewed my whole past life, and saw, that, from earliest childhood, my tastes, studies, pursuits, had all combined to fit me for this end. . . . I would become an actress." "Tears, entreaties, threats, supplicating letters" from relatives and friends could not hold her back. She set about exercising her voice, using dumbbells to strengthen her arms, taking fencing lessons and wearing the trailing skirts which her parts would require.

In June 1845, Mowatt made her debut at the Park Theater as the leading lady—there was no point in beginning anywhere but at the top, she had decided—in a popular melodrama, Bulwer-Lytton's *The Lady of Lyons*. "Mrs. Mowatt's debut as Pauline last night was one of the most triumphant we ever witnessed," wrote one critic. Even Poe found her talented and beautiful. Anna's acting career was launched.

She played leading roles at New York's Niblo's Gardens and went on to Philadelphia, Buffalo, and Boston. She spent December of 1845 in Charleston, South Carolina, doing a repertory of 16 plays, including 6 in which she had not appeared before. Fortunately, her memory was prodigious. In 1846, she toured the South and Midwest. "In the annals of the stage of all countries there is no single instance of a mere novice playing so many times before so many different audiences and winning so much merited praise as did Mrs. Mowatt during the first twelve months of her career as an actress," declared a critic.

Mowatt was not content. For so many years English plays and English actors had dominated the American theater, while American actors, though gradually making their way at home, had met with a chilly reception overseas. Only the American *Charlotte Cushman with her *Hamlet* had won grudging acceptance from Londoners. Mowatt sailed for Liverpool in 1846, determined to charm the British lion. The venture had its difficulties but also its glowing successes. The London season of 1848–49 was, in fact, the climax of Anna's career.

But her life was changing again. Early in 1851 James Mowatt died and was buried in England. Anna returned to the United States to tour. In 1854, the same year she published her autobiography, she retired from the stage and married William Fouchee Ritchie, a Richmond, Virginia, newspaper editor. In Richmond, as always, she continued her own writing. She also became a charter and active member of the Mount Vernon Association, led by *Ann Pamela Cunningham, which was dedicated to the purchase and preservation of George Washington's home.

For reasons Mowatt was unwilling to reveal, her new marriage was not a happy one. In 1864, suffering poor health, she returned to Europe, wintering in Florence with its congenial climate and people. Financial problems continued to plague her, and she dreamed of recouping her fortunes by writing or even acting once again. Among her last writings were articles for the

newly founded *San Francisco Chronicle*. She died quietly in St. Margaret's Wood, Twickenham, in July 1870, and was buried beside James Mowatt.

Anna Cora Mowatt was perhaps not a great actress but there seems no doubt that she delighted audiences with her "thrilling" voice, her beauty and stage presence, and often with novel interpretations of roles. She was especially praised for her performances as Shakespeare's young heroines Beatrice and Rosalind (and was wise enough not to attempt the tragic roles).

The mid-18th century was an age of artificial acting. Actors came down to the footlights to deliver their principal lines, making "points" to their audiences. During such speeches, everyone else on stage was unmoving, creating an almost choreographed effect. Stage crosses were made only diagonally in strict patterns. Rehearsals were few, with the actors often still holding their books the night before an opening, and the star system prevailed. In this theater, Mowatt seems to have played with a more natural and unaffected style than was customary.

Her comedy *Fashion* is included in anthologies of the early American theater and has had several 20th-century productions. It was "devised and staged" with music at the Yale Drama School as recently as 1964 and produced in a musical version Off-Broadway. *The Autobiography of an Actress* remains an entertaining account of life in a well-to-do and close-knit New York family as well as of the theatrical world which Mowatt dared to enter and to champion.

SOURCES:

Barnes, Eric Wollencott. *The Lady of Fashion: The Life and the Theatre of Anna Cora Mowatt.* NY: Scribner, 1954.

Hewitt, Barnard. *Theatre U.S.A. 1665 to 1957.* NY: McGraw-Hill, 1959.

Hughes, Glenn. *A History of the American Theatre, 1700 to 1950.* NY: Samuel French, 1951.

Mowatt, Anna Cora. *The Autobiography of an Actress.* Boston, MA: Ticknor and Fields, 1854.

SUGGESTED READING:

American Literature Series. *American Plays.* NY: American Book, 1935.

Blesi, Marius. *The Life and Letters of Anna Cora Mowatt.* Charlottesville: University of Virginia, Ph.D. thesis, 1938.

Butler, Mildred Allen. *Actress In Spite of Herself: The Life of Anna Cora Mowatt.* NY: Funk and Wagnalls, 1966.

McCaslin, Nellie. *Leading Lady.* Studio City, CA: Players Press, 1933.

Thomas, Ruth. *Women in American Theatre: Jacksonian Era.* San Diego, CA: San Diego State University, M.A. thesis, 1993.

Margery Evernden,
Professor Emerita, English Department,
University of Pittsburgh, and freelance writer

Mowbray, Anne (1472–1481)

Young bride of the duke of York. Born on December 10, 1472, in Framlingham, Suffolk, England; died on January 16, 1481, age 8, in Greenwich, London, England; buried at Westminster Abbey, London; coffin later removed and reburied next to her mother's grave at Aldgate; reinterred in Westminster in 1965; daughter of John Mowbray, 4th duke of Norfolk, and *Elizabeth Talbot (daughter of John, earl of Shrewsbury); married Richard Plantagenet, duke of York (Prince in the Tower), on January 15, 1478.

Mowbray, Elizabeth (d. 1425).

See Fitzalan, Elizabeth.

Mowbray, Isabel (fl. late 1300s)

Baroness Ferrers of Groby. Name variations: Isabel Ferrers. Flourished in the late 1300s; daughter of Thomas Mowbray (c. 1362–1399), 1st duke of Norfolk, and *Elizabeth Fitzalan (d. 1425); married Henry Ferrers; children: Elizabeth Ferrers, baroness Ferrers of Groby.

Mowbray, Margaret (fl. 1400)

English aristocrat. Name variations: Margaret de Mowbray; Margaret Howard. Flourished in the 1400s; daughter of Thomas Mowbray (c. 1362–1399), 1st duke of Norfolk, and *Elizabeth Fitzalan (d. 1425); married Robert Howard, before 1420; children: John Howard (1420–1485), 1st duke of Norfolk (r. 1483–1485); Margaret Howard (who married Thomas Danyell, baron of Rathwire); *Catherine Howard (d. after 1478, who married Edward Neville, baron Abergavenny).

Moyland, Monica (1860–1939).

See Ros, Amanda.

Mozart, Constanze (1762–1842)

German musician and wife of Mozart. Name variations: Constanze von Nissen; Constanze Weber or Constanze Weber Mozart. Born Constanze Weber on January 5, 1762, in Zell, Germany; died in 1842 in Salzburg; daughter of Fridolin Weber and Cecilia Weber; sister of **Josepha Hofer** (c. 1758–1819), Aloysia Lange (1761–1839), and **Sophie Weber** (1763–1846); married Wolfgang Amadeus Mozart (the composer), on August 4, 1782; married Georg Nikolaus von Nissen, on June 26, 1809; children: (first marriage) Raimund Leopold (b. 1783, died young); Carl Thomas

(b. 1784); Johann Thomas (b. 1786, died young); Theresa (b. 1787, died young); Anna Maria (b. 1789, died young); Franz Xaver (b. 1791).

Constanze Mozart has often been treated critically in biographies of her famous husband. Her contribution to the study of Mozart's life and works has been devalued, and she has been characterized as ignorant, petty, materialistic, and unable to appreciate Mozart's genius. Yet Mozart himself acknowledged her importance in his life, and her efforts to protect his work after his death were critical in establishing his permanent fame.

She was born Constanze Weber in 1762 in Zell, Germany, the third daughter of a poor family of Mannheim. Her mother was **Cecilia Weber**. Her father Fridolin Weber, a court musician, trained all of his daughters as singers; Constanze also learned to play the piano, but received little formal education. In 1777, she met Wolfgang Amadeus Mozart when he became a boarder in the Weber household. He soon fell in love with Constanze's older sister, *****Aloysia Lange**, but Mozart's father Leopold stopped their planned elopement.

The Webers moved to Vienna in 1780, and Fridolin died soon after, leaving his widow with four children and very little money. The next year Mozart, unemployed, boarded again with the family, where he developed a romantic friendship with Constanze, now 19. This relationship alarmed Cecilia Weber, who feared that rumors spread about her daughter and Mozart would ruin Constanze's reputation and chances for marriage. Determined to ensure her family of a permanent means of support through her sons-in-law, Cecilia Weber induced Mozart to sign a contract, without Constanze's knowledge, promising to either marry Constanze within three years or to pay her an annual stipend. In December 1781, Mozart wrote to his father that they planned to marry as soon as he had a steady income, but Leopold refused to give his blessing. He objected to his son's marriage into a family that could bring him neither the wealth nor the powerful connections he needed to launch a career as a composer.

Life for Constanze at this time was difficult. She was eager to marry and move out of her mother's house, but Mozart's financial trouble prevented the wedding. In letters, Mozart described the relationship between Constanze and her mother as tense and argumentative, made worse by Cecilia's apparent alcoholism. Their arguments sometimes led Constanze to leave home for several days at a time. Finally, in August 1782, Mozart and Constanze married in a small ceremony.

Despite its initial difficulties, it was a loving marriage. As surviving love letters from Mozart to Constanze show, the couple were devoted to one another; in their nine years together, they were rarely separated. The period of their marriage saw a general rise in Mozart's fortunes as his fame increased. He earned a fairly high income, but the couple usually spent even more than he made, leading to the stories of Mozart's poverty. Mozart's income was always fluctuating, and he was frequently in debt, but it is also true that the Mozarts were compelled to spend lavishly on their apartment and fashions to conform to the lifestyle of Vienna's elite.

Constanze gave birth to six children, which took a toll on her health, but only two sons survived infancy. The children, along with several servants and a constant stream of pupils, musicians, artists, and friends, made the household the lively, noisy, crowded environment in which Mozart worked best. Constanze enjoyed the active social life and, as a singer and pianist, was comfortable in these theatrical surroundings. She and her husband shared a musical bond as well; several of his compositions were written for her or dedicated to her. Constanze also sang opera roles or accompa-

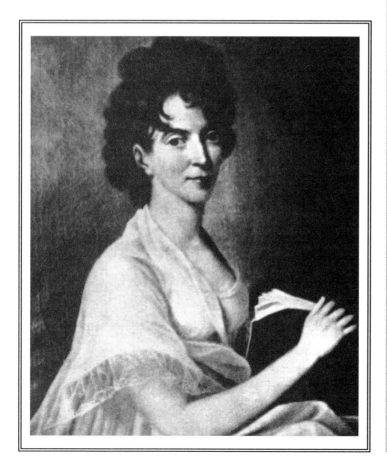

Constanze Mozart

nied Mozart on the piano while he was composing. She occasionally performed publicly in Vienna in productions of Mozart's work.

From 1788 to 1790, however, she suffered from very poor health brought on by her frequent pregnancies, and several times she sought relief at the sulfur spas of Baden. These expensive medical treatments added to the family's financial trouble and led Mozart to borrow heavily. In November 1791, Mozart himself became violently ill and told Constanze he thought he had been poisoned (the actual cause of his illness is unknown). Constanze and her sisters nursed him but he died, at age 35, in December. His widow was too grief-stricken to attend the funeral service.

Having almost no money left after paying Mozart's debts, Constanze and her sons stayed with her family for a time. Once her situation became known, however, she received a small annual pension from the Holy Roman emperor Leopold II. She was also honored at a number of benefit concerts arranged by friends and admirers of her late husband. A close friend financed the education of her two sons and others took up collections for the widow and orphans for several years after Mozart's death. Constanze was sole possessor of her husband's many unpublished manuscripts, a responsibility she took seriously. Clearly she was deeply aware of her husband's talents, and recognized the potential worth of his musical works; at the same time, she refused to sell them off carelessly. In the first years of widowhood, she only sold eight compositions, to the king of Prussia in 1792.

Her health improved greatly after her childbearing years. In 1795, she and her sister Aloysia Lange undertook a successful concert tour of the northern German states. On her return to Vienna, Constanze opened a boarding house, where in 1797 a Danish diplomat took lodgings. Georg Nikolaus von Nissen, well educated and with a strong interest in music, soon became a close friend, and together they endeavored to organize Mozart's manuscripts as thoroughly as possible. Constanze, afraid that some other composer's work might be published under Mozart's name, verified the authenticity of each page herself. In 1799, she sold a large number of these compositions to a respected music publisher, Johann André of Offenbach, whom her husband had known. She continued to work with André through the 1830s, eventually letting him publish much of Mozart's corpus of music. She also negotiated editions with another large publishing firm in Leipzig. Constanze's care in the preparation of the manuscripts and her choice of only two primary publishers allowed for the dissemination of accurate, unabridged editions of Mozart's work and provided the foundation of modern Mozart studies.

In June 1809, Constanze married von Nissen. By this time both of her sons were grown; Karl would become a civil servant in Italy, while Franz followed his father's career as a composer and pianist. Both sons were close to their mother, and subsequently developed good relationships with Georg von Nissen. Constanze's second marriage was a happy one, although much more conservative in lifestyle than her first had been. After a few years in Copenhagen, the Nissens settled in Salzburg, where they began work on Nissen's biography of Wolfgang Amadeus Mozart.

Nissen died in 1826, before the massive book was completed. Constanze arranged for another scholar to finish the manuscript, which included many of her personal reminiscences of life with Mozart. It was finally published in 1828, although the book's uneven writing quality and length prevented it from enjoying much success. After Nissen's death Constanze resided with her sister Aloysia in Salzburg, where she died on March 6, 1842, at age 80. She was buried in the Mozart family vault in Salzburg.

SOURCES:

Braunbehrens, Volkmar. *Mozart in Vienna, 1781–1791.* Trans. by Timothy Bell. NY: Grove Wiedenfeld, 1986.

Davies, Peter J. *Mozart in Person.* NY: Greenwood Press, 1989.

Laura York,
Riverside, California

Mozart, Maria Anna (1751–1829)

Gifted Austrian musician and sister of Wolfgang Amadeus Mozart. Name variations: Marianne Mozart; also known as Nännerl or Nannerl. Born on July 30 or 31, 1751, in Salzburg, Austria; died on October 29, 1829, in Salzburg; daughter of Leopold Mozart (a violinist, composer, and theorist) and Anna Maria Mozart; married Johann Baptist Franz von Berchtold zu Sonnenburg, in 1784; children: at least one son.

Born in Salzburg, Austria, in 1751, Maria Anna Mozart, called Nannerl, was five years older than her famous brother Wolfgang Amadeus Mozart. She too was considered a musical prodigy; in fact, during the early tours that the sister-brother act was taken on by their father Leopold Mozart, she received top billing. That changed as the children grew older and Wolfgang began writing and performing his own compositions.

In 1762, Nannerl and her brother toured, performing for the elector of Bavaria in Munich and for Empress *Maria Theresa in Vienna. The following year, they gave concerts in Munich, Augsburg, Mainz, and Frankfurt, then traveled on to Paris and London for extended stays. They then went for six months to the Netherlands, where both became seriously ill. They started home in 1766, but stopped in Paris and also made several appearances in Switzerland and Germany along the way.

Wolfgang Mozart thought highly of his sister's talent; long after he fled their father's control, he wrote to her in 1781 urging her to move to Vienna. Wolfgang felt she would be well rewarded financially by playing at private concerts and giving piano lessons. She did become a piano teacher, but in "dull" Salzburg, as she referred to it. Unlike Wolfgang, Nannerl did not rebel against their father, and in time brother and sister grew further apart, especially after Wolfgang married Constanze Weber (*Constanze Mozart) in 1782. (They would resume communication after their father died, but the letters exchanged dealt almost exclusively with the disposition of his estate.) Leopold turned away several of her suitors before deciding that

Maria Anna Mozart

magistrate Johann Baptist Franz von Berchtold zu Sonnenburg would be suitable. Nannerl married Sonnenburg in 1784, after which they moved to St. Gilgen. She returned to Salzburg for the birth of her first son, and left the baby in Leopold's care.

Wolfgang Amadeus Mozart died at age 35 in 1791. Maria Anna Mozart returned to Salzburg following her husband's death in 1801, and resumed giving piano lessons. She died in Salzburg on October 29, 1829, and was buried in the family plot next to her father.

SOURCES:
Schonberg, Harold C. *The Great Pianists.* NY: Simon & Schuster, 1963.

SUGGESTED READING:
Anderson, Emily, ed. *The Letters of Mozart and His Family.* New York, 1985.
Deutsch, Otto Erich. *Mozart: A Documentary Biography.* Stanford, 1965.
Landon, H. D. Robbins, ed. *The Mozart Companion.* New York, 1969.
Solomon, Maynard. *Mozart: A Life.* New York, 1995.

<div align="right">

Jo Anne Meginnes,
freelance writer, Brookfield, Vermont

</div>

Mozee, Phoebe Anne Oakley
(1860–1926).

See Oakley, Annie.

Mozzoni, Anna Maria (1837–1920)

Italian socialist and women's rights advocate. Born in Milan in 1837; died in Rome in 1920.

Anna Maria Mozzoni was a leading figure in the early years of the modern feminist movement in Italy. She was born in 1837, into a Milan family that was affluent, politically minded, and liberal. This was an era of great political upheaval in Italy, which was then less a nation than a collection of warring, foreign-dominated duchies, or regions, held by the Roman Catholic Church. After several minor wars and referendums, Italy was unified in 1861, when Mozzoni was 14, an act that brought the movement known as the Risorgimento to a close. Later Mozzoni launched what she termed the "risorgimento delle donna," or the "renaissance of women." Backed by the money her station in life allowed her—and with at least the tacit support of her family—she became involved in groups that actively espoused socialism and workers' rights. One of her strong convictions was that women should be able to enter into the paying professions, and she founded La Lega promotrice degli interessi femminili in Milan. In response to new governmental laws

that rescinded some civil-rights gains won in a 1789 revolution, she wrote a manifesto that petitioned the Italian government on 18 points regarding women's rights at home, in school, and in the workplace. For years Mozzoni also presented petitions to the government to allow women the right to vote, and spoke and wrote on a number of topics concerning women and public morals. Her published works include *La liberazione delle donne* and *L'indegna schiavitù*. She died in Rome in 1920.

SOURCES:
Uglow, Jennifer, ed. and comp. *The International Dictionary of Women's Biography.* NY: Continuum, 1989.
Zilboorg, Caroline, ed. *Women's Firsts.* Detroit, MI: Gale Research, 1997.

Carol Brennan,
Grosse Pointe, Michigan

M'rabet, Fadéla (1935—)

Algerian writer and feminist. Name variations: Fadela M'rabet or Mrabet. Born in 1935 in Constantine, Algeria; graduated from the University of Algiers.

Fadéla M'rabet was born into a religious Islamic family in Constantine, Algeria, in 1935. She graduated from the University of Algiers, and then worked with her father at the Algerian state radio station, where she was responsible for a woman's program. The eight-year Algerian war for independence from France ended in 1962, and that year M'rabet published her first book, *La Femme algérienne*, a collection of interviews with women concerning the revolution and the independence movement. Shortly thereafter, she released a second book, *Les algériennes*. M'rabet became recognized as a leading voice for feminism in Algeria. She published a third book, *L'Algérie des illusions*, in 1973.

Grant Eldridge,
freelance writer, Pontiac, Michigan

Muammer, Latife (1898–1975).
See Hanim, Latife.

Muchina, Vera (1889–1953).
See Mukhina, Vera.

Mucia (fl. 80 BCE)

Third wife of Pompey. Flourished around 80 BCE; related to the Mucii Scaevolae and the Caecilii Metelli; became third wife of Gnaeus Pompeius Strabo also known as Gnaeus Pompeius Magnus or Pompey the Great (106–48 BCE, a Roman general and consul), in 80 BCE (divorced around 63 BCE); children: (sons)

*Gnaeus Pompeius Magnus Junior and Sextus Pompeius Magnus Pius; (daughter) Pompeia. Pompey was also married to *Antistia (daughter of Publius Antistius); Aemilia (d. around 81 BCE); *Julia (d. 54 BCE); and *Cornelia (c. 75-after 48 BCE).*

Soon after the death of his second wife ***Aemilia**, the Roman general Pompey the Great married Mucia, a relative of Lucius Cornelius Sulla's most prominent supporters. Pompey was backing Sulla in a bitter struggle for power. Though the marriage was to be marked by ill feeling and infidelity and eventually terminated by divorce, it lasted 17 years, during which time Mucia gave birth to three surviving children: Pompey Junior, Sextus, and ***Pompeia** (fl. 60 BCE).

Mueller, Leah Poulos (1951—)

American speed skater. Name variations: Leah Poulos. Born Leah Poulos in Berwyn, Illinois, on October 5, 1951; married Peter Mueller (a speed skater).

Won numerous medals in international and Olympic competition; won three Olympic silver medals: in the 1,000 meters (1976), the 500 meters, and the 1,000 meters (1980).

Speed skater Leah Mueller had been competing for several years before she won an Olympic medal. At her first Olympics at Sapporo in 1972, she placed 17th in the 3,000 meters and 24th in the 1,500 meters. In 1976 in the Innsbruck Olympics, she moved to 6th in the 1,500 meters, 4th in the 500 meters, and won the silver in the 1,000 meters. After her marriage to Peter Mueller, a teammate who had won the gold in the men's 1,000 meters in Innsbruck, Mueller stopped competitive skating for two years, devoting her time to supporting her husband's training program. She returned to training in 1978 and won the World Sprint championship in 1979. In 1980 in Lake Placid, she competed in the 500 meters and the 1,000 meters, winning Olympic silver medals in both events. (***Karin Kania-Enke** took the 500-meters gold, while ***Natalia Petruseva** of the Soviet Union won the gold in the 1,000 meters.)

Karin Loewen Haag,
Athens, Georgia

Mugabe, Sally (1932–1992)

Ghanaian-born Zimbabwean political leader. Name variations: also known as "Amai," Mother of the Nation. Born Sarah Francesca Hayfron in Accra, Gold Coast (now Ghana), in 1932; died in Harare, Zimbab-

we, on January 27, 1992; had twin sister; married Robert Mugabe (first prime minister and executive president of Zimbabwe); children: son, Nhamodzenyika.

Sally Mugabe was first lady of a newly independent Zimbabwe for nearly a dozen years. For many citizens of this struggling African nation, which was experiencing a number of growing pains endemic to Third World societies, Mugabe was an inspiration and role model, particularly to Zimbabwe's educated women. She was born Sarah Francesca Hayfron in 1932 in Accra, then the British Crown Colony of the Gold Coast. Her family, which included lawyers and newspaper editors, was part of the small and increasingly confident African elite. Along with her twin sister **Edith**, she was an excellent student. By the time Sally was in her mid-teens she had become an enthusiastic follower of the independence movement led by a charismatic nationalist named Kwame Nkrumah. She decided to work as a schoolteacher, hoping to bring progress to the least privileged of her people. When the Gold Coast became an independent nation—the first in Black Africa to do so—on March 4, 1957, she had already begun her teaching career.

In 1959, the course of Sally's life changed forever when she met and fell in love with fellow teacher Robert Mugabe. Personally compatible, the couple would share similar political ideals and aspirations for the next three decades. Born in a rural area of Rhodesia in 1924, the son of a village carpenter, Robert was trained to be a teacher in a Roman Catholic mission school and, for a number of years, had gained experience teaching in one of these schools. He had known racism and discrimination from birth, living in what was at the time the British colony of Southern Rhodesia. Determined to dwell in an African nation that was ruled by its own citizens, Robert had accepted a teaching assignment in the newly independent Ghana during the summer of 1958. In May 1960, he returned home to take part in the rapidly growing black Rhodesian nationalist movement. In 1961, Sally married Robert in Salisbury, Rhodesia (now Harare, Zimbabwe) and adopted her husband's Roman Catholic religion. She would be a devout believer for the rest of her life.

The move from Ghana to white-governed Rhodesia was a profound shock for Sally Mugabe. She lived with her husband not in a spacious home like those she and her neighbors were accustomed to in Ghana, but rather in a matchbox township house in one of Salisbury's segregated districts reserved for "natives." As her husband's political career flourished, Sally Mugabe

too became a political activist in her adopted homeland, organizing women's protests which were soon banned and broken up by police. Both she and her husband were arrested because of their political activities. During this time, she became pregnant and was placed under house arrest. Although she slipped away, the stress was likely responsible for the child being stillborn. In 1963, she went to Tanzania where she gave birth to another child, a son Nhamodzenyika ("the country is suffering"). Taken by his mother to Ghana so that he could grow up in safer conditions than those found in Rhodesia, he died of cerebral malaria at age three.

Robert Mugabe was in a Rhodesian prison when his young son died. Convicted on charges of "subversive speech," he was serving the third year of what would turn out to be ten years of imprisonment and detention. The white-rule government of Prime Minister Ian Smith (which declared unilateral independence from the British Crown in November 1965, changing its official name from Southern Rhodesia to Rhodesia) refused Robert permission to attend his son's funeral. Sally Mugabe wrote later: "I am a mother. I could have gone out and grabbed Ian Smith by the throat when I had to write and tell my husband that our child had died. . . . But he taught me to realise that if you spend all your time wanting revenge you stay always in the position that you were before you gained your freedom."

Soon after her son's death, Sally moved to London, where many of the leaders of the black Rhodesian freedom movement lived. In London, she took courses and also worked at a variety of jobs including teaching at the Africa Centre, but she was often short of money. She spent long hours copying in longhand sections of books she had borrowed from a local public library; these pages were then mailed to Robert, who, incarcerated in Wha Wha Prison in the heart of Rhodesia, had decided to use his time behind bars to earn bachelor of law and bachelor of administration degrees through correspondence courses offered by the University of London. He also devoted many hours tutoring other prisoners. By the time he was finally released as part of a general amnesty in December 1974, he was studying for a master of law degree.

The Mugabes were reunited in Mozambique in November 1974. For the next five years, the struggle against Ian Smith's Rhodesian regime continued, both diplomatically and in the bush, where a bloody guerilla war was waged. As the wife of a key leader of the only nationalist organization fighting for independence, the

Zimbabwe African National Union (ZANU), Sally Mugabe was already filling the role of the yet-to-be-born nation's "Amai" (mother in the Shona language). When she appeared before Zimbabwean guerilla forces being trained in the neighboring nations of Mozambique and Tanzania, Mugabe was often hailed by the troops as their "Comrade Sally." By the end of the 1970s, the Mugabes' dream of an independent Zimbabwe—based on nonracial principles, working to achieve a socialist society, and nonaligned in the global Cold War—was finally coming to fruition. In January 1980, they returned in triumph to Rhodesia. After free elections that gave ZANU 63% of the total black vote, steps were taken to create a new government. On April 18, 1980, Robert Mugabe took the oath of office to become the first prime minister of the nascent nation, now called the Republic of Zimbabwe.

Freedom for Zimbabwe did not guarantee prosperity or a perfect democratic society. Quarrels with some of Robert Mugabe's former allies in the freedom struggle marred the first years of Zimbabwean nationhood. Throughout the 1980s, Robert Mugabe maneuvered to create a one-party system, with himself at the head. The introduction of a constitutional amendment in 1987 abolished the office of prime minister, creating a new "executive presidency" that combined the roles of head of state, head of government, and commander-in-chief of the armed forces. On December 31, 1987, he was inaugurated as Zimbabwe's first executive president. Although her husband now wielded immense power, Sally Mugabe continued to exercise at least some restraint when it came to perceptions of her own power, diplomatically avoiding the appearance of any interest on her own part.

She had been able to exercise considerable influence as a member of both the ZANU Central Committee and, more important, its Politburo in the 1980s, but she did not assume the post of secretary of the ZANU Women's League until October 1989. This took place after her husband annulled elections held by a party subsidiary whose show of autonomy had apparently displeased him. Some critics of the Mugabe regime accused Sally of having manipulated her husband in this matter. Local political observers noted that while by 1990 her husband had given up the idea of creating a one-party state in Zimbabwe, she differed with him by continuing to support the idea. Some of her political critics even tried to link her with high-level corruption, but no hard evidence of this could ever be produced. The public image she succeeded in projecting was one of dedication to charitable and relief activities, which included founding a national Child Survival Foundation, the main task of which was the channeling of international aid to various child-welfare projects. Toward the end of her life, she often spoke of her particular concern for the plight of some of Zimbabwe's most vulnerable children, those who were both impoverished and disabled.

The achievement of Zimbabwean independence in 1980 brought stability to the lives of the Mugabes, who had been together for only six out of the first nineteen years of their marriage. Now, as Zimbabwe's Mother of the Nation, Sally could charm official foreign guests with a combination of natural grace and spontaneity. Domestically, she never stopped campaigning for her husband and went on many gruelling but necessary overseas visits. At home, she also carved out for herself a role as an activist first lady, giving countless speeches, appearing at official ceremonies, and visiting schools and hospitals. In the area of fashion, too, she left her mark by wearing long African-print dresses with turban-like headdresses.

Soon after independence, Sally Mugabe was diagnosed as suffering from kidney failure. She accepted the news philosophically and for 11

Sally Mugabe

years would endure regular dialysis treatments, which were at best no more than palliative in nature. On several occasions, she suffered systemic collapses, undergoing major surgery in both London and Zimbabwe. Each time, she managed to recover, but by 1991 her body could no longer repair the physical damage brought on by a decade of severe illness. In October 1991, Zimbabwe hosted the meeting of Commonwealth heads of government, an occasion that included a visit by British Queen *Elizabeth II. The two weeks of ceremonials, festivities, and meetings took an immense toll on Sally Mugabe's fragile health. Toward the end of the events, observers noted that the usually vivacious first lady could barely summon the strength to shuffle in and out of her scheduled appearances.

After the conference, Mugabe's health continued to deteriorate. A kidney transplant was ruled out as not feasible in her weakened condition, and, although emergency surgery brought on a brief recovery, her condition declined rapidly. She died in Harare, Zimbabwe, on January 27, 1992. Although many of the citizens of her adopted country thought well of their first lady, by the time of her death in 1992 the country's problems were immense, with little prospect of improvement. Although Robert Mugabe remained popular as a near-legendary leader, his government was generally disliked. Public reaction to Sally Mugabe's death reflected the sober national mood at the start of a second decade of independence. Upon hearing the news, many workers simply wanted to know whether or not a public holiday would be declared for her funeral (it was not).

Despite Zimbabwe's problems and the widespread disillusionment among the people, Sally Mugabe's funeral was an event filled with sadness, as well as pomp and circumstance. Here, her Ghanaian heritage dominated center stage. During her life, many of the first lady's colleagues had found it difficult fully to accept her as a Zimbabwean because she had never been able to completely master with fluency all of the subtleties of Shona, the national vernacular. But now, the customs of her native Ghana were asserted with pride as she lay in state on a golden bed which had been flown in specially from Ghana. She wore an elaborate white lace dress, and her hands and neck were adorned with traditional Ghanaian gold jewelry and trade beads. Sitting around the bed, Zimbabwean Catholic nuns sang traditional songs, alternating with Ghanaian drumming and music. Reporter Andrew Meldrum called the ceremony, "a spellbinding mix of Ghanaian and Roman Catholic traditions, as well as Zimbabwean and Western customs." As thousands of Zimbabweans filed by the bed, Robert Mugabe shook hands with each one. During the mourning period of six days, he revealed the extent of his loss by commenting, "She was a great support and help to me. I don't know if I can carry on without her." After the conclusion of the final ceremony, Sally Mugabe was declared to be a National Hero of Zimbabwe and was buried alongside 16 leading national patriots at Heroes Acre. In London, where she had once lived in exile, a building was named in her honor in May 1993 by the Phoenix Women's Health Organisation of the Borough of Southwark.

The years after her death did not bring to Zimbabwe the advancements for which its people yearned. The regime she and her husband had created was close to being a one-party state, and a flourishing culture of corruption as well as economic stagnation marred Zimbabwe's social landscape. By 1998, food riots convulsed Harare, causing the deaths of at least eight people. Discontent remained strong at the start of the new millennium. In April 2000, pro- and anti-Mugabe forces clashed in the streets of the national capital. Members of the emerging anti-regime coalition, calling themselves the National Constitutional Assembly, were seriously injured when they were attacked by pro-government veterans of the war of liberation. Several of the protesters, including the journalist **Grace Kwinjeh**, were detained by police after they complained about official brutality. After two decades of independence in Zimbabwe, it was clear that the creation of a prosperous and caring society based on a respect for human rights was at least as difficult a goal to achieve as freedom once had been.

SOURCES:

Meldrum, Andrew. "Death of an African First Lady," in *Africa Report*. Vol. 37, no. 2. March–April, 1992, pp. 54–55.

——. "Zimbabwe: Uniting the Opposition?," in *Africa Report*. Vol. 37, no. 2. March–April, 1992, pp. 52–56.

"Mugabe, Sally," in *Tabex Encyclopedia Zimbabwe*. 2nd ed. Worcester, England: Quest, 1989, p. 257.

Rasmussen, R. Kent, and Steven C. Rubert. *Historical Dictionary of Rhodesia-Zimbabwe*. 2nd ed. Metuchen, NJ: Scarecrow Press, 1990.

"Resisting Change in Zimbabwe," in *The New York Times*. April 6, 2000, p. A28.

Sackey, Catherine. "Phoenix honours Sally," in *West Africa*. No. 3946. May 10–16, 1993, p. 799.

"Sally Mugabe," in *The Times* [London]. January 30, 1992, p. 17.

"Sally Mugabe, Anti-Colonialist, 60," in *The New York Times*. January 28, 1992, p. B10.

Smith, George Ivan. "Love in a Troubled Continent," in *The Guardian* [London]. February 3, 1992, p. 35.

John Haag,
Associate Professor of History,
University of Georgia, Athens, Georgia

Muhlbach, Louise or Luise (1814–1873).

See Mundt, Klara Müller.

Muir, Elizabeth (d. before 1355)

*Duchess of Atholl. Name variations: Elizabeth Mure; Elizabeth of Rowallan. Died before 1355; daughter of Adam Muir (or Mure) of Rowallan; became first wife of Robert II (1316–1390), earl of Atholl, earl of Strathearn (r. 1357–1390), king of Scots (r. 1371–1390), around 1349; children: John Stewart of Kyle, later known as Robert III, king of Scots (1337–1406, who married *Annabella Drummond); Walter Stewart, earl of Fife (r. 1362–1363); Robert Stewart, 1st duke of Albany (1339–1420, who married *Muriel Keith); *Margaret Stewart (who married John MacDonald, 1st lord of Isles); Alexander Stewart, 1st earl of Buchan, known as the Wolf of Badenach; *Marjorie Stewart (who married John Dunbar, 1st earl of Moray, and Alexander Keith of Grantown); *Elizabeth Stewart (who married Thomas de la Haye); *Isabel Stewart (who married James Douglas, 2nd earl of Douglas, and John Edmondstone); *Jean Stewart (who married John Keith, Sir John Lyon, and James Sandilands of Calder); *Katherine Stewart (who married Sir Robert of Restalrig). Robert II's second wife was *Euphemia Ross (d. 1387).*

Muir, Jean (1911–1996)

American actress. Born Jean Muir Fullarton on February 13, 1911, in New York City; died at a nursing home in Mesa, Arizona, on September 23, 1996.

Selected filmography: The World Changes *(1933);* Son of a Sailor *(1933);* Bedside *(1934);* As the Earth Turns *(1934);* A Modern Hero *(1934);* Dr. Monica *(1934);* Desirable *(1934);* Gentlemen Are Born *(1934);* Female *(1934);* The White Cockatoo *(1935);* Oil for the Lamps of China *(1935);* Orchids for You *(1935);* A Midsummer Night's Dream *(1935);* Stars Over Broadway *(1935);* White Fang *(1936);* Fugitive in the Sky *(1936);* Once a Doctor *(1937);* Her Husband's Secretary *(1937);* Draegerman Courage *(1937);* The Outcasts of Poker Flat *(1937);* White Bondage *(1937);* Dance Charlie Dance *(1937);* And One Was Beautiful *(1940);* The Lone Wolf Meets a Lady *(1940);* The Constant Nymph *(1941).*

A stately blonde, Jean Muir began her career on the Broadway stage in 1930, and was offered a contract with Warner Bros. on the strength of her performance in the play *Saint Wench* (1933). Muir's talent, however, far exceeded what the studio could offer in the way of roles, and from the late 1930s she concentrated on her stage career.

While playing the role of the mother on "The Aldrich Family" television series in 1950, Muir was named as a Communist sympathizer by the infamous Red Channels newsletter, a publication that listed suspected or rumored Communists and Communist sympathizers. Readers of Red Channels bombarded the network and the sponsor with angry phone calls and letters. As a result, Muir lost her job and was blacklisted, but the dismissal brought widespread attention to the industry's practice of ostracization. Muir denied the charges: "I am not a Communist, have never been one, and believe that the Communists represent a vicious and destructive force, and I am opposed to them." Even so, General Foods, the sponsor of the show, issued a press release stating that although it had no idea if the accusations were true, it had to dismiss Muir because she was now a controversial figure.

The ordeal took its emotional toll, and Muir suffered a long bout of alcoholism. She eventually survived her career crisis, however, and returned to Broadway and television during the 1960s. In 1968, she moved to Columbia, Missouri, taking a teaching position in the drama department at Stephens College.

Muir, Jean (1933–1995)

British fashion designer. Born Jean Elizabeth Muir in 1933 in London, England; died of cancer on May 28, 1995, in London; educated at Dame Harper School, Bedford, England, 1945–50; married Harry Leuckert, in 1955.

Worked in lawyer's office in London (1951); worked as salesgirl and fashion sketcher at Liberty's department store, London (1952–55); was a designer for Jacqmar, London (1955), and for Jaeger dress and knitwear collections, London (1956–63); was a founder-director, Jane and Jane fashion company, London (1962–66); founder-partner, with Harry Leuckert, and chief designer, Jean Muir Limited, London (from 1966).

Exhibitions: "Fashion: An Anthology" (Victoria and Albert Museum, London, 1971); "Eye for Industry" (Victoria and Albert Museum, 1986).

Concentrating on elegant and stylish tailoring instead of fashion's latest whim, Jean Muir designed clothing that is known for its quality and classic appeal. She was born in London in 1933 and studied at the Dame Harper School in Bedford, England, before going to London in

1951 and working briefly in a lawyer's office. She then became a saleswoman at Liberty's, where she also did fashion sketching from 1952 to 1955. She began working at Jaeger in 1956, and in 1961 opened a shop known as Jane and Jane. She started her own design firm, Jean Muir, in 1966.

Like designers *Coco Chanel, *Madeleine Vionnet, and *Alix Grès, Muir took an approach to design and fashion that was fundamental: clothes start with the body and fabric is a determining styling concept. She considered herself an artisan rather than an artist, noting, "Fashion is not art, it is Industry" and a beautiful design that could not be transferred into reality was useless. Her favorite clothes had classic shapes and were often made of jersey, which she favored because of the way it flowed on the female form. Muir also liked working with leather, especially suedes. The blatancy of plunging necklines and high-slit skirts did not appeal to her, and she strove to create clothes that were both refined and subtly seductive. Her clientele included *Carol Channing, Lauren Bacall, Elaine Stritch, and *Glenda Jackson.

Muir was the recipient of many fashion industry honors, including the British Fashion Writers Dress of the Year Award (1964); the Ambassador Achievement Year Award (1965); the *Harper's Bazaar* Trophy (1965); the Maison Blanche Rex International Fashion Award, New Orleans (1967, 1968, 1974); the Churchman's Fashion Designer of the Year Award (1970); the Neiman Marcus Award (1973); Mayor's Citation Award, Philadelphia (1977); the British Fashion Industry Award (1984); the Federation Française du Pret-à-Porter Feminin Award (1985); and the Design Medal, Chartered Society of Designers, London (1987). She was also named Royal Designer for Industry, Royal Society of Arts, London (1972), and a fellow of the Chartered Society of Designers, London (1978). She was awarded an honorary doctorate from the Royal College of Art, London (1981), and was created a Commander of the Order of the British Empire (CBE) in 1984. Jean Muir died of cancer at age 62 on May 28, 1995, in London.

SOURCES:

Pendergast, Sara, ed. *Contemporary Designers*. 3rd ed. Detroit, MI: St. James Press, 1997.
People Weekly. June 12, 1995.

SUGGESTED READING:

Black, J. Anderson, and Madge Garland. *A History of Fashion*. London, 1975, 1980.
Bowles, Hamish. "The Prime of Miss Jean Muir," in *Vogue* (New York). September 1995.
Fashion: An Anthology by Cecil Beaton. Exhibition catalog compiled by Madeleine Ginsburg. London, 1971.
Halliday, Leonard. *The Fashion Makers*. London, 1966.
Howell, Georgina. *In Vogue: Sixty Years of Celebrities and Fashion*. London, 1975.
McDowell, Colin. *McDowell's Directory of Twentieth Century Fashion*. London, 1984, 1987.
Muir, Jean. *Jean Muir*. London, 1981.
O'Hara, Georgina. *The Encyclopedia of Fashion from 1840 to the 1980s*. London, 1986.
Spindler, Amy M. "In London, Straining for Consistency," in *The New York Times*. October 24, 1995.

COLLECTIONS:

The Museum of Costume in Bath, England, holds a collection of Muir's clothes.

Jo Anne Meginnes,
freelance writer, Brookfield, Vermont

Muizeck, Marina (c. 1588–1614).

See Mniszek, Marina.

Mukhina, Vera (1889–1953)

Soviet Russian sculptor, noted internationally for her monumental stainless steel work **Worker and Collective Farm Woman**, *which stood a stunning 24 meters in height on top of the Soviet Pavilion of the 1937 International Exposition in Paris. Name variations: Vera Muchina; also known just as Mukhina. Born Vera Ignatevna Mukhina in Riga, Russian Empire (now Latvia), on July 1, 1889; died in Moscow on October 6, 1953; daughter of Ignaty Mukhin; married Alexei Zamkov; children: one son.*

The Soviet sculptor Vera Mukhina will forever be identified with Socialist Realism and the worst excesses of propaganda art during Joseph Stalin's dictatorship. She was an artist of international distinction, living in difficult times that necessitated making, at best, ambiguous choices. She was born into comfortable circumstances in Riga (now Latvia) in 1889, where her family had long enjoyed prosperity and social standing as hemp merchants. Her parents, however, rarely enjoyed robust health, and two-year-old Vera lost her mother to tuberculosis. Her father moved to Kiev where she was enrolled at the Feodosisky High School and began to reveal artistic talent. As a result, she took private drawing lessons at home. When she was 14, she also lost her father. After this, Mukhina moved to Kursk, continuing with her studies of painting and drawing. In 1910, she relocated to Moscow and became acquainted with a circle of wealthy merchant families, which included such noted art patrons and collectors as Ivan Morozov and Nikolai Ryabushinsky. She was also a pupil in Konstantin Yuon's art school, where *Liubov Popova and *Nadezhda Udaltsova were among

Worker and
Collective Farm
Woman *by Vera
Mukhina.*

her fellow students. For the next decade, Mukhina and Popova would be close friends, maturing together as people and artists.

Mukhina studied sculpting in Moscow for several years, attending not only Yuon's classes but those of other highly respected teachers, including Ilya Mashkov and Nikolai Sinitsyna. After recovering from a serious toboggan accident and resulting surgery in 1912, Mukhina decided to continue her art studies in Paris, which was made possible by the generous financial

support of her relatives. In Paris, she became a pupil at Emile-Antoine Bourdelle's studio at the Académie de la Grande Chaumiere. A temperamental but inspiring teacher, Bourdelle employed a method of instruction which emphasized free inquiry and experimentation. He was critical of transferring the aesthetic of Impressionism to sculpture, convinced that it could only do immense harm to the art form. He believed that the foundations of sculpture would always be clarity of construction, vigor of form, inner discipline, and a rigid observance of the laws of materials. Although Mukhina eagerly accepted many of his ideas, she was by no means a slavish devotee of the French master. She took full advantage of being in Paris, visiting the Louvre where she carefully investigated the artistic secrets of past masters, studying works which included two from ancient Egypt—a bronze walking Horus and a seated Pharaoh carved from pink granite—which taught her, as she would later note, about "the architectonics of form and concision of expression." At this early stage in her artistic development, she was already expressing her belief that "a large statue should be simple, it should express itself."

While involved with the newest trends in the arts, Mukhina also remained open to influence from the great artists of the past. These included Michelangelo, whom she admired for his power to "create titans"—an ideal and goal that became her own inspiration. She worked to perfect her technical skills, attending anatomy lectures at the Académie des Beaux-Arts. Mukhina also investigated works created by Cubist sculptors; she soon decided, however, that the artistic philosophy of Cubism was inimical to the aims of the ideal sculpture she wished to create, arguing that "Cubists reveal form, but skeletally [they lose] what is most dear, the image. When they try to depict a living person they are defeated." Almost as if she were saving up what she was learning for use on her return to Russia, Mukhina's portrait busts of her friends and studio colleagues in Paris are quite traditional, revealing few if any modernisms.

After visiting Italy's major artistic cities and archaeological sites, Mukhina went back to Moscow in the summer of 1914 and worked harder than ever to perfect her skills. Among her most impressive works from this period is a *Pieta* from the year 1916, which echoes archaic forms of stylization but still does not reveal a unified style of her own.

The Bolshevik Revolution of November 1917 provided Mukhina with a new creative stimulus. In 1918, Soviet leader Vladimir Lenin issued a decree on monumental architecture, calling on artists to spread the message of revolution and social transformation through works of art that would speak powerfully to the masses, many of whom remained illiterate and backward. Mukhina's model for a monument in honor of Nikolai Novikov, a writer who attacked the evils of serfdom in the 18th century, was enthusiastically hailed by the monumental art commission appointed by the ruling Bolshevik Party (this work, made of substandard materials, would not survive). Mukhina married the physician Alexei Zamkov in 1918 and gave birth to her only child, a son, in 1920.

Supporting the Revolution despite its heavy cost in human suffering and lives, the artist produced her first mature work of sculpture in 1922, when the young Soviet state was barely starting to recover from years of civil war, foreign intervention, and ill-conceived economic experimentation. Her *Flame of the Revolution*, a work designated as a memorial to the Bolshevik leader Yakov Sverdlov, depicts a winged female figure bearing a torch in her hand. Somewhat reminiscent of the work of Italian Futurist sculptor Umberto Boccioni, *Flame of the Revolution* is also a stylistically innovative work which symbolizes, in its dynamic imagery of flight, the whirlwind of change that had recently swept through Russia.

At the same time she created this monument, Mukhina broadened her interests to the area of design. She collaborated with *Alexandra Exter to produce designs for the motion picture *Aelita*, and also worked closely with Exter in the field of theatrical design. Mukhina also worked with the leading Soviet fashion designer of the period, Nadezhda Lamanova, whom she provided with sketches of hats and clothing which Lamanova then produced. After several years of fruitful experimentation, Mukhina returned to sculpting. Her 1926 work in wood, *Yulia*, is modeled after the Venus de Milo. Neither this work, nor *Wind*, which dates from 1927 and shows a young female nude attempting to stand upright in a fierce storm—refers to the events then taking place in the Soviet Union.

Nonetheless, the same year that *Wind* was produced, Mukhina's work indicated that she had begun to pay increasing attention to the often tragic upheavals facing her nation. Her 1927 bronze, *The Peasant Woman*, commemorated the first decade of Soviet rule. This work embodied the strength of the Slavic people of the soil, who had endured serfdom, exploitation,

wars and revolutionary turmoil. Hailed by critics and popular with the public, the bronze was purchased by the State Tretyakov Gallery, and as a reward Mukhina was given permission and funds to make a trip to Paris. The history of *The Peasant Woman* from this point on is, to say the least, highly unusual. While on exhibit in Fascist Italy in 1935, the bronze was sold to the Milan Museum, presumably because the Soviet state was badly in need of foreign currency. From Milan, Mukhina's work would eventually find its final home in the art collections of Vatican City. Some years later, the State Tretyakov Gallery filled the gap in its collection by using Mukhina's surviving plaster molds to cast a new copy of the bronze.

It was because of her marriage to Alexei Zamkov that Mukhina personally experienced how harshly interventionist the Soviet system could be in the lives of individuals. In 1930, her husband, having been denounced by a professional rival, was banned to the city of Voronezh. Determined to remain loyal to him and convinced of his innocence, Mukhina gave up her teaching post at Moscow's Higher School of Industrial Arts, where she had been an instructor since 1927, and she and her son followed her husband to Voronezh. Mukhina's family proved to be luckier than many in the Soviet Union. Because she had created a gravestone for the son of the eminent writer Maxim Gorky, the younger Gorky's vigorous intervention in the matter resulted in a lifting of the ban on Mukhina's husband, and the family was able to return to Moscow to resume their previous lives.

Starting in the early 1930s, Mukhina's sculptures took on a more detailed and true-to-life character. Her portraits from these years, while often exaggerating the most distinctive features of her sitters, were essentially realistic in nature. Often, however, they were not simply literal representations of the individual, but rather could be taken as typifications and generalized images of contemporary Soviet men and women. At the same time, she retained a sense of immediacy toward the essential personality and strengths of the person being portrayed.

Meanwhile, Mukhina continued to make models and dreamed of creating monumental sculptures. Over the course of her career, she would design approximately 20 such projects, none of which were carried out during her lifetime. Of the few that were completed after her death, virtually all were influenced by significant (and negative) changes that largely distorted and subverted her original intentions.

In 1935, she was offered the chance of a lifetime when she was selected to design the sculptural group that would stand atop the Soviet pavilion at the Paris World's Fair of 1937. The first sculptor to use stainless steel as a material, Mukhina created the monumental *Worker and Collective Farm Woman* (*Kolkhoznitsa*). Breathtaking in its immensity—24 meters in height—this idealization of the male urban proletarian and young rural woman depicted them both as perfect physical and moral specimens, true representatives of the newly imposed Stalinist artistic dogma of Socialist Realism. Brandishing their symbolic hammer and sickle, the victorious couple appeared to be striding confidently into a glorious Communist future. Many contemporary observers spoke of the work as a hymn of praise to youth, life, and the virtues of productive labor in an egalitarian society. Others, critical of the Soviet experiment in social engineering, saw little beauty in it, detecting instead a totalitarian spirit that gloried in having crushed the last vestiges of individualism.

Soviet postage stamp issued in honor of Vera Mukhina.

When it opened in 1937, the Soviet pavilion at the Paris World's Fair—facing the pavilion of Nazi Germany (designed by Albert Speer) at the foot of the Trocadero Gardens—was interpreted by most visitors as a bold visual and ideological challenge to Hitler's increasingly aggressive Third Reich. Topping an already huge exhibition building designed by Boris Iofan, *Worker and Collective Farm Woman* was an artistic embodiment of Soviet confidence in the future. The power of Mukhina's enormous work was almost enough to mask the bitter reality of Soviet life, namely that in 1937 the Great Purge was at its height. Stalin's USSR was a nation based on fear, arbitrary exercise of power, and total disregard for human rights.

Mukhina was elated by the success her effort enjoyed in Paris. Upset when the dismantled work arrived back in the USSR in badly damaged condition, she was even more disappointed some years later when the refurbished composition—set on a much-too-low pedestal despite her protestations that this would destroy its effectiveness—was displayed outdoors in Moscow's All-Union Exhibition of Economic Achievements. Dashed by this display by Soviet officialdom, she could only comment that the two noble figures now "did not fly, they only crept." Receipt of a Stalin Prize in 1941 for what was now already her best-known work did not compensate Mukhina for the poor setting in which the work had been permanently placed.

Over the course of her career, Vera Mukhina received many awards from the Soviet state, including the Order of the Red Banner in 1938, and Stalin Prizes in 1941, 1943, 1946, 1951, and 1952. She became a member of the USSR Academy of Arts in 1947 and a member of its Presidium in 1953. She was also designated a People's Artist of the USSR. Concerned during her final years about the toll taken on the arts by Stalinist dictates to produce only orthodox works of Socialist Realism, she courageously spoke in favor of artistic creativity in her last address before the Academy of Arts.

During the difficult years of World War II (known in the Soviet Union as the Great Patriotic War), Mukhina concentrated on portraiture. Her works from this period are often of high quality and display her great insight into the psychological essences of her subjects. Among these are her 1945 portrait (in wood) of the mathematician and shipbuilder Alexei Krylov. Awarded a Stalin Prize in 1946, this portrait takes on a universal aspect, presenting Krylov as both an individual and a representative of the strength of Russia's people in a war for national survival. Mukhina's 1942 plaster of Paris portrait of Colonel Bari Yusupov (cast in bronze in 1947) is another wartime work that continues to impress with its grasp of the stark times in which it was created. In her generalized symbolic image of Soviet wartime patriotism, *The Girl Partisan* (plaster of Paris 1942, cast in bronze 1951), Mukhina succeeded in creating a work that was clearly of propaganda value at the time, but also continues to resonate a generation later. With the war raging in 1944, she designed costumes for a production of Sophocles' *Electra* at Moscow's Vakhtangov Theater.

After the Allied victory over Nazi Germany in 1945, in a war which cost 30 million lives, Mukhina returned to her first love, the creation of monumental sculptures. She and other artists created a bronze and granite monument to Maxim Gorky (unveiled in Moscow in 1951), as well as collaborating on the multi-artist work *We Demand Peace!* of 1950. In the early 1950s, she worked on the façade of Moscow State University's main building, 32 stories in height, situated on the Lenin Hills area of the Soviet capital. There she created sculptures meant to reflect the desire for peace and justice that had so far largely been denied the peoples of the USSR.

Inspired by the belief that work resulting from her numerous creative interests would serve to expand the artistic vocabulary of Soviet art, Mukhina experimented with various new materials which included not only stainless steel but also polychromatic sculpture and glassware. She spent significant amounts of time during the last years of her life working with new types of artistic glass at the Leningrad Decorative Glass Factory. Although less well known than her other work, Mukhina's drawings, rendered with economy of means but replete with acute observations, constitute a veritable archive of her creative efforts. Throughout her career, she wrote essays and articles on many facets of art, many of which contain insights into both her own creative evolution and the history of art; these were collected and published in three volumes in 1960. Vera Mukhina died in Moscow on October 6, 1953—seven months after the death of Joseph Stalin. In 1954, her monument to Peter Ilyich Tchaikovsky was unveiled in Moscow. On June 25, 1989, a Soviet postage stamp was issued to commemorate the centenary of her birth. The Mukhina Higher School of Industrial Arts in Leningrad (now St. Petersburg) was renamed in her honor.

SOURCES:

Arkin, David. *Wera Muchina.* Dresden: Verlag der Kunst, 1958.

Bashinskaia, Irina Alfredovna. *Vera Ignatevna Mukhina, 1889–1953.* Leningrad: "Khudoznik RSFSR," 1987.

Bonnell, Victoria E. "The Peasant Woman in Stalinist Political Art of the 1930s," in *The American Historical Review*. Vol. 98, no. 1. February 1993, pp. 55–82.

Bown, Matthew Cullerne. *Art under Stalin*. NY: Holmes & Meier, 1991.

Cullum, Jerry. "Parodies Cast Witty Eye on End of Soviet Era," in *Atlanta Journal-Constitution*. February 13, 1998, p. Q6.

Dalton, Anne Meredith. "The Brief Appearance of Russian Experimental Sculpture in the Wake of Lenin's Plan. Four Exemplary Artists: Sergei Konenkov, Boris Korolev, Iosef Chaikov and Vera Mukhina." M.A. thesis, University of Texas at Austin, 1991.

Goodman, Susan Tumarkin, ed. *Russian Jewish Artists in a Century of Change, 1890–1990*. Munich and NY: Prestel Verlag, 1995.

Korolev, Iu K. *Vera Ignatevna Mukhina, 1889–1953: Skul'ptura, dekorativno-prikldnoe iskusstvo, grafika, teatr*. Moscow: Vrib, 1989.

Kostina, Olga. *Skulptura i vremia: Rabochii i kolkhoznitsa—skulptura V. I. Mukhinoi dlia pavilona SSSR na Mezhdunarodnoi vystavke 1937 goda v Parizhe*. Moscow: Sov. khudoznik-Komissiia SSSR po delam IUNESKO, 1987.

Milner, John. *A Dictionary of Russian and Soviet Artists 1420–1970*. Woodbridge, Suffolk: Antique Collectors' Club, 1993.

Musee Rodin, Paris. *Trois sculpteurs sovietiques: A.S. Goloubkina, V.I. Moukhina, S.D. Lebedeva*. Paris: Musee Rodin, 1971.

Rosenwasser, Natalja. "Vera Muchina (1889–1953)," in Irina Antonowa and Jörn Merkert, eds., *Berlin Moskau, 1900–1950 = Moskva Berlin, 1900–1950*. 3rd ed. Munich and NY: Prestel Verlag, 1995, pp. 329–331.

Sopotsinsky, Oleg. *Art in the Soviet Union: Painting, Sculpture, Graphic Arts*. Translated by Paul Barker, *et al*. Leningrad: Aurora Art, 1978.

Suzdalev, Petr Kirillovich. *Vera Ignatevna Mukhina*. Moscow: "Iskusstvo," 1981.

Voronova, Olga. "A Day in Three Studios," in *Culture and Life* [Moscow]. No. 3, 1973, pp. 9–11.

Wilson, Sarah. "The Soviet Pavillion in Paris," in Matthew Cullerne Bown and Brandon Taylor, eds., *Art of the Soviets: Painting, Sculpture and Architecture in a One-Party State, 1917–1992*. Manchester and NY: Manchester University Press, 1993, pp. 106–120.

Yablonskaya, M.N. *Women Artists of Russia's New Age 1900–1935*. Edited by Anthony Parton. NY: Rizzoli International, 1990.

Zopff, Maria Christina. "Die sowjetischen Pavillons auf den Weltausstellungen 1937 in Paris und 1939 in New York," in *Agitation zum Glück: Sowjetische Kunst der Stalinzeit*. Bremen: Edition Temmen, 1994, pp. 60–64.

Zotov, Aleksei Ivanovich. *Mukhina, Vera Ignatevna, narodnyi khudoznik SSSR*. Moscow: "Iskusstvo"-Massovaia biblioteka, 1941.

John Haag,
Associate Professor of History, University of Georgia,
Athens, Georgia

Mulally, Teresa (1728–1803).

See Nagle, Nano for sidebar.

Muldowney, Shirley (1940—)

American drag racer who was the first woman to win a National Hot Rod Association event title. Name variations: Cha Cha Muldowney. Born Shirley Rocque in Schenectady, New York, on June 19, 1940; daughter of a Teamster steward and laundry worker; married Jack Muldowney, in 1956 (divorced 1972); children: one son.

Was the first woman to qualify for a national event in Top Fuel (1974); was the first woman to win a National Hot Rod Association event title (1976); was the first woman to be selected for Auto Racing All American Team.

Shirley Muldowney's pink dragster was a familiar sight to racing crowds throughout America, but she had to struggle to get to the starting gate. In order to compete, Muldowney had to overcome discrimination by fellow drivers, sponsors, and racing fans, but once her day-glo dragster was at the starting line, she consistently demonstrated her skill and daring on the racetrack.

She was born Shirley Rocque in Schenectady, New York, on June 19, 1940, and was fascinated with racing cars by the time she was 14. Her boyfriend Jack Muldowney, who had a '51 Mercury with a standard shift, might have been partially responsible. Behind the wheel of the hot little car, she was hooked; she quit school at 16 to marry Jack and race cars. The couple, who had a son, formed a team—he was the mechanic and she was the driver. Her first car was a rebuilt 1940 Ford Coupe she bought for $40. Although she began racing in 1959, Muldowney did not win a major race until 1971, when she took first prize at the track in Rockingham, North Carolina. A year later, she and Jack divorced, so Shirley had to hire a new crew chief. She found Connie Kalitta, a man with an excellent reputation in the racing world.

At the beginning of her career, Muldowney raced in the Funny Car class, surviving three fiery crashes. The danger of fire is more common in this category because engines are mounted in front of the driver. At the '73 Indy, "my blower broke 1000 feet from the finish line," she said later. "I was going about 230 mph. I knew something was wrong before it blew, but it was such a good run—you can flat tell a good run—that I just didn't want to lift my foot off the accelerator." When she finally did, the car exploded. "It poured fuel all over me and set me on fire. I knew I was in a bad situation. I hit the fire bottle and then pulled my

parachute, but it burned right off. I drove behind the guy in the other lane, past a guard rail into a field and came to a stop. I got out with my helmet still blazing. My eyes were burned shut again."

Convinced that the Top Fuel class, where the engines are mounted behind the driver, was slightly safer, Muldowney became the first woman in the United States licensed to drive Top Fuel dragsters. In 1974, she was the first woman to qualify for a Top Fuel national event. Two years later, she was the first woman to win the National Hot Rod Association (NHRA) event title at the Spring Nationals in Columbus, Ohio. She broke the six-second barrier on the quarter-mile track, the first woman to do so. In 1977, she won three consecutive national events and gained the 1977 NHRA world championship title.

Despite her obvious success on the track, drag racing was difficult for Muldowney. Racing was considered a man's sport and no one

Shirley Muldowney

would sponsor her. As far as the racing world was concerned, she owed her wins to Connie Kalitta, her male crew chief. When Kalitta walked out in 1978, Muldowney had to prove he was not the reason for her success. She and her young crew were winless on the NHRA circuit for almost two years, but by 1980 driver and crew jelled. Muldowney set a record at the Winter Nationals quarter-mile track in Pomona, California, at 255 miles per hour. She then went on to break the six-second barrier at the Gator Nationals in Gainesville, Florida, where she clocked 5.705 seconds to win. In 1980, Muldowney won her second NHRA Top Fuel world championship, the first driver to win the world title more than once. The following year, she defeated her former crew chief, Kalitta, at the U.S. Nationals in Indianapolis. She also set a new drag-racing record of 5.57 seconds on the quarter-mile track, winning her first U.S. national title and a third world championship.

Muldowney survived many crashes, but a crackup in 1984 nearly took her life. As she blasted down the Sanair Speedway near Montreal at 250 miles an hour, her front tire blew out. The car flew 600 feet, breaking into pieces before stopping on an embankment. Both of Muldowney's legs were shattered, as were her pelvis, right hand, and five fingers. Her right thumb and left foot were nearly cut off. She spent almost a month in the hospital and then had to withstand five more operations. But the accident, as she said, did not kill her will to win (it also spurred the industry into making wheel and tire improvements). When the pink dragster once again pulled on to the raceway, at the 1986 Firebird International in Phoenix, Arizona, 20,000 spectators cheered Muldowney on. She had finally earned her place on the track and in the fans' hearts. In this comeback season, she had her career-best time of 5.42 seconds, racing over 267 miles per hour.

For 33 years, Shirley Muldowney was a pioneer in the racing world. She fought for opportunities, sponsors, and first place in a male-dominated sport. When she qualified for her dragster's license in 1965, the NHRA refused to accept it. When they finally had to issue the license, they refused to let her race in NHRA national events. But Muldowney kept lowering her elapsed times, increasing her top speed, and moving up from class to class. Even so, it took the NHRA three more years before it gave in. In 1982, the story of her amazing career was told in the film *Heart Like a Wheel*, starring **Bonnie Bedelia**.

SOURCES:

Duden, Jane. *Shirley Muldowney.* Mankato, MN: Crestwood House, 1988.

Jordan, Pat. *Broken Patterns.* NY: Dodd, Mead, 1977.

Woolum, Janet. *Outstanding Women Athletes: Who They Are and How They Influenced Sports in America.* Phoenix, AZ: Oryx Press, 1992.

RELATED MEDIA:

Heart Like a Wheel (113 min. film), starring Bonnie Bedelia, Beau Bridges, and Leo Rossi, 1982.

Karin L. Haag,
Athens, Georgia

Mulenga, Alice (1924–1978)

Zambian prophet and founder of the Lumpa Church. *Name variations: Alice Lenshina; Alice Lenshina Mulenga; Alice Mulenga Mubusha; Lenshina. Born Alice Mulenga in 1924 (one source cites 1927); died in prison in 1978.*

Alice Mulenga, who as Lenshina (meaning "regina" or "queen") founded Zambia's most well-known independent church, was born in 1924, in what was then the British protectorate of Northern Rhodesia. A member of the Bemba tribe, the country's largest ethnic group, she was raised as a Presbyterian. Western missionaries had flocked to Africa during the colonial occupation of the 19th century, many of them aggressively seeking converts to their various brands of Christianity; they were successful to a certain degree, with the result that throughout the 20th century indigenous African religions, including animism, ancestor worship, and a strong belief in magic and witchcraft, existed side by side (and often intermixed) with Islam and Christianity. In addition, it is estimated that over 7,000 separate religious movements in Africa have found followers, some in significant numbers, since the middle of the 19th century.

Alice Mulenga's movement began in 1953, when she underwent either a near-death experience or, as she believed, actual death and resurrection, accompanied by revelations commanding her to proselytize a new religion. Condemning traditional witchcraft and secular authority, and promising health and a "new life," Lenshina, as she became known, rapidly attracted followers and gained a reputation as a healer and a prophet. She founded the Lumpa Church (Lumpa being variously translated as "that which excels," "supreme," and "best of all"; the movement has also been called the Visible Salvation Church) around 1954. By 1960, the church could claim over 60,000 adherents to Lenshina's version of apocalyptic Christianity, which among other things forbade divorce, community responsibilities, magic, the traditional practice of polygamy, and beer.

Northern Rhodesia became the independent republic of Zambia in 1964, and in the new post-colonial era the Lumpa Church's tenet of rejection of secular authority became more problematic. Although the church was initially allied with Zambia's first government, led by President Kenneth Kaunda, the two institutions soon became involved in a dispute over taxation (which Lenshina also forbade). The struggle led to violence which that year caused the deaths of between 600 and 700 people. The church was banned by the government in 1965, and Lenshina was arrested. Many of her followers fled Zambia; those who did not were officially expelled from the country in 1970. Lenshina died, still in prison, in 1978. Despite this, the Lumpa Church remains active in parts of Zambia as an underground movement.

Karina L. Kerr, M.A.,
Ypsilanti, Michigan

Mulholland, Clara (d. 1934)

Irish novelist. Born in Belfast, Ireland, in the mid-19th century; died in Littlehampton, England, in 1934; attended boarding schools in England and Belgium.

Clara Mulholland was born in Belfast, in what is now Northern Ireland, in the mid-19th century. She received her education both at home and at boarding schools in England and Belgium. Mulholland wrote her first novel in 1880, and later wrote children's books as well. Her titles include *Percy's Revenge* (1888), *In a Roundabout Way* (1908), and *Sweet Doreen* (1915).

Grant Eldridge,
freelance writer, Pontiac, Michigan

Mulholland, Rosa (1841–1921)

Irish novelist. Name variations: Lady Gilbert; (pseudonym) Ruth Murray. Born in Belfast, Ireland, in 1841; died in Dublin, Ireland, in 1921.

Rosa Mulholland was born in Belfast, in what is now Northern Ireland, in 1841. She received a private education and subsequently made the acquaintance of Charles Dickens, who encouraged her to write and published her early stories in his periodical *Household Words.* In 1864, Mulholland released her first novel, *Dunmara,* under the pseudonym Ruth Murray; she went on

Rosa Mulholland

Safety Council; was a guest at White House Conference on Highway Safety (1954).

to produce novels for the next 50 years, including *The Wild Birds of Killeevy* (1883), *Marcella Grace* (1886), and *A Fair Emigrant* (1889).

Grant Eldridge,
freelance writer, Pontiac, Michigan

Mullens, Priscilla (c. 1602–c. 1685).

See Alden, Priscilla.

Muller, Gertrude (1887–1954)

American businesswoman and inventor, credited with inventing the first child's car seat, who was a pioneer in auto-crash product safety testing. Born Gertrude Agnes Muller on June 9, 1887, in Leo, Indiana; died of cancer on October 31, 1954, in Fort Wayne, Indiana; daughter of Victor Herbertus Muller (a businessman) and Catherine (Baker) Muller; attended International Business College in Fort Wayne, Indiana.

Worked at General Electric Company (1904–10); worked as assistant to the president and later as assistant manager of Van Arnam Manufacturing Co.; designed folding child's toilet seat, then founded Juvenile Wood Products Company (1924); designed first child's car seat and conducted auto-crash safety studies; made a National Veteran of Safety by the National

Gertrude Muller was born on June 9, 1887, in Leo, Indiana, the third of five children of Victor and **Catherine Baker Muller**. The son of German immigrants, Victor Muller was a prosperous businessman and town trustee in Leo, and the family was socially prominent until his death in 1893. Reduced circumstances then forced Catherine Muller to move with her children to Fort Wayne, where she made ends meet in enterprising ways, including taking in roomers and selling doughnuts.

Gertrude Muller spent a year at Fort Wayne's International Business College, taking secretarial instruction. She augmented her education with much reading on her own in various fields, including human development, health, and nutrition. From 1904 to 1910, she worked at the General Electric Company, then moved to the Van Arnam Manufacturing Company, a toilet seat fabricator. She rose to the position of assistant manager after four years as assistant to the president. Her first child development product design was a collapsible child's toilet seat. Called the "Toidey Seat," it was first manufactured by Van Arnam. A failed attempt to market the seats through plumbers led Muller to form her own company, Juvenile Wood Products, in 1924. She then successfully sold the seats through department stores and child specialty shops. A different informational and educational pamphlet on various progressive child-rearing practices, most of which Muller wrote herself, was included with each product; the pamphlet that accompanied the "Toidey Seat," recommending parents to encourage toilet-training and the child's resultant independence without undue vehemence, went through 26 printings and was also used by pediatricians and in home economics classes.

Juvenile Wood Products prospered even throughout the Depression, providing employment for several family members. (As plastics began to be used in place of wood, in 1944 the company was renamed the Toidey Company.) Products included a child's step-stool for the bathroom, a folding booster seat, and the first child's car seat, the "Comfy-Safe Auto-Seat." Muller was also committed to the concept of product safety. Toward that end, she was one of the first to conduct auto-crash safety studies. As a result of that dedication, the National Safety Council made her a National Veteran of Safety; she was one of the first three women to be so

honored. She was also a guest at the White House Conference on Highway Safety in 1954. Muller remained president of her company until her death from cancer of the spine on October 31, 1954.

SOURCES:

Griffin, Lynne, and Kelly McCann. *The Book of Women.* Holbrook, MA: Bob Adams, 1992.

Sicherman, Barbara, and Carol Hurd Green, eds. *Notable American Women: The Modern Period.* Cambridge, MA: The Belknap Press of Harvard University, 1980.

Ellen Dennis French,
freelance writer, Murrieta, California

Müller, Renate (1907–1937)

German stage and screen actress who committed suicide under suspicious circumstances during the Nazi era. Name variations: Renate Muller or Mueller. Born on April 26, 1907, in Munich, Germany; died after a fall from a third-story window on October 10, 1937; daughter of the editor-in-chief of the Münchener Zeitung *and a painter.*

Studied with Max Reinhardt (1924–25); appeared on the Berlin stage (1926); cast in first film (1928).

Selected filmography: Peter der Matrose *(Peter the Sailor, 1929);* Liebling der Götter *(Darling of the Gods, 1930);* Das Flötenkonzert von Sanssouci *(1930);* Die Blumenfrau von Lidenau *(1931);* Die Privatsekretärin *(Office Girl, remade in an English version as* Sunshine Susie, *1931);* Mädchen zum Heiraten *(Marry Me, 1932);* Walzerkrieg *(War of the Waltzes, also known as Waltz Time in Vienna, 1933);* Viktor und Viktoria *(1933);* Saison in Kairo *(1934);* Die englische Heirat *(1934);* Lisolette von der Pfalz *(1935);* Liebesleute *(1935);* Eskapade *(For Her Country's Sake, 1936);* Togger *(1937).*

Renate Müller's career in film began with the dawn of the sound-picture era in the late 1920s and came to an untimely end with the rise of the Nazi Party less than a decade later. Müller was born in 1907 into an affluent, intellectual family in Munich. Her mother was a painter, and her father was a historian, philosopher, and editor-in-chief of one of the most prominent newspapers in Munich. Müller grew up in that city as well as at a family home in the country in Emmering, Bavaria. An avid reader as a child, the gifted Müller also considered a career in opera, and when her family moved to Berlin in 1924 she was accepted for study at the prestigious Academy of Dramatic Art. The school was under the helm of Max Reinhardt, then a stellar figure in the German theater, and Müller's instructors

were equally celebrated; one was the film director G.W. Pabst. After a year of study, she began appearing in Berlin at the well-known Lessing Theater, where one of her first roles was that of *Fanny Elssler in Edmond Rostand's *L'Aiglon.*

Over the next few years, she gained experience in numerous roles, usually cast as a comedic actress. She also appeared with the Berlin Stadttheater before signing a film contract in 1928. Müller's first film appearance was in *Peter der Matrose* (Peter the Sailor), released in 1929. One year and a few films later, she was appearing opposite Germany's biggest star, Emil Jannings, in *Liebling der Götter* (Darling of the Gods). Her best-known role, however, came with 1931's *Die Privatsekretärin* (Office Girl). The film was an enormous box-office success, its simplistic, rags-to-riches tale seeming to appeal to German audiences at a dire time in their country's history. In the title role, Müller played a naive but ambitious young woman from the country who manages to get a job at a Berlin bank, primarily on the basis of her attractive legs. The comedy of errors involves a dinner date with a manager at the bank whom the typist believes to be someone else; in the end, he proposes. *Die Privatsekretärin* was made into both French and English versions—the English version, *Sunshine Susie*, also starred Müller—and after its success she was in great demand as an actress. She usually worked under contract to UFA, the famed cinematic production center in Germany during this era, and made numerous other well-received films. One in particular was 1934's *Viktor und Viktoria* (a 1980s remake that starred **Julie Andrews** was again a hit), in which Müller played a nightclub singer who, as a favor for a co-worker, takes his place on stage one evening; the co-worker, however, is a man who impersonates women, and the resulting turmoil surrounding her new stage role and a confused suitor drive the plot to its conclusion.

Such slightly risqué films were soon to be a thing of the past, however, with the rise of the Nazi Party in Germany. After it came to power in 1933, one of Adolf Hitler's closest associates, Joseph Goebbels, became the country's Propaganda Minister. Goebbels initially approved of Müller and her work, and she was considered "Aryan" enough—that is, fitting into the Nazis' concept of Germanic appearance, with blonde hair and blue eyes. But Müller, one of the country's most well-known stars, consistently avoided meeting Hitler despite formal invitations to the Chancellory (Goebbels reportedly wanted to set her up with the Führer), and as a result she came under suspicion for her political beliefs.

Even more dangerous for the actress was the fact that the secret police, after following her, became aware that she was dating a man of Jewish heritage. He then emigrated to England. She had to travel to London to see him, but it became increasingly difficult for her to leave the country.

Goebbels and the Ministry of Propaganda had been pressuring Müller to make one propaganda film a year, as other German film stars were also enjoined to do. Although she avoided complying for several years, she finally agreed to play a journalist in the 1937 film *Togger*. In it, Müller and a colleague battle against a plot by Jewish-Bolshevik agitators to rob Germany of freedom of the press. The irony of *Togger*'s plot in light of the situation in Germany surely was not lost on Müller. Later that same year she was beset by knee problems, and checked into a clinic for a two-week stay. On October 10, 1937, she died after a fall from a third-story window, apparently a suicide. Immediately after her death, the Ministry of Propaganda disseminated a series of rumors calculated to slander her name. She was buried in Berlin.

SOURCES:

Katz, Ephraim. *The Film Encyclopedia*. NY: Harper-Collins, 1994.

Romani, Cinzia. *Tainted Goddesses: Female Film Stars of the Third Reich*. NY: Sarpedon, 1992.

Ellen Dennis French,
freelance writer, Murietta, California

Müller-Preis, Ellen (b. 1912).

See Mayer, Helene for sidebar on Ellen Preis.

Mullins, Priscilla (c. 1602–c. 1685).

See Alden, Priscilla.

Mulock, Dinah Maria (1826–1887).

See Craik, Dinah Maria Mulock.

Mulso, Hester (1727–1801).

See Chapone, Hester.

Mu'minin, Umm al- (c. 613–678).

See A'ishah bint Abi Bakr.

Mumtaz Mahal (c. 1592–1631)

Indian empress of Persian extraction who is buried in the Taj Mahal, the most beautiful mausoleum—and, according to many, the most beautiful building—in the world. Name variations: Arjemand or Arjumand Banu; Nawab Aliya. Pronunciation: MOOM-taz mah-HALL. Born around 1592, probably in India; died after giving birth to her 14th child on June 7, 1631, in Burhanpur, India; buried in Agra, India; daughter of Asaf Khan (a noble and prime minister in the court of

the Mughal emperor Jahangir); married Prince Khurram, later known as Shah Jahan (third son of Jahangir and his successor as Mughal emperor), in April 1612; children: eight sons, including Dara Shikoh (b. 1615) and Aurangzeb (October 23, 1618–1707, who succeeded Shah Jahan as Mughal emperor), and six daughters, including **Jahanara** *and* **Roshanara**.

Married Prince Khurram at the instigation of her father, who wanted to advance her fortunes at the expense of Jahangir's empress (1612); became Khurram's constant companion for the next 19 years, earning the title Mumtaz Mahal (Jewel of the Palace) when he took the Mughal throne under the name of Shah Jahan (1628).

The Taj Mahal is considered by many connoisseurs to be the most beautiful building in the world. It stands in the popular imagination as a monument to the great love between Shah Jahan, the most powerful of the Mughal emperors, and his empress-wife Mumtaz Mahal. Shah Jahan was the son of the emperor Jahangir, grandson of the Great Mughal Akbar, and great-great-grandson of Babar who subdued the Hindus. Mumtaz Mahal was the niece of Jahangir and *Nur Jahan, the most powerful of the Mughal empresses. Mumtaz Mahal's father Asaf Khan was Jahangir's prime minister, and Asaf and his sister Nur Jahan engineered Mumtaz Mahal's marriage to Shah Jahan, who was then known as Prince Khurram. Although the prince had a reputation as a bit of a libertine (he already had two children from a previous relationship), he devoted himself to his wife after his marriage. Mumtaz Mahal accompanied him constantly on his many military campaigns against the Hindu princes of the Indian Deccan plain. Perhaps the greatest indication of his devotion, however, is the Taj itself—the "Crown of the Jewel," an unchanging memorial to his wife's memory.

The woman whose memory the Taj enshrines, however, is almost unknown. Mumtaz Mahal was not a Hindu, and, although she was born around 1592 in India and named Arjemand, she came from a Persian (and therefore Muslim) family. Her grandfather, Ghiyas Beg, had arrived from Persia to settle in India during the reign of Khurram's grandfather Akbar and sought service with him. Ghiyas Beg had married his daughter Nur Jahan, then known as Mehrunissa, to the Persian Sher Afkun; but Sher Afkun died in 1607, and Nur Jahan married Jahangir, Akbar's successor, in 1611. She was awarded the title Nur Jahan—"Light of the World"—and set about improving the status of her family. "Nur Jahan's relatives were entrusted

Mumtaz
Mahal

with the most important posts in the realm," writes S.M. Ikram. "Her father obtained a high office and her brother, Asaf Khan, in course of time, became the Prime Minister, and his daughter . . . married Prince Khurram." The Persian connection of Nur Jahan's family, Ikram continues, "attracted from Iran a large number of brilliant soldiers, scholars, poets and civil servants, who played an important role in the administration and the cultural life of Mughal India."

Arjemand was about 19 when she was married to the 20-year-old Prince Khurram. Based on what is known about the lives of well-born Mus-

lim women in India at the time, he had probably never seen her before. It was considered infamous for Muslim women in India to appear in public without wearing the veil. *Purdah* was a related and common Muslim practice of the time—the seclusion of well-born women in separate quarters, segregated from those of the household's men. "Seclusion . . . became a sign of respect and was strictly observed among the high class families of both [Hindu and Muslim] . . . communities," writes a historian in R.C. Majumdar's *The History and Culture of the Indian People.*

Eunuchs were freely employed as a means of communication between the male and female members of a royal or noble's family.

Even male doctors were not allowed to face the ailing ladies of the noble and princely families. The ladies would stir out of their houses very rarely and that, too, in covered palanquins, surrounded on all sides by servants and eunuchs.

"If, for any reason, a Muslim lady of rank discarded *purdah*, even for a temporary period," the historian concludes, "the consequences for her were disastrous. Amir Khan, the Governor of Kabul, felt no scruple in renouncing his wife when her *purdah* was broken in an attempt to save her life by leaping from the back of the elephant who had run amuck."

> *It is said that not once, for the eighteen years of their married life, did they ever spend a single day apart.*
>
> —Richard Halliburton

Given the severe restrictions on Muslim women, Arjemand's relative freedom and close association with Khurram seems even more remarkable. "He was known to have discussed all state affairs with her," writes Bamber Gascoigne, "and when state documents had been finally drafted he would send them into the harem for her to affix the royal seal." She also had a direct effect on foreign policy, and spoke out against the Portuguese slave trade and the practice of taking Hindu and Muslim children from their parents to be raised as Christians. "They were rash enough even to offend Mumtaz Mahal," declares Vincent A. Smith, "by detaining two slave girls whom she claimed."

Contemporary sources all note the fact that Arjemand accompanied Khurram everywhere, instead of remaining closeted in her harem. Since she gave birth to 14 children during her 19-year marriage, she was usually pregnant as well. And Khurram rarely stayed in one place for long. He was a fervent Muslim (unlike his father Jahangir and grandfather Akbar, both of whom showed great tolerance for Hindu beliefs and practices), and spent much of his early married life on military campaigns against the Hindu kingdoms of Ahmnedagar and Bijapur on the great Deccan plain. Arjemand was probably accompanying him from 1623 to 1626, when Khurram launched a rebellion against his father's advisors—including Arjemand's aunt Nur Jahan.

Toward the end of his reign, Jahangir had developed a drug problem, and he left much of the process of ruling in the capable hands of his wife Nur Jahan. Now Nur Jahan had a daughter named **Ladili Begum** by her first marriage to Sher Afghan, and she arranged to marry Ladili to Shahriyar, Khurram's younger brother. Prince Khurram became convinced that Nur Jahan meant to replace him as heir with Shahriyar. His suspicions were confirmed, when, failing on one of his military expeditions, Khurram was held in disgrace and Shahriyar was honored in his place. As a result, Khurram launched a rebellion that lasted for three years before he finally surrendered to the imperial forces in 1626. He was forced to give up two of his and Arjemand's surviving sons—Dara Shikoh and Aurangzeb—as pledges for his good behavior.

Asaf Khan, Arjemand's father and Khurram's only true ally during the rebellion, preferred to see his daughter as empress rather than his niece Ladili. When Jahangir died in 1627, Asaf seized and held power in the name of his son-in-law. He also recovered his grandsons from Nur Jahan's custody. "The happiness of the parents was indescribable," writes S.A.A. Rizvi. Khurram proclaimed himself Emperor Shah Jahan on January 2, 1628, and rewarded Asaf Khan with the office of *wakil*. At the same time, Arjemand was given the title "Mumtaz Mahal"—the "Jewel of the Palace." "Nur Jahan," Rizvi concludes, "was awarded a pension of two lacs of rupees and retired to Lahore, where she died in 1655."

Shah Jahan's first task as a new emperor was to eliminate all possible rivals to the throne. He then moved against the few remaining governors who had been appointed by his father or by Nur Jahan. In December 1629, he went up against Khan-i Jahan Lodi, who had been his opponent in the rebellion of 1626–29. Shah Jahan had just finished fighting Khan-i Jahan Lodi in the province of Burhanpur when the 39-year-old Mumtaz Mahal, who had been accompanying him as usual, died in June 1631. Following the delivery of her 14th child (only seven of them survived her), she had contracted a fever. "Her body," writes Smith, "was interred there temporarily, and after six months, when her mourning husband quitted the Deccan, was transferred to Agra, where it was placed in a provisional sepulchre." "She must have possessed uncommon charm," the historian concludes, "to be able to secure for so many years her husband's errant affections."

"Mumtaz Mahal had been as influential a companion to Shah Jahan as her aunt Nur Jahan to his father," writes Gascoigne:

> but whereas Nur Jahan's role had been one of dominance hers was essentially a matter of support and advice. . . . Her death left a profound gap in his existence; it was said that for two years he lived the life of one in mourning, rejecting all indulgence or ostentation, and going without gorgeous clothes or rich food or music.

Taj Mahal.

Shah Jahan's depression at the loss of his beloved wife affected him in other ways as well. Historians note that he turned away from his military campaigns at this time, letting them fall into the hands of his two eldest sons, Dara Shikoh and Aurangzeb. Instead he turned increasingly to architecture, his second-greatest passion. "He resolved to build his wife the most magnificent memorial on earth," explains Alistair Shearer. He began construction of Mumtaz's mausoleum, the Taj Mahal, in January 1632.

Shah Jahan completed the Taj in February 1643 and, according to most reports, nearly bankrupted the country in the process. The cost of the entire project amounted to more than five million rupees. Shah Jahan gathered an international team of architects, artisans, and designers that included a Persian, a Frank, a Turk, and an Italian. Peter Mundy, an English writer who visited Agra during the first months of construction, reported: "The building . . . goes on with excessive labor and cost, prosecuted with extraordinary diligence; Gold and silver are esteemed common metal, and Marble but as ordinary stone." The marble in question was imported on elephant-back from quarries in Rajasthan, hundreds of miles away. The jewels used in the decoration of the mausoleum came from as far as Tibet, Russia, and Iraq. "It is as if all the skill, expertise, and resources accumulated by the eclectic, adventurous Mughal dynasty," Shearer writes, "came together at one point in time and space to create what has become the most enduring romantic symbol of human love."

The Taj itself is not only a memorial to Mumtaz; it is also a representation of the Muslim concept of heaven. "The Mughals, originally from the steppes of Central Asia, shared their nomadic ancestors' love of gardens," Shearer writes. "Each bed was originally planted with four hundred flowers. The canals were lined with trees: cypress symbolizing death, fruit trees symbolizing life. In its heyday the garden must have been magnificent." The gardens also contain reflecting pools which mirror the image of the Taj in the same way, it is believed, that the *Qur'an* mirrors the truth of heaven. The dome of the mausoleum resembles a pearl, the jewel that rep-

resents most clearly to Muslims the perfection of Allah. In the tomb and its surroundings, Shah Jahan did his best to create on earth the paradise that he believed his queen now inhabited.

Shah Jahan and Mumtaz Mahal had had four sons who lived to adulthood. Late in his reign, however, his sons launched a rebellion against his rule, as Shah Jahan had against his own father Jahangir. In the dynastic struggle that followed, his son Aurangzeb emerged triumphant. Aurangzeb, who was an even stricter Muslim than his father, ordered the execution of his brothers and in 1658 forced his father to abdicate in his favor. Shah Jahan lived another eight years, a prisoner in his palace at Agra. "He would sit staring across the curve of the Jumna towards the memorial to his beloved wife, and his own most famous achievement, the Taj Mahal," writes Gascoigne. When the former emperor finally died, on January 22, 1666, his body was taken to the Taj and placed in a sarcophagus next to Mumtaz's.

Aurangzeb honored the memories of his father and mother and maintained the Taj throughout his reign. When he died in 1707, however, the power of the Mughals went into decline. Within 30 years of his death, Agra itself was sacked and the Peacock Throne of Shah Jahan was carried off by the Persians to Tehran and placed in the palace of the shah of Persia. Local Hindus, members of the Jhat tribe, carried off the solid silver doors that closed the gate to the tomb gardens. The Taj fell into neglect, its gardens overgrown, its stone weather-worn.

During the British Raj, the mausoleum occasionally served as a dancing-hall or as a drinking-place for unruly British soldiers. The Taj narrowly escaped destruction in the 1830s at the hands of the British governor-general, Lord William Bentinck (1828–1835), who wanted to tear the building down and ship it off to England to be sold as souvenirs. "The reason we can stand and marvel at the Taj today," Shearer notes, "is solely that Bentinck's scheme was not, in our ugly modern phrase, 'financially viable.'"

It was another governor-general, Lord Curzon, who restored Mumtaz Mahal's tomb to its original beauty and once again made it a pilgrimage spot for lovers and romantics. The American writer Richard Halliburton, one of the most popular travel writers and lecturers of the early 20th century, visited the empress' mausoleum in the 1920s and spread its reputation across the United States. Halliburton reports a story of the grace and beauty of the empress Mumtaz Mahal, the Jewel of the Palace:

Legends say that if a man and a maid greatly love each other, and have only goodness and mercy in their hearts, and if they come to the garden [of the Taj] together to watch the full moon rise, they may chance to see the sepulcher fade into mist and moonbeams. And in the mist they may see the image of the Queen, revealed for one magic moment—all beautiful and radiant.

SOURCES:
Gascoigne, Bamber. *The Great Moghuls.* NY: Harper & Row, 1974.
Halliburton, Richard. *Richard Halliburton's Complete Book of Marvels.* Indianapolis, IN: Bobbs-Merrill, 1960.
Ikram, S.M. *History of Muslim Civilization in India and Pakistan: A Political and Cultural History.* 4th ed. Lahore: Institute of Islamic Culture, 1989.
Majumdar, R.C., general ed. *The History and Culture of the Indian People: The Mughul Empire.* Bombay: Bharatiya Vidya Bhavan, 1974.
Rizvi, S.A.A. *The Wonder That Was India, Volume II: A Survey of the History and Culture of the Indian Subcontinent from the Coming of the Muslims to the British Conquests, 1200–1700.* Calcutta: Rupa, 1987.
Shearer, Alistair. *The Traveler's Key to Northern India: A Guide to the Sacred Places of Northern India.* NY: Alfred A. Knopf, 1989.
Smith, Vincent A. *The Oxford History of India, Part II.* Revised by J.B. Harrison. 3rd ed. Edited by Percival Spear. Oxford: Clarendon Press, 1958.

SUGGESTED READING:
Basham, A. L., ed. *A Cultural History of India.* Delhi: Oxford University Press, 1975.
Embree, Ainslie T., ed. and rev. *Sources of Indian Tradition, Volume I: From the Beginning to 1800.* 2nd ed. NY: Columbia University Press, 1988.
Mujeeb, M. *The Indian Muslims.* Montreal: McGill University Press, 1967.

Kenneth R. Shepherd,
Adjunct Instructor in History, Henry Ford Community College, Dearborn, Michigan

Munck, Ebba (1858–1946)

Countess of Wisborg. Name variations: Ebba Henrietta of Fulkila. Born Ebba Henrietta Munck on November 15, 1858; died on October 16, 1946; daughter of Carl Jacob Munck; married Oscar Charles Augustus (son of the king of Sweden), count of Wisborg, on March 15, 1888; children: Countess Maria Sophia Henrietta Bernadotte (1889–1974); Carl Oscar (b. 1890), count of Wisborg; Countess Sophia Bernadotte of Wisborg (1892–1936, who married Carl Marten, baron Fleetwood); Countess Elsa Victoria Bernadotte of Wisborg (b. 1893, who married Carl Cedergren); Count Folke Bernadotte (January 2, 1895–1948), count of Wisborg (a humanitarian who, having engineered the Red Cross and prisoner exchange with Nazi Germany, in turn saving many Jews, was assassinated).

Mundt, Klara Müller (1814–1873)

German novelist. Name variations: (pseudonym) Luise or Louise Mühlbach. Born Klara Müller in Neubrandenburg, Germany, on January 2, 1814; died in Berlin on September 26, 1873; married Theodore Mundt (1808–1861, a novelist and critic), in 1839.

In 1839, Klara Müller married author Theodore Mundt, a teacher at the University of Berlin and then a professor of general history and literature in Breslau. That same year, under the pseudonym Luise Mühlback, Klara Müller Mundt published her first novel. The long series of historical romances which followed earned her a large audience and a large fortune, enabling her to support her husband during the lengthy illness which preceded his death, and to build a handsome residence in Berlin, where she was a prominent figure in literary society. Her salon brought *Fanny Lewald, among others, to the attention of high society.

Mundt, an advocate of women's suffrage and changes in the social position of women, was a frequent participant in reform movements and wrote many essays on social questions. Her stories have been translated into English, and were well known in Great Britain and America. The most important of these are her historical novels, including *Aphra Behn* (3 vols., 1849), *Frederick the Great and his Court, Joseph II and His Court, Henry VIII and *Catharine Parr, *Louisa of Prussia* and Her Times, *Marie Antoinette and her Son, The Empress *Josephine, and *The Thirty Years' War*. In all, Mundt wrote more than 50 novels, some multivolume, comprising nearly 100 volumes.

Munia Elvira (995–1067)

Queen of Navarre. Name variations: Munia Mayor Sanchez. Born in 995; died in 1067; daughter of Sancho, count of Castile, and Urraca (d. 1025); married Sancho III the Great (c. 991–1035), king of Navarre (r. 970–1035); children: Garcia III, king of Navarre (d. 1054). Two other children were born to Sancho III the great and Sancha de Aybar: Ferdinand or Fernando I, king of Castile and Leon; Ramiro I, king of Aragon.

Munk, Kirsten (1598–1658).

See Ulfeldt, Leonora Christina for sidebar.

Muñoz, Jimena (c. 1065–1128)

Mistress of Alphonso VI, king of Castile and Leon, and mother of Teresa of Castile. Name variations: Munoz, Muñiz, or Múñoz. Born around 1065; died in 1128; probably daughter of Count Monnio (Muño) Muñiz and Velasquita, an aristocratic couple from the region of Bierzo; began liaison with Alphonso VI (c. 1030–1109), king of Castile and Leon, around 1080; children: Elvira (who married Raymond IV of Toulouse, count of St. Giles, and died after 1151); Teresa of Castile (c. 1080–1130), countess of Portugal.

Capture of Toledo by Alphonso VI (1085); capture of Valencia by El Cid (1094); Urban II called for First Crusade (1095); death of El Cid (1099); surrender of Valencia to Almoravids (1102); death of Raymond of Burgundy (1107); death of Sancho at battle of Uclés (1108); death of Alphonso VI (July 1, 1109); death of Alphonso I the Battler (1134).

Very little is known with certainty about the life of Jimena Muñoz. Medieval chronicles make little mention of her, except that she and Alphonso VI, king of Castile and Leon, had two illegitimate daughters. But those chronicles provide little information at all on women, including the legitimate queens. Nonetheless, Jimena was an important figure in Castile around 1100 because her daughter *Teresa of Castile laid the groundwork for Portuguese independence and because Alphonso VI appointed Jimena to political positions rarely accorded a woman who was not part of royalty. "During all his life, she maintained [Alphonso's] favor," writes Augusto Quintana Prieto, "and continued governing uninterrupted in the imposed castle of Ulver and in all its jurisdiction."

Bits and pieces of documentary evidence indicate that Jimena's parents were probably Count Monnio Muñiz and **Velasquita**, an aristocratic couple from the region of Bierzo. Jimena had three brothers (García, Pelayo, and Pedro) and a sister (**Marina**). She was probably born in Corollún around 1065, given that her two daughters by Alphonso seem to have been born between 1078 and 1083. There are indications that she was related to the king's first wife *Agnes of Poitou (1052–1078) and may have accompanied her as a lady-in-waiting to court, where she caught the king's eye. At any rate, Agnes died on June 6, 1078, and Alphonso did not remarry until 1080, to *Constance of Burgundy (1046–c. 1093).

By 1085, Jimena had apparently left court and returned to Bierzo. The king provided for his lover and their two daughters by granting Jimena the *tenencia* (tenancy and lieutenantship) of Ulver and the counties of Astorga Bierzo. She held these territories and their castles, despite opposition from other Leonese aristocrats, until Alphonso's death in 1109. Her father Monnio

helped her govern these jurisdictions. She made several donations of land to religious institutions, including the cathedral in Astorga and the monastery of San Pedro de Montes. Upon her death in 1128, she was buried in the San Andrés de Espinareda monastery.

Nonetheless, Jimena's chief influence upon history was her daughter Teresa. Although Alphonso always accorded Teresa of Castile and her sister **Elvira** respect as *infantas* (princesses), he never legitimized them. He did, however, arrange Teresa's marriage to Henry of Burgundy (a nephew of Queen Constance) and made them count and countess of Portugal. When Alphonso VI died without a male heir in 1109, his daughter *Urraca (c. 1079–1126) became ruler of Castile and Leon. Teresa and Henry resented Urraca's good fortune and her refusal to recognize their claims to Toledo, which they believed Alphonso had meant for them. They consequently resisted Urraca, the eventual result being the independent monarchy of Portugal established by Teresa's son Alphonso I Enriques in 1139.

SOURCES:

Prieto, Augusto Quintana. "Jimena Muñiz, madre de Doña Teresa de Portugal," in *Revista Portuguesa de História.* Vol. 12, 1969, pp. 223–280.

Patrice Munsel

Reilly, Bernard F. *The Kingdom of León-Castilla under King Alfonso VI, 1065–1109.* Princeton, NJ: Princeton University Press, 1988.

Kendall Brown,
Professor of History, Brigham Young University, Provo, Utah

Munsel, Patrice (1925—)

American opera singer. Born Patrice Beverly Munsel on May 14, 1925, in Spokane, Washington; only child of Audley Joseph Munsel (a dentist) and Eunice Ann (Rasmussen) Munsel; graduated from Lewis and Clark High School; attended William Herman School of Singing; had private tutoring in language, piano, theory and dramatics; married Robert C. Schuler, on June 10, 1952; children: Heidi Schuler; Rhett Schuler; Scott Schuler; Nicole Schuler.

The youngest singer to debut with the Metropolitan Opera, Patrice Munsel was born in 1925 in Spokane, Washington, the only daughter of a successful dentist. Her mother **Eunice Munsel**, also musically inclined, had high hopes for her daughter and guided her career from the beginning. As a schoolgirl, Munsel took ballet and tap-dancing lessons, and also studied "rhythmic whistling," which she later credited with developing the breath control and phrasing she used in singing. She began studying voice seriously at the age of 12, and at 16 went with her mother to New York, where she began lessons with William Herman and Renato Bellini. She was coached in operatic roles by Giacomo Spadoni, who later brought her to the attention of Wilfred Pelletier, program conductor of the popular radio show "Metropolitan Auditions of the Air." Singing the "Mad Scene" from *Lucia di Lammermoor*, Munsel became the youngest winner in the history of the show and walked away with a coveted contract with the Metropolitan. Around the same time, she signed a lucrative three-year concert contract, which began with a performance in her hometown of Spokane, to benefit the Red Cross.

For her debut with the Metropolitan on December 4, 1943, Munsel sang the role of the courtesan Philine in *Mignon*, a role she had to learn from scratch for the performance. While the audience adored the 18-year-old (dubbed the "baby coloratura"), the critics found that she lacked the poise and vocal agility for that sophisticated role. "Miss Munsel, though a young woman of phenomenal talents is far from being prepared for present glory," wrote Virgil Thomson. Other early roles included Olympia in *Tales of Hoffmann* and Gilda in *Rigoletto*, which the critics felt were also a bit beyond her. More promising was her role in *The Barber of Seville* in

1944, which was cited as "proficient"; her rendition of the popular aria "Una voce, poco fa" was singled out as particularly well performed.

Munsel finally found a comfortable niche with the Metropolitan, and continued to develop a parallel concert and recording career. She also became a popular radio entertainer and played the title role in the film *Melba* (1953), based on the life of Australian opera star *Nellie Melba. She performed with the Met until the late 1950s, after which she concentrated on musical comedy.

SOURCES:
Morehead, Philip D., and Anne MacNeil. *The New International Dictionary of Music.*
Rothe, Anna, ed. *Current Biography 1945.* NY: H.W. Wilson, 1945.

Barbara Morgan,
Melrose, Massachusetts

Münter, Gabriele (1877–1962)

German artist and co-founder of the Blue Rider movement, one of the most important schools of 20th-century German Expressionist art. Name variations: Gabriele Munter. Pronunciation: GAH-bree-el MUHn-ter. Born on February 19, 1877, in Berlin, Germany; died on May 19, 1962, in Murnau; daughter of Carl Friedrich Münter (a dentist) and Wilhelmine (Scheuber) Münter; had two brothers and one sister; attended Lyceum for Girls in Koblenz; private art lessons from the Herford art organization "Malkiste"; private lessons from the Düsseldorf professor Willy Spatz and from the sculptor Hermann Küppers in Bonn; and classes at the Ladies Academy of the Association of Women Artists in Munich and the Phalanx School in Munich; never married.

With family, moved from Berlin to Herford, Germany (1878); with family, lived in Bad Oeynhausen before moving to Koblenz (1884); enabled by inheritance from mother to chart her own course in art and art training (1897); toured and visited in the U.S. (1898–1900); met Vassily Kandinsky, the beginning of a long-term personal and professional relationship (1902); traveled to Paris with Kandinsky (1903); visited Holland and Tunisia with Kandinsky (1905); had first solo exhibition at Cologne (1908); was a founding member, with Kandinsky, of the New Artists Association of Munich (1909); purchased house in Murnau, with separate section for Kandinsky (1909); along with Kandinsky, resigned from the New Artists Association and formed a new group, the "Blue Rider" (1911); participated in the first Blue Rider exhibition (1911); exhibited 84 paintings in the 12th exhibition of Der Sturm *gallery in Berlin* (1913); partici-

pated in an exhibition of "Expressionist painting" in Dresden and Breslau (1914); with beginnings of World War I, traveled with Kandinsky to Switzerland; traveled to Scandinavia to wait for Kandinsky there, taking up residence in Stockholm (1915); held first exhibition of her paintings in Stockholm (1915); took up residence in Copenhagen (1917); held exhibition of 93 oil paintings and 18 reverse-glass paintings in Copenhagen (1919); returned to Berlin and learned of Kandinsky's remarriage (1920); rebuffed attempt by Kandinsky emissary to retrieve his paintings (1921); exhibited paintings with the Associated Women Artists of Berlin (1926); began life with journalist and free-lance art historian Johannes Eichner (1929); submitted paintings, unsuccessfully, to the Nazi-sponsored exhibition of "Great German Art" (1933); was subject of criticism by the Nazi Bavarian Minister of Arts (1937); hid much of her work from Nazi government (1937–45), and from occupying American troops (1946); saw her reputation rise in the postwar years and was hailed as one of the few remaining members of the Blue Rider; had some of her works featured in a Blue Rider retrospective show in Munich (1949); was the subject of a show prepared by Eichner which toured German cities for four years (beginning in 1950); first exhibitions of her work in U.S. were held in Los Angeles and New York (1960–61).

Major works (paintings, woodcuts, linocuts): Kandinsky (1906); Child With Bottle (1907–08); Main Street, Murnau (1908); Return from Shopping: On the Streetcar (1908–09); Boating (1910); Red Cloud (1911); Hapsburg Square, Munich (1911); From Norway, Tjellebotten (1917).

Although the German painter Gabriele Münter was often known during her lifetime as a close associate of the Russian painter Vassily Kandinsky—and although she insisted that she was an "artistic dilettante"—her reputation has moved beyond the status of being a mere Kandinsky student. Her reputation rests, instead, on her work as a pioneer of German Expressionist art in the early years of the 20th century, art which used intense colors and strong lines to depict her own subjective reactions to still lifes and landscapes. Münter was also, along with Kandinsky and Alfred Kubin, one of the three founders of the Blue Rider, one of the most important movements in 20th-century German Expressionist art.

Münter was almost born American. Fearing arrest in Germany for his political activities during the years leading up to the Revolution of 1848, Münter's father Carl Friedrich Münter

came to the United States in 1847. He worked as a proprietor of a general store until he earned a degree in dentistry at Cincinnati, Ohio. Years of moving around the United States followed, with Carl living for a time in Quincy, Illinois, where he married **Lucinde Richardson**, before moving on to live in Jackson, Tennessee. His wife died there in 1856. After a brief trip back to Germany, Carl Münter returned to Tennessee in 1857 and married Münter's mother, **Wilhelmine Scheuber**, a German immigrant.

According to family lore, only the American Civil War prevented Gabriele Münter from being born a U.S. citizen. Because of the conflict, the Münters decided to return to Germany in 1864, where a daughter and two sons were born in the late 1860s. Gabriele, born in 1877, was their youngest child. In Germany, their father built up a practice in Berlin as an "American dentist." The family then moved to Herford, Germany, in 1878, and much of Münter's childhood was spent there. After a period living in the resort town of Bad Oeynhausen, in 1884 the family moved to the town of Koblenz, at the confluence of the Rhine and Mosel rivers. Here Münter's father died in 1898; one of her brothers, August, had also died there in 1887, age 22.

Gabriele Münter's work reflects all of the artistic simplicity, loveliness, generosity, and openness with which she reacted to the world.

—Johannes Eichner

Münter demonstrated an early bent for art. "My early interest in drawing," she later wrote, "came from myself. Even as a child I practiced drawing with a pencil, particularly in drawing faces." Her first formal experience with art came at the Girls Lyceum of Koblenz, where the curriculum included a course teaching students to draw accurately by following a grid system. Münter's family encouraged her, giving her a set of watercolors when she was ten and later paying for a series of private lessons from local artists.

Münter's biographer Johannes Eichner, with whom she would spend the last 25 years of her life, insisted that she and her sister were allowed many more freedoms than most other German girls of the time. The Münter girls were not pushed into early marriages. They were allowed to ride bicycles and to smoke, and they were allowed to read controversial books and magazines. The reason, Eichner believed, was the influence of the family's American cousins, with whom they frequently visited.

After her mother died in 1897, Münter was able to use an inheritance to chart her own course of artistic training. She was not happy with the results. She began to take private artist's lessons from Professor Willy Spatz in the Women's Atelier of the Düsseldorf Academy. Yet she complained that the teaching at the academy was "not inspiring" and that "nobody seemed to take seriously the ambitions of a mere girl." For a time, she worked painting ornaments in a Düsseldorf studio and experimented by copying an oil painting in pastels.

Uncertain of what she wanted to do with art and searching for a distinctive style, Münter returned to live in Koblenz and decided, in 1898, to travel to the United States and visit her brother, Carl, who had married an American singer. She remained in the U.S. until 1900, visiting relatives in Arkansas, Mississippi, and Texas (where she joined a cattle drive), attending the St. Louis Exposition, and visiting tourist sites, such as Niagara Falls.

The two years in the United States gave her time to experiment with her drawing, which would become the basis of almost all her subsequent work. During her spare time, she sketched landscapes, family members, and plants and animals. She preferred drawing a single figure, often as part of a domestic scene, but during these years moved increasingly toward simplifying the figures she drew. It was a step toward abstraction in her art. "One cannot paint," she later observed, "what one cannot draw." Although she continued to think of her career as unfocused, the U.S. visit became a voyage of self-experimentation. Eichner maintained that her constant explorations demonstrated that she was "remarkably resistant to prevailing academic theories of artistic taste."

Münter charted her own inconsistent artistic path, filled with intense periods of experimentation as well as periods when her artistic development showed little change. When she returned to Germany in 1900, she took lessons from the Bonn sculptor Hermann Küppers for three months and then enrolled in the Academy of the Association of Women Artists in Munich. In 1902, she was highly impressed by a special exhibit of works by students of the Phalanx school, a new art school in Munich staffed by artists who wanted to work outside the existing juried system (which was used to select works to be shown in exhibits). The school also sought to introduce German art students to avant-garde foreign artists.

The main result of her decision to enroll in the Phalanx school was that she became a student of the Russian artist Vassily Kandinsky, who

showed a high degree of interest in both her and her work. Kandinsky, she wrote, explained "things in detail, clearly, and treated me as though I were a consciously striving person who can set herself problems and goals. This was something new to me and impressed me." She added that "he valued my talent highly." Kandinsky regarded her as an innate talent whom he could assist but not alter; he once told her that she had been given "everything by nature. All that I can do for you, is to protect and care for your talent so that nothing happens to it."

At Kandinsky's repeated urging, their relationship went beyond that of student and teacher. Kandinsky asked her to withdraw, for a time, from his nude modeling class, because his wife was often present. They began to travel together, often taking adjoining rooms at hotels. Their travels took them to The Hague, Tunisia, and Belgium, and they stayed in Paris together for part of 1906 and 1907. When Münter bought a house in 1909 in Murnau, in the Bavarian Alps, Kandinsky spent much of that year living in a first-floor apartment in the building.

Münter continued to experiment with her art, trying pencil sketches and then making them into paintings. When she explored techniques for outdoor paintings, Kandinsky provided advice on the use of the palette knife in landscape paintings. She also made woodcuts and, with his help, mastered the techniques of color printing with linoleum blocks. Although her woodcuts emphasized form and color, a characteristic of Expressionism, she conceded that she had really arrived at the "liberating brushmarks of Impressionism." Many of her early works sought, like those of the Impressionists, to present light and color as objectively as possible. By 1907, she had become well-enough known to exhibit six paintings in Paris and have several of her woodcuts published in a Paris periodical. When an exhibit of 80 of her paintings was held in Cologne in 1908, she had gained recognition as a professional artist.

Her work had also begun to exhibit the characteristics that would make her an early icon of German Expressionism. Her landscape paintings, which had become more flexible and less rigid, were increasingly painted in flat planes of color.

Fragment from Meditation, *1917, by Gabriele Münter.*

While her basic style was flat, there were large areas of broadly colored forms, usually with dark outlines that reflected her consistent interest in drawing. Unlike the Impressionists, she was becoming less interested in portraying objective views of light and more interested in portraying her own inward reaction to sights and events.

Landscapes and still lifes became her forte. The forms in her work were increasingly simplified, almost abstractions, but she also liked to paint people. The human face, she wrote, was itself a symbol and an abstraction. Much of her work depicted the world of the child. Many of her paintings portrayed individuals in terms of life-circumstances such as gender or marriage, but the subjects also seemed oddly disconnected from their surroundings. A child with a doll seemed to be in a room, but the room was not portrayed; a painting, *Returning from Shopping*, carried the subtitle *On the Streetcar*, but there was no clue to the whereabouts of the streetcar in the picture.

Together with Kandinsky and others, Münter was a founder in 1909 of the New Artists Association of Munich, the first exhibit of which that same year included 10 of her paintings and 11 of her prints. The association's second show, in 1910, drew works by Pablo Picasso and Georges Braque. When one of Kandinsky's paintings was rejected for showing by the New Artists Association in 1912, Kandinsky and Münter resigned from the association. They organized a counter group, the Blue Rider, and a counter exhibition of works by German, Russian, and Austrian artists. With additional paintings by Paul Klee and others, the exhibit traveled to Berlin and other parts of Germany and to Scandinavia.

The Blue Rider came to represent the avant-garde of German Expressionism and modernism in art. Many of the earliest Expressionist paintings were exhibited in *Der Sturm* gallery in Berlin. When that gallery held its 11th exhibition in 1913, the show was devoted entirely to Münter, who had 84 paintings included; a selection of the paintings was sent as a traveling exhibit to Munich, Frankfurt, Dresden, Stuttgart and Copenhagen. Münter also was included in a special showing of "Expressionist" painting in 1914 in Dresden and Breslau.

With the advent of World War I, Münter and Kandinsky moved increasingly apart, although Kandinsky had promised to marry her after he secured a divorce. They moved to Switzerland at the start of the war, since Kandinsky, as a Russian national, could not remain in Germany.

In late November, Kandinsky entered Russia, with the understanding that they would meet in Sweden. But he later wrote Münter asking that the planned meeting in Sweden be delayed, adding, "For three months I have been living alone and am comfortable with this way of life. . . . I am certain of what I want only in matters concerning art. . . . I am less certain of what I want in my personal life. . . . Maybe it is easier for me to idealize love than to achieve it."

Kandinsky did not reject the idea of their meeting in Scandinavia, however. The result was that Münter would spend the rest of the war years in Scandinavia, increasingly isolated from both artistic inspiration and from fellow German artists whose conversation and ideas had stimulated her. In July 1915, Münter had set out for Stockholm. That September, Kandinsky, claiming that tight finances made it impossible for him to stay in Sweden, wrote: "Regarding the marriage I must warn you that I cannot do it before the end of the war." Toward the end of that year, however, he did arrive in Stockholm, sharing a room with Münter.

In 1916, the two posed together for formal photographs, and Kandinsky published an essay, "On the Artist," which was dedicated to her and also edited by her, but which somehow omitted his praise of her as "a talent of distinct national character." He left for Russia in March 1916, and during the rest of that year Münter used memories of a trip to Norway to produce landscape paintings and paintings of friends. In 1917, she was invited to exhibit 31 paintings at a joint showing of the Association of Swedish Women Artists and the Association of Women Artists of Austria, held in Stockholm. That same year, she took up residence in Copenhagen, and an exhibition of 100 of her paintings, including 20 reverse-glass paintings and prints, was held in Copenhagen.

Living in Scandinavia, Münter lost touch with colleagues who had helped provide a sense of direction for her art, and she experienced increasing financial difficulties. She took commissions for portrait painting and was forced to find increasingly smaller quarters. While staying on the Danish island of Bornholm in the Baltic Sea in 1919, she advertised for students; only one replied. Nevertheless, that year she arranged an exhibition of 93 of her oil paintings and 18 of her reverse-glass paintings in Berlin.

After Münter returned to Germany in 1920, taking up residence first at Munich and then once again in Murnau, she learned that Kandinsky had remarried. In the early 1920s, Kandinsky returned to Germany to teach at the Bauhaus in Weimar, but he declined to contact Münter. Kandinsky sent emissaries to collect

paintings which he had stored in Münter's Murnau house, but she refused to respond until he contacted her personally and admitted that they had been husband and wife.

Finally, in response to an embittered letter from her, Kandinsky wrote her a letter in which he argued that "marriage can succeed only if both parties want it to. . . . I feel guilty for having broken my promise to marry you legally. . . . Please do not hate me." Gathering her thoughts for a series of notebooks she kept, Münter concluded in 1928: "I let myself be lied to and was cheated out of my love. . . . Someone asked me: Did you learn something from him as an artist? I said of course, but while he took pains to correct others, he did not do the same with me."

During the 1920s, she conceded that she was unsure of herself in art, "moving restlessly from place to place." Her paintings showed little change or development. Yet for art critics she was emerging as a symbol of modernism in German art. The first postwar exhibition of avantgarde art in Germany, the International Art Exhibition in Düsseldorf in 1922, recognized not only Münter's achievements but the work of German women artists in general, including another invited artist, *Käthe Kollwitz. Münter's work also appeared in a Berlin exhibition of the Association of Women Artists in 1926 and a Women's Art Exhibition in Berlin in 1927.

In 1929, Münter met the man with whom she would spend the last 25 years of her life, the journalist and freelance art historian Johannes Eichner. In his biography of Münter, Eichner portrayed her primarily as an artist of still lifes, perhaps the "premier" artist of that genre, and he devoted much of his time publicizing her artistic achievements. Münter and Eichner worked together in organizing an exhibition of her paintings and woodcuts, entitled "Gabriele Münter: 1908–1933."

Münter's art was not appreciated by the National Socialist government of Germany. When the Nazi government announced plans for an exhibition of "Great German Art" at Munich in 1933, intended to showpiece "healthy" German art, Münter's entries were rejected. Eichner took her to see it anyway, followed immediately by a visit to the government's exhibition of "degenerate" modern art. Nazi partisans picketed her "Gabriele Münter 1908–1933" exhibition. A special exhibition of her paintings, held in 1937 in conjunction with her 60th birthday, was publicly criticized by the Bavarian minister of art, a Nazi.

Urged by Eichner to become more commercial, she began a series of paintings of Olympia Street, a major project of the Nazi government in connection with the Berlin Olympics of 1936. But her finances had deteriorated further; in dire straits, she sold her Murnau house to Eichner, who used his own funds to renovate and update the building.

Münter and Eichner worked together to hide her paintings—first from the Nazi government and then, in 1945 and 1946, from occupying American troops. At the end of the war, her American relatives sent her a constant stream of packages containing food and clothing; in gratitude, she sent them sketches and paintings she had done during her American visit of 1898–1900.

Münter's life during the late 1940s and the 1950s—at least until Eichner's death in 1958—was filled with constant visits from critics and collectors, many from the United States, who viewed her, with some reverence, as the last living representative of the Blue Rider movement. Her works were included in a Blue Rider retrospective exhibit in 1949, and Eichner arranged for a show of many of her works which toured German cities in the 1950s. Two years before her death in 1962, Münter gained international recognition when a bicoastal exhibit of her works—in Los Angeles and New York—was held in the United States. For a woman who had insisted that she was an "artistic dilettante," it was an especially satisfying development.

SOURCES:

Eichner, Johannes. *Kandinsky und Gabriele Münter: Von Ursprüngen moderner Kunst*. Munich: Bruckmann, 1957.

Heller, Reinhold. *Gabriele Münter: The Years of Expressionism*. Munich and NY: Prestel, 1997.

Mochon, Anne. *Gabriele Münter: Between Munich and Murnau*. Cambridge, MA: Harvard University Press, 1980.

SUGGESTED READING:

Behr, Shulamith. *Women Expressionists*. Oxford: Phaidon, 1988.

Dube, Wolf Dieter. *Expressionists and Expressionism*. NY: Skira, 1983.

Lahnstein, Peter. *Gabriele Münter*. Etal: Buch-Kunstverlag, 1971.

COLLECTIONS:

Many of Gabriele Münter's and Johannes Eichner's papers and correspondence are housed in the Gabriele Münter and Johannes Eichner Foundation in Munich, Germany. The Foundation was created by her will, which expressed the desire that it be dedicated to fostering both the "appreciation" and the "production" of "modern art." There is also some correspondence of Münter's in the Getty Center for the History of Art and Humanities in Santa Monica, California. An extensive collection of Münter's works is included in the Stadtische Galerie in the Lenbachhaus in Munich. One of largest collections of German art in the United States, including a num-

ber of works by Münter, is in the Milwaukee (Wisconsin) Art Museum.

Niles Holt,
Professor of History, Illinois State University, Normal, Illinois

Murasaki Shikibu (c. 973–c. 1015)

Japanese novelist and poet whose greatest accomplishment, The Tale of Genji, *is both the world's oldest known novel and an insightful portrait of the life of the imperial court of Heian Japan—the country's "golden age." Name variations: Lady Murasaki. Pronunciation: Moo-rah-SAH-kee Shee-KEE-boo. Born around 973 (some sources cite 970, 974, or 975) in Rozanji, Kamigyo-ku, Japan; died around 1015 (some sources cite 1014 or 1025), in Japan; daughter of Fujiwara no Tametoki (a court official) and an unknown mother; married Fujiwara no Nobutaka (a court official), c. 998; children: a daughter, Masako or Kenshi (sources differ as to her name), known later as Daini no Sanmi (999–after 1078).*

Traditionally thought to have begun work on her novel The Tale of Genji *sometime after the death of her husband Nobutaka of the plague (1001); entered imperial service as a lady-in-waiting to the Empress Shoshi (c. 1005–06); compiled her* Diary *and composed poems (c. 1008–10).*

The first known novel in Asian literature—perhaps the first novel in world literature—was produced by a woman who spent most of her life in the highly refined and isolated atmosphere of Heian Japan's imperial court. Murasaki Shikibu's *The Tale of Genji* is widely considered the greatest masterpiece that Japanese literature has ever produced. "Very good critics have commented upon the astonishing 'modernity' of the tale," writes Edward G. Seidensticker in the introduction to his translation of *The Tale of Genji*, "and have called it the first great novel in the literature of the world." Reviewers assert that in complexity and psychological power it rivals Marcel Proust's *A la recherche du temps perdu* (*Remembrance of Things Past*). "In other respects the two are far apart," Seidensticker continues, "and the *Genji* reveals its Japanese origins. It is a happy combination of what can seem 'modern' and immediate to the reader from a far-distant land and century, and what must necessarily seem alien and exotic."

Very little is actually known about the author of *The Tale of Genji*. Murasaki Shikibu may not in fact be the author's name. *Murasaki*, the term for a plant used to produce a purple dye, is the name of Genji's second wife—the most important female character in the novel. *Shikibu* was one of her father's offices. Though her mother's name is unknown (it was considered disgraceful for women of good breeding to allow their personal names to be discovered), her father was Fujiwara no Tametoki, a junior member of the Fujiwara clan that dominated the imperial offices from about 967 until the 12th century. Lady Murasaki had at least two brothers who served the Heian court in different capacities: Fujiwara no Nobunori as a secretary, Josun as a priest. She also had several sisters and half-sisters who made political marriages to the advantage of the family.

The aristocratic society in which Murasaki Shikibu flourished was centered on the imperial court at Heian-kyo (present-day Kyoto) from 794 to 1185. The Japanese emperor, although honored as the descendant of the Sun Goddess, was nonetheless mostly a powerless symbol. After 967, political power was wielded by the heads of the Fujiwara family, who controlled the emperorship by marrying their daughters to the current incumbent. After the marriage produced a child, the emperor would be induced to resign and the young child would be proclaimed the new emperor. The head of the Fujiwara family then took the title of regent—exercising the true governing power—and the process would repeat itself. The system could result in complicated family ties between the regent and the emperor. Fujiwara no Michinaga, Murasaki's contemporary, had two sisters marry emperors. He was also uncle to two, father-in-law to one, and grandfather of two others.

Murasaki was probably born in Kamigyo-ku, but she spent most of her early life in her father's house in Heian-kyo. "When my brother, Secretary at the Ministry of Ceremonial, was a young boy learning the Chinese classics," she revealed in her *Diary*, "I was in the habit of listening to him and I became unusually proficient at understanding those passages which he found too difficult to grasp. Father, a most learned man, was always regretting the fact: 'Just my luck!' he would say. 'What a pity she was not born a man!'" Soon, however, she realized that such studiousness could be a disadvantage for a woman in the highly stratified Heian society. "Gradually I realized that people were saying, 'It's bad enough when a man flaunts his learning; she will come to no good,'" Murasaki concluded, "and ever since then I have avoided writing even the simplest character."

Writing among Heian women was not so rare as Murasaki suggested. Heian aristocrats lived lives of rarified pleasure far removed from the lives of common folk. "Their civilization

was, to a quite remarkable extent, based on aesthetic discrimination," writes Ivan Morris, "and, with the rarest of exceptions, every gentleman and lady was an amateur performer in one or more of the arts." Social graces—the ability to paint a picture or knowing when to wear the proper clothes or perform intricate ceremonies—helped define an individual's standing. Perhaps most important, however, was the ability to compose poetry. Since much of Heian culture was adopted from classical Chinese culture, Heian men studied Tang Chinese poetry. Only women studied and wrote in Japanese.

As a result, many Heian women became accomplished poets and prose writers. "During the period of about one hundred years that spans the world of The Tale of Genji," Morris declares, "almost every noteworthy author who wrote in Japanese was a woman." Murasaki's distinguished contemporaries included *Sei Shonagon, author of the anecdotal Pillow Book, *Izumi Shikibu, Koshikibu no Naishi, and ❧▶ Uma no Naishi. Each was an accomplished poet in her own right, and their works appeared in imperial anthologies of poetry, such as the Hyakunin Isshu (One Hundred Poems by One Hundred Poets). Although women writers continued to surface in Japanese literature through modern times, Morris concludes, "It was only during the century of the world of the shining prince that women had a virtual monopoly of famous names in Japanese prose and poetry."

More important, the female writers were responsible for the establishment of Japanese as a literary language. This was in part because they enjoyed a great deal of free time. Upper-class women "were allowed a share of inheritance and had their own houses under polygamy," notes Kazuo Oka in Murasaki Shikibu: The Greatest Lady Writer in Japanese Literature. In addition, female writers had an advantage over their male counterparts because of their familiarity with phonetic kana characters. Male courtiers were pressured to use Chinese characters, which are not ideally suited for writing Japanese. Poets such as Murasaki, Sei Shonagon, and Izumi Shikibu seized on the kana to write their works in Japanese. The female writers also introduced a new wave of realism into their native literature. "The prose writings, which were [formerly] full of ideological flowery words," writes Kazuo Oka, "became free and flexible enough to stand the description of the writer's own sensitive impressions and psychological analysis."

Despite her promising beginnings, Murasaki began her adult life like most other upper-class Heian women. In the year 996, her father Tametoki was appointed governor of the province of Echizen, north of Heian-kyo on the Sea of Japan. The appointment was not an honor. So closely did Heian gentlemen associate goodness with life in Heian-kyo that any post that took a noble away from the capital was regarded as a punishment. Scholars conclude that Murasaki accompanied him to the post on the evidence of some of her surviving poetry. Kazuo Oka, drawing on the poetry in Murasaki Shikibu shu, an anthology of her works, uses references within the poems to trace her itinerary in the journey from her father's house to his new post at Echizen, where she lived until she married in 988.

Murasaki's marriage to Fujiwara no Nobutaka, a minor official and distant relative, was typical of Heian alliances. The groom was, like her father, a provincial governor. Nobutaka was also her father's age—46 or 47 to her own 26—and he had already outlived several wives and concubines. His oldest son Takamitsu was the same age as his bride. "He had a large fortune for a provincial official. Moreover, now that he was restored to a prominent post in the Capital," Kazuo Oka explains, "he might have wished to regain his lost youth by getting married once more." Despite the difference in their ages, the couple seemed content. Kazuo Oka notes that Murasaki's poems "convey us a smell as sweet as their honey-moon and make us feel for their happy married life." Their daughter, Masako or Kenshi (sources differ as to her name) was born in the winter of 999. She would win fame as a poet under the name ❧▶ Daini no Sanmi.

❧▶ **Uma no Naishi** (fl. 10th c.)
Japanese poet. Probably born around the mid-10th century.

A contemporary of *Sei Shonagon**, Uma no Naishi also served women at court. Near the close of her life, she took Buddhist vows and withdrew to a temple.

❧▶ **Daini no Sanmi** (999–after 1078)
*Japanese poet. Name variations: Echigo no Benin. Born Kenshi or Masako in 999; still alive in 1078; daughter of ***Murasaki Shikibu** (c. 973–c. 1015) and Fujiwara no Nobutaka (a court official).*

Thirty-seven of Daini no Sanmi's poems can be found in imperial anthologies. In one, she consoles a courtier who has just lost his wife. Alluding to death, she writes: "Comfort yourself/ With the fact that it conquers/ Sorrow just as well."

Their happiness did not last. Plague swept through Japan from the winter of 1000 through the summer of 1001. A contemporary source, the *Nihon Kiryaku,* claims that "thousands of people died of the epidemic one after another, and there were innumerable dead bodies left on the roads, not to mention tens of thousands of cremated bodies." On April 25, 1001, Nobutaka died of unspecified complications at the age of 50. Murasaki wrote in the *Murasaki Shikibu shu:* "In the Palace too / Spring brings mourning; / The sky itself / Is dark, dyed black / With the sadness of it all."

If only my appetites were more mundane, I might find more joy in life, regain perhaps a little youth, and face this mortal world with equanimity.

—Murasaki Shikibu

"For the next four or five years," writes Richard Bowring, "Murasaki seems to have led a lonely widow's existence, during which she began the work of fiction that was to bring her fame and secure her a place at court." Writing *The Tale of Genji* not only gave Murasaki an occupation during the period of mourning, it offered her a way into court life as companion and teacher to the Empress ◀ **Shoshi**. Shoshi's father, Fujiwara no Michinaga, was also the head of the Fujiwara family and a distant cousin of Murasaki's. Critics suggest that Michinaga read some of the early chapters of *Genji* and decided that the author would make a suitable companion and instructor for his daughter.

Murasaki probably started *The Tale of Genji* between 1002 and 1005; the novel covers about 75 years of life in the Heian court. In it, she reveals much information about the methods and values of aristocratic Japan. Genji, the title character born in the first chapter of the book, is the son of the reigning emperor, but, since his mother is a commoner, he is reduced in rank and raised as a commoner. Throughout Genji's life, he is universally admired for his many talents—music, poetry, painting, the ability to make perfumes—as well as for his natural beauty. Murasaki gives him the title "the shining one" (*Hikaru*) and presents him as the epitome of what an aristocratic Heian gentleman should be. Probably on the basis of the novel's early chapters, Murasaki was summoned to court and assumed her duties early in 1005 or 1006.

Michinaga may have had personal reasons for summoning Murasaki. A genealogy known as *Sonpi bunmyaku,* compiled about 300 years after her death, claims that Murasaki was Michinaga's concubine. Her *Diary* and poems, however, suggest otherwise. Both works are full of references to a desire to withdraw from the world and become a nun. "I care little for what others say," she wrote in the *Diary.* "I have decided to put my trust in Amitabha [Buddha] and immerse myself in reading sutras." Yet, she added, she hesitated from taking the final steps. Some critics read this passage as meaning that Murasaki wanted to stay with Michinaga. "While it is true that Murasaki was almost totally in Michinaga's power and could hardly have withstood his demands for long," Bowring writes, "there seems to be as little foundation for the belief that she was a permanent concubine as there is for the view that she had a strongly puritanical streak in her make-up."

Murasaki's own statements in her *Diary* suggest that she was anxious to avoid romantic entanglements and leave the court. She gives a short character sketch of herself: "No one liked her. They all said she was pretentious, awkward, difficult to approach, prickly, too fond of her tales, haughty, prone to versifying, disdainful, cantankerous, and scornful. But when you meet her, she is strangely meek, a completely different kind of person altogether!" She abhorred the petty jealousies and gossip that filled court life:

> I hesitate to do even those things a woman in my position should allow herself to do. . . . I do have many things I wish to say but always think better of it. There would be no point, I tell myself, in explaining to people who would never understand, and as it would only be causing trouble with women who think of nothing but themselves and are always carping, I just keep my thoughts to myself. It is very rare that one finds people of true understanding; for the most part they judge everything by their own standards and ignore everyone else's opinion.

"On such occasions," she concludes, "I have tried to avoid their petty criticisms, not because I am particularly shy but because I consider it all so distasteful; as a result I am now known as somewhat of a dullard."

⚘▶ **Shoshi** (fl. 990–1010)

Japanese empress. Name variations: Shōshi. Flourished from 990 to 1010; daughter of Fujiwara no Michinaga (966–1028, head of the famous Fujiwara family during their period of greatest power and influence) and **Rinshi**; *had sisters Kenshi, Ishi, and Kishi, and brother Yorimichi (who became emperor); married Emperor Ichijo (died in autumn of 1011); children: two sons born between 1008 and 1010.*

The author used her fictional characters in *Genji* to comment on what she believed to be wrong with Heian society: though Genji is a paragon of Heian values, he nonetheless breaks some of the society's greatest taboos. He has a child with one of his father's secondary wives—a child who later becomes emperor in turn. He is later cuckolded himself by the son of one of his best friends. Murasaki also used *The Tale of Genji* to criticize the petty jealousies that bothered her so much. Early in the novel, Genji rejects the advances of a court woman (known as the Rokujo Lady). She broods so much over his rejection that after her death her spirit returns to bring sickness—and, in one instance, death—to two of Genji's favorite wives.

Murasaki Shikibu's diary covers about two years of court life, from the autumn of 1008 to early in 1010, the period in which Empress Shoshi gave birth to two sons, heirs to the throne. This is the last dateable reference in Murasaki's life. Critics disagree strongly about the nature of her final years and the date of her death. The traditional view—long since discredited—held that she left Shoshi's service in 1015, became a nun, and died in 1031. Most modern scholars place the date of her death sometime between 1014 and 1031. Their reasoning rests on the fact that Shoshi's husband, the Emperor Ichijo, died in the autumn of 1011. After a period of mourning, Shoshi moved from the palace to one of her father's houses, taking Murasaki with her. In 1014, Murasaki's father Tametoki suddenly resigned his offices—perhaps, some critics suggest, because of his daughter's death. Other scholars place Murasaki's death in 1017 or 1025. "The end result of all this information is, as one might expect, inconclusive," declares Bowring. "The maturity of vision in the latter part of the *Tale of Genji* suggests the later date, but in the absence of any more facts this must remain mere speculation."

Although the details of Murasaki's life remain in doubt, her accomplishments are universally recognized. In 1987, the Japanese film director Gisaburo Sugii released an *anime* (animated) version of *The Tale of Genji* that won recognition from the Japan Film Appreciation Society as a

Murasaki
Shikibu

cultural masterpiece. The Japanese Ministry of Education also honored the movie, listing it among the most significant films ever produced in Japan. *The Tale of Genji* is itself one of the major accomplishments of world literature, and modern critics agree that it was the work of one author's creativity. "The diaries of the tenth century may perhaps have been something of an inspiration for Murasaki Shikibu," writes Seidensticker, "but the awareness that an imagined predicament can be made more real than a real one required a great leap of the imagination, and Murasaki Shikibu made it by herself."

SOURCES:

Bowring, Richard. *Murasaki Shikibu: Her Diary and Poetic Memoirs*. Princeton, NJ: Princeton University Press, 1982.

de Bary, William Theodore, *et al. Sources of Japanese Tradition, Volume II*. NY: Columbia University Press, 1958.

Keene, Donald, ed. and comp. *Anthology of Japanese Literature from the Earliest Era to the Mid-Nineteenth Century*. NY: Grove Press, 1955.

Morris, Ivan. *The World of the Shining Prince: Court Life in Ancient Japan*. NY: Alfred A. Knopf, 1964.

Murasaki Shikibu. *The Tale of Genji*. Translated by Edward G. Seidensticker. NY: Alfred A. Knopf, 1976.

Sen'ichi Hisamatsu, *et al. Murasaki Shikibu: The Greatest Lady Writer in Japanese Literature*. Tokyo: Japanese National Commission for UNESCO, 1970.

SUGGESTED READING:

Murasaki Shikibu. *The Tale of Genji, Part I*. Translated by Arthur Waley. Boston, MA: Houghton Mifflin, 1929.

RELATED MEDIA:

The Tale of Genji (anime film), directed by Gisaburo Sugii, character artwork by Yoshiyuki Sadamoto, character direction by Masahiro Maeda, score by Haruomi Hosono, Asahi Publishing/ Asahi National Broadcasting Company/ Nippon Herald Films, 1987.

Kenneth R. Shepherd,
Adjunct Instructor in History, Henry Ford Community College,
Dearborn, Michigan

Murat, Caroline (1782–1839).

See Bonaparte, Carolina.

Murat, Isabella (b. 1900).

See Isabella of Guise.

Murden, Tori (c. 1963—)

The first woman and the first American to row solo across the Atlantic Ocean. Born in Louisville, Kentucky, around 1963; youngest of three children of Albert Murden (an educator) and Martha Murden; undergraduate degree from Smith College, 1985; graduate degree from Harvard Divinity School, 1989; law degree from the University of Louisville; never married; no children.

On December 3, 1999, 36-year-old Tori Murden became the first woman and the first American to row solo across the Atlantic, having made the 3,000-mile journey from the Canary Islands to Fort-du-Bas, Guadelupe, in 81 days, 7 hours, and 31 minutes, just eight days longer than the record set in 1970 by Britain's Sidney Genders. Actually, Murden arrived at her destination 24 hours or so earlier—on December 2—but waited out the extra day in the harbor so as not to disappoint her support team ("the pearls"), scheduled to arrive on December 3rd. "It would have been just unconscionable for me to land without them," said Murden. "So many people helped. They did everything but row for me." Murden's friends agreed that it was not at all unusual for her to defer to others, even during a moment of glory.

Tori Murden has been seeking challenges throughout her life. A native of Louisville, Kentucky, she holds degrees from Smith College and Harvard Divinity School, as well as a law degree from the University of Louisville. She is also a member of Sector No Limits, a team of elite athletes dedicated to testing the outer limits of endurance. She was the first woman to reach the summit of Lewis Nunatuk in Antarctica and was one of a nine-person team to ski 750 miles to the geographic South Pole, the first American to do so. Having learned to row as a freshman at Smith, Murden made her first solo attempt at crossing the Atlantic, west-to-east, in 1998, but was pulled from the water after Hurricane Danielle capsized her boat 11 times in a single day. On her 1999 crossing, Murden was almost defeated by yet another hurricane—Lenny—which moved steadily in her direction over the period of a week, and eventually buffeted her with winds that sometimes drove her backward ten miles a day. At one point, she was hurled into the water when her 23-foot, 1,700-pound boat, "American Pearl," was upended, making her wonder if she should go on. "I dare not describe my mood," she said in a message she posted on the Internet during the storm. "I am well beyond screaming at the wind."

Murden rowed an average of 12 to 14 hours a day, fueling her body with energy bars and freeze-dried meals such as scrambled eggs or spaghetti. Her boat was equipped with a desalinating pump for water, a butane stove, a satellite telephone, and a water-resistant lap-top computer, all stowed in a water-tight compartment. Solar panels provided power so she could listen to audiobooks. (*Gulliver's Travels* and *Robinson Crusoe* were favorites.) She used the "bucket-and-dump method" of toileting, and slept in a cloth

hammock, waking at intervals to check her position. On calm days, she corresponded by computer with schoolchildren, who kept track of her progress over the Internet. Although never feeling alone, Murden admitted to often being bored, and used the telephone to contact friends much more frequently than was her habit. "Before this trip, I was not a person who thought a telephone was a useful piece of equipment," she said.

When not pushing limits and setting records, Toni Murden works as development director of the Muhammad Ali Center in Louisville, a non-profit educational institution for underprivileged youths. Her future goals include tackling some of society's larger problems, although she is quite aware that it means long-term commitment. "What rowing across the ocean teaches me," she says, "is that you don't get there all at once."

SOURCES:

Huebner, Barbara. "Crossing the Atlantic into History," in *Boston Globe*. December 1, 1999.

Smolowe, Jill, and Cynthia Wang. "Fantastic Journey," in *People Weekly*. December 20, 1999.

Barbara Morgan,
Melrose, Massachusetts

Murdoch, Iris (1919–1999)

Prominent 20th-century English moral philosopher, as well as a gifted, prolific, and widely acclaimed novelist. Name variations: Dame Iris Murdoch. Pronunciation: MER-dock. Born Jean Iris Murdoch on July 15, 1919, in Dublin, Ireland; died in Oxford, England, on February 8, 1999; daughter of Irene Alice (Richardson) Murdoch (a singer) and Wills John Hughes Murdoch (a civil servant); mother's family from Dublin, father's family of Country Down sheep-farming stock; received early education at the Froebel Educational Institute, London, and the progressive Badminton School, Bristol; read ancient history, classics, philosophy at Somerville College, Oxford University, 1938–42; married John Bayley (a literary critic and Oxford professor), in 1956; no children.

Worked as temporary wartime civil servant (assistant principal) in the Treasury (1942–44, 1944–46); worked with refugees, first in Belgium, then in Austria, where she was assigned to a camp for displaced persons; received Sarah Smithson Studentship in Philosophy, Newnham College, Cambridge (1947–48); named fellow at St. Anne's College, Oxford, and appointed as university lecturer (1948), where she taught until 1963 when she was named honorary fellow; was a lecturer at the Royal College of Art (1963–67); made her debut as a writer (1954) with novel Under the Net; *made honorary member of the American Academy of Arts & Sciences (1975); made Dame of the Order of the British Empire (1987).*

Awards: James Tait Black Memorial Prize (1973) for The Black Prince; *Whitbread Literary Award (1974) for* The Sacred and Profane Love Machine; *England's most prestigious literary award, the Booker McConnell Prize (1978) for* The Sea, the Sea; The Good Apprentice *(1985) and* The Book and the Brotherhood *(1987) were both shortlisted for the Booker Prize.*

Major works—novels (dates refer to first editions, published by Chatto and Windus, London; all of her novels are available as Penguin Books in the U.S.): Under the Net *(1954);* The Flight From the Enchanter *(1955);* The Sandcastle *(1957);* The Bell *(1958);* A Severed Head *(1961);* An Unofficial Rose *(1962);* The Unicorn *(1963);* The Italian Girl *(1964);* The Red and the Green *(1965);* The Time of the Angels *(1966);* The Nice and the Good *(1968);* Bruno's Dream *(1969);* A Fairly Honorable Defeat *(1970);* An Accidental Man *(1971);* The Black Prince *(1973);* The Sacred and Profane Love Machine *(1974);* A Word Child *(1975);* Henry and Cato *(1976);* The Sea, the Sea *(1978);* Nuns and Soldiers *(1980);* The Philosopher's Pupil *(1983);* The Good Apprentice *(1985);* The Book and the Brotherhood *(1987);* The Message to the Planet *(1989);* The Green Knight *(1993);* Jackson's Dilemma *(1995).*

Plays: (with J.B. Priestly) A Severed Head *(London: Chatto & Windus, 1964); (with James Saunders)* The Italian Girl *(London: Chatto & Windus, 1968);* The Three Arrows *(London: Chatto & Windus, 1973);* The Servants and the Snow *(London: Chatto & Windus, 1973).*

Poetry: (with engravings by Reynolds Stone) A Year of Birds *(Tisbury, Wilts: Compton Press, 1978).*

Philosophy: Sartre, Romantic Rationalist *(Cambridge: Bowes & Bowes, 1953);* The Sovereignty of Good *(London: Routledge, 1970);* The Fire and the Sun: Why Plato Banished the Artists *(Oxford: Oxford University Press, 1977);* Metaphysics as a Guide to Morals *(London: Penguin, 1992, based on 1982 Gifford Lectures in Natural Theology given at the University of Edinburgh, Scotland).*

Greek mythology tells us that the flute was invented by Athena who, because Cupid dared to laugh at her disfigured face when she puffed out her cheeks playing the instrument, threw it away. It was picked up on earth by Marsyas, a satyr who played so ravishingly that he dared challenge Apollo, god of music and poetry, to a contest. Apollo won, of course, and punished Marsyas by flaying him. Iris Murdoch reads this

myth so that the agony of Marsyas became emblematic of our—anyone's—long, patient, unattainable quest for goodness. Talk of the "good" may seem odd for our day and age, when most people have the sense that their lives are increasingly determined by science, technology, and other large-scale, systemic socio-economic processes, and where morality has largely been reduced to the language of rights. Heir to enlightenment of reason, the modern subject is pictured as a solitary rational, whose inner life is resolved into acts and choices confronting an empirical world of brute facts. Assailed by anxiety and fear and a loss of direction, witness to innumerable horrors and suffering, plagued by indecision, and bereft of religion, Murdoch's work aimed to provide a rich and expansive picture of humanity against a background of values and realities that transcend us. Murdoch's prodigious output as a philosopher and as the author of 25 novels and several plays was directed toward the elaboration of a moral vocabulary for a post-theistic age. While not a Christian believer, Murdoch embraced a religious picture of human beings as fallen, as, in some sense, sinful, and in need of transcendence. Art and Eros, though they might beguile and console us, can also help to guide us out of our confusion and suffering. Religion, morality, art and eros—these are the grand thematics running through Murdoch's philosophy and novels. Her work has indebted many philosophers, and earned her an international following of devoted readers who avidly welcomed each new novel of hers as yet another treat of entertainment and ideas.

Born in Dublin in 1919, Iris Murdoch was largely raised in London, where her family had moved while she was a baby, upon her father's entry into the civil service. Later in life, she claimed, she realized that she was a "kind of exile, a displaced person." And, indeed, the outsider figures prominently, especially in her early novels. An only child, she related her writing drive to the search for imaginary brothers and sisters and her fascination with twins—the "lost, the other person one is looking for," writes Peter J. Conradi. But, she said, she "lived in a perfect trinity of love." She studied what were then called the "Classical Moderations and Greats" (the classics, history and philosophy) at Somerville College of Oxford University. Wartime exigencies placed her first as civil servant in the Treasury, from 1942 to 1944, and then with the United Nations Relief and Rehabilitation Administration (UNRRA), from 1944 to 1946, working in camps for refugees and displaced persons in Austria and Belgium.

In Brussels, Murdoch encountered the work of Jean-Paul Sartre, a French philosopher, who had elaborated the philosophy of existentialism in various novels and *Being and Nothingness*. The most fundamental and attractive feature of existentialism was the idea of freedom. The appeal of an inalienably free and heroic consciousness that could make itself and the world anew held great appeal for a generation of war-weary intellectuals. Notwithstanding the great importance that existentialism attached to the consideration and depiction of experience and its comparative willingness to discuss problems of value and morality, Murdoch was skeptical of this philosophy. It did not ultimately offer any richer picture of the human being than did British philosophy which was engrossed in a dry, abstract analysis of the meaning of concepts, and, at best, offered a picture of a free, sovereign, rational individual. She was to offer a sympathetic, yet critical look at existentialism in her first philosophical work, *Sartre: Romantic Rationalist* (1953). As she said, "We are not isolated free choosers, monarchs of all we survey, but benighted creatures sunk in a reality whose nature we are constantly and overwhelmingly tempted to deform by fantasy. Our current picture of freedom encourages a dream-like facility; whereas what we require is a renewed sense of the difficulty and complexity of the moral life and the opacity of persons." Literature she felt allowed one to rediscover a sense of the density and texture of lives. And so, it was as a mature thinker and after having written five unpublished novels that Iris Murdoch published her first novel, *Under the Net* (1954), to critical acclaim.

A stylish, sophisticated, comic novel, handled with subtle emotional pacing and balanced with lucid philosophical conversation and insight, *Under the Net,* on her own acknowledgement, introduced many of the themes that would be developed in various ways in her subsequent novels: an inquiry into the nature of the good person; the highly ambiguous relationship of art to the discovery of truth; the difficult and slow movement from illusion to reality; the necessity of theorizing, imagining, seeking deeper insight; the respect for contingency; and the relationship to art and vision to morality and reality. A first-person account narrated by a bohemian artist and amateur philosopher, the novel tracks the journey of its protagonist, as would likewise many other characters in later novels, from a self-centered, fantasy-enveloped state of being to a comparatively other-oriented (to other persons, the world), humbler and more clarified condition of desire and truth.

Iris Murdoch

The quests of her characters are however not necessarily successful and never painless or easy. People are secretly much odder, less rational, more often powered by passion and obsession than they outwardly pretend or indeed know themselves. Our reigning ideologies of ra-

tionality and our abiding faith in the sovereign will do not make it easy to acknowledge the large subterranean currents of dreams and fantasies which we unknowingly deploy to stave us from our defenselessness against history, contingency, chance and pain. And even once we have

recognized all this, the path to truth, reality, beauty, and the good is arduous and fleetingly obtained only by an unswerving discipline and what *Simone Weil (1909–1943), the famous French philosopher and mystic, who profoundly influenced Murdoch, termed "attention." Attention is respect for the contingent, the way things are, the stripping away of the intrusions of the ego. "A novel must be a house fit for free characters to live in; and to combine form with a respect for reality with all its contingent ways is the highest art of prose." One of the contingencies that frequently takes place in Murdoch's novels is man and woman falling in love intensely, abruptly, and absurdly.

> *All art is the struggle to be, in a particular sort of way, virtuous.*
>
> —Iris Murdoch

Falling in love, a characteristic and common enough experience, is for most ordinary men and women their glimpse of some sort of transcendence, an experience that permits one to see the world with newly awakened eyes. In his conception of the beautiful, Plato, as Murdoch elaborates in her book *The Fire and the Sun,* "accorded sexual love and transformed sexual energy a central place in his philosophy. . . . Eros is a form of desire for immortality, whatever we may take the good to be. . . . Love prompts anamnesis (recollection) [of the Forms—the objects of true knowledge for Plato] and the good comes to us in the guise of the beautiful." But, as in everything that Murdoch writes about, both in her philosophical views and in her novels, things are always more complicated and clarity of vision into the truth is not easily attainable. So, as she expands on Plato's Eros, she points out: "Eros is a trickster and must be treated critically. . . . The energy that could save us may be employed to erect barriers between ourselves and reality so that we may remain comfortably in a self-directed dream world." So it is also with art; its central place in our moral lives is one of the great themes of *The Fire and the Sun* and indeed of most of her novels.

Murdoch, an avowed Platonist, shares Plato's reservations, though not his hostility, about the ability of art to assist the soul in its pilgrimage from appearance and illusion to reality and knowledge. Plato held that art was a magical substitute for philosophy, aiming for plausibility and sense-gratification rather than truth. As Murdoch explains, for Plato, "art delights in trivia . . . endless proliferation of truth. The artist cannot represent or celebrate the good but only what is fantastic and extreme; whereas truth is quiet and sober and confined. Art is

sophistry . . . whose fake 'truthfulness' is a subtle enemy of virtue." However, aware of the pitfalls of art as providing consoling, false resting-places, Murdoch avers that:

> Good art provides a stirring image of pure transcendent value, a steadily visible enduring higher good, and perhaps provides for many people, in an unreligious age without prayer or sacrament, their clearest experience of something grasped as separate and precious and beneficial and held quietly and unpossessively, in the attention. . . . Good art provides work for the spirit.

Murdoch's own work was indeed animated by what she prescribed as the role of the good artist "to see the place of necessity in human life, what must be endured, what makes and breaks, and to purify our imagination so as to contemplate the real world (usually veiled by anxiety and fantasy) including what is terrible and absurd."

She resisted the labeling of herself as a philosophical novelist, pointing out that "ideas in art must suffer a sea-change." Murdoch has been described as a religious fabulist, both a fantasist and realist. She has been praised profusely for her near-Shakespearean faculty for plotting, the extraordinary control of her material, the meticulous and detailed rendering of objects, landscapes, of London, and the superb probing of the secret, hidden dream lives of her characters that uncannily resonate with some aspects of any reader's experience. Shakespeare's plays themselves were dominant influences on her work. Her extraordinary inventiveness in capturing the chaos, contingency, and ambiguity of experience was, however, directed toward the condition of truthfulness. As she told interviewer John Haffenden, "there is a sort of pedagogue in my novels. Bad novels project various personal daydreams. But the contingent nature of life and what human failings are like, and also what it's like for somebody to be good: all this is very difficult, and it is where truthfulness comes in, to stop telling yourself from telling something which is a lie." Truthfulness, grasping reality, being virtuous, all deeply tied together, depended, for Murdoch, on our ability to break out of the current of egotistic life, which is otherwise subject to ceaseless anxiety, pain, and fear. As one of her great characters, Bradley Pearson in *The Black Prince,* says:

> Wickedness . . . is usually the product of a semi-deliberate inattention, a sort of swooning relationship to time . . . never allow[ing] ourselves to focus on moments of decision. We allow the vague pleasure-seeking annoyance-avoiding tide of our being to hurry us onward until the moment when we announce

that we can do no other. There is thus an eternal discrepancy between our self-knowledge which we gain by observing ourselves objectively and our self-awareness which we have of ourselves subjectively. Our self-knowledge is too abstract, our self-awareness is too intimate and swoony and dazed.

Great art, the practices of meditation and attention as fostered by certain Buddhist philosophies, revelations brought about by love can all assist in decentering our ego, so that we are more focused and thereby gain more freedom.

Iris Murdoch lived in a house in Steeple Aston, Oxfordshire, hung with much-loved pictures by favorite artists. Early in her life, she claimed that she might have wanted to have been either a painter or a Renaissance art historian, but she got conscripted for the war and her love of philosophy and wanting to write novels soon took over. She enjoyed writing novels and started writing only after she had invented and figured out every character and incident; she also refused all assistance from editors. And even though she had a happy, fruitful married and professional relationship with her husband, literary critic and Oxford don John Bayley, she worked entirely alone on her novels and even her husband was not allowed to view her work until it was finished.

It was while she was working on what would prove to be her last novel, *Jackson's Dilemma* (1995), that she began exhibiting the first symptoms of Alzheimer's disease. Her illness was announced publicly in 1996. Murdoch's voyage from full control of her extraordinary intellect to the state of "a very nice 3-year-old," as her husband phrased it, was detailed in his 1998 book *Elegy for Iris*. Bayley's story of their unusual but deeply devoted 40-year marriage, and of the equally devoted relationship they developed as Murdoch's illness progressed, was called by a reviewer "one of the longest love letters ever written." She was cared for solely by her husband, who refused all help (but welcomed visitors) in the small and increasingly unkempt home in which they had lived so many years. They remained there together until her deterioration necessitated transferral to a nursing home, and he was at her bedside when she died, three weeks later, on February 8, 1999.

The Murdochian world, like the Swiftian or Dickensian, has entered the vocabulary as a way of pointing to certain aspects of the world. Though the cast of her characters tends to be comprised of a narrow coterie of bourgeois, educated friends and relatives, the sheer genius of her explorations of the entanglements of her characters with each other in their hunt for love, consolation, power, vision, and beatitude, and the moral energy that infuses her narrative drives, has assured Murdoch a position as one of the most interesting and powerful novelists of the 20th century. As a novelist who, with great verve and ingenuity, defined and took up the challenge to reconcile an essentially theological sentiment to transcendental meaning with the psychological constitution of her characters, she had few peers. Her work has shaped recent thought on the subjects of human identity, the relationship of religion to ethics and of moral philosophy to literature, the nature of desire, the constitution of suffering, the shortcomings of liberalism, and on the role of metaphysics as a fund of concepts that have continuing validity for human beings. Her sustained inquiry into the nature of goodness made it seem as if she were the very incarnation of Iris, the Greek goddess of the rainbow and messenger of the Gods.

SOURCES:

Bloom, Harold, ed. *Iris Murdoch: Modern Critical Views*. NY: Chelsea House, 1986.

Byatt, A.S. *Degrees of Freedom: The Novels of Iris Murdoch*. NY: Barnes & Noble, 1965.

———. *Iris Murdoch*. London: Longman, 1976.

Conradi, Peter J. *Iris Murdoch: The Saint and the Artist*. NY: St. Martin's Press, 1986.

Dipple, Elizabeth. *Iris Murdoch: Work for the Spirit*. Chicago, IL: University of Chicago Press, 1982.

Haffenden, John. Interview with Iris Murdoch, in his *Novelists in Interview*. London: Methuen, 1985.

Johnson, Deborah. *Iris Murdoch*. Indianapolis, IN: Indiana University Press, 1987.

The New York Times (obituary). February 9, 1999, pp. A1, C30.

Publishers Weekly. December 14, 1998, pp. 52–53.

Todd, Richard. *Iris Murdoch: The Shakespearean Interest*. London: Vision, 1979.

Wolfe, Peter. *The Disciplined Heart: Iris Murdoch and Her Novels*. Columbia: University of Missouri Press, 1966.

SUGGESTED READING:

Bayley, John. *Elegy for Iris*. St. Martin's Press, 1998.

———. *Iris and Her Friends*. NY: Norton, 1999.

Anil Lal,
freelance writer, Chicago, Illinois

Murdoch, Nina (1890–1976)

Australian journalist, writer, and poet. Name variations: sometimes used pen name Manin. Born Madoline Murdoch on October 19, 1890, in Melbourne, Australia; died on April 16, 1976, in Camberwell, Australia; daughter of John Andrew Murdoch (a law clerk) and Rebecca (Murphy) Murdoch; attended Sydney Girls' High School, 1904–07; married James Duncan Mackay Brown (a journalist), on December 19, 1917; no children.

Selected writings: Songs of the Open Air *(verse, 1915);* More Songs of the Open Air *(verse, 1922);* Seventh Heaven, A Joyous Discovery of Europe *(travel, 1930);* Miss Emily in Black Lace *(novel, 1930);* Portrait of Miss Emily *(novel, 1931);* She Travelled Alone in Spain *(travel, 1935);* Exit Miss Emily *(novel, 1937);* Portrait in Youth *(biography, 1948).*

Australian journalist and writer Nina Murdoch was born in Melbourne on October 19, 1890, the third daughter of law clerk John Andrew Murdoch and **Rebecca Murphy Murdoch.** She grew up in Woodburn, New South Wales, attended Sydney Girls' High School from 1904 to 1907, and then taught for a time at the Sydney Boys' Preparatory School. Establishing herself as a writer, Murdoch won a prize from the Sydney *Bulletin* in 1913 for a sonnet she wrote about Canberra, and in 1914 she joined the staff of the Sydney *Sun* as one of its first female reporters. In 1915, she published *Songs of the Open Air*, a book of verse.

Murdoch married fellow *Bulletin* journalist James Duncan Mackay Brown in December 1917. In 1922, they left the *Bulletin* and moved to Melbourne, where they worked for the *Sun News-Pictorial*. There, Murdoch became the first woman allowed to cover Senate debates. In 1927 she traveled alone through England and Europe and subsequently wrote *Seventh Heaven, A Joyous Discovery of Europe* (1930), the first of her four travel books. At that time, she also published two novels, *Miss Emily in Black Lace* (1930) and *Portrait of Miss Emily* (1931). The third novel in the "Miss Emily" trilogy, *Exit Miss Emily*, was published in 1937.

At the onset of the Depression in 1930, female employees of the Melbourne *Herald*, where Murdoch was then working, were fired in order to provide job openings for men. She turned to radio broadcasting, giving talks on travel. With the inauguration of the Australian Broadcasting Commission (ABC) in 1932, she managed children's programming, pioneering the "Argonauts' Club," which aired for only about two years but was successfully revived in similar form to run from 1941 to 1972.

When her husband moved to Adelaide in 1934 to work for News, Ltd., Murdoch followed a year later. She traveled again in Europe in 1934 and 1935, producing the 1935 travel book *She Travelled Alone in Spain*. Abroad again in 1937, she wrote articles for the Australian press warning against Nazism. Murdoch published her last book, a biography of John

Longstaff called *Portrait in Youth*, in 1948. A member of the Lyceum Club, the Incorporated Society of Authors, and the Fellowship of Australian Writers, Nina Murdoch spent her final years in a nursing home at Camberwell, Australia, where she died on April 16, 1976.

SOURCES:
Radi, Heather, ed. *200 Australian Women: A Redress Anthology.* NSW, Australia: Women's Redress Press, 1988.
Wilde, William H. *et al.*, eds. *The Oxford Companion to Australian Literature.* Melbourne: Oxford University Press, 1985.

Ellen Dennis French,
freelance writer, Murrieta, California

Murdock, Margaret (1942—)

American Olympic shooting champion. Born on August 25, 1942; attended nursing school; children: at least one.

Margaret Murdock was the first female member of a U.S. Olympic shooting team and the first woman to win a medal in an Olympic shooting competition. She won the silver medal in the small-bore rifle competition of the 1976 Olympics in Montreal at the age of 33. Although initially she was listed on the scoreboard as the winner by one point over American competitor Lanny Bassham, a clerical error and Olympic tie-breaking rules eventually determined that Bassham was the winner of the gold medal—by one point. Feeling Murdock's performance had equaled his, Bassham insisted that she share with him the highest step on the victory platform while the national anthem was played.

Murdock set many individual and team records in her sport and won 14 World team championships, 7 individual world championships, and 5 Pan American gold medals. She is the only woman ever ranked in the world's top ten shooters list of the International Shooting Union.

SOURCES:
Grace and Glory: A Century of Women in the Olympics. Washington, DC: MultiMedia Partners, 1996.
Greenspan, Bud. *100 Greatest Moments in Olympic History.* LA, California: General Publishing Group, 1995.

Ellen Dennis French,
freelance writer, Murrieta, California

Mure, Elizabeth (d. before 1355).

See Muir, Elizabeth.

Murfin, Jane (1893–1955)

American playwright and screenwriter. Born in 1893 in Quincy, Michigan; died in 1955; married Donald Crisp (an actor and director), in 1932 (divorced 1944).

Selected filmography: Daybreak (co-play basis only, 1918); The Amateur Wife (1920); The Silent Call (1921); Brawn of the North (co-writer and co-producer, 1922); Flapper Wives (also co-director, 1924); White Fang (1925); A Slave to Fashion (1925); The Savage (1926); Meet the Prince (1926); Notorious Lady (1927); Love Master (1927); Street Girl (1929); Half Marriage (1929); Leathernecking (1930); Friends and Lovers (1931); Too Many Crooks (1931); What Price Hollywood? (1932); Young Bride (1932); The Silver Cord (1933); Ann Vickers (1933); Double Harness (1933); This Man Is Mine (1934); Spitfire (1934); The Little Minister (1934); Alice Adams (co-writer, 1935); Roberta (1935); Come and Get It (1936); I'll Take Romance (1936); The Shining Hour (1938); The Women (1939); Stand Up and Fight (1939); Pride and Prejudice (1940); Smilin' Through (co-play only, 1941); Flight for Freedom (1943); Dragon Seed (1944).

Jane Murfin began as a playwright who, with her friend *Jane Cowl, wrote the hugely successful Broadway play *Smilin' Through* (1919), in which Cowl also starred. The play would be adapted for the screen three times, starring *Norma Talmadge in 1922, *Norma Shearer and Fredric March ten years later, and *Jeanette MacDonald and Gene Raymond in 1941. Murfin herself was soon a successful screenwriter in Hollywood, and in 1934 also became the first female supervisor at RKO studios. Murfin wrote the script for 1932's *What Price Hollywood?*, the original version of the story that later became *A Star is Born*. She also co-wrote (with Dorothy Yost and Mortimer Offner) the film adaptation of Booth Tarkington's Pulitzer Prize-winning novel *Alice Adams* (1935), which starred *Katharine Hepburn and Fred MacMurray. Her series of "Strongheart" scripts, starring her pet German shepherd, debuted in 1922, preceding the "Rin Tin Tin" series by two years.

SOURCES:
Acker, Ally. *Reel Women: Pioneers of the Cinema 1896 to the Present.* NY: Continuum, 1991.

Ellen Dennis French,
freelance writer, Murrieta, California

Murfree, Mary N. (1850–1922)

American novelist and short-story writer. Name variations: (pseudonyms) R. Emmet Dembry, Charles Egbert Craddock (1878–85). Born Mary Noailles Murfree on January 24, 1850, at Grantland plantation near Murfreesboro, Tennessee; died on July 31, 1922, in Murfreesboro; daughter of William Law Murfree (a lawyer and plantation owner) and Fanny Priscilla (Dickinson) Murfree; educated at home and in schools in Nashville and Philadelphia; attended Chegaray Institute, 1867–69; never married; no children.

Selected works—stories: In the Tennessee Mountains (1884), The Mystery of Witch-Face Mountain, and Other Stories (1895), The Phantoms of the Foot-Bridge, and Other Stories (1895); novels: Where the Battle Was Fought (1884), The Prophet of the Great Smoky Mountains (1885), Down the Ravine (1885), In the Clouds (1886), The Despot of Broomsedge Cove (1888), In the "Stranger People's" Country (1891), The Story of Old Fort Loudon (1899), A Spectre of Power (1903), The Amulet (1906), The Fair Mississippian (1908), The Ordeal: A Mountain Romance of Tennessee (1912), The Story of Dulciehurst: A Tale of the Mississippi (1914); frequent contributor to national literary magazines, including Lippincott's and The Atlantic Monthly.

Mary N. Murfree, whose fiction set in the Tennessee mountains established her as one of the most popular authors of her day, was born on January 24, 1850, near Murfreesboro, Tennessee, a town named for her great-grandfather. Her father William Law Murfree was a lawyer and a prosperous plantation owner, and her mother **Fanny Dickinson Murfree** came from a politically prominent family who owned plantations in Tennessee and Mississippi. At the age of four, Murfree was left partially paralyzed by a fever, a condition that most likely stimulated her interest in reading and writing. In 1856, her family moved to Nashville, Tennessee, where she and her older sister **Fanny** attended the Nashville Female Academy until 1862. Their father tutored them during the Civil War, and after the war's end they attended the Chegaray Institute, a French boarding school in Philadelphia, from 1867 to 1869.

In 1869, the family suffered severe financial losses due to the falling price of cotton. They moved back to Murfreesboro, building a smaller house to replace the mansion that had been gutted during a nearby battle. Murfree's father entertained his daughters with stories, many in local dialects. She and her father also wrote stories together during this period, and a light satiric comedy on social life, "Flirts and Their Ways," became her first published work, appearing in May 1874 in *Lippincott's* under the pen name of R. Emmet Dembry. In May 1878, *The Dancin' Party at Harrison's Cove*, by Charles Egbert Craddock, her new pseudonym, was published in the *Atlantic Monthly*.

In 1881, after Murfree moved to St. Louis with her family, Thomas Bailey Aldrich, the new editor of *The Atlantic Monthly*, urged Charles

Egbert Craddock to concentrate on mountain stories. Eight of these were published as *In the Tennessee Mountains* (1884), an instant success that is also considered one of Murfree's best books. Critics of the day called it "a milestone in American regional writing," and the book contributed greatly to the local-color movement in American fiction, in which writers strove to depict the distinct character and flavor of a region and its people. In quick succession came *Where the Battle Was Fought* (1884), *The Prophet of the Great Smoky Mountains* (1885), and *Down the Ravine* (1885), a boys' story serialized by *Wide Awake* magazine. Soon readers were wondering just who "that man Craddock" was, but Murfree's identity was kept secret until 1885, when, fearing that it would be found out anyway, she revealed the truth to Thomas Bailey Aldrich. The revelation gained nationwide publicity (there was much amazement that a woman was writing such "vigorous" fiction), and her popularity increased further. She published the novels *In the Clouds* (1886) and *The Despot of*

Broomsedge Cove (1888), and was acclaimed on a par with such other eminent local colorists as *Sarah Orne Jewett, Bret Harte, and George W. Cale; for over a decade, not one of her stories was rejected for publication.

In 1889, Murfree returned with her family to their Grantland plantation, where her writing was their chief source of income. Two years later, she published *In the "Stranger People's" Country*, now considered her most fully realized and compelling novel. Another collection of short stories, *The Phantoms of the Foot-Bridge, and Other Stories*, appeared in 1895. The public's reading taste gradually changed, however, and interest in local color faded. Pressed by financial considerations, Murfree dutifully switched to writing historical novels, including *The Story of Old Fort Loudon* (1899) and *A Spectre of Power* (1903), and also tried romances. None of these were as popular as her mountain stories had been, and eventually she returned, with some success, to the subject she knew best. Although modern-day readers and critics may have difficulty with what are generally agreed to be her stereotypical characters and intrusive authorial voice, her complete familiarity with the environment of the Tennessee mountains, and the freshness and fidelity with which she depicted both it and the people who lived there, remain worthy of attention. Murfree spent her last years blind and restricted to a wheelchair. In 1922, she was awarded an honorary doctorate from the University of the South, and died that July in Murfreesboro.

SOURCES:

Buck, Claire, ed. *The Bloomsbury Guide to Women's Literature.* NY: Prentice Hall General Reference, 1992.

Contemporary Authors. Detroit, MI: Gale Research, 1998.

Hall, Wade, in *Dictionary of Literary Biography.* Vol. 74. Detroit, MI: Gale Research, 1988.

James, Edward T., ed. *Notable American Women, 1607–1950.* Cambridge, MA: The Belknap Press of Harvard University Press, 1971.

McHenry, Robert, ed. *Famous American Women.* NY: Dover, 1980.

Salvaggio, Ruth, in *Dictionary of Literary Biography.* Vol. 12. Detroit, MI: Gale Research, 1982.

SUGGESTED READING:

American Women Writers: A Critical Reference Guide From Colonial Times to the Present, Volume I. Ungar, 1979.

Cary, Richard. *Mary N. Murfree.* NY: Twayne, 1967.

Parks, Edd Winfield. *Charles Egbert Craddock (Mary Noailles Murfree).* Chapel Hill, NC: University of North Carolina Press, 1941.

COLLECTIONS:

A collection of Murfree's papers are at Emory University Library. Her manuscripts are held at the Tennessee State Library and Archives.

Jo Anne Meginnes,
freelance writer, Brookfield, Vermont

Mary Murfree

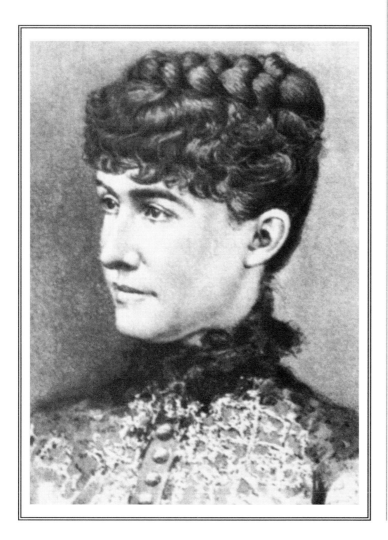

Muriella.

Variant of Muriel.

Muriella (fl. 1000)

Frankish noblewoman. *Flourished around the year 1000; first wife of Tancred of Hauteville; children: William "Bras de Fer" (died in 1046 in Italy); Drogo (murdered in 1051 in Italy); Humphrey (died 1057, leader at Civitatee in 1053); Geoffrey, count of Loritello; Serlo.*

Murnaghan, Sheelagh (1924–1993)

Irish barrister and politician. *Name variations: Sheelagh Mary Murnaghan. Born in Dublin, Ireland, in 1924; died in 1993.*

Sheelagh Murnaghan, representing Queen's University in Belfast, was the only Liberal MP ever elected to Northern Ireland's Stormont Parliament. University representation survived in Ulster for 20 years after it was abolished in Britain, which explains how Murnaghan's non-partisan voice could be heard in the notorious Stormont. For many years, she was the voice of the poor on human rights and civil liberties issues, on women's rights and economic development, and on the rights of the homeless. From 1969 to 1972, Murnaghan served on the first Northern Ireland Community Relations Commission. When Direct Rule was initiated, she served on Whitelaw's Advisory Commission. She later chaired the National Insurance and Industrial Relations Tribunals.

Murphy, Bridey (1923–1995).

See Tighe, Virginia.

Murphy, Emily (1868–1933)

Magistrate, social reformer, author, and first female magistrate in the British Empire, who initiated and led the famous "Persons Case"—a landmark case in the battle for women's rights in Canada. *Born Emily Gowan Ferguson on March 14, 1868, in Cookstown, Ontario, Canada; died at her home on October 26, 1933, in Edmonton, Alberta, Canada; daughter of Isaac Ferguson (a prominent businessman) and Emily (Gowan) Ferguson; attended the private Bishop Strachan School for Girls, 1883–87; married Arthur Murphy, on August 24, 1887; children: Kathleen (b. 1888); Evelyn; Madeleine (1893–1894); Doris (1896–1902).*

Began writing career while traveling in Europe (1898–1900); published first book (1901); moved from Ontario to the West (1903); appointed first female magistrate in British Empire (1916); formed famous "Alberta Five" to petition the Supreme Court (1927); Supreme Court victory in the "Persons Case" (1929); retired from the bench (1931).

Selected writings: Impressions of Janey Canuck Abroad *(London, Ont.: C.P. Heal, 1901);* Janey Canuck in the West *(NY: Cassell, 1910);* Open Trails *(NY: Cassell, 1912);* Seeds of Pine *(Toronto: Hodder & Stoughton, 1914);* The Black Candle *(Toronto: Thomas Allen, 1922);* Our Little Canadian Cousin of the Great North West *(Boston: Page, 1923);* Bishop Bompas *(Toronto: Ryerson Press, 1929).*

In Canadian history, Emily Murphy is known most for two important events. She was the first woman to become a magistrate in Canada, and she was the leader of a group which secured constitutional recognition that women were entitled to hold public office, a legal victory known as the "Persons Case." These two events—so important in Canadian history and Emily Murphy's life—were interconnected. It was during Murphy's first day as a police magistrate in the City of Edmonton that she was confronted with the insulting and anachronistic notion that women in Canada were not "persons." A criminal lawyer, Eardley Jackson, raised an objection challenging Murphy's jurisdiction as a judge because, as a woman, she was not a "person" within the statutes of Canada. In essence, he was arguing that she legally was not entitled to sit as a judge in the first place. This type of objection continued in Murphy's court and in that of **Alice Jamieson**, a second female magistrate who had been appointed in the City of Calgary. Eventually the issue landed in the Alberta Supreme Court, which ruled that the common law did not disqualify women from holding public office. Although this was a victory, Murphy was not satisfied. The Alberta Court decision pointed to the reality of public life in Canada but it did not change the law, leaving the question open as to whether women were "persons" in law. Eventually the issue became centered around the issue of appointment to the Canadian Senate. The Canadian constitution (the British North America or BNA act) outlined the conditions under which "properly qualified persons" could be appointed to the Senate by the Canadian government. The government, despite sustained pressure from women across the country, refused to appoint a woman on the grounds that women were not "persons" in law and, thus, not qualified. The issue remained in a stalemate until 1927, when Emily Murphy devised a

strategy which forced the issue before the courts for clarification of the meaning of the statute. Eventually, the issue came before the British Privy Council (at that time, the highest court for Canadians). After a 13-year battle which began in her courtroom, Murphy was elated to hear on October 18, 1929, that the Privy Council had declared that women in Canada were "persons."

On March 14, 1868, Emily Murphy was the third of six children born to Isaac and **Emily Gowan Ferguson** in the small Ontario town of Cookstown. Both parents were recent arrivals from Ireland. Like most Irish immigrants at this time, Isaac Ferguson had arrived in Canada penniless. However, unlike most, he succeeded as a landowner and businessman, achieving prosperity by the time he married. Ferguson's prominence was accentuated by that of his wife. Emily Gowan had social and political prestige in small-town Ontario because she was the daughter of Ogle Robert Gowan, a prominent politician and founder of the Orange Lodge in Ontario. (Orange Lodge was a secret society formed in Northern Ireland in 1795 to support Protestantism.) The family position was demonstrated each year when they headed out to the front porch to be serenaded by the Cookstown Orange Band in memory of Ogle Gowan.

Nothing ever happens by chance. Everything is pushed from behind.

—Emily Murphy

Emily Murphy also had a number of other influential and prominent relatives. A family cousin, Sir James Gowan, was a Supreme Court judge and senator while another cousin, Thomas Ferguson, was a judge. Her uncle, Thomas Roberts Ferguson, was heavily involved in the politics of the era. The experiences and roles of these relatives undoubtedly influenced the young Emily and her siblings, as did their exposure to prominent people who were entertained at the family home. Playing host to the social and political elite of the province was the norm, and on one occasion the family welcomed the prime minister of Canada, Sir John A. Macdonald, into their home.

Within this environment, Emily Murphy's childhood was happy and carefree. The family was close and loving. Throughout their lives, this intimacy was maintained through letters and occasional family get-togethers even as they moved farther apart. The family's wealth meant that Emily and her five siblings were free of the worry and labor that then confronted poorer children. They played together in their spacious yard, and days occupied by fishing, riding a pony and playing dress-up before a mirror are reflected in Murphy's later childhood memoirs.

Some of these activities reveal that Murphy's childhood was somewhat unconventional for a girl. Perhaps because of the influence of four brothers, she spent her time pursuing what were viewed as "unladylike" activities like tree climbing and fishing. Particularly noteworthy was Murphy's insistence throughout her life of riding horses astride rather than sidesaddle, which was considered the dignified pose of ladies. Said Murphy: "A girl who rides a horse sidewise looks like a heap of clothes hanging on a clothespeg, and likely to fall off at any minute."

Yet it cannot be denied that distinctions were made between male and female in the treatment of the Murphy children, most notably in education. All the children received private school educations at reputable institutions once they reached their teenage years. Emily was sent to the prestigious Bishop Strachan School for Girls in Toronto at age 15. Here the major subject areas were religion, literature, and music, with physical activity confined to such sports as croquet and tennis. The academic instruction was a continuation of the training Murphy had received at home, where music and literature had been complemented by instruction on how to write and speak properly. At Upper Canada College, however, her brothers were exposed to a much wider curriculum. The education she received was typical of that given to young ladies at the time. Women were trained for their eventual role as wives of prominent men. As such, they were expected to be ornaments to their husbands; hence, the emphasis on proper speech and the ability to sing, play an instrument, and make light conversation about "ladylike" topics, such as classic literature. Murphy never did excel at music, but she loved to read, absorbing many of the classics as well as books that were considered inappropriate.

In her first year at the school, Emily was introduced to her future husband Arthur Murphy, a meeting arranged by two of her brothers at his instigation. An attractive man, 11 years her senior, Arthur was studying to enter the ministry. Apparently, he had noticed Emily on several occasions, since their families lived in close proximity, and had decided he would like to marry her. As for Murphy, it is not clear how she felt. Over the next four years of school, she dated and flirted with a number of young men as was considered normal for a girl of her age, although years later, on reflection, she admitted, "There

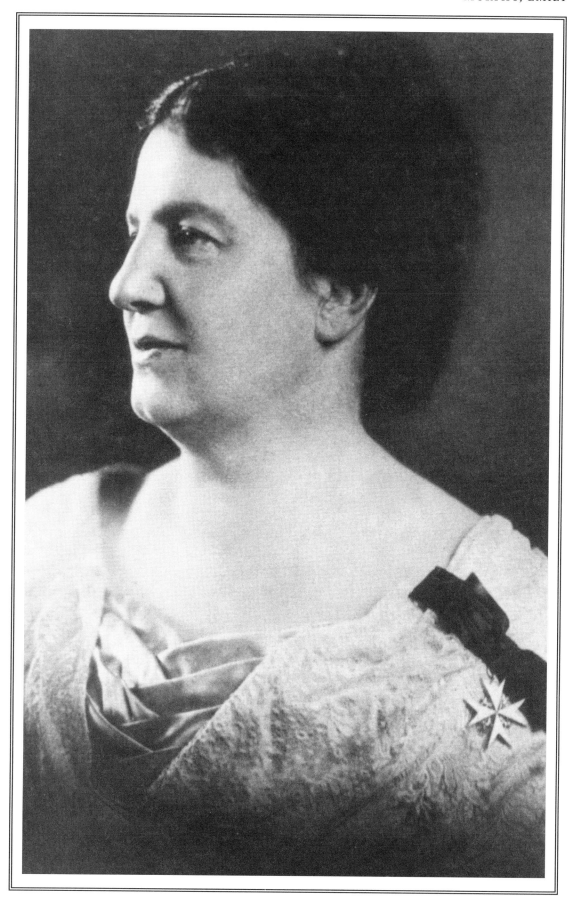

Emily Murphy

was never anyone, really, but Arthur." On August 24, 1887, just two months after Emily's graduation from school, the couple were married at the Anglican Church in Cookstown.

By that time, Arthur had become a minister with the Anglican Church and had been assigned to his first parish in Forest, a small village 160 miles southwest of Cookstown, where Murphy plunged successfully into her new role as minister's wife. She took Bible classes, organized bazaars, played the organ, and joined the missionary society. (A common activity for the wives of the middle class, these societies raised money to pay for missionary activities in foreign countries.) Still, Murphy had a playful spirit, an extremely energetic nature, and a tendency to question society's norms. These were the qualities that would lead her to make an indelible imprint on Canadian society and politics; they also had a tendency to lead her into trouble in her new role as minister's wife, such as the time she burst into laughter in church at the perceived pretentiousness of the choir leader walking up the aisle. These events probably challenged her relationship with Arthur, at least in the early years, given that he was older and much more somber. However, the couple quickly developed a strong relationship based on love and companionship. Not only did Murphy support Arthur in his career pursuits, but Arthur, over the years, became her strongest advocate as she ventured outside of her prescribed role and into the sphere of social reform, politics, and the law.

Over the next ten years, the couple moved frequently as Arthur was transferred to four different parishes. During this time, the family grew. A daughter, **Kathleen**, was born within a year of their marriage, followed by **Evelyn**. In 1893, Murphy had a third daughter, Madeleine, but the child was born premature and died after only nine months. In 1896, their fourth and final child, Doris, was born. By 1897, Arthur had developed a reputation as a dynamic preacher and compassionate minister. Consequently, he was asked to become a missionary, which required that he travel almost continuously around Ontario, preaching to different areas. He continued this role until 1903, but it was steadily enlarged when he was posted in England from July 1898 to December 1899 and then to all of Canada in the early 1900s.

These later years of constant moving and disrupted home life were difficult for Murphy. Arthur worked hard and often was not at home. At times, the family had no established residence and their income fluctuated substantially. Despite the insecurity, these years provided Murphy with opportunity to write. With Arthur away, she spent less time assisting him with his work, which left her time to pursue other activities, especially once the two older girls were off to boarding school. Murphy began to write in diary form about her experiences and impressions of the people and events she encountered. In many ways, her world view was expanding. Traveling with Arthur, she was exposed to life outside the middle class and the small-town existence she had known to that point. Once in England, Murphy spent much of her time socializing with the elite, traveling and sightseeing. The result was the publication of her first book, *The Impressions of Janey Canuck Abroad* (1901), an account of her impressions of the sights and people of Europe. In an age when reading was a popular form of entertainment, there was a large demand for books of this type. As well as being light-hearted and enjoyable to read, the book was insightful and witty, and it was an immediate success in both England and Canada.

Murphy's reputation as a writer and the demand for her work grew steadily after 1901. Shortly after the publication of her first book, she was asked to contribute to a new general interest magazine entitled *National Monthly of Canada*. Her contributions became regular, leading eventually to an appointment as women's editor and then as literary editor. Numerous other magazines also asked her to contribute articles, edit or review materials. This writing was substantial enough that on several occasions, such as the fall of 1902 when Arthur was bedridden with typhoid, Murphy was able to support the family from the proceeds.

Her life underwent a significant change in the summer of 1903, when it was decided that the family would move to Swan River, Manitoba, an unsettled area of the Canadian West. The youngest child, Doris, had died of diphtheria complications in November 1902. Combined with the fact that both Murphy and her husband had been stricken with serious bouts of typhoid earlier in the year, the family wanted fresh air and a change of lifestyle. Their move put an end to Arthur's career as a minister and led him into speculation in land, minerals, and timber, an occupation which engrossed many men in the newly opening Canadian West. For Murphy, it meant the beginning of her role in Canadian politics and law.

Initially, life in the West was quiet and relatively uneventful. Swan River was an isolated outpost, and Murphy spent her days running the

farm they had purchased (as Arthur was usually away) and writing for several magazines. Her love of the West began. During these first four years, she immersed herself in the natural environment, riding horses, fishing, and studying the local flowers and animals. Still the isolation of Swan River, particularly during the long, bitterly cold winters, probably left her lonely and restless at times.

Thus, Arthur's decision to move to Edmonton, Alberta, in 1907 was likely less of an upset for her than previous moves. Although newly settled and somewhat rough in amenities and character, Edmonton was an urban area. Murphy quickly became involved in the regular parties and social activities of the local elite. But the move to Edmonton did not merely return her to the society of other middle-class women. It also introduced her to the reform movement that was spreading across the country and was particularly active and radical in the cities of the West. The movement encompassed a large number of issues and groups, but in general was centered around the fight for women's rights (including the vote) and a new social consciousness which demanded improved facilities and social services for the care of the poor and dispossessed.

To some extent, Murphy had always pursued charitable activities in the different communities in which she lived. It was accepted at the time that the wives of affluent men should devote their time to charity. However, what was changing for women like Murphy was the belief that charitable acts were not enough and that social responsibility demanded the provision of services by the whole community through government legislation and funding. Accompanying this demand was the belief that women required a greater political voice through the vote and access to public offices. Over the next few years, Murphy became involved in a number of issues and organizations. She succeeded in ensuring the election of women as school trustees in Alberta, was involved in the suffrage movement, arranged for the establishment of public playgrounds and municipal hospitals in the city, and sat as vice-president of the Alberta Association for the Prevention of Tuberculosis. Perhaps most important to her during these years, and what may be considered her first victory, was that she forced the Alberta government, in 1911, to enact the Dower Act. This guaranteed that wives would receive one-third of their husband's estate, even if there was no will; prior to 1911, women in Alberta could work throughout their lives on the family farm only to be left destitute with widowhood.

Murphy's most significant public appointment occurred not after a long battle, but rather unexpectedly. In the summer of 1916, members of the Local Council of Women approached Murphy with a problem. Concerned with the treatment of women in the courts, they were frustrated because they had been refused entrance to the local police court on the grounds that the evidence was unfit to be heard in "mixed company." To Murphy the solution was quite simple; if the evidence was not fit for mixed company, then women must demand a new court where women would be tried *by women*. Known for her work and for being outspoken, Murphy was asked to present the proposal to the attorney-general, which she agreed to do. Prepared for a long battle, she was undoubtedly shocked when the attorney-general of Alberta not only agreed to the proposal but asked her to become the police magistrate of this new woman's court. Several days later, on June 19, 1916, Murphy was sworn in as the first female magistrate in the British Empire.

This "first" would have been enough to secure for Murphy a place in Canadian history, but her most significant victory was yet to come. The constant irritation of having her authority challenged in the court due to the dubious standing of women in Canadian law led Murphy to become involved in the movement to have women appointed to the Canadian Senate. By 1918, women in Canada could vote in federal elections and take their seat, if elected, in the House of Commons. Although the Senate was the "upper" house of the government, its role by 1918 was largely symbolic; the Commons was the actual arm of government. Still, the federal government refused to appoint a woman to the Senate, arguing rather meekly that the constitution used the term "persons" when referring to eligibility and it was not clear whether women were "persons" in law.

For the next nine years, Murphy and other women tried to effect a change by regularly petitioning the government to appoint a woman and by submitting the names of acceptable female candidates. The futility of this approach was evident by 1927, when Murphy developed a new strategy. Her brother Bill, a lawyer, informed her that there was a provision in the Supreme Court Act which stipulated that five people could petition the court for an interpretation of a constitutional point. Murphy quickly contacted four other women, all of whom were prominent, well-known figures in the Canadian women's rights and reform movements: *Nellie McClung, *Louise McKinney, *Henrietta Muir Edwards,

and *Irene Parlby. Meeting in August 1927, the "Alberta Five," as they came to be known, put together their petition. Directed to the Supreme Court of Canada, the petition asked quite simply, "Does the word Persons in Section 24 of the BNA Act of 1867 include female persons?" Yet the matter would not be settled simply or quickly.

The case was heard in March 1928, but the women were to be disappointed one month later when the decision came down. The Supreme Court argued that the BNA Act had to be interpreted within the context of when it was written (in 1867). As women did not hold any public office at that time, it could be assumed that "women" were not included in the word "persons." The decision effectively strengthened the hand of all those who wished to deny women the right to public office. However, Murphy was determined. She immediately decided they would appeal to the Privy Council in London. This final hearing was held on July 22, 1929, after which the parties had to wait three months for a decision. But the wait was worth it. On October 18, 1929, Murphy received word that the Privy Council had decided that women were indeed "persons" and, thus, entitled to appointment to the Canadian Senate. In the decision, the Court argued:

> The exclusion of women from all public offices is a relic of days more barbarous than ours . . . and to those who ask why the word [person] should include females, the obvious answer is, why should it not?

The months that followed the decision were celebratory for Murphy, for women's organizations, and for many Canadians. Congratulations poured in from all over England and Canada, from both prominent and everyday people. The "Alberta Five" were inundated with requests to attend special engagements and to make speeches. Eventually, however, attention was directed towards the government, which, it was felt, was now obligated to appoint a woman to the Senate. Many believed the obvious choice was Emily Murphy. The government apparently felt otherwise and appointed an alternate candidate, *Cairine Wilson. Whatever the reason for this decision (which is still debated), there is no doubt that Wilson was far less aggressive and outspoken than Murphy.

Despite the centrality of the "persons" case in Murphy's life, it was only one of many pursuits that occupied her time during these decades. Along with the everyday demands of her work as a police magistrate, Murphy had continued with her reform activities and her writing. During the years 1912 to 1929, she released five additional books. *Seeds of Pine* and

Open Trails were similar to the "Janey Canuck" books, as they were witty and lively descriptions of her experiences. *The Black Candle*, however, was a very different book which stemmed from her work as a magistrate. It was a detailed and comprehensive analysis of the problem of drug trafficking and addiction in Canada; even by modern-day standards, it remains an informative and insightful examination of the problem.

By 1930, Murphy was beginning to find that she was losing some of the energy that had allowed her to do so much. Around 1913, she had been diagnosed with diabetes, and although insulin was available after 1922, Murphy never used it. By the 1920s, her health was deteriorating, and she was frequently ill. In November 1931, she retired from the bench, citing the fact that she had passed the age of retirement (she was 63) and that she needed more time to devote to her writing. Though her declining health was probably also a factor, there is no doubt that she did wish to spend more time writing. In high demand by magazines and newspapers, she always had work needing completion.

For the next two years, she devoted herself to writing. On the day of her death, it is reported that she had spent her time at the library, conducting research for an article. Her death, on October 26, 1933, was unexpected. Around midnight, Murphy's daughter Evelyn heard a cry and rushed to her mother's room to find her already dead. The cause of death was reported as a cerebral emboli with diabetes as a contributing factor.

Emily Murphy's death was a shock to all who knew her, personally or through her work. Condolences were sent by people from all over Canada, including the prime minister. Newspapers and magazines paid tribute to her character and her contributions through their obituaries. Her funeral, held on October 30, was attended by hundreds. Perhaps her greatest honors came years later. In June 1938, a bronze plaque was unveiled in the Senate lobby honoring the "Alberta Five." Eventually, the National Historic Sites and Monuments Board gave Murphy their highest honor, designating her "a person of national historic importance." It was evident to all that her accomplishments had assured her an important place in Canadian history.

SOURCES:

Innis, Mary Quayle, ed. *The Clear Spirit: Twenty Canadian Women and their Times*. Toronto: University of Toronto Press, 1966.

Mander, Christine. *Emily Murphy: Rebel*. Toronto: Simon & Pierre, 1985.

Sanders, Byrne Hope. *Emily Murphy: Crusader*. Toronto: Macmillan, 1945.

Opposite page

Lizzie

Murphy

SUGGESTED READING:

James, Donna. *Emily Murphy*. Toronto: Fitzhenry & Whiteside, 1977.

Catherine Briggs, Ph.D. candidate,
University of Waterloo, Waterloo, Canada

Murphy, Lizzie (1894–1964)

Pioneer American baseball player who played first base for Ed Carr's All-Stars of Boston. Born Mary Elizabeth Murphy on April 13, 1894, possibly in Warren, Rhode Island; died on July 27, 1964; married Walter Larivee, in 1937 (died); no children.

One of six children of an Irish mill worker, Lizzie Murphy was an all-around athlete as a child, but her interest soon narrowed to baseball. At 12, she went to work at the woolen mills, but dreamed of baseball and spent her free time on the diamond. By age 15, she was playing on several amateur teams, although she sometimes doubted whether she should continue. "I about decided that baseball wasn't a game for a girl and that I'd quit," she later recalled. "But then I went to watch one of the games and got so excited I couldn't stay out. When I see a batter swinging wild or stepping back from the ball it makes me crazy to take a turn at the plate and line one out."

Murphy honed her skills on several semipro teams, playing first base, then moved up to the Providence Independents. In 1918, she signed a contract with Ed Carr's All-Stars of Boston, sometimes called the Boston All-Stars. It was a step up for Murphy, who traded her bloomers for an actual baseball uniform, with a peaked cap under which she tucked her long, reddish-brown hair. Unlike her male teammates, she had her name emblazoned back and front on her heavy wool shirt. so that everyone would know that she was indeed the woman they had come to see. Murphy was such a drawing card for the team that owner Ed Carr used her picture on his stationery. When people criticized Carr for exploiting a woman who probably could not even play, he replied: "She swells attendance, and she's worth every cent I pay her. But most important, she produces the goods." Actually, Carr did not pay her or any of his players all that much, and Murphy was forced to supplement her income by selling autographed photos of herself between innings.

For 17 years, Murphy made her living playing baseball with the All-Stars, proof enough that she delivered the goods. "No ball is too hard for her to scoop out of the dirt," Carr once boasted to reporters, "and when it comes to bat-

ting, she packs a mean wagon tongue." Murphy was especially proud of the single she hit off the great Satchel Paige during a barnstorming game.

In 1922, Murphy played in Fenway Park, in a charity game pitting the Boston Red Sox against a group of American League and New England All-Stars. She played another major league exhibition game in 1928, this time with the National League All-Stars against the Boston Braves. These two appearances made her not only the first woman to play for a major league team in an exhibition game, but the first person, man or woman, to play with both American League and National League All-Star teams.

Lizzie Murphy retired from baseball in 1935, at the age of 41. Unfortunately, there was no fat pension check waiting for her at the end of her career, so she resorted to cleaning houses, quahogging, and clamming to make a living. She married in 1937, but her husband died a few years later. A woman of great pride and spirit, she died on July 27, 1964, at age 70.

SOURCES:
Gregorich, Barbara. *Women at Play: The Story of Women in Baseball*. NY: Harcourt Brace, 1993.

Murphy, Marie Louise (1737–1814).

See Pompadour, Jeanne-Antoinette for sidebar on Marie-Louise O'Murphy.

Elizabeth Murray

Murray, Elizabeth (1626–1698)

Countess of Dysart and duchess of Lauderdale. Name variations: Bess; Elizabeth Maitland; Lady Lauderdale. Born on September 28, 1626, in St. Martin-in-the-Fields, England; died on June 5, 1698 (some sources cite 1697), in Richmond, England; daughter of William Murray, 1st earl of Dysart, and Catherine Bruce; married Lionel Tollemache, in 1648; married John Maitland, duke of Lauderdale, in 1672; children: (first marriage) Lionel (b. 1649); Thomas (b. 1651); Elizabeth Tollemache (b. 1659); Catherine Tollemache (b. 1661); William (b. 1662).

Accused of witchcraft by her enemies because of her politi-cal influence, Elizabeth Murray was active during the civil turmoil of 17th-century England. Of Scottish descent, she was one of five daughters of William Murray, close friend and courtier to King Charles I of England. She grew up in Ham House, the Murray country manor near Richmond, as well as at the royal court. Better educated than most girls of her rank, Elizabeth was even taught mathematics, history, and philosophy. In the years of her childhood, her parents were deeply involved in supporting Charles I and Queen *Henrietta Maria in their growing religious and political conflicts with Parliament as the English civil war approached. Their devotion, along with their resilience when the king's opponents tried repeatedly to confiscate their property, profoundly affected Elizabeth's character, creating in her intense royalism and a determination to retain her rights at all costs.

At age 22, she married Sir Lionel Tollemache. A wealthy baronet two years her senior, Tollemache was at the time uninvolved in the ongoing civil strife, making him an ideal husband in the eyes of the Murrays. After a private Anglican ceremony, the couple settled in the Tollemache manor in Suffolk. It proved an affectionate marriage, and together they would have eleven children, although only five would survive infancy.

In 1649, her mother **Catherine Bruce** died, and Elizabeth took her younger sisters into her home; the next year William Murray fled England to join the exiled Prince Charles, returning only briefly to England before his death in 1655. At that time Elizabeth and her husband moved to Ham House, which Elizabeth had inherited, along with the title countess of Dysart. In the early 1650s, the royalist countess began an unusual friendship with Oliver Cromwell, the Puritan military leader of the parliamentary opposition to the king who was quickly becoming the most powerful man in England. She was widely rumored by Cromwell's enemies to be his mistress, but no evidence supports it, and Elizabeth's happy marriage and Cromwell's marriage to *Elizabeth Cromwell argue against it. Elizabeth Murray seems to have cultivated the friendship out of both a genuine admiration for Cromwell and as a means of protecting her inheritance from the continued threat of confiscation by Parliament. Her influence can be seen in the fact that in 1651, at her request, Cromwell spared the life of a condemned royalist supporter, John Maitland, earl of Lauderdale. After Cromwell was named Lord Protector in 1653, Elizabeth was savvy enough to display outward signs of loyalty to the Puritan Party, while retaining her desire to see Prince Charles brought to the throne as Charles II.

As a leading social hostess with Cromwell's trust, she was not considered a political threat by Parliament, who did not interfere with her frequent travels to the Continent, or her correspondence as they did with other suspected royalists. Therefore the countess was able to continue her secret political activities with those working to bring back the monarchy, a group of nobles calling themselves the Sealed Knot. Elizabeth's associates did not advocate the violent overthrow of Cromwell's protectorate but instead worked to raise popular support for the exiled Charles II. Cromwell viewed Elizabeth as an important ally as he tried to win over the allegiance of the royalist party to consolidate his power.

Her work was coupled with the increasing burdens of motherhood through the 1650s and 1660s, but she was in excellent health and her frequent pregnancies did not slow down her political activities. Following Cromwell's death in 1658 and the return of Charles II in 1660, Elizabeth's efforts on behalf of the monarchy were recognized and financially rewarded by the new king. Thus she skillfully made the transition from public ally of Cromwell to loyal supporter of the king.

By the late 1660s, her marriage with Tollemache had broken down as she became attracted to John Maitland, the earl whose life she had saved in 1651. He was now secretary of state for Scotland and its high commissioner. Unlike Tollemache, Maitland shared Elizabeth's belief in a strong monarchical, authoritarian government. The earl respected Elizabeth's political acumen and she became a major influence on his decisions. He stayed at Ham House often, especially after Lionel Tollemache moved to France due to poor health. Rumors about the affair intensified after Tollemache's death in January 1671; Elizabeth's influence on Maitland caused much resentment among Scottish officials.

She moved to London, where she appeared frequently with Maitland at court. In December 1671, Maitland's wife died; three months later the earl and Elizabeth married. Shortly afterwards Charles II named the couple as duke and duchess of Lauderdale in reward for their loyal service. They spent some time in Edinburgh in late 1672, but returned to England to work on refurbishing and enlarging their preferred home, Elizabeth's Ham House. Both were interested in architecture and interior design, and spent lavishly on improvements to the manor.

In 1680, John Maitland resigned his offices due to failing health and a weakening of his authority in Scotland. Changes in the English polit-ical climate led Charles II to abandon his former friendship with Elizabeth and Maitland, a loss of favor which effectively ended their years of political activity, and he subsequently terminated their pensions. Coupled with the duke and duchess' extravagance, this loss of income ruined their fortunes. When Maitland died in August 1682, he left his widow deeply in debt. Elizabeth spent years trying to get Maitland's brother, the new earl of Lauderdale, to pay off her husband's debts, even filing suit against him in 1688. She seldom left Ham House after that, although she kept up a voluminous correspondence with her children. The duchess of Lauderdale died June 5, 1698, at age 72. She was buried in the Murray family vault in Petersham Church near Ham House.

SOURCES:

Cripps, Doreen. *Elizabeth of the Sealed Knot: A Biography of Elizabeth Murray, Countess of Dysart*. Kineton, England: Roundwood Press, 1975.

Laura York,
Riverside, California

Murray, Judith Sargent

(1751–1820)

American essayist, playwright, and poet who is considered North America's first important feminist. Name variations: (pseudonyms) Constantia, Mr. Vigilius, and Honora. Born on May 1, 1751, in Gloucester, Massachusetts; died on July 6, 1820, in Natchez, Mississippi; daughter of Winthrop Sargent (a shipowner and merchant) and Judith (Saunders) Sargent; tutored with brother as he prepared to attend Harvard College; married John Stevens (a sea captain and trader), on October 3, 1769 (died 1786); married John Murray (a minister and founder of the Universalist Church in America), in October 1788; children: (second marriage) George (b. 1789, died young); Julia Maria (b. 1791).

Published first essay in Gentleman and Lady's Town and Country Magazine *under pseudonym "Constantia" (1784); first husband fled to West Indies and died there (1786); married John Murray (1788); published poems in* Massachusetts Magazine *as well as essay series "The Gleaner" (1792–94); wrote failed plays* The Medium *(1795) and* The Traveller Returned *(1796); published* The Gleaner *in three volumes (1798); edited and published husband's* Letters and Sketches of Sermons *(1812–13); edited and published husband's autobiography (1816).*

Selected writings: "Desultory Thoughts upon the Utility of Encouraging a Degree of Self-Complacency, Especially in Female Bosoms" (essay, 1784); "The

Gleaner" (essay series in Massachusetts Magazine, 1792–94); The Medium (play, 1795); The Traveller Returned (play, 1796); edited Letters and Sketches of Sermons (1812–13); edited Records of the Life of the Rev. John Murray, Written by Himself, with a Continuation by Mrs. Judith Sargent Murray (1816).

Born on May 1, 1751, in Gloucester, Massachusetts, writer and feminist Judith Sargent Murray was the first of **Judith Saunders Sargent** and Winthrop Sargent's eight children. Winthrop Sargent was a prosperous shipowner and merchant, and the family was wealthy and socially prominent. Murray was an unusually well educated female for her time, sharing her brother's tutoring as he prepared to enter Harvard. She was married in 1769 at the age of 18 to sea captain and trader John Stevens, and started to write in her 20s. After beginning with poetry she soon turned to essays to express her growing concerns regarding issues generated by the American Revolution: human rights, liberty, and, by extension, the status of women. Her first published essay, entitled "Desultory Thoughts Upon the Utility of Encouraging a Degree of Self-Complacency, Especially in Female Bosoms," appeared in Boston's Gentleman and Lady's Town and Country Magazine in 1784, under the pseudonym "Constantia."

In 1786, facing debtor's prison, John Stevens fled to the West Indies, where he died soon afterward. In 1788, Judith married John Murray, a minister and the founder of the Universalist Church in America. She published several poems in 1790 in Massachusetts Magazine, and that year also published the influential essay "On the Equality of the Sexes," now considered one of the first feminist statements in America. In early 1792, she began a monthly column, "The Gleaner," for Massachusetts Magazine. These popular essays, published under the name "Mr. Vigilius," expressed Murray's opinions on various issues of the day, including equal educational opportunities for young women. She had opinions on women's need for education and economic independence compatible with those of *Mary Wollstonecraft, whose Vindication of the Rights of Woman, published in 1792, she read soon thereafter, although some of their political ideas differed. "The Gleaner" ran from February 1792 to August 1794, making Murray the first woman to become a regularly published essayist. Because of the ideas she espoused in those essays, she has also been called America's first "major" feminist.

Judith Murray tried her hand as a dramatist in 1793, writing two unsuccessful plays, The Medium and The Traveller Returned. In an effort to increase the family's income, her essays were compiled into three volumes and published by subscription (an effort headed by George Washington himself) in 1798 as The Gleaner. The essays are now considered an important part of American literature of that era, of the same stature as those by Noah Webster, essayist and critic Joseph Dennie, and poet and journalist Philip Freneau. Murray's writing slowed down thereafter, however, in particular after her husband suffered a stroke in 1809 and was paralyzed until his death in 1815. She edited his Letters and Sketches of Sermons, which was published in three volumes from 1812 to 1813, and also edited his autobiography, Records of the Life of the Rev. John Murray, Written by Himself, with a Continuation by Mrs. Judith Sargent Murray, which was published in 1816. Described by historian **Doris Weatherford** as "an unacknowledged mental giant of colonial days," Murray died at her daughter's home in Natchez, Mississippi, in 1820.

SOURCES:

Buck, Claire, ed. The Bloomsbury Guide to Women's Literature. NY: Prentice Hall General Reference, 1992.

James, Edward T., ed. Notable American Women, 1607–1950. Cambridge, MA: The Belknap Press of Harvard University Press, 1971.

McHenry, Robert, ed. Famous American Women. NY: Dover, 1980.

Read, Phyllis J., and Bernard Witlieb. The Book of Women's Firsts. NY: Random House, 1992.

Weatherford, Doris. American Women's History. NY: Prentice Hall General Reference, 1994.

Ellen Dennis French,
freelance writer, Murrieta, California

Murray, Kathryn (1906–1999)

American entrepreneur who, with husband Arthur, created and ran a successful dance-instruction business. Born Kathryn Kohnfelder in Jersey City, New Jersey, on September 15, 1906; died in Honolulu, Hawaii, on August 6, 1999; daughter of Abraham Kohnfelder (a newspaper advertising executive); married Arthur Murray (a ballroom dancer and businessman), around 1924; children: twin daughters, Jane and Phyllis Murray.

Credited with bringing ballroom dancing into the lives of millions of middle-class Americans, Kathryn and Arthur Murray turned a "dancing in a hurry" scheme into a dance-studio empire that made them millionaires and national celebrities. Kathryn Murray worked hand-in-hand with her husband and had a commanding role in the business, serving as executive vice

president of the enterprise, and writing the training manual for its numerous franchises.

Murray, the daughter of a newspaper advertising executive, was born Kathryn Kohnfelder in 1906, and grew up in Jersey City, New Jersey. She trained to be a teacher, but met and fell in love with Arthur at the age of 18, when she and a friend visited a radio station where he was teaching dance steps over the air. The couple married three months later and together established a chain of dance studios utilizing Arthur's "magic step" teaching technique, a series of dotted lines, arrows, and outlines of shoes, diagramming a particular dance. The business flourished, expanding to 500 studios, which the couple managed until 1964. The Murrays were frequently overzealous in selling their dance courses, and in 1960 signed a consent decree with the Federal Trade Commission promising to eliminate high-pressure tactics in dealing with customers.

Intermittently from 1950 to 1960, the Murrays hosted the television show "The Arthur Murray Party," which promoted their business as much as it entertained. (Robert J. Thompson, the founding director of the Center for the Study of Popular Television at Syracuse University, called the show an early infomercial, "one big advertisement for people to go to the studios.") The show's format included comedy skits, songs, and contests featuring prominent celebrity guests interacting with the Murrays. At the end of each program, Kathryn would tell the audience, "Put a little fun into your life. Try dancing," then turn to her husband and waltz off in his arms.

The show propelled the Murrays to new heights of popularity, and they enjoyed all the trappings of celebrity, including frequent newspaper coverage. They resided for many years in a series of hotels in California and New York, then purchased an apartment on exclusive Park Avenue. Most evenings they dined out with luminaries from radio, theater and publishing, although once a week they dropped into Broadway dance halls to keep abreast of the newest dance crazes, which they then simplified for middle America. Kathryn also wrote two books, *My Husband, Arthur Murray* (1960), with **Betty Hannah Hoffman**, and *Family Laugh Lines* (1966), a collection of anecdotes about her celebrity friends. In 1968, the Murrays moved to Honolulu, where Arthur died in 1991, just short of the couple's 66th wedding anniversary. Kathryn died eight years later, at the age of 92.

SOURCES:
Allen, Mike. *The New York Times* (obituary). August 8, 1999.

Barbara Morgan, Melrose, Massachusetts

Kathryn and Arthur Murray

Murray, Lilian (1871–1959)

First woman to qualify as a dental surgeon in England. Name variations: Lilian Lindsay. Born in London, England, in 1871; died in 1959; attended the Camden School for Girls and the North London Collegiate School; graduated from the Edinburgh Dental Hospital and School, 1895; married Robert Lindsay.

Lilian Murray's decision to enter the dental profession was prompted by an exchange she had with her headmistress, Miss Buss, at the North London Collegiate School for Ladies. *Frances Mary Buss had urged her to be a teacher; Murray replied, "I would rather be a ———"; she was going to say "hangman," but, oddly enough, "dentist" came out. Buss scoffed: "How ab-

surd, child! There is no such thing as a woman dentist."

Murray entered the Edinburgh Dental Hospital and School in 1892 and qualified as LDS in Edinburgh on May 20, 1895, the first woman to qualify as a dental surgeon in England. (The first woman dental surgeon to practice in England, however, was an American who had qualified in America; **Olgavon Oertzen** located her practice in Kensington in 1886.) Murray set up her practice at 69 Hornsea Rise in north London. In 1946, Lilian Murray, who would be known as Dr. Lilian Lindsay, was elected the first woman president of the British Dental Association.

Murray, Mae (1885–1965)

American silent-film actress. Born Marie Adrienne Koenig on May 10, 1885 (other sources cite 1886, 1889, and 1890), in Portsmouth, Virginia; died in 1965; married third husband, Robert Z. Leonard (a director), in 1918 (divorced 1925); married fourth husband Prince David Mdivani, in 1925 or 1926 (divorced 1933); children: (fourth marriage) Koran.

Selected filmography: To Have and to Hold *(1916);* Sweet Kitty Bellairs *(1916);* The Dream Girl *(1916);* The Big Sister *(1916);* The Plow Girl *(1916);* A Mormon Maid *(1917);* The Primrose Ring *(1917);* Princess Virtue *(1917);* Face Value *(1918);* The Bride's Awakening *(1918);* Her Body in Bond *(1918);* Modern Love *(1918);* What Am I Bid? *(1919);* The Delicious Little Devil *(1919);* The Big Little Person *(1919);* The A.B.C. of Love *(1919);* On With the Dance *(1920);* The Right to Love *(1920);* Idols of Clay *(1920);* The Gilded Lily *(1921);* Peacock Alley *(1921);* Fascination *(1922);* Broadway Rose *(1922);* Jazzmania *(1923);* The French Doll *(1923);* Fashion Row *(1923);* Mademoiselle Midnight *(1924);* Circe the Enchantress *(1924);* The Merry Widow *(1925);* The Masked Bride *(1925);* Valencia *(1926);* Altars of Desire *(1927);* Show People *(1928);* Peacock Alley *(1930);* Bachelor Apartment *(1931);* High Stakes *(1931).*

Whimsical silent-film star Mae Murray was born on May 10, 1885, in Portsmouth, Virginia. The daughter of Austrian and Belgian immigrants, she was originally named Marie Adrienne Koenig, although she would later claim that she had always been Mae Murray. She began dancing in childhood and when she was about 21 appeared on Broadway in *About Town*. She performed in several Ziegfeld Follies productions and made her screen debut in 1916 in *To Have and to Hold* with Wallace Reid. Murray was an attractive blonde who, despite minimal acting ability, became a major silent-film star. Given to vagaries and artistic eccentricities which she perhaps played up for effect, Murray was married four times. Her third marriage, in 1918, was to Robert Z. Leonard, who directed several of her better movies. Critics agree that her best performance was in Erich von Stroheim's *The Merry Widow* in 1925.

Mae Murray's career began to decline in 1926 following her marriage to fourth husband Prince David Mdivani (whose brother was once married to *Pola Negri). When he insisted she walk out on her Metro-Goldwyn-Mayer contract, she did so, and thereafter had a difficult time getting work. Murray, who divorced Mdivani in 1933, subsequently lost custody of her son and was forced into bankruptcy. She published her autobiography, *The Self-Enchanted*, to little notice in 1959 and died in obscurity in 1965.

SOURCES:

Katz, Ephraim. *The Film Encyclopedia*. NY: HarperCollins, 1994.
Schickel, Richard. *The Stars*. NY: Bonanza Books, 1962.

Ellen Dennis French,
freelance writer, Murrieta, California

Murray, Margaret (1863–1963)

British archaeologist. Born in Calcutta, India, in 1863; died in 1963; daughter of Anglo-Irish parents (her father was a merchant, her mother a missionary); educated in England.

Margaret Murray was born in Calcutta, India, in 1863, educated in England, lived in Bonn, Germany, during her teen years, and journeyed back and forth to India several times. By age 17, she was nursing in Calcutta General Hospital. Returning to England, the 23-year-old joined the suffragist movement.

As an ardent feminist, Murray was especially interested in women in ancient Egypt and enrolled at the University College London. Since advanced degrees in archaeology were largely restricted to men, she first got her degree in linguistics, knowing full well that linguists were involved with philology and the Classical civilizations. Fortunately, her professor, Sir Flinders Petrie, was receptive to women, allowing both his wife and Murray to enroll in his Egyptology classes and participate in his excavations at Abydos in the late 1890s. By 1895, Murray was teaching elementary hieroglyphics. She taught at University College from 1902, becoming assistant (1909), lecturer (1921), and assistant professor (1922). Following her retirement in 1932, Murray undertook an archaeological dig in Palestine.

Her writings include *The Splendour that was Egypt* (1931), *The Genesis of Religion*, and her autobiographical *My First Hundred Years*.

Murray, Pauli (1910–1985)

African-American civil rights and women's rights activist, lawyer, Episcopal priest, poet, and educator. Name variations: Anna Pauline Murray. Born Anna Pauline Murray on November 20, 1910, in Baltimore, Maryland; died on July 1, 1985, of cancer in Pittsburgh, Pennsylvania; daughter of William Henry Murray (a public school teacher and principal) and Agnes (Fitzgerald) Murray (a nurse); graduated from Hillside High School, Durham, North Carolina, 1926; Hunter College, B.A., 1933; Howard University, LLB cum laude, 1944; University of California, Berkeley, LLM, 1945; Yale University, JD, 1965; General Theological Seminary, MDiv cum laude, 1976; married "Billy," in 1930 (annulled).

Mother died (1914); raised by maternal grandparents and an aunt in North Carolina; after college, worked for Works Progress Administration (WPA) in Workers' Education Project; arrested on segregated bus (1940); served as field secretary for Workers' Defense League; worked with National Association for the Advancement of Colored People (NAACP) and Congress on Racial Equality (CORE) during law school; was first black deputy attorney general of California (1946); ran for New York City Council on Liberal Party ticket (1949); was associate attorney at Paul, Weiss, Rifkind, Wharton and Garrison, New York (1956–60); was a senior lecturer, Ghana School of Law (1960–61); was a member of the President's Commission on the Status of Women (1961–62); was a founding member of the National Organization for Women (NOW) (1966); served as vice-president, Benedict College, South Carolina (1967–68); was a professor at Brandeis University (1968–73); ordained to Episcopal priesthood (1977); retired from ministry (1984).

Selected writings: States' Laws on Race and Color *(1951);* Proud Shoes: The Story of an American Family *(1956);* Dark Testament and Other Poems *(1970);* Song in a Weary Throat: An American Pilgrimage *(1987).*

Pauli Murray's life was one of change and reconciliation. In her 75 years, she not only witnessed but influenced significant events in America. As a poet, lawyer, civil-rights activist, feminist, teacher, and Episcopal priest, Murray had a passionate commitment to justice, based on the interconnectedness and the common humanity of all people, regardless of race or sex.

She was conscious of the obstacles she faced as a black woman, and she determined to overcome those obstacles herself and to remove them for others. Murray believed in the sacredness of individuals created in the image of God and in the obligation to transform the earth into a place where everyone had the opportunity to fulfill their potential.

Murray was born in Baltimore, Maryland, in 1910 and orphaned at an early age. Her mother died when Pauli was four, and her father suffered from chronic illnesses until his death in Crownsville State Hospital in 1923. Pauli was sent to live in Durham, North Carolina, with her maternal grandparents, **Cornelia Smith Fitzgerald** and Robert George Fitzgerald. Probably the most important figure in her early life was her aunt and namesake, **Pauline Fitzgerald Dame**, who ultimately adopted Pauli. From her grandfather who had come south from Delaware to teach freed slaves after the Civil War, and Aunt Pauline, also a schoolteacher, Murray developed a love of learning and a devotion to education. She was always both an excellent student and an independent personality. These traits earned Murray high grades in her studies, but her challenges to authority brought her lower marks in conduct. From her grandmother Cornelia, Murray absorbed the story of Cornelia's heritage as the child of a slave and a slaveowner, whose upbringing was supervised by her father's sister, **Mary Ruffin Smith**. Both grandparents conveyed to Pauli a sense of family and racial pride, which she would later describe in *Proud Shoes: The Story of an American Family*.

Although she graduated from high school at the top of her class, Murray discovered she did not meet the admissions standards for Hunter College where she hoped to enroll. Her deficiencies made her realize that the segregated education available to black students in the South was far from equal. Determined nonetheless to attend Hunter, Murray went to live with relatives in New York City, took additional high school courses, and was admitted in 1928. To fund college during the Great Depression, which began in 1929, Murray was willing to take any of the limited and poorly paying jobs available to black women. In the summer of 1931, she even went to California to find work, and rode the rails, dressed as a teenaged boy, on her return home. While at Hunter, Murray experienced a society of women with a tradition of intellectual rigor that, she recalled in her autobiography, provided a natural training ground for feminism and leadership, enforced egalitarian values, inspired confidence in the competence of

women, and encouraged resistance to subordinate roles. During this time, Murray married a man she refers to in *Song in a Weary Throat* as "Billy." The marriage lasted only a few months and was subsequently annulled.

Employment was scarce, even after Murray graduated from college, and she barely managed to survive with jobs for the Works Progress Administration (WPA), the YWCA, and the Workers' Defense League (WDL). But if those jobs paid little in cash, they contributed richly to Murray's developing consciousness. She met strong black role models at the YWCA, independent personalities determined to rise above the limitations imposed on their race and sex and to help younger women to do the same. With the WPA Workers' Education Project, Murray developed an increasing sensitivity to issues of class. She came to see that whites too could be victims of oppression, that workers were being starved, beaten, evicted from their homes, and jailed to prevent union organizing.

There is no difference between discrimination because of race and discrimination because of sex.... [I]f one is wrong the other is wrong.

—Pauli Murray

For the Workers' Defense League, Murray traveled to raise funds for the defense of Odell Waller, a black sharecropper from Virginia accused of murdering the landlord who had cheated and threatened him. The constitutional issue involved a challenge to the poll tax. Waller had been convicted by an all-white jury drawn from the Virginia voting list of those who had paid poll taxes, a list from which blacks and other poor people were excluded. Therefore, the WDL argued, Waller had been deprived of his constitutional right to a trial by a jury of his peers. Although the effort in Waller's behalf was not successful, it may have been the determining factor in Murray's decision to apply to Howard Law School in 1941. She came to see the knowledge and practice of law as a means for dismantling the structures of segregation and injustice.

At Howard, Murray experienced a school whose small student body shared a deep commitment to ending racial discrimination. But this historically black institution was set in the environment of the segregated capital city, Washington, D.C. For Murray, these were years of intense involvement in the civil-rights struggle. She learned to discipline her intelligence and control her emotions, adopting the motto, "Don't get mad, get smart."

Murray's opposition to discrimination took the form of written words, direct actions, and legal arguments. She published a piece entitled, "Negro Youth's Dilemma," in which she challenged racial bigotry in the U.S. military. She also wrote poetry (beginning work on her poem "Dark Testament"), articles, and began corresponding with *Eleanor Roosevelt. Their friendship lasted for over three decades. For Roosevelt, Murray was a voice representing black youth that forced her to continue to examine her own views on race. The two continued to correspond and visit until, immediately before Eleanor Roosevelt's death, they served together on the President's Commission on the Status of Women.

Peaceful protest demonstrations were not a new experience for Pauli Murray. Her first arrest had come in 1935 for picketing a Harlem newspaper because of a union lockout. She had been arrested in 1940 in Petersburg, Virginia, for refusing to accept segregated seating on a bus, and she became an early practitioner of the "jail—no bail" strategy that would be used by later civil-rights demonstrators.

In 1943 and 1944, Murray and her Howard colleagues moved on two fronts to challenge discrimination in Washington, D.C., public accommodations. Murray had studied the philosophy of nonviolent direct action and believed that, combined with "American showmanship," it could achieve results. With other Howard students, she organized sit-ins at several D.C. restaurants, anticipating the sit-ins of the 1960s by two decades. Murray also uncovered an 1872 District of Columbia civil-rights law that had never been repealed. She argued that the law which granted access to public accommodations was still in effect. Although the process took a decade, in 1953 the Supreme Court ruled as Murray had argued in the *District of Columbia* v. *John R. Thompson Company.*

Perhaps Murray's most significant contribution to the dismantling of segregation laws was her seminal stance that later became incorporated in the arguments in the historic 1954 decision that outlawed school segregation, *Brown* v. *Board of Education of Topeka.* In 1896, the Supreme Court had ruled that the practice of "separate but equal" facilities for blacks and whites was not unconstitutional. Through much of the 20th century, the National Association for the Advancement of Colored People (NAACP) had chipped away at that decision by bringing a series of cases that challenged the equality of the separate facilities. In her senior thesis, Murray argued that this approach should be abandoned

Pauli
Murray

in favor of a direct attack on the constitutionality of separatism itself. She argued that setting apart one group of people from another did violence to the affected individuals by marking them with a badge of inferiority. She remembered her own experience in segregated schools where children felt the pain of rejection no matter how well behaved and studious they were.

In her legal argument, Murray relied on sociological and psychological arguments, just as NAACP lawyer Thurgood Marshall would when he argued the *Brown* case before the Supreme Court. But when Murray raised these arguments in 1944, her professors rejected her approach as "too visionary." Years later, members of the NAACP legal team recalled using Murray's thesis in their preparation for *Brown.* Likewise, Thurgood Marshall would regard Murray's book, *States' Laws on Race and Color,* as the NAACP "bible." Murray's contributions to the legal struggle over civil rights in the 1940s and 1950s were extraordinary, yet she received little public acknowledgement. Maybe Murray's ideas would have been taken more seriously and acknowledged more widely had she been male.

In her autobiography, Murray compared these efforts to running a relay. "There were times when I didn't even know the outcome of the race, other times when it was my privilege to break the ribbon at the finish line, and still others when I shared an overwhelming sense of accomplishment and exhilaration, even though my contribution had been made early in the contest, not at its culmination."

Graduated at the top of her class at Howard, Murray applied to Harvard Law School for graduate study. Whereas in 1938 the University of North Carolina had rejected her application because "members of your race are not admitted to the University," Harvard rejected her in 1944 because of her gender. Even a letter on her behalf from President Franklin Roosevelt did not help. Murray experienced the same feeling in both situations—one was based on law and involved race, the other was based on custom and involved gender. She saw them as equally unjust, as she was stigmatized on the basis of a characteristic beyond her control. With race, Murray noted that at least she had developed "coping mechanisms." With sex discrimination, she was appalled to encounter the "mild amusement" of her male colleagues, who were at the same time civil-rights activists.

After being refused admission by Harvard, Murray enrolled at the Boalt Hall of Law at the University of California, Berkeley. There she received a master's degree (LLM) in 1945, passed the California bar exam, and became a deputy attorney general of California, the first black to hold that office.

Murray returned to the East to be closer to her Aunt Pauline and Aunt Sallie, who were aging and in poor health. She moved with them to New York City where she practiced law, first in her own office, and after 1956 with the distinguished law firm, Paul, Weiss, Rifkind, Wharton and Garrison. During these years, Murray kept up with her writing, both scholarly and creative. She published *States' Laws on Race and Color* in 1951. The work, the first compilation of its kind, was done on commission for the Women's Division of the Methodist Church. It was a massive legal effort, and brought together Murray's involvement with racial issues, women reformers, and religion. In 1956, she published her family memoir, *Proud Shoes*. Reissued in 1978, the book told of her heritage, based on the oral traditions and narratives she had heard from her aunts and grandparents. Murray felt impelled to write her family history as a testimony to the contributions blacks had made to American life and as a tribute to the strong women who were her forebears. Several decades later, Alex Haley's *Roots* would capture the public imagination as a similar example of African-American family history.

Partly out of curiosity about her own African heritage, Murray accepted a position on the faculty of the Ghana School of Law from 1960 to 1961. When she returned to the States, she enrolled for graduate study at the Yale Law School where she received her degree of Doctor of Judicial Science in 1965.

In 1961, Murray had been appointed to President John F. Kennedy's Commission on the Status of Women, to the Subcommittee on Political and Civil Rights. Here, she developed the legal argument that just as the 14th Amendment prohibited racial discrimination and guaranteed "equal protection of the laws," so that amendment could be used to prohibit sex discrimination. Allowing people different legal status based on gender was, Murray wrote, "as pernicious as separate but equal." Murray also prepared legal arguments in support of keeping the prohibition against discrimination based on sex in the Civil Rights Act of 1964.

Murray continued to link women's rights and civil rights, as she saw both as inseparable parts of the fundamental issue of human rights. That perspective led her to participate as a founding member of the National Organization for Women (NOW) in 1966. She envisioned NOW as a civil-rights organization for women comparable to the NAACP.

In 1968, Brandeis University invited Murray to serve on its faculty, and she remained there for five years, first as professor of American Studies and later as Louis Stulberg Professor of Law and Politics. She also published her volume of poetry, *Dark Testament and Other Poems*.

During those years, Murray undertook to reexamine her relationship with the Episcopal Church, an institution she had found supportive and sustaining throughout her life. Suddenly struck by the absence of women in the liturgical service, Murray felt that she could not participate in an organization that treated women with discrimination. At the time, there was no Episcopal women's caucus, but individual women were speaking out, forming linkages, and reaching out to find authentic ministries even before the official church validated their roles. These women sustained each other as they challenged the church establishment. Several experiences—participation in the World Council of Churches meeting at Uppsala, Sweden; attendance at the

death of a close friend; a sense of the insufficiency of the legal system as a means of social change—convinced Pauli Murray that she had a call to the ministry. She came to feel, even though she was more than 60 years old, that all her experiences had been a preparation for her ultimate religious vocation.

Murray undertook three years of study, including a field experience at a rural Maryland church where her uncle had been vicar, and where her grandmother and aunts had worshipped. The first African-American woman to be ordained by the Episcopal Church, she celebrated her initial Eucharist at the Chapel of the Cross, in Chapel Hill, North Carolina. There her grandmother, the child of a slave and a white slaveowner, had been baptized. "Whatever future ministry I might have as a priest," Murray wrote, "it was given to me that day to be a symbol of healing."

Murray devoted the next seven years to parish work and ministry to the sick in Washington, D.C., Alexandria, Virginia, and Baltimore. She retired in 1984 and moved to Pittsburgh, where she died of cancer the following year. Her autobiography, *Song in a Weary Throat*, was published posthumously.

In her lifetime, Pauli Murray overcame countless barriers and forged many new paths that other women and minorities would be able to follow. She was among the architects of the legal strategy that toppled some of the pillars of racism and sexism. She had the courage to take on challenges in every phase of her life because she was firmly rooted in her family, her traditions, and her vision of possibility. She had a strong faith and always enjoyed a network of support in female friends and relatives. As **Caroline Ware** concludes in her epilogue to Murray's autobiography, she "pressed through confrontation toward reconciliation."

SOURCES:

Burgen, Michele. "Dr. Pauli Murray," in *Ebony*. September 1979, p. 107–112.

Giddings, Paula. "Fighting Jane Crow," in *The Nation*. May 23, 1987, p. 689–90.

Miller, Casey, and Swift, Kate. "Pauli Murray," in *Ms*. March 1980, p. 60–64.

Murray, Pauli. "The Liberation of Black Women," in *Women: A Feminist Perspective*. Edited by Jo Freeman. Palo Alto: Mayfield, 1975.

———. *Proud Shoes: The Story of an American Family*. NY: Harper and Row, 1956 (reprinted 1978).

———. *Song in a Weary Throat: An American Pilgrimage*. NY: Harper and Row, 1987.

SUGGESTED READING:

Vick, Martha C. "Pauli Murray," in *Epic Lives: One Hundred Black Women Who Made a Difference*.

Edited by Jessie Carney Smith. Detroit: Visible Ink Press, 1993.

COLLECTIONS:

Pauli Murray's papers are in the Schlesinger Library, Radcliffe College, Cambridge, Massachusetts; photographs of Pauli Murray are in the Schomburg Center for Research in Black Culture, New York.

Mary Welek Atwell,
Associate Professor of Criminal Justice,
Radford University, Radford, Virginia

Murray, Ruby (1935–1996)

Irish pop singer. Born in Belfast, Northern Ireland, in March 1935; died of liver cancer in Torquay, England, December 17, 1996.

Born in Belfast, Northern Ireland, in 1935, Ruby Murray moved to England in 1953, at age 19; within months, her first pop recording, "Heartbeat," had sold 200,000 copies. With her sweet and slightly sultry voice, she followed that with another huge seller, "Softly, Softly." By 1955, these two recordings, along with "Happy Days and Lonely Nights," "Let Me Go Lover," and "If Anyone Finds This I Love You," were all on Britain's Top 20 in the same week, a record still unbroken. Her early success carried a downside: Murray endured a long battle with alcoholism before her death in 1996.

SUGGESTED READING:

Moules, Joan. *Ruby Murray*. Cheltenham, England: Evergreen, 1995.

Murray, Ruth (1841–1921).

See Mulholland, Rosa.

Murry, Kathleen (1888–1923).

See Mansfield, Katherine.

Murska, Ilma Di (1836–1889).

See Di Murska, Ilma.

Murtfeldt, Mary (1848–1913)

American entomologist. Born in New York City in 1848; died in 1913; studied at Rockford College in Illinois, 1858–60.

Mary Murtfeldt was born in New York City in 1848 but spent most of her life with her father and sister in Kirkwood, Missouri. Ill health forced her to forego much of her schooling, and a debilitating childhood illness resulted in her dependence on crutches throughout her life. In 1868, she developed a deep interest in entomology—the branch of zoology that deals with insects—when her father became editor of *Col-*

man's *Rural World*. Through him, she met Missouri state entomologist Charles Valentine Riley and landed a job as a local assistant in the U.S. Department of Agriculture's Bureau of Entomology. In this capacity, she frequented scientific gatherings and presented many papers.

Murtfeldt made some important contributions to her field while working as Riley's assistant from 1868 to 1877. Astute in both entomology and botany, she discovered how insects affect the pollination of certain plants, and also chronicled the life histories of recently discovered and little-known insects and how they affected their host plants. One of her most noted achievements was her meticulous understanding of the yucca pollination process. When botanist S.M. Tracy published *Flora of Missouri* in 1885, he noted her extensive collection of many species found in the St. Louis area. Murtfeldt died in 1913.

SOURCES:

Ogilvie, Marilyn Bailey. *Women in Science: Antiquity through the Nineteenth Century.* Cambridge, MA: MIT Press, 1986.

Lisa Frick,
freelance writer, Columbia, Missouri

Musgrave, Thea (1928—)

*British composer whose operatic and symphonic works have established her as one of the most important composers of the 20th century. Born Thea Musgrave in Barnton, Edinburgh, Scotland, on May 27, 1928; attended Moreton Hall, Shropshire; University of Edinburgh, B.Mus., 1950; studied with Hans Gal, **Mary Grierson**, and Sidney Newman, and at the Paris Conservatoire with Nadia Boulanger and Aaron Copland; married Peter Mark (a violist and conductor), in 1971.*

Awards: Tovey Prize in Edinburgh (1950); Lili Boulanger Memorial Prize (1952); Koussevitzky Award (1972); named a Guggenheim Fellow (1974–75); has held professorships at several American universities.

Selected works—operas: The Abbot of Drimock *(1955);* The Decision *(1967);* The Voice of Ariadne *(1972–73);* Mary Queen of Scots *(1975–77);* A Christmas Carol *(1978–79);* An Occurrence at Owl Creek Bridge *(1981);* Harriet, The Woman Called Moses *(1981–84).*

Symphonies—orchestral: Divertimento *(1957);* Obliques *(1959);* Perspectives *(1961);* Sinfonia *(1963);* Festival Overture *(1965);* Nocturnes and Arias *(1966);* Concerto for Orchestra *(1967);* Clarinet Concerto *(1968);* Night Music *(1969);* Scottish Dance Suite *(1969);* Memento vitae *(1969–70);* Horn Concerto *(1971);* Viola Concerto *(1973);* Orfeo II *(1975);* Soliloquy II & III *(1980);* Peripeteia *(1981);* From One

to Another *(1982);* The Seasons *(1988); as well as numerous vocal-choral, chamber, and other works.*

Musical composition has always been an exceedingly difficult field in which to become established, as the concert-going public is often fickle as well as resistant to innovation. Many music lovers were appalled, for example, when they first heard the "unstructured" symphonies of Ludwig von Beethoven, and it was not until over a dozen years after Johannes Brahms wrote his Fourth Symphony that Vienna concertgoers allowed it to be played in their city. Today, of course, these works are celebrated standards of the "classical repertory." To diverge from accepted norms while also acquiring an appreciative listening audience has never been easy for classical composers, and, in addition, the field was for centuries essentially restricted to men; these factors make the success of Scottish-born Thea Musgrave all the more remarkable. For more than half a century, this contemporary composer has achieved enormous success on concert and opera stages worldwide, enjoyed recognition as a leading figure in international choral composition, and been renowned for her symphonies and more than half a dozen operas.

Thea Musgrave was born in 1928 in Barnton, Edinburgh, Scotland. Music was part of her upbringing as an only child, but she had no early plans to devote her life to it. After her initial education at Moreton Hall in Shropshire, in 1947 she entered the University of Edinburgh, intending to study medicine. A change of heart led her to choose music instead, and she proved to be a brilliant student, winning the Tovey Prize before receiving her bachelor of music degree in 1950. She then was given the opportunity to study in Paris with *Nadia Boulanger, the most famous teacher of composition in the 20th century, whose pupil she remained until 1954. Musgrave later said of her years of study under Boulanger:

> I was her student at the Conservatoire, where she was not permitted to teach composition. So she gave a class called "piano accompaniment." But we never did any accompanying on the piano—we did score reading, figured bass. . . . It was a general musicianship class, unbelievably stimulating. . . . In addition, I had private lessons with her every week. Yes, and there were incredible dinner parties where one could meet her students from way back, composers, all kinds of visitors from all over.

One of those students of Boulanger's "from way back" was the American composer Aaron Copland, with whom Musgrave also

studied. During her second year of study in Paris, Musgrave became the first British composer to win the *Lili Boulanger prize, an award given to promising young composers in honor of Nadia Boulanger's sister, a composer who had died young.

In 1953, while still an apprentice, Musgrave composed *A Tale for Thieves*, a ballet based on Chaucer's *The Pardoner's Tale*. The following year, she wrote the large-scale composition *Cantata for a Summer's Day*, which proved to be her first major success at its premiere at the Edinburgh International Festival in 1955. By that time, she was writing her first short opera, *The Abbot of Drimock*, based on a Scots Border tale, and the same year composed *Five Love Songs* for soprano and guitar. During this period, Musgrave was experimenting with both tonal and atonal music. In 1960, she composed *Colloquy* for violin and piano and *Trio* for flute, oboe, and piano, two works that, according to Leslie Easte, were the "cornerstone of the distinctive style that emerged later."

Musgrave's career differed from that of many composers, male or female, in that her work was performed almost immediately. In Scotland, her compositions were often performed as soon as they were written. As a result of this successful exposure, she received commissions from the City of Glasgow, the British Broadcasting Corporation (BBC), foundations, trusts, opera houses, ballet companies, American colleges and English schools. Performers courted her continuously in hopes that she would write music for them, and publishers sought to sign her to contracts. Thus, at a very early age Musgrave had overcome one of the greatest obstacles for a new composer: the fact that an unknown work must be selected for performance by other people and performed by other people, often at considerable expense, before either the composer or the work can become known. Combined with her talent, the opportunities Musgrave received, first in Scotland and then elsewhere, gave rapid rise to her composing career.

Musgrave set out on a new course in the early 1960s when, without a commission, she began composing *The Decision*, her first full-length opera. For two years, she concentrated on little else. Neither tonal nor serial, *The Decision* was hailed as a turning point in music when it was first performed in 1967. According to Easte, "The wrestling with concrete dramatic problems in 'The Decision' obviously contributed to the compelling desire to explore dramatic qualities in abstract instrumental music." The opera marked the inception of a decidedly new concept in Musgrave's work in general, an instrumental style which she described as dramatic-abstract— "dramatic" because certain instruments took on the characters of dramatis personae, and "abstract" because there was no program. From this point forward, she ventured into the realm of asynchronous music, a form in which soloists stand and move around the stage while engaging in musical dialogue with other performers. Although all parts are fully notated, they are not necessarily coordinated with other parts or with the conductor.

> *Music is a human art, not a sexual one. Sex is no more important than eye color.*
>
> —Thea Musgrave

Musgrave's next work, 1966's Chamber Concerto No. 2, was a further exploration of this form. Written in homage to the American composer Charles Ives, it involves soloists and the rest of the performers in a free interplay unusual in most musical works. In Chamber Concerto No. 3, also published in 1966, Musgrave used thematic material derived from the names of Viennese composers to create a "drama for instruments." She explained, "It explores the virtuosic possibilities of the eight players who dominate the texture in turn." In this work, each of the eight players stood up in turn to perform, thus reinforcing the link between their instrument and the Viennese composer it represented. Her Concerto for Clarinet and Orchestra, published in 1968, essentially employed two conductors: one conducted from a podium, while a "soloist-catalyst," in the role of alternative leader, was pitted by turns against different sections of the orchestra.

Musgrave also became interested in electronic music in the 1960s. She first made use of a prerecorded electronic tape in *Beauty and the Beast*, a two-act ballet written in 1968–69, in which the taped music was used to enhance supernatural effects in the action. Her highly successful three-act chamber opera *The Voice of Ariadne* (1972–73) used taped sound to an even greater extent. The story, taken from *The Last of the Valerii*, a book by Henry James which Musgrave found in 1969 while browsing in a London bookstall, involves an Italian count and his American wife who unearth a statue of Juno in the garden of their Roman villa. The count falls in love with the statue and neglects his wife, who finally reburies it in order to reclaim his love. In Musgrave's opera, there is no statue, only an ancient pedestal on which once stood not the frosty Juno but the sensuous Ariadne. Neither the stat-

ue nor Ariadne is ever seen, but her alluring, seductive voice is heard throughout the work. Of her electronic technique for this piece, Musgrave said, "I recorded the voice so that the words can always be clearly understood. . . . [W]hat I've done at certain times is to superimpose several voices, with an echo effect, and add electronic sounds suggesting the sea and distance." The count and his wife become increasingly involved with Ariadne and Theseus, her lamented lover. As the work progresses, however, Ariadne's voice becomes progressively fainter, until the count hears it no more and returns to his wife. Critic William Bender noted, "*Ariadne*'s music has the blush of innocent freshness to it. It floats from atonality to tonality and back with dramatic precision, bringing life to the libretto's strange world and humanizing its perplexed cast of characters." The same year *Ariadne* premiered, Musgrave made a series of eight broadcasts on Great Britain's Radio 3, entitled "End or Beginning," in which she discussed the use of electronic music.

Although Musgrave composed symphonic and orchestral works as well as many choral and chamber pieces, she remained preeminent in opera. Her fourth opera, and the first for which she wrote her own libretto, was *Mary Queen of Scots* (1975–77), a commission from the Scottish Opera and a natural theme given her heritage. Avoiding the tragic and gory end of the ill-fated queen, Musgrave focused on a short period of *Mary Stuart*'s life—the seven or eight years she spent in Scotland as the widow of the king of France before her fatal encounter with Queen *Elizabeth I. The main figures are Mary and her half-brother James Stewart. Musgrave's theory was that Mary, who had grown up a loved and spoiled child in France but was wanted there no longer, feared being alone in a country which she did not know. Arriving in Scotland, she sings: "No one is here to meet me. Here I am on my own." Her choices in advisors and attempts to manage prove disastrous. The opera received excellent reviews upon its premiere at the Edinburgh Festival.

Musgrave's personal life changed in 1971 when she married the violist and conductor Peter Mark, a graduate of Columbia and Juilliard who also taught the viola. Having spent much of her career living in Great Britain, she now, with her husband, began dividing her time between a home there and a house in Santa Barbara, California, overlooking the Pacific Ocean. She continued to serve on musical advisory panels for the BBC as well as on a music panel for the Arts Council of Great Britain and the executive committee of the Composers' Guild of Great Britain. When Mark was appointed artistic di-

rector of the regional opera company in Norfolk, Virginia, Musgrave increasingly spent her time in the United States.

Living in America inspired her sixth opera, *Harriet: A Woman Called Moses*, which focused on *Harriet Tubman, the 19th-century African-American abolitionist leader. Speaking of her venture into a new historical area, Musgrave said:

> Where I come from, the Underground Railroad means the London tube. To Harriet it meant something quite different, a means of getting escaped slaves to the North. But I've spent the last two and a half years writing an opera about her, and I find her story universal. The concept of people escaping from a bad situation against incredible odds, of getting out and improving their lot—this is a story to which I feel all can relate.

Harriet was not Musgrave's first American theme, for she had earlier written a BBC radio opera, *An Occurrence at Owl Creek Bridge*, based on the short story by Ambrose Bierce. *Harriet* was more reflective of American life, however, and the composer wove many Negro spirituals into the score. Although Tubman lived to the age of 93, the opera deals only with her life as a young woman, when she escaped from slavery. Musgrave became quite involved with her subject and visited the site of the farm where Tubman had lived on the Eastern Shore of Maryland. The opera premiered in Norfolk under Peter Mark's direction and was subsequently performed by the Royal Opera in London.

As her composing career progressed, Musgrave began conducting her own works. This started in a rather offhand way (she agreed to a request to conduct, and then rushed for two three-hour sessions with French musician Jacques-Louis Monod; six hours of lessons later, she was on her own), but she became the third woman to conduct the Philadelphia Orchestra and the first to conduct one of her own compositions. She also conducted the New York City Opera, the BBC Symphony Orchestra, and London's Royal Philharmonic Orchestra. "There is really very little you can learn," she noted about conducting. "You have to be a musician, which I had been trained to be. You have to know the score, which isn't too difficult in my case, because I wrote them myself. And you have to have respect for the talents of your players and understand them. Just use common sense." Musgrave particularly enjoyed working with musicians who were playing her pieces for the first time, as she felt they gave her many constructive ideas about awkward passages and ultimately saved her a great deal of time in the composition process.

The composition of music was once widely considered a skill of which women were incapable. Thus, while Musgrave might chafe at the need for mention of it, her career is representative not only of musical brilliance but of a profound change in the musical world—the success of the female composer. Born at a time when talent finally outweighed gender, Musgrave understood the shackles which bound her predecessors. Discussing why it took women so long to emerge in her field, she noted:

Well, I don't know that women composers are that new a phenomenon. You have to remember that a lot of our cultural histories have been written by men. In the 19th century it was easier for a woman to become a novelist than to become a composer. It was something you could do at home. Writing music is a little like being a surgeon: the actual experience is essential. You cannot compose without practice: you must have your work tried out and performed. . . . I think women have always had the capacity and sensibility to compose. They simply lacked the confidence and the opportunity.

Gifted with confidence and with immense talent, Thea Musgrave has richly rewarded with her compositions the musical world that gave her opportunity.

SOURCES:

"Contemporary British Composers," in *Women and Music: A History.* Ed. by Karin Pendle. Bloomington, IN: Indiana University Press, 1991.

Greenhalgh, John. "Mary Queen of Scots," in *Music and Musicians.* Vol. 28, no. 8. April 1980, pp. 16–18.

Heinsheimer, Hans. "Mistress Musgrave," in *Opera News.* Vol. 42, no. 3. September 1977, pp. 44–46.

Kuperferberg, Herbert. "Thea Musgrave: Her sixth opera, 'Harriet: A Woman Called Moses,' is premiered in Norfolk," in *High Fidelity/Musical America.* Vol. 35, no. 3. March 1985, pp. 4–5.

"A Matter of Art, Not Sex," in *Time.* Vol. 106, no. 19. November 10, 1975, p. 59.

"The Musgrave Ritual," in *Time.* Vol. 110, no. 15. October 10, 1977, p. 72.

"Musgrave, Thea." *Current Biography Yearbook 1978.* Ed. by Charles Moritz. NY: H.W. Wilson, 1978, pp. 319–322.

Porter, Andrew. "Musical Events," in *The New Yorker.* Vol. 64, no. 10. April 25, 1988, pp. 107–108.

Singer, Lawrence. "In Review: From Around the World," in *Opera News.* Vol. 55, no. 9. January 19, 1991, p. 40.

Smith, Patrick. "Thea Musgrave's New Success," in *Opera.* Vol. 36, no. 5. May 1985, pp. 492–493.

John Haag,
Associate Professor, University of Georgia, Athens, Georgia

Musgrove, Mary (c. 1690–c. 1763)

Influential intermediary between the Muskogee (Creek) tribe and English colonists, and successful trader and landowner, who made claims against Georgia based on her status among Creeks and ownership of certain Creek lands. Name variations: Mary Bosomworth; Mary Matthews; Coosaponakeesa. Born near Muskogee (Creek) town of Coweta, around 1690; died in English colony of Georgia, around 1763; daughter of regal Creek woman (name unknown) and an English man, possibly Henry Woodward or Edward Griffin (traders); educated in Pon Pon, South Carolina; married Johnny Musgrove, in 1717 (died 1735); married Jacob Matthews, in 1735; married Thomas Bosomworth, in 1744; no children.

Possibly a Beloved Woman of the Creeks; established successful trading centers in Georgia colony; was Creek interpreter, negotiator and diplomat for James Oglethorpe and Trustees of Georgia Colony (1733–47); served as interpreter for Methodism founder-evangelist John Wesley (1736); engaged in legal battle with colonial government over ownership of three coastal islands and other property given to her by Creeks (1747–62).

Trade and military reports of the colonial period in North American history presented the arrangement of Muskogee (Creek) society as male dominant. Clan membership, however, was matrilineal, and those reports also indicated the involvement of women in civil affairs. Coosaponakeesa, or Mary Musgrove as history has come to know her, was one such influential woman.

Coosaponakeesa was born among the rich rivers and forests of Creek territory just 150 years after the first Europeans traveled through the region. Already this had become a land of opportunity for the English, French, and Spanish, whose struggles for control of the territory would eventually displace the native peoples to whom it belonged. The daughter of a woman of the Creek royal line and of an Englishman who was probably a trader, Coosaponakeesa was about seven when she was taken from her home in the chief Lower Creek town of Coweta and brought to Pon Pon, South Carolina. There she remained for several years, later saying she was "baptized, Educated and bred up in the Principles of Christianity." It is unclear when she returned to her people, but the education she received stood her in good stead throughout her life, though not necessarily as the English would have imagined.

The encroachment of Europeans on Native territories upset the usual patterns of existence throughout the entire region. War among all factions was common, with the Europeans constantly bargaining against each other for the good will of various tribes. In the early 18th cen-

tury, a peace settlement was reached between South Carolina and the Yamacraw Creeks around the Savannah River.

In 1716, South Carolina sent two emissaries to seal the peace agreement. As part of the alliance, Johnny Musgrove married Coosaponakeesa, who was the niece of Brims of Coweta. Given the title "emperor" by the English, Brims was a primary Creek leader whose town was a political and spiritual center of the tribe. Political alliances sealed by marriage were common practice among the Creeks, and Brims gave this "regal woman" as a pledge of his intentions. Mary, as she became known, thus had influence not only because of her political marriage but in her own right.

The Musgroves spent some years in South Carolina and in 1732 returned to Mary's home territory, establishing a trading center on Yamacraw Bluff, near the future site of Savannah, Georgia. Mary reported they took in 1,200 pounds of deerskins in trade annually for the first few years; this was one-third of the total deerskin export of Charleston. Many of Mary's relatives and friends settled nearby, as did a band of outlaw Indians drawn by sacred burial grounds. The leader of the village, Tomochichi, was a friend to the Musgroves.

The prestige and power of the Coweta regal line reached even to the female members and is to be seen in the prestige and influence of . . . Mary Musgrove.

—David Corkran

In 1733, Mary was recommended as an interpreter to James Oglethorpe, an English general and philanthropist, when he arrived at Yamacraw Bluff. The Yamacraws were concerned by Oglethorpe's plans to found a colony for "industrious" debtors, because the agreement with South Carolina was that no white settlements would be allowed past the Savannah River. Musgrove demonstrated her diplomatic abilities, calming fears and pointing out the significant trade advantages of the proposed settlement.

A treaty between Tomochichi and Oglethorpe allowed the English settlers to found a new colony (Georgia) and the Yamacraws to keep their land; however, since the treaty violated the earlier one with South Carolina, the major headman at Coweta was invited to come and participate. Eight headmen arrived. The Musgroves interpreted and helped to work out the resulting treaty: Georgia would send traders to Creek towns, and the Creeks would permit the English to settle lands the tribe did not need, as long as

each new town provided a resting place for traveling Creeks. In addition, there were reciprocal agreements regarding punishment of injury or death by members of either party, and agreements on slavery, non-English settlers, and trade prices. In facilitating this treaty successfully, the Musgroves became a major influence with the English. Oglethorpe acknowledged them as important liaisons with the Creeks, and their cattle and crops were an essential food supply to the white colonists.

Oglethorpe took Tomochichi to England in 1734, with Johnny Musgrove as interpreter. While Johnny was gone trade suffered, because Watson, the Musgroves' partner, took the profits. When he began to drink and accused Mary of being a witch, she sued for slander and won. Then Watson assaulted her with a gun, but she overpowered him, charged him with assault, and won again. Tribe members, who supported Mary, were angered by his actions; Watson so feared them that he chased away friendly Yamacraws at gunpoint. Mary told him to leave. Instead, Watson took a servant hostage in the storeroom, and when the Yamacraws attacked, the servant was killed and Watson fled to Savannah. Finally, after continuing discord and threats, Colony Trustees appeased the Yamacraws and paid Musgrove for the loss of her servant. Things settled down after Johnny returned, and their influence with Oglethorpe increased the Musgroves' prosperity. Mary had gained a reputation as a "fighting woman."

A new treaty was signed in 1735, building on the agreement of 1733. Negotiated by both Mary and Tomochichi, the new treaty defined Georgia's limits for white settlement. The Creeks retained three coastal islands for hunting and fishing, islands which would later become central in the long-running legal feud Musgrove and her third husband would have with the colony.

Johnny Musgrove died in 1735, leaving Mary with a great deal of property and a reputation of influence with both Creeks and with Oglethorpe. She was wooed by one of her servants, Jacob Matthews, who had come to the colony as an indentured servant. After their marriage, he used Mary's fortune for his own ends, damaging it seriously. Despite her husband's profligate ways, Musgrove's influence with the Creeks was maintained due to her birthright.

In 1737, events for which Mary later gained most of her notoriety were set in motion. Tomochichi transferred all Yamacraw holdings—those recognized in the treaties of 1733 and 1735—to Musgrove. He announced this to

Georgia Trustees President William Stephens at a barbecue on Yamacraw land near Savannah; Stephens made no objection at the time. Still, Savannah leaders considered it undesirable that Mary's husband, a British citizen, had so much influence and power by land ownership through his wife. The English had recognized Tomochichi's right to cede land to Britain, but now the colonists were faced with accepting the premise that if he could grant land to Britain, then he also had the right to give Creek lands to another Creek. Colonial leaders feared taking action against the transfer due to Musgrove's trade and her influence with the Creeks. She was the link with the leaders in Coweta, and supplied beef to the colonists as well as taking responsibility for entertaining visiting Indians. Uncomfortable as they were with the transfer, they made no counter-argument to Tomochichi's move until some time later.

Shortly after this event, Oglethorpe persuaded Musgrove to establish a trade center, Mt. Venture, farther south, to improve Creek protection of the area against the Spanish in Florida and to act as a liaison with those Creeks. Mary's influence with the Creeks persuaded them to support England in the war with Spain (1739–48). Her diplomatic abilities continued to be valuable; at one point, she intervened with the Creeks at the request of President Stephens, convincing them to allow some Cherokees with Oglethorpe to return home safely.

By 1740, Jacob Matthews had become a drunkard, had joined the anti-Trustees group, and was generally making himself obnoxious, including inciting the Creeks to intimidate Savannah residents. In 1742, he sent a letter to the Trustees asking for a reward for interpreting services and for acknowledgement of Tomochichi's land grant to Mary; this was denied. Jacob's ire at the Trustees' response and his sway with Mary may have provoked the change in Musgrove's attitude toward the Georgia colonists, from her early friendship to animosity for wrongs, imagined or real, done to her. At any rate, Musgrove's dealings with the colony then took a decidedly difficult turn.

In May of 1742, Jacob died. That autumn, Spanish Yamasee warriors looted and burned the Mt. Venture trading center, destroying both buildings and goods. Nevertheless, when Oglethorpe called on Mary to interpret at Frederica, she went there and stayed until his departure for England the following year.

As he left, Oglethorpe gave Musgrove a diamond ring, £200 pounds, and the right to draw drafts on him for £2,000 more. Possibly she met her third husband, Thomas Bosomworth, then. He was described as "an adventurer from England," who had been brought over to be clerk to President Stephens but refused such a lowly position upon his arrival. When another promised position in Savannah was not open, he went back to England to be ordained a minister and was given a post in Savannah upon his return there. During this period, Mary married Thomas, who returned to England a second time, angered by the Trustees' refusal to listen to some complaints. When he wrote saying he had no intention of returning, the authorities considered his ministerial post vacant and filled it. Bosomworth did return, however, and began to manage Mary's properties.

By now the Creeks were less a wandering people and more settled, owning property and stock animals, and Musgrove was the largest property owner among them. Despite her Christian baptism and white father, she considered herself Creek and was considered so by the Indians. As a member of a royal family, she had as much right to land ownership as a headman. At this point, she owned the original Musgrove plantation, 500 acres given to Johnny Musgrove by Georgia for interpreting services, and the lands given to her by Creek leaders. Thomas began pushing her to press claims as a Creek for the three islands reserved in the 1735 treaty. She made over her Indian titles to him, angering the Georgia authorities.

Mary's properties had been ill-handled by Jacob Matthews, and the destruction of Mt. Venture by Yamasees in 1742 had piled up more debts. To pay these debts, and those being accrued by Thomas because he thought the ownership claims would be favored, Musgrove also began pressing claims for payment of interpretation services over the years. Thomas began a cattle ranch on St. Catherine's Island, making drafts against Oglethorpe who was himself bankrupt. The drafts bounced, and Thomas went to England to present Mary's claims to the Board of Trade in London and to see Oglethorpe.

Mary and Thomas hoped the Board of Trade would see things as they did, since Jacob Matthews had made application to the Georgia Trustees and appealed to Oglethorpe about these lands in the past. In the earlier request, the Trustees had told Matthews and Oglethorpe that if land was acquired from Indians, the acquisition must come either through Oglethorpe, as one of the Trustees, or through the Trustees themselves. The only possible way a claim could

be approved was if the land were given to Oglethorpe, who then recommended that the Trustees grant said land to Mary and Jacob. This position gave the Trustees legal protection and was within their rights to require, given the treaties. However, these legalities assumed that the colonists were now governors of all the lands, that European understandings of ownership and governance were the standard against which all claims would be judged, and that the Creeks had neither rights nor lands with which to give land grants.

Coweta headman Malatchi, a cousin of Musgrove's and successor to Brims, deeded to Mary and Thomas the three islands in 1747, although in the midst of the later controversy he would deny having done so. Mary's and Thomas' claims and their attempts to have a hearing and a decision in their favor came to a head that summer. In mid-July, a small party of Creeks led by Malatchi arrived in Savannah with concerns that, because of her claims and outspoken assertions about the rights of her Native American ancestry, Musgrove was to be "put in chains and sent to England." They may have received encouragement in this belief from Mary and Thomas to ensure that their behavior would intimidate residents and Trustees, as Jacob Matthews had done years earlier. Another party of Indians arrived a few days later, allegedly to meet Thomas' brother whom they had appointed as their agent to England.

The following days, until the Creeks left on August 18, brought a series of struggles both physical and mental between the supporters of Mary and Thomas and the Trustees. The friendship of the Creeks was vital for both sides. Malatchi and other leaders were unpredictable from the Trustees' point of view; the Trustees were simply swindling Indians once again, according to the Creeks. Each group believed it acted legally and within its rights. The residents of Savannah lived in fear of an outbreak of war for most of that month. The Trustees attempted conciliation and persuasion by a series of dinners and entertainments buffering the discussions of the claims. Each night, the Indian leaders heard the alternative rationale as developed and put forth by Thomas and Mary, often returning to the Trustees the next day angered anew. This pattern continued day after day, until yet another entertainment was offered and Musgrove could stand the delay no longer. She rushed into the house, according to official reports, "in the most outragious [sic] and unseemly manner, that a Woman Spirited up with Liquor, Drunk with Passion, and disappointed in

her Views could be guilty of," and asserted her claims and birthright as queen of the Creeks. She was arrested for this behavior, making Malatchi angry again. He roused the warriors to arms, but the Creeks subsided when confronted with the militia. After another night of fear, there was calm. Thomas apologized for Mary's behavior and promised to control her; after the presentation of yearly gifts from the English and another dinner, the Creeks departed.

Mary and Thomas did not give up their claims, however. In the next few years, they continued talking among the Indians and managed to gain some support. In 1750, Thomas' brother was told about their behavior and rejected them. In 1752, Mary and Thomas decided to go to England to present their case, but were sidetracked when the governor of South Carolina asked Mary to interpret and assist in settlement of a matter between Creeks and Cherokees; the governor also promised to support her claim. Mary was so successful at solving the conflict that she increased her popularity once again. She and Thomas finally reached England in 1754 and presented their case, which, because the Trustees had disbanded, was remanded to the governor of Georgia Colony.

The outgoing governor refused approval of a solution to the controversy. His successor, however, was able to see that the case was long overdue for closure, especially in light of England's need for Creek support in the war with the French and other Native American tribes. He suggested a compromise that was approved by the government in late 1759. The following year, Musgrove was given St. Catherine's Island, where she and Thomas had lived during most of the controversy, and £2,100 from the sale of the other two islands, which she and Thomas had deeded over to Georgia on agreeing to the compromise.

Mary Musgrove died about a year later, in considerably different circumstances from the "Red Stroud Petticoat and Osnabrig Shift" she wore when Oglethorpe arrived. Due to her years of battling the colonial government, she was also perhaps less congenial than the young woman who had helped negotiate treaties between the Creeks and the colonists at Yamacraw Bluff. Because of her stamina and despite her trials, wrote one historian, Mary Musgrove had "one quality which cannot but endear her to all who study her career. She was a fighter who did not know how to quit."

SOURCES:
Braund, Kathryn E. Holland. *Deerskins and Duffels: The Creek Indian Trade with Anglo-Americans,*

1685–1815. Lincoln, NE: University of Nebraska Press, 1993.

Corkran, David H. *The Creek Frontier, 1540–1783*. Norman, OK: University of Oklahoma Press, 1967.

Corry, John Pitts. "Some New Light on the Bosomworth Claims," in *Georgia Historical Quarterly*. Vol. 25, no. 3. September 1941.

Coulter, E. Merton. "Mary Musgrove, 'Queen of the Creeks': A Chapter of Early Georgia Troubles," in *Georgia Historical Quarterly*. Vol. 11, no. 1. March 1927.

SUGGESTED READING:

Jones, Charles C. *History of Georgia*. Boston: n.p., 1883.

Kidwell, Clara Sue. "Mary Musgrove" in Gretchen M. Bataille's *Native American Women: A Biographical Dictionary*. NY: Garland, 1993.

Todd, Helen. *Mary Musgrove: Georgia Indian Princess*. Savannah, GA: Seven Oakes Press, 1981.

COLLECTIONS:

"The Bosomworth Controversy Manuscript" in the Manuscript Division of the Library of Congress.

Candler, Allen D., ed. *Colonial Records of the State of Georgia*. 26 vols. Atlanta: n.p., 1904–16.

Margaret L. Meggs,
independent scholar on women's and disability issues and on feminism and religion, Havre, Montana

Musi, Maria Maddalena

(1669–1751)

Italian singer who was one of the highest paid of her era. Name variations: Known as La Mignatta (the leech). Born in Bologna on June 18, 1669; died in Bologna on May 2, 1751; daughter of Antonio Musi and Lucrezia Mignati; married Pietro degli Antoni.

In 1689, Maria Maddalena Musi was given an annual salary by Ferdinand Carlo Gonzaga, duke of Mantua. She was also given a passport and the title "virtuosa." In addition to performing privately for the duke, Musi made many public performances as well. In 1689, she sang in Sabadini's *Teodora clemente*, Legrenzi's *Guistino*, and Perti's *Siracusano*. In Naples from 1696 to 1700 and again in 1702, she received a salary of 500 Spanish doubloons. Money, titles, and privileges rained down on the singer who was extremely popular with audiences throughout Italy. She retired in 1726.

SOURCES:

Besutti, P. *La corte musicale di Ferdinando Carlo Gonzaga ultimo duca di Mantova: musici, cantanti e teatro d'opera tra il 1665 e il 1707*. Mantua, 1989.

John Haag,
Athens, Georgia

Musidora (1884–1957)

French actress, director, and producer. Born Jeanne Roques on February 23, 1884 (some sources cite 1889), in France; died in 1957; attended Jullian Academy of Fine Arts and the Schommer Studio.

Selected filmography: Les Misères de l'Aiguille *(1913)*; L'Autre Victoire *(1914)*; Bout de Zan et L'Espion *(1914)*; La Bouquetière des Catalans *(1914)*; Le Calvaire *(1914)*; Le Colonel Bontemps *(1914)*; Les Fiances de 1914 *(1914)*; Les Leçons de la Guerre *(1914)*; La Petite Réfugiée *(1914)*; Sainte Odile *(1914)*; Severo Torelli *(1914)*; Les Trois Rats *(1914)*; Tu N'Epousera Jamais un Avocat *(1914)*; L'Union Sacrée *(1914)*; La Ville de Madame Tango *(1914)*; L'Autre Devoir *(1915)*; La Barrière *(1915)*; Bout de Zan et le Poilu *(1915)*; Celui Qui Reste *(1915)*; Le Collier de Perles *(1915)*; Le Coup du Fakir *(1915)*; Deux Françaises *(1915)*; Le Fer à Cheval *(1915)*; Fifi Tambour *(1915)*; Le Grand Soufflé *(1915)*; L'Escapade de Filoche *(1915)*; Les Noces d'Argent *(1915)*; Une Page de Gloire *(1915)*; Le Roman de la Midinette *(1915)*; Le Sosie *(1915)*; Triple Entente *(1915)*; Le Trophée du Zouave *(1915)*; Les Vampires *(1915–16)*; Coeur Fragile *(1916)*; De'brouille-Toi *(1916)*; Les Fiançailles d'Agenour *(1916)*; Fille d'Eve *(1916)*; Les Fourberies de Pingouin *(1916)*; Jeunes Filles d'Hier et d'Aujourd'hui *(1916)*; Judex *(1916)*; Labourdette, Gentleman Cambrioleur *(1916)*; Les Maries d'un Jour *(1916)*; Minne or L'Ingénue Libertine *(director, producer, 1916)*; Mon Oncle *(1916)*; La Peinte du Talion *(1916)*; Le Poete et sa Folle Amante *(1916)*; Si Vous ne m'Aimez Pas *(1916)*; Le Troisième Larron *(1916)*; Les Chacals *(1917)*; Le Malliot Noir *(director, producer, 1917)*; La Vagabonde *(director, producer, 1917)*; La Flamme Cachée *(director, producer, 1918)*; La Geole *(1918)*; La Jeune Fille la plus Meri tante de France *(1918)*; Johannes Fils de Johannes Mam'Zelle Chiffon *(1918)*; Vicenta *(director, producer, 1919)*; Pour Don Carlos *(director, producer, 1920)*; Une Aventure de Musidora en Espagne *(director, producer, 1922)*; Soliel et Ombre *(director, producer, 1922)*; La Tierra de los Toros *(director, producer, 1924)*; Les Ombres du Passé *(1925)*; La Magique Image *(director, producer, 1950)*.

Born Jeanne Roques in France in 1884, Musidora became both a French cinema star and a pioneering producer-director whose abilities were widely praised. Her parents were considered bohemian; her father was a musician and philosopher, and her mother was an educated feminist who founded the literary journal *Le Vengeur* in 1897. Musidora herself was given a good education, attending the Jullian Academy of Fine Arts and the Schommer Studio. She abandoned painting for the stage in 1910, appearing at the Star Theater in a vaudeville comedy sketch. She then joined the Mount Parnasse

troupe of actors. It was while performing with this group that she adopted the stage name "Musidora," from the 1870 Théophile Gautier novel *Fortunio*.

Musidora made her screen debut in 1913, in *Les Misères de l'Aiguille* (The Sorrows of the Needle). She appeared in 15 films during the following year, including *Le Colonel Bontemps* and *La Ville de Madame Tango*. Stardom came at the end of 1915, when, costumed in a black full-body leotard, Musidora enchanted an entire generation of French moviegoers in Louis Feuillade's surreal *Les Vampires*. The fame she garnered from this film allowed her to try her hand at producing and directing. Her first attempt was to film her friend *Colette's *Minne, or L'Ingénue Libertine* in 1915, followed by *Le Malliot Noir* (The Black Leotard) in 1917; both had a distinctly surrealist flavor. *La Vagabonde* (1917), another adaptation of a story by Colette, brought Musidora her greatest acclaim as a director. She teamed with Colette again the following year to produce and direct *La Flamme Cachée*. Musidora directed several films in the 1920s, and many stage productions during the 1930s and 1940s. In 1950, she directed and starred in her last film production, *La Magique Image*. She then became a writer, publishing many articles on cinema as well as poetry, a play, and two novels. Musidora died in 1957. A documentary on her life, *Musidora*, was released in 1973. *Les Vampires* continues to be screened at art houses and revivals.

SOURCES:

Acker, Ally. *Reel Women: Pioneers of the Cinema 1896 to the Present*. NY: Continuum, 1991.

Katz, Ephraim. *The Film Encyclopedia*. NY: HarperCollins, 1994.

Ellen Dennis French,
freelance writer, Murrieta, California

Musser, Tharon (1925—)

American lighting designer. Born Tharon Myrene Musser on January 8, 1925, in Roanoke, Virginia; daughter of George C. Musser (a cleric) and Hazel (Riddle) Musser; graduated from Marion (Virginia) High School, in 1942; Berea College, Berea, Kentucky, B.A., 1945; Yale University, M.F.A., 1950; never married; no children.

One of a trio of pioneering women lighting designers that also includes *Jean Rosenthal and Peggy Clark, Tharon Musser has been a dominant lighting designer on Broadway since 1960, and is the winner of four Los Angeles Drama Critics Awards and three *Antoinette Perry (Tony) Awards, as well as countless nominations. She is also the recipient of two lifetime achievement awards: a Lifetime in Light Award from *Lighting Dimensions* magazine (1990) and the Wally Russell Award for Outstanding Lifetime Achievement (1995).

Musser was born in Roanoke, Virginia, in 1925 and attended Berea College, a work-study school in Kentucky, where she served as technical director in the college's theater, a job she came to love. She continued to study technical theater at Yale University, where her specialty narrowed to lighting design. While still at Yale, she worked at the 92nd Street YMHA in New York City, designing for children's shows, string quartets, poetry readings, and three or four dance concerts a week. After receiving her M.F.A. degree in 1950, she toured with the José Limón Dance Company, serving as lighting designer and stage manager. Musser's early years also included a stint as a television floor manager at CBS, but she was put off when she discovered she was making less money than her male counterparts, "so *adios* TV," as she put it.

Before she was permitted to design for Broadway, Musser had to pass the difficult union exam, which at the time included scenic and costume components as well as lighting. (She later worked with Rosenthal and Clark to establish a separate exam process exclusively for lighting designers.) Soon after receiving her union card, she lit her first Broadway show: the premiere production of Eugene O'Neill's *Long Day's Journey into Night* (1956), directed by José Quintero. "Brooks Atkinson's review sent me to the dictionary to see if it was complimentary or not," she recalled. "Thank God, it was."

Musser's credits mounted quickly, and came to include everything from Shakespeare to musical comedy. She has worked with the American Shakespeare Festival, the Dallas and Miami opera companies, the Mark Taper Forum, and American Ballet Theater. She has lit all of Neil Simon's plays since *Prisoner of Second Avenue* (1971) and has designed an impressive list of musicals, including *Follies* (1972), *A Chorus Line* (1975), and *Dreamgirls* (1985), all of which were directed and choreographed by the late Michael Bennett, whom she considered the ideal collaborator. She was particularly drawn to Bennett's lack of ego and his ability to get everyone to understand that the production took precedence. "He was incredible," she said. "I keep working with new people hoping to find somebody with that spark. The theatricality just oozed out of his pores."

Musser won her first Tony Award for *Follies* (1971), and her second for *A Chorus Line* (1975), for which she used the prototype LS8, the first computerized memory lighting board to be used on Broadway. "Well, if my hair wasn't white then, it would be," said Musser, recalling the trouble she had with the board, which was dubbed Sam. "A couple of years before we closed on Broadway, it got to the point where if you sneezed it went out to lunch." (Sam now resides in the Computer Museum in Boston, which Musser views as a "very respectable retirement.") Musser won her third Tony for *Dreamgirls* in which she used moving lights, yet another innovation. Thankfully, with Bennett's directing, said Musser, she could count on the dancers to hit the same mark every night. Although she admits that musicals are more lucrative than other shows, she finds that she can only live through one or two a year. "I've gotten to the point where I don't like to touch a musical unless I like the people or the product very much. They all take a lot of blood whether they're good, bad, or indifferent, but the bad ones take gallons."

Relishing the collaborative nature of theater, Musser likes to be totally involved in her projects. "It has to look like I've been there when I do a show," she says. She favors early meetings with the set and costume designers, and frequently picks up pointers from them that help clarify her own point of view. Musser tends to be spare and elegant in her designs, using as few instruments as possible to create the largest number of effects. She thinks that designers today use far too much equipment. "I call it supermarket lighting. You see mush. You don't see a point of view on that stage, just mush." In addition, she points out, all those extra instruments must be hung, focused, and maintained, causing additional problems.

Musser does not draw up her design until the last minute, and even then hands it to the shop without color, which is both her favorite part of the design and the hardest. "I tend to do it early in the morning, when I'm half asleep, otherwise I beat it to death," she says. "This blue, or that blue or that blue. . . . [C]ome on, just write

Tharon Musser with Professor Harry Morgan, 1980.

one down! Color's the easiest thing to change once you're in the theater, but nine times out of ten your first impulse will have been a good choice." Regardless of her preparation, Musser cringes through the first five lighting cues of a show's opening night, sure that nothing is going to work right. If the show is one she really cares about, the jitters become all-consuming. "I can't stand it, just don't want to know about it."

In addition to a staggering number of design projects (in one year alone she did nine shows), Musser has lectured on the theater at colleges across the country and has served as a theatrical consultant for Webb & Knapp, Radcliffe College, the American Academy of Dramatic Arts, and the New York Council on the Arts. She received the Distinguished Alumna Award from Berea College in 1973, and was awarded an honorary degree from Emerson College, Boston, in 1980.

By her 70s, Musser had become nostalgic about the old days and less patient with what she saw in the theater. "I used to think you could learn as much from something you didn't like as from something you did. Now I tend to go to dinner at intermission a lot." She also became very selective about her projects, admitting that while she was not quite ready to retire, she didn't want to push herself quite so much. "You quit, you die," she says.

SOURCES:

McGill, Raymond D., ed. *Notable Names in the American Theatre*. Clifton, NJ: James T. White, 1976.

Parker, W. Oren, and R. Craig Wolf. *Scene Design and Stage Lighting*. Orlando, FL: Harcourt Brace Jovanovich, 1990.

Pilbrow, Richard. *Stage Lighting Design: The Art, The Craft, The Life*. NY: Design Press, 1997.

Wilmeth, Don B., and Tice L. Miller, eds. *Cambridge Guide to American Theatre*. NY: Cambridge University Press, 1993.

Barbara Morgan,
Melrose, Massachusetts

Mussey, Ellen Spencer (1850–1936)

American lawyer, reformer, and founder of the Washington School of Law. Born Ellen Spencer on May 13, 1850, in Geneva, Ohio; died of a cerebral hemorrhage on April 21, 1936, in Washington, D.C.; daughter of Platt Rogers Spencer and Persis (Duty) Spencer; attended schools in Oberlin and Geneva, Ohio, Rice's Young Ladies' Seminary, Poughkeepsie, New York, Lake Erie Seminary, Painesville, Ohio, the Rockford Seminary, Rockford, Illinois, and Cornell University; married Reuben Delavan Mussey (an attorney), on June 14, 1871 (died 1892); children: two sons; two stepdaughters.

Admitted to the Washington, D.C., bar (1893); practiced alone and in occasional partnership in probate and commercial law; with Emma M. Gillett, formed the Washington College of Law (1898); served as dean of the law school (1898–1913); drafted and helped pass the Cable Act (1922).

Ellen Spencer Mussey was born on May 13, 1850, in Geneva, Ohio. The tenth of eleven children, she was the daughter of **Persis Duty Spencer** and Platt Rogers Spencer, an abolitionist and temperance advocate who was also the proponent of the widely used Spencerian script. (This penmanship style was the standard method used in the United States in the latter part of the 19th century.) When her mother died in 1862, her father turned to Mussey to run the household as well as to teach classes for him at his school on their Geneva farm. She was only 12 at the time, and after the deaths of her father and younger sister some two years later she became seriously ill. She then lived with different brothers and sisters in New York, Ohio, and Illinois until 1869, when she went to Washington, D.C., to live with her brother Henry and her sister-in-law.

In Washington, she worked at her brother's Spencerian Business College until 1871, when she married Reuben Delavan Mussey, a successful attorney who had been a brigadier general in the Union army. In 1876, when her husband experienced an attack of malaria, she began to help him in his law practice. She worked with him for the next 16 years. Following his death in 1892, Mussey applied to two different local law schools. She was refused admission to both because of her sex. Finally she was allowed to take a special oral examination and was admitted to the bar of the District of Columbia in 1893. She would be admitted to argue before the U.S. Supreme Court in 1896, and before the U.S. Court of Claims in 1897. Mussey worked briefly in partnership with **Judith Ellen Foster**, but during most of her law career she practiced alone, specializing in probate and commercial law. She also worked in international law, serving as counsel to the Swedish and Norwegian consulates for 25 years.

In 1896, with Washington lawyer **Emma M. Gillett** (1852–1927), Mussey formed law classes for several young women. When all were refused admission to law schools because of their gender (one school noting that "women did not have the mentality for law"), Mussey and Gillett opened their own institution, the Washington School of Law. Thanks largely to Mussey's ef-

forts, the school, which accepted both women and men, prospered and grew in reputation. It was eventually affiliated in 1949 with American University, but has retained its own name.

Mussey was also involved in 1896 in the passage of the Married Women's Act, a bill which gave women guardianship rights over their children and property equal to those of their husbands. She also helped to create a juvenile court system in the District and served on the District's Board of Education. In her six years on the board, she worked to establish mandatory education rules as well as a model school for mentally impaired children. She was also instrumental in the passage of the Teachers' Retirement and Pension Bill.

In 1913, as a member of the National American Woman Suffrage Association (NAWSA), Mussey led a group of lawyers in a Washington suffrage parade. Mocked, harassed, and shoved by the crowds in attendance, she suffered a stroke brought on by the stress of the event. Frail health then forced her retirement as dean of the Washington College of Law that year. Her last act of public service was to draft the Cable Act, which ended the automatic loss of citizenship for American women who married citizens of other countries. With *Maud Wood Park, she helped secure passage of the act in 1922. Mussey died of a cerebral hemorrhage in Washington, D.C., in 1936, less than a month before her 86th birthday.

SOURCES:

James, Edward T., ed. *Notable American Women, 1607–1950*. Cambridge, MA: The Belknap Press of Harvard University Press, 1971.

McHenry, Robert, ed. *Famous American Women*. NY: Dover, 1980.

Ellen Dennis French,
freelance writer, Murrieta, California

Mussolini, Edda (1910–1995).

See Ciano, Edda.

Mussolini, Rachele (1891–1979).

See Guidi, Rachele.

Mutafchieva, Vera P. (1929—)

Bulgarian historian and author of historical fiction whose research concentrates on Ottoman rule in the Balkans, while her novels deal with phases of Bulgaria's national evolution. Name variations: Vera Moutafchieva. Born Vera Petrova Mutafchieva in Sofia, Bulgaria, on March 28, 1929; daughter of Petûr Mutafchiev (1883–1943, a historian) and Nadezhda Trifonova Mutafchieva (a historian); Historical Institute of the Bulgarian Academy of Sciences, M.A., 1958, doctorate, 1978; married Jossif Krapchev; married Atanas Slavov; children: two daughters.

After the collapse and repudiation of Communism in Bulgaria in 1989, Vera Mutafchieva emerged as one of her nation's most committed intellectuals, using her prestige to help bring about a successful transition to an open society. Born in Sophia in 1929, she followed in the footsteps of her parents, Petûr Mutafchiev and **Nadezhda Trifonova Mutafchieva**, both accomplished historians. Her father, who taught Eastern European and Byzantine history at the University of Sofia for two decades until his death, was the first Bulgarian historian to consistently investigate the history of his country within a wider European framework. From both parents, Vera received a broad cultural lens for viewing events both in her country and abroad.

Life changed drastically for Mutafchieva while she was in her teens. Her father's death in 1943 left the family impoverished, a situation that was compounded the next year when Bulgaria took the first steps toward becoming a Communist People's Republic. She wanted to begin her studies at the University of Sofia, not in history, which did not yet interest her, but in one of the natural sciences or possibly in literature. This had become impossible, because as a member of a middle-class family she now found herself disadvantaged vis-à-vis Bulgaria's emerging new elite—young people of proletarian or peasant backgrounds. Under these circumstances, she made a realistic choice to focus on Ottoman studies, a field which in the late 1940s did not attract many students. The few experts still active in the area were all close to or past retirement age, and since they were all of bourgeois origins they received little support from the regime.

Mutafchieva's career strategy proved to be a successful one. After completing her undergraduate university studies in 1951, she became a permanent employee (having already been hired as a student assistant) at the Orientalistics Archive of the Cyril and Methodius. By 1955, she had gained considerable expertise in the complex area of Turkish and Ottoman history, and she enrolled as a full-time student at the Historical Institute of the Bulgarian Academy of Sciences, specializing in the history of the Ottoman Empire. Mutafchieva received a master's degree in 1958. Although she would not be awarded a doctorate in historical sciences until 1978, she was now effectively a professional historian and began working as a full-time researcher at the Historical Institute.

In 1960, she published her first study in Ottoman history. Her books and articles would total almost 70 by the late 1990s. Although her historical works were highly specialized and intended only for experts in the field, they quickly gained her a reputation that extended beyond Bulgaria. Her work was cited by scholars throughout the world, and one of her major books would appear in the United States (1988) in an English-language edition. Unlike her father, whose works were written within a nationalistic and idealistic framework, Mutafchieva's studies of Ottoman rule in the Balkans are rigorously "objective," at least to the extent that they do not exhibit the anti-Turkish biases so often found in previous generations of Bulgarian historical writing.

By the early 1960s, her energies and insights—many of them derived from intensive study of original archival documents—could no longer be contained within the confines of academic historical writing. Although she continued to produce a large number of highly regarded academic studies over the next two decades, while working at Sofia's Institute of Balkan Studies from 1963 through 1979, she also began to write historical fiction. Incorporating original historical documents into the plots of her books, and experimenting with new forms of narrative and dialogue, Mutafchieva produced a series of innovative novels that brought her to the attention of the Bulgarian literary world. In time, her creative writings—which included plays and essays as well as novels—became well known in the Balkans and the Soviet bloc.

In 1979, the dual nature of her creativity received official recognition when she was hired as a professor at the national Institute of Literature. The Gottfried von Herder Prize, awarded to her by the University of Vienna in 1980, was a sign of the high esteem in which her writings were held by the end of the 1970s. Mutafchieva's Bulgarian contemporaries took note of her achievements in 1981 by giving her the Georgi Dimitrov Award, which was followed by the City of Sofia Prize in 1986. By the 1990s, her novels had been translated into 12 languages including Czech, French, German, Hungarian-Magyar, Polish, Rumanian, Russian, and Slovak.

In her first published literary work, *Letopis na smutnoto vreme: Roman v dve chasti* (Chronicle of the Times of Turbulence, 1965–66), Mutafchieva presented her readers with an epic novel, rich in detail. There are five different plot lines, which portray both historical and fictional characters who represent the complexities of life in the Ottoman Empire in the Balkans. The work shows the tragic fates of Sultan Selim III, *kûrdzhali* (outlaw-rebel) leader Kara Feizi, and the autonomous ruler Osman Pazvanoglu, a Muslimized Slav who rose to power within the Ottoman state apparatus. The Bulgarians are depicted by the character Stano Mukhtar, whose children are also drawn on Mutafchieva's vast canvas.

By the late 1990s, Mutafchieva had published a total of 12 novels, most of them regarded by both critics and readers alike as works of genuine literary merit. Unfortunately, her novels have not appeared in English-language translations and so remain undiscovered by English-speaking readers. At the very least, Mutafchieva is one of the few writers in the 20th century to achieve distinction as both a historian and a novelist. The psychological insights that mark her novels are in many ways derived from her study of history. Thus, in her 1969 novel *Poslednite Shishmanovtsi* (The Last Shishmans), she asserts that though the Turkish invasion of Bulgaria brought with it terrible violence, it was not the violence alone that kept Bulgarians from consolidating to defend their nation; rather, it was a lack of national awareness of a common identity and a shared cultural mission that contributed to Bulgarian weakness at this stage of the nation's evolution.

Mutafchieva revealed another side to her talent in the early 1980s, when she became involved in film production. She adapted two of her novels, *Zemya zavinagi* (Land Forever, 1980) and *Nepalnotie* (Under Age, 1981), into film scripts. Most important among her cinema projects was her script for the 1981 motion picture *Khan Asparukh* (released in the United States as *The Glory of Khan*). Based on her 1980 novel *Preredcheno ot Pagane* (Pagane's Prophecy), her screenplay was used by director Ljudmil Stajkov to create an epic motion picture commemorating the 1,300th anniversary of the foundation of the Bulgarian state. The film was not only a smashing box-office success in Bulgaria, but has also been rated by many critics and scholars as the best film ever produced in that nation.

The collapse of the Communist dictatorship in Bulgaria in 1989 opened up infinite possibilities for intellectuals. Mutafchieva, who vowed to never repeat herself in any of her books, immediately became active in the public life of a nation that had never before enjoyed anything resembling a state of intellectual freedom. In her 60s, she continued to write novels, publishing a complex and subtle feminist work based on the life of Byzantine Empress *Anna Comnena in

1991. Polemics from her sharp pen appeared as articles in the now uncensored newspapers of Sofia, and Mutafchieva commented on a variety of contemporary artistic and political issues. Very much the public intellectual, she juggled a number of different roles, including a new one at the Institute of Demographic Studies at the Bulgarian Academy of Sciences. She was fully aware of the damage done by more than four decades of suffocating one-party rule and the imposition of an ideology that refused to allow dissent. Harm had been done, she lamented, to the integrity of Bulgarian intellectual life by a regime that expended as much effort bribing its scholars and artists as it did terrorizing them into a state of conformity.

Ever unafraid of venturing into new territory, in the early 1990s Mutafchieva took on a journalistic role, a move that was not free of controversy but which in 1995 led to her receipt of the first John Panitsa Award, a prize instituted to honor distinguished work in the area of mass media and investigative journalism. When she entered her 70s, she could be seen and heard in countless discussion groups, debates, and seminars. As an academic historian, even while working under the conditions of a dictatorship, Vera Mutafchieva was committed to presenting truthful pictures of the past rather than serving contemporary needs of political propaganda. As a novelist, she pursued the same goal, interweaving historical objectivity with the writer's art.

SOURCES:

Deltcheva, Roumiana. "Vera Mutafchieva (28 March 1929—)," in Vasa D. Mihailovich, ed., *South Slavic Writers Since World War II. Dictionary of Literary Biography*. Vol. 181. Detroit, MI: Gale Research, 1997, pp. 187–196.

Detrez, R. "Bulgarian Historiography," in D.R. Woolf, ed., *A Global Encyclopedia of Historical Writing*. 2 vols. NY: Garland, 1998, Vol. 1, pp. 116–118.

————. "Mutafchiev, Petûr (1883–1943)," in D.R. Woolf, ed., *A Global Encyclopedia of Historical Writing*. 2 vols. NY: Garland, 1998, Vol. 2, pp. 641–642.

Kanikova, S.I. "Mutafchieva, Vera," in Robert B. Pynsent and S.I. Kanikova, eds., *Reader's Encyclopedia of Eastern European Literature*. NY: HarperCollins, 1993, pp. 274–275.

Matejic, Mateja. Review of Vera Mutafcieva, *Poslednite Sismanovci*. 3rd ed. Sofia: Narodna Mladez, 1979, in *World Literature Today*. Vol. 55, no. 1. Winter 1981, p. 134.

Mutafchieva, Vera. *Agrarian Relations in the Ottoman Empire in the 15th and 16th Centuries*. Boulder, CO: East European Monographs-Columbia University Press, 1988.

Mutafchieva, Vera P. "The Notion of the 'Other' in Bulgaria: The Turks, a Historical Study," in *Anthropological Journal on European Cultures*. Vol. 4, no. 2, 1995, pp. 53–74.

————. *Spielball von Kirche und Thron: historischer Roman*. Translated by Hartmut Herboth. 2nd ed. Berlin: Rütten & Loening Verlag, 1974.

———— and Nikolai Todorov. *Bulgaria's Past*. Translated by Georgina Yates. Sofia: Sofia Press, 1969.

"Mutafchieva, Vera Petrova, Prof., Dr.," in Juliusz Stoyonowski, ed., *Who's Who in the Socialist Countries of Europe*. 3 vols. Munich and NY: K.G. Saur, 1989, vol. 2, p. 817.

Sharova, Krumka. "Prof. D-r Vera Mutafchieva—Uchenijat i tvoretsût" [Vera Mutafchieva—Scholar and Author], in *Istoricheski pregled* [Bulgaria]. Vol. 45, no. 6, 1989, pp. 62–66.

Witschew, Dobri. "Gespräch mit Wera Mutafschiewa," in *Weimarer Beiträge*. Vol. 37, no. 4, 1991, pp. 558–573.

John Haag,
Associate Professor, University of Georgia, Athens, Georgia

Mutayyam al-Hashimiyya
(fl. 8th c.)

Arabian singer and poet who is considered the personification of classical Arabic music. Born in al-Basra (now Iraq) during the Abbasid period; flourished in the 8th century.

Unlike many female singers, Mutayyam al-Hashimiyya was a freed woman. Born and educated in al-Basra, she lived there her entire life. Her teachers were the two most eminent musicians of the Abbasid period, Ibrahim al-Mausili and his son, Ishaq; she also studied with Badhl. She was famous for both her music and poetry, and only two songstresses ranked above her. Mutayyam al-Hashimiyya sang at the court of Caliph al-Mamun (r. 813–833) and Caliph al-Mu'tasim (833–842) before she sang for Ali ibn Hisham.

John Haag,
Athens, Georgia

Mutemwia (fl. 1420–1411 BCE)

Egyptian regent. Flourished between 1420 and 1411 BCE; possibly daughter of Tjuya and Yuya who were of high social standing; sister of *Tiy (c. 1400–1340 BCE); concubine of pharaoh Thutmose IV; mother of Amenhotep III for whom she ruled as regent until he was of age.

Mutnedjmet (c. 1360–1326 BCE)

Great Hereditary Princess and Mistress of Upper and Lower Egypt. Name variations: Eji; Metnedjenet, Mutnedjme, or Mutnodjmet. Born around 1360 BCE; possibly died in childbirth in 1326 BCE; parents unknown; sister of Nefertiti; married Haremheb (a general).

Mutnedjmet was an Egyptian queen of the New Kingdom and probably the last surviving member of the enigmatic family of Queen *Nefertiti, her sister. The parents of these women are not known, but as sister of a regnant queen, Mutnedjmet was perhaps the last surviving female member of the royal family of the 18th Dynasty and could, by marriage, lend legitimacy to the rule of her husband, the general Haremheb, who seized the throne upon the death of King Aye, the successor of Tutankhamun. She is depicted in equal size with her husband in a large statue group now in the Turin Museum. She gave birth to no living heirs, and indeed appears to have died in childbirth and been buried in Haremheb's private tomb at Saqqara near the ancient capital of Memphis, where the remains of a woman and baby were recovered by archaeologists. Lacking an heir, Haremheb took as his successor another military man, one Ramses (I), who then founded the illustrious line of 19th Dynasty rulers.

Barbara S. Lesko,
Department of Egyptology, Brown University,
Providence, Rhode Island

Muzakova, Johanna (1830–1899).

See Svetla, Caroline.

Muzio, Claudia (1889–1936)

*Italian soprano. Born Claudina Muzio on February 7, 1889, in Pavia, Italy; died on May 24, 1936, in Rome; daughter of a stage director and a singer; studied with **Annetta Casaloni** in Turin and Viviani in Milan.*

Made debut at Teatro alla Scala as Desdemona (1913–14), Covent Garden (1914), and Metropolitan Opera (1916), remaining there until 1922; appeared in Chicago (1922–32) and at Teatro alla Scala (1926–27).

Claudia Muzio was born in Pavia, Italy, in 1889, into an operatic family. Her father was a stage director at the Metropolitan Opera and Covent Garden, while her mother was a chorus singer. Muzio's recording career spanned many years, from 1911 until 1935, during which she made more than 30 recordings for EMI. Muzio appeared frequently on the stage and was the first Turandot of Buenos Aries; she also shared nine seasons in Chicago with *Rosa Raisa. Many feel that Muzio's recorded works are infused with melancholy, and she has often been portrayed as a tragic figure. Poor health plagued the singer and led to her early death. Her striking voice, however, has given her legendary status.

SUGGESTED READING:
Arnosi, E. *Claudia Muzio*. Buenos Aires, 1987.

John Haag,
Athens, Georgia

Mydans, Shelley (1915—)

American journalist and writer. Born Shelley Smith on May 20, 1915, in Palo Alto, California; daughter of Everett Smith (a professor of journalism); married Carl Mydans (a photojournalist), in June 1938.

Worked as journalist for Life *magazine (1939—); was correspondent in Manila, Europe and Far East; was a Japanese prisoner of war during World War II; wrote novel* Open City *about experiences; wrote historical novels.*

Selected writings: The Open City *(1945);* Thomas: A Novel of the Life, Passion, and Miracles of Becket *(1965); (with Carl Mydans)* The Violent Peace: A Report on Wars in the Postwar World *(1968);* The Vermilion Bridge *(1980).*

Born Shelley Smith in Palo Alto, California, in 1915, Shelley Mydans was the daughter of journalism professor Everett W. Smith. Her pursuit of journalism as a career took Mydans first to New York, where she worked as a writer-researcher for the nascent *Life* magazine. Carl Mydans, a photojournalist also working for *Life*, walked into her office one day in 1937; he "sat down in a wastebasket and started talking to **Margaret Bassett**, whose desk was two over from mine," Shelley told interviewer Larry Smith. "He sat there in the wastebasket, talking to Margaret, and his voice had all kinds of excitement in it." They married in 1938. By 1939, *Life* made the couple a reporter-photographer team and sent them on assignment to Europe and Asia; both covered Douglas MacArthur's buildup in the Philippines during World War II. In 1942, the Mydans were taken prisoner by the invading Japanese and incarcerated for 12 months in Santo Tomas in Manila and 8 months in Shanghai, an experience that informed Shelley's novel *Open City*, published in 1945.

Twenty years later, she published *Thomas: A Novel of the Life, Passion, and Miracles of Becket*, an ambitious and well-reviewed historical novel about the 12th-century English saint. Mydans collaborated with her now-famous husband on *The Violent Peace: A Report on Wars in the Postwar World*, drawing on their research in China, Korea and Japan. *The New York Times Book Review* described its contents as "some of the best war journalism of our time." In 1980, Mydans published another historical novel, *The*

Vermilion Bridge, set in 8th-century Japan. *The New York Times* praised her approach for combining "the thoroughness of a historian . . . [with] the sensitivity of a novelist."

SOURCES:

Smith, Larry. "A Picture to Remember," in *Parade*. May 25, 1997, p. 5.

<div align="right">

Paula Morris, D.Phil.,
Brooklyn, New York

</div>

Myddelton, Jane (1645–1692)

English noblewoman. Name variations: Jane Middleton. Born in 1645; died in 1692; daughter of Sir Robert Needham; married Charles Myddelton, in 1660.

Jane Myddelton, the daughter of Sir Robert Needham, was born in 1645 and as an adult gained notoriety for attracting many lovers. A rival of *Barbara Villiers, countess of Castlemaine, she was known as the great beauty of Charles II's time, and those who came under her spell included a French nobleman from Grammont, the duke of Montagu, the duke of York, and Edmund Waller. She was granted a pension by James II before her death in 1692.

<div align="right">

Lisa Frick,
freelance writer, Columbia, Missouri

</div>

Myers, Angel (b. 1967).

See Martino, Angel.

Myerson, Bess (1924—)

American television personality and political appointee who was Miss America in 1945. Born in New York City in 1924; second of three daughters of Louis Myerson (a house painter) and Bella Myerson; attended P.S. 24, in the Bronx; graduated from the High School of Music and Art; Hunter College, B.A., 1945; married Allan Wayne (a businessman), in October 1946 (divorced 1957); married Arnold Grant (an entertainment lawyer), in 1962 (divorced and remarried, divorced again in 1970); children: (first marriage) one daughter, Barra Grant.

"I'm like a phoenix," Bess Myerson has said. "I rise from the ashes." Indeed, Myerson's life has been a roller-coaster of highs and lows since 1945, when she made history as the first Jewish Miss America, then endured a series of anti-Semitic incidents that tainted her reign. It seems that for each of her successes, including a lucrative television career and several high-ranking political appointments, Myerson has suffered a corresponding setback. While her professional life soared, she endured two painful divorces, was arrested for shoplifting, had ovarian cancer and a stroke, and was involved in a number of ill-fated relationships. In 1983, her love affair with a married sewer contractor 21 years her junior led to her arraignment on charges of bribery, conspiracy and obstruction of justice. A subsequent trial, which ended in her acquittal, laid bare to the public all the foibles of her past life, some of which revealed her to be a troubled and insecure woman. While others might have been destroyed by such an ordeal, Myerson drew strength from her religion, and has since pulled her life together and become active in Jewish causes.

The middle of the three daughters of Russian immigrants, Bess Myerson grew up in the Sholom Aleichem apartments in the Bronx, an enclave of working-class Jews. A talented pianist even as a child, she had dreams of someday becoming a conductor. She graduated from the High School of Music and Art and received a bachelor's degree from Hunter College, earning her tuition by giving piano lessons. Myerson entered the Miss America contest as a lark, thinking that the $5,000 prize would help in the purchase of a new piano and maybe get her started in graduate school. It turned out to be an eye-opening experience for the stately brunette, and her initial brush with anti-Semitism. The first hint of what lay ahead was the suggestion by an official of the New York state pageant that she change her name to Betty Merrick. She refused, claiming that if she won her friends would not know it was her. "It was the most important decision I ever made," she later recalled. "It told me who I was, that I was first and foremost a Jew." As the contest progressed, rumors began circulating among the backers that if she won, it would be the end of the pageant. Several judges also received warnings. After she had captured the title, many of the sponsors in fact did pull out because they did not want a Jew representing their company. Myerson said later that when she chose to use her position to tour the country under the aegis of the Anti-Defamation League, talking to schoolchildren and community groups, pageant officials accused her "of making communist speeches sponsored by Jewish manufacturers." By the time her year as Miss America was over, Myerson was happy to be done with it.

In October 1946, not long after the end of her reign, Myerson married Allan Wayne, a young army captain she had met the previous May. In retrospect, the marriage was hasty, but it filled a void. "It's so strange," she said in *Miss America, 1945*, a biography by **Susan Dworkin**,

"You struggle for a room of your own, and you finally get it, and then you discover that you don't want to be alone in it. You cannot stop looking for love." The couple moved in with Wayne's parents, and he went to work for his father's toy company. A year later, they had a daughter, Barbara Carol (called Barra), after which Myerson became a stay-at-home housewife and mother. Soon realizing, however, that she needed a fuller life, she began to make occasional television appearances. Her career took off in 1951, when she won a spot as hostess on the game show "The Big Payoff." She was a regular panelist on the popular game show "I've Got a Secret" from 1958 to 1967, and also made guest appearances and commercials. In the meantime, her marriage to Wayne, rumored to be abusive, unraveled, and the couple divorced in 1957. Five years later, she married Arnold Grant, a successful entertainment lawyer

In 1969, Myerson was appointed Commissioner of Consumer Affairs of New York City by Mayor John Lindsay. In this post, she orchestrat-

Bess Myerson

ed one of the most progressive (and aggressive) consumer protection programs the city had ever known. Appearing on television several times a week, she exposed parking garages that damaged cars, butchers who sold bogus cuts of meat, and computer schools that operated with no computers. She even took on the Better Business Bureau for ignoring complaints from her agency. While New Yorkers embraced her as one of their favorite public officials, some of her staff found her arrogant and overbearing. "She overran her budget, then tried to blame others," said one worker. "But she was a star, so she got away with all of it." In 1971, Myerson's second marriage ended in an ugly two-year court battle fueled by Grant's possession of some of Myerson's love letters to other men and her diaries which supposedly detailed additional marital infidelities.

Soon after resigning as Commissioner of Consumer Affairs in 1973, Myerson was diagnosed with ovarian cancer, which at the time she did not talk about, even to her parents. "Cancer then was like AIDS [in the early years]. Nobody knew anything." she said. After surgery and a long siege of chemotherapy, she went back to work as a business consultant and consumer affairs activist. Two documentary television series she hosted during this period, "A Woman Is" and "In the Public Interest," were nominated for Emmy Awards. In 1977, she took an active role in the mayoral campaign of Edward Koch, and was credited with contributing substantially to his win. When political polls revealed her to be one of the most popular political figures in New York state, she decided to make her own run for the U.S. Senate. In the midst of the exhausting and ultimately futile campaign to win the Democratic nomination, Myerson began her ill-fated affair with Andy Capasso, the self-made millionaire (and friend of reputed mob boss Matty Ianniello) whom she had met through a mutual friend. "Other people she went out with may have been better looking, better educated and so forth," said a friend at the time. "But they have not treated her as kindly as he does." Although Myerson had doubts about Capasso from the beginning, he was a lifeline after her defeat in the primary. "I knew he was doing things I didn't want to know about," she confided to a friend. "But this is love, and what I do for love." Capasso helped Myerson pull her finances together following her defeat at the polls and even stuck by her through the mild stroke she suffered in 1980. (Doctors later attributed the stroke to Myerson's 40-pound weight gain during her Senate campaign.) All the while, **Nancy Capasso**, Andy's wife, was under the impression

that her husband's relationship with Myerson was strictly business.

In 1983, when Myerson was appointed by her political friend Ed Koch as Commissioner of Cultural Affairs, her relationship with Capasso was pretty much general knowledge. Eventually, Nancy Capasso learned of the affair and confronted her husband. Enraged, Andy, who had been drinking heavily, brutally beat his wife, leaving abrasions and bruises which she later had photographed as evidence. In the lengthy and unpleasant divorce proceedings that followed, the 70-year-old presiding judge, **Hortense Gabel**, awarded Nancy the then not inconsiderable sum of $1,850 a month in child support and temporary maintenance, infuriating both Capasso and Myerson. It is at this juncture that Myerson apparently made a fatal error in judgment, deciding to use her political position to manipulate the judge into lowering the award. Myerson hired the judge's 34-year-old emotionally disturbed daughter **Sukhreet Gabel** as her personal assistant, putting her on the city payroll. Sukhreet, unaware of the connection between her mother and the Capasso divorce case, went to work for Myerson on August 29, the very day that her mother heard an appeal from Capasso requesting a reduction in the maintenance and child support for his wife. Two weeks later, the payments were reduced by more than half. When a New York newspaper noted the coincidence of the hiring with the outcome of the appeal, Myerson attempted a cover-up, distancing herself from Sukhreet and later asking her to resign. Sukhreet subsequently found another job with the New York City Commission on Human Rights.

Unbelievably, the "Bess Mess," as it came to be known, was kept under wraps for three years, until March 1986, when it was unearthed by then U.S. Attorney Rudolph Guiliani, who had been investigating corruption in the Koch administration. In June 1986, the *New York Daily News* broke the story of an investigation into Capasso, who had received millions of dollars of construction contracts from the city over a five-year period. The article also outlined the Capasso divorce and Myerson's alleged role in it. A federal grand jury then subpoenaed all records from the Department of Cultural Affairs, and the story slowly began to emerge. When Myerson was called before the grand jury, she refused to testify, citing the Fifth Amendment. In January 1987, however, Capasso pleaded guilty to tax evasion charges and was fined and sent to jail, after which Myerson resigned her position. Her friend and mentor Mayor Koch was dumbfounded. "I'm aghast at what she did," he said.

Other friends of Myerson's were equally shocked. "She's always been a straight shooter," said **Linda Janklow**, a pal from childhood. "God knows how she got mixed up in all of this."

Myerson, Gabel, and Capasso were tried together in a separate trial which began in October 1988 and lasted 11 weeks. The star witness for the prosecution, Sukhreet Gabel, proved shaky and unconvincing, and in the end the three were acquitted. **Shana Alexander**, who was fascinated by the case and wrote the book *When She Was Bad*, centering on the intertwining stories of Nancy Capasso, Hortense Gable, Sukhreet Gabel, and Myerson, believes that the case was ill-suited to the courtroom. "The law deals best with facts," she said, "and the Bess Mess was essentially a tangle of emotions."

Since the trial, Myerson has kept a fairly low profile, putting her celebrity to use only to benefit religious causes. "Nothing I've done in the past is as nourishing to me as my Jewishness," she said in 1995. "I never left it, but now I can do it full time. It is as if my life has evolved to where I always wanted it to be."

SOURCES:
Alexander, Shana. "Bonus Book: A Queen of Hurts," in *People Weekly*. March 12, 1990.
Dworkin, Susan. *Miss America, 1945: Bess Myerson's Own Story*. NY: Newmarket Press, 1987.
Green, Michelle. "On the Cover: Downfall of An American Idol," in *People Weekly*. June 29, 1987, p. 44.
Soloff, Emily D. "Bess Myerson reflects on fame, Miss America, and Judaism," in *Jewish Bulletin of Northern California*. October 6, 1995.

Barbara Morgan,
Melrose, Massachusetts

Myerson, Golda (1898–1978).

See Meir, Golda.

Myia (fl. 6th c. BCE)

*Pythagorean philosopher. Born in Crotona, Italy, and flourished around 6th century BCE; daughter of Pythagoras of Samos (a philosopher, mathematician, politician, and spiritual leader) and Theano (a Pythagorean philosopher); sister of *Arignote, *Damo, Telauges and Mnesarchus; educated at the School of Pythagoras; married Milon of Crotona (also known as Milo, Mylon, and Meno).*

Myia was born to the philosopher Pythagoras and his wife *Theano, who was a member of the intellectual community he established in Crotona in the 6th century BCE. Although Myia and her sisters and brothers were brought up in

a house outside of the Pythagorean community, they were all educated at the school, which involved studying mathematics; using moderation in all things and worshipping Apollo, the god of moderation; and following the precepts of the Orphic religion (practicing kindness because of a belief in reincarnation).

The Pythagoreans believed that home and family life was the province of women, whereas men's efforts were appropriately focused on the state and society at large. It is not surprising, then, that Myia is known for the *Letter to Phyllis*, in which she advises a friend on the practice of rearing an infant. She recommends that the caretaker (the mother) be even-tempered and moderate—the Pythagorean prescription in all practical matters. In regard to the specifics of child-care, she recommends moderation in feeding, clothing, and hygiene. Extreme pampering and extreme denial are to be avoided. Extra comfort can be administered when appropriate, but timing is crucial. The importance of appropriate timing was also part of the Pythagorean lifestyle. We see this in the closing of the letter: "With the help of god [Apollo], we shall provide feasible and fitting reminders concerning the child's upbringing again at a later time."

Myia married another Pythagorean, Milon of Crotona, a famous athlete and a leading Pythagorean. A crowd wishing to expel the Pythagoreans from Crotona set fire to their house during a meeting of the Pythagorean Order. It is unclear whether Myia died in the blaze or in the ensuing persecution of the Pythagoreans in Crotona, but 38 others died, including Pythagoras and Milon.

SOURCES:

Coppleston, Frederick, S.J. *A History of Philosophy.* London: Search Press, 1946.

Guthrie, W.K.C. "Pythagoras and Pythagoreanism," in *Encyclopedia of Philosophy.* Vol. 7. Edited by Paul Edwards. NY: Macmillan, 1967.

Jamblichus, C. *Life of Pythagoras.* London: John M. Watkins, 1926.

Kersey, Ethel M. *Women Philosophers: A Bio-critical Source Book.* NY: Greenwood, 1989.

Philip, J.A. *Pythagoras and Early Pythagoreanism.* Toronto: University of Toronto Press, 1966.

Waithe, Mary Ellen, ed. *A History of Women Philosophers.* Vol. 1. Boston, MA: Martinus Nijhoff, 1987.

Catherine Hundleby, M.A. Philosophy, University of Guelph, Ontario, Canada

Myojo-tenno (1624–1696).

See Meisho.

Myongsong (1851–1895).

See Min.

Myosho (1624–1696).

See Meisho.

Myra.

Variant of Mira or Myrrha.

Myrdal, Alva (1902–1986)

Noted Swedish sociologist and UN official who won the Nobel Peace Prize in 1982 for her work in the cause of international disarmament. Pronunciation: Moor-DOLL. Born on January 31, 1902, in Uppsala, Sweden; died on February 1, 1986, of heart disease in Stockholm, Sweden; daughter of Albert Jansson Reimer and Lowa (Larsson) Reimer; graduated from special girls' gymnasium (secondary school) in Eskilstuna, 1920; graduated from the University of Stockholm, 1924; further graduate study in Britain, Germany, the United States, and Switzerland, 1925–31; received master's degree from University of Uppsala, 1934; married Gunnar Myrdal (an economist), on October 8, 1924; children: son Jan Myrdal (b. 1928); daughters, Sissela Myrdal Bok (b. 1934) and Kaj Myrdal (b. 1936).

Met Gunnar Myrdal (1919); went on a study tour of the U.S. (1929–30); suffered severe illness during stay in Switzerland (1931–32); worked as psychologist at a Swedish prison (1932–34); published first book, Crisis in the Population Problem *(1934); served as adviser to the Swedish government on housing and population (1935); founded Training College for Nursery and Kindergarten Teachers (1936); edited Labor party journal (1936–38); resided in the U.S. (1938–40, 1941–42); was a Swedish representative to International Labor Organization conference in Paris (1946); appointed director of Department of Social Affairs, United Nations (1949); appointed director of Division of Social Sciences, UNESCO (1951); was Swedish ambassador to India (1955–61); published* The Game of Disarmament *(1976); won Albert Einstein Peace Prize (1980); won Nobel Peace Prize (1982).*

Selected writings: Crisis in the Population Question *(1934);* Contact with America *(1941);* Nation and the Family *(1941); (with Viola Klein)* Women's Two Roles *(1956);* The Game of Disarmament *(1976).*

Alva Myrdal was a leading Swedish sociologist, social activist, and government figure. Starting in the late 1940s, she played a significant role in the United Nations as well. Myrdal wrote major works on such topics as school reform, women's roles in a modern industrial society, and nuclear disarmament. Much of her work was done in collaboration with her hus-

band Gunnar Myrdal, the author of *An American Dilemma,* a classic work on American race relations. She has been widely recognized as an authority on early childhood education who urged that youngsters be given a loving environment in which their individual differences were respected and cultivated. Ironically, Myrdal has been portrayed by her estranged son Jan as a mother who could not herself provide a warm and nurturing family environment. Her elder daughter, **Sissela Myrdal Bok,** has painted a more sympathetic picture of her multitalented and energetic mother.

Alva Reimer was born in the Swedish city of Uppsala on January 31, 1902, the daughter of Albert Jansson Reimer and **Lowa Larsson Reimer.** Alva's mother came from a prosperous farming family in the village of Eskilstuna in the province of Sodermanland, about 60 miles southwest of Stockholm. Her father came from a poorer rural family with ties to Sweden's Social Democratic labor movement. Albert Reimer, an activist in the both Social Democratic Party and the Swedish temperance movement, was an insurance agent at the time of Alva's birth, but he went on to become a successful building contractor. In 1914, her father took the family back to the countryside near Eskilstuna to run the farm his wife had inherited. There his political sympathies soon emerged. He built cooperative houses for members of the community, selling them to local buyers for the lowest price possible, and he soon took on local political offices. The political opinions held by Alva's mother were more conservative than those of her father, and the young girl noted that they even subscribed to different newspapers.

Alva had to struggle to get her education, since the local secondary school was reserved for the boys of the community. At her urging, Albert Reimer arranged for a small girls' secondary school to be set up, and she moved swiftly through the course, completing two years' work in one. She graduated with the highest honors in June 1922. Alva's determination to pay her father for the cost of her schooling made money a constant worry for her. Along with her family's long-standing financial ups and downs—Albert's income varied sharply over the years—this experience made Alva, in Bok's words, "punctilious about expenses" and often "parsimonious."

At the age of 17, Alva Reimer met Gunnar Myrdal, her future husband, when the young man stopped at the family farm with two other touring university students. In a daring move, she joined the group for two weeks of train travel and bicycling through the Swedish countryside. Gunnar was so impressed with the depth of her reading that, as Bok later put it, "Alva caused him to abandon for good his condescension" toward women's intellectual abilities. Alva herself was struck by her new friend's deep belief, drawn from the 18th-century Enlightenment, that greater understanding of human life and social conditions would set the stage for a vast improvement in these areas. The trip also saw the beginning of sexual relations between the two young people.

In 1922, Alva joined Gunnar at the University of Stockholm, where he studied law and she immersed herself in a variety of subjects such as European literature. She had been forced to give up an initial ambition to go to medical school and become a psychiatrist because no financial aid was available to support women pursuing such a goal. The two of them married on October 8, 1924, by which time Gunnar had won his law degree and Alva had finished her studies to obtain the Swedish equivalent of bachelor of arts. Their subsequent studies in a number of other European countries sharpened their mutual desire to work for social reform.

Alva remained awed by her husband's intellectual brilliance, and she rushed to support him in moments of discouragement. For example, Gunnar plunged into depression shortly after receiving his law degree because he saw no way to use legal work as a means to further his passionate desire to understand society. Alva quickly convinced him to turn his talents to economics, a field in which he soon acquired international eminence. But relations between the would-be social activists were often strained. Alva was disturbed by her role as intellectual helpmate and the consequent need to put aside her own ambitions. Living in continual financial straits added to her discontent. A particular trauma during the early years of their marriage was the miscarriage she suffered in the spring of 1926. Happily, her first child, a son named Jan, was born little more than a year later. Despite the burdens of motherhood, Alva continued to work for an advanced degree in psychology.

In 1929, the Myrdals left for a year's study in the United States. Both had received grants from the Rockefeller Foundation; Alva's project was to study American methodology of social psychology. Gunnar's separate project was a study of American methodology in economics and the social sciences. In a decision Alva soon regretted, they left Jan with his paternal grandparents. In the United States, Alva Myrdal worked with the

noted sociologist Robert Lynd at Columbia University; together, they set out a program for her to study American work in the field of child development. Her travels to examine this area took her from Yale University to the University of Chicago and on to the University of Minnesota. Lynd served as a key mentor in the young woman's intellectual life, encouraging her ambitions in a way no one else had so far done. Her work with *Charlotte Bühler, a noted child psychologist from Vienna, likewise had a profound effect on Alva. The young Swedish woman had never before studied under a female professor.

That year in the United States saw that country suffering from the 1929 stock-market crash and the beginning of the subsequent Depression. The Myrdals were struck by the combined phenomena of economic deprivation and government inaction. Racial and religious prejudice in the United States also tempered their enthusiasm for the qualities in American life they admired: optimism, energy, and freedom of expression. For Alva there developed a new affection for Sweden's tradition of government action in the interest of suffering members of the population. According to Bok, "They both dated their adoption . . . of radicalism to their year in the United States." Condemning the concept of "tradition," they increasingly used the word "radical" to describe their desire for basic reforms in society.

When you talk about Alva Myrdal, people become inspired. To them, she signifies happiness about life's potential, a bright faith in the future.

—Kirster Stendahl, bishop of Stockholm

In Alva Myrdal's absence, changes in the faculty at the University of Stockholm had made her pursuit of a doctorate there impossible. For example, a sympathetic mentor who had encouraged her study of Freud's doctrines had been replaced by a firm anti-Freudian. Shortly after their return, Gunnar accepted a position at the University of Geneva. Alva planned to use the opportunity of living in Switzerland to study with Jean Piaget, a rising young expert in child development at the Rousseau Institute. Her plans were shattered, however, by a second miscarriage, which led in turn to a series of serious illnesses. For a time, her life was in danger. Even after their return home, her recovery required a number of years during which she could work only part-time as a prison psychologist.

During their time abroad, the Myrdals had become interested in the issue of population.

Their perspectives differed, Gunnar approaching the topic as an economist, Alva as a psychologist. She claimed this was an advantage, writing to a friend that being "an economist and a social psychologist, united in marriage and authorship," the two of them "naturally combined to form a sociologist with the greatest of ease." Alva acquired the lasting belief that women were obliged to have children as a duty both to their country and to humanity. A young woman with only one child, she took the bold step of starting a course of instruction for parents based upon the new insights academicians had developed about child psychology. The lectures were her first experience in public speaking, and she found herself telling other, more experienced parents that their untutored instincts were insufficient to produce psychologically healthy offspring.

As her husband's career blossomed—he was appointed to a prestigious chair in economics at the University of Stockholm in 1933—Alva Myrdal found herself immersed in a combination of personal and professional concerns. Once again in good health, she had a second child, Sissela, in 1934. A third child, their second daughter Kaj Myrdal, was born in 1936. Pursuing her interest in women's social roles, Alva read deeply in the works of such writers as *Virginia Woolf, *George Sand, and *Margaret Mead; she also studied the lives of historical figures like Queen *Christina of Sweden and the Bolshevik revolutionary *Alexandra Kollontai.

Initially the Myrdals hoped to present their developing ideas on population problems in the form of articles for a Socialist newspaper, but when these were rejected for being too lengthy, the couple began to collaborate on a book. *Crisis in the Population Question* appeared in 1934, treating such emotionally charged issues as sexuality, family planning, and blueprints for government-sponsored social change. In a tone that many found harsh, strident, and intellectually arrogant, the Myrdals urged social reforms such as free health care as steps to reverse the decline in Sweden's population. The book was widely discussed, and it made the two authors famous throughout their home country. Alva was subjected to intense criticism for dealing with such questions—considered indecent for a female to do at the time. In traveling to publicize the book, she found herself confronted by angry members of her audience urging her to stay at home with her newborn child. Nonetheless, *Crisis in the Population Question* led to a series of government actions. The implementation of her parents' views provided "the foundation for Sweden's welfare state," wrote Bok.

The aftermath of publication brought Alva Myrdal a combination of frustration and success. Despite their close collaboration on the book, she found that her husband was the one asked to serve in important posts such as membership in Sweden's Population Commission. She had to settle for a position as a consultant. Similarly it was Gunnar who was asked to run for the Swedish Parliament. She turned her restless energies to setting up and running a training school for teachers in early childhood education. Established in 1936, the school let her promote

her ideas about a system of collective child care that featured well-trained staff members.

In 1938, the Myrdal family left for a two-year stay in the United States, where the Carnegie Corporation had appointed Gunnar to lead an ambitious study of American race relations. Meanwhile, Alva worked on a book entitled *Nation and Family: The Swedish Experiment in Democratic Family and Population Policy*. In it, she urged other countries to study Sweden's social reforms and to adopt them, in appropriate form, to their own conditions. The book specifically condemned the forms of family policy then prominent in Nazi Germany, and the author insisted that democratic means could be used to produce the necessary reforms. As Bok has noted, the book's tone was more restrained and its hopes for change more modestly stated than in the Myrdals' preceding 1934 publication. A notable theme in the book is the dilemma of modern women; unless they choose to remain isolated at home, they are forced to divide their time between their families and a working world that makes few accommodations to their needs.

In the spring of 1940, the Myrdals returned to Sweden. Now that World War II had broken out, their longstanding criticisms of Nazi Germany made them well aware their lives would be in danger if Adolf Hitler's forces invaded their homeland. They had considered remaining in the United States or, at least, leaving their three children with friends there. After deciding the entire family would go back, they found that the only passage available was on a Finnish freighter carrying a dangerous cargo of dynamite. Once at home in Sweden, they collaborated on a new book entitled *Contact with America*. In it, they urged Swedes not to abandon democracy. The book was inspired in part by the Myrdals' concern over such policies of the Swedish government as censoring anti-Nazi statements in the nation's newspapers. In these early years of the war, which were filled with Nazi military victories, the government felt itself forced to make such concessions to German sensibilities.

In 1941, after Gunnar had returned to the United States to continue work on his study of race relations, Alva Myrdal reluctantly joined him. She was tormented by the need to leave her children with relatives in Sweden, but she was also aware that her husband needed her help and companionship in America. The two were able to return only in late 1942, and she resumed her work at the training school while writing columns for a Stockholm newspaper. She also worked to aid wartime refugees in Sweden.

In 1947, the Myrdals relocated to Geneva where Gunnar took over the leadership of the United Nations Economic Commission for Europe. Their daughter Sissela recalled her father's isolation from the family as Gunnar immersed himself even more than usual in his work. As Bok later wrote, "Gunnar forgot birthdays altogether and social life was determined by his official needs." Alva became increasingly depressed by the twin burdens of loneliness and inactivity.

But Alva Myrdal soon found herself receiving invitations to take up a post with the United Nations. She turned down an initial offer to become assistant director of the United Nations Educational, Scientific, and Cultural Organization (UNESCO) in Paris because it conflicted with her husband's career. In 1949, however, she accepted Secretary-General Trygve Lie's invitation to direct the Department of Social Affairs of the UN Secretariat in New York. The position made her the most powerful woman in any branch of the United Nations, and it permitted her to address issues that had long interested her, such as educational and population questions, on a global scale. Accepting the post meant leaving both her husband and her children behind in Geneva. Now, at 47, notes Bok, "Alva felt that her real career had at last begun."

Rising in the UN hierarchy, Myrdal took over UNESCO's Division of Social Sciences headquarters in Paris in 1950. She also continued to turn her formidable energies to her writing. As co-author with sociologist **Viola Klein**, she published *Women's Two Roles: Home and Work*. It addressed the fact that women in advanced industrialized countries now had a life expectancy of sufficient length that they could both raise a family and subsequently play an active role in the working world. The book appeared in 1956, by which time Alva Myrdal had been appointed Sweden's ambassador to India.

Alva's relationship with her husband remained a difficult one. The two had lived apart for several years, and Gunnar had engaged in at least one extramarital affair. He had also been severely injured in an automobile accident in 1952, an event that sapped much of his energy and confidence and pushed him into prolonged depressions. He wanted to resume living with Alva, but she was uncertain; renewing the marriage might limit her new-found independence.

Alva Myrdal represented Sweden with distinction over a five-year period that ended in

April 1961. She formed a cordial relationship with Jawaharlal Nehru, India's prime minister, whom she considered one of the world's great diplomats. Believing that Sweden's transition from economic backwardness to prosperity earlier in the century held some lessons for India, she interested herself in the problem of bringing some relief from poverty to the Asian country's masses. Her sense of personal well-being grew since she was free of immediate family obligations with children now grown and independent. Gunnar had embarked on an ambitious study of Asian economics, a project in which she assisted him while fulfilling her duties as diplomat, and she saw him on his extended visits to India.

Returning to Sweden in April 1961, Alva and Gunnar Myrdal resumed their life together. They settled in the capital where Gunnar had just taken a position at the University of Stockholm. She continued to perform tasks for the Swedish foreign ministry, and one of these, a report on possible disarmament proposals the foreign minister planned to present the United Nations, turned her interests in a new direction. Although Myrdal had never before been especially concerned with nuclear disarmament, it now became her passion: "Once I had begun, I was never able to stop the search for the why's and how's of something so senseless as the arms race." Her election in 1961 to the Swedish Parliament as a member of the Social Democratic Party gave her an official position from which to present her views.

Now traveling throughout Sweden to publicize the cause of disarmament, Myrdal resumed the role she had begun in the 1930s as an prominent public speaker. She became disappointed at the lack of solid information available about the arms race, and she promoted a plan for a Swedish research institute that could fill the gap. The government-supported Stockholm International Peace Research Institute (SIPRI) was founded in 1966. She had led the planning group that conceived of the organization. Myrdal herself served as SIPRI's first chair, resigning only upon becoming minister for disarmament in the Swedish government in 1967. She also served as Sweden's chief delegate to the UN Disarmament Commission.

Myrdal retired from her Cabinet post and her role as official arms negotiator in 1973 due to poor health. Her years as a Cabinet minister had helped bring on a bitter split in the Myrdal family. Her son Jan, a longtime political radical, had been arrested by the Swedish police in December 1967 as a result of a demonstration against the Vietnam war. When his parents failed to give him the personal and legal support he ex-

pected from them, he broke off relations with a sharp comment about "Alva's government."

Alva Myrdal had been continually frustrated by the inability of smaller countries to have any influence on the United States and the Soviet Union as the two superpowers conducted apparently fruitless talks over armaments and arms limitations. Despite suffering from high blood pressure and heart disease, she began to write *The Game of Disarmament,* which appeared in 1976. The book combined a warning to the superpowers about the perils of the arms race to both their domestic and international well-being with a discussion of feasible measures to reduce the store of existing armaments. Instead of accepting royalties on the book, she saw to it that copies were sold at the lowest price possible. She also arranged for the book to go without cost to all members of the U.S. Congress, and to key government officials throughout the world. In addition, Myrdal founded a number of organizations such as the Swedish Peace Forum and the European-wide Women for Peace to further the cause of disarmament.

In 1980, Myrdal received an initial honor for her disarmament efforts in the form of the Albert Einstein Peace Prize, given for a significant contribution in preventing nuclear war. This was followed two years later when she, along with Mexican diplomat and UN official Alfonso García Robles, won the Nobel Peace Prize for their work on behalf of international disarmament. The Myrdals were now unique as a family with two Nobel Prizes won in different fields. Gunnar Myrdal had received his award in 1974 for his work in economics.

In the closing years of her life, Alva Myrdal suffered from a number of devastating ailments. Following a stroke in 1984, she developed a brain tumor that impaired her ability to speak, and thereafter she lost the ability to write even a simple letter. Brain surgery failed to alleviate the problem. In her memoir of her mother's life, Sissela Bok wrote eloquently of the panic that Alva Myrdal experienced in these last years: a woman who had depended heavily on her ability to effect change through her speaking and writing, she now found herself helpless.

The distinguished writer and public figure died on February 1, 1986, in Stockholm, at the age of 84. Gunnar Myrdal survived her only briefly, dying on May 17, 1987. First in Sweden, then throughout large parts of the world, their scholarly achievements and their concern for remedying social ills had made them famous as "the Myrdal couple." Although for decades she

had devoted the bulk of her energies to her husband's career, Alva Myrdal emerged thereafter as his peer in respect and influence.

SOURCES:

Bok, Sissela. *Alva Myrdal: A Daughter's Memoir.* Reading, MA: Addison-Wesley, 1991.

Carlson, Allan. *The Swedish Experiment in Family Politics: The Myrdals and the Interwar Population Crisis.* New Brunswick, NJ: Transaction, 1990.

Current Biography. NY: H.W. Wilson, 1980.

Schlessinger, Bernard S., and Judith H. Schlessinger. *The Who's Who of Nobel Prize Winners, 1901–1995.* 3rd ed. Phoenix, AZ: Oryx Press, 1996.

Wasson, Tyler, ed. *Nobel Prize Winners: An H. W. Wilson Biographical Dictionary.* NY: H.W. Wilson, 1987.

SUGGESTED READING:

Scobbie, Irene. *Sweden.* NY: Praeger, 1972.

Neil M. Heyman,
Professor of History, San Diego State University,
San Diego, California

Myrtale (c. 371–316 BCE).

See Olympias.

Myrtis (fl. early 5th c. BCE)

Poet of the early 5th century BCE, probably from Boeotia.

The earliest known Boeotian poet, Myrtis taught the craft of poetry to the more famous Pindar and *Corinna. Although Pindar is better known to posterity than Corinna, Myrtis' students were frequent rivals in literary contests and Corinna is said to have defeated her more famous rival several times in head-to-head competition. After one such loss, Pindar angrily referred to his feminine nemesis as a "sow." Long after all of the principals were dead, it was alleged that Corinna's stunning beauty, not her poetry, was what led to Pindar's defeat, but such rationalizations for a woman's victory over a celebrated masculine rival were easily invented after the fact in antiquity. Whatever qualities as a poet Myrtis possessed (her work is lost), Corinna thought herself far superior to her teacher in talent, and perhaps rightfully so, since Corinna published some 50 books of poetry and had a statue erected in Tanagra, the Boeotian village of her birth. Nevertheless, Myrtis' contemporary fame was enough to attract to her school some of the best poetic talent of her time. Antipater of Thessalonica, writer of epigrams, described her poetry as "sweet-sounding." Corinna referred to the poet as "clear-voiced." A 2nd-century Christian writer, Tatian, wrote of a statue of Myrtis by the sculptor Boiscus.

The only known details of Myrtis' work come from the second-century Greek writer Plutarch, who wrote a prose-narrative paraphrase of her poem about a girl named Ochna. After being jilted by her lover Eunostus, Ochna falsely accuses him of rape. Her brother kills the innocent man and Ochna, overcome with guilt and grief, commits suicide by jumping off a cliff. The scenario is typical of Greek lyric poetry, which often laments lost love.

William Greenwalt,
Associate Professor of Classical History,
Santa Clara University, Santa Clara, California

Mysie.

Variant of Margaret.

Naamah

Biblical woman. A sister of Tubal-Cain.

Naamah (fl. 900 BCE)

Biblical woman. Daughter of the king of Ammon; one of 700 wives of Solomon (c. 985–c. 925 BCE), last king of the united 12 tribes of Israel; children: Rehoboam, also seen as Rehabam, king of Israel.

Naamah, one of the 700 wives of Solomon (I Kings 11:3), was apparently the only one to bear him a son. Rehoboam succeeded his father as king of Judah and presided over the collapse of the Israelite Empire. His reign started in either 931 or 922 BCE and lasted 17 years.

Naarah

Biblical woman. Second of two wives of Ashur, of the tribe of Judah.

Naci, Gracia (1510–1569).

See Nasi, Gracia.

Naddezhda.

Variant of Nadezhda, Nadia, or Nadya.

Nadeja or Nadejda.

Variant of Nadezhda, Nadia, or Nadya.

Nadejda Michaelovna (1896–1963)

Countess of Torby. Born in 1896; died in 1963; daughter of Michael Michaelovitch (grandson of tsar Nicholas I) and Sophia, countess of Torby; married George Mountbatten, 2nd marquess of Milford Haven, in 1916; children: Tatiana and David.

Nadejda of Bulgaria (b. 1899)

Duchess of Wurttemberg. Born on January 30, 1899; daughter of *Marie Louise of Parma (1870–1899) and Ferdinand I (1861–1948), king of Bulgaria (r. 1887–1918, abdicated); married Albrecht also known as Albert Eugene, duke of Wurttemberg; children: Ferdinand Eugen (b. 1925); Margareta Louise (b. 1928, who married the viscount de Sheringon); Eugen Eberhard (b. 1930), duke of Wurttemberg; Alexander Eugen (b. 1933); Sophie of Wurttemberg (who married Antonio Ramoo Baudena).

Naden, Constance Caroline Woodhill (1858–1889)

English poet and philosopher. Born on January 24, 1858, in Edgbaston, near Birmingham, England; died on December 23, 1889; daughter of an architect; educated at a Unitarian day school in Edgbaston, and studied science at Mason College under Herbert Spencer.

Selected works: Songs and Sonnets of Springtime (1881); A Modern Apostle and Other Poems (1887); Induction and Deduction and Other Essays (1890); contributed to journals, including Journal of Science and Knowledge.

Because her mother died just after her birth, Constance Caroline Woodhill Naden was raised by her grandparents, who sent her to a day school in Edgbaston. Her hopes of becoming an artist were crushed when the Birmingham Society of Artists rejected her paintings, but in 1881 she began to study science at Mason College in Birmingham. Her lessons were supervised by Herbert Spencer, the English philosopher who explained Darwin's theory of evolution.

On the death of her grandfather, Naden inherited a large sum of money, which enabled her to travel throughout Turkey, Palestine, Egypt, and India in 1887. She settled in London in 1888 and began giving public speeches on her philosophy. With Robert Lewins, she developed a philosophical system known as "Hylo-Idealism," a form of monistic positivism—the view that reality consists of one tangible substance. Her main ideas on the subject are contained in a posthumous volume of her essays (*Induction and Deduction*, 1890), edited by Lewins. In her lifetime, Naden published two books of poetry and one of philosophy and contributed essays to scholarly

journals. Her poems made such an impression on W.E. Gladstone that he included her among the foremost English women poets of the day in an article in the *Speaker*. Her intellectual career was cut short, however, as she died at age 30.

Catherine Hundleby, M.A. Philosophy, University of Guelph, Guelph, Ontario

Nadia.

Variant of Nadezhda or Nadya.

Nadig, Marie-Thérèse (1954—)

Swiss Alpine skier. Name variations: Marie-Therese Nadig. Born in Tannebolden, Switzerland, on March 8, 1954.

Won Olympic gold medals in the downhill and giant slalom in Sapporo, Japan (1972); won Olympic bronze medal in the downhill in Lake Placid, New York (1980); won the World Cup overall (1981), the downhill (1980, 1981), the giant slalom (1981), and the combined (1981).

Swiss skier Marie-Thérèse Nadig and Austria's *Annemarie Proell-Moser will be competitively linked in the history of skiing. At the start of the 1972 Olympic Winter Games in Sapporo, Japan, 18-year-old Proell-Moser was a clear favorite in two Alpine events and under intense pressure. She was the World Cup champion in 1971 and 1972 and had six World Cup titles in her career. Nadig, age 17, had never won a World Cup race. In a major upset, Nadig won the gold medal in the downhill with a time of 1:36.68, one-third of a second faster than Proell-Moser's time. A disappointed Proell-Moser had to make do with silver. Intent on avenging her loss, the Austrian skier tore down the giant slalom course with a sensational time of 1:30.75; Nadig came in at 1:29.90, proving that her previous win was not a fluke. Proell-Moser, who again had to settle for a silver medal, was so upset by her inability to take first place at the Olympics that she publicly retired in 1975.

Thus, Proell-Moser did not compete in the 1976 Olympics that took place in her own backyard in Innsbruck, Austria. Nadig barely competed as well. Stricken by the flu, she was too sick to ski in the downhill and placed 5th in the giant slalom five days later, disappointing her many fans. It was to be *Rosi Mittermaier's year. "After Sapporo," Nadig said later, "people expected everything from me. They expected me to win all the time, and after a while I didn't know where I was."

Proell-Moser came out of retirement after the 1976 Olympics and won several championships on the circuit. In the 1980 Lake Placid Olympics, the spotlight was on the same two competitors: Nadig and Proell-Moser. This time, Proell-Moser took the gold in the downhill while Nadig had to settle for the bronze. (*Hanni Wenzel walked off with an upset and the silver, along with two gold medals in other Alpine events.) For almost a decade, these two women from two small European nations dominated skiing.

SOURCES:
Markel, Robert, Nancy Brooks, and Susan Markel. *For the Record: Women in Sports*. NY: World Almanac, 1985.
Wallechinsky, David. *The Complete Book of the Winter Olympics 1998*. NY: Overlook Press, 1998.

Karin Loewen Haag, Athens, Georgia

Nadya.

Variant of Nadezhda or Nadia.

Nagaia, Maria (d. 1612).

See Maria Nagaia.

Nagako (1903–2000)

Empress of Japan. Name variations: Princess Nagako; Nagako Kuni; Showa empress. Born in Tokyo, Japan, on March 6, 1903; died in Tokyo on June 16, 2000; eldest daughter of Prince Kuni no Miya Kunihiko, also known as Kuni Kuniyoshi (a field marshal and member of the Fushimi house), and Princess Chikako Kuni (from the noble family of Shimazu, who ruled over the feudal clan of Satsuma); graduated from the girls' middle school department of Gakushuin; married Hirohito (Emperor Showa), emperor of Japan (r. 1926–1989), on January 26, 1924 (died January 7, 1989); children: Princess Shigeko (1925–1961, who married the son of Prince Higashikuni, the first postwar prime minister); Princess Kazuko (b. 1927); Princess Atsuko (b. 1929); Crown Prince Akihito (b. 1933), later emperor of Japan (r. 1989—); Prince Masahito (b. 1935); Princess Takako (b. 1939); another daughter, born in the 1920s, died within a year of her birth.

In February 1918, Crown Prince Hirohito became engaged to the beautiful Princess Nagako, the eldest daughter of Prince Kuni Kuniyoshi, a highly placed scamp who fathered some 19 children, only six with his wife, Princess **Chikako Kuni**. Hirohito was fortunate in that he was able to choose a bride he loved, although during their six-year betrothal, he saw Nagako only nine times and never alone. She was a member of the Satsuma clan and hence was attacked

for not being a Fujiwara. Moreover, she was criticized for a strain of color blindness in her lineage, something that supposedly would taint the imperial line. Yet on January 26, 1924, the marriage took place, and on December 25, 1926, Hirohito and Nagako became emperor and empress of Japan. In November 1928, when the couple were enthroned in Kyoto, it was the first time an empress-consort took part in such a ceremony.

Puritanical in his lifestyle, Hirohito was monogamous, always remaining faithful to Nagako, and the couple would have seven children. The public and court officials grew unnerved, however, when she produced four daughters in a row: **Shigeko** (b. 1925), **Kazuko** (b. 1927), **Atsuko** (b. 1929), and one who died before age two. It was assumed that if the fifth child was a girl, Hirohito would officially take another consort. Their fifth, born to booming cannons, was son Akihito. Though Nagako astounded the public when she fed her son herself, royal convention eventually won out: at age three, he was taken from his parents and raised by attendants. She saw her son only one day a month.

For many years, Empress Nagako was Japan's "most endearing public figure," writes the London *Times*, "a smiling face in a court known for its dour inscrutability. Throughout Emperor Hirohito's reign, she was said to have lent 'genuine warmth to deadly dull imperial ceremonial,' occasionally putting a citizen at ease with a conspiratorial wink."

Historians continue to debate how much responsibility Hirohito had for World War II. Most think he was a puppet of the Japanese military. Less is known about Nagako's views on the war; during the conflict, she knitted scarves for the generals. She once described those years as "the hardest time of my life." When Hirohito surrendered, Nagako wrote to Akihito: "You father has worried every day. Although it was regrettable, Japan has been saved for good through the decision. I have to admit that B29s are well-built planes." The United States placed the blame for Japanese aggression on Prime Minister Hideki Tojo, and Hirohito was allowed to remain an emperor, though he had to deny his divinity.

Though she remained a traditionalist, Nagako seemed willing to change after the war (when American *Elizabeth Gray Vining began to teach English to Akihito, Nagako asked for lessons, too). But customs die hard, writes Nicholas D. Kristof, and Nagako was critical of her daughter-in-law, *Michiko, Akihito's wife, "for carrying her babies in public, for breast-feeding them and for trying to raise and shape her chil-

Nagako

dren herself." There was much friction between Nagako and the college-educated commoner, and their relationship would remain strained.

Nagako worked served as honorary president of the Japanese Red Cross Society. A talented artist, she was also known for her Japanese-style paintings, which she signed with the name Toen. Two collections of her works were published: *Toen gashu*, 1967, and *Kimposhu*, 1969. She was also an able singer and could play the piano, violin, and Japanese harp. Nagako became Japan's longest living empress dowager when she turned 92 in 1995, surpassing Empress **Kanshi**, who died in 1127. By then, Nagako had not been seen in public for years, living quietly in a modest home on the grounds of the Imperial Palace in Tokyo; her last official event was the 86th birthday celebration of Hirohito on April 29, 1987. She was too feeble to attend his funeral when he died in 1989.

SOURCES:

"The Dowager Empress of Japan," in *The Times* [London]. June 17, 2000, p 26.

Kristof, Nicholas D. "Dowager Empress Nagako, Hirohito's Widow, Dies at 97," in *The New York Times* (obituaries). June 17, 2000.

Nagle, Nano (1718–1784)

Irish philanthropist who, in defiance of penal legislation, established a number of poor schools and other charitable projects in Cork, introduced the Ursuline Order to Ireland, and founded her own congregation, the Presentation Order, which set a precedent for the involvement of nuns in social work. Name variations: Honora Nagle. Born Honora Nagle in 1718 (some sources incorrectly cite 1728) at Ballygriffin, County Cork, Ireland; died at South Presentation Convent, Cork, on April 26, 1784; daughter of Garret Nagle (a gentleman) and Ann (Mathew) Nagle; educated in France.

Entered a convent in France as a postulant but, convinced that her vocation lay in Ireland, returned home permanently (c. 1748); opened her first school for poor girls (c. 1755); had seven such schools, all in Cork (by 1769); launched other enterprises which included an almshouse for old women, and sick visiting and missionary work among the poor; invited the Ursuline Order to Ireland; opened first convent in Cork (1771); finding the Ursulines were prevented by their vows of enclosure from taking over all of her charitable projects, established her own congregation, the Sisters of the Charitable Instruction, later the Presentation Order (1775); received the religious habit as Sister St. John of God (1776); took her final vows and confirmed as superior of the congregation (1777).

When Nano Nagle opened her first school for poor girls sometime in the early 1750s, she was not only initiating a new departure in the field of female education, she was also acting in contravention of the law of the land. The victory in 1691 of the forces of William III over the Catholic king James II confirmed the ascendancy of the Protestant landowning class, and throughout much of the 18th century Catholics in Ireland were subject to a code of legislation which discriminated against their practice of religion, their access to education, the professions and politics, and their control of property. The extent to which the laws were applied varied widely: enforcement was strict in the early years of the century and at times of war or threatened invasion, but slackened after mid-century. Nevertheless, the main thrust of the legislation was to ensure that the ownership of land and, consequently, political influence were concentrated in Protestant hands, and in this aim it was largely success-

ful. In 1778, when the laws began to be dismantled, Catholics, who formed about 75% of the total population, held only 5% of the land, and throughout the 18th century the Parliament in Dublin was an exclusively Protestant body.

In the field of education, Catholics were forbidden by law to teach or to operate schools, and a system of charity or "charter" schools was established, through which children might be instructed in the Protestant faith. In fact, this scheme had a limited effect, and Catholic schools continued to operate illegally throughout the penal era. However, the great majority of these were for boys. While a few convent boarding schools did exist, these were fee-paying institutions, catering for girls of the Catholic upper and prosperous middle classes. Until Nano Nagle began her work in the mid-18th century, therefore, there were no schools in Ireland which could provide a free, Catholic education to the daughters of the poor. ❧▶ **Teresa Mulally**, who in 1766 opened the first Catholic school for girls in Dublin and who was to become a close friend and associate of Nano Nagle, described the plight of these "poor children of the female sex":

> They suffer all the hardships of extreme poverty; but their poverty, extreme as it is, is not the worst of their miseries. Their chief misfortune is to be without any means of instruction; for want of which they grow up in such habits of ignorance, idleness and vice, as render them for ever after not only useless, but highly pernicious to themselves and the public.

Nano herself was born into a relatively privileged sector of Irish society, the eldest of seven children of Garret and **Ann Nagle** of Ballygriffin in County Cork. Both parents were members of landed gentry families, and the Nagles, despite their Catholicism and their associations with the defeated Jacobite cause, had succeeded in retaining a considerable proportion of their ancestral lands. Nano was a high-spirited and vivacious child: this liveliness, according to her first biographer, Dr. Coppinger, was discouraged by her mother as behavior unbecoming in a young lady, but Garret Nagle defended his daughter and unwittingly anticipated her future career by declaring that "poor Nano would be a saint yet." Having received her earliest schooling at home, Nagle, like many other girls of her class, was sent to complete her education in France. After leaving school, she and her sister **Ann** remained for a number of years in Paris, where the Nagles had many friends and relatives among the Irish émigrés living there and where they enjoyed the attractions of fashionable Parisian society.

About 1746, Garret Nagle died, and Nano returned to Ireland, settling with her widowed mother and sister in Dublin. While she had, during her stay in Paris, become aware of the contrast between her own circumstances and those of the great majority of the poor, it was the example of her sister Ann which pointed her towards a more active vocation. Mother **Clare Callaghan**, writing around 1800, described the impact on Nagle of one particular incident and of Ann's subsequent death:

> She was one day requesting her sister to get made up a splendid suit of silk which she had brought for that purpose from Paris; and she was both astonished and edified when her sister disposed of the silk to relieve a distressed family. Such an action, with the death of that sister soon after and her uncommon piety before it, wrought much on the heart of Miss Nagle and served to disengage it from the fashionable world which she had tasted and enjoyed until then.

The extent of distress in 18th-century Ireland was noted by many observers: one, writing in 1738, warned that, on arrival in Dublin, "the first thing that you'd be encountered with would be the dismal prospect of universal poverty." Nagle could not fail to notice such conditions, but her concern was as much for the ignorance of religion which she noted among the poor as for their miserable physical state. As Coppinger described it:

> Her attention was soon engaged by . . . the ignorance of the lower classes here, their consequent immorality, and the ruin of their souls. . . . While they kept up an attachment to certain exterior observances, they were totally devoid of the spirit of religion; their fervour was superstitious, their faith was erroneous, their hope was presumptuous, and they had no charity.

While wishing to remedy these evils, Nagle was daunted by the difficulties involved: these included not only the restraints imposed by the penal legislation, but also the cost of such an initiative and its doubtful chances of success, as well as her own ill health. She chose instead to withdraw from the evidence of such distress, and to return to France with the intention of entering a convent there. She was unable, however, to rid herself of the conviction that her vocation lay elsewhere. Having consulted various spiritual advisers, she found that they approved her wish to return to Ireland in order to teach poor children there. Given her deep religious faith and the interaction between that and her philanthropy, this support was decisive. "Nothing would have made me come home," she told her friend, **Eleanor Fitzsimons**, many years later, "but the decision of

❧➤ Mulally, Teresa (1728–1803)

Irish educator. Born in Ireland in 1728; died in 1803.

Teresa Mulally worked as a milliner for several years before she retired around 1762 to devote herself to charitable work. She founded the first Catholic school for poor girls in Dublin in 1766 and an orphanage in 1771, which was eventually handed over to the Presentation Order which she introduced into Dublin in 1794. Though Mulally did not take vows, she managed the affairs of the school and convent until her death.

the clergyman that I should run a great risk of salvation if I did not follow the inspiration."

Nano returned to Ireland, settling with her brother and sister-in-law, Joseph and **Frances Nagle**, in Cork. There, unknown to her family, she rented a cabin, in which she set up a school for poor girls. She later described this period to Fitzsimons:

> When I arrived I kept my design a profound secret, as I knew, if it were spoken of, I should meet with opposition on every side, particularly from my immediate family as in all appearance they would suffer from it. My confessor was the only person I told of it; and as I could not appear in the affair, I sent my maid to get a good mistress and to take in thirty poor girls. . . . And, by degrees, I took in the children, not to make a noise about it in the beginning. In about nine months I had 200 children.

In setting up her schools, Nano was flouting the law which forbade Catholic education, and feared that her activities would bring trouble on her family. Her brother discovered the school's existence, wrote Nagle, only when "a poor man came to him, begging of him to speak to me to take his child into my school. On which he came in to his wife and me, laughing at the conceit of a man who was mad and thought I was in the situation of a school-mistress." In fact, the Nagles suffered no ill effects as a result of her work and, having become aware of it, offered encouragement and generous financial support. From her uncle Joseph Nagle, a wealthy Cork lawyer, she inherited "the best part of the fortune I have," which she used to expand her projects. By 1769, she had seven schools in various parts of Cork, two for boys and five for girls. The curriculum within these schools was narrow, but designed to provide academic and vocational training which would equip pupils with a future means of livelihood: the boys learned reading, writing, and arithmetic, the girls reading and needlework. However, Nagle's primary concern

in establishing her schools had been to offer spiritual instruction, and this was reflected in the centrality of religion in the teaching program and daily routine. Pupils heard mass, had morning and evening prayers and said the catechism together every day, and went to confession monthly. Nagle herself took responsibility for religious teaching, preparing pupils for their first communion and instructing them in the catechism. She found this aspect of her work deeply fulfilling, declaring wryly, "I often think my schools will never bring me to heaven, as I only take delight and pleasure in them."

The expansion of the schools forced Nagle to consider how they could be most effectively maintained and their survival ensured beyond her own lifetime. The obvious solution was to place them in the hands of one of the female religious orders, thus providing for their continuance within a permanent and securely Catholic structure. However, none of the communities then operating in Ireland were in a position to undertake this charge. While a few orders had remained in the country throughout the penal era, their freedom of action was restricted not only by the anti-Catholic legislation but also by the insistence of the Counter-Reformation church on the rule of enclosure for female religious, which prevented nuns from engaging in active social or teaching work outside their own convent enclosures. Nagle, therefore, turned once more to France, where the Ursuline Order had a number of schools for poor children as well as for the daughters of the French aristocracy. In response to her enquiries and encouragement, several young Irish women entered the Ursuline convent in the Rue St. Jacques in Paris in order to begin their novitiate. Meanwhile, Nagle supervised the building of a convent to receive them, and in May 1771 four novices, together with a mother superior, arrived from Paris to establish the first Ursuline foundation in Ireland, in Cove Lane in Cork. Six months later, in January 1772, the Ursulines opened a fee-paying school there. Twelve girls were admitted initially, but the demand for places soon made it necessary to extend the premises.

However, a difficulty soon arose in relation to the running of the poor schools, only one of which was situated within the Ursuline enclosure. While the Ursulines had been founded by *Angela of Brescia in 1534 as an unenclosed sisterhood whose members would devote themselves to an active apostolate within the wider community, their vows were subsequently amended under pressure from the ecclesiastical authorities to include strict enclosure. In choosing the order to take over her charities, Nagle had clearly failed to appreciate the limitation on their ability to do so, and she was now forced to consider an alternative course of action. Overriding the objections of the Ursulines and of the parish priest, Dr. Moylan, she took the decision to establish an entirely new type of foundation, an unenclosed congregation, whose members would be free to undertake an active apostolate entirely among the poor. In doing so, she created a precedent for female religious orders: the establishment of the Society of the Charitable Instruction of the Sacred Heart of Jesus, later the Presentation Order, marked the opening of a remarkable period of growth in Irish religious life and served as a model for the missionary and social role of nuns in 19th-century Ireland.

In January 1775, Nagle, with two associates, **Mary Fouhy** and **Elizabeth Burke**, took up residence in Nano's cottage in Cove Lane. A year later, they were joined by **Mary Ann Collins**, and on June 24, 1776, all four women took vows as Sisters of the Sacred Heart of Jesus. Soon afterwards, the community moved to a new convent, but despite the gradual relaxation of the penal laws, the nuns were still forced to act discreetly, as Nagle's account of their move reveals:

> [I] waited till the times seemed quite peaceful, yet notwithstanding we stole like thieves. I got up before three in the morning [and] had all our beds taken down and sent to the House, before any was up in the street. [I] begged of the ladies not to say a word about it to anyone . . . nor did [I] not let any person know if in the town of my friends, as I was sure [that by] acting in this manner the good work could be carried on much better than in making any noise about it.

Despite these misgivings, however, the nuns were allowed to continue peacefully in their work. This included not only teaching in the poor schools, but also Nagle's many other charities, notably the visitation and care of the old and sick. On Christmas Day 1777, the sisters, including Nano, inaugurated a longstanding tradition by entertaining 50 beggars to dinner, and in 1783 Nagle reported to her friend Teresa Mulally that she was building an almshouse for elderly women.

In 1778, Mulally visited Cork in order to discuss with Nagle the establishment of a similar foundation in Dublin. The meeting between the two was remembered some years later by a traveling companion, who has also left the only contemporary description of Nagle's physical appearance:

> The first morning after our arrival in Cork, there came a rap at our chamber door at six o'clock. . . . [T]here entered a little elderly woman with a shabby silk cloak, an old hat

Nano
Nagle

turned up, a soiled dark cotton gown, and a coarse black petticoat, drabbled halfway and dripping wet—for it had rained heavily. When she announced her name to be Nagle, they embraced for the first time with hearts congenial. . . . Miss Mulally introduced me to her. I asked her was she not afraid of taking cold. "No," she replied, "I was once suscepti-ble enough of it, but now I feel nothing."

Despite her age and worsening health, and the austerities and penances to which she sub-jected herself, Nagle continued to participate fully in the work of her foundation. On the day before the onset of her final illness, her colleague

Sister **Angela Fitzsimons** told Mulally, "She went as usual to all her schools, and was penetrated with rain, as of late she walked so slow." On the following day, Nagle set out as usual, but was forced by weakness to turn back. She died a few days later, on April 26, 1784, and was buried in the graveyard of the Presentation Convent which she had founded.

In the years immediately following Nano Nagle's death, her community encountered a number of crises. The funds which she left in her will for its support were misappropriated by the

administrator of her estate, and new aspirants were slow to come forward. In 1793, however, a new foundation was established in Killarney, and by the end of the century the Society also had houses in Dublin and in Waterford, and a second foundation in Cork. During the 19th century, it established itself all over Ireland as well as in England, the United States, Newfoundland, Australasia, and India as the Presentation Order. However, Nagle's importance lies not merely in the success of her own sisterhood. Her congregation was the first example of a new pattern of female religious life, which in the next century allowed nuns to become involved in the running of a whole range of work projects, including the management of hospitals, orphanages, hostels, and industrial schools. Above all, however, nuns were to play a vital part in the development of educational opportunities for Irish Catholic girls. These achievements were not confined to Ireland, a fact which would have delighted Nagle. "I can assure you my schools are beginning to be of service to a great many parts of the world," she told a friend in 1769, "and my views are not for one object alone. If I could be of any service in saving souls in any part of the globe, I would willingly do all in my power." Through the expansion of the Presentation Order and the work of many thousands of other Irish nuns abroad, these hopes were realized, and the work of Nano Nagle assumed an international as well as a local significance.

SOURCES:

Coppinger, Dr. *The life of Miss Nano Nagle, as sketched . . . in a funeral sermon preached in Cork on the anniversary of her death.* Cork, 1794.

O'Rahilly, Professor Alfred. "A letter about Miss Mulally and Nano Nagle," in *Irish Ecclesiastical Record.* 5th series. Vol. XL, 1932, pp. 474–481, 619–624.

Walsh, T.J. *Nano Nagle and the Presentation Sisters.* Dublin, 1959.

SUGGESTED READING:

Burke Savage, Roland. *A Valiant Dublin Woman: The Story of George's Hill.* Dublin, 1940.

Clear, Caitriona. *Nuns in Nineteenth-century Ireland.* Dublin, 1987.

Corish, P.J. *The Irish Catholic Experience.* Dublin, 1985.

Liebowitz, Ruth. "Virgins in the service of Christ: the dispute over an active apostolate for women during the counter reformation," in *Women of Spirit.* Edited by Eleanor McLaughlin and Rosemary Ruether. New York, 1979, pp. 131–152.

Raughter, Rosemary. "Female charity as an aspect of the Catholic resurgence 1750–1800," in *Pages: Arts Postgraduate Research in Progress, University College.* Vol. l. Dublin, 1994, pp. 27–36.

COLLECTIONS:

Archives, Presentation Convent, George's Hill, Dublin; Archives, South Presentation Convent, Cork.

Rosemary Raughter,
freelance writer in women's history, Dublin, Ireland

Nagródskaia, Evdokiia
(1866–1930)

Russian writer. Name variations: Evdokiia Nagrodskaia; Evdokia Nagrodskaia or Nagrodskaya. Born Evdokiia Apollonovna Golovacheva in Russia in 1866; died in 1930; daughter of Avdot'ia Panáeva (c. 1819–1893, a fiction and memoir writer) and Apollon Golovachev (a journalist); married.

Born in Russia in 1866, Evdokiia Nagródskaia was the daughter of Apollon Golovachev, a journalist, and **Avdot'ia Panáeva**, a fiction and memoir writer who played a major role in editing the liberal journal *The Contemporary* (1848–63). Nagródskaia's debut novel *The Wrath of Dionysus* created an uproar when it was first published in 1910. The bestseller's exploration of sexual and gender disorientation, unmarried mothers and women trying to balance family and career, was so popular that it went through ten international editions in only six years, and it later became the basis for a silent film that was considered racy for its time. The reputation she earned for this novel helped fuel sales of her later works, which included short stories, novels, poetry and a play.

Nagródskaia's novels are briskly paced, direct, and colored with some of the familiar themes of her era, including mystical faith, fantasy, art, androgyny, and distrust of reason. She emigrated to France with her husband following the 1917 Revolution in Russia, where her works lost favor in the changing political climate. In France, she published the historical trilogy *The River of Time* (1924–26), as well as one other novel, and died in 1930. In 1997, the first English-language translation of *The Wrath of Dionysus* was published by Indiana University Press and was hailed for its striking relevance to modern-day women.

SOURCES:

Buck, Claire, ed. *The Bloomsbury Guide to Women's Literature.* NY: Prentice Hall General Reference, 1992.

Publishers Weekly. August 11, 1997, p. 243.

Jacquie Maurice,
freelance writer, Calgary, Alberta, Canada

Nahienaena (c. 1815–1836)

Hawaiian princess. Born around 1815; died on December 30, 1836; daughter of Keopuolani (c. 1778–1823) and Kamehameha I the Great (1758–1819), king of Hawaii (r. 1810–1819); sister of Liholiho known as Kamehameha II (1797–1824), king of Hawaii (r. 1819–1824) and Kauikeaouli (1814–1854), later known as Kamehameha III, king

of Hawaii (r. 1824–1854); trained under the missionaries; married her brother Kauikeaouli (Kamehameha III), in 1834; married Leleiohoku (a chief), in 1836.

Born around 1815, Nahienaena was the daughter of *Keopuolani and Kamehameha I the Great, king of Hawaii. When her mother died, Nahienaena was entrusted to the mission in Lahaina for her Christian and secular education and to the Hawaiian chiefs for "moral guidance," splitting her allegiance in two very different ways. As was customary, Nahienaena wanted to marry her brother Kauikeaouli (Kamehameha III). Though the chiefs were delighted with the idea, the missionaries were appalled and convinced some of the chiefs to forbid it. For some time, the baptized Nahienaena, under continual scrutiny for the sake of her Christian soul, tried to follow the way of the missionaries, but her spirit was conflicted. In 1834, she married her brother. When neither the court nor the missionaries would recognize the nuptials, Nahienaena despaired. In 1835, she was excommunicated from the church for drunkenness. The following year, she married Leleiohoku, a young chief. That September, she gave birth to a son who died within a few hours. Three months later, on December 30, 1836, Nahienaena also died, from effects of childbirth. It is said that the baby was the offspring of Nahienaena and her brother, the king.

Naidu, Sarojini (1879–1949)

Indian poet and patriot, known equally for her lyric works in English that celebrate the Indian spirit, her association with Mohandas Gandhi, Nehru, and other leaders of the Indian independence movement, and her own role as a politician in colonial and post-independence India. Name variations: Sarojini Chattopadhyaya; Nayadu or Nāyadu. Pronunciation: Seh-row-JEE-nee NIE-doo. Born on February 13, 1879, in Hyderabad, India; died on March 2, 1949, in Lucknow, India, after suffering a head injury; daughter of Aghorenath Chattopadhyaya (a doctor and principal of Nizam's College, Hyderabad) and Varada Sundari (Devi) Chattopadhyaya (also seen as Shrimati Sundari Devi); married Govindurajulu Naidu (a doctor), in December 1898; children: Jayasurya Naidu; Padmaja Naidu; Ranadheera Naidu; Lilamani Naidu.

Born the eldest daughter of the highly educated Chattopadhyay family (1879); matriculated with a First Class and honors at Madras (1891); traveled to England to study at King's College, London, and at Girton College, Cambridge (1895–98); health perma-nently damaged by a breakdown (1896); published first volume of poetry, The Golden Threshold (1905); won Kaiser-i-Hind Gold Medal from Government of India (1908); sailed to England for medical treatment and became an associate of Mohandas Gandhi (1914); entered national politics as speaker for women's education and rights and Hindu-Muslim unity (1915); returned Kaiser-i-Hind Gold Medal in protest over Jallianwala Bagh massacre (colonial repression of Indian freedom movement); elected president of Indian National Congress (1925), and All India Women's Conference (1930); jailed for independence activities (1930–31, 1932–33, 1942–43); elected president of Asian Relations Conference, New Delhi (1947); served as governor of the province of Uttar Pradesh, India (1947–49).

Selected works: Songs (privately published, Hyderabad, India: 1896); The Golden Threshold (London: Heinemann, 1905); The Bird of Time (London: Heinemann, 1912); The Gift of India (reprinted from the report of the Hyderabad Ladies' War Relief Association, 1914–15); The Broken Wing (London: Heinemann, 1917); The Soul of India (1st ed., Hyderabad, India, 1917, 2nd ed., Madras, India: Cambridge Press, 1919); The Sceptered Flute: Songs of India (NY: Dodd, Mead, c. 1928); The Feather of the Dawn (Bombay, India: Asia Publishing House, 1961); Speeches and Writings of Sarojini Naidu (3rd ed., Madras, India: G.A. Natesan, [n.d.]).

Sarojini Naidu, nicknamed "The Nightingale of India" by Mohandas (Mahatma) Gandhi, was one of the most influential women in India in the 20th century. "She was not only the first Indian woman to become the President of the Indian National Congress," writes Makarand Paranjape, "but also the first woman Governor of a state in independent India. As one of the principal aides and followers of Mahatma Gandhi, she was constantly in the limelight. . . . She also had an international presence as India's cultural ambassador and spokesperson of the freedom movement." Naidu had a strong character in her own right. She won the right to study in England at age 15, contracted a marriage outside her caste at age 19, and had four children by the time she was 25; she was, at the same time, an important poet writing in English. At age 68, she was made governor of Uttar Pradesh, the most populous province of modern India. "Sarojini was an unorthodox and irrepressibly candid person," Paranjape continues, "one who could poke fun at Gandhi himself, not to speak of his more solemn, humourless and puritanical coterie. Her letters to her children . . .

reveal her as a chatty correspondent, revelling in caricature and witty gossip."

Naidu's character was undoubtedly molded by her family environment. She was the eldest child of **Varada Sundari Devi** and Dr. Aghorenath Chattopadhyaya, a professor of chemistry who later became president of Nizam College in Hyderabad. "Sarojini was brought up in the liberal intellectual and imaginative milieu of her father's home at Hyderabad," writes K.R. Ramachandran Nair, "steeped in both Hindu and Muslim cultural traditions. The early flutterings of the Nightingale were prompted by her vast reading in English literature, Hindu mythology and Urdu and Persian folklore." Sarojini was largely taught at home, learning first with her father and then with a succession of tutors. So successful was she in this process that she received a First Class award in the matriculation exams at Madras in 1891—comparable to a modern preteen passing the entrance examinations to a large American university. This was an astonishing feat for such a young girl, writes Padmini Sengupta in *Sarojini Naidu: A Biography*. "Her success was all the more surprising as the examination in 1891 was by no means easy. Neither were girls accustomed to attending school in the higher classes. Sarojini's syllabus consisted of English, a second language, Science, Mathematics, History and Geography. Some of the questions were of the B.A. standard of today." "While it was a tremendous achievement for a girl to have passed her matriculation with a First Class at the age of twelve," notes Tara Ali Baig in his biography *Sarojini Naidu*, "her mental age must have been much greater than that of her contemporaries. . . . Philosophy, science, botany, alchemy, mathematics and politics would have been such concrete elements of daily life that learning was almost by osmosis and a process infinitely more fascinating and stimulating than routine studies in school."

If I could write just one poem full of beauty and the spirit of greatness, I should be exultingly silent for ever; but I sing just as the birds do, and my songs are as ephemeral.

—Sarojini Naidu

Sarojini and other members of her family always acknowledged the influence their parents had on their careers. Her brother Harindranath felt the Chattopadhyayas were "not merely human parents," rather they were:

> rare spiritual beings, high points of evolution, two truly unworldly lights walking through the darkness of life, illuminating it

wherever they walked, casting hope and blessing on whomever they met on life's roadway; and they, Father and Mother, were one, absolutely one, sharing striking qualities of generosity and the wisdom of an unfaltering love of humanity.

Naidu also wrote of her own relationship with her father. "I don't think I had any special hankering to write poetry as a little child, though I was of a very fanciful and dreamy nature. My training under my father's eye was of a sternly scientific character. He was determined that I should be a great mathematician or a scientist, but the poetic instinct that I have inherited from him and also from my mother (who wrote some lovely Bengali lyrics) proved stronger." Dr. Chattopadhyaya was also a social revolutionary, who protested the government's secret award of a contract to a British firm in the expansion of the state railway from Hyderabad to Wadi. When Chattopadhyaya demanded that the facts of the deal be made public, he was suspended from his job in Hyderabad. "I was too young in those far off years to understand clearly or appreciate correctly the significance of their passion and their faith," Naidu wrote years later; "nor was I able to realise till long afterwards that men like these were the first though perhaps not among the most famous pioneers of the Indian renaissance."

Varada Sundari's influence was also important. "Like her husband," writes Baig, "she was a linguist . . . and she spoke to her husband in Bengali, to her children in Hindustani and to the servants in Telegu and she knew enough English to converse with her European friends, and even to write letters to them." Continues Baig:

> She had the poetic strain in her, having composed some lyrics in Bengali, in her youth and was fond of singing too in her bird-like voice. She is reported to have won the Viceroy's gold medal for singing when a student in her village school in Bengal. . . . She was a Hindu lady in the true sense, possessed as she was of an infinite capacity for love and suffering.

Naidu's introduction to the writing of poetry came, by her own account, at a very early age. "One day when I was eleven," she wrote, "I was sighing over a sum in Algebra; it *wouldn't* come right; but instead a poem came to me suddenly. I wrote it down. From that day my 'poetic career' began. At thirteen I wrote a long poem *à la* 'Lady of the Lake'—1300 lines in six days. At thirteen I wrote a drama of 2000 lines. . . . I wrote a novel, I wrote fat volumes of journals. I took myself very seriously in those days." The poem written at age 13 still exists. "It was actu-

ally published as '*Mehir Muneer: A Poem in Three Cantos* by a Brahmin Girl' in 1893, when Sarojini was fourteen," writes Paranjape.

Naidu's success in the matriculation exams won her a scholarship to attend college in Eng-

land; she left for London in 1895. One added inducement to leave the country, her biographers agree, was her early attachment for Dr. Govindarajalu Naidu, "a widower ten years her senior," according to Ramachandran Nair, "who belonged to a different caste." She fell in love

with him at age 15, the year before she left for England, and promised herself that they would one day be married. Most biographers agree that Sarojini's parents opposed the marriage, but they differ about the reasons why. Earlier biographers concluded that Govindarajalu Naidu's caste was the deciding factor; the Chattopadhyayas were Brahmins of the highest caste and traditionally could only marry other Brahmins. Caste "could, however, not have been the main [reason] for stopping the marriage," states Sengupta, "for Aghorenath was a staunch reformer and himself threw away his sacred thread"—the emblem of his status as a Brahmin. "The more likely cause was, no doubt, the fact that Sarojini was far too young to marry. She was scarcely fifteen and Aghorenath himself had spoken strongly against child-marriage." Many of Sarojini's early works, written while she was at school in England, express her love for Govindarajalu and her feelings at being separated from her intended husband, her family, and her country.

Sarojini's years in England marked the emergence of her poetic talent. "The early poems show a strain of melancholy born out of loneliness, a combination of fantasy and delight and an unbelievable command over words, phrases, rhythm and rhyme—traits which would be developed to perfection in her later poems," explains Ramachandran Nair. "Two English critics, Edmund Gosse and Arthur Symons, were struck by the unusual charm of Sarojini's poems." Gosse in particular encouraged the young girl; Sengupta says that he "beseeched Sarojini not to write of English robins and sky-larks and of 'village bells' calling 'parishioners to church' but to set her poems firmly among the mountains, the gardens, the temples, to introduce to us the vivid populations of her own voluptuous and unfamiliar province; in other words, to be a genuine Indian poet of the Deccan, not a clever machine-made imitator of the English classics." Sarojini took Gosse's advice, and many of the Indian-themed poems she produced during the remainder of her time in England and Europe appeared in her first collection of verse, *The Golden Threshold* (1905).

Upon her return to India in 1898, Sarojini promptly married Govindarajalu Naidu. She was still only 19, but the marriage proved a happy and fruitful one. She settled with her husband in Hyderabad and had four children. She also produced nearly all the works that make up her poetic *oeuvre* during the same period, the first two decades of the 20th century. "In the early years," writes Baig, "poetry was the main focus of Sarojini Naidu's intellectual life; the

centre of her inner being. This was understandable, living as she did in the heart of the finest Islamic culture; for Hyderabad had retained all the glamour and values of princely Persia and its ruling Prince was a poet of great distinction. . . . Here, as in the past in Islamic societies, poets were the conscience and sensitive heart-strings of the people. They used the technique of versifying to explore the depths of the soul and emotions. Poets could do no wrong; their vision was acclaimed; their wisdom and insight became the catchwords of the people."

Sarojini's own poetry was acclaimed by many of her contemporaries for its light, delicate sense of rhythm and its evocation of a romantic, mystical India. Many of the poems from *The Golden Threshold* evoke the songs of the common people. "Though several of her themes are light and ephemeral," writes Ramachandran Nair, "Sarojini's poetry is intensely Indian. She has poetised the sights and sounds, situations and experiences familiar to us. Though she reached the peaks of excellence only rarely, for sheer variety of themes, range of feelings, colour, rhythm, fancy and conceit, metaphor and similes Sarojini remains unsurpassed even today." The poems in *The Golden Threshold* are the kind of songs that Varada Sundari might have sung to her daughter, such as the famous "Palanquin-Bearers":

> Lightly, O lightly, we bear her along,
> She sways like a flower in the wind of our song;
> She skims like a bird on the foam of a stream
> She floats like a laugh from the lips of a dream.
> Gaily, O gaily we glide and we sing,
> We bear her along like a pearl on a string.

Naidu won the Government of India's Kaiser-i-Hind Gold Medal in 1908 in recognition of her accomplishments. English critics would eventually reject her aesthetic as Edwardian fluff and nonsense, and post-Independence Indian critics, on anti-colonial grounds, would object to her use of English and European-style lyrics. Toward the close of the 20th century, however, critics viewed Naidu's poetry and other early writings as expressing, in a very subdued manner, a protest against colonialism and the loss of Indian traditions to the modern, mechanized world. "As a sensitive Indian living in the semi-feudal state of Hyderabad, part of the larger British Empire in India," Paranjape explains, "Sarojini, like other Indian artists and intellectuals, had to deal with the question of cultural preservation and identity."

Using conventions derived from Sanskrit and Persian-influenced Urdu poetry, and types and attitudes classified in other Indian sources, Naidu

attempted to preserve a picture of traditional India. "What Sarojini tried to do was to offer an entry into this unspoiled India," writes Paranjape. "Of course, it would have been too painful to portray it with all the horrors of its poverty, inequality, disease, and suffering; if only these were glossed over, then a very attractive image of India would emerge, traditional, vivid, vibrant, colourful, and joyous. All these factors contributed to her attempt at offering to Indians a picture of themselves which they might be proud of, something that might salvage some of their crippled self-respect as a colonized and humiliated people."

In this sense, Sarojini's poetry led directly to her role in Indian politics and the struggle for Indian independence. She applied the same talent seen in her poetry to public speaking. "Sarojini Naidu ranks among the best speakers in English whom India has ever produced," writes Sengupta. "As her main subjects were national freedom, the emancipation of women, messages to the youth of India, and Hindu-Moslem unity, she was in great demand in all parts of India the moment it was realised that a young Indian girl with a golden voice was available. Sarojini concentrated mostly on these four subjects, which were the burning topics of the day." Naidu met the man most responsible for her political career, Mohandas Gandhi, while visiting England in 1914. "On seeing him," writes A.N. and Satish Gupta, "at first she burst into peals of happy laughter, for he could present to her an amusing and unexpected vision of a famous leader. He lifted his eyes and laughed back at her and offered her the meal he was taking, which as she says, was an 'abominable mess.'" Nonetheless from this point on, Naidu and Gandhi were lifelong allies in an association that would last until the Mahatma's assassination in 1948.

By the time of her meeting with Gandhi, Naidu already occupied an important position among English-language writers, and was ranked with another Indian poet, Rabindranath Tagore, in English literature. However, after the publication of *The Broken Wing* (1917), says Ramachandran Nair, she "did not write any substantial poetry; the poet in her gave place to the fiery patriot." She took part in protests against the colonial government in November 1921 and read the presidential address to the Indian National Congress the following month. She was elected president of the Indian National Congress at Kanpur in 1925, succeeding Gandhi. In 1928, she lectured in America on the problems of Indian independence and the rights of women. She supported Gandhi's famous Salt *Satyagraha,* in which the Mahatma and many

followers broke restrictions (intended to boost government tax revenue) on making salt from seawater, in 1930. She supported the rights of Indians in South Africa, visiting that country in 1924 and 1934. Sarojini also gave personal support to Gandhi during some of his most trying protests, including his long fast of 1943 protesting the continuing British presence in India. She was herself jailed three times for her anticolonial activities, in 1930–31, 1932–33, and 1942–43.

Naidu's greatest contribution to the struggle for Indian independence was probably her talent for public speaking. "Her flawless English, grasp of the subject, oratorical power interlinked with flashes of wit, humour and irony and the human approach she adopted won her applause and admiration wherever she spoke," relates Ramachandran Nair. She was especially noted for her acute sense of humor, which she shared with Gandhi. "Both loved a joke especially at themselves," Ramachandran Nair writes. "Sarojini was often described as 'the licensed jester of the Mahatma's little court.'" Gandhi "was indulgent and affectionate towards her and warm-heartedly tolerated all her jokes at his expense. She called him the 'Mickey Mouse' of Indian politics and remarked that 'it costs a great deal of money to keep Gandhiji living in poverty.'" "Of all things that life or perhaps my temperament have given me," said Naidu, "I prize the gift of laughter as beyond price." Writes Baig:

> All through her life this earthy wit was to make her presence everywhere a pure delight, but more than that was her gift of bridging emotional situations with a jest. When approached by a trembling admirer after her thundering oration at the Asian Relations Conference in Delhi in 1947 with the words, "Oh Mrs. Naidu, that was such a wonderful speech, I nearly wept," she turned to the girl and said, "Nearly wept? What do you mean? Everyone else was weeping!"

Naidu continued her efforts on behalf of Indians, both Hindu and Muslim, after India achieved its independence in 1947. She and Gandhi both objected to the British plan to partition India into two states, Pakistan (with a majority Muslim population) and India (with a majority Hindu population). Both believed that the country's future lay in crossing religious boundaries. British fears of popular unrest, however, proved too strong, and Gandhi and Naidu were forced to work for Hindu-Muslim unity in other ways. In 1947, Sarojini accepted the governorship of the United Provinces—renamed Uttar Pradesh—in northern India. The new province, with its large population, tested her abilities to bring former enemies together. "She mentioned,"

writes Sengupta, "that she sent the Governor General a bracelet (Raksha Bandhan) which Hindu women, high or low, sent to those men whom they honoured and trusted and relied on as friends. Rajput queens sent these on full moon nights, she said, to Moghul Emperors." In a letter to the former British governor, Naidu wrote:

> I don't know how long I shall be in these provinces, but my one real gift has been having full scope and bearing real fruit. My gift of friendliness. Men and women who have not spoken to each other for years meet under my roof every day in a cordial manner after an initial moment of uncertainty. . . . [O]h yes—the lions and the lambs lie down very pleasantly together in my green pastures. Each of us can only do our best, as Browning says: "There shall never be one lost good." What a comforting belief.

Sarojini Naidu was still in office on her 70th birthday, on February 13, 1949. She had suffered a head injury three days previously, and the resulting headache became worse and worse. Her health, never very robust, began to break down. She was hospitalized and, on the morning of March 2, 1949, she died. "Sarojini Naidu's most enduring contributions to India," writes Baig, "were her involvement in the reality of human life rather than politics, in the fight for independence, and her deep insight into the people's need. It was the human being who came first with her always, not doctrines or creeds; the dictates of love, not the narrow dictates of mere principle."

SOURCES:

Baig, Tara Ali. *Sarojini Naidu.* "Builders of Modern India" series. New Delhi, India: Publications Division, Ministry of Information and Broadcasting, Government of India, 1974.

Dwivedi, Amar Nath. *Sarojini Naidu and Her Poetry.* Allahabad, India: Kitab Mahal, 1981.

Gupta, A.N., and Satish Gupta. *Sarojini Naidu's Select Poems, with an Introduction, Notes and Bibliography for Further Study.* Bareilly, India: Prakash Book Depot, c. 1976.

Gupta, Rameshwar. *Sarojini, the Poetess.* Delhi, India: Doaba House, 1975.

Khan, Izzat Yar. *Sarojini Naidu, the Poet.* New Delhi, India: S. Chand, 1983.

Mishra, Laxmi Narayan. *The Poetry of Sarojini Naidu.* "Indian Writers" series. Delhi, India: B.R. Publishing, c. 1995.

Nageswara Rao, G. *Hidden Eternity: A Study of the Poetry of Sarojini Naidu.* Soripato: Sri Venkateswara University, 1986.

Paranjape, Makarand, ed. and author of introduction and commentary. *Sarojini Naidu: Selected Poetry and Prose.* New Delhi, India: Indus-HarperCollins India, 1993.

Perspectives on Sarojini Naidu. Ghaziabad, India: Vimal Prakashan, 1989.

Prasad, Deobrata. *Sarojini Naidu and Her Art of Poetry.* Delhi, India: Capital Publishing House, 1988.

Rajyalakshmi, P.V. *The Lyric Spring: A Study of the Poetry of Sarojini Naidu.* New Delhi, India: Abhinav Publications, 1977.

Ramachandran Nair, K.R. *Three Indo-Anglian Poets: Henry Derozio, Toru Dutt, and Sarojini Naidu.* New Delhi, India: Sterling, 1987.

Sengupta, Padmini Sathianadhan. *Sarojini Naidu: A Biography.* NY: Asia Publishing House, 1966.

Kenneth R. Shepherd,
Adjunct Instructor in History, Henry Ford Community College, Dearborn, Michigan

Nairne, Carolina (1766–1845)

Scottish poet and songwriter. Name variations: Lady Caroline Nairne; Carolina Oliphant; Baroness Nairne; (pseudonyms) B.B., Mrs. Bogan of Bogan, and Scottish Minstrel. Born Carolina Oliphant on August 16, 1766, at Gask in Perthshire, Scotland; died on October 26, 1845, at Gask; daughter of Laurence Oliphant and Margaret (Robertson) Oliphant; married Major William Murray Nairne, later 5th Baron of Nairne, in 1806 (died 1829); children: William Nairne (1808–1837).

Selected works: "Charlie Is My Darling"; "Land o' The Leal"; "Caller Herrin"; "The Hundred Pipers"; "Will Ye No Come Back Again?"; "The Laird o' Cockpen"; "John Tod"; "Bonnie Charlie's noo awa"; Lays From Strathearn (1846); Life and Songs (1869).

Baroness Carolina Nairne was born in 1766 at Gask in Perthshire, Scotland, to a family with a paternal lineage going back to Scottish royalty. An attractive, well-mannered girl known as "pretty Miss Car" and "the Flower of Strathearn," young Carolina could also dance, sing, and play so well she earned the attention of Neil Gow, the eminent Scottish fiddler. Her first lyric, "The Pleuchman" (plowman), written in 1792, was inspired by the poet Robert Burns, whom she read often and to whose work her own would later be compared.

In 1798, she traveled with her brother to England, where she wrote what is possibly her most famous lyric, "Land o' The Leal," a song about homesickness. In 1806, she married her cousin, Major William Murray Nairne, who in 1824 would become the fifth baron of Nairne. Although Carolina was an excellent lyricist and wrote many celebrated Jacobite songs and humorous ballads, William never knew it. Due, as it has been said, to her shyness, she wrote in complete anonymity, under the name "B.B." (Mrs. Bogan of Bogan), and even her editors did not know her true identity. A collection that included Scottish melodies for which she wrote words as

well as her own original songs was published with the author listed as "Scottish Minstrel." Of her talent, one author remarked that in "vivacity, genuine pathos and bright wit her songs are surpassed only by Burns," and she is also frequently ranked with James Hogg. Among her most popular Jacobite songs were "The Hundred Pipers," "Wha'll be King but Charlie?" and "Charlie is my darling," which was still a well-known folk song in the 20th century.

Nairne and her husband had one child, William, in 1808, and thereafter she dedicated most of her energy to educating her frail son. In 1823, she found him the best tutors she could, and later traveled with him to European resorts, hoping to improve his health. Her husband died in 1829, and her son died in Brussels in 1837, after which she soothed herself by traveling for several years. In 1843, Nairne suffered a stroke but carried on with church and charity work as anonymously as she had written. Shortly before her death in 1845, she agreed to permit publication of her poems—again, anonymously. They appeared in 1846 as *Lays From Strathearn*. A later edition, which included a memoir of Nairne, was published in 1869 as *Life and Songs*.

SOURCES:
The Concise Dictionary of National Biography. Oxford: Oxford University Press, 1992.
Kunitz, Stanley J., and Howard Haycraft, eds. *British Authors of the Nineteenth Century.* NY: H.W. Wilson, 1936.

Jacquie Maurice,
freelance writer, Calgary, Alberta, Canada

Nakajima Shoen (1863–1901).
See Kishida Toshiko.

Nakajima Toshiko (1863–1901).
See Kishida Toshiko.

Nakshedil Sultana (c. 1762–1817).
See De Rivery, Aimee Dubucq.

Nala Taihou (1835–1908).
See Cixi.

Naldi, Nita (1899–1961)
Italian-American actress. Born Anita Donna Dooley on April 1, 1899, in New York City; died in 1961.

A leading lady of the 1920s, Nita Naldi was brought to the attention of the American public through her work in the Ziegfeld Follies. Moving to Hollywood, she was typecast as a screen siren in such silents as *Dr. Jekyll and Mr. Hyde* (1920), *The Unfair Sex* (1922), *Blood and Sand* (1922),

The Ten Commandments (1923), *Cobra* (1925), *A Sainted Devil* (1925), *The Marriage Whirl* (1926), and *The Lady Who Lied* (1927). The arrival of sound put an end to her movie career.

Nalkowska, Zofia (1884–1954)
Polish novelist and a leading member of the "psychological school" in interwar Polish literature, who presided over a preeminent literary salon in Warsaw. Name variations: Zofja; Zofia Gorzechowski-Nalkowska; Zofia Rygier-Nalkowska; Nalkovskoi. Born in Warsaw, Russian Poland, on November 10, 1884; died in Warsaw on December 17, 1954; daughter of Waclaw Nalkowski (1851–1911, a geographer and publicist); married Leon Rygier.

Zofia Nalkowska was a major figure in Warsaw's intellectual life in the first half of the 20th century. Active in both the arts and politics, she was a leader of Poland's literary underground during the German occupation (1940s) and supported the creation of a Socialist society in Poland after 1945. Born in Warsaw in 1884, she grew up at a time when Poland was under foreign rule. Of the three occupying powers—Austria-Hungary, the German Reich, and Russia—Russia was the harshest, and Warsaw was under its jurisdiction. Zofia's father Waclaw Nalkowski was an esteemed geographer and publicist, and many of Warsaw's foremost intellectuals visited her home where the ambience was typical of the Polish intelligentsia; her family was extremely nationalistic and devoted to artistic and moral ideals. Her father, who divided his energies between his scientific pursuits, journalism, and Polish nationalist activities directed against the repressive Russian occupation regime, was a bold thinker and strongly influenced Zofia. Her intellectual talents revealed themselves in her early years. Unwilling to attend Russian-controlled schools, at age 15 she took classes at one of Warsaw's illegal "flying universities," institutions that were organized by Polish intellectuals in defiance of tsarist bans on the teaching of the Polish language, history and literature. In her youth, the attractive Zofia was reputed to have had many love affairs and to have enjoyed flirting with poets, such as Ludwik Licinski, who were said to be hopelessly infatuated with her.

Nalkowska made her literary debut in 1898, when she had barely entered her teens, by publishing verse in the influential modernist periodical *Chimera*. Starting in her 20s, she published a series of novels, including *Kobiety* (Women,

1906), *Rówiesnice* (Contemporaries, 1909), *Narcyza* (Narcissa, 1910), *Ksiaze* (The Prince, 1910), and *Weze i róze* (Serpents and Roses, 1915). Along with the collections of stories entitled *Koteczka, czyli biale tulipany* (Pussycat, or the White Tulips, 1909) and *Lustra* (Mirrors, 1913), these technically accomplished volumes all analyzed female personalities from the perspective of two literary and philosophical luminaries of the late 19th and early 20th centuries, Oscar Wilde and Friedrich Nietzsche. Nalkowska's writings from these first decades are suffused with an often self-conscious spirit of modernism centered on an individualism that virtually ignores society's impact on specific members of the community. In all of these works, the psychology of love is examined in almost clinical detail. Nalkowska's lyrical style makes great use of symbolism and is characteristic of the writing of the Young Poland movement.

After the tragedies and privations of World War I, the achievement of Polish independence in November 1918 brought little if any euphoria to Nalkowska and most of her contemporaries. From its birth, the Polish Republic was plagued by problems. Poverty, both rural and urban, was widespread. The number of non-Polish minorities—Belarussians, Germans, Jews, and Ukrainians—comprised one-third of the population, and they voiced countless grievances against the ruling Poles of the new state. Exploited industrial workers and landless peasants also demanded major social reforms. Illiteracy marred the social landscape (by 1931, according to the official census of that year, 23.1% of the population, or 8 million, were unable to read and write). By the late 1930s, the situation had worsened. The regime, which in 1926 had become a virtual dictatorship headed by Marshal Józef Pilsudski, responded to the nation's problems with inaction, suppression of dissent, and, after Pilsudski's death in 1935, anti-Semitic demagogy and disastrous concessions to Nazi Germany.

The trauma of war and the disillusionment that accompanied the achievement of Polish independence resulted in a new direction for Nalkowska's writing. In 1920, she published *Hrabia Emil* (Count Emil), a novel set in wartime which contrasts an individual's moral conscience with the cruelty of a collective under stress. In her next novel, *Charaktery* (Characters, 1922), Nalkowska's protagonists were more rooted in real life than those of her earlier works.

In 1922, she moved from Warsaw to the border town of Grodno (now in Belarus). There Nalkowska became aware of the poverty in the town and the surrounding rural region. These oppressive conditions reached their nadir in the Grodno jail, where inhumane conditions were imposed upon both common criminals and political prisoners who opposed the Pilsudski dictatorship and the exploitation of the poor by the local *szlachta* (nobility) landowners. Incensed, Nalkowska took up her pen to appeal to the consciences of her fellow Poles. Writing extensively about conditions at the Grodno jail in articles and pamphlets, she depicted in stark prose the plight of the town's political prisoners; their situation was symbolic to her of the socially and economically oppressive regime which controlled Poland.

Determined to write psychological novels that explored good and evil as well as the ways in which people's personalities are colored by history and by the time in which they live, she pleased critics and readers alike with her 1923 novel *Romans Teresy Hennert* (Teresa Hennert's Love Affair). Triggered by the dramatic changes in her life, Nalkowska adopted a style grounded in critical realism in order to present her readers with examinations of authentic, recognizable moral issues.

After her experiences in Grodno, Nalkowska was active in organizations protesting the police-state tactics of the Pilsudski rule. She played a major role in organizing Polish writers, whose economic status was often precarious. She was a co-founder of the *Zwiazek Zawodowy Literatów Polskich* (Trade Union of Polish Writers) and was active in lobbying for the law guaranteeing authors' copyright, which was passed by the Polish Sejm (parliament) in 1926. Nalkowska was one of the most dynamic members of the literary association PEN in Warsaw from the time of its founding in 1924 until the German invasion of 1939. This club was a meeting place for most of Poland's recognized and aspiring authors, and it hosted gatherings for visiting literary personalities. Maintaining contacts with foreign PEN clubs, she visited the Czech PEN in Prague (1930), among others. Nalkowska's foremost contribution to Poland's literary profession during the decades between the two world wars was Warsaw's most important literary salon, over which she confidently presided. Here the nation's distinguished writers, artists and political leaders met in an atmosphere of brilliance and innovation.

In addition to her involvement in Poland's political and intellectual life, Nalkowska continued to perfect her craft. In 1925, she published the novel *Dom nad lakami* (The House Beyond the Meadows), and she ruffled feathers in War-

saw's conservative literary and political circles with her 1927 novel *Choucas* (Choucas), an angry, uncompromising protest against all forms of nationalism and militarism. Her novel *Niedobra milosc* (The Wrong Kind of Love, 1928) is more centered on the dilemmas of individuals. Nalkowska also wrote two plays during this period, *Dom kobiet* (A House of Women, 1930) and *Dzien jego powrotu* (The Day of His Return, 1931). Directed by **Marie Przybylko-Potocki,** *Dom kobiet* was presented to receptive audiences at Warsaw's Polish Theater in March 1930.

Generous in her support of young talent, Nalkowska lobbied on behalf of one of interwar Poland's most gifted writers, Bruno Schulz (1892–1942), a Jew who would later die in the Holocaust. Schulz taught in a gymnasium in Drohobycz, and in the 1930s, when visiting Warsaw to confer with a publisher, he stayed with Nalkowska. By this time, she had been divorced from her second husband, and a brief affair took place between the older, successful author and the young literary hopeful from the provinces. As both Schulz's lover and patron,

Nalkowska was able to bring his writings to the attention of Warsaw's all-decisive literary circles. Details of their intimate relationship will probably never be known; Schulz's side of their correspondence was destroyed during the Holocaust, and her letters too have vanished, possibly burned by her before she died.

In 1935, Nalkowska published what would be one of her most important novels. *Granica* (The Border) chronicles the life of Zenon Ziembiewicz, a character who summed up the profound disillusionment the author and many of her contemporary artists experienced during the "somber '30s." Ziembiewicz symbolized the evolution of many Poles, from student radical to an official of the unpopular Pilsudski regime. As governor of a city, he orders the shooting of protesting industrial workers. In his private life, too, Nalkowska depicts him as trapped in a moral quicksand of his own making. At the end, he becomes a victim of an enraged woman whom years before he had seduced and abandoned. Polish critics regard *Granica* as an indictment of the *Sanacja* ("Sanitation") military and

Polish stamp issued on December 30, 1969, in honor of Zofia Nalkowska.

political clique that (mis)governed Poland from 1926 through 1939, and the work has stood the test of time as a major achievement of 20th-century Polish literature.

In 1939, Europe hovered on the brink of war. That year, Nalkowska published the innovative novel *Niecierpliwi* (The Impatient Ones). Her existential novel *Wezly zycia* (Knots of Life), an even more sophisticated experimental work, was completed at this time but would not appear in print until 1948, three years after the end of World War II. The war was an unmitigated catastrophe for the Polish nation and people. More than six million Poles—half of them Jews—died in combat, of hunger and torture, and in concentration and extermination camps. No longer young, Nalkowska somehow survived in German-occupied Warsaw.

With the end of the occupation, she became one of the leaders of Poland's intellectual reconstruction. Although she had never been a Communist and never joined the Polish United Workers Party, the postwar party of the new Soviet-approved regime, Nalkowska realized the dictates of the historical moment, namely that Poland had to accept a subordinate role as part of a region in which Moscow, the victor over Hitlerism, was the dominant force.

Her first postwar book, *Medaliony* (Medallions), was published in 1946. This indictment of German Nazi inhumanity took the form of an anthology of recollections of German atrocities which she collected from war survivors. To underline the seriousness with which she undertook this assignment, she also served as a member of the Glowna Komisja Badania Zbrodni Niemieckich (Main Commission for the Investigation of German War Crimes). She accepted election as a deputy to the Sejm, which—although as much if not more of a rubber-stamp parliament than it had been previously—nevertheless represented a tenuous link to the past that Nalkowska, a willing part of the new Poland, did not wish to sever completely.

Despite her advancing years, Nalkowska remained active in Polish literary life. She served on the editorial board of one of the most influential of the postwar literary weeklies, *Kuznica* (The Forge). In 1953, she was awarded the State Prize of the Polish People's Republic. That same year, she published a book for young readers, *Mój ojciec* (My Father). On December 17, 1954, Zofia Nalkowska died in a Warsaw reborn from the rubble of war. At the time, her desk was filled with a number of unpublished manuscripts which would be printed over the next years. In 1957, a volume of essays and sketches appeared, *Widzenie bliskie i dalekie* (A Close and Far View), followed the next year by a nonfiction book on individuals she had known, *Charaktery dawne i ostatnie* (Old and Last Characters). Of great importance for students of Polish literary history was the publication in stages, starting in 1970 and finally ending in 1988, of her extensive set of diaries. Covering her adult life, from 1899 to the years before her death, these volumes—unfortunately not yet translated into English—document the growth of a major writer's skill and provide both casual readers and scholars with a panoramic view of modern Polish history.

Zofia Nalkowska was for many decades one of her nation's major literary figures. Not only a brilliant author, she was also an irresistible personality whose intelligence, charm, and moral authority enabled her to preside over a salon which, for more than a decade, was held in awe as the undisputed site of encounter for some of Poland's most brilliant talents.

SOURCES:

Adamczyk, Danuta. "Spolka Nakladowa 'Ksiazka' (1904–1914): Z Dziejow Wydawnictw PPS" [*Ksiazka* Publishing, 1904–1914: From the Publishing History of the Polish Socialist Party], in *Z Pola Walki*. Vol. 29, no. 2, 1986, pp. 3–23.

Bazilevskij, Andrej. "Wien in den Augen polnischer Schriftsteller (Von der ersten Teilung Polens bis zum Zweiten Weltkrieg)," in Gertraud Marinelli-König and Nina Pavlova, eds., *Wien als Magnet? Schriftsteller aus Ost-, Ostmittel- und Südosteuropa über die Stadt.* Vienna: Verlag der Österreichischen Akademie der Wissenschaften, 1996, pp. 199–222.

Brudnicki, Jan Zdzislaw. *Zofia Nalkowska, 1884–1954: Poradnik bibliograficzny.* 2nd ed. Warsaw: Biblioteka Narodowa, 1969.

Czerwinski, E.J., ed. *Dictionary of Polish Literature.* Westport, CT: Greenwood Press, 1994.

Faron, Boleslaw. *Prozaicy dwudziestolecia miedzywojennego: Sylwetki.* 2nd ed. Warsaw: Wiedza Powszechna, 1974.

Ficowski, Jerzy, ed. *Letters and Drawings of Bruno Schulz, with Selected Prose.* Translated by Walter Arndt and Victoria Nelson. NY: Fromm International, 1990.

Gasiorowski, Zygmunt. Personal communication.

Grynberg, Henryk. "Nosim Shel Hashoah Basifrut Hapolanit" [The Holocaust in Polish Literature], in *Shvut* [Israel]. Vol. 6, 1978, pp. 108–115.

Kirchner, Hanna. "Nalkowska—Prolegomena do Gombrowicza," in Zdzislaw Lapinski, ed., *Gombrowicz i Krytycy: Wybor i Opracowanie.* Cracow: Wydawnictwo, 1984, pp. 573–586.

Kridl, Manfred, ed. *An Anthology of Polish Literature.* NY: Columbia University Press, 1957.

Krzyzanowski, Julian. *A History of Polish Literature.* Warsaw: PWN—Polish Scientific Publishers, 1978.

Lerski, George J., ed. *Historical Dictionary of Poland, 966–1945.* Westport, CT: Greenwood Press, 1996.

Literature and Tolerance: Views from Prague. Prague: Readers International-Czech Center of International P.E.N., 1994.

Milosz, Czeslaw. *The History of Polish Literature.* 2nd ed. Berkeley, CA: University of California Press, 1983.

Musienko, S.F. "Grodnenskii Period v Tvorchestve Zof'i Nalkovskoi" [The Grodno Period in the Writings of Zofia Nalkovska], in *Sovetskoe Slavianovedenie.* No. 1, 1984, pp. 46–56.

———. "Istoriia Odnogo Pis'ma (Ili Novoe o Zof'e Nalkovskoi)" [The History of a Letter, or Something New About Zofia Nalkovska], in *Sovetskoe Slavianovedenie.* No. 4, 1988, pp. 85–89.

Nalkowska, Zofia. *Kobiety (Women): A Novel of Polish Life.* Translated by Michael Henry Dziewicki. NY: Putnam, 1920.

———. "A Wartime Diary. Translated by Edward Rothert," in *Polish Perspectives.* Vol. 14, no. 3, 1971, pp. 32–44.

Nowicki, Ron. *Warsaw: The Cabaret Years.* San Francisco, CA: Mercury House, 1992.

Szczepanski, Jan. "The Polish Intelligentsia Past and Present," in *World Politics.* Vol. 14, no. 3. April 1962, pp. 406–420.

Topass, Jan. "Sophie Nalkowska," in *Pologne* [Paris]. Vol. 12, no. 1, 1931, pp. 334–340.

Wróbel, Piotr, and Anna Wróbel, eds. *Historical Dictionary of Poland: 1945–1996.* Westport, CT: Greenwood Press, 1998.

John Haag,
Associate Professor of History,
University of Georgia, Athens, Georgia

Namakelua, Alice K. (1892–1987)

Hawaiian composer, guitarist, singer, and teacher. Born in Honolulu, Hawaii, on August 12, 1892; died in April 1987 in Hauula, Honolulu.

Named the person who contributed the most to Hawaiian music by the Hawaiian Music Foundation in 1972, Alice Namakelua was raised in a musical family and began singing at age five. By age eight, she was playing the slack key guitar. The composer of over 180 songs, Namakelua taught these to children in order to ensure that Hawaiian culture would endure in the next generation.

John Haag,
Athens, Georgia

Nampeyo (c. 1860–1942)

Hopi-Tewa potter. Name variations: Nampayu; The Old Woman; Snake Woman, Snake Girl or Tsu-mana. Born Nampeyo on the Hopi First Mesa called Hano, northeast Arizona, around 1860; died on July 20, 1942, in Hano; daughter of Kotsakao, also called Qotca-ka-o (a Tewa woman of the Corn Clan), and Kotsuema also called Qots-vema (a Hopi man of the Snake Clan); married Kwivioya, in 1879 (marriage annulled, date unknown); married Lesou, in 1881 (died 1932); children: (second marriage) four daughters, Kwe-tca-we, Ta-wee, Po-pong-mana, and Tu-hi-kya; one son, Qoo-ma-lets-tewa (died 1918).

Interest began in ancient (Sikyatki) pottery (1892); pottery noticed by visiting anthropologists, Dr. Jesse W. Fewkes and Walter Hough of the Smithsonian (1895–96); first exhibition of pottery at Field Museum in Chicago, Illinois (1898); exhibition and sales of pottery through Fred Harvey's (a commercial trading post), Grand Canyon, Arizona (1907); second exhibition in Chicago (1910); work continued while passing on techniques that begin "Sikyatki Revival" in pottery throughout Hopi tribe though she was blind by 1920.

Along the lonely back roads of northeast Arizona, mesas rise sharply in dramatic contrast with the vast plains of the high desert. Atop the mesas, when one looks closely, a village appears as if it had been carved from the giant clay formations. If visitors dare negotiate the insanely steep angle, a single mule trail will deposit them in one of the oldest surviving villages in North America. This is the Hopi village called Hano on First Mesa and the birthplace of a woman who became the finest Hopi potter of her generation, single-handedly starting what became a renaissance in Hopi pottery. Her name was Nampeyo.

She was a child of mixed heritage. Her mother's tribe, the Tewas, had migrated from New Mexico in the 17th century during the Spanish invasions. More warrior-like than the peaceful Hopis, the Tewas were welcomed to stay if they agreed to guard the Hopi against the Ute raiders. When Nampeyo was born 150 years later, around 1860, the Tewas and Hopis were living in peaceful co-existence while maintaining separate customs and languages. Thus, in the Hopi tradition, her paternal grandmother named her "Tsu-mana" (Snake Girl), but the Tewas referred to her as "Nampeyo" which also means Snake Girl or Snake Woman in their language. Because Tewa society is matriarchal, Nampeyo became a member of her mother's Corn Clan.

She learned her pottery-making skills from her Hopi grandmother. Pottery-making by southwest indigenous people dates back to at least 600 CE. Though the methods for constructing the pottery had not changed, the decorative elements and the ceramic styles had declined sharply by the mid-1800s because of the demise of the ancient pueblos, in particular that of Sikyatki.

Decorative elements that appear on the cookware or clothing are drawn from each

tribe's unique religious beliefs or world views. When Nampeyo first began making her pots, Hopi motifs had been diluted by the influence of Spanish, Tewa or Zuni designs, most frequently "Mera," the rain bird. Even the clay used by the Hopi potters was inferior. Nampeyo's brilliance was not only her superior natural gifts as an artist, but her ability to recognize the importance of reclaiming the long-lost Hopi symbols. At the same time, she went beyond imitation and became inspiration for continuing generations of Hopi potters.

Nampeyo's skills were "discovered" by anthropologist Jesse W. Fewkes, director of the Hemenway archaeological expedition, around 1895. Fewkes had hired a team of native diggers, among them Nampeyo's husband Lesou, to excavate the site at Sikyatki. There they unearthed enormous amounts of shattered remnants of the ancient polychrome pottery. But Nampeyo and Lesou had already been collecting bits of ancient potsherds and working with ancient designs, and Fewkes noticed her interest in recreating the ancient designs. Because her artistic ability was superior to most of the potters he'd seen, Fewkes knew he was witnessing a rebirth of the ancient form.

Fewkes and Walter Hough of the Smithsonian Institution made sure that Nampeyo's work achieved recognition, and Hough purchased examples of her work for the museum's collections. Concurrently, Nampeyo began selling her wares commercially, first to the Keams Canyon post and then to the Fred Harvey Company which operated a chain of hotels and restaurants along the old Santa Fe railroad line.

In 1898, Nampeyo and Lesou were invited to exhibit her wares in Chicago by George A. Dorsey, curator of anthropology at the Field Museum of Natural History. She also continued her relationship with the Fred Harvey Company and, in 1907, was hired to exhibit and sell her pots at the company's Grand Canyon Lodge. In 1910, Nampeyo returned to Chicago for a second exhibition which again brought her publicity as well as patrons for her work.

Though Nampeyo was nearly blind by 1920, she continued to mold pottery, while her four daughters and Lesou, until his death in 1932, took over the job of painting the ancient designs. One of her daughters, **Po-pong-mana**, called "Fanny" in English, became a celebrated potter in her own right. Fanny passed her skills onto her daughter, also known as Fanny, who continued the artistic revival her grandmother Nampeyo had started over 100 years ago.

SOURCES:
"An Appreciation of the Art of Nampeyo and Her Influence On Hopi Pottery," in *Plateau: A Quarterly Continuing Museum Notes*. Vol. 15. January 1943, pp. 43–45.
McCoy, Ron. "Nampeyo: Giving the Indian Artist a Name," in *Indian Lives: Essays on Nineteenth- and Twentieth-Century Native American Leaders*. Edited by L.G. Moses and Raymond Wilson. Albuquerque, NM: University of New Mexico Press, 1993.
Nequatewa, Edmund. "Nampeyo, Famous Hopi Potter," in *Plateau: A Quarterly Continuing Museum Notes*. Vol. 15. January 1943, pp. 40–43.

SUGGESTED READING:
Ashton, Robert. "Nampeyo and Lesou," in *American Indian Art Magazine*. Vol 1., no. 3. Summer 1976, p. 30.
Bunzel, Ruth. *The Pueblo Potter*. New York, 1969.
Kramer, Barbara. *Nampeyo and Her Pottery*. 1996.

Deborah Jones,
freelance screenwriter, Studio City, California

Nana Yaa Asantewaa (c. 1850–1921).

See Yaa Asantewaa.

Nandi (c. 1760s–1827)

Zulu queen. Born in the 1760s in what is now South Africa; died in 1827; married Zulu chief Senzangakhona (or Senzangakhoma), around 1787; children: at least one son, Shaka (born around 1787), Zulu chief.

Nandi, whose name means "a woman of high esteem," was born into the Langeni tribe in the mid-18th century, in what is now South Africa. Around 1787, she had an illicit affair with Senzangakhona, the chief of the Zulu tribe, and gave birth to Shaka, who would later become one of the greatest Zulu chiefs and African military leaders. Although Senzangakhona then married her, Nandi was condemned as a disgrace by the Zulu and the Langeni, both because of her pregnancy and because she and her husband were considered too closely related to be married. Abuse at the hands of the Zulu forced Nandi and Shaka to return to her tribe, only to be cast out once more during the famine of 1802. They then found refuge with the Mthethwa (Mtetwa) people, whose chief Dingiswayo was in the process of creating a powerful military state. Shaka proved to be a fearless warrior and rose through the ranks of the Mthethwa army, being named by Dingiswayo as his successor before Dingiswayo's assassination in 1817.

Senzangakhona died around 1815, and Shaka soon claimed the chieftainship of the Zulu by force. Nandi's close relationship with her son, who never married, gave her unheard-of power. Reputed to have been bad-tempered even before

her misfortunes, she was called Ndlorukazi, "The Great She Elephant," and used her position to take revenge on her enemies. Under Shaka's rule, the Zulu became a powerful, even legendary, military force, some 40,000 strong; his establishment of all-female regiments has been attributed to the example set for him by his warrior-mother.

Nandi died in 1827. Shaka ordered a time of public mourning during which no crops could be planted, all milk was to be poured out, and all pregnant women killed. He ordered his mother's young handmaidens to be placed with her in the grave, and he set 12,000 soldiers to guard it for a year. Summary executions set off a massacre which claimed the lives of some 7,000 people in the course of a three-month period. The terror stopped when **Mnkabayi**, a close friend and sister-in-law of Nandi's, plotted a successful coup carried out by Shaka's half-brother Dingane (Dingaan), who assassinated Shaka and took over the chieftainship in 1828.

SOURCES:

Lipschutz, Mark R., and R. Kent Rasmussen. *Dictionary of African Historical Biography.* 2nd ed. Berkeley, CA: University of California Press, 1986.

Uglow, Jennifer S., comp. and ed. *The International Dictionary of Women's Biography.* NY: Continuum, 1989.

<div align="right">

Lisa Frick,
freelance writer, Columbia, Missouri

</div>

Nanny (fl. 1730s)

Afro-Jamaican chieftainess and key leader of the Maroons, descendants of escaped slaves who maintained their freedom by successfully waging guerilla warfare against white planters.

Nanny's date of birth and death are unknown to historians, and most details of her life are little more than tantalizing fragments. But her feats as a leader of the Maroons remain vivid in Jamaica's national consciousness. A major personality in her nation's history, she has embodied the spirit of defiance and pride of Jamaica's black population both during and after the savage era of slavery in the New World. Examples of resistance by both indigenous peoples and imported Africans against their slave masters are numerous. Among the most successful acts of organized defiance was that carried out by Jamaica's runaway slaves, the Maroons. They came from a number of different places. As early as the 16th century, when Jamaica was under Spanish rule, some Arawak Indians destined for enslavement escaped into the island's craggy hill regions to live in freedom. Another community of free mountain people was descended from Moor and Berber soldiers of fortune who arrived in the early 1500s. By far the largest number of Maroons, however, were those Africans who had escaped from slavery by establishing communities in the virtually impenetrable mountain range of midwestern Jamaica. Here they created viable settlements that retained many African traditions.

In 1655, a British fleet of 38 ships entered Kingston harbor. Desperate officials of the Spanish Crown gathered together slaves whose masters had fled, promising them clothes, money and freedom if they pledged to fight the British invaders until reinforcements arrived from Cuba. After the British conquered the island, they too made promises, in a bid to motivate a growing number of free blacks, the Maroons, to fight for Great Britain against Spanish attempts to return to the island. A regiment of blacks, led by Juan Lubola (Juan de Bolas), quickly became a seasoned military unit with members who were doubtless aware that they would be of crucial importance to the British effort to retain control of Jamaica. The leader of the Spanish forces, Don Cristoval Arnaldo Ysasi, noted ruefully: "All these negroes are very capable and experienced, not only as to the roads but as to all the mountains and most remote places." British Major General Sedgewick was aware of the double-edged sword inherent in the strategic decision to arm them: "Of the Blacks there are many who are like[ly] to prove thorns and pricks in our sides. They will be a great discouragement to the settling of a people here."

By the end of the 17th century, the Maroons were firmly established in their remote mountain retreats. They wished to be left alone to live in freedom and retain their African traditions. Whenever British forces appeared on their lands, they fought with a lethal combination of intelligence and tenacity. Rarely if ever did the British have the benefit of surprise: burdened with supplies and weapons, the Crown's soldiers wore colorful (and miserably hot) uniforms as they advanced, at best five miles a day, into the mountain jungles. Marching single file, the often undernourished and ill soldiers moved toward what was frequently their doom. In defense of their lands, Jamaica's Maroons communicated among themselves with *gombay* drum signals that relayed messages up the steep mountain passes. Some units relied on the mournful notes of the *abeng*, a cured cow-horn instrument, to pass on strategic information to their allies. Unlike the British, the Maroon warriors were able to take full advantage of surprise; fear of ambush consistently sapped the invaders' morale.

Although there were probably not more than a thousand Maroons living freely in the Jamaican mountains in the year 1700, they could not be subdued or re-enslaved. Their defiance of the planters posed a constant threat to the entire system of slavery upon which the colonial regime was based. With a European population that was outnumbered more than ten to one by their slaves, the island's population of Maroons, who could not be crushed, served as a beacon of hope for the slave majority and an admission of white weakness. While absentee plantation owners lived ostentatious lives in London, their overseers and accountants in Jamaica often walked apprehensively through dense fields of towering sugar cane, knowing that the next instant could find them victim to a bloody Maroon ambush.

Voicing the planters' fears, a Jamaican governor pleaded for more assistance from the British Crown: "The teror [sic] of them spreads itself everywhere and the ravages and barbarities they commit have determined several planters to abandon their settlements. The evil is daily increasing. Our other slaves are continually deserting to them in great numbers and the insolence of them gives us cause to fear a general defection." In what turned out to be little more than an exercise in futility, the island's Assembly passed 44 Acts to suppress the Maroons, squandering a staggering £250,000.

The Maroons, regarded by whites as an all-encompassing embodiment of the black will to overthrow slavery, were by no means a united society. Having been formed over the centuries largely through chance opportunities for freedom, they never became completely homogeneous, but rather fashioned a protean collection of settlements united as much by the need to fight against the forces of re-enslavement as by any shared cultural experiences. They were descendants of Arawaks, Spanish-speaking Maroons, runaways from Barbados, refugees from shipwrecked slave ships, and even a few Madagascans. Some could point with pride to bloodlines that linked them to fierce Ashanti and Coromante warrior ancestors. Since they initially spoke many different African languages, over the years the Maroons evolved a common language, one based on a basic English vocabulary utilizing a West African grammar, that enabled their different villages to remain in contact with one another.

The women of Jamaica's several mountain settlements played a key role in maintaining the Maroons' cultural identity. Many of them were famous for their knowledge of the complex rituals and traditions of Obeah (Obi), an African-based "occult science" comparable to Voodoo in Haiti and Candomblé in northeast Brazil. Women often took part in battles and, as a result of their prowess in war, Maroon towns—like Diana, Molly, and Nanny—were named in their honor. Nanny was by far the most famous and respected leader of the Maroons, and she was uniquely honored by having two settlements named after her.

Surviving evidence suggests that she was a formidable military tactician, even if some exaggeration crept into the most detailed description of her, which comes from Phillip Thicknesse, a contemporary white observer of events in Jamaica. After accusing Nanny of sentencing a white emissary to death, Thicknesse described her as "The Old Hagg [who] had a girdle round her waist, with (I speak within compass) nine or ten different knives hanging in sheaths to it, many of which I doubt not had been plunged into human flesh and blood." The British authorities in Jamaica officially refused to accept the political authority of female military and spiritual leaders like Nanny, and it is therefore not surprising that contemporary documentation on her from the colonial side is scarce.

Nanny enjoyed a reputation of having slain British soldiers in battle with her own hands, and even in her own lifetime she was said to have the power to summon forth supernatural forces on behalf of her people. She was by no means unique, for women were often integral fighters in battles between former slaves and white soldiers. (In Dutch Surinam, the uprising of the "Seramica rebels" succeeded in maintaining the freedom of a group of slaves in 1728–30, and the uprising was crushed only when eleven of the captured rebels, eight of them women, were executed. Of the eight women, six died in agony on the rack, while the other two were decapitated. A contemporary observer, John Stedman, noted that "such was their resolution" under torture that the women submitted to these horrors "without uttering a sigh.")

Although Nanny most likely died some time in the middle of the 18th century, her military exploits lived on in the oral traditions of Jamaica's black population, both free and slave, well into the 19th century, as legends and inspirational tales about her were passed from generation to generation. These included a story that attributed to her the ability to catch British cannonballs between her buttocks and to fart them back into the ranks of the enemy forces with deadly effect. Larger-than-life tales of Nanny's defiance served

to maintain the morale of the Maroon population at times when the fainthearted began to doubt the wisdom of continuing to resist. As a guerilla warrior par excellence, she embodied the martial skills of a people at home in their environment and thus at a great advantage over their invader enemies. An exasperated Governor Trelawny reported in 1738: "Here the greatest difficulty is not to beat, but to see the enemy. . . . In short, nothing can be done in strict conformity to the usual military preparations and according to a regular manner, bushfighting as they call it being a thing peculiar to itself."

Since Jamaica achieved its independence in August 1962, Nanny has been celebrated as one of the island nation's historical giants. Jamaican artists, including beloved poet *Louise Simone Bennett, have often referred to Nanny's heroic deeds in their works. Even Jamaican banknotes pay homage to "Nanny of the Maroons." She is depicted on the current $500 note, in circulation since 1994.

SOURCES:

Agorsah, Kofi. "Archaeology and the Maroon Heritage in Jamaica," in *Jamaica Journal*. Vol. 24, no. 2, 1992, pp. 2–9.

Black, Clinton Vane de Brosse. *The Story of Jamaica, from Prehistory to the Present*. London: Collins, 1965.

Bush, Barbara. "Defiance or Submission? The Role of the Slave Woman in Slave Resistance in the British Caribbean," in *Immigrants and Minorities*. Vol. 1, no. 1, 1982, pp. 16–38.

———. *Slave Women in Caribbean Society, 1650–1838*. Bloomington: Indiana University Press, 1990.

Campbell, Mavis Christine. *The Maroons of Jamaica, 1655–1796: A History of Resistance, Collaboration and Betrayal*. Granby, MA: Bergin & Garvey, 1988.

Carey, Beverly. *The Maroon Story: The Authentic and Original History of the Maroons in the History of Jamaica, 1490–1880*. Gordon Town, Jamaica: Agouti Press, 1997.

Cooper, Carolyn. "That Cunny Jamma Oman: Female Sensibility in the Poetry of Louise Bennett," in *Race & Class*. Vol. 29, no. 4. Spring 1988, pp. 45–60.

Craton, Michael. *Testing the Chains: Resistance to Slavery in the British West Indies*. Ithaca, NY: Cornell University Press, 1982.

Ebanks, Roderick. "The Maroons of Jamaica: An African Response to Colonial Oppression in the Western Diaspora, c. A. D. 1500–1750," in *Sankofa*. No. 2, 1976, pp. 79–85.

Henry, Lennon Claude. "The Maroons and Freedom in Jamaica," M.A.T. thesis, Portland State University, 1969.

Karas, Josh David. "'The Enemy in Our Bowels': Maroons of Jamaica, 1655–1739," Honors Paper, Duke University, 1993.

Mair, Lucille Mathurin. *The Rebel Woman in the British West Indies During Slavery*. Kingston: Institute of Jamaica, 1995.

Reidell, Heidi. "The Maroon Culture of Endurance," in *Américas*. Vol. 42, no. 1, 1990, pp. 46–49.

Robinson, Carey. *The Fighting Maroons of Jamaica*. Jamaica: William Collins and Sangster, 1971.

———. *The Iron Thorn: The Defeat of the British by the Jamaican Maroons*. Kingston, Jamaica: Kingston, 1993.

Schafer, Daniel Lee. "The Maroons of Jamaica: African Slave Rebels in the Caribbean," Ph.D. dissertation, University of Minnesota, 1973.

Thicknesse, Philip. *Memoirs and Anecdotes of P. Thicknesse*. 2 vols. London: Printed for the Author, 1788.

Tuelon, Alan. "Nanny—Maroon Chieftainess," in *Caribbean Quarterly*. Vol. 19, no. 4. December 1973, pp. 20–27.

Williams, Joseph J. *The Maroons of Jamaica*. Chestnut Hill, MA: Boston College Press, 1938 (Anthropological Series of the Boston College Graduate School, Vol. 3, no. 4, serial no. 12, December 1938).

John Haag,
Associate Professor of History,
University of Georgia, Athens, Georgia

Nansen, Betty (1873–1943)

Danish actress. Born in Denmark in 1873; died in 1943.

Selected filmography: A Woman of Impulse *(1915);* For Her Son *(1915);* A Woman's Resurrection *(1915);* Anna Karenina *(1915);* The Celebrated Scandal *(1915).*

A dark-haired beauty, Betty Nansen was a celebrated stage and screen star in Denmark before coming to the United States in 1914 to star for Fox. During 1915, she made a series of six silent pictures, including *Anna Karenina*, after which she returned to Denmark.

Nanthilde (610–642)

*Queen of Austrasia and the Franks. Name variations: Nantilde. Born in 610; died in 642; became second wife of Dagobert I (c. 606–639), king of Austrasia (r. 629–634), king of the Franks (r. 629–639), in 629; children: Clovis II (634–657), king of Neustria and Burgundy (r. 639–657), king of the Franks (r. 639–657). Dagobert's first wife was *Ragnetrude.*

Nanye'hi (1738–1822)

The last Ghigan of the Tsa-la-gi or Cherokee Nation, who was head of the Woman's Council, member of the Council of Chiefs, and the only woman to speak on behalf of a native nation during treaty negotiations. Name variations: called Nancy Ward by the English; (tribal nickname) Tsistu-na-gis-ka (Wild Rose); known as the Ghigan or Ghi-gan (Beloved Woman); also referred to as Ghi-ga-u and Agiyagustu (Honored Woman). Born Nanye'hi (a derivative of the

tribal name for "spirit people"), a member of the Ani-wa-yah or Wolf Clan, sometime in 1738 in the Cherokee capital, Chote, located on the Little Tennessee River; died in the spring of 1822 at Womankiller Ford, near Benton, Tennessee; daughter of Tame Doe of the Wolf Clan, and an unidentified member of the Delaware Nation; married Kingfisher of the Ani-Ka-Wi, or Deer Clan, in early 1750s (died 1755); married Bryan Ward, in late 1750s; children: (first marriage) Fivekiller (or Hiskyteehee) and Catharine; (second marriage) Elizabeth Ward.

Distinguished herself in battle with the Creek Indians and invested with the office of Ghigan (1755); used powers of the Ghigan to save the lives of settlers (1776); led the Cherokee Nation in treaty negotiations (1781); participated in negotiating the Treaty of Hopewell with the colony of South Carolina (1785); lobbied to keep Cherokee land intact (1817); lost her homeland in the Hiwassee Purchase and relocated to Womankiller Ford (1819).

In the summer of 1755, the War Council of the Cherokee Nation decided it could no longer tolerate the continual intrusion of the Creek Indians into what had been known for centuries as Cherokee territory. Before the battle, the chief warrior donned the traditional raven's head and eagle feather, took up his blood-red weapons, and led his followers in a ritual dance. Beginning slowly, then gaining in tempo, the warriors pretended to strike the enemy with clubs, the dance reaching a crescendo with four loud war whoops. That the war dance happened at all was due only to the approval of the Woman's Council. For in traditional Cherokee life, in times of war and peace, women held the power of life and death.

/Legend has it that when she died] a light rose from her body, fluttered like a bird around the room, and finally flew out the open door.

—Jack Hildebrand

The Cherokees engaged the enemy in the dense forests near Taliwa (just north of present-day Atlanta, Georgia). Accompanying her warrior husband Kingfisher was the beautiful, young Nanye'hi. The battle was vicious and bloody, combining traditional hand-to-hand guerilla warfare with the modern blunderbuss supplied by the Europeans. As the fight raged on, Nanye'hi hid behind a log chewing her husband's lead bullets to make them rougher and more deadly. To her horror, Kingfisher was shot and killed before her eyes. Rather than flee in terror, Nanye'hi picked up the weapon and

charged into battle as strong as any of her male counterparts. When the day was done, the Cherokees had chased the Creeks from their homeland. For her extraordinary courage, Nanye'hi, now a young widow with two children, was invested with the highest honor her nation could bestow, that of Ghigan or "Beloved Woman." That title made her head of the Woman's Council, gave her voting rights on the Council of Chiefs, and granted her supreme pardoning powers for the tribe. Essentially, she assumed the responsibility of the most important position in the Cherokee Nation at the tender age of 17.

When Nanye'hi was born in 1738, Cherokee territory ran across the backbone and into the valleys of what is now called the Great Smoky Mountains. Four large settlements divided into approximately eight villages of 300 Cherokees were nestled along the banks of two mighty river systems that feed these lush woodlands. Nanye'hi's village, Chote, was in the heart of the nation, located on the headwaters of the Tuskegee and Little Tennessee rivers.

The largest native tribe in North America, the Cherokees were organized under one principal chief, Nanye'hi's uncle Attakullakulla (Leaningwood). Because the tribe was spread over a considerable distance, the four settlements had to function alone in daily political and military life. In the North, the tribe fought the Shawnee and traded with the settlers in the colony of Virginia. In the South, they fought the Creeks and traded with the whites of the Carolinas. This physical division became important when, in years to come, the English began to manipulate the tribe, often lying to the Cherokees, in their struggle with the French for power along the frontier.

But in 1730, the English were anxious to curry favor with the Cherokees. To that end, Attakullakulla and several members of the Council of Chiefs were received in London at the court of George II as visiting royalty. From that meeting came the Articles of Friendship and Commerce that solidified friendly relations between the Cherokees and the English. The Cherokees promised to trade only with the English if the English agreed to no further encroachments on Cherokee territory.

When Nanye'hi was growing up, life was good. White traders or native visitors from friendly tribes were often seen in her village, and occasionally one of these men would ask to marry into one of the Cherokee clans. Nanye'hi's father was a Delaware Indian who had asked for permission to marry **Tame Doe,**

Nanye'hi's mother, who was a member of the Wolf Clan. Because the Cherokee Nation was matriarchal, it fell to the women of the seven clans to decide whether to accept or reject the newcomer's request. If accepted, the person, whether white or native, would be expected to live according to Cherokee ethics and moral codes. Writes Fred Gearing, "The single focus which created pattern in Cherokee moral thought was the value of harmony." Though often misinterpreted as being pro-white, preserving this single ethical notion was to become Nanye'hi's life's work.

As a little girl, Nanye'hi and her brother, Tuskeegeeteehe (Longfellow), were taught tribal customs passed down for centuries. They learned to plant and cultivate the three types of *Tsalu* (corn)—the staff of life for the tribe—and the religious ceremonies that accompanied every stage of its cultivation and harvest. Cherokee life centered around the village, around the home. Traditional "women's work," that of child-rearing, meal preparation and basket-weaving, while often scorned in white society, was revered in Cherokee life, and a young warrior who married into his wife's clan was expected to share in that work.

Nanye'hi married Kingfisher, a member of the Deer Clan, when she was about 14 years old. Their two children, Fivekiller and Catharine, were raised as members of Nanye'hi's mother's Wolf Clan. Unfortunately, by the mid-1750s, events were happening around the young couple and their two children that would not only forever alter the Cherokee clan system but would threaten the very existence of the tribe. Though the English had courted favor with the Cherokees and had signed a treaty agreeing to certain boundaries, English settlers had begun significant encroachments upon Cherokee land. To make matters worse, notes Ronald N. Satz, "English colonials in Charleston had deliberately fermented war between the Cherokee and Creeks in order to obtain Indian slaves to sell in the West Indies."

It was during one of these Cherokee-Creek skirmishes that Kingfisher lost his life and Nanye'hi was catapulted into national prominence. Once she was vested with the title Ghigan, it became her responsibility to head the seven-member Woman's Council, to determine what would become of any prisoners of war, and to decide when and with whom the Cherokee Nation would engage in either treaty negotiations or battle. Nanye'hi, who has been described as tall and beautiful, "with long, silken black hair, large piercing black eyes and an im-

perious, yet kindly air," did not hesitate to take charge. Her voice would be heard around the council fires and at the negotiating table for the next 60 years.

The period following Nanye'hi's rise to power was one of the most critical in Cherokee history. As more whites insisted upon settling on Cherokee land, relations with the English and colonial governments deteriorated. Unlike the early fur traders, many of the newcomers weren't interested in peaceful coexistence with their Cherokee neighbors; as far as they were concerned, the Cherokees were savages. These new settlers usurped Cherokee land and then insisted that the natives be forcibly removed. The English government, in its desire to keep the French from becoming too powerful in the region, kowtowed to the demands of the settlers even though that meant breaking treaty after treaty. Needless to say, the Cherokees were disturbed by the government's actions.

The situation reached a breaking point in early 1760 when the Cherokees laid siege to the English Fort Loudon. Acting in retaliation for the brutal murder of a number of Cherokees at the hands of white frontiersmen, a group of young warriors, including Attakullakulla's son Dragging Canoe, attacked the fort without the consent of either Nanye'hi or her uncle Attakullakulla. After months of strenuous negotiations, the chief (with Nanye'hi by his side, it was said) finally worked out a peaceable agreement with the English—much to the displeasure of a growing number of Cherokee warriors.

Complicating the issue for Nanye'hi was her second marriage, in the late 1750s, to Bryan Ward, a white settler. Though Ward was accepted into the Wolf Clan and their daughter **Elizabeth Ward** was raised as a Cherokee, many of Nanye'hi's clanspeople were becoming increasingly uneasy, not only with mixed marriages but with any close association with white settlers, as it became apparent that the white man did not honor his word. Perhaps this is one reason Bryan Ward returned to his white wife in early 1760. Though he and Nanye'hi continued to be on the best personal terms, Ward never returned to live with his Cherokee family. Nanye'hi and Elizabeth were occasional guests in the Ward household, and this was probably when her English friends began to refer to Nanye'hi as Nancy Ward.

During the early 1760s, English and French conspiracies that played one native nation against the other took on a more sinister tone. It was understood, if not expressly stated, that if the Cherokees, the Creeks and the Shawnees killed

one another, there would be that many less warriors to bother the European settlers. Of course, when face-to-face with the tribes, the English and French insisted upon negotiated peace treaties. The double-talk was particularly disruptive for the Cherokees, because the distance between their four settlements gave the whites ample time to play one group against another. The deception did much to undermine Cherokee morale, which was exactly the intention.

Had Nanye'hi been aware of these hidden agendas, she surely would not have made continued attempts to reach peaceful resolutions. Because traditional Cherokee ethos does not allow disharmony, however, she made every effort to negotiate a lasting peace between the whites and her increasingly distraught nation. But in 1776, when English encroachments against the Cherokees turned violent, the frustrated tribe had little choice but to fight back. The Council of Chiefs gathered around the council fire and voted unanimously for war. Nanye'hi gave her approval and set about preparing an herbal potion known as the "Black Drink," which was shared by every warrior prior to battle.

What Nanye'hi did next has often been misinterpreted as a betrayal of her people, because she sent a messenger to warn the settlers of the impending attack. However, most historians fail to point out that the traditional Cherokee moral code absolutely forbade the killing of women and children. The events that followed support the notion that she was observing that ethical tradition. It seems that all of the women and children reached the safety of the fort before the battle began, with the exception of **Lydia Bean** who was captured by Cherokee warriors. Bean was tied to a stake, and the hotheaded warriors were ready to burn her alive when Nanye'hi arrived on the scene. Legend has it that she waved a swan's wing, the symbol of her office, and insisted that the woman be freed: "No woman shall be burned at the stake while I am the Beloved Woman."

Rather than immediately returning Bean to the whites, Nanye'hi kept her in Chote. The reason for this is unclear but, given the hostilities, it may have been too dangerous for white or Cherokee to travel. In any event, Bean made herself useful during her stay with the Cherokees by teaching Nanye'hi the value of raising dairy cattle, a custom previously shunned by native people. Nanye'hi learned to make butter and cheese, and after Bean returned to her home, Nanye'hi began keeping her own herd of what the natives referred to as "the white man's buffalo."

Attakullakulla died in 1778, leaving Nanye'hi as one of the only Cherokee leaders interested in reaching a negotiated peace treaty with the increasingly vindictive whites. But even Nanye'hi's beliefs were tested when, in 1780, the English overran her beloved village of Chote, burning it to the ground. Nanye'hi and her family not only lost all of their possessions but were taken prisoner by the same white settlers she had befriended.

Though she was released from white custody soon thereafter, the destruction of Chote, the heart of the Cherokee nation, had a devastating effect on Nanye'hi. For the first and only time since assuming the position of "Beloved Woman," she broke all ties with her former white friends. For nearly a year, she went into seclusion, going so far as to halt trade with white settlers, a dramatic step since trade had become a necessary element in the Cherokee economy.

It was clear that in the not-too-distant future, Nanye'hi would have to make some decisions on behalf of her tribe. Because of the ever-encroaching whites, the Cherokees were divided on issues of war. Many warriors wanted to drive the whites from their land—regardless of a moral code that honored harmony above all else. Others, weary of the fighting and bloodshed, decided the best course would be to move west. All agreed that it was becoming impossible to behave honorably with people who broke their word. With the future of the tribe at stake, Nanye'hi was deeply concerned over how she would lead a splintered Cherokee Nation when she received word that the English wanted to negotiate a peace treaty, again.

It was 1781. The white commissioners sent by the fledgling Continental Congress to negotiate and to "adjust boundaries" waited for a week before word arrived that the Cherokees were ready to deal. The whites probably anticipated an easy negotiation. They knew the tribe was divided on what to do with its land, and in addition, the leadership was aging or dead. Attakullakulla's son and heir apparent, Dragging Canoe, had no intention of making peace and was on the run from white soldiers. The white commissioners were confident that they faced a native nation in philosophical and political turmoil.

To their dismay, the Cherokees were united. Onitossitah, one of the most profound native leaders, was the first to speak in response to the English demands that more Cherokee land be ceded to the settlers. He left no doubts when he said: "On principles of fairness and in the name of free will and equality, I must reject your de-

mand. . . . Were we to inquire by what law or authority you set up a claim, I answer, none!"

The eloquence and passion of Onitossitah, however, had no effect on the resolve of the white commissioners. It appeared that negotiations would end in failure or worse. But then, as Samuel Cole Williams writes, "There was an occurrence that is without parallel in the history of the West. An Indian woman spoke in treaty negotiations." Addressing the commissioners, Nanye'hi rose and said, "[W]e are your mothers; you are our sons. Our cry is all for peace; let it continue. This peace must last forever. Let your women's sons be ours; our sons be yours. Let your women hear our words." Nanye'hi's words and commanding presence had an overwhelming impact on the commissioners. They backed down. No Cherokee land was appropriated, and for the next 35 years Cherokees and whites lived in relative peace.

But, as time passed, the white government changed and with it the attitude toward the Cherokees. Treaties negotiated years before no longer met the needs of the ever-expanding population of whites who wanted to move west. Thus, the Cherokees were forced further into the Tennessee Valley. Resistance on the part of the natives was becoming impossible, not only because they were increasingly outnumbered but because their population had been reduced due to outbreaks of smallpox.

In 1817, the remaining Cherokee Council held a meeting to decide, once again, the fate of its nation. Though now old and too ill to attend, Nanye'hi sent a message to her fellow clanspeople urging the council to do whatever it must to hang on to the remaining Cherokee land, even if that meant certain death. Betrayed once too often by the whites she had tried to befriend, she said, "Cherokee mothers do not wish to go to an unknown country. We raised you on the land we now have. . . . [S]ome of our children wish to go over the Mississippi, but this act . . . would be like destroying your mothers. We beg of you not to part with any more of our land . . . but keep it for our growing children for it was the good will of our Creator to place us there."

Nanye'hi's wish was not to be. In 1819, the Cherokees could no longer resist the white invaders. The Hiwassee Purchase took Nanye'hi's property, forcing her to move to a village called Womankiller Ford. It was there that she died in 1822. Because of the changing tribal structure, no other woman was appointed to take her place, making Nanye'hi the last Cherokee to hold the title "Beloved Woman."

SOURCES:

Foreman, Carolyn Thomas. *Indian Women Chiefs*. Norman, OK: University of Oklahoma Press, 1954.

Gearing, Fred. "Priests and Warriors: Social Structures for Cherokee Politics in the Eighteenth Century," in *American Anthropologist*. October 1962.

Lewis, Thomas N., and Madeline Kneberg. *Tribes That Slumber: Indian Times in the Tennessee Region*. Knoxville, TN: University of Tennessee Press, 1958.

Satz, Ronald N. *Tennessee Indian Peoples From White Contact to Removal 1540–1840*. Knoxville, TN: University of Tennessee Press, 1979.

Starr, Emmet. *History of the Cherokee Indians*. Tulsa, OK: Oklahoma Yesterday, 1979.

Williams, Samuel Cole. *Tennessee During the Revolutionary War*. Knoxville, TN: University of Tennessee Press, 1954.

COLLECTIONS:

General Nathanael Greene Papers located in the Manuscript Division of the Library of Congress.

"Recollections of Jack Hildebrand as Dictated to Jack Williams, Esq. at the Home of Hildebrand in 1908" located in the Cleveland Public Library in Cleveland, Tennessee.

Deborah Jones, screenwriter, Studio City, California, and member of the Cherokee Nation and 7th-generation granddaughter of Nanye'hi

Naomi (fl. 1100 BCE).

Napier, Sarah (1745–1826).

Naples, grand duchess of.

Naples, queen of.

Naples, regent of.

Natalya
Narishkina

eyesight and appears to have been epileptic, to succeed his father Alexis; the Narishkins, however, pressed for Peter, who, though only ten, was already a bright and promising youth. Natalya's rival stepdaughter *Sophia Alekseyevna won over the *streltsy,* or musketeers. Between May 15 and 17, 1682, a drunken and angry *streltsy* burst into the Kremlin, were bravely met by Natalya, then murdered everyone they encountered, including Artamon Matvyeev, Natalya's guardian, best friend, and chief supporter, and Ivan Narishkin, her brother. The slayings were witnessed not only by Natalya but also by her son Peter, and are blamed for his subsequent tendency to convulsions. The patriarch of the Russian church then engineered an agreement that provided for Ivan and Peter to reign jointly under the regency of Sophia.

When Peter was 17, he thwarted a coup and had Sophia sent to a nunnery. Still at an age when sailing and drinking came first, however, he left state affairs to his mother. To calm her wild son, Natalya arranged a marriage for him with *Eudoxia Lopukhina, but to no avail. While Peter continued to spend his time sailing in the north, Natalya continued to run the country. Her efforts to free women from the binding tradition of the *terem* were passed down to her son when he finally became tsar as Peter I the Great. Bullying his nobles into shaving their beards and adopting Western dress and behavior, Peter forced them to allow their women out of their traditional seclusion, and he Europeanized court life.

Narishkina, Natalya (1651–1694)

Russian empress and regent. Name variations: Natalia Naryshkin, Naryshkina, Narushkin or Narushkina. Born Natalya Cyrilovna Narishkina into the powerful Narishkin family of Russian nobles on August 22, 1651; died on January 25, 1694; daughter of Cyril Narishkin (or Naryshkin) and Anne Leontiev Narishkina (d. 1706); sister of Ivan Narishkin (or Naryshkin); became second wife of Alexis I (1629–1676), tsar of Russia (r. 1645–1676), around 1670 or 1671; children: Peter I the Great (1672–1725), tsar of Russia (r. 1682–1725); Theodora (1673–1676); Natalya Romanov (1674–1716).

Upon the death of Tsar Alexis I in 1676, his second wife, the gentle Natalya Narishkina, moved to the nearby village of Preobrazhenskoye with her children, Peter and *Natalya Romanov. The new tsar Theodore III had no male heir, however, and when he died in 1682, Natalya became regent for her ten-year-old son Peter, and the hostility between the Narishkin (or Naryshkin) family and the family of Alexis' first wife, ◄ Maria Miloslavskaia, came to a head.

The Miloslavskys wanted Maria's son Ivan, another son who suffered from poor health, bad

Miloslavskaia, Maria. See Sophia Alekseyevna for sidebar.

Nasi, Gracia Mendes (1510–1569)

Portuguese businesswoman, patron of the arts, and head of an underground Jewish organization, who orchestrated the boycott of the port of Ancona. Name variations: Beatrice de Luna; Beatrice Mendes; Gracia Mendes; Doña Gracia Nasi or Naci. Gracia's family name was Nasi; with their conversion to Christianity, the family changed it to de Luna. Born Beatrice de Luna in Portugal in 1510; died in 1569 in Istanbul, Turkey; buried in Jehoshaphat Valley, Palestine; though parents unknown, her ancestors had been Jewish courtiers to the kingdoms of the Iberian peninsula since the 11th century; educated by tutors; married Francisco Mendes, in 1528, in Lisbon, Portugal (died 1536); children: Reyna Mendes.

With Inquisition established in Portugal, relocated to Antwerp (1536); relocated to Venice (1545), denounced and imprisoned by Venetian authorities; released from prison (1549); relocated to Ferrara (1550) and became a declared Jew; with family, moved to Is-

tanbul (1553); organized a trade boycott of Ancona in retaliation for the deaths of 24 Jews (1556); obtained special permission from Suleiman to build a new Jewish settlement at Tiberias (1561).

Since the days of the Roman Empire, Sephardic communities flourished in Spain; their attachment to the land was deep and enduring. Counted among them were merchants, scholars, theologians, bankers, ambassadors, poets, and courtiers. Many, like Isaac Abrabanel, served the crown of Castile or other Iberian monarchies.

The Castilian reconquest of Granada in 1492 signaled the high water mark of efforts to re-Christianize the peninsula. Spanish nationalism gained momentum as the persecution of religious minorities increased under the Inquisition. In 1492, King Ferdinand and Queen *Isabella I of Castile issued a ruthless edict, which read in part:

> Don Ferdinand and Dona Isabel . . . resolve to order all and said Jews and Jewesses out of our kingdoms and that they never return nor come back to any of them . . . upon punishment that if they do not thus perform and comply with this, and are to be found in our said kingdoms and seigniors and have come here in any manner, they incur the penalties of death and confiscation of all their belongings for our treasury.

Many initially fled to nearby Portugal. Within a year, however, they again faced the choice of a forced conversion, expulsion, or death.

Among them were the Nasi family, whose ancestors had been Jewish courtiers to the kingdoms of the Iberian peninsula since the 11th century. The Nasis, like many Jews, became nominal Christians and changed their name to de Luna. Known as Marranos, a name derived from the old Spanish term for swine, these converts practiced their faith secretly. Whenever possible, they rested on the Sabbath, avoided proscribed foods, and celebrated Passover. Overtly, however, they embraced the Catholic faith.

The early life of Gracia Nasi, born Beatrice de Luna in Portugal in 1510, has been obscured by the mists of time, but we can divine from her later life the strong religious influences of her upbringing. The Gracia Nasi of future fame, however, only emerged from the shadows of history with her marriage to the wealthy businessman Francisco Mendes in 1528. She was a woman "of obvious beauty, exceptional ability and, above all, remarkable force of character," wrote Cecil Roth:

> [S]he combined inherited acumen with a woman's tenderness and an inexhaustible

depth of Jewish sympathy. There was, however, nothing as yet to suggest that she was one of the outstanding women in an age peculiarly rich in female characters—perhaps the most noteworthy Jewess in all history.

For Gracia Nasi and the Marranos of Portugal, 1536 was a year of tragedy. On May 23, an office of the Holy Inquisition was established in Lisbon. As well, Francisco Mendes died suddenly, leaving her a widow. In accordance with Francisco's last wishes, the administration of the Mendes business empire fell to his younger brother, Diogo Mendes, and to Nasi.

With the persecution of Portuguese Marranos increasing daily, Nasi fled to Antwerp, the commercial center of northern Europe. It was here that Diogo Mendes had established a branch of the family business in 1512. Mendes business interests extended across Europe and the Middle East, and the family's dominance of the spice trade allowed them to extend loans to the monarchs of England, Germany, Portugal, and Turkey.

Antwerp rapidly became a way station for Jews in transit to havens of safety in Italy, Palestine, and the Ottoman Empire. Using their extensive business connections, Gracia and her brother-in-law organized a Jewish underground. Nasi provided the refugees with detailed instructions, identifying which roads to avoid, where to find accommodations, and where emergency assistance could be secured. Before setting out, the refugees were provided with money and the names and addresses of Mendes agents, who reported on local conditions at various stages of the journey. Through the vast Mendes banking empire, Gracia also insured the safe transfer of refugees' assets to their points of destination.

News of Mendes' activities soon reached the ears of Habsburg emperor and Spanish king Charles V. Persecution of the Jewish community increased, and the family came under increasing scrutiny. In 1543, Nasi decided to leave Antwerp and relocate elsewhere. Her plans were foiled, however, by the untimely death of Diogo that year. Thus, the leadership of the Mendes empire fell to her. Increasingly, she turned for advice to her nephew, Joseph Nasi.

Leaving him in control of the Antwerp operations, Gracia secretly fled in 1544. She was accompanied by her niece, her daughter **Reyna Mendes**, and her sister-in-law **Brianda Mendes**, the widow of Diogo. At length, Joseph managed to liquidate a large portion of the family's property, circumventing the ever-increasing financial and legal pressures of Charles V.

Nasi resettled in Venice. Her travels were typical of many Sephardic exiles, who moved from place to place until finally reaching the safety of the Ottoman Empire. Ever conscious of the need to divide both personal and financial risk, over the years Nasi had accumulated a substantial fortune in Istanbul. But misfortune soon intruded while she was still in Venice. In a dispute over the settlement of Diogo Mendes' estate (held in trust by Nasi), Brianda Mendes publicly denounced her sister-in-law as a Jew. In 1545, Nasi was imprisoned by Venetian authorities, and all of the Mendes family assets were frozen.

The Turkish sultans were dynamic and far-seeing rulers, who encouraged the immigration of skilled and talented Jews to their dominions. Upon learning of the Spanish expulsion of the Jews, then Sultan Bayezid II had reacted by exclaiming, "You call Ferdinand a wise king, he who impoverishes his country and enriches our own!" Joseph Hamon, Suleiman the Magnificent's Jewish physician and a friend of the Mendes family, persuaded the sultan to intervene on Gracia's behalf. The French ambassador to Venice reported:

> The bailo [bailiff] of this government in Constantinople informs [the Venetians] that the principal reason for the despatch of the special envoy is to ask them in the name of the sultan to hand over to him the Portuguese, [Nasi], together with her daughter and her property, to take them with him to Constantinople. Rumour adds that the said [Nasi] has married her daughter, or promised her, to the son of a certain Hamon, a Jew, physician to the Grand Signior, who favours him more than any other person of his own creed. About this matter there is a great deal of talk, to the dishonour and prejudice of the said [Nasi]. The substance is that it is now clear that she and all her tribe has been and is one of the sects of the Marranos, having pretended to be Christian, in order to become rich by trading freely with all merchants.

For the time being, however, it was impractical to accept Ottoman protection. Nasi was well aware of the risks involved. Not only would such a manoeuvre endanger the European agents employed by the family, but it would also lead to the confiscation of Mendes business assets throughout the continent.

Ottoman protests and numerous bribes, however, did secure the release of Nasi in 1549. She was reunited with her daughter, and together they made their way to Ferrara, where they were assured of immunity from religious persecution by Duke Ercole II. Surprisingly, Brianda soon followed. It is impossible to explain her sudden appearance in Ferrara. However, she was welcomed back into Nasi's household, if not entirely back into her sister-in-law's confidence.

In 1550, the Republic of Venice expelled all Venetian Marranos. Following Nasi's example, many sought refuge in neighboring Ferrara. There they were guaranteed the right to openly practice Judaism, even though ostensibly they were Christians.

Nasi's stay in Ferrara proved to be a watershed in her life. Like many of her compatriots, she shed her Christian guise and proclaimed her faith in Judaism. It was here that she took on her original family name of Nasi (up until then, she had been known as Beatrice Mendes). The word *Nasi* or *Naci* is Hebrew for leader, while Gracia was a name she was called as a child. Her nephew Joseph also took the name Nasi.

Shortly after her arrival, she became well known as a patron of the arts. Her best-known act of sponsorship was the translation and publication of the *Ferrara Bible*. This famous work was undertaken with the approval of the Holy Office of the Inquisition, and was dedicated "to the Very Magnificent Lady: Doña Gracia Naci." In the same year, Samuel Usque's *Consolation for the Tribulations of Israel* appeared. Also published under the patronage of Gracia, the work was designed to smooth the integration of Marranos into the Jewish community.

During an outbreak of the plague in 1552, the duke of Ferrara was forced by public opinion to expel the Jews of Ferrara briefly. Nasi fled to Venice, where she was once again imprisoned. After her release, she decided that the time had come to seek refuge in the Ottoman Empire.

Many Jews viewed immigration to the east as part of God's plan to bring them closer to the land of Israel. Indeed, Cecil Roth described the Ottoman Empire as "the vestibule and gateway to the Promised Land." Suleiman the Magnificent's empire was at the height of its military and economic might. It was a state which outshone its contemporaries, and far outpaced European monarchies in religious tolerance. All minorities were guaranteed substantial legal and religious independence. An anonymous writer described the situation: "We have no words to record the enlargement and deliverance that has been achieved by the Jews in this place."

In 1553, when Nasi reached Istanbul, she was acknowledged as the leader of the Jewish community there and settled in the exclusive district of Galata, occupying a spectacular villa. She fulfilled a pledge long ago made to her departed

husband Francisco. Through her agents in Lisbon, his body was exhumed and transported to Palestine, where it was interred in the Jehoshaphat Valley, outside of Jerusalem. Nasi also organized a consortium of Muslims and Jews in Istanbul to trade in such varied commodities as spices, wheat, and wool. As well, she undertook the funding of Jewish hospitals and schools, the subsidy of Jewish students, and the translation and printing of Jewish texts. Nasi was also responsible for the foundation of several synagogues, including La Senora or ha-Giveret, which was named in her honor and still stands.

As in the past, Nasi continued her efforts to aid Spanish and Portuguese refugees. Saadiah Lungo, a poet and the reader at a synagogue in Salonica, wrote allegorically that Nasi was always willing "to receive the groaning wayfarers who returned to the service of their Creator so tired and weary that every knee would have faltered but for this great House, which was appointed from Heaven to have mercy upon them. . . . Every soul of the House of Jacob that comes to take refuge under the Pinions of the Divine Presence—she was their mother and suckled them from her comforting breast."

The most dramatic episode of Nasi's long struggle against intolerance occurred in 1555. At the instigation of the Inquisition, 24 Jews were burned to death in Ancona, while 100 more were imprisoned. Part of the Papal States, Ancona had long been a free port. A substantial Jewish community had grown up in the city, and freedom from persecution also attracted large numbers of Marranos. However, with the election of the fanatical Pope Paul IV in May 1555, this tolerant atmosphere quickly changed.

In response to the Ancona incident, Gracia flexed her political muscles. She recruited Suleiman to assist her, and even dictated the stern letter which he dispatched to the pope. The ultimatum read in part:

> [Y]ou will be pleased to liberate our above mentioned . . . subjects, with all the property which they had and owned. . . . By so doing, you will give us occasion to treat in friendly fashion your subjects and the other Christians who traffic in these parts.

To back up his threat, Suleiman ordered the seizure of all Anconan vessels in Turkish waters. There was little more that he could do, however, save military action, which he was already undertaking against the Christian west. Pope Paul IV agreed to release all Turkish subjects, but steadfastly refused to stop his persecution of other Jews.

More decisive measures were needed. Nasi undertook the organization of an international boycott against Ancona, and Istanbul's Jewish community initially responded with enthusiasm. Many European Jews also joined the effort. However, as with many later boycotts, the effectiveness of the measure was hotly contested. Many Jews, both inside the Ottoman Empire and without, wondered aloud whether they were not merely hurting those they sought to protect—the Jews of Ancona. Others, with a strong economic interest in the Ancona trade, sought to block the initiative altogether.

Initially, the boycott was strongly felt in Ancona. Many bankruptcies occurred among Christian merchants, and there was a severe shortage of Turkish goods. However, trade slowly increased in subsequent months, as Jewish traders began to defect. In an effort to stem the hemorrhage, Nasi wrote to all the rabbis of the empire, urging them to remember the suffering of their coreligionists. The measure proved ineffective, and at length the boycott collapsed. No cargo owned by the Mendes family, however, ever passed through the port of Ancona again.

The failure of the Ancona boycott underlined the disunity of the international Jewish community. In 1565, Nasi obtained special permission from Suleiman to build a new Jewish settlement at Tiberias, in Palestine. She began to colonize the city in an effort to create a safe haven for Jews. It is also possible that Nasi envisioned Tiberias as the nucleus of a future Jewish state. In the same year, she ordered construction of a magnificent villa in Tiberias, which she intended to occupy. Ill health, however, forced her to postpone her eastward journey. She died at the age of 59, her dream of seeing the Promised Land unfulfilled. At her request, she was buried beside her husband in the Jehoshaphat Valley of Palestine.

News of Gracia Nasi's death spread rapidly throughout Europe and the Middle East. Wherever Jews lived, memorial services were held. Saadiah Lungo expressed their collective sense of loss:

> Of all we treasure most we stand bereft
> Throughout the lands of thy dispersal, Ariel;
> And every mother-town in Israel
> Weeps for the fate of those in anguish left.
> Gone is the glitter;
> My morning is bitter,
> And broken my heart.

Gracia Nasi was the preeminent businesswoman of her day. Her odyssey was one common to Sephardic Jews. With one eye firmly cast over their shoulders, they lived their lives in constant dread of the Holy Inquisition. Unlike most

of her contemporaries, however, Nasi fought a stubborn rearguard action against the forces of intolerance. Her impressive career reached its zenith with her single-minded defense of the Jews of Ancona. To this day, she remains a legendary figure among the Jews of Turkey. Indeed, her defiance of Pope Paul IV is a testament to her steely courage and adroit intelligence. Time and again, Nasi demonstrated her mastery of commerce and diplomacy. Her efforts to save thousands of Jews took on international dimensions. The idea of a Jewish haven in Palestine, although not new, was given impetus by her moral and monetary patronage. Indeed, one could argue that Gracia Nasi deserves to be known as one of the founders of the modern Israeli state.

SOURCES:

Gerdes, Jane S. *The Jews of Spain: A History of the Sephardic Experience.* Toronto: Macmillan, 1992.

Henry, Sondra, and Emily Taitz. *Written Out of History: Our Jewish Foremothers.* NY: Biblio Press, 1990.

Marcus, Jacob R. *The Jews in the Medieval World.* NY: World, 1960.

Newman, Abraham A. *The Jews in Spain.* NY: Octagon Books, 1969.

Roth, Cecil. *The House of Nasi: The Duke of Naxos.* NY: Greenwood Press, 1948.

SUGGESTED READING:

Roth, Cecil. *The House of Nasi: Dona Gracia.* NY: Greenwood Press, 1947.

<div align="right">

Hugh A. Stewart, M.A.,
Guelph, Ontario, Canada

</div>

Nassau, duchess of.

See Pauline of Wurttemberg (1810–1856).
See Charlotte (1896–1985).

Nasser, Tahia (1923—)

First lady of Egypt. Name variations: Tahia Kazem. Born Tahia Mahmoud Kazem in 1923 in Cairo, Egypt; daughter of a successful merchant; attended a French preparatory school in Cairo; married Gamal Abdel Nasser (1918–1970, a military officer and later president of Egypt, from 1956 to 1970), in 1944; children: daughters **Hoda Nasser** *(b. 1946) and* **Mona Nasser** *(b. 1947); sons Khaled Nasser (b. 1949), Abdel-Hamik Nasser (b. 1951), and Hakim Amer Nasser (b. 1953).*

Tahia Nasser was born Tahia Mahmoud Kazem in 1923 into a prosperous family in Cairo, Egypt. After her parents died and one of her two sisters married, she went to live with her only brother, who owned a rug factory near the Abbassia military academy. She soon met Gamal Abdel Nasser, an instructor at the academy and a friend of her brother's who often visited the Kazem household. The somber and independent-minded soldier, who had lost his mother as a boy, was drawn both to Tahia's kindness and to her domestic abilities and soon asked her brother for her hand. Although he was rejected for quite some time, he continued to request her hand until finally his proposal was accepted. They were married through a Muslim marriage contract in 1944.

Egypt, which had been under British domination since the 19th century, had been made a British protectorate during the First World War, after which Egyptian resentment, riots and strikes had led in the early 1920s to the reestablishment of the monarchy. However, Britain continued to maintain a strong military presence in the country, the Egyptian government was riven with internecine strife, and nationalist movements gained strength, particularly after the Second World War. Tahia Nasser knew Gamal was a political man; he wore a scar from a 1935 anti-British demonstration in which he had been beaten and jailed. When she arrived one night in 1949 at a Cairo train station to pick him up, she watched as military police hauled him away to answer charges that he had been plotting against the government. By then they had three children, two girls and a boy, and she began living in constant fear for her husband and family.

By 1952, unknown to Tahia, Gamal was leading the secret Free Officers Committee, an organization operating within the Army which harbored deep resentment at British influence in Egypt. Over the previous ten years, the Free Officers had developed into an independence movement, its members infuriated by what they perceived to be the weakness and despotism of King Farouk and a corrupt military command. Although Gamal never discussed such things with her, Tahia had suspicions that he was involved in some sort of political intrigue. Finally, after finding a box of hand grenades under their bed and a pile of leaflets from the Free Officers Committee under a car seat, her suspicions were confirmed.

In the small hours of July 23, 1952, Tahia was awakened by gunfire. Not long after, she listened to Radio Cairo announce that the Free Officers had taken control of the city. By July 26, the bloodless coup headed by her husband had forced King Farouk into exile, and Tahia was moving her family into a military compound. Gamal subsequently declared Egypt a republic and moved up through various high-level ministerial positions. By 1956, he had squeezed out the active prime minister and taken the office of president himself. Tahia Nasser became the first lady of Egypt, and her anxieties and fears subsided some-

what. She voted in elections regularly after Egyptian women were given the right to vote that year.

Gamal insisted on a rather simple home life for himself and his family—evidence of his contempt for the extravagances of the royal family which had preceded them. Their official residence, well-to-do but hardly ostentatious, seems to have suited her well. Tahia ran the household in the smooth, efficient, and routine manner that her husband required. In her spare time she played piano, did needlepoint, and watched films with her husband in their home theater; they shared a passion for motion pictures.

Unlike many other first ladies, Tahia seldom attended public functions, which her husband usually hosted or went to alone. She appeared in very few official photographs before the visit to Egypt in 1964 of Soviet premier Nikita Khrushchev and his wife **Nina Petrovna Khrushchev.** (Although she had traveled in 1959 with Gamal and their children to Yugoslavia, where she met and was photographed with Josip Broz and his third wife *****Jovanka Broz Tito,** those photographs did not appear in the Egyptian press.) It is unclear whether this arrangement was her desire or her husband's demand, but her virtual invisibility had benefits. She was said to be quite content with her obscurity, which gave her privacy and enabled her to continue her modest, family-oriented routine even after her husband took high office. She shopped in local stores, attended the opera, and sipped coffee in cafés without being recognized, enjoying a personal freedom known by few wives of national leaders in the 20th century.

Heavy Egyptian losses in the Arab-Israeli Six-Day War led Gamal to attempt to resign from the presidency in 1967. He was convinced to stay on, however, and died in office in 1970, after which Tahia continued living in their family home. One author described Tahia Nasser in 1967 as "happy because she is close to the man she married." Perhaps she wished for little more than to be free of the haunting anxiety that comes with being the wife of El Raís (the president), as she referred to him with people she did not know, in a troubled part of the world.

SOURCES:

Commire, Anne, ed. *Historic World Leaders.* Vol. 1. Detroit, MI: Gale Research, 1994.

Frederick, Pauline. *Ten First Ladies of the World.* NY: Meredith Press, 1967.

Jacquie Maurice,
freelance writer, Calgary, Alberta, Canada

Nassif, Malak Hifni (1886–1918).

See Egyptian Feminism.

Tahia Nasser

Natalia Sheremetskaia (1880–1952).

See Sheremetskaia, Natalia.

Natalie of Hesse-Darmstadt
(1755–1776)

Russian royal. Born Natalie Wilhelmina on June 25, 1755; died in childbirth on April 26, 1776; daughter of *****Caroline of Birkenfeld-Zweibrucken (1721–1774) and Louis IX (b. 1719), landgrave of Hesse-Darmstadt; married Paul I (1754–1801), tsar of Russia (r. 1796–1801), on October 10, 1773; children: one (b. 1776). Following Natalie's death, Paul married* *****Sophia Dorothea of Wurttemberg.**

Nathalia Keshko (1859–1941)

Queen of Serbia. Name variations: Natalya, Natalie. Born in 1859; died in 1941; daughter of a Russian military officer; educated in Paris; married Milan II (I), prince of Serbia (r. 1868–1882), king of Serbia (r. 1882–1889, abdicated 1889, died 1901), around 1875 (divorced c. 1889); children: Alexander (1876–1903), king of Serbia (r. 1889–1903, who married Draga).

Became princess of Serbia (c. 1875); became queen of Serbia (1882); divorced from King Milan II

while out of the country (c. 1889); banished by decree from Serbia and forcibly ejected (1891).

The history of the Balkans has long been one of feuds, intrigue, warfare and bloodshed, and the brief period of the Obrenovich dynasty in Serbia is no exception. Held by the Ottoman Empire from the late 14th century, but coveted as a pawn by the powerful empires of Russia and Austria-Hungary, Serbia was granted autonomy in 1829 through the Treaty of Adrianople that ended war between Russia and the Ottoman Empire. For some years power swung between the rival Karageorgevitch and Obrenovich factions, as the country began to copy the structure of European countries with a monarchy, ruling assembly, and diplomatic ties to other nations and states; by the time Serbia gained sovereign nationhood through the Congress of Berlin in 1878, the Obrenovichs had held the throne for nearly two decades, and Princess Nathalia Keshko was wife of the ruling prince and mother of the heir to the throne.

Born in 1859 in Moldavia (then a part of Rumania), Nathalia Keshko was the daughter of a well-to-do landowner and officer in the Russian army. She was raised in the aristocratic manner of Russian gentry and as a teenager was sent to finishing school in Paris. Throughout her life, she was acknowledged as a religious, chaste, and genuinely charitable woman (although it was her voluptuous figure, faithfully reproduced in a portrait, which initially won her future husband's attention). Both during and after her reign as queen of Serbia, she also proved herself capable of political machination, adroit manipulation of public opinion, cruelty, and a fierce stubbornness.

Nathalia Keshko's future husband, Milan (II), had been declared prince of Serbia after the 1868 murder of his father's cousin, Prince Michael, by partisans of the Karageorgevitch clan. Still a teenager when he took the throne, Milan began to remake its capital, Belgrade, into a city on par with those of other European nations. He was a man of great charm, if a spendthrift, and was generally adored by his subjects. Still, his diplomats had been having some difficulty finding him a bride both suitable and willing to live in the comparative discomforts of the fledgling nation, and having given up on assorted high-ranking princesses of Europe offered Nathalia Keshko's portrait to the prince for his inspection. Their marriage was a great event, the beginning of an enduring affection that Serbs would hold for Nathalia, as was the birth of a male heir, Alexander, in 1876. Tsar Alexander II of Russia was the baby's godfather, and gave him the nickname "Sasha." Yet despite these outward ties to Russia, which wished to be the dominant influence in East Central Europe, in 1877 Milan forged an alliance with Austria-Hungary by signing a secret treaty.

Nathalia Keshko's marriage began with the couple besotted by one another, but quickly deteriorated. The prince had been expecting to use a portion of his wife's dowry to pay off gambling debts, and was no doubt disappointed to find that the dowry was in land investments, none of which she would be persuaded to sell. Soon enough he was dallying with other women, events Nathalia was informed of by certain pro-Russian factions at the palace. In 1882, Milan declared himself king of Serbia, and Nathalia became queen. They fought violently on the occasions he was in Belgrade, and she was known to insult him publicly. In 1885, Milan led an army into war against Bulgaria. Serbia lost, and the king became the object of various elaborate assassination plots. These all failed, but apparently caused him to seek comfort from **Artemesia Christich**, the wife of his private secretary. Her hold on him soon grew so strong that even educated subjects like the king's councilors thought she was using witchcraft; Milan began speaking to confidantes about divorcing Queen Nathalia and marrying his mistress. Christich, who had a son named Obren with the prince, around 1887, was divorced by her husband. At this point Nathalia and her son were urged to go abroad for the boy's education. Not long after their arrival in Wiesbaden, Germany, rumors began to circulate that Christich was now the queen of Serbia. Nathalia Keshko wrote imploring letters to Milan, wishing to return, but he refused to allow it. He then sent her notice that he had petitioned the Holy National Church for a divorce, and told her to send their son back to Belgrade.

This act was seen as heartless when it was publicized in Serbia and throughout Europe, and Nathalia enjoyed great public support for her cause. Kaiser Wilhelm II of Germany asserted that he would not let the boy return to such a father, but reneged on his word after the political ramifications of such a stand had been pointed out to him. When a Serbian general accompanied by German police went to Nathalia Keshko's home in Wiesbaden to remove Alexander, she brandished a gun at them and threatened to fire. She was outnumbered, however, and easily disarmed, and the boy was taken from her and returned to Belgrade. King Milan's support in Serbia, even among his own Obrenovich faction, declined after this event, and even more so after the church granted his di-

vorce. In 1889, while Nathalia was traveling through Europe, he wrote a liberal new constitution and abdicated the throne. Alexander became ruler through three regents, and after his father left the country Nathalia Keshko returned to Belgrade. She was welcomed back by enthusiastic crowds, but as a result of instructions left by Milan was initially not allowed to see her son. Taking a house near the palace, she daily tried to visit him in tragicomic entreaties that drew large crowds of onlookers. When finally Nathalia was permitted to see Alexander, she set to work turning him against the regents.

To the Serbian people Nathalia Keshko remained their queen, and she was often praised for her charitable works. Because of her wide public support, the regents feared that Milan would return to again eject her from the country, then help himself to treasury funds and depart for the casinos of Europe. She was banished from Serbia by decree of Parliament, a decree she ignored. When her son was enjoined to read it aloud to her, Nathalia replied, "I will yield only to force." The assembled dignitaries were horrified when they understood that she did indeed mean physical force, but eventually took her at her word. In May of 1891, a detachment of police came to her home in Belgrade to escort her across the border. She stalled throughout the day as a crowd gathered outside; when the police finally ushered her out, the crowd rushed the carriage, rescued her, and then battled with the police. Again the police apprehended her and spirited her away to the Grand Hotel, where she was rescued and brought home by another crowd. There an armed guard of supporters remained outside her door while riots briefly raged in the streets. In the middle of the night a detachment of soldiers scaled the wall and managed to put her on a train.

Nathalia Keshko settled among the fashionable in Biarritz, where she entertained numerous nieces and nephews and took pity upon a young, poverty-stricken Serbian widow. By most accounts a naturally bovine, placid woman, *Draga Mashin became Nathalia's lady-in-waiting. Milan had also been banished from Belgrade; having run through the funds his country had given him to stay away, he wrote a letter to Nathalia threatening to kill himself if she did not send him a loan. This letter she sent to French newspapers, which gleefully published it along with her reply that he should uphold the dignity of their son and stop behaving "like an actress."

In 1893, the secret treaty with Austria-Hungary was uncovered and publicized widely.

Great political turmoil in Belgrade resulted in the 16-year-old Alexander, with the backing of the army, dismissing the regents and declaring himself king. He ordered his parents (unsuccessfully) to reconcile and went to visit his mother in Biarritz, where he was received with much ceremony and fell in love with Draga. Both she and Nathalia accompanied him back to Belgrade, where Nathalia reestablished herself as queen and attempted to influence her son. The ruling Radical Party dealt with this by ignoring the king except to demand his signature, so Alexander scrapped his father's constitution in favor of the previous, autocratic one. This won him no popularity, nor did his attempt to correct perceptions of his mother's undue influence by forcing Nathalia to leave Belgrade again. She returned to Biarritz. Shortly after discovering some intimate correspondence from Alexander to Draga, Nathalia threw Draga out of her house and mounted an international campaign to slander her. Draga went to Belgrade, where Alexander further alienated himself from his country by making her his mistress and, later, his wife.

Nathalia Keshko never saw her son again. She died in 1941, a generation after the Obrenovich dynasty ended when King Alexander and Queen Draga were brutally murdered and thrown from a palace window by army officers loyal to the Karageorgevitchs.

SOURCES:
Kelen, Betty. *The Mistresses: Domestic Scandals of Nineteenth-Century Monarchs.* NY: Barnes & Noble, 1966.

Carol Brennan,
Grosse Pointe, Michigan

Nathalie Sheremetskaia (1880–1952).
See Sheremetskaia, Natalia.

Nathan, Annie Florance (1867–1951).
See Meyer, Annie Nathan.

Nathan, Maud (1862–1946)

American social reformer and suffragist. Born on October 20, 1862, in New York City; died on December 15, 1946, in New York City; daughter of Robert Weeks Nathan (a member of New York Stock Exchange and a railroad general passenger agent) and Annie Augusta (Florance) Nathan; sister of Annie Nathan Meyer (1867–1951); educated at private schools in New York and a public high school in Green Bay, Wisconsin; married Frederick Nathan (a stockbroker), in 1880; children: Annette Florance Nathan (c. 1887–1895).

Formed Consumers' League of New York with Josephine Shaw Lowell and others (1890); became president of the league (1897); became probably the first woman to give a speech in a synagogue in place of a rabbi's sermon (1897); was first vice president, Equal Suffrage League of New York, and chair of the suffrage committee of the Progressive (Bull Moose) Party (1912); resigned as president of the Consumers' League and named honorary president for life (1917).

Selected writings: The Story of an Epoch-Making Movement *(1926);* Once Upon a Time and To-day *(autobiography, 1933).*

Born in New York City on October 20, 1862, Maud Nathan was the second of four children of Robert Weeks Nathan and **Annie Florance Nathan**, both members of prominent New York City families of Sephardic Jewish descent. She was the elder sister of *Annie Nathan Meyer, an author and founder of Barnard College, and a cousin of the future U.S. Supreme Court Justice Benjamin Cardozo. Educated at private schools in New York until her father, a member of the New York Stock Exchange, failed in business and was forced to take a job as a railroad general passenger agent in Green Bay, Wisconsin, Maud completed her formal education in the Green Bay public high school and graduated in 1876. After her mother died in 1878, Maud and her siblings returned to their mother's and father's families in New York City. At the age of 17, she was married on April 7, 1880, to her first cousin Frederick Nathan, a prominent stockbroker twice her age. The couple had one child, Annette Florance, some seven years later.

Following her marriage, Nathan became involved with several charitable organizations, and served as director of the nursing school at the Mount Sinai Hospital as well as a director of the Hebrew Free School Association. She also lent her support to the New York Exchange for Women's Work and the Women's Auxiliary of the Civil Service Reform Association. In 1890, Nathan, reformer *Josephine Shaw Lowell, and other women formed the Consumers' League of New York, an organization devoted to industrial and retail reforms. She also served in 1894 as a vice president of the Woman's Municipal League of New York. In addition to her philanthropic work, Nathan was noted for her needlework skills and singing ability, and was a prominent society figure in New York City and Saratoga, New York. This period of her life came to an abrupt end when her eight-year-old daughter died in 1895. At the urging of her friend Lowell, Nathan attempted to overcome her grief by becoming more active in public affairs. In 1897, she was elected president of the New York Consumers' League, a post she would hold for 20 years. She later was a member of the executive committee as well as vice president of the National Consumers' League after its founding in 1898.

The league attempted to involve the public in forcing businesses to treat employees more fairly. It published "white lists" of stores that acted properly and allowed well-run businesses to add a "consumers' label" to their product. The league excluded all employers and employees from its membership, and urged not only fair employment practices but also an honest day's work from employees. The organization worked effectively for state legislation, and fought to protect this legislation when challenged in court. Although not as influential as Lowell or the general secretary of the national body, *Florence Kelley, Nathan was recognized as an important and unceasing advocate for reform. From 1902 to 1904, she also served as chair of the industrial committee of the General Federation of Women's Clubs.

While she was lobbying state lawmakers, Nathan discovered that the opinions of voteless women were most often ignored. Eventually, she devoted more and more of her time and effort to fighting for women's suffrage, through the Equal Suffrage League of New York, of which she served as its first vice president, and the National American Woman Suffrage Association (NAWSA). Her efforts in this direction were strongly supported by her husband, who traveled extensively with her throughout the country in a car hung with American flags, rounding up audiences to listen to her speak. However, her two brothers and her cousin Benjamin Cardozo were critical of her position on female suffrage, and her sister Annie Nathan Meyer even wrote letters to newspapers denouncing Nathan's views. (Nathan wrote back to the same papers.) She concentrated most of her energies for suffrage in New York State, although in 1912 she served as women's suffrage chief in Theodore Roosevelt's Bull Moose campaign. A noted speaker who was admired for her sense of humor, she also lectured about American women's struggle for suffrage at international conferences. (Fluent in French and German, she occasionally served as an interpreter at these conferences as well.)

Descended from Sephardic Jews, Nathan regularly attended an influential old synagogue in New York City, although she has been described by one biographer as "cherish[ing] Judaism for its universal truths rather than for its

traditional forms." In 1897, she was asked to read a paper on "The Heart of Judaism" at New York's Temple Beth-El in place of a rabbi's sermon, making her probably the first woman to play such a part in an American Jewish worship service. This speech espoused her belief that Judaism is basically a love of righteousness, including social justice.

Nathan's husband died in 1919, one year before the passage of the 19th Amendment granting women the right to vote. Although she remained a strong supporter of the Consumers' League (about which she wrote in *The Story of an Epoch-Making Movement*, published in 1926) and the League of Women Voters, she devoted most of her later years to traveling, her friends, and the writing of her autobiography, which was published in 1933 as *Once Upon a Time and To-day*. In the middle years of the Depression, she attacked Franklin Roosevelt's tax policies and (as a wealthy woman herself) what she regarded as his hostile attitude towards the wealthy. Maud Nathan died at her home in New York City on December 15, 1946, at age 84, and was buried in Cypress Hills Cemetery in Queens, New York.

SOURCES:

Edgerly, Lois Stiles, ed. *Give Her This Day*. Gardiner, ME: Tilbury House, 1990.

James, Edward T., ed. *Notable American Women, 1607–1950*. Cambridge, MA: The Belknap Press of Harvard University Press, 1971.

McHenry, Robert, ed. *Famous American Women*. NY: Dover, 1980.

Read, Phyllis J., and Bernard L. Witlieb. *The Book of Women's Firsts*. NY: Random House, 1992.

SUGGESTED READING:

Antler, Joyce. *The Journey Home: Jewish Women and the American Century*. NY: The Free Press, 1997.

Lagemann, Ellen Condliffe. *A Generation of Women*. Cambridge, MA: Harvard University Press, 1979.

<div align="right">

Jo Anne Meginnes,
freelance writer, Brookfield, Vermont

</div>

Nathoy, Lalu (1853–1933)

Chinese-born ex-slave and entrepreneur. Name variations: Polly Bemis. Born in 1853; died in 1933; married.

Lalu Nathoy was kidnapped from China when she was 18 years old, then sold to a slave trader en route to America. On her arrival, she and several other Chinese women were sold at a public auction, to men who wanted either wives or money-earning prostitutes. Her buyer, who named her Polly Bemis, forced her to work in a saloon in Idaho. Eventually, through her bravery and wit, and despite enormous prejudice in the West toward the Chinese, Nathoy made friends and with their help won her freedom. She became a successful entrepreneur, had a happy marriage, and earned the respect of her fellow townspeople.

Nation, Carry (1846–1911)

Militant American temperance leader who led a campaign of saloon-smashers in Kansas and became a national celebrity. Born Carry Amelia Moore (first name often erroneously spelled Carrie) in Garrard County, Kentucky, on November 25, 1846; died in Leavenworth, Kansas, after a period of hospitalization, on June 9, 1911; daughter of George Moore (a Kentucky slaveowner) and Mary Campbell Moore; obtained a teaching certificate from the Missouri State Normal School (now Missouri State University, Warrensburg); married Charles Gloyd (a doctor), in 1867 (died c. 1868); married David Nation (a journalist, lawyer, and minister), in 1877 (divorced 1901); children: (first marriage) one daughter, Charlien.

Moved with husband David Nation to Medicine Lodge, Kansas, a prohibition state (1889); began saloon smashing campaign at Medicine Lodge, Kiowa, and Wichita, Kansas (1900); divorced by David for desertion (1901); began national lecture tours; went on lecture tour of Britain (1908); published her autobiography (1909).

A list of uncompromising reformers and justice-seekers enlivens American history, among them John Brown. Carry Nation was a reformer of the same stripe, contemptuous of compromise, willing to suffer repeated arrests and imprisonments as witness to her belief that alcohol was an unmitigated evil. After 54 years of obscurity and suffering, Nation emerged suddenly in the opening years of the 20th century brandishing a hatchet and amazing crowds with her saloon-smashing exploits.

Carry Nation was born in Garrard County, Kentucky, in 1846. Her father George Moore, whom she idolized as her "angel on earth," was a prosperous Kentucky stock-dealer and plantation owner. His lettering of Carry's name in the family Bible just after her birth explains the unusual spelling and suggests that he was not well educated. Carry's mother **Mary Campbell Moore** suffered from recurrent mental delusions and believed that she was Queen *Victoria—Mary's own mother, brother, and sister had all gone mad. The family indulged these fantasies as far as possible, addressed Mary as "Your Majesty," and helped her to dress regally, even

to the extent of letting her wear a cut-glass and crystal crown while driving around in a plush carriage. Mary reciprocated by violently abusing her daughter Carry, who was sheltered with relatives for months at a time. Later Carry's own daughter **Charlien Nation** would show signs of mental derangement, as did Carry herself in the closing years of her life.

*C*arry went about her latest 'hatchetation' episode in deadly earnestness. With each swing of the gleaming hatchet, she shouted, 'For your sake, Jesus.' One blow destroyed the five-hundred-dollar bar mirror. The long row of liquor bottles and decanters were dragged from the sideboard and systematically smashed. Carry hefted the heavy iron cash register above her head and hurled it into the street. . . . Carry then slashed the rubber tube that carried the beer from the tanks to the bar faucets The Senate Bar was a tangle of wreckage and its attackers were ankle-deep in beer.

—Arnold Madison

Nation's autobiography describes nostalgically her childhood life among the family slaves, who taught her a lurid array of superstitious beliefs. Like many Southern whites, she always regretted the end of slavery and what seemed to her the subsequent estrangement of two formerly friendly races. As a girl, Carry experienced visions of angels and had an evangelical "born again" experience at the age of ten, in a Disciples of Christ church. After a spellbinding sermon one Sunday, and in an agony of conscience over some trivial misdeeds, "I began to weep bitterly," she wrote, "some power seemed to impel me to go forward and sit down on the front bench. I could not have told anyone what I wept for, except it was a longing to be better." The next day she was baptized by total immersion "and although it was quite cold and some ice in the water I felt no fear. . . . I know God will bless the ordinance of Baptism, for the little Carry that walked into the water was different from the one who walked out." For the rest of her life, a buoyant sense of divine approval helped her face severe tribulations. In the late 1850s and early 1860s, the family moved frequently between Kentucky, Texas, and Missouri, her father hoping vainly that a new scene would restore his wife's sanity. Frequent moves, and then the onset of the Civil War, shattered the family's fortunes, especially when their Missouri farm near the border with "bleeding

Kansas" was plagued by outlaw groups and deserters from both sides.

In 1863, the Union army occupation commander ordered the family to move to Kansas City, and there Carry began to attend school regularly. She showed an aptitude for history and scripture, and became a Sunday School teacher. Back in Missouri at the war's end, she fell in love with the family's lodger, schoolteacher Charles Gloyd, a demobilized Union army doctor. Overcoming parental objections, she married him in 1867, just prior to her 21st birthday, and they moved to Holden, Missouri. To her dismay, he turned out to be an incurable alcoholic, and all her efforts to reform him, including howling and pounding on the door of the Masonic lodge where he spent his evenings, failed. She left him in 1868 and returned to her sternly prohibitionist parents, learning six months later that Gloyd had died of alcohol poisoning. After a childhood of near-invalidism due to a digestive disorder, Carry had steadily gained strength, and as an adult was 6' tall and weighed about 175 pounds. She now resolved to support herself, her baby, and her recently widowed mother-in-law, by teaching school. She attended the normal school in Warrensburg, Missouri, then took a job as primary teacher in her adopted home of Holden. Four years later, she lost the job due to the petty intrigues of a schoolboard member, but rather than leave the area she accepted a marriage proposal from a local journalist and part-time preacher, David Nation. It was a loveless marriage of convenience, however, and they soon found out that they were incompatible partners, not least because he was deceitful. She declared later: "Oh husbands and wives, do not lie to each other, even though you should do a vile act; confess to the truth of the matter! There will be some trouble over it, but you can never lose your love for a truthful person."

Carry had hoped that David would provide security for her daughter and mother-in-law. He proved unsuccessful both as a writer and as a lawyer, however, so he moved on with his family to try his luck in the small Texas town of Columbia. Again she kept the family going by taking the arduous job of a small-town hotel manager, which she stuck at for ten years. Her daughter suffered from a hideous, disfiguring sore on her face, and her mouth locked shut so tightly that the local doctor had to knock her front teeth out in order to force food into her mouth through a metal tube and prevent starvation. Through all these hardships, Nation tried to console herself with prayer and was in constant communication and bargaining with God, still tormented by an

overactive conscience and inclined to take the blame for all misfortunes on herself.

Nation bought a larger hotel, near Richmond, Texas, despite its apparent vulnerability to fire, and continued her hard work for a grow-ing number of dependents. She ran a non-de-nominational Sunday School in the dining room and, during a drought in the summer of 1885, led a prayer meeting in the local Methodist Church basement to plead with God for rain. He answered the call and sent forth three days of

rain, which led some townspeople to think she was a miracle worker, others that she was lucky. Her luck certainly held out during a catastrophic fire in 1889 which burned down half the town, including the house right next door to her hotel, but left the hotel itself undamaged. While the guests had fled, she had stayed inside praying for God's mercy and said that from this time on she never again feared fire.

Later that year, Carry and her husband sold the hotel, driven out of town by a feud which led to a severe beating for David, and moved to Medicine Lodge, Kansas. There he became a preacher but his sermons had so little verve that he was not reappointed after the first year. Carry sat in the front pew and shouted instructions and criticisms at the top of her voice, becoming a local oddity whom people came from miles around to watch on Sunday mornings. During a three-day religious vigil several years later, when she felt the constant presence of Jesus, she realized that her mission on Earth was to fight the menace of alcohol, which had certainly had a severely adverse effect on her own life (she now learned that her daughter and son-in-law were themselves heavy drinkers). Since 1880, Kansas had been officially a "dry" state, but in fact the liquor trade flourished more or less openly. There were seven bars in the town of Medicine Lodge alone. Carry Nation's first act of resistance, early in 1900, was to kneel with one Mrs. Eliot, the wife of chronic drinker, outside the bar in which he was carousing, and pray at the top of her voice. The noise, and the spectacle, scared away the bar's patrons, and Nation, emboldened, ordered the town's authorities to live up to the state constitution and close down all the other bars.

The Women's Christian Temperance Union (WCTU) was the largest women's organization of the era, and for decades it worked city by city and state by state to prohibit the manufacture, sale, and consumption of alcoholic drinks. Nation joined the local branch and became a lecturer and jail visitor, pleading the cause of sobriety. Always charitable and forgiving despite her sometimes ferocious stage presence, she helped care for "fallen women," and reviled the sexual double standard. Wrote Nation:

> There are diamonds in the slush and filth of this world. Happy is he who picks them up and helps to wash the dirt away, that they may shine for God. I am very much drawn to my fallen sisters. Oh! the cruelty and oppression they meet with! If the first stone was cast by those who were guiltless, those who were to be stoned would rarely get a blow.

Most WCTU women prided themselves on orderly conduct and legal methods, but Nation's hard experiences led her to favor a more militant approach, and she won the support of several other determined women in the area who wanted to close down the saloons. Nation gathered crowds when she sang hymns outside another bar in mid-1900, won some of the onlookers over to her side, and shamed the local marshal into closing down the bars and alcohol shops. After an attack on the store of O.L. Day, which culminated in her rolling a whisky barrel into the street and bursting it open with a mallet, the local "wets" retaliated by smashing her windows and threatening to burn her house to the ground. Undeterred, she showed up in court to argue against granting Day a license to sell "medicinal" liquor and had the satisfaction of seeing his business fail a few weeks later.

Next Carry Nation moved to the wilder town of Kiowa, 20 miles to the south, and smashed the windows and bar mirrors of a large saloon, overturning tables and chairs, and ripping "sporting" (salacious) pictures off the walls. Then she challenged local officials to arrest her, or admit that by conniving with the liquor trade they were themselves law breakers. Indecisive, they warned her to leave town, but not before word had spread of her exploits and been picked up by the local press. From that time on, she became a local celebrity and was asked to speak to temperance groups, even to appear on stage in *Ten Days in a Barroom*. Her jump into the national spotlight came later in December of that year when she attacked the Hotel Carey's Annex bar in Wichita after a night spent on her knees in fervent prayer. One rock destroyed a thousand-dollar mirror, another defaced a large nude painting, then she began to swing an iron bar, shattering bottles, tables, glasses and the elaborate cherrywood bar, all the time chanting: "peace on earth, goodwill to men" and other Biblical slogans.

Arrest and imprisonment followed, but, as the date of her trial grew near, she received a stream of messages of support, offers of legal help, and enjoyed the hymns of revival meetings held within earshot of her tiny cell. Inside the jail, Nation befriended the criminals, who paid her the tribute of writing a poem about her bravery and kindness to them. As national publicity about the coming case intensified, the state authorities decided to drop the charges against Carry Nation, but no sooner was she released than she made a passionate speech to the Wichita branch of the WCTU. Until then they had frowned on her methods but now many of them

changed their minds and joined her in a new bar-smashing foray. For the first time, in January 1901, she wielded the hatchet which was to become her hallmark. She was re-arrested but again released without trial, then set off to repeat her work in the town of Enterprise, where her attacks were met not only by angry drinkers but also by their wives and the prostitutes who worked in the bars.

Her campaign reached a climax in Topeka, the state capital, where she destroyed another bar, with the help of three sturdy assistants, evaded prosecution, and addressed the state legislature which was considering repeal of the state's "dry" laws (but now decided to preserve them). This was also the occasion on which she arranged for model hatchets to be made, signed with her name, and sold as souvenirs to pay the cost of her campaigning, travel, and fines. Nation moved straight onto the lecture circuit, finding that, after 54 years of drudgery and privation, she was an instant success and a national celebrity. She also began a prohibition newspaper, *The Smasher's Mail*, which she enlivened by reprinting a selection of the threatening letters she received every month.

Meanwhile, her husband David was feeling increasingly neglected. Nation did not want his company on tour or on campaign, despite his willingness to join her, and he began to complain to the press, who were now hungry for all Nation-related news, that she had deserted him. When he filed for divorce, she said she was not surprised, that she had no respect for him, and that for years he had been an "encumbrance" on her life. This marital upheaval and the almost simultaneous death of her brother J.W. Moore, however, sent Carry into a spell of depression, and when she came to trial in Kansas City for an earlier incident she entered a plea of insanity. The judge ignored it, she was convicted, but was freed on bail before sentencing, and revived her spirits by leading a group of children on an anti-saloon attack in Crawfordsville, Indiana.

In September 1901, Nation lectured in Coney Island, New York. She had been a persistent critic of President William McKinley, whom she nicknamed "The Brewer's President" for his reluctance to take strong measures against the alcohol manufacturers and traders, and now she learned that he had been shot by an anarchist. Asked for her opinion, she said she had no sympathy for the assassin but none for the president either. The crowd booed, and when the press misquoted her the next day, alleging that she had praised the assassin, her reputation plummeted.

At a series of lectures in the following weeks, she was heckled, pelted with rotten eggs, and stoned. Nation retreated for a while to Kansas but was soon back in public, this time on the college lecture circuit, and the next year appearing in burlesque theaters, which seemed to her one of the best places to surprise an audience which would otherwise never hear her message.

Personal problems continued to pursue her, particularly the chronic alcoholism of her own daughter Charlien. In addition, another of her publishing ventures, *The Hatchet*, was confiscated by federal marshals as obscene because it contained an editorial warning young men against masturbation, and led to another prosecution. She was exonerated and in 1906 moved her operation to Washington, D.C., where a sympathizer lent her an apartment free of charge for five years and other temperance enthusiasts arranged further speaking engagements. In the winter of 1908–09, she toured Great Britain, remarking after some rough encounters with hecklers that "Scotland is much nearer to Hell than Kansas" and that the British House of Lords ought to be renamed "the House of Frauds." She was pelted with rotten vegetables in London theaters, but won enthusiastic applause from pro-temperance Britons.

Carry Nation spent the last years of her life in an Arkansas cottage, but still made frequent speaking excursions, and suffered a stroke while lecturing in Eureka Springs, Missouri, in 1911. She died five months later and was buried beside her mother, in Belton, Missouri. Although the WCTU and the more respectable temperance organizations had frowned on her methods, they had to admit that she had given their movement an immense publicity boost by forcing the public to take notice of the issue. Within a decade of her death, the national Prohibition experiment was under way.

SOURCES:

Asbury, Herbert. *Carry Nation*. NY: Knopf, 1929.

Lee, Henry. *How Dry We Were: Prohibition Revisited*. Englewood Cliffs, NJ: Prentice Hall, 1963.

Madison, Arnold. *Carry Nation*. Nashville, TN: Thomas Nelson, 1977.

Nation, Carry. *The Use and Need of the Life of Carry A. Nation*. Topeka: F.M. Steves, 1909.

Taylor, Robert L. *Vessel of Wrath: The Life and Times of Carry Nation*. NY: New American Library, 1966.

Patrick Allitt,
Professor of History, Emory University, Atlanta, Georgia

Natwick, Mildred (1908–1994)

American actress. Born on June 19, 1908, in Baltimore, Maryland; died on October 25, 1994, in New

York City; daughter of Joseph Natwick and Mildred Marion (Dawes) Natwick; attended Bryn Mawr School, Baltimore, and Bennett Junior College, Millbrook, New York; never married; no children.

Selected theater: made New York debut as Mrs. Noble in Carry Nation (1932); made London debut as Aunt Mabel in The Day I Forgot (1933); appeared as Drusilla Thorpe in Amourette (1933), Pura in Spring in Autumn (1933), Mrs. McFie in The Wind and the Rain (1934), Mrs. Venables in The Distaff Side (1934), May Beringer in Night in the House (1935), Mrs. Wyler in End of Summer (1936), Ethel in Love from a Stranger (1936), Miss Proserpine Garnett in Candida (1937), the Widow Weeks in Missouri Legend (1938), Bess in Stars in Your Eyes (1939), Mother McGlory in Christmas Eve (1939), Milly in The Lady Who Came to Stay (1941), Madame Arcati in Blithe Spirit (1941), Dolly Talbo in The Grass Harp (1952), Volumnia in Coriolanus (1954), Madame St. Pe in Waltz of the Toreadors (1957), Kathie Morrow in The Day the Money Stopped (1958), Miriam in The Firstborn (1958), the Mother of Marie-Paule, Angele, and Armand's Mother in The Good Soup (1960), Charlotte Orr in Critic's Choice (1960), Mrs. Banks in Barefoot in the Park (1963), Ida in 70 Girls 70 (1971).

Mildred
Natwick

Selected filmography: The Long Voyage Home (1940); The Enchanted Cottage (1945); Yolanda and the Thief (1945); The Late George Apley (1947); A Woman's Vengeance (1948); The Kissing Bandit (1948); Three Godfathers (1949); She Wore a Yellow Ribbon (1949); Cheaper by the Dozen (1950); The Quiet Man (1952); Against All Flags (1952); The Trouble with Harry (1955); The Court Jester (1956); Teenage Rebel (1956); Tammy and the Bachelor (1957); Barefoot in the Park (1967); If It's Tuesday This Must Be Belgium (1969); The Maltese Bippy (1969); Trilogy (1969); Daisy Miller (1974); At Long Last Love (1975); Kiss Me Goodbye (1982); Dangerous Liaisons (1988).

The gifted supporting player Mildred Natwick graced the stage, screen, and television for almost five decades, bringing to life a dazzling array of eccentric and endearing characters. Reviewing her role as the mother in Neil Simon's Broadway comedy Barefoot in the Park (1963), Walter Kerr called the actress "the most hilarious woman in the Western Hemisphere." Although Natwick never won an Oscar or a Tony (she was nominated several times), she was awarded an Emmy for her 1973–74 television series "The Snoop Sisters," in which she and *Helen Hayes played mystery writers turned amateur sleuths.

Born in 1908 in Baltimore, Maryland, Natwick began acting after college and made her first stage appearance as Widow Quin in *The Playboy of the Western World* at the Vagabond Theater in her hometown. In 1932, following a stint with the National Junior Theater Company in Washington, D.C., Natwick made her Broadway debut as Mrs. Noble in *Carry Nation*. Small of stature and rather sharp-featured, she was pegged for character roles early in her career, and even as a young woman was able to play characters much older than herself. A veteran of over 40 stage productions, Natwick was memorable as the idiosyncratic secretary in G.B. Shaw's *Candida*, and as the zany medium in Noel Coward's *Blithe Spirit*, for which she received a Tony nomination. As the shrewish wife in Jean Anouilh's play *Waltz of the Toreadors* (1957), Natwick won the praise of critic Brooks Atkinson, who characterized her performance as "protean," one that "rides the whirlwind with a great sweep of venomous extravagance."

Appearing in films from 1940 on, Natwick made four movies with director John Ford: *The Long Voyage Home* (1940), *The Three Godfathers* (1949), *She Wore a Yellow Ribbon* (1949), and *The Quiet Man* (1952). The actress repeated

her Broadway role as the mother in the 1967 film version of *Barefoot in the Park*, for which she received an Academy Award nomination as Best Supporting Actress.

Mildred Natwick was never known to shy away from a challenge, and in 1971, age 63, she made her singing debut in the John Kander-Fred Ebb musical *70 Girls 70*, playing the leader of a circle of elderly fur thieves and winning a second Tony nomination. (The show, however, had only a brief run.) Natwick was approaching retirement age when she went into the successful television series "The Snoop Sisters." She made her last film appearance in *Dangerous Liaisons*, in 1988. Natwick, who never married, made her home in New York City, where she died at the age of 89.

SOURCES:

Huzinec, Mary. "Passages," in *People Weekly*. November 7, 1994.

Katz, Ephraim. *The Film Encyclopedia.* NY: Harper-Collins, 1994.

McGill, Raymond D., ed. *Notable Names in the American Theater.* Clifton, NJ: James T. White, 1976.

"Obituary," in *Boston Globe*. October 27, 1994.

"Obituary," in *The Day* [New London, CT]. October 26, 1994.

Barbara Morgan,
Melrose, Massachusetts

Navarre, queen of.

Navarro, Mary de (1859–1940).

See Anderson, Mary.

Navratilova, Martina (1956—)

Czech-born record-breaking tennis champion who won 167 singles championships (18 in Grand Slam tournaments), 165 doubles championships, 55 mixed-doubles championships, and 9 Wimbledon championships. Pronunciation: (originally) Nav-RAH-tee-low-VAH; (according to American media) NAV-rah-ti-LOW-vah. Born Martina Subertova on October 18, 1956, in Prague, Czechoslovakia (now the Czech Republic); daughter of Jana (Semanska) Subert Navratil and Miroslav Kamil Subert; stepdaughter of Miroslav Navratil; never married; no children.

Began playing tennis at age six (1962); began professional training at nine (1965); at 13, was the youngest player on the Czech national tennis team (1969); was allowed by the Communist government then in power to travel to the U.S. (1973) to compete on the U.S. Tennis Association circuit; during another U.S tour, decided to defect and seek American citizenship (1975), which was granted (1981); during years of professional play, won 167 singles events, including 9 Wimbledon titles and 4 U.S. Open titles, and was credited with being among the first women to use rigorous strength training to bring a highly aggressive and physically demanding style to the women's circuit; by the time of retirement from singles play (1994), had won a record-setting $20 million in prize money; though career was complicated by her public candor about her sexuality, continues to act as a well-known speaker for gay and women's rights; inducted into the Tennis Hall of Fame in Newport (2000).

Martina Navratilova was barely six years old when she first stepped onto a tennis court. "The moment I stepped onto that crunchy red clay, felt the grit under my sneakers, felt the joy of smacking a ball over the net," she said of that day in 1962 in her native Czechoslovakia, "I knew I was in the right place." Tennis would bring her, among other things, a settled childhood in the midst of political upheaval, a means to escape Communist oppression, and a way to make her way in her adopted homeland.

Tennis was a constant in her family background. Martina's grandmother **Agnes Semanska** had once beat **Vera Sukova** to win a Czech national tournament, while an uncle had played at the national level; and her mother **Jana Semanska** had once seemed destined for similar honors until giving up a tennis career rather than

submit to a father who drove her relentlessly to better her game. Jana chose skiing as a replacement sport and was working as a ski instructor at a resort near the German border when she met and married Miroslav Subert (pronounced *Shu*bert) and moved with him to a village in the Krkonose mountains in which the chief business was a ski resort called Martinovka. The resort provided them both with employment (Miroslav was the chief of the resort's ski patrol) and also the name for their daughter, born on October 18, 1956, in Prague, where Jana's family were still living. In keeping with Eastern European tradition, the child carried a feminine version of her father's last name and was known as Martina Subertova. Jana's return to Martinovka with her baby provided Martina with her earliest memories of gliding down brilliant white mountains under bright blue skies.

We must be proud of who we are, and we cannot do that while we hide.

—Martina Navratilova

After three years of marriage, however, Jana found it increasingly difficult to deal with the erratic moods of her highly emotional husband. She left him to return with Martina to a single room on her mother's estate in the town of Revnice, just outside Prague, where Martina grew up in the bosoms of her beloved maternal and paternal grandmothers. Jana had grown up privileged on this estate which once boasted 30 acres and a grove of fruit trees. Following the Communist takeover in 1948, the estate was confined to the house (now shared with other families) and the red-clay tennis court which was falling into disrepair and used more often for soccer games. "I think my mother and my grandmother carried a sense of *litost,* a Czech word for sadness, that I picked up," wrote Navratilova, "a feeling of loss at the core of their souls."

In later years, Navratilova would barely remember Miroslav, but would trace her sense of dislocation to his sudden loss. Indeed, she did not learn of his death until several years after the fact, when her mother casually mentioned that Miroslav had died in a hospital from a stomach ailment; and Martina was 23 before she was told the truth—that although Miroslav had, as Jana said, been hospitalized at the time of his death, he had actually committed suicide in the wake of a love affair which had ended badly. Further childhood turmoil stemmed from the fact that, with her gangly body and close-cropped hair, Navratilova was often mistaken for a boy. Store clerks would direct her to the boys' section; old women would mistake her for a Boy Scout and

ask her assistance in crossing the street. "Somehow I had the sense of things being out of focus, out of place," Navratilova later said, "the sense that I should be somewhere else."

Not long after moving back to Prague, Jana joined the city's tennis club and met Miroslav Navratil, another member with whom she was often teamed for friendly doubles matches. "Mirek," as everyone called him, earned his living as an accountant but was an enthusiastic athlete. He also shared Jana's interest in the West and, like her, had taught himself English. The two married in July 1961 and presented Martina with a half-sister, named for her mother, two years later. By all accounts, the marriage was stable and the family lived in an upstairs room on the Revnice estate. It was Mirek who first led his stepdaughter onto the court that day in 1962 and noticed her enthusiasm for hitting the ball back to him with unusual force for a six-year-old; and it was Mirek who continued to hit the ball back to her for hours over the next three years, telling Martina all the while that she would be a champion player and to imagine playing at Wimbledon one day. As her tennis idol, Navratilova chose Australian Rod Laver, nicknamed "Rocket Rod" for the speed of his court style, after seeing Laver play on television. "Women didn't play like him, not then," Navratilova said. "But if ever there was a player I wanted to copy, it was Laver."

When she was nine years old, her stepfather took her to Davis Cup player George Parma, then Czechoslovakia's best tennis player and coach, who gave lessons at the country's only indoor court at the western edge of Prague. Without Parma's blessing and guidance, tennis hopefuls were unable to play during the bitterly cold winter months. But after Parma hit balls to her for half an hour, driving them especially hard out to the sideline to test Martina's agility, he agreed to take her on as a student with one lesson a week. "He was the most patient coach a kid could have," Navratilova said of Parma. "He would never shout or downgrade me in any way." Parma's first step was to break Martina of the two-handed backhand Mirek had taught her, taking her right hand off the racquet and giving her a few more inches of reach. Telling her that "ordinary shots are what make the game," Parma added subtlety to Martina's game and encouraged her to play the baseline instead of constantly rushing the net. Parma was so impressed with Navratilova's ability that he soon added a second lesson to the weekly schedule and entered her in his junior program, even though she was three years younger than the minimum age

Martina
Navratilova

and had to obtain special medical permission to compete outside her age group. Martina still recalls with some amazement that Parma never charged for his time and, even more important, taught her to see tennis as a lifestyle rather than just a game. "Compete whenever you have the

chance," he told her. "Get to see the world. Sports is one way you'll be able to travel."

During this time, it was her generous paternal grandmother, **Andela Subertova**, who became Martina's emotional mainstay. "I loved

Grandma Subertova so much that she almost did not get into this book," wrote Navratilova in her autobiography. "Every time I started to talk about her, I would break into tears, and feel weak and tired deep inside." When Navratilova journeyed into Prague to train, Andelda, who lived in a small apartment in the Klamovka section, would sometimes be waiting at the tram with a container of carrot salad, urging, "Eat it; it's good for your eyes." She was the voice of approval, the steadfast friend no matter what. On Friday nights, Martina would stay over with her.

Despite her enthusiasm for Parma's advice, however, by the time Navratilova had begun competing in tournaments in other parts of the country, travel outside Czechoslovakia was becoming problematic. The Soviet Union had already installed a puppet government in neighboring Hungary after its invasion of that country in 1956, the year of Navratilova's birth; now, ten years later, the Communist Party line imposed on Czechoslovakia's struggling independent government was becoming harder to ignore. Even though Jana and Mirek refused to join the party, public expressions of support for Western ideas were dangerous and no one was allowed to travel outside the country without express permission. Reaction to the oppression produced the "Prague Spring" of 1968, when a flood of articles and speeches openly challenged the Communist Party's stranglehold. Moscow's answer was swift and brutal. On August 21, 1968, while Navratilova was playing in Prague's Pilsner tournament, Russian tanks rolled through the streets of the city and crushed any hope of the liberals' search for "socialism with a human face."

All bets were off; the rules had changed. Navratilova resented the Russians, the loss of Czechoslovakia, the constant propaganda against the U.S. that did not jibe with the American movies and the actions of *Katharine Hepburn and Spencer Tracy, whom she dearly loved. After trouncing two Russian girls in doubles around that time, Martina walked to the net and said, "You need a tank to beat me." She was being pressured to join the Communist Youth Party; the implied threat for noncompliance was the ruin of her tennis career. "I saw my country lose its verve, lose its productivity, lose its soul," wrote Navratilova. "For someone with a skill, a career, an aspiration, there was only one thing to do: get out." Among the 120,000 Czechs who defected to the West during the year after Moscow's invasion were George Parma and his family. He mailed a regimen for her, and her stepfather took over and followed it.

But Parma's advice about the liberating possibilities of tennis proved true when Navratilova was allowed to travel to West Germany in 1969 as a member of the Czech national tennis team. It was the first time she had been outside the country, and she could hardly ignore the change in atmosphere once the train carrying her north crossed the border into prosperous West Germany, with its supermarkets, shiny Western-manufactured cars, and well-dressed people. Although she was the youngest member of the Czech team, Martina's handy defeat of much older German women during tournament play brought her for the first time to the attention of the larger world of tennis outside Czechoslovakia. Rewarded for her performance with a membership in Prague's prestigious Sparta Club, an elite sports club open only to the country's best athletes, Martina returned to West Germany in 1970 and played in tournaments throughout Eastern Europe and in Russia during the next two years. At 16, she made it to the finals of the Czech National championships and defeated the country's top-ranked player 7–5, 6–4 to become Czechoslovakia's second highest-ranked player. By the time she arrived in England for her first indoor tournament on a wooden court, the startling energy and athleticism of her game brought so much press attention that the BBC predicted she would be the next Wimbledon champion.

By now, the government-controlled Czech Tennis Federation trusted Navratilova well enough to announce early in 1973 that it would send her on the U.S. winter circuit along with the country's third-ranked woman, **Marie Newmannova**, who had already played in America and who was allowed to travel without a bodyguard and to handle her own winnings. Martina's winnings, on the other hand, would be automatically handed over to the Federation while she herself lived on a small weekly allowance. But she would be playing the same circuit as some of the world's top-ranked players, among them *Evonne Goolagong, *Virginia Wade and the woman who would become alternately Martina's nemesis and best friend, *Chris Evert. "I saw her when she was . . . just a skinny little kid with a terrific forehand," Virginia Wade recalled of her first sight of the new European player on the circuit. "Even then I knew she would one day be a champion."

More important was Navratilova's immediate love affair with America. She still remembers stepping off the plane in Florida with the same sense of belonging as the day she first walked onto a tennis court in Prague. "When I came [to the United States], it was like going home again,

to a world somebody had taken from me," she said. The tour provided another revelation, too, when Navratilova defeated **Helga Masthoff** in St. Petersburg, Florida, in her first match on a hard-packed clay court in humid, semi-tropical conditions. The match lasted three and half hours before Martina swept the last two sets. "That match told me something," Navratilova remembers. "I knew I could be in the top ten. I really could be one of the best, I told myself. I can beat these people." The Czech Tennis Federation enthusiastically agreed and next sent Martina to her first French Open, where she advanced to the quarterfinals before losing to Evonne Goolagong; to her first Wimbledon, where she won her first two rounds before losing her third round to **Patti Hogan**; and on to the U.S Open in Forest Hills, New York. During the tournament, Navratilova met business manager Fred Barman, who agreed to take her on as a client.

By the time she returned home in 1974, Navratilova was more famous in Czechoslovakia than Jan Kodes, then the Czech men's champ, and claimed that ill-feeling from the male-dominated Tennis Federation was behind veiled warnings from colleagues that she was becoming too Westernized. "You've got to cool it," Martina remembers Vera Sukova, the Czech women's coach, telling her. "You'll get yourself in trouble and everybody else in trouble. Just play the game." Sukova's warning seem justified when, during her next American tour in 1975, Navratilova decided to stay on after her last scheduled match in Boston and play in a tournament in Florida without telling her parents, the Federation, or anyone else back home. She had played brilliantly during that year's Virginia Slims tour, beating Chris Evert for the first time at Washington and then defeating, in turn, Virginia Wade, *Margaret Court and Evonne Goolagong to win the U.S. Indoors championship in Boston. But the telegram sent to Florida by the Czech Tennis Federation took no account of these victories and demanded that she return immediately to Prague. Instead, she finished the tournament and then went home, to face a great deal of anger.

The stern reprimand she received in Prague did not prevent Martina from refusing to stay with the Czech team during the French Open in Paris; she moved instead into the same hotel in which her doubles partner at the Open, Chris Evert, was staying. "Seeded players could get reservations and good rates at one of the fancy hotels, and since I was seeded second and playing doubles with Chris, I thought it natural for us to stay in the same hotel. I never gave it a sec-

ond thought." The pressure continued to mount when the Federation hinted that Navratilova would not be allowed to play in the U.S. Open, a decision that was rescinded at the last minute after Jan Kodes himself convinced the Federation that Martina's probable win at Forest Hills would be good for the country's image. "Even with permission to leave the country, I could feel their control tightening," Navratilova said. "They were treating me like a little girl."

The night before she had left Prague, she had taken a walk with her stepfather, who told her that if she defected to the U.S. to stay there, even if they begged her to return. Her mother had told her previously that she did not want to know if Martina were going to defect. "I packed my clothes, fussed around the house, tried to sleep, and went to the airport the next morning knowing there was a chance I would never see my family or my homeland again."

It was during play at a warmup tournament outside New York before the Open that Navratilova finally made up her mind to defect, although no one watching her play against Chris Evert at Forest Hills knew the reason for an apparent, and highly uncharacteristic, lack of concentration that led to her loss to Evert in the semifinals. Fred Barman had, in fact, arranged for a meeting that very evening with U.S. immigration officials in Manhattan. At a press conference the next morning, Navratilova said her decision had nothing to do with politics and everything to do with tennis. "I wanted to be a world class tennis player," she later said. "I never thought of it as a defection." The Czech Tennis Federation thought otherwise. "Martina Navratilova has suffered a defeat in the face of Czechoslovak society," its official press statement read. "Navratilova had all possibilities in Czechoslovakia to develop her talent, but she preferred a professional career and a fat bank account." She would have to wait five years before she could become an American citizen, five years before she could fly over a Soviet bloc country without being fearful of making an unscheduled landing and being hauled off the plane. In 1981, Navratilova gained full U.S. citizenship.

Moving into a room in Fred Barman's Beverly Hills home until the furor over her defection died down, Navratilova returned to her old form on the court and played to standing ovations around the country. She had arrived at a time when women's tennis had begun attracting as much attention and support as its male counterpart, thanks to the brilliant playing of such stars as *Billie Jean King, Margaret Court, Virginia Wade and the player who fascinated Martina the

most, Chris Evert. "Even before I met her, she stood for everything I admired in this country," Navratilova said of Evert. "Poise, ability, sportsmanship, style." Evert was already seeded among the top women players in the world by the time she defeated Martina in their first meeting in Akron, Ohio, during Navratilova's first American tour in 1973; by 1975, the year of her defection, Martina had evened the score with her victory over Evert in Washington. Over the next 20 years, the two women would trade first and second rankings with such dizzying frequency that even Martina tactfully admitted in the mid-1980s that "things get a little touchy on both sides when we talk about our accomplishments." But their friendship managed to survive their rivalries on the court. "I'll never forget that when I first came around, insecure and lonely, Chris Evert was there to say hello," Navratilova wrote.

By 1976, however, the loneliness and insecurity had begun to affect Martina's game. The strain surfaced during quarterfinals play at Wimbledon against Britain's **Sue Barker**, when Navratilova openly challenged what seemed a bad call in Barker's favor by shouting to the judges, "I wonder if you called it that way because she's British!" The challenge, and Navratilova's subsequent withdrawal from the match before the third set, was widely reported in the international press. Her game completely fell apart at that year's U.S. Open during first round play against **Janet Newberry**, when Martina repeatedly and inexplicably, to observers at least, burst into tears. "I never saw anybody so miserable, so totally out of control," Newberry commented afterward. Navratilova still remembers the match as the most embarrassing loss of her long career and winced at the nickname that the press adopted for her, "the Choker."

But help arrived in the person of *Sandra Haynie, a top-ranked player on the women's golf circuit who was among the audience watching Martina's downfall at the U.S. Open. Navratilova was introduced to Haynie by a mutual friend and sensed that Haynie's optimism and disciplined training methods could pull her out of her slump. Buying a house in Dallas, Texas, where Haynie lived, Martina adopted a regular workout schedule developed by Haynie and, on Haynie's advice, returned to her former strategy of aggressively playing the net rather than playing the baseline—the kind of defensive reaction forced on her by Chris Evert's playing style. "Stop playing Chris' game," Haynie succinctly put it. The advice proved sound. While Navratilova had won only two tournaments in all of 1976, she began 1977 by defeating Evert in

finals play at Washington and went on to win six more tournaments. The following year brought 37 straight tournament wins, including 7 finals matches against Billie Jean King, *Rosie Casals and Evonne Goolagong, among others, before Martina captured her first Wimbledon title by defeating Chris Evert a second time, 2–6, 6–4, 7–3. By the end of 1978, just two years after her game had fallen apart, Martina Navratilova was seeded #1 in world rankings.

There were momentous events of a more personal nature that year, too. Navratilova had noticed during her first year in America that she found comfort in the support and camaraderie of her fellow players on the circuit. "They were professionals, their lives not always defined by men," she later said of her attraction to women. "A lot of it has to do with freedom." During the 1978 tour, Navratilova had met novelist **Rita Mae Brown**, who was developing a story idea for a new book in which a Czech character figured prominently. There had been several brief affairs by the time Navratilova met Brown, although for some years afterward Martina would publicly either deny her homosexuality or claim she was bisexual. After several meetings and hours talking on the telephone with Brown while she toured, the two women set up house together in Charlottesville, Virginia. "There was something very direct about her mind," said Navratilova, "something I had never encountered in a woman before." Equally impressive was Brown's total lack of interest in sports which, as time passed and the two women settled into a comfortable domestic life, was held responsible on the circuit for a noticeable decline in Martina's game. By 1980, Navratilova had lost her #1 ranking to Chris Evert. "Martina's tennis was her business, it wasn't my business," Brown claimed after the relationship had ended, but conflict seemed inevitable. The friction only increased when Martina's family visited the United States in 1979 and were openly critical of her sexual orientation in general and her relationship with Brown in particular. "Our relationship wasn't all that physical to begin with, but I was attracted to her emotionally and especially intellectually," Navratilova wrote. "That's what makes me suspicious of all the sexual labels. I hate it when people have a preconceived notion of what you are. No matter what you say, you'll come out the way they want you to be. I was romantically involved with somebody who wrote and told funny stories and had a cat named Baby Jesus and happened to be a woman. Yet the strongest part of her, the part that most attracted me, was the verbal, mental, social, psy-

chological part of her." Brown was openly gay; her book *Rubyfruit Jungle* was openly gay. Though Navratilova never discussed their relationship in an interview and the mainstream press remained silent, the scandal magazines made hay. Further turmoil ensued when, in 1981, Martina met *Nancy Lieberman-Cline, who had been playing for the Dallas Diamonds in the newly formed Women's Basketball League before an injury forced her early retirement. The resulting tensions finally burst into the open when Martina left Brown for Lieberman-Cline. Gossip on the circuit was that Brown had fired a pistol at Navratilova during one particularly emotional dispute, although Brown later claimed that the weapon had fired accidentally when she hurled it across the room in anger. "If I were going to shoot at somebody, I wouldn't miss," Brown said. "I have very, very good hand-eye coordination."

Lieberman-Cline was more than a new love interest, however, for it was her rigorous and physically demanding workouts that brought Martina's game to new heights of power and aggressive play. "Nancy got me in shape the only way she knew how: the hard way," Navratilova later wrote. "I was discovering true pain in my body for the first time in my life." Lieberman-Cline's prescription included daily runs of up to five miles, weight-training, basketball and a strict low-fat diet, all blended with psychological techniques to boost self-confidence. ("Nancy taught Martina to hate me," Chris Evert once said.) Martina had lost over 20 pounds by the end of 1981, weighing in at a trim 147 and scotching another moniker she had earned in earlier and heavier years, "The Great Wide Hope." At the end of 1982, after two years playing under Lieberman-Cline's guidance, Navratilova became the first female athlete in any sport to win more than $1 million in one season. She was making so much money, in fact, that her garage held over a dozen cars, including a Rolls-Royce. The entourage with which she traveled—including Lieberman-Cline, a dietician, a masseur, and a chiropractor—came to be called "Team Navratilova." She was also becoming a favorite with tournament crowds: "They weren't cheering Martina the Complainer, Martina the Czech, Martina the Loser, Martina the Bisexual Defector," she wrote. "They were cheering me."

But only two things really mattered now—regaining her #1 ranking and capturing the only Grand Slam title that had so far eluded her, the U.S. Open. By 1983, she had accomplished both, facing Chris Evert in finals play for the 39th

time in almost 10 years on the circuit. Evert had taken the #1 seed away from her three years earlier, but now Martina battled Evert to the fourth match point, when Evert sent the ball outside and gave Navratilova a 6–1, 6–3 victory and the first of four U.S. Open titles. "I jumped into the air, but I quickly remembered the champion on the other side of the net, and how gracious she had always been to me. I had to show her the same respect. I rushed to the net, and Chris Evert Lloyd—my grandmother's favorite player—was there waiting. She put her arm around me and patted my head with her racquet. Then, arm in arm, we walked off the court." Martina credits the victory not to Lieberman-Cline, but to **Renee Richards**. Richards, a transsexual who had formerly been known as Richard Raskind before qualifying for the women's tour in 1977, had suggested a more refined, analytical approach on the court and had worked with Navratilova for nearly a year before disputes with Lieberman-Cline ended the working partnership. Martina herself ended her relationship with Lieberman-Cline in 1984, but she continued to play her game with a muscular, aggressive, and risky style that changed women's tennis. "She tended to come up with some outrageous stuff," **Pam Shriver** said of Navratilova during their doubles partnership that racked up 20 Grand Slam titles during the mid-to-late 1980s. "But a lot of times it came off and worked for her."

In May 1984, someone new was in the Team Navratilova booth at the French Open at Roland Garros: **Judy Nelson**, a mother of two boys. Navratilova beat Evert once again in the finals for her fourth straight Grand Slam victory. The spotlight was on the winner—and her entourage. When Nelson and Navratilova arrived at Wimbledon that summer the British press had been primed. One reporter pushed in with "Are you still a lesbian?" Martina countered with "Are you still the alternative?" On the court, she beat Evert once again in the finals. By 1990, when Navratilova won her record-setting ninth Wimbledon title, she walked off the court and into the arms of Nelson, which the commentators noted with delight. (Their later breakup, to Navratilova's chagrin, would be just as public.)

After 1990, Martina found herself facing much younger players who had studied her game and learned their lessons well. Her 6–4, 6–2 loss to *Gabriela Sabatini at the Virginia Slims tournament in New York in November 1991 was followed by similar difficulties until, at Wimbledon in 1994, Navratilova lost in finals play by a whisker to **Conchita Martinez**, who had been a little girl when Martina won her first Wimbledon

nearly 20 years earlier. With a curtsy to the royal box and a salute to the cheering crowds with their 90-second standing ovation, Navratilova scooped up a bit of turf from Centre Court as a souvenir and officially retired from professional singles play. She was 37 years old, had earned over $20 million in her 21 years of professional play, and had been ranked the #1 player in the world seven times. She had won 18 Grand Slam singles titles, 37 Grand Slam doubles titles, and was the all-time leader among both women and men with 167 singles titles to her credit.

The media could not find enough superlatives to thank her for the years and years of sensational tennis. Frank DeFord wrote that she had always "been the other, the odd one, alone: left-hander in a right-handed universe, gay in a straight world; defector, immigrant, the (last?) gallant volleyer among all those duplicate baseline bytes. . . . [S]he was the European among Americans; she leaves as the American among Europeans—and the only grown-up left in the tennis crib." In her last match on November 15, 1994, fittingly at Madison Square Garden, they raised a red banner with a yellow tennis ball to the rafters in her honor, "the first such tribute at the Garden," wrote AP tennis writer Steve Wilstein, "for any woman and appropriate for the most successful tennis player, man or woman, in history."

Today, Navratilova is an outspoken advocate of women's rights and anti-discrimination legislation, appearing at rallies and legislative hearings around the country. In addition, she actively manages her Martina Youth Foundation for underprivileged children. But on the rare occasions when she steps onto a court to play an exhibition game, the fire is still there. "Martina revolutionized the game by her superb athleticism and aggressiveness, not to mention her outspokenness and her candor," Chris Evert once said of her old rival and friend. Evert, in fact, was quick on the defense when Martina publicly announced her lesbianism in the 1980s. "I would tell my children to look at the way she conducts herself on the court," Evert told *Sports Illustrated*. "Look at how she fights for every point. And look how honest she is with people. I guess a lot of parents aren't ready for that yet." Honesty has always been high on Navratilova's list of virtues, and it is one she learned early on, on a gritty clay court in Prague as her stepfather lobbed balls back to her. "He told me I would win at Wimbledon some day," she once recalled. "And I believed him."

Charles Bricker once spoke of the admiration Navratilova had earned "since she came to the United States in 1973, a shy, awkward woman-child desperately seeking a country and a personal identity. When that lithe, muscular figure is gone from professional tennis, it won't be the carefully tuned athletic body or her rare skills we will miss most. It will be her guts." Her outrage at injustice to anyone "would not be muzzled." Eventually, talk of her lifestyle was superseded by talk of her honesty.

SOURCES:
Blue, Adrienne. *Martina Unauthorized*. London: Gollancz, 1995.
Kindred, Dave. "Earning a Piece of History," in *The Sporting News*. Vol. 218, no. 2. July 11, 1994.
Kort, Michele. "Martina Navratilova," in *Working Woman*. Vol. 21, no. 11. November–December, 1996.
Navratilova, Martina, with George Vecsey. *Martina*. NY: Alfred A. Knopf, 1985.
Shmerler, Cindy. "The End of an Era," in *Women's Sports and Fitness*. Vol. 16, no. 8. November–December, 1994.

SUGGESTED READING:
Faulkner, Sandra, with Judy Nelson. *Love Match: Nelson vs. Navratilova*. NY: Birch Lane, 1993.
Kirkpatrick, Curry. "The Passion of a Champion," in *Newsweek*. November 14, 1994, p. 58.

Norman Powers,
writer-producer, Chelsea Lane Productions, New York

Nawab Aliya (c. 1592–1631).

See Mumtaz Mahal.

Nayadu, Sarojini (1879–1949).

See Naidu, Sarojini.

Naylor, Genevieve (1915–1989)

American photographer who specialized in fashion, advertising, and photojournalism. Born in Springfield, Massachusetts, in 1915; died in Dobbs Ferry, New York, in 1989; attended private elementary schools; graduated from Miss Hall's School, Pittsfield, Massachusetts; attended Vassar College, Poughkeepsie, New York; studied at the Art Students League and the New School for Social Research, New York City; married Misha Reznikoff (a painter), in 1946; children: Michael (b. 1947); Peter (b. 1950).

One of the first female photojournalists employed by the Associated Press, Genevieve Naylor was inspired by *Berenice Abbott, whom she studied with after coming to New York in 1935. Naylor spent four years with the Associated Press beginning in 1937, and then worked for the U.S. State Department from 1941 to 1943, photographing Brazilian life under the aegis of the "Good Neighbor Policy." A solo exhibition of her Brazilian photographs was held at the

Museum of Fine Arts, New York, in 1943, after which Naylor went to work for *Harper's Bazaar* (following in the footsteps of *Louise Dahl-Wolfe). Crediting art director Alexey Brodovitch as a mentor, she remained at the magazine until 1958. In the meantime, she married Russian painter Misha Reznikoff, with whom she had studied painting while she was in high school in Pittsfield, Massachusetts. The couple had two sons, Michael and Peter.

While at *Harper's*, Naylor also freelanced for *McCall's*, *Vogue*, *Cosmopolitan*, *Holiday*, and *Fortune*, and produced a number of serious photojournalism stories for *Look*. From 1953 to 1965, she also created advertising layouts, including some for Revlon and Coca-Cola. Naylor, who retired in 1975, died in Dobbs Ferry, New York, in 1989.

SOURCES:
Rosenblum, Naomi. *A History of Women Photographers*. NY: Abbeville Press, 1994.

Nazar, Krystyna (b. 1924).

See Moszumanska-Nazar, Krystyna.

Nazimova, Alla (1879–1945)

Russian actress who enjoyed a varied career as silent-film star, director, producer, and as one of the most brilliant theater actresses of her era. Pronunciation: Allah Naz-IM-ohvah. Born Mariam Adelaida Leventon on June 4, 1879, in Yalta, Russia; died on July 13, 1945, in Hollywood, California; attended boarding school in Odessa during her teens; attended the Dramatic School in Moscow, 1896–98; upon graduation, out of 5,000 students, was awarded the highest honor, a gold medal that allowed her an internship at Stanislavski's Moscow Art Theater; for two years, studied acting under the world-famous director Constantin Stanislavski; married Paul Orlenev also seen as Orlenieff (a prominent Russian actor), around 1902 (separated 1905); married Charles Bryant (under common law), around 1914 (separated after ten years).

Entered acting school at age 17; married Paul Orlenieff (c. 1902) and embarked on joint productions of plays; after Russian officials forbade production of their early Zionist play, The Chosen People (1904), they presented the play in Berlin, London, and after moving permanently, in New York; enjoyed significant success on the stage, specializing in Ibsen plays (1906–16); made 17 movies, becoming one of the reigning silent-film stars (1916–25); returned to the stage (1925), acting, directing and taking occasional movie and radio roles until her death from heart disease at age 66 (1945).

Selected filmography: War Brides *(1916);* Toys of Fate *(1918);* Revelation *(1918); (also executive producer)* An Eye for an Eye *(1919); (also exec. prod. and co-screenwriter)* Out of the Fog *(1919); (also exec. prod. and co-screenwriter)* The Brat *(1919);* The Red Lantern *(1919); (also exec. prod.)* Stronger Than Death *(1920); (also prod.)* The Heart of a Child *(1920);* Madame Peacock *(1920); (also prod. titles, art dir., co-editor)* Billions *(1920); (also prod. and dir.)* Camille *(1921); (also prod.)* The Doll's House *(1922); (also prod.)* Salome *(1922);* Madonna of the Streets *(1924);* The Redeeming Sin *(1925);* My Son, My Son *(1925);* Escape *(1940);* Blood and Sand *(1941);* In Our Time *(1944); (as the Marquesa)* The Bridge of San Luis Rey *(1944);* Since You Went Away *(1945).*

Alla Nazimova, whose life was one of genius and influence, had an intriguing impact on the lives and careers of those with whom she came in contact. She was born Mariam Adelaida Leventon in 1879 in Yalta, Russia, the daughter of a successful chemist. Over the next few years, the family would live in Yalta, Odessa, and Switzerland. "We had all the conventional reserves and prejudices of the average Russian middle-class family," she said. Initially, she showed little promise with schooling: "I was dull and slow. I could never understand mathematics, I wouldn't even try. . . . I was practically always at the foot of the class." Music was her one talent; with lessons, she learned to play the violin "quite well" and subsequently taught herself to play piano. "But on the whole, I was stupid when it came to learning anything. And up to the time I was sixteen I hadn't a single dream, or ambition, that might have made me want to learn."

Then Nazimova had occasion to meet two women who belonged to an amateur dramatic company. Working with them while they memorized their lines, she read the other parts, later claiming, "As a result, before my visit ended, I had determined that I would become an actress." In reality, the reason was more mundane. At that time in Russia, Nazimova felt that her only options were to marry, become a teacher, or go on the stage. Turning down the first two as unsatisfactory, she found that "the only thing left was the stage." Acting, however, was considered disreputable by the middle class. After a year of trying to gain support from her family, her brother grudgingly yielded to her plan, although he insisted on one thing: instead of joining a theater group directly, she must study at the Dramatic Academy in Moscow. Said Nazimova, "I have never ceased to be grateful to him."

To gain entry to the academy, each applicant had to recite a poem. Nazimova's peripatetic childhood had left her with a confusing accent, a mixture of Russian, German, and French. At the end of her recital, the professor admitted he had not understood a word. Nonetheless, to her surprise, she was accepted into the academy.

While in later years Nazimova would embody the glamorous ideal that surrounded film stars when the "star system" reigned supreme, she once described her teen-aged self as dull and overweight. "I know how I must have appeared: a self-satisfied, fat awkward girl. They called me 'the barrel.' I was the kind of child that was always running into the furniture; partly because I was awkward." The academy tackled this problem immediately. To develop quickness and grace, all students had rigid training in ballet and fencing. Nazimova slimmed down to a weight acceptable for leading ladies, and later came to be known for the infinite physical mutations she took on to make each part believable. Alexander Kirkland noted: "Few dancers have had more perfect control of their bodies and their faces."

My heart was born in a deep shadow, and I can never stay out in the sun very long, because it blinds me.

—Alla Nazimova

Under the tutelage of the academy professors, Nazimova began to stand out from other students. Her creative performance in the play *Magda* caused her bitterness and frustration, for the teacher refused to believe that Alla had not seen, and mimicked, another actress playing the role. She was later vindicated when the same professor handed the class an unproduced play to read; her performance so amazed him that he complimented her "marvelous quickness of perception." Nazimova considered this a turning point: "Before that, I had thought very little about myself. I had been absorbed in my work, but in an objective way. I hadn't speculated much over my own possibilities. But when he said that to me, before the whole class, something woke up in my mind—or my soul. From that time, I knew what ambition was. It put into me the one thing I had lacked before—a burning purpose."

After three years at the academy, Nazimova finished at the head of her class and was awarded a coveted medal that allowed her to intern with the country's most famous theater company, the Moscow Art Theater. Constantin Stanislavski, a co-director of the theater, now considered one of the greatest directors in history, worked with a world-class acting company. While this was truly a valuable opportunity for the young actress, Nazimova spent most of her year with the theater studying acting and learning stage management techniques with the other director, Vladimir Nemirovish-Danchenko. Only once did she get to perform with the company, speaking one line in the play *Ivan the Terrible.*

At the end of her internship, Nazimova had to choose between working with the company or going elsewhere. "I could go into the company there, taking minor parts at first . . . or I could turn my back on Moscow, go away to the provinces, and be at least temporarily forgotten. I chose to be forgotten." For the next three years, she worked in small towns in the provinces. In the first, Kostroma, she had to learn two new plays each week while giving two performances a night. "It is true that I had little time to spare for studying . . . [but] I was training my memory. I was acquiring a repertoire. And I was learning to think quickly." Her dedicated work, and her decision to learn in the provinces, allowed her to take on the lead role in numerous plays.

Around 1902, Nazimova was employed by a "theater for working people" in Petrograd (now St. Petersburg). There she met Paul Orlenieff, whom she called "the greatest actor in Russia." They married and formed a team to co-produce plays. "Then came the step which has controlled my life ever since," said Nazimova. Orlenieff was alarmed at the warm reception given to an anti-Jewish play, *The Contrabandists,* and decided to stage *The Chosen People,* to represent an opposing viewpoint. The imperial government under Tsar Nicholas II, newly threatened by the fear of a nihilist revolt, censored the Orlenieff-Nazimova production. Expressing outrage, Orlenieff convinced Nazimova to help gather a company and tour *The Chosen People* outside Russia. The drama had a successful run before Russian audiences in Berlin and London before the couple moved the play, and their lives, to New York City.

The New York Russian theater community did not prove as satisfying to the newcomers as they had expected. Most Russian immigrants were poor. While the theater was an important part of their lives, they could ill afford the token admission and the actors received little more than a starvation-level salary. Nazimova asked her family to send her a return ticket to Moscow. But after returning home, she found herself curiously dissatisfied. "I saw things that hurt me to the very depths of my soul: students driven to the police station by Cossacks, who whipped them as if they were cattle. . . . And I felt that

Alla
Nazimova

America had made it impossible for me ever again to live in such a country." Although she was offered a contract at one Moscow's best theaters, Nazimova chose instead to return to America, where Orlenieff promised to build a theater to house their company.

When Orlenieff's optimistic plans fell through, he and Nazimova found themselves performing in a small room at the back of a saloon, with *Emma Goldman, the noted anarchist, as their press agent. Though critics praised their work while noting their unfortunate finan-

cial difficulties, Orlenieff soon tired of performing on stages so drastically poorer than those he had worked on in Russia; he urged Nazimova to return there with him. She resisted, determined to learn English and become accepted by a wider audience in New York.

"Uptown" people had heard of the little theater that was on the verge of being closed for lack of funds. As word circulated of Nazimova's skill, friends arranged an interview for her with producer Lee Shubert. Speaking through an interpreter, Shubert offered Nazimova a five-year contract—if she could learn to speak English. Determined, Nazimova took her first English lesson in June 1906. A scant five months later, she appeared in her first English-language play, in the title role of *Hedda Gabler*. According to Kirkland: "Their applause shook the city. The notices scarcely mentioned the play, they were so filled with acclaim for the actress." Critic Arthur Ruhl compared the formerly clumsy Alla to "a leopard."

Nazimova solidified her standing in her next English-language play, where her transformation into another character made her initially unrecognizable to the audience. She soon earned a reputation for her versatility, exotic beauty, and glamour. Over the next few years, she experimented with different types of theater, ultimately realizing that her forte lay with the classics. In time, she would come to be known as the premier Ibsen actress.

Entertainment in the United States was then in transition. Though vaudeville and theater dominated, silent motion pictures were beginning to be shown nationwide. Ultimately, the movies would mark the end of vaudeville but during the early 1900s there was an interesting mix of the three mediums, two well-established institutions and the newcomer that was going to dwarf them both. Acting in any medium was considered a barely reputable profession. Many hotels displayed signs saying, "No Actors or Dogs Allowed."

In 1914, during the run of the successful play *Bella Donna,* Nazimova announced her marriage to her leading man, Charles Bryant. Newspapers carried the story but noted their inability to find any information on when Mr. and Mrs. Charles Bryant had acquired their marriage certificate. In truth, they had not, because it was a common-law marriage; Nazimova had been unable to obtain a divorce from Orlenieff in Russia. This would later cause her great distress when, upon her breakup with Bryant, the facts became public.

The following January, Nazimova toured in the pacifist one-act *War Brides*. With war looming, the public responded well to the piece, making it one of vaudeville's biggest successes and a significant financial triumph for Nazimova. "I believe profoundly in the power of thought," she said, "and it seemed to me that if I could stir millions of people to thinking against the horror of war it might accomplish something. . . . It was a tremendous experience. Everywhere I went, the theaters were decorated with flags; not by the owners, but by the people of the town itself." But the mood changed abruptly as the United States entered World War I. "People did not want to think of its horrors then. They shrank from its ghastliness. And where people had stood up and cheered the play—the audiences sat silent." In 1916, as Nazimova attempted to turn the piece into a motion picture, she encountered her first of several experiences with American censorship; the government shut down filming. In order to proceed, Nazimova changed the setting of the play to Germany, and realized her first motion-picture success.

In 1917, Nazimova signed a contract with the Metro Picture Corporation (later Metro-Goldwyn-Mayer) for a series of motion pictures. An astute entrepreneur, she negotiated an unprecedented contract, guaranteeing her a significant salary, her own production crew, and final approval on all actors, cast, and the director. During this period, Nazimova was leading a dual personal life. While openly married to Bryant, she also was involved with women, a fact well known in the industry. When she produced the 1917 play *'Ception Shoals*, she gave her close friend **Edith Davis** a small part. Davis and Nazimova (affectionately called "Zim") were close friends and rumored lovers. Though Davis eventually married, they continued their warm relationship, and in 1920, Davis would shock her family by naming Nazimova the godmother of her newborn child, Nancy Robbins. Nancy, strongly influenced by the many actors her mother knew, considered Nazimova to be one of her favorites. As she grew older, she followed her mother and godmother into acting, and a variety of small parts came her way. Her fame, however, came in later years, for Nancy Robbins (who used the name Nancy Davis for the stage) eventually married another actor, Ronald Reagan. When he was elected president of the United States in 1980, ***Nancy Reagan** became the nation's first lady.

In 1918, Nazimova signed a 99-year lease for a large piece of property at 8080 Sunset Boulevard in Hollywood. To complement the large house and numerous fruit trees, she added a pool that was said to be shaped like the Baltic Sea. The pool

was to become a gathering place for the writers, actors, and directors who were shaping movies in the 1920s. *Dorothy Parker, Somerset Maugham, *Lillian Hellman, and later *Katharine Hepburn, F. Scott Fitzgerald, and Clark Gable, were all frequent visitors to what became known as the Garden of Alla. Later, after it was turned into a hotel, a young Norma Jeane Baker would come to stay there, hoping to be discovered. She would use the name *Marilyn Monroe.

Nazimova had an affinity for discovering talent. In 1919, she spotted an extra in a movie and offered him the male lead in her next movie, *Camille*, based on the life of *Alphonsine Plessis, with a screenplay by *June Mathis. The actor was Rudolph Valentino; the movie, released in 1921, was a triumph. From this chance happening, Nazimova and Valentino developed a close and mutually beneficial friendship. *Dorothy Arzner also got her first break, working on continuity for Nazimova's production company, during the shooting of 1920's *Stronger than Death*.

Now openly gay, Nazimova developed a significant reputation for flamboyance. An ardent vegetarian and frequent host of seances, she was a character even by Hollywood standards. Around her she gathered a host of prominent stars who were also homosexual. While not hiding their sexual orientation from the movie community, they offered carefully groomed appearances for public and media consumption. During much of this time, Nazimova was still married to Charles Bryant. Though Valentino, the dream lover of millions of American women, married twice to foster his public persona as a heterosexual, each marriage was arranged by Nazimova to one of her gay friends. (His second wife was Nazimova's lover, *Natasha Rambova.) Nazimova once remarked that Valentino had a greater interest in foreign motorcars than in women. Historical records rarely portray anything but the carefully cultivated façades of celebrities of this era, however, which effectively obscures and minimizes Hollywood's extensive gay and lesbian community and their contributions to filmdom's early days.

By 1922, Nazimova, often known only by her last name, had become Metro's top moneymaker. That year she separated from the studio and staked her savings on an ambitious project, producing and directing Oscar Wilde's *Salome*. In tribute to the playwright, the entire cast was to be homosexual. When the movie was released, she "gave away the directing credit to her husband, Charles Bryant," writes **Ally Acker**. The movie met with disastrous reviews. It also

Alla Nazimova

embroiled Nazimova in the middle of a heated argument about the merit of establishing a rating or censorship system for Hollywood movies. By 1922, 32 state legislatures were considering bills for censorship. The country was engaged in a battle between conservatives pushing for censorship and liberals balking at the idea of restricting free speech. In 1923, when *Salome* was shown to the New York Censorship board, the examining censor wrote: "This picture is in no way religious in theme or interpretation. In my judgment, it is a story of depravity and immorality made worse because of its biblical background." Censors demanded that several scenes be removed before they would allow the film to be shown. Worse for Nazimova, the movie was a box-office failure which stripped her of her assets. Her extravagant lifestyle was over. The houses in Paris and Switzerland were sold to cover debts. Notes Vito Russo: "The posturing and highly stylized exaggeration were alien to the broader general public unable to find a frame of reference for the excesses in visual style

that such films presented." Truly avant-garde, Nazimova's excesses and bold conceptions were historic. (In a roundabout tribute, pop singer **Cindy Lauper** would use Nazimova's unorthodox style and penchant for wild headresses as the basis for her 1988 music video, "True Colors.") After *Salome,* Nazimova would work in Hollywood only a few more years. Talking films replaced silent films and, as happened to many other actors, her accent did not carry well into the new medium.

In 1926, when Nazimova sold her property on Sunset Boulevard, the new owners turned it into a hotel, the Garden of Allah, and built 25 bungalows around the pool. Nazimova arranged to live on the property in one of the bungalows. The Garden of Allah would continue its reign as a social center until it was sold and then destroyed in 1959.

Some contemporaries viewed Nazimova's exit from motion pictures as a blessing, since her movies appealed to increasingly smaller audiences. But her talent as an actress in the theater was appreciated universally, and in 1925 she returned to the American and European stage. Her difficult days were put to rest in 1928 with her appearance in Anton Chekhov's *The Cherry Orchard.* According to Kirkland, "It was the rebirth of a great star, and as such was celebrated by the press and public alike." With only a few exceptions, every one of her subsequent works was strongly received. Notes Kirkland, "The critics of this generation bestowed accolades on her art as generously as had their forerunners in 1906." Nazimova would not return to film until 1940 in *Escape.* Through the early 1940s, she continued to take small parts in movies, explored the occasional radio show, but relied on theater for her main support. On June 13, 1945, at age 66, Alla Nazimova died in Hollywood of coronary thrombosis.

SOURCES:

Acker, Ally. *Reel Women.* NY: Continuum, 1991.

"Exit Alla—With Flowers," in *Newsweek.* July 23, 1945, p. 83.

Howes, Keith. *Broadcasting It: An Encyclopedia of Homosexuality on Film Radio and TV in the UK 1923–1993.* London: Mackays, 1993.

Kanin, Garson. "Tales from the Garden of Allah," in *Architectural Digest.* April 1990, p. 54.

Kelley, Kitty. *Nancy Reagan: The Unauthorized Biography.* NY: Simon and Schuster, 1991.

Kirkland, Alexander. "The Woman from Yalta," in *Theatre Arts.* December 1949, p. 28.

Mullett, Mary B. "How a Dull, Fat Little Girl Became a Great Actress," in *American Magazine.* April 1922, p. 19.

Murray, Raymond. *Images In The Dark.* Philadelphia, PA: TLA Publications, 1995, p. 230.

"The Russian Theatre Comes in Waves," in *Theatre Arts.* August 1944, p. 476.

Russo, Vito. *The Celluloid Closet: Homosexuality in the Movies.* NY: Harper & Row, 1987, p. 161.

Vanity Fair. February 1988, p. 61.

SUGGESTED READING:

Lambert, Gavin. *Nazimova: A Biography.* NY: Knopf, 1997.

Scout, freelance writer, Washington, D.C.

Neagle, Anna (1904–1986)

British actress. Name variations: Dame Anna Neagle; also performed under the name Marjorie Robertson. Born Marjorie Robertson at Forest Gate, London, England, in October 20, 1904; died in 1986; only daughter and one of three children of Herbert William Robertson (a captain in the British Maritime Service) and Florence (Neagle) Robertson; graduated from St. Albans High School, Herts., England; married Herbert Wilcox (a film producer and director), in 1943 (died 1977); no children.

Theater: made her stage debut in The Wonder Tales *(Ambassadors' Theatre, London, 1917); in the chorus of* Bubbly *(Duke of York's Theatre, London, June 1925); in the chorus of* Rose Marie *(Drury Lane Theatre, London, March 1926); in the chorus of* Charlot Revue *of 1926 (Prince of Wales Theatre, London, 1926); in the chorus of* The Desert Song *(Drury Lane Theatre, London, April 1927); in the chorus of* This Year of Grace *(London Pavilion, March 1928); dancer in* Wake Up and Dream *(London Pavilion, March 1929); made New York debut with same show (Selwyn Theatre, December 1929); appeared as Mary Clyde-Burkin in* Stand Up and Sing *(Hippodrome Theatre, London, March 1931),* Rosalind *in* As You Like It *and* Olivia *in* Twelfth Night *(Regent's Park Open Air Theatre, London, May 1934); appeared in title role in* Peter Pan *(London Palladium, Christmas 1937); toured in* French Without Tears *(1944); appeared as* Emma Woodhouse *in* Emma *(St. James's Theatre, London, February 1945),* Carol Beaumont, Nell Gwynn, Victoria *and* Lilia Grey *in* The Glorious Days *(Palace Theatre, London, February 1952),* Stella Felby *in* The More the Merrier *(Strand Theatre, London, 1960),* Ruth Peterson *in* Nothing is for Free *(Lyceum, Edinburgh, July 1961); toured as* Jane Canning *in* Person Unknown *(1963); appeared as* Lady Hadwell *in* Charlie Girl *(Adelphi Theatre, London, December 1965),* Sue Smith *in* No, No, Nanette *(May 1973),* Dame *Sibyl Hathaway in* The Dame of Sark *(Duke of York's Theatre, London, 1975); toured as* Janet Fraser *in* The First Mrs. Fraser *(March 1976); made Silver Jubilee appearance in* Most Gracious Lady *(Theatre*

Royal, Windsor, 1977); appeared as Comtesse de la Brière in Maggie *(Shaftesbury Theatre, London, October 1977); toured in* My Fair Lady *(1978).*

Selcted filmography: Should a Doctor Tell? *(1930);* The Chinese Bungalow *(1931);* Goodnight Vienna *(Magic Night, 1932);* The Flag Lieutenant *(1933);* The Little Damozel *(1933);* Bitter Sweet *(1930);* The Queen's Affair *(1934);* Nell Gwynn *(1934);* Peg of Old Drury *(1935);* Limelight *(1936);* The Three Maxims *(1936);* London Melody *(Girl in the Street, 1937);* Victoria the Great *(1937);* Sixty Glorious Years *(1938);* Nurse Edith Cavell *(US, 1939);* Irene *(US, 1940);* No, No, Nanette *(US, 1940);* Sunny *(US, 1941);* They Flew Alone *(Wings and the Woman, 1942);* Forever and a Day *(US, 1943);* The Yellow Canary *(1943);* I Live in Grosvenor Square *(A Yank in London, 1945);* Picadilly Incident *(1946);* The Courtneys of Curzon Street *(The Courtney Affair or Kathy's Love Affair, 1947);* Spring in Park Lane *(1948);* Maytime in Mayfair *(1949);* Elizabeth of Ladymead *(1949);* Odette *(1950);* The Lady with the Lamp *(1951);* Derby Day *(1952);* Lilacs in the Spring *(Let's Make Up, 1954);* King's Rhapsody *(1955);* My Teenage Daughter *(1956);* These Dangerous Years *(prod. only, 1957);* No Time for Tears *(1957);* Wonderful Things *(prod. only, 1958);* The Man Who Wouldn't Talk *(1958);* The Heart of a Man *(prod. only, 1959);* The Lady Is a Square *(1959).*

At the height of her career, actress Anna Neagle was heralded as "England's first lady of the screen," although she might well have remained a West End "chorus girl" had it not been for film producer and director Herbert Wilcox, who starred her in a string of successful movies. "As a box-office star-maker, my masterpiece was, of course, Anna Neagle," proclaimed Wilcox, who was also credited with introducing to film Charles Laughton and Dame *Sybil Thorndike, among others. While her film career flourished, Neagle continued to appear in stage plays and musicals. With all of her fame and success, however, the actress never won the acclaim of the critics, who often questioned the depth of her talent. It was the public alone that embraced Neagle's girl-next-door image and fueled her enduring career.

Born Marjorie Robertson in Forest Gate, London, in 1904, Neagle was the youngest of three children of **Florence Neagle Robertson** and William Robertson, a captain in the British Merchant Marine. (One of her two brothers, Stuart Robertson, became a well-known concert singer.) By her own admission, she enjoyed an idyllic childhood. "Of all the good fortune I've had," she once told an interviewer, "the greatest

Anna
Neagle

was a happy home life during my childhood." Neagle began attending dancing school at age 10 and at 13 made her stage debut in *The Wonder Tales*, a Christmas show at the Ambassadors' Theatre, although her father was then opposed to her performing. She attended boarding school at St. Albans, where she briefly flirted with the idea of becoming a dance and gymnastics teacher. By graduation, however, her father had fallen ill, and she was forced to find a job. The quickest route to a paycheck at the time turned out to be a spot in the chorus of a musical called *Bubbly* (1925), at the Duke of York's Theatre.

Neagle spent the next five years in the choruses of some of London's top musicals of the day—*Rose Marie*, *The Desert Song*, and Noel Coward's *This Year of Grace*. In 1929, she went to New York City with the revue *Wake Up and Dream*, and while there began another round of singing and dancing lessons with hopes of breaking out of the chorus. Returning to England a year later, she began auditioning, but found herself almost paralyzed with nerves. After landing

only bit parts in two forgettable films, *Should a Doctor Tell?* (1930) and *The Chinese Bungalow* (1931), she was rescued by Jack Buchanan, who had performed a leading role in *Wake Up and Dream* and was now producing a show of his own, *Stand Up and Sing*. Taking a chance, but limiting her contract for the prior-to-London tryout in case she did not work out, he cast her in a small role. "He gave me my first glimmer of self-confidence," Neagle said of Buchanan, to whom she always remained grateful. In 1931, Wilcox offered her a role opposite Buchanan in his film *Goodnight, Vienna* (1932). By the end of the three-week shoot, he had fallen in love with his protégé, although it would be 1943 before he obtained a divorce from his wife and was free to marry her.

The most memorable of Neagle's early films and the one that established her as a star was Wilcox's remake of *Nell Gwynn* (1934), which he had originally made with *Dorothy Gish in the title role. It was followed by *Peg of Old Drury* (1935), in which Neagle portrayed *Peg Woffington. In 1937, the Neagle-Wilcox team launched a series of historical films, the first of which, *Victoria the Great* (1937), brought them financial success. The film was also well received by most of the critics, although James Agate, who found Neagle's portrayal a bit vacuous, could not resist referring to her as "Victoria the Little." The reviewer for the *Spectator*, while pointing out that the film omitted many events in the 60-year reign of Queen *Victoria, concluded that "if the limits are too narrow, the excellence of the portrayals . . . the authenticity of the settings, and the beauty of the photography make up for much." American critics, generous in their praise, went so far as to proclaim it the best film out of England so far. Basking in success, Wilcox and Neagle immediately went to work on a sequel, *Sixty Glorious Years* (1938), which abruptly ended their run of good luck. "Anybody who possesses even a small acquaintance with the history and the personalities of the nineteenth century must recognize that the thing is a travesty of the truth," proclaimed the irate reviewer of the *New Statesman and Nation*. (The team also shot Nurse *Edith Cavell* in 1939.)

During the war years, the couple made several films on the RKO lot in Hollywood, including updates of the musicals *Irene* (1940), *No, No, Nanette* (1940), and *Sunny* (1941). Addressing Neagle's performance in the first of these, Bosley Crowther of *The New York Times* wrote that she performed "with all the city charm and grace of a self-conscious musical comedy actress trying to be a Dresden china Pollyanna doll." Following the short Anglo-British effort *Forever and a Day* (1943), Wilcox and Neagle returned to England where they turned out *They Flew Alone* (1942), in which Neagle portrayed English flyer *Amy Johnson. They followed the bio-pic with a melodrama, *The Yellow Canary* (1943).

Neagle's film career peaked in the 1940s and early 1950s, when she was voted the United Kingdom's best-loved star for seven years straight. Particularly successful movies of this period included *Picadilly Incident* (1946), *The Courtneys of Curzon Street* (1947), *Spring in Park Lane* (1948), and *Odette* (1950). By this time, Neagle and Wilcox had married, an event which prompted a BBC dramatization of their romance, with the couple portraying themselves. By all accounts, the relationship was unusually close. "Her marriage to Herbert is even more remarkable than their relationship at work," said a friend. "Total absorption in each other, the one complementing the other—not just occasionally, but always. Their behaviour to each other is touching and exemplary."

While her film career flourished, Neagle had frequently returned to the stage. In the spring of 1934, she appeared at the Regent's Park Open Air Theatre, portraying Rosalind in *As You Like It* and Olivia in *Twelfth Night*. At Christmas in 1937, she was featured as Peter Pan at the London Palladium. She then toured England and the Continent with Rex Harrison and Roland Culver in *French Without Tears*, and in the title role of Gordon Glenn's adaptation of the *Jane Austen novel *Emma*, which opened at the St. James's Theatre in London in February 1945, but had an abbreviated run because of the war. Most of Neagle's stage efforts were panned by the critics, including her performance in *The Glorious Days* (1953), a revue of sorts recapping her film successes. Kenneth Tynan, referring to the show as "Anna Neagle rolled into one," penned a review bordering on personal attack. Despite his vitriol, the show stayed afloat for 256 performances.

During the 1950s, Wilcox began to lose his magic touch, and by 1960 the film company that he and Neagle had formed in 1934 was bankrupt. Though they were forced to sell their personal property and move to a flat in Brighton, Neagle remained undaunted. "The entire theatrical profession, together with a legion of fans, admired her great courage when Herbert Wilcox was bankrupt," said Herbert de Leon, Neagle's agent and a close friend. "She sold her jewels and worked like a Trojan until their debts were

paid." Her perseverance eventually paid off. In 1965, after a tour in the thriller *Person Unknown*, she opened at the Adelphi in *Charlie Girl*, an old-style musical which she called "the sort of family show audiences have been waiting for." With no support from the critics (Russell Taylor thought the plot "out of the Ark," though it suited the talents of the cast and "what was so very wrong with that?"), the show ran for 2,000 performances, then enjoyed a successful tour in Melbourne and Auckland. In 1969, during the run of the show, Neagle was named a Dame of the British Empire.

In 1973, following successful cancer surgery, Neagle appeared in the role of Sue Smith in a revival of *No, No, Nanette*, called a "creaking disaster" by *Plays and Players*, but attracting audiences for an eight-month run all the same. In 1976, she toured as Janet Fraser in *The First Mrs. Fraser*, and for the Silver Jubilee in 1977 appeared in *Most Gracious Lady* at the Theatre Royal in Windsor. Even after the death of her husband that year, Neagle kept working, undertaking a demanding tour as Henry Higgins' mother in *My Fair Lady* in 1978. The actress apparently worked right up until her death in 1986, continuing to enchant audiences and confound critics to the very end.

SOURCES:

Johns, Eric. *Dames of the Theatre*. New Rochelle, NY: Arlington House, 1974.

Katz, Ephraim. *The Film Encyclopedia*. NY: Harper-Collins, 1994.

Morley, Sheridan. *The Great Stage Stars*. Australia: Angus & Robertson, 1986.

Shipman, David. *The Great Movie Stars: The Golden Years*. Boston, MA: Little, Brown, 1995.

Rothe, Anne, ed. *Current Biography 1945*. NY: H.W. Wilson, 1945.

Barbara Morgan,
Melrose, Massachusetts

Neal, Patricia (1926—)

American actress who won an Academy Award for her performance in Hud. *Born Patsy Louise Neal on January 20, 1926, in a mining camp in Packard, Kentucky; eldest of three children (two girls and a boy) of William Burdette Neal (a transportation manager of the Southern Coal and Coke Company) and Eura Mildred (Petry) Neal; graduated from Knoxville High School, Knoxville, Tennessee, 1943; attended Northwestern University, Evanston, Illinois, 1943–45; married Roald Dahl (a writer), on July 2, 1953 (divorced November 1983); children: Olivia (1955–1962); Tessa (b. 1957); Theo (b. 1960); Ophelia (b. 1964); Lucy (b. 1965).*

Selected theater: first appeared on stage at the Barter Theater (Abingdon, Virginia, 1942); performed at the Eaglesmere Playhouse (Eaglesmere, Pennsylvania, summer 1945); appeared as Claire Walker in the pre-Broadway tryout of Bigger than Barnum *(Wilbur Theater, Boston, Massachusetts, April 1946), "Wildcat" in summer stock tryout of* Devil Take a Whittler *(Westport Country Playhouse, Westport, Connecticut, summer 1946); made Broadway debut as Regina Giddens in* Another Part of the Forest *(Fulton Theater, November 1946); appeared as Martha Dobie in* The Children's Hour *(Cornet Theater, December 1952), Lady Teazle in* The School for Scandal *and Blacksmith in* The Scarecrow *(Theater de Lys, June 1953), Nancy Fallon in* Roomful of Roses *(Playhouse Theater, 1955); made London debut as Catherine Holly in* Suddenly Last Summer *(Arts Theater, London, 1958); appeared as Mrs. Keller in* The Miracle Worker *(Playhouse Theater, New York, 1959).*

Selected filmography: John Loves Mary *(1949);* The Fountainhead *(1949); (cameo)* It's a Great Feeling *(1949);* The Hasty Heart *(US-UK, 1950);* Bright Leaf *(1950);* Three Secrets *(1950);* The Breaking Point *(1950);* Operation Pacific *(1951);* Raton Pass *(1951);* The Day the Earth Stood Still *(1951);* Weekend With Father *(1951);* Diplomatic Courier *(1952);* Something for the Birds *(1952);* Washington Story *(1952);* La tua Donna *(It., 1954);* Stranger From Venus *(Immediate

Patricia Neal and Gary Cooper in Ayn Rand's The Fountainhead.

Disaster, *UK, 1954); A Face in the Crowd (1957); Breakfast at Tiffany's (1961); Hud (1963); Psyche 59 (UK, 1964); In Harm's Way (1965); The Subject Was Roses (1968); The Road Builder (The Night Digger, UK, 1971); Baxter (UK, 1972); Hay que matar a B (B Must die, Sp., 1973); Happy Mother's Day—Love, George (Run Stranger Run, 1973); Nido de Vidudas (Widow's Nest, Sp., 1977); The Passage (UK, 1979); Ghost Story (1981); An Unremarkable Life (1989); Caroline? (1990); A Mother's Right: The Elizabeth Morgan Story (1992); Heidi (1993); Cookie's Fortune (1999).*

In her autobiography, *As I Am*, actress Patricia Neal writes that her life has been likened to a Greek tragedy, from the brain-damaging injury of her son in 1960 and the death of her young daughter two years later, to her own nearly fatal series of strokes in 1965 and the dissolution of her 30-year marriage in 1983. Following her strokes, Neal endured a grueling two-year struggle to reclaim her life, then went on to reestablished her career in 1968, winning another Oscar nomination for Best Actress. She credits stubbornness with getting her through the most difficult times and helping her to cope with the residual effects of her strokes. "You don't give in," she told **Marian Christy** of the *Boston Globe* in 1988. "I don't like adversity. Who does? When bad things happen, I fight. Life is tough. Some people are luckier than others. I don't think I'm lucky. My father had a saying: 'If you call upon a thoroughbred, he gives you all the blood, sinew and heart in him. If you call upon a jackass, he kicks.' I seldom kick."

Neal was born in 1926, in Packard, Kentucky, but her family (which eventually included two siblings, Margaret and Pete) moved to Knoxville, Tennessee, when she was three. She was bitten by the acting bug at the age of ten. "I was in a Methodist church and a woman got up and did monologues," she recalls. "She was funny and serious. Then and there, in that church, I wished for that. I, too, wanted to be an actress." Her parents responded to her newfound passion by allowing her to study dramatics with a local teacher, during which time she also performed readings locally. In high school she was active with the Thespians, and during the summer between her junior and senior year she worked as an apprentice at the Barter Theater in Abingdon, Virginia, where in addition to her back-stage duties she played a few small roles. After graduation, she studied drama at Northwestern University for two years, then made her way to New York, supporting herself with a variety of jobs while she made the rounds. Her first

true break came when she auditioned for a role in a Theater Guild production of *A Moon for the Misbegotten* by Eugene O'Neill, who took a shine to the young actress. Although she was not cast in the show, O'Neill was instrumental in getting her a role in the summer tryout of a new play, *Devil Take a Whittler*, at the Westport (Connecticut) Playhouse. Fortuitously, ***Lillian Hellman** saw Neal perform in Westport, and immediately tapped her for the part of Regina in her blistering family chronicle *Another Part of the Forest*, a role for which Neal won the Donaldson Award, the Drama Critics Circle Award, and the first Tony Award ever conferred (an engraved compact). Following the play, Neal was swamped with offers, including a lucrative deal with Warner Bros., which she found irresistible. "I went to Hollywood too young in my career," she said later. "Looking back now, I wish I had stayed longer on Broadway. The theater is the only place to learn to act."

Neal made her movie debut opposite future president Ronald Reagan in *John Loves Mary* (1949), a comedy romp for which she was ill prepared and completely unsuited. "Patricia Neal shows little to recommend her for further comedy roles," wrote Bosley Crowther in his review for *The New York Times* (February 5, 1949). "Her looks are far from arresting, her manners are slightly gauche, and her way with a gag line is painful. She has a long way to go and a lot to learn." Neal fared little better with her next film, the screen adaptation of ***Ayn Rand**'s *The Fountainhead* (1949), although it catapulted her into a passionate romance with her co-star Gary Cooper, 25 years her senior and married to **Veronica "Rocky" Cooper**. Neal became pregnant and had an abortion; Cooper would not divorce his wife. "I was very, very much in love with him," she told Christy. "I was very, very hurt by Gary Cooper. I loved him. I adored him. It just didn't work out. It shouldn't have worked. Things turned out just as they should. But I'm very sorry I had our baby aborted. I worried too much about my mother's reaction to her pregnant, unmarried daughter." Soon after ending the affair, Neal met British writer Roald Dahl (author of numerous chillingly sardonic stories for adults as well as such children's classics as *Charlie and the Chocolate Factory* and *James and the Giant Peach*) at a party at Lillian Hellman's house and married him on the rebound in 1953. Once wed, Neal wanted nothing more than to have a child, but she had to undergo treatment to repair a blocked fallopian tube before she was able to conceive. The Dahls' much-anticipated first baby, Olivia, was born in 1955.

Meanwhile, the couple commuted between homes in England and in New York, where Neal had resumed her stage career in 1952, realizing that most of the 13 films she made for Warner Bros. were a waste of her talent. Her Broadway comeback as Martha Dobie, a teacher who is driven to suicide following a child's allegations of lesbianism, in Hellman's play *The Children's Hour*, brought her critical acclaim and reestablished her as an actress with some clout. She also appeared in a revival of *The School for Scandal* at the Theater de Lys and, in 1955, was again on Broadway in **Edith Sommer**'s *A Roomful of Roses*, which was well received but not a huge hit.

Upon her return to New York, Neal had resumed her membership in the Actors Studio, and it was through Elia Kazan, one of its founding members, that she was offered the female lead in the film *A Face in the Crowd* (1957), a role she felt she could not refuse although she was ambivalent about making another movie. Drawn to the project as much for the opportunity to work with Kazan as anything else, she turned in a memorable performance as a woman who discovers a hillbilly singer (Andy Griffith) and transforms him into a popular television personality, only to watch him become a monster. The completion of the film coincided with the imminent birth of Neal's second child, **Tessa Dahl**, who joined sister Olivia in the growing Dahl family.

Neal's career choices were now somewhat limited by family demands, but still included a substantial smattering of film, stage, and television roles. In 1958, the actress made her London debut as Catherine Holly in Tennessee Williams' *Suddenly Last Summer*. In his tribute to Neal's performance, Kenneth Tynan alluded to the "power and variety of her dark-brown voice, on which she plays like a master on the cello." (The accolades for Neal's performance were so profuse that she called it the "hardest professional blow of my life" when *Elizabeth Taylor was signed to star in the movie version of the play.) Neal next accepted the minor role of the mother in William Gibson's *The Miracle Worker*, about the young *Helen Keller, and starring **Anne Bancroft** as ✤▶ **Anne Sullivan Macy** and **Patty Duke** as the young Keller. "It was just another part for me, but a relationship with Helen Keller was also seeded deep within me that I have treasured ever since," Neal writes in her autobiography. "Helen has strengthened me in my own personal, private darkness for years." Neal was forced to leave the play for the approaching birth of her third child, a son Theo.

Theo was just four months old when tragedy struck. His nanny was pushing him in his carriage on Fifth Avenue in New York when a taxi jumped a green light, smashing into the carriage and hurling it 40 feet across the street with Theo inside. It slammed into the side of a car, pinning the baby's head in the metal wreckage of the carriage. He remained in critical condition for days, and over the course of the next several years required eight brain operations to drain the fluid that kept collecting in his skull. The Dahls, who had continued to summer in England, moved there permanently after the accident, hoping it would provide a safer environment in which to raise their children, but while Theo was still recovering, the couple's first child Olivia died very suddenly from a rare form of measles. She was just seven. "The horror was not to be able to do a thing," Neal recalls. "At five o'clock she was fine—measles, but fine, and asleep. At midnight she was dead. During those hours I saw my bright, beautiful child's mind unmistakably overcome and destroyed. I did not want life at all costs. My husband did." Roald's three sisters took charge of the funeral arrangements, assuring Neal that it would be better for her not to see Olivia in death, but to remember her only as a living child. Neal would forever be haunted by the fact that she missed saying goodbye to her daughter. Later, believing that perhaps God was punishing her, she joined the Church of England "to make amends." She also went back to work, thinking that the family might be doomed if she did not keep it "moving emotionally and financially."

After completing a segment for a television series, Neal was offered the small role of Alma in the movie *Hud*, starring Paul Newman. In a role described by Crowther as "a rangy, hard-bitten slattern with a heart and a dignity of her own," Neal gave a virtuoso performance and won an Academy Award as Best Actress. The news of the award reached the actress in England, where she was also celebrating another pregnancy. Her hope at the time was that a new baby, while not replacing Olivia, might bring some healing to her troubled family.

Ophelia Dahl entered the world on May 12, 1964. Not long thereafter, the family was invited to Hawaii, where Neal shot *In Harm's Way*, with John Wayne. Because she was scheduled to begin work on a new film in January 1965, the Dahls settled in California for the winter, renting a home in Brentwood. Neal found herself pregnant again and was three months along as filming got under way. Just returned home from one of the first days of shooting, the actress was bathing her daughter, when she experienced a sharp pain in her head. She knew something was

Macy, Anne Sullivan. See Keller, Helen for sidebar.

terribly wrong, as she staggered into the bedroom to lie down. While her husband was phoning for help, she lost consciousness. "The last thing I remember thinking was, I have children to care for," she recounts in her autobiography. "I have another inside me. I can *not* die."

Neal suffered a series of three strokes that day, one at home and two at the UCLA Medical Center, where she was taken for emergency treatment. The actress remembered nothing about the following four weeks in the hospital; she learned later about that critical time by talking to friends and by reading her husband's diaries and Barry Farrell's book *Pat and Roald*. (She also learned later that while she was unconscious, the UPI put her obituary on the wire.) As soon as it was feasible, Neal underwent a sevenhour operation, which revealed a massive aneurysm that had released blood clots into her brain. Even with the removal of the clots, it was doubtful that she would pull through. When she finally awoke after weeks in a coma, her right side was completely paralyzed, she had no power of speech, and as she put it later, "my mind just didn't work." On top of that, she suffered maddening double vision, which she later said "miraculously disappeared" after she drank some champagne.

Although Neal lived, it was through the dogged determination of her husband and friends that she recovered. Faced with a shortage of therapists, Roald organized neighbors and friends in a rotating schedule to come in and help. "I wanted to lie back and do nothing, and that is exactly what I would have done, if Roald hadn't made me go on," Neal said, adding that she would forever be grateful to those who stood by her. "They came because they knew I was in trouble . . . and they came because I needed help. They came for free, for love, and I'll remember that till the day I die." Later, **Valerie Eaton-Griffith** became Neal's primary teacher. Her warmth, patience, and sympathy balanced Roald's more aggressive approach. "There was no doubt that I needed a master like Roald to demand I aim for the sky," Neal writes. "But it would take a teacher like Valerie who could kneel down and help me lift myself up out of the cabbage patch."

Four months after leaving the hospital, Neal gave birth to a daughter, **Lucy Dahl** (dubbed "the miracle baby"), and two years later, she walked onto the stage of the Waldorf-Astoria to deliver a speech on behalf of brain-injured children. It was an act of courage, and before she uttered a word of her meticulously rehearsed 13-minute speech, the actress received a standing ovation from the audience of 2,000, many of them in the entertainment business. At the end of her talk, the audience stood and cheered once more. "I knew then that my life had been given back to me for something more than I had imagined," Neal writes. "Mind you, I had no idea what that could possibly be. But I knew at that moment that Roald the slave driver, Roald the bastard, with his relentless scourge, Roald the Rotten, as I had called him more than once, had thrown me back into the deep water. Where I belonged." (The story of her recovery was documented in the 1981 television movie *The Patricia Neal Story*, in which Neal was portrayed by British actress *Glenda Jackson and Dahl by Dirk Bogarde.)

Shortly after her triumphant speech, Neal was a presenter at the Academy Award ceremonies, where her Hollywood friends welcomed her back with prolonged applause. That same year, she received the Heart of the Year award from the American Heart Association, presented to her by President Lyndon Johnson at the White House. Perhaps the most significant of Neal's undertakings at this time, however, and the most frightening to her, was her return to acting. The project was the film version of Frank Gilroy's play *The Subject Was Roses*, about a returning veteran's difficulty in communicating with his family. Cast as Nettie, the mother, Neal initially had difficulty learning her lines and finding her rhythm, but she prevailed. At the film's premiere in New York City in 1968, she received another standing ovation when she entered the theater. "I was being applauded before I performed or even uttered a word," she recalled. "I was a hit—just for being alive."

Neal was nominated for an Academy Award for her comeback performance, an assurance to the actress that she was once again respected as a professional by her peers. At home, however, her reentry into the family was not as successful. Although her husband and children treated her with love and consideration, she felt that she had lost her position as an independent and authoritative mother and wife. She blamed herself for much of the problem. "I desperately wanted to serve my children, but mine was in no way the selfless, hidden service of a healthy mother who does her job and never has to be noticed or thanked. . . . I was still wrestling with my own selfishness, which many individuals recovering from a long illness must do. And I was, emotionally, very much a child and needed constant reassurance and attention. When I didn't get it, I could conjure the blackest of moods." Eventually, Neal came to accept that her chil-

dren would remain closer to their father than to her. While this fact was difficult to assimilate, she later came to recognize it as simply another part of the aftermath of her strokes. (When they were grown, Neal would forge a new and satisfactory relationship with her children.)

Throughout the 1970s, Neal made a series of movies in which she played women dealing with a serious illness in one way or another. She also starred in the television movie "The Homecoming," which inspired the popular series "The Waltons." Neal won an Emmy for her portrayal of Olivia Walton and was offered a number of other "mother" roles. In addition to acting, she began a second career as a speaker, traveling around the United States and England to share her experience with other stroke victims and their caregivers.

In 1983, Neal faced yet another blow—the break-up of her 30-year marriage to Dahl. "It's just the saddest thing that could happen, my husband divorcing me," she told a reporter at the time. "My husband met another woman—not that she's been the only one through the years." The other woman in this case was **Felicity Crossland**, a young divorcée who had arrived at the Dahls' doorway nine years earlier to deliver a dress to Neal for an upcoming coffee commercial. The two women soon became best friends, which made Crossland's involvement with her husband even more difficult for Neal to accept.

During this period, Neal received some help from an unlikely source: **Maria Cooper**, Gary Cooper's adult daughter, whom Neal had met and befriended while working on a film in France in 1978. It was Maria who introduced Neal to the Benedictine monastery of Regina Laudis, a cloistered nunnery in Bethlehem, Connecticut, where she was encouraged to piece together the fragments of her life by speaking her memories into a tape recorder. It took Neal five years, but she did indeed get her life back. Later, in 1988, she published the results of her therapeutic journey as an autobiography. "Remembering was laborious," she writes. "Remembering was humbling. It was painful beyond all words, and then, finally, remembering was purifying, and it began to give me peace."

SOURCES:

Christy, Marian. "Stubbornness has been a Blessing for Patricia Neal," in *Boston Globe*. May 1, 1988.

Farrell, Barry. *Pat and Roald*. NY: Random House, 1969.

Katz, Ephraim. *The Film Encyclopedia*. NY: HarperCollins, 1994.

Longcope, Kay. "Patricia Neal Faces a Painful Divorce," in *Boston Globe*. August 31, 1983.

McGill, Raymond D., ed. *Notable Names in the American Theater*. Clifton, NJ: James T. White, 1976.

Moritz, Charles, ed. *Current Biography 1964*. NY: H.W. Wilson, 1964.

Neal, Patricia, with Richard DeNeut. *As I Am: An Autobiography*. NY: Simon and Schuster, 1988.

Thomas, Jack. "The Miracle of Recovery: Patricia Neal's return to health came from guts, love," in *Boston Globe*. December 6, 1981.

Barbara Morgan,
Melrose, Massachusetts

Nearing, Helen (1904–1995)

American author and pioneer of simple living who is regarded as a "great-grandparent" of the American back-to-the-land movement and a major personality of modern environmentalism. Born Helen Knothe in Ridgewood, New Jersey (some sources indicate New York, New York), on February 23, 1904; died in an automobile accident near her home in Harborside, Maine, on September 17, 1995; daughter of Frank Knothe and Maria Obreen Knothe; sister of Alice Knothe; married Scott Nearing (1883–1983), in December 1947; no children.

In 1932, Helen Nearing and her husband Scott Nearing abandoned New York City and "a dying acquisitive culture" for a Vermont homestead. Through hard work and simple living, they became 75% self-sufficient. In the early 1950s, when she was in her late 40s and he was over 70, they started from scratch once more, on a small farm in Maine. Of the Nearings' many books, *Living the Good Life* (1954) became a virtual bible of homesteaders starting out in the late 1960s and was much admired, if not always emulated, by counterculture youth. By the end of the 1960s, they had become "senior gurus" for many disenchanted members of a rebellious generation.

The Nearings, who turned their backs on American materialism, came from backgrounds of wealth and social standing. In 1904, Helen Knothe was born in Ridgewood, New Jersey (some sources indicate New York City), into an affluent, individualistic family. Her father was a banker, and both of her parents were vegetarians and

Helen Nearing

theosophists. Aspiring to become a concert violinist, Helen studied music in Europe. She then traveled the globe; dabbled in Indian mysticism for a time, spending the years 1921–25 as a follower of the renowned Hindu spiritual leader Krishnamurti; and spent several years in Australia searching for answers to life's mysteries. Upon meeting Scott Nearing in 1928, she knew she had found her life partner.

Born in 1883, Scott Nearing came from a privileged Pennsylvania family. His grandfather Winfield Scott Nearing ruled the coal-mining town of Morris Run with an iron fist, earning the title "Tsar Nearing" for his opposition to workers' attempts to improve their lives by forming unions. Scott early developed a social conscience, and after earning a doctorate in economics he became an activist and a university professor. While teaching first at Swarthmore College and then at the Wharton School of Finance of the University of Pennsylvania, he campaigned against what he believed to be one of the greatest social evils of the day, child labor. In 1915, while Nearing was an assistant professor at Wharton, he was fired by the school's pro-business trustees, many of whom owned manufacturing plants that employed children. The case became nationally celebrated as an example of the assault on academic freedom by powerful external (and internal) forces.

Two years later, when he was a faculty member of the University of Toledo, Scott was again at the center of a raging controversy due to his opposition to World War I, which the United States had entered in April 1917. As an active member of the antiwar Socialist Party, he attacked the institution of war as "organized destruction and mass murder." His highly unpopular views clashed with those of the great majority of the population, and once again he was fired from his academic position. In 1918, after publishing an impassioned antiwar tract entitled *The Great Madness*, he was indicted by the U.S. government under the Espionage Act and charged with treason. The eloquence of Scott's defense at his February 1919 trial resulted in an acquittal. He was the only major pacifist opponent of the war to escape conviction and imprisonment during a period of national hysteria. Remaining in the Socialist Party until 1922, Scott ran unsuccessfully against Fiorello La Guardia for the congressional seat from New York's 14th District. In 1927, he joined the minuscule Communist Party of the United States (CPUSA) but found its rigid discipline incompatible with his need for intellectual freedom. After having defied the party by publishing a book on imperialism that differed from Leninist orthodoxy, in early 1930 he was publicly expelled from the CPUSA with an announcement published in the *Daily Worker*. By 1924, his marriage to **Nellie Seeds**, which had produced two sons, had all but ended in a separation. When he met Helen Knothe, 21 years his junior, in 1928, his life changed radically.

For several years after they began living together (they would not marry until December 1947, after the death of Scott's first wife), Helen worked at menial jobs to provide Scott with the time and money to write books and pamphlets which sold relatively few copies, particularly once the Depression began in 1929.

In 1932, they left New York City. Said Helen, "If you are poor, it is better to be poor in the country, where you can grow your own vegetables, than in a town." With a down payment of $300, they purchased for $1,100 an eroded 65-acre farm on a mountain slope called Pike Valley near the town of Jamaica, in the southern "wilderness" section of Vermont. Facing Stratton Mountain in the foothills of the Green Mountains, their property at Pikes Falls was midway between Brattleboro and Bennington, on a back road that left Route 30 and circled over Taylor Hill at an elevation of about 1,800 feet. Over the next years, the Nearings became homesteaders, their goal being self-sufficiency. This they achieved by producing "goods and services . . . consumed directly, without the intervention of the market. In our case we raised food and ate it, cut fuel and burned it, constructed buildings and lived in them, thus eliminating the major cash costs of living." Over a period of two decades, the Nearings built nine stone and three wooden buildings on their farm. They organically regenerated the depleted soil of their property by converting leaves, grass, and other organic substances into compost which they spread on their gardens. Within a few years, they accomplished a job of "soil restoration that would have taken nature unassisted at least a century."

As strict vegetarians, the Nearings eschewed processed foods, meat, fish, and dairy products as well as alcohol, coffee, and tea. Their diet consisted of 50% fruit and fruit juices, 35% vegetables (with an emphasis on leafy plants), 10% fats (vegetable oils and nuts), and only 5% protein (from grains, dried beans and peas, seeds, and nuts). They kept no animals, used almost no animal products, ate very little cheese or butter, and consumed milk or eggs only on rare occasions. In Scott's words, "By these means we freed ourselves from the slaughterhouse diet;

from the corresponding enslavement to animals of all those who practice animal husbandry; and from the high protein diet so unhealthfully prevalent in the United States."

To earn the relatively small amount of cash they needed to live, they created—without relying on animal labor or machines—a maple-sugar farm of 4,200 buckets. Happy to have mastered the details of successfully practicing the "pre-industrial household craft" of maple sugaring, in 1950 Helen published a book with Scott (largely written by herself) entitled *The Maple Sugar Book: Being a Plain Practical Account of the Art of Sugaring to Promote an Acquaintance with the Ancient as well as the Modern Practice. Together with Remarks on Pioneering as a Way of Living in the Twentieth Century.* But America's mood in 1950 was dominated by Cold War phobias, and few people were interested either in starting maple-sugar farms or embarking on the difficult life that was homesteading.

By the early 1950s, the Nearings had established a successful routine that they described as "living the good life." Visitors often noted the differences between the two, not only in age, but in personality and temperament. Helen was described as "imbued with a Pythagorean strain of mysticism and the arts," while Scott was thought to possess "an Aristotelian vein of rationalism and science." Both thrived on a strenuous, ascetic life. Their days were divided exactly as follows: four hours for "bread labor" (tending their garden and making their cash living); four hours for reading, study, and writing; and four hours for social activities and service to the world community. Sunday was free of bread labor. Although they owned and used an automobile and pickup truck, they never owned power tools and, because they had no livestock, had no need for machines to make winter fodder. They never owned a baler, mower, or tractor. By building up their successful maple-sugar operation, they created a business which "wed socialism and capitalism into a working philosophy." It also enabled them to pay for travel during the winter season, when they visited friends throughout the world.

In 1952, after two decades in Vermont, the Nearings sold their farm, the reason being that nearby Stratton Mountain was being developed as a ski resort. They had also become subject to the constant traffic of those who had read articles about their simple life and wanted to meet them personally. They bought a 140-acre abandoned farm in Harborside, Maine, at that time one of New England's backwaters. Because they

did not believe in the profit system, the Nearings deeded most of their Vermont land, by now increased to 700 acres, to the town of Winhall as a nature preserve. They sold the remainder only for the cash and labor they had put into it, taking $15,000 for a property that at the time was appraised at four times that figure.

In 1954, when the Nearings published *Living the Good Life,* it met with a largely indifferent reception. Only 3,000 copies sold the first year, and by the end of the 1960s it had sold a total of less than 20,000 copies. By the time its reprint edition appeared in 1970, however, the United States had become a vastly different country, one in which young people were receptive to alternative ideas, and sales quickly soared. Hailed as a *Walden* appropriate for the problems and aspirations of the late 20th century, the Nearings' book was to be particularly popular in the turbulent 1970s, when it went through 17 printings. By the late 1990s, total sales of *Living the Good Life* would number well over 250,000 copies.

From 1973 to 1976, the Nearings (she in her 70s and he in his 90s) built with their own hands an impressive stone house in Harborside. They remained in superb health and largely self-sufficient, producing at least 85% of their food and all of their fuel except gasoline for their car. In Maine, their cash crop was not maple syrup but blueberries. Other than this, they were free of the money economy. By the 1970s, they were earning sizable royalties from their books, but except for their travel expenses, which were frugal, this wealth would not be spent by them.

By the late 1960s, the Nearings' Harborside home—named Forest Farm and perched above the dark rocks of Spirit Cove, a small inlet of Penobscot Bay—was withstanding countless visitors looking to "drop out" of what they saw as an inhuman system of materialism and exploitation. In one year, Helen counted 2,300 callers. Their mailbox bore no name, but next to a stone workshop on their property the inevitability of guests was acknowledged by a roughly hand-lettered wooden sign that advised: "Help Us Live the Good Life: Visitors 3–5."

The Nearings often spoke and wrote of community, but neither in Vermont nor in Maine did they ever establish close ties with their neighbors, many of whom remained suspicious of them as outsiders. During the Cold War, they were under surveillance by the FBI, and negative comments on them were elicited from neighbors. Late in life, when Helen was asked if she had any regrets about their homesteading

experience, she answered: "Our failure to make headway with our neighbors in Vermont." The Nearings, particularly Scott, were known sometimes to come across as cranky, preachy, or both, but their honesty and integrity impressed millions of readers of their books and visitors to their farmsteads.

In August 1983, Scott Nearing died peacefully in their Maine home at the age of 100. Helen refused to mourn for long, continuing to live the good life, tending her garden, writing several books, and meeting with visitors. In her later years, she made a few concessions to the advancing modern world, using a telephone, freezer, and water pump, and she continued to drive a car. But a washer and dryer given to her by well-wishers remained in her basement, never hooked up.

In the last years of her life, Helen gave away or sold to kindred ruralists all but four of the original 140 acres she and Scott had moved to in 1952. She remained active and in good health up to the day of her death. On September 17, 1995, 91-year-old Helen was driving herself to see the Cuban film *Strawberry and Chocolate* when her pickup truck ran off the road and hit a tree just outside her farm, killing her instantly. Her friends brought her body back to the house she and Scott had built. Placed on a bed of herbs, she was dressed in purple Indian robes and covered with an embroidered South American cloth.

At the time of her death, the four remaining acres she lived on, known as the Good Life Center, passed on to the Trust for Public Land, which has kept the Nearings' stone house and walled gardens open to the public. A few months before her death, Helen Nearing had summed up her ideals at an Earth Day celebration: "Let the earth breathe quietly through the seasons. We should try to leave a better place for our being here. Real stewardship and brotherhood must underlie all our practices on earth."

SOURCES:

Ball, Terence. "Nearing, Scott (1883–1983)," in William P. Cunningham *et al.*, eds., *Environmental Encyclopedia.* Detroit, MI: Gale Research, 1994, pp. 556–557.

Bedell, Robert K. "What Sent the Nearings To a Wilderness Life," in *The New York Times.* September 28, 1995, p. A16.

Belk, Russell W., and Richard W. Pollay. "Images of Ourselves: The Good Life in Twentieth Century Advertising," in *Journal of Consumer Research.* Vol. 11, no. 4. March 1985, pp. 887–897.

Brinkerhoff, Merlin B., and Jeffrey C. Jacob. "Quasi-Religious Meaning Systems, Official Religion, and Quality of Life in an Alternative Lifestyle: A Survey from the Back-to-the-Land Movement," in *Journal for the Scientific Study of Religion.* Vol. 26, no. 1. March 1987, pp. 63–80.

Cook, Joan. "They Lived Today's Ideas Yesterday," in *The New York Times Biographical Edition.* April 28, 1971, p. 1411.

Ellis, William N., and Odom Fanning. "The New Ruralism," in *Habitat.* Vol. 2, no. 1–2, 1977, pp. 235–245.

Fowler, Glenn. "Scott Nearing, Environment, Pacifist and Radical, Dies at 100," in *The New York Times Biographical Service.* August 1983, p. 975.

Hackett, Bruce, and Seymour Schwartz. "Energy Conservation and Rural Alternative Lifestyles," in *Social Problems.* Vol. 28, no. 2. December 1980, pp. 165–178.

"Helen Nearing," in *The Economist.* Vol. 337, no. 7935. October 7, 1995, p. 117.

"Helen Nearing," in *The Times* [London]. September 21, 1995, p. 21.

Horowitz, Daniel. "Consumption and Its Discontents: Simon N. Patten, Thorstein Veblen, and George Gunton," in *The Journal of American History.* Vol. 67, no. 2. September 1980, pp. 301–317.

Jackson, W. Charles. "Quest for the Good Life: Helen and Scott Nearing and the Ecological Imperative," M.A. thesis, University of Maine, 1993.

Markson, Elizabeth W. Review of Helen Nearing, *Wise Words on the Good Life: An Anthology of Quotations* (1980), in *The Gerontologist.* Vol. 26, no. 5. October 1986, pp. 588–591.

McCaig, Donald. "Helen Nearing: The Good Life Lives On With America's Premier Homesteader," in *Country Journal.* Vol. 17, no. 1. January–February, 1990, pp. 56–60.

McQuiston, John T. "Helen K. Nearing, Maine Writer, Dies at 91," in *The New York Times.* September 19, 1995, p. B8.

Nearing, Helen. *Loving and Leaving the Good Life.* White River Junction, VT: Chelsea Green, 1995.

———. *Wise Words for the Good Life.* White River Junction, VT: Chelsea Green, 1999.

Nearing, Helen, and Scott Nearing. *Continuing the Good Life: Half a Century of Homesteading.* NY: Schocken Books, 1979.

———. *The Good Life: Helen and Scott Nearing's Sixty Years of Self-Sufficient Living.* NY: Schocken Books, 1989.

———. *The Good Life Album of Helen and Scott Nearing.* NY: E.P. Dutton, 1974.

———. *Living the Good Life: Being a Plain, Practical Account of a Twenty Year Project in a Self-Subsistent Homestead in Vermont.* Harborside, ME: Social Science Institute, 1954.

———. *Living the Good Life: How to Live Sanely and Simply in a Troubled World.* Introduction by Paul Goodman. Reprint ed. NY: Schocken Books, 1970.

———. *The Maple Sugar Book.* Reprint ed. White River Junction, VT: Chelsea Green, 2000.

Nearing, Scott. *The Conscience of a Radical.* Harborside, ME: Social Science Institute, 1965.

———. *The Making of a Radical: A Political Biography.* NY: Harper and Row, 1972.

———. *A Scott Nearing Reader: The Good Life in Bad Times.* Edited by Steve Sherman. Foreword by Helen K. Nearing. Metuchen, NJ: Scarecrow Press, 1989.

Saltmarsh, John A. *Scott Nearing: An Intellectual Biography.* Philadelphia, PA: Temple University Press, 1991.

Schrecker, Ellen W. *No Ivory Tower: McCarthyism and the Universities*. NY: Oxford University Press, 1986.

Whitfield, Stephen J. *Scott Nearing: Apostle of American Radicalism*. NY: Columbia University Press, 1974.

RELATED MEDIA:

Living the Good Life With Helen and Scott Nearing (videocassette), Bullfrog Films, Olney, Pennsylvania, 1977.

John Haag,
Associate Professor of History,
University of Georgia, Athens, Georgia

Necker, Anne Louise Germain

(1766–1817).

See Staël, Germaine de.

Necker, Suzanne (1739–1794).

See Staël, Germaine de for sidebar.

Necker de Saussure, Albertine Adrienne (1766–1841).

See Staël, Germaine de for sidebar.

Neel, Alexandra (1868–1969).

See David-Neel, Alexandra.

Neel, Alice (1900–1984)

American painter who was known for her portraits. Born on January 28, 1900, in Merion Square, Pennsylvania; died on October 13, 1984, in New York City; third of four children (two girls and two boys) of George Neel (a railroad clerk) and Alice Concross (Hartley) Neel; attended public high school in Colwyn, Pennsylvania; graduated from the Philadelphia School of Design for Women (now the Moore College of Art), 1925; married Carlos Enríquez (an artist), on June 1, 1925 (separated 1930); lived with Kenneth Doolittle (a sailor), 1931–33; lived with José Santiago (a musician), 1935–39; children: Santillana Enríquez (1926–1927); Isabella Lillian Enríquez (b. 1928); Richard Neel (b. 1939); Hartley Stockton Neel (b. 1941).

The American painter Alice Neel often referred to herself as "a collector of souls," alluding to the expressionist portraits that comprise the bulk of her work, though she also painted landscapes, cityscapes, interiors, and still lifes. Consigning to canvas her family, friends, and lovers, as well as celebrities and derelicts, the artist sought to record the human comedy—much the way Balzac did in literature—revealing through them a unique and poignant insight into 20th-century life. "Alice Neel's highly personal art reveals her private emotions and the realities of her world," writes William D. Paul, Jr. "But more importantly, she shares with us her remarkable ability to penetrate the psyches, minds, and emotions of her subjects. More often

than not, the candor of Alice's vision has left her sitters ruthlessly exposed, stripped of veneer, for all the world to see." Neel was personally acquainted with much of the pain and vulnerability she frequently exposed in others. For many years, her life was dominated by her volatile relationships with men, several of whom abused and deserted her, and one who literally destroyed most of her work. She lost one child through death and was forced by economic adversity to send another away, resulting in a nervous breakdown that nearly ended her life. Finally, like so many artists, particularly women, Neel went unrecognized by her peers and the public for years. It was well into the 1960s before she began to capture the attention of the art world and not until 1974, ten years before her death, that a long-overdue retrospective exhibition of her work was held at the Whitney Museum in New York.

The third of four children (two girls and two boys), Alice Neel was born in 1900 in Merion Square, Pennsylvania, but grew up in the little town of Colwyn, where the family moved when she was three months old. "There was no culture there," she later recalled. "I hated that little town. I just despised it. And in the summer I used to sit on the porch and try to keep my blood from circulating." Even as a child, Neel had the feeling that she was destined for something other than an ordinary life. She was alternately terrified and fascinated by the world around her and by the creations of her own imagination. "I was attracted by the morbid and excessive, and everything connected with death had a dark power over me. I was early taken to Sunday School where the tale of Christ on the Cross would send me into violent weeping and I'd have to be taken home." After high school, where she took typing and stenography instead of art, Neel took and passed the civil service exam and got a job with the Army Air Corps in Philadelphia, during which time she also attended the School of Industrial Art at night. She held several civil service jobs before committing herself to a career in art and enrolling at the Philadelphia School of Design (now Moore College), a women's school. At the time, men were an overwhelming factor in her life, and she said she chose a college with only women students so she could concentrate on her work. In the summer of 1924, however, she attended the summer school of the Pennsylvania Academy in Chester Springs and met Carlos Enríquez, a Cuban aristocrat whom she found irresistible. "I was in love with him. He was gorgeous. Not only that, he was an artist. That was one of the best loves I had, really."

Neel married Carlos in 1925 and went with him to Havana where they enjoyed "the life Bohème." They lived with his wealthy family for a time, then moved into an apartment on the waterfront. In Havana, Neel had her first solo exhibition and her first child, Santillana, who died of diphtheria a year later, after the couple had moved back to New York. She expressed her overwhelming grief in the watercolor *Requiem* (1928) and in a later oil painting, *Futility of Effort* (1930), which grew out of a newspaper article about the accidental hanging of a child from a crib. She called the black-and-white painting, which depicts a tiny figure dangling helplessly in the framework of a large bed, "a combination of my own tragedy and that event." **Cindy Nemser** called the work "the catalyst that unleashed Alice Neel's ever-increasing power to document the human reality born out of her own feeling, her own reactions to external events. No matter how Neel's style has varied in line and color over the years, this stark portrayal of feeling, this empathetic involvement with human concerns, remains the essence of her art."

In 1929, Neel gave birth to another daughter, Isabella (called Isabetta), but a year later Carlos left her to go to Paris. Unable to support their daughter, Neel had to send her to Cuba to be raised by her husband's family. She returned to Philadelphia where she recorded her loneliness in dozens of paintings containing stark images in garish hues of green, red, and yellow. The works signaled a nervous breakdown that incapacitated her for a year. She blamed the illness on her inability to grieve for her daughters, and described it as a little death every day. Following her slow recovery, she returned home, then visited a friend in Stockton, New Jersey, where she met Kenneth Doolittle, a sailor with whom she moved to Greenwich Village. In the winter of 1934, in a jealous rage over her developing relationship with Harvard-educated John Rothschild, Doolittle slashed and burned 60 of Neel's painting and 200 drawings and watercolors. She barely escaped the rampage with her life, and soon afterwards took up with a Puerto Rican nightclub singer by the name of José Santiago, with whom she lived for five years. Together, they had a son Richard (b. 1939), after which José ran off with a young saleswoman at Lord and Taylor's. Neel had a second son Hartley (b. 1941) with another paramour, Sam, a "mad" Russian intellectual who also turned out to be jealous and possessive. She left him when he began to abuse her son Richard.

During the Depression years, Neel participated in the Public Works of Art Project (PWAP), and the easel project of the subsequent Work Projects Administration (WPA), programs that kept her off the dole. For the latter, she produced a picture every six weeks, often working at night while her children slept. Her social realist paintings of this period are somber in color, complementing the anguish of their subjects. One work, *Synthesis of New York* (1933), shows people huddled in coats with skeletal faces trudging to the subway, while another, *The 9th Avenue El* (1935), depicts two wretched souls standing on the street corner. Other works capture the faces of Spanish Harlem, where she resided with José. One particularly moving painting, *T.B. Harlem* (1940), is of a young Puerto Rican man following surgery for tuberculosis, his ribs bandaged and his head thrown back on the pillow much like Christ's head resting on the Cross. The painting was not exhibited until 1971, when her alma mater Moore College held an exhibit of her work. "The galleries didn't like anyone else but Jesus Christ to be on the Cross," Neel commented. Another of her more controversial paintings—a nude portrait of her friend Joe Gould (1933), revealing a triple set of genitalia seen from different angles—was also hidden away until the Moore College exhibit.

Neel continued to live in Harlem throughout the 1940s and the 1950s. This was a particularly difficult period for the painter, who was passed over by dealers, critics, and patrons in favor of the new abstract, nonfigurative artists. "When I go to a show today of modern work I feel that my world has been swept away," she said in her honorary doctorate address at Moore College of Art in 1971, "and yet I do not think it can be so that the human creature will be forever *verboten*." Neel continued to produce portraits, receiving some recognition in 1960, when her painting of Frank O'Hara (1960), the poet and curator of the Museum of Modern Art, appeared in *Art News*. Throughout the '60s, she continued to capture attention, as part of a group show at the Kornblee Gallery in New York and as the recipient of the Longview Foundation Prize awarded by Dillard College, which also purchased her portrait of political activist Stewart Mott (1961). She created portraits of numerous other celebrities, including feminist leader *Kate Millett (for the August 31, 1970, cover of *Time* magazine), composer Virgil Thomson (1971), and artists Andy Warhol (1970), *Isabel Bishop (1974), and *Marisol (1981), among others.

The actual process of producing a portrait began for Neel with the choice of size and type of canvas. Subjects arrived at her studio wearing

whatever they wished, although she sometimes requested an outfit she had seen them in previously and liked. During the settling-in period, Neel talked with her subjects (or her "victims" as she sometimes called them), while she observed their faces and body language. "Before painting when I talk to the person, they unconsciously assume their most characteristic pose, which in a way involves all their character and social standing—what the world has done to them and their retaliation." She then divided the canvas and in thinned ultramarine paint drew the outlines and features of the subject (and of the furniture if applicable). She finished the work by filling in the outline with color, which took anywhere from three days to a week. Critic Robert Taylor suggests that Neel's portraits represent a confrontation wherein Neel probed for psychological truth beyond what the subject wanted her to see. "She does this through deliberate anatomical distortion, posture, or even by using clothing as an aspect of characterization—as in 'David Bourdon and Gregory Battcock,' the latter [a critic of underground film and experimental art] in his underwear, the former [a *Life* magazine art editor] in corporate uniform of a business suit, striped tie and collar clip." Neel likened her portrait painting to an LSD trip in which she became the person she was portraying. "Sometimes," she said, "I feel awful after I paint. Do you know why? Because I go back to an untenanted house. I leave myself and go out to that person and then when I come back there is a desert."

Quite apart from Neel's "gallery" portraits were those of the people closest to her, the men she had loved, her sons Richard (a lawyer) and Hartley (a doctor), and her grandchildren. Neel had hoped that her children would also pursue careers in the arts, but since they did not, she consoled herself with Richard's wife Nancy, a New Englander who possessed a true understanding and appreciation of art. Nancy, who came to serve as Neel's private secretary and assistant, also modeled regularly for her mother-in-law, once when she was pregnant, reclining on her side, with "the guilty party" as Neel referred to Richard, in the background. Pregnancy, as one of women's natural cycles, fascinated Neel, and it became a major theme in her work. "It's a very important part of life and it was neglected," she said. "I feel as a subject it's perfectly legitimate, and people out of false modesty, or being sissies, never showed it. . . . Also, plastically, it is very exciting. Look at the painting of Nancy pregnant: it's almost tragic the way the top part of her body is pulling the ribs."

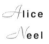

Although known for her "human creatures," Neel also painted first-rate landscapes, cityscapes, and still lifes, a collection of which was exhibited at the Tisch Gallery at Tufts University in 1991. **Christine Temin**, who called the exhibition a "revelation," reviewed the show for the *Boston Globe*. "Seen from across the large gallery," she wrote, "Neel's paintings are forceful; close up, they fascinate. Clear color, flattened forms, quavering outlines, often in blue—the stylistic signatures of Neel's portraits are here, too." Many of Neel's cityscapes were painted from her own apartment in Manhattan, where she lived from 1927 until her death in 1984. Temin found them "Hopperesque," stark and quiet, with little action. She singled out the urban painting *Night* (1959), which is completely devoid of detail. "An accumulation of sorrowful black verticals, reminiscent of rain or tears, is broken only by a blaze of artificial yellow light in a window that remains an enigma." **Pamela Allara**, the art historian and former Tufts faculty member who organized the show, writes of Neel "knitting together her environment with her feelings," particularly in *Sunset, Riverside Drive* (1957), which she likens in emotional clout to Edvard Munch. "A yellow orb is reflected by a shimmering swath in the water" she writes.

"The greenery at the river's edge is engaged in a manic dance." Even when painting flowers, which she loved, Neel avoided the sentimentality of detail, although her works on nature are free of angst. In *Still Life, Rose of Sharon* (1973), the viewer senses Neel's simple joy in capturing nature's beauty.

Alice Neel continued to paint into old age, the gray hair and plump grandmotherly appearance of her later years making her outrageous comments and well-defined ego sometimes difficult to reconcile. While her art and her family continued to occupy much of her time, she retained an active interest in the world at large and was always eager to share her hard-earned knowledge with younger artists. ("I would tell these classes of art students, the more experience you get, the better, if it doesn't kill you. But if it kills you, you've gone too far.") The Whitney retrospective in 1974, which included only the artist's portraits, led to a more extensive survey organized by the Georgia Museum of Art in Athens in 1975. This was followed by a series of smaller exhibitions across the United States, as well as one at the Artists' Union in Moscow in 1981. Though beset by cataracts and ill health, Neel continued to paint up until a month before her death at age 83 on October 13, 1984.

SOURCES:

Garraty, John A., and Mark C. Carnes, eds. *American National Biography.* Oxford: Oxford University Press, 1999.

Hills, Patricia. *Alice Neel.* Foreword by William D. Paul, Jr. NY: Harry N. Abrams, 1983.

Moritz, Charles, ed. *Current Biography 1976.* NY: H.W. Wilson, 1976.

Nemser, Cindy. "Alice Neel: Portraits of Four Decades," in *Ms.* October 1973, pp. 48–53.

Taylor, Robert. "Neel portraits evoke energy of personality," in *Boston Globe.* October 19, 1980.

Temin, Christine. "Revelations Abound at Alice Neel Show," in *Boston Globe.* October 18, 1991.

Barbara Morgan,
Melrose, Massachusetts

Nefertari (c. 1295–1256 BCE)

Chief queen of Pharaoh Ramses the Great of ancient Egypt and a great beauty, judging from contemporary paintings. Name variations: Nefertary; Nefertari-Merymut. Born around 1295 BCE; died in 1256 BCE (some sources cite 1255); married Ramses II, king of Egypt (r. 1304–1236 BCE), around 1280; children: one daughter; one son Amem-hir-khopshef (died young).

Nothing is known of the parentage of Nefertari, the favorite queen of Ramses II's youth. They were married for at least 25 years (c. 1280–1265 BCE), and she gave birth to his first son and first daughter. He apparently favored her over his other "chief wife" **Esenofer** (Istnofret), because it is Nefertari who appears prominently on Ramses' monuments. An entire temple was dedicated at Abu Simbel in Nubia, celebrating Nefertari as the earthly manifestation of Hathor, the goddess of love. In year 21 of her husband's reign, Nefertari exchanged written greetings and gifts with the queen of the Hittites upon the conclusion of a peace treaty between these two superpowers of the age. Nothing more is heard of her after the 25th year of Ramses II's reign, when she must have died and been buried in her magnificent tomb, discovered in 1904, which is hewn into a mountain in the Valley of the Queens near modern Luxor, 315 miles south of Cairo. (Other important wives of Ramses were **Bint-Anath**, **Meryetamun**, and **Hentmira**.)

Barbara S. Lesko,
Department of Egyptology, Brown University,
Providence, Rhode Island

Nefertiti (c. 1375–1336 BCE)

*Ancient Egyptian queen who appears to have ruled with her husband (and if so was the only queen of the pharaonic period known to have done this) and may have even ruled independently for a short time following her husband's death. Name variations: Nefertiit, Nefretiti, Nofretete or Nofretiti. Born around 1375 BCE; died in 1336 BCE; parents unknown; probably the daughter of the sun-king Amenhotep III (known as The Magnificent) and one of his many wives; sister of *Mutnedjnet (c. 1360–1326 BCE); married Amenhotep IV, later known as Akhenaten (c. 1385–1350 BCE), pharoah of Egypt; children: six daughters, Meritaten, Meketaten, Ankhesenpaaten (Ankhesenpaten), Neferneferuaten minor, Neferneferure, and Satepenre.*

Although Nefertiti is perhaps the most famous woman from the land of the Pharaohs, she remains an enigma. No one is so much a symbol of ancient Egypt, yet so imperfectly understood. Her parents are unknown, but she was married to the most powerful monarch in the world of her time. The date of her marriage and that of her death are unknown. Whether the period of her greatest power and influence was early in her husband's reign (c. 1348 BCE) or at its end (c. 1338 BCE) is debatable. What *is* known is that she was extraordinarily beautiful and enjoyed great prominence and power during her adulthood and, after her death, her memory was hated and the object of a systematic persecution.

During the winter of 1912–13, German archaeologists working at the site of the ancient city at Tell el-Amarna discovered Queen Nefertiti's now-famous painted portrait bust toppled over on the floor in the ruins of the studio of an ancient sculptor named Thutmose. Ever since its display and publication in 1923, this image of Nefertiti has been universally adored, and the sculpture—the long graceful neck supporting the lovely and serene face under the soaring conical crown (which was hers alone)—has been constantly reproduced around the world on everything from jewelry to postage stamps. She and her family have captured the imagination of many and been the subject of novels, films, and an opera.

Nefertiti's name meant "The beautiful one has come" and would seem to suggest she arrived from elsewhere, but no one knows this for certain. Most likely, she was not foreign, but an Egyptian by birth and probably the daughter of the sun-king Amenhotep III (known as The Magnificent) by one of his many wives. Nefertiti is not believed to have been born to his first wife and consort Queen *Tiy, however, whose four daughters are known.

Amenhotep III, who was the mightiest king of the world in his time, was granted the princesses of several foreign nations in marriage, and these royal women came from Syria, Mitanni, Babylon, and Anatolia to seal friendly diplomatic relations between their countries and Egypt. Nefertiti could well have been the issue of any such union with a foreign princess, as no monument contains the name of her parents. The most important of the foreign princesses to marry Amenhotep III was surely **Gilukhepa**, daughter of the king of Mitanni, then Egypt's chief rival for power in the Middle East. Amenhotep had to ask Gilukhepa's father at least five times for her hand in marriage. He finally relented and the Mitannian princess journeyed to Egypt escorted by a retinue of over 300 women of her country. There is a slight chance that Gilukhepa maintained an important position at the Egyptian court, having assumed an Egyptian name, perhaps even Nefertiti, but this is speculative.

Raised in the palace, probably the royal residence in the fertile Fayum depression where the Egyptian queens had for generations owned land and factories and resided in independent splendor, Nefertiti had a "great nurse and governess" named **Teye** who was the sister-in-law of the Great Queen Tiy. The term *nurse* is loosely applied in Egyptian, given even to men who were tutors, and thus the sister-in-law of the queen

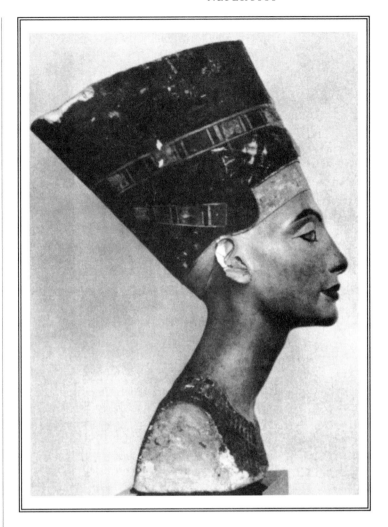

need not have been a wet-nurse, but could have been a teacher to a foreign princess who would have needed to learn the language and customs of the Egyptians. At any rate, Nefertiti may well have learned to read the difficult hieroglyphic script, and she also learned to drive a pair of horses from a chariot single-handed.

Whether because she was a foreigner or the daughter of a lesser queen of the pharaoh, Nefertiti was not married to the heir to the throne, but to a sickly prince, named Amenhotep (IV) after his father. The heir apparent also may not have been robust, as this Prince Thutmose died long before his father. This unexpected turn of events thus propelled the younger Amenhotep and Nefertiti to the throne and rulership of the Egyptian empire. The prince Amenhotep IV had spent much of his formative years as a priest in the temple of the sun god, Re-Harakhty, in ancient On, east of the capital city of Memphis. He exhibited true religious devotion and scholarship, as well as a talent for poetry. The traditional ways of viewing the deity and viewing

Nefertiti

mankind and the world around him—all were pondered by this thoughtful, introspective man. He was not the type of person interested in the hands-on running of a vast empire, but fate had placed him in such a role.

Whereas princes of his dynasty had always been trained as warriors and sportsmen (Amenhotep III had bagged over 100 lions in one hunt) and had traditionally been portrayed in art as perfect physical specimens, this earnest and sickly young man could not support falsehood. Thus when his father died after a long reign of 38 years, Amenhotep IV not only became ruler over the Egyptian empire, but began to declare new policies that would rock the tradition-bound homeland. The most apparent of these was the immediate change in artistic styles. Royal artists were taught, by the king himself one informs us, to depict him as he really appeared, scrawny of neck, haggard of face, with an overgrown jaw, prominent breasts and belly, fat thighs on spindly legs—not at all a healthy athletic figure.

Unfortunately the artists in their enthusiasm to please their young king began to portray everyone with similar characteristics, as if anxious to flatter their sovereign by imitation. Thus colossal statues of Amenhotep IV and his chief queen, now in the Cairo Museum, present grotesque forms and caricatures for faces and have even been termed "disturbing." If the beautiful portrait bust of Nefertiti, which dates to many years later, had not been discovered, the world would never have known how attractive the young queen of Egypt truly was.

It was Nefertiti's prime duty to bear the next heir to the throne, which tradition decreed should be a son. Instead her first born was a daughter (**Meritaten**), as was the next (**Meketaten**), and the next (**Ankhesenpaaten**), and the next (**Neferneferuaten minor**), and the next (**Neferneferure**), and the next (**Satepenre**), until six little princesses filled the palace. Due to the odd appearance of Amenhotep IV, it is sometimes written that he must have suffered from Froelich's syndrome (an endocrinal disorder that affects sexual maturation) and should not have been able to father children at all. If so, another mystery concerning Nefertiti appears. Who would have fathered these daughters? The first three were certainly born while the old king Amenhotep III still lived, and his name even appears on the stone sarcophagus of the second daughter who died young. However, he could not have been the progenitor of the last three, unless there was a long co-regency between Amenhotep III and IV, which is not impossible but doubted by many scholars. It is also possible that the speculation about his son's health may be overblown. Indeed, the young king also had secondary wives, and one of these, named **Kiya**, may well have borne him a son or two, although this is not certain either. On the other hand, numerous progeny must have been born to Amenhotep III by his many wives and concubines, and his son's famous successor King Tutankhamun could have been one of Amenhotep III's sons.

Nefertiti, however, was not discarded for her failure to bear a male heir and remained the Great Royal Wife. Indeed, very early in the reign she was allowed unusual prominence, which should indicate her husband's high regard, indeed, dependence upon her.

His religious meditations had led him to advance the worship of the sun disk and its light, as the giver of all life and thus worthy of the highest devotion. Bestowing most of his royal patronage on the Aten, as the disk was called, Amenhotep IV had built several new temples to his god in the midst of the great religious center in ancient Thebes, home of the King of the Gods, Amun-Re. His temples to the Aten not only were dedicated to a newly promoted deity, but exhibited innovative designs, truly new styles in architecture: soaring piers and open courts and larger-than-life images carved on their walls.

Significantly, it is Nefertiti the queen who is portrayed as chief celebrant of this cult of the sun's disk on a majority of the walls so far recovered at Karnak. It is the queen's image which is cast several meters high on the walls, standing alone before the altar with its tower of offerings, or accompanied by her first born, singing the god's praises. Some have questioned whether the queen's ubiquitous presence in the cult place is indicative of her role in founding this "new religion," which has been termed the first monotheism. In promoting the "new" cult of the Aten, the king and queen were deliberately ignoring the cults of the huge pantheon of Egyptian deities. Withdrawal of royal support meant temples of other gods throughout the land were closed and their lands and personnel either confiscated for the Aten cult or left to flounder on their own.

The fundamental information of Nefertiti's status in the realm and in the religion was not discovered until the 1960s when the wall scenes from these demolished temples were recovered and studied. They had been carved on walls built quickly from small-sized stones which, in the years following her dynasty, had been pulled down and recycled as stuffing for pyloned gates

built by later pharaohs. Nefertiti's portrayal, alone without the king, officiating in the state cult is startling and unprecedented. Nefertiti is also shown at Karnak with a throne dais decorated with images of bound female captives placed so she would stand on them. Her performance of rituals without the king is taken by scholars as a testament to her powerful position in the realm, probably co-regent. Perhaps her gifted but introspective husband, whether due to ill health or personal preference, opted to concentrate on his religious writings and teachings and left the day-to-day government of Egypt to Nefertiti. The royal couple did share scenes of cultic service as well as regal audiences and award ceremonies.

Rather than crowd the Aten's shrines into the confines of Karnak, the not so hospitable home of Amun-Re, it was deemed desirable to grant Aten a city of his own, where numerous temples might be built and all inhabitants could serve the true god. Soon the young royal couple was looking at real estate and in the Fourth Year of the reign, a site was located in middle Egypt, half-way along the Nile between Thebes and Memphis, a wide plain whose aridity had discouraged settlers previously. Because it had never been associated with any other deity or ruler, Amenhotep thought it the perfect place to build the city for the Aten and stated on its boundary markers that he would not allow his queen or anyone else to dissuade him from the selection. This statement indicates the queen was given to making her opinion known and perhaps had indeed argued against the choice of so poorly watered a wilderness. Nonetheless, here in the Fifth Year, a vast new capital was laid out—it would come to have 45,000 inhabitants, large for an ancient city. The royal inscription mentioned above also stated that besides several temples to the Aten, there would be built separate palaces for the queen and the king. Also a royal family tomb would be hewn in the eastern hills, so that the king, queen, and their children could all be interred together, another departure from the usual arrangements of the royal family, but an indication that they were close. Indeed, the surviving artistic monuments of this new city are replete with unprecedented scenes of royal family togetherness, intimacy, and informality: the royal family at dinner; the royal couple kissing each other while out riding in their chariot; their young daughters clambering for attention and being embraced by the doting parents. No other children of the king appear in the art. Perhaps in an attempt to make up for the loss of familiar old goddesses and favorite divine triads,

which featured a god, his goddess consort, and their son, the Aten religion substituted an earthly royal family that was intimately involved with the sun god and would receive the prayers of their subjects and convey their gratitude and petitions on high. Indeed, it has been suggested by scholars that the king and queen took the place of the primeval couple Shu and Tefnut (air and moisture), first "beings" created by the androgynous creator god Atum, whose role the Aten now assumed. Certainly much indicates Nefertiti was revered like a goddess in the Aten cult and, indeed, her lofty headdress imitates that in which Tefnut is usually shown. Prayers carved on the aristocracy's tomb walls are addressed to the Aten, the king and the queen, and the image of Nefertiti replaced those of the traditional four protective goddesses on the corners of her husband's sarcophagus.

Once the royal family settled in the new capital, their names were changed to further emphasize their close relationship to and adoration of the sun disk. Amenhotep IV was now known as Akhenaten (or Akhaniaty) and his wife appended to her flattering name Neferneferuaten ("Perfect are the beauties of the Aten"). The poet-king composed lengthy paeans to his god; at the beginning of some hymns to the Aten, he referred to the worship of the disk as well as of the king and Nefertiti. No distinction seems to have been made among these three in the early years of the reign; they were all meant to be worshipped as a triad.

The new city, strung out along the east bank of the Nile for eight kilometers, was named Horizon of the Aten or Akhetaten, and included one of the largest palaces known from the Middle East of any period: over 750 meters in length. The major Aten temple was actually composed of several independent shrines open to the sky. Here again the king and queen, accompanied by their eldest daughter, predominate in the decoration. By Year 12, the royal family must have felt the city was ready to be shown off, and they held a grand reception, greeting among others an array of international emissaries from African, Aegean and Asiatic lands and receiving their gifts (portrayed by the Egyptians as tribute). Both foreigners and the Egyptians were usually shown in obsequious poses. The kissing of the ground before pharaoh, the deeply bowing servants and guards, are commonplace in the art of Akhetaten, but not typical of traditional Egyptian art.

Tombs were hewn in the cliffs, just beyond the city, for the important people of the court

and government. Often on the doorjambs of these tombs were engraved prayers addressed by the deceased to the king and Nefertiti, begging for benefits, such as long life. It is clear that people thought, or were taught to think, that Nefertiti had the powers of a goddess, but she is also depicted as kings traditionally were. One wall scene of a public building depicted a Nile boat with a painting on its cabin's outer wall showing Nefertiti in an aggressive pose associated with kings, smiting a foreign captive with a scimitar. This boat also has its large steering oars decorated with heads of Nefertiti. While in the previous reign her mother-in-law, Queen Tiy, had also, quite exceptionally, used some of this iconography and was, incidentally, much involved in sharing the rule of the empire with her husband, the most aggressive depictions are found only with Nefertiti. In a scene depicting her together with her husband, Nefertiti is portrayed seated on an elaborate stool, while the king sits on a plain one. On one monument from Akhetaten, she appears next to her husband wearing the kingly "blue helmet" coronation crown while Akhenaten wears the traditional double crown of Upper and Lower Egypt. All such pharaonic iconography, meant to portray an invincible ruler, does not appear to have been applied to queens previously and increases the probability that Nefertiti had unprecedented powers.

Such evidence prompted J.R. Harris in 1973 to propose that Nefertiti was co-regent with her husband and then succeeded him as pharaoh. Indeed, a female ruler of the late 18th Dynasty was recalled by the historian Manetho 1,000 years later. Unfortunately, feelings ran so strongly in ancient Egypt against Akhenaten for his lack of support for the traditional pantheon of deities, that his monuments and those of his family were thoroughly attacked and pulled down during the century following his death, making research on this period extremely difficult. The scholarly speculations are based on the tantalizing evidence outlined above plus later art from this period. Increasingly, Nefertiti was shown in relief scenes wearing a helmet-like headdress rather than the Tefnut crown. There is one revealing statuette showing her alone and obviously middle-aged and wearing this crown. A silver scarab bearing only her name was found in an ancient shipwreck off the coast of Turkey. Also, in the next dynasty, her image in particular was often defaced, suggesting that later generations blamed her for assuming too much power or having excessive influence in the realm.

Confusing the reconstruction of the history of the Amarna period is the appearance of other names associated with the name Nefertiti but also with her second name Neferneferuaten. The name Ankhkheperure is found with Neferneferuaten, but also in company with the eldest daughter's name and also used as a pre-nomen for Smenkhkare. It has been assumed that this last name fits the supposedly male remains buried in Tomb 55 of the Valley of the Kings (where the name itself does not appear). This, however, would mean that there were two distinct people, one man and one woman, sharing the same name. This would be, if true, a very strange and unprecedented occurrence.

Nefertiti's name Neferneferuaten appears in inscriptions a few times linked with Akhenaten and also with their daughter Meritaten who is described as a "chief queen." That the daughter could be a "queen" to her mother's "king" has at least one historical precedent earlier in this same dynasty, when *Hatshepsut took her daughter Neferure as her queen for ritual purposes. Careful scholarly detective work of recent years has found no evidence of the name Smenkhkare linked to Akhenaten, suggesting that the name appeared in use only after the king's death. This does not mean such a person did not play a royal role at the close of this family's history, but indicates an appearance of the name after the Akhenaten-Nefertiti co-regency and before Tutankhamun's reign.

Thus Nefertiti may well have used the name Neferneferuaten first as queen and then as ruler, when she also adopted the name of Smenkhkare. One inscription from Theban Tomb #139 would allow a three-year reign for the female pharaoh, but part, perhaps most, of this reign was probably as co-regent with her husband. It has been suggested that Nefertiti and Akhenaten shared the rule of the Egyptian empire by having Nefertiti concentrate on domestic affairs in Egypt and Akhenaten deal with foreign affairs and the military. However, significant developments in the religion of the Aten took place late in Akhenaten's reign which suggest that he was much involved in thinking through the characteristics of his god. The concept of Shu and Tefnut seems to have been dropped late in his reign in favor of a single patriarchal monotheism, which excluded Nefertiti. Whether this indicates a rupture of their personal relationship or merely a change in Akhenaten's religious thinking cannot now be known, but if Nefertiti survived, her role in the last years would have developed along political lines and lessened in its theological character. She then became Akhenaten's heir and ruled alone briefly after his death. If this reconstruction is

correct, Nefertiti joins the small and select group of women who were pharaohs in ancient Egypt.

The other reconstruction of the history states that with Akhenaten's death, Nefertiti stepped aside and allowed her now mature and married daughter Meritaten to assume the rulership with her husband, Smenkhkare. If this were the case, it may mean that Nefertiti was not well, perhaps she had become blind—a liability for those who stare intently at the sun frequently—or she may have died. There was at this time a plague raging in Egypt and its Eastern territories, and possibly this was responsible for so many deaths in the royal family at one time (the younger daughters of the family are heard of no more), and both Meritaten and Smenkhkare do not seem to have ruled more than one year.

Nefertiti must have been an energetic woman who exerted a powerful influence over her husband. Whether this was for good or ill, we cannot say. She certainly was supportive of his religious ideas, but his absorption with his new religion led him to neglect his foreign policy, which at best was weak and indecisive, at worst disastrous for Egypt. The closing of the temples throughout the land undoubtedly caused economic problems as masses would have been left unemployed, although much of this would have been offset by the building of the new capital, which was achieved at phenomenal speed. The reign was marked by innovations in art, architecture, and religion, as well as in education which was eased and probably extended to more people due to the introduction into the curriculum of the spoken idiom. Previously only the defunct classical form of the language was taught in the schools.

Because Akhenaten unleashed a fanatic attack on all the graven images and names of the other gods during his last years, one must consider that he may have become increasingly mentally unstable, suggesting perhaps a reason why his queen would have had to assume more responsibilities in the rulership. Even more than being a replacement for other goddesses, a female's assumption of supreme ruling power was usually rewarded with later persecutions on the state monuments, and this could easily explain the later defacement of Nefertiti's monuments.

The pharaoh Smenkhkare (Nefertiti?) was succeeded by a mere child, Tutankhamun, whose parentage is unknown, but who was sired by either Akhenaten or Amenhotep III. Because he was so young, probably but nine years of age, when he inherited the throne, the decisions of government were made for him by the highest

officials, and presumably chief of these was the brother of Queen Tiy, the aged vizier Aye. He removed both his sister's and Nefertiti's bodies to Thebes and laid them in a small tomb in the Valley of the Kings, just as Tiy's and his parents had been buried in a small tomb in the same illustrious burial place of kings some years earlier.

Until recently, the burials in Kings' Valley #55 have been responsible for a misleading reconstruction of events in the royal family. When first discovered in 1907 by the American Theodore Davis, the toppled walls of a golden shrine featuring the image and names of Tiy and her husband and an elaborate mummy case of a royal person from which the names had been removed were assumed to belong all to one and the same person. A gynecologist who viewed the body proclaimed it a woman's (due to the wide pelvis and absence of male genitals), and Davis was convinced he had both the tomb and the body of Queen Tiy. Unfortunately, soon afterward, rough handling of the mummy reduced it to dust except for a few bones. Years later, anatomists studying the jaw were so impressed with its similarity to Tutankhamun's that they pronounced the remains in Tomb #55 male and around 20 years old at death. This tied in perfectly with the theory that a young man with the name of Smenkhkare had been able to insinuate himself between Nefertiti and her husband and became Akhenaten's favorite, successor, and son-in-law.

When careful reassessment of all monuments and inscriptions convinced some scholars in the last quarter of the 20th century that Smenkhkare was merely another identification for Nefertiti, they were still confronted by the problem of the burial of the "young man" in Tomb #55. However, latest scientific tests now strongly suggest this mummy was not of such a young person, but someone who had reached their late 30s. There is also, judging from what remains today, a 30% chance of the remains being female, but there is an even greater probability when the first eyewitness accounts of the discovery of the body are taken into account (as the excavators and the first medical examiner saw not only mummy wrappings, but facial and bodily remains—far more than recent researchers have been able to deal with). Thus the likelihood grows that the coffin and remains from Tomb #55, now in the Cairo Museum, are those of Nefertiti, who was returned to Thebes in a coffin once intended for the secondary wife Kiya. A more splendid coffin, canopic equipment, and gilded statuettes created for Nefertiti's pharaonic burial were appropriated for Tutankhamun when he died prematurely. The

mummy of Akhenaten may then have been left behind at the capital he founded, interred in the royal tomb he had intended for his entire family. In the following 19th Dynasty, perhaps during the reign of Ramses II which saw the destruction of the Atenist capital, the tomb and the burials were vandalized. If, on the other hand, the coffin originally made for a woman was for some reason needed to replace that of the king's (who should have had his own funerary equipment assembled long before he died), it may be that Akhenaten's remains were removed to Thebes in the secondary coffin of Tomb #55. In that case the body of Nefertiti has been lost.

To later generations the names of Akhenaten and Nefertiti and their immediate successors were anathema. Akhenaten had not comported himself as an ideal Egyptian king. He did not himself lead his armies on war campaigns and he had shared his rule with a woman who may have been blamed for pushing the discriminatory cult in which she originally played such a prominent role. Nefertiti had the misfortune to live her very public life during a period which experienced a devastating plague that took many lives. To ancient minds, this plague was a sign of the displeasure of the deities who had been stripped of their temples and wealth. It would have been no wonder if the terrified citizenry felt no love for this royal family. In the years following their demise, Akhenaten was referred to as "that criminal" and the monuments and burial places of his family were desecrated.

On the other hand, the sincerity of his quest for truth and the spirituality of his Aten hymns, so similar in theme and phraseology to the 104th Psalm, have won Akhenaten a place in the hearts of many in the past century who have discovered him. This, combined with Nefertiti's beauty and mystery, has caused Nefertiti and Akhenaten to be remembered and respected far beyond the imagining and the wishes of those who persecuted their children and their memory.

The famous painted bust of Nefertiti has had an interesting history itself since discovery. Hidden by the Germans in a salt mine during the Second World War, she was discovered by American troops and given back, not to Egypt, but to the Germans. However, in more recent years the Egyptian government has demanded her return. This has so far been refused as Nefertiti is the centerpiece of the large Amarna collection in Berlin and something of a cult object there as well.

SOURCES:

Allen, J.P. "Nefertiti and Smenkh-ka-re," in *Goettinger Miszellen*. Vol. 141, 1994, pp. 7–17.

Cooney, J.D. *Amarna Reliefs from Hermopolis in American Collections*. Brooklyn, NY: Brooklyn Museum, 1965.

Gardiner, A.H. "The So-called Tomb of Queen Tiye," in *Journal of Egyptian Archaeology*. Vol. 14, 1928, pp. 10–25.

Harris, J.E. "Who's Who in Room 52?," in *KMT: A Modern Journal of Ancient Egypt*. Vol. 1, no. 2. Summer 1990, pp. 38–42.

Harris, J.R. "Akhenaten or Nefertiti?," in *Acta Orientalia*. Vol. 38, 1977, pp. 5–10.

———. "Neferneferuaten," in *Goettinger Miszellen*. Vol. 4, 1973, pp. 15–17.

———. "Neferneferuaten Regnans," in *Acta Orientalia*. Vol. 36, 1974, pp. 11–21.

———. "Nefertiti Rediviva," in *Acta Orientalia*. Vol. 35, 1973, pp. 5–13.

Martin, G.T. *The Royal Tomb at El 'Amarna*. 2 vols. London: Egypt Exploration Society, 1976, 1989.

———. Review of J. Samson's "Amarna, City of Akhenaten and Nefertiti" in *Journal of Egyptian Archaeology*. Vol. 60, 1974, pp. 267–268.

Morkot, R. "Violent Images of Queenship and the Royal Cult," in *Wepwawet: Research Papers in Egyptology*. Vol. 2, 1986, pp. 1–9.

Redford, D.B. *History and Chronology of the Eighteenth Dynasty of Egypt*. Toronto: University of Toronto Press, 1967.

———. "Studies on Akhenaten at Thebes, II. A Report on the Work of the Akhenaten Temple Project of the University Museum, The University of Pennsylvania, for the year 1973–74," in *Journal of the American Research Center in Egypt*. Vol. 12, 1975, pp. 9–14.

——— and R. Winfield Smith. *The Akhenaten Temple Project*. Vol. 1. Warminster: Aris & Phillips, 1976.

Reeves, C.N., ed. *After Tut'ankhamun: Research and excavation in the Royal Necropolis at Thebes*. London: Kegan Paul, 1992.

Samson, J. *Amarna, City of Akhenaten and Nefertiti: Nefertiti as Pharaoh*. Warminster: Aris & Phillips, 1978.

———. "Nefertiti's Regality," in *Journal of Egyptian Archaeology*. Vol. 63, 1977, p. 93.

Wilson, John A. "Akh-en-Aton and Nefert-iti," in *Journal of Near Eastern Studies*. Vol. 32, 1973, pp. 235–241.

SUGGESTED READING:

Aldred, C. *Akhenaten and Nefertiti*. NY: Viking Press, 1973.

———. *Akhenaten, King of Egypt*. London: Thames and Hudson, 1988.

Lesko, B.S. *The Remarkable Women of Ancient Egypt*. 3rd ed. Providence, RI: B.C. Scribe Publications, 1996.

Redford, D.B. *Akhenaten the Heretic King*. Princeton, NJ: Princeton University Press, 1984.

Samson, J. *Nefertiti and Cleopatra: Queen-Monarchs of Ancient Egypt*. London: Rubicon Press, 1985.

Tyldeseley, Joyce. *Nefertiti: Egypt's Sun Queen*. NY: Viking, 1999.

COLLECTIONS:

The largest assemblages of funerary equipment and sculptures of Nefertiti and her family are exhibited in the Egyptian Museum of Antiquities, Cairo. The famous bust of Nefertiti and art from the city of Akhetaten is on exhibit at the Egyptian Museum in Berlin. However, significant pieces of statuary are also owned by

the Louvre in Paris. American collections, at New York's Metropolitan Museum of Art, the Brooklyn Museum, and the Museum of Fine Arts, Boston, in particular, have mainly wall reliefs from the buildings erected at Tell el-Amarna and then torn down in the 19th Dynasty. Tens of thousands of inscribed and decorated blocks from the buildings at Karnak temple were discovered recycled as stuffing within several later pylons built there. Some of these talatat are on display at the Luxor Museum in Egypt.

RELATED MEDIA:

Akhnaton, play by *Agatha Christie, London, 1973.

Akhnaten, an opera in three acts, by Philip Glass, libretto by Philip Glass in association with Shalom Goldman, Bryn Mawr, PA: 1984.

The Egyptian, film produced by D.F. Zanuck, starring *Jean Simmons, Victor Mature, and *Gene Tierney, directed by M. Curtiz, 20th Century-Fox, 1954.

Merezhkovsky, Dmitri. *Akhnaton, King of Egypt* (novel). Translated by Natalie A. Duddington. NY, 1927.

Stacton, David. *On a Balcony* (novel). NY, 1959.

Vidal, Nicole. *Nefertiti* (novel). Paris, 1961.

Waltari, Mika. *The Egyptian* (novel). Translated by Naomi Walford. NY, 1949.

Barbara S. Lesko,
Department of Egyptology, Brown University,
Providence, Rhode Island

Neff, Hildegarde (b. 1925).

See Knef, Hildegarde.

Nefrusobek (fl. c. 1787–1783 BCE).

See Sobek-neferu.

Negri, Ada (1870–1945)

Italian poet whose literary reputation suffered due to Mussolini's enthusiasm for her works. Born in Lodi on February 3, 1870; died in Milan on January 11, 1945; daughter of Giuseppe Negri and Vittoria Cornalba Negri; had a brother, Annibale; married Giovanni Garlanda, in 1896; children: daughters Bianca and Vittoria.

With the publication of her book of verse *Fatalita* in 1892, Ada Negri became famous overnight as a voice of working-class protest. Born into conditions of poverty in the small town of Lodi near Milan, she was the first Italian woman writer to spring from the proletariat. The favor which was bestowed on her by the Fascist regime marred her literary reputation, but Negri's work is now in the process of being reevaluated by scholars.

She was born in 1870, into a life of privation. Her easygoing father Giuseppe spent the few lire he earned as a cabby with his friends in local taverns. He died when Ada was one year old, and her mother **Vittoria**, left penniless, was forced to work in the local textile factory. The

family was split up: Ada and her mother moved in with Vittoria's mother **Giuseppina Cornalba**, who was a concierge at the Cingia family palace, while Ada's brother Annibale moved in with his uncle, a teacher who along with his wife ran a boardinghouse for his pupils. Ada grew up with her grandmother, helping her with chores, and often played with the aristocratic girls of the Cingia family. Feeling humiliated by her family's humble status, Ada was sensitive to issues of social distinctions and inequalities from her earliest years. Living in what she would later describe as "a damp hovel," she was determined to find a means of escaping.

With the encouragement of relatives, she excelled in her school work and enrolled in a local normal school to prepare for a teaching career. Negri completed her studies in July 1887 and began teaching in early 1888. After some temporary work, she was assigned to a poor, remote village, Motta-Visconti, where at age 18 she found herself facing a large class of unruly peasant children. Negri gained mastery over her class by emphasizing rewards rather than punishments; for example, positive student responses were rewarded with freshly baked sweet rolls from the bakery of her landlord's daughter.

In her free time, Negri wrote poetry, the best of which she began sending to several newspapers in the province of Lombardy. Some of her verse soon appeared in the Milanese periodical *Illustrazione Popolare.* Before long, the established writer **Sofia Bisi Albini** visited Negri in Motta-Visconti, then published an article about the poet-schoolteacher in the prestigious Milan newspaper *Corriere della Sera.* In 1892, Negri's poetry volume *Fatalita* (Fate) was published by Emilio Treves. This work was an immediate sensation in Italy, and Negri became nationally known. *Fatalita,* despite some stylistic imperfections and a simplicity of view, moved readers with Negri's sense of social justice. While condemning the upper classes—for their sloth and obsessive love of food, jewelry and ostentatious clothing—Negri's poems praised the working class for their honest, decent nature and willingness to labor long hours for virtually no material rewards. *Fatalita* made Ada Negri a hero to the growing Italian Socialist movement. The volume created a sensation in Italian literary and intellectual circles, and few were surprised when she was awarded the Milli Prize for poetry in 1894.

Fatalita appeared during a time of great social turmoil in Italy, when strikes and workers' demonstrations were being violently suppressed by the police and army. In contrast to some of the

bombastic literary productions of the day, Negri's poems sounded authentic, for the simple reason that they had been penned by a writer who had personally witnessed and experienced social injustice. Negri was branded "the Red Maiden" by conservatives and devout Roman Catholics for allegedly stirring up class hatred, and *Fatalita* was entered by the Roman church on its infamous Index of Prohibited Books, the *Index Librorum Prohibitorum*, in 1893. In an Italy where most intellectuals were fiercely anti-clerical, such measures only served to make her even more popular as "a daughter of the people" and as an "anti-literary" social female poet whose raw talent ignored the rules of the café literati set.

In her next book of poems, *Tempeste* (Tempests, 1896), Negri continued to explore the themes that had aroused so much public interest. While also popular with readers, this book met with considerable negative criticism from some of the leading literary figures of the day, including Benedetto Croce and Luigi Pirandello, who remarked on a defective metric form in some of the verse, a general weakness of imagination, and feeble generalizations.

Several of the most powerful poems in *Tempeste* were inspired by Negri's feelings for her lover, a Socialist activist named Ettore Patrizi. After Patrizi emigrated to California, where he founded an Italian-language newspaper in San Francisco and fell in love with another woman, Negri responded to her disappointment by marrying a wealthy industrialist, Giovanni Garlanda, in 1896. The couple had two daughters, Bianca and Vittoria, the latter dying only a month after birth. The marriage was in trouble from the start, with Negri's husband wanting to transform her into a model middle-class wife, and Negri increasingly involved in the literary and political ferment taking place in Milan. Although the marriage would drag on until 1913, when Negri formally separated from him to live in Zurich, Switzerland, by the first years of the new century it had become clear to her that the union was a failure.

In her 1904 collection of poems entitled *Maternita* (Maternity), Negri's emphasis was on neither social injustices nor the individual's search for love, but rather motherhood. Stylistically, too, the book represents a distinct evolution, reflecting new, more subtle influences in her verse, including the work of Gabriele D'Annunzio and Giovanni Pascoli, two of the dominant authors of the day. In poems that reflect the grief of mothers upon the deaths of their children, Negri rarely mentions fathers.

Negri's next books—including *Esilio* (Exile, 1914), a book of poems prompted by the final collapse of her marriage in 1913, and *Le solitarie* (Solitary Women, 1917), a collection of short stories relating the lives of unhappy women—were artistically powerful statements that were obviously autobiographical in nature. During her stay in Switzerland during World War I, Negri met and fell in love with a builder; their relationship lasted less than a year due to his death in 1918 during the Spanish influenza pandemic. The feelings unleashed by this, the great love of her life, are found in the poetry collection *Il libro di Mara* (Mara's Book, 1919), a work many critics hold to be the most personal ever written by Negri.

At the start of the 1920s, Negri's poetry began to be appreciated for its subtle elements, and a number of composers, including the renowned Ottorino Respighi, set some of her verse works, including *"Notte"* (Night), to music. With the most passionate years of her life now receding, in 1921 Negri published an autobiographical novel, *Stella mattutina* (Evening Star), in which she describes with detached sensitivity her childhood and school years in Lodi. *Stella mattutina* became a durable success with the Italian reading public, selling over 60,000 copies between 1921 and 1943. Restraint also characterizes *Finestre alte* (High Windows), her 1923 collection of short stories which contrasts considerably with her 1925 poetry collection *I canti dell'isola* (Songs of the Island). The latter work is an exuberant celebration of the sun-drenched island of Capri, which for a Northern Italian like Negri was an almost hallucinatory and sensuous experience. Works that followed during these years were the prose collection *Le strade* (Roads, 1926), *Sorelle* (Sisters, 1929), the book of verse *Vespertina* (Evening Star, 1930), and *Di giorno in giorno* (From Day to Day, 1932), the last of which contained travel sketches and portraits of people she had met.

A major poetic achievement was *Il dono* (The Gift, 1936), which earned Negri the coveted Firenze Prize. She ended the decade with a work of somewhat lesser scope, the prose miscellany *Erba sul sagrato* (Grass on the Church Square, 1939). Throughout these years between the two World Wars, Italians looked forward to reading not only Negri's books but also her finely crafted journalism. Her work appeared on the *terza pagina* (third pages) of Italy's leading newspapers, which featured articles by renowned intellectuals offering their opinions on a broad range of issues.

Negri lived the last two decades of her life in Benito Mussolini's Fascist Italy. Mussolini, a jour-

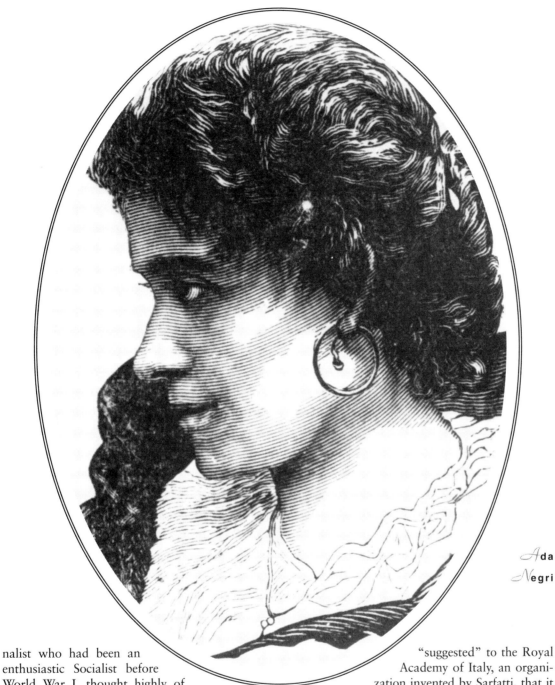

Ada Negri

nalist who had been an enthusiastic Socialist before World War I, thought highly of Negri's early works and had met her early in his political career through their mutual friend *Margherita Sarfatti. Striking a Socialist pose, Mussolini wrote a very favorable review of Negri's *Stella mattutina* for the July 9, 1921, issue of the Fascist newspaper *Il Popolo d'Italia*. Although the Fascist ideology and regime were hostile to women's rights, Mussolini attempted to win over a handful of talented women like Negri. In 1926, he proposed her for the Nobel Prize in literature, an award which instead went that year to another Italian woman, *Grazia Deledda. Perhaps to soften this blow, in 1930 the dictator "suggested" to the Royal Academy of Italy, an organization invented by Sarfatti, that it bestow its Mussolini Prize on Negri. This award opened the door to others. In 1938, she received the Gold Medal of the Ministry of Education for her poetry, an honor that was followed in 1940 by her being chosen, at Mussolini's insistence, as a full member of the previously all-male Royal Academy of Italy. When Negri became the first, and only, woman member of this Fascist-blessed body, she had the right to be addressed as "Your Excellency," received a monthly stipend, and could travel first class on the national railroad network on a pass, carry a sword, and wear a plumed hat.

By the time World War II began in 1939, Negri apparently had written most of what she wanted to say to the world. Her final thoughts would appear in her last two books, both published posthumously: the volume of poetry *Fons amoris* (Fountain of Love, 1946) and the collection of short stories *Oltre* (Beyond, 1947). Both volumes received little in the way of positive critical attention or an enthusiastic readership. Few readers in postwar Italy were drawn to Negri's late-career interest in religion and mysticism, which in *Oltre* is manifested in the hagiographically drawn lives of Saint *Catherine of Siena and Saint *Thérèse of Lisieux.

In the decades after 1945, most readers ignored Negri, while critics considered her to be either an artistically passé writer or an intellectual tainted by association with the hated Mussolini. Although these judgments were in many ways exaggerated, or even unfair, they persisted for many decades. Only now, more than 50 years after her death, has it become possible to begin viewing Negri's achievements in a more dispassionate fashion. Written during World War II, Negri's last poem in her posthumously published *Fons amoris* reveals her desire for peace:

> A day will come, from the lamentation of
> millennia,
> when love will triumph over hate, love alone
> will
> reign
> in the houses of men. That dawn
> cannot but shine: in each drop of blood
> that soaked and dirtied the earth,
> lies the virtue that is preparing it
> in the aching shadow of the afflictions of
> every
> race.

Negri did not live to see the dawn of what she hoped would be a better world. She died in Milan on January 11, 1945.

SOURCES:

"Ada Negri's New Poems," in *The Times Literary Supplement* [London]. No. 939. January 15, 1920, p. 34.

Allen, Beverly, Muriel Kittel, and Keala Jane Jewell, eds. *The Defiant Muse: Italian Feminist Poems from the Middle Ages to the Present: A Bilingual Anthology.* NY: Feminist Press, 1986.

Anderton, Isabella Mary, ed. *Tuscan Folk-Lore and Sketches, Together with Some Other Papers, with a Biographical Note by Her Brothers H. Orsmond Anderton and Basil Anderton.* London: A. Fairbairns, 1905.

[Blomberg, A.M. von.] "Ada Negri," in *The Bookman.* Vol. 11, no. 3. May 1900, pp. 252–255.

Costa-Zalessow, Natalia. "Ada Negri," in *Dictionary of Literary Biography*, Vol. 114: *Twentieth-Century Italian Poets.* Detroit, MI: Gale Research, 1992, pp. 158–165.

De Grazia, Victoria. *How Fascism Ruled Women: Italy, 1922–1945.* Berkeley, CA: University of California Press, 1993.

Dvie poetessy narodnago goria (Ada Negri i Mariia Konopnitskaia) [Two Poetesses of the People's Sorrow (Ada Negri and Maria Konopnicka)]. St. Petersburg, Russia: n.p., 1906.

Gibbs, Adriana M. "Trauma and Faith in the Work of Ada Negri," D.M.L. thesis, Middlebury College, 1983.

Goldberg, Isaac, ed. *Italian Lyric Poetry: An Anthology.* Girard, KS: Haldeman-Julius, 1925.

Hullinger, Edwin W. "Italian Women Are Slowly Winning Their Rights," in *The New York Times Magazine.* March 28, 1926, p. 9.

Mazzoni, Cristina. "Impressive Cravings, Impressionable Bodies: Pregnancy and Desire from Cesare Lombroso to Ada Negri," in *Annali d'Italianistica.* Vol. 15, 1997, pp. 137–157.

Merry, Bruce. "Ada Negri (1870–1945)," in Rinalda Russell, ed., *Italian Women Writers: A Bio-Bibliographical Sourcebook.* Westport, CT: Greenwood Press, 1994, pp. 295–301.

———. "Ada Negri: Social Injustice and an Early Italian Feminist," in *Forum for Modern Language Studies.* Vol. 24, no. 3. July 1988, pp. 193–205.

Negri, Ada. *Fate and Other Poems.* Translated by A. von Blomberg. Boston, MA: Copeland and Day, 1898.

———. *Morning Star.* Translated by Anne Day. NY: Macmillan, 1930.

"New Foreign Books," in *The Times Literary Supplement* [London]. No. 1314. April 7, 1927, p. 251.

Pasquini, Luigi, ed. "Lettere di pace e guerra di Ada Negri," in *Nuovo Antologia.* Vol. 495, 1965, pp. 365–384.

Pea, D. Mauro. *Ada Negri.* Bergamo: Cattaneo, 1960.

Perella, Nicolas J. *Midday in Italian Literature: Variations on an Archetypical Theme.* Princeton, NJ: Princeton University Press, 1979.

Persone, Luigi M. "Vita poetica di Ada Negri," in *Nuova Antologia.* Vol. 494, 1965, pp. 336–352.

Phelps, Ruth Shepard. *Italian Silhouettes.* NY: Alfred A. Knopf, 1924.

Pickering-Iazzi, Robin Wynette. *Mothers of Invention: Women, Italian Fascism, and Culture.* Minneapolis, MN: University of Minnesota Press, 1995.

———. *Unspeakable Women: Selected Short Stories Written by Italian Women During Fascism.* NY: Feminist Press, 1993.

Reisig, Lisa. "Re-Engendering the Canon: The Influence of Gender in the Poetry of Marceline Desbordes-Valmore and Ada Negri," Honors essay, Curriculum of Comparative Literature, University of North Carolina at Chapel Hill, 1994.

Rendi, Renzo. "The Literary Scene in Italy," in *The New York Times Book Review.* January 19, 1941, pp. 8, 19.

Room, Adrian. *Dictionary of Pseudonyms.* Jefferson, NC: McFarland, 1998.

Russell, Rinalda, ed. *The Feminist Encyclopedia of Italian Literature.* Westport, CT: Greenwood Press, 1997.

Schure, Edouard. *Precurseurs et revoltes.* Paris: Perrin et Cie., 1920.

Whitfield, John Humphreys. *A Short History of Italian Literature.* Westport, CT: Greenwood Press, 1976.

Opposite page

Pola Negri

Wood, Sharon. *Italian Women's Writing, 1860–1994.* Atlantic Highland, NJ: Athlone, 1995.

John Haag,
Associate Professor of History,
University of Georgia, Athens, Georgia

Negri, Pola (1894–1987)

Polish-born actress. Born Barbara Apollonia (or Appolonia) Chalupec or Chalupiec in Lipno or Janowa, Poland, on December 31, 1894 (some sources cite 1897 and 1899); died in San Antonio, Texas, on August 1, 1987; only surviving child of Jerzy Chalupec (a tin master) and Eleanora (de Kielczeska) Chalupec; attended a convent school; attended the Warsaw Imperial Academy of Dramatic Arts; married Count Eugene Dambski (a diplomat), in 1920 (divorced 1922); married Prince Serge Mdivani, in 1927 (divorced 1931); no children.

Selected filmography: Slaves of Passion *(1914);* Beast *(1915);* The Black Book *(1915);* His Last Exploit *(1916);* Zona *(1916);* Students *(1916);* Arabella *(1916);* Zügelloses Blut *(1917);* Die Toten Augen *(1917);* Der gelbe Schein *(*The Yellow Ticket, *1918);* Mania *(1918);* Die Augen der Mumie Ma *(*The Eyes of the Mummy, *1918);* Carmen *(*Gypsy Blood, *1918);* Das Karusell des Lebens *(1919);* Madame Dubarry *(*Passion, *1919);* Comptesse Doddy *(1919);* Geschlossene Kette *(1920);* Das Marthyrium *(1920);* Sumurun *(*One Arabian Night, *1920);* Marchesa d'Armiani *(1921);* Vendetta *(1921);* Arme Violetta *(*The Red Peacock, *1921);* Die Bergkatze *(*The Mountain Cat, *1921);* Sappho *(*Mad Love, *1921);* Die Dame im Glashaus *(1922);* Die Flamme *(*Montmartre, *1922);* Bella Donna *(1923);* The Cheat *(1923);* *(cameo)* Hollywood *(1923);* The Spanish Dancer *(1923);* Shadows of Paris *(1924);* Men *(1924);* Lily of the Dust *(1924);* Forbidden Paradise *(1924);* East of Suez *(1925);* The Charmer *(1925);* Flower of Night *(1925);* A Woman of the World *(1925);* The Crown of Lies *(1926);* Good and Naughty *(1926);* Hotel Imperial *(1927);* Barbed Wire *(1927);* The Woman on Trial *(1927);* Three Sinners *(1928);* The Secret Hour *(1928);* Loves of an Actress *(1928);* The Woman from Moscow *(1928);* The Woman He Scorned *(1930);* A Woman Commands *(1932);* Fanatisme *(1932);* Mazurka *(1935);* Moskau-Shanghai *(1936);* Madame Bovary *(1937);* Tango Notturno *(1938);* Die fromme Lüge *(1938);* Die Nacht der Entscheidung *(1938);* Hi Diddle Diddle *(1943);* The Moon-Spinners *(1964).*

The exotic actress Pola Negri was a publicist's dream when she landed on American shores in 1922. Already the veteran of a series of films by

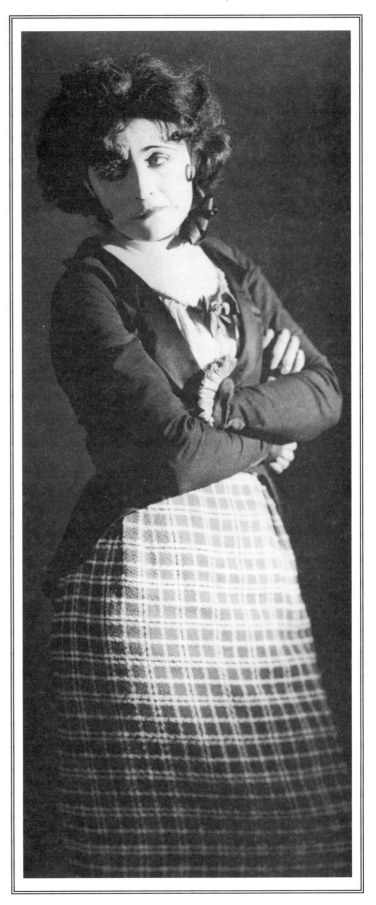

the brilliant German director Ernst Lubitsch (1892–1947), she had captured the imagination of U.S. filmgoers with her starring role in *Madame Dubarry* (1919), which had crossed the ocean as *Passion*. While Negri's Hollywood films were not of lasting value, her dark, mysterious persona and colorful love life made her one of the most enticing and enduring personalities of the American silent era. Most of her memorable work, however, was done in Poland and Germany.

Born into impoverished nobility in 1894, Negri began life as Barbara Chalupec, in Lipno or Janowa, Poland, then a Russian territory. Her mother earned her living as a cook, while her father, a Slovakian immigrant tin master, became involved in Poland's fight for independence and was exiled to a Siberian prison in 1905. Somehow her mother found a way to send Negri to the Imperial Ballet School, although a bout with tuberculosis interrupted her dancing career. She then transferred to the Imperial Academy of Dramatic Arts, after which she enjoyed some success on the stage in Warsaw, acting under her new stage name adapted from Italian poet *Ada Negri. Pola made her film debut as a dancer in *Niewonica Zmyslow* (*Love and Passion*), a movie she financed and wrote herself. This early effort led to a contract with the Polish Sphinx Company for seven films, all of which were directed by Alexander Hertz. Negri next turned up on the stage in Berlin, playing a harem girl in Max Reinhardt's revival of *Sumurun* (1916). At the time of her arrival in Berlin, the social, economic and political structures in Germany were crumbling, but the film industry was flourishing. Negri stayed on, distinguishing herself in the historical films of comic actor-turned-director Ernst Lubitsch, particularly *Carmen* (1918) and *Madame Dubarry* (1919), the latter of which was exported to the United States with great success. (Theodore Huff called her performance in the film "colourful" and "almost never equalled for vitality and emotional depth.") While rising to stardom, Negri was also married briefly (1920–22) to Count Eugene Dambski, the first of her two titled husbands.

As a result of the popularity of her German films, and possibly because of Lubitsch's growing world reputation, Negri was lured to Hollywood by Paramount, which offered her a large paycheck and star treatment. Arriving in 1922, she was cast as the murderous vamp in *Bella Donna* (1923), the farfetched tale of an adventurer who, after being forsaken by her lovers and her husband, walks into the sands of Egypt and is eaten by a panther. Moviegoers who flocked to see the German import were disappointed, al-

though the public relations department at Paramount sweetened Negri's debut by inventing a feud between her and established studio star *Gloria Swanson. Negri next appeared in a remake of *The Cheat* and in *The Spanish Dancer* (both 1923), followed by four films in 1924, including *Forbidden Paradise*, her only American film directed by Lubitsch. She then made an excursion into light comedy with *A Woman of the World* (1925), in which she played a scandalous titled foreigner who lands in a small Midwestern town to visit relatives. Despite her flair for drawing-room comedy, the brooding star seemed hopelessly out of place, a fact of which she was all too well aware: "There was no more call on my abilities as an actress than there was on one of Ziegfeld's showgirls," she later said about her treatment in America.

Negri's off-screen life was as closely watched as anything on screen; reporters followed her every move. A stormy romance with Charlie Chaplin, to whom she was briefly engaged, provided grist for the gossip mill, as did her exotic red nail polish and her Russian-style turbans and high boots. In 1925, she began a supposedly passionate affair with screen idol Rudolph Valentino, whose wife *Natasha Rambova had just left him. In her autobiography, Negri's first dance with Valentino, which occurred just minutes after their meeting at a costume party, is recorded in lavish prose: "I did not look at him because I felt the beauty of his features was as deceptive as the matador's suit that covered his body," she wrote. "As the savage primitive beat emerged from behind the sophistication of the tango, the gilded drawing room walls receded and I felt as if we were on the edge of a jungle. Once more I was gripped by terror as Valentino's true sexuality reached out and captured me." (In fact, Valentino's true sexuality is generally agreed to have been homosexual.)

The reputed romance flourished until Valentino's untimely death in the summer of 1926, following his operation for appendicitis and gastric ulcers. In a dramatic outpouring of grief, Negri threw herself on Valentino's coffin, then fainted at the funeral. "How should I have behaved?" she wrote. "I simply reacted to despair in the only way of which I was capable—naturally and spontaneously." While her histrionics may have been sincere, the American press fairly crucified her in print. The public never took her seriously again.

Paramount, however, still had Negri under contract, and had to make what use they could of their tarnished star. Between 1927 and 1928,

she appeared in seven films, the best of which were two directed by Mauritz Stiller: *Barbed Wire* (1927), an anti-war drama, and *Hotel Imperial* (1927), another war film which many consider the best movie she made in Hollywood. Her days at Paramount ended with *The Woman from Moscow* (1928), although by this time career considerations had taken a back seat to yet another ill-starred marriage. The new bridegroom was Serge Mdivani, one of three brothers who during the 1920s and 1930s made a career out of marrying as many actresses and heiresses as time and their good looks would allow. (David Mdivani married *Mae Murray; Alexis Mdivani married *Barbara Hutton.) Serge was possessive and jealous, and the union was stormy from the start. The couple enjoyed a brief period of stability when Negri became pregnant and gave up working, but after she miscarried and took up her career once again, the relationship deteriorated. After Negri lost her fortune in the 1929 stock-market crash, Mdivani realized that his lifestyle would be seriously curtailed and left the actress for good. Negri pretty much avoided romance after that, except for a brief relationship with British millionaire and aviator Glen Kidston, to whom she was engaged before his death in a plane crash.

During the early 1930s, Negri worked in England and France. RKO tapped her for an American comeback in *A Woman Commands* (1932), in which she sang a beautiful rendition of "Paradise," but her deep speaking voice and heavy accent were unacceptable for talkies. In 1935, she returned to Germany, where she made another series of successful movies, beginning with *Mazurka* (1935), a film about mother-love that was said to have to been a favorite of Adolf Hitler. She continued to work in Germany during the Nazis' rise to power, provoking insinuations, some of which she attempted to address in her autobiography *Memoirs of a Star* (1970). In it, she disavowed a rumored relationship with Hitler, insisting that she had never met him. "I was no more responsible for the fact that I happened to be Hitler's favorite movie star than I was for the crimes committed by the inmates of Alcatraz, who had once voted me their favorite star." She also pointed out that Nazi propagandist Joseph Goebbels thought she was Jewish and had tried on several occasions to expel her from the country. Negri did not leave Germany until her homeland of Poland was invaded, when she joined the Red Cross in France. She returned to the United States on a re-entry visa in 1941 and made one more comeback attempt in the comedy *Hi Diddle Diddle* (1943), a back-

stage story in which she played a temperamental opera singer married to Adolphe Menjou. The movie failed at the box office, and the actress slipped into oblivion.

Pola Negri lived quietly in New York for several years, then resurfaced in Santa Monica, California, where she shared a residence with retired radio personality **Margaret West**. The two became well known in Hollywood for their extravagant parties and their art collection, although their exact relationship always remained something of a mystery. In 1958 they relocated to San Antonio, where West died suddenly in 1963. Negri was devastated by the loss, but found some solace in performing a cameo in the Disney children's adventure, *The Moonspinners* (1964). She spent her final years in ill health, but apparently harbored no regrets about her extraordinary life. "The past was wonderful: it was youth and exhilaration," she wrote at the end of her autobiography. "I would not have missed it for worlds. The present is tranquil; it is age and a little wisdom. . . . I would relinquish neither inner scars not external glories. . . . There is even a certain edge of triumph in the peacefulness of my present life." Pola Negri died on August 1, 1987.

SOURCES:

Garraty, John A., and Mark C. Carnes, eds. *American National Biography*. Oxford: Oxford University Press, 1999.

Golden, Eve. "The Opportunist: Pola Negri on her (more or less) Centenary," in *Classic Images*. December 1997, pp. 4–7.

Katz, Ephraim. *The Film Encyclopedia*. NY: HarperCollins, 1994.

Lamparski, Richard. *Whatever Became of . . . ?* NY: Crown, 1967.

Negri, Pola. *Memoirs of a Star*. NY: Doubleday, 1970.

Shipman, David. *The Great Movie Stars: The Golden Years*. Boston, MA: Little, Brown, 1989.

Uglow, Jennifer S., ed. *The International Dictionary of Women's Biography*. NY: Continuum, 1985.

Barbara Morgan,
Melrose, Massachusetts

Neher, Carola (1900–1942)

Acclaimed German actress of the Weimar Republic who emigrated to the USSR where she was falsely accused and convicted of having engaged in anti-Soviet activities. Name variations: Karoline Josefovna Henschke. Born Karoline Neher in Munich, Germany, on November 2, 1900; died of typhus in the Sol-Ilezk transit camp, near Orenburg, USSR, on June 26, 1942; daughter of Josef Neher and Katerina Ziegler Neher; married Alfred Henschke, an expressionist author known as Klabund, in 1925; married Anatol Becker; children: son Georg Anatol Becker.

Closely associated with the plays of Klabund and Bertolt Brecht, Carola Neher was one of the most talented and popular actresses to perform during Germany's ill-fated experiment with democracy, the Weimar Republic. In another time, she might well have lived to a ripe old age, rich in fame and adulation; instead, seeking refuge from Nazism, she spent the last six years of her short life wrongly imprisoned in Stalin's Soviet Union.

Born Karoline Neher in Munich in 1900, she grew up in a lively, artistic family. Her father Josef, whom her mother **Katerina** had married in 1899 as a widow with two children, performed with the Munich Philharmonic Orchestra. He spent considerable time with Carola and his other children, all of whom inherited a love of music. Katerina helped support her growing family by running a tavern (*Weinstube*) attached to their home that became a favorite meeting place for Munich's musicians and artists. Fascinated by the tavern's guests, Carola often imitated them, to the amusement of her siblings and

Carola Neher

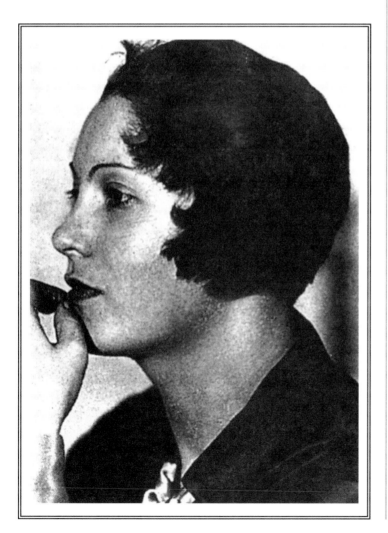

occasional annoyance of her mother. Nonetheless, Katerina soon became convinced that her outgoing daughter would one day become "a great artist."

By the time Neher entered her teens, family tensions were increasing. Her father's love of wine now revealed itself as alcoholism. Although he declared Carola to be his favorite daughter, they had strong, independent personalities which often clashed. He recognized her musical talents (she played the piano) but decided that after her graduation from commercial high school she should become a schoolteacher. Carola, however, had other thoughts, and in June 1917 she began working at Munich's Dresdner Bank, where she remained until October 1919. This was a time of radical change. Neher lived through the unexpected defeat of the German Reich, the end of the Wittelsbach monarchy in Bavaria, the proclamation of a Soviet Republic (which was quickly suppressed in a bloody White Terror), and the profound national humiliation represented by the "dictated" Treaty of Versailles. In 1919, an unknown war veteran named Adolf Hitler returned to Munich, where he had lived before the war, and joined an obscure political sect, the German Workers Party, which he would soon transform into a mass movement calling itself the Nazi Party. Although the revolutionary upheavals that began in 1917 would affect the course of Neher's life, for her the most important event took place within her family in 1919, when her father died from the ravages of alcoholism.

Around this time, Neher was drawn to acting. She began appearing on stage in Munich and was soon dancing on stage in Baden-Baden. By 1922, she was regularly employed at Munich's prestigious Kammerspiele. Soon after, she met the young playwright Bertolt Brecht (1898–1956), and the two became lovers. Through Brecht's influence, she got a role in the motion picture *Mysterien eines Frisiersalons* (Mysteries of a Barber Shop), which starred comedian Karl Valentin. Her career now thriving, Neher could be seen regularly on stage in several German cities, including Breslau (now Wroclaw, Poland), where she secured a contract at the Vereinigtes Theater.

In 1925, Neher married the expressionist author Klabund. Born Alfred Henschke in 1891, Klabund had been diagnosed as being tubercular in 1906, almost two decades before his marriage to Neher, and spent the rest of his life in and out of sanatoria; by the time Neher met him, he had become for Weimar intellectuals the epitome of

the doomed poet. Neher and Klabund had an unconventional marriage and were often separated for long periods as each pursued their own goals.

Through men such as Brecht and Klabund, Neher became increasingly enmeshed in the subculture of radical ideas and politics. Brecht was a Marxist and sympathized with the Communist Party of Germany (KPD), whereas Klabund's political beliefs, while also radical, were less ideologically doctrinaire. (After having first enthusiastically supported the German cause in World War I, Klabund became disillusioned and turned vehemently against it in 1917. In 1919, after the collapse of the Bavarian Soviet Republic, he was briefly imprisoned in Munich by the forces of the counter-revolution.) Neher, who was not a systematic political thinker, was attracted to men like Brecht and Klabund for their strong personalities and the ideals they espoused. Disgusted with the mediocrity of republican politics, she felt at home in Weimar Germany's leftist circles where artists and intellectuals sympathized with the new world which they were convinced was embodied by the KPD and the Soviet Union.

During her brief marriage to Klabund, Neher became one of the best-known actresses on the German stage. Among many other roles, she appeared in several of her husband's stage works, including the premiere performances in 1925 of his *Der Kreidekreis* (The Chalk Circle), in which she took the role of Haitang. (Brecht later borrowed much from this play when he wrote his own *Caucasian Chalk Circle*.) In April 1926, she starred in the premiere of Klabund's *Brennende Erde* (Burning Earth) in Frankfurt am Main. By the end of that year, having been discovered by influential director Viktor Barnowsky, Neher was starring in several Berlin theaters, and she succeeded in winning over even Berlin's most jaded critics. Stephan Grossmann noted that her mere appearance served to produce "mass intoxication in the theater." Alfred Polgar described her as "young, pretty, charming, and cute, with a cat's face marked by an impudent little nose and round, lively eyes." With her earthy persona, she could bring "the voice of the street" to virtually any stage.

In 1927, Neher starred in her husband's play *XYZ* when it premiered at Vienna's prestigious Burgtheater. The same year, she played Cleopatra in George Bernard Shaw's *Caesar and Cleopatra* at the Burgtheater. In the summer of 1928, she began rehearsing the role of Polly Peachum for the premiere performance of *Die Dreigroschenoper* (The Threepenny Opera) by Brecht and Kurt Weill. In mid-August, however, Neher bowed out

and left Berlin to be with her husband when he died at a sanatorium in Davos, Switzerland.

It was customary for Brecht to write the parts in his plays with specific actors in mind, and the role of Polly in *Die Dreigroschenoper* had been crafted to Carola Neher. It was therefore not surprising when she was chosen to play Polly in the stage revival of 1929, as well as in the film version directed by G.W. Pabst. The sardonic anti-bourgeois tone of the Brecht-Weill work delighted the radical Weimar intelligentsia while infuriating conservatives, particularly the rising Nazi movement. The motion picture, which has become a cinema classic, boasted of a number of stars in addition to Neher, including **Valeska Gert**, *****Lotte Lenya**, and Ernst Busch. The Berlin premiere, on February 19, 1931, was a great success. But a week later in Nuremberg, a Nazi stronghold, the film's performance was marred by disturbances, including the launching of stink bombs and firecrackers, as well as physical attacks on members of the audience.

Among Neher's other successes were the roles of Eliza in Shaw's *Pygmalion* (Deutsches Theater, Berlin, 1928) and Magdalena in Walter Hasenclever's *Ehen werden im Himmel geschlossen* (Marriages are Made in Heaven). Not all of her roles, however, were successful. In September 1929, she appeared at Berlin's Theater am Schiffbauerdamm in *Happy End*, a collaborative effort between Dorothy Lane (**Elisabeth Hauptmann**), Brecht, and Weill—which the press unanimously scorned. Despite the brilliant cast, with Neher in the star role of Salvation Army member Lilian Holiday, and other talented actors of the day including *****Helene Weigel**, Kurt Gerron and Peter Lorre, the weakly constructed comedy failed to make an impression on either critics or audience, and the production closed after only a few days.

Much more successful vehicles for Neher's talents included the 1930 review by Friedrich Hollaender, *Ich tanze um die Welt mit dir* (I'll Dance Around the World with You), and the role of Marianne in Hungarian playwright Ödön von Horváth's *Geschichten aus dem Wiener Wald* (Tales from the Vienna Woods), which premiered in Berlin in 1931. Critical response to the latter, surrealistic work was enthusiastic, with influential critic Polgar describing Neher simply as "this madonna from Vienna's eighth district." In April 1932, Neher's participation in a Berlin Radio broadcast of excerpts from seven scenes of Brecht's *Die heilige Johanna der Schlachthöfe* (St. Joan of the Stockyards) marked another artistic milestone in her career.

The press praised the broadcast—in which Neher worked in the same recording studio with Weigel, Busch, Lorre, and Fritz Kortner—as a brilliant presentation of a major play. This broadcast would be Neher's last major appearance before the German public.

By the end of 1932, major changes were to take place in her private life. During a stormy affair with the conductor Hermann Scherchen, she became pregnant and suffered a miscarriage, and it was Neher who broke off the relationship. While attending classes at Berlin's Marxist Workers' School, she met and fell in love with Anatol Becker, an ethnic German engineer from Bessarabia, a province of Rumania. As a committed Communist and ardent member of the KPD, Becker impressed Neher, who had grown increasingly critical of the superficial "parlor pinks" in her circle who seemed merely to mouth leftist clichés. Although many close to her did not feel that Carola and Anatol were a natural pair, her infatuation with him continued, and in 1932 she surprised, even shocked, her family and friends with their decision to marry.

In early 1933, Neher planned to participate in a Berlin stage presentation of Brecht's *Die heilige Johanna der Schlachthöfe*, but Adolf Hitler was appointed chancellor of the German Reich on January 30, 1933. Within weeks, the Reichstag fire (most likely set by the Nazis) gave Hitler's minions a pretext to unleash an anti-Marxist and anti-democratic reign of terror that allowed his National Socialists to turn Germany into a totalitarian Third Reich. Because he was an active Communist, Becker's life was at risk in a Germany full of newly established concentration camps. He and Neher escaped to the relative safety of Prague, where many anti-Nazi émigrés found refuge in the first stage of the dictatorship. Prague was sympathetic to the plight of anti-fascist intellectuals, and at first it appeared that Becker and Neher would remain there. By the autumn of 1933, she was appearing as a guest artist in Shakespeare's *Taming of the Shrew* on the stage of Prague's New German Theater. The following year, however, she accompanied her husband when he decided to relocate to the Soviet Union.

They moved to Moscow, where overcrowding, poor food, and compromises in other basics made daily life a trial. Believing that he could contribute to the building of Communism, Anatol regarded his work as an engineer in a Moscow factory as a worthwhile investment of his skills and energy. Unlike her husband, who had been raised in poor Rumania and adjusted easily to Soviet conditions, Neher found adaptation to life there very difficult after living in relative luxury in Berlin. Having arrived not as a refugee actress but as the wife of a Communist engineer, she also found it challenging to find a place in the Moscow theater scene. Eventually, she obtained a suitable position as a director's assistant at the film unit of Mezhrabpom (the International Workers' Relief). Learning the Russian language and adapting to a new cultural tradition also proved to be difficult. By 1935, however, she was starting to settle down into a routine of professional activities. Her scheduled work included giving drama lessons to members of the Deutsches Theater Kolonne Links (German Theater Column Left), a group of émigré German-speaking actors led by Gustav von Wangenheim. Neher also made a number of special appearances at Moscow's Club for Foreign Workers. These included evenings dedicated to the words and music of Brecht and Weill, to the revolutionary music of Hanns Eisler, and to the verse and music of Erich Mühsam, a leftist poet who had been murdered in a Nazi concentration camp in 1934. During this period, Neher also made broadcasts to Germany over Moscow Radio and wrote articles on drama for the German-language newspaper *Deutsche Zentral-Zeitung*.

In honor of Brecht during his visit in May 1935 to the Soviet capital, Neher and fellow émigré actor Alexander Granach presented an evening of Brecht's songs and dramatic recitations. Brecht was happy to see his old flame again but was concerned that Neher had not found work equal to her talents; he also noted in a letter to Helene Weigel that she had become "rather stout and very nervous."

Although life was hard in Moscow, the Soviet Union was working to industrialize and under Joseph Stalin gave the appearance of having become an anti-fascist bulwark. All appearances of even partial normality in the Soviet Union, however, would prove to be deceptive. While her husband worked long hours as an engineer to increase Soviet industrial production, Neher worked to improve the professional level of the émigré artists whom she hoped might one day—under the direction of such artists as Wangenheim, Erwin Piscator, and possibly herself—create a viable German-language theater in the Soviet Union. One such plan (which did not come to fruition) was to create a German theater in the city of Engels, situated in the German Volga Republic, of which Neher was expected to be one of the star performers. These hopes were put on hold when in December 1934 she became the mother of a son, Georg Anatol Becker.

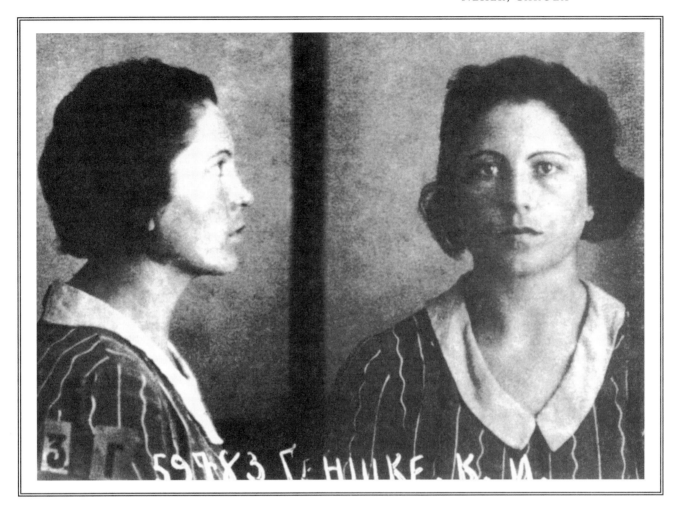

Carola Neher's happiness was to be short-lived. Anatol was arrested in April 1936 on charges of being part of a Trotskyite group that planned to assassinate Stalin and others in Red Square during the May Day celebrations. On June 25, 1936, "Karoline Josefovna Henschke" was also arrested in Moscow by the dreaded secret police, the NKVD. She had been denounced by fellow actor Gustav von Wangenheim. Anatol and Carola never saw one another again. Neither parent would ever see their son again, either; he was placed in a state orphanage when his mother was taken into custody. Years later, in the 1990s, historians would reconstruct Neher's last years in the USSR by using documents from the KGB Archives. Absurdly accused of espionage, Anatol Becker was shot in 1937. In an equally absurd miscarriage of Soviet justice, Neher was accused of being a messenger for the "Prague Trotskyite Center" led by one Erich Wollenberg, as well as having falsely claimed to be a KPD member. Believing herself incapable of enduring more torture as a prisoner in Moscow's infamous Lubianka prison, a desperate Neher made an unsuccessful suicide attempt, inflicting superficial cuts on her wrist. On July 16, 1937, the Military Collegium of the Supreme Court of the USSR sentenced her to ten years at hard labor. She was taken to Kazan penitentiary to serve out her sentence.

By 1937, rumors about her situation prompted Brecht to take action on Neher's behalf. He turned to the novelist Lion Feuchtwanger, whose books supporting the purges had made him very much persona grata with the Soviet regime and who had been able to secure the release of Neher's colleague Alexander Granach from a Soviet prison. In a May 1937 letter to Feuchtwanger, Brecht asked him if he could "do something about Neher."

> She is said to have been jailed in Moscow, I don't know why, but I really can't think of her as a danger to the survival of the Soviet Union. Maybe some sort of love trouble. In any case she is not a worthless person, but I doubt if they know it in the USSR, she hasn't had a real chance to show what she could do. . . . All my own questions have gone unanswered and that worries me.

Neher was arrested by the Soviet NKVD on June 25, 1936.

Two more letters from Brecht to Feucht-wanger are a barometer of the playwright's increasing concern about the actress. In June 1937, he wrote:

> Do you think you might approach Stalin's secretary for information about Neher? In view of the only too well justified counter-measures against Goebbels' networks in the USSR, a mistake is always possible. . . . If Neher has actually been involved in treasonable machinations, there's nothing we can do to help her, but perhaps by calling attention to her great talents as an artist, one might get them to speed up proceedings and give her case special attention (which in view of her reputation . . . would be a good thing for the Soviet Union).

Neher's fate came up once more in a letter dated late November 1937 in which Brecht asked Feuchtwanger almost in desperation, "What really can we do for poor CN?" Brecht had hoped Feuchtwanger might work a similar miracle for Neher as he had for Granach, but this was not to be. Resigned but still shaken, Brecht wrote a poem about Neher, in which he recalled: "The letters I wrote to you/ Remained unanswered. The friends I asked to assist you/ Are silent. I can do nothing for you."

Despite his concern about Neher's fate, Brecht said nothing publicly. Over the next two decades, until his death in East Berlin, he made a number of behind-the-scenes attempts to discover more information on what had happened to her. As late as 1952 and 1955, when Brecht had become the GDR's cultural superstar, his requests for information about Neher from high Soviet officials brought no answers. While Neher was still alive and imprisoned, anti-Stalinist German émigrés aware of her fate singled out Brecht for harsh criticism for having remained silent. In October 1938, writing in the Paris-based German Trotskyite journal *Unser Wort* (Our Word), Walter Held challenged Brecht in an open letter: "You, Herr Brecht, knew Carola Neher. You know that she is neither a terrorist nor a spy, but rather was a brave human being and a great artist. Why do you remain silent? Is it because Stalin finances your publication *Das Wort* (The Word)—this, the least truthful, most depraved publication ever put out by German intellectuals?" Brecht never responded to this harsh indictment of his silence. But the boldness of Held's attack on Stalinism proved to be catastrophic for Held and his family. In 1940, while fleeing from the Nazis in a desperate attempt to emigrate to the United States, Held and his family had no choice but to cross the Soviet Union via the Trans-Siberian Express in order to reach a Pacific port and a waiting ship. NKVD agents removed him and his entire family from the train and killed them.

We know about Carola Neher's years in Soviet prisons and labor camps from the memoirs of three survivors of these institutions: **Evgenia Ginzburg**, *Margarete Buber-Neumann**, and **Hilde Duty**. All three women were impressed by the dignity and courage Neher exhibited. In the struggle to retain her own humanity, and to assist her fellow prisoners in their efforts to hold on to theirs, Neher never surrendered. In 1940, she was transferred to Moscow's Butyrki prison. Despite her four years of imprisonment, fellow prisoner Ginzburg still saw in her "a face of unusually tender beauty and charm." "With the deft movement of an actress used to playing in adventure films," Neher skillfully concealed in her luxuriant blonde hair a pair of earrings, a present from her husband whom she believed to be dead, from the watchful eyes of the female wardens.

She had been taken to Butyrki to be prepared for transfer to Nazi Germany. In the case of Margarete Buber-Neumann such a transfer did in fact take place, but Neher would never again see Germany or life as a free woman. On April 16, 1940, German officials informed the Soviets that they had decided not to accept Carola Neher for repatriation to Germany. The reasons for this remain unclear, but perhaps it was for the bureaucratic reason that Neher had been stripped of her German citizenship in November 1934 and thus was no longer subject to the authority of the Third Reich.

Soon after this, an officer of the NKVD offered to release Neher if she agreed to do espionage work for his organization. She refused. After ten days—which included several days in a frigid cell with no food or blankets, followed by excellent rations and a luxurious goose-down pillow—the officer returned to make the same offer. Again Neher refused. She then was transferred from Butyrki to still another prison in the town of Orel. The last of Neher's letters to survive was written in the Orel prison. Dated March 10, 1941, it is addressed to the children's home where her son, then age six, was living:

> The undersigned is the mother of the German child Becker, Georg Anatolevich, born 1934 in Moscow. . . . Since I have not heard anything for one and a half years, I would like to ask you to answer the following questions: How is my son developing, both emotionally and physically? How is his health? . . . Is it possible that he still remembers his mother? Might I possibly request a recent photograph of him? . . . Is he musically inclined?

Has he learned to draw, and if so, could you possibly send me one of his drawings? . . . I look forward impatiently to receiving your response. I thank you from the bottom of my heart for all of the kindnesses you can do for my beloved child. . . . Please excuse the mistakes in this letter: I have not mastered the Russian language.

The letter remained unanswered.

During her six years of imprisonment, Neher received only two or three letters providing her with information about her son. One of these, from a kind (and courageous) nursery school worker, informed her that the little boy was happy and doing well, was in good health, and loved to dance. Neher treasured the one photograph of her son that had been sent her in prison, which showed him with a teddy bear under his arm. She would never learn that at age six he was adopted by an abusive Russian woman. Eventually he would live in Odessa, completely ignorant of the identity of his mother and father until, by accident in the 1960s, he discovered the secret of his parents' demise. Georg Becker did not see photographs of his parents until 1972. After establishing contact with his mother's family in Munich, in 1975 he emigrated to West Germany, where he became a successful teacher at a Bavarian music conservatory.

In Neher's last year of life, the start of Nazi Germany's attack on the Soviet Union in June 1941 meant the systematic bombing by the Luftwaffe of the city of Orel. For several days, the inmates of Orel's prison endured the terrifying attack without protective shelter. In August 1941, as German troops rapidly moved across the steppes, Neher and the other Orel prisoners were released so they could be evacuated, the final destination being Siberia. They would spend the winter of 1941–42 in the Ural transit camp of Sol-Ilezk, situated south of Orenburg in a desolate region bordering on Kazakhstan. Inadequate living conditions led to a typhus epidemic among all of the prisoners. The only German woman prisoner to survive Sol-Ilezk, Hilde Duty, wrote of Neher's last days: "We helped one another as best we could. It was the fifth day of her illness, and they took Carola to what passed as our sick bay. Two days later—on June 26, 1942—one of our fellow prisoners returned from there to report, 'Carola has found deliverance' (*Carola ist erlöst*). We never saw her again." A Russian prisoner reported that Neher's last words to her comrades had been a command, to "live long lives." Entered on her card in the camp file was only one word, "withdrawn," and the date, with no other details, not

even the fact of death (or a cause of death). The location of her grave is unknown, as is true for virtually all the victims of Stalinist terror.

As part of the process of de-Stalinization, Carola Neher's case was reviewed by Soviet judicial authorities in the late 1950s. Her guilty sentence of 1937 became legally null and void, she was declared to be innocent of all charges, and in January 1959 she was declared to be posthumously rehabilitated. This new verdict of the Military Collegium of the Supreme Court of the USSR was publicly announced on August 13, 1959.

Although Neher's fate was well known in West Germany, having been written about in the memoirs of Margarete Buber-Neumann and in several biographical studies, the subject remained virtually taboo in the German Democratic Republic (GDR), where the reputations of KPD leaders Wilhelm Pieck and Walter Ulbricht—men who had survived Stalinist purges and denunciations—had to be protected. As damning archival documents show, these men had failed to intervene on behalf of Neher and many other innocent German émigrés in the Soviet Union. With the demise of the GDR in 1990, all Germans had the freedom to learn what had happened to one of Weimar Germany's most popular stars. In 1992, a street was named in her honor in the Hellersdorf section of Berlin. Previously known as Ernst Kramer Strasse, it had been a memorial to a former GDR minister of transportation. Carola Neher Strasse is a reminder of the loss that was suffered when Neher died before she could give the world the full measure of her talent.

SOURCES:

Brecht, Bertolt. *Bertolt Brecht Letters*. Translated by Ralph Manheim. Edited, with commentary and notes, by John Willett. NY: Routledge, 1990.

Buber-Neumann, Margarete. *Als Gefangene bei Stalin und Hitler: Eine Welt im Dunkel*. Stuttgart: Seewald Verlag, 1985.

Diezel, Peter. "Gestorben in Sol-Ilezk," in *Sonntag*. No. 10, 1990.

———. "Hilda Duty—Zellengefährtin von Carola Neher," in *Exil*. Vol. 12, no. 2, 1992, pp. 24–42.

Fuegi, John. *Brecht and Company: Sex, Politics, and the Making of Modern Drama*. NY: Grove Press, 1994.

Gaehme, Tita. *"Dem Traum folgen": Das Leben der Schauspielerin Carola Neher und ihre Liebe zu Klabund*. Cologne: Dittrich-Verlag, 1996.

Georg, Manfred. "Carola Neher," in *Die Weltbühne*. Vol. 26, no. 1. December 31, 1929, pp. 35–36.

Gill, Anton. *A Dance Between Flames: Berlin Between the Wars*. NY: Carroll & Graf, 1993.

Ginzburg, Evgeniia Semenovna. *Journey into the Whirlwind*. NY: Harcourt, Brace and World, 1967.

Granach, Alexander. "Antifaschistische Künstler in der Sowjet-Union," in *AIZ: Das Illustrierte Volksblatt* [Prague]. Vol. 15, no. 6. February 6, 1936, pp. 94–95.

Haarmann, Hermann, Lothar Schirmer, and Dagmar Walach. *Das "Engels" Projekt: Ein antifaschistisches Theater deutscher Emigranten in der UdSSR (1936–1941)*. Worms: Georg Heintz, 1975.

Hecht, Werner. *Brecht Chronik 1898–1956*. Frankfurt am Main: Suhrkamp Verlag, 1997.

Hepp, Michael, and Hans Georg Lehmann, eds. *Die Ausbürgerung deutscher Staatsangehöriger nach den im Reichsanzeiger veröffentlichten Listen*. 3 vols. Munich and NY: K.G. Saur, 1985–1988.

Hildebrandt, Dieter. *Ödön von Horváth in Selbstzeugnissen und Bilddokumenten*. Reinbek bei Hamburg: Rowohlt, 1975.

Institut für Geschichte der Arbeiterbewegung, Berlin. *In den Fängen des NKWD: Deutsche Opfer des stalinistischen Terrors in der UdSSR*. Berlin: Dietz Verlag, 1991.

Kaulla, Guido von. *Und verbrenn in seinem Herzen: Die Schauspielerin Carola Neher und Klabund*. Freiburg im Breisgau: Herder Verlag, 1984.

Klier, Freya. *Verschleppt ans Ende der Welt: Schicksale deutscher Frauen in sowjetischen Arbeitslagern*. 2nd ed. Berlin: Ullstein Verlag, 1997.

Krischke, Traugott. *Horváth auf der Bühne, 1926–1938: Dokumentation*. Vienna: Verlag der Österreichischen Staatsdruckerei, 1991.

———. *Horváth-Chronik: Daten zu Leben un Werk*. Frankfurt am Main: Suhrkamp Verlag, 1988.

Müller, Reinhard, ed. *Die Säuberung. Moskau 1936: Stenogramm einer geschlossenen Parteiversammlung*. Reinbek bei Hamburg: Rowohlt Taschenbuch Verlag GmbH, 1991.

Mytze, Andreas, ed. "Carola Neher," in *europäische ideen*. Vols. 14–15, 1976.

"Neher, Carola," in Frithjof Trapp *et al.*, eds., *Handbuch des deutschsprachigen Exiltheaters 1933–1945*. Vol. 2: *Biographisches Lexikon der Theaterkünstler*. Munich: K.G. Saur, 1999, Part 2, L–Z, pp. 694–695.

Petzet, Wolfgang. *Theater die Münchner Kammerspiele, 1911–1972*. Munich: Kurt Desch Verlag, 1973.

Pike, David. *German Writers in Soviet Exile, 1933–1945*. Chapel Hill: University of North Carolina Press, 1982.

Polgar, Alfred. "Geschichten aus dem Wiener Wald," in *Die Weltbühne*. Vol. 27, no. 46. November 17, 1931, pp. 756–757.

Rühle, Günther. *Theater für die Republik 1917–1933 in Spiegel der Kritik*. Frankfurt am Main: S. Fischer Verlag, 1967.

Scherbakowa, Irina. "Carola Neher (1900–1942)" in Irina Antonowa and Jörn Merkert, eds. *Berlin Moskau 1900–1950*. Munich: Prestel, 1995, pp. 332–334.

Semprun, Jorge. *Le retour de Carola Neher*. Paris: Gallimard, 1998.

Umbenennungen. Berlin: Edition Luisenstadt, 1993.

Wegner, Matthias. *Klabund und Carola Neher: Eine Geschichte von Liebe und Tod*. Berlin: Ernst Rowohlt Verlag, 1996.

Willett, John. *The Theatre of the Weimar Republic*. London: Holmes & Meier, 1988.

RELATED MEDIA:

Brecht, Bertolt. "Die heilige Johanna der Schlachthöfe" (Berliner Funkstunde, April 11, 1932, original recording with Carola Neher, Helene Weigel, Ernst Busch, Fritz Kortner, Peter Lorre, and Paul Bildt), tape from collection of the Deutsches Rundfunkarchiv, broadcast on DeutschlandRadio-Deutschlandfunk, February 17, 1998.

Halamicková, Jana. "Der steile Aufstieg und das stumme Ende der Schauspielerin Carola Neher," broadcast on the Kulturforum des Norddeutschen Rundfunks, June 7, 1992.

Kreiler, Kurt. "Theater ohne Schminke: Carola Neher im Portrait," broadcast on Norddeutscher Rundfunk/NDR, October 29, 1985.

Schwiedrzik, Wolfgang. ". . . und fragen: wen sollen wir töten? Die Schauspielerin Carola Neher zwischen Weimar und GULAG," broadcast on Deutschlandfunk, November 17, 1982.

<div align="right">

John Haag,
Associate Professor of History,
University of Georgia, Athens, Georgia

</div>

Nehru, Kamala (1899–1936).

See Gandhi, Indira for sidebar.

Nehru, Vijaya Lakshmi (1900–1990).

See Pandit, Vijaya Lakshmi.

Nehushta (fl. 610 BCE)

Biblical woman. *Flourished round 610 BCE; daughter of Elnathan of Jerusalem; married Jehoiakim, king of Judah; children: Jehoiachin, successor to the throne of Judah.*

Neilson, Adelaide (1846–1880)

English actress. *Name variations: Lilian Adelaide Neilson. Born Elizabeth Ann Brown in Leeds, England, in 1846 (some sources cite 1847 and 1848); died in Paris, France, on August 15, 1880; daughter of an actress named Brown or Browne; married Philip Henry Lee (divorced 1877).*

The child of a strolling player, an actress named Brown, Adelaide Neilson worked in a factory as a girl and at age 15 made her way to London. Here she secured employment, because of her beauty, as a member of the ballet at one of the theaters. After receiving some instruction from veteran actor John Ryder, Neilson played for a number of years in various stock and traveling companies. In 1865, she appeared in Margate as Julia in *The Hunchback*, a character with which her name would long to be associated. She also gained notable success as *Amy Robsart in an adaptation of Scott's *Kenilworth*. For the next few years, she played at several London and provincial theaters in various parts, including Rosalind, Rebecca in *Ivanhoe*, Beatrice, and Viola, as well as Isabella in *Measure for Measure*.

In November 1872, she arrived in America to appear as Juliet at Booth's Theater, New York; her intelligence, beauty, and talent made her a great favorite, and she returned year after

year, touring America in 1874, 1876, and 1879. She not only achieved distinction on the American stage, but accumulated a considerable fortune. Adelaide Nielson's career was cut short by her sudden death in Paris in August 1880.

"The acting of Adelaide Neilson, was exceptionally remarkable for the attribute of inspiration," wrote her contemporary, William Winter, in *Other Days*. "At moments her voice, countenance, and demeanor would undergo such changes, because of the surge of feeling, that her person became transfigured, and she was more like a spirit than a woman. She possessed a poetic soul, and that is why her radiant presence in the balcony scene of 'Romeo and Juliet' diffused a golden light of romance, and why her action in the potion scene was thrilling and pathetic, with a fire of imagination, a truth and depth of feeling, that could not be resisted and cannot be forgotten."

Neilson, Julia (1868–1957).

See Braithwaite, Lilian for sidebar.

Neilson, Lilian Adelaide (1846–1880).

See Neilson, Adelaide.

Neilson, Nellie (1873–1947)

American historian and the first woman president of the American Historical Association. Born on April 5, 1873, in Philadelphia, Pennsylvania; died on May 26, 1947, in South Hadley, Massachusetts; daughter of William George Neilson (a metallurgical engineer) and Mary Louise (Cunningham) Neilson; Bryn Mawr College, A.B., 1893, M.A., 1894, Ph.D., 1899.

Taught at Mt. Holyoke College, Massachusetts (1902–39), and chaired history department (1903–39); awarded honorary doctorates from Smith College (1938) and Russell Sage (1940); became president of the American Historical Association (1943).

A dedicated and meticulous scholar, Nellie Neilson was born in Philadelphia in 1873, the eldest of six children. She majored in Greek and English at the newly founded Bryn Mawr College, near her hometown, graduating in 1893, and by 1899 had also earned an M.A. and a Ph.D. in history from Bryn Mawr. From 1897 to 1902, she taught in Philadelphia.

In 1902, Neilson transferred to Mt. Holyoke College in Massachusetts, where she worked first as a history instructor, then as a professor of European history, and, from 1905, as a professor of history. As chair of the college's history department from 1903 to 1939, she helped to create a robust department and an impressive specialized library. She found history an adventurous subject, "to be loved and cultivated for its own sake," and was a tireless researcher who ardently promoted the importance of honors and graduate work.

In 1898, Neilson had published her doctoral dissertation, *Economic Conditions on the Manors of Ramsey Abbey*. Continuing to write academic articles and books during summers and leaves of absence, she crossed the Atlantic repeatedly, even during World War I, to study historical records in England. She primarily concerned herself with medieval English economic, legal, and agrarian history, and became known in both Great Britain and the United States as a respected authority on those subjects. She was admired for her ability to fuse scholarship and teaching, and to support general historical concepts with impeccable detail. Among the other publications she either wrote or edited were *A Terrier of Fleet, Lincolnshire, from a Manuscript in the British Museum* (1920), *The Cartulary and Terrier of the Priory of Bilsington, Kent* (1928), *Year Books of Edward IV* (1931), and *Medieval Agrarian Economy* (1936), designed for use as a college text.

Neilson was an active member of several professional organizations in her field, including the Royal Historical Society, and fully cognizant of her part in the struggle of women scholars to gain respect for their achievements. She was the first woman to publish a volume in the "Oxford Studies in Social and Legal History" series (*Customary Rents*, 1910), and to edit a yearbook of the Selden Society. She was also the first woman to publish an article in the *Harvard Law Review* and to be elected as a fellow of the Mediaeval Academy of America. After serving on the council and board of editors of the American Historical Association, and as its vice president, in 1943 Neilson became its first woman president.

A great lover of the outdoors who enjoyed climbing in the Adirondack mountains, horseback riding, and ice skating, Neilson was also an early aficionado of skiing. When a heart attack in 1925 hindered her active lifestyle, she learned to drive and often toured the Connecticut Valley. Nellie Neilson died of cerebral arteriosclerosis in her home in South Hadley, Massachusetts, on May 26, 1947.

SOURCES:

James, Edward T., ed. *Notable American Women: 1607–1950*. Cambridge, MA: The Belknap Press of Harvard University Press, 1971.

Mainiero, Lina, ed. *American Women Writers*. NY: Frederick Ungar, 1982.

Read, Phyllis J., and Bernard L. Witlieb. *The Book of Women's Firsts*. NY: Random House, 1992.

Jacquie Maurice,
freelance writer, Calgary, Alberta, Canada

Neilson, Sandy (1956—)

American swimmer. Born on March 20, 1956.

American swimmer Sandy Neilson won Olympic gold medals in the 100-meter freestyle, the 4x100-meter freestyle relay, and the 4x100-meter medley relay in Munich in 1972.

Neilson-Terry, Phyllis (b. 1892).

See Terry, Ellen for sidebar.

Nein, Jo (1873–1942).

See Anker, Nini Roll.

Neithotep (fl. c. 3100 BCE)

Queen of ancient Egypt's 1st Dynasty. Name variations: Neith-hotep or Neith-hetep. Flourished around 3100 BCE; probably wife of King Aha (Ahamenes); aunt of King Djer.

Neithotep, queen of ancient Egypt's 1st Dynasty and probable wife of King Aha, second ruler of that dynasty, is believed to have served as regent for her nephew, King Djer. She was buried in an enormous tomb of 21 chambers at the site of Nagada, in Upper Egypt. Her importance in the kingdom is assumed from a seal with her name placed, as a king's would be, within a so-called palace-façade design. The figure of her namesake goddess Neith, the most powerful goddess of the age, was carved above this.

Barbara S. Lesko,
Department of Egyptology, Brown University,
Providence, Rhode Island

Nelken, Margarita (1896–1968)

Spanish art critic, feminist, and politician during the Second Republic. Name variations: Margarita Nelken Mansberger; Margarita Nelkin; Margarita Nelken de Paul. Born in Spain in 1896; died in Mexico in 1968.

Born in 1896 and a native of Madrid, Margarita Nelken established a reputation as a painter and art critic. She had exhibitions of her paintings in the major continental cities and wrote for the principal art journals of Europe and South America. Meanwhile, she also became involved in leftist politics, partly from determination to improve the condition of Spanish women.

In 1931, when the Spanish Second Republic was created following the abdication of King Alphonso XIII, Nelken became directly engaged in the political turmoil that beset Spain between the two world wars. She stood as a candidate from Badajoz for the Constituent Cortes (national assembly) in 1931 and was elected. Representing the Spanish Socialist Workers' Party, Nelken was re-elected in both 1933 and 1936. During the Civil War, she joined the Spanish Communist Party and adopted an unexpectedly extremist position. Her criticism of other parties in the leftist coalition contributed to divisions among the Republican ranks and weakened the war effort against Franco's Nationalists. Fleeing Spain in 1939 at the end of the war, she went to Mexico, where she became a leading figure in artistic circles. Nelken died in Mexico in 1968.

Among her writings are *La condición social de la mujer en España* (1922); *Tres tipos de vírgenes* (1929); *Las escritoras españolas* (1930); *Por*

*Margarita
Nelken*

qué hicimos la revolución (1936); and *El expresionismo en la plástica mexicana de hoy* (1964).

Kendall W. Brown,
Professor of History, Brigham Young University, Provo, Utah

Nelkin, Margarita (1896–1968).

See Nelken, Margarita.

Nelly (b. 1899)

Greek photographer. Name variations: Elly Seraidari or Seraïdari. Born Elly Souyoultzoylou in Aydin, Asia Minor (now Turkey), in 1899; married Angelos Seraidari, also seen as Seraidaris (a pianist), in 1929.

In 1927, for a French publication, Nelly shot a series of photographs of French ballerina **Mona Paiva** dancing nude on the Acropolis, an exercise in creativity that caused a scandal in the Greek press but introduced a new movement and expressiveness into the art of photography. Known later for her portraits, documentations, and landscapes, as well as her nudes, Nelly was also the first Greek photographer to use color, beginning with autochrome plates.

Born Elly Souyoultzoylou in Aydin, Asia Minor (now Turkey), in 1899, Nelly, as she came to be called, studied piano and painting along with photography as a young woman, and had her first exhibition at the Academy of Fine Arts in Dresden, along with one of her teachers Franz Fiedler. (She also studied with Hugo Erfurt.) In 1925, she returned to Athens and began working professionally, documenting in pictures the neighborhood children and scenes of refugee life. Her career flourished through the early 1930s, when she created celebrity portraits and landscapes which were used to promote tourism. Nelly and her husband, pianist Angelos Seraidari, were on a visit to the United States when World War II broke out, and they decided to stay, settling in New York. They did not return to Greece until 1966.

During the 1980s, two exhibitions of Nelly's work were mounted in Greece: the first was a retrospective by the Parallaxis Association at the Vafopoulio Cultural Center in Thessaloniki in 1985; the second was a solo exhibit entitled "Nelly, Photographer of the Inter-War Period," organized by the Association for Studies in Modern Greek Culture and General Education and the Bane Museum in Athens in 1987. In 1983, **Vera Palma** and Alkis Xanthakis created the film *Nelly, the Asia Minor Photographer*, which was produced under the aegis of the Greek Ministry of Culture.

SOURCES:

Rosenblum, Naomi. *A History of Women Photographers*. NY: Abbeville Press, 1994.

Barbara Morgan,
Melrose, Massachusetts

Nelson, Alice Dunbar (1875–1935).

See Dunbar-Nelson, Alice.

Nelson, Ann.

See America³ Team.

Nelson, Cindy (1955—)

American Alpine skier. Born Cindy Nelson in Lutsen, Minnesota, on August 19, 1955; third of five children whose parents owned a small ski resort and taught skiing.

Won four World Cup titles; won U.S. downhill titles (1973 and 1978), U.S. slalom titles (1975 and 1976), and the U.S. combined title (1978); won a bronze Olympic medal at Innsbruck (1976).

Cindy Nelson's parents owned a small ski resort on Lake Superior in Lutsen, Minnesota, so she was skiing by age two. By 11, Nelson was winning a number of local and regional races under the tutelage of coach Heli Schaller. Though Nelson often made as many as 60 practice runs a day, one ski writer pondered how she became a downhiller. Unlike the Alpine courses of Europe, the training hills around her home, he wrote, were "not a whole lot steeper than a parking lot."

At 15, Nelson qualified for the U.S. World Cup team, and by 16 she was competing against some of Europe's best skiers. She placed 12th and 13th in her first two World Cup downhills. Not long after Nelson qualified for the U.S. Olympic Team in 1972, however, she dislocated her hip after flying 30 feet in the air. As she watched the 1972 Olympics on television, she seriously considered retiring, but was back on the slopes in 1973. That year she won the national downhill title, and in 1975 and 1976 she took the slalom title. At the Innsbruck Olympic Games in 1976, Nelson, an underdog because of inconsistency in pre-Olympic races, won the bronze, coming in .66 of a second behind gold-medal winner ***Rosi Mittermaier** of West Germany.

Nelson continued to train, competing in an average of 40 races each year. In 1978, she won the national downhill title again and the combined championship as well. She also competed in the slalom, the giant slalom, and the downhill in the 1980 Lake Placid Olympics, though her best place was a seventh in the downhill. Two years later, she led the U.S. women's ski team to

Cindy
Nelson

its first Nations Cup, a prize given to the team with the most World Cup points at season's end. While training for the 1984 Olympics, Nelson injured her right knee. Although she withdrew from the downhill, she skied with a brace in the slalom and finished 19th.

In addition to her athletic abilities, Nelson was known for her team spirit. The 1970s were not an easy time for American skiers, as organizational and morale problems plagued the squad. Nelson's steady determination emboldened her teammates; as she noted, "The important thing is that you have to keep going."

SOURCES:

Jacobs, Linda. *Cindy Nelson: North Country Skier.* St. Paul, MN: EMC Corp., 1976.

Woolum, Janet. *Outstanding Women Athletes.* Phoenix, AZ: Oryx Press, 1992.

Karin L. Haag,
freelance writer, Athens, Georgia

Nelson, Clara Meleka (1901–1979)

Hawaiian teacher, singer, musician, and dancer who was best known for her comic Hawaiian hula. Name variations: danced under the name Hilo Hattie. Born Clara Meleka Haili in Honolulu, Hawaii, on October 28, 1901; died in Kaaawa, Oahu, on December 12, 1979; one of five children of George and Rebecca Haili; attended Kaahumanu Elementary School; graduated from the Territorial Normal School; married John Baxter, in 1920 (divorced); married Milton Douglas, in 1926 (divorced); married Theodore Inter, in 1930 (divorced); married Carlyle Nelson (a violinist), in 1949.

An elementary school teacher for many years before she ventured into show business, Hawaiian-born Clara Nelson, or Hilo Hattie as she came to be called, became particularly well known for her unique comic hula, which she usually performed to the tune "Hilo Hattie (Does the Hilo Hop)" as part of a nightclub act. Nelson's repertoire also included a group of English and Hawaiian songs which became classics of her day, among them "The Cockeyed Mayor of Kaunakakai," "Princess Pupule," "Manuela Boy," and "Holoholo Ka'a."

At age 38, Nelson's stage career began when she joined the Royal Hawaiian Girls' Glee Club, a group of homemakers, secretaries, and teachers who performed at the Royal Hawaiian Hotel during summer vacations. By 1936, she had perfected her comic hula, which she had previously performed to entertain her young students. In 1940, after school administrators objected to her after-hours activities, she quit teaching and pursued the act full-time. That year, she also made her first film, *Song of the Islands*, with *Betty Grable, in which she danced to "Hawaiian War Chant." Later films including *Miss Tatlock's Millions* (1948), *Ma and Pa Kettle at Waikiki* (1955), and *Blue Hawaii* (1960), with Elvis Presley.

Nelson toured the mainland until the outbreak of World War II, when she moved to San Francisco. There she performed at the St. Francis Hotel, becoming a favorite with soldiers. Following the war, Nelson briefly returned to Hawaii, then moved to Los Angeles, so she could be close to performing venues in Hollywood and Las Vegas. In 1960, she returned to Hawaii, where she was a headliner at the Village Hotel's Tapa Room for many years. She performed there and in other popular island hotels well into the 1970s, despite advancing age, heart problems, and a bout with cancer. Her popularity was such that on her 74th birthday, she was honored with "A Hilo Hattie Love Affair," a gala held at the Hawaiian Village Hotel and attended by 1,500 friends and admirers. As was typical of her, she insisted that the evening be a benefit for the Easter Seal Society, one of many charities she supported.

One of Nelson's last performances was with Hawaiian singer Don Ho in Las Vegas in 1977. In June of that year, following a show in Palo Alto, California, she suffered a massive stroke which left her partially paralyzed and unable to speak. Her fourth husband, Carlyle Nelson, nursed her at home until her death on December 12, 1979.

SOURCES:
Peterson, Barbara Bennett, ed. *Notable Women of Hawaii*: Honolulu, HI: University of Hawaii Press, 1984.

Barbara Morgan,
Melrose, Massachusetts

Nelson, Frances Herbert (1761–1831).
See Hamilton, Emma for sidebar.

Nelson, Harriet.
See Hilliard, Harriet.

Nelson, Lady (1761–1831).
See Hamilton, Emma for sidebar.

Nelson, Marjorie (b. 1931).
See Jackson, Marjorie.

Nelson, Marjorie (1937—)
Australian softball player. Name variations: Midge Nelson. Born in 1937.

During the 1960s and 1970s, Marjorie Nelson, also known as "Midge," became one of Australia's greatest softball players. Her 18-year career began in 1960 and included a record four World Series appearances with the Australia team, in 1965, 1970, 1974, and 1978. Nelson's incredible talent was a major contribution to Australia's World Series victory in 1965, and she also captained the teams for the 1974 and 1978 series. She set another record by playing in 23 consecutive national title games, mostly with the Victoria team. Her career batting average was .205 with a fielding average of .944. Nelson retired in 1978, the same year that she was awarded a British Empire Medal (BEM) in recognition of her services to softball. She was inducted into the International Hall of Fame in 1983. In 1985, she was inducted into the Sport Australia Hall of Fame, and the Midge Nelson medal was created to honor the most valuable player in the Australian national championships.

Rebecca Parks,
Detroit, Michigan

Nelson, Maud (1881–1944)
American baseball player. Name variations: Maud Brida; Maud Nielson; Maud Olson; Maud Dellacqua. Born Clementina Brida on November 17, 1881, in Tyrol, Austria; died in Chicago, Illinois, on February 15, 1944; married John B. Olson, Jr. (a baseball owner-manager), around 1911 (died 1917); married Constante Dellacqua (a chef), in 1922 or 1923; children: (stepson) Joe Dellacqua.

Although Maud Nelson dominated the early years of women's baseball, as a player, a scout, a manager, and owner of some of the top female teams of the day, her name has pretty much been lost to history. Her obscurity is due, at least in part, to the variety of names she used during her lifetime—Brida, Nelson, Nielson, Olson, and Dellacqua—and to the fact that she was a modest woman, not given to self-promotion. Many of the women who played under her management never knew about her early years as a world-renowned Bloomer Girl pitcher, or about her finesse at third base.

Nelson was born in 1881 in a Tyrolean village in Austria and immigrated to the United States with her family at an early age, although it is not known where they settled. Nelson's life remains a mystery before the age of 16, when the petite brunette joined the barnstorming Boston Bloomer Girls as their starting pitcher. By the fall of 1897, the Bloomers had played in ball fields up and down the East Coast and in October of that year traveled to Eugene, Oregon, where the *Eugene Guard* praised their "professionalism," and their "hard snappy game." Everywhere they played, Nelson was singled out for her talent. In 1900, the *Cincinnati Enquirer* reported that the Bloomer Girls defeated the Union City team 3–1, then went on to acknowledge the pitching staff. "The feature was the pitching of the Misses Maud Nelson and **Edith Lindsay**, only three hits being made off them." Nelson became such a draw that she had to pitch every day, although sometimes she struck out a side for three or so innings, then turned the game over to another pitcher. As well, late in the game, Nelson might switch over to play third base, "the hot corner," according to **Barbara Gregorich**, "where players must stop bullets, recover, and make the long throw to first base with great accuracy and velocity. That Nelson played this position, particularly in late innings, testifies to her skills and instincts." Gregorich goes on to mention that Nelson was also a fairly decent hitter.

After leaving the Bloomer Girls at the age of 27, Nelson became a starting pitcher for the Cherokee Indian Base Ball Club. At 30, she met and married John B. Olson, Jr., and joined him as owner-manager of the Western Bloomer Girls. Nelson immersed herself into her new duties, and gained a reputation for getting things done. She did everything from training to booking games and recruiting new players.

When her husband died in 1917, Nelson rejoined the Boston Bloomer Girls for a spell and also managed a women's team for the Chicago Athletic Club. In 1922 or 1923, she married Constante Dellacqua, a chef and a widower with a young son. With Dellacqua, she put together yet another team, the All Star Ranger Girls, which she managed until the Depression made it difficult to sustain a team. After 40 years in baseball, Maud Nelson lived out her retirement years in a house near Wrigley Field in Chicago. She died there on February 15, 1944. Gregorich notes that three generations of women owe their professional baseball careers to Maud Nelson: "She was the first and the greatest: the reliable starter and the keeper of the flame."

SOURCES:

Gregorich, Barbara. *Women at Play: The Story of Women in Baseball*. NY: Harcourt Brace, 1993.

Barbara Morgan,
Melrose, Massachusetts

Nelson, Midge (b. 1937).

See Nelson, Marjorie.

Nelson, Sara (b. 1918).

See Nelsova, Zara.

Nelson, Viscountess (1761–1831).

See Hamilton, Emma for sidebar.

Nelsova, Zara (1918—)

Canadian-American musician who was one of the preeminent cellists of her time. Name variations: Sara Nelson. Born Sara Nelson in Winnipeg, Canada, on December 23, 1918; daughter of Gregor Nelsov, a flautist and graduate of the St. Petersburg Conservatory; studied with her father; also studied with Dezsö Mahalek, Herbert Walenn, Pablo Casals, Emanuel Feuermann, and Gregor Piatigorsky; married Grant Johannesen (an American pianist).

Was the first North American cellist to tour the Soviet Union (1966); known for her close collaboration with Ernest Bloch, the composer, as well as for concertizing and teaching.

Zara Nelsova was born in 1918 in Winnipeg, Canada, the youngest of three daughters of Gregor Nelsov, a flautist. She began playing the cello at age four-and-a-half, when her father woke her one cold morning and presented her with a full-size cello. Finding the instrument much too large to handle, the child cried bitterly. So Gregor had a viola converted into a small cello for her to play. Nelsova's progress was so rapid, she was playing in public by age five.

Where some fathers might have seen three daughters, he saw a professional musical trio. One was started on the violin, the other on the piano, and Zara continued to learn the cello. The girls' relationship with their father-teacher was loving. Still young, the sisters played throughout Canada and won the Manitoba Festival, while Zara won first place as a soloist as well. Sir Edward Bairstow and Sir Hugh Robertson arranged for a grant from the Ministry of Education so that the sisters might study music abroad. In 1929, the family sailed for England.

Life was not easy in London. The family moved into a tiny two-room flat in a seedy part of town known as Little Venice. Gregor discov-

ered that his daughters were too young to enter the Royal College of Music. Even so, he insisted that they practice, so while Zara played her cello for six hours in one corner of the room, her sister played the violin in the other. In this difficult atmosphere of competing melodies, Zara honed her enormous powers of concentration which would stand her in good stead. Prominent neighbors in the musical world began to look after the girls' future. The eminent critic Alfred Kalisch happened to live in the apartment opposite and arranged for them to meet his sister, **Constance Hoster**. Hoster served on a committee with Lady Battersea (**Constance de Rothschild**), Audrey Melville, Edith Debenham, and **Elsa Warren** to organize funds for needy musicians. "They were wonderful to our family," said Nelsova. "I don't know what we would have done without their help because we had no money at all."

In the meantime, the family met many prominent musicians. Herbert Walenn had Zara admitted to the London Violoncello School and insisted on teaching her himself. She also met John Barbirolli, one of his students, who worked with her. "I would often go to his house and play to him," said Nelsova, "and he made me aware of an entirely different style of playing—a bigger style—and most important of all was that I attribute my sound to Barbirolli." Mischel Cherniavsky and **Laurie Kennedy**, principal cellist of the BBC Symphony Orchestra, helped as well. When the Canadian Trio debuted at Wigmore Hall, they attracted considerable attention. Soon there were concerts at the Royal College of Music and with the London Symphony Orchestra, conducted by Sir Malcolm Sargent.

When Zara was 17, her parents decided to move to Australia, leaving her with her older sisters. But her sisters became ill, and Nelsova found herself in the position of having to support the Trio. Though times were difficult, they survived and prospered with the help of many friends. In 1936, Nelsova debuted as a soloist at Wigmore Hall to rave reviews. Engagements increased as the clouds of war rolled over Europe. The sisters decided to return to Canada in 1939, using money left them in the will of Constance Hoster. They tried to book tickets on the *Athenia*, but there was no room. The *Athenia* would be torpedoed by German U-boats, with the loss of all on board. A week later, the sisters sailed on the *Duchess of Atholl*, which narrowly missed being hit as well.

Arriving in Toronto for Christmas of 1939, the sisters took up residence at the YWCA. As refugees, they were well looked after, but they had no place to practice, until someone offered the boiler room, which proved an excellent place in bitter cold weather. One day while Nelsova was practicing, she looked up to find ten faces staring at her through the boiler-room window. Outside were members of the Canadian Broadcasting Orchestra who had been rehearsing in a nearby church when they heard her playing and sought the source. They arranged for Nelsova to meet people of note in the music world; it was in this way that she was engaged by Arthur Fiedler to play with the Boston Pops. The following year, Charles Münch arranged for her to solo with the Boston Symphony. She became the principal cellist with the Toronto Symphony Orchestra and formed a second Canadian Trio with *Kathleen Parlow and Sir Ernest MacMillan.

Nelsova continued to study whenever she could. Emanuel Feuermann, the great cellist, tutored her for several weeks when she was 23. She also studied at Tanglewood and Rockport for several summers with Gregor Piatigorsky, who helped her prepare for a recital debut at the Town Hall in New York in 1942, and with Pablo Casals, an enlightening experience for a cellist. Nelsova's relationship with the composer Ernest Bloch began in the late 1940s. At that time, the 68-year-old was living on a beach in the remote village of Agate Beach, Oregon. Nelsova joined him there, and they played and discussed music. She asked him to compose cello music for her, and eventually he did write three unaccompanied cello works; because performer and composer had worked together, she had opened his mind to the concept of unaccompanied string texture. In 1949, she played his work *Shelomo* at a festival of his music in London, later recording it under his baton.

Nelsova remained a determined musician. The rigors of childhood practice had made her extremely durable. In 1953, seven weeks after major back surgery, she was scheduled to play at a Wigmore Hall recital. Confined to St. Bartholomew's Hospital, in Smithfield, England, she was determined to get out of bed and practice her cello. She asked the staff if there were somewhere she might practice undisturbed. At that time, the hospital was in the process of renovation, and the division between the surgical and psychiatric wards was nonexistent. So, six days after surgery, the nurses led her to an empty ward which was perfectly quiet. Though Nelsova noted that the walls were lined with leather and that there were no handles on the door, she began playing happily and thought nothing further of it. Soon someone looked in, shut the door, and locked it. No doubt, they assumed

that a woman in the psychiatric ward playing a cello in a dressing gown should not be allowed to roam free. She banged on the door for some time before she convinced them that she was, in fact, a cellist, and performed beautifully at her recital a few weeks later.

Though she began teaching at the Juilliard School in 1962, Nelsova continued to tour widely in Europe, and North and South America, and in 1966 was the first North American cellist to play in the Soviet Union. She appeared as a soloist with more than 30 orchestras throughout the world. After her marriage to pianist Grant Johannesen, the two played together many times. Nelsova also recorded frequently, often playing on a 1735 Pietro Guarneriusa or a 1726 Stradivarius (or "Marquis de Corberon," as the instrument was named). This marvelous instrument, too priceless for her ever to purchase, was a bequest of Audrey Melville, one of the women on the committee which helped Nelsova as a child. Zara Nelsova was regarded as the most outstanding cellist of her time; a "player of magnificent presence, grand verve, consummate skill and unflagging strength," wrote critic Kenneth Winters.

SOURCES:

Campbell, Margaret. "Independent Achievement," in *The Strad*. Vol. 99, no. 1179. July 1988, pp. 556–559.

Kallman, Helmut, Gilles Potvin, and Kenneth Winters, eds. *Encyclopedia of Music in Canada*. 2nd ed. Toronto: University of Toronto Press, 1992.

Uscher, Nancy. "Zara Nelsova and Ernest Bloch. The Story of a Friendship and a Musical Partnership," in *Strings*. Vol. 2, no. 4, 1988, pp. 20–25.

John Haag,
Associate Professor of History,
University of Georgia, Athens, Georgia

Nemchinova, Vera (1899–1984).

See Danilova, Alexandra for sidebar.

Nemcová, Bozena (c. 1817–1862)

Czech writer who was the first woman to occupy a major place in Czech literature. Name variations: Bozena Nemcova; Barbora Nemcová; Bozhena Nemtsova; Barbara Pankl; Betty Pankl. Born Barbara Nowotny, most likely in Vienna, in 1817 (although February 1820 has traditionally been accepted as her birth date); died in Prague, Czechoslovakia, on January 21, 1862; daughter of Maria Magdalena Theresia Nowotny, later known as Theresia Pankl (1797–1863) and Johann Pankl (1794–1850); had eleven brothers and sisters; married Josef Nemec; children: daughter, Theodora "Dora" Nemec; sons, Hynek, Jaroslav (Jarous), and Karel Nemec.

The first Czech woman writer of distinction, whose masterpiece *Babicka (The Grandmother)* is a landmark in the history of her nation's prose, Bozena Nemcová had origins sufficiently mysterious to mislead generations of biographers. An illegitimate child, she was baptized Barbara Nowotny in the Roman Catholic Church of the Holy Trinity in Vienna-Alservorstadt on February 5, 1820, and it was long assumed that she had been born a day or two earlier; thus her place and date of birth traditionally have been given as Vienna on February 4, 1820. Also according to tradition, her mother was Maria Magdalena Theresia Nowotny (**Theresia Pankl**), a servant in the employ of Duchess **Wilhelmine von Sagan**, and on August 7, 1820, Barbara Nowotny became legitimized as Barbara Pankl (called Betty) due to her mother's marriage in Böhmisch Skalitz (modern-day Ceská Skalice, Czech Republic) to Johann Pankl, a coachman also employed by the duchess.

In recent years, Adolf Irmann and other scholars have investigated the details of Nemcová's ancestry, discovering many new facts as well as tantalizing discrepancies and unresolved questions. At this point, the best evidence suggests that the child who eventually became Bozena Nemcová was born not in 1820, but most likely in 1817. Some documentation points to the possibility that Barbara Nowotny, later Barbara Pankl, was not the child of the servant Theresia Pankl. Who her actual mother was remains unknown, but some scholars have argued that the elements of the entire story point toward an aristocratic woman who became pregnant and then gave her child to a servant to raise. Irmann has even suggested the possibility that the girl's biological mother was the duchess, but admits that this question must remain open to speculation until more conclusive data comes to light.

What is known about Nemcová's childhood is that it was happy. She was largely brought up by her grandmother, **Magdalena Cuda Novotná** (c. 1770–1841), a loving woman rooted in the traditional culture of the Czech peasantry, who would serve as the model for Nemcová's *Babicka* (1855). Nemcová grew up in the seemingly idyllic world of the estate on which her parents were servants. These years, spent in what literary historian Arne Novák called "an enchanted corner of the Krkonos foothills," would turn out to be the only carefree ones of her short, tragic life. As a young girl, Nemcová was fully bicultural and bilingual, moving back and forth between the Czech peasant world of her grandmother and mother and the German culture of her father, her school, and many of her friends.

She was drawn to German Romantic poetry, including that of Heinrich Heine, and her first writings were poems in German. Her love of literature was reflected in her memorization of many of the greatest masterpieces of German verse, old and new.

A beautiful, intelligent young girl, with good manners, Nemcová became increasingly attracted to many of the young aristocratic males in the town of Ratiboritz, where she lived starting in 1833. Worried that her daughter might succumb to the passions of youth, Theresia hurriedly made plans to arrange a "proper" marriage for her. Soon a groom was found in Josef Nemec (1805–1879), a former professional soldier, who worked as a customs official for the Austrian monarchy. Besides being a dozen years older than his wife-to-be, Nemec was a dour, unimaginative type whose personality was incompatible with that of a poetry-loving, dreamy young girl. The couple married in September 1837, in the same Viennese Church of the Holy Trinity in which Theresia Pankl had wed 17 years earlier.

In 1842, they moved to Prague, where the bride's life changed significantly. Nemcová's interest in politics had been minimal until then, whereas Josef was a passionate Czech nationalist. This meant that only Czech was to be spoken at home, and as children arrived on the scene they would learn only Czech from their parents (though German continued to be taught in schools). Now known as Barbora Nemcová, she caved in to pressure from her husband to stop reading (or writing) German poems and novels. Eventually, she chose to burn the German verse she had written in earlier years. Nemcová took instruction to improve her Czech grammar and diction, which had been essentially the rural, peasant language spoken by her mother and grandmother. Within a few years she mastered the learned forms of the Czech language, and also became a committed Czech nationalist, convinced of the rightness of the Czech cause in creating a distinct Slavic culture in the ancient but now German-controlled provinces of Bohemia and Moravia.

Living in the Czech metropolis opened up a new world for Nemcová, a world of compelling ideas and fascinating people who stood in sharp contrast to her unresponsive husband. She moved in a stimulating circle of intellectuals, one of whom was a young poet, Václav Nebesky. Nemcová's first poem, an expression of the friendship between them, was an appeal to Czech women to join their men in the struggle for the nation's freedom: "From the Urals to the Sumava, from the Balkans to the Vltava, the Slav rose to conquer glory." Verse of such nationalist intensity from a literary neophyte created a sensation, bringing her instant acclaim. That poem, "Zenam ceskym" ("To Czech Women"), appeared in print in the magazine *Kvety* in 1843, establishing her national reputation as an artist to watch. At this time, she changed her first name from the German-derived Barbora to the more Czech-sounding Bozena.

Lacking a higher education, Nemcová did not feel she was qualified to tackle more complex literary forms, and her friends often had to encourage her. Her physician (and later lover), Josef Cejka, who knew *George Sand, understood Nemcová's talent and suggested she write fairy tales. His advice was perceptive; even her first efforts received high ratings from the Czech writer Karel Erben, a master of traditional folk tales. Between 1845 and 1848, Nemcová published a series of fairy tales in seven successive parts. Written from memory and lacking any framework or academic concepts, they were at times lacking in scholarly objectivity. As she herself would admit in a letter: "This fairy tale is not a true folk tale; a part of the subject comes

Czech postage stamp honoring Bozena Nemcová.

from my childhood memories; I took a fancy to it and made up the rest." Believing that in essence "authenticity" probably could never be achieved once an author had made the decision to write down, and adapt for readers' interests, the national heritage of folk tales, Nemcová noted in an 1846 letter: "When I hear a fairy tale all twisted and confused, I cannot resist making changes. In some places I add and in others I delete, especially the ugly parts."

By 1848, when the various nationalities of the Austro-Hungarian empire rose up to achieve their freedom, Bozena Nemcová's literary reputation was on the ascendancy. Her personal life, however, was in crisis; her marriage was crumbling, and because she and her husband were deemed to be Czech nationalists and politically unreliable, Josef's bureaucratic career in the customs service had hit a wall, with no promotions and raises. Financially, the couple's situation deteriorated from year to year. With four children, several of whom were in poor health, the situation was demoralizing. Starting in 1850, Josef was stationed in West Hungary (Slovakia), while Nemcová and the children remained in Prague. She and Josef would never again live together as husband and wife, though she visited him four times over the next few years. In Prague, Nemcová coped with raising her children, but the small amounts of money her husband sent were barely sufficient to pay for life's basics. She and her children ate food of poor quality (if they could afford to eat at all) and lived in a near-hovel of miserable rooms in one of Prague's poorest neighborhoods. Quite probably as a result, Hynek, her eldest and favorite son, died in October 1853 of tuberculosis, age 16.

Throughout the 1850s, when it had become obvious to Nemcová that her marriage was dead, she engaged in various forms of escapism. Never good at managing her household, she squandered her limited budget, forcing her to beg friends for money to buy food for her children, a situation that never improved given "her almost childlike inability to know the value of money." Once, after her friends had raised a large sum to help her, she immediately offered almost all of it to a writer who was also in debt. With what little remained, she had a splendid dinner prepared and invited her closest friends over to celebrate. **Anna Cardová-Lamblová**, the sister of one of Nemcová's lovers, commented in later years on "that fiery, desirable, perhaps even destructive woman. . . . [E]verything about her was charming. . . . She had many admirers and . . . many women envied her and condemned her free behavior and the way she was celebrated

among literati. . . . Mrs. Nemcová was very fearless. She went . . . where nobody else dared to go. Living freely, without responsibility, she bore criticism with a smile."

Nemcová's trips to Slovakia to collect material for fairy tales caused her friends to criticize her for not producing the works of significant literature they were convinced she was capable of writing. Despite the perceptiveness of these criticisms, it must also be noted that Nemcová's love of the rural population of Slovakia helped strengthen cultural ties between the Slovak and Czech cultures in later generations. The first Czech writer to describe the beauty of the Carpathian mountains, she wrote with intensity about those who lived in the primeval beech forests and braved the bears of that region. She spent hours writing long and eloquent letters to friends, family, and members of the Czech intelligentsia. Although these letters would one day appear in print and be praised for both content and style, at the time they were appreciated only by their recipients and brought their author neither fame nor fortune.

Another sign of the instability of Nemcová's life were her many love affairs. Consistently over the almost 25 years of their marriage, her husband was verbally and even physically abusive to her, and in an 1860 letter to her son Karel she noted that "considering my nature it is a terrible fate to be tied to a coarse man." Among her lovers were Nebesky, Josef Cejka, Vilem Dusan Lambl, Ignac Hanus, Jan (Ivan) Helcelet, Hanus Jurenka, and Frantisek Matous Klácel. None of these affairs brought her happiness, and her youthful beauty rapidly faded as financial cares and emotional turmoil destroyed both her sense of well-being and her health.

In 1855, Nemcová published the book that would make her an immortal of Czech literature. *Babicka* (*The Grandmother*), which for more than a century has been the most revered volume in the Czech language, recounts one year of rural life. Obviously autobiographical, Nemcová's work gives detailed accounts of folk customs that reflect an idealized, harmonious world which, in fact, never existed. Babicka is the mother of a manorial official's Germanized wife who instinctively raises her grandchildren as solidly loyal and devout Czechs. Wisdom incarnate, Babicka advises the local duchess and countess as easily as she imparts traditional truths to the villagers. With her loving heart, horse sense, and superstitions, the grandmother is a figure of extraordinary strength, resoluteness, and solidity. The novel, which is actually a Biedermeier idyll and a series of

sketches, restricts its action to interpolated tales in which the natural ordered rural life of Czech peasants is upset by foreigners. In one of these, a girl is raped (or seduced) by a Hungarian soldier, which makes her pregnant and eventually causes her to slip into a state of madness. None of the constituent parts of *Babicka* detract from one another, the entire book being an organic whole. Novák praised the book: "The figure of the grandmother, incorporating the Slavic ideal of motherhood, shines forth like a beneficent autumn sun, and the story, full of goodness and beauty, unfolds against an enchanting background of an equally maternal Nature; human beings grow, live and are lulled to sleep in Nature's lap."

Bozena Nemcová's final years continued to be tragic. Dying of cancer, she remained impoverished. Some of her best friends, including the great novelist *Caroline Svetla, had broken off their friendships because of her irregular lifestyle. Toward the end of 1861, her husband brought her from Litomysl, where she had been living, back to Prague. Here she died, still destitute, on February 21, 1862. Ironically, Nemcová's funeral was a grandiose affair, as reported by the *Moravské Noviny* (Moravian News): "The procession, led by a clergyman who had slandered her earlier, included her hearse, decorated with laurel wreaths and an artistically embroidered Slav tree. There were colored flags donated by the 'Czechoslav Daughters' to the writer of *The Grandmother*. . . . On both sides, Czech girls in mourning marched with lit candles, then younger writers. . . . Behind the coffin were members of the family . . . [C]arolina Svetlá . . . Prince Thurn-Taxis, representatives of the provincial and imperial deputies, the mayor, the vice-mayor, writers, doctors, professors, students, etc. and an endless multitude. . . . [E]ternal glory to her memory!"

Although her other works are read and respected by Czechs, it is for having written *Babicka* that Bozena Nemcová remains beloved by her people. Written by a tormented woman in an attempt to recapture the happiness she had known in the vanished world of her youth, this book has served to inspire Czechs on more than one occasion when their nation found itself in peril. During World War I, when she was imprisoned in Vienna, *Alice Garrigue Masaryk wrote to her mother *Charlotte Garrigue Masaryk, the American-born wife of Thomas G. Masaryk: "Dear Mother,— These days I have been in the Ratiborice Valley with *Babicka*. I was tired and remained in bed. Every movement required an effort; and I took *Babicka* into my hands and lived there with her. I was moved by her loving righteousness, her right-

eous kindness, which flowed from a deep heart. A closed, concentric world—simple and beautiful. In the present-day rush, in the atmosphere of steam, electricity, intellectualism, and Ibsenism, this book acts like a healing potion."

In 1939, with Czech independence about to be snuffed out by the Third Reich, the simple truths contained in *Babicka* again gave hope to Czechs. In his volume of poetry *Our Lady Bozena Nemcová*, published in that terrible year, Frantisek Halas gave voice to a small but proud nation's determination to defend, if only in spirit, its national traditions. *Babicka* has been translated into over 20 foreign languages, and by the centenary of its author's death in 1962 the book had appeared in print in an astonishing 312 Czech editions. Bozena Nemcová has been honored in countless ways over the years. Among the most recent commemorations are a 30-Heller postage stamp issued on February 26, 1962, and a portrait of her on the 500-Crown banknote of the series issued in 1993 by the newly established Czech Republic.

SOURCES:

Bryner, C. "Bozena Nemcová and *Jane Austen," in Sixth International Congress of Slavist, Prague, 1968. *Canadian Papers Presented at the VI International Congress of Slavists in Prague, 1968*. Vancouver: Extension Department, University of British Columbia, 1968.

Chudoba, Frantisek. *A Short Survey of Czech Literature*. NY: E.P. Dutton, 1924.

Demartis, Jaroslava Marusková. "Stile Letterario e Impegno Nazionale nella Prosa di Bozena Nemcová" [Literary Style and National Commitment in the Prose of Bozena Nemcová], in *Annali della Scuola Normale Superiore di Pisa*. Vol. 4, no. 2, 1974, pp. 479–536.

Guski, Andreas, ed. *Zur Poetik und Rezeption von Bozena Nemcovás "Babicka."* Wiesbaden: Otto Harrassowitz Verlag, 1991.

Halas, Frantisek. *Nase pani Bozena Nemcová, 1939*. Prague: Ceskoslovensky Spisovatel, 1953.

Harkins, William E., ed. *Anthology of Czech Literature*. NY: King's Crown Press, Columbia University, 1953.

Iggers, Wilma Abeles. *Women of Prague: Ethnic Diversity and Social Change from the Eighteenth Century to the Present*. Oxford, England: Berghahn Books, 1995.

Irmann, Adolf. "Eine literaturhistorische Urkundenfälschung?," in *Österreich in Geschichte und Literatur*. Vol. 17, no. 3, 1973, pp. 168–182.

Karskaia, T.S. "N.S. Leskov i Bozhena Nemtsova (K Voprosu o Tvorcheskikh Kontaktakh Pisatelia)" [N.S. Leskov and Bozena Nemcová: The Writer's Creative Contacts], in *Sovetskoe Slavianovedenie*. No. 2, 1973, pp. 44–52.

Nejedly, Zdenek. *Bozena Nemcová*. Prague: Svoboda, 1950.

Nemcová, Bozena. *The Disobedient Kids and Other Czecho-Slovak Fairy Tales*. Translated by William H. Tolman and Prof. V. Smetánka. NY: Harper & Brothers, 1921.

————. *The Grandmother: A Story of Country Life in Bohemia.* Translated by Frances Gregor. Chicago: A.C. McClurg, 1891.

————. *Granny: Scenes from Country Life.* Westport, CT: Greenwood Press, 1976 (reprint of 1962 Prague Artia edition).

————. *The Shepherd and the Dragon: Fairy Tales from the Czech of Bozena Nemcová.* Translated by Eleanor Edwards Ledbetter and William Siegel. NY: Robert M. McBride, 1930.

Novák, Arne. *Czech Literature.* Edited by William E. Harkins. Translated by Peter Kussi. Ann Arbor, MI: Michigan Slavic Publications, 1976.

Novotny, Miloslav, ed. *Zivot Bozeny Nemcová: Dopisy a Dokumenty.* 6 vols. Prague: Ceskoslovensky Spisovatel, 1951–1959.

Pynsent, Robert B. "Nemcová, Bozena," in Pynsent, Robert and S.I. Kanikova, eds., *Reader's Encyclopedia of Eastern European Literature.* NY: Harper-Collins, 1993, p. 280.

————, ed. *Czech Prose and Verse: A Selection with an Introductory Essay.* London: Athlone Press, University of London, 1979.

Roth, Susanna. "Bozena Nemcová: Sehnsucht nach einem anderen Leben," in Alena Wagnerová, ed., *Prager Frauen: Neun Lebensbilder.* Mannheim: Bollmann Verlag, 1995, pp. 11–34.

Salvaberger, Erika. "Bozena Nemcová und Wien: Der literarische Werdegang," in *Österreichische Osthefte.* Vol. 13, no. 4, 1971, pp. 349–353.

Soucková, Milada. *The Czech Romantics.* The Hague: Mouton, 1958.

Svadbová, Blanka. "Bozhena Nemtsova v Progressivnoi Cheshkoi Kritike Mezhvoennogo Dvadtsatiletiia" [Bozena Nemcová in Progressive Czech Critical Literature in the Twenty-Year Interval Between the Two World Wars], in *Sovetskoe Slavianovedenie.* No. 6, 1977, pp. 46–57.

Tille, Václav. *Bozena Nemcová.* 9th ed. Prague: Odeon t. Mir 1, 1969.

————, ed., *Myslenky Bozeny Nemcová.* Prague: J. Laichter, 1920.

Urban, Zdenek. "Bozena Nemcová a Slovanstvo" [Bozena Nemcová and Slavdom], in *Slovansky Prehled.* Vol. 41, no. 2, 1955, pp. 71–72.

Wittemann, M. Theresia. *Draussen vor dem Ghetto: Leopold Kompert und die "Schilderung jüdischen Volkslebens" in Böhmen und Mähren.* Tübingen: Max Niemeyer Verlag, 1998.

COLLECTIONS:

Bozena Nemcová Museum, Ceská Skalice, Eastern Bohemia, Czech Republic.

Museum of Czech Literature, Hradschin Palace, Prague, Czech Republic.

John Haag,
Associate Professor of History,
University of Georgia, Athens, Georgia

Nemenoff, Genia (1905–1989)

French pianist who was known for her duo piano work with her husband. Born in Paris, France, on October 23, 1905; died in New York City, on September 19, 1989; married Pierre Luboshutz (1891–1971), a pianist.

Born in Paris in 1905, Genia Nemenoff studied at the Paris Conservatoire with Isidor Philipp. After a successful Paris debut and tours throughout Europe, she married pianist Pierre Luboshutz, and together they established a duo-piano team. Settling in the United States, they made a successful New York debut in January 1937 under the name "Luboshutz & Nemenoff." Their annual concert tours enabled audiences throughout the U.S. and Canada to become acquainted with the full range of the duo-piano literature. Nemenoff and her husband also taught; from 1962 to 1968, they served as joint heads of the piano department at Michigan State University.

John Haag,
Athens, Georgia

Nemerov, Diane (1923–1971).

See Arbus, Diane.

Nemours, duchess of.

See Philiberta of Savoy (c. 1498–1524).
See Nemours, Marie d'Orleans, duchess de (c. 1625–1707).
See Victoria of Saxe-Coburg (1822–1857).

Nemours, Marie d'Orleans, duchess de (c. 1625–1707)

*French memoir writer. Name variations: Mlle. de Longueville; Marie de Longueville. Born Marie de Longueville around 1625; died in 1707; daughter of Henry, the duc de Longueville, and Louise de Bourbon-Soissons; stepdaughter of *Anne Geneviève, Duchesse de Longueville (1619–1679).*

Marie d'Orleans, duchess of Nemours, was born around 1625, the daughter of Henry, duc de Longueville, and **Louise de Bourbon-Soissons**, and later the stepdaughter of ***Anne Geneviève, Duchesse de Longueville**, sister of the Prince of Condé. Marie regretted her father's involvement in the Fronde during 1648–53 and wrote of it in her well-known memoirs. During the minority of Louis XIV, the Fronde waged civil war against the court because of humiliations inflicted on the nobility and heavy fiscal impositions laid on the people, beginning with resistance to measures enacted by Cardinal Mazarin. Because the Fronde fell under the weight of its own intrigue and strife, the name *frondeur* became a term of political reproach. English king James II, then the duke of York, proposed to Marie, but France's regent ***Anne of Austria** would not agree to the marriage. Marie

d'Orleans was also a good friend and patron of *Mme de Villedieu.

Nenadovich, Persida (1813–1873)

Princess of Serbia. Name variations: Persida Nenadsowitsch. Born on February 13, 1813; died on March 29, 1873; daughter of Jevrem Nenadovich; married Alexander (1806–1885), prince of Serbia (r. 1842–1858), on May 20, 1830; children: Peter I (1844–1921), king of Serbia (r. 1903–1921); Arsen or Arsène Karadjordjevic or Karageorgevitch (b. 1859, who married Aurora of San Donato).

Neris, Salomeja (1904–1945)

Lithuanian poet who remains the most popular poet of the Lithuanian language. Name variations: Salomeja Bacinskaite-Buciene or S. Bacinskaite-Buciene. Born Salomeja Bacinskaite in Kirsai, Vilkaviskis-Vilkavishky Raion, Russia (now Lithuania), on November 17, 1904; died in Moscow on July 7, 1945; married Bernardas Bucas (a sculptor); children: one.

Selected works: Anksti ryta *(Early in the Morning, 1927);* Pedos smely *(Prints in the Sand, 1931);* On Thin Ice *(1935);* Diemedziu zydesiu *(I Will Bloom Like the Wormwood, c. 1936);* Egle 'alciu karaliene *(Egle, Queen of the Snakes, 1940);* "Poem to Stalin" *(1940);* "Yasnaya Polyana" *(1942);* "Bolseviko kelias" *(The Path of the Bolshevik, early 1940s);* Dainuok, sirdie, gyvenima *(Sing to Life, My Heart, 1943);* Lakstingala negali neciulbeti *(The Nightingale Cannot Help But Sing, 1945);* My Land *(posthumously published in Russia, 1947).*

Salomeja Neris, Lithuania's most beloved poet, once called her land a "droplet of amber." Situated on the Baltic Sea, with beaches that yield much of the world's amber, Lithuania has a complex history. Despite its small population (estimated at 2.5 million in the mid-1920s and nearly 4 million in the year 2000, though a high percentage are ethnic Russians), medieval Lithuania was for a considerable period one of Eastern Europe's great powers. In 1410, Grand Duke Vytautas, who ruled over a large empire extending from the Baltic to the Black Sea, radically changed the power balance of Eastern Europe by winning the battle of Grünewald, decisively crusing the Teutonic Knights with his Polish, Russian, Czech, and Tartar allies. Lithuania slowly declined after this, with its aristocracy becoming Polonized. Only illiterate peasants continued to speak the Lithuanian language and celebrate traditional folkways, but these would be revived by the Romantic movement of the 19th century. A small but growing group of intellectuals defied the tsarist policy of Russification, calling for a linguistic and cultural renaissance based on the Lithuanian language and spirit. Among the peasantry, the names of pagan divinities, once central to an ancient national mythology, would surface again and again, both in their songs and common speech. Dreams of a free Lithuania had to wait until the world began to change radically in 1914. World War I, which brought about an eclipse of Russian power in the Baltic region, made possible the creation of an independent Lithuanian state in November 1918.

Born Salomeja Bacinskaite in the village of Kirsai near the town of Vilkaviskis, Salomeja Neris could later look back on the first decade of her life as being almost idyllic. Her family were prosperous peasants and, until German troops occupied Lithuania in the autumn of 1915, food was always plentiful. She grew up with a love of the rural landscape and the rich folklore, lyrical folk songs and fairy tales that were an integral part of Lithuania's peasantry. Although a virtual civil war raged until 1920, Salomeja's life was tranquil, as she immersed herself in books. She devoured the classics, Russian, German and other masterpieces of world literature. Soon she began to write verse, and in 1923 saw her first poem appear in print. In 1927, she published her initial collection of verses, *Anksti ryta* (Early in the Morning). The poems were influenced by the spirit of Romanticism and a conservative Roman Catholic Weltanschauung. A dreamer and idealist, Neris found her favorite authors in those who most deeply stirred her emotions. These included the Romantic and idealist masters Heine, Mickiewicz, and Schiller. She was also influenced by the writings of Goethe, Pushkin, Baudelaire, and Verlaine, and, among her contemporaries, *Anna Akhmatova, Rainer Maria Rilke, and Alexander Blok. Throughout her writing career, she cherished these authors' works and translated them into elegant Lithuanian prose and verse.

In 1928, after graduating from the University of Vytautas the Great in Kaunas, Neris began teaching at a rural secondary school. During the next few years, besides writing poems, she witnessed much poverty, for despite having achieved independence, Lithuania remained a poor agrarian country. In the 1920s, estimated adult illiteracy was about 30%, and compulsory education for the population would not be introduced until 1930, largely because of a severe shortage of Lithuanian-speaking teachers. Political repression also marred Lithuanian public life. Early in its independence, the country had

abandoned democracy on the pretext of combating an alleged "Communist threat." In December 1926, representing only a minority of the Lithuanian national political spectrum, an anti-Marxist, anti-democratic dictatorship was established through a coup d'etat.

During her first years as a teacher, Neris eagerly sought out new experiences. She traveled to Western Europe and discovered a vibrant intellectual scene that was barely hinted at in her languishing homeland. In the West, she was introduced to the ideas of such innovative writers as Louis Aragon, Bertolt Brecht, and Federico Garcia Lorca, whose influences left their mark on her next book of verse, *Pedos smely* (Prints in the Sand). This 1931 collection of poems was hailed by critics and embraced by readers for being as melodious as it was passionate.

In 1931, Neris joined a left-wing artists' organization, The Third Front, some of whose members were sympathetic to Communism. To be thus affiliated in an anti-Marxist dictatorship entailed risks, but Neris felt that she had to take a stand, and began to publish poetry of social criticism in *Trecias frontas* (Third Front), the journal of her new circle of friends. She announced her break with the notion of art for art's sake, vowing: "From now on, I consciously oppose the exploiters of the working class and shall try to combine my work with the actions of the oppressed masses so that my future poetry will become a weapon in their struggle." She declared her sympathy with the revolutionary cause: "I am with those who are not afraid to swim in raging seas." Between 1931 and 1934, many of her verses appeared in the illegal newspapers and journals of the banned Lithuanian Communist Party.

Despite the sometimes dry, humorless ideological prose that Neris chose to use when expositing on her political ideals, she remained a productive artist throughout the 1930s. In her third collection of poems, *On Thin Ice* (1935), she portrayed the working people of Lithuania as they attempted to free themselves from poverty, ignorance, and oppression. Her next book, *Diemedziu zydesiu* (I Will Bloom Like the Wormwood), has been read by thousands of Lithuanians. For them, *diemedziu* (wormwood) symbolizes the continuous, eternal thread of life, and expresses one of the eternal motifs of poetry, the duel that goes on between life and death.

> Before I was born
> The lilac had blossomed
> And after I die
> It will bloom as before. . . .

In 1937, Salomeja Neris and her husband, sculptor Bernardas Bucas, settled in Lithuania's capital, Kaunas. Even though her views were abhorrent to the ruling elite, they had to concede that she was a poet of distinction, and her job as a teacher of Lithuanian literature in one of the capital's leading gymnasia, where she was adored by her students, gave her a degree of economic security that few writers had in the 1930s.

The late 1930s marked the rapid end of Lithuania's illusory period of independence as an independent Baltic state. In March 1939, Nazi Germany seized the port city of Memel (Klaipeda), a center through which passed annually three-quarters of Lithuania's exports and two thirds of its imports. In October, after Nazi Germany had defeated Poland in a Blitzkrieg that marked the first act of World War II, Lithuania was forced to sign a pact with the USSR granting the Soviets garrison privileges in the country. In return, Lithuania gained the city and district of Vilnius (Vilna), which had previously been part of Poland. In mid-July 1940, Lithuania's precariously retained independence ended when it was annexed by the Soviet Union, which on August 3 formally admitted it as the 14th constituent republic of the USSR. Although most Lithuanians despaired over these changes, Neris and her friends looked upon them as a dream come true. She wrote an adulatory "Poem to Stalin" and read it as a deputy to the Supreme Soviet of the USSR, at the session in which Lithuania was admitted to the Soviet Union. Not everything that flowed from Neris' pen in the fateful year of 1940 was as propaganda-laden, for she also published *Egle 'alciu karaliene* (Egle, Queen of the Snakes), a narrative poem derived from traditional folk motifs.

Neris had long feared a fascist attack, and it came suddenly in the early hours of June 22, 1941. She was evacuated along with her baby, first to Penza and Ufa, and then finally to Moscow. Neris now felt compelled to write poetry that would rally the people, and her poems became part of spirit of the new Soviet patriotism that Joseph Stalin, abandoning the dogma of Marxist internationalism, would use to win "the Great Patriotic War." With Leningrad besieged by Hitlerite hordes and with advance Nazi columns sighted in the Moscow suburbs, Neris vowed that "the fascist tanks will not pass." Although these words seem prosaic now, at the time they were resonant. Neris wrote simple yet eloquent war poems that spoke of the justness of the Soviet cause, the evil of fascism, and the certainty of final victory. These poems were published immediately, appearing in journals and newspapers not only in Lithuanian but in Russian and other lan-

Lithuanian postage stamp honoring Salomeja Neris.

guages of the Soviet federation. Her verse was circulated in the front-line Lithuanian units of the Red Army and also dropped by Red Air Force planes into Nazi-occupied Lithuania.

Although her health was precarious (she was described by Eduardas Miezelaitis, one of her former students, as "a fragile woman with a courageous heart"), Neris visited combat units as they departed for the front. On one such occasion, in autumn 1942, she read poetry to members of the 16th Lithuanian Infantry Division, which had assembled in Yasnaya Polyana prior to moving to the front. Facing the soldiers who stood in a semi-circle, she read her verse to them from on top of an army truck. Later that day, Neris and Miezelaitis paid a brief visit to the grave of Leo Tolstoy, whose headstone had been desecrated during the occupation of his home by the Nazi invaders. The gravesite had been temporarily restored by some of the Lithuanian troops, and the entire incident so moved Neris that she wrote "Yasnaya Polyana," in honor of the Soviets who had shed so much blood.

Soon after, news filtered back to her of the fierce battles into which the Lithuanian soldiers she had met in Yasnaya Polyana had been thrown. Many, and probably most, of those young men now lay dead on the battlefield. Neris was particularly shaken by one episode related by soldiers who had survived the carnage. After the battle, they had found the body of a dead soldier, his chest riddled with machine gun bullets. In the breast pocket of his tunic, against his heart, there was a blood-stained scrap of newspaper with verse by Neris:

> We love our country
> By deeds, not words. . . .

Although her wartime poetry was occasioned by the needs of the hour, much of it remains powerful. Writing evocative lyrical poetry was as natural for Neris as breathing, and thus even in works that are blatantly propagandistic, like the long poem *Bolseviko kelias* (The Path of the Bolshevik), the reader is struck by the juxtaposition between tender lyricism and "harsh, wooden Stalin-worshiping rhetoric." In 1943, with the war still raging, Neris published the book that many readers would later look upon as her artistic testament, the collection of poems and tales in verse entitled *Dainuok, sirdie, gyvenima* (Sing to Life, My Heart). Still a favorite in Lithuania is the poem that begins:

> Sing, my heart, sing without pause,
> Of life, and the sun, and the sky,
> Of the warm caress of the sandy path,
> And of clouds adrift on high.

Salomeja Neris' health collapsed in 1944, and although she was briefly able to return to Lithuania, she soon had to return to Moscow for medical attention. It was here that she died, greatly mourned by her friends and readers, on

July 7, 1945. Just before her death, her last collection of poetry, *Lakstingala negali neciulbeti* (The Nightingale Cannot Help But Sing), was published in recently liberated Kaunas. After her death, the fame of Salomeja Neris continued to grow. For her collection *My Land*, published in a Russian translation after her death, Neris was posthumously awarded a State Prize of the USSR in 1947. For her wartime efforts, she received the Order of the Great Patriotic War, First Class, and in 1954 was posthumously awarded the title of People's Poet of the Lithuanian Soviet Socialist Republic. She was also honored by being depicted on a Soviet 40-kopeck postage stamp issued on November 17, 1954. Because of her immense talent and the love of her land which permeates so much of her verse and transcended her political allegiances (and limitations), Salomeja Neris remains hugely popular in post-Soviet Lithuania.

SOURCES:

Anicas, Jonas. "'Kryziaus zygis' pries S. Neri," in *Literatura ir Menas*. November 17, 1984, p. 5.

Areska, Vitas. *Salomeja Neris*. Kaunas: Sviesa, 1974.

Wilma
Neruda

Bukauskiene, Terese. "Buti svyturiu: Salomejos Neries 75-osioms gimimo metinems," in *Literatura ir Menas*. Nos. 46–48, 1979, p. 16.

Issakovich, Valeria. "Talking with a Control Editor about Poetry (An Interview with Peter Tempest)," in *Soviet Literature*. No. 9, 1983, pp. 124–135.

Karvelis, Ugné. "Lithuanie: Une littérature écartelée," in *Europe: Revue mensuelle*. Vol. 70, no. 763–764. November–December 1992, pp. 122–128.

Kubilius, Vytautas. *Salomejos Neries lyrika*. Vilnius: Vaga, 1968.

Kuzmickas, Vincas. "S. Neris—A. Achmatovos lyrikos verteja," in Kostas Doveika, ed., *Lietuviu poetikos tyrinejimai*. Vilnius: Vaga, 1974, pp. 311–336.

Miezelaitis, Eduardas. "'Sing, My Heart,'" in *Soviet Literature*. No. 11, 1984, pp. 134–140.

Noreikene, S.J. "Sovetsko-Litovskie Kul'turnye Svyazi, 1920–1940 Godov" [Soviet-Lithuanian Cultural Contacts, 1920–1940], in *Voprosy Istorii*. No. 12, 1976, pp. 112–131.

Pazusis, Lionginas, and Rita Dapkus. *Songs of Life and Love: Five Lithuanian Poets*. Vilnius: Vaga, 1989.

Silbajoris, Rimvydas. "Neris, Salomeja," in Robert B. Pynsent and S.I. Kanikova, eds., *Reader's Encyclopedia of Eastern European Literature*. NY: HarperCollins, 1993, p. 282.

Slinkstiene, N. *Salomejos Neries memorialinis muziejus*. Vilnius: Mintis, 1974.

Venclova, Antanas. *Salomeja Neris (1904–1945): Poetes Biografijos Metmenys*. Brooklyn, NY: Isleido LLD Moteru Komitetas, 1947.

John Haag,
Associate Professor of History,
University of Georgia, Athens, Georgia

Neruda, Wilma (c. 1838–1911)

Czech violinist who was a well-known concert violinist and teacher. Name variations: Wilma Maria Franziska Neruda; Norman-Neruda; Lady Hallé. Born Vilemína Maria Franziska Neruda in Brünn, Moravia, on March 21, probably in 1838 (some sources cite 1839); died in Berlin, Germany, on April 15, 1911; daughter of Josef Neruda (an organist and teacher); sister of Amálie Nerudová (a pianist) and Viktor Neruda (a cellist); married Ludwig Norman (a Swedish conductor and composer), in 1864 (died 1885); married Sir Charles Hallé (German-born pianist and conductor), in 1888 (died 1895).

Born around 1838 into a family of distinguished violinists and musicians dating from the 17th century, Wilma Neruda played the violin before she walked. Her father, a professional violinist and organist, was her first teacher, and she later studied with Leopold Jansa. Wilma often played with her sister **Amálie Nerudová**, a pianist, and her brother Viktor Neruda, a cellist. When Wilma was nine, the children debuted in London, where critics called them a "remarkably clever trio." Although she was the

youngest, Wilma was the featured performer. A month later, she was engaged to play at the Philharmonic Society's Concert. Writing of the performance, William Bartholomew commented in a letter to a friend:

> A little girl, a child in years and person, but a perfect miniature Paganini, played last night to the Philharmonic audiences a concerto of de Bériot's on the violin. Her tone, her execution, especially with the bow hand, were all perfect—the latter is beautiful: her graceful and elastic wrist produced some of the most sparkling staccatos by up and down bowing that I have ever heard.

In 1864, when Wilma Neruda was 25, she was dubbed "The Queen of Violinists" in Paris and considered to be the female counterpart of Joseph Joachim, the famous violinist. Said Joachim, when he recommended her to conductor Charles Hallé for consideration, "Mark this, when people have given her a fair hearing, they will think more of her and less of me." In addition to her solo concert career, Neruda also played first violin with the London Philharmonic Quartet and with the Joachim Quartet.

In 1864, Neruda married Ludwig Norman, the Swedish Opera conductor, and became professor of violin at the Stockholm Royal Academy of Music. She left Norman in 1869 and lived in London, appearing in concerts with the Philharmonic Society and the Monday "Popular" series. After his death in 1885, she married Sir Charles Hallé in 1888 and was known as Lady Hallé. Neruda was a pioneer at a time when women violinists were still a relatively rare commodity; symphony orchestra positions were not yet open to women and they could play only in concert. She was among the first to enter a field dominated by men, and her undisputed talent enabled her to achieve great success.

SOURCES:
Campbell, Margaret. *The Great Violinists*. NY: Doubleday, 1981.

John Haag,
Athens, Georgia

Nesbit, Edith (1858–1924)

British novelist, poet, short-story writer and children's author. Name variations: E. Nesbit; (pseudonyms) Mrs. Hubert Bland, Edith Bland. Born on August 15 or 19, 1858, in London, England; died on May 4, 1924, at Jesson St. Mary's, New Romney, Kent, England; daughter of John Collis Nesbit and Sarah Nesbit; attended private schools in England, France, and Germany; married Hubert Bland (a journalist), in 1880 (died 1914); married Thomas Terry Tucker (a marine engineer), in 1917; children: (first marriage) Paul, Iris, Fabian; (adopted) Rosamund (Mrs. Clifford Sharp) and John.

Founded, with Bland, the socialist Fabian Society (1884); published first book (1885); published first children's book (1890).

Selected writings for children: The Story of the Treasure Seekers (1899); The Wouldbegoods (1901); The Five Children and It (1902); The Phoenix and the Carpet (1904); The New Treasure Seekers (1904); The Railway Children (1906, adapted to film, 1972); The Story of The Amulet (1906); The Enchanted Castle (1907); The House of Arden (1908); Harding's Luck (1909); The Magic City (1910); The Wonderful Garden (1911); Wet Magic (1913); Long Ago When I Was Young (1966).

Selected writings for adults: (with Hubert Bland and others) The Prophet's Mantle (1885); Lays and Legends (1886–92); Grim Tales (1893); The Secret of the Kyriels (1899); Thirteen Ways Home (1901); The Red House (1902); Ballads and Lyrics of Socialism 1883–1908 (1908); Fear (1910); Dormant (1911);

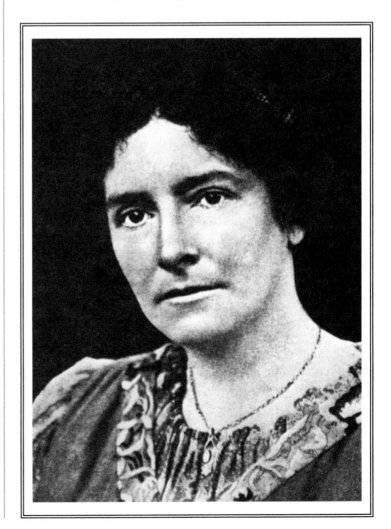

Edith Nesbit

Wings and the Child (1913); The Incredible Honeymoon (1916); The Lark (1922); Many Voices (1922); E. Nesbit's Tales of Terror (ed. Hugh Lamb, 1988).

A prolific British writer who wished to be known as a poet but instead gained fame for her children's books, Edith Nesbit wrote plays, poetry, verse, novels, and short stories for all ages. She is now known to adults mainly for her ghost stories, while her most popular and enduring children's books detail the adventures of the Bastable family in stories based roughly on both her memories of the big brood in which she had blossomed as a child as well as the large family she herself later had.

Nesbit, born in London in 1858, was a roguish tomboy as a child, the youngest of six brothers and sisters. Her father, who had headed up an agricultural college, died when she was three or four. She was sent to boarding school, and when her family later began traveling across France and Germany she was educated in convents, which she despised. (At an early age she displayed a marked dislike for Germany by writing a contemptuous couplet about it.) Through her older sister **Mary Nesbit** she met a number of the leading Pre-Raphaelites, including Dante Gabriel Rossetti, Algernon Swinburne, and William Morris, while she was still quite young. In 1872, her family settled into a country house in Kent, England, an environment which would echo throughout much of her work.

In 1876, Nesbit published her first story in the *Sunday Magazine*, and in 1880, seven months into a pregnancy, she married journalist Hubert Bland. Early in their marriage Bland was stricken with smallpox and his brush-making business floundered. Nesbit was forced to support the family, which she did primarily by publishing novels and articles, though on occasion also by writing and decorating greeting cards. For years afterward, she continued to earn most of the family income, occasionally in collaboration with Bland. They shared fervent socialist sympathies, and in 1884 their political activity led them to the formation, with some friends, of the Fabian Society. Hoping to further "the reconstruction of Society in accordance with the highest moral principles," the group advocated a gradual transformation of capitalist society through socialism and progressive reform; among its early members were *Annie Besant, George Bernard Shaw, Sidney and *Beatrice Webb (later the founders of the London School of Economics), Sidney Olivier, and H.G. Wells. An intellectual circle filled with enormously in-

fluential thinkers and writers, the Fabian Society, and the ideas it proposed, nurtured England's fledgling Labour Party and remains the oldest socialist organization in England. Nesbit's political beliefs also found expression in her 1908 collection of verse titled *Ballads and Lyrics of Socialism 1883–1908*.

Bland's infidelities were no secret, and Nesbit, who had three children during their marriage and also, it is believed, several affairs of her own, adopted two of his illegitimate children into their bustling household. She espoused such radical ideas as psychic research and dress reform, and the bohemian couple hobnobbed with prominent artists, writers, and politicians. Bland eventually began editing a magazine called *To-Day*, which published two of George Bernard Shaw's early novels. He and Nesbit, along with Shaw and some others, collaborated with H.G. Wells on the novel *The Prophet's Mantle* in 1885. (Wells, despite their friendship, rather harshly illustrated the couple's eccentric private life in his 1934 work, *Experiments in Autobiography*.)

Nesbit published her first book of poetry, *Lays and Legends*, in 1886, but it was only as she reached her 40s that she began to garner real success, and then not for her poems but for her children's stories. Her Bastable family series, which appeared first in magazines and then in book form, began in 1899, with *The Story of the Treasure Seekers*. With these stories, Nesbit created a new form of juvenile literature. Unlike most children's books of the day, her works sought to entertain rather than to moralize or educate, and her young characters were quite realistic. Her biographer **Doris Langley Moore** notes that Nesbit once commented, "When I was a little child I used to pray fervently, tearfully, that when I should be grown up I might never forget what I thought, felt, and suffered," and she appears to have succeeded. Other books about the Bastables were *The Wouldbegoods* (1901) and *The New Treasure Seekers* (1904). While she based these lifelike adventures in reality, with books like *The Five Children and It* (1902), *The Phoenix and the Carpet* (1904), and *The Enchanted Castle* (1907) she adopted the motifs of fantasy and time travel. Her much-beloved *The Railway Children* was published in 1906. As the Victorian age drew to a close, Nesbit's stories helped to influence new ideas and styles in children's literature.

In 1914, Bland died, and an exhausted Nesbit watched as World War I took its toll on the sales of her works. She was granted a civil-list pension in 1915 for her services to literature, and in 1917 she married engineer Thomas Tucker, a

widower and old friend. Now "peaceful and contented," she did not write much after the war. In 1922, she and Tucker moved to a bungalow in Kent. Nesbit fell ill the following year and died in May 1924. A number of her ghost stories, realistic except for the horrifying twist, continue to be reprinted in "best of" anthologies, including "Man-Size in Marble," "The Shadow," "The Mystery of the Semi-detached," and "John Charrington's Wedding." A good number of her children's books remain well loved and in print. In 1964 Gore Vidal, writing in *The New York Review of Books*, noted that "she [created] a world of magic and inverted logic . . . the child who reads her will never be quite the same again."

SOURCES:

Contemporary Authors. Vol. 137. Detroit, MI: Gale Research.

Drabble, Margaret, ed. *The Oxford Companion to English Literature.* 5th ed. Oxford and NY: Oxford University Press, 1985.

Kunitz, Stanley J., and Howard Haycraft, eds. *Twentieth Century Authors.* NY: H.W. Wilson, 1942.

Schlueter, Paul, and June Schlueter, eds. *Encyclopedia of British Women Writers.* NY: Garland, 1988.

Uglow, Jennifer S., ed. *The Continuum Dictionary of Women's Biography.* 2nd ed. NY: Continuum, 1989.

Vidal, Gore. *The New York Review of Books.* 1964.

SUGGESTED READING:

Briggs, Julia. *A Woman of Passion: The Life of Edith Nesbit, 1858–1924.* New Amsterdam, 1991.

Moore, Dorothy Langley. *E. Nesbit: A Biography.* Rev. ed. Chilton, 1966.

RELATED MEDIA:

The Railway Children (102-min. film), starring *Dinah Sheridan*, Bernard Cribbens, William Mervyn, and Jenny Agutter, 1972.

<div align="right">

Jacquie Maurice,
Calgary, Alberta, Canada

</div>

Nesbit, Evelyn (1884–1967)

American model-actress who became part of a sensational scandal when her ex-lover, architect Stanford White, was murdered by her millionaire husband. Name variations: Evelyn Nesbit Thaw; Mrs. Harry Thaw; Florence Evelyn Nesbit. Born Florence Evelyn Nesbit on December 25, 1884, in Tarentum, Pennsylvania; died on January 17, 1967, in Santa Monica, California; only daughter and one of two children of Winfield Scott (a lawyer) and Elizabeth Nesbit; attended elementary school in Philadelphia, Pennsylvania; did not receive high school diploma; married Harry Kendall Thaw (a millionaire), in 1905 (divorced 1916); married performer Jack Clifford (divorced 1919); children: (first marriage) one son, Russell Thaw.

Although Evelyn Nesbit was a woman of considerable accomplishments (biographer **Paula Uruburu** calls her America's "first supermodel"), she is remembered primarily in association with the revenge murder of nationally renowned architect Stanford White, who was shot to death by Harry K. Thaw, the heir to a Pennsylvania railroad fortune and Nesbit's husband from 1905. The killing, which occurred on the evening of June 25, 1906, at the roof-top theater at Madison Square Garden (ironically, a building designed by White), dominated newspapers for weeks and resulted in two sensational trials at which Nesbit was a star witness. Thaw was eventually incarcerated in a mental institution, where he remained until 1922. Nesbit, her reputation sullied, struggled unsuccessfully to reignite her career and get her life back on track. "Stanny White was killed," she once said, "but my fate was worse. I lived."

Auburn-haired Nesbit was already a beauty at 15, when she arrived in New York from Pittsburgh with her widowed mother. She had no trouble finding work in the city, coming quickly to the attention of such renowned photographers

Evelyn Nesbit

and artists as Carroll Beckwith, Frederick Church, and Herbert Morgan, and posing for some of the numerous advertisements which had just begun to appear in newspapers at the turn of the century. As her career blossomed, she served as the model for George Grey Bernard's famous sculpture *Innocence* (now in the Metropolitan Museum of Art), and for the Charles Gibson sketch "The Eternal Question," which first appeared in *Collier's* magazine. In 1901, Nesbit won a role in the popular British import *Floradora*, at which time she caught the eye of the dashing and successful architect Stanford White, whose penchant for much younger women was already well established. White pursued Nesbit with abandon, buying her expensive gifts, paying for singing lessons, and establishing her and her mother in an elegant New York apartment hotel. Despite the fact that White was 48 and married, Nesbit, with the blessings of her mother, became his mistress. Stories abound about White's sexual proclivities. In one of his several Manhattan apartments, he had installed a red-velvet swing, which Nesbit made use of while naked. "Don't forget, I was only 16 and I enjoyed swinging," she told a reporter some years later.

After a year, however, with no proposal from White, Nesbit began casting about for a husband, although this may have been at her mother's instigation. "I think her mother realized that she had a beautiful daughter," suggests Uruburu, "and was just dangling her out there hoping to attract the man with the most money." Enter "mad Harry" Thaw, the spoiled heir to a $40 million railroad fortune, who was even more flamboyant and dangerous than White. Known for his outrageous behavior (he once tried to ride his horse in the lobby of the ritzy Union Club), he plied Nesbit with roses wrapped in $50 bills. Despite his reputation, and her own uneasy feeling that he was "a mighty peculiar person," Nesbit was attracted to his money. "I was so sorry for him," she said later. "And . . . we'd been so terribly poor." While Thaw professed undying love for Nesbit, his jealousy and disdain for White dominated their relationship, and Nesbit frequently fell victim to his emotional and physical abuse.

In the midst of her busy social life, Nesbit continued to pursue the theater, appearing in several ill-fated musicals, including *The Wild Rose*, *Tommy Rot*, and *The Girl from Dixie*. In 1905, however, she abandoned her career and married Thaw, believing it might be her last chance at a rich husband. They settled in the Thaw family estate in Pittsburgh ("Lyndhurst"), but traveled often to various cities in the United States and abroad. Thaw remained obsessed with Nesbit's past affair with White and apparently dreamed of revenge. He got his chance in June 1906, on a visit to New York, when he and Evelyn attended the premiere of the musical *Mamzell Champagne*, at Madison Square Garden's roof-top theater. Sitting at another table was Stanford White. Toward the end of the show, Thaw approached White's table and pumped three bullets into the architect's head, killing him instantly.

Throughout the media circus that preceded Thaw's first trial, Nesbit remained loyal to her husband. Her sensational testimony, carefully orchestrated by California defense lawyer Delphin Delmas (hired by Thaw's mother), chronicled her youthful seduction by White and was instrumental in deadlocking the jury. At a second trial the following year, however, Thaw was found not guilty by reason of temporary insanity and sent away to the New York Asylum for the Criminally Insane at Matteawan, New York. During the early years of his incarceration, Nesbit's relationship with him and his family deteriorated, and she was left on her own. (Thaw divorced Nesbit in 1916, disavowing paternity of a boy, Russell, whom she had given birth to while he was confined.)

As Nesbit's source of income dried up, she was forced to return to her career. In 1913, she traveled to Europe to appear in the musical *Hello Ragtime*, with Jack Clifford, whom she married in 1916 after her divorce from Thaw. The marriage floundered, as did Nesbit's career, and she was plagued by drug problems. Some later business ventures, including several speakeasies, never got off the ground, and in 1922 she tried unsuccessfully to end her life by taking poison; a second attempt four years later also failed.

During the 1930s, Nesbit made a bit of a comeback in burlesque and cabaret, but by the end of the decade she was forced to live with her son in Hollywood. Work came her way again in 1955, when she served as a consultant on the film version of *The Girl in the Red Velvet Swing*, based on her affair with White, whom she looked back on as "the most wonderful man I ever knew." She found some contentment in her final years, teaching sculpture and painting, and enjoying her three grandchildren. She died in Santa Monica, California, on January 17, 1967. Two autobiographies chronicle Nesbit's life: *The Story of My Life* (1914) and *Prodigal Days* (1934).

SOURCES:

Garraty, John A., and Mark C. Carnes, eds. *American National Biography*. Vol. 16. Oxford, England: Oxford University Press, 1999.

Kohn, George C. *Encyclopedia of American Scandal.* NY and Oxford: Facts On File, 1989.

"Stanford White & Evelyn Nesbit," in *People Weekly.* February 12, 1996.

RELATED MEDIA:

The Girl in the Red Velvet Swing (109 min. film), starring Ray Milland, **Joan Collins**, Farley Granger, and *Cornelia Otis Skinner, directed by Richard Fleischer, Twentieth Century-Fox, 1955.

<div align="right">

Barbara Morgan,
Melrose, Massachusetts
</div>

Nesbitt, Cathleen (1888–1982)

British-born actress. Born Cathleen Mary Nesbitt on November 24, 1888, in Cheshire, England; died on August 2, 1982, at her home in London; only daughter and one of the four children of Thomas Nesbitt (a captain in the Royal Navy) and Mary Catherine (Parry) Nesbitt; Queen's University, Belfast, Ireland, B.A.; also studied at Lisieux and at the Sorbonne, Paris; married Cecil Beresford Ramage (a lawyer), in November 1922; children: son Mark and daughter Jennifer.

Selected theater: made London debut as Angele in The Cabinet Minister *(1910); joined the Irish Players (1911); made New York debut as Molly Byrne in* The Well of the Saints *(with the Irish Players, December 1911); appeared as Deirdre in* Deirdre of the Sorrows *(London, 1913),* Phoebe Throssell *in* Quality Street *(London, 1913), in the title role in* Duchess of Malfi *(1919), as Belvidera in* Venice Preserv'd *(1920),* Mona *in* Spring Cleaning *(1925),* Margaret Fairfield *in* A Bill of Divorcement *(1929),* Katherina *in* The Taming of the Shrew *(1935),* Thérèse Raquin *in* Thou Shalt Not . . . *(1938),* Queen Gertrude *in* Hamlet, Queen of France *in* Henry V, *and* Lady Loddon *in* Libel *(all on tour with the Old Vic, 1939),* Goneril *in* King Lear *(1940),* Julia Shuttlethwaite *in* The Cocktail Party *(New York, 1950),* Countess Gemini *in* Portrait of a Lady *(1954),* Mrs. Higgins *in* My Fair Lady *(New York, 1956), the* Grand Duchess *in* The Sleeping Prince *(New York, 1956),* Lady Headleigh *in* The Claimant *(London, 1964),* Madame Voynitsky *in* Uncle Vanya *(New York, 1973).*

Selected filmography: The Frightened Lady *(Criminal at Large, 1932);* The Passing of the Third Floor Back *(1935);* The Beloved Vagabond *(1936);* Gaslight *(Angel Street, 1940);* Fanny by Gaslight *(Man of Evil, 1940);* The Agitator *(1945);* Jassy *(1947);* Nicholas Nickleby *(1947);* Madness of the Heart *(1949);* So Long at the Fair *(1950);* Three Coins in the Fountain *(1954);* Black Widow *(1954);* Desiree *(1954);* An Affair to Remember *(1957);* Separate Tables *(1958);* The Parent Trap *(1961);* Promise Her Anything *(1966);* The Trygon Factor *(1967);* Staircase *(1969);* Villain *(1971);* French Connection II *(1975);* Family Plot *(1976);* Full Circle *(1977);* Julia *(1977).*

In a career that spanned seven decades, British-born actress Cathleen Nesbitt delighted audiences in England and America in hundreds of plays, ranging from the classics to musicals, and including both serious and comic roles. She played with the prestigious Irish Players, the Abbey Theater, and the Old Vic, and appeared in films and on American television. Blessed with a strong constitution that allowed her to work well past retirement age, Nesbitt reprised her role as Mrs. Higgins in a revival of *My Fair Lady* when she was in her 90s.

Nesbitt was born in 1888 in Cheshire, England, the only girl in a family of boys. (One of her brothers, Thomas Nesbitt, was also an actor; her other two brothers would be killed during World War I.) Nesbitt was well educated, receiving her B.A. at Queen's University in Belfast and also studying at the Sorbonne in Paris. She was encouraged in her dramatic studies by both *Sarah Bernhardt and by the Irish playwright Lady *Augusta Gregory, who invited her to join the Irish Players not long after Nesbitt had made her London debut in *The Cabinet Minister* (1910). It was with the Irish Players that Nesbitt first came to New York, debuting on Broadway as Molly Byrne in *The Well of the Saints* (1911). She also appeared in the American première of John Millington Synge's bitter Irish comedy *The Playboy of the Western World* (1911), during which a group of Irish patriots rioted, hurling fruits and vegetables at the actors.

Returning to Dublin, Nesbitt enjoyed a busy but less violent stint with the Abbey Theater, and in 1913 acted six leading roles on the London stage, including Deirdre in *Deirdre of the Sorrows* and Phoebe Throssell in *Quality Street*. In 1916, she was back on Broadway playing Ruth Honeywill in *Justice*, opposite John Barrymore, one of her most successful roles.

During World War I, Nesbitt served as a censor and an interpreter while continuing to perform. Following a crammed 1917–18 theatrical season in London, she toured the United States in *General Post*, then returned to Broadway to appear in *The Saving Grace*. Her career continued to hum along during the decades of the 1920s and 1930s, although following her marriage to lawyer Cecil Beresford Ramage in 1922, and the arrival of two children, her appearances in America tapered off.

After an absence of over 20 years, Nesbitt returned to Broadway in 1950, in T.S. Eliot's verse

drama *The Cocktail Party*. While the critics found her portrayal of the meddlesome guest Julia Shuttlethwaite delightful, Nesbitt told interviewers that she did not understand the character at all, a confidence she also shared with the playwright. Always gracious, however, she was quick to add that she enjoyed the role "as a technical exercise." Nesbitt stayed on in New York for the 1951–52 season, playing the worldly-wise great-aunt in *Gigi* (1951), opposite **Audrey Hepburn*, and the Long Island society matron in *Sabrina Fair*, with **Margaret Sullavan* and Joseph Cotten. Her performance garnered more praise from *The New York Times'* critic, Brooks Atkinson: "Cathleen Nesbitt plays the rich mother of the Larrabee boys with a graciousness that is never formal and a humor that is kindly and urbane."

In the winter of 1954, Nesbitt played the acerbic Countess Gemini in the ill-fated *Portrait of a Lady*, William Archibald's dramatization of the Henry James novel. "Whenever Miss Nesbitt . . . appeared, the play suddenly came to unexpected, though brief life," wrote Richard Watts, Jr. in the *New York Post*. Walter Kerr of the *Herald Tribune* also credited Nesbitt with providing the play's high points, calling her "the only performer to bring any sense of wit, or of pointed social meaning, to the well-intentioned venture." Nesbitt enjoyed a longer run when she joined the cast of *My Fair Lady* (1956) as Professor Higgins' mother, a role that Atkinson noted she carried off with "grace and elegance," words frequently used to characterize the actress herself.

Cathleen Nesbitt made occasional appearances in both British and English films, beginning in 1932 with a role in *The Frightened Lady* (*Criminal at Large*). She also appeared on television, receiving particular acclaim for her performances in two original plays: "The Primary Colors" on "Goodyear Playhouse" and "Sister" on the "Alcoa Hour," both in 1956. Later, she appeared on "The Farmer's Daughter" and "Upstairs, Downstairs." In her later years, Nesbitt wrote an autobiography, *A Little Love and Good Companions*, published in 1973. The actress died in 1982.

SOURCES:

Current Biography. NY: H.W. Wilson, 1956.

Hartnoll, Phyllis, and Peter Found. *The Concise Oxford Companion to the Theater*. Oxford: Oxford University Press, 1993.

Katz, Ephraim. *The Film Encyclopedia*. NY: Harper-Collins, 1994.

Barbara Morgan,
Melrose, Massachusetts

Nesbitt, Louisa Cranstoun (1812–1858).

See Nisbett, Louisa Cranstoun.

Nesmith, Bette Clair (1924–1980).

See Graham, Bette Nesmith.

Nessim, Barbara (1939—)

American painter and illustrator. Born on March 30, 1939, in New York City; graduated from the High School of Industrial Arts (now called High School of Art and Design), 1956; Pratt Institute, New York, B.F.A., 1960; studied painting at the Art Students League; married in 1980.

Influenced by her clothing-designer mother, illustrator and painter Barbara Nessim knew from an early age that she wanted to be an artist. In the seventh grade, she was enrolled in an art class for gifted students, and in the ninth grade she broke her leg and could not attend school, so she pursued her art training at home. "I had some instruction that included three hours of regular education and three hours of art a week. . . . I learned how to learn," Nessim later explained in an interview. "During that time I had a teacher, **June Howard Mahl**, who taught me the basics of art, like working with black and white and gray. . . . I learned stippling, drawing from what was in your pocketbook, and how to break down shapes and forms. That's what really got me focused." At Mahl's suggestion, she later attended the High School of Industrial Art, where she took as many art courses as academics.

Graduating in 1956, Nessim enrolled at Pratt Institute, in Brooklyn, New York, where she studied illustration and painting under Fritz Eichenberg, Jacob Landau, and Richard Lindner. She then won a scholarship to a summer program at Pratt Graphic Center, where she was a student of Michel Ponce de Leon. Here, Nessim began producing a new kind of linear etchings with applied local color ("monotype etchings," she called them), which were indicative of her penchant for bending the "rules." Nessim credits her friend and teacher Bob Weaver with helping her relate her art to her thoughts. He went through her sketchbooks with her, page by page, helping her to understanding exactly what she was doing. "I was tracking my thoughts," she said later. "I was doing my work as a subconscious effort, and it was coming out as a conscious thing. There were certain things in my books that were very narrative, were explaining my life to me. Certain feelings that I had about looking at the world through a man's eyes, or how women and men related to each other."

Nessim's off-beat outline technique and often grotesque imagery hardly conformed to the

requisites of commercial art at the time, and so she had trouble finding illustrating jobs. "I was too weird for regular magazines; I was too strange," she recalled. (Henry Wolf was one exception, using her work occasionally for *Show* magazine.) Most of her early assignments were with *Playboy*-type magazines, and even they were infrequent. To supplement her income, she also worked as a textile designer, doing plaids, stripes, and colorings. After three years, upon the advice of friends who insisted she was more of a fine artist than an illustrator, she began painting, recording on canvas the same themes of female imagery and women's relationship to the world that had driven her drawings and prints.

Eight years after graduation, Nessim was still having trouble finding work as an illustrator, even though her paintings were winning awards and her work was influencing other artists. But although she tried to bend her hard-edge vision into something more acceptable, her illustrations simply did not complement story-telling in the usual way. "Even though I thought of my work as narrative, it's only in a very subconscious way. It's not narrative as in 'now I'm going to tell you a story,' but it twists and turns and bends." Around this time, Nessim became friendly with art director Uli Boege, who was also an artist. He taught her how to translate her personal symbols into pictures that would better represent a story; he also showed her how to subtly alter her style so that art directors and editors could better relate to it. Although it was a frustrating experience, Nessim learned to control and change the symbols in her work to make them more understandable to the reader. By the early 1970s, she was working for *New York* magazine, and her success accelerated throughout the decade, partly due to the advent of *Ms.* magazine and the women's movement, which, according to Nessim, is what she is all about. From that time on, her work has appeared in most of the major magazines,

From 1967, Nessim has combined teaching with her other work, holding positions at the School for Visual Arts, Pratt Institute, and Parsons School of Design. "I teach the basics of illustration," she says, "how to get a concept. I also teach a little bit about business. I try to demystify this hocus-pocus." In 1980, Nessim also became involved in computer art, which she uses in conjunction with her other work, not as a replacement. "It's a tool and a medium all in one, which is historic," she says. "It responds to you. You can make a 'family tree' off of your original work. I coined that phrase because I can't think of anything more appropriate—you're branch-

ing off the original and after many stages, you still have that original image intact."

SOURCES:

Falk, Peter Hasting, ed. *Who Was Who in American Art 1564–1975*. Vol. II. Madison, CT: Sound View Press, 1999.

Heller, Steven, ed. *Innovators of American Illustration*. NY: Van Nostrand Reinhold, 1986.

Barbara Morgan,
Melrose, Massachusetts

Nesta.

Variant of Agnes.

Nesta Tewdr (fl. 1090)

*Mistress of Henry I. Name variations: Nesta Tewdwr. Flourished around 1090; daughter of *Gladys* and Rhys ap Tewdr or Tewdwr (Tudor), king of Deheubarth; mistress of Henry I, king of England (r. 1068–1135); children: Robert (c. 1090–1147), 1st earl of Gloucester.*

Nestor, Agnes (1880–1948)

American trade unionist and labor reformer. Born Agnes McEwen Nestor in Grand Rapids, Michigan, on June 24, 1880; died in Chicago, Illinois, on December 28, 1948; one of four children of Thomas Nestor and Anna (McEwen) Nestor; attended public and parochial schools in Grand Rapids through the eighth grade; never married; no children.

Awarded honorary Doctor of Laws degree from Loyola University (1929); was vice-president, International Glove Workers Union (IGWU, 1903–06 and 1915–38); served as secretary-treasurer, IGWU (1906–13); was general president, IGWU (1913–15); was director of research and education, IGWU (1938–48); was a member of the National Women's Trade Union League (WTUL) executive board (1907–48); served as president, Chicago WTUL (1913–48); was a member, National Committee on Federal Aid to Education (1914), Woman's Committee of the United States Council of National Defense (1918), Illinois Commission on Unemployment and Relief (early 1930s), and Illinois Minimum Wage Law Advisory Board (1935). Publications: several articles and an autobiography, Woman's Labor Leader *(1954).*

When Agnes Nestor began working in Chicago's Eisendrath Glove Factory, she was a frail-looking 17-year-old. Frequently ill, Nestor was soon moved by the exploitative conditions of her industry to lead her fellow women workers out on a ten-day strike in 1898. Under her

leadership, the strike was successful. No longer would the workers have to pay "machine rent" to their employer, and the union was recognized. Four years later, in 1902, Nestor was a delegate to the founding convention of the International Glove Workers Union. She would serve the IGWU in a variety of leadership positions the rest of her life.

Agnes Nestor joined the Women's Trade Union League (WTUL) in 1906. The WTUL was a cross-class alliance of women interested in bringing trade unionism and education to working-class women, as well as an advocate of legislation protecting working women. Nestor was one of the few working-class women who rose to prominence within the WTUL. In 1907, she joined the national executive board and in 1913 she became president of the Chicago branch. She would hold both positions until her death in 1948. Although she saw trade unionism as the best protection for all workers, Nestor recognized that for a variety of reasons fewer women than men joined unions. Therefore, she was also an advocate of protective labor legislation which would improve the conditions of labor for women regardless of their union status.

In 1909, at the request of national WTUL president ◀❧ **Margaret Dreier Robins**, Nestor testified before the Illinois legislature on the need for restriction of hours for women in industry. An impassioned speaker, Nestor testified that her own poor health was the direct result of working twelve or more hours a day, six days a week. In 1909, the Ten-Hour bill became law in Illinois, in large part due to the efforts of Agnes Nestor. Two years later, she won the fight to have the bill extended to cover women in retail and clerical work as well as in manufacturing. Nonetheless, the Ten-Hour bill was itself a compromise, as Nestor and other supporters had originally asked for an eight-hour day. The eight-hour day would not become law in Illinois until 1937 and once again Nestor played a key role in seeing that legislation to passage. Small in stature (5' tall) with delicate features, Nestor would be referred to as a "factory girl" even as a grown woman. She was at the same time recog-

❧▶
Robins,
Margaret Dreier.
See Dreier
Sisters.

*𝒜***gnes**
*𝒩***estor**

nized as a tireless advocate for the improvement of working conditions for women.

SOURCES:

Conn, Sandra. "Three Talents: Robins, Nestor, and Anderson of the Chicago Women's Trade Union League," in *Chicago History.* No. 9, 1980–1981, pp. 234–247.

Nestor, Agnes. *Woman's Labor Leader.* Rockford, IL: Bellevue Books, 1954.

COLLECTIONS:

Agnes Nestor Papers, Chicago Historical Society.

The National Women's Trade Union League papers, Library of Congress.

Kathleen Banks Nutter,
Manuscripts Processor at the Sophia Smith Collection,
Smith College, Northampton, Massachusetts

Netherlands, governor-general of the.

See Margaret of Parma (1522–1586).

See Maria Christina (1742–1798).

Netherlands, queen of the.

See Frederica Wilhelmina of Prussia (1774–1837).

See Anna Pavlovna (1795–1865).

See Sophia of Wurttemberg (1818–1877).

See Wilhelmina for sidebar on Emma of Waldeck (1858–1934).

See Wilhelmina (1880–1962).

See Wilhelmina for sidebar on Juliana (b. 1909).

See Wilhelmina for sidebar on Beatrix (b. 1938).

Netherlands, regent of the.

See Margaret of Austria (1480–1530).

See Mary of Hungary (1505–1558).

Netherlands, stadholder of the.

See Maria Elisabeth (1680–1741).

Nethersole, Olga (1863–1951)

English actress. Name variations: Olga Isabel Nethersole. Born in Kensington, England, on January 18, 1863 (some sources cite 1866 or 1870); died on January 9, 1951; daughter of Henry Nethersole (a solicitor); educated in London and on the Continent.

An English actress of Spanish descent, Olga Nethersole was born in London in 1863 and made her stage debut at Brighton in 1887 as Lettice Vane in *Harvest.* From 1888 to 1894, she played important parts in London under John Hare at the Garrick, successfully opening as Janet Preece in Pinero's *The Profligate.* In 1894, she joined the management of the Court Theatre. She also toured in Australia and America, playing leading parts in modern plays, notably as Fanny Legrand in Clyde Fitch's stage version of *Sapho.* Based on an 1884 novel by French writer Alphonse Daudet about an "immoral" woman who takes numerous lovers, the play sparked an uproar when Nethersole brought it to New York City in 1900. Particularly offensive to respectable sensibilities was the fact that the play ended not with the downfall or death (à la *Camille*) of the heroine, which would have been appropriate retribution for her wicked ways, but with her alive and well and exiting the stage with a lover, presumably on their way to a bedroom. The New York Society for the Suppression of Vice was outraged, and Nethersole was hauled into court and charged with "violating public decency." During the weeks of her trial, the story was fodder for newspapers across the country, and the public was on her side. One of the witnesses called to testify was a police officer who informed the court that he had seen the play half a dozen times, "in the line of duty," and had not been the slightest bit offended. The jury acquitted Nethersole in 15 minutes, and audiences clamored to see her when she went back on stage in *Sapho.* The play was also produced in London in 1902. It was not media hype but her powerful acting, however, that made a strong impression in a number of other plays, including *Carmen,* in which she again appeared in America in 1906. Nethersole was created a Commander of the British Empire (CBE) in recognition of her acting skills.

Neuber, Caroline (1697–1760)

German actress and theater manager who played a crucial role in initiating sweeping reforms on the German stage. Name variations: Frederika Neuber; Friederike Caroline Neuber; Friedericke Karoline Neuber; Carolina Neuber; "die Neuberin." Born Friederike Caroline Weissenborn on March 9, 1697, in Reichenbach, Vogtland, Saxony; died destitute in Laubegast near Dresden on the night of November 29–30, 1760; daughter of Daniel Weissenborn and Anna Rosina Weissenborn; married Johann Neuber (1697–1759); no children.

Was the leader (Prinzipalin) of the most important troupe of traveling players in Germany (1720s–30s); raised the standards of theater by abolishing improvisation and introducing tragic drama into the repertory; though initially successful, spent final years in obscurity; today "die Neuberin" is universally honored as a towering figure in the history of the German theater.

Germany, or more properly "the Germanies," was a region of Central Europe that found itself

devastated when the Thirty Years' War finally ended in 1648. In some areas, as much as one-third of the population had died of starvation and disease. Economically and culturally, the region would take generations to recover. This was a time that witnessed the flourishing of baroque drama in Spain and the onset of France's great era of *tragédie classique*, while in Italy and elsewhere audiences were being drawn to the *Commedia dell'arte*. Even warfare and its aftermath had not ended theatrical life in German-speaking areas, and everywhere jesters and strolling players followed in the train of armies. When a truce or lasting peace arrived, these acting troupes could always be certain of a welcome in towns and villages yearning for a few hours of escape. At aristocratic courts, and in urban marketplaces or fairgrounds, or even in village inns, actors and comedians found appreciative audiences. With few exceptions, these "plays" were crude affairs, knockabout farces and improvisations full of scatological language and primitive physical humor.

The brutal nature of most people's lives during this period was reflected on the stage, which was filled with such coarse characters as Bernardon or Kasperl, all of them loosely based on the somewhat more refined Harlequin figure of the *Commedia dell'arte*. Since audiences howled with delight over these stage antics, and were willing to part with their precious copper coins to see them, actors and theater directors in the many wandering German troupes had little incentive to upgrade their material. More often than not, these strolling players (*Komödianten*) presented the perennially popular *Haupt- und Staatsaktion*. These were slapdash, partially improvised spectacles in which historical events were reenacted, customarily interspersed with comic scenes invariably dominated by the vulgar Hanswurst. By the first decades of the 18th century, a small group of German actors and intellectuals had become disgusted and began to embark on a crusade for change.

Caroline Neuber, who was to play a key role in the reform of the German stage, was born Friederike Caroline Weissenborn in 1697, in Reichenbach in the Vogtland region of Saxony. She grew up in the town of Zwickau in comfortable material circumstances, her father Daniel being a judge and lawyer. He was also a tyrant, refusing to make any concessions to his intelligent, strong-willed daughter. At the same time, he believed that she should receive a substantial humanistic education, which in future years proved to be an invaluable asset to her. Neuber was determined to assert herself, which led to further abusive behavior by her father. When she attempted to escape

with her lover Gottfried Zorn, one of her father's law clerks, Daniel had his disobedient daughter arrested, and for a period of 13 months (May 1712–June 1713) she was held in prison. After her release, her home environment remained turbulent, and in 1717 Neuber was finally able to flee an intolerable situation. She ran off with Johann Neuber, a Latin student of humble origins (he was born into a peasant family in a nearby village). The penniless couple wanted above all else to escape from Zwickau, and this was accomplished when, while in the town of Weissenfels, they became members of the touring theater troupe led by Christian Spiegelberg.

In 1718, while their troupe was performing in Braunschweig, Caroline and Johann were married. Neuber displayed leadership from the start of her stage career, becoming de facto director of the Spiegelberg troupe as early as 1720. Sometime soon after, the couple joined another, better known, theatrical troupe, the Elenson-Haak Ensemble. Over the next few years, Neuber's dramatic talents would blossom as she became one of the troupe's most respected players. In 1727, the Neubers took over the direction of the Elenson-Haak troupe, and over the next few years were able to improve its artistic quality significantly, to the point that it received official recognition in the form of patents and privileges from a number of territorial rulers in North and Eastern Germany. Thus, by the mid-1730s Caroline Neuber could, if she so wished, describe herself with a Baroque flourish as director of the Royal Polish and Electoral Saxon (*Polen-Kursachsen*) Comedians, as well as the Principal (*Prinzipalin*) of the High-Princely Brunswick-Lünenburg-Wolfenbüttel German Court Players (*Komödianten*). Her troupe would be awarded a similar title in Schleswig-Holstein as well.

Despite these successes, Neuber remained dissatisfied with the state of German theater. The very survival of her troupe was precarious at best, for they had to be on the move much of the year, performing in Leipzig during the great Fairs, and then traveling to the lesser towns and aristocratic courts when audiences dried up in the few large cities. During these travels, the company was dependent on the largesse of the rich, and the success of Neuber's entertainments often hinged on her skill at ingratiating herself with the various lesser officials of the households of the local courts where she wished her company to perform. Often, food was scarce and accommodations primitive.

For want of better material, her troupe was usually forced to perform the popular and well-

DEUTSCHE BUNDESPOST
Medea
30
CAROLINE NEUBER
1697-1760
1975

DDR 50
*1697
F.C.Neuber
STAUF BITZER

German postage stamps honoring Caroline Neuber.

entrenched *Haupt- und Staatsaktionen,* which amused audiences with bloody tales of martyrdom, murder, and warfare. Unsophisticated audiences screamed with delight when stereotyped heroes and heroines appeared on stage, backed by tricks and wonders, that included devils, storms, and fire-spouting dragons. Plots barely existed, while history and myth jostled one another with a sublime disregard for either logic or plausibility. The main attractions were preceded and followed by farces and stage spectacles which were little more than buffoonery and noisemaking.

Actors led marginal lives. Generally regarded by solid burghers as outcasts from society, players were usually equated with Gypsies (Roma) and vagabonds. Actresses were universally regarded as females of low or no virtue. Neuber, determined to change this situation, resolved that her theater company would have as good a reputation offstage as on. She saw to it that young unmarried actresses lived in her house or under her maternal chaperonage. When they were not on stage acting or rehearsing, the ac-

tresses gathered in Neuber's sitting room to sew their costumes, chatting and gossiping—all under the watchful eye of "die Neuberin." Young male actors also boarded with Neuber, thus being kept away from local taverns and gambling dens. They, too, ate at her table and helped out with the countless details of managing a theater, which included the preparation of playbills, the painting of scenery, and so on.

By the late 1720s, Neuber had met Johann Christoph Gottsched (1700–1766), a professor at the University of Leipzig, who was intent on reforming German literature and drama from the ground up. The alliance they forged was to be of crucial significance not only for her own future, but for theater in Germany. She worked closely with Gottsched to improve the quality of the plays staged by her troupe, as well as the quality of their presentation. She insisted that her actors commit their lines to memory, speak them with accuracy, and give proper emphasis to measure and rhythm. Amazingly, this was the first time in the history of the German theater that what took place on stage had been worked out in such de-

tail. She also grouped actors for the best possible effect, crafting crowd scenes designed to elicit powerful responses from the audience.

From the start of their informal partnership, Gottsched and Neuber respected each other's talents. It was from Gottsched, writing in October 1725 in his "moral weekly" *Die vernünftigen Tadlerinnen* (The Reasonable Fault-Finding Ladies), that Neuber's acting ability received its first enthusiastic review, indeed its first review ever. In 1731, he entrusted his play *Der sterbende Cato* (The Dying Cato) to the Neuber troupe. Announced to the Leipzig public as being nothing less than "the first original tragedy in German," the play was in fact a dry-as-dust academic hodgepodge, the pedantic Gottsched's rearrangement of parts taken from Deschamps and mixed with an adaptation of Addison's tragedy. The Swiss art critic Johann Jakob Bodmer's assessment of Gottsched that he had "manufactured his plays with scissors and paste" was essentially on target, but this mattered little when Neuber staged *Der sterbende Cato*.

Playing the role of Portia, Neuber was able to breathe life into the script, and the play was a great success with the Leipzig public. Ever the purist, Gottsched was disappointed that his play had not been presented in Roman costumes, but Neuber knew she had to respond to public tastes and expectations, and she recognized that if Gottsched's play, lacking in dramatic power, were presented "straight," it could easily have become tedious. She overcame this by transforming his pseudo-classicist treatise into an evening of entertaining, exciting theater. Generally acknowledged to be a brilliant comic actress, Neuber was able to inspire her actors with much of the stage presence and vitality that she possessed.

Caroline Neuber was in agreement with Gottsched on the necessity of taking up the battle against the ubiquitous Hanswurst. It was Martin Luther who had introduced him into the written language, noting that the name should be generally applied to "coarse, boorish persons who pretend to be wise, and yet speak in an unreasonable and clumsy way." Although the character of Hanswurst had been around for centuries, embedded in German culture, on the stage his classic portrayer was the puppet player Josef Anton Stranitzky, who in the early 1700s created the modern figure of Hanswurst. Audiences loved his bawdy irreverence as he appeared in *Haupt- und Staatsaktionen*, delivering his off-color commentaries on the lifestyles of the rich and famous.

In 1737, a decade after Neuber and Gottsched had embarked on their joint campaign, she felt ready to engage in a final battle with the primary symbol of the national theater's backwardness. Once more established in Leipzig after having survived a setback when another troupe had challenged her supremacy, she now prepared to exorcise Hanswurst. The deed was accomplished in a solemn *Vorspiel*—a curtain-raiser meant to precede the main play of the day. Neuber wrote a number of these, in which she presented the gist of her reform under the guise of allegorical dialogues. On this occasion, in October 1737, performing with her troupe in the stall-like theater set up in front of the Grimmaisch Gate, she appeared as a player in her own *Vorspiel*, filling the role of Thalia and wearing Minerva's helmet on her powdered wig. While wielding Wisdom's spear in her right hand, Neuber attacked Hanswurst in an antique *pas de charge*. She was attended by an array of nymphs and Muses in looped skirts, low-necked tight-fitting bodices, and high-heeled slippers. Slaughtered by this horde, Hanswurst was mourned by Venus, the devil, a night watchman, and "a crowd of petty rhymsters and ragged ballad-mongers." While he was being carried off stage, the Muses burst into a triumphant song, but not before Hanswurst made one last defiant and indecent gesture toward the audience. Although an actor portraying Apollo pronounced a funeral oration, followed by Neuber who solemnly intoned while the curtain was being drawn, "Hanswurst is dead! There is no more Hanswurst!," this trickster would remain popular with the German public for at least another generation. Most German theatergoers preferred to have their plays interrupted by Hanswurst rather than sit through an evening of poorly translated Racine or, worse, have to endure one of Gottsched's soporific adaptations of a foreign play. Over the next few years, Neuber had to accept the reality of the situation and continue to adapt her theatrical repertory to audience desires. Although he appeared in different guises, Hanswurst remained alive and kicking on the German stage, and in Neuber's theater.

By the late 1730s, Neuber became increasingly exasperated with the lack of public support for theater reform. In 1739, after the close of an unsuccessful season with her troupe in Hamburg, she spoke out in public in another of her *Vorspiele*. On this occasion, she seemed to forget that actors, no matter how talented, were in fact humble servants among their social betters who chose to honor them with their patronage. Although Neuber's *Vorspiel* was relatively innocuous, her sentiments were revealed in the playbill for the evening's performance, in which she

made less-than-complimentary references to "those who have not been able to see us, those who have not ventured to see us, or those who have not been willing to see us." In a caste-based society, this sort of talk was a sign of insolence—or worse—coming from a mere *Komödiant*, and a woman to boot. Not surprisingly, Hamburg's citizenry were insulted, and the city's Bürgermeister closed down Neuber's theater.

Her next independent streak led to a conflict with her ally Gottsched. Their problems began when Gottsched demanded that Neuber's company perform Voltaire's *Alzire* in a translation by his wife, **Luise Adelgunde Gottsched.** Since the troupe was already using a version she considered far superior, Neuber refused. A bitter argument permanently ruptured the friendship. Unwilling to let the matter rest, Neuber decided to poke fun publicly at her former friend, namely on the stage of her theater. Her attacks took the form of a burlesque of Gottsched's ideas concerning costume, a matter they had never been able to agree on. He had long advocated that actors wear ultra-simple and essentially "abstract" garments, including sandals, whereas Neuber's troupe continued to dress in only slightly changed versions of the latest Paris fashions. She staged the third act of her former friend's *Dying Cato* with the type of costumes prescribed by its author—and worse—which meant that the actors wore pink tights under flowing robes, creating the illusion that their legs and feet were bare. Critics and audiences were upset by the spectacle, some laughing with scorn but others denouncing the experiment as indecent.

Neuber continued her attacks on Gottsched. In a *Vorspiel* entitled *The Most Precious Treasure*, the main character, "the Faultfinder," appeared on stage dressed as Night wearing a star-spangled cloak, as well as bat wings on his shoulders, a dark lantern in his hand, and a crown of tinsel around his head. A huge success with audiences, the piece furthered the estrangement between Gottsched and Neuber. He now wrote polemics against Neuber, her husband, and their company, but in doing so inflicted damage on himself as well. Until this point, Gottsched had enjoyed immense authority as a virtual dictator of the German literary scene, but the display of pettiness on his part served to greatly weaken his grip over cultural life in German-speaking Central Europe.

In an attempt to restore her frayed reputation, Neuber accepted an invitation from Russian empress *Anna Ivanovna** and in 1740 undertook the arduous journey with her troupe in order to perform in St. Petersburg. Unfortunately, the empress died soon after their arrival, and the desired patronage did not materialize from the new favorites that soon appeared in the Romanov court. On her return to Leipzig, Neuber was forced to disband her troupe. A few years later, in 1744, she reconstituted the company, in many instances luring back veteran performers, and was soon successfully touring the Germanies, garnering appreciative audiences in Dresden, Frankfurt am Main, Hamburg, and Kiel. As often as she could, she brought her players back to Leipzig. Here the Neuber troupe was particularly popular with students from the local university, some of whom appreciated tales of her satirical attacks on their stodgy professor, Herr Gottsched. Among the most enthusiastic of these young men was a theology student named Gotthold Ephraim Lessing (1729–1781). Lessing had fallen in love with Fräulein Lorenz, the troupe's ingenue, but soon he was discussing more serious matters with Neuber.

Lessing's infatuation with the theater gravely weakened whatever interest he may once have had in theological matters, and caused his parents much concern, but the hours he spent in Neuber's theater taught him the essentials of stagecraft and the elements that made up a living theatrical experience. Lessing initially translated foreign dramas for the Neuber company but soon was writing his own plays. In January 1748, his comedy *Der junge Gelehrte* (The Young Scholar) was premiered by the Neuber troupe in Leipzig. The play's success—he was fêted by his friends as a future Molière—did much to convince Lessing that he did indeed have a future as a playwright and author; he would one day be celebrated as the first German playwright and critic of distinction.

For Neuber, assisting a brilliant young man of the theater like Lessing would be a last triumph. From this point on, her problems compounded. Much of the trouble was financial, for she had never been able to think in strictly economic terms when it came to mounting a play. Her love of fine costumes often made it impossible to achieve profits, and by 1750 she again had to disband her troupe. In what would now be a time of increasing difficulties for the aging actress and former *Prinzipalin*, her husband Johann remained a pillar of strength. No longer a young woman, she attempted to build a career as a solo actress, appearing for a time at Vienna's *Karntnerthor-Theater*, but her style struck audiences and critics alike as old-fashioned and ineffective. She and her husband wandered around Germany for a time, acting and teaching, but eventually they became destitute. In Dres-

den, a friend offered them a room, and it was here that Johann Neuber died in 1759.

A year later, gravely ill, penniless, and largely forgotten by her contemporaries, Caroline Neuber knocked at the door of a peasant's house in the town of Laubegast, outside Dresden. Knowing that she was an actress, and believing that *Komödianten* were rarely people of high moral standing, the peasant at first refused to let her in. In the end, however, the old, ill woman was given refuge. Soon, on the night of November 29–30, 1760, she died. According to long-hallowed tradition, since the Church had forbade the burial of actors in consecrated ground, the peasant (in whose home she had died and who had grown to respect her) was compelled to bury her in a remote corner of the local graveyard. He dug her grave himself at night and lowered her coffin over the graveyard wall, because it was not allowed to pass through the church gate. However, recent research argues that this story, which has been part of theater lore for generations, is not authentic. Neuber was in fact accorded a normal if modest funeral and burial.

Sixteen years after her death, a memorial to Caroline Neuber was erected on the highway at Laubegast, honoring her for having "introduced good taste on the German stage." This remarkable woman fought long and hard to liberate the German theater. Without her efforts, Germany's classic writers Lessing, Goethe, and Schiller would not have had the kind of theater that provided their works with a worthy forum. Neuber has been honored in countless ways in Germany and German-speaking areas of Europe in the generations since her death. In recent years, the postal authorities of both the German Federal Republic and German Democratic Republic issued postage stamps in her honor, the GFR with a 30-pfennig stamp depicting Neuber as Medea issued on November 16, 1976, and the GDR with a 50-pfennig portrait stamp issued on January 25, 1972. In 1995, a Neuber Museum was inaugurated in Reichenbach in the house where she had been born almost three centuries earlier.

SOURCES:

Berthold, Margot. *A History of World Theater*. NY: Frederick Ungar, 1972.

Brown, John Russell, ed. *The Oxford Illustrated History of Theatre*. Oxford: Oxford University Press, 1995.

Brown, Julia Hastings. "Der Beitrag von Luise Adelgunde Gottsched und Friederike Caroline Neuber zur Entwicklung des deutschen Theaters im 18. Jahrhundert." Thesis, Wheaton College, Norton, Massachusetts, 1984.

Buck, Elmar. "Die Neuberin—ein Theatermythos," in *Die Deutsche Bühne*. Vol. 68, no. 4. April 1997, pp. 24–27.

Daunicht, Richard and Lieselotte Scholz, eds. *Die Neuberin: Materialien zur Theatergeschichte des 18. Jahrhunderts [Studienmaterial für die künstlerischen Lehranstalten, Theater und Tanz, 1956, Heft 2]*. Berlin: Ministerium für Kultur, Hauptabteilung Künstlerische Lehranstalten, 1956.

Devrient, Eduard. *Geschichte der deutschen Schauspielkunst*. New edition by Rolf Kabel and Christoph Trilse. 2 vols. Munich: Langen Müller Verlag, 1967.

Flaherty, Gloria. "Lessing Among the Actors," in *Lessing Yearbook*. Vol. 13, 1981, pp. 69–84.

Gadberry, Glen W. "Stages of Reform: Caroline Neuber in the Third Reich," in *Text & Presentation: The Journal of the Comparative Drama Conference*. Vol. 11, 1991, pp. 25–30.

Garland, Henry B. *Lessing: The Founder of Modern German Literature*. NY: Macmillan-St. Martin's Press, 1962.

Gilder, Rosamond. *Enter the Actress: The First Women in the Theatre*. Reprint ed. Freeport, NY: Books for Libraries Press, 1971.

Günther, Wolfram. "Neuber (*Neuberin*, bis 1718 Weissenborn), Friederike Caroline," in *Neue Deutsche Biographie*. Vol. 19, 1999, pp. 100–101.

Harris, Edward P. "From Outcast to Ideal: The Image of the Actress in Eighteenth Century Germany," in *German Quarterly*. Vol. 54, no. 2. March 1981, pp. 177–187.

Kindermann, Heinz. *Theatergeschichte Europas, IV. Band: Von der Aufklärung zur Romantik (1. Teil)*. Salzburg: Otto Müller Verlag, 1961.

Kord, Susanne. "Frühe dramatische Entwürfe: Drei Dramatikerinnen im 18. Jahrhundert," in Hiltrud Gnug and Renate Möhrmann, eds., *Frauen—Literatur—Geschichte: Schreibende Frauen vom Mittelalter bis zur Gegenwart*. Stuttgart: Metzler Verlag, 1999, pp. 231–246.

Lamport, F.J. *Lessing and the Drama*. NY: Clarendon Press, 1981.

Londré, Felicia Hardison. *The History of World Theater: From the English Restoration to the Present*. NY: Continuum, 1991.

Mantzius, Karl. *A History of Theatrical Art in Ancient and Modern Times*. Vol. 5: *The Great Actors of the Eighteenth Century*. Translated by Louise von Cossel. NY: Peter Smith, 1937.

Mechtel, Angelika. *Die Prinzipalin: Ein Roman*. Frankfurt am Main: S. Fischer Verlag, 1994.

Möhrmann, Renate. "Von der Schandbühne zur Schaubühne: Friedericke Caroline Neuber als Wegbereiterin des deutschen Theaters," in Sara Friedrichsmeyer, *et al.*, eds., *The Enlightenment and Its Legacy: Studies in German Literature in Honor of Helga Slessarev*. Bonn: Bouvier Verlag, 1991, pp. 61–71.

———. "Friederike Caroline Neuber (1697–1760): Eine Wegbereiterin des deutschen Theaters," in Annemarie Haase and Harro Kieser, eds., *Können, Mut und Phantasie: Portraits schöpferische Frauen aus Mitteldeutschland*. Weimar: Böhlau Verlag, 1993, pp. 45–56.

Neuber, Friedrike Karoline. "Das Schäferfest; oder, Die Herbstfreude, ein deutsches Lustspiel in Versen," in Fritz Brüggemann, ed., *Gottscheds Lebens- und Kunstreform in den zwanziger und dreissiger Jahren: Gottsched, Breitinger, die Gottschedin, die Neuberin*. Darmstadt: Wissenschaftliche Buchgesellschaft, 1966, pp. 216–294.

Oelker, Petra. *"Nichts als eine Komödiantin": Die Lebensgeschichte der Friederike Caroline Neuber.* Weinheim and Basel: Beltz Verlag, 1993.

Reden-Esebeck, Friedrich Johann, Freiherr von. *Caroline Neuber und ihre Zeitgenossen: Ein Beitrag zur deutschen Kultur- und Theatergeschichte.* Reprint edition edited by Wolfram Günther. Leipzig: Zentralantiquariat der Deutschen Demokratischen Republik, 1985.

Rudin, Bärbel, and Marion Schulz, eds., *Friederike Caroline Neuber: Das Lebenswerk der Bühnenreformerin. Poetische Urkunden, 1. Teil.* Reichenbach-Vogtland, 1997.

Schmidt-Graubner, Elly. *Die Neuberin, Passion einer Rebellin. Roman.* Leipzig: O. Janke Verlag, 1938.

Schüddekopf, Carl. "Caroline Neuber in Braunschweig," in *Jahrbuch des Braunschweigischer Geschichtsvereins* [Wolfenbüttel]. Vol. 1, no. 1, 1902, pp. 115–148.

Stümcke, Heinrich. *Die Frau als Schauspielerin.* Leipzig: F. Rothbarth Verlag, 1905.

Trilse, Christoph, Klaus Hammer and Rolf Kabel. *Theaterlexikon.* Berlin: Henschelverlag Kunst und Gesellschaft, 1977.

Völker, Klaus. "Biographie, Kein Spiel," in *Theater Heute.* No. 11, November 1993, pp. 68–71.

Weisenborn, Günther. *Die Neuberin: Komödiantenstück.* Berlin: Bruno Henschel und Sohn, 1949.

Wendland, Heide. *Komödianten ohne Maske: Erzählung um Caroline Neuber, genannt Neuberin.* 2nd ed. Berlin: Rütten & Loening Verlag, 1958.

Ziessler, Herbert. *Vom Leben und Wirken der Frau Neuberin.* Nietzschkau im Vogtland: Rat der Stadt Reichenbach im Vogtland, Neuberinausschuss, 1957.

John Haag,
Associate Professor of History,
University of Georgia, Athens, Georgia

Neuber, Frederika or Friederike

(1697–1760).

See Neuber, Caroline.

Neuberger, Maurine B. (1906–2000)

U.S. Democratic senator (November 8, 1960–January 3, 1967). Born Maurine Brown on January 9, 1906, in Cloverdale, Oregon; died on February 22, 2000, in Portland, Oregon; daughter of Walter T. Brown (a physician) and Ethel Kelty Brown (a teacher); earned teacher's certificate from the Oregon College of Education, 1925; University of Oregon, B.A., 1929; graduate work at the University of California-Los Angeles; married Richard L. Neuberger (a journalist and later a U.S. senator), in 1945 (died 1960); married Philip Solomon (a psychiatrist), in 1964 (divorced 1967).

Served in Oregon state House of Representatives (1951–55); served in U.S. Senate (1960–67).

The daughter of a country doctor and a schoolteacher, Maurine B. Neuberger was descended from Scotch-Irish Oregon pioneers. In 1925, she obtained her teacher's certificate from the Oregon College of Education, and began her teaching career at a private school in Portland, Oregon. She soon transferred to a public-school system to teach physical education and dance, but after a few years resumed her own studies. She graduated with a B.A. from the University of Oregon in 1929, and afterward did graduate work at the University of California in Los Angeles.

The trim, athletic Neuberger met her future husband, Richard L. Neuberger, in 1936. After he fulfilled his wartime Army duty, they were married in December 1945. By this time Neuberger was already active in civic and education groups, including the League of Women Voters, but her political career began in earnest in 1946 when she assisted her husband with his campaign for Democratic senator of the Oregon State Senate. He was finally elected in 1948. In 1950, Neuberger won her own seat in Oregon's legislature when she was elected to the state House of Representatives. Her election made the Neubergers the first married couple to serve concurrently in both chambers of a state legislature.

With their salaries as elected officials quite low, they made most of their living through collaborative journalism on Northwest political issues, which Neuberger both co-wrote and illustrated with her own photographs. In 1954, they published *Adventures in Politics: We Go to the Legislature.* Neuberger concentrated mostly on educational and consumer issues in the House of Representatives, sponsoring bills such as those which established programs for both learning-disabled and gifted children. A popular vote-getter who was described in 1960 by the *New York Post Magazine* as having a "refreshing candor [flowing from] a relaxed sureness about her own . . . political morality," and by her husband as having "marched to the top of the ballot blurting out exactly what is on her mind," she was re-elected in 1952 and 1954 by sizable margins.

In 1954, her husband was elected to the U.S. Senate (the first Democrat so elected in Oregon in 40 years), and at the end of 1955 Neuberger gave up her state House seat to accompany him to Washington, D.C. Working as his unpaid assistant, she researched impending bills, prepared radio and newsletter information for his Oregon constituency, and in 1959 attended a congress of NATO in London. Then, abruptly, she was thrust into the political spotlight when her husband suffered a cerebral hemorrhage and died in March 1960, just two days before the filing deadline for the primary election. Numerous influential figures in politics and the press, including journalist

*Doris Fleeson and *Margaret Chase Smith, the Republican senator from Maine, urged her to run for what remained of her husband's term as well as for the next full term. Neuberger, who declared her candidacy just under the wire, ran unopposed for the short-term special election and triumphed over a former governor in the general election, becoming only the third woman in U.S. history to win a full Senate term.

After taking office in 1961, Neuberger served on the Agriculture Committee, the Banking and Currency Committee, the Committee on Commerce, a Special Committee on Aging, and a Committee on a Parliamentary Conference with Canada. She supported a bill to cap campaign expenditures and allow federal government subsidies for congressional and presidential campaigns, asserting the bill would keep candidates from having to rely on "political fat cats." Neuberger was well ahead of her time in this issue. She voted for federal grants to states' educational television programs, temporary extension of unemployment payments, a minimum wage hike, and redevelopment aid for high-unemployment areas. She supported foreign tourism in the United States, tax deductions for child care, an end to the use of "national origins

quotas" in the American immigration system, and funding for establishment of the President's Commission on the Status of Women. She backed the expansion of the federal highway system, while at the same time urging highway billboard control. She also sponsored a bill to create the Oregon Dunes National Seashore, a project which had been a favorite of her late husband, although this effort was unsuccessful.

An unaffected woman who once modeled a bathing suit at a Washington, D.C., charity event (and during the ensuing brouhaha in the national press simply noted, "If I go swimming, I do wear a bathing suit, you know"), Neuberger was known for her warmth and forthrightness. She was fond of hiking, swimming, and hula dancing, and periodically spoke at Unitarian church conferences. She chose not to run for reelection in 1965, in part because of her distaste for the extensive fund-raising necessary to mounting a successful campaign. After leaving the Senate in 1966, she gave lectures on consumer and women's issues, and taught American government classes at Reed College, Radcliffe Institute, and Boston University. In 1969, two years after the end of her second marriage, she returned to Oregon, where she lived in Portland and was active in civic and social life. A mentor to younger female politicians and mentally alert until the end of her long life, Neuberger died of a bone marrow disorder in Portland on February 22, 2000.

SOURCES:

Current Biography, 1961. NY: H.W. Wilson, 1961.
Office of the Historian. *Women in Congress, 1917–1990.* Commission on the Bicentenary of the U.S. House of Representatives, 1991.
The Oregonian (obituary). February 23, 2000.

Jacquie Maurice,
freelance writer, Calgary, Alberta, Canada

Maurine B. Neuberger

Neumann, Hanna (1914–1971)

German mathematician and educator. Name variations: Hanna von Caemmerer. Born Hanna von Caemmerer on February 12, 1914, in Berlin, Germany; died on November 14, 1971, in Canada; daughter of Hermann Conrad von Caemmerer (a historian and archivist) and Katharina von Caemmerer; graduated from the University of Berlin, c. 1936; Oxford University, Ph.D., 1944, D.Sci., 1955; married Bernhard Neumann, in 1938; children: Irene (b. 1939); Peter; Barbara (b. 1943); Walter (b. 1946); Daniel (b. 1951).

Born in Berlin in 1914, Hanna Neumann was the youngest of three children of Hermann von Caemmerer, a historian who came from a

family of Prussian officers, and **Katharina von Caemmerer**, a descendant of French Huguenots who had moved to Prussia to escape persecution during the latter half of the 18th century. Hermann von Caemmerer was killed early in World War I, and the family was forced to live on his sparse war pension. As the children grew up, they both attended school and worked to help support the family; when Neumann was 13, she tutored younger children. She gave up her hobby of growing plants when she discovered the world of mathematics, and as a young student showed a talent both for mathematics and for the natural sciences. Neumann studied for two years at a private school and then at the Augusta-Victoria-Schule, a grammar school for girls, where she formed a lasting friendship with one of her teachers, Fraulein Otto.

In 1932, Neumann entered the University of Berlin. She concentrated on mathematics and physics, but had eclectic interests and followed the German tradition of attending lectures on a wide variety of subjects; among these were lectures given by Wilhelm Köhler, a founder of Gestalt therapy, and ones on Dante by Roman Guardini, a Roman Catholic theologian. She was greatly impressed by several of her math professors, including Ludwig Bieberbach, who motivated her to study geometry, and particularly Erhard Schmidt and Issai Schur, who introduced her to the farther reaches of algebra and analysis. Most of her new friends at the university were mathematicians, including Bernhard Neumann, whom she would later marry. Her first year of studies coincided with the rise of Nazism in Germany, and when she and Bernhard, who was Jewish, became engaged, they were forced to keep their relationship a secret. Bernhard left Germany in 1934 and went to Cambridge, England, while Neumann, intent on obtaining a doctoral degree, stayed in Berlin to finish her studies. At that time, "mixed" marriages had become illegal in Germany, and people of Jewish ancestry were not permitted to attend the universities. She was outspoken about her opposition to the Nazis and was one of a number of students who protected Jewish lecturers from harassment by guarding the doors of their classrooms during lectures and preventing Nazi supporters from entering. As a result of her activities, she lost her job at the Mathematical Institute. She and Bernhard kept their correspondence secret. When it came time for her examinations, she was advised to take the *Staatsexamen*, which reflected the breadth of a student's studies, rather than trying to obtain a doctoral degree by orally defending a thesis on a specific area of study. During her defense she would have been interrogated on her "political knowledge," possibly uncovering her anti-Nazi views. Given the political atmosphere at the time, this was good advice, and she followed it even though it meant she graduated without a doctoral degree.

Neumann was then accepted as a research student at Göttingen. By 1938, however, she gave up her studies due to the worsening situation in Germany and moved to England, where she and Bernhard were married. They lived in Cardiff, Wales, where their first child was born in 1939, but were then forced to leave due to restrictions placed on aliens. Within a week of their move to Oxford, Bernhard was interned, leaving Neumann alone with one young child and another on the way. (A few months later he would be released into the British Army.) Housing in England was scarce due to the large numbers of refugees from Europe, and in 1942 she and her two children moved into a trailer on a farm. At night, with the aid of candlelight, she worked on her doctoral thesis on the problem of determining the subgroup structure of free products of groups with an amalgamate subgroup. Neumann submitted her thesis in 1943, some months before her third child was born, and received a Ph.D. from Oxford University in April 1944.

After the war ended in 1945, Neumann and her husband moved their family to Hull, where they both found teaching positions at University College. Their fourth child was born there the following year. Bernhard took a position at Manchester University in 1948, while Neumann remained in Hull with their children. (Their fifth child would be born in 1951, and from time to time Neumann would attempt to find a position at Manchester University.) She was very involved with her students, many of whom became prominent mathematicians, and was well known for her enthusiastic approach to teaching and for the weekly gatherings of students and colleagues at her house. During her 12 years at University College, Neumann eventually became senior lecturer. She worked on group theory and published many papers, and in 1955 she earned a D.Sci. from Oxford. In 1958, she was appointed to a lectureship in the faculty of technology at Manchester University. She brought many new teachers and researchers along with her, and became involved in the Mathematical Society.

Neumann and her husband took a joint leave from their positions at Manchester in 1961 and went to New York, where they held positions at the Courant Institute of Mathematical Sciences. During this time Bernhard accepted an offer to start a research department of mathematics at the

Australian National University, and Neumann obtained a position there as a reader (now called a professional fellow). Although she expected to be involved in research when she moved to Australia in 1963, she was instead offered the newly created chair of Pure Mathematics in the National University's School of General Studies. (This also made her Australia's first woman professor of mathematics.) Neumann again busied herself with her students and her family, and her earlier love for botany was revived when, using royalties from some of her published work, she purchased a camera with which she photographed the flowers and trees of Australia.

By the mid-1960s, the teaching of mathematics was changing throughout the world, and many Australian educators were unfamiliar with the new methods. Neumann helped to reorganize her own math department, gave lectures, designed new syllabi, trained teachers, talked to parents, and talked to schools. Her mission was to educate the community about math in order to create a favorable atmosphere for learning, and to lessen the "fear of math," particularly among young girls. In the following years, she was elected vice-president of the Australian Association of Mathematics Teachers, and president of the Canberra Mathematical Association. Her lectures were typically focused on group varieties and the Hopf problem, and she was invited to lecture all over Australia, Europe, the United States, and Canada. While on one such lecture tour through Canada in 1971, Neumann became ill and admitted herself into a hospital. Shortly thereafter, she fell into a coma and never regained consciousness. She died two days later, on November 14, 1971.

SOURCES:

Radi, Heather, ed. *200 Australian Women: A Redress Anthology*. NSW, Australia: Women's Redress Press, 1988.

Young, Robyn V., ed. *Notable Mathematicians: From Ancient Times to the Present*. Detroit, MI: Gale Research, 1998.

Christine Miner Minderovic, freelance writer, Ann Arbor, Michigan

Emma Nevada

Neumann, Margarete Buber

(1901–1989).

See Buber-Neumann, Margarete.

Nevada, Emma (1859–1940)

American opera singer. Name variations: Mrs. Raymond Palmer. Born Emma Wixom on February 7, 1859 (some sources cite 1852 and 1861), in Alpha, California; died on June 20, 1940, in Liverpool, England; daughter of William Wallace Wixom (a physician) and Maria (O'Boy) Wixom; graduated from Mills Seminary (later Mills College) in Oakland, California, 1876; studied in Vienna with Mathilde Marchesi; married Raymond Spooner Palmer (a physician), in 1885; children: Mignon Nevada (b. March 18, 1885).

Debuted at Her Majesty's Theater in London as Amina in La Sonnambula *(1880); debuted in Milan (1881); debuted at Opéra Comique in Paris as Zora in* La Perle du Brésil *(1883); made American debut at the New York Academy of Music (1884); taught voice in England for several years (after 1910).*

Born near the gold-mining town of Nevada City, California, on February 7, 1859, Emma Nevada began singing at an early age. She performed "The Star-Spangled Banner" at a benefit when she was only three years old, and dreamed of the opera as she sang to cigar boxes decorated with pictures of Queen *Victoria and Prince Albert. She sang often at her church in Austin, Nevada, and was showered in gold pieces when she sang for miners in Virginia City. After the death of her mother **Maria** in 1872, she and her father William Wixom returned to California, where she entered Mills Seminary and studied voice. She embarked on a study tour to Europe following her graduation and eventually became a pupil of the eminent vocal teacher ***Mathilde Marchesi**, with whom she trained for three years.

Under the stage name Emma Nevada, she made her formal debut at Her Majesty's Theater in London on May 17, 1880. Her flute-like voice was small but she used it expertly—Sir Thomas Beecham immediately christened her "a natural coloratura equal to any of her contemporaries." Over the next two years, Nevada sang in cities across Italy, including an appearance at La Scala in Milan which was reportedly arranged for her by composer Giuseppe Verdi. In 1883, she opened at the Opéra Comique in Paris, where she and fellow American ***Marie Van Zandt** both won accolades, and in 1884 she appeared in *The Rose of Sharon* at London's Covent Garden, singing a role written especially for her. Later that year, she was well received upon her American debut in *La Sonnambula* at the New York Academy of Music, and as the American tour continued into the next year enjoyed a particularly hearty welcome in California.

In 1885, Nevada returned to Europe and married Raymond S. Palmer, a physician who also became her manager. After a less brilliant but still successful second American tour, she returned to Europe, where she spent most her life thereafter. Also in 1885 in Paris, she had her only child, ❧▶ **Mignon Nevada**, who later became an operatic soprano. Emma's career continued to thrive as she toured Europe for several years; a favorite of the British royal family, she gave command performances for Queen Victoria and her successor Edward VII. She counted among her friends *Sarah Bernhardt and the queen of Spain, *Maria Christina of Austria, sometimes singing for the latter in the queen's chambers while Mignon played with the boy king Alphonso XIII. Her most popular roles included those in *Faust, Lakmé, The Tales of Hoffman, Mireille, The Barber of Seville, Mignon*, and *Lucia di Lammermoor*.

In 1899, Nevada returned to the United States to give a concert series at the Metropolitan Opera House in New York. She performed in America again in the winter of 1901–02, and for the last time in 1907. She retired in 1910 after singing *Lakmé* in Berlin, and for several years after that taught voice in England. Nevada lived with her daughter during the last years of her life, and died in Liverpool in June 1940.

SOURCES:

James, Edward T., ed. *Notable American Women, 1607–1950*. Cambridge, MA: The Belknap Press of Harvard University Press, 1971.

McHenry, Robert, ed. *Famous American Women*. NY: Dover, 1980.

Warrack, John, and Ewan West. *The Oxford Dictionary of Opera*. Oxford: Oxford University Press, 1992.

Jacquie Maurice,
freelance writer, Calgary, Alberta, Canada

Nevada, Mignon (1885–1970).

See Nevada, Emma for sidebar.

Nevejean, Yvonne (1900–1987)

Belgian head of the National Child Welfare Organization who supervised children's homes throughout Belgium, defying Nazis by saving the lives of over 3,000 Jewish children during the Holocaust. Name variations: Yvonne Feyerick-Nevejean. Born in 1900; died in 1987.

On May 10, 1940, the military might of Nazi Germany smashed into Belgium, France, and the Netherlands. On May 28, after putting up a doomed struggle, the Belgian Army surrendered and its small country came under German

❧▶ **Nevada, Mignon** (1885–1970)

English opera singer. Name variations: Mignon Palmer. Born Mignon Palmer in Paris, France, on March 18, 1885 (some sources cite August 14, 1886, but likely incorrect); died in Redwood City, California, in September 1970; daughter of Emma (Wixom) Nevada (1859–1940, an opera singer) and Raymond S. Palmer (a physician); studied with mother Emma Nevada.

The daughter of American opera singer *Emma Nevada, soprano Mignon Nevada made her debut in Rome in 1907, followed by a debut at Covent Garden, London (1910), in Paris (1920), and in Milan (1923). She was particularly praised for her interpretations of Desdemona, Mimi, Lakmé, Zerlina, and Marguerite.

military rule, which remained in force until a civil administration was formed in July 1944. Even at that late stage in the war the Nazis still anticipated annexing Belgium directly to the Greater German Reich in the form of two territorial units, which were designated Reichsgau Flanders and Reichsgau Walonia. Long before this, the essence of National Socialism had revealed itself to the Belgian population. Central to Nazi rule was the imposition of the racial regime that had long existed at home in the Reich. This included extending the anti-Semitic Nuremberg Laws of 1935 to the Jewish population of Belgium. At the time of the German invasion, Belgium's Jewish population numbered 65,696. When the occupation ended in the fall of 1944 with the appearance of victorious Allied troops on Belgian soil, a grim tally revealed that 28,902 Jewish men, women, and children had perished, representing 44% of the total Jewish population. However, despite more than four years of systematic efforts by the Nazis and their Belgian collaborators to first demoralize and finally deport Belgium's Jews to death camps in the eastern territories of the German Reich, 56% of these endangered individuals had managed to survive. Both Jews and non-Jews played important roles in slowing down and frustrating the machinery of annihilation.

After the first, preliminary stage of occupation ended in November 1940, Reich Marshal Hermann Göring ordered the "Aryanization" of the Belgian economy, which included the plundering of Jewish assets and property by German business enterprises. By the spring of 1942, the terror was accelerated and Jewish businesses, including the important diamond industry in Antwerp, systematically began being seized from their legal Jewish owners. After a general draft

of Jewish labor was announced in March 1942, turning Belgian Jews into slaves, a decree of May 27 of the same year ordered all Jews to wear the yellow badge whenever they appeared in public. In summer 1942, the Nazis began deporting Belgian Jews to Auschwitz as well as to other camps, including Bergen-Belsen, Buchenwald, and the women's camp of Ravensbrück.

Probably the most threatened group within the Belgian Jewish community were its infants and children. Soon after the mass deportations began in the summer of 1942, Yvonne Nevejean, the director of the l'Oeuvre National de l'Enfance (National Child Welfare Organization or ONE), received a request from the Belgian Jewish Defense Committee asking whether she could find places to shelter Jewish children who were now clearly in danger of being sent to the death camps. Without going through the formalities of consulting the ONE board for authorization, Nevejean agreed to help, despite the risks to her own life. Telling no one, she quickly began to organize a complex system for placing scores, then hundreds, and finally thousands of at-risk Jewish children in sites of safety. Over a period of more than two years, Nevejean was able to place between 3,000 and 4,000 Jewish children of various ages in foster homes, convent boarding schools, and orphanages run by ONE.

Separate files were kept for the Jewish children, listing both their old and new identities. Trusted associates were sent out to locate the children, who were then taken either to a ONE transit facility or directly to a safe house. In each instance, circumstances dictated how much or how little would be revealed concerning a child about to be entrusted to the care of a boarding school or convent. For security reasons, the parents of Jewish children were never told where their daughters or sons had found refuge. Messages between parents and children did, however, pass between ONE couriers. Nevejean's concerns included not only placing the Jewish children with reliable caretakers, but also finding ways to sustain them once they were out of danger. She had to provide all-important food ration coupons. When funds were needed, as they often were, to help pay for board and lodging, she provided money that in many instances had been parachuted or smuggled in overland by operatives of the Belgian government-in-exile in London.

Nevejean took advantage of any means to save the lives of Jewish children, who eventually would become known simply as "Yvonne's children." Through underground channels, she received word of a planned transfer of a group of Jewish children who had been staying in a German-controlled orphanage. The Nazi plan, which went into operation on the night of October 30, 1942, was to relocate a group of 58 Jewish children from the orphanage to the transit camp that had been established at Malines-Mechelen. From there, they would be shipped to Auschwitz and death. Nevejean met with Belgium's *Elizabeth of Bavaria (1876–1965), the much-loved queen mother who, though German-born, had become a hero for all Belgians because of the courage, dignity, and patriotism she had displayed during World War I. As honorary president of ONE and as a woman who detested intolerance, Elizabeth persuaded a German general to authorize sparing the children. The details of the release of the children and their supervisors were worked out by Léon Platteau, a sympathetic official of the Belgian Ministry of Justice.

Nevejean depended on a large network of men and women in the Belgian underground movement to provide safe homes for Jewish children. In one such instance, the Sisters of Charity of Besançon were in charge of the Queen Elizabeth Home, situated in a castle (the Château du Faing) and under the sponsorship of the queen mother. Located in the isolated village of Jamoigne-sur-Semois, the home in 1941 had been transformed into a center for the care of disabled children. With the knowledge and support of Elizabeth herself, the castle facility served for several years as a refuge for Jewish children. At any time during this period, over 80 of the home's residents—at least half of the total—were Jewish. They had been brought to the home through the efforts of Nevejean and one of her most dependable collaborators, Father (later Abbé) Joseph André. But the heroes on the ground in Jamoigne-sur-Semois were the home's manager, **Marie Taquet-Martens**, who was in charge of the countless details of the daily routine, and her husband, Major Emile Taquet, who took care of administration and coordination with ONE headquarters in Brussels. As much as was possible in an institutional setting, the children received warm care in the Queen Elizabeth Home. After the war, one of the children recalled their experience in the castle home: "For us, the manor became a vacation camp."

Another organization, the Comité de Defense des Juifs (CDJ), also was able to save the lives of Jewish children. For more than two years, **Andrée Herscovici** took them to foster homes where they found safety. When she joined the Comité, Herscovici changed her name and identity, an act that put her at risk of being de-

BELGIQUE-BELGIË

Yvonne NEVEJEAN (1900-1987)

1996 (5a) anne Velghe

EUROPA

16

ported to Germany. In other instances, prewar friendships played a role. **Germaine Belline** and **Liliane Gaffney**, acting independently of an organized rescue group, saved the lives of 30 of their Jewish friends, including children, by giving them the identification documents of relatives who lived abroad. Finally, Jewish members of the Belgian resistance movement, including **Esta Heiber** and her husband, placed themselves in perilous situations by working to place Jewish children with non-Jewish individuals, families, and institutions.

Nevejean and her colleagues faced the constant risk of denunciation by Belgian collaborators. Despite the magnitude of ONE's work, only a small number of rescuers and rescued children were arrested by the Germans. Although the Gestapo offices in Brussels were well aware of the existence of an extensive rescue network designed to save Jewish children, with only one or two exceptions, they failed to disrupt the efforts headed by Mme Nevejean. In August 1944, with the defeat of the Third Reich now a certainty, diehard Gestapo fanatics in Brussels

made plans to capture and kill as many of Belgium's Jews as they could. A desperate Jewish underground appealed to Nevejean to save still more children. A member of the Jewish underground, **Marie Blum-Albert**, recalled later, "I can never forget the determination, the diligence, the heart with which Mme Nevejean applied herself to this task." Nevejean telephoned convents, hostels, and homes for war orphans and prisoners' children, pleading with them and with various men and women of influence to obtain shelter for children in homes that were already severely overcrowded.

In 1965, Yvonne Nevejean was honored by Israel's Yad Vashem Holocaust Martyrs' and Heroes' Remembrance Authority, which named her one of the Righteous Among the Nations, a Gentile who had risked her life to save Jewish children during the dark days of the Holocaust. At Nevejean's funeral in August 1987, **Yvonne Jospa**, a former member of the wartime Jewish Defense Committee, praised her for having been "committed, without reservation and despite all the dangers, to the rescue of Jewish children,

Belgian postage stamp honoring Yvonne Nevejean.

motivated by her love of children, her ideological rejection of all forms of racism, her struggle against the Nazi occupation." Nevejean was also honored on a Belgian 16-Franc postage stamp, issued on May 6, 1996.

SOURCES:

Brachfeld, Sylvain. *Ils n'ont pas eu les gosses: l'histoire de plus de 500 enfants juifs sans parents fichés a la Gestapo et placés pendant l'occupation allemande dans les homes de "Association des Juifs de Belgique" (A.J.B.).* Institut de Recherche sur le Judaïsme Belge, 1989.

Garfinkels, Betty. *Les Belges face a la persécution raciale, 1940–1944.* Brussels: Éditions de l'Institut de Sociologie de l'Université Libre de Bruxelles, 1965.

Jewish Museum of Belgium (Joods Museum van België-Musée Juif de Belgique), Brussels, Belgium, biographical research files.

Kless, Shlomo. "The Rescue of Jewish Children in Belgium During the Holocaust," in *Holocaust and Genocide Studies.* Vol. 3, no. 3, 1988, pp. 275–287.

Mechelen Museum of Deportation and the Resistance (Museum van Deportatie en Verzet-Pro Museo Judaico V.Z.W.) Mechelen-Malines, Belgium, biographical research files.

Michman, Dan. "Belgium," in Israel Gutman, ed., *Encyclopedia of the Holocaust.* 4 vols. NY: Macmillan, 1990, Vol. 1, pp. 160–169.

———, ed. *Belgium and the Holocaust: Jews, Belgians, Germans.* Oxford: Berghahn Books, 1998.

Paldiel, Mordecai. "Nevejean, Yvonne (d. 1987)," in Israel Gutman, ed., *Encyclopedia of the Holocaust.* 4 vols. NY: Macmillan, 1990, Vol. 3, pp. 1059–1060.

———. *The Path of the Righteous: Gentile Rescuers of Jews During the Holocaust.* NY: KTAV, 1993.

Silver, Eric. *The Book of the Just: The Unsung Heroes Who Rescued Jews from Hitler.* NY: Grove Press, 1992.

Steinberg, Lucien. *Le Comité de défense des Juifs en Belgique, 1942–1944.* Brussels: Éditions de l'Université de Bruxelles, 1973.

Steinberg, Maxime. *L'etoile et le fusil.* 4 vols. Brussels: Vie ouvriere, 1983–1986.

Yad Vashem, the Holocaust Martyrs' and Heroes' Remembrance Authority Archives, Jerusalem, Israel, biographical research files.

<div align="right">

John Haag,
Associate Professor of History,
University of Georgia, Athens, Georgia

</div>

Nevelson, Louise (1899–1988)

One of the greatest 20th-century American sculptors who struggled through the 1930s and 1940s, **then made a fortune after age 60 by recycling junk found on New York streets into assemblages and by designing environmental sculptures.** *Name variations: Leah, Leike. Pronunciation: NEV-el-son. Born Leah Berliawsky on September 23, 1899, in Pereyaslav, 50 miles southeast of Kiev, Russia (modern-day Ukraine); died of cancer on April 17, 1988; daughter of Isaac Berliawsky (a wood and junk dealer) and Zeisel (called*

Minna in America) Smoleranki; attended public schools, graduating from Rockland (Maine) High School in 1918; studied painting and drawing with 🖎▶ **Theresa Ferber Bernstein** *and William Meyerowitz and voice with* **Estelle Liebling** *in New York, 1920; studied at the Art Students League with Kenneth Hayes Miller and Kimon Nicolaides, 1929; studied in Munich with Hans Hofmann briefly in 1931; apprenticed with Diego Rivera and studied modern dance with* **Ellen Kearns**, *1932; studied at Atelier 17 under Peter Grippi and Leo Katz, 1953–55; married Charles S. Nevelson, on June 12, 1920 (separated 1931, divorced 1941); children: son Myron (Mike, b. February 23, 1922).*

Awards: United Society of American Artists (1959); Chicago Institute (1959); Ford Foundation gift for Tamarind Workshop, Norfolk Museum (1963); honorary degree from Western College for Women, Oxford, Ohio (1966); honorary degree from Harvard University (1967); Brandeis University Creative Arts award for sculpture (1971); Skowhegan medal for sculpture (1971); AIA award (1977); American Academy of Arts and Letters Gold Medal (1983); National Medal of the Arts from President Ronald Reagan (1985).

Brought by family to America (1905); father became a junk dealer (c. 1910); began to educate herself in all the arts as well as metaphysics; her husband lost his fortune (1924–29); went to Europe to study art, spending the winter in Paris (1932–33); worked for the WPA (1935–39); had first solo show, at Nierendorf Gallery (1941); traveled to Europe (1948), Mexico (1950); works acquired by the Whitney Museum, the Brooklyn Museum, and the Museum of Modern Art (1956–58); teamed with dealer Arnold Glimcher (1961); work included in U.S. Pavilion, at the XXXI Biennale Internazionale D'Arte, Venice (1962); completed 26 editions of lithographs at the Tamarind Lithography Workshop, Los Angeles, and became president of Artists' Equity (1963); her sculptural wall, Homage to 6,000,000 II, *purchased by Israel Museum, Jerusalem; gave a gold wall,* An American Tribute to the British People, *to the Tate Gallery, London; elected president of National Artists' Equity (1966); had first retrospective exhibition at Whitney Museum of American Art in New York and elected vice-president of International Association of Artists and head of Advisory Council on Art of the National Historic Sites Foundation (1967); diagnosed with cancer (1987); died at home in April and memorial service held (October 1988) at the Metropolitan Museum of Art, New York.*

Works in permanent collections: Art Institute of Chicago; Birmingham Museum of Art; Brandeis Uni-

versity; Carnegie Institute; Farnsworth Museum, Rockland, ME; Joseph H. Hirshhorn Collection; Lincoln Center for the Performing Arts, NY; Metropolitan Museum of Art; Museum of Fine Arts of Houston; Newark Museum of Art; New York University; Princeton University; Queens College; Riverside Museum; Tate Gallery, London; University of Nebraska; Whitney Museum of American Art.

Commissions: aluminum sculpture, South Mall Project, Albany, NY (1968); Cor-ten steel sculptures, Binghamton, NY, and Scottsdale, AZ (1972); monumental wood sculpture, World Trade Center, NY (1972); Bicentennial Dawn, Federal Courthouse, Philadelphia, PA (1976); Erol Beck Chapel of the Good Shepherd, St. Peter's Lutheran Church, NY (1976).

Louise Nevelson was an artistic genius. She applied her talents not only to the sculptures which would eventually earn her a prominent place among the crème de la crème of American art history, but also to her own persona as the legendary Empress of Modern Art. Her life was the hard-won success story of an artist so driven to succeed that decades of little or no recognition could not thwart her efforts. By the time she finally received widespread critical acclaim and the accompanying financial riches, Nevelson was in her 60s. Even after her position in the art world was secure, she suffered alternating periods of severe depression, drunkenness and rage. Several times in her life, she had visions, convinced that she saw portions of her sculptures shift or energy moving through space. Once able to, she spent lavishly, and, near the pinnacle of her career at age 70, she typically worked in her studio wearing long, fake black eyelashes to emphasize her dark eyes, a sable coat over jeans and a plaid shirt, with an exotic scarf hiding her hair like a turban. Those who did not know her story might have found it hard to imagine that as a strikingly beautiful young artist she had once stood in front of expensive shops in order to pick up men who would take her inside to buy her clothes and fancy meals. Materials for her sculptures were frequently gathered early in the morning when she walked the streets of New York with a wheelbarrow to pick up junk before the city trash haulers collected it from the gutters.

She was born Leah Berliawsky in 1899 to Isaac Berliawsky and **Zeisel Smoleranki Berliawsky**, Jewish parents whose ancestors had lived from the cutting and sale of wood in a village near Kiev in anti-Semitic tsarist Russia. Russian Jews were restricted as to where they could live and which occupations they could practice, and

❦▸ **Bernstein, Theresa Ferber** (b. 1903)
American painter. Born in Philadelphia, Pennsylvania, in 1903; married William Meyerowitz (a painter).

they were periodically murdered by the non-Jewish populace with government approval. Consequently, thousands of Jews emigrated to North America around the turn of the century. Several members of Isaac's family escaped these conditions to settle in New England, but as the youngest son in a family of 14 children he was expected to stay behind to care for his parents. After his father died of cancer, in 1902 he too left Russia, taking along only his mother who intended to live with one of her daughters. Isaac left his pregnant wife Zeisel behind with their two children, Nathan and two-and-a-half-year-old Leah, intending to earn enough money in America to send for them. Separation from her father was so traumatic that Nevelson did not speak for a year and a half, the first of many periods of withdrawal and depression in her life.

I want to be a sculptor, I don't want color to help me.

—**Nine-year-old Louise Nevelson to her school librarian**

Via cart, train and steamer, Isaac reached America. Settling in Maine, he worked first as a woodcutter. Later he was employed in a lime quarry in Rockland, a shipbuilding and mining town, with only two dozen Jewish families, which served as a summer playground for the rich who arrived by yacht or steamer to stay in luxury hotels. When the time came for Isaac's family to join him, 28-year-old Zeisel endured the awesome overland journey from the Ukraine to Hamburg, then travel by steamer to Liverpool, with her three young children. During the Atlantic crossing, Zeisel fell into a lingering state of depression from being permanently separated from her parents.

Isaac had arranged for a relative to meet their steamer in Boston when it arrived from New York. The first thing this man did was to give them all new names to go with their new country; at that moment, five-year-old Leah became "Louise." Reunited in Rockland (1905), the family lived for several years in a rooming house near the docks with other immigrants. Now known by the name Minna, Louise's mother immediately became pregnant again. Isaac worked as a peddler and junk dealer using a pushcart to haul discarded items from the local

dump—an unglamorous recycling business which did, however, provide a good livelihood. During World War I (1914–18), when ordnance was valuable, he made bullets from scrap metal. It is possible that he was a bootlegger, which could account for the government's denial of his request for citizenship in 1916. He also sold used lumber and eventually got into construction, which led to purchasing heavily mortgaged real estate. The first house he built for the family had no outside plumbing and no glass in the windows (later he modernized it). By the time Nevelson was in high school, the women in her family dressed more expensively than most; in fact, her mother overdressed in matching black fur hats and coats, following the trend of European aristocrats of her day. Isaac was also willing to pay for expensive piano and voice lessons for his three daughters.

Nevelson was chosen to be captain of the girls' basketball team; nevertheless, she always felt the stigma of having been a poor, Orthodox Jewish immigrant, as well as a junkman's daughter. Despite her dazzling facial beauty and tall (5'7"), athletic figure, she had no prospect of finding a husband locally. Learning English was difficult for her because the family spoke Yiddish at home. As a teenager, she already showed her rebelliousness against conventional, patriarchal, New England small-town society by dressing in eccentric ways. Throughout her life, she rearranged the facts and chronology of her existence to create her own reality; for example, she told people her father was a merchant or had a warehouse of antiques, although she acquired her scavenging from him. And she had a lifelong infatuation with aristocracy and royalty.

Nevelson was an average student in school, but even her grade-school teachers recognized her exceptional artistic talent. Her parents cared little as to which particular career she pursued, but they firmly expected that she (and not Nathan, the oldest and only male) would be the one in the family to achieve grandeur, perhaps as an actress or movie star with her sparkling eyes, dark brown hair and olive complexion. Meanwhile, Nevelson watched her mother take to her bed for months at a time, and, while Louise empathized with her misery and sought to please her, she resolved not to repeat her mother's life of victimization.

Louise took the commercial course in high school, and to graduate she interned as a legal stenographer. Bernard Nevelson, a Jewish New York shipowner, visited the attorney's office at which she worked and invited Louise, whom he

found attractive, to dinner. Bernard may have fallen in love with her, but, already married, he arranged for his 38-year-old bachelor brother Charles to meet her. Before their first date, Louise told her mother that she thought Charles would propose and that she would accept because a woman simply needed to have a husband. Given her previous resolution not to wed, she probably saw marriage to a man she frequently described as a "Wall Street millionaire" as the only escape from life in Rockland. Marriage to Charles Nevelson would also make her first in her family to acquire U.S. citizenship. Moreover, her only role models in Rockland were her art teachers who had worked their way through art school, yet whom she ridiculed for being "dried up old maids." The couple had a long engagement, allowing time for her to visit New York. Louise later said that Charles, whom she never loved, promised his virgin bride many things before their marriage; these included expecting no housework, being sympathetic to her artistic ambitions, and giving her unusual freedom for a wife. In any case, a few months before her 21st birthday in 1920, they were married by a rabbi at a Boston hotel and set off for a honeymoon-business trip to New Orleans and Cuba.

In New York, Louise Nevelson settled into the social life of wealthy Jewish society—shopping, playing cards, going to teas and concerts. In the exciting, postwar metropolis, she was exposed to the arts for the first time, and she tried to educate herself in all of them. During the ensuing years, she wrote poetry; took acting lessons from Princess **Norina Matchabelli** (from whom she first heard about the fourth dimension); studied voice and modern dance; had minor operatic roles; and took great interest in metaphysics. Gradually, however, she moved toward the realization of her childhood dream of becoming a sculptor. At age 30, about the time she saw Picasso's cubist paintings, which made an indelible impression on her, Nevelson enrolled at the Arts Students League, the only American art school devoted to avant-garde ideas and artistic freedom.

The ecstacy of her search for self-fulfillment was interrupted by the loss of the Nevelsons' fortunes (1924–29) and by the unexpected birth of their son Myron (Mike) less than two years after the marriage. When told she was pregnant, Nevelson hyperventilated. The child was born by Cesarian section, and his birth triggered in Nevelson a serious depression, which she managed to pull out of by throwing herself into art. The tension increased in her marriage as she rebelled against motherhood, while feeling guilty because

she loved her son but did not want her ambition thwarted. As she began to dress more eccentrically and enrolled in evening classes, Charles became more critical and controlling. She moved out in 1931. By then, Charles, who still hoped to get her back, could only afford to give her $10 a week in exchange for which she cleaned his hotel room and took care of his laundry.

Nevelson's family realized how unhappy she was, and still held onto their expectation that she would somehow become famous. They supplied the money for her art study abroad. In Paris during the winter of 1932–33, a lonely Nevelson, torn by maternal guilt, wrote suicidal poetry. When she returned to New York, she briefly rejoined Charles and Mike but soon moved out definitively.

During the 1930s, Nevelson could not make a living from the sale of her work. At times, she stole or moved when she fell behind in the rent. Admittedly sexually promiscuous, she used her lovers to buy her the extravagant things she had become accustomed to enjoying when she and Charles were rich. For example, she met arriving ships at the wharf to solicit the stevedores who came ashore with their paychecks, or she "window-shopped" on Fifth Avenue. When women friends asked her how she got the gorgeous clothing she wore to openings and parties, her velvety voice responded in crude but truthful language: "By f—ing, my dear, f—ing."

Due to her late start, marriage, and part-time study, by her late 30s Nevelson was quite frustrated. When finally allowed to exhibit her work in a show of young sculptors at the Brooklyn Museum in 1935, she was the oldest artist in the group. From later that year until 1939, she was employed as an art teacher by the Works Progress Administration (WPA), a New Deal agency that created jobs for the unemployed. By 1937, her penniless husband left New York to find work. He filed for divorce in 1941.

During World War II, Nevelson's situation was somewhat improved, although she was drinking a good deal. Between 1933 and 1945, she maintained a friendship with the painter Louis Eilshemius who eventually gave her 181 paintings. Her son Mike supported her by sending home checks from his salary in the merchant marine. By providing sexual favors for the owner, she had her first solo show in 1941 at the Nierendorf Gallery, an exhibition that at last won her critical acclaim. But when nobody bought the sculptures, Nevelson experienced more depression, binged and exploited men. The war brought Surrealists to America; and their

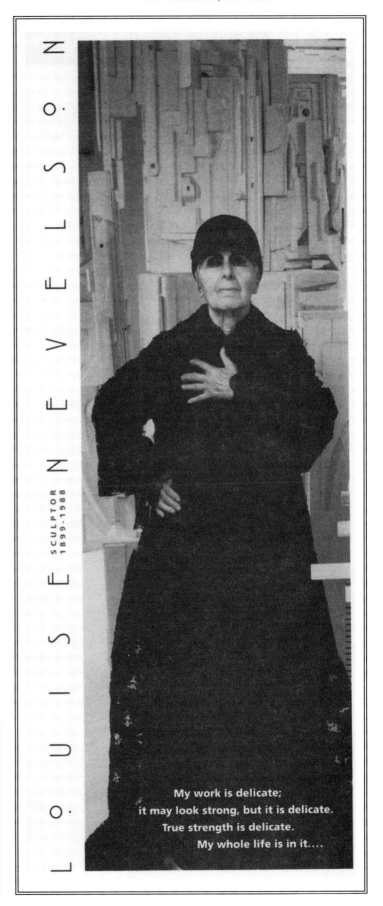

LOUISE NEVELSON

SCULPTOR 1899-1988

My work is delicate; it may look strong, but it is delicate. True strength is delicate. My whole life is in it....

artistic movement influenced new work of Nevelson's, which was constructed from junk and debris selected for their forms and then painted all one color, starting with a "black period." In 1943, when after a daring show of circus figures nothing sold, she destroyed 200 paintings and most of her sculptures to avoid storage fees. A further blow was the death of her beloved mother.

After the war, Nevelson's brother Nathan and her sister **Anita** bought her a house on 30th Street, and having her own home seemed to stabilize her mentally. But with the death of her dealer Karl Nierendorf in 1947, she lost the encouragement of a man who had compared her to Picasso. Without him to represent her, the art establishment ignored Nevelson. Now looking middle-aged, she frequently passed out and insulted people at parties and openings. In 1948, after she had a hysterectomy, her sister took her to Europe (1848) and to Mexico (1950) to help her shake off depression and resume sculpting.

In the 1950s, after she recovered from menopause, Nevelson's energy intensified. She made terra-cotta animals, birds and figures as well as etchings related to Mayan culture. While she won more acclaim, sales of her works were typically $200 or less—too little to make a decent living. In 1954, she started teaching in a continuing-education program for $40 a week. When her house was slated for demolition as part of a slum clearance project, she started to work in wood again. As neighboring structures were razed, she set out at three or four o'clock in the morning with a wheelbarrow to gather free materials. Joining the Church of Scientology seemed to bolster her creativity; but, in 1957, she experienced such fear in the process of doing a sculptural self-portrait that she abandoned working in the round. Thereafter, she started to make the filled boxes, and then walls of filled boxes, that became her hallmark. Toward the end of the decade, many of her walls were donated to major museums and her house was overflowing with sculptures. Yet, almost 60, she still had too few sales to be financially independent.

In 1958, **Martha Jackson** invited Nevelson to join her gallery in an arrangement in which she advanced the artist $20,000 against sales of her work. This enabled Nevelson to purchase a building at 29 Spring Street in lower Manhattan. In 1960, she would sign a similar two-year contract with Daniel Cordier Gallerie in Paris. Despite recognition, she was stubbornly bitter about her years of neglect and was known to become obscene and offensive in public. (When she was omitted from an exhibition at the Museum of Modern Art [MoMA], she attended the opening and urinated on a tub of ice cubes.) Of her lingering resentment, Nevelson would later tell **Barbara Braun** of *Publishers Weekly*: "Wouldn't it have been nice, when I was struggling, the complexion was in the right place, the ass was in the right place, if someone could have given me something to make it a bit more cheerful." As some of the anger passed, she shifted the color of her sculptured walls from black to white, which she said represented a transition from living in the shadows to a marriage with the world. The inclusion of an all-white room-sized assemblage of hers in a show at MoMA during 1959 put the official stamp on Nevelson's recognition by the art establishment.

The 1960s were characterized by a revival of sculpture in America. Nevelson represented the new wave, since she was a colorful personality as well as a major artist. She added new materials—mirrors, plexiglass and aluminum—to her boxes. Her sales grossed $80,000 in 1961, indicating that she was firmly established in the commercial market. After winning two prizes, in 1962 she sold her first museum piece to the Whitney Museum for $11,000. Then came her "metallic gold period." She dressed in gold lamé clothing with matching shoes at the opening of her gold-painted sculptural walls. Disappointment with sales at the Jackson Gallery led Nevelson to transfer to the Sidney Janis Gallery, a move which left her broke. She was saved from misery by a Ford Foundation fellowship as guest artist at the Tamarind Lithography Workshop in Los Angeles where she completed 500 lithographs valued at $150,000 and restored her self-confidence.

By the end of the 1960s, Arnold Glimcher of Pace Gallery became her dealer, which he would remain for the rest of her life. Glimcher wisely advised her to take commissions for monumental outdoor metal sculptures. These free-standing designs represented a return to sculpting in the round. Glimcher's idea paid handsomely; by the end of the 1970s, Nevelson was one of the three best-known outdoor sculptors in the U.S., along with Henry Moore and Alexander Calder. She once remarked: "I enjoy the fact that a woman artist in America can collect wooden scraps from the street, put them together and sell them to the Rockefellers for $100,000."

To evoke a persona in keeping with her status, Nevelson dressed in Arnold Scaasi's custom-designed clothes, which were made from rich fabrics like brocade, velvet, lace, and tulle, often with sequins. She overdressed as her mother had

in furs and fine clothes to make herself feel beautiful again, and in her late 70s she did appear on the international best-dressed list (1977).

In 1979, the Farnsworth Museum in Rockland opened its first Nevelson exhibit. At a luncheon held in her honor, the mayor presented her the key to the city before 400 townspeople. In New York, the 1979–80 season celebrated her 80th birthday with Mayor Edward Koch presenting Nevelson with a cake and dancing with her to the tune "Louise." In 1980, the Whitney Museum held a retrospective show of her work with the catalog essay written by Edward Albee.

With the help of studio assistants and her companion of 25 years, **Diana MacKown**, Nevelson continued to do good work into her 80s and was in fact at the height of her ability. Always a chain-smoker, in 1987 she was diagnosed with lung cancer that metastasized to her cerebellum. She died at her New York home in April 1988, contented with her life. In accordance with her wishes, her remains were cremated and no funeral was held. Six months later, a memorial service took place at the Medieval Sculpture Hall of the Metropolitan Museum, one of the museums to which she had donated several million dollars' worth of art. In 1969, John Canaday had described Nevelson in *The New York Times*: "You would have to saw her in two and file one half under 'Mystic Romantic' and the other under 'Rational-classical,' but all you would prove is that she is in a class by herself."

SOURCES:
Braun, Barbara. "Louise Nevelson," in *Publishers Weekly*. December 16, 1883.
Glimcher, Arnold. *Louise Nevelson.* 2nd rev. ed. NY: Dutton, 1976.
Gordon, John. *Louise Nevelson.* NY: Whitney Museum of Art, 1967.
Lipman, Jean. *Nevelson's World.* NY: Hudson Hills Press and Whitney Museum of American Art, 1983.
Lisle, Laurie. *Louise Nevelson: A Passionate Life.* NY: Summit, 1990.
Slatkin, Wendy; *The Voices of Women Artists.* Englewood Cliffs, NJ: Prentice Hall, 1993.
Watson-Jones, Virginia. *Contemporary American Women Sculptors.* Phoenix, AZ: Oryx Press, 1986.
Wilson, Laurie. *Louise Nevelson: Iconography and Sources.* NY: Garland, 1981.

SUGGESTED READING:
Andersen, Wayne. *American Sculpture in Process: 1930–1970.* Boston, MA: New York Graphic Society, 1975.
Kramer, Hilton. *The Age of the Avant-Garde.* NY: Farrar, Straus & Giroux, 1973.

RELATED MEDIA:
"Dawns and Dusks: taped conversations with Diana MacKown," NY: Scribner, 1976.
"Louise Nevelson: art & life; an interview with the daring and distinguished sculptor" (27 min. phonotape), Center for Cassette Studies, 1973.
"Louise Nevelson in Process," in volume 3 of *Portrait of an Artist* (motion picture and videocassette, 30 min., color), directed by **Susan Fanshei** and **Jill Godmilow**, produced in Chicago for WNET-THIRTEEN for Women in Art, 1977.
"Louise Nevelson, interviewed by Arnold Glimcher for Archives of American Art" (phonodisc), Washington, DC: Archives of American Art, 1973.

June K. Burton,
Associate Professor Emeritus at the University of Akron, Ohio

Nevers, countess of.

See Agnes de Nevers (r. 1181–1192).
See Yolande of Burgundy (1248–1280).
See Margaret of Flanders (1350–1405).

Nevers, duchess of.

See Henrietta of Cleves (r. 1564–1601).
See Charlotte of Vendôme.
See Margaret of Vendôme.
See Catherine of Lorraine.

Nevers, princess of.

See Louise Marie de Gonzague (1611–1667).

Neveu, Ginette (1919–1949)

French violinist. Born in France in 1919; died in an airplane crash in 1949; studied at the Paris Conservatory.

A child prodigy, French violinist Ginette Neveu made her debut in Paris in 1926, at the age of seven, and went on to study with Carl Flesch at the Paris Conservatory. Neveu was barely known in the United States, but she was a close friend of English conductor John Barbirolli and often played at his concerts and recorded with him. Sadly, her promising career was cut short when she was killed in a plane crash at the age of 30.

Neveu was particularly acclaimed for her performances of the concerti of the Finnish composer Jean Sibelius (1865–1957), some of which were recorded in the 1940s. In 1998, a recording she made in 1946 with the New York Philharmonic (under the baton of Barbirolli) was re-released, giving those who had never heard her play the Symphony No. 2, Violin Concerto, an opportunity to do so. The recording, transferred and restored from the original 78, is quite remarkable, according to John McKelvey who reviewed the issue for the *American Record Guide*. "Her intonation is flawless, her tone bright, clear, and smooth but also big and forceful in forte passages," he writes about Neveu. "It

Ginette Neveu

never goes raw and coarse, even under intense pressure. She performs the Sibelius as though it were child's play. Her tempos are in the mainstream, and her interpretation is clear-eyed and unsentimental, though by no means expressionless or dispassionate."

SOURCES:

McKelvey, John P. Review in *American Record Guide*. Vol. 61, no. 6. November–December 1998, p. 314.

Neville, Alice (c. 1406–1463).

See Montacute, Alice.

Neville, Alice (fl. 1480s)

Sister of the Kingmaker. Flourished in the 1480s; daughter of Richard Neville (b. 1400), 1st earl of Salisbury, and *Alice Montacute (c. 1406–1463); sister of Richard Neville, earl of Warwick (1428–1471, known as Warwick the Kingmaker); married Henry Fitzhugh, 5th Lord of Fitzhugh of Ravensworth; children: *Anne Fitzhugh; Richard Fitzhugh.

Neville, Anne (fl. 1440–1462).

See Holland, Anne.

Neville, Anne (1456–1485).

See Anne of Warwick.

Neville, Anne (d. 1480).

See Beaufort, Joan (c. 1379–1440) for sidebar.

Neville, Catherine (c. 1397–1483)

*Duchess of Norfolk. Name variations: Katherine Neville. Born around 1397; died in 1483; daughter of *Joan Beaufort (1379–1440) and Sir Ralph Neville of Raby, 1st earl of Westmoreland; second wife of John Mowbray (1415–1461), 3rd duke of Norfolk; married Sir Thomas Strangeways; married John, viscount Beaumont; married Sir John Wydeville. John Mowbray's first wife was *Anne Bourchier (c. 1417–1474).*

Neville, Catherine (fl. 1460)

*English aristocrat. Name variations: Katherine Neville. Flourished around 1460; daughter of Richard Neville (b. 1400), earl of Salisbury, and *Alice Montacute; sister of Richard Neville, earl of Warwick (1428–1471, known as Warwick the Kingmaker); married William Bonville, Lord Harrington, also seen as Lord Haryngton; married William Hastings, 1st Lord Hastings; children: (first marriage) Cecily Bonville (1460–1530), Baroness Harrington; *Anne Hastings (d. after 1506).*

Neville, Catherine (d. 1476).

See Stafford, Catherine.

Neville, Cecily (1415–1495)

*Duchess of York. Name variations: Cecily, duchess of York; Lady Cecily Neville; Cecily of York; the Rose of Raby. Born on May 3, 1415, in Raby Castle, Durham, England; died on May 31, 1495, at Berkhempsted or Berkhamsted Castle, Hertfordshire, England; daughter of Joan Beaufort (1379–1440) and Sir Ralph Neville of Raby; married Richard, 3rd duke of York, Lord Protector, in 1424 (died 1460); children: Joan (1438–1438); Anne Plantagenet (1439–1476); Henry (b. 1441, died young); Edward IV (1442–1483), king of England (r. 1461–1483); Edmund (1443–1460), earl of Rutland; *Elizabeth de la Pole (1444–1503), duchess of Suffolk; *Margaret of York (1446–1503); William (b. 1447, died young); John (b. 1448, died young); George (1449–1478), duke of Clarence; Thomas (born c. 1451, died young); Richard III (1452–1485), king of England (r. 1483–1485); Ursula (born c. 1454, died young).*

Cecily Neville was an important figure in England's Wars of the Roses. She and her husband, Richard, 3rd duke of York, founded the House of York, and helped two of their sons become kings. One of nine surviving children of the powerful earl of Westmoreland and *Joan Beaufort, Cecily was the great-granddaughter of King Edward III on her mother's side. In 1423, her young royal cousin, Richard Plantagenet, became her father's ward and came to live with the Neville family at Raby Castle; a betrothal was soon arranged between the two children. Some time the next year, Richard married the "Rose of Raby," as Cecily was popularly called because of her beauty. It was common for noble families to make marriage contracts—essentially alliances between families—for children, and for the young couples to live separately until they were adults. Cecily's first child *Anne Plantagenet was born in 1439, suggesting that she and Richard began to live together in the late 1430s.

They were a close couple, and despite the disorder of the years of civil warfare they helped create, Cecily and Richard were rarely separated. In 1449, she accompanied him to Ireland, where he governed for Henry VI; she also traveled with him across England and France. Cecily had at least twelve children, of whom seven survived infancy. Much of her daily routine was taken up by her maternal duties and her extensive responsibilities as mistress of a large household. But the duchess, as ambitious as her husband, was also an active participant in the political struggles which emerged between Richard and King Henry VI. The king was mentally unstable and easily controlled by his advisors as well as by his queen, *Margaret of Anjou (1429–1482); Margaret came to lead the effort to save King Henry's throne from the duke of York, who actually had the stronger claim to be king. When Richard made the bid for power which created open civil conflict, Cecily's ambitions for her growing family led her to devote herself to his cause, working to increase support for him among the northern cities.

In 1459, she and her three youngest children were taken into custody by Queen Margaret of Anjou's army at Ludlow after Duke Richard was defeated in battle. The Yorkists were charged with treason by Parliament, who put Cecily's sister ❧➤ Anne Neville, duchess of Buckingham, in charge of the captive Cecily. She was treated well during those months with the duke and duchess, and the king provided a large income for her support. Cecily was allowed to meet with Henry VI and pleaded successfully with him to spare the lives of captured Yorkists and to return some of the York property he had confiscated. After her release in the summer of 1460, the duchess rejoined her husband and children to continue the fight for the throne. In November, Duke Richard was proclaimed Protector of England. The victory was short-lived, however, and he and one of his sons were killed in battle on December 30. Her grief only reinforced Cecily's determination that the House of York should rule, and after sending her younger sons to Burgundy for protection, she supported the claim of her eldest son Edward. It was at Cecily's London estate, Baynard Castle, that Edward was proclaimed king in March 1461.

Edward IV relied heavily on his mother's counsel in the early years of his reign. While he consolidated his power on the battlefield, Cecily was tireless in her efforts to win the support of the Londoners for the new king. Her vocal disapproval of Edward's secret marriage in 1464 to *Elizabeth Woodville weakened her sway over him. She also had an unfortunate relationship with her son George, duke of Clarence. George sided with the Lancastrian party in the 1470s and plotted against King Edward. To bolster his own claim to the throne, he spread a rumor that Edward was not really the duke of York's son but Cecily's son by an affair with a soldier, and so was unfit to rule. There was no truth to the story, which Cecily vehemently denied, but it shows that George was willing to insult his mother's honor for his own benefit. She sought to forgive his insult, however, and even pleaded for his life before Edward had George executed for treason.

By 1480, Cecily, now about 65 years old, had retired to her estates at Berkhamsted and took the vows of the Benedictine order. Always a pious woman, she had grown increasingly religious in her later years. She did support her son Richard (III), who took the throne in 1483 after Edward IV's death, but she did not attend his coronation and made no public appearances. Although the duchess never forgot her earlier ambitions to the throne, and continued to use the royal heraldic arms of England, her political days were over. She spent most of her time reading the devotional texts in her extensive library and attending private services. The death of King Richard III in 1485 marked the end of the House of York's rule; Cecily had outlived the dynasty she had worked hard to create, surviving all but two of her children. She died in 1495 at the age of 80 and, following the terms of her will, was buried beside her husband at Fotheringay Castle.

SOURCES:

Cheetham, Anthony. *The Life and Times of Richard III.* London: Weidenfeld & Nicolson, 1972.

◄❧
*Neville, Anne
(d. 1480).* See
Beaufort, Joan for
sidebar.

Weir, Alison. *The Wars of the Roses.* NY: Ballantine Books, 1995.

Laura York,
Riverside, California

Neville, Cecily (fl. 1480s)

*Countess of Warwick. Name variations: Cecily Beauchamp; Cecily Tiptoft. Flourished in the 1480s; daughter of Richard Neville, 1st earl of Salisbury, and *Alice Montacute (c. 1406–1463); sister of Richard Neville, earl of Warwick (1428–1471, known as Warwick the Kingmaker); married Henry Beauchamp, duke and 6th earl of Warwick, around 1433; married John Tiptoft, 1st earl of Worcester; children: (first marriage) Anne Beauchamp (c. 1443–1449, died at age six).*

Neville, Eleanor (c. 1413–1472).

See Beaufort, Joan (c. 1379–1440) for sidebar.

Neville, Eleanor (fl. 1480s)

*Countess of Derby. Flourished in the 1480s; daughter of Richard Neville, 1st earl of Salisbury, and *Alice Montacute (c. 1406–1463); sister of Richard Neville, earl of Warwick (1428–1471, known as Warwick the Kingmaker); married Thomas Stanley, earl of Derby; children: George Stanley, Lord Strange (d. 1497); Edward Stanley, Lord Monteagle (d. 1523).*

Neville, Elizabeth (c. 1383–?).

See Holland, Elizabeth.

Neville, Isabel.

See Ingoldsthorp, Isabel.

Neville, Isabel (1451–1476)

*Duchess of Clarence. Born on September 5, 1451, in Warwick Castle, Warwickshire, England; died on December 14, 1476, in Warwick Castle; buried at Tewkesbury Abbey, Gloucestershire, England; daughter of Richard Neville, earl of Warwick, and *Anne Beauchamp (1426–1492); married George, duke of Clarence, July 4, 1469; children: Anne (b. 1470, died in infancy); *Margaret Pole (1473–1541), countess of Salisbury; Edward, earl of Warwick and Surrey (1475–1499); Richard (1476–1477).*

Neville, Jane (d. 1538)

Baroness Montagu. Name variations: Jane Pole. Died in 1538; daughter of George Neville, 4th Lord Bergavenny, and Margaret Fenne; married Henry Pole

(son of *Margaret Pole), baron Montagu (died 1538); children: at least one son. Jane Neville may have died in the Tower along with her husband.

Neville, Jane (d. 1593).

See Howard, Jane.

Neville, Joan (fl. 1468)

*English noblewoman. Name variations: Joan Bourchier. Flourished around 1468; probably born in 1450; daughter of John Bourchier, 1st baron Berners, and *Catherine Howard (fl. 1450); married Henry Neville (died in battle in 1469); children: Richard Neville, 2nd baron Latimer (1468–1530).*

Neville, Joan (fl. 1480s)

*Countess of Arundel. Name variations: Joan Fitzalan. Flourished in the 1480s; daughter of *Alice Montacute (c. 1406–1463) and Richard Neville, 1st earl of Salisbury; sister of Richard Neville, earl of Warwick (1428–1471, known as Warwick the Kingmaker); married William Fitzalan, 13th earl of Arundel; children: Thomas Fitzalan, 14th earl of Arundel (1450–1524).*

Neville, Joanna (c. 1379–1440).

See Beaufort, Joan.

Neville, Lucy

*English noblewoman. Daughter of John Neville, marquess of Montagu and earl of Northumberland, and *Isabel Ingoldsthorp; sister of *Margaret Neville (b. 1466); married Sir Anthony Browne; children: *Anne Browne (d. 1511, who married Charles Brandon [1484–1545], duke of Suffolk).*

Neville, Margaret (d. 1372)

*Countess of Northumberland. Name variations: Margaret Percy. Died on May 12, 1372; daughter of Ralph Neville, 2nd baron Neville of Raby, and *Alice Audley (d. 1374); married William Roos, 4th baron Ros; married Henry Percy, 1st earl of Northumberland, on July 12, 1358; children: Henry Percy (Hotspur); Thomas Percy; Ralph Percy. Margaret Neville is portrayed in William Shakespeare's Henry IV, Part 2.*

Neville, Margaret (d. 1396).

See Stafford, Margaret.

Neville, Margaret (c. 1377–c. 1424)

*Duchess of Exeter. Born around 1377; died around 1424; interred at Bury St. Edmunds Abbey, Suffolk; daughter of Sir Thomas Neville of Horenby, and **Joan Furnivall**; married Thomas Beaufort, duke of Exeter, before February 15, 1403; children: Henry Beaufort.*

Neville, Margaret (b. 1466)

*Duchess of Suffolk. Name variations: Margaret Mortimer; Margaret Brandon. Born in 1466; death date unknown; daughter of John Neville, marquess of Montagu and earl of Northumberland, and *Isabel Ingoldsthorp; married John Mortimer; married Charles Brandon (1484–1545), 1st duke of Suffolk (r. 1514–1545), before February 7, 1506 (annulled in 1507). Charles Brandon was also married to *Mary Tudor (1496–1533), *Anne Browne (d. 1511), and *Catharine Bertie (1519–1580).*

Neville, Margaret (d. 1506)

*Sister of the Kingmaker. Born before 1460; died after November 20, 1506; interred at Colne Priory; daughter of *Alice Montacute (c. 1406–1463) and Richard Neville (b. 1400), 1st earl of Salisbury; sister of Richard Neville, earl of Warwick (1428–1471, known as Warwick the Kingmaker); married John de Vere, 13th earl of Oxford; married William Hastings, Lord Hastings; children: (second marriage) Edward Hastings, Lord Hastings.*

Nevilles, Sis (c. 1893–1987).

See Cotten, Elizabeth.

Newall, Bertha Surtees (1877–1932).

See Phillpotts, Bertha Surtees.

Newburgh, countess of.

See Radcliffe, Charlotte Maria (d. 1755).

Newby-Fraser, Paula (1962—)

Zimbabwan-born American triathlete. Born in Harare, Zimbabwe, in 1962; daughter of Brian Newby-Fraser (a businessman) and Elizabeth Newby-Fraser (a psychologist); graduated from college in 1984.

Won the national Ironman Triathlon in the women's division, South Africa (1985); finished third in her first world-class Ironman race (1985); finished second in the Hawaii Ironman Triathlon, later named winner after first-place finisher was disqualified (1986); eight-time Ironman Triathlon world champion (1986, 1988, 1989, 1991–94, 1996); finished third in the Hawaii Ironman and the Ironman world cham-

pionships (1987); four-time Ironman Japan champion (1988, 1990–92); four-time Nice International Triathlon champion (1989–92); named Greatest All-Around Female Athlete in the World by "Wide World of Sports" and the Los Angeles Times (1989); named Professional Athlete of the Year by the Women's Sports Foundation and Female Pro Athlete of the Decade by the Los Angeles Times (1990); three-time Ironman Europe champion (1992, 1994, 1995); three-time Ironman Lanzarote champion (1994, 1995, 1997); Ironman Canada champion (1996); two-time Ironman Australia champion (1996, 1997); Ironman South Africa champion (2000); inducted into Breitbard Hall of Fame at Hall of Champions Sports Museum (2000).

Paula Newby-Fraser's legendary endurance made her the dominant force in the women's field of Ironman Triathlon events from 1988 through the 1990s. Called the "greatest all-around female athlete in the world," "the Queen of Multisport" and "the Empress of Endurance," she was born to wealthy parents in Harare, Zimbabwe, in 1962. The family moved to Durban, South Africa, where her father owned a large industrial paint company, when she was still a child. In Durban, she learned ballet and took swimming lessons, proving herself such an excellent swimmer that she earned a national ranking while still in high school. By the time she reached college, however, she had had enough of athletics, and did not take them up again until she was working full-time after her college graduation in 1984. Wanting to lose weight, Newby-Fraser started jogging. Soon, she added aerobics and weight-lifting to her exercise regimen. She became aware of triathlons, grueling competitions that include swimming, bike riding, and running. When an Ironman triathlon, one of the most important of the year, was held in her hometown, Newby-Fraser watched the race but did not participate. It was not long, however, before she and her boyfriend bought bikes and began riding and running each day. Just two months after she purchased her bike, in January 1985, she entered her first triathlon. Not only did she win this race, she also set a new women's course record, and was one of the top ten finishers. Three months later, she won the national Ironman Triathlon in the women's division and earned a free trip to Hawaii to compete in the annual Ironman Triathlon.

Newby-Fraser trained casually for this competition, which consisted of a 2.4-mile swim, a 112-mile bike race, and a 26.2-mile run, hoping just to be able to complete it. She had never biked 112 miles in one week, let alone in one

day, and had never run a marathon of any kind. In addition, when she got to Hawaii she found the heat oppressive. Much to her surprise, she nonetheless finished third. Having observed the competition in her first-ever world-class Ironman race, she quickly determined that she could win the event with the proper training. Newby-Fraser then moved to southern California and began training and competing in earnest, winning $25,000 in her first year of American triathlon competition.

In California, she met triathlete Paul Huddle, who helped her to increase her training load and has since become her longtime companion. The hard work paid off in 1986, when she finished second in that year's Hawaii Ironman Triathlon, behind **Patricia Puntous**. Puntous was later disqualified for drafting on her bike, and Newby-Fraser was named the winner. She won $17,000 in prize money and gathered numerous endorsement contracts and sponsorships. The following year, she placed third in both the Hawaii Ironman and the Ironman world championships. After that, Newby-Fraser dominated the competition, and over the next eight years she won the women's Hawaii Ironman Triathlon seven times, breaking records in the bike course and the marathon. In 1992, she set a women's course record of 8:55:28 that remained unbroken for years. The next year, she won the race again, even after having lost six months of training due to a stress fracture to her ankle. Through 1995 she won 21 major ultra-distance races. Her domination in the field led to her being named Professional Athlete of the Year in 1990 by the Women's Sports Foundation. As her winning streak continued, she garnered book offers and became an advocate for women's fitness.

In 1994, after she won her seventh Hawaii Ironman competition, Newby-Fraser announced that the 1995 Hawaii Ironman event would be her last. After initially leading in that race, she collapsed from dehydration and exhaustion 200 feet from the finish line. In a dramatic finish, 22 minutes later she dragged herself over the line, and into fourth place. Despite her stated goal of retirement, Newby-Fraser has continued to compete in triathlons, amassing 23 Ironman world championships by the year 2000. One of these was the first-ever Ironman South Africa in 2000, for which she returned to her childhood home and handily beat the competition while her parents watched. Now a U.S. citizen who lives and trains in Encinitas, California, she also runs a business that makes athletic apparel for women and has published two books on fitness, *Cross-Training: The Complete Training Guide for All*

Sports (with Gordon Bakoulis Bloch, 1992) and *Paula Newby-Fraser's Peak Fitness for Women* (with John M. Mora, 1995). Named one of the top five professional female athletes of the last 25 years by the U.S. Sports Academy, CNN and *USA Today* in 1997, Newby-Fraser was inducted into the Breitbard Hall of Fame of the San Diego Hall of Champions in February 2000.

SOURCES:

Johnson, Anne Janette. *Great Women in Sports*. Detroit, MI: Visible Ink, 1998.

Jo Anne Meginnes,
freelance writer, Brookfield, Vermont

Newcastle, duchess of.

See Cavendish, Margaret (1623–1673).

Newcomb, Ethel (1875–1959)

American pianist. Born in Whitney Point, New York, in 1875; died in Whitney Point, New York, on July 3, 1959.

Ethel Newcomb studied in Vienna with Theodor Leschetizky from 1895 to 1903. While there, she performed concertos with the Vienna Symphony Orchestra. Leschetizky kept her on as his assistant from 1904 through 1908, and eventually she wrote an interesting memoir about her teacher and colleague. At her 1904 London debut, she performed concertos by Schumann, Chopin, and Saint-Saëns under the baton of Richard Strauss. The bulk of her career took place in the United States.

SUGGESTED READING:

Newcomb, Ethel. *Leschetizky as I Knew Him*. NY: D. Appleton, 1921.

John Haag,
Athens, Georgia

Newcomb, Josephine L. (1816–1901)

American philanthropist. Name variations: Josephine Le Monnier Newcomb. Born Josephine Louise Le Monnier on October 31, 1816, in Baltimore, Maryland; died on April 7, 1901, in New York City; daughter of Alexander Le Monnier and Mary Sophia (Waters) Le Monnier; educated primarily in Europe; married Warren Newcomb (a merchant), in 1845; children: son (died young); H(arriott) Sophie Newcomb (1855–1870).

Established, through $100,000 donation, H. Sophie Newcomb Memorial College for women at Tulane University, New Orleans (1887).

Josephine Newcomb was born into a well-to-do Baltimore family in 1816. Because her father, wealthy businessman and Parisian native Alexander Le Monnier, believed his three children should go abroad for their education, as a girl Newcomb traveled throughout Europe and the Near East. Shortly after her return to the United States in 1831, her mother **Mary Sophia Le Monnier** died and Alexander Le Monnier's fortune was lost. The family subsequently lived with Newcomb's married sister in New Orleans, Louisiana, and on a summer trip she met prosperous young wholesaler Warren Newcomb. They were married in December 1845, after which they lived in New Orleans, Louisville, Kentucky, and New York City. The couple lost their first child, a son, while he was still an infant; their second child, **H. Sophie Newcomb**, was born in 1855.

Intent on providing their daughter with the best nurturing and education they could, Warren Newcomb retired in 1863 so that he could take his family to Europe. Three years later, he died, leaving Josephine and Sophie a fortune. Though Newcomb turned her attentions to her child, Sophie contracted diphtheria in 1870 and died, at age 15. Newcomb was so distraught that for some years friends were afraid she might lose her sanity. She eventually recovered from her grief, and from 1877 to 1882 set about developing her inheritance and looking for the perfect memorial to her beloved Sophie. She assumed a modest lifestyle in New York City, exercising her considerable business skills and increasing her wealth while she considered possible memorial projects.

In 1882, Josephine Newcomb donated sizable sums to Washington and Lee University in Lexington, Virginia, and to the Confederate Orphan Home in Charleston, South Carolina. She gave funds to help establish schools for poor girls and for the deaf, and made other donations, but was not satisfied that these were the right remembrancers for her daughter. When in 1886 a longtime friend suggested that she establish a women's college at the new Tulane University in New Orleans, Newcomb finally found the perfect memorial. She gave $100,000 to Tulane, and in 1887 the university opened the first independent women's college attached to a men's college in America, the H. Sophie Newcomb Memorial College for women. Although she left most of the administration to the university, Newcomb did stipulate that the college commemorate Sophie's birth and death with Episcopalian services, and occasionally tried the patience of administrators when she decided to personally oversee college business.

Pleased with the college's progress over the years, Josephine Newcomb continued to support it with donations. A reserved but sometimes witty woman with simple tastes in clothes, she died at a friend's home in New York City in 1901. Her lifetime donations to her daughter's memorial—including her entire estate, which was left to Newcomb College—totaled $3,600,000.

SOURCES:

James, Edward T., ed. *Notable American Women, 1607–1950.* Cambridge, MA: The Belknap Press of Harvard University Press, 1971.

McHenry, Robert, ed. *Famous American Women.* NY: Dover, 1980.

Jacquie Maurice,
freelance writer, Calgary, Alberta, Canada

Newell, Harriet Atwood

(1793–1812)

One of the first American women to travel overseas as a missionary. Born Harriet Atwood on October 10, 1793, in Haverhill, Massachusetts; died on November 30, 1812, on the Isle of France (now Mauritius); daughter of Moses Atwood (a merchant) and Mary (Tenny) Atwood; attended Bradford Academy in Massachusetts, 1806–07, also attended a private academy, 1810; married Samuel Newell (later a missionary), on February 9, 1812, at Haverhill, Massachusetts; children: Harriet (born prematurely in 1812 and died five days later).

One of the first two American women to travel overseas as a missionary, along with Ann Hasseltine Judson, and the first American missionary to die on foreign soil (1812).

The third of nine children, Harriet Atwood Newell was born to devout Christian parents in Haverhill, Massachusetts, on October 10, 1793. During the two years she attended Bradford Academy (1806–07), she demonstrated her intelligence and kept a journal which recorded her religious awakening. Unlike the emotional conversion of her friend Nancy Hasseltine, who as *Ann Hasseltine Judson* would later join her on her missionary endeavors, Newell experienced a calm and logical acceptance of her faith. In 1808, her father died of tuberculosis, and the following year she decided to join the Haverhill (Massachusetts) Congregational Church and devote her life to serving God. In 1810, she attended a private academy and spent a few weeks with her sister **Mary Atwood**, who was teaching at the Byfield (Massachusetts) Academy.

In October 1810, Harriet met her future husband Samuel Newell, a Harvard graduate

who was attending Andover (Massachusetts) Theological Seminary. Her friend Hasseltine agreed to marry another Andover student, Adoniram Judson, and Samuel proposed to Newell in April 1811. She feared that her fragile health might interfere with his plans to become a foreign missionary in India, but months later decided to marry him, well aware that the journey would be difficult and that she could expect never to return to see her family.

On February 9, 1812, they were married in Haverhill, Massachusetts, and ten days later, with the Judsons, sailed from Salem on the *Caravan* for Calcutta, India. They arrived in India on June 16, the first American missionaries in the country. After spending a few weeks with British missionaries at Serampore, they were ordered by the British East India Company, which at the time virtually ruled the country and was opposed to attempts to Christianize Indians, to return to America. The company reconsidered after a few days, however, and granted them permission to go to the Isle of France in the Indian Ocean. Newell was pregnant when she embarked with her husband on August 4. The voyage proved difficult and lengthy, and she was ill much of the time; a daughter whom they named Harriet was born prematurely on the ship, dying only five days later. She was buried at sea. On October 31, the boat docked at Port Louis, Isle of France, and Newell was brought ashore, weak from tuberculosis and childbirth. She died a month later, on November 30, 1812, in a mud-walled cottage on the island. Her husband continued his work in Ceylon and Bombay and died less than ten years later. Harriet Newell's grave at Port Louis was marked with a monument by the American Board of Commissioners for Foreign Missions, and her brief career, perceived by some as almost martyr-like, became for years an inspiration to aspiring overseas missionaries.

SOURCES:

Edgerly, Lois Stiles, ed. *Give Her This Day*. Gardiner, ME: Tilbury House, 1990.

James, Edward T., ed. *Notable American Women, 1607–1950*. Cambridge, MA: The Belknap Press of Harvard University Press, 1971.

Read, Phyllis J., and Bernard L. Witlieb. *The Book of Women's Firsts*. NY: Random House, 1992.

Jo Anne Meginnes,
freelance writer, Brookfield, Vermont

Newlin, Dika (1923—)

American composer, pianist, critic, musicologist, and professor. Born in Portland, Oregon, on November 22, 1923; Michigan State University, B.A., 1939, University of California at Los Angeles, M.A., 1951; awarded the first Ph.D. in musicology granted by Columbia University, in 1945.

Dika Newlin studied with some of the foremost musicians of the 20th century, including Arnold Schoenberg, Artur Schnabel, Rudolf Serkin, and Roger Sessions. She received her B.A. from Michigan State University in 1939, her M.A. from the University of California at Los Angeles in 1951, and her Ph.D. from Columbia University in 1945, for which she wrote *Bruckner, Mahler, Schoenberg*. She was a Fulbright fellow in Vienna (1951–52) and established the music department at Drew University, teaching there from 1952 to 1965. In 1957, Newlin was awarded the Mahler medal by the Bruckner Society. In 1965, she became professor of musicology at North Texas State University in Denton where she remained until 1973, when she was appointed director of Montclair State College's electronic music library. In 1978, Newlin developed a new doctoral program in music for Virginia Commonwealth University. In addition to numerous compositions in the 12-tone idiom, Newlin has written about Arnold Schoenberg and has translated his works.

John Haag,
Athens, Georgia

Newman, Angelia L. (1837–1910)

American church worker and reformer. Name variations: Angie Newman; Angelia Louise French Thurston Kilgore Newman. Born Angelia Louise French Thurston on December 4, 1837, in Montpelier, Vermont; died on April 15, 1910, in Lincoln, Nebraska; daughter of Daniel Sylvester Thurston and Matilda Benjamin Thurston; attended Lawrence University in Appleton, Wisconsin, 1857–58; married Frank Kilgore (died c. 1856); married David Newman (a merchant), on August 25, 1859 (died 1893); children: (second marriage) Cora Fanny (b. 1860); Henry Byron (b. 1863).

Angelia L. Newman, called Angie, was born in 1837 to a Methodist family in Montpelier, Vermont, the eldest of four girls. Her mother **Matilda Thurston** died when Newman was about seven, and her father Daniel Thurston, a farmer, tanner, currier, and prominent citizen, remarried shortly thereafter; her younger half-brother by this marriage, John Mellen Thurston, would later become a U.S. senator. Newman attended an academy in Montpelier and briefly taught school before her family relocated to Wisconsin, where at age 18 she married a Methodist minister's son, Frank Kilgore. Kilgore

died before their first anniversary, and Newman began teaching at a public school and attended Lawrence University for one term. In August 1859, she married merchant David Newman, with whom she had two children: **Cora Fanny Newman**, born in 1860, and Henry Byron Newman, born in 1863. The family moved to Lincoln, Nebraska, in 1871.

Angelia Newman was apparently an invalid from 1862 to 1875, when her pulmonary condition was cured "in answer to prayer." She was urged to become active in Methodist causes by her husband, who was a longtime Methodist Sunday School superintendent, so she joined the Women's Foreign Missionary Society and soon became secretary of its western branch. As part of the society, Newman organized missionary trips into the frontier of western Nebraska, raised funds to aid missionary work in India and elsewhere, and wrote numerous articles for its magazine, the *Heathen Woman's Friend*. Newman was a forceful lecturer, advocating missionary work abroad and calling those who opposed the missionary movement "the heathen at home"—a term which became the title of her widely distributed 1878 pamphlet.

In the late 1870s, in part due to lack of support within the church establishment for foreign missionary work by women, Newman and other leading churchwomen began to focus on missionary projects within the United States. After a trip to Salt Lake City taken for health reasons, Newman returned home convinced that the city was "to all intents [as] foreign" as any place overseas. The Mormon practice of polygamy, she believed, substituted "the *Harem* for the *Home*," and in her speeches she argued that Mormonism was not a religion. She advanced the already well-known campaign of *Ann Eliza Young, the 27th wife of Mormon leader Brigham Young, who had filed for divorce from her husband in 1873. Although the publicly favored Edmunds-Tucker Act of 1882 outlawed polygamy, the Mormon Church did not officially follow suit until 1890, in order to gain statehood. Newman sustained her offensive against the Mormons, becoming secretary of the Mormon Bureau of the Woman's Home Missionary Society and superintendent of the Mormon Department of the Woman's Christian Temperance Union (WCTU).

Newman sought to establish a refuge in Salt Lake City for Mormon wives and children who were left homeless by the enforcement of the Edmunds-Tucker Act. To this end, she worked in Washington, D.C., from 1885 to 1891, testifying before a Senate committee and submitting petitions, and in 1886 helped to win a $40,000 Congressional grant to create a home for refugee Mormon wives in Utah. In 1887, she became the first woman appointed as a lay delegate to the General Conference, the Methodist legislative body, although she was not seated due to what the male delegates termed "female ineligibility." For 12 years, she was state superintendent of jail and prison work for the WCTU, and beginning in 1889 lectured on temperance and "social purity." Nebraska governors appointed her a delegate to the National Conference of Charities and Correction every year from 1883 until 1892, and she was active in several other organizations as well, including the National Council of Women and the Daughters of the American Revolution.

After her husband died in 1893, Newman traveled to Hawaii—"a natural mission field," as she characterized it—where she evidently worked as a hospital inspector. She so approved of President William McKinley's policies that she praised them in her privately printed *McKinley Carnations of Memory* in 1904. Still working hard in her late 60s, she continued to give lectures on foreign travel to the women of Lincoln, Nebraska. An embodiment of the affluent American Methodist women of her time, much admired for her oratory and her dedication both to her Christianity and to reform, Angelia Newman died in 1910 at age 72.

SOURCES:

James, Edward T., ed. *Notable American Women, 1607–1950*. Cambridge, MA: The Belknap Press of Harvard University Press, 1971.

Jacquie Maurice,
freelance writer, Calgary, Alberta, Canada

Newman, Frances (1883–1928)

American writer and librarian. Born on September 13, 1883 (some sources cite 1888), in Atlanta, Georgia; died on October 22 (or 28), 1928, in New York City; daughter of William Truslow Newman (a judge) and Frances Percy (Alexander) Newman; attended Agnes Scott College, Decatur, Georgia, 1900–01; attended the Library School of the Atlanta Carnegie Library; studied at the Sorbonne in Paris, 1923; never married.

Selected writings: The Short Story's Mutations: From Petronius to Paul Morand *(1924);* "Rachel and Her Children" *in H.L. Mencken's* American Mercury *(1924);* The Hard-Boiled Virgin *(1926);* Dead Lovers Are Faithful Lovers *(1928); (translator and author of introduction)* Six Moral Tales from Jules Laforgue *(1928).*

Born into a prominent Atlanta family on September 13, 1883, Frances Newman was the

youngest child of William Truslow Newman, a U.S. district judge, and **Frances Alexander Newman**, a descendant of the founder of Knoxville, Tennessee. Growing up in the shadow of three attractive older sisters, Newman spent long hours in her father's library. An attempt at age ten to write her own novel was dropped abruptly after one of her sisters discovered and laughed at it. Educated in private schools in Atlanta, New York City, and Washington, she later attended Agnes Scott College in Decatur and the Library School of the Atlanta Carnegie Library.

Newman began her career as a librarian in 1913 at the Florida State College for Women, and was first published while working at a later job in the catalogue and circulation departments of the Carnegie Library in Atlanta. Her book reviews appeared in the library's bulletins and in local and New York newspapers, where their acerbic and crushing criticism caught the attention of James Branch Cabell and H.L. Mencken (himself a master of crushing criticism). They encouraged her to develop her writing talent, and in 1924 her short story "Rachel and Her Children" appeared in Mencken's *American Mercury*. It won an O. Henry Award that year. The story's cynical and ironic mood was to become characteristic of Newman's later novels. In 1924, she also published *The Short Story's Mutations*, a discriminating compilation with an astute critical preface.

Deep and complex, her first novel *The Hard-Boiled Virgin* was published in 1926. The book's title and subject matter, about a woman who deliberately sets out to smash all her illusions, were deemed so distasteful that it was banned in Boston. In 1928, Newman published her second novel, *Dead Lovers Are Faithful Lovers*. Some of her fellow writers had great admiration for her originality and faith in the potential of her talent, although her few works, extraordinary as they were for their time, were never very popular with the public. Many readers were put off by her penchant for literary allusion and her esoteric style; for example, *The Hard-Boiled Virgin* has no dialogue. Nonetheless, Carl Bohnenberger felt she "created in the short space of [a few] years a style utterly new to American letters," while her friend James Branch Cabell believed that she might have ranked among the best writers in America if she had lived long enough.

In 1928, Frances Newman traveled to Paris to begin research on a translation of Jules Laforgue's short stories. While there, she began experiencing eye trouble which neither French nor, later, American doctors were able to diagnose or treat. Suffering impaired vision, she nevertheless continued the arduous translations by dictation, and went to New York to meet with publishers in October 1928. She was found unconscious in her hotel room there, and died two days later from what has been variously attributed to either a probable brain hemorrhage or suicide by poisoning.

SOURCES:

Contemporary Authors. Vol. 110. Detroit, MI: Gale Research, 1984.

James, Edward T., ed. *Notable American Women, 1607–1950*. Cambridge, MA: The Belknap Press of Harvard University Press, 1971.

Kunitz, Stanley J., and Howard Haycraft, eds. *Twentieth Century Authors*. NY: H.W. Wilson, 1942.

Jacquie Maurice,
freelance writer, Calgary, Alberta, Canada

Newman, Julia St. Clair (1818–?)

Creole swindler. Born in 1818; educated in France.

Earning her livelihood through a series of scams and thefts, Julia St. Clair Newman landed in prison in London at the age of 19 and earned a name for herself as one of the most incorrigible prisoners in British history. Of Creole descent, she was born in 1818 and spent her childhood in the West Indies before attending school in France, where she may have acquired the social graces and talent as a singer and musician she was said to display when she so chose. She later moved to London and began her criminal career; her favorite scam involved renting rooms and then selling off her landlady's possessions.

In 1837, Newman was convicted of swindling and incarcerated in Millbank Prison. An unruly prisoner, she attacked the wardens, provoked other prisoners to rebel, and threw food at the jailers. After several failed attempts at suicide, she tried to starve herself to death. Jailers force-fed her, labeled her insane, and placed her in solitary confinement in a straitjacket. Newman chewed her way out of the jacket. At a loss as to how to control her, authorities sentenced her to banishment. She was sent on the convict ship *Nautilus* to the penal colony in Australia, where she vanished from history.

SOURCES:

Nash, Robert Jay. *Look for the Woman*. NY: M. Evans, 1981.

Lisa Frick,
freelance writer, Columbia, Missouri

Newman, Pauline (1887–1986).

See Miller, Frieda S. for sidebar.

Newmar, Julie (1935—)

*American actress. Born Julia Chalane Newmeyer on August 16, 1935, in Los Angeles, California; daughter of Donald Newmeyer (a professor and former professional football player) and **Helen Jesmar** (an actress); studied at the University of California in Los Angeles.*

Selected filmography: Seven Brides for Seven Brothers *(1954);* Li'l Abner *(1959);* The Rookie *(1959);* The Marriage-Go-Round *(1960);* For Love or Money *(1963);* Mackenna's Gold *(1969);* The Maltese Bippy *(1969);* Up Your Teddy Bear *(1970);* Hysterical *(1983);* Evils of the Night *(1986);* Body Beat *(Dance Academy, It., 1988);* Nudity Required *(1990);* Ghosts Can't Do It *(1991); (cameo as herself)* To Wong Foo, Thanks for Everything, Julie Newmar *(1995).*

Born in 1935 in Los Angeles, California, to a mother who had been in the Ziegfeld Follies and a father who had played for the Chicago Bears, Julie Newmar studied piano and dance as a child and first appeared in films as a dancer. After making her screen acting debut in *Seven Brides for Seven Brothers* (1954), she appeared on Broadway in *Silk Stockings*, a musical based on the movie *Ninotchka* with a score by Cole Porter. Newmar won a Tony Award as Best Supporting Actress in her next Broadway play, *Marriage-Go-Round*, and later reprised the role on screen (1960). Tall, attractive, and well built, she had by that time attracted attention as a pinup girl. She has appeared in movies, on stage, and on television since the 1960s, gaining particular fame, and a cult following, for her guest role as Catwoman on the "Batman" television show (a part later played by *Eartha Kitt) and her role as the beautiful robot on the 1960s series "My Living Doll," which ran for one season. In 1995, she made a cameo appearance in the movie *To Wong Foo, Thanks for Everything, Julie Newmar.*

Lisa Frick,
freelance writer, Columbia, Missouri

Newport, Matilda (c. 1795–1837)

American-born Liberian hero whose courage during an attack on pioneer free black settlers in 1822 came to represent the ideals of the Americo-Liberian elite in the West African republic. Born, perhaps in Philadelphia, around 1795; died in Monrovia, Liberia, in 1837; married Thomas Spencer; married Ralph Newport.

Liberia and Ethiopia are the only African countries never colonized by a European power. From the start of its national existence, Liberia was linked, for better or worse, to the United States. The end of the transatlantic slave trade in the early 19th century saw the emergence of efforts by white abolitionists and humanitarians to repatriate former slaves to their African homeland. As early as 1787, 1,500 free blacks were settled in the British colony of Sierra Leone on the west coast of Africa. Drawing on this as an example, in 1816 a group of American abolitionists organized the American Colonization Society (ACS). During this period, several organizations dedicated to repatriating former slaves to Africa had been set up by individuals of African ancestry, but the ACS was the most influential group devoted to achieving this goal. Led by wealthy white men, including political leaders James Madison and Henry Clay, the ACS brought together those who represented two diametrically opposing viewpoints, namely abolitionists who saw the end of slavery and resettlement in Africa as the only path to a restoration of the human dignity of African-Americans, and supporters of slavery who regarded the existence of free blacks on American soil as a threat to the South's "peculiar institution" and wanted to return as many as possible to their native continent.

In addition to some funds provided by the U.S. government, the ACS financed its efforts by selling memberships to free blacks, a significant number of whom had achieved economic success as farmers, professionals, and small businessmen. Lifetime membership cost $30 and did not necessarily mean that the holder planned to go to Africa. By 1825, an impressive amount, estimated as being "not less than $50,000," had been raised by this method. The first concrete effort at repatriation and colonization took place in 1820, when the ship *Elizabeth*, with a group of 86 men, women, and children, landed on Sherbro Island, today part of Sierra Leone. Over the next months, many succumbed to disease, and the survivors were forced to move to Freetown, the main village of Sierra Leone. After their health and morale had been restored, the settlers returned to a new settlement site named Cape Mesurado. With their numbers having been augmented by another group of free black expatriates from the States, the settlers negotiated with the local African population to achieve permanent ownership of the land they were occupying; after 1824, it would be called Liberia.

Relations between the former slaves from the United States and the African tribal chiefs were difficult and often hostile. Warfare broke out between the indigenous people and the newcomers from America, and, during Liberia's first few years of existence, the fate of the abolitionist

experiment was highly precarious. Convinced that the newcomers had no right to the land they claimed as their own, hundreds of tribal warriors armed with muskets launched a vigorous attack on December 1, 1822. It appeared as if the settlers were doomed to annihilation until Matilda Newport, a veteran free black settler who had arrived on the *Elizabeth,* took matters into her own hands. At a desperate stage in the fighting, she dropped a hot coal from the pipe she was smoking into a nearby cannon. The cannon's explosion so frightened and demoralized the attacking forces that they panicked and dispersed, and the tide of battle shifted dramatically in favor of the Liberians. From this point on, the Liberian experiment was no longer in danger of being obliterated.

At first, little was made of Newport's deed. She survived the conflict and in 1825 married her second husband Ralph Newport, himself a survivor of the same battle. In October 1836, Ralph died when his canoe capsized while he was attempting to board the schooner *Caroline* in Monrovia harbor. Matilda died of pleurisy in

Liberian stamp issued in honor of Matilda Newport.

Monrovia in 1837. By the time of Matilda Newport's death, around 3,000 Americo-Liberians had formed the nucleus of an elite group that would rule the new nation, which declared itself a Commonwealth in 1838. With the proclamation of the Republic of Liberia on July 26, 1847, the black nation became a sovereign power by formally severing its links to the American Colonization Society. Throughout the second half of the 19th century, as Liberians struggled to both defend their nation and define their nationhood, the example of Matilda Newport increasingly took on a near-mythic quality. Although contemporary sources had apparently never taken the trouble to document her bravery in the heat of battle, her deed entered national consciousness through oral testimony and nationalist literature, thus becoming part of the new nation's historical traditions.

In 1916, the Liberian Legislature declared December 1 to be Matilda Newport Day, making it a permanent national holiday. As a symbol of the Americo-Liberian ruling minority, Newport and the story of her resourcefulness served

to sum up that group's self-image of energy, advanced culture, and vision of a bright future for the black Republic. Politicians, preachers, and teachers all spoke in superlatives of the virtues of Newport, who in the words of Liberian **Irene A. Gant** was described in 1908 as "the heroine and deliverer of the Liberian people," her nation's equivalent of *Joan of Arc. On December 1, 1947, the Republic's postal authorities issued a series of commemorative postage stamps in Newport's honor.

By the 1960s, the need to integrate the majority of Liberia's tribal peoples into the national community meant that the image of a pioneer heroine embodying the ideals of the Americo-Liberian minority might have to be sacrificed. The celebration of Matilda Newport Day began to be questioned both privately and in public forums, since it had always meant much less to the nation's tribal majority than to the Americo-Liberian elite who ruled from their virtual political and cultural enclave of Monrovia. The sudden termination of Americo-Liberian rule, which took place in a bloody 1980 military coup, brought about the end of the Matilda Newport celebration. As Liberia entered a period of disintegration and chaos in the 1980s, the decisive example of "our noble Matilda" was unable to inspire Liberians to resolve their differences in ways that might bring about the peace and reconciliation that the nation yearned for.

SOURCES:

Cassell, C. Abayomi. *Liberia: History of the First African Republic*. NY: Fountainhead, 1970.

Dunn, D. Elwood, and Svend E. Holsoe. *Historical Dictionary of Liberia*. Metuchen, NJ: Scarecrow, 1985.

Gant, Irene A. "Liberian Womanhood," in *Liberia*. Bulletin No. 32. February 1908, pp. 25–28.

Henries, A. Doris Banks. *The Liberian Nation: A Short History*. NY: Collier-Macmillan International, 1966.

"Latest From Liberia: Deaths," in *The African Repository, and Colonial Journal*. Vol 13, no. 2. April 1837, p. 134.

Tuttle, Kate, and Elizabeth Heath. "Liberia," in Kwame Anthony Appiah and Henry Louis Gates, Jr., eds., *Africana: The Encyclopedia of the African and African American Experience*. NY: Basic Civitas Books, 1999, pp. 1156–1160.

West, Richard. *Back to Africa: A History of Sierra Leone and Liberia*. London: Jonathan Cape, 1970.

Yancy, Ernest Jerome. *Historical Lights of Liberia's Yesterday and Today*. Tel Aviv: Around the World Publishing House, 1967.

John Haag,
Associate Professor of History,
University of Georgia, Athens, Georgia

Ney, Anna (1900–1993).

See Pasternak, Josephine.

Ney, Elisabet (1833–1907)

Flamboyant German artist who sculpted major European figures of the day and spent the second half of her career in Texas, where she contributed to the development of an arts community. Name variations: Elise, Elisabeth. Pronunciation: NAY. Born Franzisca Bernadina Wilhelmina Elisabeth Ney on January 26, 1833, in Münster, Westphalia; died on June 29, 1907, at her studio in Austin, Texas; daughter of Johann Adam Ney (a stonemason) and Anna Elisabeth (Wernze) Ney; attended St. Martin's Girls Seminary in Münster; graduated from the Bavarian Art Academy in Munich, 1853, and the Berlin Art Academy, 1854; married Edmund Duncan Montgomery (a physician), on November 7, 1863, in Funchal, Madeira; children: Arthur (1871–1873); Lorne (b. 1872).

Studied art in Munich (1852) and in Berlin (1854); exhibited at Paris Salon (1861); lived in Madeira and sculpted Sursum (1863–65); traveled to Caprera to sculpt Garibaldi (1865); moved to Austrian Tyrol (1866); returned to Munich (1867); commissioned for Munich Polytechnikum (1868); traveled to Italy (1869); sculpted King Ludwig II of Bavaria and abruptly left Germany (1870); arrived in New York and moved to Georgia (1871); moved to Texas (1873); exhibited German works in San Antonio (1890); established studio in Austin and contracted for the 1893 World's Columbian Exposition in Chicago (1892); became president of new Association of the Texas Academy of Liberal Arts (1894); completed self-portrait and gathered works in Europe for 1904 St. Louis World's Fair (1903); completed Lady Macbeth (1905); died and buried at Liendo (1907); Formosa studio purchased to create Elisabet Ney Museum (1908); works and personal papers donated by her husband to the University of Texas (1910).

Selected works: bust of King Ludwig II of Bavaria (1869), Hohenschwangau Castle, Munich; King Ludwig II of Bavaria (1870), Herenchiemsee Castle, Munich; Giuseppe Garibaldi (1865), Otto von Bismarck (1867), King Ludwig II of Bavaria (1870), Sursum (Genii of Mankind, 1864), Prometheus Bound (1866), The Young Violinist (Lorne Ney Montgomery, 1886), William Jennings Bryan (1901), among others, Elisabet Ney Museum, Austin; Sam Houston (1892), Stephen F. Austin (1893), National Statuary Hall, Washington, D.C., Texas State Capitol, Austin, and University of Texas Center for American History, Austin, which also houses Oran Roberts (1882); Albert Sidney Johnston Memorial (1902), Texas State Cemetery, Austin; Elisabet Ney (self-portrait, 1903), Liendo Plantation, Hempstead; Lady Macbeth (1905), Smithsonian National Museum of American

Art, Washington, D.C., and University of Texas Harry Ransom Humanities Research Center, Austin; angel marker for grave of **Elisabeth Emma Schnerr** *(1906), Der Friedhof cemetery, Fredericksburg, Texas. Bombings in World War II destroyed many of Ney's German commissions.*

When Elisabet Ney's mother told her red-haired, blue-eyed daughter the story of **Sabina von Steinbach*, who worked alongside her father at the sculpting of the south portal of the Strassburg cathedral and then completed the carving after his death, her intention was simply to offer a lesson in piety. But the message absorbed by the willful young Elisabet was of a girl who achieved fame through stonecarving, and the story became the inspiration for her career as a sculptor.

From quite early, my life has been a protest against the subjection to which women were doomed from their birth.

—Elisabet Ney

Ney was born on January 26, 1833, and christened Franzisca Bernadina Wilhelmina Elisabeth Ney by her parents Adam Ney, a stonemason, and **Anna Ney**. The family lived in Münster, a predominantly Catholic city and the capital of Westphalia, where the tone of cultural life was set by two women: Princess ❧▶ **Amalie von Galitzin**, who gathered a salon of artists and intellectuals at her estate, and novelist and poet **Annette von Droste-Hülshoff*. According to **Bride Nell Taylor**, who wrote the "authorized" account of Ney's life upon which many of the sculptor's biographers rely, Ney showed fierce independence from an early age, and often fought with her older brother Fritz as he tried to keep her within the bounds of what was considered appropriate female behavior. (A more recent writer, **Emily Fourmy Cutrer**, suggests that Ney exaggerated her daring rebel persona.) She won her first major victory over her mother by refusing traditional dress in favor of drape-style clothing she made herself in imitation of carvings done by her father. Both Taylor and biographer **Jan Fortune** portray the girl as her father's favorite, reading his books, copying his sketches, and dabbling with charcoal, clay and marble dust as she played in his atelier. Ney never acknowledged being taught by her father, however.

At age 17, she stunned her parents by announcing that she would study art at the Academy of Art in Berlin, and would never marry. She reportedly gained their permission to leave home first by going on a hunger strike and then by winning the support of Munich's Bishop Müller, who interceded on her behalf. He also encouraged her to study not in Protestant Berlin but in Catholic Munich, which gloried in its art community and housed numerous important art collections. There she began her studies in 1852 at the private school of history painter Johann Baptiste Berdellé. Through Berdellé, she met architect Gottfried von Neureuther, who would later help her to obtain commissions. Also around this time Ney was invited by a fellow student, **Johanna Kapp**, to visit her family in Heidelberg. In the home of philosopher Christian Kapp, Ney met a Scottish medical student named Edmund Montgomery, and the two fell in love. She began to explore the liberal theology and philosophy she heard discussed, and later recalled that Montgomery "echoed the revolt in her own soul."

While she was studying with Berdellé, Ney repeatedly, and unsuccessfully, applied for admission to the Munich Academy; she was reportedly denied because the school's director feared that her presence would disrupt the male students. Finally she was admitted, and spent almost two years studying there under the supervision of Max Widnmann, who trained his students in the execution of every aspect of the sculptural process. (Although Ney later claimed that she had been the first woman admitted to the academy, she was in fact only the first to be admitted to study sculpture.) She received her certificate of completion from the Munich Academy in 1853 and moved to Berlin, prompted by a desire both to be near Montgomery, who was then a student at the University of Berlin, and to fulfill her childhood dream of studying with sculptor Christian Daniel Rauch. According to Taylor, Ney's approach to Rauch was "like an assault upon a fortress," implying that he did not like to teach, and rarely took students, particularly female students. In reality, Rauch took many students, including women, and Ney did nothing extraordinary to obtain his mentorship; like other young artists, she submitted a sketch for his assessment and was readily admitted to his studio. (He also helped her gain admission to the Berlin Academy, from which she would graduate in 1854.)

Working with Rauch's live models brought more realism to Ney's portraits. As she gained in experience, she turned increasingly from her early interest in religious and idealized works (one of her first commissions, in 1857, had been an idealized statue of St. Sebastian for Bishop Müller) to portraiture. These portraits were generally in the form of busts and medallions, and the move may have been dictated by the market-

place. In Ney's lifetime, commissions for institutional monuments declined both in number and scope, while commissions (from church, state, and the wealthy elite) for portraiture in busts and medallions increased. The trend was of benefit to women sculptors, who usually had not received thorough training in human anatomy, because it allowed them to circumvent both that lack of training and the presumed limitations of women's physical strength.

In addition to the training she received from Rauch, who was a court sculptor and member of the artistic and intellectual elite, Ney gained some important introductions, in particular to the diplomat Karl Varnhagen von Ense. She sculpted his portrait and attended his salon, which not only brought her commissions but influenced her mind. Ney embraced the German Enlightenment ideas discussed there of secularism and classical humanism that emphasized reason and the development of personality, as well as the "pre-feminism" of Varnhagen's deceased wife, *Rahel Varnhagen. As related to Ney by the diplomat and his niece, ✤➤ Ludmilla Assing, this philosophy encouraged women toward intellectual progress, emancipation, and the grasping of opportunities. While Cutrer notes that Ney did not mention Rahel in her letters or in her reminiscences with Taylor, the biographer also points to a false statement Ney made to a reporter in 1904, that "you might also say I have Jewish traditions and that is why I spell my name without the final 'h,'" and suggests that Ney dropped the "h" from her name to emulate Rahel's dropping of the "c" from her own.

Ney's next major portrait, in 1859, was of philosopher Arthur Schopenhauer, who was then enjoying acclaim for his gloomy ideas after years of indifference from the public. Edmund Montgomery later recounted that Ney was intent on giving Schopenhauer (who had had a troubled relationship with his mother *Johanna Schopenhauer and held a very low opinion of women in general) "a lesson" about female abilities. On a more practical level, Rauch had recently died, and the young artist was in need of both the commission and the attention such a celebrated subject could bring. While finishing this bust, she received a commission to model George V, king of Hanover. The king was so pleased with the results that he later commissioned two more busts as well as a portrait of Ney done by the court painter Friedrich Kaulbach. The portrait was entitled *L'artiste*, suggesting that it was a commemoration of the elevation of her reputation. Her newfound celebrity did not stem solely from the skill of her

✤➤ **Galitzin, Amalie von** (1748–1806)
German princess. Name variations: Princess Gallatzin, Gallitzin, Galitzyn, or Golitsin. Born Amalie von Schmettau in Berlin, Germany, on August 28, 1748; died in Angelmode, near Munster, Westphalia, on August 24, 1806; married Prince Dimitri Alexeivitch Galitzin (1738–1803, a Russian diplomat, ambassador to the court of France and The Hague).

✤➤ **Assing, Ludmilla** (1821–1880)
German writer. Born at Hamburg, Germany, on February 22, 1821; died at Florence, Italy, on March 25, 1880; niece of Karl Varnhagen von Ense and *Rahel Varnhagen (1771–1833).

Ludmilla Assing edited several works of her uncle Karl Varnhagen von Ense as well as several by Alexander von Humboldt. From 1863 to 1864, she was imprisoned for libel by the Prussian government.

sculpting, however; there was an element of curiosity about a woman in such a profession, and just as she had earlier worn unusual clothes, now she wore her hair cut short. Such an affront to social custom in the mid-19th century drew attention to her ahead of her art.

Ney moved in artistic and intellectual circles upon her return to Berlin from Hanover, but without much work. She exhibited the Schopenhauer bust and a bust of scientist Eilhardt Mitscherlich at the Paris Salon of 1861, and then received a commission from her home city of Münster for life-size statues to be installed in a new parliament building. For over a year she studied the likenesses of four Westphalian heroes: 14th-century noble Englebert van der Mark, 15th-century soldier Walter von Plattenberg, 18th-century author Justus Moser, and 18th-century official Franz von Furstenburg. The completed statues were arranged in traditional poses but outfitted in contemporary dress, which was somewhat progressive for the time. She next completed a bust of playwright Tom Taylor while on a visit to Montgomery in England. Ney visited him there again in September 1863, then traveled to the islands of Madeira, off the west coast of Africa, to "spend the winter months in the South." On November 7 of that year, she was married to Montgomery by the British consul at Funchal, the capital of Madeira. According to Taylor's account, the marriage was a "galling humiliation" for Ney, and took place only because Montgomery feared his reputation as a physician would be jeopardized by their unconventional relationship. (Some evidence for this may perhaps be seen in

the couple's later behavior in Texas, when they could not be bothered to tell their neighbors they were married.) Whatever the circumstances, however, they remained on Madeira for several years; Ney opened a studio in Funchal, and Montgomery established a medical practice.

In 1865, Ney traveled to Caprera, off the Mediterranean coast of Sardinia, to request permission to sculpt a portrait of the Italian revolutionary General Guiseppe Garibaldi. In her journal, Ney described the persuasive tactics she used on the general, which included telling him of the length of her journey, her longstanding interest in him as a subject, and the inadequacy of existing portraits. After he granted permission for the project, she moved into his household, and they developed a close relationship while she completed both a bust and a statuette of him. (The latter was exhibited in the London National Academy Exhibition, but brought her no new commissions.) This was the beginning of the chain of events which would give rise to speculation about Ney's political involvement in the unification of the German empire.

Garibaldi, who was an ally of Prussia, fought briefly against Austria in 1866. That year Prussia also briefly (in what is known variously as the Seven Weeks' War or the Austro-Prussian War), and successfully, went to war with Austria, and finally, also in 1866, Ney and Montgomery moved to the Austrian Tyrol. They took with them their housekeeper **Crescentia "Cencie" Simath**, who many years later revealed herself as the messenger between Ney and Garibaldi. In 1867, Ney received a commission to do a bust of Otto von Bismarck, prime minister of Prussia, for Garibaldi's ally King Wilhelm I of Prussia. Some historians speculate that Garibaldi arranged the work so that Ney could act as a political agent between himself and Bismarck. That same year Ney traveled to Munich to do a portrait of King Ludwig II of Bavaria (the "mad king"), who was one of the last holdouts against Bismarck's plan for a united Germany. While this may perhaps also point to her involvement in political intrigue, Ludwig was passionate and profligate about art, and Ney may have sought to sculpt him simply because of her connections with some of his artists.

In early 1868, Ney received a commission to portray Iris and Mercury and chemists Friedrich Wohler and Justus von Liebig for the Munich Polytechnikum. Cutrer believes that the Wohler bust represents the first use of French Romantic sculptural characteristics in Ney's work and marks a stylistic change towards greater liveli-

ness. When this work was completed, she enlisted the help of her friend Neureuther, the architect, to show a pencil sketch of it to King Ludwig. By winter, Ney had permission to sculpt the king in the guise of a Knight of St. George, although he did not actually get around to providing her with a sitting until February. The project almost ended as soon as it had begun when, failing to show sufficient deference to the king in their initial meeting, Ney measured him "with as much indifference as if he were a yard of carpet." Matters were smoothed over, however, and, though Ludwig broke off the work after a few more sessions that month, he resumed sitting for her the following August. Their relationship shifted to a more personal level after Ney began reading from Goethe's *Iphigenia* whenever he showed signs of becoming troubled during their sessions. Cutrer suggests that the two also conversed about the political climate and Bavaria's possible unification with Prussia. In November 1870, when she had completed her model of Ludwig and had cast it in plaster, the king inadvertently signed a document that put Bavaria into the new German nation and requested Prussia's King Wilhelm I to become the nation's emperor. The following month Ney obtained a passport, and in mid-January, with Montgomery and Cencie, sailed on the SS *Main* from Bremen to America.

Biographers disagree on what exactly may have precipitated her flight: Vernon Loggins suggests that she decided not to influence Ludwig and feared punishment from Bismarck, while Montgomery's biographer Ira Stephens argues that she either failed to persuade the king to her position or began to sympathize with his. Cutrer, noting that no document exists to substantiate any of these possibilities, proposes that Ney might have grown to dislike Bismarck, or that Ludwig learned of her involvement with Prussia. Politics aside, the move may have reflected a change in Ney's and Montgomery's approach to life, a view supported by her *Genii of Mankind* (*Sursum*) and *Prometheus Bound*, both completed without commission. *Sursum* suggests her belief in the need for mankind to progress to a higher plane through cooperation, and, according to her journals, *Prometheus Bound* (modeled in 1867, while she was living in the Austrian Tyrol) was inspired by Garibaldi's exile away from the people he had tried to assist. Ney also had begun reading the works of the French philosopher Jean-Jacques Rousseau, and she later told Taylor that she and Montgomery had hoped to create a utopian community in the States. In later interviews and conversations with friends, Ney evad-

Elisabet
Ney

ed questions about her reasons for emigration to America. Whatever the actual circumstances, one of Germany's most famous sculptors virtually disappeared from the art world that winter, not to resurface until the World's Columbian Exposition of 1893, over 20 years later.

After arriving in New York City, Ney and Montgomery traveled to Georgia, where by mid-February 1871 they had purchased land in Thomasville and built a two-story, nine-room "log castle." Their first son Arthur was born later that year, much to the horror of neighbors who

believed that the bloomer-wearing Ney was not married to Montgomery. When the townspeople grew convinced that their German neighbors were establishing a "free love" colony, the couple began looking for other places to live. They were on a trip to Wisconsin to visit another German emigré, Theodor Bayrhoffer, when they stopped in Minnesota for the birth of their second son Lorne. Ney and Montgomery then turned their attention toward Texas, which had attracted a sizable German population. She traveled by steamer to Galveston in search of a house, and was shown the Liendo Plantation near Hempstead. Reportedly, she looked out over the property from the second-floor balcony and declared, "Here is where I shall live and die!"

Shortly after the family moved in, Arthur died from diphtheria in 1873. Running the plantation proved to be beyond either Ney or Montgomery, who preferred to busy himself with scientific research in his laboratory. Nonetheless, despite their lack of success at managing the corn and cotton grown by day laborers and tenant sharecroppers, they inexplicably used mortgage financing to increase their landholdings several times over the next decade. (In 1880, they operated a sawmill in Montgomery County to harvest plantation lumber, and eventually shifted to cattle raising and dairying.) Except for a few German immigrants, they had little contact with their neighbors, whose suspicions about the newcomers were compounded by Ney's eccentricity as a mother. She refused to allow Lorne to play with other children, dressed him in what the neighbors termed to be "frocks," and insisted on educating him herself; perhaps not surprisingly, their relationship grew increasingly fractious. Throughout his life, Ney literally molded Lorne, keeping plaster casts of his arms, hands and feet. She did a bust, completed around 1886, of him as a young man, which became known as *The Young Violinist* and later occupied a prominent position in her studio, but her attempts to mold him into an idealized being of the sort found in Rousseau's teachings were thwarted by the rebellious Lorne. He was finally sent away to one school after another, showing little interest in study and a propensity to get into trouble.

Montgomery began to participate more actively in the community of Hempstead in the late 1880s, becoming active in local Democratic party politics and community affairs, giving lectures, and developing a friendship with future Texas governor Oran Roberts. Ney, too, attempted to become involved in local affairs, but met more resistance than her husband. One hindrance was her unconventional appearance; she often appeared in public in a white flannel robe, and rode astride her horse, in pants, rather than sidesaddle in a long skirt, all of which was outside the local standards of both fashion and decency. The fact that the couple continued to conceal their marriage also resulted in gossip; they even went so far as to list themselves as bachelor and spinster on the 1880 census. (The truth of their marriage could be found in Montgomery's application for citizenship in 1884, but the neighbors did not check such records.) Ney's real "sin" appears to be her refusal to conform to late 19th-century ideas about "true womanhood": she never exhibited the acceptable characteristics of domesticity, piety, purity, and submissiveness.

In 1882, lacking both subjects for her work and a suitable audience, Ney turned to the state capital at Austin. A tentative agreement with the governor for statuary to decorate the new state capitol building fell through, apparently the victim of Texans' preference for great height over ornamentation. The following year she sought a commission from *der Vierziger*, a German intellectuals' group in San Antonio, for a monument to Texas Congressman Gustav Schleicher. By then aged 50, Ney stayed more than three weeks in San Antonio to create a bust for Schleicher's memorial in the National Cemetery; the committee chose to use a 20-foot high obelisk instead. After this failure, she attempted to attract clients through publicity, and in 1887 traveled to Galveston to model her friends the Runges, who were prominent in the city. Ney donated her Schleicher bust to the state the following year, in hopes that it would be prominently displayed in the capitol, and arranged for her German attorney to ship six of her earlier busts, including those of Bismarck, Garibaldi, and King Ludwig. It took more than a year for the works to reach her, but they finally went on exhibit in San Antonio in September 1890.

In the summer of 1892, the Board of Lady Managers and their leader, **Benedette Tobin**, approached Ney for advice on presenting Texas at the World's Columbian Exposition scheduled to open in Chicago the following spring. The group hoped to exhibit two statues and three busts in the fair's Texas building, but lacked the finances to commission the works. Ney explained that there was not enough time for such works to be completed in marble, but that plaster could be done. Although the committee had not intended to hire her, she offered to forego remuneration and to produce the two statues at cost. In September 1892, Ney signed a contract for the cre-

ation of statues of Texas impresario Stephen F. Austin and of Sam Houston, the state's first governor. She then hired contractors to build, in the Austin suburb of Hyde Park, a studio she had designed. She and her husband went further into debt to finance the building costs, and when she moved in she found that the builders had not included the windows specified in the plans, and that the roof and the mortar in the limestone walls leaked. Nonetheless, the opening of the studio, which Ney named Formosa, appears as a sudden move back into her professional life. Some biographers have intimated that she hoped to win the respect of her son, who had moved back home to the plantation the previous year, but she also may have realized the effect that isolation at Liendo had had upon her. Unable to rise above the financial burdens of the plantation, Ney and Montgomery had been stuck in Texas, where a population busy creating the infrastructure for their state had little interest in visual arts. Commissions for public sculpture had all but disappeared since the early days of Spanish colonization, and the few that did exist went to local stonemasons; most artists in 19th-century Texas were painters who lived in the German settlements and could not support themselves with their art.

Getting materials for her work proved equally daunting. She found clay near Austin, but eventually had to borrow a skeleton from the superintendent of the police asylum to model the first statue of her commission. Relatives of Houston and Austin were helpful, however, and offered engravings, artifacts, and detailed descriptions to aid her work. *Sam Houston* was completed by April, but the statue of Austin was not ready in time for the World's Fair; she was further frustrated by being unable to enter her European pieces there. That July, Lorne eloped with a local girl, and when Ney vented her anger against his new wife it opened a rift with her son that lasted to the end of her life. Nonetheless, she threw herself into her work. She completed the statue of Austin despite the passing of the deadline, hoping that funds would be raised for both works to be cut in marble for display in the state capitol. Her hopes rested on signs of a rising interest in urban beautification across the country and in Austin, and in the concurrent creation of several organizations interested in Texas history, including the Daughters of the Republic of Texas (DRT), the Texas State Historical Association, and a chapter of the United Daughters of the Confederacy. She completed six busts between 1893 and 1895, only one of which, a portrait of Governor Francis Lubbock, she received payment for.

Ney also pursued her idea of establishing a school of sculpture. In 1893, when she petitioned the legislature for funds, the scope of her idea had expanded beyond fine arts to include all liberal arts. "The Mission of Art," as described in her speech, was to make art part of society and to create "a veritable industrial Democracy . . . in which all citizens shall, by means of well regulated cooperative industry . . . become sufficient masters of their time and energy" and enjoy the beauty they created. More pragmatically, she argued that Texans lost money by relying on outsiders to provide architecture, art, sculpture and woodcarving. In 1894, Ney led a group of officials and citizens in creating the Association of the Texas Academy of Liberal Arts under state charter, and she served as the group's president. But the association lacked funding, and the speculation that still swirled around her did not enhance chances of public support. (Her hopes for this project died, finally, in 1901, when the legislature voted to create what later became Texas Women's University in Denton.)

Part of Ney's difficulties, both in receiving commissions and in attracting people to her plans, stemmed from her habit of seeking support primarily from men. This strategy had arisen from her successful experiences in Europe, but it did not fit the situation in Texas. Men rarely participated in the cultural sphere there; those who propelled the development of cultural institutions and the arts in the state were generally women. Although in 1894 Ney sent a paper titled "Art for Humanity's Sake" to the first State Council of Women, during this period she continued to focus on politically connected men, not the women who knew or were related to them, for support of her work. However, in the spring of 1897, about the time that she was again lobbying legislators to reproduce *Sam Houston* and *Stephen F. Austin* in marble for the state capitol, the Daughters of the Republic of Texas requested a marble copy of *Austin* for the National Statuary Hall in Washington, D.C., and she learned that women might be better allies for her work. Additional difficulties were caused that same year, after she sought and lost the commission for a monument in Galveston to Texas Revolution heroes, when she publicly debated the artistic merit of other state monuments both erected and planned. These unsolicited comments may have lost her local support, as her efforts against the design of a Confederate monument at the capitol may have cost her many other commissions (although the design was, in the end, changed). The sculptor brought

in to cast that memorial, a recent Italian emigré named Pompeo Coppini, took such a liking to Texas that he settled there and subsequently competed with Ney, often successfully, for commissions, though she continued to consider herself the only true sculptor in the state. A final, and perhaps most serious, difficulty was the fact that her style and themes remained European, and never truly reflected American culture.

Despite her stubbornness and eccentricities, Ney enjoyed the company of friends, particularly children, and often hosted picnics or Easter-egg hunts at her studio. She lent money when she could, and she entreated her friends on the behalf of others while the family continued to subsist by borrowing money, which they would either give away or use to repay other creditors. In 1895, they received word that her attorney in Munich had succeeded in selling her German studio, and that Bavaria wished to purchase the statue of King Ludwig. Ney netted $10,000 from the transactions; in celebration, she chartered a boat on Lake McDonald to give a party for her friends.

In 1900, while waiting for the DRT to raise the funds needed for the marble copy of *Austin*, Ney persuaded Populist presidential candidate William Jennings Bryan to sit for a portrait. (It would prove to be the only one she completed of a national figure in America.) **Ella Dancy Dibrell**, the new chair of the DRT, visited Ney about that time to express her interest in having both *Austin* and *Houston* placed in Washington. Through her husband, a state senator, Dibrell energetically sought funding from the legislature for the carving of *Sam Houston*. In June 1901, the legislature accepted Ney's gift of the models of those two statues and marked funds for them to be cut in marble for the state capitol; later that fall, it appropriated further funds for the statues to be placed in Washington. During the next year, Ney received $8,000 from the state for the two statues and arranged contracts for duplicates to go to Washington. Now approaching 70, she also modeled a bust of Governor Joseph Sayers, and during his sittings explained her views on public monuments in Texas. In October 1901, the state legislature appropriated $10,000 for a memorial to Texas Civil War hero Albert Sidney Johnston, and in December 1902, after submitting a clay model showing Johnston being carried off the battlefield at Shiloh, Ney signed the contract to oversee the memorial. The following year, while she was busy completing that statue in order to ship it to Europe to be cut in marble, more than 3,000 Texans attended the unveiling of *Houston* and *Austin* in the Texas

capitol's south hall. She also completed a portrait medallion of the University of Texas' first dean of women, **Helen Marr Kirby**, and hurried to complete a self-portrait (begun nearly 40 years earlier), so that she might oversee its cutting in Europe.

Ney left for Europe in November 1903. In Germany, she gathered works for exhibition in both the Texas building and the Palace of Fine Arts at the upcoming St. Louis World's Fair, and in Seravezza, Italy, she oversaw the execution of her recent works in marble. By March 1904, she had finished the memorial to Johnston, duplicates of Houston and Austin, a bust of Christ, her self-portrait, and several medallions and busts, a burst of productivity that took its toll. Upon her return from Europe, Ney attended the St. Louis World's Fair. She disliked the placement of her works next to those of her rival Coppini and resented the absence of a catalog (hastily, she made explanatory cards and attached them to her works), but primarily she was disappointed that her *Albert Sidney Johnston* received only a bronze medal.

Back in Austin, Ney completed a statue of Lady Macbeth (*Gruoch) which she first had modeled four years earlier. In 1905, without the strength to return to Europe, she had the marble for the statue and a stonecutter sent to her in Austin. Her correspondence with German contralto *Ernestine Schumann-Heink reveals that Ney viewed this last major work as something of a self-portrait, embodying the artist as anguished martyr. That spring, she divided her time between Montgomery at Liendo and her circle of friends in Austin; in May, after she suffered a severe heart attack, her husband joined her at her studio. She died there in her second-floor living quarters on June 29, 1907, and was buried at Liendo.

In 1908, after failing health and precarious finances prevented Montgomery from preserving Formosa and Ney's works (their son Lorne had already sold what he could of the studio's contents), Ney's friends stepped in. Formosa was purchased to create a museum to Ney, and *Lady Macbeth* went on loan to the National Museum of American Art. Montgomery retained rights to the collection, which he donated to the University of Texas in 1910, one year before his death, with the stipulation that it stay at Formosa as long as the site remained a museum honoring Ney. In 1911, the women who had surrounded Ney and supported her work in Austin formed the Texas Fine Arts Association, to oversee the museum and promote arts in the state.

SOURCES:

Barrington, Carol. "George Custer, Sam Houston, and Elisabet Ney add to the intrigue of Life at Liendo," in *Texas Highways*. Photographs by J. Griffis Smith. Vol. 41, no. 1. January 1994, pp. 38–45.

Bishop, Nancy. "Elisabet Ney: trailblazing talent of Texas' cultural frontier," in *Texas Highways*. Photographs by Jennifer Van Gilder. Vol. 41, no. 1. January 1994, pp. 14–21.

Cutrer, Emily Fourmy. *The Art of the Woman: The Life and Work of Elisabet Ney*. Lincoln, NE: University of Nebraska Press, 1988.

Fortune, Jan, and Jean Burton. *Elisabet Ney*. NY: Alfred A. Knopf, 1943.

Taylor, Bride Nell. *Elisabet Ney, Sculptor*. Rev ed. Austin, TX: Thos. F. Taylor, 1938.

SUGGESTED READING:

Goar, Marjory. *Marble Dust: The Life of Elisabet Ney, an Interpretation*. Austin, TX: Eakin Press, 1984 (a historical novel).

Loggins, Vernon. *Two Romantics and Their Ideal Life: Elisabet Ney and Edward Montgomery, 1835–1911*. NY: Odyssey Press, 1946.

Long, Sandra. "Arthur Schopenhauer and Elisabet Ney," in *Southwestern Review*. Vol. 69. Spring 1984, pp. 130–147.

Von Rosenberg, Marjorie. *Elisabet Ney, sculptor of American heroes*. Austin, TX: Eakin Press, 1990 (juvenile).

Wood, Sarah Lee Norman. "The Heroic Image: Three Sculptures by Elisabet Ney." Thesis. Austin, TX: University of Texas, 1978.

RELATED MEDIA:

Elisabet Ney: artist, woman, Texan (140 slides, 1 audio cassette), San Antonio, TX: Institute of Texas Cultures, 1983.

COLLECTIONS:

Elisabet Ney Museum, a National Historic Site, 304 East 44th Street, Austin, Texas.

Liendo Plantation, Hempstead, Texas, a Texas historic landmark on the National Register of Historic Places. Private residence open for tours the first Saturday of every month.

Materials concerning Elisabet Ney, her work, and the Elisabet Ney Museum may be found in the following collections: Elisabet Ney Papers, Center for American History, University of Texas; Ney Museum Archives; Montgomery Collection, Fondren Library, Southern Methodist University; Austin-Travis County Collection, Austin Public Library; Daughters of the Republic of Texas Archives; Texana Collection, DeGolyer Library, Southern Methodist University.

University of Texas Institute of Texas Cultures at San Antonio.

Laura Anne Wimberley, Ph.D.,
Texas A&M University, College Station, Texas

Ney, Elly (1882–1968)

German pianist, widely known for her performance of Beethoven. Born in Düsseldorf, Germany, on September 27, 1882; died on March 31, 1968, at Tutzing, Bavaria; descendant of France's Marshal Ney; married

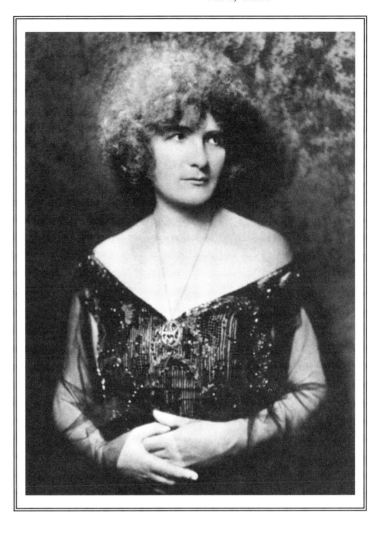

Willem van Hoogstraten (a conductor), in 1911 (divorced 1927); married P.F. Allais.

Elly
Ney

Elly Ney was born in Düsseldorf, Germany, in 1882 and studied first at the Cologne Conservatory under Isidor Seiss and Karl Bottcher and then with Theodor Leschetizky and Emil von Sauer. Her Vienna debut took place in 1905, and her talents were recognized when she won both the coveted Mendelssohn and Ibach prizes. A master of the German repertoire, she taught for many years at the Cologne Conservatory. On tour, she sometimes gave fine performances of the Tchaikovsky First Piano Concerto (e.g, at the Proms concerts in London in 1930). Ney made the first recording of Richard Strauss' *Burleske* for Piano and Orchestra. In recognition of her countless fine Beethoven performances, in 1927 she was awarded the freedom of the city of Bonn. Recordings made at the end of her career testify to her insights into Beethoven's musical and spiritual universe. A fervent German nationalist, she enthusiastically supported the Third

Reich and published statements to that effect in the German musical press.

John Haag,
Athens, Georgia

Nezhdanova, Antonia (1873–1950)

Russian soprano. Name variations: Antonina Nezhdanova. Born in Russia in 1873; died in 1950.

Russian soprano Antonia Nezhdanova was one of the great singers of imperial Russia. She made her debut in Moscow in 1902 in Glinka's *A Life for the Tsar* and was immediately engaged by the Bolshoi. Throughout the 30 years of her career, along with the Russian repertoire, she sang most of the high repertoire: Gilda, Lakmé, Juliette, Frau Fluth in *The Merry Wives of Windsor*, The Queen of the Night, Queen Marguerite in *Les Huguenots*, Ophélie, and Zerlina in *Fra Diavolo*. She also sang the more dramatic roles, such as Desdemona and Tosca. Nezhdanova confined her career to Russia, with the exception of the 1912 season at Monte Carlo and Paris, where she sang Gilda in *Rigoletto* with Caruso and Ruffo.

Ngo Dinh Nhu, Madame (b. 1924).

See Nhu, Madame.

Ngoyi, Lilian (1911–1980)

South African leader in the struggle against apartheid, president of the African National Congress Women's League (ANCWL) and of the Federation of South African Women (FSAW), who was banned for her activism and held under government restriction for almost 20 years. Name variations: Lilian Masediba Ngoyi; Lilie; Masediba (a common name among the Pedi, one of the northern-Sotho groups, meaning "stable pool of water" and signifying women as a source of life or energy and reliability); maNgoyi (Ma or mama is a common Southern African salutation for a prominent or elderly woman). Born Lilian Masediba Ngoyi in 1911 at Pretoria, South Africa; died on March 11, 1980, in Orlando Township, Johannesburg; married John Ngoyi, in 1936; children: three.

Lilian Ngoyi's life spanned much of the most critical period in the political history of South Africa, during which its minority white population kept brutal control of the country through one of the worst systems of racial oppression in the modern world. One year after her birth, South Africa's entire indigenous population lost access to 87% of their country through the imposition of the 1912 Natives Land Act, kickstarting the formalization of the government's racist policies that would come to be codified as apartheid after the 1948 election of the Nationalist Party. In 1958, racial oppression had become so refined that Ngoyi's challenge to new Prime Minister Hendrik Verwoerd was dismissed as frivolous. In part due to her relentless work for the liberation of South Africa, however, by the time she died in March 1980, resistance against oppression had gathered irreversible momentum.

Little is known about Ngoyi's parents or early childhood. She was born in the capital city of Pretoria in 1911, to a Pedi father who worked first in the mines and later as a packer in a local shop, and a mother who worked as a domestic servant in the homes of white families. Her parents made considerable sacrifices to see that she received an education, at the primary school at Kilnerton, Pretoria, where she completed the standard program of eight years. They were also passionate churchgoers, according to **Julia Wells**, but as she grew up Ngoyi resisted the institution as an instrument of white domination. For a time she studied nursing, but gave it up when the glaring contradictions of caring for the sick within a framework of racial oppression became impossible to stomach. Ngoyi eventually left Pretoria for the nearby city of Johannesburg, where she settled in Orlando, one of the group of southwestern black townships known collectively as Soweto. In 1936, she married John Ngoyi, with whom she had three children.

South Africa's urban areas (including Soweto) held the most manifest and persistent examples of racial oppression, in the forms of poor housing, inadequate sanitation and social services, and restrictions on freedom of movement. By the same token, they were also hothouses for heightening political consciousness among the blacks who lived there, as Ngoyi did. In addition, after training as a seamstress she worked from 1945 to 1956 as a machinist in a clothing factory. There she came into contact with the Garment Workers' Union, which from the 1930s into the 1960s was at the forefront of organized resistance to militant pro-Afrikaner and anti-black economic policies. In the '30s and '40s, particularly, it was strong in defending the rights of its members to decent work conditions and security of employment. Ngoyi joined the union as one of a new generation of activist women who proved to be politically skillful, disciplined and militant in their outlook. Beginning in the

late 1940s, she was increasingly attracted to the African National Congress (ANC), the black political organization of South Africa. When the newly elected white Nationalist Party officially established its racist policy of apartheid in 1948, the ANC became radicalized in self-defense. In 1952, the congress went on the offensive against unjust and draconian laws with its Defiance Campaign, and Ngoyi joined the ANC to take part. A widow at the age of 40, she quickly distinguished herself in the campaign as an effective, energetic, and courageous politician, and a brilliant public speaker.

Throughout the 1950s, Ngoyi linked the struggles of women with the campaigns and objectives of the ANC. In 1953, she was elected president of the ANC Women's League (ANCWL), a post she held until 1963. With the formation of the Federation of South African Women (FSAW) on April 17, 1954, she became one of the new group's four vice-presidents, representing the Transvaal branch. In 1955, she made a trip overseas (which, according to Wells, was the "event of her life"), visiting Italy, Eastern Europe, and China, the country that left her with the most favorable impression. She returned home with a renewed sense of conviction about the need to win freedom, whatever the cost, for the people of South Africa. That same year, she joined the Transvaal ANC executive committee, and by February of the following year her spirited fight to establish in South Africa a society both color-blind and non-sexist had led *Drum* Magazine to describe her as a "masterpiece of bronze" (although clearly her determination was made of steel). At the Transvaal Women's Day Conference, her eloquent description of the hardships endured by black men in South Africa under apartheid caused women to weep, and recruited followers even among the country's white women, whom the government tried to portray as the greatest beneficiaries of apartheid. Ngoyi welcomed whites to the struggle, as she welcomed all colors and classes, if they were prepared to renounce the privileges they enjoyed based on skin color.

One white woman who did not need to be recruited was activist *Helen Joseph, with whom Ngoyi had been friends since they had worked together in 1952 against the new government policy that required black women to carry passes. Secretary-director for the Transvaal of the Medical Aid Fund of the Garment Workers' Union, Joseph was also a member of the Congress of Democrats (COD), a white South African organization of liberals and radicals against apartheid. In August 1956, when Ngoyi

Lilian Ngoyi

became president of the FSAW, Joseph became the federation's secretary, and their close association would continue for many years, during which each would be subject to bannings, restrictions, and arrests. One of the first actions they organized in the FSAW took place on August 9, 1956, when Ngoyi and Joseph were among those who led some 20,000 women from all over the country in a march on the Union Buildings in Pretoria. One of the country's biggest anti-pass demonstrations, the event included 30 minutes of silence in protest of apartheid and the pass laws as well as Ngoyi's challenge to the unseen members of the government to address the "women of Africa," whose husbands had "built this place." Inside the Union Buildings, officials arranged a safe escape through a side passage for Prime Minister Johannes Strijdom.

In December 1956, Ngoyi became the first woman ever elected to the ANC national executive committee. Also towards the end of that year, she was among 156 anti-apartheid activists

(including Joseph, Nelson Mandela, Walter Sisu-lu, and *Ruth First) arrested and charged by the government with treason. The complicated case, which has since come to be known as the Treason Trial, would last some four years and end with the acquittal of all the defendants. Meanwhile the Defiance Campaign increased in intensity, and from 1958 to 1963 Ngoyi was subjected to banning and periods of imprisonment.

While Johannesburg was Ngoyi's primary political base, her work for the FSAW and the ANCWL frequently took her to nearby Pretoria and to other parts of South Africa as well. When she made an appearance in Winburg, a rural town close to Johannesburg and one of the first places that the government imposed passes, local women honored her with a bonfire fueled by the burning of their passes. This was an action considered so radical that even the ANC advised against it. In March 1960, police in Sharpeville, a township 40 miles south of Johannesburg, fired into the crowd at a demonstration against apartheid, killing over 60 people and wounding nearly 200 more. In the aftermath of what would become known as the Sharpeville massacre, Ngoyi spoke against the formation of pistol clubs by white women who felt the need to defend themselves against increased militancy and violence. Soon thereafter, she was held in jail five months for her part in the anti-pass campaigns.

Freedom does not come walking towards you. It must be won. As women we must go on playing our part.

—Lilian Ngoyi

In her efforts to transform her country, Ngoyi addressed two strands in the struggle for human rights. In a speech delivered at Port Elizabeth in September 1961, she called for a confrontation with the forces of white privilege, warning black South Africans that freedom would not "walk to them." In the same speech, she called upon women to be weapons in their own struggle, for she saw, in the government restriction of black women to rural areas and the imposition of passes to justify their presence in urban areas, not only racism but also the systematic subordination of women to patriarchal values. She dedicated women's struggle to the struggle of the ANC, and with such a broad vision was able to work with both women and men for the dignity and rights deserved by all human beings.

From 1958 until the end of her life, Ngoyi lived either under a ban order, government restrictions (which among other things prevented her from being quoted), or strictures imposed from being listed as a communist. In October 1962, she received a banning order restricting her to Orlando Township. She also served a 90-day detention, which included 71 days spent in solitary confinement. Thereafter, banning orders against her were renewed every five years through 1975, and from 1963 until her death she was restricted to her home. Nonetheless, she was a bridge between generations as well as between different racial communities and social classes, and many young people in Orlando Township were inspired by the example of her presence. In 1976, when hundreds of blacks in Soweto—many of them children—were killed while protesting the compulsory teaching of Afrikaans in their schools, she was again a moral reference point.

Ngoyi died in Orlando Township in March 1980, still restricted to her house by the government. She never lost her belief that the government's oppression would be defeated. In a 1977 interview with Julia Wells, she still foresaw "freedom in our life time." Memorial services organized after her death revealed both how sophisticated the struggle against apartheid had become and how close she remained to her country's people. Ten years after her death, negotiations between the ANC and the white government resulted in the repeal of apartheid legislation. Four years after that, in 1994, the country's first multiracial elections were held and Nelson Mandela was elected president. Freedom came, as she had believed it would. August 9th, the day of the women's march on Pretoria in 1956, is now celebrated in South Africa as National Woman's Day.

SOURCES:

Gerhart, G.N., and T. Karis. *From Protest to Challenge.* Vol. 4. Stanford University Press, 1973.

Lodge, T. *Black Politics in South Africa since 1945.* London: Longman, 1983.

Personal interview with Dr. Julia C. Wells on July 5, 1995, Rhodes University.

Walker, C. *Women and Resistance in South Africa Cape Town.* David Philip, 1991.

Wells, J.C. *We Have Done with Pleading.* Johannesburg: Ravan Press, 1991.

———. *We Now Demand.* Witwatersrand University Press, 1993.

Ackson M. Kanduza,
Department of History, University of Swaziland,
Kwaluseni, Swaziland

Nguyen Thi Dinh (1920–1992)

Vietnamese revolutionary, considered the outstanding woman in modern Vietnamese history and known as the "general of the long-haired army," who led the insurrection against the French colonial regime in Ben Tre Province (1945), as well as the Ben Tre upris-

ing against the U.S.-backed Diem regime (1960), and became deputy commander of the South Vietnam Liberation Forces. Name variations: Madam Dinh. Pronunciation: Wen Tee Dingh. Born Nguyen Thi Dinh on March 15, 1920, in Luong Hoa village, Giong Taom District, Ben Tre Province, in the Mekong Delta of southern Vietnam; died on August 26, 1992, in Ho Chi Minh City, Vietnam; daughter of Nguyen Van Tien (father) and Truong Thi Dinh (mother); married Nguyen Van Bich, in 1938 (died July 12, 1942); married Nguyen Huu Tri (referred to as Hai Tri in Dinh's memoir No Other Road to Take*), in 1945 (died 1990); children—first marriage: one son, Nguyen Ngoc Minh (referred to as On in Dinh's memoir, May 10, 1940–May 4, 1960).*

Married the revolutionary intellectual Nguyen Van Bich (1938), who was arrested three days after the birth of their son, Nguyen Ngoc Minh (1940); Bich died in French prison, Puolo Condore (July 12, 1942); arrested by the French (July 19, 1940) and spent three years in Ba Ra prison camp; released to house arrest (1943); led a Viet Minh takeover of the provincial capital of Ben Tre (August 1945) and elected to the executive committee of the province; served on a delegation to Hanoi and transported a large shipment of arms to the South, running through a French naval blockade (1946); led the uprising in Ben Tre Province against the Diem regime (January 1960) and appointed to the leadership committee of the National Liberation Front (NLF) in Ben Tre; became a member of the presidium of the NLF Central Committee (1964); elected chair of the South Vietnam Women's Liberation Association (1965) and appointed deputy commander of the South Vietnam Liberation Armed Forces; elected president of the Vietnam Women's Union (May 1982), where she served until retirement (April 1992).

On March 15, 1960, over 5,000 women and children from six different villages marched on an army post in Mo Cay district town, Ben Tre Province. The women wore mourning bands in memory of 20 youths who had been arrested, killed, then buried in conspicuous graves around an army post at Phuoc Hiep village. Carrying their children and wearing ragged clothes, the women surrounded the district headquarters, demanding an end to brutality against the peasant population and compensation for the families of the dead. "The district chief was scared out of his mind and shouted to the soldiers to shut the gates tightly and not to allow anyone to enter," recalled Nguyen Thi Dinh in her memoir *No Other Road to Take.* "The people stayed in front of the district headquarters, defecating and urinating on the spot, and refused to go home." For five days and five nights the women stayed, among them a blind girl who "sang guerrilla songs which left the soldiers reflective and less arrogant." As the days passed, more women arrived to join the demonstrators, singing and encouraging the soldiers to desert. In the end, the district chief agreed to the demands of the people and withdrew all the army troops from Phuoc Hiep village. The successful struggle of the women in Mo Cay district initiated other women's actions, and Nguyen Thi Dinh, an organizer of the demonstration, came to be known as the general of "the long-haired army."

Nguyen Thi Dinh was born in 1920 in Ben Tre Province, an area of the lower Mekong River to the south of Saigon, with a strong tradition of anti-colonial struggle. The French colonization of Vietnam began with a naval attack on Danang in 1858, and by 1893 the French navy had conquered the entire Indochina peninsula. However, the Vietnamese had a long history of struggle against more powerful invaders, beginning with the *Trung sisters of the 1st century CE, who rode into battle against Chinese invaders on elephants and later drowned themselves in the Hat River, refusing defeat. Nguyen Thi Dinh was the daughter of a peasant family in which everyone worked hard in order to have enough to eat. As a ten-year-old, she woke up at two or three in the morning to take fish by a small boat, or *sampan,* to the market to sell. At night, neighbors gathered at her family's house to hear her brother read from "Luc Van Tien," an epic by the 19th-century scholar Nguyen Dinh Chieu, author of patriotic poems written during the early period of resistance to the French conquest. Ben Tre Province had been under foreign occupation for over 50 years.

Both of Nguyen Thi Dinh's parents were devout Buddhists and supporters of the Communist movement against French colonization. Her beloved brother, Ba Chan, joined the Indochinese Communist Party in 1930, the year it was founded. According to historian **Christine Pelzer White,** for Dinh and her family, Buddhism and Communism coexisted. In fact, "Dinh thought that they were the same thing since several of her brother's comrades lived in a pagoda disguised as monks." Dinh was drawn into the revolutionary movement by her family; she cooked for Communist meetings at her parents' house and hid leaflets under her fish to distribute on her way to the market.

At the end of 1930, Dinh's brother Chan was arrested by the "puppet" village officials, who were governing for the French. Because

Dinh was the youngest of the family, and least likely to excite suspicion, she rowed her *sampan* over two miles each day to bring Chan food. While visiting him at the prison, she witnessed scenes of brutality against old and young people alike. Dinh wrote in her memoir:

> Many men were beaten until they passed out, blood trickling from their mouths, heads and feet, and dyeing the cement floor a greyish and purplish color. I loved my brother and I hated the soldiers so intensely that I wanted to run out to hold them back and defend my brother, but I was too frightened and so I just stood there, frozen, and wept in anger. . . . And it was at that moment that a thought sprang into my innocent mind: "Why are good and capable men who are loved by the people and their families, like my brother Ba Chan, suddenly being beaten so savagely?"

Though Chan was released after half a year, his imprisonment impressed upon Dinh the necessity for an uprising against the French and their local officials. She had decided to become a revolutionary.

Conflicts arose with her family when Dinh reached puberty. She began spending a great deal of time away from home on dangerous missions and often returned late at night. Concerned about her safety and virtue, her parents pressured her to get married. Dinh, however, refused, declaring that she wanted only to work for the revolution. If she had to marry, she said, she wanted to marry a revolutionary—a man who would support her desire to devote her life to revolutionary work. When she was 17, she had a meeting in her parents' garden with a friend of her brother, a famous intellectual and revolutionary, Bich Thuan. In her memoir, she later described his playful questioning:

> —Let me ask you truthfully, why do you want to marry a revolutionary?
>
> I plucked a few tangerine leaves and then said: —Because I want to leave and work for the revolution as you're all doing.
>
> —In your opinion, what kind of man should your husband be?
>
> I was so embarrassed I did not know what to say, but out of respect for him [I had to come up with a] reply: —He must permit me to work for the revolution, he must treat my parents well and love me for the rest of his life. . . .
>
> —If your husband is in the revolution, he might be killed, and sometimes he might even be jailed for nine or ten years, do you think you can wait for him that long?
>
> I lowered my eyes, my cheeks were burning with embarrassment, and then I said hesitantly: —Yes.

They were married at the end of 1938.

In 1940, three days after Dinh gave birth to their only son, Bich was arrested and sent to the notorious French island prison, Puolo Condore. Haunted by memories of her brother's internment, Dinh feared for her husband's safety. Then, on July 19, 1940, when her son On was only seven months old, Dinh was also arrested and sent to Ba Ra, a prison in the mountains near the Cambodian border. "When I thought of our situation—my husband in jail in one place, me in exile in another, and the baby separated from both his parents—my heart broke to pieces." Forced to perform corvée labor, Dinh and the other prisoners were whipped and tortured. At the end of 1943, suffering from cardiac disorder, she was sent back to her home where she was put under house arrest. Three months later, she was told that Bich had died in prison.

In 1944, the anti-colonial Viet Minh movement had become strong. Dinh made contact with the Viet Minh and was assigned to organize the women in Chau Thanh district. When the people seized power from the provincial French authorities in Ben Tre in August 1945, Dinh carried the flag, "leading thousands of people armed with knives, sticks, flags, bright red banners and placards, pouring into the province town." During the uprising, the prisoners at Puolo Condore were liberated. Dinh went to greet the returning prisoners, still hoping that Bich might be alive.

> I felt close to tears, but at the same time my heart was filled with happiness because I had done exactly what Bich had told me when I went to see him in jail with On in my arms. Now I also found out that during the entire time he was in Puolo Condore, until his death, he had always expected me to do just that.

After the successful uprising in Ben Tre Province, Dinh was assigned to the Province Women's National Salvation Association. She worked at the village and district levels to build up the women's network, and at the end of 1945 she was elected to the executive committee of the Women's Association. The same year, she married her second husband, Nguyen Huu Tri. As husband and wife, they performed revolutionary tasks and production labor, farming their share of rice fields. Dinh described him as a productive farmer who excelled at clearing forest land. "Our life was hard but happy."

In 1946, Dinh was chosen by the Province Party Committee to travel with other delegates to the North, meet with President Ho Chi Minh, and ask for weapons to supply the struggle in the South. Ho granted their request, but told them

that the country was poor; in order to arm themselves to fight well against the French, they would have to seize more weapons. Dinh, along with two 50-year-old men and two youths, loaded the weapons onto a small boat, and, running a French naval blockade, smuggled them to the South. She continued to operate in Ben Tre Province.

In the years 1950–54, French repression was fierce in Ben Tre. Many of Dinh's comrades were killed in battle or captured and killed in detention. Dinh faced death many times, but always managed to survive using her wits and various disguises to evade enemy detection. Once, discovered hiding in a bunker, she smeared herself with mud and said indignantly to a French soldier, "Please pull me out, young man! I'm just a woman hiding down here." Seeing that Dinh had been apprehended, an old woman "ran over, her face distorted with weeping and scolded me: What kind of a daughter are you that you don't listen to me! I told you to stay home." The woman then turned to the commander and pleaded, "Sir, my daughter is an innocent person, please let her go back to take care of her baby." When the soldiers were distracted, Dinh and the old woman were able to escape. In 1954, in concert with the decisive battle of Dien Bien Phu, guerrilla war erupted violently in the South, and the French were defeated. The Vietnamese war of independence had been successful, and peace came temporarily to Vietnam.

Accords were signed at the Geneva Conference, which ended July 20, 1954. The agreement contained a ceasefire and divided Vietnam at the 17th parallel into two separate political territories, the Democratic Republic of Vietnam in the North, and the State of Vietnam in the South. Viet Minh troops who had fought against the French were asked to move to the North, and French Union Forces were asked to regroup to the South. General elections for reunification were scheduled for July 20, 1956. In the North, Ho Chi Minh remained the popular leader; in the South, the United States supported the regime of Ngo Dinh Diem.

For the first time in five years, Nguyen Thi Dinh was reunited with her son and husband. The family had to decide whether to regroup to the North or stay in the South. Dinh's son, On, wanted to go to the North to study. Though Dinh wanted him to remain with her, she also wanted him to become educated "and later continue the unfinished work of his father." So On went to the North, while Dinh stayed behind in the South with her husband, who was ill. Soon—as a result of the repression in the South against former Viet Minh activists—Dinh and her husband had to separate in order to continue the struggle. Now, the struggle was against repression from the Diem government and for implementation of the Geneva Accords, which had promised elections.

Beginning in July 1955, the most significant development of Diem's rule was the large-scale, protracted, bloody persecution of the Communists and other ex-Viet Minh members. The oppression escalated in January 1956 with an ordinance which legalized concentration camps. By 1959, persecution reached its peak; thousands of people were arrested, a high percentage of them shot. According to **Marilyn Young** in *The Vietnam Wars: 1945–1990*:

> Tens of thousands of those who had, one way or other, fought against the French under the banner of the Viet Minh were arrested, jailed, sent to "reeducation camps." . . . Agitation for the 1956 national elections was taken as proof of subversion, and perhaps as many as twelve thousand people were executed, upward of fifty thousand imprisoned.

Elections were not allowed to take place. During this period, Dinh had to disguise herself and operate from various hideouts. She once took on the guise of a trader; another time, she assumed the cloak of a nun to escape soldiers. Her brother's son, Di, was arrested, tortured, then shot. The time came when political struggle was no longer adequate, and armed military action seemed necessary.

In the face of this enormous and imposing force of the people, I felt like a small tree standing in a vast and ancient forest. For me there was no other road to take.

—Nguyen Thi Dinh

Early in 1960, Dinh and her comrades in Ben Tre Province began to plan for an armed uprising. They had very few guns, so they produced knives, machetes and other handmade weapons, including "sky-horse" rifles: steel pipes which shot pellets and glass shards dipped in snake poison. On January 17, 1960, the attack began. They tricked the enemy by making fake guns and creating explosions to frighten government troops; one of their objectives was to capture weapons from the government. At this time, women began a campaign of face-to-face political confrontations with government troops, denouncing brutality and urging soldiers to desert.

In 1960, North Vietnam began to actively direct and assist the guerrilla warfare in the South. In September, Ben Tre launched another

wave of uprisings, which was even more successful than the first. It spread throughout the entire province and lasted 22 days. In December, the National Liberation Front (NLF), a Southern mass organization with Communists at its core, was founded. Derogatorily called the "Vietcong," the organization would carry on a war that would increasingly threaten Diem and his American supporters. Six days after the founding of the NLF, a rally was held in Ben Tre Province. Ten thousand people attended, and the NLF Committee for the Ben Tre Province was introduced; Nguyen Thi Dinh served as its representative at the rally. The armed units had expanded, and Ben Tre had almost a full battalion of troops. There were now many battalions of women, "long-haired" troops dedicated to political struggle. As the deputy commander of the South Vietnam Liberation Forces, Nguyen Thi Dinh continued to organize women in villages and hamlets. She was elected to the ruling presidium of the Central Committee of the NLF in 1964. The two-pronged (political and military) struggle for the liberation of the South was to continue until victory in 1975.

Attempting to halt the spread of Communism, the U.S. began bombing North Vietnam in 1964, and in 1965 began sending ground troops, escalating the war. By the end of 1967, 500,000 American troops were in Vietnam. General Nguyen Thi Dinh led the People's Liberation Armed Forces (PLAF) in the war for the Mekong Delta. As noted by Jerold Starr in the *Lessons of the Vietnam War*, all PLAF members were volunteers:

> Women constituted one-third to one-half of the main-force troops and forty percent of the PLAF's regimental commanders. . . . PLAF's regional fighting units had an even higher percentage of women. These full-time fighters operated only in the region where they lived. Another group, militia women, made up local self-defense units which fought when their area was attacked. These women also kept the villages fortified with trenches, traps and spikes.

There were a number of all-women platoons. Women specialized in commando operations, reconnaissance, communications and nursing. Women were in special forces and also dug tunnels, carried supplies, set booby traps, evacuated the wounded and buried the dead.

In 1975, the People's Liberation Armed Forces and the North Vietnamese Army achieved victory. The war left two million Vietnamese killed and four million wounded; 131,000 women were left widowed in Vietnam, and there were 300,000 orphans, approximately 15,000 of them Amerasian. As many as 300,000 Vietnamese still remain missing, and there are 360,000 disabled war victims. The task of rebuilding the country has been immense.

In 1982, Nguyen Thi Dinh became president of the Vietnam Women's Union, which merged the women's organizations of the North and the South. For the next ten years, she used her skill as an organizer to help establish the Union at the village, district, province and national levels. By the time of her retirement as president in 1992, the Vietnam Women's Union had achieved a membership of 11 million.

In a meeting in Ho Chi Minh City on July 26, 1992, one month before her death, Dinh reflected:

> How did I survive all those years? You've got to be extremely alert, sensitive, clever and resourceful in order to turn an adverse situation to your advantage. . . . Had we been fearful, we would have either been killed or died of nervousness. In 1960 the South Vietnam government declared a reward of $1,200,000 for anyone who could get hold of me. They thought that if I were arrested the revolution would lose its force. They didn't realize that the revolution was carried on by the whole people, not only me.

Nguyen Thi Dinh died on August 26, 1992, in Ho Chi Minh City. The Women's Union continues to organize and to act as a powerful advocate for Vietnamese women, representing women in the government, designing new laws, serving to protect women's rights, and insuring implementation of policies which protect women.

SOURCES:

Eisen, Arlene. *Women and Revolution in Viet Nam*. London: Zed Books, 1984.

Elliott, Mai V., trans. *No Other Road to Take: Memoir of Mrs. Nguyen Thi Dinh*. Ithaca, NY: Department of Asian Studies, Cornell University, 1976.

"Meeting with Nguyen Thi Dinh and U.S. women's delegation." Transcript translated by Bich Thu Doan. Ho Chi Minh City, Vietnam, July 26, 1992.

Starr, Jerold M., ed. *The Lessons of the Vietnam War*. Pittsburgh: Center for Social Studies Education, 1991.

White, Christine Pelzer. "Love, War, and Revolution: Reflections on the Memoirs of Nguyen Thi Dinh," in *Indochina Newsletter*. Issue 68. March–April 1991, pp. 1–8.

Young, Marilyn B. *The Vietnam Wars: 1945–1990*. NY: Harper Collins, 1991.

COLLECTIONS:

Correspondence, papers, and memorabilia are located at the Museum of Vietnamese Women, Hanoi and Ho Chi Minh City, and the Vietnam Women's Union, Hanoi.

Kathryn McMahon, Ph.D.,
author of *Heroes and Enemies: War, Gender and Popular Culture*
for the series "Gender and Political Theory: New Contexts"
(Lynne Rienner Publishers)

Nhu, Madame (1924—)

*Official hostess of President Ngo Dinh Diem of the Republic of Vietnam, the wife of his powerful brother Ngo Dinh Nhu, and a fiery actor in the politics of U.S.-Vietnamese relations. Name variations: Madame Ngo Dinh Nhu; Tran Le Xuan. Born Tran Le Xuan (pronounced Trahn Lay Shuen); daughter of Tran Van Chuong (a large landowner in central Vietnam and ambassador to U.S.) and Nam Tran Tran van Chuong also known as **Madame Tran van Chuong** (Vietnamese councilor of the French Union); attended the prestigious Lycee Albert Sarraut in Hanoi; married Ngo Dinh Nhu, in 1944; children: daughter Tran Le Thuy.*

As sister-in-law of the unmarried Ngo Dinh Diem, became acting first lady of the Republic of South Vietnam (1955); became founding president of the paramilitary Women's Solidarity Movement (1961); lost power and went into exile in France upon the assassination of her husband (1963).

Born into a Vietnam torn by deeply disruptive forces, the woman who was to attain a worldwide reputation as "Madame Nhu" was a daughter in one her country's most powerful families, the Tran, and married into another, the Ngo. From 1955 to 1963, these ties placed her at the epicenter of Vietnamese politics, where she earned a reputation as an extremist supporter of the regime of her brother-in-law, Ngo Dinh Diem, the president of the Republic of Vietnam. But during that time, she also fought to modernize her country, and in particular to liberate its women from traditional Confucian feudalism.

The name Tran Le Xuan means "beautiful spring," suggesting a tranquility rarely found in the adult life of the woman to whom it was given at birth. She lived during modern Vietnam's most turbulent times, when its people experienced the occupation and control of their country by both France and Japan, a war fought on their soil against the United States, and finally the revolutionary Communist regime of Ho Chi Minh that came to power in 1975.

Vietnam's most recent struggle against foreign domination began in the middle of the 19th century, but it had been making adjustments to outside powers since long before that. In the 1840s, it was the French who slowly occupied and conquered the country, believing it to be a region rich in mineral resources and also wanting it as a base for additional expansion into neighboring south China. In an effort to cloak the harsh realities of their colonial domination, they left in place the traditional Vietnamese government, a monarchy seated at the central Vietnamese city of Hue, but further weakened anti-colonial resistance by separating the country into three administrative divisions: Tonkin in the north, centered upon Hanoi; Annam in the center, with the national capital at Hue; and Cochin China in the south, with its center at Saigon. Combined with these divisions were the adjacent countries of Cambodia and Laos, also under French control, which altogether made up French Indochina.

The Vietnamese resisted the French invasion from the beginning. Vietnam's people had come together as a unified country as early as the 10th century, and always lived under China's long shadow. Over the next 900 years, while the Chinese often occupied Vietnam and were continually a threat to its sovereignty, the Vietnamese managed to hold onto their independence in part through their shrewd adaptations of Chinese ways in the service of their own purposes. One such borrowing was Confucianism, the dominant political philosophy of China, with its roots deep in the rice-raising countryside of both China and Vietnam. Confucianism enjoined a rigidly hierarchical society centered upon the family in which the power of the father, and by extension, of most men over most women, was nearly absolute.

> *For a moment, however brief in history, some part of America's prestige, if not security, seems to lie in the pale pink palm of her exquisite little hand.*
>
> —Clare Boothe Luce

In Vietnam, however, women held far stronger positions than most of their Chinese sisters. This was probably true because the Vietnamese viewed their freedom from China as taking precedence over everything else. In Chinese society, for example, soldiers and the military were held in low regard, subordinated to the control of Confucian scholars. But the Vietnamese effectively combined the soldier and the scholar in one role, and preferred strong active women who might defend the nation. One of the primary national cults of Vietnam is that of the *Trung sisters, two women who resisted the Chinese as early as 40 CE, when they led one of the feudal states that would coalesce much later into Vietnam. Like many Vietnamese women, Tran Le Xuan personally identified with the Trung sisters from her childhood.

In contrast to the Chinese, the French arrived to conquer Vietnam with modern arms and a strong industrial base. The undeniable power of the French invaders presented a dilemma for the influential families of Vietnam, who were ac-

customed to sharing political control at the court at Hue and to functioning as local administrators in the Confucian hierarchy. Since the French had cleverly left the hollow shell of the Vietnamese court standing at Hue, it was a relatively easy step for many such families simply to begin collaborating with the French, which is what the Tran family did, and for their service to the colonial power they were richly rewarded. While maintaining their local sovereignty, they probably grew even more powerful under the French, and avoided the destruction that was generally the fate of families who resisted the colonials.

The fact that her family served the French opened many doors to Tran Le Xuan. She entered the French Lycee Albert Sarraut in Hanoi, probably in the late 1930s, and secured a modern education, although she later dropped out. She became fluent in French, but never learned to write in Vietnamese. Her excellent French later served her well in her travels in support of her husband's family and their government.

In the 1930s, what would later be known as World War II began in Asia, when Japan followed on the heels of European imperialists by invading China. For a while, the Chinese traded territory for time, so that by 1941, when their conflict became a theater of World War II, the Japanese were bogged down in a costly guerrilla war. Japanese military men then allied with Germany, and hence became allies of the conquered (collaborationist) French government, the Vichy regime. Previous to that, the Japanese had already entered Vietnam directly, in 1940, believing it would assist them in subduing China.

The new occupation presented collaborationist Vietnamese families like the Tran with a fresh dilemma: whether or not to serve the Japanese. Tran Le Xuan's family chose to do so. This was a much more difficult decision than their earlier support of the French, however, and it may have been one of the sources of the later obvious rift between Tran Le Xuan and her parents. The Japanese were cruel masters, who seized local rice for their own troops; in a resultant famine in 1944, millions of Vietnamese died.

It was during these war years that Tran Le Xuan met and married Ngo Dinh Nhu, and soon gave birth to a daughter, **Tran Le Thuy**. The Ngo family, like the Tran, had accepted the French, even to the point of giving up their indigenous Buddhist religion and becoming Catholic. The most noted member of the family was Ngo Dinh Diem, the future first president of the Republic of Vietnam, who had been born in 1901 in Hue, where his father served the Vietnamese court.

Diem was one of nine children, and in traditional Vietnamese fashion, as he rose in prominence he continually counted upon his family to aid him. Some said that the most able member of the family was not Diem himself, but his younger brother, Ngo Dinh Nhu, born in 1910. But it was Diem who had caught the eye of the French and was known to be a tireless worker (although sometimes very self-centered and stubborn). In 1933, he had become minister of the interior, a Cabinet position in the puppet administration of the last Vietnamese emperor under the French, Bao Dai. Unlike many collaborators, however, Diem was a Vietnamese nationalist first and foremost. When the French refused to allow the puppet administration more independence, he resigned his office and left Vietnam. Traveling widely, including in the United States, he thus escaped the opprobrium of working for either the French or the Japanese. and eventually settled in France, where many Vietnamese lived in exile.

In contrast to the Tran and the Ngo families, there were many Vietnamese who chose to resist both the French and the Japanese. Many of these were attracted to the Vietnamese Communist Party, long led by the enigmatic Ho Chi Minh. Born in 1890, Ho ceaselessly resisted the French, usually from abroad. Like many Asian nationalists, he believed that the aid of the revolutionary Communist regime of the Soviet Union might be crucial to his struggle for independence. He began to work with the Soviets and gained revolutionary experience both in France and in China. In 1941, Ho founded the Viet Minh, a front group composed of many organizations but dominated by the Vietnamese Communist Party. While World War II lasted, the Viet Minh worked with allied military and intelligence officers in the jungles along the Sino-Vietnamese border. Repression by the French and atrocities of the Japanese such as the famine of 1944 worked to the advantage of the Viet Minh, and in the wilds of the northern frontier region their military forces grew steadily stronger.

At the end of WWII, with Germany and Japan defeated, the French returned to Vietnam. But the war had weakened the French and strengthened Vietnamese nationalism, and the Vietnamese, led by Ho Chi Minh, were soon in a new war with the French. The Viet Minh were strongest in the northernmost of the three French colonies, Tonkin; while they had many supporters there, in the center and the south, and staged minor military campaigns, the French nonetheless had better control in those regions.

Outside Southeast Asia, the postwar period was increasingly dominated by a new strug-

gle: the Cold War between the Soviet Union and the United States. The U.S., believing that Communists everywhere were directly controlled by the Soviet Union, chose to support the French in Vietnam, and was soon paying almost the total cost of the French effort to re-

gain control. But Ho and his general, Vo Nguyen Giap, were masters at fighting guerrilla war in their own land, and in 1954 the French were defeated in a climactic battle at Dienbienphu, putting the north of Vietnam under the control of the Viet Minh.

The United States refused to accept the prospect of Vietnam becoming Communist, seeing such an event as a Soviet victory. Instead it began to throw its support behind non-Communist Vietnamese nationalists, soon led by Ngo Dinh Diem. With U.S. aid, Diem declared the foundation of a new country in the center and south of Vietnam, the Republic of South Vietnam. The agreement which ended the French role in Vietnam, the Geneva Accords, stated that the two governments, popularly known as North Vietnam and South Vietnam, would be separated pending a future election.

Ngo Dinh Diem inherited a terrible situation and, many feel, was unable to improve upon it. While he did establish a government in the south, most of his generals had in fact fought for the French, his bureaucrats were largely northern Catholics who were resented by the southern Buddhist peasantry, and Diem himself ruled with an iron but capricious hand.

The central issue facing the Diem regime was control over land. In the places where the Viet Minh had been dominant, the land had been turned over to the peasants. When the Diem regime returned it to its original owners, who were usually absentee landlords, the local people were alienated. When other protests were made against the notorious corruption of the regime, all opposition was declared to be Communist-inspired and violently stamped out. When Diem did make a few feeble attempts at land reform, he merely alienated his powerful conservative supporters. Even the mother and father of Tran Le Xuan, now Madame Nhu, became covert enemies of the Diem regime (while serving it in prestigious posts), because tracts of their lands had been confiscated.

In this complex situation, Madame Nhu became the central female figure. Since Diem had not married, she assumed the role of official hostess, as the wife of his younger brother; in effect, she became the first lady of the Republic of Vietnam. It was she who organized the earliest public demonstration in support of Diem's new government.

Madame Nhu also relied on her name and Diem's control of the political structure to have herself elected a member of the National Assembly, the legislative chamber of the Vietnamese government. Using her name and authority, she rammed through a number of pieces of legislation, including laws dealing with such diverse issues as marriage, divorce, adultery, prostitution, boxing, dancing, beauty contests, and fortune-telling. The point of these was to break the hold of Vietnamese Confucian tradition, but within a rather puritanical framework which was also intended to resist the worst elements of Western influence. For example, Madame Nhu declared it illegal for Vietnamese women to have their breasts surgically enlarged, believing this fashion to be a result of Western decadence.

Madame Nhu paid particular attention to women's issues, and lectured widely. But whatever influence she might have had as a modern Vietnamese feminist figure was always compromised by her close ties to the Diem government. In 1961, she was the founding president of the Women's Solidarity Movement, a paramilitary organization intended to raise the status of women, but also to mobilize them in support of Diem's government.

According to Vietnamese tradition, Diem relied heavily upon his brothers, and Ngo Dinh Nhu in particular became exceedingly powerful. He controlled the secret police, the Can Lao party—a group created to provide a democratic façade for Diem's increasingly tyrannical rule—and was generally believed to be the power behind the throne. Madame Nhu, with her excellent French and her wide experience abroad, became the international envoy for the Diem regime.

Americans found her fascinating. The United States, because of its own relative isolation from Asia and from Asian peoples, found Asian women especially exotic and alluring. A series of attractive Asian women, beginning with Madame Chiang Kai-shek (*Song Meiling), had found ways to manipulate this American proclivity to the advantage of their own family or country. Madame Nhu, like *Imelda Marcos of the Philippines, was soon seen by Americans in this stereotypical fashion. One pole of the stereotype was sexual attraction, as Madame Nhu was slim and beautiful and never hesitated to flirt with men of any nationality. But the other pole was a more negative one, by which the same attractiveness could be interpreted as sly, violent, and manipulative—an embodiment of the "Dragon Lady," a term frequently applied to Madame Nhu.

The Diem government soon found itself confronted not only by a Communist insurgency, but by Buddhist-led demonstrations. When Ngo Dinh Nhu's police attacked Buddhist demonstrators, the Buddhists responded with a traditional weapon: self-immolation, a practice in which particularly devout monks publicly burned themselves to death to demonstrate their selfless and principled opposition to the government. When Madame Nhu referred to these hor-

rifying events as "barbecues" and reportedly offered to provide the gasoline for more, such outrageous and impolitic statements inspired international demonstrations against the Diem government. But others found Madame Nhu's pronounced anti-Communism not only appropriate but necessary. *Clare Boothe Luce, a noted American conservative political figure (who also attracted a fair share of controversy), pronounced Madame Nhu to be "beautiful, dynamic, courageous, and intelligent."

But the real issue in Vietnam remained who would control the countryside: the Communists, or the government of South Vietnam. Diem's repressive measures were inadequate and simply inspired more resistance. The U.S. demanded increasingly greater control over Vietnamese military forces, but Diem and Ngo Dinh Nhu, seeing the Americans as a potential threat to Vietnamese independence, resisted. Finally the American supporters of the regime tired of Diem's capricious rule, Ngo Dinh Nhu's repression, and their joint failure to successfully prosecute the war against the rural Communist insurgency. Whether Americans directly encouraged a coup, or perhaps even ordered one, is yet unclear, but on November 1, 1963, a coup was staged by generals of the Diem regime. Madame Nhu was on a speaking tour in the U.S. at the time, but it was reported that some members of her elite female bodyguard died in defense of the presidential palace. The following day, both Diem and Ngo Dinh Nhu were captured and shot to death. As the coup unfolded, Madame Nhu denounced the U.S. for its support of the overthrow, saying, "All the devils of hell are against us," and went into exile in France.

The tragedy of Madame Nhu, and to a considerable degree of both her husband and her brother-in-law, was their attempt to follow a middle course. At a time when Vietnam could not halt the irresistible forces of history, they tried to straddle the line between traditional authoritarianism and modern democratic government, between Vietnamese nationalism and Vietnamese willingness to compromise with overwhelmingly powerful foreign states. In the growing confrontation between Ho's northern government and the United States, the U.S. would search for years for additional southern alternatives to Ho's Communism, and never find them. After decades of war, with millions of Vietnamese casualties, and tens of thousands for the U.S., the divisive war would end in 1975, with the Communists victorious. But the Communists proved unable to create a prosperous and democratic Vietnam, and for many of the millions who left the country to become refugees abroad, the government of the Ngo brothers, Diem and Nhu, and of the acerbic and colorful Madame Nhu, came to be seen as their country's last best hope for an independent non-Communist existence.

SOURCES:

Anderson, David L. "Madame Ngo Dinh Nhu," in *Dictionary of the Vietnam War.* Edited by James S. Olson. NY: Greenwood Press, 1988.

Fitzgerald, Frances. *Fire in the Lake: The Vietnamese and the Americans in Vietnam.* NY: Vintage Books, 1972.

Hammer, Ellen J. *A Death in November: America in Vietnam, 1963.* Oxford: Oxford University Press, 1987.

Luce, Clare Boothe. "The Lady Is for Burning: The Seven Deadly Sins of Madame Nhu," in *National Review.* November 5, 1963.

Warner, Denis. *The Last Confucian: Vietnam, Southeast Asia, and the West.* Baltimore, MD: Penguin Books, 1963.

SUGGESTED READING:

Karnow, Stanley. *Vietnam: A History.* NY: Viking, 1983.

Sheehan, Neil. *A Bright and Shining Lie: John Paul Vann and America in Vietnam.* NY: Vintage Books, 1989.

RELATED MEDIA:

Several episodes in the PBS television series, "Vietnam: A Television History," provide excellent footage of the early years of the war and the Diem regime, together with many images of Madame Nhu.

Jeffrey G. Barlow,
Professor in the Department of Social Studies at Pacific University, Forest Grove, Oregon, and **Christine A. Richardson**, Lincoln High School and Lewis & Clark College, Portland, Oregon

Niboyet, Eugénie (1797–1883)

French journalist, novelist, and advocate for women's rights. Name variations: Eugenie Niboyet. Born in 1797; died in 1883.

Selected writings: Les Deux Frères (*The Two Brothers, 1839*); Lucien (*1841*); Quinze Jours de vacances (*A Fortnight's Holiday, 1841*); Souvenirs d'enfance (*Childhood Memories, 1841*); Dieu manifesté par les oeuvres de la création (*God as Manifested by the Works of the Creation, 1842*); Cathérine II (*1847*); (memoirs) Le Vrai Livre des femmes (*The True Book of Women, 1862*).

Eugénie Niboyet, who began her literary career by translating English novels into French, had published a number of her own works by the time she founded the socialist journal *La Paix des deux mondes* (Peace in Both Worlds) in 1844. A committed pacifist and champion of the poor and downtrodden (of whom there were many in the Paris of those years), she was aligned for a period with the Saint-Simonians, followers of the social reformer and utopian Saint-Simon who is considered the founder of French social-

ism. Among the tenets of his philosophy was full rights and development for women.

In Paris during the turbulent year of 1848, which began with a revolution in February and ended in December with the overwhelming election of Napoleon III as president, Niboyet founded *La Voix des Femmes* (Women's Voice), the first feminist socialist daily newspaper in France. Run by a central committee of women including Niboyet, *Jeanne Deroin, **Désirée Gay**, and **Amelie Pray**, the paper printed articles by socialists, republicans, women and men from both the working class and the middle class, and foreigners. In 45 issues published from March through June, Niboyet's newspaper advocated education, suffrage, and economic reform for women. (At the time, many French men were also denied the franchise.) The proposed education was to be equal to that available to men, although all classrooms would be strictly segregated by gender, and the reason offered for allowing women to develop their intellects was to permit them to raise their children with higher moral and social values. Suffrage was sought so that the special nurturing and inspirational qualities of women could permeate and correct the harshness of the (male) public sphere. Finally, economic reforms of women's work would assist in strengthening working-class families and eliminating prostitution.

The provisional government was not persuaded and denied women's suffrage. Niboyet was often caricatured in the press, and meetings of the paper's related Club des Femmes were frequented by men who came to jeer and mock. (The club was finally disbanded by the police as a public nuisance.) As well, tensions grew between Niboyet and the more radically socialist Deroin and Gay, with the latter two severing their connections to the paper at the end of April. Nine more issues of *La Voix des Femmes* were published before it folded. Towards the end of the year, the temporary government that had gained its power from the uprising of the many poor and unemployed and unenfranchised passed suffrage for all adult male citizens. Niboyet's memoirs of 1848 were published as *Le Vrai Livre des femmes* (The True Book of Women) in 1862. She died in 1883.

Lisa Frick,
freelance writer, Columbia, Missouri

Nicaea (fl. 300 BCE).
See Arsinoe II for sidebar.

Nicaea, empress of.
See Irene Lascaris for sidebar on Anna Angelina (d. 1210?).

See Philippa of Lesser Armenia.
See Marie de Courtenay (fl. 1215).
See Constance-Anna of Hohenstaufen.
See Helen Asen of Bulgaria (d. 1255?).
See Theodora Ducas (fl. 1200s).
See Anna of Hungary (d. around 1284).
See Irene of Montferrat (fl. 1300).
See Irene of Brunswick (fl. 1300s).
See Anne of Savoy (c. 1320–1353).
See Irene Asen.
See Helena Cantacuzene (fl. 1340s).
See Maria-Kyratza Asen.
See Gattilusi, Eugenia.
See Helena Dragas (fl. 1400).
See Anna of Moscow (1393–1417).
See Sophie of Montferrat.
See Maria of Trebizond (d. 1439).
See Magdalena-Theodora Tocco.
See Gattilusi, Caterina.

Nicarete of Megara (fl. 300 BCE)
Greek philosopher. Flourished in 300 BCE; studied with Stilpo.

Nicarete of Megara is known to have studied with the philosopher Stilpo, in Megara, Greece. Among Stilpo's other students was Zeno, who founded the movement of Stoicism in philosophy. Stilpo was allayed with the Cynics, who wished to do away with the desires of normal society by living a simple and scholarly life. Nicarete sided more with Socrates who was actively involved in his society, while following an independent philosophical credo. Though she may have been a hetaerae (courtesan) and Stilpo's mistress, there are indications that Nicarete was a noble. As well, Stilpo's reputation for temperate behavior would have suffered if she had been his mistress.

Catherine Hundleby, M.A. Philosophy,
University of Guelph, Guelph, Ontario, Canada

Nicaula (fl. 10th c. BCE).
See Sheba, Queen of.

Nice, Margaret Morse (1883–1974)
Internationally known American ornithologist. Born on December 6, 1883, in Amherst, Massachusetts; died on June 26, 1974, in Chicago, Illinois; daughter of Anson Morse (a history professor) and Margaret (Ely) Morse; Mt. Holyoke College, B.A., 1906; Clark University, M.A., 1915; married Leonard Blaine Nice (a medical professor), in 1909; children: Constance Nice (b.

1910); Marjorie Nice (b. 1912); Barbara Nice (b. 1915); Eleanor Nice (1918–1928); Janet Nice (b. 1923).

Served as president of the Wilson Ornithological Society (1938–39); awarded Brewster Medal of the American Ornithological Union (1942); awarded honorary doctorate from Mt. Holyoke College (1955) and from Elmira College (1962).

Selected writings: (with Leonard Blaine Nice) The Birds of Oklahoma (1924, rev. ed., 1931); Studies in the Life History of the Song Sparrow (2 vols., 1937 and 1943, rep. ed., 1964); The Watcher at the Nest (1939); (autobiography) Research Is a Passion With Me (1979).

Although Margaret Morse Nice did not earn a doctoral degree, hold a faculty position, or receive university funding, she established herself as one of the world's best-known ornithologists and bird behaviorists. She was the first to accomplish a long-term study of an individual bird in its natural habitat and the first woman to be elected president of a prominent American ornithological society.

Nice was born in Amherst, Massachusetts, on December 6, 1883, the fourth of seven children of Anson and **Margaret Morse**. The family's house was surrounded by two acres of orchards and gardens, and both her parents loved nature and outdoor activities. Her father, a history professor at Amherst College, was also an avid gardener, and her mother, who had studied botany at Mt. Holyoke College, spent time teaching her daughter the names of local wildflowers. By the time Nice was 12 years old, she had begun to record her observations of the birds in her garden and publish her findings in a weekly self-published newspaper, entitled *Fruit Acre News*.

After attending elementary school and high school in Amherst, in 1901 Nice enrolled in Mt. Holyoke College, becoming the third woman in her mother's family to attend there. She studied languages and natural sciences, including ornithology, which at the time was taught in the zoology department and primarily consisted of studying and identifying species of dead, stuffed birds. Nice received her B.A. in 1906, and from 1907 to 1909 attended Clark University in Worcester, Massachusetts, as a biology fellow. There she also met her future husband, Leonard Blaine Nice, whom she married in August 1909. The following year, she published her first ornithological paper in the *Journal of Economic Entomology*. The fruits of two years' worth of detailed observation and research, "The Food of

the Bob-white" reflected Nice's talent for gathering and organizing information. Her first child was born that year as well, and in 1911, the family moved to Cambridge, where Leonard attended medical school. In 1912, the Nices had another child and the following year moved to Normal, Oklahoma, where Leonard became head of the physiology department at the University of Oklahoma. Tied to the home while raising her young children, Nice became increasingly intrigued by child development and psychology, particularly the acquisition of language. She earned an M.A. in psychology from Clark University in 1915, and over the following two decades published 18 articles on child psychology.

Several years after receiving her degree from Clark, Nice began to apply her fascination with psychology and behavior to bird communities. With the encouragement of **Althea Sherman**, an amateur ornithologist and friend who warned about the dangers of becoming absorbed by household duties, Nice wrote and published several articles about Oklahoma's birds. In 1924, she published *The Birds of Oklahoma*, coauthored with her husband. In all, between 1920 and 1965 she would write approximately 250 research reports and articles about birds.

In 1927, Leonard Nice accepted a teaching position at Ohio State University in Columbus, Ohio. The family moved to a house near the Olentangy River, a lowland wilderness area that attracted a large variety of nesting and migrating birds. There Nice accomplished her most significant studies, on mourning doves, warblers and, most important, song sparrows. She followed the principles of the English ornithologist H. Eliot Howard, who had described the territorialism of small birds in his 1920 book *Territory in Bird Life*. Her primary interest was in song sparrows, and her research began with putting colored bands on birds which she had also named and numbered. By doing so, she was able to observe the individual behavior of a bird and outline the bird's life history. Nice was the first to conduct this type of observation and research, and her work with song sparrows established her as one of the world's principal ornithologists and behaviorists. The German evolutionary biologist Ernst Mayr claimed that Nice had begun "a new era in American ornithology. . . . She early recognized the importance of a study of bird *individuals* because this is the only method to get reliable life history data." (Despite her rising prominence, she was not invited to join the local, all-male ornithology club, although her husband was.) During the time she studied song sparrows, she published *Studies in the Life History of the Song*

Sparrow (1937, 1943) and *The Watcher at the Nest* (1939), which was intended for general readers. Nice's efforts were supported by her husband and by her children, who were often asked to climb trees and observe nests.

In 1936, Leonard Nice joined the faculty at Chicago Medical School, and the family moved to Hyde Park, near the University of Chicago, which Nice found to be a poor place to carry out her research on birds. Using information she had previously collected, she continued to write about the life histories, territorialism, courtship, sexual dominance, and behavior of birds. She also wrote about ecology and conservation, the latter a subject in which she became increasingly outspoken. Nice wrote about the dangers of pesticides, the misuse of wildlife preserves, and the killing of albatrosses on Midway Island, and became dedicated to educating the public about a variety of conservation issues. She belonged to several ornithological and conservation associations, and was associate editor of the journal *Bird-Banding* for several years. She also translated ornithological papers from a number of foreign languages into English, exposing Americans to European ornithology. In 1938 and 1939, she was the first woman to serve as president of the Wilson Ornithological Society, and in 1942 she was awarded the Brewster Medal of the American Ornithologists' Union. She also received honorary doctorates from Mt. Holyoke College in 1955 and from Elmira College in 1962, and in 1969 the Wilson Ornithological Society began awarding the Margaret Morse Nice grant, which was reserved for amateur ornithologists. Nice died in Chicago at the age of 90, in 1974.

SOURCES:

Bailey, Brooke. *The Remarkable Lives of 100 Women Healers and Scientists*. Holbrook, MA: Bob Adams, 1994.

Bailey, Martha J. *American Women in Science*. Santa Barbara, CA: ABC-CLIO, 1994.

McMurray, Emily, ed. *Notable Twentieth-Century Scientists*. Detroit, MI: Gale Research, 1995.

Sicherman, Barbara, and Carol Hurd Green, eds. *Notable American Women: The Modern Period*. Cambridge, MA: The Belknap Press of Harvard University Press, 1980.

SUGGESTED READING:

Nice, Margaret Morse. *Research Is a Passion With Me* (autobiography). Toronto: Consolidated Amethyst, 1979.

Stresemann, Erwin. *Ornithology: From Aristotle to the Present*. 1975.

Trautman, Milton B. "In Memoriam: Margaret Morse Nice," in *The Auk*. July 1977.

COLLECTIONS:

Personal and professional papers of Margaret Morse Nice are located at the Cornell University Libraries. Milton Trautman's *A Partial Bibliography of Margaret Morse Nice* (1976) is available through the Museum of Zoology, Ohio State University.

Christine Miner Minderovic,
freelance writer, Ann Arbor, Michigan

Nicesipolis (d. around 345 BCE)

*Thessalian noblewoman. Died around 345 BCE, 20 days after birth of daughter Thessalonike; niece of Jason of Pherae, a tyrant and prominent player in Thessalian politics; became one of the many wives of Philip II of Macedon, in the 340s; children: *Thessalonike (c. 345–297 BCE).*

Nicholas, Princess (1882–1957).

See Helena of Russia.

Nicholls, Rhoda Holmes (1854–1930)

English-born watercolor painter. Born Rhoda Carleton Marion Holmes in Coventry, England, on March 28, 1854; died in Stamford, Connecticut, on September 7, 1930; daughter of a vicar; studied in London at the Bloomsbury School of Art; studied in Rome as a member of the Circello Artistico; married Burr H. Nicholls (an American painter), in 1884.

Rhoda Nicholls was born in 1854 in Coventry, England, the daughter of a vicar. After her marriage to American painter Burr H. Nicholls, she moved to America in 1884 and settled in New York City. Her Venetian watercolors and her illustrations for William Dean Howells' *Venetian Life* are representative of her brilliant and individual style. Four of her paintings are in the Boston Art Club and two in the Boston Museum. Nicholls' work received the tribute of various medals and awards at exhibitions in New York and elsewhere. For many years, she taught art classes at the William Chase School in Shinnecock, Long Island; she also taught at the Art Students League in New York City.

Nichols, Anne (1891–1966).

See Ball, Lucille for sidebar.

Nichols, Clarina (1810–1885)

American journalist and women's rights leader. Name variations: Mrs. C.I.H. Nichols; Clarina Irene Howard Nichols. Born Clarina Irene Howard on January 25, 1810, in West Townshend, Vermont; died on January 11, 1885, in Potter Valley, California; daughter of Chapin Howard (a landowner and businessman) and

Birsha (Smith) Howard; educated at district school and attended an academy for one year; married Justin Carpenter (a Baptist preacher), on April 21, 1830 (divorced February 1843); married George W. Nichols (a newspaper publisher), on March 6, 1843 (died 1855); children: (first marriage) Birsha C. Carpenter, Chapin Howard Carpenter, Aurelius O. Carpenter; (second marriage) George B. Nichols (b. 1844).

Opened a girls' seminary in Herkimer, New York (1835); returned to Vermont and began writing for the Brattleboro newspaper (1840); married publisher of Brattleboro's Windham County Democrat, George W. Nichols, and assumed editorial duties at the paper (1843); wrote series of editorials on the subject of married women's property rights which led to the passage of legislation by the Vermont legislature (1847); led failed campaign to secure the vote for women in district school elections (1852); lectured extensively, mainly on women's rights (early 1850s); settled in Kansas Territory (1855), where she wrote articles and lectured on women's rights; addressed Kansas legislature on need for married women's property law (1860); moved to Washington, D.C. (1863); returned to Kansas and unsuccessfully campaigned with Susan B. Anthony toward full women's suffrage in the state (1867); moved to California to live with her son (1871).

As a newspaper editor and women's rights leader, Clarina Nichols played an important role in helping women to obtain legal rights to inherit, own, and bequeath property; she also worked to obtain the vote for women. She was born on January 25, 1810, to Chapin and **Birsha Smith Howard** of West Townshend, Vermont; her father was a large landowner and at various times ran a number of businesses, including a tannery, tavern, shoe store, and blacksmith shop. She received what was then a fairly good education for a woman, attending public schools, and spent one year at an academy.

Nichols married Justin Carpenter, a Baptist preacher, in Townshend on April 21, 1830. They moved shortly thereafter to Herkimer, New York, where she raised three children and opened a girls' seminary around 1835. By 1839, however, she had returned to Townshend without her husband, and the following year began writing for Brattleboro's *Windham County Democrat* newspaper. Nichols was divorced from her first husband in February 1843, and in March she married George W. Nichols, 25 years her senior, who was the publisher and printer of the paper. The next year a son, George B., was born. Nichols assumed editorship of the paper and increased its scope to include literary pieces and ed-

itorials supporting various reform movements. A series of editorials she wrote on the lack of property rights available to married women led in 1847 to laws passed by the Vermont legislature which guaranteed married women the right to inherit, own, and bequeath property. This legislation was subsequently expanded. Nichols was also instrumental, through her editorials and speeches, in gaining support for legalizing joint property deeds for married couples, permitting women to insure their husbands' lives, and broadening inheritance rights for widows. In 1852, she campaigned for women to have the right to vote in district school meetings. Although a speech she gave failed to convince the legislature to enact such legislation, she won sympathy and support for her cause.

Nichols eventually became a sought-after lecturer, who sprinkled her talks with personal experiences and the liberal use of Biblical quotations. She was an avid knitter, and her habit of knitting on trains on the way to speaking engagements often surprised people who had falsely assumed that she was not domestic. As Nichols became known outside the state of Vermont, she was invited to speak at women's rights conventions and attended the "Whole World's Temperance Convention" in 1853. That fall, with the encouragement of her husband, she joined physician *Lydia Folger Fowler in a 900-mile speaking tour to Wisconsin sponsored by the Woman's State Temperance Society.

In 1853, the *Democrat* went out of business, and the next year the family prepared to move to Kansas. Nichols and her two older sons joined a Kansas-bound party sent by the New England Emigrant Aid Company, arriving in Lawrence, Kansas, on November 1, 1854. She soon went back to Vermont for her husband and the following spring returned to Kansas with him and their younger children. Their Missouri River steamboat ran aground during the journey, at which point she took advantage of her captive audience to organize and address a women's rights meeting on board. The family took up residence near Ottawa, Kansas, where her husband died in August 1855. After settling his estate in Vermont, she moved with her daughter and youngest son to Wyandotte County, Kansas.

As the territory moved closer to statehood, Nichols wrote a steady stream of newspaper articles campaigning for the inclusion of women's rights clauses in the Kansas constitution. She also lectured and circulated petitions on behalf of the Kansas Woman's Rights Association, founded in 1859. When the state constitution

was written in Wyandotte (later Kansas City), it granted women equal rights to education, to custody of their children, and to the vote in local school matters, all largely because of Nichols' ceaseless campaigning. She also worked for ratification of the constitution. Representing the Kansas Woman's Rights Association, she spoke about the need for a married women's property law in front of a joint session of the first state legislature in 1860. It was not until 1867, however, that such a law was passed.

Between 1863 and 1866, Nichols lived in Washington, D.C., working first in the Quartermaster's Department and then as the matron of the Georgetown home run by the National Association of the Relief of Destitute Colored Women and Children (1865–66). In 1867, she was among the women who joined *Susan B. Anthony in a push for women's suffrage in Kansas. (They were unsuccessful.) In December 1871, Nichols moved to Mendocino County, California. Although her health had begun failing, she wrote articles for a local farm journal, the *Rural Press*, before her death at the home of her son George in Potter Valley, California, on January 11, 1885.

SOURCES:

Edgerly, Lois Stiles, ed. *Give Her This Day*. Gardiner, ME: Tilbury House, 1990.

James, Edward T., ed. *Notable American Women, 1607–1950*. Cambridge, MA: The Belknap Press of Harvard University Press, 1971.

McHenry, Robert, ed. *Famous American Women*. NY: Dover, 1980.

SUGGESTED READING:

Barry, Louise. "The Emigrant Aid Company Parties of 1854," in *Kansas Historical Quarterly*. May 1943.

Cabot, Mary R., ed. *Annals of Brattleboro*, 1921.

Morgan, Perl W., ed. *History of Wyandotte County, Kansas, Volume I*, 1911.

Nichols, Clarina. "Reminiscences," in *Elizabeth Cady Stanton*, et al., *History of Woman Suffrage, I*, 1881, pp. 171–200.

———. "The Responsibilities of Woman, A Speech . . . at the Woman's Rights Convention" (Worcester, Oct. 15, 1851), 1854.

COLLECTIONS:

Various articles by Clarina Nichols published in the *Windham County Democrat* are available in scattered copies at the Vermont State Library, Montpelier, Vermont.

Jo Anne Meginnes,
freelance writer, Brookfield, Vermont

Nichols, Lee Ann (c. 1956–1994).

See Lowney, Shannon for sidebar.

Nichols, Maria Longworth (1849–1932).

See Storer, Maria.

Nichols, Mary Gove (1810–1884)

American author, lecturer, and practicing physician who advocated proper health practices for women and led the early free-love movement in demanding radical changes in marriage. Name variations: as author, nonfiction works up to 1848 are by Mary Gove; most of her fiction under the pseudonym Mary Orme. Pronunciation: NI-ckles. Born Mary Sargeant Neal on August 10, 1810, in Goffstown, New Hampshire; died on May 30, 1884, in London, England, of breast cancer; daughter of William A. Neal and Rebecca R. Neal; had little formal education; married Hiram Gove, on March 5, 1831 (divorced 1848); married Thomas Low Nichols, on July 29, 1848; children: (first marriage) **Elma Penn Gove** (b. March 1, 1832); (second marriage) **Mary Wilhelmina Nichols** (b. November 5, 1850).

Converted to Presbyterianism and then Quakerism (c. 1825); moved with husband to Weare, New Hampshire (1831), then to Lynn, Massachusetts (c. 1837); took up study of principles of health; gave first lectures on health for women in Boston (1838); toured northeastern states with health lectures (1838–41); left husband (1841); studied water-cure methods in New England and New York (1842–45); moved to New York City (1845); operated a water-cure boarding house (1845–50); met Thomas Low Nichols (1847); married (1848) after Hiram Gove divorced her; operated health schools in New York state with new husband and embraced the free-love movement (1851–53); lived at Modern Times, on Long Island, then the center of free love (1853–55); became a spiritualist medium (1854); moved to Cincinnati (fall 1855); opened Memnonia, school of life and health, in Yellow Springs, Ohio (July 1856); converted to Roman Catholicism with family (March 29, 1857); left with family for England (1861); operated water-cure establishment in Malvern (1867–72).

Selected writings: Lectures to Ladies on Anatomy and Physiology (Boston: Saxton and Peirce, 1842); Uncle John; or, "It is too much trouble" (NY: Harper & Brothers, 1846); Experience in Water-Cure (NY: Fowler and Wells, 1849); Agnes Morris (NY: Harper and Brothers, 1849); The Two Loves: or, Eros and Anteros (NY: Stringer and Townsend, 1849); Mary Lyndon or, Revelations of a Life (NY: Stringer and Townsend, 1855); A Woman's Work in Water Cure and Sanitary Education (London: Nichols, 1874); (with T.L. Nichols) Marriage (Cincinnati: Valentine Nicholson, 1854).

The 1847 Christmas Eve party in New York City included reformers seeking to establish earthly utopias and literary figures hoping for

fame if not much fortune. New York was the center of the most advanced ideas and home to the most earnest reformers in the United States. Edgar Allan Poe was there and recited his "Raven." One of the guests, a small, dark-haired woman, with piercing black eyes, embodied many of the most radical trends of the day. She had moved to New York two years before, where she wrote for Poe's *Broadway Journal* and other magazines and built a small medical practice at her boarding house based on water cure. Nothing that Mary Gove did, however, went without controversy. Family members of one of her patients discovered to their horror that she had left her husband and that her boarding house included alcoholics and radicals. The Christmas party would change her life more completely than she could have imagined. There she met a journalist whom she regarded immediately as "a mere dandy." But along with her reservations came an attraction, or as it was called at the time, affinity, for Thomas Low Nichols. The two became lovers in the following months and eventually man and wife. Together, they would work to advance causes that Mary Gove had long before embraced—health reform for women, marriage reform (later called free love), and a social reform that would include higher spiritual values.

Mary Gove Nichols was born Mary Neal in 1810, in Goffstown, New Hampshire, the third of four children of William and **Rebecca Neal**. Some time after 1820, the family moved to Craftsbury, Vermont, where Nichols suffered from homesickness and other ailments. She later attributed her religious conversion, at about age 15, to ill health. Adolescence proved an especially trying time. Nichols joined the Presbyterian church, a move that distanced her from her beloved but freethinking father. Then a quarrel with the Presbyterian minister's wife effectively ended her association with the church. Because she was too bright for the town's schoolmistress, Nichols soon had to pursue her education on her own; her studies included works on physiology borrowed from her brother who was studying medicine. By age 18, she was writing stories and poems for local newspapers. After succeeding in becoming certified, she taught in a local school.

Nichols then turned to the Quaker religion. As there were no Quakers in Craftsbury, her knowledge of their lives and beliefs came from her reading. Soon, she was adopting their simple dress and peculiar form of speech. In 1831, she married Hiram Gove, a Quaker from Weare, New Hampshire, but the union went sour from the beginning. Hiram, who was much older than she, took for granted that his wife should obey him in everything. Because he had failed in business years before and was still paying his debts, the couple needed Nichols' income from needlework, writing, and later from teaching. In 1832, their first daughter, Elma Penn, was born. Four later pregnancies, however, ended either in miscarriages or infant deaths. Nichols found the Quakers of Weare, including her husband, narrow and unsympathetic. When the family moved to Lynn, Massachusetts, the climate of the new religious community remained the same. Her idealized view of the religion was effectively destroyed.

> *W*hen will woman cease to be an appendage . . . ; the miserable mother of miserable men and more wretched women?
> —**Mary Gove Nichols**

Mary's difficult pregnancies and general poor health led her to further study in medical texts and brought her into the health-reform movement. In the early 1830s, Sylvester Graham, a Yankee lecturer and writer, had started a revolution in the American understanding of health and sickness by condemning personal habits as the major causes of disease. His message appealed strongly to Nichols, who attended all of Graham's lectures when he came to Lynn in 1837. She soon became so active and well known for her advocacy of health reform that another leading health reformer, William A. Alcott, endorsed Nichols as a lecturer on health for women. She began speaking in Boston in 1838 and, in the following years, traveled throughout the northeast, drawing audiences of 400 to 500 women interested in regaining their health. By 1840, she had written articles, under a pseudonym, for the *Boston Medical and Surgical Journal.*

Nichols became the first and one of the most important advocates of healthy habits for women. The movement to educate women about their bodies, and so give them greater control over their lives, became a primary force in women's liberation in the 19th century. "Health is maintained by a simple nourishing diet, pure air, exercise, cleanliness, and the regulation of the passions," she wrote in *Experience in Water-Cure.* Like Graham and Alcott, Nichols assumed that the perverse practices of society distorted human life and consequently created sickness. Attacks on poor diet were at the center of the health-reform movement, especially eating meat and spicy foods, and drinking alcohol. For women, however, the harm of custom went further. In her *Lectures to Ladies,* Nichols pointed

out that middle-class women took little exercise and adopted fashions "as repugnant to health as they could well be contrived, even had the contrivers sought after the most deleterious mode." From the heavy load of hair, wig, and bonnet to the tight shoes she wore, the middle-class woman bore an enormous weight of bad dressing habits. Nichols repeatedly condemned the "death grasp of the corset" that compressed and collapsed the lungs. By 1853, she briefly adopted the Bloomer costume that eliminated many of the layers of garments that women wore and so allowed greater freedom of movement. Nichols was the first woman to speak out on the evil consequences of masturbation as a problem for young women. She warned that too much sexual gratification, of whatever kind, could cause disease.

The success of Nichols' lectures contrasted darkly with the continued deterioration of her marriage. In Philadelphia, she spoke to an audience of both men and women, a practice still new and unrespectable. But she found support from the medical men of the city. In both Philadelphia and Baltimore, her lectures were received "with all the favor I could ask," she wrote to her friend John Neal. Yet Hiram Gove took the money from her lecture tours as his due under the property laws of the day. Even though her earnings from writing and lecturing had become the major support for the family, she had no control over any money she made. Nichols' personal conflict eventually convinced her that life with her husband had become unbearable and formed the basis for her continued questioning of marriage as an institution.

In 1841, one of her audiences voted to give her a purse with $35 in gold. She used the money to leave Hiram and the Quaker religion. Taking her daughter with her, Nichols went to live with her father, who managed to keep Hiram away. While there, she published her first book, *Lectures to Ladies* (1842). She also met Henry Gardiner Wright, an Englishman who had come to America to live in one of the many utopian communities of the time. Wright greatly improved Nichols' understanding of water cure, a new medical practice that included frequent bathing in a variety of forms, such as showers, wet sheets, and sitzbaths. From the mid-1840s, Nichols worked as a water-cure physician or hydrotherapist. She studied at a well-known resort in Brattleboro, Vermont, then practiced as the resident physician in Lebanon Springs, New York, in 1844. The brief stay with her father proved an idyllic interlude. She fell in love with Wright and lived free from the domestic tyranny of Hiram Gove. Unfortunately, Wright was also

married, and soon returned to England. Around 1845, Nichols' father died. Hiram Gove took advantage of his wife's vulnerability to remove Elma to a Quaker community for several months. With no legal means of regaining her child, Nichols accepted the help of a lawyer who simply led the child out of the community.

Mother and daughter escaped to New York City, where they stayed initially with Dr. Joel Shew in his water-cure establishment. To support Elma and herself, Nichols wrote short fiction under the pseudonym Mary Orme for *Godey's Lady's Book* and other magazines. During her stay in New York, she also wrote her first novels and became well known in New York's literary circles. One of her admirers was the Southern novelist Charles Wilkins Webber. Nichols also met Poe and tried to gather some support for his work. Poe apparently helped her, as well, since he edited the *Broadway Journal* that published her story "The Gift of Prophecy." But literature could never become a full-time occupation for Nichols. With the help of a young Jewish Southerner, Marx Edgeworth Lazarus, Nichols opened a water-cure boarding house in New York. Although a trained physician, Lazarus believed in the health-reform movement and enlisted Nichols' care for his sister, **Ellen Lazarus**, who had traveled north in search of help for her chronic illness. Ellen became the first of several residents and patients at Nichols' establishment. The boarders followed a Graham diet and a water-cure regimen, and gained insights into disease and health from Mary's teaching.

Residents of the boarding house held a wide range of beliefs; several supported the movement to build utopian communities as envisioned by the French theorist Charles Fourier. Albert Brisbane, the leader of the American Fourierist movement, frequently visited Nichols' establishment. The residents freely discussed ideas ranging from new forms of ownership and industry to the end of slavery and the reform of marriage. In her autobiography, *Mary Lyndon*, Nichols described the boarding house as "a general depôt of ultraisms in thought." The free exchange of ideas, and the unchaperoned mingling of men and women at a time when middle-class women rarely spoke with unrelated mates, left the boarding house without a respectable reputation. "I hear nothing of that establishment except that it is considered to be a place unfit for persons of good character to be connected with," wrote one of Ellen Lazarus' relatives. When Ellen returned home later in 1846 one of her aunts became convinced that "Mrs. Gove is a dangerous person." Another was shocked that

Mary
Gove
Nichols

"Ellen uses terms familiarly which shock her [Aunt's] ear and whatever good she may have gained it is most offensively mingled with such knowledge as no lady ought to know exists."

In 1847, when Mary met the journalist Thomas Low Nichols at the Christmas Eve party, a courtship followed that included frequent letters and visits. Although Mary was still married, they decided to live together despite social disapproval. At almost the same time, however, Hiram Gove, who wanted to remarry, instituted divorce proceedings. Mary and Thomas were married on July 29, 1848, by a Swedenborgian minister. They had one child, Mary Wilhelmina, born in 1850. Health and marriage reform became central to their work in the years following. Thomas attended New York University's medical school for one year, emerging as Dr. Nichols and becoming a practicing physician. In general, he spent more of his time writing and publicizing their shared plans and ideas, Mary Nichols remained the primary medical practitioner. In many cases, Thomas adopted his wife's ideas and elaborated them in his writings. "We were," he recalled in *Nichols Health Manual,* "a mutual inspiration and help to each other." Together, they opened the American Hydropathic Institute in Septem-

ber 1851, with 25 students of both sexes. In 1852, they moved to Port Chester, New York, to open a summer school for women.

Controversy swirled around the Nicholses, however, and eventually ended their efforts to establish a health school in the East. With other advanced thinkers of the time, they had questioned the value of the institution of marriage. In their own lives, they had committed themselves to one another despite social conventions that would have forbidden such a relationship. Not surprisingly, they were among the first to embrace the free-love ideas that appeared in the early 1850s, and Mary Nichols became the best-known woman to advocate free love before the Civil War. Building on the ideas of Brisbane, Lazarus, Josiah Warren, and other writers of the middle 19th century, she and her husband asserted that love could never be bound by social conventions, and that the only genuine love between men and women was a love that could freely change. In a collaborative work entitled *Marriage*, Thomas expressed the couple's belief that "marriage and slavery are alike the grave of human liberty." If destroying marriage meant undermining a corrupt society, then they were ready for the consequences: "Let it be destroyed; the sooner the better." Their turn to free love effectively barred their writings from the *Water-cure Journal*, leading them in 1853 to begin *Nichols Journal*. Under various names, this publication continued until 1856. By 1853, they proposed to establish Desarollo, the Institute of Life, at Josiah Warren's individualist community of Modern Times, on Long Island. Conflicts with Warren, who never supported free love, and the growing controversy surrounding their doctrines, forced the Nicholses to abandon Desarollo and their tract of land in Modern Times.

They moved to Cincinnati in the fall of 1855, determined to open a community dedicated to physical and spiritual renewal. About one year before, Mary Nichols had discovered, as did many women in the rapidly growing spiritualist movement of the time, what she believed was the ability to communicate with spirits of the dead. Messages from beyond the grave extolled her efforts to form a society that would bring its members to the highest level of human existence. She and Thomas promoted both the Progressive Union, which was to be a network of like-minded individuals devoted to spiritual, physical, and social perfection, and Memnonia, a community built on the principles of the Progressive Union and supported by donations from Progressive Union members. Early in 1856, they managed to lease a water-cure establishment at Yellow Springs, 70 miles northwest of Cincinnati. Despite local resistance, the spiritualists in Yellow Springs supported the Nicholses, and in July 1856 they opened Memnonia to about 20 students. The small community followed a regimen of water cure, early morning seances, and close study of the most important reform literature.

By 1856, however, Mary and her husband were moving to new intellectual and spiritual terrain. Earlier that year, they had announced their Law of Progression in Harmony which stated that love might be free, but that sexual intercourse should take place only when a couple intended to have children. While most free lovers believed that the passions should be carefully controlled, they quickly divided over the Nicholses' Law of Progression in Harmony, with most holding that sex every year or so was too infrequent. The spiritual development of Mary and Thomas, however, soon went beyond alienating a few free lovers. Mary Nichols claimed that in the winter of 1856 she began to receive messages from various Roman Catholic spirits, including St. Francis Xavier and St. Ignatius Loyola. These spirits explained Catholicism and urged the Nicholses to convert. On March 29, 1857, Thomas and Mary Nichols, along with Elma Gove, were received into the Roman Catholic Church. They spent a few months in study and meditation at a convent school of the Ursulines in Ohio, after which they continued their work as advocates of health, lecturing to and working with Catholic religious orders from the Great Lakes to the Gulf of Mexico.

In 1860, the Nicholses returned to New York City to establish a water-cure practice, but soon became involved in the political upheavals surrounding secession. Opposing the Union cause, they sailed for England, where they remained active in spiritualist circles and wrote for a variety of publications. They also published their own magazine, *Herald of Health*. During the late 1860s, Mary Nichols lost her sight to cataracts for five years, until two operations around 1869 restored her vision. From 1867 to 1872, the couple ran a water-cure establishment at Malvern. After they moved back to London, she continued to see patients in their lodgings. Just as she had been in the vanguard of health reform and free love, Mary Nichols remained an outspoken advocate for Roman Catholicism and the rights of women. She wrote to *Paulina Wright Davis that "veneration for woman" had always "existed in the hearts of true Catholics." In the same letter, written about ten years before her death in 1884, Mary Gove Nichols provided the best summary of her own life's work in her wish for the future:

"I heartily bid God speed to every righteous effort to promote the freedom of woman in love and wisdom, and the consequent purity and health of her own life and that of her children."

SOURCES:

Blake, John B. "Mary Gove Nichols, Prophetess of Health," in *Proceedings and Addresses of the American Philosophical Association*. Vol. 106. June 29, 1962, pp. 219–234.

Gleason, Philip. "From Free Love to Catholicism: Dr. and Mrs. Thomas L. Nichols at Yellow Springs," in *Ohio Historical Quarterly*. Vol. 70. October 1961, pp. 283–307.

Nichols, Mary Gove. *Mary Lyndon or, Revelations of a Life*. NY: Stringer and Townsend, 1855.

Nichols Journal (title varies), 1853–1856.

Noever, Janet Hubly. "Passionate Rebel: The Life of Mary Gove Nichols, 1810–1884," Ph.D. dissertation, University of Oklahoma, 1983.

Papers of George Mordecai in the Southern History Collection, University of North Carolina, Chapel Hill. These include the correspondence of Marx Edgeworth Lazarus, Ellen Lazarus, and various Lazarus and Mordecai aunts.

Papers of Paulina Wright Davis, Vassar College Library.

Richards, Irving T. "Mary Gove Nichols and John Neal," in *The New England Quarterly*. Vol. 7. July 1934, pp. 335–355.

Stearns, Bertha-Monica. "Two Forgotten New England Reformers," in *New England Quarterly*. Vol. 6. March 1933, pp. 59–84.

SUGGESTED READING:

Nissenbaum, Stephen. *Sex, Diet, and Debility in Jacksonian America: Sylvester Graham and Health Reform*. Westport, CT: Greenwood Press, 1980.

Spurlock, John C. *Free Love: Marriage and Middle-Class Radicalism in America, 1825–1860*. NY: New York University Press, 1988.

COLLECTIONS:

American Antiquarian Society, Worcester, Massachusetts.

University of Virginia, Alderman Library, Manuscripts Department, Charlottesville, Virginia.

John C. Spurlock,
Associate Professor of History, Seton Hill College,
Greensburg, Pennsylvania

Nichols, Minerva Parker

(1861–1949)

American architect. Name variations: Minerva Parker. Born on May 14, 1861, in Chicago, Illinois; died on November 17, 1949, in Westport, Connecticut; daughter of John Wesley Parker (a schoolteacher) and Amanda Melvina (Doane) Parker (a seamstress); graduated from Philadelphia Normal Art School, 1882; completed architectural course at Franklin Institute, 1886; married William Ichabod Nichols (a Unitarian minister), on December 22, 1891; children: Adelaide Nichols (b. 1894); Caroline Tucker Nichols (b. 1897); John Doane Nichols (b. 1899); William Ichabod Nichols (b. 1905).

Took over employer's architectural practice (1888); taught architectural and historical ornament at Philadelphia School of Design for Women (1880s and 1890s); won first place in an architectural competition to design a pavilion at the World's Columbian Exposition at Chicago (1893); retired (1896).

One of the first American women to become a successful working architect, Minerva Parker Nichols was born on May 14, 1861, in Chicago. She was the younger of two daughters of **Amanda Doane Parker** and John Wesley Parker, a schoolteacher who enlisted in the Illinois volunteers during the Civil War and died in a field hospital. Amanda Parker supported her family by working as a seamstress while Nichols studied at the Illinois Normal Primary School, at a convent school in Dubuque, Iowa, and at another school in Chicago. When her mother remarried and moved to Philadelphia, Nichols went with her and enrolled at the Philadelphia Normal Art School.

Nichols picked up an interest in architecture from her grandfather, Seth Brown Doane, who was an architect as well as a mechanic and builder. In 1882, she began working as a draftsman in the office of Philadelphia architect Frederick G. Thorn, Jr, where she learned the art and business of architecture. Four years later, she also completed a course in architectural drawing at the Franklin Institute. In 1888, Thorn relinquished his practice to Nichols, who was just completing her apprenticeship. For the next seven years, she maintained a successful business, involving herself in every aspect of designing, planning, and constructing buildings (a contractor noted, "She knows not only her business, but mine too"). In her residential designs, she combined medieval with Eastlake or Furness detail, and championed individual styles for each room in a house, while some of her other projects used Moorish, Renaissance, or colonial styles. Although she concentrated on building private homes in the Philadelphia suburbs, Nichols also constructed two factory buildings for a Philadelphia spaghetti manufacturer. Her two most noted buildings were for women's clubs, both named the New Century Club; the first opened in January 1892 at 124 South 12th Street in Philadelphia, and the second opened 12 months later in Wilmington, Delaware. For several years, she also taught with her friend *Emily Sartain at the Philadelphia School of Design for Women.

Minerva Nichols received national attention in 1893 when she won first place in an architectural competition at the World's Columbian Ex-

position in Chicago for her design of a pavilion in honor of *Isabella II, the Spanish queen who funded Columbus' journey to America. Although the winning entry was never constructed, the exposition also awarded Nichols a diploma of honorable mention for her work at the Philadelphia School of Design for Women. In 1896, her husband William Ichabod Nichols, a Unitarian minister whom she had married in 1891, became general secretary of the Bureau of Charities of Brooklyn, New York. After moving with her family to New York City, Nichols limited her work to a few commissions for family and friends. She died on November 17, 1949, in the home of her older daughter in Westport, Connecticut, which was also the last home she had designed.

SOURCES:

James, Edward T., ed. *Notable American Women, 1607–1950.* Cambridge, MA: The Belknap Press of Harvard University Press, 1971.

Jacqueline Mitchell,
freelance writer, Detroit, Michigan

Nichols, Ruth (1901–1960)

Pioneering American aviator who set world records for speed, altitude, and distance. Born Ruth Rowland Nichols on February 23, 1901, in New York City; died on September 25, 1960, in New York City, an apparent suicide; first of two girls and two boys of Erickson Nichols and Edith Corlies Nichols; educated at Wellesley College; never married; no children.

Raised in comfortable circumstances and educated at Wellesley College; decided to pursue a career as a pilot when air travel was a risky and highly competitive sport; despite several serious crashes and resulting injuries, set world records for speed, altitude and distance, becoming along the way the first woman licensed to fly a seaplane, the first woman to fly nonstop between New York and Miami, Florida, the first woman to attempt a solo transatlantic crossing, and the first woman licensed as a commercial airline pilot; used her skills during World War II to organize an airborne ambulance corps and to fly around the world for UNESCO's Children's Relief Fund; spent her last years working for the Civil Air Patrol, and set her last world speed record (1958) in a twin-engine jet; inducted into the National Aviation Hall of Fame (1992).

Ruth Nichols always remembered the first time she flew through the clear blue sky of a summer's day, an 18-year-old girl who until then had been terrified of heights. "Suddenly, I felt like laughing," she wrote of that day in 1919. "What had I been afraid of? This was only air. A minute ago, I had been an earthbound caterpillar. Now, I was an airborne butterfly. I was free as the air itself. I wasn't afraid of *anything* any more."

It was an odd statement, given that the comfortable circumstances of her early life would have seemed more than adequate protection against threats and dangers. Born on February 23, 1901, the first of the two girls and two boys raised by Erickson and **Edith Corlies Nichols**, Ruth had grown up in an elegant brownstone in one of Manhattan's best turn-of-the-century neighborhoods as well as her family's country home in suburban Rye, and had been educated in the city's best private schools. Her father's family was among the elite referred to by New York society as "the 400," and Erickson himself had found enough time off from his successful investment firm to become one of Teddy Roosevelt's Rough Riders during the Spanish-American War of the 1890s. Dashing and adventurous, Erickson Nichols traced his family's descent from the Viking explorer Leif Erickson and adopted as his favorite motto, "Try anything once." But it was Edith's sense of propriety and social position that seemed to cast a shadow over young Ruth, who sometimes referred as an adult to the "multiple and complicated fears" of her childhood. Edith Nichols had been raised as a Quaker but had adopted the more socially prevalent faith of the Episcopalian Church on her marriage. She applied her Quaker sense of responsibility to seeing that her children followed the rules of proper New York society, leaving her first-born daughter torn between her contradictory parents and wishing for a way to unite "an adventurer's heart and a Quaker spirit."

It was her father who opened the door to a possible solution by taking her to an aviation show in Atlantic City during the summer of 1919 to mark her graduation from finishing school. World War I had ended just a year before, and the public was fascinated with the derring-do of the men who had flown the first air war in military history during the four-year conflict. Erickson bought his daughter a ten-minute ride in the rickety biplane flown by Eddie Stinson, one of the most famous of the aviation aces from the war. The fear of disappointing her father was stronger than Nichols' fear of heights, but it was with barely controlled panic that she climbed into the passenger's seat behind Stinson and firmly shut her eyes as the plane rattled into the air. Her nervous state was not helped when Stinson decided to fly a loop-the-loop, leaving her dangling upside down for several seconds with Atlantic City swooping, as it seemed, above her head. But by the time Stinson guided the plane to

a safe landing, Nichols had learned an important lesson. "My willingness to go up in an airplane might have been sheer bravado," she later wrote, "but there was also a determination to overcome my fear by accepting the challenge of terrifying forces over which I believed I had no control." In the skies, she had found freedom.

Her next step was a decision to attend college and become a doctor—heresy to her tradition-bound mother, but supported by her influential and beloved "Aunty Angel," her mother's unmarried aunt and a strong-willed believer in the social liberalism of the Quaker faith. "If thee wants to go to college, thee go," said Aunty Angel in her preferred Quaker idiom. Ruth duly entered Wellesley College in 1920, although she agreed to her mother's demand two years later that she use her February semester break during the winter social season to travel to Miami for her formal "coming out" to society as a debutante. Even here, in the midst of cotillions and full dance cards, Nichols struck another blow for freedom by accepting an offer of a ride in the "flying boat" piloted by Harry Rogers, a gallant flying ace from the war who had become nationally famous for his barnstorming tours.

In these early days of aviation, when safe landing fields (not to mention safe landing gear) were scarce, pontoon planes that could take off and land on water were common, and Rogers had found the relatively calm waters off Miami a reliable setting during the winter months for his air shows and flying school. Although Nichols had not asked for flying lessons when she had been introduced to Rogers by one of her brothers, she found herself briefly taking the controls during her first flight with the famous pilot. "I grasped the wheel on the control yoke, and I was sold forever," she later said, "feeling the power of my own hands managing this fierce and wonderful machine, keeping this heavy craft thundering through the sky and directing her course." Rogers agreed to take her on as a student, at an impressive fee of $60 an hour, and proceeded to teach his young socialite-turned-aviator the rudiments of flying. Known as much for his quick temper and salty language as for the precision of his instruction, Rogers stressed the importance of proper safety procedures by telling Nichols, "I'd rather be known as the oldest pilot than the best." The lesson was driven home after several weeks when Ruth landed Rogers' plane at too slow a speed, sinking the hull deeply in the water, scraping a rock and cutting a gaping hole in the plane's hull—a hole no one noticed until Rogers himself taxied out for a flight but found himself sinking instead. "He punctuated his lessons with

scorching language and an occasional clout to the head," Nichols ruefully recounted years later. But it was under Rogers' guidance that she became the first American woman to be licensed as a seaplane pilot, even as she successfully completed four years of college and graduated from Wellesley in 1924.

Given a world tour as a graduation present, Nichols traveled through China, India, and the Far East and began to feel the first glimmer of her Quaker background's social conscience. The disparity between the grinding poverty of native peoples and the affluent lifestyle of their colonial rulers profoundly impressed her. "A deep unrest began in me then and the stirrings of a determination to do something to help these people," she said. "I didn't know what, or how—I only knew that somehow, some day, I must." It would be some years yet, however, before Nichols would find the answer in the cockpit of an airplane.

For the year following her return from her travels, it seemed as if she were grounded even as Charles Lindbergh made aviation history with the first non-stop transatlantic flight between New York and Paris. Bowing once again to family pressures, Nichols had taken a job in a New York bank as an assistant manager for the special women's departments, an accepted form of sexual segregation in the world of finance and most other parts of early 20th-century life. The job was dull, the surroundings claustrophobic, and the pay below that for a similar man's position, but it was Edith Nichols' hope that her daughter would meet a suitable future husband with a prosperous banking career. By New Year's Eve of 1927, Ruth found herself frustrated, depressed and alone at the family's house in Rye, not being in suitably good spirits to celebrate the holiday. "I hadn't conformed to accepted social patterns and I had not sought a niche in humanitarian fields," she later remembered. "I'd been the girl who was going to find freedom and a career in the vast domains of the sky." But as midnight approached, the telephone rang and Harry Rogers came to her rescue.

Rogers proposed that Nichols join him as co-pilot for aviation's first attempt at a non-stop flight from New York to Miami. With the help of a wealthy backer who would join them on the trip, Rogers had purchased a new seven-seat, single-engine seaplane and had laid out a straight southwestward course 70 miles offshore, meaning that the journey entirely over water would present many of the same challenges that had faced Lindbergh. The trio of

fliers took off from Rockaway Naval Air Station on the shore just outside New York City after sunrise on an early January morning in 1928. Twelve hours later, the plane gently splashed to a landing off of Miami after an uneventful flight. Even though Nichols had taken the controls from Rogers only when her mentor needed sleep, the press was fascinated with the "Society Flyer" and "The Flying Deb" who had become the first woman to fly non-stop along the East Coast. But the telegram Nichols received from her beloved Aunty Angel meant more to her than any headline. "More power to thee, child," it said simply.

Truly, you must have wings for life, as there is no living without flight.

—Ruth Nichols

Thanks to Rogers' thoughtful offer and the publicity it generated, 1928 marked the beginning of a career for Nichols that would rival that of her contemporary, *Amelia Earhart. She chalked up another first within days of her landing in Miami by becoming aviation's first female executive, as the sales manager for Sherman Fairchild's airplane manufacturing business. Fairchild shrewdly took the measure of Ruth's value in promoting the aviation industry and billed her as "Ruth Nichols, Daring Aviatrix" for her first public speech in Newburgh, New York, in February 1928, during which Nichols struck the themes she would use in the months to come. She extolled air travel as the wave of the future, assured her audiences of its safety and practicality, and called for ambitious programs to build a network of airports from coast to coast serving every part of the country. But Ruth, Fairchild, and other aviation enthusiasts found no way to refute the fact that, at a minimum of $15,000 apiece, airplanes were hardly within the reach of most Americans. By mid-1928, Nichols found herself speaking to audiences of wealthy stockbrokers, oil barons and industrialists to promote a new idea—a chain of country clubs devoted exclusively to flying, much as other clubs were devoted to golfing or horseback riding. After helping to set up the first such club in Hicksville on Long Island, Ruth embarked on a national flying tour using two single-engine planes donated by the Curtiss Airplane Company in which she took advantage of her newly won license to fly land-based airplanes in addition to seaplanes. The tour which began in the spring of 1929 made a huge circle around the country, covering 12,000 miles, with safe landings in 43 states and lectures in 96 cities before Nichols touched down again in New York in October 1929. She was just in time for the stock-market crash that began the Great Depression and put an end to further ideas of flying playgrounds for the wealthy.

Surprisingly, the Depression did little to hinder the growth of America's love affair with flying. Stories of daredevil pilots competing in air races were a welcome relief from the grim economics of the time, and Nichols' name was frequently to be found in the listings—especially when she entered the first air race for women, dubbed "The Powder Puff Derby," from Santa Monica, California, to Cleveland in 1929. Her precarious experiences during the National Air Races which followed, with two forced landings and a runway mishap that left her plane wrecked but Ruth herself unhurt, were followed avidly in the press. "When I look back," Nichols said in the late 1950s, "I realize that those early planes, top-notch aircraft of their day, were fragile, unstable, death-defying mechanisms, as different from today's multi-engine clippers as the Model-T Ford differed from a modern limousine." Despite the obvious risks, there were enough female pilots by the fall of 1929 for Nichols and Amelia Earhart to create a national organization which took its name, "The Ninety-Nines," from the number of its founding members.

Over the next year, Ruth's name entered the record books twice more after she met Clarence Chamberlin, another war-trained aviator who had become the first pilot to fly from New York to Germany in a plane he had designed himself, which he called the Crescent. Ruth became the sales manager for Chamberlin's Crescent Aircraft Company early in 1930 and, with Chamberlin, made the first air delivery of New York newspapers to Chicago in the spring of that year. "She has an uncanny feeling for drift and held her course much more accurately, for instance, than I do," Chamberlin said after the flight. "At any minute she could tell exactly where we were. She is not only a fine pilot, but has the rare gift of common sense." It was Chamberlin who first suggested the idea of a transatlantic flight to Nichols, although it would be another year before the attempt would be made.

Meanwhile, Ruth sold Chamberlin Crescents to the fledgling commercial airlines then just forming and was invited to be among the first passengers to make American Airlines' inaugural "through" flight from Atlanta to Los Angeles. The country's system of airports had grown sufficiently by 1930 to allow travelers to make the entire journey from coast-to-coast by air, avoiding night travel by train—although the

Ruth
Nichols

lack of nighttime navigation systems still meant that Nichols and her fellow passengers had to spend a night on the ground before continuing on to the West Coast, arriving in Los Angeles nearly two days after leaving Atlanta. The transcontinental flight inspired Ruth to attempt on her own a more ambitious coast to coast route, flying a specially modified Lockheed Vega. Leaving New York on November 24, 1930, Nichols arrived in Burbank on December 1 after overnight stops in Ohio, Kansas, Texas, and New Mexico. Her arrival in California in

just under 17 hours' flying time set a new women's record. After a week's rest in Los Angeles, she began her return journey to New York, taking advantage of strong tail winds to reach Wichita in just 7 hours and continuing on from Kansas to Roosevelt Field outside New York City in 6 hours and 20 minutes. Her eastbound flying time of 13 hours and 21 minutes was an hour over the existing record, although she had completed her journey in less time that it had taken Charles Lindbergh and had set another women's record for speed.

By March 1931, Nichols had added again to her growing list of aviating accomplishments by flying another Lockheed Vega up to 28,743 feet, setting a world's record for altitude at a time when pressurized cabins and heating systems had yet to be developed. Wearing long underwear, four sweaters, a leather flying suit, fur-lined boots and helmet, and heavy mittens, she had to rely on oxygen carried from a tank under her seat through a tube clasped in her teeth to keep from passing out in the thin air as the temperature dropped to 60 degrees below zero. Not long after flying higher than anyone else, Nichols flew faster, too, entering the 1931 National Speed Trials and clocking in at over 210 miles per hour, breaking the previous record set by Amelia Earhart. But her biggest challenge, becoming the first woman to fly solo across the Atlantic, lay ahead.

Throughout the first half of 1931, Nichols successfully campaigned for financial backing from a number of private investors and from the CBS radio network and Paramount Newsreels, which was granted exclusive rights to film and promote the flight. At the same time, she and Clarence Chamberlin had been outfitting another Vega for the attempt, adding extra fuel tanks, the latest advances in instrumentation and, at Lindbergh's suggestion, an emergency radio system. Ruth named her aircraft *Akita*, from a Native American verb meaning "to explore" or "to discover." As preparations neared completion, Nichols paid a visit to her beloved Aunty Angel and asked to be formally received into the Quaker fellowship, citing her deep respect for the American Friends' tradition of pacifism and its belief in the power of love and compassion. Aunty Angel saw to it that Ruth's request was honored, and announced she would soon set sail for France to be among the first to greet Ruth when her plane landed in Paris.

On the morning of June 22, 1931, Nichols took off from Floyd Bennett Field in New York and set *Akita* on a course for New Brunswick,

Nova Scotia, for a refueling stop before beginning her Atlantic crossing. "I felt like laughing aloud, like singing," she later wrote of her emotions that morning as the Manhattan skyline slipped away beneath her. "All the years of my preoccupations with airplanes, all the months of preparation, all the weeks of day and night work in the hangar had been leading up to this moment." The northeastward flight was uneventful, but Nichols grew concerned when the tiny New Brunswick airport appeared on the horizon. The runway seemed too short for her to land a plane so heavily laden with fuel. Then, too, she was attempting her landing to the west, into a blinding setting sun. Her fears proved well-founded when it became apparent as she touched down at one end of the runway that she would never be able to slow and stop *Akita* before running off the opposite end into heavy woods. She pulled back off the runway at the last moment and attempted to climb sharply, but *Akita*'s tail brushed the treetops and shattered, sending the plane plummeting to the ground. "All I did was wrench back and wreck ship. Everything under control," Nichols telegraphed her family, but the truth was that she had suffered five broken vertebrae, a dislocated knee and serious internal injuries. She was confined to a hospital bed for two months with her lower body in a plaster cast.

But such was her determination to try again that she disregarded warnings from her doctors on release from the hospital and convinced her family to take her for long drives as a way to accustom herself to the pain of sitting for long periods. By early fall of 1931, she had taken the reconstructed *Akita* for a test flight, still wearing a body cast and forced to rely on helpers to lift her in and out of the cockpit; and in October, she announced she would try to break the women's long distance record with another transcontinental flight to the West Coast and back. Flying a southern route from New York, then west to California and east to Nevada and across the Midwest, Nichols landed in Louisville, Kentucky, after having covered 1,950 miles, accomplishing her goal of setting a new distance record. More important, she had covered more miles than the distance from Newfoundland to Ireland, her intended route for another attempt at an Atlantic crossing. But disaster struck again when fumes from a backfire set *Akita* aflame on the ground in Louisville, leaving the plane in ruins for the second time in four months.

Undaunted, Nichols took to the lecture circuit to raise money for repairs and for her intended solo flight to Europe, only to watch in

dismay as Amelia Earhart flew from New York to Ireland in May 1932 to become the first woman to fly solo across the Atlantic. Ruth's reaction was to set herself a more difficult task—to fly the nearly 4,000 miles to Paris in a nonstop flight with no refueling once she took off from New York. Preparations for the flight included a trip to France to tour the coastline and familiarize herself with landmarks and, as a test run once *Akita* was again ready to fly, a transcontinental flight from New York to Los Angeles during the summer of 1932. For the first time, Nichols combined her private and public lives by agreeing to airdrop campaign literature on her way to the West Coast for President Herbert Hoover, running for re-election that year against the Democratic candidate, Franklin Roosevelt. "As a Quaker, I had long been an admirer of the President's integrity, courage and statesmanship," Nichols said. "If I could help him in such a way, I was eager to do so." She tactfully refrained from pointing out that the Republican Party had agreed to underwrite the costs of the flight in return for her help. But disaster overtook her again on the morning of her takeoff from New York, on November 3, just a few days before the election. A landing gear malfunction as she hurtled down the runway sent *Akita* spinning off the tarmac, leaving Nichols unhurt but grounding the plane for a third time. All hopes of a solo flight to Europe were dashed.

By the end of 1932, Nichols found herself in low spirits. "I came back to the grim fact that I had had three major aircraft failures in one year, and that I seemed to be hopelessly grounded as far as a professional pilot's career was concerned." There was some slight solace in the invitation late in 1932 to participate in the unveiling of the monument to the Wright Brothers at Kitty Hawk, North Carolina, the site where America's first manned aircraft had taken to the skies three decades earlier; and Ruth's presence at the controls of the inaugural flight of Chamberlin's New York and New England Airways, from Long Island to Hartford, made her the first woman to fly a commercial airliner. But Chamberlin's airline went bankrupt early in 1933, forcing Nichols to enter barnstorming tournaments and to act as the pilot for sightseeing flights to keep herself aloft. Plans to repair *Akita* and fly from California to Hawaii were scotched when, once again, Amelia Earhart beat her to it. Then, in October 1935, Nichols was severely injured for the second time in four years when a seven-passenger Condor she was co-piloting on a publicity flight crashed and burst into flames near Troy, New York, after one of its engines caught fire. The pilot later died of his injuries while Ruth, who was thrown from the plane, underwent three operations and plastic surgery to repair her own multiple injuries. "In the end I came out with a shorter and what I thought was a better looking nose than before," Nichols said, glossing over the two painful years of recovery that followed the crash.

By 1937, she had regained her commercial pilot's license and had taken to the air again as troubling events in Europe led to talk of another World War. Learning that the pacifist American Friends Service Committee, a proactive arm of the Quakers, was planning what it called an Emergency Peace Campaign, Nichols suggested that aviation was the common bond between countries and proposed undertaking a world peace tour by air. "Most fliers have an outlook instinctively international, and no matter what their nationality, they speak the same language. They share the freedom of the skies," Nichols noted, although she might also have said that such a feat would make her the first woman to fly around the world. With the Committee's approval, Ruth began crisscrossing America by air to raise money for the tour, only to find that the majority of Americans she met were unconcerned about turmoil in distant countries. Their apathy and lack of financial support for the tour shocked her but only hardened her vow to put aviation at the service of peace, even if a round-the-world air tour did not seem possible. It seemed the honor of setting the women's record would once again go to Amelia Earhart, who embarked on just such a journey on May 1, 1937, from Miami. Two months later, however, radio contact was lost with Earhart's plane after she took off from New Guinea. Nichols discounted the ensuing speculation, which continues to this day, that Earhart somehow survived the presumed crash or, more inexplicably, did not crash at all but deliberately chose to disappear. "I feel . . . that Amelia flew on across the trackless Pacific until her last drop of fuel was gone, and then sank quickly and cleanly into the deep blue sea," Nichols wrote 20 years after Earhart's disappearance.

In 1939, Nichols at last found a way to combine her love of flying with her humanitarian instincts. After Hitler's invasion of Poland that year made another World War inevitable, she prepared for America's entry into the conflict by forming what she called Relief Wings, an airborne ambulance corps enlisting the services of private aircraft and civilian personnel that could be quickly organized in time of war. By the end of 1941, when the Japanese bombing of Pearl Harbor propelled America into World War

II, Nichols' network of emergency aviation centers in 36 states became the backbone of the government's new Civilian Air Patrol (CAP). While the war raged, Ruth served as an adviser to the CAP, volunteered for Red Cross duty, and began teaching aviation to women at Long Island's Adelphi University, the nation's first such course.

With the war's end, Ruth finally got to make her round-the-world flight—not to set a record this time, but to help the United Nations assess the effects of the war on the world's children. "Here was work into which I could put my heart as well as my hands," said Nichols, "and for which I could finally unite an adventurer's heart with a Quaker spirit." Starting from Hartford in the summer of 1948, Ruth flew west to California and then on to Japan, Thailand, India, and Greece before stopping in Rome for rest. The report she and her fellow UN workers later developed estimated there were some 60 million needy children left homeless and without sufficient food or health care after the devastation of the war. Leaving Rome for London, Nichols was offered passage home on a commercial flight from the United Kingdom to New York which was forced to ditch in the Irish Sea after developing engine trouble. Everyone survived the emergency landing, but Ruth would not soon forget the long, cold night spent in a life raft before rescue planes and ships arrived.

Ruth Nichols spent the postwar years working for the Civilian Aviation Patrol, although record-setting still ran strong in her blood. She became the first woman to pilot a twin-engine jet in 1955, and set new speed and altitude records in 1958 by flying a jet aircraft at more than 1,000 miles per hour at 51,000 feet. Still, the world Nichols had known in those early days of aviation was long gone. While it had taken her the better part of a week to reach California 30 years before, new jet aircraft routinely made the crossing in little more than six hours; and while Ruth had nearly frozen to death flying at close to 30,000 feet, passengers at that altitude now sat in pressurized, heated comfort, dining on hot meals. A few of the older airline pilots may have remembered the name Ruth Nichols, but to a nation which would soon launch its first spacecraft, the air exploits of the early century were forgotten. So it was that news of Nichols' passing on September 25, 1960, barely registered with most Americans. She had been found dead in her New York apartment, an apparent suicide. She was just 59.

Perhaps the powerful attraction of the sky proved too strong for her in the end. "When life gets too cluttered and stuffy on the ground," she wrote in her autobiography published in 1957, "I can still take to the privacy and freedom of the sky, and there adjust my sights to distant vistas not yet contacted."

SOURCES:

Howes, Durward, ed. *American Women*. Vol 3. Los Angeles, CA: American Publications, 1939.

Nichols, Ruth. *Wings For Life*. Philadelphia, PA: Lippincott, 1957.

Sicherman, Barbara and Carol H. Green, eds. *Notable American Women: The Modern Period*. Cambridge, MA: Belknap Press, 1980.

<div align="right">Norman Powers,
writer-producer, Chelsea Lane Productions, New York</div>

Nicholson, Dorothy Wrinch
(1894–1976).

See Wrinch, Dorothy.

Nicholson, Eliza Jane (1849–1896)

American newspaper publisher, journalist and poet.

Name variations: Eliza Jane Poitevent; Eliza Jane Holbrook; (pseudonym) Pearl Rivers. Born Eliza Jane Poitevent on March 11, 1849, in Hancock County, Mississippi; died on February 15, 1896, in New Orleans, Louisiana; daughter of William James Poitevent (a lumberman and shipbuilder) and Mary Amelia (Russ) Poitevent; graduated from the Female Seminary of Amite, Louisiana, 1867; married Alva M. Holbrook (an editor and newspaper publisher), on May 18, 1872 (died 1876); married George Nicholson (a newspaper business manager), on June 27, 1878 (died 1896); children: (second marriage) Leonard Kimball (b. 1881); Yorke Poitevent Tucker (b. 1883).

Published poetry in writing anthology (1869); became literary editor of the New Orleans Picayune (1870); became publisher of the Picayune after husband's death (1876); elected president of the Women's National Press Association (1884); became first honorary member of the New York Woman's Press Club.

Born into a large family in Hancock County, Mississippi, in 1849, Eliza Jane Nicholson was raised by her aunt and uncle on their farm, due to her mother's weak health. She started writing poetry in her early teens, and at 18, after graduating from the Amite Female Seminary in Louisiana, began submitting poetry to magazines and newspapers. These poems were signed "Pearl Rivers," a pen name taken from the river that ran by her parents' property. Nicholson's work soon appeared in the New York *Home Journal*, the *New Orleans Times*, and what would become the focus of her career, the *New Orleans Picayune*. (The paper had been named by its founders after

a Spanish coin worth 6¼ cents to underscore the fact that it cost less than its competitors.) By the time she was 20, she had been featured in an anthology of Southern authors.

The editor and owner of the *Picayune* was a transplanted Northerner named Alva Morris Holbrook, whom Nicholson met while on a visit to her grandfather in New Orleans. Holbrook, who was 41 years her elder, soon offered her the job of literary editor for the newspaper, which she accepted around 1870 despite opposition from her family. She lived with her grandfather and was paid $25 per week for work which included preparing the Sunday paper's literary section and choosing which poems would be published in the daily editions. Despite their age difference, Nicholson and Holbrook established a personal as well as a professional relationship. They were married in 1872, shortly after Holbrook had sold the *Picayune* to allow Nicholson to pursue her poetry.

However, she had time only to publish a collection of her poems, *Lyrics* (1873), before the paper reverted to Holbrook, because the new owners were unable to keep it afloat. Nicholson and her husband returned to newspaper work, and a little more than a year later, when she was 26, Holbrook died. She inherited ownership of the *Picayune* as well as its $80,000 debt. Once again ignoring the wishes of her parents, she rejected their advice to liquidate and instead took control of the newspaper.

Now the first woman in the Deep South to be publisher of a major newspaper, Nicholson set the paper's course in her opening editorial: the *Picayune* would be an independent, anti-Reconstruction newspaper for the whole family. With the paper's editor José Quintero and its business manager George Nicholson, who became co-owner when she married him in 1878, she added special departments for women and children, and in 1879 began running a column of society news. (This innovation was at first resisted in conservative New Orleans, but later became quite popular.) The paper's contents grew to include fashion, household hints, theater gossip, medical advice, a complaint department and comics, and Sunday editions frequently published fiction by noted writers, including Rudyard Kipling, Mark Twain, and Frank Stockton. Nicholson also used the paper to champion such causes as the Society for the Prevention of Cruelty to Animals and the free night school run by **Sophie B. Wright** (1866–1912). Although her new husband was 30 years her senior, they seem to have had both a good marriage and a good working relationship; with Nicholson overseeing editorial content and George supervising business matters, the paper paid off all its debt and more than tripled its circulation.

Although Nicholson apparently was not an advocate for women's suffrage, she believed that women should be self-sufficient, and was a strong supporter of women in the newspaper business. Among those whom she hired were **Martha R. Field**, who became a special correspondent to Washington, D.C., and other cities, and *Elizabeth Meriwether Gilmer, who was working at the *Picayune* when she began writing the advice column that would later make her a national figure as Dorothy Dix. In 1884, Nicholson was elected president of the Women's National Press Association and was the first honorary member of the New York Woman's Press Club. (Also in the 1880s, apparently, residents in a small community newly joined to the railroad asked her to rename their town; she did so, and Picayune, Mississippi, now a small city some 35 miles from New Orleans, is believed to be the first town in America named after a newspaper.)

As the *Picayune* grew increasingly successful, she spent more of her time at her summer home in Bay St. Louis, Mississippi, with her husband and two young sons. She also resumed writing poetry. She was in the midst of preparing a collected edition of her work when her husband died of influenza. Ten days later, on February 15, 1896, Nicholson died in New Orleans of the same disease. She was 46. Renamed the *New Orleans Times-Picayune* in 1914 after a series of mergers, the newspaper continues to publish daily. Arrangements Nicholson made prior to her death ensured that her sons would gain control of the paper when they came of age, and her eldest, Leonard K. Nicholson, served as publisher from 1922 to 1952.

SOURCES:

Edgerly, Lois Stiles, ed. *Give Her This Day: A Daybook of Women's Words*. Gardiner, ME: Tilbury House, 1990.

James, Edward T., ed. *Notable American Women, 1607–1950*. Cambridge, MA: The Belknap Press of Harvard University Press, 1971.

McHenry, Robert, ed. *Famous American Women*. NY: Dover, 1980.

Jacqueline Mitchell,
freelance writer, Detroit, Michigan

Nicholson, Margaret

(c. 1750–c. 1828)

English would-be assassin who attempted to take the life of King George III of England. Born around 1750; died in Bethlehem Hospital on May 28, 1826 or 1828.

A housemaid by trade but suffering from mental instability, Margaret Nicholson became infamous when she attempted to kill King George III of England as he alighted from his coach at St. James's Palace on the evening of August 2, 1876. Stepping from the shadows, Nicholson asked if she might present a petition to the king. As he paused, she brandished a dessert knife and tried to plunge it into his chest, but succeeded only in tearing his sleeve. As the guards surrounded her, the king recognized her mental state and asked them not to harm her. "Then he came forward, and showed himself to all the people," writes *Fanny Burney, who heard the story from the king himself, "declaring he was perfectly safe and unhurt; and then gave positive orders that the woman should be taken care of, and went into the palace, and had his levee." Nicholson was judged insane by the court and confined to Bethlehem Hospital, where she remained for the rest of her life. The incident inspired comic verses by Percy Bysshe Shelley and Thomas Jefferson Hogg. As for the king, another more serious attempt on his life occurred on May 13, 1800, when James Hadfield tried to shoot him at the Drury Lane Theatre. The bullet, however, only penetrated the pillar of the box where he was seated, and he was spared once again.

SOURCES:

Brooke, John. *King George III*. London: Constable, 1972.

The Concise Dictionary of National Biography. Oxford: Oxford University Press, 1992.

Nash, Jay Robert. *Look for the Woman*. NY: M. Evans, 1981.

Barbara Morgan,
Melrose, Massachusetts

Nicholson, Winifred (1893–1981)

British painter. Name variations: painted under name Winifred Dacre, early 1930s until 1945. Born Winifred Roberts in 1893 in England; died in 1981; eldest daughter of Charles Roberts (a politician) and Cecilia (Howard) Roberts; studied at the Byam Shaw School of Art, London; married Ben Nicholson (a painter), in 1920 (divorced): children: Jake Nicholson; Kate Nicholson (an artist); Andrew Nicholson.

Selected works: Mughetti (1921); Polyanthus and Cineraria (1921); Cyclamen and Primula (c. 1922); Fire and Water (1927); Ben and Jake (1927); Jake and Kate on the Isle of Wight (1931–32); Paris Light (c. 1933–34); Blue Heptagons (1935); Outward (1936); Honeysuckle and Sweetpeas (1950); Isle of Canna (1951); Mrs. Campbell's Room of 1951 (1951); Live Pewter (1959); Copper and Capari (1967); Night and Day (1970s); Accord (1978); Prismatic Five (1979); The Gate to the Isles (1980).

Classified as a painter of flowers and acclaimed for the color and luminosity of her works, British artist Winifred Nicholson was well known in London art circles from the mid-1920s until the start of the Second World War, a period that coincided with her marriage to artist Ben Nicholson. During that time, she had four large solo exhibitions in commercial London galleries and sold the greatest number of her works. After her husband left her to live with *Barbara Hepworth, Nicholson's popularity began to decline, although she was financially and artistically secure and apparently had no need of public approbation. There was a period of renewed interest in the artist in the mid-1970s, when a few of the pioneering abstract paintings she did in Paris during the 1930s resurfaced, but it was not until 1987, six years after her death, that the Tate Gallery in London mounted a major retrospective of her work.

Winifred Nicholson was born in 1893 into wealth and privilege; her mother **Cecilia Howard Roberts**, an amateur artist, was a member of the aristocratic Howard family which owned areas of land in Yorkshire and Cumbria. Nicholson was raised in the family's luxurious country homes, and received her early art training from her grandfather George Howard, 9th earl of Carlisle, who instructed her in the Pre-Raphaelite mode of drawing and painting directly from nature. From an early age, Nicholson was both fascinated and inspired by flowers because of their vast range of colors. Later, she would construct her flower paintings not by form, but by color harmonies. As a young woman, Nicholson studied under John Byam Shaw in London, immersing herself in his technique of sharply delineated details and symbolism. At the age of 26, she traveled with her father Charles Roberts to India, where she was strongly influenced by the intense light and distinctive colors around her. The experience helped liberate her style from the confines of her art-school training into something more bold and individualistic.

In 1918, Winifred met Ben Nicholson, a young painter who was still unsure about making art his career. Having already committed herself to painting, she served as an impressive model for him, and the two fell in love and married in 1920. They divided their time between London and the Villa Capriccio, a house perched on a hillside overlooking Lake Lugano in Switzerland that was purchased for them by Winifred's father. After 1924, Winifred acquired a farmhouse in Cumbria, where she lived off and on until her death. While Ben pursued his paint-

ing with a professional fervor, Nicholson combined her artwork with the domestic duties that fell her way. Although she kept studios at her various residences, she often painted atop the kitchen table or used the back of a chair as an easel. Some of her early paintings are of the farmhouse's open fireplace with its adjoining oven, a frequent outpost since the house had neither gas nor electricity. When children came along, and there were three, Nicholson often used them as the subjects of her paintings. She found painting and motherhood complementary, although not always easy to reconcile. "She wrote about 'life' and 'art' sometimes pulling in different directions," explain **Teresa Grimes, Judith Collins**, and **Oriana Baddely** in *Five Women Painters*, "but if you can achieve a harmony between them, 'the two dragons become friends and helpmates.'"

A painting titled *Mughetti* (1921) is representative of Nicholson's early flower paintings. It depicts a pot containing lily of the valley given to her by her husband, still wrapped in white tissue paper from the florist. She viewed this work

as a "coming-of-age" painting and considered it one of her best. It personified the emotion of love for her, because of the way the paper enfolds the flowers. "The idea of marriage I had when we married is expressed in *Mughetti*," the artist recalled. "I remember thinking of it while I painted. Love and the secret lovely things that it unfolds." She used the idea again in *Polyanthus and Cineraria* (1921), this time showing two flowering plants in their paper wrappers.

When Nicholson exhibited 27 of her paintings in May 1923, she was credited by critic Frank Rutter as having inventing a new kind of flowerpiece, in which the flowers in a vase or jar appear in front of an extensive landscape, with the middle ground excluded. Nicholson employed this technique to explore the relationship between the small, live plants, and the larger horizons of their environment. Another critic, Christopher Neve, expands on Nicholson's innovative style:

> Often her most memorable paintings include tender, budding flowers in the foreground with a luminous depth beyond, cul-

Winifred Nicholson

minating in a rhythmic horizon of fells. Her subject became flowers and space, the flowers like sparks of pure colour against a mysterious radiance in which the eye is free to focus back and forth.

One of Nicholson's most popular flower paintings, *Honeysuckle and Sweetpeas* (c. 1945–46), has been part of the Aberdeen Art Gallery since 1950. Like *Mughetti*, it is an emotionally charged painting, highly colorful in hues of yellow complemented by Nicholson's favorite tint of violet. The authors of *Five Women Painters* call this work "a marvellous example of Winifred Nicholson's ability to create luminosity; it is not just a representation of two vases containing flowers but also a magical picture that seems to emit both light and colour. It has a radiant quality which is characteristic of Winifred Nicholson's work in general."

In 1933, following her separation from her husband, Nicholson took the children and went to live in Paris, renting a third-floor flat overlooking the Seine. For five years, she mingled with the important artists working in the city at the time—Piet Mondrian, Constantin Brancusi, Cézar Domela, Jean Helion, Naum Gabo, and Alberto Giacometti. She did a great deal of experimenting with color, shape, and light at the time, although she did not share these works with the public. "These were years of inspiration," she later wrote, "fizzing like a soda water bottle. . . . Boundaries and barriers were broken down. . . . We talked in the cafés of the new vision, the new scale of music, the new architecture—unnecessary things were to be done away with and art was to be functional." Nicholson held firmly to the belief that her work should be "functional," in that she liked her paintings to be viewed in a domestic setting. Two of her favorite exhibition spaces were Kettle's Yard Gallery in Cambridge, and the LYC Gallery in Brampton, Cumbria, both created in old houses where the curators were in residence.

For the most part, Nicholson's lifestyle belied her background. Money was important only if there were a pressing need (a school tuition bill, for example), and then she might scurry to sell a painting. Otherwise, she lived simply with few luxuries; she made all her own and her children's clothing, which led her to a lifelong interest in fabrics. Her approach to painting was pragmatic as well. "You set out your colours and you start to paint and you don't stop until you've finished," she once replied when asked how she approached a work. She painted fast, usually completing a painting in one sitting, and if she wasn't pleased she turned the canvas over and started again. Many of her paintings are worked on both sides of the canvas; some were reprimed so that one painting covers another.

In one of her first Paris paintings, *Paris Light* (c. 1933–34), Nicholson experimented with reflected light and prismatic color, subjects that continued to fascinate her throughout her career. In her quest to discover different qualities of light and ranges of color, she traveled a great deal, making pilgrimages to the remote Scottish islands of South Uist, Skye, Canna, Rhum, and Eigg, and journeying to Greece and North Africa in 1960, with her daughter Kate, also an artist. At age 82, Nicholson purchased two small glass prisms ("portable rainbow machines," she called them), and created a series of pictures by holding them in front of her subject. In the last few months of her life, she corresponded with a research physicist, discussing with him the subjects of light and color. In one of her last letters to him, she likened the liberating quality of color to that of love. "And so all paradoxes can be surmounted by Love or shall we say colour. Is that why my heart leaps up when I behold a rainbow in the sky."

In 1979, Nicholson had begun preparing a book about color theory which she planned to call *The Scale of the Rainbow*. Since she did not complete the work before her death, her son Andrew compiled a posthumous collection of her writings and paintings under the title *Unknown Colour*.

SOURCES:
Grimes, Teresa, Judith Collins, and Oriana Baddely. *Five Women Painters*. Oxford: Lennard, 1989.

Barbara Morgan,
Melrose, Massachusetts

Nickerson, Camille (1888–1982)

African-American composer, musician, and educator. Name variations: Camille Lucie Nickerson; The Louisiana Lady. Born on March 30, 1888 (some sources cite 1887, while Social Security Index cites 1894), in New Orleans, Louisiana; died on April 27, 1982, in Washington, D.C.; daughter of William Joseph Nickerson (a bandleader and violinist) and Julia Ellen Nickerson (a music teacher); graduated with bachelor of music degree from Oberlin Conservatory; completed master's degree thesis; never married; no children.

Selected works: "Go to Sleep, Dear"; "I Love You"; "Mister Banjo"; "Mam'selle Zi Zi"; "Susanne, Bel Femme"; "Suzanne"; "Christmas Everywhere"; "The Women of the U.S.A."; "A Precious Lullaby"; "When Love Is Done"; and "Lizette."

Born on March 30, 1888, in New Orleans, Camille Nickerson grew up surrounded by musicians. Her father William Joseph Nickerson was a violinist, music teacher, and bandleader, and her mother **Julia Ellen Nickerson** played the violin and cello, taught music, and organized a "ladies' orchestra" which she also conducted; two of her brothers also became musicians. A child prodigy, at age nine Nickerson was the pianist for the Nickerson Ladies' Orchestra, conducted by her father. She also tutored many local children in her father's studio.

Nickerson's father sent her to Oberlin Conservatory for more formal music training, and there she studied piano, organ, voice, theory, history, and composition. Her early training in music served her well during her Oberlin years; instructors put her in charge of various choral groups and bestowed on her membership in Phi Kappa Lambda, the national honor society in music. During this time, Nickerson's childhood appreciation for the Creole music so prevalent in New Orleans became an academic pursuit, as she used the research facilities available to her to compile existing lyrics and melodies and to compose her own Creole arrangements.

Upon her graduation from Oberlin, Nickerson resumed teaching at the Nickerson School of Music, and also began a career as a concert musician. Taking the stage name "The Louisiana Lady," she began to dress in Creole costume to lend an air of authenticity to her performances, and audiences loved her. Despite her success, however, Nickerson was more committed to broadening an understanding of Creole music at the academic level, and surprised many when after several successful seasons she gave up her performing career and joined the music faculty at Howard University. From 1926 to 1962, Nickerson molded numerous aspiring musicians, earning her students' respect with her demanding teaching style. During her tenure, she also became a Rosenwald fellow in order to collect and transcribe Creole music in Louisiana as the basis of her graduate study. While documenting a wealth of Creole music, her research uncovered important and previously overlooked accomplishments made by black American musicians. She continued to give occasional private performances, and was lauded during a tour of France in 1954. Camille Nickerson retired with the title of professor emerita in 1962, and remained affiliated with Howard University until her death from pneumonia at the school's hospital on April 27, 1982.

SOURCES:

Bailey, Brooke. *The Remarkable Lives of 100 Women Artists.* Holbrook, MA: Bob Adams, 1994.

Smith, Jessie Carney, ed. *Notable Black American Women.* Detroit, MI: Gale Research, 1992.

COLLECTIONS:

The Camille Nickerson Papers are held in the Moorland-Spingarn Research Center at Howard University, Washington, D.C.

Jacqueline Mitchell,
freelance writer, Detroit, Michigan

Nicks, Stevie (1948—)

American rock singer and composer who gained fame with the singing group Fleetwood Mac. Born Stephanie Lynn Nicks on May 26, 1948, in Phoenix, Arizona; first of two children of Jess Nicks and Barbara Nicks; married Kim Anderson (divorced).

Taught to sing by her grandfather and was appearing with him informally as early as age four; formed first band in high school and began performing professionally in college, opening in San Francisco rock clubs for such acts as Janis Joplin and Jimi Hendrix (mid-1960s); released one unsuccessful album with co-performer and lover Lindsay Buckingham before the two were asked to join Fleetwood Mac; became one of the band's two lead singers; performed with the band throughout its active life of some 20 years, with several songs written by her among the band's biggest hits; has also pursued a solo career as a songwriter and performer, her work noted for its mystical overtones and complex lyrics.

Stevie Nicks remembers how hard it was making a living in the music business, and how easy it was to accept the offer that brought her to the top of that quixotic industry. She had been working as a waitress for $1.50 an hour, plus tips. After spending the last of her savings to record an album with her boyfriend Lindsay Buckingham that went nowhere, the opportunity came to join Fleetwood Mac. "I think we should definitely do this because we could be dead by next year because of lack of food," Stevie remembers telling Lindsay.

The first of two children born to Jess and **Barbara Nicks** on May 26, 1948, in Phoenix, Arizona, little Stephanie Lynn Nicks had grown up affluent in New Mexico, Utah, and Texas as her father's successful career as a business executive sent the family all over the Southwest before they finally settled in San Francisco in the early 1960s. Stevie (who had trouble pronouncing "Stephanie" as a youngster and had adopted the more easily pronounced nickname) credits her grandfather, Aaron Jess Nicks, for an early love of music-making. A.J., a country and western singer, was so impressed with his granddaugh-

ter's voice that he taught her the guitar and tried to convince her parents to let him form an act with her—a proposal that was swiftly rejected. Even so, Stevie would often accompany her grandfather to local clubs, standing on tables to sing. While A.J. encouraged Stevie's musical talent, it was Barbara Nicks who provided the mystical context of the songs her daughter would later write and perform. Barbara's enthusiasm for reading fairy tales and fantasy stories instilled in Stevie an attraction for the occult. "I love the mysterious, the fantastic," Nicks once told a journalist. "I like to look at things otherworldly and say, 'I wonder what goes on in there?'"

Stevie was writing her own songs by the time she was in high school in San Francisco and had formed her own band, which she called The Changing Times, to perform at school functions. During her senior year, she met and fell in love with Lindsay Buckingham, with whom she would form a long-standing romantic and musical partnership. Stevie and Lindsay, with two other friends from school, began performing professionally as the Fritz Raybyne Memorial Band, which survived even after Stevie graduated from high school, while Lindsay, a junior at the time she met him, still had a year left at Menlo-Atherton High. Nicks commuted from San Jose State University, where she had enrolled, to join the others for rehearsals and for performances in the Bay Area. The band had the good fortune to come into its own when San Francisco was home to such pioneering performers as Jimi Hendrix, *Janis Joplin, Creedence Clearwater Revival, and The Mamas and the Papas (which included *Cass Elliot and *Michelle Phillips). Fritz opened for all of them at such legendary venues as the Fillmore and the Hungry I. Nicks was particularly fascinated with Joplin. "I was absolutely glued to her," Stevie once said, remembering the visceral connection between Joplin and her audiences. "It was there I learned a lot of what I do onstage."

She learned her lessons well; so much so that by 1970, the male members of Fritz were growing resentful of the fact that their slim, blonde-haired lead singer was getting all the attention. The resulting tensions led to the band's breakup in 1971, although Stevie and Lindsay continued their relationship and she dropped out of San Jose State to move to Los Angeles, much to her parents' disapproval. Two years later, after the couple had signed a deal with Polydor Records and released what came to be known as The Buckingham-Nicks Album, Stevie found the waitressing job. She had spent her last $100 on a blouse to wear for the cover photograph of the album (which, as it turned out, was discarded in favor of a topless shot), but the sales figures were so dismal that Stevie and Lindsay were forced to give up their apartment and move in with a friend. Her parents would only offer help, they said, if Stevie would move back to San Jose and return to school. "I'd get some money from them here and there. But . . . if I was going to be here in L.A. doing my own trip, I was going to have to do it on my own," said Nicks. Then, along came Mick Fleetwood.

Fleetwood had been one of the three founding members of the English band Fleetwood Mac, with guitarist Peter Green and bass player John McVie, in 1968. All three had met while playing for John Mayall's Bluesbreakers. In 1974, as Fleetwood Mac was preparing to record its first album in America, Fleetwood happened to visit the studio where Stevie and Lindsay had recorded their disastrously received record the year before. When the studio owner played the record as a demonstration of the studio's acoustics, Fleetwood found himself listening more to the music itself, particularly to Buckingham's guitar work. The fact that Fleetwood only accepted Stevie to induce Buckingham to join the band led to some initial tension, but it soon became obvious that Stevie's voice blended perfectly with the band's other "girl" singer, **Christine McVie** (then John's wife), to help form the distinctive sound of the band that became one of rock's most influential and copied groups for two decades.

The band was famous for its smooth harmonies and tight instrumentation, but as had happened with her old band Fritz, it was Stevie Nicks who got a lot of the attention. Dressed in swirling capes, long skirts and boots, and with her flowing dark blonde hair, she was a magnet for viewers to fix on. And like her idol Janis Joplin, Stevie seemed to connect with the audience on a level much deeper than the music, although the songs she contributed to the band's repertoire were a big reason for its success. Indeed, Nicks gave the band its only song to reach #1 in America, "Dreams," and one of its most durable hits with 1975's "Rhiannon," a song she had written two years earlier based on a story drawn from Welsh folklore. She offered the song as soon as she and Buckingham were hired, after listening to every previous album the band had recorded. "I sat in my room and listened to all of them to try and figure out if I could capture any theme or anything," Nicks once recalled. "And what I came up with was the word mystical—that there is something mystical that went . . . through all [the band's members]." "Rhiannon" was thoroughly infused with just that quality to such an extent that fans are still trying to decode its cryptic lyrics, which include:

Stevie
Nicks

She is like a cat in the dark
And then she is the darkness

Stevie herself has never fully explained her meaning, saying only, "Everything I write comes from reality, and then I throw a little fairy dust over it."

Fleetwood Mac's durability during the 1970s and 1980s was due in large part to the intimacy among its members, although the romantic complications that sometimes developed threatened to upset the delicate balance that held the band together. One band member was fired after it was

discovered he was having an affair with Mick Fleetwood's wife; another left after he and Christine McVie became lovers (John and Christine later divorced); and Stevie and Lindsay Buckingham ended their own relationship of ten years just as the band's landmark *Rumours* album was released in 1977, a project that all would later admit had been almost derailed several times by the band's internal stresses. It was a tribute to the band's cohesion that neither Stevie, Lindsay, John nor Christine, left the group after their mutual breakups. "What would we have done?" Nicks wondered aloud some years after the end of the affair. "Sat around L.A. and tried to start new bands? Nobody wanted to do that. We liked touring. We liked making money, and we liked being around a band. It was just, 'grit your teeth and bear it.'" Still, when Mick Fleetwood rejected her song "Silver Springs," about her breakup with Buckingham, in favor of Buckingham's song about *his* breakup with *her,* "Go Your Own Way," Nicks made her displeasure known. Stevie, reported rock journalist Bob Brunning, "screamed with anger, frustration and shock." Since she was having an affair with Fleetwood at the time, the dispute was even more painful.

Dreams unwind

Love's a state of mind.

—Stevie Nicks, from "Rhiannon"

Nicks' short-lived marriage to Kim Anderson was also widely reported in the music press. Anderson had been married to a close friend of Stevie's who had died of leukemia, and Stevie at first reported that she had been fulfilling a promise to marry and care for Anderson after she left Lindsay Buckingham. But later, as the pending divorce was announced, Nicks reported she had received a sign "from beyond the grave" to end the marriage. At other times, however, she spoke of her connection to the mystical in more positive terms, especially when it came to writing music. "I feel there are good spirits everywhere, when I'm writing my songs, helping me," she said. "I just feel them and I feel good." Among those inspirational spirits were Oscar Wilde and John Keats, two of her favorite authors whose works she would randomly open to find a line or two as the germ of an idea for a song. Even her brief periods as a child attending Catholic schools were used in crafting her music, Nicks citing her fondness for Gregorian chant as an influence on the structure of her songs. And while her themes were frequently about lost love and its tragic consequences, she insisted that there was a lesson to be learned from them. "I don't

write really happy songs," she admitted, "but I don't ever write a song that leaves people with no hope. I try to make it so that people say . . . life goes on, no matter how bad or what kind of tragedy you're involved in."

By the late 1980s, as Fleetwood Mac seemed to reach a plateau in its development, Nicks released her first solo album, *Bella Donna,* while continuing to tour and perform with the band. But it was "Silver Springs," the same song that had led to her earlier outburst, that was at the center of her decision to leave Fleetwood Mac for good. By mutual agreement, the band as a group owned any songs its individual members wrote for it; but even so, Nicks claimed that Mick Fleetwood's refusal to let her include a solo version of the song for her 1991 album *Timespace* convinced her it was time to make the break. For the next six years, she performed and recorded as a solo act, with mixed results, until the announcement was made that Fleetwood Mac would temporarily reunite in 1997 for their *Rumours* tour, in honor of the album that had made the band's reputation 20 years earlier. The world tour was capped in January of 1998 with a ceremony at New York's Waldorf-Astoria Hotel, during which Nicks and the rest of Fleetwood Mac were inducted into the Rock and Roll Hall of Fame.

Nicks continues to write and perform, still citing her belief in protective spirits and mystical inspiration as sources of her art. "My fantasy is giving a little bit of the fairy princess to all the people out there that maybe don't have Hans Christian Andersen books, and the Grimms' fairy tales," she says. "I dream only of giving a little fairy tale to people."

SOURCES:
Adelson, Martin and Lisa. "Stevie Nicks," as part of the World Wide Web site *Cyberpenguin,* dedicated to the band Fleetwood Mac.
Wincenstein, Edward. *Stevie Nicks, Rock's Mystical Lady.* Tulsa, OK: Momentary Pleasures Press, 1993.

Norman Powers, writer-producer, Chelsea Lane Productions, New York

Nicola.

Variant of Nicole.

Nicole.

Variant of Nicola.

Nicole of Lorraine (c. 1608–1657)

Duchess of Lorraine. Name variations: Nicola of Lorraine. Reigned from 1624 to 1625; born around 1608; died in 1657 in Lorraine; daughter of Henry II, duke

of Lorraine (r. 1608–1624), and Margherita Gonzaga (1591–1632); married Charles III also seen as Charles IV (d. 1675), duke of Lorraine (r. 1625–1675), in 1624; no children.

Nicole of Lorraine was born around 1608 into the ruling family of the duchy of Lorraine, a large province on the border of France and modern Germany. She was her father's only surviving child on his death in 1624 and succeeded him as ruler, but she had little chance to establish a regime. Her paternal uncle, Francis of Vaudémont, wished to rule in her place, and so he arranged with her mother *Margherita Gonzaga for Nicole to marry his eldest son Charles immediately following her accession. In the 17th century, it was difficult for a woman to rule in her own name once she married, since by law she was then subject to her husband, and popular opinion saw a woman's reign as a time of weakness. Francis of Vaudémont used the opposition by the nobility and the citizenry to Nicole's reign to pass a law in 1625 prohibiting female succession in Lorraine, thereby deposing Nicole in less than one year.

Francis then was acclaimed the new duke, but he abdicated in favor of his son, Nicole's husband, who then succeeded as Charles IV, duke of Lorraine. Nicole thus retained her position as duchess but lost her authority. Charles' wavering foreign policies against France would cause him to lose the duchy several times before his death. He spent much of his time away from Lorraine fighting in the Thirty Years' War, abdicating temporarily in 1634. Nicole, who had no children, would remain in Lorraine throughout her life. Duke Charles was imprisoned in Spain at the time of Nicole's death in 1657.

SOURCES:
Jackson-Laufer, Guida. *Women Who Ruled*. Santa Barbara, CA: ABC-CLIO, 1990.
Putnam, Ruth. *Alsace and Lorraine, from Caesar to Kaiser*. NY: Putnam, 1915.

Laura York,
Riverside, California

Nicolson, Victoria Mary, Lady
(1892–1962).

See Sackville-West, Vita.

Nic Shiubhlaigh, Maire (1884–1958).

See Shiubhlaigh, Maire Nic.

Nidetch, Jean (1923—)

American entrepreneur who founded Weight Watchers. Born Jean Slutsky on October 12, 1923, in Brooklyn, New York; eldest of two daughters of David Slutsky (a cabdriver) and Mae (Fried) Slutsky (a manicurist); graduated from Girls' High School, Brooklyn, New York; briefly attended City College of New York; married Martin Nidetch, on April 20, 1947 (divorced around 1973); children: son who died young; David (b. 1952); Richard (b. 1956).

"I'm sure that my compulsive eating habits began when I was a baby," theorized Jean Nidetch in *The Story of Weight Watchers*, her book about the successful weight-loss business she started in 1963. "I don't really remember, but I'm positive that whenever I cried, my mother gave me something to eat." As a result, Nidetch explains, she developed into a chubby child, a fat teenager, and a seriously overweight adult. By 1945, when she met her future husband Martin Nidetch, she wore a size 20 dress. "We ate together," she writes of their courtship. "We didn't go dancing or bowling, or roller-skating. We ate." After marrying in April 1947, the couple lived in Tulsa, Oklahoma, then War-

Jean
Nidetch

ren, Pennsylvania, before returning to New York, where Martin went to work for a limousine service. By 1956, Jean had given birth to three boys, the first of whom died as an infant, and had developed an outgoing personality to compensate for her ungainly body. "After all, if you're fat, you have to make a joke about your weight before somebody else does," she wrote.

Having held a variety of jobs during the early years of her marriage, Nidetch now joined every organization she could find, and usually ended up heading all of them. Along with her frantic round of activities, she continued to eat and diet compulsively, trying every manner of weight-loss plan and appetite-suppressant on the market. In 1961, carrying 214 pounds on her 5'7" frame, and desperate for help, she signed up at the New York City Department of Health Obesity Clinic. Given a reasonable diet, she was instructed to lose two pounds a week and to return to the clinic each week for a weigh-in. She followed the diet faithfully, but locked herself in the bathroom at night and gorged on cookies. Unable to confide her secret eating to her family, or to anyone at the clinic, Nidetch called up some of her overweight friends and invited them over to talk. Soon all of her friends went on the diet with her and, as they encouraged and supported each other, all began losing weight. Thus, Weight Watchers was born.

Within several months, Nidetch had a group of 40 women attending her weekly meetings, which she had moved from her living room to the basement of her apartment building. By October 1962, she had reached her goal weight of 142 pounds and had turned her compulsive eating into a drive to help others. Two members of the group, Albert and **Felice Lippert**, convinced her to go into business, and in May 1963, the Lipperts and the Nidetches formed a corporation and opened Weight Watchers, conducting meetings in a loft over a movie theater in Little Neck, New York. Five years later, when the corporation went public, it had 81 franchises in 43 states and 10 franchises abroad.

While Albert Lippert oversaw the organization's enterprises, including a monthly magazine, a television program, several summer camps for overweight children, and a line of food products, Nidetch served as public relations director, taking the message to audiences around the country. "She is part *Tallulah Bankhead (marathon talker), part *Ethel Merman (loud), and part **Joan Rivers** (funny)," wrote Louis Botto in *Life* after witnessing her in action. Nidetch also made regular appearances on radio and television,

and, in addition to *The Story of Weight Watchers* (1970), authored two cookbooks: *The Jean Nidetch Weight Watchers Cookbook* (1968) and *The Weight Watchers Program Cookbook* (1973). In 1973, Nidetch sold the company to the H.J. Heinz Corporation for $71.2 million, negotiating a healthy consulting contract for herself in the process.

The Weight Watchers system has remained pretty much the same over the years. Members, who must have at least ten pounds to lose, pay a modest registration (there are no contracts) and a minimal fee per weekly meeting. After a weigh-in, the members discuss their progress and receive encouragement from the group leader, a graduate of the program. For a long time, the diet was essentially the same one that Nidetch had received from the New York Department of Health, emphasizing lean meat, fish, skim milk, and fruits and vegetables. In keeping with changing lifestyles, however, Weight Watchers has adopted the mantra "a real diet for real life" and has expanded its menus to include such foods as pizza, burgers, ice cream, and French fries, in moderation, of course. It is perhaps Weight Watchers' simplicity that has accounted for it dominance among diet plans and the backing it continues to receive from the medical community. "It's reasonable, widely available and a sound nutrition program," notes Dr. Kelly Brownell, co-director of the Obesity Research Clinic at the University of Pennsylvania. "There's group support and accountability. Before WW there was very little organized help for the obese."

Nidetch divorced her husband around 1973, claiming that they had grown "in different directions," and moved to California, where she took delight in her new-found fame and fortune. She then turned her attention to overweight children. "They are victims of our times," she says. "They're packed with fast food. And these are bright kids. They know you live longer with good nutrition."

SOURCES:

Moreau, Dan, and Jennifer Cliff. "Change agents: Jean Nidetch knew that Weight Watchers' success hinged on more than a diet," in *Changing Times*. August 1989, p. 88.

Moritz, Charles, ed. *Current Biography 1973*. NY: H.W. Wilson, 1973.

Barbara Morgan,
Melrose, Massachusetts

Niedecker, Lorine (1903–1970)

American poet who lived in poverty and rural isolation in southern Wisconsin, publishing little during her lifetime, but was well known in experimental po-

*etry circles in the U.S., Great Britain, and Japan.
Name variations: Lorine Neidecker. Pronunciation:
Knee-deck-er. Born Lorine Faith Neidecker (later
changed to Niedecker) on May 12, 1903, on Black-
hawk Island, near Fort Atkinson, Wisconsin; died in
Madison, Wisconsin, December 31, 1970, of a cere-
bral hemorrhage; daughter of Henry Neidecker (a
fisherman) and Theresa "Daisy" (Kunz) Neidecker;
received public schooling and two years at Beloit Col-
lege, 1922–24; married Frank Hartwig, on November
29, 1928 (divorced 1942); married Albert Millen, on
May 26, 1963.*

*Began correspondence with Louis Zukofsky
(1931); moved to New York (1933–34); after return
to family in Wisconsin, moved to Madison, where she
began four years of work on Federal Writers' Project
(1938); had five poems published in avant-garde* New
Directions *(1936); published in* Il Furioso *(1939);
published first poetry collection,* New Goose *(1946);
began correspondence with poet and editor Cid Cor-
man (1960); after marriage to Millen and move to
Milwaukee, began most vital and creative phase
(1964); featured in Corman's journal* Origin *(1966);
published last book,* My Life By Water *(1969); com-
plete works published (1985).*

Collections of poetry: New Goose *(1946);* My
Friend Tree *(1961);* North Central *(1968);* T&G
(1969); My Life by Water *(1969). Posthumous collec-
tions:* Blue Chicory *(1976);* This Granite Pail *(1985);*
From This Condensery *(complete works, 1985).*

The life of Lorine Niedecker is perhaps the
bleakest and most isolated of any modern Amer-
ican poet: she grew up with a mother who was
deaf, she spent most of her life on a small island
where only a handful even knew she wrote poet-
ry, she spent her 50s cleaning hospital floors, she
survived Wisconsin winters until she was 60
without indoor plumbing or a car, she married
badly twice, and her two closest lovers refused
marriage: one—her poetic friend and mentor—
insisted on an abortion she did not want. And
yet to think of her life as unmitigated misery is
to misunderstand what she eventually realized—
that the creation of poetry was the center of her
desires and had to be protected from whatever
threatened her ability to write. She accepted no
marriage, no occupation, no material security,
and no place to live that interfered with her in-
tellectual life. The unique result of that life lies
outside the conventional poetics that dominate
most of this century's poetry. Beginning in the
1930s, she and other Objectivist poets (Louis
Zukofsky, George Oppen, Charles Reznikoff,

Carl Rakosi, and William Carlos Williams) tried
to move beyond the practices of T.S. Eliot, Ezra
Pound, and Robert Frost, and in the 1950s and
1960s, another generation of young rebels like
Ed Dorn and Allen Ginsberg would look to her
work for inspiration.

Lorine Niedecker was born in southern
Wisconsin in 1903 in the small resort communi-
ty called Blackhawk Island, where she was
named after the doctor's wife. Blackhawk Island
is actually a peninsula on the southern end of
Lake Koshkonong and on the east bank of the
Rock River as it flows south and west to the
Mississippi. At the beginning of the century,
southern Wisconsin was famed for its scenery
and lakes and attracted vacationers from nearby
Chicago. While the wealthy flocked to such re-
sorts as Lake Geneva, working-class European
Americans visited spots like Blackhawk Island,
with a place reserved farther down river for
African-American vacationers.

Much of the island was owned by Henry
Neidecker, who seined carp, rented out some
property he owned, and, for a time, operated the
island's largest tavern, the Fountain House. His
wife **Daisy** was the daughter of Gottfried and
Theresa Kunz, who originally owned and oper-
ated the Fountain House. Because the island was
a resort, there were few permanent residents and
fewer children. Like her daughter, Daisy grew up
alone. Shortly after bearing Lorine, Daisy slowly
began to lose her hearing, until she was com-
pletely deaf some 20 years later.

Henry worked hard so he could send his
daughter to a nearby private college, Beloit Col-
lege, and in her poetry, Niedecker celebrated his
easygoing manner in the face of adversity. She
also admired his care for nature, particularly the
way he spent his last years planting poplar trees.
Henry had faults, however, that Niedecker also
explored in her verse. He drank too much and
cheated on his wife. Legend has it that Daisy
stopped having sex with Henry soon after the
birth of their only child, and that Henry was
later seduced by Gertrude (Gerdy) Runke. Gerdy
and her husband Otto apparently engineered the
affair in order to fleece Henry, and one result
was that by Henry's death only two houses
would remain in his ownership.

When writing about Daisy, Niedecker most-
ly remembered her mother's bitterness, about
Henry's infidelity and about island life. Black-
hawk Island floods every spring, and Daisy com-
plained acridly about the damage the floods
wreaked on both home and garden—buckling
floors, washing good soil away, bringing snakes

and other animals into the house, and forcing her to clean and redecorate the house anew each year. Niedecker remembered Daisy's dying words as "I need / floors. Wash the floors, Lorine!— / wash clothes! Weed!" In other poems, Niedecker recalls better moments, particularly of Daisy's sensitive appreciation of nature.

The young Niedecker grew up outdoors, attending to the small and great changes that take place in river and marsh country. This country attracted a varied and rare wildlife, and as an adult, she knew the names and habits of all the flora and fauna, but as a child, she listened to the lore of her parents and of her grandfather Kunz, who also taught her nursery and folk rhymes. When she reached school age, her parents moved five miles away to the nearest town, Fort Atkinson. When she entered seventh grade, they moved back to the island, letting her stay with a Fort Atkinson neighbor during the school week. During high school, she became increasingly interested in literature, and she published a poem in her senior yearbook.

In the fall of that year, 1922, Niedecker entered Beloit College and changed the spelling of her last name from "ei" to "ie," presumably to aid pronunciation. The choice to enter college was an important one. The 1920s were the age of the so-called "New Woman": women had secured the right to vote in 1920, and had been setting the agenda for two decades of reform work. Many women, seeing college as a route to reform, became doctors, lawyers, professors, and settlement-house workers. Beloit College had dynamic professors in geology and evolution (two subjects that would later dominate her poetry), and it offered a debate club for women that addressed political subjects, which Niedecker joined. The college itself, however, was marked by social divisions. Niedecker was just barely able to afford school, and could not afford to join a sorority, which at the time was an important route to social advancement. Classmates in both high school and college saw her as a social outsider, the poor girl from the island.

In 1924, after just two years of college, Niedecker dropped out of school and returned to Blackhawk Island to help out her family. Daisy had by then lost her hearing altogether. Four years later, in 1928, Niedecker began working as a librarian's assistant at Dwight Foster Public Library in Fort Atkinson, living with her cousin's family during the week and visiting home on the weekends. On Thanksgiving Day of that year, she married Frank Hartwig, a construction worker, but the very next year Hartwig lost his job at the start of the Great Depression, and when they failed to make their house payments in Fort Atkinson, the young couple returned to their parents' homes in 1930 and remained permanently separated. In August 1930, Niedecker stopped working at the library. Virtually no information is available about this brief, 18-month marriage, except that it was essentially over in 1930. The two remained friendly and saw each other occasionally, and Niedecker did not file for divorce until 1942.

In the meantime, Niedecker was learning about poetry. Beginning in high school, she had studied the movements that had changed the face of U.S. poetry and had prepared to take her place in the second generation of modernist poets. During the 1910s and 1920s, the first generation of modernists (those born in the 1880s) had swept away Victorian poetic conventions by rejecting archaic language and a mellifluous poetic line for a more colloquial diction and for new, experimental forms, including pastiche and nonmetrical or "free" verse. While Victorian poetry frequently celebrated the progress of society in sentimental terms, modernist poetry more often documented society's decline. Modernists had seen the sanguine and moral world of their Victorian parents ripped apart by World War I, by new theories grounded in science (Darwin, Freud, and Marx), and by widespread social struggles for the rights of workers, women, and African-Americans.

Although the second generation, born in the century's first decade, continued to develop modernist literary techniques, it applied them to rather different ends. While the first generation attempted to rebuild culture by appealing to mythic structures and sometimes by turning to fascist politics, the second generation—which had been born and raised in the reform-minded Progressive era, and which had come of age during the prosperous 1920s and the Great Depression of the 1930s—turned more often to the politics of the left, frequently joining the thriving Socialist and Communist parties. One dominant literary mode of this generation was "proletarian literature," which eschewed difficult modernist techniques in order to arouse the masses to political action. While the first generation had become alienated intellectuals, the second generation became activists.

During this time (the 1920s and early 1930s), Niedecker read the poetry journals of the day and paid special attention to *Poetry* magazine, published in nearby Chicago by the now legendary *Harriet Monroe*. Monroe had

succeeded in making the Midwest an important literary center, and for over a decade, since 1912, she had been publishing the freshest, most experimental voices she could find. Most of the first-generation modernists published there, and in 1931, she signaled her continued interest in the new by asking the young Louis Zukofsky to guest-edit an issue devoted to his work and that of his friends. She also asked him to describe and name the circle. In the February issue, Zukofsky characterized a tendency he called Objectivism, a focus on "historic and contemporary particulars" and the process through which they emerge. In this formulation, Zukofsky announced his allegiance to political critique but not to the "social realism" of his contemporaries who were writing proletarian literature. He wanted instead to merge modernism and Marx, believing that modernist experiments with language could reveal what Marx called "dialectical materialism," the way that material circumstances and culture affect each other and together create the reality we experience.

Six months after reading the Objectivist issue of *Poetry*, Niedecker wrote Zukofsky, launching a 40-year correspondence as well as her career as a serious poet. For the first 15 years, they wrote at least once a week about the craft of poetry, and in the winter of 1933–34, Niedecker moved to New York, planning to make her future there. Zukofsky introduced her to his poet-friends and to the literary and cultural advantages of the city. Soon she moved in with him and later became pregnant. She wanted to stay in New York, but Zukofsky wanted her to have an abortion. When she offered to return unmarried to Blackhawk Island and raise the child with her parents, Zukofsky again insisted on abortion, and she complied. Not long afterward, she returned to Wisconsin and continued her correspondence with Zukofsky until her death.

Deciding to stay in Wisconsin permanently, Niedecker moved up to Madison in 1938. For four years, she first wrote and then edited research for the Federal Writers' Project, which produced the *Wisconsin Guide* and grounded her more thoroughly than ever in the history of the region. During this time, she also wrote scripts for radio station WHA, including an adaptation of William Faulkner's novel *As I Lay Dying*. After four years, however, she tired of city life and returned to Blackhawk Island in 1942 to live with her parents. That same year, she finally divorced Frank Hartwig. Two years later, she began work as a proofreader for the agricultural journal *Hoard's Dairyman,* walking the five miles to her job in Fort Atkinson.

By 1946, at the age of 43, Niedecker had enough poems for a small Illinois press to publish her first volume, *New Goose*. Earlier, she had published six poems in avant-garde journals: five in *New Directions* in 1936 and another in *Il Furioso* in 1939. The poems in *New Goose* marked her evolution beyond the Victorian verse of her high school years and beyond her apprentice work, which had imitated *Emily Dickinson and Ezra Pound. The title of the volume referred on the one hand to the newness of her verse—its Objectivist emphasis on the particular and on process and its frequently surreal use of imagery—and on the other hand to the Mother Goose rhymes which she had heard from her grandfather and which lent the poetry much of its rhythm. Throughout her career, Niedecker would distinguish herself from other Objectivists through her astute use of rhythm and rhyme. She gave away only three copies of the volume in Fort Atkinson, preferring instead that no one she knew think of her as a poet.

They fished in beauty
It was not always so.
—Lorine Niedecker

The following year, 1947, Niedecker had a small, one-and-a-half-room house built for herself on Blackhawk Island near the bank of the Rock River. The 1950s were to prove a difficult time. In 1950, her eyesight began to fail, forcing her to quit the proofreading job she had held for six years. Her vision, like her mother's, had always been weak, and she had worn thick glasses since childhood, but now she was reduced to reading with a magnifying glass. In 1951, Daisy died, followed three years later by Henry, in 1954. Her father's death left Niedecker shaken, and she withdrew from society for a time, perhaps suffering a nervous breakdown. Renting out the two houses left to her, she found she could live without working if she managed her expenses very carefully. Tired of that burden, in 1957 she secured a job cleaning floors in the Fort Atkinson hospital, again walking the five miles into town, even during winter.

In the 1960s, Niedecker experienced a personal and poetic rebirth. In the 14 years since the publication of *New Goose*, she had published steadily in small, avant-garde journals, and in 1960, she began corresponding with the poet Cid Corman, who lived in Japan and edited the avant-garde journal *Origin*. By this time, her correspondence with Zukofsky had turned from poetry to his failing health and his desire to be recognized more broadly as a poet, and so Corman provided

her with a fresh opportunity to discuss her craft. During this time, Niedecker briefly dated Harold Hein, a Madison dentist with whom she shared her intellectual pursuits. Although she hoped to marry him and move to Florida, where he had some property, he made clear that he was her "no marriage / friend." In 1961, at age 57, she published *My Friend Tree* with a small Scottish press and installed indoor plumbing. Finally no more trips outdoors were needed in winter to pump water. Poet Ed Dorn wrote the introduction for the book, and it was warmly reviewed by the influential writers Gilbert Sorrentino, Jonathan Williams, and Robert Creeley.

Two years later, in early 1963, Albert Millen, a housepainter who lived and worked in Milwaukee, was vacationing at Blackhawk Island and rented one of Niedecker's houses. They quickly fell in love and married on May 26. In his youth, Millen had belonged to the Industrial Workers of the World (IWW), a radical labor union that in the first two decades of the century had posed a serious challenge to organized labor by accepting women, African-Americans, and unskilled laborers into its membership. A national raid in 1917 and a subsequent trial of 101 leaders in 1918 resulted in the collapse of the organization. While Niedecker still kept Marx on her bookshelf, Millen wanted her to take it down, perhaps fearing the anti-Communist hysteria whipped up by Wisconsin Senator Joseph McCarthy in the 1950s.

Later that year, Niedecker quit her six-year job at the hospital, and the next year, 1964, she moved into Millen's home in Milwaukee, returning to Blackhawk Island on weekends and holidays. The next four years in Milwaukee were active ones, personally and professionally. Niedecker called Millen her "connection to life," and friends and neighbors noticed that she was brighter and happier than she had been for years. An outdoors enthusiast like herself, her father, and grandfather, Millen brought with him four adult children from a previous marriage and six grandchildren. Since he owned a car, he took Niedecker on long tours that helped her create a new kind of poetry based on what she called "reflections," an "awareness of everything influencing everything." Many of the images for these later poems come from the trips the couple made to South Dakota in 1965, the upper peninsula of Michigan in 1967, and Minnesota and North Dakota in 1968.

During these years in Milwaukee and afterward, Niedecker's social world expanded and her influence grew. She accepted visits from poet and publisher Jonathan Williams and the British poet Basil Bunting in 1967, from Zukofsky and his wife, the composer **Celia Thaew Zukofsky**, in 1968, and Cid Corman and his wife, **Shizumi Konshini**, in 1970. All of these men pressured Niedecker to raise her profile in the poetic world. For two decades, in the 1940s and 1950s, American poetry had grown increasingly academic, but the advent of the Beat writers in the late 1950s, including Allen Ginsberg and Jack Kerouac among others, as well as the publication of Robert Lowell's *Life Studies* in 1959, signaled a new desire for experimental poetry. Young poets were looking for models outside the modernist mainstream and were rediscovering the Objectivist poets. Meanwhile, the work of young poets like Charles Olson and Robert Duncan in turn stimulated Niedecker's own poetic development. Milwaukee was the center of some activity, and Niedecker enjoyed the university and the museums, but she turned down numerous requests for readings and visits from younger writers. She did allow Corman to record her reading some of her poems. In the meantime, she poured herself into the greatest writing and publishing activity of her life. Journal editors began requesting her poetry, the July 1966 issue of Corman's *Origin* featured her work, and she published three books of poetry—*North Central* (1968), *T&G* (1969), and *My Life By Water* (1969).

For all the renewal Millen brought to Niedecker's life, he also brought great pain. He was drunk on their wedding night and frequently thereafter, he was occasionally jealous, and he had little understanding of her work or intellectual life. As she put it in one poem, "I married / and lived unburied." In 1968, Millen retired, and the couple returned to Blackhawk Island permanently. They built a spacious house on the bank of the Rock River just 50 feet from the small house she had built for herself almost 20 years earlier. Millen agreed to her demand that the house be built extra high to evade the flood waters, and later that year they added on a garage after she sold her correspondence with Zukofsky to the University of Texas. Zukofsky had resisted the sale, feeling the letters were too private, but finally agreed after being promised they would not be published until after his death.

Later that winter, Niedecker suffered from headaches and dizzy spells and spent ten days in the hospital. Two years later, on December 1, 1970, she suffered a cerebral hemorrhage and lost the ability to speak. When she contracted lobar pneumonia, she was moved from Fort Atkinson to Madison, where she died the next day, December 31, 1970. Three days later, she

was buried next to her parents at Union Cemetery in Sumner, just outside Blackhawk Island. A blizzard prevented Millen's daughters from attending the burial, but his son went, while Millen stayed home and destroyed Niedecker's journals. Although some friends suspected that he wanted to destroy her negative portrayals of him and their marriage, Millen himself claimed that Niedecker had asked him to burn the journals. She left behind a manuscript collection of poems entitled "Harpsichord & Salt Fish."

The response of the literary community to Niedecker's death was immediate and profound. In 1973, Jonathan Williams published a collection by various poets (including Ed Dorn and Allen Ginsberg) entitled *Epitaphs for Lorine*, and in 1975, the avant-garde journal *Truck* dedicated a special issue in her honor. As her literary executor, Cid Corman edited and published a collection of her poetry, *Blue Chicory*, in 1976, featured her work in a special issue of his journal *Origin* (July 1981), allowed her letters to him to be published in 1983, and edited and published a volume of her selected poems, *The Granite Pail*, in 1985. Later that year, her complete works were published, entitled *From This Condensery*. The year 1993 saw the publication of her letters to Zukofsky, and a collection of critical essays about her, *Lorine Niedecker: Woman and Poet*. A previous book of criticism, *The Full Note*, had been published in 1983.

The complete body of Niedecker's work is slim, numbering only 300 pages, but the brevity belies the depth she achieved. She liked to compare the writing of poetry to a condensing factory or "condensery" and wondered in one poem what her co-workers in the print shop would say "if they knew / I sit for two months on six lines / of poetry." Niedecker's typical poem runs between five and fifteen lines, usually untitled. Many of the poems describe her life on Blackhawk Island, either directly or in dramatic monologues, and her observations range from nature to historical figures, and from town and country people to her parents, friends, and lovers. When she condensed these experiences into the brief space of her poems, she did not reduce the complexity of her experience. Instead she used all of the poetic devices at her disposal—including puns, rhymes, punctuation, and line breaks—to reveal in language the interrelated processes through which things, people, and experience become.

Niedecker claimed that she "literally went to school to William Carlos Williams and Louis Zukofsky," and she included on her "immortal cupboard" works by Emily Dickinson, Henry David Thoreau, Lucretius, Marcus Aurelius, John Muir, George Santayana, D.H. Lawrence, Edward Dahlberg, and Basho. Her experiments with haiku significantly broadened the suggestiveness of the form through her use of colloquialisms and quietly stunning rhymes and line breaks, and during her poetic rebirth in the 1960s, she reinvented the long poem for herself. Earlier in her career, she had built sequences out of shorter poems, many of them addressed to Zukofsky's son Paul, a violinist with whom she was very close. Many of these poems include quotations from letters she and Zukofsky had exchanged about Paul, thus beginning her long experimentation with turning the intimacy of correspondence into the intimacy of poetry. In 1965, she crafted the Zukofsky letters she later sold to the University of Texas into a sequence of quotations intended to reveal the "deep-in spot in [Zukofsky's] being," turning a simple collection into a kind of poem. Although Zukofsky refused to let her publish the 370-page manuscript, she used her experience in producing it to create her long poems about the lives and correspondence of William Morris, Thomas Jefferson, and Charles Darwin.

At the same time, Niedecker experimented with long poems that might be termed metaphysical. She counted as one of her strengths the fact that she was raised outside organized religion, and in her late, long poems "Lake Superior," "Traces of Living Things," and "Wintergreen Ridge" (which is focused on women's collective agency), she grounds her metaphysics in evolutionary theory and in her own experience of poetry. If Darwin had taught her that "In every part of every living thing / is stuff that once was rock," then the processes of poetry had taught her that "everything influenc[es] everything." These developments perhaps reach a peak in the other long poem from this period, the great "Paean to Place," in which Niedecker united her new, metaphysical mode (the poetry of "reflections") with the subject matter that had animated so much of her career, the lives of herself and of her parents on a place called Blackhawk Island.

With Lorine Niedecker's complete works so recently before us, poets, readers, and critics alike have only now become open to her influence. How far she takes us depends on how closely we listen to her subtle facility with words, a facility far more sensitive to the silent interstices between things than that possessed by perhaps any other modern poet. Others might imitate Byron's lover, who "walked in beauty like the night," but Niedecker, like her fellow is-

landers, "fished in beauty"—she lived in a beautiful world and gathered it into herself in the very same motion.

SOURCES:

Breslin, Glenna. "Lorine Niedecker: Composing a Life," in *Revealing Lives: Autobiography, Biography, and Gender*. Edited by Susan Groag Bell and Marilyn Yalom. Albany, NY: State University of New York Press, 1990.

Faranda, Lisa Pater. *"Between Your House and Mine": The Letters of Lorine Niedecker to Cid Corman, 1960 to 1970*.

———. "Lorine Niedecker," in *Dictionary of Literary Biography*. Vol. 48, pp. 304–319.

Knox, Jane Shaw. *Lorine Niedecker*. Fort Atkinson, WI: Dwight Foster Public Library, 1987.

SUGGESTED READING:

Penberthy, Jenny. *Niedecker and the Correspondence with Zukofsky, 1931–1970*. NY: Cambridge University Press, 1993.

COLLECTIONS:

Correspondence with Zukofsky and other materials are at the Humanities Research Center of the University of Texas at Austin. Correspondence to Cid Corman is in the Berg Collection in the New York Public Library. The manuscripts collected for "Harpsichord & Salt Fish" are in the Mulgar Memorial Library at Boston University.

Michael Tomasek Manson,
Assistant Professor of Literature, The American University,
Washington, D.C.

Niederkirchner, Käte (1909–1944)

German anti-Nazi who was celebrated in the German Democratic Republic as a hero and martyr of the resistance. Name variations: Käthe Niederkirchner; Katja Niederkirchner. Born in Berlin, Germany, on October 7, 1909; executed at Ravensbrück concentration camp on September 27, 1944; daughter of Michael Niederkirchner (1882–1949) and Helene Niederkirchner; sister of Max, Paul, Helene, and Mia.

Involved in anti-Nazi activities before Hitler came to power; moved to the Soviet Union (1933); during World War II, made broadcasts to Germany over Moscow Radio and was involved in educational work among German prisoners of war; captured after parachuting into Nazi-occupied Poland (October 1943); after interrogations and torture, taken to the Ravensbrück concentration camp and executed there (1944).

Käte Niederkirchner became a highly controversial figure after East and West Germany were unified in October 1990. The struggle over which historical memories would be appropriate for the new Germany intensified with each passing year; by 1995, a street named in Niederkirchner's honor in the heart of Berlin was changed to another, less divisive designation. Only a few years earlier, the situation had been dramatically different. In the former East Germany, the German Democratic Republic (GDR), Käte Niederkirchner had for decades enjoyed the status of a revered martyr of the resistance movement, celebrated for having given her life in 1944 in the conflict with Hitlerite Germany. Countless streets, squares, parks, and schools were named in her honor in the GDR, and her life story was enshrined in its history books and popular literature.

Käte Niederkirchner was born in Berlin in 1909 into a working-class family. Her father Michael Niederkirchner had grown up in his native city of Budapest as a member of an ethnic German family. A pipefitter, he earned his living as a skilled worker and was from his earliest years an active member of the Hungarian Social Democratic Party. Käte's mother **Helene Niederkirchner** also had memories of an impoverished childhood, having grown up in Slovakia as a member of a landless rural family. In 1905, the Niederkirchners moved to Germany, living first in Regensburg and then settling in Berlin, where Michael was able to find steady employment. Having been a trade unionist as well as a socialist in Hungary, in Berlin he became a member of the political party of the German working class, the Social Democrats. He also became an active member of his trade union, the Deutscher Metallarbeiterverband (German Metal Workers Union or DMV); by early 1914, he had become a union leader, serving as branch representative of pipefitters within the DMV organization.

While growing up, Käte heard much talk of politics at home and soon became aware of the cross currents swirling through the Social Democratic and trade union subculture of Berlin. These political controversies would be dwarfed by the start of World War I in August 1914. Like all German families, the Niederkirchners were affected by the conflict. Since he (and his entire family) had retained their Hungarian citizenship, Michael was drafted to serve in the armed forces of Austria-Hungary. In March 1915, when he became a Russian prisoner of war, Helene and her five children found themselves in a precarious situation. Survive they did, but over the next four years the family lived with ever-diminishing food rations, inadequate heat for their flat, and a shortage of clothing and shoes. Helene worked long hours in a Berlin armaments factory, but the Niederkirchners were fortunate in that Michael returned from the war in early 1919 (more than three million German soldiers perished), and no one succumbed to tuberculosis or other diseases linked to the severe malnutri-

tion that was a universal fact of life, particularly among members of the industrial proletariat.

While Michael was a prisoner of war, Russia had overthrown the tsar, gone through a brief episode of chaotic democracy, and in November 1917 had experienced a revolutionary takeover by Vladimir Lenin and his radical Marxist Bolshevik Party. Michael had become even more radicalized. Soon after his return, he joined the pro-Bolshevik Independent Social Democratic Party (USPD). By 1920, he had become dissatisfied with USPD policies and joined the Communist Party of Germany (*Kommunistische Partei Deutschlands* or KPD).

During these years, Käte grew into an intelligent, sensitive young woman. She had a close relationship with her father and often had long conversations with him on political topics. Profoundly influenced by his political views, she became a Communist activist, first joining the "Fichte" workers' sports organization. By age 16, she was a member of the Young Communist League of Germany (KJVD), and in 1929 she became a full-fledged member of the KPD. Throughout the life of the ill-fated Weimar Republic (1919–33), Käte and indeed the entire Niederkirchner family were involved in some of Germany's most intense left-wing politics.

Käte made her living as a seamstress; she also learned typing and stenography. Although denied a higher education because of her working-class background, she was intellectually curious, loved music and literature, and studied foreign languages on her own. She also attended countless KPD meetings and rallies and spent hours working with unemployed women, a group whose numbers increased dramatically during the winter of 1929–30 with the onset of the world economic depression.

As an active Communist, it was only a matter of time before Niederkirchner encountered the hostility of the German authorities toward "Bolshevik agitators." In November 1932, she was arrested after having given a particularly militant speech to an assembly of women. She was expelled from Germany in 1933 as an "undesirable alien." Even more at risk during these years was her father Michael, now a leading member of the KPD (he was one of the party's leading trade unionists and in 1929 was elected a member of the Central Committee). In 1933, only weeks after Adolf Hitler and the Nazi Party came to power in Germany, the KPD was destroyed in a reign of terror. Although Germany's Communists had long proclaimed themselves to be a revolutionary movement, they were in fact

pitifully ill-prepared to wage the kind of class warfare that might bring them to power. Revolutionary rhetoric was no substitute for the kind of political pragmatism, a blend of terror and persuasion, that the Nazis had perfected. In late February 1933, Michael was arrested hours after the Reichstag fire gave the Nazis a pretext to create their anti-Communist dictatorship. After brutal mistreatment in several concentration camps, he was expelled from Nazi Germany in June 1934—an exile made possible because he had retained his Hungarian citizenship despite almost three decades of residence in Germany.

By the end of 1934, the Niederkirchner family had resettled in the Soviet Union. Despite difficult living conditions, initially the USSR appeared to them to be truly the land of socialism. With the second Five Year Plan underway, all signs pointed to the successful construction of a new, egalitarian socialist society. But soon, the malignant nature of the Stalinist dictatorship began to reveal itself. With the start of the great purge in 1936, German exiles lived lives of terror. Despite their loyal record, the Niederkirchners were not spared from the general bloodletting: in 1938, Käte's brother Paul was arrested by the dreaded Soviet NKVD and absurdly ac-

GDR postage stamp honoring Käte Niederkirchner.

cused of espionage. A contemporary source has testified that Paul died in Moscow's Butyrka prison, most likely after torture. Then Michael became seriously ill.

On June 22, 1941, Nazi Germany launched a massive attack on the Soviet Union. Although their ranks had been decimated by the paranoia of Stalin's regime, the anti-Nazi Germans in the USSR offered their services, including Käte who volunteered for front-line duty with the Red Army. Though her request was approved, it was decided that she could be best utilized behind the lines, visiting prisoner-of-war camps and explaining to captured German soldiers how they had been misused by Hitler's regime.

Käte also underwent intensive training for many months as a parachutist and irregular member of the Soviet armed forces. Finally, in early October 1943, Niederkirchner and another German exile, Theodor Winter, were to be parachuted into German-occupied territory. Their mission was to travel to Berlin and establish contact with the small but still active Communist resistance cells operating in the capital. They parachuted successfully out of a Soviet plane, landing at night in the vicinity of the small town of Parzow, in the Lublic district. By chance, Käte landed not in an open field but in a tall tree. When Winter, assisted by Polish partisans, found her tangled high in the tree the next morning, she was still unconscious. She was brought down safely and after several days of rest was sufficiently recuperated to embark on the next phase of the dangerous mission. While on her journey to Berlin, Niederkirchner was arrested at the Danzig (modern-day Gdansk, Poland) train station. Winter succeeded in getting to Berlin, but he too was soon captured and murdered by the Nazis, most likely in April 1945.

Over the next months after her capture, Käte was moved from prison to prison and subjected to interrogations and torture. Finally, convinced that they could extract no important information from her, her captors sent her to the infamous Ravensbrück concentration camp for women. Between September 21 and 27, 1944, certain that she had only days to live, Niederkirchner wrote down a series of notes which included a farewell letter to her family dated September 25: "You must inform my dear and ever-steadfast father that I did not dishonor him. I betrayed no one." On September 27, 1944, a few hours before her execution, Niederkirchner penned her last note: "27.9.44. In the morning. This morning the commandant came and announced the verdict to me in a manner that was so mocking, debased and filthy. These people are of course so habituated to murder that they derive special pleasure when they feast their eyes on the sufferings of their victims. But he had no such luck with me. Most likely it will take place tonight." Niederkirchner's final notes and letters were preserved by other Ravensbrück internees.

Michael died in 1949, while Helene survived as a revered *Parteiveteranin* (party veteran), dying in East Berlin in June 1967. On September 3, 1959, a semi-postal stamp with Käte Niederkirchner's portrait was issued by the GDR post office. Because of its proximity to the Reichstag building, the Niederkirchnerstrasse in the heart of Berlin's government district (after 1990 the site of newly united Germany's Parliament), managed to offend many conservative politicians. In the eyes of some, the street honored not a German heroine, but a wartime Soviet parachute agent and Communist traitor. In 1995, the street officially took on a more traditional mantle, that of "Am Preussischen Landtag."

SOURCES:

Buchmann, Erika, and Komitee der Antifaschistischen Widerstandskämpfer in der DDR. *Die Frauen von Ravensbrück*. Berlin: Kongress-Verlag, 1961.

Hervé, Florence, and Ingeborg Nödinger. *Lexikon der Rebellinnen: Von A bis Z*. Dortmund: edition ebersbach, 1996.

Institut für Geschichte der Arbeiterbewegung, Berlin. *In den Fängen des NKWD: Deutsche Opfer des stalinistischen Terrors in der UdSSR*. Berlin: Dietz Verlag, 1991.

Jacobeit, Sigrid. *Kreuzweg Ravensbrück: Lebensbilder antifaschistischer Widerstandskämpferinnen*. Cologne and Leipzig: Röderberg Verlag-Verlag für die Frau, 1987.

————, and Elisabeth Brümann-Güdter. *Ravensbrückerinnen*. Berlin: Edition Henrich, 1995.

Jahnke, Karl Heinz. *Ermordet und Ausgelöscht: Zwölf deutsche Antifaschisten*. Freiburg im Breisgau: Ahriman-Verlag, 1995.

Karau, Gisela. "Wilhelm Pieck vor 120 Jahren geboren. Entschlossen zu Berija marschiert," in *Neues Deutschland* [Berlin]. January 3, 1996, p. 10.

Kramer, Jane. "The Politics of Memory," in *The New Yorker*. Vol. 71, no. 24. August 14, 1995, pp. 48–54, 56–65.

Kraushaar, Luise. *Deutsche Widerstandskämpfer: Biographien und Briefe*. 2 vols. Berlin: Dietz Verlag, 1970.

Malvezzi, Piero, and Giovanni Pirelli, eds. *Und die Flamme soll Euch nicht versengen: Letzte Briefe zum Tode Verurteilter aus dem europäischen Widerstand*. Zurich: Steinberg-Verlag, 1955.

Panitz, Eberhard. *Käte Niederkirchner: Eine biographische Erzählung*. Revised ed. Schkeuditz: GNN Verlag Sachsen, 1995.

————. "Käte Niederkirchner: Eine deutsche Gewissensfrage," in *Neues Deutschland* [Berlin]. December 17–18, 1994, p. 9.

Partington, Paul G. *Who's Who on the Postage Stamps of Eastern Europe*. Metuchen, NJ: Scarecrow Press, 1979.

Salomon, Eleonore. "'Ich hätte doch so gern die neue Zeit erlebt': Käte Niederkirchner," in *Beiträge zur Geschichte der Arbeiterbewegung*. Vol. 23, no. 1, 1981, pp. 94–110.

Umbenennungen. Berlin: Edition Luisenstadt, 1993.

Weber, Hermann. *Die Wandlung des deutschen Kommunismus: Die Stalinisierung der KPD in der Weimarer Republik*. 2 vols. Frankfurt am Main: Europäische Verlagsanstalt, 1969.

Zorn, Monika. *Hitlers zweimal getötete Opfer: Westdeutsche Endlösung des Antifaschismus auf dem Gebiet der DDR*. Freiburg im Breisgau: Ahriman-Verlag, 1994.

Zörner, Guste, ed. *Frauen-KZ Ravensbrück*. Frankfurt am Main: Röderberg-Verlag, 1982.

John Haag,
Associate Professor of History,
University of Georgia, Athens, Georgia

Nielsen, Alice (c. 1870–1943)

American singer of light and grand opera. Born on June 7, around 1870 (some sources cite c. 1868), in Nashville, Tennessee; died on March 8, 1943, in New York City; daughter of Erasmus Ivarius Nielsen (a laborer) and Sarah (Kilroy) Nielsen (a department store worker); educated at St. Teresa's Academy; married Benjamin Nentwig (a church organist), in 1889 (divorced 1898); married LeRoy R. Stoddard (a plastic surgeon), in 1917 (divorced); children: (first marriage) Benjamin.

Became a star with The Bostonians (1896); played the leading role in The Serenade; *founded the Alice Nielsen Comic Opera Company (1898); was the leading American female star in light opera (late 1890s); made grand opera debut in Italy (1903); played roles in* Don Giovanni, Le Nozze di Figaro, La Bohème, Il Barbiere de Siviglia, Don Pasquale, L'Enfant Prodigue, *and* The Sacrifice.

Born on June 7, around 1870, Alice Nielsen grew up with her four siblings in Kansas City, Missouri. Her father reportedly died of wounds received during his service in the Union Army, and her mother supplemented her pension as a soldier's widow through work in a department store. Nielsen indulged her love of singing early on by performing on city sidewalks and collecting pennies for her songs. She had little formal training as a singer beyond her experience in a church choir and some instruction from a local music teacher, but her talent earned her a major role in a juvenile-company production of Gilbert and Sullivan's *Mikado* around 1886.

Nielsen's love of the stage won out over her first husband Benjamin Nentwig, a church organist. They married on May 7, 1889, but separated soon after the birth of her first and only child, Benjamin. Leaving her young son in the care of her in-laws, she formed the Chicago Church Choir Company with three other young singers and a manager and embarked on a brief, unsuccessful tour through Missouri. Nielsen then joined the Burton Stanley traveling opera company, which eventually took her to California. There she was invited to join the Tivoli Opera Company, and studied with **Ida Valerga**, one of the company's stars. Nielsen made her debut in a starring role in Donizetti's *Lucia di Lammermoor*.

However, it was not until 1896, when she joined The Bostonians, at the time the country's premiere light opera company, that she found true fame as a singer. Nielsen's rich voice and impressive range, combined with a natural charm and enthusiasm, quickly launched her from understudy roles to the leading role of a new operetta, *The Serenade*. Her success in this part was such that she decided to form her own company, the Alice Nielsen Comic Opera Company, in 1898. During its two-year existence (at the end of which she was called "the leading woman star in light opera on the American stage"), the

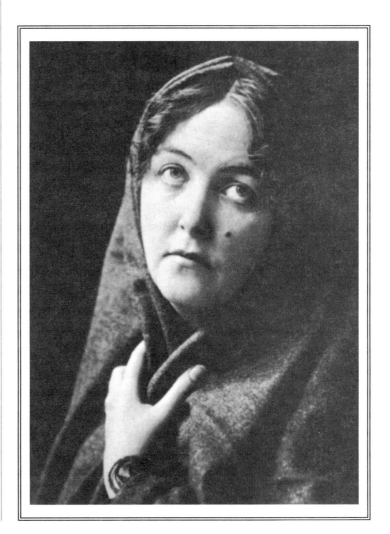

Alice Nielsen

company's most important production was *The Fortune Teller*, which had successful runs in New York and London. While in England, Nielsen found many admirers, including the impresario Henry Russell, Jr., and patrons who financed her training for grand opera and arranged for her to perform for the king. After studying in Italy, she made her operatic debut in Naples in December 1903. There, she also made the acquaintance of actress *Eleonora Duse, and the two toured together for a time.

Nielsen sang several important roles with the Royal Opera at Covent Garden in London beginning in the spring of 1904, including Zerlina in Mozart's *Don Giovanni*, Susanna in *Le Nozze di Figaro*, and Mimi in Puccini's *La Bohème*. In addition to these celebrated productions, she played Rosina in Rossini's *Il Barbiere de Siviglia* and Norina in Donizetti's *Don Pasquale* for the New Waldorf Theater in London. The production of the latter opera also toured the United States, and in 1909 Nielsen joined the Boston Opera Company. She played Lia in the first American production of Debussy's *L'Enfant Prodigue* in 1910, and created the role of Chonita for Frederick Converse's *The Sacrifice* the following year. Nielsen also made occasional appearances with the Metropolitan Opera Company during this time, and in 1917 returned to operetta in Rudolf Friml's *Kitty Darlin'*. That same year, she married a plastic surgeon from New York City, LeRoy R. Stoddard, whom she would later divorce.

Between 1921 and 1923, Nielsen gave a series of concert recitals with the Boston Symphony Orchestra. She then lived quietly in New York City, almost wholly dependent upon the financial support of friends, until her death on March 8, 1943.

SOURCES:

James, Edward T., ed. *Notable American Women, 1607–1950*. Cambridge, MA: The Belknap Press of Harvard University Press, 1971.

McHenry, Robert, ed. *Famous American Women*. NY: Dover, 1980.

Jacqueline Mitchell,
freelance writer, Detroit, Michigan

Nielsen, Asta (1881–1972)

Danish-born actress who was one of the earliest and greatest stars of silent movies. Born in Copenhagen, Denmark, on September 11, 1881; died in 1972; attended children's school of Copenhagen's Royal Theater; married Peter Urban Gad (who directed her in 30 films); married four more times; children: (first marriage) one daughter.

Filmography in Germany, except as noted, includes: Afgrunden *(The Abyss, Denmark, 1910)*; Ved Faenslets Port *(Denmark, 1910)*; Livets Störme *(Denmark, 1911)*; Belletdanserinden *(Denmark, 1911)*; Den Sorte Dröm *(Denmark, 1911)*; Der fremde Vogel *(1911)*; Der schwarze Traum *(1911)*; Die Sünden der Väter *(1911)*; Zigeunerblut *(1912)*; Die arme Jenny *(1912)*; Das Mädchen ohne Vaterland *(1912)*; Der Totentanz *(1912)*; Engelein *(1913)*; Die Filmprimadonna *(1913)*; Die Suffragetten *(1913)*; Der Tod in Sevilla *(1913)*; Elena Fontana *(1914)*; Die ewige Nacht *(1914)*; Das Feuer *(1914)*; Die Tochter der Landstrasse *(1914)*; Weisse Rosen *(1914)*; Zapatas Bande *(1914)*; Das Liebes-ABC *(1916)*; Das Eskimo-Baby *(1917)*; Die Rose der Wildnis *(1917)*; Der Fackelträger *(1918)*; Das Ende vom Lied *(1919)*; Rausch *(Intoxication, 1919)*; Der Idiot *(The Idiot, 1920)*; Der Reigen *(1920)*; *(also producer, starred in title role)* Hamlet *(1920)*; Die Spielerin *(1920)*; Die geliebte Roswolskys *(1921)*; Irrende Seelen *(1921)*; *(as *Mata Hari)* Die Spionin *(1921)*; Die Buchse der Pandora *(Pandora's Box, 1922)*; Fräulein Julie *(Miss Julie, 1922)*; Vanina Vanini *(Vanina, 1922)*; Erdgeist *(1923)*; I.N.R.I. *(Crown of Thorns, 1923)*; Die Frau im Feuer *(1924)*; Hedda Gabler *(1924)*; Lebende Buddhas *(1924)*; Die freudlose Gasse *(Street of Sorrow or The Joyless Street, starring *Greta Garbo, 1925)*; Atheleten *(1925)*; Die Gesunkenen *(The Sunken, 1925)*; Dirnentragödie *(Tragedy of the Street or Women Without Men, 1927)*; Gehetze Frauen *(1927)*; Kleinstadtsünden *(Small Town Sinners, 1927)*; Laster der Menschheit *(1927)*; Unmögliche Liebe *(Impossible Love, 1932)*.

"Incomparable" Asta Nielsen was born in Copenhagen, Denmark, in 1881, at a time of extreme poverty and illness for her family. Her autobiography *The Tenth Muse* describes the harsh conditions under which her mother toiled to make enough money for a household of four to survive, especially during her father's extended illnesses. As well, Asta's beloved sister, **Johanne**, suffered from rheumatic fever throughout her life which several times brought her to the point of death. At age 14, Nielsen was expected to earn her living as a servant or shop assistant. She had, however, set her heart on a career in the theater, as her only opportunity to express her grief at the death of her father and the continuous sufferings of her sister. She wanted to speak for all the sick, poor, and suffering in the world. Expectedly, Asta's mother disapproved of her daughter's choice of occupation which seemed farfetched and unproductive. Johanne, however, supported Asta's dreams, both emotionally and financially, with her meager earnings as a factory worker.

Asta's determination brought her to the Royal Theater of Copenhagen, where a director took an interest in her and trained her for a debut there. Disenchanted with the possibilities for advancement, she joined a smaller Copenhagen theater and subsequently went on a tour of Scandinavia doing minor parts. Back in Copenhagen, she played at The New Theater before her debut in 1910 in the silent film *The Abyss*. It was written by the artistic director of the theater (who was also her husband), Peter Urban Gad. The film was a smashing success, a breakthrough for Asta as well as for the Danish film industry. Nielsen's ability to convey the emotions of her character without a single word was unsurpassed. She understood the demand for genuine expression and asked that her solo parts be filmed without prior rehearsals. In role after role, she lent her unique talent for mime to present the fate of "sad ladies of unfortunate virtue."

After her debut, film offers poured in from Germany, which was then moving into the forefront of film production. By 1911, she was Germany's leading movie star, known as the "Duse of the Screen." Nielsen would appear in 70 films. In 1920, she formed her own company, Art Film, and made *Hamlet* with herself in the title role. In 1932, she returned to the stage where she played the lead in *Romantik* and appeared as *****Alphonsine Plessis** in *The Lady of the Camelias*. She acted in one sound film, *Impossible Love* (1932), before returning to Denmark for political reasons.

In 1961, Nielsen received the German film industry's medal of honor and in 1963 was accorded both Germany's gold medal of achievement and an honorary prize from the Danish government. In 1969, she received the Danish Authors' prize for her memoirs *The Tenth Muse* (*Die Tiende Muse*).

SOURCES:

Nielsen, Asta. *Den Tiende Muse*. Copenhagen: Gyldendal, 1966.

Robinson, David, ed. *The History of World Cinema*. NY: Stein and Day, 1973.

Shipman, David, ed. *The Story of Cinema*. NY: St. Martin's Press, 1982.

Inga Wiehl,
Yakima Valley Community College, Yakima Valley, Washington

From the movie Engelein, *starring Asta Nielsen.*

Niemann, Gunda (1966—)

German speedskater. Name variations: Gunda Niemann Kleemann; Gunda Niemann-Stirnemann. Born on September 9, 1966, in Sondershausen, Germany; married.

Won the European championships (1989–92, 1994–96) and came in second (1997); won the World championships in the 5,000 meters by 5.30 seconds (1991) and by 6.55 seconds (1993); won Olympic gold medals in the 3,000 and 5,000 meters and a silver in the 1,500 meters in Albertville (1992); won an Olympic gold medal in the 5,000 meters and a bronze in the 1,500 meters at Lillehammer (1994); named "German Athlete of the Year" (1995); took first place at the World championships in the 1,500, 3,000, and 5,000 meters (1997).

The German speedskating champion Gunda Niemann began her spectacular career in 1983. From 1989 to 1992, she won consecutive European championships; two years later, she repeated another three-year reign (1994–96), then placed second in 1997. In 1992, in the Albertville Olympics, Niemann came into the 3,000-meter competition holding the world record time of 4:10.80, and edged out her training partner **Heike Warnicke** for a gold medal with a time of 4:19.90. Warnicke took a silver with 4:22.88; *****Emese Hunyady** of Austria won the bronze. In the 5,000 meters, three Germans stood on the podium when 5'5" Niemann took her second gold medal; Warnicke repeated for the silver, and *****Claudia Pechstein** placed third.

By the 1994 Olympics, in Lillehammer, Niemann was the overwhelming favorite in the 3,000 and 5,000; she had not lost a 3,000-meter race in three years, and in 1993 she had broken *****Yvonne van Gennip**'s 1988 world record in the 5,000 with a time of 7:13.29. But 450 meters into the race, Niemann fell when her left skate hit a lane marker. Russia's **Svetlana Bazhanova** won the gold medal; Hunyady came in second, and Pechstein was third. In the 5,000 meters, Pechstein beat out her teammate with a time of 7:14.37; Niemann placed second with 7:14.88. **Hiromi Yamamoto** of Japan came in third.

In the 1998 Olympics at Nagano, Niemann was once again the favorite, having placed first at the World championships in the 1,500, 3,000, and 5,000 meters in 1997. She was the last to skate in the 1,500 meters and had to skate alone: the other skater had dropped out because of flu. Even so, Niemann won a silver medal with a time of 1:58.66. *****Marianne Timmer** of the Netherlands took the gold with a new world record time of 1:57.58. In the 5,000 meters, Niemann became the first woman to skate under the seven-minute mark, with a time of 6:59.65. As Niemann circled the oval on her warm-down lap, with a stuffed animal under her arm, fans and fellow competitors applauded. Niemann shushed them, aware that there were two skaters to go. One of them was her teammate, Claudia Pechstein. A few minutes later, Pechstein became the second woman to skate under seven minutes with a time of 6:59.61, snatching the gold from Niemann's grasp by $\frac{4}{100}$ths of a second. But Niemann had her second silver medal of the Nagano games. She then went on to win the gold in the 3,000 meters; it was a German sweep. In doing so, Niemann equaled the Winter Games record of eight individual medals held by East German speedskater *****Karin Kania-Enke** and Norwegian cross-country skier Bjorn Dahlie.

Nienhuys, Janna

"Dutch Nurse of Sumatra" who was captured during World War II and interned in a Japanese concentration camp. Born in the Netherlands; attended high school in the town of Haarlem; attended the Sorbonne in Paris for one year; received R.N from Binnen Gasthuis, Amsterdam; married Hendrick Nienhuys (an agricultural consultant), around 1937; children: two daughters, Marieke and Caroline.

Janna Nienhuys was one of over 100,000 nurses of World War II who cared for the sick and injured in enemy-occupied villages, in prisoner-of-war hospitals, and in internment and concentration camps in war-torn countries. Called the "Dutch Nurse of Sumatra," Nienhuys saved the lives of many women and children in the Sumatran internment camps, where she and her two young daughters were also prisoners for three years.

Nienhuys was raised in the Dutch town of Haarlem, where she met and fell in love with her future husband Hendrick Nienhuys, the grandson of Jacobus Nienhuys, the founder of the Dutch Sumatra tobacco industry. They planned to marry and settle in Sumatra, where Hendrick intended to follow in his grandfather's profession. While Janna waited for Hendrick to finish his advanced agricultural studies and to serve in the Dutch military, she studied for a year at the Sorbonne in Paris, then returned home to attend teachers' college. Thinking that she might face some medical problems in the tropical climate of the East Indies, she impulsively enrolled for

nurses' training and after three years earned an R.N. from the Binnen Gasthuis in Amsterdam.

Janna and Hendrick finally married in 1937, and immediately left for Sumatra, settling on a tobacco plantation outside of Medan, where Hendrick was employed as an agricultural consultant. Their first house was primitive, without electricity or running water, but they had five dedicated Sumatran servants to take care of their every need. The couple had a daughter and enjoyed an idyllic life until 1939, when Hitler invaded Poland. Initial concern gave way to true alarm in April 1940, when Rotterdam was bombed, and the Nienhuyses realized that they were cut off from Holland entirely. In 1941, they traveled to the United States to visited Hendrick's parents, who had fled there from occupied Holland. When they returned, they took up residence in a more modern house in Medan. By that time, it was clear that Sumatra would figure highly in Japan's quest for territory, and to prepare for possible invasion, the Dutch women of Medan organized a Civil Defense Corps for which Janna, who had just given birth to her second daughter, taught a first-aid course.

Following the attack on Pearl Harbor, when the Netherlands East Indies declared war on Japan, Hendrick left his wife and children to fight for Sumatra. Meanwhile, Janna, the only trained nurse in the area, continued her Civil Defense work, readying the women of Medan for what appeared to be inevitable attack. They had their first hands-on experience in the wake of a Japanese air raid, during which a number of young Sumatran soldiers were injured. They performed magnificently, treating the wounded and keeping them comfortable until the Red Cross arrived to transport them to the hospital.

The small armies of the Dutch East Indies were helpless against the invasion of the Japanese, and on March 11, 1942, Janna was confronted by several Japanese soldiers stealing supplies from her kitchen larder. Days later, several officers entered her house without knocking and ordered her to pack her things and move out. Janna collected what household supplies she could carry and with her young children took refuge in the house of a friend. A month later, the entire town—now only women and children—was rounded up in the town square and then taken to a deserted rubber plantation, where they were interned under Japanese guard.

Placed in dozens of small houses originally built for Sumatran workers, the women and children lived six to each 9x9 room. They slept on the floor, and the able-bodied chopped trees and cleared land for planting, under the careful watch of their Japanese guards. Food, though scarce, was adequate for the adults, but not for the children, although the Sumatran women were expert at utilizing native plants for spices to enhance the bland food. Nienhuys quickly assumed the position of camp nurse, using what few medical supplies she had thought to pack with her household goods. She treated cuts and scrapes, tended to the malnourished children, and even delivered the babies of women who had conceived before their internment. Without a doctor to consult, she frequently relied on intuition and common sense, which worked in most instances, although a number of the younger children died during their first year in camp.

By the end of the first year, food rations were cut and hunger became an ever-present problem, and Janna feared more and more for her own children. She also knew nothing of her husband's plight, as news from the outside never reached the camp. The women were eventually ordered to pack up and once again march to the train, which transported them deep into the jungle. They were then marched through the rain and thick mud to yet another converted rubber plantation, surrounded by barbed wire. This time, they were housed in long wooden barracks with earth floors and wooden benches along the sides, providing them with no privacy. Sanitation was primitive and as the level of the wells sank, water was rationed. What food was available was inedible, and Janna was eventually forced to trade the treasured diamond she had hidden in one of the children's rag dolls for a single cup of rice. She continued to tend the sick and injured, although she was now completely out of supplies and there was little she could do but make her patients comfortable and see to it that they did not die alone.

In August 1945, the women first heard through the camp grapevine that the war had ended. The truth of the rumor became clear when British planes flying overhead dropped food parcels by parachute. British doctors also arrived in camp, bringing supplies and medicines. The Japanese provided the women with lists of prisoners who had died in captivity, and Nienhuys was relieved each time her husband's name was not included. One day in September, she was brought a note in her husband's handwriting. "Where are you?" it read. Janna scribbled a reply, hoping it would reach him, but there was never an answer.

The women prisoners were not immediately released, as the English occupation army had to arrange transportation and a place for them to

stay. They left camp in small groups, but Janna stayed on to tend the sick until the camp was emptied. Finally, she was free to go and was thankfully reunited with Hendrick, who had also been taken prisoner soon after the Japanese invasion of Sumatra. He had contacted beriberi in captivity, and was very ill. Over the next several months, Nienhuys performed her final wartime duty, nursing her husband back to health.

SOURCES:
McKown, Robin. *Heroic Nurses.* NY: Putnam, 1966.

Barbara Morgan,
Melrose, Massachusetts

Niepce, Janine (1921—)

French photographer. Born in Meudon, France, in 1921; degree in art and archaeology, Sorbonne, 1945.

A distant relative of pioneering French photographer Nicéphore Niepce, Janine Niepce was a trailblazer in her own right, becoming one of France's first women photojournalists. Born in 1921 into a family of vineyard owners in Meudon, France, Niepce graduated from the Sorbonne in 1945, then went to work for the bureau of tourism. In 1950, she opened Prix Niepce (of which she served as president), and in 1955 she joined Rapho, a photo agency in Paris. From 1960 to 1968, she participated in five traveling exhibitions organized by the minister of foreign affairs. She photographed in India (1963), Brazil (1968), and Cambodia and Japan (1970), and contributed photographs to a book on *Simone de Beauvoir (1978). From 1981 to 1985, she created photographic documentaries on men and women and new technology.

Niepce had two solo exhibitions: at the Musée Nicéphore Niepce, Chalon-sur-Saône, France (1979) and at the Centre Georges Pompidou in Paris (1983). The latter was titled "Des Femmes et des métiers non traditionnels." She was honored as a chevalier of the Ordre des Arts et Lettres in 1981 and received the Légion d'Honneur in 1985. In 1992, a retrospective of her work, "Janine Niepce, France 1947–1992," was mounted at the Espace Electra in Paris.

SOURCES:
Rosenblum, Naomi. *A History of Women Photographers.* NY: Abbeville Press, 1994.

Niese, Charlotte (1854–1935)

Prolific German author whose works, now forgotten, were extremely popular with the German middle class for nearly 50 years. Name variations: (pseudonym) Lucian Bürger. Born in Burg, on the island of Fehmarn, on June 7, 1854; died in Altona-Ottensen near Hamburg, on December 8, 1935; daughter of Emil August Niese (mother's name unknown); sister of Benedictus Niese (1849–1910, a noted professor of ancient history).

The vagaries of taste can consign a once-popular artist to oblivion. Such is the case of Charlotte Niese, a prolific German writer whose historical novels, set mostly in Northern Germany, were once immensely popular, selling hundreds of thousands of copies over a period of nearly half a century. Like many of her readers, she grew up in a pre-industrial world of peasant traditions and unquestioned adherence to moral, social, and political hierarchies. Although these began to be challenged in the final decades of the 19th century by the rise of cities, an assertive working class, women demanding equality, and intellectuals keen to create a new world order, the forces of tradition remained strong. Niese's many novels presented an idealized view of this older, and apparently more solid Germany. Her characters were morally untainted by modernity. The women were pure, the men instinctively patriotic, and the villages and towns in which they lived were permeated by a German *geist* of idealism, sacrifice for the greater good of the *gemeinschaft* (moral community), and belief in the power of a stern Lutheran God. None of these books remain in print today, and their author is essentially unknown, even among literary scholars.

Charlotte Niese was born in 1854 in the town of Burg on the North German island of Fehmarn where her father was a Lutheran pastor and school director. She grew up in Burg, as well as in the towns of Riesebye and Eckernförde. After her father died in 1869, Niese moved to Altona, where she prepared for her teacher-qualification examinations. She passed these with distinction in Schleswig and then worked for some years as a private tutor in aristocratic households, including the von Krogh family in North Schleswig, the Delius family in the Rhine Province, and the prestigious Holstein family (the Brockdorff-Ahlefelds) in Ascheberg. In 1881, Niese moved to Plön to live with her mother and began to write. To gather materials and experiences, she traveled to Italy and Switzerland. She was encouraged in her writing by one of her brothers, Benedictus Niese, a noted professor of ancient history. In 1886, Niese published her first novel, *Cajus Rungholt,* followed two years later by *Auf halbverwischten Spuren* (On Half-Obliterated Tracks). Set in

places she knew and loved in the north of Germany, these historical novels appealed to readers who wanted to be entertained.

Niese spent two years in the United States with another brother who lived there, and after her return to Germany published a memoir of her trip, *Bilder und Skizzen aus Amerika* (Pictures and Sketches from America, 1891). This book, mostly unknown and never translated into English, contains observations of an America on the eve of becoming a world power. It also provides insights into the mentality of a conservative woman exposed to ideas that threatened her world. From this time on, Niese was a successful author. Most of her novels and short stories were set in Holstein or in the area around Hamburg, places she knew and loved, and changed relatively little in content or mood over the next decades. To modern readers, these books appear simplistic in plot and moralistic in tone. The system of values in which they are grounded died in the trenches of World War I.

In her 1924 autobiography, *Von Gestern und Vorgestern* (From Yesterday and the Day before Yesterday), Niese remained convinced of the wisdom of traditional German ideals. Her books are a reflection of the strengths—and to a considerable degree, the illusions—of the German middle classes as they were thrown into a world of rapid change. When they came to power in the early 1930s, the Nazis claimed that they too were defenders of the traditional values of German *Kultur*. Many of the readers of Niese's books, still attracted to her sentimental, naive plots and characterizations, believed that Adolf Hitler would restore those ideals of Old Germany, purging the land of Jewish materialism and Marxist class hatreds. The simple world of rural Germany depicted in Niese's books could in fact never be restored. Only war resulted from Nazi pseudo-conservatism, and Charlotte Niese, who died in 1935 as an old, respected regional writer, was spared experiencing the destruction by firestorm of her beloved city of Hamburg in 1943. Opportunists to the end, the Nazis reprinted one of Niese's nationalist tales, *Das Lagerkind* (The Camp Child), in 1940, and reprinted 30,000 copies in 1944, no doubt as an act to restore morale.

SOURCES:

"Charlotte Niese," in *Tägliche Rundschau* [Berlin]. July 5, 1918.

Degener, Herrmann A.L. *Wer ist's? Zeitgenossenlexikon.* 4th rev. ed. NY: G.E. Stechert, 1909.

Kammerhoff, Ernst. "Charlotte Niese," in *Reichsbote* [Berlin]. June 7–9, 1914.

———. *Charlotte Niese.* Leipzig: Verlag für Literatur, Kunst und Musik, 1910.

Lüdtke, Gerhard, ed. *Kürschners deutscher Literatur-Kalender: Nekrolog 1901–1935.* Reprint ed. Berlin and NY: Walter de Gruyter, 1973.

Niese, Charlotte. *Bilder und Skizzen aus Amerika.* Breslau: Schottlaender Verlag, 1891.

———. *Das Lagerkind.* Stuttgart: Thienemann Verlag, 1944.

———. "Der Krieg und die Frauen," in *Tägliche Rundschau* [Berlin]. September 23, 1914.

———. *Von Gestern und Vorgestern: Lebenserinnerungen,* mit einer Vorrede von Reinhold Conrad Muschler. 3rd ed. Leipzig: F.W. Grunow Verlag, 1924.

"Niese, Charlotte," in Franz Brümmer, *Lexikon der deutschen Dichter und Prosaisten vom Beginn des 19. Jahrhunderts bis zur Gegenwart.* 6th revised ed. Nendeln, Liechtenstein: Kraus Reprint, 1975, Vol. 5, pp. 138–139.

Poeck, W. "Charlotte Niese," in *Deutsche Tageszeitung.* June 7, 1914.

Sagarra, Eda. "Quellenbibliographie autobiographischer Schriften von Frauen im deutschen Kulturraum 1730–1918," in *Internationales Archiv für Sozialgeschichte der deutschen Literatur.* Vol. 11, 1986, pp. 175–231.

Ward, Robert E. *A Bio-Bibliography of German-American Writers 1670–1970.* White Plains, NY: Kraus International, 1985.

Weber, B. "Charlotte Niese," in *Hamburger Nachrichten.* June 6, 1914.

John Haag,
Associate Professor of History,
University of Georgia, Athens, Georgia

Niese, Hansi (1875–1934)

Austrian actress-singer who was the darling of the Viennese stage for more than four decades. Name variations: *Johanna Niese; Hansi Niese-Jarno. Born Johanna Niese in Vienna, Austria, on November 10, 1875; died in Vienna on April 4, 1934; daughter of August Niese; married Josef Jarno (1865–1932, an actor and theater director), in 1899; children: daughter,* **Hansi Jarno** *(1901–1933, an actress).*

Still regarded as the most popular actress in the history of Vienna, Hansi Niese was born there into comfortable middle-class circumstances in 1875, her father being a German-born paper manufacturer. She was drawn to the stage early on and, at age ten, appeared in the role of Franzi in the long-forgotten play *Hasemanns Töchter*. Her debut, which took place in a tavern in the Viennese suburb of Speising, was made possible by the chance appearance of a modest touring company of actors, and by her insistence that she be allowed to act, despite her lack of stage experience. By 1890, even before she celebrated her 15th birthday, Hansi Niese was appearing on stage at the theater in the provincial town of Znaim. In 1891, she performed at the theater in

Czernowitz, Bukovina, a provincial but sophisticated administrative center far from Vienna.

Over the next few years, Niese rapidly became a seasoned actress, appearing in a number of the Habsburg Empire's provincial theaters, including those in Abbazia, Gmunden, and the spa resort of Karlsbad. As her experience and reputation grew, Niese, although still in her teens, rapidly ascended the professional ladder. Theater managers soon discovered that she also possessed a pleasant singing voice, and as early as 1891 she was appearing successfully in operettas in mostly ingenue roles. In 1893, not yet 18, Niese returned in triumph to her home city of Vienna, appearing before enthusiastic audiences at the Raimundtheater. Soon, Vienna's critics were vying for superlatives to praise her. The critical consensus was that the young actress was nothing less than the worthy successor to the triumvirate of **Therese Krones** (1801–1830), who in the 1820s had created the role of Youth in Ferdinand Raimund's classic play *Der Bauer als Millionär* (The Peasant as Millionaire), **Josephine Gallmeyer** (1838–1884), the darling of Vienna's theatergoers for several decades, and *Marie Geistinger (1833–1903), the beloved "Queen of the Viennese Operetta."

From 1893 to 1899, Niese performed with great success at the Raimundtheater. Her talent enabled her to avoid guilt by association with the theater's director, an anti-Semitic ideologue named Adam Müller-Guttenbrunn. Unlike many Viennese of her time, Niese was free of such prejudices. Her reputation continued to grow during these years, and in the summer of 1898 she performed at the Neues Theater in Berlin. The actor-director of the theater, Budapest-born Josef Jarno, invited Niese to return the next summer for another engagement. Their relationship soon became much more than a professional one, and in 1899 they were married in Budapest; the marriage would be long and happy. After two highly successful summer seasons in Berlin, Niese and her husband returned to Vienna. In February 1900, she appeared at Vienna's prestigious Theater in der Josefstadt, earning critical and popular acclaim for her performance in the title role of Radler's farce *Unsere Gusti* (Our Little Augusta). In 1901, the Jarno family grew by one when the couple's only child, a daughter named Hansi, was born.

Niese, by now a much-beloved and highly successful actress, was a perfect partner for Jarno, who has been described as one of the most energetic figures in the commercial theater in the early 20th century. As manager of both the venerable Theater in der Josefstadt and the considerably less prestigious Lustspieltheater, Jarno utilized his wife's acting talents and offered an overlapping program of plays. Substantial profits from light comedies gave him the funds to mount expensive and often risky new plays by controversial playwrights of the day, including Maeterlinck, Shaw, Strindberg, and Wedekind. Unlike Vienna's unadventurous establishment theaters, such as the Burgtheater and the Deutsches Volkstheater, Jarno's theaters brought the more open-minded among Vienna's theater-going public into contact with the best and newest trends in contemporary international drama. These plays, presented in what Jarno called his "literary evenings," were usually transformed into memorable experiences because of the presence on stage of Hansi Niese.

Among the more notable of Jarno's Vienna presentations in the first years of the 20th century was his production at the Lustspieltheater in 1906 of Arthur Schnitzler's *Zum grossen Wurstel*. In the Theater in der Josefstadt, among the many successes was the 1913 German-language premiere of Ferenc Molnár's *Liliom*, in a translation from the original Hungarian script by Alfred Polgar. This play, one of the last triumphs of the prewar Viennese stage, featured Jarno in the starring role and Niese in one of the major supporting roles. In the years before 1914, when Vienna's cultural life thrived as its society slid toward war, Niese enjoyed the adulation of much of Vienna. Her charm and unforced spontaneity in the roles—a number of them, like Buchbinder's 1907 operetta *Die Försterchristl*, specially written for her—made her extraordinarily popular. She became simply "die Niese"—a woman who embodied the simple, naive charm of old Vienna.

As time went by, Vienna's audiences became convinced that many of Niese's classic roles should be performed only by her. After she had appeared in 300 performances in one year in *Die Försterchristl*, it seemed inconceivable that any other actress could ever take that role. In a number of instances, this proved to be true, for as soon as she stopped performing in a play, it vanished from the stage. Playwright and novelist Arthur Schnitzler noted in his diary in November 1908, after having attended a "decent" performance in the Lustspieltheater, that her contribution to the drama had been *ausserordentlich* (extraordinary). Much later, in January 1923, after an evening at the Raimund theater, Schnitzler once again referred to Niese in his diary, simply describing her as one of the "great artists" he had been fortunate to experience during his lifetime.

Multifaceted, Niese performed not only in traditional Viennese operettas and farces, but by 1910 had mastered the art of dramatic acting as well. Above all, she appeared in many of the starring roles of the plays of Gerhart Hauptmann, including Rose Bernd, Frau John, Hanne Schäl, and Mutter Wolffen. After her husband bowed out of managing the Theater in der Josefstadt in 1923, Niese continued to perform in Vienna, appearing on the stages of most of the city's major theaters, including the Lustspieltheater, where she was a major drawing card from 1923 through 1927. From 1925 through 1931, Niese appeared on the boards of the Renaissancebühne, and during the 1928–29 season she also could be seen at the Carltheater. Besides making a number of phonograph recordings, Niese appeared in several silent films, but neither she nor the critics were completely pleased with her performances.

In the early 1930s, when the world was in an economic depression and brown-shirted hordes marched menacingly in Vienna's streets, Niese found herself facing the greatest challenges of her life. In January 1932, her husband died, leaving behind substantial debts. Niese felt obligated to repay them and appeared in films to earn money. This time, the films were talkies, and her performances in such productions as *Kaiserwalzer* (Emperor Waltz) and *Purpur und Waschblau* (Purple and Wash Blue) were among the best of her entire career, once again delighting her fans and creating many new ones as well. But life now would be filled with few triumphs, only tragedies, the worst of which was the death of her daughter Hansi. The young Hansi, who had herself become a successful actress of stage and screen, died in Vienna in March 1933. Her mother attempted to carry on, but the burden became too heavy to bear. Hansi Niese died suddenly of heart failure in Vienna, while attending a concert, on the evening of April 4, 1934. All Vienna mourned her passing, and she has since been honored in several ways, including being interred in an Ehrengrab (Grave of Honor Gruppe 14C/4) in the city's Central Cemetery. In 1952, a monument honoring Niese was unveiled at the Volkstheater.

SOURCES:

Ackerl, Isabella, and Friedrich Weissensteiner. *Österreichisches Personen Lexikon*. Vienna: Ueberreuter Verlag, 1992.

Bab, Julius. *Schauspieler und Schauspielkunst*. 3rd ed. Berlin: Oesterheld Verlag, 1926.

———, and Willi Handl. *Deutsche Schauspieler: Porträts aus Berlin und Wien*. Berlin: Oesterheld Verlag, 1908.

———, et al. *100 Jahre Deutsches Theater Berlin, 1883–1983*. Berlin: Henschelverlag Kunst und Gesellschaft, 1983.

Bahr, Hermann. *Glossen zum Wiener Theater, 1903–1906*. Berlin: S. Fischer Verlag, 1907.

———. *Rezensionen Wiener Theater, 1901 bis 1903*. Berlin: S. Fischer Verlag, 1903.

Biographical file, Arbeitsgemeinschaft "Biografisches Lexikon der österreichischen Frau," Institut für Wissenschaft und Kunst, Vienna.

Braunwarth, Peter Michael, Susanne Pertlik, and Reinhard Urbach, eds. *Arthur Schnitzler—Tagebuch 1903–1908*. Vienna: Verlag der Österreichischen Akademie der Wissenschaften, 1991.

———, *Arthur Schnitzler—Tagebuch 1923–1926*. Vienna: Verlag der Österreichischen Akademie der Wissenschaften, 1995.

Bund österreichischer Frauenvereine. *Frauenbilder aus Österreich: Ein Sammlung von zwölf Essays*. Vienna: Obelisk Verlag, 1955.

Czelechowski, Maria. "Hansi Niese," Ph.D. dissertation, University of Vienna, 1947.

Degener, Herrmann A.L. *Wer ist's? Zeitgenossenlexikon*. 4th rev. ed. NY: G.E. Stechert, 1909.

Fontana, Oskar Maurus. *Das grosse Welttheater: Theaterkritiken 1909–1967*. Vienna: Amalthea Verlag, 1976.

———. *Wiener Schauspieler: Von Mitterwurzer bis Maria Eis*. Vienna: Amandus-Edition, 1948.

Gregor, Joseph. *Geschichte des österreichischen Theaters von seinen Ursprüngen bis zum Ende der ersten Republik*. Vienna: Donau Verlag, 1948.

Havelka, Hans. *Der Wiener Zentralfriedhof*. Vienna: J&V Edition, 1989.

Hansi Niese in Ludwig Anzengruber's play Der Meineidbauer, Berlin, 1900.

Herzer, Rudolf. "Unbekanntes über Hansi Niese," in *Wiener Zeitung.* Vol. 245, no. 168. July 20, 1952, p. 4.

Kindermann, Heinz. *Theatergeschichte Europas, VIII. Band: Naturalismus und Impressionismus, I. Teil: Deutschland-Österreich-Schweiz.* Salzburg: Otto Müller Verlag, 1968.

Kosch, Wilhelm. *Deutsches Theater-Lexikon: Biographisches und bibliographisches Handbuch.* Vol. 2. Vienna: Verlag Ferdinand Kleinmayr, 1960, pp. 900, 1654.

Marktl, E. "Niese Johanna (Hansi), Schauspielerin," in Eva Obermayer-Marnach, ed., *Österreichisches Biographisches Lexikon 1815–1950.* Vol. 7, 1978, pp. 124–125.

Marktl-Futter, Edith. "Jarno, Hansi, geb. Niese," in *Neue Deutsche Biographie.* Vol. 10. Berlin: Duncker & Humblot, 1974, pp. 356–357.

"Mme. Hansi Niese," in *The Times* [London]. April 5, 1934, p. 12.

Niese, Hansi. "Hansi Nieses Werdegang. Von ihr selbst erzählt," in *Velhagen & Klasings Monatshefte* [Berlin]. Vol. 27, no. 3, 1913, pp. 551–555.

Yates, W.E. *Theatre in Vienna: A Critical History, 1776–1995.* Cambridge, England: Cambridge University Press, 1996.

John Haag,
Associate Professor of History,
University of Georgia, Athens, Georgia

Nietzsche, Elisabeth (1846–1935).

See Förster-Nietzsche, Elisabeth.

Nightingale, Florence (1820–1910)

Pioneer nurse and public-health advocate, who is considered one of the great heroines of Victorian England for her nursing work in the Crimean War. Born in Florence, Italy, on May 12, 1820; died in London, England, on August 13, 1910; buried in the family grave at East Wellow (in deference to her wishes, the offer of burial in Westminster Abbey was declined); daughter of William Edward Nightingale and Fanny (Smith) Nightingale; had one sister, Parthenope Nightingale; educated by governesses, by her father at home, and by extensive European travel; never married; no children.

Superintendent of a London nursing home (1853); served in the Crimean War (1854–56); had no subsequent official appointments but was a perpetual political lobbyist on health-reform issues.

Florence Nightingale was one of the great heroines of Victorian England, and tales of her selfless service in the Crimean War edified two generations of British children. Lytton Strachey tried to smash the myth when, in *Eminent Victorians*, he wrote that she was a "bitter creature" possessed by "a demon" and that she was one of the age's most ruthless and manipulative women. Both versions were exaggerations:

Nightingale was heroic *and* intolerant, just as she was both deeply traditional and, in her distinctive way, a precursor of feminism.

She was born in Florence in 1820, where her rich and leisured family was staying as part of a three-year tour, and named after the city. The Nightingales returned to England a year later and then divided their time between houses in London, Derbyshire, and the New Forest. Rich and privileged, Florence grew up with every material advantage and showed intellectual flair. Her father took command of her education when she was 12 and taught her Latin, Greek, Italian, and French in addition to history and mathematics. She also developed a passion for statistics and on a second family trip to Italy when she was 17 she recorded details of distances and speeds in her notebooks. That was also the year when she became convinced that God had called her to a special work, though for a long time she could not bring the nature of His call into sharp focus.

Attractive, intelligent, and popular, Nightingale won the attention of several suitors, but she turned down the two most ardent of them, her cousin Henry Nicholson and the poet and parliamentarian Richard Monckton Milnes. She found the family's perpetual round of social calls and the restraints imposed on her as a young heiress irksome, and began to withdraw into long reveries which her family interpreted as signs of possible mental illness. Feeling trapped, and often involved in bitter arguments with her mother and sister, she even considered suicide, and sank into ever lower spirits in the late 1840s and early 1850s as she turned 30.

Gradually, she determined that her vocation was nursing. The family was horrified. The social status of nurses was low; contemporary cartoons show nurses as slovenly drunkards, often promiscuous. The Nightingales wanted to protect their gifted daughter from what they saw as a degrading waste of her life. One biographer describes the hospitals of the era, in which Nightingale proposed to work:

> The huge wards, with beds jam packed together, were filthy, their floors and walls saturated with blood and ordure, and the "hospital smell" was such as to induce nausea in anyone entering a ward for the first time. The patients were filthy and verminous; bedding stank and was seldom changed; infections of every kind were prevalent; gangrene was rife. The surgeons with their blood-bespattered clothes and unsterilized knives spread infection as well as agony and terror among their patients.

Florence
Nightingale

After a long succession of arguments with her family, she went to Kaiserwerth, in Germany, where a nursing school had been established. There she learned the elements of nursing, on the basis of which she was able, two years later, to get a job as superintendent of the Institution for the Care of Sick Gentlewomen in London's Harley Street. Her parents were totally opposed to this work, and the privileged society ladies on the home's board were amazed at Nightingale's efficiency and her unseemly stubbornness to get her own way. From the beginning, she was interested

as much in organization as in actual hands-on nursing, though in this job she had to do a great deal of both, and teach her employees by example. The next year, 1853, she nursed the dying in one of London's worst cholera epidemics.

In 1854, Britain went to war against Russia in the Crimea. The war was made famous by the Charge of the Light Brigade, a notable disaster in British military annals, soon to be commemorated in Alfred, Lord Tennyson's poem. The blundering of the British military leadership was reported by William Russell, a London *Times* correspondent. Russell also reported that British casualties of the war were being ill-treated at inadequate hospitals in the Turkish town of Scutari, across the Black Sea from the Crimea. Florence Nightingale, reading Russell's reports, resolved to help, and set out for Constantinople with 38 volunteers, half of them nurses of the old type whose only motive was the prospect of regular pay. Most of the rest were Roman Catholic sisters, whose presence scandalized the Anglican Church establishment. In her preparations, however, Nightingale was backed by Sidney Herbert, secretary of state, who had earlier befriended her and admired both her skill in planning and her determination.

At times, among her intimates, [Florence Nightingale's mother] almost wept. 'We are ducks,' she said with tears in her eyes, 'who have hatched a wild swan.' But the poor lady was wrong; it was not a swan that they had hatched; it was an eagle.

—Lytton Strachey

For a privileged woman to appear at the scene of a war, amid the gruesome carnage of a military hospital, there was no precedent in British history. Dr. Menzies, the head of the hospital, and the army's medical chief, Dr. John Hall, were unhelpful and resentful, especially as Nightingale quickly discovered that they had neglected elementary sanitary arrangements. The building, a former Turkish army barracks, was immense but virtually unfurnished—there were no tables in the place, even for operations, and no cooking equipment to feed the thousands of sick and wounded men. In Strachey's vivid description:

> Huge sewers underlay the building, and cesspools loaded with filth wafted their poison into the upper rooms. The floors were in so rotten a condition that many of them could not be scrubbed; the walls were thick with dirt; incredible multitudes of vermin swarmed everywhere.

Nightingale at once began to spend money which a *Times* subscription had raised, on suitable food, stoves, linens, and other supplies. The doctors' early resistance to having nurses at work in the wards evaporated when hundreds more wounded men appeared following the battle of Balaklava that winter. Nightingale witnessed amputations, sometimes without chloroform anesthetic, and the deaths of hundreds from wounds, shock, disease, and even starvation. She was vexed when Sidney Herbert, her ministerial ally, permitted another 46 volunteer women, none of them trained as nurses, to come from England to Scutari where they were more hindrance than help. She sent them on to another makeshift hospital at Therapia, and subsidized them with her own money to get their work properly under way. To her annoyance, this group, led by Mary Stanley, who was in the process of converting to Catholicism, spent as much time on religious as on medical work, despite the horrible conditions. From both groups, some nurses had to be sent back to England for drunkenness and sexual improprieties.

At Scutari, Nightingale improved sanitation as far as possible, carried out repairs to a ruined part of the hospital and built a boiler-laundry on her own initiative and at her own expense. She arranged for the men to be laid out in all available spaces, including the corridors. Walking the rounds of the whole hospital, which she did every evening, carrying a lamp, gave rise to the sobriquet "Lady of the Lamp" about which Longfellow later wrote a sentimental poem. Soldiers stopped cursing in her presence and, it was widely reported, kissed her shadow as it passed by. These nightly rounds of the hospital encompassed four miles of corridors in all; one of Nightingale's assistants described it:

> It seemed an endless walk and was not easily forgotten. . . . Miss Nightingale carried her lantern, which she would set down before she bent over any of the patients. I much admired her manner to the men—it was so tender and kind. . . . The hospital was crowded to its fullest extent. The building, which has since been reckoned to hold, with comfort, seventeen hundred men, then held between three and four thousand.

It needed great presence of mind for Florence Nightingale to remain patient in the face of remediable obstacles. Keeping her temper while confronting military obstructionism and red tape required superhuman self-control. Often food, linen, shirts, boots, and other vital supplies were landed at Scutari, but she was forbidden to use them until they had been guided

Florence Nightingale (center) at Scutari during the Crimean War.

through official army channels, which could take weeks or even months.

The winter of 1854–55 witnessed an outbreak of scurvy among the neglected men, and hundreds were disabled by frostbite. In the worst weeks of bitterly cold weather, three-quarters of the British army (which was nearly 40,000 strong) was sick or wounded. Florence Nightingale sent a constant stream of angry but informative letters to Secretary of State Herbert, and he passed some of them on to Queen *Victoria, who sent her a letter of congratulation and a medal. Bit by bit, Nightingale remedied the worst abuses of the system but even so was powerless to prevent a death rate of more than 100 each week, many of which could have been prevented, even by the limited medical methods of the time. A mixture of military and medical disasters brought down the government early in 1855 and Herbert lost his position. Herbert's successor, Lord Panmure, also sympathized with Nightingale and organized a Sanitary Commission along lines she had suggested to investigate the Crimea. The Commission was led by John

Sutherland, who became a lifelong friend to Nightingale and was a pioneer in British public health and sanitation. Under his supervision, the Scutari water supply was purified, drains cleared, rubbish removed efficiently, beds replaced, and the walls whitewashed with lime.

When the weather was warmer, Nightingale crossed the Black Sea to visit the front lines at Balaklava and Sebastopol. There too, her determined reform work won the admiration and support of some officers, and the resentment and obstruction of others. She was doubtless a difficult, obstinate person, hated to be contradicted, and could not bear any signs of human weakness in those around her. After a year of working ceaselessly, she collapsed with a fever at Balaklava and was in imminent danger of death. News of her sickness reached England and set off a wave of grieving, for, by now, Nightingale was a national hero. A dispatch from the British commander Lord Raglan that she was recovering provoked national rejoicing. Though she returned to Scutari, the fever left permanent marks on her health. Now that the hospitals were in

good order, she turned to other reforms, trying to reduce drunkenness among the soldiers and to offer convalescents the chance to read or, for the many illiterates in the ranks, to learn reading for the first time. She also arranged a system whereby soldiers could send all or part of their pay back to families in Britain. This arrangement, which the men entered into confident of Nightingale's absolute trustworthiness, helped their families at home and, by removing disposable income, made drunkenness and gambling less of a temptation in the camps.

Nightingale stayed in the Crimea and Scutari for another year, plagued by rivalries among the services, jealousies among army medical personnel, and calumnies spread by women she had reprimanded. Angry and suspicious, at times she sounded paranoid and at her worst accused even her loyal followers of betraying her trust. Luckily, her good qualities outweighed these weaknesses, and she remained the center of popular and political enthusiasm at home. The secretary of state issued a clarifying order in March 1856 declaring that she was "the General Superintendent of the Female Nursing Establishment of the Military hospitals of the Army" and that "the Principal Medical Officer will communicate with Miss Nightingale upon all subjects connected with the Female Nursing Establishment, and will give his directions through that lady." It was a victory for her but it came only two weeks before the war ended, and after supervising the evacuation of the remaining hospital patients she prepared to go home.

Hating publicity and reluctant to face official celebrations, she traveled home incognito and appeared before her family in Derbyshire unannounced. She turned down all invitations except one from Queen Victoria, whom she visited at her Scottish home, Balmoral. She told the queen that the entire system of military medicine must be overhauled so that catastrophes like the Crimea would not recur in future campaigns. With the queen's backing, she helped organize a Parliamentary Royal Commission, and lobbied to make her old friend Sidney Herbert chair. As a woman, she could not be a member, but she wrote a massively documented 1,000-page account of her experiences in the war which served as the basis of the commission's deliberations. The burden of the report was that the army should improve its *preventive* medical arrangements and forestall epidemics by feeding, clothing, and caring better for its men before they fell sick. Through statistical studies, she found English barracks to be so unhealthy that even during peacetime the army's death rate was far higher than the general population's, even though it was recruited from among the nation's youngest and healthiest men. Bacteria and viruses had not yet been discovered, and the nature of disease transmission was not properly understood. Nightingale and her followers knew from firsthand experience, however, that lack of ventilation, lack of cleaning, and poor sanitation all made hospital wards more dangerous to their inhabitants and deduced that the same problems afflicting barracks would make them unhealthy too. Bad in England, these conditions were worse in India, and she devoted much time in the late 1850s and early 1860s to gathering detailed information about the vile conditions endured by soldiers in the Indian empire.

The commission reports she helped midwife were followed up by practical reforms, under the supervision of Herbert but with Nightingale as guiding genius. From this time forward, barracks and hospitals were built to new designs, with better ventilation, and the soldiers began to receive a better diet and more humane treatment. After further bureaucratic struggles, the Army built its own medical school, as Nightingale had asked, but still threw up obstacles to its success. Herbert, overcome by her exhausting demands and increasingly sick, died in 1861, aged only 51. Far from sympathizing in his last days, she hectored him to work harder than ever in the time remaining to him. Only after his death was she stricken with remorse at having imposed so heavily upon him. From then on, she grieved for him as "the Master" with almost the same ardor that Queen Victoria showed in lamenting the recently dead Prince Albert.

Nightingale's *Notes on Hospitals* (1859) outlined her plans for reforming both civil and military hospitals. Every detail caught her attention, and the book, frequently reprinted, became a guide to European and American cities and governments planning new medical facilities. She also tried to introduce systematic gathering of statistics so that the nature of diseases and their frequency, mortality rates, ages at death, and other basic health matters, could be tabulated for the whole country, something never previously attempted. *Notes on Nursing*, another book from 1859, was her most popular, and under its example the level of nursing care available in Britain began gradually to rise, stimulated by the launching of an experimental nursing school at St. Thomas' Hospital, London. Full of detailed suggestions for training effective nurses, *Notes for Nurses* included this telling passage:

I would earnestly ask my sisters to keep clear of both the jargons now current everywhere, of the jargon, namely, about the "rights of women," which urges women to do all that men do, merely because men do it, and without regard to whether this *is* the best thing women can do; and the jargon which urges women to do nothing that men do, merely because they are women. . . . Surely woman should bring the best she has, *whatever* that is, to the work of God's world, without attending to either of these cries.

She never gave any energy to the women's suffrage cause even though she agreed that women should have the suffrage; "I think no one can be more deeply convinced than I." She had learned instead how to intrigue effectively behind the scenes and how to win the loyalty and devotion of men in power. Many of the most prominent men in public life devoted themselves to her causes, often getting scant thanks in return but never freeing themselves from her grip. Her largest writing project was an 800-page book of philosophy and theology, *Suggestions for Thought to the Searchers after Truth Among the Artisans of England* (1860), which included her proofs of the existence of God. Lytton Strachey quipped that "her conception of God was certainly not orthodox. She felt towards Him as she might have felt towards a glorified sanitary engineer; and in some of her speculations she seems hardly to distinguish between the Deity and the Drains."

Ever since her return from the Crimea, Florence Nightingale had been sick, and by the late 1850s thought she was at the brink of death. In fact, she would live on for another 50 years, outliving most of her family and friends, but throughout the last five decades she was a permanent invalid, carried outside only rarely and living for the most part on a couch in her South Street house in London. She continued to work an exhausting schedule on reform projects, however, and was so busy that she often sent away visitors unless they had come on business. Even some of her best friends from earlier days were denied access and no one was too important to be turned away; she even refused to receive the queen of Holland who came on a courtesy call.

Among the many causes to which Nightingale gave her time and energy in later years were the alleviation of puerperal fever in childbirth wards, the relief of the sick poor in workhouse wards, and constant attention to the suffering of both civil and military populations in India. A long succession of viceroys visited her before setting off for the subcontinent, and although she never went there, she exerted her will at every level of Indian life in trying to improve sanitary conditions and nutritional standards.

In 1901, she virtually lost her eyesight but still lived on for another nine years in the care of devoted servants. She died in 1910, aged 90, believing that her most valuable work had been achieved not in the Crimean War but in the later decades, as nurses trained according to her methods spread throughout the empire and hospital standards improved everywhere. "In Miss Nightingale's own eyes," as Strachey wrote, "the adventure of the Crimea was a mere incident—scarcely more than a useful stepping-stone in her career. . . . For more than a generation [afterwards] she was to sit in secret, working her lever; and her real life began at the very moment when, in the popular imagination, it had ended." She was, unquestionably, the single most important source for the transformation of nursing and a major contributor to carrying out the ideals of public health in society.

SOURCES:

Bullough, Vern, Bonnie Bullough, and Marietta Stanton. *Florence Nightingale and Her Era: A Collection of New Scholarship.* NY: Garland, 1990.

Huxley, Elspeth. *Florence Nightingale.* NY: Putnam, 1975.

Goldie, Sue M. *I Have Done My Duty: Florence Nightingale in the Crimean War.* Iowa City: University of Iowa Press, 1987.

Strachey, Lytton. *Eminent Victorians,* 1918 (reprinted by Chatto & Windus, 1948).

Vicinus, Martha, and Bea Nergaard. *Ever Yours, Florence Nightingale: Selected Letters.* Cambridge, MA: Harvard University Press, 1990.

Woodham-Smith, C.B. *Florence Nightingale: 1820–1910.* London: Constable, 1950.

SUGGESTED READING:

Cook, Sir Edward. *The Life of Florence Nightingale.* 2 vols. London: Macmillan, 1913.

Cope, Zachary. *Florence Nightingale and the Doctors.* London: Museum Press, 1958.

Nightingale, Florence. *Notes on Matters Affecting the Health, Efficiency and Hospital Administration of the British Army.* London: Harrson, 1858.

———. *Notes on Nursing: What it is and What it is Not.* London; Harrison, 1860.

Seymer, Lucy. *Florence Nightingale's Nurses: The Nightingale Training School.* London: Eyre and Spottiswoode, 1960.

COLLECTIONS:

For extensive collections of personal and political papers see W.J. Bishop and S. Goldie, *A Bio-Bibliography of Florence Nightingale.* London, 1962.

Patrick Allitt,
Professor of History, Emory University, Atlanta, Georgia

Niihau, queen of.

See Kapule, Deborah (c. 1798–1853).

Nijinska, Bronislava (1891–1972)

*Russian-born ballet dancer, choreographer and teacher. Name variations: Bronislawa Nijinskaya or Nijinskaia; (nickname) Bronia. Pronunciation: Ni-ZHIN-ska. Born Bronislava Fominichna Nijinskaia in Minsk, Russia, on January 8, 1891; died of a heart attack in Pacific Palisades, California, on February 22, 1972; daughter of Foma Nijinsky and Eleonora Nikolaevna Bereda Nijinskaia, both ballet dancers; sister of Vaslav Nijinsky (a ballet dancer); sister-in-law of *Romola Nijinska (1891–1978); attended Imperial Ballet School (St. Petersburg), 1900–08; married Alexander Kotchetovsky (a ballet dancer), in 1912; married Nicolas Singaevsky (a ballet dancer); children (first marriage): Irina (b. 1913); Leon.*

Bronislava Nijinska, known as Bronia, was born to a ballet family and spent her entire professional life in the world of ballet: first as a ballerina, then as a choreographer, and finally as a teacher of ballet. Her parents, Foma Nijinsky and **Eleonora Bereda**, were both Polish by na-

Bronislava Nijinska

tionality and dancers by profession. Her brother, Vaslav Nijinsky, was to become one of the greatest male dancers of the 20th century, and both of her husbands would be dancers.

Bronia was born in Minsk, where her father's troupe was performing, on January 8, 1891. She and her two older brothers spent their early years moving from city to city in European Russia, watching their parents perform. This nomadic existence came to an end sometime in the middle of the 1890s when Eleonora left her philandering husband and settled in St. Petersburg with her children. Their financial hardships were eased somewhat when Vaslav and Bronia were admitted to the Imperial Ballet School in the Russian capital. After eight years of rigorous training, entirely paid for by the state, Bronislava graduated "with distinction" in 1908.

In that same year, she joined the famed Maryinsky Theater and began the first of her three careers, that of a classical ballerina. She started in the corps de ballet but by 1911, when she left the company to protest her brother's dismissal, she was performing minor solo roles as well. During the Maryinsky's summer recess in 1909 and annually thereafter, Vaslav and Bronislava also danced with Serge Diaghilev's Ballets Russes in Paris. While never gaining the stature of her brother, Nijinska was given major roles in *Carnaval, Petrushka,* and other modern ballets put on by Diaghilev. She also helped her brother form his own company in 1914, recruited dancers for him in Russia, and served as his principal ballerina during a brief season in London.

In July 1912, Nijinska married a fellow dancer, Alexander Kotchetovsky, and the following year their first child, Irina, was born. Bronislava and her family spent the war years in Russia where her son Leon was born. In 1915, probably without her husband whom she subsequently divorced, she moved to Kiev, where she opened a ballet school, served as ballet mistress for the Kiev Opera, and started to develop her modernist theories concerning choreography. These ideas undoubtedly were influenced by the avant-garde and collectivist movements which swept through the Russian artistic community before and after the Bolshevik Revolution. In 1921, she left Soviet Russia, more for economic than political reasons, taking her two children and her mother on a hazardous journey to Austria.

Shortly after their escape, Nijinska started her second and most notable career, that of a choreographer for the Ballets Russes in Paris and Monte Carlo. She was in fact the first woman ever to gain prominence as a choreographer. Be-

tween 1921 and the end of 1924, she choreographed eight ballets for Diaghilev. These were a curious and uneven mixture of classical Russian technique, Soviet collectivism, and French impressionism. Her insistence on pure dance form, abstract sets, and stylized movement put her in the forefront of what came to be known as "neoclassical choreography." Her two masterpieces, Stravinsky's *Les Noces* (1923) and Poulenc's *Les Biches* (1924), are "her enduring monuments" and are still performed by ballet companies.

In January 1925, Nijinska left Ballets Russes over Diaghilev's hiring of a new choreographer, George Balanchine. For the next 13 years, she worked for at least eight different ballet companies in Europe and South America, sometimes as a choreographer, but increasingly as a ballet mistress or director. For a brief period from 1932 to 1934, she ran her own company, the Théâtre de la Danse, in Paris. In 1938, Nijinska moved to California where she opened a ballet school in Los Angeles and started her third career as a highly respected teacher of dance. After the Second World War, she supplemented her teaching duties by serving as ballet mistress for the Grand Ballet du Marquis de Cuevas. In the 1960s, she assisted Sir Frederick Ashton in mounting revivals of *Les Biches* and *Les Noces* in London's Covent Garden; these performances, in the opinion of Horst Koegler, "confirmed her reputation as one of the formative choreographers of the twentieth century." Her last position, at the age of 76, was as the director of the Buffalo Ballet. She died in California, shortly after the death of her second husband, Nicolas Singaevsky, on February 22, 1972.

SOURCES:

Buckle, Richard. *Nijinsky*. London: Weidenfeld and Nicolson, 1971.

Garafola, Lynn. *Diaghilev's Ballets Russes*. NY: Oxford University Press, 1989.

Koegler, Horst. *The Concise Oxford Dictionary of Ballet.* 2nd ed. London: Oxford University Press, 1982.

SUGGESTED READING:

Nijinska, Bronislava. *Early Memories*. Translated by Irina Nijinska and Jean Rawlinson. NY: Holt Rinehart and Winston, 1981.

<div align="right">

R.C. Elwood,
Professor of History, Carleton University, Ottawa, Canada

</div>

Nijinska, Romola (1891–1978)

*Hungarian-born writer and wife of the great Russian-born ballet dancer Vaslav Nijinsky. Name variations: Romola Nijinsky, Nijinskaia, or Nijinskaya. Pronunciation: Ni-ZHIN-ska. Born Romola de Pulszky in Budapest, Hungary, in 1891; died in Paris on June 8, 1978; daughter of Károly de Pulszky (director of the National Gallery of Hungary), and Emilia Markus (an actress); attended Lycée Fénelon (Paris); married Vaslav Nijinsky (a Russian ballet dancer), on September 10, 1913; sister-in-law of *Bronislava Nijinska (1891–1972); children: Kyra Nijinsky (1914–1998, a dancer); Tamara Nijinsky (b. 1920).*

In early March 1912, Romola de Pulszky went to the Budapest Opera House to watch the famed Ballets Russes perform. Much to her disappointment the company's star dancer, Vaslav Nijinsky, was indisposed. The 21-year-old woman returned the next night. This time, she was not disappointed. As she later recalled:

> Suddenly a slim, lithe, cat-like Harlequin took the stage. Although his face was hidden by a painted mask, the expression and beauty of his body made us all realize we were in the presence of genius. An electric shock passed through the entire audience. Intoxicated, entranced, gasping for breath, we followed this superhuman being, the very spirit of Harlequin incarnate; mischievous, lovable. The power, the featherweight lightness, the steel-like strength, the suppleness of his movements, the incredible gift of rising and remaining in the air and descending in twice as slow a time . . . proved that this extraordinary phenomenon was the very soul of the dance. With complete abandon the audience rose to its feet as one man, shouted, wept, showered the stage with flowers, gloves, fans, programmes, *pêle-mêle* in their wild enthusiasm. This magnificent vision was Nijinsky.

Nijinsky was indeed at the height of his career in 1912 and was widely considered to be the finest and most innovative male dancer in Europe. Some have since suggested that he was the greatest dancer of the 20th century.

Romola was soon obsessed with Nijinsky, becoming what a later generation would have called a ballet "groupie." She went to all of the remaining performances of the Ballets Russes in Budapest, followed the company to Paris for its summer season, and was in the audience when it moved on to Vienna. She attended all of Nijinsky's performances, watched rehearsals, and quizzed other dancers about him. Her pursuit became somewhat easier when the director of the Ballets Russes, Serge Diaghilev, allowed her to take private lessons with the group's ballet master with the view of eventually joining the corps de ballet. In the summer of 1913, she tagged along when the company, minus its director who feared seasickness, went on a tour of South America. To be closer to its star dancer, she bought a first-class ticket for the 21-day crossing of the Atlantic. On board, she had her first exten-

sive meeting with Nijinsky; by the end of the voyage, he had proposed; and on September 10, 1913, they were married in Buenos Aires.

It was a highly unlikely union: Vaslav was Russian, Romola Hungarian; he spoke Russian, Polish, a little French but no Hungarian; she was fluent in Hungarian, English and French but knew no Russian; he was a highly strung and reclusive dancer, she was a well-connected "society girl" with no obvious talents; he was the lover of the company's homosexual director, Serge Diaghilev. Their marriage, against all odds, lasted 37 years.

Romola Nijinska came from a wealthy and cultured background. Her father Károly de Pulszky was descended from a distinguished Polish family which had emigrated to Hungary in the 18th century. At the time of her birth, he was the founder and director of the Hungarian National Gallery. Her mother **Emilia Markus** was reputed to be the finest Hungarian dramatic actress of her time. According to Romola, her parents' marriage was not happy and not long lasting. Some time in the 1890s, her father was falsely accused of knowingly buying fake pictures in Italy for his gallery. He fled in disgrace to Australia and in 1899, at age 46, shot himself. Romola and her older sister **Tessa de Pulszky** were educated first by English governesses in Budapest and then, after their mother had remarried, at the Lycée Fénelon in Paris. She also studied both acting and ballet. Thanks to her upbringing, she was well mannered, stylishly dressed, and had many influential friends in the Hungarian artistic community. She thus had little difficulty being accepted on the fringes of the Ballets Russes and in financing her obsession.

Diaghilev, upon learning of his star's marriage, felt "robbed" of his favorite and out of spite fired him as the Ballets Russes' leading dancer and choreographer. Nijinsky was dumbfounded and hurt. He tried forming a company of his own in early 1914 and arranged for an engagement in London. Unfortunately, his business skills proved unequal to his artistic talents and the venture had to be abandoned after only 16 performances. In June 1914, Kyra, the Nijinskys' first child, was born. A month later, while they were on a family visit to Budapest, the First World War broke out, curtailing all possibility of further dancing in Europe. As a Russian citizen, Nijinsky and his immediate family were put under house arrest by the Austro-Hungarian government. It was not until April 1916, and then only after the intercession of Diaghilev, that Nijinsky and Romola were allowed to leave Vi-

enna and to rejoin the Ballets Russes in the United States. After a five-month tour of North America, Diaghilev used legal arguments to force Nijinsky to make another tour of South America. Distracted and embittered, he danced for the last time in public on September 26, 1917, in Buenos Aires.

When the Nijinskys returned to Europe, they chose to live in neutral Switzerland. Vaslav decreed that he would not dance for the duration of the war and that he would never again work for Diaghilev. Romola later argued that the unforgiving director of the Ballets Russes had intentionally undermined her husband's mental well being through various machinations. His isolation and inactivity in Switzerland may also have contributed to his frustrations. Whatever the cause, Nijinsky became increasingly withdrawn, subject to hallucinations, and sometimes violent. In the winter of 1918–19, he was diagnosed as suffering from schizophrenia. Romola resisted efforts by her parents to have him institutionalized and suggestions that she should divorce him. In the words of Richard Buckle, "now began Romola Nijinska's thirty years of hope, despair, struggle, poverty and heroism."

The family, increased in size by the birth of Tamara in June 1920, lived modestly for the next decade in St. Moritz, Vienna and Paris. In the search for a cure for her husband's illness, Romola tried Christian Science, faith healers, and a trip to Lourdes. In 1929, she was finally forced to institutionalize him so that she could earn some money through a lecture tour in the United States. She raised additional funds by writing Nijinsky's biography in 1933 and by editing his diary in 1936. A year later, through the use of new insulin shock therapy, Nijinsky's health improved sufficiently for Romola once again to care for him at home. They spent the Second World War in Hungary and Austria, cut off from all sources of financial support, and fearful that Vaslav would be arrested as a Russian citizen or exterminated because of Nazi policies concerning the mentally ill. After being liberated by the Soviet army in 1945, Romola and her ailing husband lived peacefully and uneventfully in Vienna, Mittersill, Austria, and finally in a cottage in the English countryside. Two years after Vaslav's death from kidney failure in 1950, Romola published a third book entitled *The Last Days of Nijinsky*. Little is known of her own last days. She died in Paris on June 8, 1978, at the age of 86.

SOURCES:
Buckle, Richard. *Nijinsky.* London: Weidenfeld and Nicolson, 1971.

Nijinsky, Romola. *Nijinsky*. London: Victor Gollancz, 1933.

R.C. Elwood,
Professor of History, Carleton University, Ottawa, Canada

Nikola, Helene Knez (1765–1842)

Serbian wife of Karageorge, the founder of Serbian independence. Born in 1765; died on February 8, 1842; daughter of Odor Knez Nikola; married George Petrovich Hospodar or Gospodar, known as Karageorge (Kara George or KaraGjorgje, 1752–1817), founder of Serbia independence and ruler of Serbia (r. 1804–1813); children: Alexander (1806–1858), prince of Serbia (r. 1842–1885).

Nikolayeva, Tatiana (1924–1993)

Russian pianist who played many premieres, especially of the composer Dmitri Shostakovich. Name variations: Tatiana Nikolayeva Petrovna; Tatyana Nikolaeva. Born in Bezhitz (near Bryansk), USSR, on May 4, 1924; died in San Francisco, California, on November 22, 1993.

Received the award of Honored Artist of the Russian Soviet Federated Socialist Republic (1955).

Tatiana Nikolayeva was born in the Soviet Union in 1924. At age five, she began piano study with her mother, then became a pupil of Alexander Goldenweiser at the Moscow Conservatory, graduating in 1947. After winning first prize in piano at the 1950 Bach Bicentennial Festival in Leipzig, she launched a significant career in the Soviet Union and Eastern Europe. She began to teach at the Moscow Conservatory in 1959, achieving the rank of professor in 1965. Nikolayeva played many premieres, including the Twenty-four Preludes and Fugues of Dmitri Shostakovich. She assisted the composer during the composition of this major work, which she often performed in public (she gave its world premiere performance in 1952) and recorded on two occasions. She was also a prolific composer, producing symphonies, piano concertos, chamber music and solo piano pieces. Nikolayeva suffered a fatal cerebral hemorrhage while performing the Shostakovich Preludes at a recital in San Francisco, and died in that city on November 22, 1993.

SOURCES:

Canning, Hugh. "Grand piano," in *Sunday Times* [London]. January 17, 1993, section 8, page 18.

Fanning, David. "Leaves from the Diary," in *Gramophone*. Vol. 68, no. 814. March 1991, pp. 1627–1628.

Gold, Gerald. "24 Fugues Played Twice by One Pianist," in *The New York Times*. August 4, 1991, section 2, p. 20.

Finch, Hilary. "Babushka plays Bach," in *The Times* [London]. January 13, 1993, p. 30.

Oestreich, James R. "Tatyana Nikolayeva's New York Debut (at Last)," in *The New York Times*. November 1, 1993, p. C15.

———. "Tatyana Nikolayeva, 69, Dead; Pianist and Shostakovich Expert," in *The New York Times*. November 24, 1993, p. D18.

"Pianist Has Stroke," in *The New York Times*. November 16, 1993, p. C16.

Richards, Denby. "Tatyana Nikolaeva at the Wigmore," in *Musical Opinion*. Vol. 116, no. 1381. January 1993, p. 9.

Rockwell, John. "Playing Variations on Shostakovich," in *The New York Times*. October 25, 1992, section 2, pp. 21, 40.

Yampol'sky, I.M. "Nikolayeva, Tat'yana (Petrovna)," in *New Grove Dictionary of Music and Musicians*. Vol. 13, p. 247.

John Haag,
Athens, Georgia

Niles, Blair (1880–1959)

American travel writer and novelist. Name variations: Blair Rice Niles. Born Mary Blair Rice in 1880 in Coles Ferry, Virginia; died in 1959; daughter of Henry Crenshaw Rice and Gordon (Pryor) Rice; educated at home and at a school in Massachusetts; married William Beebe (a naturalist, later divorced); married Robert Niles, Jr. (an architect).

Selected writings: Our Search for Wilderness *(1910);* Casual Wanderings in Ecuador *(1923);* Colombia, Land of Miracles *(1924);* Black Haiti *(1926);* The Biography of an Unknown Convict *(1928);* Condemned to Devil's Island *(1928);* Free *(1930);* Strange Brother *(1931);* Light Again *(1933);* Maria Paluna *(1934);* Day of Immense Sun *(1936);* Peruvian Pageant *(1937);* The James *(1939);* East by Day *(1940).*

Blair Niles was born in 1880 into one of the first families of Virginia, whose ties to the state dated back to early colonial days; closer to the time of her birth, her grandfather had been a member of Congress and later a Confederate general during the Civil War. Niles spent her formative years on her family's plantation in Coles Ferry, Virginia, although she also attended a school in Massachusetts. At a young age, she married naturalist William Beebe and accompanied him on scientific explorations around the globe. On their visits to Mexico, Venezuela, Trinidad, British Guiana, Europe, Egypt, Ceylon, India, Burma, Borneo, China, and Japan, Niles met many American and European scientists and explorers. She traveled through the wilderness on horseback, at times living in the jungle, and befriended everyone she met, from Indians to bandits to explorers. Upon

her return with Beebe from the South Pacific and South America, she wrote *Our Search for a Wilderness* (1910).

Following a divorce from Beebe, she married New York architect Robert Niles, Jr., an avid explorer-photographer with whom she began making expeditions to Central and South America. On a trip to French Guiana, she collected material for her immensely popular book *Condemned to Devil's Island* (1928). Niles was said to be the only woman ever to have set foot on the island that housed the infamous French penal colony, and she and her husband the only foreigners to have visited. Robert Niles' photographs appeared in her later works *Casual Wanderings in Ecuador* (1923), *Colombia, Land of Miracles* (1924), and *Black Haiti* (1926). Some of the success of her books has been attributed to the fact that she researched each country extensively before traveling there.

Following her trip to Devil's Island, in 1927 she began a study of male homosexuals (or "inverts," as homosexuals were then called) in New York City. This resulted in *Strange Brother* (1931), a novel about a sensitive young man and the tragedy that befalls him. Her other works include *The Biography of an Unknown Convict*

Anna Q. Nilsson

(1928), *Free* (1930), *Light Again* (1933), *Maria Paluna* (1934), *Day of Immense Sun* (1936), and *East by Day* (1940). A travel book, *Peruvian Pageant* (1937), earned her the City of Lima's gold medal on the 117th anniversary of the independence of Peru in 1938. Niles, who lived on Park Avenue in New York City when not traveling, also wrote short stories for magazines and book reviews, as well as *The James* (1939), about Virginia's James River, for Farrar & Rinehart's "Rivers of America" series. In 1941, she was awarded the ***Constance Lindsay Skinner** Medal by the Women's National Book Association and the Booksellers' League.

SOURCES:

Davidson, Cathy N., and Linda Wagner-Martin, eds. *The Oxford Companion to Women's Writing in the United States.* NY and Oxford: Oxford University Press, 1995.

Kunitz, Stanley J., and Howard Haycroft, eds. *Twentieth Century Authors.* NY: H.W. Wilson, 1942.

Lisa Frick,
freelance writer, Columbia, Missouri

Nilsson, Anna Q. (1889–1974)

Swedish-born actress of the silent era. Born Anna Querentia Nilsson, in Ystad, Sweden, on March 30, 1889; died in Hemet, California, on February 11, 1974; married Guy Coombs (an actor), in 1916 (divorced); married John Gunnerson (a shoe manufacturer), in 1923 (divorced 1925).

Selected filmography: Molly Pitcher *(1911);* War's Havoc *(1912);* Under a Flag of Truce *(1912);* The Siege of Petersburg *(1912);* The Soldier Brothers of Suzanna *(1912);* The Battle of Bloody Ford *(1913);* Prisoners of War *(1913);* Shenandoah *(1913);* The Breath of Scandal *(1913);* Uncle Tom's Cabin *(1913);* Retribution *(1913);* The Ex-Convict *(1914);* The Man in the Vault *(1914);* Wolfe—Or the Conquest of Quebec *(1914);* The Haunting Fear *(1915);* Regeneration *(1915);* Barbara Fritchie *(1915);* The Scarlet Road *(1916);* Who's Guilty? *(series, 1916);* The Supreme Sacrifice *(1916);* Infidelity *(1917);* The Moral Code *(1917);* The Inevitable *(1917);* Seven Keys to Baldpate *(1917);* Over There *(1917);* The Trail to Yesterday *(1918);* The Heart of the Sunset *(1918);* No Man's Land *(1918);* The Vanity Pool *(1918);* Auction of Souls *(1919);* Cheating Cheaters *(1919);* Venus in the East *(1919);* Soldiers of Fortune *(1919);* The Love Burglar *(1919);* Her Kingdom of Dreams *(1919);* The Luck of the Irish *(1920);* The Thirteenth Commandment *(1920);* The Toll Gate *(1920);* One Hour Before Dawn *(1920);* The Fighting Chance *(1920);* In the Heart of a Fool *(1920);* The Brute Master *(1920);* Without Limit *(1921);* The Oath *(1921);* The Lotus

Eater *(1921)*; What Women Will Do *(1921)*; Why Girls Leave Home *(1921)*; Three Live Ghosts *(1922)*; The Man from Home *(1922)*; Pink Gods *(1922)*; The Rustle of Silk *(1923)*; The Isle of Lost Ships *(1923)*; Hearts Aflame *(1923)*; Adam's Rib *(1923)*; The Spoilers *(1923)*; Ponjola *(1923)*; Innocence *(1923)*; Painted People *(1924)*; Flowing Gold *(1924)*; Between Friends *(1924)*; Broadway After Dark *(1924)*; The Side Show of Life *(1924)*; Vanity's Price *(1924)*; Inez from Hollywood *(1924)*; If I Marry Again *(1925)*; The Top of the World *(1925)*; The Talker *(1925)*; The Splendid Road *(1925)*; One Way Street *(1925)*; Winds of Chance *(1925)*; The Greater Glory *(1926)*; Midnight Lovers *(1926)*; Miss Nobody *(1926)*; Too Much Money *(1926)*; Her Second Chance *(1926)*; Easy Pickings *(1927)*; Lonesome Ladies *(1927)*; Babe Comes Home *(1927)*; The Masked Woman *(1927)*; Sorrell and Son *(1927)*; The Thirteenth Juror *(1927)*; Blockade *(1928)*; The Whip *(1928)*; The World Changes *(1933)*; The Little Minister *(1934)*; School for Girls *(1935)*; Paradise for Three *(1938)*; The Trial of Mary Dugan *(1941)*; They Died with Their Boots On *(1942)*; Crossroads *(1942)*; The Great Man's Lady *(1942)*; Cry Havoc *(1943)*; The Valley of Decision *(1945)*; The Secret Heart *(1946)*; The Farmer's Daughter *(1947)*; Cynthia *(1947)*; It Had to Be You *(1947)*; Fighting Father Dunne *(1948)*; The Boy with Green Hair *(1948)*; In the Good Old Summertime *(1949)*; Adam's Rib *(1949)*; Malaya *(1950)*; The Big Hangover *(1950)*; Sunset Boulevard *(1950)*; Show Boat *(1951)*; The Law and the Lady *(1951)*; An American in Paris *(1951)*; Seven Brides for Seven Brothers *(1954)*.

Born in 1889 in Ystad, Sweden, Anna Q. Nilsson was still a teenager when she began earning money to finance a trip to New York. Arriving in the city in 1907, she was spotted in front of Carnegie Hall by artist Carol Bickwith who asked the blonde beauty to pose for him. Nilsson subsequently gained some prominence as the Stanlow Poster Girl, which led to work as a photographer's model. In 1911, she signed with the Kalem Company, one of the early movie crews in New York, and that year made her debut in *Molly Pitcher*. Nilsson's career remained in high gear until 1925, when she shattered her hip in a horseback-riding accident. She endured three surgeries and a long recuperation before she was able to walk again, and her career suffered as a result. "At first I was heartbroken that my career was ended but I get over things very quickly," she said later. Nilsson made an easy transition into a more prosaic life, taking up travel and charity work. In 1933, she began accepting bit parts in talkies, although she found the industry much changed. "Everything was so different from when I had worked before and I never had much confidence in myself." She nonetheless continued to accept occasional cameos, including one playing herself in *Sunset Boulevard* (1950). Her last role was a bit in *Seven Brides for Seven Brothers* (1954). Nilsson, who had two brief marriages, spent her later years in a senior citizen project in Sun City, California, where she enjoyed some celebrity as a film personality.

SOURCES:

Katz, Ephraim. *The Film Encyclopedia*. NY: HarperCollins, 1994.

Lamparski, Richard. *Whatever Became of . . . ?* 3rd Series. NY: Crown, 1970.

Barbara Morgan,
Melrose, Massachusetts

Nilsson, Birgit (1918—)

Swedish soprano, best known for her major Wagnerian roles—all three Brünnhildes in the Ring *cycle, Isolde in* Tristan, *Elsa in* Lohengrin, *Elisabeth and Venus in* Tannhäuser. *Born in Vastra Karups, Sweden, in 1918; daughter of Ole Nilsson (a farmer); studied with Joseph Hislop; married Bertil Niklasson, on September 10, 1948.*

Formal debut with Stockholm Opera as Lady Macbeth (1947); appeared at Glyndebourne as Elektra in Idomeneo *(1951); appeared as Elsa in Bayreuth (1954), singing there for 16 years; made debut at Covent Garden (1957), Teatro alla Scala (1958), and Metropolitan (1959), singing there until her retirement (1982).*

Birgit Nilsson was universally regarded as a world-class Wagnerian soprano and heir to *Kirsten Flagstad. The power and force of her voice were legendary. Born in 1918 on a farm in southern Sweden, she was expected to follow the career path of her parents. Long days in the rows of beet fields cooled her enthusiasm for farming, but she did agree to attend a domestic science college. Her studies there came to an abrupt end, however, when a voice teacher from the town of Aastrup heard her sing. He arranged for an audition at the Stockholm Royal Academy of Music where she was accepted in 1941, earning first place over 47 applicants for two vacancies.

Nilsson made her informal debut in 1946 as Agatha in *Der Freischütz*. She was a substitution with only three days' notice and paid for it in nerves and tears and contradictory reviews; critics raved about the volume and musicality of her singing, while the Royal Opera labeled her "un-

musical and untalented." The fact that she premiered all but three of her later roles at the Royal Opera in Stockholm proves there was a change of opinion.

Her actual breakthrough came with the role of Lady Macbeth in 1947. She sang ten performances in three weeks and looked forward to each, she said, "the way a child looks forward to Christmas." The part was an invitation to demonstrate her considerable dramatic talent, underscored by her ability to glide from one pitch or tone to another with perfect progression.

Nilsson's first important foreign engagement was as Elektra in Mozart's *Idomeneo* at Glyndebourne in 1951. It was followed by her appearance as Elsa at Bayreuth in 1954 and as Brünnhilde in a complete *Ring* cycle in Munich in 1955. Best known for main Wagnerian roles, Nilsson eventually sang Isolde in *Tristan und Isolde,* all three Brünnhildes in the *Ring* cycle, Elsa in *Lohengrin,* and both Elisabeth and Venus in *Tannhäuser.* In the 1960s she and Wieland

Birgit
Nilsson

Wagner would collaborate at Bayreuth for memorable productions of the *Ring* cycle and *Tristan und Isolde.*

On her American debut in San Francisco in 1956, as Brünnhilde in *Die Walküric,* one critic called Nilsson "the nearest thing we have heard to Flagstad since Flagstad herself." London, too, hailed her as Flagstad's heir when she made her Covent Garden debut as Brünnhilde in the *Ring.* As Turandot, she opened the 1958–59 season at La Scala during the Puccini centenary celebration, a supreme distinction for a non-Italian performer. In 1959, her debut at the Metropolitan Opera received glowing front-page coverage in major New York City newspapers.

Although chiefly known as a Wagnerian— she performed *Tristan and Isolde* 209 times— Nilsson also sang Mozart and Strauss, Donna Anna in *Don Giovanni* and Elektra being her best roles. (Noting the importance of lighter roles for maintaining the flexibility of her voice, she once commented, "I have not been good to Mozart, but Mozart has been very good to me.") *Turandot, Tosca,* and *Aïda* also were Italian specialties. Before her retirement in 1984, Nilsson had appeared in all the great opera houses in the world, most frequently at the New York's Metropolitan Opera, Milan's La Scala, and London's Covent Garden. She had also sung for 16 summers at the Bayreuth Festival. Nilsson has left a fine series of recordings, including an especially distinguished *Ring* cycle in collaboration with conductor Sir Georg Solti. She spent some of her time during her retirement at the farm on which she had been born, and continued giving occasional, highly anticipated master classes through the 1990s.

SOURCES:

International Dictionary of Opera. Detroit, MI: St. James Press, 1993.
Nilsson, Birgit. *My Memoirs in Pictures.* Translated by Thomas Teal. NY: Doubleday, 1981.
Rosenthal, Harold. *Great Singers of Today.* London: Calder and Boyars, 1966.
Tommasini, Anthony. "An Isolde Legend Salutes the Future," in *The New York Times.* December 18, 1999. pp. B1, B16.

Inga Wiehl,
Yakima, Washington

Nilsson, Christine (1843–1921)

Swedish soprano. Name variations: Kristina. Born August 20, 1843, in Sjöabol, Sweden; died on November 22, 1921, in Stockholm; studied in Stockholm with Franz Berward; and with Wartel, Massé, and Delle Sedie in Paris; married Auguste Rouzaud, in

1872 (died 1882); married Count A. de Casa Miranda, in 1887 (died 1902).

Debuted at the Théâtre-Lyrique in Paris as Violetta in Verdi's La Traviata *(1864); debuted in same role in London (1864); created Ophélie in* Hamlet *for the Paris Opéra (1868); debuted at Covent Garden (1868); made U.S. debut at the Academy of Music in New York (1871); sang for the opening of the new Metropolitan Opera (1883) as Marguerite in* Faust.

George Bernard Shaw called Christine Nilsson, "the most gifted of our leading soprani. That position she has made good . . . by the force of her inborn dramatic instinct and the charm of a voice whose beauty asserts herself in spite of a most destructive method of production." Acknowledging that Nilsson could sing beautifully despite bad technique, Shaw also lauded her dramatic genius: "We are carried away in defiance of bad phrasing, breathing in awkward places, willful trifling with the tempo to the destruction of all rhythm, and any other liberty which the impulsive audacity of the singer may suggest. Her acting at the death of Valentine, once witnessed [in Gounod's *Faust*], cannot easily be forgotten; and in the church scene she attains the highest tragic expression." Clearly Nilsson overcame her vocal flaws with her dramatic abilities, as she was one of the leading sopranos of her day.

Christine Nilsson was born into an impoverished family on August 20, 1843, in Sjöabol, Sweden. As a girl, she sang and performed on the violin at popular gatherings. In 1857, M. Tornérhjelm, a man of wealth, recognized the beauty of her voice while she was performing at a fair in Ljungby and funded her musical studies. In 1860, she was heard in the concert halls in Stockholm and Uppsala, and then went to Paris, where, after four years' study, she made her debut in the role of Violetta at the Théâtre Lyrique on October 27, 1864.

Between that date and 1872, when she married Auguste Rouzaud (who would die in 1882), she was the leading prima donna. Her first appearance in London was in 1867. A year later, on March 9, she made her first appearance in the Paris Opera House as Ophélie in *Hamlet*. Although she began her career in France, Nilsson appeared in many European capitals. She became especially well known for her Queen of the Night in Mozart's *Die Zauberflöte* (*The Magic Flute*). Her voice was pure, flexible, and true in its upper range, though weaker in the lower. As her career progressed, the high notes were lost, but she had a powerful dramatic range with which to compensate.

She visited the United States in 1870, sang in St. Petersburg in 1872, in America in 1873–74 and 1882, in Germany and Austria between 1876 and 1877, as well as in Spain and Scandinavia. After appearing at the new Metropolitan Opera in 1883, Nilsson gave 59 performances in six months. She performed only until 1887, retiring after her second marriage to a Spanish count, A. de Casa Miranda.

SOURCES:

Franzén, Nils Olof. *Christina Nilsson: en svensk saga*. Stockholm, 1976.

Headland, T. *Christine Nilsson: the Songbird of the North*. Rock Island, IL: 1943.

John Haag,
Athens, Georgia

Christine Nilsson

Nimmo, Mary (1842–1899).

See Moran, Mary Nimmo.

Nin, Anais (1903–1977)

Twentieth-century avant-garde writer and poet, self-mythologized by the publication of her diaries, and famed for her unconventional lifestyle. Name variations: Anaïs Nin. Pronunciation: ANNA-ees Nin. Born on February 21, 1903, in Nuilly (near Paris), France; died of cancer on January 14, 1977, in Los Angeles, California; only daughter and oldest of three children of Rosa Culmel Nin (a singer of French and Danish extraction) and Joaquin Nin (a Spanish composer and concert pianist); attended public grammar schools in New York up to the sixth grade; left school at 15; self-educated; studied psychoanalysis in France under Otto Rank in the 1930s and 40s; married Hugh P. Guiler, also known as Ian Hugo, in Havana, Cuba, in early March 1923; married Rupert Pole (claimed she married him while still married to Guiler).

Parents separated (1914); moved from France to New York and began writing her extensive diary as a letter-collection to her estranged father (1914); returned to France (1930); published first book, D.H. Lawrence: An Unprofessional Study *in Paris (1932); returned to New York after World War II and settled in Greenwich Village; bought a printing press and released her own books; received first recognition in America (1944) for*

Under a Glass Bell, *illustrated with engravings by husband Hugh Guiler (Ian Hugo); published first volume of her Diary (1966); later practiced psychoanalysis, lectured at Harvard, and taught or tutored writing at the International College in Los Angeles.*

Selected writings: D.H. Lawrence: An Unprofessional Study *(Paris: E.W. Titus, 1932);* The House of Incest *(Paris: Siana Editions, 1936);* The Winter of Artifice *(Paris: The Obelisk Press, 1939, and NY: printed by hand on Nin's own press, 1942);* The All-Seeing *(NY: printed by hand on Nin's press, 1944);* Under a Glass Bell *(NY: printed by hand on Nin's press, 1944);* This Hunger *(NY: Gemor Press, 1945);* Ladders To Fire *(NY: E.P. Dutton, 1946);* Children of the Albatross *(NY: E.P. Dutton, 1947);* The Four-Chambered Heart *(NY: Duell, Sloan and Pearce, 1950);* A Spy in the House of Love *(Paris, New York, 1954);* Seduction of the Minotaur *(Denver: Alan Swallow, 1961);* The Diary of Anais Nin: 1931–1934 *(NY: The Swallow Press and Harcourt, 1966);* The Diary of Anais Nin: 1934–1939 *(NY: The Swallow Press and Harcourt, 1967);* Unpublished Selections From the Diary *(Athens, OH: Duane Schneider Press, 1968);* The Diary of Anais Nin: 1939–1944 *(NY: Harcourt, 1969);* The Diary of Anais Nin: 1944–1947 *(NY: Harcourt, 1971);* Delta of Venus: Erotica by Anais Nin *(NY: Harcourt, 1977);* Fire: From *A Journal of Love*: The Unexpurgated Diary of Anaïs Nin, 1934–1937 *(NY: Harcourt Brace, 1995);* Nearer the Moon: The Unexpurated Diary of Anais Nin, 1937–1939 *(NY: Harcourt, 1996).*

In 1914, shortly after her parents separated, Anais Nin, along with her mother and her two younger brothers, journeyed from their home in Spain, boarded a ship and crossed the Atlantic Ocean to begin a new life in America, specifically New York City. Nin was 11 years old. During her 13-day sea journey, she chronicled the events aboard ship in detail, including drawings of her departure and arrival. She intended to send a complete description of the trip and of the new country to her father with the hope that he would follow. Nin's letters were never sent, however; her mother felt the notes were too precious to mail overseas, and so they were kept safe. Out of these travel journals, conceived as letters to her estranged father, grew Anais Nin's immense diary: over 50 volumes' worth of personal chronology, written throughout her life. The manuscripts were drafted in longhand in her native French, and later in English, with selected sections in Spanish. Beginning in 1966, Nin allowed publication of her diaries after realizing that many of the people and ideas mentioned

within in them had influenced the shape of the world, and in particular the artistic community.

Nin's diaries have been treasured not only for their content but for their context, for she vividly describes the Paris art community of the 1930s and 1940s, recording her conversations and friendships with the likes of Henry Miller, *Martha Graham, *Maya Deren, and Isamu Noguchi. Her subjects are extraordinary, but it is her manner of description that is of the highest importance. She utilizes a "poetic style" of language that rebels against sterile, sparse prose, and once noted, "I intend the greater part of my writing to be received directly through the senses, as one apprehends painting and music." Perhaps because she learned English as her third language, or perhaps because of her innate talent, Anais Nin has become one of a handful of accepted American writers who are celebrated for their experimentation with the nature of text.

Anais Nin was born in Nuilly, near Paris, France, on February 21, 1903, the first of her parents' three children and their only daughter. Her father Joaquin Nin was a Spanish composer and concert pianist; her mother **Rosa Culmel Nin** was a dancer of Danish and French descent. Anais' childhood was spent in Europe, where she learned to speak Spanish and French with equal fluency. Upon separating from her husband, Rosa Nin decided to move to America with her three children, a decision that went against Anais' wishes. As a child, she maintained a great hope that her father would someday return to his family. Joaquin Nin never did come to America, choosing instead to remain in Europe to pursue his own career and life. Nin speculates, "It may have been my mother's wish to take us into another culture which he could not follow." Her father is mentioned frequently in her diary, and is alluded to in some of her fiction.

The America of her dreams was not at all similar to the New York that greeted Anais: she was expecting "Indian" tents and found instead tall skyscrapers blotting out the sun and the sky. Language became a major fascination. After learning English, she began utilizing it to express her ideas and emotions, and cultivated a passion for the language. Her writings in English display a distinctive quality of playing, or painting, with words. Nin felt that French was the language of her heart, Spanish was the language of her ancestors, and English was the language of her intellect. The writing in her diaries is explicitly trilingual; she uses whichever language best expresses her thought. At other times, access to different languages provides shelter from opposing

cultural ideals; in her early diary, on September 22 and 23, 1921, Nin can speak of the frank sexuality depicted in the journal of *Marie Bashkirtseff only in French. She writes, "I want to be free to be indignant, to be angry, to discuss her opinions with her, to contradict her, blame her, and with the heat of battle ahead of me, I find that French (the language of my heart) has more vigor and brilliance."

As a child, Nin exhibited a flair for the unconventional. She was not fond of American schooling from the outset, mostly because it strove to constrain her creativity and to regulate her free-form thoughts. In her early drawings, she depicted her school window with prison bars. At 15, she could no longer endure the restrictions put upon her and dropped out of school. When asked her motivation for quitting, Nin replied that her teacher had discouraged her persistent questioning and had criticized her use of "precious," "pretentious" and "over-literary" English. Nin never finished her formal education. Instead, she began to educate herself by reading the books in the public library, alphabetically from A to Z. At 16, she felt the need to attempt one college course, so she enrolled in a short-story class at Columbia University. Again, Nin was discouraged by structural rigidity. "They started to tell me that the stories I was writing had no beginning and no end," she said later, "something they're still telling me today." She dropped out of the course and pursued writing on her own.

Quitting school enabled Nin to dedicate time to her favorite pursuits of reading, writing in her diary, and studying, but only for a while. The Nin family was in part supported by a business in Cuba owned by Rosa's relatives. With the collapse of the sugar market after World War I, the family began to struggle financially, but Nin was forbidden by her mother to work until 1922, when their monetary situation demanded nothing less. She worked first with her mother, who had a job sewing and mending, but soon began modeling. Her change in social status, called a travesty by her wealthy Cuban relatives, is reflected upon in her early diary (largely unedited and released after her death). Nin herself was disappointed but not daunted. She was surprised by the physical exertion of working—in both modeling and sewing—and she was somewhat uncomfortable modeling and posing for a male photographer. However, she soon mastered her distaste and began to market herself profitably. She notes in her diary that she began seeking out those painters who were shunned by other models so that she would have

more work. Her popularity grew, and soon Nin was modeling not only for artists, but also for shops and fashion shows. In 1922, she was featured as a Gibson Girl for a *Saturday Evening Post* cover. Her diary entries contain musings about her own loss of innocence, and describe her feelings of exhaustion due to work, but they also focus on love.

"Love and Labor! That is now the sum of my life," Nin wrote in her diary in mid-1922. Around this time, she became serious about her relationship with Hugh Guiler, also known as Ian Hugo, who would become her husband about a year later. Although she had many suitors and had expressed deep love in her diary for her cousin Eduardo Sanchez, Guiler impressed her with his intellect, social class, and artistry. Educated to be a banker-businessman, he later became an artist and directed films, and would illustrate most of Nin's books. At the time of their courtship, he traveled often. When they did see each other, they would have long and much-valued intellectual conversations. Nin expresses

Anais Nin

feelings of anticipation for his return, professions of love, and—nearing the time of their marriage—reservations about marriage itself. They were wed in Havana, Cuba, in late 1923.

In general, Guiler is almost never mentioned in the diaries that were published while she was alive (and which she edited herself). Instead, the diaries make mention of many other important figures who were obviously very much a part of her life. Always drawn to the creative scene, she moved to Paris in 1930 and became active in avant-garde literary, dance, music and art circles. The 1930s Paris art scene is one of the most exciting and romanticized periods in European history. Freud had only recently (around 1905) exposed the existence of the subconscious and the possible meaning of dreams, and his ideas gained in popularity throughout the early 20th century. As a response to, or perhaps as a fore-shadowing of, Freud's work, Surrealism had sprung up in Europe, taking some form within all of the arts. Dada and Surrealism, as well as other types of creative rebellion against structure and tradition, were in full swing by the time Nin reached Paris, and she became a major theorist and practitioner of rebellion.

Whenever I felt I had to choose between two things, I always ended up taking it all in.

I never wanted to choose one against the other, but to harmonize and fuse them into one.

—Anais Nin

Nin's first book, *D.H. Lawrence: An Unprofessional Study,* an exploration of gender roles in artistic society, was published in French in Paris (1932). In it, Nin writes, "The modern woman desires also to build her own world directly, not through the man. The woman who creates a world directly is the artist-builder woman." Her publisher went bankrupt due to lack of interest in her books. Until 1961, when it was re-released in English, her work on Lawrence was almost unknown within the literary world. It informed her writing style immensely, however, as she tried to expand his theories in her fiction. "Lawrence was an important influence," she said, "because he sought a language for instinct, emotion, intuition, the most inarticulate parts of ourselves." In 1936, her *The House of Incest* was published. It, too, went unnoticed until much later. Despite the obvious setbacks, she continued to write, although she published only one other work in France.

While in Paris, Nin formed intimate and lasting friendships with many well-known fig-

ures, the same people who populate her published diary and whose association initially spurred public interest in her writings. These friends included Henry Miller, Antonin Artaud, Lawrence Durrell, and Dr. Otto Rank, a psychoanalyst and a contemporary of Freud. Nin studied with Rank and practiced psychoanalysis: in later interviews, she attributed her emotional stability and love of life and self to psychoanalysis. Infused both by psychoanalysis and the trends of her artistic community, Nin's work exhibits a dreamlike quality that has been both criticized and critically acclaimed. Her writings would continue to be influenced by her involvement in the 1930s Paris art scene long after she moved away.

Nin returned to New York in the early 1940s and settled in Greenwich Village, which boasted a community of artists much like the one in Paris: indeed, many of her old friends, now growing in fame as painters, sculptors, authors, filmmakers and dancers, were returning to post-World War II America. Encouraged by their society, Nin bought a printing press and began releasing her own books, illustrated by her husband's engravings. Each book had to be hand-set and hand-printed; the first, *Winter of Artifice* (1942), took eight months to just set. *Under a Glass Bell* (1944), a collection of short stories, was also completely set by hand. The results were worthwhile, however, for in 1944 *The New Yorker* literary critic Edmund Wilson wrote: "Perhaps the main thing to say is that Miss Nin is a very good artist, as perhaps none of the literary Surrealists is. 'The Mouse,' 'Under a Glass Bell,' 'Rag Time,' and 'Birth' are really beautiful little pieces." Nin was finally receiving some appreciation.

Her real success came with the release of her diary; published in four volumes (beginning in 1966), it covered her life from 1931 to 1947. The diary had "long been a legend of the literary world," as one critic wrote in the early 1940s. Nin edited each section before publication, opening her original diary manuscripts and typing out her words, rearranging "here and there, for clarity." She claimed to have retained about half of the original material, leaving out only the passages about people who would not appreciate mention. (Perhaps her husband was one of these.) The published portions focus mainly on her famous artist friends, her social life, and her writing. Many critics have cited the silences and discrepancies in the diary's contents, and have alluded to her succumbing to public pressure to expose the famous people with whom she was intimate. Other, more favorable, commentators

focus on her style and her underlying study of the female mind and of woman's place within a masculine social structure.

Nin's work can be, and often has been, analyzed in layers: at the outermost layer, she writes about her own interaction with famous friends. Another layer reveals a woman's analysis of daily living and loving, told with a budding feminist consciousness and a bohemian sense of autonomy. Beneath that, finally, can be found the question of intent and intentionality, for Nin mythologized her life through the device of her published diaries. Her editing process allowed her to recreate her life, omitting those details that she did not want to show the world while ostensibly exposing her private life. Her knowledge of life as a well-read woman, historical figure, artist-writer, wife and breadwinner impacts the recreation of her diary, and she writes the myth of her life, as she did her fiction, as a dreamlike series of meaningful events.

Another layer of Nin's work is the context of her life and writing. Her connection to fa-

mous men was obviously the catalyst in bringing about her popularity, for it began due to an upsurge in scholarship about the male writers and intellectuals whom she knew in the 1930s. Her friendship with Henry Miller was especially instrumental in the discovery of her work. In 1939, Miller released a glowing essay in praise of Nin's talents as a diarist which remained the main source of information about the diary before its publication. He writes, "Still a young woman she has produced on the side in the midst of an immensely active life, a monumental confession which when given to the world will take its place beside the revelations of St. Augustine, Petronius, Abelard, Rousseau, Proust and others." Such comparisons naturally made Miller's many devotees anxious to read Nin. Nonetheless, she has never received the same attention as Miller, and despite its power her work has remained largely unappreciated except as a tool for understanding those important men surrounding her life. In the "official" canon of 20th-century American literature, much of which was

From the movie Henry and June, *based on Nin's relationship with Henry and June Miller, starring Maria Medeiros as Anais, Fred Ward as Henry, and Uma Thurman as June.*

written by men, she is usually relegated to the subgroup of "women writers." Nin was acutely aware of her secondary position within this hierarchy. In a 1971 interview with **Priscilla English**, responding to the male critics who denigrated her work due to its focus on and through female characters: "I'm coming into my own; I've been rewarded. The attitude of the forties was very narrow, very chauvinistic in every possible way. . . . [F]or instance, Surrealism was a dirty word, a sort of curse. So was fantasy—to talk about dreams was insane." She seemed content with the improvement she saw in her own lifetime, and with her growing popularity.

The last ten years of Nin's life were rewarding ones. Her literature was finally being discussed; she lectured to thousands at Harvard and at the University of California at Berkeley; she began teaching at the International College in Los Angeles; and a documentary film, *Anais Observed: A Film Portrait of a Woman as Artist*, was made about her life. In 1974, 76 articles about Nin and her work were published. Happily, she was able to enjoy her own success before her health began to fail in the mid-1970s. She died of cancer on January 14, 1977. After her death, several editions of her diary, including more of the original material from her manuscripts, were released. Guiler, who survived her, donated a collection of her papers to the library at the University of California at Los Angeles, which includes her diaries, book manuscripts, letters, and other papers. The late 1970s also saw publication of two collections of erotic fiction—*Delta of Venus* and *Little Birds*—that she had written on commission from an older man in Paris early in her career. Nin had been paid $1 per page with explicit instructions to "leave out the poetry," but these stories, like her other fiction and nonfiction, resonate with her Surrealistic style.

Nin's published diaries, far from answering definitively questions about her life, only heighten readers' curiosity: what was she really like, and what really happened? Are her diaries a fictionalized version of reality, or an actualized version of fiction? The question probably cannot be answered. What is certain is that Nin has presented us with a *version* of her life story, written in her highly artistic style. Nin insisted on being photographed and filmed with soft-filtered lenses, making her pictures and movies slightly out of focus, dreamlike. She always dressed extravagantly for the public, claiming that she was creating a persona, and extending the statement by saying that we all are always creating a persona; especially in her last years, Nin presented herself as a living work of Surrealist art. Her art surrounds her at all times; we are able to obtain a few concrete facts about her, but even these have been shrouded in her own self-created mystery.

SOURCES:

Cutting, Rose Marie. *Anais Nin: A Reference Guide.* Boston, MA: G.K. Hall, 1985.

Franklin, Benjamin. *Anais Nin: A Bibliography.* OH: Kent State University Press, 1973.

Nin, Anais. *Delta of Venus.* NY: Harcourt Brace Jovanovich, 1977.

———. *The Early Diary of Anais Nin, Volume Two: 1920–1923.* NY: Harcourt Brace Jovanovich, 1982.

Snyder, Robert. *Anais Nin Observed: From a Film Portrait of a Woman as Artist.* Chicago, IL: Swallow Press, 1976.

Zaller, Robert. *A Casebook on Anais Nin.* NY: Meridian, 1974.

SUGGESTED READING:

Bair, Deirdre. *Anaïs Nin.* NY: Putnam, 1995.

Miller, Henry. "Un Être Étoilique," from *The Cosmological Eye.* NY: New Directions, 1939.

Nin, Anais. *The Diary of Anais Nin.* NY: Harcourt Brace Jovanovich, 1972.

COLLECTIONS:

Nin's diaries, correspondence, manuscripts and related papers, beginning in 1913, are located at the University of California at Los Angeles, University Library Special Collections.

RELATED MEDIA:

Anais Observed: A Film Portrait of a Woman as Artist, produced by Robert Snyder, Masters & Masterworks Productions, 1973.

Henry and June (film), based on books by Anais Nin, starring **Uma Thurman**, Fred Ward, and **Marie de Medeiros** as Anais Nin, Universal, 1991.

Tanya Carelli,
freelance writer in science fiction and women's studies,
San Diego, California

Ninnoc (fl. 6th c.)

British saint and abbess. Flourished in the 6th century in Brittany; daughter of Brochan, king of north Britain; never married; no children.

A Saxon princess, Ninnoc was the daughter of King Brochan of north Britain. Although reportedly she was supposed to inherit the kingdom on her father's death, she instead chose to give her life to God. She refused to marry and gained permission to move to Brittany. Her piety and strong sense of devotion led many other Saxon nobles to follow her. In Brittany, she was given a settlement near the town of Blemur, where she founded a monastery and became its abbess. Her fame spread across Brittany, and the abbey soon became known as Lannennoc after its founder.

Ninnoc was an able administrator and was said to have taught agricultural techniques to the settlers of Brittany; she also fostered other land improvements, such as a massive tree-planting project to provide sustenance to the Bretons and allow them to live better. Ninnoc gained a reputation as a protector of women; in artistic depictions of her, she is often shown with a stag lying at her feet, said to represent the abused women who found shelter and protection at Lannennoc. She was also reported to be able to effect miracles. Ninnoc was canonized some years after her death.

Laura York,
Riverside, California

Ninon de Lenclos (1623–1705).

See Lenclos, Ninon de.

Nisbet, Frances (1761–1831).

See Hamilton, Emma for sidebar on Frances Nelson.

Nisbett, Louisa Cranstoun (1812–1858)

English actress. Name variations: Miss Mordaunt. Born in 1812; died on January 15, 1858; daughter of Frederick Hayes Macnamara (an actor whose stage name was Mordaunt); married Captain John Alexander Nisbett, in 1831 (killed 1831); married Sir William Boothby, Bart., in 1844 (died 1846).

Louisa Cranstoun Nisbett was born in 1812, the daughter of Frederick Hayes Macnamara, an actor who used the stage name Mordaunt. As Miss Mordaunt, she had considerable experience, especially in Shakespearean leading roles, before her first London appearance in 1829 at Drury Lane as Widow Cheerly in Andrew Cherry's *Soldier's Daughter*. Her beauty and zest made her an immediate favorite in a large number of comedy parts, until she married Captain John Alexander Nisbett in 1831 and retired. Her husband, however, was killed the same year in a fall from his horse, and she was compelled to return to the stage in 1832.

Nisbett was the original Lady Gay Spanker of *London Assurance* (1841). In 1844, she gave up the stage once more to marry Sir William Boothby, Bart. Two years later, he died and Nisbett was back on stage as Lady Teazle in Sheridan's *School for Scandal*. She also appeared as Portia, Constantine in *The Love Chase,* and Helen and Julia in *The Hunchback*. It was as Lady Teazle that she made her final appearance in 1851. She died on January 15, 1858.

Nissen, Constanze von (1762–1842).

See Mozart, Constanze.

Nissen, Erika (1845–1903)

Norwegian pianist who performed many of Edvard Grieg's works, often with the composer as conductor. Born in Kongsvinger, Norway, in 1845; died in 1903; children: Karl Nissen (1879–1920), the composer.

Erika Nissen studied first with her sister and then in Berlin and Paris. She gave recitals in London and eventually throughout Europe. Returning to Norway, she became a popular teacher in Oslo. Specializing in contemporary Scandinavian music, Nissen gave the premiere performances of Christian Sinding's Piano Quintet in 1888 and his Piano Concerto (which is dedicated to her) in 1890. She performed Edvard Grieg's Piano Concerto on many occasions with the composer conducting. Grieg dedicated the piano version of his *Holberg Suite* to her. She was the first teacher of her son Karl Nissen, who had a successful career.

John Haag,
Athens, Georgia

Nissen, Greta (1906–1988)

Norwegian actress. Born Grethe Ruzt-Nissen on January 30, 1906, in Oslo, Norway; died of Parkinson's disease in Montecito, California, on May 15, 1988.

Selected filmography: Lost—A Wife *(1925);* In the Name of Love *(1925);* The Wanderer *(1925);* The King on Main Street *(1925);* The Love Thief *(1926);* The Lady of the Harem *(1926);* The Popular Sin *(1926);* The Lucky Lady *(1926);* Blonde or Brunette *(1927);* Blind Alleys *(1927);* Fazil *(1928);* The Butter and Egg Man *(1928);* Women of All Nations *(1931);* Transatlantic *(1931);* Ambassador Bill *(1931);* Good Sport *(1931);* The Silent Witness *(1932);* Rackety Rax *(1932);* The Unwritten Law *(1932);* The Circus Queen Murder *(1933);* Melody Cruise *(1933);* Best of Enemies *(1933);* On Secret Service *(Spy 77, UK, 1933);* Red Wagon *(UK, 1934);* Honors Easy *(UK, 1935).*

A ballerina and stage actress before turning to films, Norwegian beauty Greta Nissen was under contract to Hollywood's Paramount Studio from 1925 through 1928, during which time she starred in a number of popular silent films. Scheduled for the lead in *Hell's Angels* (1930), the blue-eyed blonde was replaced by *Jean Harlow when the film became a talkie. At the end of her career, Nissen returned to the stage

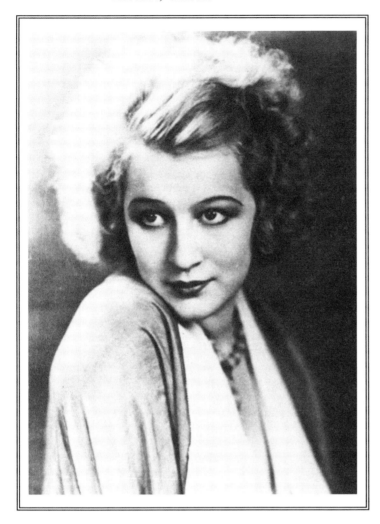

and made several British films, the last of which was *Honors Easy* in 1935.

Nithsdale, countess of.

See Maxwell, Winifred (1672–1749).

Nitocris (c. 660–584 BCE)

Reigned as Thebes' high-priestess for 70 years, linking upper Egypt with lower Egypt. Born around 660 BCE; died in 584 BCE; daughter of Nabu-Shezibanni, known as Psammetichus or Psametik; adopted by Shepenupet II, in 656.

Nitocris was born around 660 BCE, the daughter of Nabu-Shezibanni, known as Psammetichus, a noble from the Egyptian city of Sais. Nitocris, which means "Neith is victorious" (Neith was a warrior goddess of Sais), was a popular name during the period when Egypt was ruled by pharaohs from Sais. When the last great Assyrian king Ashurbanipal (r. 668–627 BCE)

conquered Egypt in 663 BCE, he was helped by Psammetichus, an ambitious aspirant to the Egyptian throne who was in part motivated to cooperate with the Assyrians by the desire to rid Egypt of the declining Nubian dynasty which controlled much of upper (southern) Egypt. When Ashurbanipal left Egypt to devote himself to pressing problems elsewhere, he put Psammetichus in charge of the ancient land as his client-king. Psammetichus assumed the status of pharaoh in 663 BCE, thus founding Egypt's 26th ruling dynasty since the unification of upper and lower Egypt around 3000 BCE. Psammetichus paid tribute to Ashurbanipal until 651 BCE, when it became clear that an accumulation of problems elsewhere made it unlikely that the Assyrian king would ever return to Egypt. Even before this statement of independence, Psammetichus did everything he could to consolidate his control of Egypt as far south as the First Cataract. This he had trouble doing, especially in the extreme south, for Ashurbanipal in the midst of his conquest had flattened the ancient royal city of Thebes, then a stronghold of Nubian rule.

Despite Ashurbanipal's military success, he had not completely eradicated the Nubian influence in Thebes because, at least technically, the local source of political authority was the high-priestess of the area's most important god—the solar deity, Amun. This priestess drew her influence from the fact that she was believed by the local population to be the "wife of Amun." The holder of this office when Psammetichus came to power was **Shepenupet II**, a woman with Nubian ties. Thus, to assert his authority in the south and effectively reunify Egypt after a period when its traditional northern and southern regions had been politically split, Psammetichus had his daughter Nitocris adopted by Shepenupet II in 656 BCE, so that when the latter died, Nitocris became "Amun's wife."

Nitocris was introduced to Thebes with a show of might, although Psammetichus made sure that the local population's religious beliefs were respected. Thus, when Shepenupet II died, Nitocris inherited her priesthood, a position which she held—linking upper Egypt with lower Egypt—until her death in 584 BCE, a period of almost 70 years. Her assumption of the religious duties associated with her status as "Amun's wife" anchored her dynasty's political control over Thebes and the south. The link worked so successfully that it became the policy by which the 26th dynasty secured the loyalty of its southern subjects, for in turn, Nitocris adopted **Ankhnesneferibre** in 595 BCE as her daughter and heir. Ankhnesneferibre, the daughter of the

reigning pharaoh Psammeticus II, later adopted **Nitocris II**, the daughter of Amasis, in 570 BCE. Nitocris II was the last of her dynasty to reign as Thebes' high-priestess, for she held the post when the Persians dethroned her father and added Egypt to their empire in 526 BCE.

William Greenwalt,
Associate Professor of Classical History, Santa Clara University,
Santa Clara, California

Nitocris (fl. 6th c. BCE)

Legendary Babylonian queen. Said to have flourished in the early 6th century BCE; said to have married Labynetus; children: Labynetus.

Nitocris is said to have been the wife of Labynetus and mother of Labynetus. However, she represents a legendary composite of a queen alleged to have had an Assyrian background, mistakenly thought by Herodotus to have been responsible for major works in northern Mesopotamia and Babylon in the early 6th century BCE. Called a woman of great intelligence, Nitocris was credited with planning a strategic defence of Babylonia against the encroachment of her enemy, the Medes (from modern Iran). Chief among her works is said to have been the engineering of the Euphrates River so as to redirect its straight channel into a meandering one, supposedly both to lessen the force of the river's flow and to create obstacles which would limit the river's usefulness as a military highway. Associated with this project was the construction of major reservoirs, intended to trap significant amounts of water from the swiftly flowing stream for local use (in fact, such projects were known on the Euphrates). Also attributed to Nitocris was the construction of the first bridge across the Euphrates which linked the two halves of the city of Babylon split by the river (a bridge with removable planking, which could be taken up at night to limit illicit traffic). A third anecdote associated with Nitocris concerns her tomb, supposedly placed in the fortifications above one of Babylon's most important gates. Herodotus writes that an inscription attached to this tomb read: "If any lord of Babylon is hereafter bereft of funds, he may open this tomb and replenish from its contents as much as he likes. However, he can only do this if he is in dire need. Otherwise, no good will come from violating my rest." It is said that when the Persian king Darius opened the tomb, he was assaulted by another inscription which admonished: "If you had not been excessively greedy and eager to get money by the vilest of means, you would never have violated my tomb."

It is clear that in Herodotus' mind this Nitocris represented the archetype of a worthy monarch, who both served her subjects and represented a moral example with the power to chastise those who did not. However, no such queen is known from Near Eastern records, and the name Nitocris is Egyptian in origin. It is likely that Herodotus misunderstood his sources for Nitocris and probably attributed to this fictitious monarch achievements which should be credited to Nebuchadnezzar II and to **Amyntis** (his wife from Media), who was probably the inspiration behind the famous "Hanging Gardens of Babylon"—itself a prodigious user of available water.

William Greenwalt,
Associate Professor of Classical History, Santa Clara University,
Santa Clara, California

Nivedita, Sister (1867–1911)

Irish-born disciple of Hindu spiritualism and a leader in the cause of Indian nationalism and independence.
Name variations: Margaret Noble. Born Margaret Elizabeth Noble at Dungannon, County Tyrone, Ireland, on October 28, 1867; died in Darjeeling in eastern India, on October 12, 1911; daughter of Samuel Noble and Mary (Hamilton) Noble; never married.

Destined to be known in India as Sister Nivedita (meaning "the dedicated soul"), Margaret Noble was born in Dungannon, Ireland, in 1867, the daughter of Samuel and **Mary Noble**. Her ancestry and early years provided a groundwork for what was to be a life dedicated to spiritualism and nationalism. Of Anglo-Saxon descent, Margaret's family had moved to Ireland from Scotland five centuries before her birth and had put the cause of country above religion and race. Her grandfather John Noble was a Protestant minister in the Wesleyan Church in Northern Ireland but sided with the Roman Catholics against the pro-English "Church of Ireland." Her father was a shopkeeper in the small town of Dungannon. He gave up his business when Margaret was a year old, sold his house, and the family moved to England where Samuel enrolled as a theological student at the Wesleyan Church in Manchester.

Taught to read from the family Bible by her grandmother, Margaret was early introduced to religious life and thinking. She often joined her father and grandfather on their visits to the poor, developing an inclination toward service that was to be a mainstay of her life. Before Samuel's death at the young age of 34, he advised Mary Noble about their daughter: "When God calls

her, let her go. She will; spread her wings. . . . She will do great things."

Margaret's widowed mother enrolled her two daughters in Halifax College, a school run by the Congregationalist Church. There, in an atmosphere of rigid discipline, the headmistress concerned herself with moral education and intellectual development, and the environment greatly influenced Margaret. She passed her examinations and left the school determined to earn her own living.

She was 18 when she became a schoolteacher in 1884, teaching literature and history in an English Lake District school. Rather than impose a prepared course of study, Noble used her lessons as a means to examining her pupils' reactions. She then spent a year at an orphanage in Rugby, England, where 20 girls were taught to become maidservants. At age 21, Noble became a secondary schoolteacher in a large mining center in Wrexham. She also published articles in local papers, including "A Visit to a Coal Mine, by a Lady" and "A Page from Wrexham Life."

Noble was interested in the work of two well-known educators, Pestalozzi and Froebel. She was also influenced by the British sociologist Patrick Geddes, organizer of the Paris Exposition. Drawn to his theories regarding the evolution of society in relation to the environment, she became Geddes' secretary.

While Noble cherished her Irish nationalism, she became English in her social habits. She met the Russian revolutionary Peter Kropotkin when he came to speak to the "Free Ireland" circle, and Noble recognized in him the voice of her father, seeing Kropotkin as a leader of the oppressed.

By 1892, Noble's intellectual gifts had earned her a distinguished position in London's high society at the Sesame Club (a social club for men and women). She opened a school at Wimbledon with a broad conception of education for girls. Three years later, when the Hindu Monk Swami Vivekananda of Calcutta, India, visited England, Noble attended his religious lectures. In the first weekend class she attended (on Bhakti Yoga) as well as the second (on the divinity of man), Vivekananda spoke of religion without dogmas, without liturgies, and without penances. He saw ignorance, selfishness, and greed as bringers of suffering, an idea with which Noble strongly identified. She found in Vivekananda's message of Hinduism, with wisdom drawn from Sri Ramakrishna, the Hindu spiritual saint of Calcutta, a religion whose foundations, classification of elements, and forms of worship could

be discussed scientifically. Noble declared herself the Swami's disciple by addressing him as "Master." Urged by Vivekananda to help women in India, she felt that her future work was there.

In 1898, she went to Calcutta, and on March 25 she received from Vivekananda the name "Nivedita." She was consecrated into *Bramacharya* (life of celibacy). Said Vivekananda: "Sister Nivedita is another gift of England to India." In her modest home in Calcutta, she started a new way of life, facing the challenges of beginning in a new country.

She had arrived in India with no thought beyond helping Vivekananda in his religious and educational work, but her nationalist tradition quickly made her identify with India's struggle for independence. It was not long before she was appointed to a position within the Indian nationalist organization, which had its headquarters in Bengal. Aurobindo Ghosh was the organization's chief leader. Dreaming of a unified India, which would stand for the recreation of the Dharma (true faith), Sister Nivedita saw India as organically, not merely mechanically, united: the North produced prophets, the South priests.

Nivedita stood "surety" for the Bengali revolutionary Bhupendra Nath Dutta (the youngest brother of Swami Vivekananda), who was arrested for sedition as the editor of the *Jugantar* newspaper. Taking an active part as a member of the executive committee of the Revolutionary Party in Bengal, Nivedita was disillusioned with the anti-India attitude of the British government. In 1902, she criticized schools in British India for what she regarded as the lack of a central ethical and moral standard. She was present at the Calcutta University Hall when Lord Curzon made his convocation speech in 1905. Nivedita condemned the speech, which was critical of Indian nationalism.

Nivedita was also instrumental in helping to assert the spiritual import of Indian fine arts. She inspired E.B. Havell, the principal of the Government School of Art in Calcutta, who became the first English art critic to defend Indian art from vulgar attacks by British critics. The great Indian artist Rabindranath Tagore, who turned to the national style of Indian art, was also influenced by Nivedita, as was the famous Bengali artist Nanda Lal Bose.

Asked by Vivekananda to improve education for the women of India, Nivedita traveled widely to raise funds for a girls' school. To both collect money and inform the Western public about India, she left for Europe and America in

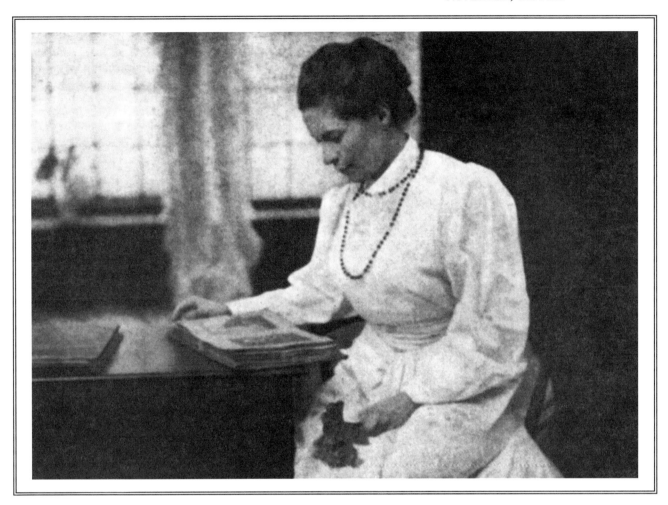

1899 and organized the "Ramakrishna Guild of Help" while in the West. Many times rebuffed on her journey, Nivedita returned to India in 1902, the year of Vivekananda's death. Feeling that she should not confine herself to the Ramakrishna Order, which had been started by Vivekananda, she decided to focus on his idea of nation-making. She traveled to different parts of India to obtain knowledge of the people and to propagate his views. In Bombay, where she spoke on "The Unity of Asia" and "Hindu Mind in Modern Science," she was applauded when she concluded: "European science" can "now observe with the utmost accuracy the laws governing molecular physics. . . . But even this science was nothing to what the grotesque-looking Yogi studies in his solitude—Nature."

In her lecture tours throughout India in 1902, Nivedita addressed youths on nationalism. She gave to the revolutionaries' center in Calcutta the library she had amassed of books on nationalist movements in various countries. While in Baroda in western India, she looked into Aurobindo Ghosh's revolutionary work at close quarters. She suggested that Aurobindo, whom she admired, should shift his activities out of the reach of the British-Indian police, and it seems that Aurobindo went to the French territory in the south of India in order to do so. She was also familiar with the work of **Sarala Devi**, the Holy Mother of the Ramakrishna Order, who forged a link between the Bengali and Punjabi revolutionary groups.

Meanwhile Nivedita did not forget her original goal of advancing the cause of women's education. Vivekananda had encouraged Nivedita to produce great women to match the values of the modern world: "Your education, sincerity, purity, immense love, determination and above all, the Celtic blood make you just the woman wanted." Her first experimental school had been in existence from November 1898 to the end of May 1899. In 1903, her new creation, the Nivedita School on Nivedita Street in Bagh Bazar (in north Calcutta) opened its doors. This school for girls was able to group together, with their parents' consent, children from such widely different castes as Brahmin, Kayastha, and Gowala.

Sister Nivedita

To encourage boys' education as well, Nivedita sent some young men to Japan, England, and America where they were trained in pharmaceutical goods, glass-blowing, and the handling of metals. When they returned to India, she helped them to establish their own businesses, for she wanted to have dealers in the marketplace who used modern tools and machines. In order to popularize Indian goods, she prepared the "National Swadeshi Exhibitions" in Calcutta during the session of the Indian National Congress Party.

By 1906, Sister Nivedita was vigorously associated with many aspects of Indian public life. When floods and famine struck East Bengal that year, she consoled the weak, addressed women's meetings, and preached the use of Swadeshi goods and the boycott of British ones. She stressed the need to take to *Charkha* (spinning wheel to make clothes) and other useful crafts; regarding peasants, she remarked that those who paid the revenues should have the right to control the expenditures.

Nivedita aligned herself to the ancient Hindu philosophy and saw the *Bhagavad Gita* (a long poem composed by Brahmins) as an authoritative pronouncement on the Hindu society. She believed that the *Gita* was specially written for the benefit of women and the working classes, who, as destitute of classical learning, had little chance of studying these great scriptures. She placed high honor on the status of women, advocating that where women are honored gods are pleased; felt that the Laws of Manu were for domestic happiness; and subscribed to the proverb, "Thou shall not strike a woman, even with a flower."

Between 1907 and 1911, Nivedita took two trips to America and England. In 1907–08, she again became a part of high society in London. Intending to found a pro-Indian information center there, she explained in her journalistic writings at the time that the British policies toward Calcutta politicians were unduly harsh. She was in close contact with the publicist and poet Wilfrid Scawen Blunt, husband of ◄ **Anne Blunt**, who urged England's withdrawal from Indian affairs, and discussed the Indian freedom issue with British labor leader Keir Hardie. Meanwhile, the British government in India passed the Newspaper Act which suppressed all the nationalist papers.

After an absence of 15 years, she visited Ireland, noting the same longing for liberty. She then arrived in America where she served as a journalist and as a mother figure to many Hindu

Blunt, Anne. See Lovelace, Ada Byron, countess of, for sidebar.

youths living abroad. Upon her return, India was in turmoil; even the Balur Monastery was regularly watched by the British government police. Although failing in health, a confident Nivedita declared, "Mother India will know victory." She died in Darjeeling in North Bengal, at age 44, very much a daughter of India. Bengal gave her a national funeral, Calcutta offered her memorial tributes at the Town Hall, and her ashes were distributed to many places.

Sister Nivedita arrived in India at a time when Vivekananda was pointing the country in new directions, and she added to this movement toward social and political emancipation. She became a "sister to all Indians" while at the same time forging a link with the West. Like Vivekananda, Nivedita believed that India should borrow relevant aspects of education and science from the West but remain committed to its ancient ethical and religious values. She preserved much of her thinking in print and her works include an account and study of Vivekananda's life entitled *The Master As I Saw Him.*

SOURCES:
Nivedita, Sister. *The Wave of Indian Life.* Calcutta: Longmans, Green, 1918.
Raymond, Lizelle. *The Dedicated: A Biography of Nivedita.* NY: John Day, 1953.

SUGGESTED READING:
Datta, Bhupendra Nath. *Swami Vivekananda: Patriot = Prophet: A Study.* Calcutta: Nababharat, 1954.
Madhavananda, Swami, ed. *The Complete Works of the Swami Vivekananda.* Calcutta: Sree Gouranga Press for the Advaita Ashrama, 1922.

Santosh C. Saha,
formerly Assistant Professor of History, Cuttington University, Liberia

Nixon, Agnes (1927—)

American creator and writer of soap operas. Born Agnes Eckhardt in Chicago, Illinois, in 1927; graduated from Father Ryan High School, Nashville, Tennessee; attended St. Mary's College, South Bend, Indiana; transferred to Northwestern University; married Robert Nixon (died 1997); children: four.

The undisputed "Queen of the Soaps" since the death of her former employer *Irna Phillips, Agnes Nixon has been writing soap operas for four decades, and is the creator of two of the longest-running afternoon dramas on television: "One Life to Live" and "All My Children."

Nixon was born in 1927 in Chicago, Illinois, during the Depression, but was raised in Nashville, Tennessee, where she moved with her mother when she was three months old. While her mother worked outside the home, Agnes was

brought up by her grandmother and aunts in a strict Catholic environment. At an early age, she became hooked on the "funny papers" which she not only read faithfully, but acted out. When she was old enough, she took dramatic lessons from the woman who also served as the organist at the church her family attended. After high school, Nixon attended St. Mary's College in South Bend, Indiana, then transferred to Northwestern, where she majored in drama but slowly gravitated to classes in creative writing. "I began to love writing," she recalled. "Not just the story—I had always loved the story—but I began to love the words, the rhythm, the sound, the speech."

In 1946, fresh out of college, Nixon began scouting out writing jobs, although her father wanted her to join him in his burial-garment business. To show his daughter the impracticality of her career choice, he arranged an interview for her with Irna Phillips, a friend of his who also happened to be the queen of radio soap operas at the time. Nixon took along a script she had written and read it aloud to Phillips, who hired her on the spot. Though Nixon's father was incredulous, he mentally reconciled the matter by assuming that his daughter had been hired due to his influence. Nixon worked for Phillips for six months, then moved to New York, where she eked out a living doing freelance work. After a slow start, she began selling original scripts to some of the many popular television dramas, among them "Studio One," "Robert Montgomery Presents," "Philco Theater," and "Hallmark Theater." "You had to write an hour show and they didn't have tape in those days," she recalled. "It was all live—it was exciting, wild." Around this time, Agnes met Robert Nixon, then an executive for the Chrysler Corporation. They were married four months after their first date, and Nixon settled in as a housewife and mother. But it was not long before she went back to work for her old boss Irna Phillips, writing dialogue for Phillips' show "The Guiding Light."

Living in Philadelphia, where Bob had been transferred, Nixon kept house and raised four children, all the while writing the daily daytime soap opera. When Phillips became busy with other shows, Nixon took over as head writer of "The Guiding Light." Eventually she was asked to take over the serial "Another World," which had slipped badly in the ratings. After that show became #2 in the ratings, the network asked Nixon to create her own show. Thus, on July 15, 1968, "One Life to Live" premiered and went on to become one of the most popular shows on the network. It was also groundbreaking with its inclu-

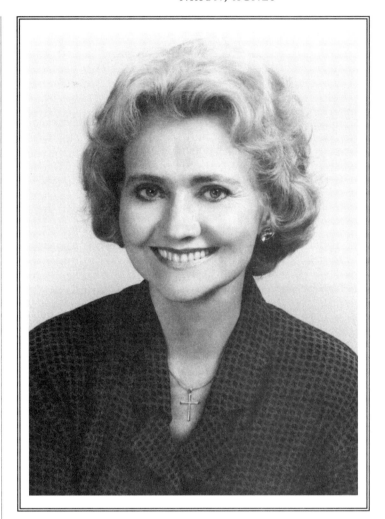

sion of story lines about African-Americans and a lower-income Polish family. "I got a lot of recognition from that show," Nixon later recalled. "And I gained a lot of confidence from its success."

Meanwhile, she had been working for several years on another TV serial, "All My Children," which would turn out to be another blockbuster, although she had a difficult time with it in the developmental stage. Nixon had taken it along on a family vacation to St. Croix in 1965 and, on the return home, the suitcase containing the manuscript was lost. It was miraculously recovered a few months later, only to be turned down by the sponsors, after which she put it away for awhile. When "One Life to Live" became popular, the network asked her to create another soap, and her husband, who had since given up his job to form a production company with his wife, suggested that she dig up the "All My Children" script. The soap premiered on January 4, 1970, and in January 2000 celebrated 30 years on the air. Some of its actors have spent their entire careers inhabiting Pine Valley, the

Agnes Nixon

show's fictitious locale, among them **Susan Lucci**, who in 1999 finally won an Emmy for her role as Erica Kane, after 18 nominations and 17 no wins. (Nixon says that Lucci knows her character about as well as anyone. "So if she says, 'I don't think Erica would do that,' I listen.")

Nixon has pretty much always worked at home in suburban Philadelphia, employing a housekeeper and cook and an assistant, and communicating by phone with writers, production staffs, and even actors. (Visits to the set are limited to special occasions, like a "wedding" in the story or the yearly Christmas party for the cast and crew.) For many years, she produced the story line for "All My Children" in her garret-like studio, roughing out the day's outline on a legal pad, then dictating it into a tape recorder. A draft was then typed up by an assistant and sent to the dialogists. Her ingredients for soap opera success: "Make 'em laugh, make 'em cry, make 'em wait." In addition to keeping in contact with all the writers of the show by telephone, Nixon also attends story conferences four times a year. "These are real 'lemon sessions,'" she says. "By that I mean everyone lays it on the line. Everyone says what they think hasn't worked, what was a lemon." Through the years, Nixon has sandwiched lecture dates and other personal appearances into her busy writing schedule.

In 1983, Nixon created another daytime drama, "Loving," which also ran for a number of years, but did not enjoy the longevity of her other shows. She also wrote the story for the mini-series "The Mansions of America," which aired in 1981. "All My Children," however, remains Nixon's favorite. "All my characters are my children," she said. "I care about them."

SOURCES:

Brown, Lester. *Les Brown's Encyclopedia of Television.* Detroit, MI: Invisible Ink, 1992.

Wakefield, Dan. *All Her Children.* Garden City, NY: Doubleday, 1976.

RELATED MEDIA:

"Intimate Portrait," a biography of Nixon, aired on Lifetime cable network, narrated by Judith Light, 1994.

Barbara Morgan,
Melrose, Massachusetts

Nixon, Julie (1948—)

American first daughter and author. Name variations: Julie Nixon Eisenhower. Born on July 5, 1948, in Whittier, California; second daughter of Richard M. Nixon (1913–1994, U.S. president, 1969–74) and Pat Nixon (1912–1993); graduate of Smith College, Northampton, Massachusetts, 1970; Catholic Univer-

sity of America, Washington, D.C., M.A. in elementary education; married David Eisenhower (a lawyer), on December 22, 1968; children: Jennie Eisenhower; Alex Eisenhower; Melanie Eisenhower.

Julie Nixon was born in Whittier, California, on July 5, 1948, the daughter of Richard Nixon and *Pat Nixon and the younger sister, by two years, of *Tricia Nixon. Julie's birth gave her mother a second reason to worry about raising a family while supporting her husband's political aspirations. While Julie frequently cried when Pat left her for the campaign trail, she later flourished in the public spotlight, developing into a charming and articulate speaker. During the Watergate debacle, it was in fact Julie who became her father's defender, prompting journalist **Nora Ephron** to write: "In the months since the Watergate hearings began, [Julie] has become her father's . . . First Lady in practice if not in fact."

Like her sister, Julie attended a variety of schools, both public and private, in California, New York, and Washington. She decided to attend Smith College after visiting the Northampton campus during a family vacation in Massachusetts, although her mother had hoped she would attend a coeducational college to "have some fun." In college, Julie reconnected with David Eisenhower, whom she had not seen since the 1957 inauguration of his grandfather, President Dwight D. Eisenhower. She and David, a student at nearby Amherst, fell in love and married on December 22, 1968, less than a month before Richard Nixon took the oath of office as president. (During the previous six months, the two of them had traveled to 33 states campaigning.) The newlyweds returned to a new apartment in Northampton, where they lived while completing their college degrees. Julie found her adjustment to married life hampered by the constant presence of the Secret Service, but even more so by the anti-Nixon sentiment on the Smith campus, which was fueled by the nation's continuing involvement in Vietnam. The couple did not even attend their 1970 graduation ceremonies because officials at both Smith and Amherst could not guarantee their safety. They celebrated the occasion instead at Camp David.

While David served in the Navy for three years, Julie joined her family in the White House and worked on a master's degree in elementary education at nearby Catholic University of America. When David returned, he entered George Washington University Law School, and the couple took up residence in nearby Bethesda, Maryland. From 1973, Julie worked at Curtis

Publishing Company, which owned *The Saturday Evening Post, Holiday*, and four children's magazines.

From the earliest days of Watergate, Julie Nixon became the family spokesperson in her father's defense, and by the time of the president's resignation, she had given over 125 interviews throughout the country. "She was not only accessible to the media but asked for some speaking engagements and TV appearances herself, knowing in advance that questions would be asked about Watergate," writes Lester David. "Always she was charming, poised, attractive, and agile-minded. They loved her everywhere." On May 7, 1974, at the height of the crisis, Julie and David conducted an interview in the East Garden, at which time she told the media that her father intended to "take this constitutionally down to the wire." "The media," she said, "must be reassured from members of the family that my father is not going to resign." Julie and her sister Tricia continued to believe that their father should not give up the fight, although in the end other opinions prevailed.

Julie Nixon continued to support her parents throughout the legal battles of the post-resignation period, and during both her father's illness and surgery and her mother's stroke, which occurred shortly after David's graduation from law school. On August 15, 1978, almost as a salute to her mother's recovery, Julie gave birth to the Nixons' first grandchild Jennie. (The Eisenhowers had two more children, Alex and Melanie, who, with Tricia's son Christopher, brought the tally of Nixon grandchildren to four.) In 1986, Julie paid tribute to her mother with the publication of *Pat Nixon, The Untold Story*, which, in addition to shedding light on the enigmatic first lady, provides an insider's look at some of the extraordinary events that shaped the country's history.

SOURCES:

David, Lester. *The Lonely Lady of San Clemente: The Story of Pat Nixon*. NY: Thomas Y. Crowell, 1978.

Eisenhower, Julie Nixon. *Pat Nixon: The Untold Story*. NY: Simon and Schuster, 1986.

Nixon, Pat (1912–1993)

American first lady (1969–1974). Name variations: (nickname) Buddy. Born Thelma Catherine Patricia Ryan on March 16, 1912, in Ely, Nevada; died on June 23, 1993; youngest of three children and only daughter of William Ryan (a copper miner) and Katharina (Halberstadt) Bender Ryan, a widow with two children; graduated from Excelsior Union High School, Artesia, California; attended Fullerton Junior College, 1931; *B.S. in merchandising from the University of Southern California (cum laude), 1934; married Richard M. Nixon (1913–1994, U.S. president, 1969–74), on June 21, 1940, in Riverside, California; children: Tricia Nixon (b. 1946); Julie Nixon (b. 1948).*

One of the many junkets Richard and Pat Nixon made together when he was vice president under Dwight D. Eisenhower was a goodwill tour of South America in 1958. Warned in advance of growing anti-American sentiment, and encountering angry crowds of students when they were in Peru, the Nixons were nonetheless unprepared for the mass of demonstrators, jeering and spitting, that greeted them at the airport in Venezuela, their final stop. During the motorcade into Caracas that followed, the vice president's car was halted by a man-made barricade of empty cars, then surrounded by a mob of 500 who beat on the car with clubs and pipes, smashing the windows and nearly upturning the vehicle. Behind Richard Nixon's car, riding with the wife of the foreign minister and military aide Don Hughes, Pat Nixon sat wondering if her husband would escape with his life while her own car was also pummeled with rocks, one smashing with enormous force into a window a few inches from her face. She remained calm throughout the ordeal, even restraining and comforting the frantic wife of the foreign minister. (Pat later told her daughter Julie that she was more angry than frightened.) Hughes, who had survived combat in World War II and in Korea, told reporters later that Pat Nixon had "more guts" than he had ever seen. His appraisal was echoed by Bob Hartmann, who watched the attack from the press truck and later filed the first dispatch back to the United States, calling Pat Nixon "magnificent." Even the vice president praised his wife as "probably the coolest person in the whole party." But Pat Nixon's strength and composure under siege, probably her greatest asset, was frequently viewed as aloofness by a public that never warmed to her. "The cameras that caught the angular planes of her face missed the soft contours of her heart," wrote **Bonnie Angelo** in a *Time* ar-

ticle shortly after Pat Nixon's death in 1993. "Her Republican cloth-coat persona was no match for the glamour of her predecessors, *Jacqueline Kennedy, international trendsetter, and *Lady Bird Johnson, poetic beautifier of highways." Angelo went on to suggest that much of Pat Nixon's image problem stemmed from her fierce loyalty to her husband, a man who "from his ambitious first days in politics to the catastrophic final days, . . . could not shake the visceral distrust of the public and the media."

Born in 1912 in a miner's shack in Ely, Nevada, and christened Thelma Catherine Ryan, Nixon was dubbed Pat by her Irish-American father because she had arrived on the eve of St. Patrick's Day. (Later, she legally changed her name to Patricia to honor her father.) When she was two, the family, which included two older brothers and an older half-brother and half-sister from her mother's previous marriage, moved to Artesia, California, where they attempted to eke out a living on a truck farm, without the aid of electricity or running water. She remembered that period in her life as primitive and difficult. "I didn't know what it was not to work hard," she said. Her mother died of stomach cancer in 1926, but despite taking over the additional household chores, Nixon maintained a high average in high school and also had roles in both the junior and senior class plays. A classmate, **Marcia Elliott Wray**, called her "the unchallenged actress of the class."

After graduation, Nixon worked as a cleaning woman and bank teller while attending Fullerton Junior College, a few miles away. She was remembered from that time as a good-looking, energetic, and self-confident, even adventuresome, young woman. In 1931, a year after her father died of silicosis (black-lung disease), she seized an opportunity to go to New York, agreeing to drive an elderly couple 3,000 miles cross-country in their ancient Packard touring car. Once there, she secured a job at Seton Hospital for the Tubercular and enrolled in Columbia University for an intensive summer course in radiology. Living Spartanly and saving her money, she returned to California in 1933 and enrolled at UCLA. Pat supported herself with a variety of jobs, including working as an extra in films. She graduated cum laude in 1937, and immediately obtained a job as a business-education teacher at the high school in Whittier, California, where Richard Nixon, newly graduated from Duke University, had just returned to begin practicing law. The two met when they were both cast in the Whittier Community Players' production of *The Dark Tower*, a dreary mys-

tery melodrama. On the night they met, Richard told Pat that he intended to marry her. "I thought he was crazy," she said later. But he persevered for three years, and on June 21, 1940, they were married in a small Quaker ceremony. Afterwards, with $200 between them, they took off for a honeymoon in Mexico.

During the war, while Richard served with the Navy in the South Pacific, Pat worked for the Office of Price Administration in San Francisco, where she was quickly promoted through the ranks to the position of price analyst, at a more than respectable salary of $3,200 a year. When Richard returned from the war, he was promptly drafted to run for Congress from Whittier. Pat, then pregnant with her first child, was ambivalent about his new career in politics, but sensed her husband's eagerness. "I could see it was the life he wanted," she said, "The only thing I could do was to help him, but it would not have been a life that I would have chosen." Although she refused to make political speeches and insisted that their home be kept a refuge where she could raise her family in a normal fashion, she threw herself wholeheartedly into the campaign, serving in the background as his office manager. In February 1946, *Tricia Nixon was born; three weeks later, Pat was back in the campaign office.

After Richard's victory, the family moved to Washington, where Pat ran her husband's congressional office, and where their second daughter *Julie Nixon was born on July 5, 1948. In 1950, when Richard beat *Helen Gahagan Douglas in a bitter campaign for the Senate that Washington journalist Earl Mazo called "the most hateful one California had experienced in many years," the family moved from a cramped duplex to a more comfortable home in Spring Valley. But Pat's attitude toward the political arena had not warmed. When Richard was drafted as Eisenhower's running-mate in 1952, she was bitterly opposed to his candidacy, although once the campaign was underway she stood by him, insisting that he defend himself against charges of unethical use of an $18,000 "slush fund." In an emotionally charged speech upholding his honor (later dubbed the "Checkers" speech because of his mention of the family dog), he made several references to his wife, including his famous allusion to her "respectable Republican cloth coat." Pat particularly hated that speech, despite the avalanche of supportive telegrams it generated. "Why do we have to tell people how little we have and how much we owe?," she had asked him.

Two full terms as second lady of the land culminated in another whirlwind Nixon campaign, this time for the presidency against John F. Kennedy. The narrow defeat (in the closest election since the Harrison-Cleveland race in 1888) was a bitter disappointment for Pat, although tears were quickly replaced by her joy at returning to private life in California, where Richard joined a Los Angeles law firm. After his unsuccessful run for governor of California—a campaign Pat was against from the beginning—the family moved to New York, where Richard became a partner in a Wall Street law firm. One of the happiest events of this time was the wedding of Julie Nixon to Dwight Eisenhower's grandson, David Eisenhower, in December 1968. (Three years later, in June 1971, Tricia would marry Ed Cox in a ceremony in the Rose Garden of the White House.)

Pat Nixon had precious little time to savor life out of the spotlight, as Richard returned to politics and was elected president over Hubert Humphrey in November 1968. The grueling campaign that preceded the election had been carried out in an atmosphere of rage over the lingering war in Vietnam. "Hey, hey, LBJ, how many kids did you kill today?" was the frequent taunt leveled at then-president Lyndon Johnson by the angry demonstrators who dogged his every move. Pat Nixon once again took up her husband's cause, believing that he was the man who could bring order out of the chaos, but having no illusions about the possibility of failure. Her efforts during the campaign had inspired Dick Schaap of the *New York Post* to dub her "the quintessential candidate's wife."

Unlike other first ladies, Pat refused to be identified with a single project. Instead, she divided her time between several causes, including education, community self-help, and volunteerism. One of her chief priorities was refurbishing 14 of the 36 rooms of the White House, for which she raised the money herself from private sources. In addition, she had the White House art work catalogued and began the practice of displaying national treasures in the East Room, so that visitors could see them. In her quiet manner, she managed to acquire more fine American furnishings for the White House than any other first lady, although no one ever knew of her accomplishment. "She wouldn't allow anybody to give her the credit," said White House curator Rex Scouten. Pat was equally low-key about entertaining, keeping the White House dinners small and sedate in comparison to those of the Kennedy administration. She saved her more overt hospitality for the Ameri-

can public, in an effort to make the White House more accessible. She arranged tours to be given to the blind, the hearing-impaired, and the physically challenged, and she initiated candlelight tours at Christmas, as well as seasonal garden tours in October and April. She also spent four hours each day, usually in the evening, personally replying to her mail.

As first lady, Pat Nixon traveled extensively, visiting American troops in Vietnam (the first first lady to visit a war zone since *Eleanor Roosevelt), and serving quite successfully as a foreign emissary. Angelo suggests that she "blossomed visibly in direct ratio to the distance between her mission and the inhibitions imposed on her at home." In 1970, Pat helped ease tensions with Peru when she traveled to towns and villages devastated by earthquakes, delivering supplies and consoling survivors. She was also warmly received in West Africa during a tour in 1972.

Following the reported break-in at the Watergate complex in 1972, and the succession of congressional committees and special prosecutors that investigated Richard's link to the burglary, Pat steadfastly proclaimed her husband's innocence, insisting that it was a minor scandal compared to his accomplishments, and chastising the media for blowing it out of proportion. By 1974, however, the administration had all but collapsed, and Pat could not even conduct her volunteer projects without being greeted by jeers from demonstrators calling for her husband's resignation. Once asked how she remained calm through it all, she replied: "I hate complainers, and I made up my mind not to be one," she replied. "So if it's cold, I tell myself it's not cold and if it's hot, I tell myself it's not hot. And you know it works."

By August 1974, the president had lost the support of Congress and was forced to leave office. It was during his resignation speech that Pat Nixon cried openly in public for the first time. By the next day, however, when he bid farewell to his staff, she had regained her stoic composure, even though her husband failed to acknowledge her in his parting remarks. Following the speech, the Nixon family, arm in arm, left the White House lawn by helicopter. It was the last time the public would ever see Pat Nixon.

In 1976, after seeing her husband through the aftermath of Watergate, as well as a bout with phlebitis that required surgery, Pat Nixon suffered a stroke which left her partially paralyzed. The family blamed it on the sensational Woodward-Bernstein book *The Final Days*, in which the authors implied that Richard had been

dangerously unbalanced and that Pat became reclusive and drank heavily. "For mother," wrote Julie Nixon, "the most unbearable part of the book was the analysis of her marriage as loveless." With great fortitude, Pat recovered from that stroke and another in 1980, after the couple had moved to New York. In her later years, she drew her greatest joy from her grandchildren, whom she adored. Pat was further weakened by emphysema and died on June 23, 1993, shortly after being diagnosed with lung cancer.

One of the last of Pat Nixon's "official" acts was to pose for a White House portrait, which she did only reluctantly after five years of prodding from White House curator Clem Conger and her daughters. The portrait was painted at the Nixon retirement home in San Clemente, California, by the artist *Henriette Wyeth, who was particularly impressed by Pat's delicate beauty, noting that her eyes were like none she had ever seen. "The eyes reveal an unusual spirit. They are the eyes of a sixteen-year-old girl—an expression of great sweetness," she later told Julie. "She has maintained a kind of fragile beauty about her life," Wyeth wrote. "When she looked out the window at the hummingbirds, I liked the expression then in her eyes best. She still believes despite injustices."

SOURCES:

Angelo, Bonnie. "The Woman in the Cloth Coat," in *Time*. July 5, 1993, p. 39.

Beck, Melinda. "'Love Bears All Things,'" in *Newsweek*. July 5, 1993, p. 65.

David, Lester. *The Lonely Lady of San Clemente: The Story of Pat Nixon*. NY: Thomas Y. Crowell, 1978.

Eisenhower, Julie Nixon. *Pat Nixon: The Untold Story*. NY: Simon and Schuster, 1986.

Garraty, John H., and Mark C. Carnes, eds. *American National Biography*. Oxford: Oxford University Press, 1999.

Moritz, Charles, ed. *Current Biography 1970*. NY: H.W. Wilson, 1970.

Barbara Morgan,
Melrose, Massachusetts

Nixon, Tricia (1946—)

American first daughter. Name variations: Patricia Nixon; Tricia Nixon Cox. Born Patricia Nixon on February 21, 1946, in Whittier, California; eldest daughter of Richard M. Nixon (1913–1994, president of the U.S., 1969–74) and Pat Nixon (1912–1993); attended Horace Mann Elementary School, Washington, D.C.; attended Sidwell Friends, a coeducational private Quaker school in Washington; graduated from Finch College, New York City, in 1968; married Edward Cox (a lawyer), on June 12, 1971: children: Christopher Cox (b. March 14, 1979).

The eldest of the two daughters of Richard and *Pat Nixon, Tricia Nixon was born in February 1946, during her father's first run for Congress. Her early days were spent in the care of her paternal grandmother **Hannah Nixon**, so that Pat could return to the campaign. Throughout her childhood, Tricia lived in and out of the public eye, as her mother sought to keep the lives of her children normal amid the demands of the political arena. Of the two Nixon daughters, Tricia was "introverted," as Pat put it, and later dubbed "The Thinker," while younger sister *Julie was known as "The Talker." Tricia's education reflected the family's transitory lifestyle, and she required considerable adjustment to each new classroom environment. She completed her education at Finch College in Manhattan, commuting each day while living at home. A modern European history major, she was elected class president in her junior year and was a member of the academic honor society.

Tricia was still living at home when the Nixons took up residence in the White House in January 1969. (Julie had just married David Eisenhower and was living in Massachusetts.) Tricia soon became "assistant first lady," presiding over a number of events in her mother's absence and uncharacteristically hosting a television tour of the family quarters of the White House with Mike Wallace. More meaningful to her at the time was her volunteer work under the auspices of the Urban Service Corps, which involved tutoring two students from one of Washington's inner-city schools.

As the petite, pretty, unmarried daughter of the president, Tricia's presence in the White House was carefully monitored by the press. In 1970, she ended speculation by announcing her engagement to Edward Cox, a young man from a prominent New York family whom she had met at a school dance in 1963. While Edward completed his second year of law studies at Harvard, Tricia and Pat planned the elaborate White House wedding which took place in the Rose Garden on June 12, 1971, under the scrutiny of an impressive array of guests and scores of reporters. After the wedding, the couple settled in New York City, where Edward took up the practice of law.

Following her marriage, Tricia stayed out of the public spotlight, although she returned to Washington for family holiday gatherings and was present during the crucial events of the Watergate scandal. As the drama unfolded, Tricia commuted between New York and Washington as much as possible to be with her parents, al-

though, unlike Julie, she was never comfortable speaking out publicly on Watergate issues. Tricia continued to provide behind-the-scenes support during and after her father's resignation, and throughout his subsequent illness and her mother's stroke in 1976. On March 14, 1979, Tricia gave birth to a son Christopher, who along with Julie's three children brought great joy to the Nixons' later years.

SOURCES:

David, Lester. *The Lonely Lady of San Clemente; The Story of Pat Nixon*. NY: Thomas Y. Crowell, 1978,

Eisenhower, Julie Nixon. *Pat Nixon: The Untold Story*. NY: Simon and Schuster, 1986.

Njinga (c. 1580s–1663)

Angolan warrior queen and proto-nationalist who ruled for 40 years, alternately defeating and allying herself with the Portuguese, Dutch, and local tribes. Pronunciation: Oon-ZHIN-ga. Name variations: Jinga; Nzinga; Singa; Zinga or Zhinga; Nzingha Mbande or Mbandi. Born Njinga Mbandi in the 1580s in Angola; died in Angola in 1663; married many men as she had her own harem.

Baptized a Christian, and allied herself with the Portuguese (1622); took the throne after brother died under mysterious circumstances (1624); began fighting the Portuguese after their failure to honor their treaty (1624); forced to flee her kingdom (1629); established a new kingdom in Matamba; closed the main slave trail, blocking Portuguese access to slave producing areas (1630s); expanded Matamba into the largest state in the area and shifted alliance to the Dutch (1640s); forced the Portuguese from the area (1648); shifted alliance back to the Portuguese (1650); signed a formal treaty with the Portuguese (1656); ruled in peace until her death (1663); established a dynasty of female leaders which ruled after her death for 100 years.

Africa is famous for its powerful queens, and one the best known was Queen Njinga of Matamba, who reigned for 40 years, beginning around the 1620s, and established a female dynasty which succeeded her upon her death. A proto-nationalist leader, Njinga maintained her power by adopting contradictory strategies which ultimately succeeded.

The Portuguese arrived on the African continent in the late 1400s and within less than a century established an expansive slave trade to supply the labor for their plantations in Brazil. In the 1570s, when they reached what is now modern Angola, they found a group of decentralized states—African kingdoms based on a kinship of loosely related family members. In each kingdom, the family members banded together to capture the throne, and the king then ruled along with a number of powerful nobles who represented a check on his power. The structure of government was not at all rigid, and politically skilled nobles frequently vied to capture the kingship. Losing factions often viewed defeat as no more than a temporary setback and the struggle for royal power would begin again almost as soon as a new ruler was crowned. One of the most important of these kingdoms was Ndongo, which had been formed by the Mbundu by the late 15th century. The king of Ndongo was called *Ngola*, the word from which the Portuguese derived *Angola*.

The decentralized form of government in the region was in the midst of change. As rulers moved to consolidate their authority in the late 16th and early 17th centuries, they began to assert their right to hereditary command rather than submitting to election by noble families. At the same time, these rulers became increasingly dependent on royal slaves rather than the territorially based nobles. Slaves in Africa did not share the low status to which their brethren in the Americas were subjected. They were more like the janissaries in Turkey, who had the status of slaves but in reality could move into positions of great authority. Rulers collected large numbers of slaves and made use of their loyalty to consolidate their power. Slaves managed court affairs, formed the army's elite and officer corps, became judicial and military supervisors over territorial nobles, and were allowed to collect taxes from the nobility.

After the Portuguese arrived in Angola, they initially did not advance their territorial hold far beyond the lower Kwanza River and the coastal plain. But from 1612 to 1622, they enlisted Imbangala warriors and won a series of stunning military victories which changed the balance of power in the region. The Imbangala were bands of mercenary soldiers, as well as cannibals, who recruited their members by enslaving adolescent boys. Led by democratically selected commanders, they were ruthless and determined. The Imbangala brought the Mbundu state to near-total collapse, and it was under these circumstances that Njinga would ally herself with the Portuguese.

She first appears in the historical record around 1621–22, when she arrived in the Portuguese colony of Luanda, claiming to be an emissary of her brother Mbandi of Ndongo, the Ngola (king). Her desire to ally herself with the

Europeans was driven by internal politics. At the time, she was caught in a struggle with two African leaders, Hari a Kiluanji and Ngola Hari. Although Ngola Hari had fought to keep the Portuguese out of the Angolan highlands to the east of Luanda, Njinga was willing to reach a compromise with the Europeans in order to stave off Hari a Kiluanji. In 1622, she accepted Christian baptism, which quickly won the hearts of the devout Europeans. Two years after her arrival in Luanda, her brother died under mysterious circumstances. Njinga claimed his kingdom of Ndongo and joined in a treaty that opened Mbundu lands to Portuguese slave traders. With the advantage of Portugal's material and military might behind her, Njinga returned home to eliminate all domestic opponents to her rule, and she welcomed missionaries to her capital.

A cunning and prudent Virago, so much addicted to arms that she hardly uses other exercises; and withal so generously valiant that she never hurt a Portuguese after quarter given, and commanded all her slaves and soldiers alike.

—Captain Fuller, speaking of Queen Njinga

Njinga's seizure of power in Ndongo violated established norms of the Mbundu. Although she claimed to be a close relative of the king, the Mbundu had not yet established hereditary succession; even if they had, she would have been excluded because her mother was a slave. Another deterrent to her assumption of power was the Mbundu opposition to females assuming any title. Although women often ruled other African tribes as queens, the Mbundu expressly forbade women to take the kingship of Ndongo. Njinga's seizure of power, therefore, was actually a coup. She continued the process of centralization begun by earlier rulers, basing her power entirely on the support of royal slaves rather than noble families. Through force of character, she was able to establish a precedent for female leadership which would outlast her reign.

Her alliance with the Portuguese was a tactical one and proved to be short-lived. In 1624, the new Portuguese governor withdrew the promise of his predecessor to remove a fortress on Njinga's lands. About this same time, Njinga began offering asylum to slaves fleeing Portuguese plantations near the coast. When the Portuguese retaliated by backing another pretender to the Ndongo throne, Njinga redoubled her efforts to attract slaves escaping from the

Europeans. In their gratitude, these new arrivals became her loyal and devoted subjects.

When the Imbangala had a falling out with the Europeans, Njinga formed a powerful new alliance with these warriors, which was strengthened by their tradition of granting political power to kinless women. As the Imbangala controlled the south side of the Kwanza River, Njinga was able to exploit this position to launch numerous attacks against Portuguese slave traders. But the Imbangala coalition also proved short-lived, and in 1629 Njinga was forced to flee her kingdom of Ndongo. She settled in a lowland area on the northeastern fringes of the old Ngola state, the political structure of which had been left in disarray by the Portuguese-Imbangala raids from 1617 to 1621. Once known as the kingdom of Matamba, the area was now without a ruler. Matamba had a tradition of queens as rulers in ancient times, and Njinga was able to reestablish her power there over a new kingdom.

Control over the movement of slaves often meant control over a region's wealth and power. Njinga soon began trading slaves again. In the 1630s, she closed the main slave trail, blocking Portuguese access to the slave-producing areas along the Kwango. Although she sold some slaves to Europeans, she kept many as mercenaries, and in this way resurrected the Matamba kingdom. In 1635, she succeeded in forming a large coalition—with the states of Matamba, Ndongo, Congo, Kassanje, Dembos, and Kissamas. From her position as head of this alliance, Njinga forced the Portuguese to retreat. As well, Portugal was shifting focus from its overseas territories, because it had more pressing affairs at home: economic and social decline and hostilities with Spain. The Dutch took advantage of the situation by occupying Luanda in 1641. By the 1640s, when Njinga began to make alliances with Dutch slavers, Matamba was the largest state in the region. With her new allies, Njinga managed to dominate both the highlands and lowlands, and in 1648 the Portuguese finally withdrew from the region.

During the 1640s, Njinga decided to "become a man," that is, she took on certain trappings as a means to overcome what was still regarded by some as the illegitimacy of her gender to rule. She took several husbands and required them to dress in women's clothing. They slept among her ladies-in-waiting under the threat of death if they touched them sexually. Among powerful women in central Africa, there were precedents for similar gender shifts; in the Kongo, for example, ruling upper-class women

Njinga being received by the Portuguese governor.

had the right to marry several men and to dispose of them as they saw fit.

Njinga appointed women to high government positions and recruited them for her armies. She equipped a battalion of ladies-in-waiting as soldiers and used them for her personal bodyguard. She led her troops into battle for many years. When armed for war, she was clad in animal skins, with a sword slung from her neck, an ax at her girdle, and bows and arrows in her hands. Two of her sisters were also warriors: Kifunji, who was killed by the Portuguese, and Mukumbu, whom she had to ransom from them.

In 1650, the Dutch left Angola. Having fought the Portuguese for more than two decades, Njinga allied herself with them once again. A formal treaty was signed in 1656 and would remain in force until the end of her life. She embraced Christianity once again, welcomed missionaries to her court, allowed free passage of Portuguese merchants, and promised to deliver a quota of slaves to them each year. Her return to Christianity probably had more to do with maintaining her authority than any true religious conversion. Since many of those whom she ruled continued to view her as a usurper, it was impossible to further alienate them, and the conversion essentially created a small ruling party of Angolan Catholics comprised of Njinga, her relatives and supporters, and the Portuguese.

A powerful individual, Njinga was both wily and intelligent. During one negotiating session with the Portuguese, the Europeans deliberately failed to provide a chair for the queen, intending to humble her. Njinga responded by ordering one of her servants down on his hands and knees, and sat regally on his back, making the Europeans look ridiculous. Political dexterity allowed her to adapt to constantly changing conditions. Conversion to Christianity, adoption of ritual cannibalism, and reconversion to Christianity were means to advance her goal. She saw religious affiliation as having more to do with political power than with faith, a perspective not unlike that of certain European monarchs, including England's Henry VIII. She battled prejudice against her gender, lineage, and race, while in control of two successive kingdoms. Njinga never gave up the notion that she was the queen of Ndongo, even when she was forced to relocate in Matamba or to surrender territory to the Portuguese. In the end, she had shaped a state that tolerated her authority and built up a base of loyal supporters. For 40 years, she remained a power to be reckoned with in Angola. Tales of the cunning and power of Queen Njinga, well known in Africa, became widespread in Europe.

Her legacy was a dynasty of queens who ruled the combined kingdoms of Ndongo and Matamba. Women ruled for at least 80 of the 104 years following Njinga's death. Her succes-

sors included **Verónica I** (who became queen in 1681), followed by **Ana I** (d. 1744), **Verónica II** (crowned in 1756), and **Ana II** (d. 1767).

SOURCES:

Birmingham, David. *Trade and Conflict in Angola: The Mbundu and their Neighbours under the Influence of the Portuguese 1483–1790.* Oxford: Oxford University Press, 1966.

Fraser, Antonia. *Boadicea's Chariot: The Warrior Queens.* London: Weidenfeld & Nicolson, 1988.

Martin, Phyllis M. *Historical Dictionary of Angola.* London: Scarecrow Press, 1980.

Miller, Joseph C. "Nzinga of Matamba in a New Perspective," in *Journal of African History.* Vol. 16, no. 2, 1975, pp. 201–216.

Thornton, John K. "Legitimacy and Political Power: Queen Njinga, 1624–1663," in *Journal of African History.* Vol. 32, no. 1, 1991, pp. 25–40.

Karin Loewen Haag,
writer, Athens, Georgia

Nkrumah, Fathia (c. 1931—)

Egyptian-born first lady of Ghana. Name variations: Helen Ritz Fattiah; Fathia Halim Ritzk; Madam

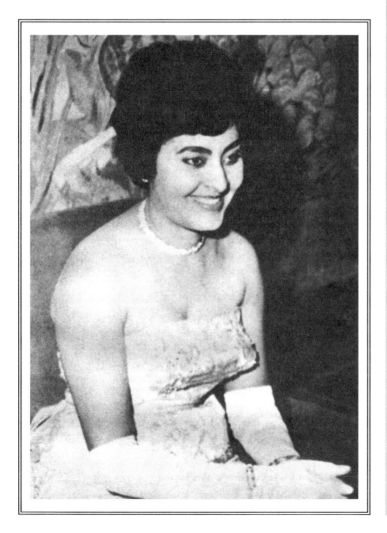

Fathia Nkrumah. Born in Egypt around 1931; father was a clerk in the Egyptian telephone company; educated primarily by the Sisters of Our Lady of the Apostles; also studied Arabic at the University of Cairo; married Kwame Nkrumah (prime minister and then life-president of Ghana), in December 1957; children: sons Gamal (b. 1959) and Sékou (b. 1963); daughter Samia Nkrumah (b. 1960).

The eldest of five children born to a Coptic clerk and his wife in Cairo, Egypt, Fathia Nkrumah was in her mid-20s and living in a modest home in the Cairo suburb of Zeitun with her widowed mother when a friend of Kwame Nkrumah's arrived in Egypt. Nkrumah, the first prime minister of the newly independent African nation of Ghana (formerly Gold Coast), had been told by a soothsayer that "Africa's messiah will be the son of an African man and an Egyptian woman" (or so the story goes). A passionate Pan-Africanist whose dream was a united Africa, Nkrumah sent a friend to find him an Egyptian wife, apparently with the approval of Egyptian president Gamal Abdel Nasser, who was also a friend. Presented with several pictures of prospective brides, the prime minister reportedly was impressed with two young Muslim women, but decided on Fathia because he too was Christian. They were married in a private civil ceremony in December 1957 at Christianborg Castle in Accra, the capital city of Ghana; the wedding may have been the first time they met. The bride spoke no English, and the English-speaking groom spoke no Arabic.

News of the prime minister's marriage was announced to the public only after the ceremony was complete. Single Ghanaian girls and women who had dreamed of marrying the popular, powerful bachelor were upset, but many others who had not held such dreams also were upset at his selection of a white woman for his wife; memories of the British who long had held the country as a colony were still fresh. As well, Fathia was shy by nature, unable to speak the language, and living in a totally foreign culture, none of which were helpful in making a good impression on observers. Her husband enlisted several British-born and African-American women to assist in her acclimation, and she also took English-language instruction. Despite his marked intelligence and excellent education, Nkrumah held traditional 1950s views on a wife's place, and accounts of their closeness vary. Fathia, who inclined to plumpness, apparently became preoccupied with maintaining a slim figure to suit his taste. (According to one source, on the rare occasions that

average Ghanaians spoke of their first lady the topic was invariably whether her weight was up or down.) Although she once may have even tried to return to Egypt, they had three children: Gamal (born 1959) and named after the Egyptian president, a daughter named Samia (born 1960), and Sékou (born 1963), who was named after Sékou Touré, the president of Guinea.

Meanwhile Nkrumah had become more and more occupied with his vision of a united Africa, favoring foreign policy to the vast detriment of the domestic situation. His regime became increasingly authoritarian as political opponents were suppressed, the economy foundered, and foreign debt mounted; despite a personality cult that grew around him, encouraged by his followers, unrest became widespread. When assassination threats increased, Fathia and her family moved from Christianborg Castle to the heavily fortified, isolated Flagstaff House in Accra. By the first years of the 1960s, while Nkrumah was increasingly isolated from the public for his own safety, Fathia began appearing at more public functions, and served as the chief patron of the National Council of Ghana Women and honorary chief of the Ghana Girl Guides. On February 24, 1966, however, while Nkrumah was out of the country, the Ghanaian armed forces and police seized control of the government. Fathia and her three small children fled the country on a plane sent by Gamal Nasser.

Kwame Nkrumah lived the rest of his life in exile in Guinea, and died in 1972. Ignatius Katu Acheampong instituted a coup in Ghana that same year; during his years as head of state, he invited Fathia and her children back to Ghana, where they lived for a time. After Acheampong was deposed in 1978, however, they were again made unwelcome, and later stripped of their house. In 1997, in what was perceived as a gesture of reconciliation, Ghanaian president Jerry Rawlings invited Fathia Nkrumah to attend the celebrations marking the 40th anniversary of Ghana's independence. She sat in a front-row seat.

SOURCES:
Frederick, Pauline. *Ten First Ladies of the World.* NY: Meredith Press, 1967.

Jo Anne Meginnes, freelance writer, Brookfield, Vermont

Noadiah

Biblical woman.

A false prophet, Noadiah was an agent of Tobiah and Sanballat who bribed her to stir up discontent among the people of Jerusalem, and in doing so, to hinder Nehemiah's efforts to rebuild the ruined walls of the city. However, Nehemiah paid little heed to Noadiah or to any of his enemies, finishing the wall in 52 days.

Noah

Biblical woman. One of the five daughters of Zelophehad, of the tribe of Manasseh; sister of *Mahlah, *Hoglah, *Milcah, and *Tirzah.

Noah and her four sisters were granted special permission by Moses to inherit their father's property after he died leaving no male heirs. Moses' judgment eventually became the general law of the land.

Noailles, Adrienne de (1760–1807).
See Lafayette, Marie Adrienne de.

Noailles, Anna de (1876–1933)
Leading French poet of the early 1900s, whose themes ranged from love, nature, and patriotism to death and oblivion. Name variations: Anna-Elisabeth, Comtesse Mathieu de Noailles; Princesse de Brancovan. Pronunciation: noh-I; brä-ko-V. Born Anna-Elisabeth de Brancovan on November 15, 1876, in Paris, France; died on April 30, 1933, in Paris; daughter of the Cretan-Greek Ralouka (Rachel) Musurus and Rumanian Prince Grégoire Bassaraba de Brancovan; educated at home by a succession of mostly German governesses; married Count Mathieu-Fernand-Frédérick-Pascal de Noailles also known as Mathieu de Noailles (a French soldier, born April 13, 1873), in 1897 (separated 1912); children: son, Anne-Jules-Emmanuel-Grégoire (1900–1979).

Published 24 books and scores of individual poems, articles, prefaces, and contributions to collective works over a 32-year period (1901–33); wrote three novels, but the bulk of literary output was poetry; was a member of the Academy of Belgium and recipient of both the Archon Déspérouses Prize and the Grand Prix of Literature of the French Academy; was the first woman awarded the red cravate of a Commander of the Legion of Honor.

Selected writings: Le Coeur innombrable (1901); L'Ombre des jours (1902); La Nouvelle Espérance (1903); Le Visage émerveillé (1904); La Domination (1905); Les Eblouissements (1907); Les Vivants et les Morts (1913); De la rive d'Europe à la rive d'Asie (1913); Les Forces éternelles (1920); Les Innocentes ou la sagesse des femmes (1923); L'Honneur de Souffir

(1927); Poèmes d'Enfance (1928); Exactitudes (1930); Le Livre de ma Vie (1932); Derniers Vers (1933).

On Anna de Noailles' 19th birthday, reports Claude Mignot-Ogliastri, her mother admonished the future poet: "If you want to marry, do not publish any verses . . . and try to wear a corset!" This bit of practical advice was highly indicative of the contemporary matrimonial expectations placed on eligible women of class, and Noailles' late teens had been a whirl of social functions preparatory to the match-making: balls, operas and theater outings were capped by formal coming-out parties, all accompanied by interminable toiletries. Various utterances against the strictures of the corset leave room for doubt as to whether she submitted to the torments of the whalebone but, either by design or coincidence, she did wait a suitable six months after the wedding to publish, soon embarking on a long and successful literary career.

Anna de Noailles was born in 1876 in Paris, in an opulent mansion at 22, Blvd. de La-Tour-Maubourg. Wealth, culture, social standing and a cosmopolitan lifestyle were hallmarks of both her parents' backgrounds. Her father, the Rumanian prince Grégoire Bassaraba de Brancovan, was a scion of the ancient Moldavian dynasty that had given its name to Bessarabia. The Brancovans had reigned over the Danubian principality of Walachia, an uneasy vassaldom of the Ottoman Turks, since 1601. Indeed, one ancestor had been executed in Constantinople for having signed a treaty with Russian tsar Peter I the Great. The gruesome family coat-of-arms—an armed horseman with the head of a Turk impaled on the point of his sword—eloquently illustrated the tense relationship between vassal and overlord. Anna's grandfather, Georges Demetrius Bibesco, was the last reigning *hospodar,* or Moldavian and Walachian prince. After the liberal revolutions of 1848, when events forced him to abdicate, the Brancovans moved from Bucharest to Paris. In France, Anna's father studied at the prestigious officers' academy of Saint-Cyr, founded by Napoleon I, venerating the severe discipline and deprivation endured at that elite school. Not surprisingly, he was a stern authoritarian, but also appreciated poetry and liked to cite classical verses. Embarking on a distinguished career in the army, like his brother Georges, who attended the General Staff School and was awarded the Grand Office of the Legion of Honor, Brancovan fought in both the Mexican and Franco-Prussian wars. Noailles remembered many an evening spent listening to her father reminisce over the wars, exhilarating

politics, and intricate high-stakes diplomacy of France under Napoleon III. Repeated themes such as the shameful loss of Alsace-Lorraine to the hated Bismarck undoubtedly contributed to the development of Anna's ardent patriotism. Yet politically, Brancovan was no monarchist, despite his royal lineage. Noailles' biographer, Mignot-Ogliastri, stressed that, while both sides of her family had close connections with the Ancien Régime as well as the Napoleonic nobility, the Brancovans and Musuruses (on the maternal side) were heart and soul behind the Republic. Anna loved her father dearly, and his death on October 15, 1886, provoked intense grief in the young girl of nine.

Anna's mother **Ralouka Musurus** was born in Constantinople into a prominent Cretan literary family. Ralouka's brother Paul wrote poetry, including a "perfect sonnet" dedicated to Victor Hugo, as Noailles put it, while her maternal grandfather had translated the *Divine Comedy* into Greek. The Musuruses' social standing equalled that of the Brancovans, and Ralouka Musurus' father, Musurus Pacha (1807–1891), was a Turkish diplomat who had served the Sublime Porte as ambassador to the Court of St. James, where he was held in great esteem by Queen *Victoria. (Noailles reported, perhaps with some exaggeration, that her mother was "raised on the knees of Victoria.") Thus, Anna's mother spent most of her youth in Britain, where she mastered English, while Musurus Pacha attended historic conferences in Paris and London. It was in London that the dashing, eligible Grégoire Brancovan married the talented Ralouka Musurus on May 25, 1874. Noailles described her mother as a perfect beauty, resembling the "gracious Venus' of the museums of Athens." Musically gifted, Ralouka was by all accounts an accomplished pianist, and Anna recalled spending many an evening sitting by the open fireplace, listening to her play music for the family. Noailles was very close to her mother, who inspired her with a deep empathy for the unfortunate in life. When Ralouka died on September 26, 1923, Noailles would be greatly affected, later writing: "I am happy that my mother has written some poems that, perhaps, shall not slip into oblivion."

Noailles had two siblings: an older brother and a younger sister. Constantin was drawn to literature, much like his sister, and later directed *La Renaissance Latine,* a literary review. **Hélène (de Caraman-Chimay)**, younger than Anna by one year, was gifted both in letters and in sculpture, and published in her brother's journal; she married the Belgian prince Alexandre de Caraman-

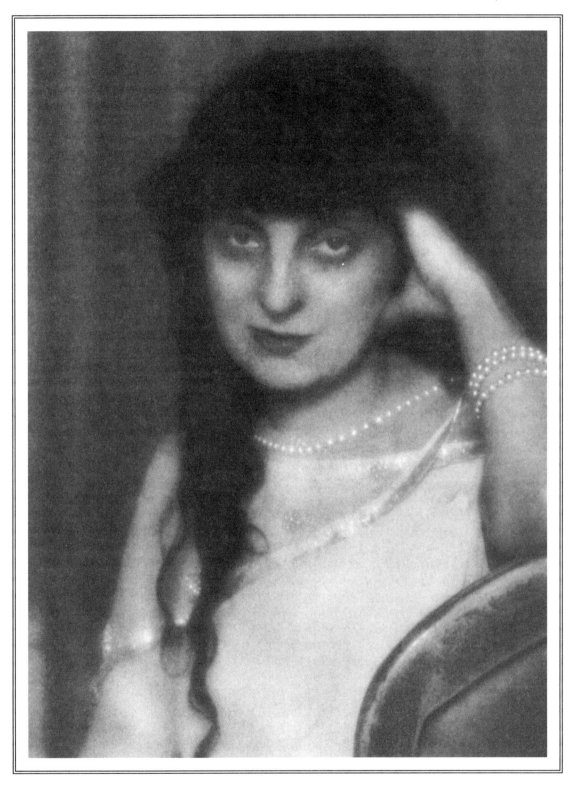

Chimay. Noailles was very attached to her sister, seeing or writing her daily throughout life until Hélène died of pneumonia on March 4, 1929.

Born in a lavish aristocratic villa with ceilings decorated by Auguste Renoir, Anna spent

most of her youth in an elegant Parisian townhouse at 34, Avenue Hoche, half-way between the Champs-Élysées and the Parc Monceau, to where the family had moved in 1879. Potted palm trees, two pianos, Gobelin tapestries, staircases covered with thick red carpets, gracefully

appointed salons and a gallery of ancestral portraits typified that cultivated aristocratic fin-de-siècle residence. An extensive household staff was presided over by a faithful old Bavarian maître d'hôtel, and before her father died, the family had formal luncheons every Sunday, to which the most prominent literary and political figures were invited. Such society dinners might include caviar, oysters, spiced hors d'oeuvres, a long main course and bottles of pink champagne, for Noailles' mother hosted one of the top ten Parisian salons.

Yet little Anna was unhappy in her childhood home, apparently a lonesome child despite the fact that she was admired by all as exceptionally talented. Suffering through the endless social visits of her mother, she recalled how conversations revolved around interminable political and colonial reminiscences. At home, the vista from her window was stifling and bereft of nature, and frequent depressions confined her to bed. She remembered praying to God for a child born of her body alone, "another little Anna who . . . would console and understand me." Thus, during the bleak Parisian winters she dreamed of the family's country residence at Amphion, on the shores of Lac Léman, near Evian in Savoy.

In the salons, it is always the Countess, she will come, she's coming, there she is, and suddenly servants fall silent, conversations cease, everyone . . . rises on tiptoes the better to see.

—Louis Perche

Noailles habitually spent at least four months of the year at Amphion, until 1900, after which her visits became shorter and more sporadic. The estate, purchased by her father from Count Alexander Walewski, a bastard son of Napoleon and *Marie Walewska, consisted of a châlet and a "château" designed by Viollet-le-Duc. The family's steam-yacht, the *Rumania*, lay waiting at a private port on the banks of the lake. Summer carriage rides through the surrounding countryside alternated with yacht outings up and down the lake, to visit the Rothschilds, Talleyrands, and La Rochefoucaulds, while the evenings were filled with light-hearted parties, balls, and masquerades. Noailles asserted that the lovely countryside of Savoy inspired in her the love of nature ("Far from her, I would die"), and the desire to "communicate, intact and still alive, bathed in its dew, adorned with its stars" the world's beauty to all who would hear, that were to figure so prominently among the themes of her poetry. Fire, the light of the sun,

and certain plants seem to have possessed a special inspirational quality while Noailles, as she put it, "listened to the voice of the Universe."

Sadly, a privileged adolescence was marred by constant health problems that deprived her of many a joyful activity. Sensitive both physically and emotionally, Noailles suffered from insomnia early on. Visiting Constantinople in 1887, after the death of her father, she came down with an indeterminate fever, and as a young girl on the verge of puberty was stricken with an appendicitis which became chronic, at one point necessitating the use of morphine to alleviate the excruciating pain. Not surprisingly, themes frequently evoked in early poems are of sick and dying children, death, and pity for the unhappy and downtrodden.

Anna's education was typical for her gender and class: while her brother was sent off to secondary school, the two sisters' German governesses—along with the French tutors, music and drawing, gymnastic and riding masters—were instructed to provide a grounding in modern languages and "good" literature, at the same time imparting the artistic accomplishments and social graces desired by prospective suitors. (Noailles was to become a gifted pianist, and during the last decades of her life turned to pastels, her work even being displayed in a Paris exhibition.) Informal history lessons administered by Anna's father served to nourish a pride in both parents' distinguished ancestry, while instilling a deep love for the adoptive homeland. French, the family language, was her mother tongue, but Anna's German became perfect, and her English—learned from an Irish tutor—was good, while Greek and Latin were not considered necessary for a girl's education. Devouring Grimms' and Perrault's fairy tales along with the Arabian Nights as a young girl, she was by her late teens reading broadly in the more serious fare of 17th- and 18th-century literature.

With her family's literary background (uncle Paul made her learn his favorite Parnassian poems by heart), one is not surprised to find Noailles writing her first poems, proudly circulated among friends and acquaintances, during her early teens. While, as a child, her French tutor directed readings in Anatole France, Paul Bourget, and Pierre Loti, she herself cited as her most important influences the works of Alfred de Musset ("the young girls' . . . first and pure lover"), along with Pierre Corneille, Jean Racine and Victor Hugo. Of the latter, she wrote: "He subjugated me entirely and I was his child." As a young woman, Anna was a voracious and eclec-

tic reader, and the range of her preferred authors ran from Voltaire and Rousseau to *Mme de Staël and *George Sand, Emile Zola and Frédéric Mistral, whom she met when she was eight.

On August 17, 1897, after a courtship befitting her class, Anna *faisait une bonne partie* (made a good match) with her marriage to Count Mathieu de Noailles in the village church of Publier near Amphion. The society wedding—previously announced in the Paris dailies *Gaulois* and *Figaro*—included a formal contract, civil and church ceremonies, fireworks, and an official ball. The groom's pedigree was as long as his name, for he stemmed from one of the greatest French aristocratic houses, tracing its lineage back to the 12th century, and including statesmen, church prelates, soldiers, and diplomats. The count's grandfather, Duke Paul de Noailles had been an ambassador, historian and academician, and his father Jules wrote books on political economy. Mathieu himself had served in the army from 1891 to 1895, and then entered the reserve. The newlyweds made their first residence in Paris at 109, Avenue Henri-Martin, moving to 40, rue Scheffer, in Passy in August of 1910. Their son, Anne-Jules-Emmanuel-Grégoire, was born on September 18, 1900.

Anna de Noailles made her literary debut in the *Revue de Paris,* on February 1, 1898, with a collection of poems entitled *Litanies.* This was soon followed by *Bittô* (1900) and *Exaltation* (1900). Hardly a year later, on May 8, 1901, the prestigious Paris publisher Calmann-Lévy issued *Le Coeur innombrable,* a poetic anthology replete with eloquently sensualist evocations of nature in general, the French countryside in particular. It immediately received great acclaim and was awarded the prestigious Prix Archon Despérouses by the French Academy. *L'Ombre des jours,* her second extended collection of poems, followed shortly thereafter (1902). Noailles' brilliant literary career had begun.

In 1903, Noailles published her first of a series of three novels, all of which dealt with the psychology of love, and contained numerous autobiographical elements. *La Nouvelle Espérance* was recommended for, but ultimately not awarded, the first Prix Goncourt. In it, the heroine's mother dies early and young Sabine refuses any food for days on end, an event which recalls Anna's own three-day prostration at her father's death. Sabine's loss of faith at age 15 also echoes the author's severe religious doubts during her adolescence. The Brancovan background, moreover, is revealed when Anna has Sabine become interested in politics and display a profound love

of France and its historical glories. The influence of her sentimental German governess, finally, is reflected in the main character's constant search for a true, enduring, and boundless love, clearly another autobiographical reference by Noailles, who affirms that, from early childhood: "I depended entirely on the affection of all beings."

In 1904, *Le Visage émerveillé,* a fictitious diary of a nun torn between the clandestine love for a young man, for which she feels no sin, and her devotion to the convent, provoked something of a scandal—despite its highly moral end—for its publication coincided with the political movement leading to the separation of church and state. Yet it was defended by Barrès and admired by Marcel Proust. Her last completed novel, *La Domination* (1905)—the story of a desperate search for love—met with a hostile reception by critics, maybe because, contrary to her first two novels, the protagonist was male. *Octave* remained unfinished.

After her mixed success with novels, Noailles returned to what she clearly did best, poetry. The following years witnessed the publication of a good dozen anthologies, most of which were very well received by critics and the general public. *Les Eblouissements* (1907), which included the characteristic nature poem "la Prière devant le Soleil"—termed by Proust "the most beautiful thing written since Antigone"—consolidated her renown. *Les Vivants et les morts* (1913) was widely acclaimed both in France and Britain, where the *Times* called her the "greatest poet the 20th century had produced in France and even perhaps in Europe."

The advent of the Great War marked a hiatus for the Noailles family, as it did for a whole European generation: Anna was not to publish again until 1920, and her husband was mobilized in August, as a lieutenant in the 27th Dragoons. He served in the trenches for three years and was promoted to captain in 1917, earning one of the first Croix de Guerre, as well as the Legion of Honor, for gallantry on the battlefield. Though the two spouses had finalized an amicable separation on February 14, 1912, before the Tribunal of the Seine, Anna visited Mathieu repeatedly on the front. Towards the end of the war, he served in Morocco, returning to France in August 1918.

Given the profoundly nationalistic sentiments of France from the wars of Napoleon III, through the Third Republic's colonial expansion, to the bloody showdown with Germany, one is hardly surprised to find numerous poems of Noailles' echoing the spirit of the age, such as

"Regard sur la frontière du Rhin" (1912), "Les Soldats de 1914" (1914), and "Commémoration de Verdun: La glorification et l'espérance" (1921). The anthology *Les Forces éternelles* (1920) was an exaltation of the heroes of 1914–18 and marked Noailles' apotheosis. Indeed, on June 4, 1921, she was elected to the Belgian Royal Academy of Language and Literature, and on July 1, 1921, awarded the French Academy's Grand Prix de Littérature, only three years after it had first been granted a woman. The august Academy itself, however, still kept its doors closed to women at that time. Proposed for the Legion of Honor as early as 1904, she received that distinction in 1931.

Thematically, much of her poetry was impregnated with a Kantian view of the cosmos, an ardently pantheistic love of creation, as evident in frequent images of fusion with nature. Though raised in the Russian Orthodox faith, and a convert to Catholicism upon her marriage, Noailles was in fact a materialist, highly skeptical of any belief in an immortal soul. Other recurring themes included the mysteries of the Orient and the cult of youth; travel, marked by a fascination first with trains, later with the modern technology of motorcar and aeroplane; and a highly sensualist love poetry, which shocked many male readers due to its assertion of female sexuality. After 1913, her work took a profound turn towards the somber, dealing with the search for God and a preoccupation with the mysteries of death and nothingness.

Noailles published her articles, poems, and serializations mainly in the periodicals *Revue des Deux Mondes, Revue de Paris,* and *Revue Hebdomadaire,* but also in *La Revue Européenne, Revue de France* and *Minerve Française.* In addition to the well-known Calmann-Lévy and Fayard, which produced the bulk of her books, her publishers also included Grasset and Hachette, Fasquelle and the *Nouvelle Revue Française.*

Politically, Noailles was staunchly republican and imbued with a deep patriotism. When the Dreyfus Affair convulsed France during the 1890s, Noailles (and her husband) vehemently spoke out, in public, in favor of the accused, for in politics as in private life, she had a deep sympathy for the victims of injustice; Proust witnessed Anna breaking out in uncontrollable sobs on hearing of Dreyfus' arrest. La Rochefoucauld reports that when war broke out in 1914, she wrote a friend: "France cannot perish, for the gods defend her." Visiting Strasbourg when hostilities had ceased, she was overjoyed to find the flag of the German Reich replaced by the French tricolor. Yet her patriotism was tempered by a pacifist vein, for in war, she believed Death was the only true victor. After the war, she placed her confidence for the future of Europe in the newly founded League of Nations, in 1925 even accompanying her friend Paul Painlevé, president of the French delegation, to observe that body in session at Geneva.

Regarding the women's movement, Mignot-Ogliastri called her politically "prudent, but realistic," while her views on the division of gender roles in society were rather more conservative. Here her attitude was not untypical for her class and profession. She once told a journalist:

> I am not a feminist in the too limited sense many have wanted to give the term, but I wholeheartedly support the demands of women as a natural principle. Think . . . of the social and educative role elected women could play in Parliament. Who could better comprehend the soul of the small and humble, and take an interest in their fate? Will we not envisage a day when, looking back with surprise, it had been necessary to wait so long for this elementary justice?

She supported the suffrage movement in a letter to the president of the French Senate, and in 1930 was the only woman judge on the jury of the Miss Europe contest. In fact, when women still rarely figured in public occasions, Noailles was asked to inaugurate a memorial to the poet Mistral, delivered the official eulogy for the French transatlantic aviators Coste and Bellonte at the Paris City Hall, and participated in the official breakfast given by Foreign Minister Aristide Briand in honor of Charlie Chaplin.

Physically, Noailles was petite, attaining an adult height of just under five feet. But her fine features, long black hair, and large green eyes—admired by numerous contemporaries—captivated all beholders. She was perfectly aware of her beauty, as of her personal charm, and flaunted both with gusto. Courted by Parisian society, she dominated salon gatherings, enjoying every moment. Numerous eyewitnesses, such as her close friends Jean Cocteau and *Colette, have left eloquent descriptions of her rather studied social appearances.

Noailles had a poor constitution all her life. Cocteau—himself an opium addict—reported that she overindulged in sleeping drugs during adulthood. Many disbelieved her lamentations, while friends respected her quiet suffering. Frequent consultations of various specialists, along with numerous voyages to health spas, availed nothing, and the sources are mute on the nature

of her debilitating illness. In any case, by 1912 her health began failing to the point that she ceased the perpetual traveling of better times and became bed-ridden part of the day for the rest of her life. Indeed, her health became so delicate that visitors always arrived with apprehension, her devoted maid Sara frequently answering queries with "Madame la Comtesse has not yet risen"; and even habitual guests often waited 45 minutes for Noailles to appear. Many friends associated her later years with the closed, dark sickroom in her fifth-floor Paris apartment, where even at noon the "black hour of sleep, of suffering," reigned, according to Colette.

Anna de Noailles died at home on April 30, 1933, in the presence of her husband, son, and daughter-in-law. The exact cause of death is unknown, but was possibly a cerebral tumor. The government offered her family an official ceremony, held in the Madeleine church on May 5. Her body was interred in the Bibesco-Brancovan family vault in Père-Lachaise cemetery, while her heart was buried separately in a monumental stele in Publier, close to her cherished Amphion. The epitaph reads: "Here sleeps my heart, vast witness of the world."

SOURCES:

Berl, Emmanuel. "Elle a scintillé sur mon enfance," in *La Comtesse de Noailles: Oui et Non*. Edited by Jean Cocteau. Paris: Perrin, 1963.

Cocteau, Jean, ed. *La comtesse de Noailles: Oui et Non*. Paris: Perrin, 1963.

Colette, Sidonie-Gabrielle. "Discours de réception de Madame Colette, successeur de la Madame de Noailles à L'Académie Royale de Belgique," in *La Comtesse de Noailles: Oui et Non*. Edited by Jean Cocteau. Paris: Perrin, 1963.

Duchet, Claude, ed. *Histoire littéraire de la France, 1873–1913*. Paris: Editions Sociales, 1978.

Harvey, Sir Paul, and J.E. Heseltine, eds. *Oxford Companion to French Literature*. Oxford: Clarendon Press, 1959.

*La Rochefoucauld, Edmée de. *Anna de Noailles*. Paris: Editions Universitaires, 1956.

Mignot-Ogliastri, Claude. *Anna de Noailles: une amie de la Princesse de Polignac* [*Winnaretta Singer]. Paris: Méridiens Klincksieck, 1987.

———, ed. *Jean Cocteau. Anna de Noailles. Correspondance*. Paris: Gallimard, 1989.

Noailles, Anna de. *Le livre de ma vie*. Paris: Mercure de France, 1976.

Perche, Louis. *Anna de Noailles*. Paris: Pierre Seghers, 1964.

Thieme, Hugo P., ed. *Bibliographie de la littérature française, 1800–1930*. Vol. II. Paris: E. Droz, 1933.

COLLECTIONS:

Correspondence, personal papers, and the manuscript originals of many of Noailles' literary works are in the possession of the Bibliothèque Nationale in Paris.

William L. Chew III,
Professor of History, Vesalius College,
Vrije Universiteit Brussel, Brussels, Belgium

Noailles, Anne Claude Laurence, duchesse de (d. 1793).

See du Barry, Jeanne Bécu, Comtesse for sidebar.

Noailles, duchess de.

See du Barry, Jeanne Bécu, Comtesse for sidebar of Anne Claude Laurence (d. 1793).

Noailles, Marie-Laure de
(1902–1970)

*French patron of the arts and salonnière who was one of the most important influences in the artistic and intellectual life of Paris for many decades. Name variations: Marie Laure de Noailles; Viscountess de Noailles; Marie-Laure Bischoffsheim. Born Marie-Laure Henriette Anne Bischoffsheim on October 31, 1902, in Paris, France; died in Paris on January 29, 1970; daughter of Maurice Bischoffsheim and Marie-Thérèse de Chevigné; married Vicomte or Viscount Charles de Noailles; children: two daughters, **Laure de Noailles** and **Nathalie de Noailles**.*

Born in a palatial house in Paris on Halloween in the year 1902, Marie-Laure Bischoffsheim would grow up to become Marie-Laure de Noailles, one of the 20th century's most generous and imaginative patrons of the arts. When Noailles was only 18 months old, her father Maurice Bischoffsheim died of tuberculosis, and she inherited his vast fortune. Her father belonged to an enormously wealthy Jewish banking family that could easily stand comparison to the Rothschilds. From her mother **Marie-Thérese de Chevigné**'s family, the little girl inherited not money (by aristocratic standards, they were quite poor) but tradition and breeding. Her mother's family was descended from three famous literary figures of quite different traditions. The most venerable of these was *Laure de Noves, the beloved Laura of the Renaissance literary giant Petrarch. Marie-Laure's maternal grandmother, the elegant **Comtesse de Chevigné**, became the model for Marcel Proust's duchesse de Guermantes in his monumental novel *A la Recherche du Temps Perdu*. Another ancestor had a less reputable literary connection: the notorious Marquis de Sade. As well, Noailles was a descendant of the Marquise *Marie Adrienne de Lafayette** and the Marquis de Lafayette.

As a child, Marie-Laure was in frail health, but by the time she entered her teen years she had become quite hale, "an anorexically svelte tomboy, aware of posture, dressed to kill," said

her friend Ned Rorem. As an adult, Noailles thought she looked like Louis XIV. She did possess a striking physiognomy, and *Janet Flanner has described her as having "a strange, fascinating medieval face, horizontally cut in half by a high forehead that shortened the even features and seemed to separate them from the intellectual cranium above, beneath which her black eyes shone or stared haughtily." A voracious reader from her earliest years, Noailles kept abreast of literary trends but was also well read in the great works, having completed a 24-volume set of Henry James, as well as most of the French, German, and Russian classics, along with Dickens, George Eliot (*Mary Anne Evans), and Thomas Hardy. She also had a good command of poetry, being able to recite from memory countless poems. Of the many anecdotes about her erudition, one refers to her honeymoon voyage to Cuba in 1922, after she had wed, in an arranged marriage, an equally wealthy aristocrat named Viscount Charles de Noailles. Marie-Laure declined to disembark in Havana, being much too immersed in Sigmund Freud's *General Introduction to Psychoanalysis.* One of Charles' more interesting gifts to his wife in the early years of their marriage was a portrait drawing of her by Pablo Picasso.

Although Viscount Charles was bisexual, two daughters—Laure and Nathalie—were born to the couple. The marriage was in many ways happy, despite the absence of a shared bedroom. Charles was an expert on French gardens, had exquisite taste, and like Marie-Laure was interested in the arts. In 1930, Charles and Marie-Laure de Noailles funded (for a million francs, a fabulous sum during that first full year of the world economic depression) an innovative film by two eccentric Spanish geniuses, Luis Buñuel and Salvador Dali. The film, *L'Age d'or,* now a classic, was then considered by many to be, in the words of James Lord, "blasphemous, indecent and scandalous." The premiere screening took place in the opulent ballroom of the de Noailles mansion on the Place des États-Unis. The ballroom, all gilt and mirrors transported piece by piece from a Sicilian *palazzo,* with a ceiling painted by Solimena, had been altered at great expense, without, however, blunting the room's rococo splendor, so that films could be shown. The mostly aristocratic audience was amused (or staggered) by a film in which one bizarre image followed another, and as a climax there was an invocation of a personality greatly beloved by the Surrealists, Marie-Laure's outrageous ancestor, the Marquis de Sade, complete with the principal figures of his most shocking work, *The Hundred and Twenty Days of Sodom,* presented not as themselves but as Jesus

Christ and his disciples. Not surprisingly, when *L'Age d'or* was shown publicly some months later, it caused a riot, with fascist toughs throwing stink bombs in the theater and the press debating its social value, if any. A week after this, the film was banned by the authorities and all available copies were confiscated.

Throughout the 1920s and 1930s, Noailles was an enthusiastic music patron, especially supporting the remarkable group known as Les Six. The six composers (Georges Auric, Louis Durey, Arthur Honegger, Darius Milhaud, Francis Poulenc and *Germaine Tailleferre), whose shared philosophy was one of opposition to the then-dominant impressionist and romantic traditions of French music, all had compositions commissioned by Marie-Laure and Charles. Among the most important works made possible by the generosity of the Noailles' were Francis Poulenc's *Aubade* and *Le Bal Masqué. Aubade* was given its premiere with original choreography by *Bronislava Nijinska before a select audience at the Place des Etats-Unis. Writes Lord: "On a stage mounted in the garden, there were entertainments of various kinds: Gothic dances in the 'heraldic' style of the Beaumonts, a magic lantern projecting Jean Hugo's drawings with music by Georges Auric, and finally Francis Poulenc's *Aubade,* commissioned by the Noailles, with the composer himself at the piano, surrounded by eighteen instrumentalists."

Other composers whose work was made possible by the Noailles' patronage included Henri Sauget, who composed a commissioned opera, *La Voyante* (The Seer). Even non-French composers, including the brilliant Kurt Weill, creator of *Die Dreigroschenoper* (The Threepenny Opera), benefited from their generosity. In December 1932, only weeks before Adolf Hitler became Germany's chancellor, Weill saw the Paris premiere of his school opera *Der Jasager* (The Yes-Sayer), made possible by generous support from Marie-Laure and Charles de Noailles. For a number of weeks in 1933, Weill, by now a refugee from a newly Nazified Germany, lived at the Noailles palace. There, he composed one of his most impressive works, *Die sieben Todsünden* (The Seven Deadly Sins), described by Weill as a "spectacle in nine scenes" and dedicated to the viscountess and viscount. After World War II, Marie-Laure continued to scout out and support talented young composers, including the American Ned Rorem, who went to Paris in 1949 intending to stay a month. Instead, he stayed for nine years, many of them as a guest at the Place des États-Unis. Recognizing his talent, Marie-Laure was his patron and introduced him to Paris high society.

Throughout the 1930s, despite the world economic crisis and political chaos in France and elsewhere, the intellectual and artistic life of Paris remained brilliant, in no small measure because of the generosity and imagination of Noailles and her husband. In their mansion, invited guests discovered more than an inherited treasure house. In later years, one could find inside the entrance a Frigidaire-sized, compressed automobile by César standing next to an ancient Greek marble Apollo. Besides the resplendent statuary, which included a gilded Bernini bronze, there were rare tapestries, magnificent furniture, and thousands of volumes in precious leather bindings. In Marie-Laure's sitting room hung her portraits by Picasso, confronting one of her pair of inherited (from her paternal grandfather) Goyas. (There were three Goyas in the palace, two of which were generally held to be among his great masterpieces.) In the parchment-lined salon, designed by Jean-Michel Frank, a Dali hung opposite a Rubens. A daring collector, Marie-Laure was among the first to purchase works that would later be deemed modern classics, including ones by Bérard, Chirico, and Chagall. She had hung in the dining room a huge Italian equine portrait, a large horse viewed from its hindquarters; the guest of honor was always placed facing the painting. The treasures held in the Noailles residence included canvases by Braque, Degas, Delacroix, Géricault, Klee, Rembrandt, Van Dyck, and Watteau.

Many paintings by her own hand could be seen displayed in the palace as well. These were by no means works of inferior quality; a talented artist, Marie-Laure de Noailles showed her pictures at the prestigious Salon de Mai. Structurally informal, rather like the visionary canvases of Turner, they sold well. She also wrote three novels, and Aldous Huxley said that her fiction was among the few contemporary novels that he felt certain would survive (though they have not stood the test of time). Her novella *La chambre des écureuils* (The Squirrels' Room), which was privately printed and publicly distributed in France during World War II, recounted Marie-Laure's experience of having been sexually abused in her youth by her stepfather Francis de Croisset. The story bore, as far as she was concerned, a striking resemblance to **Françoise Sagan**'s hugely successful 1954 novel, *Bonjour tristesse*. Marie-Laure wanted—but finally decided not—to sue Sagan and her publisher for plagiarism. The viscountess de Noailles also wrote a book of poems, *Cires Perdues*, which in Janet Flanner's opinion was "imbued with the illogic and ambiguity then fashionable."

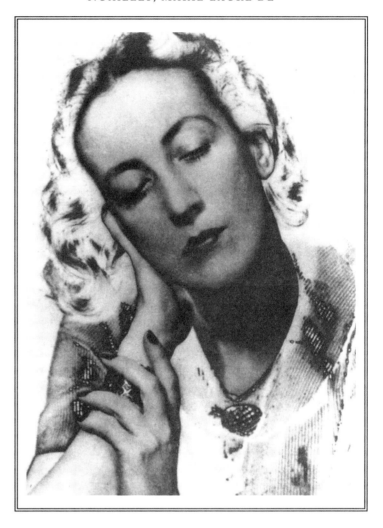

Marie-Laure de Noailles

Although her books and paintings reveal considerable talent and intelligence, Marie-Laure de Noailles' greatest achievement was her ability to preside with style and understanding over Paris' outstanding center of intellectual and artistic energy, her palace on the Place des États-Unis, for more than 40 years. Her intimate "Déjeuners littéraires," to which no more than eight top artists and thinkers would be invited (including such superstars as Jacques Lacan), set the tone for future decades of French—and Western—intellectual development. On other occasions, balls with 200 guests were as dazzling as any such affairs in the past centuries. Wrote Lord: "Her generosity, in fact, was exceptional and an interesting, contradictory aspect of her nature. Though unusually acquisitive and possessive, she was virtually extravagant in the largesse she distributed to those she cared for, especially if they happened to be in straitened circumstances."

The viscountess' choice of friends and lovers was eclectic (among others, she had extended relationships with the brilliant conductor and com-

poser Igor Markevitch, as well as with the less-than-brilliant Spanish painter Oscar Dominguez). During World War II, Marie-Laure, who was one-quarter Jewish according to the Nazi Nuremberg Racial Laws, engaged in a love affair with a German officer of Austrian birth. Seeking new experiences into her advanced years (she supported the student uprising of 1968 by attempting to communicate and share ideas with the radicals), Noailles exhibited a lust for life to her very last days. Shrieking "I don't want to die," she expired at her mansion, Place des États-Unis No. 11, on January 29, 1970.

SOURCES:

Boissiére, Jean-François. *Traité du Ballet, illustré de gravures a l'eau-forte par Marie Laure*. [Paris]: Édité par Le Degré Quarante et un, 1953.

Buckland, Sidney, and Myriam Chimenes, eds. *Francis Poulenc: Music, Art and Literature*. Aldershot, England: Ashgate, 1999.

Buñuel, Luis. *L'Age d'Or: Correspondence Luis Buñuel—Charles de Noailles: Lettres et Documents (1929–1976)*. Paris: Centre Georges Pompidou, 1993.

Drew, David. *Kurt Weill: A Handbook*. Berkeley, CA: University of California Press, 1987.

Emden, Paul H. *Money Powers of Europe in the Nineteenth and Twentieth Centuries*. Reprint ed. NY: Garland, 1983.

Flanner, Janet. "Foreword," in Horst, *Salute to the Thirties*. NY: Viking Press, 1971, pp. 3–10.

Gold, Arthur, and Robert Fizdale. *Misia: The Life of Misia Sert*. NY: Alfred A. Knopf, 1980.

Heyden-Rynsch, Verena von der. *Europäische Salons: Höhepunkte einer versunkenen weiblichen Kultur*. Munich: Artemis & Winkler Verlag, 1992.

Laure, Marie [pseud., Marie-Laure Bischoffsheim, Vicomtesse de Noailles]. *Cires Perdues*. Paris: Pierre Seghers, [1953].

Lord, James. *Six Exceptional Women: Further Memoirs*. NY: Farrar Straus Giroux, 1994.

Milhaud, Madeleine. *Catalogue des Oeuvres de Darius Milhaud*. Geneva and Paris: Slatkine, 1982.

Rorem, Ned. *Knowing When to Stop: A Memoir*. NY: Simon & Schuster, 1994.

———. *The Paris and New York Diaries of Ned Rorem: 1951–1961*. San Francisco: North Point Press, 1983.

———. *Setting the Tone: Essays and a Diary*. NY: Coward, McCann & Geoghegan, 1983.

Schmidt, Carl B. *The Music of Francis Poulenc (1899–1963): A Catalogue*. Oxford: Clarendon Press, 1995.

"Viscountess de Noailles of Paris, Patron of Avant-Garde, Dies," in *The New York Times Biographical Edition*. January 30, 1970, p. 247.

<div align="right">

John Haag,
Associate Professor of History,
University of Georgia, Athens, Georgia

</div>

Noailles, viscountess de.

See Noailles, Marie-Laure de (1902–1970).

Noble, Margaret (1867–1911).

See Nivedita.

Noce, Teresa (1900–1980)

Italian activist, labor leader, journalist and feminist who served as a parliamentary deputy and advocated sweeping social legislation on behalf of mothers. Name variations: "Estella" (underground name used during her years as a political émigré in France). Born in Turin, Italy, on July 29, 1900; died in January 1980; married Luigi Longo.

Worked as a turner for Fiat Brevetti and later became a journalist, writing for Il grido del popolo *and* Ordine nuove *(1914–17); joined the Socialist Party (1919); became a member of the founding generation of the Italian Communist Party (1921); oversaw the Communist Youth Federation and their periodical* La voce della gioventù *(1920s); helped instigate the anti-fascist strikes of the female workers in the rice fields (1934); organized movements in both Italy and France, becoming a leader of the women's Communist Party in France; edited a number of periodicals, including* La voce della donne, *an anti-fascist periodical founded by women (1934); escaped from a concentration camp and aided the French Resistance; captured by the Gestapo and interred in the Ravensbrück concentration camp; returned to a liberated Italy (1945); as a member of the central committee of the Communist Party, worked to form the Italian Republic; had a long and successful career in public life, including election to the Italian Parliament, selection as general secretary of the textile workers union, and election to the Central Committee of the PCI; was a driving force in achieving passage of a comprehensive maternity law (1950).*

Selected works: Nuestros hermanos, los internacionales *(1937);* Tra gli eroi ed i martiri della liberta *(1937);* Gioventù senza sole *(1938);* Teruel martirio e liberazione di un popolo! *(1939);* Ma domani fara giorno *(1952);* Rivoluzionaria professional *(1974);* Vivere in piedi *(1978);* Estella: Autobiographie einer italienischen Revolutionärin *(1981).*

A self-declared "professional revolutionary," Teresa Noce was born in the northern Italian industrial city of Turin on July 29, 1900. The second child of an unmarried working-class mother, Noce grew up in poverty. At age ten, she began working at the local Fiat factory. To protest low pay, long hours (ten hours a day), and poor factory conditions, by age 12 Teresa was active in her plant's union, joining demonstrations. In 1915, she and thousands of other workers took to the streets to denounce Italy's entrance into World War I. She remained active in union affairs throughout the war, becoming increasingly militant as the conflict dragged on. Starting in 1919, she became an active member

of the Young Socialist movement, and for the next several years was one of Turin's most active working-class leaders in a period when the workers of northern Italy occupied their factories and many observers believed the nation was moving toward a revolution.

The dreams (and fears) of a workers' revolution in Italy in the early 1920s turned out to be illusions. The conservative forces rallied, finding their savior in a renegade militant Socialist named Benito Mussolini who headed a violent mass movement calling itself Fascism. In 1921, convinced that the moderate tactics of the Socialist Party would never be able to meet the challenges of Fascism, Noce resigned from the Socialists and became a charter member of the newly founded Italian Communist Party (Partito Comunista Italiana or PCI). In October 1922, Mussolini was appointed prime minister, and in stages, by using both terror and political deceit, he imposed a Fascist dictatorship on Italy. By 1925, both the Socialist and Communist parties had been outlawed, but Noce continued her agitation among workers on an illegal basis. It was during this period that she met her future husband Luigi Longo, an up-and-coming PCI functionary.

By the early 1930s, Mussolini's secret police, the OVRA, had succeeded in smashing most of the Communist cells that served as nuclei of anti-Fascist resistance throughout Italy, particularly in areas of industrial and peasant discontent. In the spring of 1934, Noce organized one of the last acts of working-class resistance, a rice workers' strike. Fascist authorities succeeded in crushing the strike, but Noce was able to escape to Paris, where a large group of anti-Fascist exiles lived. There, Noce quickly emerged as a leading figure in Italian exile politics. She took advantage of the new PCI party line, a "unity of action" pact signed between the formerly warring Socialists and Communists in August 1934, to work alongside Socialist exiles on the propaganda front.

In one of the most successful signs of the new spirit of unity on the Left, Noce became editor of a weekly journal, *Grido del popolo* (The People's Cry), which was greeted enthusiastically by political émigrés who often had little to be optimistic about. In its pages, anti-Fascist Italians in France and elsewhere received the latest information from the underground cells still active in Italy, reports that were critical of the pro-Fascist news often found in the French bourgeois media. Noce kept *Grido del popolo* on track, calling for agitation both within and outside Italy for improved conditions for the industrial

working class, and for the abolition of the Special Tribunals that had sentenced anti-Fascists to long prison terms. Noce's strong editorial hand resulted in clear, framed demands for amnesties for political prisoners of Fascism. *Grido del popolo* emphasized the situation of the PCI leader Antonio Gramsci, a brilliant intellectual who was dying of tuberculosis in one of Mussolini's prisons. The campaign led by Noce reached its climax with mass demonstrations of Italian anti-Fascist exiles, joined by French workers and intellectuals, in the streets of Paris.

Throughout the 1930s in Paris, Noce was active not only as a journalist but as a PCI organizer. She was interested in women's issues, although her growing influence within the Communist Party meant that most of her time went into "general political work." She believed that with the achievement of socialism, which would follow the demise of both Fascism and capitalism, discrimination against women would rapidly become a thing of the past. In the crisis-plagued 1930s, however, the bulk of her energies went into hastening the end of the Mussolini dictatorship, and into participating in the general struggle against other Fascist regimes, including the growing menace represented by Adolf Hitler's Third Reich. One of the ways Noce hoped to alert the world to the Fascist threat was by reporting the civil war that broke out in Spain in the summer of 1936. She traveled to Spain to see for herself how the embattled Republic was fighting against not only the domestic Fascist elements led by Francisco Franco, but against the "volunteer" armies sent by Hitler and Mussolini to assist Franco. Based on her observations, she wrote several appeals in pamphlet form to report to the world on the Spanish struggle. In early 1939, Noce saw her hopes of defeating Fascism shattered when the Spanish Republic succumbed to the superior armed forces of the opposition.

Noce remained in France when that nation surrendered to Nazi Germany in June 1940. Unbowed, she quickly helped to organize anti-Nazi cells within the Italian exile community in Paris. During this period, she eluded arrest on many occasions, using the underground name "Estella" as a leader of an effective partisan unit. Eventually, however, her luck ran out, and she was arrested and deported to the infamous German concentration camp for women, Ravensbrück. Noce, who survived the horrors of Ravensbrück, was liberated in the spring of 1945. As soon as transportation was available, she returned to Italy, which had only recently been freed of German occupation forces. Mussolini had been executed by Communist partisan

forces in the final days of the war, and Italian Communists enjoyed immense popularity, being able to boast of a record of two decades of resistance to Fascism that had cost the PCI many lives and much suffering.

In the years after 1945, Noce was one of the few universally recognizable women in the world of Italian Communism (other women of note within PCI circles were **Giulietta Ascoli** and **Camilla Ravera**). Among the many honors and responsibilities that now came her way were election to the PCI Central Committee, election to the Italian Parliament, and selection as general secretary of the textile workers union. (In that capacity, she was a founder of *La voce dei tessili*, the voice of the union.) Noce was in fact virtually the only woman in the post-World War II Italian labor movement to hold a position of national leadership and prominence. Her years of party work and her past, as a survivor of dangerous underground assignments and a Nazi concentration camp, gave her immense prestige among both PCI rank-and-file and leadership circles. Noce refused to become a rubber stamp for either the Italian party hierarchy or "the Soviet comrades" during the final, paranoid years of the Stalin dictatorship. Displaying a spirit of independence rare at the time, even within the PCI hierarchy (it would flourish in later decades, when the PCI exemplified a "Eurocommunism" free of Soviet control), in 1951 Noce was one of only two members of the Italian Communist leadership to vote against a "proposal" made to the PCI by Soviet dictator Joseph Stalin. The issue was one of PCI chair Palmiro Togliatti residing permanently in Prague (or Moscow) rather than Rome, clearly enabling Stalin to exert much more control over the Italian Communist movement. Togliatti objected to the idea and did not return to Moscow for a visit until after Stalin died in 1953. Even though her vote put her at odds with the great majority of her Communist colleagues, Noce voted her conscience and was vindicated by later events.

It was in the area of women's issues that Noce was able to accomplish what many observers of contemporary Italian society would argue has been her most lasting legacy. Under Fascism, and before as well, Italy's women had been denied full legal and civic equality. The post-1945 era saw a surge of reformist energies that would result in significant changes on this front. An organization that Noce was strongly identified with at this time was the Unione Donne Italiane (Italian Women's Union or UDI), which had its roots in the anti-Fascist women's front that Noce had led in Paris in the 1930s.

Another source of membership for the UDI were the armed units of women partisans, Gruppi di Difese (Defense Groups), who were active in the anti-Fascist struggle from 1943 through 1945. Officially founded in Rome in September 1944, the UDI claimed to be a non-partisan organization when it was in fact informally but strongly allied with the PCI on all major issues.

Soon after the war, women members of the left-wing parties to the Italian Parliament, headed by Noce, led a mass crusade for a comprehensive maternity law. The UDI—which has averaged 400,000 members since its founding—mobilized its resources for the campaign, which as it turned out would last several years. Not surprisingly, the campaign met with strong opposition from employers, but it was sporadically and often only halfheartedly opposed by the forces of political Catholicism, meaning Catholic women's groups, the Italian church, and indirectly the papacy. Led by Noce and other parliamentary deputies, a UDI victory was achieved in 1950, when a sweeping law was passed giving protection to working mothers, prescribing compulsory and paid leave for pregnant women two months before and three months after birth, and defining a number of provisions for mothers of children under one year. Highly progressive for its day, the law remains in force after a half-century. When Teresa Noce died in January 1980, one of the most remarkable women in her nation's modern history passed from public life.

SOURCES:

Albini, Maria Brandon. "Témoignages Italiens," in *Europe: Revue mensuelle*. Vol. 56, no. 592–593. August–September 1978, pp. 206–208.

Andreucci, Franco, and Malcolm Sylvers. "The Italian Communists Write Their History," in *Science & Society*. Vol. 40, no. 1. Spring 1976, pp. 28–56.

Beccalli, Bianca. "The Modern Women's Movement in Italy," in *New Left Review*. No. 204. March–April 1994, pp. 86–112.

Bono, Paola, and Sandra Kemp, eds. *Italian Feminist Thought: A Reader*. Oxford: Basil Blackwell, 1991.

Bravo, Anna. "Donne, Guerra, Memoria," in *Il Ponte*. Vol. 51, no. 1. January 1995, pp. 36–58.

Casmirri, Silvana. *L'unione donne italiane (1944–48)*. Rome: Quaderni della FIAP, 1978.

Delzell, Charles F. *Mussolini's Enemies: The Italian Anti-Fascist Resistance*. Princeton, NJ: Princeton University Press, 1961.

Hellman, Judith Adler. *Journeys Among Women: Feminism in Five Italian Cities*. NY: Oxford University Press, 1987.

Hervé, Florence, and Ingeborg Nödinger. *Lexikon der Rebellinen: Von A bis Z*. Dortmund: edition ebersbach, 1996.

Lanchester, Fulco. "Il PCI dalla Resistenza al Dopoguerra: Rassegna su recenti Studi e Testimonianze," in *Politico*. Vol. 40, no. 1, 1975, pp. 141–149.

Noce, Teresa. *Estella: Autobiographie einer italienischen Revolutionärin.* Frankfurt am Main: Cooperative, 1981.

———. *Gioventù senza sole.* 3rd ed. Rome: Editori Riuniti, 1972.

———. *Ma domani fara giorno.* Rome: Editori Riuniti, 1965.

———. *Nuestros hermanos, los internacionales.* Madrid: Ediciones del Soccoro Rojo, 1937.

———. *Rivoluzionaria professionale.* Milan: La Pietra, 1974.

———. *Teruel martirio e liberazione di un popolo!* Barcelona: A. Núñez, 1939.

———. *Tra gli eroi ed i martiri della liberta.* Madrid: Brigate internazionali, 1937.

———. *Vivere in piedi.* Milan: G. Mazzotta, 1978.

Slaughter, M. Jane. "Noce, Teresa," in Frank J. Coppa, ed., *Dictionary of Modern Italian History.* Westport, CT: Greenwood Press, 1985, p. 295.

———. "Unione Donne Italiane," in Frank J. Coppa, ed., *Dictionary of Modern Italian History.* Westport, CT: Greenwood Press, 1985, p. 426.

Spriano, Paolo. *Storia del Partito Comunista Italiano.* Reprint. 5 vols. Turin: Giulio Einaudi, 1976.

Urban, Joan Barth. *Moscow and the Italian Communist Party: From Togliatti to Berlinguer.* Ithaca, NY: Cornell University Press, 1986.

John Haag,
Associate Professor of History,
University of Georgia, Athens, Georgia

Noddack, Ida (1896–1978)

German chemist, co-discoverer of the element Rhenium, who was one of the first to see that the work of the physicist Enrico Fermi might prove that atomic fission was possible. Pronunciation: NOD-ack. Born Ida Eva Tacke in Lackhausen-Wesel am Rhein, Germany, on February 25, 1896; died in 1978; daughter of Adelbert Tacke and Hedwig Danner Tacke; received a diploma from the Technical University of Berlin-Charlottenburg, 1919; received a doctorate from the same school, 1921; married Walter Noddack (a chemist), on May 20, 1926 (died December 7, 1960).

Received an honorary doctorate from the University of Hamburg (1966); recipient of the Liebig Commemorative Medal of the Society of German Chemists (1931); awarded the Scheele Medal of the Swedish Chemical Society (1934), and the Grand Cross of Merit of the Federal Republic of Germany (1966).

Selected writings: (co-authored with her husband) Das Rhenium (Leipzig: Leopold Voss, 1933); Entwicklung und Aufbau der chemischen Wissenschaft (Freiburg im Breisgau: Hans Ferdinand Schulz Verlag, 1942).

Although she was a co-discover of the element Rhenium and was one of the first scientists to see that the experiments of the physicist Enrico Fermi would make possible the principle of atomic fission, Ida Noddack gained little public acclaim for her work. Biographies of famous scientists would occasionally mention her husband Walter, with whom she conducted most of her research, but her name was generally ignored or commented on only briefly. Fermi even ignored her letter to him in 1934 which pointed out (five years before it was achieved in a laboratory) that his work raised the possibility that atoms could be "split."

She was born Ida Tacke in Lackhausen-Wesel am Rhein, Germany, in 1896, the daughter of Adelbert Tacke and **Hedwig Danner Tacke**. After earning her doctorate degree at the Technical University of Berlin-Charlottenburg in 1921, Ida worked in the laboratories of the German General Electric Society from 1921 through part of 1924, and in the laboratories of the Siemen and Haisle Company from 1924 through part of 1925. She met her future husband Walter when she assumed a research position in 1925 in the laboratories of the German Research Institute in Berlin. She would remain there for ten years.

Together, the team of Ida Tacke and Walter Noddack concentrated on investigating two of the "missing elements" in the Periodic Table of the Elements compiled by the Russian physicist and chemist Dmitri Mendeleev, elements number 75 and 43. In 1871, Mendeleev had arranged all known elements in order of increasing atomic weight. Where gaps appeared in his table, he left open spaces. These were assumed to be elements which necessarily existed, but which had not yet been discovered. Since he concluded that the chemical and physical characteristics of the elements would recur in a predictable manner as one moved higher and higher in his Periodic Table, the characteristics of the missing elements could be guessed. The challenge was to discover them in nature.

The missing elements number 75 and 43 occupied Group VIIA of Mendeleev's system. In that group, the only known element was manganese. Although manganese was the tenth most common element found in the earth's crust, it became apparent to Ida and Walter that these missing elements had to be very rare, so rare that they might be impossible to detect.

One "missing" element, hafnium, had already been discovered by other scientists, who used X-rays to study minerals containing zirconium. The X-ray results indicated that hafnium could be found in almost every mineral containing zirconium. When the X-ray spectra of manganese ores were examined, however, there were no signs of the missing elements 75 and 43.

Ida and Walter, working with another chemist, Otto Berg, tried a different approach. Assuming that element 75 must appear in very tiny amounts in the ores of other metals, they systematically used X-rays to examine a variety of ores. In 1925, they found the new element in platinum ores and in a mineral called columbite, although they had to enrich its concentration about 100,000 times; it turned out to be so rare that only about one milligram of the element could be found in one ton of the earth's crust.

By processing 600 kilograms of ore from Norway, they were able, by the following year, to produce one gram of the new element. They chose to name the element Rhenium, after the Latin word for the Rhine river, along which Ida had been born.

They described their continuing research on the new element in a book, *Das Rhenium,* which they published in 1933. They also became the authors of numerous articles in chemical journals, including *Zeitschrift fur Inorganische Chemie* (Journal for Inorganic Chemistry), *Zeitschrift fur physikalische Chemie* (Journal for Physical Chemistry), and *Die Naturwissenschaften* (the Sciences). To rebut critics who questioned whether they had really discovered a new element, they published and read more than 100 scientific papers. After the marriage of Ida and Walter in 1926, many of these appeared under the joint authorship of "Drs. Walter and Ida Noddack."

As the discoverers of Rhenium, they secured a profitable patent on the process of extracting the element from molybedum ores. At first, industry found Rhenium hard to work with, since it is difficult to maintain in its pure form, cannot be worked hot, hardens quickly, and is quick to combine with other elements. But the new element had many practical uses. Rhenium is useful in electrical contacts, where it withstands electrical erosion and outperforms other metals such as tungsten and platinum. Because it is resistant to water, it has been used as parts of magnets in marine engines. Since it has a high melting point and retains its strength at high temperatures, it has been used in high temperature thermocouples. It has also been used in electronic tubes, fountain pen points, and instrument bearings.

The Noddacks also searched for the other "missing element," element number 43. They believed that they had discovered it in 1925 in the mineral niobite. They named the new element Masurium, after a section of Prussia. Their claim was challenged, however, and today credit for discovering the new element—renamed "technetium,"' the name used in modern Periodic Tables—is given to the scientists Emilio Segre and C. Perrier, who found that the element did not exist in nature and could be produced only through artificial means, by using an atomic accelerator called a cyclotron. In fact, Rhenium proved to be the last of the elements to be discovered which was stable and not radioactive.

Ida's joint work with her husband may explain at least some of the lack of public recognition of her work, since their achievements were often listed mainly under her husband's name. They continued their collaboration through the rest of their lives, until his death in 1960, mainly doing photochemical research and experimenting with Walter's idea that every element was present in every mineral, even if the concentration of some elements was too small to detect.

Geographically, her career paralleled his. When he changed university or laboratory positions, she did the same, so that they always were able to work on joint projects. After leaving the German Research Institute in 1935, Ida Noddack worked in the Department of Physical Chemistry at the University of Freiburg from 1935 to 1941. During the early 1940s, both Noddacks continued their research at Bamberg. From 1947 through 1955, they worked in the physical chemistry department of the University of Strasbourg, France, then left in 1956 to work in the Philosophical-Technological High School of Bamberg, where they remained for the rest of their professional careers.

In her most significant project independent of her husband's work, Ida in 1934 wrote an article for the *Journal of Applied Chemistry* (*Angewandte Chemie*) which suggested that the physicist Enrico Fermi was misinterpreting the results of experiments in which he bombarded the nuclei of uranium atoms with neutrons. Fermi thought that he was producing new, "transuranium" elements; Ida Noddack suggested that the uranium nuclei were instead "splitting," undergoing a fission process in which isotopes, or variations, of the uranium atom were being produced. She mailed her article to Fermi, but he rejected her perceptive observation. Only five years later, the process of fission was actually accomplished in a German laboratory as the result of the work of Otto Hahn, Fritz Strassman, and *Lisa Meitner.

Despite that disappointment, Ida received many honors from fellow scientists. She was awarded the first prize of the Department of Chemistry and Metallurgy at the Technical University of Berlin-Charlottenburg in 1919 for her

student work; her research also brought her the Justus-Liebig medal of the Association of German Chemists in 1931 and the Scheele medal of the Swedish Chemical Society in 1933. She was made an honorary member of the German Academy of Natural Science, the Frauenhofer Society, and the Spanish Society for Physics and Chemistry.

During World War II, the Noddacks produced only one major writing, *The Development and Growth of the Science of Chemistry*. That book appeared to portray them as patriotic Germans who showed no enthusiasm for the National Socialist, or Nazi, government of Germany. They wrote that "long ago, nations discovered that chemistry is a power and a weapon in the lives of people, and most states have made great efforts, to bring their science and chemistry to the level of the Germans." But they added that the "struggle . . . is fought with the weapons of the intellect," and added that the future would be determined by "education." By implication, military victory in the war was less important than the growth of the intellect and education.

The postwar years brought further honors. In 1966, Ida Noddack was awarded both an honorary doctorate from the University of Hamburg and the Grand Cross of Merit from the German Federal Republic. Her early recognition of the possibility of nuclear fission led American nuclear physicist Glen T. Seaborg to include her 1934 article, in the original German, in a book of landmark scientific publications on uranium and fission. By the time of her death in 1978, a more subtle honor arrived: books on the lives of famous scientists began to give her a separate listing. Beside the listings for "Walter Noddack" also appeared sections on "Ida Tacke Noddack."

SOURCES:

Druce, J.G.F. *Rhenium DVI-Manganese, the Element of Atomic Number 75*. Cambridge University Press, 1948.

Sidgwick, N.V. *The Chemical Elements and Their Compounds*. Oxford: Clarendon Press, 1950.

Tyler, P.W. *Rhenium*. Washington, DC: U.S. Bureau of Mines, 1931.

SUGGESTED READING:

Asimov, Isaac. *Asimov's Biographical Encyclopedia of Science and Technology: The Lives and Achievements of 1510 Great Scientists from Antiquity to the Present, Chronologically Arranged*. Garden City, NY: Doubleday, 1982.

Jaffe, Bernard. *Crucibles: The Story of Chemistry from Ancient Alchemy to Nuclear Fission*. NY: Dover, 1976.

Seaborg, Glenn T., ed. *Transuranium Elements: Products of Modern Alchemy*. Stroudsburg, PA: Dowden Hutchinson and Ross, 1982.

Niles Holt,
Professor of History, Illinois State University, Normal, Illinois

Noemi (fl. 1100 BCE).

See Ruth for sidebar on Naomi.

Noether, Emmy (1882–1935)

German theoretical mathematician who pioneered the study of cross product and abstract algebra, and who contributed to the discovery of the theory of relativity. Name variations: Amalie Emmy Noether. Born in Erlangen, Germany, on March 23, 1882; died in Bryn Mawr, Pennsylvania, on April 14, 1935; daughter of Ida (Kaufman) Noether and Max Noether; attended Städtischenen Höheren Töchterschule, University of Göttingen, University of Erlangen; never married; no children.

Awarded the Alfred Achermann-Teubner Memorial Prize for the Advancement of Mathematical Studies (1932).

Passed the Bavarian state teacher's examination (1900); enrolled at the University of Erlangen (1900); passed the Bavarian state high school teacher's examination (1903); enrolled at the University of Göttingen (1903); withdrew from the University of Göttingen (1904); enrolled at the University of Erlangen (October 1904); awarded Ph.D. by the University of Erlangen (December 1907); invited to teach at the University of Göttingen (1915); awarded the honorary position of Associate Professor without Tenure (1919); granted a lectureship in algebra (1923); was a visiting professor, University of Moscow (1928); was a visiting professor, University of Frankfurt (1930); attended the International Mathematical Congress, Zurich, Switzerland (September 1932); dismissed from the University of Göttingen (April 7, 1933); was a visiting professor, Bryn Mawr College, Pennsylvania (1933); lectured regularly at the Institute for Advanced Study, Princeton University (1934); joined the American Mathematical Society (1934).

Selected writings: (Edited by N. Jacobson) Gesammelte Abhaudlungen (Collected Papers, NY: Springer-Verlag, 1983).

The oldest of four children, Emmy Noether was born in Erlangen, Germany, in

Emmy Noether

1882, the daughter of **Ida Kaufman Noether** and Max Noether. She experienced a typical childhood for a girl of her class: finishing schools and musical instruction were followed by lessons in French and English. In 1900, Noether took the Bavarian state teacher's examination, and passed with a grade of "very good." She seemed poised for a traditional career teaching languages in an all-girls' school.

Although women were admitted to the universities of France, England, and Italy, such was not the case in Germany. The historian Heinrich von Treitschke exemplified the conservatism of the era:

> Many sensible men these days are talking about surrendering our universities to the invasion of women, and thereby falsifying their entire character. This is a shameful display of moral weakness. They are only giving way to the noisy demands of the press. The intellectual weakness of their position is unbelievable. . . . The universities are surely more than mere institutions for teaching science and scholarship. The small universities offer the students a comradeship which in the freedom of its nature is of inestimable value for the building of a young man's character.

Max Noether was a respected mathematician at the University of Erlangen. Known as "the Father of Algebraic Geometry," he exposed his daughter to theoretical mathematics from an early age. Two of her three brothers also went on to become distinguished scientists; Alfred Noether received a doctorate in chemistry, while Emmy's youngest brother Fritz became a physicist.

In the judgment of the most competent living mathematicians, fraülein Noether was the most significant creative mathematical genius thus far produced since the higher education of women began.

—Albert Einstein

In 1900, German universities began to admit female students. They did not, however, grant degrees to women, except under exceptional circumstances. Encouraged by her father, Noether enrolled at the University of Erlangen, becoming one of only two female students there. At the same time, she also studied for the high school certification examination, which she passed in 1903.

Though certified to teach high school, Noether was determined to pursue a career in mathematics, so she enrolled at the University of Göttingen. Göttingen, which figured so prominently in the mathematics of the 18th and 19th cen-

turies, was home to Felix Klein, Otto Blumental, Hermann Minkowski, and David Hilbert. Within a few months, however, Noether returned to the University of Erlangen when it announced that it would grant formal degrees to women. Paul Gordan, a colleague of Max Noether, acted as Emmy's supervisor, and strongly influenced her views on algebraic invariants. For many years afterwards, his photograph hung in her study. In December 1907, Emmy Noether passed her oral examination *summa cum laude* and was awarded a Ph.D.

Noether's doctoral thesis "On the Complete Systems of Invariants for Ternary Biquadratic Forms" was considered to be an uninspired effort by contemporary mathematicians. Indeed, Noether herself dismissed the work as a "jungle of formulas." However, her thesis was widely applied by physicists, who dubbed it "Noether's theorem." As Peter G. Bergmann noted: "Noether's theorem, so-called, forms one of the corner stones of work in general relativity as well as certain aspects of elementary particle physics." For the next several years, Noether worked as an unpaid research assistant at the University of Erlangen, delivering lectures for her father, whose health was in an increasingly fragile state.

By 1915, Noether's reputation as a mathematician had spread to Göttingen, where David Hilbert and Felix Klein were tackling the tricky problem of the theory of relativity. Noether was invited to contribute her expertise. Her elegantly simple formulations of several of Einstein's concepts greatly impressed the eminent scientist. Albert Einstein wrote to Hilbert on May 24, 1918:

> Yesterday I received from Miss Noether a very interesting paper on invariant forms. I am impressed that one can comprehend these matters from so general a viewpoint. It would not have done the Old Guard at Göttingen any harm, had they picked up a thing or two from her. She certainly knows what she is doing.

Noether was already the author of several articles by the time she reached Göttingen. Although she was beginning to emerge as one of Germany's top mathematicians, a suitable position was difficult to secure. As **Teri Perl** noted, "Göttingen now gave doctoral degrees to women, jobs, however, were another matter."

Both Klein and Hilbert supported Noether's fight for a permanent teaching position. However, strong opposition emerged from the non-scientists of the university. An unidentified opponent is reported to have argued:

> How can it be allowed that a women become a Privatdozent (lecturer without pay)? Hav-

ing become a Privatdozent, she can then become a professor and a member of the university senate. . . . What will our soldiers think when they return and find that they are expected to learn at the feet of a woman?

Exasperated by the obdurate comments of his colleagues, Hilbert is said to have exclaimed, "I do not see that the sex of the candidate is an argument against her admission as a Privatdozent. After all, we are a university, not a bathing establishment!" Hilbert's role as Noether's patron illustrates the dependent position women still found themselves in when the question of career advancement arose. Defying his colleagues, he arranged for Noether to lecture frequently in his classes.

The attempted Communist revolt in Germany in 1918 profoundly influenced Noether's political ideals. While she had never before been aligned with a political faction, the failure of the revolution led to Noether's membership in the Social Democratic Party. In latter years, she expressed strong pacifists sentiments. But the proclamation of the Wiemar Republic in 1919, greatly enhanced the legal status of women in Germany. In the same year, Noether was awarded the title of "Associate Professor without Tenure." The honorary position required no teaching and did not include a salary. Nevertheless, Noether was treated like a full professor, a recognition of her superior mathematical abilities. In 1923, she was granted a lectureship in algebra, which provided a tiny income. Writes Noether's nephew Gottfried:

> Unquestionably, she had the mathematical ability to compete with the best. Even though the legal position of women had changed under the German Republic, old prejudices continued to persist. That there was prejudice against women in academic circles was clearly demonstrated by the fact that Noether was denied election to the Göttingen Gesellschaft de Wissenschaften [Göttingen Academy of Sciences]. . . . But additional reasons quite likely played a role too. She was a Jew; during the early 1920s, she was a member of the Social Democratic Party in Germany; she was a lifelong pacifist.

Noether's lectures were characterized by a relaxed and informal approach, which contrasted markedly with that of her male colleagues. She enjoyed considerable popularity with the student body. Her scholars were nicknamed "the Noether Boys," and Norbert Wiener wrote that "her many students flocked around her like a clutch of ducklings about a motherly hen."

While most contemporary mathematicians were obsessed with the computational analysis of algebra, the axiomatic approach had only recently been explored in the works of Karl Weierstrass, Friedrich Dedekind, *Sophia Kovalevskaya, and Hilbert. The publication of Bertrand Russell's *Principia Mathematica* delved into the symbolic aspect of mathematics. This novel approach opened new horizons for abstract algebra, and propelled it into the forefront of contemporary mathematical research.

While at Göttingen, Noether began to work on the general theory of ideals, which owed much to Max Noether's Residual theorem. The breadth of her talents became increasingly evident with the joint publication in 1920 of an article on differential operators. The paper also revealed Noether's new interest in the axiomatic analysis of algebra. Her research into ideals formed the basis for the application of axiomatic methodology to mathematical research.

Noether also worked closely with Helmut Hasse and Richard Brauer. Hasse expanded Noether's theory of cross products connected with the theory of cyclic algebras, thus proving that the common algebraic number field moved in cycles. Herman Weyl called the Brauer-Hasse-Noether theorem "a high water mark in the history of algebra." As Lynn Osen pointed out, some of Noether's "importance to algebra has roots in her work with others, in instances where her original ideas took final shape in the work of her students or collaborators."

By 1924, the Mathematical Institute of Göttingen was split from the faculty of Philosophy. The institute received a new building in 1929, and for the first time in her career Noether had her own office. The establishment of the Mathematical Institute fulfilled Felix Klein's dream that one day Göttingen would become the "Mecca of Mathematics." In the minds of many, the university was elevated to the status of one of the foremost mathematical institutes in the world, along with Moscow, Paris, and Berlin.

Noether was invited to spend a semester at the University of Moscow in 1928. Though the series of lectures which she delivered brought her additional acclaim, it was still insufficient to capsize the burdensome weight of prejudice at Göttingen. Her host, Paul Alexandrov, noted that she adapted well to our "Moscow ways." She was also invited to lecture at the University of Frankfurt in 1930.

In 1932, the quality of Noether's research was finally acknowledged with the Alfred Achermann-Teubner Memorial Prize for the Advancement of the Mathematical Sciences. Pre-

sented as a tribute to all of Noether's research, the award came with an honorarium of 5,000 reichmarks. In September, Noether attended the International Mathematical Congress in Zurich, where she was the only woman to be given a plenary session. A summary of her work, read at the conference, was the highlight of the event. Among the delegates attending were Herman Weyl, Helmut Hasse, Edmund Landau, and Richard Courant.

The election of the National Socialist Party in 1933 spelled the end of academic freedom in Germany. Though most scholars remained neutral, universities were among Hitler's first victims. At the University of Göttingen, brown shirts and swastikas were soon seen everywhere on the campus. Noether received the following notification from the Ministry of Sciences, Arts, and Public Education: "On the basis of paragraph 3 of the civil service code of April 7, 1933, I hereby withdraw from you the right to teach at the University of Göttingen."

On April 26, 1933, the newspaper *Göttingen Tageblatt* announced that six Jewish professors had been fired, including Noether and Courant. More firings would follow, the newspaper warned ominously. As Courant, then head of the Mathematical Institute, noted, "Aryan students want Aryan mathematics and not Jewish mathematics." Wrote Saunders MacLane, a former Noether student:

> The institute did continue to operate during the spring semester, but under evident conditions of strain with many faculty searching for suitable positions in other countries and many students hurrying to get theses done. By the following semester over the half the people . . . were elsewhere and the great days of Göttingen were fatally interrupted.

The German nation suffered an intellectual hemorrhage, as members of the intelligentsia sought refuge in the liberal democracies of the West and the Soviet Union. The persecution of Jewish academics forced them to emigrate. Like many of her colleagues, Noether chose the United States, where, with the help of *Anna Johnson Pell Wheeler, she was offered the position of visiting professor at Bryn Mawr College. Richard Courant secured a position at New York University. Fritz Noether, however, resigned his position at the University of Breslau and moved to a research institute in Tomsk, Siberia.

For the first time in her career, Noether enjoyed a modicum of employment security. At Bryn Mawr, as at Göttingen, she was a favorite of the students. "She loved to walk," notes Clark Kimberling:

> She would take her students for a jaunt on a Saturday afternoon. On these trips she would become so absorbed in her conversations on mathematics that she would forget about the traffic and her students would need to protect her.

Noether also lectured frequently at the Institute for Advanced Study at Princeton University, where Albert Einstein was now teaching. In 1934, Bryn Mawr created a fellowship and a scholarship in her honor. As well, she joined the American Mathematical Society. While efforts were underway to secure her a tenured position, she died suddenly while undergoing surgery to remove a tumor. Abraham Flexner, director of the Institute for Advanced Study, wrote on April 25, 1935: "The last year and a half had been the happiest in her whole life, for she was appreciated at Bryn Mawr and Princeton as she had never been in her own country."

Emmy Noether was at the height of her intellectual power, and her sudden death at the age of 53 shocked most of her colleagues. Unlike many mathematicians, Noether's most productive years occurred in later life. Her theoretical work in the field of algebra was greatly facilitated by her legendary ability to abstract ideas. Wrote Einstein:

> In the realm of algebra in which the most gifted mathematicians have been busy for centuries, [Noether] discovered methods which have proved of enormous importance in the development of the present day younger generation of mathematicians.

The impact of Emmy Noether's work was felt far beyond the realm of mathematics. Her research on invariants contributed to the discovery of the theory of relativity, and to the advancement of particle physics. "Noether's theorem" is still used by physicists today.

Although celebrated academically, Noether never secured appropriate employment in Germany. The victim of discrimination as a woman and as a Jew, Noether bore her circumstances philosophically. When one of her students attended a meeting in Nazi garb, she is reported to have laughed. Nevertheless, many of Noether's colleagues deplored the lack of recognition accorded to her. Paul Alexandrov rebuked the "high-ranking Prussian academic bureaucracy" for refusing to acknowledge Noether's talents by granting her a permanent academic appointment.

Despite continual discrimination, Noether devoted her life to research and to teaching, and the impact of her teaching was profound. Among her most distinguished students were Max Deuring, Hans Fitting, W. Krull, and ✥➧ Olga Taussky

Todd. All made notable contributions to the study of mathematics. Emmy Noether rightly deserves to be known as the most influential female mathematician to have lived thus far, and her pioneering efforts in the fields of cross product algebra and abstract algebra earned her a place among the most distinguished mathematicians of the 20th century.

SOURCES:

Bell, E.T. *The Development of Mathematics.* NY: McGraw-Hill, 1945.

Dick, A. *Emmy Noether, 1882–1935.* Basel: Birckhäuser, 1981.

Jones, Lorella, M. "Intellectual Contributions of Women to Physics," in *Women of Science: Righting the Record.* G. Kass-Simon and Patricia Farnes, eds. Bloomington: Indiana University Press, 1990.

Osen, Lynn M. *Women in Mathematics.* Cambridge, MA: MIT Press, 1974.

Perl, Teri. *Math Equals.* Menlo Park, CA: Addison-Wesley, 1978.

Srinivasan, B., and J. Sally, eds. *Emmy Noether in Bryn Mawr: Proceedings of a Symposium Sponsored by the Association for Women in Mathematics in Honour of Emmy Noether's 100th Birthday.* NY: Springer-Verlag, 1983.

SUGGESTED READING:

Brewer, J.W., and Martha K. Smith, eds. *Emmy Noether: A Tribute to Her Life and Work.* NY: Dekker, 1981.

Hugh A. Stewart, M.A.,
Guelph, Ontario, Canada

Nofretete (c. 1375–1336 BCE).

See Nefertiti.

Nogarola, Isotta (c. 1416–1466)

Italian scholar and writer. Born around 1416 in Verona, Italy; died in 1466, buried in Santa Maria Antica in Verona; daughter of Bianca (Borromeo) Nogarola and Leonardo Nogarola; sister of Angela and Ginevra Nogarola; educated by tutors.

Works: a philosophical dialogue on Adam and Eve (written in 1451 and published in 1563); an oration on the life of St. Jerome (1453); Opera quae Supersunt Omnia (1886); and many letters.

Isotta Nogarola was born around 1416 in Verona, Italy. The Nogarolas were of noble lineage, and her aunt, **Angela Nogarola**, was a poet. Isotta received the same Renaissance education under Matteo Bosso and Martino Rizzoni as her sisters, **Angela** and **Ginevra**. Early on, she was renowned for her intellect and for her beauty, which brought with it several offers of marriage, but she was no longer looked upon as an attractive novelty as she grew older. At age 23, her youth and attractiveness were considered to have gone, and her women friends mocked what were

✥➤ **Todd, Olga Taussky** (1906–1995)

Austrian-American mathematician. Name variations: Olga Taussky-Todd. Born on August 30, 1906; died in Pasadena, California, on October 7, 1995.

Trained in number theory, Olga Taussky Todd worked with David Hilbert at the University of Göttingen; she emigrated to America around the same time (during the Nazis' early years in power) as other members of the Hilbert school, including *Emmy Noether.

regarded as her intellectual pretensions. Although she continued to write poetry, oration, and dialogue, Nogarola could find no place in the community of humanist scholars, men who praised her only as an unusual woman and refused to accept her as a peer. She complained of suffering "men's denigrations in words and fact."

Sexual slander against her and her siblings, particularly bad for Nogarola who was already perceived as something of a freak, increased her social difficulties. Moved by the desire to clear the haze of ensuing scandal, she chose to become a virgin scholar of religion, attached to no particular order. Nogarola—feeling the need to choose between the comforts of ordinary life, including companionship, and her love of scholarship—found in religious study a more acceptable course for a woman to pursue than humanism. As she did so, her scholarship was accepted and praised by both men and women.

In 1438, she moved to Venice to escape the war between the Venetian Republic and Milan. She returned to Milan in 1441, befriended Ludovico Foscarini, a public official who was the son of the doge of Milan, and ran a salon for intellectual discussion. Foscarini became her close friend and confidant. Although he admired and supported her choices in life, he refused to make similar ones for himself when she encouraged him to abandon his worldly career. Foscarini and a female contemporary, Costanza Varano (*Costanza Sforza*), saw Nogarola's lifestyle as a stroke of independence, but for her it was a choice that bowed to convention. She lived on her own property, probably with her mother, **Bianca Borromeo**, and spent most of her time in a "book-lined cell." Her life was progressively more solitary and meager, the latter being a result of choice rather than poverty, as at least a certain amount of luxury was still at her disposal. She corresponded with, and was visited by, the intellectuals of the region, especially Foscari-

ni. Much admired for their elegance and insight, Nogarola's letters were distributed widely, even outside of Italy. In the late 1600s, 564 of her letters could be found in one Parisian library.

Among Nogarola's works, of particular interest is her dialogue on Adam and Eve, composed in 1451 and based on a correspondence with Foscarini, which was published posthumously by her descendent Count Francesco Nogarola. Foscarini held the conventional position, based on the Bible and Saint Augustine's commentary, that Eve was responsible for the fall of humanity, but Nogarola argued that Eve was less responsible than Adam because she was weaker and had less knowledge. As Adam was stronger, she reasoned, he committed a greater sin and was responsible for the misery of all humanity, whereas Eve was responsible only for herself. Moreover, Eve succumbed only to the innate human desire for knowledge.

Nogarola's life became increasingly bleak, despite her intellectual success once she turned to religious study. Foscarini left Milan for another posting in Brescia and her mother died, leaving her alone. She had been chronically ill at least since 1453, possibly as a result of emotional hardship, complaining of pain particularly in her stomach. Her immersion in her studies had always been to the neglect of her health, and after her doctor died her health further declined. She died in 1466.

SOURCES:

Kersey, Ethel M. *Women Philosophers: a Bio-critical Source Book*. NY: Greenwood Press, 1989.

King, Margaret L. "The Religious Retreat of Isotta Nogarola (1418–1466): Sexism and Its Consequences in the Fifteenth Century," in *Signs*. Vol. 3, 1978, pp. 807–822.

Russell, Rinalda. "Isotta Nogarola," in Katharina Wilson, ed., *Encyclopedia of Continental Women Writers*. NY: Garland, 1991.

Catherine Hundleby, M.A. Philosophy,
University of Guelph, Guelph, Ontario, Canada

Nolan, Kathleen (1933—)

American actress who was the first woman president of the Screen Actors Guild. Born on September 27, 1933, in St. Louis, Missouri.

Best known for her role as Kate, the spunky farm wife on the popular television series "The Real McCoys" (1957–63), actress Kathleen Nolan was also the first woman president of the Screen Actors Guild, a position she held from 1975 to 1980.

Born in 1933 into a St. Louis-based show-business family, Nolan began performing with her parents on a Mississippi showboat as soon as she could walk. After high school, she left for New York, where she studied with renowned Sanford Meisner at the Neighborhood Playhouse and was an early member of the Actors Studio. In 1954, she landed a role on the live television series "Jamie," which starred Brandon de Wilde. She appeared on Broadway that same year, as Wendy in the musical version of James M. Barrie's *Peter Pan*, starring *Mary Martin. Nolan subsequently reprised her role in two television productions of the popular show.

In 1957, Nolan auditioned and won the role of Kate on "The Real McCoys," a gentle comedy about a rural family struggling to make ends meet. The show, starring veteran actor Walter Brennan as the patriarch Amos McCoy and Richard Crenna as Kate's husband Luke, was the forerunner of such family-oriented programs as "The Andy Griffith Show" and "Petticoat Junction." Nolan thought it was the universal problems that faced the McCoys that made the show so compelling. "We had a very large following of everyday folks" who could relate to the fact "that we saved the money in a cookie jar and that we had to have a discussion about what it was going to be spent on. I feel that the show had this real connection and honesty about it."

Nolan decided the leave the show after the fifth season, thinking it would be a wise career move to depart while she was "riding high." Although the series lasted for another season, Crenna noted that it was never the same after Nolan left. "That relationship was very special. The cast was very sad to see Kathleen leave. We missed her." The actress subsequently starred in the series "Broadside" and also made numerous guest appearances on other series, including "Charlie's Angels," "Bewitched," and "The Big Valley."

In 1975, Kathleen Nolan was the first woman elected to serve as president of the Screen Actors Guild (SAG), the union of motion picture performers, which was established in 1933 and is affiliated with the AAAA and the AFL. That year, despite the union's history of predominantly male leadership, Nolan had petitioned as an independent candidate and won with a two-to-one victory margin. She also continued to act and direct on stage, screen, and television, and in February 2000 guest starred as the meddling matriarch Amanda Wingfield in a revival of Tennessee Williams' *The Glass Menagerie*, staged by the PlayMakers Repertory Company on the campus of the University of

North Carolina, Chapel Hill. The actress has homes in New York and Los Angeles.

Barbara Morgan,
Melrose, Massachusetts

Nolan, Mae Ella (1886–1973)

U.S. Republican congressional representative (January 23, 1923–March 3, 1925) who was the first woman elected to Congress to serve her husband's unexpired term. Born Mae Ella Hunt on September 20, 1886, in San Francisco, California; died on July 9, 1973, in Sacramento, California; attended public schools, St. Vincent's Convent, and the Ayres Business College in San Francisco; married John I. Nolan (a politician), in 1913 (died 1922).

Elected to complete her late husband's unexpired term in the U.S. House of Representatives (1923); became the first woman to serve as chair of a committee in the House of Representatives (1923).

Born in San Francisco on September 20, 1886, Mae Ella Hunt was educated in public schools, at St. Vincent's Convent, and at the Ayres Business College in San Francisco. In 1913, she married John I. Nolan, a California politician who had recently been elected to the House of Representatives on Theodore Roosevelt's Progressive Party (Bull Moose) ticket. Less than ten years later, and one week after his reelection to a sixth term in Congress, her husband died. On January 23, 1923, a special election was held to fill his unexpired term and the subsequent term. Running against three male opponents, Nolan handily defeated her closest challenger by over 4,000 votes. Barely three years after American women gained the right to vote, she became the first woman to be elected to Congress to complete her husband's unexpired term. She served the one month remaining in the 67th Congress, and the full term of the 68th Congress, during which she was the only woman in Congress.

Assigned to the Labor Committee (which in the pre-Depression years was somewhat of a dumping ground for first-term members of Congress), Nolan made good her campaign pledge to carry out her husband's issues, which included labor legislation and his proposal to introduce a minimum daily wage of three dollars for federal employees. Having received the backing of the Union Labor Party during her campaign, Nolan opposed the Equal Rights Amendment in support of the American Federation of Labor, which rejected it on the grounds that it would eliminate hard-won safeguards for women. (Many other prominent women in the public sphere then op-

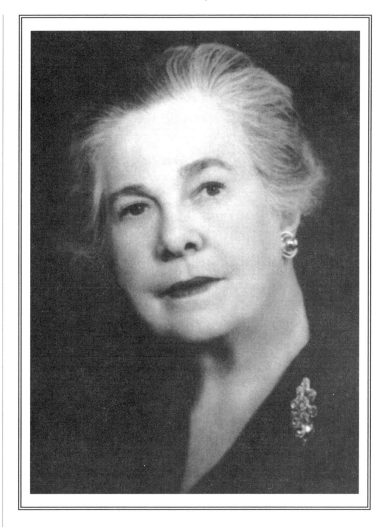

posed the amendment for the same reason.) She also served on the Woman Suffrage Committee, and in December 1923 took over as chair of the Committee on Expenditure in the Post Office Department, thus becoming the first woman to head a congressional committee. During her one complete term in Congress, she also helped gain passage of several bills important to her congressional district, including one authorizing construction of a federal building and another which transferred the Palace of Fine Arts from the Presidio to the city of San Francisco. Nolan never made a single speech during her terms in Congress, and did not seek reelection to a second full term. She returned to San Francisco, and later moved to Sacramento, where she died on July 9, 1973.

SOURCES:

Office of the Historian. *Women in Congress, 1917–1990.* Commission on the Bicentenary of the U.S. House of Representatives, 1991.

Read, Phyllis J., and Bernard L. Witlieb. *The Book of Women's Firsts.* NY: Random House, 1992.

Jo Anne Meginnes,
freelance writer, Brookfield, Vermont

Mae Ella Nolan

Nona (c. 305–c. 374).

See Nonna.

Nongqause (c. 1840–c. 1900)

19th-century Xhosa woman whose vision resulted in the great cattle sacrifice of 1856–57. Name variations: Nongqawuse. Born around 1840 in what is now South Africa; died around 1900.

Nongqause was born into the Xhosa tribe in what is now South Africa around 1840, at a time when the Boers and the British were pushing into the territory the Xhosa, a settled people who cultivated cattle and agriculture, had long occupied. In 1856, Nongquase had a vision in which her ancestors promised the Xhosa a millennium of freedom from European intruders in exchange for the sacrifice of their material wealth. She disclosed her revelation to her uncle Mhlakaza, who was also a prophet, and he relayed the prophecy to Sarili, the leader of the Gcaleka Xhosa.

The Xhosa greatly venerated visions and dreams. To fulfill Nongqause's vision, Sarili ordered over 150,000 cattle killed and crops and grain reserves destroyed, an action which took some ten months to complete. The hoped-for freedom never arrived, but widespread devastation did, as tens of thousands of Xhosa perished in the ensuing famine. Many others had to move to Cape Colony to seek assistance from or work for white settlers in order to survive. Mhlakaza was killed for his part in the tragedy. Nongqause escaped the fate of her uncle by fleeing to British colonial authorities, who took her into "protective custody." She was eventually released, after which she lived quietly until her death sometime around the turn of the 20th century.

Ruth Savitz,
freelance writer, Philadelphia, Pennsylvania

Nonna (c. 305–c. 374)

Religious woman who was the wife and mother and grandmother of bishops. Name variations: Nona. Born around 305 CE; died around 374; daughter of Christian parents from the Anatolian province of Cappadocia; married Gregory (bishop of Nazianzus), around 320; children: daughter Gorgonia; two sons, Caesarius and Gregory Nazianzus, also seen as Gregory Nazianzen (329–389).

The daughter of Christian parents of some means from the Anatolian province of Cappadocia, Nonna married a pagan named Gregory around 320. Of an extremely religious nature,

Nonna convinced her husband to convert to Christianity (he is said to have done so after the prayers of Nonna caused him to have a religious vision) in the year 326, after which his piety became so famous that he was ordained and then made the bishop of Nazianzus. This was a period, shortly after the legalization of Christianity, in which the rules governing clerical celibacy were by no means uniform. Although Gregory's zealous religiosity was renowned, his orthodoxy was not always so, for he was made a bishop before he had mastered the intricacies of the era's various theological disputes. Thus, he occasionally fell victim to doctrinal error, which he freely admitted when the "orthodox" position was illuminated for him, most often by Nonna.

The pious couple produced three children, all of whom were eventually recognized as saints by the Eastern Church: a daughter, **Gorgonia**, and two sons, Caesarius and Gregory Nazianzus. Gregory Nazianzus especially achieved prominence by the end of his ecclesiastical career, and has ever since been known as one of the four great "doctors" of the Greek Orthodox Church. According to this son, Nonna was the model Christian spouse, loving Jesus first and her family second; she is reported as having always succumbed to her husband's authority, while simultaneously always remaining his superior in piety. In addition, Gregory praised Nonna for rejecting cosmetics and the fancy attire common to women of her status, for balancing her time between running her household and doing social work (especially championing the interests of widows and orphans), for admiring virginity even as she reared a family, for embracing asceticism while distributing her personal wealth among the poor, and (perhaps on the darker side) for shunning pagans and pagan culture as vile.

Nonna's ambitions for her offspring are made evident in the career of Gregory, whom she wanted to receive the best possible philosophical and theological education. To become trained in these fields, Gregory left home to study first in the Cappadocian city of Caesarea, thereafter to move on to Caesarea in Palestine, to Alexandria, and ultimately to Athens as he exhausted the educational opportunities present in each city. Despite being separated for years as the children sought enlightenment through religious education far from Nazianzus, the family remained emotionally close, often dreaming of one another during moments of sickness and crisis. Perhaps the most intriguing such episode as reported by Nonna's son Gregory involved his maritime journey from Palestine to Alexandria,

during which a great storm almost sunk the ship he was on. As he later attested (having confirmed to his satisfaction the truth of his tale), Nonna shared his jeopardy in a dream at the very moment of his greatest physical danger.

With schooling finished, Gregory returned to the town of his birth, intent on a life of monastic solitude. Instead, his father ordained him as a priest and relied upon him to help run the Nazianzian diocese. Thereafter, the younger Gregory spent much of his time near his parents, both taking and giving comfort through their love of Jesus and each other. The lives of Nonna and Gregory the elder were not without their sorrows, for in about 360 they experienced in quick succession the deaths of Gorgonia and Caesarius. Nevertheless until the end of their days, they continued to enjoy the company of the younger Gregory, who, in about 374, was present at the death of his father, and shortly thereafter, at the death of Nonna herself.

<div align="right">William Greenwalt,

Associate Professor of Classical History,

Santa Clara University, Santa Clara, California</div>

Nonsuch, Baroness (c. 1641–1709).

See Villiers, Barbara.

Nonteta Bungu (c. 1875–1935)

South African who founded the Church of the Prophetess Nonteta in 1918. Born in Mnqaba, in what is now South Africa, around 1875; died of stomach and liver cancer in an insane asylum in Pretoria, South Africa, in May 1935.

A prophet of the Xhosa tribe, Nonteta Bungu was born around 1875 in the small village of Mnqaba, on the southeastern coast of what is now South Africa. The existence of the Xhosa had been undergoing a seismic shift since the late 18th century and the beginning of the Frontier Wars against the Boers, who sought more and more Xhosa land, and had received a terrible blow in 1856, when a vision received by a young woman named *Nongqause caused them to slaughter all their cattle and destroy all their crops in expectation of supernatural intervention against the Europeans; the result was mass starvation. When the worldwide influenza epidemic of 1918–19 struck the Xhosa, Nonteta Bungu began to have visions during her bouts of fever, dreaming that God was punishing the earth for the sins of the people. On her recovery, she began preaching against alcohol, adultery, and the eating of pork. She "read" from her bare

hands when she spoke, and eventually founded the Church of the Prophetess Nonteta.

Although Nonteta Bungu did not expressly preach against the white government, she became a victim of the government crackdown on dissident, black-led religious sects during the early 20th century. She was arrested and imprisoned in a local insane asylum in 1921. When her followers continued to visit her there, she was transferred to the Weskoppies Asylum in Pretoria. Before she was taken away, she told her followers, "I will return in a different form," and, "Look to the Americans—they will help you one day." In 1927, over 30 of her parishioners walked the 600 miles to Pretoria to see her again. Although the doctors at the asylum agreed that her mental condition did not warrant her imprisonment, in accordance with the government's wishes they kept her there until her death in 1935 from stomach and liver cancer. Her followers did not hear of her passing until two weeks later. When they asked for her body, they were told it had already been buried in an unmarked pauper's grave and would not be given up.

In 1973, while South Africa's government was still in the hands of the white minority, Professor Robert Edgar of Howard University went to Mnqaba to conduct research. There he met some of the approximately 1,000 followers Nonteta Bungu's church still claims. Upon his return in 1997, he found the church elders still upset about the desecration of their saint. Believing that the new African National Congress-led government would be sympathetic to this quest, he set about trying to find Nonteta Bungu's grave. With the assistance of Coen Nienaber, a forensic archaeologist, he did indeed locate her remains; as the asylum authorities had noted in their records, she had been buried without a coffin atop the coffin of another inmate in an unmarked grave. After conclusive identification of her body, Edgar and Nienaber obtained $5,000 from the provincial government to transport her back to Mnqaba.

In November 1998, the remains of Nonteta Bungu were laid to rest on a hilltop with 600 mourners participating in a long, song-filled service, fulfilling her prophecy 63 years after her death.

SOURCES:
The New York Times. November 18, 1998.

<div align="right">Malinda Mayer,

writer and editor, Falmouth, Massachusetts</div>

Noonuccal, Oodgeroo (1920–1993).

See Walker, Kath.

Noor al-Hussein (1951—)

Queen of Jordan. Name variations: Lisa Halaby. Born Elizabeth Najeeb Halaby on August 23, 1951, in Washington, D.C.; oldest of three children of Najeeb Elias Halaby (a lawyer and businessman) and Doris (Carlquist) Halaby; attended the National Cathedral School, in Washington, D.C.; attended the Chapin School, New York City; attended the Concord Academy, in Concord, Massachusetts; graduated from Princeton University, in 1974; married Hussein Ibn Talal also seen as Hussein bin Talal, known as Hussein (1935–1999), king of Jordan (r. 1952–1999), on June 15, 1978; children: Prince Hamzah (b. 1980); Prince Hashim (b. 1981); Princess Iman (b. 1983); and Princess Raiyah (b. 1986); stepchildren: eight from the king's three previous marriages, including Abdullah, king of Jordan (r. 1999—). King Hussein's first marriage, to a distant Egyptian cousin, ended in divorce in 1956; he then married Britain's Antoinette Gardiner in 1961; they were divorced in 1972; his third wife Queen Alia was killed in a helicopter crash in 1977.

On June 15, 1978, Lisa Halaby, a 25-year-old Princeton-educated architect, wed 42-year-old King Hussein of Jordan, thus becoming the first American-born queen of an Arab Muslim nation. On the eve of the wedding, Halaby, who was raised a Protestant, converted to Islam and, in accordance with Jordanian tradition, took the Arabic name Noor al-Hussein (Light of Hussein). Following a conventional Islamic ceremony, in which the queen was the only woman present, the newlyweds honeymooned at the king's Red Sea resort at Aqaba. While journalists around the world seized upon the fairy-tale aspect of the union, both the queen and her adopted country faced enormous challenges.

Queen Noor's background and privileged upbringing was certainly a plus in preparing for a royal future. She was the oldest of three children of Swedish-born Doris Carlquist Halaby and Arab-American Najeeb Halaby, a former Navy test pilot and lawyer who served as head of the Federal Aviation Administration under President John F. Kennedy. She grew up in Washington, D.C., and New York, and received her early education at some of the most prestigious schools in the country. During the summers, she traveled abroad and was always involved in "something interesting," said one of her classmates. In 1969, she enrolled at Princeton University, becoming a member of its first coeducational class. She majored in architecture and urban planning, taking a leave of absence midway through her sophomore year to study photography in Colorado,

where she also worked part-time as a waitress and skied. Following her graduation in 1974, she went on an expedition to Australia to photograph rare birds.

During the 1970s, Halaby toyed with the idea of becoming a journalist, but a renewed interest in her Arab roots led her instead to accept a job as an assistant to *Marietta Tree, a former diplomat and a director of Llewelyn-Davies, Weeks, the British architectural firm which had been commissioned to replan the city of Tehran. Halaby continued her Middle East connections throughout the decade, working on the master plan for Arab Air University in the Jordanian capital. "I can't explain why, but going there was something I knew I had to do," Noor told Milton Viorst of *Parade*. "I wanted to let it become a part of me, and I wanted to become part of it. It was the Arab blood in me that I identified with and that I wanted to discover." Employees of the city's InterContinental Hotel, where she lived briefly, recall the lanky blonde beauty hanging around in cutoffs and creating a stir in the lobby by greeting her then-boyfriend with a fervent embrace.

Halaby also attended many social functions in Amman, and thus became acquainted with her future husband, King Hussein, who at the time was mourning the loss of his third and very popular wife, Queen Alia, who had died in a helicopter crash in 1977. (The king's two earlier marriages had ended in divorce.) By 1978, friendship had blossomed into romance, although the relationship was kept secret. "We courted on a motorcycle," the queen told Dominick Dunne for an article in *Vanity Fair*. "It was the only way we could get off by ourselves." After a brief, six-week courtship, the king proposed.

Following the announcement of the couple's engagement in Amman, there was a public outcry because the king had not chosen an Arab wife; there was also heated speculation as to what title would be bestowed on the bride-to-be. Marvin Howe of *The New York Times* pondered: "How will this very American girl fit into this very closed Arab kingdom?" But the young queen, who still faced some criticism as an outsider, made an exceptionally smooth transition into her new life, despite the challenges of round-the-clock bodyguards (a reminder of the more than 20 assassination attempts that had been made on the king's life) and the details of handling the large royal household, which included Queen Alia's three children, whom Noor later adopted, and five children from the king's other marriages. After her first year, during

which she studied Arabic and the Muslim religion, Noor was upbeat. "I think I have been accepted by the majority of people here in a way I never expected and with such a warmth it's been overwhelming," she told the *Christian Science Monitor*. "It's given me a lot more confidence and strength than I would otherwise have had. I don't feel any regrets."

Between 1981 and 1986, the royal couple added four more children to their family (two daughters and two sons), increasing the queen's duties considerably. In addition to her official responsibilities, which included heading up the nation's charities, Noor focused much of her outside work on educational development within her country, helping to found the Royal Endowment for Culture and Education and the Jubilee School, a high school for gifted students. She also worked to preserve and celebrate Jordan's cultural heritage and pursued the delicate issues of women's rights and opportunities. For the most part, the queen stayed out of politics, even though her husband's rule became more tenuous after the 1967 Seven Days' War, when Israel defeated its Arab neighbors and occupied the West Bank. In 1984, when Hussein, frustrated over the stalemate in the peace process, lashed out at the United States for its unequivocal support of Israel, Noor added her own voice to his criticisms, making several speeches in the United States reflecting her support of the Arab position in the conflict. "We see an America whose foreign aid to Israel pays for military action against Arab civilians and helps Israel in her violations of human rights, which have been documented and censured by the world community," she said in a speech at the Foreign Policy Association and the World Affairs Council in Washington, D.C., in 1984. "If a lasting peace in the Middle East is ever to be realized, it is time for the United States to bring its practices in line with an active and unambiguous exercise of the principles that govern its democracy."

After Iraq invaded Kuwait in 1990, and Hussein elected not to join the coalition against Iraq, Noor again openly stood by her husband, claiming that should relations between Jordan and the United States deteriorate, she would continue to support Jordan. However, as *Newsweek* reported in an article in 1999, the queen also helped improve her country's image at the time by opening the palace to journalists and taking Western reporters to tour the Jordanian camps for refugees from Kuwait and Iraq. As a result, she became something of a celebrity. She replaced the late Princess *Diana in the campaign against land mines and launched her own Web site, all of which was detailed in the press.

"None of that endeared her to her critics, who complained about her shopping and accused her of corruption," suggested *Newsweek*. "Some called her Jordan's *Imelda Marcos.**"

Throughout the years, the queen's marriage was not without its low points; there were often rumors about the king and other women. Hussein's diagnosis of non-Hodgkin's lymphoma in 1998, however, brought the couple closer. Noor later said that the six months the two spent together in the United States during the king's treatment was one of the most enriching times of their 20-year union. While living at the Mayo Clinic, and handling Jordanian duties by e-mail, they drove around town in a Volkswagen Beetle, wandered bookstores, and took walks in the woods. "These moments meant much more to us than ever before, knowing that each one was God's gift," said Noor. When they returned to Jordan in mid-January, they were greatly optimistic, convinced that the 63-year-old king had been cured. However, within a week, Hussein grew weak and feverish, and doctors, suspecting a return of the cancer, ordered him back to the United States. Noor remained hopeful as her husband began a new round of treatment, but it soon became apparent that the disease had reached a terminal stage. They immediately returned to Jordan so that Hussein could die at home. As he lay on his death bed, Noor and her children stole time from their own vigil to join the crowd of Jordanians, gathered outside in the winter rainstorm, "to offer them some peace, and to ask them to pray for him," she said.

Following Hussein's death on February 7, 1999, Queen Noor was forbidden by Arab Muslim tradition from participating in funeral arrangements or in the ceremony itself. She spent the funeral day sequestered with other royal women and dignitaries. The following day, however, the gates of the palace were opened and Noor, dressed in black and wearing the traditional white lace *yani* on her head, greeted the hundreds of mourners who had come to pay their respects. She received thousands more Jordanians throughout the 40-day mourning period that followed, winning hearts with her courage and strength.

Just prior to his death, Hussein had published a 14-page letter in which he bitterly chastised his brother Hassan and replaced him as heir with his son Abdullah, 37. (The king had intended to name as his heir Noor's eldest son Prince Hamzah, 18, his favorite. However, facing the possibility that there might not be time to train Hamzah for the throne, he chose instead the

more mature Abdullah.) Although Noor has relinquished her position to Abdullah's wife **Rania**, it is certain that she will retain a place in Jordan's future, especially if Abdullah designates Prince Hamzah as his own heir. Now that she is free from the constraints of being the wife of a sitting king, there is speculation that she will speak out even more forcefully on the touchy subjects of democracy and human rights. Very near to her heart at present, however, is the nascent King Hussein Foundation, whose mission is to promote debate and to further the king's efforts to modernize the Arab world. Whatever her endeavors, Queen Noor still feels the powerful presence of her husband. "On a spiritual level," she told *Time* reporter Scott Macleod, "I feel we are still making the journey together."

SOURCES:

Current Biography. NY: H.W. Wilson, 1991.

Dunne, Dominick. *Vanity Fair.* January 1991.

King, Laura. "Sequestered mourning for Jordan's queen," in *The Day* [New London, CT]. February 10, 1999.

"The Light of His Life," in *Newsweek.* February 8, 1999, p. 42.

"A Lion in Winter," in *Newsweek.* February 8, 1999, pp. 40–42.

Macleod, Scott. "Talking With a Queen," in *Time.* March 29, 1999, p. 50.

Mustain, Gene. "American-born queen has been Hussein's 'light,'" in *The Day* [New London, CT]. February 7, 1999.

Viorst, Milton. *Parade.* April 14, 1986.

Barbara Morgan,
Melrose, Massachusetts

Noor Inayat Khan (1914–1944).

See Khan, Noor Inayat.

Noor Jahan (1577–1645).

See Nur Jahan.

Nordern, Helen Brown (b. 1907).

See Lawrenson, Helen.

Nordica, Lillian (1857–1914)

American mezzo-soprano. Born Lillian Norton in Farmington, Maine, on December 12, 1857; died after a shipwreck in Batavia, Java, on May 10, 1914; youngest of six children of Edwin Norton (a photographer) and Amanda Elizabeth (Allen) Norton; graduated from the New England Conservatory of Music, 1876; married her second cousin Frederick A. Gower, in 1882 (disappeared after a balloon ascension, presumably drowned in English Channel, 1885); married Zoltan Döme (a tenor), on May 28, 1896 (divorced 1904); married George Washington Young (a New Jersey banker), on July 29, 1909.

Debuted at the Teatro Manzoni in Milan (1879); debuted at the Paris Opéra (1882), Covent Garden (1887), Metropolitan Opera (1891).

Born Lillian Norton in Farmington, Maine, in 1857, into an established and talented New England family, Lillian Nordica studied with James O'Neill at the New England Conservatory for four years before debuting at Madison Square Garden. Deciding she needed further training, she attended the Milan Conservatory where Antonio Sangiovanni trained her and also persuaded her to use the name "Nordica," since "Norton" was difficult to articulate in Italian.

Lacking great beauty and vocal gifts, Nordica had determination and pluck as well as common sense. Her temperament was moderate and conciliatory, a quality greatly appreciated in the world of prima donnas. After debuting as Donna Elvira at the Teatro Manzoni in Milan, Nordica performed throughout Europe, where she became known as "the Lily of the North." She was coached extensively by *Cosima Wagner for the

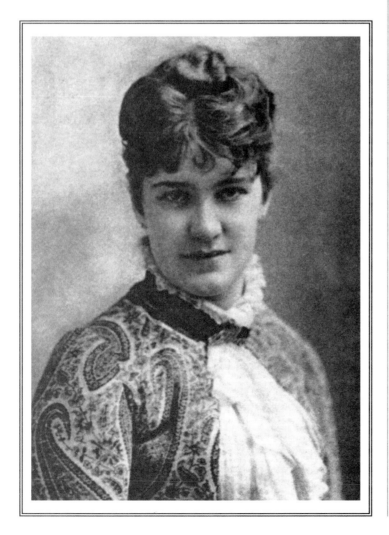

Lillian Nordica

role of Elsa in *Lohengrin* given at Bayreuth in 1892. During her years at the Metropolitan from 1893 to 1909, she became best known for her Wagnerian roles and hoped to establish an "American Bayreuth." (She was known for her insistence on singing opera in English.) Lillian Nordica had less success in her private life. Married three times, she was quoted as saying that she was "just a poor picker of husbands."

On November 25, 1913, following a performance in Melbourne, Australia, Nordica was returning home from Sydney by boat when the ship struck a coral reef in the Torres Strait. After several days, it was finally able to reach land, but the singer had developed pneumonia from exposure. She died a few months later in Java.

In an article for a magazine, Nordica once cautioned budding singers: "I remember hearing a woman say she could sing right through and not move her face at all. Not at all! Rather, you must give the meaning of the song in the expression of your face. . . . If you are singing about the 'joyous, joyous spring,' you do not want to look as if you were going to a funeral in autumn."

SOURCES:

Edgerly, Lois Stiles, comp. and ed. *Give Her This Day: A Daybook of Women's Words.* Tilbury House, 1990.

Glackens, I. *Yankee Diva: Lillian Nordica and the Golden Days of Opera.* New York, 1963.

<div align="right">

John Haag,
Athens, Georgia

</div>

Nordstrom, Ursula (1910–1988).

See Margaret Wise Brown for sidebar.

Norelius, Martha (1908–1955)

Swedish-born Olympic swimmer who was the first woman to win successive gold medals. Born on January 29, 1908, in Stockholm, Sweden; died on September 23, 1955.

Won an Olympic gold medal in the 400-meter freestyle in Paris (1924); won Olympic gold medals in the 400-meter freestyle and the 4x100-meter relay in Amsterdam (1928).

Born in Stockholm, Sweden, on January 29, 1908, Martha Norelius grew up in the United States. As she developed as a swimmer, she was reportedly the first woman to adopt what was then a distinctly male style of swimming: holding her head and elbows high, keeping her back arched and using a six-beat kick. The method worked; she won the gold medal in the 400-meter freestyle in the 1924 Olympics (beating *Gertrude Ederle in the process), and in the 1928

Olympics won another gold in the same competition, making her the first woman to win Olympic gold medals in two consecutive Games. She also won the gold for her role as a member of the victorious 4x100-meter freestyle relay team in 1928.

In the two years prior to her second Olympic victory, Norelius set more than 30 world records in swimming events ranging from 50-meter races to marathons. One of her more significant wins was her first-place finish in the $10,000, 10-mile William Wrigley Marathon in Toronto, Canada. Norelius, who died in 1955, was inducted into the International Swimming Hall of Fame in 1967.

<div align="right">

Lisa Frick,
freelance writer, Columbia, Missouri

</div>

Norfolk, countess of.

See Isabel (fl. 1225).
See Hayles, Alice (d. after 1326).

Norfolk, duchess of.

See Isabel (fl. 1225).
See Bourchier, Anne (c. 1417–1474).
See Margaret (c. 1320–1400).
See Fitzalan, Elizabeth (d. 1425).
See Howard, Margaret (fl. 1450).
See Howard, Anne (1475–1511).
See Tylney, Agnes (1476–1545).
See Howard, Elizabeth (1494–1558).
See Audley, Margaret (d. 1564).
See Leyburne, Elizabeth (d. 1567).

Norgate, Kate (1853–1935)

British historian. Born in St. Pancras, London, England, on December 8, 1853; died at Gorleston-on-Sea, England, on April 17, 1935; daughter of Frederick Norgate (a bookseller) and Fanny Norgate.

Born the only child of Frederick and **Fanny Norgate** in London, England, on December 8, 1853, Kate Norgate developed an interest in history through her association with a prominent literary group in Norwich, where she met and was given much encouragement by the famed English historian John Richard Green.

By 1877, Norgate was conducting research in the British Museum for what would become her two-volume *England under the Angevin Kings.* After its publication in 1887, her talent was immediately noted by E.A. Freeman, who lauded her work in the *English Historical Review.* The book established Norgate as a solid historian who showed a knack for understanding original sources and expressing them in a

clear, spirited narrative. As the work of a self-taught woman historian, the book also helped to level the playing field between male and female historians by undermining the notion that women were not as capable as men in the field of history. Norgate's later books included *John Lackland* (1902), *The Minority of Henry the Third* (1912), and *Richard the Lion Heart* (1924), which followed the life of Richard I. She also teamed up with *Alice Stopford Green to help with an illustrated edition of Green's *Short History of the English People* (1892–1894).

Although an estimable historian, Norgate was little-known in her later years, and the only accolade she received came with her election as an honorary fellow of Somerville College, Oxford, in 1929. She died in Gorleston-on-Sea, England, on April 17, 1935.

Lisa Frick,
freelance writer, Columbia, Missouri

Noris, Assia (1912—)

Russian-born actress. Born Anastasia von Gerzfeld on February 26, 1912, in Petrograd (St. Petersburg), Russia; married three times: her second husband was director Mario Camerini.

Films include: Tre Uomini in Frak *(1932);* La Signorina dell'Autobus *(1933);* Giallo *(1933);* Quei Due *(1934);* Darò un Milione *(1935);* Una Donna fra Due Mondi *(Between Two Worlds, 1937);* Il Signor Max *(1937);* Grandi Magazzini *(1939);* Dora Nelson *(1939);* Una Romantica Avventura *(1940);* Un Colpo di Pistola *(1941);* Una Storia d'Amore *(1942);* Le Capitaine Fracasse *(Fr., 1943);* I Dieci Comandamenti *(The Ten Commandments, 1945);* Che Distinta Famiglia! *(1945);* Amina *(Egypt, 1949);* La Celestina *(1964).*

Born in Russia in 1912, the daughter of a Ukrainian woman and a German officer, Assia Noris rose to prominence in Italian films of the 1930s and early 1940s. Many of her movies were directed by her second husband, Mario Camerini, and co-starred Vittorio De Sica, who was a matinee idol before he became a director. Around 1945, Noris married her third husband, a British military officer, and emigrated to Egypt. She made only two films after that, one in 1949 and the last in 1964.

Norman, Decima (1909–1983)

Australian track star. Name variations: Clara Decima Hamilton. Born Clara Decima on September 9, 1909, in Tammin, Western Australia; died on August 29, 1983; adopted daughter of Francis Norman and Elizabeth Norman; attended Perth College; married Eric Hamilton (a former rugby player); no children.

Born on September 9, 1909, in Tammin, Western Australia, Decima Norman first became noted for her athletic and track skills while attending Perth College. Even though Norman posted times superior to most other track athletes qualifying for the 1936 Olympics, she was ignored by Australian Olympic officials because Western Australia did not have an official athletics association to act as her sponsor. Norman apparently formed the Western Australian Women's Amateur Athletic Association in 1936 to enable women to enter competition as members of a registered club, although there are no official records of its existence.

Norman became famous at the 1938 Empire Games (now the Commonwealth Games), in which 15 countries and 464 athletes competed in Sydney. At the age of 29, which was considered advanced by track standards, Norman won five gold medals: in the individual 100 yards, 220 yards, and broad (long) jump, and as a team member on the 440- and 660-yard medley relays. She trained in Sydney for the state championships in 1939, where she set an Australian record for the 90-yard hurdles and won the broad jump despite having little training in the sport. Norman planned to compete in the 1940 Olympics, but World War II cancelled the competition and ended her athletic career.

Decima Norman went on to become an astute businesswoman with interests in a restaurant and a night club. She actively campaigned for sports, particularly women's sports, in Western Australia, and also supported women athletes with personal donations, advice, and fundraising. For her services to sports, Norman was awarded an MBE. She married former New Zealand Rugby Union footballer Eric Hamilton, and the couple eventually retired to Albany, Western Australia. In 1982, she was appointed official custodian of the baton of the Royal Commonwealth Games, flying from Australia to England to receive it from Queen *Elizabeth II. Norman died of cancer one year later, on August 29, 1983. In 1986, the Western Australian Institute of Sport inducted her into its year-old Hall of Champions.

SOURCES:

Radi, Heather, ed. *200 Australian Women: A Redress Anthology.* NSW, Australia: Women's Redress Press, 1988.
Vamplew, Wray, *et al.*, eds. *The Oxford Companion to Australian Sport.* Melbourne: Oxford University Press, 1992.

Jacqueline Mitchell,
freelance writer, Detroit, Michigan

Norman, Dorothy (1905–1997)

American photographer, writer, and civil rights activist who was an intimate and biographer of photographer Alfred Stieglitz. Born Dorothy Stecker on March 28, 1905, in Philadelphia, Pennsylvania; died on April 12, 1997, in East Hampton, New York; third of three children of Louis Stecker and Ester Stecker; attended Fairmont School, Washington, D.C., and the Mary C. Wheeler School in Providence, Rhode Island, 1920–21; attended Smith College, 1922–23; attended the University of Pennsylvania, 1924–25; married Edward Norman (heir to Sears, Roebuck fortune), on June 10, 1925 (divorced 1953); children: Nancy (b. 1927); Andrew (b. 1930).

Selected works: Dualities *(1933);* (co-editor) America and Alfred Stieglitz *(1934);* (editor-publisher) Twice a Year: A Semi-Annual Journal of Literature, the Arts and Civil Liberties *(1938–48);* (editor-publisher) Stieglitz Memorial Portfolio *(1947);* (editor) Selected Writings of John Marin *(1949);* The Heroic Encounter *(1958);* Alfred Stieglitz: Introduction to an American Seer *(1960);* (editor) Jawaharlal Nehru, The First Sixty Years *(Vol I & II, 1965);* The Hero: Myth/Image/Symbol *(1969);* Alfred Stieglitz: An American Seer *(1973);* (editor) Indira Gandhi: Letters to an American Friend *(1985);* Encounters—A Memoir *(1987).*

Dorothy Norman is frequently remembered for her close relationship with photographer Alfred Stieglitz, whom she met in 1927, and who subsequently became her mentor and her lover, despite the fact that he was 40 years her senior and they were both married to others. In a foreword to *Intimate Visions,* a collection of Norman's photographs published in 1993, Edward Abrahams calls Norman the unofficial keeper of the Stieglitz legacy, referring to her two volumes of testimonials about his place in American life and her definitive biography of him in 1973. But Norman also became a commanding photographer in her own right, her small black-and-white images likened by one museum curator to the poems of *Emily Dickinson: "private, quiet, intimate." She was also a poet, the editor of her own intellectual journal, a columnist for the *New York Post*, and an activist for civil liberties and Indian independence.

Dorothy Norman was born in 1905, raised in a well-to-do Jewish family in Philadelphia, Pennsylvania, and attended private schools in Washington, D.C., and Providence, Rhode Island. She then went on to Smith College and the University of Pennsylvania. A self-described

rebel who shunned a life of "bridge and mahjongg and petty gossip," she immersed herself in liberal causes, calling her involvement a guilty reaction to her protective and privileged youth. In 1925, she married Edward Norman, a wealthy but mentally unstable young man who was given to sudden rages. The newlyweds settled in New York, where Edward went to work for the Cooperative League and Norman became involved in Roger Baldwin's American Civil Liberties Union (ACLU). She later joined the Urban League, and became part of *Margaret Sanger's efforts to spread the word about birth control.

In 1927, pregnant with her first child (the Normans would have two, Nancy and Andrew), Dorothy first wandered into Stieglitz's Intimate Gallery on Park Avenue, which was dedicated to the study of seven American artists. Intrigued by a John Marin work on exhibit, she made a return visit to the gallery, at which time she encountered Stieglitz who was answering a young woman's inquiry about the meaning of a particular painting. "You might as well ask what life means," Stieglitz replied. "If an artist could explain his work in words, he wouldn't have had to create it." Compelled by this simple philosophy and fascinated by the man himself, Norman made many return visits to the gallery, eventually entering into an intimate relationship with the photographer. Stieglitz, who at the time was married to *Georgia O'Keeffe, found a soulmate in his young devotee. "You know me," he once wrote to her. "You are the only one who does or ever did—or ever will—completely." Norman called Stieglitz her "lifeline," but often struggled to reconcile the affair with her marriage. "Does our love really interfere with the rest of our lives," she asked herself. "With the lives of those closest to us? Or, does it contribute? We never think of breaking up our marriages. We are nourished by and nourish them. Each of us loves the core of the rest of our lives. I want to hurt or tear apart nothing."

As their relationship developed, Norman convinced Stieglitz to open another gallery, An American Place, on Madison Avenue, and took on the responsibility of raising funds for the new project. The gallery, Stieglitz's third, opened in 1929. Norman assisted in managing the gallery, which also served as a laboratory where artists could both exhibit their work and discuss it with their peers. In the process, she became acquainted with Stieglitz's avant-garde circle of friends, including such artists as John Marin, Arthur Dove, Marsden Hartley, Charles Demuth, and Gaston Lachaise, and such writers as Lewis

Dorothy Norman

Mumford, William Carlos Williams, Theodore Dreiser, Sherwood Anderson, and e.e. cummings. In 1934, with Waldo Frank and others, Norman published *America and Alfred Stieglitz*, a series of essays on the photographer and his place in American culture.

In 1938, Norman launched her own periodical, *Twice a Year: A Semi-Annual Journal of Literature, the Arts, and Civil Liberties*, which was published out of An American Place and dedicated to Stieglitz. Over the ten-year life of the journal, Norman published writings by

Thomas Mann, Franz Kafka, Sherwood Anderson, *Anais Nin, and Federico Garcia Lorca, among others. From 1942, she also served as a columnist for the *New York Post* ("A World to Live In"), writing on such subjects as civil liberties and discrimination.

Stieglitz took many photographs of Norman over the course of their relationship and also nourished her growing interest in photography, although as a rule he did not take students. In the spring of 1931, he lent her a camera and instructed her in its use and darkroom techniques. He often wrote critiques on the backs of her early prints, ending his notations with the initials I L Y (I Love You), or I B O (I Bow Out), meaning she had mastered a particular problem and needed no further assistance. Many of Norman's photographs were of her beloved Stieglitz and the artists and writers she had contact with at An American Place. Her portraits, which became her best-known works, are small, intense in contrast, and sometimes uniquely cropped with the corner or top of the head missing. "When I took portraits I wanted most of all to make close-ups that showed as much as possible of the face," she wrote. "Its expressiveness must come through in order to illuminate character." Norman was also fascinated by the buildings of New York (until what she called "toy pseudo-skyscrapers" took over the city and she lost interest), and the scenery of Cape Cod, where she spent her summers. She particularly loved the spires of the churches, reaching to the heavens. "The pure white form of a steeple ascending over the Cape Cod landscape seemed to me a perfect icon of man's relationship to an ideal that he is ever reaching to touch and surpass."

Following the devastating blow of Stieglitz's sudden death in July 1946, Norman's life took another unusual turn. Always interested in Indian independence, she met and befriended Jawaharlal Nehru during one of his early visits to New York. She became instrumental in helping him advance his cause in America and later became his guest for celebrations surrounding the founding of the Republic of India. She published a two-volume collection of his writings and speeches in 1965, as well as a volume of her correspondence with his daughter *Indira Gandhi, in 1985.

In 1953, on advice of both her lawyer and a psychiatrist, Norman divorced Edward, after which she divided her time between New York City and a former potato farm she purchased on Long Island. Still involved with the art world, in 1955 she worked with Edward Steichen on *The Family of Man* exhibit, choosing captions for the worldwide collection of prints. She also created an exhibition of symbolic art entitled *The Heroic Encounter*, which opened at the Willard Gallery in New York in 1958, and then toured under the auspices of the American Federation of Art.

During her later years, Norman completed her definitive biography, *Alfred Stieglitz: An American Seer* (1973). In 1968, having become the recipient of almost all of Stieglitz's photographs, she established the Alfred Stieglitz Center at the Philadelphia Museum of Art, which now houses the collection as well as photographs by other photographers. Dorothy Norman's last publication was her autobiography, *Encounters—A Memoir* (1987).

SOURCES:

Barth, Miles, ed. *Intimate Visions: The Photographs of Dorothy Norman*. San Francisco, CA: Chronicle Books, 1993.

Norman, Dorothy. *Encounters: A Memoir*. NY: Harcourt Brace Jovanovich, 1987.

"Obituary," in *The Day* [New London, CT]. April 15, 1997.

Barbara Morgan,
Melrose, Massachusetts

Norman, Goodwife (fl. mid-17th c.) and Mary Hammon (c. 1633–?)

American colonial women tried for lesbianism.

In 1649, Goodwife Norman and Mary Hammon, citizens of Plymouth in the Massachusetts Bay Colony, were charged with "lude behavior upon a bed." As is well known, Puritan authorities were strict in their religious beliefs and severe in their punishments of crimes, sins, and minor social infractions (all of which they considered fairly synonymous). Norman's first name is unknown, as are all other personal facts about her; "goodwife" was a form of civil address, much like "Mrs.," which usually was applied to married women but occasionally was used for unmarried women. Mary Hammon, who was recorded as being 16 years old in 1649, was acquitted of the charges. Norman was found guilty and sentenced to "public acknowledgment" of her crime, civic humiliation being a favorite punishment of Puritan authorities. She is thought to be the first woman in America convicted of lesbianism.

SOURCES:

Read, Phyllis J., and Bernard L. Witlieb. *The Book of Women's Firsts*. NY: Random House, 1992.

Lisa Frick,
freelance writer, Columbia, Missouri

Norman-Neruda, Wilma (c. 1838–1911).

See Neruda, Wilma.

Normand, Mabel (c. 1893–1930)

American actress and comedian of the silent screen.
Name variations: early in career, worked under name
Mabel Fortescue. Born in New York, Massachusetts,
or Rhode Island, on November 10, 1893 (also seen as
November 2, 1892, and November 16, 1894); died of
tuberculosis in Monrovia, California, on February 23,
1930; one of the surviving three children (two girls
and a boy) of Claude G. Normand (a stage carpenter
and pit pianist) and Mary J. (Drury) Normand; mar-
ried Lew Cody (a screen actor), on September 17,
1926; no children.

Selected filmography: Over the Garden Wall
(1910); Picciola (1911); Betty Becomes a Maid (1911);
Subduing of Mrs. Nag (1911); The Squaw's Love
(1911); The Diving Girl (1911); Her Awakening
(1911); The Eternal Mother (1912); The Mender of
Nets (1912); The Fatal Chocolate (1912); (also co-
dir.) Tomboy Bessie (1912); Oh Those Eyes! (1912);
Cohen Collects a Debt (1912); The Water Nymph
(1912); The Flirting Husband (1912); Mabel's Adven-
tures (1912); Mabel's Stratagem (1912); The Mistaken
Masher (1913); Mabel's Heroes (1913); A Red Hot
Romance (1913); Her New Beau (1913); Mabel's
Awful Mistake (1913); The Speed Queen (1913); For
Love of Mabel (1913); Mabel's Dramatic Career
(1913); The Gypsy Queen (1913); Cohen Saves the
Flag (1913); The Gusher (1913); In the Clutches of the
Gang (1914); Mabel's Stormy Love Affair (1914);
(also dir.) Won in a Closet (1914); Mabel's Strange
Predicament (1914); (also co-dir. with Sennett) Mabel
at the Wheel (1914); (also co-dir. with Chaplin)
Caught in a Cabaret (1914); (also dir.) Mabel's Nerve
(1914); The Fatal Mallet (1914); (also co-dir. with
Chaplin) Her Friend the Bandit (1914); (also co-dir.
with Chaplin) Mabel's Busy Day (1914); (also co-dir.
with Chaplin) Mabel's Married Life (1914); (also dir.)
Mabel's New Job (1914); Gentlemen of Nerve (1914);
Tillie's Punctured Romance (1914); (also co-dir. with
Eddie Dillon) Mabel's and Fatty's Wash Day (1915);
(also co-dir. with Dillon) Mabel's and Fatty's Simple
Life (1915); The Little Band of Gold (1915); (also co-
dir. with Roscoe "Fatty" Arbuckle) Fatty and Mabel
Viewing the World's Fair at San Francisco (1915); The
Little Teacher (1915); My Valet (1915); Stolen Magic
(1915); Fatty and Mabel Adrift (1916); Bright Lights
(1916); Dodging a Million (1918); The Floor Below
(1918); Joan of Plattsburg (1918); The Venus Model
(1918); Back to the Woods (1918); Mickey (1918);
Peck's Bad Girl (1918); A Perfect 36 (1918); Sis Hop-
kins (1919); The Pest (1919); When Doctors Disagree
(1919); Upstairs (1919); Jinx (1919); Pinto (1920);
The Slim Princess (1920); What Happened to Rosa
(1920); Molly O (1921); Oh Mabel Behave (1922);
Suzanna (1923); The Extra Girl (1923); One Hour
Married (1926); Raggedy Rose (1926); Should Men
Walk Home? (1927).

Considered by some to have been one of the greatest comedians of the silent screen, Mabel Normand was also one of the film industry's early woman directors, taking the helm in many of the early Keystone comedies she made for Mack Sennett, and co-directing some of her later films with Charlie Chaplin, Eddie Dillon, and Roscoe "Fatty" Arbuckle. Barely five feet tall, with huge dark eyes and curly brown hair, Normand would do anything for a laugh, and is credited with establishing a classic slapstick gesture when she impulsively threw a custard pie at the unsuspecting actor Ben Turpin. The actress, a stickler for detail, also did all of her own stunts, once fearlessly hurling herself off a high cliff into a river to pursue a canoe manned by her supposed enemy. At the height of her success, Normand began to live her personal life on the edge as well, and in the end sacrificed both her health and her career. She died in her mid-30s of tuberculosis.

Facts about Normand's early life are obscure; she was born around 1893 in New York, Massachusetts, or Rhode Island (her mother had family in Providence), one of three children of an itinerant vaudeville pianist and a working mother. A rumor once surfaced that she was educated in a Massachusetts convent, but that is highly unlikely. As Mack Sennett once observed, "Her formal education was as sketchy as shorthand." When she was in her early teens, the family moved to Staten Island, New York, and Normand went to work as an illustrators' and photographers' model. She posed for famous artists Charles Gibson and James Montgomery Flagg, who did covers for such magazines as *The Saturday Evening Post,* and appeared in numerous advertisements, including some for Coca-Cola. At 16, encouraged by a friend, she applied for film work at Biograph, then located on East 14th Street in New York City. There, she met producer-director Mack Sennett, who not only hired her on the spot but became her on-again, off-again paramour for years. Their tempestuous relationship was the subject of the 1974 musical *Mack and Mabel,* starring Robert Preston and **Bernadette Peters.** By the time she appeared in *The Diving Girl* (1911), clad in a daring pair of black tights, she was an unqualified star. When Sennett left Biograph in 1913 to join the Keystone Film Company in California, he took Normand with him. At the new studio, Normand

encountered Charlie Chaplin, who appeared with her in some 11 pictures, including *Mabel's Strange Predicament* (1914), in which he introduced his famous Little Tramp character. Although Normand was frequently called a "female Chaplin," it may well have been that Chaplin was a "male Normand." "Perhaps [Chaplin's] greatest debt is owed Mabel Normand," writes Sam Peeples in *Classic Film Collector*. "A study of her films, made before Chaplin came to this country, show entire routines, gestures, reactions, expressions that were later a part of Chaplin's characterizations."

The successful six-reeler *Tillie's Punctured Romance* (1914) was Normand's last picture with Chaplin, after which Sennett starred her with Roscoe "Fatty" Arbuckle in the successful "Fatty and Mabel" comedies. By 1916, however, Normand was pressing for better parts, and Sennett responded by setting up the Mabel Normand Feature Film Company for that purpose. The first production under the new company was the feature film *Mickey*, which Sennett shelved until 1918, although it contained Normand's best performance to date. Portraying a country tomboy up against high society, she delivered a delightfully layered performance, proving that her talent went far beyond slapstick. When it was finally released, the picture was an enormous financial success, although Normand received little of the take.

In the meantime in 1917 Normand moved to the Goldwyn studios, becoming one of its first name stars and earning a reputed four-figure weekly salary. Over a three-year period, she made 16 feature films for Goldwyn, including *The Venus Model* (1918), *Peck's Bad Girl* (1918), *Sis Hopkins* (1919), and *The Slim Princess* (1920), none of which were as successful as her earlier short films. Separated from Sennett for the first time in seven years, Normand acquired an increasingly extravagant lifestyle that included all-night parties and alleged drug addiction. She also became more and more undisciplined and difficult to work with, frequently causing costly production delays. When Sennett requested that she be released from her contract to make another picture with him, Goldwyn, who supposedly was also in love with the star, let her go. Together again, she and Sennett made *Molly O* (1921), which seemed destined for even greater success than *Mickey* until Normand's fast living unexpectedly caught up with her.

On the evening of February 2, 1922, the prominent director William Desmond Taylor was found shot to death in his Hollywood bun-

galow, following a visit by Normand (as well as a separate visit by *Mary Miles Minter). Normand was reportedly romantically involved with him. As the murder investigation got under way, it was rumored that Taylor had been killed because he was protecting Normand, who was being blackmailed for drug addiction. Although there was never any proof of the accusations, and the murder remained unsolved (though many think the killer was **Charlotte Shelby**, Minter's mother), the case led to public outcry and a brief banning of Normand's films.

Sennett stood by Norman during her ordeal and starred her in two films, *Suzanna* (1923) and *The Extra Girl* (1923). The latter had just been released, and Normand seemed on the brink of a comeback, when a second scandal erupted. This time, Normand's chauffeur, Horace A. Greer, shot wealthy Hollywood millionaire Courtland S. Dines, supposedly with Normand's gun. The actress' career was further damaged and never got back on track.

In 1925, following vocal coaching to try to improve her tiny voice, Normand made her stage debut in *The Little Mouse*, which never made it to Broadway. She then went to work for Hal Roach, making several two-reel comedies, but

Mabel Normand

they never caught on. On September 17, 1925, Normand unexpectedly eloped with actor Lew Cody, who had played the villain in *Mickey*. Stephen Burstin characterizes the marriage as a "spur-of-the-moment stab at happiness." Just two years later, however, doctors discovered that the actress had tuberculosis, and she spent the next three years in and out of hospitals. Up until her death, Normand was haunted by the murder that destroyed her career. "Do you think God is going to let me die and not tell me who killed Bill Taylor?" she asked a friend from her deathbed.

Sixty-seven years after her death, Normand's English great-nephew, the Reverend Stephen Normand, sold the star's remaining effects at auction in London. The collection, which fetched $5,000, included around 100 photographs, Normand's small pocket address book and, most curiously, three carbon typescripts, with hand-written changes, of Mack Sennett's autobiography *King of Comedy* (1954). As for Normand's tarnished image, her great-nephew said: "She was actually a very kind and generous woman. I have spoken to many scholars and people who have known Mabel, and no one has a bad word to say about her. She became entangled in some famous scandals of her day, but she was simply someone who was in the wrong place at the wrong time."

SOURCES:

Acker, Ally. *Reel Women*. NY: Continuum, 1991.

Burstin, Stephen. "Mabel Normand's Remaining Effects Examined," in *Classic Images*. No. 267. September 1977, pp. 22–23.

Garraty, John A., and Mark C. Carnes, eds. *American National Biography*. Vol. 16. NY: Oxford University Press, 1999.

James, Edward T., ed. *Notable American Women, 1607–1950*. Cambridge, MA: The Belknap Press of Harvard University Press, 1971.

Katz, Ephraim. *The Film Encyclopedia*. NY: Harper-Collins, 1994.

McHenry, Robert, ed. *Famous American Women*. NY: Dover, 1980.

SUGGESTED READING:

Fussell, Betty Harper. *Mabel*, 1984.

Barbara Morgan,
Melrose, Massachusetts

Normandy, duchess of.

See Poppa of Normandy.
See Gisela Martel (d. 919).
See Emma of Paris (d. 968).
See Judith of Rennes (c. 982–1018).
See Papia of Envermeu (fl. 1020).
See Gunnor of Denmark (d. 1031).
See Sybil of Conversano (d. 1103).
See Matilda of Anjou (1107–1154).

Normanton, Helena (1883–1957)

British lawyer. Born in London, England, in 1883; died in 1957; graduated from London University; studied at Dijon, France, obtaining qualifications in French language, literature and history; married Gavin Clark, in 1921.

First woman to be accepted by the Inns of Court, England (1919); second woman to be called to the Bar in England (1922); one of the first women to be named King's Counsel in England (1949); first woman to be elected to General Council of the Bar in England.

Helena Normanton graduated with first-class honors from London University and, after studying in France, entered the Middle Temple in 1919. This made her the first woman accepted by the Inns of Court, and in 1922 she became the second woman called to the Bar (Dr. *Ivy Williams was the first). Normanton practiced primarily in the Central Criminal Court, earning a reputation for "earnestness and learned quotations." In 1949, she became one of the first women to be made a King's Counsel in England and the first to be elected to the General Council of the Bar. She was influential in the International Society of Women Lawyers and the International Federation of Business and Professional Women. She became president of the Married Women's Association, causing controversy by her memorandum to the Royal Commission on Marriage and Divorce, the makeup of which she regarded as not representing the principle of "equal partnership." So strong were her feelings on this issue that she resigned, causing a split that led to the formation of a separate Council of Married Women. Normanton also wrote several books, including *Sex Differentiation in Salary* and *Everyday Law for Women*.

Jacqueline Mitchell,
freelance writer, Detroit, Michigan

Noronha, Joana de (fl. c. 1850)

Argentinean-Brazilian feminist, journalist, and literary critic. Name variations: Joana Paula Manso de Noronha. Born in Argentina; flourished around 1850; married a Portuguese violinist-composer (separated).

After separating from her Portuguese husband, a violinist and composer, Argentinean-born Joana de Noronha relocated to Rio de Janeiro, Brazil, where she became a journalist and literary critic. During a visit to the United States in 1846, she noted how women there were attempting to improve their status, and upon her return to Brazil she started a progressive feminist

paper, *O journal das senhoras*. The project met with considerable hostility and after six months she was in such dire financial straits that she was forced to relinquish the paper to **Violante Atabalipa de Bivar e Vellasco**, who served as its editor until 1855, when it ceased publication. (Vellasco later founded her own journal, *O domingo*, in 1874.) *O journal das senhoras* was a watershed publication, however, and influenced later radical feminist journals, such as *O sexo femminiso* (1873) and *A familia* (1888).

Norrell, Catherine Dorris
(1901–1981)

American congressional representative (April 1961–January 1963). Born on March 30, 1901, in Camden, Arkansas; died on August 26, 1981, in Warren, Arkansas; daughter of William and Rose Dorris; attended high school in Monticello; attended Ouachita Baptist College, Arkadelphia; graduated from University of Arkansas, Fayetteville; married William Norrell (1896–1961, a U.S. congressional representative), in 1922; children: one daughter, Julia Norrell.

Taught music in public schools, Arkansas; was director of music department at Arkansas A&M College; elected as a Democrat to the 87th Congress (1961), taking husband's seat after his death; served until January 3, 1963; was deputy assistant secretary of state for Educational and Cultural Affairs (1963–65); served as director, U.S. Department of State Reception Center, Honolulu, Hawaii (1965–69).

Catherine Dorris Norrell was born on March 30, 1901, in Camden, Arkansas, the daughter of William Dorris, a Baptist preacher, and **Rose Dorris**. The family moved around Texas, Tennessee, and Arkansas during Catherine's childhood. She graduated from Monticello High School in her home state, attending Ouachita Baptist University in Arkadelphia and then the University of Arkansas in Fayetteville. Trained as a pianist and organist, she taught music in public schools and served as director of the music department of Arkansas A&M College in Monticello.

She married William Norrell in 1922, and they had one daughter, Julia. When her husband entered Congress in 1939, Catherine Dorris Norrell worked as his staff assistant. She was also an active member of various women's organizations, and in 1959–60 served as president of the Congressional Club of Congressmen's Wives.

Partly paralyzed after a stroke in 1954, William Norrell died after a second stroke in

Catherine Dorris Norrell

February 1961. When a special election for his congressional seat was held in April that year, Catherine Dorris Norrell stood against four other candidates and won election as a Democrat to the House of Representatives from the 6th District of Arkansas. Hers was a commanding victory, out-polling the second-place opponent by a 2–1 margin, but her career in Congress was short-lived: her district was already slated for absorption into two other districts in 1962.

Norrell took the oath of office on April 25, 1961, and sat on the Committee on Post Office and Civil Service. She had campaigned promising to continue her husband's work, and her focus in Congress was on the economic prosperity of her district. She worked to protect the area's clay, textile, and lumber industries through tariffs and other government regulations, and sponsored legislation prohibiting interstate and foreign commerce in goods imported from Cuba. Concerned with the status of women, she was also a sponsor of the Equal Rights Amendment.

In April 1962, Norrell announced she would not be a candidate for reelection. Following her retirement, she was appointed by President John F. Kennedy as deputy assistant secretary of state for Educational and Cultural Affairs, serving

from 1963 to 1965. From 1965 to 1969, she was director of the State Department's reception center in Honolulu, Hawaii. Norrell lived the final years of her life in Monticello, Arkansas, and died in Warren, Arkansas, in 1981. She was buried in Oakland Cemetery in Monticello.

SOURCES:

Office of the Historian. *Women in Congress, 1917–1990.* Commission on the Bicentenary of the U.S. House of Representatives, 1991.

Paula Morris, D.Phil.,
Brooklyn, New York

Norris, Kathleen (1880–1966)

Prolific American novelist and short-story writer. *Born Kathleen Thompson in San Francisco, California, on July 16, 1880; died on January 18, 1966, in San Francisco; daughter of James Alden Thompson (a bank manager) and Josephine (Moroney) Thompson; studied briefly at the University of California, Berkeley; married Charles Norris (an editor and writer), in 1909 (died 1954); children: Frank (b. 1910); Josephine and Gertrude (twins, b. 1912, died in infancy); adopted four others, including her sister's three orphaned children.*

Selected writings: Mother *(1911);* The Rich Mrs. Burgoyne *(1913);* Saturday's Child *(1914);* The Story of Julia Page *(1915);* Undertow *(1917);* Josslyn's Wife *(1918);* Sisters *(1922);* Certain People of Importance *(1922);* The Callahans and the Murphys *(1924);* Noon *(autobiography, 1925);* Hildegarde *(1926);* The Foolish Virgin *(1928);* Margaret Yorke *(1930);* Second Hand Wife *(1932);* Wife for Sale *(1933);* Heartbroken Melody *(1938);* The Runaway *(1939);* The Venables *(1941);* Dina Cashman *(1942);* Corner of Heaven *(1943);* The Secret of Hillyard House *(1947);* High Holiday *(1949);* Shadow Marriage *(1952);* Miss Harriet Townshend *(1955);* Family Gathering *(autobiography, 1959).*

Born in San Francisco, California, on July 16, 1880, Kathleen Norris began her life in affluence, thanks to her father's position as a bank manager. Her parents James and **Josephine Thompson** were popular in the city's Irish community, and fostered an affectionate home for their six children. Norris was especially close to her lively and optimistic father, although her mother's devout Roman Catholicism also left a deep impression. When she was about ten, the family moved across the San Francisco Bay to Mill Valley, a village so rural that the children's main education came not from their occasional visits to the country school but from their father's wealth of books and magazines. Although

Norris briefly attended a Dominican convent school, upon the family's return to San Francisco she opted to stay home to help her mother with her four younger siblings rather than continuing her education.

In 1899, both her parents died within a month of each other, leaving only some $500 in savings. Along with her sister and brother, Norris began working to support the family, taking jobs as varied as caretaker for children and invalids, sales clerk, bookkeeper and librarian. She began writing to earn extra income, receiving $15.50 from a newspaper for "The Colonel and the Lady," her first published story. After briefly studying at the University of California at Berkeley, she took a position as society editor of the *Evening Bulletin*, and later worked as a reporter on the San Francisco *Examiner*. She enjoyed the work and, although the *Bulletin* discharged her and the Associated Press assured her that writing was not her calling, she never gave up journalism entirely, even after she became an established novelist.

In 1909, Norris married Charles Norris, an editor who later became a realist novelist. (He was also the brother of the late Frank Norris, whose shocking 1899 novel *McTeague* remains a classic of the realist school of writing.) The couple moved to New York City, where Norris, freed from the burden of caring for her younger siblings, devoted herself to writing at the brisk pace of two novels per year. Her first novel, *Mother* (1911), drew from her family and her Irish-American background, and was an instant success. Thereafter, she stuck closely to this wholesome formula of ordinary folk with ordinary problems and dreams, focusing primarily on family stories and love stories (her one exception was a foray into realism, 1922's *Certain People of Consequence*, which sold poorly). Written in an easy, fluent style that had mass appeal, Norris' novels celebrated the traditional wife and mother, illustrated the worth of simple values and simple goodness, and invariably concluded with the proverbial happy ending. The very sentimentality and romanticism which made her so popular with readers kept her from critical acclaim, although even critics praised her powers of observation and accurate depictions of contemporary Irish-American life. It is primarily for this documenting of a now vanished life and culture that her books are still read. Norris also frequently contributed short stories to popular magazines, including *McClure's*, *Woman's Home*, *Ladies' Home Journal*, *Good Housekeeping* and the *Saturday Evening Post*. Over the five decades of her writing career, she

produced over eighty novels, two autobiographies, a play, short stories, poems, magazine articles, newspaper pieces and even a 1940s radio serial. All told, her novels sold ten million copies, and although she never won any literary awards she was one of the most popular and commercially successful authors of her time.

Though her novels never betrayed her political views, Norris was not afraid to stand up for her beliefs in public. She was a pacifist who spoke out in favor of disarmament, an active suffragist (despite the female characters in her novels), a supporter of Prohibition and a charter member of the isolationist America First group that fought to keep the U.S. out of World War II. After the war, she campaigned against nuclear testing and capital punishment. While her husband Charles held contrary views on many of these issues, and they belonged to different religions—he was Episcopalian, while she remained staunchly Catholic—their marriage was, by all accounts, enduring and affectionate. Throughout her career, Norris drew on his constant support, while he acted as her agent and as a buffer from distractions and interruptions. He died of a heart ailment in 1954, and in the late 1950s she was crippled by arthritis that forced her to spend four years in a San Francisco hospital. She continued writing until she was 80, and spent the last few years of her life living with her son Frank. Norris died of congestive heart failure in San Francisco on January 18, 1966.

SOURCES:

Kunitz, Stanley J., and Howard Haycraft, eds. *Twentieth Century Authors*. NY: H.W. Wilson, 1942.

Sicherman, Barbara, and Carol Hurd Green, eds. *Notable American Women: The Modern Period*. Cambridge, MA: The Belknap Press of Harvard University Press, 1980.

Weatherford, Doris. *American Women's History*. NY: Prentice Hall, 1994.

COLLECTIONS:

The Kathleen Norris Papers are held at the Stanford University Library in Stanford, California; other collections of Norris' papers and items relating to her are held at the Bancroft Library at the University of California at Berkeley and at the California State Library in Sacramento.

Jacqueline Mitchell,
freelance writer, Detroit, Michigan

North, Marianne (1830–1890)

English naturalist and flower painter. Born at Hastings, England, on October 24, 1830; died at Alderly, Gloucestershire, on August 30, 1890; eldest daughter of a Norfolk landowner; descendant of Roger North (1653–1734).

Marianne North was born in Hastings, England, in 1830, the daughter of a Norfolk landowner. She trained as a vocalist under **Madame Sainton Dolby**, but her voice failed; she then devoted herself to painting flowers. After the death of her mother in 1855, she constantly traveled with her father, who was then member of Parliament for Hastings. When he died in 1869, North resolved to realize her early ambition of painting the flora of distant countries. In 1871–72, she went to Canada, the United States, and Jamaica, then spent a year in Brazil, where she did much of her work at a hut in the depths of a forest. In 1875, after a few months at Tenerife, she began a journey round the world, and for two years was occupied in painting the flora of California, Japan, Borneo, Java, and Ceylon. After another year spent in India, she returned and exhibited a number of her drawings in London. Her subsequent offer to present the collection to the botanical gardens at Kew was accepted, and new buildings, designed by James Ferguson, were erected for the exhibition.

At Darwin's suggestion, North went to Australia in 1880, and for a year painted there and in New Zealand. Her gallery at Kew was opened in 1882. In 1883, after she visited South Africa, an additional room was opened at the Kew gallery. In 1884–85, she worked at Seychelles and in Chile. North's careful, exact documentation of a far-ranging wealth of plant life remains an important part of the scientific record.

Northampton, countess of.

Northumberland, countess of.

Northumberland, duchess of.

Norton, Caroline (1808–1877)

English author who, through personal experience, became an authority on, and campaigner for the reform of, the law relating to women. Name variations: Caroline Sheridan, Lady Stirling-Maxwell; (pseudonym)

Pearce Stevenson. Born Caroline Elizabeth Sarah Sheridan on March 22, 1808, in London, England; died in London on June 15, 1877; daughter of Thomas Sheridan (a public official) and Caroline Henrietta (Callander) Sheridan; granddaughter of Richard Brinsley Sheridan and Elizabeth Linley; sister of the British poet Helen Selina Blackwood (Lady Dufferin, 1807–1867); educated at home and at a boarding school in Surrey; married George Chapple Norton, in 1827; married William Stirling-Maxwell, in 1877; children: (first marriage) Fletcher Norton (b. 1829); Thomas Brinsley Norton (b. 1831); William Norton (b. 1833).

Began career as a writer (1829); moved among fashionable society in London and shared close friendship with Lord Melbourne which led to her husband bringing a court case alleging adultery (1836); subsequently was separated from children and campaigned for access to them; influenced passage of Infant Custody Bill (1839); further disputes with her husband contributed to case for reforming divorce and married women's property laws (1857); continued successful writing career until her death.

Selected writings: A Voice from the Factories: A Poem *(John Murray, 1836);* The Separation of Mother and Child by the Law of Custody of Infants Considered *(Ridgway, 1837); (as "Pearce Stevenson")* A Plain Letter to the Lord Chancellor on the Infant Custody Bill *(Ridgway, 1839);* The Child of the Islands *(Chapman & Hall, 1845);* English Laws for Women in the Nineteenth Century *(privately printed, 1854);* A Letter to the Queen on Lord Cranworth's Marriage and Divorce Bill *(Longman, Brown, Green & Longmans, 1855);* The Lady of la Garaye *(Macmillan, 1862).*

In the spring of 1836, the troubled marriage of George Norton and Caroline Sheridan Norton took a new turn. For several years, the couple had inflicted on each other a variety of painful treatment: he physically, by violent attacks against her person, she by humiliating words and defiant actions. For the most part, the couple's three small sons had been spared involvement in the bitter quarrels that had taken place, but, having decided to break with his wife, George Norton spirited them away from the family home while their mother was briefly absent. He followed up this action by accusing the then prime minister of committing adultery with his wife. The court that heard his petition quickly decided there were no grounds to the accusation, but it was to be several years before Caroline Norton gained access to her children. Her campaign for justice affected the position of all wives and mothers in Victorian England; before it was over, she had helped to reform the law as it related to the custody of children, married women's property, and divorce.

"All the Sheridans," Lord Melbourne once told Queen *Victoria, "are a little vulgar." He might have added that members of the family were noted also for their vivacity, charm, and wit, and for a tendency to become involved in disputes, scandals, and financial scrapes. Caroline maintained this colorful tradition. Her grandfather was the great playwright Richard Brinsley Sheridan, author of *The Rivals* and *The School for Scandal*, and also for over 30 years a Whig member of the House of Commons. He died in poverty in 1816, but was accorded a splendid funeral procession and buried in Westminster Abbey. Her father Thomas Sheridan was born in 1775, the only son of Richard Brinsley Sheridan and *Elizabeth Linley, the beautiful and musically gifted "Maid of Bath" with whom he had eloped. Thomas Sheridan's life, like that of his father, was often dramatic. In his late 20s, to escape both the aftermath of a divorce case in which he was cited as co-respondent and his creditors, he moved, as Lord Moira's *aide de camp*, to Edinburgh where he met and in 1805 eloped with ✤➤ **Caroline Henrietta Callander (Sheridan)**. She too was noted for her charm and physical attractiveness.

Caroline Norton

Within a few years, the couple had four children; the third, Caroline, was born in London on March 22, 1808. Thomas Sheridan, through his father's political influence, had been found a sinecure, as muster-master general of Ireland (a post that did not require him to move from his villa in Tunbridge Wells or his town house in London). In 1813, he was appointed as colonial paymaster at the Cape of Good Hope, where residence was essential, but also desired in the hope that the southern African climate would alleviate the consumption from which he suffered. After a few years, however, he died and his widow returned to England in 1817 with her two sons, born at the Cape. Caroline had remained with two aunts in Scotland, but now the children were brought up together at Hampton Court, in a grace and favor residence—the social and political connections of the family had again proved of assistance.

Caroline's upbringing was apparently happy, creative, and somewhat disorderly. Before she reached her teens she had decided she would be a writer, and one early effort, *The Dandies' Rout*, was taken by a publisher and printed as a small book. In the absence of a father, the children were hard to control and seemingly because of this Caroline was sent to a small school in Surrey, near Wonersh Park, the seat of Lord Grantley. It was a fateful move. Within a few months, at the age of 16, she came to the notice of George Norton, Lord Grantley's younger brother who was then in his mid-20s. She seems hardly to have been aware of Norton, who wrote to her mother to ask for Caroline's hand in marriage. Mrs. Sheridan, while not agreeing to his request, did not reject the possibility of a later courtship.

In the London season of 1826, Caroline came out; that is, she attended a round of social occasions, the genteel conventions of which scarcely concealed a ruthlessly competitive marriage market. Upper-class girls, urged on by their parents, were desperate to marry well, and a good marriage was measured by the wealth and status of the husband. A young woman who failed to marry at all faced social isolation. Paid employment was frowned upon and in any case few opportunities for it existed. Spinsterhood was regarded as an unfortunate and involuntary condition. Though an acknowledged beauty—her expressive eyes and olive skin were widely noticed—with a lively and amusing personality, Caroline's season ended without a suitable offer of marriage. One sister, *Helen Selina Blackwood, who had also come out, was engaged to the heir of Lord Dufferin, while her other sister, ❧ Georgiana (Seymour), was expected to make

a brilliant match (she became the wife of the duke of Somerset's heir); these circumstances helped to persuade Caroline to reconsider George Norton's proposal.

In the summer of 1827, Caroline Sheridan became Caroline Norton—or, as she styled herself, the Hon. Mrs. Norton, for she had an acute awareness of her station in life. As her husband, a barrister, had become a member of Parliament for Guildford in 1826, his prospects appeared good. However, he was a Tory, while Caroline held to the family's Whig allegiance. In 1830, he lost his seat, Caroline informing Georgiana:

> Norton's election is lost, and with that mixture of sanguine hope, credulity and vanity which distinguishes him he assures me that, although thrown out, he was the popular candidate; that the opponents are hated, and that all those who voted against him did it with tears.

Her contemptuous tone reflected the antipathy that had quickly developed between the couple.

❧ **Sheridan, Caroline Henrietta Callander** (1779–1851)

English author. Name variations: Caroline Campbell; Caroline Henrietta Callander. Born Caroline Henrietta Callander in 1779; died in 1851; daughter of Colonel Callander, afterwards Sir James Campbell (1745–1832); married Thomas Sheridan (1775–1817, a poet, public official, and son of playwright Richard Brinsley Sheridan), in 1805; children: Helen Selina Blackwood, Lady Dufferin (1807–1867); Caroline Norton (1808–1877); and Lady Georgiana Seymour (later duchess of Somerset).

Along with producing three novels, including *Carwell, or Crime and Sorrow* (1830), Caroline Henrietta Sheridan was a celebrated beauty and the mother of the oft-quoted "three beauties": Lady *Helen Selina Blackwood, *Caroline Norton, and Lady *Georgiana Seymour, later duchess of Somerset. On the death of her husband in 1817 while in Colonial Service, Caroline Sheridan was granted grace and favor and resided at Hampton Court.

❧ **Seymour, Georgiana** (b. around 1809)

*Duchess of Somerset. Name variations: Lady Georgiana Seymour; Georgiana Sheridan. Born Jane Georgiana Sheridan around 1809; daughter of Thomas Sheridan (a public official) and *Caroline Henrietta Callander Sheridan (1779–1851); granddaughter of Richard Brinsley Sheridan and *Elizabeth Linley; sister of *Caroline Norton (1808–1877) and *Helen Selina Blackwood, Lady Dufferin (1807–1867); married Edward Adolphus Seymour (1804–1885), 12th duke of Somerset.*

George's outbursts of temper, which if Caroline did not provoke she did little to appease, sometimes ended with attacks on her person. These did not stop after her family remonstrated with him. Indeed, the Sheridans' unconcealed scorn perhaps made his behavior worse. However, in the circumstances, there was little Caroline could do. They already had one child, Fletcher, born in 1829, and, as there were phases in which the marriage was less intolerable, she tended to pursue those things that interested her and leave her husband to his own devices. She began her career as a writer. Her first book, *The Sorrows of Rosalie: A Tale, with other Poems,* was widely praised on its appearance in 1829 when its Byronic style appealed to the literary taste of the day. She followed it with other verses and took over the editorship of the fashionable *Belle Assemblée and Court Magazine.* A second son, Thomas Brinsley, was born in 1831 and a third, William, two years later.

*C*aroline Norton was a natural prima donna. . . . She was vital, warm-hearted, impulsive, temperamental, egotistic and not quite a lady.

—David Cecil

Caroline Norton's strikingly good looks, artistic accomplishments (she sang pleasantly and set some of her own lyrics to music), social connections—and perhaps her flirtatious and gossipy manner—enabled her to establish a small salon that was frequented by such literary and political figures as the young Benjamin Disraeli, *Mary Shelley, and Samuel Rogers. Meanwhile, George had been appointed, at a salary of £1,000 per year, as a police court magistrate. Caroline had secured this post by pleading, in the manner of the time, to the Whig home secretary, Lord Melbourne, reminding him of his friendship with her grandfather and asking that a paid appointment be found for her husband. Melbourne had decided to visit Caroline in person and, captivated by her, formed an intimate friendship which did not lessen when he became prime minister in 1834.

For a few years George Norton apparently remained unconcerned by his wife's eminent admirer, although the couple's marriage was still marked by quarrels. Matters came to a head in 1836 when Georgiana suggested that Caroline should visit her country house for Easter, bringing the children but not her husband. In response, George arranged for his sons to be moved to Wonersh Park, refused to allow his wife to return to their home, and announced that he intended to sue for divorce, on the grounds of her adultery

with Melbourne. The case came to court in June 1836. According to the law, Caroline had no standing in it, and could neither appear nor be legally represented. However, Sir John Campbell, the lawyer appearing on behalf of Melbourne, tore the case to shreds, and the jury, without even leaving the courtroom, returned a verdict against George Norton. Although at the time it was believed that political enemies of Melbourne had instigated the case, there were also those who assumed that he and Caroline were guilty. Even in public, she had treated him with great familiarity. The earl of Malmesbury recalled an occasion in 1835 at the French ambassador's when she "talked in a most extraordinary manner and kicked Lord Melbourne's hat over his head." He added that the "whole corps diplomatique were amazed." Yet both maintained their innocence, and modern authorities tend to take them at their word (although Clarke Olney, the editor of their correspondence, has suggested that, at the least, their friendship was more emotionally charged than most).

Despite the court having rejected George Norton's case, the law as it existed allowed him to deny his wife any access to their children. For the next few years, Caroline attempted to maintain contact with her sons. Her husband, depending on his moods, allowed occasional meetings, including a week's visit at Christmas, 1841. In July 1842, William fell from his pony, became ill, and died before Caroline could arrive. After this, Fletcher and Thomas were allowed to spend part of their holidays from Eton school with their mother.

While involved in these personal negotiations, she had taken part in a campaign to reform the law relating to child custody. In connection with this, she wrote two pamphlets, *The Separation of Mother and Child by the Law of Custody of Infants Considered* (1837) and, using the pseudonym Pearce Stevenson, *A Plain Letter to the Lord Chancellor on the Infant Custody Bill* (1839)—the latter after the House of Lords had held up the Child Custody Bill earlier passed by the Commons. The new legislation allowed a court to transfer custody of children under the age of seven to the mother, and after seven to allow visiting rights should the father reclaim legal custody.

By the mid-1840s, Caroline Norton's life had regained some stability. She was still regarded as one of the most accomplished and handsome hostesses in London; the scandal involving Melbourne did her little harm socially. Her reputation as an author grew. In 1840, Hartley Co-

leridge wrote of her as "the Byron of Modern Poetesses," while Charles Dickens, who had taken a close interest in her campaign to gain access to her sons, professed to admire her literary work. The income from her writings was considerable—as she pointed out to the prime minister, Sir Robert Peel, in 1843 when vainly making a claim for the vacant post of Poet Laureate. According to law, George Norton could take any of his wife's property, including income she received for writing, as, though separated, they were still legally married. In fact, he paid her an allowance, but when in 1851 Caroline's mother died, leaving her an annuity, he decided to reconsider the financial arrangements between them. He was infuriated to discover that his wife had also received money from Melbourne, who had died in 1848. This rekindled his suspicions of misconduct between them, and he ceased to pay her allowance. She retaliated by leaving unpaid her bills and referring creditors to her husband, who was legally responsible for her debts.

Another court case followed when a carriage-maker sued George for the debt Caroline had incurred. Again, personal details became freely available to those who were curious about the disputatious couple. Both wrote to *The Times* to add to the information that had been made public. In another pair of pamphlets, *English Laws for Women in the Nineteenth Century* (1854) and *A Letter to the Queen on Lord Cranworth's Marriage and Divorce Bill* (1855), Caroline vehemently argued the case for reform of the laws relating to divorce and married women's property. She mixed together details of her own marriage, cases of other women who had suffered from the way the law was applied, and more general arguments for change.

She was not alone in campaigning for new legislation. Others, such as *Barbara Bodichon, were also pressing for reform, usually independently of Caroline who was often regarded as too personally involved in the issue. Some reformers also held the view that but for her own unhappy marriage she would have shown little concern for the hardships endured by wives who suffered the harsh treatment of their husbands and then that of the courts. Her lack of feminist sympathies is evident in her letter to *The Times* in 1838: "The natural position of woman is in inferiority to man. Amen! That is a thing of God's appointing, not of man's devising. I have never pretended to the wild and ridiculous doctrine of equality." She repeated similar views in her pamphlet of 1854, although perhaps such sentiments were expressed as a way of disarming some opponents. In 1857, the law was changed,

both to make divorce a little easier to obtain and to give a degree of protection to the property of women. In subsequent years, gradually, though slowly, the rights of women were recognized.

In 1854, Caroline's son Thomas Brinsley Norton, true to Sheridan impetuosity, married a peasant girl he had met on the island of Capri and in the two years following became the father of a son and a daughter. Caroline helped to bring up the children, and perhaps thus gained a little consolation for the broken upbringing of her own sons. Although the death of son Fletcher Norton in 1859 was another personal blow, she continued to enjoy a high reputation with the reading public. Her novels, *Stuart of Dunleath* (1851), *Lost and Saved* (1863) and *Old Sir Douglas* (1867), have melodramatic scenes and improbable plots; their passionate and impulsive heroines have been regarded as semi-autobiographical. Though once widely admired, neither her poetry nor her prose has retained its appeal. Some of her writing exists in modern editions, issued mainly for scholars rather than for the wider public; one modern critic has linked her with other Victorian writers, popular in their day but not since, as one of "a flight of lame ducks."

It is her struggle to reform the law and the intensity of her own experiences that give Caroline Norton a place in history, combined with a vivid and powerful personality and the impact it had on her contemporaries. Her later years were spent in relative tranquility. She and George Norton met occasionally when he visited their grandchildren, though when he died in 1875 she is said to have complained that he had not lived long enough to make her Lady Grantley (George's elder brother, Lord Grantley, died shortly after and the title passed to Thomas Brinsley Norton).

There was one more twist in the plot of her own life. In March 1877, when in fading health, she married Sir William Stirling-Maxwell, a Scottish landowner and long-standing admirer. She died just over three months later, on June 15, and was buried at Keir in Scotland where her second husband held property. After her death, several diaries and memoirs by figures in society and politics appeared in print giving their authors' impressions of Caroline. A novel by George Meredith, *Diana of the Crossways* (1884), was modeled on incidents in her life. One account of 1854 by Lady *Elizabeth Eastlake leaves a vivid pen portrait of a remarkable personality:

> Mrs Norton . . . is a beautiful and gifted woman: her talents are of the highest order, and she has carefully cultivated them—has

read deeply, has a fine memory, and wit only to be found in a Sheridan. No one can compare with her in telling a story—so pointed, so happy, and so easy; but she is rather a professed story-teller, and brings them in both in and out of season, and generally egotistically. Still she has only talents—genius she has nothing of, or of the genius-nature nothing of the simplicity, the pathos, the rapid changes from mirth to emotion. No, she is a perpetual actress, consummately studying and playing her part, and that always the attempt to fascinate—she cares not whom. Occasionally I got her to talk thinkingly, and then she said things which showed great thought and observation—quite oracular, and not to be forgotten. I felt at first that she could captivate me, but the glamour soon went off. If intellect, and perfect self-possession, and great affected deference for me could have subjugated me, I should have been her devoted admirer.

SOURCES:

Acland, Alice. *Caroline Norton.* London: Constable, 1948.

Cecil, David. *Melbourne.* London: Constable, 1955.

Chedzoy, Alan. *A Scandalous Woman: The Story of Caroline Norton.* London: Allison & Busby, 1996.

Forster, Margaret. *Significant Sisters: The Grassroots of Active Feminism, 1839–1939.* London: Secker & Warburg, 1984.

Hoge, James O., and Clarke Olney, eds. *Letters of Caroline Norton to Lord Melbourne.* Columbus, OH: Ohio State University Press, 1974.

Olney, Clarke. "Caroline Norton to Lord Melbourne," in *Victorian Studies.* Vol. 8, no. 3, 1965, pp. 255–262.

Perkins, Jane Gray. *The Life of Mrs. Norton.* London: John Murray, 1909.

Smith, Charles Eastlake, ed. *Journals and Correspondence of Lady Eastlake.* London: John Murray, 1895.

Ziegler, Philip. *Melbourne: A Biography of William Lamb, 2nd Viscount Melbourne.* London: Collins, 1976.

SUGGESTED READING:

Holcombe, Lee. *Wives and Property: Reform of the Married Women's Property Law in Nineteenth-century England.* Toronto and Buffalo: Toronto University Press, 1983.

Stone, Lawrence. *The Road to Divorce: England 1530–1987.* Oxford: Oxford University Press, 1990.

<div align="right">

D.E. Martin,
Lecturer in History, University of Sheffield, Sheffield, England

</div>

Norton, Lillian (1857–1914).

See Nordica, Lillian.

Norton, Mary (1903–1992)

English author who is known for her "Borrowers" series. Born Mary Pearson on December 10, 1903, in London, England; died on August 29, 1992; daughter of Reginald Spenser Pearson (a physician) and Mary Savile (Hughes) Pearson; attended convent schools in England; married Robert Charles Norton (a shipping magnate, on September 4, 1926 (died); married Lionel Bonsey, on April 24, 1970; children: Ann Mary, Robert George, Guy, Caroline.

Actress with the Old Vic Theatre Company, London, England (1925–26); actress in London (1943–45); served two years with the British War Office in England, and two years with the British Purchasing Commission in New York, during World War II.

Awards: Carnegie Medal (1952) and Lewis Carroll Shelf Award (1960), both for The Borrowers.

Selected writings—juvenile: The Magic Bed-Knob *(illus. by Joan Kiddell-Monroe, Dent, 1945);* Bonfires and Broomsticks *(illus. by Mary Adshead, Dent, 1947);* Bed-Knob and Broomstick *(rev. ed. of* The Magic Bed-Knob *and* Bonfires and Broomsticks, *illus. by Erik Blegvad, Harcourt, 1957);* Are All the Giants Dead? *(illus. by Brian Froud, Harcourt, 1975).*

The "Borrowers" series, all illustrated by **Diana Stanley** *to 1971 unless otherwise noted:* The Borrowers *(Dent, 1952);* The Borrowers Afield *(Dent, 1955);* The Borrowers Afloat *(Dent, 1959);* The Borrowers Aloft *(Dent, 1961);* The Borrowers Omnibus *(Dent, 1966);* Poor Stainless: A New Story about the Borrowers *(Dent, 1971);* The Adventures of the Borrowers *(4 vols., Harcourt, 1975);* The Borrowers Avenged *(illus. by *****Pauline Baynes***, Kestrel, 1982).*

Although she wrote only eight novels in a career that extended from 1943 to 1982, Mary Norton is considered one of the major mid-century British children's authors. From the time of the appearance of her first novel, *The Magic Bed-Knob: or, How to Become a Witch in Ten Easy Lessons* (1943), Norton demonstrated a superb fusion of what T.S. Eliot called "tradition and the individual talent." She combined elements of her own experiences, transformed to meet the needs of her fantasies, with recognizable aspects of genres popular in British children's fiction in the first half of the 20th century. Her 1952 work *The Borrowers*, winner of the distinguished Carnegie Medal, quickly assumed status as a classic. The five sequels to that book developed what critic **Gillian Avery** called "a powerful mythology."

Born Mary Pearson on December 10, 1903, in London, the only daughter of Reginald and **Mary Pearson**, Norton spent most of her childhood in Leighton Buzzard, a small country town in Bedfordshire County. With her brothers, the nearsighted Mary wandered through the countryside and on rainy days joined them in homemade theatricals. Her house and the surrounding area were to form the settings for the five novels and one short story of the "Borrowers"

series—*The Borrowers, The Borrowers Afield* (1955), *The Borrowers Afloat* (1959), *The Borrowers Aloft* (1961), *Poor Stainless: A New Story about the Borrowers* (1971), and *The Borrowers Avenged* (1982). In her childhood, said Norton in an interview with Jon C. Stott, the idea for her most famous creations was born: "I think the first idea—or first feeling—of *The Borrowers* came through my being shortsighted: when others saw the far hills, the distant woods, the soaring pheasant, I, as a child, would turn sideways to the close bank, the tree roots, and the tangled grasses." Trailing along after her brothers, she often daydreamed: "Moss, fern-stalks, sorrel stems, created the mise-en-scéne for a jungle drama. . . . But one invented the characters—small, fearful people picking their way through the miniature undergrowth." Norton did not discuss her childhood reading, but echoes in her novels of the works of *E. Nesbit, Kenneth Grahame, *Frances Hodgson Burnett, and J.M. Barrie suggest their influence.

As a young adult living with her parents in Lambeth, a suburb of London, Norton audaciously suggested to a dinner guest, the actor-impresario Arthur Rose, her wish to become an actress. During the 1925–26 season, she performed as an understudy at London's Old Vic Theatre. These experiences, which she described as the most memorable of her life, also influenced her writing. For example, in *The Borrowers Afield* she says of her heroine: "Arrietty wandered out to the dim-lit platform; this, with its dust and shadows—had she known of such things—was something like going back stage." Episodes in her novels often resemble dramatic scenes, with two or three characters interacting in an indoor or confined set.

In 1926, Mary married Robert Norton, a member of a wealthy shipowning and trading family from Portugal. Until the outbreak of World War II, she lived with their four children on a relatively isolated country estate several miles from Lisbon. When the war began, she moved back to London with her children, while her husband remained in Portugal. Her life in Portugal, cut off as it was from extended family and friends, seems to have influenced her portrayal of Homily, the mother of the central character in the "Borrowers" series. Arriving back in London, she may well have felt like Homily: "homeless and destitute. . . . And strange relations . . . who didn't know she was coming and whom she hadn't seen for years."

As the political conditions in Europe worsened during the late 1930s, Norton remembered

Mary Norton

the tiny imaginary people of her childhood: "It was only just before the 1940 war . . . that one thought again about the Borrowers. There were human men and women who were being forced to live . . . the kind of lives a child had once envisaged for a race of mythical creatures." Unable to support her family on the income she received first from the British War Office in London and then from the British Purchasing Commission in New York, she began writing essays, translations, and children's stories, including her first novel, *The Magic Bed-Knob* (1945). The book follows three children, Carey, Charles, and Paul Wilson, who live in the country during the bombing of London. They befriend Miss Price, a shy neighbor who is taking a correspondence course in witchcraft and who places a spell on a bed-knob, thus allowing the three to travel magically anywhere they wish. With her, they are transported to a South Seas island where, through the agency of her magic, they narrowly escape being eaten by cannibals. The book was a critical success. "This story has all the makings of [a classic]," declared *The New York Times Book Review*. The *Library Journal* acclaimed it a "modern masterpiece."

The sequel, *Bonfires and Broomsticks*, appeared in England in 1947. (It would not be

published in the United States until a decade later when it was revised and combined with her first book under the title *Bed-Knob and Broomstick*.) Back in the country to spend the summer with Miss Price, the Wilsons discover that the bed-knob can be used for time as well as space travel and wish themselves into the later 17th century, where they meet Emelius Jones, an inept sorcerer whom they bring back to their own time. When he returns to his own era, he is condemned to be burned at the stake for witchcraft. Miss Price and the children rescue him, and the two adults marry and live in the 17th century. *The New York Times Book Review* found this sequel to be "just as good as the first," while poet John Betjeman called it "quite the best modern fairy story I have read."

Norton's first two novels gave promise of the excellence of the books to come. *The Borrowers*, Norton's third and greatest novel, was published in 1952 to almost instant critical acclaim. Marcus Crouch comments: "Of all the winners of the Carnegie Medal [awarded annually by the British Library Association to the best children's novel of the preceding year], it is the one book of unquestioned, timeless genius." Still widely read, it has been made into two television specials (one in England and one in the United States). The novel is about a species of tiny people, identical to human beings, who live beneath the floorboards of old country houses, borrowing food and supplies left lying about by the large occupants of the dwellings; specifically the novel focuses on Pod and Homily Clock and their daughter, Arrietty, the last three Borrowers living in a house reminiscent of the one in which Norton spent her childhood. The events of their lives are recounted to a young girl, Kate, by Mrs. May, an aging relative whose knowledge of the Borrowers came to her from her brother who, as a child, had met and interacted with the little people.

Norton's skilled use of description plays an important part in the story's credibility. Articles small to human beings are presented as huge from a Borrower's point of view. Discarded sheets of writing paper are made into wallpaper; a wire fly swatter is transformed into a safety door, keeping their apartments safe against mice. Insects are the size of birds; a drop of dew is as large as a marble; a clump of wood violets and clover is "a jungle." The conclusion to *The Borrowers* leaves the way open for further stories about the Clock family, the next of which was published in 1955. *The Borrowers Afield* opens a year after the telling of the first story, as Kate and Mrs. May depart for Firbank Hall, the house where the Clocks lived. The girl meets old

Tom Goodenough who, when he was a boy, had been told by Arrietty about her family's escape and travel to the old cottage where Tom lived. He gives Kate the diary Arrietty had kept during their odyssey, and she uses this, along with his reports, to create a narrative that she records for her own children. The novel, which the *Times Literary Supplement* called "that rare thing, an entirely successful sequel" and *The New York Times Book Review* considered "in some ways even better [than *The Borrowers*]," answered many of the questions presumably asked by readers of the first volume but also raised new ones to be dealt with in subsequent novels.

The Borrowers Afloat, the last of the series to use a narrative framework, appeared in 1959. This was followed by *The Borrowers Aloft* (1961), the fourth novel of the series which has been considered the least successful, falling into predictable plot patterns of setting up house, capture, escape, and relocation. Called by one reviewer "somewhat more contrived," the novel includes far more detailed but less functional accounts of the technical activities of borrowing.

Norton's next major work, *Are All the Giants Dead?* (1975), marked a new direction in her children's fiction. It tells the story of James, an average boy who is taken by Mildred, a middle-aged writer, to the land where famous fairy-tale characters live after their major adventures have been completed. James meets Jack-of-the-Beanstalk and Jack-the-Giant-Killer, who are depressed because the former cannot grow a beanstalk for the latter to climb to the land of the last, apparently invincible giant. With James' assistance, the two recover their self-esteem, and Dulcibel, the princess who must marry a frog, learns to control her own future. The adventures over, James finds himself back in his own bedroom. **Margery Fisher**, the distinguished British children's literature reviewer, called the novel "unexpected, but as brilliant, beguiling, and original as could possibly be wished."

In 1982, Norton, with the encouragement of her English editor, published a manuscript she had been working on for several years, *The Borrowers Avenged*. This novel, which brings the series to closure, is unlike the earlier works in the series in that it contains a great deal of satire about conditions of 20th-century English life. In addition to their implicit comments on modernization, the books of the "Borrowers" series present a picture of English country life at the time of the author's childhood. In many ways the books of this series, recounting as they do the wanderings and many temporary homes of the

Clocks, reflect Norton's life after World War II. Although she gave little personal information about her life from 1945 onward, she lived in several different places, including London, Essex, West Cork, Ireland, and Bideford, England. Norton died at Hartland, England, on August 29, 1992.

SOURCES:

Davenport, Julia. "The Narrative Framework of *The Borrowers*: Mary Norton and Emile Brontë," in *Children's Literature in Education*. Vol. 49, 1983, pp. 75–79.

Hand, Nigel. "Mary Norton and 'The Borrowers,'" in *Children's Literature in Education*. Vol. 7, 1972, pp. 38–55.

Kuznets, Lois. "Permutations of Frame in Mary Norton's 'Borrowers' Series," in *Studies in the Literary Imagination*. Vol. 18, 1985, pp. 65–78.

Rustin, Michael and Margaret. "Deep Structures of Fantasy in Modern British Children's Books," in *Lion and the Unicorn*. Vol. 10, 1986, pp. 60–82.

Stott, Jon C. "Anatomy of a Masterpiece: *The Borrowers*," in *Language Arts*. Vol. 55, 1976, pp. 538–544.

Thomas, Margaret. "Discourse of the Difficult Daughter: A Feminist Reading of Mary Norton's *Borrowers*," in *Children's Literature in Education*. Vol. 84, 1992, pp. 39–48.

Wolf, Virginia L. "From the Myth to the Wake of Home: Literary Houses," in *Children's Literature*. Vol. 18, 1990, pp. 53–67.

RELATED MEDIA:

Bedknobs and Broomsticks (117-min. film), starring **Angela Lansbury**, Roddy McDowall, and David Tomlinson, Walt Disney Productions, 1971.

"The Borrowers" (television special), starring Eddie Albert, **Tammy Grimes**, and *Judith Anderson, NBC-TV, December 14, 1973.

Freely adapted from a sketch by **Jon C. Stott**, University of Alberta, for *Dictionary of Literary Biography, Volume 160: British Children's Writers, 1914–1960*. The Gale Group, 1996, pp. 197–206

Norton, Mary T. (1875–1959)

First Democratic woman elected to Congress without being preceded by her husband, who served in the 69th–81st Congresses (March 4, 1925–January 3, 1951). Name variations: Mary T. Hopkins Norton. Born Mary Teresa Hopkins on March 7, 1875, in Jersey City, New Jersey; died on August 2, 1959, in Greenwich, Connecticut; attended Packard Business College in New York City; married Robert Francis Norton, in 1909 (died 1934); children: one (died in infancy in 1910).

Following the death of her only child, opened a day nursery in association with a local church (1910); became first woman to serve on the Democratic State Committee (1921–44); served on Board of Freeholders (1923); won election to the House of Representatives from New Jersey's 12th District, and became first woman elected from the East (1924); chaired the District of Columbia Committee (1932–37); served as chair of the House Labor Committee (1932–47); credited with the enactment of the Fair Labor Standards Act (1938); was the first woman to head the Democratic Party in New Jersey (1932); became a member of the Democratic National Committee (1944); retired from Congress (1951).

Born in Jersey City, New Jersey, in 1875, Mary T. Norton was unable to attend college because her father did not believe in educating women. She had, however, graduated from the local high school, and she attended a business college in New York City where she learned skills which enabled her to support herself until her marriage to Robert Francis Norton in 1909. After the death of her only child the following year, Norton opened a children's nursery in association with a local Catholic church. Some years later, while searching for coal for the nursery during the privations of World War I, she met and gained the help of Jersey City's powerful mayor and political boss, Frank Hague. After the passage of the 19th Amendment three years later, Hague, wanting the votes of the newly enfranchised women, announced to Norton that she was to head the Democratic women of the city. He also persuaded her to preside over a large meeting of women he had organized, the featured speaker at which was *Carrie Chapman Catt.

Norton quickly organized a Democratic women's committee in every county of the state. Soon after, Hague urged her to run as a freeholder (the equivalent of a county commissioner), an office she won in 1923. In 1924, she ran for Congress, at Hague's suggestion and with his encouragement. (And with his prodding; when initially she protested that she knew nothing of Congress, he replied, "Neither do most congressmen.") When she won the election, she became the first woman Democrat elected to Congress without having been preceded by her husband. (*Jeannette Rankin, the first woman member of Congress, had been elected as a Republican in 1916.) Norton was also the first woman elected to Congress from the East. From the start of her term in 1925, she learned quickly and served her constituents well, despite the fact that she was given bottom-of-the-basement assignments. One of these was to the Labor Committee, which in the booming 1920s seemed of little importance. Another was to the District of Columbia Committee, which she chaired from 1932 to 1937, turning the assignment from a hindrance into an opportunity and championing equality for district voters; she

brought such enthusiasm to the job that she became known as the "first woman mayor of Washington."

In 1932, as the Depression gripped the country, seniority rules brought Norton to the chair of the House Labor Committee. This made her only the second woman to chair a congressional committee (the first was *Mae Ella Nolan). She opposed an Equal Rights Amendment for the same reason that a good number of liberal and political women such as *Eleanor Roosevelt did, which was fear that it would negate years' worth of hard-fought protective legislation. As chair of the Labor Committee until 1937, Norton worked with Secretary of Labor *Frances Perkins and was instrumental in engineering legislation that changed both the American economy and the nation's treatment of workers; much of it still shapes the country today. She is credited with the enactment of the Fair Labor Standards Act, passed in 1938 as part of President Franklin D. Roosevelt's New Deal policies, which among other things regulated a maximum working week for many employees and set the first permanent, national minimum wage. Norton worked to obtain equal pay for women laborers, and played a part in passing the Social Security Act, a piece of

Mary T. Norton

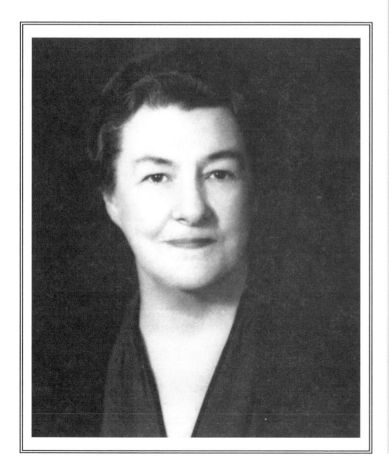

legislation that radically changed America. These new laws helped to prevent strikes and other labor disruptions during World War II (some historians have credited the Allied win to better production of weapons and other necessary equipment), and also resulted in accepted roles for labor unions and in the modernization of management practices.

Norton resigned from the Labor Committee in 1947, when Republicans gained control of the House. During the 77th Congress, she served as chair of the Committee on Memorials, and during the 81st Congress, which was her last term, on the Committee on House Administration.

A member of the New Jersey Democratic State Committee from 1921 to 1944, Norton also played an active role in Democratic Party politics in her home state during her years in Congress. In 1932, she became the first woman to head the Democratic Party in New Jersey, a position she held until 1935 and one that also made her the first woman to be a state chair of any national political party. She served again as head of the New Jersey Democratic Party from 1940 to 1944, when she became a member of the Democratic National Committee. Norton chaired the Platform and Credentials committees at the party's 1948 national convention, and headed the Administration Committee in 1949.

In 1951, at age 75, she retired from an increasingly Republican-dominated Congress. She next worked through 1952 as chair of the Woman's Advisory Committee of the Defense Manpower Administration in the U.S. Department of Labor. In the last years of her life she wrote her autobiography, which remains unpublished. Mary T. Norton died in Greenwich, Connecticut, on August 2, 1959.

SOURCES:

Office of the Historian. *Women in Congress, 1917–1990*. Commission on the Bicentenary of the U. S. House of Representatives, 1991.

Read, Phyllis J., and Bernard L. Witlieb. *The Book of Women's Firsts*. NY: Random House, 1992.

Weatherford, Doris. *American Women's History*. NY: Prentice Hall, 1994.

COLLECTIONS:

Mary T. Norton's papers are held at Rutgers University in New Jersey.

Jo Anne Meginnes,
freelance writer, Brookfield, Vermont

Norway, queen of.

See Thora (fl. 1100s).

See Frithpoll, Margaret (d. 1130).

See Richiza (fl. 1200s).

See Inga (fl. 1204).

See Margaret (d. 1209).

See Kanga (fl. 1220).

See Margaret of Norway (1261–1283).

See Margaret (d. 1270).

See Ingeborg of Denmark (d. 1287).

See Bruce, Isabel (c. 1278–1358).

See Euphemia of Rugen (d. 1312).

See Margaret I of Denmark (1353–1412).

See Blanche of Namur (d. 1363).

See Dorothea of Brandenburg (1430–1495).

See Christina of Saxony (1461–1521).

See Dorothea of Saxe-Lauenburg (1511–1571).

See Charlotte Amalia of Hesse (1650–1714).

See Louise of Mecklenburg-Gustrow (1667–1721).

See Anne Sophie Reventlow (1693–1743).

See Louise of England (1724–1751).

See Carolina Matilda for sidebar on Maria Juliana of Brunswick (1729–1796).

See Maud (1869–1938).

See Sonja (1937—).

Noskowiak, Sonya (1900–1975)

German-born photographer of portraits, still lifes, landscapes, and architecture. Born in Leipzig, Germany, on November 25, 1900; died in Greenbrae, California, in April 1975.

Born in Leipzig, Germany, photographer Sonya Noskowiak spent her early years in Valparaiso, Chile, then emigrated with her family to Sacramento, California, around 1915. In the late 1920s, while she was employed as a receptionist in the studio of photographer Johan Hagemeyer in Carmel, California, she made the acquaintance of Edward Weston, with whom she subsequently had both a personal and professional relationship. She was a founding member of his Group f/64, and also contributed to its first exhibition in 1932, held at the M. H. de Young Memorial Museum in San Francisco.

In 1935, Noskowiak went out on her own, opening a studio in San Francisco where she specialized in portraits and fashion layouts. (Among some of her best-known portraits are those of Jean Charlot, *Martha Graham, and John Steinbeck.) During the 1930s and 1940s, she worked for the Works Projects Administration (WPA), photographing historical architecture in various locations and identifying and

recording geometric forms in the industrial landscape. In 1940, she did a stint photographing for the Oakland Army Base.

Noskowiak, who won a prize at the annual exhibition of the San Francisco Society of Women Artists in 1936, was represented in the exhibition entitled "Scenes from San Francisco," held at the San Francisco Museum of Art in 1939. In 1965, ten years before her death, her work was included in a WPA exhibition at the Oakland Museum, in Oakland, California.

SOURCES:

Rosenblum, Naomi. *A History of Women Photographers.* NY: Abbeville Press, 1994.

Notestein, Ada (1876–1973).

See Comstock, Ada Louise.

Nourmahal (1577–1645).

See Nur Jahan.

Nourse, Elizabeth (1859–1938)

American-born artist who was noted for her paintings of European peasant life, particularly women and children. Born in Cincinnati, Ohio, in 1859; died in October 1938; graduated from the Cincinnati School of Design; studied at the Académie Julian, Paris; never married; no children.

Working in a style described by Los Angeles critic Henry J. Seldis as a "forerunner of social realist painting," expatriate artist Elizabeth Nourse spent most of her career living in Paris and became well known for her depictions of European peasant women and children, although she also painted portraits, still lifes, and landscapes. Her work represented a trend toward more contemporary subjects and realistic depictions begun by earlier European painters, such as Jean-François Millet (1814–1875) and Jean-Désiré Gustave Courbet (1819–1877).

A direct descendant of ❧ Rebecca Nurse, who was tried and executed as a witch in 1692, during the infamous Salem trials in Massachusetts, Nourse was born in 1859 and raised in Cincinnati, Ohio. Her twin sister **Louise Nourse**, also a painter, married the renowned wood-carver Benn Pitman. Elizabeth attended the Cincinnati School of Design, studying sculpture, china painting, and wood-carving along with painting. When both her parents died, she supported herself and her sister by teaching and serving as an interior decorator for some of the wealthy residents of the city. In 1887, ignoring the advice of friends to accept a secure position as drawing in-

Nurse, Rebecca. *See Witchcraft Trials in Salem Village.*

structor at her alma mater, she left to continue her studies in Paris, taking Louise with her. As it turned out, Elizabeth returned to Cincinnati only once, in 1891, to oversee a triumphant solo exhibition of her work at the Cincinnati Art Museum.

In Paris, Nourse studied at the Académie Julian, then as an independent student of Émile Carolus-Duran (1837–1917), who was also the teacher of John Singer Sargent (1856–1925) and Jean-Jacques Henner (1829–1905). Within a year of her arrival, she submitted a painting to the prestigious Paris Salon, which not only accepted it but hung it "on the line" (at eye-level), an honor almost unheard of for a newcomer.

Throughout her career, Nourse traveled throughout Europe, even as far as Russia, researching peasant life and recording it through detailed realistic paintings. Although small in stature and described as frail, she went to extreme lengths to achieve authenticity in her work, traveling to obscure areas to find her models and often working outdoors for long hours. The realism she achieved is evident in *Fisher Girl of Picardy* (1889), which depicts a young woman and boy silhouetted against a gray, stormy cloud, their attention fixed on the horizon. "The composition is compact; the feel of the weather and color of the sky are precisely observed," writes **Charlotte Rubinstein**. "And the figures are above eye-level, emphasizing a heroic aspect."

From 1891, when she was honored at the Cincinnati Museum, which also purchased her painting *Peasant Women of Borst* (1891), Nourse began piling up awards. She was exhibited at the Chicago Exposition in 1893, where she won a gold medal for *The Family Meal* (c. 1893), portraying a peasant family gathered around a table saying grace. Another of her paintings, *Good Friday*, showing peasant women praying in church, was reproduced in books about the fair. In 1895, Nourse was elected an associate of the Société Nationale des Beaux-Arts, one of the first women to be so honored by the newly formed association. French sculptor Auguste Rodin (1840–1917) spoke highly of her work, as did other artists of note.

After 1900, Nourse's style softened and became more linear, perhaps influenced by the Art Nouveau movement and by the mysticism of Eugène Carrière (1849–1906). Still, her works retained their characteristic strength and compassion. "With clear, strong strokes she interprets the life of the poor and humble," wrote a Paris journalist in 1906. "Through the homely scenes which she loves to depict, shine forth the fundamental truths of humanity." But Nourse's compassion was not confined to the canvas. During World War I, she remained in Paris, helping refugees and the wounded and frequently putting herself in harm's way. In 1921, Notre Dame University acknowledged her heroism by awarding her the Laetere Medal. She was the first woman to be so honored. The artist remained devoutly Catholic throughout her life, and was a member of the lay group Third Order of St. Francis.

SOURCES:

Falk, Peter Hastings, ed. *Who Was Who in American Art.* Vol. II. Madison, CT: Sound View Press, 1999.

Hill, Ann, ed. *A Visual Dictionary of Art.* Greenwich, CT: New York Graphic Society, 1974.

Rubinstein, Charlotte Streifer. *American Women Artists: from Early Indian Times to the Present.* NY: Avon, 1982.

SUGGESTED READING:

Burke, Mary Alice Heekin. *Elizabeth Nourse, 1859–1938: A Salon Career.* Washington, DC: Smithsonian Institution Press, 1983.

Barbara Morgan,
Melrose, Massachusetts

Nourse, Rebecca (1621–1692).

See Witchcraft Trials in Salem Village.

Novaës, Guiomar (1895–1979)

*Brazilian pianist who dominated the American and European concert stage with her Romantic performances. Name variations: Guiomar Novaes; "Paderewska of the Pampas." Born into a family of 19 children in Sao Joao da Boa Vista, Brazil, on February 28, 1895; died in Sao Paulo on March 7, 1979; daughter of Manoel da Cruz and Anna (De Menezes) Novaës; studied at the Paris Conservatoire under Isidor Philipp; married Octavio Pinto (1890–1950, Brazilian composer and architectural engineer), in December 1922; children: **Anna Maria Pinto** (a vocalist); Luiz Octavio Pinto (an engineer).*

Guiomar Novaës began playing piano at age four. Until she was 14, her teacher was Luigi Chiafarelli in Sao Paulo. Because of her obvious talent, the Brazilian government sent her to France for further study in 1909; Novaës was awarded first place among 389 applicants to the Paris Conservatoire. She had stunned a jury consisting of Claude Debussy, Gabriel Fauré and Moritz Moszkowski with her playing of, among other pieces, Schumann's Carnaval and Chopin's A-flat Ballade. Novaës then studied with Isidor Philipp, who further developed her prodigious talent. She gave her Paris debut recital six months before formally graduating from the

Conservatoire in July 1911. Along with her diploma, she received a *premier prix* award. Her 1912 London debut was a triumph.

In 1915, Novaës arrived in New York and took the town by storm. After her fourth New York recital, she was heralded as "one of the seven wonders of the musical world." Normally tough New York critics searched for superlatives to describe the exquisite artistry of the young Brazilian. In the *New York Sun*, W.J. Henderson asserted that "only Paderewski or Hofmann could have equalled her." Veteran critic James Huneker pronounced her "the Paderewska of the Pampas." Although essentially a musician of the Romantic school, Novaës was not a monumental performer. She only performed works she strongly believed in and felt personally close to, avoiding works not suited to her temperament. For decades, Novaës was identified with the works of Chopin and Schumann, and with the more lyrical works of Beethoven. Whatever music she touched was turned into poetry. Her Chopin recitals were sold out weeks in advance.

Her last New York recital, in Avery Fisher Hall in 1967, was an emotion-laden event. Appearing as aristocratic as ever, Novaës performed with a nonchalant dignity that at the end brought some in the audience to tears. The program contained standard fare, Beethoven's *Waldstein* sonata and Chopin's *Funeral March* sonata, but her last encore took her audience back to the heyday of colorful Romanticism, for she played the musically mediocre but pianistically breathtaking Fantasy on the Brazilian National Hymn by the 19th-century American composer Louis Moreau Gottschalk. Novaës' farewell to New York was an exercise in pyrotechnics, and it brought the audience to its feet.

Novaës made many recordings over the decades, but only a few of these fully captured her subtle art. Among the best were her readings of the Chopin Mazurkas, the Debussy Preludes, and selections from Mendelssohn's Songs without Words. For her 1950s recordings for the Vox record label, she was praised for her stylish performances of the works of Beethoven, Chopin and Schumann. Her recording of the Moonlight Sonata was described as caressing the music "lovingly and thoughtfully." Her reading of the Beethoven Sonata Op. 31, no. 2 had her giving "the drama and poetry of the music full value in a searching interpretation." Novaës received many awards from the Brazilian government for her efforts to promote music in Brazil and enhance Pan-American cultural exchanges.

Guiomar Novaës

SOURCES:

De Motte, Warren. *The Long Playing Record Guide.* NY: Dell, 1955.

Doyle, John G. "Novaes [Pinto], Guiomar," in *New Grove Dictionary of Music and Musicians.* Vol. 13, p. 432.

Dubal, David. *The Art of the Piano.* NY: Summit Books, 1989.

Schonberg, Harold C. *The Great Pianists.* Rev. ed. NY: Simon & Schuster, 1987.

John Haag,
Athens, Georgia

Novak, Eva (1899–1988)

American film actress. Born in St. Louis, Missouri, in 1899; died of pneumonia in Woodland Hills, California, on April 17, 1988; younger sister of silent star Jane Novak (1896–1990); married; children: two daughters.

Selected filmography: The Speed Maniac *(1919);* The Feud *(1919);* Silk Husbands and Calico Wives *(1920);* The Daredevil *(1920);* Desert Love *(1920);* Up in Mary's Attic *(1920);* The Testing Block *(1920);* The Torrent *(1921);* O'Malley of the Mounted *(1921);* Society Secrets *(1921);* The Smart Sex *(1921);* The Rough Diamond *(1921);* Trailin' *(1921);* Sky High *(1922);* Chasing the Moon *(1922);* The Man from

Hell's River *(1922)*; The Man Who Saw Tomorrow *(1922)*; Temptation *(1923)*; Boston Blackie *(1923)*; The Man Life Passed By *(1923)*; The Battling Fool *(1924)*; Racing for Life *(1924)*; The Beautiful Sinner *(1924)*; Laughing at Danger *(1924)*; The Triflers *(1924)*; The Fearless Lover *(1925)*; Sally *(1925)*; Irene *(1926)*; No Man's Gold *(1926)*; 30 Below Zero *(1926)*; Red Signals *(1927)*; The Medicine Man *(1930)*; Phantom of the Desert *(1930)*; The Bells of St. Mary's *(1945)*; Blackmail *(1947)*; Four Faces West *(1948)*; I Jane Doe *(1948)*; Hellfire *(1950)*; Sunset Boulevard *(1950)*; Tall Man Riding *(1955)*; Sergeant Rutledge *(1960)*; The Man Who Shot Liberty Valance *(1962)*; Wild Steed *(1965)*.

The younger sister of silent star *Jane Novak, Eva Novak began her career as a Mack Sennett Bathing Beauty, then settled into feature films. Although considered less talented that Jane, Eva made her mark in Westerns and action movies, frequently playing opposite Tom Mix and performing her own stunts. Like Jane, Eva's

Jane Novak

career dwindled as sound came in, but she made a comeback in the 1940s and continued playing occasional character roles through the mid-1960s.

Novak, Jane (1896–1990)

American actress of the silent era. Born in St. Louis, Missouri, on January 12, 1896; died in Woodland Hills, California, on February 6, 1990; elder sister of silent star Eva Novak (1899–1988); married Frank Newburg (an actor, divorced); children: a daughter.

Selected filmography: The Sign of Angels *(1913)*; The Kiss *(1914)*; A Little Madonna *(1914)*; Hunger Knows No Law *(1914)*; Into the Light *(1915)*; The Scarlet Sin *(1915)*; A Little Brother of the Rich *(1915)*; The Target *(1916)*; The Iron Hand *(1916)*; The Eyes of the World *(1917)*; The Innocent Sinner *(1917)*; The Spirit of '76 *(1917)*; The Tiger Man *(1918)*; Selfish Yates *(1918)*; The Claws of the Hun *(1918)*; A Nine O'clock Town *(1918)*; The Temple of Dusk *(1918)*; String Beans *(1918)*; Treat 'Em Rough *(1919)*; The Money Corral *(1919)*; Man's Desire *(1919)*; Wagon Tracks *(1919)*; The Wolf *(1919)*; Behind the Door *(1920)*; The Great Accident *(1920)*; The River's End *(1920)*; Isobel or the Trail's End *(1920)*; Roads of Destiny *(1921)*; The Other Woman *(1921)*; Kazan *(1921)*; The Rosary *(1922)*; Belle of Alaska *(1922)*; Colleen of the Pines *(1922)*; Thelma *(1922)*; Divorce *(1923)*; Jealous Husband *(1923)*; The Man Life Passed By *(1923)*; The Lullaby *(1924)*; The Man Without a Heart *(1924)*; The Prude's Fall *(UK, 1924)*; The Blackguard *(UK-Ger., 1925)*; The Danger Signal *(1925)*; The Substitute Wife *(1925)*; Lazybones *(1925)*; Lost at Sea *(1926)*; Closed Gates *(1927)*; What Price Love *(1927)*; Free Lips *(1928)*; Redskin *(1929)*; Hollywood Boulevard *(1936)*; Ghost Town *(1937)*; The Yanks Are Coming *(1942)*; Desert Fury *(1947)*; The File on Thelma Jordan *(1950)*; Paid in Full *(1950)*; The Boss *(1956)*.

Said to have been discovered by a director who saw her photograph on the dressing table of her aunt, Vitagraph star **Anne Schafer**, Jane Novak was still a teenager when she began her film career in 1913. During the next decade and a half, she made over 100 features and shorts, playing opposite such stars as Harold Lloyd, Hobart Bosworth, Charles Ray, Edmund Low, Richard Dix, Buck Jones, and William Hart, to whom she was also once briefly engaged. Over the course of her career, Novak invested her earnings in various business ventures with film director Chester Bennett, earning a fortune, then losing everything in the stock-market crash of 1929. Jane's younger sister *Eva Novak was

also a silent star, and the two appeared together in *The Man Life Passed By* (1923), directed by Victor Schertzinger. Novak, who was married and divorced from actor Frank Newburg, did not survive the advent of sound, although she had small roles in a handful of talkies. The actress died in 1990.

Barbara Morgan,
Melrose, Massachusetts

Novak, Kim (1933—)

American actress, known especially for her performances in Picnic *and* Vertigo. *Born Marilyn Pauline Novak on February 13, 1933, in Chicago, Illinois; daughter of Joseph Novak (a railroad employee), and Blanche Novak; attended William Penn Elementary School, Chicago; graduated from Farragut High School, Chicago; attended Wright Junior College, Chicago; married Richard Johnson (a British actor), in 1965 (divorced 1966); married Robert Malloy (a veterinarian), in 1976; no children.*

Selected filmography: The French Line *(bit, 1954);* Pushover *(1954);* Phffft *(1954);* Son of Sinbad *(bit, 1955);* Five Against the House *(1955);* The Man with the Golden Arm *(1955);* Picnic *(1956);* The Eddy Duchin Story *(1956);* Jeanne Eagels *(1957);* Pal Joey *(1957);* Vertigo *(1958);* Bell Book and Candle *(1958);* Middle of the Night *(1959);* Strangers When We Meet *(1960);* Pepe *(1960);* Boys' Night Out *(1962);* The Notorious Landlady *(1962);* Of Human Bondage *(1964);* Kiss Me, Stupid *(1964);* The Amorous Adventures of Moll Flanders *(UK, 1965);* The Legend of Lylah Clare *(1968);* The Great Bank Robbery *(1969);* Tales that Witness Madness *(UK, 1973);* The White Buffalo *(1977);* Schöner Gigolo *(Gigolo or Just a Gigolo, Ger., 1979);* The Mirror Crack'd *(UK, 1980);* Es hat mir sehr gefreut *(Ger., 1987);* The Children *(UK-Ger., 1990);* Liebestraum *(1991).*

An unusual combination of classic beauty and earthy sexuality, Kim Novak was one of Hollywood's most popular stars during the 1950s and early 1960s, particularly after her performance as the dreamy young ingenue in the film adaptation of William Inge's *Picnic* (1956). Ironically, in 1962, just as she was beginning to emerge as a capable dramatic actress, Novak purchased a ranch in Carmel, California, and cut back on her movie work. "I was so insecure then, I just didn't have any control over my life," she later recalled. "The studio told me how to wear my hair and makeup, what clothes to wear, even who I should date to get the most publicity. I constantly resented being made over." Novak

made few films after 1969, but found balance in her life by raising and selling llamas, and indulging her love of animals.

Of Slavic heritage on her father's side, Novak was born in 1933 and raised in Chicago, Illinois, where her father worked for the Chicago-Milwaukee Railroad. As a youngster, she was extremely tall and thin, causing her to withdraw, even from her family. To help her daughter, **Blanche Novak** persuaded her to join the Fair Teen Club, a group for teens sponsored by a Chicago department store. Novak was immediately drafted for the group's fashion shows, and ultimately won a scholarship to modeling school. After high school, she continued to model part-time while attending Wright Junior College, where she majored in art. In 1953, she left college to tour the country as "Miss Deepfreeze," demonstrating refrigerators. When the tour ended in San Francisco, Novak went on to Los Angeles and registered with a modeling agency. Two weeks after her arrival, she was chosen as one of 15 models to appear in Columbia Pictures' *The French Line* (1954). Singled out for a screen test, she was hired and cast as a gun moll in *Pushover* (1954), with Fred MacMurray. At the time, *Variety* reported that Columbia was grooming the young blonde as a rival of ***Marilyn Monroe**. Other reports maintained that studio chief Harry Cohn viewed Novak as a possible replacement for his demanding and rebellious star, ***Rita Hayworth**.

In 1955, with only four films to her credit, Novak was selected as the top motion picture discovery of the year by six magazines and by the Foreign Press Association of Hollywood. Her next three films, *The Man with the Golden Arm* (1955), *Picnic* (1956), and *The Eddy Duchin Story* (1956), capitalized on the moody and temperamental aspects of her personality, a holdover from the shyness and insecurity of her teen years. "If you've got a woman character who's losing a lover, dying of an incurable disease, going to prison or being swindled out of her life savings, then you need Novak," said one director at the time. "She doesn't have to act. She can just turn on her own worries and frustrations."

Novak's portrayal of Madge in *Picnic* perhaps best personifies the brooding dreaminess that is inherent in all her performances. Although she later admitted that she felt tremendously inadequate in the role, the critics were lavish in their praise. "Kim Novak . . . is a joy to behold," wrote the reviewer for *The New York Times*. "Although the role is not expansive, she manages to convey the confusion and yearning

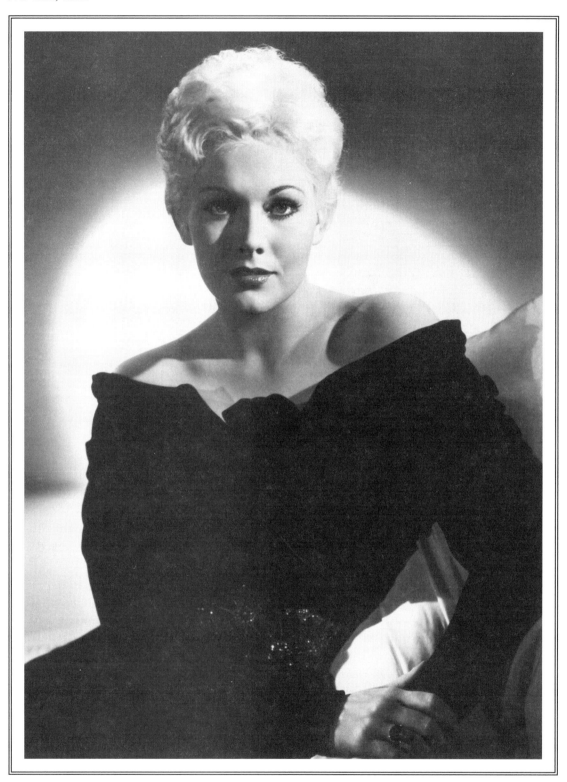

of a maid who is weary of being called beautiful and is soulfully seeking something more substantial." Director Joshua Logan, who originally resisted casting Novak because of her inexperience, later changed his mind. "She is a sensitive and creative girl," he said. "She is as gifted as she is exquisite and can handle anything from boredom to terror with impact." The actress went on to leading roles in *Jeanne Eagels* (1957), *Pal Joey* (1957), and the Alfred Hitchcock thriller *Vertigo* (1958), although she remained dubious about her success. "Miss Novak

responds to her sudden success as though she were convalescing from a hearty hit on the head with a gold brick," observed *Mademoiselle* (June 1956). "This moody girl, given to surges of temper, distrusts the glamorous life, is wary of comfort, says she's frightened it will spoil her."

During her heyday, Novak was linked romantically to many celebrities, including two of her co-stars, Frank Sinatra and Cary Grant. In 1958, she made headlines when a sports car given to her by the son of Dominican dictator Rafael Trujillo became a topic of concern in the United States Congress. The actress was married briefly to Richard Johnson, her co-star in the British-made *The Amorous Adventures of Moll Flanders* (1965), from whom she parted on good terms. In 1976, she married veterinarian Robert Malloy, whom she met when he came to her ranch to treat one of her animals. From then on, she made only a few movies, including several German films, and a television movie, "The Man from the South," a 1981 update of an old Hitchcock drama. At that time, she talked to a reporter about her brief but intense movie career. "You know, it's strange," she said. "I wouldn't want to go through it all again, and yet I wouldn't want to change it either. Of course, you only feel that way looking back."

SOURCES:

Current Biography 1957. NY: H.W. Wilson, 1957.

Katz, Ephraim. *The Film Encyclopedia*. NY: Harper-Collins, 1994.

"Kim Novak in her Best Role," in *Boston Globe*. January 23, 1981.

"Kim Novak is Having Fun at 51," in *Boston Globe*. February 23, 1985.

<div align="right">

Barbara Morgan,
Melrose, Massachusetts

</div>

Novak, Nina (b. 1927).

See Danilova, Alexandra for sidebar.

Novákova, Teréza (1853–1912)

Czech regionalist writer and ethnographer who is regarded as one of the masters of the realist novel in Czech literature. Name variations: Tereza Novakova; Theresa Lanhaus. Born Teréza Lanhausová in Prague, Czechoslovakia, on July 31, 1853; died in Prague on November 13, 1912; married; children: at least four.

Born in Prague five years after the failed political revolution of 1848, Teréza Nováková grew up in an atmosphere permeated by Czech cultural nationalism. Although many Czechs did not believe that political freedom from Austrian rule was possible, most were convinced that as a

people they needed to create a cultural tradition which could compete with that of the Austro-Germans, who looked down on them as ignorant peasants and servants. Nováková began writing short stories and novels while still in her teens, but these early works lack an original style, are derivative of Romanticism, and waver "between sentimentality and Byronism," writes Arne Novák. Didacticism informs her early published works, which deal with such issues as "true" and "hollow" patriotism and the major public controversies of the day, particularly the nationality conflicts between Czechs and Germans in the city of Prague.

During the last years of her life, after fate had dealt Nováková major blows (by 1908, her husband and four of her children had died), she retired from Prague to live in the city of Litomysl. She remained in regular contact with Prague's lively intellectual community by corresponding with a number of friends, including Adolf Heyduk, Alois Jirásek, Otakar Theer, and **Ruzena Svobodová** (1868–1920). For most of her life, Nováková had lived in the world of the Prague intelligentsia. One of her mentors during the formative years of her literary career was the lyric Romantic writer ***Caroline Svetla** (1830–1899), whose biography Nováková published in 1890. Both Nováková and Svetla were heavily influenced by specific regions of Bohemia, Svetla by the Jestedi area and Nováková by the unspoiled countryside of easternmost Bohemia. Nováková made extensive field trips to this region, studying the various aspects of folk culture there not only from the view of a writer and artist, but also from an ethnographic perspective. These investigations resulted in several important publications, including *Kroj llidovy a národni vysiváni na Litomyslsku* (Folk Costume and Embroidery in Litomysl, 1890) and *Z nejvychodnejsich Cech* (From Easternmost Bohemia, 1898). In 1895, she was able to share her knowledge of the folkways of the Czech peasantry with her Prague colleagues by participating in the famous Czech Ethnographic Exhibition that took place that year, contributing both written essays of her observations and authentic costumes she had collected in villages.

Although Teréza Nováková was born and would die in Prague, her writings set in that tradition-soaked city are considered to be among her weaker works. They include *Z mest i ze samot* (From the Cities and From Loneliness, 1890) and *Malomestsky román* (A Petty Bourgeois Novel, 1890). Both critics and readers were much more enthusiastic about Nováková's stories and novels set in Eastern Bohemia. Although not overtly po-

litical, these works reflect the determined attitudes of Czech nationalists in the closing decades of the 19th century, when Prague's intellectuals were inspired by a "neo-Revivalist" ideology based on the Czech national revival movement of the early 1800s that had created a modern Czech consciousness. The collection of stories set in Eastern Bohemia, *Ulomky 'uly* (Chunks of Granite, 1902), pleased critics and readers alike, and set the stage for a successful series of regional works that have become classics.

Nováková regarded history as a vast storehouse of human experience that could serve modern society as it struggled to move closer to national liberation and social justice. In her novel *Jan Jilek*, set during the late Middle Ages when the Protestant Czech Brethren rose up to protest the corruptions of the Roman Catholic Church, she drew a clear analogy between that period in her nation's past and the working-class struggle for social justice in modern times. The same theme is treated in *Jiri Smatlán*, a novel in which a poor weaver decides to improve his world by joining the Social Democratic movement. In the novel *Na Librove grunte* (On the Libra Estate), class struggles between peasants and landlords during the revolutionary upheavals of 1848 are depicted in great, and often tragic, detail.

Although all of these books paint positive portraits of an exploited peasantry and proletariat fighting for its rights, Nováková's sympathy for her subjects did not blind her to the fact that, in history, the deserving do not always win. In *Drasar*, one of her last books, the protagonist, who was based on an actual member of the national revival movement, fails to achieve his goals. Both individuals and society are profoundly flawed, she argues, thus making it difficult if not impossible to translate ideals into reality. Modern readers have found many of Nováková's works to be too polemical. At the same time, in recent years critics have shown a growing respect for her ability to fill rich historical canvases with stunning details, based either on her knowledge of Czech history or her ethnographic investigations.

As a feminist, Nováková made a case for both social legislation and transformation of attitudes that would lift the burdens society placed on women at all of life's stages. From 1897 to 1907, she edited the journal *Zensky svet* (Women's World). She also wrote *The Hall of Fame of Czech Women* (1894) and *From the Women's Movement*, a volume published in 1912, the year of her death. Teréza Nováková died in Prague on November 13, 1912. Publica-

tion of her collected works, which began in 1914 under the editorship of Arne Novák but was delayed by war and the creation of the Czechoslovak Republic in 1918, was finally completed in 1930, when the 17th and final volume of the set came off the press. Nováková's major works continue to be read in the Czech Republic, and she is regarded as one of the indispensable writers of a classic period of the Czech nation's cultural renaissance.

SOURCES:

Chaloupka, Otakar. *Teréza Nováková, a vychodni Cechy.* Havlickuv Brod: Vychodceské nakl., 1963.

"Dopisy Terézy Novákové Zdenku Nejedlemu," in *Ceska Literaturá.* Vol. 24, 1976, pp. 53–64.

Forst, Vladimir. "Jedna Zapomenuta prace Terézy Novákové," in *Ceská Literaturá: Casopis pro Literarni Vedu.* Vol. 13, 1965, pp. 146–154.

Janácková, Jaroslava. "Osobnost a Konvence: Nad Prvni Knihou Korespondence Terézy Novákové" [Personality and Convention: The First Book of the Correspondence of Teréza Nováková], in *Ceská Literatura.* Vol. 37, no. 5, 1989, pp. 447–450.

Kellnerová, Anna. "Prvni narodopisne studie Terézy Novákové a jeji ucast Narodopisne vystave Ceskoslovanske," in *Cesky Lid: Narodopisny Casopis.* Vol. 58, 1971, pp. 291–294.

Mamatey, Professor Victor. Personal communication.

Novák, Arne. *Czech Literature.* Translated by Peter Kussi. Edited by William E. Harkins. Ann Arbor, MI: Michigan Slavic Publications, 1976.

———. *O Tereze Novákové.* Ceska Trebova: F. Lukavsky, 1930.

Pynsent, Robert B. "The Liberation of Woman and Nation: Czech Nationalism and Women Writers of the Fin de Siecle," in Robert B. Pynsent, ed., *The Literature of Nationalism: Essays on East European Identity.* NY: Macmillan-St. Martin's Press in Association with the School of Slavonic and East European Studies, University of London, 1996, pp. 83–155.

———, and S.I. Kanikova, eds., *Reader's Encyclopedia of Eastern European Literature.* NY: HarperCollins, 1993.

Svadbová, Blanka. "Praha a Litomysl v Rané Tvorbe Terézy Novákové" [Prague and Litomysl in the Early Work of Teréza Nováková], in *Ceská Literatura,* Vol. 34, no. 3, 1986, pp. 208–226.

———. "Teréza Nováková, a Czech Regionalist Writer," in *Ceská Literatura,* Vol. 29, no. 5, 1981, pp. 398–415.

———. "Z Listáre Terézy Novákové: Vzájemná Korespondence s Adolfem Heydukem" [From Teréza Nováková's Letters: Correspondence with Adolf Heyduk], in *Ceská Literatura.* Vol. 32, no. 1, 1984, pp. 75–87.

———, and Irena Stepanová. "Tereza Novakova a jei narodopisne prace," in *Cesky Lid: Narodopisny Casopis.* Vol. 80, no. 2, 1993, pp. 109–117.

John Haag,
Associate Professor of History,
University of Georgia, Athens, Georgia

Novalis, Laura de (1308–1348).

See Noves, Laure de.

Novarra-Reber, Sue (1955—)

American cyclist. Name variations: Sue Novarra. Born Sue Novarra in Flint, Michigan, on November 22, 1955.

Was the youngest woman to win the world sprint championship (1975); won the title again (1980); won the U.S. sprint championships (1972, 1974, 1975).

Sprint cycling champion Sue Novarra-Reber was born in Flint, Michigan, in 1955. When she was 19, in 1975, she was the youngest woman to ever win the world sprint championship, a feat she repeated in 1980. But the 1984 women's Olympic cycling event to be held in Los Angeles would not include the sprint; it would be limited to road only. Although Novarra-Reber had been a seven-time national track champion, she switched to road racing so that she could compete in Los Angeles, a transition that was made over a period of years. In 1982, she became national champion in the road race. She won two road-race stages of the Coors International Classic and the Eastern Division of the *Self* magazine Cycling Circuit. In 1983, she was second to Sweden's **Marianne Berglund** in the Ruffles Tour of Texas. Novarra-Reber won two stages of the French Tour and took the *Self* Cycling Circuit (East) for the second time. She placed second in the criterium nationals. Because of her sprint experience, she had a strong finishing kick. Although the switch from sprint to road had seemed successful, Novarra-Reber did not make the 1983 world team, nor did she qualify for the Olympics. During her last year of racing, in 1984, she won the Central Park Grand Prix in New York.

SOURCES:

Markel, Robert, Nancy Brooks, and Susan Markel. *For the Record. Women in Sports.* NY: World Almanac, 1985.

Karin Loewen Haag,
Athens, Georgia

Novella (d. 1333)

Italian university instructor of law. Born in Bologna in the early 1300s; died in 1333.

The daughter—and most promising student—of a Bolognese law professor, Novella caused an uproar when she lectured in her father's place on the few occasions he was not able to attend class. Not only were 14th-century university officials horrified at the thought of a woman in such a position of authority, they also believed that a female teacher would incite lust in the classroom, and that the students, over-

come with desire, would not be able to focus on her lectures. No one more qualified than Novella could be found to fill in, however, so a compromise was reached; she lectured from behind a curtain to shield her students from her feminine body. Novella died in 1333.

Lisa Frick,
freelance writer, Columbia, Missouri

Novello, Antonia (1944—)

American physician who was surgeon general of the United States from 1990 to 1993. Born Antonia Coello on August 23, 1944, in Fajardo, Puerto Rico; oldest of three children of Antonio Coello and Ana Delia Coello (a school principal); University of Puerto Rico, B.S., 1965, M.D., 1970; pediatric training at the University of Michigan, Ann Arbor, Michigan; training and residency in pediatric nephrology at the University of Michigan Medical Center (1973–74), and Georgetown University Hospital, Washington, D.C. (1974–75); Johns Hopkins University School of Public Health, M.A., 1982; married Joseph Novello (a psychiatrist), in 1970; no children.

On March 9, 1990, Antonia Novello took the oath of office as the first woman and the first Hispanic surgeon general of the United States, embarking on a mission to "protect, improve, and advance the health of all the American people." Appointed to the office by President George Bush, and replacing the often outspoken and controversial C. Everett Koop, Novello was decidedly more diplomatic and nurturing than her predecessor in pursuing her own special interests, which included providing health care for minorities, women, and children, and protecting the nation's youth from the dangers of tobacco and alcohol. In 1993, Novello was replaced by President Bill Clinton's appointee *Joycelyn Elders and went on to serve as a special representative to UNICEF.

Antonia Coello Novello was born in 1944 in Fajardo, Puerto Rico, the eldest of three children. Born with a dysfunctional colon, and in and out of hospitals until she was 18, she dreamed of becoming a pediatrician, a goal supported by her mother, the long-time principal of a local junior high school. Novello received both her B.S. and M.D. degrees from the University of Puerto Rico, then continued her training in pediatrics at the University of Michigan Medical Center and at Georgetown University Hospital. In 1982, she added to her already formidable credentials by receiving a master's degree in public health from the Johns Hopkins University

School of Public Health. In the summer of 1987, she attended the John F. Kennedy School of Government at Harvard, where she participated in a program for senior managers.

For two years beginning in 1976, Novello had a private practice in pediatrics and nephrology in Springfield, Virginia, but she gave it up when she became too emotionally involved with her young patients. She then went to work for the U.S. Public Health Service, serving as a project officer in the artificial kidney and chronic uremia programs at the National Institutes of Health (NIH). She quickly worked her way up through the ranks and in 1986 was named deputy director of the National Institute of Child Health and Human Development, one of the top positions at the NIH. During the four years she held that position, she also worked on Capitol Hill, serving as a legislation fellow with the Senate Committee on Labor and Human Resources. As a fellow, she contributed to the drafting and enactment of the National Organ Transplant Act of 1984, and also helped draft the labels for cigarette packages that warn of the dangers of smoking.

No one was more surprised than Novello when she was nominated for surgeon general. Unlike that of her predecessor, Novello's nomination and confirmation hearing proceeded smoothly, although she was rigorously quizzed on the abortion issue to determine that she shared the administration's anti-abortion policy. "Having been born with a congenital defect makes me think that everything has a chance to live," she told confirmation committee members, but later said in an interview that she preferred not to discuss the issue. "Women have to move a little bit away from abortion as the only important issue to tackle." At her swearing-in ceremony, Novello's comments reflected both her immense pride of accomplishment and her sense of humor. "The American dream is alive and well today," she said. "West Side Story comes to the West Wing."

Novello's background and training made her particularly sensitive to the health-related problems of women, children, and minorities, and in her two-and-a-half years in office she made those issues a priority. She was especially zealous in attempting to lower the numbers of children who started smoking, and to that end targeted the tobacco industry. In March 1992, she made headlines when she held a joint news conference with James S. Todd, the executive vice-president of the American Medical Association, to urge R.J. Reynolds to withdraw its ads featuring the cartoon character Joe Camel. Nov-

ello also expressed concern about the growing number of women smokers. "Call it a case of the Virginia Slims woman catching up with the Marlboro Man," she told an interviewer for the *Republican Woman* (February–March 1991). Novello was equally tough on the alcohol industry for misinforming, misleading, and targeting youth. She particularly criticized ads that "make drinking look like the key to fun and a wonderful and carefree lifestyle."

Novello viewed the increasingly reported incidents of domestic violence as another issue of public health, calling it "a cancer that gnaws at the body and soul of the American family," and urging more research into an effective way to curb the violence. She also advocated expanded educational programs for AIDS and for the prevention of childhood and work-related injuries, and expressed concern about the serious deficiencies in the health care of Hispanic-Americans.

Novello has been characterized as dynamic, fast-thinking, and extremely approachable, "*Mother Teresa meets *Margaret Thatcher," said her husband Joseph Novello, a psychiatrist who at one time hosted a popular radio talk show. As surgeon general, she attempted to unlock bureaucratic channels, to "remove fear, open doors, listen, educate, assist. I know that if I make good sense and I'm understood, people might be willing to make some good changes," she told an interviewer.

Novello's career has been peppered with honors and awards. She is the recipient of the Public Health Service Surgeon General's Exemplary Service Medal and Medallion, the Public Health Service Meritorious Service Medal, and the Achievement Award of the National Conference of Puerto Rican Women. Since 1986, concurrent with her other posts, Novello has been a clinical professor of pediatrics at the Georgetown University School of Medicine. She is also the author of more than 75 articles and chapters of books pertaining to her medical specialty.

SOURCES:
Graham, Judith, ed. *Current Biography.* NY: H.W. Wilson, 1992.
Read, Phyllis J., and Bernard L. Witlieb. *The Book of Women's Firsts.* NY: Random House, 1992.

Barbara Morgan,
Melrose, Massachusetts

Novello, Clara (1818–1908)

*English soprano. Name variations: Countess Gigliucci. Born Clara Anastasia Novello on June 10, 1818, in England; died in 1908; daughter of Vincent Novello (a pianist and composer); sister of **Cecilia Novello** (a*

singer), Mary Sabilla Novello (a soprano), and Joseph Alfred Novello (a bass singer); married Count Gigliucci, on October 22, 1843.

Clara Novello was born into an English musical family in 1818. At age nine, she was given singing and piano lessons. In 1829, she entered the Paris Conservatoire, but had to return to England the following year because of the turmoil over Charles X and the Restoration. She made her successful debut in 1833 at a concert in Windsor and was immediately engaged for the Ancient and Philharmonic Concerts, the Worcester Festival, and the Westminster Abbey Festival. In 1837, Mendelssohn invited Novello to appear at the Gewandhaus concerts in Leipzig where she earned his praise and that of Schumann; she then went on to Berlin, Vienna, St. Petersburg, and Dusseldorf.

In 1839, she journeyed to Italy to study for the stage, becoming a pupil of Micheroux in Milan. She made her opera debut at Padua in Rossini's *Semiramide* on July 6, 1841, followed by appearances in Rome, Milan, Bologna, and Modena. Returning to England in March 1843, she appeared at the Drury Lane. On her marriage to Count Gigliucci on October 22, 1843, she retired from public life for the next seven years. Novello met with her greatest success appearing in oratorio in England in 1851 and made one last opera appearance on stage in England, in the *Puritani* at Drury Lane on July 5, 1853. Her greatest triumphs followed at the opening of the Crystal Palace (June 10, 1854) and at Handel Festivals (1857 and 1859). She then moved to Italy.

Novello-Davies, Clara (1861–1943)

Welsh choral conductor and singing teacher. Name variations: Clara Davies; Clara Novello Davies. Born Clara Novello Davies in Cardiff, Wales, in 1861; died in 1943; daughter of Jacob Davies (a choral conductor); married David Davies, in 1882; children: daughter Myfanwy (died in infancy); David Ivor Novello Davies (1893–1951, who composed musicals and popular songs under the name Ivor Novello).

Clara Novello-Davies was born in 1861 in Cardiff, of Welsh stock on both sides of the family. Her father Jacob Davies, a choral conductor, named her after *Clara Novello, as a tribute to the singer. Taught music by her father, Clara appeared publicly as an accompanist at age 12. She married David Davies in 1882, and their home became a center of musical life in Cardiff.

Her first child, a daughter Myfanwy, died at 11 weeks in 1884. Her son David Ivor Novello Davies (1893–1951), whom she taught, would become a composer of enormously popular musicals and songs under the name Ivor Novello. He was also a playwright and composed the World War I song "Keep the Home Fires Burning."

Novello-Davies' enormous energy and flamboyant character enabled her to lead a musical life in Cardiff, London, and New York. In 1885, she assembled the first Ladies' Choir in Wales, with 100 voices, while continuing to run a music school in her home. In 1893, she founded and conducted a Welsh Ladies' Choir which she took to compete at the World's Fair in Chicago, returning home with the first prize, a gold medal. As a result, she was asked to train singers for the Metropolitan Opera in New York, and also toured Britain, France, South Africa, and the United States with her choir. They sang to Queen *Victoria at Osborne House in 1894, after which they enjoyed royal patronage and added the adjective "royal" to their title. The following year, they gave 70 concerts in the United States, wearing their national costume. They also visited the Paris Expositions of 1900 and 1937; on the latter occasion, the French government bestowed three decorations on Novello-Davies.

Clara Novello-Davies was a friend of David Lloyd George and visited the prime minister at No. 10 Downing Street. Her son dedicated one of his songs to *Megan Lloyd George. Clara was also close to the actress *Mrs. Patrick Campbell, and regarded the singer *Adelina Patti, who had come to live in South Wales, as her rival. To the Welsh public, she was affectionately known as "Mam" (the Welsh word for mother). Novello-Davies wrote an autobiography, *The Life I Have Loved*, in 1940, and died at her house on Park Lane, London, in 1943.

SOURCES:

Glamorgan Record Office.

Harding, James. *Ivor Novello*. London: W.H. Allen, 1987.

Noble, Peter. *Ivor Novello*. London: Falcon Press, 1951.

Elizabeth Rokkan,
translator, formerly Associate Professor, Department of English,
University of Bergen, Norway

Noves, Laure de (1308–1348)

Beloved of Petrarch. Name variations: Laure de Noves; Laura de Novalis; Laura de Noyes; Madame de Sale. Born in 1308; died of the plague in Avignon, France, on April 6, 1348; daughter of Audibert de Noves of Avignon; married Hugues de Sale of Avignon; children: eleven.

Laura, a French woman beloved by Petrarch and celebrated in his poems, was in reality Laure de Noves who was later Madame de Sale. When Petrarch first beheld her on April 6, 1327, she was in the church of Avignon. By the time she died of the plague on April 6, 1348, she had given birth to 11 children. Petrarch detailed in over 300 sonnets and canzoni all the minuscule incidents of his attachment. They were, wrote Sismondi in his *Literature of South of Europe,* "those precious favors which, after an acquaintance of fifteen or twenty years, consisted at most of a kind word, a glance not altogether severe, a momentary expression of regret or tenderness at his departure, or a deeper paleness at the idea of losing her beloved and constant friend."

Novotna, Jana (1968—)

Czech tennis player. Born on October 2, 1968, in Brno, Czechoslovakia (now Czech Republic).

Tennis champion Jana Novotna was born in 1968 in Brno, Czech Republic. Her career began in 1986, she turned professional in 1987, and, by the time she announced her retirement after losing in the third round to **Anke Huber** at the U.S. Open in 1999, she had won 24 career singles, 72 doubles titles, and earned over $10 million. Novotna's long-sought victory at Wimbledon in 1998 helped her make the decision to bow out. "I said throughout my career that winning one Grand Slam would be a dream come true for me. It finally did happen."

For years recognized as the best player on the women's circuit without a Grand Slam victory, Novotna made it to the finals at Wimbledon in 1993 and 1997, only to lose the matches in the last moments. In 1993, her aggressive game against *Steffi Graf suddenly collapsed from a near-sure victory into a 4–1 third set, after which she famously sobbed on the shoulder of Princess *Michael of Kent. In 1997, she was beaten in the finals by **Martina Hingis**. The following year, she played against **Nathalie Tauziat** (the first French woman to make it to the finals at Wimbledon since *Suzanne Lenglen in 1925). In a victory she dedicated to her longtime coach **Hana Mandlikova**, a Czech who during her own playing career in the 1980s had won four Grand Slam titles but never captured Wimbledon, Novotna roared back from an uncertain second set to score five straight points in the tiebreaker and win the match 6–4, 7–6 (7–2). The third time, as promised by the duchess of Kent (a fellow Czech), had indeed proved the charm.

Novotna, Jarmila (1907–1994)

Czech soprano. Born Jarmila Novotna on September 23, 1907, in Prague, Czechoslovakia; died on February 10, 1994, in New York City; daughter of a banker; married Baron George Daubek, in 1931; children: one son, one daughter.

Made debut at the National Theater in Prague in La Traviata (1926); appointed soprano of the Berlin State Opera (1928); sang at the Vienna Staatsoper (1933–38); appeared with the Metropolitan Opera Company (1939–45).

Jarmila Novotna, a Czech-born lyric soprano, was a famous star on opera stages throughout the world. She studied in Prague with *Emmy Destinn and made her debut with the Prague National Opera at the age of 17 as Marenka. She sang Gilda in 1928 at the Verona Arena. From 1933 to 1938, she sang at the Vienna Staatsoper, also appearing regularly at Salzburg as Octavian, Euridice, Countess Almaviva, Pamina, and

Jarmila Novotna

Frasquita. Novotna created the title role in Lehár's *Giuditta* in 1934 in Vienna.

After Arturo Toscanini heard her perform in Salzburg and Vienna, Novotna was invited to the Metropolitan Opera in New York in 1928, but she declined because she did not want to be separated from her fiancé, Baron George Daubek, whom she would marry in 1931. She was in New York, however, when Hitler's troops entered Czechoslovakia in 1938. Returning to her occupied country, she managed to get her husband and children to Vienna and by 1939 was performing Madame Butterfly in San Francisco.

During World War II, Novotna recorded *Songs of Lidice* in memory of the victims of the Nazi massacre in her homeland. She was accompanied on the piano by Jan Masaryk, the son of *Charlotte Garrigue Masaryk and Thomas Masaryk, the former president of Czechoslovakia. Known for her musicianship and expressiveness, Novotna appeared 193 times with the Metropolitan Opera. Her acting ability and regal bearing made her a natural for the opera stage. She was so talented as an actress that Max Reinhardt, the German director, urged her to devote her talents to the theater. Louis B. Mayer was equally impressed, and she appeared in such films as *The Great Caruso* and *The Search*.

Jarmila Novotna performed in opera houses throughout the world and made many recordings. She also sang Smetana's *The Bartered Bride* for a European film. Her last appearance was in Vienna in 1957. She had moved there with her husband the previous year and lived in Austria until his death in 1981. She then moved permanently to New York, where she became a familiar figure in music circles.

John Haag,
Associate Professor of History,
University of Georgia, Athens, Georgia

Noyes, Clara Dutton (1869–1936)

American nurse and educator. Pronunciation: noise. Born on October 3, 1869, in Port Deposit, Maryland; died on June 3, 1936, in Washington, D.C.; daughter of Enoch Dutton Noyes and Laura Lay (Banning) Noyes; graduated from Johns Hopkins School for Nursing, 1896.

Founded first American school for midwives (1911); received Florence Nightingale Medal of the International Red Cross (1923); received French Medal of Honor (1929); inducted into the Hall of Fame of the American Nurses Association (1998).

One of the most prominent professional nurses of the early 20th century, Clara Dutton Noyes instituted many standardized procedures, maintained the Red Cross' reserve of trained nurses for emergency service, and founded the first school for midwives in America. She was born in Port Deposit, Maryland, on October 3, 1869, the daughter of **Laura Banning Noyes** and Enoch Dutton Noyes. Her father was a veteran of the Civil War and a descendant of the Reverend James Noyes, who had settled in Salem, Massachusetts, in 1634. Noyes attended private schools for her early education and later studied at the Johns Hopkins School for Nursing, from which she graduated in 1896. She then became head nurse at Johns Hopkins, holding that position until 1897, when she was appointed superintendent of the nurses' training school of Boston's New England Hospital for Women and Children. She worked there until 1901, when she took the job of superintendent of nurses at St. Luke's Hospital in New Bedford, Massachusetts.

In 1910, Noyes moved to New York, where she worked as superintendent of nurses at Bellevue and Allied Hospitals. At this time, statistics showed that approximately 50% of attended births used the services of a midwife. This may have reflected the large number of European immigrants newly arrived in America, for use of a midwife was customary practice in Europe. In Europe, however, it was mandatory that midwives complete a rather demanding apprenticeship, while in America there was no formal training available for midwives. Recognizing the need for adequately trained midwives, in 1911 Noyes founded the Bellevue School for Midwives. It was the first school for midwives in the United States and the only school for midwives that was publicly funded prior to its closing in 1938. During several of her years at Bellevue, from 1912 to 1915, Noyes also served as president of the National League of Nursing Education.

With the encouragement of *Jane Arminda Delano, a fellow nurse and one of the heads of the American Red Cross, Noyes resigned from her job at Bellevue in 1916 to enter the Red Cross. She was subsequently appointed director of the Bureau of Nursing within the organization's Department of Military Relief. With the United States' entry into World War I in 1917, Noyes was appointed command of the mobilization and deployment of a corps of trained nurses to cover 54 base hospitals. She was also in charge of organizing numerous relief expeditions during the war. At the same time, she accomplished the task of improving and standardizing courses of instruction for Red Cross nurses

as well as standardizing various treatment procedures and surgical dressings. The great demand for nurses led to the creation of a special department of field nursing, of which Noyes was named director in 1918. In this capacity, she was in charge of the assignments for all the Red Cross nurses and equipment for the U.S. Army, Navy, and Public Health Service, both within the United States and abroad. It was estimated that Noyes enrolled, organized, and assigned over 20,000 trained nurses during World War I.

In 1919, Noyes succeeded her late friend and mentor Delano as national director of the Department of Nursing of the American Red Cross, a position she would hold for the rest of her life. The same year, she also became chair of the National Committee on Red Cross Nursing Service, a post requiring the coordination of over 200 state and local committees comprised of Red Cross nurses. Noyes was known as someone who could organize major nursing departments and vast numbers of people, and was vocal in calling for the standardization of education, basic procedures, and materials used in nursing procedures. During the early 1920s, she was asked to visit and observe Red Cross facilities in Western and Eastern Europe in order to make recommendations for the development of public-health services and nursing schools. Her job had, essentially, become global.

Under Noyes' leadership, the Red Cross reserve of trained nurses was ready and available for emergency service, with over 60,000 registered by the mid-1930s. They served during the influenza pandemic of 1918–19 and assisted those in need after natural disasters such as hurricanes and floods; over 600 were involved after the Los Angeles earthquake of 1933. She also implemented training programs for Red Cross nurses to become educators, teaching home health care, hygiene procedures, and simple nursing procedures, which was of great service during the Depression.

In the course of her career, Noyes also served on numerous committees and worked as a lecturer, consultant, and educator. She received many awards from American and foreign governments for her exemplary service to the field of nursing, including the *Florence Nightingale Medal of the International Committee of Red Cross Societies, the American Red Cross Service Medal, the Patriotic Service Medal of the American Science Association and the National Institute of Social Sciences, the French Medal of Honor, and the Honorary Cross of the Latvian Red Cross Society. Clara Dutton Noyes died in

Washington, D.C., on June 3, 1936, at the age of 66. In 1998, she was inducted into the American Nurses Association's Hall of Fame.

SOURCES:

Encyclopedia of American Biography. New Series. NY: American Historical Society, 1992.

McHenry, Robert, ed. *Famous American Women.* NY: Dover, 1980.

Read, Phyllis J., and Bernard L. Witlieb. *The Book of Women's Firsts.* NY: Random House, 1992.

Christine Miner Minderovic,
freelance writer, Ann Arbor, Michigan

Noyes, Laura de (1308–1348).

See Noves, Laure de.

Nugent, Luci Baines (b. 1947).

See Johnson, Luci Baines.

Nun Ensign, The (1592–1635).

See Erauso, Catalina de.

Nurbanu (1525–1583).

See Reign of Women.

Nur Jahan (1577–1645)

Empress of Mughal India, brilliant political and military strategist, architect, and diplomat, who had absolute control in the Mughal court. Name variations: Noor Jahan or Jehan; Nur Mahal or Nourmahal; Mehr-on-Nesa, Mehrunnisa, Mehr-un-nisa, Mihm-un-Nisa, Mehrunissa, or Mehrunnissa. Born Mehr-un-nisa in 1577 in Qandahar, Persia (Iran); died in 1645 in Lahore, India (now in Pakistan); daughter of Mirza Ghiyas Beg (a literary artist in Tehran) and Asmat Begum; educated by private tutors; studied Persian culture and language as well as tradition and languages of adopted country, India; married Ali Quli (Sher Afghan or Afkun), in 1594 (died 1607); married Prince Salim (1569–1627), later Jahangir, 4th Mughal emperor of India (r. 1605–1627), in 1611; children: (first marriage) Ladili Begum or Ladli Begum.

Rewriting women back into history, particularly Medieval Indian history, has often illuminated the power and influence of these women which was formerly discussed only within the context of the imperial stature of their husbands, fathers, and/or sons. Nur Jahan's story is one of political dexterity, military competence, and cultural achievements. As cultural manifestations change, her legend has reached mythological proportions; some of the reality of her life remains shrouded in mystery. There is no denying, however, that Nur Jahan, as the wife of Emperor Jahangir and de facto ruler of India, made im-

portant contributions to the history of the Mughal Empire in India, working the social and cultural conventions to her advantage and taking the Mughal Empire to greater heights. In the process of her political maneuvering, she retained her integrity, and that of the house of the Mughals, and thus she has won considerable esteem and admiration.

Nur Jahan would become the empress of Mughal-only India in 1611. The nomadic Mughals had established their dynasty in 1526. Even though they ruled for a little over 250 years between the 16th and the 18th centuries, a mere blip in India's history, each ruler reinforced the charismatic brand of the dynasty. The subcontinent continues to reverberate with the legacies of the rule; the ghosts of the Mughals still haunt India and Pakistan. Nur Jahan became empress when the Mughals had already successfully branded Hindustan (India) with their particular seal. India had been unified, a successful socio-political and cultural system set in place, a rich and profitable trade established. The Mughal court became the envy of all Asia and Europe. Despite the riches and fame of the Mughal royalty, the women of the imperial household were bound to the *purdah* system in keeping with the injunctions of Islam. Their identity and self extended no further than the guarded gates of the palace harem. They were seldom seen and never heard. Given this scenario, Nur Jahan's high profile during her husband's reign becomes even more remarkable. She broke away from the conventions and participated fully in the empire's administration. She had traveled a long road to become the empress of Hindustan, and it is to her sole credit that she assumed the stature that she did.

Circumstances of her birth were dramatic. She was born in a caravan in 1577 as it wound through the inhospitable mountainous regions near Qandahar, a town on the border of Persia and Mughal India. Her parents, Mirza Ghiyas Beg and **Asmat Begum**, were fleeing Tehran to seek their fortune in Emperor Akbar's court at Agra. When the caravan was attacked by dacoits (armed robbers who traveled in gangs), the infant was abandoned, but another member of the caravan retrieved the baby, then named Mehrunnisa, and returned her to her parents. She was their fourth child. This tale has often informed the legend associated with the resiliency of Nur Jahan. Some say the signs of future greatness were present from the day she was born.

As the daughter of successful immigrant Persians of noble lineage, her childhood years were spent like those of most children of other accomplished families. She grew up in the women's quarters at court, learning the arts and letters of her native Persia. She also traveled near her adopted home, thus acquainting herself with the traditions and practices of Hindustanis, both Muslims and Hindus. Sources of the time portray her as vivacious, alluring, and compelling.

Nur Jahan

Following the tradition of the time, she was given in marriage to Ali Quli, a Persian adventurer, at the young age of 17. Though it was a rather unremarkable match, she was beginning to manifest her remarkable bearing. Ali Quli was an outstanding sharpshooter, who earned the title of Sher Afghan or "Tiger Slayer" while part of the retinue of Prince Salim (later Emperor Jahangir). Mehrunnisa's expert skills at hunting and shooting developed during her first marriage. In later years, she would become the best markswoman in Jahangir's hunting retinue, once bringing down four tigers with six bullets. A poet in attendance to the shoot praised her in verse: "Though Nur Jahan be in form a woman, / In the ranks of men she's a tiger-slayer."

In 1605, Mehrunnisa had her only child, whom she loved dearly, with Ali Quli; her daughter **Ladili Begum**, "The Beloved One." In years to come, Mehrunnisa would avoid using her daughter as a marital pawn in palace intrigues. Both mother and daughter would spend their widowhood together and, upon their deaths, would be buried side by side in a garden of Nur Jahan's design.

Mehrunnisa was widowed in 1607. A gap in historical events from this time to 1611, when she married Emperor Jahangir, has given rise to a number of spurious fables about Jahangir deliberately killing Ali so that he could marry the beautiful and accomplished Mehrunnisa. Jahangir had a gentle and contemplative side to his nature, but when angered he showed all the characteristics of an oriental potentate, including elaborate displays of cruelty to defeated enemies. It would be a disservice to the life of

Mehrunnisa, however, to invest these tales of her first husband's death with truth.

Though she had no children with Jahangir, she was a loving stepmother to his children from other wives. She was particularly fond of Prince Khurram, later the builder of the Taj Mahal as Emperor Shah Jahan, and took a strong interest in educating and molding him as the future Mughal emperor. After Mehrunnisa became Empress Nur Jahan ("Light of the Palace") in 1611, her phenomenal and remarkable career commenced.

Within the first six months of her marriage, Nur Jahan assumed the reins of the empire. It was an easy acquisition of power, made easier by the emperor's excessive love of drinking and opium, leading to his disinterest in administration, and by Nur Jahan's perceptiveness and charm. Nur Jahan's family had held high positions in the Mughal court, hence she was no stranger to the extent and authority of government. Historical documentation is replete with details of the method, speed and efficiency with which she appeared on the imperial scene, virtually obliterating her husband's position in the empire. Her assumption of authority marked a phase of extraordinary affluence and peace in the history of the Mughal Empire.

Nur Jahan stood forth in public; she broke through all restraint and custom, and acquired power by her own address, more than by the weakness of [her husband] Jahangir.

—Alexander Dow

Nur Jahan's political accomplishments as empress are well documented. It might even be said that, cognizant of her regal position, she may have consciously attempted to establish an enduring reputation for herself. Most remarkable of all is the rapidity with which she emerged on the political frontline. The first unprecedented act was to add her own name, "Nur Jahan, the Queen Begum," to the emperor's signature in all letters and grants of appointment, allowing her to control the passage of all levels of promotions and demotions in the imperial government service. She next took a special interest in the condition of women in the empire. Her favorite cause was procurement of sufficient dowries for the marriages of orphan girls. She held an informal court where she received, and passed judgment on, petitions from court nobles. The empress struck coins in her name, thus granting to herself an important aspect of sovereignty; it was an unparalleled act in Mughal history. She traded with European merchants and collected

duties from traveling merchants from other provinces. She assigned herself the task of inspecting the credentials of all foreign emissaries to the Mughal Court. She even conducted international diplomacy with high-placed women in other countries, to wit, the queen mother of Turan. Intelligent and judicious, Nur Jahan tested the extent to which she could conduct the administration and made certain that while her own family flourished it was in no way at the expense of the empire. She recognized her limits; she knew her acts were unconventional but made sure that the integrity of the imperial household was not compromised. All these actions indicate her adoption and dispensation of power commensurate with the position of any sovereign ruler. Nur Jahan wielded the scepter, earning the reputation of a woman "worthy to be a queen."

Nur Jahan was an adept military leader as well. Historians, among them her husband, have recorded her valiant efforts at quelling several revolts in the empire. With the help of the emperor's loyal forces, she usually won the military campaigns that she planned and executed. On one occasion, she rode out to battle on an elephant carrying her granddaughter (who had been seriously injured) on her lap. During the skirmish, the elephant was also severely wounded, but Nur Jahan did not retreat until she had broken through the enemy lines.

Though Nur Jahan is remembered in India as the most powerful of all Mughal women, there is more to this extraordinary woman than her political and military dexterity. She left an indelible mark on art, architecture, fashion, poetry, and cooking—an imprint so memorable that after four centuries Indians still recognize their debt to her. It is in these realms that we see, read, and hear her story as she told it. Nur Jahan's legacy can be seen in the spectacular mausoleums, gardens, and mosques, or in the current fashion of women's clothing, or even in the menus of Mughalai restaurants in India and the United States.

Nur Jahan's architectural contributions include the merging of Persian and Indian styles. She had a discriminating eye and was married to a man who was equally appreciative of, and sensitive to, aesthetic appeal. Nur Jahan's name is attached to two magnificent buildings: the tombs of her father and of her husband. Her father's mausoleum, built in 1622, is located in Agra (unfortunately, it is often eclipsed by the more famous tomb, the Taj Mahal). An exquisite garden-tomb of Mughal India, her father's mausoleum is

the first example of inlaid marble work in a style that evolved directly from the Persian tile-mosaics. It is a handsome sight with intricate lattice work and semiprecious stones laid in pietra dura. One may even claim that Nur Jahan set the precedent for the architectural style of the Taj Mahal. Emperor Jahangir had commenced building his tomb in his living years in Lahore; Nur Jahan completed the ethereal marble structure after his death. Her taste is evident in the dainty marble inlay work; her love of nature visible in the delicate floral patterns; her affection for her imperial husband palpable in her painstaking devotion to the completion of the mausoleum.

The most beguiling of Nur Jahan's artistic contributions was the most ephemeral—gardening. A prolific garden designer, she has been called the "greatest garden lover of them all." The imperial couple were devoted to gardens, a Persian tradition that they kept alive. For Emperor Jahangir, gardens were a manifestation of private indulgence. But Nur Jahan elevated a personal recreation into an imperial pursuit. Jahangir's gardens in Kashmir are breathtaking. Of no small significance are Nur Jahan's gardens. One of the most notable is the Noor Afshan (Light Scattering) in Agra, completed around 1619. It is the oldest recognizable Mughal garden in India. Others are the Noor Manzil (Abode of Light) and Moti Bagh (Garden of Pearls), both in Agra, and the Shah Dara (Royal Threshold) in Lahore which surrounds her husband's tomb. The gardens have beautiful fountains and cascades running through the center of the geometric squares. She erected large open pavilions between the cascades so that in the summer the breeze was cooled by the water as she sat in the open-air structures reading or writing poetry. The gardens had flowers all year round, excellent fruit trees and vines, and an abundance of water. In his memoirs, Jahangir has recorded numerous occasions when the couple spent weeks in various gardens enjoying each other's company. Nur Jahan's designs reflect the affluence of her empire as much as her enthusiasm and ardor for her Persian tradition.

Nur Jahan's artistry was not limited to regal creations. A pragmatic woman, she recognized that travelers needed taverns, particularly in the incredible heat of India, and ordered the construction of such inns or *sarais*. These sarais, with resting places for approximately 500 horses and 2,000 travelers, were run by the empire. She had gardens planted on each side of the sarais for the pleasure of the weary travelers. A religious woman, a believer in Islam, Nur Jahan also had mosques constructed, the most outstanding of which is in Srinagar, Kashmir. Erected in 1623 and called the Shahee Masjid (Imperial Mosque), it is built exclusively of stones.

While Nur Jahan's public creations have endured and may still be visited, her advancements in domestic arts are just as existent, albeit tempered by four centuries. The culinary tradition of India attributes several dishes to Nur Jahan. She was particularly adept at creating meat preparations; new recipes of rare and distinguished taste have endured the tests of palate and time. One may still find these in Mughal restaurants and cookbooks. Central to domestic arts is dress and fabric. Stitched instead of wrapped clothing, longer skirt lengths, a type of tight trouser (*paijama*), and fashionably designed scarves are attributed to Nur Jahan's revolution in designing and executing haute couture. She also left some of her favorite embroidery patterns in the trellis and lattice work on the buildings. Nur Jahan's textiles of choice include silver-threaded brocade and lace, flowered muslin, and lightweight muslin for veils. The most popular outfits in modern-day India are the Nur Jahani styles of apparel and pattern.

Nur Jahan's interests extended to literature and painting as well. She came from a literary and scholarly family, and thus composed fairly competent poetry. Well versed in Arabic and Persian, she wrote under the name of Makhfi, "the concealed one." Some of her best verse was extemporaneous, usually of a joking quality when she teased her husband. Once Jahangir wore a garment in which rubies were used in place of buttons. As soon as she saw him, Nur Jahan composed a verse:

> It is not the ruby you wear on your robe,
> It is a drop of my blood that has seized you by
> the collar.

Also attributed to Nur Jahan are the following verses created during a stroll in the gardens with her husband:

> It appears not that it is stars shining in the sky,
> But that the sky has spread pebbles for playing
> by the Emperor.
> When I pass through the garden in such beauty
> and perfection,
> A cry of "blessed" arises from the nightingales'
> souls.

Nur Jahan was a patron of other women poets whose works survive and display poetry of a high order. Her patronage extended to painting as well. The royal couple encouraged the miniature painting form, and the increasing depiction of women in these paintings has been attributed to her beneficence and encouragement. She also collected a vast number of paintings from Euro-

pean merchants which inspired her to encourage the use of secular topics in paintings. The benefactions of the empress adorn the National Museum and private collections in India.

The glorious and illustrious reign of, arguably, the most distinguished of all Mughal queens came to a sudden end. When Emperor Jahangir died on October 28, 1627, leaving the question of succession undecided, Nur Jahan had been maneuvering to have her son-in-law Shahriyar, Ladili Begum's husband and Prince Khurram's younger brother, be the next emperor. However, her stepson Prince Khurram, whom she had loved and raised, had other plans. Nur Jahan had grown suspicious of Khurram and had resented his growing influence over Jahangir, despite the fact that Khurram had begun his rise to preeminence with her help. She had tried to build up Shahriyar's prospects as a counterweight to Khurram's influence, in the hope that she would be able to remain influential after Jahangir's death. Even though she used all her resources to assist her son-in-law in the war of succession, it was one battle that the indefatigable empress did not win. Shahriyar proved unable to make good his claim to the throne. Khurram sent messages to Nur Jahan's brother Asaf Khan (father of *Mumtaz Mahal) ordering that all possible rivals be put to death, and Asaf's subordinates hastened to obey, killing at least four, including Nur Jahan's son-in-law Shahriyar.

Prince Khurram took the throne in 1628 as Shah Jahan. Asaf Khan was rewarded with the position of chief minister, and Nur Jahan was sent to a dignified exile where she was permitted to live on for 18 years by avoiding intrigues. Her daughter, widowed by Shahriyar's murder, joined her, and they spent the rest of their days in the seclusion of their home in Lahore. Nur Jahan wore only white clothes and went to no public celebrations. We know very little of her life in Lahore except that she lived in a house of her own design surrounded by beautiful gardens. She was frustrated, but accepted her severely curtailed powers because she was "too positive a character to quibble when her defeat was plain."

It may be fair to speculate that she spent a large part of her time in charity and religious activities. Nur Jahan visited her husband's tomb often and was faithful to his memory. The irony is that Shah Jahan, whom she had promoted until the last years of her husband's life, launched a visceral attack to eliminate her from all historical memory. He withdrew from circulation all coins stamped with her name, defamed her, and cleansed his administration of her presence. It is to the credit of the charismatic empress that history and tradition continue to laud and appreciate her. Nur Jahan died in Lahore on December 18, 1645. After a modest funeral she was buried in a tomb of her own design. Her mausoleum reflects a minute facsimile of the elegant and brilliant patterns and decorations she once loved. It stands as a metaphor of the last barren days of Nur Jahan's life. On her grave is the inscription:

> On our lone grave no roses bloom,
> No nightingale would sing;
> No friendly lamp dispels the gloom,
> No moth e'er burns its wing.

SOURCES:

Aziz, Abdul. "A History of the Reign of Shah Jahan (Based on Original Sources)," in *Journal of Indian History*. Vol. 6, no. 1–3, 1927, pp. 235–257.

Findly, Ellison Banks. *Nur Jahan: Empress of Mughal India*. NY: Oxford University Press, 1993.

Mishra, R. *Women in Mughal India*. New Delhi, India: Munshiram Manoharlal, 1967.

Nath, Renuka. *Notable Mughal And Hindu Women in the Sixteenth and Seventeenth Centuries, A.D.* New Delhi, India: Inter-India, 1990.

SUGGESTED READING:

Dow, Alexander. *The History of Hindostan*. Vol. 3, *From the Death of Akbar to the Settlement of the Empire Under Aurunzebe*. London: S. Beckert & P.A. De Hondt, 1770 (reprint, New Delhi, India: Today and Tomorrow's Printers, 1973).

Findly, Ellison Banks. "Religious Resources for Secular Power: The Case of Nur Jahan," in *Women and Religion* volume, edited by Debra Campbell. *Colby Library Quarterly*. Vol. 25, no. 3. September 1989, pp. 129–148.

———. "Nur Jahan and the Idea of Kashmir," in B.K. *Thapar Commemorative Volume*, edited by M.C. Joshi. New Delhi, India: Archaeological Survey of India.

Brahmjyot K. Grewal,
Assistant Professor of History at Luther College, Decorah, Iowa

Nur Mahal (1577–1645).

See Nur Jahan.

Nurpeissova, Dina (1861–1955)

Kazakh composer and dombrist who preserved many Kazakh traditions. Born in Beketai-Kum, Kazakhstan, in 1861; died in Alma-Ata, Kazakhstan, on January 31, 1955.

At the dawn of the 20th century, Kazakh women were not permitted to sing among men, and dancing was prohibited for both sexes. Islamic religion also forbade documentation of everyday life in paintings or art. In consequence, artistic abilities were concentrated in music, and

musicians preserved the history and culture of Kazakhstan in their work. Although Moscow and Leningrad were far away, the radical changes initiated by the Bolshevik Revolution of November 1917 began to be felt even in remote Kazakhstan.

By the early 1920s, a new type of professional singer and composer, the female Kazakh artist, began to appear in the fairs, bazaars, tea-houses and *kümis* (fermented mare's milk) houses. One of these pioneers was Mayra (**Magira Samsutdinova**, 1896–1929) who defied the old customs restricting women. Mayra performed in public singing Russian and Tatar songs to the accordion as well as Kazakh songs to the dombra, a type of lute which is the national instrument of Kazakhstan.

Following in Mayra's footsteps, Dina Nurpeissova became a virtuoso on the dombra. Her father taught her to play this and other traditional instruments, thus handing down ancient rituals which are passed from one generation to the next. In 1936, Nurpeissova received a prize in Moscow when her compositions were performed by the mixed National Kazakh Kolkhoz Choir. She was made a National Artist of the Kazakh SSR in 1944. Like musicians before her, Nurpeissova performed sitting cross-legged on a rug, improvising accompaniment on the dombra as she sang of her homeland.

John Haag,
Athens, Georgia

Nurse, Rebecca (1621–1692).

See Witchcraft Trials in Salem Village.

Nurubanu (1525–1583).

See Reign of Women for sidebar on Nurbanu.

Nussbaum, Karen (1950—)

American labor activist. Born on April 25, 1950, in Chicago, Illinois; attended University of Chicago; married; children: three.

Was co-founder and executive director of 9to5, the National Association of Working Women (1973–93); elected president of Union District 925, Service Employees International Union (1981); served as director of the Women's Bureau at the U.S. Department of Labor (1993–96); was director of the Working Women's Department, AFL-CIO (1996—).

A native of Chicago, Karen Nussbaum attended the University of Chicago for a time before dropping out and moving to Boston, where she took a job as a clerk-typist at Harvard Uni-

versity. Dismayed by the low pay she received (just two dollars an hour), the lack of benefits and vacation time, and the general lack of respect shown her at work, she began talking to other women similarly employed and discovered that many of them felt the same way. Shortly thereafter, about 50 women who worked in various offices at Harvard decided to form an organization. Their research showed that despite the fact that office workers were both key components of the American economy and the largest of all job categories, they were overwhelmingly female and in the lowest pay category. By 1973, the Harvard group expanded to include the entire Boston area. The Boston group then joined with similar groups in other cities to form 9to5, the National Association of Working Women, of which Nussbaum became executive director. Aiming to advance the rights of "pink collar" workers, the organization worked to improve the wages, work environments, and promotion opportunities of its members. Banks, insurance companies, universities, and publishing houses have all, at times, been pressured by 9to5 to improve the treatment of their office workers. (The group also provided the inspiration for the popular 1980 movie *9 to 5*, starring **Jane Fonda**, **Lily Tomlin** and **Dolly Parton**.)

To provide 9to5's members with an agent to negotiate collective bargaining agreements, Nussbaum and her association formed a local branch of the Service Employees International Union (SEIU). In 1981, they formed a national union, District 925 of the SEIU, to organize the secretarial and clerical workers of the United States. While Nussbaum became president of the union, it remained a separate entity from 9to5. During this period, she also co-authored several books, including *9 to 5: The Working Woman's Guide to Office Survival* (1983) and *Sitting on the Job: How to Survive the Stresses of Sitting Down to Work* (1989), appeared on television and testified before Congress.

In 1993, President Bill Clinton appointed Nussbaum director of the Women's Bureau of the U.S. Department of Labor. During her tenure, she focused on promoting fair pay and benefits, child care and family leave, and job training and advancement. In 1996, she left the Department of Labor to become the first head of the newly created Working Women's Department at the AFL-CIO.

SOURCES:
Gareffa, Peter M., ed. *Newsmakers: 1988 Cumulation.* Detroit, MI: Gale Research, 1989.

SUGGESTED READING:
Business Week. December 3, 1984.

Esquire. December 1986.
Forbes. September 12, 1983.
Mother Jones. April 1982.
Nation. March 14, 1981.
The New York Times. March 4, 1981, March 29, 1981.
Nussbaum, Karen, coauthor. *9 to 5: The Working Woman's Guide to Office Survival*. NY: Viking, 1983.
Progressive. February 1984.

Jo Anne Meginnes,
freelance writer, Brookfield, Vermont

Nüsslein-Volhard, Christiane

(1942—)

Nobel Prize-winning German biologist and genetic researcher. Pronunciation: noos-line. Name variations: Nusslein-Volhard; Nuesslein-Volhard. Born Christiane Volhard on October 20, 1942, in Magdeburg, Germany; daughter of Rolf Volhard (an architect) and Brigitte (Haas) Volhard (a musician and painter); received degrees in biology, physics, and chemistry, Johann-Wolfgang-Goethe-University, 1964; received diploma in biochemistry, Eberhard-Karls University, 1968; University of Tübingen, Ph.D., 1973; postdoctoral work at Biozentrum Basel, Basel, Switzerland, 1975–76, and University of Freiburg, Freiburg, Germany, 1977; married a man named Nüsslein (divorced).

Received the Albert Lasker Medical Research Award (1991); awarded the Nobel Prize for Medicine or Physiology (1995).

In 1995, Christiane Nüsslein-Volhard became the tenth woman to win the Nobel Prize for Medicine as well as the first German woman to win a Nobel Prize for science. She earned the award for her genetic research on the fruit fly, and her contributions to the field of genetics may help to explain why certain birth defects occur.

Nüsslein-Volhard was born on October 20, 1942, in Magdeburg, Germany, the second of five children of Rolf Volhard, an architect, and **Brigitte Volhard**, a painter and musician. The family considered accomplishments in art and music to be far more important than academic achievement, but Nüsslein-Volhard's passion for the sciences remained consistent throughout her childhood, and her parents eventually accepted the fact that she would not become an artist of some sort. She did, however, learn how to play the flute and sing.

Nüsslein-Volhard received degrees in physics, biology, and chemistry from Johann-Wolfgang-Goethe-University in 1964, and earned a diploma in biochemistry from Eberhard-Karls University in 1968. She continued her education at the University of Tübingen, where she earned a Ph.D. in biology and genetics in 1973. She also did post-

doctoral work in Basel, Switzerland, and in Freiburg, Germany. Married for a short time to a man named Nüsslein, she retained his name in combination with her own after they divorced.

In 1978, after completing her postdoctoral work, Nüsslein-Volhard became affiliated with the European Molecular Biology Laboratory (EMBL), where she teamed up with Eric Wieschaus, another developmental biologist. Both scientists were intrigued with the process by which a single cell egg, which naturally divides into trillions of cells, eventually differentiates into specialized complex cells. In other words, they wanted to learn how cells "knew" to become, for example, lung tissue, vertebrae, or skin. To accomplish this task, they used *Drosophila*, the common fruit fly, which is often used in genetic research labs because of its incredibly rapid life cycle and embryonic development. Male fruit flies were fed a substance that damaged their DNA. The males would mate with females, which, in turn, produced embryos that were either dead or mutated. Nüsslein-Volhard and Wieschaus bred approximately 40,000 fruit fly families, each with some type of defect, and studied each embryo with a specially equipped microscope that allowed both scientists to view and study the embryo specimen at the same time. They found that the majority of mutations had only a minor effect on development but other mutations caused extraordinarily strange defects. After some time, they were able to identify the specific genes that determined organ arrangement and body shape. By studying what went askew, the pair found that of the fruit fly's some 20,000 genes, only 139 were essential for early development. In 1980, their research was published in the British scientific journal *Nature*. In the years that followed, Nüsslein-Volhard and Wieschaus published several other papers regarding their genetic research. Another of their important discoveries was that the mother's genes pass on genetic codes (morphogens) that essentially tell other genes what to do.

Much of their research was based upon work conducted in the 1940s by Edward Lewis, a pioneer in the field of genetics. Nüsslein-Volhard's research took Lewis' work several steps further by demonstrating that only a limited number of genes actually control development in fruit flies and that other, higher, organisms have similar genes that perform similar functions. This research made it possible for scientists to construct genetic "blueprints" for all life forms. Scientists have since been able to isolate genes that cause specific birth defects and some miscarriages. Her research has also been utilized in the field of in-vitro fertilization.

In 1985, Nüsslein-Volhard returned to Tübingen to serve as director of the Max-Planck-Institut for Developmental Biology. In 1991, she and Wieschaus received the prestigious Albert Lasker Medical Research Award. She spent more time studying fruit flies, but later switched her research interests to the zebra fish, which she has kept since the mid-1990s in a huge ultramodern fish tank (Fischhaus) in Tübingen. A more complex organism than the fruit fly, the zebra fish contains a notochord, or rudimentary spinal cord, thus classifying it as a vertebrate. In addition, zebra fish embryos develop outside the mother's body and are conveniently transparent, which makes observation of organ growth easy. Some of her colleagues were skeptical and critical of her new line of research but amidst all the negative attention surrounding zebra fish genetics, Nüsslein-Volhard, Eric Wieschaus, and Edward B. Lewis were awarded the Nobel Prize for Medicine in 1995. The following year she worked at Boston's Massachusetts General Hospital and published a 481-page guide to the zebra fish's genetic structure. Nüsslein-Volhard is known for her eye for detail and sense of humor; one of the genes that causes an enlarged heart in zebra fish was named the *santa gene.*

Genetic research has been a controversial subject, made all the more so with the cloning of Dolly the sheep and the success of the Human Genome Project; some people believe that geneticists will one day have the ability to produce super-humans. But Nüsslein-Volhard has dismissed those concerns. When she accepted her Nobel Prize she said, "No one has in their grasp the genes that make humans wiser, more beautiful, or that make blue eyes." She also noted that the research has helped people "become wiser, understand biology better, and understand how life functions." Still, as one member of the 1995 Nobel committee observed of the prize-winning research conducted by Nüsslein-Volhard and her colleagues, "They let the genie out of the bottle."

SOURCES:
The Day [New London, CT]. October 10, 1995.
Rooney, Terrie M., ed. *Newsmakers.* Issue 1. Detroit, MI: Gale Research, 1998.
Time Magazine. October 23, 1995, p. 83.

<div align="right">**Christine Miner Minderovic**,
 freelance writer, Ann Arbor, Michigan</div>

Nuthall, Betty (1911—)

British tennis champion. Born in England in 1911; daughter of Stuart Nuthall.

> Won the British Junior championship (1924); won seven more titles in this event (1925, 1926, 1927); won the women's singles in the Westgate-on-Sea tournament (1925); won the U.S. mixed doubles championship with George Lott (1929, 1931).

A tennis prodigy trained by her father, Betty Nuthall beat the reigning American champion *Molla Mallory in an early round at Wimbledon in 1927, though she never made it past the quarterfinals. In 1930, Nuthall defeated **Anna Harper** in the finals of the U.S. singles at Forest Hills, the first player from overseas, and the only English woman, to do so before *Virginia Wade. She also took the doubles with her partner **Sarah Palfrey**, a win that she would reprise in 1931 with **Eileen Whittingstall** and in 1933 with **Freda James.**

But Nuthall, who came from the suburb of Surbiton in nearby Surrey, could never break her Wimbledon jinx: over a span of 20 years, she was a four-time semiquarter singles finalist, a four-time doubles semifinalist, and a three-time mixed semifinalist. She is said to have lost her fire after her father's unexpected death in 1925: Stuart Nuthall, who was undergoing a routine operation for tennis elbow, died from complications with the anesthetic.

Nuttall, Zelia (1857–1933)

American archaeologist. Name variations: Mrs. Z. Nuttall. Born Zelia Maria Magdalena Nuttall in San Francisco, California, on September 6, 1857; died at Casa Alvarado, Mexico, on April 12, 1933; second of six children of Robert Kennedy Nuttall (a physician) and Magdalena Parrott Nuttall; married Alphonse Louis Pinart (a French ethnologist), in 1880 (separated 1884, divorced 1888); children: Nadine Pinart (b. 1882).

A leading authority on Mexican archaeology and ancient picture writing, Zelia Nuttall made extensive studies in antiquities, history, and languages. She first came into prominence in 1886 through the publication of her work on "The Terra Cotta Heads of Teotihuacan" in the *American Journal of Archaeology.* Following that, she published several important works, including *The Fundamental Principles of Old and New World Civilization* and *Book of the Life of Ancient Mexicans.* In 1908, Nuttall was named honorary professor of the National Museum of Mexico.

Nutting, Mary Adelaide (1858–1948)

Canadian-born American leader in professional nursing and nursing education. Name variations: Adelaide Nutting. Born on November 1, 1858, in Quebec, Canada; died on October 3, 1948, in White Plains,

New York; daughter of Vespasian Nutting (a county clerk for the circuit court) and Harriet Sophia (Peasley) Nutting (a seamstress); educated at a local academy, a convent school, and Bute House in Montreal; graduated from the Johns Hopkins Hospital Training School for Nurses, 1891; never married; no children.

Entered the Johns Hopkins Hospital School for Nurses in Baltimore, Maryland (1889), and graduated with the first class (1891); stayed on at Johns Hopkins and became the superintendent of nurses and principal of the training school (1894); served as president, National League of Nursing Education (1896, 1909); helped to establish and served as director of a nursing education program at Teachers College of Columbia University (1899); co-authored four-volume History of Nursing *(1907–12); awarded the first Mary Adelaide Nutting Medal by the National League of Nursing Education (1944).*

Instrumental in raising the standards for nursing education and bringing it into universities, Mary Adelaide Nutting was born in 1858 in Quebec, Canada, and grew up in nearby Waterloo, not far from the Vermont border. Her father Vespasian Nutting was a county clerk of the circuit court, known as kind and gentle but not a particularly good provider, and so her mother **Harriet Peasley Nutting**, who was considered an intellectual, helped support her five children with her sewing skills. Nutting was educated at a local academy, and spent an additional year at a nearby convent school and another at a private school in Montreal. She also had lessons in music and art, and when the family moved to Ottawa she studied the piano. In her early 20s, she spent one year teaching music at a girls' school of which her sister was principal in Saint John's, Newfoundland. Most of this period, however, was spent at home, helping with her family's financial survival. Conscious of how circumstances had constrained her mother's abilities and life, Nutting gradually realized that she wanted to do more with her own life. In 1889, on the day before her 31st birthday, she entered the first class of the newly established Johns Hopkins Hospital Training School for Nurses in Baltimore, Maryland.

She graduated in 1891 and stayed on for two years as head nurse and then as assistant superintendent of nurses. In 1894, Nutting succeeded *****Isabel Hampton Robb** as superintendent of nurses and principal of the training school. In the latter capacity, she instituted many changes, including a new three-year curriculum, improvements in teaching facilities and personnel, the introduction of an eight-hour day and better living quarters for

students. By 1901, she had also developed a six-month preliminary program for nursing students; the concept of actually teaching the basics to student nurses before putting them to work (often for 60-plus hours a week) was an innovation at a time when nursing schools were attached to hospitals that wanted cheap nursing staff and did not much care about their training. Nutting also added to the graduate staff for supervision and teaching, initiated scholarships and a fee for the preliminary course, and encouraged students to participate in the new field of visiting nursing. She helped to create a nursing library at Johns Hopkins, which led to her co-authoring of the multi-volume *History of Nursing* (1907–12) with **Lavinia L. Dock**.

One of Nutting's greatest achievements was her participation in establishing professional standards in the field of nursing. To help achieve this, she became active in the American Society of Superintendents of Training Schools for Nurses of the United States and Canada (later the National League of Nursing Education), serving as president in 1896 and again in 1909, as vice-president in 1897, and as secretary in 1903 and 1904. She devoted her life to bringing the education of nurses to universities, where nursing students could take advantage of the wider educational opportunities available (e.g., biology and public health). To meet basic professional needs, in 1900 she also helped to establish the *American Journal of Nursing*. Nutting was instrumental in setting up an experimental program in hospital economics at Teachers College of Columbia University in New York City. This program allowed nurses to attend courses in psychology and household economics while the Society of Superintendents provided financial support and teachers for new courses dealing specifically with hospitals and training schools. From 1899 to 1907, she traveled back and forth from Baltimore to New York City as a part-time teacher in the program. In 1907, she left Johns Hopkins and became a full-time professor in institutional management at Teachers College, making her the first nurse to be appointed to a university chair. She became head of the school's department of nursing and health upon its creation in 1910, a post she would hold until her retirement in 1925, and in which capacity she helped to shape the developing field of public-health nursing.

Despite being physically frail, Nutting was active in national and international committee work. During World War I, when the need for nurses was critical, she withstood pressure from many directions to drop all nursing standards. She also served as chair of the education committee of the National League of Nursing Education

(1903–21) and led a project which resulted in the publication of the *Standard Curriculum for Schools of Nursing* (1917). Along with *Josephine Goldmark and others, she was a member of the Rockefeller Foundation committee which helped produce Goldmark's important 1923 study *Nursing and Nursing Education in the United States*. Nutting believed deeply that problems in nursing education were all derived from a complete dependence upon hospitals, and that the basic need for schools of nursing was to have a sound economic basis. For this reason, she worked constantly for endowment funds for nursing schools.

An avid reader and active suffragist, Nutting was a member of the Cosmopolitan Club of New York City, chief founder of the Women's Faculty Club at Columbia, and a founder of the American Home Economics Association. Among the honors she received were the Liberty Service Medal (World War I) of the National Institute of Social Sciences, an honorary M.A. from Yale University (1922), and the honorary presidency of the *Florence Nightingale International Foundation (1934). In 1944, the National League of Nursing Education established the Mary Adelaide Nutting Medal, which bears an image of her sculpted by *Malvina Hoffman; Nutting was the first recipient. She died in her sleep in 1948 in White Plains, New York, less than a month before her 90th birthday.

SOURCES:

Edgerly, Lois Stiles, ed. *Give Her This Day*. Gardiner, ME: Tilbury House, 1990.

James, Edward T., ed. *Notable American Women, 1607–1950*. Cambridge, MA: The Belknap Press of Harvard University Press, 1971.

McHenry, Robert, ed. *Famous American Women*. NY: Dover, 1980.

Read, Phyllis J., and Bernard L. Witlieb. *The Book of Women's Firsts*. NY: Random House, 1992.

SUGGESTED READING:

Christy, Teresa E. *Cornerstone for Nursing Education: A History of the Division of Nursing Education of Teachers College, Columbia University, 1899–1947*, 1969.

Cremin, Lawrence, *et al. A History of Teachers College, Columbia University*, 1954, pp. 53–56.

Goostray, Stella. "Mary Adelaide Nutting," in *American Journal of Nursing*. November 1958.

Johns, Ethel, and Blanche Pfefferkorn. *The Johns Hopkins Hospital School of Nursing, 1889–1949*, 1954.

Roberts, Mary M. *American Nursing*, 1954.

Stewart, Isabel M., and Anne L. Austin. *A History of Nursing*. 5th edition, 1962.

COLLECTIONS:

Personal and professional files covering Nutting's life are in the archives at Teachers College of Columbia University in New York City; the school also holds a 1906 portrait of Nutting by *Cecilia Beaux.

Jo Anne Meginnes,
freelance writer, Brookfield, Vermont

Nwakuche-Nwapa, Flora (1931–1993).

See Nwapa, Flora.

Nwapa, Flora (1931–1993)

Nigerian novelist and publisher, the first African woman to write and publish a novel in English, who changed African literary traditions regarding the portrayal of women. Name variations: Flora Nwakuche-Nwapa. Pronunciation: N-WOP-pa. Born Flora Nwanzuruahu Nwapa on January 13, 1931, in Oguta, Nigeria; died at University of Nigeria Teaching Hospital, Enugu, Nigeria, on October 16, 1993; oldest of six children of Christopher Ijoma Nwapa (a landowner and managing director of a British palm oil exporting company) and Martha Onyenma Onumonu Nwapa (a schoolteacher); attended Archdeacon Crowther Memorial Girls School, C.M.S. Central School, and Queens College, Lagos; University College, Ibadan, B.A., 1957; University of Edinburgh, Scotland, Diploma in Education, 1958; married Chief Gogo Nwakuche, in 1967; children: daughter Ejine (b. 1959); son Uzoma (b. 1969); daughter Amede.

Published first book (1966); received citations for Officer of the Niger (Oon, 1982); granted University of Ife merit award for authorship and publishing (1985); served on Commonwealth Writers Awards Committee, African Studies Association, Children's Literature Association of Nigeria, African Literature Association, Association of Nigerian Authors.

Selected writings: Efuru (1966); Idu (1971); This Is Lagos, and Other Stories (1971); Never Again (1975); Wives at War, and Other Stories (1980); One Is Enough (1981); Women Are Different (1986); Cassava Song and Rice Song (1986).

Children's books: Emeka: The Driver's Guard (1972); Mammywater (1979); My Tana Colouring Book (1979); My Animal Number Book (1979); The Miracle Kittens (1980); Journey to Space (1980); The Adventures of Deke (1980).

From the exalted griots, the human repositories of history, to the 1986 Nobel Laureate in Literature Wole Soyinka, the literature of Africa has been dominated by male writers. Nigeria's Chinua Achebe, South Africa's Bloke Modisone, Mark Mathabane, K. Kgostisile and others have all eloquently shared their stories of African life and culture. The woman, however, was usually depicted as somewhat irrelevant and relegated to subordinate roles behind the man. As these writers gained more prominence in literary circles around the world, the female African writer was curiously absent. During the "literary '60s," and

with a growing interest in the events on the African continent, a reappraisal of women in African life and literature was in order. This male dominance in literature was now ripe for challenge, and Flora Nwapa stepped up. "The male writers have disappointed us a great deal by not painting the female character as they should paint them," said Nwapa. "When I write about women in Nigeria, in Africa, I try to paint a positive picture."

Born on January 13, 1931, Nwapa would one day tell Dr. **Marie Umeh** in one of her last interviews: "There was nothing in me when I was in school that made me feel that I was going to be a writer. It was one of those things just happened. . . . I write because I want to write. I write because I have a story to tell." As a child growing up in Oguta, she was encouraged by the examples of the Igbo women around her who were intelligent, creative and industrious—"leaders in trade and commerce." They benefited the community spiritually, educationally, economically, and emotionally. At no time were these women expected to subordinate their skills and talents to the men. "In Oguta, women have certain rights that women elsewhere, and in other parts of the country, do not have," Nwapa added. Certainly, such early exposure to strong women was to impact Nwapa's development as a person and as an author. Reading and listening to stories were important parts of her life as a youngster.

Nwapa gave African women an authentic identity in literature by introducing a female literary tradition at a time when little or nothing of a realistic nature had been written.

—Marie Umeh

She was born into two prominent Nigerian families—Nwapa Nduka and the Onumonu Uzaru—and her parents were an early influence, especially her mother **Martha Onyenma Nwapa** who was one of the most prominent women in Oguta. Martha was the first woman to obtain the "customary standard six examinations" from St. Monica's, a missionary school in the town. A studious woman, she went on to teach school in Oguta and encouraged all her children to develop a love for reading. Flora's father, Christopher Ijoma Nwapa, was an important landowner and managing director of one of Britain's largest exporting companies; his primary business was the foreign sale of palm oil, a major commodity used by the British to manufacture soap and other products. Later known as Chief Nwapa, he had acquired a vast amount of land in Oguta and on some of his property palm trees were plentiful. He was also a strong Nigerian nationalist.

At an early age, Flora attended the C.M.S. Central School and the Archdeacon Crowther Memorial Girls School. In 1950, she took post secondary courses at Queens College, Lagos. After completing her studies, Nwapa taught briefly at Priscilla Memorial Grammar School in Oguta, a school founded by her uncle, Chief Richard Nzimiro, the first mayor of Port Harcourt, and her illustrious aunt *****Mary Nzimiro**. Nwapa was soon in pursuit of another diploma at Edinburgh University in Scotland. She received her Diploma in Education in 1958 and then visited Europe, observing the various cultures.

On her return to Nigeria that same year, she worked with the Ministry of Education, Calabar; she also taught briefly at the Queen's School in Enugu in 1959, the year that her first child, daughter Ejine, was born. During this busy time, when Nwapa was undertaking motherhood and a new position at the University of Lagos as an administrator, she honored a quiet urge within herself and began her first novel. *Efuru,* with a female protagonist new to Nigerian literature, was published in 1966 by Heinemann Educational Books in London.

The stories of Nwapa's youth influenced the narrative in *Efuru*. She recalled that as a child she would call on anybody who promised to tell her a story. "I would sit down and listen," she said, "and when I went to high school, I had read practically everything that I could find. I am sure that contributed to my writing." She had always enjoyed sitting with the elders and listening: "I read a lot of books. I listened to a lot of stories, moonlight stories told by women in Oguta." The stories of the Lake Goddess were especially memorable to her. The popular belief among the Igbos was that the Lake Goddess had super power, and through it she could guarantee prominence, peace and power to both men and women.

Published in 1966, *Efuru* appeared just before the Nigerian civil war (1967–70) and received little notice in a Nigeria embroiled in chaos. With the government broken down, Nwapa was among the many Igbos who left Lagos and returned to Eastern Nigeria. While the war raged on, she remained in Enugu. Africa's first published female novelist was not then celebrated or promoted in her own country. However, the ravages of war could not stifle the significance of her pioneer voice, and word of *Efuru* began to seep outside of Nigeria's borders.

Flora Nwapa

Nwapa became a name in international literary circles. Because of her work, African women would no longer be seen through the prism of male writers and depicted as their ancillary appendages. Said Dr. Ernest N. Emenyonu, provost, Alvan Ikoku College of Education, Owerri:

The significance of *Efuru* . . . was more than the historical fact of a pioneer work. Flora Nwapa created in it, female characters that were at once unique, unconventional. The typical female characters created by male writers before then were docile, subservient and mindless women. . . . They existed only

for the services they provide inside their home for their children and husbands.

In Nwapa's *Efuru,* the heroine was uncharacteristic of the perceived role of the traditionally viewed African woman. Intelligent, independent, creative, and industrious, Efuru made her own decisions. In short, she destroyed the myth of the female's insignificance in African life. Nwapa herself would have been considered atypical, especially for her time. She shared the qualities of her heroine and had a keen sense of social responsibility.

While she was living in Oguta during the war, her personal life took a new turn. In 1967, she married, and her second child, a son Uzoma, followed in 1969. As a wife and mother, Nwapa believed in the integrity of the family. Her husband, wealthy industrialist Chief Gogo Nwakuche, encouraged and supported her efforts, agreeing with her that African women needed to be aware that their "self-actualization is an inalienable right, not a male preserve." Nwapa's second book, *Idu,* was published in 1971. Later that year, she had her third child, a daughter Amede, and she also accepted an important government position. As minister for Health and Social Welfare, and later minister for Lands, Survey and Urban Development, Nwapa worked in the Igbo area, earning high praise. Chief among her accomplishments was the Oguta Lake project. In Imo State, she is remembered as "the lady who opened up Oguta Lake for tourism and made the government build an ultra modern facility with a golf course at Oguta." A hospital was also built during her term of office. When a coup d'état ended her government career, she decided to write full time.

In 1976, she founded Tana Press, Ltd., followed by Flora Nwapa Books, Ltd. Her aim was twofold: to publish children's books which would teach children "to value their own rich culture, and to encourage more women to write books." Her first self-published adult books were *This Is Lagos, and Other Stories, Never Again, Wives at War, and Other Stories,* and *One Is Enough.* Tana Press also published her two lengthy poems, *Cassava Song* and *Rice Song,* as well as her children's books.

Nwapa's work showed her versatility as a writer. *This is Lagos* (1971) cautioned about the dangers of city life; *Never Again* (1975) dealt with the civil war; *One Is Enough* (1981) addressed the practice of polygamy; and *Women Are Different* (1986) concerned the "dynamism of Nigerian womanhood in the face of challenge." In all her writings, the theme is consistent—the elevation of women in Africa and a heightening of their sense of self-worth in a society of male dominance. With both her work and life, Nwapa is regarded as having "opened up what we might call women's space for African women and African women writers."

While running her successful businesses, Nwapa made a name for herself in international circles. Her books were distributed abroad, and she received invitations for lecture appearances from as far away as Louisiana in the United States. In 1976, Nwapa was a visiting lecturer at the Alvan Ikoku College of Education, Owerri. She was Nigeria's representative at the Bologna International Children's Book Fair in 1981 and presented a paper in Sierra Leone, "Writing and Publishing for Children," in 1983. In 1984, she attended the First Feminist Book Fair in London. Later that same year, she lectured on African Literature at several universities in the United States, including Ames, Austin, Lincoln and Northwestern. In 1985, Nwapa attended an international conference at Michigan State University, East Lansing, and presented a paper, "The Black Woman Writer and the Diaspora," in Nairobi, Kenya. Among the other papers she presented at conferences both in Africa and abroad were "Nwanyibu: Womanbeing and African Literature," "Priestesses and Power Among the Riverine Igbos," "The Image of the New Woman," and "Women and Creative Writing in Africa." Invited to the Zimbabwe Book Fair, she spoke on "An African Woman as Publisher." Nwapa received a special citation from the University of Ife, the "Ife Merit Award on Authorship and Publishing." Her first novel, *Efuru,* was translated into French and Dutch.

With all of the invitations, Nwapa's popularity rose at home. In 1989, she was appointed a visiting professor in creative writing at the University of Maidururi and became a member of the University of Harin Governing Council. In 1990, she was appointed to the Commission on the Review of Higher Education. Two years later, Nwapa was appointed a member of the Committee for the Ziks Center in Zugeru.

Between 1991 and 1993, she was again invited on a lecture tour of several major American colleges and universities, including Loyola, Trinity, Sarah Lawrence, Rutgers, New York University, and John Jay College of Criminal Justice. While on this tour, she was offered a one-year visiting professorship at East Carolina University in Greenville, North Carolina, during the 1993–94 academic year. Her arrival was anxiously anticipated by students and faculty

who had heard her speak there the year before. As well, the popularity of her books captured the attention of an American publisher, Africa World Press in Lawrenceville, New Jersey. With their release of *Never Again, One Is Enough, Women Are Different, This Is Lagos,* and *Wives at War,* Nwapa's readership vastly increased in the United States.

On October 16, 1993, Flora Nwapa died of pneumonia at the University of Nigeria Teaching Hospital in Enugu. She was survived by her mother, husband, two daughters (both attorneys), and one son (also an attorney). Respected by African writers of both sexes, she is remembered as Africa's "literary foremother." Many woman, especially writers, are grateful for the road she paved during her 30 years as Africa's premier woman of letters.

SOURCES:
Eulogy of family members. Enugu, Nigeria, 1993.
Umeh, Marie. "Signifying the Griottes: Flora Nwapa's Legacy of (Re)Vision and Voice," in *Research In Africa Literature.* Vol. 26. Summer 1995, p. 114.

SUGGESTED READING:
Chukere, Gloria. *Gender, Voices and Choices.* Enugu, Nigeria: Dimension, 1995.
Umeh, Marie. "The Poetics of Economic Independence for Female Empowerment: An Interview with Flora Nwapa," in *Research in African Literature.* Vol 26, no. 2. Summer 1995, p. 22.
Wilentz, Gay. *Binding Cultures: Black Women Writers in Africa and the Diaspora.* Bloomington, IN: Indiana University Press, 1992.

Kathryn E.I. Gibson,
Assistant Professor of English-Speech, City
University of New York, New York

Nyad, Diana (1949—)

American marathon swimmer. Born on August 22, 1949, in New York City; studied at Lake Forest College, Illinois, and New York University.

Became the first person to swim Lake Ontario from north to south; set record for the fastest swim around the island of Manhattan at 7 hours and 57 minutes (1975); completed the longest open-water swim in history, 102.5 miles (1979).

Diana Nyad, who was born in New York City on August 22, 1949, but raised in Ft. Lauderdale, Florida, found her passion at the age of ten, when she discovered swimming. Her family was non-athletic, and tried to get her to pursue the piano instead. By 12, she had dreams of becoming an Olympic swimmer and adopted a rigorous schedule of workouts in the early morning, after school, and in the evening. A high-caliber backstroker through her teens, she

hoped to make the 1968 Olympics. Two years before the Games, however, she contracted viral endocarditis, an infection of the heart, and spent several months in bed. She sustained a serious loss of muscle, and with it the loss of her speed and her Olympic dreams.

Nyad's career, however, was just about to begin. One of her coaches introduced her to marathon swimming, and by 1969 she was fully engaged in competition. From 1969 to 1977, she was the world's top female distance swimmer. During this time, she completed a spectacular solo swim, becoming the first person to traverse Lake Ontario from north to south. Swimmers had traditionally started at the south shore where the Niagara River empties into the lake, creating a current that gives swimmers a great push northward, but Nyad wanted to fight the currents from Niagara Falls as she made her way to the shore. She also wanted to be the first to swim a round trip across the lake. Even *Florence Chadwick, the first to swim the English Channel in both directions, had failed to tra-

Diana
Nyad

verse rugged Lake Ontario, one of the coldest of the Great Lakes and 32 miles wide where Nyad planned to attack.

Her first eight hours went well. She made great time, and the navigator aboard her scout boat predicted that she would be at the shore in less than 14 hours. But then the wind picked up, and Nyad was soon fighting five-foot waves. More than 18 hours passed before she made it to shore. Wrapped in a blanket, she took a 15-minute rest ("the quickest [15] minutes I've ever known," she later recalled), then waded back into the water. The winds had changed direction again, and again she had to fight combative waves. Nyad lost consciousness after just over 20 hours of swimming, failing to make her round trip, but she was still the first person to cross the lake from north to south.

Nyad also wanted to swim around Manhattan, resurrecting what had been a traditional men's race around the island prior to World War II. In the fall of 1975, she embarked on the swim but had to quit because of severe cold, wind, and rain; she also came down with a virus, probably caused by the polluted waters. She tried again 11 days later, and made it around the island in 7 hours and 57 minutes, breaking the old record that had been set nearly 50 years before. In August 1978 she pursued another dream, that of swimming 100 miles in the open ocean at a time when the record for open-sea swimming was 60 miles. She set out to swim from Cuba to Florida, something no one else had ever done. Although a storm prevented her from completing the trip, before she was forced to stop she had made it 79 miles north of Havana, after swimming 41 hours and 49 minutes. (In 1997, *Susan Jean Maroney would become the first person to be documented completing the swim from Cuba to Florida.) Nyad mounted a similar adventure the following year. On August 21, 1979, she set out to swim from the island of Bimini, in the Bahamas, to the coast of Jupiter, Florida. She made it in just 27 hours and 38 minutes, completing the longest open-water swim in history—102.5 miles.

During her years as a marathon swimmer, it was not uncommon for Nyad to swim isolated for 24 hours or more. She often hallucinated during these times, and joked that each swim was worth six months of visits to a psychiatrist. Nyad was also a champion for women's rights, using her position to speak up for equality of the sexes. In 1975, *Ms.* magazine named her Woman of the Year, as it would in each of the following five years. In 1978, she wrote *Other Shores*, exploring the physical and emotional growth that

evolved from her intense drive to succeed. Nyad's desire for adventure had gotten her expelled from her first college after she parachuted from the fourth floor of the women's dorm. When she finally settled down at Lake Forest College in Illinois, she proved she could be a serious student by earning all A's. She later worked on her Ph.D. in literature at New York University. She turned to television correspondence and also became a regular on National Public Radio, focusing on women's achievements in the sports world. Nyad was named to the halls of fame at Lake Forest College and Pine Crest Preparatory School, where she graduated from high school, and in 1986 was inducted into the Women's Sports Foundation International Sports Hall of Fame.

SOURCES:
Gleasner, Diana C. *Women in Sports: Swimming.* NY: Harvey House, 1975.

Hollander, Phyllis. *100 Greatest Women in Sports.* NY Grosset & Dunlap, 1976.

Oglesby, Carole A., *et al.*, eds. *Encyclopedia of Women and Sport in America.* Phoenix, AZ: Oryx, 1998.

Lisa Frick,
freelance writer, Columbia, Missouri

Nyankoma, Efua (1924–1996).

See Sutherland, Efua.

Nyembe, Dorothy (1930–1998)

South African anti-apartheid leader. Name variations: Dorothy Nomzansi Nyembe; Mam D. Born in Thalane, KwaZulu-Natal, South Africa, on December 31, 1930 (some sources cite 1931); died on December 17, 1998, in KwaZulu-Natal; children: at least one daughter.

Dorothy Nyembe spent her life fighting against the oppression of black South Africans. Born in rural KwaZulu-Natal in 1930, she joined the African National Congress (ANC) in her early 20s—eventually becoming deputy chair of the local ANC Women's League—and was jailed for two years as a result of her participation in the 1952 Defiance Campaign. During the campaign, thousands of blacks protesting apartheid entered white-only establishments and broke curfews and pass laws, which mandated the carrying of identity papers and rigid limitation of travel within the country by blacks.

In 1956, Nyembe led a Natal women's protest against the pass laws and also led boycotts against beer halls. She was endorsed out of Durban in 1959, and was detained for five months during the State of Emergency of 1960. That same year the ANC was declared an illegal

organization by the white government. Nyembe continued working with the congress as it went underground, and upon the inception the following year of its liberation army, the Spear of the Nation (Umkhonto we Sizwe), was one of the first members to join. She represented the Women's Federation in the South African Congress of Trade Unions in 1962, and in 1963 was sentenced to three years' imprisonment for her work on behalf of the ANC. Upon her release in 1966, she was placed under strict banning orders by the government, but nevertheless continued working clandestinely against apartheid. Nyembe was arrested again in 1968, tortured, and charged with violating the Terrorism Act and the Suppression of Communism Act. She was sentenced to 15 years' imprisonment at the infamous Barberton Prison.

After serving the full term of her sentence (during which time the Soviet Union bestowed on her its USSR People's Friendship Award), Nyembe was released from prison in 1984 and resumed working in the ANC. Nelson Mandela was released from prison in 1990, and the ANC began negotiating with the government. Nyembe was one of the ANC members who participated in 1993 in the drafting of a new, democratic constitution, which granted the vote to all adult citizens and effectively marked the end of apartheid. During the historic 1994 elections that swept Mandela into the presidency, Nyembe was elected a member of Parliament. Popularly called "Mam D" by younger members of the ANC, she was revered for her long participation in the struggle for the people. Dorothy Nyembe died at her home in December 1998, while preparing for celebrations to mark the 37th anniversary of the founding of the Spear of the Nation.

SOURCES:
Herald-Leader (Lexington, KY). December 28, 1998.
Uglow, Jennifer, ed. and comp. *The International Dictionary of Women's Biography.* NY: Continuum, 1989.

<div align="right">

Howard Gofstein,
freelance writer, Oak Park, Michigan

</div>

Nyro, Laura (1947–1997)

American singer and songwriter. Pronunciation: Nero. Born Laura Nigro on October 18, 1947, in the Bronx, New York City; died of ovarian cancer on April 8, 1997, in Danbury, Connecticut; daughter of Louis Nigro (a piano tuner and jazz trumpeter) and Gilda (Mirsky) Nigro (a bookkeeper); attended High School of Music and Art, Manhattan; married David Bianchini (a carpenter), in 1971 (divorced); lived with partner **Maria Desiderio** *(a painter); children: son Gil Bianchini.*

Selected songs: "Wedding Bell Blues," "Eli's Coming," "Stoney End," "And When I Die," "Art of Love," "Save the Country," "Stoned Soul Picnic," "Sweet Blindness," "Broken Rainbow."

Selected albums: More Than a New Discovery *(re-released as* Laura Nyro *and as* The First Songs*);* Eli and the Thirteenth Confession; New York Tendaberry; Christmas And The Beads of Sweat; Mother's Spiritual; Laura—Live at The Bottom Line; Stoned Soul Picnic: The Best of Laura Nyro; Walk the Dog and Light the Light.

Born in the Bronx in 1947 and a songwriter even as a young child, Laura Nyro made her first professional sale at age 19, with "And When I Die," a hit first for Peter, Paul and Mary and later for Blood, Sweat and Tears. She would go on to write a number of other songs that became huge hits for other performers, including "Stoney End" (**Barbra Streisand**), "Eli's Coming" (Three Dog Night), and "Wedding Bell Blues," "Stoned Soul Picnic," and "Sweet Blindness" (all recorded by the Fifth Dimension). Greatly respected by fellow performers and songwriters, and revered by a cult following, Nyro nonetheless never had a commercial hit as huge as did other performers who recorded her songs. In both her studio and her live performances, she was more interested in expressing herself as an artist than in pleasing the widest possible audience. (A widely reported story that may be apocryphal tells of her being booed off the stage at the Monterey Pop Festival for straying from the event's established psychedelic-rock theme.) A singer with a three-octave range and a voice that has been described as both "a rich, charcoal-smudged alto" and a "melting, pure-toned soprano," she relished her freedom as a songwriter to express her social and political leanings through her work. As well, an early contract negotiated for her by David Geffen left her financially comfortable for life.

Nyro's genre is not easily labeled, as she synthesized elements of soul, jazz, rock, and blues. She grew up listening to classical music and such artists as *Billie Holiday and *Leontyne Price at home, and was deeply influenced by Curtis Mayfield and the Impressions, doo-wop, John Coltrane, *Mary Wells, *Martha Reeves of Martha and the Vandellas, and other Motown girl groups like the Shirelles. *Stereo Review* noted, "She wrote the most unexpected songs . . . a dazzling display of lyrical and musical innovation," while Jon Pareles wrote in *The New York Times* that she "linked high flown poetry to the ecstatic emotions of soul music."

Nyro released 12 albums in the course of her 30-year career (plus several renamed re-releases), including 1997's *Stoned Soul Picnic: The Best of Laura Nyro*.

She took a hiatus from performing and recording after the birth of her son in the late 1970s, releasing her next album, *Mother's Spiritual*, in 1984. In 1985, she wrote the title song for *Broken Rainbow*, a documentary about the forced relocation of the Navajo which won an Academy Award; it is considered one of her finest social protest songs. A U.S. tour in 1988, her first in ten years, was dedicated to the animal-rights movement and resulted in the album *Laura—Live at The Bottom Line*, released the following year. Although she appeared fairly infrequently, it was always to glad crowds, as at the Newport Folk Festival in 1989 and a tour of Japan in 1994. In 1993, she released her first studio album in nine years and what would be her last original album, *Walk the Dog and Light the Light*. The album contains "To a Child," a lullaby written for her son, as well as a studio version of "Broken Rainbow."

Like her contemporaries *Carole King and *Joni Mitchell, Nyro was a pioneer in giving an authentic female voice to her work, defying the industry dictum that men should write songs for female performers. She retained control over her art and her business throughout her career, and in the process created a distinctive and highly individual sound that has influenced several generations of songwriters and singers. She died of ovarian cancer at her home in Danbury, Connecticut, on April 8, 1997. A tribute album, *Time and Love: The Music of Laura Nyro*, was released that year.

SOURCES:
Boston Globe. April 10, 1997.
The Day (New London, CT). April 10, 1997.
People Weekly. April 21, 1997, p. 145; December 1997, p. 185.
Time. April 21, 1997, p. 37.

<div align="right">

Howard Gofstein,
freelance writer, Oak Park, Michigan

</div>

Nzimiro, Mary (1898–1993)

*Nigerian merchant and philanthropist active in the commercial, educational and political development of her country. Name variations: Lady Nzimiro. Born Mary Nwametu Onumonu on October 16, 1898, in Oguta, Igboland, Nigeria; died on January 16, 1993, in Oguta, Nigeria; daughter of Chief Onumonu Uzaru (one of first two warrant chiefs for Oguta appointed by Britain's Queen *Victoria), and Madam Ruth Onumonu (a trading magnate in palm produce); attended Sacred Heart School in Oguta; graduated from a convent school in Asaba, 1920; married Richard Okwosha Nzimiro (the first mayor of Port Harcourt), in 1920; children: Priscilla Nzimiro (a doctor); (stepchildren) Richard, Ifediora, and Nnamdi.*

Started trading in palm oil, salt and European manufactured goods (1921); built William Wilberforce Academy (later renamed Priscilla Memorial Grammar School), first of two secondary schools she established at Oguta (1945); became the principal factor for the United African Company (UAC) for their eastern zone (1948); was a member of the National Council of Nigeria Citizens (NCNC, 1950s); earned her husband the position of first mayor of Port Harcourt (1956); was agent for the UAC, hosted twice by Queen Elizabeth II of England (early 1960s); was a founding member of Nigeria's YWCA at Port Harcourt, and built Nzimiro Memorial Girls' Secondary School in honor of her husband (1966); organized Igbo women in support of the Biafran soldiers during the Nigerian civil war (1967–70).

For Igbo women of Nigeria, as is true for women in other African nations, trading has long been an important occupation. Nonetheless, while much information exists about their male counterparts, the economic roles played by these merchants has received only perfunctory treatment. A European missionary, G.T. Basden, who lived among the Igbo for over two decades, reported in *Among the Ibos of Nigeria*:

> Marketing is the central feature in the life of every Igbo woman, and to be successful in trade is the signal for generous congratulation. By this, a woman's value is calculated; it affects her position and comfort; a man considers it in the choice of a wife, and a husband's favour is bestowed or withheld largely according to the degree of his wife's success in the market.

Mary Nzimiro was one of the women Igbo traders who distinguished themselves during Nigeria's colonial period under British rule.

At the time of Nzimiro's birth in Oguta in 1898, Nigeria was a major producer of cocoa, palm oil, and palm kernel—products which became very important following the industrial revolution in Europe during the 18th and 19th centuries. In return for these exports, Britain sold Nigeria manufactured materials, such as textiles, beverages, and salt. As a result of international trading, primarily between Nigeria and Britain, two major occupations emerged in Nigeria: traders (dealing in both local and imported products) and producers of raw materials. Nzimiro, a trader in both palm produce and

European manufactured goods, was to emerge as one of Nigeria's most successful merchants.

Born Mary Nwametu Onumonu, Nzimiro was the first of six children of the Igbo chief Onumonu Uzaru and Madam **Ruth Onumonu**. Mary's mother, a rich palm-produce merchant from the 1890s to the 1940s, maintained London accounts for Mary and her younger sister **Margaret Oputa** in the 1930s. It would be Ruth who initiated Mary into the business.

In 1914, Mary was the first girl to be enrolled at the Roman Catholic Sacred Heart School at Oguta. She was later sent to the Catholic Convent School at Asaba, where she graduated in 1920. That same year, she returned to Oguta, at age 22, and married the handsome Richard Nzimiro, a clerk with United African Company (UAC), the company through which her mother had established the British trade contacts.

In their first year of marriage, Richard's job with the UAC took the couple to live in Illah, where Mary began to trade in salt, which she sold at the markets at Nkwo Illah and Eke Ebu. Since these markets were unreachable by motor transport, she traveled by canoe. The couple also lived in Onitsha (1923–25), then Opobo (1940–44), before settling in the prosperous city of Port Harcourt in 1945. There she increased her dealing in general goods to include textiles, gunpowder, and cosmetics through the UAC. She also opened up a cosmetics shop, where she sold imported perfumes, creams, and soaps.

Nzimiro's enterprises grew so prosperous that she eventually asked her husband to resign his job to help her manage the business. In 1948, aided by her mother's influence, she became the principal factor for the UAC, a company for which she was also to serve as agent for their eastern zone. As factor, she represented the company in Ghana and Sierra Leone, handling the transfer of consignments to coordinators who then moved them to distributors. As her business prospered, her wealth and fame as a trader increased, and her name became synonymous with the UAC. Although she had the services of a lawyer, Barrister Goziem Onyia, Nzimiro appears to have operated without benefit of a manager or accountant while controlling capital likely amounting to hundreds of thousands, if not millions, of pounds. In 1950, during a routine sales probe, Nzimiro testified that her estimated monthly turnover was £6,000–£8,000. She also entered into a manufacturing venture, producing men's undershirts, and later owned two gas stations, at Port Harcourt and in Lagos, from which she collected an estimated annual rent of £25,000 in the 1980s.

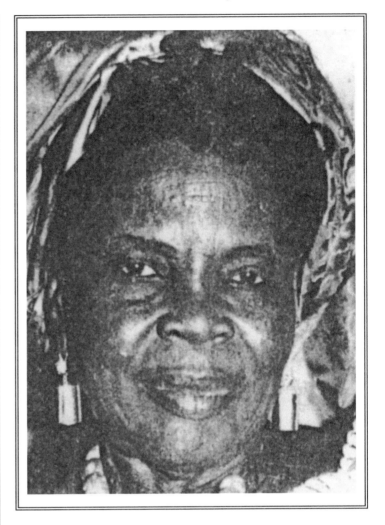

Mary Nzimiro

Heavily involved in Nigeria's political struggles during the 1940s–'50s, Nzimiro joined the National Council of Nigerian Citizens (NCNC), one of the nation's most influential political parties in 1946. Eventually, along with a Mrs. Ekpo at Aba and Mrs. Okoye, Nzimiro would be in charge of the council's women's wing and would be known as the mother of the party. Her home in Port Harcourt became the port of call and transit station for all NCNC delegations. She and her husband toured with Dr. Nnamdi Azikiwe, known as "Zik," during the campaigns that led to his election as the president of Nigeria's first government as a republic. The contributions made by Nzimiro and her husband to Nigeria's public life led to her husband's election as the first mayor of Port Harcourt in 1956.

Their only daughter **Priscilla Nzimiro** went to Glasgow, Scotland, to study medicine and became the first Igbo woman to become a medical doctor. Mary sent her three stepsons—Richard, Nnamdi and Ifediora—whom she raised from childhood, overseas for their university educa-

tions and sponsored the ceremonies for their initiations into Ogbu Agu, the highest title available to Oguta men.

As her prosperity grew, Nzimiro became a philanthropist, particularly in the field of education. In 1945, with her husband, she founded the William Wilberforce Academy (famous as "Wee Wee") at Oguta, which the couple continued to support and nourish. After the death of Priscilla Nzimiro in Glasgow in 1950, the academy was renamed the Priscilla Memorial Grammar School. (The Nzimiros' niece, novelist *Flora Nwapa, briefly taught there.) Crossing ethnic boundaries, Mary Nzimiro awarded scholarships to Ghanaians, Sierra Leonians and Nigerians. She also provided the means for several women in her family to study domestic science and fashion.

A veritable Amazon among traders.

—Sylvia Lelth-Ross

Nzimiro's success brought an invitation of the directors of the UAC at Manchester for her first overseas tour in 1948, to England. In 1954, she was accompanied by her younger sister Margaret Oputa and Margaret's husband Chukwudifu Oputa, who would eventually be a chief justice of the Federal Republic of Nigeria, on a trip to France and Switzerland. On other visits to Britain, Mary was twice hosted by Queen *Elizabeth II and Prince Philip, duke of Edinburgh. On one such visit, she emphasized Nigeria's rich cultural heritage by appearing in traditional African dress.

At home, Nzimiro had by this time received the honorary title of Ogbuefi and was only the second woman to be initiated into the Ikwamuo society, which was said to be the reserve of men. In 1956, during one of their overseas trips, the Nzimiros became members of Moral Re-Armament founded by Frank Buchman. In 1961, Mary made a world tour under the sponsorship of the UAC, accompanied by her close friend **Elina Mends**. Yet another world tour was sponsored by the UAC in 1963.

In 1966, Nzimiro established the Nzimiro Memorial Girls' Secondary School, named after her husband, who had died in 1959. The two schools for which she was responsible could be seen as Nzimiro's greatest contribution to national development. That same year, she joined several other women in founding a branch of the Young Women's Christian Association (YWCA) at Port Harcourt, which offered young women modern training in domestic skills and operated inexpensive lodgings for women who had come to Port Harcourt seeking work but had no place to stay.

During the 1967–70 civil war in Nigeria, Mary Nzimiro was involved in the food drive to support the Biafran soldiers against the government. She traveled throughout the eastern region of the country, collecting clothing and food for distribution to soldiers in the army camps. While she was away on one such trip, the Nigerian army entered and occupied Port Harcourt. As a supporter of the Biafran forces, she could not go back and so returned instead to her hometown of Oguta, where she continued her work for the Biafrans and remained throughout the war.

Nzimiro's investments included landed property in Port Harcourt, where she had bought and developed seven houses, at least one of which was near "Millionaire's Row." In *Four Guineas: A Journey Through West Africa*, *Elspeth Huxley* writes:

> I was taken for a drive along Millionaire's Row (its proper name is Bernard Car street). One of its richest householders is Mrs. Mary Nzimiro, the U.A.C.'s biggest customer. Starting as an ordinary market mammy, through buying palm oil and selling merchandise, she has become one of the wealthiest people in West Africa and, on her occasional visits to London, is dined and wined at the Savoy by the directors of the company. . . . The houses of Millionaire's Row are three or four stories high, flat-roofed, and built of concrete blocks in modern style. Balconies with rounded corners give the buildings a look of big white battle ships, anchored so close together that the crew could almost shake hands from bridge to bridge. Each house is full of many banquets.

Mary Nzimiro fought bravely for the eventual liberation of Nigeria. Her role in Nigeria's independence movement was acknowledged and commended by the nation's first prime minister, Abubakar Tafawa Balewa. But at the end of the war, the government allowed the return of only three of Nzimiro's seven houses—No 4A and B Amadi Layout and No 9 Port Johnson—and the woman who had once been a veritable merchant princess never returned to live in Port Harcourt. Perhaps she found it too disheartening to live there, considering how much she and her husband had contributed to the city's welfare and growth. Nzimiro died in Oguta on January 16, 1993, having left an indelible mark on the commercial, political, and educational landscapes of Nigeria.

SOURCES:

Basden, G.T. *Among the Ibos of Nigeria.* Ibadan: Ibadan University Press, 1982.

Boserup, Ester. *Women's Role in Economic Development.* London: George Allen and Unwin, 1970.

Buchman, Frank N.D. *Remaking the World: The Speeches of Frank N.D. Buchman.* London: Blandford Press, 1947.

Ekechi, F.K. "Aspects of Palm Oil Trade at Oguta (Eastern Nigeria), 1900–1950," in *African Economic History*. Vol. 10, 1981, pp. 37–65.

Ekejuba, Felicia. "Omu Okwei: The Merchant Queen of Ossomari—A Biographical Sketch," in *Journal of Historical Society of Nigeria*. Vol. 3, no. 4, 1967, pp. 633–646.

Harries, J.S. "Papers on the Economic Aspect of Life Among Uzuitem Ibo," in *Africa*. Vol. 14, 1943, pp. 12–23.

Huxley, Elspeth. *Four Guineas: A Journey Through West Africa*. London: Chatto & Windus, 1957.

Interviews with Mrs. Margaret Ntianu Oputa, retired nursing sister, Umudei, Oguta, Igboland, Nigeria, August 9–10, 1993; Honourable Justice Chukwudifu Oputa, retired Justice of the Federal Republic of Nigeria, Umudei, Oguta, August 9–10, 1993; and Lady **Martha Onyenma Nwapa** (mother of Flora Nwapa), ex-teacher and trader, Abatu, Oguta, August 4–5, 1993.

Ottenberg, Phoebe V. "The Changing Economic Position of Women Among the Afikpo Ibo" in William R. Bascom and M.J. Herskovits, eds., *Continuity and Change in African Cultures*. Chicago, IL: University of Chicago Press, 1959.

"Toll for the Great—The Great Mary Nzimiro," in *Memorial Bulletin*. February 13, 1993.

SUGGESTED READING:

Mba, Nina. *Nigerian Women Mobilized Women's Political Activity in Southern Nigeria, 1900–1965*. Berkeley: Institute of International Studies, 1982.

Gloria Ifeoma Chuku,
Lecturer in History, School of Humanities,
Imo State University, Owerri, Imo State, Nigeria

Nzinga (c. 1580s–1663).

See Njinga.

\mathcal{A}CKNOWLEDGMENTS

Photographs and illustrations appearing in *Women in World History, Volume 11,* were received from the following sources:

Courtesy of Department of Library Science, American Museum of Natural History, photos by C. Chesek (Neg. No. 2AS 18464, Neg. No. 131549), **pp. 55, 57;** Photo by Kathy Baker, **p. 225;** Photo by Jerry Bauer, **p. 393;** Photo by Samuel Brody, **p. 665;** Courtesy of Special Collections, California Polytechnic State University, **p. 437;** National Archives of Canada, PA 136738, **p. 557;** © Capital Cities-ABC, Inc., 1989, **p. 831;** Courtesy of the EEA Aviation Center, Oshkosh, Wisconsin, **p. 775;** Courtesy of the Elisabeth Ney Museum, Austin, Texas, **p. 745;** Oil painting by Hans Hansen, 1802, **p. 512;** Photo by Lewis Hine, **p. 483;** Photo by Horst, **p. 173;** Courtesy of the Wallace Kirkland Papers, Jane Addams Memorial Collection, The University Library, University of Illinois at Chicago, **p. 607;** Photo by Imogen Cunningham, **p. 379;** Courtesy of the International Swimming Hall of Fame, **pp. 89, 913;** Courtesy of the Embassy of Japan, **pp. 103, 599;** Photo by Ray Jones, **p. 335;** Courtesy of Nina MBA, University of Lagos, Lagos, Nigeria, **p. 911;** Courtesy of the Library of Congress, **p. 113** (photo by Arnold Genthe), **pp. 179, 186, 203, 469** (photo by Helen Marcus), **pp. 489, 505, 635;** © Metro-Goldwyn-Mayer, 1939, **p. 201;** Photos by Nadar, **pp. 65, 333;** Courtesy of National Hot Rod Association, **p. 526;** Drawing by Sean O'-Sullivan, **p. 139;** Photo by Frank Powolny, **p. 163;** Painting attributed to Raphael, **p. 315;** Photo by Man Ray, **p. 843;** Courtesy of Doris Rich, **p. 269;** Photo by Eugene Robert Richee, **p. 167;** Photo by Norman Seeff, **p. 191;** Courtesy of the National Portrait Gallery, Smithsonian Institution, photo by Alexander Bender, **p. 477;** Fragment of photo by Albert Sans Southworth and Josiah Johnson Hawes, **p. 331;** Photo by Edward Steichen, **p. 86;** Photo by Alfred Stieglitz, **p. 870;** Photo by Janet Stone, **p. 549;** Courtesy of Sun Photo, photo by Irving H. Phillips, Jr., **p. 559;** Courtesy of the U.S. House of Representatives. **pp. 93, 94, 148, 274, 718, 861, 876, 886;** Courtesy of the U.S. National Ski Hall of Fame Archives, **p. 690;** © Universal Pictures, **p. 823;** Courtesy of Verso, New York City, **p. 23;** © The Walt Disney Company, 1987, **p. 341;** © Warner Bros., 1949, **p. 655;** © WNBA Enterprises, LLC, photo by Sandy Tenuto, **p. 125.**

ISBN 0-7876-4070-0

90000